Art and the Empire City
New York, 1825–1861

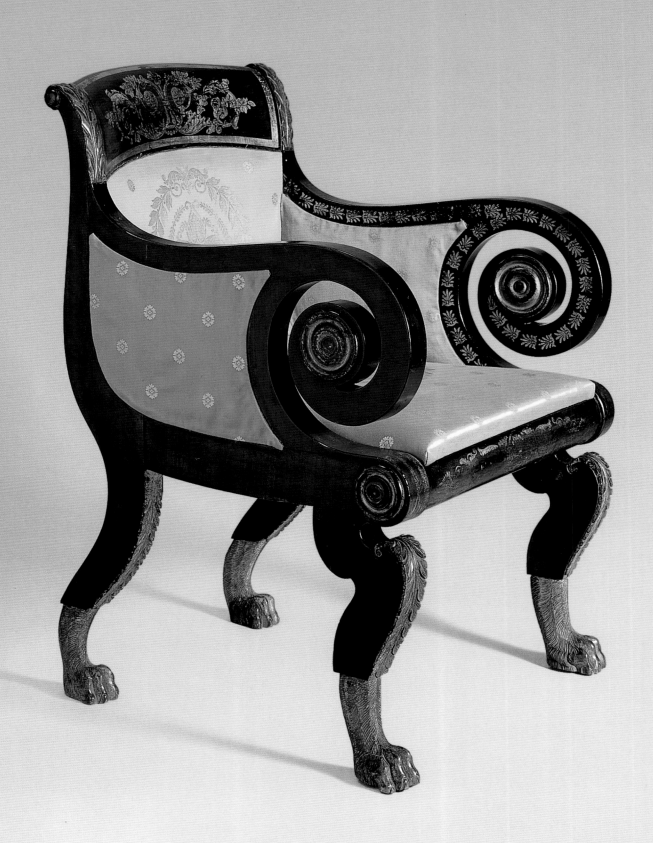

# Art and the Empire City
# New York, 1825–1861

Edited by Catherine Hoover Voorsanger and John K. Howat

The Metropolitan Museum of Art, New York

Yale University Press, New Haven and London

This volume has been published in conjunction with the exhibition "Art and the Empire City: New York, 1825–1861," organized by The Metropolitan Museum of Art, New York, and held there from September 19, 2000, to January 7, 2001.

The exhibition is made possible by ⬅ *Fleet*

The exhibition catalogue is made possible through the support of the William Cullen Bryant Fellows.

Published by The Metropolitan Museum of Art, New York

John P. O'Neill, Editor in Chief
Carol Fuerstein, Editor, with the assistance of Margaret Donovan
Bruce Campbell, Designer
Peter Antony and Merantine Hens, Production
Robert Weisberg, Computer Specialist
Jean Wagner, Bibliographer

New photography of Metropolitan Museum objects by Joseph Coscia Jr., Anna-Marie Kellen, Paul Lachenauer, Oi-Cheong Lee, Bruce Schwarz, Eileen Travell, Juan Trujillo, Karin L. Willis, and Peter Zeray, the Photograph Studio, The Metropolitan Museum of Art

Galliard typeface designed by Matthew Carter
Printed on Phoenix Imperial 135 gsm
Separations by Professional Graphics, Rockford, Illinois
Printed and bound by Arnoldo Mondadori, S.p.A., Verona, Italy

Jacket/cover illustration: Detail, cat. no. 143, William Wellstood, after Benjamin F. Smith Jr., *New York, 1855, from the Latting Observatory,* 1855
Frontispiece: Cat. no. 221, Unknown cabinetmaker, Armchair, ca. 1825
Endpapers: fig. 5, John Randel Jr., adapted and published by William Bridges, *This Map of the City of New York and Island of Manhattan as Laid Out by the Commissioners,* 1811

Library of Congress Cataloging-in-Publication Data

Art and the empire city : New York, 1825-1861 / edited by Catherine Hoover Voorsanger and John K. Howat.
    p.  cm.
    Exhibition held Sept. 19, 2000 through Jan. 7, 2001 at the Metropolitan Museum of Art, New York.
    Includees bibliographical references and index.
    ISBN 0-87099-957-5 (hc. : alk. paper)—ISBN 0-87099-958-3 (pbk. : alk. paper)—0-300-08518-4 (Yale University Press)
    1. Art, American—New York (State)—New York—Exhibitions. 2. Art, Modern—19th century—New York (State)—New York—Exhibitions. I. Voorsanger, Catherine Hoover. II. Howat, John K. III. Metropolitan Museum of Art (New York, N.Y.)

N6535.N5 A28 2000
709'.747'10747471—dc21
        00-041855

# Contents

Sponsor's Statement    vi
*Terrence Murray, FleetBoston Financial*

Director's Foreword    vii
*Philippe de Montebello*

Lenders to the Exhibition    viii

Preface and Acknowledgments    x
*John K. Howat, Catherine Hoover Voorsanger*

Contributors to the Catalogue    xv

Note to the Reader    xvi

ESSAYS

Inventing the Metropolis: Civilization and
Urbanity in Antebellum New York    3
*Dell Upton*

Mapping the Venues: New York City
Art Exhibitions    47
*Carrie Rebora Barratt*

    Appendix A, Exhibition Venues    66

    Appendix B, Exhibitions and Auctions    75

Private Collectors and Public Spirit:
A Selective View    83
*John K. Howat*

Selling the Sublime and the Beautiful: New York
Landscape Painting and Tourism    109
*Kevin J. Avery*

Modeling a Reputation: The American Sculptor
and New York City    135
*Thayer Tolles*

Building the Empire City:
Architects and Architecture    169
*Morrison H. Heckscher*

The Currency of Culture: Prints in New York City    189
*Elliot Bostwick Davis*

"A Palace for the Sun": Early Photography in
New York City    227
*Jeff L. Rosenheim*

"Ahead of the World": New York City Fashion    243
*Caroline Rennolds Milbank*

The Products of Empire: Shopping for Home
Decorations in New York City    259
*Amelia Peck*

"Gorgeous Articles of Furniture": Cabinetmaking
in the Empire City    287
*Catherine Hoover Voorsanger*

Empire City Entrepreneurs: Ceramics and Glass
in New York City    327
*Alice Cooney Frelinghuysen*

"Silver Ware in Great Perfection": The Precious-
Metals Trades in New York City    355
*Deborah Dependahl Waters*

WORKS IN THE EXHIBITION

*Checklist of the Exhibition*    575

*Bibliography*    599

*Index*    618

*Photograph Credits*    636

# Sponsor's Statement

Fleet is proud to sponsor the exhibition "Art and the Empire City: New York, 1825–1861" at The Metropolitan Museum of Art. This beautiful exhibition, which celebrates New York's evolution into the country's cultural and commercial heart, is especially close to ours. Featuring works by Thomas Cole, Frederic E. Church, Gustave Herter, and Tiffany and Company, among many others, this exhibition of more than 310 objects is a visual celebration of the innovative spirit of New York and its unparalleled ability to lead the way for our country and the world.

This sponsorship, our first at The Metropolitan Museum of Art, marks a true coming of age for our company. FleetBoston Financial has evolved into a world-class provider of dynamic financial services, bringing innovative thinking and expertise to more than 20 million customers throughout the United States, Latin America, Asia, and Europe. Our customers and communities depend upon us for innovation in consumer and commercial banking, investment banking, institutional and individual investment services, and for creative investments in our communities. In that regard, we are pleased to fund the largest school-pass program in the Museum's history, issuing free admission passes to 1.5 million schoolchildren and their families throughout New York City. With this program and this exhibition, we hope to convey our unwavering commitment to the arts and our stakeholders and to playing a vital role in the glorious future of the Empire City.

We hope you enjoy the exhibition and, for many years to come, the treasures and history depicted in this catalogue.

Terrence Murray
*Chairman and Chief Executive Officer*
*FleetBoston Financial*

# Director's Foreword

The years 1825 to 1861 are those between the completion of the Erie Canal and the outbreak of the Civil War. This was a time of remarkable growth, when the small and lively city of New York became a great and vibrant metropolis. One of the most extraordinary developments that marked the period was an astonishing flowering of all the arts, a flowering that assured the city its place as the cultural capital of the nation. The Metropolitan Museum is proud to present "Art and the Empire City: New York, 1825–1861," an exhibition that offers an exceptionally broad selection of the finest examples of the visual arts produced or acquired during the memorable years it covers. Together the exhibition and its accompanying catalogue illuminate the nature, range, and refinement of those objects as well as the cultural life of the era.

The Museum is deeply grateful for the generosity of the eighty-four institutions and private individuals whose loans of objects of significant quality allow us to display the history of art in New York City rather than the history of New York City as seen in its art. A particular debt is owed to The New-York Historical Society and the Museum of the City of New York, which, not surprisingly, after the Metropolitan Museum made by far the largest number of loans. Other sister institutions also granted multiple loans that were essential to the realization of our exhibition; especially important were those from The New York Public Library; the Brooklyn Museum of Art; the Museum of Fine Arts, Boston; the Rare Book and Manuscript Library of Columbia University; and Columbia's Avery Architectural and Fine Arts Library.

Many acknowledgments follow, but here I wish to single out for particular notice John K. Howat, Lawrence A. Fleischman Chairman of the Departments of American Art at the Metropolitan Museum, for originating the concept of the exhibition and for his leadership throughout its realization, and Catherine Hoover Voorsanger, Associate Curator, Department of American Decorative Arts, and Project Director, for her exceptional skills as organizer and diplomat, which guaranteed success in the enterprise.

Undertakings of this importance and scale require significant financial expenditure, and various organizations have made major contributions in this respect. The Metropolitan Museum is extremely grateful to Fleet and its Chairman, Terrence Murray, for their generous support of the exhibition. The support provided by the Homeland Foundation is also noteworthy, as it has helped to make possible the conservation of several objects in the exhibition. In addition, the Museum is thankful for the assistance provided by the Private Art Dealers Association, Inc. Conner-Rosenkranz has also kindly provided support for this project. The publication accompanying the exhibition was made possible by the William Cullen Bryant Fellows of the Metropolitan Museum.

Philippe de Montebello
*Director*

# Lenders to the Exhibition

Albany, Albany Institute of History and Art  277

Baltimore, The Baltimore Museum of Art  288

Baltimore, The Walters Art Gallery  50

Baton Rouge, Louisiana State University Museum
of Art  302

Bennington, Vermont, Bennington Museum  270

Boston, Museum of Fine Arts  11, 23, 35, 125, 130, 131,
147, 154, 237

Boston, Society for the Preservation of New Eng-
land Antiquities  215

Brooklyn, Brooklyn Museum of Art  13, 26, 33,
89A, B, 149, 224, 244, 262, 298

Brooklyn, St. Ann and the Holy Trinity Church  280

Chicago, The Art Institute of Chicago  105, 247

Cincinnati, Cincinnati Art Museum  164

Cooperstown, New York State Historical Associa-
tion  28, 282A, B

Corning, New York, The Corning Museum of
Glass  273–75

Dallas, Dallas Museum of Art  289, 300

Detroit, The Detroit Institute of Arts  285

Fort Worth, Texas, Kimbell Art Museum  44

Hartford, Connecticut, Wadsworth Atheneum  24

Kansas City, Missouri, Hallmark Photographic Col-
lection, Hallmark Cards, Inc.  171, 173, 174,
177, 194

Kansas City, Missouri, The Nelson-Atkins Museum
of Art  241

Lexington, Kentucky, Henry Clay Memorial Foun-
dation, located at Ashland, The Henry Clay Estate
296

London, The National Gallery  47

London, Royal Institute of British Architects
Library  82, 83

Los Angeles, The J. Paul Getty Museum  185–91

Los Angeles, The Los Angeles County Museum
of Art  34

Milwaukee, Milwaukee Art Museum  245

Minneapolis, The Minneapolis Institute of Arts  54

Newark, The Newark Museum  60, 252, 303

New Haven, Yale Center for British Art  49

New Haven, Yale University Art Gallery  57

New Paltz, New York, Huguenot Historical
Society  65

New York, Art Commission of the City of
New York  2

New York, Columbia University, Avery Architectural
and Fine Arts Library  79, 86–88, 93, 99, 100, 103

New York, Columbia University, Rare Book and
Manuscript Library  146

New York, Congregation Emanu-El  305

New York, Cooper-Hewitt, National Design
Museum, Smithsonian Institution  218

New York, Donaldson, Lufkin & Jenrette Collection
of Americana  1

New York, Gilman Paper Company Collection  160,
169, 175, 178, 196

New York, Grace Church  95

New York, Mercantile Library Association  58

New York, The Metropolitan Museum of Art  4, 9,
14, 15, 17, 20–22, 29, 31, 32, 39, 41–43, 48, 51–53, 55,
59, 62, 66, 68, 69, 71, 73–77, 80, 81, 84, 85, 97, 102,
113–16, 118–23, 127, 129, 132–35, 142, 144, 145, 148,
153, 156, 158, 165A, B, 195, 197–200, 202, 205, 212–14,
216, 217, 219, 223, 225, 235, 236A, B, 240A–C, 242,

243, 246, 248, 251, 257, 259, 260, 269, 272, 276, 278, 279, 281A, B, 291–95, 301, 307, 308

New York, Municipal Archives, Department of Records and Information Services 192, 193

New York, Museum of the City of New York 25, 38, 63, 141, 150, 151, 199, 200, 203–5, 220, 238, 239, 253, 268, 284, 301, 306, 310

New York, National Academy of Design 6, 8

New York, The New-York Historical Society 7, 27, 40, 45, 46, 61, 67, 70, 72, 78, 94, 96, 104, 110–12, 152, 155, 162, 167, 170, 172, 179, 182–84, 209, 283A, B, 297

New York, The New York Public Library 5, 30, 106–9, 143, 157, 159, 163, 181

New York, Parish of Trinity Church 304

Norfolk, Virginia, Chrysler Museum of Art 64, 166

Pittsfield, Massachusetts, The Berkshire Museum 10

Portland, Maine, Victoria Mansion, The Morse-Libby House 249

Richmond, Virginia, Valentine Museum 201

Rome, New York, Jervis Public Library 90, 91

Tarrytown, New York, Historic Hudson Valley 3, 207

Tarrytown, New York, Lyndhurst, A National Trust Historic Site 234

Toledo, Ohio, The Toledo Museum of Art 36

Trenton, New Jersey State Museum 263, 264

Washington, D.C., Library of Congress 92, 124, 126, 211

Washington, D.C., National Gallery of Art 37

Washington, D.C., National Portrait Gallery, Smithsonian Institution 56, 161, 168

Washington, D.C., Octagon Museum 101

Washington, D.C., Smithsonian Institution Libraries 98

Winterthur, Delaware, Winterthur Museum 221, 254, 265, 271, 287

Worcester, Massachusetts, American Antiquarian Society 117, 137, 139, 140

Worcester, Massachusetts, Worcester Art Museum 12

Mrs. Sammie Chandler 233

Mr. and Mrs. Gerard L. Eastman, Jr. 290

Jock Elliott 138

Mr. and Mrs. Stuart P. Feld 250

Arthur F. and Esther Goldberg 266

Frederick W. Hughes 229

Matthew R. Isenburg 176, 180

Richard Hampton Jenrette 231, 232

Kaufman Americana Foundation 255

Mr. and Mrs. Jay Lewis 256, 258, 261, 267

Gloria Manney 16, 18, 19

Robert Mehlman 299

Leonard L. Milberg 128

Mulberry Plantation, Camden, South Carolina 222

Dr. and Mrs. Emil F. Pascarelli 227

D. Albert Soeffing 309

Mr. and Mrs. Peter G. Terian 228, 230

Mark D. Tomasko 136

Janet Zapata 208

Anonymous lenders 206, 210, 226, 286

# Preface and Acknowledgments

With the exhibition "Art and the Empire City: New York, 1825–1861" and the publication of this volume, the Metropolitan Museum presents the engaging story of how New York became a world city and assumed its vital role as the visual arts capital of the nation—a position it retains as we enter the twenty-first century.

The organizers of the exhibition and the authors of the catalogue have considered the full range of the visual arts and the related themes that assumed major importance in the city, and the nation as well, in the four decades prior to the Civil War. The physical and cultural growth of New York City; the city's development as a marketplace for art and a center for public exhibitions and private collecting; new departures in architecture, painting, and sculpture; printmaking, a fine art and a democratic one; the new medium of photography; New York as a fashion center; the embellishment of the domestic interior; changing styles in furniture, and the evolution of the ceramics, glass, and silver industries are the primary subjects represented by the works chosen for the exhibition and discussed in the essays contained herein.

A coherency of historical, cultural, and artistic forces in the years 1825 through 1861 provides ample license for the choice of these dates as the framework for the exhibition. The year 1825 was critical: it was then that the Erie Canal was completed, after sections of the waterway opened in 1820 and 1823, making a crucial contribution to the robust financial condition of both the city and state of New York. By 1825 the city had surpassed all other American seaports to become the financial and commercial center of the nation. During the antebellum years New York City grew physically, commercially, and culturally with such vigor that it earned not only the enthusiastic epithets the Empire City and the Great Emporium but also attracted the sometimes envious, and frequently bemused, attentions of the world.

The cultural component of New York's dramatic burgeoning was as significant as its aggressive commercial expansion. The year 1825 saw the establishment of the National Academy of Design, which became the focus of fine arts activities in the city throughout the pre–Civil War era. The concurrent development of other institutions, associations, and professions devoted to the arts and an increase in the numbers of people involved in the production of the arts were among the most notable signs that New York was becoming a metropolis of primary importance and considerable cultural sophistication. With Broadway at the heart of the Great Emporium, New York was transformed into the nation's major manufacturing and retailing center, the depot for luxury goods both made in and around the city and imported from abroad. Despite occasional catastrophic fires (in 1835 and 1845, notably) and financial depressions (in 1837 and 1857, for example) visited on the city, the New York art world flourished in the decades prior to 1861. But this felicitous situation came to a painful end that year.

Southern forces fired on Fort Sumter on April 12, 1861, to begin the Civil War. In both the North and South energies that had been applied to trade, building prosperity, and creating a rich and sophisticated culture in America were turned toward the conflict. The impact of the war on the New York art world was immediate. As Charles Cromwell Ingham, acting president of the National Academy of Design, reported in May 1861, "the great Rebellion has startled society from its propriety, and war and politics now occupy every mind. No one thinks of the arts, even among the artists, patriotism has superceded painting, and many have laid by the palette and pencil, to shoulder the musket. . . ." The post–Civil War years witnessed significant growth in and support for the visual arts of all kinds: thus, the Metropolitan Museum, founded in 1870, and many other great institutions were established. However, in cosmopolitan New York City there emerged a renewed appreciation of both early and contemporary European art and decoration, and there was a concomitant waning of interest in American culture. It was a decidedly new cultural climate.

Planning and executing an exhibition and a book of the magnitude of the present project is an extended process that involves many individuals who must be acknowledged. "Art and the Empire City" is the largest exhibition undertaken by the Museum's Departments

of American Art since 1970, when "19th-Century America" celebrated the institution's one-hundredth birthday, and it has been over five years in the making. It is also unique in its focus, for, while aspects of the arts in America during this period have been examined previously, until now the subject of New York as the primary crucible for the nation's visual arts has not been addressed.

Our first thanks are to Philippe de Montebello, Director of the Metropolitan Museum, who endorsed the exhibition and stood behind it from its inception. We are also deeply grateful to the lenders, whose names appear elsewhere in this catalogue, for generously allowing us to show their works, many of which normally do not travel, and to hundreds of colleagues throughout this country and abroad, whose willing collaboration guaranteed the project's successful realization. Special gratitude is due to The New-York Historical Society and the Museum of the City of New York, which have lent more works than any other institution save the Metropolitan Museum. Their curatorial and administrative staffs, under the leadership of Betsy Gotbaum and Robert Macdonald, respectively, have supported our endeavors wholeheartedly. Our indebtedness to the sponsors whose financial assistance has been crucial is detailed in the Director's Foreword.

"Art and the Empire City" was conceived in the early 1990s, with the understanding that the visual arts of the second quarter of the nineteenth century in America had not been studied adequately. H. Barbara Weinberg, Alice Pratt Brown Curator of American Paintings and Sculpture at the Metropolitan Museum, and Paul Staiti and Elizabeth Johns, J. Clawson Mills Fellows in the American Wing in 1991–92 and 1992–93, respectively, helped frame the questions we needed to address. At first the scope of our inquiry was national, but over time it became clear that New York City should be our focus. Kenneth T. Jackson, Jacques Barzun Professor of History and Social Sciences, Columbia University, and editor of the *Encyclopedia of New York,* took an interest in our undertaking early on and served as an informal advisor throughout. Historians Kenneth Myers, Postdoctoral Fellow in 1995–96, and Valentijn Byvanck, Predoctoral Fellow in 1996–98, contributed valuable perspectives

during the planning of the exhibition, which began in earnest in 1995.

In 1996 and 1997 many colleagues participated in a series of seminars on exhibition themes and the selection of objects, and to them we express our appreciation. Ulysses G. Dietz, Donald L. Fennimore, Katherine S. Howe, Frances G. Safford, D. Albert Soeffing, Kevin L. Stayton, and Deborah Dependahl Waters discussed silver and other metalwork with us; Alan M. Stahl guided our choice of medals. Mary-Beth Betts, Elizabeth Blackmar, Andrew Dolkart, Sarah Bradford Landau, Peter Marcuse, the late Adolph K. Placzek, Dell Upton, and Mary Woods contributed views on architecture, city planning, and related subjects. Michele Bogart, Valentijn Byvanck, H. Nichols B. Clark, David B. Dearinger, Linda Ferber, Elizabeth Johns, David Meschutt, Jan Seidler Ramirez, Paul Staiti, and John Wilmerding conferred on American paintings and sculpture, and Stephen R. Edidin made recommendations about foreign works. Mary Ann Apicella, Frances Bretter, Wendy A. Cooper, Barry R. Harwood, Peter M. Kenny, John Scherer, Thomas Gordon Smith, Page Talbott, and Deborah Dependahl Waters shared their knowledge of furniture. Florence I. Balasny-Barnes, Barbara and David Goldberg, Esther and Arthur Goldberg, and Emma and Jay Lewis participated in a discussion of ceramics. Georgia B. Barnhill, Thomas P. Bruhn, Nancy Finlay, Harry S. Katz, Shelley Langdale, Leslie Nolan, Wendy A. Shadwell, and John Wilmerding consulted on the history of printmaking and print collecting. Laurie Baty, Dale Neighbors, Mary Panzer, Sally Pierce, Alan Trachtenberg, Julie Van Haaften, and, later, Herbert Mitchell advised us about early American photography.

Valentijn Byvanck recommended the portraits shown, and Janet Zapata selected the jewelry. Phyllis D. Magidson of the Museum of the City of New York worked closely with Caroline Rennolds Milbank on choosing the costumes and related accoutrements. Chantal Hodges researched bookbindings. Laurence Libin, Research Curator, Department of Musical Instruments at the Metropolitan Museum, served in an adjunct curatorial capacity.

In every aspect of the preparation of both the exhibition and the catalogue, we have been supported by

our superb research assistants, who have contributed significantly in matters both scholarly and professional. Medill Higgins Harvey, who coordinated the research campaign, was a supremely accomplished leader. Julie Mirabito Douglass directed research pertaining to collectors and with Medill Harvey compiled a bibliography of nineteenth- and twentieth-century sources, which provided the curators with a platform from which to embark on studies of their own. For assistance during this phase of the project, we are grateful to have had access to the Seymour B. Durst Old York Library Collection and especially thank Eva Carrozza, former Librarian, for her help. While the icons of American painting and sculpture of our period were well known from the outset, masterpieces in the other arts were not well documented. In search of objects from New York that might have been dispersed nationwide, hundreds of art museums, historic-house museums, historical societies, and regional centers were contacted. To all who answered our queries, and to those who hosted our visits, we extend appreciation. Jeni L. Sandberg took charge of periodical research. Her insightful survey of periodicals and travelers' accounts published between 1825 and 1861 yielded the raw material on which many of the catalogue essays and the themes of the exhibition are predicated.

Austen Barron Bailly researched foreign works of art and oversaw countless administrative and art-historical details. Brandy S. Culp skillfully researched art patrons, surveyed manuscript collections, and managed the database of exhibition objects. In the last task she relied on the indispensable assistance of Frances Redding Wallace, as well as the support of Jennie W. Choi of Systems and Computer Services. Jodi A. Pollack coordinated the photography for the catalogue with consummate efficiency. Cynthia Van Allen Schaffner contributed expert research assistance and unflagging support of myriad kinds.

During the course of the project, the staffs of the libraries of many institutions graciously assisted our researchers. We thank the following institutions and individuals: the library of The New-York Historical Society, especially Richard Fraser, Megan Hahn, Wendy S. Raver, and May Stone; the New York Society Library, especially Heidi Haas, Janet Howard, and Mark Piel; the New York Biographical and Genealogical Library, especially Joy Rich; The New York Public Library, especially Virginia Bartow, Robert Rainwater, and Roberta Waddell; Janet Parks and the staff of the Avery Architectural and Fine Arts Library, Columbia University; Claudia Funke and Jennifer Lee of the Rare Books and Manuscript Library, Columbia University; Special Collections, Baker Library, Harvard Business School, Cambridge, Massachusetts, especially A. F. Bartovics; Stephen Van Dyk, Cooper-Hewitt, National Design Museum, New York; W. Gregory Gallagher, The Century Association, New York; Judith Gelernter, The Union Club, New York; Burt Denker, Decorative Arts Photographic Collection, and E. Richard McKinstrey, Gail Stanislow, and Eleanor McD. Thompson, Winterthur Museum Library, Delaware; Linda Ayres and C. Ford Peatross, Library of Congress, Washington, D.C.; and Brian Cuthrell and Henry Fulmer, South Caroliniana Library, University of South Carolina, Columbia. Our work was enriched by the holdings of the Archives of American Art, Washington, D.C.; the Boston Public Library; and the Inventories of American Paintings and Sculpture, Smithsonian Institution, Washington, D.C. William H. Gerdts, Professor Emeritus of Art History, City University of New York, shared nineteenth-century exhibition reviews in his files. Last, but certainly not least, we acknowledge our colleagues in the Thomas J. Watson Library, Metropolitan Museum, especially Kenneth Soehner, Arthur K. Watson Chief Librarian, Linda Seckelson, Robert Kaufmann, and Katria Czerwoniak.

Graduate, undergraduate, and high-school interns, as well as volunteers, contributed invaluable assistance, without which we could not have realized this project. They combed primary documents for information on works of art, artists and manufacturers, collectors and dealers, and other subjects germane to our efforts. In this category we thank: Mary Ann Apicella, Lisa Bedell, Gilbert H. Boas, Rachel D. Bonk, Alexis L. Boylan, Millicent L. Burns, Vivian Chill, Elizabeth Clark, Amy M. Coes, Claire Conway, Gina D'Angelo, Tara Dennard, Jennifer M. Downs, Cynthia Drayton, Margarita Emerson, Dinah Fried, Michal Fromer, Kevin R. Fuchs, Palma Genovese, Angela George, Alice O. Gordon, Joelle Gotlib, Rachel Ihara, Carol A. Irish, Jamie Johnson, Melina Kervandjian, Lynne Konstantin, Amy Kurtz, Barbara Laux, Katharine P. Lawrence, Ruth Lederman, Karen Lemmey, Josephine Loy, Constance C. McPhee, Andrea Miller, Mark D. Mitchell, Jennifer Mock, Francesca Pietropaolo, Anne Posner, Katherine Reis, Katherine Rubin, Emily U. Satloff, Suzannah Schatt, Elizabeth Schwartz, Lonna Schwartz, Nanette Scofield, Sheila Smith, Susan Solny, David Sprouls, Lois Stainman, Susan Stainman, Jennifer Steenshorne, Margaret Stenz, Rush Sturges, Michele L. Symons, Jeffrey Trask, Barbara W. Veith, Daphne M. Ward, Julia H. Widdowson, Jennifer

Wingate, and Katharine Voss. Amy M. Coes, Barbara Laux, Heather Jane McCormick, Jodi A. Pollack, and Cynthia Van Allen Schaffner wrote masters' theses that contributed to our knowledge of furniture making in the Empire City.

The subject of the exhibition spawned several graduate courses, which resulted in useful new research. Princeton students Peter Barberie, Peter Betjemann, Lorna Britton, Thomas Forget, Andrew E. Herschberger, Gordon Hughes, Sarah Anne Lappin, and Mark D. Mitchell enlarged our understanding of nineteenth-century printmaking through their work for a seminar conducted in 1997 by John Wilmerding, Christopher B. Sarofim '86 Professor of American Art, and Elliot Bostwick Davis. In 1999 the Ph.D. program in Art History at the City University of New York offered a broadly focused seminar in conjunction with "Art and the Empire City" taught by Professor Sally Webster and several of the exhibition's curators. The same year Paul Bentel and Dorothy M. Miner initiated a year-long study of the Empire City itself with students in the Historic Preservation Program at Columbia University.

Many other colleagues, collectors, friends, and family members extended themselves in countless ways. In particular, we are grateful for the help of Clifford S. Ackley, Sue Allen, Lee B. Anderson, Elizabeth Bidwell Bates, Thomas Bender, John Bidwell, Mosette Broderick, Sally B. Brown, Frank Brozyna, Nicholas Bruen, Douglas G. Bucher, Stanley and Sara Burns, Richard T. Button, Teresa Carbone, Sasha Chermayeff, Janis Conner and Joel Rosenkranz, Holly Connor, Tom Crawford, Anna T. D'Ambrosio, Leslie Degeorges, Ellen Denker, Ed Polk Douglas, Stacy Pomeroy Draper, Richard and Eileen Dubrow, Inger McCabe Elliott, Richard Fazzini, Stuart P. Feld, David Fraser, Margaret Halsey Gardiner, Max Harvey, Donna J. Hassler, Ike Hay, Paul M. Haygood, Sam Herrup, Peter Hill, Erica Hirshler, R. Bruce Hoadley, Anne Hadley Howat, Margize Howell, Joseph Jacobs, Mr. and Mrs. Charles F. Johnson, Richard Kelly, Julia Kirby, Joelle Kunath, Leslie LeFevre-Stratton, Margaretta M. Lovell, Bruce Lundberg, Maureen McCormick, Brooks McNamara, Mimi and Ron Miller, Patrick McCaughey, Richard J. Moylan, Marsha Mullin, Arlene Katz Nichols, Arleen Pancza-Graham, John Paolella, David Scott Parker, Martin H. Pearl, Joanna Pessa, the late Churchill B. Phyfe, Dr. and Mrs. Henry Pinckney Phyfe, Mrs. James D. Phyfe, Catha Rambusch, Hugo A. Ramirez, Sue Welsh Reed, Ethan Robey, Mary P. Ryan, Annamarie V. Sandecki, Cynthia H. Sanford, Arlene Palmer

Schwind, Lisa Segal, Mimi Sherman, Kenneth Snodgrass, Jane Shadel Spillman, S. Frederick Spira, Theodore E. Stebbins Jr., Diana and Gary Stradling, Laura Turansick, Bart Voorsanger, Malcolm Warner, Fawn White, Shane White, Robert Wolterstorff, Sylvia Yount, and Philip D. Zimmerman.

Colleagues throughout the Museum supported our efforts with good grace, good advice, and assistance. We offer warm thanks to Mahrukh Tarapor, Associate Director for Exhibitions, and her assistants Martha Deese and Sian Wetherill; Doralynn Pines, Associate Director for Administration; Linda M. Sylling, Associate Manager for Operations and Special Exhibitions; Emily Kernan Rafferty, Senior Vice President for External Affairs; Nina McN. Diefenbach, Chief Development Officer; Kersten Larsen, Deputy Chief Development Officer, her predecessor Lynne Morel Winter, and Sarah Lark Higby, Assistant Development Officer; Missy McHugh, Senior Advisor to the President; Kay Bearman, Administrator for Collections Management; and Jeanie M. James and Barbara W. File, Archives. Aileen K. Chuk, Registrar, deserves special notice for her seemingly effortless coordination of the comings and goings of the many objects in the exhibition.

For important loans from within the Museum, we thank Everett Fahy, John Pope-Hennessy Chairman, European Paintings; George R. Goldner, Drue Heinz Chairman, Drawings and Prints; Maria Morris Hambourg, Curator in Charge, Photographs; J. Kenneth Moore, Frederick P. Rose Curator in Charge, Musical Instruments; Olga Raggio, Iris and B. Gerald Cantor Chairman, European Sculpture and Decorative Arts; and Myra Walker, Acting Associate Curator in Charge, Costume Institute. We are also grateful to Maxwell K. Hearn, Asian Art; Deirdre Donohue, Minda Drazin, Emily Martin, and Chris Paulocik, Costume Institute; Heather Lemonedes, Valerie von Volz, David del Gaizo, John Crooks, and Stephen Benkowski, Drawings and Prints; Katharine Baetjer, Keith Christiansen, Walter Liedtke, and Gary Tinterow, European Paintings; and Thomas Campbell, James David Draper, Johanna Hecht, Danielle O. Kisluk-Grosheide, and William Rieder, European Sculpture and Decorative Arts; as well as Giovanni Fiorino-Iannace, Antonio Ratti Textile Center. Particular recognition is owed to Helen C. Evans, Medieval Art, and Malcolm Daniel, Photographs, for exceptional collegial support.

The extraordinary expertise of the Museum's conservators has been of central importance. Gratitude is due to Marjorie Shelley, Conservator in Charge, Ann Baldwin, Nora Kennedy, Margaret Lawson, Rachel

Mustalish, Nancy Reinhold, and Akiko Yamazaki-Kleps, Paper Conservation; Dorothy Mahon, Paintings Conservation; Elena Phipps, Textile Conservation; Mindell Dubansky, Watson Library; James H. Frantz, Conservator in Charge, Hermes Knauer, Yale Kneeland, Jack Soultanian Jr., and especially Marinus Manuels, who was assisted by Tad Fallon, and Pascale Patris, Objects Conservation. Nancy C. Britton, Objects Conservation, merits special mention for her extensive investigation and interpretation of nearly all the upholstered furniture in the exhibition. She was assisted by Susan J. Brown, Hannah Carlson, L. Ann Frisina, Charlotte Stahlbusch, and Agnes Wnuk. We also thank Mary Schoeser, who researched furnishing fabrics in England, Guy E. O. Evans, John Buscemi, and Edward Goodman for help with upholstery research.

Jeffrey L. Daly, Chief Designer, with the assistance of Dennis Kois, expertly shepherded the exhibition through its preliminary laying out. Daniel Bradley Kershaw inventively designed the exhibition, and Sophia Geronimus created the compelling graphics, while Zack Zanolli worked his usual magic with the lighting. We also thank installers Jeffrey W. Perhacs, Fred A. Caruso, Nancy S. Reynolds, Frederick J. Sager, and Alexandra Wolcott.

Kent Lydecker, Associate Director for Education, and Nicholas Ruocco, Stella Paul, Pia Quintaro, Alice I. Schwarz, Jean Sorabella, and Vivian Wick are among the colleagues in the Education Department who created lively special programs to enhance the exhibition. Other members of the Education Department to whom we are grateful are Rika Burnham, Esther M. Morales, and Michael Norris. Hilde Limondjian, General Manager of Concerts and Lectures, also produced special events. Harold Holzer, Vice President for Communications, and his staff members Elyse Topalian and Egle Zygas skillfully publicized "Art and the Empire City." Valerie Troyansky and her merchandizing team brought out handsome products to accompany the exhibition.

On behalf of all the authors of the catalogue, we express our sincere thanks to John P. O'Neill, Editor in Chief, and his outstanding staff for making this magnificent book a reality. Carol Fuerstein, our lead editor, masterminded the massive editing project with crucial assistance from Margaret Donovan and additional expert help from Ellyn Allison, Ruth Lurie Kozodoy, and M. E. D. Laing. Jean Wagner, with assistance from Mary Gladue, verified the accuracy of the notes and created the bibliography. Peter Antony and Merantine Hens, with assistance from Sally VanDevanter, superbly executed the production, and Robert Weisberg adroitly managed the desktop publishing. Bruce Campbell is responsible for the book's elegant design. For producing the lion's share of the photographs used in the book, we thank Barbara Bridgers, Manager, the Photograph Studio, and her staff, especially Joseph Coscia Jr., Anna-Marie Kellen, Paul Lachenauer, Oi-Cheong Lee, Bruce Schwarz, Eileen Travell, Juan Trujillo, Karin L. Willis, and Peter Zeray. Eugenia Burnett Tinsley printed the black-and-white images, and Chad Beer, Josephine Freeman, and Nancy Rutledge contributed administrative and archival assistance. Jerry Thompson photographed sculpture in the American Wing as well as other objects. We are extremely grateful to colleagues who supplied photographs of exhibition objects and images for the essays in record time. We are appreciative also of the help received from Deanna D. Cross, Diana H. Kaplan, Carol E. Lekarew, Lucinda K. Ross, and Sandra Wiskari-Lukowski in the Museum's Photograph and Slide Library.

For enduring the inconveniences occasioned by this project for more than five years, we thank all our colleagues in the American Wing, especially Peter M. Kenny, Curator and Administrator, his assistant Kim Orcutt, and her predecessor the late Emely Bramson. As always, we are grateful to our administrative assistants Noe Kidder and her predecessor Kate Wood, Dana Pilson and her predecessor Julie Eldridge, Ellin Rosenzweig, and Catherine Scandalis and her predecessor Yasmin Rosner. Our technicians Don E. Templeton, Gary Burnett, Sean Farrell, and Rob Davis are the best in the business and we are grateful for their participation. Finally, we salute our fellow curators, the authors of this mighty tome. "Art and the Empire City: New York, 1825–1861" and its accompanying volume are the product of your collective expertise and collaboration.

John K. Howat
*Lawrence A. Fleischman Chairman,*
*Departments of American Art*

Catherine Hoover Voorsanger
*Associate Curator, Department of*
*American Decorative Arts*

# Contributors to the Catalogue

KEVIN J. AVERY, Associate Curator, Department of American Paintings and Sculpture, The Metropolitan Museum of Art

CARRIE REBORA BARRATT, Associate Curator, Department of American Paintings and Sculpture, and Manager, The Henry R. Luce Center for the Study of American Art, The Metropolitan Museum of Art

ELLIOT BOSTWICK DAVIS, Assistant Curator, Department of American Paintings and Sculpture, The Metropolitan Museum of Art

ALICE COONEY FRELINGHUYSEN, Curator, Department of American Decorative Arts, The Metropolitan Museum of Art

MORRISON H. HECKSCHER, Anthony W. and Lulu C. Wang Curator, Department of American Decorative Arts, The Metropolitan Museum of Art

JOHN K. HOWAT, Lawrence A. Fleischman Chairman, Departments of American Art, The Metropolitan Museum of Art

CAROLINE RENNOLDS MILBANK, fashion historian

AMELIA PECK, Associate Curator, Department of American Decorative Arts, The Metropolitan Museum of Art

JEFF L. ROSENHEIM, Assistant Curator, Department of Photographs, The Metropolitan Museum of Art

THAYER TOLLES, Associate Curator, Department of American Paintings and Sculpture, The Metropolitan Museum of Art

DELL UPTON, Professor of Architectural History, University of California, Berkeley

CATHERINE HOOVER VOORSANGER, Associate Curator, Department of American Decorative Arts, The Metropolitan Museum of Art, and Project Director, "Art and the Empire City: New York, 1825–1861"

DEBORAH DEPENDAHL WATERS, Curator of Decorative Arts and Manuscripts, Museum of the City of New York

*Medill Higgins Harvey, Austen Barron Bailly, Brandy S. Culp, Julie Mirabito Douglass, Jodi A. Pollack, Jeni L. Sandberg, and Cynthia Van Allen Schaffner,* research assistants

# Note to the Reader

Spelling and punctuation of original titles are standardized according to modern usage. Modern titles are listed first, preceding period titles in parentheses.

The photographer Victor Prevost's work survives primarily as waxed paper negatives. The three original works by him in this exhibition are reproduced as negatives. The Prevost photographs illustrated in the essays are reproduced from new gelatin silver prints made for this book from original negatives.

All works in the exhibition are illustrated in a section of the catalogue that immediately follows the essays. Works are grouped by medium as follows: paintings (portraits, portrait miniatures, American paintings, foreign paintings); sculpture (foreign, American); architectural drawings and related works; watercolors; prints, bindings, and illustrated books (American works, foreign prints); photography; costumes; jewelry; decorations for the home; furniture; ceramics;

glass; silver and other metalwork. Within each category works are arranged chronologically, unless the point of a comparison supersedes the significance of chronology. Abbreviated captions are provided.

Fuller information on the exhibited works appears in the checklist, which is arranged in the same order as the illustrated works. For measurements in the checklist, height precedes width, precedes depth or length, precedes diameter. Measurements of sculpted busts include the socle. Measurements of daguerreotypes are based on the standard plate size and do not include the case. Unless otherwise specified, artists were active in New York City, works were made in New York City, and original owners were residents of New York City. For most works, the title, subject, sitter, or inscription communicates the object's relevance to the exhibition. For others, an explanatory sentence or noteworthy information is given.

# Art and the Empire City
# New York, 1825–1861

# Inventing the Metropolis: Civilization and Urbanity in Antebellum New York

*DELL UPTON*

On October 26, 1825, the canal boat *Seneca Chief* left Buffalo at the head of a parade of gaily decorated craft to celebrate the opening of the Erie Canal. On November 4 the procession reached New York City, where a small flotilla carrying members of the City Council and other New York dignitaries greeted it (cat. no. 118). Twenty-nine steamboats and a host of sailing vessels and smaller craft formed a circle three miles in diameter around the *Seneca Chief*. Governor De Witt Clinton (cat. nos. 4, 122B), the canal's most ardent promoter, lifted a keg of Lake Erie water high above his head, then poured it into the ocean. Other participants added waters from the Mississippi, Columbia, Orinoco, La Plata, and Amazon rivers, as well as from the Nile, Gambia, Thames, Seine, Rhine, and Danube. The party landed at the Battery and led a great parade up Broadway to City Hall, and ultimately to a dinner for three thousand at the Lafayette Theatre.[1]

As the celebrants understood, the Erie Canal—imagined for a century, projected for thirty years, and under construction for eight—cemented New York's position as the "capital of the country," in the words of the painter and inventor Samuel F. B. Morse.[2] New York had emerged from the Revolution as the new nation's largest city, surpassing Philadelphia, the colonial metropolis. By 1825 New York's economic dominance was secured, as a result of its favorable location and year-round harbor, the establishment of regular transatlantic packet lines on the Black Ball Line in 1818, and its good fortune in being the site where Britain chose to dump its surplus textiles after the War of 1812, which gave it primacy in the national dry-goods market (cat. no. 35; fig. 1).[3] If New York had no equal by the time the Erie Canal was completed, the "artificial river" nevertheless assured the city's future preeminence at the geographical and financial center of a web of national and international commerce. Not only did the canal's path set the pattern for

I am grateful to Michele H. Bogart, Margaretta M. Lovell, Mary P. Ryan, Catherine Hoover Voorsanger, and Shane White for comments on an earlier draft of this essay.

1. E. Idell Zeisloft, ed., *The New Metropolis: Memorable Events of Three Centuries, 1600–1900, from the Island of Mana-hat-ta to Greater New York at the Close of the Nineteenth Century* (New York: D. Appleton, 1899), pp. 83–84; Mary P. Ryan, *Civic Wars: Democracy and Public Life in the American City during the Nineteenth Century* (Berkeley: University of California Press, 1997), pp. 61–68.
2. Samuel F. B. Morse (1831), quoted in Paul J. Staiti, *Samuel F. B. Morse* (Cambridge: Cambridge University Press, 1989), p. 150. See also Evan Cornog, *The Birth of Empire: DeWitt Clinton and the American Experience, 1769–1828* (New York: Oxford University Press, 1998), pp. 104–6, 171.
3. See Robert Greenhalgh Albion, *The Rise of New York Port (1815–1860)* (New York: C. Scribner's Sons, 1939; reprint, Boston: Northeastern University Press, 1984), pp. 16–38; and Eugene P. Moehring, "Space, Economic Growth, and the Public Works Revolution in New York," in *Infrastructure and Urban Growth in the Nineteenth Century* (Chicago: Public Works Historical Society, 1985), p. 31.

Fig. 1. William Guy Wall, *New York from the Heights near Brooklyn*, 1823. Watercolor and graphite. The Metropolitan Museum of Art, New York, The Edward W. C. Arnold Collection of New York Prints, Maps, and Pictures, Bequest of Edward W. C. Arnold, 1954 54.90.301

4. See Cornog, *Birth of Empire,* pp. 161–72; and Carol Sheriff, *The Artificial River: The Erie Canal and the Paradox of Progress, 1817–1862* (New York: Hill and Wang, 1996), pp. 5, 18–21.

5. *A Philadelphia Perspective: The Diary of Sidney George Fisher Covering the Years 1834–1871,* edited by Nicholas B. Wainwright (Philadelphia: Historical Society of Pennsylvania, 1967), p. 197.

6. Lady Emmeline Stuart-Wortley, *Travels in the United States, etc. during 1849 and 1850* (New York: Harper and Brothers, 1851), p. 13; "Monumental Structures," *New-York Mirror, and Ladies' Literary Gazette,* December 12, 1829, p. 183.

7. Northern Star, "The Observer: The City of New-York," *New-York Mirror, and Ladies' Literary Gazette,* November 15, 1828, p. 147.

8. Mrs. Felton, *American Life: A Narrative of Two Years' City and Country Residence in the United States* (Bolton Percy: The Author, 1843), p. 35.

9. Timothy Dwight, *Travels in New-England and New-York,* 4 vols. (New Haven: Timothy Dwight, 1821–22; facsimile edited by Barbara Miller Solomon, Cambridge, Massachusetts: Harvard University Press, 1969), vol. 3, p. 330.

10. Stuart-Wortley, *Travels,* p. 13; "The City of Modern Ruins," *New-York Mirror,* June 13, 1840, p. 407.

11. "Widening of Streets," *New-York Mirror,* November 2, 1833, p. 143.

12. E. E., "Letters Descriptive of New-York, Written to a Literary Gentleman in Dublin, No. II," *New-York Mirror, and Ladies' Literary Gazette,* January 6, 1827, p. 187.

13. John F. Watson, *Annals of Philadelphia . . . to Which Is Added an Appendix, Containing Olden Time Researches and Reminiscences of New York City* (Philadelphia: E. L. Carey and A. Hart, 1830), appendix p. 74.

14. "Editor's Easy Chair," *Harper's New Monthly Magazine* 21 (June 1860), p. 127.

15. "Great Cities," *Putnam's Monthly* 5 (March 1855), pp. 257, 256.

urban, railroad, road, and communication networks focused on the Empire City (cat. nos. 145, 152), but its construction also attracted foreign investment to the city and assured the dominance of New York–based capital in the nation's economy.[4]

The story of antebellum New York is the story of New Yorkers' struggle to come to grips with a city exponentially larger than any ever before known on the American continent. By 1825 its population had passed 125,000. That figure was in turn dwarfed by the nearly 815,000 people who lived in New York thirty-five years later. After a visit in 1847 the Philadelphia diarist Sidney George Fisher noted ruefully, "Philad: seems villagelike."[5]

To visitors New York was the "Empress City of the West," the "queen of American cities," the "London of the Western world."[6] As impressed as these visitors were, they could not match New Yorkers' own self-absorption. There was no aspect of their town that did not seem vaster or more numerous, grander or meaner, more sophisticated or cruder, more refined or more debased, more virtuous or more vicious than elsewhere. No element was too subtle to escape attention or too trivial to convey some vitally significant insight into the life of the city. Confronted with the "little world" they lived in, New Yorkers marveled.[7]

However great it had become, antebellum New York was still a work in progress over which hung a pervasive "air of newness."[8] "The bustle in the streets, the perpetual activity of the carts, the noise and hurry at the docks which on three sides encircle the city; the sound of saws, axes, and hammer at the shipyards; the continually repeated views of the numerous buildings rising in almost every part of it, and the multitude of workmen employed upon them form as lively a specimen of 'the busy hum of populous cities' as can be imagined," observed Yale University president Timothy Dwight.[9] But a work in progress was, from another perspective, a "half-finished city," a "city of perpetual ruin and repair. No sooner is a fine building erected than it is torn down to put up a better."[10] New York would be a "fine place—if they ever got it done."[11]

New Yorkers' public bravado was tempered by an equally public uncertainty about the city's standing and its future. What did it mean to be the Empire City, "the greatest commercial emporium of the world"?[12] As early as 1830 a New York–born historian of Philadelphia discerned in his birthplace "the very ambition to be the metropolitan city," a quality which "gave them cares which I am willing to see remote enough from Philadelphia."[13] All agreed that quantity—mere size and wealth—was not enough. Some elusive qualities

of character and accomplishment were also necessary. "It is curious and melancholy to observe how little manly and dignified pride New York has in its own character and position," lamented *Harper's New Monthly Magazine.* "A man may be large; but if his size be bloat, there is nothing imposing in it."[14]

"Great cities," claimed another essayist, are "the greatest and noblest of God's physical creations on earth." The nineteenth century was an age of great cities, and the greatest were characterized by "Civilization" and "Urbanity" (as well as by Protestant Christianity and the English language). The first meant "'making a person a *citizen*;' that is—the inhabitant of a city," developing the ability to live responsibly and effectively with one's neighbors; the second, "the quality, condition, or manners of the inhabitant of a city," cultivating the ability to live with style. This was not to suggest, the writer added hastily, "that the bustling, staring, heedless, rude, offensive manners of most self-important inhabitants of *some* modern commercial cities are the perfected result of the highest possible civilization, or are the acme of genuine urbanity."[15]

Antebellum New Yorkers pursued many paths to bringing civilization, or citizenship, and urbanity to their city and its residents. Art was one path, for it offered both diagnostic and ideal images that helped educated New Yorkers define themselves and influence the development of their city, and it embodied the refinement that urbanity implied. At the same time, the arts were deeply embedded, intellectually and practically, in antebellum New York's urban demographic upheaval and economic efflorescence. They were commodities and spectacles—"public entertainments"—offered for sale alongside laxatives and fine carriages and freak shows and houses and operas and food and women's bodies and fashionable clothing and grain futures. Art was shown and sold cheek by jowl with these other commodities and spectacles on the streets, in stores and offices, and (except for the brothels) in the classified columns of New York's newspapers. Thus consideration of the arts entails understanding them in the context of the entire universe of material culture that defined antebellum New York, including the planning and construction of the city, its verbal and pictorial representations, and its consumption of a vastly expanded world of goods and images.

## Regulating New York

New York's phenomenal economic and demographic growth was dramatically visible in its urban landscape. At the time of the Revolution the city was

confined to the southern end of the otherwise-rural Manhattan Island. Antebellum New Yorkers often described the colonial section of their city (those streets south of City Hall Park—then called simply "The Park") as "essentially defective," "a labyrinth—a puzzle—a riddle—incomprehensible to philosophers of the present day."[16] It was nothing of the sort. Laid out by the Dutch as a rough grid (adapted to the shoreline) with major streets paralleling the East River waterfront and perpendicular streets leading back into the core of the island, the city was continually extended in the process of land reclamation along the shore (cat. no. 124; fig. 2).

The colonial district was embellished and rationalized (or "regulated," as it was called) as money and occasion permitted. When New York emerged from the Revolution heavily damaged by British military occupation and by a disastrous fire of 1776 that burned much of the city west of Broad Street, city officials took advantage of the destruction to modify Broadway's grade as it descended from Wall Street to Bowling Green and to straighten and widen some streets.[17] The improvement of the old town continued through the antebellum era, particularly during the 1830s, when Ann, Cedar, and Liberty streets were straightened and widened, William and Nassau streets enlarged, and Beekman, Fulton, and Platt streets newly cut.[18] During the same years the waterfront was continually redeveloped as landfill extended the shoreline into the river (cat. no. 119).

In the years following the Revolution urbanization began to creep along the East River beyond the Common, which comprised the present City Hall Park and the land adjacent to it, and the Collect Pond to the north. By the end of the eighteenth century a patchwork of gridded plats lay between the Park and Houston Street. Some had been created by the city from its common lands in the decades after the Revolution. Others were laid out by private landowners as urban development moved northward. In the east Henry Rutgers issued ground leases for his farm along the East River, laying the foundations of the present Lower East Side. In the west Trinity Church, a major landowner in Manhattan from colonial times to the present, subdivided some of its properties, notably to create Hudson, or Saint John's, Square as an elite residential enclave focused on Saint John's Church, Trinity's chapel of ease. The section of Broadway that passed through these private grids was the scene of the most active retail commercial development during the three decades after 1825 (cat. no. 123).[19]

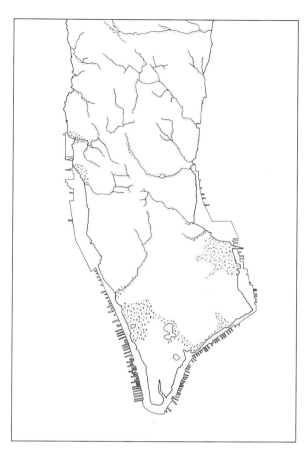

Fig. 2. *Water Courses of Manhattan,* 1999. Line drawing by Sibel Zandi-Sayek, after Egbert L. Viele, *Sanitary and Topographical Map of the City and Island of New York,* 1865, reprinted in Paul E. Cohen and Robert T. Augustyn, *Manhattan in Maps, 1527–1995* (New York: Rizzoli International Publications, 1997)

Then the city exploded (fig. 3). By 1828 the streets had been paved and gaslit as far north as Thirteenth Street across most of the island.[20] At midcentury urban development had reached Madison Square, and by the opening of the Civil War outlying residential neighborhoods were being built in the Thirties and Forties (cat. no. 136; fig. 4).

In the second quarter of the nineteenth century New York was an irregular collection of mostly regular grids, a patchwork but not a labyrinth. As a correspondent to *Putnam's Monthly* noted, in terms more measured than those of most of his contemporaries, lower Manhattan was "quite irregular. This irregularity, however, is in the position of the streets, rather than in their direction," as he demonstrated by comparing lower Manhattan to a baby's bootee with a few misplaced threads.[21]

Although the old city was no medieval maze, it was dramatically different from those parts north of Houston Street (and especially north of Fourteenth Street) that were shaped by the single most dramatic

16. Thomas N. Stanford, *A Concise Description of the City of New York . . .* (New York: The Author, 1814), quoted in Hendrik Hartog, *Public Property and Private Power: The Corporation of the City of New York in American Law, 1730–1870* (Chapel Hill: University of North Carolina Press, 1983), p. 159; "The Walton Mansion-House.—Pearl Street," *New-York Mirror,* March 17, 1832, p. 289.

17. Paul E. Cohen and Robert T. Augustyn, *Manhattan in Maps, 1527–1995* (New York: Rizzoli International Publications, 1997), p. 94.

18. "Late City Improvements," *New-York Mirror, and Ladies' Literary Gazette,* March 27, 1830, p. 303; "Widening of Streets," *New-York Mirror,* November 2, 1833, p. 143; "City Improvements," *New-York Mirror,* November 3, 1833, p. 175; John F. Watson, *Annals and Occurrences of New York City and State, in the Olden Time . . .* (Philadelphia: H. F. Anners, 1846), pp. 144–45.

19. Elizabeth Blackmar, *Manhattan for Rent, 1785–1850* (Ithaca: Cornell University Press, 1989), pp. 30–31, 41; Peter Marcuse, "The Grid as City Plan: New York City and Laissez-Faire Planning in the Nineteenth Century," *Planning Perspectives* 2 (September 1987), p. 297; Edward K. Spann, "The Greatest Grid: The New York Plan of 1811," in *Two Centuries of American Planning,* edited by Daniel Schaffer (Baltimore: Johns Hopkins University Press, 1988), pp. 14–16. Marcuse's and Spann's essays, along with Hartog, *Public Property,* chap. 11, are the best treatments to date of the evolution of New York's plan between the Revolution and the mid-nineteenth century, and they are the sources of the following paragraphs, unless otherwise noted.

20. Watson, *Annals and Occurrences of New York City,* pp. 144–45.

21. "New-York Daguerreotyped. Group First: Business-Streets, Mercantile Blocks, Stores, and Banks," *Putnam's Monthly* 1 (February 1853), p. 124.

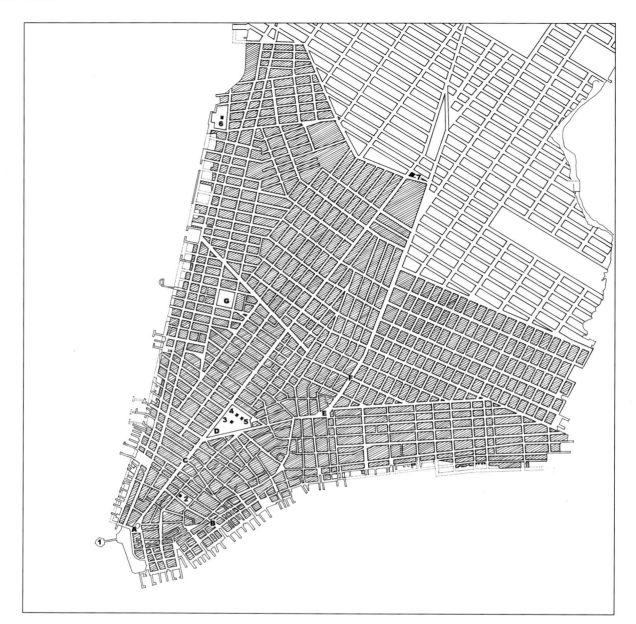

A. Bowling Green
B. Wall Street
C. Broadway
D. The Park
E. Chatham Square
F. The Bowery
G. Hudson (Saint John's)
   Square

1. Castle Clinton
2. Branch Bank of the
   United States
3. City Hall
4. Old Almshouse
5. The Rotunda
6. New York State Prison
7. Vauxhall Gardens

Fig. 3. *New York Settlement in 1820*, 1999. Line drawing by Sibel Zandi-Sayek, after Egbert L. Viele, *Sanitary and Topographical Map of the City and Island of New York*, 1865, reprinted in Paul E. Cohen and Robert T. Augustyn, *Manhattan in Maps, 1527–1995* (New York: Rizzoli International Publications, 1997)

22. Cohen and Augustyn, *Manhattan in Maps*, p. 102; Hartog, *Public Property*, pp. 167–75.

physical project to achieve civilization and urbanity, the Commissioners' Plan of 1811 (fig. 5). This was the work of a blue-ribbon panel appointed by the state legislature in 1807 to make a long-range plan for the city's growth after the Common Council and property owners had been unable to agree on a satisfactory course of action. The three commissioners in turn hired John Randel Jr. to survey the island. Together Randel and his employers established the all-encompassing framework for nearly every subsequent urban development in Manhattan.

Randel made three large maps on which he later drew the plan chosen by the commissioners, a grid that

was divided into 200-by-800-foot blocks extending up the island as far as 155th Street. For a decade after the plan's publication, the young surveyor and his assistants tramped Manhattan placing marble posts at the sites of all future intersections, although the regulation and construction of streets and avenues proceeded on a block-by-block basis as urbanization moved northward over the course of the nineteenth century.[22]

In creating the plan the commissioners and their surveyor carefully considered the nature of cities and the future of their own, as they made clear in the "Remarks" issued to accompany William Bridges's

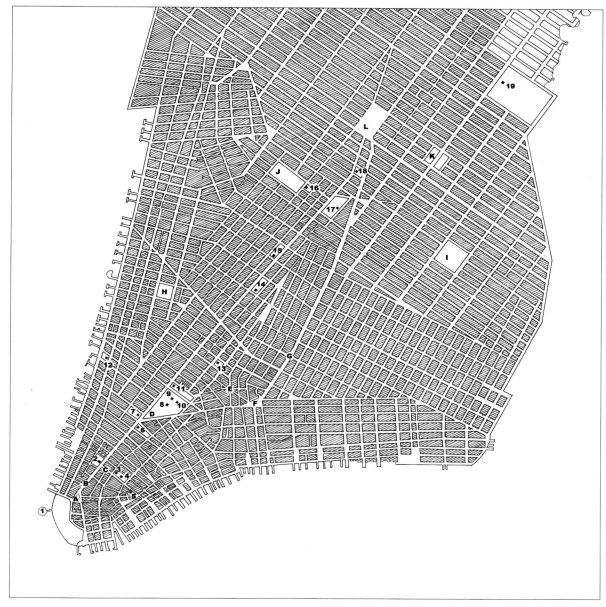

A. Bowling Green
B. Broadway
C. Wall Street
D. The Park
E. Five Points
F. Chatham Square
G. The Bowery
H. Hudson (Saint John's) Square
I. Tompkins Square
J. Washington Square
K. Stuyvesant Square
L. Union Square

1. Castle Garden
2. Trinity Church
3. Custom House
4. Branch Bank of the United States
5. Second Merchants' Exchange
6. American (Barnum's) Museum
7. Astor House
8. City Hall
9. Old Almshouse
10. The Rotunda
11. A. T. Stewart store (The Marble Palace)
12. Edgar H. Laing stores
13. New York Halls of Justice and House of Detention (The Tombs)
14. E. V. Haughwout store
15. Niblo's Garden
16. New York University
17. La Grange Terrace/ Colonnade Row
18. Grace Church
19. Bellevue institutions

Fig. 4. *New York Settlement in 1860*, 1999. Line drawing by Sibel Zandi-Sayek, after Egbert L. Viele, *Sanitary and Topographical Map of the City and Island of New York*, 1865, reprinted in Paul E. Cohen and Robert T. Augustyn, *Manhattan in Maps, 1527–1995* (New York: Rizzoli International Publications, 1997)

published version. In a famous passage they reported that "one of the first objects" they had considered was

*whether they should confine themselves to rectilinear and rectangular streets, or whether they should adopt some of those supposed improvements by circles, ovals, and stars, which certainly embellish a plan, whatever may be their effect as to convenience and utility. In considering that subject, they could not but bear in mind that a city is to be composed principally of the habitations of men, and that strait-sided, and right-angled houses are the most cheap to build and the most convenient to live in. The effect of these plain and simple reflections was decisive.*

In addition, they wanted to devise a plan that would mesh with "plans already adopted by individuals" in a way that would not require major adjustments.[23]

The product was New York's famous grid. Looking back half a century after the creation of the Commissioners' Plan, Randel boasted that many of its opponents (who objected to the costs of the improvements and to their conflict with already established land uses and building dispositions) had been forced to admit "the facilities afforded by it for the buying,

23. "Remarks of the Commissioners for Laying out Streets and Roads in the City of New York, under the Act of April 3, 1807," in *Manual of the Corporation of the City of New York*, edited by David T. Valentine (New York: The Council, 1866), p. 756.

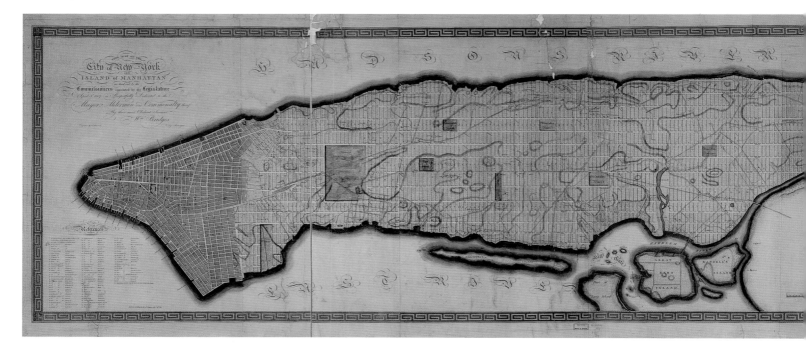

Fig. 5. John Randel Jr., cartographer; adapted and published by William Bridges, *This Map of the City of New York and Island of Manhattan as Laid Out by the Commissioners*, 1811. Hand-colored line engraving on copper. Library of Congress, Washington, D.C., Geography and Map Division

24. John Randel Jr. (1866), quoted in Spann, "Greatest Grid," p. 26.

25. On the new economic theories, see Joyce O. Appleby, *Economic Thought and Ideology in Seventeenth Century England* (Princeton: Princeton University Press, 1978); for their influence in the early republic, see Joyce O. Appleby, *Capitalism and a New Social Order: The Republican Vision of the 1790s* (New York: New York University Press, 1984).

26. "Remarks of the Commissioners."

27. [Samuel L. Mitchill], *The Picture of New-York; or, The Traveller's Guide, through the Commercial Metropolis of the United States, by a Gentleman Residing in This City* (New York: I. Riley and Co., 1807), pp. 128–43.

28. Edward K. Spann, *The New Metropolis: New York City, 1840–1857* (New York: Columbia University Press, 1981), pp. 144–45.

29. "Washington Market," *Gleason's Pictorial Drawing-Room Companion*, March 5, 1853, p. 160.

and improving real estate, on streets, avenues, and public squares, already laid out and established on the ground by monumental stones and bolts."[24]

Still, the 1811 plan was not *simply* a partition for resale. Although it has been criticized for its lack of public squares and broad processional avenues conducive to civic grandeur and ritual, these already existed in the old city. As the plan was being drawn, a monumental new city hall was rising on the Park at the head of Broadway (cat. nos. 186, 254), then and throughout the antebellum era New York's principal processional street.

The Commissioners' Plan can most accurately be described as the embodiment of an economically informed vision of urban society. It was created at a time when large-scale merchants and public officials were converting to economic theories that envisioned commerce as an all-encompassing, impersonal, systematic exchange of commodities rather than, as it had traditionally been regarded (and still was by many small traders), a series of discrete, highly personal, morally tinged relationships.[25]

This sense of trade as a commodity system was incorporated most explicitly in the commissioners' provision of a large marketplace (for foodstuffs and other "provisions") between First Avenue and the East River, and Seventh and Tenth streets. Eventually, they argued, householders would recognize that their time and money could be more efficiently spent shopping in a centralized venue than among the city's many dispersed marketplaces. At the same time, vendors would enjoy a more stable clientele and a more predictable demand, which "has a tendency to fix and equalize prices over the whole city."[26]

The commissioners' vision, unexceptionable to modern eyes, marked a radical change in the time-honored conception of the relationship between urban government and the markets. One of the functions of European and American city governments was to protect the food supply. City officials determined the sites of marketplaces, rented stalls, set market hours, controlled the quality, weight, and sanitary condition of goods sold, and most of all regulated prices. In the early nineteenth century New York had one main market, the Fly Market, replaced by Fulton Market in 1816 (cat. no. 120), and seven local ones.[27] At midcentury there were thirteen.[28] The Commissioners' Plan envisioned a single large market whose prices would be governed by competition rather than law. This was the de facto system by the middle of the nineteenth century when, as one journalist noted of Washington Market, the traditional rules for pricing, quantity, and quality, although stringent, were "dead letters, for they are seldom or never carried into execution."[29]

Increasingly New York's city government stepped away from economic regulation and devoted itself instead to creating the infrastructure that would enable an ostensibly benign system to operate freely.

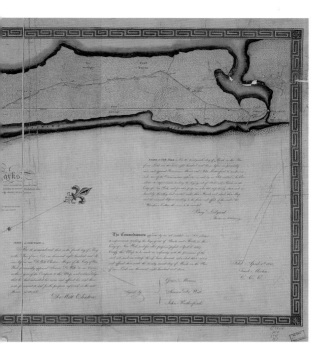

Even had they wished to continue regulation, New York's superior harbor (cat. no. 121) and good fortune in controlling access to the easiest inland route, which were the foundations of its power, also integrated it into a world economy no longer susceptible to local control.[30] The opening of the Erie Canal in 1825 and the completion of the transatlantic cable in 1858 reinforced the city's position as a key node in the geography of trade (cat. nos. 307–309).

The Commissioners' Plan, revised in minor ways and published in definitive form in 1821, laid out both the intellectual assumptions and the physical framework within which New York grew throughout the antebellum period. The theoretically grounded belief in a systematic economic order inspired a conception of the city as a spatial system that would articulate all uses and all users, permitting maximum freedom of individual action while ensuring transparent overall order. Again this differed from traditional concepts, which regarded urban spaces as static, unrelated aggregations of adjacent properties gathered around public spaces. Early-nineteenth-century writers sometimes used the analogy of a table, with a grid of "cells," each of which varies independently in its values but stands in clear relationship to every other one. It was an appropriate metaphor for the image of the articulated grid, which the New York commissioners shared with their merchant counterparts in other cities throughout the new nation.[31]

In New York, as in other American cities, public officials threw themselves into the business of regulation with a vengeance, cutting and filling and smoothing to make Manhattan Island resemble as closely as possible the flat surface and regular lines of the Commissioners' Plan. The Collect Pond and the Swamp, the Beekman property east of City Hall Park, were drained, watercourses were filled, the shoreline was extended, and, one by one, hills were leveled and valleys and ravines filled (cat. no. 124). The *Evening Post* complained in 1833 of the many plans "for opening new streets, widening others, ploughing through church yards, demolishing block after block of buildings, for miles in length, filling up streets so that you can step out of your second story bed room window upon the side walk, and turning your first story parlors and dining rooms into cellars and kitchens, with various other magnificent projects for changing the appearance of the city, and for preventing any part of it from ever getting a look of antiquity."[32] "The great principle which governs these plans is, to reduce the surface of the earth as nearly as possible to dead level," complained the poet and academic Clement Clark Moore.[33] Moore was right, but his objections and those of his fellow landowners had less to do with the intention than with the assessments levied against them for work adjacent to their properties.

The campaign to supply the city with water, the most conspicuous and, in some New Yorkers' minds, the most heroic effort to regulate the city, strikingly illustrates the power of the systematic urban vision. New Yorkers obtained their water from wells far into the nineteenth century. As neighborhoods were populated, the city typically ordered the provision of wells and pumps along with the paving of streets. The earliest efforts to create a systematic water supply also depended on wells.[34] One after another those few of these schemes that progressed beyond the planning stage failed. Even as other cities, such as Philadelphia and New Orleans, managed to get their water systems under way, New York's efforts stalled.[35]

The major difficulty lay in the conception of the government's role. City corporations like New York's had traditionally accomplished major public works by offering construction incentives to private landowners.[36] At the beginning of the nineteenth century the city decided to undertake in its own name an ambitious plan to obtain water from the Bronx River. It was opposed by those who did not believe that the city should take on a project with uncertain financial returns and by others who regarded such works as

30. Amy Bridges, *A City in the Republic: Antebellum New York and the Origins of Machine Politics* (Cambridge: Cambridge University Press, 1984), p. 1.

31. Dell Upton, "Another City: The Urban Cultural Landscape in the Early Republic," in *Everyday Life in the Early Republic,* edited by Catherine E. Hutchins (Winterthur, Delaware: Henry Francis Du Pont Winterthur Museum, 1994), pp. 67–70; Dell Upton, "The City as Material Culture," in *The Art and Mystery of Historical Archaeology: Essays in Honor of James Deetz,* edited by Anne E. Yentsch and Mary C. Beaudry (Boca Raton, Florida: CRC Press, 1992), pp. 53–56.

32. Untitled item, *Evening Post* (New York), February 26, 1833.

33. Quoted in Cohen and Augustyn, *Manhattan in Maps,* p. 108.

34. E. Porter Belden, *New-York: Past, Present, and Future; Comprising a History of the City of New-York, a Description of Its Present Condition and an Estimate of Its Future Increase,* 2d ed. (New York: G. P. Putnam, 1849), p. 37; Edward Wegmann, *The Water-Supply of the City of New York, 1658–1895* (New York: J. Wiley and Sons, 1896), pp. 3–10; "Corporation Notice" (advertisement), *New-York Evening Post,* September 30, 1826, p. 3.

35. Jane Mork Gibson, "The Fairmount Waterworks," *Philadelphia Museum of Art, Bulletin* 84 (summer 1988), pp. 2–11; Gary A. Donaldson, "Bringing Water to the Crescent City: Benjamin Latrobe and the New Orleans Waterworks System," *Louisiana History* 28 (fall 1987), pp. 381–96.

36. Hartog, *Public Property,* pp. 8, 21–24, 62–68.

Fig. 6. *Map of the Great Fire of December 16, 1835.* Wood engraving, from *Atkinson's Casket* II (January 1836), p. 38. Courtesy of the American Antiquarian Society, Worcester, Massachusetts

37. Wegmann, *Water-Supply,* pp. 11–12.

38. Belden, *New-York,* p. 38; Wegmann, *Water-Supply,* pp. 12–14; "Pure and Wholesome Water," *New-York Mirror, and Ladies' Literary Gazette,* December 22, 1827, p. 190. The Manhattan Company merged with Chase National Bank in 1955 to become the Chase Manhattan Bank.

39. "Pure and Wholesome Water," p. 190.

40. Wegmann, *Water-Supply,* pp. 16–37; Larry D. Lankton, *The "Practicable" Engineer: John B. Jervis and the Old Croton Aqueduct* (Chicago: Public Works Historical Society, 1977), pp. 4–16.

41. Wegmann, *Water-Supply,* pp. 49–51, 57–59; Lankton, *"Practicable" Engineer,* p. 24.

42. "The Croton Aqueduct," *Niles' National Register,* July 16, 1842, pp. 308–9; Wegmann, *Water-Supply,* pp. 39–40, 55.

43. "Croton Aqueduct," pp. 308–9. The editors added that the Egyptian-style architecture of the distributing reservoir was "well fitted by its heavy and imposing character for a work of such magnitude."

44. Belden, *New-York,* p. 41.

business opportunities rather than public obligations and wished to reap the profits themselves. Some of the latter, including Aaron Burr, obtained a charter as the Manhattan Company in 1799 and set up operations on Chambers Street. They dug a well, built a small reservoir, and began to lay wooden pipes through the streets of the city.[37]

In the early nineteenth century state legislatures commonly allowed private undertakers of public projects such as waterworks and canals to establish banks in order to finance themselves. The Manhattan Company's charter permitted them to raise capital as they saw fit and to make whatever use they wished of it over and above the costs of building and operating the works. The company concentrated its efforts on its banking enterprise and pumped only as much water as was necessary to protect its franchise, a practice that it maintained until the end of the nineteenth century, fighting off all attempts to charter bona fide water companies to serve New York.[38]

By the 1830s the water supply desperately needed reconstruction: public wells had become polluted, and firemen were hampered by lack of water in extinguishing major fires, such as the conflagration of December 16 and 17, 1835, which destroyed much of lower Manhattan's business district (cat. nos. 110, 111; fig. 6).[39] With the publicly financed construction of

the Erie Canal to offer as precedent, the city negotiated with the state the right to explore potential sources of water from newly drilled wells on Manhattan Island, from the Bronx River, and from the more distant Croton River. Engineer David B. Douglass was hired to draft a report, which favored the Croton River as the only source capable of supplying the anticipated population of the city over the next several decades. When the Common Council and the voters approved the project, Douglass was named project engineer and began work in May 1835. His lack of progress led to his replacement in the fall of 1836 by John B. Jervis, an engineer who had learned his profession during eight years' employment in the construction of the Erie Canal.[40]

Within a year construction of the water system was in full swing along the forty-one-mile aqueduct that connected a dam, created six miles upstream from the mouth of the Croton River, to a double receiving reservoir between Sixth and Seventh avenues and Seventy-ninth and Eighty-sixth streets, in an area that would later become Central Park. From there water was conducted to a distributing reservoir on Murray Hill (cat. no. 90), on the present site of the New York Public Library.[41]

The builders' most vexing problem was to devise a means of carrying the water across the Harlem River. After considering an inverted siphon under the river and a pipe laid across a suspension bridge (the suggestion of renowned suspension-bridge builder Charles Ellet), the Water Commission and its engineers chose to build a 1,450-foot aqueduct, now known as High Bridge, across the river (cat. no. 91).[42]

The Egyptian-style architecture of the distributing reservoir and the High Bridge's resemblance to a Roman aqueduct were meant to remind New Yorkers that their new waterworks rivaled the greatest monuments of antiquity. The Baltimore-based *Niles' National Register* wondered whether New Yorkers were aware of the magnitude of their achievement. In constructing "this stupendous structure" they were "surpassing ancient Rome in one of her proudest boasts. None of the hydraulic structures of that city, in spite of the legions of slaves at her command, equal, in magnitude of design, perfection of detail, and prospective benefits, this aqueduct."[43] Guidebook writer E. Porter Belden agreed that the aqueduct dwarfed all modern engineering works and rivaled ancient Rome's Aqua Marcia and Anio Novus.[44]

The waterworks projects called into question some basic assumptions that underlay the sense of the city as a system, specifically the beliefs that the pursuit of

individual advantages would mesh smoothly into an overarching general good and that government should be a neutral arbiter rather than an active agent of development. The interests of the Manhattan Company directly conflicted with those of the city at large. Nor was the Croton Waterworks as neutral as it seemed. Its construction was embraced by the Democratic city administration, which saw it as a way to employ four thousand party faithful, mostly Irish, and was driven forward by its contractors in the face of repeated strikes and disturbances on the part of their underpaid, overworked laborers. After its completion water was supplied to the populace only through public hydrants and even then over the objections of the water commissioners, who believed that ordinary people "abused" the privilege. Only paying customers—well-to-do householders and businesses—had water delivered directly to them.[45]

## Republican New York

A day of civic ritual and public merriment marked the official opening of the Croton Waterworks on October 14, 1842. A parade moved from the Battery up Broadway to Union Square, down the Bowery, across East Broadway, and back to City Hall Park. The procession threaded its way through some of the most emblematic New York spaces, connecting the elite and plebeian shopping streets along Broadway and the Bowery and the rich and poor neighborhoods at Union Square and East Broadway. The last marchers passed City Hall Park just as the head of the procession was returning to it down Chatham Street, forming a human chain that tied the city's diverse neighborhoods to the center of its political universe at City Hall and the Park, where speeches and choral odes solemnized the day.

These festivities produced a sense of oneness in democratic fellowship among New Yorkers of all classes (or at least among those who wrote about it). It was the "proud consciousness which every citizen of New-York felt that his or her own cherished and honored city had, in this mighty undertaking, accomplished a work with no superior," a "gratification such as it is not often the pleasant lot of a municipal people to enjoy," wrote the *New World*.[46]

After the parades, speeches, and illuminations the *New World*'s correspondent concluded:

*There was much, . . . very much—indeed we may say everything—in this celebration—to excite*

*strongly the most grateful feelings and reflections. . . . [T]here was the sense of grandeur always called into being by the sight . . . of a great multitude, animated by one impulse, and moving or acting in the attainment of a common object. Nor was the proud reflection absent, that under the benign influence of political institutions which give and secure to every man his equal share in the general rights, powers, and duties of citizenship; amid this great convulsion, as it may be called—this mighty upheaving and commingling of society—where half-a-million of people were brought together into one mass as it were, there was not a guard, a patrol, a sentry, not even a solitary policeman, stationed any where to hold in check the ebullition of social or political excitement; that there was need of none.*[47]

The *New World*'s observer articulated a characteristically republican vision of New York society, but one that was rapidly fading by the time the Croton Waterworks opened. At its heart was the seductive image of a diverse population acting freely but as though animated by a single will.

A republic was a polity of independent but related citizens who shared essential values and qualities but were differentiated in the degree to which they possessed them. Sometimes republicans made the point by comparing citizens to currency, whose denominations represented various quantities of the same essential value. The simile led one ambitious scholar of "National Arithmetic" to attempt to set a monetary value on the population of the United States and to use that to calculate the inevitable increase in national wealth.[48]

The central theoretical problem of republicanism was to reconcile economic and political liberty with order and the notion of a single overarching public good. How could one allow citizens the maximum self-determination and still hope to have an orderly society? As it was worked out by the earliest American political theorists, a republic depended heavily on the concept of virtue, a quality of character that prompted its members to discipline themselves and to subordinate personal interests to the larger good. Virtue depended on the inculcation of common values into citizens who, whatever their differences, all possessed an inherent, trainable moral sense.[49] Because republicans could not imagine the state's surviving without roughly equivalent degrees of knowledge, values, and goals among all its citizens, they asserted the necessity of "republican equality," of a society not rent by

45. Bridges, *City in the Republic*, p. 130; Edwin G. Burrows and Mike Wallace, *Gotham: A History of New York City to 1898* (New York: Oxford University Press, 1999), pp. 625–28; Wegmann, *Water-Supply*, pp. 64–65.
46. "The Croton Celebration," *New World*, October 22, 1842, p. 269.
47. Ibid.
48. [Samuel Blodget], *Thoughts on the Increasing Wealth and National Economy of the United States of America* (Washington: Printed by Way and Groff, 1801), pp. 7–10.
49. Dell Upton, "Lancasterian Schools, Republican Citizenship, and the Spatial Imagination in Early Nineteenth-Century America," *Journal of the Society of Architectural Historians* 55 (September 1996), pp. 243–46.

50. Gwendolyn Wright, *Building the Dream: A Social History of Housing in America* (New York: Pantheon Books, 1981), pp. 24–25.

51. Ronald Schultz, *The Republic of Labor: Philadelphia Artisans and the Politics of Class, 1720–1830* (New York: Oxford University Press, 1993), pp. 6–7; Margaretta M. Lovell, "'Such Furniture as Will Be Most Profitable': The Business of Cabinetmaking in Eighteenth-Century Newport," *Winterthur Portfolio* 26 (spring 1991), pp. 27–28; Sean Wilentz, *Chants Democratic: New York City and the Rise of the American Working Class, 1788–1850* (New York: Oxford University Press, 1984), pp. 61–103; Howard B. Rock, *Artisans of the New Republic: The Tradesmen of New York City in the Age of Jefferson* (New York: New York University Press, 1979), pp. 142–43; Bridges, *City in the Republic*, pp. 102–7.

52. Blackmar, *Manhattan for Rent*, pp. 51–61; Rock, *Artisans*, pp. 295–301; Wilentz, *Chants Democratic*, pp. 27–35; Elva Tooker, *Nathan Trotter, Philadelphia Merchant, 1787–1853* (Cambridge, Massachusetts: Harvard University Press, 1955), pp. 60, 137–38.

53. Watson, *Annals and Occurrences of New York City*, p. 205.

54. Appleby, *Capitalism and a New Social Order*, pp. 14–15; Rowland Berthoff, "Independence and Attachment, Virtue and Interest: From Republican Citizen to Free Enterpriser, 1787–1837," in *Uprooted Americans: Essays to Honor Oscar Handlin*, edited by Richard Bushman et al. (Boston: Little, Brown, 1979), pp. 97–124.

55. Brooke Hindle, *The Pursuit of Science in Revolutionary America, 1735–1789* (Chapel Hill: University of North Carolina Press, 1956), pp. 260–62; John C. Greene, *American Science in the Age of Jefferson* (Ames: Iowa State University Press, 1984), pp. 52–57; Robert E. Schofield, "The Science Education of an Enlightened Entrepreneur: Charles Willson Peale and His Philadelphia Museum, 1784–1827," *American Studies* 30 (fall 1989), p. 21; Charles Coleman Sellers, *Mr. Peale's Museum: Charles Willson Peale and the First Popular Museum of Natural Science and Art* (New York: W. W. Norton, 1980), pp. 193, 214.

excessive disparities, or excessively visible disparities, of wealth and condition.[50]

Republican equality was most strongly emphasized in the "artisan republicanism" favored by craftsmen and small tradesmen. Artisan republicanism endorsed the workers' long-held belief that every economic actor, high or low, earned a niche in society by providing a service to the community and that each person consequently had a right to a "competency," the resources necessary to live an independent life with access to the necessities and comforts appropriate to his or her station. Self-respect demanded economic independence as a sign of public recognition. For artisans, then, republicanism incorporated an ideal of independent existence based on the ownership of one's own residence and place of business. Its echoes can be heard in the commissioners' "Remarks," in their assumption that the city they laid out would primarily be a city of individual residences.[51] Artisan republicanism viewed society as a network of interdependent relationships and obligations. Artisans were responsible for their apprentices' and employees' welfare, and their patrons were in turn responsible for theirs. Artisans and merchants counted on a loyal clientele, making unseemly competition among themselves unnecessary.[52] The historian John Fanning Watson, who decried the "painted glare and display" of capitalist competition (even though he was one of its prime movers in Philadelphia), emphasized this difference as he looked back nostalgically on business practices in prerevolutionary New York. "None of the stores or tradesmen's shops then aimed at rivalry as now," he wrote in 1843; "they were content to sell things at honest profits, and to trust an earned reputation for their share of business."[53]

For some patrician conservatives, on the other hand, republicanism was a hierarchical concept that emphasized the variations among individuals in the desirable qualities of citizenship. Those who traditionally ruled should continue to rule, but on the basis of superior virtue and wisdom rather than inherited privilege. Like artisans, although for different reasons, they worried about the consequences of extreme differences between the top and the bottom of republican society. They sought to marshal their personal social and cultural authority over their inferiors in defense of stability.

Eventually a third variety, liberal republicanism, emerged as the dominant strain. This emphasized the degree of personal liberty that was permitted if society and the economy were assumed to be governed by higher ordering forces that would act no matter what individuals might do. Liberal republicanism replaced the call for self-denying virtue with a definition of virtue that stressed enterprise and self-reliance in promoting one's own and one's dependents' welfare. Self-interest would be restrained by the self-regulation of a market-based political economy, integrating disparate individual goods into a common one.[54]

Republicans of all stripes hoped that universal public education would inculcate republican equality and civic virtue. In early-nineteenth-century America knowledge was still popularly imagined in Enlightenment terms: to list and classify was to know. At his celebrated museum in Philadelphia, for example, the artist, scientist, and educator Charles Willson Peale amassed an ever-expanding collection of natural history specimens and a portrait gallery of American patriots that grew to nearly one hundred paintings as he added politicians, American and European scientists and artists, and (as he grew older) Americans famous for their longevity. Peale wished to create an articulated, totalizing system of knowledge that would educate his fellow Americans for republican citizenship.[55]

Given these assumptions, it is easy to understand how the grid might have been viewed as the spatial order most likely to encourage republican equality by coordinating citizens' activities and interests. The grid was particularly congenial to the republican concept of knowledge, for it was thought to facilitate the *separation* and *classification* (two ubiquitous watchwords of antebellum cultural life) that Americans then valued in every aspect of human activity. New York's gridded spaces satisfied the republican love of a kind of order that could be laid out in a simple, quickly and easily grasped scheme.

Yet the prospects for republican community seemed threatened by significant changes in the social and economic structure. Liberal republicanism's embrace of capitalist political economy eventually eradicated the mutual dependency that artisan republicans advocated. Until the late eighteenth century employers had provided the necessities of life—food, shelter, clothing—in addition to or in place of wages, and had exercised broad control over their employees' lives. Male heads of households assumed the same rights of social and moral direction over those who worked for them as over their relatives.[56]

Traditional labor relations disintegrated under the impact of the new commodity-driven, capitalist economy. Employers rapidly abandoned responsibility for their workers' social and spiritual, as well as their economic, welfare, substituting a simple wage-labor system. Workers may have gained independence from paternalistic supervision, but they were rarely paid

enough to enjoy their freedom or to compensate for some of the material benefits they had derived from living under their employer's roofs. Artisan employers, too, suffered the loss of a dependable living, as advertising, display windows, and longer hours marked the growing desire for customers' immediate patronage rather than their long-term loyalty.[57]

The new, rough-and-tumble, laissez-faire capitalism transformed the lives of New Yorkers of all classes. The old colonial mercantile and agrarian elite were affected as surely as small shopkeepers, artisans, and laborers. Those who clung to their former habits entered upon a long decline, while others discovered ways to profit from urban land speculation and invested in banks, insurance companies, manufacturing, the infrastructure, and retail sales. By the time of the Civil War 115 millionaires resided in New York. They and their predecessors of a generation or two earlier—men such as banker John Pintard, auctioneer and diarist Philip Hone (cat. no. 58), fur trader and land speculator John Jacob Astor, merchant and art collector Luman Reed (cat. no. 9), and banker and art collector Samuel Ward—formed a self-designated elite who increasingly retreated into luxurious seclusion.[58]

The new elite dismayed many of their fellow citizens, for republican equality survived in popular sentiment even though it was theoretically outmoded by liberal republicanism. At midcentury the journalist Caroline M. Kirkland criticized the new rich of Fifth Avenue for building houses "in luxury and extravagance emulating the repudiated aristocracy of the old world" (cat. no. 185).[59] Another journalist took the opposite tack: those mansions were "the spontaneous outgrowth of good old Knickerbocker industry, enterprise and thrift, engrafted on a freedom-loving and liberal spirit, and are scarcely possible under any other than republican institutions." Consequently everything along Fifth Avenue was "suggestive of equality, although wealth has made that equality princely."[60]

The social and economic elite withdrew from their traditional political activism in the quarter-century before the Civil War, as they had from urban social life, leaving politics in the hands of new, up-from-the-ranks career politicians who catered to middling and lower-class constituencies. As economic interests diverged and ethnic and class divisions hardened, the extension of the franchise to all white men and the active participation of working-class men in politics made the process of governing the city more democratic, but also more fragmented and more difficult, and the eighteenth-century assumption of a single public good collapsed.[61]

Republican values appeared to be threatened from below as well as from above. By 1860 just under half of the city's population was foreign born, with most immigrants having arrived after 1845. Of these the Irish-born comprised about 30 percent of the population and the German-born another 15 percent. Only 1.5 percent were African Americans, down from just under 10 percent in 1820. Their numbers had remained roughly stable since then as the white population expanded, after having kept pace with the city's growth in the decades just before the opening of the Erie Canal. In 1825 a few remained enslaved or held as indentured servants under the provision of New York State's Gradual Manumission Act of 1799. They were finally freed in 1827, but African Americans remained at the bottom of New York's social and economic hierarchies.[62]

In the opinion of many middling and elite New Yorkers, these groups—immigrants and blacks—formed the cadres of a vast army of paupers, criminals, and lunatics. Beginning with the construction of the New York State Penitentiary on the Hudson River side of Washington Street between Christopher and Perry streets in Greenwich Village in 1796–97, the city was encircled by a growing corps of institutions intended to rescue and reform New Yorkers—almost exclusively poor New Yorkers—from their failures as republican citizens, substituting institutional oversight for the personal relationships and direct supervision of dependents that well-off urbanites had abandoned with the advent of wage labor.[63] These new institutions included the complex of a hospital, jail, workhouse, and almshouse built at Bellevue in 1816 to replace their predecessors around City Hall Park; a third generation of the same institutions built on Blackwell's (now Roosevelt) Island between 1828 and 1859; the Bloomingdale Insane Asylum, successor to the wing for lunatics in the old New York Hospital on lower Broadway; the House of Refuge, or reform school, on the parade grounds (Madison Square); and a dizzying assortment of asylums—for deaf mutes, the blind, orphans, Jewish widows and orphans, Protestant half-orphans, Roman Catholic orphans, friendless "respectable, aged, indigent females," friendless boys, aged and ill sailors (the Sailors' Snug Harbor), magdalens (reformed prostitutes), and female ex-convicts. *Peterson's Monthly* counted twenty-two asylums plus eight hospitals in New York City in 1853.[64]

In addition to meticulously separating and classifying their charges among these institutions, their founders all assumed the need for separation and classification within each institution, and they assumed as well that gridded spaces, like those that organized

56. Appleby, *Capitalism and a New Social Order*, pp. 59–78, 95–96; Blackmar, *Manhattan for Rent*, pp. 60–68.

57. Bridges, *City in the Republic*, pp. 11, 50–54, 70–71; Blackmar, *Manhattan for Rent*, pp. 61–68.

58. Cornog, *Birth of Empire*, p. 162; Blackmar, *Manhattan for Rent*, pp. 36–43; Alan Wallach, "Thomas Cole and the Aristocracy," *Arts Magazine* 56 (November 1981), pp. 98, 103–4; Spann, *New Metropolis*, pp. 205–11.

59. C[aroline] M. Kirkland, "New York," *Sartain's Union Magazine of Literature and Art* 9 (August 1851), p. 149.

60. "Fifth Avenue," *Home Journal*, April 1, 1854, p. 2.

61. Bridges, *City in the Republic*, pp. 62, 71–75, 127–31; Ryan, *Civic Wars*, pp. 8–11, 108–13. The wealthy continued to be active behind the scenes as financial contributors and party functionaries, but their authority was diminished.

62. Nathan Kantrowicz, "Population," in *The Encyclopedia of New York City*, edited by Kenneth Jackson (New Haven: Yale University Press, 1995), pp. 921–23; Rock, *Artisans*, p. 14; Spann, *New Metropolis*, p. 430; Bridges, *City in the Republic*, pp. 39–41; Eric Homberger, *The Historical Atlas of New York City: A Visual Celebration of Nearly 400 Years of New York City's History* (New York: H. Holt and Co., 1994), p. 45; Shane White, *Somewhat More Independent: The End of Slavery in New York City, 1770–1810* (Athens: University of Georgia Press, 1991), pp. 38, 47, 53–55, 153–54.

63. [Thomas Eddy], *An Account of the State Prison or Penitentiary House, in the City of New-York; by One of the Inspectors of the Prison* (New York: Isaac Collins and Son, 1801), pp. 17–18.

64. "The Benevolent Institutions of New-York," *Peterson's Monthly* 1 (June 1853), pp. 673–86.

SUBURBAN GOTHIC VILLA.

Fig. 7. Alexander Jackson Davis, architect and artist, *House of William C. H. Waddell, Fifth Avenue and Thirty-eighth Street, Perspective and Plan*, 1844. Watercolor and ink. The New York Public Library, Astor, Lenox and Tilden Foundations, Miriam and Ira D. Wallach Division of Art, Prints and Photographs, The Phelps Stokes Collection

65. Quoted in Samuel L. Knapp, *The Life of Thomas Eddy; Comprising an Extensive Correspondence with Many of the Most Distinguished Philosophers and Philanthropists of This and Other Countries* (New York: Conner and Cooke, 1834), p. 76.

66. Belden, *New-York*, p. 49; "A Visit to the Tombs Prison, New York City," *Frank Leslie's Illustrated Newspaper,* November 29, 1856, pp. 388–89; John Haviland, "Description of the House of Detention, New York, 1835–38, and List of Other Works," manuscript, 1846, p. 6, Simon Gratz Collection, case 8, box 11, Historical Society of Pennsylvania, Philadelphia.

good citizens, could correct—civilize—errant ones. By the second quarter of the nineteenth century, all large institutional buildings were planned on a grid of identical cells or rooms opening off one or both sides of a corridor. Ideally each prisoner, inmate, or patient was assigned to a separate unit. This isolated the subject and prevented infection of the body or of the character, for as the Quaker merchant and reformer Thomas Eddy noted of prison inmates, where criminals were housed in groups, "each one told to his companions his career of vice, and all joined by sympathetic villainy to keep each other in countenance."[65]

The New York State Prison at Auburn, converted to separate cells in 1819–21 partly at Eddy's urging, and the renowned Eastern State Penitentiary at Philadelphia (1821–36) established separate cells for individual

offenders as the standard of up-to-date prison design. New York City's antebellum penal institutions followed this model, most notably in the jail portion of the New York Halls of Justice and House of Detention (1835–38), popularly known as the Tombs and built on Centre Street near City Hall to replace the old Bridewell (cat. no. 83). Its architect, John Haviland, had made his reputation as the architect of the Eastern State Penitentiary. In the House of Detention portion of the Tombs, a freestanding 142-by-45-foot block on three levels, the 148 separate cells, "constructed after the model of the State Penitentiary at Philadelphia," were additionally "divided into four distinct classes for *prisoners,* and rooms for male and female, white and black vagrants" (cat. no. 82).[66] In this way, jailers could mete out food, reading matter, labor, and human contact individually. Most important, in his

Fig. 8. *Modest Artisan-Type Houses, Gay Street, Greenwich Village, New York*, buildings, second quarter 19th century; photograph by Dell Upton, July 1998

cell, "where he is unseen and unheard, nothing can reach [the convict] but the voice which must come to him, as it were, from another world."[67]

The failure of the cell system was evident by the 1840s, and institutional discipline relaxed. When the Swedish novelist and travel writer Fredrika Bremer visited the Tombs in the 1850s, she found the prisoners sharing cells and even worse, "walking about, talking, smoking cigars."[68] Although New Yorkers continued to voice hopes for republican community

after the 1830s, they turned their main attention to the excitements of commercial society.

### Selling New York

Liberal republicanism and capitalist enterprise had transformed the landscape of antebellum New York. Until the late eighteenth century merchants and artisans commonly lived in or beside their places of business or work, in households that included their servants,

67. Knapp, *Life of Thomas Eddy*, p. 94.
68. Fredrika Bremer, *The Homes of the New World; Impressions of America*, translated by Mary Howitt, 2 vols. (New York: Harper and Brothers, 1853), vol. 2, p. 605.

Fig. 9. Seth Geer, designer and builder, *La Grange Terrace, Astor Place*, buildings, 1833; photograph by Dell Upton, July 1998

Fig. 10. *Grove Court, Greenwich Village, New York: Rear Tenements behind a Street of Modest Working-Class and Artisans' Houses,* buildings, ca. 1850; photograph by Dell Upton, July 1998

69. Diana diZerega Wall, "The Separation of Home and Workplace in Early Nineteenth-Century New York City," *American Archeology* 5, no. 3 (1985), pp. 185–86; Blackmar, *Manhattan for Rent,* pp. 78, 100–105.

70. Spann, *New Metropolis,* p. 220.

71. James Gallier, *Autobiography of James Gallier, Architect* (Paris: E. Briere, 1864; reprint, New York: Da Capo, 1973), p. 18.

72. "Marble Houses at Auction" (advertisement), *Evening Post* (New York), March 28, 1833, p. 4. As a result of ambiguity in the record, the authorship of La Grange Terrace has long been a matter of disagreement. See, for instance, "Building the Empire City" by Morrison H. Heckscher in this publication, p. 179.

apprentices, and employees. As they disengaged from these, merchants began to move away from their waterfront stores and residences, slowly at first, then in earnest around 1820, with artisans following suit a decade later.[69] The city's builders and its growing coterie of professional architects erected comfortable, sometimes luxurious, houses for the mercantile migrants near the western side of the island and up its center at the advancing urban edge, near Washington Square, Bond Street, and Astor Place, on Union Square, and then (after the mid-1840s) up Fifth Avenue, the hotbed of the "Codfish Aristocracy," as the new rich were called (cat. nos. 185, 188; fig. 7).[70]

Before Fifth Avenue was developed, all but the wealthiest New Yorkers were satisfied to live in dwellings erected by speculative builders, most often created as ready-made commodities fitted to the demands of the grid rather than to those of individual clients. They ran the gamut from endless rows of small, two-to-four-room houses for artisans up to substan-tial semidetached houses (cat. nos. 84, 85; fig. 8). Builders for middling and well-to-do tenants sometimes retained architects to design relatively standardized facades to enliven highly standardized plans, paying a few dollars for a drawing that might be dashed off in a morning (cat. nos. 87, 88).[71] At the upper end were luxurious, architecturally ambitious rows such as La Grange Terrace (Colonnade Row) on Lafayette Place (now Astor Place), carved out of Vauxhall, the old pleasure garden on John Jacob Astor's land (cat. no. 86; fig. 9). Designed and built by the developer Seth Geer, this "splendid Terrace Row" of marble-fronted houses was offered at auction by Geer in April 1833.[72] Even those wealthy enough to construct freestanding residences, such as Luman Reed, who was said to have "the most expensive house in New York" in 1835, and Samuel Ward, often relied on a master builder to construct a more or less standard Georgian-plan house, sometimes distinguished by an architect-designed facade.[73]

Even the brisk rate of construction that characterized New York building through most of the antebellum era was inadequate to accommodate the growing urban population. By 1840 the city was engulfed in a housing crisis from which it never emerged.[74] While well-off people enjoyed improved accommodation, more and more wage earners were paying higher and higher rents for smaller and worse quarters. Houses meant for one family were subdivided, often with a

Fig. 11. *Gotham Court, Five Points,* 1850. Wood engraving, from *Frank Leslie's Sunday Magazine* 5 (June 1879), p. 643

different family or tenant group in every room. Buildings of the flimsiest and most insubstantial sort were converted to dwellings for those who were too poor to afford anything better or who were excluded from it by racial discrimination. On a lot on Ludlow Street, between Grand and Hester streets, were "7 or 8 huts in close connection, . . . mere sheds," subdivided into more than fifty rooms occupied by 60 to 100 African Americans in 1830.[75] Four years later an alderman complained to the council about that portion of Laurens Street (now West Broadway) between Canal and Spring streets: at number 33 he found 21 whites and 96 blacks in residence, with 10 more of the latter living in a small building at the rear; this address and its nine nearest neighbors had a total population of 280 whites and 173 blacks, an average of 45 people per house.[76]

To take advantage of the need for low-end housing that these documents reveal, new buildings were erected as tenant dwellings in backyards and in districts heavily occupied by working people, where, after the 1830s, speculators constructed three-story tenements for multifamily occupancy in place of the older, subdivided two-story single-family houses (fig. 10).[77] A few developers built rental housing that looked forward to post–Civil War practices, such as the seven-story tenement reputedly constructed at 65 Mott Street in the 1820s, or Silas Wood's Gotham Court of 1850, near Murderer's Row in the Five Points district (fig. 11). This six-story structure provided ten-by-fourteen-foot, two-room apartments for 140 families. By 1855 reformers found the situation so dire that they erected the first model tenement, the Workingmen's Home, designed by architect John W. Ritch. Familiarly known as the Big Flat, this philanthropic building stood just north of Canal Street on a lot spanning Mott and Elizabeth streets. Within a few years it had become a problem in its own right.[78]

Even middle-income people, especially if they were single, turned to multiple-occupancy housing, such as the "well regulated lodging-house . . . fitted up with all the modern improvements, the furniture entirely new and of the best quality" that was advertised in the *Home Journal* in 1850, and to boardinghouses, hotels, and rooms in private houses.[79] Like their impoverished fellow citizens, middle-class families were often forced to "a species of uncomfortable communism," the sharing of houses, "so that the direct order of the family is lost."[80]

Although workplaces and living quarters were beginning to be separated and residential districts to be differentiated by class and race, and although, crudely speaking, the west side of Manhattan was more

73. Thomas U. Walter, Diary, 1834–36, p. 33, Thomas U. Walter Papers, Athenaeum of Philadelphia. Both Reed's and Ward's houses were designed and built by Isaac G. Pearson, although Alexander Jackson Davis apparently made a facade drawing for Reed's; see Ella M. Foshay, *Mr. Luman Reed's Picture Gallery: A Pioneer Collection of American Art* (New York: New-York Historical Society, 1990), pp. 32, 50. Philadelphia architect Thomas U. Walter, who visited both houses in 1835, attributed them to the "pseudo Architect" Pearson, "a merchant from Boston who thought he had peculiar talents for architecture, and left his mercantile persuits [*sic*], plunging headlong into the practice of the art, without a single qualification." See Walter, Diary, 1834–36, pp. 22–24 (quotes), 33–34.

74. Blackmar, *Manhattan for Rent,* pp. 204–12.

75. Deposition of Doctor Knapp, in *The People v. Barclay Fanning,* District Attorney Indictment Papers, New York, May 14, 1830.

76. "Laurens Street, New York," *Niles' Weekly Register,* June 28, 1834, p. 303.

77. Blackmar, *Manhattan for Rent,* pp. 70, 199–201.

78. Richard Plunz, *A History of Housing in New York City: Dwelling Type and Social Change in the American Metropolis* (New York: Columbia University Press, 1990), pp. 5–7; Robert H. Bremner, "The Big Flat: History of a New York Tenement House," *American Historical Review* 64 (October 1958), pp. 54–62.

79. "Rooms with Breakfast Only" (advertisement), *Home Journal,* January 1, 1850, p. 3; Blackmar, *Manhattan for Rent,* pp. 134–35, 197–98. The *Home Journal* lodging house was at the corner of Broadway and Bleecker Street.

80. "New York Society," *United States Magazine, and Democratic Review* 31 (September 1852), p. 253.

Fig. 12. *May Day in New York*. Wood engraving, from *Harper's New Monthly Magazine* 12 (May 1856), p. 862. Courtesy of the American Antiquarian Society, Worcester, Massachusetts

81. Alice B. Haven, "A Neighborhood," *Godey's Lady's Book and Magazine* 62 (January 1861), p. 33.

82. "May-Day," *New-York Mirror*, February 29, 1840, p. 287; "First of May in New York," *Gleason's Pictorial Drawing-Room Companion*, May 10, 1851, p. 21; "Effects of Moving," *Niles' Weekly Register*, May 9, 1835, p. 172; "House-Hunting," *New-York Mirror*, February 29, 1840, p. 287; Felton, *American Life*, p. 52.

83. *Longworth's American Almanac, New-York Register, and City Directory for the Sixty-Second Year of American Independence* (New York: Thomas Longworth, 1837), pp. 17–22.

84. Alexander Mackay, *The Western World; or, Travels in the United States in 1846–47: Exhibiting Them in Their Latest Development Social, Political, and Industrial; Including a Chapter on California*, 2d ed., 3 vols. (London: R. Bentley, 1849), vol. 1, pp. 83, 87 (quote); E. E., "Letters Descriptive of New-York, Written to a Literary Gentleman in Dublin, No. III," *New-York Mirror, and Ladies' Literary Gazette*, January 13, 1827, p. 195.

prosperous than the east, New York was organized on a microscale rather than a macroscale, like most other cities of the first half of the nineteenth century in Europe and America. However exclusive the block or row in which one lived, one was never far from a factory or from people of a different class or ethnicity. This was painfully obvious to Mrs. Ballard, the protagonist of a *Godey's Lady's Book and Magazine* story. She and her husband, Fred, lived in a block of four houses on Nineteenth Street, west of Eighth Avenue, that were "unexceptionable," but "one had to pass certain tenement houses to reach them, and the entire square [block] presented an incongruous mixture of comfort and squalor which one often sees in respectable localities in New York city." The Ballards each suffered their own particular torments in the mixed neighborhood. For him it was "the noisy children swearing on the sidewalk near their pleasant home," while for her it was "the rag man's cart with its noisy bell." The rag man "must have" lived in a rear tenement behind their house, for he tied his dogs to the curbstone in front.[81]

If they were used to mixed neighborhoods, New Yorkers were also used to frequent changes of scene occasioned by the tight housing market and the rapid development of the city. Even wealthy homeowners such as Philip Hone or George Templeton Strong periodically sold their houses and moved farther uptown. Renters of all classes were accustomed to the annual spectacle of Moving Day, May 1, when all leases expired and tenants scrambled to find cartmen who would move them (fig. 12). The streets were full of vehicles rushing from one location to the other, and the failure of a single tenant to move before a new one arrived could induce a chain paralysis that might end up in police court. A side effect of the moving-day custom was that New Yorkers enjoyed an extensive view of the ways their social peers lived. One journalist described two (probably fictitious) sisters who made a hobby of house hunting as a pretext for sniffing out scandalous gossip about their neighbors.[82]

New York's burgeoning antebellum residential neighborhoods complemented its booming commercial and industrial districts. On Wall Street, the center of finance and channel of European capital into the Empire City, banks proliferated (cat. nos. 38, 71). Fifteen of the twenty-nine banks in Manhattan in 1837 were located on or just off Wall Street, along with the Custom House and a succession of merchants' exchanges that culminated in Isaiah Rogers's monumental marble building of 1836–42. Its predecessor, Josiah R. Brady and Martin Euclid Thompson's

Fig. 13. *Broadway, New York, from Canal to Grand Street, West Side,* 1856. Tinted lithograph by Julius Bien, published by W. Stephenson and Company. The Metropolitan Museum of Art, New York, The Edward W. C. Arnold Collection of New York Prints, Maps, and Pictures, Bequest of Edward W. C. Arnold, 1954  54.90.1171

exchange of 1825–26 (cat. nos. 74, 75), had been destroyed in the Great Fire of December 16 and 17, 1835, together with much of the rest of Wall Street and its environs.[83] Along the waterfronts, on Pearl and Front and South streets, wholesale merchants were so busy that they commandeered the sidewalks to stack goods, leaving pedestrians "to jump over boxes, or squeeze yourself, as best you can, between bales of merchandize."[84]

Although New York is no longer commonly thought of as an industrial city, its position at the center of a trade network and its new waterworks made it an industrial power in the mid-nineteenth century. Croton water, used as a raw material in the chemical industry and to supply steam power to a host of other manufacturers, underpinned a 550-percent increase in industrial investment in Manhattan in the two decades after 1840. In 1860 there were over four thousand factories of various sizes scattered throughout the city.[85] There were few New Yorkers of any social class who did not live in close, often vexatious, proximity to several of them.[86]

Retail shops snaked up Broadway and pushed out along its side streets. At the time of the opening of the Erie Canal the premier shopping district centered around City Hall Park, with the portion of Broadway

south of Wall Street given over to elite residences and small hotels (cat. nos. 109, 123). Over the decades the retail district moved gradually north, passing Washington Square by the beginning of the Civil War (cat. no. 180; figs. 13–15).

85. Moehring, "Space, Economic Growth, and the Public Works Revolution," pp. 34–35.

86. See Christine Meisner Rosen, "Noisome, Noxious, and Offensive Vapors: Fumes and Stenches in American Towns

Fig. 14. *Broadway, from Warren to Reade Streets,* ca. 1855. Tinted lithograph with hand coloring by Dumke and Keil, published by W. Stephenson and Company. The Metropolitan Museum of Art, New York, The Edward W. C. Arnold Collection of New York Prints, Maps, and Pictures, Bequest of Edward W. C. Arnold, 1954  54.90.1044

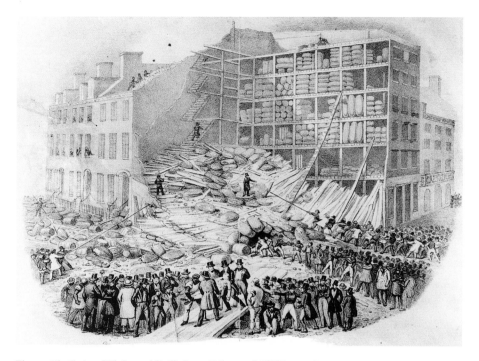

Fig. 15. *The Ruins of Phelps and Peck's Store, Fulton and Cliff Streets, May 4, 1832,* 1832. Lithograph by Edward W. Clay. Collection of The New-York Historical Society

and Cities, 1840–1865," *Historical Geography* 25 (1997), pp. 67–82.

87. "The Peculiar Advantages of Shopping at Columbian Hall" (advertisement), *Christian Parlor Magazine* 9 (1852), p. 2; "Shopping in New-York," *Home Journal,* November 17, 1849, p. 4.

88. [William M. Bobo], *Glimpses of New-York City, by a South Carolinian (Who Had Nothing Else to Do)* (Charleston: J. J. McCarter, 1852), p. 162.

89. Dickens, *American Notes* (1842), in *American Notes and Pictures from Italy* (London and New York: Oxford University Press, 1957), p. 83; Kirkland, "New York," p. 150.

90. [Bobo], *Glimpses of New-York City,* pp. 117–19; "Economy" (advertisement), *Evening Post* (New York), October 22, 1832, p. 4; "A Card" (advertisement), *Morning Courier and New-York Enquirer,* November 1, 1832, p. 1; Madisonian, "Sketches of the Metropolis. The Streets of New-York. Broadway–Chatham-Street," *New-York Mirror,* April 13, 1839, pp. 329–30.

91. "Modern Buildings," *New-York Mirror,* March 15, 1834, p. 295.

92. John F. Watson, *Annals of Philadelphia and Pennsylvania in the Olden Time,* 2d ed.

Broadway was not the only commercial strand. Grand Street was the discount shopping district, while Canal and Catherine streets were also popular retail thoroughfares.[87] On the Bowery, according to South Carolina visitor William Bobo, one could find goods equal to those offered on Broadway at prices 15 to 20 percent lower.[88] Most of the Bowery's businesses, however, dealt in more ordinary commodities such as ready-made clothing, cooked meats, and lively entertainment. One of the city's principal showplaces, the often-burned Bowery Theatre, was located there, along with a zoo and a riding school.[89] Chatham Street and Chatham Square, which connected the southern end of the Bowery to the Park, were the home not only of sidewalk booksellers, pawnbrokers, old-clothes merchants, and "mock auction" houses (where the bidding was rigged against the unsuspecting) but also of silversmiths, jewelers, furniture dealers, and shoe stores (cat. no. 178). Chatham Square was a Jewish residential center (the city's oldest Jewish cemetery is there), and so many Chatham Street merchants were Jewish that it was sometimes referred to as "Jerusalem." It was also the site of the Italian Opera House, which failed and was converted to the National Theatre, a favorite working-class venue.[90]

A stroll along any of these streets in the antebellum decades would have made clear how comfortably the grid accommodated commerce (figs. 13, 14).

Each owner filled his property as he or she saw fit, but the lot lines and the street network articulated the individually defined units into a legible overall order. Each wholesale and retail store was often arranged as a grid within a grid for the same purpose (figs. 15, 16).

Over time commercial prosperity and soaring real-estate values encouraged more and more intensive lot coverage, causing individual structures to balloon upward. This "babel style of building" was already noteworthy in the 1830s.[91] By 1860 it was possible to read a street's real-estate history in its cornice lines, superimposed like archaeological strata (figs. 13, 14). The lowest were the two- and three-story buildings constructed during the 1820s and 1830s. By the 1840s the stories grew taller, and sometimes a fourth or fifth floor was added. After about 1850 six- or seven-story buildings broke what a frantic John Fanning Watson called, in reaction to the same changes in Philadelphia, "the former *line* of equality, and beauty." "*A city building on top of the former!*" he exclaimed. "*All go now on stilts!*"[92] The upward trajectory continued throughout the century. These antebellum buildings, designed to make more intensive use of a lot, were products of real-estate theories that, combined with newer building technologies, produced the skyscrapers of the late nineteenth century.

In commercial streets the thinnest of architectural membranes separated public space from private, and merchants discovered that it was to their advantage to make this membrane as permeable as possible. In wholesale districts granite-piered shopfronts, an idea introduced from Boston about 1830, superseded the round-arched fronts of the 1820s (fig. 17).[93] The granite piers permitted wider openings and less separation between store and street. For the same reasons cast-iron piers replaced granite at midcentury. Except for these thin supports, the fronts of the buildings were completely opened up to extend the circulatory space of the sidewalk into the stores and to spill their contents onto the sidewalk. There they were sheltered by block-long rows of awnings, supported on curbside posts, that commandeered public space as a commercial showroom.[94] In retail districts the process of opening up led from the bow or "bulk" windows of the late eighteenth century to the large plate-glass shopfronts of midcentury (fig. 14). In unpretentious shopping districts such as the Bowery, even retail stores might have open fronts. One visitor discovered that in the Bowery's most commercial stretches, no residences or offices interrupted the unbroken line of open-fronted shops, so that "the sides of the streets

Fig. 16. *Salesroom, Main Floor, Haughwout Building, New York*. Wood engraving by Nathaniel Orr and Company, from *Cosmopolitan Art Journal* 3 (June 1859), p. 142. The Metropolitan Museum of Art, New York, The Thomas J. Watson Library

(Philadelphia: J. B. Lippincott, 1868), p. 591. These lines were written for Watson's "Final Appendix of the Year 1856."

93. One journalist identified Ithiel Town's Pearl Street store for Arthur Tappan as the first granite-piered warehouse in New York; see "The Architects and Architecture of New York," *Brother Jonathan*, May 27, 1843, pp. 91–92.

94. Mackay, *Western World*, vol. 1, p. 87; Asa Greene, *A Glance at New York: Embracing the City Government, Theatres, Hotels, Churches, Mobs, Monopolies, Learned Professions, Newspapers, Rogues, Dandies, Fires and Firemen, Water and Other Liquids, &c., &c.* (New York: A. Greene, Craighead and Allen, Printers, 1837), pp. 7, 10.

95. [Bobo], *Glimpses of New-York City*, p. 163; Kirkland, "New York," p. 150.

appear to be all door, and the walls only separate the different concerns."[95]

Whatever their size or date these buildings were constructed as layers of open, flexible, but carefully arranged space, unbroken except for stairs. This is evident in an unusually detailed interior description of the renowned Haughwout Building, built in 1856 at the corner of Broadway and Broome Street as the second home of E. V. Haughwout and Company (cat. no. 98). Like many antebellum retailers Haughwout's manufactured much of what it sold, and it decorated or embellished merchandise procured from other suppliers as well. The new building was a "monster manufacturing and sales establishment" that "embraces

Fig. 17. *Wholesale Store, 200 Block, Water Street, New York,* building, 1827; photograph by Dell Upton, July 1998

*Plate XLIX.*

Elevations and Sections of Columns and Capitals.

ARCHITECTURAL IRON WORKS,—NEW-YORK.

Fig. 18. *Cast-Iron Components*. Lithograph, from *Badger's Architectural Iron Work Catalogue* (New York: Baker and Godwin, 1865), pl. 49. Cooper-Hewitt, National Design Museum, Smithsonian Institution, Washington, D.C.

96. "Department of Useful Art. First Article. The Haughwout Establishment," *Cosmopolitan Art Journal* 3 (June 1859), pp. 141–47, quote on p. 141. The Haughwout firm was founded in 1832. The Haughwout Building's steam-powered elevator was Elisha Otis's first commercial installation, although other kinds of mechanical elevators had been used in New York at least since Holt's Hotel opened on Fulton Street in 1832. See Sarah Bradford Landau and Carl W. Condit, *Rise of the New York Skyscraper, 1865–1913* (New Haven: Yale University Press, 1996), pp. 35–36; and "Holt's Marble Building," *Morning Courier and New-York Enquirer*, January 1, 1833, p. 2.

97. Carl R. Lounsbury, "The Wild Melody of Steam: The Mechanization of the Manufacture

more in value and interest than any single building in the world (if we except the Crystal Palace at Sydenham, England)," according to a journalist who visited it soon after it opened. The seven stories, five above ground and two below, were arranged like a grain mill, meaning that goods entered at the lowest level, the cellar, and were taken by steam-powered elevator to the top. There they were processed on the fourth and fifth floors, before filtering down, level by level, as far as the basement, where "plain and heavy goods (crockery)" for ships, hotels, and the wholesale trade were sold, along with seconds. The first floor offered silver and silver plate, as well as antiques and luxury items such as bronze and Parian statuettes (fig. 16); china and glass occupied the second floor; and Haughwout's original stock-in-trade, chandeliers and lamps, was displayed on the third.[96]

As in many commercial buildings, vaults extended under the sidewalks. Borrowing a page from the

organizational patterns of contemporary textile mills, where ancillary services were confined to projecting towers to keep the manufacturing floor free of obstructions, Haughwout's shipping and receiving clerks worked in the vaults under Broadway and Broome Street, leaving the cellar floor unencumbered. Other offices were located at the rear of the first floor, a legacy of eighteenth- and early-nineteenth-century merchants' counting houses.

The fabrication of antebellum commercial structures was as rationalized as their operation. Building construction was organized by modules based on the customary sizes of building materials. American and British bricks were made to a standard size that determined wall thicknesses, wall heights, and the size and position of openings. Timbers, window lights, and other components were also made to standard proportions. This meant that many building parts could be prefabricated off site. With the introduction of steam machinery in the second quarter of the nineteenth century, sash-and-blind factories turned out vast numbers of standardized doors, windows, shutters, mantels, and decorative elements.[97]

Beginning with James Bogardus's remodeling of John Milhau's drugstore at 183 Broadway in 1848, ironmasters made cast-iron decorative elements and entire facades that could be fastened to commercial structures such as the Haughwout Building, whose facades were fabricated by the pioneer cast-iron manufacturers Daniel D. Badger and Company (cat. no. 98; fig. 18).[98] Cast iron offered economies of scale in production over even the wooden components produced by sash-and-blind factories. Rather than carving the same decorative element in an endless series of wooden or marble blocks, the artisan could make

Fig. 19. *Haughwout Building*, constructed 1856; photograph by Dell Upton, November 1999

a single wooden mold from which an infinite number of cast-iron elements could be formed.[99] This promoted building design that was as modular as the street grid, with monumental facades built up of many small, repeated elements (fig. 19).

### Consuming New York

Haughwout's rationalized spatial organization, building process, and business practices served the consumption of luxury goods, a distinctly irrational social process. Consumption is the construction of self through seeking, acquiring, and appreciating material objects; we might describe it as a search for personal urbanity. It hinges on the promise that in purchasing an object, the consumer acquires access to some desirable but intangible experience that cannot be directly bought. Consumption aims less to satisfy a desire for a social identity than one for the sense of secure being that the sociologist Colin Campbell calls, simply, *pleasure*. Pleasure encompasses both sensory stimulation—"an 'excited state in us' "—say, in the feel of a silk garment, the sound of a song well sung, or the glint of the polished surfaces of a mahogany table, and the satisfaction that these sensations create.[100] Since such pleasures produce only a momentary sense of fulfillment, the process of consumption never comes to an end but exists as a constant state of desire, acquisition, and renewed desire.

The material language of consumption in antebellum New York was borrowed from the preindustrial aristocracy. To nineteenth-century eyes cast-iron classical ornament (and the marble ornament to which it referred) gave the city's retail stores the air of "mercantile palaces."[101] Haughwout's was a "palace of industry" (cat. no. 98).[102] According to the editor of *Harper's*, an immigrant, on first beholding A. T. Stewart's dry-goods store or Broadway's luxury hotels such as the Irving, the Astor House, and the Saint Nicholas, would be likely to ask: "What are these splendid palaces?"[103] On the one hand, such buildings served to democratize American luxury as a form of republican equality: "*Here* palaces are for the people."[104] On the other, they offered New Yorkers the luxuries of the "repudiated aristocracy" that Caroline Kirkland challenged.

The association of mass-produced consumer goods with the tastes and prestige of aristocracy was a sales technique invented by English ceramic manufacturer Josiah Wedgwood in the eighteenth century, but luxury-goods vendors in antebellum New York found that it was still effective a century later.[105]

The journalist who visited Haughwout's store was careful to list the prestigious commissions that the firm had received—from the governor-general of Cuba, Czar Nicholas II of Russia, the "Imaum of Muscat," and the United States government as a gift to the emperor of Japan, among others.[106] To buy the same chandelier as Nicholas II would not make the purchaser a czar, or cause him to be mistaken for one, but it offered the possibility that by inhabiting the same material world he might enjoy some of the sybaritic pleasures that the czar commanded—that he might, in short, feel czarlike.

The association with specific elite customers at establishments such as Haughwout's was corollary to an evocation of luxury that began with the architectural imagery of the long procession of "palaces" that lined Broadway and continued inside each one, where customers found counters "heaped in wild profusion with every imaginable dainty that loom and fingers and rich dyes and the exhausted skill of human invention have succeeded in producing—drawn together by the magic power of taste and capital."[107] Profusion was the key. Shoppers confronted items too numerous to count or to experience individually. The generalized experience of luxury en masse promised nonspecific, and thus potentially more intense, pleasure.

Alexander T. Stewart, who emigrated from Ireland and opened a store at 283 Broadway in 1823, quickly mastered and refined these techniques. For that reason he enjoyed a reputation throughout the antebellum period as New York's premier dry-goods merchant, a man with a "character for urbanity, fairness of dealing and the immense stock of goods," at a time when dry goods accounted for over half the city's business.[108] His success eventually made him the second wealthiest property owner in New York, after William B. Astor, and allowed him to become one of the city's premier art collectors.[109]

In 1844 Stewart began to construct a five-story "*drygoods palace*" on Broadway at Chambers Street (soon extended to Reade Street), across from "the low-browed and dingy long-room" he had occupied for two decades: " 'Shopping' is to be invested with architectural glories—as if its Circean cup was not already sufficiently seductive."[110] The project attracted great interest, spurred by the tantalizing refusal of the architect Joseph Trench to let his design be published before the building was finished (cat. no. 96).[111] The interior of A. T. Stewart's was organized around a light court, treated as a hall 100 feet by 40, 80 feet high, topped by a dome. As befit a royal setting, the

of Building Materials, 1850–1890," in *Architects and Builders in North Carolina: A History of the Practice of Building,* by Catherine W. Bishir et al. (Chapel Hill: University of North Carolina Press, 1990), pp. 212–19, 221–26.

98. "New Uses of Iron," *Home Journal,* October 21, 1854, p. 2; Margot Gayle and Carol Gayle, *Cast-Iron Architecture in America: The Significance of James Bogardus* (New York: W. W. Norton, 1998), pp. 77–81, 224–25.

99. See James Bogardus [with John W. Thompson], "Cast Iron Buildings" (1856), in *America Builds: Source Documents in American Architecture and Planning,* edited by Leland M. Roth (New York: Harper and Row, 1983), p. 72; and Gayle and Gayle, *Cast-Iron in America,* pp. 220–21.

100. Colin Campbell, *The Romantic Ethic and the Spirit of Modern Consumerism* (Oxford: Basil Blackwell, 1987), p. 63; Peter Lunt, "Psychological Approaches to Consumption: Varieties of Research—Past, Present and Future," in *Acknowledging Consumption: A Review of New Studies,* edited by Daniel Miller (London: Routledge, 1994), p. 249.

101. "Mercantile Palaces of New York," *Frank Leslie's Illustrated Newspaper,* June 20, 1857, p. 38.

102. "Palace of Industry," *The Independent,* May 7, 1857, p. 1.

103. "Editor's Easy Chair," *Harper's New Monthly Magazine* 7 (November 1853), p. 845.

104. "Fashionable Promenades," *United States Review,* n.s., 2 (September 1853), p. 233.

105. Neil McKendrick, "Josiah Wedgwood and the Commercialization of the Potteries," in *The Birth of a Consumer Society: The Commercialization of Eighteenth-Century England,* by Neil McKendrick, John Brewer, and J. H. Plumb (Bloomington: Indiana University Press, 1982), pp. 108–12.

106. "Department of Useful Art," pp. 143–44.

107. "Shopping in Broadway," *Holden's Dollar Magazine* 3 (May 1849), p. 320.

108. "New-York Daguerreotyped. Business-Streets, Mercantile Blocks, Stores, and Banks," *Putnam's Monthly* 1 (April 1853), p. 356; "The Dry Goods Stores of Broadway," *Home Journal,* October 27, 1849, p. 3 (quote). New York imported 75

percent of the nation's textiles; see Moehring, "Space, Economic Growth, and the Public Works Revolution," p. 31.

109. Spann, *New Metropolis*, p. 208.

110. "Diary of Town Trifles," *New Mirror*, May 18, 1844, p. 104; "Topics of the Month," *Holden's Dollar Magazine* 1 (March 1848), p. 187.

111. "Architecture," *Broadway Journal*, March 22, 1845, p. 188.

112. "New-York Daguerreotyped," p. 358; "Dry Goods Stores of Broadway," p. 3.

113. Alice B. Neal, "The Flitting," *Godey's Lady's Book and Magazine* 54 (April 1857), p. 331.

114. "Shop Windows," *New-York Mirror, and Ladies' Literary Gazette*, September 27, 1828, p. 93.

115. "Directions to Ladies for Shopping," *Anglo American*, October 26, 1844, p. 14.

116. Alexander Walker, *Woman Physiologically Considered, as to Mind, Morals, Marriage, Matrimonial Slavery, Infidelity and Divorce* (New York: N.p., 1843), pp. 7–10; "Literary Notices. Domestic Duties," *American Ladies' Magazine* 2 (January 1829), p. 45; Mary R. Mitford, "Shopping," *New-York Mirror, and Ladies' Literary Gazette* January 31, 1829, pp. 233–34; "Going a Shopping," *Arthur's Home Magazine* 2 (November 1853), pp. 329–31.

117. "Shopping in Broadway," p. 320.

118. "Why People Board," *Godey's Lady's Book* 46 (May 1853), p. 476.

119. "The Wife's Error," *Godey's Lady's Book* 46 (June 1853), p. 495.

120. Bridges, *City in the Republic*, p. 81.

121. "Directions to Ladies for Shopping," p. 14; "Literary Notices. Domestic Duties," p. 45; "Shopping in Broadway," p. 320.

122. "Shopping in Broadway," p. 320.

123. "Shop Windows," *New-York Mirror, and Ladies' Literary Gazette*, September 27, 1828, p. 93.

walls of his "Marble Palace" were hung with paintings, while merchandise—"every variety and every available style of fabrics in the market"—was piled on every surface and suspended from the ceilings and even the dome (cat. nos. 201, 219).[112] This spectacle finally overcame Mrs. Cooper, the protagonist of an Alice B. Neal short story, on a visit to Stewart's: "She cared very little for dress, and could look at the gorgeous brocades, suspended in the rotunda, as quietly as she did at the painted window-shades of her opposite neighbor. It cost no effort to pass by the lace and embroideries of the intervening room, or to turn her back upon the enticing cloaks and mantles beyond; but those fleecy blankets, those serviceable table-covers, the rolls of towelling, and, above all, the snowy damask piled endwise, as children do their cob-houses, were a sore temptation."[113]

Nineteenth-century commentators recognized the ways in which sales techniques stimulated desire, even if they could not always put their fingers on them. The *New-York Mirror, and Ladies' Literary Gazette* described shop windows as the staging ground of a dance of desire that involved both consumer and merchant. The passerby who "looks attentively and delightedly at a shop-window, pleases two people. He pleases himself by indulging his curiosity, or by gratifying his taste; and he pleases the shopkeeper by the unartificial homage which he thus pays to the taste which arranged the articles, and by the promise which he thus holds out of the probability of his becoming a purchaser."[114] The *Anglo American*, too, sensed the nonspecific nature of consumer desire, offering a vignette of the shopper who sets out in search of a specific item, only to end up with a whole wardrobe as the result of the clerk's inquiry as to "'whether there is any other article today?' Whether there is or not, let the shopman show you what wares he pleases; you will very likely desire one or more of them."[115]

Women were already stereotyped as the primary shoppers and the most avid and helpless of consumers. As weak-minded creatures with tenuous senses of selfhood, they were peculiarly susceptible to the blandishments of goods for sale, for their sensibilities were powerful but their reason was not.[116] Shopping seemed to produce in them "unnatural excitements," and in some unfortunates "a morbid excitement of the organ of acquisitiveness," leading them to shoplift.[117] Worse, consumption seemed to violate the ideology that identified women as the keepers of higher values in the home, and therefore as creatures who existed outside the realm of commerce. Domestic moralists decried middle-class women's willingness to sacrifice "the very root and foundation of domestic privacy, and love, and faith" by taking in boarders, an act that they attributed to a craving for "ornamental statuettes, vases, clocks, and literally 'what-nots.'"[118]

Shopping was the complement of business: while men toiled to earn money at the Merchants' Exchange, women spent it at the "Ladies' Exchange"—Stewart's.[119] Yet antebellum political economy recognized only production and accumulation as healthy economic activities.[120] In consuming, women entered the economy at the wrong end, for consumption was a kind of fraud. If a woman bought, she squandered her husband's laboriously acquired wealth; if she simply browsed, she cheated male clerks out of their livelihoods; if she shoplifted, she committed the equivalent of stock speculation and fraudulent bankruptcy.[121]

As the antithesis of production, consumption threatened republican values, particularly the rights of men to the fruits of their labor. Women were "the empresses and sultanas of our republican metropolis," seated before counters heaped with luxurious goods, while their husbands were "slaves of the dirty mines and dingy laboratories of Wall street and 'down town' . . . delving their lives out to wring from the accidents, the mistakes and the necessities of society the yellow dust that invests their ambitious household divinities with these magnificent adornments."[122]

## The World in Little

The political economy of consumption dramatically challenged a primordial assumption of republican citizenship, which emphasized the pursuit of knowledge as a path to virtue and the obligation of the learned and the talented to instruct their fellow citizens. The impulses to investigate and to educate were alive in New York intellectual life and popular culture throughout the antebellum era, but more and more they flowed through commercial channels. "We have heard of a young man who learned geography by means of mapsellers' windows," wrote the *New-York Mirror, and Ladies' Literary Gazette* in 1828. "That was certainly stealing knowledge; but he could not afford to pay for it, and therefore, the theft was easily forgiven."[123]

The expansive Enlightenment confidence in the human ability to encompass all knowledge was subsumed by New Yorkers' sense of their power to acquire anything the world offered. "Every article which can please the fancy is here daily exposed to the gaze of the curious," wrote the pseudonymous

Fig. 20. *The Five Senses—No. 1, Seeing.* Wood engraving, from *Harper's New Monthly Magazine* 9 (October 1854), p. 714. Courtesy of the American Antiquarian Society, Worcester, Massachusetts

Madisonian.[124] In the words of another observer of the city, "Whatever art has manufactured for the comfort and convenience of man, is exposed for sale in her markets. If Europe affords a luxury, it is there; and if Asia has aught rich or splendid, *money* will procure it in New-York."[125]

Not only merchandise but also lectures, theatrical performances, minstrel shows, symphonic, vocal, and band concerts, operas, freak shows, public gardens, fireworks displays, botanical exhibits, commercial museums and galleries, and other diversions were available for a price along New York's great commercial streets, side by side with the more carnal delights available in the many saloons and brothels scattered throughout the city, but particularly thick in the mid-nineteenth century in the entertainment district of Broadway.

As it was commercialized, though, the universal popular education of republican ideals was transformed into privatized spectacle, its content from public knowledge to salable commodity, its purpose from civic training to personal pleasure (fig. 20). Spectacle emphasized the striking and exaggerated fragment over the systematic totality, astonishment over understanding, passive consumption over active investigation, gratification over edification.

The process was most evident in the transformation of such characteristically republican institutions as Charles Willson Peale's Philadelphia Museum, which was briefly reincarnated at the corner of Broadway and Vesey Street in New York by his son Rubens. The younger Peale presented his Museum and Gallery of the Fine Arts, which opened on October 26, 1825, the day of the Erie Canal celebration, as an enterprise with the same intent and format as his father's, but his instructive human prodigies soon became a collection of freaks to compete with the American Museum across Broadway.[126] After P. T. Barnum bought the American Museum in 1840, General Tom Thumb was usually in residence there (cat. no. 168), and from time to time customers could inspect such sights as a "real *Albiness* and his mighty *highness*, the Irish Giant," or "*fifteen Indians and Squaws . . . in their* NATIVE *costume*," who were "well authenticated as the first people of their important tribes." A journalist who covered the Native Americans' appearances wondered whether, "in becoming a shilling show at the Museum, they have entered civilized society upon a stratum parallel to their own."[127]

Freak shows and the like were offered under the guise of "rational amusement" and republican education, not only at the American Museum but at more

124. Madisonian, "Sketches of the Metropolis," pp. 329–30.
125. Northern Star, "The Observer," p. 147.
126. Sellers, *Mr. Peale's Museum*, pp. 249, 256–57; "Fourth of July. Peale's Museum" (advertisement), *New-York Evening Post,* July 1, 1826, p. 3; "Peale's Museum" (advertisement), *New-York Evening Post,* July 14, 1826, p. 2; "American Museum" (advertisement), *New-York Evening Post,* October 1, 1832, p. 1.
127. "American Museum," *The New-Yorker,* May 12, 1838, p. 125; "Sketches of New-York," *New Mirror,* May 13, 1843, p. 86. Many of the Indians died in New York before they could return to their homes.

Fig. 21. *The Aztec Children: Two Active, Sprightly, Intelligent Little Beings.* Wood engraving, from *The Republic* 3 (February 1852), unpaginated advertisement at end of issue

interest and sparked a debate over whether the children were "specimens of a historic race now extinct" or merely "idiotic dwarfs."[129]

New Yorkers made little effort to distinguish "high" from "low" culture among these offerings. Instead the entertainment offered for sale in antebellum New York was classified as moral, uplifting, and respectable or immoral, debasing, and disreputable. While Barnum assured visitors to his American Museum that the exhibitions were "conducted with the utmost propriety," and the hybrid or semihuman Indian from Mexico was commended for her "refined taste and remarkable disposition," a journalist attacked the drama *Camille*, then playing in New York, as a work in which "the morals of a courtesan [are] presented for the admiration of youth." It was an "attempt to make consumption and the interior of a sick room, a subject fit only for the wards of a hospital, attractive and artistic," which he thought "melancholy proof of a depraved public taste."[130]

Consequently a hybrid experience awaited most patrons of the city's commercial pleasures. The public gardens that antebellum New Yorkers enthusiastically patronized offer a good example of the routine mixture of what would now be thought of as radically different kinds of entertainment. Public gardens did not necessarily include gardens in the commonly understood sense of the term, although that was their origin. Instead they were primarily staging areas for any sort of entertainment for which New Yorkers would willingly pay.

Niblo's Garden, opened by William Niblo at 576 Broadway in 1828, was the best known and probably the favorite of these establishments (fig. 22).[131] At first music and fireworks were Niblo's staples, but he continually added attractions. On July 15, 1839, he offered the Ravel family's "astonishing performance on the CORD ELASTIQUE," along with "THREE ROMAN GLADIATORS" by three of the Ravels; then, after intermission, "L'UOMO ROSSO: Or, the Unforeseen Illusion," a "pantomime" that featured "a full Gallopade, by the Corps-de-Ballet of 30 persons." In addition Niblo's own orchestra played two overtures.[132] Early on Niblo added Italian opera and "Vaudevilles" to his bill, and at other times he presented military bands, operatic ballets, and Signor Gambati, a celebrated valve trumpeter.[133] On one occasion visitors could examine a panorama of Jerusalem, based on a David Roberts painting.[134] Niblo's "was more like a bazaar of all amusements, than a mere theatre, a garden, or a *salon de plaisir.*"[135] At the same time its owner assured the public that "efficient officers" were present

128. "The Hybrid or Semi-Human Indian" (advertisement), *New-York Daily Times*, December 8, 1854, p. 5.
129. "Two Living Specimens of the Aztec Race" (advertisement), *The Independent*, January 1, 1852, p. 4; "The Aztec Children," *The Independent*, January 15, 1852, p. 10.

genteel institutions as well. Masonic Hall offered "the hybrid or semi-human Indian from Mexico," purportedly a cross between a woman and an orangutan, whose appearances were said to be "daily thronged by medical or scientific men."[128] At the New York Society Library one could see the famed Aztec Children, "a PIGMEAN VARIETY OF THE HUMAN RACE!" (fig. 21). Again the exhibition was claimed to be of scientific

Fig. 22. *Niblo's Garden, Broadway, New York*. Wood engraving, from *Gleason's Pictorial Drawing-Room Companion* 2 (March 6, 1852), p. 145. Courtesy of the American Antiquarian Society, Worcester, Massachusetts

to prevent the admission of "improper persons," by which he meant unaccompanied women.[136]

Public gardens were traditionally relandscaped and embellished anew each year to keep patrons from becoming bored. Niblo not only regularly reconfigured his garden but also filled it with "saloons," theaters, and concert halls, all cast in the palatial imagery of consumerism, to house his long-running acts.[137] On September 18, 1846, Niblo's Garden burned, destroying his greenhouses, theaters, and workshops.[138] The fate of the site was uncertain until the *Home Journal* reported in 1849 that William Niblo had "regained possession of the field of his former triumphs" and intended to rebuild a theater, garden, restaurant, dancing saloon, and arbor.[139] In that year the rebuilt theater became the home of the New York Philharmonic.

## The Urban Spectacle

The consumption of goods and images transformed the concept of republican citizenship. Theoretically New Yorkers knew there was a difference between outward appearance and the true self. In his diary Philip Hone wrote a brief essay, "Dress," in which he commented on the responsibility of older men and women to dress well: "An old House requires painting more than a new one." But they also ought to dress appropriately, soberly and not gaudily. He was scandalized by the refusal of his friend Daniel Webster to appear "in the only dress in which he should appear—the

respectable and dignified suit of black." Instead Webster was fond of "tawdry," multicolored clothes: "I was much amused a day or two since by meeting him in Wall Street, at high noon, in a bright, blue Satin Vest, sprigged with gold flowers, a costume incongruous for Daniel Webster, as Ostrich feathers for a Sister of Charity, or a small Sword for a Judge of Probates. There is a strange discrepancy in this instance between 'the outward and visible form, and the inward and spiritual grace,' the integuments and the intellect."[140]

In practice, though, New Yorkers were beginning to judge one another by their public presentation. The respectable and those who aspired to respectability adopted new codes of refinement that identified them to one another visually, set them apart from their neighbors, and rendered them more like people of similar social standing in other parts of the world.[141] As Caroline Kirkland observed, New York was "fast assuming a cosmopolitan tone," making it "difficult to speak of any particular style of manners as prevailing."[142] This code of gentility emphasized bodily comportment and speech, tasteful consumption, and highly selective sociability. The satirist Francis J. Grund was amused to see how assiduously the New York gentry avoided their fellow citizens: "our fashionable Americans do not wish to be seen with the people; they dread that more than the tempest."[143]

Gentility was learned behavior. Readers of the *Home Journal* could seek out the services of Madame Barbier, at 4 Great Jones Street, to teach them "a cultivated

130. "American Museum," *Ladies' Companion* 19 (July 1843), p. 154; "Hybrid or Semi-Human Indian," p. 5; "The Church. All-Soul's Church.–(Unitarian)," *United States Magazine* 4 (April 1857), p. 417.

131. "Niblo's," *Gleason's Pictorial Drawing-Room Companion*, May 14, 1853, p. 308.

132. "Niblo's Garden" (advertisement), *Morning Courier and New-York Enquirer*, July 15, 1839.

133. "Niblo's Garden," *New-York Mirror*, June 7, 1834, p. 391; "Niblo's Garden," *The New-Yorker*, May 26, 1838, p. 158; "Niblo's Garden Is Now Open for the Season" (advertisement), *Evening Post* (New York), June 30, 1836, n.p.; "Niblo's Garden," *Ladies' Companion* 11 (May 1839), p. 50; "Niblo's Garden," *Evening Post* (New York), June 30, 1836.

134. "Fine Arts—Niblo's," *Ladies' Companion* 2 (February 1835), p. 192; "The Diorama," *New-York Mirror*, January 3, 1835, p. 214.

135. "The New Niblo," *Home Journal*, April 21, 1849, p. 2.

136. "Niblo's Garden Is Now Open for the Season"; George G. Foster, *New York by Gas-Light and Other Urban Sketches*, edited by Stuart M. Blumin (Berkeley: University of California Press, 1990), p. 157.

137. "Niblo's Garden," *The Corsair*, June 15, 1839, p. 219; "Niblo's

Garden," *Ladies' Companion* 11 (May 1839), p. 50; "Niblo's" (*Gleason's*), pp. 308–9.

138. Philip Hone, Diary, entry for September 18, 1846, The New-York Historical Society; microfilm available at the Thomas J. Watson Library, Metropolitan Museum; "Niblo's" (*Gleason's*), p. 308.

139. "New Niblo," p. 2.

140. Hone, Diary, entry for March 29, 1845, The New-York Historical Society.

141. Richard L. Bushman, *The Refinement of America: Persons, Houses, Cities* (New York: Knopf, 1992); John F. Kasson, *Rudeness and Civility: Manners in Nineteenth-Century Urban America* (New York: Hill and Wang, 1990); Cary Carson, "The Consumer Revolution in Colonial British America: Why Demand?" in *Of Consuming Interests: The Style of Life in the Eighteenth Century,* edited by Cary Carson, Ronald Hoffman, and Peter J. Albert (Charlottesville: University Press of Virginia for the United States Capitol Historical Society, 1994), p. 521.

142. Kirkland, "New York."

143. Francis J. Grund, *Aristocracy in America from the Sketch-Book of a German Nobleman,* 2 vols. (London: Richard Bentley, 1839), vol. 1, p. 19.

manner of speaking" French and of Clark's Broadway Tailoring, nearby at the corner of Broadway and Bleecker Street, to obtain men's clothes that "impart ease and elegance to the figure," even "TO THOSE WHO HAVE NO TASTE," with the assistance of Clark's "gentlemanly assistants."[144] Although it was learned, gentility was also thought to signal some essential difference between the genteel and the hoi polloi. Some groups, notably African Americans and the Irish, were constitutionally unable to learn gentility, while ordinary white artisans and working-class men and women never quite got it. Try as they might, they fell far short of the mark or overshot it laughably (fig. 23). Conservative satirists such as the cartoonist Edward W. Clay made a living lampooning their efforts (fig. 31).[145]

In short, while early republicans emphasized the essential similarities among all citizens, antebellum New Yorkers began to stress the differences. Immigration and the growing segregation of social classes within the city meant that, as midcentury passed, middle-class and well-to-do New Yorkers had less contact with their inferiors and knew less about them. Increasingly the city seemed to them to be populated with men and women whose departure from the neutral standard of refined behavior was at best picturesque, at worst threatening. In art, literature, journalism, theater, and other forms of popular culture,

better-off New Yorkers viewed their poorer neighbors as spectacles only slightly less exotic than the Aztec Children (figs. 24, 25).

As they confronted this human spectacle, New York's cultural arbiters turned toward what the art historian Elizabeth Johns has called *typing*, a process that tamed the complexity of the antebellum city by grouping its occupants into a limited number of generic characters.[146] Visual and verbal reporters also imagined urban spatial types as habitats for their human types, mapping a series of distinctive social regions onto the evenly articulated grid of republican New York.

Writers and artists heightened the effect of typing by juxtaposition, a technique that we have already seen employed in merchandising and one that was an artistic cliché by midcentury. To set the most disparate human and spatial types into the closest possible proximity transformed the classificatory list of eighteenth-century science into a dramatic, high-relief portrait of nineteenth-century New York. In this mode one writer described the ships in New York harbor as national types: there were the "Yorker," the "substantial representative of Old England," the "Dutchman," the "clumsy Dane," the Norwegian polacca, and the "'long-limbed' brigs and schooners that come from 'down east.'"[147]

Despite the rapid growth of their city and the mixture of people and activities that characterized every block of it, New Yorkers seized on a handful of sites as emblematic of fundamental truths about its makeup. Wall Street, Five Points, the Bowery, and, most of all, Broadway were particular favorites.

Wall Street, with the elite Trinity Church at its head and the docks at its foot, punctuated by the great banking houses, by Brady and Thompson's Merchants' Exchange (cat. no. 74), succeeded by that of Isaiah Rogers, and by the grand Greek Revival Custom House (cat. no. 81), stood for contemporary New York as a financial center in all its positive and negative aspects. Because so much of the street was burned in the fire of 1835 (cat. nos. 110, 111; fig. 6), there was little to remind one of the past; it spoke of New York's present and its future. In Wall Street, "the far-famed mart for bankers, brokers, underwriters, and stock-jobbers," "Every thing is on a grand scale [and] the talk is of millions."[148] But in an age when a large portion of the political public was suspicious of "speculation" as a nonproductive drain on the economy and an assault on those who worked for an honest living, Wall Street was also seen as the home of "*Shylocks* and *over-reachers,* yclept Money

Fig. 23. *Life in New York, No. 4, Inconveniency of Tight Lacing, Saint John's Park, September 28, 1829.* Lithograph by Anthony Imbert. The Library Company of Philadelphia

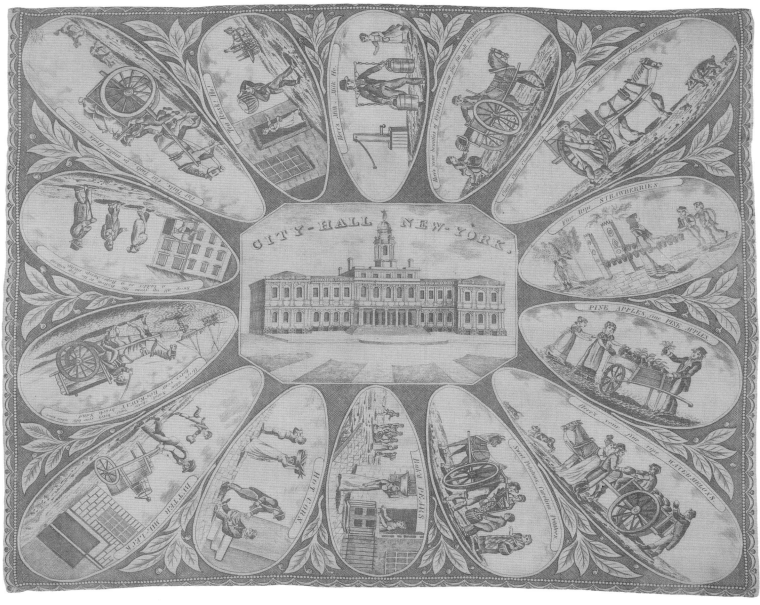

Fig. 24. Manufacturer unknown, probably English for the New York City market, The Cries of New York commemorative handkerchief, 1815–20. Copperplate-printed cotton. The Metropolitan Museum of Art, New York, Rogers Fund, 1968  68.60

Brokers," who "carry on their occult operations against the fortunes and opulence of the unwary and credulous portion of the community."[149] The disruption of traffic occasioned by reconstruction after the fire brought out New Yorkers' feelings. Forced to pick their way through the confusion, passersby muttered "what d—d nonsense!," which registered "generally expressed feelings of bitterness against the banks—for bearing so hard on the mercantile community," in the opinion of George Templeton Strong.[150] Antebellum Americans were acutely aware of the volatility of individual fortunes, and Wall Street seemed to exemplify that: "We never pass Wall-street without a shudder. Who knows but what at the

moment we pass it, some infernally ingenious speculator is planning a financial juggle by which he is to make a fortune, and at least fifty of us to be ruined somehow or other right off!"[151]

A wood engraving of the street in 1855 shows a busy thoroughfare lined with substantial buildings, including the Merchants' Exchange at the left (fig. 26). According to the accompanying text, the sidewalk swarms with types personifying Wall Street's suspect character. The artist

*has shown us the "bulls and bears," the curb stone brokers, the speculators in "fancies," the heavy capitalists, the needy "shinners," all who blow bubbles*

144. "Madame Barbier" (advertisement), *Home Journal,* October 6, 1855, p. 3; "Clark's Broadway Tailoring" (advertisement), *Home Journal,* May 3, 1851, p. 3.

145. Nancy Reynolds Davison, "E. W. Clay: American Political Caricaturist of the Jacksonian Era" (Ph.D. dissertation, University of Michigan, Ann Arbor, 1980).

146. Elizabeth Johns, *American Genre Painting: The Politics of Everyday Life* (New Haven: Yale University Press, 1991), pp. xii–xiii, 12–22.

147. Northern Star, "The Observer"; "Editor's Drawer," *Harper's*

*New Monthly Magazine* 9 (August 1854), p. 421.

148. "Street Views in New-York. Wall-Street," *New-York Mirror*, January 21, 1832, pp. 225–26; "Wall-street," *New-York Mirror*, December 6, 1834, p. 183.

149. E. E., "Letters Descriptive of New-York . . . No. III," p. 195.

150. George Templeton Strong, Diary, entry for October 5, 1839, The New-York Historical Society.

151. "Fashionable Promenades," p. 235.

152. "New York in 1855 and 1660," *Ballou's Pictorial Drawing-Room Companion*, April 21, 1855, p. 248. The writer of the article, published in a Boston periodical, confuses the Merchants' Exchange, illustrated in fig. 26, with the Custom House, not represented.

153. [Nathaniel P. Willis], "Diary of Town Trifles," *New Mirror*, May 18, 1844, p. 104; Moehring, "Space, Economic Growth and the Public Works Revolution," p. 34.

Fig. 25. Nicolino Calyo, *The Hot-Corn Seller,* 1840–44. Watercolor. Museum of the City of New York, Gift of Mrs. Francis P. Garvin in Memory of Francis P. Garvin Rowse

NEW YORK IN 1855.

Fig. 26. *New York in 1855.* Wood engraving, from *Ballou's Pictorial Drawing-Room Companion,* April 21, 1855, p. 248. Courtesy of the American Antiquarian Society, Worcester, Massachusetts

and buy bubbles, who disperse wealth and pursue wealth, congregated about the choicest abodes of Plutus, the haunts of mammon, in the great imperial city. You see men there who live in palaces, and dispense a regal hospitality away up town—you behold flashy adventurers whose whole wealth is on their backs—many a wealthy old Israelite who could draw a check for two hundred thousand dollars at a moment's notice, and yet who dresses as shabbily as an "o'clo" man, while young Judea exhibits his degeneracy in varnished boots, oiled mustachios, finger-rings, chains and a diamond breastpin.[152]

The juxtaposed types and the casually employed ethnic stereotype leapt from the writer's mind far more readily than they did from the illustration.

At the opposite end of the economic ladder, Five Points stood for the worst that could be feared of an enormous democratic city (figs. 11, 27). The name was derived from the since-vanished irregular intersection of five streets: Mulberry, Anthony (now Worth), Cross (Park), Orange (Baxter), and Little Water (no longer extant); but it applied more generally to the Sixth Ward just northeast of City Hall, north of Chatham Street, on and around the filled-in Collect Pond (fig. 4). This "Valley of Poverty" was represented as a collection of run-down housing and questionable businesses, occupied by some of New York's poorest citizens, although it was also an important industrial district, the scene of various sorts of metal fabrication and sugar and confectionery manufacture.[153] Bogardus's and Badger's ironworks stood just two blocks from the notorious intersection. As early as 1810 Five Points' population was one-quarter black or foreign born. Later in the century most of the former had left, but three-quarters of the district's residents were immigrants.[154]

To outsiders Five Points was the place where society seemed to sink below the horizon of viability. When Charles Dickens inspected the neighborhood—after carefully procuring the protection of two policemen—he visited a house in which "mounds of rags are seen to be astir, and rise slowly up, and the floor is covered with heaps of negro women, waking from their sleep." The language implies that the women were barely human, as Dickens suggested more openly in observing that many of New York's free-roaming pigs seemed to headquarter themselves in Five Points. "Do they ever wonder why their masters walk upright in lieu of going on all-fours? and why they talk instead of grunting?" Like nearly every other visitor, Dickens

thought he knew the reason for what he saw: for the people as for the buildings, "debauchery" had made them "prematurely old."[155]

Five Points threatened the respectable because it offered abundant and unabashed lower-class entertainment. It appeared to outsiders that every building contained a bar. The neighborhood also boasted the highest concentration of brothels in the city, including seventeen on a single block.[156] Moreover, the streets seemed to be filled with idle people with nothing on their minds—least of all honest work.[157]

As a type of depravity, Five Points slipped easily from the pages of reformers' and travelers' tracts into the lurid "lights and shadows" literature of mid-century that purported to show respectable urbanites hidden aspects of their cities. It figured, for instance, in George G. Foster's sensationalist *New York by Gas-Light* (1850), a work claiming "to discover the real facts of the actual condition of the wicked and wretched classes."[158]

From another vantage point Five Points took on a very different cast. Careful observers recognized that it was less a resort for criminals than a neighborhood for the working poor in which most people's plight owed more to destitution than to vice. It was a district, as George Templeton Strong memorably put it, of "warens [*sic*] of seamstresses to whom their utmost toil in monotonous daily drudgery gives only bare subsistence in a life barren of hope & of enjoyment."[159] When the perceptive Swedish visitor Fredrika Bremer toured the neighborhood about 1850, most of the people she met seemed to her "wretched rather through poverty than moral degradation."[160]

The evidence of modern archaeology and historical research, which depict Five Points as a hub of working-class life and culture rather than as a haven for criminal behavior, supports Bremer's conclusion.[161] The bars were small businesses and centers of a lively neighborhood conviviality that won over even Dickens, who described his visit to the black-owned Almack's sympathetically.[162] Given the cramped quarters most Five Pointers occupied, bars and the streets were natural sites of social life and, as the historian Christine Stansell has pointed out, important for fostering networks of mutual assistance among women and as places where children scavenged to help support their families.[163] The life of Five Points was flavored with a keen patriotism and an active involvement in the politics of city and nation. As Dickens noted, "on the bar-room walls are coloured prints of Washington and Queen Victoria of England, and the American Eagle."[164]

Fig. 27. *The Old Brewery.* Wood engraving, from B. K. Peirce, *A Half Century with Juvenile Delinquents; or, The New York House of Refuge and Its Times* (New York: D. Appleton and Company, 1869), p. 208. The New York Public Library, Astor, Lenox and Tilden Foundations

If Five Points was not the birthplace of all vice in the city, neither was it the only poor or mixed-race neighborhood. West Broadway and its extension, Laurens Street, and parts of Corlears Hook and of the waterfront were comparable places.[165] It was the closeness of Five Points to the city's center of government that made it so striking and so easy to visit, and thus one of the emblematic neighborhoods of New York. The careful siting of the Tombs between City Hall and Five Points in the 1830s dramatized the contrast. Few observers missed the connection. Dickens, Bremer, and Nathaniel Parker Willis all combined visits to the slum and to the prison.

The most titillating aspect of Five Points was its proximity to New York's two emblematic thoroughfares, Broadway and its plebeian double, the Bowery. Broadway, the "grand feature" of New York and "the pride of the Yorkers," was "like nothing in existence but itself": "In this most cosmopolitan of our cities, this great artery of life is the most cosmopolitan of streets" (cat. nos. 109, 123; figs. 13, 14).[166]

The frenetic activity that masked Broadway's motley, ever-changing sequence of houses and commercial buildings—architecturally a "confused assemblage of high, low, broad, narrow, white, gray, red, brown, yellow, simple and florid," "its glories . . . rather traditional

154. J. A. Lobbia, "Slum Lore," *Village Voice*, January 2, 1996, pp. 34, 36.

155. Dickens, *American Notes*, pp. 88–90.

156. Ibid., p. 89; Timothy J. Gilfoyle, *City of Eros: New York City, Prostitution, and the Commercialization of Sex, 1790–1920* (New York: W. W. Norton, 1992), pp. 34, 38–41.

157. [Willis], "Diary of Town Trifles," p. 105.

158. Foster, *New York by Gas-Light*, p. 69.

159. Strong, Diary, entry for July 7, 1851, The New-York Historical Society.

160. Bremer, *Homes of the New World*, vol. 2, p. 602.

161. Lobbia, "Slum Lore," pp. 34, 37.

162. Dickens, *American Notes*, pp. 90–91.

163. Christine Stansell, *City of Women: Sex and Class in New York, 1789–1860* (Urbana: University of Illinois Press, 1987), pp. 41–42, 50.

164. Dickens, *American Notes*, p. 89.

165. Stansell, *City of Women*, p. 42; Blackmar, *Manhattan for Rent*, p. 176.

166. "Transformations of Our City," *New-York Mirror*, January 30, 1836, p. 247; "Broadway," *New-York Mirror, and Ladies' Literary Gazette*, September 9, 1826,

p. 55; "Broadway, New York, by Gaslight," *Ballou's Pictorial Drawing-Room Companion*, December 13, 1856, p. 381.

167. "City Improvements. The New Custom-House," *New-York Mirror*, August 23, 1834, p. 57.

168. "Broadway as Proposed to Be," *Home Journal*, October 22, 1847; "Genin's Bridge," *Gleason's Pictorial Drawing-Room Companion*, December 25, 1852, p. 416.

169. Strong, Diary, entry for August 24, 1845, The New-York Historical Society.

170. Madisonian, "Sketches of the Metropolis," p. 329.

171. "Sketchings. Broadway," *The Crayon* 5 (August 1858), p. 234.

172. Edward S. Abdy, *Journal of a Residence and Tour in the United States of North America, from April, 1833, to October, 1834*, 3 vols. (London: J. Murray, 1835), vol. 1, p. 69.

173. Strong, Diary, entry for July 7, 1851, The New-York Historical Society; "Things in New York," *Brother Jonathan*, March 4, 1843, p. 250.

174. "Sketchings. Broadway," p. 234; Felton, *American Life*, p. 33.

175. "Astor's Park Hotel," *Atkinson's Casket* 10 (April 1835), p. 217; "Town Gossip. Glass Walk over Broadway," *Home Journal*, November 17, 1849, p. 2.

176. "Stewart's Temple," *Morris's National Press*, April 18, 1846, p. 2.

177. "Facts and Opinions of Literature, Society, and Movements

than actual"—excited New Yorkers and visitors alike.[167] The human mass, with pedestrians crowded so densely on the sidewalks that someone proposed to build a glass-paved mezzanine above, and packed into so many vehicles that the hatter John N. Genin built a pedestrian bridge across the street from his shop at 214 Broadway to Saint Paul's Chapel, stood for all of New York (fig. 28).[168]

This "river deep & wide of live, perspiring humanity" encompassed the entire democratic public of America, represented, as always, by types.[169] There were "the gay and serious—the wealthy and the houseless, the clothed in purpose and the half-clad in linsey-woolsey."[170] There were newsboys and immigrants, merchants and clerks. "French and German dry goods jobbers, Bremen merchants, Jew financiers, southern, eastern, and western speculators and peculators, auctioneers, men of straw and men of substance; New York, New Orleans, Hamburg, Liverpool, San Francisco, Boston, and Cincinnati are huddled together in a six cent omnibus pélé-mélé with St. Louis, Lyons, Charleston, Manchester, and Savannah; all rushing to—Wall street, Broad street, Pearl street, Front street, South street," wrote a correspondent in *The Crayon*. Unlike other parts of the New York business district, Broadway was heavily populated by "the lady-element," whom the writer described as "rather of a mixed character": a "small sprinkling of lady-like women" along with "a great number of undomesticated ladies, not necessarily of doubtful character, but ladies unattached." The journal went on to include in the lady-element "many female day-dreamers, lounging women, or she-loafers, whose hopeless vacancy of mind calls for the stimulant of the noise, the shops, the dust, the variety of faces, of the hissing, seething street."[171] The English visitor Edward S. Abdy was "not a little surprised" to encounter unaccompanied women on Broadway in the 1830s.[172]

The Broadway crowd mixed occupations, origins, and genders, as well as social classes and races. Although they were seldom mentioned in the celebratory catalogues of the street's denizens, beggars were common on Broadway, including "hideous troops of ragged girls, from 12 years down," described by Strong in his diary, and the beggars who took shelter in the portico of the Astor House hotel.[173] Small-time vendors and a wide variety of roving tradespeople sought business along the street, filling the air with their distinctive identifying cries (figs. 24, 25). *The Crayon* recorded the "mixture of races," including blacks and Asians, on Broadway, while the English visitor Mrs. Felton experienced the great street as "the fashionable lounge for all the black and white belles and beaux of the city."[174]

If Broadway was the epitome of democratic New York, it also stood for the fissures in urban society. The street had its fashionable and unfashionable sides. The west side, on which the Astor House and the other luxury hotels stood, nearer to the wealthy residences along Greenwich Street, was the fashionable side, where one was "sure to find the elite of the commercial metropolis."[175] The east side, toward the commercial waterfront and Five Points, and also toward Wall Street, was the unfashionable side. One journalist hoped that the completion of A. T. Stewart's elegant new store at the northeast corner of Broadway and Chambers Street in 1846 would draw carriage trade east, and create "a fair division" of foot traffic between the two sides.[176]

What Broadway was to the fashionable shopping streets of Europe, what the east side of Broadway was to the west side, the Bowery was to Broadway as a whole: its "democratic rival."[177] The Bowery, too, had its fashionable and unfashionable sides, but they mirrored Broadway's: its west side was the unfashionable, "dollar" side, while the other was the "shilling" side "from the fact . . . that all the fancy stores are upon that side."[178]

Tellingly, the Bowery, unlike Broadway, was not punctuated by a single church. It had no time for the formalities or pieties of respectable life. Compared to Broadway, the Bowery was "wrapt in no cloak of convention or pseudo-refinement. The fundamental

Fig. 28. *Genin's New and Novel Bridge, Extending across Broadway, New York*. Wood engraving by John William Orr, from *Gleason's Pictorial Drawing-Room Companion*, December 25, 1852, p. 416. Courtesy of the American Antiquarian Society, Worcester, Massachusetts

business of life is carried on as being confessedly the main business; not, as in Broadway, as if it were a thing to be huddled into a corner, to make way for the carved work and gilding, the drapery and colour of the great panorama."[179]

If Broadway was the haunt of many urban types, but most notably of the "fashionables," the Bowery was home to one type, the Bowery "b'hoy" and his brash but amiable "g'hal." Mose and Lize (names derived from characters in Benjamin A. Baker's 1848 play *A Glance at New York*) were ambiguous figures. In one sense they were quintessential Americans, genuine and unsophisticated people indistinguishable from "the rowdy of Philadelphia, the Hoosier of the Mississippi, the trapper of the Rocky Mountains, and the gold-hunter of California," according to George Foster. All these types embodied the *"free development of Anglo-Saxon nature"* (cat. no. 127).[180] In this light the Bowery b'hoy seemed a frontiersman in his own city. Like the figure of the Western trapper in the antebellum genre paintings discussed by Elizabeth Johns, he evidently lived a free life that his more respectable chroniclers envied even as they condescended to it.[181] William Bobo compared the "pale and sickly beings who pace languidly" along Broadway with the heartier Bowery b'hoys and g'hals who inhabited the Bowery. In this respect, the b'hoy and g'hal were unurbane and nearly uncivilized.

When Lize and Mose were described in detail, though, they seemed quintessentially urban, and at least parodically urbane. Lize was "independent in her tastes and habits," moved with "the swing of mischief and defiance," spoke in a loud and hearty voice, and dressed "'high' . . . in utter defiance of those conventional laws of harmony and taste imposed by Madame Lawson and the French mantua-makers of Broadway."[182]

Mose strode along,

*black silk hat, smoothly brushed, sitting precisely upon the top of the head, hair well oiled, and lying closely to the skin, long in front, short behind, cravat a-la-sailor, with the shirt collar turned over it, vest of fancy silk, large flowers, black frock coat, no jewelry, except in a few instances, where the insignia of the [fire] engine company to which the wearer belongs, as a breastpin, black pants, one or two years behind the fashion, heavy boots, and a cigar about half smoked, in the left corner of the mouth, as near perpendicular as it is possible to be got [fig. 29].*[183]

The b'hoy and his g'hal were avid consumers of popular entertainments, with opinions on theater, litera-

ture, and politics as strong as any journalist's. Indeed, one journalist, Walt Whitman, sang their praises and occasionally adopted the persona of the b'hoy in his writings.[184] Although the Broadway stroller knew few people except those in his immediate circle, the Bowery b'hoy "speaks to every acquaintance he meets, and is hail-fellow-well-met with every body, from the mayor to the beggar."[185]

The Bowery b'hoy's volunteer-fire-company insignia declared his membership in a significant institution in antebellum New York. In addition to providing a necessary public service, fire companies were quasi-gangs offering male camaraderie and an active role in the city's transition from the world of the patrician public servant to that of the career politician up from the ranks (cat. no. 176).[186] The real Bowery boys who joined them were men employed in lower-middle-class occupations in shops and industries. In fire companies or as members of gangs (including one called, confusingly, the Bowery Boys), they were not so much the criminals they were often reputed to be as engaged political activists happy to glad-hand during election campaigns but ready to back up their loyalties with their fists when necessary. During one of the periodic nativist episodes in New York political life, the Bowery Boys and an Irish gang, the Dead Rabbits (fig. 30), conducted a protracted and bloody skirmish in the streets of Five Points. This "battle between Irish blackguardism & Native Bowery Blackguardism," on the Fourth of July 1857, ended with the two sides joining forces to fight the police.[187]

"A good big cigar placed in his mouth at the proper angle to express perfect content with himself and perfect indifference to all the rest of the world put the last and finishing touch" on the Bowery b'hoy's appearance.[188] Cigars, ubiquitous on antebellum American streets, where they were smoked by men and boys of all classes and even by some lower-class women, were objects of wide discussion and multiple significance. Edward W. Clay's *The Smokers*, a lively image of a New York street, vividly depicts the way the cigar's pervasive, offensive odor claimed public space as a male domain (fig. 31). Plebeian cigar smoke emphasized the overbearing, even claustrophobic presence of the lower classes. In the eyes of the respectable (like the Whig propagandist Clay), cigars stood for unwanted democratic equality. Their smoke clung to the clothes of the genteel and pursued them into their homes.[189] Indeed, Strong noted in his diary that on a hot day the entire city smelled like "the stale cigar smoke of a country bar room."[190]

In urban literature, the cigar-smoking b'hoy was the type of "the Democracy," the worldly lower-class

of the Day," *Literary World*, January 11, 1851, p. 32.

178. [Bobo], *Glimpses of New-York City*, p. 13.

179. Kirkland, "New York," p. 150.

180. Foster, *New York by Gas-Light*, p. 170.

181. Johns, *American Genre Painting*, pp. 60–100.

182. Foster, *New York by Gas-Light*, pp. 175–76.

183. [Bobo], *Glimpses of New-York City*, pp. 164–65.

184. David S. Reynolds, *Beneath the American Renaissance: The Subversive Imagination in the Age of Emerson and Melville* (New York: Knopf, 1988), pp. 508–12.

185. [Bobo], *Glimpses of New-York City*, pp. 164–65.

186. Bridges, *City in the Republic*, pp. 74–75.

187. Ibid., pp. 29–31, 76–77; "The Riot in the Sixth Ward," *Frank Leslie's Illustrated Newspaper*, July 18, 1857, pp. 108–9; Strong, Diary, entry for July 5, 1857 (quote), The New-York Historical Society; Luc Santé, *Low Life: Lures and Snares of Old New York* (New York: Farrar Straus Giroux, 1991), pp. 200–204.

188. Henry Collins Brown, ed., *Valentine's Manual of the City of New York for 1916–7*, new series (New York: Valentine Company, 1916), p. 111.

189. "Customs of New-York," *New-York Mirror, and Ladies' Literary Gazette*, July 5, 1828, p. 23.

190. Strong, Diary, entry for September 5, 1839, The New-York Historical Society.

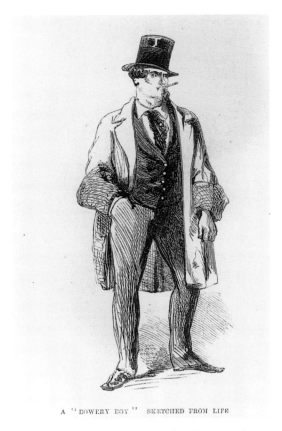

Fig. 29. *A Bowery Boy.* Wood engraving, from *Frank Leslie's Illustrated Newspaper,* July 18, 1857, p. 109. Courtesy of the American Antiquarian Society, Worcester, Massachusetts

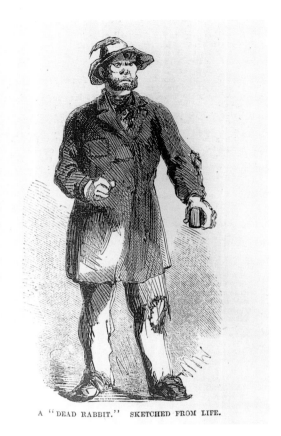

Fig. 30. *A Dead Rabbit.* Wood engraving, from *Frank Leslie's Illustrated Newspaper,* July 18, 1857, p. 109. Courtesy of the American Antiquarian Society, Worcester, Massachusetts

191. [Bobo], *Glimpses of New-York City,* p. 165.

192. "Frazee's Bust of John Jay," *New-York Evening Post,* March 21, 1832, p. 2; "The Late Awful Conflagration in New York," *Atkinson's Casket* 11 (January 1836), p. 29; Frederick S. Voss, with Dennis Montagna and Jean Henry, *John Frazee, 1790–1852, Sculptor* (exh. cat., Washington, D.C.: National Portrait Gallery, Smithsonian Institution; Boston: Boston Athenaeum, 1986), pp. 32–33, 77.

193. Voss, Montagna, and Henry, *John Frazee,* p. 31; Bridges, *City in the Republic,* pp. 19, 104–7. In the parlance of artisan republicanism, a workingman was anyone, including a shopkeeper or small businessman, who made a living by his own efforts rather than through financial speculation. Although the Workingman's Party was short-lived and unsuccessful at the polls, it bequeathed several of its active figures and its central ideas to both the Whigs and the Democrats in Jacksonian New York;

urbanite determined to have his say in the degentrified politics and civic life of post-Jacksonian America. He was "a fair politician, a good judge of horse flesh . . . and renders himself essentially useful, as well as ornamental, at all the fires in his ward." Compared to this engaging specimen the Broadway man "is not only a fop but a ninny, knows about as much of what is going on out of the very limited circle of his lady friends, as a child ten years old." His cigar smoking is limited to a single cigar after dinner, after which this emasculated dandy visits a lady friend, "if he should be lucky enough to have one."[191] Once again the b'hoy seemed at least as enviable as he was contemptible.

### The Arts in the Empire City

Many New Yorkers believed that the visual and decorative arts were essential to the effort to bring both civilization and urbanity to the Empire City. Early in the antebellum era republicans conceived art as a form of manual and intellectual accomplishment that should be directed to the edification of fellow citizens, who in turn were expected to support art for patriotic reasons. Artists inspired by republican civic values acted in this spirit to create portraits for public places (cat. nos. 1, 2, 55). John Frazee's bust of John Jay (fig. 111), commissioned by Congress for the Supreme Court's chamber in the United States Capitol, was displayed to the public in New York's Merchants' Exchange before being sent to Washington; four thousand people reportedly came to see it. The same building housed Robert Ball Hughes's statue of Alexander Hamilton (fig. 110), which was destroyed with the exchange itself in the fire of 1835.[192]

Works such as these were hailed as examples of the native genius of American artisans and marvelous products of American industry on a par with complex machine tools or suspension bridges. There is evidence that some artists also saw themselves as artisans, socially and economically, with all that implied for their understanding of their place in society, their manner of working, and their right to a competency. Frazee, for example, was an active member of the Workingmen's Party, the last and most eloquent bastion of artisan republicanism in New York politics.[193]

The Workingmen promoted the idea that society was a family in which people of various stations in life should assist one another for the common good. This viewpoint animated self-made architects of the first forty years of the nineteenth century, men such as New York's Minard Lafever, who bootstrapped themselves up from the status of builders and who then often published builders' guides and handbooks with the express intention of offering their brethren the means to advance themselves as well.[194]

Belief in the civic role of art and in the artist as honest artisan survived throughout the antebellum decades. In the last years before the Civil War New Yorkers could visit a gallery of historical art in City Hall or they could pay a quarter to see that "sublime tableau of beauty and patriotism," James Burns's painting *Washington Crowned by Equality, Fraternity, and Liberty* at the Apollo Rooms.[195] They could also enjoy the marbles of Erastus Dow Palmer (cat. no. 69), hailed by the cognoscenti as a self-taught specimen of native genius who had transformed himself from carpenter to sculptor solely through "his own innate ideas of excellence."[196]

As time passed, those who clung to the notion of art's civic value were increasingly pessimistic about the fate of republicanism. Samuel F. B. Morse's conservative Calvinist beliefs led him to fear for the future of the nation. As he understood it, his mission, like that of his Puritan forebears, was to call the people to reform. As an artist, Morse sought to use the "refining influences of the fine arts" to stem "the tendency in the democracy of our country to low and vulgar pleasures and pursuits."[197] He and such of his contemporaries as Thomas Cole (cat. nos. 10, 62, 161) evoked the traditional aesthetic hierarchy that gave history painting—exemplary images from the historical or mythic past—the highest value and hoped, usually in vain, to sway their fellow citizens through uplifting portrayals of legitimate leadership and an uncorrupted past. Patrons such as Philip Hone or Luman Reed, who purchased and sometimes publicly exhibited works by Morse and Cole among others, also saw art in this light. To the same ends they commemorated worthy ancestors through the fledgling New-York Historical Society (cat. no. 104), served on church vestries, and helped to organize and govern the prisons, asylums, and other so-called therapeutic institutions of the antebellum era (cat. no. 73). All served the common goal of recapturing civic and moral authority in a city rapidly slipping from their grasp.[198]

Just as the republican ideal of the citizenry as members of a common family disintegrated, so the notion

see Bridges, *City in the Republic*, pp. 19, 22–23.

194. Dell Upton, "Pattern Books and Professionalism: Aspects of the Transformation of American Domestic Architecture, 1800–1860," *Winterthur Portfolio* 19 (summer/autumn 1984), pp. 116–17.

195. "Public Buildings of New-York," *Putnam's Monthly* 3 (January 1854), p. 12; "Apollo Rooms, 410 Broadway" (advertisement), *Evening Post* (New York), October 2, 1849, p. 3; "Apollo, 410 Broadway" (advertisement), *New-York Daily Tribune*, October 2, 1849, p. 3.

196. "Palmer's Marbles," *Frank Leslie's Illustrated Newspaper*, December 20, 1856, p. 42.

197. Staiti, *Samuel F. B. Morse*, pp. 2–5, 67–68; Edward Lind Morse, ed., *Samuel F. B. Morse, His Letters and Journals*, 2 vols. (Boston: Houghton Mifflin, 1914), vol. 2, p. 26 (quote).

198. Staiti, *Samuel F. B. Morse*, pp. 71, 75; Wallach, "Thomas Cole," p. 101; Joy S. Kasson, *Marble Queens and Captives: Women in Nineteenth-Century Sculpture* (New Haven: Yale University Press, 1990), p. 17; Thomas Bender, *New York Intellect: A History of Intellectual Life in New York City from 1750 to the Beginnings of Our Own Time* (New York: Knopf, 1987), pp. 126, 128.

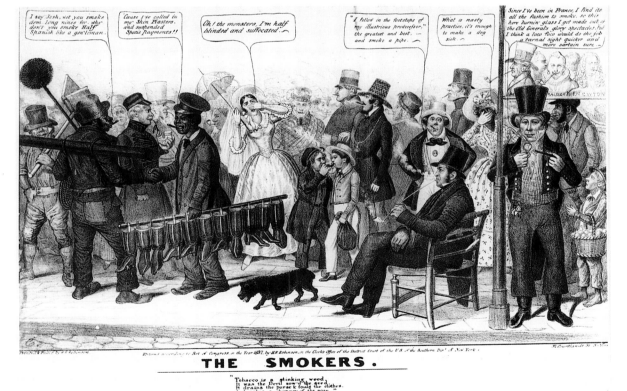

Fig. 31. *The Smokers*, 1837. Lithograph by Edward W. Clay, printed and published by H. R. Robinson. The Library Company of Philadelphia

199. Angela L. Miller, *The Empire of the Eye: Landscape Representation and American Cultural Politics, 1825–1875* (Ithaca: Cornell University Press, 1993), pp. 2, 7–10; Spann, *New Metropolis*, pp. 235–39; "Editor's Easy Chair," *Harper's New Monthly Magazine* 15 (June 1857), p. 128.

200. "American Art," *New York Quarterly* 1 (June 1852), pp. 229–51, 230 (quote).

201. "Cheap Art," *The Crayon*, October 17, 1855, p. 248; T. W. Whitley, "The Progress and Influence of the Fine Arts," *Sartain's Union Magazine of Literature and Art* 10 (March 1852), p. 213; "Knowledge and Patronage," *Atkinson's Casket* 7 (January 1832), p. 27; "Fine Arts in New York," *United States Magazine* 4 (April 1857), pp. 413–14; Upton, "Pattern Books," pp. 123, 128.

202. Clarence Cook, "Shall We Have a Permanent Free Picture Gallery?" *The Independent*, July 5, 1855.

203. "Free Galleries of Art," *Home Journal*, May 7, 1854, p. 2.

204. "Fine Arts in New York," pp. 413–14.

205. "The Bryan Gallery," *United States Magazine* 4 (May 1857), p. 526.

206. Johns, *American Genre Painting*, pp. 42, 59.

207. [A. J. Downing], "Critique on the February Horticulturist," *The Horticulturist* 7 (April 1852), p. 174.

208. "The Growth of Taste," *The Crayon*, January 17, 1855, pp. 33–34.

209. "Taste in New-York," *New York Quarterly* 4 (1855), pp. 56, 59.

210. A. J. Downing, *The Architecture of Country Houses, Including Designs for Cottages, Farmhouses, and Villas . . .* (New York: D. Appleton and Co., 1850), p. 20; Upton, "Pattern Books," pp. 125–26. The other two books by Downing were *A Treatise on the Theory and Practice of Landscape Gardening, Adapted to North America . . .* (New York: Wiley and Putnam, 1841) and *Cottage Residences; or, A Series of Designs for Rural Cottages and Cottage Villas, and Their Gardens and Grounds Adapted to North America* (New York: Wiley and Putnam, 1842).

211. W. L. Tiffany, "Art, and Its Future Prospects in the United States," *Godey's Lady's Book* 46 (March 1853), p. 220; "Knowledge and Patronage," p. 27.

of art fragmented, and the concept of art as a civic expression weakened. The arts continued to stir national pride and to be understood as expressions of national identity, but gradually they came to seem more a matter of urbanity than citizenship. One common answer to the question, What makes a city a metropolis? was "A proper respect for Art."[199]

Writers about art and architecture spoke of the artist's duty to address "all classes, because he appeals to sympathies common to the race, and is thus truly national."[200] To do so, however, required some education of the public taste through exhibitions, reproductions, and exhortation, if only to create a market for good works.[201] More important, the progress of urbanity required the enduring influence of art in civic life, and in the 1850s some New Yorkers began to call for the establishment of a "permanent free picture gallery" to supplement ephemeral commercial exhibitions and the annual shows of the National Academy of Design (for which admission was charged), then the only places where ordinary New Yorkers could enjoy the fine arts.[202] The *Home Journal* urged the state to establish free galleries of art as moral supplements to the mundane vocational training offered in public schools and colleges.[203] The *United States Magazine* agreed, but observed that one of the problems with such an institution was "the difficulty of preserving the rooms from the intrusion of disreputable persons"; security guards like those found in Stewart's would do the trick, the editors thought.[204] Like Thomas Jefferson Bryan, who opened the Bryan Gallery of Christian Art on Broadway at Thirteenth Street, most gallery operators found that a 25-cent admission charge was essential to preserve "that quiet and elegant taste" such a setting required.[205] Although the commercial galleries professed to welcome the serious-minded artisan and the respectable poor, they were anxious to exclude the "sovereigns," the patrician term for those lower-class Americans who asserted their right to participate in politics and social life on an equal footing with everyone else.[206] The sovereigns' appreciation of art was allegedly epitomized by the one overheard to say of Horatio Greenough's statue of Washington: "I say Bob—if I had a hammer, I'd crack this nut on that old chap's toes!"[207]

In some minds, then, art was transformed from a medium for reinforcing ties of republican citizenship to a medium for cultivating and demonstrating personal urbanity. A subtle shift in the concept of taste, defined simply by *The Crayon* as "the capacity of receiving pleasure, from Beauty in some form," transferred art from the realm of the universally accessible and instructive to one that required an arcane and highly developed sensibility.[208] As with gentility, of which taste was one major index, not everyone could be educated. A critic advised the opera conductor at the Academy of Music not to bother trying to please the patrons in the galleries, since those in the parquet and dress circles were much more capable of appreciating his work. He compared "An admiration for fine bearing on the street, for high-born features or noble-gifted" ones to "superior judgment, a vigorous intellect, and ambition with deep-moved feeling" and concluded that "the *elite* of society . . . are ever the patrons of genuine art."[209]

The landscape gardener and architectural popularizer Andrew Jackson Downing made the same point less stridently as he worked out his aesthetic theory in three books published between 1841 and 1850. Downing borrowed his premise from the British writer and horticulturist J. C. Loudon, who argued that everyone could appreciate those aspects of art and architecture that were accidents of history and culture, such as historical styles, while the deeper forms of beauty were based on geometrical principles and required close study. Downing inverted the relationship, assigning the "absolute" beauty of geometry to the realm of the widely accessible while arguing that the cultural elements of architecture were "the expression of elevated and refined ideas of man's life" and "the manifestation of his social and moral feelings." These higher forms of expression were beyond the grasp of uneducated men and women, who would only make themselves ridiculous by striving to attain them.[210]

While conceptions of the arts' social value varied widely, everyone understood that they had to come to terms with the democratic, commercial milieu of the new nation. Reception of the arts was shaped by the reality that, whatever else they might be, they were commodities, thrown in among and often indistinguishable from, the many other goods to which New Yorkers' money gave them access. The jeweler W. L. Tiffany thought wealthy Americans bought art as they "bought cotton and corn" or "as they buy a watch or a buhl cabinet" (fig. 32).[211] They guarded their artistic property closely rather than sharing the uplifting power of their collections with the public.[212]

If artworks were commodities to be snapped up by the wealthy and even the not-so-wealthy, they were also the stuff of popular spectacle, along with every other form of entertainment. The *Literary World* conveyed a vivid sense of this in its review of

MR. BROWN VISITS A PICTURE FACTORY
*For the purpose of purchasing Paintings for his magnificent Gallery of Art.*
BROWN. "I want a pictur 4 by 5 exactly, as I have jest that space to spare."
DEALER. "Any particular subject—Moonlight, Eruption of some of the Volcanoes, or a domestic subject, or—"
BROWN. "Don't care what subject, or who is the Painter, so that it is 4 by 5 exactly."
*(Brown is accommodated.)*

Fig. 32. *Mr. Brown Visits a Picture Factory*. Wood engraving, from *Harper's Weekly*, January 16, 1858, p. 48. The Metropolitan Museum of Art, New York, The Irene Lewisohn Costume Reference Library

an exhibition of Edward Augustus Brackett's *Shipwrecked Mother and Child*, 1850 (fig. 123):

*Although the deficiency of vital power and true growth in the public entertainments of New York, is by no means slight nor accidental, there is never a lack in variety and numbers, of popular exhibitions. We can always range the scale pretty freely, from the tiny Aztecs up to Mons. Gregoire, the stone-breaking Hercules; from the negro burlesque two minutes and a half long, to the complex opera of three hours; from the amateur farce of the "spout-shop," to the elaborate tragedy of the legitimate "temple of the drama." In the pictorial we are quite as opulent, and find no end to sketches, scratches, and colorings—from the chalk outline on the fence, to the mature finish of the Napoleon at Fontainebleau. Sculpturewise, we claim the entire circle of achievement, beginning, if you please, with the faces and heads casually knocked out of free-stone and granite by the house-mason's hammer,*

*up to a work like this "Shipwrecked Mother and Child," wrought by the finest chisel, from the pure marble, by the patient and well tempered genius of Brackett.*[213]

Brackett's work fared poorly in this market and went unsold, despite having been shown in New York, Philadelphia, and Boston.[214]

The fine arts' status as commodity and spectacle inflected every attempt to assign them a significant role in the creation of civilization and urbanity. For collectors such as Luman Reed, acquired wealth bought art, which in turn bought entrée to the social circles to which he believed his wealth entitled him.[215] Like others of his kind Reed focused his buying on contemporary American works when it became clear that many of the "old masters" favored by earlier American collectors were fraudulent or were otherwise bad investments.[216]

During the antebellum decades some artists and architects groped toward a view of art as a separate realm—"a higher and better realm," in historian Thomas Bender's words—of human experience from the everyday world of ordinary people. But the realization of such an ideal was conditioned by the artists' and architects' own circumstances. In these transitional years many of them combined the then new but now familiar romantic notion of artist as a kind of prophet of the spiritual with a more traditional aspiration to gentility, cultivation, and acceptance as the social peers of their patrons.[217]

To succeed, artistic and social claims required reciprocal acknowledgment by patrons and the public, and it was slow in coming. The artist's traditional relations with both survived long into the antebellum years. Artists, like other sorts of manual workers, were accustomed at first to producing commissioned works, usually portraits, for known clients—what artisans called "bespoke" works. While continuing to depend on the goodwill of wealthy patrons, artists increasingly sought a larger audience, working on speculation for sale through exhibitions and even, through such organizations as the American Art-Union and the Cosmopolitan Art Association, for mass distribution by means of reproductions.[218] This required that they compete in the commercial marketplace on its own terms. William Sidney Mount admonished himself in his diary to "Paint pictures that will take with the public. . . . In other words, never paint for the few, but for the many."[219] T. W. Whitley, the author of an article on the state of the fine arts published in *Sartain's* magazine, offered in a newspaper advertisement "to paint

212. "Fine Arts," *Putnam's Monthly* 1 (March 1853), pp. 351–52.
213. "The Fine Arts. A 'Brackett' in Public Amusements," *Literary World*, April 10, 1852, p. 268.
214. Kasson, *Marble Queens and Captives*, pp. 101–2.
215. Wallach, "Thomas Cole," pp. 103–4; Johns, *American Genre Painting*, p. 32.
216. Neil Harris, *The Artist in American Society: The Formative Years, 1790–1860* (New York: Clarion Books, 1970), p. 103; Foshay, *Luman Reed's Picture Gallery*, pp. 16, 52.
217. Bender, *New York Intellect*, pp. 121–24, 128–30 (quote); Harris, *Artist in American Society*, pp. 94, 98; Upton, "Pattern Books," pp. 112–13.
218. Foshay, *Luman Reed's Picture Gallery*, pp. 14–16, 60; Johns, *American Genre Painting*, pp. 75–76; "The Greek Slave!" (advertisement), *Spirit of the Times*, January 27, 1855, p. 598; Kasson, *Marble Queens and Captives*, p. 9; Harris, *Artist in American Society*, p. 106.
219. Quoted in Staiti, *Samuel F. B. Morse*, p. 236.

220. Whitley, "Progress and Influence of Fine Arts," pp. 213–15; "Landscape Painting" (advertisement), *Evening Post* (New York), May 23, 1849, p. 3.

221. Fisher, *Philadelphia Perspective*, p. 198.

222. "Christ Healing the Sick," *Broadway Journal*, September 13, 1845, p. 155; Dell Upton, ed., *Madaline: Love and Survival in Antebellum New Orleans* (Athens: University of Georgia Press, 1996), p. 255.

223. Kevin J. Avery and Peter L. Fodera, *John Vanderlyn's Panoramic View of the Palace and Gardens of Versailles* (New York: The Metropolitan Museum of Art, 1988), pp. 18–21, 33.

224. "Public Buildings," *New-York Mirror, and Ladies' Literary Gazette*, September 25, 1829, pp. 89–90; "Panorama of Jerusalem" (advertisement), *The Expositor*, December 8, 1838; "New Panorama," *The Knickerbocker* 11 (June 1838), p. 572; "The Last Week at the Minerva Rooms" (advertisement), *New York Herald*, December 3, 1849, p. 3; "Evers's Grand Panorama of New York and Its Environs," *Evening Post* (New York), November 20, 1849, p. 2; "City Saloon" (advertisement), *Morning Courier and New-York Enquirer*, July 15, 1839.

225. "Public Buildings," p. 89.

226. "City Saloon."

227. Harris, *Artist in American Society*, p. 100.

228. "The Fine Arts. A 'Brackett' in Public Amusements," p. 268.

229. Morse, *Samuel F. B. Morse*, vol. 1, pp. 276–77; Staiti, *Samuel F. B. Morse*, pp. 64–65, 149–69; Bender, *New York Intellect*, pp. 122, 127–30; Upton, "Pattern Books," pp. 109–50; Mary N. Woods, *From Craft to Profession: The Practice of Architecture in Nineteenth-Century America* (Berkeley: University of California Press, 1999), pp. 28–38. The American Institution of Architects folded quickly. Its successor, the American Institute of Architects, was organized in 1857 under the aegis of New York architect Richard Upjohn.

230. For the development of this sense of cultural hierarchy in the late nineteenth century, see Lawrence W. Levine, *Highbrow/Lowbrow: The Emergence of Cultural Hierarchy in America* (Cambridge, Massachusetts: Harvard University Press, 1988).

Landscapes at every price," in a style that would "compare favorably with the works of our city artists," as well as to copy old master landscapes and to restore damaged paintings.[220]

Other artists and entrepreneurs exhibited works commercially. The sculptor Hiram Powers, established in Italy since 1837, sent a version of his celebrated *Greek Slave* to America in 1847, expecting to make about $25,000 from its tour of major cities (cat. no. 60).[221] A Mr. Morris, "a well-known amateur," sent one version of Benjamin West's *Christ Healing the Sick* on a similar tour of American cities, while entrepreneur George Cooke compiled a "National Gallery of Paintings," featuring John Gadsby Chapman's portrait of Davy Crockett, that he exhibited in New York for some time before taking it for an extended stay in New Orleans.[222]

Whatever their professional aspirations, then, both artists and architects were embedded in the marketplace of commodities and spectacles, as the history of panoramas illustrates. John Vanderlyn attempted to make a living by exhibiting his panorama of Versailles (figs. 33, 34) in the purpose-built New-York Rotunda on the Park (cat. no. 70), but his effort was doomed to failure by his inattention to business.[223] Vanderlyn also rented and exhibited other painters' panoramas of Paris, Mexico City, Athens, and Geneva, while at different venues antebellum New Yorkers were offered panoramic views of Jerusalem (by the artist Frederick Catherwood), Niagara Falls, the Great Lakes, and their own city, as well as one of "the Infernal Regions."[224]

Panorama painters differed in their aspirations to fine-art status, but all pitched their works to the public as illusionistic spectacles. The light in Vanderlyn's Rotunda "seems to give life and animation to every figure on the canvass. . . . so complete is the illusion . . . that the spectator might be justified in forgetting his locality, and imagining himself transported to a scene of tangible realities!"[225] "The Infernal Regions" were enlivened with the skeletons of executed Ohio criminals and preceded by "NIGHT ILLUSIONS! Produced by the New Philosophical Apparatus (lately from London) called the NOCTURNAL POLYMORPHOUS FANTASCOPE."[226]

Ideology as well as commerce bound antebellum art to the world of spectacle. When a painter such as Morse argued for the fine arts' refining and elevating qualities, he accepted the traditional notion of them as a moral and civic force. Successful artists accommodated the widely held belief that art must be criticized within the scope of popular understanding, not

arcane theories.[227] Like other forms of cultural expression, fine art was to be read narratively and evaluated morally. "We need not speak of such a work in any technicalities," wrote the *Literary World*'s critic in praise of Brackett's *Shipwrecked Mother and Child*. "The mother and child belong to human nature at large," and thus to the public rather than to the connoisseur.[228]

Artists and architects responded to the market context by organizing themselves professionally. The National Academy (cat. no. 105), founded by Morse and his colleagues in 1825 in opposition to the patron-dominated American Academy of the Fine Arts, and the American Institution of Architects, convened by a group of New York, Boston, and Philadelphia architects in 1836, were among the first fruits of these professional aspirations.[229] These organizations were aimed less at establishing the high-art claims of either group than at situating them within the marketplaces of ideas and services as men with something distinctive to sell. They sought to create a group identity through publicity (publications and exhibitions), training, ostracism of amateurs, and the definition of a common body of professional knowledge.

At the end of the antebellum era claims that the arts and their makers inhabited a realm of expression inherently superior to that of popular culture began to be more widely voiced.[230] Some writers started to treat the artist as a man of feeling and talent—"we should call the former Love and the latter Power"—which set him apart from ordinary mortals, as taste distinguished the connoisseur from the unenlightened viewer on the other side of the easel.[231] In architecture professional skill, defined early in the century as a body of empirical knowledge—"architectural science"—accessible to anyone willing to study, was redefined as a mysterious quality available only to those few with talent and formal professional training.[232] Occasionally people referred to this quality—and by extension to the person possessing it—as *genius,* by which they meant surpassing brilliance, not the characteristic quality of a place or a source of inspiration, as the word had been traditionally understood.[233] Even these claims must be seen in the context of the market. Part of their purpose was to distinguish the professional product from that of others—amateurs, craftsmen—by distinguishing the professional himself.

This new aesthetic elitism met vigorous opposition among New Yorkers. Few were willing to accept either a single standard of taste in the arts or its confinement to a small segment of the population. Nor would many New Yorkers agree to a hierarchy of pleasures or commodities that set the fine arts at its

Fig. 33. John Vanderlyn, *The Palace and Gardens of Versailles,* circular panoramic painting created for display in the Rotunda, 1818–19. Oil on canvas. The Metropolitan Museum of Art, New York, Gift of Senate House Association, Kingston, N.Y., 1952  52.184

Fig. 34. Detail of *The Palace and Gardens of Versailles* (fig. 33)

231. "Feeling and Talent," *The Crayon*, January 10, 1855, front page.

232. Upton, "Pattern Books," pp. 120–28.

233. Strong wrote that John Cisco "Thinks [the English immigrant architect Jacob Wrey] Mould a genius; So does Dix;" Strong, Diary, entry for April 26, 1860, The New-York Historical Society.

234. "Daniel in the Lion's Den," *New York Herald*, October 31, 1849, p. 3.

235. "Powers's Statuary" (advertisement), *Evening Post* (New York), October 2, 1849, p. 2.

236. "The Greek Slave!", p. 598.

237. "Panorama Saloon" (advertisement), *New York Herald*, November 1, 1849, p. 3.

238. "Wallhalla" (advertisement), *New York Herald*, May 21, 1849, p. 3.

239. Foster, *New York by Gas-Light*, pp. 77–78.

240. "Franklin Theatre" (advertisement), *New York Herald*, October 31, 1849, p. 3.

241. "Wallhalla, 36 Canal Street" (advertisement), *New York Herald*, October 31, 1849.

242. Foster, *New York by Gas-Light*, p. 157.

243. "Model Artists," *New York Herald*, December 13, 1849, p. 2.

244. Bender, *New York Intellect*, p. 121; Fisher, *Philadelphia Perspective*, pp. 198–99; "Palmer's 'White Captive,'" *Atlantic Monthly* 5 (January 1860), pp. 108–9; "The Art of the Present," *The Crayon*, May 9, 1855, pp. 289–90; Kasson, *Marble Queens and Captives*, pp. 46–72. On verisimilitude and prurience in Western high and popular art, see David Freedberg, *The Power of Images: Studies in the History and Theory of Response* (Chicago: University of Chicago Press, 1989), chaps. 9, 12.

pinnacle. They embraced spectacle in all its commercial variety. On Broadway in 1849 those with 25 cents to spend could see a watercolor painting of Daniel in the Lion's Den—twenty feet by twelve, so one received value for money—along with a collection of what purported to be old-master oil paintings ("Corregio, Poussin, &c."), and, as if those were not enough, there was "the genuine Egg Hatching Machine, in which chicks are seen bursting the shell, in the presence of visiters." [234]

The contest for cultural authority often took the form of a struggle for control of the contexts that would determine the meaning of iconic visual images. Powers's *Greek Slave* was one of the most popular, and was certainly the most hotly contested, of icons in antebellum New York. When it was exhibited for the sculptor's benefit at the Gallery of Old Masters, along with his *Fisher Boy* (fig. 73), *Proserpine* (fig. 119), and *Andrew Jackson* (cat. no. 55), it was shown in the context of paintings by "the best old masters," making them part of "the choisest [sic] and most instructive collection of works of Art ever brought to this country." [235]

The statue was a hit in New York, and as a result it was absorbed into the world of luxury consumption and commercial spectacle all the more quickly. The Cosmopolitan Art Association included an original version in its first annual distribution of prizes to its members. [236] Suddenly the *Greek Slave* materialized all over the city. In 1849 the Panorama Saloon at the corner of Lispenard Street and Broadway announced the exhibition of a panorama of paintings of classical subjects, the finest of their sort "in spite of 'Art Union' criticism or 'Scorpion' slander." They included "a more faithful representation of the Greek Slave." [237]

The same year New Yorkers enjoyed a flurry of exhibitions of "model artists" staging tableaux vivants after famous works of art. At the Wallhalla, a hall on Canal Street, Professor Hugo Grotin offered his "celebrated Marble Statues and Tableaux Vivants, represented by 25 ladies of unparalleled beauty, graces, and accomplishments." [238] In *New York by Gas-Light* Foster described the Wallhalla as a hall over a stable, with a prominent bar dispensing crude firewater, an atmosphere redolent of horse and cigar, and a floor covered with mud and tobacco juice. To the accompaniment of a badly played violin and piano, a model portrayed Venus, Psyche, and the Greek Slave, her body covered only by a flimsy, hand-held veil of gauze. [239] At the Franklin Theatre on Chatham Square, Madame Pauline's model artists offered an equally

eclectic gallery of well-known images, including "the Three Graces," "Venus Rising from the Sea," "The Rape of the Sabines," and "The Greek Slave." [240]

New Yorkers were unsure whether these were blatant striptease shows or legitimate entertainment. An advertisement for the Wallhalla's "Classical Museum of Art" assured readers that the performance was conducted in "the most decent manner." [241] Foster, characteristically, labeled them "disgusting exhibitions." [242] A correspondent of the *New York Herald* saw in tableaux vivants "an illegitimate offshoot from those that are perfectly correct and proper—such, for instance, as that of the beautiful piece of sculpture by Power [sic]—the Greek slave." [243]

The panoramas and tableaux challenged genteel and professional definitions of the content and purposes of art. At the Panorama Saloon the old demand of truth to life and the desire for a verisimilitude bordering on illusionism, a common point of discussion in mid-nineteenth-century professional and popular art criticism, were reasserted as the proper goal of the artist. Tableaux vivants openly addressed the strong erotic content that respectable critics and viewers saw but euphemized in such statues as the *Greek Slave* or Palmer's *White Captive* (cat. no. 69), and defied genteel views of art as the uplifting attempt to transform "this hard, angular, and grovelling age" into "something beautiful, graceful, and harmonious" that shows us "always the image of God." [244] Popular reinterpretations of the *Greek Slave* insisted on anchoring the experience of art firmly in the realm of sensory pleasure, in the process tying the urbane to urban spectacle rather than to refined moral or intellectual experience.

## The Palace and the Park

In their confrontations with the changing city and with each other, the ideals of civilization and urbanity, of republican citizenship and metropolitan refinement were themselves transformed. Yet both concepts informed New York's self-definition throughout the antebellum decades and animated the two great urban projects of the 1850s, the New York Crystal Palace, for the New-York Exhibition of the Industry of All Nations, and Central Park.

The Crystal Palace exhibition was conceived in the wake of the phenomenal success of the first modern world's fair, the London Great Exhibition of 1851, and of its iron-and-glass building, the original Crystal Palace. The Association for the Exhibition of the Industry of All Nations was chartered by the New York State legislature in April 1852 to undertake a fair in New

Fig. 35. Charles Gildemeister and George J. B. Carstensen, architects, *New York Crystal Palace, Ground and Gallery Plans*, 1852. Lithograph, from *Appleton's Mechanics' Magazine* 3 (February 1853), pp. 35–36. Courtesy of the American Antiquarian Society, Worcester, Massachusetts

York City.[245] A competition for the design of the exhibit hall, which the organizers assumed from the beginning would resemble the London Crystal Palace, attracted several noteworthy competitors, including Andrew Jackson Downing, cast-iron entrepreneur James Bogardus, and Joseph Paxton, architect of the London building. The winners, New York architect Charles Gildemeister and the Danish immigrant architect George J. B. Carstensen, designed an iron-and-glass structure with two tall, perpendicular galleries, 365 feet long and 68 feet high, forming a Greek cross crowned by a dome 100 feet across (cat. nos. 141, 218). The angles between the arms were filled in at ground level to create an octagonal footprint.[246]

In many respects the New York Crystal Palace was the valedictory festival of artisan republicanism. Its organizers aimed to stir patriotic feelings of admiration for American "triumphs of genius and industry," to promote the diffusion of mechanical skill and the growth of manufacturing, and to educate the public.[247] An equestrian statue of George Washington stood under the dome, and the *Literary World* recommended that busts and portraits of American "sons of light" (inventors) be placed in the building.[248] Works of art, including the *Greek Slave*, were scattered throughout, but their status was ambiguous (cat. no. 179). The picture gallery was predictably described as "a school of taste," but most journalists concentrated on art's role as a civic lesson (as in the statue of Washington, "the grandest of Nature's models") or as a species of artisanry.[249] By housing a

"Republican lesson on the capacities of man, the dignities of labor, and on the obligations of society to genius and toil" in a "People's Palace," "the institutions of civilized life are put upon a firmer basis and each one is brought to feel how nearly his neighbor's interest is allied to his own."[250]

Located on the western half of the blocks delineated by Fortieth and Forty-second streets, between Fifth and Sixth avenues, the Crystal Palace, like the streets of the commercial city, combined rational organization with picturesque presentation. The colorful massing and impressive size of the building (somewhat diminished, everyone thought, by its unfortunate proximity to the even more imposing Croton Reservoir) disguised its layout as an extensive structural grid (fig. 35).[251] In line with the principles of the London exhibition,[252] the exhibits were organized systematically, falling into thirty-one subcategories and distributed throughout the space on a grid with a twenty-seven-foot module; the products of the United States were separated from those of other nations.[253] To the knowing visitor, a first glimpse of the building offered "a dazzle; a thousand sparkles and rainbows; light and movement undistinguishable for a while; then, as the eye settled, order emerging here and there; . . . vast climaxes of Art, Industry, and Invention, extending away and away in long perspective on every side; . . . in which various national emblems and devices suggest the world-wide interest of an Industrial unity" (cat. no. 142). The combination of order and profusion implied totality: the

245. "Association for the Exhibition of the Industry of All Nations" (advertisement), *New-York Daily Tribune*, April 5, 1852, p. 3.

246. "Notices and Correspondence. The American Association for the Exhibition of the Industry of All Nations," *Appleton's Mechanics' Magazine* 2 (September 1882), p. 216; "The New-York Crystal Palace," *National Magazine* 2 (January 1853), pp. 80–81. Carstensen had designed the Tivoli Gardens and the Casino in Copenhagen.

247. "Association for the Exhibition of the Industry of All Nations," p. 3.

248. "The Crystal Palace—Opening of the Exhibition," *New-York Daily Times*, June 18, 1853, p. 4; "The Industrial Exhibition," *Literary World*, September 25, 1852, p. 202.

249. "The American Crystal Palace," *Illustrated Magazine of Art* 2 (1853), p. 263; "The Great Exhibition and Its Visitors," *Putnam's Monthly* 2 (December 1853), p. 579.

250. "The Crystal Palace," *New-York Daily Times*, June 20, 1853, p. 4; "The Crystal Palace," *New-York Daily Times*, May 20, 1853, p. 4.

251. "World's Exhibition—1853," *New-York Daily Tribune*, April 23, 1853, p. 5; "The New York Crystal Palace," *The Albion*, July 23, 1853, p. 357.

252. "Movements at the Crystal Palace—General Arrangements and Regulations," *New-York Daily Tribune*, June 24, 1853, p. 7.

253. "The Crystal Palace—Opening of the Exhibition," p. 4; "The American Crystal Palace," *Illustrated Magazine of Art* 2 (1853), pp. 254–55.

254. "Great Exhibition and Its Visitors," pp. 578–79.

255. Ibid., p. 578.

256. "Movements at the Crystal Palace—General Arrangements and Regulations," p. 7.

257. "Editor's Easy Chair," *Harper's New Monthly Magazine* 7 (June 1853), pp. 129–30.

258. *Morning Courier and New-York Enquirer*, May 25, 1853, p. 3; "Our Crystal Palace," *Putnam's Monthly* 2 (August 1853), p. 122.

259. "The New York Crystal Palace," *Gleason's Pictorial Drawing-Room Companion*, April 23, 1853, p. 269.

260. Strong, Diary, entry for October 5, 1858, The New-York Historical Society.

261. "Godey's Arm-Chair. Barnum," *Godey's Lady's Book* 48 (May 1854), p. 469.

262. "Our Window," *Putnam's Monthly* 10 (July 1857), pp. 135–38.

263. "The Latting Observatory," *Christian Parlor Magazine* 10 (1853), pp. 378–79; "Destruction of the Latting Observatory," *Frank Leslie's Illustrated Newspaper*, September 13, 1856, pp. 213–14.

264. "World's Exhibition—1853," p. 5; "The Surroundings of the Crystal Palace," *Evening Post* (New York), April 26, 1853, p. 2; "The Crystal Palace," *New-York Daily Times*, June 16, 1853, p. 4.

265. "Progress of the Crystal Palace," *New-York Daily Times*, June 28, 1853, p. 1; "The Crystal Palace," *New-York Daily Times*, June 16, 1853, p. 4.

Crystal Palace seemed to contain everything worth seeing in the world of human ingenuity, so that visitors "resented any blanks in the picture" created by the incomplete state of the exhibition on opening day.[254]

If the aims and organizing principles of the Crystal Palace exhibition sound like those of Peale's museum, they were transformed by the rituals of consumption. World's fairs perfected the spectacle of juxtaposition, while their claims of totality also implied the ability to consume without limit. Fashionable visitors, who were "not famed for their rational curiosity," were nevertheless willing to visit because the exhibition seemed to promise a glimpse of "the Art and Elegance of All Nations."[255]

The resemblance of world's fairs to department stores, a familiar theme among historians today, already resonated with visitors to the first fairs in London and New York. The New York organizers borrowed a page from Stewart's and other dry-goods emporiums in surrounding their visitors with goods, suspending "light and showy articles" from the gallery railings and carpets from the gallery girders. The walls were covered with mirrors, paper hangings, and decorative furniture.[256] Inevitably the editor of *Harper's New Monthly Magazine* described Broadway, "when it is completed," as "the three-miles-long nave of a Crystal Palace, for admittance to which no charge is made."[257]

The Crystal Palace exhibition was a private undertaking, but, argued the *Morning Courier and New-York Enquirer*, "it enjoys something of the prestige that attaches to a public enterprise." It was chartered by the state, its site was leased to it by the city, and it was endorsed by the federal government. More important, it bore the burden of defending the national honor in presenting American products in a favorable light.[258] Yet critics chose to see it as merely another commercial spectacle, the "simple speculation of a few private individuals."[259] When the building burned on October 5, 1858, Strong wrote it off as the final bursting of a "bubble rather noteworthy in the annals of N. Y."[260]

If members of the elite thought the Crystal Palace too involved in spectacle to succeed as an educational endeavor, other New Yorkers thought it too genteel to succeed financially, and fail it did. During the uncertainty about the future of the building and its contents that followed the closing of the original exhibition, Barnum briefly stepped in to take it over. *Godey's Lady's Book* thought him the best person to make it succeed and certainly a better choice than the "old fogy concern" that had initiated the enterprise, whose members "had about as good an idea of managing an establishment like the Crystal Palace as they had of earning the money which their fathers left them."[261] Yet even Barnum could not make a go of it, and rather than inaugurating the improvement of the Crystal Palace's fortunes, his advent was said to have initiated the decline of his own.[262]

The Crystal Palace was the central attraction in a zone of commercial spectacles that quickly grew up around it, housed in temporary and poorly built structures of all sorts (cat. no. 141). Although it was unofficial and unwanted, this was the liveliest segment of the fair and the most popular among the "sovereigns." Its centerpiece was Waring Latting's Observatory, a 315-foot wooden tower adjacent to the fairgrounds on Forty-second Street that offered patrons a panoramic view of New York and its environs (cat. no. 143). Latting incorporated an art gallery, a refreshment saloon, and an ice-cream parlor to support his business, but few visitors were willing to expend the labor to walk to the top of the "Heaven-kissing peak" and the tower failed. It was sold to a firm of stonecutters, who used it for storage until it burned on August 30, 1856.[263]

In the streets surrounding the Crystal Palace, saloons, gaily decorated with flags and featuring crowd-pleasing attractions such as a group of mechanized wax figures that struck bells, were more eagerly patronized.[264] Balladmongers wandered the streets selling lyrics to the latest minstrel tunes. Animal sideshows, a merry-go-round, and a moving panorama of Mount Vesuvius also beckoned fun seekers. In short, there were all the makings of a modern midway, the kinds of things attractive to "mechanics and laboring men, with their wives and children, apprentice boys, and the miscellaneous group which such a show usually collects," along with seamstresses and their boyfriends, and stage drivers. The whole presented a scene of "drunkenness and rowdyism" reminiscent of the Fourth of July.[265] Central Park was meant to supplant entertainment such as this.

In the early nineteenth century, public open spaces were valued as urban "lungs" that ventilated the city, dispelling miasmas, dangerous natural gases to which epidemic diseases were attributed. The commissioners provided relatively few such spaces in the 1811 plan because they were thought less necessary in New York than in other cities. Manhattan was a relatively narrow island, and the commissioners believed that the breezes from the two rivers would dispel hazardous gases. Open spaces were also valued as promenades for fashionable men and women. Promenading was

a ritual of seeing and being seen by one's peers, preferably out of the sight of the "sovereigns." A promenading ground was a constricted space, laid out in a circle or oval so that people could walk and talk without worrying about changing direction and, more important, so that they could observe one another without violating a cardinal rule of gentility, not to stare directly at another person.[266] The preexisting squares of New York made perfectly adequate promenading grounds, although Francis J. Grund observed that "the people follow their inclinations and occupy what they like; while our exclusives are obliged to content themselves with what is abandoned by the crowd."[267]

By the 1840s New York's booming population had outgrown the existing parks and squares, and no new ones were created as the terrain between Twenty-third and Fiftieth streets was developed at midcentury.[268] Pressure on the city's open spaces increased as they became "recreation grounds," places of more active sociability than promenading entailed.

It was at this time that certain New Yorkers began to conceive of a new kind of park, one that would "be the resort of the student, of the professional man, of the artist, of the mechanic; of the invalid, of the young and the old. All classes and ages would resort to it to enjoy the simple pleasures of exercise, of walking and talking in the open air."[269] Advocates of such new-style parks accused the commissioners of forgetting or deliberately omitting land for something that had not been imagined in 1811, and they disparaged New York's existing parks and squares: "we have nothing worthy to be called a park," declared the Reverend Henry M. Field.[270] In 1849, in a famous essay originally published in his magazine *The Horticulturist,* Downing called attention to the widespread use of churchyards and the new rural cemeteries, such as Brooklyn's Green-Wood, for recreation, as evidence of an opportunity available to the city.[271]

The city seized the opportunity soon afterward, with an initial effort in 1851 to acquire Jones Wood, a tract that lay along the East River between Sixty-sixth and Seventy-fifth streets. In 1853 the legislature granted expropriation rights over the present site of the park, and in 1856 Frederick Law Olmsted and Calvert Vaux won a competition for the design of the new public grounds with their Greensward Plan (cat. nos. 192, 193; fig. 36).[272]

Vaux once described Central Park as the "big art work of the Republic," meaning that he saw it as a specimen of republican simplicity and civic engagement, but it was republican in more ways than that.[273]

Its naturalistic imagery often distracts us from its urban character, as a product of the systematic, diverse city of the 1850s (cat. no. 151). Olmsted and Vaux thought of the park as a retreat, but they also recognized that its size and location required it to be integrated into the working and residential city outside; accordingly they devised a multilevel pattern of circulation that separated internal from through traffic and vehicles from pedestrians. Thus the park was linked to the circulatory system of the city grid.

Central Park was, furthermore, a product of the urban economy. It was promoted by merchants and property owners who recognized its potential as a magnet that would bring them riches. Once it was clear that the park would be realized, elite development on the Upper East Side was facilitated by city-sponsored construction of streets, sewers, gas lines, and water mains.[274]

The process of converting the open, irregular site into the dramatic, highly artificial "rural" landscape of Central Park was a major engineering project that created "the most imposing industrial spectacle to be seen upon the continent" while it was under way.[275] The work was undertaken with such alacrity because New York's Democratic mayor, Fernando Wood, saw it as an opportunity to employ a thousand of his supporters each day—the "small army of Hibernians" that Strong observed toiling there—during slack economic times.[276] Ironically, like the Croton Waterworks (whose receiving reservoirs were located within the park), this public work was a product of the kind of immigrant-directed political patronage that scandalized most of the park's genteel proponents.

The nuts-and-bolts origins and infrastructure of Central Park served a vigorous crusade for urban uplift, in which all kinds of wholesome recreation would combine to improve the quality of civic and personal life. In Olmsted's eyes much of Central Park's good work would be done by the landscape itself. Where an early republican educator might have sought to improve his neighbors through systematic instruction, Olmsted looked for an inward transformation inspired by New Yorkers' direct experience of spiritual resources previously available only through landscape painting.[277] The Greensward Plan offered a heterogeneous mixture of cultural and recreational facilities, including a concert hall, a sculpture walk, a formal garden, and playgrounds—anything that would edify the public (cat. no. 153). Art, music, and nature were all expected to produce the same result: an elevation of public sensibilities nearer to those of genteel men and women.

266. "Landscape Gardening. Public Squares," *Godey's Lady's Book* 47 (September 1853), p. 215.
267. Grund, *Aristocracy in America,* vol. 1, p. 19.
268. Moehring, "Space, Economic Growth, and the Public Works Revolution," pp. 38–39.
269. Henry M. Field, "The Parks of London and New York," *Christian Parlor Magazine* 6 (1850), p. 64.
270. Field, "Parks of London and New York," p. 64; "City Improvements," *Morris's National Press,* March 7, 1846, p. 2.
271. A. J. Downing, "Public Cemeteries and Public Gardens" (1849), in his *Rural Essays,* edited by George W. Curtis (New York: G. P. Putnam, 1853), pp. 154–59.
272. The well-known history of Central Park's creation is told best and most completely in Roy Rosenzweig and Elizabeth Blackmar, *The Park and the People: A History of Central Park* (Ithaca, New York: Cornell University Press, 1992).
273. Quoted in Rosenzweig and Blackmar, *Park and the People,* p. 136.
274. Elizabeth Blackmar, "Uptown Real Estate and the Creation of Times Square," in *Inventing Times Square: Commerce and Culture at the Crossroads of the World,* edited by William R. Taylor (New York: Russell Sage Foundation, 1991), p. 56; Moehring, "Space, Economic Growth, and the Public Works Revolution," p. 42.
275. "The Lounger. The Central Park," *Harper's Weekly,* October 1, 1859, p. 626.
276. Strong, Diary, entry for June 11, 1859, The New-York Historical Society; Bridges, *City in the Republic,* p. 123; Rosenzweig and Blackmar, *Park and the People,* pp. 151–58.
277. Rosenzweig and Blackmar, *Park and the People,* pp. 131, 239–41; Miller, *Empire of the Eye,* pp. 12–15.

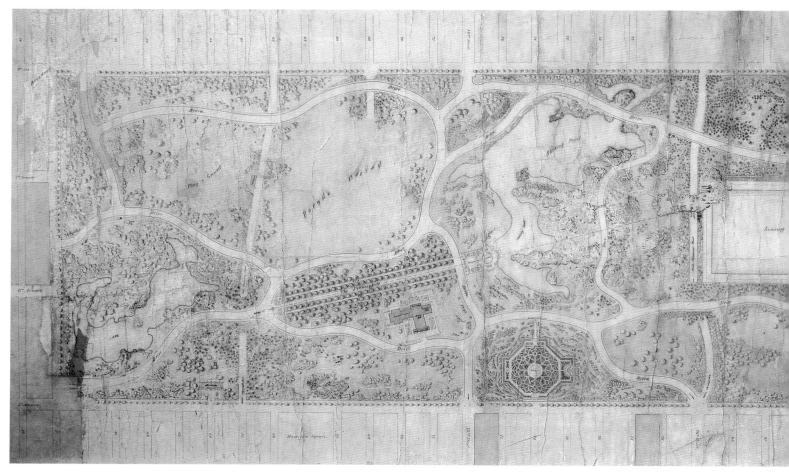

Fig. 36. Frederick Law Olmsted and Calvert Vaux, landscape architects, *"Greensward" Plan for Central Park,* 1858. Pen and ink. New York City Department of Parks, The Arsenal

278. Clarence Cook, "More About the Permanent Free Picture Gallery," *The Independent,* August 23, 1855, p. 265.

Central Park is often interpreted as an antiurban gesture, but it was one of several related tools in the quest for urbanity, as the art critic Clarence Cook, who campaigned vigorously for the park, a public library, and a public art gallery, acknowledged: "How much drunkenness and opium eating does any reasonable man suppose there would be in New-York, Boston, or Philadelphia, or in any large city or town, if there were in each of these places proper provision for the amusement of the people?"[278]

Two founding documents, coincidentally nearly identical in size—the Commissioners' Plan of 1811 and the Greensward Plan of 1858—bracket this essay. The first

took the entire city as its subject and the second encompassed a major redesign of one section of it. They are often set up as opposing visions, the former artificial and utilitarian, an unimaginative, money-minded approach, the latter natural and romantic, an attempt to ameliorate the worst effects of its ill-considered predecessor. It seems more accurate to see them as complementary blueprints for citizenship and urbanity during the decades between the opening of the Erie Canal and the opening shots of the Civil War. If it succeeded, Central Park's planners thought it would create a harmonious, virtuous urban community without class antagonisms—very much like the one that early republicans envisioned—while creating a real-

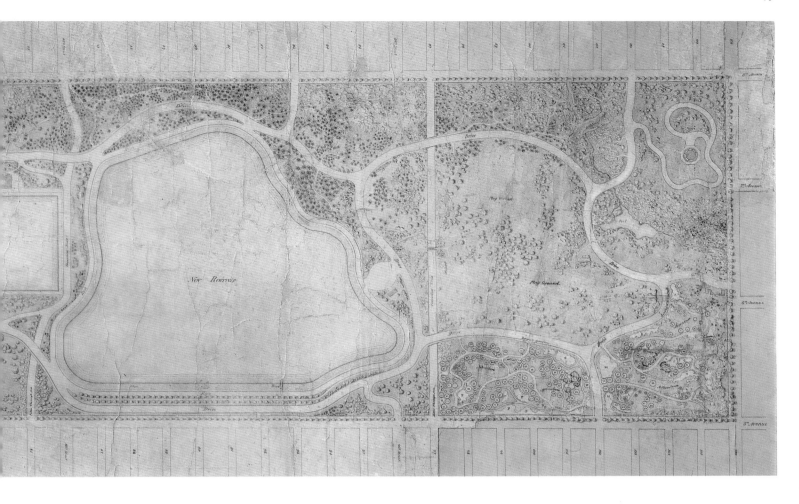

estate bonanza for themselves.[279] The park, however, would be based not on republican equality (although Vaux did evoke that idea) or on the transparency of universally disseminated knowledge, but on a commonality of feeling inculcated by public institutions.[280]

This was the final answer to the question of what was required to make New York a metropolis. "Our city has hotels that surpass in splendor and extent most of the public hotels of Europe; an Academy of Music that will compare favorably with the best Opera-houses in the Old World; and with our new Park, which the public will insist on having, we shall lack but one of the most attractive features of the great European capitals (and this we shall soon have)—their galleries of art."[281] In the 1850s New York's elite remained convinced that cultural authority, not republican equality, was the key to social and political harmony, and they began to call for the establishment of free public institutions—parks, art galleries, and libraries foremost among them—that would transmit these values to the masses.[282] Central Park, brought to completion by a political machine catering to the people that the elite were trying to reach, was the first fruit of this campaign. The Civil War interrupted it, and when it resumed after the war, New York's elite took direct control of the process, organizing such Gilded Age monuments to cultural authority as The Metropolitan Museum of Art.

279. Field, "Parks," p. 64; "The Lounger. The Central Park," p. 626; Blackmar, "Uptown Real Estate," p. 56.

280. Rosenzweig and Blackmar, *Park and the People,* pp. 136–37.

281. *Frank Leslie's Illustrated Newspaper,* January 26, 1856, p. 102.

282. Cook, "Shall We Have a Permanent Free Picture Gallery?"; Cook, "More About the Permanent Free Picture Gallery," p. 265; Carol Duncan, *Civilizing Rituals: Inside Public Art Museums* (London: Routledge, 1995), pp. 54–55.

# Mapping the Venues: New York City Art Exhibitions

*CARRIE REBORA BARRATT*

In June of 1818, only shortly before the beginning of our period, a notice in the New York *National Advocate* of peculiarly Knickerbockerian parodic tone described the city's cultural enterprise as owing its welfare to seven men, "the same auspicious number as the wise men of Greece."[1] These men not only gave impetus to the visual arts, literature, and science but also provided "the sole support of the character of this state." They moved through their cultural affairs with the sort of efficiency possible only in a very small world, as they took their seats first as the executive cabinet of the New-York Historical Society and then, after they "brushed one another's coats of the cobwebs from the shelves and books, and marched off, Indian file, into the *next* room," proceeded to convene as the Philosophical Society, the Medical Society, the Bible Society, and finally the Academy of Arts. "We are," they sang in unison around the last board table, "the guardians of the pierean spring, and we will deal it out like soda water."

Tongue-in-cheek but bitingly accurate, the article portrayed New York's cultural establishment, in which the few dominated the few in an art world that was highly circumscribed. It would be another four decades before authority was effectively transferred from a tiny committee of elite comrades to an enormous cast of art dealers, auctioneers, curators, and impresarios, in which trained professionals were outnumbered by mere claimants to expertise that no one else presumed to assert.

Before midcentury an impromptu exhibition at the City Dispensary could rival a fully orchestrated show at the New-York Athenaeum. And the owner of an artists' supply shop could hold an auction in competition with one run by a saloonkeeper who might make better sales because in the evening he illuminated his lots by gaslight and served refreshments. The two major art institutions in town, the American Academy of the Fine Arts and the National Academy of Design, moved their operations from hall to hall and, when finally settled in spaces of their own, evidently let their rooms to one and all for diverse exhibitions apart from their own shows. Supplementing these veritable *Kunsthallen* were displays in store windows, hospitals, artists' studios, patrons' parlors, and other disparate spots. "Auction house" was a contradiction in terms, as most auctioneers had no permanent homes but rented space from various and sundry establishments for the day or week. Some venues were surely more prestigious than others, and some surely more appropriate for art, but relevant criteria had not yet been established. It is telling that the Marble Buildings at Broadway near Ann Street, across from Saint Paul's, were described in 1836 as having "the most complete and beautiful public exhibition room in America,"[2] praise that makes us now wonder why this place languishes in obscurity save for a few mentions in passing. No institution had a monopoly on either talent or the ability to attract viewers. There were paintings to be purchased on virtually every corner from many salesmen who dealt not only in art but in other commodities as well. For artists there was a teeming market characterized by myriad choices and strategies.

The map of New York's antebellum art scene can be plotted, and the list of venues and exhibitions can be charted, as the appendixes to this essay demonstrate.[3] The richer picture, however, can be neatly, if not completely, conveyed in series of vignettes, beginning with the so-called discovery story of the landscape painter Thomas Cole, a tale that encapsulates the configuration of the New York art scene on the brink of the second quarter of the nineteenth century.[4]

## Thomas Cole and His Many Dealers

Cole arrived in the city in the spring of 1825 and placed a number of works with George Dixey, a carver and gilder who plied his trade and sold art supplies on Chatham Street. A local merchant, George W. Bruen, purchased at least one of the pictures for $10 and, after subsequently meeting with the artist, sent the young man to the Catskills to seek fresh inspiration. By early fall Cole was back in New

This essay could not have been written without the expert research assistance of Gina d'Angelo, Austen Barron Bailly, Amy Kurtz, and Lois Stainman. The author is most grateful for their help.

1. Kaleidoscope, "First View in the Chamber of Vision," *National Advocate* (New York), June 23, 1818.
2. "Opening of Dioramas," *New York Herald*, December 22, 1836.
3. The story of art venues throughout the United States in this period has been told in Neil Harris, *The Artist in American Society: The Formative Years, 1790–1860* (New York: Braziller, 1966), esp. pp. 139–72; Lillian B. Miller, *Patrons and Patriotism: The Encouragement of the Fine Arts in the United States, 1790–1860* (Chicago: University of Chicago Press, 1982), esp. pp. 254–83; and Alan Wallach, "Long-Term Visions, Short-Term Failures: Art Institutions in the United States, 1800–1860," in *Art in Bourgeois Society, 1790–1850*, edited by Andrew Hemingway and William Vaughan (Cambridge: Cambridge University Press, 1998), pp. 297–313.
4. The phrase "discovery story" was coined, and the tale most recently retold, by Alan Wallach, "Thomas Cole: Landscape and the Course of American Empire," in *Thomas Cole: Landscape into History*, edited by William H. Truettner and Alan Wallach (exh. cat., Washington, D.C.: National Museum of American Art, Smithsonian Institution; New Haven: Yale University Press, 1994), pp. 23–24. See also Ellwood C. Parry III, *The Art of Thomas Cole: Ambition and Imagination* (Newark: University of Delaware Press, 1988), pp. 21–27; and Carrie Rebora, "The American Academy of the Fine Arts, New York, 1802–1842" (Ph.D. dissertation, City University of New York, Graduate Center, 1990), pp. 79–80.

Fig. 37. Thomas Cole, *Lake with Dead Trees (Catskill)*, 1825. Oil on canvas. Allen Memorial Art Museum, Oberlin College, Oberlin, Ohio, Gift of Charles F. Olney, 1904  1904.1183

The primary sources for the story are: An Artist [William Dunlap], "To the Editors of the *American*," *New-York American,* November 15, 1825, reprinted in the *New-York Evening Post,* November 22, 1825; An Artist [William Dunlap], "To the Editors of the *American*," *New-York American,* November 22, 1825; "A Review of the Gallery of the American Academy of Fine Arts," *New-York Review, and Atheneum Magazine* 1 (December 1825), pp. 77, 1 (January 1826), p. 153; and William Dunlap, *History of the Rise and Progress of the Arts of Design in the United States,* 2 vols. (New York: George P. Scott, 1834), vol. 2, pp. 359–60.

York with several new paintings, three of which Bruen helped him place at the artists' supply shop of the antiquarian William A. Colman. Cole, reportedly counseled by Bruen, asked $20 for each canvas. Colman offered them for sale at $25.

In short order, the pictures sold to three of Cole's colleagues: John Trumbull bought a view of Kaaterskill Falls (unlocated), William Dunlap got *Lake with Dead Trees* (*Catskill*) (fig. 37), and Asher B. Durand procured a scene of the ruins of Fort Putnam (unlocated). Dunlap and Durand quickly placed their purchases in the exhibition on view at the American Academy of the Fine Arts, which had opened in October, a month before the paintings changed hands. Almost as swiftly, Dunlap sold his Cole for $50

to Mayor Philip Hone, who was accustomed to free-market transactions of this kind, as he had once run an auction and commission business in textiles, tea, liquor, and fine arts with his brother. Trumbull also added his Cole to the exhibition at the Academy, of which he was president, but waited another month, however, until sometime in December. He wished first to show his purchase privately to the Baltimore collector Robert Gilmor Jr., to his nephew by marriage Daniel Wadsworth, and to the businessman and Academy board member William Gracie before putting it on public view. Each of these men would commission a work from Cole within the next few months.

This story of Cole's brilliant entry into New York, which expedited the successes of his subsequent

career, is a key chapter in the artist's biography. Moreover, the episode reveals the complicated and flexible workings of New York's contemporary art scene, which was populated by characters who slipped in and out of their roles to suit the situation at hand. First there was Dixey, who played a minor part in the narrative as the owner of a shop to which an artist might have gone for assistance. Many artists' supply shops sold works of art as an extension of their primary business and as a favor to their clients, a practice that engendered additional business: the paintings were made of the very materials purchased by their creators, who responded by buying more supplies. Furthermore, these artists had nowhere else to turn, since there were few formal galleries in the city, and those few, such as Michael Paff's establishment, preferred European pictures. The modest price Dixey charged for Cole's works suggests that the relationship between shop owner and artist was based on the granting of favors rather than on hopes for great profits, although Dixey surely took a bit off the top.

Then there was Bruen. There is no reason to doubt that he cherished Cole's work, nor to suspect that his assistance to the artist was motivated purely by monetary interests. But Bruen did take Cole for his protégé for a single summer, introduced him to a new dealer, and doubled his prices. While Bruen was initially a patron in the most traditional sense, he later became a middleman; in the latter role he did not buy all the works that resulted from the Catskills trip he financed but shepherded to market certain examples, the display and sale of which may have inflated the value of his own Coles. Bruen helped Cole place his pictures with Colman, who not only sold art supplies like Dixey but was in addition a seasoned book dealer. Although the precise details of how Colman marketed Cole's paintings—their placement in the shop, his business methods, and the like—are lost to history, it is clear that the works sold rapidly and at asking price.

An element of happenstance in the story of Cole's discovery in New York pervades traditional retellings of it: Trumbull went to Colman's, where he bought a Cole, and when he praised it to his friend Dunlap, Durand overheard him by chance. Yet the purchases made by Dunlap, Durand, and especially Trumbull were not entirely fortuitous. Colman owed Trumbull money for pictures—either painted or owned by Trumbull—he had sold at his shop. The financial relationship between the two men is pertinent since Trumbull did not, in fact, pay $25 for his Kaaterskill Falls picture but was out of pocket only the difference between that price and what Colman owed him.

Colman, in turn, forfeited the cash he might have received from another client for Cole's painting but may have profited by bartering with Trumbull rather than paying him.

Trumbull was no stranger to art dealing, which had, in fact, been a critical component of his career since the 1790s, when he took partners in Paris and amassed a collection of old master paintings for sale at Christie's, London.[5] The pictures not sold at auction Trumbull brought to New York in 1804, when he displayed them in a riding stable and offered them again. As president of the American Academy from 1816, he exerted considerable influence on the market, orchestrating myriad purchases of pictures for the Academy, for himself, and for individual artists and patrons.[6]

Trumbull undertook most of his enterprises to enhance his career and the Academy's stature rather than as strictly lucrative ventures. He promoted himself as the city's keenest connoisseur, one of the few, as the *Commercial Advertiser* reported, who would have recognized, as he did, a Domenichino if he saw it.[7] A talented, clever, and resourceful man with an abiding interest in every aspect of New York's art scene, Trumbull participated in what would now be considered multiple professions. His involvement with Cole brought most of them into play. As a painter, he greatly admired Cole's artistic skills and vision. As the head of the American Academy, he wished to cultivate Cole and other contemporary artists whose work suited his exhibition program and collecting initiatives. As an enterprising participant in New York's art scene at large, Trumbull took part in transactions between artists such as Cole and collectors that in some cases were remunerative and in others extended his controlling influence. In fact, Cole scarcely made a sale in the decade after the purchase of the Kaaterskill picture that cannot in some fashion be linked to Trumbull's machinations.[8]

Perhaps the most important part of the Cole discovery story emerges after the purchase of the Kaaterskill painting, when the impact of Trumbull's interest in the young artist became significant. At this point the roles of Dixey, Bruen, and Colman began to diminish. Dunlap and Durand merely followed through, as pawns for Trumbull, making it possible for him to have all three of Cole's pictures for the fall exhibition at the Academy, which, after all, was a sales gallery. Taking the paintings from Colman's to the Academy did not remove them from the market but transferred them to a more advantageous venue. In a matter of months the value of Cole's work

5.  For more detailed information on Trumbull's collecting efforts in the 1790s, see Irma B. Jaffe, *John Trumbull: Patriot Artist of the American Revolution* (Boston: New York Graphic Society, 1975), pp. 172–75.
6.  On Trumbull and the American Academy, see Rebora, "American Academy of the Fine Arts," pp. 57–101.
7.  "An Old Picture," *Commercial Advertiser* (New York), October 20, 1827.
8.  See Wallach, "Thomas Cole," p. 35; and Alan Wallach, "Thomas Cole and the Aristocracy," *Arts Magazine* 56 (November 1981), pp. 94–106.

9. The price is recorded in Cole's letter to Wadsworth of December 4, 1827, a year after the picture was bought and paid for. See J. Bard McNulty, ed., *The Correspondence of Thomas Cole and Daniel Wadsworth* (Hartford: Connecticut Historical Society, 1983), p. 25.

10. For a detailed account of the founding of the National Academy of Design, see Rebora, "American Academy of the Fine Arts," pp. 244–336.

11. This characterization was most recently put forward in Rachel Klein, "Art and Authority in Antebellum New York City: The Rise and Fall of the American Art-Union," *Journal of American History* 81 (March 1995), p. 1536.

12. Denon, "The Two Academies," *New-York Evening Post*, May 17, 1828. For a complete account on the war of words in New York papers during the summer of 1828, see Rebora, "American Academy of the Fine Arts," pp. 287–305.

quintupled, as it escalated along parallel trajectories of price and place of sale, from $10 at Dixey's, to $25 at Colman's, to $50 at the Academy, where Dunlap brought *Lake with Dead Trees* to Hone's attention.

The nature of free and flexible trade allowed Dunlap to keep the profit he realized in the sale to Hone rather than share it with Cole; Dunlap justified himself by pleading his straitened circumstances, but in any event there existed no market regulation or precedent that would have compelled him to be generous to Cole. Trumbull also would certainly have held on to any extra profits if he had sold the artist's Kaaterskill view to Gilmor, Wadsworth, or Gracie. The prices for Cole's landscapes remained high, in some measure thanks to Trumbull, whose nephew Wadsworth paid $50 for his Cole (Wadsworth Atheneum, Hartford), a picture reportedly identical to Trumbull's and commissioned at Trumbull's behest.[9]

### The House of Trumbull, Barclay Street

The single most important figure on the New York art scene before his death in 1843, Trumbull wielded tremendous influence in many spheres. Notoriously irascible, especially in his later years, he is typically regarded as an anachronistic figure, a thorn in the side of those with more modern views. He was, as is commonly recounted, the old man who moved his *retardataire* institution in a direction other than that desired by the community of artists, which, under the leadership of Samuel F. B. Morse in 1825, founded the National Academy of Design. Morse began to organize his colleagues by hosting socials in his spacious Canal Street studio. These soirees quickly evolved into the New York Association of Artists and, within months, into the National Academy, which offered classes, lectures, and an exhibition of contemporary paintings and sculpture by local American artists each spring. The National Academy's success can be gauged by the favorable reviews of its shows, the great legacies of the artists trained there, and the impressive number of important paintings it exhibited over the years. Morse's idea that his academy would coexist with Trumbull's proved untenable, and the two institutions operated competitively until the American Academy ultimately closed in 1842.[10] In writing about their rivalry, historians have always favored the artists, who are cast as industrious, modern, and democratic foils to Trumbull's idle, old-fashioned, and elite board of directors.[11] Such stereotypes fuel the story of a clash between progressive forces and tradition-bound cultural authority, at least in the version of

history that considers the American Academy useless. The American Academy's demise as a meaningful institution is allegedly proved by its increasing lack of connection with contemporary American art in the 1830s and 1840s. Yet the American Academy was never involved in this field; its vital concern, both before and after the founding of the National Academy, was the market for old masters and contemporary European painting. This was a market that owed its existence in New York in significant measure to Trumbull, who had been its driving force since his return from abroad in 1804.

The sometimes antagonistic coexistence of the two rival academies reflected the flourishing and complicated nature of New York's art market. Editorials published in the papers during the summer of 1828, when the National was still new and the American still smarting from the sting of competition where there had been little before, agreed on just one point: the city required only one institution for the fine arts. One of the first and most vehement editorialists, a supporter of the National, writing in the *New-York Evening Post* described the American's dearth of lectures, classes, and "any evidence of prosperity and of energetic and discreet government."[12] The exhibitions at the American, he explained, consisted of works "by all manner of artists, *known* and *unknown*, *ancient* and *modern* . . . and there are *huge* copies, and *little* copies, and *whole* copies, and *half* copies, and *good* copies, and *bad* copies; indeed it is a sort of Noah's ark, in which were things of every kind, *clean* and *unclean*, *noble animals*, and *creeping things*."

The National, by promising contrast, offered all of the things deemed missing from the American's program—lectures, classes, and exhibitions of contemporary work by local artists—and this, according to the author, was all the city needed. Yet the city could not have done without the bad copies and creeping things, for these were an intrinsic part of its art world and have continued to be so to this day. The modern National would have to coexist with the antiquated American, which thrived precisely by continuing to present the sort of art described so disparagingly in the *Evening Post*.

The American Academy was New York's host to all that was inappropriate for the National; its inclusiveness should not be interpreted in a negative light, for on its walls was a world of art that would move to multiple venues during the late 1840s and 1850s. It is true that Trumbull's institution featured much that is now known to have been of spurious attribution and provenance. But it would have been impossible

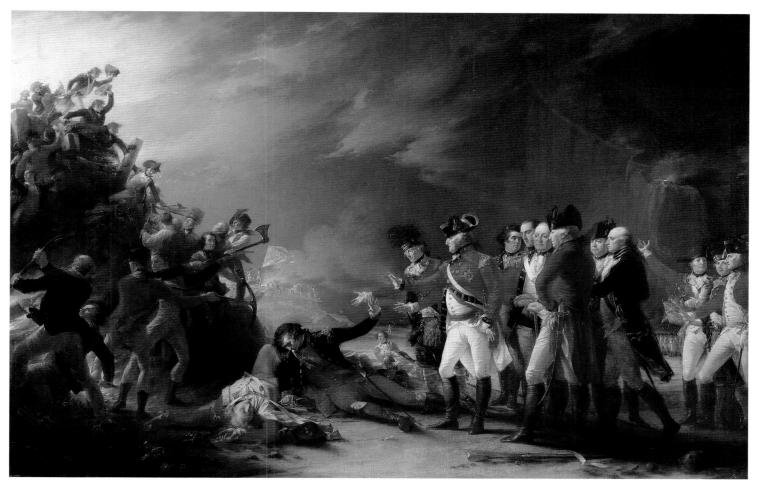

Fig. 38. John Trumbull, *Sortie Made by the Garrison at Gibraltar,* London, 1789. Oil on canvas. The Metropolitan Museum of Art, New York, Purchase, Pauline V. Fullerton Bequest; Mr. and Mrs. James Walter Carter and Mr. and Mrs. Raymond J. Horowitz Gifts; Erving Wolf Foundation and Vain and Harry Fish Foundation Inc. Gifts; Gift of Hanson K. Corning, by exchange; and Maria DeWitt Jesup and Morris K. Jesup Funds, 1976  1976.332

for any American establishment of the early nineteenth century to consistently put forward impeccable works, for no one of the period, neither Trumbull nor any other collector in this country, had the connoisseurship skills necessary to judge art of various dates and cultures. In the 1820s and 1830s the American Academy opened the market, took risks, and, ultimately, presented in microcosm all the elements of the vital, multifaceted, complicated art scene that burgeoned in the following decades.

Trumbull shaped his institution for would-be patrons and collectors seeking the broadest experience of art, and he did this at a time when and in a place where there were plenty of mistakes to be made. A man of contradictory tendencies, he espoused the grandest traditions of art but had a business sense that led him to show unknown works of many kinds.[13] Between 1828 and 1839 the American Academy hosted nine exhibitions of old masters, each one brought to New York by a different entrepreneur, ranging in character from irreproachable to criminal. The collection of Antonio Sarti of Florence came to the American Academy in December 1828 on the advice of the collector, sometime dealer, and American Academy board member Pierre Flandin, who did not so much vouch for the collection as simply introduce Signor Sarti as his friend.[14] The prospect of having over two hundred Italian paintings in the Academy's gallery was enough for Trumbull, who did not see the collection before extending Sarti a contract, and the show was apparently more than satisfactory for the nearly two thousand visitors who saw it during its first two weeks. The crowds came in steady numbers for six weeks and then increased in mid-April 1829, after Sarti authorized the Academy to offer the entire collection at public auction in the gallery.

The Sarti sale was not Trumbull's first venture into the auction business. During the summer of 1828 he had orchestrated a silent auction for his own *Sortie Made by the Garrison at Gibraltar,* 1789 (fig. 38), a work painted in London that depicted a British military victory over the Spanish. Trumbull had failed to

13. On Trumbull's contradictory nature, see Jules David Prown, "John Trumbull as History Painter," in *John Trumbull: The Hand and Spirit of a Painter,* by Helen A. Cooper et al. (exh. cat., New Haven: Yale University Art Gallery, 1983), p. 22.

14. See American Academy of the Fine Arts, Minutes (BV), November 3, 7, 1828, The New-York Historical Society; and American Academy of the Fine Arts, *Exhibition of Rare Paintings at the Academy of Fine Arts, New York* (exh. cat., New York, 1828).

Fig. 39. Benjamin West, *King Lear*, London, 1788; retouched 1806. Oil on canvas. Courtesy of the Museum of Fine Arts, Boston, Henry H. and Zoë Oliver Sherman Fund  1979.476

15. [John Trumbull], "Trumbull's Picture of Elliott's Sortie from Gibraltar," *Commercial Advertiser* (New York), October 20, 1827; [John Trumbull], "American Academy of the Fine Arts," *Commercial Advertiser* (New York), June 2, 5, 6, 14, 28, 1828.

16. See Carrie Rebora Barratt, "John Trumbull and the Art of War," manuscript available for inspection.

17. [Trumbull], "American Academy of the Fine Arts," June 6, 1828.

18. See Carrie Rebora, "Robert Fulton's Art Collection," *American Art Journal* 22 (1990), pp. 40–63.

sell the picture abroad and kept it under wraps in his New York studio for nearly twenty-five years before mounting it at the Academy in 1828—to great fanfare that he generated by advertising the painting as "splendid and faultless" and by penning anonymous laudatory reviews.[15] The presentation was a single-picture exhibition meant to draw attention to Trumbull and the American Academy during a summer of heated public debate between the two academies.[16] The precise details of the military event depicted would have been lost on most New Yorkers, but Trumbull may have hoped that those caught up in the battle between the academies would read the painting's key figures—the victorious aging General George Elliott and the defeated young Don Juan de Barboza—as allegorical representations of the two institutions. He wrote in the New York *Commercial Advertiser* of his picture, "The victor stands in the full blaze and splendor of light and glory—the vanquished [hero], dies in the deep gloom of adversity and despair."[17] This, he perhaps thought, was how Samuel F. B. Morse ought graciously to lie down and die in the face of a more powerful force.

In the end, Trumbull was disappointed to find not only that his grand canvas had little if any impact on the relationship between the academies but also that there was little interest in the *Sortie* among New York collectors. He was pleased, however, to sell the picture to the Boston Athenaeum. The sale encouraged him in his desire to bring the art marketplace into his academy, and in October 1828 he used the site for an auction of the paintings in Robert Fulton's collection—principally Shakespearean subjects by Benjamin West, including *King Lear*, 1788 (fig. 39), and *Ophelia before the King and Queen*, 1792 (Cincinnati Art Museum)—which had been on loan at the Academy since 1816 and were being sold by Fulton's heirs.[18]

For two of these events Trumbull called in others to make the sales: John Boyd for the Fulton pictures and Michael Henry for Sarti's collection. Neither had a space of his own and neither was ever heard of again: they were auctioneers for a day. If Trumbull's Academy received a percentage of the profits for use of its rooms, it is not recorded, but the institution was certainly enriched by the entrance fees paid by everyone, whether mere spectator or ready buyer. In the view of

Fig. 40. Joshua Reynolds, *George Clive (1720–1779) and His Family,* London, 1765–66. Oil on canvas. Staatliche Museen zu Berlin, Preussischer Kulturbesitz, Gemäldegalerie 78.1

those who believed—or still believe—that an institution bearing the name Academy must be untainted by commercialism, Trumbull defiled his galleries by welcoming public sales in them. However, those who have observed that he was among the first Americans to recognize that art can be a business may consider him not impure but prescient.

In 1830 the very existence of the American Academy was threatened when it was forced to leave its quarters in the New York Institution in City Hall Park. In response to this crisis, Trumbull mounted the extraordinarily controversial exhibition of Richard Abraham's collection of European paintings. This collection, according to the catalogue published by Abraham, an English picture dealer and conservator, included Leonardo's *Virgin of the Rocks,* Titian's *Magdalen in the Wilderness,* Raphael's *Adoration,* and works by Velázquez, Andrea del Sarto, Watteau, Van de Velde, Ruisdael (cat. no. 47), Lodovico Carracci, Murillo (cat. no. 44), and Tiepolo. Although it is now known that the vast majority of the pictures were copies, at the time of the show the authenticity of the works was not at issue. Dunlap summed up

generally held opinion when he described them as "the best pictures from old masters which America had seen."[19] They were, in any event, notorious because of "the peculiar circumstances attending their importation." Abraham, it was charged, had "collected a number of good pictures, under various pretences," having duped their English owners.[20] He was arrested on his arrival in New York, and the collection went on view and was auctioned under the aegis of Goodhue and Company, the agency responsible for the pictures after his imprisonment. His victims in England pressed charges but were nonetheless keen to sell their family treasures in America.

The exhibition was a huge success, reflecting the strength of the New York market. Thousands of people saw the show—paying steep admission prices of 50 cents for a single entry or $3 for the season—and the critics applauded loudly. The reviewer in the *Morning Courier and New-York Enquirer* was dumbfounded: "Language would convey but a faint idea of the effect which is produced upon the mind in examining [the paintings]."[21] As the closing act at the Academy's old building, the show epitomized Trumbull's mission: to

19. Dunlap, *Rise and Progress,* vol. 1, p. 305.

20. American Academy of the Fine Arts, Minutes (BV), February 4, 1830, The New-York Historical Society.

21. "Paintings.—Academy of Arts," *Morning Courier and New-York Enquirer,* March 24, 1830. See also C., "The Pictures," *New-York American,* April 2, 1830; C., "The Pictures at the Academy," *New-York Mirror,* April 3, 1830, p. 307; "Academy of Fine Arts," *Commercial Advertiser* (New York), April 5, 1830.

Fig. 41. Francis Danby, *The Opening of the Sixth Seal*, Dublin, 1828. National Gallery of Ireland, Dublin

22. "Paintings by the Great Masters, Barclay Street," *Evening Post* (New York), December 26, 1832. See American Academy of the Fine Arts, *A Descriptive Catalogue of the Paintings, by the Ancient Masters, Including Specimens of the First Class, by the Italian, Venetian, Spanish, Flemish, Dutch, French, and English Schools* (New York: W. Mitchell, 1832).

keep the visitors coming by maintaining an edge on the market—that is, to show and sell what could be seen nowhere else in the city.

The American Academy moved to Barclay Street, next door to the Astor Hotel; David Hosack, a founding director, donated the land behind his home for the new building, which was designed by Trumbull, who also acted as contractor. The reopening was fraught with anxiety and the Academy's position remained tenuous, but during the 1830s Trumbull pursued his two basic goals: to continue to show European art and, of course, to keep the doors open. His struggles of the early 1830s resulted in a lively series of exhibitions. In 1831, for example, the Academy's season opened with a display of Trumbull's own paintings of scenes from the American Revolution, which ran almost concurrently with a showing of Horatio Greenough's sculpture *Chanting Cherubs* (unlocated; see fig. 108), and closed with the single-picture

exhibition of George Cooke's copy of Gericault's *Raft of the Medusa* (New-York Historical Society). John Watkins Brett, "a gentleman of great wealth and taste in England" and a friend of Trumbull, presented his collection at the Academy in 1832, causing the *Evening Post* critic to proclaim that "no collection surpassing it has been exhibited in this city."[22] Brett's pictures included Sir Joshua Reynolds's *Self-Portrait in Doctoral Robes*, 1773 (private collection), and his *George Clive (1720–1779) and His Family*, 1765–66 (fig. 40); Benjamin West and Robert Livesay's *Introduction of the Duchess of York to the Royal Family of England*, about 1791 (National Trust, Upton House, Oxfordshire); and forty-five other European paintings, most of which were of undisputed pedigree.

The schedule for 1833 was a product of Trumbull's relationship with Brett, who brought to New York Claude-Marie Dubufe's *Temptation of Adam and Eve* and *Expulsion from Paradise*, 1828 (unlocated; see

figs. 42, 43), and Francis Danby's *Opening of the Sixth Seal,* 1828 (fig. 41). Trumbull supplemented this roster with a showing of James Thom's comedic sculptural group *Tam O'Shanter, Souter Johnny, the Landlord and Landlady* (unlocated). The next year saw presentations of Cole's enormous *Angel Appearing to the Shepherds,* 1834 (Chrysler Museum, Norfolk, Virginia), Robert Ball Hughes's *Uncle Toby and Widow Wadman* (unlocated), four views of Rome by Giovanni Paolo Panini (see cat. no. 48), the collection of the Marquis de Gouvello, and immense dioramic paintings. In 1835 Brett's collection returned and was followed by Daniel Blake's collection of old masters, more sculpture by Thom, and more history paintings by Trumbull. With no precise method of selection or exacting criteria, Trumbull took what came and was pleased by the crowds that kept his Academy open.

According to this rather haphazard approach, he allowed his institution to become the city's principal venue for large shows and odd shows. By about the mid-1830s the American Academy faced competition from the Marble Buildings, the City Dispensary, Clinton Hall, Masonic Hall, Reichard's Art Rooms, and John Vanderlyn's New-York Rotunda (see cat. no. 70), and myriad storefronts as well as from the increasingly professional National Academy of Design. The business of exhibitions, which had proved reasonably profitable for Trumbull, was expanding to accommodate growing demand from New Yorkers, and new venues were springing up to take over. Trumbull's Academy closed not because it was overwhelmed by the power of the National Academy, as most have suggested, but because it was superseded by these new establishments.

At this point even the officers of the National Academy found the competition too threatening and the potential profits too attractive to pass up and rented its galleries out for displays of private collections and for auctions. In 1842, nearly two decades after the academies debated on matters of principle and purpose, the American Academy shut its doors. Ironically, it closed just as the National Academy was mounting an exhibition and auction of old masters. The two academies had become one.

### Dubufe's Adam and Eve Paintings and the Art Unions

*The Opening of the Sixth Seal* by Francis Danby was a spectacular component of the American Academy's 1833 program of exhibitions. This Irish artist's splendid interpretation of Revelation 6:12–16 was a type of picture never before seen in this country and

influenced several key American painters, including Cole and Durand. But the Danby exhibition, in fact, had nothing on the other two shows presented that year. Crowds flocked to see Thom's statues based on Robert Burns's verse: there were hundreds of visitors every day and even more came on the occasions when Mr. Graham, "the blind Scotch poet," recited from Burns in the galleries.[23] Thom's Ayrshire stone alehouse tableau, large as life, reported *The Knickerbocker,* was "so much written about . . . that every phrase of critical eulogy has been exhausted."[24]

But not even this novel group could hold a candle to Claude-Marie Dubufe's two fourteen-by-twelve-foot paintings of Adam and Eve. Dubufe was a French student of David chiefly known for his portraits. He executed the Adam and Eve pictures, advertised as "Grand Moral Paintings," in 1828 for Charles X of France, who was forced to sell them when he abdicated in 1830. Brett showed the giant canvases at the Royal Academy and the British Institution in London before introducing them to America in a two-month exhibition at the Boston Athenaeum in late 1832, after which he brought them to New York.[25] The paintings elicited a storm of favorable reviews, a poet wrote ten stanzas on them, and Dunlap, who judged the pictures "very beautiful," recorded in his diary that the exhibition was "unusually successful many days yealding 100 dollars y[e] day."[26] The *New-York Mirror* reported that "throngs of visitors have crowded to examine them, with lavish exclamations of surprise and delight."[27] One commentator was inspired to remark "But this is not a picture—'tis the life."[28] This was extravagant praise indeed for a painter considered in European circles to be merely competent. The only detractors in New York were sermonizers on the inherent vice and licentiousness of art.[29] An apparently timid bunch, they waited to speak out until the Dubufes left the Academy. But they were not gone for long.

Dubufe's paintings—not only those of Adam and Eve but other canvases as well—were the rage of the New York art critics and viewing public alike for nearly three decades. In 1833, when there was something for everyone in the city, Dubufe's biblical pictures successfully vied with the annual exhibitions of the American Institute of the City of New York and the National Academy of Design, which respectively featured amateur painting and contemporary American art and, as always, were well attended. Dubufe's work returned to the American Academy in 1836 and 1838 and appeared in New York in the intervening year at the Stuyvesant Institute. In the few years they were absent from the city, between 1833 and 1836, Dubufe's

23. "Tam O'Shanter," *Morning Courier and New-York Enquirer,* June 19, 1833.

24. "The Group from Tam O'Shanter," *The Knickerbocker* 2 (July 1833), p. 69.

25. For the complete history of the pictures and the American tour, see Kendall B. Taft, "*Adam and Eve* in America," *Art Quarterly* 22 (summer 1960), pp. 171–79.

26. J. M. M., "Adam and Eve," *New-York American,* March 8, 1833; *Diary of William Dunlap (1766–1839),* edited by Dorothy C. Barck, 3 vols. (New York: New-York Historical Society, 1931), vol. 3, pp. 643 (entry for January 3, 1833), 663 (entry for March 5, 1833). See also advertisement, *New-York American,* January 4, 1833; *Morning Courier and New-York Enquirer,* January 4, 1833; "Fine Pictures," *New-York American,* January 12, 1833; "Adam and Eve," *New-York Commercial Advertiser,* February 25, 1833; and "American Academy of Fine Arts," *American Monthly Magazine* 1 (March 1833), pp. 61–62.

27. "The Paintings of Adam and Eve, at the American Academy," *New-York Mirror,* March 30, 1833, pp. 306–7.

28. J. M. M., "Adam and Eve."

29. See True Modesty, "The Two Grand Moral Paintings," *New-York Mirror,* June 1, 1833, p. 379; and W. W., "Acknowledgment o the Piece Signed 'True Modesty,'" *New-York Mirror,* June 15, 1833, p. 399. The editor prefaced W. W.'s comments with a note reporting that the journal had received "several communications . . . pro and con" on True Modesty's article; although he had not intended to use any of them, he explained, he printed excerpts from W. W.'s piece because it discussed the question of displaying prints of nude figures in shop windows. See also "Fine Arts," *New-York Literary Gazette, and Journal of Belles Lettres, Arts, Sciences, &c.,* September 15, 1834, p. 28.

30. "Adam and Eve," *New-York American*, December 3, 1836.

31. "The Fine Arts," *New-York Mirror*, September 30, 1837, p. 112.

32. Advertisement, *New-York American*, December 20, 1838.

33. "News of the Week," *Literary World*, January 13, 1849, p. 36.

paintings reportedly enlightened more than three hundred thousand viewers across the country. The *New-York American* attributed to each of these anonymous viewers "soundness of judgment and purity of taste" and reported that "there is scarcely one such visitor, who dissents from the high encomiums which have been awarded by the best connoisseurs to these pictures, as works of art, and by the present moralists for their salutary effect upon the mind and feelings."[30]

The high encomiums awarded to the pictures as works of art were no doubt undeserved, and it may well be that Dubufe was so successful in America primarily because he produced admirable paintings expressing admirable values as opposed to extraordinary paintings expressing indifferent values. By the late 1830s for most Americans the didactic component was the most important element of art.

When an exhibition of Dubufe's *Don Juan and Haidee* and *Saint John in the Wilderness* (both unlocated) inaugurated the gallery at the new Stuyvesant Institute in 1837, a reviewer for the *New-York Mirror* hailed the enormous pictures as "striking and well-conceived" and altogether appropriate for the new edifice, which honored the memory of the last director general of the New Netherlands.[31] And if the grouping of Peter Stuyvesant, Dubufe, Lord Byron, and biblical subject matter represented here seems eccentric by today's standards, it well reflected the eclectic tastes of the New York art audience of 1837. By 1838, when the two paintings from the Stuyvesant show were joined by Dubufe's *Circassian Slave* and *Princess of Capua* (both unlocated) at the American Academy, the artist needed no introduction to this appreciative audience, which was treated to the musical accompaniment of two aeolian harps that added "to the enchantment of the scene."[32]

It is tempting to propose that Dubufe may have been popular in New York not because his work was didactic but because it was spectacle rather than fine art, akin to illuminated paintings, dioramas, and other pictures suited more for entertainment than for serious contemplation. New York was full of this sort of material in 1837, when the Dubufe show was at the Stuyvesant and works of similar stripe were on view elsewhere: D. W. Boudet's *La Belle Nature* and *Daphne de l'Olympe* (both unlocated) at 17 Park Row, Dunlap's *Christ Healing the Sick* after West (unlocated) at the American Museum, and a mosaic picture of the ruins of Paestum at the American Academy. Throughout the 1830s Vanderlyn's New-York Rotunda presented panoramas of exotic sites like so many theatrical offerings, one booked after the other, providing

audiences with vicarious experiences of trips to faraway lands. Nineteenth-century observers rarely distinguished between the content of these shows, now considered low art, and the American paintings displayed at the National Academy and the American Art-Union or the old masters at the Lyceum Buildings, today's high art. Advertisements for exhibitions of all kinds were pitched to the same audiences and ran in the same newspapers, and the proprietors of galleries made their selections unbound by precise criteria. If such criteria had been in place, the mosaic picture would have been shown at the American Museum, a curiosity cabinet dedicated primarily to natural science and objects of random type, and Dunlap's paintings would have found their place at the more elite American Academy.

Matchups between venues and offerings remained unpredictable throughout the antebellum era. Perhaps one of the most unpredictable occurred in 1849, when Dubufe's Adam and Eve paintings returned to the city yet again, this time to the National Academy of Design. The show opened in January at the National's space in the New York Society Library. The Dubufe installation, like an exhibition of old masters booked for the Academy's large room later in the year, was undoubtedly meant to raise revenues needed to erect a building at Broadway and Bond Street. The National Academy did not entirely compromise its stated mission with these exhibitions—its galleries were used exclusively for the annual show of contemporary American painting by local artists between April and July. Nonetheless the Dubufe event in particular speaks of the competitive nature of the New York art market and the strategies many establishments were forced to adopt to remain financially viable. For the National Academy, founded with exacting programmatic standards, it must have been strange indeed to reprise a show that had originated sixteen years earlier at its archrival, the American Academy. The *Literary World* noted that it was hard to believe but true that "the celebrated Paintings . . . are the same."[33]

Yet, in fact, the National Academy Dubufes may not have been the American Academy Dubufes. The original pictures were destroyed by fire, but there is no indication where or when. It is known that John Beale Bordley painted copies during the winter of 1833–34, when the paintings were in Philadelphia. Bass Otis is said also to have copied them, and it is probable that other sets were made as well; thus by the 1840s numerous versions were traveling. Even if the National Academy had the originals, they would

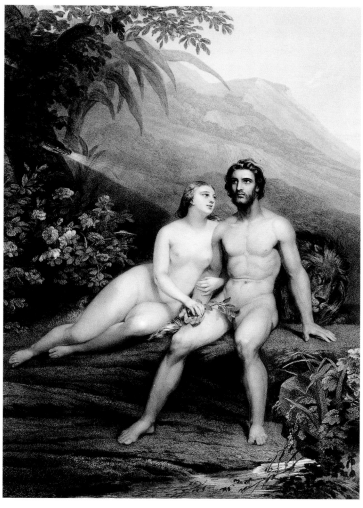

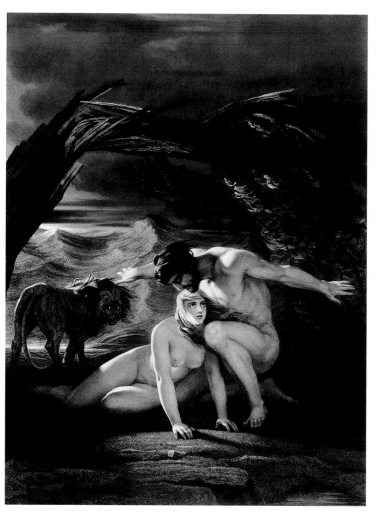

Fig. 42. Henry Thomas Ryall, after Claude-Marie Dubufe, *The Temptation of Adam and Eve*, London, 1860. Engraving. The British Museum, London

Fig. 43. Henry Thomas Ryall, after Claude-Marie Dubufe, *The Expulsion from Paradise*, London, 1860. Engraving. The British Museum, London

have been in a poor state of preservation: owing to their tremendous size, they must have been rolled and unrolled many times and, it seems certain, retouched by local artists at every stop. In any event, the announcement of the National's show explained that the paintings had been touring England, Ireland, and Scotland for eleven years to the delight of "one million seven hundred thousand persons," a statement that simultaneously accounted for their absence from America and added to their cachet as significant works of art.[34]

In 1849 the National presented the best of American painting, undisputed masterpieces by Frederic E. Church, Daniel Huntington, Emanuel Leutze, and Asher B. Durand, the Academy's president, who was represented by eleven pictures including his homage to Cole, *Kindred Spirits*, 1849 (cat. no. 30). The stark contrast between the American works and Dubufe's paintings of Adam and Eve underscores the complicated

nature of the exhibition scene. The *American Metropolitan Magazine* voiced the hope that the public would show some discrimination when considering the Dubufes: "These pictures, which some fifteen years ago were visited by thousands, the most successful Art exhibition that ever took place in this country, are again brought before the public; but we hope, for the sake of pure and correct taste, with not quite that extraordinary success that attended them before. Through such works as these Art is degraded."[35]

The competition for viewers and buyers of art in 1849 was fierce. Frequent auctions held by new professional houses, including Cooley; Dumont and Hosack; Leavitt (figs. 44, 45); Leeds; and Royal Gurley, brought more and more art objects to the attention of New Yorkers. Artists accustomed to selling their works through the National Academy or from their studios began to turn to auction houses, as did private collectors. The Lyceum Gallery, home of Gideon

34. "Return from Europe," *Home Journal*, January 6, 1849, p. 3.

35. "Fine Arts," *American Metropolitan Magazine* 1 (February 1849), p. 110.

Fig. 44. Trade card for Leavitt, Delisser and Company, 377–379 Broadway, ca. 1856. Wood engraving by William(?) Howland. Collection of The New-York Historical Society

Fig. 45. *Interior of Messrs. Leavitt and Delisser's Salesroom, Broadway, New York,* 1856. Wood engraving, from *Frank Leslie's Illustrated Newspaper,* April 5, 1856, p. 264. Courtesy of the American Antiquarian Society, Worcester, Massachusetts

36. "Lyceum Gallery—Old Masters," *Literary World,* March 10, 1849, p. 227.

37. "Fine-Arts Depository," *The Knickerbocker* 33 (February 1849), p. 170; "The Dusseldorf Gallery," *Home Journal,* May 5, 1849, p. 2.

Nye's collection of old masters, was in its second year of operation and actively promoted itself as a public venue.[36] The Paris print publisher and dealer Goupil, Vibert and Company, which had opened for business in the Lafarge Building at Broadway and Reade Street in 1848, was celebrating its arrival in New York by showing "worthy specimens" of modern European painting, including two—Ary Scheffer's *Holy Women at the Sepulchre,* 1845 (fig. 46), and Ferdinand Georg Waldmüller's *Letting Out of School,* 1841 (fig. 47)—that were described as "nails driven into the floor of the year, which shine and brighten with time and frequentation."[37] The Düsseldorf Gallery was inaugurated in April 1849 to great fanfare. Its proprietor, John

Fig. 46. Ary Scheffer, *The Holy Women at the Sepulchre,* 1845. Oil on panel. Manchester City Art Galleries, Manchester, England 1924.17

Fig. 47. Ferdinand Georg Waldmüller, *Letting Out of School,* Düsseldorf, 1841. Oil on wood. Staatliche Museen zu Berlin, Preussischer Kulturbesitz, Nationalgalerie

Godfrey Boker (formerly Johann Gottfried Bocker), had arrived in the city early in the year with the Kraus collection of paintings by artists trained at the Düsseldorf Academy, which he had bought with money he had earned as a wine merchant and statesman.[38] He hung the pictures at the Church of the Divine Unity on Broadway (fig. 48) and received unqualified praise, and the subsequent opening of the gallery was hailed as "an event of unusual magnitude in the way of Art."[39]

The New-York Gallery of the Fine Arts drew crowds, although its popularity would wane over the years; its 1848 installation, composed principally of American paintings collected by the late Luman Reed, complemented the National's typical American shows and attracted many visitors, but probably fewer than came to see the Dubufes the next year.[40] The much-maligned American Art-Union was flourishing early in 1849. For about a decade the Art-Union had been distributing engravings to $5 subscribers, who were entered in a Christmas lottery for one of the paintings it purchased each year.[41] There was no love lost between the Academy and the Art-Union, which bought works from local artists just before the Academy annuals; in fact, it may have been pressure from the Art-Union that drove the Academy to take up Dubufe.[42]

The Art-Union was successful despite adverse publicity and direct competition from the International Art Union, a similar organization developed by Goupil's. (The International differed in that it distributed European as well as American engravings and paintings and every year sent an American artist to Europe for two years of study.)[43] One writer likened the excitement surrounding the American Art-Union's December lottery to the thrills of the Gold Rush: "Not even the golden visions of California have been able wholly to banish from the minds of the fifteen thousand subscribers the pleasant thought that they were possibly to become each one a possessor of a fine picture as a small goldmine return for their ventured five dollars."[44] The big winner in December 1848 took home Cole's four-picture series The Voyage of Life (see figs. 49, 60), a prize so exceptional that word went out that the Art-Union intended to buy it back from the journeyman printer from Binghamton whose number came up that eventful night. Others grumbled that for every fine painting by Cole there were countless inferior works awarded to lottery winners throughout the country who knew no better.[45] Some of this carping may have originated with advocates of the International Art Union or the National Academy, and some

members of the Academy proposed establishing their own Painters' and Sculptors' Art Union.[46]

Partisans of each union fought it out in the papers, and by November 1849 the American was losing ground under full attack for falsifying its charter and misspending its members' dues, among other offenses.[47] One clever writer described the American Art-Union's unethical business practices obliquely, substituting shawls for paintings and pocket handkerchiefs for engravings.[48] The American Art-Union survived only until 1852, but the International, with the solid financial support of Goupil's, was unshakable, especially after it rented the grand and ornate Alhambra Building for its exhibitions in 1854. However, already in 1849, the year after the International was established, its managers had ensured against failure by offering subscribers a print of The Prayer by New York's favorite artist, Dubufe, at last giving Americans a chance to have what they clamored for: a Dubufe in every home.

Fig. 48. Artist unknown, after David H. Arnot, Exterior of the Düsseldorf Gallery (Church of the Divine Unity), 1845. Lithograph by pen work. Collection of The New-York Historical Society

38. See R. H. Stehle, "The Düsseldorf Gallery of New York," New-York Historical Society Quarterly 58 (October 1974), pp. 305–14; and William H. Gerdts, "Die Düsseldorf Gallery," in Vice Versa: Deutsche Maler in Amerika, amerikanische Maler in Deutschland, 1813–1913, edited by Katharina Bott and Gerhard Bott (exh. cat., Berlin: Deutsches Historisches Museum; Munich: Hirmer, 1996), pp. 44–61.

39. "Dusseldorf Gallery," p. 2.

40. See Abigail Booth Gerdts, "Newly Discovered Records of the New-York Gallery of the Fine Arts," Archives of American Art Journal 21, no. 4 (1981), pp. 2–9; and Ella M. Foshay, Mr. Luman Reed's Picture Gallery: A Pioneer Collection of American Art (New York: Harry N. Abrams, 1990), pp. 19–20.

41. See Patricia Hills, "The American Art-Union as Patron for Expansionist Ideology in the 1840s," in Art in Bourgeois Society, 1790–1850, edited by Andrew Hemingway and William Vaughan (Cambridge: Cambridge University Press, 1998), pp. 314–39; Miller, Patrons and Patriotism, pp. 160–72; and Klein, "Art and Authority in Antebellum New York City," pp. 1534–61.

42. Justice, "The American Art-Union and the Academy of Design," Home Journal, November 19, 1849, p. 3.

43. See "International Art Union," Literary World, December 23, 1848, p. 959.

44. "The Fine Arts," American Metropolitan Magazine 1 (January 1849).

45. K., "A Suggestion for the Art-Union," Literary World, March 3, 1849, p. 201.

46. Thomas S. Cummings, Historic Annals of the National Academy of Design, New-York Drawing Association, . . . from 1825 to the Present Time (Philadelphia: George W. Childs, 1865), p. 218.

47. On the disputes, see "American Art-Union," Literary World, April 7, 1849, p. 318; "The Art-Union Distributions," The Independent, April 19, 1849, p. 80; Cousin Kate, "The International Art Union," Home Journal, April 28, 1849, p. 2; G. G. Foster, "International Art Union," The Knickerbocker 33 (May 1849), p. 452; "The American Art-Union," The Independent, July 5, 1849, p. 121; "The Fine Arts," Literary World, October 6, 1849, p. 298; "The Art-Union

Fig. 49. Thomas Cole, *The Voyage of Life: Youth*, 1840. Oil on canvas. Munson-Williams-Proctor Arts Institute, Utica, New York, Museum Purchase 55.106

Controversy," *Home Journal*, October 10, 1849, p. 2; "The Two Art-Unions," *Home Journal*, October 13, 1849, p. 2; and "The American Art-Union and Messrs. Goupil, Vibert, and Co.," *Literary World*, October 13, 1849, p. 317. Various articles were reprinted in *Bulletin of the American Art-Union* 2 (October 1849), pp. 2–12, (November 1849), pp. 10–15.

48. See "How the American Art-Union Belies Its Charter; or, Is What Would Be Disreputable Dealing, in a Lottery of Shawls, Honest in a Lottery of Pictures," *Home Journal*, November 3, 1849, p. 2. See also Lois Fink, "The Role of France in American Art" (Ph.D. dissertation, University of Chicago, 1970), pp. 188–91.

49. Henry James, *A Small Boy and Others* (London: Macmillan, 1913), p. 278.

50. "The Fine Arts," *Emerson's Magazine and Putnam's Monthly* 5 (December 1857), p. 754.

## The Great Emporium of New York in 1857

The big business of art, or at least the business of art that was bigger than it had ever been before, changed the nature of art institutions in New York and determined their success or failure through the 1850s. The days of Colman's and Dixey's storefront dealerships were over; Colman modified his business by separating the sale of art supplies and books from that of paintings, which he took out of the shop and reserved for large auctions consigned to professional auctioneers. The other artists' supply shop dealers gave way to larger, more professional establishments, such as Goupil's; Williams, Stevens and Williams; the National Academy of Design; the Düsseldorf Gallery, and a growing number of auction houses. In later years Henry James described the dazzling array of art available along Broadway in those days, when he was still a teenager:

*Ineffable, unsurpassable those hours of initiation which the Broadway of the 'fifties had been, when all was said, so adequate to supply. If one wanted pictures there were pictures, as large, I seem to remember, as the side of a house, and of a bravery of colour and lustre of surface that I was never afterwards to see surpassed. We were shown without doubt, . . . everything there was, and as I cast up the items I wonder, I confess, what ampler fare we could have dealt with.*[49]

It is hard to imagine a richer cultural milieu than that in place in New York by about 1857, when the art market survived the Panic, one of the worst financial calamities of the century. Nearly five thousand businesses went under that year. Yet by December 1857, when most businesses were still surveying the damage done by the Panic, it could be reported that "New York is the center of much that is rare and attractive in [the fine arts]."[50]

The season had started off strong and continued apace. Before the failure of the New York branch of the Ohio Life Insurance and Trust Company in August, which signaled the crisis, "the finest oil picture ever

painted on this side of the Atlantic,"[51] Church's *Niagara* (fig. 50), went on view at Williams, Stevens and Williams on Broadway. The dealers had been in business since the mid-1840s, at first principally as purveyors of looking glasses, picture frames, and art supplies, but had expanded and professionalized their involvement in the market by the early 1850s. Immediately upon Church's completion of *Niagara* they purchased the picture, as well as its copyright, from the artist. The painting was displayed in New York and London, where sales of chromolithographs of it yielded even greater profits than those accruing from the exhibitions. The New York showing, which opened in May 1857, was a staggering success for the artist, the owners, and the viewers. The numerous visitors, awestruck by Church's accomplishment, must have shared the sentiments of the critic for *The Albion*: "The more one looks at it, the less there is to say about it; the deeper and more absorbing the enjoyment."[52]

Williams, Stevens and Williams may have begun negotiations with Church early on. The proprietors did not commission *Niagara*, but surely knew that others would see the picture in progress, as studio visits were common by this time. A reporter for *Putnam's Kaleidoscope* recommended giving New York the epithet "the Artist City, or the City of Studios," in recognition of the more than three hundred spaces for artists open for independent business each day.[53] Many artists shared room in buildings dedicated to such studios, among them the old Art-Union Building,

the Tenth Street Studio Building, and the Dodworth Studio Building, while others rented single rooms and shop fronts. Some advertised opening hours. Knowledgeable collectors and critics previewed, reserved, and purchased works destined for the annual exhibitions at the National Academy. Clever collectors in the great emporium of New York shopped early and often, rather than wait for the public opening of the show. Works acquired from the studio might still be shown at the Academy, with the buyer listed as the lender.

In 1857 the National Academy was still the city's principal gallery of contemporary art, both for exhibitions and sales. The institution had never been stronger. Housed in an appropriate building of its own at the corner of Tenth Street and Fourth Avenue, and with a more clearly defined mission than in previous decades, the venerable Academy had a high profile among New York's community of artists, collectors, and viewing public. It was a reassuring presence in a burgeoning and increasingly international art marketplace. As the *New-York Daily Times* put it on the occasion of the annual of 1857, "very glad then we are to see the doors of the National Academy once more opened—the good old doors of the good old place," and the critic of *The Albion* wrote that "it would be difficult to find a pleasanter lounge than the Academy Rooms."[54] Reviewers declared that the 1857 exhibition was the finest ever presented by the Academy and singled out for particular praise Church's

51. "Church's Niagara," *The Albion*, May 2, 1857, p. 213. For a similar opinion, see "The Fine Arts," *United States Democratic Review*, n.s., 4 (June 1857), pp. 628–29.

52. "Church's Niagara," p. 213.

53. "A Morning in the Studios," *Putnam's Kaleidoscope* 9 (May 1857), p. 555.

54. "The National Academy Exhibition," *New-York Daily Times*, May 27, 1857, p. 2; "The Academy Exhibition," *The Albion*, June 6, 1857, p. 273.

Fig. 50. Frederic E. Church, *Niagara*, 1857. Oil on canvas. Corcoran Gallery of Art, Washington, D.C., Museum Purchase, Gallery Fund 76.15

Fig. 51. Francis William Edmonds, *Time to Go*, 1857. Oil on canvas. The Montgomery Museum of Fine Arts, Montgomery, Alabama, The Blount Collection

55. See above noted reviews and "Exhibition of the National Academy: Third Notice," *New-York Daily Times*, June 20, 1857, p. 4; "The Fine Arts," *Emerson's United States Magazine* 5 (July 1857), pp. 91–93.

56. "An Hour's Visit to the National Academy of Design," *Frank Leslie's Illustrated Newspaper*, July 11, 1857, pp. 88–90.

57. "Sketchings. The Venerable Rembrandt Peale," *The Crayon* 4 (July 1857), p. 224. See also "An Hour with Rembrandt Peale," *Harper's Weekly*, June 13, 1857, p. 373; "Rembrandt Peale, the Artist," *Ballou's Pictorial Drawing-Room Companion*, October 17, 1857, p. 241.

*Andes of Ecuador* (fig. 70), an untitled landscape by John F. Kensett, Francis William Edmonds's *Time to Go*, 1857 (fig. 51), and John W. Ehninger's *Foray* (unlocated).[55] *Frank Leslie's Illustrated Newspaper* published line engravings of several paintings in the show and portraits of nine of the principal exhibitors, announcing "a new era" for pictures in which "money to purchase them is abundant . . . the prices willingly paid our artists for their works, and the large commissions given out show that a movement has at last been made in the right direction, and our wealthy men are learning the fact that there is intellectual and money value in the happy creations of genius."[56]

*Leslie's* and others celebrated American art, wishfully pronouncing that the dubious old masters had had their day in New York. In September many papers rejoiced in the presence of Rembrandt Peale, who came to town to lecture on his portraits of Washington and to exhibit his huge *Court of Death*, 1820 (Detroit Institute of Arts), which he had first

shown in New York a quarter century earlier. Peale himself garnered more attention than did his painting. Hailed as a genius, he was characterized as a man who had known the country's Founding Fathers yet, remarkably, still remained vital in the modern age. "The halo of Washington's personality seemed also to reflect upon the artist, investing him with peculiar attractiveness," noted one commentator.[57]

The "new era" of American art notwithstanding, in 1857 traveling shows of paintings from Europe were more, rather than less, numerous; the pictures were, however, new rather than old. At the Düsseldorf Gallery (fig. 52), Boker maintained a core display of prized works by Leutze, Karl Friedrich Lessing, Christian Köhler, and other notables, while constantly adding to and refining the collection so that his presentation was always fresh. Henry James described how he had returned again and again to see the "new accessions . . . vividly new ones, in which the freshness and brightness of the paint, particularly lustrous in our copious light, enhanced from time to

time the show," noting also that the "gothic excrescences" and "ecclesiastical roof" of the old church in which the Düsseldorf pictures hung enhanced the experience of the collection.[58] But Boker apparently suffered reverses during 1857 and sold the collection as well as its building, the Church of the Divine Unity, to Chauncey L. Derby.

Derby represented the Cosmopolitan Art Association, an art union based in Sandusky, Ohio, that would use the church as the site of its New York branch. Among those who mourned the loss of the Düsseldorf Gallery and considered art unions illegal and destructive to art, the Cosmopolitan Art Association was, in the words of an observer in *The Crayon*, "one of those fungus inspirations that are entirely supported by the corruptions of commercial life . . . in short, a gross humbug."[59] Others, however, lauded "this meritorious and triumphantly successful institution," which, in fact, prevailed; the Cosmopolitan's New York gallery remained open for three years at the church and in 1860 was transformed by Derby and his brother Henry W. into the Institute of Fine Arts, a combination salesroom and exhibition hall (fig. 53).[60]

Uniting sales and exhibitions, the Derbys competed with other major dealers in the city, all of whom experimented with variations on the same marketing strategy, building inventories of modern European pictures and mounting shows of them. The American Academy had initiated this scheme in the 1830s, albeit haphazardly, applying it to both American and European paintings, and Goupil's professionalized it in the 1850s. Goupil's had nimbly engineered its entrance to New York in 1846 by sending an agent, Michael Knoedler, to test the market for French and British prints and European paintings. Knoedler opened Goupil's first New York gallery in 1848 and significantly influenced the burgeoning collectors' market by establishing the International Art Union the next year to spread a taste for European painting. Knoedler's program was brilliant in that it embraced American as well as European art. Not only did the Union devote some of its profits to the education of American artists but in 1850 Goupil's also offered a partnership to the popular local art supplier and occasional dealer in American painting William Schaus. That year, thanks to Schaus's participation, the International Art Union distributed the print after William Sidney Mount's *The Power of Music* (figs. 69, 164). Goupil's subsequently commissioned other works from Mount and published series of portraits of distinguished Americans and views of American scenery, all executed by American artists.

Once the American component of the business was in place, by about 1852, Knoedler focused on modern European art: that year Goupil's showed Paul Delaroche's *Napoleon at Fontainebleau*, 1845 (fig. 54); by 1855 the gallery was full of pictures by Delaroche, Scheffer, and Horace Vernet; and in 1857, shortly after Knoedler bought out the business and made it his own (fig. 55), the firm mounted a grand exhibition of

58. James, *Small Boy*, p. 278.

59. "The Cosmopolitan Art Association," *The Crayon* 4 (August 1857), p. 252.

60. "Cosmopolitan Art Association," *Ballou's Pictorial Drawing-Room Companion*, December 19, 1857, p. 389.

Fig. 52. *Interior View of the Düsseldorf Gallery.* Wood engraving by Nathaniel Orr, from *Cosmopolitan Art Journal* 2 (December 1857), p. 57. The Metropolitan Museum of Art, New York, The Thomas J. Watson Library

Fig. 53. *Interior View of the Cosmopolitan Art Association, Norman Hall.* Wood engraving by Nathaniel Orr, from *Cosmopolitan Art Journal* 1 (November 1856), p. 94. The Metropolitan Museum of Art, New York, The Thomas J. Watson Library

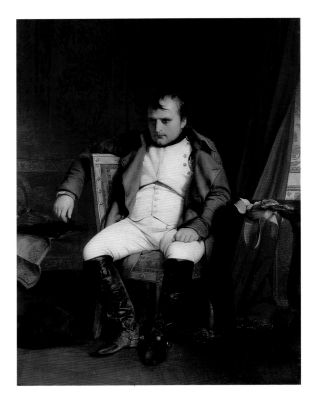

Fig. 54. Paul Delaroche, *Napoleon at Fontainebleau*, Paris, 1845. Oil on canvas. Museum der Bildenden Künste, Leipzig

greater impact, caused even more of an uproar. Typical of the ecstatic reviews that appeared in every paper is the notice published in *Frank Leslie's Illustrated Newspaper*, which proclaimed that it is "one of the most remarkable paintings ever exhibited on this continent."[62] Not one writer missed the opportunity to remark that the picture was all the more extraordinary for having been painted by a woman—"all executed by the delicate hand of a lady!," as one commentator put it.[63]

Gambart's third venture in 1857 was an exhibition of modern British paintings mounted in the galleries of the National Academy. Like the two French shows, it opened in October, and, like them, it had great success, despite the reigning economic crisis; indeed, of the three presentations it probably caused the most impressive stir. The selection favored Pre-Raphaelites, including William Holman Hunt, Ford Madox Brown, and Arthur Hughes, and was novel for Americans in that over half of the more than 350 pictures were watercolors, which were not yet considered appropriate for serious work or exhibition in this country. Critics uniformly praised the meticulousness and

modern French painting at the old American Art-Union building with the assistance of Ernest Gambart. Gambart, a Belgian-born London dealer who took his inventory on the road, as Brett had done two decades earlier, brought to Goupil's a collection of well over two hundred paintings by Jules Breton, Thomas Couture, Jean-Léon Gérôme, Tony Robert-Fleury, Constant Troyon, Vernet, and Charles-Edouard Frère. Goupil's had entered the market by wooing collectors of American art and within less than a decade created New York's first gallery of French painting.[61]

Gambart helped Goupil's put together this exhibition, but he was very much an independent entrepreneur and simultaneously worked with the competition. It is to him, indeed, that the city owed a considerable part of its late fall exhibition schedule in 1857. Goupil's display of French paintings included two works by the celebrated Rosa Bonheur, in addition to a portrait of her by Dubufe. But Gambart saved her spectacular *Horse Fair*, 1853–55 (cat. no. 51), for a separate showing, a single-picture exhibition at Williams, Stevens and Williams. If *Niagara* had created a sensation when Williams and company presented it, *The Horse Fair*, over twice the size of Church's picture and with far

61. On Gambart, see Jeremy Maas, *Gambart: Prince of the Victorian Art World* (London: Barrie and Jenkins, 1975); and Lois M. Fink, "French Art in the United States, 1850–1870: Three Dealers and Collectors," *Gazette des Beaux-Arts*, ser. 6, 92 (September 1978), pp. 87–100.

62. "The Fine Arts—Rosa Bonheur," *Frank Leslie's Illustrated Newspaper*, October 17, 1857, p. 310; see also "Rosa Bonheur's 'The Horse Fair,'" *The Albion*, October 3, 1857, p. 477; and "Rosa Bonheur," *Emerson's Magazine and Putnam's Monthly* 5 (November 1857), p. 640.

63. "Female Artists," *Ballou's Pictorial Drawing-Room Companion*, November 14, 1857, p. 317.

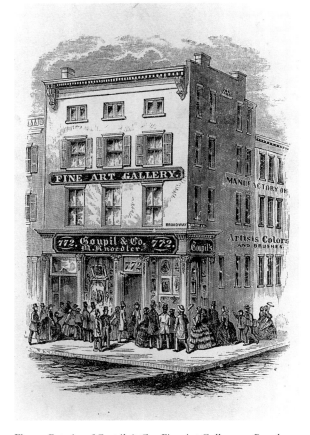

Fig. 55. *Exterior of Goupil & Co., Fine Art Gallery, 772 Broadway*, ca. 1860. Wood engraving by Augustus Fay. Courtesy of the American Antiquarian Society, Worcester, Massachusetts

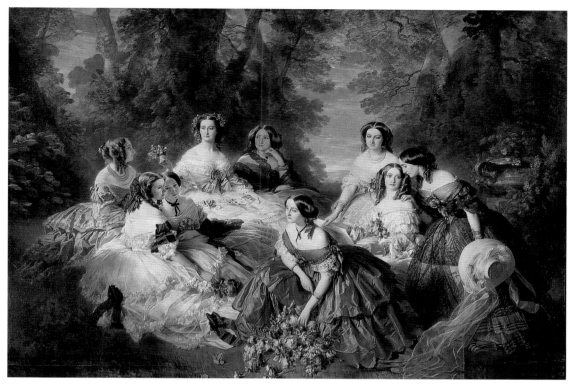

Fig. 56. Franz Xaver Winterhalter, *The Empress Eugénie Surrounded by Her Ladies-in-Waiting,* Paris, 1855. Château de Compiègne

intensity of the British pictures, which were invariably compared to the more broadly painted French works on display up the street.[64]

All over the city, galleries offered an array of choices. By November viewers of the French pictures at the Art-Union building would undoubtedly have been advised to stop by Goupil's gallery to see the German Franz Xaver Winterhalter's *Empress Eugénie Surrounded by Her Ladies-in-Waiting,* 1855 (fig. 56). Visitors to the British exhibition could also have looked at the collection of August Belmont in adjacent galleries at the Academy. A New York banker whose career took him to Europe as United States Minister to The Hague, Belmont had acquired over one hundred paintings, mainly French, Belgian, and Dutch, which were "liberally thrown open to the public" for the fall season.[65] Down the block at Leeds's, an art lover could have seen J. M. Burt's collection of European paintings prior to its auction. "We rolled up to see the new pictures," wrote the editor of *Harper's New Monthly Magazine* in December. "There was the great Rosa Bonheur, the *Horse Market* [*sic*], and the new French Gallery, and the New English Gallery, and the old German or Düsseldorf Gallery, and the old Bryan or Christian Gallery."[66] It was "a new era . . . what more could be expected or wished?"[67]

64. See Brownlee Brown, "The French Gallery and the Horse Market," *The Independent,* October 29, 1857, p. 1; and "Pictures in New York," *Frank Leslie's Illustrated Newspaper,* October 31, 1857, p. 342.

65. "The Belmont Collection," *The Albion,* December 26, 1857, p. 621.

66. "The Easy Chair," *Harper's New Monthly Magazine* 16 (December 1857), pp. 129–30.

67. "The Old World Coming to the New," *The Albion,* October 24, 1857, p. 513.

# Appendix A

The following are venues culled from periodical advertisements, exhibition reviews, exhibition catalogues, and city directories. Artists' studios and private collections are included only if they advertised exhibitions or were open to the public. Complete dates of operation are listed when available, but addresses are given only for the period under discussion.

### American Academy of the Fine Arts
*1802–42*
*1816–30   New York Institution, City Hall Park, Chambers Street*
*1831–42   8½ Barclay Street*
Founded as New York Academy of Arts with subscriptions from businessmen, physicians, and politicians. Purchased plaster casts after Greek and Roman statues in Musée Napoléon, Paris, and acquired paintings. Incorporated as American Academy of the Arts in 1808; in 1816 renamed itself American Academy of the Fine Arts and began annual exhibitions of contemporary painting and sculpture and renting the gallery to artists for single-picture exhibitions and to dealers for display of old masters. From 1816 to 1826 sponsored series of annual discourses on the arts delivered by patrons. Upon dissolution sold sculpture collection to National Academy of Design and paintings to Wadsworth Atheneum, Hartford.

### American and Foreign Snuff Store
### (Mrs. Newcombe's Store)
*ca. 1830s   297¼ Broadway*
Dry-goods and sundries shop run by wife of miniature painter and carpenter George Newcombe. Held 1836 exhibition of a wood sculpture of a Highlander by Anthony W. Jones.

### American Art-Union
*1839–53*
*1839–40   410 Broadway*
*1842–47   322 Broadway*
*1847–53   497 Broadway*
Founded by artist and entrepreneur James Herring as Apollo Association for the Promotion of the Fine Arts in the United States to maintain a free public gallery and exhibit, purchase, and sell works by Americans. Changed name to American Art-Union in 1842. Mounted annual exhibitions, selected a painting to be engraved for distribution to subscribers, purchased paintings, and also sculpture, for award by lottery, and held auctions. In 1853 presented exhibition of paintings treating life of George Washington as a benefit for New-York Gallery of the Fine Arts. Published *Transactions of the Apollo Association* (1839–43); *Transactions of the American Art-Union* (1844–50); *Bulletin of the American Art-Union*

(1848–53). Dissolved after it was accused of illegal business practices.

### American Female Guardian Society
*1834–1946*
*1834–at least 1857   29 East Twenty-ninth Street*
Founded as New York Female Moral Reform Society to protect women and children from the dangers of city life. Incorporated in 1849 as American Female Guardian Society. Issued various publications pertinent to its mission and in 1857 hosted exhibition of Rembrandt Peale's *Court of Death*.

### American Institute of the City of New York
*1827–77   various addresses*
Held annual fairs primarily featuring manufactured goods, among them items related to agriculture, but also including paintings, sculpture, and decorative arts. Moved offices frequently but held most fairs at Masonic Hall, Niblo's Garden, or, by 1844, National Academy of Design; site of 1855 fair was Crystal Palace. Hosted annual addresses, delivered at close of each exhibition, and published annual reports (1841–77).

### American Museum
*1790–1874*
*1817–25   New York Institution, City Hall Park, Chambers Street*
*1826–27   130 Chatham Street*
*1830–65   Marble Buildings, 218–222 Broadway*
Natural history museum and cabinet of curiosities founded by John Scudder as Tammany Museum; name changed to American Museum in 1810 and taken over by P. T. Barnum in 1841. Occasionally mounted exhibitions of paintings and sculpture, especially panoramas and large spectacle pictures.

### Apollo Association (see American Art-Union)

### Appleton's Building
*1854–60   346–348 Broadway*
Opened as space for artists' studios by owner, publisher Daniel Appleton and Company; remodeled in 1857, adding seventy-five square feet of exhibition space and reconfiguring upper floors.

### Arcade Baths
*1827–30   39 Chambers Street*
Exhibition hall, principal rooms of National Academy of Design

### Artists' Fund Society of New York
*1859–75   Broadway and Tenth Street*
Founded to provide financial support to widows and

children of artists. Each member contributed a work to an exhibition and auction, a benefit for the survivors of an artist chosen by AFS. First exhibition, held in 1860, mounted at National Academy of Design for benefit of the AFS itself. Miniaturist Thomas Seir Cummings was founding president.

### William Henry Aspinwall's Gallery
*1859–75  99 Tenth Street*
Private gallery attached to home of Aspinwall; built to house his collection of European paintings and opened to the public "upon stated occasions" during 1859 and perhaps thereafter.

### William Aufermann
*1859–61  694 Broadway*
Picture dealer

### David Austen Jr.
*1852  497 Broadway*
Auctioneer

### Bangs (see also Cooley)
*1837–1903*
Cooley and Bangs (1837–38); Bangs, Richards and Platt (1839–48); Bangs, Platt and Company (1849–50); Bangs, Brother and Company (1851–58); Bangs, Merwin and Company (1858–76); Bangs and Company (1876–1903)
*1837–44  196 Broadway*
*1845–50  204 Broadway*
*1851–60  13 Park Row*
Auctioneer of European paintings, especially old masters, and coins, manuscripts, and books

### Barnum's Museum (see American Museum)

### F. J. Bearns
*1842  139 Fulton Street*
Auctioneer

### William Beebe
*1848–49  91 Liberty Street*
Picture importer

### Thomas Bell and Company
*1825  80 Broadway*
*1843  32 Ann Street*
Auctioneer

### August Belmont's Collection
*1857–90  109 Fifth Avenue*
Gallery at home of Belmont housing his collection of European paintings formed while he traveled; opened to "the visitor who comes properly commended." In 1857 exhibition of collection held at National Academy of Design, as benefit for the city's poor.

### James Bleecker and Company (Bleecker and Van Dyke)
*1840  Broadway and Chambers Street*
Auctioneer, principally of European paintings

### Bourne's Depository
*1827–29  359 Broadway*
Shop of George Melksham Bourne, who exhibited engravings and also sold them as well as decorative stationery, sheet music, and drawing materials

### John Brady
*1854–60*
*1854–55  36 Catherine Street*
*1855–56  22½ Catherine Street*
*1857–60  36 Catherine Street*
Picture dealer

### Charles Brandis
*1850–61*
*1850–52  566 Fourth Avenue*
*1860–61  200 East Houston Street*
Picture dealer

### Browere's Gallery of Busts and Statues
*1821–34*
*1821–26  315 Broadway*
*1827  92 Nassau Street*
*1828  154 Nassau Street*
*1828–29  34 Arcade Street*
*1830–31  512 Pearl Street*
*1832–34  78 Christopher Street*
Studio, gallery, and shop of sculptor John Henri Isaac Browere, who specialized in taking life masks of famous Americans

### Bryan Gallery of Christian Art
*1852–59*
*1852–53  348 Broadway*
*1853–54  843 Broadway*
*1855–57  839 Broadway*
*1859  Cooper Union, 41 Cooper Square*
Gallery, open by appointment, of Thomas Jefferson Bryan's private collection of more than two hundred paintings, nearly half of them Dutch or Flemish. Bryan presented the collection to New-York Historical Society in 1867.

### Thomas Campbell
*1851–52  25 Pine Street*
Picture dealer

### Century Association
*1847–present*
*1847–49  495 Broadway*
*1849–50  435 Broome Street*
*1850–52  575 Broadway*
*1852–56  24 Clinton Place*
*1857–91  42 East Fifteenth Street*
Social club primarily for artists and writers; exhibits permanent collection of paintings by many artist-members and a distinguished group of portraits. Holds temporary exhibitions, especially in conjunction with club's annual Twelfth Night Festival.

**John Childs**

*1852–53    84 Nassau Street*
Picture dealer, formerly a print colorer

**Chinese Assembly Rooms**

*ca. 1850–55    539–541 Broadway*
Venue rented primarily for displays of large panorama paintings

**City Dispensary**

*1835    113 White Street*
Hosted October benefit exhibition of collection of Joseph Capece Latro, archbishop of Taranto, Naples.

**City Hall (see Governor's Room)**

**City Saloon**

*1834    Broadway opposite Saint Paul's Chapel*
Exhibition hall and café

**Clinton Hall**

*1830–69    9 Beekman Street*
Exhibition hall used by National Academy of Design, Apollo Association, New-York Gallery of the Fine Arts, and for display of various private collections. Taken over by Leavitt auction house in 1869.

**William A. Colman (Colman's Store)**

*1821–50*
*1821–24    45–46 William Street*
*1824–28    86 Broadway*
*1829–36    237–239 Broadway*
*1836–45    205 Broadway*
*1846–50    203 Broadway*
Artists' supply shop and antiquarian bookstore, which also assembled extensive inventory of oil paintings and engravings for sale. Made many major sales through auction houses such as Park Place House, Royal Gurley, Leeds, and James E. Cooley.

**Edmund I. Cook**

*1857–62*
*1857–58    614 Broadway*
*1860–62    618 Broadway*
Picture dealer

**George Cooke**

*1832–33    86 Broadway*
Picture gallery of painter

**Cooley (see also Bangs; Horatio Hill)**

*1833–66*
James E. Cooley (1833–36, 1850–66); Cooley and Bangs (1837–38); Cooley, Keese and Hill (1846–48); Cooley and Keese (1849–50)
*1833    134 Cedar Street*
*1834    151 Broadway*
*1837–38    196 Broadway*
*1846–50    191 Broadway*
*1850    304 Broadway*
*1850–63    377–379 Broadway*
Auction house, which originated in Boston as Cooley and Drake, for books and fine arts. Held sales for William A. Colman in 1850. Shared rooms at 377–379 Broadway with Leavitt and with Lyman.

**Cooper Union for the Advancement of Science and Art**

*1859–present    41 Cooper Square*
Private college founded by inventor and philanthropist Peter Cooper. Offers instruction in art, architecture, and engineering, and free public lectures and exhibitions pertinent to its teaching mission. Absorbed New-York School of Design for Women in 1858.

**Cosmopolitan Art Association**

*1854–62*
*1857–59    Church of the Divine Unity, 548 Broadway*
*1860–62    Institute of Fine Arts, 625 Broadway*
Founded in Sandusky, Ohio, by Chauncey L. Derby as art union and to promote fine arts through exhibitions, distribution of works to subscribers, and publication of monthly *Cosmopolitan Art Journal* (1856–60). Main operation remained in Ohio, but New York branch installed in Church of the Divine Unity, building owned by Düsseldorf Gallery when that establishment was purchased by CAA. Became Institute of Fine Arts, combination salesroom and gallery, upon transfer to building owned by Derby's brother, art dealer Henry W.

**Crayon Gallery (G. W. Nichols Gallery)**

*1860    768 Broadway*
Site of exhibition space and studios rented out to artists by George Ward Nichols

**John Crumby**

*1851–60*
*1851–52    25 Pine Street*
*1852–58    87 Cedar Street*
*1858–60    347 Broadway*
Picture dealer

**Crystal Palace**

*1853–58    Sixth Avenue and Tenth Street*
Cast-iron and glass building opened for New-York Exhibition of the Industry of All Nations, 1853–54, America's first world's fair. Included picture gallery that was rented out after the fair closed in 1854.

**Mrs. Dassel's Home**

*1859    30 East Twelfth Street*
Residence of now obscure artist Herminia Borchard Dassel; upon Dassel's death was site of exhibition and sale by lottery, organized by committee headed by Henry T. Tuckerman, to benefit her children.

**David Davidson**

*1855–56    109 Nassau Street*
Picture dealer

**Dexter's Store (Elias Dexter)**
*1860      562 Broadway*
Exhibited and sold by subscription the Saint-Mémin collection of portraits, as engraved by Jeremiah Gurney from artist's original proofs. Dexter also rented studio space on the premises to artists.

**Dioramic Institute (see Marble Buildings)**

**S. N. Dodge**
*1858      189 Chatham Square*
Presumed dealer to whom paintings and drawings in William Ranney's studio were consigned by the artist's widow in 1858.

**Dodworth Studio Building**
*early 1850s–85*
*early 1850s    806 Broadway*
*1858          896 Broadway*
*early 1860s    204 Fifth Avenue*
Opened by Allen Dodworth as spaces for artists' studios. Site of group shows and opening-night receptions organized by Artists' Reception Association, formed in 1858, the year series of Art Conversazioni was advertised. Exhibitions, which included nonresident foreign artists as well as artists in residence, may have taken place in room otherwise devoted to Dodworth's Dance Academy. By 1860 ARA had sixty members and gave three receptions annually.

**John Doyle**
*1827      237 Broadway*
Auctioneer

**Simeon Draper**
*1858      497 Broadway*
Auctioneer

**Dumont and Hosack**
*1848–54    11 Wall Street*
Auctioneer

**Düsseldorf Gallery (see also Cosmopolitan Art Association)**
*1849–62*
*1849–56, 1858–59   Church of the Divine Unity,*
*                    548 Broadway*
*1857               497 Broadway*
*1860–62            Institute of Fine Arts, 625 Broadway*
Exhibition and sales space for collection of Düsseldorf School paintings owned by wine merchant John Godfrey Boker. Collection, which Boker continually sold from and added to, bought by Cosmopolitan Art Association in 1857. Although Düsseldorf Gallery retained its name, its pictures were sold or distributed by CAA. Last remaining pictures in collection sold in 1862.

**T. Fitch and Company**
*1831      151 Broadway*
Auctioneer

**Pierre Flandin**
*1850–53    293 Broadway*
Venue of picture dealer who had been active for decades without permanent gallery

**William H. Franklin and Son**
*1832, 1846    68 Wall Street*
Auction house, probably evolved from Franklin and Mindurn, established in 1816

**Frazer's Gallery**
*1840      322 Broadway*
Held exhibition and sale of American portraits, many by John Trumbull, and landscape paintings.

**Peter Funk Picture Making Establishment**
*1856      Broadway*
Produced copies of American paintings.

**Ernest Gambart**
*1857–67    various addresses*
Belgian-born London print and painting dealer located in rented spaces; brought touring exhibitions to United States. First American ventures: simultaneous exhibitions of French painting at Goupil and Company, British painting at National Academy of Design, and Rosa Bonheur's *Horse Fair* at Williams, Stevens and Williams

**Michael Genings**
*1852–53    283 Third Avenue*
Picture dealer

**John B. Glover**
*1841–45    Granite Buildings*
Auctioneer

**Goupil and Company**
*1846–57*
*1846–53    289 Broadway*
*1854–57    366 Broadway*
New York branch of Paris print and picture dealers; Michael Knoedler was American agent. Changed name from Goupil, Vibert and Company in 1850, after death of Vibert. Sold artists' supplies as well as fine art. In 1848 established International Art Union to exhibit and distribute European paintings. In 1857 hosted first exhibition of French paintings in America, which evolved into annual event at successor firm Knoedler and Company.

**Governor's Room, City Hall**
*1815–present*
Long gallery housing approximately sixty portraits; used for government receptions and open to public occasionally.

**William Gowans**
*1839–43*
*1839–42    New-York Long Room, 169 Broadway*
*1843       Waverly Sales Room, 204 Broadway*
Auctioneer

**James Griffen**
*1858–59    7 Chambers Street*
Picture dealer

**Royal Gurley (see also Horatio Hill)**
*1831–49*
Pearson and Gurley (1831–32); Royal, Gurley and
Company (1833–41, 1846–49); Gurley and Hill
(1842–46); George H. Gurley (1848)
*1831–41, 1842–46    New-York Long Room, 169 Broadway*
*1841                20 John Street*
*1846–49             304 Broadway*
Auctioneer of books and paintings

**Oliver Halsted**
*1825        3 Law Buildings*
Auctioneer

**George M. Harding**
*1854–56    6 Division Street*
Picture dealer

**Amos Hawley**
*1827        22 Wall Street*
Auctioneer

**Mr. Henry's New-York Gallery of Fine Arts**
*1827–30    100 Broadway*
Gallery of European paintings

**Horatio Hill (see also Cooley; Royal Gurley)**
*1846        169 Broadway*
Auctioneer

**Martin Hoffman and Sons**
*1826        63 Wall Street*
Auctioneer

**Hubard Gallery**
*1824–25    208 Broadway*
Gallery of William James Hubard, silhouettist

**Institute of Fine Arts (see Cosmopolitan Art
Association)**

**International Art Union (see also Goupil
and Company)**
*1848–50*
Founded by Goupil and Company to exhibit paintings
and prints and sell and distribute them to subscribers.
Dealt principally in European art, unlike similar Ameri-
can Art-Union, which focused on American works.
Profits used to send Americans abroad to study art.
Published *International Art Union Journal* (1849–50).

**William Irving and Company**
*1853        8 Pine Street*
Auctioneer

**Jordan and Norton**
*1854–55    356 Broadway*
Auctioneer

**Philip Keefe**
*1830–31    72 Oliver Street*
Picture dealer

**John Keese (see also Cooley)**
*1855        337 Broadway*
Auctioneer

**Joseph Kelbley**
*1852–53    346 Seventh Avenue*
Picture dealer

**Elijah C. Kellogg**
*1858–59    6 West Fourteenth Street*
Picture dealer

**Michael Knoedler and Company (see also
Goupil and Company)**
*1857–present*
*1857        289 Broadway*
*1858–59    366 Broadway*
*1859–69    A. T. Stewart mansion, 772 Broadway*
Successor to Goupil and Company, which Knoedler,
Goupil's American agent, bought out. Continued to
pursue Goupil's sales and exhibition policies but gradu-
ally shifted focus to American art.

**Joseph Koeble**
*1850–60*
*1850–52    161 Third Avenue*
*1852–54    161 and 163 Third Avenue*
*1855–57    163 Third Avenue*
*1857–58    167 Third Avenue*
*1858–60    142 Third Avenue*
Picture dealer

**George Lambert**
*1855–58*
*1855–58    343 Broadway*
*1857–58    12 Fourth Avenue*
Picture dealer

**Landscape Gallery**
*1835        311½ Broadway*
Held exhibition "Richardson's Gallery of Landscape
Paintings," twenty scenes of America, England,
Scotland, and Asia to be distributed by lottery.
Artist was presumably Scottish landscape painter
Andrew Richardson.

**Leavitt**
*1856–92*
Leavitt, Delisser and Company (1856); George A.
Leavitt and Company (1857–64, 1871–92); Leavitt,
Strebeigh and Company (1866–71)
*1856–60    377–379 Broadway*
*1860        24 Walker Street, 21 Mercer Street*

One of city's busiest auction houses, shared Broadway rooms with Cooley and with Lyman. Founded by George A. Leavitt and partners Richard L. Delisser and John K. Allen. Specialized in book and fine art auctions.

## Leeds

*1848–70*
Henry H. Leeds and Company (1848–59); Henry H. Leeds and Miner (1864–70)
*1848      290 Broadway*
*1849–53    8 Wall Street*
*1854–56    19 Nassau Street*
*1857–59    23 Nassau Street*
City's leading auction house at midcentury; held several important auctions each year.

## Joseph Lemonge

*1857–61    159 Second Avenue*
Picture dealer

## Philip Levy

*1856–58    3 North William Street*
Picture dealer

## Levy's Auction Room (Aaron Levy)

*1830–44*
R. N. Hamson and A. Levy (1830); Levy's Auction Room (1834–43); Levy and Spooner (1844)
*1834–37    128 Broadway*
*1837–38    18 Cortlandt Street*
*1839–43    151 Broadway*
*1844      72 Greenwich Street*
Auctioneer specializing in old masters pictures and European, statuary. In 1838 held six-day sale of Michael Paff's collection of more than one thousand paintings in store rented from Mr. Platt, 6 Spruce Street. Sold business to Jonathan Leavitt.

## Lithographic Office

*1836      Corner of Nassau and Spruce Streets*
Sold engravings.

## S. L. Loewenherz

*1855–57    128 Nassau Street*
Picture dealer

## George W. Lord and Company

*1853–54    356 Broadway*
Auctioneer, branch of Lord and Carlile of Philadelphia

## E. H. Ludlow and Company

*1840–75*
*1840      11 and 13 Broad Street*
*1852–55    11 Wall Street and 2–3 New Street*
*1856      12 Pine Street*
*1857      11 Pine Street*
*1858–60    14 Pine Street*
*1860–75    3 Pine Street*
Major auction house; sold collection of Philip Hone in 1852 and of Charles M. Leupp in 1860.

## Valentine Lutz

*1850–62*
*1850–51    184 Bowery*
*1852–53    185 Bowery*
*1854–62    142 Third Avenue*
Picture dealer

## Lyceum Gallery (Lyceum of Natural History)

*1833–49*
*1833–37    Centre and White Streets*
*1848–49    563 Broadway*
Displayed and researched mineralogical and zoological specimens from New York State; let its space for various exhibitions, including shows of Audubon's drawings and old masters from collection of Gideon Nye.

## Lyman

*1839–58*
Lewis Lyman and Company (1839, 1853–58); Lyman and Rawdon (1851–52)
*1839      27 Wall Street*
*1851–58    377–379 Broadway*
Auctioneer, shared Broadway rooms with Cooley and with Leavitt

## Lyrique Hall

*1859      765 Broadway*
Housed various shows, including single-picture exhibition of Frederic E. Church's *Heart of the Andes.*

## Marble Buildings (Dioramic Institute)

*1835–37    Broadway near Ann Street*
Presented changing displays of dioramas; operated by W. J. and H. Harrington, who advertised themselves as "transparent painters."

## Masonic Hall

*1826–43    314–316 Broadway*
Space rented out for fairs, dances, circus performers, magicians, and, less often, as exhibition hall for private collections.

## W. McGavin

*1841–42    47 Liberty Street*
Picture dealer

## Bernard McQuillin

*1844–58*
*1844–52    44 Catherine Street*
*1852–53    40 and 44 Catherine Street*
*1854–58    40 Catherine Street*
Picture dealer

## William Mead and Company

*1844–60    112 Bowery*
Picture dealer

### Mechanics' Institute of the City of New York
*1833–61    Castle Garden*
Held annual fairs at Castle Garden and Niblo's Garden and hosted annual addresses. Fairs included paintings and sculpture and some fine decorative arts, but bulk of the numerous entries were manufactured goods. Published circular (1835–37).

### Menger's
*1860    Dey Street*
Housed July exhibition of Jasper F. Cropsey's *Four Seasons*.

### Merchants' Exchange
*1827–35; 1842–present*
*1827–35        44 Wall Street*
*1842–present    55 Wall Street*
Occasional site of exhibitions and sales held by local dealers and auctioneers, including Henry H. Leeds's auction of Hiram Powers's *Greek Slave* in 1857 and Cosmopolitan Art Association's sale of William Randolph Barbee's *Fisher Girl* in 1860

### Thomas J. Miller and William L. Morris Jr.
*1856    25 Wall Street*
Auctioneer

### Mills
*1816–31*
P. L. Mills and Company (1816–17, 1820–22); Mills, Minton and Company (1818–19); Mills and Minton (1823–30); Mills Brothers and Company (1831)
*1816        211 Pearl Street*
*1818–20    148 Pearl Street*
*1821        58 Wall Street*
*1823–30    178 Pearl Street*
*1831        151 Pearl Street*
Auctioneer

### T. M. Moore and Company
*1828    43 Maiden Lane*
Auctioneer

### Homer Morgan
*1849    1 Pine Street*
Auctioneer

### National Academy of Design
*1825–present*
*1825–26    exhibitions, 287 Broadway; classes, Chambers Street*
*1827–30    Arcade Baths, 39 Chambers Street*
*1830–40    Clinton Hall, 9 Beekman Street*
*1840–49    348 Broadway*
*1850–54    663 Broadway*
*1855–56    548 Broadway*
*1857        663 Broadway*
*1858–64    Broadway and Tenth Street*
Founded by New York Association of Artists (also known as Drawing Association) after that group unsuccessfully attempted to merge with American Academy of the Fine Arts. Modeled after Royal Academy, London; mounts annual exhibitions of works of living artists, offers classes and lectures, and grants honors to members. Special exhibitions have included shows of Richard Worsam Meade Collection, 1831, and British and French pictures, 1857. Upon establishment began building permanent collection, requiring each member to donate a portrait of himself or herself and another work.

### New-York Athenaeum
*1824–60*
*1824–32    New York Institution, City Hall Park, Chambers Street*
*1835–60    Athenaeum Building, Broadway and Leonard Street*
Private library that borrowed paintings and drawings from private collections for display in its rooms. Such exhibitions included "Francesco Annelli's Private Gallery of Paintings," 1836, and "W. Hayward's Collection of Pictures," 1837. In 1860 announced plans for annual appropriation to an American painter or sculptor for study abroad, but no such allocations were made. Merged with New York Society Library in 1860.

### New-York Gallery of the Fine Arts
*1844–58*
*1844, 1850–52    National Academy of Design, 348 Broadway and 663 Broadway*
*1844–48    New-York Rotunda, City Hall Park, Chambers Street*
*1848–58    New-York Historical Society, various addresses*
Evolved from private gallery of Luman Reed; constituted of his collection of European and American paintings; purchased by son-in-law, Theodore Allen, and business partner, Jonathan Sturges. Collection, augmented after Reed's death, conceived as basis of a national gallery. Donated to New-York Historical Society in 1858.

### New-York Historical Society
*1804–present*
*1804–57    various addresses*
*1857–1908    Second Avenue and Eleventh Street*
Founded by business and government leaders to collect, display, and preserve material pertaining to history of United States, in particular New York State. Began building portrait collection early on; in 1858 received donation of New-York Gallery of the Fine Arts collection.

### New-York Long Room
*1822–39    143 Front Street, 169 Broadway, and various nearby addresses*
Space rented by auctioneers, including C. W. Oakley, William Gowans, Royal Gurley, Horatio Hill, and J. Pearson.

### New-York Rotunda
*1818–70    City Hall Park, Chambers Street*
Erected by John Vanderlyn for display of his *Palace and Gardens of Versailles*, 1818–19. This panorama and others shown there until 1829, when building was taken over by New York City and space was used for various offices. In 1844 city gave space rent-free to New-York Gallery

of the Fine Arts, which remained there until 1848, after which time building served governmental functions.

## New-York School of Design for Women
*1846–58    487 Broadway*
Provided artistic training for women, primarily in practical disciplines of wood engraving, china painting, and decorative pattern design. Held public lectures and exhibitions and sales of students' work. Merged with Cooper Union for the Advancement of Science and Art.

## New York Society Library
*1754–present*
*1825–27    16 Nassau Street*
*1827–36    33 Nassau Street*
*1836–40    12 Chambers Street*
*1840–56    346 Broadway*
*1856–1937  109 University Place*
New York's first institutional library, held occasional exhibitions, including Thomas Cole's series The Voyage of Life, 1840, and paintings by Claude-Marie Dubufe, 1849.

## Niblo's Garden
*1828–46; 1849–95*
*1828–46    576 Broadway*
*1849–95    576 Broadway*
Fashionable coffeehouse and saloon run by William Niblo. Hosted theatrical performances, concerts, and exhibitions of panoramas and paintings.

## G. W. Nichols Gallery (see Crayon Gallery)

## Albert H. Nicolay
*1853    National Academy of Design, 663 Broadway*
Auctioneer

## Paff's Gallery of Fine Arts
*1811–38*
*1820–33    221 Broadway*
*1836–38    10 Barclay Street*
*1838    204 Fulton Street*
Michael Paff, New York's earliest dealer in European art, opened his business on Broadway.

## Painting Rooms
*1836    359½ Broadway*
Sales shop and studio of James De Jongh and Franklin B. Ladd, portrait and miniature painters

## Panorama Building
*1834    Mercer and Prince Streets*
Venue for panoramas by Frederick Catherwood and Robert Barker

## Park Place House
*1832–36    239 Broadway*
Venue for auction sales, including that of William Colman's inventory of oil paintings

## Peale's New York Museum and Gallery of the Fine Arts
*1825–43    The Parthenon, 252 Broadway*
New York branch of Peale family's natural history and fine arts museum in Philadelphia; operated by Rubens and Rembrandt Peale

## J. Pearson (see also Royal Gurley)
*1830–31    169 Broadway*
Auctioneer

## Marshall Pepoon
*1860    52 Wall Street*
Mounted exhibition of Heinrich Anton Heger's *Cathedral at Halberstadt* in July 1860.

## John Pfeiffer
*1857–58    335 Broadway*
Picture dealer

## L. Power and Company
*1826    46 Maiden Lane*
Auctioneer

## Luman Reed's Gallery
*1832–36    13 Greenwich Street*
Third floor of Reed's home, converted by collector into private art gallery for exhibition of his Flemish, Dutch, German, Italian, and American paintings; open to public once a week. Collection, sold after death of Reed to his son-in-law, Theodore Allen, and business partner, Jonathan Sturges, became New-York Gallery of the Fine Arts.

## Reichard's Art Rooms
*1840    226 Fifth Avenue*
Space for auction of statues by Chauncey Bradley Ives

## Henry E. Riell and Jacob Arcularious
*1842    304 Broadway*
Auctioneer

## T. P. Rossiter's Studio House
*1856–60    17 West Thirty-eighth Street*
House designed by Richard Morris Hunt; opened by narrative painter Thomas P. Rossiter as art school and exhibition space for works by many artists. Admission on Wednesdays was free and on Thursdays and Fridays by tickets sold at color shops and bookstores.

## J. Sabin and Company
*1860    Broadway at Fourth Street and Lafayette Place*
Auctioneer

## Schaus Gallery
*1820–91*
*1820s    204 Fifth Avenue*
*1854–55    303 Broadway*
*1855–56    311 Broadway*
*1857–61    629 Broadway*

Artists' supply shop run by importer and art collector William Schaus, who kept inventory of paintings for sale. Between 1850 and 1852 Schaus was a partner in Goupil and Company.

## Schenck
*1860–76*
Edward and F. H. Schenck (1860); Edward Schenck (1860–76)
*1860–76   141 Broadway*
Auctioneer, principally of European art

## C. S. Smith
*1843      27 Jay Street*
Auctioneer

## Snedecor's
*1855–61   544 Broadway and 38 White Street*
Auctioneer
Shop for artists' supplies, frames, mirrors, where proprietor John Snedecor also sold paintings, primarily by American artists.

## Stollenwerck and Brothers (Washington Divan)
*1817–36   157 Broadway*
From 1817 exhibited Stollenwerck's *Mechanical Panorama* and later also displayed old master and modern paintings. New York venue for Colonel McKinney's collection of portraits of American Indians in 1836

## Stuyvesant Institute
*1837–56   659 Broadway*
Building with picture hall that was site of numerous exhibitions of painting and sculpture by American and foreign artists as well as of antiquities and other material

## Alexander H. Taylor
*1841–45*
*1841–42   138 Fulton Street*
*1842–43   212 Norfolk Street*
*1843–45   87 Cedar Street*
Picture dealer and picture cleaner

## Tenth Street Studio Building
*1857–1920   15 Tenth Street*
Building designed by Richard Morris Hunt; included twenty-five studios and a double-height exhibition gallery. Studios were generally open to public on Saturdays, and group exhibitions were held in gallery. Some artists lent their studios to friends for exhibitions.

## Tuttle and Ducluzeau
*1846–48   88 William Street*
Auctioneer

## University Building
*1837–94   Washington Square East*
Building with studio spaces rented to artists by New York University starting in 1837. Most artists held informal exhibitions of their work in their studios.

## John L. Vandewater and Company
*1852      12 Wall Street*
Auctioneer

## Washington Divan (see Stollenwerck and Brothers)

## Waverly House
*ca. 1851–67   697 Broadway*
Studio building designed by Thomas P. Rossiter, often opened for exhibitions of works by artists in residence, including Louis Lang, John F. Kensett, and John Casilear.

## James H. Weeks
*1822–37   Successively at 406, 404, 93, and 423 Pearl Street*
Dry-goods shop and bookstore that sold and exhibited prints

## Wiggins and Pearson
*1826–28*
*1826      68 William Street*
*1828      Mr. Henry's New-York Gallery of Fine Arts,*
*           100 Broadway*
Auctioneer

## Wilkins, Rollins and Company
*1840      322 Broadway*
Auctioneer

## Williams, Stevens and Williams
*1810–59*
*1851–59   353 Broadway*
Art gallery, shop for looking glasses, and importer and manufacturer of prints, books, and artists' supplies. Firm, founded by John H. Williams, his son George H. Williams, and Colonel Stevens, held many exhibitions.

## Wills and Ellsworth
*1860      66 Liberty Street*
Auctioneer

# Appendix B

## Exhibitions and Auctions

The following exhibitions and sales are culled from periodical advertisements, exhibition reviews, and exhibition catalogues. Dates of openings are indicated by the citation of a single month or month and day, when available; closing dates are given when known. Unless sale or auction is noted, the event is an exhibition. The following abbreviations are used: AAFA, American Academy of the Fine Arts; AAU, American Art-Union; AICNY, American Institute of the City of New York; NAD, National Academy of Design. * signifies accompanied by a published catalogue.

### 1825

*May 12,* Eleventh Exhibition, part 1, AAFA *

*October 25, 1825–January 6, 1826,* William Dunlap, *Death on the Pale Horse,* AAFA

*October 26,* Eleventh Exhibition, part 2, AAFA *

*December,* Panorama of Athens, New-York Rotunda

### 1826

*January 10–April 15,* Jacques-Louis David, *Coronation of Napoleon,* AAFA

*May 10,* auction, Old Masters, L. Power and Company *

*May 10,* Twelfth Exhibition, AAFA *

*May 14–July 16,* First Exhibition, NAD *

*May 17,* Jacques-Louis David, *Coronation of Napoleon,* Washington Hall

### 1827

*February 15,* auction, New York Collection of European Art, Mills and Minton *

*May 6–July 16,* Second Exhibition, NAD *

*May 17,* Thirteenth Exhibition, AAFA *

*October,* François-Marius Granet, *Capuchin Chapel,* Washington Hall

*October,* Mr. Henry's New-York Gallery of Fine Arts

### 1828

*March 10,* William Bullock and John and Robert Burford, Panorama of Mexico, New-York Rotunda

*May 6–July 10,* Third Exhibition, NAD *

*May 15,* Exhibition and sale, Ancient Paintings, Mr. Henry's New-York Gallery of Fine Arts

*May 23,* auction, Paintings by Francis Guy and Dutch and Flemish Masters, Wiggins and Pearson *

*May–September,* William Dunlap, *Christ on Calvary,* Arcade Baths

*May,* Fourteenth Exhibition, AAFA *

*October 29,* auction, Benjamin West, Paintings from Fulton Collection, John Boyd at AAFA

*October,* First Fair, AICNY

*December 2,* Antonio Sarti Collection of Old Masters, AAFA *

### 1829

*April 18,* Panorama of Geneva, New-York Rotunda

*April 23,* auction, Antonio Sarti Collection of Old Masters, Michael Henry at AAFA

*May 11–July 13,* Fourth Exhibition, NAD *

*May 16,* Fifteenth Exhibition, AAFA *

*May 19,* auction, Ancient Paintings, Mr. Henry's New-York Gallery

*September 18,* Hugh Reinagle, *Belshazzar's Feast,* AAFA

*October 9,* auction, Paintings, Engravings, and Ephemera, T. M. Moore and Company *

*October,* Second Fair, AICNY

### 1830

*March 24–December 10,* Richard Abraham Collection of Old Masters, AAFA *

*April 22,* auction, Paintings, R. N. Hamson and A. Levy *

*May 1–July 5,* Fifth Exhibition, NAD *

*August 30,* National Gallery of Old and Modern European Masters, Arcade Baths

*August 30,* Hugh Reinagle, *Belshazzar's Feast,* Peale's New York Museum and Gallery of the Fine Arts

*October,* Third Fair, AICNY

### 1831

*April 15–October 8,* John Trumbull, Paintings, AAFA *

*April 28–July 9,* Sixth Exhibition, NAD *

*April 30–December 1,* Horatio Greenough, *Chanting Cherubs,* AAFA

*May 5,* auction, Mr. Rodgers Collection, 128 Broadway

*August,* James Ward, Paintings of Cattle, NAD *

*September–November,* Richard W. Meade Collection of European Paintings, NAD *

*October 15, 1831–February 1, 1832,* George Cooke, *Raft of the Medusa,* AAFA

*October,* Fourth Fair, AICNY

*November 11,* George Cooke, Paintings, William A. Colman *

### 1832

*February,* William Dunlap, Historical Paintings, NAD

*March–June,* De Saireville Collection of European Paintings, 271 Broadway

*May 12,* Fourteenth Exhibition, AAFA *

*May 21–July 8,* Seventh Exhibition, NAD *

*June 8,* auction, William A. Colman Collection of Paintings, Park Place House

*September 19–December 31,* John Watkins Brett Collection of Old Masters, AAFA *

*October,* Fifth Fair, AICNY

*November 10,* D'Angier, Sculptures, Park Place House

1833

*January 1–April 15,* Claude-Marie Dubufe, *Temptation of Adam and Eve* and *Expulsion from Paradise,* AAFA

*January,* John Watkins Brett Collection of Old Masters, AAFA *

*February 20,* Thomas Cole, Italian Paintings, Broadway and Wall Street

*May 8–July 6,* Eighth Exhibition, NAD *

*May 10–June 11,* James Thom, *Tam O'Shanter, Souter Johnny, the Landlord and Landlady,* AAFA *

*June 10,* Fifteenth Exhibition, AAFA *

*September 9,* Francis Danby, *Opening of the Sixth Seal,* AAFA *

*September,* Samuel F. B. Morse, *Gallery of the Louvre,* Broadway and Pine Street

*October,* Sixth Fair, AICNY

*November 7, 1833–January 1834,* James Thom, *Tam O'Shanter, Souter Johnny, the Landlord and Landlady,* AAFA *

*November,* Baron Christian Burckhardt Collection of Old Masters, Broadway and Chambers Street

1834

*March–June,* Thomas Cole, *Angel Appearing to the Shepherds,* AAFA

*April 17–June 14,* Robert Ball Hughes, *Uncle Toby and Widow Wadman,* AAFA *

*April 25–July 5,* Ninth Exhibition, NAD *

*June 16–July 26,* Giovanni Paolo Panini, Paintings, AAFA *

*June 30–July 1,* M. Le Marquis de Gouvello Collection, AAFA *

*September 11,* Dioramic Paintings, AAFA

*October,* Seventh Fair, AICNY

*November 1,* Tapestries of Raphael's Cartoons and Rubens's *Crucifixion,* City Saloon

1835

*April 24–June 30,* John Watkins Brett Collection of Old Masters, AAFA *

*May 5–July 4,* Tenth Exhibition, NAD *

*June 30,* Daniel Blake Collection of Old Masters, AAFA *

*Summer,* Mr. Saunders Collection of European and American Paintings, Stollenwerck and Brothers

*September,* H. Harrington, Moving Panorama of Lunar Discoveries and Diorama of the Deluge, Marble Buildings

*September,* First Fair, Mechanics' Institute of the City of New York, Castle Garden

*October 13,* James Thom, *Tam O'Shanter, Souter Johnny, the Landlord and Landlady* and Other Works, AAFA

*October 28,* John Trumbull, Paintings, AAFA *

*October,* Eighth Fair, AICNY

*October,* Joseph Capece Latro Collection, City Dispensary *

*November,* exhibition and sale, Richardson's Gallery of Landscape Paintings, Landscape Gallery

*December 12,* Sixteenth Annual Exhibition, AAFA *

*December,* H. Harrington, Dioramas, Marble Buildings

*December,* H. Harrington, Grand Moving Diorama, American Museum

1836

*April 9–July 9,* Benjamin West, *Death on the Pale Horse,* AAFA

*April 27–July 9,* Eleventh Exhibition, NAD *

*June,* H. Harrington, Dioramas, Marble Buildings

*June,* Henry Inman after C. B. King, Gallery of Portraits of American Indians, Stollenwerck and Brothers

*July 4,* Anthony W. Jones, Statue of a Highlander, American and Foreign Snuff Store

*July,* Stanfield's Great Moving Panorama, Niblo's Garden

*September,* Second Fair, Mechanics' Institute of the City of New York, Castle Garden

*September,* auction, Ancient and Modern Paintings, Thomas Bell at Stollenwerck and Brothers

*October,* Francesco Annelli's Private Gallery of Paintings, New-York Athenaeum

*October,* Thomas Cole, Course of Empire series, NAD

*October,* Ninth Fair, AICNY

*December 3,* Claude-Marie Dubufe, *Temptation of Adam and Eve* and *Expulsion from Paradise,* AAFA

*December,* H. Harrington, Dioramas, Marble Buildings

1837

*January,* W. Hayward, Collection of Pictures, New-York Athenaeum

*March,* D.W. Boudet, *La Belle Nature* and *Daphne de l'Olympe,* 17 Park Row

*April 21–July 4,* Twelfth Exhibition, NAD *

*May,* William Dunlap after Benjamin West, *Christ Healing the Sick,* American Museum

*September,* Claude-Marie Dubufe, Paintings, Stuyvesant Institute

*September,* Third Fair, Mechanics' Institute of the City of New York, Niblo's Garden

*October–November,* Mosaic Picture of the Ruins of Paestum, AAFA

*October,* George Catlin, Indian Gallery

*October,* Tenth Fair, AICNY

1838

*March 25–31,* auction, part 1, Michael Paff Collection, Levy at Mr. Platt's Store *

*April 1,* auction, part 2, Michael Paff Collection, Levy at Mr. Platt's Store *

*April 23–July 7,* Thirteenth Exhibition, NAD *

*June 16–October 12,* Mr. Sanguinetti's Collection of Ancient Italian Paintings, AAFA *

*July,* Thomas Sully, *Queen Victoria,* AAFA

*October,* Eleventh Fair, AICNY *

*October,* Exhibition of Works of Modern Artists, Apollo Association *

*November 19,* Claude-Marie Dubufe, Dioramic Pictures and Four Paintings, AAFA *

*November 19,* Exhibition of American Paintings (The Dunlap Exhibition), Stuyvesant Institute *

1839

*January,* Exhibition of Paintings (American Artists and Choice Old Masters), Apollo Association *

*January,* W. Hayward's Gallery of Old Masters, AAFA *

*April 17,* auction, Frederick Catherwood, Watercolors, Drawings, and Paintings, Levy's Auction Room *

*April 24–July 6,* Fourteenth Exhibition, NAD *

*May 8–December 30,* John Clark Collection of Old Italian Paintings, AAFA *

*May 9–22,* Alfred J. Miller, Paintings and Drawings of the Rocky Mountains, 410 Broadway *

*May,* Francesco Annelli's Private Gallery of Paintings, AAFA

*May,* Exhibition of Paintings (American Artists and Choice Old Masters), Apollo Association *

*June,* Thomas Sully, *Queen Victoria,* 155 Broadway

*August,* John Clark Collection of Old Italian Paintings, 281 Broadway *

*October,* John James Audubon, Drawings, Lyceum Gallery

*October,* Exhibition of Paintings (American Artists and Choice Old Masters), Apollo Association *

*October,* Twelfth Fair, AICNY

*October,* Benjamin West, *Christ Rejected,* Stuyvesant Institute

*November 4,* auction, John Clark Collection of Old Italian Paintings, Lyman at AAFA *

*November,* Panorama of Lima, New-York Rotunda

*November,* Alexander Vattemare Collection, NAD

1840

*January 22,* auction, Chauncey Bradley Ives, Statues, Reichard's Art Rooms

*February,* Exhibition of Paintings, Apollo Association *

*March 25,* auction, Old Masters, Levy *

*April 23,* auction, Old Masters, James Bleecker at Granite Buildings *

*April 27–July 8,* Fifteenth Exhibition, NAD *

*May 4–June 8,* Old Masters, AAFA *

*May 26,* auction, Old Masters, Wilkins, Rollins and Company *

*July,* Frederick Catherwood, Panorama of the Eternal City, New-York Rotunda

*September 18,* auction, Old Masters, Bleecker and Van Dyke *

*September,* Exhibition of Paintings, Apollo Association *

*October,* Thirteenth Fair, AICNY

*November,* John Clark Collection of Old Italian Paintings, 333 Broadway *

*December,* Thomas Cole, The Voyage of Life, New York Society Library

1841

*March,* Exhibition of Paintings, Apollo Association *

*May 3–July 5,* Sixteenth Exhibition, NAD *

*June 18,* auction, Modern European Paintings, John B. Glover *

*October,* Exhibition of Paintings, Apollo Association *

*October,* Fourteenth Fair, AICNY

*November 8,* auction, Old Masters, Levy's Auction Room *

*November 8,* auction, Old Masters, Henry E. Riell and Jacob Arcularious *

1842

*April 27–July 9,* Seventeenth Exhibition, NAD *

*April–December,* Annual Free Exhibition, AAU

*October 12,* auction, Old Masters, Henry E. Riell at NAD *

*October,* John Clark Collection of Old Italian Paintings, 281 Broadway

*October,* Fifteenth Fair, AICNY

1843

*March,* Daniel Huntington, *Pilgrims' Progress,* Granite Buildings

*April 12,* auction, William Franquinet Collection, Levy's Auction Room *

*April 27–July 4,* Eighteenth Exhibition, NAD *

*April–December,* Annual Free Exhibition, AAU

*October 3,* auction, J. C. Wadleigh Collection, C. S. Smith *

*October,* Sixteenth Fair, AICNY

*October,* Robert Walter Weir, *Embarkation of the Pilgrims* *

*December 7,* auction, Old Master and Modern Paintings, Thomas Bell and Company *

*December,* George Harvey, Watercolors and Oils, 232 Broadway *

1844

*April 24–July 6,* Nineteenth Exhibition, NAD *

*April–December,* Annual Free Exhibition, AAU

*June 12,* auction, Professor Kleynenberg Collection, Levy and Spooner *

*October,* Francesco Annelli, *The End of the World,* Apollo Association *

*October,* Leclerc, Paintings, NAD

*October 1844–September 1845,* New-York Gallery of the Fine Arts, Clinton Hall *

*October,* Seventeenth Fair, AICNY *

*November 13,* auction, A. Cor Collection, Levy and Spooner *

1845

*January 14,* auction, Modern European Paintings, John B. Glover *

*April 17–July 5,* Twentieth Exhibition, NAD *

*April–December,* Annual Free Exhibition, AAU

*May,* Titian, *Venus,* 449 Broadway

*September 1845–1848,* New-York Gallery of the Fine Arts, New-York Rotunda

*October,* Eighteenth Fair, AICNY

1846

*February 14–March 15,* The Inman Gallery (Henry Inman Memorial Exhibition), AAU *

*April 16–July 4,* Twenty-first Exhibition, NAD *

*April–December,* Annual Free Exhibition, AAU

*October 15,* auction, Modern Paintings, Tuttle and Ducluzeau *

*October,* Nineteenth Fair, AICNY, Niblo's Garden
*November 7,* John Vanderlyn, *Landing of Columbus,*
 NAD
*November,* H. K. Brown, Statues, Bas-reliefs, and Busts,
 NAD *
*December 4,* auction, William A. Colman Collection,
 William H. Franklin and Son *

1847
*March,* Emanuel Leutze, *The Court of Henry VIII,*
 AAU
*April 2–July 3,* Twenty-second Exhibition, NAD *
*April–December,* Annual Free Exhibition, AAU
*June 25,* auction, Joseph Bonaparte Collection, James
 Bleecker and Company *
*August 1847–January 1848,* Hiram Powers, *Greek Slave,*
 NAD
*October,* Twentieth Fair, AICNY

1848
*March 22,* auction, James Thomson Collection, Dumont
 and Hosack *
*April 3–July 8,* Twenty-third Exhibition, NAD *
*April 19,* auction, John G. Chapman, Paintings, Dumont
 and Hosack *
*April,* Thomas Cole Memorial Exhibition, AAU *
*April,* Gallery of Old Masters (Gideon Nye Collection),
 Lyceum Gallery *
*May–December,* Annual Free Exhibition, AAU
*May,* Opening Exhibition, Goupil, Vibert and Company
*June 8,* auction, Royal Gurley inventory, Cooley, Keese
 and Hill *
*June 29,* auction, Daniel Stanton Collection, Henry H.
 Leeds and Company *
*October 30,* auction, Paintings, Cooley, Keese and Hill
*October,* John Frazee, Design for Washington
 Monument, AAU *
*October,* Paul Delaroche, *Napoleon Crossing the Alps,*
 Goupil, Vibert and Company
*October,* Twenty-first Fair, AICNY
*November,* Old Masters, Lyceum Gallery
*December,* Exhibition of Paintings, International Art
 Union *

1849
*January,* Claude-Marie Dubufe, *Temptation of Adam
 and Eve* and *Expulsion from Paradise,* New York
 Society Library
*March,* Gallery of Old Masters (Gideon Nye
 Collection), Lyceum Gallery *
*April 3–July 7,* Twenty-fourth Exhibition, NAD *
*April 18, 1849–August 1857,* Paintings and Drawings by
 Artists of the Düsseldorf Academy, Düsseldorf
 Gallery *
*April 25,* auction, Charles de la Forest Collection,
 Henry H. Leeds and Company *
*April–December,* Annual Free Exhibition, AAU
*May,* Paintings, International Art Union, LaFarge
 Building *
*October,* Twenty-second Fair, AICNY

*October–December,* Hiram Powers, Sculptures, Lyceum
 Buildings
*November 8,* auction, Aaron Arnold Collection, Homer
 Morgan
*Autumn,* Old Masters (Gideon Nye Collection), NAD *
*December 17,* auction, William A. Colman Collection,
 through Henry H. Leeds and Company *

1850
*January–March,* Daniel Huntington, Paintings, AAU
*April 3,* auction, J. P. Beaumont Collection, Henry H.
 Leeds and Company *
*April 10,* auction, William A. Colman Collection,
 James E. Cooley *
*April 15–July 6,* Twenty-fifth Exhibition, NAD *
*April–December,* Annual Free Exhibition, AAU
*May,* Gallery of Old Masters, Niblo's Garden
*June 18,* auction, Gideon Nye Collection, James E.
 Cooley
*September 23,* New-York Gallery of the Fine Arts,
 Clinton Hall, NAD *
*October,* William Dunlap, *Death on the Pale Horse,*
 Stoppani's Building
*October,* Twenty-third Fair, AICNY
Ten Thousand Things on China and the Chinese,
 Chinese Assembly Rooms *
Roman Gallery of Ancient Pictures, Stuyvesant Institute *
Velázquez, *Charles I,* Stuyvesant Institute *

1851
*April 8–July 5,* Twenty-sixth Exhibition, NAD *
*April–December,* Annual Free Exhibition, AAU
*October 28–30,* auction, Williams, Stevens and Williams
 Inventory, Henry H. Leeds and Company *
*October 1851–February 1852,* Emanuel Leutze, *Washington
 Crossing the Delaware,* Stuyvesant Institute
*October,* Twenty-fourth Fair, AICNY
*November 11,* auction, Reverend Samuel Farmar
 Collection, Lyman and Rawdon

1852
*March 31–June 12,* Edward Augustus Brackett, *Ship-
 wrecked Mother and Child,* Stuyvesant Institute *
*April 1,* auction, Private Collection, Lyman and Rawdon *
*April 13–July 7,* Twenty-seventh Exhibition, NAD *
*April 28,* auction, Philip Hone Collection, E. H. Ludlow
 and Company *
*May 5,* auction, John A. Boker Collection, Henry H.
 Leeds and Company *
*May–June,* Peter Stephenson, *Wounded Indian,*
 Stuyvesant Institute
*June 9,* auction, Paintings, Bangs, Brother and
 Company *
*October 27,* auction, Williams, Stevens and Williams
 Inventory, Leeds *
*October,* De Brakekleer Collection of Paintings by the
 Belgian Masters, 518 Broadway *
*October,* Twenty-fifth Fair, AICNY
*November 23,* auction, Paintings and Decorative Arts,
 Leeds at NAD *

*December 15–17, 30,* auction, AAU Inventory, David
Austen Jr. at AAU *

*December 1852–1857,* Bryan Gallery of Christian Art,
843 Broadway *

## 1853

*February 24,* auction, Private Collection of Paintings,
Henry H. Leeds and Company *

*March 5,* The Washington Gallery of Art, AAU

*April 19–July 9,* Twenty-eighth Exhibition, NAD *

*April 28,* auction, J. P. Beaumont Collection, Henry H.
Leeds and Company *

*June,* De Brakeleer Collection of Paintings by the
Belgian Masters, 547 Broadway *

*July 14, 1853–October 5, 1858,* Crystal Palace Exhibition *

*July 26,* auction, Paintings and Decorative Arts,
Henry H. Leeds and Company *

*July,* Edward Augustus Brackett, *Shipwrecked Mother
and Child,* Stuyvesant Institute

*October 8–10,* auction, Rhenish-Belgian Gallery of
Paintings, Leeds at NAD *

*October,* Twenty-sixth Fair, AICNY

*November 23,* auction, Brooklyn Art Association
Inventory, Henry H. Leeds and Company *

*December 6,* auction, Paintings and Decorative Arts,
William Irving and Company *

*December 16,* auction, Paintings, Albert H. Nicolay *

Theodore Kaufmann, Paintings of Religious Liberty,
the artist's studio, 442 Broadway *

## 1854

*March 22–April 25,* Twenty-ninth Exhibition, NAD *

*May,* Washington Exhibition in Aid of the New-York
Gallery of the Fine Arts, AAU

*October 31,* auction, Private Collection, Henry H. Leeds
and Company *

Henry Abbott Collection of Egyptian Antiquities,
Stuyvesant Institute *

## 1855

*February,* A. T. Derby, Watercolor Portraits, Williams,
Stevens and Williams

*February,* Horace Vernet, *Joseph and His Brethren,*
Goupil and Company

*March 14–May 10,* Thirtieth Exhibition, NAD *

*March,* William Sidney Mount, *The Power of Music,*
Williams, Stevens and Williams

*April,* Thomas Duncan, *The Triumphant Entry of
Prince Charles Edward into Edinburgh,* Williams,
Stevens and Williams

*April,* Daniel Maclise, *Sacrifice of Noah,* Goupil and
Company

*May,* Richard Ansolell, *Dogs and Their Game*
(7 Paintings), Williams, Stevens and Williams

*May,* John Rowson Smith, Panorama of the Tour of
Europe, Chinese Assembly Rooms *

*June,* Lilly Martin Spencer, Paintings, Schaus Gallery

*September,* Ary Scheffer, *Dante and Beatrice,* Goupil
and Company

*October,* Richard Greenough, *Young Shepherd Boy*

*Attacked by an Eagle,* and Charles Baxter, *The
Spanish Maid,* Williams, Stevens and Williams

*October,* Twenty-seventh Fair, AICNY *

*October,* various artists, Summer Studies, Dodworth
Studio Building

*November,* Thomas Faed, *Shakespeare in His Study*
and *Milton in His Study,* Williams, Stevens and
Williams

*December 18,* auction, Private Collection, Henry H.
Leeds and Company *

*December,* Thomas Faed, *Sir Walter Scott and His
Literary Friends at Abbotsford,* and N. Gasse, *Galileo
at Florence,* Williams, Stevens and Williams

## 1856

*March 14–May 10,* Thirty-first Exhibition, NAD *

*April 1,* auction, Oil Paintings, Henry H. Leeds and
Company *

*April 17,* auction, Oil Paintings and Engravings,
Henry H. Leeds and Company *

*April,* James Smillie, Engravings after Thomas Cole,
The Voyage of Life, Spingler Institute

*June,* Paul Delaroche, *Marie Antoinette on Her Way
from the Tribunal,* Goupil and Company

*October 28,* auction, J. P. Beaumont Collection,
Henry H. Leeds and Company *

*October,* Twenty-eighth Fair, AICNY *

*November 10,* auction, Edward Brush Corwin Collection,
Bangs, Brother and Company *

*November,* John Martin, Judgment series, Williams,
Stevens and Williams

*December 1856–April 1857,* Erastus Dow Palmer, Marbles,
Church of the Divine Unity

## 1857

*February 20,* auction, paintings from Ferdinand Joachim
Richardt's Niagara Gallery, Henry H. Leeds and
Company *

*March 26,* auction, A. E. Douglass Collection, Henry H.
Leeds and Company *

*May 5,* auction, Goupil and Company Inventory and a
Private Collection, Henry H. Leeds and Company *

*May 28,* auction, William Schaus Collection, Henry H.
Leeds and Company *

*May 28,* Thirty-second Exhibition, NAD *

*May,* Frederic E. Church, *Niagara,* Tenth-Street Studio
Building

*May,* Frederic E. Church, *Niagara,* Williams, Stevens
and Williams

*June,* auction, Hiram Powers, *Greek Slave,* Leeds at
Merchants' Exchange

*June,* Robert Walter Weir, *Embarkation of the Pilgrims,*
Williams, Stevens and Williams

*September 28,* Frederic E. Church, *Niagara,* Williams,
Stevens and Williams

*September,* Rembrandt Peale, *Court of Death,* American
Female Guardian Society

*October 20, 1857–February 1858,* Exhibition of British Art,
Williams, Stevens and Williams at NAD *

*October–November,* Twenty-ninth Fair, AICNY *

*October 1857–March 1858*, Exhibition of French Paintings, Goupil and Company at AAU *

*October*, Rosa Bonheur, *The Horse Fair*, Williams, Stevens and Williams

*November 5*, auction, J. M. Burt Collection, Henry H. Leeds and Company *

*November 18*, auction, Paintings, Henry H. Leeds and Company *

*November 1857–January 1860*, Erastus Dow Palmer, *The White Captive*, Schaus Gallery

*November*, Franz Xaver Winterhalter, *Empress Eugénie Surrounded by Her Ladies-in-Waiting*, Goupil and Company

*December*, August Belmont Collection, NAD

*December 1857–January 1858*, Hiram Powers, *Greek Slave*, Düsseldorf Gallery

### 1858

*January*, reception and exhibition, Dodworth Studio Building

*February 4*, auction, D. D. Byerly Collection, Henry H. Leeds and Company *

*February 9*, auction, Dr. S. Spooner Collection, Henry H. Leeds and Company *

*March*, George Hering, *The Village Blacksmith*, and T. Buchanan Read, *Spirit of the Waterfall*

*April 2*, Edward Troye, Oriental Paintings, Apollo Association

*April 13–June 30*, Thirty-third Exhibition, NAD *

*April 22*, auction, Joseph Fagnani Collection, E. H. Ludlow and Company

*May*, Gideon Nye Collection of Old Masters, AAU *

*May*, William T. Ranney, Memorial Exhibition and Sale, S. N. Dodge

*June 9*, auction, Paintings, Bangs, Brother and Company *

*July*, F. Wenzler, *A Scene in Berkshire County, Mass.*, Dodworth Studio Building

*September 28*, Frederic E. Church, *Niagara*, Williams, Stevens and Williams

*October 21*, auction, J. Swinbourne, Mr. Jenkins, and G. W. Alson Collections, Henry H. Leeds and Company *

*December 20*, auction, Paintings to Benefit William T. Ranney Fund, Henry H. Leeds and Company *

*December*, Louis Sonntag, *Dream of Italy*, Williams, Stevens and Williams

### 1859

*January*, Mrs. Dassel's Works, Mrs. Dassel's Home

*January*, Exhibition, International Art Union

*February*, benefit exhibition, Régis-François Gignoux, *Niagara by Moonlight*, Goupil and Company

*March 16, 17*, auction, Goupil and Company Inventory, Henry H. Leeds and Company *

*March*, opening of William Henry Aspinwall's Gallery

*March*, opening of August Belmont's Collection

*March*, Paintings and Drawings by Artists of the Düsseldorf Academy, Düsseldorf Gallery *

*April 7*, auction, Modern Paintings, Henry H. Leeds and Company *

*April 13–June 25*, Thirty-fourth Exhibition, NAD *

*April 19, 20*, auction, Paintings, Henry H. Leeds and Company *

*April 27, 28*, Frederic E. Church, *The Heart of the Andes*, Lyrique Hall

*April 29–May 23*, Frederic E. Church, *The Heart of the Andes*, Tenth Street Studio Building

*September–November*, Exhibition of British and French Paintings, NAD *

*September–December 5*, Frederic E. Church, *The Heart of the Andes*, Tenth Street Studio Building

*October–November*, Hiram Powers, *Washington at the Masonic Altar*, Goupil and Company

*November 5*, Louis Sonntag, *Dream of Italy*, Düsseldorf Gallery

*November 10*, auction, Rollin Sandford and James Journeay Collections, Henry H. Leeds and Company *

*November*, Chevalier Pettich, Statues, Cooper Union for the Advancement of Science and Art

*November*, Thomas P. Rossiter and Louis Remy Mignot, *The Home of Washington after the War*, NAD

*December*, auction, J. P. Beaumont Collection, Henry H. Leeds and Company *

*December*, Paul Akers, *Dead Pearl Diver*, Düsseldorf Gallery

### 1860

*January 31–February 1*, auction, Snedecor's Inventory, Henry H. Leeds and Company at NAD

*January*, Exhibition of Paintings, International Art Union *

*January*, reception and exhibition, Dodworth Studio Building

*January*, Charles Barry, Crayon Drawings, Crayon Gallery

*February 29*, auction, George H. Hall, Paintings and Studies, Henry H. Leeds and Company *

*February*, Thomas Crawford, *Dancing Jennie*, Düsseldorf Gallery

*February*, First Exhibition, Artists' Fund Society *

*February*, reception and exhibition, Dodworth Studio Building

*March*, reception and exhibition, Dodworth Studio Building

*March*, reception and exhibition, T. P. Rossiter's Studio House

*March*, Thomas P. Rossiter, Scriptural Paintings, T. P. Rossiter's Studio House *

*April 14–June 16*, Thirty-fifth Exhibition, NAD *

*April 24*, auction, Paintings and Decorative Arts, Henry H. Leeds and Company *

*April*, Leonard Volk, Statuette of Senator Douglas, Crayon Gallery

*May 22, 23*, auction, William E. Burton Collection, Henry H. Leeds and Company *

*May*, Paintings and Drawings by Artists of the Düsseldorf Academy with the Jarves Collection of Old Masters, Düsseldorf Gallery, Institute of Fine Arts *

*July*, Jasper Cropsey, Four Seasons, Menger's

*July,* Heinrich Anton Heger, *Cathedral at Halberstadt,* Marshall Pepoon

*August,* Charles-Balthazar-Julien Févret de Saint-Mémin, Engravings, Dexter's Store

*October 13,* auction, Paintings, Manuscripts, and Engravings, Bangs, Merwin and Company *

*October 19,* auction, Paintings, Henry H. Leeds and Company *

*October 24,* auction, Paintings, Henry H. Leeds and Company *

*November 13,* auction, Charles M. Leupp Collection, Ludlow *

*November,* Exhibition of French and Flemish Paintings, Goupil and Company *

*December 5,* auction, French and Belgian Paintings, Henry H. Leeds and Company *

*December 12,* auction, Modern Paintings, Henry H. Leeds and Company *

*December 14,* auction, Modern Paintings, Henry H. Leeds and Company *

*December 18,* auction, Snedecor's Inventory, Henry H. Leeds and Company *

*December 19,* auction, A. d'Heyvetter Collection, Edward and F. H. Schenck *

*December 24,* auction, Paintings and Decorative Arts, Henry H. Leeds and Company *

*December,* George Loring Brown, *The City and Harbor of New York* and Paintings by American Artists, Crayon Gallery

*December,* Exhibition of Paintings and Sculpture, Artists' Fund Society

1861

*January 24,* auction, Fine Modern Oil Paintings, Henry H. Leeds and Company *

*February 6,* auction, French and Flemish Paintings from Goupil and Company, Henry H. Leeds and Company *

*February 20,* auction, French, Flemish, and American Paintings, Schenck *

*March 28,* auction, Italian Paintings, Bangs *

*April 20–June 17,* Thirty-sixth Exhibition, NAD *

*May 4,* auction, Modern Paintings and Watercolors, Bangs *

*May,* Frederic E. Church, *The Icebergs,* Goupil and Company

*December 15,* auction, Paintings by George L. Brown, Henry H. Leeds and Company *

# Private Collectors and Public Spirit: A Selective View

*JOHN K. HOWAT*

The dramatic growth in the number of private art collectors in New York City during the years 1825 through 1861 reflected the concurrent rapid development of an increasingly great metropolis. In 1825 New York City, which is to say the small urban cluster gathered at the bottom of Manhattan Island, had a population of about 166,000. Society was presided over by a prosperous but not very large group of leaders—landholders, merchants, bankers, lawyers, manufacturers (including sophisticated craftsmen), physicians, educators, politicians, a few artists and writers, and people of leisure—only a few of whom had traveled extensively abroad. These leaders had only a circumscribed knowledge and experience of fine-art objects, especially items from other cultures, and only a limited access to art publications. New York, like the nation, was in its cultural youth.

By 1861 the city, still legally constituted only of Manhattan Island, boasted more than 820,000 citizens (1,000,000 in Greater New York, which unofficially included Brooklyn), who composed a population remarkable for its diversity and entrepreneurial verve.[1] In a brief thirty-six years revolutionary changes in technologies, modes of travel and communication, industry and commerce—and in their capitalization—provided the backdrop for a much expanded, considerably wealthier group of people who devoted themselves to acquiring fine art in many of its varieties. New York City's world of visual arts was transformed from a small, close-knit, mostly private, and somewhat naive community into a large, complicated, and sophisticated one with a much broader view of the role of the arts in public life. By 1861 this art world was primed and poised to help inaugurate a great age—one that continues to this day throughout the nation—in which art acquisition became better informed and public art museums and galleries were established through the generosity of philanthropists.

Before 1825 the city had a limited number of institutions, whether public, private, or commercial, that concerned themselves with the visual arts. The thoughtful but quite small band of civic leaders who established and supported these organizations—men such as De Witt Clinton, Asher B. Durand, Dr. John W. Francis, Robert Fulton, Philip Hone, Dr. David Hosack, the brothers Edward and Robert Livingston, Samuel F. B. Morse, John Trumbull, John Vanderlyn, and Gulian Crommelin Verplanck—either had no personal collections, or relatively small ones, or, as in the case of the artists Durand, Trumbull, and Vanderlyn, had larger aggregations of their own works, with some by other artists.

One noteworthy, although hardly typical, collector during these early years was Eliza Jumel (1775–1865), who, before her marriage to the wealthy Stephen Jumel, had been a prostitute in Rhode Island. In 1817 Mme Jumel put her large collection of European paintings on view at the American Academy of the Fine Arts, apparently in the hope of gaining entrée to New York society. The attempt failed, and on April 24, 1821, the collection was auctioned. The sale catalogue of 242 items, prepared by one Claude G. Fontaine, was solemnly titled *Catalogue of Original Paintings. From Italian, Dutch, Flemish and French Masters of the Ancient and Modern Times, Selected by the Best Judges from Eminent Galleries in Europe and Intended for a Private Gallery in America.*[2] Famous artists' names abounded therein, with glaring misspellings—as in "Cannoletty," "Goltius," and "Pictro di Cortone"—that provided an insight into the naïveté with which the collection had been formed and catalogued.

The items that were not sold at the 1821 auction were later used to decorate Mme Jumel's house in Harlem Heights, now known as the Morris-Jumel Mansion. An 1862 visit to the mansion was recorded by an awestruck Miss Ann Parker in her diary:

> *Everything looked as if it was many years since they dusted, and the atmosphere was very disagreeable—as though fresh air was unknown. These two halls had inlaid tables, choicely and beautifully set-in gilt frames, hanging baskets and etageriers covered with articles of virtue. The walls were hung with*

1. For population figures in 1825 and 1860, see Ira Rosenwaike, *Population History of New York City* (Syracuse: Syracuse University Press, 1972), p. 33.
2. See Michel Benisovich, "Sales of French Collections of Paintings in the United States during the First Half of the Nineteenth Century," *Art Quarterly* 19 (autumn 1956), p. 288.

Opposite: detail, fig. 59

3. Miss Ann Parker, Diary, typed transcript, Jumel Papers, box 1, folder 14, Manuscript Collection, New-York Historical Society.

4. William Dunlap, *History of the Rise and Progress of the Arts of Design in the United States,* 2 vols. (New York: George P. Scott, 1834; new ed., 3 vols., edited by Frank W. Bayley and Charles E. Goodspeed, Boston: C. E. Goodspeed and Co., 1918), vol. 3, p. 270.

*rare paintings—one especially, a full length of General Washington, which was my admiration. . . . She was very magnificent and amiable in her manners and conversation and called our attention to the superb paintings on the walls, where they were bought, etc.*[3]

Mme Jumel died in 1865, having lived for decades as an aged curiosity, surrounded by her pictures and furniture in a setting of famous disarray (fig. 57).

The more typical art collector in New York during the late 1820s and early 1830s was part of a small, progressive, and public-minded group, engaged in a scope of admirable although restricted activities. The growing importance of this group was made clear in 1825, when the conflict surrounding the establishment of the National Academy of Design took center stage in the public press. The unpleasant public and private running battle between supporters of the elitist American Academy of the Fine Arts (most prominently the elderly portraitist Trumbull) and of the younger artists who banded together to form the National Academy (most prominently Morse and William Dunlap) was waged for almost two decades. Yet, despite the prevailing thunderous art weather, Trumbull, Dunlap, and Durand (the latter one of the new guard) found it possible to unite in their enthusiasm for the work of the fledgling Thomas Cole, himself a founding member of the National Academy. All three purchased

landscapes by Cole when they were shown in a shop window in 1825, as did patrons such as Hone, Verplanck, and Hosack, who relied on their position as cultural benefactors in order to straddle the gulf between the two camps (see "Mapping the Venues" by Carrie Rebora Barratt in this publication, pp. 47–50). These patrons had started out as supporters of the American Academy, which was the regular showplace in the city for traveling European "collectors," many of whom were in fact dealers who came to New York to work a rich market. When the Academy dissolved in 1842, the same collectors became loyal backers of the new organization, founded and dominated by artists.

At the center of the city's cultural world was Dunlap (1766–1839), a painter of only moderate distinction but a prolific playwright, biographer, historian, diarist, and theater manager. Dunlap's position was doubly assured by the publication in 1832 of his *History of the American Theatre,* followed two years later by his two-volume *History of the Rise and Progress of the Arts of Design in the United States.* The latter, the first published history of the visual arts in the nation, is still consulted regularly as a rich compilation of facts and anecdotes. The work ends with a nine-page discussion entitled "Collections of Pictures," for which Dunlap apologized unnecessarily: "In our extensive country these are so far asunder, and my knowledge of them so imperfect, that I fear my readers may exclaim, as it regards my account of them, 'O lame and impotent conclusion.'"[4] The collections listed ranged along the Atlantic coast, from Boston to Baltimore, but, understandably enough, given Dunlap's residence in New York City, most were concentrated there.

Also understandable was Dunlap's focus on the collection of Philip Hone (1780–1851; cat. no. 58, fig. 58), who had made a comfortable fortune before retiring in May 1821 to turn his attention to other interests. An active social leader, admirable diarist, and enthusiastic art collector, Hone would serve a one-year term as mayor in 1825. Shortly after his retirement, Hone traveled to England, where he ordered a canvas from each of the two best-known American painters resident in London: from Charles Robert Leslie, *Slender, Shallow, and Anne Page,* 1825 (unlocated; first version, also 1825, Yale Center for British Art, New Haven), and from Gilbert Stuart Newton, *Old Age Reading and Youth Sleeping,* ca. 1821–25 (unlocated). Both artists were intimates of the famous New York author Washington Irving, who doubtless recommended their work to his close friend Hone, still in the early stages of forming a collection.

Fig. 57. Abraham Hosier, *Hall of the Roger Morris or Jumel Mansion, Harlem Heights, Manhattan,* ca. 1830s. Watercolor. Museum of the City of New York, Gift of Mrs. Eliot Tuckerman

Because New York was relatively small and its art enterprise limited, the arrival of the two pictures in the city in late 1825 caused something of a furor in the local press. Among the several notices that appeared, this one in the *New-York Review* helped to establish Hone as an important art patron:

*The present seems to be an auspicious era for the Fine Arts in our city. Our corporation [has] always liberally encouraged every attempt at improvement; and now we have, in our chief magistrate, Philip Hone, Esq. a man whose taste and knowledge make him competent to judge of merit, and whose liberality has displayed itself by the patronage of living artists. Mr. Hone is no collector of old pictures. The picture dealers . . . have not in him a dupe or a customer. He encourages painters, by employing the meritorious; and his walls honour, and are honoured by, the works of Leslie, Newton, Wall, Cole, Peale, and other artists, who are thus stimulated to persevere in the road to perfection.[5]*

In 1834 Hone supplied Dunlap with a list of pictures in his collection, to be published in the *Rise and Progress*. It contained entries on works (including copies after several old masters) by fourteen American artists, among whom were Cole, Morse, Dunlap himself, Vanderlyn, Rembrandt Peale, Robert Walter Weir, and William Guy Wall. Only three of the painters listed—one each from England, Scotland, and France—were not American. With pardonable parochial pride Hone wrote Dunlap, "The above are all the works of artists now living, and I do not know of a finer collection of modern pictures. I have several old pictures, some of which are dignified by the names of celebrated painters; but I do not esteem them sufficiently to induce me to furnish you with a catalogue."[6] Like the reporter for the *New-York Review*, Hone was obviously aware that picture dealers in the city were known to sell—or, at the best, were routinely suspected of handling—pictures of doubtful authenticity and condition. In fact, throughout the period in question (as indeed before and after), the world of New York collectors was loosely divided between those who, like Hone, preferred the safer road of acquiring works by living artists and those who sought the more recherché but riskier works by "old masters," or at least by European artists who were securely deceased.

On April 28, 1852, Hone's collection was sold at a posthumous auction. The catalogue recorded almost three hundred items, including small statuary, paintings, prints (many portraits and historical scenes),

Fig. 58. Shobal Vail Clevenger, *Philip Hone*, 1839. Plaster. Collection of The New-York Historical Society, Gift of James Herring 1862.7

and French and English medals. Among the European artists listed—presumably including some that Hone did "not esteem . . . sufficiently" and again with some misspellings—were "Von Ostade," "Cannaletto," "Gerard Dow," Ruisdael, Turner, Hobbema, and Murillo.[7]

For those collectors who preferred to seek out "old masters" primarily, the chief art dealer in the city was Michael Paff (d. 1838). A German immigrant, probably from Baden-Württemberg, Paff arrived in New York in 1784 on the same ship as John Jacob Astor, both having been attracted by the golden prospects presented by the new United States of America. The two competed in the business of selling musical instruments and sheet music until 1802, when Paff and his brother bought out Astor's interests in that field (Astor had by then gone on to establish himself as a leader in the North American fur trade). Before long Paff also had moved beyond selling musical effects, and by 1811 he was in the business of operating his own art gallery.

5. *New-York Review* notice reprinted in "Fine Arts," *New-York Evening Post*, May 6, 1826.

6. Dunlap, *Rise and Progress*, vol. 3, p. 277.

7. E. H. Ludlow, *Inventory of Paintings, Statuary, Medals, &c. &c., the Property of the Late Philip Hone . . . Wednesday, April 28, 1852* (sale cat., New York: P. Miller and Son, 1852).

Within a few years Paff rose to prominence in New York, both by meeting the city's newly perceived needs for the "old masters" and by presenting himself as a private collector of substance.[8] More than fifty years after Paff's death, Asher Durand's son John recalled that during his father's youth native works of art were sold in obscure frame makers' shops, while Paff more grandly offered works such as "The Last Supper by Michael Angelo"—having arrived at that attribution because the number of pavement stones (ten) depicted in the room was the same as the number of letters in the artist's name (Buonarotti). In retrospect, John Durand commented sardonically, "It is needless to say that Paff proved the authenticity of other originals by similar evidence."[9] Yet, despite such perceptions of charlatanism, Paff was liked and respected in the city for his engaging and enthusiastic artistic boosterism.

After Paff's death his private collection of more than one thousand paintings and sketches and eighty-four engraved reproductions was auctioned in sales lasting six days. The preface to the sales catalogue eulogized Paff briefly, stating that "more than 35 years of his life were devoted with undiminished zeal to the collection of *Rare and Valuable Paintings*— they were his great source of delight, he seemed but to live in the enjoyment of them, and it was always with reluctance he parted with a fine Picture, at however large a price."[10] It is tantalizing to think that perhaps a few of Paff's pictures may have been given proper attributions, for names such as Van Dyck, Rubens, Rembrandt, Tintoretto, Titian, Raphael, and Dürer are among the many hundreds enthusiastically scattered throughout his catalogue. Unfortunately there is no feasible way to trace the provenances of these paintings.

A collection of old masters clearly more distinguished than Paff's was that formed by the merchant Richard Worsam Meade (1778–1828). A native of Philadelphia, Meade had spent many years in Cádiz, where he was able to acquire what at the time was thought to be one of the most important groups of Italian, Spanish, and Flemish pictures yet imported to America. In September 1831 the *New-York Mirror,* the weekly paper most concerned with the arts in the city, discussed the posthumous preauction exhibition of Meade's collection and named Titian, Veronese, Domenichino, Murillo, and Rubens as among the artists represented. Also of considerable interest was a bust of George Washington (cat. no. 52) carved in 1795 by the Italian sculptor Giuseppe Ceracchi, which Meade had bought from the widow of the Spanish

ambassador to the United States. The Metropolitan Museum now owns this work, which is thought to be the only sculptural bust for which the notoriously impatient Washington ever sat.

Although Meade's business affairs had ended in controversy with both the Spanish and American governments, the *New-York Mirror* praised him warmly as a collector: "He secured and transmitted to his native country a treasure of art, such as had never been before possessed by an American citizen. A collection of genuine, authentic specimens, from which we may form a judgment, and by which we may model a taste, founded on a comparison of the works of some of the most celebrated masters."[11] Mrs. Meade, who had placed the collection on sale, retained ownership of the Ceracchi until her death in 1852, when Gouverneur Kemble of New York purchased it from her estate.

By 1835 New York City, already the brawling commercial and financial center of the nation, could claim leadership of the nation's art community as well. Primary among the developments that had led to such prominence were the advent of the American Academy of the Fine Arts in 1802, Paff's establishment as a dealer in 1811, the founding of the National Academy in 1825, and the 1834 publication of Dunlap's *Rise and Progress,* which described the flourishing relationship among artists and collectors. Despite occasional financial recessions, the city presented itself during the antebellum period as a pot of gold wherein amateurs could form collections and friendships that marked them as men of taste supporting, in their private way, the growing interest in the arts. Some collectors, remarkable for their local pride and pugnacious self-assertion in every area of public life, felt called upon to make regular pronouncements on the excellence of the city's artists and to support them with purchases. Others attempted, with less personal involvement, to recapture the cultural glories of the European past by forming collections that included old master paintings, drawings, and prints in addition to antiquities and decorative arts.

Luman Reed (1787–1836), who began collecting about 1830, is the ideal model for the first type of patron. As Mrs. Jonathan Sturges, widow of Reed's business partner, later recalled,

*Mr. Reed had conceived the idea of a picture gallery in his new house. . . . Mr. Reed's first essay was with Michael Paff, the principal "old picture" dealer of the period in New York. A few pictures were purchased, but Mr. Reed had too much*

8. Malcolm Goldstein, "Paff, Michael," in *American National Biography,* edited by John A. Garraty and Mark C. Carnes (New York: Oxford University Press, 1999), vol. 16, pp. 895–96.

9. John Durand, *The Life and Times of A. B. Durand* (New York: C. Scribner's Sons, 1894; facsimile ed., New York: Kennedy Graphics, 1970), p. 66.

10. *Catalogue of the Extensive and Valuable Collection of Pictures, Engravings, and Works of Art . . . Collected by Michael Paff . . .* (sale cat., New York: A. Levy, Auctioneer, 1838), p. 1.

11. "Exhibition of Paintings, Collected in Spain by the Late Richard W. Meade, Esq.," *New-York Mirror,* September 17, 1831, pp. 86–87.

Fig. 59. William Sidney Mount, *Bargaining for a Horse (Farmers Bargaining)*, 1835. Oil on canvas. Collection of The New-York Historical Society, Gift of the New York Gallery of Fine Arts 1858.59

*intuitive good sense to be taken in by such "old pictures" as were on sale at that period of our country's history, and he soon began to look around among our own artists, sought their personal acquaintance and examined their works and purchased with great good taste and judgement.*[12]

Cole, Durand, William Sidney Mount, and George Flagg were the primary beneficiaries of Reed's interest.[13] Despite Mrs. Sturges's recollections, however, Reed's house on Greenwich Street, designed by Isaac G. Pearson, also contained a large collection of paintings by Flemish, German, Dutch, Italian, English, and Scottish artists.[14] The heart of the collection, still kept intact at the New-York Historical Society, is Cole's five-picture series, The Course of Empire, 1833–36 (figs. 91–95), arguably the artist's most successful effort in an ideal mode. In a far more realistic manner, Mount's *Bargaining for a Horse*, 1835 (fig. 59), remarkable for its tight composition and careful finish, is probably the finest genre scene in the Reed collection. Reed, a very generous man, allowed interested members of the public to visit his art gallery, located on the third floor of his house, as well as to consult his collection of art books and printed reproductions.

Jonathan Sturges (1802–1874) followed in Reed's footsteps as a collector, beginning in the late 1830s. As described by Henry T. Tuckerman in 1867, his collection was not large—just under three dozen examples—and was composed primarily of works commissioned from his friends, eleven of New York's best

12. Mrs. Jonathan Sturges [Mary Pemberton Cady], *Reminiscences of a Long Life* (New York: F. E. Parrish and Company, 1894), p. 158.

13. See Ella M. Foshay, *Mr. Luman Reed's Picture Gallery: A Pioneer Collection of American Art* (New York: Harry N. Abrams in association with the New-York Historical Society, 1990), for an admirable and complete discussion of Reed's collecting accomplishments.

14. Ibid., pp. 123–92.

Fig. 60. Thomas Cole, *The Voyage of Life: Manhood*, 1840. Oil on canvas. Munson-Williams-Proctor Arts Institute, Utica, New York, Museum Purchase  55.107

15. Henry T. Tuckerman, *Book of the Artists, American Artist Life, Comprising Biographical and Critical Sketches of American Artists: Preceded by an Historical Account of the Rise and Progress of Art in America* (New York: G. P. Putnam and Son; London: Sampson Low and Co., 1867), p. 627.

16. "Our Private Collections, No. II [Jonathan Sturges]," *The Crayon* 3 (February 1856), pp. 57–58.

17. William S. Mount, Memorandum, April 6, 1851, New-York Historical Society, quoted in Franklin Kelly, "Mount's Patrons," in *William Sidney Mount, Painter of American Life*, by Deborah J. Johnson et al. (exh. cat., Museums at Stony Brook; New York: American Federation of Arts, 1998), p. 118.

18. See Kelly, "Mount's Patrons," pp. 109–28.

artists.[15] Durand painted more than a dozen canvases for Sturges, including copies after European masters and four of his own landscape compositions, among the latter *In the Woods*, 1855 (cat. no. 31), a superb example of the high quality of Sturges's acquisitions. Cole's *View on the Catskill, Early Autumn*, 1837 (Metropolitan Museum), Charles Cromwell Ingham's *Flower Girl*, 1846 (cat. no. 32), and three canvases by Mount, especially *Farmers Nooning*, 1836 (The Museums at Stony Brook), maintain the Sturges standard. Like so many of his contemporaries, Sturges had an extensive collection of prints, many of which were reproductions of famous European masterworks. *The Crayon*, which published a description of the Sturges collection in 1856, singled out the holdings of prints after Turner for praise; *Crossing the Brook*, numbered and signed by Turner, although actually made by an artist he had hired, was thought to be the only print after that painting in America.[16]

Despite the acuity of his eye and his eagerness to support contemporary artists, Sturges achieved his greatest renown from the leadership and support he provided to the New-York Gallery of the Fine Arts, established in 1844. This gallery had as its nucleus the Reed Collection, which had been purchased from the Reed family by Sturges and T. H. Faile (another business associate of Reed), among others. Although ultimately unsuccessful, it was meant to be the first public museum in New York devoted solely to the visual arts. In 1851 Mount acknowledged Sturges's gifts as both art administrator and collector: "Since the death of Luman Reed, no man in this city, holds a more prominent place in the affections of artists & the public, than . . . Jonathan Sturges. He has apartments richly decorated with paintings, and busts, by native artists, and I believe, has but *one mirror*, which reflects well his taste."[17]

During the 1830s and 1840s most New York collectors acquired modestly, usually for the purpose of fitting out their parlors and sitting rooms. They would attend the annual exhibition of the National Academy, which presented artworks available for purchase and, in the accompanying catalogue, lists of what had already been sold to collectors.[18] It was rare

that a collector would acquire large groups of pictures, as Reed had, with the benevolent interest of exhibiting them to the public. Or that one would aim to establish a permanent public art gallery in New York City, as Sturges had in his attempts to build the New-York Gallery.

Occasionally, large-scale commissions by private collectors would reflect the hope, regularly reiterated in the press, of a more lasting, public art venue. Probably the most significant single commission received by any New York painter after the death of Luman Reed and before the Civil War was the one agreed on in 1839 by Cole and Samuel Ward (1786–1839), a prominent New York banker. The contract for the series The Voyage of Life stipulated that "the four paintings are to be 6 or 7/4 or 5 feet wide and high and to be executed in the style of those by the same artist known as 'The Course of Empire.'" (The latter series had been ordered by Reed from Cole and was completed in 1836, shortly after the collector's death.)[19]

The theme of The Voyage of Life, 1839–40 (see figs. 49, 60), a man's struggle through life, guided by religion, had particular appeal for Ward, a deeply devout man whose faith had been tested some years before by the death of his much-beloved wife. His daughter Julia Ward Howe noted that her mother's death caused Ward such pain that he immediately sold his elegant, beautifully furnished house on Bowling Green. The new home that he subsequently built, at the corner of Broadway and Bond Street, was then somewhat removed from the city center;[20] there, the Ward family studied, read widely, and played and listened to music. Describing her father as "a man of fine tastes, inclined to generous and even lavish expenditure," Howe remarks that "he filled his art gallery with the finest pictures that money could command in the New York of that day."[21] Yet she also relates that, one day not long before he died, he was visited by the famous English writer and authority on European art Anna Jameson. Jameson "asked to see my father's pictures. Two of these, portraits of Charles First and his queen, were supposed to be by Van Dyck. Mrs. Jameson doubted this."[22] Perhaps Ward, too, was a victim of yet another dubious attribution and sale by Paff.

When Ward died, in 1839, the country was still reeling from the Panic of 1837, and complications relating to his affairs, mostly involving real estate properties, had left his legatees short of cash. It was not until early 1841, following rather difficult negotiations with Samuel Ward Jr., that Cole received payment for The Voyage of Life; after a very successful

public exhibition, the suite of pictures was sent to the Ward house.[23]

Sturges's dream of a permanent public art gallery and Ward's ambitious, large-scale collecting, perhaps with the same dream in mind, were also reflected in a proposal promulgated in 1835 by the Connecticut-born architect Ithiel Town (1784–1844), well known in New York as the senior partner of Alexander Jackson Davis. An inventive and immensely productive architect, Town patented in 1820 a highly successful new design for a bridge truss. From this he enjoyed income sufficient to allow him to travel twice to Europe, where he fed his insatiable appetite for books (mostly on art and architecture), engravings, paintings, sculpture, coins, armor, and antiquities.[24] Town's proposal bore the imposing title *The Outlines of a Plan for Establishing in New-York an Academy and Institution of the Fine Arts, on Such a Scale as Is Required by the Importance of the Subject, and the Wants of a Great and Growing City, the Constant Resort of an Immense Number of Strangers from All Parts of the World. The Result of Some Thoughts on a Favourite Subject.* In it, Town suggested that shares be sold in a stock company that would operate a bipartite organization composed of an academy run by artists and an art gallery governed by the stockholders.[25]

Town's concept was a generous expansion of the ideas embodied in the National Academy, of which he had been a cofounder a decade earlier. His specific and lengthy recommendations covered every aspect of financing, organization, and governance. As to the collections, they were to consist of

> *sculptures, bass-reliefs [sic], and paintings, ancient and modern; an extensive library of books relating to the fine arts, books of engravings, and engravings of history and mythology, portraits, etc.; coins and medals, ancient and modern; models of architecture, ancient and modern; drawings of all kinds; specimens and relics of antiquity of all kinds, such as vases, candelabra, ancient armour, etc.; specimens and objects of natural history; also, curious specimens of the mechanic's and manufacturer's arts; models of curious and useful inventions and improvements, especially such articles of improvements as relate to the fine arts, either directly or more remotely;—all of which to be obtained from time to time by the president and board of control, and arranged by them in the several buildings constructed and fitted up for the purpose.*[26]

While this passage has not been documented as a blueprint for the organization in 1852 of London's

19. Ellwood C. Parry III, *The Art of Thomas Cole: Ambition and Imagination* (Newark: University of Delaware, 1988), p. 226.
20. Julia Ward Howe, *Reminiscences, 1819–1899* (Boston and New York: Houghton Mifflin and Company, 1899) p. 12.
21. Ibid., p. 46.
22. Ibid., p. 41.
23. Parry, *Art of Cole*, p. 259.
24. Jack Quinan, "Town, Ithiel," in *The Dictionary of Art*, edited by Jane Turner (New York: Grove, 1996), vol. 31, pp. 231–32.
25. Ithiel Town, *The Outlines of a Plan for Establishing in New-York an Academy and Institution of the Fine Arts . . .* (New York: George F. Hopkins and Son, 1835), passim.
26. Ibid., p. 11.

Victoria and Albert Museum or in 1870 of the Metropolitan Museum, its congruence with both museums' founding plans is remarkable. A good idea was clearly in the air.

In 1836 Town removed to New Haven, where he had maintained a part-time residence for years. Three years later, the Hartford writer Lydia H. Sigourney, an extraordinarily prolific author of unremarkable prose and poetry, published a description of Town's New Haven library, housed in a classic double-cube room in his residence on Hillhouse Avenue:

*In the second story, is a spacious apartment, forty-five feet in length, twenty-three in breadth, and twenty-two in heighth, with two sky-lights, six feet square. . . . There, and in the lobbies, and study, are arranged, in Egyptian, Grecian and Gothic cases, of fine symmetry, between nine and ten thousand volumes. Many of these are rare, expensive, and valuable. More than three fourths are folios and quartos. A great proportion are adorned with engravings. It is not easy to compute the number of these embellishments—though the proprietor supposes them to exceed two hundred thousand. There are also some twenty or twenty-five thousand separate engravings—some of them splendid executions of the best masters, both ancient and modern. In these particulars, this library surpasses all others in our country. There are also one hundred and seventy oil paintings, besides mosaics, and other works of art, and objects of curiosity.[27]*

In 1842 Town returned to New York City, where, after his death two years later, his collection was dispersed in a series of large auction sales.

Town's partner, Davis (1803–1892), was a noted collector of prints, which, because they were relatively inexpensive and easy to store and transport, offered an attractive basis for the formation of a large collection. As early as 1831 Davis bought four etchings of Roman scenes by Piranesi, and in 1844 he began to acquire aggressively at New York print auctions, including the posthumous sales of Town's collection. Davis ultimately brought together a very large holding of prints, numbering in the several hundreds, many of which are now in the Department of Drawings and Prints of the Metropolitan Museum. Most of the prints depicted architectural subjects, but there were also many reproductions of paintings (by artists such as Poussin, Rubens, Coypel, West, and Trumbull), as well as landscapes, religious, literary, and historical scenes, and portraits of famous people. These print materials, buttressed by numerous books and

the architect's own drawings and sketches, formed a distinguished library, typical of the best of such American collections in the pre–Civil War years.

Another avid collector of engravings was John Allan (1777–1863), a native of Scotland who had immigrated to New York as a teenager. While pursuing a modest career as a bookkeeper, commission agent, and rent collector, Allan also assembled an extensive library and a substantial art collection. In 1864 the well-known bibliographer and bookseller Joseph Sabin prefaced the 330-page catalogue of Allan's posthumous sale with this notice: "The Collection . . . was at once the pride, the pleasure, and the occupation of its late venerable owner for upwards of half a century, and is of so varied and interesting a character as to warrant some few remarks upon its leading specialties."[28] Among the "specialties" provided in Sabin's table of contents are books, autograph letters, engravings, watercolors and drawings, oil paintings, coins and medals, snuffboxes, seals, watches, silver plate, antique china, bronzes, arms and armor, and antiquities.

Books occupied the largest section of Sabin's catalogue, but the next largest (some twenty-six pages) was given over to 638 lots of engravings, containing more than eleven thousand individual images. Most of these were merely reproductions, "well suited to the taste of some 'Illustrator,'"[29] as Sabin commented. Since almost every lot heaped together batches of prints under a general description, it is almost impossible to identify the individual works or to determine their quality. Occasionally individual prints are listed, as, for example, Durand's engraving *Musidora*, which depicts a scene from James Thomson's poem *The Seasons* (fig. 61).

Reproductive prints, which had great value to those interested in the visual arts at a time long before art books became common, were also featured in the collection of Edward Brush Corwin (d. 1856). On November 10, 1856, Sabin published his hefty catalogue of Corwin's library and collection, with a title page listing the contents of the collector's bulging shelves: "[A] rare, curious, and valuable collection of books, tracts, autographs, Mss., engravings, paintings, &c. . . . Comprehending an immense assemblage of books in almost every department of literature . . . illustrated books, bibles, and biblical literature, old theology and sermons, history and biography, and books relating to America, Mss., autographs, &c., also, line and mezzotint engravings, oil paintings, &c., &c."[30] After reviewing the thousands of books, Sabin commented on the engravings, which were given a large, separate section of their own. He noted that Corwin "had

27. Lydia H. Sigourney, "Residence of Ithiel Town, Esq.," *Ladies' Companion* 10 (January 1839), pp. 123–26; see also Parry, *Art of Cole*, p. 245.

28. Joseph Sabin, *A Catalogue of the Books, Autographs, Engravings, and Miscellaneous Articles Belonging to the Estate of the Late John Allan* (sale cat., New York, 1864), p. iii. I am grateful to Elliot Bostwick Davis, Assistant Curator, Department of American Paintings and Sculpture, Metropolitan Museum, and Georgia Barnhill, Andrew W. Mellon Curator of Graphic Arts, American Antiquarian Society, Worcester, Massachusetts, for information on print collectors, especially that found in Barnhill's lecture "Print Collecting in New York to the Civil War," delivered in April 1986 at the National Academy of Design.

29. Sabin, *Catalogue of Estate of John Allan*, p. v.

30. Joseph Sabin, *Catalogue of the . . . Collection of . . . the Late Mr. E. B. Corwin* (sale cat., New York: Bangs, Brother and Co., November 10, 1856), title page.

Fig. 61. Asher B. Durand, *Musidora*, 1825. Engraving. The Metropolitan Museum of Art, New York, Gift of Mrs. Frederic F. Durand, 1930 30.15.1

some practical acquaintance with the art [of engraving], and particularly a keen perception of all those niceties which distinguish a good from a poor impression of a print; and noticeable among the numerous examples of art, will be very fine specimens of

Bartolozzi, Sharp, Woollett, Wille, Finden, among European artists; while of American subjects there are many of the choicest productions of the burin."[31] Over twelve hundred engravings are cited, 145 of which, by Francesco Bartolozzi, recorded the compositions of other artists.

Another collection rich in engravings, but assembled for working purposes, was that of Durand (1796–1886), the grand old man of New York's art world. Durand had pursued a varied career, first as a young engraver, then as a portrait and genre painter, and finally as an august landscape painter. It is fair to assume that his collection was formed mostly before the Civil War, when he produced many landscapes under the influence of Turner. His estate sale, held consecutively on April 13 and 14, 1887, contained his own numerous oil studies, "a choice collection of Fine Illustrated Art Books,"[32] and an immense collection of engravings, some his own originals, many others after Turner, and some reproducing works by artists such as Bartolozzi, Raffaello Morghen, William Sharp, and Robert Strange.

Like many other artists, John M. Falconer (1820–1903) formed a sizable collection of paintings, watercolors, and engravings that he used as models for his work. Falconer was a native of Edinburgh who came to New York in 1848 and built a career as an etcher and a painter of portraits, genre subjects, and landscapes. During the 1850s he corresponded regularly with Mount, who shared with him an interest in prints after the genre pictures of David Wilkie. The

31. Ibid., p. vii.
32. *Executor's Sale: Studies in Oil by Asher B. Durand, N.A., Deceased, Engravings by Durand . . . and Others* (sale cat., New York: Ortgies' and Co., April 13, 14, 1887).

Fig. 62. James A. Suydam, *Paradise Rocks,* Newport, 1865. Oil on canvas. National Academy of Design, New York, Bequest of James A. Suydam

Fig. 63. Rembrandt van Rijn, *The Descent from the Cross: The Second Plate*. The Netherlands, 1633. Etching and burin. The Metropolitan Museum of Art, New York, Gift of Henry Walters, 1917  17.37.69

33. Anderson Auction Company, *Catalogue of the Interesting and Valuable Collection of Oil Paintings, Water-Colors and Engravings Formed by the Late John M. Falconer* (sale cat., New York, April 28, 29, 1904), passim.

34. *The Diary of George Templeton Strong*, edited by Allan Nevins and Milton Halsey Thomas (New York: Macmillan Company, 1952), vol. 4, p. 34, entry for September 16, 1865.

35. Bangs, Merwin and Co., *Catalogue of a Choice Private Library. Being the Collection of the Late Mr. James A. Suydam* (sale cat., New York, November 22, 23, 1865).

36. David Dearinger, "James Augustus Suydam," in *Catalogue of the Permanent Collection of Paintings and Sculpture of the National Academy of Design*, edited by Abigail Booth Gerdts (New York: Hudson Hills Press, forthcoming).

37. Eliot C. Clark, *History of the National Academy of Design, 1825–1953* (New York: Columbia University Press, 1954), p. 86.

38. *Boston Transcript*, May 2, 1896.

39. J. R. W. Hitchcock, *Etching in America* (New York: White, Stokes, and Allen, 1886), p. 49.

auction catalogue of Falconer's collection, issued in 1904, listed almost 350 prints, including dozens by Durand, five by Rembrandt, and twelve each by Turner and Wilkie.[33]

James A. Suydam (1819–1865), member of an old New York Dutch family, enjoyed an inheritance, augmented by his own business successes, that allowed him to retire early to study painting as an amateur and to travel abroad. A member of the Century Association since 1849, Suydam was a popular figure in New York's art world, although his landscape paintings were not by any means unconventional (fig. 62). After his death, on September 16, 1865, George Templeton Strong recorded this acerbic opinion of the man and his art: "Poor Jem Suydam dead of dysentery at North Conway. . . . He devoted himself to landscape art some years ago, first as amateur and then professionally, and was represented at every academy by pictures that embodied no sentiment of any kind, but that shewed he had made himself a very good painter. An excellent fellow, with a streak of the Dutchiness that belongs to his race."[34]

The catalogue of the posthumous sale of Suydam's library, drawings, and engravings lists more than one hundred original and reproductive prints; featured are works by old masters such as Rembrandt, Dürer,

Ostade, and Raphael and contemporaries including Rosa Bonheur, Ary Scheffer, and George Caleb Bingham.[35] The Department of Drawings and Prints of the Metropolitan Museum houses several dozen Rembrandt etchings from the collection, including multiple copies of *The Adoration of the Shepherds, The Raising of Lazarus,* and *The Descent from the Cross* (fig. 63). Most important to Suydam's lasting good name was his generous bequest of $50,000 to the National Academy, along with his collection of ninety-two paintings by contemporary American and European artists.[36] The pictures, including splendid examples by Frederic E. Church, John F. Kensett, Charles-Édouard Frère, and Andreas Achenbach, were appraised by the Academy at $12,821.[37]

From the perspective of long-range importance to American public collections, probably the greatest group of prints assembled in New York City before the Civil War was that belonging to Henry Foster Sewall (1816–1896). Sewall, born in New York City, was a descendant of Samuel Sewall, chief justice of Massachusetts in the early eighteenth century, and was associated with the New York shipping firm of Grinnell, Minturn and Company, owners of the great clipper *Flying Cloud*. He began to collect in 1847, bought a few prints (by Durand, Dürer, and Rembrandt) at the Corwin sale in 1856, and, according to his obituary in the *Boston Transcript*, "left one of the finest collections of early prints in the world, outside of the public art museums of England, France and Germany."[38] Because of his business, Sewall was well placed to involve himself directly and beneficially in the European print market. As J. R. W. Hitchcock pointed out in 1886, "he was, with the exception of a Scotchman temporarily resident here, the only American correspondent of Edward Evans, then the chief print-seller of London. The latter sent out by sailing-vessels portfolios of prints from which Mr. Sewall made his selections, thus beginning a collection chosen with singular discrimination, and now famous among print lovers."[39]

When Sewall's collection of approximately twenty-three thousand prints was put on the market after his death, the Museum of Fine Arts in Boston bought it at the urging of Sylvester R. Koehler, the first curator of the museum's Print Department. The funds for the purchase came from the bequest of Harvey D. Parker, proprietor of Boston's famous Parker House Hotel, and thus the collection is named for him rather than Sewall. The annual report of the trustees of the museum, issued at the close of 1897, quoted Koehler's perspicacious evaluation of the collection, the single

Fig. 64. Albrecht Dürer, *The Fall of Man (Adam and Eve)*, Germany, 1504. Engraving. Courtesy of the Museum of Fine Arts, Boston, Harvey D. Parker Collection P246

most remarkable acquisition of prints by an American art museum:

> *If Mr. Sewall had a penchant, it was for old prints, and the engravers, etc. of the 15th, 16th, 17th, and 18th centuries are therefore more fully represented in the collection he made than those of the 19th century, more especially those of the first half of it. This, however, is quite fortunate for the Museum, as in the prints heretofore acquired by it, mostly by gift, the prints last alluded to very decidedly preponderate. The richness of the collection in Dürer [see fig. 64] and Rembrandt is sufficiently evidenced by the exhibition which opened to-day, and its wealth in other departments,—old Germans, old Netherlanders, old Italians, followers of Rembrandt, Ostade, French etchers of the 17th century (Claude, Callot, etc.), French portraits, and so on,—will be demonstrated by future exhibitions.[40]*

In the past half century, historians of American art during the antebellum period have emphasized both the development of the domestic school and the avidity with which American paintings and sculptures were acquired by collectors at home. This is understandable, since the rise of an indigenous school was indeed an exciting act of social will, a cultural tale that had not been retold properly since the 1880s.

However, as William G. Constable noted in 1963, it is also significant that, while men such as Reed and Sturges were forming their collections of American works, others were searching abroad—in Europe and farther afield—and bringing together intriguing groups of paintings, sculptures, antiquities, and decorative arts.[41] These would later have a considerable impact on fashions in American collecting, especially during the post–Civil War years, when domestic landscape, genre, and history painting fell from favor.

James C. Colles (1788–1883), a native of New Jersey, made his fortune in mercantile pursuits in New Orleans before retiring in 1840. By 1845 Colles and his family had spent three productive years collecting in Europe. For their new home at Tenth Street and University Place in New York, Colles had bought a group of "old master" paintings bearing dubious attributions (Raphael, del Sarto, Leonardo) as well as sculptures by Thomas Crawford, an American residing in Rome, and the Italian Lorenzo Bartolini. While in Amsterdam, in 1843, he had acquired various works of antiquarian interest, including many Buhl-work furnishings, for the New York residence. Most significant were his lavish purchases in Paris: clocks, lamps, mantel garnitures, Sèvres porcelains, a large, specially ordered Aubusson carpet, and a drawing-room suite (see cat. no. 236A, B). In 1843 Colles commissioned a sofa, dressing table, and sideboard, among other pieces, from Auguste-Émile Ringuet-Leprince, then one of the most fashionable furniture makers and upholsterers in Paris; subsequently, as part of his voluminous correspondence with Leprince, he continued to order additional furnishings (see "'Gorgeous Articles of Furniture': Cabinetmaking in the Empire City," by Catherine Hoover Voorsanger in this publication, pp. 309–12).[42] As a showcase for European art treasures, and especially for contemporary French decorative arts, the Colles house set the standard for elegance and sophistication in New York.

Colles's son-in-law, John Taylor Johnston (1820–1893), was also a patron of Ringuet-Leprince and a distinguished collector of the work of contemporary artists. Trained as a lawyer at Yale, he made investments in New Jersey and Pennsylvania railroads that soon earned him a substantial fortune. Equally early in his career, in the 1840s, Johnston began to travel abroad, collecting modern paintings as he went, while also buying pictures from artists in New York. By 1870, when he was elected the first president of the newly established Metropolitan Museum of Art, Johnston had amassed the largest collection of contemporary paintings in New York City. At its largest,

40. Trustees of the [Boston] Museum of Fine Arts, *Twenty-second Annual Report, for the Year Ending December 31, 1897* (Boston, 1898), pp. 12–13.

41. William G. Constable, *Art Collecting in the United States of America* (Edinburgh: Thomas Nelson and Sons; Paris: Société Française d'Éditions Nelson, 1963), p. 27.

42. Emily Johnston de Forest, *James Colles, 1788–1883, Life and Letters* (New York: Privately printed, 1926), passim.

Fig. 65. J. M. W. Turner, *Slave Ship*, England, 1840. Oil on canvas. Courtesy of the Museum of Fine Arts, Boston, Henry Lillie Pierce Fund 99.22

43. See Caroline Williams, "The Place of the New-York Historical Society in the Growth of American Interest in Egyptology," *New-York Historical Society Quarterly Bulletin* 4 (April 1920), pp. 3–20; and John D. Cooney, "Acquisition of the Abbott Collection," *Brooklyn Museum Bulletin* 10 (spring 1949), pp. 16–23.

just before its dispersal at auction in 1876 to raise capital for Johnston's railroad interests, the collection contained more than 100 American works (mostly oils but also several dozen drawings and watercolors) and about 210 from Europe (more than half of which were oils). American masterworks abounded, among them Church's *Twilight in the Wilderness,* 1860 (Cleveland Museum of Art), and *Niagara,* 1857 (fig. 50); Cole's series The Voyage of Life, 1839–40 (formerly in the Ward collection; see figs. 49, 60), and *The Mountain Ford,* 1846 (Metropolitan Museum); Winslow Homer's *Prisoners from the Front,* 1866 (Metropolitan Museum); and Turner's *Slave Ship,* 1840 (fig. 65). The familiar European names are too numerous to mention in full: Meissonier, Isabey, Corot, Bouguereau, Gérôme, and Delacroix are but a few.

Dr. Henry Abbott (1812–1859), British by birth and a New Yorker by occasional residence, was the first in the United States to form an important collection of Egyptian antiquities.[43] Abbott spent the years 1832 to 1852 in Cairo, eventually acquiring more than two thousand ancient Egyptian artifacts. He brought about half of these to New York in 1852, with the aim of selling the entire group to any institution for $60,000 ($40,000 less than the value he placed on it). At the same time, Abbott hoped to turn a profit by exhibiting the collection at the Stuyvesant Institute for an entrance fee of 50 cents a person. The collection remained on view, and available for purchase, after Abbott returned to Cairo in 1854.

Nothing happened until rumors cropped up that the group was being offered for sale in Europe. With that as a goad, shortly before Abbott's death in March 1859, a group of trustees of the New-York Historical Society, led by William C. Prime, raised $55,000 for the purchase, an amount that was apparently

acceptable to Abbott. Late in June 1860, while details of the purchase agreement were still being worked out with his estate, *Frank Leslie's Illustrated Newspaper* wrote the following:

*We rejoice that the Historical Society have received this noble collection, the only one in the country really deserving the name of a museum in the higher sense of the word. Let us trust that in time other museums, illustrating other races, may be added to it, until finally New York shall boast an institution which will make her the first city in the world at which the scholar and the artist may acquire practical knowledge of the past, and be thereby qualified to criticise correctly and erect a soundly based standard of judgment on men, works of literature and art. The first step has been taken; let us trust that the intelligence and liberality of our citizens will accomplish the rest.*[44]

The collection was finally acquired officially by the Society on December 31, 1860, but not until *Harper's Weekly* had robustly browbeaten New York for its laggard behavior in not purchasing the collection sooner:

*That little city [Boston] does not call herself a metropolis, but somehow these things have a metropolitan air. Shall we not march with her, side by side, in these good works? The largest ships—the most spacious warehouses—the most "palatial residences"—the most expensive balls—the most unblushing and enormous taxes—the utmost civic corruption—are not, alone, enough to make a great metropolis. What renown the little Tuscan city of Florence has in history! It was not because the Medici were merchant princes. It was because the traders were not content that their city should be a shop, and so made it a museum, a library, a gallery—and collected in it, so far as they could, the choicest results of human genius in every department.*[45]

The greatest assemblage of Egyptian antiquities in the United States until early in the twentieth century, the Abbott collection was transferred on long-term loan to the Brooklyn Museum in 1937.[46] It was purchased for Brooklyn's permanent collection in 1948, using the Wilbour Fund, and remains the most important group acquisition of Egyptian objects in the history of the museum (see fig. 66).[47]

Prime (1825–1905; fig. 67), who was instrumental in the initial purchase of the Abbott collection, was a distinguished collector, scholar, and author who also counted Egyptian art among his many interests. The son of a Presbyterian minister and country-school headmaster, he was born in relatively modest circumstances in a small upstate New York village. He graduated from Princeton in 1843, studied law, and began to practice in New York City in 1846. In 1851 he married Mary Trumbull (d. 1872) of Stonington, Connecticut, and thereafter the couple collected as a pioneering team, acquiring in a wide range of media: pottery, porcelain, and European woodcuts in particular but also coins, medals, and seals. In 1855 they made their first trip to Egypt and began to collect ancient Egyptian artifacts. In 1857 Prime published two books that reflect the couple's religious and scholarly interests: *Tent Life in the Holy Land* and

Fig. 66. *Family Group, Possibly Iru-Ka-Ptah and His Family,* Egypt (reportedly from Saqqara), Old Kingdom, Fifth Dynasty, ca. 2240–2200 B.C. Painted limestone. Brooklyn Museum of Art, Charles Edwin Wilbour Fund 37.17E

44. "The Abbott Egyptian Museum," *Frank Leslie's Illustrated Newspaper,* June 30, 1860, p. 83.
45. "The Lounger. A Metropolitan Meditation," *Harper's Weekly,* April 23, 1859, p. 259.
46. Cooney, "Acquisition of Abbott Collection," p. 17.
47. Ibid., p. 22.

Fig. 67. Fridolin Schlegel, *William Cowper Prime*, 1857. Oil on canvas. Collection of The New-York Historical Society, Gift of Benjamin L. Prime, his great-grandson 1953.188

48. William C. Prime, *Coins, Medals, and Seals, Ancient and Modern* . . . (New York: Harper and Brothers, 1861).

49. William C. Prime, *The Little Passion of Albert Durer* (New York: J. W. Bouton, 1868).

*Boat Life in Egypt and Nubia.* Four years later he left the practice of law to become a full-time journalist and writer, publishing *Coins, Medals, and Seals, Ancient and Modern,* which confirmed the scholarly seriousness of his and his wife's collecting.[48] Prime had an abiding interest in early European prints, particularly those with religious themes, and in 1868 he published one of the earliest books of facsimiles after Dürer's work issued in this country.[49]

Prime was also a powerful early figure behind the growth of art museums and art education in the United States. Deeply involved in the establishment of the Metropolitan Museum, he served as an original trustee and later as a vice president before he resigned in 1891 to protest the opening of the museum on Sundays. In 1884 he was named the first professor of art history at Princeton, to which he and his wife bequeathed their collection. The couple's view of art collecting is stated in Prime's *Pottery and Porcelain of All Times and Nations* (1878), an important early discussion of the subject in America:

*Every man and woman should have a hobby. . . . No pleasure is more profitable than that found in surrounding one's daily life with works of the Great Artist or of man, arranged and classified in such way as to please the eye, afford instruction, or form material for intelligent study and examination.*

*The refining influences which attend the formation of such collections are ample reward for time, labor, and money expended on them, if there were no other compensation.*[50]

Among the wealthiest and most insightful of the collectors with wide-ranging interests was James Lenox (1800–1880), the founder of the Lenox Library, today an essential constituent of the New York Public Library's Astor, Lenox, and Tilden Foundations. To some, Lenox is best known as the starchy Presbyterian philanthropist who formed the largest private collection of Bibles in the nation, including the first Gutenberg Bible brought to America. Yet his scope and impact as an art collector were far broader, dating from his early years, when, as a young man of fortune, he traveled widely in Europe and began to collect with a catholic taste. Despite his predictable beginnings in partnership with his financially astute father, Robert, a merchant and real estate investor, James's "mind was rather on music, gems, engravings, paintings, fine arts and literature, than on merchandize."[51] Soon after his father's death in 1839, the very wealthy James retired from business to study, to collect, and to pursue philanthropic activities—all in an exceedingly private way.[52] He bought secretly, shared his treasures with a limited circle of friends, and quietly gave large sums of money to numerous charities.

Incorporated in 1870, the Lenox Library was located on Fifth Avenue between Seventieth and Seventy-first Streets and was housed in a building that Lenox commissioned from Richard Morris Hunt (today, the Frick Collection occupies the site). Over the next decade Lenox showered his library with treasures, many of which were paintings from his residence at 53 Fifth Avenue. These were largely by contemporary English and American artists, with a considerable sprinkling of French, German, and Netherlandish examples. Among the English artists included were Constable, Gainsborough, Raeburn, Reynolds, and Turner; some of the Americans were Church, Cole, Morse, Copley, Leslie (who, resident in England, was a regular adviser to Lenox), Daniel Huntington, and Henry Inman.

In his biography of Lenox, Henry Stevens recorded how, in 1845, Leslie acted on behalf of Lenox in negotiations with a surly Turner for the purchase of one of the master's great works, *Staffa, Fingal's Cave*, 1832 (cat. no. 49). Lenox did not care for the picture when he first received it and complained by letter to Leslie. Shortly thereafter he wrote again, repenting: "Burn my last letter, I have now looked *into* my 'Turner' and it is all that I could desire. Accept best thanks."[53]

*Fingal's Cave*, a memorable study of water, mist, clouds, smoke, and light, shared Lenox's walls with Church's *Cotopaxi*, 1862 (Detroit Institute of Arts), which is among the finest studies of similar effects by an American painter.

Lenox's philanthropic and wide-reaching vision is exemplified by his purchase, for $3,000, of the so-called Nineveh Marbles (fig. 68). This massive group of alabaster bas-reliefs, dating to about 870 B.C., was described by Stevens as "13 slabs [twelve, in fact], about a foot thick . . . generally about $7\frac{1}{2}$ feet high, and averaging 6 feet in width, the whole, ranged side by side, measuring 72 feet 2 inches."[54] Despite their then popular name, the slabs actually came from the northwest palace of Ashurnasirpal II at Nimrud, located some twenty miles south of Nineveh. The quest for Assyrian antiquities such as these had begun in the 1840s, as French and English excavators (most notably, Austen Henry Layard) worked digs at Nineveh and Nimrud. By the late 1840s both the Louvre and the British Museum had impressive displays of

50. William C. Prime, *Pottery and Porcelain of All Times and Nations with Tables of Factory and Artists' Marks for the Use of Collectors* (New York: Harper and Brothers, 1878), p. 17.

51. Henry Stevens, *Recollections of James Lenox and the Formation of His Library,* edited by Victor H. Paltsits (New York: New York Public Library, 1951), p. 4.

52. It is characteristic of Lenox that he is said to have directed on his deathbed that "no particulars of his early life and career should be given for publication." *New-York Times,* February 19, 1880.

53. Stevens, *Recollections of James Lenox,* pp. 40–43.

54. Ibid., pp. 95–96.

Fig. 68. *Ashurnasirpal II, King of Assyria,* Assyria (from present-day Nimrud, Iraq), ca. 870 B.C. Alabastrous limestone. Brooklyn Museum of Art, Gift of Hagop Kevorkian 55.155

Fig. 69. William Sidney Mount, *The Power of Music*, 1847. Oil on canvas. The Cleveland Museum of Art, Leonard C. Hanna, Jr. Fund 1991.110

55. For a full history of the Lenox marbles, see Robert H. Dyson Jr., "A Gift of Nimrud Sculptures," *Brooklyn Museum Bulletin* 18 (spring 1957), pp. 1–13. I am grateful to Richard Fazzini, Curator of Egyptian, Classical, and Middle Eastern Art, Brooklyn Museum of Art, for this reference.

56. R. W. G. Vail, *Knickerbocker Birthday: A Sesqui-Centennial History of the New-York Historical Society, 1804–1954* (New York: New-York Historical Society, 1954), p. 109.

57. *The Crayon* 3 (January 1856), pp. 27–28 (Wolfe); (February 1856), pp. 57–58 (Sturges); (April 1856), p. 123 (Cozzens); (June 1856), p. 186 (Leupp); (August 1856), p. 249 (Roberts); (December 1856), p. 374 (Magoon).

Assyrian materials on exhibit. When the Nineveh Marbles were shopped around the international art market by several English entrepreneurs in 1853, they were deemed by both museums to be unnecessary additions to their collections. After they were also rejected by potential buyers in Boston in 1858, Lenox acquired them for immediate gift to the New-York Historical Society. So heavy that they had to be kept in the basements of the two buildings afterward occupied by the Society, the marbles (known as the Lenox Collection of Nineveh Sculptures) were placed on long-term loan at the Brooklyn Museum in 1937, when the Society changed its collection policy; in 1955 the museum purchased the pieces with help from the Hagop Kevorkian Foundation.[55]

Despite the subsequent history of the marbles, Lenox's gift to the Society was of remarkable museological importance, as the Society's director, R. W. G. Vail, recalled in 1954: "These splendid works of ancient art, the only others from the same site being in the British Museum and the Louvre, added greatly to the prestige and interest of the Society's art gallery during the period when we took the entire field of art history for our province."[56] On view today at the Brooklyn Museum, they are still regarded as one of the finest sets of Assyrian reliefs in the United States. And, although the Lenox Library no longer exists as a separate organization and Lenox's art collection has been dispersed, he still remains one of the greatest and most influential of New York's early collectors.

From January through December 1856 *The Crayon* published a series of articles, entitled "Our Private Collections," that briefly described six New York City art collections.[57] In addition to Sturges, the collectors discussed were John Wolfe, the Reverend Elias L. Magoon, Charles M. Leupp, Abraham M. Cozzens, and Marshall O. Roberts. This selection was presumably meant to highlight the city's most important private assemblages of art, which, *The Crayon* noted, were largely unknown to the public. What is most obvious in reviewing the characterizations of these collections is how examples of contemporary European art were becoming nearly as numerous in them as works by living Americans (the latter were almost

Fig. 70. Frederic E. Church, *The Andes of Ecuador,* 1855. Oil on canvas. Reynolda House, Museum of American Art, Winston-Salem, North Carolina 1966.12.21.01

all by artists active in New York). Wolfe (ca. 1821–1894), for instance, who later advised his cousin Catharine Lorillard Wolfe (1828–1887) on the formation of her European collection, concentrated almost wholly on nineteenth-century English, French, Flemish, and German (especially Düsseldorf School) paintings. The names of Leslie, Clarkson Stanfield, Delacroix, Alexandre Calame, Barend Cornelius Koekkoek, Andreas Schelfhout, Johann Peter Hasenclever, and Ferdinand Georg Waldmüller stand out prominently in Wolfe's listing, dwarfing his holdings of a few pictures by the Americans Durand, John Thomas Peele, and Thomas Hewes Hinckley.

The large collection acquired by Magoon (1810–1886), parts of which were later foundation blocks for the collections of Vassar College and the Metropolitan Museum, focused on contemporary sketches, watercolors, and oils from both Europe and America. Magoon, who must have been an annoying presence on the art scene, regularly coaxed pictures at low prices from almost every important painter in midcentury New York, including Church, Jasper F.

Cropsey, Thomas Doughty, Durand, Eastman Johnson, Kensett, Louis Lang, Mount, Robert Walter Weir, and William Trost Richards. From among Magoon's large holdings of English and European works *The Crayon* singled out those depicting "monumental antiquities" and noted that "through extraordinary success in that specialty [he] has acquired, probably, the best collection in America."[58] His group of five drawings by Turner was apparently also remarkable. The fact that Magoon made his treasures available for study was recognized by *The Crayon* as an important contribution to New York's art milieu: "Artists and Amateurs are much indebted to his enthusiasm for these foreign contributions to the Art-treasures of our city, and certainly to his courtesy for the facilities afforded for their inspection."[59]

Leupp (1807–1859), a remarkably successful New York merchant who, like many of his contemporaries, had achieved wealth through hard work and sage investments, put together a superb group of American and European paintings and sculptures during the 1840s and 1850s. After Leupp's death

58. "Our Private Collections, No. VI [E. L. Magoon]," *The Crayon* 3 (December 1856), p. 374.

59. Ibid.

Fig. 71. Emanuel Leutze, *Washington Crossing the Delaware*, Germany, 1851. Oil on canvas. The Metropolitan Museum of Art, New York, Gift of John S. Kennedy, 1897  97.34

60. James T. Callow, "American Art in the Collection of Charles M. Leupp," *Antiques* 118 (November 1980), pp. 998–1009.

61. "Our Private Collections, No. III [A. M. Cozzens]," *The Crayon* 3 (April 1856), p. 123.

62. "Our Private Collections, No. IV [Marshall O. Roberts]," *The Crayon* 3 (August 1856), p. 249.

63. *Mr. Robert M. Olyphant's Collection of Paintings by American Artists . . .* (sale cat., New York: R. Somerville, December 18, 19, 1877).

by suicide, his collection—much admired then, as it would be today—was dispersed at auction on November 13, 1860. Among its American works were Cole's *Mountain Ford,* 1846, later owned by John Taylor Johnston (Metropolitan Museum), Emanuel Leutze's *Mrs. Schuyler Burning Her Wheat Fields on the Approach of the British,* 1852 (cat. no. 34), Mount's *Power of Music,* 1847 (fig. 69), and Henry Kirke Brown's forceful marble bust of William Cullen Bryant, 1846–47 (cat. no. 61).[60] Leupp's small group of European pictures contained paintings of cattle, genre scenes, landscapes, and a portrait each of Napoleon and Marat.

Of those named in *The Crayon* series, Sturges, Cozzens, and Roberts—along with Robert M. Olyphant and Robert L. Stuart—would probably have been deemed the most important by New York artists in the late 1850s, for these collectors were their major patrons.

Cozzens (1811–1868), a founding member of the Century Association, was active in managing the American Art-Union during the 1840s, serving as its president in 1850 and 1851; he was also a regular supporter of the National Academy. Always a steady friend of the city's artists, he had formed a collection

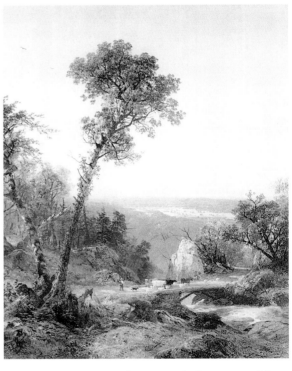

Fig. 72. John F. Kensett, *White Mountain Scenery,* 1859. Oil on canvas. Collection of The New-York Historical Society, on permanent loan from the New York Public Library, The Robert L. Stuart Collection, 1944

characterized by *The Crayon* as "conspicuous for the large proportion of American pictures it contains."[61] Especially noteworthy among the almost sixty contemporary American canvases were *The Andes of Ecuador*, 1855 (fig. 70), by Church; *The Beeches*, 1845 (Metropolitan Museum), by Durand; *Columbus before the Queen*, 1843 (Collection of Mrs. James H. Frier), by Leutze; and *The Microscope*, 1849 (Yale University Art Gallery, New Haven), by Robert Walter Weir.

Roberts (1814–1880) began his career humbly enough, as a ship's chandler, but he soon made an immense fortune in the shipping business (in association with William Henry Aspinwall) and in railroads. Thus possessing the means to support a youthfully acquired taste for pictures, he went on to assemble probably the largest holding of American paintings in the nation: in 1867 Tuckerman listed more than 110 such pictures belonging to Roberts. Although *The Crayon* had not recorded many of these in its 1856 article, it did comment on the collection's American focus and singled out Leutze's *Washington Crossing the Delaware*, 1851 (fig. 71), for special mention.[62] Roberts's sharp eye for quality continued to set an example for New York collectors for many years.

Olyphant (1824–1918) worked for his father in the China trade before achieving great success with the Delaware and Hudson Canal Company. He was an intimate friend of Kensett, who may have advised him in forming his collection of more than one hundred American paintings, recorded by Tuckerman in 1867. As early as 1854 Olyphant began buying pictures from Kensett and other New York artists, expressing a preference for genre scenes and landscapes. His collection grew to include works by Church, Cole, Cropsey, Sanford Robinson Gifford, William Stanley Haseltine, Eastman Johnson, Leutze, Arthur Fitzwilliam Tait, Elihu Vedder, and Worthington Whittredge. When Olyphant's collection was sold in 1877, the catalogue noted that many of the pictures had become well known through regular public exhibition, especially at the National Academy,[63] where the preauction display was mounted.

A highly successful sugar refiner, Stuart (1806–1882) formed an enormous collection of contemporary pictures, sculptures, and books. He began collecting in the 1850s, buying major works by American artists, notably Durand's *Franconia Notch*, 1857 (New York Public Library, on long-term loan to the New-York Historical Society), and Kensett's *White Mountain Scenery*, 1859 (fig. 72). Later he added perhaps his greatest acquisition, Johnson's *Negro Life at the South*, 1859

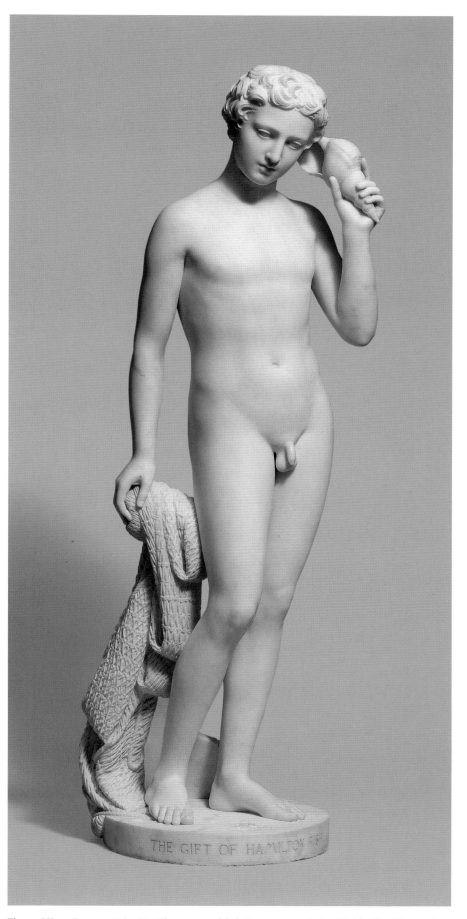

Fig. 73. Hiram Powers, *Fisher Boy*, Florence, modeled 1841–44; carved 1857. Marble. The Metropolitan Museum of Art, New York, Bequest of Hamilton Fish, 1894  94.91

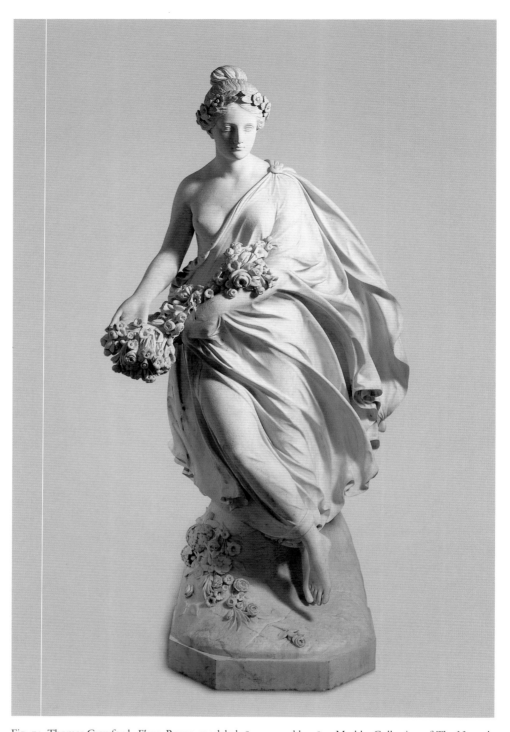

Fig. 74. Thomas Crawford, *Flora*, Rome, modeled 1847; carved by 1853. Marble. Collection of The Newark Museum, Newark, New Jersey, Gift of Franklin Murphy, Jr., 1926  26.2786

64. *Catalogue of Mrs. R. L. Stuart's Collection of Paintings* (New York: Privately printed, 1885).

(cat. no. 40). In the 1860s Stuart began acquiring European pictures by such artists as Bouguereau, Hugues Merle, Jules Breton, and Eugène Verboeckhoven. A catalogue of the collection prepared in 1885, after Stuart's death, listed 49 American artists and 112 Europeans;[64] some years later his wife gave the collection to the New York Public Library.

Several prewar collectors in New York had larger than usual holdings of American sculpture. First among these was Hamilton Fish (1808–1893), one of New York State's most prominent political figures, who had served successively as a member of Congress, the lieutenant governor and governor of New York, a United States senator and secretary of state. During the 1850s Fish was a very active patron of American sculptors, traveling with his family to Europe from 1857 to 1859 in order to cultivate his artistic taste. In all, Fish bought ten marbles by Erastus Dow Palmer,

seven by Hiram Powers, and one by Crawford.[65] He later bequeathed to the Metropolitan Museum Powers's *Fisher Boy*, 1841–44 (fig. 73); Palmer's *Indian Girl*, 1853–56 (fig. 125), and *White Captive*, 1857–58 (cat. no. 69); and Crawford's *Babes in the Wood*, ca. 1850 (fig. 114)—all extraordinary additions to the Museum's young collection of American sculpture.[66] Fish's interest in marble carving extended to mantelpieces, one of which (cat. no. 220) was produced for his New York house by the firm of Fisher and Bird.

Another New Yorker of the late antebellum period who had a considerable impact on the public display of privately owned sculpture was Richard K. Haight (1797–1862), who had commissioned Crawford's *Flora* (fig. 74) in 1849 and received it in 1853.[67] The same year, *Flora* was displayed at the Crystal Palace exhibition along with Powers's *Greek Slave*, a version of 1847 (cat. no. 60); both marbles have long been together in the collection of the Newark Museum. In August 1860 *The Crayon* reported a rumor that Haight intended to present *Flora* to "the Central Park" for display;[68] sometime afterward, the work was shown in the park, in the Arsenal on Fifth Avenue, along with eighty-seven plaster casts of other works by Crawford, donated by the artist's widow. In 1867 Tuckerman referred to these sculptures as being on view in the "Central Park Museum, N.Y." (the Arsenal), which may be credited as the first art museum within Central Park.[69] Later the collection was transferred to "the Mt. St. Vincent buildings at McGown's Pass [in Central Park, near the East Drive and 105th Street] . . . for use as a statuary gallery and museum."[70] These structures were destroyed by fire in 1881, along with some of the artworks, so it is not clear how *Flora* survived to join the collection of the Newark Museum.

As the sculpture collections of Fish and Haight were being made available to a wider audience, three other collectors—Thomas Jefferson Bryan, Aspinwall, and August Belmont—were themselves forming impressive quasi-public galleries of paintings. Bryan (1802–1870; fig. 75) was born in Philadelphia and, as the son of a wealthy partner of Astor, was able to indulge his taste for fine art early in life. In 1829, six years after graduating from Harvard College, Bryan began a sojourn in Paris that lasted until 1850, when he took up residence in New York City. During those two decades Bryan assembled a collection of 230 European paintings, including works by old masters from the Italian, Spanish, German, Dutch, Flemish, French, and English schools; he also acquired a number of American paintings. The quality and

Fig. 75. Thomas Sully, *Thomas Jefferson Bryan*, 1831. Oil on canvas. Collection of The New-York Historical Society, The John Jay Watson Fund 1960.26

importance of the works varied widely, and many of the rosy attributions made during Bryan's lifetime have been downgraded in subsequent years. Certain paintings are still highly regarded, however, for the collection did contain authentic works by masters such as Rembrandt, Rubens, Dürer, Giotto, Raphael, Scheggia (see cat. no. 42), Poussin, and Watteau.

After Bryan's offer to donate the collection to a public institution in Philadelphia was refused, he put it on long-term public view in New York, beginning in 1852 at 348 Broadway. Richard Grant White, the father of the architect Stanford White, was commissioned to prepare the accompanying *Catalogue of the Bryan Gallery of Christian Art, from the Earliest Masters to the Present Time*.[71] White described the gallery as having "in its historical character, an importance not possessed by any other ever opened to the public in this country. The rise and progress of each of the great schools . . . can be traced by characteristic productions of those schools, in all the stages of their development, which hang upon these walls."[72] He also pointed out an admirable characteristic of Bryan's undertaking: "It has been the aim of the proprietor to collect a gallery which should not only give pleasure to casual visitants, but afford efficient aid to the student of the history of Art."[73] White pussyfooted

65. David B. Dearinger, "American Neoclassic Sculptors and Their Private Patrons in Boston" (Ph.D. dissertation, City University of New York, 1993), vol. 2, p. 687.

66. Thayer Tolles, ed., *American Sculpture in The Metropolitan Museum of Art, Volume 1, A Catalogue of Works by Artists Born before 1865* (New York: The Metropolitan Museum of Art, 1999), pp. 64–66, 68–71.

67. For a detailed discussion of the commission, see Lauretta Dimmick, "A Catalogue of the Portrait Busts and Ideal Works of Thomas Crawford (1813?–1857), American Sculptor in Rome" (Ph.D. dissertation, University of Pittsburgh, 1986), pp. 448–62.

68. "Domestic Art Gossip," *The Crayon* 7 (August 1860), p. 231, cited in Dimmick, "Portrait Busts of Crawford."

69. Tuckerman, *Book of Artists*, p. 622.

70. Winifred E. Howe, *A History of The Metropolitan Museum of Art* (New York: The Metropolitan Museum of Art, 1913), p. 42.

71. See [Richard Grant White], *Catalogue of the Bryan Gallery of Christian Art, from the Earliest Masters to the Present Time* (New York: George F. Nesbitt and Co., 1852); and Richard Grant White, *Companion to the Bryan Gallery of Christian Art . . .* (New York: Baker, Godwin and Co., Printers, 1853).

72. White, *Companion to Bryan Gallery*, p. iv.

73. Ibid., p. ix.

Fig. 76. Bartolomé Esteban Murillo, *The Immaculate Conception*, Spain, ca. 1660–70. Oil on canvas. The Detroit Institute of Arts, Gift of James E. Scripps, 1989  89.70

*triptychs, of angular saints and seraphs, of black Madonnas and obscure Bambinos, of such market and approved "primitives" as had never yet been shipped to our shores. . . . I doubt whether I pro-claimed that it bored me—any more than I have ever noted till now that it made me begin badly with Christian art. I like to think that the collec-tion consisted without abatement of frauds and "fakes" and that if those had been honest things my perception wouldn't so have slumbered; yet the principle of interest had been somehow compro-mised, and I think I have never since stood before a real Primitive, a primitive of the primitives, without having to shake off the grey mantle of that night.[75]*

More recently, and more knowledgeably, Constable wrote of the collection (now at the New-York His-torical Society) that though "there are no great mas-terpieces . . . there are many that are of much interest and considerable merit."[76]

Bryan's attempt to provide the people of New York with an art-historical survey of European and Ameri-can painting—and, in fact, to establish something like a national gallery of art—was a generous, even revo-lutionary, one; the need for such a resource contin-ued for many years, until the Metropolitan Museum began to build its paintings collections in later dec-ades. Bryan offered his collection, augmented by more European and American paintings, to the Soci-ety in 1864; six years later, as he lay dying onboard a ship bound from France to New York, he stipulated in writing that his more recent acquisitions should be added to the gift (the size of the collection has sub-sequently been reduced through deaccessioning and sales). Although Bryan was not actually "the first art collector and connoisseur in New York City,"[77] he should be remembered for the resonating value of his ideals and public spirit.

In the mid-1850s Aspinwall (1807–1875), a New York merchant who had amassed a vast fortune as an importer, shipping magnate, and railroad investor, retired from daily involvement in business to devote himself to charitable affairs, travel, and art collecting. Taking up the latter interest with the same energy that had marked his previous entrepreneurial activities, Aspinwall traveled widely in Europe, where he made lavish purchases of art. By 1857 his acquisitions had begun to attract attention in New York. Of particular note was a large Murillo canvas titled *The Immaculate Conception*, ca. 1660–70 (fig. 76), which was remarked on in *The Crayon* before it went on exhibition at

74. Ibid., pp. iv–v.

75. Frederick W. Dupee, ed., *Henry James: Autobiography—A Small Boy and Others, Notes of a Son and Brother, The Middle Years* (Princeton: Princeton University Press, 1983), pp. 152–53.

76. Constable, *Art Collecting*, p. 29.

77. John E. Stillwell, "Thomas J. Bryan—The First Art Collector and Connoisseur in New York City," *New-York Historical Soci-ety Quarterly Bulletin* 1 (January 1918), pp. 103–5.

around the most problematic aspect of the collection by noting that "the author declines to express any opin-ion upon the authenticity of the many pictures here which bear some of the greatest names in art; but he wishes it to be understood that he does this solely on account of his entire want of confidence in his ability to speak with the least authority upon that subject."[74]

The gallery was not a great success and was subject to the sneers of many, including Henry James, who recalled his visit there as a boy:

*Deep the disappointment, on my own part, I remem-ber, at Bryan's Gallery of Christian Art. . . . It cast a chill, this collection of worm-eaten diptychs and*

Williams, Stevens and Williams, a commercial gallery, in January 1858.[78] That exhibition was apparently just a convenient way station for the famous canvas, since by January 1859 construction had been completed on an art gallery added to Aspinwall's house on Tenth Street.

The house was originally designed about 1845 by the architect Frederick Diaper, an English immigrant who was also responsible for several banks on Wall Street and the New York Society Library building, erected in 1840. The new gallery, designed by James Renwick Jr., had a separate entry from the street, which facilitated the visits by the public that Aspinwall allowed several days a week. Its entrance corridor contained several dozen works of art, both paintings and sculptures, many of which bore attributions (to Leonardo, Pontormo, and Titian, for example) that today would probably seem overenthusiastic. Mixed in with these were more modern works attributed to Gainsborough, Lawrence, Romney, Scheffer, and Bertel Thorvaldsen, as well as pictures by the Americans Gilbert Stuart (a portrait of George Washington) and Richard Caton Woodville. Beyond, in a large room that combined gaslight with natural light (introduced through concealed openings in the ceiling), were hung eighty-five pictures arranged densely in multiple rows, as was characteristic of the time. The famous Murillo held pride of place on the east wall (fig. 77). Works attributed to European masters of the fifteenth through the nineteenth century—"school of Raphael" through Jacques-Raymond Brascassat—predominated, but there were also a few paintings by the New York artists Régis-François Gignoux, Hinckley, Huntington, Kensett, and Frederick R. Spencer, as well as by the expatriate American John Rollin Tilton. Adjacent was a small gallery, illuminated and installed in the same manner as the larger one, containing two dozen pictures, most of which were landscapes, seascapes, animal subjects, and genre scenes by northern painters of the seventeenth through the nineteenth century; among the American works found there was Church's *Beacon, off Mount Desert Island,* 1851 (fig. 78). The collection was explained in a printed catalogue provided by Aspinwall.[79]

The public greeted Aspinwall's gallery enthusiastically and soon had another reason to rejoice. At about the same time, Belmont's picture gallery was also opened to them for several days a week, free of charge for artists and art students. The banker Belmont (1816–1890) had first begun to build his fortune in the 1830s as the New York representative of the

Rothschild interests; he had formed his collection from 1853 to 1857, while serving as the American minister to The Hague. The collection was reviewed in *The Crayon* for January 1858, after its exhibition at the National Academy,[80] and was then installed in a gallery in Belmont's house.

Unlike Aspinwall, Belmont had bought only pictures by living European artists. Those he chose—painters such as Bonheur, Calame, Meissonier, Theodore Rousseau, Constant Troyon, Horace Vernet, Koekkoek, and Meyer von Bremen—were all eminently acceptable to current taste, which was then evolving in favor of European art as opposed to American. Commenting on the cosmopolitan nature of Belmont's collection, *The Crayon* noted that it

*embraces master-pieces by many of the first artists of continental Europe, and it contains masterly Art. The pictures come to us from a land where Art is beyond price; where money fails to tempt Art from the hands of comparative poverty, where statues in honor of artists stand in the thorough-fares, where fêtes are held to rejoice over artistic success, and from a land where artists have represented the people. No wonder that the Art of continental Europe is, and always has been, the Art of the world, for Art there stands at the head of*

78. "Domestic Art Gossip," *The Crayon* 4 (October 1857), p. 316.

79. *Descriptive Catalogue of the Pictures of the Gallery of W. H. Aspinwall, No. 99 Tenth Street, New-York* (n.p., 1860).

80. *The Crayon* 5 (January 1858), p. 23.

MR. ASPINWALL'S GALLERY—EAST END.

Fig. 77. *The East End of Aspinwall's Principal Gallery.* Wood engraving from *Harper's Weekly,* February 26, 1859, pp. 132–34. The Metropolitan Museum of Art, New York, The Irene Lewisohn Costume Reference Library

Fig. 78. Frederic E. Church, *Beacon, off Mount Desert Island*, 1851. Oil on canvas. Private collection

81. Ibid.
82. "Shall New York Have a Public Gallery of Paintings?" *Harper's Weekly*, February 19, 1859, p. 114.
83. Ibid.

*popular thought and feeling in recognized fellow-ship with the greatest subjects of human interest—Law and Religion.*[81]

The advent of Aspinwall's and Belmont's galleries elicited from *Harper's Weekly* the presumptuous proposal "that the owners of these galleries should, by their wills, bequeath them to the city. The reasons urged in favor of this suggestion are, first, the strong probability that, in a country of vicissitudes like this, no gallery of works of art can be expected to remain over two generations in the same family; secondly, the public advantage of having a great gallery of paintings in this city; and lastly, the uselessness, as a general rule, of galleries kept exclusively for private inspection."[82] Forging on in the same vein, *Harper's* discussed possible sources of funds needed to build such a gallery: "There are half a dozen men in New York who could afford to build, in the Central Park, an edifice for a city gallery. Mr. William B. Astor, for

instance, would no doubt be delighted to have such an opportunity of using his wealth to noble advantages, and transmitting his name to posterity side by side with his father's."[83]

The beginning of the Civil War, in April 1861, closed many chapters in American life. By the war's end, the nature of the artist's life—fully chronicled in 1867 by Tuckerman's *Book of the Artists, American Artist Life*—had completely changed. Most noticeable was a radical shift in the taste of collectors, away from Hudson River landscapes and ideal marble figures toward the more painterly, realistic, and worldly works being created across the Atlantic, especially in the ateliers of France, Germany, and Holland. As collectors in New York City embraced the new tastes, many of the older artists, such as Durand, Church, and Albert Bierstadt, were stranded without active patronage. That the seeds of this change were sown in the years 1825 to 1861 is demonstrated in John Durand's *Life and Times*

*of A. B. Durand* (1894), which, except for its defensive tone, is one of the best artistic records of the period. The real theme of Durand's book is—to paraphrase Dunlap—the Rise and Decline of the American school of painting, as represented by the career of his father. For this decline Durand blamed the importation of European art to this country, beginning with the opening of the Düsseldorf Gallery in New York in 1849. To him the collection of Wolfe (composed mostly of Düsseldorf School pictures), the display of Bonheur's *Horse Fair,* 1853–55 (cat. no. 51), and other contemporary French works, and the far-reaching impact of John Ruskin's writings completed the damage, as collectors with new fortunes (unlike those whose wealth had been acquired earlier) deserted the artists of America.

At the close of his book, a downcast Durand came to this conclusion:

*The American school of art is an invisible factor among literary and other intellectual products of the country. As far as native productions are concerned, they are scattered over the country, hidden away in private houses and displayed in gloomy drawing-rooms, where sunlight scarcely ever penetrates. . . . Even when American works find their way out of private collections before the public, or,*

*again, are purchased by local institutions, they are hung in proximity to works of older schools, inspired by different sentiments and executed according to different methods: American art thus suffers by comparison.*[84]

Despite his sadness over the eclipse of American art, Durand did take the broader view: "In thus attributing the decline of the American school of art to the diversion of the native patronage which once insured its development, I do not deprecate or depreciate the result. On the contrary, one cannot too highly esteem the introduction into the country of foreign treasures of art of incalculable value in every sense."[85]

There was one indication, however, that the collectors who earlier had been the main support of American artists and designers continued to think well of their work: these patrons generously donated American paintings, sculptures, and other objects in later years, when the great public museums, like the Metropolitan, began the formation of their collections. The ethos of civic spirit that had characterized the prewar art world carried over into a new era, as the establishment of great institutions—museums, zoos, colleges, and hospitals—became the order of the day. And New York City, thanks in no small part to its art collectors, was in the forefront of the movement.

84. Durand, *Life and Times of A. B. Durand,* p. 191.
85. Ibid., p. 195.

# Selling the Sublime and the Beautiful: New York Landscape Painting and Tourism

*KEVIN J. AVERY*

## Cole and the Age of American Landscape Painting

America's age of landscape is often said to have begun in New York City in October 1825. It was then, according to the well-known story, that Colonel John Trumbull, the painter of the American Revolution and, as president of the American Academy of the Fine Arts, dictator of art matters in the city, discovered Thomas Cole, the father of the Hudson River School. As the account goes, Trumbull spotted three paintings of Hudson River and Catskill Mountain subjects in a local bookstore and art supply shop; he instantly purchased one, prevailed on two artist friends to buy the others, sought out and extravagantly praised Cole, the young painter of the pictures, and encouraged connoisseurs from New York and elsewhere to patronize him.[1] Cole's discovery took place within days of the celebration marking the opening of the Erie Canal, which more than any other single factor contributed to the rise of New York as the Empire City, America's first and most important metropolis.[2] Cole and the Empire City began their ascent at the same moment.

However, no group of artists sprang up instantly around Cole. For years he operated as a landscape painter in New York virtually without company or rivals. The fraternity of Cole's followers did not blossom and coalesce much earlier than about 1845. Even Asher B. Durand, Cole's contemporary and successor as the leader of New York landscapists, did not begin to focus on painting landscapes until about 1840. To be sure, when a community of landscapists did develop, it dominated American painting for at least a quarter century; some of its finest products were executed long after the beginning of the Civil War, which defines the final limit of this exhibition's purview. But during Cole's lifetime, American landscape painting was only in its formative stages as a movement.

Moreover, American landscape painting was not cultivated by Cole alone, or, in the years immediately preceding his death in 1848, by Cole and Durand together. Rather, the emergence and gradual growth of the school, as well as the meteoric rise of Cole's

own career, were part of the development of a broad landscape culture that took shape in New York and was lent impetus by the city. Paradoxically, it was precisely New York's preeminence among the nation's cities and its rapidly accelerating urbanization that gave rise to an American landscape culture. New York's commercial energy—empowered by a great natural harbor and river, which made the canal project possible, and primed by the expanded trade with the interior of the United States that the canal allowed—stimulated appreciation of the natural landscape. At the same time, restless Gotham was the foil against which America's natural places played, attracting city dwellers as refuges. Not least, for both foreigners and natives, excepting New Englanders, New York became the principal departure point in America for the most popular natural resorts of the time.

New York's landscape culture manifested itself principally in literature, tourism, suburban living, and urban parks, as well as in painting. To deal with all of those categories fairly would require a book-length exploration. This essay will, therefore, be confined chiefly to two areas, literature and, especially, tourism, concentrating on the resorts typically portrayed by the artists of the Hudson River School. With a few exceptions, artists chose the most popular destinations, and their pictures reinforced as well as reflected that popularity. These destinations—both at home and abroad—included the Catskill Mountains, Lake George, the White Mountains of New Hampshire, Newport, and Italy, most of which were painted by Cole, beginning in the early years of his career.

## The Literary Context for Cole

Since Cole's appearance in New York in 1825 was such an important moment in the history of New York's landscape culture, we should explore the immediate context of this event. He had spent the whole of 1824 trying to be a landscape painter in Philadelphia, where he is reported to have compared his youthful

The author gratefully acknowledges the generous assistance of the following individuals in the preparation of this essay: Joelle Gottlieb, Vivian Chill, Claire Conway.

1. Cole's discovery is discussed and documented in detail in Ellwood C. Parry III, *The Art of Thomas Cole: Ambition and Imagination* (Newark: University of Delaware Press, 1988), pp. 24–27. See also "Mapping the Venues," by Carrie Rebora Barratt in this publication.
2. See Parry, *Art of Cole*, p. 21, for a discussion of the timeliness of the beginning of Cole's career in reference to the opening of the Erie Canal.

3. For Cole's life before he moved to New York, see Ellwood C. Parry III, "Thomas Cole's Early Career: 1818–1829," in *Views and Visions: American Landscape before 1830,* by Edward C. Nygren et al. (exh. cat., Washington, D.C.: Corcoran Gallery of Art, 1986), pp. 163–66. His envy of Doughty and Birch was reported by his earliest biographer, William Dunlap, *A History of the Rise and Progress of the Arts of Design in the United States,* new ed., edited by Frank W. Bayley and Charles E. Goodspeed (Boston: C. E. Goodspeed and Co., 1918), vol. 3, p. 148.

4. Parry, "Cole's Early Career," pp. 163–66.

5. Parry, *Art of Cole,* p. 23; Parry, "Cole's Early Career," pp. 167–69.

6. Bryant's early life and career are described in Charles H. Brown, *William Cullen Bryant* (New York: Charles Scribner's Sons, 1971), pp. 77–172. See also the detailed chronology of Bryant's life in Henry C. Sturges and Richard Henry Stoddard, eds., *The Poetical Works of William Cullen Bryant* (New York: D. Appleton and Company, 1910), pp. xxxiii–lxv, esp. pp. xliv–xlix. The standard portrait of Knickerbocker culture in New York, including discussion of Bryant, James Fenimore Cooper, Washington Irving, and other writers and their relationship to such artists as Cole and Durand, is James T. Callow, *Kindred Spirits: Knickerbocker Writers and American Artists, 1807–1855* (Chapel Hill: University of North Carolina Press, 1967), esp. chap. 1, "The New York Background," pp. 3–37.

7. A detailed chronology of Cooper's life and work is given in James Fenimore Cooper, *The Leatherstocking Tales,* vol. 1 (New York: Library of America, 1985), pp. 869–81, with his activities in New York City before his sojourn in Europe of 1826 to 1834 on pp. 871–73.

8. Charles Ingham quoted in Callow, *Kindred Spirits,* p. 13: the first recorded minutes of the Sketch Club were kept at the house of John L. Morton, in 1829, but the minutes indicate that the club had met earlier. See also Thos. S. Cummings, *Historic Annals of the National Academy of Design, New-York Drawing Association, . . . from 1825 to the Present Time* (Philadelphia:

efforts unfavorably with the mild, picturesque, park-like scenes fashioned by local painters Thomas Birch and Thomas Doughty.[3] When he went to New York the following year, it was chiefly to rejoin his parents and sisters, whom he had left in Steubenville, Ohio, when he began his artistic odyssey in 1822. Cole's family too had felt the need to move to improve its fortunes, and no American city held out more opportunities than New York in 1825, particularly in view of the coming opening of the canal.[4]

Soon after arriving in New York, Cole traveled north on the Hudson River to make sketches upstate for the pictures that launched his reputation.[5] Yet in New York City itself he could also find inspiration, for by 1825 a literature of landscape, if not yet a landscape painting tradition, was blossoming here. The Wordsworthian poet William Cullen Bryant, with whom Cole is portrayed in Durand's *Kindred Spirits* (cat. no. 30), was born and raised in New England but had settled for good in New York just a few months before the painter arrived. Publication of his nature poems in Boston journals as early as 1817 and of his first collection of verse, in 1821, had earned Bryant a name in New England but not a livelihood while he labored with increasing reluctance as a lawyer in Massachusetts. Then he accepted an invitation to coedit a new publication in New York, the *New-York Review, and Atheneum Magazine,* and this position eventually led to his appointment as editor of the city's principal daily, the *New-York Evening Post.*[6] That reliable job remained the perch from which Bryant presided over New York's landscape culture until his death in 1878, when the Hudson River School was falling from its preeminent place in American art.

The novelist James Fenimore Cooper was second only to Bryant as an influential literary figure in the rising landscape culture of New York in the early nineteenth century. Like Bryant and Cole, Cooper was not a native of the city: he was born in Burlington, New Jersey, and was raised in Cooperstown, an upstate New York settlement that his father had founded.[7] But by 1820, with the publication of his first novel, he had begun to socialize with the poet Fitz-Greene Halleck and the artist William Dunlap, among others in New York. In 1822 he formed the first salon in the city, the Bread and Cheese Club, which welcomed both writers and artists. The Bread and Cheese Club was short lived, dissolving with Cooper's departure for Europe in 1826; but it was succeeded by the Sketch Club, composed of several members of the Bread and Cheese along with such newcomers as Cole, who reportedly hosted the first

"regular meeting."[8] Cooper's early Leatherstocking Tales *The Pioneers* (1823) and *The Last of the Mohicans* (1826) bear the impress, respectively, of the author's youth in upstate New York and the "fashionable tour"[9] he took of the Lake George–Lake Champlain area; enormously well received by the public, they played an important part in popularizing the upstate regions in which they are set. And by the time Cooper left New York, he had already created a mythology of the state as both a frontier and a theater of American history. Cole rapidly exploited this mythology:[10] among his earliest narrative landscapes, painted in 1826 and 1827, are four pictures with scenes from *The Last of the Mohicans* (see cat. no. 24), two of which are set in the wilderness of upstate New York.

Also important among the city's principal literary exponents of landscape culture in our period was Washington Irving, the eldest and the only native New Yorker among the trio. Although he had left New York for Europe in 1815 and did not return until 1832, his contribution to the culture was significant. By the time of his departure he had published *A History of New-York* (1809; cat. no. 137), under the pseudonym Diedrich Knickerbocker, and *The Sketch Book of Geoffrey Crayon, Gent.* (1819–20), as Geoffrey Crayon. The first made the author famous in America, the second brought him renown both at home and in England, where he was living when it was published.[11] While Irving's voice in these early works is essentially that of a fabulist, the volumes do include delightful scenic sketches. The *History* is a satirical account of the formation of New York City, but one chapter consists of a broad declamation of the glories of the Hudson River's shores up to the highlands, as surveyed by Peter Stuyvesant during a cruise upriver in a galley.[12] And the well-known tale "Rip Van Winkle" in *The Sketch Book* is set in the Catskills and is replete with evocative descriptions of the view into the Hudson River valley from the mountain ledges (see cat. no. 23); of Kaaterskill Clove (see fig. 98), in sight of which Rip takes his legendary nap; and of Kaaterskill Falls.[13] All became subjects for Cole and his successors, the Hudson River School of landscape painters.

### The Pictorial Context for Cole

The immediate pictorial context for Cole's landscapes appeared almost contemporaneously with Bryant's *Poems,* Cooper's *The Pioneers,* and Irving's *Sketch Book.* That context was *The Hudson River Portfolio* (see cat. no. 114; figs. 79, 152), the work of the

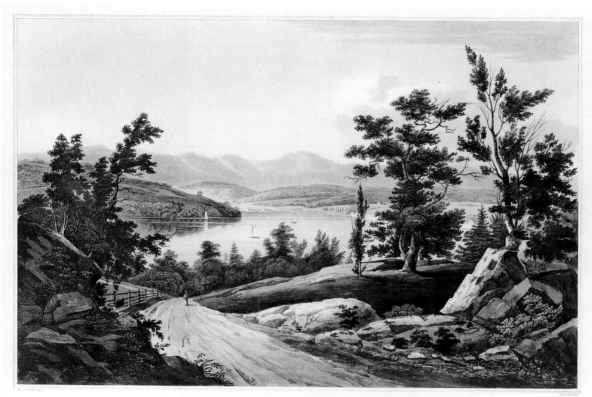

VIEW NEAR HUDSON.

Fig. 79. John Hill, after William Guy Wall, *View near Hudson*, 1822, from *The Hudson River Portfolio* (New York: Henry J. Megarey, 1821–25), pl. 15 (later pl. 12). Aquatint with hand coloring. The Metropolitan Museum of Art, The Edward W. C. Arnold Collection of New York Prints, Maps, and Pictures, Bequest of Edward W. C. Arnold, 1954  54.90.158

aquatint engraver John Hill and the watercolorist William Guy Wall. Both artists were born abroad, Hill in England, Wall in Ireland. In 1816 Hill emigrated from London to Philadelphia, where he produced the landmark *Picturesque Views of American Scenery* between 1819 and 1821. Based on the drawings of the English-born Philadelphia landscape painter Joshua Shaw, *Picturesque Views* included a single narrow image of the Hudson. The river did, however, become a major subject for Hill's burin when he was engaged to engrave the plates for the aquatints of Wall's watercolors that became *The Hudson River Portfolio*.[14] The series had been proposed by Wall, who had departed Ireland for New York in summer 1818 and had executed his watercolors of the Hudson River "During a Tour in Summer of 1820."[15] The New York artist John Rubens Smith was originally hired to engrave Wall's images, but by August 1820 Hill was approached by the publishers to replace him. Less than two years later, swayed by his publisher and completely preoccupied with the *Portfolio* project, Hill moved with his

family to New York and the rich opportunities Hudson River images would bring him.[16]

## The Tourist Context for Cole; the Catskills

Like Wall, most visitors to upstate New York before 1820 maintained their distance from the Catskills. Horatio Spafford's entry on the Catskills in his 1813 *Gazetteer of the State of New-York* discloses only that they are "the largest and most extensive [mountains] in the state"—an inaccurate claim (the Adirondacks were later discovered to be higher)—that a turnpike made the vicinity of the range's eastern summits accessible, and that from their heights "the view is inexpressively grand."[17] But some travelers were taking Spafford's hint; before 1817, for example, former Yale president Timothy Dwight had ascended to the lofty ledge called Pine Orchard, site of the future Catskill Mountain House hotel, admired "the distinct and perfect view" of the hundred miles of Hudson River valley below him, as well as the Kaaterskill Clove and its spectacular waterfalls.[18] By the time Cole arrived in

George W. Childs, 1865), pp. 110–11.

9. The term is derived from the title of the guidebook by Gideon M. Davison, *The Fashionable Tour in 1825: An Excursion to the Springs, Niagara, Quebec, and Boston* (Saratoga Springs: G. M. Davison, 1825).

10. For an excellent discussion of the role of Cooper's early novels in the popularization of the Catskill Mountains, see Kenneth Myers, *The Catskills: Painters, Writers, and Tourists in the Mountains, 1820–1895* (exh. cat., Yonkers: Hudson River Museum of Westchester, 1987), pp. 34–36, with a discussion of Cole's paintings of the Catskills on pp. 40–46.

11. A chronology of Irving's life and work appears in Washington Irving, *History, Tales, and Sketches: Letters of Jonathan Oldstyle, Gent., Salmagundi; . . . A History of New York; . . . The Sketch Book of Geoffrey Crayon, Gent.,* edited by James W. Tuttleton (New York: Library of America, 1983), pp. 1093–1102.

12. Ibid., pp. 622–25.

13. Ibid., pp. 773–77. For a discussion of Irving's descriptions of the Hudson River and the Catskills in relation to tourism, see Myers, *Catskills,* pp. 33–34.

14. For *Picturesque Views of American Scenery,* see Richard J. Koke, *A Checklist of the American Engravings of John Hill (1770–1850) . . .* (New York: New-York Historical Society, 1961), pp. 16–26; Nygren et al., *Views and Visions,* pp. 46–54, 268–69, 289–90; Gloria Gilda Deák, *Picturing America, 1497–1899: Prints, Maps, and Drawings Bearing on the New World Discoveries and on the Development of the Territory That Is Now the United States* (Princeton: Princeton University Press, 1988), pp. 213–14. For a detailed account of Hill's engagement as the engraver of *The Hudson River Portfolio,* see Richard J. Koke, "John Hill, Master of Aquatint, 1770–1850," *New-York Historical Society Quarterly* 43 (January 1859), p. 87. For *The Hudson River Portfolio* in general, see Donald A. Shelley, "William Guy Wall and His Watercolors for the Historic *Hudson River Portfolio,*" *New-York Historical Society Quarterly* 31 (January 1947), pp. 25–45; Koke, *Checklist of American Engravings of Hill,* pp. 29–41; Nygren et al.,

*Views and Visions*, pp. 54–58, 298–301; and Deák, *Picturing America*, pp. 217–18.

15. Prospectus for *The Hudson River Portfolio*, quoted in Deák, *Picturing America*, p. 217.

16. See Koke, "John Hill, Master of Aquatint," pp. 84–86, 92–94.

17. Horatio Gates Spafford, *A Gazetteer of the State of New-York* . . . (Albany: H. C. South-wick, 1813), p. 9.

18. Timothy Dwight, *Travels; in New-England and New-York*, 4 vols. (New Haven: Timothy Dwight, 1821–22), vol. 4, pp. 122–25.

19. Horatio Gates Spafford, *A Gazetteer of the State of New-York* (Albany: B. D. Packard, 1824; reprint, Interlaken, New York: Heart of the Lakes Publishing, 1981), pp. 414–15; see also "Ten Days in the Country," *Commercial Advertiser* (New York), August 26, 1824, p. [2], September 25, 1824, p. [2]; Davison, *Fashionable Tour in 1825*, pp. 41–43; and Theodore Dwight, *The Northern Traveller* (New York: Wilder and Campbell, 1825), pp. 15–18. These and other guides directing tourists to Pine Orchard and vicinity are discussed in Myers, *Catskills*, pp. 50–63.

20. "Descriptive Journal of a Jaunt up the Grand Canal; Being a Letter from a Gentleman in New-York, to a Lady in Washington, in August, 1825," *Atheneum Magazine* 1 (October 1825), pp. 381–82.

21. Ibid., p. 383.

22. Dwight, *Northern Traveller*, p. iii.

23. An Amateur [James Kirke Paulding], *The New Mirror for Travellers; and Guide to the Springs* (New York: G. and C. Carvill, 1828), p. 219.

24. [Thomas Hamilton], *Men and Manners in America* (Edinburgh: William Blackwood, 1833), vol. 2, p. 381.

25. Parry, *Art of Cole*, pp. 38–49.

26. These paintings are *Landscape, with Figures, a Scene from Last of the Mohicans*, 1826 (Terra Museum of American Art, Chicago) and *Gelyna (View near Ticonderoga)*, 1826 and 1829 (Military History Museum, Fort Ticonderoga, New York). Another may be *Landscape, Scene from "The Last of the Mohicans,"* 1827 (Van Pelt Library, University of Pennsylvania, Philadelphia). For these paintings, see Parry, *Art of Cole*, pp. 47–51.

New York, in 1825, Spafford's *Gazetteer*, two guide-books, and the local newspapers were touting the new hotel at Pine Orchard, where only a scattering of intrepid white travelers had stood before.[19]

The Catskill Mountain House was no doubt established in response to the increase in Hudson River traffic brought about after 1810 by the advent of the steamboat; and its builders surely anticipated the surge in tourism that would follow the completion of the Erie Canal. Thus travel to Pine Orchard and the surrounding Catskill areas that were the early subjects of Cole and his successors proliferated as a direct consequence of New York's rising enterprise and new economic preeminence. Dynamic Gotham, it might be said, in this way fostered Cole's predilection for the sublime, the aesthetic of the dramatic and fearsome in landscape.

If the relationship between the perception of natural wonders and the heroic projects of civilization was not represented by the members of the Hudson River School, it was sometimes addressed by urban tourists inspired by the painters' haunts. One such was a "gentleman in New-York" who in October 1825 wrote an account of "a jaunt up the Grand Canal" to Utica between a stop at Pine Orchard and a visit to the famed Trenton Falls on the Mohawk River near Utica. In the eyes of this observer, and presumably in the view of others of his time, nature was an artist. From the ledge at Pine Orchard he conjured up the heavenly loom on which nature "weaves her clouds," and he was "awestruck" by "the towering vault of solid rock, as if built by art"[20] that is the cave behind Kaaterskill Falls. The "Grand Canal" the gentleman traveler saw as a comparable prodigy. He regarded as "fairy-work" the engineering miracle that made possible the novel sensation of "floating . . . in a large and lofty barge, through fields, and directly in front of houses" (see cat. no. 106) or upon an aqueduct spanning the eleven-hundred-foot width of the rushing Mohawk River.[21] Theodore Dwight, nephew of Timothy, in his *Northern Traveller*, a guidebook published in New York in 1825, was similarly moved, observing that the "magnificence of the [canal] itself," not merely the novelty of riding upon its gentle course, had already "attracted vast numbers of travellers."[22] Yet few artists other than topographical specialists such as Hill portrayed either the canal or much of the scenery visible from it. America lacked its John Constable to glorify the man-made waterway's utilitarian function. And the landscape it made accessible to New Yorkers tended to lose its picturesque qualities, changing irresistibly, apace with the

city itself, as ever more towns and industry rose up along its banks.

## Saratoga and Lake George

Other sites rarely painted were Saratoga Springs and nearby Ballston. Although both lacked picturesque appeal, they were highly popular stops in the fashionable tour that America's first affluent classes undertook through New York State, New England, and lower Canada: their attraction was originally based on the therapeutic value of the mineral waters of their springs. When New Yorker James Kirke Paulding wrote of "the singular influence of beauty" at Saratoga and Ballston in his 1828 *New Mirror for Travellers*, he was referring not to the scenery, which he found ordinary at best, but to the young women who congregated there, attracting men of all ages.[23] A few years later, however, an Englishman visiting both resorts summarily dismissed even their social life when he observed: "If Saratoga was dull, Ballston was stupid."[24]

It could scarcely be said that nearby Lake George was not beautiful or a favored subject for artists. Cole visited Lake George as early as spring or early summer 1826 and painted it several times within the next year,[25] and his followers among the second generation of the Hudson River School—John F. Kensett, David Johnson, and Sanford Robinson Gifford—portrayed the area frequently through the Civil War period and after. To be sure, the purely picturesque character of Lake George appealed to the painters, but at least part of its attraction for Cole and contemporary tourists derived from its military past.

Two old forts (or their ruins), William Henry and George, occupied points on the south and middle of the thirty-mile-long lake, and Fort Ticonderoga was located near the northern tip of Lake George on Lake Champlain. Adding notably to its cachet as a military theater, Cooper had made Lake George (which he called by its Native American name, Horican) the focal setting of his most popular novel, *The Last of the Mohicans*, which addressed the collision of Native American and European cultures inflamed by the French and Indian Wars. In fact, writings about the conflict directly inspired Cole: one of his paintings of the Lake George–Lake Champlain region illustrates in the foreground a scene from *The Last of the Mohicans*, another a legendary episode of the war from a different source.[26]

Relative to Saratoga Springs, which already boasted several large hotels by the second decade of the

LAKE GEORGE.

Fig. 80. Peter Maverick, *Lake George*, New York. Engraving, from Theodore Dwight, *The Northern Traveller* (New York: Wilder and Campbell, 1825), opp. p. 120. The New York Public Library, Astor, Lenox and Tilden Foundations

nineteenth century, Lake George was a belated discovery of the new tourist class. The earliest accommodation on the lake may have been what Yale naturalist Benjamin Silliman Jr. reported was the Fort George barrack until shortly before his visit to the area in 1819, about the time a public house opened at nearby Caldwell.[27] However, the numbers of visitors to upstate New York who wished to see beautiful water, not merely drink it as at Saratoga, gradually increased, and Lake George more than rewarded them. Writers were paying more attention too. Indeed, by the time Cole stopped there Lake George had been extolled at length in at least four books, two published in the year of the Canal opening.[28] Moreover, by then a steamboat had been launched to ferry tourists from Fort George north to the isthmus on which Fort Ticonderoga on Lake Champlain is located.[29] The authors of all of the guides agreed on Lake George's principal virtues: historical resonance, its vast extent (best viewed from south to north); its innumerable islands (several are conspicuous in a number of Kensett's canvases [see fig. 81]), one—Tea Island—equipped with a summerhouse offering refreshments;[30] its sublime foil of mountains, chiefly on the eastern shore (a British visitor in 1833 compared the eastern aspect to Windermere, in the English Lake District, but found the features of Lake George's setting "bolder and more decided"[31]), and its pastoral cultivated land on the western shore; the mirrorlike waters that became a window allowing the angler to select his quarry as much as thirty feet beneath the surface from the abundant shoals of trout. If the men fished, the ladies could collect "the beautiful crystals of quartz," six-sided prisms that studded so-called Diamond Island and other locations.[32]

Among contemporary observers it was Theodore Dwight, in his *Northern Traveller*, who best described Lake George's scenic appeal—later reflected so conspicuously in the paintings of Kensett and his colleagues:

> *This beautiful basin with its pure crystal water is bounded by two ranges of mountains, which in some places rising with a bold and hasty ascent from the water, and in others descending with a graceful sweep from a great height to a broad and level margin, furnish it with a charming variety of scenery, which every change of weather, as well as every change of position presents in new and countless beauties. The intermixture of cultivation with the wild scenes of nature is extremely agreeable; and the undulating surface of the well tilled farm is often contrasted with the deep shade of the native forest, and the naked, weather beaten cliffs, where no vegetation can dwell. . . . To a stranger who visits Lake George under a clear sky, and sails upon its surface . . . the place seems one of the most mild and beautiful on earth.*[33]

It was the mildness of Lake George, not the mutability of its weather and the wild aspects of its environment described by Dwight, that became a leitmotiv of visitors' accounts and the characteristic subject of Hudson River School interpretations of the place, in particular Kensett's and Johnson's paintings. Even when tourists abounded, the lake in this mood offered the greatest contrast to urban hubbub and the calmest refuge. English author Harriet Martineau evoked the placid atmosphere and dolce-far-niente attitude induced by the lake on a fine day when she and her friends from New York sailed out to Tea Island one morning in the mid-1830s:

> *[Tea Island] is a delicious spot, just big enough for a very lazy hermit to live in. There is a teahouse to look out from, and, far better, a few little reposing places on the margin; recesses of rock and dry roots of trees, made to hide one's self in for thought and dreaming. We dispersed; and one of us might have been seen, by anyone who rode round the island, perched in every nook. The breezy side was cool and musical with the waves. The other side was warm as July, and the waters so still that the cypress twigs we threw in seemed as if they did not mean to float away.*[34]

In his *Northern Traveller* Dwight disparaged the image of Lake George (fig. 80) that accompanied his text on the area, insisting that "no exertion of art can produce anything fit to be called a resemblance of such a noble exhibition of the grand and beautiful

27. Benjamin Silliman, *A Tour to Quebec in the Autumn of 1819* (London: Sir Richard Phillips and Co., 1822), p. viii.

28. Ibid., pp. 48–65; Davison, *Fashionable Tour in 1825*, pp. 92–97; Dwight, *Northern Traveller*, pp. 92–97; Spafford, *Gazetteer of State of New-York* (1981), pp. 55, 73, 272.

29. Davison, *Fashionable Tour in 1825*, p. 95.

30. Ibid., p. 93.

31. [Hamilton], *Men and Manners in America*, vol. 2, p. 368.

32. Silliman, *Tour to Quebec*, pp. 51–52.

33. Dwight, *Northern Traveller*, pp. 119–20.

34. Harriet Martineau, *Retrospect of Western Travel* (London: Saunders and Otley; New York: Harper and Brothers, 1838), vol. 2, pp. 226–27.

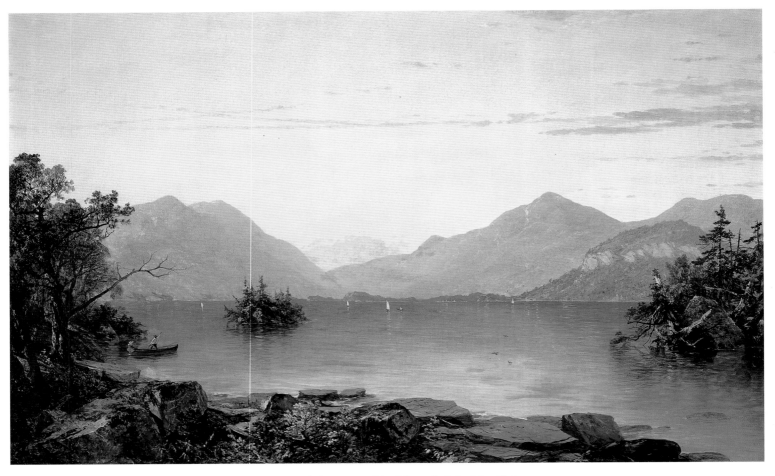

Fig. 81. John F. Kensett, *Lake George*, 1856. Oil on canvas. Adirondack Museum, Blue Mountain Lake, New York  65.079.01

35. Dwight, *Northern Traveller*, p. 120.

36. Parry, "Cole's Early Career," p. 178; see also Parry, *Art of Cole*, pp. 54–55. For modern perspectives on nineteenth-century artists in the White Mountains, see Donald D. Keyes, "Perceptions of the White Mountains: A General Survey," in *The White Mountains: Place and Perceptions* (exh. cat., Durham: University Art Galleries, University of New Hampshire, 1980), pp. 41–49.

37. Parry, *Art of Cole*, pp. 81–82, 218–19; Parry, "Cole's Early Career," pp. 178–83.

features of creation."[35] The remark is surely appropriate in reference to Cole's few paintings of Lake George and vicinity, the first pictorial accounts of the area, which were, in fact, rather limited scenically. Not until the 1850s would Cole's followers take up the subject again. Only then, with pictures by Kensett, Johnson, and Gifford, would painters' visions of the leisure charms of the lake equal their celebrations by writers.

### The White Mountains

In July 1827, on the heels of his visits to the Catskills and Lake George, Cole made a brief but signal excursion to the White Mountains of New Hampshire. As Ellwood Parry has observed, the White Mountains "became Cole's new passion, overwhelming his earlier fondness for the Catskills and Lake George."[36] After a sojourn in the state of barely a week, Cole painted several pictures with New Hampshire scenery, some of which included views of Mount Chocorua as a prominent feature. Among these are some of his earliest historical landscapes (see cat. no. 24). He visited

the region again, with the Boston landscape painter Henry Cheever Pratt, in the following year, and once more, with Durand, in the summer of 1839, when he produced another White Mountain picture.[37]

Cole's first visit might not have occurred when it did had it not been urged on him by his patron Daniel Wadsworth of Hartford, who had been to the White Mountains the year before. Yet even without Wadsworth's intervention, Cole doubtless would have gone there before long. The establishment of accommodations in the White Mountains in the early nineteenth century, a great natural calamity that took place there, and the attention the region drew in publications that appeared in New York and elsewhere after the Erie Canal opened lured ever increasing numbers of tourists through the second quarter of the nineteenth century. Like Lake George, however, the area did not become a subject for Cole's followers until the 1850s, when New Hampshire attracted second-generation Hudson River School painters led by Durand. Small wonder, for by midcentury the White Mountains had evolved into one of the required tourist destinations in the eastern states.

Once discovered by travelers, the White Mountains were dubbed "the Switzerland of the United States,"[38] including as they do the Northeast's tallest mountain, Mount Washington (at 6,288 feet), and several neighboring high peaks christened with the names of other early presidents. But America's first Alps (tourists would not discover the grandeur of the Rocky Mountains for many years) were an inhospitable, indeed potentially lethal, wilderness during the early days of the Republic, and visitors needed at least one place of shelter. That refuge was supplied by the settlements established about the time of the Revolution by the Rosebrook and Crawford families in the region of the Notch, located between the Presidential and Franconia Ranges of the White Mountains. Later, Abel Crawford and his son, Ethan Allen Crawford, became the sole—and eventually the principal—hoteliers in that breathtaking chain of summits. The father established an inn in 1803, and by 1819 he and his son had already cleared a path to the top of Mount Washington; seven miles from the inn they built a camp where travelers hiking to the peak could rest for the night before continuing the ascent.[39]

In his *Northern Traveller* Theodore Dwight wrote at length of the journey from Boston to Concord, thence to Center Harbor, Red Mountain, Squam Lake, Lake Winnipesaukee, and up along the Saco River through the Notch to the Crawford farm, from which he ascended Mount Washington with Ethan Crawford, calling the view "sublime and almost boundless."[40] Although he described in some detail the wonders of the region for "the man of taste," he was rather apologetic about what he considered to be the summary nature of the descriptions of the landscape he provided and promised to improve on them in future editions.[41] He quickly did, but less to keep his word than to report on an event in the Notch that would decisively affect tourism in the White Mountains for years to come. In summer 1826 the Switzerland of the United States suffered, in Dwight's words, "*avalanches de terre*,"[42] terrific landslides induced by the swelling and raging course of the Saco through the Notch during a storm. The slides buried the Willeys, an isolated family living in the Notch, but spared their house, which they had fled. Alert to the commercial potential of the news, in 1827 Dwight and his publisher produced an insert describing the catastrophe and tipped it into the second "improved and extended" edition of his guide, published in 1826. Thanks to the natural disaster, noted the author in this insert, "the route [through the Notch] will offer many new objects interesting to an intelligent traveller. . . .

Scarcely any natural occurrence can be imagined more sublime."[43] Dwight guaranteed that the traces of the event "will always furnish the traveller with a melancholy subject of reflection."[44]

Through human tragedy, then, a region that by dint of its high, steep mountains had called forth the sublime became an even more powerful vehicle for expressing exalted and terrifying emotions. What Timothy Dwight had perceived as a titanic natural boulevard and amphitheater dwarfing the monuments of antiquity[45] became for his nephew Theodore brooding ruins created by nature's assault on its own splendors. In his *Sketches of Scenery and Manners in the United States* of 1829, Theodore Dwight wrote repeatedly of the contrast between his recollections of the pastoral Saco River valley before the avalanches and the present reality of the wasteland of much of the site, between the devastated parts of the Notch, which made nature seem "the enemy of civilization and humanity," and the mild sections of the valley that were left unscathed: "From the spot whence the traveller looked back, to admire the green meadow below, and the crowds of forest trees which invested the mountains, unbroken except here and there by a few gray rocks, the avalanches I have mentioned are all visible, each of them a course which no human power could have resisted, and before which the pyramids of Egypt might have been shaken if not swept away."[46]

Signs of the disaster persisted for years, with only spots of what Harriet Martineau called "rank new vegetation" gradually spreading and covering the natural wreckage.[47] The Willey house continued to stand amid the blasted landscape, a vestige of pioneer life in America, in much the same way that the

38. Dwight, *Northern Traveller*, p. 173.
39. The history of the Rosebrook and Crawford settlements in the White Mountains is summarized in Arthur W. Vose, *The White Mountains* (Barre, Massachusetts: Barre Publishers, 1968), pp. 76–80. See also R. Stuart Wallace, "A Social History of the White Mountains," in *White Mountains: Place and Perceptions*, p. 26.
40. Dwight, *Northern Traveller*, p. 183.
41. Ibid., p. 173.
42. Theodore Dwight, *The Northern Traveller*, 2d ed. (New York: A. T. Goodrich, 1826), p. 312.
43. Ibid., pp. 311–12.
44. Ibid., pp. 311, 313.
45. Dwight, *Travels; in New England and New York*, vol. 2, p. 152.
46. [Theodore Dwight], *Sketches of Scenery and Manners in the United States* (New York: A. T. Goodrich, 1829), pp. 69, 77.
47. Martineau, *Retrospect of Western Travel*, vol. 2, p. 112.

Fig. 82. Daniel Wadsworth, *Avalanches in the White Mountains*. Engraving, from [Theodore Dwight], *Sketches of Scenery and Manners in the United States* (New York: A. T. Goodrich, 1829), opp. p. 59. The New York Public Library, Astor, Lenox and Tilden Foundations

Fig. 83. Thomas Cole, *View of the White Mountains*, 1827. Oil on canvas. Wadsworth Atheneum, Hartford, Connecticut, Bequest of Daniel Wadsworth 1848.17

48. Quoted in J. Bard McNulty, ed., *The Correspondence of Thomas Cole and Daniel Wadsworth: Letters in the Watkinson Library, Trinity College, Hartford, and in the New York State Library, Albany, New York* (Hartford: Connecticut Historical Society, 1983), p. 26.

49. Cole quoted in Louis Legrand Noble, *The Course of Empire, Voyage of Life, and Other Pictures of Thomas Cole, N.A. . . .* (New York: Lamport, Blakeman and Law, 1853; reprint, edited by Elliot S. Vesell, Hensonville, New York: Black Dome Press, 1997), p. 67.

50. Benjamin G. Willey, *Incidents in White Mountain History . . .* [3d] ed. (Boston: Nathaniel Noyes, 1856).

rediscovered dwellings of Pompeii and Herculaneum preserve traces of ancient Roman domestic life.

The landslides and their aftermath not only attracted tourists but also inspired artists. Wadsworth's 1826 visit to the White Mountains could well have been motivated by the catastrophe, for he made a drawing of the avalanche paths in the Notch for Dwight's *Sketches of Scenery and Manners in the United States* (fig. 82). Although Cole never painted the scene of the Willey deaths, he drew the fatal slides for reproduction as a print (fig. 150) and represented avalanche paths on the shoulders of Mount Washington in a painting of the peak he made for Wadsworth in late 1827 (fig. 83), and he referred to the large numbers of scorings he observed "about nine miles from Crawford's [inn]" in a letter of December 8 of that year to Wadsworth.[48] His painting *A View of the Mountain Pass Called the Notch of the White Mountains*, 1839 (fig. 84), seems more directly to evoke the catastrophe and acknowledges the tourist traffic in the Notch. In the foreground a lone horseman approaches the Crawford house, while in the background a stagecoach departs from the dwelling, moving in the direction of the Notch's narrow defile. The house is portrayed as a refuge amid looming mountains cloaked by storm clouds and rain at left and lashed raw in places by landslides. These details and the boulder perched precariously on a rocky knob overlooking the house are of a piece with both Dwight's vision and Cole's own characterization of the Notch as a place that nature had chosen as a "battleground" of the elements.[49]

Fascination with the Willey site was waning by 1856 despite efforts to perpetuate it. That year Benjamin Willey, brother of the elder Willey killed in the slide, published a history of the White Mountains in which the tragedy figures prominently.[50] By then also a 12½-cent admission was being charged for a guided tour of the Willey house, but Samuel Eastman, author of the 1858 travel book that cited this attraction, maintained that "there was nothing within the ruinous edifice of sufficient interest to warrant even this trifling

Fig. 84. Thomas Cole, *A View of the Mountain Pass Called the Notch of the White Mountains (Crawford Notch)*, 1839. Oil on canvas. National Gallery of Art, Washington, D.C., Andrew W. Mellon Fund 1967.8.1

expense."[51] Clearly, the visitors who were flocking to the White Mountains were coming for other kinds of attractions. Their change of focus was at least partly a consequence of the passage of time: interest in the calamity understandably faded over the years, and tourists, no longer keenly interested in old news, were able to perceive the natural beauties of the Notch and take pleasure in the benign aspects of the region.

In great measure, the change in taste was due to proliferating accommodations and improved transportation. By 1855 guide writer John H. Spaulding identified four "mammoth hotels" in the White Mountain area as well as many smaller inns. One of these was built on the summit of Mount Washington, on whose flank, he reported, a "macadamized" path was being constructed to allow a convenient ascent.[52] A key improvement was made in the early 1850s, when the Atlantic and St. Lawrence Railroad was cut through to Gorham, bringing visitors to the very base of the White Mountains.[53] For that matter, railroads now connected any number of points in New

England. Eastman's book contains fourteen pages of advertisements for railroads as well as accommodations, and provides thirteen different routes, using many combinations of boats, trains, and stagecoaches, to the White Mountains.[54] Seven of those routes, moreover, originated at New York City, "the point of immediate departure," Eastman indicated, "for Southern, Western, and we may add, a large portion of European travel into New England."[55] Whereas the area had earlier been considered the preserve of landed gentlemen such as Daniel Wadsworth, who hoped to be awed by overwhelming sights, now it was presumed that the typical traveler was a resident of a large city who wished simply to escape, in Spaulding's words, "[to] free circulation of fresh mountain air, and pure water . . . a pleasant and healthful contrast to the sickly, pent-up city street, where floats a hot atmosphere of pestilence and death."[56]

Thus, the White Mountains came to be embraced by city dwellers, who sought them as a refuge; and they were being tamed—so much so that by the eve of

51. Samuel Coffin Eastman, *The White Mountain Guide Book* (Concord, New Hampshire: Edson C. Eastman, 1858), pp. 50–52.

52. John H. Spaulding, *Historical Relics of the White Mountains. Also, a Concise White Mountain Guide* (Mt. Washington: J. R. Hitchcock, 1855), pp. 71, 74, 76.

53. Willey, *Incidents in White Mountain History*, p. 262.

54. Eastman, *White Mountain Guide Book*, pp. 153–67; for the routes to the White Mountains, see ibid., pp. 89–108, 132.

55. Ibid., p. 1.

56. Spaulding, *Historical Relics*, p. 71.

Fig. 85. James Smillie, after John F. Kensett, *Mount Washington from the Valley of Conway*, 1851. Steel engraving. Courtesy of the American Antiquarian Society, Worcester, Massachusetts

57. Thomas Starr King, *The White Hills; Their Legends, Landscape and Poetry* (Boston: Isaac N. Andrews, 1859).

58. For Ruskin's influence on American artists, see Roger Stein, *John Ruskin and Aesthetic Thought in America, 1840–1900* (Cambridge, Massachusetts: Harvard University Press, 1967); and Linda S. Ferber and

the Civil War Boston cleric and guide writer Thomas Starr King could call them the "White Hills."⁵⁷ It was in this light that the next generation of landscape artists arriving from New York and Boston with the rest of the tourists tended to picture them. The new pastoral vision was shaped not only by vacationers' growing preference for the beautiful over the sublime but also by the new aesthetics the artists brought with

them. These aesthetics were profoundly influenced by the ideas of the English critic John Ruskin, who in his *Modern Painters* (1843–60) championed an art based on the exacting representation of the details of nature rather than the artist's emotional interpretation of scenery.⁵⁸ The new values were articulated by Durand in *The Crayon*, the short-lived New York periodical that became the voice of Ruskinian aesthetics in America. In *The Crayon* Durand published his now-famous "Letters on Landscape Painting" promoting plein-air painting and accurate rendering of detail, particularly in foreground elements, as the basis of a naturalistic landscape art.⁵⁹ Durand and his colleagues turned to this new naturalism exactly at the moment in the 1850s when they began frequenting the White Mountains, so that the region virtually became the laboratory of New York landscape painting aesthetics in the period.

In describing the White Mountain environment in a letter to *The Crayon*, Durand elucidated his aesthetic bias by explicitly rejecting the aspects of the landscape that called forth associations with the sublime, aspects preferred by his predecessor Cole (and many of Cole's patrons): "For those who have the physical strength and mental energy to confront the [sublime] among the deep chasms and frowning precipices, I doubt not it would be difficult to exaggerate . . . the full idea of 'boundless power and inaccessible majesty' represented by such scenes. But to one like myself, unqualified to penetrate the 'untrodden ways' of the latter, the *beautiful* aspect of White Mountain scenery is by far the predominant feature."⁶⁰ In the same letter he touted the many opportunities to enjoy beautiful scenery on excursions from his headquarters in North Conway but happily admitted that he had not yet made many such trips and felt no need to:

> There is enough immediately before me for present
> attention. Mount Washington, the leading feature
> of the scene when the weather is fine . . . rises in all
> his majesty, and with his contemporary patriots,
> Adams, Jefferson, Munroe [sic], &c., bounds the
> view at the North. On either hand, subordinate
> mountains and ledges slope, or abruptly descend to
> the fertile plain that borders the Saco, stretching
> many miles southward, rich in varying tints of green
> fields and meadows, and beautifully interspersed
> with groves and scattered trees of graceful form and
> deepest verdure: rocks glitter in the sunshine among
> the dark forests that clothe the greater portion of
> the surrounding elevations; farmhouses peep out
> amidst the rich foliage below, and winding roads,

Fig. 86. David Johnson, *Study, North Conway, New Hampshire*, North Conway, 1851. Oil on canvas. The Cleveland Museum of Art, Mr. and Mrs. William H. Marlatt Fund 1967.125

*with their warm-colored lines, aided by patches of richly tinted earth break up the monotony, if monotony it can be called, where every possible shade of green is harmoniously mingled.*[61]

The passage can stand as a fair description of Kensett's renowned painting *The White Mountains—Mount Washington,* 1851 (Davis Museum and Cultural Center, Wellesley College, Massachusetts), which was engraved (fig. 85) for the American Art-Union's thirteen thousand subscribers the year it was painted.[62] As in Durand's text, the sublime element of the scene—snow-draped Mount Washington—abides in the background, a mere foil for the beautifully detailed farm valley spread before it. The artists' penchant for sacred particulars is revealed more conspicuously in oil sketches and studies by Durand, Kensett, Johnson (see fig. 86), Samuel Colman, Aaron Shattuck, and other New York artists featuring the "delicious '*bits*'"[63] Durand spied along the streams near North Conway:

*now the luxurious fern and wild flowery plants choke up the passage of the waters, and now masses of mossy rock and tangled roots diversify the banks, and miniature falls and sparkling rapids refresh the Art-student, and nourish the dainty trout. Along these streams at all reasonable times, you are sure to see the white umbrella staring amidst the foliage. I meet these signals of the toiling artist every day.*[64]

The vision of the painters who frequented the White Mountains was quite literally expressed by Thomas Starr King in 1859 in *The White Hills; Their Legends, Landscape and Poetry,* one of the most popular tour guides of the time. In his preface King explained that he had planned to organize the book "artistically," under such headings as rivers, passes, ridges, and peaks but had been persuaded to make it a more conventional guide to White Mountain localities that would be "a stimulant to the enjoyment of them."[65] It was with the last aim in mind that King not only quoted liberally from poetry by Bryant, Emerson, Longfellow, and Whittier, as well as British and Continental Romantics but also invoked New York, Boston, and old master painters to enhance his verbal portraits of the scenery. In his most memorable use of this conceit he transformed the White Mountains, as seen from North Conway in changing light and weather conditions, into a salon of landscape paintings:

*But what if you could go into a gallery . . . where a Claude or a Turner was present and changed the sunsets on his canvas, shifted the draperies of mist and shadow, combined clouds and meadows and ridges in ever-varying beauty, and wiped them all out at night? Or where Kensett, Coleman [sic], Champney, Gay, Church, Durand, Wheelock, were continually busy in copying from new conceptions the freshness of the morning and the pomp of evening light upon the hills, the countless passages and combinations of the clouds, the laughs and glooms of the brooks, the innumerable expressions that flit over the meadows, the various vestures of shadow, light, and hue, in which they have seen the stalwart hills enrobed? Would one visit then enable a man to say that he had seen the gallery?*[66]

## Newport

The bias toward pastoral experience that characterized pictorial and literary responses to the White Mountains beginning in the 1850s had its counterpart in contemporary interpretations of Newport, Rhode Island, the preeminent shore resort in America during most of the nineteenth century. Kensett became especially well known for his depictions of the coastline at Newport. His first visits to the town, presumably in 1852 or a little earlier, correspond almost exactly with its emergence as a fashionable resort, frequented in particular by wealthy New Yorkers. These initial forays may have been inspired by encounters with the coastal paintings of Cole or Church.[67] However, the character of his Newport pictures contrasts with the tempestuous, ominous marines of such models: serene and pellucid, they create the standard for his own views of other shore locations, in Massachusetts and Long Island, and for coastal scenes by several other painters, including Sanford Robinson Gifford, Worthington Whittredge, William Stanley Haseltine, and William Trost Richards.

Whatever encouraged his early visits, Kensett was undoubtedly the first artist to exploit Newport's quite sudden popularity—or rather its revival as a resort in the mid-nineteenth century. Since the early 1700s the town had attracted southern planters seeking escape from the subtropical heat of summer in the lower American colonies. Simultaneously, thanks to its excellent harbor Newport became a serious commercial rival of Boston, Philadelphia, and (then) lowly New York, and one that could boast its own culture: beginning with Bishop George Berkeley, who lived in Newport for three years, starting in 1728, the city

William H. Gerdts, *The New Path: Ruskin and the American Pre-Raphaelites* (exh. cat., Brooklyn: Brooklyn Museum, 1985).

59. A. B. Durand, "Letters on Landscape Painting," *The Crayon* 1 (January–June 1855), pp. 1–2, 34–35, 66–67, 97–98, 145–46, 209–11, 273–75, 354–55.

60. A. B. Durand, North Conway, August 20, 1855, "Correspondence," letter to the Editors, *The Crayon* 2 (August 1855), p. 133.

61. Ibid.

62. Carol Troyen, "The White Mountains—Mt. Washington, 1851," in *American Paradise: The World of the Hudson River School,* edited by John K. Howat (exh. cat., New York: The Metropolitan Museum of Art, 1987), pp. 149–51.

63. Durand, Letter to Editors, p. 133.

64. Ibid.

65. King, *White Hills,* p. vii.

66. Ibid., pp. 176–77.

67. For discussion of the coastal pictures of Cole and Church, see Parry, *Art of Cole,* pp. 300–301, 307–8; see also Franklin Kelly et al., *Frederic Edwin Church* (exh. cat., Washington, D.C.: National Gallery of Art, 1989), pp. 43–46, 159–62; and John Wilmerding, *The Artist's Mount Desert: American Painters on the Maine Coast* (Princeton: Princeton University Press, 1994), pp. 27–43, 69–103.

68. The summary of Newport's history is drawn from the following sources: John Collins, *The City and Scenery of Newport, Rhode Island* (Burlington, New Jersey: Privately printed, 1857), p. 3; James G. Edward, *The Newport Story* (Newport: Remington Ward, 1952), pp. 7–11; and C. P. B. Jefferys, *Newport: A Short History* (Newport: Newport Historical Society, 1992), pp. 9–42.

69. Tyrone Power, *Impressions of America; during the Years 1833, 1834, and 1835*, 2d ed., 2 vols. (Philadelphia: Carey, Lea and Blanchard, 1836), vol. 2, pp. 16–17.

70. Jefferys, *Newport*, pp. 47–49.

71. Ibid., p. 43; [John Ross Dix], *A Hand-book of Newport, and Rhode Island* (Newport: C. E. Hammett Jr., 1852), p. 159.

72. [Dix], *Hand-book of Newport*, pp. v, vii.

73. Ibid., p. 69.

74. George William Curtis, *Lotus-Eating: A Summer Book* (New York: Harper and Brothers, 1852), p. 165.

75. George C. Mason, *Newport Illustrated in a Series of Pen and Pencil Sketches* (Newport: C. E. Hammett Jr., 1854), p. 50.

76. Quoted in ibid., pp. 50–51.

became the center of a varied community of scientists, artists, architects, editors, theologians, and furniture makers. The American Revolution, however, turned the budding metropolis into a virtual ghost town. The British occupied Newport for three years, destroying its wharves and many of its buildings, even bearing off its church bells and municipal records to New York, which would surpass her sisters as an Atlantic port early in the succeeding century.[68]

Newport would never recover as a commercial power, but it struggled through the early 1800s to reassert its identity as a resort. As late as 1833 an English visitor described Newport as "relatively deserted"; however, he could not help admiring its seaside ambience, mild climate, and handsome streets —all of which put him in mind of the Isle of Wight on England's west coast—and he recommended that Newport follow the English model of the "cottage resort" to enhance its attractiveness to summer vacationers.[69] A few scattered private summerhouses were built in the 1830s, and the middle of the next decade saw serious real estate speculation led by Alfred Smith, a Newport native who had made his first fortune as a tailor in New York and then doubled it by buying and selling property for cottage development in his hometown.[70] By this time there were already one or two steamers a day traveling between New York and New England ports that stopped at Newport; but, with the introduction of overnight service to Newport in 1847, by 1852 the number of daily trips there from Gotham had increased to five.[71] Thus, the pieces were in place for Newport's renaissance, which, to be sure, reached its zenith during the Gilded Age but was well under way by midcentury, if art and literature are any measure.

The commercial and cultural past of Newport determined the town's evolution into a resort with a character different from that of others, except perhaps Saratoga Springs, which it surpassed as a summer mecca for wealthy urban society. Unlike most of those who frequented the Catskills, Lake George, or the White Mountains, many visitors to Newport, as to Saratoga, had no particular interest in picturesque landscape or affection for the outdoors; rather, it is safe to say, they came primarily to socialize with the fashionable crowd with which they mixed in the city. On the other hand, unlike Saratoga, Newport had beautiful scenery. Therein lay a conflict for the writers who promoted Newport and, in some measure perhaps, for its landscape portraitists: which of its various attractions should they commend or describe?

That Newport was promoted as a retreat from the infernal city is plain from the tourist literature that began sprouting up along with the rows of splendid "cottages" in the 1850s. John Ross Dix, in the dedication of his *Hand-book of Newport, and Rhode Island* of 1852, waxed poetic on how "unto Newport's sands repair / the town-tired gentlemen and ladies," adding in his preface that he himself, "glad to escape for a season from the Babel of a great city, chose Newport as a sometime residence."[72] In connection with Newport's four beaches, he emphasized that "to people who, month after month, are pent in populous cities, there is a positive coolness in the sound of [the word "Newport"]. On bright, summer days, when the stifling heat causes one to pant and perspire, how welcome the mere idea of a watering place, such as Newport!"[73] In his *Lotus-Eating: A Summer Book* of 1852, George William Curtis referred to Newport as "a synonyme of repose."[74] And in *Newport Illustrated* of 1854 George C. Mason invoked the reminiscences of the Unitarian divine William Ellery Channing and the verse of the aesthete Henry T. Tuckerman in touting the spiritual and psychic benefits of wandering Newport's beaches.[75] Intoned Tuckerman in his poem "Newport Beach":

> *Then here, enfranchised by the voice of God,*
> *O, ponder not, with microscopic eye,*
> *What is adjacent, limited and fixed;*
> *But with high faith gaze forth, and let thy thought*
> *With the illimitable scene expand,*
> *Until the bond of circumstance is rent,*
> *And personal griefs are lost in visions wide*
> *Of an eternal future! . . .*[76]

Such elevated rhetoric was perhaps a bit misplaced, since the beaches in question were the scenes of

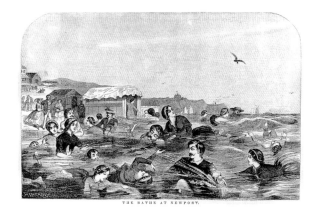

Fig. 87. *The Bathe at Newport.* Wood engraving, from *Harper's Weekly,* September 4, 1858, p. 568. The Metropolitan Museum of Art, New York, The Irene Lewisohn Costume Reference Library

Fig. 88. John William Orr(?), after John F. Kensett, *The Cliff Walk, Newport*. Wood engraving, from George William Curtis, *Lotus-Eating: A Summer Book* (New York: Harper and Brothers, 1852), p. 192. The New York Public Library, Astor, Lenox and Tilden Foundations

frivolities and improprieties·that most writers observed with some degree of scorn. Dix, for example, perceived ideal female beauty to be profaned during the morning bathing hours at Easton's Beach (see fig. 87), where he winced at more than one baggily attired "marine monster" who emerged from the bathing house that a "charming, lovable sort of creature" had entered. He was relieved that, once the

young women had finished "splashing and paddling in the water with all their might, as unlike mermaids as possible," they compensated for their "moist deshabille by their rosy, refreshed and beaming looks, when they once more came forth, like rosy Christians, from their sea-side toilets."[77]

But the phenomenon of social bathing that seemed to threaten the aesthetic and moral chastity of Newport was merely a single, visible symbol of a more pervasive pollution affecting many resorts—Newport the most egregious among them—according to Curtis. In *Lotus-Eating,* which Kensett illustrated, he devoted two chapters to Newport, but the first was almost wholly a peroration decrying "Fashion upon the sea-shore."[78] It was not so bad, said the author, that city people had discovered havens such as Newport; it was what of the city they brought along with them that was to be despised:

> we Americans are workers by the nature of the case,
> or sons of laborers, who spend foolishly what they
> wisely won. And, therefore, New York, as the social
> representative of the country, has more than the
> task of Sisyphus. It aims, and hopes, and struggles,
> and despairs, to make wealth stand for wit, wisdom
> and beauty. In vain it seeks to create society by

77. [Dix], *Hand-book of Newport,* pp. 72, 74. For similar commentary on the bathing scene at Easton's Beach, see Mason, *Newport Illustrated,* p. 51.
78. Curtis, *Lotus-Eating,* p. 165.

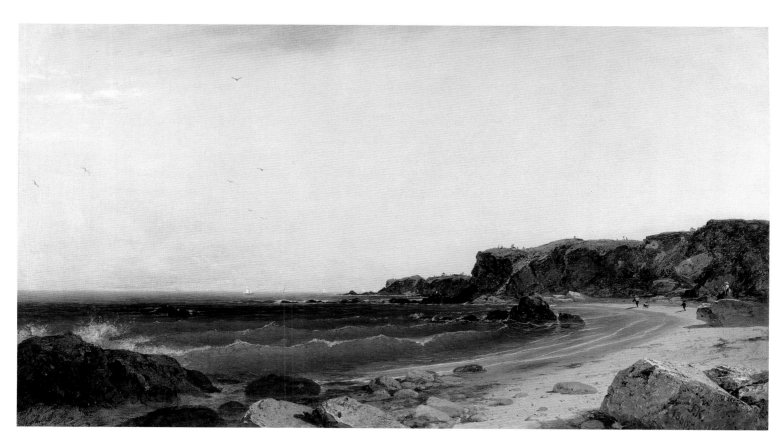

Fig. 89. John F. Kensett, *Forty Steps, Newport, Rhode Island,* 1860. Oil on canvas. Collection of Jo Ann and Julian Ganz, Jr.

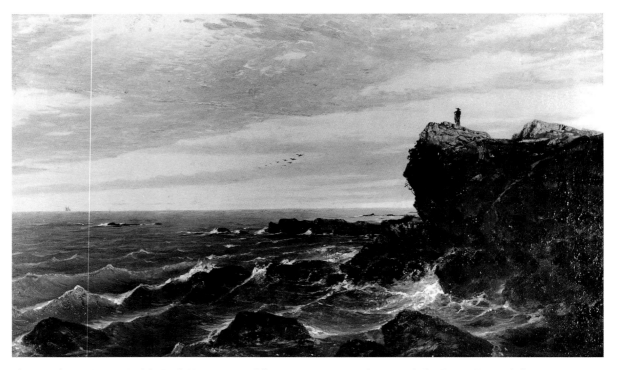

Fig. 90. John F. Kensett, *Berkeley Rock, Newport,* 1856. Oil on canvas. Frances Lehman Loeb Art Center, Vassar College, Poughkeepsie, New York, Gift of Matthew Vassar  1864.0001.0049.000

79. Ibid., pp. 173–74, 176.
80. Ibid., p. 184.
81. [Dix], *Hand-book of Newport,* p. 57.
82. Curtis, *Lotus-Eating,* p. 183.
83. Mason, *Newport Illustrated,* pp. 70–71; [Dix], *Hand-book of Newport,* p. 140.

*dancing, dressing, and dining, by building fine houses and avoiding the Bowery. . . . Wealth will socially befriend a man at Newport or Saratoga, better than at any similar spot in the world, and that is the severest censure that could be passed upon those places.*[79]

When Curtis called Newport "a synonyme of repose," he was remembering it in earlier times or referring not to the clamorous high season but to "the serene beauty of September." Then, he noted (perhaps alluding to those mermaids on Easton's Beach), "Fashion, the Diana of the Summer Solstice, is dethroned; that golden statue is shivered, and its fragments cast back into the furnace of the city, to be again fused and moulded."[80]

Most notably among the major Hudson River School painters, Kensett acknowledged the urban leisure class in his landscapes. Nowhere are these wealthy travelers more in evidence than in his paintings of Newport, and in few of them more than in the *Forty Steps, Newport, Rhode Island,* 1860 (fig. 89), a portrait of a popular spot along the scenic cliffs on the town's ocean side. Yet staffage is never a prominent feature of Kensett's landscapes, and even here the human presence is inconspicuous. The forty steps themselves, a wooden stairway down to the beach constructed by a "wealthy and considerate gentleman,"[81] are not visible; and only close inspection

reveals a generous sprinkling of fashionably attired figures, mostly women, atop the cliff in the distance, verifying Curtis's declaration that "it is thus the finest ocean-walk, for it is elevated sufficiently for the eye to command the water, and [with its grass extending to the precipice] is soft and grateful to the feet, like inland pastures" (see fig. 88).[82]

Such works notwithstanding, Kensett's Newport pictures are as often deserted as not, except for the occasional fisherman and the immaculate sail accenting the horizon. The gentle forms of his many Beacon Rock paintings (see cat. no. 37) offer no hint that Fort Adams, represented by the terraced mounds on the left of each image, was the site of a weekly military band concert as well as drills and artillery exercises. These events attracted flotillas of civilians from Newport harbor,[83] but Kensett could not have seen the bustling crowds from the distant viewpoint he deliberately chose.

It is no wonder that Kensett sanitized his Newport, emphasizing the beauties of its sea, land, and sky and minimizing the presence of the urban society Curtis disparaged. Given his collaboration with Curtis on *Lotus-Eating* and his association with enlightened, nature-loving patrons such as Jonathan Sturges of New York—who bought one of the artist's earliest pictures of Beacon Rock (cat. no. 37)—his choice was inevitable; it was assured as well, of course, by the tradition of reverence for nature that formed him.

Inevitable also was his interest in the theological and philosophical tradition that the natural environment of Newport seems to have encouraged. This was a tradition he addressed quite literally in one of his earliest Newport paintings, *Berkeley Rock, Newport* (fig. 90); here he posed the lone figure of Bishop Berkeley, looking out to sea, on the rock named for him, the site at which he was said to have composed his *Alciphron; or the Minute Philosopher* of 1732.

Kensett also addressed the resemblance of Newport's atmosphere to that of Venice, a theme pursued by Curtis and other writers. Most effectively among his American contemporaries, he approximated the warmth and transparency of Canaletto's Venetian views, evoking, for example, Curtis's description: "[Newport's climate] is an Italian air. These are Mediterranean days. They have the luxurious languor of the South."[84] Luxurious they may have been, but they were not immodest, for Kensett's vision is appropriate to the moralizing strain in Curtis's summary characterization of Newport's climate as "bland and beautiful. It is called bracing, but it is only pure."[85] Kensett's Newport pictures and the paintings of Massachusetts and New Jersey beaches that he, Gifford, Haseltine, and Alfred Bricher produced supply evidence, which Curtis could not find in New York's winter society itself, "that the city has summered upon the seaside."[86]

## Italy

When Dix stood on Easton's Beach enjoying the balm of Newport's scenery and climate, he spied offshore "one of the great Atlantic ferry-boats—a floating bridge between the old world and the new," noting that "frequently are the ships of the Collins's line seen from here, as they speed their way to or from New York."[87] To be sure, by the 1850s fashionable travelers found Europe to be nearly as accessible as any of the American resorts discussed here. The adaptation of steam power to ocean vessels accomplished by midcentury had reduced the time it took to cross the Atlantic from as many as three to four weeks under sail to as few as ten days with steam power. Moreover, once Europe's shores were reached, travel was relatively cheap. To tour economically in the Old World one need not have been as hearty as the young Bayard Taylor, who boasted in his *Views A-Foot* of 1846 that his trek, mostly on foot, across England and the Continent cost him a mere $492.[88] As early as 1838, in *The Tourist in Europe*, the New York publisher George P. Putnam had been telling Americans expressly how to

save money and, that equally precious metropolitan commodity, time when traveling abroad.[89]

Nowhere in Europe could the traveler better economize than in Italy, where our necessarily brief remarks on Old World travel and American landscape art are focused. The Grand Tour, that extended sojourn on the Continent that was part of the education of northern Europeans, especially the Germans and the British, had attracted Americans from the colonial period until the Civil War and beyond. Among the notable Americans who took the Grand Tour were the expatriate artists Benjamin West and John Singleton Copley in the early era and Cole during the time of our study.

For Americans—and especially for citizens of New York, the fastest-growing city in the United States—Europe above all served as a point of comparison with their own country. As descendants of the immigrants who had founded American civilization, they felt obliged to explore their cultural roots. These included their roots in antiquity, which, in the Age of Enlightenment, became a powerful focus of interest for northern Europeans. Yet Americans brought with them to Europe the seasoning of a young civilization struggling with great but brutalizing success to extend its empire over a vast, obdurate natural domain with the modern equivalent of aqueducts, engineering marvels such as the Erie Canal. Italy in particular wore conspicuously the imposing monuments of the Western world's greatest early empire, perceived as a model of republican government for at least part of its history. But the monuments were only vestiges, ruins returning to nature and betokening the impermanence of lofty ideals and enterprise. The parent Europe, then, was both model and cautionary example to the child America, depending on the point of view.

For early-nineteenth-century American tourists, as for their British counterparts, travel to the Continent became safe only after the end of the Napoleonic Wars, in 1815. Among the Americans to visit Italy following the wars was Theodore Dwight, who wrote of the Grand Tour in his earliest published book, *Journal of a Tour in Italy, in the Year 1821,* which appeared in 1824. His commentaries in this volume offer some of the first notes of skepticism sounded in regard to the experience of Italy: staring in the face of divided and, to his mind, "degraded" modern Italy, still attired in the tattered finery of her ancient past, he was deeply pessimistic.[90] He seems to have most enjoyed his visit to Herculaneum and Pompeii, where "we mix with the subjects of Rome" in exploring their dwellings preserved beneath the ash.[91] But the uncanny perfection

84. Curtis, *Lotus-Eating*, p. 179.

85. Ibid., p. 180.

86. Ibid., p. 187.

87. [Dix], *Hand-book of Newport*, p. 43.

88. J. Bayard Taylor, *Views A-Foot; or, Europe Seen with Knapsack and Staff* (New York: Wiley and Putnam, 1846), p. 393. Two recent indispensable sources for bibliography on nineteenth-century Americans in Italy are William J. Vance, *America's Rome*, vol. 1, *Classical Rome* (New Haven: Yale University Press, 1989); and Theodore E. Stebbins Jr. et al., *Lure of Italy: American Artists and the Italian Experience, 1760–1914* (exh. cat., Boston: Museum of Fine Arts, 1992).

89. [George P. Putnam], *The Tourist in Europe: or, A Concise Summary of the Various Routes, Objects of Interest, &c. in Great Britain, France, Switzerland, Italy, Germany, Belgium, and Holland; with Hints on Time, Expenses, Hotels, Conveyances, Passports, Coins, &c.; Memoranda during a Tour of Eight Months in Great Britain and on the Continent* (New York: Wiley and Putnam, 1838), p. 5.

90. An American [Theodore Dwight], *A Journal of a Tour in Italy, in the Year 1821* (New York: Printed by Abraham Paul, 1824), p. 118.

91. Ibid., p. 110.

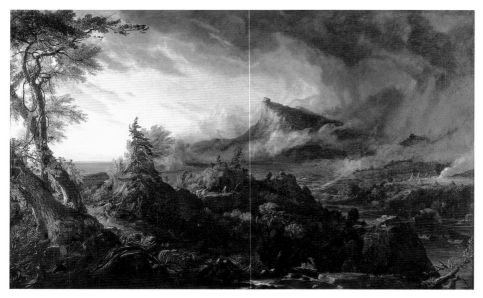

Fig. 91. Thomas Cole, *The Course of Empire: The Savage State*, 1834. Oil on canvas. Collection of The New-York Historical Society 1858.1

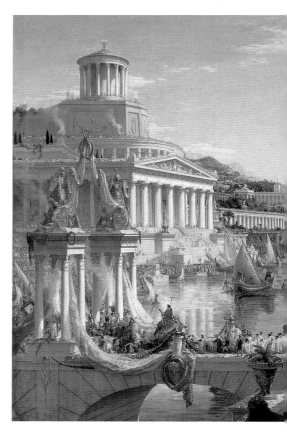

Fig. 93. Thomas Cole, *The Course of Empire: The Consummation of Empire*, 1835–36. Oil on canvas. Collection of The New-York Historical Society 1858.3

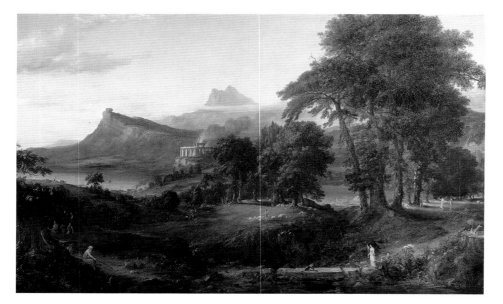

Fig. 92. Thomas Cole, *The Course of Empire: The Pastoral or Arcadian State*, 1834. Oil on canvas. Collection of The New-York Historical Society 1858.2

92. Ibid., pp. 112–13.
93. Ibid., p. 211.
94. Ibid., p. 210.

of these remains merely accentuated the contrast with the present: "And seen from this place, how does the present world appear? A mass of bones and ashes of men; a melancholy shore, which the waves of time have strewed with the wrecks of nations, and heaps of broken sceptres."[92] His ruminations only darkened as he entered Rome from the "dreary desert"[93] of the Campagna:

> *How unlike is such a scene as this, to the first view of one of our American cities; . . . Instead of the cheerful and exhilarating sight of a savage wilderness retreating before the progress of a free and*

*enlightened society, and a new continent assuming the aspect of fertility and beauty, under the influence of an enterprising population, and a generous form of government; . . . here we have the poor remains of that mighty city—the cradle and the grave of an empire so long triumphant on earth— now dwindling away before the wide-spread desolation which surrounds it, and shrinking back upon itself, as if for dread of an invisible destroyer.[94]*

Still, Dwight conceded the beauty of such natural sites as the Bay of Naples and Vesuvius and the view from Tivoli over the Campagna toward Rome, "one

Fig. 94. Thomas Cole, *The Course of Empire: Destruction*, 1836. Oil on canvas. Collection of The New-York Historical Society 1858.4

Fig. 95. Thomas Cole, *The Course of Empire: Desolation*, 1836. Oil on canvas. Collection of The New-York Historical Society 1858.5

of the most precious morsels of composition in the world,"[95] which Cole, Gifford, and many other American artists interpreted on canvas. Moreover, the splendors of painting and sculpture at the Vatican galleries and the magnificence of Roman architecture, which Dwight found unsettling, challenged his American, inherently democratic distrust of imperial show and prompted at least a hint of envy: "I wished that America might possess such specimens of the arts. . . . The cultivation of painting and sculpture in our country should be promoted by every one who has the power; though architecture must have its limit among a people where there are no kings nor nobles, and where there

ought to be no aristocracy. Beyond that limit, it would not be patriotic not to wish architecture extended."[96]

Although James Fenimore Cooper, like Dwight, suffered few illusions about modern Italy, his Yankee origins did not dampen his enthusiasm for it or for the remnants of ancient Rome. Unlike Dwight, Cooper went to Europe with an entrée, for his novels were already known and popular in England and France, making him welcome in foreign society upon his arrival[97]—which may account for his more positive attitude. Moreover, he had had enough experience of both the physical environment and the culture of New York (a culture he had, after all, stimulated) to

95. Ibid., p. 279.

96. Ibid., p. 414.

97. Cooper, *Leatherstocking Tales*, p. 873 (chronology): Of his reception in Paris, Cooper remarked in a letter to a friend, "The people seem to think it marvelous that an American can write."

Fig. 96. Thomas Cole, *Aqueduct near Rome,* Florence, 1832. Oil on canvas. Washington University Gallery of Art, St. Louis, purchase, Bixby Fund, by exchange, 1987

98. James Fenimore Cooper, *Excursions in Italy,* 2 vols. (London: Richard Bentley, 1838), vol. 1, pp. 202–3.

99. Ibid., p. 203.

100. Ibid., p. 294.

101. Ibid., vol. 2, pp. 201, 202–3.

102. For Cole's travels in Europe, see Parry, *Art of Cole,* pp. 95–130, 263–72.

103. Ibid., pp. 116–18. Cole dubbed the series "The Cycle of Mutation" or "The Epitome of Man" when he first conceived it.

compare Gotham with Italian cities and find it pathetically wanting. In his *Excursions in Italy* of 1838, he sniffed at the turbid green waters of New York's harbor and the backdrop of her puny Palisades in contrast to the azure Bay of Naples lying in the shadow of Vesuvius and the Apennines.[98] Both in Naples and at Rome, his worshipful admiration of ancient and modern architecture, weighed against his recollections of the occasional "Grecian monstrosities and Gothic absurdities" scattered about New York,[99] caused him to predict that centuries hence Gotham would leave no trace "beyond imperishable fragments of stone. . . . Something [of the durability of Roman architecture] may be ascribed to climate, certainly; but more is owing to the grand and just ideas of these ancients, who built for posterity as well as for themselves."[100] Cooper concluded: "Rome is a city of palaces, monuments, and churches, that have already resisted centuries; New York, one of architectural expedients, that die off in their generations like men. . . . I would a thousand times rather that my own lot had been cast

in Rome, than in New York, or in any other mere trading town that ever existed. As for the city of New York, I would 'rather be a dog and bay the moon, than such a Roman.'"[101]

Sharply contrasting responses to Italy such as those of Dwight and Cooper were encompassed by Cole in pictures he conceived and sometimes painted during his own Grand Tours. These journeys Cole undertook after his northern tours of the Catskills, Lake George, and the White Mountains and after he started to produce heroic landscapes based on biblical history. The first trip, begun in 1829, included a sojourn in Italy from June 1831 to October 1832; the second, in 1841–42, was spent mostly in mainland Italy and also in Sicily.[102] In The Course of Empire series, 1834–36 (figs. 91–95), conceived during his first visits to Florence, Cole in effect illustrated Dwight's moral view of Italy.[103] Here he conjured up an unnamed classical city in five pictures representing the civilization's rise *(The Savage State* and *The Pastoral or Arcadian State),* apogee *(The Consummation of Empire),*

and decline (*Destruction* and *Desolation*). Cole clearly meant the series as "the grand moral epic" a contemporary critic declared it to be.[104] *Destruction* and *Desolation* dramatize to striking effect, respectively, the sacking of the empire by invaders and its skeletal remains; and even *Consummation,* with the alabaster splendor of its colonnades and temple piles, hints at the hubris and corruption that will bring the society down. Yet at the same time, Cole's aim was surely to communicate, even exaggerate, the splendor of that empire and of the ancient Italy suggested and idealized in the middle picture. He said so himself in his program for the series published in a contemporary magazine: "In this scene is depicted the summit of human glory. The architecture, the ornamental embellishments, &c., show that wealth, power, knowledge, and taste have worked together, and accomplished the highest meed of human achievement and empire."[105] Indeed, he endowed his empire with a verticality that Rome never owned (and that New York would assume only in the twentieth century).

Cole seems also to have expressed American ambivalence toward Italy in his view of the Campagna, *Aqueduct near Rome* of 1832 (fig. 96). The skull at the base of the composition reminds the viewer of the many Roman tombs scattered across the Campagna. But more importantly, it functions as a conventional memento mori, alluding to the vanity of the human enterprise that built the aqueduct. Yet Cole showed this monument—the "*spine* to the skeleton of Rome," in Taylor's words[106]—bathed in the mild yellow light of evening, eloquently and poetically ameliorating the moral embodied in the skull. Conveyed above all is awe in confronting a grandeur that has persisted through the ages and has even been enhanced by the passage of time. Taylor wrote of the Coliseum, "A majesty like that of nature clothes this wonderful edifice,"[107] but his observation is eminently applicable to the aqueduct as Cole has presented it here.

Although Cole conjured up an ancient classical city, portrayed Roman ruins, and even painted a view of modern Florence, *View of Florence from San Miniato,* 1837 (The Cleveland Museum of Art), he never essayed a picture of New York, the city in which he attained success. In fact, views of New York City by his successors are exceedingly rare as well.[108] The painters by and large left portrayal of the city to the topographical watercolorists and printmakers, no doubt because of New York's deficiencies as a potential landscape subject: it lacked heroic or even picturesque, that is, irregular, terrain; it had, as Cooper

suggested, few impressive public buildings (most were wood structures); and nothing about it suggested permanence, let alone monumentality. Gotham was an ideal place in which to produce landscape paintings but not a good subject for them. Thus it may be said that Cole and his followers expressed Cooper's attitudes not only in what they painted but also in what they did not paint.

In our period American apprehensions of Italy evolved, until tourists were more often charmed by the contrast between grandeur and ruination than struck by its moral implications. It would seem that the softening of attitude was impelled by literature and, less often, by the example of painting. Most important in this respect was Byron's *Childe Harold's Pilgrimage.* With increasing frequency through the second quarter of the century, travel accounts and tour guides that appeared in New York invoke the poem with reference to European scenery, particularly its descriptions of the Rhine and the Alps in canto 3 and Italy in canto 4.[109] Indeed, in the third edition of his *Italian Sketchbook* of 1848 Tuckerman referred to Byron as "an intellectual and ideal *cicerone.*"[110] Byron's pessimistic message in *Childe Harold,* a ruminative tour of the Continent, is little different from those offered in the prose of historians Edward Gibbon and the Comte de Volney—but it was poetry. It sang of human vanity, clothing it in rhyming verse that proved irresistible to tourists—who undoubtedly recited appropriate passages in the course of their travels—and imposed its romance and lyricism on sites that Americans might otherwise have regarded dismissively, fearfully, neutrally, or perhaps not at all.

Cole's pictures of Roman scenery are imbued with the spirit of the British Romantics, above all Byron. Not only *Childe Harold* but also other works by Byron inspired Cole: he painted a scene from *Manfred,* set in the Swiss Alps, which he, in fact, never visited. It therefore is fitting that the young Knickerbocker writer Nathaniel Parker Willis, in *Pencillings by the Way,* his published journal of his European tour of 1836, often enlisted Byron or Cole, and occasionally both, to help him describe particular locales. Like other authors Willis was inspired to invoke Byron by his encounter with the tomb of Cecilia Metella on the Campagna, on which occasion he recalled that "Nothing could exceed the delicacy and fancy with which Childe Harold muses on this spot." And, then, as he peered out from one of the tomb's "lofty turrets" over the dusty plain "to the long aqueducts stretching past at a short distance, and forming a chain of noble

104. *American Monthly Magazine,* n.s., 2 (November 1836), p. 513, quoted in Parry, *Art of Cole,* p. 186.

105. Cole, in *American Monthly Magazine,* p. 514, quoted in Parry, *Art of Cole,* p. 168.

106. Taylor, *Views A-Foot,* p. 337.

107. Ibid., p. 328.

108. At the very end of our period the Boston landscape painter George Loring Brown produced *The Bay and City of New York,* 1860 (Sandringham House, Norfolk, England), a view of the city from Weehawken, New Jersey. Measuring ten feet wide, it was surely the most ambitious portrait in oils of New York painted to that time. Among the very few New York landscapists to represent the city in oils by 1861 were Robert Havell Jr., an English immigrant, in a work of 1840; Jasper F. Cropsey, in pictures of 1856 and later; and Charles Herbert Moore, in a canvas of 1861. All adopted the point of view from Weehawken, originated by Wall in a watercolor of 1824 (Metropolitan Museum). I am grateful to Gerald L. Carr for information on Brown's paintings. For Havell's and Cropsey's paintings, see William S. Talbot, *Jasper F. Cropsey, 1823–1900* (Ph.D. dissertation, New York University, 1972; reprint, New York: Garland Publishing, 1977), pp. 389–90; for Moore's painting, see Ella M. Foshay and Sally Mills, *All Seasons and Every Light: Nineteenth Century American Landscapes from the Collection of Elias Lyman Magoon* (exh. cat., Poughkeepsie, New York: Vassar College Art Gallery, 1983), pp. 77–78.

109. For Byron's impact on Victorian travelers, see Maxine Feifer, *Going Places: The Ways of the Tourist from Imperial Rome to the Present Day* (London: Macmillan, 1985), p. 161.

110. Henry T. Tuckerman, *The Italian Sketchbook,* 3d ed. (New York: J. C. Riker, 1848), p. 210. Tuckerman gave the title "Byronia" to a chapter of his book, pp. 209–13.

Fig. 97. Sanford Robinson Gifford, *On the Roman Campagna, a Study*, 1859. Oil on canvas. Frances Lehman Loeb Art Center, Vassar College, Poughkeepsie, New York, Gift of Matthew Vassar 1864.0001.0034.000

111. N. P. Willis, *Pencillings by the Way* (1836; "First Complete Edition," New York: Morris and Willis, 1844), p. 82.

112. See also *The Roman Campagna* (private collection), illustrated in Ila Weiss, *Poetic Landscape: The Art and Experience of Sanford R. Gifford* (Newark: University of Delaware Press, 1987), p. 204.

113. Ibid., p. 70.

114. James Jackson Jarves, *Italian Sights and Papal Principles, Seen through American Spectacles* (New York: Harper and Brothers, 1856), p. 350.

115. Ibid.

116. [Dwight], *Journal of a Tour in Italy*, p. 210.

117. Willis, *Pencillings by the Way*, p. 76.

118. Sanford R. Gifford, "European Letters," vol. 2, March 1856–August 1857, p. 122, Archives of American Art, Smithsonian Institution, quoted in Weiss, *Poetic Landscape*, p. 195.

arches from Rome to the mountains of Albano," he turned to "Cole's picture of the Roman Campagna [fig. 96] . . . one of the finest landscapes ever painted" to perfect the impression he recorded.[111]

Several second-generation Hudson River School artists made pilgrimages to the aqueduct on the Campagna and painted it from the point of view adopted by Cole. The subtle differences between Cole's picture and the interpretations of his disciples testify to the shifting perceptions of American visitors to Italy. It is hardly surprising that Gifford eliminated from his two small views (see fig. 97)[112] the moralizing detail of the skull seen in Cole's picture, and it is even more significant that he ignored the imposing signs of the passage of time, such as the medieval tower rising from the aqueduct's foundations. The aqueduct in Gifford's *On the Roman Campagna, a Study*, 1859 (fig. 97), no taller than the mountains of Albano in the background, whose slopes echo the monument's contours, seems a natural eminence, in contrast to the majestic presence in Cole's canvas. With its prosaic afternoon light and shepherd and flock in the foreground, Gifford's picture is like a *veduta*, comparable to Kensett's views of Newport, while Cole's poetically lit composition, by comparison, has the flavor of a *capriccio*, a picturesque or classical fantasy.

Certainly the turn toward relatively realistic interpretations on the part of Gifford and other young New York landscape painters was influenced by the Ruskinian aesthetic of truth to nature (while he was in England in 1855, Gifford had visited Ruskin at Oxford).[113] But they were moved as well by the difficult emergence of a united modern Italy through a struggle that began in 1848 and ended in 1870, when

Rome was absorbed into the new nation. The effects of the revolution in Italy were impossible to overlook for any American traveling in that country. American views of the political changes occurring there ranged from benignly hopeful to rabidly condemnatory, depending upon the events of the moment. In 1848, for example, Tuckerman published Pope Pius IX's portrait as the frontispiece to his *Italian Sketchbook*, in the expectation, shared by many, that the new and progressive pontiff would support the revolutionary movement. But eight years later, after Pius had fled riots in Rome and returned, as a reactionary, under the protection of France's Napoléon III, James Jackson Jarves savaged the city of the Caesars in his jeremiad of 1856, *Italian Sights and Papal Principles, Seen through American Spectacles*. For him it was "an isolated wreck amid the sea of the Campagna, clinging convulsively to the rock on which she foundered,"[114] with the Roman Catholic leadership grasping in vain at the extinct authority of empire. He, like Cooper, contrasted Rome with New York, but through the other end of the telescope: he saw "New York [as] . . . a focus of enterprise and riches, giving birth yearly to rival cities."[115]

As a modern American landscape painter, Gifford, who was patriotic but did not express strong political opinions, adopted the sympathetic view of Italy. For him and many of his contemporaries, the perception of a modern nation rising from the ashes of a long-dead empire cast the light of the present—of ordinary day—over the land and the vestiges of its antique civilization. It was a perception that lifted the elegiac twilight from the landscape, transforming it from what Theodore Dwight considered "the grave of an empire"[116] into a new frontier, the semblance of an American prairie. When Gifford produced his first major painting of an Italian scene, his *Lake Nemi*, 1856–57 (cat. no. 36), he preferred the natural landscape, distilled through its atmosphere, to ruins. Surely he was attracted by the beauty of the volcanic lake itself, which Willis had called "one of the sweetest gems of natural scenery in the world."[117] Although Gifford's emphasis on the reflective disklike surface of the water may well allude to the Latin designation of the lake as Speculum Dianae, or the mirror of Diana, the Roman goddess, the painter's main purpose was not to evoke such associations but to glorify natural phenomena. As his letters from Europe reveal, he was inspired by the pure visual effect of the lake contemplated under the light of the moon,[118] which he translated into the sun and radiant daylight in his picture. In fact, *Lake Nemi* reminded Hudson River School

Fig. 98. Sanford Robinson Gifford, *Kaaterskill Clove*, 1862. Oil on canvas. The Metropolitan Museum of Art, New York, Bequest of Maria DeWitt Jesup, from the collection of her husband, Morris K. Jesup, 1914  15.30.62

Fig. 99. Julius Schrader, *Baron Alexander von Humboldt,* Berlin, 1859. Oil on canvas. The Metropolitan Museum of Art, New York, Gift of H. O. Havemeyer, 1889  89.20

119. At Gifford's memorial service in 1880, Whittredge recalled of *Lake Nemi,* "It was treated in such a way that an American familiar with some of the small lakes among our hills could easily as he stood before it imagine himself at home." *Gifford Memorial Meeting of The Century . . . November 19th, 1880* (New York: Century Rooms, 1880), p. 37.

120. The exhibition of *The Heart of the Andes* is described at length in Kevin J. Avery, *Church's Great Picture: The Heart of the Andes* (exh. cat., New York: The Metropolitan Museum of Art, 1993), pp. 9, 33–44.

painter Worthington Whittredge of an American lake scene,[119] while Gifford's later Kaaterskill Clove pictures (see fig. 98), bathed in the same light, have an Italian quality. The dreamy, picturesque glow in all of them is unspecific, burning away details of place and time, and expressing a nostalgic longing for an indefinable not-here and not-now.

### Vicarious Tourism and "The Heart of the Andes"

Neither the American taste for the Grand Tour nor merely vacationing in the northeastern United States accounts for the phenomenal popularity of Frederic E. Church's *Heart of the Andes* of 1859 (cat. no. 41; fig. 101) and the artistic progeny it inspired in succeeding decades. At the end of our period, the

painting assured the status of Church, whose technical dexterity and commercial success made him Cole's most important follower. Like the tale of Cole's discovery, the story of the most acclaimed American landscape painting of the nineteenth century has been told often.[120] Just after the painting was put on view in April 1859, Church contracted for its sale to a New York collector for $10,000, an enormous sum in its time; during its three-week debut on Tenth Street, twelve thousand people paid 25 cents each to see the picture; it went to London for exhibition in the summer; returned for a showing of three months in New York; and then toured seven more American cities until March 1861. To be sure, *The Heart of the Andes* offered myriad attractions, and the artist exercised entrepreneurial genius in promoting it in a

spectacularly theatrical display. However, unlike the views of Cole and of Church's colleagues, *The Heart of the Andes* did not represent a tourist destination known and loved by Americans, for only the rarest of the painting's original viewers had been to the Andes.

Still, it is fair to say that the culture and industry of travel helped make *The Heart of the Andes* a prized commodity. For if few members of Church's audience had seen South America, let alone wished to visit that largely undeveloped continent, many of them had read the eloquent, rapturous descriptions of it written by Alexander von Humboldt (fig. 99). Perhaps the nineteenth-century's most adventurous traveler and its first great natural scientist, Humboldt was a native of Prussia. He made a five-year expedition at the turn of the eighteenth century that ranged through the northern part of South America, Mexico, and Cuba and concluded with a visit to the United States, and he later explored southwestern Asia.[121] In an age before the first intrepid tourists attempted the ascent of Mont Blanc in the Alps or the relatively low Mount Washington in New Hampshire, Humboldt had climbed almost to the top of Chimborazo in Ecuador, at the time of his feat believed to be the tallest mountain in the world and the snowy peak that Church later portrayed in *The Heart of the Andes*.

More important in our context, over the five decades after his first expedition Humboldt published a succession of books describing his journey. In these he proposed the equatorial New World, with its unsurpassed geological, climatic, botanical, and zoological range, as a microcosm of global nature.

Most of Humboldt's writings were published in cheap English editions that had a vast audience.[122] In *Personal Narrative of Travels to the Equinoctial Regions of America*, which appeared in English translation in 1852–53, Humboldt sought to recapture for the reader his initial impressions of South America's tropical rain forests in a passage that the foreground of *The Heart of the Andes* closely evokes:

*[The traveler] feels at every step, that he is not on the confines but in the centre of the torrid zone; . . . on a vast continent where everything is gigantic,—mountains, rivers, and the mass of vegetation. If he feel strongly the beauty of picturesque scenery he can scarcely define the various emotions which crowd upon his mind; he can scarcely distinguish what most excites his admiration, the deep silence of those solitudes, the individual beauty and contrast of forms, or that vigour and freshness of vegetable life which characterize the climate of the tropics.*

121. Humboldt's career is summarized and documented in ibid., pp. 12–13.

122. The most important of these are Alexander von Humboldt and Aimé Bonpland, *Personal Narrative of Travels to the Equinoctial Regions of America, during the Years 1799–1804*, 3 vols., translated and edited by Thomasina Ross (London: H. G. Bohn, 1852–53) and especially Humboldt's last, culminating work, *Cosmos: A Sketch of a Physical Description of the Universe*, 5 vols., translated by E. C. Otté (London: H. G. Bohn, 1849–58). See Avery, *Church's Great Picture*, p. 57 n. 8. Church's personal library included both of the English editions cited.

123. Humboldt and Bonpland, *Personal Narrative*, vol. 1, p. 216.

124. Louis L. Noble, *Church's Painting: The Heart of the Andes* (New York: D. Appleton, 1859); Theodore Winthrop, *A Companion to The Heart of the Andes* (New York: D. Appleton, 1859).

Fig. 100. Frederic E. Church, *The Icebergs*, 1861. Oil on canvas. Dallas Museum of Art, Anonymous Gift 1979.28

Fig. 101. Photographer unknown, possibly J. Gurney and Son, *"The Heart of the Andes" in Its Original Frame, on Exhibition at the Metropolitan Fair in Aid of the Sanitary Commission, New York, April 1864*. Stereograph (one panel shown). Collection of The New-York Historical Society

Fig. 102. *Oak Sideboard by Rochefort and Skarren*. Wood engraving by John William Orr, from B. Silliman Jr. and C. R. Goodrich, eds., *The World of Science, Art, and Industry Illustrated from Examples in the New-York Exhibition, 1853–54* (New York: G. P. Putnam and Company, 1854), p. 111. The Metropolitan Museum of Art, New York, The Thomas J. Watson Library

125. Church's exhibition strategies are detailed in Avery, *Church's Great Picture*, pp. 33–36; and especially in Kevin J. Avery, "*The Heart of the Andes* Exhibited: Frederic E. Church's Window on the Equatorial World," *American Art Journal* 18 (winter 1986), pp. 52–60.

126. Parry used the term "landscape theater" to describe panoramic exhibitions and the panoramic pictorial strategies adopted by Thomas Cole in his landscapes; see Ellwood C. Parry III, "Landscape Theater in America," *Art in America* 59 (December 1971), pp. 52–56.

127. Humboldt, *Cosmos*, vol. 2, pp. 456–57. Humboldt's recommendations for subject matter are discussed in Avery, "*Heart of the Andes* Exhibited," p. 61.

128. The history of panoramas is summarized in Kevin J. Avery, "Movies for Manifest Destiny: The Moving Panorama Phenomenon in America," in *The Grand Moving Panorama of Pilgrim's Progress* (exh. cat., Montclair, New Jersey: Montclair Art Museum, 1999), pp. 1–12. A thorough study of the panorama phenomenon is Stephan Oettermann, *The Panorama: History*

*It might be said that the earth, overloaded with plants, does not allow them space enough to unfold themselves. The trunks of the trees are everywhere concealed under a thick carpet of verdure; . . . By this singular assemblage, the forests, as well as the flanks of the rocks and mountains, enlarge the domains of organic nature. The same lianas which creep on the ground, reach the tops of the trees, and pass from one to another at the height of more than a hundred feet. Thus, by the continual interlacing of parasite plants, the botanist is often led to confound one with another, the flowers, the fruits, and leaves which belong to different species.*

*We walked for some hours under the shade of these arcades, which scarcely admit a glimpse of the sky.*[123]

Humboldt's descriptions of this kind unquestionably had enormous appeal for New Yorkers and certainly contributed to their appreciation of *The Heart of the Andes*. That this was recognized is indicated by the fact that texts reflecting Humboldt's views and even his discursive style were included in two programs sold at the New York exhibitions of the picture.[124]

As advertisements for the exhibition advised, viewers could enhance the sense of vicarious expedition encouraged by the texts with opera glasses, which allowed them to isolate and magnify sections of the picture and eliminate their awareness of the artifice of the frame. Church tailored that frame to foster the illusion that a real landscape was displayed. By designing it with a paneled embrasure and adorning it with curtains and a sill, he made the frame look like a window on the scene, yet he suppressed its imposing presence by staining it dark and keeping the gallery dark, concentrating all the available light on the image of the landscape.[125] Thanks to these spectacular strategies and the grand, panoramic scale of the picture, the exhibition became "landscape theater."[126]

Church's use of panoramic pictorial strategies, or landscape theater, can be attributed in part to the direct influence of Humboldt, who in *Cosmos*, his culminating work, promoted circular panoramas as "improvements in landscape painting on a large scale" and recommended the tropics, specifically the equatorial New World, as subjects for them.[127] However, the artist was also exploiting a broader, more popular current in the urban culture that was connected to travel: the taste for moving panoramas, which blossomed in the 1840s and 1850s.[128]

The huge moving panoramas were for the most part a kind of folk art, the primary purpose of which

was not to offer an aesthetic experience but to provide a vicarious travel experience for the eastern, urban middle-class viewers who paid a quarter or 50 cents each to see them. Although these panoramas came to depict all manner of subjects, they most typically showed landscapes, both native and foreign, as was appropriate to their scale and format. The destinations they offered imaginary tourists were neither urban nor fashionable: their usual subject was the frontier, regions visited by explorers or the occasional merely curious traveler, or regions settled by immigrants.[129] Among the moving panoramas of the mid-1840s, the most renowned was John Banvard's "three mile painting" of the banks of the Mississippi, viewed as if floating down the river. Hugely popular, Banvard's panorama was seen by 175,000 people in New York in 1848 and subsequently by millions in Great Britain.[130] The Mississippi panorama was followed by panoramas of the Far West—among them several Gold Rush subjects—and of the Arctic, Mexico, and areas as far south as Costa Rica.

The source for these themes was frequently the expeditionary literature that had become popular about midcentury. Humboldt's writings, of course, were central examples of the genre, but there were many others as well. One of the most famous (and still one of the most readable) was Captain Elisha Kent Kane's *Arctic Explorations* of 1856.[131] Kane's thrilling account of his nearly disastrous journey to the Arctic and his miraculous escape not only provided the subject matter for two moving panoramas but also fueled Church's determination to sail to Newfoundland in 1859 and, on his return to New York, to paint *The Icebergs*, 1861 (fig. 100).[132]

The popularity of *The Heart of the Andes* was not based entirely on the appeal of panoramas and

tourist culture; it rested as well on the strong taste that emerged in the 1850s for the display of large, ambitious easel paintings, most of which were European. Examples were Rosa Bonheur's *The Horse Fair*, 1853–55 (cat. no. 51), and John Martin's Judgment Pictures, 1853 (Tate Gallery, London; see cat. no. 159), the latter the closest precedent for Church's painting in terms of size, landscape subject matter, and date.[133] Yet Church's picture went beyond the other grand-scale easel paintings in an important respect: it commodified the tourist impulse and in so doing responded to the consumerism that increasingly characterized affluent urban culture in the nineteenth century. Perhaps even more significantly it symbolized in the terms of landscape painting the growing global access and exchange seized by New Yorkers. Following Humboldt's literary lead, Church figuratively put the entire earth on canvas, describing tirelessly in its foreground the New World's botanical wealth and conveying the continental extent of that wealth in the infinite distances he suggested. This bounty of botany Church served up in a frame (fig. 101) that was likened to both a window and a theatrical proscenium.[134] However, the frame is also readily comparable to the highly embellished sideboards (see fig. 102) included in the New York Crystal Palace exhibition of 1853, which offered wares of all kinds to the public. Thus it is not merely a frame but what a contemporary critic called "a piece of furniture . . . in very good taste,"[135] and as such it presented the innumerable blossoms, fruits, leaves, grasses, birds, and butterflies of the picture as items to be consumed conceptually. Victorian New Yorkers apprehended the landscape portrayed in *The Heart of the Andes* in the same acquisitive spirit in which they approached the world it idealized.

*of a Mass Medium* (New York: Zone Books, 1997).

129. Several frontier moving panoramas are briefly described in Avery, "Movies for Manifest Destiny," pp. 6–8; and more thoroughly in Oettermann, *Panorama*, pp. 323–42; and Kevin J. Avery, "The Panorama and Its Manifestation in American Landscape Painting, 1795–1870" (Ph.D. dissertation, Columbia University, New York, 1995), vol. 1, pp. 108–203.

130. Joseph Earl Arrington, "John Banvard's Moving Panorama of the Mississippi, Missouri, and Ohio Rivers," *Filson Club History Quarterly* 32 (July 1958), pp. 224–27.

131. Elisha Kent Kane, *Arctic Explorations: The Second Grinnell Expedition in Search of Sir John Franklin, 1853, '54, '55*, 2 vols. (1856; reprint, London: T. Nelson and Sons, 1861).

132. For the Kane panoramas of the Arctic regions, see Avery, "Panorama and Its Manifestation," vol. 1, pp. 143–51. For others that anticipate Church's *Icebergs*, see Gerald L. Carr, *Frederic Edwin Church—The Icebergs* (Dallas: Dallas Museum of Fine Arts, 1980), pp. 34–41.

133. Ibid., pp. 27–28.

134. A description of the original frame and a consideration of its stylistic sources are given in Avery, "*Heart of the Andes* Exhibited," pp. 55–60.

135. "An Innovation," *The Albion*, April 30, 1859, p. 213, quoted in Avery, "The *Heart of the Andes* Exhibited," p. 60.

# Modeling a Reputation: The American Sculptor and New York City

*THAYER TOLLES*

Between 1825 and 1861 American sculptors had an equivocal relationship with New York City. Henry Kirke Brown held high aspirations for the Empire City, writing from abroad in 1844: "For to tell the truth, for me, as a sculptor, I would prefer being in New York to Florence, on all accounts." Yet just over two years later the disillusioned artist wrote from his Broadway studio: "You don't know how changed a man I am since I came to this bedlam of a city. I have lost my quick way of doing things, and have become . . . drawn into the vortex and confusion of business. . . . The sound of B'way is like a distant thunder, it is the most unartistlike city on the face of the globe in my opinion."[1] Brown was hardly alone in his view, for many other antebellum sculptors arrived at similar conclusions and settled in locales (oftentimes foreign) more conducive to the making of art. Still, these men were entrepreneurs as well as artists, tied by necessity to New York. There was no better place to exhibit, publicize, and market sculpture—and indeed goods of nearly every type—in the United States during this period, when American sculptors were achieving professional status, their work was becoming a salable commodity, and the city was maturing as the national hub of commercial enterprise and material consumption. A subtext throughout these turbulent years is New York's quest to commission and install a public sculpture of national significance, one that would symbolically and physically proclaim the city as the leading cosmopolitan tastemaker in matters aesthetic and civic.

Before the 1820s sculpture in New York, and throughout America, was in an embryonic state of development; an article of 1827 on the condition of the arts rightly summarized the situation: "in sculpture there has been little more than an attempt."[2] The city's first public monuments were ordered by the assembly of the State of New York from London sculptor Joseph Wilton in 1768 and dedicated in 1770: a marble full-length portrait of William Pitt, earl of Chatham, located at Wall and William Streets, and a lifesize gilded lead equestrian of King George III that stood on a fifteen-foot marble pedestal in Bowling Green. These statues did not survive for long, however. *King George* was destroyed by ardent patriots after the reading of the Declaration of Independence on July 9, 1776, and melted down for bullets for the Continental Army; in retaliation British troops mutilated *Pitt* in November 1777 (fragments of both *King George* and *Pitt* are at the New-York Historical Society). Even after independence, Americans continued to award sculpture commissions to Europeans. More highly skilled than native artists and craftsmen, these Europeans brought from abroad the Neoclassical aesthetic and high standards for portrait statuary that young American sculptors would emulate as wood yielded to marble as the medium of choice.

In the early decades of the nineteenth century foreign sculptors began to settle in New York, integrating themselves with moderate impact into its artistic fabric. Irish-born John Dixey emigrated in 1801 and for more than two decades carved architectural decoration. His best-known effort, the figure of Justice of about 1818 erected atop the new City Hall designed

For research assistance for this essay, the author is grateful to Alexis L. Boylan, Julie Mirabito Douglass, and Karen Lemmey.

Dates given for sculpture in this text indicate when the piece was modeled.

1. Henry Kirke Brown to Ezra P. Prentice, March 8, 1844, and Brown to his wife Lydia L. Brown, November 4, 1846, Henry Kirke Bush-Brown Papers, vol. 2, pp. 422, 548/28, Manuscript Division, Library of Congress, Washington, D.C.
2. "Literature, Fine Arts, Amusements," *New-York Mirror, and Ladies' Literary Gazette*, July 28, 1827, p. 20.

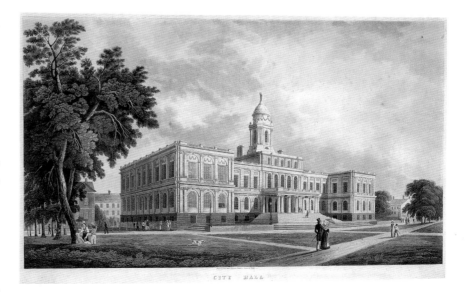

Fig. 103. John Hill, after William Guy Wall, *City Hall*, 1826. Aquatint with hand coloring. The New York Public Library, Astor, Lenox and Tilden Foundations, Miriam and Ira D. Wallach Division of Art, Prints and Photographs, The Phelps Stokes Collection, Print Collection

Opposite: detail, fig. 125

Fig. 104. Alexander Jackson Davis, *City Hall Park,* 1826. Watercolor, pen, and black ink heightened with white. The Metropolitan Museum of Art, New York, The Edward W. C. Arnold Collection of New York Prints, Maps, and Pictures, Bequest of Edward W. C. Arnold, 1954 54.90.172

3. William Coffee to Thomas Jefferson, September 8, 1820, Thomas Jefferson Papers, Manuscript Division, Library of Congress, Washington, D.C., quoted in Anna Wells Rutledge, "William John Coffee as a Portrait Sculptor," *Gazette des Beaux-Arts,* ser. 6, 28 (November 1945), p. 300.

4. Quoted in H. W. French, *Art and Artists in Connecticut* (Boston: Lee and Shepard, 1879; reprint, New York: Kennedy Graphics, Da Capo Press, 1970), p. 49. The busts entered the sculpture collection of the American Academy of the Fine Arts.

5. "Statue of Washington," *New-York American,* December 10, 1822, p. 2.

by John McComb Jr. and Joseph-François Mangin (fig. 103), was destroyed by fire in 1858 (a lightweight copper copy replaced it in 1887). By 1816 William Coffee arrived from England, having worked as a terracotta modeler in London and Derby. In New York he completed and exhibited animal paintings as well as small terracottas and plasters of various subjects. Although New York served as his base, Coffee roved the East Coast for portrait commissions, and he had no affection for the town. Thus, when yellow fever scourged New York in 1820, he wrote his patron Thomas Jefferson of his dislike for "this stinking Pestilential City."[3] In 1827 the peripatetic Coffee finally settled in Albany. Thomas Coffee, also British, was resident in New York between 1830 and 1869. He churned out portraits and ideal groups, exhibiting them at venues ranging from the National Academy of Design to the Mechanics' Institute of the City of New York. And then there was the Florentine-born Giorgio (Pietro) Cardelli, whose example reveals how a sculptor's success in New York was subject to the approbation of its cultural establishment. In 1817 Cardelli received a commission from Colonel John Trumbull, history painter, portraitist, and newly elected president of the American Academy of the

Fine Arts, for busts of himself and his wife. Trumbull found the casts unacceptable and admonished Cardelli: "You cannot be a popular sculptor in New York if I refuse to indorse you."[4] The chastised artist soon gave up on sculpting—and New York—in favor of itinerant portrait painting.

It was to an immigrant sculptor that the city's cultural leaders turned in their ongoing concern, if not embarrassment, that New York, unlike several urban rivals, had no public statue of George Washington. Regarding monumental sculpture as a barometer of taste and refinement, self-made businessman Philip Hone, physician and Columbia professor David Hosack, and Trumbull banded together in 1822 and formed a short-lived committee to commission a bronze "Statue . . . worthy of the dignity and fame of the Hero, and of the munificence and public spirit of this city."[5] By the following year Enrico Causici, a native of Verona, Italy, was laboring on an equestrian statue of Washington in his Warren Street studio. In 1824 his thirteen-foot model, on a twenty-foot pedestal, was displayed first at the Arsenal at the corner of Elm and Leonard streets for a 25-cent admission fee and subsequently at the American Academy's exhibition gallery. Although Causici had not officially earned

the commission, the committee fanned out into the city's wards soliciting funds from private citizens to have his work cast in bronze. One newspaper cut to the heart of the matter, observing that "it concerns our honor that it should be [erected]."[6] Despite high praise for the sculpture's quality, the effort fell short, suggesting that reluctance to devote funds—public or private—to the arts rather than the character of the design thwarted the undertaking. (This scenario would be replayed several times over the next decades.) When the model was erected in City Hall Park (fig. 104) for the Fourth of July festivities of 1826, calls were renewed for "the first city in America . . . to dedicate a statue to America's first man."[7] Again, attempts to finance the casting failed, and the plaster model, which had remained on view for several months, fell into disrepair.[8]

If New Yorkers were hesitant to underwrite a statue of a national hero, even if produced by an Italian, they eagerly embraced European-made sculpture by established masters. The American Academy of the Fine Arts could boast of a collection of plaster casts that were for the most part copies after the most esteemed ancient examples. Assembled beginning in 1802 through the efforts of Robert Livingston when he was in Paris as United States minister to France, the collection had grown to impressive proportions within a short period, although by the early 1820s the omnipotent Trumbull allowed aspiring young artists only extremely restricted access to it for study.[9] Represented in these holdings were works by a few contemporary Europeans, such as Jean-Antoine Houdon (see cat. no. 53) and the venerated Neoclassicist Antonio Canova, whose *Creugas*, 1795–1801, *Damoxenes*, 1795–1806, *The Graces*, 1812–16, and *Aerial Hebe*, 1796, went on view in the cast gallery in May 1824 for admiration and, ultimately, emulation. In his seminal opening address for the Academy's 1824 annual exhibition, Gulian Crommelin Verplanck remarked on the institution's moral obligation to enlighten New Yorkers in aesthetic and intellectual matters by means of such casts: "The possession of these fine casts we consider of great importance to our improvement in the arts. Who knows but that the inspection of these admirable models may arouse the dormant genius of some American Canova."[10] Also in 1824 the Academy elected as honorary members the Italian Raimondo Trentanove, a favored pupil of Canova (who had been so elevated in 1817), and Danish Neoclassicist Bertel Thorvaldsen, an act calculated to emphasize the institution's connections to Europe and to counter criticisms of American cultural provincialism.

While foreign artists earned coveted commissions for the adornment of American public spaces, native carvers filled an unending need for more utilitarian goods, such as grave markers and mantelpieces. Stonecutters flourished in New York, among them Morris and Kain, a firm that served a clientele that extended as far as South Carolina, and similar establishments operated by the Frazee brothers and Fisher and Bird (see "The Products of Empire" by Amelia Peck in this publication, pp. 263–64). The wood-carving trade also thrived in the city through midcentury, in tandem with the construction of wood-hulled sailing vessels and steamships—an enterprise vital to the economy of the city, whose East River was, in turn, at the epicenter of the American shipbuilding industry. Wood-carvers, epitomized by father and son Jeremiah and Charles Dodge, supplied enormous numbers of lifesize figures and other decorative elements for not only the prows of ships but also the shop fronts of merchants, notably tobacconists. New Yorkers embraced these vernacular traditions tied to practical use and the city's commercial livelihood while only minimally patronizing sculptors who produced marble portraits and ideal figures in the Neoclassical style.

The leading local sculptor of promise during the 1820s was John Frazee, who initially made a name as a stonecutter and designer of mantels and tombstones. From 1818 until 1829 he and his brother William operated a successful marble-cutting shop; so successful was it, in fact, that the brothers purchased their own marble quarry in Eastchester, New York, in 1826 to supply material for the steady stream of commissions that came to them. In the early 1820s Frazee began to make the coveted transition from artisan to artist: in 1824, under the auspices of the American Academy of the Fine Arts, he modeled a bust of the Marquis de Lafayette (unlocated), the "Nation's Guest," who was then on a triumphant American tour. From a life mask he took of the living icon Lafayette, Frazee hoped to replicate plaster busts for the public. He was not able to carry out his plan, but the competency of the portrait led the New York Bar to commission him to produce the *John Wells Memorial* for the interior of Grace Church. (Executed in 1824–25, it was transferred in the mid-1840s to Saint Paul's Chapel.) This posthumous bust, the first documented likeness cut in marble by an American, surmounts an ornamental tablet with a dedicatory epitaph, thus uniting Frazee's artisanal and sculptural talents.

6. "Statue of Washington," *New-York American*, November 23, 1824, p. 2. For further discussion of these fund-raising efforts, see Dorothy C. Barck, "Proposed Memorials to Washington in New York City," *New-York Historical Society Quarterly Bulletin* 15 (October 1931), pp. 80–81.

7. "Statue of Washington," *New-York American*, June 24, 1826, p. 2.

8. Not only did the city fail to pay for the casting but in 1831 its Common Council also refused to compensate Causici for $6,000 in claimed expenses. Furthermore, Baltimore joined the growing number of American cities that had erected public monuments to Washington when in November 1829 it dedicated a sixteen-foot marble statue of the president by Causici himself.

9. Evidence of Trumbull's ill will toward young artists is captured in his caustic comment: "these young men should remember that *the gentlemen* have gone to a great expense in importing casts, and that they (the students) have no property in them. . . . They must remember that beggars are not to be choosers." Quoted in William Dunlap, *History of the Rise and Progress of the Arts of Design in the United States*, 2 vols. (New York: George P. Scott, 1834), vol. 2, p. 280.

10. Reprinted in "The Fine Arts," *Atlantic Magazine* 1 (June 1824), p. 155. A transcript of the address is in the Gulian Crommelin Verplanck Papers, Manuscript Department, New-York Historical Society. For the 1824 annual exhibition, see Carrie Rebora, "The American Academy of the Fine Arts, New York, 1802–1842" (Ph.D. dissertation, City University of New York Graduate Center, 1990), pp. 368–71. For a listing of casts in the Academy's collection, see ibid., pp. 537–45.

11. John Frazee to Academy secretary Archibald Robertson, June 10, 1824, American Academy of the Fine Arts Papers (BV), vol. 1, item 71, Manuscript Department, The New-York Historical Society.

12. "The Autobiography of Frazee, the Sculptor," part 2, *North American Quarterly Magazine* 6 (July 1835), pp. 17–18.

13. Frederick S. Voss, with Dennis Montagna and Jean Henry, *John Frazee, 1790–1852, Sculptor* (exh. cat., Washington, D.C.: National Portrait Gallery, Smithsonian Institution; Boston: Boston Athenaeum, 1986), pp. 74–75.

14. "The Exhibition of the National Academy of Design, 1827. The Second," *United States Review and Literary Gazette* 2 (July 1827), p. 261.

15. "Browere the Sculptor," *New-York American*, November 19, 1825, p. 2.

16. For Jefferson's versions of the incident, see Thomas Jefferson to James Madison, October 18, 1825, James Madison Papers, Manuscript Division, Library of Congress, Washington, D.C.; and Thomas Jefferson to John H. I. Browere, June 6, 1826, Jefferson Papers, Library of Congress, quoted in David Meschutt, *A Bold Experiment: John Henri Isaac Browere's Life Masks of Prominent Americans* (Cooperstown: New York State Historical Association, 1988), p. 20. See also David Meschutt, "'A Perfect Likeness': John H. I. Browere's Life Mask of Thomas Jefferson," *American Art Journal* 21, no. 4 (1989), pp. 11–13.

17. I. N. Phelps Stokes, *The Iconography of Manhattan Island, 1498–1909, Compiled from Original Sources and Illustrated by Photo-intaglio Reproductions of Important Maps, Plans, Views, and Documents in Public and Private Collections*, 6 vols. (New York: Robert H. Dodd, 1915–28), vol. 5 (1926), p. 1658 (May 22).

As New York's most proficient marble sculptor, Frazee was soon welcomed into the city's inner circle of artists. The American Academy named him a full academician in June 1824, in tacit recognition of his new standing as a professional artist. In his acceptance letter Frazee wrote of his ambition to be an "American Canova" and of his elevated artistic calling, declaring: "I have done nothing, save to grasp the chissel [*sic*] and approach the block; and thus I stand waiting the will of Heaven and the voice of my Country to direct the stroke. If it be true that I am the first American that has lifted the tool, then it is not less true that I have before me an arduous task—Nevertheless, I am not disheartened—nor shall I shrink from the undertaking."[11] The formidable challenge he faced was made all the more difficult by Trumbull's unwillingness to advocate younger artists, an unwillingness underscored by the irascible colonel's "sincere" opinion that "there would be little or nothing wanted in [sculpture], and no encouragement given to it in this country, for yet a hundred years!"[12] It is not surprising, then, that Frazee changed his institutional allegiance to become the only sculptor among the founding members of the National Academy of Design, organized in 1825 by and for artists in opposition to the patron-dominated American Academy.

Frazee's vivid self-portrait of 1827 (fig. 105) conveys in three dimensions his vision of himself as a pioneering American sculptor. The inscription on the front of the herm base translates as "he himself made it in the fifty-second year of American Liberty," announcing his status as a self-assured independent artist and suggesting that he is no less than a founding father of American sculpture by linking his work to the birth of American liberty.[13] When Frazee displayed *Self-Portrait* (as "Bust of Himself") in the second annual exhibition of the new academy in 1827, it was deemed "well finished . . . showing the judicious selection of parts and precise marking, which are indicative of the real sculptor. The likeness is, in some degree, sacrificed to general effect." The equivocal nature of these remarks mirrors contemporary attitudes toward the dualities and conflicts of Frazee's career during the 1820s and 1830s. At once an artisan with a thriving practice in decorative sculpture as well as an ambitious fine artist, Frazee was not entirely satisfied: although he produced commanding and sought-after portraits in the Neoclassical mode in his role as sculptor, he longed to create imaginative figural compositions "in the higher departments of sculpture."[14] Moreover, paradoxically, his very success as an artisan was a disadvantage, for the rigorous labors of

carving stigmatized in an era that held that the creative process resided in the act of modeling in clay rather than working in stone.

John Henri Isaac Browere was also an accomplished portrait sculptor in New York during this period, but one whose acceptance as a fine artist remained marginal at most. A New York native of Dutch descent, he began to experiment with taking life masks in the city before setting off in 1817 for a two-year tour of Europe. When he returned to New York, he refined the process and materials of mold making, creating a lighter-than-usual plaster that hardened rapidly, the exact composition of which he closely guarded. In 1825 he twice made masks of the Marquis de Lafayette, at first unsuccessfully in New York and later with better results in Philadelphia. This effort gained Browere renown, and he subsequently traveled the East Coast taking life masks of prominent Americans, including New Yorkers Hosack, Hone, De Witt Clinton, and the popular actor Edwin Forrest. From each life mask the artist made a plaster positive, which he secured to an armature supporting a chest and shoulders swathed in a classicizing drape; the result was a highly objective portrait bust marked by a stylistic hybrid of naturalism and Neoclassicism that particularly appealed to Americans over the next several decades.

Browere was never able to infiltrate the artistic establishment, mainly because that establishment believed his replicative technique of taking life masks produced mere physiognomic facsimiles of his subjects rather than true sculpture. He was dogged by a judgment that labeled him an "eccentric genius . . . *eccentric* in his manners, and *coarse* in his taste of composition."[15] And despite undeniable proficiency and the testimonials of satisfied sitters, he was often the victim of negative press. Most persistent among the stories published in East Coast papers was one asserting that he had badly injured and nearly suffocated the elderly Thomas Jefferson during the process of taking facial molds, although the alleged victim denied the charge.[16]

Whatever his disappointments, Browere managed to show his busts with some frequency. On Independence Day 1826, the very date of Jefferson's death, Browere exhibited a full-length polychromed plaster portrait of the former president in City Hall, a display he had proposed to the city's Common Council in May 1825.[17] The statue was flanked with Browere's busts of John Adams, 1825 (fig. 106), and Charles Carroll of Carrollton, 1826 (both New York State Historical Association, Cooperstown), fellow signers of the Declaration of Independence (the three forming an appropriate ensemble with Causici's equestrian

Fig. 105. John Frazee, *Self-Portrait*, 1827. Plaster. National Academy of Design, New York

Fig. 106. John Henri Isaac Browere, *John Adams*, Quincy, Massachusetts, 1825. Plaster. New York State Historical Association, Cooperstown

18. [A. T. Goodrich], *The Picture of New-York, and Stranger's Guide to the Commercial Metropolis of the United States* (New York: A. T. Goodrich, 1828), p. 375.

19. John H. I. Browere to John Trumbull, July 12, 1826, John Henri Isaac Browere letters, microfilm reel 2787, frame 600, Archives of American Art, Smithsonian Institution, Washington, D.C.

20. *The Diary of Philip Hone, 1828–1851,* 2 vols., edited by Allan Nevins (New York: Dodd, Mead and Company, 1927), vol. 1, p. 33, entry for December 24, 1830.

21. "Statue of Hamilton," *New-York Evening Post,* November 24, 1829, p. 2; ibid., December 12, 1829, p. 2; "Arts and Sciences: Statue of Clinton," *New-York Mirror,* February 13, 1830, p. 251; and "Works of Art," *New-York Evening Post,* November 4, 1831, p. 2.

*Washington* installed in City Hall Park). In addition, Browere displayed his busts for an admission fee in order to "hand down to posterity, the features and forms of distinguished American personages, as they actually were at the period of the execution of their likenesses."[18] These he showed in the Gallery of Busts and Statues he operated in his studio, the location of which frequently changed and which perhaps was inspired by the popular example of John Scudder's American Museum on Broadway.

Under the pseudonym Middle-Tint the Second, Browere also wrote art criticism, often vituperative in tone, that may have alienated both William Dunlap of the National Academy and Trumbull of the American Academy. Testifying to this possibility is an acrimonious letter of 1826 to Trumbull in which Browere wrote: "the very illiberal and ungentlemanlike manner in which Col. Trumbull treated the execution . . . of my portrait Busts [of Jefferson, Adams, and Carroll when shown in New York] . . . has evidenced a personal ill-will and hostility to me."[19] Browere hoped the federal government would commission bronze casts of his plasters of eminent personages for exhibition in Washington, but funding was not forthcoming; nor

were any of the honors a gifted sculptor in New York would have expected. He remained an outsider, never elected to membership in the National Academy of Design or the American Academy of the Fine Arts. In September 1834 he succumbed to cholera, and his reputation soon faded into obscurity.

The reception of Robert Ball Hughes was very different. This talented artist arrived in New York from England in 1829 and earned instant cachet with the city's cultural elite, for he had studied at the Royal Academy of Arts and worked in the studio of Neoclassical sculptor Edward Hodges Baily, a follower of John Flaxman, the leading Neoclassical sculptor and draftsman of his time in England. The credentials and technical proficiency of this ambitious foreigner immediately raised the standards for sculptors in New York. Hughes served as a lecturer in sculpture at the National Academy of Design in 1829 and 1830, and in 1831 he was named an honorary member of both the National Academy and the American Academy, evidence that each institution was eager to lay claim to him. He was soon awarded three coveted monumental commissions, ones that Frazee no doubt had hoped to earn. In late 1829 Hughes produced a model for the first, a marble statue of Alexander Hamilton for the Merchants' Exchange, the heart of commercial New York, to be funded through the subscriptions of city businessmen. When the preliminary model was accepted in December 1830, committee member Hone offered it high praise: "I have no doubt that if the artist finishes the statue agreeably to the promise given by the model, it will be the best piece of statuary in the United States."[20] He designed but never executed the second, a full-length portrait of De Witt Clinton requested in early 1830 by the Clinton Hall Association for the area in front of Clinton Hall. Finally, in 1831 Hughes completed his plaster altorelief model for the third, the *Bishop John Henry Hobart Memorial,* a reclining portrait of the dying bishop attended by an allegorical figure of Religion in the tradition of Flaxman's funerary monuments. Translated into marble, it was dedicated in Trinity Church in 1835.[21]

Hughes's accomplishments must have made a considerable impression on Trumbull, for he ardently supported the sculptor. Trumbull, who himself had studied in London, with Benjamin West, clearly felt a kinship with the London-trained Hughes. As the most important figure in the New York art world, Trumbull welcomed the Englishman into the inner circle of the American Academy, in 1830 allowing him use of its sculpture gallery to produce his full-size working

model for the statue of Hamilton. By making Hughes a sort of artist in residence, Trumbull all but guaranteed the sculptor's loyalty and linked the American Academy with the Hamilton project, the most prestigious monumental sculpture commission begun in New York to date.[22] He further aided Hughes by encouraging prominent New Yorkers to come to him with orders for portraits in lifesize plasters and marbles as well as in smaller waxes, and by procuring restoration projects for him.[23] About 1833 Hughes commenced a bust of Trumbull; the result (cat. no. 57) is arguably his finest sculpture. The dramatic portrait, which reflects the sitter's forceful and acerbic personality, represents Trumbull less as an artist than as an American colonel and patriot, with the badge of the Order of the Cincinnati prominently visible. Any friendship that developed between Trumbull and Hughes seems to have cooled over the years after the bust was made, as the sculptor repeatedly badgered the painter for payment so that his model could be translated into marble (the marble was not completed until at least 1840).[24]

The 1830s, like the 1820s, saw sculptors establishing themselves in New York; in the new decade, however, the emerging artists made use of a new phenomenon, the single-sculpture exhibition, a vehicle for publicity and a means of attracting patronage and generating profit. The first such event of the decade, the presentation of Boston-born Horatio Greenough's ideal group *Chanting Cherubs,* 1829–30 (unlocated; see fig. 108), was a harbinger of a new generation of rising native talent, which looked to New York more as a center for marketing art than as a place in which to make sculpture. Educated in the classics at Harvard College, Greenough brought a nonartisanal, intellectual background to the practice of sculpture, a background with which moneyed patrons clearly felt a kinship. In 1825 he traveled to Rome, where he met Thorvaldsen and encountered the riches of antiquity. Greenough returned to Boston for a year in 1827 and modeled portraits of prominent sitters. At this time he gained entrée with New York's leading cultural figures, meeting Samuel F. B. Morse and Dunlap, as well as William Cullen Bryant and Thomas Cole. In May 1828, just before Greenough returned to Italy to settle in Florence for two decades, he was elected an honorary member of the National Academy of Design. A year later the Academy named him a lecturer in sculpture, although his residence abroad made this title, and that of professor, granted later, purely honorific. However,

the bestowing of these positions indicated acceptance not only of the medium of sculpture but also of the highly educated and socially elevated Greenough as its most favored native practitioner. Indeed, in the eyes of the Academy's leaders, he quickly superseded Frazee in the role of American genius sculptor.[25]

In Florence, in winter 1828–29, Greenough modeled a bust of American novelist James Fenimore Cooper (fig. 107), who would become a lifelong friend as well as an instrumental patron and advocate. Cooper, pleased with the result, commissioned *Chanting Cherubs,* which was based on Raphael's painting *Madonna of the Baldachino* in the Palazzo Pitti, Florence. Greenough's marble was first exhibited in spring 1831 in Boston, where the response was decidedly mixed, engendering debates about propriety and prudery. In fact, the two nude angels were "napkinned" with dimity aprons tied around their waists. When the group went on view in November 1831 at the American Academy in New York, where the Boston events had been followed eagerly by the press,[26] reactions varied as well: the general public was lukewarm, while more enlightened connoisseurs saluted Cooper for his liberal and patriotic patronage of a kindred artist. Despite positive press coverage and an alluring advertisement touting the piece as "an object of considerable curiosity" and "the *first* [multifigure group] ever executed by an *American Sculptor,*"[27] the exhibition drew fewer visitors in New York than in Boston. According to Greenough's friend New York attorney Peter Augustus Jay, some literal-minded residents of the city failed to appreciate the group's sentiment and felt duped because the figures did not actually sing; embarrassed by their ignorance, he lamented: "I wish the scene of this story lay anywhere but in New York, but it cannot be helped, and I must continue to consider my townsmen as a race of cheating, lying money getting blockheads."[28] Still others criticized the derivative nature of *Chanting Cherubs,* complaining that it lacked the spark of artistic genius since it was copied after another work. Such discontent notwithstanding, Cooper left the marble in New York for public display at the National Academy in 1832 and at the American Academy in 1833. *Chanting Cherubs* remained at the American Academy until 1837, when it was removed to safety to a private home during a ruinous fire.

Like Greenough, Hezekiah Augur was a native New Englander who lived outside New York when he showed his work in the Empire City. An autodidact wood-carver resident in New Haven, in 1823 he attempted to develop a machine for carving stone

22. Minutes of the American Academy of the Fine Arts, December 11, 1829, and January 2, 1830, American Academy of the Fine Arts Papers, Manuscript Department, New-York Historical Society; and Rebora, "American Academy," p. 78.

23. Trumbull asked Hughes to conserve Wilton's damaged statue *William Pitt, Earl of Chatham* (fragments at the New-York Historical Society), then languishing on City Hall grounds but in the Academy's care since 1811. In 1831–32 he secured for him a second restoration project, that of Canova's badly burned statue of Washington, 1820, for the State House in Raleigh, North Carolina (fragments at North Carolina Museum of History, Raleigh). Although Hughes reportedly accepted payment, he never carried out the work. See Philipp Fehl, "John Trumbull and Robert Ball Hughes's Restoration of the Statue of Pitt the Elder," *New-York Historical Society Quarterly* 56 (January 1972), pp. 7–28.

24. The correspondence is held in the John Trumbull Papers, Manuscripts and Archives, Yale University Library, New Haven, Connecticut. Reprinted in Thomas B. Brumbaugh, "A Ball Hughes Correspondence," *Art Quarterly* 21 (winter 1958), pp. 423–27.

25. Evidence of Greenough's social and artistic ascendancy in New York is revealed in Dunlap's *Rise and Progress,* which devotes some fifteen pages to him and gives Frazee just three. Although Dunlap (ibid., vol. 2, p. 268) deemed Frazee "without a rival at present in the country," later Thomas Seir Cummings tellingly wrote, "he was entirely self-educated, and therefore, perhaps, wanting in that exterior refinement which would have rendered him popular." See Thomas S. Cummings, *Historic Annals of the National Academy of Design, New-York Drawing Association . . . from 1825 to the Present Time* (Philadelphia: George W. Childs, 1865), p. 230. See also Frazee's unsigned diatribe, "American Statuaries," *North American Quarterly Magazine* 5 (January 1835), pp. 204–7; also discussed in Voss, Montagna, and Henry, *John Frazee,* p. 41. The article pointedly concludes: "If we are Americans, let us cherish and caress our own [Frazee] in our

Fig. 107. Horatio Greenough, *James Fenimore Cooper*, Florence, 1828–29. Marble. Courtesy of the Trustees of the Boston Public Library

Fig. 108. *Horatio Greenough's "Chanting Cherubs."* Wood engraving, from *Illustrated News,* January 8, 1853, p. 24. Avery Architectural and Fine Arts Library, Columbia University, New York

Fig. 109. Hezekiah Augur, *Jephthah and His Daughter,* New Haven, ca. 1828–32. Marble. Yale University Art Gallery, New Haven, Connecticut, Gift of the Citizens of New Haven 1835.11

in collaboration with Samuel F. B. Morse, then also settled in New Haven.[29] When Augur exhibited a bust based on a copy of the head of *Apollo Belvedere* at Morse's Broadway studio from December 1824 to January 1825, he was heralded as a "Yankee Phidias."[30] The sculptor continued to build his reputation in the city while living in New Haven, displaying marble portrait busts in the 1827 and 1828 annuals of the National Academy of Design, of which Morse was president. In 1828 Augur was elected an honorary member of the National Academy.

Thus, Augur was no stranger to New York when he showed his half-size statues *Jephthah and His Daughter,* ca. 1828–32 (fig. 109), between November 1832 and January 1833 at Park Place House on Broadway—his most successful use of the Empire City as a marketing base. The pair, based on Judges XI: 34–35, presents an appealing moral melodrama: the figures are shown at a moment of supreme remorse and anguish, when Jephthah returns from battle and meets his only daughter, whom he now must sacrifice to fulfill

a vow to God. The group was well received by critics, becoming Augur's most celebrated accomplishment. One writer, for example, commended the execution, remarking, "if such an evidence of enthusiastic love for the fine arts and of talent overcoming difficulties without aid, does not arouse the feelings of our public, let genius despair, and all men turn to buying and selling and changing of money, in or out of the Temple."[31] Despite such critical approbation, the statues failed to sell in New York; the citizens of New Haven, however, purchased them for Yale University in 1835. Indeed, Augur had extremely limited financial success: when Dunlap published his 1834 history of the arts in America, he wrote extensively of Augur but noted the sculptor's complaint that "he has received [an] abundance of compliments and little money."[32] Although Dunlap and other writers who were eager to celebrate the emergence of American talent seized on Augur as an exemplar of the new breed, they seem to have been attracted largely by his qualities of Yankee perseverance and mechanical ingenuity (revealed in

own land, and leave all foreigners [Hughes] and residents in foreign countries [Greenough] to the enjoyment of their transatlantic fame!" ([Frazee], "American Statuaries," p. 207).

26. See, for instance, "Greenough's *Chanting Cherubs,*" *New-York Evening Post,* May 17, 1831, p. 2; and "*Chanting Cherubs,*" *New-York Commercial Advertiser,* May 20, 1831, p. 2. On *Chanting Cherubs,* see Nathalia Wright, "The Chanting Cherubs: Horatio Greenough's Marble Group for James Fenimore Cooper," *New York History* 38 (April 1957), pp. 177–97.

27. Advertisement, *New-York Evening Post,* November 23, 1831, p. 3.

28. Peter Augustus Jay to James Fenimore Cooper, April 1, 1832, in *Correspondence of James Fenimore-Cooper,* 2 vols., edited by his grandson James Fenimore Cooper (New Haven: Yale University Press, 1922), vol. 1, p. 264.

29. The two men abandoned this effort after they discovered that Thomas Blanchard had received a patent for a carving machine in 1820. See Paul J. Staiti, *Samuel F. B. Morse* (Cambridge: Cambridge University Press, 1989), p. 102.

30. Untitled item, *New-York American*, January 6, 1825, p. 2.

31. "For the Evening Post," *Evening Post* (New York), November 12, 1832, p. 2.

32. Dunlap, *Rise and Progress*, vol. 2, p. 440.

33. For examples, see Z., "Sculpture and Sculptors in the United States," *American Monthly Magazine* 1 (May 1829), pp. 130–31; "Mr. Augur's Statues," *New-York Daily Advertiser*, October 8, 1831, p. 2; and "Hezekiah Augur," *American Historical Magazine* 1 (February 1836), pp. 44–53.

34. On Thom, see his obituary in "Chronicle of Facts and Opinions. Thom, the Sculptor," *Bulletin of the American Art-Union*, May 1850, p. 28. According to this obituary, which was reprinted from the *Evening Post*, Thom died in New York, having come to the United States "some fourteen years ago in pursuit of a runaway debtor." He was employed for a time as a stonecutter on Trinity Church.

35. *Exhibition. Tam O'Shanter, Souter Johnny, and the Landlord and Landlady, Executed in Hard Ayrshire Stone, by the Self-taught Artist, Mr. J. Thom* [New York, 1833?]. Souvenirs such as a lithograph showing the group and a publication titled *The Life of Thom* were available for purchase at the exhibition thanks to the ministrations of an enterprising manager named J. H. Field.

36. Rebora, "American Academy," p. 407.

37. See, for instance, "Miscellaneous Notices. Sculpture," *American Monthly Magazine* 3 (May 1834), p. 213, which proclaims "the present group to be the finest piece of sculpture that has ever been produced in the United States." The exhibition was accompanied by a pamphlet, *Description of the Colossal Group of Uncle Toby and Widow Wadman, by Ball Hughes. Now Exhibiting at the American Academy of Fine Arts, Barclay-Street* [New York, 1834].

38. "Statue of Washington," *New-York Evening Post*,

the tools and inventions he produced).[33] In fact, Augur's impact remained marginal.

Under Trumbull's stewardship, the American Academy in its waning years judiciously continued in its limited way to promote sculptors. Among these was the self-taught Scottish sculptor James Thom, whose overwhelming popularity was one of the more curious phenomena of the 1830s.[34] Thom's four lifesize Ayrshire stone statues, titled *Tam O'Shanter, Souter Johnny, the Landlord and Landlady*, were first displayed at the Academy between May and June 1833 and from November 1833 until January 1834. Based on a poem by Robert Burns, they depicted a scene in an alehouse where the characters are "enjoying with most comic satisfaction the undisturbed possession of their ale and the chimney corner."[35] In the Empire City, art—whether high or low—like theater or opera and other music, could be situated within the spectrum of popular entertainment, as the vulgar theme and crude execution of Thom's group asserted. It was a curious choice for installation at the Academy, which had long promoted itself as an arbiter of moral and aesthetic standards for the public, but then the exhibitions of the figures had had considerable success in England and Scotland. The experiential nature of the first Thom show at the Academy was underscored by recitations held there by Mr. Graham, "the blind Scotch poet," who soon was presenting Burns's poem nightly, with the group illuminated by gaslight.[36] An audience said to number in the thousands was entertained and enchanted by a sculptural tableau that seemed to capture a theatrical moment frozen in time, but Academy officers were criticized for lowering the institution's aesthetic standards and pandering for profit.

Thom's group appeared at the Academy for a third time in October 1835, this time in expanded form with *Old Mortality and His Pony, Willie and Allan*, a self-portrait, and statues of Burns and Sir Walter Scott. The novelty of Thom's work apparently had worn off, for this installation failed to turn a profit (the sculptures did, however, tour East Coast cities). Nevertheless, Thom's approach had a certain influence. In an apparent attempt to capitalize on the dramatic popular success of the *Tam O'Shanter* ensemble, Hughes exhibited his lifesize plaster *Uncle Toby and Widow Wadman* (unlocated) at the Academy between April and June 1834, shortly after Thom's second New York installation ended. Like Thom's *Tam O'Shanter*, Hughes's group was comic theater played out in sculpture: drawn from Laurence Sterne's novel *Tristram Shandy*, it represented the moment when Toby looks for a speck of dust in Mrs. Wadman's eye. Unlike the Scotsman's first two New York displays, the presentation of *Uncle Toby and Widow Wadman* was not profitable and closed after two months, despite glowing reviews.[37]

During the 1830s, while single-sculpture exhibitions were proliferating, the movement to erect a statue of George Washington in New York continued, albeit haltingly. When Greenough's *Chanting Cherubs* was on view at the American Academy in 1831, the sculptor was asked to prepare a model for a proposed monument, which he completed that year. Visitors to the exhibition were encouraged to contribute to this endeavor, and at the same time the National Academy council resolved to support Greenough's project, a rare instance of concord between the rival institutions.[38] The subscription effort failed, but Greenough's labors were not in vain: in 1832 he became the first American sculptor to receive a major commission from the United States government, for a colossal seated statue of Washington for the rotunda of the United States Capitol, which was installed in 1841.[39] Another attempt to collect money was made in April 1833, when the New York State legislature incorporated the New York Monument Association to raise $100,000 for a memorial to Washington. By early 1834, however, the campaign was defunct (less than $1,000 had been gathered), and for nearly another decade there would be no further action in this regard.

While attempts to erect a monument to a national icon foundered, a memorial for a tragic local hero was realized when Hughes's statue of Alexander Hamilton was unveiled in the rotunda of the Merchants' Exchange on Wall Street in April 1835. The event represented a symbolic intersection of art and commerce, for the brilliant Federalist Hamilton had powerfully advanced New York's financial and mercantile interests during his service as the nation's first secretary of the treasury from 1789 to 1795. The work itself, the first marble portrait statue carved in the United States, brought honor to the city; but it was an honor achieved at the cost of tension, for Hughes had refused to use Frazee's marble or to employ his workshop, choosing instead to import Carraran marble and British carvers to execute the piece. After a flaw appeared in the back of the marble block, Hughes altered the composition, embellishing the contemporary dress of the figure with a flowing mantle. For Hamilton's facial features, the sculptor presumably relied on John Dixey's copy of Giuseppe Ceracchi's bust, which had been presented to the New-York Historical Society in 1809

and was considered the authoritative likeness of the martyred statesman.

The *Alexander Hamilton*, which with its gray granite pedestal stood fifteen feet high, drew admiring crowds and earned universal praise. A notice in the *New-York Commercial Advertiser* speaks for the body of critical reviews: "It is a magnificent production, worthy of the man in whose honor it was formed, of the liberality in which the city of New York is indebted for its possession, and of the talents and high reputation of the sculptor, Mr. Hughes." Trumbull offered his own ringing endorsement: "There are very few pieces of statuary superior to this and not twenty-five sculptors in the universe who can surpass this work."[40] Eight months after its completion, the sculpture—and the optimism attending its presence—were destroyed in the Great Fire of December 16–17, 1835, which ravaged twenty square blocks of the city's pier and commercial districts.

Calls to raise funds through subscriptions for a new statue of Hamilton arose in early 1836; some, like the following plea in the *New-York Mirror*, assumed a tone of urgency:

*There are few cities of the civilized world, at all, comparable with New-York in other respects, which has not greatly surpassed her in matters of taste. . . . Do our wealthy fellow-townsmen know that there is a certain censure directed against New-York by the inhabitants of other cities and countries.* We have no statues. *There is no reason why we should not have them. Their influences in no way militate against the spirit of a republick any more than music and dancing. On the contrary, they perpetuate in the minds of the people ideas of nobleness, patriotism and virtue. . . . there is no good reason why the citizens of New-York, who expend thousands in wine and tawdry furniture, should not apply some of their vast incomes to painting and sculpture.*[41]

However, the effort to raise another public sculpture was ill timed: the city faced an enormous rebuilding project after the fire, and the Panic of 1837 ushered in a decade of commercial uncertainty, reduced fortunes, and flagging confidence.

Hughes cast some of his sculptures in plaster for a popular market that was developing slowly in spite of the economic downturn. One of the first artists in America to replicate his work in this manner, he resourcefully cast twenty eight-inch plaster statuettes from his reduced model of the *Alexander Hamilton* (fig. 110) in about 1835. Among a number of other such plasters he produced were casts of his bust of

Fig. 110. Robert Ball Hughes, *Alexander Hamilton*, 1835. Plaster. Museum of the City of New York, Gift of Mrs. Alexander Hamilton and General Pierpont Morgan Hamilton 71.31.12

Washington Irving, ca. 1836 (National Portrait Gallery, Smithsonian Institution, Washington, D.C.). Of the Irving replicas, which were available for $15 each in 1836, one writer remarked, "at this price the Knickerbockers alone should send Mr. Hughes more commissions . . . in a single day, than he would be able to execute in a lifetime."[42] Yet Hughes, like his statue of Hamilton, was ultimately unlucky in New York, for the enterprising artist who had captured the most important monumental portrait commissions of the

December 2, 1831, p. 2. See also a notice describing the monument project that ran for several consecutive days in the *New-York Evening Post* and that noted (December 10, 1831, p. 3): "the total proceeds of the Group of Cherubs, now open in Barclay street, will be added to the subscription list." (The exhibition, however, did not yield a profit.)

39. The progress of the commission was closely followed in the New York press. See, for instance, "Statue of Washington," *Niles' Weekly Register,* October 27, 1832, pp. 141–42. The marble was later moved outdoors to the Capitol grounds and is now in the National Museum of American History, Smithsonian Institution, Washington, D.C. The statue, which depicted Washington as a modern-day deity in classical dress, was widely criticized.

40. "Statue of Hamilton," *New-York Commercial Advertiser,* April 20, 1835, p. 2; John Trumbull quoted in Georgia Stamm Chamberlain, "The Ball Hughes Statue of Alexander Hamilton," in *Studies on American Painters and Sculptors of the Nineteenth Century* (Annandale, Virginia: Turnpike Press, 1965), p. 6. For John Frazee's sharply dissenting view, never published, titled "Statue in Breeches," see Linda Hyman, "From Artisan to Artist: John Frazee and the Politics of Culture in Antebellum America" (Ph.D. dissertation, City University of New York, 1978), pp. 127–30.

41. "New Statue of Hamilton," *New-York Mirror,* April 9, 1836, p. 327.

42. "Bust of Washington Irving," *New-York Mirror,* September 10, 1836, p. 83.

Fig. 111. John Frazee, *John Jay,* modeled 1831; carved, 1834–35. Marble. Collection of the City of New York, courtesy of the Art Commission of the City of New York

day was almost always impoverished. About 1838 he left the Empire City for Philadelphia and by the early 1840s settled in the Boston area, where, in 1847, he cast his seated statue of Nathaniel Bowditch for Mount Auburn Cemetery, Cambridge. The first bronze monument produced in this country, it was cast defectively—another piece of bad luck for Hughes. Thus, the sculptor's career, so promising on his arrival in New York, was perhaps marked more by misfortune than honor. He ended his life in obscurity, specializing in pyrography, the art of burning sketches into wood using a hot poker.

When Hughes came to New York, he had irrevocably changed the landscape of taste and patronage and replaced John Frazee as the clear local favorite of the cultural establishment. To the bitter Frazee's mind,

his rival's popularity was evidence of America's continuing dependence on imported talent to assert artistic refinement: "if some of our people were told of an *American sculptor*, and attempted to compare his merits with those of other artists abroad, a sneer and a smile of contempt would be his reward," he complained.[43] Still, during the 1830s Frazee earned prestigious commissions, including one awarded by the United States Congress in March 1831 for a bust of John Jay, first chief justice of the United States and scion of a powerful New York family, to be placed in the Supreme Court chamber in the United States Capitol. Frazee's posthumous portrait of the highly respected Jay was based on a likeness taken in 1792, during the subject's lifetime, by Ceracchi (United States Supreme Court, Washington, D.C.). In 1832 Frazee enjoyed what was arguably his finest moment in New York, when he arranged for his *John Jay* (fig. 111) to be exhibited in the Merchants' Exchange, where it is said to have drawn upward of four thousand visitors a day.[44]

The popularity of this portrait bust gives pause, for the sculptures that attracted great crowds were usually works that entertained as spectacle—such as Greenough's *Chanting Cherubs* and Thom's *Tam O'Shanter*. It may be that some who flocked to see Frazee's piece were lured by notices, probably placed by the artist, in newspapers. One such invited New Yorkers to "call and examine [the bust]—*gratis*" before it was shipped to Washington, adding, "gentlemen are respectfully solicited to bring their ladies with them. . . ."[45] Moreover, the *John Jay* elicited uniform and unstinting praise of the sort recorded by a columnist of the *New-York Mirror*: "That so delicate and beautiful a piece of workmanship should have been executed by one of our countrymen in New-York, created universal astonishment."[46]

The renown of Frazee's worthy portrait of Jay carried the sculptor's reputation for the next several years, as he filled a growing demand for likenesses of venerable leaders in politics and business. Among these was his heroicizing 1832–34 portrait of one of Manhattan's five wealthiest residents, self-made financier Nathaniel Prime (cat. no. 56), a piece that in all likelihood was ordered in 1832 as a retirement gift from Prime's business associates, Samuel Ward and James Gore King.[47] The Prime bust, in which a naturalistic likeness coexists with classicizing conventions of draped shoulders and unincised pupils, represented a watershed in Frazee's career. Ward's cousin, Thomas Wren Ward, saw it in Frazee's studio in mid-1833 and was much impressed. He subsequently convinced the Boston Athenaeum,

of which he was treasurer, to order portraits from the artist, first of Nathaniel Bowditch, then of Daniel Webster, and eventually five others, in effect elevating Frazee from a sculptor of local note to one of national reputation. Moreover, the artist's importance in the Empire City was underscored in 1837, when a marble replica of his portrait of John Jay was presented by the subject's daughter to New York's City Hall and the city acquired his bust of John Marshall of about 1835.

Still, Frazee considered his glass half empty and believed himself consistently undone by the accomplishments of others and the thwarting of his efforts to obtain public patronage. Obsessed about his legacy as the self-proclaimed first American sculptor, Frazee published a two-part autobiography in 1835, detailing an arduous climb from humble roots and the creation of his stonecutting business, through which his "labours have contributed to raise this beautiful, although accessary [sic] art, to an elevated standard of taste." He outlined his career as a portrait sculptor and confidently announced: "If my countrymen continue to appreciate my labours, I may hope soon to exhibit something of greater interest and merit in the art, than mere *heads and shoulders of men*. . . . I intend, erelong, to sculpture the WHOLE FIGURE."[48] However, his wish to move beyond portrait busts was incompatible with the desires of his patrons; Frazee would never produce full-length figures or the more prestigious ideal subjects he longed to create. In 1835 he began gradually to abandon sculpture as his primary profession, ostensibly because he was appointed architect and superintendent of New York's new Custom House (now the Federal Hall National Memorial). But lack of consistent private patronage also motivated him, as did "the *cool treatment* . . . of Government. . . ." This last indignity, Frazee wrote, "has . . . almost made me resolve never to lift the chisel again in America."[49] He did continue to sculpt, but on a very limited basis.

Frazee's disavowal of foreign talent was based largely on his competitive relationship with Hughes, but he did not entirely reject European artists. Indeed, he developed a harmonious and fruitful partnership with Robert E. Launitz, a well-educated Latvian-born sculptor, who arrived in New York in 1828 after studying for several years in Rome with Thorvaldsen. For whatever reason, this pedigree did not threaten Frazee, who employed Launitz as a journeyman carver in the marble business he ran with his brother. In 1831 Launitz and Frazee initiated a partnership in an ornamental stonecutting firm, "by the union of genius and talent, [to] render their works in every respect worthy

43. John Frazee to his brother Noah Frazee, February 2, 1835, John Frazee Papers, microfilm reel 1103, frame 350, Archives of American Art, Smithsonian Institution, Washington, D.C.

44. "Occurrences of the Day. Frazee's Bust of Jay," *New-York Evening Post*, March 23, 1832, p. 2.

45. "Bust of John Jay, by Frazee," *New-York Evening Post*, March 21, 1832, p. 2.

46. "The Fine Arts. Sculpture. Frazee's Bust of John Jay," *New-York Mirror*, March 31, 1832, p. 310.

47. See Hyman, "From Artisan to Artist," pp. 118–20; and Voss, Montagna, and Henry, *John Frazee*, p. 82.

48. "Autobiography of Frazee, the Sculptor," part 2, pp. 16, 21. The first installment of the autobiography was published in *North American Quarterly Magazine* 5 (April 1835), pp. 395–403. Frazee must have felt a particular need to publish this lengthy treatise because Dunlap had drastically edited the manuscript the sculptor provided for Dunlap's *Rise and Progress*, published in 1834 (see note 25 above).

49. John Frazee to Robert Launitz, April 18, 1837, Robert Launitz Papers, Mellen Chamberlain Collection, Department of Rare Books and Manuscripts, by courtesy of the Trustees of the Boston Public Library. On Frazee as an architect, see Louis Torres, "John Frazee and the New York Custom House," *Journal of the Society of Architectural Historians* 23 (October 1964), pp. 143–50. Frazee remained in the post of architect and superintendent at the Custom House until 1842 and served there as inspector of customs from 1843 to 1847.

Fig. 112. Edward Augustus Brackett, *Washington Allston*, Boston, modeled 1843; carved 1843–44. Marble. The Metropolitan Museum of Art, New York, Gift in memory of Jonathan Sturges, by his children, 1895  95.8.2

Design was New York's premier exhibition venue, yet its commitment to presenting sculpture in its annuals was random at best for many years, in large part due to the paucity of local artists and to logistical problems attendant on the display, lighting, and shipping of works. Thus, while no sculpture was exhibited in 1839 or 1840, the annual of 1841 featured no fewer than eighteen pieces by ten sculptors, among them Greenough, Hughes, Ives, and Launitz. Again in 1846 no sculpture appeared, moving one critic to lament: "Tell us, oh ye POWERS, and CRAWFORD'S, and KNEELANDS, and PERICOS [*sic*], and *persecutors*— ye of the [Academy's] council, we mean—what is the *upshot* of all this negligence, or indifference, or whatever else ye please to term it."[60] The Academy's inconsistency, in fact, did have a positive result in one respect: it encouraged sculptors to install their works in studios and rented spaces, where they could show at any time of the year, control viewing conditions and publicity, and charge admission.

One of the forums for American sculpture was the American Art-Union. During its short but intense life span of 1842 to 1853, the Art-Union displayed works by Americans and gave out paintings and sculptures as premiums in annual lotteries offered to a national body of subscribers, who each year paid $5 to participate. (The phenomenally popular organization met its end when this method of distribution was declared in violation of state antilottery laws.) The proportion of sculpture in relation to the total number of works exhibited by the Art-Union was extremely small, and very few examples in marble were included among the lottery prizes. In fact, the organization's support of sculpture was symbolic: the mere presence of sculpture in the displays and lotteries increased public awareness of the medium and situated it within the mass market for American art.

Logistics may have played a part in the Art-Union's decision to show and distribute so few works in marble: sculpture was difficult and expensive to ship (the prizewinner assumed the cost), and artists generally hesitated to pay for the translation of a plaster into stone before earning a commission. Whatever the reasons for this dearth, the sculptors whose works were commissioned as lottery prizes, such as Brown, Mozier, and Brackett, had direct ties to the managers of the organization. Thus it was through the auspices of the institution's president, William Cullen Bryant, that Brackett's portrait bust of Washington Allston, 1843 (fig. 112), based on a death mask of the recently deceased painter, became a prize. The first sculpture distributed by the Art-Union, this naturalistic marble

Fig. 113. Francis Michelin, after Thomas Crawford and Frederick Catherwood, *Proposed Colossal Statue of Washington for the City of New York*, 1845. Lithograph with tint stone. The Metropolitan Museum of Art, New York, The Edward W. C. Arnold Collection of New York Prints, Maps and Pictures, Bequest of Edward W. C. Arnold, 1954 54.90.721

was awarded to P. G. Buchan of Rochester, New York.[61] Whether Buchan ever took ownership is unknown, but it is likely that he did not or that he resold it, for several years after the drawing a marble replica, probably the version awarded in the lottery, was in the collection of Jonathan Sturges, a member of the Art-Union's committee of management. It was not uncommon for the prizes distributed by lottery to follow such circuitous paths of ownership, but it was more usual for works of art to make their way quite directly from the Empire City into homes throughout the country. This typical route is illustrated by the example of *Diana*, ca. 1850 (cat. no. 65), by Mozier, who had retired from New York's world of commerce and moved to Florence in 1845 to pursue his career as

60. "The Fine Arts. National Academy of Design. Smaller Saloon," *Morris's National Press*, June 20, 1846, p. 4.

61. "Transactions at the Annual Meeting of the American Art-Union for 1844," in *Transactions of the American Art-Union, for the Promotion of the Fine Arts in the United States, for the Year 1844* (New York, 1844), p. 4. See also Thayer Tolles, ed., *American Sculpture in The Metropolitan Museum of Art, Volume I: A Catalogue of Works by Artists Born before 1865* (New York: The Metropolitan Museum of Art, 1999), p. 74.

62. *The Diary of George Templeton Strong* [vol. 1], *Young Man in New York, 1835–1849,* edited by Allan Nevins and Milton Halsey Thomas (New York: Macmillan, 1952), p. 297; "Fountains," *Broadway Journal,* June 7, 1845, p. 354.

63. "Monuments to Mr. Clay," *Broadway Journal,* January 11, 1845, p. 22, quoted in Jacob Landy, "The Washington Monument Project in New York," *Journal of the Society of Architectural Historians* 28 (December 1969), p. 293.

64. See *Description of J. Frazee's Design for the Washington Monument (in Four Large Drawings) Now Exhibiting at the Art-Union* (New York: Printed by Jared W. Bell, 1848); and "Editor's Table," *The Knickerbocker* 32 (November 1848), p. 473.

65. Editor's note, in [Charles Sumner], "Crawford's *Orpheus,*" *United States Magazine, and Democratic Review* 12 (May 1843), p. 455; William Mitchell Gillespie, *Rome: As Seen by a New Yorker in 1843–4* (New York: Wiley and Putnam, 1845), p. 187. On *Orpheus,* see Lauretta Dimmick, "Thomas Crawford's *Orpheus*: The American *Apollo Belvedere,*" *American Art Journal* 19, no. 4 (1987), pp. 47–84.

66. On this subject, see David Bernard Dearinger, "American Neoclassic Sculptors and Their Private Patrons in Boston," 2 vols. (Ph.D. dissertation, City University of New York, 1993).

a sculptor. Mozier's chaste, classicizing portrait of the Roman goddess was awarded in 1850 to Levi Hasbrouck of New Paltz, New York, a farming community about seventy miles north of New York City. The bust was transported to New Paltz by wagon soon thereafter and installed in Hasbrouck's home, Locust Lawn (now administered by the Huguenot Historical Society), where it remains today.

Throughout this period the movement to erect a monument to Washington in the city endured. It gathered steam in July 1843, when the Washington Monument Association of the City of New York was established and started to raise funds. In June 1844 the Association made a preliminary selection of Calvin Pollard's design for a 425-foot Gothic-style tower, a choice it continued to favor over subsequent submissions, such as Thomas Crawford and Frederick Catherwood's design of 1845, a proposal for a 75-foot cast-iron figure on a 55-foot granite pedestal (fig. 113). The search faltered as New Yorkers considered the various merits and failings of the designs, and many despaired. George Templeton Strong, for example, noted that the choices were "all on a scale of impracticable splendor and magnitude, and with two exceptions, all execrable," and the *Broadway Journal* commented, "we have long since given up all expectation of ever seeing a Washington Monument in New York."[62]

Yet the movement revived in October 1847, when a cornerstone for the monument was laid with great ceremony at Hamilton Square, a large tract on the city's outskirts between Sixty-sixth and Sixty-eighth streets and Third and Fifth avenues. Again Pollard's design was tentatively selected, although many New Yorkers protested that its style was aesthetically and symbolically unfit for an American hero, one observer remarking: "a Gothic monument, in honour of Washington, is the very sublime of nonsense."[63] Still, the Association solicited yet more designs. In autumn 1848, at the American Art-Union, Frazee displayed an ambitious drawing for a memorial to Washington in the form of a domed building topped by an allegorical statue of History, which he estimated would cost more than $1,000,000 and take ten years to complete. Although it earned plaudits from the public, this flamboyant conception, as well as many other designs, was rejected in a popular contest (with votes purchased at $1 each) in favor of Minard Lafever's Egyptian obelisk. The Association's subscription drive was discontinued in 1849, and Lafever's monument was never erected.[64]

New Yorkers were inconsistent in their support of homegrown talent Thomas Crawford. Crawford spent his first years in Rome producing stern classicizing portrait busts as well as copies after the antique. Among the former were a small number commissioned by New Yorkers, including a likeness of Matthias Bruen of 1837 (New Jersey Historical Society, Newark) and one of Mrs. John James (Mary Hone) Schermerhorn of 1837 (New-York Historical Society). However, when Crawford progressed from bread-and-butter portraits to the more prestigious realm of ideal compositions, Bostonians, not New Yorkers, encouraged him. It was Boston attorney and future United States senator Charles Sumner who raised the funds to translate into marble for the Boston Athenaeum Crawford's first achievement in this idiom, the masterly *Orpheus,* 1839–43 (Museum of Fine Arts, Boston). And it was the Boston Athenaeum that showed the *Orpheus* in spring 1844 with five other examples of Crawford's work, in the first one-person exhibition held for a sculptor in America.

That Boston had outdone New York did not go unnoticed: "It is a sin and a shame that Boston should have been suffered by New York to possess itself of the Orpheus. . . . The only atonement that can be made . . . will consist in an order for some other work of kindred inspiration from the same chisel," observed one critic. William Gillespie, in his *Rome: As Seen by a New Yorker,* was more succinct: "Should not the native city of the sculptor secure from him at least one great work?"[65] Boston consistently outstripped New York as a source of steady patronage for expatriate American Neoclassicists in general, thanks to the efforts of several extraordinary individuals, a strong appreciation of classical civilization on the part of its educated citizens, and the presence of the taste-making Athenaeum.[66]

Even though Crawford married into New York's prestigious Samuel Ward family in 1844, he continued to have difficulty earning support in the Empire City. During three trips back to the United States to solicit orders, the sculptor attracted only a limited number of private patrons for ideal compositions in New York. To be sure, some of these individuals were important: among them were Henry Hicks, for whom Crawford executed the lighthearted *Genius of Mirth,* 1842 (cat. no. 59), an ideal subject of the sculptor's own choosing, and also *Mexican Girl Dying,* by 1846 (Metropolitan Museum); Richard K. Haight, who ordered *Flora,* modeled in 1847 (fig. 74); and Hamilton Fish, who commissioned *The Babes in the Wood,*

Fig. 114. Thomas Crawford, *The Babes in the Wood*, Rome, modeled ca. 1850; carved 1851. Marble. The Metropolitan Museum of Art, New York, Bequest of Hamilton Fish, 1894 94.9.4

ca. 1850 (fig. 114), a poignant rendering of a brother and sister in eternal slumber.[67] Crawford above all the sculptors of the first generation of American Neoclassicists succeeded as a master of public statuary, earning major commissions for the United States Capitol and a monument to Washington for the grounds of the Virginia State House in Richmond. Yet even in this area his achievement in New York fell short. A scheme Hone initiated in 1844–45 to employ Crawford to produce a statue of Henry Clay for the new Merchants' Exchange "or some other suitable place"[68] failed, and no other public projects were forthcoming from the city.

The sculptor faced an additional problem: certain New York collectors were unwilling to allow public display of their works by Crawford, limiting his exposure and thus his opportunities to attract new clients. Hicks, for instance, through his early purchases helped Crawford establish a New York presence but ultimately frustrated the artist by limiting public exhibition of his two sculptures. He probably refused a request from Crawford to include *Mexican Girl Dying* in the National Academy's annual of 1848; and he declined to show his pieces subsequently at other public venues, despite "a personal application to him for that purpose during my last visit to the United States," according to a letter from Crawford to New York lawyer Theodore Sedgwick.[69] Crawford encouraged Sedgwick to approach Hicks for permission to show *Genius of Mirth* and *Mexican Girl Dying* at the Crystal Palace in New York in 1853, but if any attempts were made by the lawyer, who was president of the fair, they proved futile. Although his efforts to present an ideal subject to the public were thwarted, Crawford did have some success in showing the elegant portrait of his wife, Louisa, which he modeled in 1845 (cat. no. 63). Crawford must have hoped this bust would become a showpiece, an ambition that probably accounts for the high degree of finish and detail lavished on it, from the innovative floral termination

67. For a list of works produced by Crawford that records his patrons, see "Mr. Crawford's Works," *Literary World,* March 2, 1850, pp. 206–7.

68. *Diary of Philip Hone,* vol. 2, p. 724, entry for December 28, 1844. Hone recorded that $10,000 would be needed to fund the project.

69. Thomas Crawford to Theodore Sedgwick, January 20, 1853, Mss. Crawford, Manuscript Department, The New-York Historical Society. See also Lauretta Dimmick, "A Catalogue of the Portrait Busts and Ideal Works of Thomas Crawford (1813?–1857), American Sculptor in Rome" (Ph.D. dissertation, University of Pittsburgh, 1986), pp. 526–27.

70. N. Cleaveland, "Henry Kirke Brown," *Sartain's Union Magazine of Literature and Art* 8 (February 1851), p. 137. For another contemporary account of Brown's early years in New York, see "Brown's Studio," *Bulletin of the American Art-Union* 2 (April 1849), pp. 17–20. See also Wayne Craven, "Henry Kirke Brown: His Search for an American Art in the 1840's," *American Art Journal* 4 (November 1972), pp. 44–58.

71. Henry Kirke Brown to Lydia L. Brown, October 12, 1846, Bush-Brown Papers, vol. 2, p. 548/11, Library of Congress.

72. Henry Kirke Brown to Ezra P. Prentice, November 21, 1846, Bush-Brown Papers, vol. 2, p. 548/30, Library of Congress.

73. Henry Kirke Brown to Lydia L. Brown, July 4, 11, 1847, Bush-Brown Papers, vol. 2, pp. 548/51, 548/57, Library of Congress.

to the elaborate hairstyle and the intricate arrangement of drapery. The portrait was exhibited at the American Art-Union galleries in 1849 and four years later at the great Crystal Palace fair, where it was accorded an honorable mention, a high point in Crawford's relationship with New York.

Although New York had no public monument by Crawford and saw little of his work in exhibitions during the artist's life, his sculpture was shown in abundance in the city after his early death. Some eighty-seven plasters donated by Crawford's widow were presented to the Board of Commissioners of Central Park in 1860 and eventually were joined by Haight's gift of the marble *Flora*. Further, five marbles, including the *Dying Indian Chief*, 1856 (New-York Historical Society), from Crawford's design for a pediment of the United States Capitol, were on display at the New-York Historical Society throughout the 1860s, and *Dancing Girl (Dancing Jenny)* was exhibited at New York's Düsseldorf Gallery during the same period.

Henry Kirke Brown was the first American-born sculptor to achieve a solid reputation as a member of the New York artistic establishment. Of this determined advocate for American independence from European sculptural models and materials, one contemporary critic accurately observed: "It was his ambition to become, not a European, but an American sculptor. To him it seemed that, if a school of art, with characteristics in any degree national, is ever to grow up among us, its work must be done mainly upon American ground, and amidst American influences."[70] His deep-seated nationalism notwithstanding, he followed a rigorous course of study in Italy from 1842 to 1846, first in Florence and then, after 1844, in Rome. Abroad he developed a network of American patrons, artists, and writers, among whom were Bryant, Charles M. Leupp, and Henry G. Marquand. It was largely on the advice of this circle that Brown decided to settle in New York when he came back to America.

Brown quickly made a place for himself in the burgeoning cultural community of New York, developing close friendships with artists Asher B. Durand, Henry Peters Gray, and Daniel Huntington. In colorful letters the sculptor described his enthusiastic reception and active social schedule, including a festive evening with managers of the American Art-Union, where, he wrote, "they quite 'Lionized' me."[71] While in Rome he had been urged to display his

works in New York on his return, and he did so with dispatch, thereby announcing that a sculptor of talent was now resident on American shores. In rented gallery space at the National Academy of Design in November 1846, Brown exhibited fifteen works in what was the first one-person show mounted for a sculptor in New York. Only one portrait was included; the rest were classicizing ideal compositions modeled in Italy that the artist hoped to translate from plaster into marble on commissions from New Yorkers. However, he failed to attract many new patrons, for the exhibition was poorly attended and almost entirely ignored by the press.

Although he was well liked and well connected and maintained that he was "gratified by the interest manifested in [the National Academy show] by the first Artists here and people generally,"[72] Brown was disappointed in New York. He complained of the city's comparatively high cost of living and of being able to find only one competent assistant; and to his wife he lamented: "I have worked in this infernal city now some eight months and am worse off in almost every respect than when I came here. . . ." and "My improvement in the art is comparatively at an end if we stay here."[73] To make ends meet, he was obliged to design ceremonial sword hilts as well as utilitarian objects such as vases and candelabras for Ball, Tompkins and Black, a New York firm specializing in silver wares that for a time was owned by his patron Marquand.

But gradually Brown began to find acceptance for his work, especially with newly moneyed patrons for whom collecting brought social entrée and who hoped an embrace of American art implied patriotic values. In December 1846 Leupp commissioned him to execute a portrait of their mutual friend Bryant; the resulting likeness of 1846–47 (cat. no. 61) typifies Brown's marble busts from the late 1840s in its presentation of a highly realistic likeness elaborated with a conventional classicizing drape. Another important commission of this time may have come from Sturges, who was already well acquainted with Brown's work—he had shown interest in acquiring a replica of *Ruth*, 1845 (fig. 115), during the artist's Rome days, and he owned Brown's *Good Angel Conducting the Soul to Heaven*, by 1850 (unlocated). Sturges likely ordered a bust of Thomas Cole that was completed by 1850 (cat. no. 62); probably commissioned after the painter's death in 1848, it may have been based on a daguerreotype by Mathew Brady, ca. 1846 (cat. no. 161), that was on display in the photographer's Broadway studio by the late 1840s.

Brown also began to have good fortune in terms of showing his work on a regular basis. Two of his Italian pieces, *Ruth* and *Boy and Dog*, 1844 (New-York Historical Society), were given to the New-York Gallery of the Fine Arts in 1846 by, respectively, Eliza Hicks and Leupp. These went on view with the entire New-York Gallery of the Fine Arts collection at the New-York Rotunda in City Hall Park, where Brown briefly had his studio. Additionally, thirteen of his sculptures were featured in the 1850 annual exhibition of the National Academy of Design, including the *Cole* and the *Good Angel Conducting the Soul to Heaven,* lent by Sturges.

By mid-1848 Brown, like many other New Yorkers past and present, moved across the East River to Brooklyn. There he was able to enjoy more spacious living and working quarters (large enough for keeping a tame bear and deer) and still maintain social and business ties to nearby Manhattan. Until 1857, when Brown removed permanently to Newburgh, New York, Brooklyn remained for him a refuge from the urban chaos and constant interruptions in Manhattan of which he complained. In Brooklyn Brown's career truly began to thrive, as a passage in a letter he wrote to Huntington reveals: "My little tree of hope is planted here and its roots are spreading by nourishing waters, and tho' a very little plant at first is now beginning to spread its branches towards the light."[74] With the assistance of two French workmen and a little ingenuity, Brown established a foundry in his Pacific Street studio to cast his earliest bronzes as well as jewelry and other metalwork for Ball, Tompkins and Black.

Brown, more than any other individual, inspired the American Art-Union to expand its mission, originally focused on the distribution of paintings and prints, and promote sculpture, specifically the small bronze, as a democratic national art with potential appeal for a wide American audience. In 1849 the Art-Union's managers named a special committee to investigate the possibility of distributing bronze sculptures to its subscribers. The group's report makes clear, but does not explicitly state, that its favorable response was determined primarily by the success of Brown's foundry: "There has always been a difficulty in this country in obtaining proper workmen, which is the principal reason why reduced copies in bronze have not already been made of several exquisite statues, modelled by our own artists. . . . This obstacle has been removed, and there are here at present several persons, lately arrived from Europe, who are fully competent to undertake this kind of work." Shortly before

Fig. 115. Henry Kirke Brown, *Ruth,* Rome, 1845. Marble. Collection of The New-York Historical Society

it issued its report, the committee passed a resolution calling for Brown to model a statuette "illustrative of Indian form and character" for replication in an edition of twenty.[75]

Brown promptly complied, and casts of *The Choosing of the Arrow* (fig. 116), a nude man drawing an arrow from his quiver, based on sketches from the sculptor's 1848 trip to Mackinac Island, were distributed in 1849—but not without some objection to the figure's nudity. Unable to comprehend the symbolic import of a naturalistic American subject rendered in an "American" medium (bronze rather than imported marble) or, for that matter, to appreciate the piece in purely visual terms, one journalist wrote: "the bronze is so near to the natural copper of the skin, that there is nothing to modify the complete disgust with which its undisguised nakedness must be looked upon. . . . what any modest person can do with such a 'prize,' except to refuse to receive it, is difficult to imagine."[76]

74. Henry Kirke Brown to Daniel Huntington, December 24, 1852, Bush-Brown Papers, vol. 3, p. 639, Library of Congress.

75. "Bronze Statuettes," *Bulletin of the American Art-Union* 2 (April 1849), p. 10.

76. "Nudity in Art," *Home Journal,* January 5, 1850, p. 2. The article further notes that Art-Union officials hastily affixed removable tinfoil fig leaves so badly constructed that "the concealment, at the best, was just so partial as to be worse than complete exposure."

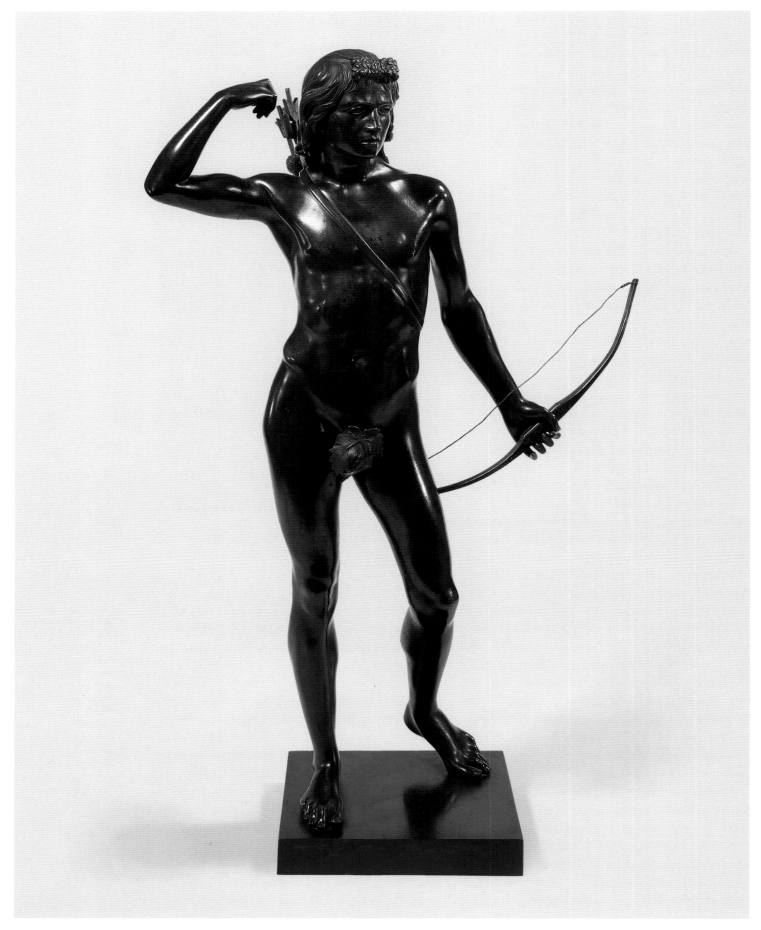

Fig. 116. Henry Kirke Brown, *The Choosing of the Arrow*, 1849. Bronze. Amon Carter Museum, Fort Worth, Texas

Fig. 117. Victor Prevost, *Daniel Appleton's Bookstore, Lower Broadway, with Henry Kirke Brown's "Plato and His Pupils,"* 1854. Modern gelatin silver print from original waxed paper negative. Collection of The New-York Historical Society

in 1852 on the facade of Daniel Appleton's bookstore on lower Broadway (fig. 117), Ames and Brown focused their attention on a statue of De Witt Clinton for Green-Wood Cemetery (fig. 118), which was funded by public subscription through the Clinton Monument Association. As a promotional publication for the memorial noted, the bronze medium was deliberately selected to place the *Clinton* within a distinguished artistic lineage: "A bronze statue is not only one of the most significant and durable tributes which can be offered to the memory of a deceased statesman, but it has been rendered by historical associations one of the most appropriate also."[77]

The monument did indeed serve the memory of Clinton, recalling his public career in two bas-reliefs on its base, "The Digging of the Erie Canal" and "Commerce on the Erie Canal." Like contemporaneous portraits with realistic likenesses and draped terminations, the ambitious $10\frac{1}{2}$-foot figure is a stylistic hybrid: the naturalistically rendered subject appears in modern dress but with an incongruous Roman mantle and sandals. Yet the contemporary clothes make Clinton more an American statesman than an idealized hero—and in this respect the memorial established a

77. *Monument to De Witt Clinton* (New York, ca. 1849), quoted in Michael Edward Shapiro, *Bronze Casting and American Sculpture, 1850–1900* (Newark: University of Delaware Press, 1985), p. 49.

Reactions of this kind notwithstanding, the Art-Union pursued its program, for the production and distribution of works of art in quantity was perfectly suited to the rapidly growing appetite for the arts, however prudish or untutored the viewing audience. The Art-Union's inaugural attempt in the area of sculpture replicas was followed in 1850 by its distribution of six bronze casts of a bust of George Washington of about 1850 by longtime New York sculptor Horace Kneeland and twenty of Brown's *Filatrice,* 1850 (cat. no. 66). The latter, an unobjectionable figure of a peplos-clad spinner, eschews the American subject matter of *The Choosing of the Arrow* and reflects the sculptor's lingering penchant for the classicizing themes of his Italian sojourn.

Because he lacked the facilities to cast large projects, Brown, beginning in 1851, turned to the Ames Manufacturing Company in Chicopee, Massachusetts, which specialized in casting cannons and swords. He and James Tyler Ames collaborated to develop a firm able to cast oversized sculptures, initiating a tremendously productive working relationship and establishing a resource for other American artists, who formerly had to rely exclusively on European foundries. After casting Brown's bas-relief *Plato and His Pupils,* installed

Fig. 118. Henry Kirke Brown, *De Witt Clinton,* 1850–52. Bronze. The Green-Wood Cemetery, Brooklyn

78. "City Intelligence: Statue of De Witt Clinton," *New York Herald,* May 25, 1853, p. 4, cited in Stokes, *Iconography of Manhattan Island,* vol. 5, p. 1849; "The Clinton Statue," *New-York Daily Times,* September 21, 1853, p. 4.

79. *Morning Courier and New-York Enquirer,* August 31, 1847, quoted in Samuel A. Roberson and William H. Gerdts, "The Greek Slave," *The Museum* (Newark), n.s., 17 (winter-spring 1965), pp. 16–17. On the *Greek Slave,* see also Wunder, *Hiram Powers,* vol. 1, pp. 207–74, vol. 2, pp. 157–68; Linda Hyman, "*The Greek Slave* by Hiram Powers: High Art as Popular Culture," *Art Journal* 35 (spring 1976), pp. 216–23; and Joy S. Kasson, *Marble Queens and Captives: Women in Nineteenth-Century American Sculpture* (New Haven: Yale University Press, 1990), pp. 46–72. The *Greek Slave* shown in New York in 1847 is now in the collection of the Corcoran Gallery of Art, Washington, D.C. Subsequent showings in New York featured the Newark Museum's marble (cat. no. 60).

80. *Diary of Philip Hone,* vol. 2, p. 819, entry for September 13, 1846.

81. *Sarmiento's Travels in the United States in 1847,* translated by Michael Aaron Rockland (Princeton: Princeton University Press, 1970), pp. 277–78.

82. [Horace Greeley], "City Items. Powers's Great Statue," *New-York Daily Tribune,* August 26, 1847, p. 2.

83. "The Crystal Palace. Progress of the Exhibition," *New-York Daily Times,* August 19, 1853, p. 4.

new standard for American portrait statuary. Cast in April 1852, the bronze was placed in front of City Hall from May to September 1853 prior to its unveiling in Green-Wood Cemetery later that year.[78]

However impressive, Brown's achievements—and in fact those of any New York artist, entrepreneur, or showman of the 1840s and 1850s—must be considered within the context of Hiram Powers's extraordinary impact and international fame. In August 1847 Powers's marble *Greek Slave,* 1841–43 (cat. no. 60), made the first stop on its national tour, which lasted until 1849. This ideal figure, a full-length nude representing a young female prisoner, alluded to the atrocities the Turks committed during the Greek War of Independence and by implication to the ongoing American debate over slavery. Shown until early January 1848 at the exhibition gallery of the National Academy of Design, the statue attracted thousands of viewers. Among the throngs who paid admission, it was noted, "the grey-headed man, the youth, the matron, and the maid alike [were awed]. . . . Loud talking men are hushed into a silence . . . groups of women hover together as if to seek protection from the power of their own sex's beauty."[79] Hone wrote in his diary of the crowds and concluded, "I have no personal acquaintance with Powers, nor had I with Praxiteles; but . . . I certainly never saw anything more lovely."[80]

The figure's nudity gave some pause, although it provoked less criticism in New York than in other American cities. As one visitor to the National Academy reported: "The first few days there was a great scandal, but finally the prigs lifted their eyes and accustomed themselves to contemplating the artistic beauty in that looking glass of marble."[81] Apologists argued that the statue's classicizing style as well as the subject's evident Christian devotion in the face of adversity excused her undress. Thus, Horace Greeley offered moral approbation in the *New-York Daily Tribune*: "But in that nakedness she is unapproachable to any mean thought. The very atmosphere she breathes is to her drapery and protection. In her pure, unconscious naturalness, her inward chastity of soul and sweet, womanly dignity, she is more truly clad than a figure of lower character could be though ten times robed."[82] The need to supply moralizing justifications of this sort and to satisfy the popular thirst for information led Miner Kellogg, manager of the statue's tour, to assemble a descriptive pamphlet; this included an excerpt from an article in defense of the figure's nudity by the Reverend Orville Dewey that appeared in the *Union Magazine* of October 1847 and a history of the *Greek Slave* and Powers's career, along with promotional puffs.

After traveling to cities from Boston to New Orleans, the *Greek Slave* returned to New York between October and December 1849, this time for exhibition at the Lyceum Gallery on Broadway. Here it was joined by Powers's commanding portrait of Andrew Jackson, 1834–35 (cat. no. 55), his oft-replicated ideal bust *Proserpine,* 1844–49 (fig. 119), and the nude *Fisher Boy,* 1841–44 (fig. 73), the last enhanced with a fig leaf to maintain standards of propriety. All four were installed in the Gallery of Old Masters, which housed sixty paintings from the well-known collection of Gideon Nye, an honor that accorded them additional status. Although this display was not as profitable as the first New York exhibition of the piece, the cumulative impact of the two showings on residents of the Empire City was nothing short of phenomenal. As an artistic icon the *Greek Slave* exemplified "good" or "correct" taste and thus instructed New Yorkers in the formation of that taste. Moreover, it inspired an unprecedented response in forms of popular culture (see "Inventing the Metropolis" by Dell Upton in this publication, pp. 38, 40), including poems and engravings, as well Parian ware, plaster, and alabaster reductions sold in emporiums and peddled on the streets by Italian image-vendors. If the *Greek Slave* represented the highest form of artistic achievement, it was also a spectacle on a par with P. T. Barnum's Fejee Mermaid, Ethiopian Serenaders, and other curiosities.

Powers's showing at the New York Crystal Palace exhibition, while impressive, was not equally overwhelming. This fair, the New-York Exhibition of the Industry of All Nations, opened in July 1853 and offered a broad viewing public the largest assemblage of sculpture presented to date on American shores (see cat. no. 179). A veritable maze of mechanical and useful objects, as well as fine and decorative arts, the display asserted a continuing American predilection for foreign works, rather than demonstrating the ascendance of native talent, as its organizers had intended. Of the American submissions, Powers's works attracted the most attention, drawing "a constant circle of humanity. . . . Artists, amateurs, countrymen and citizens alike."[83] The *Greek Slave* (cat. no. 60; fig. 186), *Proserpine, Fisher Boy,* and *Eve Tempted,* 1839–42 (National Museum of American Art, Smithsonian Institution, Washington, D.C.; see fig. 120), collectively earned an honorable mention,

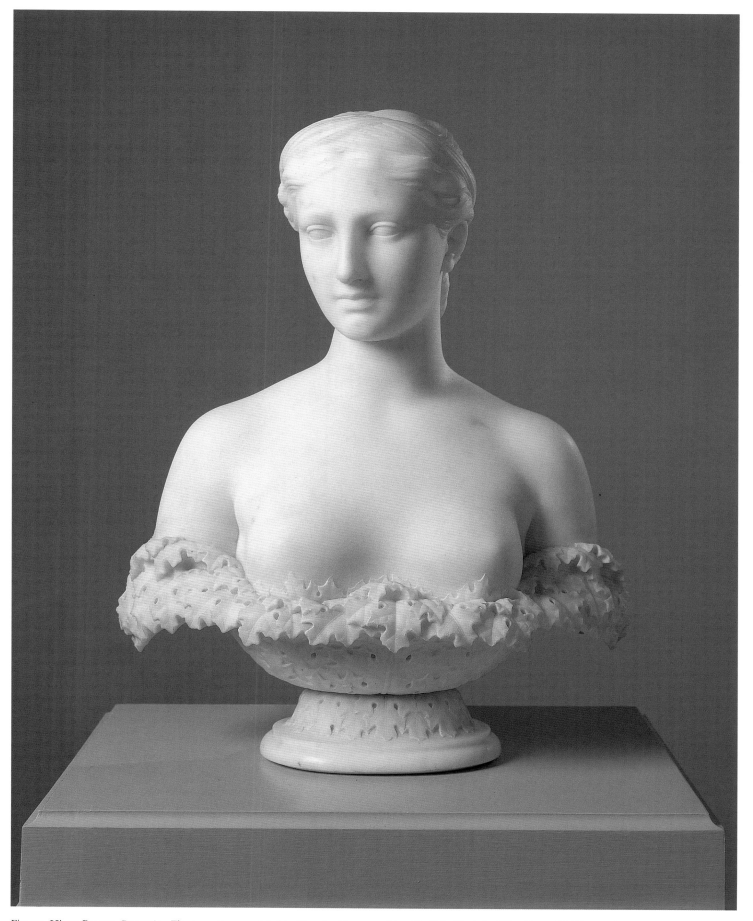

Fig. 119. Hiram Powers, *Proserpine*, Florence, 1844–49. Marble. Chrysler Museum of Art, Norfolk, Virginia, Gift of James H. Ricau and Museum Purchase 86.505

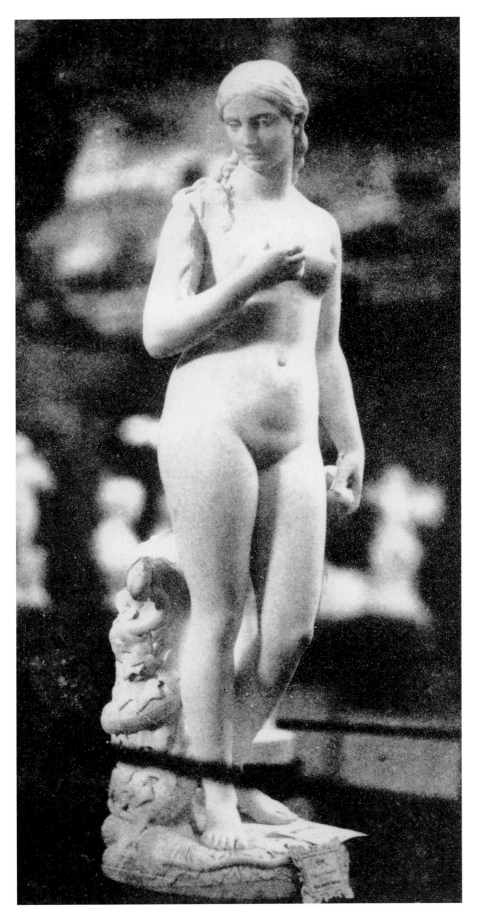

Fig. 120. Victor Prevost, *Hiram Powers's "Eve Tempted" at the Crystal Palace*, 1853–54. Modern gelatin silver print from waxed paper negative. Collection of The New-York Historical Society

as did Crawford's marble bust of his wife and Thomas Ball's plaster statuette of Daniel Webster. There was wonder "that the far-famed statuary of Mr. Hiram Powers is not quite so highly rated as it has been hitherto by the public at large;"[84] but this was not surprising, for the jury was composed of artists such as Morse, Asher B. Durand, and Brown, who, although champions of American painters and sculptors, held uncharitable opinions of the expatriate Powers. Furthermore, Powers's offerings had to compete with a rich array of foreign sculptures in plaster, marble, and bronze, including Baron Carlo Marochetti's colossal equestrian statue of George Washington and August Kiss's *Amazon*. Thorvaldsen, at the height of his American popularity, was represented by several sculptures, key among them a marble replica of *Ganymede and the Eagle*, 1817–29 (cat. no. 54), and massive plaster models for the highly ambitious multifigure group *Christ and the Apostles*, begun in 1821, from the Church of Our Lady in Copenhagen,[85] and these too vied for attention.

The Crystal Palace exhibition, with its competing and dizzying range of goods, and the continuing phenomenal success of the *Greek Slave* popularized the private patronage of sculpture in New York: the wealthy buyers who unevenly supported native-born sculptors were eclipsed by clients from a broader socioeconomic base who eagerly collected inexpensive foreign and American works in plaster, Parian ware, and bronze as symbols of refinement and taste. One purveyor of such works was the Cosmopolitan Art Association, founded in 1854 by Chauncey L. Derby to encourage and popularize the fine arts through the publication of a monthly journal and a lottery-based distribution of both paintings and sculpture. The Cosmopolitan Art Association solicited sculpture far more extensively than had its unlucky predecessor the American Art-Union, evading antilottery laws by holding its drawings in Sandusky, Ohio, while mounting its displays in New York. In the Cosmopolitan's inaugural year Derby purchased a replica of the *Greek Slave* for the organization; exploiting its universal familiarity to maximum promotional effect, he used it to attract subscribers by making it a prize. The statue was awarded to a Pennsylvania resident in 1855 and repurchased by the Cosmopolitan for $6,000 in 1857 at an auction held in the rotunda of the Merchants' Exchange.[86] In 1858, after a showing at the Düsseldorf Gallery (fig. 121), managed by Derby, the *Greek Slave* was again awarded by lottery, this time to a Cincinnati woman, who immediately sold it to New York department-store magnate A. T. Stewart.

The Cosmopolitan Art Association shrewdly purchased many other works that reflected the popular, if not always sophisticated taste of its patrons. Inexpensive Parian-ware sculptures had become favorite domestic adornments by this period and had proliferated on the market; one advertisement run repeatedly by a Maiden Lane proprietor boasted of more than 400 selections.[87] Accordingly, the Association's stock included many ideal statuettes in Parian ware as well as in bronze, along with portrait busts of notable statesmen and authors and such items as a reduced copy of Kiss's *Amazon*, distributed in 1856, and 112 sets of mounted photographs of Thorvaldsen's familiar bas-reliefs *Night* and *Day*, given out in 1860. In 1860 John Rogers, newly arrived in New York from Chicago, executed a fifteen-inch plaster after William Randolph Barbee's marble *Fisher Girl*, ca. 1858 (fig. 122), which had been purchased by the Association in 1859. Capitalizing on the fashion for Parian ware, the Association had copies in the medium cast by W. T. Copeland in England and distributed eleven of them in 1861. Rogers himself would go on to achieve fame catering to a broad audience with inexpensive tinted plaster groups—anecdotal vignettes of everyday American life—publicized through modern marketing tactics, including the use of mail-order catalogues and a studio showroom.

During the 1850s American sculptors attempted to match Powers's astounding success in New York; with the twin goals of turning a profit and attracting new patrons, they produced ideal works with timely implications and dramatic resonance and displayed them in rented spaces or any of the growing number of the city's commercial galleries. If James Thom and Robert Ball Hughes in the 1830s had aspired to amuse and entertain their audiences, their commercially astute successors of the 1850s manipulated and excited the emotions of viewers. Edward Augustus Brackett's lifesize Vermont marble group *Shipwrecked Mother and Child*, 1850 (fig. 123), typifies the genre. The artist's finest achievement and only ideal composition, it was shown between March and June 1852 at the Stuyvesant Institute, a Broadway hall that was a favorite exhibition venue. Although it went unsold, the piece appealed powerfully to viewers' morbid curiosity about victimization and death. It also responded to a widespread contemporary fascination with shipwrecks, which inspired numerous prints and songs. In Boston, where *Shipwrecked Mother and Child* was shown before it

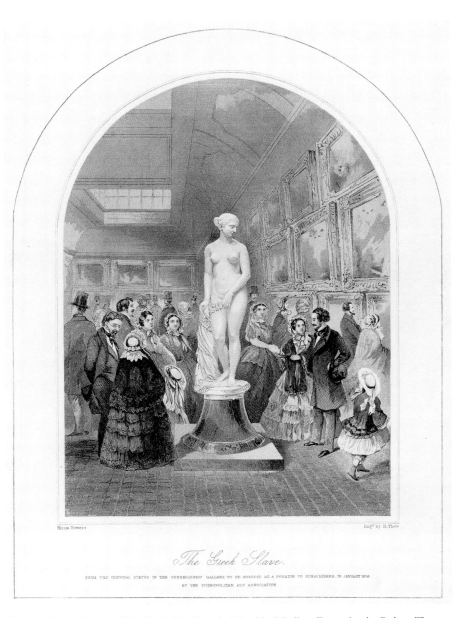

Fig. 121. *Hiram Powers's "The Greek Slave" at the Düsseldorf Gallery.* Engraving by Robert Thaw, from *Cosmopolitan Art Journal* 2 (December 1857), between pp. 40 and 41. The Metropolitan Museum of Art, New York, The Thomas J. Watson Library

appeared in New York, the group inspired encomiums by the likes of statesman and orator Edward Everett and sculptor Greenough. Greenough considered the image when viewed at a proper distance "no longer marble, but poetry," and an anonymous critic wrote that "we felt, after a little while spent in its presence, with what dramatic truth the conception had been wrought out. We were on the sea-shore with the artist, the storm was raging far out, the ship was laboring, the blow was struck, the mother and the child engulphed [*sic*], the rugged shore received them."[88] Viewers in the general audience agreed, reading the composition as a narrative that transported them to the realm of watery death.

84. "Fine Arts. The Prizes at the New York Crystal Palace," *The Albion*, January 28, 1854, p. 45. On Powers's response to the judging, which occurred before the fair opened, see Wunder, *Hiram Powers*, vol. 1, pp. 252–53.

85. See *How to See the New York Crystal Palace: Being a Concise Guide to the Principal Objects in the Exhibition as Remodelled, 1854. Part First. General View,—Sculpture,—Paintings* (New York: G. P. Putnam and Co., 1854), pp. 25–29. See also "The Chronicle. American Art and Artists. Exhibition of Models of Works by Thorwaldsen,"

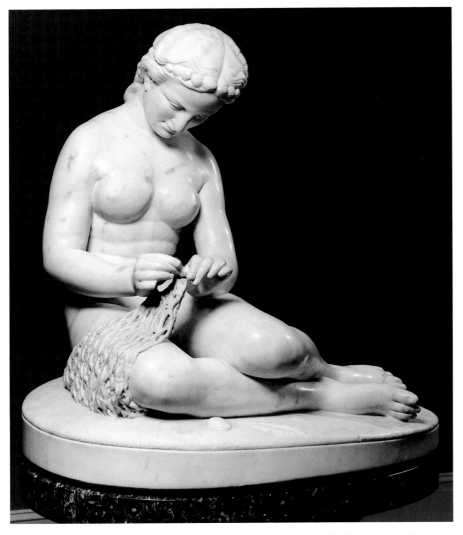

Fig. 122. William Randolph Barbee, *The Fisher Girl*, Florence, ca. 1858. Marble. National Museum of American Art, Smithsonian Institution, Washington, D.C., Museum Purchase 1968.140

Not only shipwrecks but also the romantic notion, then current, of Native Americans as an exotic and vanishing race fed the popular imagination and was an important source of subject matter for sculptors. It inspired Peter Stephenson's *Wounded Indian,* ca. 1848–49 (fig. 124), for example, which was shown in 1851 at London's Crystal Palace and from May to June 1852 at the Stuyvesant Institute, overlapping for a time with Brackett's *Shipwrecked Mother and Child.* The public appetite for the dramatic themes of these works was matched by an appreciation of their visual realism, conveyed by virtuoso displays of carving. That this appreciation compensated for deficiencies in emotional expression is suggested by reviewers who found no perceptible storytelling qualities in *The Wounded Indian* but praised the realistically rendered ethnic characteristics and bloody gash and the complex pose of the figure, noting that "the interest in the work seems to us to centre rather in the accurate anatomical imitation, than in any ideality or sentiment" and "the subject is not a pleasing one; but it is executed with fidelity and force."[89]

While Powers's American reputation was made by a nationwide tour of the *Greek Slave,* it is fair to say that the self-taught Erastus Dow Palmer was catapulted to fame primarily in New York and by New Yorkers. In September 1846, as a cameo cutter and aspiring sculptor, Palmer visited New York to get modeling tools and materials; two years later he cut and displayed cameos in the city in a temporary studio he set up for the purpose on Franklin Street. At this time Palmer

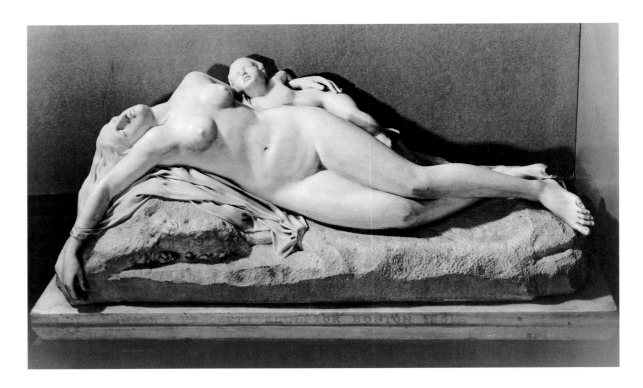

Fig. 123. Edward Augustus Brackett, *Shipwrecked Mother and Child,* Boston, 1850. Marble. Worcester Art Museum, Worcester, Massachusetts, Gift of Edward Augustus Brackett 1909.64

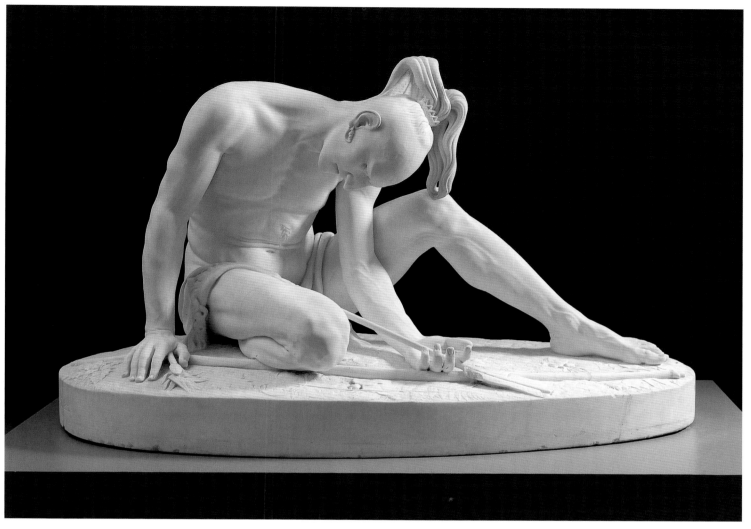

Fig. 124. Peter Stephenson, *The Wounded Indian*, Boston, modeled ca. 1848–49; carved 1850. Marble. Chrysler Museum of Art, Norfolk, Virginia, Gift of James H. Ricau and Museum Purchase 86.522

began seriously to pursue a career as a sculptor in Albany, where he established a studio and later served as mentor for numerous assistants, several of whom became accomplished sculptors in their own right. Palmer had devoted local patrons, but he shrewdly determined to showcase and market his work in New York, capitalizing on his proximity to the city, an easy trip down the Hudson River. That he considered contact with New York vital is captured in a passage from a letter of 1850 he wrote to John P. Ridner of the American Art-Union: "I wish you to lay it [the bas-relief *Morning*] before the committee of the Art-Union asking them to order it in the marble . . . [I] shall be very glad if they do as I am very desirous to have *one* thing at least of mine go there. . . . I need not say that I can dispose of it here at any moment. . . . I wish for my own sake to have it go to N.Y."[90] *Morning* did indeed go to New York, and beyond, for the Art-Union bought the bas-relief and awarded it as a

prize to John Sparrow of Portland, Maine, in the institution's lottery of 1850.

The sale and subsequent disposition of *Morning* constituted the first instance of Palmer's successful introduction of his work to an urban and, in turn, national audience. From Albany in the early 1850s Palmer continued to cultivate his relationship with New York, forging connections with many of the most powerful cultural figures of the metropolis, including patrons Hamilton Fish and Edwin D. Morgan, and artists Frederic E. Church and Daniel Huntington. In April 1856 Palmer's growing reputation as a self-taught genius was substantially enhanced with the publication of a laudatory article Henry T. Tuckerman had written after a visit to the sculptor's Albany studio.[91]

The following October a committee of twenty distinguished citizens invited Palmer to exhibit in New York. As a result, twelve of his works, "The Palmer Marbles," were displayed at the hall of the Church of

*Bulletin of the American Art-Union*, August 1851, p. 78; and "The Exhibition of Sculpture in the Crystal Palace," *New-York Daily Times*, July 1, 1853, p. 1.

86. An engaging account of the auction is given in "Appendix. The Greek Slave," in Cosmopolitan Art Association, *Catalogue of Paintings by Artists of the Academy at Dusseldorf . . .* (New York, 1857), pp. 33–34.

87. See, for instance, "Parian Marble Statuettes," *The Crayon*, January 10, 1855, p. 32.

88. Horatio Greenough to Richard Dana, February 23, 1852, reprinted in *New-York Daily Tribune*, March 29, 1852, p. 5; "The Fine Arts. A 'Brackett' in Public Amusements," *Literary World*, April 10, 1852, p. 268.

89. "Statue of the Wounded Indian," *New-York Daily Tribune*, May 25, 1852, p. 6; "Fine Arts.

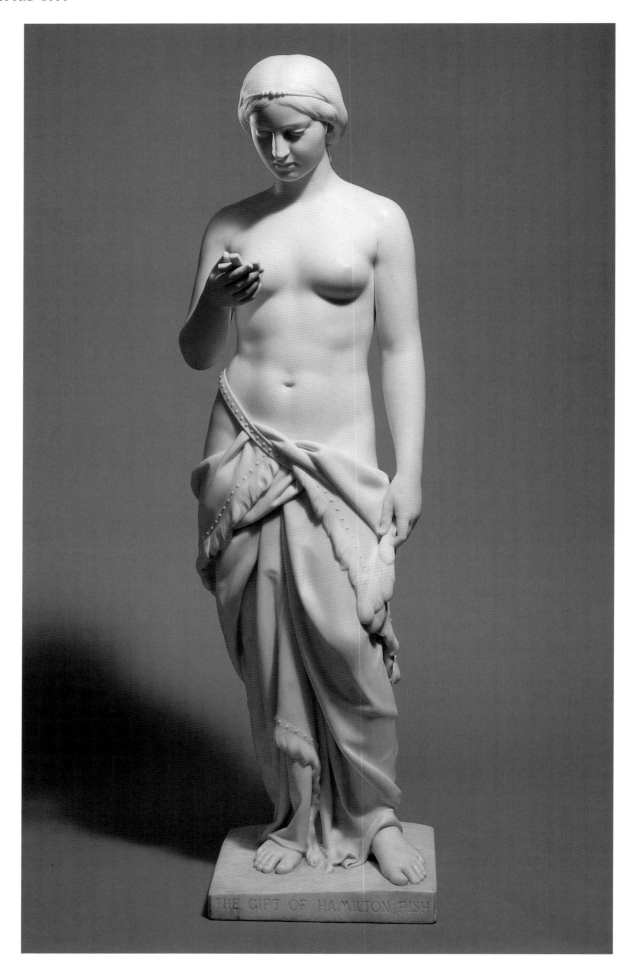

Fig. 125. Erastus Dow Palmer, *Indian Girl* or *The Dawn of Christianity,* Albany, modeled 1853–56; carved 1855–56. Marble. The Metropolitan Museum of Art, New York, Bequest of Hamilton Fish, 1894  94.9.2

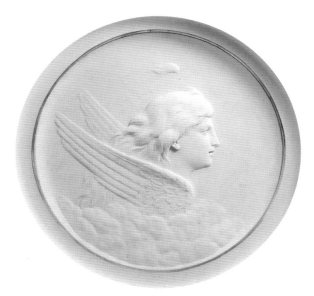

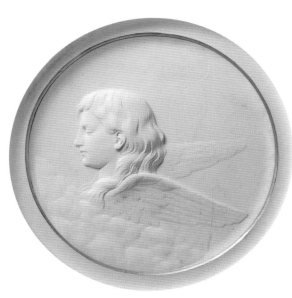

Fig. 126. Erastus Dow Palmer, *Morning,* Albany, modeled 1850; carved 1854. Marble. Collection of the Albany Institute of History and Art, Gift of Thomas Woods 1993.46.2

Fig. 127. Erastus Dow Palmer, *Evening,* Albany, modeled 1851; carved probably 1854. Marble. Collection of the Albany Institute of History and Art, Gift of Thomas Woods 1993.46.1

the Divine Unity on Broadway between December 1856 and April 1857.[92] Among these were the semi-nude statue *Indian Girl,* or *The Dawn of Christianity,* 1853–56 (fig. 125), commissioned by Fish; four allegorical busts, including *Spring,* 1855 (Pennsylvania Academy of the Fine Arts, Philadelphia), lent by the Cosmopolitan Art Association; and five relief medallions, including *Morning,* 1850, and *Evening,* 1851 (figs. 126, 127). The exhibition marked a pivotal moment in Palmer's career, attracting extensive critical notice, nearly all positive. Many observers celebrated the sculptor as a native-born talent and lauded the patriotism of his themes and his patrons. One reviewer commended the marbles to any "person in our city, who claims to have taste," while another remarked, "It must be a very dull soul that could step from the Vanity Fair of Broadway into this Exhibition, and not be possessed with something of the charm that pervades it."[93] Attention focused on the exhibition's centerpiece, the *Indian Girl,* which the Reverend A. D. Mayo praised at length in the accompanying catalogue, arguing that the subject's imminent conversion to Christianity pardoned her seminudity. To those eager to assert an American cultural identity, Palmer's marbles, like Brown's bronzes, offered proof that the nation was able to produce meaningful art as well as worthy manufactured goods.

Within months of the show's closing, Fish commissioned Palmer to make a full-length figure to accompany his *Indian Girl.* Palmer's response was

*The White Captive,* 1857–58 (cat. no. 69), a portrayal of a young pioneer girl who has been kidnapped by Native Americans and stripped of her nightdress, a piece that balances the meaning of its pendant: as the artist explained, the *Indian Girl* was meant "to show the influence of Christianity upon the Savage," while *The White Captive* reveals "the influence of the Savage upon Christianity."[94] Fish permitted *The White Captive* to be displayed in a solo exhibition at the Broadway gallery of William Schaus, a move calculated to make money for Palmer in the short term and to encourage new commissions. Between November 1859 and January 1860 viewers paid 25 cents to see the sculpture, installed alone in Schaus's carpeted main room. Standing beneath a canopy, the statue was illuminated by gaslight filtered through a tinted shield that lent its marble surface a realistic fleshlike tone. The figure surmounted a rotating pedestal with "an attendant . . . always present to put in motion the simple mechanism at the first request." More than three thousand people reportedly visited Schaus's gallery in the first two weeks of the exhibition, with attendance at times climbing to upward of four hundred a day.[95]

Palmer must have deliberately chosen the subject of *The White Captive* to elicit comparisons with Powers's *Greek Slave,* which was a recurrent presence in New York and as recently as June 1858 had made an appearance in the city when a replica was distributed by the Cosmopolitan Art Association. To be sure, Powers's figure purports to represent a victim of the

Statue of the Wounded Indian," *The Albion,* June 12, 1852, p. 285.

90. Erastus D. Palmer to John P. Ridner, June 14, 1850 (BV), American Art-Union, Letters from Artists, The New-York Historical Society.

91. See [Henry T. Tuckerman], "The Sculptor of Albany," *Putnam's Monthly* 7 (April 1856), pp. 394–400.

92. See Committee to Erastus D. Palmer, October 1, 1856, and Palmer's reply of October 6, reprinted in "Palmer's Exhibition of Sculpture," *Evening Post* (New York), November 11, 1856; and *Catalogue of the Palmer Marbles, at the Hall Belonging to the Church of the Divine Unity, 548 Broadway, New York* (Albany: J. Munsell, 1856).

93. "Palmer's Marbles," *Frank Leslie's Illustrated Newspaper,* December 20, 1856, p. 42; "Fine Arts. The Palmer Marbles," *The Albion,* December 18 [i.e. 13], 1856, p. 597.

94. Erastus D. Palmer to John Durand, January 11, 1858, Dreer Collection, Historical Society of Pennsylvania, Philadelphia, on microfilm (reel P21, frame 27) at the Archives of American Art, Smithsonian Institution, Washington, D.C. For further discussion of the polarized worlds of such subjects, see Kasson, *Marble Queens and Captives,* pp. 73–100.

95. Quoted in J. Carson Webster, *Erastus D. Palmer* (Newark: University of Delaware Press, 1983), p. 29; see also "Metropolitan Art Exhibitions," *New York Herald,* December 2, 1859, p. 4.

96. "Art. Palmer's 'White Captive,'" *Atlantic Monthly* 5 (January 1860), p. 109; [Henry T. Tuckerman], "Palmer's Statue, the White Captive," *Evening Post* (New York), November 10, 1859, p. 1. The latter text was printed as an accompanying broadside for the exhibition. It was republished numerous times, including in Henry T. Tuckerman, *Book of the Artists, American Artist Life, Comprising Biographical and Critical Sketches of American Artists: Preceded by an Historical Account of the Rise and Progress of Art in America* (New York: G. P. Putnam and Son, 1867; reprint, New York: James F. Carr, 1967), pp. 359–60.

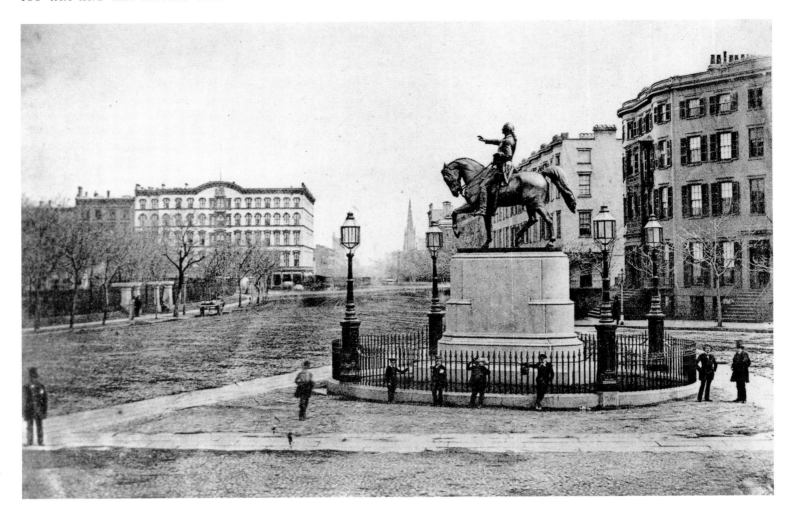

Fig. 128. *Union Square and Vicinity, with Henry Kirke Brown's "George Washington,"* ca. 1860. From I. N. Phelps Stokes, *The Iconography of Manhattan Island* (New York: Robert H. Dodd, 1918), vol. 3, addenda pl. 27 B-a. The Metropolitan Museum of Art, New York, The Thomas J. Watson Library

97. "Wonderful Development of American Art—Uprising of Enthusiasm," *New York Herald,* December 5, 1859, p. 6; "The Vagabond. Painting and Statuary," *Sunday Times and Noah's Weekly Messenger,* November 20, 1859, p. 1. See also "Art Matters," *New York Dispatch,* November 19, 1859, p. 7, which surveys American and European art on view in New York galleries during the 1859 season.

Greek War of Independence against the Turks, and Palmer's a character in a frontier conflict, but each portrays a full-length female figure caught in a moment of adversity whereby her nudity is pardonable, her purity preserved, and her Christianity triumphant. However, there are significant stylistic and conceptual distinctions. Powers's *Slave* shows classicizing Greek proportions and emotional impassivity, while Palmer's *Captive* reveals a preference for naturalism, with its fleshy body and expressive face. Furthermore, with *The White Captive* Palmer answered a persistent call for subjects drawn from the American experience. And he was shrewdly responding as well to a contemporary fascination with stories of kidnapped white women, such as the real Jane McCrea and Olive Oatman and the fictional heroine Ruth from Cooper's 1829 novel *The Wept of Wish-ton-Wish*. His apt choice drew applause; one writer, for example, wrote of the subject: "It is original, it is faithful, it is American; our

women may look upon it, and say, 'She is one of us.'" Moreover, Tuckerman proclaimed the figure "thoroughly American," and an exemplar of the moral superiority of the civilized nation.[96]

The exhibition of *The White Captive* emerged not only as a financial and popular success but also as a highlight of the rich—and richly—American art season of autumn 1859 for discriminating viewers. Church's epic *Heart of the Andes*, 1859 (cat. no. 41) was also on view in New York, as were Paul Akers's dramatic sculpture *Dead Pearl Diver*, 1858 (Portland Museum of Art, Maine), and large canvases by William Page, William L. Sonntag, and Louis Mignot and Thomas P. Rossiter. Nationalist critics praised this collective American creativity; one writer heralded it as "the inauguration of [a] new art epoch." Another proclaimed Palmer and Church, neither of whom had yet been to Europe, as "the product[s] of American civilization and

culture . . . developments of American genius; manifestations of American character."[97]

Palmer's role in the creation of a new, independent American art must be considered alongside Henry Kirke Brown's triumphant realization of his monument to George Washington (fig. 128) in 1856. A successful subscription effort for the financing of the statue, concluded just before its dedication, had been led by an indefatigable shipping merchant, James Lee, who collected more than $29,000 from ninety-seven individuals. Lee's democratizing plan had limited individual contributions to $500, and the subscription list featured not only the city's new patrons and civic leaders but also lesser lights among the citizenry. With financial backing, Brown was able to proceed. He modeled the likeness of his dignified but unapologetically naturalistic *Washington* on a copy of Houdon's authoritative portrait bust, which he borrowed from Hamilton Fish, and based the uniform on one of Washington's garments that was preserved at the United States Capitol; the prancing steed was drawn from the best examples of Roman equestrian monuments. By May 1855 the Ames Manufacturing Company had completed casting and the pieces were sent to Brooklyn for finishing and assembly by a talented band of assistants, notably John Quincy Adams Ward, who had served in Brown's studio since 1849. Finally, New York saw the culmination of its long battle to erect a public monument to the first president, a memorial that a contemporary termed a necessary element "in a great city's existence":[98] Brown's *George Washington* was dedicated at the southern tip of Union Square on the Fourth of July 1856.

The unveiling of the statue, witnessed by some twenty thousand spectators, can be seen as a metaphor for the difficult but ultimately successful struggle of American sculptors to define themselves in New York between 1825 and 1861. The tarpaulin over the bronze became tangled around the horse's legs and the rider's arms, but after a brigade of firemen with a ladder freed the covering, "the noble statue was revealed to the eager gaze of the delighted multitude; a universal shout rent the air; hundreds of pistols that had been expressly loaded for the occasion . . . went off in a simultaneous explosion."[99] This crowning achievement of sculpture in New York was a tangible symbol of the cosmopolitanism achieved by American sculptors in the years between 1825 and 1861 and a validation of their art's progress during that period, a period that initiated a remarkable era of public sculpture and artistic professionalism in the post–Civil War Empire City. New York's evolution as an art capital was at least matched by the evolution of its sculptors and their understanding of the city's benefits and limitations; as Henry Kirke Brown discerned in 1858: "Brooklyn and New York seem different to me from what they used to. I see that it is myself that has changed more than they."[100]

98. "Brown's Equestrian Statue of Washington," *Frank Leslie's Illustrated Newspaper*, July 19, 1856, p. 86. For the history of the commissioning of the statue and its modeling, too extensive to retell here, see James Lee, *The Equestrian Statue of Washington* (New York: John F. Trow, printer, 1864); Agnes Miller, "Centenary of a New York Statue," *New York History* 38 (April 1957), pp. 167–76; and Shapiro, *Bronze Casting and American Sculpture*, pp. 56–59. For the brief collaboration between Brown and Greenough on the equestrian statue of Washington, see Nathalia Wright, *Horatio Greenough: The First American Sculptor* (Philadelphia: University of Pennsylvania Press, 1963), pp. 274–76.

99. "Inauguration of the Washington Statue—Imposing Spectacle—Rev. Dr. Bethune's Address," *New-York Daily Times*, July 5, 1856, p. 1.

100. Henry Kirke Brown to Lydia L. Brown, October 26, 1858, Bush-Brown Papers, vol. 4, p. 1038, Library of Congress.

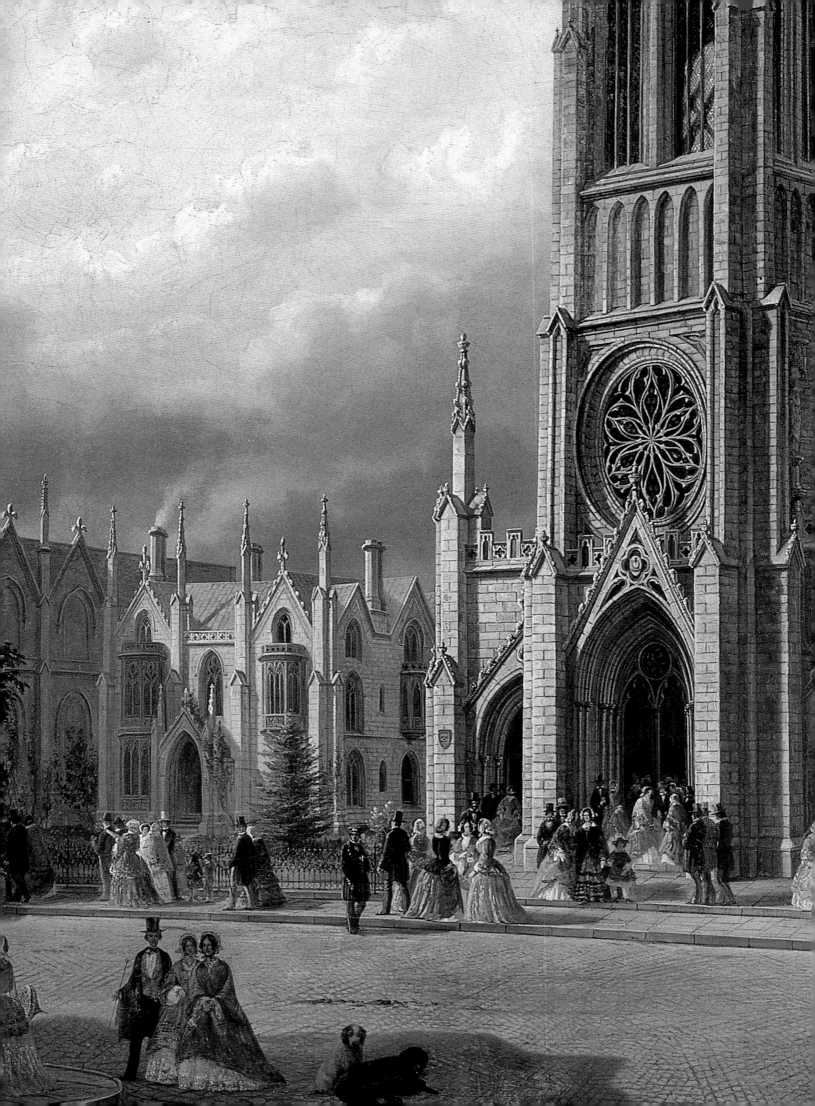

# Building the Empire City: Architects and Architecture

## MORRISON H. HECKSCHER

Compared with Boston, Philadelphia, and Washington, D.C., New York City in 1825 was an architectural backwater. The city had had no brilliant professionals like the native-born Charles Bulfinch or the immigrant Benjamin Henry Latrobe, no inspired amateur like Thomas Jefferson. It was not a capital city that could readily command monumental governmental structures; nor did the steady northward grasp of its street grid allow them many appropriately dramatic sites. Nevertheless, such was the city's rapid growth and accumulation of wealth over the next thirty-five years, such was its primacy as the commercial center of the nation, such was the sheer amount of building, that architects naturally gravitated there. By 1860, it is fair to say, New York had become the center of architectural activity in America; it was even the seat of the recently founded American Institute of Architects.[1]

The years 1825 through 1840, the heyday of the Greek Revival in New York, are best seen through the eyes and writings of Alexander Jackson Davis, illustrator and artist as well as architect.[2] Davis was born in New York City, but he was raised upstate and later trained as a printer in Alexandria, Virginia. By 1823 he was back in the city, where he studied at the American Academy of the Fine Arts and later at the Antique School of the National Academy of Design. His first job, beginning in 1825, was as an illustrator for A. T. Goodrich's pocket-sized visitors' guides; the next year, he worked as a draftsman for the architect Josiah R. Brady. In 1827 Davis went into business as an "Architectural Composer" (his listing in Longworth's city directory), supplying drawings on demand for builders and architects. At the same time, he began a more or less systematic effort to record the buildings of the city. As part of this project, he provided illustrations, principally of prominent new buildings, for *Views of the Public Buildings in the City of New-York,* an elegant folio of lithographs published by Anthony Imbert in 1827–28. Twelve of Davis's subjects were printed in the *Views,* eight in 1827 and four in 1828 (see cat. nos. 70–72). In addition, between 1827 and

1832, Davis drew public buildings for the *New-York Mirror,* including historic structures threatened with demolition. These images proved to be invaluable since nearly all the buildings he recorded were subsequently demolished. Finally, of course, there are Davis's own designs, as well as his voluminous daybooks and journals, all of which are rich sources of information concerning the world of New York architecture. In light of this valuable legacy, Davis probably looms somewhat larger in history than he did in life.

Davis's composite illustration for the September 1829 *New-York Mirror* (fig. 129), mostly taken from the Imbert lithographs, gives a fair summary of the city's public architecture at the time.[3] The stylistic extremes are represented by the overtly Roman Rotunda (top left), built in 1818 to exhibit John Vanderlyn's paintings, and possibly designed by the artist himself, and the decoratively Gothic Masonic Hall, 1825 (bottom right), by the landscape painter Hugh Reinagle. The other four images depict important buildings by the two most prominent architects in New York, Brady and Martin Euclid Thompson.

By the mid-1820s Brady was the elder statesman of the local architectural scene. Davis described him as "at that time . . . the only architect in New York who had been a practical builder and ingenious draughtsman, writer of contracts and specifications."[4] Most of Brady's designs, such as the Greco-Georgian-Gothic church that later became the B'nai Jeshurun Synagogue (fig. 129, lower left), tend toward the awkward or naive. Yet the classical facade of his Second Unitarian Church, Mercer Street, 1826 (cat. no. 72; fig. 129, upper right), "covered with a beautiful white cement, in imitation of marble,"[5] exhibits an unexpected monumentality and clarity, and must reflect the influence of Thompson, his sometime collaborator.[6] Although Thompson was more than a quarter of a century younger than Brady, the two worked well together. Davis captured the easy informality of their relationship when describing how, one day in 1826, Thompson entered Brady's office unannounced and whisked Davis

In thanks for many years of friendship and wise counsel, this essay is dedicated to the memory of Adolf K. Placzek, who, first as Avery Librarian at Columbia University and later as a member of the New York City Landmarks Commission, was a tireless advocate for the study and preservation of New York City's architectural patrimony. Let me also acknowledge the advice of Herbert Mitchell and Amelia Peck and, on all things Davisean, the late Jane B. Davies. For research assistance, my thanks to Kevin R. Fuchs, Jeni Lynn Sandberg, and Thomas Rush Sturges III.

1. For some of the most creative and thought-provoking writing about nineteenth-century American architecture, see William H. Pierson Jr., *American Buildings and Their Architects,* vol. 1, *The Colonial and Neo-Classical Styles* (Garden City: Doubleday, 1970), and vol. 2, *Technology and the Picturesque: The Corporate and the Early Gothic Styles* (Garden City: Doubleday, 1978). For New York City architecture from 1825 to 1850, Talbot Hamlin, *Greek Revival Architecture in America: Being an Account of Important Trends in American Architecture and American Life Prior to the War between the States* (London: Oxford, 1944; reprint, New York: Dover Publications, 1964), remains essential reading.

2. See Carrie Rebora, "Alexander Jackson Davis and the Arts of Design," in *Alexander Jackson Davis, American Architect, 1803–1892,* edited by Amelia Peck (exh. cat., New York: The Metropolitan Museum of Art and Rizzoli, 1992), pp. 23–39.

3. Alexander Jackson Davis, Daybook, [vol. 1], February 1828–September 1853, p. 69 (April 4, 1829), New York Public Library: "Six building[s] on a sheet of Bristol board, of a quarto size, for *Mirror* $12-." All but one of the images, the B'nai Jeshurun Synagogue, were originally issued in 1827 as lithographs by Imbert.

Fig. 129. Alexander Jackson Davis, *Public Buildings in the City of New York: Rotunda, Chambers Street; Merchants' Exchange, Wall Street; Second Unitarian Church, Mercer Street; B'nai Jeshurun Synagogue, Elm Street; United States Branch Bank, Wall Street; Masonic Hall, Broadway*, 1829. Wood engraving by William D. Smith, from *New-York Mirror and Ladies' Literary Gazette*, September 26, 1829, opp. p. 89. Collection of The New-York Historical Society

4. Quoted in Roger Hale Newton, *Town & Davis, Architects: Pioneers in American Revivalist Architecture, 1812–1870, Including a Glimpse of Their Times and Their Contemporaries* (New York: Columbia University Press, 1942), pp. 83, 92.

5. "Public Buildings," *New-York Mirror, and Ladies' Literary Gazette*, September 26, 1829, p. 90.

6. By contrast, Brady's contemporary John McComb Jr.—the architect, with Joseph-François Mangin, of the City Hall, about 1803–12, and the city's leading builder-architect for the first two decades of the century—never

away for another job: "As I was amusing myself in shading some prints of the city-hall in Mr Brady's office . . . Mr. Thompson, architect, called, and in his blunt way told me 'to pack up for a trip to the North.'"[7]

Thompson first appears in the city directories in 1816, as a carpenter; in 1823 he is listed as an architect-builder. By then his first major commission, the Branch Bank of the United States, 1822–24 (cat. no. 71; fig. 129, bottom center), was under construction on the north side of Wall Street, directly east of the old Custom House. His next, the Merchants' Exchange, on the south side of Wall Street, designed in conjunction with Brady, was begun in 1825.[8] The focus of its plan is the great trading room with apsidal ends

and flanking columns (cat. no. 75; fig. 130; see also cat. no. 251). These handsome marble-clad buildings, which transformed the face of Wall Street and, in the case of the Exchange, served as the preeminent symbol of the city's commercial importance, catapulted Thompson to prominence in his profession.

Thompson's two buildings exemplified the best of the eclectic classicism that then characterized the city's architecture. The Branch Bank was partly Palladian (the treatment of its three projecting center bays suggesting a pedimented portico) and partly Grecian (the orders and the molding profiles). The Exchange (cat. no. 74; fig. 129, top center) was, in broad outline, a larger version of the Bank, but all its details were

Grecian. The handling of the Exchange's three center bays, with colonnade and cupola, was closely modeled on contemporary English practice. All across England, in the years of peace, prosperity, and rapid urban growth after Waterloo, towns and cities felt the need for new public buildings—town halls, custom houses, post offices. An act of 1818 even authorized the expenditure of one million pounds on new church buildings, known as the "Commissioners' Churches."[9] To provide the requisite gravitas, these buildings were enlivened with Greek colonnades and antae (pilasters formed by thickening the end of a wall), full entablatures, and parapets. The same circumstances held true in burgeoning New York City, and with very much the same result. Thompson's Merchants' Exchange, for example, shares features with Francis Goodwin's Old Town Hall, Manchester, 1822–24: a broad, two-story block with giant-order Ionic columns screening a central entrance porch, the whole surmounted by a continuous entablature, an attic story, and a raised central dome.[10]

To keep abreast of the latest designs from London, New Yorkers consulted English books. For information on technology and construction, they depended on the builders' manuals published by Peter Nicholson; for facade treatments, they found models in books by Nicholson and William Pocock.[11] The illustrations in T. H. Shepherd's *Metropolitan Improvements* (London, 1827), a book promoting Regency London, were demonstrably influential. From one plate in Shepherd, for example, the ambitious young New Yorker Minard Lafever borrowed the facade of John Soane's Holy Trinity, Marylebone, 1826–27, and the circular tower of Robert Smirke's Saint Mary's, Wyndam Place, 1821–23, combining them as his own design for a church in the "Grecian Ionic Order," which appeared in his *Young Builder's General Instructor* (1829).[12] That the portico and tower of Lafever's church design have much in common with Thompson's Exchange reflects the similar British antecedents of both.

Meanwhile, in October 1825, Ithiel Town, an engineer, inventor, and architect from New Haven, arrived on the scene.[13] The establishment of Town's office would signal the beginning of a new era in New York architecture, for his influence would bring about two fundamental changes. The Regency eclecticism of most buildings would be replaced by an archaeologically correct Greek Revival style, introduced by Town. And the carpenter-builders who had been responsible for such buildings would give way to trained designers, as Town's office became the incubator for the fledgling architectural profession.

Just slightly older than Thompson, Town started out as a carpenter in Connecticut, worked a number of years with the Boston architect and builder Asher Benjamin, and then set up his own practice in New Haven. In 1816 he turned to bridge building and four years later took out a patent on a bridge truss, which soon made him wealthy. This circumstance enabled him to return to the practice of architecture in New Haven, but as a designer rather than as a builder, as well as to indulge his passion for books, scholarship, travel, and cultivated society. In 1824 Town designed a bank building in the form of a Greek Ionic temple, using as his inspiration engravings in the early volumes of James Stuart and Nicholas Revett's *Antiquities of Athens* (London, 1762–1830), the most influential source for the Greek Revival.

Once in New York, Town associated with prominent residents such as the artist and inventor Samuel F. B. Morse. When Morse organized the National Academy of Design in 1825, he invited Town, Thompson, and the sculptor John Frazee to be the founding members representing architecture. The next year Town built the New York Theatre (later renamed the Bowery Theatre), with facades on the Bowery and Elizabeth Street, his first structure in the city and the first there in the true Greek Revival style. His original design was for a hexastyle (six-column) Doric porticoed front, in the manner of a Greek temple; what was actually built (fig. 131) was a Doric distyle in antis (two columns between antae).[14]

The New York Theatre immediately spawned a number of eye-catching progeny, all porticoed like Doric temples but serving a variety of purposes: in 1827, Thompson's tetrastyle (four-column) Phenix Bank,

Fig. 130. Charles Burton, artist; Martin Euclid Thompson and Josiah R. Brady, architects, *Exchange Room, First Merchants' Exchange, 35–37 Wall Street*, ca. 1831. Sepia watercolor. Collection of The New-York Historical Society

gave up his attachment to the British tradition of Wren and Gibbs, of Adam and Chambers, shied away from the younger generation, and, by the mid-1820s, was out of the picture.

7. Alexander Jackson Davis, Pocket Diary, May 29, 1826, Metropolitan Museum, 24.66.1420.

8. For the Merchants' Exchange, see Lois Severini, *The Architecture of Finance: Early Wall Street* (Ann Arbor: UMI Research Press, 1983), pp. 31–36 (the first Exchange), 41–47 (the second). Some authors have considered the Exchange's original location, in the Tontine Coffee House, from 1782 to 1827, as the first Exchange, but that building was not purpose-built and probably should not be so regarded.

9. See John Summerson, *Architecture in Britain, 1530–1830*, 4th ed. (Harmondsworth: Penguin, 1963), pp. 305, 314–15.

10. For an illustration of the Old Town Hall, see ibid., pl. 212A.

11. For example, Peter Nicholson, *The New Practical Builder and Workman's Companion*, 2 vols. (London: Thomas Kelly, 1823–25), vol. 2, pl. 23: "Principal Elevation of a Chapel," 1823; and William Pocock, *Designs for Churches and Chapels . . .* (London: J. Taylor, 1819; [2d ed.], 1824), pls. 25–27. I am indebted to Herbert Mitchell for these references.

12. Minard Lafever, *The Young Builder's General Instructor . . .* (Newark, New Jersey: W. Tuttle, 1829), pl. 65. For Lafever's debt to Shepherd, see Jacob Landy, *The Architecture of Minard Lafever* (New York: Columbia University Press, 1970), p. 28.

13. For Town, see Newton, *Town & Davis*.

14. "The entire front is the boldest execution of the doric order in the United States, and is also more exactly according to the true spirit and style of the best Grecian examples in the detail, than any other specimen yet executed. Had there been six columns in front, as was originally intended by the architect, but prevented by a wish on the part of the proprietors for greater economy of room, this would unquestionably have been the most perfect as well as boldest specimen of Grecian Doric in the country." A. T. Goodrich, *The Picture of New-York, and Stranger's Guide to the Commercial Metropolis of the United States* (New York: A. T. Goodrich, 1828), p. 381.

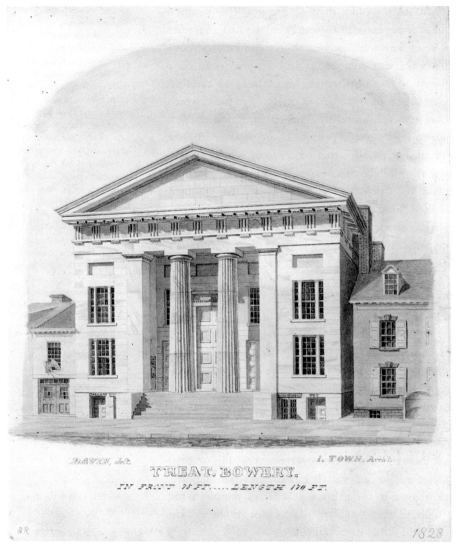

Fig. 131. Alexander Jackson Davis, artist; Ithiel Town, architect, *New York (Bowery) Theatre, Elizabeth Street Facade*, 1828. Watercolor. The Metropolitan Museum of Art, New York, The Edward W. C. Arnold Collection of New York Prints, Maps, and Pictures, Bequest of Edward W. C. Arnold, 1954 54.90.25

Davis credited Town with having introduced, during his first years in the city, a number of features that became important to the design vocabulary of New York buildings, including several that would come to typify the local style. He mentions not only temple-inspired porticoes (both hexastyle and distyle in antis) but also blocks of terrace housing, vertical stone piers for storefronts, and Doric or Ionic front doors for houses.[16] Thompson was clearly closely involved with Town in the introduction of the Greek Revival style. Indeed, during 1827–28 the two men were briefly in partnership together, with offices at 32 Merchants' Exchange, in Thompson's splendid new building. In 1828, at the National Academy, they jointly exhibited drawings for the Church of the Ascension. The same year, Davis moved his drawing practice nearby, to 42 Merchants' Exchange, and Goodrich's guide mentioned the "Architectural Room" of Town, Thompson, and Davis at the Exchange.

In his unswerving commitment to Town, Davis attempted to downplay Thompson's considerable talents:

> *Mr Town was the first to introduce a pure taste in classical architecture. . . . Mr Town was assisted by Thomas Rust, a draftsman, and associated with Martin E. Thompson, Builder, for a time. After Mr. Town withdrew from these, nothing creditable for an architect was designed or executed by them, which goes to prove that Mr. Town was possessed with invention, and a proper feeling for the beauties of moral classical art . . . the best Gothic also was introduced by Mr. Town.*[17]

15. When the New York Theatre burned in 1828, its replacement, the New Bowery Theatre, was built according to Town's original design.

16. As compiled by Davis and transcribed in Newton, *Town & Davis*, pp. 61–64.

17. Transcribed from Davis's Journal, p. 11, Metropolitan Museum, 24.66.1401; the Avery Architectural and Fine Arts Library, Columbia University, New York, version of the journal is quoted in Newton, *Town & Davis*, p. 60.

Wall Street; in 1828, Thompson and Town's hexastyle Church of the Ascension, Canal Street (fig. 132); and, also in 1828, Town's New Bowery Theatre.[15] Thereafter, the temple portico—popular icon of the Greek Revival—was widely accepted for buildings of all sorts. In June 1828 Davis made his own debut as an architectural designer with an ambitious and accomplished proposal for remodeling the old almshouse, which had been constructed in 1778 on the north side of City Hall Park, facing Chambers Street, and was then home to the National Academy of Design. He envisioned a hexastyle portico, placed in the middle of the long Chambers Street facade and leading into a central domed area; tetrastyle porticoes marked either end (cat. no. 73).

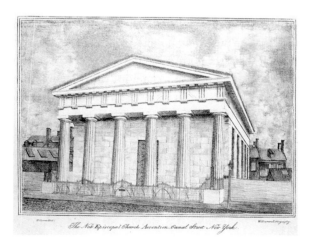

Fig. 132. Michael Williams, artist; Martin Euclid Thompson and Ithiel Town, architects, *Church of the Ascension, Canal Street*, ca. 1828. Lithograph. The Metropolitan Museum of Art, New York, Gift of Mary Knight Arnold, 1974 1974.673.45

By contrast, when Lafever illustrated the Church of the Ascension in his *Young Builder's General Instructor,* calling it "as good a model of the Grecian Doric order, if not superior, to any yet erected in this city," he gave exclusive credit for the design to Thompson.[18]

For whatever reason, probably the natural competition between two men of similar ages and talents, the Town-Thompson partnership did not outlast 1828, and the promising Thompson faded from center stage. Town turned instead to Davis. The two had known each other since 1827, and it was in Town's library, on March 15, 1828, that Davis had first studied Stuart and Revett's *Antiquities,* which led him to choose architecture as his calling.[19] At twenty-five, nineteen years Town's junior, Davis was artistic and romantic in temperament, a brilliant draftsman, and a compulsive archivist—everything Town, an engineer and inventor, was not. The partnership began on February 1, 1829, with a move into offices at 34 Merchants' Exchange and flourished for more than six years, with Town often traveling and Davis managing the office.[20] On a drawing of the Exchange's floor plan (cat. no. 75), Davis precisely delineated the office layout and even included his own bed. In the fall of 1829 Town left Davis in charge and set off on the Grand Tour (England, France, and Italy), which would give him firsthand experience of European architecture as well as the opportunity to purchase a great many books for his library (see "Private Collectors and Public Spirit" by John K. Howat in this publication, pp. 89–90). The urbanity Town gained during his travels was clearly reflected in the firm's schemes of the early 1830s.

Among the most remarkable things to come out of the Town and Davis office in those first, heady years from 1829 to 1831 were a number of splendid renderings by Davis of truly visionary designs. These proposals for various projects are characterized by screens of giant-order pilasters and continuous vertical strip windows, all in a distinctive, pared-down classical idiom. Included are designs for the Astor House (cat. nos. 77, 78), for a block of terrace houses (cat. no. 85), and for Thompson's Merchants' Exchange, shown as Davis would have designed it (cat. no. 76). On the last, the colonnade screens a veritable wall of glass— the vertical strip window (what Davis called his "Davisean" window) taken to its logical conclusion. None of these superbly creative abstract studies was built, and nothing else like them was dreamed of elsewhere in America; they were a century ahead of their time.

All told, in the early 1830s the Town and Davis architectural firm had no equal in New York. Town had his incomparable library and personal experience of the Grand Tour; Davis, the outstanding draftsman and artist, ran the office and welcomed students and other architects. The center for architectural activity in the city, the firm was as close to an atelier as then existed. As James Gallier, an Irish architect who first arrived in New York in April 1832, later recollected, "There was at that time, properly speaking, only one architect's office in New York, kept by Town and Davis."[21] In 1843, when Town briefly rejoined Davis, eight years after their partnership had been dissolved, a local periodical editorialized: "A large proportion of this improvement, so observable throughout our city and State, has been brought about by the unceasing exertions of ITHIEL TOWN and ALEXANDER J. DAVIS, to whose designs in villas, cottages, bridges and public buildings, we shall devote these articles. They occupy a commodious suite of rooms (No. 93) in the Merchants' Exchange, Wall Street, and possess the most valuable library in this country."[22]

During the years Town and Davis were together, they competed aggressively for almost every public building project in the city, winning a number, but by no means all, of the commissions for which they made submissions.[23] Their most important success was the Custom House on Wall Street, 1833–42, the principal United States government building erected in New York City in the years before the Civil War. The original design (cat. no. 81), a magnificent octastyle (eight-column) Greek Doric temple in white marble, is closely modeled on the Parthenon, except that antae replace the side columns and a ribbed dome rises up from the roof. The plan (cat. no. 80) is dominated by a great hall in the shape of a Greek cross. The section (cat. no. 79), one of Davis's most bravura renderings, is emblematic of his passion for the project. Town and Davis had no say in the actual construction of the Custom House, and Davis was deeply dismayed when, in the interests of economy and efficiency, the exterior dome and the inner row of portico columns were sacrificed. Construction was finally completed in 1842, and even in its reduced state, the building loomed magnificently at the head of Broad Street, overshadowing its old-fashioned neighbor, Thompson's Branch Bank (cat. no. 71). Today, the Custom House survives as Federal Hall.

The partners, Town in particular, also sought new business far and wide, winning commissions for the state capitols at Indianapolis, Indiana, 1831–35, and

18. Lafever, *Young Builder's General Instructor,* p. 83, pls. 10, 52.
19. Davis, Daybook, p. 13, New York Public Library.
20. Ibid., pp. 495–511.
21. James Gallier, *Autobiography of James Gallier, Architect* (Paris: E. Briere, 1864; reprint, New York: DaCapo Press, 1973), p. 18.
22. "The Architects and Architecture of New York," *Brother Jonathan,* May 20, 1843, p. 62.
23. Among Town and Davis's other executed New York City commissions were three churches and a Lyceum of Natural History (all Grecian), two public asylums (one Tuscan, one Gothic), and, with Dakin, the main building (Gothic) of the University of the City of New York (now New York University).

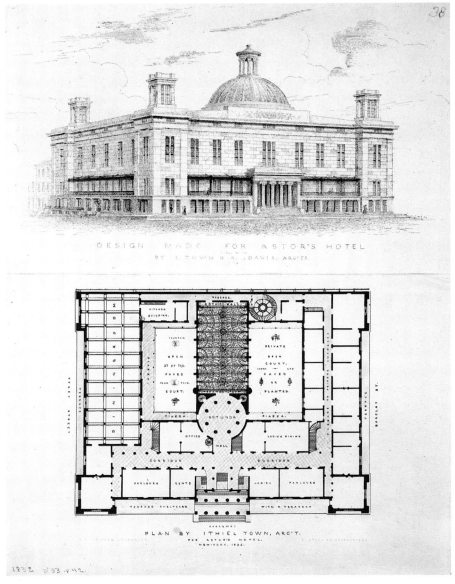

Fig. 133. Alexander Jackson Davis, artist; Ithiel Town and Alexander Jackson Davis, architects, *Design Made for Astor's Hotel*, 1834. Lithograph with watercolor highlights. The Metropolitan Museum of Art, New York, Harris Brisbane Dick Fund, 1924  24.66.1146

24. For the Tombs, see Richard G. Carrott, *The Egyptian Revival: Its Sources, Monuments, and Meaning, 1808–1858* (Berkeley: University of California Press, 1978), pp. 146–78.

25. William H. Eliot, *A Description of the Tremont House, with Architectural Illustrations* (Boston: Gray and Bowen, 1830).

Raleigh, North Carolina, 1833–40. They were unsuccessful in competing for the Patent Office in Washington, D.C., 1832–34, and (when no longer partners) for the state capitol at Springfield, Illinois, 1837. Worse yet, back home, they lost out on three of the greatest architectural competitions of the time—the Halls of Justice, the Astor House hotel, and a new Merchants' Exchange. These commissions went to two architects without prior connections to New York City, John Haviland of Philadelphia and Isaiah Rogers of Boston, each of whom was selected because he was an acknowledged expert in a specialized type of building.

In 1835 the city decided to build a new house of detention and held an open competition to select its designer. While the second premium was shared by two New Yorkers (one of them Davis), the first was won by Haviland, the internationally acclaimed architect of Philadelphia's Eastern State Penitentiary, 1821–36. Haviland's design for New York's Halls of Justice and House of Detention, popularly called The Tombs, 1835–38 (cat. nos. 82, 83), was the masterpiece of the Egyptian Revival in America.[24] He and his colleague, Thomas Ustick Walter (later one of the architects of the United States Capitol), had both recently employed the same style—thought to embody enlightened justice and eternal wisdom—in Philadelphia, the center of prison reform in the nation.

The process of selecting an architect for the Astor House hotel was more circuitous. John Jacob Astor, the richest man in America and a major owner of New York real estate, lived on the west side of Broadway, between Vesey and Barclay streets, facing the tip of City Hall Park—one of the city's busiest and most fashionable intersections. In 1831 he began to acquire adjacent lots for the purpose of building a hotel on the site. Town and Davis had already, during the previous year, made studies for a project called the Park Hotel at this location. These designs, some of their best and most creative, provide circumstantial evidence that they were working for Astor. In one (cat. no. 77), an austere colonnade of giant-order square columns recalls Karl Friedrich Schinkel's Altes Museum, Berlin, 1822–30, although no direct connection can be demonstrated. In another (cat. no. 78), Davis experimented with a Corinthian colonnade and a central dome; the multistoried, recessed "Davisean" fenestration, barely visible behind the columns, is characteristic of Davis's emerging style. In what must be their final scheme, judging from the fact that Davis had it engraved, Town did away with the colonnade in favor of projecting corner pavilions topped by square towers (fig. 133).

In the end, however, Astor chose to engage Rogers, the architect responsible for Boston's Tremont House, 1828–29, a hotel with a dignified exterior and innovative plan that had been made famous by William H. Eliot's laudatory monograph of 1830.[25] Astor charged Rogers to build a hotel that would best the Tremont in size, cost, and splendor—which Rogers proceeded to do. He devised an austere and monumental exterior of Quincy granite (fig. 134), with antae at the corners and a Doric porticoed entrance, and then lavished his attention on the hotel's plumbing and interior appointments. Erected between 1834 and 1836, the Astor House was surpassed in size and luxury (but not in architectural grandeur) by uptown hotels in the

early 1850s; it was demolished in part in 1913 and totally in 1926.

Rogers was still in New York at work on the Astor House in December 1835 when Thompson's seven-year-old Merchants' Exchange became the most high-profile victim of the great fire that laid waste a large area south of Wall Street and east of Broadway. Perfectly positioned to enter the competition for the replacement, Rogers ultimately won out over Town and Davis. However, his design—the Wall Street elevation with a magnificent raised Ionic colonnade, the whole surmounted by a central dome (fig. 135)—is very much in the Town and Davis idiom: for the colonnade and central dome, see one of their designs for the Astor House (cat. no. 78); for the raised colonnade, see John Stirewalt's 1833–34 drawing of the facade of their terrace-house project, La Grange Terrace (cat. no. 86). Only the Quincy granite, hard, gray, and resistant to weathering, was foreign to New York practice. Rogers remained in New York until 1841, supervising the construction of the Exchange, which was finally completed in 1842. It survives today, although surmounted by an additional story.

Few of the names of the students and apprentices who passed through the Town and Davis firm are recognizable today, but that does not lessen the influence of these acolytes in spreading wide the firm's classical style and professional practices, particularly in the South.[26] Best known of these is James H. Dakin, a carpenter from Dutchess County, New York.[27] In October 1829 Dakin began drawing under Davis's supervision, quickly becoming a skilled draftsman and watercolorist, very much in his master's manner. Between May 1832 and November 1833, when the firm was busy with major projects and exploring the possibility of establishing an office in Washington, D.C., to handle government commissions, Dakin was actually a partner in the firm. In addition to being involved in such major projects as the Custom House, the Astor House hotel, and La Grange Terrace, he was the principal designer of a number of public buildings, including the Greek Revival Washington Street Methodist Episcopal Church, Brooklyn, 1832, and the Gothic Revival main building of the University of the City of New York (now New York University), 1833 (fig. 136). During the same period he also prepared illustrations for Lafever's *Beauties of Modern Architecture*. Thereafter, Dakin opened his own office, where Gallier (who subsequently described him as a man of genius) briefly worked for him. Both architects soon left New York for New Orleans, and it is not surprising that the public buildings of the 1830s

and 1840s in that city and in New York are almost indistinguishable.

While neither a pupil of Town and Davis nor a Greek Revival architect of any note, Lafever was the author of the finest and most influential American pattern books of the Greek Revival style.[28] Born near Morristown, New Jersey, he settled as a carpenter-draftsman in Newark in 1824 and moved to New York City three or four years later. He and Gallier later opened an architect's office together, Gallier recalling

26. Davis took seventeen students between 1829 and 1861, according to Mary N. Woods, *From Craft to Profession: The Practice of Architecture in Nineteenth-Century America* (Berkeley: University of California Press, 1999), p. 62.

27. For Dakin, see Arthur Scully Jr., *James Dakin, Architect: His Career in New York and the South* (Baton Rouge: Louisiana State University Press, 1973).

28. For Lafever, see Landy, *Architecture of Minard Lafever*.

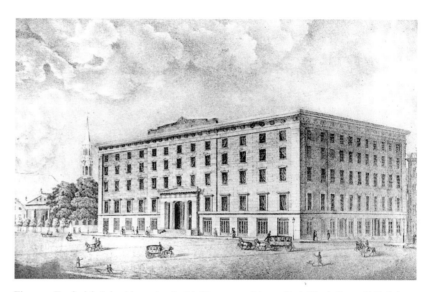

Fig. 134. Frederick Schmidt, artist; Isaiah Rogers, architect, *Park Hotel (Later Called the Astor House), Broadway between Vesey and Barclay Streets,* 1834. Lithograph by George Endicott, from I. N. Phelps Stokes, *The Iconography of Manhattan Island* (New York: Robert H. Dodd, 1918), vol. 3, pl. 22a. The Metropolitan Museum of Art, New York, The Thomas J. Watson Library

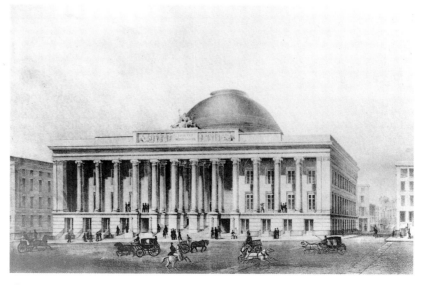

Fig. 135. Cyrus L. Warner, artist; Isaiah Rogers, architect, *Second Merchants' Exchange, 31–37 Wall Street,* 1837. Lithograph by John H. Bufford, from I. N. Phelps Stokes, *The Iconography of Manhattan Island* (New York: Robert H. Dodd, 1918), vol. 3, pl. 118. The Metropolitan Museum of Art, New York, The Thomas J. Watson Library

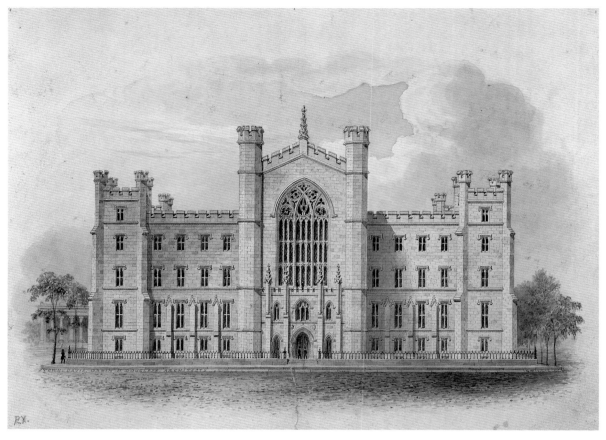

Fig. 136. Alexander Jackson Davis, artist; Ithiel Town, Alexander Jackson Davis, and James H. Dakin, architects; David B. Douglass, engineer, *University of the City of New York (now New York University), Washington Square, Facade of Main Building,* ca. 1833. Watercolor. The Metropolitan Museum of Art, New York, The Edward W. C. Arnold Collection of New York Prints, Maps, and Pictures, Bequest of Edward W. C. Arnold, 1954  54.90.24

29. Gallier, *Autobiography,* p. 20.

30. Lafever, *Young Builder's General Instructor,* p. 83.

31. In the caption to plate 32 of *The Beauties of Modern Architecture, Illustrated by Forty-eight Original Plates Designed Expressly for This Work* (New York: D. Appleton, 1835), Lafever acknowledged the work of "Mr. James H. Daken [*sic*], whose talents, taste and ideas, are of the first order, and by the writer held in very high esteem."

32. Minard Lafever, *Modern Builders' Guide* (New York: Henry C. Sleight, Collins and Hannay, 1833), preface, p. 4.

that "we obtained from the builders orders for as many drawings as we could well make; but I found it very disagreeable work, and so badly rewarded."[29] Gallier ultimately resolved his frustrations by moving to New Orleans, Lafever by preparing architectural books.

Lafever's first book, *The Young Builder's General Instructor,* promoted a version of the eclectic Greco-Roman classicism then being practiced in England by architects such as Soane and Smirke. In New York in 1829, however, the pure Greek Revival mode introduced by Town had begun to supersede this style. In fact, Lafever's praise in the *General Instructor* for Thompson's Greek Doric Church of the Ascension[30] and Phenix Bank has the feel of an afterthought and suggests he realized that the book was out of date even before its publication. Lafever actually withdrew the *General Instructor* from print and produced instead two handsome volumes targeted to promote the authentic Greek Revival to builders of New York row houses.

Lafever's *Modern Builders' Guide* came out in 1833 and went through seven editions by 1855; *The Beauties of Modern Architecture* was issued in 1835. Both books contained compilations of previously published material: technical texts from Nicholson, descriptions of major monuments from Stuart and Revett, and plates depicting Greek temples and details of the Greek orders. What was new and important about them, however, were the Grecian designs for use in town houses (a number drawn by Dakin),[31] both for front doors and for parlor fittings, including walls, windows, and columnar screens, all ornamented with great imagination and beauty. Lafever's elegant palmettes and anthemia quickly became the canon for Greek Revival ornament throughout America. Although Lafever acknowledged having consulted with Brady and Thompson,[32] he made no mention of Town or Davis, the rival faction. Ironically, Lafever built only one significant classical building, the First Reformed Dutch Church, Brooklyn, 1834–35; his fame as an architect rests on Gothic Revival churches.

During the period 1825 through 1861 housing was the bread and butter of New York's building business. As the city's population swelled, so did the demand for new houses—row after row on street after street. The city's grid plan, adopted in 1811 and calling for

cross streets just two hundred feet apart, led to standardized building lots of twenty-five by one hundred feet, as well as to relatively standardized facades. City guidebooks delighted in reporting the number of new houses built in a given year. In 1828 Goodrich estimated a total of thirty thousand houses in the city, up from seventeen thousand in 1817—an average of nearly twelve hundred new houses per year, enough to fill twenty city blocks. The great majority of these houses were modest, two-story affairs, but some were fine, first-rate dwellings, three or four stories in height.[33]

Construction of houses was, for the most part, the realm of the builder rather than the architect. Longworth's directory for 1831–32 listed eighty-two builders in New York; drawings exist that depict the row houses built by two of these, Samuel Dunbar and Calvin Pollard,[34] and there is documentation concerning the involvement in housing projects of three others—Gideon Tucker, John Morss, and Seth Geer.

As New York grew and its commercial and industrial areas expanded downtown, so its fashionable residential areas moved inexorably uptown. Traditionally, the

Fig. 137. Attributed to Martin E. Thompson, *Columbia College, Plot Plan for Chapel Street Houses,* 1830. Ink. Avery Architectural and Fine Arts Library, Columbia University, New York

best houses had been found on State Street, facing the Battery, and around Bowling Green. That focus changed about 1820, and over the next fifteen years, the entire area west of Broadway and north to Canal Street was built up with fine houses.

Columbia College's development of lands adjacent to its campus, a two-block area west of Broadway and City Hall Park, is a case in point. What distinguishes this project is not the architecture, which is typical, but the survival of a number of drawings (attributed to Thompson) that shed a great deal of light on the domestic architecture of the period.[35] On the plot plan (fig. 137), a row of houses is laid out on the west side of Chapel Street, between Murray and Robinson streets; at first six houses were contemplated, each twenty-nine feet wide, but this was changed to seven, each twenty-five feet wide. A rendering of the seven facades (cat. no. 87) was endorsed, on April 1, 1830, by William Johnston, Columbia's treasurer, and by the builders, Tucker and Morss. The facades are little different from those found on turn-of-the-century New York houses in the Federal style, except that one, at the far left, has a front door flanked by Greek Doric columns, a motif that is repeated in the more detailed drawing for a single house on Columbia's land (cat. no. 88). This Doric entrance clearly derives from the distinctive New York domestic doorway that Town had introduced about 1828. Although the neighborhood developed by Columbia was popular for a short while, the building of Astor's hotel on nearby Broadway was the death knell for the area as a residential enclave.

The spread of first-rate housing north of Houston Street was to continue with little change until midcentury. Exemplifying this process was the development, between 1831 and 1833, of a group of handsome four-story brick houses on the north side of Washington Square, known as The Row (made famous by Henry James, and still intact). By 1835 fine houses were being built south and east of the Square, on Bleecker, Bond, and Great Jones streets, and on Lafayette and Saint Mark's places. West of the Square, in Greenwich Village, more modest dwellings were the norm, and these survive in considerable numbers today.

Typical of the later houses in the area north of Houston is one built in 1844–45 for Samuel Tredwell Skidmore at 369 Fourth Street (now 37 East Fourth Street), just three lots east of the house of his cousin Seabury Tredwell (now the Merchant's House Museum, 29 East Fourth Street), which had been erected in 1831–32. To prepare drawings and specifications for the house (figs. 138, 139), Skidmore employed Thomas

33. For New York City houses, see Charles Lockwood, *Bricks and Brownstone: The New York Row House, 1783–1929, an Architectural and Social History* (New York: McGraw-Hill, 1972).

34. The Dunbar drawings are at the Museum of the City of New York and Pollard's are at the New-York Historical Society.

35. Hamlin, *Greek Revival,* p. 136.

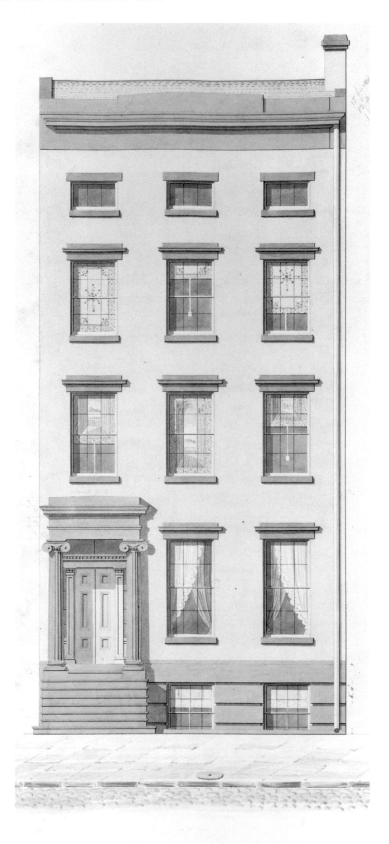

. Principal . Elevation .

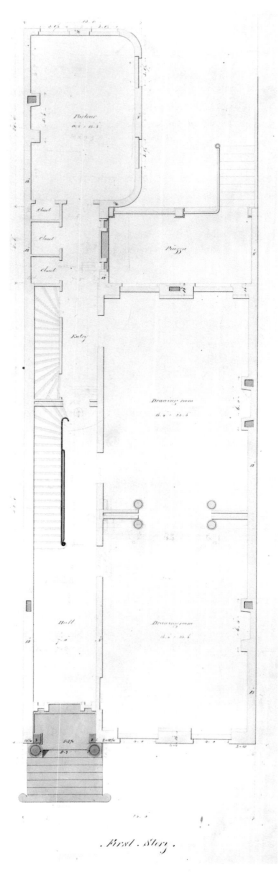

. First Story .

Fig. 138. Thomas Thomas and Son, *Samuel T. Skidmore House, 369 Fourth Street, Principal Elevation*, 1844. Ink and watercolor. Courtesy of The Winterthur Library, Winterthur, Delaware, Joseph Downs Collection of Manuscripts and Printed Ephemera 70X30.1

Fig. 139. Thomas Thomas and Son, *Samuel T. Skidmore House, 369 Fourth Street, Floor Plan*, 1844. Ink and watercolor. Courtesy of The Winterthur Library, Winterthur, Delaware, Joseph Downs Collection of Manuscripts and Printed Ephemera 70X30.2

Thomas and Son, one of a number of new firms of English immigrant architects.[36] The plans for the house, which was brick with brownstone trim, are much more complete than those drawn up for Columbia College fourteen years earlier. Both show similar facades, however, except that the Skidmore house does not have the pitched roof of the Columbia design.

Town and Davis did not usually involve themselves in the building of everyday residences, but they were fascinated with the problem of designing a group of houses as a unified whole, the so-called block or terrace, in order to achieve monumentality. Davis credited Town with the first such block development in New York, citing Town's 1828 project on Greenwich Street for Henry Byard.[37] Although no image of that project survives, the partners' keen interest in such designs is suggested by entries in Davis's accounts for 1830 and 1831 (referring, for example, to a "study for a block of dwelling Houses/Ionic/chaste")[38] as well as by a number of Davis's own drawings. Their favored facade treatment for residential blocks may be seen in the proposal for Syllabus Row (cat. no. 84), a seventeen-bay, seven-house design, and in the dramatic perspective of a cross-block terrace development (cat. no. 85), sixteen bays and eight houses per side. In both, a rusticated ground floor is surmounted by giant-order pilasters between the second- and third-story windows and by an all-encompassing full entablature.

The same facade treatment, except for the "chaste" Ionic pilasters having been replaced by richly carved freestanding Corinthian columns, is found on the most famous of all the New York terrace-house projects, La Grange Terrace, begun in 1832 on Lafayette Place, due east of Washington Square, and surviving in part today. Described in 1833 as "the terrace, *par excellence*,"[39] it was developed and constructed by Geer, the city's leading builder. Davis's accounts indicate that Geer paid him handsomely for the designs.[40] The only extant drawing (cat. no. 86), by John Stirewalt, who was in Davis's employ from November 1833 to April 1834, shows the facade as executed, except that the roof terrace was not built and the final design had a width of twenty-eight rather than eighteen bays. Similar freestanding Greek Revival structures, with comparable colonnades or temple porticoes, were being designed at the same time for country houses, among them the Matthew Clarkson Jr. mansion, built in Flatbush, Brooklyn, about 1835 (cat. no. 89A, B).

The layout of the New York row house followed a standard convention that had been adopted to accommodate the exigencies of the long, narrow lots resulting from the 1811 grid. The basement, with the kitchen,

36. The drawings and specifications are in the Joseph Downs Collection of Manuscripts and Printed Ephemera, Winterthur Library, Henry Francis Du Pont Winterthur Museum, Winterthur, Delaware. The specifications include estimates from the mason (David Lauderback, $5,900) and the carpenter (W. Ellis Blackstone, $5,200). See also Carol Emily Gordon, "The Skidmore House: An Aspect of the Greek Revival in New York" (Master's thesis, University of Delaware, Newark, 1978).

37. Newton, *Town & Davis,* p. 63.

38. Davis, Daybook, March 1, 1830, p. 89, New York Public Library.

39. *Atkinson's Casket* 8 (November 1833), p. 505.

40. In April 1832, $30 for "drawing La Grange Terrace, Lafayette Place, so named by me, for Seth Geer . . . Perspective view" (Davis, Daybook, p. 131, New York Public Library); between May and October, $200, of which he paid Dakin $100, for "designs and drawings for the interiors of La Grange Terrace" (Davis, Journal, p. 26, Metropolitan Museum, 24.66.1400).

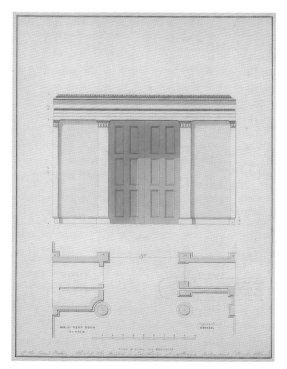

Fig. 140. Alexander Jackson Davis, *Columnar Screen Wall between Parlors, Plans and Elevation,* ca. 1830. Ink and watercolor. The Metropolitan Museum of Art, New York, Harris Brisbane Dick Fund, 1924  24.66.612

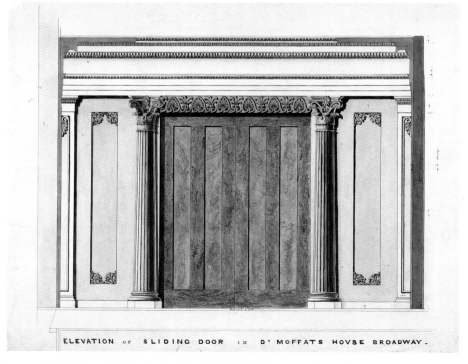

Fig. 141. Calvin Pollard, *Parlor Sliding Door, Dr. Moffat's House, Broadway, Elevation,* 1844. Ink and watercolor. Collection of The New-York Historical Society, Pollard Collection  44

was half below grade. The raised first floor was reached by outside steps along one side (the traditional New York stoop), leading to the front door and a long, narrow stair hall from which doors opened into a pair of large, matching parlors (see fig. 139). In houses of the 1820s, the parlors were nearly square and separated by pairs of closets with folding doors between them. By 1830, in the larger Greek Revival houses, the matching parlors were much longer and were separated only by a narrow wall that encased a pair of sliding double doors, flanked by pairs of Ionic or Corinthian columns. Davis, in a drawing from about 1830 (fig. 140), proposed a number of different ways to link matching parlors. Beneath an elevation showing sliding mahogany doors and flanking pilasters are two alternate plans: at the left, a wall cut away to accommodate a column and, at the right, a freestanding column.

The canonical solution to linking two parlors—pairs of columns flanking sliding doors—is seen in the plan of the Skidmore house (fig. 139) and also in an elaborate rendering of the same date for the house of a Dr. Moffat on Broadway (fig. 141). Designed by Pollard, now risen from builder to architect, the Moffat house has Corinthian columns and a band of carved anthemia in the architrave above the door opening, both of which come directly from Lafever's *Beauties of Modern Architecture*. A columnar screen treatment following Davis's suggestion to carve away part of a wall appears in Francis H. Heinrich's group portrait of about 1850 of the Fiedler family in their parlor at 38 Bond Street (fig. 211), probably the most faithful contemporary illustration of the parlors of a New York Greek Revival town house. And the same architect's famous idealized portrayal of a pair of Greek Revival parlors (cat. no. 112) depicts two pairs of Ionic columns, without doors, an unusual treatment found only in the grandest of houses, such as those of La Grange Terrace (cat. no. 86).

The year 1835 was the last in which Town and Davis dominated the city's architectural community: on May 1, just after Town received his second engineering patent and went back to bridge building, they terminated their partnership, and on December 16 Davis was burned out of his office in the Great Fire. On May 1 of the next year Davis settled permanently into new quarters in the building recently completed for the University of the City of New York, to the designs of Town and Dakin, on Washington Square (fig. 136).

On his own, Davis would maintain an active practice, designing statehouses, asylums, libraries, and other public buildings, but he would not adapt in the following decades to the wrenching changes taking place in New York City, particularly in the commercial and residential spheres. Increasingly, Davis's attention would turn to domestic architecture, which offered him the best opportunity to pursue his love of the picturesque. As early as 1834 he had begun designing Gothic villas for sites overlooking the Hudson River, and in 1837 he published *Rural Residences* "with a View to the Improvement of American Country Architecture."[41]

In some ways, *Rural Residences* was similar to Davis's *Views of the Public Buildings in the City of New-York* from a decade before; both were lavishly produced, issued in parts, and never completed. But in others it was a new kind of publication—a house pattern book, offering prospective clients choices of styles and floor plans—distinct from, for example, Lafever's manuals for builders and carpenters. Realizing the potential of such an idea, the landscape architect Andrew Jackson Downing of Newburgh, New York, promptly engaged Davis to provide illustrations for his forthcoming *Treatise on the Theory and Practice of Landscape Gardening, Adapted to North America . . . with Remarks on Rural Architecture* (1841). As a result, woodcut illustrations of Davis's designs were widely disseminated, both in the *Treatise* and in Downing's two succeeding volumes, *Cottage Residences* (1842) and *The Architecture of Country Houses* (1850). Davis's 1855 design for Ericstan (cat. no. 102), John J. Herrick's castleated villa at Tarrytown, exemplifies this side of his work.

It is perhaps symptomatic of Davis's resistance to change that the two grandest houses built in New York in the mid-1840s, both of which were designed by him, were dinosaurs from day one. John Cox Stevens's magnificent classical palace, built in 1845, was downtown on College Place, an area already going commercial. William C. H. Waddell's Gothic villa on Fifth Avenue and Thirty-eighth Street, from the previous year, was squarely in the line of much denser residential development. Built in the wrong place at the wrong time, both mansions would be demolished within a decade.

No picture of New York's architecture in the 1830s and 1840s would be complete without mention of the massive distributing reservoir built on Murray Hill. Located on the west side of Fifth Avenue, between Fortieth and Forty-second streets, the highest ground in the vicinity, the reservoir was completed in 1842. With its forty-foot-high brick walls, battered in the Egyptian Revival manner, it was the only visual manifestation within the city of the Croton Aqueduct,

41. From the dedication in Alexander Jackson Davis, *Rural Residences* (New York: The Author, 1837).

an altogether unprecedented public-works project. The cholera epidemic of 1832 had finally forced the city to confront its chronic failure to provide a reliable, safe water supply. In 1834 the legislature passed an act to supply the city with "pure and wholesome water"; in 1835 the Croton River, forty miles away in Westchester County, was selected to be the source; and in 1836 John B. Jervis was made chief engineer of the Croton Aqueduct. When completed, the remarkably extensive system spanned forty miles and encompassed the Croton Dam, a bridge at Sing Sing, another over the Harlem River (High Bridge), sixteen tunnels, 114 culverts, thirty-three ventilators, six waste weirs, and the reservoir. The drawings from Jervis's shop—including artistic renderings of the distributing reservoir (cat. no. 90) and engineering presentations of High Bridge (cat. no. 91) and a pipe chamber (cat. no. 92)—are works of art in themselves. Combining architecture and engineering, they indicate the high degree of professionalism required to effect the urban improvements vital to the welfare of the nineteenth-century city.[42]

Several developments from the 1830s through the 1850s continued to advance the movement toward architectural professionalism. In the early 1830s the great majority of American architects were native-born artisans, coming from the ranks of carpenter-builders. The best of them relied on self-education and perseverance to meet the challenge of designing and executing public buildings of an unprecedented size and complexity. Thompson and his Merchants' Exchange and Town and Davis and their Custom House are but two instances. Such men ultimately developed interests in common with office-trained professionals such as the Philadelphia architects Haviland, originally a pupil of James Elmes in London, and William Strickland, a pupil of Latrobe. In December 1836 twenty-three American architects—including eight from New York (among them Town, Davis, Lafever, and Rogers), five from Boston, and four from Philadelphia—met at the Astor House with the goal of forming an association, to be known as the American Institution of Architects, that would aim to promote professionalization in the practice of architecture. Strickland was to be president, Davis vice president, and Thomas Ustick Walter secretary. In the end, however, nothing came of the effort, in part because of the financial panic of 1837, in part because of rivalries between Philadelphia and New York. It would be another twenty years before the time would be ripe for such a society.[43]

Concurrent with these efforts at organization was an influx of trained architects from abroad, which would irrevocably alter New York's architectural complexion. Those newcomers who stayed and thrived would be active participants in the commercial and residential growth of the city. The first wave was from England: in 1833 Thomas Thomas; in 1838 his son Griffith; about 1835 Frederick Diaper; and in 1839 Richard Upjohn. The second was from the Continent: in 1843 Leopold Eidlitz, trained in Vienna; and in 1848 Detlef Lienau, trained in Berlin and Paris. The third was, again, from England: in 1852 Jacob Wrey Mould and Frederick Withers; and in 1856 Calvert Vaux (the last two came to New York after first working for Downing in Newburgh).

And, of course, there was Gallier, who succinctly recalled the New York architectural scene on his arrival from Ireland in 1832:

> The majority of people could with difficulty be made to understand what was meant by a professional architect; the builders, that is, the carpenters and bricklayers, all called themselves architects, and were at that time the persons to whom owners of property applied when they required plans for building; the builder hired some poor draftsman, of whom there were some half dozen in New York at that time, to make the plans, paying him a mere trifle for his services.

But, Gallier added, "All this was soon changed . . . and architects began to be employed by proprietors before going to the builders; and in this way, in a short time, the style of buildings public and private showed signs of rapid improvement."[44]

It was Upjohn who would prove to be the single most influential of New York's immigrant architects.[45] Like Town a generation before, he would act as a catalyst by transforming architectural styles and by elevating the practice of architecture to a new level of professionalism. In particular, he introduced the true Gothic Revival to American church architecture.[46] Symbolic, perhaps, of the pending changes in architectural style, building materials, and geographic location was the fate of Town and Thompson's trendsetting Church of the Ascension on Canal Street (fig. 132). Destroyed by fire in 1839, the year of Upjohn's arrival in New York, this marble structure with a Greek-temple facade was rebuilt by Upjohn in 1840–41 in brownstone in the Gothic Revival style, on Fifth Avenue and Tenth Street.

Upjohn had left England for America in 1829 and had lived in Boston from 1834 to 1839. In 1835, while working for the architect Alexander Parris, he had met Dr. Jonathan Mayhew Wainwright, rector of Trinity

42. For the Croton Aqueduct, see *The Old Croton Aqueduct: Rural Resources Meet Urban Needs* (Yonkers: Hudson River Museum of Westchester, 1992).

43. Woods, *From Craft to Profession*, pp. 28–32.

44. Gallier, *Autobiography*, p. 18.

45. For Upjohn, see Everard M. Upjohn, *Richard Upjohn and American Architecture* (New York: Columbia University Press, 1939).

46. For the Gothic Revival, see Phoebe B. Stanton, *The Gothic Revival and American Church Architecture: An Episode in Taste, 1840–1856* (Baltimore: Johns Hopkins University Press, 1968; reprint, 1997).

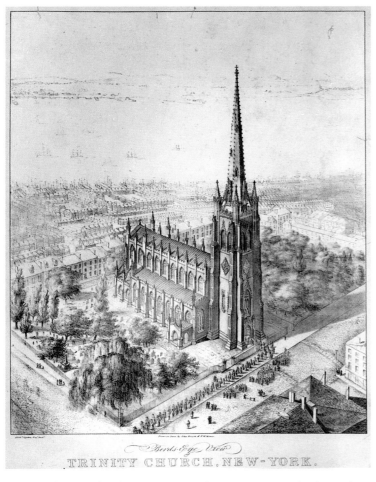

Fig. 142. John Forsyth and E. W. Mimee, *Bird's-Eye View, Trinity Church, Broadway, opposite Wall Street*, 1847. Lithograph. The Metropolitan Museum of Art, New York, Gift of Mrs. Edmund R. Burry, 1948  48.132.31

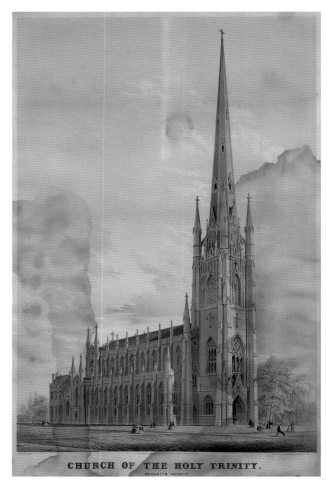

Fig. 143. Fanny and Seymour Palmer, artists; Minard Lafever, architect, *Church of the Holy Trinity, Brooklyn* (now St. Ann and the Holy Trinity Church), ca. 1844. Lithograph. Collection of St. Ann and the Holy Trinity Church, Brooklyn

47. A. W. N. Pugin, *The True Principles of Pointed or Christian Architecture Set Forth in Two Lectures Delivered at St. Marie's, Oscott* (London: J. Weale, 1841), ill. p. 50.

48. Quoted in *Catalogue of Ferdinand Richardt's Gallery of Paintings of American Scenery, and Collection of Danish Painting Exhibited at the Rooms of the National Academy of Design, Tenth Street, between Broadway and Fourth Avenue* (New York, 1859). I am indebted to Lynn Hoke, Assistant Archivist, Grace Church, for this reference.

Church in Boston. When Wainwright accepted the post of rector of Trinity Church in New York, three years later, and discovered that the church building was dangerously unstable, he naturally called on Upjohn for help. And when the decision was made to build anew, Upjohn was engaged for the task.

There had been a few modest attempts at serious Gothic Revivalism in the city—witness Saint Peter's, Chelsea, 1836–38, by the poet and amateur architect Clement Clarke Moore—but nothing to compare with the size, richness, and erudition of Upjohn's new Trinity Church, located on Broadway, facing Wall Street. Upjohn submitted his first studies in September 1839, but it would be two years before the design was finalized (cat. no. 93) and the cornerstone laid, and nearly seven before the church was consecrated, on May 21, 1846. A bird's-eye view of the completed building (fig. 142) shows it towering over the city.

A devout Anglican, Upjohn viewed churches both as sacred vessels and as buildings having a pragmatic purpose. He thus sought out those specific features of Gothic churches—principally the long, high nave with clerestory windows, side aisles, and a chancel—that would serve the contemporary liturgical needs of the Episcopal Church. Ironically, this kind of functional Gothic Revival style was chiefly promulgated through the writings of the English Catholic convert A. W. N. Pugin. In fact, the executed design for Trinity bears a striking resemblance to the illustration of an "ideal church" in Pugin's *True Principles of Pointed or Christian Architecture*, published in London early in 1841.[47] Upjohn was obviously au courant with the latest developments in English church architecture.

Trinity was the oldest and richest Anglican parish in New York, and its new building had a profound impact on the numerous churches being constructed in the city. First to feel its effect was Grace Church, Trinity's immediate neighbor on Broadway. In the early 1840s, following its fashionable congregation uptown, Grace secured a dramatic site at the bend of

Broadway at Tenth Street; in 1843 the church hired James Renwick Jr. to design its new building. Renwick, later famous as the architect of Saint Patrick's Cathedral, was at this time only twenty-five years old. The son and namesake of a distinguished professor of natural philosophy at Columbia, he created for Grace a masterly essay in the Gothic Revival style. Grace followed Trinity in its general conception (central entrance tower, high nave, chancel), but the two buildings differed dramatically in appearance. Renwick's use of white marble and allover decoration produced an effect that was light, airy, and elegant, while Upjohn's use of brownstone was massive, enclosed, and severe: the connoisseur as opposed to the doctrinaire. Ferdinand Joachim Richardt's painting of Grace (cat. no. 95), described as "taken from 10th street and represent[ing] the congregation leaving the church at the end of Sunday afternoon service,"[48] was exhibited in 1859 at the National Academy, virtually next door on Tenth Street.

Trinity and Grace were but the largest and most elaborate of dozens of important Gothic Revival churches built in New York during the 1840s and 1850s. Lafever, although best remembered for his Greek Revival pattern books, made a specialty of them, particularly in Brooklyn. His masterpiece was the large and luxurious Holy Trinity, Brooklyn Heights, 1844–47 (fig. 143), noted for its exceptional stained-glass windows by William Jay Bolton (see cat. no. 280).

In 1846, having just made his name with Grace Church, Renwick was commissioned by a newly formed congregation to build the Church of the Puritans at the southwest corner of Broadway and Fifteenth Street, on Union Square. His design for the handsome twin-towered facade (cat. no. 94), a characteristic French Gothic formula, was inspired by the famous Abbey Church of Saint-Denis, near Paris, but with one major change. Renwick transformed the pointed Gothic windows of the French church into round-arched ones, thus giving Manhattan its first Romanesque church. In this he was following Upjohn's lead at another Congregational church, Brooklyn's Church of the Pilgrims, 1844, in which the architect had selected the Romanesque style as most appropriate for the nonliturgical Congregationalists.[49] Closer to the heart of the Empire City, Eidlitz, who had come from Vienna just three years before, was beginning a vast Romanesque hall for Saint George's in Stuyvesant Square.

Trinity and Grace stood like magnificent Gothic bookends south and north on Broadway, but in between, all was business. What had been in the 1820s

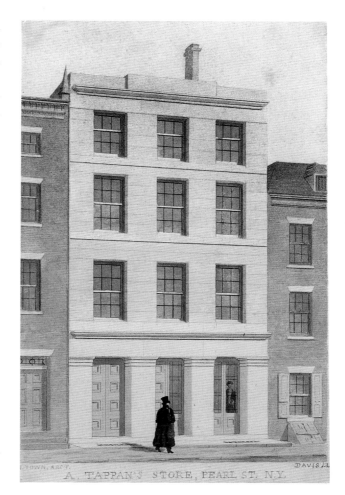

Fig. 144. Alexander Jackson Davis, artist; Ithiel Town, architect, *Arthur Tappan Store, 122 Pearl Street,* ca. 1829. Watercolor. The Metropolitan Museum of Art, New York, The Edward W. C. Arnold Collection of New York Prints, Maps, and Pictures, Bequest of Edward W. C. Arnold, 1954  54.90.123

the most fashionable residential street in town became during the 1840s the center of retail commerce. Along its sidewalks stretched a great chain of department stores and hotels, a mix of new building types and old architectural styles, a whole new architecture of commerce.[50]

It all began with A. T. Stewart, the retail genius who had come to New York from Ireland in 1818.[51] In 1846, after having operated dry-goods stores out of existing buildings on three different Broadway sites, Stewart constructed his famous Marble Palace on the southeast corner of Broadway and Reade Street. Prior to this, most New York storefronts, whether purpose-built or inserted in existing row houses, were of a distinctive post-and-lintel construction in which one-piece granite posts supported granite lintels. The prototype had been introduced in 1829 with Town's building at 122 Pearl Street for the store of Lewis and Arthur Tappan (fig. 144). Stewart's structure was

49. The connection between the two churches is noted in Gwen W. Steege, "The *Book of Plans* and the Early Romanesque Revival in the United States: A Study in Architectural Patronage," *Journal of the Society of Architectural Historians* 46 (September 1987), p. 217. It was also the subject of a lecture by William H. Pierson Jr., entitled "James Renwick's Church of the Puritans," and given at Grace Church, New York, October 5, 1996.

50. Broadway is the focus of Ellen W. Kramer's brilliant overview of New York City at midcentury, "Contemporary Descriptions of New York City and Its Public Architecture ca. 1850," *Journal of the Society of Architectural Historians* 27 (December 1968), pp. 264–80.

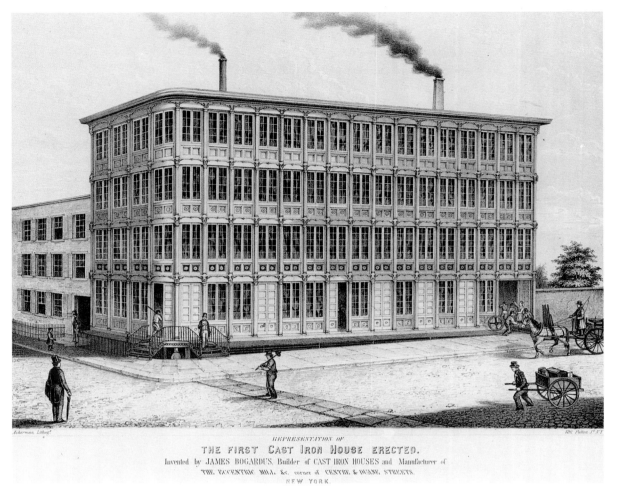

REPRESENTATION OF

THE FIRST CAST IRON HOUSE ERECTED.

Invented by JAMES BOGARDUS, Builder of CAST IRON HOUSES and Manufacturer of

THE ECCENTRIC MILL, &c. corner of CENTRE & DUANE STREETS.

NEW YORK.

Fig. 145. James Ackerman, artist; James Bogardus, architect, *James Bogardus's Factory: "The First Cast-Iron House Erected,"* 1849 or 1850. Lithograph. Museum of the City of New York, Gift of Mrs. Elon Hamilton Hooker  39.339

51. For the New York department store, see Winston Weisman, "Commercial Palaces of New York: 1845–1875," *Art Bulletin* 36 (December 1954), pp. 285–302.

52. *Broadway Journal,* March 22, 1845, p. 188. For Trench and Snook, see Mary Ann Smith, "John Snook and the Design for A. T. Stewart's Store," *New-York Historical Society Quarterly* 58 (January 1974), pp. 18–33.

53. *Broadway Journal,* March 22, 1845, p. 188.

revolutionary in several ways. It introduced both a new building type to New York, the purpose-built department store, and a new architectural style, the Anglo-Italianate, or palazzo, based on the architecture of London clubs. It was also the first dry-goods store to have exterior walls clad in marble and huge plate-glass windows protected by rolling cast-iron shutters (such windows had become practical when the duty on glass was repealed in London in 1845).

The architects of Stewart's store were the little-known Joseph Trench, in 1845 said to have "erected some of the finest street fronts in the country," and his young partner, John Butler Snook, at the beginning of a long and productive New York career.[52] The Corinthian columns and pilasters on the ground floor were made by Ottaviano Gori, the city's leading marble cutter (see "The Products of Empire" by Amelia Peck in this publication, p. 265), and the shutters were supplied by the recently arrived iron

manufacturer Daniel D. Badger. The upper three floors, in the palazzo style—their astylar walls (that is, without columns or pilasters) easily subdivided by the use of quoins and pedimented window frames—were well suited to accommodate expansion. A surviving design for the first of several extensions, down Broadway and along Chambers Street (cat. no. 96), shows the original unit essentially being repeated.

To some extent, the ease of expansion must have informed Stewart's choice of style; he would also have been aware, however, that in England the palazzo style was seen as a symbol of the rising political power of the middle classes—in effect, as a symbol of urbanity and wealth. Even before the store was built, a New York paper reported of it that "the style of architecture . . . makes a nearer approach to some of the facades of the London Club houses than that of any building in the city."[53] The reference is clearly to Charles Barry's two clubs on Pall Mall, the Travellers',

1829–31, and the Reform, 1837–40; the designs for the former had been published in 1839, those for the latter in 1843.[54]

Although the Astor House long reigned as the city's premier hotel, it was Stewart's store, with its endlessly repeatable Anglo-Italianate modules, that served as the model for most of the hotels built on Broadway in the late 1840s and the 1850s. Two of the finest—the Metropolitan, between Houston and Prince streets, 1850–52, and the Saint Nicholas, a block below, at Spring Street, 1853, both by Trench and Snook—were built in anticipation of the Crystal Palace exhibition of 1853. The grandest was Griffith Thomas and William Washburn's Fifth Avenue Hotel at Twenty-third Street, 1857–59.

By 1850 Stewart's success had precipitated a rush of new shops along Broadway. Outstanding among them, for its building as well as for the variety and quality of its goods, was E. V. Haughwout and Company, manufacturers and retailers of glass, china, tablewares, and lighting fixtures. The massive five-story, twenty-three-bay structure, with fronts on both Broadway and Broome Street, had cast-iron facades notable for their beautifully proportioned Venetian Renaissance ornament. The design was by John P. Gaynor, an architect not otherwise of consequence in New York, but the cast iron was from Badger, one of the leaders in the business. Badger's firm, Architectural Iron Works of the City of New York, was incorporated in 1856, the year the Haughwout Building was constructed. When, in 1865, he published a catalogue of the firm's work,[55] pride of place—the first illustration after the title page and view of the factory—was given to the Haughwout Building (cat. no. 98). Today it is the best-known iron-front structure in Manhattan and one of the two earliest surviving examples of such buildings (the other is the Cary Building, 1856, also by Badger).

Although the Haughwout Building was a true cast-iron structure—that is, one with a multistory, self-supporting, totally iron front—it was not the first to be built. That honor goes to a factory (fig. 145) that the inventor James Bogardus designed for himself in 1847 at the corner of Duane and Centre streets.[56] In 1848 Bogardus erected a new four-bay, five-story facade for Dr. John Milhau's pharmacy at 183 Broadway, and in 1849 he built a group of stores for Edgar H. Laing at the corner of Washington and Murray streets, from which only fragments survive (see cat. no. 97). The Laing storefronts were virtually identical to the facade of Bogardus's own factory. Four stories high, with simple Doric colonnettes flanking rectangular windows,

these structures were the modest precursors of the Haughwout and the myriad other cast-iron commercial buildings that today make up one of the city's unique treasures, the Cast-Iron District, located south of Houston Street.

By the 1850s Fifth Avenue had clearly become the new residential address of choice.[57] Originating at Washington Square, the avenue had been opened to Thirteenth Street in 1824, to Twenty-fourth Street in 1830, and to Forty-second Street in 1837. Since the completion of that last, large extension exactly coincided with the great financial panic, nothing much happened anywhere along the thoroughfare for several years. The first tangible evidence of the future residential growth was the relocation to the avenue of two fashionable churches: the Church of the Ascension at Tenth Street in 1840, and the First Presbyterian Church at Eleventh Street in 1842. After 1846 development was rapid.

One particularly influential house, on Sixteenth Street, just off Fifth Avenue, was that designed in 1846 for Colonel Herman Thorne by Trench and Snook. As the architects' design for Stewart's store transformed the facades of commercial New York, so did their Thorne house, with its introduction of the Italianate style, have a profound effect on the city's domestic architecture. The large, square, freestanding house was of brownstone, not marble, but otherwise its upper floors—with slightly projecting center bay, pedimented window surrounds, and bold cornice—were not unlike those of Stewart's emporium.[58] (The ground floor, which had a covered porch and round-arched windows, could not so readily be compared to a storefront.) Praised for its restrained elegance, the house was immediately emulated, first on Fifth Avenue and later as the prototypical brownstone row house in the Italianate style. Even Davis tried out the new mode, with a double house on Twelfth Street, just off Fifth, in 1847.

In 1850 Hart M. Shiff, a French-born merchant recently arrived in New York from New Orleans, commissioned Lienau to build a mansion at 32 Fifth Avenue, at Tenth Street (cat. nos. 99, 100). Lienau, whose thorough technical training in Germany had been followed by several years in Henri Labrouste's atelier in Paris, used the opportunity to introduce the French Renaissance style to New York.[59] The walls of the Shiff house were red brick, the trim brownstone. The roof—a visible emblem of the Second Empire style, marked "*à la mansard*" in the specifications—was the first of its kind in the city and was widely remarked upon. At the end of the decade, in 1859,

54. Charles Barry, *The Travellers' Club House* (London: J. Weale, 1839); *Surveyor, Engineer and Architect*, 1843.

55. Daniel D. Badger, *Illustrations of Iron Architecture Made by the Architectural Iron Works of the City of New York* (New York: Baker and Godwin, 1865); reprinted as *Badger's Illustrated Catalogue of Cast-Iron Architecture* (New York: Dover Publications, 1981).

56. For Bogardus, see Margot Gayle and Carol Gayle, *Cast-Iron Architecture in America: The Significance of James Bogardus* (New York: W. W. Norton, 1998).

57. See Mosette Broderick, "Fifth Avenue, New York, New York," in *The Grand American Avenue, 1850–1920*, edited by Jan Cigliano and Sarah Bradford Landau (exh. cat., New Orleans: Historic New Orleans Collection; Washington, D.C.: Octagon Museum, 1994), pp. 3–34.

58. For the Thorne house, see Lockwood, *Bricks and Brownstone*, pp. 132–33, ill.

59. See Ellen W. Kramer, "The Architecture of Detlef Lienau, A Conservative Victorian" (Ph.D. dissertation, New York University, 1958).

John Jacob Astor II would simply build a larger version of the same structure uptown, on Fifth at Thirty-third Street.

In September 1855 the architect Richard Morris Hunt settled in New York after nine years in Paris, having been the first American to study architecture at the École des Beaux-Arts. Hunt's initial commission was a modest house on Thirty-eighth Street, just off Fifth, for Thomas P. Rossiter, a painter and friend from Paris. The architect's elegantly rendered study of the three-story, four-bay limestone-and-brick facade (cat. no. 101) featured French Renaissance elements, including much-simplified echoes of the Pavillon de la Bibliothèque at the Louvre, on which he himself had labored. The only features characteristic of a traditional New York house were the partly raised basement, the stoop, and the flat roof. In fact, in order to make it blend better with its neighbors, the house was actually constructed with an extra story and faced with two varieties of brownstone. The Rossiter house is important as the first American work by a man who was to be the nation's leading architect during the last third of the century. But it is perhaps best remembered today as the subject of a legal dispute that helped establish the principle that architects are professionals entitled to commissions based on a percentage of the cost of construction.[60]

Although known mainly for his Gothic Revival churches, Upjohn was also an accomplished practitioner in two additional styles—the Italianate (for country houses) and the Romanesque (for urban secular structures). For the Trinity Building, 1851–52, an office structure adjacent to Trinity churchyard, Upjohn employed the heavy cornice and plain, flat walls of the palazzo style but punctuated the walls with Romanesque round-arched windows. Together with his son Richard Michell, he chose a similar treatment in 1856 for the great mansion (cat. no. 103) that Henry Evelyn Pierrepont engaged him to erect in Brooklyn Heights.[61] A massive block, four stories above a raised basement, its flat, bare walls of warm red New Jersey freestone interrupted by arched openings of darker Connecticut brownstone, the Pierrepont mansion was the finest Romanesque town house ever built in New York.

Buoyed by expansive and prosperous times during the 1850s, many of the city's urban institutions chose to build themselves permanent homes. In 1855 the Union Club erected a splendid structure, in the London-club style, on Fifth Avenue at Twenty-first Street. Shortly thereafter, the New-York Historical Society followed suit. Having purchased a lot at Eleventh Street and

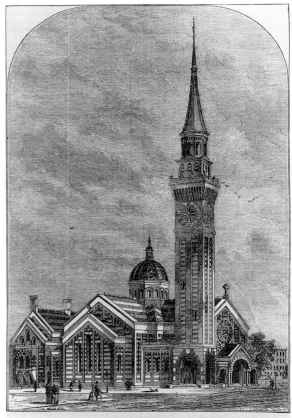

ALL-SOULS' CHURCH, CORNER OF FOURTH AVENUE AND TWENTIETH ST., NEW YORK.

Fig. 146. Jacob Wells; artist, Jacob Wrey Mould, architect, *All Souls' Church, Fourth Avenue at Twentieth Street*, 1859. Wood engraving by Augustus Fay and Edward P. Cogger, from *Ballou's Pictorial Drawing-Room Companion*, August 20, 1859. Courtesy of the American Antiquarian Society, Worcester, Massachusetts

Second Avenue (after Fifth, the most fashionable new residential street), the society hired Charles Mettam and Edmund A. Burke to design its headquarters in the palazzo style, termed by the society "Italian-Roman-Doric."[62] Although neither Mettam and Burke nor their design was particularly distinguished in the architectural milieu of the time, the partners' presentation rendering (cat. no. 104)—all that survives of the building—is exceptionally attractive.

The National Academy was more adventurous. It began its search for a location in 1859, purchased a lot at the corner of Fourth Avenue and Twenty-third Street in 1860, and then began the lengthy process of selecting an architect. Those originally proposed for consideration were Eidlitz (from Vienna), Mould (from London), and Hunt (from the École in Paris). In the end, however, the academy chose Peter Bonnett Wight, a native New Yorker who had trained with Thomas R. Jackson, once Upjohn's chief draftsman.[63] It was not until 1862 that a final design was agreed to, and construction dragged on into 1865. Wight's design

60. See Paul R. Baker, *Richard Morris Hunt* (Cambridge, Massachusetts: MIT Press, 1980); for the Rossiter house, see ibid., pp. 80–87.

61. For Upjohn's involvement with Pierrepont, see Judith Salisbury Hull, "Richard Upjohn: Professional Practice and Domestic Architecture" (Ph.D. dissertation, Columbia University, New York, 1987), pp. 319–37, 562–65.

62. Quoted in R. W. G. Vail, *Knickerbocker Birthday: A Sesqui-Centennial History of the New-York Historical Society, 1804–1954* (New York: New-York Historical Society, 1954), p. 98.

63. For Wight, see Sarah Bradford Landau, *P. B. Wight—Architect, Contractor, and Critic, 1838–1925* (exh. cat., Chicago: Art Institute of Chicago, 1981).

was inspired by Mould's dramatic All Souls' Unitarian Church (fig. 146), 1853–55, just three blocks to the south. That building, Mould's first major commission in New York (the tower was never executed), was the first in America to employ polychromatic construction materials. Wight's exotic, polychrome design (cat. no. 105), with the cornice and the diamond pattern of the brick-and-stone walls strongly suggesting the Doge's Palace, Venice, represents an early instance of the influence in New York of the English writer and critic John Ruskin.

By the mid-1850s New York's architects had come to recognize the need for a professional association, and it was Upjohn who was to provide the impetus. He had labored, he claimed, "under the most adverse circumstances when the profession was in its infancy . . . [and] in an isolated position."[64] In February 1857 twelve New York architects assembled in his office and agreed to establish a society to "promote the scientific and practical perfection of its members and elevate the standing of the profession."[65] They chose to keep the membership select, drawing it from their immediate circle of acquaintances, and to limit it principally to New York City, no doubt remembering that the failure of the American Institution of Architects in 1836–37 was in good part because of regional rivalries. Their new organization was to be called the American Institute of Architects, the first viable professional association of architects in the United States. On April 15, with elaborate ceremonies in Davis's great Gothic Revival chapel at the University of the City of New York, the AIA celebrated the adoption of its constitution. The first board of trustees included Upjohn (president), Walter (first vice president), Hunt (librarian), and Davis. Years later, from 1888 to 1891, Hunt would serve as president, having become the leading American proponent of the architectural profession.

All told, then, in the years 1825 through 1861, New York City had transformed itself in the realm of architecture from a calm backwater to the turbulent mainstream. Its architects, at first native-born carpenter-builders, at the end of the period were largely immigrants who had been professionally trained. Its buildings evolved from local variations on English classical designs into structures reflecting the full panoply of Revival styles—the English ecclesiological Gothic, the Venetian Gothic, the Anglo-Italianate, the French Renaissance. Its building materials changed from red brick to white marble, brownstone, and cast iron. Wall Street, with its banks and exchanges, became the symbol of the architecture of finance; Broadway, with its hotels and department stores, the symbol of the architecture of commerce; and Fifth Avenue, with its palatial residences, the symbol of the architecture of private pleasure. New York, by way of becoming a world-class city, had become the epicenter of American architecture.

64. Quoted in Woods, *From Craft to Profession*, p. 33.
65. Ibid.

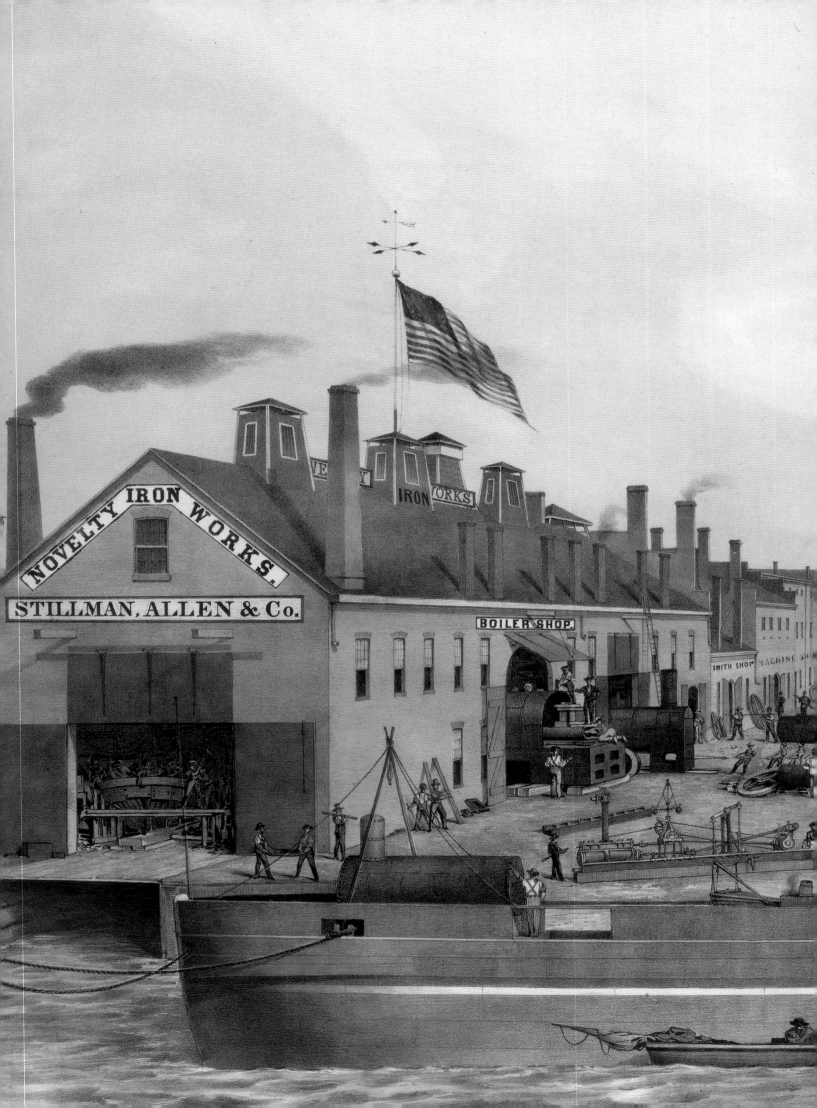

# The Currency of Culture: Prints in New York City

## ELLIOT BOSTWICK DAVIS

Between the opening of the Erie Canal in 1825 and the beginning of the Civil War in 1861, printmaking in New York City flourished on an unprecedented scale. The popularity of city views of this era among early-twentieth-century collectors—which is reflected in Isaac Newton Phelps Stokes's six-volume *Iconography of Manhattan Island*—has obscured the fact that reams of prints of many other types were also produced by New York presses during those years. Those of exceptionally high quality, which supported New York's aspiration to be the cultural capital of the United States, attracted an elite circle of connoisseurs, while the popular marketplace demanded a spectrum of prints in the form of currency, maps, illustrations for books and periodicals, and political cartoons, as well as vast quantities of trade cards, billheads, and advertising materials beyond the scope of the present exhibition. Indeed, as a response to the combined momentum of rising artistic standards and increasing mass production, a consciousness of the city's manifest destiny emerged. Nowhere is this more clearly evident than in the printed views of Manhattan, which grew ever more expansive and proclaimed the metropolis "The Empire City" as early as 1855.

Between 1825 and 1861 the burgeoning of New York as a bustling marketplace for domestic and foreign goods worked to the great advantage of the city's numerous commercial industries, including the printing trade. As the primary port of entry into the United States following the opening of the Erie Canal, Manhattan welcomed to its shores a steady supply of highly skilled artists and printers from Europe. Regular packet-boat service and cost-efficient wharves and warehouses (see fig. 170) expedited the flow of all the supplies and equipment necessary to produce prints, especially the prized limestone ideally suited to lithography that was imported from Bavaria. Iron foundries throve in their proximity to the North River (now known as the Hudson), and printers were able to update their presses and equipment, incorporating the latest technological developments from abroad.

The official opening of the Erie Canal ensured that all roads of the Empire State led to the Port of New York (see cat. no. 118). To commemorate that occasion, several of the most prominent American engravers practicing in the city joined forces with the newly arrived French lithographer Anthony Imbert to create an ambitious presentation volume with extensive printed illustrations documenting the elaborate celebration (cat. no. 117). Entitled *Memoir, Prepared at the Request of a Committee of the Common Council of the City of New York, and Presented to the Mayor of the City, at the Celebration of the Completion of the New York Canals*, the book included a splendid illustration by Archibald Robertson of the fleet preparing to form in line when the boat *Seneca Chief*, conveying De Witt Clinton and his entourage, approached the lower tip of Manhattan near Battery Park at the culmination of the aquatic festivities (cat. no. 118). Imbert required two lithographic stones to capture the grandiose scene in its entirety—a complex and expensive undertaking. Earlier panoramic views of New York Harbor generally represented the city from the vantage point of a small vessel at sea level. Charles-Balthazar-Julien Févret de Saint-Mémin's engraving of New York from Brooklyn Heights, drawn with a pantograph in 1798 (fig. 147), exemplifies this earlier topographical style, which derived from detailed drawings required for planning military campaigns.[1] In contrast, Robertson designed an atmospheric view from the elevated promenade of the Battery. An instructor in one of the first drawing academies in New York City, Robertson was a highly proficient draftsman capable of fully collaborating with Imbert in the lithographic process, which was relatively new in the United States. Because of his artistic abilities and his role as a major figure in the New York art world, the Committee of Arrangements for the canal celebrations had made Robertson head of its Department of Fine Arts, which would prepare the illustrations for the *Memoir*. Exploiting the ability of the lithographic crayon to render subtle gradations of tone, Imbert drew Robertson's image on stone with the assistance of Félix Duponchel.[2] A former

The author wishes to thank Georgia B. Barnhill, Andrew Mellon Curator of Graphic Arts, The American Antiquarian Society; John Wilmerding, Christopher B. Sarofim '86 Professor of American Art, Princeton University; and Catherine Hoover Voorsanger for reading an earlier draft of this essay and for their insightful comments. She also thanks Ellyn Childs Allison, John S. Paolella, and Carol Fuerstein for their attentive editing of the manuscript; and Heather Lemonedes, John Crooks, Constance C. McPhee, Marguerita Emerson, Mark D. Mitchell, and Katherine P. Lawrence for their research assistance on the American prints in the Metropolitan Museum.

1. See Gloria Gilda Deák, *Picturing America, 1497–1899: Prints, Maps, and Drawings Bearing on the New World Discoveries and on the Development of the Territory That Is Now the United States* (Princeton: Princeton University Press, 1988), p. 144.
2. John Carbonell, "Anthony Imbert: New York's Pioneer Lithographer," in *Prints and Printmakers of New York State, 1825–1940*, edited by David Tatham (Syracuse: Syracuse University Press, 1986), p. 18.

Fig. 147. Charles-Balthazar-Julien Févret de Saint-Mémin, *A View of the City of New York from Brooklyn Heights,* 1798, first issued 1850. Engraving on three sheets, first state. The New York Public Library, Astor, Lenox and Tilden Foundations, Miriam and Ira D. Wallach Division of Art, Prints and Photographs, The Phelps Stokes Collection, Print Collection P. 1796–E–44

3. Ibid., pp. 17, 39 n. 8. As Carbonell notes, "not only do different copies have different combinations of plates, but several of the lithographs exist in variant states." See also Harry T. Peters, *America on Stone: The Other Printmakers to the American People. A Chronicle of American Lithography Other Than That of Currier & Ives, from Its Beginning, Shortly before 1820, to the Years When the Commercial Single-Stone Hand-Colored Lithograph Disappeared from the American Scene* (Garden City: Doubleday, Doran, and Co., 1931; reprint, New York: Arno Press, 1976), pp. 228–35.

4. Carbonell, "Anthony Imbert," p. 39 n. 8.

member of the French navy, Imbert was responsible for the depiction of the vessels, but it was Robertson who likely enlivened the composition by contrasting thick clouds of black smoke made by steamships with the white clouds of exploding gunpowder emanating from the canons in the lower foreground and near the hull of the tall ship just offshore.

The *Memoir* also included lithographs printed by Imbert of the numerous associations that participated in the celebrations. Fire companies are represented in several illustrations, and the symbols of such important guilds as the chair-makers' society also appear (fig. 234). The novelty of the lithographic medium and its association with scientific reportage may have discouraged Robertson from choosing it for the portraits in the *Memoir.* Instead, he and Imbert enlisted the foremost engravers of the day, including

Peter Maverick, Asher B. Durand, and James Barton Longacre, to portray the prime movers of the canal project, De Witt Clinton and Cadwallader Colden, a former mayor of New York who was the author of the *Memoir.* Nevertheless, thirty-seven of the fifty-four illustrations in the book were lithographs, all but two printed by Imbert.[3] Robertson and Imbert even included a plate reproducing a facsimile of a letter dated July 6, 1826, in order to demonstrate the practical applications of transfer lithography.[4] Just as the opening of the Erie Canal was a watershed in the history of New York City, so Robertson and Imbert's ambitious project served to set a high standard for New York lithographers, who would soon follow their lead.

In 1825 lithography was still considered a novelty in the United States. Robertson lauded the medium

Fig. 148. John Rubens Smith, *Portrait of a Lady [Mrs. John Rubens Smith?]*, 1821–22. Lithograph. Courtesy of the American Antiquarian Society, Worcester, Massachusetts

as a "curious discovery" of "useful importance" not unworthy of comparison with "Fulton's application of steam to the purposes of navigation."[5] The technique operates on the principle that oil and water do not easily mix.[6] To execute a lithograph, the artist first draws an image on a stone—during the antebellum period most often limestone—with greasy crayons, pens, or pencils. The drawing is then affixed to the stone by means of a solution of gum arabic and nitric acid to prevent the ink from spreading. The stone is washed with water, which dampens the exposed areas. Printer's ink is then rolled over the entire surface, and the grease in the ink adheres to the sticky surface of the prepared drawing but not to the wet surface of the stone. The stone is inked and covered with paper. After passing through a printing press, the paper reveals a mirror image of the original drawing.

Introduced in Germany by Aloys Senefelder in 1796, lithography was first attempted in the United States by the portrait painter and engraver Bass Otis, who in 1819 produced what is frequently considered the first American lithograph, a crudely executed landscape with a mill.[7] Shortly thereafter, William Armand Barnet and Isaac Doolittle brought to New York their firsthand knowledge of lithography as it was practiced in Paris. Their early efforts drew praise from the *American Journal of Science and Arts* in 1821: "Messrs. Barnet & Doolittle have in their possession, a great variety of lithographic prints, which sufficiently evince the adaptedness of the art to an elegant as well as a common style of execution. The finest things done in this way are really very beautiful; and they possess a softness which is peculiarly their own."[8] Barnet and Doolittle produced lithographs of some quality, exemplified by the execution of a delicate portrait by British-born artist and printmaker John Rubens Smith (fig. 148). But lithographs cost twice as much as copperplate engravings, and the partners became discouraged. By June 1822 Barnet returned to France, after selling the firm they had established to geologist William Leseur, who himself lamented the lack of patronage for lithography in New York. Writing to the former proprietors, Leseur observed: "In order for lithography to succeed here it is necessary for there to be more connoisseurs of fine arts than there are now. You only find a few individuals who have portfolios full of engravings, and those who have them send them to auction to get rid of them."[9]

With the entrepreneurial spirit that would bolster New York City's bid to become the business capital of the country, various local printers continued to try their hands at lithography, despite the failure of Barnet and Doolittle. The engraver Peter Maverick had

Fig. 149. Peter Maverick, after Thomas Lawrence, *The Daughters of Charles B. Calmady*, 1829. Lithograph. Courtesy of the American Antiquarian Society, Worcester, Massachusetts

5. Cadwallader D. Colden, *Memoir, Prepared at the Request of a Committee of the Common Council of the City of New York, and Presented to the Mayor of the City, at the Celebration of the Completion of the New York Canals* (New York: Printed by Order of the Corporation of New York by W. A. Davis, 1825), conclusion. p. 398, Department of Drawings and Prints, Metropolitan Museum.

6. As described in Peter C. Marzio, *The Democratic Art, Chromolithography, 1840–1900: Pictures for a 19th-Century America* (Boston: David Godine, 1979), pp. 8–9, with descriptive definitions of single-color, hand-colored, tinted lithographs, and chromolithographs on p. 9.

7. See Sally Pierce, with Catharina Slautterback and Georgia Brady Barnhill, *Early American Lithography: Images to 1830* (exh. cat., Boston: Boston Athenaeum, 1997), pp. 10–11, 80–81. See also Peter C. Marzio, "American Lithographic Technology before the Civil War," in *Prints in and of America to 1850*, edited by John D. Morse, Winterthur Conference on Museum Operation and Connoisseurship, 16th, 1970 (Charlottesville: University Press of Virginia, 1970), pp. 215–56; and Joseph Jackson, "Bass Otis, America's First Lithographer," *Pennsylvania Magazine of History and Biography* 37 (1913), pp. 385–94.

8. "Notice of the Lithographic Art," *American Journal of Science and Arts* 4 (October 1821 [1822]), p. 170, as quoted in Pierce, Slautterback, and Barnhill, *Early American Lithography*, p. 11.

9. Quoted in Pierce, Slautterback, and Barnhill, *Early American Lithography*, p. 12.

10. For a detailed account of Maverick's career, see Stephen DeWitt Stephens, *The Mavericks, American Engravers* (New Brunswick, New Jersey: Rutgers University Press, 1950); and Peters, *America on Stone*, pp. 273–75.

11. See Mary Bartlett Cowdrey and Theodore Sizer, *American Academy of Fine Arts and American Art-Union, 1816–1852* (New York: New-York Historical Society, 1953), vol. 2, *Exhibition Record*, pp. 351–52.

12. Several figures in the foreground of Thompson's print are usually identified as his wife, daughters, and sister. See Olive S. De Luce, "Percival DeLuce and His Heritage," *Northwest Missouri State Teachers College Studies*, June 1, 1948, pp. 73–74. The two prints that recall Thompson's *New York Harbor from the Battery* are an engraving, *Arrival of the Great Western Steam Ship, Off New York Bay of New York* (1838), published by W. & H. Cave of Manchester, England, and a tinted lithograph, *Bay of New York from the Battery* (1838) by an artist identified by the initials H. D.

13. Carbonell, "Anthony Imbert," pp. 12–13; Peters, *America on Stone*, p. 228.

14. See I. N. Phelps Stokes, *The Iconography of Manhattan Island, 1498–1909, Compiled from Original Sources and Illustrated by Photo-intaglio Reproductions of Important Maps, Plans, Views, and Documents in Public and Private Collections*, 6 vols. (New York: Robert H. Dodd, 1915–28), vol. 3 (1925), p. 603. Stokes writes: "The [New-York Historical] Society owns also one of the original brown wrappers, bearing the following inscription: 'Views of the Public Buildings, Edifices and Monuments, In the Principal Cities of the United States, Correctly drawn on Stone by A. J. Davis. Printed and Published by A. Imbert, Lithographer, 79 Murray-Street, New-York. . . . The Work will be issued in Numbers, each containing 4 Plates; The first number to each City, will be ornamented with a title page and a vignette;—The Price of Subscription is per number, . . . \$2:00. Each Plate Separately, . . . 0:50. Subscriptions are received at the Office of the Publisher, 79 Murray-Street,

Fig. 150. Anthony Imbert, after Thomas Cole, *Distant View of the Slides That Destroyed the Willey Family, White Mountains*, ca. 1828. Lithograph. Courtesy of the American Antiquarian Society, Worcester, Massachusetts

experimented with the new technique on a small scale to augment his thriving trade in portraits, banknotes, and maps. Maverick was an accomplished draftsman, and the skill he achieved in lithography is evident in *The Daughters of Charles B. Calmady* (fig. 149), a print of 1829 after an oil painting by Thomas Lawrence.[10] Maverick would also produce numerous popular lithographs for book illustrations and sheet-music covers.

One lithographer who would rapidly match Imbert's success was British immigrant Thomas Thompson. A painter who exhibited regularly at the American Academy of the Fine Arts, the Apollo Association (later the American Art-Union), and the National Academy of Design, where he became an associate member in 1834,[11] Thompson undertook what would become a milestone of early American lithography because of its unprecedented scale. In 1829, utilizing Saint-Mémin's and Imbert's technique of joining several sheets together to form one panorama, Thompson joined three large lithographs to form a continuous, well-populated scene of New York Harbor from the

southern tip of the Battery promenade (cat. no. 121). Although Thompson did not continue to produce lithographs, his print, which is now rare, inspired several other similar scenes of an elegant assembly of New Yorkers strolling along the Battery.[12]

Meanwhile, Imbert continued in business at a number of downtown addresses until at least 1835,[13] and he succeeded in attracting some of the foremost American artists to experiment with lithography. The distinguished architect Alexander Jackson Davis collaborated with him to produce a portfolio of depictions of public buildings in New York (see cat. nos. 70–72). The inscription on one of the extant portfolio wrappings indicates that Imbert intended to publish subsequent portfolios of public buildings located in the principal cities of the United States; however, as with many printmaking projects planned during the first half of the nineteenth century, the subsequent installments were abandoned.[14]

Thomas Cole, who would later change the course of American landscape painting, found his way to Imbert's

press while he was struggling to establish himself professionally. In hopes of raising funds for a trip to Europe through the sale of prints, Cole produced two lithographs printed by Imbert that reflect his interest in the American wilderness.[15] Perhaps inspired by Robertson's reportage for the *Memoir,* Cole based one of them on a dramatic location he himself had visited. Intended to appeal to human curiosity in the wake of a natural disaster, *Distant View of the Slides That Destroyed the Willey Family, White Mountains* of about 1828 represents the raging forces of nature that inspire awe, an essential component of Cole's notion of the sublime (fig. 150). Describing the scene in a journal entry for October 1828, Cole recalled his sense of utter desolation as he gazed at the Willey house, miraculously left standing by a landslide that killed all the members of the household, who had rushed outside.[16] The distinctive bald patches on the slope evoke Cole's contemporaneous paintings of Kaaterskill Clove in the Catskills, and they may have inspired his rendering of a similarly scarred mountainside in the central background of *The Oxbow* (Metropolitan Museum), a monumental canvas he painted for New York art patron Luman Reed in 1836. Although modest in scale, the two early prints designed by Cole and executed by Imbert represent some of the earliest efforts by an American painter to create high-quality landscapes in the medium of lithography.

Imbert kept a keen eye on the popular-print market. Views of street life in New York were in demand and they often took the form of humorous satires. Seeking to engage an ever broader audience, Imbert issued a series of lithographic caricatures entitled Life in New York that are reminiscent of the popular etchings Life in Philadelphia produced by Edward W. Clay.[17] In one of these an urban dandy is shown comically striving to climb New York's social ladder while encumbered by fashionably tight lacing (fig. 23). One of Imbert's more unusual popular lithographs, which combines portraiture and social commentary, depicts the formidable Mr. John Roulstone of the New York Riding School (fig. 151). Rendered by an anonymous artist and printed by Imbert, the image depicts the imposing figure of the elegantly dressed Roulstone. The inscription below the scene, which testifies to the print's preparation "in compliance with the unanimous vote of the class," expresses the high regard of Roulstone's students for their teacher.[18] The large scale of the lithograph suggests the enormous resources of fashionable New Yorkers put through their paces by Roulstone. The work was probably commissioned by students of the riding school, and

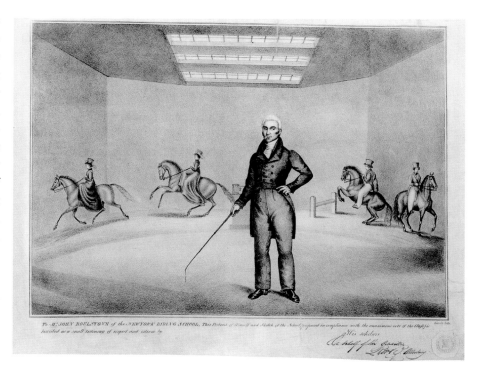

Fig. 151. *Mr. John Roulstone of the New York Riding School,* ca. 1829. Lithograph published by Anthony Imbert. Collection of The New-York Historical Society, Print Room

the cost of designing and printing the image was passed on to subscribers, who presumably received a portrait of their beloved instructor.

Despite the fine work done by Imbert and other lithographers, high-quality printmaking was dominated by aquatint engraving. An intaglio process, aquatint achieves effects that are tonal rather than linear, much like those of a watercolor wash. To effectively imitate watercolors, the early aquatints created in New York City were generally prepared with black or sepia ink and later hand colored, although aquatints could also be printed in colors. Paul Sandby, father of the eighteenth-century British watercolor school, was the first artist to use the aquatint process in England, having learned the technique from a friend who had purchased the secret from the inventor, Jean-Baptiste Le Prince.[19] Aquatint was promoted vigorously in London by print publisher Rudolph Ackermann, whose instruction manuals and art periodical, the *Repository of Arts, Literature, Fashions, Manufactures, &c.,* were imported into the United States during the early nineteenth century and served as models for aspiring American printmakers and publishers.

By 1816 British-born printmaker John Hill had arrived in America, where he fostered the popularity and success of the medium. Hill, who began his career in Philadelphia that year, recognized the merits

Behr & Kahl's Book Store, 359 Broadway; Judah Dobson, 108 Chestnut-street, Philadelphia; Fielding Lucas, Baltimore.' " See also Deák, *Picturing America,* p. 234.

15. See Janet Flint, "The American Painter-Lithographer," in *Art and Commerce: American Prints of the Nineteenth Century. Proceedings of a Conference Held in Boston May 8–10, 1975, Museum of Fine Arts, Boston, Massachusetts* (Charlottesville: University Press of Virginia, 1978), p. 129, for the dating of the two Cole lithographs, *Distant View of the Slides That Destroyed the Willey Family, White Mountains* and *The Falls at Catskill,* and the likelihood that both were printed at Imbert's press.

16. Cole wrote in his journal: "The sight of that deserted dwelling (the Willee House) standing with a little patch of green in the midst of that dread wilderness of desolation called to mind the horrors of that night (the 28th of August, 1826) when these mountains were deluged and rocks and trees were hurled from their high places down the steep channelled sides of the mountains—the whole family perished and

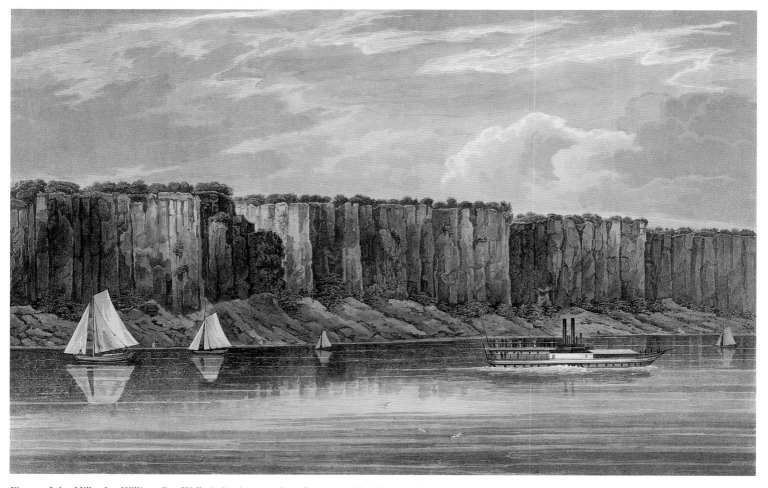

Fig. 152. John Hill, after William Guy Wall, *Palisades,* 1820, issued 1823–24, *The Hudson River Portfolio* (New York: Henry J. Megarey, 1821–25), pl. 19. Aquatint with hand coloring, proof before letters. The Metropolitan Museum of Art, New York, The Edward W. C. Arnold Collection of New York Prints, Maps, and Pictures, Bequest of Edward W. C. Arnold, 1954  54.90.601

yet had they remained in the house they would have been saved—though the slides rushed on either side they avoided it as though it had been a sacred place. A strange mystery hangs over the events of that night. . . . We looked up at the pinnacles above us and measured ourselves and found ourselves as nothing . . . it is impossible for description to give an adequate idea of this scene of desolation." Flint, "The American Painter-Lithographer," p. 129.

17. See Carbonell, "Anthony Imbert," pp. 27–28; and Nancy Davison, "E. W. Clay and the American Political Carica-ture Business," in *Prints and Printmakers of New York State,* pp. 91–110.

18. The original print is housed in the Print Room of the New-York Historical Society. I am grateful to Wendy Shad-well, Curator of Prints, The New-York Historical

of aquatint as a means of producing a series of printed scenes that could be used as models for aspiring ama-teur painters and decorative artists. He used aquatint in his portfolio *Picturesque Views of American Scen-ery,* 1821. Inspired by the success of Baltimore pub-lisher Fielding Lucas, who had issued an extensively illustrated drawing book in 1815, Hill also produced thirteen aquatint plates for a similar manual that was published by Henry J. Megarey in New York City in 1821. A popular success, Hill's *Drawing Book of Land-scape Scenery: Studies from Nature* established his reputation, and he was soon approached by Irish-born watercolorist William Guy Wall to engrave the illustrations for a project in aquatint, *The Hudson River Portfolio.*[20]

The success of early-nineteenth-century aquatint endeavors in the United States depended upon the close collaboration of artist, printmaker, and publisher. It required the keen eye of an accomplished print-maker like Hill to translate the watercolor washes of the artist's original composition as black and white

tones; moreover, the printmaker supervised the hand coloring of the aquatints to ensure their close resem-blance to the original watercolors. Regardless of the quality of the final prints, the publisher's ability to attract subscribers for future installments and to sell the works in the marketplace determined the ulti-mate success or failure of a project. Wall, the premier watercolorist of the day, whose work was greatly admired by Thomas Jefferson, interested Megarey in the project and he agreed to publish Wall's watercolor views along the historic Hudson.[21] That Wall and Hill worked hand in glove on *The Hudson River Portfolio* is strikingly clear. Wall had initially com-missioned John Rubens Smith to render the plates for the portfolio. Although he was an accomplished mez-zotint engraver, Smith found that aquatint eluded his talents, and he abandoned the venture. Hill reworked several of Smith's plates and devoted himself to the project for the next five years.

The resulting suite of picturesque vistas selected from vantage points along the 315-mile river served

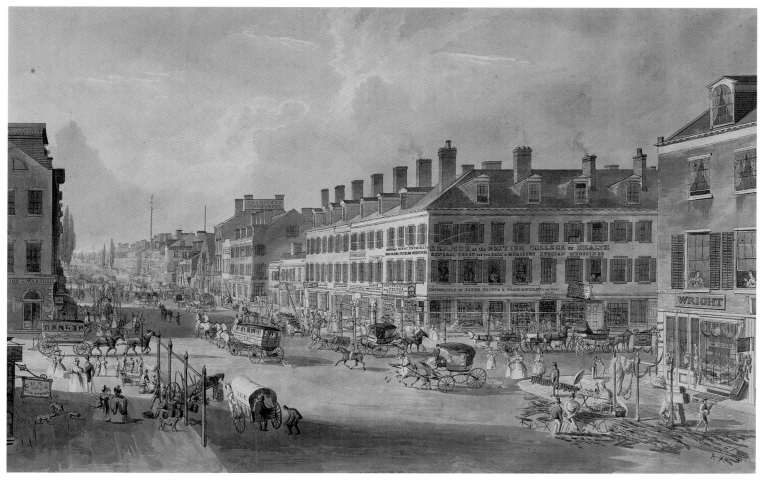

Fig. 153. Thomas Hornor, *Broadway, New York,* ca. 1834. Pen and ink with wash. The New York Stock Exchange Lunch Club, New York City

to focus public attention on the indigenous American landscape, setting the stage for the development of the Hudson River School of landscape painting. John F. Kensett, a second-generation member of the school, found inspiration for his series of paintings of the Shrewsbury River in Wall and Hill's *Palisades* (fig. 152), with its distinctive horizontality and glistening reflections of sailboats on the surface of the water.[22] The imagery of *The Hudson River Portfolio* also served decorative artists. Given the crisp appearance of the etched lines delineating the areas of aquatint tone, the scenes could be readily transferred to porcelains. Plate 20 in the *Portfolio,* a view of New York City from Governors Island, appears on one of a pair of Paris porcelain vases dating from the 1830s,[23] complementing a scene showing the Elysian Fields, Hoboken, on the other vase (fig. 266).

In 1822, at the urging of Megarey, Hill moved to New York City and established his residence and workroom on Hammond Street, which he depicted in a watercolor dated 1825 (Metropolitan Museum).[24]

Hill's business immediately flourished in Manhattan. Although he alone received the credit and commissions for the work, he relied upon his wife to print the plates he etched and on his daughters, Caroline and Catherine, to hand color the prints under his watchful eye.[25] Domestic printshops like Hill's would be replaced about the middle of the century by large workshops, such as those owned by George Endicott and Nathaniel Currier, both of whom employed numerous artists, printers, and colorists. Hill supervised the reissue of *The Hudson River Portfolio* plates throughout the late 1820s and early 1830s, when he worked with Megarey's successor, the firm of G. and C. and H. Carvill.[26] He also trained his son, John William Hill, who became a successful printmaker and artist in his own right in New York City.

Securing patronage for large printmaking projects like *The Hudson River Portfolio* proved challenging. Several extant watercolors associated with prints made during the 1820s and 1830s indicate that artists produced finished drawings that would

Society, for her assistance throughout the course of this project.

19. See Dale Roylance, "Aquatint Engraving in England and America," in *William James Bennett: Master of the Aquatint View,* by Gloria Gilda Deák (exh. cat., New York: New York Public Library, 1988), p. 4.

20. For a thorough discussion of Hill's career and his involvement in *The Hudson River Portfolio,* see Richard J. Koke, "John Hill, Master of Aquatint, 1770–1850," *New-York Historical Society Quarterly* 43 (January 1959), pp. 51–117. Koke notes (p. 88) that on September 4, 1821, Hill brought with him to Philadelphia a copy of one of Wall's original drawings to engrave.

21. Ibid., p. 86.

22. Elliot Bostwick Davis, "Training the Eye and the Hand: Drawing Books in Nineteenth-Century America" (Ph.D. dissertation, Columbia

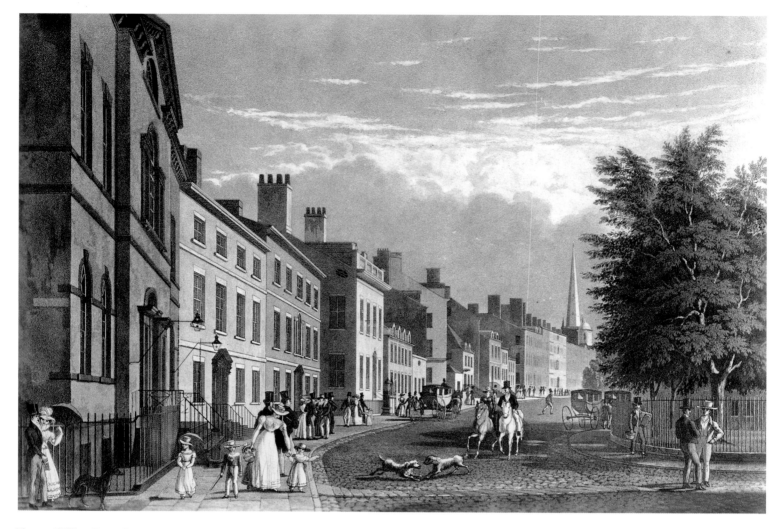

Fig. 154. William James Bennett, *Broadway from the Bowling Green*, ca. 1826. Aquatint, from *Megarey's Street Views in the City of New-York* (New York: Henry J. Megarey, 1834). The New York Public Library, Astor, Lenox and Tilden Foundations, Miriam and Ira D. Wallach Division of Art, Prints and Photographs, The Phelps Stokes Collection, Print Collection C. 1826–E–114

University, New York, 1992), p. 256.

23. See Alice Cooney Freling-huysen, "Paris Porcelain in America," *Antiques* 153 (April 1998), p. 563 n. 44.

24. See Koke, "John Hill," pp. 92–94, for the various residences of the Hill family before they acquired the two-story brick building on Tenth Street that the artist owned until his death, in 1850.

25. Ibid., p. 97.

26. Ibid., p. 103.

27. For the original documents, consult the New-York Historical Society, Manuscript Division, Francis. The first, a form of promissory note, is dated February 1834. Also quoted in Stokes, *Iconography*, vol. 3, pp. 625–27. I am grateful to Mark Mitchell of Princeton University for obtaining transcriptions of the documents.

serve not only as models for the engraver but also as samples to attract subscribers. Occasionally, proofs were used for the same purpose. Wall and Hill's *Palisades* is likely an example of such a prepublication proof, pulled before the final lettering was added to the plate and then hand colored. A highly finished drawing (fig. 153) by another of Hill's collaborators, British-born Thomas Hornor, represents a similar effort to stimulate interest in an ambitious plan (never realized) to publish several large-scale aquatint views of the city. Hornor strengthened his drawing with fine outlines in pen and ink to suggest the look of the engraving that would follow (cat. no. 123). His efforts to attract subscribers are recorded in an exchange of letters with Dr. John W. Francis, an eminent New York physician and patron of the arts. In one of the rare documents describing the terms of patronage for a print produced at the time, Hornor acknowledges receipt of a loan of $500 from Dr. Francis and "several

gentlemen" for his view of New York Harbor from the East River. In return, Francis and the other contributors stood to receive a set of prints "colored in imitation of highly finished Drawings."[27]

Hill's preeminence as master of the printed aquatint in New York during the early nineteenth century was threatened only by William James Bennett, who immigrated to New York from Britain in 1826, just as the era that would be called the Golden Age of aquatint was reaching its peak.[28] Trained in London at the Royal Academy of Arts, Bennett observed the principles of the British watercolor school as practiced at its highest level by Thomas Girtin, J. M. W. Turner, and his own teacher, Richard Westall. Through his association with Hill in England, where they both produced aquatint illustrations for Ackermann, Bennett was swiftly embraced upon arrival by Hill's circle of English artist-friends at work in New York.

Bennett's first major project was a suite of New York City views for Megarey. Like many other print portfolios of the early nineteenth century, including *The Hudson River Portfolio* and *Views of the Public Buildings in the City of New-York*, Bennett's proposal was envisioned on a scale grander than could be supported by the existing market for prints. Although *Megarey's Street Views in the City of New-York* was initially conceived as a group of twelve prints issued in four sets of three, only the first installment ever appeared.[29] Recalling British precedents, particularly the view of Leicester Square published in Ackermann's *Repository of Arts* (1812), Bennett's *Broadway from the Bowling Green* from the Megarey project (fig. 154) invests New York City with all the trappings of eighteenth-century Georgian towns in Britain.[30] For this view of about 1826, Bennett selected a row of building facades along a cobbled street that suggests the graceful curve of the Royal Crescent at Bath. Moreover, like Thomas Thompson's monumental *New York Harbor from the Battery* (cat. no. 121), Bennett's scene is populated by fashionably dressed New Yorkers who have an air of cosmopolitan elegance. The two other scenes in the suite (cat. nos. 119, 120) show New York City's thriving waterfront and mercantile districts and represent Bennett's tribute to the brash and bustling commercial life of his new home.

Bennett's aquatints are among the finest of the period, owing to his adeptness at imitating the appearance of colored washes, a skill that was much appreciated by artists who wished to expand the market for their own watercolors by issuing prints of them. John William Hill collaborated with Bennett on one of the most spectacular folio views of New York from Brooklyn Heights (cat. no. 128). It was conceived as the pièce de résistance in a series of nineteen views of American cities published by Lewis P. Clover and Megarey. Several other artists collaborated with Bennett to create scenes of major American ports for the series, including Mobile, Alabama, and Charleston, South Carolina—two southern cities that shipped their goods for northern markets through New York. Bennett and his publishers undoubtedly sought the patronage of wealthy merchants in all three cities whose fortunes swelled owing to their involvement in the cotton trade. Although the elevated topography of Brooklyn Heights had long attracted early printmakers, Hill bested them by climbing upon a rooftop for an even higher vantage point. Hill's sense of humor can be detected in the central foreground. As though to underscore the lofty elevation of the

bird's-eye view, he included several pigeons roosting just below.

Inspired by the Hudson River School painters, particularly Cole, Bennett devoted himself to rendering in aquatint the atmospheric effects of the American landscape as captured in watercolor by British-born artist George Harvey. Working in the fifteenth-century Northern Renaissance tradition of depicting landscape at different times of the day and year, Bennett and Harvey planned a portfolio of forty atmospheric studies of ancient forests in Ohio and Canada at different hours and seasons.[31] Entitled *Harvey's American Scenery*, the first installment of four aquatints and a title page (fig. 155) was published with an accompanying text by Washington Irving in 1841. The prints were rendered with great refinement and treated with carefully stippled applications of hand coloring in a labor-intensive process that resulted in a close approximation of Harvey's watercolors. To rally support for the publication, the American Art-Union offered ten sets in its annual lottery, but the project foundered, suggesting that interest in aquatinted views—a field dominated by British-born artists and engravers—had begun to decline in the New York City print world.[32]

The reputation of one British-born printmaker, Robert Havell Jr., preceded his arrival in New York City in 1839 and remained elevated owing to the popularity of the double-elephant-folio engravings with aquatint and hand coloring he had made after John James Audubon's watercolors for *The Birds of America* (1827–38). Havell produced two colorful panoramas of New York Harbor from the North and East rivers before midcentury (cat. no. 129; fig. 156).[33] That this artist's American prints were known in England is suggested by his collaboration with Rudolph Ackermann, the name and address of whose firm appear on the fifth state of Havell's *Panoramic View of New York (Taken from the North River)*. The popularity of Havell's scenes of New York Harbor inspired Italian-born Nicolino Calyo, who settled in New York City about 1835, to produce copies of the prints as gouache drawings.[34] Calyo is best known today for his gouaches of the Great Fire (cat. nos. 110, 111) and his charming studies of peddlers crying their wares on the streets of New York (see fig. 25).

Several British-born dealers ran successful printshops in New York City beginning in the 1820s. One of the most important of these emporiums was established by George Melksham Bourne, who in 1828 was responsible for republishing the popular Wall views *New York from the Heights near Brooklyn* (fig. 1)

28. See Deák, *William James Bennett*, p. 28; and Koke, "John Hill," pp. 69, 109.

29. Deák, *Picturing America*, pp. 238, 244–45.

30. Deák, *William James Bennett*, p. 30.

31. Deák, *Picturing America*, pp. 315–18. See also Barbara N. Parker, "George Harvey and His Atmospheric Landscapes," *Bulletin of the Museum of Fine Arts* (Boston) 41 (February 1943), p. 8; and Donald A. Shelley, "George Harvey and His Atmospheric Landscapes of North America," *New-York Historical Society Quarterly* 32 (April 1948), p. 106.

32. Those who received sets are listed in Cowdrey and Sizer, *American Academy of Fine Arts and American Art-Union*, vol. 1, *Introduction*, p. 173.

33. See Deák, *Picturing America*, p. 336.

34. I am grateful to Leonard L. Milberg for bringing these works to my attention.

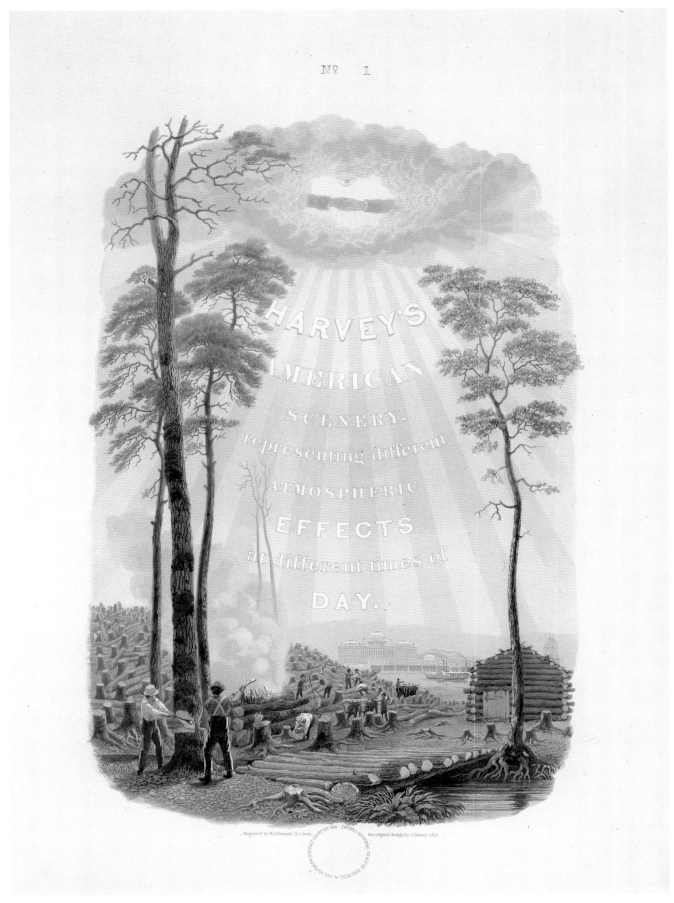

Fig. 155. William James Bennett, after George Harvey, Title page to *Harvey's American Scenery, Representing Different Atmospheric Effects at Different Times of Day* (New York: Printed by Charles Vinten, 1841), 1841. Aquatint with hand coloring. The New York Public Library, Astor, Lenox and Tilden Foundations, Miriam and Ira D. Wallach Division of Art, Prints and Photographs, The Phelps Stokes Collection, Print Collection

Fig. 156. Robert Havell Jr., *Panoramic View of New York, from the East River*, 1844. Engraving and aquatint with hand coloring. The Metropolitan Museum of Art, New York, The Edward W. C. Arnold Collection of New York Prints, Maps, and Pictures, Bequest of Edward W. C. Arnold, 1954 54.90.643

and *New York from Weehawk* (Weehawken), first printed by Hill in 1823.[35] Bourne, who also sold stationers' and artists' supplies from his store at 359 Broadway, was probably the shop owner targeted for criticism by the *New-York Mirror*, which devoted an entire column to the "obscenity of printshop-windows" in 1833, only two years before Durand created his controversial large-scale engraving of John Vanderlyn's nude *Ariadne Asleep on the Island of Naxos* (cat. no. 125). Americans were not yet ready to accept nudes—either in paintings, prints, or, for that matter, sculptures—as suitable subjects for contemplation by the public. According to the anonymous journalist who wrote the *Mirror* article: "Immoralities, so obvious and so gross, demand the prompt attention of every conductor of a public press."[36] So great was his outrage that he actually envisioned a situation in which Mrs. Trollope might constructively criticize American society (the English writer's *Domestic Manners of the Americans* had been published in England the previous year):

> *If Mrs. Trollope, instead of caricaturing the poor or the uneducated people, scattered over half settled tracts of country, had held up a few of the New-York printshop-windows to the astonishment and disgust of the British public, she would have wandered less from the truth, and the notoriety of the facts would have kept us dumb, or been testified to by all her countrymen as well as our own. We trust, hereafter, to see this loathsome and insolent trash withdrawn. Shall decency be thus outrageously violated, in the most frequented promenades of the city, merely that the attention may be attracted of now and then half a dozen customers, who are willing to encourage impropriety? Such an impudent insult to men, as well as to women and children, has been endured long enough.[37]*

For the most part, British engravers in New York concentrated their efforts on high-quality aquatints for connoisseurs; American engravers, meanwhile, were honing their skills by producing prints for the popular and commercial markets. Based in Newark, New Jersey, Peter Maverick rose to prominence as the most important American printmaker to New York City during the early decades of the nineteenth century. To support himself and his large family, which included sixteen children by 1822, Maverick diversified his output, making engravings for illustrated books, maps, banknotes, and trade cards. He also trained many apprentices who eventually set up shop in the metropolitan region. In 1816, as a tribute to Maverick's personal achievements and his dedication to training students, Archibald Robertson invited the master printer to join the American Academy of Arts (later known as the American Academy of the Fine Arts). Like Robertson, who taught drawing at his own New York Academy, Maverick engraved plates for a book of elementary exercises for apprentices.

Among Maverick's most important pupils was Asher B. Durand, an artist who would later dominate the field of engraving and landscape painting in New York City. After finding his way to Maverick's Newark shop as a young man, Durand set to work lettering Maverick's plates and copying from prints.[38] At the end of his apprenticeship, in 1817, Durand entered into partnership with Maverick and by October of that year had established himself in

35. Koke, "John Hill," pp. 100, 103.
36. *New-York Mirror*, August 10, 1833, p. 47.
37. Ibid.
38. See Stephens, *The Mavericks*, p. 48.

Fig. 157. Asher B. Durand, after John Trumbull, *The Declaration of Independence,* 1821. Engraving, second state. The Metropolitan Museum of Art, New York, Bequest of Charles Allen Munn, 1924 24.90.1514

39. Ibid., p. 53.

40. For a more extensive description of the relationship between banknote engraving and painting of the period, see Maybelle Mann, "The Arts in Banknote Engraving, 1836–1864," *Imprint* 4 (April 1979), pp. 29–36.

41. See William H. Dillistin, "National Bank Notes in the Early Years," *The Numismatist,* December 1948, pp. 796–97.

42. I am particularly grateful to Mark D. Tomasko for sharing with me his expertise on American banknotes and the New York banknote industry. See Mark D. Tomasko, *Security for the World: Two Hundred Years of American Bank Note Company* (exh. cat., New York: Museum of American Financial History, 1995).

New York City in the business, renamed Maverick and Durand. It was there in 1820 that the history painter and portraitist John Trumbull inquired about commissioning an engraving to promote his painting *The Declaration of Independence* (fig. 157), a proposition Durand accepted; in so doing he engendered the wrath of Maverick, who severed their partnership.[39]

Since commissions to reproduce paintings were few and far between, Durand concentrated on the bread-and-butter business of banknote engraving in order to survive, as did other leading American artists of the period, including Durand's own pupil John Casilear, as well as James Smillie and Kensett. Between 1836 and 1863, when there were no federal regulations or standards for printed paper money, New York City emerged as a mecca for banknote engravers.[40] Even after Congress authorized a national currency in 1863, paper money continued to be printed by private companies in New York until

1875, when the work was divided between the Continental Bank Note Company in New York, which printed the green backs of the bills, and the Columbian Bank Note Company in Washington, D.C., which printed the black fronts and seal of the Bureau of Engraving and Printing.[41]

Banknote engravers were expected to supply fanciful vignettes of allegorical figures, detailed portraits, and an elaborate array of calligraphic strokes. These were executed with a tool called the graver, which the artist had to wield with virtuoso skill in order to foil counterfeiters. With the advent of black-and-white photography in 1840, counterfeiters could create photographic reproductions of bills, but printers kept one step ahead of them by printing the bills in colored inks. Green was eventually selected as the color for federal currency because it was the most difficult to simulate when color photography was in its infancy.[42]

Between 1824 and 1833 Asher Durand and his brother Cyrus dedicated themselves to designing paper currency. Benefiting from the technical expertise of Cyrus and of Asa Spencer, who are credited with inventing the geometric lathe for engraving the intricate linear designs on banknotes,[43] Asher formed a partnership in 1828 with Jacob Perkins, a technological innovator of the steel die and cylinder diesinker.[44] One of Durand's sample sheets dating from the years when he was associated with Perkins illustrates his inventiveness and facility as an engraver and attests to his command of the current technology (cat. no. 116). The sample sheet is a display of vignettes, many in the form of allegorical figures and their attributes. It was mailed around the country to bankers responsible for selecting the motifs and designs for bills issued by the institutions they represented (see cat. no. 115). The creases on the sample reflect the folding and unfolding that occurred as the sheet made its way through the mail service, a means of marketing prints that would be exploited later in the century to maximum effect by the popular New York lithographer Currier and Ives.

In 1830 Durand tested the market for high-quality reproductive engravings after paintings by American artists. He engraved two of Bennett's oils, *Weehawken from Turtle Grove* (fig. 158) and *The Falls of Sawkill, near Milford, Pike County, Pennsylvania*, for a project entitled *The American Landscape*. Poet William Cullen Bryant was to provide the text, and Durand planned to execute sixty engravings after works by the leading landscape painters of the day to fill ten volumes of six prints each. A writer for the *New-York Mirror*, which was instrumental in cultivating an audience for print production in New York City, endorsed Durand's project in the following terms:

> *To those who are fond of the charms of nature in all her grandeur, loneliness, and magnificence, as well as in her softer features; to those who feel their hearts warm and expand at the contemplation of* American *scenery, pictured by American artists, and embellished by American writers, we warmly recommend this production. It would reflect disgrace on the taste as well as the patriotism of our countrymen were it to fall to the ground for want of patronage.*[45]

Although *The American Landscape* was abandoned after publication of the first installment of six prints, the *New-York Mirror* reproduced Bennett's two designs

for engravings by Durand in 1833 along with accompanying descriptions by Bryant.

In the early 1830s Durand began work on an engraving after John Vanderlyn's oil of 1812, *Ariadne Asleep on the Island of Naxos*, an important American painting with a classical theme, which he had purchased with the intention of copying it as a print. When Durand's large engraving appeared in 1835, it received high praise from a small circle of New York artists and connoisseurs, notably the avid print collector Henry Foster Sewall, who purchased several of the progressive proofs (see cat. no. 125).[46] But despite its virtuosity, Durand's *Ariadne* was a financial failure, most likely because of its controversial subject matter, a female nude. Thereafter Durand turned his attention to painting, executing only an occasional engraving, such as a few small plates for James Barton Longacre and James Herring's monumental *National Portrait Gallery of Distinguished Americans*. Although Durand failed to interest sufficient individual collectors in purchasing prints of *Ariadne*, he set a high standard for the American engravers who followed him in the 1840s and 1850s, when the market for reproductive prints of American paintings blossomed with the support of the Apollo Association and its successor organization, the American Art-Union.

43. See Alice Newlin, "Asher B. Durand, American Engraver," *Metropolitan Museum of Art Bulletin*, n.s., 1 (January 1943), pp. 165–70. See also John Durand, *The Life and Times of A. B. Durand* (New York: C. Scribner's Sons, 1894), pp. 70–72.

44. See Newlin, "Asher B. Durand," pp. 165–70. Newlin writes (p. 167): "Perkins substituted steel for copper, which had previously been the standard material for engraved plates. The small bank-note designs were engraved on separate plates of soft steel, which were then hardened by a process he invented. These intaglio designs were transferred, under heavy pressure, in a transfer press to a soft steel cylinder, from one half to three inches wide, on which the designs then appeared in relief. The cylinders, or transfer rolls, were in turn hardened and served as dies from which a complete intaglio plate for a bank note could be rolled out in the press by combining a number of vignettes, portraits, or decorative and denominational designs in any variety desired." See also Henry Meier, "The Origin of the Printing and Roller Press," *Print Collector's*

Fig. 158. Asher B. Durand, after William James Bennett, *American Landscape, Weehawken from Turtle Grove*. Engraving, from the *New-York Mirror*, April 20, 1833. The Metropolitan Museum of Art, New York, Gift of Mrs. Frederic F. Durand, 1930  30.15.59

*Quarterly* 28 (1941), pp. 9–55; and Barbara Gallati, "Asher B. Durand as an Engraver," in *Asher B. Durand, an Engraver's and a Farmer's Art* (exh. cat., Yonkers: Hudson River Museum, 1983), p. 16.

45. *New-York Mirror,* January 8, 1831, p. 214, as quoted in Deák, *William James Bennett,* pp. 34–35.

46. The *American Monthly Magazine* (5 [April 1835], pp. 159–60) exalted Durand's achievement in the medium of engraving, which had already begun to fall out of favor in Manhattan.

47. Edward K. Spann, *The New Metropolis: New York City, 1840–1857* (New York: Columbia University Press, 1981), pp. 37–38. Harper's inexperience, however, contributed to his becoming "the first in a long line of reform-minded mayors who vanished from government almost as quickly as they came."

48. For an excellent discussion of the *National Portrait Gallery* and its context, see Gordon M. Marshall, "The Golden Age of Illustrated Biographies," in *American Portrait Prints: Proceedings of the Tenth Annual American Print Conference,* edited by Wendy Wick Reaves (Charlottesville: University Press of Virginia, for the National Portrait Gallery, Smithsonian Institution, 1984), pp. 29–82; and Robert G. Stewart, *A Nineteenth-Century Gallery of Distinguished Americans* (exh. cat., Washington, D.C.: National Portrait Gallery, Smithsonian Institution, 1969).

49. Edwin G. Burrows and Mike Wallace, *Gotham: A History of New York City to 1898* (New York: Oxford University Press, 1999), p. 433.

50. For an excellent overview of the role of the popular press in portraying the nineteenth-century American city, see Sally Lorensen Gross, *Toward an Urban View: The Nineteenth-Century American City in Prints* (exh. cat., New Haven: Yale University Art Gallery, 1989).

51. In a lengthy article entitled "A History of Wood Engraving," by An Amateur Artist, *Graham's* noted: "It may not probably be known to ordinary readers that while a copper-plate-engraving begins to fail after two or three thousand copies have been taken from it, and is worthless after six or

The financial panic of 1837 notwithstanding, New York City's mercantile class prospered, and with prosperity came leisure and a desire to cultivate literary and cultural pursuits. New Yorkers began to stock their private libraries with books, many of which were temptingly illustrated with engravings. That a background in book publishing was considered not unworthy of a political leader was reflected in the overwhelming victory in the mayoral election in April 1844 of James Harper, founder of Harper and Brothers publishing house.[47] New York offered fertile ground for major printing houses, which required large-scale presses, a steady supply of paper, and a substantial workforce. With the rise of the printing trade, the city began to rival Philadelphia and Boston as a major center for publishing of all kinds. One of the first important illustrated books produced during the Empire City's development into a major printing and publishing center was the *National Portrait Gallery of Distinguished Americans,* a collaborative effort between Philadelphia artist Longacre and New York artist Herring (see cat. no. 122A, B). Before securing the full financing he required, Longacre began work in late 1830 or early 1831 on a project he had long dreamed of realizing, a book of illustrated biographies of distinguished Americans.[48] When Herring issued his own prospectus for a similar project in October 1831, it came as a complete shock to Longacre that there existed a rival in a field he believed was his alone. The two artists joined forces, however, and together they planned a publication that resembled Herring's proposal for a literary portrait gallery of figures from America's past and present that would commemorate their contributions to the rising nation. Attempting to reach as broad an audience as possible, the partners issued the series in several formats, utilizing papers of different qualities and several bindings, including both cloth and special embossed plaque bindings of long-grained green or red morocco, as well as unbound sheets. Despite various financial setbacks, the *National Portrait Gallery,* produced in four volumes between 1833 and 1839, stands among the highest achievements of American engravers during the first half of the nineteenth century.

Along with magazines and books, newspapers flourished in New York, and they were increasingly accompanied by illustrations. Since 1818 packet boats had been departing on a regular schedule from New York Harbor to Liverpool and Le Havre, bringing international news and publications back to the city.[49] As the distance between New York and the rest of the world narrowed, readers of the popular press began to expect the latest reportage. Illustrated newspapers thrived as editors realized that stories were more titillating when accompanied by spectacular pictures of people and current events.[50]

Most popular newspapers and periodicals were illustrated with wood engravings, which were considered technologically unsophisticated by metal-plate engravers, who were assured a place above the salt in the hierarchy of printmakers. There were several practical reasons why wood engravings supplanted engravings on steel in the popular press. Paramount was the fact that wood engravings could be printed at the same time as movable type and on both sides of a sheet of paper; they were thus cheaper and more efficient to use than metal engravings, which had to be printed on a different kind of press and on separate pages from the type. Moreover, the end-grain blocks on which wood engravings were cut were tougher than copperplates and nearly as durable as steel plates.[51] Further tipping the scales in favor of wood engravings was the fact that large illustrations could be prepared quickly by dividing the composition among several blocks and farming them out to a fleet of cutters, who worked simultaneously on small portions of the image. When all the blocks had been completed and were bolted together, the master cutter was responsible for joining the lines between them to form one continuous composition. The aesthetics of the humble and ubiquitous wood engraving also had its admirers; *Gleason's Pictorial Drawing-Room Companion* published the following assessment of the technique in 1852:

> The taste for wood engraving has, . . . constantly grown, and now gives employment to a host of admirable artists, both as designers and as engravers. . . . The number of periodicals, especially weekly ones, that are now illustrated by wood engravings is great. The great beauty, taste and finish of the illustrations, and the spirit with which all the important passing events are seized upon, and by which whole galleries of scenes of the hour are given, making the chief personages of the day, and the places in which they perform their public duties, or pursue their pleasures, as familiar to the eye, as the press does to the mind, deserve particular notice.[52]

Innumerable wood-engraved illustrations of a vast range of subjects were produced in New York City between the opening of the Erie Canal and the beginning of the Civil War. This is in part attributable to

Fig. 159. John Gadsby Chapman, *Christ Healing Bartimeus,* frontispiece to the New Testament. Wood engraving, from *The Illuminated Bible, Containing the Old and New Testaments, Translated Out of the Original Tongues, and with the Former Translations Diligently Compared and Revised* (New York: Harper and Brothers, Publishers, 1846). The Metropolitan Museum of Art, New York, Harris Brisbane Dick Fund, 1939 39.93

PERSPECTIVE.

144

horizontal line through the point on which his leading figure stands, he takes the height of that figure (say six parts, or six feet), which, reduced to a scale on that line, gives all that he requires as a basis for after-operations. He must now decide upon the point of sight, which necessarily gives with it the line of the horizon, then the distance of the picture, etc. If he desires to tesselate the floor, for instance, lines drawn from the point of sight through the divisions on this horizontal line will repeat the scale as justly on the ground line and throughout the whole perspective plan of the picture as if he had begun as first suggested; the horizontal line first assumed, serving the practical purposes of a base line and with equal efficiency.

62. Again, as in the case of a view that it would be almost impracticable, if it were even necessary, to reduce to a measured perspective plan, we may select any one object which may be considered as a definite standard, and on such premises reduce all other objects and details into perfect perspective harmony, by means most simple and easy. In the case before us, it would be as difficult as unnecessary to draw a geometrical plan. It is easier to tesselate a

pavement and define every inch of it than to tesselate the traceless ocean, and yet do objects floating on its calm or disturbed surface come as equally within the government of the laws of perspective. Here we have all our lines of operation and verification to assume, except our line of the horizon and point of sight. Whichever object we select as our standard, if it be the sloop (B) nearest to us, for instance, we take its full height by a perpendicular from its vane to a central point between the water lines which mark its floating position on the perspective plane of the picture (64), and connect the extreme points of this perpendicular with the point of sight. We next decide upon the position of the ship (A) by the line F F. Supposing the ship (A) to be *three* times the height of the sloop (B), a perpendicular elevated anywhere on the line F F three times the height that the sloop would be if she were perspectively on that line (F F), will give the true height of the ship as exemplified; for it is evident that if the sloop were at the same distance as the ship (A), that is, on the line F F, her height would appear as indicated— a b —etc. Again, still more remote from us, let us suppose another ship (D) *four* times the height of the sloop, the horizontal line G G expressing that distance. By a like process do we attain the height of the ship D under such circumstances; while another ship (H), still more remote, supposed to be of the same height as A, may be thus equally, and by a similar method, brought into true

Fig. 160. John Gadsby Chapman, *Perspective in a Marine Scene*, from *The American Drawing-Book: A Manual for the Amateur and Basis of Study for the Professional Artist* (1847; New York: W. J. Widdleton, 1864), p. 144. The Metropolitan Museum of Art, New York, Harris Brisbane Dick Fund, 1954  54.425.2

improvements in technology that made it possible to reproduce both wood engravings and text by means of stereotyped plates. *Ballou's Pictorial Drawing-Room Companion* noted in 1857 that the American public's hunger for pictures was becoming insatiable: "The demand for pictures and engravings is gradually increasing among the people of our country as the means for procuring them becomes more abundant."[53] The more pictures and illustrations there were available, the more of them people wanted.

One of the most successful graphic artists in New York City, John Gadsby Chapman, produced two books with wood-engraved illustrations that appealed to a wide audience and sold so well that the artist

was able to retire to Italy. *The Illuminated Bible* (see fig. 159), which Chapman undertook in 1836, was issued in 1846 and carried the imprint of Harper and Brothers, the largest publishing house in New York City. The artist rendered the images so skillfully and in such fine detail that the illustrations resemble prints pulled from copper or steel plates. The publication was thus produced by the most economically efficient means and offered exceptionally good value because metal-plate engravings were thought at the time to bestow distinction on illustrated books.[54]

In 1847, at the height of a crusade to mandate drawing instruction in public schools, Chapman's *American Drawing-Book* was published in New York City, where it received high praise. Soon after the first installment appeared, the *Literary World* issued a lengthy notice encouraging readers to accept as an "axiom of education" Chapman's motto "Any one who can learn to write can learn to draw."[55] For the expanded edition of this comprehensive drawing book, published initially in 1858, Chapman enlisted Durand to render one of the landscape illustrations (cat. no. 132). *The American Drawing-Book* was widely favored by school boards for use in public schools and also served aspiring amateur and professional artists who did not have access to formal training. Self-taught artists such as Fitz Hugh Lane used the wood-engraved illustrations in *The American Drawing-Book* as the basis for their own drawings and oils.[56] Many of Lane's panoramic seascapes of Boston, as well as his view of New York Harbor (cat. no. 35), recall Chapman's diagrams for rendering perspective in a marine scene, for instance. The popularity of *The American Drawing-Book* ultimately cultivated among American artists and their patrons a taste for marine pictures that could be analyzed according to Chapman's specific drawing instructions (see fig. 160).

Daguerreotyped portraits became popular during the 1840s, replacing more expensive oil portraits in bourgeois households, although not among the wealthy or socially prominent. Recognizing a new source of illustrative material to please their readers, the editors of newspapers and books began to commission wood and steel engravings after daguerreotypes and print them along with stories printed with steel type. One noteworthy example of an engraving appeared as the frontispiece of the first edition of Walt Whitman's *Leaves of Grass*, published in 1855 (cat. no. 146).[57] By virtue of its association with the increasingly ubiquitous medium of daguerreotypy (see cat. no. 163), the portrait would have suggested to the readers of Whitman's book of poems that the

Fig. 161. After Winslow Homer, *The Ladies' Skating Pond in the Central Park, New York*. Wood engraving, from *Harper's Weekly*, January 28, 1860. The Metropolitan Museum of Art, New York, Harris Brisbane Dick Fund, 1928  28.111.1 (3)

author was a man of the people. Whitman's unconventionality and informality are conveyed by his open collar, broad-brimmed hat, and air of approachability, in contrast to the stiff poses and costumes of the subjects of the traditional portraits engraved on steel in the *National Portrait Gallery*.

Manhattan gradually eclipsed Boston and Philadelphia as a destination for aspiring artists seeking gainful employment in printmaking. Winslow Homer's early career as a printmaker illustrates this shift in opportunities during the final decade before the Civil War. From the 1830s until the 1850s, Boston was home to several active print workshops that employed apprentices. Between 1855 and 1857 the firm of John H. Bufford, who was an acquaintance of Homer's father, trained the young artist in lithography. Homer described his life at Bufford's, churning out lithographs to illustrate sheet music and books, as "bondage" and "slavery."[58] After completing his apprenticeship, Homer set up on his own in Boston as a freelance illustrator for a number of popular periodicals. Designing wood engravings based on sketches from life became his strong suit, and in 1857 he began working for *Harper's Weekly*. After producing several illustrations for the rising New

York periodical, Homer moved to Manhattan in 1859. The following year he took a studio at the main building of the University of the City of New York in Washington Square. The first drawing based on New York City life he submitted to *Harper's Weekly* shows the elegant crowd that gravitated on crisp winter days to the newly opened Central Park Skating Pond (fig. 161). Charles Parsons made a brilliant lithograph of the same subject about 1861 for Currier and Ives (cat. no. 153). As if to announce his arrival in New York City's art world, Homer boldly inscribed his signature below the figure of a graceful and dynamic male skater; the artist's calligraphic flourishes rendered on the wood block move with the same ease as the young man's blade on the ice.

While engraved illustrations proliferated in the popular press, the market for reproductions of major American and European paintings also strengthened. In 1835 Durand's engraving of Vanderlyn's *Ariadne Asleep on the Island of Naxos* had been a financial failure, chiefly because of its subject matter, but also because a class of newly sophisticated urban plutocrats had not yet come into existence in the United States. By 1860 there were 115 millionaires in New York City, and they and other wealthy business leaders

eight thousand, fifty or sixty thousand can be taken from wood-blocks, and yet more from steel, without detriment." *Graham's American Monthly Magazine of Literature, Art, and Fashion* 41 (December 1852), p. 568.

52. "Thomas Bewick," *Gleason's Pictorial Drawing-Room Companion,* March 6, 1852, p. 156.

53. "Something about Pictures," *Ballou's Pictorial Drawing-Room Companion,* November 21, 1857, p. 333. There was a simultaneous increase in the number of wood engravings that accompanied advertisements published in periodicals. Rita S. Gottesman has observed that from the publication of the first newspaper in New York City in 1725 until the end of the eighteenth century, only eighty-four newspaper advertisements were accompanied by wood engravings. See Rita S. Gottesman, "Early Commercial Art," *Art in America* 43 (December 1955), p. 34.

54. Sinclair Hamilton, *Early American Book Illustrators and Wood Engravers, 1670–1870* (Princeton: Princeton University Press, 1968), pp. 90–91.

Fig. 162. John Casilear, after Daniel Huntington, *A Sibyl*, 1847. Engraving published by the American Art-Union. Courtesy of the Pennsylvania Academy of Fine Arts, Philadelphia, John S. Phillips Collection 1876.9.32b

55. "How to Learn to Draw," *Literary World*, February 12, 1848, p. 29.

56. For a more detailed discussion of Chapman's drawing book and its impact on Lane, see Elliot Bostwick Davis, *Training the Eye and the Hand: Fitz Hugh Lane and Nineteenth Century American Drawing Books* (exh. cat., Gloucester, Massachusetts: Cape Ann Historical Association, 1993).

57. The caption states that the engraving is based on a daguerreotype; however, the original has never come to light.

58. As quoted in Nicolai Cikovsky Jr., "The School of War," in *Winslow Homer*, by Nicolai Cikovsky Jr. and Franklin Kelley (exh. cat., Washington, D.C.: National Gallery of Art, 1995), p. 17.

59. See Spann, *New Metropolis*, esp. chap. 9, "Wealth," pp. 205–41.

60. The prints were: *General Marion Inviting a British Officer to Dinner*, engraved by John Sartain after John Blake White (1840), and *The Artist's Dream*, engraved by John Sartain after George H. Comegys (1841); for illustrations, see Maybelle Mann,

were ready to spend lavishly, on works of art as well as on clothing, jewelry, furniture, and entertainment.[59] The middle class, too, had become more sophisticated and was eager to acquire the trappings of culture. Reproductive engravings on steel found a new market, and new avenues opened up for their distribution and sale.

Each year, beginning in 1840, the Apollo Association, a New York institution engaged in promoting American art, offered its members a print of a painting by an American artist. In 1840 and 1841 the association's gifts to its membership were standard fare: engravings depicting a scene of the Revolutionary War and an allegory titled *The Artist's Dream*.[60] In 1842 the selection committee favored what was then considered "high art": an engraving by Stephen Alonzo Schoff after Vanderlyn's painting *Caius Marius on the Ruins of Carthage*. Their choice was lauded in the popular press as "one of the finest specimens of art in its kind ever produced in this country."[61]

Five years later the association, which had been renamed the American Art-Union in 1842, published a resolution in its *Bulletin* that described the criteria used to select prints for distribution among its members: "Resolved, That it is the duty of this Association to use its influence to elevate and purify public taste,

and to extend among the people, the knowledge and admiration of the productions of 'HIGH ART.'"[62] It seemed, however, to the editor of the *Bulletin*, William J. Hoppin, that the committee's selection that same year of a mezzotint after George Caleb Bingham's *Jolly Flatboatmen* (cat. no. 127) failed to reflect the principles expressed in the resolution. The very name of the print, he claimed, "gives a death blow to all one's preconceived notions of 'HIGH ART.'"[63] Hoppin singled out for praise the other print offered to subscribers that year, Casilear's 1847 engraving after Daniel Huntington's painting *A Sibyl* (fig. 162), describing it as a work that "will amply atone for all that the other may lack."[64] In fact, Bingham's pyramidal composition is based on one of Raphael's great altarpieces, but his subject of boatmen dancing and singing on the Mississippi was so authentically American and so candidly presented that it seemed naive to many critics. In contrast, Huntington's portrait of a sibyl is a pastiche and its sources are obvious: Michelangelo's sibyls painted for the Sistine Chapel and Federico Barocci's proto-Baroque madonnas with eyes cast heavenward. A debate about what constituted "high art" ensued, and since the New York art world tended to favor European reproductive engravings, which were considered to be in that exalted category, the latter began to flood the marketplace as more and more European dealers established a foothold in Manhattan.

The ability of the American Art-Union to attract subscribers derived not so much from its annual gift of prints as from the lotteries of important oil paintings by American artists held annually on the association's Broadway premises. A lithograph by French-born Francis D'Avignon showing the distribution of prizes at an 1846 Art-Union lottery documents the social importance of these occasions (fig. 163). In 1848 the association's membership doubled because the offering that year consisted of four well-known paintings, Cole's Voyage of Life series (see figs. 49, 60). The *Literary World* described the excitement that gripped New York during the weeks before the drawing:

*Everybody is the friend of the Art-Union . . . In the shifting panorama of dress, action, expression, and character, [one] would find a complete epitome of the city life . . . gentlemen . . . who drop in between nine and ten in the morning . . . are merchants in South and Front Street . . . Lawyers, brokers, stockjobbers, and financiers there are too, who on their "down town" way, give five minutes to the arts . . . [in] the middle of the day, [the] scene*

*grows brighter with bevies of ladies . . . it is in the evening . . . that the Art Union is in all its glory . . . Here they all . . . are, from the millionaire of 5th Avenue, to the B'hoy [tough] of the 3rd, from the disdainful beauty of Fourteenth Street . . . to the belle of the Bowery . . . all . . . are unanimous in their amazement at the stupendous realization to somebody's five dollars, which will be afforded in Cole's four famous pictures.*[65]

As Art-Union members became more savvy about American painting, they demanded greater variety in the subscription prints. As the *Boston Daily Advertiser* expressed it in 1848:

*The public have, long ago, seen quite too much of "The Jolly Flat-boat Men." . . . On every other center table will be Darley's illustrations [cat. nos. 133, 134], in every other parlor will hang the picture of Queen Mary [The Signing of the Death Warrant of Lady Jane Grey]. . . . There is, therefore, really no inducement for a subscriber to induce his friends to subscribe with him, for they will all together become weary of the pictures which meet them every day as they pass from house to house in friendly intercourse.*[66]

Since the process of producing a large engraving such as James Smillie's *Voyage of Life: Youth* after Cole (cat. no. 130) was labor-intensive, it was in fact advantageous for the Art-Union to diversify its offerings. In 1850 the association distributed a suite of smaller engravings to its members. The subjects reflect a range of interests among subscribers, including genre scenes (*The Card Players,* engraved by Charles Burt after Richard Caton Woodville, and *The New Scholar,* engraved by Alfred Jones after Francis William Edmonds), historical subjects (*The Image Breaker,* engraved by Alfred Jones after Emanuel Leutze), and, for the first time, landscapes (*The Dream of Arcadia,* engraved by Smillie after Cole, and *Dover Plains,* engraved by Smillie after Durand). The selection was highly acclaimed in the *Literary World,* which called the prints "pictorial treasures, now transmitting to thousands of homes through the country, making our painters among the authors and their books of the country, by the extent and character of diffusion."[67] The American Art-Union was eventually brought down by its lottery system, which was declared illegal. When the institution closed in 1853, it had inculcated in the American public an appreciation for native art.[68] At the same time, Americans were becoming

Fig. 163. Francis D'Avignon, after T. H. Matteson, *Distribution of the American Art-Union Prizes at the Tabernacle, Broadway, New York, December 24, 1846.* Lithograph printed by Sarony and Major and published by John P. Ridner, 1847. The Metropolitan Museum of Art, New York, The Edward W. C. Arnold Collection of New York Prints, Maps, and Pictures, Bequest of Edward W. C. Arnold, 1954 54.90.1056

more sophisticated about European art, as reproductive engravings arrived from foreign ports on New York City's wharves each day and were rapidly purchased by dealers and auction houses. The demand for European prints was so great that New Yorkers were willing to compromise on quality. As New York art connoisseur and print publisher Shearjashub Spooner recounted, "I have seen thousands of mockproofs sold at auction in New York, from which, if they were mezzotints, the bloom was entirely worn off. . . . The London Art Journal frequently comes to us so much worn as to be useless except for the designs. They send us *pastiches,* or imitations of the old masters, and we buy them and hang them up in our rooms, and invite the connoisseur to see them, to excite his pity or contempt."[69]

British print purveyors continued to thrive in New York City throughout the 1840s and 1850s, although during those years Manhattan came of age as a center for print publication and began to compete successfully for prime projects initiated abroad. In several widely publicized incidents that document New York's rivalry with London's printing establishments, original English copperplates of famous works were shipped to New York City and used to produce American editions. In 1852 Spooner, who was an avid

*The American Art-Union,* rev. ed. (exh. cat., Jupiter, Florida: Distributed by ALM Associates, 1987), pp. 36–37.

61. Quoted in ibid., p. 5. See also Jay Cantor, "Prints and the American Art-Union," in *Prints in and of America to 1850,* pp. 300–301.

62. Quoted in Mann, *American Art-Union,* p. 15.

63. Quoted in ibid.

64. Quoted in ibid., citing *Literary World,* April 3, 1847, p. 209, as the source of Hoppin's article.

65. *Literary World,* November 25, 1848, p. 853, as quoted in Mann, *American Art-Union,* p. 19.

66. Quoted in Cantor, "Prints and the American Art-Union," p. 314.

67. "The Gallery of the American Art-Union," *Literary World,* May 10, 1851, p. 380. See also *Literary World,* November 30, 1850, p. 432; and Mann, *American Art-Union,* pp. 23–24.

68. According to Charles E. Baker, the following precepts for an American school of art were issued in the various publications of the American Art-Union: "Break the shackles of the past / Renounce subservience to Europe / Develop individuality / Paint native subject matter."

Fig. 164. Alphonse-Léon Noël, after William Sidney Mount, *The Power of Music*, 1847. Lithograph with hand coloring published by Goupil, Vibert and Company. The Museums at Stony Brook, Stony Brook, New York, Museum Purchase, 1967  67.12.1

See Charles E. Baker, "The American Art-Union," in Cowdrey and Sizer, *American Academy of Fine Arts and American Art-Union*, pp. 65–68. This passage is quoted in Mann, *American Art-Union*, p. 22.

69. Shearjashub Spooner, *An Appeal to the People of the United States in Behalf of Art, Artists, and the Public Weal* (New York: J. J. Reed, Printer, 1854), p. 12.

70. *The American Edition of Boydell's Illustrations of the Dramatic Works of Shakespeare, by the Most Eminent Artists of Great Britain. Restored and Published with Original Descriptions of the Plates* (New York: Shearjashub Spooner, 1852). The print of West's *King Lear* reproduced a painting that Robert Fulton had acquired together with West's *Ophelia* for his art collection housed in New York City. See Carrie Rebora, "Robert Fulton's Art Collection," *American Art Journal* 22, no. 3 (1990), pp. 41–63.

print collector, issued the first American edition of John and Josiah Boydell's *Shakespeare Gallery* using the original plates that the English engravers had prepared in London from 162 oil paintings of scenes from Shakespeare's plays, including an engraving after Benjamin West's *King Lear* (cat. no. 156; fig. 39).[70] Praising John Boydell as "the father of engraving in England," Spooner decried British attempts to sabotage his own efforts. After British journalists sought to libel his work in popular illustrated English newspapers that circulated widely in the United States, Spooner obtained his own certificate of approbation, signed in 1848 by numerous members of New York City's inner circle of art connoisseurs, who heartily endorsed his efforts to attract American subscribers.[71] The copperplates engraved by British artist Havell for American naturalist John James Audubon's double-elephant portfolio of *The Birds of America*, which had been published in London, traveled with Audubon to New York City in 1839.[72] Two decades later, working with the original copperplates, which had suffered damage in a fire, as well as with the hand-colored

Havell engravings, German immigrant Julius Bien combined forces with Audubon's son John Woodhouse Audubon to produce a double-elephant-folio edition of color lithographs offered at half the price of the original edition (see cat. no. 149).

During the 1840s French print dealers found the New York marketplace increasingly responsive to their wares. In 1846 Michael Knoedler traveled to "the American Athens" to establish a branch for his employer, Adolphe Goupil, and the following year he was joined there by Léon Goupil and William Schaus.[73] In October 1848 the New York press announced the opening of the firm—Goupil, Vibert and Company (later Goupil and Company)—which began to compete directly with the American Art-Union for the privilege of publishing engravings after foremost works by American artists. In 1848 William Schaus established the International Art-Union for Goupil, Vibert, ostensibly to cultivate a taste for European masterpieces in America but also to disperse its stock of contemporary French paintings, which were not popular abroad but appealed to a New York audience

eager for European sophistication.[74] In 1851 Goupil and Company symbolically undercut the American Art-Union, an avid promoter of Leutze's work, when it purchased the second version of Leutze's monumental painting *Washington Crossing the Delaware* (fig. 71) directly from the artist for $6,000.[75] Goupil also wooed American artist William Sidney Mount, who produced several lithographs after his own paintings with the French publisher, most notably *The Power of Music* (fig. 164), which was advertised in Goupil's French catalogue in 1850.[76] Mount, who did not have the opportunity to travel abroad, favored Goupil's International Art-Union, and observed in 1850: "I have long had a desire to see France, her great painters are dear to me. The works of Le Sueur, Le Brun, Poussin, Claude, Guérin, Regnault, Perrin, Jouvenet, Lairesse, David, and latterly, the Vernets, Delaroche, Scheffer, Debuffe [*sic*], etc., all have given me instruction and pleasure (principally through engravings of their works)."[77]

Periodicals of the era devoted to art are replete with the latest offerings to be found at Goupil. Indeed, the French dealer played a leading role in developing a taste in America for nineteenth-century French painting, and it is likely thanks to Goupil that an engraving after Paul Delaroche's *Hemicycle* received a silver medal at the New York Crystal Palace exhibition in 1853. In 1854 Spooner noted, probably in reference to Goupil's Broadway establishment (see fig. 55), "There are not only frequent day sales, where a catalogue of 150 or 200 pictures are offered, but there are two establishments in Broadway where French pictures and prints, books, &c., are sold every evening."[78] Spooner estimated that "New York alone cannot pay less than half a million annually"[79] on French prints and pictures, a sum that reflects the universality of the fashion since the consumers who bought prints were frequently on a more limited budget than those who bought paintings. In 1855 Goupil offered two engraved reproductions of paintings by nineteenth-century French artists that were received by the New York press with great acclaim: *Joseph Sold by His Brothers* after Horace Vernet, and *Dante and Beatrice* after Ary Scheffer (fig. 165). Goupil encouraged New York collectors to find virtue in these literary pictures, and they did in droves. In October 1855 *Putnam's Monthly,* which exhorted readers to see the Scheffer engraving, reported that the work on view at Goupil was "finer" than the painting, which had been much admired by New York audiences when it was exhibited there in 1848.[80]

Since the seventeenth century, reproductive prints depicting major monuments of Western art had

Fig. 165. Narcisse Lecomte, after Ary Scheffer, *Dante and Beatrice*, 1855. Engraving, proof before letters. The Metropolitan Museum of Art, New York, Gift of Mrs. Alice G. Taft, Miss Hope Smith, Mrs. Marianna F. Taft, Mrs. Helen Bradley Head, and Brockholst M. Smith 45.78.10

71. Spooner, *Appeal*, p. 23. The certificate published the following assessment of the proofs pulled by Spooner: "We, the undersigned, having examined some of the original copperplates of *'Boydell's Illustrations of Shakspeare,'* and compared the proofs taken from them by Boydell himself, with those taken by *Dr. S. Spooner*, within the last few weeks, from a number of the plates restored by him, give it as our deliberate opinion and judgment, that his efforts to restore this magnificent work, have, so far, proved entirely successful; and we heartily recommend it to the American public as being in every respect worthy of their liberal patronage, and as eminently calculated not only to gratify those who may become its possessors, but also, to encourage and promote the advancement of the Fine Arts in our country."

72. The bibliography on Audubon is extensive. See especially Waldemar H. Fries, *The Double Elephant Folio: The Story of Audubon's Birds of America* (Chicago: American Library Association, 1973); Peter C. Marzio, "Mr. Audubon and Mr. Bien: An Early Phase in the History of American Chromolithography," *Prospects*, 1975, pp. 138–54; Ann Lee Morgan, "The American Audubons: Julius Bien's Lithographed Edition," *Print Quarterly* 4 (December 1987), pp. 362–78; and Annette Blaugrund, "John James Audubon: Producer, Promoter, and Publisher," *Imprint* 21 (March 1996), pp. 11–19.

73. Hélène Lafont-Couturier, "'Le bon livre' ou la portée éducative des images éditées et publiées par la maison Goupil," in *État des lieux* (Bordeaux: Musée Goupil, 1994), pp. 30–31. I am grateful to Richard MacIntosh of the Carnegie Museum, Pittsburgh, and Pierre-Lin Renié of the Musée Goupil for their generous assistance in locating Goupil prints and for bringing this catalogue to my attention.

74. Ibid., p. 31. See International Art Union, *Prospectus* (New York: Printed by Oliver and Brother, 1849).

75. Cantor, "Prints and the American Art-Union," p. 20. See also John K. Howat, "Washington Crossing the Delaware," *Metropolitan Museum of Art*

Fig. 166. Raphael Morghen, after Leonardo da Vinci, *The Last Supper*, 1800. Engraving, fifth state. The Metropolitan Museum of Art, New York, Gift of Lucy Chauncey, in memory of her father, Henry Chauncey, 1935  35.85.94

provided American artists with a basis for their training. Three art institutions in New York—the American Academy of the Fine Arts (founded in 1802); the National Academy of Design (founded in 1825); and the Cooper Union for the Advancement of Science and Art (founded in 1859)—maintained collections of reproductive prints for the use of artists and amateurs who were unable to travel abroad to view the European masters firsthand. The stipulation in the 1817 bylaws of the American Academy of the Fine Arts that the "tracing or chalking" of prints was strictly forbidden provides evidence for the common practice among artists of copying prints.[81] The National Academy of Design established a library as one of its initial projects, and in 1838 its council appropriated $400 to be used by the academy's president, Samuel F. B. Morse, for the purchase of books and engravings during his forthcoming sojourn in Europe.[82] The Cooper Union, which initiated regular drawing classes and opened a free reading room in November 1859, allowed both men and women access to books and current periodicals illustrated with prints between the hours of eight in the morning and ten at night, in order to fulfill the dream of founder Peter Cooper, who hoped to draw workers from "less desirable places of resort."[83] The importance of the role of reproductive engravings in New York art academies is expressed by a gesture of Morse, who was often considered an American Leonardo because of his artistic talent and scientific inventions. When he left his post as president of the National

Academy, Morse presented his successor, Durand, with Raphael Morghen's engraving after Leonardo's *Last Supper* (fig. 166).[84]

Connoisseurs, perhaps anxious to temper their conspicuous consumption with social acceptability, emphasized the role of prints in cultural edification. Spooner, for example, observed that collecting prints was a useful activity, elevating personal taste generally and combining entertainment and instruction. In his introduction to *A Biographical and Critical Dictionary of Painters, Engravers, Sculptors, and Architects* (1852), this keen collector wrote that his passion afforded "an interesting amusement for every stage in life. . . . As with a masterful painting, so with the engraving, more beauties will constantly be discovered; so that a portfolio of fine prints is a source of endless instruction, amusement, and gratification—not only to the possessor, but to his friends and acquaintance[s]."[85] In his *Appeal to the People of the United States* of 1854, in which he requested government support for his proposal to execute engravings after the major masterpieces of Western art housed in the Musée du Louvre, Spooner attested that "these works were intended as a great treasury of art; from which not only artists, but the whole world might derive instruction and profit."[86]

Like Spooner, the wealthy art amateur Luman Reed, who assembled the foremost private New York collection of American art during the period, found prints a source of endless instruction, amusement, and gratification. Reed, who never traveled abroad,

gathered a large quantity of reproductive engravings after the great painters of the Italian Renaissance, which he used to hone his powers of discrimination (see cat. no. 155; fig. 167). Eager to share his collection with American artists and the public, who could visit his residence at 13 Greenwich Street once a week, Reed commissioned print connoisseur and architect Alexander Jackson Davis to design his picture gallery. Davis created a setting in which visitors could enjoy prints along with the paintings. In addition to two ottomans and twelve mahogany chairs, the gallery was furnished with "long, low mahogany tables . . . where the large books of engravings could be conveniently laid and examined."[87] In this room, Cole may have consulted Reed's impression of an engraving after Rubens's *Amazons on the Moravian Bridge*, 1623 (New-York Historical Society), an inspiration for the battling figures displayed in the foreground of *Destruction*, one of the five paintings in The Course of Empire series Reed commissioned from the artist (see figs. 91–95).

Although many of the private print collections formed between 1825 and 1861 in New York are now dispersed, extant auction catalogues and inventories of print collections that entered public institutions reveal certain preferences among the city's print connoisseurs of those years.[88] Attributions made in these lists to the great Italian Renaissance masters Leonardo, Raphael, and Michelangelo would be considered more than generous today. Art patrons who had taken the Grand Tour of Europe—John Allan and Spooner, for example—acquired reproductive engravings after major monuments no doubt as souvenirs of their firsthand experience of European art. In addition to Italian Renaissance art (see cat. no. 155; fig. 167), the national schools that are most strongly represented are the Flemish and Dutch (see cat. no. 154), French (see cat. no. 158), British (see cat. nos. 156, 157), and German. Within those schools there was a marked preference for eighteenth- and nineteenth-century British mezzotints and reproductive engravings and fine Northern Renaissance woodcuts and engravings, especially by the masters Albrecht Dürer (see fig. 64) and Lucas van Leyden. When prints are listed separately in the catalogues and inventories, a preference for intaglio prints, whether original works or

*Bulletin* 26 (March 1968), pp. 292–93. As Howat notes: "The *Bulletin of the American Art-Union* for April 1851 could not hide its displeasure with Leutze over its willingness to deal with Goupil, reminding its readers that the American Art-Union had 'done a great deal to advance Mr. Leutze to the position he now occupies.' The *Bulletin* went on to comment dryly: 'Mr. Goupil, it is said, is one of the best judges of art in Europe. He visited Düsseldorf on purpose to see this picture, and bought it immediately upon Leutze's own terms, viz., 10,000 thalers—about $6,000 of our money.'"

76. Lafont-Couturier, "'Le bon livre,'" p. 33.

77. William Sidney Mount to Goupil, Vibert and Co., Feb[ruary] 14, 1850, New-York Historical Society, quoted in Georgia Brady Barnhill, "Print Collecting in New York to the Civil War," delivered at the Eighteenth North American Print Conference, New York, April 1986, p. 14; and reproduced in Alfred Frankenstein, *William Sidney Mount* (New York: Harry N. Abrams, 1975), p. 160. Goupil was successful in promoting Mount's genre paintings abroad through his prints, especially those rendered on stone by French lithographers. One of several lithographs of minstrels executed by Mount with French printmakers, *Just in Tune* was published as a two-color lithograph, included as the third plate of a drawing book entitled *Études de portraits et groupes* (1850). See Lafont-Couturier, "'Le bon livre,'" p. 35.

78. Spooner, *Appeal*, p. 11.

79. Ibid.

80. "Plastic Art," *Putnam's Monthly* 6 (October 1855), p. 448; *Literary World* 3 (December 1848), p. 983.

81. *The Charter and By-laws of the American Academy of Fine Arts, Instituted February 12, 1802 under the Title of the American Academy of the Arts. With an Account of the Statues, Busts, Paintings, Prints, Books, and Other Property Belonging to the Academy* (New York: David Longworth, 1817), p. 20. See Davis, "Training the Eye and the Hand," chap. 3, "Drawing Books and Art Academies in the United States," esp. pp. 40–41: "The initial provisions allowed no book or print to be removed from the library,

Fig. 167. Conrad Metz, after Michelangelo Buonarroti, *Detail from the "Last Judgment,"* 1808–16. Soft-ground etching. Collection of The New-York Historical Society 1858.92.069

although every Academician and Associate was allowed free access to the materials, and 'upon application to the Keeper of the Academy or Librarian' was 'permitted to make sketches from the books or prints.'"

82. Eliot C. Clark, *History of the National Academy of Design, 1825–1953* (New York: Columbia University Press, 1954), pp. 18–19. See also Archives of the National Academy of Design, *Constitution and Bylaws of the National Academy of Design with a Catalogue of the Library and Property of the Academy* (New York: I. Sackett, 1843), pp. 27–30.

83. Thomas Micchelli, "Ex Libris Anno 1859: Books from the Original Cooper Union Reading Room," exhibition mounted December 10, 1998, through February 19, 1999. I am grateful to Dana Pilson, Administrative Assistant, Department of American Paintings and Sculpture, Metropolitan Museum, for calling this reference to my attention.

84. *Studies in Oil by Asher B. Durand, N.A., Deceased. Engravings by Durand, Raphael Morghen, Turner, W. Sharp, Bartolozzi, Wille, Strange, and Others, . . .* (Executor's sale, Ortgies' Art Gallery, 845 and 847 Broadway, New York, April 13–14, 1887), lot 54.

85. *A Biographical and Critical Dictionary of Painters, Engravers, Sculptors, and Architects from Ancient to Modern Times; with Monograms, Ciphers, and Marks Used by Distinguished Artists to Certify Their Works* (New York: George P. Putnam, 1852), p. xi. I am grateful to Georgia Brady Barnhill for this quotation, which she cites in "Print Collecting in New York to the Civil War," as an insert between pages 10 and 11.

86. Spooner, *Appeal*, p. 5.

87. Mrs. Jonathan Sturges [Mary Pemberton Cady], *Reminiscences of a Long Life* (New York: F. E. Parrish and Company, 1894), quoted in Ella M. Foshay, "Luman Reed, a New York Patron of American Art," *Antiques* 138 (November 1990), p. 1076.

88. I am indebted to Georgia Brady Barnhill for generously lending me a typescript of her lecture on New York print collections.

89. Quoted in Foshay, "Luman Reed," p. 1078.

90. I am indebted to Sue Reed,

reproductions, is evident. Only the occasional lithograph appears, usually a portfolio reproducing European scenery.

The general interest in both the Italian Renaissance masters and the Dutch and Flemish schools was encouraged by British art pundits, including John Burnet, whose popular instruction manual intended for professional and amateur artists, *A Practical Treatise on Painting, in Three Parts* (London, 1828), was read by collector Reed and artist Mount, among others. Burnet advised that "painters should go to the Dutch school to learn the art of painting, as they would go to a grammar school to learn languages. They must go to Italy to learn the higher branches of knowledge."[89]

The largest private print collection assembled in New York between 1825 and 1861 that survives relatively intact is Henry Foster Sewall's; his twenty-five thousand impressions became the core of the print holdings at the Museum of Fine Arts, Boston.[90] Sewall, whose goal in building his collection was comprehensiveness, sought prints by the Northern Renaissance school and acquired a fine selection of works by Rembrandt (see cat. no. 154), Dürer, and Lucas, among others. He also purchased a substantial group of contemporary American prints, among them Alexander Jackson Davis's lithographic portfolio *Views of the Public Buildings in the City of New-York* (see cat. nos. 70–72) and proofs representing several states of Durand's engraving *Ariadne* (cat. no. 125).

The popularity of American genre scenes at mid-century is reflected in the number of subjects in this category published by the American Art-Union. At the same time an interest in European genre scenes prevailed among print connoisseurs. One important New York collector living in Europe between 1829 and 1850, Thomas Jefferson Bryan (fig. 75), became infatuated with Jean-Antoine Watteau's distinctive presentation of the fête galante. Pursuing an interest unusual among his contemporaries, he acquired several fine examples of etchings after that French master to round out his collection of paintings, which were exhibited at the Cooper Union beginning in 1858, when they were highly acclaimed in the *Cosmopolitan Art Journal*.[91] Mount found inspiration in prints after paintings by the Scottish genre artist David Wilkie, whose influence was bolstered by the British popular press. One of the most widely read European art publications in New York, the *London Art Journal*, provided an engraving after Wilkie's *Blind Fiddler* (cat. no. 157) as a premium for subscribers, one of whom may have presented a copy to Mount.[92]

Catching the wave of interest in European reproductive engravings as it trickled down to those of more modest means, Andrew Jackson Downing recommended them as interior decoration in his influential book of 1850, *The Architecture of Country Houses*: "Nothing gives an air of greater refinement to a cottage than good prints or engravings hung upon its parlor walls. In selecting these, avoid the trashy, coloured show-prints of the ordinary kind, and choose engravings or lithographs, after pictures of celebrity by ancient or modern masters. The former please but for a day, but the latter will demand our admiration forever."[93] During the decade that followed, many New Yorkers took Downing's suggestion, whether they were living in a country or an urban residence.[94] In 1860 a Washington Square dealer named H. Smith, who stocked large and small reproductive lithographs of "single heads, groups, small and large full-length figures, flowers, fruit, and sacred subjects, by Portals, Chazal, Brochart, Rosa Bonheur, and others, colored by Carrie A. Rowand (Frost)," reminded the public that "scarcely any drawing-room is considered furnished without one or more paintings of this description."[95]

Already by 1857, when *Ballou's Pictorial Drawing-Room Companion* published an article titled "Something about Pictures," engravings of the highest quality were within the means of middle-class New Yorkers despite the financial panic of that year:

*Colored and plain engravings are also another great means of pictorial pleasure and profit to our people; and here too we are struck with the great increase which there has been of late years in the demand for these works. Formerly, a few engravings piled up in one corner of booksellers' stores, supplied the whole demand, and were regarded as a drug by the trade, in consequence of their slow sale. Now there are large, commodious stores in all our cities and large towns, devoted exclusively to the sale of engravings, and the business affords ample present returns, and favorable prospects of steady increase. And with this great increase in the demand there has been a corresponding improvement in the character of the pictures, so that fine engravings which in former days were scarce, and of such high cost as to be found only in the portfolios of the rich, are now by improvements in the art, and a more extended market for them, made so cheap and plenty, as to put it within the reach of our citizens of moderate means to adorn their dwellings with them.*[96]

As *Ballou's* further observed: "Side by side with the growth of the business in engravings, we witness also the increased demand for paintings. Almost every one now decorates his walls with oil paintings, and at a very moderate expense, and there is a constant change for the better going on in the quality of these pictures."[97]

For those who desired oil paintings but could afford only prints, engravings were colored by hand in the New York printshops. The process was expedited by using stencils to apply broad swaths of color; nonetheless, applying pigment to create the fine details required precision and time. To meet the demand for inexpensive colored prints, a huge lithography industry developed in the city.[98] Although lithographic stones were more expensive initially than metal plates, the rapidity and ease with which designs could be drawn on the stones ultimately made lithographs cheaper than intaglio prints, which were prepared by the more laborious process of engraving a metal plate. Recognizing that by virtue of its speed and cheapness lithography served the masses, the young Nathaniel Currier described his fledgling New York lithographic firm—which he founded in 1835 and ran in partnership after 1857 with James Ives—as purveyors of "Colored Engravings for the People."[99] From 1857 until 1907—the lifetime of the firm—approximately seven thousand subjects were issued, and hundreds of each were sold to Americans in all walks of life.

Following the lead of the American Art-Union, Currier and Ives built a national distribution system that enabled the firm to dominate the marketplace for prints suitable for framing. The working parts of this well-oiled print-selling machine included the "traveling agent-peddler, the inscrutable fancy-goods middleman, the direct mail-order systems, the risky branch showrooms, and the fiercely competitive premium systems of national magazines."[100] The numerous subject categories for lithographs produced

Shelley Langdale, Clifford Ackley, and Patrick Murphy of the Museum of Fine Arts, Boston, for their generous assistance with researching Sewall, whose prints, which were purchased for the museum with funds from the Parker Bequest, are listed in four volumes housed in the Department of Prints, Drawings, and Photographs.

91. "Some Notices of Metropolitan Art-Wealth," *Cosmopolitan Art Journal: A Record of Art Criticism, Art Intelligence, and Biography, and Repository of Belle-Lettres Literature* 3 (1858–59), p. 85, published the following assessment of Bryan's collection: "Next in value and interest is the Bryan collection of Old Masters, now in the Cooper Institute building, on free exhibition. This gallery is also the fruits of the efforts of one man, Mr. Bryan, who has devoted a large fortune to the purchase of undoubted originals by the old painters, of the Italian, Spanish, Dutch, Flemish and French Schools, with a very few by the early English artists. . . . Some public institution ought to be possessed of this superb collection. It is barely possible that the worthy proprietor and the noble Peter Cooper may place it upon the basis of a perpetual charity, for the benefit of the School of Design for Women, now in successful operation in the Institute."

92. An example of the Wilkie engraving published by the *London Art Journal* is housed in the Department of Drawings and Prints, Metropolitan Museum.

93. A. J. Downing, "Treatment of Interiors," in *The Architecture of Country Houses* (New York: D. Appleton and Co., 1850; facsimile ed., with a new introduction by J. Stewart Johnson, New York: Dover Publications, 1969), p. 372.

94. See also E. McSherry Fowble, "Currier & Ives and the American Parlor," *Imprint* 15 (autumn 1990), pp. 14–19.

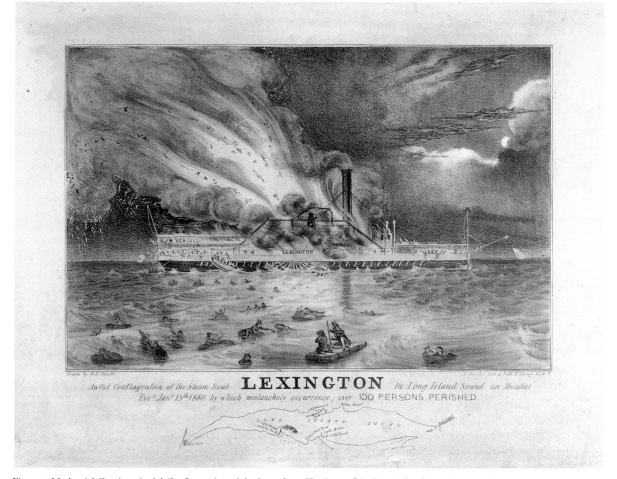

Fig. 168. Nathaniel Currier, *Awful Conflagration of the Steamboat "Lexington" in Long Island Sound on Monday Evening, January 13, 1840, by which Melancholy Occurrence over 100 Persons Perished*, 1840. Lithograph with hand coloring, published by Napoleon Sarony. Courtesy of the American Antiquarian Society, Worcester, Massachusetts

Fig. 169. Louis Maurer, *Preparing for Market*, 1856. Lithograph printed in colors with hand coloring by Currier. The Metropolitan Museum of Art, New York, Bequest of Adele S. Colgate, 1962  63.550.548

95. "Large and Small Crayon Lithographs," *Godey's Lady's Book and Magazine* 60 (June 1860), p. 565.

96. "Something about Pictures," *Ballou's Pictorial Drawing-Room Companion*, November 21, 1857, p. 333.

97. Ibid.

98. For a thorough discussion of the early years of chromolithography in the United States, see Marzio, *Democratic Art,* esp. chaps. 1–4.

99. The Currier and Ives bibliography is extensive. See Harry T. Peters, *Currier & Ives: Printmakers to the American People. A Chronicle of the Firm, and of the Artists and Their Work, with Notes on Collecting; Reproductions of 142 of the Prints and Originals, Forming a Pictorial Record of American Life and Manners in the Last Century; and a Checklist of All Known Prints Published by N. Currier and Currier & Ives,* 2 vols. (Garden City: Doubleday, Doran and Company, 1929–31); and *Currier and Ives: A Catalogue Raisonné. A Comprehensive Catalogue of*

by Currier and Ives—Views, Political Cartoons and Banners, Portraits, Historical Prints, Certificates, Moral and Religious Prints, Sentimental Prints, Prints for Children, Country and Pioneer Home Scenes, Humor, Sheet Music Covers, Mississippi River Prints, Railroad Scenes, Emancipation, Speculation, Horse Prints, and Sporting Events—attest to the firm's resourcefulness and thoroughness in leaving no stone unturned by their lithographers.[101] As the saying goes, fires always sell newspapers, and they certainly sold prints in a city frequently ravaged by flames. After establishing himself as a lithographer in New York, Currier rapidly made his early reputation with a lithograph of the burning of the Merchants' Exchange and reinforced it with the *Awful Conflagration of the Steamboat "Lexington,"* illustrating a disaster that occurred on Long Island Sound in January 1840 (fig. 168).[102]

Although several account books that record the firm's transactions survive, the edition sizes of particular prints are unknown. The only example that has been documented is a print in a series designed by Thomas Worth titled Darktown Comics, which was published in an edition of 73,000.[103] Given the number of prints that survive today, it is reasonable to assume that the editions were large; the range of subjects was broad enough to ensure mass appeal. Astute at marketing, Currier and Ives essentially produced prints on speculation and maintained a large inventory. One 1851 sales catalogue indicates that the company had on hand 22,364 impressions.[104]

Currier and Ives implemented two types of print production. Whereas early lithographers such as Imbert worked closely with a single artist or patron to produce a print in an edition of perhaps fifty to one hundred copies, Currier and Ives was obliged to hire a group of artists and colorists to work together in a factory-like setting.[105] For maximum efficiency, the shop was organized so that designers were responsible for developing compositions and drawing them on the stones; after the lithographs were printed in black ink, they were colored in assembly-line fashion, as described by Currier and Ives scholar Harry Peters, based on his discussions with former members of the firm:

*The "stock prints" were colored, in the [work] shop on the fifth floor at 33 Spruce Street, by a staff of*

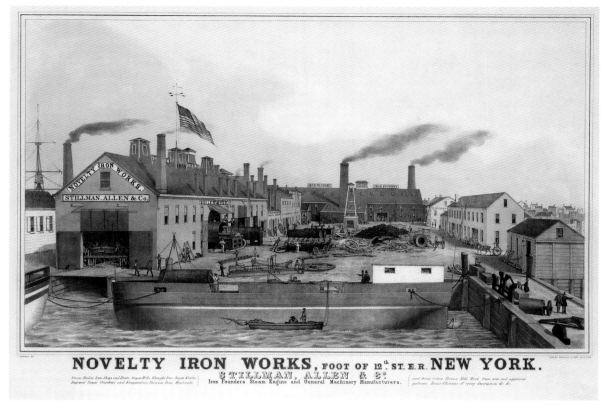

Fig. 170. George Endicott, after J. Penniman, *Novelty Iron Works*, 1841–44. Lithograph printed in colors with hand coloring. The Metropolitan Museum of Art, New York, The Edward W. C. Arnold Collection of New York Prints, Maps, and Pictures, Bequest of Edward W. C. Arnold, 1954  54.90.588

*about twelve young women and girls, all trained colorists and mostly of German descent. They worked at long tables, from a model. Many of these models were colored by Mr. Maurer and Mrs. Palmer, and all were first approved by one of the partners. The model was put in the middle of the table, in a position that made it visible to all. Each colorist would apply one color, and then pass the print on to the next colorist, and so on until the print had been fully colored. It would then go to the woman in charge, who was known as the "finisher," and who would touch it up where necessary.*[106]

Outside the workshop Currier and Ives supported a cottage industry of print designers and artists who submitted sketches for compositions and performed hand coloring, much of which was done by women working at home.

Before any print went into production, it was subject to final approval by one of the partners, and thus, despite their varied subjects and formats, lithographs by Currier and Ives displayed a characteristic appearance. Whether one considered their coloring brilliant or gaudy, that they appealed to a popular audience

was undisputed. None other than Charles Dickens alluded to their ubiquitous presence in New York when he recalled in his *American Notes* of 1842:

*So far, nearly every house is a low tavern; and on the barroom walls, are colored prints of Washington, and Queen Victoria of England, and the American Eagle. . . . [And] as seamen frequent these haunts, there are maritime pictures by the dozen: of partings between sailors and their ladyloves, portraits of William, of the ballad, and his Black-eyed Susan; of Will Watch, the Bold Smuggler; of Paul Jones the Pirate, and the like: on which the painted eyes of Queen Victoria, and of Washington to boot, rest in as strange companionship, as on most of the scenes that are enacted in their wondering presence.*[107]

Dickens's observations are consistent with Currier and Ives's own advertisements, which touted its pictures as "most interesting and attractive features for Libraries, Smoking Rooms, Hotels, Bar and Billard Rooms, Stable offices or Private Stable Parlors. Also, for display by dealers in Harness, Carriages, and House

the Lithographs of Nathaniel Currier, James Merritt Ives, and Charles Currier, Including Ephemera Associated with the Firm, 1834–1907 (Detroit: Gale Research, 1984).

100. Peter C. Marzio, "Chromolithography as a Popular Art and an Advertising Medium: A Look at Strobridge and Company of Cincinnati," in *Prints of the American West: Papers Presented at the Ninth Annual North American Print Conference*, edited by Ron Tyler (Fort Worth: Amon Carter Museum, 1983), p. 109.

101. Peters, *Currier & Ives*, pp. 209–10.

102. See James Brust and Wendy Shadwell, "The Many Versions and States of *The Awful Conflagration of the Steam Boat Lexington*," *Imprint* 15 (autumn 1990), pp. 2–13.

103. Peters, *Currier & Ives*, p. 42.

104. Ibid., p. 49.

105. Ibid., pp. 33–34.

106. Ibid.

107. Charles Dickens, *American Notes for General Circulation* (London: Chapman and Hall, 1842), chap. 6, pp. 137–38, as

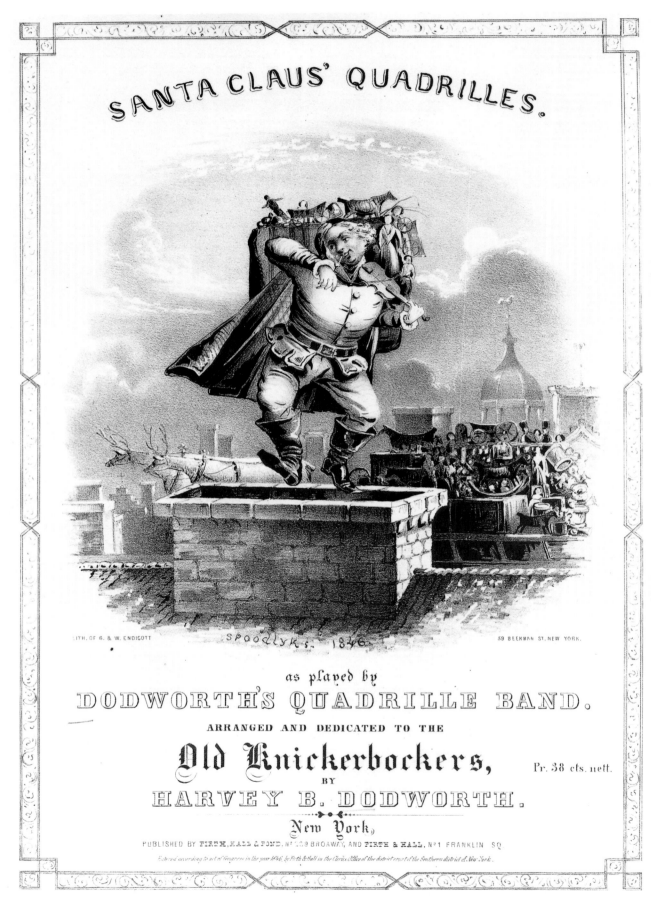

Fig. 171. George and William Endicott, after "Spoodlyks" (possibly George T. Sanford), *Santa Claus's Quadrilles*, 1846. Lithograph. Courtesy of the American Antiquarian Society, Worcester, Massachusetts

Furniture of all descriptions."[108] In short, they were considered suitable decoration for a variety of public and commercial settings and were displayed in much the same way as other popular lithographs of the period, such as those by the firms of Endicott and Fay (see figs. 170, 173).

Among the designers who worked for Currier and Ives, those who demonstrated superior draftsmanship —Fanny Palmer, Parsons, Worth, and Louis Maurer— were frequently permitted to sign their names on the stone or include them in the margin of a print. That selective distinction likely served not only to enhance the value of particular prints but also to reward and retain such artists, who otherwise might have severed ties with the firm. Maurer's *Preparing for Market* (fig. 169) represents the cream of popular lithographic production in New York and shows Currier at its best.[109] Urban dwellers besieged by grit, noise, and bustling activity pined for the idyllic agrarian existence portrayed in many of the firm's characteristic prints, such as this one of 1856. Maurer, who was often the draftsman chosen to design the trotting scenes

THE NEW-YORK ELEPHANT, Pl.3.

NATIONAL MONUMENT
to be erected at the top of New City-Hall.

Fig. 172. Adam Weingartner, *The New York Elephant*, from *The American Museum* (New York, 1851), pl. 3. Lithograph. The Metropolitan Museum of Art, New York, The Edward W. C. Arnold Collection of New York Prints, Maps, and Pictures, Bequest of Edward W. C. Arnold, 1954 54.90.1310 (3)

Fig. 173. Augustus Fay, *Temperance, but No Maine-Law,* 1854. Lithograph. The Metropolitan Museum of Art, New York, The Edward W. C. Arnold Collection of New York Prints, Maps, and Pictures, Bequest of Edward W. C. Arnold, 1954 54.90.1054

quoted in Peters, *Currier & Ives,* pp. 41–42.

108. "Portraits of the Great Trotters, Pacers, and Runners: Currier & Ives' Celebrated Cheap Popular Edition," as quoted in Marzio, *Democratic Art,* p. 61.

109. Harry S. Newman, *Best Fifty Currier & Ives Lithographs, Large Folio Size* (New York: Old Print Shop, 1938); and *Currier & Ives: The New Best Fifty* (Fairfield, Connecticut: American Historical Print Collectors Society, 1991).

Fig. 174. James A. Walker, *The Storming of Chapultepec, September 13, 1847*, 1848. Chromolithograph with hand coloring, published by Sarony, Major and Knapp. Amon Carter Museum, Fort Worth, Texas  1974.48

110. For an excellent and thorough discussion of the firm of George Endicott and its successors, see Georgia Brady Bumgardner, "George and William Endicott: Commercial Lithography in New York, 1831–51," in *Prints and Printmakers of New York State*, pp. 43–66. On Endicott's contribution to lithographic portraiture and his image of Fanny Elssler, in particular (cat. no. 126), see Wendy Wick Reaves, "Portraits for Every Parlor: Albert Newsam and American Portrait Lithography," in *American Portrait Prints*, pp. 83–134.

111. See Peters, *America on Stone*, pp. 171–79.

112. Spann, *New Metropolis*, p. 405.

113. Burrows and Wallace, *Gotham*, p. 435 n. 1; the authors observe that cheap docks "kept wharfage rates down, enhancing the port's competitiveness."

that became increasingly popular after midcentury, displays his mastery of equine anatomy front and center in this composition; moreover, the unmatched pair of farm horses, one dapple gray and one black, exhibit to full effect his ability to coax the widest range of tones from the lithographic crayon. The bountiful display of produce from the farm, proudly exhibited in the foreground, would have undoubtedly caught the eye of savvy New York consumers, who were accustomed to choosing the best from a large selection of goods spread out to tempt them along the emporium of Broadway.

Although Currier and Ives dominates the story of lithography in New York City, the firm was not without its share of competition. Beginning in 1839 George Endicott ran a highly respected printing establishment, often employing the same artists as Currier and Ives. In addition to a steady business in printing sheet-music covers, George Endicott, the firm later named G. and W. Endicott and Endicott and Company, produced fine promotional lithographs printed in colors.[110] While located at 22 John Street in New York, Endicott issued *Novelty Iron*

*Works* (fig. 170), a lithograph that likely served to aggrandize the manufacturer.[111] The quality of the draftsmanship and the details of the activities at the wharf suggest that the image may have appealed to both suppliers and clients of the factory, which was the largest manufacturer of steam engines in New York.[112] The lithographer vividly conveys New York City's ability to facilitate light manufacturing owing to its superior port and warehouses.[113] The extent to which dock-front activity supported a whole host of industries is charmingly represented in the foreground, where several workers are dwarfed by the scale of a cast-iron wheel.

Endicott and other New York lithographers also supplied popular lithographs for sheet-music covers that would appeal to prospective purchasers and look attractive when displayed on the piano in a domestic setting. One such example of thousands produced by the firm shows an early picture of Santa Claus, who, after the fashion of Saint Nicholas, prepares to climb down a chimney. Produced by Endicott in 1846 and drawn by an artist identified only as "Spoodlyks," the print (fig. 171) recalls an engraving published in the

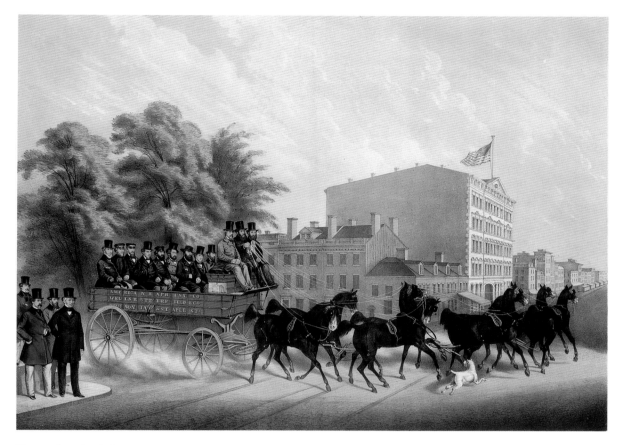

Fig. 175. Otto Bottischer, *Turnout of the Employees of the American Express Company*, 1858. Lithograph with hand coloring printed by Sarony and Major. The Metropolitan Museum of Art, New York, The Edward W. C. Arnold Collection of New York Prints, Maps, and Pictures, Bequest of Edward W. C. Arnold, 1954 54.90.763

*New-York Mirror* in 1841, purportedly the earliest depiction of Santa Claus in the United States.[114]

Another acknowledged master of lithography in the Empire City was Francis D'Avignon, who, in collaboration with Mathew B. Brady, produced one of the finest illustrated biographies of the time, *The Gallery of Illustrious Americans* (1850), which celebrated national unity by highlighting the virtues of twelve eminent Americans from every region of the Union. Considered without equal in the field, even in Europe, D'Avignon's portraits (see cat. no. 165A), based on daguerreotypes by Brady, were praised by New York lithographer Charles Hart as "highly finished, and classical in style, possessing all the beauty of the very best schools of lithographic art."[115] The book included biographical descriptions by Charles Edwards Lester that cast the twelve subjects as present-day republicans true in spirit to the ideals of ancient Rome and America's Founding Fathers.[116] Regally bound in royal blue cloth stamped in gold (cat. no. 165B), the volume took the "first prize away from all the world" at the 1851 Crystal Palace exhibition in London.[117]

The firm of Nagel and Weingartner produced not only important commemoratives of the Crystal Palace exhibition in New York but also sarcastic caricatures in the spirit of the British periodical *Punch* and the French *Charivari*. A previously unpublished lithographic pamphlet bearing the monogram of one of the firm's partners, Adam Weingartner, reflects that artist's special talent for caricature and inventiveness. Issued on April Fool's Day, 1851, the pamphlet vividly pokes fun at life in New York City. In one scene Weingartner alludes to P. T. Barnum's curiosities on view at the American Museum at Broadway and Ann Street: forming the body of an elephant representing Gotham are stonemasons and street people of every type found on Broadway (fig. 172).

Popular lithographers frequently produced prints with a political message. Currier and Ives contributed numerous examples, many of which were drawn by Worth. On occasion, political caricature achieved a scale and a level of finish more typical of fine prints. An example is Augustus Fay's lithograph of the Gem Saloon at the corner of Broadway and Worth (formerly Anthony) Street. Bearing the inscription

114. For discussion of the *New-York Mirror* frontispiece by Roberts after Ingham, see Jock Elliott, *"A Ha! Christmas": An Exhibition of Jock Elliott's Christmas Books* (exh. cat., New York: Grolier Club, 1999), pp. 44–45. Elliott suggests that the image in the *New-York Mirror* actually appeared before the same image was published in the *Dollar Magazine: A Monthly Gazette of Current American and Foreign Literature, Fashion, Music, and Novelty* 1 (January 1841).

115. See Charles Hart, "Lithography, Its Theory and Practice, Including a Series of Short Sketches of the Earliest Lithographic Artists, Engravers, and Printers of New York," 1902 manuscript, p. 175, Manuscript Division, New York Public Library. For a thorough discussion of D'Avignon, see William F. Stapp, "Daguerreotypes onto Stone: The Life and Work of Francis D'Avignon," in Reaves, *American Portrait Prints*, pp. 194–231.

116. In his description of Daniel Webster, for example, Lester associates the great orator with none other than General George Washington in the following passage: "July 4, 1826, our greatest festival, just half a century after the Declaration of Independence, two patriarchs of Freedom [Jefferson and Adams] left their blessing on the Nation, and died almost at the same hour. The day was hallowed by a holier consecration; and Webster commemorated the services of the ascended patriots. Finally, on the 22nd of February, 1832, which completed the century of Washington, he portrayed the character of the great deliverer. With these August names and occasions, the genius of Webster is linked forever." Charles Edwards Lester, *The Gallery of Illustrious Americans . . .* (New York: M. B. Brady, F. D'Avignon, C. E. Lester, 1850), Webster biography. I am grateful to Peter Barberie of the Princeton University graduate seminar on American prints for his research on *The Gallery of Illustrious Americans*.

117. Reflecting upon his achievements in an article published in *The World* in 1891, Brady recalled his work on *The Gallery of Illustrious Americans*: "In 1850 I had engraved on stone twelve great pictures of mine, all Presidential personages like

Scott, Calhoun, Clay, Webster, and Taylor; they cost me $100 a piece for the stones, and the book sold for $30. John Howard Payne, the author of 'Home, Sweet Home,' was to have written the letter-press, but Lester did it. In 1851 I exhibited at the great Exhibition of London, the first exhibition of its kind, and took the first prize away from all the world." George Alfred Townsend, "A Man Who Has Photographed More Prominent Men Than Any Other Artist in the Country—Interesting Experiences with Well Known Men of Other Days Look Pleasant," *The World*, April 12, 1891, p. 26.

118. Spann, *New Metropolis*, pp. 348–49.

119. Peters, *America on Stone*, p. 351; and Marzio, *Democratic Art*, pp. 49–51.

120. Quoted in Peters, *America on Stone*, p. 356.

121. Hart, "Lithography, Its Theory and Practice," as quoted in Marzio, "Chromolithography as Popular Art," p. 106.

122. Marzio, *Democratic Art*, p. 92.

"Temperance, but No Maine-Law," Fay's print of 1854 (fig. 173) displays a New York City barroom in all its glory. Businessmen at their leisure gulp down oysters, seal a deal with a handshake, gaze at the taxidermy display under glass, or dine in semiprivacy within a curtained banquette. The tavern, famous for housing the largest mirror in Manhattan, reflects one New York saloonkeeper's aspiration to sophistication expressed in the heavily encrusted ornamentation on the frame and the front panel of the bar. The men imbibing spirits support the inscription, which expresses opposition to a proposal—vigorously debated—to shut down all saloons or at least to enforce the laws requiring drinking establishments to close on Sundays.[118]

Along with political caricatures, New York lithographers offered a range of popular illustrations of contemporary events at home and abroad. Napoleon Sarony, who became one of the most successful lithographic publishers in New York, established his reputation with Currier's print of the burning of the steamboat *Lexington* in 1840 (fig. 168).[119] Sarony excelled at creating large compositions populated by numerous figures, such as the folio-sized prints of the Mexican War produced in partnership with Henry B. Major, who had also worked with Currier (see fig. 174). The partners rose to prominence printing the four folio prints of Commodore Perry's expedition to Japan in 1853. Sarony also worked with military lithographer Lieutenant Colonel Otto Bottischer, who drew on stone an animated scene of the top-hatted employees of the American Express Company sitting on the rapid stagecoaches for which the company was known (fig. 175). By 1859 Sarony and Major were dueling with Currier and Ives for preeminence as the leading lithographic firm in New York, proclaiming in one four-page advertisement that the company occupied four floors at 49 Broadway, had forty presses, and produced work "better than any done in this country, equalling that done abroad."[120]

Following the European upheavals of the 1848 Revolution, a number of German lithographers, notably John Bachmann, Charles Magnus, and Julius Bien, traveled to New York City, where they could take advantage of higher wages, "securing two dollars a day against forty and fifty cents a day in Germany."[121] The desperate need for skilled lithographers was reflected in United States immigration laws, which favored artisans trained in the field and encouraged them to join American firms. Although immigrant lithographers were allowed to bring in their own tools and other equipment duty free, they were not

Fig. 176. Nagel and Weingartner, Inscription page for John James Audubon's *Birds of America*, 1840–44. Lithograph with hand coloring. Museum of the City of New York, Gift of Arthur S. Vernay

allowed exemptions on "machinery or other articles imported for use in any manufacturing establishment," since these would enable them to compete with established American lithographic firms.[122]

Bachmann, who frequently published with the lithographic mapmaker Magnus, was an innovator of the bird's-eye view of Manhattan and a staunch promoter of the image of New York as the Empire City. Typical of the earlier city views that presented the panorama of bustling New York Harbor from sea level or slightly above it are examples by Bennett (cat. no. 128) and Havell (cat. no. 129). Henry Papprill, who with John William Hill made a spectacular aquatint of New York City from the steeple of Saint Paul's Chapel (cat. no. 135), took New Yorkers fascinated with city views to new heights from a traditional vantage point, the church steeple. In 1851 Williams, Stevens and Williams, the Broadway print dealer, advertised a "splendid Bird's-Eye View of the Empire City" in a commercial register published in New York. According to the advertisement, "To the mind of a

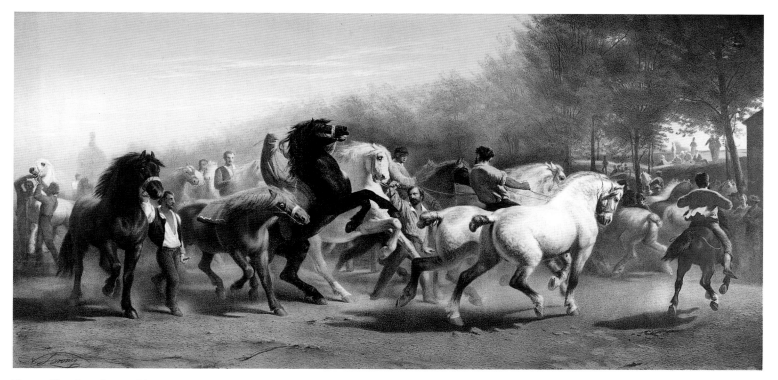

Fig. 177. Napoleon Sarony, *The Horse Fair, after the Celebrated Painting by Rosa Bonheur*, 1859. Lithograph printed in colors, published by Sarony, Major and Knapp. Courtesy of the American Antiquarian Society, Worcester, Massachusetts

stranger, this picture at once conveys a perfect idea of the exact location of New-York, with reference to surrounding parts, making it a most desirable acquisition to the Counting House of the Merchant, and a very satisfactory description to a friend abroad."[123] In 1855 William Wellstood and Benjamin F. Smith Jr. went higher still to view southern Manhattan from the "Heaven-kissing peak" of Latting Observatory (cat. no. 143).[124] The same year, perhaps inspired by Honoré Daumier's lithograph of French photographer Nadar sailing above Paris in a balloon, Bachmann produced a sky-high view of the Empire City, in which a flying machine hovers at the center of the uppermost margin (cat. no. 145). Bachmann later produced the most impressive antebellum view of Manhattan in his circular image *New York City and Environs* (cat. no. 150). He artfully distorted the landmass of the island to resemble the shape of North and South America, configuring New Jersey, to the west, as Asia and, to the east, Brooklyn and Queens as Europe and Africa. In Bachmann's image New York City looms at the center of the world.[125]

Until the late 1840s lithographs were printed in black and white and carefully colored by hand. Production of popular lithographs increased dramatically when skilled printers could effectively print in color using tint stones.[126] By inking a stone with a single color, such as blue for the sky or brown for the buildings, broad areas of color could be printed in a single pass through the press. In the case of DeWitt Clinton Hitchcock's *Central Park, Looking South from the Observatory*, 1859 (cat. no. 151), for example, the swaths of grass made possible by the Greensward Plan for the park and the urban sprawl surrounding it were printed on tint stones of green and brown.

With the advent of chromolithography came elaborately illustrated gift books. During the midcentury decades, about one thousand of these presentation volumes were produced.[127] New York City competed fiercely—although not always successfully—with Boston and Philadelphia for prime commissions, which previously were colored by hand. Between 1845 and 1854, Philadelphia printer John T. Bowen, for example, managed to edge out New York lithographers in the competition for the job of printing the hand-colored elephant-folio and octavo editions of John James Audubon's *Viviparous Quadrupeds of North America*, produced in collaboration with the artist's sons, Victor and John Woodhouse Audubon, who resided in Manhattan.[128] New York, however, did achieve one

123. *United States Commercial Register Containing Sketches of the Lives of Distinguished Merchants, Manufacturers, and Artisans with an Advertising Directory at Its Close* (New York: George Prior, 1851), New York Advertisements, p. 2, describes the print as follows: "Just completed. The only accurate and comprehensive View of New-York City & Environs. This VIEW is taken from opposite the easterly side, over Williamsburgh, and presents the entire length and breadth of the great CITY of NEW-YORK, delineating the outline of the *Jersey Shore*—showing *Jersey City* and *Hoboken*, the *North River, Governor's* and *Staten Islands*, the extensive *Bay* and the *Narrows*: on the left, a large portion of *Brooklyn*—the *Navy Yard* and *Williamsburgh* in the foreground. Against *New-York* reposes the forest of Shipping—its great Commercial stamp; while the *River* is studded with Steamers and Sailing Vessels.

DRAWN with the most careful regard to accuracy of position and perspective, in the relative location and height

of every prominent object, it combines an admirable view and an interesting picture." I am grateful to Austen Barron Bailly, Research Assistant, Department of American Paintings and Sculpture, Metropolitan Museum, and Brandy Culp, Research Assistant, Department of American Decorative Arts, Metropolitan Museum, for providing me with this reference.

124. *Frank Leslie's Illustrated Newspaper,* September 13, 1856, p. 214.

125. For European nineteenth-century bird's-eye views and panoramas, see Ralph Hyde, *Panoramania! The Art and Entertainment of the 'All-Embracing' View* (London: Barbican Art Gallery and Trefoil Publications, 1988); and Stephan Oettermann, *The Panorama: History of a Mass Medium,* translated by Deborah L. Schneider (New York: Zone Books, 1997).

126. For the rise of chromolithography in New York City, see Marzio, *Democratic Art,* esp. chap. 3, "New York and Düsseldorf: Mecca and Inspiration," and chap. 4, "The Giants of New York Lithography," pp. 41–63.

127. See Daniel Francis McGrath, "American Colorplate Books, 1800–1900" (Ph.D. dissertation, University of Michigan, Ann Arbor, 1966), p. 104; and Ralph Thompson, *American Literary Annuals and Gift Books* (New York: H. W. Wilson Company), 1936, p. i.

128. William S. Reese, *Stamped with a National Character: Nineteenth Century American Color Plate Books* (exh. cat., New York: Grolier Club, 1999), pp. 56–61.

129. McGrath, "American Colorplate Books," p. 104, as quoted in Thompson, *American Literary Annuals and Gift Books,* p. i.

130. McGrath, "American Colorplate Books," p. 105.

131. Ibid., p. 112.

132. Much has been published on Audubon's *Birds of America.* See especially Fries, *Double Elephant Folio;* and Blaugrund, "Audubon: Producer, Promoter, and Publisher," pp. 11–19.

133. Marzio, "Chromolithography as Popular Art," p. 116. Marzio notes that the practice of tinting chromolithographic photographs was common among firms such as Louis Prang of Boston, P. S. Duval of Phila-

Fig. 178. Felix Octavius Carr Darley, *The Bee Hunter.* Steel engraving, from *The Cooper Vignettes* (New York: James G. Gregory, 1862). The Metropolitan Museum of Art, New York, The Elisha Whittelsey Collection, The Elisha Whittelsey Fund, 1964  64.667

notable first in the field of chromolithographic book illustration. The first American book with tinted lithographs was produced there in 1848: *Squier's Ancient Monuments of the Mississippi Valley,* with pictures by lithographer Sarony working with two tint stones.[129] Some of the finest gift books of the 1840s and 1850s were published in New York. They include Thomas W. G. Mapleson's *Lays of the Western World* (1848) and *Songs and Ballads of Shakespeare* (1849).[130] From 1852 to 1856 Charles Mason Hovey's *Fruits of America,* published simultaneously in Boston and New York, established a standard for quality chromolithography in an American book.[131] The volume offered an unprecedented number of plates—ninety-six in all—and demonstrated the strength of the medium in its ability to render color brilliantly.

In 1858 Bien attempted one of the most ambitious chromolithographic projects ever—the replication of Havell's hand-colored aquatints and engravings for Audubon's *Birds of America.*[132] Bowen's smaller, octavo version of *The Birds* with hand-colored lithographs (1826–39) had proved so popular that New Yorkers chose a set of the volumes to present to Jenny

Lind following the Swedish singer's Manhattan debut at a concert in 1850 to benefit the widows and orphans of the city's firemen (see cat. no. 239; fig. 176). In collaboration with John Woodhouse Audubon, Bien created 105 chromolithographs based on 150 of the elder Audubon's original compositions, doubling up on a single sheet smaller birds drawn to scale. Through a variety of painstaking applications of color that mixed during the printing process, Bien managed to re-create on large lithographic stones the texture of the metal plates Havell had meticulously prepared. This monumental undertaking brought Bien little financial reward, since subscribers reneged on their commitment at the outbreak of the Civil War, despite the high quality of the first plate, *Wild Turkey* (cat. no. 149). Bien nonetheless persevered as a printer, later focusing his efforts on custom-made "chromos" executed for publishers and art dealers, chromolithographic illustrations to accompany federal geological surveys, and tinted chromolithographic photographs.[133]

Chromolithographs on a scale befitting the Empire City and promoting its image as the cultural capital of the United States were displayed in Manhattan. For example, in 1858 the major art and print dealer Williams, Stevens and Williams advertised its exhibition of eminent landscape painter Frederic E. Church's oil painting *Niagara* (fig. 50) along with "a *fac-simile* of this celebrated Picture, beautifully printed in colors, after the original."[134] No project seemed to be too large for New York lithographers to consider. While Bien was at work reproducing Audubon's watercolors for *The Birds of America* as color lithographs, Sarony and Major, who by then had invited Joseph Knapp on board as a third partner, took on the reproduction of Rembrandt Peale's celebrated twenty-four-foot-long painting, the *Court of Death,* as a large color lithograph. Printed in 1859, the work was praised by Peale himself shortly before his death: "The Drawing is correct, and the Colouring (considering the difficulty of the process and its cheapness) gives a good idea of the Painting."[135] Popular as well were chromolithographic reproductions of European oil paintings, among them the monumental *Horse Fair* by the French artist Rosa Bonheur (cat. no. 51; fig. 177), which was also printed just before the Civil War by Sarony, Major and Knapp.

While lithographers were enticing readers with color illustrations, engravers were busy perfecting their illustrations to accompany writings by American and European authors. Many aspiring artists produced engraved book illustrations to supplement their incomes until they could establish themselves as

painters. Others, such as New York engraver Felix Octavius Carr Darley, devoted themselves to the medium, creating banknotes, reproductive engravings, and some of the finest book illustrations produced prior to the Civil War.[136] Darley played a major role in creating the cult of George Washington through his immensely popular steel and wood engravings for Washington Irving's five-volume *Life of George Washington*, published between 1857 and 1859 by George P. Putnam, a leading New York publisher. Correctly anticipating good sales, Putnam supported Darley's proposal to produce large prints for the biography, including a monumental engraving titled *The Triumph of Patriotism* (1858), in which Washington is shown leading his troops into New York City in 1783 with all the confidence of a Roman emperor. Following the publication of Darley's successful lithographic outline illustrations for Sylvester Judd's novel *Margaret* and for two of Washington Irving's best-loved tales of Knickerbocker New York, "The Legend of Sleepy Hollow" and "Rip van Winkle" (see cat. nos. 133, 134), W. A. Townsend and Company of New York City commissioned the artist to produce illustrations for James Fenimore Cooper's complete works, which were published between 1859 and 1861. *The Cooper Vignettes* (see fig. 178) swiftly became de rigueur volumes for a proper New York library. Advertised by Townsend as a "monument of

American Art," Darley's work consisted of 64 steel engravings and 120 wood engravings dispersed among 32 volumes.[137]

As private libraries multiplied in New York City, many fine binderies sprang up to meet the demand for beautiful books. Enhancing the visual appeal of gift books were richly colored bindings stamped in gold.[138] Each year *The Garland*, a popular gift book published between 1847 and 1855, offered the purchaser a choice of three different gilt bindings stamped on either scarlet or purple morocco, for a total of six different volumes, each of which included different chromolithographed decorations, such as a page for a personal inscription.[139] Gift books were snatched up by a largely female audience, who bestowed them on family members and friends to mark holidays and special occasions. Especial favorites for the Christmas season were Dickens's *A Christmas Carol in Prose* (1844) and later imitations of it, such as W. H. Swepstone's *Christmas Shadows, a Tale of the Poor Needle Woman* (cat. no. 138), its accompanying blue binding stamped in gold with a picture of a poor needleworker appearing as an apparition before her miserly employer. Washington Irving's *History of New-York* of 1809, written under the pseudonym of its fictitious protagonist, Diedrich Knickerbocker, was issued in many subsequent editions, including one produced by Putnam in 1850 (cat. no. 137). Centered on the

delphia, and Strobridge of Cincinnati.

134. "At Williams, Stevens, Williams & Co.'s," *The Independent*, September 30, 1858, p. 5. On May 2, 1857, *The Albion* reported on *Niagara* (p. 213): "With spirit and judgment, Messrs. Williams & Co. have stepped in and become purchasers of this rare work, their intention being to carry it to London, (where it will undoubtedly create a sensation,) and have it there drawn and printed in colours by the chromo-lithographic process. They have paid Mr. Church, we understand, $4,500, for the picture and the copyright; and he is further to receive one half the price at which it may be finally sold."

135. Rembrandt Peale to Tristram Coffin, July 3, 1860, Joseph Downs Collection of Manuscripts and Printed Ephemera, The Winterthur Library, Henry Francis Du Pont Winterthur Museum, Winterthur, Delaware, as quoted in Marzio, *Democratic Art*, p. 51.

136. See Nancy Finlay, *Inventing the American Past: The Art of F.O.C. Darley*, with a foreword by Roberta Waddell (exh. cat., New York: New York Public Library, 1999). I am grateful to Nancy Finlay,

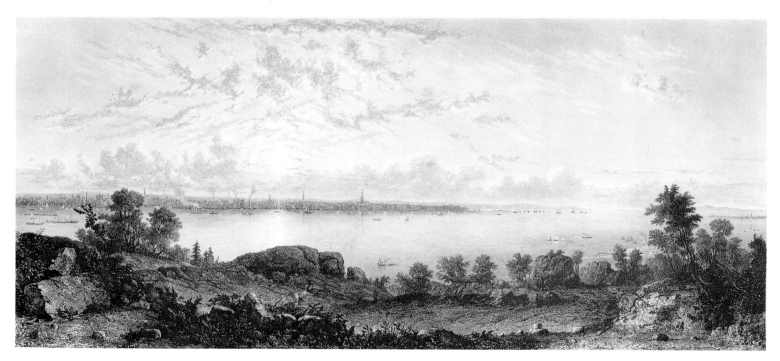

Fig. 179. George Loring Brown, *Bay of New York*, 1861. Etching. Museum of the City of New York

Roberta Waddell, Elizabeth Wycoff, and the entire staff of the Prints Division of the library for their assistance with this project.

137. Ibid., p. 20.

138. For an excellent discussion of innovations in nineteenth-century American book-binding, see Sue Allen, "Machine-Stamped Bookbindings, 1834–1860," *Antiques* 115 (March 1979), p. 567. For American bookbindings, see especially Edwin Wolf, *From Gothic Windows to Peacocks: American Embossed Leather Bindings, 1825–1855* (Philadelphia: Library Company of Philadelphia, 1990).

139. McGrath, "American Color-plate Books," p. 108.

140. Burrows and Wallace, *Gotham*, p. 417.

141. Marzio, *Democratic Art*, p. 83.

142. For the technological transformation of the chromolithographic industry during the 1860s, see ibid., esp. chap. 5, "Tools, Techniques, and Tariffs," pp. 64–93.

143. Spann, *New Metropolis*, p. 406.

144. Marzio, *Democratic Art*, pp. 17–18. Marzio notes that Sarony and Bien in New York and British-born printmaker William Sharp, who immigrated to Boston about 1830, practiced photography as well and became involved in reproducing photographs lithographically.

145. See Clifford S. Ackley, "Sylvester Rosa Koehler and the American Etching Revival," in *Art and Commerce: American Prints of the Nineteenth Century: Proceedings of a Conference Held in Boston, May 8–10, 1975* (Charlottesville: University Press of Virginia, 1978), pp. 143–51; Maureen C. O'Brien and Patricia C. F. Mandel, *The American Painter-Etcher Movement* (exh. cat., Southampton, New York: Parrish Art Museum, 1984); and Thomas P. Bruhn, *The American Print: Originality and Experimentation, 1790–1890* (exh. cat., Storrs: William Benton Museum of Art, University of Connecticut, 1993).

binding of the front cover is a silhouette of Diedrich, whose surname, derived from the Dutch words *knicker* (to nod) and *boeken* (books), came to identify Irving's circle.[140] The larger format of the 1855 edition of *The Knickerbocker Gallery* (cat. no. 140) was probably intended to appeal to men as well as the usual audience of women. This publication was offered in a wide selection of leathers stamped with motifs ranging from floral borders to an image of Washington Irving's home Sunnyside, near Tarrytown, a popular gathering place for Knickerbocker writers.

Even before the Civil War, the steam-operated press was beginning to challenge the handpress, particularly in the realm of printing popular lithographs. In 1859 New York lithographer Charles Hart recalled an incident that reflected the intense competition between man and machine that would dominate the post–Civil War print world:

> *[The printers] then came up to the table, by the windows, where the steam press and hand press work were lying side by side, and while the excited printers were pointing out the superiority of the hand press work [the operator of the steam press] . . . placed his hands, one under each pile of work, and lifting them suddenly mixed both lots of work in one indistinguishable mass upon the table. "Now gentlemen" [he said], . . . "Separate, if you can, the hand press from the steam press work." That was an impossibility. Great indeed was the indignation of the printers. . . . But they still declared the hand press work was the better.[141]*

In the late 1850s chromolithography was on the brink of evolving from the skilled craft of creating hand-tooled prints, such as those made by Bien, to the mechanized industry it would become as the steam-driven presses took over at the end of the 1860s.[142]

As New York City developed into the commercial capital of the United States, printing firms became increasingly specialized. By 1861 the city was responsible for 30 percent of the nation's printing and publishing; the industry employed more than five thousand printers, bookbinders, engravers, typefounders, and others needed to meet the demand for printed materials and pictures.[143] As the steam-driven presses and stamping machines enabled New York printers to produce ever larger editions of prints and books, printing giants such as Currier and Ives and Harper and Brothers were able to outstrip the competition. Smaller printmaking firms were forced to specialize in

popular advertisements and custom-printing jobs. At the outset of the period covered in this catalogue, printmakers worked in a variety of mediums, including engravings on wood and metal as well as lithographs. After the Civil War two major New York printers, Sarony and Bien, developed their businesses by reproducing photographs lithographically.[144]

By 1861 the outlook of New Yorkers had become cosmopolitan, thanks to their easy access to books, periodicals, and printed works of art and to a growing interest in foreign travel. With the support of newly wealthy art connoisseurs, many New York artists were able to go abroad, and there they developed a growing appreciation of prints as original works of art rather than as reproductions. During their Grand Tours of Europe, bourgeois Americans had an opportunity to see great works of art firsthand and they, too, became increasingly disenchanted with reproductive engravings after, for instance, the Italian Renaissance masters, which had been so eagerly sought by New York art patrons at midcentury. The travelers began to favor original etchings of familiar European sights that they could bring back to New York City as souvenirs of their tours.

Two Americans who created such etchings for the New York market are the expatriate John Gadsby Chapman (see cat. no. 147), who retired to Italy and became a leader of the circle of Americans living in Rome, and the Boston landscapist George Loring Brown (see cat. no. 131). By 1861 the American Etching Revival, which would dominate printmaking in New York City during the 1870s and 1880s, was under way.[145] When H.R.H. the Prince of Wales visited New York in October 1860, he was presented with a monumental painting of Manhattan by Brown, and the painting was widely reproduced as an etching (fig. 179).

The New York Etching Club was established in the city in 1877 to celebrate the new preference among connoisseurs for original etchings over engravings and lithographs. The next generation of New York print lovers would form the Society of Iconophiles and seek to assemble large collections of views of Manhattan, expressing their fascination with American printmaking and with the rise of the United States on the international stage following World War I. As their predecessors had, early-twentieth-century business magnates often chose Curriers and views of old New York to decorate their Manhattan offices and clubs, and many of those collections of fine nineteenth-century prints may still be seen in

their original settings. Among them, Edward W. C. Arnold's collection of approximately 2,500 prints, maps, and pictures of New York City at the Metropolitan Museum remains one of the most outstanding examples in Manhattan, along with those formed by Isaac Newton Phelps Stokes and Amos F. Eno, both of which are now at the New York Public Library.[146] The enthusiastic efforts of the Iconophiles to recover many of the splendid prints of New York during its flowering as the Empire City were forgotten during World War II, when the Works Progress Administration's Federal Art Project supported an innovative printmaking division in New York City that forged an interest in lithography and silkscreen. The scope of the present exhibition permits only a fleeting glimpse of the wealth of prints produced in New York City between 1825 and 1861; it would be difficult to imagine or comprehend the ascent of the Empire City without the rich store of images that rolled off its presses during those years.

146. See Stokes, *Iconography of Manhattan Island*, vol. 1 (1915), pp. xiii, xxi, where many of the other print collectors in Stokes's circle are listed.

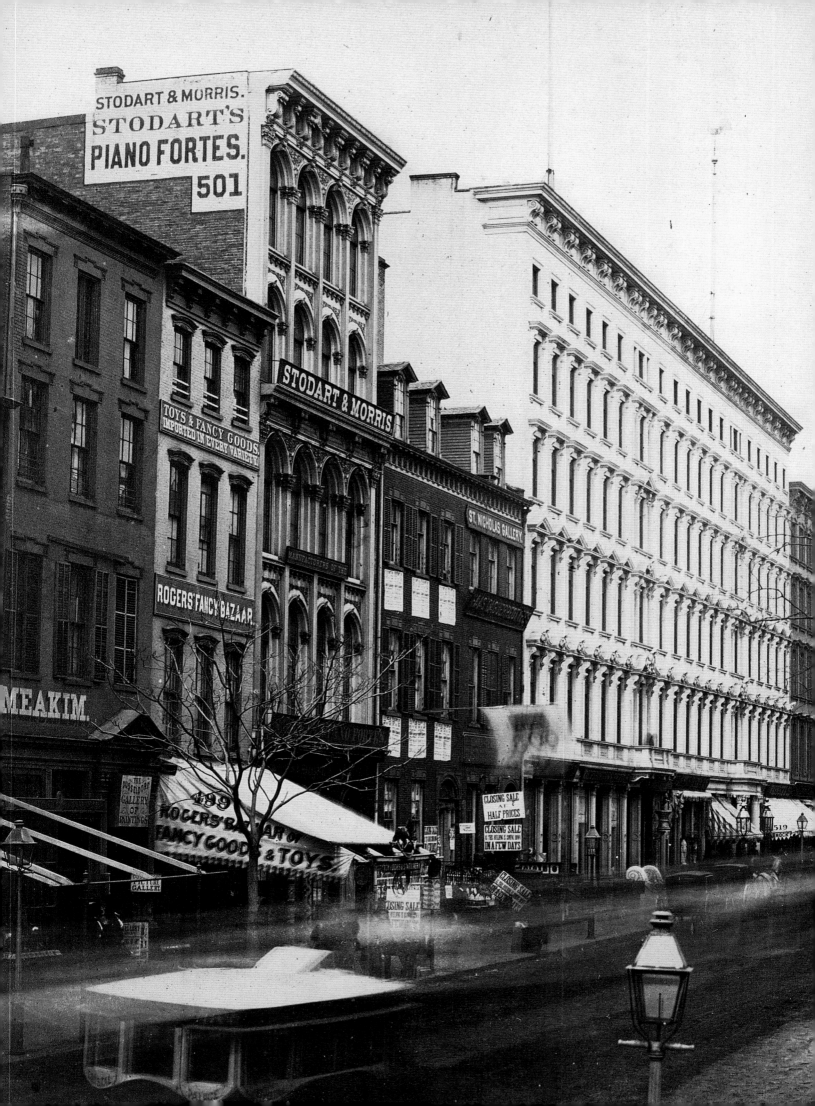

# "A Palace for the Sun": Early Photography in New York City

*JEFF L. ROSENHEIM*

*Wonderful wonder of wonders!! Vanish equa-tints and mezzotints—as chimneys that consume their own smoke, devour yourselves. Steel engravers, copper engravers, and etchers, drink up your aquafortis, and die! There is an end of your black art . . . The real black art of true magic arises and cries avaunt. All nature shall paint herself—fields, rivers, trees, houses, plains, mountains, cities, shall all paint themselves at a bidding, and at a few moment's notice.*

—*The Corsair*, April 13, 1839

In 1825—when that marvel of engineering the Erie Canal opened, and when goods of all varieties began to flow into New York and to transform it from a small city into the financial capital of America—photography did not exist. Even the word "photography" would not be coined for another decade and a half. The first successful photographic experiments with cameras and light-sensitive silver materials were still years away, and the idea itself had only begun to germinate in the minds of a few isolated scientists in Europe. It is remarkable that by the start of the Civil War, just over twenty years after the medium's birth in 1839, photography had emerged as the most common form of visual language in America, present in even the most humble of homes and used to record the features not only of statesmen, poets, and industrial tycoons but also of soldiers, urban laborers, mothers, infants, and the recently deceased. In New York City hundreds of photographers vied with one another for clients, offering lavish studios (often referred to as "temples") on the upper floors of buildings on and just off Broadway.

The story of this remarkable revolution begins in October 1832, when Samuel F. B. Morse, New York's most celebrated portrait painter of the age, had an epiphany, not of the artistic but of the technological sort. Bound for New York from France aboard the packet ship *Sully,* he conceived of a new form of long-distance communication based on magnetism and electricity. By 1835, when he was appointed Professor

of the Literature of the Arts of Design at the University of the City of New York, Morse the painter had traded his brush for a metal lathe and had become an inventor. He had developed and constructed the first telegraph machine, an apparatus that used electrical impulses to transmit a coded message from one place to another. Rather than actively continuing his painting career, Morse directed most of his creative energy during the subsequent years to refining the electric telegraph, "which produced a revolution in his life, and on the commerce and intercourse of mankind."[1]

Despite the rearrangement of his priorities, Morse still relied on art to support himself. Using fees paid by his art students for instruction in painting and aesthetics, Morse continued to improve on his invention until August 1837, when he publicly exhibited the telegraph in the large hall of his university. This was immediately followed by an application to the patent office and by a formal presentation to Congress in the winter of 1837–38. Although he remained dedicated to the arts as both professor and president of the National Academy of Design, Morse believed that the telegraph would bring him wealth and fame. Surprisingly, he was unsuccessful in his attempt to convince the United States government to subsidize his experiments; the small amount of money he received fell far short of the funding required to produce the large coils of wire across which his telegraph would communicate. Nor could his meager income as a professor meet the expenses required to promote the telegraph and create the necessary infrastructure.

Seeking capital, Morse traveled in late 1838 and 1839 to England and France, hoping to sell the patent rights to his invention. He had no success in England, as competitors there were developing their own ideas about how to use electromagnetism. When he arrived in France in the spring of 1839 he made his presentation to the Académie des Sciences, where just a few months earlier another painter and inventor, Louis-Jacques-Mandé Daguerre, the proprietor of the Paris Diorama theater, had shown an equally astonishing invention—a seemingly magical process that held an

This essay is dedicated to Malcolm Daniel, my colleague in the Department of Photographs. Without his wisdom, generous spirit, and superb organizational skills, " 'A Palace for the Sun' " would still be latent—like the earliest photographic experiments, a half-formed image without any real substance. For the kind invitation to participate in this grand endeavor to celebrate the "Great Emporium," I thank John K. Howat and Catherine Hoover Voorsanger. Their dedication and patience provided encouragement when it was most needed. Like many research projects, this one was greatly enriched by a team of assistants who photocopied volumes of original documents and read through hours of microfilm. I especially thank Suzannah Schatt, who performed this grueling work as an indefatigable volunteer research assistant. The quotation that introduces this chapter is taken from "The Pencil of Nature: A New Discovery," *The Corsair*, April 13, 1839, pp. 70–71.

1. Samuel Irenaeus Prime, *The Life of Samuel F. B. Morse, LL.D., Inventor of the Electro-magnetic Recording Telegraph* (New York: D. Appleton and Company, 1875), p. 249.

Opposite: detail, fig. 190

Fig. 192. Alexander Gardner, *Antietam Battlefield,* 1862. Albumen silver print from glass negative. Gilman Paper Company Collection, New York

often heavily overpainted with ink, crayon, and oils in order to flatter the sitters, something not possible with daguerreotypes. In *The Crayon,* for instance, Gurney and Fredricks advertised that they had "just patented their new process for taking Photographic Impressions on Canvas." They boasted that their "IMPORTANT DISCOVERY!" possessed "correctness of delineation and beauty . . . with two short sittings, and a trifling expense." The same listing noted that the gallery also offered "other various styles of colored Parisian Photographs, taken as usual, and at no other establishment in America."[41]

In 1856 Mathew Brady welcomed the services of Alexander Gardner, an operator skilled in the use of both glass-plate negatives and the paper-print process. Brady eventually became less engaged in the manipulation of plates and chemicals, preferring to use the assistance of Gardner in the mechanical aspects of the process. Instead of occupying himself with technique, the studio founder—who had begun to lose his eyesight—focused his attention on the arrangement of the sitters, their physical and psychological comfort, and, perhaps most important, the promotion of his business. By January 1858 Brady was managing two separate portrait studios in New York and one in the nation's capital.

Brady specifically advertised all the new photographic processes in the city's important newspapers and magazines. With this technology, negatives could be enlarged to yield lifesize prints that still retained excellent detail, color, and tone. Brady's impressive "imperial" portraits, measuring 17 by 21 inches and selling for the substantial sum of $50 to $500 apiece, were a huge success. Cornelia Van Ness Roosevelt, wife of Congressman James J. Roosevelt, sat for such a portrait dressed in a tiered skirt of silk taffeta, a pagoda-sleeved bodice, and a black lace shawl (cat. no. 196). Pinned to her collar is a portrait miniature, likely a daguerreotype of her husband. Mrs. Roosevelt presents herself in the highest fashion of the day as a central figure in the social and intellectual world of New York.

Among Brady's other notable subjects was the eighth president of the United States, Martin Van Buren, a seasoned statesman whose own clout was synonymous with that of the Democratic Party (cat. no. 195). He held office as attorney general and governor of New York, United States senator, secretary of state, and vice president under Andrew Jackson. Short in stature, Van Buren was a shrewd political stalwart whom the press dubbed "The Little Magician." By the mid-1850s, however, Van Buren had fallen out of

(fig. 191), which first appeared in New York in 1856. Cheaper to produce than a daguerreotype—but technically inferior to it—an ambrotype is a unique image produced on a silver-coated sheet of glass. Set into a miniature case, it was exceptionally popular for a few years, before paper photography completely replaced it and the daguerreotype by the beginning of the Civil War.

The coup de grâce to both the daguerreotype and the ambrotype was the successful introduction into America in the summer of 1859 of the carte de visite, a small photograph, most often a portrait, mounted on a card measuring approximately 4 by 2½ inches. There are conflicting opinions as to who introduced this novelty in the United States, but Fredricks is generally given the honor.[39] Using a special camera apparatus that produced eight simultaneous images on a single glass plate, photographers were quickly able to produce inexpensive portraits, which then could be freely distributed by the sitter as a visiting or calling card. Almost immediately the fashion for collecting cartes de visite swept the world—a phenomenon that captivated even Queen Victoria, who by report kept albums of them and "could be bought and sold for a Photograph!"[40]

As the decade ended, in an effort to differentiate themselves from the mass of "mere practitioners," the major photographic artists continued to introduce new styles of portraiture. The most ambitious began to sell large-format portraits on paper or canvas, which were

39. See Marcus A. Root, *The Camera and the Pencil; or, The Heliographic Art* (Philadelphia: M. A. Root, 1864; reprint, Pawlet, Vermont: Helios, 1971), p. 381.

40. Eleanor Julian Stanley Long, *Twenty Years at Court, from the Correspondence of the Hon. Eleanor Stanley, Maid of Honour to Her Late Majesty Queen Victoria 1842–1862* (London: Nisbeet and Co., 1916), p. 377; quoted in William C. Darrah, *Cartes de visite in Nineteenth Century Photography* (Gettysburg, Pennsylvania: W. C. Darrah, 1981), p. 6.

41. "Photographic Oil Paintings on Canvas," *The Crayon,* July 25, 1855, front page.

political favor. Nonetheless, he was just the right type of American Brady could use to promote his burgeoning New York portrait practice. Brady's portrait disguises Van Buren's small size and recalls his former prominence as an American president, one of only four living in 1855.

Alongside Brady's, Gurney's, and Harrison's portraits of a wide range of New Yorkers—from aristocratic Knickerbockers, to prominent politicians, to Brooklyn delivery boys—are likenesses of an altogether different sort. Photography was first put to service for the identification and apprehension of criminals in the late 1850s. In New York, 450 photographs of known miscreants could be viewed by the public in a rogues' gallery at police headquarters, the portraits arranged by category, such as "Leading pickpockets, who work one, two, or three together, and are mostly English." Yet, the reading of individual portraits is not always self-evident. Would the seemingly affable young man in the overcoat and silk tie appear villainous without the caption "Amos Leeds—Confidence Operator" below his portrait (cat. no. 177)?

In 1856 a preliminary plan for the improvement of a large tract of land that came to be known as Central Park was drawn up by the city's chief engineer. Within a year the commissioners had selected the proposal submitted by Frederick Law Olmsted and Calvert Vaux, one of thirty-three submitted to a competition. The schematic design for their firm's elaborate program of bridges, walkways, and fountains survives in the municipal archives. Olmsted and Vaux employed Brady to produce photographs of the existing outlines of the terrain, which they used to construct their Greensward Plan, a series of "before" and "after" scenes on large presentation boards showing the proposed transformation of the landscape (cat. nos. 192, 193). On virtually every board, the designers presented an engraved map of their plan marking a particular feature and vantage point, a photograph entitled "Present Outlines," and a small oil painting, "Effect Proposed." In perhaps the most ambitious landscape project ever undertaken in America, photography played an integral role in communicating Olmsted and Vaux's task and vision. For the modern New Yorker, Brady's photographs remain the singular evidence of the terrain's original topography before

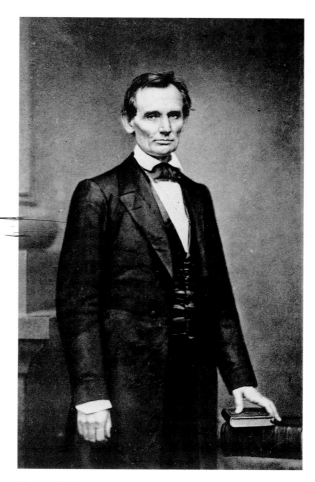

Fig. 193. Mathew B. Brady, *Abraham Lincoln*, 1860. Carte de visite; salted paper print from glass negative. National Portrait Gallery, Smithsonian Institution, Washington, D.C. NPG.96.179

its transformation. If these landscapes seem reticent and rather undramatic compared to the luxury of Brady's studio portraits, they do, nevertheless, serve as a precedent for what would soon occupy the artist: a five-year effort to document the Civil War, which would divide the century as it did the country (fig. 192). One could argue that Brady's first war portrait was of a tall young lawyer from Illinois named Abraham Lincoln, who spoke to a large Republican Party audience at the Cooper Union on February 27, 1860 (fig. 193). When elected president in the fall, Lincoln simultaneously acknowledged the astonishing power of both New York politics and the new medium of photography: "Brady and the Cooper Institute made me President."[42]

42. Quoted in Mary Panzer, *Mathew Brady and the Image of History* (exh. cat., Washington, D.C.: Smithsonian Institution Press for the National Portrait Gallery, 1997), p. 169.

# "Ahead of the World": New York City Fashion

*CAROLINE RENNOLDS MILBANK*

It was a rare visitor to the Empire City during the nineteenth century who was not struck by the spectacle of stylish persons promenading up and down the avenues, by the diversity and quality of the shops, and by those wondrous must-see bazaars, the large department stores. Evidently the onetime colony had gone a long way toward shaking off its reputation for social backwardness. As for the early American style of unpretentious simplicity that honored the ideals of a new republic, it had proven no match for the alluring range of wares offered in what was becoming the greatest shopping city in the world.

Arriving in New York City, one docked at the southern end of Manhattan and proceeded up its widest, most accessible thoroughfare, Broadway. When travelers published their impressions of the new country they almost always commented on the hustle and bustle of this main artery (see fig. 194). What in 1819 seemed to a delighted British observer "one moving crowd of painted butterflies"[1] became, as the city ballooned in size, more intimidating to others: in 1853 a Swedish visitor worried, "I merely think of getting across the street alive,"[2] and a Russian writer grumbled in 1857, "Starting in the morning until late in the evening, Broadway and the adjoining streets are crowded with magnificently dressed women and with Americans rushing about on business. Despite the wide sidewalks, the crush is so great that one cannot make a step without poking someone with elbows or body. If you want to excuse yourself or if you wait for apologies, the American has flown by like an arrow."[3]

1. Frances Wright, *Views of Society and Manners in America in a Series of Letters from That Country to a Friend in England during the Years 1818, 1819, 1820* (London: Longman, Hurst, Rees, Orme and Brown, 1822), p. 28.
2. Fredrika Bremer, *The Homes of the New World: Impressions of America,* 2 vols., translated by Mary Howitt (London: Arthur Hall, Virtue and Co., 1853), vol. 2, p. 12.
3. Alexandr Borisovich Lakier, *A Russian Looks at America,* translated from the 1857 Russian ed. and edited by Arnold Schrier and Joyce Story (Chicago: University of Chicago Press, 1979), p. 65.

APRIL SHOWERS.

Fig. 194. After Winslow Homer, *April Showers,* 1859. Wood engraving, from *Harper's Weekly,* April 2, 1859, p. 216. The Metropolitan Museum of Art, New York, The Irene Lewisohn Costume Reference Library

Opposite: detail, cat. no. 205

Fig. 195. *Fall and Winter Fashions for 1835 and 1836 by James G. Wilson, New York*, shown in front of houses at 714–716 Broadway built in 1833 for hat manufacturer Elisha Bloomer, 1835. Lithograph with hand coloring by Curtis Burr Graham. Collection of The New-York Historical Society

4. Charles Dickens, *American Notes for General Circulation* (London: Chapman and Hall, 1850), p. 55.

5. William Thomson, *A Tradesman's Travels in the United States and Canada in the Years 1840, 41, and 42* (Edinburgh: Oliver and Boyd, 1842), p. 15.

6. Lady Emmeline Stuart-Wortley, *Travels in the United States, etc., during 1849 and 1850*, 3 vols. (London: R. Bentley, 1851), p. 268.

7. James Fenimore Cooper, *America and the Americans: Notions Picked up by a Travelling Bachelor*, 2 vols., 2d ed. (London: Published for Henry Colburn by R. Bentley; Edinburgh: Bell and Bradfute; Dublin: John Cuming; 1836), p. 194.

8. *Frank Leslie's Ladies Gazette of Fashion* 3 (January 1855), p. 2.

That the crowds were "magnificently dressed" remained undisputed (see figs. 195, 196). In an 1850 description of his visit to New York, Charles Dickens wrote, "Heaven save the ladies, how they dress! We have seen more colours in these ten minutes, than we should have seen elsewhere, in as many days. What various parasols! What rainbow silks and satins! What pinking of thin stockings, and pinching of thin shoes, and fluttering of ribbons and silk tassels, and display of rich cloaks with gaudy hoods and linings!"[4] Showy or prosperous-looking attire was not restricted to women: a visiting tradesman described a fellow boarder "who came out about five years ago, with only one coat; now he has plenty, sports a gold watch, and a silver-headed cane."[5] Another writer noted, "A mob in the United States is a mob in broad-cloth. If we may talk of a rabble in a republic, it is a rabble in black silk."[6]

## Selling Fashion

Although Philadelphia, Boston, and New Orleans, like New York, were port cities known for their sophistication, only the Empire City became a shopping mecca regularly mentioned in the same breath as Paris and London. Broadway could "safely challenge competition with most if not all of the promenades of the old world," wrote James Fenimore Cooper.[7] Exclusive to New York was the great range of its emporiums, from showman A. T. Stewart's department store (perhaps the world's first) to the small but extravagantly luxurious establishments run by modistes or couturiers, milliners, fancy-goods dealers, and jewelers. As one journalist declared in 1855, "The windows in Broadway alone are enough to make the money leap from one's pocket, if in these times any one is fortunate enough to have any."[8]

AUTUMN & WINTER FASHIONS FOR 1849 & 1850 BY A. WHEELER No 4. COURTLAND ST. NEW YORK.

Fig. 196. *Autumn and Winter Fashions for 1849 and 1850 by Saxony and Major,* shown in the Astor House ballroom and outside the hotel on Broadway, 1850. Lithograph with hand coloring by Asa H. Wheeler. Museum of the City of New York, The J. Clarence Davies Collection

Most likely the windows that were the cynosure of all eyes belonged to Stewart, a successful and influential merchant and a visionary who became one of New York's first millionaires. The Irish-born Stewart got his start in 1823 selling a shipment of Irish laces at 283 Broadway, then slightly north of the most fashionable area. The great appeal of a dry-goods store (from which the department store would develop) was that for the price of a packet of pins one could gaze in wonder at a thousand-dollar shawl. Sensing the possibilities of something bigger, Stewart expanded and moved his business several times until, in 1846, he built his "Marble Palace" (see fig. 197). While most shops occupied the ground floor of a residentially scaled building about twenty-five feet wide,[9] this new marble-faced structure (cat. no. 96), perhaps the first ever built specifically to be a store, was far larger. Both

architecturally and in terms of its offerings, it would be enormously influential. Its plate-glass windows, which had to be imported, struck the public as extravagant and novel. A rotunda provided interior light. Inside were impressive columns, wall and ceiling frescoes, ornate chandeliers, and gaslights. Features that awed visitors most were the size of the space, the height of the mirrors, the number of mirrors and windows, and, of course, the profusion of goods. These included carpets, sold on the basement levels; upholstery and drapery fabrics; dress goods; silk goods; embroidery; fancy articles; shawls, displayed in a shawl room; and hosiery and gloves, in their own room.[10] As in the early days of Stewart's shop, fine lace and lace articles (see cat. no. 201) were always available. On the top floor was a wholesale department from which dry-goods merchants from around

9. Harry E. Resseguie, "Stewart's Marble Palace—the Cradle of the Department Store," *New-York Historical Society Quarterly* 48 (April 1964), p. 131.

10. The variety of goods available at A. T. Stewart made it easy to buy a trousseau there. The list of purchases made in preparation for an 1850 marriage by Elizabeth Ann Valentine of Richmond, Virginia, and her parents, survives as part of the Valentine Museum collection, along with some of the items on it (including her wedding veil of Irish Carrickmacross lace [cat. no. 201]). The list gives an idea of what were considered necessities for setting up a young lady in a new household: dresses of silk, muslin, and calico; handkerchiefs; bonnets for outdoor wear, headdresses for evening parties, caps

Fig. 197. *A New York Belle, Noon and Night: The Secrets of the Crinoline Silhouette, as Demonstrated by a Patron of A. T. Stewart,* 1846. Lithograph published by H. H. Robinson. Museum of the City of New York, The Harry T. Peters Collection 57.300.548

to wear at home; a cashmere scarf, a crepe shawl, a silk mantilla; pretty nightgowns and caps; gaiter boots and slippers; as well as many other items.

11. *New-York Times,* November 19, 1858, p. 8.
12. Ibid.
13. *Godey's Lady's Book* 48 (May 1854), p. 479.
14. Ibid.

the country could acquire stock. Dazzling though it was, the Marble Palace was expanded a number of times until by 1858 it boasted a frontage of 151 feet on Broadway and 175 feet on Reade and Chambers streets.[11] At that time the *New-York Times* called A. T Stewart "the largest dry-goods establishment in the world," with a stock valued at from "three to five millions of dollars."[12]

Stewart's influence extended beyond the world of dry goods. During the 1850s all kinds of fashion businesses in New York began to emulate his innovative approach. George Brodie, one of New York's most enterprising clothing merchants (see cat. no. 199; fig. 198), specialized in luxurious wraps of all sorts, which were sold ready-made. As was typical for a New York business, Brodie manufactured the garments and then sold them directly to customers on a retail basis, as well as wholesale to other merchants. If an effusive (and probably paid-for) editorial published in 1854 in *Godey's Lady's Book* can be believed, Brodie's was unusually impressive for a limited, specialized establishment. While most store windows of the period displayed a small, somewhat static array of merchandise, Brodie's beckoned the customer with

such novelties as lifesize mechanical mannequins. *Godey's* described the large windows: "in reality, small Crystal palaces for the accommodation of two slowly revolving dames in court costume of brocade or *soie d'antique,* bearing upon their regal shoulders the chef d'oeuvres of the establishment, whether velvet, guipure, or taffeta. . . . At their feet are thrown, in apparent careless, but really artistic confusion, other designs not less elegant and attractive. These figures are of wax, modeled and colored from life. . . ."[13] Once inside, the visitor ascended a staircase covered by velvet runners to a richly carpeted main salon lined with white and gold French wallpaper and suggestive of "a drawing-room rather than a business establishment. . . . Here there are piles of the most elegant and costly styles of mantillas and scarfs . . . the busy crowd of purchasers flutter back and forth, exclaiming, 'rapturizing,' choosing, and trying on the profusion of styles before them."[14] On the floor above were showrooms catering to the wholesale trade, whence Brodie's wraps were shipped all over the United States, to Canada, and to the West Indies; farther up still were the embroidery workrooms. The handwork executed in these rooms, the hallmark of Brodie garments,

was thought to rival European examples. The best laces and ornately woven silks were always imported, but embroidered goods were luxuries that could be manufactured by American entrepreneurs, since embroidery was easily taught and mastered, and a business dealing in the craft might start small and grow as needed.

Initially, the fashions pictured in American magazines—the first such appearance was in 1830, in *Godey's Lady's Book*—were styles purchased or copied from French or English sources. By the 1840s *Godey's* was publishing, in addition to French fashions, designs described as "Americanized."[15] In the 1850s the magazines that covered fashion[16] began to rely less and less on French looks and to show drawings of American designs, for the first time describing actual clothing available in actual stores. Many more fashion goods were being produced in New York now, an expansion that accommodated the growing population of the city itself, which had tripled in size in a quarter of a century. Magazine articles noted enlargements and improvements to stores as well as fashion innovations. Much of what was newsworthy in 1855 was extravagantly luxurious, like the "magnificent set of white guipure point lace, a scarf, two flounces, a handkerchief, a berthe" available for $500 at A. T. Stewart, or the diamond-and-ruby earrings in the shape of pendant blossoms for $800 at Ball, Black and Company. Also of interest were technological novelties, such as the devices that gave a pinked or crimped edge to silks, displayed at Madame Demorest's. Perhaps the city's favorite fabric in 1855 was a white moiré antique available at Arnold Constable and Company, which was singled out because it had been manufactured for the Paris Exposition of 1855.[17]

Newspaper and magazine write-ups about "opening days" make clear which were the city's most fashionable shops at the end of the decade. A. T. Stewart, Lord and Taylor, and Arnold Constable and Company were *the* stores for dry goods. Brodie's main competition for elegant cloaks, mantillas, and wraps was the Mantilla Emporium of George P. Bulpin, who displayed at the New York Crystal Palace exhibition of 1853 a sumptuously embroidered velvet cloak that had been made, he proclaimed, entirely in America. Top dressmakers included Madame Deiden, Madame Plazanet (who advertised that she had been the fitter at Deiden), Madame Ferrero (see fig. 201), and Madame Ralling, also a milliner. (Rare was the practitioner of either trade who did not adopt the title "Madame.") The leading milliners, Madame Tillman and Madame Harris, were both associated with

Parisian establishments—Madame Harris with Duteis, silk flower purveyor to Empress Eugénie of France. (Mary Todd Lincoln ordered bonnets and headdresses from Madame Harris throughout her White House stay.) John N. Genin was a renowned hatter, providing beaver and silk top hats for men, caps and other hats for men and boys, and tailored hats for ladies; he also expanded his business to include children's and women's clothing, lingerie, and furs, all sold at his shop on Broadway (see figs. 28, 203). William Jennings Demorest and his wife, (Madame) Ellen Curtis Demorest, ran an establishment of unusual range: their New York store featured a full-service dressmaking department (see fig. 204), their paper dressmaking patterns and fashion magazines were distributed around the world, and they later marketed such items as perfumes and cosmetics, sheet music, skirt elevators (which raised a skirt so the wearer could step onto a curb), even bicycles.[18]

Not only were the stores places to find every sort of marvelous creation, but shopping also became an ever more acceptable pastime; it was something ladies

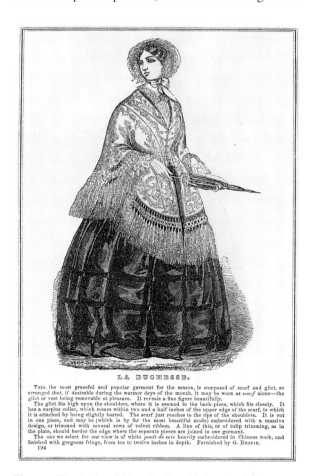

LA DUCHESSE.

This, the most graceful and popular garment for the season, is composed of scarf and gilet, so arranged that, if desirable during the warmer days of the month, it may be worn as *scarf* alone—the gilet or vest being removable at pleasure. It reveals a fine figure beautifully.

The gilet fits high upon the shoulders, where it is seamed to the back-piece, which fits closely. It has a surplus collar, which comes within two and a half inches of the upper edge of the scarf, to which it is attached by being slightly basted. The scarf just reaches to the tips of the shoulders. It is cut in one piece, and may be (which is by far the most beautiful mode) embroidered with a massive design, or trimmed with several rows of velvet ribbon. A line of this, or of tulip trimming, as in the plate, should border the edge where the separate pieces are joined in one garment.

The one we select for our view is of white *poult de soie* heavily embroidered in Chinese work, and finished with gorgeous fringe, from ten to twelve inches in depth. Furnished by G. Brodie.

194

Fig. 198. *"La Duchesse" Mantilla Furnished by Brodie.* Wood engraving by William Roberts, after Lewis Towson Voight, from *Godey's Lady's Book,* August 1853, p. 194. The Metropolitan Museum of Art, New York, The Irene Lewisohn Costume Reference Library

15. Other aspects of European culture were "Americanized" as well. According to Dinitia Smith, "Christmas trees became popular only after 1848, when the *Illustrated London News* published a drawing of Queen Victoria, Prince Albert and their children gathered around a tree hung with ornaments. That image was transformed for New World consumption when it appeared in *Godey's Lady's Book* in 1850, democraticized with the removal of the Queen's coronet, and Albert's mustache, sash and royal insignia." Dinitia Smith, "Spirit of Christmas Past and Present, All Stuffed into One Man's Collection," part 2, *New York Times,* December 15, 1999, p. B17.

16. Besides *Godey's Lady's Book* these included *Peterson's Magazine, Graham's American Monthly Magazine of Literature and Art,* and *Frank Leslie's Ladies Gazette of Fashion.*

17. *Frank Leslie's Ladies Gazette of Fashion* 3 (January 1855), pp. 2 (quote), 12 (earrings); ibid. 3 (March 1855), p. 42 (moiré).

18. For information about the career of the Demorests, see Ishbel Ross, *Crusades and Crinolines: The Life and Times of Ellen Curtis Demorest and William Jennings Demorest* (New York: Harper and Row, 1963).

Fig. 199. *"The Rose of Long Island," Miss Julia Gardiner and Gentleman in Front of Bogert and Mecamly's, 86 Ninth Avenue*, 1839 or 1840. Lithograph with hand coloring by Alfred E. Baker. Museum of the City of New York, Gift of Miss Sarah Gardiner 39.5

maid of honor, drew an unfavorable comparison: "American ladies bestow those hours of leisure, which English women of the same class give to drawing, to the study of nature, and to mental cultivation, almost wholly on personal adornment."[20]

In Europe it was customary for a purveyor of quality goods to obtain permission to display a royal warrant;[21] in republican America merchants turned early to the idea of publicity featuring celebrities. In 1824 a hatter sent General Lafayette one of his creations and presented additional hats to Lafayette's son, ostensibly in recognition of our country's debt to the general but probably also hoping to promote his wares as Lafayette-worthy.[22] In 1839 Julia Gardiner, a society belle known as "The Rose of Long Island" and the future wife of President John Tyler, allowed her picture to appear in an advertisement for a store called Bogert and Mecamly's, an event that sparked considerable controversy (fig. 199).[23] By midcentury the savviest merchants were sending articles of clothing to prominent persons in order to advertise their patronage. Genin, possibly New York's best-known hatter, generated a great deal of publicity by delivering a riding hat to singer Jenny Lind—newly arrived from Sweden in 1850 to begin what would be a wildly successful tour—and then selling duplicates known as "the Jenny Lind hat" at his store.[24] President Millard Fillmore wrote several letters, beginning in 1851, to the New York tailor Charles Patrick Fox, thanking Fox for fabric, for an offer to make him a pair of pantalons (pants), and for fitting him for a suit of clothes.[25] In 1852 a newspaper called *The Lily* published a testimonial about the Genin hat that had been sent as a present to its editor, Amelia Bloomer, and helpfully furnished Genin's address for anyone wanting to order a hat of her own.[26]

New York merchants set many precedents for the presentation and selling of clothing throughout the country. Their innovations included the new and widely copied architectural settings (Marshall Field advertised his Chicago store as the Stewart's of the West),[27] an emphasis on all things French, and the unabashed use of celebrity cachet, as well as set prices, advertising, use of catalogues and promotional booklets, and organized displays of the latest wares. These last ranged from coordinated "opening days," when stores displayed their latest imports and creations to both customers and the press, begun in the 1850s, to exhibitions such as the annual fairs of the American Institute of the City of New York, which were precursors of international expositions such as those at the Crystal Palace in London in 1851 and in New York in 1853.

19. Marie Fontenay de Grandfort, *The New World*, translated by Edward C. Wharton (New Orleans: Sherman, Wharton and Co., 1855), p. 18.

20. Amelia M. Murray, *Letters from the United States, Cuba, and Canada* (New York: G. P. Putnam and Company, 1856), p. 146.

21. A hat owned by Queen Victoria and made by one of her suppliers is labeled "W. C. Brown Riding & Fancy Hatter, To Queen Victoria, The Empress of the French, and the Elite of Europe, 13 & 14, New Bond Street," illustrated in Kay Staniland, *In Royal Fashion: The Clothes of Princess Charlotte of Wales*

could do without chaperones, and thanks to such instore enhancements as art exhibitions, lectures, and architectural novelties, it even acquired the gloss of a cultural excursion. That American women occupied their time thus was occasion for comment. Wrote a Frenchwoman, "Broadway is to New York what the *Boulevard des Italiens* is to Paris. It is the general *rendezvous* of the fashionable ladies, who go from store to store, looking at the newest stuffs or examining the latest styles of jewelry. They call this 'shopping.' A New York lady, without a hundred dollars a month to spend in these rounds, would look upon herself as the most unfortunate woman in the world."[19] Another observer from Europe, Queen Victoria's

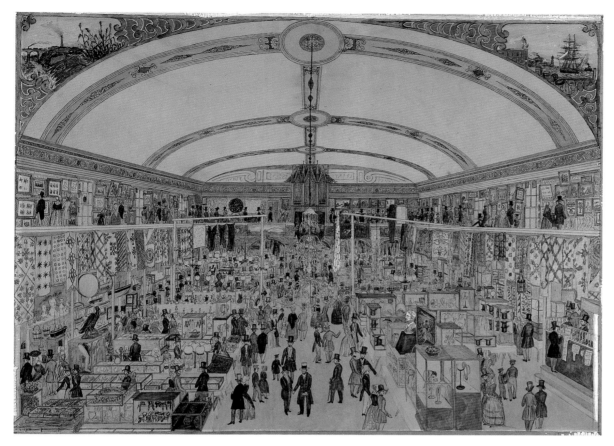

Fig. 200. Benjamin J. Harrison, *Annual Fair of the American Institute at Niblo's Garden*, 1845. Watercolor. Museum of the City of New York 51.119

## Manufacturing Clothes

It was natural for the manufacture of ready-to-wear clothing to expand dramatically in an American setting. The biggest advantage of early ready-made clothing was not that it might cost less but that its production saved considerable time and effort. Well into the nineteenth century, the process of acquiring a dress was complicated. Although bills of sale from the period record the price of a "robe," the consumer who purchased that robe was really buying the stuff, trimmings, and other necessities for making a dress. The fabric was then taken to a dressmaker or modiste, or just brought home, to be made into a full article of clothing; if it was done professionally, this added to the cost.[28] The typical consumer of fashion in the late eighteenth or the nineteenth century had to be quite knowledgeable about fabrics and construction. Fashion plates—black-and-white engravings that sometimes had been hand colored—were the only visual information about styles available and necessarily were more like recipes that could be interpreted than directions that had to be followed exactly. Before the invention of the paper pattern, first demonstrated by the Demorests in 1854, the process of having a dress made

involved participating in its design, and not everyone had the talent, patience, or interest for this. Jane Austen, for example, who was attentive to fashion in a general way, wrote in a letter of 1798, "I cannot determine what to do about my new Gown; I wish such things were to be purchased ready made."[29]

American ready-made men's clothes were for sale in New York by the mid-eighteenth century, and by the beginning of the nineteenth century the city was already producing ready-made clothing for women and children as well as uniforms for servants and sailors, along with a variety of items such as fancy dress, hats, wigs, shoes, and every kind of printed fabric. In the course of the nineteenth century New York became not just a giant of retail but the center of a rapidly growing garment industry, fed by the city's ideal location for incoming and outgoing goods, a constantly renewed immigrant workforce, and an explosion of new technologies. Some of the innovations, such as the sewing machine and the paper pattern graded for size, had applications at home as well as in business. Manufacturing benefited from the invention of power-driven looms that wove specialty fabrics and machines that made lace, covered buttons,

and Queen Victoria, 1796–1901 (London: Museum of London, 1997), p. 152.

22. Cooper, *America and the Americans*, p. 238.

23. Posing for an advertisement lithograph was simply not done: not by established matrons, not by actresses, and certainly not by young ladies of the social stature of Julia Gardiner, whose prominent New York family had settled and owned Gardiner's Island. No other such occurrence in that period is known. To rub salt in the Gardiner family wound there were the facts that the store, forgotten today except for this one episode, was less than fashionable (the family patronized A. T. Stewart); that Julia was shown ostentatiously dressed; and worst of all that she was shown practically arm-in-arm with "an unidentified older man, clad like a dandy in top hat and light topcoat . . . carrying an expensively wrought cane." Had a young lady ventured out for an unchaperoned promenade with such a scamp in real life, her reputation would have been ruined. As it was, the Gardiners "were embarrassed and humiliated" and sent her to Europe. That Julia's reputation survived is perhaps most clearly proven by her marriage five years later, in 1844, to then-President John Tyler. See Robert Seager II, *And Tyler Too, A Biography of John and Julia Gardiner Tyler* (New York: McGraw-Hill Book Company, 1963), p. 35.

24. For more information about Genin's career, see Wendy Shadwell, "Genin, the Celebrated Hatter," *Seaport, New York's History Magazine*, spring 1999, pp. 22–27.

25. Fox eventually included all the letters in his book, Charles Patrick Fox, *Fashion: The Power That Influences the World*, 3d ed. (New York: Sheldon and Co., 1872), pp. 204–5.

26. *The Lily* (Seneca Falls) 4 (March 1852), front page.

27. Lloyd Wendt and Herman Kogan, *Give the Lady What She Wants! The Story of Marshall Field & Company* (Chicago: Rand McNally, 1952), pp. 58–59.

28. Examples of dressmakers' fees are given in *Godey's Lady's Book* 48 (June 1854), p. 572. "No city dressmakers, with any pretense to good style, will undertake to make a dress for less than three dollars. In the really fashionable shops, $4.75 is the charge of

making a basque waist, apart from the skirt—silk, buttons, all trimmings charged separately in the bill; so that you have from seven to nine, and even fifteen dollars to add to your two yards and a half of silk, the quantity usually purchased for a basque."

29. Jane Austen to an unknown correspondent, in Claire Toma-lin, *Jane Austen: A Life* (New York: Alfred A. Knopf, 1997), p. 110.

Fig. 201. *Emerald Green Velvet Bonnet from the Establishment of Madame V. Ferrero, 5 Great Jones Street,* 1854. Wood engraving, from *Frank Leslie's Gazette of Paris, London and New-York Fashions,* January 1854, p. 7. The Metropolitan Museum of Art, New York, The Irene Lewisohn Costume Reference Library

printed in many colors on fabrics, tucked or embroidered, or cut through several layers of fabric at once. The development of aniline (man-made) dyes made rich, strong colors more obtainable and affordable than ever before.

The manufacture of clothing in America was less expensive than importation, since it did away with shipping and especially import taxes; and it was patriotic, which suited the independent American spirit. From 1828 on, the American Institute of the City of New York held an annual fair at which awards were given for excellence in the areas of agriculture, horticulture, manufactures, commerce, and the arts (see fig. 200). Items of clothing of all sorts were to be seen there, as they were later at expositions such as the Crystal Palace exhibitions in the early 1850s. New York–made articles included—in addition to boots and shoes (rubber, patent leather, cork soled) and hats (of fur plush, for fur, along with rare plumage, was still one of America's most abundant natural resources)—corsets, umbrellas, clothing of homegrown merino wool, even homespun silk from the cocoons of silkworms fed on peanut plants. Evidently New York's fashion ingenuity was applied to producing what people wanted at least as much as to supplying what they needed.

Technology's greatest contribution to fashion was to make good-quality clothes widely available. Although Americans did not invent ready-to-wear, they perfected its mass manufacture, marketing, and distribution; by the end of the nineteenth century, what was produced in New York and sold throughout

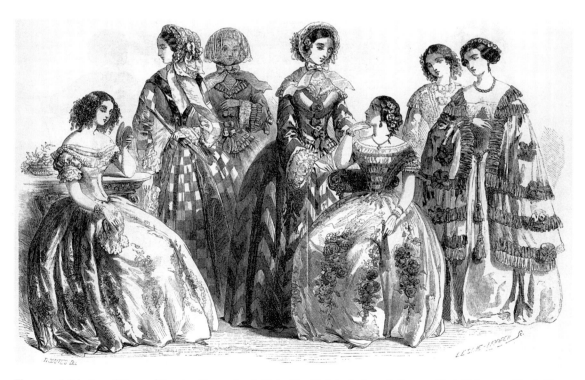

Fig. 202. *A Selection of Day and Evening Dresses Available in New York,* including a ball gown (far left) imported by A. T. Stewart and others made from materials available at A. T. Stewart and Arnold Constable and Company, 1854. Wood engraving by Leslie and Hooper, after Edward Waites, from *Frank Leslie's Gazette of Paris, London and New-York Fashions,* January 1854, p. 9. The Metropolitan Museum of Art, New York, The Irene Lewisohn Costume Reference Library

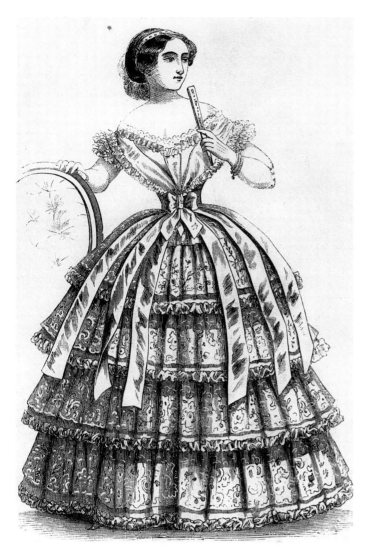

Fig. 203. *Ball Gown Made by Genin with Silk from A. T. Stewart and Lace from Genin*, 1854. Wood engraving, from *Frank Leslie's Gazette of Paris, London and New-York Fashions*, May 1854, p. 85. The Metropolitan Museum of Art, New York, The Irene Lewisohn Costume Reference Library

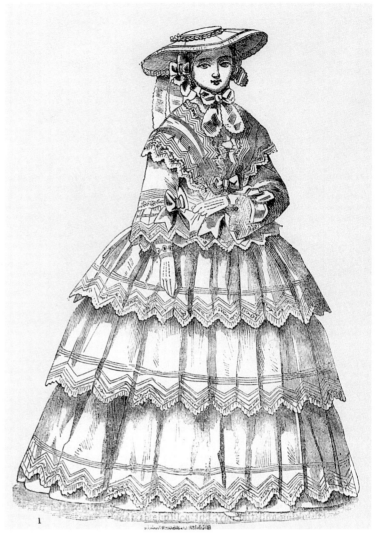

Fig. 204. *Country Excursion Dress Made by Madame Demorest*, 1854. Wood engraving, from *Frank Leslie's Gazette of Paris, London and New-York Fashions*, August 1854, p. 144. The Metropolitan Museum of Art, New York, The Irene Lewisohn Costume Reference Library

the country was a profusion of well-made, well-fitting clothes for men, women, and children, obtainable in every price range. When, well into the twentieth century, European couture houses decided to dip into the lucrative market of better ready-to-wear, they turned to New York manufacturers for machinery, skilled workers, and expertise.

## Fashion and Manners

Technology affected not just how clothes were produced and distributed but also how they looked. Men's clothing, the first to be standardized and mass-produced, as the nineteenth century unfolded grew soberer and simpler than ever before. First the frock coat and long trousers and then the lounge suit (pre-

cursor of the business suit) became a uniform that had an equalizing effect. In the previous century both sexes had worn powdered wigs, colorful brocaded and embroidered silks, shoes with heels and elaborate buckles. As a definite masculine style emerged that was tailored and somber, women's clothes became far more feminine by comparison, particularly in silhouette and degree of decoration (see figs. 201–204). Novel types of ornament could now be produced in copious amounts by machine, and changing attitudes toward display and ostentation encouraged the proliferation of elaborate effects. Moreover, as the population became increasingly upwardly mobile, new codes of behavior abetted consumerism.

The republic had certainly come a long way since George Washington's schoolboy days, when he kept a

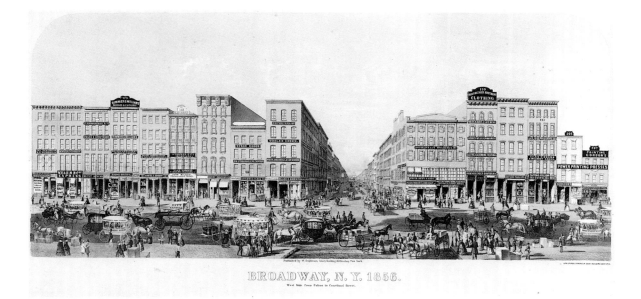

Fig. 205. *Broadway, West Side from Fulton Street to Cortlandt Street*, 1856. Tinted lithograph, published by W. Stephenson. The Metropolitan Museum of Art, New York, The Edward W. C. Arnold Collection of New York Prints, Maps, and Pictures, Bequest of Edward W. C. Arnold, 1954  54.90.1161

workbook of rules about decent and polite comportment. Its numbered maxims included these: "7th: Put not off your Cloths in the presence of Others, nor go out your Chamber half Drest. . . . 13th: kill no Vermin as Fleas, lice ticks &c in the Sight of Others, if you see any filth or thick Spittle put your foot Dexterously upon it if it be upon the Cloths of your Companions, Put it off privately, and if it be upon your own Cloths return thanks to him who puts it off. . . . 51st: Wear not your Cloths, foul, unript or Dusty but see they be Brush'd once every day at least and take heed tha[t] you approach not to any uncleanness."[30] By the late eighteenth century advice about clothing etiquette was somewhat more developed, but it still had a simple message: "Dress should only second beauty, and not shroud it; the choice, and heap of ornaments, are the foil."[31]

Yet in a few decades the dictates of etiquette had multiplied, reinforcing a newly strong relationship between consumerism and propriety. Rules of civilized conduct prescribed what ladies and gentlemen should wear at all hours of the day and for all types of occasions. Magazine coverage of etiquette was closely intertwined with that of fashion, and the advice given was so specific that an insecure customer paying close attention could purchase secure fashion footing:

*For morning excursions, or what is called shopping, it is the very best taste to be dressed with the most unpretending simplicity—in the darkest colors,*

*without either flowers, feathers, or jewelry. The elegance of the cut of the garments; the neatness of the black gaiter boot; the fineness of the texture of the handkerchief, and the plain cambric or India muslin undersleeves and collar, are alone sufficient marks of distinction. No lace, except Valenciennes, is admissible in early morning costume; no bracelets, excepting plain gold circles round the wrist. . . . As the day advances towards its meridian, all its useful avocations having been performed, the time for displaying the elegancies and richness of the fashions arrives. Visits are supposed to be paid, and the object of being in the street is that of promenading and meeting friends and acquaintances [see fig. 205]. Even now, however, there are certain colors, materials and forms, which should never be worn in the street. No precious stones are made for sunlight—they are made to glisten beneath the brilliant chandelier of a ball-room, and appear tawdry at all other times. Now, rich embroideries may be worn—richer laces, and lighter colors, though sky blue, pink and yellow, should be studiously avoided. . . . In the early morning toilette, dark gloves—gray, brown and olive green, should be worn. In the afternoon toilette, all the more delicate tints, straw color being the best, are allowed. White kid gloves should on no occasion be worn in the street.*[32]

It is no coincidence that just when fashion was turning into a more exacting dictator and the role of the fair sex was becoming increasingly connected with

30. *George Washington's Rules of Civility and Decent Behavior in Company and Conversation,* edited by Charles Moore (Boston: Houghton Mifflin Company, 1926).

31. *The Ladies' Friend* (Philadelphia: Matthew Carey, 1793), p. 38.

32. *Graham's American Monthly Magazine of Literature and Art* 46 (February 1855), p. 195.

display, a small group of women were beginning the first push for suffrage. This too had fashion repercussions. In the 1830s Frances Wright, the author of a popular book about American society who had left Scotland for the United States and become an abolitionist, utopian, and defender of equal rights for women, was spotted in Turkish trousers. The 1840s saw anticorset societies. In 1851 a small band led by Amelia Bloomer adopted an antifashion uniform consisting of a knee-length dress worn over voluminous Turkish trousers. The public response to this costume was intense, so much so that its original wearers abandoned it in hope of being able to concentrate on other areas of women's rights. The outfit continued to be worn, however, as a political statement and for active sports. In 1858 *Godey's Lady's Book and Magazine* published an engraving of a feminine gymnastic costume by Madame Demorest featuring what had come to be called "bloomers."[33]

During the nineteenth century fashion became newsworthy in a way it had never been before. Journalism had generally treated the latest styles as one of women's domestic interests and grouped them with sentimental stories, songs, crafts projects, articles on health, and recipes; but now a consideration of highly entertaining Dame Fashion began to seep into the general culture. Absurd novelties such as immense sleeves, anything related to hoop skirts, and, of course, the bloomer costume were fodder for political cartoonists and commentators. Excessive display, ever on the increase, was becoming news. In 1840 a private costume ball given by Henry Brevoort was described on the front page of the *Morning Herald*, occasioning a great hue and cry about the invasion of privacy. Nevertheless readers lapped up all the details about who was there and what was worn—the paper even published floor plans of the house.[34] Thus was born an insatiable appetite for information about society and fashion. In a pattern that would continue, the ball was both fawningly described and (in another article) satirized.[35] By 1860, when the renowned Prince of Wales ball took place, a number of newspapers devoted front-page articles to speculation about what people might wear and descriptions of what they did wear.[36]

### Dresses for Two New York Balls

Of garments from our period definitively known to have been purchased or worn in New York—or anywhere else, for that matter—relatively few survive. Articles of dress disappear over time because they are remade, discarded, or too fragile to last. The origins of most clothes that survive from the nineteenth century and earlier are unknown. Labels had yet to come into common use; much of the information supplied by donors of clothes to museums has been lost; and what remains is not always reliable, since a donor may easily be a generation off when trying to recollect the owner of a garment. Thus it is remarkable to be able to compare dresses known to have been worn to two historic New York balls almost four decades apart, one given for General Lafayette in 1824 (fig. 206) and the other feting the Prince of Wales in 1860 (cat. nos. 204, 205). Each dress well exemplifies, for its own era, the height of fashion in Manhattan. An examination of the way one style developed into the other provides a brief history of the period's modes and mores.

In the early years of the nineteenth century the dominant style continued to be the one known as Empire, a look that alluded to the ideals of the French Revolution and had been fashionable internationally since that time. It might also aptly be called republican dress, since its hallmarks were simplicity, a comparatively natural silhouette, and plain, unassuming fabrics. The Empire style was meant to recall the dress of ancient Greece and Rome and followed the lines of antique sculpture almost literally: dresses were white and columnar, with high waists. This narrow silhouette, interpreted in sheer, revealing fabrics, was demanding to wear, since it left little room for artificial aids such as corsets. On the other hand, the unconstricting design freed the body, and the use of relatively inexpensive fabrics such as muslin made high fashion affordable to many more women. (Strict adherence to the year-round mode for lightweight fabrics could have dire consequences, however—pneumonia came to be known as "the muslin disease.")

Empire characteristics—simple lines, a high waistline, a preference for white, unpretentious fabrics such as muslin and gauze, embroidery in noncolor thread (white or metallic) to suggest a classical precedent—all appear in the Lafayette ball dress. The cut-steel necklace also worn that evening (see fig. 206) typifies another aspect of Revolutionary dress that well suited a republic: nothing could be less royal than jewelry made of a common metal rather than a precious one. The Lafayette dress was made of imported fabric, perhaps obtained from an establishment similar to the one that advertised in 1803, "Received by the latest importation from Calcutta, a trunk of the most fashionable Gold and Silver worked Muslin."[37]

33. *Godey's Lady's Book and Magazine* 56 (January 1858), p. 68, caption: "'The Metropolitan Gymnastic Costume' from Demorest's Emporium of the Fashions, 375 Broadway, New York."
34. *Morning Herald* (New York), March 2, 1840, front page.
35. Ibid., February 19, 1840.
36. Newspapers and illustrated weeklies covering the fete included the *New-York Times,* the *New York Herald*, and *Harper's Weekly.*
37. From an advertisement placed by "Ephm. Hart, No. 50 Broadstreet," in *The Arts and Crafts in New York 1800–1804*, a collection of advertisements assembled by Rita S. Gottesman (New York: New-York Historical Society, 1965), p. 347.

38. Three evening dresses in the collection of the Valentine Museum, Richmond (L.55.2, V.60.14.3, V.60.14.4A,B), are associated with balls given in Virginia in Lafayette's honor. Compared with the two dresses in New York collections known to have been worn for similar occasions the same year (Museum of the City of New York, 33.112.1; Metropolitan Museum, 1979.346.8), the Virginia examples are considerably more fashionable. They are all made of rich silks brocaded with small figures; one is in a burnished brown that looks ahead to the dark yet intense colors of the 1830s. The trimmings, including rows of cording, puffs of sheer silk, dog-tooth edging, three-dimensional appliqués, and sheer ruffles edged with satin bands, are just the kind of dressmaker details seen in fashion plates.

One dress (V.60.14A,B) has a sash printed with a small portrait of General Lafayette. Other items printed with his likeness and worn in his presence include men's kid gloves and a lady's fan, kerchief, and gloves. The engraved image of Lafayette copied on a pair of man's kid gloves (New-York Historical Society, 1949.118ab) is by Asher B. Durand.

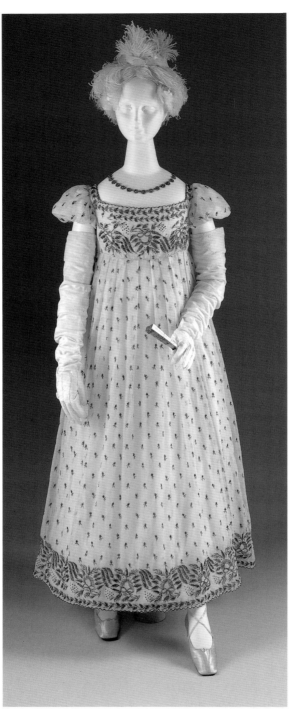

Fig. 206. Ball gown worn by Elizabeth Champlin to the Lafayette Ball at Castle Garden, September 14, 1824. Silver-embroidered muslin imported from India, 1824. Museum of the City of New York, Gift of Mrs. Frederick S. Wombell 33.112.1

Necklace, part of a parure worn to the Lafayette Ball, English, ca. 1820. Cut steel. Collection of The New-York Historical Society 1920.11–17

Long gloves, 1810s–20s. Linen, bias-cut. Museum of the City of New York, Gift of Miss Elisabeth B. Brundige 30.44.4

Fan, European, early 19th century. Spangled net and ivory. The Metropolitan Museum of Art, New York, Gift of Miss Agnes Miles Carpenter, 1955 55.43.12

That a type of fabric considered stylish in 1803 was thought worthy of wearing to a grand ball in 1824 is not unlikely. Fabrics were precious, and dresses were often remade to suit the next generation of wearers. Moreover, early in the century, styles changed slowly. Fads, such as the turbans so loved by First Lady Dolley Madison, could last for years and years. The simple cut of the Lafayette dress resembles not the styles of contemporaneous fashion plates but those of about five years earlier. Comparison of this dress with several others worn the same year in Virginia for celebrations of Lafayette's visit there reveals that in the 1820s New Yorkers, although well dressed, were less up-to-date than Virginians. While the New York dress could have been worn some years earlier, the examples from Virginia, with their darker colors, silk fabrics, and intricate dressmaking details, relate closely to fashion plates of the day and to the color palette of the coming decade.[38]

As the 1830s opened, a new silhouette appeared that seems a harbinger of things to come. The waistline dropped closer to its natural position and the skirt began to assume the shape of a bell. The fuller skirt was balanced by various widening devices at the shoulder such as pelerines or cape collars or, for more formal dress, wide, open necklines. Silk, usually woven with a subtle texture, was much worn. Gauzy whites gave way to browns, mustards, indigo, and rose, rich but somber colors that mirrored the relative absence of color in the uniform men had adopted. It would be the last time in the century that the two sexes complemented each other in dress by similarity rather than by contrast (see cat. nos. 197, 198).

From the 1830s on, novelty most often took the form of exaggeration. Sleeves ballooned, making observers worry lest their wearers take off; such sleeves were followed in the 1840s by tight-fitting ones, which were so impractical, critics complained, that they could be worn only by women who did not need to lift a finger. The one constant was growth in the size of the skirt, the part of the dress best suited to amplification for the sheer sake of display. As long as skirts got their fullness from layers of petticoats there remained a limit to their possible girth, but by the 1850s and 1860s, crinolines—lightweight contraptions made of steel, whalebone, and fabric tape—allowed skirts to reach frequently lampooned proportions (see fig. 197). Although utterly of their period, 1860 dresses, with their fitted bodices and full skirts, convey an air of the previous century. While the manufacture, materials, and distribution of attire had been modernized, women's clothes had over the course of the nineteenth century become more and more constraining because

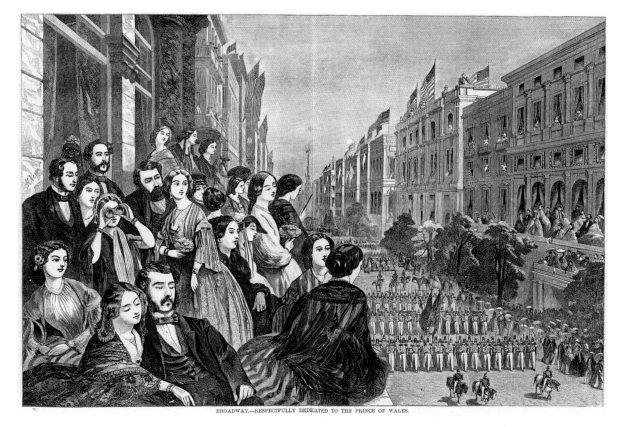

Fig. 207. *Broadway—Respectfully Dedicated to the Prince of Wales,* 1860. Wood engraving by John McNevin, from *Harper's Weekly,* October 6, 1860, pp. 632–33. The Metropolitan Museum of Art, New York, The Irene Lewisohn Costume Reference Library

of increased physical mass, the restrictiveness of corsets, bustles, and hoops, and the oppressive degree of compliance now required by society's conventions.

That fashionable New York had forsaken republican simplicity could not have been made clearer than it was on the night of October 12, 1860, when a lavish ball celebrated the much heralded visit of Albert Edward, Prince of Wales, the future King Edward VII (see fig. 207). Whereas several decades earlier America's proud anti-British stance had been remarked on by many (including the sharp-tongued Frances Trollope), and General Lafayette had been feted as a political—almost a moral—hero, the Prince of Wales was purely and extravagantly Royalty, not to mention an eligible bachelor. Costliness and luxury were the order of the day. Already sumptuous ball gowns were made more elaborate with accessories: no lady felt completely dressed without a headdress; a bouquet holder (see cat. no. 204) with a nosegay by New York's top florist, Chevalier and Brower; gloves of white kid; a fan; a lace-edged handkerchief; slippers or gaiter boots of silk satin; a wrap, or *sortie de bal,* preferably white; and, especially, a parure, or matched set, of jewels (see fig. 208). Diamonds—previously scarce because they had to be imported and in any case regarded as too

flashy in an immediately post-Revolutionary America—were here so prevalent that the fete acquired another name, the Diamond Ball. The *New-York Times* reported, "One splendid *rivière* which recently astounded the city in the cases of Tiffany was most charmingly displayed upon the graceful beauty of Mrs. Belmont. . . . We have already spoken of Mrs. Morgan and her diamonds, and of Mrs. Belmont and her diamonds. We might go on the same way, with perfect truth, to speak of half the ladies of New York and their diamonds."[39]

After diamonds, the element of attire most mentioned was lace, the costliest material of the time, comparable in price to precious stones. Numerous dresses were described as being entirely composed of this painstakingly handmade stuff, which would have seemed too ostentatious even five years before.[40] None of these survive; lace was too valuable not to be reused in another garment. Fortunately, a number of dresses worn to the grand ball for the Prince of Wales still exist,[41] along with accessories and outer garments —far more than for any other event of the nineteenth century—and of these, several showcase silks woven in Lyon that were among the finest fabrics available anywhere in the world. In an attempt to revive the

39. *New-York Times,* October 13, 1860.

40. *Graham's American Monthly Magazine of Literature and Art* 46 (January 1855), p. 97, noted, "There is very little real guipure [a lace made without a net ground] in America. For, though the May-Flower brought over so many things and came over at the very time guipure was the height of fashion, its sage and stately matrons were not likely to bring anything which, like this lace, recalled the painted dames and the follies of the court from which they fled."

41. Most of them were donated to the Museum of the City of New York.

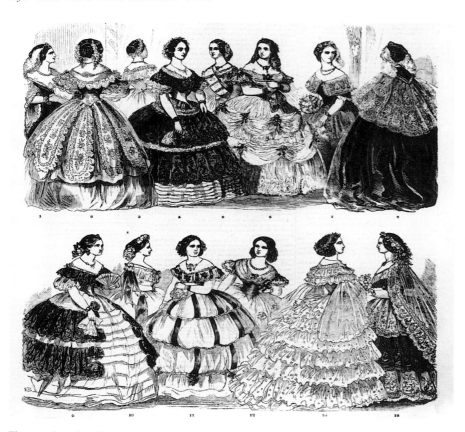

Fig. 208. *Superb Toilettes of the Ladies of New York, at the Grand Ball Given in Honor of the Prince of Wales at the Academy of Music, October 18, 1860,* 1860. Wood engraving, from *Frank Leslie's Illustrated Newspaper,* October 27, 1860, p. 1. Museum of the City of New York 92.51.80

42. The two-piece dress (Museum of the City of New York, 47.146.1–2) worn by a Quaker woman is made of silk taffeta in shades of periwinkle and beige woven with a design of patterned stripes alternating with narrow floral bands, and is trimmed with beige handmade lace and trios of periwinkle silk satin bands. The cape (47.146.3) is of bright pink serge lined with white quilted taffeta and is trimmed on the flat collar and down the front with bands of pink and lavender loop-edged braid. A mention in *Frank Leslie's Monthly* 7 (November 1860), p. 467, of George A. Hearn's shop at 425 Broadway could have been describing this dress material: "if we could fancy the style of goods that Quakeresses dressing themselves like 'the world's people' would select for their *début*—the dainty tiny patterns, the quiet colours, the judicious and very slight intermingling of bright hues with sober slate or delicate fawn—the general air of excellence rather than of showiness, we shall have some idea of the sorts of silks which are to be had here in great abundance."

French silk industry, dormant since Napoleon's time, Louis-Philippe had encouraged couturiers to make liberal use of the looms' products, and a ball gown worn that evening is attributed to Worth et Bobergh, the couture house most closely associated with implementing this plan. While the silhouette is rather simple, with an off-the-shoulder neckline, a narrow, corseted waist, and a tiered skirt held out by a crinoline, all of which had been in style for almost a decade, the material is nothing short of spectacular: coral velvet cut to a ground of silver gauze. According to information handed down with the dress, the material had been woven in Lyon for the empress of Russia and another piece obtained for the use of the Gardiner family. (The dress was worn to the Prince of Wales ball by the wife of David Lyon Gardiner, Julia Gardiner Tyler's brother.)

A second Prince of Wales ball dress of superb cut velvet from Lyon (cat. no. 205) was likely made in New York. In shades of brown and other colors, it is trimmed at the neckline and sleeves with a particularly fine point-de-gaze lace that would have stood out that evening even among stiff competition. The fabric itself is a fine example of a trompe l'oeil textile: in this case,

velvet designed to look like swags of floral lace on a ground of point d'esprit. It was created on the loom *en disposition,* that is, with a pattern intended to be used in a specific way. Accordingly, the dress is fashioned to best display the fabric: the part of the cloth with the largest pattern is used for the overskirt, that with a narrower band of corresponding design for the tiered underskirt, and that with a still narrower strip of pattern to ornament the cap sleeves and the cuffs of the day bodice (not shown here) and the cap sleeves of the evening waist. An uncut piece of the same textile in another color exists. The dress appears to have been made by an able modiste who used care and caution in handling this top-quality fabric.

Even a dress and wrap worn to the ball by a Quaker woman are of very fine fabric, a bright, brocaded silk.[42] The textile design is much more reserved, however, and the style of the dress more covered up than those of the other ball gowns. Beyond the special restraint of religious conviction demonstrated here, the factors that regulated style of dress were age and marital status: older ladies, or "matrons," could display elaborate cut velvets and laces; younger women, particularly unmarried ones, were expected to choose less showy tulle, tarlatan, and other light, gauzy stuffs. A bell-skirted frock of white tulle remained popular garb for debutantes and prom-goers well into the following century.

The coral and silver dress attributed to Worth et Bobergh is one of three Prince of Wales ball gowns that appear to be Parisian in origin. Open for business less than three years when the ball was held, Worth et Bobergh had been founded by the English-turned-French master Charles Frederick Worth, who was destined to become one of the most celebrated and influential couturiers of all time. Another dress bears the label of Worth's closest rival, Émile Pingat, then also new in the business. The third dress, although not certainly from Paris, is likely to have been made there as well, since it was worn to a ball given at the Tuileries by Napoleon III and Empress Eugénie before it appeared at the Prince of Wales event.[43] While in New York the world of clothing was becoming a vast mix of department stores, specialty shops, custom or couture houses, and manufacturers and retailers of ready-to-wear, in mid-nineteenth-century Paris the fashion structure was beginning to revolve around elite couture houses. Instead of buying fabric at a top draper's and taking it to a modiste, one might have a dress made by a couturier (conducting himself like an *artiste*), a procedure that was brand new. Well-traveled, well-heeled New Yorkers were, typically, among the first clients of French couture.

Despite obvious differences, the dresses New Yorkers wore to the Prince of Wales ball share some important characteristics with the gown worn to the Lafayette ball decades earlier. With the exception of two of the Paris-made dresses, the Pingat creation and the ball gown worn to the Tuileries, which are elaborately cut in accordance with the latest fashion plates, the dresses of both eras have what can be described as simple silhouettes.[44] The most elaborate aspect of the designs is the fabrics, which are the best the world had to offer. Because New Yorkers had access to all the very latest fashions, it is safe to assume that they preferred simpler designs that did not detract from connoisseur-level silks and laces. The Paris-made clothes are more sophisticated in cut, but the workmanship of dresses made in the two centers seems equal. In treasuring fine materials New Yorkers were perhaps holding on to their colonial past, when "clothing was much more difficult to obtain than food or shelter" because importing textiles was extremely expensive and making them at home was enormously time-consuming.[45]

Scarcely three months after the Prince of Wales ball, Mary Todd Lincoln celebrated her husband's election with a shopping expedition in New York City. Newspaper and magazine accounts of the marvelous New York–made clothes worn that notable evening must have been on her mind as she sought to outfit herself appropriately for her future role as First Lady (see fig. 209). Offered credit, easily persuaded by able salesclerks to overspend, and flattered by the attentions of reporters following her around, Mrs. Lincoln spent freely: at A. T. Stewart she bought more than one black lace shawl for $650 each as well as a camel-hair shawl for $1,000. There seems to have been no celebrity discount for the wife of a new president likely to be involved in a civil war. Once in the White House, she wrote to her favorite New York stores placing order after order.[46] It was often said that Mrs. Lincoln lived in fear that her husband would fail to be reelected, as this would result in the calling in of all her debts—and some idea of those debts is given by her Washington dressmaker, Elizabeth Keckley, who quoted her remark, "I owe altogether about twenty-seven thousand; the principal portion at Stewart's, in New York."[47] The First Lady subsequently tried to liquidate what she clearly felt were real commodities, but the attempt backfired, and for the rest of her life she regarded her unmade silks, lace flounces, and other New York purchases as her most valuable possessions.

Mrs. Lincoln was hardly the only one to succumb to the allure of New York's wares. After the Civil War extravagance proliferated, so much so that in reaction there arose expressions of moral indignation. In a book published in 1869, *The Women of New York*, George Ellington included a disapproving yet fawningly detailed chapter entitled "Extravagance in Dress." "In the matter of female dress New York City is ahead of the world," he wrote. "The women of Boston may be well and richly dressed, but the prevailing fashions are always toned down to a more sensible and classical elegance, which is well-befitting the Athens of America. Brains rule at the Hub; gold is the god in Gotham. The quiet dames of Philadelphia are much more plainly clad than their Manhattan sisters; while even the women of Cincinnati, Chicago and St. Louis do not go to such extreme lengths as those of the metropolis."[48] That New York women had become walking displays of dry goods was only the beginning. From the Gilded Age on, every generation would have to come to terms with conspicuous consumption in its most visible form: dress.

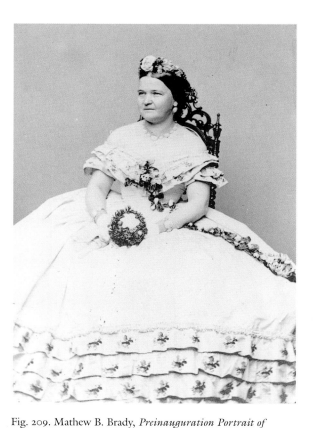

Fig. 209. Mathew B. Brady, *Preinauguration Portrait of Mary Todd Lincoln*, wearing the Tiffany pearl parure (cat. no. 211) as well as a fashionable ball gown likely made with silk brocade purchased during her New York trip, taken in Washington, D.C., 1861. Albumen silver print from glass negative. Collection of The New York-Historical Society

43. The Pingat ball gown and the dress worn to the Tuileries are in the collection of the Museum of the City of New York. The former (61.193) is pale mauve pink silk satin with bands of embroidered flowers and ivory silk fringe, and the latter (46.315) is ivory silk taffeta trimmed with lavender. Like many Prince of Wales dresses, they have never been photographed.

44. While the construction of the 1860 dresses may seem elaborate, it is not actually complicated; gathering even a wide tubular skirt into a waistband and making tiers or ruffles would be among the first sewing skills acquired by any novice.

45. Claudia Kidwell and Margaret C. Christman, *Suiting Everyone: The Democratization of Clothing in America* (Washington, D.C.: National Museum of History and Technology, Smithsonian Institution, 1974), p. 21.

46. For Mary Todd Lincoln's letters to such favorite Manhattan merchants as J. Dartois, who sold trimmings; E. Uhlfelder, a dealer in fancy goods; Edwin A. Brooks, famous for shoes and boots; George A. Hearn, dry goods; May and Company, which billed her $628.01 for, among other items, eighty-four pairs of gloves; and Madame Harris, known for exclusive hats, see Justin G. Turner and Linda Levitt Turner, *Mary Todd Lincoln: Her Life and Letters*, reprint (New York: Fromm International, 1987).

47. Elizabeth Keckley, *Behind the Scenes: Formerly a Slave, but More Recently Modiste, and Friend to Mrs. Lincoln; or, Thirty Years a Slave and Four Years in the White House* (New York: G. W. Carleton & Co., 1868), p. 149.

48. George Ellington, pseud., *The Women of New York; or, The Under-world of the Great City . . .* (New York: New York Book Co., 1869), p. 28.

# The Products of Empire: Shopping for Home Decorations in New York City

*AMELIA PECK*

New York City, also known as the "Great Emporium," became a shopping capital that rivaled London and Paris during the middle of the nineteenth century. Goods from all over the world could be found in the stores lining Broadway. This essay will survey what was available to New Yorkers in the way of mantels, carpets, wallpapers, and upholstery goods and services between 1825 and 1861 and discuss some of the principal merchandisers and manufacturers of these home decorations.

During this period consumers in New York became less dependent on European products. In a fervor of nationalism following the War of 1812, Americans demanded that domestic manufacturers produce goods that equaled those made in Britain and France. Some industries, such as marble working and carpet weaving, quickly rose to the challenge; others, such as wallpaper manufacture and silk weaving, took a few additional decades to perfect their products.

As New York City grew northward, the main shopping district shifted accordingly. In the 1820s and 1830s many of the businesses investigated in this study were located in small shops on or near Pearl Street. By the 1850s most had moved into palatial stores on Broadway. This grand avenue—the city's widest north-south artery—changed during these decades from a residential street to one lined with stores, theaters, and hotels.[1] Among other things, Broadway became the amusement destination for city dwellers. As the economy grew, allowing more and more people to purchase myriad goods, shopping took on a recreational quality. Large stores with huge glass display windows, such as A. T. Stewart's magnificent dry-goods emporium (commonly called the "Marble Palace") on Broadway, attracted people to the area. Even such specialty shops as wallpaper and carpet warehouses assumed grand proportions to match the grand scale of Broadway.

It is interesting and somewhat surprising to discover that the female consumer did not take on a much more active role during this period. In fact, things remained much as they had been in earlier times. Women continued to be the primary shoppers for clothing textiles, household linens, and basic kitchen furnishing items. The large dry-goods palaces on Broadway, such as A. T. Stewart (which opened its doors in 1846) and Lord and Taylor (which followed suit in 1860), catered to women shoppers. These embryonic department stores, which had begun their existence downtown in the 1820s (A. T. Stewart in 1823 and Lord and Taylor in 1826), sold fabrics, trimmings, and accessories for clothing, adding household linens to their inventories by 1840 but not expanding into carpets and upholstery fabrics until the 1850s.[2] Men held the purse strings more tightly for home furnishings. Although the women of the household energetically researched and spoke their minds about these major purchases for the home, the male wage earners in the family had a proportionately larger vote. This pattern changed during the Civil War, when women were obliged to act more independently in the realms of family and work. Home life itself was redefined after 1865; men became preoccupied with the dramatic expansion of business and industry during the postwar years and left the domestic sphere completely to women, who at that time emerged as the primary shoppers for the home.[3]

Perhaps the most interesting change in the way people shopped during the middle of the nineteenth century lies in the realm of the psychological. Consuming became a pleasure often fraught with discomfort. Contemporary journalism celebrates the grand shops opening on Broadway, the high quality of the goods, and the opportunities for both social and personal transformation that items such as new wallpaper or a beautiful carpet could bring to a purchaser. By contrast, much of the fiction of the period focuses on the purchase of goods inappropriate to the buyer's class and lifestyle, things that are too expensive and ultimately bring misfortune to the owner. High anxiety about shopping had entered the arena. Before the industrial revolution, when wealth and class were determined by land ownership, only a small segment of society had the means to purchase luxury

The author would like to thank Carol Irish, Lonna Schwartz, Rachel Bonk, and Anna Maria Canatella, as well as the exhibition staff, for their help in researching this essay.

1. For more on the history of Broadway, see Charles Lockwood, *Manhattan Moves Uptown: An Illustrated History* (Boston: Houghton Mifflin Company, 1976); and David W. Dunlap, *On Broadway: A Journey Uptown over Time* (New York: Rizzoli, 1990).

2. Lord and Taylor's first known advertisement, published in the *New-York Enquirer,* October 30, 1826, was for plaid silk dress fabric and other items of apparel, such as cashmere shawls. An 1838 sales receipt lists Lord and Taylor as "Dealers in Dry Goods, Irish Linens, Sheetings, Diapers, Shawls, Laces, Gloves, Silk & Cotton Hosiery, &c." For both, see *The History of Lord & Taylor* (New York: Lord and Taylor, 1926), pp. 7, 14. In 1857–58 they advertised both "carpetings and upholstery goods" (*The Albion,* May 16, 1857, p. 240) and "Fashionable Dry Goods . . . for Fall and Winter Wear" (*The Albion,* November 20, 1858, p. 563).

3. For perspectives on women and consumerism, see *Making the American Home: Middle-Class Women and Domestic Material Culture, 1840–1940,* edited by Marilyn Ferris Motz and Pat Browne (Bowling Green, Ohio: Bowling Green State University Popular Press, 1988), especially the essay "American Women and Domestic Consumption, 1800–1920: Four Interpretive Themes," by Jean Gordon and Jan McArthur, pp. 27–47.

Opposite: detail, fig. 222

Fig. 210. Manufacturer unknown, probably Italian, Mantel with caryatid supports, ca. 1830. Marble. The Metropolitan Museum of Art, New York, Purchase, 1977 1999.125

goods for the home; now almost anyone could afford inexpensive but decorative American-made wallpaper or brightly colored American-woven ingrain carpet. It became increasingly hard to use the furnishing of home interiors as an index of social class. Newly purchased brownstones owned by upper-level clerks could be decorated quite well for relatively little money. Home decorating had always been a way to declare one's status in society; now, as more and more people had attractive and well-furnished homes, the established gentry began to feel concern about society's more permeable boundaries.

As a reflection of this class discomfort, a new type of economic moralism began to appear in novels and magazine stories, many of which were written and edited by members of the traditional elite. The subtext of these narratives may be interpreted as a warning to the nouveaux riches. This new city-based middle class, made up of people from rural New England as well as the more threatening immigrants from Ireland and the British Isles, was being told to know its place; making and spending too much money and attempting to rise in society were portrayed as potentially disastrous. A good example of this type of parable is found in the novel *Fashion and Famine* (1855) by Ann S. Stephens, a well-respected

editor and writer who was educated in Connecticut, where her father managed several woolen mills. Second in popularity in its day only to *Uncle Tom's Cabin,* it tells the story of Ada Wilcox Leicester, a very unhappy woman who lives in a grand house, surrounded by all the luxuries New York City could offer. Ada was once an innocent country girl, but she let herself be corrupted by the evil Mr. Leicester, a liar and a womanizer, who filled her head with the promise of material wealth in order to "have his way with her." Ada is finally redeemed after her father convinces her to give up her material possessions, since they are not the key to true happiness. She transforms her house into a charity home for destitute old gentlewomen (gone are the heavy carpets and the silken draperies, replaced with India straw matting and white muslin curtains) and reenters the moral world.

Another recurring plot is illustrated by "Sparing to Spend; or, The Loftons and the Pinkertons" (1853) by T. S. Arthur, a top editor and writer of the day, who traced his lineage back to a Revolutionary War officer. The tale charts the parallel lives of two couples. The husbands are both clerks with similar positions, but one wife is modest and careful in her spending while the other is grandiose and a spendthrift.[4] The grandiose wife, Flora Pinkerton, convinces her husband to

Fig. 211. Francis H. Heinrich, *The Ernest Fiedler Family, 38 Bond Street, New York,* ca. 1850. Oil on canvas. Courtesy of Nicholas L. Bruen

buy expensive furniture and a big house that is far beyond their means. She snubs the modest wife, Ellen Lofton, who is not sufficiently fashionable to be her friend. All this spending eventually drives Pinkerton to wreck his career by stealing money from his employer in order to maintain the image his wife is trying to project. The modest Loftons rise slowly and steadily in the world and eventually are in a position to be kind and helpful to the ruined couple. The message of the story is that it is immoral to be showy and to live beyond one's means. When the novel was reviewed in *Godey's Lady's Book,* its message was spelled out clearly: "The high moral aim of the present volume is 'to exhibit the evils that flow from the too common lack of prudence, self-denial, and economy in young people at the beginning of life; and also to show, by contrast, the beneficial results of a wise restriction of the wants to the means.' No one will rise from the perusal of this naturally written story without feeling himself strengthened in all good and honorable resolutions."[5] Yet this must have been a hard message to live by when Broadway beckoned.

## Mantels

Marble yards were important, lucrative businesses in New York City from about 1830 on. They provided builders and homeowners with exterior products—such as marble facing, which was most often used for large public buildings and hotels—and interior products, such as marble floor tiles and carved mantelpieces. When the fashionable, picturesque cemeteries were created in the areas surrounding Manhattan (the first, established in 1838, was Green-Wood Cemetery in Brooklyn), fancy and often figural monuments became a large segment of a typical marble yard's business.

Before 1825 in Federal-period New York, mantels in even the best houses were usually made of wood ornamented with composition material, a plasterlike substance. If a very grand house had a real marble mantel, it was imported from Europe. After 1825 and through the 1830s, most row houses built in lower Manhattan had imported mantels in their parlors, often carved in Italy of white statuary marble. One Italian model with two classically draped maidens who hold the mantel entablature and shelf on their heads was especially popular. The Metropolitan Museum owns an example that came down through the Hewitt family, and it may have been installed originally in one of the houses of Colonnade Row (1833) on Lafayette Street (fig. 210). A portrait of the Fiedler family painted about 1850 in the parlor of their house, which dates to about 1830, still proudly displays a mantel of the same type (fig. 211).

4. T. S. Arthur, "Sparing to Spend; or, The Loftons and the Pinkertons," parts 1–4, Arthur's *Home Magazine* 1 (February 1853), pp. 365–74, (March 1853), pp. 413–31, (April 1853), pp. 494–512, (May 1853), pp. 572–86.

5. *Godey's Lady's Book* 48 (January 1854), p. 81.

Fig. 212. Fisher and Bird, Mantel depicting scenes from Jacques-Henri Bernardin de Saint-Pierre's *Paul et Virginie* (1788), 1851. Marble. Museum of the City of New York, Gift of Mrs. Edward W. Freeman, 1932 32.269a–h,j

6. See *The New York Business Directory, for 1840 & 1841* and for *1850 & 1851* . . . (New York: Publication Office, 1840 and 1850); and *Manufactures of the United States in 1860; Compiled from the Original Returns of the Eighth Census* (Washington, D.C.: Government Printing Office, 1865).

7. The 1871 edition of *The Marble-Workers' Manual*, first published in New York in 1856, contained an appendix listing the appearance and properties of marbles found in many American states. Vermont is especially rich in various marbles, which were quarried from the Green Mountains. White marble from West Rutland was said to surpass Italian white statuary marble in quality. See *The Marble-Workers' Manual*, . . . translated from French by M. L. Booth (Philadelphia: Henry Carey Baird, 1871). Some of the earliest advertisements for marble sculpture, such as those placed by John Frazee in the *Workingman's Advocate*, March 5, 1831, p. 6, state that monuments, fountains, and so forth could be provided in either American or foreign marble.

8. Advertisements for Alexander Roux and Julius Dessoir (*The Albion,* November 20, 1858, p. 564) listed wood

At the end of the 1830s the marble-working industry boomed when steam-powered tools became available for cutting marble. In 1833 there were only four marble manufacturers listed in the New York City directories; by 1840 nine yards appeared under "Marble Manufacturers and Dealers." The number rose to thirty-seven in 1850–51, and according to the special schedule of the 1860 federal census devoted to the products of industry, there were in that year forty marble-cutting establishments in New York City, with 832 employees and an annual product of $1,260,949.[6] Fancy mantels became more common as time went on because the new steam-powered drills and saws lowered the cost of cutting the stone at the quarry and also reduced the time spent performing the gross carving. Also during this period, quarries were discovered in the United States that provided marble adequate for mantels intended to adorn the less important rooms of a house.[7] Better methods of transportation in and out of the city also had a positive effect on the marble industry.

Throughout the period of this study, Italian white statuary marble was always the first choice for parlor mantels. By 1840 New York craftsmen were proficient at carving high-style mantels from imported Italian stone. It is likely that some of the carvers employed by the marble yards were highly trained Italian immigrants; the late 1840s saw great unrest in Italy, and at that time the first small wave of skilled Italian

workers made their way to New York. While some immigrants opened their own businesses, the majority of the names of owners of marble enterprises in the 1850–51 New York business directories seem to be Anglo-Saxon.

As is true today, there was always a demand for good secondhand mantels. A truly special figural mantel, such as the *Paul et Virginie* example made by Fisher and Bird for Hamilton Fish (cat. no. 220; fig. 212), was often salvaged and reinstalled in another place after the house for which it had been made was sold or torn down. After Fish's death, in 1893, publisher William H. Appleton bought the *Paul et Virginie* mantel; it is unclear whether it was acquired at auction, bought through a dealer, or purchased directly from the family. By then more than forty years old and certainly out of style, it was installed in the parlor of Appleton's Riverdale house.

Other materials for mantels, such as cast iron and, once again, wood, gained popularity during the 1850s. Highly decorative carved wood examples were available through fine cabinetmakers, such as Alexander Roux and Julius Dessoir.[8] Cast-iron mantels, marbleized to deceive the eye, were often used for secondary rooms or throughout lesser houses (see fig. 213). One of the leading cast-iron mantel companies in New York placed the following advertisement in 1853:

*THE SALAMANDER MARBLE COMPANY invite attention to their unique and splendid assortment of MARBLEIZED IRON MANTELS, COLUMNS, TABLE TOPS, &c., &c., exhibiting at their Warerooms, 813 Broadway.*

*This new and beautiful combination obtained the GOLD MEDAL at the last Fair of the American Institute, and is pronounced by scientific men to be one of the most practically useful improvements of the*

Fig. 213. Manufacturer unknown, Mantel, United States, ca. 1850. Painted cast iron. Location unknown

*present age. It possesses many advantages over real marble, being cheaper, more durable, and capable of resisting a greater amount of heat, whilst it so closely resembles it, that the most practised eye can scarcely discover the difference.*[9]

Another company, the New York Marbleized Iron Works, which had its manufactory at 401–405 Cherry Street, claimed that its mantels were "about one-third the cost, in comparison with all other kinds of Mantels; also [they have] the advantage of being packed and sent with safety to any part of the country."[10] As this advertisement indicates, both cast-iron and marble mantels made in New York were shipped to many other areas of the United States, places that did not have skilled labor, an active harbor, or easy access to sources of natural stone—advantages that brought New York City's marble industry to prominence during the middle of the nineteenth century.

## Retailers and Manufacturers

FISHER AND BIRD was for many years the premier marble-working firm in New York.[11] One of the founders, John Thomas Fisher, arrived in New York from Dublin in 1829. He married Eliza Bird of Orange County, New York, and in 1832 started the business with two of his brothers-in-law, Clinton G. Bird and Michael Bird. It is not known who among them had marble-working expertise. They used both imported and American marble stocks and offered a variety of products to their customers. Although they advertised among their wares finished mantels from Europe, it seems likely that they cut and carved most of their marble products on their New York City premises

---

*Firm names:* **Fisher and Bird** (1832–85), **Robert C. Fisher** (1885–1915)
*Owners:* John T. Fisher (d. 1860), Michael Bird (not listed after 1853), Clinton G. Bird (d. 1861), Robert C. Fisher (1837–1893; son of John T. Fisher, joined business in 1854, succeeded father as senior partner in 1859), Clinton G. Bird II (son of Michael Bird, joined business in 1861)
*Locations*

| | |
|---|---|
| 1832–35 | 354 Broome Street |
| 1836–52 | 287 Bowery |
| 1853 | 287 Bowery and 899 Broadway |
| 1854 | 287 Bowery and 904 Broadway |
| 1855 | 287 Bowery, 904 Broadway, and 460–465 Houston Street |
| 1856–60 | 287 Bowery and 460–465 Houston Street |
| 1861–1915 | 97–103 East Houston Street |

---

(fig. 214). The long-lived firm was large and apparently profitable. In the 1860 federal census, Fisher and Bird was described as having $50,000 worth of invested capital, sixty-five employees, and an average monthly payroll of $2,000. The firm reported annual sales as follows:

| | |
|---|---|
| *mantels* | $30,000 |
| *marble tiling* | 17,000 |
| *funerary monuments* | 11,000 |
| *monument stock* | 11,000 |
| *marble blocks* | 10,000 |
| *marble slabs* | 10,000 |
| *other articles* | 5,000 |
| *Total* | $94,000[12] |

Fisher and Bird sold both relatively modest mantels from stock and extremely luxurious custom examples. In 1846 a customer ordered ten stock mantels for his house at a total cost of $480, plus $14.40 for shipping insurance. The price tag for the most expensive piece was $100; the cheapest cost him $27.50.[13] At the

mantels among the products they could supply.

9. *Illustrated News* (New York), February 5, 1853, p. 94.

10. Ibid., April 2, 1853, p. 222.

11. Biographical information on John Thomas Fisher and the Birds may be found in the entry on Robert Cockburn Fisher (son of John Thomas), in *America's Successful Men of Affairs: An Encyclopedia of Contemporaneous Biography*, edited by Henry Hall (New York: New York Tribune, 1895), vol. 1, p. 239. Information about their business comes from New York City directories and advertisements they placed in newspapers and journals, such as one in the *Cottage Keepsake; or, Amusement and Instruction Combined . . .* (Philadelphia: J. E. Potter, 1857), p. 63, in which they advertise stocking "American and Foreign Marble Mantels."

12. See *Manufactures of the United States in 1860*.

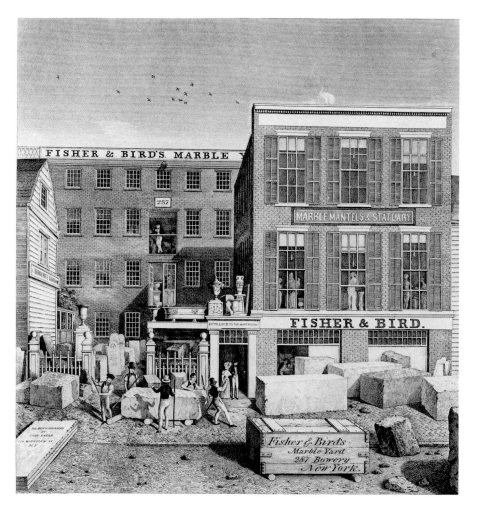

Fig. 214. *Fisher and Bird's Marble Yard, 287 Bowery, New York*, ca. 1836. Engraving and etching by John Baker. The Metropolitan Museum of Art, New York, The Edward W. C. Arnold Collection of New York Prints, Maps, and Pictures, Bequest of Edward W. C. Arnold, 1954 54.90.673

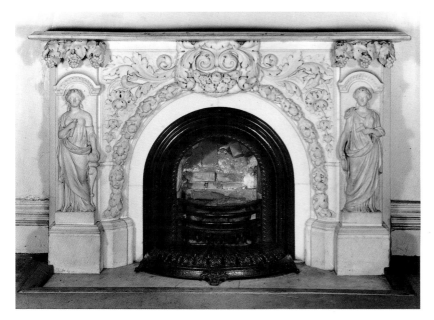

Fig. 215. Fisher and Bird, Mantel with figural supports, 1857. Marble. Litchfield Villa, New York City Parks Department Headquarters, Prospect Park, Brooklyn

13. We know that they were stock designs because the invoice lists them by design numbers. The most expensive was number one and the least expensive was number fourteen. Fisher and Bird to Mr. David [ ], invoice, December 31, 1846, Joseph Downs Collection of Manuscripts and Printed Ephemera, no. 97 x 28.8,

other end of the spectrum was the figural mantel that wealthy Hamilton Fish ordered for his New York parlor in 1851. Custom designed and custom carved, Fish's mantel depicted scenes from the French novelette *Paul et Virginie* and probably cost many hundreds of dollars (cat. no. 220; fig. 212). Another figural mantel attributed to Fisher and Bird was specified by architect Alexander Jackson Davis for the parlor of Litchfield

Fig. 216. Alexander Jackson Davis, *Study for Dining-Room Mantel at Knoll, Tarrytown, New York*, 1839. Ink, wash, and graphite. The Metropolitan Museum of Art, New York, Harris Brisbane Dick Fund, 1924  24.66.56

Villa in 1857.[14] Although Edwin Litchfield, the owner of this grand Brooklyn house, grumbled at paying $550 for the white Carrara marble mantel, which features two completely carved allegorical female figures, pay he did; the piece survives in the house today (fig. 215). In 1866, for $325, Davis commissioned Fisher and Bird to make the mantel carved of exotic deep-red and tawny marbles that still stands in the dining room at Lyndhurst in Tarrytown, New York.[15] Clearly, Fisher and Bird was the manufacturer of choice for the best-quality mantels of the day.

UNDERHILL AND FERRIS was also a stable and well-established marble yard. One of the first large manufacturers of marble mantels in New York, the firm won a silver medal for "a beautiful Cararra marble fire place" in 1834 at the seventh annual fair of the American Institute of the City of New York.[16] In 1840 Alexander Jackson Davis ordered all the Gothic Revival mantels he had designed for Knoll (later Lyndhurst) in Tarrytown, New York, from Underhill and Ferris. A number of drawings for these mantels survive; the one for the mantel in the original dining room (today the room is the library) includes information about prices, the marble, and possible choices of makers (fig. 216). The mantel selected by Davis's clients, William and Philip R. Paulding, was of white statuary marble, and it was made by Underhill and Ferris for $200. Philip Paulding was very well pleased with Underhill and Ferris's work; in a letter to Davis, he pronounced the mantels for the house "extremely elegant" and gloated, "How the ladies will *dote* on them."[17] In the 1848–49 volume of the *New-York Mercantile Register*, the firm ran a large illustrated advertisement, naming itself a "Marble Factory and Marble Works" and calling attention to its holdings of "the largest and most elegant assortment of superior Marble Mantels ever exhibited in this country." The

*Firm names:* **Underhill and Ferris** (1821–50), **John H. Ferris** (1851–52), **Ferris and Taber** (1852–57), **Augustus Taber** (1858–87)
*Owners:* Edmund Underhill (left business in 1850), John H. Ferris (left business in 1858), Augustus Taber (d. 1898; son-in-law of John H. Ferris, joined business in 1852)
*Locations*

| | |
|---|---|
| 1821–24 | Greenwich Avenue at Beach Street |
| 1825–37 | 64 Beach Street |
| 1838–51 | 372 Greenwich Avenue |
| 1852–57 | 386 Greenwich Avenue |
| 1858–72 | 713 Water Street |
| 1873–87 | 714 Water Street |

advertisement continued, "Monuments and ornamental Marble work in general for sale, and the Trade supplied on the most liberal terms at the old establishment Steam Marble Works of UNDERHILL & FERRIS."[18] In 1853 the firm, now called Ferris and Taber, contributed a "sculptured" mantelpiece and a marble vase and pedestal to the New York Crystal Palace exhibition. Although the company won an honorable mention for the mantel, its artistic standards were probably not as high as Fisher and Bird's. In 1857, the same year Davis ordered the $550 parlor mantel for Litchfield Villa from Fisher and Bird, he purchased the next most expensive mantel for the house from Ferris and Taber. Described as having spiral columns, and destined for either the dining room or the first-floor bedchamber, it cost only $150.[19] This mantel was probably competently made but more ordinary than those at the high end of Fisher and Bird's list. After John H. Ferris retired from the business in 1858, his son-in-law, Augustus Taber, turned the company into a wholesale marble business.[20]

Unlike the principals of Fisher and Bird and Underhill and Ferris, OTTAVIANO GORI was first and foremost a marble sculptor. However, during the 1850s he ran a major retail marble showroom specializing in both monuments and mantels. A photograph taken by Victor Prevost about 1853 shows Gori's establishment in all its splendor (fig. 217). Standing on the west side of Broadway between Nineteenth and Twentieth streets, Gori's warerooms display monuments outside at street level, while smaller, more delicate statuary can be glimpsed through the second-story windows. Although nowhere to be seen in the photograph, mantels were an important part of Gori's business, judging from the sign on the building, where marble mantels are the first item listed. Gori probably emigrated from Italy after completing his training there; he first appears in New York City directories listed as a sculptor. By 1840 he called himself a sculptor and scagliola (imitation marble) manufacturer; in his most complete directory entry (for 1848–49), he lists himself as "sculptor and modeller, marble mantels, statuary, monuments &c., scagliola and plaster ornaments." Some of Gori's most prominent works were the ornamental capitals, each depicting "a cornucopia intertwined with the caduceus of Mercury, the god of commerce," made for the interior of A. T. Stewart's 1846 Marble Palace dry-goods emporium.[21] At the 1853 Crystal Palace exhibition, Gori received an honorable mention for a "mantelpiece of variegated marble."[22] In 1855 the New York State census reported that Gori had invested $40,000 in his "Marble

*Firm names:* **Ottaviano Gori** (1837–58, 1861–64),
**Gori and Bourlier** (1859–61)
*Owners:* Ottaviano Gori, Alfred J. B. Bourlier
*Locations*

| | |
|---|---|
| 1837–38 | 73 Bleecker Street |
| 1838–39 | 566 Broadway |
| 1839–40 | 35 Dey Street |
| 1840–41 | 16 and 18 Downing Street |
| 1841–42 | 428 Broadway |
| 1842–43 | 99 Merchants' Exchange |
| 1843–45 | 315 Broadway |
| 1845–51 | 893 Broadway |
| 1851–58 | 895 and 897 Broadway |
| 1858–60 | 895 Broadway |
| 1861–64 | West Fifty-second Street |

Manufactory," that the annual value of his product, listed only as "Statuary," was $80,000, and that he had fifty men and six boys working for him, earning an average monthly wage of $60.[23]

Surprisingly, in spite of the appearance of Gori's grand establishment, the mantels that Davis ordered from him for Litchfield Villa were probably relatively modest, judging by their prices; in the list of invoices at the end of Davis's personal specifications for the Litchfield job, this notation appears: "June 1857 Chimney pieces of O. Gori, one 90./one 40./one 60./one 18./one 20. . . . $228.00."[24] Soon after, the business ran into trouble. According to the reports of R. G. Dun and Company, a financial rating service, in 1857 Gori was doing a "large & flourishing trade" and owned twenty-four lots of real estate in Harlem as well as six other houses and lots in other parts of the city. He also had the contract to furnish the marble front for Eno's Hotel on Broadway. But the financial panic of 1857 combined with real-estate speculation must have adversely affected his business. In March 1858 he was trying to raise money by selling his real estate and his marble business. By 1860 the business had failed, and Gori had left for Italy, although Gori's wife, Catherine, and his partner, Alfred Bourlier, continued running the firm in New York in a small way until 1864. In the late 1850s Gori also opened a marble business in San Francisco that probably existed only until 1861.[25]

## Floor Coverings

Between 1825 and 1861 the carpet business in New York City was, for the most part, a wholesaling and retailing industry. During the 1820s and 1830s almost all the carpets sold in the city were made in England, Scotland, or France. Oilcloths also came from the British Isles, and straw matting was imported from

courtesy The Winterthur Library, Henry Francis Du Pont Winterthur Museum, Winterthur, Delaware.

14. Edwin Litchfield to Alexander J. Davis, February[?] 5, 1857, Davis Collection (27–14), Avery Architectural and Fine Arts Library, Columbia University, New York. This mantel can be attributed to Fisher and Bird on the basis of references to the firm that Davis made in his daybook. In the entry for July 24, 1857, he describes a visit to Fisher and Bird with members of the Litchfield family and other clients, most probably to check on the progress of this mantel and to show it off to the other members of the party. Davis Collection I, Daybook vol. 2, p. 102, Avery Architectural and Fine Arts Library.

15. A. J. Davis daybook, June 22, 1866. Davis Collection I, Daybook vol. 2, p. 254, Avery Architectural and Fine Arts Library. Lyndhurst, a property of the National Trust for Historic Preservation, is a house museum open to the public.

16. American Institute of the City of New York, Judges' reports, 7th Annual Fair, 1834, American Institute, case 2, Manuscript Department, The New-York Historical Society.

17. Philip R. Paulding to Alexander J. Davis, November 16, 1841, Archives, Lyndhurst, Tarrytown, New York.

18. *New-York Mercantile Register,* 1848–49, p. 261.

19. List of invoices paid, Davis's own copy of the specifications for Litchfield Villa, Brooklyn, vol. 15, 24.66.1414, Department of Drawings and Prints, Metropolitan Museum.

20. R. G. Dun Reports, December 10, 1860, and May 28, 1862 (New York vol. 375, p. 200), R. G. Dun & Co. Collection, Baker Library, Harvard University Graduate School of Business Administration, Cambridge, Massachusetts.

21. "Stewart's New Dry Goods Store," *New York Herald,* September 18, 1846, p. 2, col. 5.

22. *Official Catalogue of the New-York Exhibition of the Industry of All Nations, 1853* (New York: George P. Putnam and Co., 1853), class 27, no. 9; Association for the Exhibition of the Industry of All Nations, *Official Awards of Juries . . . 1853* (New York: Printed for the Association by William C. Bryant and Co., 1853), p. 60,

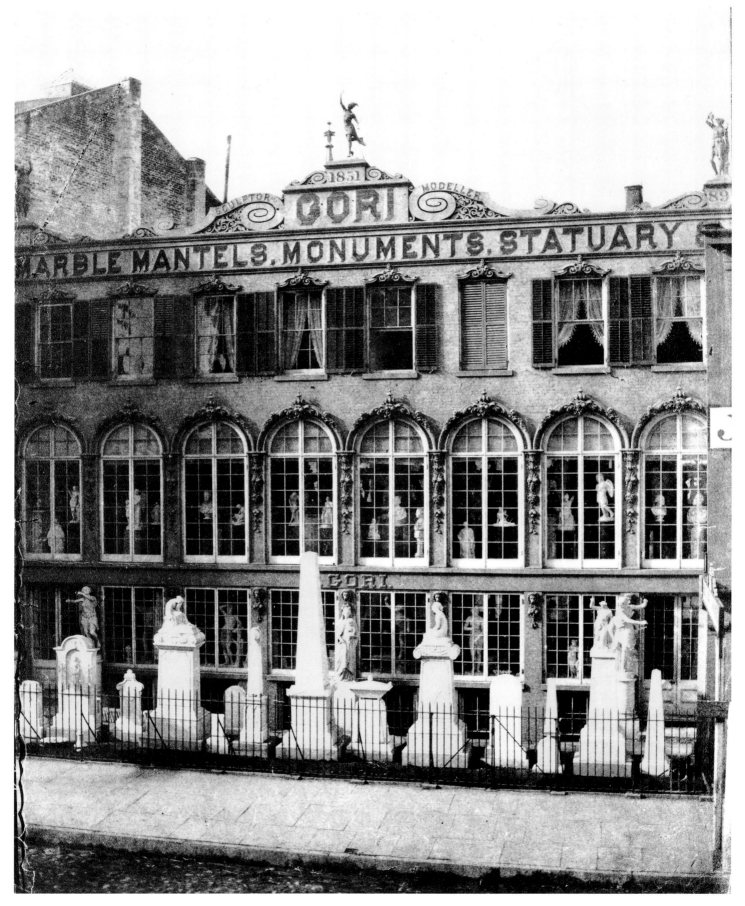

Fig. 217. Victor Prevost, *Ottaviano Gori's Marble Establishment, 895–897 Broadway,* ca. 1853. Modern gelatin silver print from waxed paper negative. Collection of The New-York Historical Society, Gift of Mr. Samuel V. Hoffman, 1906

Fig. 218. Manufacturer unknown, United States, Venetian carpet (detail), ca. 1825. Wool and cotton. The Metropolitan Museum of Art, New York, Gift of Mrs. Roger Donoho, 1931 31.24

Fig. 219. Manufacturer unknown, probably British, Brussels carpet (detail), ca. 1860. Wool, cotton, and linen. The Metropolitan Museum of Art, New York, Gift of Mrs. William Brown Meloney, 1941 41.196

India and China. Launched in a small way in the late 1820s, using only handlooms, American carpet manufacture began to gather strength after Erastus Bigelow invented the first power carpet loom, in 1843. Although most of the large producers were located in Pennsylvania, Connecticut, and Massachusetts, at least two carpet mills, Alexander Smith and A. and E. S. Higgins, existed in the New York City vicinity in 1850.

At the beginning of our period, wool two-ply flat-woven carpets, known as ingrain carpets, were by far the most popular and readily available textile floor covering in New York. The largest producers were located in Kidderminster, England, and Kilmarnock, Scotland. Ingrain was woven in strips about thirty-six inches wide, and these were sewn together and stretched to cover the entire floor of a room, wall to wall. Venetian carpet, a warp-faced flat-woven textile with multicolored stripes (see fig. 218), was also very popular in the early decades of the nineteenth century. The advertisement quoted below indicates that this brightly striped product was probably intended only for halls and stairways, but some people used it to cover the floors of entire rooms.[26] Along with these cheaper types some finer British floor coverings were imported, such as Brussels (looped pile; see fig. 219) and Wilton (cut pile) carpeting. When Albro and Hoyt (1828–57), a carpet retailer that eventually turned to marketing oilcloths, opened a shop in 1828, its management placed an advertisement that suggests the relative popularity of the wares offered: "The Subscribers having taken the house No. 105 Bowery, are making requisite alterations, which will be completed by the 12th day of March, when they will open 50 or 60 bales fine and superfine Ingrain Carpeting. Received by the latest arrivals from Europe 15 or 20 bales superfine and low priced Venetian Carpeting, for halls and stairs: will also offer for sale a general assortment of Brussels and Willow Hearth Rugs, Table & Piano Covers, Floor Baizes, Oil Cloths, India Matting, &c."[27]

During the 1830s and 1840s ingrain carpets remained in style; however, in the 1850s a multitude of floor-covering products suddenly became available to the consumer, and what might be described as a carpet mania ensued.

THE CARPET TRADE. *It is singular what a remarkable taste the American shows for a good carpet. It seems to be impossible for him to walk comfortably through life without a carpet under his feet. Every man who occupies a few square feet of house-room must have the brick or boards protected from his tread by so much carpeting . . . the well-to-do American . . . believes in enjoying life; and considering that carpets contribute to life's enjoyment, he does not hesitate to spread everywhere he is accustomed to tread with a due quantity of three-ply, or Tapestry, or Brussels, or Turkey.*[28]

In 1859 England exported $2,174,064 worth of carpets of all types to the United States, while France, which produced the highest-quality handmade Aubussons, exported only $10,317 worth.[29] Carpets of all prices were available to all types of consumers. George E. L. Hyatt, of 273 Canal Street, a dealer in carpets of middling quality who probably priced his stock at the

copies of both at the New York Public Library.

23. New York State Census, 1855, Eighteenth Ward, First Election District.

24. List of invoices paid, Davis's own copy of the specifications for Litchfield Villa, Brooklyn, vol. 15, 24.66.1414, Department of Drawings and Prints, Metropolitan Museum.

25. R. G. Dun Reports, August 7, 1857 (New York vol. 378, p. 331), R. G. Dun & Co. Collection, Baker Library, Harvard University Graduate School of Business Administration.

26. For an example of striped carpeting used wall to wall, see the watercolor of 1832 by Deborah Goldsmith titled *The Talcott Family* (Abby Aldrich Rockefeller Folk Art Collection, Williamsburg, Virginia).

27. "Carpet Store," *New-York Evening Post*, March 4, 1828, p. 3.

28. "The Carpet Trade," *Scientific American*, July 7, 1860, p. 18, reprinted from *United States Economist*.

29. *Manufactures of the United States in 1860*; reprinted in *American Industry and Manufactures in the 19th Century: A Basic Source Collection*, vol. 6 (Elmsford, New York: Maxwell Reprint Company, 1990), p. liii.

lower end of the scale, listed his inventory as follows in 1858:

*Velvet Carpets from $1.25 to 1.62½ per yard*
*Tapestry Brussels from .90 to 1.12½ per yard*
*Brussels from 1.00 to 1.25 per yard*
*Three-ply Carpets from 1.00 to 1.12½ per yard*
*Ingrain, All Wool from .50 to .80 per yard*
*Ingrain Cotton and Wool from .25 to .37½ per yard.*[30]

He also stocked oilcloths, Venetian carpeting, matting, and druggets (a kind of basic flat-woven rug used under dining tables to protect finer carpeting), but they are not priced in the advertisement. At the top end of the scale, in 1854 W. and J. Sloane sold Mr. J. G. Fisher, of 33 West Nineteenth Street, "Velvet Medallion Carpeting" for $2.50 per yard, Brussels carpeting for $1.60 per yard, and three-ply ingrain carpeting for $1.30 per yard.[31]

Carpeting a main room, such as a parlor, entailed a major family expenditure, often as much as $200 (Mr. Fisher's velvet medallion carpet and velvet border cost him $181.86). This purchase was much suffered over, since the variety of choices was so great and the dictates of fashion were so rigid. In the late 1850s and early 1860s *Godey's Lady's Book and Magazine* published a number of short stories, some humorous, some serious, that discussed the implications, both visual and moral, of choosing the appropriate carpet to correctly express a family's station in life.[32]

Oilcloth floor coverings were manufactured early in New York City, perhaps soon after the War of 1812. Made of wide-width (seamless) canvas that had been coated with layers of a mixture of oil and paint, they could be purchased either in plain colors or printed with patterns. They were used most frequently in hallways or other high-traffic areas, as they wore relatively well and were easy to clean. By the end of the period under consideration, most oilcloth sold in New York City was made there.[33]

Two major carpet manufacturers were active in the New York City area beginning in the late 1840s. A. and E. S. Higgins was started in the 1830s as a retail carpet company by Alvin and Elias S. Higgins, young men who had come to New York City from Maine. According to *A Century of Carpet and Rug Making in America* (1925):

*In 1840 they began the manufacture of carpeting on a small scale, making Ingrains only. In 1841 they established a factory at Jersey City and four years later they opened a new carpet mill in Brooklyn which was destroyed by fire shortly afterwards. They*

*secured another factory at Haverstraw, New York, which they occupied for three years, at the same time establishing a mill at Paterson, New Jersey, and buying the carpet mill of Richard Clark at Astoria, Long Island. In 1847 they built a mill at 43rd Street and North River [the Hudson], to which they moved all the looms and machinery from their other plants, adding Body Brussels and Tapestries to Ingrains previously made.*[34]

The retail business continued for a while under the aegis of Peterson and Humphrey. A. and E. S. Higgins was one of the first American carpet manufacturers to use power looms; it was known for manufacturing tapestry and velvet carpets on Bigelow's invention. The New York City factory seems to have operated until 1900; in 1882 the firm employed more than a thousand people and produced more than 3.4 million yards of carpeting each year. The Higgins firm merged with the Hartford Carpet Company in 1901.

Alexander Smith opened his first small carpet-making factory about 1847 in the town of West Farms, New York, today a neighborhood in the central Bronx. He began with twenty-five handlooms but soon changed the factory over to power weaving. Smith won a silver medal, the highest prize awarded for carpeting at the 1853 New York Crystal Palace exhibition. The citation read, "for Novelty of Invention, Elegance of Design and Color, Economy of Material, &c. in Two-Ply Ingrain Tapestry Carpets."[35] "Ingrain Tapestry" may refer to an ingrain carpet that had a multicolored printed warp. After fires at the West Farms factory in 1862 and 1864, Smith moved his concern to Yonkers, New York, where it prospered until 1954.[36] Smith, Higgins, and twenty-six other manufacturers from New York State (nine in New York City proper) produced 2,293,544 yards of carpeting in 1860 (the total for the entire country was 13,285,921 yards), making the need for imported carpeting almost a thing of the past.[37]

*Retailers*

WILLIAM W. CHESTER and THOMAS L. CHESTER were brothers who worked together in a carpet firm for fifteen years and then competed with each other for another ten; according to extant documents, however, they kept up cordial family relations. Both together, beginning in 1816, and separately they were successful carpet merchants. Surviving receipts indicate that the Chesters supplied carpets to many scions of the older New York families, including Samuel Tredwell Skidmore, a dry-goods wholesaler, and Evert A. Duyckinck, a writer and editor. Neither

30. *The Albion*, September 11, 1858, p. 443.

31. W. and J. Sloane to J. G. Fisher, Esq., invoice, March 28, 1854, Bella Landauer Collection, Floor Coverings Box, Department of Prints and Photographs, The New-York Historical Society.

32. Alice B. Neal, "The Tapestry Carpet; or, Mr. Pinkney's Shopping," *Godey's Lady's Book and Magazine* 52 (January 1856), pp. 15–19; Alice B. Haven, "The Story of a Carpet," *Godey's Lady's Book and Magazine* 58 (June 1859), pp. 531–37; Mary W. Janvrin, "A Great Bargain," *Godey's Lady's Book and Magazine* 62 (May 1861), pp. 418–24.

33. See *Manufactures of the United States in 1860*, reprinted in *American Industry: Basic Source Collection*, p. liv.

34. *A Century of Carpet and Rug Making in America* (New York: Bigelow-Hartford Carpet Company, 1925), p. 20.

35. Industry of All Nations, *Official Awards of Juries . . . 1853*, p. 58.

36. Rick Beard, *In the Mill* (exh. brochure, Yonkers, New York: Hudson River Museum, 1983).

37. *Manufactures of the United States in 1860*, reprinted in *American Industry: Basic Source Collection*, p. lix.

brother appears to have advertised; perhaps their business was so well established that only word-of-mouth recommendations were necessary. When the brothers split up in 1832, for unknown reasons, they kept shops within a block of each other on Broadway. They seem to have worked together again between 1843 and 1847. In 1836 Thomas L. Chester provided the carpets and floor cloths for the Astor House, the first great hotel built in New York City. At that date he owned a shop at 203 Broadway (see fig. 220) that was extremely modest by comparison with the grand carpet-selling emporiums of the 1850s (see figs. 221, 222). For this plum of a job he was paid $14,182.09.[38] No images survive of William's store, from which, in 1845, he furnished Mr. Skidmore with carpeting for every room in his new house at 369 Fourth Street, for the price of $631.28.[39]

Both Chesters served as judges at the American Institute fairs in the 1830s. William appears never to

*Firm names:* **W. W. and T. L. Chester** (1816–31), **W. W. Chester** (1832–47), **T. L. Chester** (1832–53)
*Owners:* William W. Chester (d. 1869), Thomas L. Chester, Stephen M. Chester (son of Thomas L. Chester, joined W. W. Chester in 1836), John N. Chester (son of Thomas L. Chester, joined T. L. Chester in 1840)
*Locations*
W. W. and T. L. Chester
1816        7 Park Place
1817–31    191 Broadway

W. W. Chester
1832–47    191 Broadway

T. L. Chester
1832–42    203 Broadway
1843–47    191 Broadway
1848–53    323 Broadway

38. "Inventory of the Furniture in the Astor House, August 1st, 1836," p. 13, Astor Papers, Astor House Box, Manuscript Department, The New-York Historical Society.
39. Skidmore Papers, Joseph Downs Collection of Manuscripts and Printed Ephemera, no. 70 x 53.52, courtesy The Winterthur Library.

Fig. 220. *Broadway Sights,* view of T. L. Chester and Company Carpet Store, 203 Broadway, ca. 1837. Lithograph by John H. Bufford. Collection of The New-York Historical Society, Bella Landauer Collection

Fig. 221. Billhead with view of Peterson and Humphrey's Carpet Store, 379 Broadway, 1853. Wood engraving by Nathaniel Orr. Collection of The New-York Historical Society, Bella Landauer Collection

Fig. 222. *Interior of Peterson and Humphrey's Carpet Store, 379 Broadway,* 1853. Wood engraving, by Nathaniel Orr, from *The Illustrated American Biography* (New York: J. M. Emerson and Company, 1853), vol. 1, p. 31. The Metropolitan Museum of Art, New York, The Elisha Whittelsey Collection, The Elisha Whittelsey Fund, 1958  58.521.1

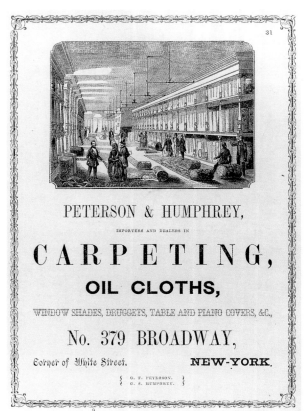

40. William W. Chester, Last Will and Testament, March 11, 1869, New York City Records Department, Liber 26, p. 384.
41. "The Palaces of Trade," *International Monthly Magazine of Literature, Science, and Art* 5 (April 1852), pp. 436–41.
42. Ibid., p. 438.
43. R. G. Dun Reports, July 15, 1848, for example. A report of June 15, 1852, states, "Are s[ai]d to be back[e]d by 'A. T. Higgins' who furnishes them with facilities," and one of August 16, 1854, relates, "They buy principally of 'Higgins & Co.'" For all the foregoing entries, see R. G. Dun Reports (New York vol. 365, p. 121, vol. 192, p. 569), R. G. Dun & Co. Collection, Baker Library, Harvard University Graduate School of Business Administration. For more about A. and E. S. Higgins, see *Century of Carpet and Rug Making in America,* pp. 19–22.

have married. In his will of March 11, 1869, he left most of what he owned to his brother Thomas and his brother's children. The will also reveals that he was involved in the very institutions and activities that engaged the elite of New York society. In addition to money, William left his various relatives the paintings and books he had collected, as well as his share in the New York Society Library, his pew at the Mercer Street church, his family seal, and an estate on Staten Island. William W. Chester may have been an early trustee of the University of the City of New York (now New York University); in his will he bequeathed the university "my portrait now hanging in the Chancellor's room of that Institution." In addition to property and investments, William left $30,500 to his heirs, a goodly sum for a carpet salesman.[40]

PETERSON AND HUMPHREY was in some ways more typical of midcentury retail carpet firms than the T. L. Chester company. The partnership rode the crest of the affluent 1840s and 1850s but failed in the years just before the Civil War. Both George F. Peterson and George S. Humphrey were experienced carpet salesmen, but neither seems to have had great financial means. They started out as a relatively small firm working out of a series of Pearl Street locations and in the 1850s raised enough money from a backer to build a big store on Broadway. Their huge "carpet house" at the corner of Broadway and White Street (see fig. 221)

was much illustrated during the period, both in advertisements and in newspaper articles dedicated to "palaces of trade."[41] A print of the interior of their selling floor is one of the very few illustrations of nineteenth-century carpet shopping known today (fig. 222).

In 1852 the store was described as follows: "[This] imposing edifice on the corner of Broadway and White-street . . . is one of the improvements of the city made during the last year. In the great carpet-house of Peterson & Humphrey are offered the productions of the best looms in the world, in a variety and profusion probably unequalled elsewhere in America. The principal saloon is like a street, and it is almost always thronged with people."[42] The image of the interior shows dapper salesmen unrolling bales of strip carpeting for well-dressed couples on a half-block-long sales floor. The racks holding rolls of carpet rise up through three levels, forming building-like structures to each side of the room, which is perhaps eighteen feet high.

In spite of its extravagant premises and nonstop advertising, Peterson and Humphrey was never on particularly sound financial footing. It was backed by A. and E. S. Higgins and took over that firm's retail business after 1847. According to the R. G. Dun credit reports, either Peterson or Humphrey was a nephew of one of the Higgins brothers.[43] An advertisement

*Firm names:* **George F. Peterson** (1844, 1859–64),
**Peterson and Humphrey** (1845–47, 1849–57),
**Peterson, Humphrey and Ross** (1848),
**G. S. Humphrey and Company** (1859–62),
**E. A. Peterson and Company** (1859–72)
*Owners:* George F. Peterson, George S. Humphrey
(d. 1898), David S. Ross, Edwin A. Peterson
(perhaps son of George F. Peterson)
*Locations*
George F. Peterson
1844        462 Pearl Street

Peterson and Humphrey, Peterson, Humphrey and Ross
1845        440 Pearl Street
1846–47   454 Pearl Street
1847–51   432 Pearl Street
1852–56   379 Broadway
1857        524 Broadway

G. S. Humphrey
1859–62   524 Broadway

George F. Peterson
1859–64   315 Canal Street

E. A. Peterson
1859–72   315 Canal Street

from 1847 proclaims: "Peterson, Humphrey & Ross, having purchas[ed] the entire stock of carpetings, druggets, oil-cloths &c., in the large and spacious Carpet Warerooms No. 432 Pearl-street, formerly owned by Messrs. A. & E. S. Higgins, are now prepared to offer their friends and the public the above stock, together with recent purchases, at prices far below the market."[44]

Peterson and Humphrey seems to have served as the Higginses' outlet in New York City, but the manufacturer's carpets were not the only wares sold by the retailer.[45] In its heyday, during the mid-1850s, Peterson and Humphrey cleared about $75,000 in profit each year; however, by March 1857 the firm had failed because of bad debts, perhaps a casualty of the financial panic of 1857. Although members of the original firm continued in the carpet business for a few years, they never flourished as they had in the splendid carpet house at 379 Broadway.

By contrast, the W. AND J. SLOANE company flourished into the twentieth century. After completing his training as a carpet weaver at an Edinburgh mill, William Sloane emigrated from Scotland to the United States in 1834. He worked for the Connecticut carpet-weaving firm of Thompson and Company for almost a decade before opening his own carpet warehouse in 1844, with some backing provided by Thompson and Company, whose wares he surely

stocked.[46] William's older brother John joined the business in 1853. The first Sloane shop was located at 245 Broadway in a three-story Federal-style town house with a converted first floor (see fig. 223). From the beginning, the firm catered to the high end of the market. The earliest receipt for Sloane's found during the course of research for this exhibition shows that in 1845 the wealthy dry-goods merchant Samuel Tredwell Skidmore purchased two Persian rugs, for $25 each, from William Sloane.[47] There is no evidence to suggest that any of the other carpet retailers discussed here sold Persian rugs; thus, Sloane's must have been one of a very few places that stocked such luxury goods. When the Clarendon Hotel was

44. "Carpetings," *Home Journal,* January 16, 1847, p. 3.

45. Their advertisements stated that they stocked carpets "selected from the most celebrated Factories in Europe and this country." *New York Mercantile Register,* 1848–49, p. 118.

46. In the *New York Business Directory for 1840 & 1841,* Thompson and Company is listed as one of only three carpet manufacturers selling its products in New York. The firm's listing stated that Thompson's showroom was at 8 Spruce Street and that it sold "Brussels, Ingrain, &c." For more on Sloane's relationship with Thompson and Company, see R. G. Dun

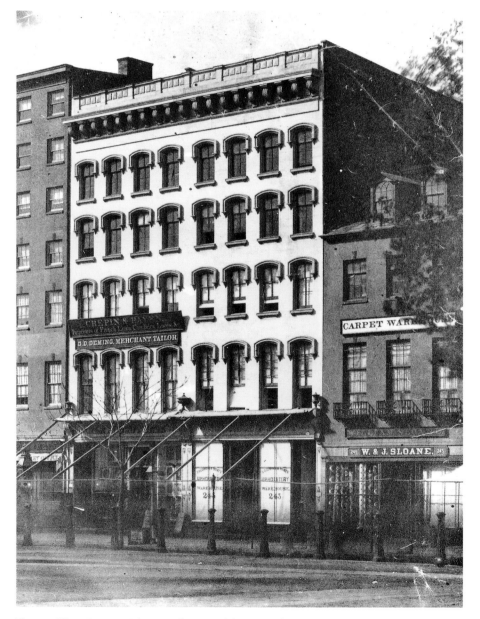

Fig. 223. Victor Prevost, *Solomon and Hart Upholstery Warehouse, 243 Broadway, and W. and J. Sloane Carpet Warehouse, 245 Broadway, New York City,* 1854. Modern gelatin silver print from waxed paper negative. Collection of The New-York Historical Society, Gift of Mr. Samuel V. Hoffman

*Firm names:* **William Sloane** (1844–52),
**W. and J. Sloane** (1853–1960s)
*Owners:* William Sloane (1810–1879; retired from the firm in 1864), John Sloane (b. before 1810; retired from the firm in 1860), John Sloane (1834–1905; son of William Sloane), Douglas Sloane (son of William Sloane)
*Locations*

| | |
|---|---|
| 1844–55 | 245 Broadway |
| 1856–59 | 501 Broadway and 56 Mercer Street |
| 1859–66 | 591 Broadway |

Business conducted through the 1960s at various locations

renovated in 1858, the management used Sloane's stellar reputation as a selling point, advertising that their new carpets were "carefully selected, of the most approved styles and quality, from the establishment of W. & J. Sloane."[48] In 1859 R. G. Dun and Company reported that the firm was prosperous and had "the custom of a lar[ge] number of first class families; sell mostly fine goods."[49] The store at 591 Broadway was considered by the editor of *Carroll's New York City Directory* (1859) to be "one of the greatest sights in N. Y."[50] An advertisement found in the same publication describes the wide range of Sloane's wares:

*Strangers visiting New York are invited to examine our establishment, the largest building in the world devoted to the exclusive sale of Carpets. Our great advantage in buying and manufacturing, guarantees us to sell lower than any house in the trade, and our goods will be found superior in quality and style.*

*$250,000 worth of English Medallion Bordered Carpets! English Royal Tapestry Velvet Carpeting! English Four-Frame Brussels Carpeting! English Tapestry Brussels Carpeting! English Imperial Three-Ply Carpeting! Floor Oil Cloths, from one to eight yards wide. India Mattings, White and Checkered; Mats, Rugs, Gold and Painted Window Shades, Druggets, French and English Table and Piano Covers. Cocoa Matting, 1½, 2, 3, 4, 5 and 6 feet wide, for Churches, Offices, Hotels and Steamboats at the most unprecedented low prices.*[51]

As the notice suggests, William's familiarity with carpeting manufacture meant that the firm had a hand in the production of at least some of the goods sold at the shop. His longstanding ties to Thompson and Company were also surely an advantage; however, Thompson seems to have failed in 1851 (the firm was reorganized as the Hartford Carpet Company). William

managed to survive the crash, probably by aligning himself with other manufacturers both in the United States and abroad. At the time of his death, in 1879, William was a director and shareholder of the Bigelow Carpet Company of Massachusetts and of the Alexander Smith and Sons Carpet Company of Yonkers, New York, two of the leading carpet manufacturers in the country.[52] It is likely that he stocked carpets manufactured to his special order from those two firms, and he may have had the same relationship with mills in England and Scotland. In the mid-1860s, soon after William retired, the firm was worth between $200,000 and $300,000.

### Wallpaper

Producers and retailers of wallpaper—more often called paper hangings during our period—found New Yorkers to be insatiable consumers of their wares. New wallpaper was the answer to many decorating problems: it was available in many different grades and at a wide range of prices; it was easily installed; and it was produced in myriad fashionable patterns. The novelty factor was important to the consumer. As *Godey's Lady's Book and Magazine* observed in 1857: "There is nothing, perhaps, that adds more to the beauty of a parlor, or in fact any other apartment, than a well-selected, handsome wall-paper. It is better than painting or frescoing, as one gets tired in time of a permanent fixture; while, at the same time, wallpaper is cheaper, and even more beautiful. . . . With wall-paper, you can make a change, which sometimes becomes necessary to suit a different style of furniture."[53]

The earliest advertisements from the period of this study reveal a ready market for both high-style French paper hangings and the cruder products of the fledgling American industry. In the 1820s wallpapers were advertised and sold by wholesale importers to upholsterers, who were the primary wallpaper retailers. In 1823 a merchant named F. Chazournes with offices "upstairs" at 162 Pearl Street took out an advertisement addressed "TO UPHOLSTERERS. Twenty-two bales French paper hanging, handsome patterns, for sale by the bale or in smaller quantity." In 1824 Calvin W. How and Company, located farther downtown at 135 Pearl Street, advertised "8000 rolls American made Room Papers, of various qualities, on hand and for sale at reduced prices," and two years later E. Malibran, of 31 South Street, offered "10 cases superb Velvet Papers, new patterns, worthy of the attention of upholsterers and others, as they are suitable for this or the South American market, for sale low to close a

Reports, for February 16, 1849, May 27, 1851, and September 23, 1851 (New York vol. 192, p. 564), R. G. Dun & Co. Collection, Baker Library, Harvard University Graduate School of Business Administration.

47. Skidmore Papers, Joseph Downs Collection of Manuscripts and Printed Ephemera, no. 70 x 53.66, courtesy The Winterthur Library.

48. *The Albion*, September 11, 1858, p. 443.

49. R. G. Dun Reports, October 25, 1859 (New York vol. 192, p. 564), R. G. Dun & Co. Collection, Baker Library, Harvard University Graduate School of Business Administration.

50. G. Danielson Carroll, *Carroll's New York City Directory . . .* (New York: Carroll and Company, 1859), p. 69.

51. Ibid.

52. See the biography of William Sloane in *America's Successful Men of Affairs*, p. 605.

53. "Paper Hangings," *Godey's Lady's Book and Magazine* 54 (April 1857), p. 376.

Fig. 224. Manufacturer unknown, probably New York City, Wallpaper, ca. 1850. Roller-printed paper. The Metropolitan Museum of Art, New York, Gift of Mrs. Adrienne A. Sheridan, 1956  56.599.12

Fig. 225. Manufacturer unknown, probably French, Wallpaper, ca. 1850. Paper with wool flocking. The Metropolitan Museum of Art, New York, Anonymous Gift, 1923  23.133.10

consignment."[54] Very little paper was imported from England or from countries on the Continent other than France. The French were the masters of wallpaper manufacturing at the time, and Americans avidly bought both their scenic papers, which illustrated exotic landscapes and peoples, and their more typical floral and trompe l'oeil designs. Until the latter part of the nineteenth century French papers were considered better designed than American papers, with more elegant patterns and subtler coloration.

In the mid-1820s a few retailers of paper hangings and bandboxes opened businesses in New York City offering both imported and American goods. At that time the American paper-hangings industry, which had been established in the late eighteenth century, was centered in New England and Philadelphia, but by 1840 twenty-five wallpaper concerns were listed in the New York business directories and ten of them appear as manufacturers as well as retailers. Also included in that number are a few firms, such as John Constantine, Phyfe and Brother, and Barnett L.

Solomon, that specialized in upholstery but sold wallpaper as well. Wallpapers could also be purchased at the shop of a "decorator," although few such professionals existed at the time. George Platt is one of the few about whom something is known. He advised and assisted clients in much the same way as interior designers do today, and he also retailed all types of decorative items for the home. Sidney George Fisher of Philadelphia visited Platt's shop at 60 Broadway with his brother and sister-in-law in 1847:

*Went with Henry and Sarah Ann to Platt's, who is a 'decorateur' and furnishes everything connected with the interior ornamental work of houses. Saw quantities of elegant things, furniture, mirrors, picture frames, paper hangings, etc. Had no idea before of the beauty of French paper. The various patterns for drawing & dining rooms, halls & libraries were really works of art. The prices are immense, ranging from $5 to $10 per piece, whereas the best American is only $1. Henry chose some of the handsomest for his house.*[55]

54. *New-York Evening Post,* April 25, 1823; *New-York Daily Advertiser,* May 19, 1824; *New-York Gazette and General Advertiser,* June 13, 1826.

55. Nicholas B. Wainwright, ed., *A Philadelphia Perspective: The Diary of Sidney George Fisher Covering the Years 1834–1871* (Philadelphia: Historical Society of Pennsylvania, 1967), p. 198.

Throughout the first half of the nineteenth century, French wallpaper remained expensive, owing in part to the high tariffs (in some years as much as 40 percent) placed on them in order to encourage the American industry. However, in 1850 Thomas Faye, a New York retailer who also manufactured wallpaper, placed an advertisement in the *Home Journal* that indicates Americans remained undaunted by the cost of buying French:

> INTERIOR DECORATIONS. *The Subscribers, sole Agents in America for many of the best French Factories, call the attention of those who intend refitting their houses, to their rich and splendid stock of Paper Decorations, for the walls of parlors, halls, boudoirs, saloons, drawing and dining-rooms, &c., &c. They are constantly receiving direct from Paris, Lyons, Constance and other cities of the continent all the latest styles and patterns in doré velouté, doré maroguin, double satin, Lambris, Bordures, Camés, &c., &c. A full assortment of samples can be seen, from which special importations can be made when desired, by steamer, in from two to three months.*[56]

Comparison shoppers would have discovered, too, that some of the simpler French papers were not much more expensive than American examples (see figs. 224, 225). Thomas Faye sold a French Emboss Stripe paper to Evert A. Duyckinck for 75 cents a roll and two different types of Satin paper, probably of American manufacture, for 25 and 50 cents a roll, respectively. The cost of papering one of Duyckinck's rooms with the 25-cent paper was $9.18. This included $3.75 for the wallpaper, plus $1.20 for twenty-four yards of velvet (possibly flocked) border, and $4.23 for hanging the paper.[57]

After about 1840 American wallpaper manufacturers began to experience some success with a timesaving mechanized cylinder-printing process.[58] Although roller-printed paper made before 1860 is often poorly designed and printed and the best papers continued to be block printed by hand throughout the period of this study, the mechanization of the American wallpaper industry made it possible even for consumers with very little money to enliven their homes with bright, clean, and colorful wallpapers.

### Retailers and Manufacturers

FRANCIS PARES and THOMAS FAYE were wallpaper merchants in New York City between 1824 and 1886. They each had a paper-hangings business before becoming partners in 1837; after their partnership broke up in 1846 they became competitors. Francis

Pares began as a maker of trunks and bandboxes in 1824. In an 1829 advertisement, the earliest found for his shop, he lists his wares as: "PAPER HANGINGS, TRUNKS, and BANDBOXES.—*Francis Pares.* . . . keeps constantly on hand, for sale, an extensive assortment of Paper Hangings, imported directly from Paris; also, of his own manufacture, Pedlars', Merchants', and Fancy Trunks, wholesale and retail; Bandboxes in nests for shipping."[59] He may have specialized in providing goods to retailers outside the New York area, since an advertisement placed in 1831 announces: "BANDBOXES.—Southern merchants and Milliners may be supplied with Bandboxes in nests for shipping, made of the best materials, and will be sold at the lowest prices at the old established manufactory of F. PARES, No. 379 Pearl st."[60] Bandboxes, such as the one illustrated here (fig. 226), were used for storing small items of clothing, for example collars (in pre-twentieth-century terminology "bands," hence the name "bandbox"), and as hatboxes. Some of the earliest known American block-printed decorative papers appear on bandboxes. Although these papers are similar to wallpapers, many of them were designed exclusively for bandboxes. Views of notable buildings, such as New York's Castle Garden (see fig. 226), were particularly popular for bandboxes.

*Firm names:* **Francis Pares** [and Company] (1824–36, 1846–66), **Thomas Faye** [and Company] (1835–36, 1851–77, 1883–86), **Pares and Faye** (1837–46), **Faye, Donnelly and Company** (1877–82)
*Owners:* Francis Pares, Thomas Faye (1810–1892)
*Locations*
Francis Pares

| | |
|---|---|
| 1824–36 | 379 Pearl Street |
| 1847–53 | 379 Pearl Street |
| 1854–56 | 59 Chambers Street |
| 1857–59 | 336 Broadway |
| 1860 | 836[?] Broadway |
| 1861 | 828 Broadway |
| 1862–66 | 828 Broadway and 45 Beaver Street |

Pares and Faye

| | |
|---|---|
| 1837–46 | 379 Pearl Street |

Thomas Faye

| | |
|---|---|
| 1835–36 | 367 Pearl Street |
| 1851–54 | 436 Pearl Street |
| 1855 | 257 Broadway |
| 1856–60 | 257 Broadway and 152–156 West Twenty-ninth Street |
| 1861–64 | 257 Broadway |
| 1865–69 | 814 Broadway |
| 1870–86 | 810 Broadway |

56. *Home Journal*, June 8, 1850, p. 3.

57. Thomas Faye and Company to Mr. E. A. Duyckinck, invoices, August 24, 1859 (the French Emboss Stripe), and May 3, 1856 (the Satin paper), Duyckinck Family Papers, New York Public Library.

58. For good overviews of the effects of mechanization on the American wallpaper industry, see Elizabeth Redmond, "American Wallpaper, 1840–1860: The Limited Impact of Early Machine Printing" (Master's thesis, University of Delaware, Newark, May 1987); and Karen A. Guffey, "From Paper Stainer to Manufacturer: J. F. Bumstead & Co., Manufacturers and Importers of Paper Hangings," in *Wallpaper in New England*, by Richard Nylander et al. (Boston: Society for the Preservation of New England Antiquities, 1986), pp. 29–37.

59. *Workingman's Advocate*, October 31, 1829, p. 3.

60. Ibid., March 5, 1831, p. 6.

Fig. 226. Manufacturer unknown, Bandbox depicting Castle Garden, ca. 1835. Wood and block-printed paper. Collection of The New-York Historical Society 1937.1627

In 1835, although he was still manufacturing bandboxes, Pares was also selling very expensive imported wallpapers from his shop. To a Mr. Van Gorder of Warren, Ohio, he sold two sets of scenic paper, which he called The Suberbs [sic] of Rome, by an unidentified French maker for $60 per set.[61] It was to be hung in the parlor of an inn and coach stop in Warren.[62]

Thomas Faye, a native of Galway, came to America in 1818 as a child of eight. He went into the wallpaper business in 1835. The masthead on his receipts for that year lists his firm as the "Successors to Thomas Day, Jun., Importers and Dealers in Paper Hangings, and Manufacturers of Bandboxes."[63] In 1837 Pares and Faye formed a partnership and seem to have discontinued the manufacture of bandboxes. An 1840 advertisement makes it apparent that the firm continued Pares's wholesale business, selling mainly to the trade and especially to merchants outside New York:

> *Paper Hangings Borders etc. Pares and Faye No. 379 Pearl Street, offer to the trade and others, on terms of great reduction, the most extensive assortment of the newest patterns and styles of gold and silver, velvet and satin French Paper Hangings, Borders, Fireboard Prints, Views, Statues, Ceilings, etc. Also American Satin and Common Paper Hangings, from the most eminent manufactories, at the lowest manufacturers' prices. Merchants and others from all parts of the country are earnestly solicited to call and examine for themselves.*[64]

An 1845 advertisement was even more specific about the clients Pares and Faye preferred, announcing that

". . . Merchants, Dealers, Housekeepers, Landlords and others are respectfully invited . . . to call."[65] One of those "others" who bought papers from Pares and Faye happened to be the president of the United States. In a letter of about 1840, toward the end of his term, Martin Van Buren asked Mrs. Benjamin F. Butler, the wife of an Albany lawyer and politician, for her help and advice on choosing papers from the samples he had been sent from Pares and Faye's shop. Van Buren was in the midst of refurbishing a house in Kinderhook, New York, as his retirement home and, being a widower, he felt the need of a woman's advice in making his wallpaper choices. He numbered the papers he liked and suggested the rooms in which to install each paper. He had no opinion about some rooms, telling Mrs. Butler, "For the rest you must decide for yourself."[66]

After Pares and Faye parted company in 1846, both men continued to import fine French papers and both listed themselves as wallpaper manufacturers on their billheads. Pares sold printed window shades (perhaps like the Crystal Palace paper of cat. no. 218) as well as paper hangings. It is not known whether Pares actually made much paper; on the other hand, production appears to have been a significant part of Thomas Faye's business, because he proudly displayed pictures of both his store and his "manufactory" at 152–156 West Twenty-ninth Street at the top of his billheads (see fig. 227). Faye had some success with the papers he manufactured; in 1855 one of them won a gold medal at the American Institute fair. He seems to have retired briefly between 1859 and 1861; after that, he ran the business until 1886, perhaps with the help of his nine children. Faye also owned considerable real estate both on Broadway and in the Washington Heights area of Manhattan, which brought additional income to his family.[67] Pares left the paperhangings business in 1866; he was listed simply as a merchant in New York City directories until 1881.

CHRISTY AND CONSTANT, another long-lived firm, was one of the major wallpaper manufacturers in America during the nineteenth century. It is first listed in the New York City directories as a manufacturer of paper hangings in 1844, the year that Thomas Christy's brother-in-law, Samuel S. Constant, became his partner. However, a late 1830s receipt from Thomas Christy and Company, 65 Maiden Lane, describes the business as "Importers and Manufacturers of French and American Paper Hangings," implying that Christy may have been manufacturing wallpaper from the time he started his business.[68] In addition to manufacturing, the firm seems to have maintained a retail

61. The archives of the Wallpaper Department, Cooper-Hewitt National Design Museum, Smithsonian Institution, New York, has a copy of Pares's invoice to Van Gorder. According to Catherine Lynn, who saw photos of the paper design Van Gorder called The Suberbs [sic] of Rome while researching her ground-breaking book *Wallpaper in America from the Seventeenth Century to World War I* (New York: W. W. Norton, 1980), it is identical to one that has been called *Les Bords de la Rivière* in the twentieth century. See ibid., p. 226, colorpl. 36.

62. Charles B. Proctor, Warren, Ohio, to Catherine Lynn, May 8, 1973, archives of the Wallpaper Department, Cooper-Hewitt National Design Museum.

63. Thomas Faye and Company to Mr. W. Porter, invoice for $20.94 in wallpapers, April 25, 1835, Joseph Downs Collection of Manuscripts and Printed Ephemera, no. 66 x 71.2, courtesy The Winterthur Library.

64. *New-York American*, October 2, 1840, p. 3.

65. *Evening Post* (New York), March 29, 1845, p. 3.

66. Martin Van Buren to Mrs. Benjamin F. Butler, n.d., Joseph Downs Collection of Manuscripts and Printed Ephemera, no. 77 x 58, courtesy The Winterthur Library.

67. Biographical information about Thomas Faye has been gleaned from the not completely accurate biography of him written in *America's Successful Men of Affairs*, p. 233.

68. Thomas Christy and Company to an unknown customer, invoice dated August 28, 183[ ], photocopy in the files of the Wallpaper Department, Cooper-Hewitt National Design Museum.

Fig. 227. Billhead with views of Thomas Faye and Company Store, 257 Broadway, and Manufactory, 152–156 West Twenty-ninth Street, 1859. Lithograph by Alexander Robertson, Henry Seibert, and James A. Shearman. The New York Public Library, Duyckinck Family Papers, Manuscripts and Archives Section

Fig. 228. *Christy, Constant and Company Paper-Hangings Manufactory, 510–544 West Twenty-third Street, New York*, ca. 1861–71. Lithograph by Endicott and Company. Collection of The New-York Historical Society, Print Room

Firm names: **Thomas Christy and Company** (1838–40), **Christy and Robinson** (1841–43), **Christy and Constant** [and Company] (1844–71), **Christy, Constant and Shepherd** (1872–73), **Christy, Shepherd and Garrett** (1874–84), **Christy, Shepherd and Walcott** (1885–87)
Owners: Thomas Christy (d. 1874), Samuel S. Constant (d. 1885; retired in 1874), John D. Robinson, Thomas Christy Shepherd (nephew of Thomas Christy, joined firm in 1872), Charles R. Christy (son of Thomas Christy took over the business in 1874), William Garrett, [ ] Walcott
Locations

| | |
|---|---|
| 1838–40 | 65 Maiden Lane |
| 1841–48 | 61 Maiden Lane |
| 1849–50 | 60 Maiden Lane and 21 Liberty Street |
| 1850–55 | 60 Maiden Lane, 21 Liberty Street, and 328 West Twenty-third Street |
| 1855–60 | 48 Murray Street and 328 West Twenty-third Street |
| 1861–62 | 48 Murray Street and 512 West Twenty-third Street |
| 1863–64 | 25 Murray Street and 512 West Twenty-third Street |
| 1865–71 | 29 Warren Street, 25 Murray Street, and 512 West Twenty-third Street |
| 1872–73 | 501 Broadway, 56 Mercer Street, and 512 West Twenty-third Street |
| 1874–87 | 510 West Twenty-third Street |

business through the end of the 1840s. An advertisement in the 1848–49 New-York Mercantile Register states that the shop stocked "PAPER HANGINGS, BORDERS, FIRE BOARD PATTERNS and CURTAIN PAPERS, in all varieties and styles, and of the best qualities. As C. & C. manufacture the article extensively, it enables them to offer their goods on the most advantageous terms, WHOLESALE and RETAIL."[69] Christy and Constant wallpapers won awards at the American Institute fairs of 1844 and 1846.[70] After 1850 it is likely that the partners concentrated primarily on manufacturing and their wholesale business, since they seem not to have advertised in the popular newspapers and journals and never opened a store on Broadway, remaining on Maiden Lane from 1838 to 1855, and on Murray Street from 1855 to 1864. The large Christy and Constant factory at West Twenty-third Street near Tenth Avenue began producing wallpapers in 1850 (see fig. 228). In 1868 the building was described as "one of the most imposing, in external appearance, of the manufacturing establishments of New York, and one of the largest of its kind in the United States."[71] In the special schedule of the 1860 federal census devoted to industry, Christy and Constant's annual product was valued at $250,000.

The report also noted that the firm employed 150 people (148 men and 2 women), had a capital investment of $150,000, and stocked $80,000 worth of raw materials (paper, paints, and fuel).[72]

The wallpapers that the firm manufactured had complex designs and were produced by two different printing techniques. In the 1860s the first floor of the factory held four large roller printers, each of which had the capacity to print twenty-four thousand yards of paper a day. The machines had a dozen rollers each, so that twelve separate colors could be printed in a single operation (see fig. 229). The second floor housed the hand-printing department, "where all the higher grades of Paper Hangings, including Gold and Velvet Papers . . . are produced."[73] On the three floors above were other large mechanical printing presses, machines for polishing papers with satin or glossy grounds, and large areas set aside for grinding pigments and mixing the paints used to print the papers. There does not seem to have been a design department at the factory; according to an account published in 1868, "The principal designer of this firm resides in France, which, it must be conceded, is the world's centre, in all that relates to Ornamental Art."[74] Doubtless, the firm produced all types of papers in all grades of quality, including some that may have rivaled the papers produced in France, but rarely before the 1880s did wallpaper manufacturers mark their products. Only one identifiable piece of Christy and Constant paper is known today.[75] Why the firm went out of business in 1887 remains unknown. Further research may show that it was bought out by another wallpaper company.

Tiny by comparison with Christy and Constant, the firm of PRATT—later PRATT AND HARDENBERGH—started out as wholesalers in the mid-1840s but by the mid-1850s had begun to pursue a retail business. In 1854 it placed an advertisement in The Independent, announcing: "PRATT & HARDENBERGH, Manufacturers and Importers, No. 360 Broadway, New-York, have added to their wholesale business A RETAIL DEPARTMENT, and are constantly receiving all the new varieties of WALL AND PAPER DECORATIONS, from the most eminent manufacturers of Europe which, with the best styles of American production, they will be pleased to exhibit to any and all who may call upon them, either with a view of purchasing, or to see the perfection this branch of manufacture has obtained."[76] That same year the company announced that it was planning to manufacture an American scenic paper equal in every way to the enormously popular French scenic papers. In a laudatory article

69. New-York Mercantile Register, 1848–49, p. 309.
70. See List of Premiums Awarded by the Managers of the Seventeenth Annual Fair of the American Institute, October 1844 [New York, 1844], p. 11; and List of Premiums Awarded by the Managers of the Nineteenth Annual Fair of the American Institute, October 1846 [New York, 1846], p. 20; copies of both in the library of the New-York Historical Society.
71. J. Leander Bishop, A History of American Manufactures from 1608 to 1860, . . . 3 vols. (Philadelphia: Edward Young and Co., 1868), vol. 3, p. 179.
72. Manufactures of the United States in 1860.
73. Bishop, History of American Manufactures, p. 180.
74. Ibid.
75. Nylander et al., Wallpaper in New England, p. 192.
76. The Independent, April 27, 1854, p. 135.

Fig. 229. *Printing the Paper,* interior views of Christy, Shepherd and Garrett, 1880. From *Scientific American,* July 24, 1880, front page. The New York Public Library, Astor, Lenox and Tilden Foundations, The Science and Technology Research Center

published in *Glances at the Metropolis* (1854), Pratt and Hardenbergh's store is described and its ambitions are discussed:

> But a sight of all the rooms of the most beautifully decorated dwellings in New York gives but a faint conception of the immense scope of variety, the genius and labor that strike the eye and kindle the fancy, in going through the vast Paper Hanging Establishment of PRATT, HARDENBERGH & Co., 390 [sic] Broadway. These young men, who are masters of this branch of luxurious commerce, opened their magnificent store last spring. It was built for them, and they have directed all its interior proportions with special reference to the convenience of visitors, and an artistic display of their goods. . . . They are the only House of the Trade in New York, that retails Paper Hangings of their own manufacture.
>
> There has hitherto been one thing to be desired in this department of Commerce—American Scenes. . . . We are rejoiced to learn that these accomplished young men are preparing to manufacture original styles of Paper, which will illustrate our own History and scenes. In this laudable design they will be greeted by praise, and be rewarded by the most generous appreciation.[77]

The passage above is followed by a poem entitled "Lines inscribed to Pratt, Hardenbergh & Co., on hearing that they had determined to manufacture Wall Paper illustrated with scenes from American History and Landscape." The poem is anti-European in tone, citing beautiful American landscapes that more than equal those found in Europe. The subtext is pro-American manufacturers and proposes that they can rival French firms such as Zuber, which had been producing papers showing American scenes since the 1830s.[78] Despite all the high hopes thus expressed, Pratt and Hardenbergh did not achieve a lasting success, possibly because the business was just too small. According to the 1855 New York State census records, it manufactured only $13,000 worth of paper that year and had a mere six employees.[79] Also the firm must have been hand printing its papers, which was enormously time consuming; this can be surmised because the census lists the value of the company's tools and machinery at only $100. According to the R. G. Dun credit reports, it was never financially strong, no matter how affluent the shop may have appeared. By October 21, 1856, the company had failed, although it limped along for a few more years, selling off stock to meet debts, finally closing in 1858.[80]

---

Firm names: **J. H. and J. M. Pratt** (1845–50), **John Pratt** (1851), **Pratt and Hardenbergh** (1851–58)
Owners: James H. Pratt, John M. Pratt, John P. Hardenbergh
Locations

| | |
|---|---|
| 1845 | 21 South William Street |
| 1846–47 | 141 Pearl Street |
| 1848–49 | 138 Pearl Street |
| 1850–51 | 159 Pearl Street |
| 1851–53 | 32 Broadway |
| 1854–58 | 360 Broadway |

---

Like Pratt and Hardenbergh, SUTPHEN AND BREED (later SUTPHEN AND WEEKS) must have received a large infusion of capital in the mid-1850s that it used to open a store on Broadway. Both companies kept their palatial shops for only a few years. Teneyck Sutphen had been a dry-goods merchant from 1840 to 1854, at which point he turned to wallpaper with his new partner, John B. Breed, and moved the business from Pine Street to 404 Broadway, where they opened a grand store (see figs. 230, 231). The existing illustrations of Sutphen and Breed's provide a wonderful record of the appearance of wallpaper emporiums in the 1850s, a time when there was a great deal of excitement over the transforming possibilities that wallpapers held for even the humblest room. As an 1855 editorial in the *Home Journal* euphorically expressed it:

> Within the last year, so much has been done for the interior decoration of our private, and many of our public buildings, that we may say with propriety, that the walls, heretofore so bare and unmeaning, are now beginning to assume a character that adds much to the pleasures and enjoyments of refined life. The production of paper of elegant designs, and of untold variety—placed in the hands of skilful decorators, who take their multiplied beauties, and, by new art, cut and arrange them, with reference to each room —is the very perfection of this especial business. Now, instead of that eternal sameness which once prevailed, we have the most pleasing variety and fitness.[81]

---

Firm names: **Sutphen and Breed** (1854–57), **Sutphen and Weeks** (1858–61)
Owners: Teneyck Sutphen, John B. Breed, Fielder S. Weeks
Locations

| | |
|---|---|
| 1854–59 | 404 Broadway |
| 1860–61 | 100 Liberty Street and 105 Cedar Street |

---

77. Charles Edwards Lester, ed., *Glances at the Metropolis* (New York: Isaac D. Guyer, 1854), p. 37.

78. See Zuber's papers called *Vues du l'Amérique du Nord* (1834–36), illustrated in Lynn, *Wallpaper in America*, p. 193.

79. New York State Census, 1855, Sixth Ward, Second Election District.

80. R. G. Dun Reports, October 21, 1856 (New York vol. 365, p. 134), R. G. Dun & Co. Collection, Baker Library, Harvard University Graduate School of Business Administration.

81. "Interior Decorations," *Home Journal*, March 23, 1855, p. 3.

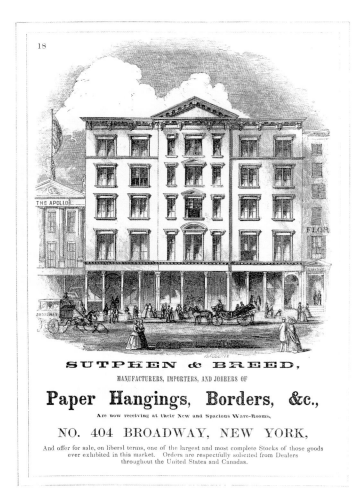

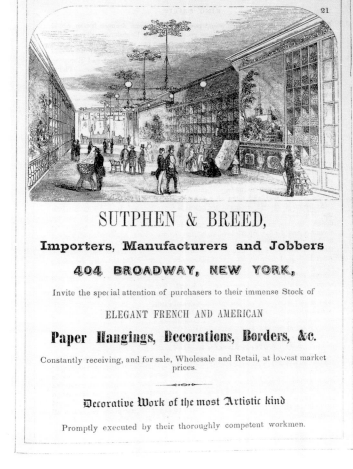

Fig. 230. *Exterior of Sutphen and Breed's Paper-Hangings Store, 404 Broadway,* 1855. Wood engraving by William Roberts, after A. Waud(?), from *The Illustrated American Biography* (New York: J. M. Emerson and Company, 1855), vol. 3, p. 18. The Metropolitan Museum of Art, New York, The Elisha Whittelsey Collection, The Elisha Whittelsey Fund, 1958  58.521.3

Fig. 231. *Interior of Sutphen and Breed's Paper-Hangings Store, 404 Broadway,* 1855. Wood engraving by William Roberts, after A. Waud(?), from *The Illustrated American Biography* (New York: J. M. Emerson and Company, 1855), vol. 3, p. 21. The Metropolitan Museum of Art, New York, The Elisha Whittelsey Collection, The Elisha Whittelsey Fund, 1958  58.521.3

82. "Elegant Parlor Papers and Decorations," *The Independent,* March 30, 1854, p. 101.

83. Lynn, *Wallpaper in America,* p. 218.

84. All information in this paragraph was found in the R. G. Dun Reports (New York vol. 193, p. 625, vol. 195, p. 849, vol. 364, pp. 55, 58), R. G. Dun & Co. Collection, Baker Library, Harvard University Graduate School of Business Administration.

85. Statistics from the federal census of 1860, in Bishop, *History of American Manufactures,* vol. 3, pp. 119–22.

Sutphen and Breed apparently specialized in imported papers; in an 1854 advertisement announcing that the firm had "removed from their old stand in Pine street to the new and spacious building, 404 Broadway," it listed the French manufacturers whose wares it carried, including "Zuber, Delecourt, Lamperlier, Deguette, Mader, Gillon, and other Paris makers."[82] The illustration of the interior of the store shows clearly distinguishable French scenic papers, such as Eldorado over the paneled dado on the right, and Isola Bella on the left, both of which were made by Zuber.[83] The firm must have had a setback after the financial panic of 1857. Breed left the business in July 1857, perhaps taking capital with him. Fielder S. Weeks joined Teneyck Sutphen in 1858, and in 1860 Sutphen and Weeks moved back downtown to 100 Liberty Street to run a wholesale paper-hangings business. In 1862 the partnership was dissolved. In 1869 Sutphen changed his speciality, becoming a partner in a large Brooklyn carpet business.[84] Weeks continued to run a wholesale wallpaper concern until 1875.

## Upholstery

Although the upholstery trade was never a major one in New York City, upholsterers performed essential services for many New Yorkers between 1825 and 1861. In comparison with the larger home-decoration industries discussed in this essay, upholstery workshops were numerous but small-scale. In 1860 there were twenty-four upholstery shops in the city, employing a total of ninety-five men and eighty women. Small though it was, this trade had a yearly product worth $653,460 — only about $140,000 less than the paper-hanging business, which employed nearly five hundred people.[85] Upholsterers were skilled tradespeople who charged relatively high

prices for their services and were patronized, for the most part, by middle- and upper-class New Yorkers.

From the 1820s into the 1840s New York City upholsterers seem to have followed the traditional practices of the upholstery trade, which had their origins centuries earlier in Europe. These tradesmen concerned themselves with many aspects of a room's appearance, providing curtains as well as the requisite rods, rings, and ornaments; wallpapers; upholstery for furniture (sometimes also the wood frames); bed hangings; mattresses; and pillows. An advertisement placed in 1832 by the short-lived firm of Dickie and Murray gives a comprehensive description of the traditional upholsterer's realm:

*DRAWING AND DINING ROOM CURTAINS, UPHOLSTERY &c. &c. DICKIE & MURRAY, Upholsterers in general, No. 152 Fulton street, respectfully inform their friends and the public, that they are now ready to execute any orders for drawing room, dining room, and bed room curtains, which will be made from the newest and best designs. . . .*

*D. & M. also furnishes and stuffs every kind of Cabinet Furniture in a superior manner. . . .*

*They have also for sale, which have either been imported or made to their order, a great variety of material for curtains or furniture, amongst which are viz. sattin damask furniture in patterns for sofas, chaise lounges, chairs, &c. with a new style satin for curtains to match, including galloons, cord, tassels, bell pulls, &c. for each sett of furniture.*

*India satin damask of the most fashionable colours; French furniture cottons of the newest styles; worst'd damasks; moreens; chintzes, &c. A great variety of fringes; gallons, cords, tassels, &c.*

*Orris Lace, of all colours, a new article for Curtains, and the first ever imported into this market, which they particularly recommend as a trimming for India Damask. They are likewise manufacturing an entire new style of cornices of most superior workmanship & got up entirely for their style of curtains. They have also constantly on hand a large assortment of feather beds, mattrasses, palliasters, paper hangings, &c. &c.*[86]

The most expensive items purchased from upholsterers were undoubtedly bed hangings and window curtains. Precious silk was the fabric of choice for high-style draperies, and many homeowners paid hundred of dollars for the curtains in a main-floor room, including the fabric trimmings and fancy hardware. The well-known 1833 broadside for furniture makers Joseph Meeks and Sons (cat. no. 225) advertises both bed hangings and curtains. Bedsteads shown on the broadside could be purchased for $50 to $100 apiece; if they were bought complete with hangings, the prices jumped to $200 to $600 per bed. The three sets of window curtains on the broadside were $200 to $300 per pair. Using silk often doubled the price of furniture: upholstered with haircloth, one advertised mahogany sofa sold for $100; with silk, it cost $150 to $200.

In the beginning of the period of this study, upholsterers purchased their fabrics from wholesale merchants and importers, but by the later years larger upholstery firms such as Solomon and Hart had begun to import textiles directly. Either way, they must have made money by retailing the fabrics and trimmings to their customers, as well as earning a modest sum for the upholstery fabrication. The firm of Isaac M. Phyfe reupholstered a leather chair for Evert A. Duyckinck in 1855. An existing invoice details what this relatively modest job entailed and reveals the interesting fact that upholsterers did not make a large amount of money for their day-to-day work:

| | |
|---|---|
| *4 Skins for chair* | *$7.—* |
| *6 Springs* | *.38* |
| *1½ Yds burlap & 1 Yd Muslin* | *.35* |
| *2½ lbs hair* | *1.09* |
| *5 Yds Gimp* | *.78* |
| *Restuffing Chair* | *5.00* |
| *Cartage* | *.75* |

The job fetched $15.35, including materials.[87]

Upholstery was one of the few trades in which men and women were employed in about equal numbers, judging from the 1860 federal census cited above. Women probably did much of the stitching and trimming, while men may have done more of the foundation work. In some cases, women owned upholstery workshops. We know that Eleanor D. Constantine inherited the workshop at 182 Fulton Street that she had run with her husband before his death, and *Wilson's Business Directory of New-York City* also lists several other women—Elizabeth Bedell at 13 Sixth Avenue, Jane Ferrin at 131 Canal Street, Mary B. McKinney at 228 Hudson Street, and Harriet Pomroy at 303 Division Street—as owners of upholstery workshops in 1850.

During the 1840s cabinetmakers began to advertise that they could provide many of the same services as upholsterers. Joseph Meeks and some others seem to have supplied clients with curtains and mattresses as early as the 1830s, but Meeks probably subcontracted that part of his business.[88] In 1844 Alexander Roux, a recent emigrant from Paris, advertised "Cabinet furniture, hair & spring mattresses, &c. made to order.

86. *New-York Evening Post,* October 1, 1832, p. 1. Dickie and Murray was in business between 1832 and 1834.

87. Isaac M. Phyfe to Evert A. Duyckinck, invoice, June 15, 1855, Duyckinck Family Papers, New York Public Library.

88. Conversation with Jodi Pollack, June 1999.

Always on hand a variety of curtain ornaments; and Curtains made to order in the most fashionable style."[89] In a business directory of 1840–41, six New York firms listed themselves both as manufacturers and dealers of cabinet furniture and as upholsterers. They were C. A. Baudouine at 332 Broadway; Deming, Bulkley and Company at 56 Beekman Street; A. Eggleso at 137 Broadway; M. W. King at 365 Pearl Street; Joseph N. Riley at 47 Beekman Street; and J. and W. C. Southack at 196 Broadway. By the end of the period of this study, the general upholsterer who provided interior-decorating services was being supplanted by high-end cabinetmakers, among them Léon Marcotte, Pottier and Stymus, and Gustave Herter, who supervised all aspects of a grand house's interior, not just the "soft" furnishings.[90] There were also professional decorators, such as the aforementioned George Platt. Paper-hangings retailing gradually became its own profession, until by the 1860s wallpaper was no longer necessarily included in the list of products an upholsterer provided. After centuries of overseeing the decoration of houses, upholsterers shortened their list of services until it became much more like what we know today: they upholstered furniture framed by a cabinetmaker, produced curtains, and often retailed fabric purchased from a wholesaler for a client's specific chair or curtain.

## Retailers and Manufacturers

JOHN CONSTANTINE, the son of an English cabinetmaker who had immigrated to the United States in 1793, ran a business in New York from 1818 until 1845 that was probably very like a traditional European upholstery practice. An inventory taken of Constantine's shop soon after his death shows that he served as an interior decorator to his wealthy clients, supplying them with many decorative products.[91] At that time his shop on Fulton Street held thousands of pieces of wallpaper of all different varieties, as well as "4 Sets Landscape" paper, seemingly underpriced at $15 per set. His holdings in wallpaper were valued at $2,919.81. The "Contents of Glass Cases" in the shop included yards of fabrics, such as worsted damask, chintz, moreen, and green baize, and gimps and trims of all types. The stock of fine covering yardage was surprisingly limited; Constantine may have used fabric provided by his clients, or perhaps he went to wholesale textile merchants for expensive silk goods on a job-by-job basis. He stocked more trimmings than wide goods; the shop had silk cords, fringes, tassels, worsted tassels, and gimps and "18 pieces wide

galoon" at $6 each. The high price of this trim may indicate that it was the type of galloon made of silk or wool interwoven with gold threads. Next on the inventory came all that was needed for making up upholstered chairs and beds—from the moss, horsehair, and feather stuffing to the decorative hardware for the centers of bed canopies and fancy bed crowns. Constantine stocked furniture frames for upholstered pieces normally found in bedrooms, such as "Cott frames," "Bed chair frames," and screens with either six or eight leaves. He also had numerous ready-made mattresses, bolsters, and pillows. In addition, the inventory lists drapery supplies, such as figural pole ends and curtain pins, as well as the makings of window shades and finished shades painted with designs or landscapes. The final two pages of the inventory list all the hundreds of pieces of hardware he stocked, both utilitarian and decorative. The value of the goods in Constantine's shop came to $6,559.36.

The inventory of the items in his home, which was in the same building as his shop, suggests the relative affluence a well-placed upholsterer enjoyed.[92] Among other things, Constantine and his wife owned three haircloth-covered sofas, one dozen mahogany chairs, two sideboards, two breakfast tables and a dining table, mahogany and "curled maple" bedsteads, three looking glasses, and a piano.

Constantine's brother Thomas was a cabinetmaker in New York between 1817 and about 1827; after that, he sold mahogany to other cabinetmakers. In 1817–18 Thomas received the commission to produce all the chairs for the United States Senate in Washington. It is believed that Thomas and John worked together on this commission, since from 1818 to 1820 they shared a shop at 157 Fulton Street. In 1823 John was hired to provide new draperies, the Speaker's chair, and a canopy for that chair for the North Carolina State House. The carved mahogany chair frame appears to

89. *The Gem, or Fashionable Business Directory, for the City of New York* (New York: George Shidell, 1844), p. 23. Roux arrived in New York City in 1836 and was first listed as an upholsterer, adding cabinet furniture to his business a few years later.

90. For more on this later period, see Katherine S. Howe, Alice Cooney Frelinghuysen, and Catherine Hoover Voorsanger, *Herter Brothers: Furniture and Interiors for a Gilded Age* (exh. cat., New York: Harry N. Abrams, in association with the Museum of Fine Arts, Houston, 1994).

91. "Inventory of the Estate of John Constantine dec. / Filed June 12, 1846," Joseph Downs Collection of Manuscripts and Printed Ephemera, no. 54.106.12, courtesy The Winterthur Library.

92. The announcements of John Constantine's death invite "Friends of the family . . . to attend the funeral from his late residence, No. 182 Fulton st." See *Evening Post* (New York), October 23, 1845; and *New York Herald*, October 24, 1845.

*Firm names:* **John Constantine** (1818–45), **Eleanor D. Constantine** (1846–54), **John Constantine** [Jr.] (1854–64)
*Owners:* John Constantine (1796–1845), Eleanor D. Constantine (b. 1805; widow of John Constantine, not listed after 1854), John Constantine (son of John and Eleanor Constantine)
*Locations*

| | |
|---|---|
| 1818–20 | 157 Fulton Street |
| 1820–21 | 218 Broadway (rear) |
| 1821–28 | 162 Fulton Street |
| 1828–53 | 182 Fulton Street |
| 1854–64 | 201 Bleecker Street |

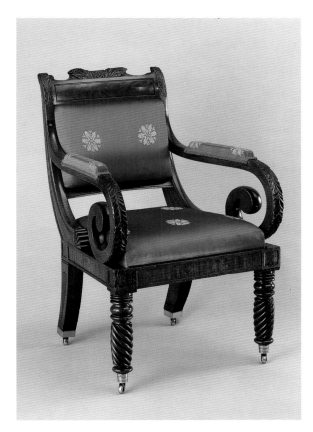

Fig. 232. Thomas Constantine, cabinetmaker; John Constantine, upholsterer, Chair for the Speaker of the North Carolina Senate, 1823. Mahogany; original underupholstery, replacement showcover. North Carolina Division of Archives and History, Raleigh 91.171.1

be from Thomas's shop. John's original invoice for the job, dated July 19, 1823, still exists. In it he charged $1,650 "to furnishing draperie of Crimson Damask and ornaments complete for 6 windows, and a canopy & chair for the Speaker of Senate in the Capitol."[93] Contemporary viewers described the draperies as trimmed with gold fringe and tassels, which were looped up through the beak of a large gilt eagle that stood above each window.[94] Unfortunately, the State House burned to the ground in 1831, and the Speaker's chair was one of the few furnishings saved from the building. When it was brought to Colonial Williamsburg in 1992, conservators discovered that the underupholstery of the chair (not the showcover) was original and could be attributed to John Constantine (fig. 232); this is the one example of his work that survives.[95]

John Constantine was a judge of the upholstery division of the American Institute fair in 1830, and he installed wallpaper with gilt borders at Mr. Evert Duyckinck's in 1840.[96] Constantine's wife, Eleanor, probably ran the shop from the time she inherited it in 1845 until 1854, when her son John took over and moved the business to 201 Bleecker Street. In 1860,

when the credit checkers of the R. G. Dun Company visited the shop, they found no one there but an old woman, perhaps Eleanor, "who states that J Constantine is not in bus[iness] there, alth[ou]g[h] his name appears abov[e] the door, she refused to state who is the proprietor of the store, or give her own name — There is a very small stock on hand & not the appearance of much bus[iness]."[97]

The PHYFE name is usually associated with Duncan Phyfe, the famous nineteenth-century maker of New York furniture, but in their day Duncan Phyfe's nephews were also well known as fine upholsterers. The sons of Duncan's brother John, a grocer, they were in business, working both in collaboration with their uncle's cabinetmaking firm and on their own, from the 1820s until just before the Civil War. The eldest of the sons, Isaac M. Phyfe, had his own upholstery business between 1830 and 1860; his brothers, James, William, Robert, and George, and James's son, John G. Phyfe, ran their firm from 1824 to 1861.

An early mention of the Phyfe brothers' work as upholsterers appeared in the *New-York Mirror* in 1829. Contained in a short description of an event called the Bachelors' Fancy Ball, it was highly complimentary: "The decorations of the ballroom in the city-hotel were, on the present occasion, unsurpassed in elegance and splendour. The arrangements, the ornaments, inscriptions, &c. were designed and executed by the Messrs. Phyfe, upholsterers in Maiden-lane, with the aid of Mr. Snooks, the carpenter."[98] The Phyfe brothers seem to have done a significant portion of their business in room decoration, namely, designing window draperies complete with cornices or other ornamental hanging systems to match upholstered furniture and coordinating wallpaper. The firm may have had practices similar to John Constantine's; by comparison, companies that opened their doors a bit later in the century, such as Solomon and Hart, made a good deal of their profit through the importation and sale of fine furnishing fabrics. The Phyfe brothers did import some items for sale: a receipt of 1830 made out to a Mr. D. W. Coxe lists the items J. and W. F. Phyfe (then of 44 Maiden Lane) could provide. In addition to hair mattresses and feather beds, the receipt states that the firm imported "paper hangings, fringes, &c." Indeed, Mr. Coxe purchased "30 Yds Silk Fringe" and "100 Yds Silk Galloon" from the brothers in yardages large enough to suggest that he may have been planning to retail the goods, rather than use them on his own furniture.[99]

Some of the best-documented work completed by the Phyfe brothers was done in collaboration with their

93. Invoice, Box 2, Treasurer's and Comptroller's Papers, North Carolina Archives, Capitol Buildings, Raleigh, North Carolina.

94. Wendy A. Cooper, *Classical Taste in America, 1800–1840* (exh. cat., Baltimore: Baltimore Museum of Art; New York: Abbeville Press, 1993), p. 231.

95. Raymond L. Beck, "Thomas Constantine's 1823 Senate Speaker's Chair for the North Carolina State House: Its History and Preservation," *Carolina Comments* (Raleigh: North Carolina State Department of Archives and History) 41 (January 1993), pp. 25–30.

96. Duyckinck Family Papers, New York Public Library.

97. R. G. Dun Reports, November 7, 1860 (New York vol. 194, p. 728), R. G. Dun & Co. Collection, Baker Library, Harvard University Graduate School of Business Administration.

98. *New-York Mirror, and Ladies' Literary Gazette*, February 21, 1829, p. 263.

99. J. and W. F. Phyfe to Mr. D. W. Coxe, Esq., invoice, December 2, 1830, Misc. mss. Phyfe, J. & W. / F., Manuscript Department, The New-York Historical Society.

*Firm names:* **J. and W. F. Phyfe** (1824–33), **R. and W. F. Phyfe** (1833–35), **Phyfe and Brother** [James Phyfe and Robert Phyfe] (1835–43), **James Phyfe and George W. Phyfe** [separate listings, but at the same location] (1844–47), **James Phyfe** (1847–51), **Phyfe and Company** [James Phyfe, John G. Phyfe, and James Jackson] (1851–57), **Phyfe and Jackson** [John G. Phyfe and James Jackson] (1857–61)
*Owners:* James Phyfe (1800–87), William F. Phyfe (1803–42), Robert Phyfe (b. 1805), George W. Phyfe (b. 1812), John G. Phyfe (son of James Phyfe), James Jackson
*Locations*

| | |
|---|---|
| 1824–26 | 34 Maiden Lane |
| 1826–32 | 44 Maiden Lane |
| 1832–52 | 43 Maiden Lane |
| 1852–57 | 323 Broadway |
| 1857–61 | 706 Broadway |

uncle Duncan Phyfe. In early 1842 the firm (then known as Phyfe and Brother) billed for the upholstery for many pieces of furniture made by Duncan Phyfe and his son James Duncan for Millford Plantation in central South Carolina (see fig. 233).[100] The house was built between 1839 and 1841 for John L. Manning and his wife, Susan Hampton Manning. In addition to upholstering the Duncan Phyfe–made furniture, Phyfe and Brother supplied the plantation house with drawing-room curtains topped with gilt cornices, as well as more pedestrian items, such as bed canopies, mattresses, bolsters, pillows, and silk fringe and tassels.[101]

Phyfe and Brother was especially esteemed for its ornamental curtain and drapery arrangements. In 1840 it sold a 13½-foot length of "Velvet Curtain bar" to Mrs. Duyckinck, enough for three windows. Included in the same order were three pairs of gilt curtain ornaments and thirty brass curtain rings.[102] In 1853 an advertisement for Phyfe and Company read "Upholstery, Paper Hangings and Interior Decorations, Wholesale and Retail."[103]

ISAAC M. PHYFE, the independent eldest brother, may have concentrated on less showy upholstery work. The few bills that have survived for work done by him are for jobs such as reupholstering a leather chair and making linen chandelier covers and crimson moreen valances for a bookcase.[104] (It was common practice to make overhanging fabric valances on the edges of bookshelves to protect fine bindings from light and dirt.) Isaac left the upholstery business between 1842 and 1845, and during those years he worked as a "U. S. Inspector," perhaps examining items that came into the port. He opened a shop on Broadway five

years before his brothers did and in 1859 served as a judge of the upholstery category at the American Institute fair.

During the 1830s and 1840s the firm of SOLOMON AND HART supplied New Yorkers with a wide variety of fine fabrics and upholstery services. An advertisement placed in the *New-York Commercial Advertiser* on September 2, 1844, gives a wonderful description of the European textiles that they stocked:

*FALL UPHOLSTERY GOODS—Just received per Utica, Ville de Lyon and other packets from France; also, per steamers Hibernia and Caledonia, from England, the largest and handsomest assortment of the above goods that can be found in the city. . . . Among a variety of other articles will be found the following:*

*Rich French Silk Brocatels, various colors; Satin de Laines, a large assortment; Worsted; Satin striped and watered Tabouretts; India Satin Damasks; Chintz Furnitures, French and English; Printed Lustrings, French, large variety; Velvet Plush, figured, plain and striped, all colors; Satin and other Galloons, all widths and colors; broad and narrow Gimps; gilt and French Cornices, Bands, Pins, Clasps, &c.; Lace and embroidered Curtains, all sizes; Painted Window Shades, all sizes and prices; English Chintz and white and buff Hollands for shades.—Together with every other article in the Upholstery line.*[105]

In 1844 the shop moved to 243 Broadway (see fig. 223) and the owners added French, English, and American wallpapers to their line, advertising them extensively. By the 1850s Solomon and Hart had become the leading upholstery firm in the city. It displayed both curtains and wallpapers at the 1853 New

*Firm name:* **Isaac M. Phyfe** (1830–60)
*Owner:* Isaac M. Phyfe (b. 1796)
*Locations*

| | |
|---|---|
| 1830–31 | Tryon Row and Chatham Street (paperhanger) |
| 1831–32 | 11 Ann Street (paperhanger) |
| 1833–34 | 51 John Street (upholsterer) |
| 1834–35 | 59 Church Street |
| 1835–36 | 256 Greenwich Street |
| 1836–42 | 128 William Street |
| 1845–47 | 15 Rose Street |
| 1847–49 | 669 Broadway |
| 1849–54 | 687 Broadway |
| 1854–60 | 893 Broadway |

100. For the complete history of the decoration of Millford Plantation, see Thomas Gordon Smith, "Millford Plantation in South Carolina," *Antiques* 151 (May 1997), pp. 732–41.

101. Phyfe and Brother to John Laurence Manning, invoice, January 7, 1842, Williams-Chesnut-Manning Families Papers, South Caroliniana Library of the University of South Carolina, Columbia; cited in Smith, "Millford Plantation."

102. Phyfe and Brother to Mrs. Duyckinck, invoice, September 29, 1840, Duyckinck Family Papers, New York Public Library.

103. A. D. Jones, *The Illustrated American Biography, . . .* vol. 1 (New York: J. M. Emerson and Co., 1853), p. 89. Although, as the title promises, this volume contains some biographical sketches, it is actually a book of advertisements for merchants in New York and Boston.

104. Isaac M. Phyfe to Evert Duyckinck, receipts, June 18, 1852, and June 15, 1855, Duyckinck Family Papers, New York Public Library.

105. *New-York Commercial Advertiser,* September 2, 1844, p. 4, col. 7.

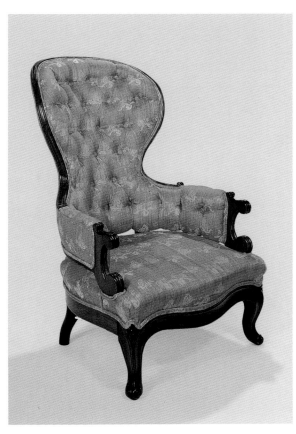

Fig. 233. Attributed to Phyfe and Son, cabinetmaker; Phyfe and Brother, upholsterer, Armchair for Millford Plantation, Clarendon County, South Carolina, 1842. Chestnut; replacement upholstery. Private collection

York Crystal Palace exhibition and was the only American firm to win an honorable mention in the upholstery category. An 1857 advertisement described not only the goods the company had for sale but also the services, such as curtain making, it could provide: "S. & H. being Practical upholsterers, purchasers can have their curtains, &c., made up in the best style, and after the Newest French Designs, received by

Firm names: **Solomon and Hart** (1834–38, 1843–64), **Barnett L. Solomon** (1838–43), **B. L. Solomon and Sons** (1864–85)
Owners: Barnett L. Solomon, Henry I. Hart (d. 1863), Isaac S. Solomon (son of Barnett L. Solomon), Solomon B. Solomon (son of Barnett L. Solomon)
Locations
1834–42   449 Broadway
1842–44   187 Broadway
1844–58   243 Broadway
1858–64   369 Broadway and 229 Chrystie Street
1864–68   369 Broadway
1868–79   657 Broadway
1879–85   29 Union Square

every steamer from their House in Paris."[106] This description is somewhat unclear: were the curtains being sent by steamer from France, or were the "newest designs" sketches for curtains? It has not been ascertained if Solomon and Hart actually had a "house"—that is, a retail establishment—in Paris; however, by the 1860s the firm did have a store in San Francisco.[107]

The great success of Solomon and Hart is particularly interesting because the owners were both Jewish, a fact that is made much of in the R. G. Dun credit reports. An early entry on the firm, dated November 10, 1851, reveals that the owners "are Jews—was started some 10 [to] 12 years ago by his fath[er], a Pawnbroker in the Bowery reputed wealthy, who is said to have given the y[ou]ng man cap[ital] at starting." On March 1, 1853, the reporter from Dun noted "D[oin]g a large & profitable bus[iness]. Have rem[ove]d to B'way where they h[a]v[e] built a large store." His next remark, "Are decidedly the best Israelite ho[use] in this city" (the firm was estimated to have over $40,000 in capital at this time), must be evaluated in light of the fact that there were very few large Jewish-owned businesses catering to a high-end clientele in mid-nineteenth-century New York. None of the other Dun reports read in the course of preparing this essay mentions the religion of the merchant whose credit is being investigated.[108]

In 1863 Henry I. Hart died in Halifax, England (a noted textile manufacturing center), no doubt while he was on a buying trip. The firm continued under Barnett L. Solomon and his two sons; after 1866 it expanded its line, listing itself as "importers of upholstery goods, house linens & paper hangings: manufacturers of furniture & window shades" in the New York City directories.[109] The business survived until 1885.

This essay examines only a small number of the many businesses intent upon furnishing the thousands of new houses that sprang up along the streets of New York City between 1825 and 1861. The reader of this survey of a handful of the manufacturers and retailers in a mere four industries should bear in mind that there were many others who provided the comforts of home to New Yorkers—painters and stencilers, gilders, plaster molders, makers of mirrors, picture frames, and window cornices, and producers of chandeliers and other lighting fixtures. This essay was written in the hope of inspiring further research into the products and practices of these important yet mostly forgotten craftsmen of the nineteenth century.

106. *Frank Leslie's Illustrated Newspaper*, November 1, 1857, p. 561.
107. The R. G. Dun credit reports for January 1, 1864, state that after Henry I. Hart's death, in 1863, "the business will be continued in NY & San Francisco by Barnet [*sic*] L. Solomon & Sons" (New York vol. 191, p. 420), R. G. Dun & Co. Collection, Baker Library, Harvard University Graduate School of Business Administration.
108. Ibid., p. 406.
109. H. Wilson, comp., *Trow's New York City Directory* (New York: John F. Trow, 1870), p. 1040.

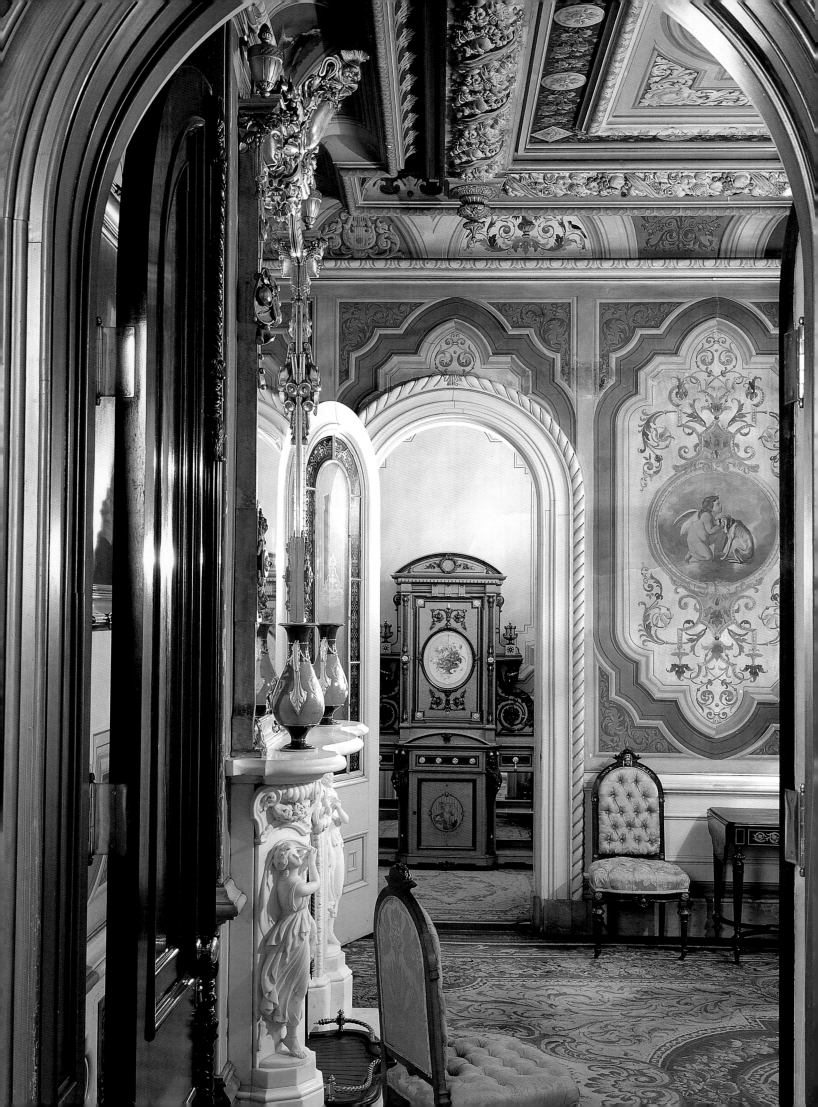

# "Gorgeous Articles of Furniture": Cabinetmaking in the Empire City

*CATHERINE HOOVER VOORSANGER*

Among the thousands of tradesmen and artisans marching in the Grand Canal Celebration on November 4, 1825, were two hundred members of the Chair-Makers' Society—mechanics, journeymen, and apprentices. They proudly held aloft a two-sided banner that juxtaposed, on one side, a figure of Plenty with a side chair posing before a stand of native Indian corn, with a furniture manufactory at the edge of New York Harbor in the distance; the other side showed the chair makers' arms and tools as well as the products of their industry (fig. 234). The mottoes on the banner, "By Industry We Thrive" and "Rest for the Weary," conveyed the traditional republican values that the marchers professed—commitment to craft, a sense of responsibility to the community, and a belief in the importance of an individual's contribution to society.[1] To produce boxes that held commemorative medals coined for the occasion (cat. no. 282A, B), Duncan Phyfe, the most lionized cabinetmaker of the day, collaborated with the turner Daniel Karr, employing bird's-eye maple and cedar procured from the western forests and transported to New York on the *Seneca Chief*, the first canal boat to enter New York Harbor. Even as they celebrated the completion of the Erie Canal, and understood what it portended for their city, the chair makers and other members of the New York furniture making trades could not have predicted how much their world would be transformed in the decades before the Civil War. In fact, no word so aptly describes cabinetmaking in the second quarter of the nineteenth century as "change"—in the methods of producing and marketing furniture, in the relationship between mechanics and journeymen, and in the structure of an industry inundated by immigrant artisans and subjected to the vicissitudes of the economy.

This profound transformation is reflected in the constantly evolving appearance of the furniture itself. Indeed, the exciting multiplicity of styles represented in New York furniture from 1825 to 1861 is the most obvious evidence of how colorful and complex a story there is to be told. Furniture and, by extension, the

public reception rooms in private dwellings in which it was displayed, were obvious and calculated visual indicators of wealth, taste, and social standing, by which the social elite of New York (a relatively small segment of the population) judged themselves and each other.[2] In addition to using possessions and surroundings as a means of self-definition, New Yorkers were endeavoring to create a great world city on a par with London and Paris.[3] And, in satisfying both needs, they had regular recourse to Europe as a source of culture and tradition. American cabinetmakers and decorators, many of them European-born, naturally turned to European examples for the most fashionable designs. But, more often than not, they transformed these prototypes, making objects that are often extremely original. At their best, they are superb in quality, as the pieces selected for this exhibition demonstrate.

In the second quarter of the nineteenth century not only did New York become the largest furniture-manufacturing center in the country, eclipsing Philadelphia and Boston, but it also became known for producing the finest, most stylish handcrafted and custom-made furniture in America. "New York is the depot for everything made in a limited quantity," the author Virginia Penny advised her readers, "and for everything new in style."[4] Once the Erie Canal connected New York to the western states with inexpensive transportation, the city's primacy as the capital of American commerce and culture was assured. Cabinetmaking (and its allied trades) benefited from this newly established link with the West and from New York's hegemony in international and domestic trade, manufacturing, and finance. By the 1850s it had become one of the largest industries in the city.

The goal of achieving world-city status was understood to depend on the growth of New York's population, which, by extension, would result in an expanding clientele for the city's merchants, tradesmen, and artisans, including the cabinetmakers. In 1820, when the city's population exceeded Philadelphia's for the first time, there were nearly 124,000

Many people have contributed to the preparation of this essay over a long period, only some of whom can be mentioned here. My first thanks are to Cynthia V. A. Schaffner for invaluable research assistance and support. I am indebted as well to Medill Higgins Harvey, Austen Barron Bailly, Brandy S. Culp, and Jodi A. Pollack not only for research assistance but also for their superb management of myriad details involved in bringing this book to fruition. Without Jeni L. Sandberg's periodical research, the story could not have been told. Mary Ann Apicella, Nancy C. Britton, Barry R. Harwood, Peter M. Kenny, Thomas Gordon Smith, and Dell Upton generously shared insights and constructive criticisms, as did Bart Voorsanger. I sincerely thank Margaret Donovan for her deft and judicious editing, Carol Fuerstein for her refinements of the text, and Jean Wagner for her passionate attention to bibliographic accuracy.

The title of this essay is abridged from Thomas Mooney's comment, "The Americans begin to make gorgeous articles of furniture now," in Thomas Mooney, *Nine Years in America . . . in a Series of Letters to His Cousin, Patrick Mooney, a Farmer in Ireland,* 2d ed. (Dublin: James McGlashan, 1850), p. 150. For the sake of convenience, I have used the term "cabinetmaking" throughout to refer to all aspects of the furniture-making trade.

1. See Sean Wilentz, "Artisan Republican Festivals and the Rise of Class Conflict in New York City, 1788–1837," in *Working-Class America: Essays on Labor, Community, and American Society,* edited by Michael H. Frisch and Daniel J. Walkowitz (Urbana: University of Illinois Press, 1983), pp. 37–77. The description of the elements in the banner is drawn from Cadwallader D. Colden's *Memoir* (cat. no. 117), pp. 373–74.

2. In 1820 De Witt Clinton commented, "I find cabinetmakers in employ all over this country, and it is an

Opposite: Gustave Herter, cabinetmaker and decorator; James Templeton and Company, Glasgow, carpet manufacturer; painted wall and ceiling decorations attributed to Giuseppe Guidicini, Reception room, Victoria Mansion, Portland, Maine, the home of Ruggles Sylvester Morse and Olive Ring Merrill Morse. Victoria Mansion, The Morse-Libby House, Portland, Maine

occupation which deserves encouragement. I always judge the housewifery of the lady of the mansion by the appearance of the sideboard and the tables." Cited in Burl N. Osburn and Bernice B. Osburn, *Measured Drawings of Early American Furniture* (Milwaukee, Wisconsin: Bruce Publishing Company, 1926; unabridged and corrected republication, New York: Dover Publications, 1975), p. 70.

3. See Sven Beckert, "The Making of New York City's Bourgeoisie, 1850–1886" (Ph.D. dissertation, Columbia University, New York, 1995), pp. 29–132.

4. Virginia Penny, *How Women Can Make Money* (1863; reprint, New York: Arno Press, 1971), p. 446, as cited in Richard Stott, *Workers in the Metropolis: Class, Ethnicity, and Youth in Antebellum New York City* (Ithaca: Cornell University Press, 1990), p. 130.

5. Ira Rosenwaike, *Population History of New York City* (Syracuse: Syracuse University Press, 1972), pp. 33–36.

6. "Population of This City . . .," *New-York Mirror*, October 29, 1825, p. 11.

7. These figures are from Rosenwaike, *Population History of New York*, p. 33.

8. "Great Cities," *Putnam's Monthly* 5 (March 1855), pp. 254, 259.

9. The 1825 figure is drawn from the Berry Tracy Archives, Department of American Decorative Arts, Metropolitan Museum.

10. "The Industrial Classes of New York," *New York Herald*, June 18, 1853, p. 2: 3,000 cabinet makers, 300 carvers, 400 upholsterers, and 300 chair makers.

11. "Chronicle. Erie Canal Navigation," *Niles' Weekly Register*, September 4, 1824, p. 16.

12. *Hunt's Merchants' Magazine* 8 (1843), pp. 526–29, cited in Stott, *Workers in the Metropolis*, p. 56.

13. "Industrial Classes of New York," p. 1. In 1830, for example, Jesse Cady, at 30 South Street, advertised "Fancy Cabinetware. For Exportation. Portable writing desks, of mahogany, rosewood, &c. suitable for Buenos Ayres, the Mexican and South America markets, finished in every variety of style, for sale in quantities to suit." *Commercial Advertiser* (New York), March 27, 1830. See also "General Convention of the Friends

Fig. 234. *Chair-Makers' Emblems Represented on the Front and Back of the Chair-Makers' Society Banner*, 1825. Lithograph by Anthony Imbert from Cadwallader D. Colden, *Memoir, Prepared at the Request of a Committee of the Common Council of the City of New York, and Presented to the Mayor of the City, at the Celebration of the Completion of the New York Canals* (New York: Printed by W. A. Davis, 1825), opp. p. 373. The Metropolitan Museum of Art, New York, Harris Brisbane Dick Fund, 1941 41.51

inhabitants.[5] On the eve of the Canal celebration, the *New-York Mirror* proudly announced a new record—an estimated 170,000 inhabitants, an "astonishing" increase—and predicted that just "a few more years will place New-York among the proudest emporiums in the world."[6] During the 1830s New York surpassed Mexico City in size, becoming the largest metropolis in the Western Hemisphere. With a population of almost 630,000 in 1855 and close to 814,000 by 1860 (and the greater metropolitan area comprising more than one million),[7] New York saw itself fast closing in on its European counterparts. Equating size and population with importance, *Putnam's Monthly* proclaimed in 1855 "*the great phenomenon of the Age is the growth of great cities.* . . . New York . . . is greater than Paris or Constantinople, and will evidently be hereafter (in the twentieth century, if not sooner) greater than London."[8]

Keeping apace of the city's growth, cabinetmaking shops proliferated. In 1825 there were approximately 250 cabinetmakers in New York (not including carvers, gilders, turners, japanners, upholsterers, and makers of chairs, looking glasses, and frames, who were listed separately in the city directory that year).[9] In 1853 the *New York Herald* estimated 3,000 cabinetmakers, a twelvefold increase, among an industry that

employed about 4,000.[10] Accordingly, the volume of furniture production increased exponentially, not only to meet the needs of the local clientele and those who traveled to New York to furnish their houses but also to supply pieces for exterior markets. In this way, New York set the style for the rest of the country, as statistics make abundantly clear. The city of Utica, for example, received ten tons of furniture in one week during the summer of 1824.[11] In 1843 a total of 4,149 tons was shipped from New York along the Canal.[12] Ten years later, when the furniture produced in New York annually was valued at $15 million, nearly eighty-five percent of the city's output was destined for the South, Southwest, California, and South America and even as far away as China.[13]

Furniture making in New York was stratified by both quality and quantity, and even the best shops produced middle-range goods. Some of the better New York cabinetmakers, including Deming and Bulkley and Joseph Meeks and Sons, seized upon improved transportation systems and distributed their own furniture through warehouses they established in southern cities such as Charleston and New Orleans.[14] Many small New York shops that produced middle- and lower-grade goods sold their wares to wholesale merchants who dispersed them. Even though the vast

majority of the furniture made in New York was at the lower end of the quality scale, it was perceived as better than equivalent European manufactures, as Thomas Mooney, an Irish traveler in America, observed in 1850: "The inventive Americans are certainly before the English or Irish in the rapidity with which they get up work, and the high-finish they impart to cheap goods; it is likely they do not finish *fine* work better than we do, but it is certain that they do finish cheap work much better, quicker, and cheaper."[15]

As New York developed, various logistical problems made it increasingly uneconomical for dozens of industrial concerns, including some manufacturers of machinery, bricks, soap, textiles, and hats, to expand their operations within the city.[16] Crowding on the city's streets was legendary, and before the 1850s only Fulton Street connected the east and west shores of Manhattan. Real estate prices escalated wildly throughout the antebellum period (sometimes tripling within just a few years), and many manufacturers found it more profitable to sell their land than to stay in business.[17] Others chose to maintain a retail presence in lower Manhattan while moving their factories farther afield. Like most port cities, New York had little usable waterpower. New Jersey therefore beckoned, with falls and rivers, cheaper land, a lower cost of living, and, eventually, an extensive rail system, which was in place by 1860. Brooklyn, then a separate city, also became a haven for certain industries, such as glass, ceramics, and iron, that not only caused pollution but also posed serious fire hazards to Lower Manhattan, which was densely built.[18] An industrial belt was thus formed around New York, extending its economic boundaries and helping to supply its local, national, and international markets.

Cabinetmakers and other craftsmen such as goldsmiths, makers of shoes, boots, and cigars, and those involved in the needle trades, could afford to stay in Manhattan precisely because they had modest real estate requirements. Until after the Civil War the typical cabinetmaking shop was small and had its workshop and wareroom within the same narrow, multistoried building.[19] Proximity to the port and to related industries was essential; for cabinetmakers, these industries were lumber merchants, sawmills, dealers, auction houses, and craftsmen in allied businesses (upholsterers and turners, for example). Moreover, the inner-city trades depended almost entirely on hand labor, which was in plentiful supply from the early 1830s on, as hundreds of thousands of European immigrants disembarked in New York. Constantly changing styles helped keep cabinetmaking labor-intensive, and, as a result, New York shops were slow to mechanize until after the Civil War.[20]

By 1855 more than 80 percent of New York workers were foreign born.[21] German craftsmen, both skilled and semiskilled, dominated cabinetmaking and piano making (a separate but related industry)[22] and constituted a major cultural, economic, and political force. Nearly 125,000 Germans immigrated to the United States in the 1830s, followed by nearly half a million between 1840 and 1850.[23] By 1861 their population in New York equaled that of the fourth largest city in the nation.[24] The vast majority of cabinetmakers—those who ran the middle- and lower-end shops—were clustered on the Lower East Side, and that area became known as Kleindeutschland because of the concentration of Germans who lived and worked there.

Nearly all the high-end cabinetmakers, whose work is the subject of this essay, lined Broadway, above City Hall, in the heart of the most elegant shopping district, their warerooms and manufactories dotted among posh hotels, purveyors of luxury goods, dress shops, and daguerreotypists. By the 1850s these included the elite of the New York cabinetmaking world: Charles A. Baudouine, J. H. Belter, Julius Dessoir, Gustave Herter, Edward Whitehead Hutchings, Léon Marcotte, Auguste-Émile Ringuet-Leprince, and Alexander Roux. Closer to City Hall, at 194 Fulton Street, Duncan Phyfe maintained his long and prolific practice until 1847. Still farther downtown, on Broad Street, and later on Vesey Street, Joseph Meeks and Sons, and subsequently J. and J. W. Meeks, continued a family-owned business that dated back to 1797. Belter, at 547 Broadway by 1853, was the only one of this group to so substantially enlarge his operations in the antebellum period that he had to seek larger quarters uptown. In 1856 he moved his factory to Third Avenue near Seventy-sixth Street, then an urban hinterland, occupying a five-story brick structure equivalent in size to half a city block, which he had built. For retailing purposes, however, Belter opened a new showroom at 552 Broadway, adjacent to Tiffany and Company, at the center of the carriage trade.[25]

As time went on, master cabinetmakers became more entrepreneurial businessmen and designers than craftsmen. By the 1850s many had enlarged their operations to supply the full spectrum of interior decoration, including carpets, draperies, upholstery, and wallpapers. Many of their luxury goods, among them fine silks and other fabrics, were of necessity imported from Europe because nothing of comparable quality was yet manufactured in the United States. Some of the high-end cabinetmakers (Roux and Marcotte,

of Domestic Industry, Assembled at New York October 26, 1831. Reports of Committees. Manufacture of Cabinet Ware," *Niles' Weekly Register*, addendum to vol. 42, p. 11: "The article [furniture], has become one of considerable export. It is carried in American ships to canton [*sic*], in China, South America and the West Indies."

14. On Deming and Bulkley, see Maurie D. McInnis and Robert A. Leath, "Beautiful Specimens and Elegant Patterns: New York Furniture for the Charleston Market, 1810–1840," in *American Furniture 1996*, edited by Luke Beckerdite (Hanover, New Hampshire: University Press of New England for the Chipstone Foundation, 1996), pp. 137–74. On the Meeks firm in New Orleans, see Jodi A. Pollack, "Three Generations of Meeks Craftsmen, 1797–1869: A History of Their Business and Furniture" (Master's thesis, Cooper-Hewitt, National Design Museum, and Parsons School of Design, New York, 1998), chap. 3.

15. Mooney, *Nine Years in America*, p. 150.

16. For this discussion, I have relied on Richard B. Stott, "Hinterland Development and Differences in Work Setting: The New York City Region," in *New York and the Rise of American Capitalism: Economic Development and the Social and Political History of an American State, 1780–1870*, edited by William Pencak and Conrad Edick Wright (New York: New-York Historical Society, 1989), pp. 45–71.

17. Ibid., pp. 46–48. Edwin G. Burrows and Mike Wallace, *Gotham: A History of New York City to 1898* (New York: Oxford University Press, 1999), p. 576.

18. See Joshua Brown and David Ment, *Factories, Foundries, and Refineries: A History of Five Brooklyn Industries* (Brooklyn: Brooklyn Educational and Cultural Alliance, 1980). I am grateful to Cynthia H. Sanford, Brooklyn Historical Society, for supplying me with a copy.

19. See Catherine Hoover Voorsanger, "From the Bowery to Broadway: The Herter Brothers and the New York Furniture Trade," in Katherine S. Howe, Alice Cooney Frelinghuysen, and Catherine Hoover Voorsanger, *Herter Brothers: Furniture and Interiors for a*

*Gilded Age* (exh. cat., New York: Harry N. Abrams, in association with the Museum of Fine Arts, Houston, 1994), pp. 56–77, 242–46.

20. See ibid. This observation is based on the Products of Industry schedules attached to the U.S. Censuses taken in New York in 1850 and 1860 as well as on the "Special Schedule for Industry other than Agriculture" attached to the 1855 New York State Census.

21. Robert Ernst, *Immigrant Life in New York City, 1825–1863* (1949; reprint, New York: Octagon Books, 1979), cited in Stott, *Workers in the Metropolis*, p. 3.

22. See Nancy Jane Groce, "Musical Instrument Making in New York City during the Eighteenth and Nineteenth Centuries," 2 vols. (Ph.D. dissertation, University of Michigan, Ann Arbor, 1982); and Aaron Singer, "Labor Management Relations at Steinway and Sons, 1853–1896" (Ph.D. dissertation, Columbia University, New York, 1977).

23. Mack Walker, *Germany and the Emigration, 1816–1885* (Cambridge, Massachusetts: Harvard University Press, 1964), cited in Charles L. Venable, "Germanic Craftsmen and Furniture Design in Philadelphia, 1820–1850," in *American Furniture 1998*, edited by Luke Beckerdite (Hanover, New Hampshire: University Press of New England for the Chipstone Foundation, 1998), p. 41.

24. Stanley Nadel, *Little Germany: Ethnicity, Religion, and Class in New York City, 1845–80* (Urbana: University of Illinois Press, 1990), pp. 1, 17–18, 22.

25. Generally these cabinetmakers had additional workshop space in contiguous buildings. See Voorsanger, "From Bowery to Broadway," pp. 63–64.

Photographs of documents relating to the construction of Belter's building have been given to the Winterthur Library, Henry Francis du Pont Winterthur Museum, Winterthur, Delaware, by Richard and Eileen Dubrow, Courtesy of the Service Collection, Grant A. Oakes.

26. On Baudouine, see Ernest Hagen, "Personal Experiences of an Old New York Cabinet Maker," written in Brooklyn, October 1908, quoted in its entirety in Elizabeth A. Ingerman, "Personal Experiences

Fig. 235. *Drawing-Room.* Engraving, from Thomas Hope, *Household Furniture and Interior Decoration* (London: Longman, Hurst, Rees, and Orme, 1807), pl. 6. The Metropolitan Museum of Art, New York, Harris Brisbane Dick Fund, 1930 30.48.1

notably) had relatives in France who acted as business partners, shipping furniture and decorative accessories; others, such as Baudouine, made regular trips to Europe to assess what was in vogue.[26] Still others must have relied on American agents posted abroad, as a journalist reported in 1843: "We have a large colony of Americans in Paris engaged in the business of exporting French fabrics, elegancies, and conveniences, for this country, and almost none of the same class in England."[27] Ultimately, as the city expanded northward, many successful cabinetmakers seem to have made fortunes in real estate speculation. Baudouine, perhaps the best example, left an estate estimated at nearly $5 million upon his death in 1895.[28]

As early as 1830 the lives of the cabinetmakers and the journeymen who fabricated their products began to diverge. Relationships between employers and employees were strained throughout the antebellum period by workers' demands for higher wages, reduced hours, and a shorter work week, goals that were hard to achieve in the face of constant competition from newly arrived immigrants. And among the immigrants themselves, the Germans were actively involved in the movement for workers' rights.[29] The disparity in lifestyles between owners and workers was becoming increasingly visible. As one European visitor observed, the American "mechanic" "dresses like a member of Congress; and his wife and daughters are dressed like the wife and daughters of a rich New York merchant, and like them, follow the Paris fashions. His house is warm, neat, comfortable; his table is almost as plentifully provided as that of the wealthiest of his fellow citizens."[30]

Even the most affluent New Yorkers did not have homes with ostentatious exteriors; their town houses were meant to read as identical units (see cat. no. 87). Mrs. Trollope, a famous English visitor who was enthusiastic about her experiences in New York, recounted in 1832 that although she had "never [seen] a city more desirable as a residence," she found that "the great defect in the houses is their extreme uniformity—when you have seen one, you have seen all."[31] Behind the brick and marble facades of the 1820s and 1830s there were beautiful interiors and elegant furnishings in the classical style. In the summer of 1832 the wealthy businessman Matthew Morgan wrote to his friend James C. Colles, a merchant in New Orleans, about venturing from Staten Island into the city to witness the construction of new houses. One of these, that of Luman Reed, in Greenwich near the Battery, most impressed Morgan, both for its unusually large size (about one and half times the width of a normal New York town house of the period) and for the elegance of its appointments:

*The principal story has a white marble base in the hall and parlours and for the pilaster and frieze between the parlours. The Chimney and pier glasses are set in the walls with frames of the same material. Italian marble mantels and mahogany doors polished as highly as any cabinet work ever is. . . .*

*Take it altogether perhaps it's not equalled by any house in the city, every part of it is completely finished. Silver plated knobs on every door in the house.[32]*

The cost of a typical highly finished three-story house, on a twenty-five-by-fifty-two-foot lot, was about $10,000 or $11,000, Morgan reported, but Reed's house cost much more. From what he could gather, $16,000 to $17,000 would obtain a lot and house such as "our city [New Orleans] cannot produce."[33]

The social aristocracy of New York spared no expense in furnishing their houses. "The dwelling-houses of the higher classes are extremely handsome, and very richly furnished," Mrs. Trollope wrote admiringly in 1832. "Silk or satin furniture is as often, or oftener, seen than chintz; the mirrors are as handsome as in London; the cheffoniers [sic], slabs, and marble tables as elegant."[34] An exquisite watercolor rendering of about 1830 by the architect Alexander Jackson Davis (cat. no. 112) allows us to imagine the scale and stately ambience of such an interior. A pair of Corinthian pilasters and a mahogany door with a pedimented frame from a distinguished classical house in Brooklyn called Clarkson Lawn, dating to about 1835 (cat. no. 89A, B) are also illuminating in this context.

Davis's meticulous rendering illustrates the level of sophistication to which wealthy New Yorkers aspired. Its delicate white-and-gold sofa, which may have been imported from Europe, bears no specific reference to any extant piece of New York furniture;[35] yet the size and disposition of the mantel mirror and paintings, as well as the side table, klismos chairs, and torchère, compare closely with those of designs in *Household Furniture and Interior Decoration* (London, 1807) by Thomas Hope, a wealthy British connoisseur of the Regency period (fig. 235). Although Davis's two round center tables with tapering, three-sided concave supports have Renaissance prototypes, his use of the form is no doubt based on Hope's plate 39, a design for a "round monopodium or table in mahogany."[36] There is also a surviving counterpart, made in New York, that demonstrates the practical application of this particular Hope design in America: a richly decorated center table of this form, with rosewood and rosewood-grained mahogany veneers and an expensive black "Egyptian" marble top (cat. no. 222) made in 1829 for Governor Stephen D. Miller of South Carolina by Barzilla Deming and Erastus Bulkley, who had begun as early as 1818 to aggressively market New York furniture in Charleston.[37]

The splendid gilded decoration on the Deming and Bulkley table incorporates several different techniques

and draws on a number of French and English design sources for inspiration; the lyre-and-foliate motif on the base, for example, clearly derives from Hope's plate 39. While Hope's text recommended inlays of ebony and silver for such a piece, here the exquisite gilded decoration on the base, superimposed on the deep hue of the rosewood-grained veneer, conveys a different dual impression than that intended in the prototype: not only of metal inlay but also of marquetry executed in light-colored woods (a type of decoration seen on French furniture of about the same date).[38] The gilded swan-and-fountain motif on the apron derives from quite another source: a specific, nearly identical gilt-bronze mount made in Birmingham, England.[39] The overlapping ellipses carefully drawn and inscribed in gold on the plinth emulate die-cut inlaid brass, as does a small rim of repeated elements around the base of the apron. Finally, the snub-nosed dolphins (a Deming and Bulkley trademark) are freehand-gilded and highlighted with penwork to create the illusion of three-dimensional carving.[40]

of an Old New York Cabinet-Maker," *Antiques* 84 (November 1963), pp. 576–80.

27. "Sketches of New-York," *New Mirror*, May 13, 1843, p. 85.

28. *New York Herald*, January 14, 1895, p. 10. At the time of his death, Baudouine owned fifteen commercial properties, including the Baudouine building (1895), which still stands at 1181–1183 Broadway. My thanks to Kate Wood for sharing her unpublished paper on the Baudouine Building (December 1998).

29. See Sean Wilentz, *Chants Democratic: New York City and the Rise of the American Working Class, 1788–1850* (New York: Oxford University Press, 1984).

30. Michael Chevalier, *Society, Manners and Politics in the United States, Being a Series of Letters on North America*, translated from 3d French ed. (Boston: Weeks, Jordon and Company, 1839; reprint, New York: A. M. Kelley, 1966), p. 431.

Fig. 236. Asher B. Durand, after Samuel F. B. Morse, *The Wife*, 1830. Engraving, from *Atlantic Souvenir* (Philadelphia: H. C. Carey and I. Lea, 1830). The Metropolitan Museum of Art, New York, Gift of Randolph Gunter, 1959 59.627.3

31. Mrs. [Frances] Trollope, *Domestic Manners of the Americans* (London: Whittaker, Treacher and Co.; New York, reprinted for the booksellers, 1832), pp. 269–70.

32. Matthew Morgan to James Colles, July 29, 1832, in Emily Johnston de Forest, *James Colles, 1788–1883: Life and Letters* (New York: Privately printed, 1926), p. 83.

33. Ibid.

34. Trollope, *Domestic Manners of Americans*, p. 269.

35. John Morley compares this sofa to contemporary Italian furniture, specifically that of Filippo Pelagio Palagi (1775–1860). John Morley, *The History of Furniture: Twenty-five Centuries of Style and Design in the Western Tradition* (Boston: Little, Brown and Company, 1999), p. 217. A white-and-gold Italian drawing-room suite with turquoise blue and gold silk upholstery (Peabody-Essex Museum, Salem, Massachusetts) was acquired by Joseph Peabody in 1827 as a wedding gift for his daughter Catherine Peabody Gardiner. See Gerald W. R. Ward, *The Andrew-Safford House* (Salem, Massachusetts: Essex Institute, 1976), fig. 6.

36. Morley, *History of Furniture*, pp. 215–17, fig. 192. See also Thomas Hope, *Household Furniture and Interior Decoration* (London: Longman, Hurst, Rees and Orme, 1807); reprinted as *Regency Furniture and Interior Decoration*, with corrections and a new introduction by David Watkin (New York: Dover Publications, 1971), ill. opp. p. 30, pls. 20, 22, 39. Davis owned a copy of Hope's book, which he recorded in his notebook under "Furniture Practical Examples for Americans," A. J. Davis Collection, Todd System notebook, F-U, transcribed by Cynthia V. A. Schaffner, New York Public Library.

37. For a discussion of this table, see McInnis and Leath, "Beautiful Specimens," pp. 153–55. The firm of Deming and Bulkley is first listed in New York by *Longworth's American Almanac, New-York Register, and City-Directory* (New York: Thomas Longworth, 1820); it continued to be listed until 1850, with its last appearance being in *Doggett's New York City Directory for 1850–1851* (New York: John Doggett Jr., 1850). Erastus Bulkley was advertising furniture in

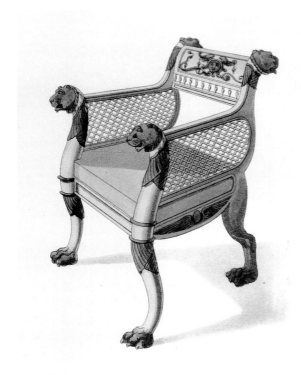

Fig. 237. *Drawing-Room Chair.* Aquatint with hand coloring, from George Smith, *A Collection of Designs for Household Furniture and Interior Decoration* (London: J. Taylor, 1808), pl. 56 (detail). The Metropolitan Museum of Art, New York, Harris Brisbane Dick Fund, 1930  30.48.2

Contemporary with Davis's rendering, an engraving by Asher B. Durand after *The Wife* by Samuel F. B. Morse depicts a handsome, although more modest parlor (fig. 236).[41] The scrolled sofa with paw feet, the little footstool, and the armchair in Morse's painting find general parallels in English design sources, such as George Smith's *Cabinet-Maker and Upholsterer's Guide* (London, 1828)[42] and Thomas King's *Modern Style of Cabinet Work Exemplified* (London, 1829). These probably document furniture Morse had at hand.

The style of New York furniture of the late 1820s has been called "Greek Revival" or "Empire" during the twentieth century; more recently, the period term "Grecian" has come into use. "Grecian," as applied to furniture of the 1820s and 1830s was synonymous with "modern" style, a synthetic version of Neoclassicism, rather than one based on purely archaeological prototypes.[43] Grecian furniture of the later 1820s differs from New York's delicate Federal-period furniture that was in favor up to about 1820 in that it is conspicuously assertive, featuring bold, architectonic forms and exaggerated elements (large bolection moldings, beefy scrolls) as well as classical details (anthemia, paw feet, Ionic capitals) that become inflated in scale.

Fig. 238. Duncan Phyfe, Window bench (one of a pair), made for Robert Donaldson, Fayetteville, North Carolina, 1823. Rosewood veneer; probably pine; gilding; replacement underupholstery and showcover. Brooklyn Museum of Art, Gift of Mrs. J. Amory Haskell  42.118.13

Fig. 239. Robert Fisher, Secretary-bookcase, 1829. Ebonized wood, mahogany veneer; painted and gilded decoration; replacement fabric; glass. Collection of Mr. and Mrs. Peter G. Terian

It shares some of these characteristics with Grecian architecture, which became fashionable in the mid-1820s and was much admired for "its Doric simplicity and grandeur."[44] (See "Building the Empire City" by Morrison H. Heckscher in this publication, pp. 171–80.) The ongoing publication (and republication) of James Stuart and Nicholas Revett's *Antiquities of Athens* (volumes 4 and 5 of which were published in 1816 and 1830, respectively) was also an important stimulus.[45] The Grecian style included elements inspired by Egyptian as well as ancient Greek architecture and furniture. Moreover, in its curvilinear outlines and in its lavish use of curling acanthus ornament and scrolling foliate embellishments (which often seem more Roman than Greek), the

Grecian style held the seeds of the Rococo Revival style predicated on naturalistic ornament that would become dominant by 1850, encompassing both the Louis XIV Revival and Louis XV Revival styles under its rubric.[46]

Although its maker remains anonymous, a highly animated ebonized armchair, with sweeping scroll arms, low-relief carving, gilded details, and resolutely forward-facing front and back legs terminating in animal feet, must surely have been manufactured in New York about 1825 (cat. no. 221). Both its stance and its form pay homage to ancient Greek and Egyptian furniture, as transformed in Hope's designs and in those of Smith's first publication, *A Collection of Designs for Household Furniture and Interior Decoration*

Charleston as early as 1818. Deming and Bulkley begin to advertise in Charleston about 1820 and remained active there until at least 1840. The table is documented to 1829 (not 1828 as stated in McInnis and Leath, "Beautiful Specimens," pp. 154–55, n. 38) by a letter from Deming and Bulkley to Stephen D. Miller, April 26, 1829, which describes shipping the marble top for the table.

38. See relevant French examples in Janine Leris-Laffargue, *Restauration, Louis Philippe* (Paris: Éditions Massin, 1994), pp. 58–59.

39. McInnis and Leath, "Beautiful Specimens," pp. 155, 173 n. 39.

40. On gilded ornamentation, see essays by Donald L. Fennimore and Cynthia Moyer in *Gilded Wood: Conservation and History* (Madison, Connecticut: Sound View Press, 1991). See also John A. Courtney Jr., "'All that Glitters': Freehand Gilding on Philadelphia Empire Furniture, 1820–1840" (Master's thesis, Antioch University, Baltimore, Maryland, 1998); and Cynthia Van Allen Schaffner, "Secrets and 'Receipts': American and British Furniture Finishers' Literature, 1790–1880" (Master's thesis, Cooper-Hewitt, National Design Museum, and Parsons School of Design, 1999).

41. See Paul J. Staiti, *Samuel F. B. Morse* (Cambridge: Cambridge University Press, 1989), pp. 129–30, 260, 278. I thank Valentijn Byvanck for bringing this image to my attention.

42. This volume is frequently dated 1826; however, as many of its plates are dated 1828, the compilation must be assigned the later date.

43. For this discussion, I have drawn on *Neo-Classical Furniture Designs: A Reprint of Thomas King's "Modern Style of Cabinet Work Exemplified," 1829*, with a new introduction by Thomas Gordon Smith (New York: Dover Publications, 1995). See also Thomas Gordon Smith, *John Hall and the Grecian Style in America* (New York: Acanthus Press, 1996).

44. "Public Buildings," *New-York Mirror, and Ladies' Literary Gazette*, August 23, 1828, p. 49, col. 1.

45. For example, an 1828 entry in Davis's daybook: "First study of Stuart's Athens from which I date professional practice." A. J.

Fig. 242. Attributed to Nicholas Biddle Kittell, *Mr. and Mrs. Charles Henry Augustus Carter,* ca. 1848. Oil on canvas. Museum of the City of New York, Gift of Mrs. Edward C. Moen  62.234.12

Duncan Phyfe and Sons label tacked to the interior under the top. The firm included both of Phyfe's sons, James and William; it is listed in the city directories for 1837–38 through 1839–40; when William left the firm in 1840, it became Duncan Phyfe and Son, active from 1840 through 1847, when Phyfe terminated his business.

70. The tables are in a private collection. The Stirling papers are in the Rare Book Library, Louisiana State University, Baton Rouge. There is no Phyfe bill of sale, but the transfer of funds to Phyfe in February 1837 from Brown Brothers by Stirling's factor, Burke Watt and Company of New Orleans, is documented by a ledger entry. I am grateful to Deborah D. Waters for alerting me to the Stirling commission, and to Paul M. Haygood for sharing his research on Lewis Stirling and his furniture.

time. Such deceptively simple volumes and the monochromatic appearance of mahogany-veneered furniture are appreciated today for their intrinsic elegance and craftsmanship, but in 1833 they may have elicited Colonel Thomas Hamilton's remark that New York drawing rooms struck him as "comfortable," but "plain." Noting the absence of the "Buhl" tables, ormolu clocks, gigantic mirrors, and japanned cabinets that he was accustomed to seeing in England, he concluded, "In short, the appearance of an American mansion is decidedly republican."[78]

In fact, Grecian ultimately became the most characteristically republican style, for it was both distinctively American and national in scope. There were so many inventive interpretations of its exuberant curvilinear forms in the 1830s and 1840s that, in the absence of labels, regional differences are often difficult to distinguish. Many Grecian pieces were composed of identical, or nearly identical, elements that were combined in various furniture forms. This flexible method of design, which encouraged economy as

well as high volume in a piecework system, was one of the factors that allowed New York cabinetmakers to export their furniture to the American South. Joseph Meeks established a presence in New Orleans as early as 1820.[79] A bold Meeks and Sons center table with a black "Egyptian" marble top, one of the firm's most aesthetically successful pieces, identical to number 27 on the Meeks broadside, is preserved at Melrose, a renowned Grecian house in Natchez, Mississippi. It was probably acquired by the McMurrans of that city at the time of their marriage in the early 1830s and moved with the family to Melrose when it was built in 1845.[80]

By the 1850s the meaning of the term "Grecian" had evolved again: it now connoted greatly simplified, rectilinear forms with painted decoration instead of veneers. "Modern Grecian furniture has the merit of being simple, easily made, and very moderate in cost," Andrew Jackson Downing stated in *The Architecture of Country Houses* (1850), in which he equated the style with painted "cottage" furniture. "Its universality is partly owing to the latter circumstance, and partly to the fact that by far the largest number of dwellings are built in the same style, and therefore are most appropriately furnished with it."[81]

As early as the 1830s the hegemony of Neoclassicism was beginning to be challenged by other sources of design, and by 1850 the consumer of furniture would be confronted by a multiplicity of choices that had been inconceivable just a quarter century before. The Gothic style, never fully eclipsed in England after the Middle Ages, gained momentum in the late 1820s and the 1830s as it became associated with the social reform effort led by the architect and designer A. W. N. Pugin, who became the most vociferous and influential polemicist for the style. In London, several important Gothic projects were under way by the mid-1830s, most notably the design of the new Houses of Parliament by Charles Barry, with interior details by Pugin, which began construction in 1836.

Although full-blown Gothic motifs did not proliferate in American furniture until the 1840s, harbingers of the style emerged in the 1830s. Under the influence of England, American cabinetmakers began to incorporate Gothic details into Grecian forms; number 28 on the 1833 Meeks broadside, for example, is a wardrobe that has recessed panels with Gothic arches on the doors.[82] By the early 1840s Gothic-style furniture was being manufactured with details borrowed from churches, such as window tracery (popular for the backs of chairs), crockets, and finials. Gothic furniture was used in domestic interiors alongside

Grecian pieces, as the portrait of Mr. and Mrs. Carter (fig. 242) illustrates. A powerful, thronelike rose-wood armchair (fig. 243) is an excellent example of a contemporaneous cabinetmaker's conception of the Gothic style. The chair can be attributed to Thomas Brooks on the basis of details that relate it to a documented twelve-piece suite of walnut parlor furniture that he made for Roseland Cottage, the Woodstock, Connecticut, retreat of Henry Chandler Bowen, a wealthy dry-goods merchant from Brooklyn.[83] Its fluidly carved handholds are draped with a stylized wilted-leaf motif, thought to be a Brooks hallmark, that melds into the carving on the arm supports, which end in an acanthus flourish where the support meets the rail.[84]

Alexander Jackson Davis was the major exponent of the Gothic style in America prior to the Civil War. With his older partner, Ithiel Town, the young Davis had established a reputation as an architect with his Grecian designs. Under the influence of Pugin he began to design Gothic Revival houses and furniture in the early 1830s (see "Building the Empire City" by Morrison H. Heckscher in this publication, p. 180).[85] Davis gained his understanding of the style by studying British architectural and design publications; from 1825 until 1827 he had access to plates from *Gothic Furniture* (London, 1828) by A. C. Pugin, the father of A. W. N., several of which appeared in Rudolph

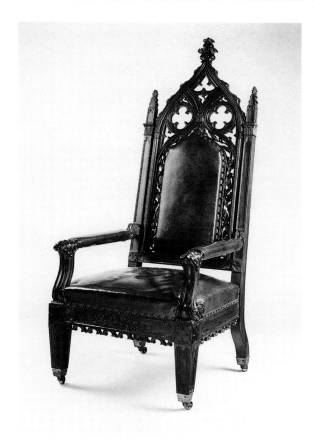

Fig. 243. Attributed to Thomas Brooks, Armchair, ca. 1847. Rosewood; replacement upholstery; casters. The Metropolitan Museum of Art, New York, Gift of Lee B. Anderson, 1999 1999.461

Fig. 244. *Gothic Furniture [Episcopal Chair, Table for a Boudoir, Drawing-Room Chair].* Etching with aquatint and hand coloring, from Rudolph Ackermann's *Repository of Arts, Literature, Fashions, Manufactures, &c.,* ser. 3, November 1, 1825, pl. 29, opp. p. 307. The Metropolitan Museum of Art, New York, Harris Brisbane Dick Fund, 1942 42.74.2

71. *New-York Commercial Advertiser,* October 23, 1839.

72. Illustrations showing the use of pier mirrors in American interiors are rare. See a painting by Oliver Tarbell Eddy, *The Children of Israel Griffith,* ca. 1844 (Maryland Historical Society, Baltimore, 18.9.1), in Smith, *Hall and Grecian Style in America,* pl. 21; and Augustin Édouart, *Family in Silhouette* [New York City], 1842 (Winterthur Museum), in Elisabeth Donaghy Garrett, *At Home: The American Family, 1750–1870* (New York: Harry N. Abrams, 1990), p. 154.

73. A sofa related to the couch shown here (cat. no. 232) is in the Columbia Museum of Art, South Carolina. The Millford commission is extensively documented in the Williams-Chesnut-Manning Families Papers at the South Caroliniana Library, the University of South Carolina, Columbia. Additional papers are at the South Carolina Historical Society, Charleston, and the State Historical Society, Madison, Wisconsin. See Thomas Gordon Smith, "Millford Plantation in South Carolina," *Antiques* 151 (May 1997), pp. 732–41. My thanks are due to Brandy Culp, for her thorough reading of the family papers, and to Margize Howell and Mrs. Charles F. Johnson for photographs of Millford.

74. "Couch," derived from the medieval "*couche*" (bed), is the English term for a daybed, known as a *méridienne* or *lit de repos* in France. Thomas King, in *The Modern Style of Cabinet Work Exemplified* (1829), distinguished between sofas, which had two ends, and couches, which had one, as did the *New-York Book of Prices* for 1834. The couch had a long history in the nineteenth century. See a related French example with similar banded ornament in Leris-Laffargue, *Restauration, Louis-Philippe,* pp. 38–39. See also "Chaises Longues," pl. 10 (and also pl. 136) in George Smith, *Smith's Cabinet-Maker and Upholsterer's Guide . . .* (London: Jones and Company, 1828), used as the source for the upholstery presentation on this piece.

75. *New-York Book of Prices* for 1834, pl. 9. The showcover on this chair has been added for the exhibition. Its color was based on period sources from the early 1840s, such as *Le*

*Garde-meuble,* and on the color of some of the fabrics listed in Duncan Phyfe's auction sale of 1847, cited in note 76.

76. One Meeks and Sons table dated to 1829–35 is probably from a set. See Pollack, "Three Generations of Meeks Craftsmen," p. 127. The auctioneer James Bleecker listed "quartette and card tables" in 1839. *New-York Commercial Advertiser,* October 23, 1839. The 1847 catalogue of the sale of Duncan Phyfe and Son's inventory also includes mention of "quartett" tables. Edgar Jenkins, Auctioneer, *Peremptory and Extensive Auction Sale of Splendid and Valuable Furniture, on . . . April 16, and 17, . . . at the Furniture Ware Rooms of Messrs. Duncan Phyfe & Son, Nos. 192 and 194 Fulton Street . . .* (sale cat., New York: Halliday and Jenkins [1847]), copy in the Winterthur Library.

77. See Teresa A. Carbone, *American Paintings in the Brooklyn Museum of Art: Artists Born by 1876* (Brooklyn, forthcoming).

78. [Thomas Hamilton], *Men and Manners in America* (1833; reprint, with additions from the 1843 ed., New York: Augustus M. Kelley, 1968), p. 103. We do not know whom Colonel Hamilton was visiting when he made this remark. "Buhl" is the nineteenth-century version of the French "Boulle," connoting a decorative form of marquetry made with tortoiseshell and/or metals (usually silver or brass) in the manner of André-Charles Boulle (1642–1732).

79. See Pollack, "Three Generations of Meeks Craftsmen," pp. 24–27 and chap. 3. Joseph Meeks advertised the opening of a furniture warehouse in New Orleans as early as 1820. His two sons operated a furniture store there from 1830 to 1839.

80. The table is illustrated and discussed in Wendy A. Cooper, *Classical Taste in America, 1800–1840* (exh. cat., Baltimore Museum of Art; New York: Harry N. Abrams, 1993), pp. 215, 217. It no longer bears its original Meeks and Sons label. The price of the table, with an "Egyptian marble" top, was listed on the Meeks broadside as $100.

81. A. J. Downing, *The Architecture of Country Houses* (New York: D. Appleton and Company, 1850; reprint with a new introduction by J. Stewart Johnson, New York: Dover Publications, 1969), p. 413.

Fig. 245. *Cast-Iron Table Supports Designed by Robert Mallet.* Wood engraving, from J. C. Loudon, *An Encyclopaedia of Cottage, Farm, and Villa Architecture and Furniture* (1833; new ed., London: Longman, Brown, Green, and Longmans, 1842), pp. 704–5, fig. 1341. Courtesy of the American Antiquarian Society, Worcester, Massachusetts

Ackermann's influential serial publication *Repository of Arts, Literature, Fashions, Manufactures, &c.*; one of Ackermann's plates (fig. 244) was saved by Davis among his own furniture designs.[86] He accumulated an extensive library that included such British books as Henry Shaw's *Specimens of Ancient Furniture* (London, 1836), A. W. N. Pugin's *Gothic Furniture in the Style of the Fifteenth Century* (London, 1835), and J. C. Loudon's influential treatise *An Encyclopaedia of Cottage, Farm, and Villa Architecture and Furniture* (London, 1833), which Davis often consulted.[87]

It was accepted practice to leaf through such books for design ideas. Robert Donaldson, owner of the Phyfe window bench (fig. 238), called at Davis's office in January 1834 "to look for a gothic villa in books, and get a design for residence."[88] Philip R. Paulding, proprietor of Knoll, later renamed Lyndhurst, in Tarrytown, New York, inquired about the whereabouts of a design for a bookcase that Davis

had promised him, "I think you told me you found it going in [*sic*] one of your books."[89] Davis typically charged his clients $3, $4, or $5 to design a piece of furniture. His sketches were translated into walnut and oak (the woods most favored for Gothic furniture), in Westchester by cabinetmakers Richard Byrne and Ambrose Wright, and in New York by William Burns and his various partners; while in business with Peter Trainque, Burns was known for "the most correct Gothic furniture."[90]

Loudon recommended that Gothic houses be furnished in the Gothic style and that the entire commission be put under the direction of a competent architect. The latter was an innovative concept for American architects, and Davis enthusiastically embraced it. Thus, he designed not only the house but also the interiors and furniture for Knoll, which was built between 1838 and 1842 on the bluffs above the Hudson River for two-term New York mayor William

Paulding and his son Philip. The interiors, redolent of romantic medievalism, were appreciatively described in the press:

> *This is a perfect specimen of the most beautiful of the pointed [Gothic] styles, and the whole interior is in keeping with the style. Mr. Davis has designed every article of furniture, so that every chair and every table would appear . . . to be at home in its place . . . as a necessary part of the whole. . . . Every window is of enameled glass, and the panes made of the small diamond shape. The coloured light thrown into the rooms when the sun shines . . . carries back the association to the olden times. There is, too, something aristocratic . . . (which we take to be gentlemanly) in these gorgeous windows . . . ; the lofty halls with ribbed ceilings of oak; the gothic sculptures; the regular irregularities of the rooms; the luxury of the bay windows and oriels . . . towers, and pinnacles, lawns and terraces . . . —all these are found in the estate of Mr. Paulding, and they remain a perpetual monument of a pure and cultivated taste.*[91]

A wheel-back chair in oak (cat. no. 234)—one of a pair that Davis designed, probably about 1845, for the reception hall at Knoll—is among the earliest documented pieces of Gothic Revival furniture made in America. Davis's daybooks record that he began to conceive of furniture for the Pauldings in 1841, when he mentioned "fifty designs for furniture," and continued through 1847.[92] The chair is typical of antebellum Gothic Revival seating furniture in its appropriation of Gothic tracery for the dominant motif. It also displays a purposive stiffness, which Loudon said "belongs to the style."[93] Davis inventively adapted the wheel-shaped back from a cast-iron table support designed by an Irish engineer named Robert Mallet that was published in Loudon's *Encyclopaedia* (fig. 245). Cast-iron furniture was still a new idea, having been introduced in England during the early 1830s.[94] Loudon advocated its use in domestic settings because it was inexpensive and practical. Some of the designs he published emphasize structure over style to such an extent that they seem more protomodern than Gothic. Although there is no evidence that Davis designed any cast-iron pieces, he was sympathetic to the innovative use of the material and its possible applications to furniture, inscribing in his notebook Loudon's desire that "our furnishing ironmonger's [*sic*] would direct a portion of that power of invention . . . now almost exclusively occupied in

contriving bad fireplaces, to the improving of the designs, and lowering the price of cabinet furniture, by the judicious introduction of cast iron."[95]

A later Davis design (cat. no. 235), also documented by drawings, was probably first conceived about 1857 in conjunction with the architect's most ambitious castellated villa, Ericstan, 1855–59, the Tarrytown seat of the wealthy flour merchant John J. Herrick (see cat. no. 102).[96] By any standard, this walnut chair is one of the most aesthetically refreshing pieces of American Gothic furniture. Here again, there seems to be a relationship between Davis's design and the medium of cast iron: the way the sculpted vertical tracery elements of the chair back flow over the top of the crest is more characteristic of cast metalwork than of traditional cabinetmaker's joinery, and is even more remarkable here because hand craftsmanship is employed. The carved "ears" at the edges of the crest, an allusion to similar designs on medieval spires and canopies, are typical elements on Gothic Revival furniture. The delicate, animated legs, however, are unusual. Canted in front and ending in stylized hoofed feet poised as if *en pointe*, they recall little deer hooves, even including abstract dewclaws. These feet and the protruding "knees" at the juncture of the legs and the seat rail are both elements found in the cast-iron garden furniture then being made for the newly created urban parks and for the rustic landscapes of rural residences.[97]

While some took issue with Davis and his collaborator Downing for "corrupting the public taste, and infecting the parvenues with the mania of Gothic Castle-building,"[98] there were actually relatively few Gothic residences as monolithic or imposing as Knoll and Ericstan. In architecture the style was more typically disseminated in the form of designs for unpretentious rural cottages made of wood, not stone. And these were not necessarily furnished in the Gothic style, because, as Downing explained, "there has been little attempt made at adapting furniture in this style to the more simple Gothic of our villas and country houses in America."[99] In urban residences, Gothic decoration was generally confined to libraries, where—paradoxically, in an era in which technological advances made books accessible to everyone—it recalled medieval scholarship and the monastic preservation of knowledge.

Gothic furniture was also criticized. Downing, echoing Pugin, objected that it was often "too elaborately Gothic—with the same high-pointed arches, crockets, and carving usually seen in the front of some cathedral," which resulted in interiors that were "too ostentatious and stately."[100] As an alternative, Downing

82. See many examples in Katherine S. Howe and David B. Warren, *The Gothic Revival Style in America, 1830–1870* (exh. cat., Houston: Museum of Fine Arts, 1976).

83. See Amy M. Coes, "Thomas Brooks: Cabinetmaker and Interior Decorator" (Master's thesis, Bard Graduate Center for Studies in the Decorative Arts, New York, 1999), pp. 36–41, 58–61.

84. The motif may be a stylized oak leaf, in keeping with the acorns in the pierced carving on the chair back. Collectors' accounts are the basis for the suggestion that this detail is a Brooks hallmark. I am grateful to Lee B. Anderson and David Scott Parker for sharing their expertise in Gothic Revival furniture.

85. See also Amelia Peck, ed., *Alexander Jackson Davis, American Architect, 1803–1892* (exh. cat., New York: The Metropolitan Museum of Art and Rizzoli, 1992); Jane B. Davies, "Gothic Revival Furniture Designs of Alexander J. Davis" *Antiques* 111 (May 1977), pp. 1014–27; and Stanley Mallach, "Gothic Furniture Designs by Alexander Jackson Davis," (Master's thesis, University of Delaware, Newark, 1966).

86. Davis's copy of this plate is among his drawings housed in the Avery Architectural and Fine Arts Library, Columbia University.

87. Davis acquired a copy of Loudon's *Encyclopaedia* on September 8, 1835. Davis, Daybook, vol. 1, p. 1, New York Public Library. Published in 1833, Loudon's book was reissued (with revisions) in 1835, 1836, 1839, 1842, 1846, 1847, 1850, 1857, 1863, and 1867, attesting to its widespread popularity. See the preface to *Loudon Furniture Designs from the Encyclopaedia of Cottage, Farmhouse and Villa Architecture and Furniture, 1839* (East Ardsley: S. R. Publishers, 1970).

88. Davis, Daybook, January 15, 1834, vol. 1, p. 157, transcribed by Cynthia V. A. Schaffner, New York Public Library.

89. Davis, Correspondence, N-13-f (undated), A. J. Davis Collection, Avery Architectural and Fine Arts Library, transcribed by Cynthia V. A. Schaffner. Davies, "Gothic Revival Furniture Designs," p. 1027, n. 35, postulates an 1844 date.

90. Downing, *Architecture of Country Houses* (reprint), p. 440.

91. "The Architects and Architecture of New York," *Brother Jonathan,* July 15, 1843, pp. 301–3.

92. Davis Journal, vol. 1, p. 59, Department of Drawings and Prints, Metropolitan Museum (24.66.1400). One related drawing for this chair is in the A. J. Davis Collection, Avery Architectural and Fine Arts Library; the other is in the collection of the Museum of the City of New York. The identity of the cabinetmaker is suggested by an entry in Davis's Daybook, vol. 1, p. 457: "R. Byrne, Cabinet maker, White Plains, made Paulding's chairs," transcribed by Cynthia V. A. Schaffner, New York Public Library. The date of this entry is not clear; it appears in a section titled "Visiting Cards."

   Richard Byrne came to America from Ireland in about 1833 and moved to White Plains in March or April 1845, according to the obituaries cited in Mallach, "Gothic Furniture Designs," pp. 132–33 (and notes, pp. 108–9). On the basis of these obituaries and the Davis diary entry cited above, a date of about 1845 is probable for the Knoll hall chairs.

93. J. C. Loudon, *An Encyclopaedia of Cottage, Farm, and Villa Architecture and Furniture,* . . . new ed. (London: Longman, Brown, Green, and Longmans, 1842), p. 1094.

94. J. Ian Cox, "Cast-Iron Furniture," in *Encyclopedia of Interior Design,* vol. 1, pp. 232–33.

95. Davis, Todd System Notebook, page F, transcribed by Cynthia V. A. Schaffner, New York Public Library.

96. The drawings are in the Avery Architectural and Fine Arts Library, Columbia University, A. J. Davis Collection (194000100432), and in the Department of Drawings and Prints, Metropolitan Museum (24.66.1892); the latter bears a later inscription. When oak versions of this form were discovered in the possession of Herrick descendants, the date for the design seemed confirmed. The walnut versions of the chair, such as this one, have details that differ slightly from those in oak and thus are thought to be variants of the Ericstan chairs. See Henry Hawley, "American Furniture of the Mid-Nineteenth Century," *Bulletin of the Cleveland Museum of Art* 74 (May 1987), pp. 186–93.

97. Cynthia V. A. Schaffner observed the subtle relationship of this

Fig. 246. *Antique Apartment—Elizabethan Style.* Wood engraving by John William Orr, from A. J. Downing, *The Architecture of Country Houses* (New York: D. Appleton and Company, 1850), fig. 184. Courtesy of the American Antiquarian Society, Worcester, Massachusetts

proposed Elizabethan or Flemish furniture for use in Gothic houses because these styles provided a successful combination of the picturesque and the domestic; moreover the admixture of styles could be justified on the basis of European precedents.[101] He also endorsed the Elizabethan style for interiors, because it had a "homely strength and sober richness" and was "addressed to the feelings, and capable of wonderfully varied expression."[102] It is telling that Downing gave as the best reason for the introduction of Elizabethan architecture to the United States "the natural preference which Europeans, becoming naturalized citizens among us, have for indulging the charm of old associations, by surrounding themselves by an antique style that has been familiar. . . ."[103] As his example of a fine Elizabethan interior, he chose an illustration from Sir Walter Scott's Waverly novels (fig. 246) that depicted a coffered ceiling, wainscoted oak wall paneling, tapestries, twisted columns, scrollwork, and "heavy and quaint carving in wood."[104] The effect was "often grand and sombre, always massive, rich, and highly picturesque—as well as essentially manorial

and country-like."[105] The Elizabethan dining room of James Penniman's "princely residence" (measuring about forty-six by eighty-five feet), built in 1846 on the south side of Union Square, was commended in the press, which noted in particular its "mantel . . . of fine statuary marble, each side being supported by two figures in armour, nearly the size of life," its busts in period costume, and its fresco-painted decorations.[106]

A portfolio cabinet attributed to the firm of J. and J. W. Meeks, successor to Joseph Meeks and Sons, which dates to about 1845, illustrates an American interpretation of the Elizabethan style (cat. no. 233).[107] It opens on one side to reveal a maple-veneered interior in which serpentine-shaped dividers create four vertical slots, probably designed to hold bound volumes or perhaps prints. Fretwork similar to that seen on the sides and gallery of the cabinet is a notable feature of Meeks furniture produced in the 1840s,[108] as is the machine-carved ripple moldings, which have precedents in seventeenth-century German and Dutch Baroque cabinets. The cabinet's most

prominent feature, the colorful "Berlin" needlework panel depicting a scene from *Romeo and Juliet*, emphasizes the link with the Elizabethan.[109]

The evocation of "old associations" and the equation of interior decoration with "something aristocratic" reflected values that New Yorkers, starting in the 1840s, increasingly came to prize. Objects with age became desirable indicators of established social position, for, among other things, they implied a long, distinguished family lineage. A new nostalgia for family heirlooms, especially those from the late eighteenth century, gave expression to an incipient Colonial Revival movement, which was to be even more strongly articulated after the Civil War. "The fact is, my friend," asserted an anonymous speaker in a brief tale called "The China Pitcher," "it is all the fashion to be unfashionable now. The older a thing is, the newer it is":

> Garrets are ransacked, old cellars, lumber-rooms, and auction-shops, and everything turned topsy-turvy . . . pillaged over and over again by people who, six months ago, had their great-grandmother's [eighteenth-century] chairs lugged off into the wood-house, and stowed way for kindling-stuff. . . . something new in the shape of old furniture is always sure to turn up, at a prodigious bargain; some undoubted original, of great worth, in the finest possible preservation, which had been most unaccountably overlooked, as well as most unaccountably spared, for nobody knows how many generations. . . .
>
> In short . . . the struggle now is between the families of yesterday and the families of the day before. The oldest furniture, and the ugliest, always did belong, and always must belong, of course, to the oldest families.[110]

The term given to all things old, odd, and "ugly" was "rococo." "Those . . . who have been lately in France will be familiar with the word," the *New Mirror* advised in 1844. "It came into use about four or five years ago, when it was the rage to look up costly and old-fashioned articles of jewelry and furniture. . . . A chair, or a table, of carved wood, costly once but unfashionable for many a day, was *rococo*. . . . *things intrinsically beautiful and valuable*, in short, but *unmeritedly obsolete*, were rococo."[111] The term would come to be synonymous with "Old French"—Louis XIV and Louis XV—styles revived during this period.

The mania for old things spurred the frenzied sport of shopping conducted in other people's houses, especially on May 1, when leases were up, and because of

frequent bankruptcies throughout the period. (See "Inventing the Metropolis" by Dell Upton in this publication, p. 18.) As the November 1848 *Home Journal* reported, "NEW-YORK is the greatest place in the world for sudden *sellings out*," but there was little embarrassment in doing so. "People build houses and furnish them as if for twenty generations, occupy them for a year or two, and sell out at auction; and so frequent is this summary laying down of splendor, that the discredit and mortification which would attach to it in older countries is here scarce thought of—the national love of change being its sufficient apology, if one were at all needed."[112] Grand tours of Europe usually preceded such sales, the *Home Journal* explained: "these suddenly enriched tourists pick up, and ship home, such articles of furniture as strike their fancy in foreign cities."[113] "The amount of importation of articles of luxury and taste" was "surprising," and "with the facility with which [such goods] soon come to the hammer, New-York [was] perhaps the best place in the world to purchase costly and curious furniture second hand."[114] Moreover, buying at auction combined "a good deal of the excitement of gambling"[115] with the opportunity to see "how every class '*furnishes*,' which is a considerable feature of living."[116] Sometimes a sorry sham was uncovered. "My suspicions, . . . that the fine furniture displayed by Mrs. B. at her party, was all borrowed for the occasion, were well founded," sniffed one nosy neighbor in a squib called "House-Hunting," "for her house is to let, and I examined it from garret to cellar; there was neither ottoman nor piano in the parlour—not a piece of French furniture in the house."[117] The "perfect mania"[118] for auctions also brought about the inevitable traumas associated with impulse buying, as numerous moralistic tales published in the popular press attested.[119]

Major fluctuations in the economy and imprudent expenditures by the socially ambitious were unfortunate stimuli to the secondhand furniture market. The Panic of 1837 plunged many New Yorkers into financial ruin. Philip Hone, who was a retired auctioneer in addition to his many other accomplishments, confided to his diary that "one of the signs of the times is to be seen in the sales of rich furniture, the property of men who a year ago thought themselves rich, and such expenditures justifiable, but are now bankrupt."[120] The effects of the depression dragged on for several years. In the spring of 1839 Hone attended an auction at the home of John L. Bailey of Lafayette Place, where the pictures, statuary, French hangings, mirrors, and such were "all of the most costly

chair to cast-iron garden furniture. Its upholstery has been re-created by Nancy C. Britton on the basis of Davis's own furniture designs and colored plates in Ackermann's *Repository* (for example, fig. 244); a related chair in the Museum of the City of New York is the source for the configuration of the box seat. The blue rep fabric replicates a fragment of period upholstery from a mid-nineteenth-century chair in the Museum of Fine Arts, Boston. Davis's drawings show the use of yellow-gold trim, and Loudon recommended both gold and silver trims on Gothic chairs made for domestic use.

98. "Our New Houses," *United States Magazine, and Democratic Review* 21 (November 1847), p. 392.

99. Downing, *Architecture of Country Houses*, p. 440.

100. Ibid.

101. Ibid.

102. Ibid., pp. 449, 391.

103. Ibid., p. 391.

104. Ibid., p. 392.

105. Ibid.

106. "A Princely Residence," *Morris's National Press*, April 11, 1846, p. 2.

107. The portfolio cabinet can be strongly attributed on the basis of a labeled J. and J. W. Meeks sofa table on loan to the Art Institute of Chicago that has similar bilaterally symmetrical supports.

108. Fretwork of this kind (*découpure*) first appears about 1844 in *Le Garde-meuble*.

109. Such needlework scenes, more common in midcentury fire screens than in case pieces, were stitched onto a canvas, stretched around a frame, and then inserted into the piece. Downing (*Architecture of Country Houses*, reprint, p. 436) illustrated a related piece by Alexander Roux, an "escritoire" (drop-front desk), next to a set of shelves with similar fretwork decoration, also by Roux.

110. "The China Pitcher," *New Mirror*, April 8, 1843, pp. 4–5. Such references contradict the opinion currently held by decorative arts scholars that the Antiques Movement—which advocated furnishing the home with old furniture (and equated old furniture with domestic virtue)—dates to the 1870s or slightly before. See George Whiteman, "The Beginnings of Furnishing with Antiques," *Antique Collector* 43 (February 1972), pp. 21–28;

Stefan Muthesius, "Why Do We Buy Old Furniture? Aspects of the Authentic Antique in Britain, 1870–1910," *Art History* 11 (June 1988), pp. 231–54; Julia Porter, "Antiques Movement," in *Encyclopedia of Interior Design*, vol. 1, pp. 28–30.

111. "Chit-Chat of New-York [The Rococo]," *New Mirror*, February 17, 1844, p. 318.

112. "Oddities in Furniture," *Home Journal*, November 18, 1848, p. 2.

113. Ibid.

114. Ibid.

115. "Attending Auctions," *Morris's National Press*, May 9, 1846, p. 2.

116. *New Mirror*, May 11, 1844, p. 90.

117. "House-Hunting," *New-York Mirror*, February 29, 1840, p. 287.

118. "Attending Auctions," p. 2.

119. For example, Fanny Smith, "My Experience in Auctions," *Peterson's Magazine* 25 (1854), pp. 113–16.

120. *The Diary of Philip Hone, 1828–1851*, edited by Allan Nevins (New York: Dodd, Mead and Company, 1927), vol. 1, p. 252, entry for April 10, 1837.

121. Philip Hone, Diary, entry for April 19, 1839. This passage does not appear in the published *Diary*, cited above. I am grateful to Jeffrey Trask for reviewing on microfilm the original manuscript in its entirety.

122. For example, in 1824 John T. Boyd and Company advertised a "large and general assortment of new and second-hand furniture," in the *New-York American*, May 13, 1824. In 1833 James C. Smith, a New York auctioneer, sent an important shipment of furniture, attributed to Phyfe, to Hyde Hall, the home of George Clarke, on Otsego Lake in central New York. See Douglas R. Kent, "History in Houses: Hyde Hall, Otsego County, New York," *Antiques* 92 (August 1967), pp. 187–93. Ira Cohen maintains that the auction system in New York, in use since the War of 1812, was done in by the economic crisis of 1837, after which the number of licensed auctioneers greatly declined. See Ira Cohen, "The Auction System in the Port of New York, 1817–1837," *Business History Review*, autumn 1971, pp. 488–510, esp. p. 510. But the auction sales of furniture seem to have been part of the distribution system for such goods in New York. Thomas Mooney included a long section

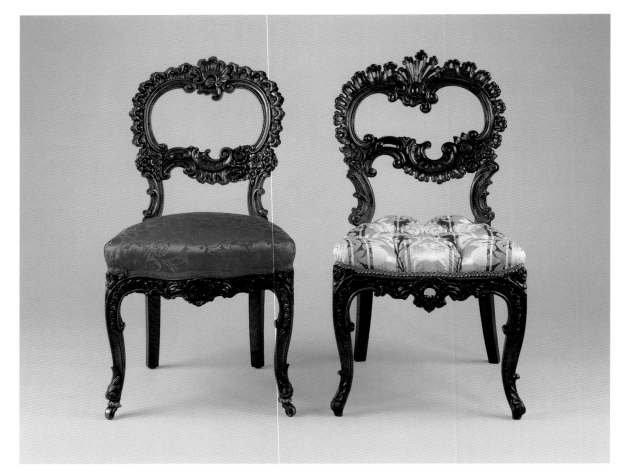

Fig. 247. (left) Possibly J. and J. W. Meeks, Side chair, ca. 1850. Rosewood; probably replacement underupholstery, replacement showcover; casters. The Metropolitan Museum of Art, New York, Gift of Bradford A. Warner, 1969  69.258.9
(right) Cabinetmaker unknown, New York City, Side chair, ca. 1850. Rosewood; probably replacement underupholstery, replacement showcover. The Metropolitan Museum of Art, New York, Friends of the American Wing Fund, 1992  1992.81

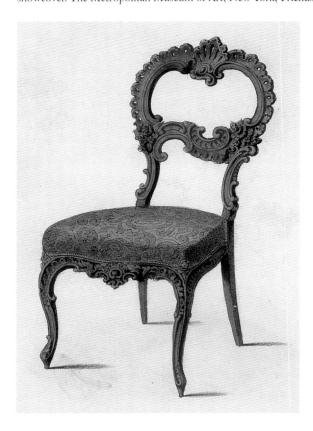

Fig. 248. Désiré Guilmard, designer, *Chaise de fantaisie*. Lithograph with hand coloring, from *Le Garde-meuble, ancien et moderne*, livraison 35, no. 194 (Paris, 1844). Smithsonian Institution Libraries, Cooper-Hewitt, National Design Museum Branch, New York

descriptions suitable for [a] european Nobleman with an income of £50,000 . . . and yet this man was probably never worth half that Sum, but swam upon the treacherous stream of commercial Speculation. . . . There are now, every day, three or four sales of such furniture. . . ."[121]

While the appreciation for old things may have been new, purchasing secondhand furniture was an established custom in New York.[122] There were "*mock auction shops*" in certain parts of town, Chatham Square notably, which were to be avoided (see cat. nos. 177, 178),[123] and no doubt a certain amount of fudging about the merchandise was to be expected no matter how reputable the auctioneer: "The furniture was made by Phyfe of course, . . . [It] was inventoried, and catalogued, and all the English names turned into French. French is so fashionable, and things in that winning language, command such excellent prices."[124] The resale market created its own class of dealers who purchased to sell again. Daniel Marley, a dealer in secondhand furniture and rococo curiosities, starting in 1840, was one of the city's first antique dealers, although that particular term did not come into common use until later in the century.[125]

The reason it had become "a famous time" to buy secondhand furniture was that French furniture had "come in lately with a rush" and everyone was "furnishing anew, *a la Francaise,* from skylight to basement."[126] Among the upper echelons of society, the predominance of Gallicism over Anglicism was striking. As one objective observer recounted, "The French language is heard all over a crowded drawing-room; and with costume entirely, and furniture mainly French, it is difficult . . . not to fancy ones self on the other side of the Atlantic."[127] French taste was embraced wholeheartedly, and there was even national pride taken in the fact that "with a separation of only twenty-miles from the French coast, the English assimilate not at all . . . while we [Americans], at a distance of three thousand miles, copy them with the readiness of a contiguous country."[128] Interest in the Louis XIV style was part and parcel of this pervasive Francophilia. "The style of interior decoration, so much in vogue in the days of Louis XIV, has lately been revived," *Brother Jonathan* reported in 1843. "It is elaborate and gorgeous in the highest degree—an immense quantity of gilding being used. . . . It is adapted about as well to one style [of] building as another, not being strictly appropriate to any. The Elizabethan character best accords with it, and the florid Roman seems to claim some consanguinity."[129]

From the late 1820s on, aristocratic New Yorkers had indulged in a taste for imported French furniture[130]—a taste that American cabinetmakers and journeymen viewed as a threat. In 1835 New Yorkers were shocked when a public sale of French furniture at the City Hotel was disrupted by journeymen and apprentices who had recently been on strike for wage increases and were determined that no foreign furniture should be sold in New York. Rich tapestry upholstery was slashed with knives, and French-polished pieces were scratched and mutilated. "The Devil is in the people," Philip Hone wrote in his diary that evening.[131] The press noted that the troublemakers were mostly German immigrant journeymen and that some master cabinetmakers had "openly justified the proceedings."[132]

In the ensuing decade, however, American cabinetmakers capitalized on New Yorkers' growing love of antiques and their adoption of French styles.[133] "The cabinet-maker who judiciously comes from the antique," Dr. George Washington Bethune, a clergyman, counseled in 1840, "will find the most ready demand for his furniture."[134] New York cabinetmakers, such as Duncan Phyfe, who had been working in the Grecian idiom had to accommodate this new trend. "So marked is this change of taste, and the new school of furnishing, that the oldest and most wealthy of the cabinet warehouse-men in this city has completely abandoned the making of English furniture," the *New Mirror* reported in 1844, perhaps referring to Phyfe. "He sold out an immense stock of high-priced articles last week at auction, and has sent to France for models and workmen to start new with the popular taste."[135] An upholstered armchair attributed to Phyfe that survives from Millford Plantation (fig. 233) may be of a type unfamiliar to modern eyes, but by the 1840s such a *fauteuil confortable* would have been deemed among the most fashionable Parisian designs. A portrait of the Fiedler family from about 1850 (fig. 211) shows similar chairs being used to update the drawing room, or front parlor, of a New York town house on Bond Street built in the 1830s.

The New York market enticed many accomplished cabinetmakers from Europe. The Frenchman Alexander Roux had come to America in 1835, going into business as an upholsterer on Broadway (1836–43), and thereafter as a cabinetmaker.[136] The German cabinetmakers who immigrated to America in the 1840s were also prepared to take advantage of the new market for French styles. Of these, Julius Dessoir, J. H. Belter, Anthony Kimbel, and Gustave Herter all managed to avoid the Kleindeutschland shops

on auctioneers in *Nine Years in America*, which begins (p. 132), "The root of auctioneering lies in New York, the great emporium of imported goods."

123. Mooney, *Nine Years in America*, p. 90.

124. K. K., "The Fashionable Auction, or the Mysterious Purchaser," *Arcturus* 3 (May 1842), pp. 417–18.

125. The term "antique dealer" first appeared in London trade directories in 1886. See Porter, "Antiques Movement," p. 28. During the 1840s Marley's shop was on Ann Street near P. T. Barnum's American Museum, which may have prompted one commentator to liken the "labyrinthine" shop to a rich museum. "Oddities in Furniture," p. 2; see also "To Seekers of Furniture," *Home Journal*, April 14, 1849, p. 2. Marley's old things were more valuable than new ones, it was said, and one-fifth the price. "On Furnishing a House," *Home Journal*, November 17, 1849, p. 1. Sypher and Company was the successor to Daniel Marley. See F. J. Sypher, "Sypher & Co., a Pioneer Antique Dealer in New York," *Furniture History* 28 (1992), pp. 168–79.

126. *New Mirror*, May 11, 1844, p. 90.

127. "Sketches of New-York," *New Mirror*, May 13, 1843, p. 85.

128. Ibid.

129. "The Architects and Architecture of New York," p. 301. The "florid Roman" style of architecture probably referred to the Corinthian order. See the gilded table made for Edwin Clark Litchfield (cat. no. 244) in its original setting, a drawing room with Corinthian columns and decorated pilasters (fig. 250).

130. For example, W. F. Pell and Company advertised a sale of "Splendid Parisian Furniture" in the *New-York Evening Post*, October 26, 1829. Horatio N. Davis, at 286 Broadway, opposite the Washington Hotel, boasted in 1835 that he had "received from Paris a rich Mahogany Bedstead, together with the most approved style of French Drapery" and, subsequently in 1836, "the latest French and English designs for fitting-up and decorating drawing-rooms." *Spirit of the Times*, December 12, 1835, p. 7, February 27, 1836, p. 16. James Bleecker advertised "HAND-SOME NEW FRENCH PARLOR FURNITURE, just imported" in

the *Evening Post* (New York), March 15, 1841, p. 2.

131. *Diary of Philip Hone*, vol. 1, p. 157, entry for April 29, 1835.

132. "Fruits of the Trades' Union," *Niles' Weekly Register,* May 9, 1835, p. 171. In reporting the event, *Niles' Weekly Register* sympathized with the owner of the damaged goods. In view of the expense involved, if the French furniture were to have sold without a loss, it "must have sold for the *fashion* of it."

133. "Oddities in Furniture," p. 2. "The imitation of second-hand furniture was resorted to, at last, by the despairing furniture-dealers, and to avoid any look of *newness* in furniture, has every [*sic*] since been thought indispensable to style. . . ."

134. "Influence of Art," *The New-Yorker,* July 4, 1840, p. 248.

135. *New Mirror,* May 11, 1844, p. 90.

136. See note 203 below.

137. Dessoir, a Prussian (in spite of his French-sounding name) is discussed in note 209 below. Belter is discussed in note 217 below. Kimbel arrived in New York about 1847 (his death certificate, dated 1895, states that he had been in New York for forty-eight years). He was the principal designer for Baudouine for several years, perhaps starting in 1847, at 351 Broadway, and continuing at 335 Broadway from 1849 to either 1851 or to about 1854, when Baudouine closed his shop. See note 214 below. The information on Kimbel is drawn from a chronology prepared by Medill Higgins Harvey. Herter has been the subject of recent scholarly study. See Howe, Frelinghuysen, and Voorsanger, *Herter Brothers*; and Catherine Hoover Voorsanger, "Gustave Herter, Cabinetmaker and Decorator," *Antiques* 147 (May 1995), pp. 740–51.

138. The copies of *Le Garde-meuble* deposited with the Bibliothèque Nationale in Paris indicate that publication commenced in 1839. (Pencil inscriptions and, later, date stamps record when the copies were received by the library.) Approximately fifty-four lithographed plates were issued each year, and publication continued well into the twentieth century. See Jean Adhémar, Jacques Lethève, and François Gard, *Inventaire du fonds français après 1800* (Paris: Bibliothèque Nationale, 1958), vol. 10, pp. 48–50. See also Kenneth L. Ames, "Designed in France: Notes on the Trans-

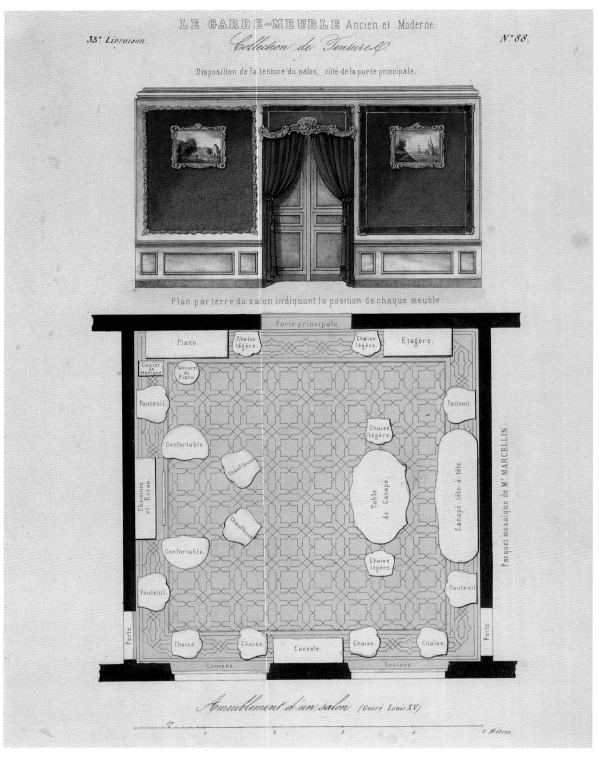

Fig. 249. *Ameublement d'un salon (genre Louis XV)*. Lithograph with hand coloring, from *Le Garde-meuble, ancien et moderne,* livraison 33, no. 88 (Paris, 1844). Smithsonian Institution Libraries, Cooper-Hewitt, National Design Museum Branch, New York

and were working on Broadway within a short time after arriving.[137]

Published French designs, along with news reports and illustrations of Parisian industrial expositions, were well known to New York cabinetmakers. A major source, issued serially as loose plates, was *Le*

*Garde-meuble, ancien et moderne,* published in Paris by Désiré Guilmard starting in 1839.[138] Evidence of the relevance of this publication to American cabinetmakers is demonstrated by two charming, nearly identical rosewood side chairs (fig. 247). Each has a scalloped back, punctuated by a voided, asymmetrical

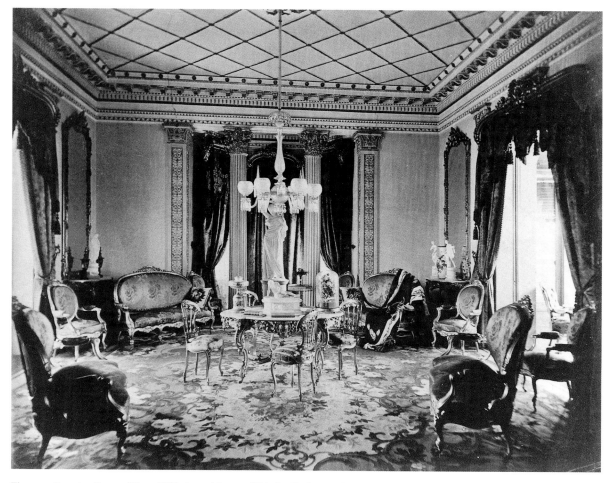

Fig. 250. *Drawing Room of Grace Hill,* the residence of Edwin Clark Litchfield and Grace Hill Hubbard Litchfield, Brooklyn, decorated ca. 1857; photograph by B. J. Smith, ca. 1876–86, showing center table (cat. no. 244). The New York Genealogical and Biographical Society, New York

mission of French Style to America," *Winterthur Portfolio* 12 (1977), pp. 103–14.

139. One of the chairs at the Metropolitan Museum (69.258.9) is attributed to J. and J. W. Meeks by family tradition. The mate to the other (1992.81) is in the Brooklyn Museum of Art. Two virtually identical designs, presumably copied from Guilmard's, were published, respectively, in Mainz, Germany, in 1846 and in 1853 by Wilhelm Kimbel, Anthony Kimbel's father. See Georg Himmelheber, *Deutsche Möbelvorlagen, 1800–1900* (Munich: Verlag C. H. Beck, 1988), p. 424 (no. 2708); and Heidrun Zinnkann, *Mainzer Möbelschreiner der ersten Hälfte des 19. Jahrhunderts* (Frankfurt am Main: Schriften des Historischen Museums, 1985), p. 345 (no. 221).

cartouche, a motif that has roots in eighteenth-century engravings but which is unusual in American Rococo Revival furniture. The slight differences between the two pieces suggest two makers working from a common source, a supposition that seems to be confirmed by the appearance of a related *"chaise de fantasie"* designed by Guilmard and published in *Le Garde-meuble* in 1844 (fig. 248).[139]

In addition to publishing designs for furniture, upholstery, and draperies, *Le Garde-meuble* occasionally printed floor plans and views of rooms that showed recommended arrangements of furniture and the number of pieces considered appropriate for a high-style drawing room. In one plate (fig. 249), twenty-four pieces in the Louis XV style are indicated. A series of large pieces appear along the four walls: clockwise from the top, a piano (with a stool and a canterbury to hold sheet music), an étagère, a *canapé tête-à-tête* (see cat. no. 236A) with a *table de canapé* (a sofa table, in lieu of a center table) in front of

it, a console (a table supported by two front legs and placed against a wall), and the chimneypiece, shielded by a fire screen. The seating furniture includes, in ascending order of size, four *chaises légères* (small, lightweight reception chairs), four *chaises* (side chairs), two *chauffeuses* (called slipper, or sewing, chairs in America), four *fauteuils* (armchairs), and two large *confortables* (large upholstered armchairs, often tufted). With the possible exception of the piano, the furniture was likely en suite, rendered in one style and in matching upholstery.

The extent to which the arrangement of American drawing rooms after 1840 conformed to such a plan is difficult to ascertain because there are few period images of interiors and because most photographs showing such furniture in situ are much later in date. Nevertheless, there is one photograph that is instructive in this regard—that of the drawing room of Grace Hill, the Brooklyn villa of Mr. and Mrs. Edwin Clark Litchfield designed by Alexander Jackson Davis

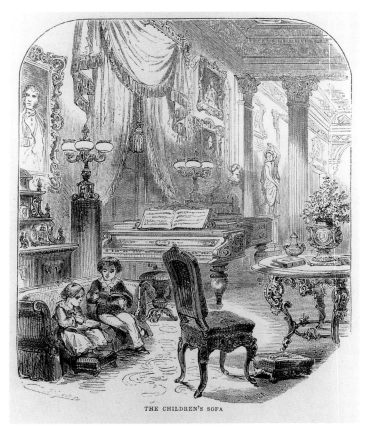

Fig. 251. *The Children's Sofa*, frontispiece to Jacob Abbott, *John True; or The Christian Experience of an Honest Boy* in *Harper's Story Books: A Series of Narratives, Dialogues, Biographies, and Tales for the Instruction and Entertainment of the Young* (New York: Harper and Brothers, Publishers, 1856). Wood engraving by John William Orr, after Carl Emil Doepler. Courtesy of the American Antiquarian Society, Worcester, Massachusetts

140. Raymond S. Waldron Jr., "The Interior of Litchfield Mansion," *Park Slope Civic Council, Civic News* 29 (April 1966), pp. 20–21. Nine pieces survive in the collection of the Brooklyn Museum of Art: two sofas, two armchairs, four side chairs, and the center table, along with three pairs of red silk draperies, and two pieces of sculpture. Some of the seating furniture retains its original red silk damask; other pieces were reupholstered in 1956 by Ernest LoNano. Microanalysis by the Forest Products Laboratory, USDA, Madison, Wisconsin, reveals the wood used in the center table to be a poplar (*Populus sp.*) of European or American origin. The gilding is laid on a red bole under which there is white gesso. The interior sides of the skirt are painted with a matte ocher-yellow color not seen in contemporaneous New York furniture.

141. Davis, Daybook, p. 106, October 13, 1857, transcribed by Amelia Peck, A. J. Davis

(fig. 250). It shows a large suite of gilded French furniture, all embellished with intertwined Ls, comprising a center table with dove gray marble (cat. no. 244), four sofas, four armchairs, four side chairs, and four consoles with looking glasses above them. The same red silk damask fabric was used for the upholstery, striking against the burnished gold surfaces of the furniture, and for the draperies.[140] The furniture was disposed in a circular arrangement within the rectangular room, with the center table positioned where the axis of the colonnaded bay window and entrance met that of the windows on the side walls. As was the current fashion in France, the room was painted a neutral light color (probably ivory or white) with details and moldings picked out in gold. Davis specified a diaper pattern on the ceiling, marbleized painted decoration for the architraves, an imitation bronze finish for the sashes, and doors "painted and grained in imitation of old oak, varnished with copal root oak."[141] No doubt the "Aubusson" carpet was brightly colored to harmonize with the room.

Litchfield and his wife had ordered the suite between 1855 and 1857 in Europe, where they had traveled while their residence, designed in the Italianate style, was under construction. The Litchfields returned from Europe in the spring of 1857. In October Davis noted a visit to Brooklyn: "Went to Litchfields. The family had moved into the new house and were placing the furniture."[142] A frontispiece from a children's storybook of the mid-1850s (fig. 251), although obviously depicting an imagined interior, captures the imposing character of another upscale New York drawing room of the time; however, the diminutive Grecian sofa at the lower left, a family heirloom perhaps, and the piano seem anachronistic amid the ornate picture frames, swathes of draped fabric, and French furniture with cabriole legs.

Imported furniture such as the Litchfield suite was a status symbol among affluent New Yorkers, not only because of its style and the cachet of being French but also because of its exorbitant cost. Since the 1820s there had been a stiff 30 percent tariff on imported furniture. The General Convention of the Friends of Domestic Industry, held in New York in 1831, reported that protective tariffs had almost eliminated foreign imports.[143] Many well-to-do New Yorkers skirted the tariff, buying furniture and other decorative objects during their European sojourns. Others were effectively discouraged by it. In Paris in 1843 Howard Henderson, a colleague of James Colles, investigated the costs of French furniture and concluded, "American furniture must answer my purpose. The duty is 30 per cent, packing, transportation to Havre and freight home will render it very dear."[144]

As a result of the craze for all things French, several of the Broadway cabinetmakers, taking advantage of their own European backgrounds, began to import, as well as to make, furniture in the pedigreed styles of the European nobility. Starting in the mid-1840s, for example, Roux advertised furniture that he had commissioned in France:

> *Rich French Furniture. Alexandre Roux, Nos. 478 and 480 Broadway, having just returned from Paris, where he had made a very rich and choice selection of Furniture, manufactured in the finest and latest styles, . . . he has now ready for show a Bookcase, of black walnut, which for neatness and elegance of finish has never been equalled in this country, being after the styles of Henry 7th.[145]*

"We have no aristocracy of blood," scoffed Edgar Allan Poe in response to this phenomenon, "having,

therefore . . . fashioned for ourselves an aristocracy of dollars. . . . The people naturally imitate the nobles. . . . In short, the cost of an article of furniture has . . . come to be . . . nearly the sole test of its merit in a decorative point of view."[146] But neither Poe nor any other critic could stem the desire of New Yorkers to present themselves as cosmopolitan world citizens, which meant abandoning the old allegiances to British culture. "New-York is much more like Paris . . . than like an Anglo-American metropolis," *Morris's National Press* reported in its inaugural volume in 1846:

> *It is true that the good old Knickerbocker blood still flows purely in many aristocratic veins, and . . . couples respect to the men, and worship to the women, who inherit it. True, also, that the full, steady-flowing, energetic stream of the pure Puritanic fluid which flowed at Bunker Hill, imbues us with its inimitable and unflagging business energies. But the literature, the amusements, the social peculiarities, the habits . . . the more etherial essence of society—are emphatically French in their inexhaustible brilliancy, gaiety, and sparkle. In fact, New-York is rapidly becoming a most delightful* moyennais *of all the good qualities and brilliant characteristics of all the nations of Europe—a sort of world-focus into which the rays from the whole horizon are concentrated.*[147]

The correspondence between Colles (retired and soon to be a New Yorker), who was traveling in Europe between 1841 and 1844, and Matthew Morgan in New York provides a vivid firsthand account of New Yorkers' interest in the historical styles and furniture of France. Even during the extended banking crisis that had begun in 1837, Morgan was able to afford a magnificent new house near Washington Square, which was just being developed as the latest fashionable residential neighborhood. Amid descriptions of other people's bankruptcies, he noted in December 1842: "We have the Croton Water in every story, even the attic."[148] He was having the parlors ornamented in the "Louis Quatorze style," and thought that he might need to call upon Colles "to procure us a few things that come out with your own plunder."[149] Mrs. Samuel Jaudon of New York wrote to her friend Mrs. Colles in Paris to say that the Morgan drawing room "will be a stylish, elegant affair. . . . They have finished it in the most elaborate and gorgeous style of Louis XIV and when arranged will have a fine effect to us *Americans*. . . ."[150] In praising the Louis XIV style, a local periodical hastened to remark that "many of the

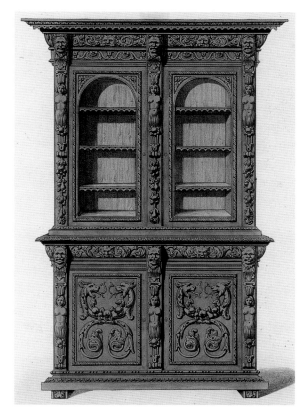

Fig. 252. Pierre Ribaillier, designer and cabinetmaker, *Dressoir-Renaissance (vieux bois)*. Lithograph with hand coloring, from *Le Garde-meuble, ancien et moderne*, livraison 72, no. 417 (Paris, 1850). Smithsonian Institution Libraries, Cooper-Hewitt, National Design Museum Branch, New York

excesses" of the original style had been avoided, lest it seem too rich for republican blood.[151] Blue was beginning to replace crimson as the modish color for upholstery,[152] and damask was de rigueur.[153]

In selecting furnishings and interior decoration schemes for their residences, the Morgans, Jaudons, and Colleses were assisted by a Parisian cabinetmaker, Auguste-Émile Ringuet-Leprince. Upon orders from his clients, Ringuet-Leprince shipped to New York entire rooms of furniture, carpets, looking glasses, wallpapers, decorative objects, and sculpture. Mrs. Jaudon was insistent nearly to the point of rudeness that Mrs. Colles do her the favor of ordering furnishings from Ringuet-Leprince (including two "Buhl" tables like Mr. Morgan's) while she was in Paris, because "we on this side feel as if everything [is] so much handsomer, and better, and desirable that comes from Paris."[154]

Colles corresponded regularly with Ringuet-Leprince while he was traveling in Europe and after his return to New York, ordering items to furnish the house he purchased late in 1844 at 35 University Place, between Tenth and Eleventh streets. The scale of the house

Collection, Avery Architectural and Fine Arts Library.

142. Ibid., document H1-2-0, May 1857.

143. "General Convention of the Friends of Domestic Industry," p. 11.

144. Howard Henderson, Paris, to James C. Colles, traveling in Naples, Italy, January 30, 1843, transcribed by Henry Metcalf (no. 630), James Colles Papers, Manuscripts and Archives Division, New York Public Library (hereafter Colles Papers). The Colles correspondence is voluminous, numbering some twelve hundred letters. Henry Metcalf, Colles's grandson, organized the letters chronologically and transcribed most of them, sometimes not completely. Some of the transcribed letters were subsequently edited and published with additional commentary by De Forest in *James Colles*. I am indebted to Brandy Culp for her detailed review of these original documents.

145. "Rich French Furniture," *Evening Post* (New York), October 14, 1846, p. 2. The style of "Henry 7th" was the French equivalent to the British Elizabethan, or Jacobean, Revival style.

146. Edgar Allan Poe, "The Philosophy of Furniture," *Burton's Gentleman's Magazine and American Monthly Review* 6 (May 1840), p. 243.

147. "Franco-Americanism," *Morris's National Press*, April 14, 1846, p. 2.

148. Matthew Morgan, New York, to James Colles, Paris, December 9, 1842, transcribed by Henry Metcalf (no. 622), Colles Papers. The house and grounds were worth $30,000, at a time when "Wall Street would not sell for 25 percent of the values of 1836." Ibid. See above, pp. 290–91.

149. Ibid.

150. Mrs. Jaudon, New York, to Mrs. Colles, Paris, May 12, 1843, in De Forest, *James Colles*, p. 170.

151. "The Architects and Architecture of New York," *Brother Jonathan*, July 15, 1843, p. 301.

152. Mary Davenport, "Mildred," *Godey's Lady's Book and Ladies' American Magazine* 26 (May 1843), p. 217.

153. "Neighbours," *New Mirror*, December 2, 1843, p. 137.

154. Mrs. Jaudon, Hell Gate, to Mrs. Colles, Paris, July 14, 1844, in De Forest, *James Colles*, p. 203.

155. James Colles to Ringuet-Leprince, Paris, December 28, 1844, transcribed by Henry Metcalf (no. 770), Colles Papers.

156. Two armchairs from the suite, no longer retaining the original showcover, remain in family hands. The French upholstery and European cabinetmaking woods used in this suite support its attribution to Paris rather than to New York, where Ringuet-Leprince was in business during the 1850s.

The suite has previously been dated as late as about 1854, and its provenance is confused in earlier publications. Its history is made clear by a letter in the Metropolitan Museum's Archives from Emily Johnston de Forest, the Colleses' grand-daughter, to Preston Remington, dated April 10, 1931, which reads, in part: "The furniture . . . belonged to my grand-father, Mr. James Colles, who then lived at 35 University Place. It was made in Paris in 1843 by Ringuet Le Prince, the famous Parisian Cabinetmaker and upholsterer. He was the father-in-law [brother-in-law] of Leon Marcotte, who held the same position in New York from about 1850. . . ." My thanks go to Priscilla de Forest Williams, a descendant, for her assistance with the history of the Colles suite.

157. See Ringuet-Leprince, Paris, to James C. Colles, c/o C. P. Leverich, New York City, January 2, 1845, accompanied by an invoice dated December 7, 1844 (no. 772½); and October 13, 1845, accompanied by an invoice dated December 7, 1844; April 23, 1845; and September 25 [1845], translated and transcribed by Henry Metcalf (no. 804), Colles Papers. A stylistically related piece, a superlative mid-nineteenth-century ebonized table with brass inlay, large figural and other gilt-bronze mounts, and possibly European woods (beech, hickory, white pine, and oak) is in the collection of the Brooklyn Museum of Art (86.4).

158. See James Colles to Ringuet-Leprince, December 28, 1844 (no. 770, transcribed); April 23, 1845 (no. 788, transcribed); May 14, 1845 (no. 790, transcribed); December 15, 1845 (no. 809, transcribed); Ringuet-Leprince to James Colles, January 30, 1845 (no. 773, neither translated nor

was impressive: its drawing room, second parlor, and dining room were each approximately eighteen by twenty-eight feet, and the ceilings were fourteen feet high.[155] In 1843, while in Paris, Colles had selected an ebonized Louis XV–style drawing-room suite embellished with chased ormolu mounts and richly upholstered in rose, red, and ivory silk brocatelle, which survives in remarkable condition (cat. no. 236A, B). Two sofas, four armchairs, and four side chairs from the suite descended in the family, along with a center table and a fire screen with an Aubusson-tapestry panel; except for two armchairs, all of these pieces were given to the Metropolitan Museum in 1969.[156] The Colles suite is an extraordinary document—perhaps unique in the United States—of high-style French drawing-room furniture and upholstery from the 1840s.

Invoices from Ringuet-Leprince indicate that other ebonized pieces with gilt-bronze decoration were shipped to the Colleses. These included three pieces of "Buhl" furniture (a large corner cabinet with two mirrored doors and Florentine-bronze "caryatides" and two matching corner cabinets), all with brass inlays, black marble, and gilt-bronze mounts.[157]

For his second parlor, Colles chose rosewood seating furniture in the Louis XVI style, upholstered in garnet-colored plush and trimmed with silk galloon, to which he later added a second sofa and an étagère. His dining-room furniture, in the Louis XV style, was also of rosewood: an extension table, a sideboard with carved decoration and a mirror, and ten side chairs and two matching armchairs with sprung horsehair seats upholstered in tufted green morocco leather, with draperies in green fabric to match. In addition, Colles anticipated needing enormous looking glasses, "4 plates each 6 feet wide, 7 feet 7 inches high, and 2 plates for piers each 3 feet 4 inches wide by 10 feet 6 inches high English measure," and later two richly gilded Louis XVI frames and chimney glasses. For her bedroom, Mrs. Colles was to have a rosewood bedstead and armoire in the Renaissance style, and a wool-and-silk damask with wide blue-and-white stripes for the draperies, bed curtains, and coverlet, a sofa, and six chairs.[158]

A first-quality Aubusson carpet in the spirit of Louis XIV, with "fine stripes with a centerpiece," was duly ordered for the drawing room and took four months to make.[159] Ringuet-Leprince had four suggestions for the wall treatments in the drawing room and the backdrop for the black-and-gold furniture. His letter of June 1845 offers a rare insight into interior decoration during the era of Louis-Philippe (1830

to 1848), although we do not know which scheme the Colleses decided on:

*The best would be to cover the walls with stuff like your curtains, hung in panels surrounded by gilt moldings. The second best way would be to panel the walls with moldings and insert in the panels Louis XIV relief ornaments, all of which would be painted white. The third way, paper the wall with crimson velvet paper, plain or damasked, and paneled with gilt moldings. The fourth way, use white and gold paper or white velvet paper, with gilt moldings.*[160]

On several occasions Colles expressed interest in "old oak" furniture, regretting that he had not chosen that up-to-the-minute look instead of rosewood for his dining-room suite and also that he had not acquired an oak bookcase he had seen at Ringuet-Leprince's Paris establishment. "Old oak," known in France as "*vieux bois*" or "*vieux chêne,*" was just coming into vogue at the time, in response to the desire for furniture with the appearance of age. The bookcase Colles mentioned might have resembled a Renaissance-style

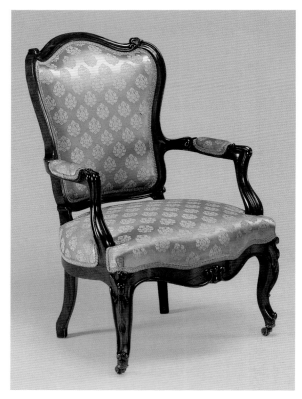

Fig. 253. Charles A. Baudouine, Armchair, purchased by James Watson Williams, Utica, New York, 1852. Rosewood, ash; replacement underupholstery and showcover. Munson-Williams-Proctor Arts Institute, Utica, New York; Proctor Collection PC.423.8

case piece illustrated in *Le Garde-meuble* in 1850 (fig. 252). Ringuet-Leprince may have had the carving done by hand, or he may have produced such pieces with the aid of new techniques that imitated the effect of carving. One, patented in England in 1840, was a pyrotechnic method of embossing wood by applying a red-hot mold under ten to thirty tons of pressure to a dampened surface. When the char was cleaned off, and any additional carving or undercutting done by hand, the end result was the appearance of "old oak."[161]

Colles's correspondence with Ringuet-Leprince continued through 1847 while the Frenchman supplied flocked wallpaper, ceiling papers, and a grand chandelier for the new Opera House at Astor Place that Colles, Morgan, and others were involved in building. With France in turmoil as a result of political uprisings in 1848, Ringuet-Leprince decided to expand his American clientele. He approached Colles about coming to New York with his brother-in-law, the architect Léon Marcotte, to set up a business that would design interiors for hotels and other buildings, supply elements such as papier-mâché and carved-wood ornaments for use as interior architectural decorations, and import furnishings made by his fabricators in Paris, Aubusson, and Lyon.[162] He

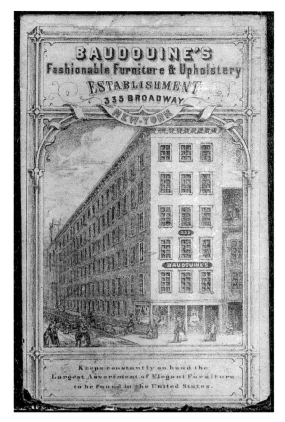

Fig. 254. Label of Charles A. Baudouine. Wood engraving, from back of imported lady's writing desk (cat. no. 237), 1849–54. Courtesy of the Museum of Fine Arts, Boston

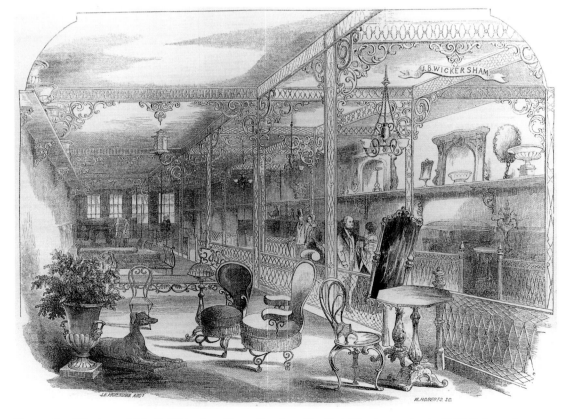

Fig. 255. *Iron Warehouse of John B. Wickersham, No. 312 Broadway, New York.* Wood engraving by K. W. Roberts, from *Gleason's Pictorial Drawing-Room Companion,* February 4, 1854, p. 76. Courtesy of the American Antiquarian Society, Worcester, Massachusetts

transcribed); April 15, 1845 (no. 790A, translated); October 13, 1845 (no. 804, translated and transcribed), Colles Papers.

159. Ringuet-Leprince to Colles, June 16, 1845 (no. 793, translated); October 13, 1845 with detailed invoice (no. 804, invoice translated), Colles Papers.

160. Ibid., June 16, 1845 (no. 793, translated).

161. See Edwards, *Victorian Furniture,* pp. 57–61. For mentions of "old oak," see Colles to Ringuet-Leprince, letters nos. 762, 770, 773, 788, 790B, 795, 807, and 809, Colles Papers.

162. Ringuet-Leprince, Paris, to Colles, New York, March 30, 1848 (no. 846B, translated); and Colles to Ringuet-Leprince, May 9, 1848 (no. 847, transcribed), Colles Papers.

163. Colles to Ringuet-Leprince, May 9, 1848 (no. 847).

164. See Nina Gray, "Leon Marcotte: Cabinetmaker and Interior Decorator," in *American Furniture 1994,* edited by Luke Beckerdite (Hanover, New Hampshire: University Press of New England for the Chipstone Foundation, 1994), pp. 49–72.

165. See Phillip M. Johnston, "Dialogues between Designer and Client: Furnishings Proposed by Leon Marcotte to Samuel Colt in the 1850s," *Winterthur Portfolio* 19 (winter 1984), pp. 257–75.

166. See B. Silliman Jr. and C. R. Goodrich, eds., *The World of Science, Art, and Industry Illustrated from Examples in the New-York Exhibition, 1853–54* (New York: G. P. Putnam and Company, 1854), pp. 47, 52. The ebonized cabinet was also illustrated in "The American Crystal Palace," *Illustrated Magazine of Art* 2 (1853), p. 261.

167. The suite came in the form of two gifts: one (68.69.1–11) from Mrs. D. Chester Noyes, and the other (68.165.1–6) from her sister Mrs. Douglas Moffat.

168. I am grateful to Priscilla de Forest Williams for assisting me with the dating of this suite to ca. 1856, an assignment that differs slightly from that given in Gray, "Leon Marcotte."

169. Hagen, in Ingerman, "Personal Experiences," p. 578. The facts of Baudouine's life and career are drawn from a chronology prepared by Cynthia V. A. Schaffner.

170. This building is pictured on his billhead. See Anna T. D'Ambrosio, ed., *Masterpieces*

of American Furniture . . .
(Utica: Munson-Williams-
Proctor Institute, 1999), p. 84.

171. See ibid., pp. 82–84. Both the
worktable and the letter of
July 11, 1846, from which the
citation is taken, are in the
Munson-Williams-Proctor
Institute.

172. Ibid., pp. 85–87.

173. *The Diary of George Templeton
Strong*, edited by Allan Nevins
and Milton Halsey Thomas
(New York: Macmillan Com-
pany, 1952), vol. 1, p. 347, entry
for March 27, 1849.

174. Stephen Garmey, *Gramercy
Park . . .* (New York: Balsam
Press, 1984), p. 83. Garmey
states that this was said to be
the first time a professional
decorator was privately engaged
in New York, but he does not
supply a footnote.

175. *The Andrews & Co. Stranger's
Guide in the City of New-York*
(Boston: Andrews and Co.,
1852). Baudouine was the only
cabinetmaker or upholsterer
listed in this tourist pamphlet.

176. Ingerman, "Personal Experi-
ences," pp. 577–78. The follow-
ing descriptions and quotations
are taken from this source. The
original manuscript differs
slightly.

177. In the 7th Federal Census,
1850, Products of Industry
Schedule, Abel Swift at 53
Bowery in the Tenth Ward
reported 125 male "hands,"
and George Ebbinghausen in
the Thirteenth Ward reported
98, both firms operating in
Kleindeutschland. Baudouine's
Broadway competitors, Hutch-
ings, Roux, and Dessoir,
reported 75, 45, and 20 male
hands, respectively, in the
same census. Baudouine was
not listed in the 1850 census,
and Hagen is thus the only
source of information about
the very large size of his shop.

178. "Henry H. Leeds, Auctioneer.
MAGNIFICENT SALE of the rich-
est description of Furniture,
carved in the most elaborate
manner, covered with the rich-
est materials, and in the latest
Paris fashions, manufactured at
the well-known establishment
of Mr. C. A. Baudouin [*sic*] . . .
to be sold without reserve."
*Home Journal*, October 26,
1850, p. 3. The sale was to be
held November 5, 6, and 7.
Although no auction catalogue
has been located, the detailed
list of items published in the
*Home Journal* documents
the contents of Baudouine's
warerooms.

was also considering becoming involved in the silver-plating and gilding of bronze ornaments and decorative objects, because he had heard that no one in America was doing this kind of work. What Ringuet-Leprince envisioned, in short, was a comprehensive interior-design business of a kind that did not yet exist in New York. With Colles's cautious encouragement—"the great mass of purchasers, although desirous of having furniture themselves of late taste, look *very closely* at the cost"[163]—Ringuet-Leprince and Marcotte arrived in New York in the fall of 1848.

With entrée to the Colleses' elite social circles, and with Marcotte as the New York partner (Ringuet-Leprince traveled back and forth between Paris and America), the business became successful immediately.[164] Known first, while in Paris, as Maison Ringuet-Leprince (1840–48), then as Ringuet-Leprince and L. Marcotte (1848–60), and finally becoming L. Marcotte and Company in 1860 (at the time of Ringuet's retirement), the firm had a factory and showroom in New York and offered goods in a variety of styles. The French-born merchant and financier Hart M. Shiff was among its wealthy clients in the city, while those farther afield included William Shephard Wetmore of Newport, for whom a suite of ebonized ballroom furniture was made about 1853, and Samuel Colt of Hartford, who, starting in 1856, commissioned household furnishings and decorations.[165] In 1853 Ringuet-Leprince and L. Marcotte displayed several pieces at the New-York Exhibition of the Industry of All Nations, including an impressive carved sideboard (made in New York) and an ebonized cabinet with marquetry panels and gilt-bronze mounts (made in Paris).[166]

Colles's daughter Frances married the railroad executive and art patron John Taylor Johnston in 1850, and the couple moved into a new house at 8 Fifth Avenue in 1856. Their ballroom was decorated with an ebonized suite of Louis XVI–style furniture, highlighted with striking gilded mounts and yellow silk damask upholstery, ordered from Ringuet-Leprince and L. Marcotte. The Louis XVI style was just coming into vogue in Paris under the Second Empire, thanks to Empress Eugénie, the new bride of Napoleon III (see fig. 56). Seeking to emulate Marie-Antoinette, wife of Louis XVI, in whose royal palaces (the Louvre, the Tuileries, Fontainebleau, Compiègne, and Saint-Cloud) she was living, Eugénie avidly advocated the revival of late-eighteenth-century taste. In 1855 the style, dubbed "Louis Seize-Impératrice," was one of those featured at the Paris Exposition Universelle.

The Johnston suite comprised two sofas, two armchairs (see cat. no. 248), six side chairs, two lyre-back chairs, three cabinets, a table, and a fire screen, all of which descended in the family until the suite was given to the Metropolitan Museum in 1968.[167] The ebonized surface and deeply tufted sprung seats are typical of the period, but not of its eighteenth-century antecedents; the modern showcover of yellow silk damask recalls eighteenth-century fabrics. Some of the pieces incorporate fruitwood veneers (apple and pear) that are associated with French rather than American cabinetmaking. This suggests that Ringuet-Leprince forwarded at least some of them from Paris to New York. As extraordinary in its quality and provenance as the Colles furniture, the Johnston suite is a remarkable document of patrician taste in New York in the mid-1850s.[168]

Among the native-born cabinetmakers, Charles A. Baudouine played a central role, both as an enterprising cabinetmaker and as an importer of French furniture and fittings. The American-born son of a customs gauger of French Huguenot descent, Baudouine was

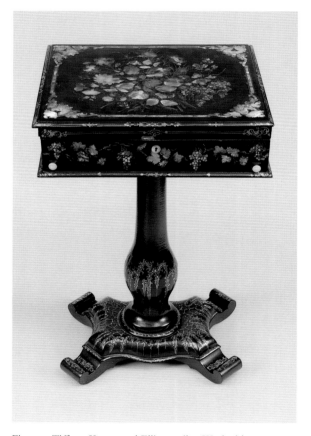

Fig. 256. Tiffany, Young and Ellis, retailer, Worktable, 1850–55. Papier-mâché; mother-of-pearl and gilded decoration; crimson watered silk, crimson velvet, paper; gold and mother-of-pearl sewing implements. Courtesy of Locust Grove, Poughkeepsie, New York  NY0136300–00012

a self-made man, according to Ernest Hagen.[169] He started in the cabinetmaking business in 1829, married a milliner in 1833, and with her nest egg of $300 opened a small cabinetmaking workshop at 508 Pearl Street that specialized in mahogany chairs and sofas. In 1839 he moved to 332 Broadway, the first of three addresses along the thoroughfare, and five years later appeared (alongside Phyfe and Roux) in *The Gem, or Fashionable Business Directory, for the City of New York,* advertising his firm as "Chas. A. Baudouine's Fashionable Cabinet Furniture and Upholstery Manufactory and Warehouse." His business clearly expanding, Baudouine again moved northward in 1845 to a four-story building at 351 Broadway.[170] It was from there, in July 1846, that the lawyer James Watson Williams of Utica, New York, procured a rosewood-and-mahogany worktable for his fiancée. Williams was jubilant about his purchase, writing to his intended that "after looking [in] various places for a gift for you, I have selected at Baudouine's, a work table which I am sure must please you . . . the most approved French pattern."[171] In 1852, after his marriage, he returned to Baudouine, then at 335 Broadway, to purchase a suite of rosewood seating furniture upholstered in green "tapestry," which included two sofas, two armchairs (see fig. 253), and four side chairs along with a "multiform" table that was cleverly designed in halves that could serve as a center table when placed together or function separately as gaming tables, or, when the tops were closed, as individual consoles.[172]

Baudouine's reputation as one of the leading cabinetmakers of the day is supported by an 1849 entry in George Templeton Strong's diary concerning the anticipated cost of furnishing "Palazzo Strong" (on Twenty-first Street) in rosewood and red satin. "Confound the word *Dollar,*" Strong exclaimed in exasperation. "If I hadn't spent money like an extravagant fool in my bachelor days I should have enough now to be able to tell her [his much adored wife, Ellen] to march down to Baudoine's [*sic*] and order right and left whatever pleased her fancy. . . ."[173] Although Baudouine evidently did not decorate Strong's new house, he was engaged about 1851 to furnish the twin town houses built by the industrialist Cyrus West Field and his brother the lawyer David Dudley Field on Twenty-first Street, near Gramercy Park. Acting as both cabinetmaker and interior decorator, he created rooms in which "Louis XIV furniture abounded, as did Italian draperies, Greek statues, marble mantels, and frescoed ceilings."[174] By taking on the role of decorator, Baudouine was apparently ready to give Ringuet-Leprince and Marcotte a run for their money.

In 1849 Baudouine expanded again, into a much larger building (see fig. 254) at 335 Broadway, at the corner of Anthony Street. His salesroom was described in the 1852 *Stranger's Guide* as one of the greatest attractions in the city; it was said to be 275 feet long and to house an incalculable variety of costly and luxurious seating furniture as well as "various *et ceteras* of modern comfort and embellishment."[175] (A rare, perhaps unique, illustration of a contemporary New York wareroom [fig. 255] conveys some sense of such long interior spaces.) Hagen, who worked for Baudouine for about two years at this location, starting in 1853,[176] remembered his boss as a tall, gentlemanly person, "like an army officer," who spoke French fluently and "went to France every year and imported a great deal of French furniture and upholstery coverings, French hardware, trimmings, and other materials used in his shop." He states that Baudouine employed about 70 cabinetmakers and about 130 others (carvers, varnishers, and upholsterers); if these figures are correct, the firm probably was the largest cabinetmaking operation in the city.[177] Curiously, in 1850, shortly after moving into 335 Broadway, Baudouine auctioned off his entire inventory.[178] He did not display furniture at the Crystal Palace exhibition in 1853, and continued in business at this address only until May 1854, when he gave up his upholstery and furniture manufactory and temporarily opened an office at 475 Broadway. In the course of the next four decades, Baudouine turned his attention to his real estate investments and to his avocation as a four-in-hand driver. An R. G. Dun and Company report in 1856 was extremely succinct regarding the independently wealthy Baudouine: "Living on his income."[179]

Some furniture imported by Baudouine survives, including a small Rococo Revival lady's writing desk (cat. no. 237), or *bonheur du jour,* which bears Baudouine's label from the years 1849–54 (fig. 254) and is additionally stenciled "From C. A. Baudouine" with his address. The painted decoration is extremely fine, resembling contemporary enamel jewelry (see cat. no. 210) in its vibrantly colored floral bouquets and exotic birds. It also recalls the character of painted Paris-porcelain plaques set into eighteenth-century Louis XV furniture, but here the highly naturalistic articulation of roses, fuchsias, tulips, dahlias, morning glories, lilies of the valley, and forget-me-nots among lacy gold filigrees on a black ground is quintessentially of the mid-nineteenth century and clearly a product of the Second Empire.[180]

Baudouine and others imported a wide variety of papier-mâché goods, which became extremely popular

179. R. G. Dun and Company report, April 12, 1856 (New York Vol. 191, p. 1421). R. G. Dun & Co. Collection, Baker Library, Harvard University Graduate School of Business Administration.

180. See, for example, Odile Nouvel-Kammerer, *Napoléon III: Années 1880* (Paris: Éditions Massin, 1996), pp. 58–61. While cottonwood and aspen are poplars indigenous to both North America and continental Europe, they are not commonly recorded in American furniture. The attribution to France is further supported by words inscribed on the table: the right drawer is inscribed in pencil with the letter *D,* and the left with the letter *G,* suggesting a French cabinetmaker's designation of *droite* (right) and *gauche* (left). Such painted furniture also bears a resemblance to contemporary papier-mâché furniture (see fig. 256). For comparable French painted and papier-mâché examples, see Philippe Jullian, *Le style Second Empire* (Paris: Bachet et Cie, n.d.), pp. 92–93, 111.

181. Carry Stanley, "Ada Lester's Season in New York," *Peterson's Magazine* 25 (1854), p. 181.

182. Edwards, *Victorian Furniture,* pp. 124–34. In 1848 papier-mâché chairs said to be the first manufactured in the United States were exhibited at the American Institute Fair. "Scientific. Papier Mache Chairs," *Niles' National Register,* November 15, 1848, p. 316. By 1850 Henry L. Ibbotson, agent for Jennens, Bettridge and Sons (the largest British manufacturer of papier-mâché pieces), was established at 218 Pearl Street. *Home Journal,* June 8, 1850, p. 3. The next year, W. R. Fullerton, 275 Broadway, advertised his "Papier Mache Ware-Room" as the only store of its kind in America; see *Home Journal,* February 8, 1851.

183. "Diary of Town Trifles," *New Mirror,* May 18, 1844, p. 106. The worktable is inscribed in gold paint on the interior of the case.

184. "Jenny Lind at the Castle Amphitheater," *International Miscellany of Literature, Art and Science,* October 1, 1850, p. 448.

185. Burrows and Wallace, *Gotham,* p. 815.

186. Hagen, in Ingerman, "Personal Experiences," pp. 578–79.

187. Ibbotson advertisement, *Home Journal,* June 8, 1850, p. 3. See also *Home Journal,* September 14, 1850, p. 3 (pianofortes); Fullerton advertisement, *Home Journal,* February 8, 1851, p. 3; and "Chairs, Chairs," *The Independent,* May 13, 1852, p. 80.

188. The bookcase bears a large paper label with an illustration of Brooks's Cabinet Warehouse at 127 Fulton Street, corner of Sands Street, in Brooklyn. A line drawing and description of the bookcase and the engraved gold box (unlocated) were published with admiring comments by *Gleason's Pictorial Drawing-Room Companion* ("Memorial for Jenny Lind," June 21, 1851, p. 121). When the bookcase and books were given to the Museum of the City of New York, they were accompanied by a rosewood-veneered cabinet that served as a pedestal for the smaller piece. Because there are no period descriptions or illustrations of the larger cabinet, the bookcase is exhibited without it. My thanks are extended to Deborah D. Waters for allowing the Metropolitan to show the tabletop bookcase on its own, and to Amy M. Coes for her research on Brooks; see note 83 above.

189. London's fair comprised 18,109 exhibits from sixty-one foreign states, while New York's had 4,390 exhibits, one half of which were from twenty-four foreign countries. Nearly 30 percent of the American exhibits were displays of decorative arts. The New York exhibition was the first international world's fair to include painting and sculpture as well as decorative arts. This information is drawn from Janna Eggebeen, "Applied Arts at the New York Crystal Palace Exhibition, 1853–1854: Mirror to Victorian Culture," manuscript, 1999.

190. By the time of the 1853 exhibition, the sobriquet "Empire City," which expressed these cosmopolitan yearnings, was in common use. For example, Isabella Lucy Bird, an English visitor to New York in 1854, observed that the city "possesses the features of many different lands, but it has characteristics peculiarly its own; and as with its suburbs it may almost bear the name of the 'million-peopled city,' and as its growing influence and importance have earned it the name of the Empire City, I need not apologise for dwelling at some

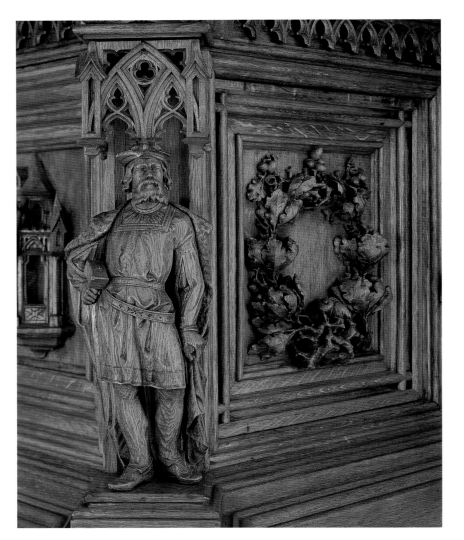

Fig. 257. Gustave Herter, designer; Bulkley and Herter, cabinetmaker, Bookcase (detail of cat. no. 241), 1853. White oak; eastern white pine, eastern hemlock, yellow poplar; leaded glass not original. The Nelson-Atkins Museum of Art, Kansas City, Missouri (Purchase: Nelson Trust through the exchange of gifts and bequests of numerous donors and other Trust properties) 97–35

by the mid-1840s. As brightly colored as painted furniture, these were often inlaid with mother-of-pearl against a coal black ground. A mother-of-pearl-inlaid papier-mâché worktable, lined with crimson velvet and watered silk and furnished with gold and mother-of-pearl sewing implements (fig. 256), closely resembles one described as being in a New York drawing room in 1854.[181] It was probably made in England or France, although some papier-mâché goods were produced in America at least by 1848.[182] This piece was sold in New York by the "enterprising luxurifers" Tiffany, Young and Ellis, whose "brilliant curiosity shop" at the corner of Broadway and Warren Street was enlarged in 1844 by a second-story showroom where worktables and chairs were featured.[183]

Baudouine was one of many entrepreneurial manufacturers and merchants to seize upon the tremendous popularity of Jenny Lind, a Swedish soprano who was lured to America for a twenty-one-month concert tour by P. T. Barnum, who guaranteed her $150,000 plus expenses. The arrival of "the Swedish Nightingale"

was hailed as "the most memorable event thus far in our musical history," and, thanks to Barnum's advance publicity, her first American concert, on September 11, 1850, in the Castle Garden amphitheater, was attended by "the largest audience ever assembled for any such occasion in America."[184] Lind's reputation for moral virtue, which equaled the fame of her voice, helped to garner a following among homemakers, charity ladies, and writers of sentimental fiction.[185] Cabinetmakers soon recognized an audience that would respond if Lind's name were attached to their latest home furnishings. Hagen recollected:

> Some of Boudouines [sic] *most conspicuous productions were those rosewood heavy over decorated parlour suits* [sic] *with round perforated backs generally known as "Belter furniture" from the original inventor* John H. Belter. . . . *At Baudouine's place this furniture was called the Jenny Lind setts* [sic], *on account of Jenny Linds singing in Castle Garden under Barnums protection at*

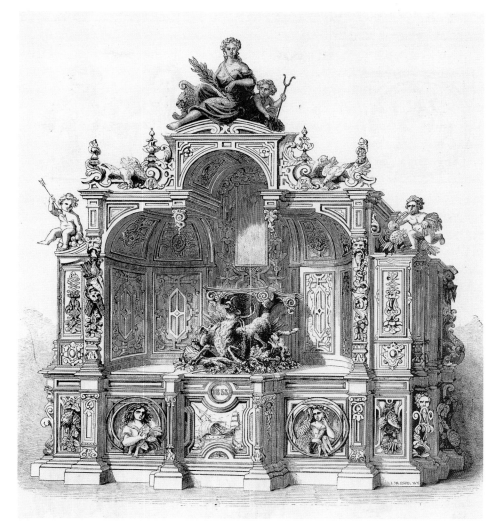

Fig. 258. Gustave Herter, designer; Bulkley and Herter, cabinetmaker; Ernest Plassman, carver, *Buffet.* Wood engraving by John William Orr, from B. Silliman Jr. and C. R. Goodrich, eds., *The World of Science, Art, and Industry Illustrated from Examples in the New-York Exhibition, 1853–54,* (New York: G. P. Putnam and Company, 1854), p. 168. The Metropolitan Museum of Art, New York, The Thomas J. Watson Library

*the time. This furniture was all the style at that time amongst the wealthy New Yorkers. He used to get 1200 a sett. They were generally covered in large flowered silk brocades or brocatelle.*[186]

The Jenny Lind fad started before her arrival in America and continued for several years after her departure. Henry L. Ibbotson, the New York agent for the English papier-mâché manufacturer Jennens, Bettridge and Sons, advertised "folios bearing facsimile likenesses of Jenny Lind, taken from the original," several months before the singer even arrived. In reporting on the manufacture of fifty thousand pianofortes in New York the previous year, the *Home Journal* predicted, a few days after the Castle Garden concert, that "the Jenny Lind furor will probably very greatly increase the demand for pianos this year." Ibbotson's competitor, W. R. Fullerton, announced in 1851 that the Jenny Lind Cabinet and Bride-Work Tables "would amply repay one for a visit" to his "Papier Mache Ware-Room." The next year, the Ornamental Iron Furniture company listed Jenny Lind sewing chairs among its products.[187]

The magnanimous Lind donated $10,000 of the proceeds of her Castle Garden concert to charities, including $3,000 to the Fire Department Fund to benefit widows and orphans. To express their gratitude, the firemen presented her with a copy of the resolutions they had passed in her honor, housed in an elaborately engraved box made of California gold, along with a specially bound set of John James Audubon's seven-volume *The Birds of America* (New York, 1840–44; cat. no. 239; fig. 176). The firemen commissioned Thomas Brooks of Brooklyn, rather than any of the Broadway cabinetmakers, to make a rosewood tabletop bookcase to hold the volumes (cat. no. 238). Visible through glass-paneled doors, the books are separated from one another by turned ivory columns. There are two allegorical figures at the top, on either side of a silver presentation plaque; one, holding a lyre and a paper scroll, represents Music and the Genius of Song; the other, resting on

length. . . ." Isabella Lucy Bird, *The Englishwoman in America* (1856; reprint, Madison: University of Wisconsin Press, 1966), p. 333.

191. The illustrations were engraved under the supervision of Carl Emil Doepler, from daguerreotypes by H. Whittemore; the names of the engravers, for the most part, accompany each image. A comparison of illustrations with exhibited pieces that have survived attests to their accuracy. I thank my colleague Jeff L. Rosenheim for bringing the daguerreotype sources for the illustrations to my attention.

192. Hagen recalled that "gorgeous heavy carvings" were the style about 1855–56. Ingerman, "Personal Experiences," p. 579.

193. Silliman and Goodrich, *World of Science, Art, and Industry,* p. 169.

194. R. G. Dun and Company report, September 12, 1854 (New York Vol. 191, p. 451). R. G. Dun & Co. Collection, Baker Library, Harvard University Graduate School of Business Administration.

195. Apparently, Herter and Bulkley showed additional pieces. See "The Crystal Palace," *Morning Courier and New-York Enquirer,* July 27, 1853, p. 3.

196. See Thomas Chippendale, *The Gentleman and Cabinet-Maker's Director,* 3d ed. (London: Printed for the author, 1762; reprint, New York: Dover Publications, 1966), pl. C. See also Voorsanger, "From Bowery to Broadway," pp. 61, 64–65, 244. Clive Wainright pointed out that John Weale reprinted Chippendale's designs in England as early as 1834. By 1836 Weale had published *Chippendale's One Hundred and Thirty-three Designs . . .* (London: J. Weale, 1834), as well as other reprints of eighteenth-century pattern books. See Clive Wainright, "The Dark Ages of Art Revived, or Edwards and Roberts and the Regency Revival," *Connoisseur* 198 (1978), pp. 95–105.

197. There are two women flanking the salient center bay: one (proper right) holding a painter's palette and a brush (damaged); the other (proper left), a lyre and a sheet of music. At each corner there is a male figure, one (proper right; fig. 257) holds a sculptor's mallet and a finishing chisel (damaged); the other (proper left) holds an architectural model of

a cathedral and a drawing implement.

198. The anonymous carver, no doubt an immigrant craftsman, could have been Herter himself, or may have been Ernst Plassman, who is associated with another of Herter's exhibition pieces. See note 201 below.

199. See Silliman and Goodrich, *World of Science, Art, and Industry,* p. 93, for an illustration and mention of Herter's responsibility for the design. In their text, Silliman and Goodrich describe this and the other example displayed by Brooks as rosewood étagères (pp. 12, 93), but they list this piece in their table of contents as a rosewood buffet. The *Official Awards of Juries* records Brooks as receiving a bronze medal and special notice for "Excellence of Design and Execution of Walnut Buffet" (presumably the rosewood piece under discussion here), but it omits mention of Herter in conjunction with it. Association for the Exhibition of the Industry of All Nations, *Official Awards of Juries* (New York: William C. Bryant and Co., 1853), p. 58. Curiously, Brooks is not listed at all in Class 26 (Decorative Furniture and Upholstery, including Papier-maché, Paper-hangings and Japanned Goods) in the *Official Catalogue of the New-York Exhibition of the Industry of All Nations, 1853* (New York: George P. Putnam and Co., 1853), pp. 82–85. This illustrates the inconsistency of these sources, which must be used in tandem rather than as individual, authoritative records.

200. For an image of the Fourdinois piece, see Howe, Frelinghuysen, and Voorsanger, *Herter Brothers,* p. 39.

201. Silliman and Goodrich record Herter as the designer of this piece, but they also state that he collaborated on its construction with Ernst Plassman, a sculptor whom they credit with the carving. See Silliman and Goodrich, *World of Science, Art, and Industry,* pp. 168–69, which also states that the buffet was displayed by Bulkley and Herter. Plassman was not mentioned in either the *Official Catalogue,* where Herter alone is recorded as the author of the "richly carved oak buffet," or in the *Official Awards of Juries,* in which he received Honorable Mention for "fine Carving on Oak Buffet."

a cornucopia of flowers and holding coins in her extended hand, represents Charity.[188]

On July 14, 1853, with the opening of the New-York Exhibition of the Industry of All Nations, Brooks and other New York cabinetmakers had an opportunity to exhibit their furniture in an international forum. This world's fair, the first in the United States, was held in the Crystal Palace, a domed cast-iron-and-glass building, cruciform in plan, that was situated on Reservoir Square (behind the distributing reservoir of the Croton Aqueduct, between Fortieth and Forty-second Streets, now Bryant Park; see cat. nos. 141, 142, 179). In the scope of its international displays and in its stated mission to educate and edify the public, the fair emulated London's Great Exhibition of 1851, held under the aegis of Prince Albert. (It was approximately one third the size of the London exhibition, however, and, as a purely private enterprise, received no government support.)[189] Although not a financial success, as the London enterprise had been, the New York Crystal Palace exhibition—and, indeed, the Empire City itself—symbolized the aspirations of a nation seeking its place on the international stage of art and culture.[190] Many of the decorative arts exhibited at the Crystal Palace were illustrated in wood engravings compiled by two scientists, Benjamin Silliman Jr. and Charles Rush Goodrich, who published them in *The World of Science, Art, and Industry Illustrated from Examples in the New-York Exhibition, 1853–54* (New York, 1854). Since these engravings were based on daguerreotypes, they present a remarkably faithful record of the contents of the exhibition, clearly more accurate and detailed in the rendering of textile patterns, carving, and other decorative motifs than would have been the case before the invention of photography.[191]

Most of the American furniture shown at the Crystal Palace was characterized by the "gorgeous heavy carvings" that, in the 1850s, became the hallmark of fine furniture manufactured in the United States, regardless of whether it was Gothic Revival, Renaissance Revival, or a reinterpretation of the styles favored by eighteenth-century French kings.[192] Competitors such as Brooks, Dessoir, Herter, Roux, Ringuet-Leprince and Marcotte, and Rochefort and Skarren (see fig. 102) vied for attention with one extraordinary piece after another, many of them large buffets or bookcases profusely carved with naturalistic ornamentation. Such highly wrought furniture was seen as indicative of a mature and cultivated society and the mark of a world city. As Silliman and Goodrich noted, "The tendency of civilisation is always from plainness to

ornament. . . . The wealth, the manners, the refinement, all that relates to the social condition of a people, may be deduced from the history of their furniture. The condition of commerce, and of the industrial and fine arts, is contained in such a history, and [thus] the mutations of furniture are as important to be known as the changes of governments."[193]

It was at the New York Crystal Palace that Gustave Herter achieved public notice for the first time. The eldest son of a Stuttgart cabinetmaker, he had arrived in America five years earlier, at the age of eighteen, as one of the "Forty-eighters" who escaped political and economic turmoil in Europe by embarking for New York. He seems to have bypassed working in the Lower East Side shops as either a journeyman or an apprentice, for soon after his arrival he was employed as a silver designer for Tiffany, Young and Ellis. The Broadway cabinetmaker Hutchings took notice and introduced Herter to high-end cabinetmaking circles. By 1853, after a brief partnership with Auguste Pottier,

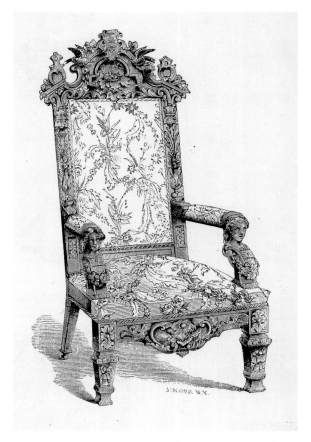

Fig. 259. Julius Dessoir, designer and cabinetmaker, *Armchair.* Wood engraving by John William Orr, from B. Silliman Jr. and C. R. Goodrich, eds., *The World of Science, Art, and Industry Illustrated from Examples in the New-York Exhibition, 1853–54* (New York: G. P. Putnam and Company, 1854), p. 191. The Metropolitan Museum of Art, New York, The Thomas J. Watson Library

who was to become his major competitor after the Civil War, Herter was in business with Erastus Bulkley. He was quickly recognized for his "good abilities as a designer of patterns for rich furniture."[194] From the outset, even though he initially described himself as a sculptor, Herter established himself as a designer rather than as a carver or cabinetmaker per se.

Only twenty-three when the Crystal Palace opened, young Herter was nothing if not ambitious: eager to make his mark, he designed three monumental pieces for the exhibition.[195] Displayed by the newly established firm of Bulkley and Herter, an immense three-bay Gothic-style bookcase in carved oak (cat. no. 241) was awarded a bronze medal for design and workmanship. No one remarked at the time that for the massing and outline of the piece Herter had relied heavily on the example of a Gothic bookcase by the eminent eighteenth-century British cabinetmaker Thomas Chippendale, whose designs had been reprinted by the mid-1830s.[196] Herter did, however,

make the conceit his own by altering many of the details, among them the shape of the glazing pattern on the doors, the number of spires, and the carved decorations on the base. The latter include, standing under Gothic canopies, four fully carved figures in medieval dress that represent the arts of sculpture (fig. 257), painting, music, and architecture.[197] Panels adroitly carved in deep relief are embellished with wreaths of oak leaves and acorns as well as with winding ribbons and leaves that curl around frames fashioned from rustic branches. The whole is a tour de force of the carver's art, although we do not know the identity of the talented artisan who executed the work.[198]

Herter also designed a rosewood étagère that was made and exhibited by Thomas Brooks. Whether Brooks commissioned Herter, or Herter hired Brooks to execute his design is not entirely clear.[199] But his pièce de résistance was a buffet—the form preferred by midcentury cabinetmakers for exhibition pieces

Plassman was possibly responsible for the composition of some carved details. A sketchbook dated 1852–53, still in Plassman family hands, contains sketches of several elements on the sideboard. See Heather Jane McCormick, "Ernst Plassman, 1822–1877: A New York Carver, Sculptor, Designer and Teacher" (Master's thesis, Bard Graduate Center for Studies in the Decorative Arts, 1998), pp. 50–53, figs. 39–43.

202. Silliman and Goodrich, *World of Science, Art, and Industry,* p. 169.

203. Roux (1813–1886) arrived in New York in 1835, according to his death certificate. He started in business as an upholsterer in 1836 (according to the text on his printed labels, and the R. G. Dun and Company credit report of August 12, 1851 [New York Vol. 190, p. 397], R. G. Dun & Co. Collection, Baker Library, Harvard University Graduate School of Business Administration). He was first listed in the city directories in 1837, and listed as a cabinetmaker in 1843. (Doggett's city directory of 1842 listed Roux as an importer at 106 Bowery in the same year Longworth's listed him as an upholsterer at 478 Broadway.) He was recommended highly by Downing in the *Architecture of Country Houses* (1850), which also included several illustrations of furniture from Roux's shop. By 1855, Roux was one of the pre-eminent cabinetmakers in New York, as confirmed by the New York State Census, 1855, Special Schedule: Industry Other than Agriculture (New York County, Ward 8, District 1, lines 27–33, enumerated July 5, 1855), which reported that he had $20,000 in real estate, $3,000 in machinery and $30,000 in raw materials, and produced an annual product worth $144,000 while employing 120 men. In 1860, the federal census recorded a substantially larger figure ($200,000) in real and personal estate invested in the business, but a slightly smaller shop (80 men) and annual product ("furniture of all kinds, $100,000"). United States, Census Office, 8th Census, 1860, Products of Industry Schedule, New York City, Ward 8, p. 30. This information is drawn from a chronology prepared by David Sprouls.

Fig. 260. Anthony Kimbel, artist; Bembé and Kimbel, cabinetmaker and decorator, *A Parlor View in a New York Dwelling House.* Wood engraving by Nathaniel Orr, from *Gleason's Pictorial Drawing-Room Companion,* November 11, 1854, p. 300. Courtesy of the American Antiquarian Society, Worcester, Massachusetts

204. Silliman and Goodrich, *World of Science, Art, and Industry,* pp. 162–63. As illustrated, Roux's black walnut sideboard had mirrored panels behind the shelves. Three related sideboards are known: the mate to this one, in the Newark Museum; a rosewood version with white marble, in the Art Institute of Chicago; and an identical oak model, with rose-colored marble, in a private collection.

205. Joseph Jeanselme, a noted Parisian cabinetmaker, showed a related example at the 1849 Paris Industrial Exposition. It is illustrated in J. M. W. van Voorst tot Voorst, *Tussen Biedermeier en Berlage: Meubel en Interieur in Nederland, 1835–1895,* 2d ed., 2 vols. (Amsterdam: De Bataafsche Leeuw, 1994), vol. 2, p. 662. In 1844, at the same exhibition, Ringuet-Leprince had shown a rectilinear version of the form, which was published by Désiré Guilmard in *Le Garde-meuble, album de l'exposition de l'industrie* (Paris, 1844), pl. 11. Roux followed Ringuet's 1844 model closely in a sideboard now in a private collection; see Eileen Dubrow and Richard Dubrow, *American Furniture of the 19th Century, 1840–1880* (Exton, Pennsylvania: Schiffer Publishing, 1983), p. 168. Seymour Guy's 1866 painting *The Contest for the Bouquet: The Family of Robert Gordon in Their New York Dining Room* (Metropolitan Museum, 1992.128) illustrates a similar sideboard in the home of a founding trustee of the Metropolitan; see *Metropolitan Museum of Art Bulletin* 50 (fall 1992), pp. 54–55.

206. See Kenneth L. Ames, *Death in the Dining Room and Other Tales of Victorian Culture* (Philadelphia: Temple University Press, 1992), pp. 44–96.

207. *Official Awards of Juries,* p. 58.

208. Pairs of sideboards are extremely unusual in post-Federal American dining rooms; this one may be unique to the 1850s. The Metropolitan's sideboard is not marked, but it can be identified by its close similarity to the wood engraving published by Silliman and Goodrich, *World of Science, Art, and Industry,* pp. 162–63. The Newark piece (92.72), the motifs of which were a departure from the canon, bears an impressed mark (A. Roux) on the top edge of one of the front drawers. The nineteenth-century provenance of the sideboards is not yet

(see cat. no. 243; fig. 102)—that was imposing both in its architectural scale and in its baroque verisimilitude. The iconography of this piece (fig. 258) was drawn from imagery of the hunt, the harvest, and the sea, motifs commonly used in dining rooms from the mid-nineteenth century on. What appears to have been a nearly lifesize stag, writhing beneath the attack of a hunting dog, is carved in the round and set inside an altarlike niche, the centerpiece of the composition. Birds and allegorical figures of plenty—Ceres holding a sheaf of wheat and two small putti perched, respectively, on piles of peaches and pineapples—are positioned on the crest, while three deeply sculpted reserves along the base are decorated with marine motifs.

This grandiose oak buffet was a calculated riposte to its show-stopping predecessor, a sideboard similar in scale and themes that was displayed at the London Crystal Palace exhibition by Alexandre-Georges Fourdinois, a prodigious Parisian cabinetmaker much patronized by Napoleon III and Eugénie, newly crowned as emperor and empress of France.[200] Herter did not hesitate to measure himself against Fourdinois, knowing that his own reputation would be enhanced by the comparison.[201] In describing this piece, Silliman and Goodrich remarked on the transformation of American furniture by European designers and craftsmen, "citizens by adoption," who, like Herter, brought with them the benefits of artistic education and training, supplemented by familiarity with "good models" of decorative art. In their minds, Herter's buffet "mark[ed] an era in our social existence—the transition period when the domestic appointments of our fathers are being replaced by the costly and elaborate furniture of Europe."[202]

Like Herter, Alexander Roux was a citizen by adoption who capitalized on his European heritage. But unlike Herter, by the time of the 1853 exhibition, Roux had been in America for close to twenty years and was already well established on Broadway, advertising himself as a French cabinetmaker.[203] He gauged his potential clientele differently than Herter did, displaying among several pieces of furniture a black walnut sideboard in the French Renaissance style (cat. no. 243 is a version of this piece), which while lavishly carved was also eminently practical. Modest in scale—a mere seven and a half feet high—the sideboard was "not too large for the use and style of moderately wealthy families."[204] This form, featuring a superstructure of shelves placed on a cabinet base, was called a *buffet étagère* in French (and dubbed an "étagère sideboard" by Downing). An invention of

the mid-nineteenth century, the type gained popularity in America about 1853 and remained a nearly ubiquitous feature in upper-class dining rooms for nearly a quarter century.[205] A stag's head framed by the heads of snarling dogs crowns the piece, while similar dogs' heads top the S-shaped scrolls supporting the lower shelf. At the sides, bold C and S scrolls are lined with wheat ears and cattails, and adorned with pendent clusters of plump, clearly defined fruits and vegetables. On the center doors, trophies of the hunt and the sea—three game birds and a hare on one, bass intertwined with a lobster, an eel, and a brace of oysters on the other—are sculpted in high relief. Although such motifs are typical of midcentury sideboards, these are distinguished by superb carving and bounteous details.[206] The jurors at the fair (William Gibson, a stained-glass maker; George Platt, an interior decorator; and John Sartain, an engraver) awarded Roux a bronze medal and "special notice" for "General Excellence in Carved and Upholstered Furniture."[207]

Among its contemporaries, the sideboard shown here is rare not only for its quality, early date, and firmly documented maker, but also because it was one of a pair, which suggests a special commission from a wealthy client, perhaps someone who had visited Roux's exhibit at the Crystal Palace. Its mate, now in the Newark Museum, is identical in form but differs in certain details. A steer's head framed by blossoms and sheaves of wheat and cattails replaces the stag and dogs at the top, for example, and the bouquets of fruits, vegetables, nuts, and berries vary slightly throughout. When paired, the sideboards contrast the untamed forest with the cultivated landscape and allude as well to the four seasons: the hunt sideboard representing fall and winter, the other the harvest months of spring and summer.[208]

Julius Dessoir, a neighbor of Roux and Herter on Broadway, has until now been best known by an engraved illustration in Silliman and Goodrich of an armchair in the Louis XIV style (fig. 259), which, as the official catalogue confirms, was one of a pair en suite with a sofa that the cabinetmaker displayed along with other pieces at the Crystal Palace.[209] Miraculously, the suite remained intact over the intervening years and was given to the Metropolitan Museum in 1995 (cat. no. 240A–C); it is presented publicly for the second time in this exhibition. Commended by Silliman and Goodrich for carving that was executed with taste and spirit,[210] this suite represents Dessoir's most ambitious work and constitutes a rare surviving example of Louis XIV Revival furniture manufactured in the United States. The tall backs, relatively

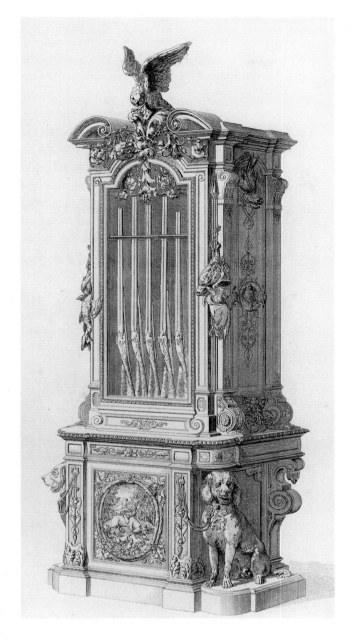

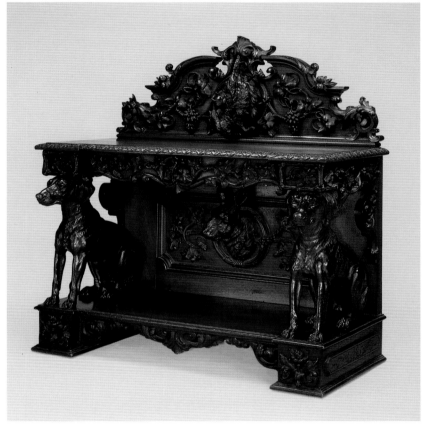

Fig. 261. Michel Liénard, designer; Jeanselme and Son, cabinetmaker, *Louis XIII Gun Case in Oak,* exhibited at the Exposition Universelle, Paris, 1855. Wood engraving, from J. Braund, *Illustrations of Furniture, Candelabra, Musical Instruments from the Great Exhibitions of London and Paris, with Examples of Similar Articles from Royal Palaces and Noble Mansions* (London: J. Braund, 1858), pl. 3. The Metropolitan Museum of Art, New York, The Thomas J. Watson Library

Fig. 262. Attributed to Alexander Roux, Sideboard, 1855–60. Black walnut. Brooklyn Museum of Art, Gift of Benno Bordiga, by Exchange 1995.15

low seats, trapezoidal legs, and densely carved rosewood are aspects identified with the style. Each chair is embellished with expertly carved Rococo scrolls, cartouches, and flowers, as well as a crest on which a pair of sculpted birds flank a nest containing their fledglings. Fully carved youths and smaller putti entwined in leafy arabesques are among the elements that distinguish the sofa.

The suite is also remarkable in that each of its pieces retains its original underupholstery—an aspect of nineteenth-century American seating furniture that is so often carelessly destroyed—and thus presents a completely accurate profile. The showcover has been chosen to capture the spirit of the floral pattern on the original textile, as shown in the illustration published by Silliman and Goodrich. Although its green color

may be a surprise to some, because so much mid-nineteenth-century furniture has been reupholstered in red or purple, there is ample period documentation to support the choice. Small fragments on the Dessoir suite testify to an original showcover in sea-foam green and the contemporaneous seating furniture acquired in 1852 by James Williams from Baudouine (fig. 253) was covered in "green tapestry," according to the bill of sale. In 1854 Michel-Eugène Chevreul's seminal research into color theory, initially published in France in 1839, was issued in English for the first time, as *The Principles of Harmony and Contrast of Colours.* Chevreul's influential theories favored a palette that seems already to have been in use. The fashion editor of *Peterson's Magazine* reported in 1855 that vivid reds, cherry and orange-reds—such as scarlet, nacarat,

clear. In 1984 they were sold at auction from a house in Newport, Rhode Island, called Lansmere and were purchased by Paul Martini, a New York dealer, who sold them to Margot Johnson, who in turn placed them in their respective museums.

209. Born in Prussia in 1801, Dessoir came to America sometime between 1835 and 1841. He is listed in the city directories for the first time in 1842, as a cabinetmaker working at 88 Pitt Street. For a short while, between 1843 and 1845, he was at 372 Broadway. By 1845, and until 1851, he was located at 499 Broadway, and from 1851 until 1865, at 543 Broadway, adjacent to Belter and to

Herter, who moved to Belter's building, at 547 Broadway, in 1854. Dessoir ceases to be listed in 1866, apparently having moved to Greenburgh, New York, in Westchester County, where he died in 1884. This information is drawn from a chronology prepared by Julia H. Widdowson. See also Howe, Frelinghuysen, and Voorsanger, *Herter Brothers,* pp. 64–65.

In 1853 Dessoir also showed a bizarre octagon table with mermaidlike caryatid supports, paired rams on the apron, grotesques on the base, and lion's-head feet, along with a much-praised rosewood bookcase that is vacuous in comparison with Herter's; both were illustrated in Silliman and Goodrich, *World of Science, Art, and Industry,* pp. 175, 173, respectively. He also exhibited library and console tables that were not illustrated.

210. Silliman and Goodrich, *World of Science, Art, and Industry,* p. 191. (The authors state that the wood was black walnut.)

211. "Colors in Furniture," *Peterson's Magazine* 27 (1855), pp. 218–19. Fragments of the original showcover indicate an early form of tapestry weave, probably manufactured in northern France or in England. Nancy C. Britton deserves special thanks for her scholarly contribution to the choice of the replacement showcover, as well as for her masterly reupholstering of these pieces. I am also grateful to Mary Schoeser for her research on 1850s furnishing fabrics in England.

212. Henry Ashworth, *A Tour in the United States, Cuba, and Canada . . .* (London: A. W. Bennett, 1861), p. 10.

213. Charles Richard Weld, *A Vacation Tour in the United States and Canada* (London: Longman, Brown, Green and Longmans, 1855), p. 367.

214. It is not clear what Kimbel was doing in New York between 1851 and 1854; it is possible, even likely, that he worked for Baudouine until establishing his own firm in February 1854. Were this the case, Baudouine's seemingly abrupt decision to close his shop in May 1854 might have been prompted by the loss of his chief designer. Bembé died in 1861, and the next year Kimbel formed a partnership with Joseph Cabus. Their firm, Kimbel and Cabus,

and aurora—for decades the most popular colors for furniture fabrics and carpets (see cat. no. 13) were now to be proscribed because they competed with the colors of mahogany and rosewood, whereas light green, by virtue of its being in contrast, was complementary not only to reddish woods but also to gilding and to complexions, whether pale or rosy. "We must assort rose or red-colored woods, such as mahogany, with green stuffs; yellow woods, such as citron, ash-root, maple, satin-wood, &c., with violet or blue stuffs; while red woods likewise do well with blue-greys, and yellow woods with green-greys. . . . Ebony and walnut can be allied with brown tones, also with certain shades of green and violet." "Just now," the editor told the reader, ". . . rose-wood sofas and chairs, covered with green cloth, are all the rage; and drawing-rooms are filled with this style, irrespective of the color of the carpet, the paper hangings, or the curtains."[211]

By the mid-1850s furniture such as the Dessoir suite would have been used in a drawing room on lower Fifth Avenue, by then the most desirable residential district. The Italianate style, with its attendant allusions to Renaissance nobility, had replaced Grecian as the favorite choice for a residence. Houses were considerably larger than they had been twenty years earlier, and travelers to New York in the 1850s and early 1860s often remarked on the magnificence of the city's mansions. One recalled visiting a drawing room (or perhaps a ballroom) that was 135 feet long; many commented on the "lavish outlay" typically expended by the inhabitants.[212] "The power of wealth here, is abundantly conspicuous," English barrister Charles Richard Weld recounted in 1855. "Every quarter of the globe has been subsidised to minister to the gratification of the merchant prince, who, despite his professions, is no longer the simple republican trader."[213] Rosewood furniture in the Rococo Revival (or "Old French") styles was considered the height of luxury for New York drawing rooms in the mid-1850s, as evidenced by a rare depiction of such a parlor from "the magnificent mansion up town of one of the most eminent . . . merchants," drawn and published in 1854 by Anthony Kimbel, an up-and-coming young cabinetmaker on Broadway (fig. 260). Kimbel, from a distinguished family of cabinetmakers, upholsterers, decorators, and furniture dealers in Mainz, Germany, apprenticed with Fourdinois and Guilmard in Paris before coming to New York about 1847. With this background, it is not surprising that he became the principal designer for Baudouine, for whom he worked from about 1848 until at least 1851. Helped by financial

backing from Anton Bembé, his uncle and partner in Germany, Kimbel established Bembé and Kimbel early in 1854, and later that year, through his drawing, showed the public what his new company could provide.[214] The interior was extolled for being a fitting abode for a man of refinement, and the furniture—executed in a kinetic, curvilinear Louis XV Revival style that, not surprisingly, relates to contemporary German designs—was praised as the production of a master hand. The author of the commentary accompanying the image observed that, in Bembé, the firm had "the advantage of an eminent European connection" but also astutely remarked that although the New York branch received all the newest European designs as soon as they appeared, "the furniture . . . manufactured . . . by Bembé and Kimbel, No. 56 Walker Street, is not altogether French in design. . . . Mr. Kimbel['s] . . . unique styles appear to be American modifications of those now in vogue abroad."[215]

This observation can be applied equally to nearly all the high-style New York furniture from this period. The Broadway cabinetmakers, most of them Europeans by birth and training, were well aware of current fashions, but, in the last analysis, furniture made in New York can rarely be mistaken for its French or English counterparts. While the Litchfield family's Parisian center table (cat. no. 244) is splendid in its gilded surface and dove gray marble top, it would not be confused with its American cousin, Roux's rosewood étagère (cat. no. 246), which is, notably, not gilded and is more richly and densely carved.[216] Similarly, although many contemporary European sofas share the general outline of Belter's elaborate rosewood sofa (cat. no. 245), few can match its Rococo Revival exuberance—carved flowers and arabesques erupt from a basket set within a dynamically undulating crest rail—or the magnificent refinement of its thin, laminated structure.[217] The extraordinary carving on a resplendent fire screen with an imported needlework panel by a yet unknown maker (cat. no. 247) almost assuredly was done in New York. The sculpted vines that wind sinuously around the standards at either side of the screen and across the crest are certainly as fine as anything of the type produced in Europe at the time. Similarly, the cabinetmaker responsible for the casework on a magnificent piano made by Nunns and Clark in 1853 (cat. no. 242) is unknown, but the masterly naturalistic carving is tangible evidence that the shop was one of the best in the business.[218]

Just at the time the Rococo Revival reached its apogee in New York, the Exposition Universelle, held in Paris in 1855, introduced new interpretations

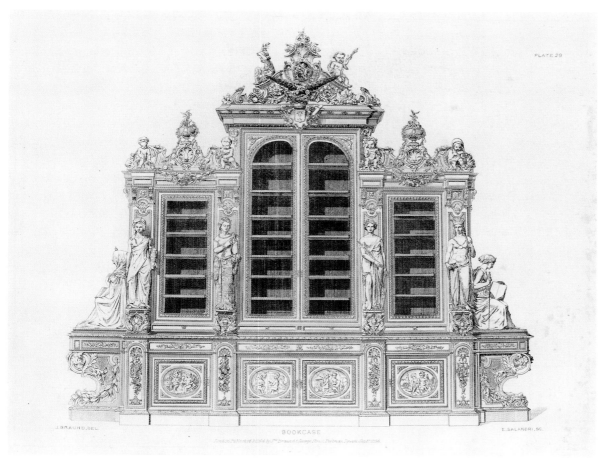

Fig. 263. Beaufils, cabinetmaker, *Renaissance Library Bookcase, Carved in Walnut*, exhibited at the Exposition Universelle, Paris, 1855. Wood engraving, from J. Braund, *Illustrations of Furniture, Candelabra, Musical Instruments from the Great Exhibitions of London and Paris, with Examples of Similar Articles from Royal Palaces and Noble Mansions* (London: J. Braund, 1858), pl. 29. The Metropolitan Museum of Art, New York, The Thomas J. Watson Library

of furniture forms, styles, and decoration that would resonate in the work of American cabinetmakers well into the next decade. Access to the visual record of the exhibition was no doubt abetted by the publication of numerous illustrations of pieces in the exhibition in John Braund's *Illustrations of Furniture, Candelabra, Musical Instruments from the Great Exhibitions of London and Paris* (London, 1858). Braund, an Englishman who in his preface identified himself as a furniture designer, envisioned his forty-nine plates as "subjects for the study of the artist in ornamental design, and as examples for the manufacturer to imitate, or improve."[219] His plate 7, for instance—a Louis XVI "Buhl" cabinet "in ebony and brass, mounted in or-molu," with gilt-bronze figural mounts and an oval plaque depicting Hercules with Cerberus, exhibited by "Charmois" (probably Christophe Charmois) in 1855—may have served as inspiration for a series of cabinets with metal plaques depicting Orpheus made by Herter between 1858 and 1864.[220] Much of the furniture at the exposition,

however, still incorporated the literal naturalism that was characteristic of the 1850s.

Braund chose not to illustrate Fourdinois's massive hunt sideboard from the 1851 London exhibition, regardless of its notoriety, perhaps because the conception did not have much practical domestic application. However, the mastiffs on Fourdinois's piece are the antecedents of the full-size hunting hounds on a piece that he did picture—a gun cabinet in the so-called Louis XIII style that was designed by Michel Liénard, manufactured and displayed at the Paris exposition of 1855 by Jeanselme and Son, and purchased by Empress Eugénie for Napoleon III (fig. 261).[221] The Jeanselme cabinet, in turn, may have inspired the canine sentinels on a black walnut server (fig. 262) that is attributed to Roux on the basis of its American woods (and perhaps because of the sense of humor shown by the cabinetmaker). Unaware of the proximity of their prey, the dogs stand at rapt attention, staring forward into space, while the rabbit, rendered totally out of scale—perhaps to indicate that it looms large in the

became known for furniture in the Modern Gothic style after the Civil War.

215. "A Parlor View," *Gleason's Pictorial Drawing-Room Companion*, November 11, 1854, p. 300.

216. Almost no gilded furniture is attributed to New York (or American) cabinetmakers of the 1850s. Two gilded, laminated rosewood sofas attributed to J. H. Belter are in the Virginia Museum of Fine Arts, Richmond, but the gilding is almost certainly a later nineteenth- or early twentieth-century addition. For an illustration of one sofa, see Cynthia Van Allen Schaffner and Susan Klein, *American Painted Furniture, 1790–1880* (New York: Clarkson Potter Publishers, 1997), p. 95.

217. John [Johann] H. Belter was born in 1804 in the village of Hilter (in the jurisdiction of Iburg) in the kingdom of Hannover, located in northwestern Germany near the Dutch border. He emigrated to the United States in 1833, became a naturalized citizen in 1839, and was first listed as a cabinetmaker in New York in 1844, at 40½ Chatham Street. The 1846 directories list him at 372 Broadway until 1853–54, when he moved to no. 547, where he stayed only through 1855. Belter's German passport and certificate of naturalization are among the papers cited in note 25 above. See also Ed Polk Douglas, "The Belter Nobody Knows," *New York–Pennsylvania Collector*, October 1981, pp. 11–12, 14–16; and Ed Polk Douglas, "The Furniture of John Henry Belter: Separating Fact from Fiction," *Antiques and Fine Art*, November–December 1990, pp. 112–19.

218. Nunns and Clark exhibited a piano, not illustrated in Silliman and Goodrich, at the Crystal Palace exhibition of 1853. Given the elaborate casework on this piece (as well as the materials used in the keyboard), it is thought that this piano might be that submission; it is clearly an exhibition piece. See Laurence Libin, "Keyboard Instruments," *Metropolitan Museum of Art Bulletin* 47 (summer 1989), p. 47.

219. J. Braund, *Illustrations of Furniture, Candelabra, Musical Instruments from the Great Exhibitions of London and*

*Paris, with Examples of Similar Articles from Royal Palaces and Noble Mansions* (London: J. Braund, 1858), preface (dated February 1856).

220. See Voorsanger, "Gustave Herter," p. 744, for an illustration of one of these.

221. Liénard is credited with the design of the Jeanselme and Son gun case by Denise Ledoux-Lebard, *Le mobilier français du XIXᵉ siècle, 1795–1889: Dictionnaire des ébénistes et des menuisiers* (Paris: Les Éditions de l'Amateur, 1989), p. 376. At least one other case piece in the 1855 Paris Exposition Universelle, a Renaissance-style "*buffet dressoir*" by Pierre Ribaillier and Paul Mazaroz, which was also purchased by Napoleon III, similarly utilized large sculpted hunting dogs as part of the composition. For an illustration, see Braund, *Illustrations of Furniture*, pl. 1.

222. *Ballou's Pictorial Drawing-Room Companion*, September 20, 1856, p. 188, discusses the "Gladiatorial Table" (a table supported by a carved figure of a nude gladiator holding a sword) that had been displayed at the London Crystal Palace in 1851 by J. Fletcher of Cork: "The introduction of sculpture in various forms into our drawing-rooms is a revival of the ancient classic taste, . . . Beautifully carved book-cases and buffets are now very common in our fashionable houses. Not many years since all such articles were imported from abroad, but now, in all our great cities there are manufacturers of these articles, and our American forests furnish an inexhaustible supply of material for them."

See also Howe, Frelinghuysen, and Voorsanger, *Herter Brothers*, p. 159 (the large carved dogs that served as fireplace guardians). This woodwork in Thurlow Lodge (1872–73), a Herter Brothers commission in Menlo Park, California, was once assumed to be by Herter Brothers. Rediscovered in San Francisco, where it remained throughout the twentieth century, the chimneypiece is clearly marked by Guéret Frères, a Parisian firm.

223. Burrows and Wallace, *Gotham*, p. 846.

224. "Removing upstairs" is mentioned in an advertisement placed by the auctioneer in the *New York Herald* on

Fig. 264. Édouard Baldus, *Detail of the Pavillon Rohan, Louvre, Paris,* ca. 1857. Salted paper print from glass negative. École Nationale Supérieure des Beaux-Arts, Paris  PH3782

minds of its predators—looks on from the center of the backboard behind them; the rabbit's ultimate destiny, however, is reflected in the dead game suspended from the backsplash at the top of the piece. Furniture with sculpted figures such as these was acknowledged to be au courant by the American press, although American furniture with animals rendered in lifesize (or greater than lifesize) proportions is rare.[222]

The economic panic of 1857, which affected virtually everyone in New York, must have wreaked havoc with cabinetmakers' businesses, even if only temporarily. (Horace Greeley, editor of the *New-York Daily Tribune*, attributed part of the problem to a foreign trade imbalance caused by New Yorkers' lust for imported luxury goods, including "gaudy furniture.")[223] Although Roux, for example, had stellar credit ratings throughout the 1850s, in November 1857 he held a large auction sale to liquidate his entire stock "on account of removing upstairs"; the accompanying catalogue published by the auctioneer, Henry H. Leeds, lists over five hundred objects.[224] On the other hand, Bembé and Kimbel seemed to have survived in good form, thanks perhaps to the substantial wealth of the remote partner; moreover, in 1857 the firm was commissioned to make carved armchairs for the House of Representatives to the

design of Thomas Ustick Walter, architect of the United States Capitol.

The year 1858 marked a turning point, even though the economy had not yet fully recovered. Roux took on his foreman, Joseph Cabus, as a partner, although the association was short-lived.[225] Dessoir began to advertise that he was "also prepared to take orders for Interior Decorations, such as Stationary Bookcases, Wood Mantles [*sic*], Pier and Mantle Frames, Wood Chandeliers and Brackets, Figures for Newel Posts or Alcoves, &c., in every variety of Woods." George Platt, who had long since been in "decorations" (vending wallpapers and window shades, in particular, in addition to furniture, picture frames, and mirrors), ran a similar advertisement adjacent to Dessoir's in the same publication, in which he listed decorative painting, paneling, and cabinetwork as well as his other stock. He was feeling the heat of "strong competitors . . . [who] interfere materially with his bus[iness] . . ." the Dun report stated in 1858; moreover, he was "not popular." On the same page, Roux also announced the enlarged scope of his offerings, and that he was similarly ready to "execute all orders for the Furnishing of Houses," including architectural woodwork, ". . . in the best manner and at the lowest rates."[226] Meanwhile, Hutchings was "trying to get out of the bus. [and] . . . retire," although in the end he persevered and recovered financially.[227]

In 1858 Herter decided to establish his own firm, dissolving his partnership with Bulkley by mutual consent. Although not many specific details are known about Herter's activities between 1853 and 1858, he had clearly been successful in making contacts with the right architects and with wealthy clients. "Whoever selected the furniture deserves high praise for it, as well as the man who made it," *The Crayon* stated in August of that year in a squib about the Italianate house that Richard Upjohn had designed for Henry Evelyn Pierrepont in Brooklyn (see cat. no. 103). "It is said to have been furnished by Herter. We have heard of him in other places, and feel safe in predicting that he will make his mark in this country before long."[228] The trade card with which Herter promoted his eponymous firm proclaimed that he could do it all, manufacturing not only "decorative furniture" but also "fittings of banks and offices."[229]

The exact circumstances of Herter's commission to decorate the entire Italianate mansion belonging to Ruggles Sylvester Morse and his wife, Olive, in Portland, Maine (designed by Henry Austin of New Haven), are not precisely known, although it may well have been the assignment that inspired Herter to start

Fig. 265. Gustave Herter, designer and cabinetmaker; E. F. Walcker and Company, Ludwigsburg, Germany, manufacturer, Six-thousand-pipe organ for the Boston Music Hall, Methuen Memorial Music Hall, Methuen, Massachusetts, 1860–63. Black walnut. Courtesy of *The Magazine ANTIQUES*

his own business.[230] Known today as Victoria Mansion, the Morse-Libby House, the building is intact, with most of its original furnishings, carpets, French passementerie, gas lighting fixtures, French porcelains, silver, and stained glass, and many paintings and sculpture. With more than one hundred examples of furniture and fixtures attributed to or supplied by Herter's workshop, the mansion is an extraordinary time capsule of high-style interior decor dating to about 1860.[231]

Herter was fully conversant with the most fashionable styles of interior decoration under the Second

November 5 and 7, 1857, probably meaning that Roux was contracting his space and giving up his street-level sales room. Henry H. Leeds, auctioneer, *Catalogue of Rich Cabinet Furniture Comprising a Large and Rich Assortment of Rosewood, Walnut, Oak, Buhl, and Marqueterie, at Alex. Roux & Co., 479 Broadway* (sale cat., New York: Henry H. Leeds and Co., November 11–12, 1857).

225. R. G. Dun and Company reported on December 14, 1858, that Cabus had "lately" become a partner with a small interest in the firm. Roux was said to be worth $75,000 and the business was deemed profitable, with excellent credit, and doing good business with the "best class of customers" (New York Vol. 190, p. 397), R. G. Dun & Co. Collection, Baker Library, Harvard University Graduate School of Business Administration. A subsequent report (recorded on the same page), in 1860, notes the dissolution of Roux and Cabus's partnership from the business. In 1862 Cabus joined Anthony Kimbel to form Kimbel and Cabus (1862–82).

226. Dessoir, Platt, and Roux, advertisements, *The Albion*, November 20, 1858, p. 564. R. G. Dun and Company report on Platt, October 18, 1858 (New York Vol. 367, p. 364), R. G. Dun & Co. Collection, Baker Library, Harvard University Graduate School of Business Administration.

227. R. G. Dun and Company report, February 27, 1858 (New York Vol. 190, p. 398), R. G. Dun & Co. Collection, Baker Library, Harvard University Graduate School of Business Administration. Earlier in 1857 the same company had reported that Hutchings had "removed his wareroom to the 2nd floor of the building, the 1st floor is being altered for other bs. . . ." R. G. Dun and Company report, June 24, 1857, ibid. The information on Platt and Hutchings cited here is drawn from chronologies prepared by Medill Higgins Harvey.

228. "Sketchings. The Residence of H. E. Pierrepont, Esq. Brooklyn," *The Crayon* 5 (August 1858), p. 236.

229. For an illustration, see Howe, Frelinghuysen, and Voorsanger, *Herter Brothers*, p. 80.

230. Arlene Palmer has surmised that during a trip to New York

in June 1858, Ruggles and Olive Morse commissioned Herter to decorate their new home. See Arlene Palmer, *A Guide to Victoria Mansion* (Portland, Maine: Victoria Mansion, 1997), p. 9.

231. Although nothing can equal a visit to the mansion itself, see Howe, Frelinghuysen, and Voorsanger, *Herter Brothers,* pp. 128–38; Susan Mary Alsop, "Victoria Mansion in Maine: Preserving a Rare Gustave Herter Interior," *Architectural Digest* 51 (September 1994), pp. 46, 50, 52, 54, 56; Voorsanger, "From Bowery to Broadway"; Arlene Palmer, "Gustave Herter's Interiors and Furniture for the Ruggles S. Morse Mansion," *Nineteenth Century* 16 (fall 1996), pp. 3–13 (and cover); Palmer, *Victoria Mansion.*

232. For more on this iconography, see Hugh Honour, *The European Vision of America* (exh. cat., Cleveland: Cleveland Museum of Art, 1975). For an alternate interpretation, see Palmer, "Herter's Interiors," p. 10. Prior to its publication in Braund, *Illustrations of Furniture,* pl. 29, the Bordeaux cabinet was singled out in an American periodical, "Taste in the Manufactures of Paris," *The Albion,* July 28, 1855, p. 353. The author commented, "The tendency of French designers to deal in the extravagant has been undoubtedly fostered and developed under the Empire. At the present time, to be costly is to be fashionable. . . . The present Exhibition is an evidence of this craving for gold and marble; . . . for furniture, at once uncomfortable and dazzling. The Bordeaux bookcase, carved in solid wood, is perhaps the only simple piece of French furniture in the Universal Exhibition."

233. See Malcolm Daniel, *The Photographs of Edouard Baldus* (exh. cat., New York: The Metropolitan Museum of Art, 1994).

234. Braund, *Illustrations of Furniture,* pls. 15, 18.

235. I thank Robert Wolterstorff, Director, Victoria Mansion, for this observation.

236. With regard to post-1860 British furniture, see Christopher Wilk, ed., *Western Furniture, 1350 to the Present Day, in the Victoria and Albert Museum* (New York: Cross River Press, 1996), pp. 164–65.

Empire in France, where the taste of Empress Eugénie held sway. Accordingly, and setting a standard that his firm followed for the next two decades, Herter employed the ivory-and-gold palette favored in France for the walls and woodwork of the drawing room; this was augmented by gilded mirrors and soft pastel tones in the imported carpet, silk-satin draperies, and decorative wall and ceiling paintings in the style of Louis XV. In striking contrast, opulent dark rosewood highlighted with gilding was used for the window cornices and furniture. The original champagne-colored silk upholstery punctuated by scarlet tufting buttons embroidered with gold thread on the seating furniture was trimmed with complex French passementerie (gimp and fringes) made of silk in gemstone colors.

The rosewood drawing-room furniture, conceived en suite, is unified by carved winged figures on the sofa and armchairs, center table, and console table. Herter modeled the seating furniture on a chair by Fourdinois that was published by Braund in his compendium of 1858 and which is particularly memorable for the little putti forming its arm supports, as well as for its cloven-hoof feet and hairy legs. Continuing this idea, Herter posted larger cherubs—veritable toddlers with protuberant bellies and tasseled headdresses—at the four corners of the center table. On the console table (actually a large pier table), two cabriole front legs terminate in mature female figures, one with thickly plaited braids, the other with unbound tresses, and each with a gilt-bronze turtle on her breast; these recall European allegorical depictions of America as a female Indian warrior, who often holds a tortoise. Given that Herter seems to have known Braund's publication, one of its illustrations (fig. 263), a large bookcase shown in 1855 by the French firm Beaufils from Bordeaux, is particularly relevant in this context. Of the four female figures, emblematic of the four continents, shown on the facade, America (on the far right) is depicted as an Indian with a feathered crown and long braids, and a turtle in her right hand.[232]

The masterpiece of the Morse mansion furniture is the cabinet of figured maple and rosewood that Herter designed for the reception room (shown outside the mansion for the first time in this exhibition; cat. no. 249; p. 286). Here Herter turned to the venerable Renaissance for inspiration; but it was the Renaissance as interpreted by Parisian cabinetmakers of the Second Empire, who witnessed and were clearly influenced by the architectural expansion of the "new" Louvre undertaken by Louis Visconti and Hector Lefuel starting in 1848, under the aegis of Napoleon III. This massive enterprise was well documented in photographs by Édouard Baldus (see fig. 264), and it is possible that American cabinetmakers knew the project firsthand through their travels to Paris.[233] The Herter cabinet's arched pediment (reiterated above the drawer that opens to reveal a small writing surface above the lower cabinet), salient verticality, open shelves, and solid scrolled supports at either side are all compositional devices shared with contemporary French exhibition pieces, such as Guilmard's "Renaissance" oak sideboard shown in 1855 and the walnut "Renaissance" cabinet exhibited by Jeanselme and Son in 1851.[234] Like these, Herter's cabinet is an exhibition piece. As the most elaborate object in the house, it stands alone in splendor in a small room that gives onto the reception room. Successive arched doorways and colorfully painted walls and ceiling create a theatrical framework for the cabinet (see p. 286), which, as it is on a perpendicular axis with the front hall, is one of the first things a visitor sees on entering the house.

Herter created a piece that is uniquely his, despite its similarities to contemporary French examples. His cabinet is striking for its use of the golden bird's-eye maple, which contrasts elegantly with rosewood components, among them beautifully carved caryatids with long hair and exotic, partially gilded headdresses that echo the iconography used in the drawing room; notable also are the gilded earrings on the figures above, which are echoed in the jewel-like drawer pulls on the cabinet.[235] Although maple furniture was not unknown in nineteenth-century America, ebonized wood, mahogany, rosewood, and black walnut had dominated the cabinetmaker's palette between 1825 and 1860. The predominant use of a light-colored wood (*bois clair*) accented by a darker one has antecedents in nineteenth-century French and German cabinetmaking practices and was to become more prevalent in American, and British, furniture after 1860.[236] Herter festooned this architectonic case piece with myriad decorative devices—relief-carved and partially gilded grapevines, ribbons, and a wreath, shapely urns, large rosewood rosettes, animated Renaissance-inspired scrollwork, and gilt-bronze mounts (the rectangular sunflower mount is a particular Herter hallmark) and hardware—all prioritized in a system of primary, secondary, and tertiary decoration that is one of the distinguishing features of his furniture. The oil-on-canvas panel depicting a pastel bouquet on the upper cabinet, used in lieu of a porcelain plaque, and the coquette shown in the marquetry panel below hark back to the era of Fragonard and Boucher. Such an

amalgamation of decorative vocabularies is characteristic of the Second Empire, particularly during the 1860s, but Herter succeeded in interpreting that French language in an entirely original manner.

Herter's work on the Morse mansion was nearly complete by the summer of 1860. The outbreak of the Civil War, in April 1861, interrupted his relationship with Morse, who was a hotelier in New Orleans; Morse remained in the South and did not return to Portland until 1866.[237] It is difficult to calculate the consequences of the war for cabinetmakers in New York, as business papers are virtually nonexistent, reliable accounts are hard to come by, and details gleaned from public records are scant and not always fully illuminating. By 1861 a chapter in American cabinetmaking was closing. Phyfe had died in 1854, Belter would die in 1863. Both Baudouine and Ringuet-Leprince retired once and for all in 1860. Dessoir continued to operate at 543 Broadway until 1865. Joseph W. Meeks retired in 1859, but his brother, John, continued in business until 1863. Upon the death of Bembé in 1861,

Kimbel dissolved his company, starting up again in 1862 with Cabus as his partner. The credit report issued for Roux in 1861, although otherwise excellent, described his business as "slack."[238] Herter's credit report intimated that he would survive the disruption caused by the war by applying himself "strictly to business," the business being making gunstocks for the Union Army.[239] What Dun and Company failed to mention, however, was the commission Herter had received in 1860 to design and manufacture the casework for a monumental six-thousand-pipe organ being made in Germany for the Boston Music Hall Association (fig. 265). The breathtaking product of his endeavor—equivalent in height to a five-story New York town house, gloriously carved in black walnut, and featuring a dozen sculpted herms, each more than ten feet tall—was at once a testament to the level of accomplishment achieved by cabinetmakers of the Empire City and a harbinger of the grandiloquent ambitions that would define the metropolis in the postwar Gilded Age.[240]

237. In November 1862 Morse gave Herter a deed to the house and its contents against an outstanding debt of $15,000. The discovery of this document was the first clue to Herter's authorship of the interior decorations. Palmer, "Herter's Interiors," pp. 6, 13 n. 16.

238. R. G. Dun and Company report for November 4, 1861 (New York Vol. 190, p. 397), R. G. Dun & Co. Collection, Baker Library, Harvard University Graduate School of Business Administration.

239. Ibid., October 7, 1861 (New York Vol. 191, p. 451).

240. The details of the Boston Music Hall commission are recounted in Voorsanger, "Gustave Herter."

# Empire City Entrepreneurs: Ceramics and Glass in New York City

*ALICE COONEY FRELINGHUYSEN*

In their desire to acquire an urbanity equal to that of cosmopolitan society abroad, New Yorkers of the antebellum era surrounded themselves with the lavish physical trappings of stylish society, first and foremost with "fancy goods" imported from Europe. Local retailers proliferated in the burgeoning marketplace that served these New Yorkers, especially from the 1820s on, when a new type of commerce arose that allowed merchants to present a wide variety of wares to satisfy every need. New York overtook the ports of Boston, Philadelphia, Baltimore, and Charleston as the nation's leader in transatlantic trade after the opening of the Erie Canal in 1825. The expansion of trade between Europe and New York led to a broader representation of imported goods from a larger number of countries, making a wide range of luxury products newly available. It did not take long for entrepreneurs to recognize an opportunity in this strong marketplace, and they began to compete with the import trade by establishing domestic manufactures and producing goods similar to foreign products.

## Imports

Fine porcelains from England and France were de rigueur for formal dining in the city, and a glittering assortment of richly cut European glass adorned many a sideboard. In the earliest years of the century Americans relied heavily on members of the diplomatic corps stationed in France to select fashionable ceramics and glassware and negotiate purchases for them.[1] By the mid-1820s and the 1830s, however, as numerous advertisements that appeared in newspapers demonstrate, French porcelain was readily available from shops in the commercial district of New York. For imported ceramics and glass it was increasingly retailers, rather than manufacturers and shippers, who dominated almost all aspects of the trade. Establishments such as Ebenezer Collamore (later Davis Collamore and Company), George Dummer and Company, Haughwout, Tingle and Marsh, Ovington Brothers,

Thomas A. Rees, and Baldwin Gardiner, to name only a few, could be found up and down Broadway and other commercial streets. The myriad house furnishings they offered included, in particular, English glass and French and English pottery and porcelain. Early in the century, when George Dummer opened his retail business at 112 Broadway, he advertised "a large and fashionable assortment of fine English and East India China, Rich Cut Glass, &c."[2] Decades later J. K. Kerr of 813 Broadway was selling "a large lot" of luxury dinnerware consisting of "white French China Dining Sets, for $20; elegant Tea Sets, Paris decoration, for $7; 500 dozen white French China Dining Plates, for 12s. per dozen; 800 dozen Cups and Saucers, best French, for 12s. per dozen . . . 200 dozen oval French Dishes, all sizes," as well as "Oyster Dishes, Soup Tureens, etc.," and "Gold Band Cake Plates."[3]

The social elite favored elegant white porcelain made in and around Paris. From the 1820s to midcentury most Parisian porcelain exported to America was unadorned except for a gold band, although sometimes it was further embellished with a monogram or cipher, also in gold. Lavishly decorated French porcelains were very costly. When George Hyde Clarke ordered a large number of furnishings for his estate in Cooperstown, New York, from Baldwin Gardiner's Furnishing Warehouse at 149 Broadway, his most expensive purchase was a set of dishes with hand-painted polychrome flowers on a yellow ground—"one porcelain Dining & dessr Service, rich bouquet and yellow border"—for $500.[4]

Some of the most impressive imported porcelains were specially ordered dinner services and elaborate ornamental vases that carry portraits of national heroes or topographical views of American cities. New Yorkers fully subscribed to this taste for elaboration: of all the Paris porcelain vases with American city views known to survive, those depicting New York are the most numerous. A very grand vase features a view of New York from Governors Island along with sumptuous gilding (cat. no. 250);[5] on one of a pair of smaller vases is a different view of Manhattan from

The following people were especially helpful to me in sharing their research, knowledge, ideas, and collections: Arthur Goldberg, David Goldberg, Jay Lewis, Arlene Palmer, and Diana and Gary Stradling. In addition, I benefited greatly from research conducted by Angela George, Medill Higgins Harvey, Jeni Sandburg, Cynthia Van Allen Schaffner, and Barbara Veith, particularly with regard to periodicals and New York City directories.

1. For a discussion of French porcelain imported into America, see Alice Cooney Frelinghuysen, "Paris Porcelain in America," *Antiques* 153 (April 1998), pp. 554–63.
2. *New-York Evening Post,* April 15, 1810. Dummer opened his retail business in New York in 1810. Two surviving pieces of imported porcelain bear the mark of his firm. One is an English pitcher with the arms of Cadwallader D. Colden and his wife (Colden had been one of the major promoters of the Erie Canal and an important figure in early-nineteenth-century New York). For an illustration of the pitcher and a French plate also marked by the Dummer firm, see Jane Shadel Spillman and Alice Cooney Frelinghuysen, "The Dummer Glass and Ceramic Factories in Jersey City, New Jersey," *Antiques* 137 (March 1990), pp. 706–17, ill. p. 709.
3. "French China," *Home Journal,* November 11, 1854, p. 3.
4. The bill of sale is in the George Hyde Clarke Family Papers, Division of Rare Books and Manuscripts Collections, Cornell University Library, Ithaca, New York. For an illustration of the large tureen from the service, see Frelinghuysen, "Paris Porcelain in America," p. 558, pl. 9.
5. The scene was taken from a series of twenty prints published in 1821–25 called *The Hudson River Portfolio.*

Fig. 266. Maker unknown, French (Paris), Pair of vases depicting views of New York City from Governors Island (left) and the Elysian Fields, Hoboken (right), 1831–34. Porcelain, overglaze enamel decoration, and gilding. The Metropolitan Museum of Art, New York, Rogers Fund, 1917 17.144.1,2

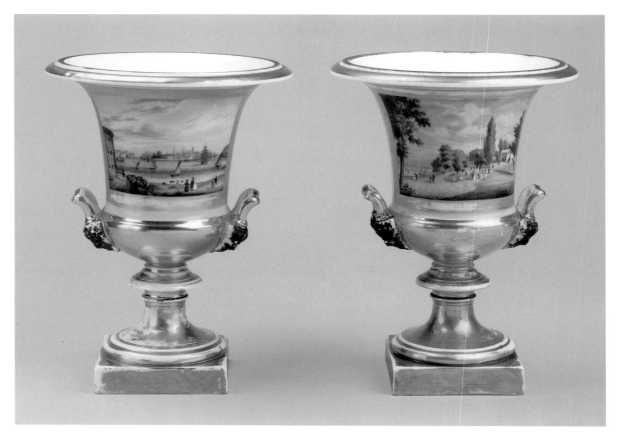

Fig. 267. Maker unknown, French, decorated by E. V. Haughwout, New York City, Pitcher probably depicting view of Fifth Avenue Hotel, France, 1859–60. Porcelain, overglaze enamel decoration, and gilding. The Metropolitan Museum of Art, New York, Gift of Emma and Jay A. Lewis, 1995  1995.26

Governors Island (fig. 266, left); and another pair depicts lower Broadway and the interior of the Merchants' Exchange (cat. no. 251). The Parisian artists responsible for these pieces faithfully copied the views from a popular portfolio of contemporaneous engravings[6] but reduced the number of people visible and depicted them in fashionable attire, giving their New York scenes an air of elegant cosmopolitanism.

By the 1850s the few retailers who held the major share of the market in imported French porcelain also had acquired or had an interest in factories in Paris or in Limoges in central France, which had become a major porcelain-making center by midcentury. Now they could produce goods to their own specifications, dictating designs that would suit American tastes; the porcelain they ordered was either decorated abroad or brought to workrooms in New York for embellishment. Thomas Rees, an importer and dealer in French china at 78 Maiden Lane, advertised that he could supply his clients with "White, Band and Decorated Dinner, Tea and Dessert Ware" and "Fancy China Articles in great variety" directly from a factory in Limoges.[7] In 1850 D. G. and D. Haviland, which had a business relationship with Rees, announced that on hand at its 47 John Street showrooms were "decorated TABLE WARE and PARLOR ORNAMENTS . . . done by the house in France."[8]

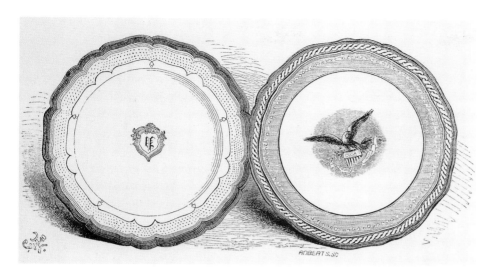

Fig. 268. *Two plates with the Cipher of the President and the Arms of the United States.* Wood engraving by Robert Roberts, from B. Silliman Jr. and C. R. Goodrich, eds., *The World of Science, Art, and Industry Illustrated from Examples in the New-York Exhibition, 1853–54* (New York: G. P. Putnam and Company, 1854), p. 129. The Metropolitan Museum of Art, New York, The Thomas J. Watson Library

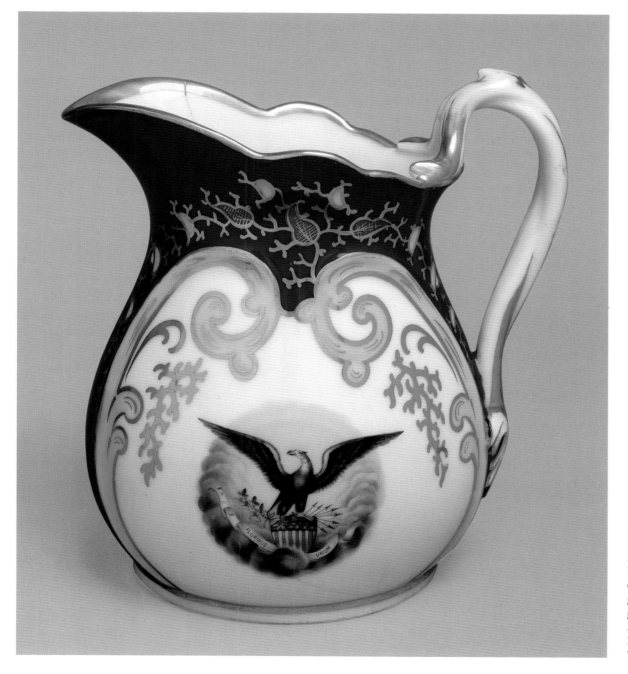

Fig. 269. Maker unknown, French, decorated by Haughwout and Dailey, New York City, Pitcher, ca. 1853–60. Porcelain, over-glaze enamel decoration and gilding. The Metropolitan Museum of Art, New York, Friends of the American Wing Fund, 1996   1996.560

6. The scenes on these two vases were taken from two prints in a portfolio of thirty-nine engravings entitled *Views in New York and Its Environs,* published in New York and London by Peabody and Company, 1831–34. The two prints were engraved by Barnard and Dick; the view of lower Broadway was done from a drawing by James H. Dakin.

7. Thomas A. Rees and Company advertisement, in A. D. James, *The Illustrated American Biography . . .,* 3 vols. (New York: J. M. Emerson and Co., 1853–55), vol. 3, p. 221. Whether Rees owned the Limoges factory is not known.

8. D. G. and D. Haviland established their export firm in 1838 and became Haviland Brothers and Company in 1852. From 1846 to 1853 David Haviland was associated with Thomas Rees in the export business. See Jean d'Albis and Céleste Romanet, *La porcelaine de Limoges* (Paris: Sous le Vent, 1980), p. 133. "Porcelain," D. G. and D. Haviland, New York, and Haviland and Co., Limoges, advertisement, *The Independent,* November 7, 1850, p. 184.

9. Jean d'Albis, *Haviland* (Paris: Dessin et Tolra, 1988), p. 14.

10. "Art and Manufactures," *Home Journal,* March 22, 1851, p. 3.

11. From 1831 the Haughwout firm was controlled by a succession of different partnerships. It is cited in New York City directories as P. N. Haughwout and Son (1831–38), Woram and Haughwout (1838–52), Haughwout and Dailey (1852–54), Eder V. Haughwout (1855/56–56/57), and E. V. Haughwout and Company (1857–60/61).

12. Woram and Haughwout, 561 Broadway, "R. and G. Dun Reports," January 3, 1851 (New York Vol. 191, p. 481), R. G. Dun & Co. Collection, Baker Library, Harvard University Graduate School of Business Administration, Cambridge, Massachusetts.

13. A hotel-ware plate in a private collection carries a mark for E. V. Haughwout with both a Broadway address and a Parisian one, "24, R. de Paradis Poissre."

14. The coral-like motif in gold appears on two other Haughwout pitchers. One, for which bills survive, was ordered by Samuel Francis Du Pont from E. V. Haughwout in 1853; see Maureen O'Brien Quimby and Jean Woollens Fernald,

New York was not only a marketplace for European wares bought by its own residents but also the center for importing goods to be shipped on to many other cities, and the demand for such items grew at an unprecedented rate in our period. The quantity of wares exported by the Haviland firm alone increased from 753 barrels in 1842 to 8,594 barrels in 1853.[9] One commentator noted the range of that market: the products were for use in "hotels, steamboats, the private mansions of the rich, and the growing elegant boarding-houses, after the manner of the Clarendon [Hotel]."[10]

E. V. Haughwout's establishment on Broadway was one of the largest and oldest china and glass retailers in antebellum New York.[11] In 1850 it was purchasing as much as $60,000 worth of porcelain from one firm in Paris,[12] and it may have had its own interest in a French factory.[13] In 1849 Haughwout's established on the top floor of its three-story suite of showrooms a sizable decorating workshop, a response to the increased demand for decorated French porcelain. French-made goods could now be custom painted on the premises, greatly facilitating the process of filling orders from private consumers for personalized dinner services and from commercial establishments for wares with identifying images. Among such goods produced by Haughwout's were decorated water pitchers and cream pitchers—items much used in hotels—with an architect's rendering of what is probably the Fifth Avenue Hotel (fig. 267).

In an effort to secure presidential patronage, Haughwout's exhibited two sample dinner services at the New York Crystal Palace exhibition of 1853. An illustration showing plates from the two services was published at the time of the fair (fig. 268). One features the monogram of President Franklin Pierce; the other, in what is described in the text as the Alhambra pattern, had a blue border and in the center the great seal of the United States. A pitcher with a matching pattern displays both the seal and an elaborate gilded embellishment that includes a "coral" motif characteristic of Haughwout decoration (fig. 269).[14] Pierce ordered the first service but not the second. However, the pattern of the latter set was ultimately selected by Mrs. Lincoln for a service she purchased in 1861, with the request that the border be of "Solferino," a bright purplish red, rather than blue.[15] Haughwout encouraged his patrons to visit not just his extensive showrooms but the decorating studios as well, the province of "numbers of young women, . . . who are painting flowers, fruits, and groups of figures upon various articles, especially those large and beautiful (if rather

too brilliant) vases, now so very fashionable."[16] The last remark aptly describes three exuberant Rococo Revival style vases featured in the same illustration as the presidential plates. One of these was part of the Haughwout exhibit, and the other two were from Haviland and Company's Limoges factory. Their style, characterized by a profusion of leafy ornament that obscures the vessel form, also marks a pair of French vases from an unknown firm but probably made in Limoges specifically for export to America. These feature scenes illustrating Harriet Beecher Stowe's *Uncle Tom's Cabin,* which was first published in Paris in 1853 (cat. no. 252).[17]

A far less expensive alternative to French porcelain was white earthenware with transfer-printed decoration, a speciality of the potteries in Staffordshire, England. This attractive, durable ware became a staple in American homes throughout the antebellum period. An extensive trade between America and England commenced shortly after the War of 1812, and by the 1830s earthenware was Britain's fifth most important export to the United States.[18] In the highly competitive market of the moment the Staffordshire firms produced pottery with mainly blue underglaze transfer-printed decoration in a bewildering number of designs. Soon they began to offer commemorative wares of specifically American interest with subjects drawn from a myriad of readily available prints—of American cities, notable American buildings, and significant American events such as the opening of the Erie Canal or the celebrated arrival of General Lafayette at Castle Garden in the Battery (cat. nos. 253, 254).[19] Nearly forty different views of New York City alone appear on transfer-printed ceramics from Staffordshire.

Many of the Staffordshire firms established relationships with New York importing and retailing businesses. The Clews Pottery, for example, worked with Ogden, Ferguson and Company, commission merchants, but there are several plates with Clews marks, one transfer-printed with a scene of Lafayette's arrival at Castle Garden, that bear the inscription of John Greenfield, a New York City retailer and importer of ceramics at 77 Pearl Street.[20] New York was on Staffordshire potter John Ridgway's itinerary when in 1822 he made a special trip to the United States to establish ties with merchants and retailers. Several of the Staffordshire potteries with a large stake in the American market, such as those of Ridgway, William Adams, and E. Mayer and Son, opened their own agencies in New York to service their extensive importing and re-exporting businesses there.[21]

The Ridgway firm even developed special patterns for a line of "fine vitreous earthenware for the United States market" that it promoted at the 1851 Crystal Palace exhibition in London. Ridgway also prepared teacups in the "New American fluted shape," with simple designs printed in blue or pink and "filled in with colours." [22] A number of these New York importers considered starting their own potteries in New York. Other English products, such as relief-molded earthenware pitchers and "feather-edged" white earthenware with sponged decoration, found a ready market in America as well. Beginning in the mid-1840s figures of Parian ware and other ornamental ceramics made by the English firms Minton and Copeland were as much in favor in the Empire City as the highly decorative French vases and pitchers produced in Limoges.

## Ceramics Made in New York City

The flourishing trade in French and English wares was accompanied by American expressions of concern about the extensive reliance on imported goods and its ultimate impact on the country's economic well-being. These sentiments eventually gave rise to a series of government-imposed tariffs on imports. The first protective tariff after the War of 1812 was levied in 1816, but it did little to encourage domestic production. Stronger tariff acts were passed in 1824, 1828, and 1832, and these undoubtedly acted as a stimulus for the growth of domestic manufactures, including glass and ceramics. [23] The protectionist climate of opinion was articulated in countless newspaper editorials, such as those in Hezekiah Niles's *Weekly Register*. Societies and institutes for the promotion of American manufactures sprang up, among them the American Institute of the City of New York, founded in 1827, which closely followed the new glass and ceramics industries.

The development of manufacturing in New York paralleled the tremendous growth of the Empire City, fed in part by the explosion of commercial activity in lower Manhattan after the opening of the Erie Canal. During this auspicious period, about 1814 to 1828, the manufacture of fine porcelain was attempted by three New York–area firms—Decasse and Chanou, Dr. Henry Mead, and the Jersey Porcelain and Earthenware Company of Jersey City—in an effort to break into the established market for luxury porcelains imported from France and England. Making porcelain was not an easy matter. It required specialized raw materials generally not locally available, complex

techniques, and a mastery of sophisticated kiln and clay technology. Moreover, the decorating process was more complicated for porcelain than for other wares: a great deal of labor went into the painstaking detail work of the ceramic artist and the subsequent firings of different enamel colors, and the costs of the materials, firing, and burnishing of the gilding were high. The entire undertaking necessitated large sums of capital and involved considerable risk. The three new firms that took it on had many things in common. They were founded by ambitious entrepreneurs; according to written accounts, they utilized only American materials, yet employed skilled French workers; and they all suffered continual difficulties that resulted in early failures.

Two of the firms were located on Lewis Street between Delancey and Rivington streets, in the buildings of a defunct copper factory. Henry Mead began production of porcelain on this site about 1816; a lone surviving vase is evidence of its quality. [24] Lack of capital and the inability to find suitable workers plagued the factory, [25] whose demise was reported by a New York newspaper in 1824. [26]

Louis Decasse and Nicolas Louis Édouard Chanou, both from France, took over Mead's defunct factory and established their own. A tea set with elaborate gilded decoration attests to the superb quality of the wares they produced during the three years of their partnership (cat. no. 255; fig. 270). The firm's mark is made up of the surnames of the two partners, the great seal of the United States, and the name of the city of manufacture (fig. 271)—an expression of the proprietors' pride in having made a premium porcelain from American materials in New York. Although Decasse and Chanou made porcelain comparable in quality to French products, they based the style of their tea sets on English shapes to cater to the specific tastes of the market. A similar approach was followed in France: Édouard Honoré, proprietor of the Parisian porcelain factory Dagoty et Honoré, which enjoyed a successful export trade with America, told the French minister of commerce in 1834, "For three to four years I have been producing goods to designs which the Americans have been sending me and which resemble English designs." [27]

In December 1825 the Jersey Porcelain and Earthenware Company was founded by New York City importer George Dummer in Jersey City, a block away from the glass factory he had founded the previous year. [28] This location was proximate to the New York markets; to the port of New York, which enabled the firm to attract skilled immigrant labor; and to

"A Matter of Taste and Elegance: Admiral Samuel Francis Du Pont and the Decorative Arts," *Winterthur Portfolio* 21 (summer/autumn 1986), p. 113, fig. 10. The other pitcher is in the collection of the Museum of the City of New York.

15. Margaret Brown Klapthor, *Official White House China, 1789 to the Present* (Washington, D.C.: Smithsonian Institution Press, 1975), pp. 80–82.

16. "Art Manufactures: Ornamental Porcelains," October 1853, publication unknown, photocopy, departmental files, Department of American Decorative Arts, Metropolitan Museum.

17. A number of pairs of such vases exist, in several different sizes and with varying polychrome decoration. One pair is the collection of the Museum of the City of New York; for another set, see *Nineteenth Century Decorative Arts* (sale cat., New York: Christie's East, October 27, 1998), lot 176; and for another, Jill Fenichell, Inc., New York.

18. F. Thistlethwaite, "The Atlantic Migration of the Pottery Industry," *Economic History Review* 11 (December 1958), pp. 264–78, esp. p. 267.

19. British firms were poised to act swiftly to take advantage of an eager market. In December 1824, for example, only four months after Lafayette was given a triumphal welcome in New York Harbor, transfer-printed views of the scene were being loaded onto ships in Liverpool heading to America.

20. The Clews plate with an underglaze blue-printed scene of the landing of General Lafayette is marked "J. GREENFIELD'S/ China Store/No 77/Pearl, Street./New York" (Metropolitan Museum, 14.102.288). A soup plate marked Clews bears a circular impressed mark: "John Greenfield, Importer of China & Earthenware, No 77, Pearl Street, New York." Greenfield's firm is listed in New York City directories from 1817 to 1843. See Frank Stefano Jr., "James and Ralph Clews, Nineteenth-Century Potters, Part I: The English Experience," *Antiques* 105 (February 1974), pp. 324–28.

21. John Ridgway and John Mayer each had such a presence in New York as an importer that they were listed in a New York City directory of 1846 among wealthy "non-residents" of the

city. See Thistlethwaite, "Atlantic Migration of Pottery Industry," p. 267.

22. The quotations are from a publicity handbook published by Ridgway for its Crystal Palace exhibit. The line of earthenware included services described as "Montpelier Shape, Light Blue Palestine," "Flowing Mulberry Berlin Vase," and "White China Glaze Ware" (nos. 340–42). A copy of the handbook is at the Bodleian Library, Oxford; the text is reproduced in Appendix III of Geoffrey A. Godden, *Ridgway Porcelains,* 2d ed. (Woodbridge, Suffolk: Antique Collectors' Club, 1985), pp. 221–54, with United States references on pp. 221–22.

23. F. W. Taussig, *The Tariff History of the United States,* 5th ed. (New York: G. P. Putnam's Sons, 1900), pp. 68–69.

24. The vase is in the Philadelphia Museum of Art. See Alice Cooney Frelinghuysen, *American Porcelain, 1770–1920* (exh. cat., New York: The Metropolitan Museum of Art, 1989), pp. 78–79, no. 4.

25. In 1820 Mead petitioned the New York Common Council to discuss the "practicability of employing the paupers in the Alms House and criminals in the Penitentiary in the manufacture of porcelain." Quoted in Arthur W. Clement, *Our Pioneer Potters* (New York: Privately printed, 1947), p. 66.

26. *Commercial Advertiser* (New York), December 1824.

27. Quoted in Régine de Plinval de Guillebon, *Paris Porcelain, 1770–1850,* translated by Robin R. Charleston (London: Barrie and Jenkins, 1972), p. 303.

28. The company was incorporated on December 10, 1825. Its establishment was announced eight months later by Hezekiah Niles, an avid promoter of American manufactures; see "Manufactures, &c.," *Niles' Weekly Register,* August 12, 1826, p. 422.

29. Ibid.

30. Thomas Tucker to General Bernard, January 31, 1831, Tucker Letter Books, Rare Book Collection, Philadelphia Museum of Art Library.

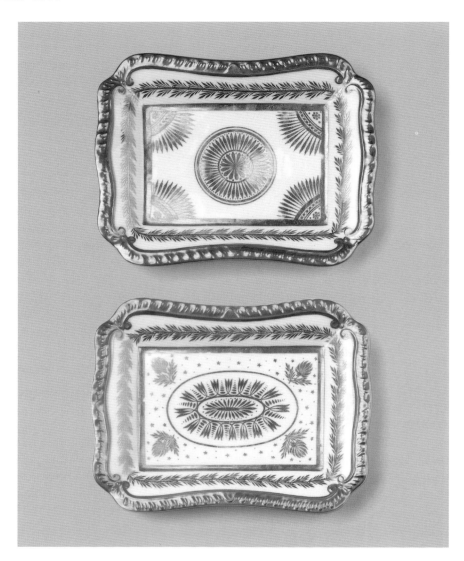

Fig. 270. Decasse and Chanou, Two plates, or stands, from tea service (cat. no. 255), 1824–27. Porcelain with gilding. The Metropolitan Museum of Art, New York, Lent by Kaufman Americana Foundation

important waterways—a strategic placement that served as a model when porcelain factories were established in Brooklyn two decades later. Employing a labor force said to number nearly one hundred, presumably made up of both immigrant and native-born workers, it was the largest pottery in operation in America at the time. Its wares, based like Mead's on current French styles, were reputedly "executed with great ingenuity and perfection, after the finest models of the antique."[29]

In spite of the quality of their products, all three of these early enterprises were too hampered by the difficulties of porcelain making to compete economically with French firms. Moreover, it was speculated that the French were taking advantage of a lax customs office in New York to avoid paying the tax on imports. Thomas Tucker, then director of a porcelain firm in Philadelphia, wrote in 1831 to United States Senator Simon Bernard: "I suffer materially from the duplicity of the French Manufacturers. They are continually in the habit of shipping porcelain to

New York under a false invoice below the real market value of the article, and by this means evade a part of the duty."[30]

Although competition with European porcelain making proved impossible, an initiative in another type of ware had a very different outcome. In 1828 David Henderson, a Scotsman, together with his brother James, purchased Dummer's defunct factory. The following August it was noted in *Niles' Weekly Register* that "The manufacture of a very superior ware, called 'flint stone ware' is extensively carried on

Fig. 271. Detail of mark from tea service made by Decasse and Chanou (cat. no. 255; fig. 270)

by Mr. Henderson, at Jersey City, opposite New York. It is equal to the best English and Scotch stone ware, and will be supplied in quantities at $33\frac{1}{3}$ *per cent.* less, than like foreign articles will cost, if imported."[31] The Henderson pottery was to enjoy a twenty-seven-year success.[32] It supplied modestly priced ceramics for the growing market of consumers who could not afford expensive French porcelains, with their painted and gilded decoration. The Hendersons relied heavily on English designs, experimented with different clay bodies and modes of decoration, and based their methods and factory practices on those of Staffordshire firms. The Henderson brothers' systems were new in America and became the model for a significant reorganization of pottery making here. The process was divided into parts according to the skills and functions involved, and the resultant assembly-line method yielded newly standardized products while it saved time. The earliest wares were thrown on a potter's wheel and then decoration was applied (see cat. no. 256), but within a few years the manufacture had become increasingly mechanized: more economical molds were used to form the shape of the vessel and its decoration at the same time (see fig. 272). The wares that were produced featured elaborate relief decoration and were strong and light bodied.

Responding to market demands, utilizing the native skill of immigrant workers, and in some cases actually fabricating products from English molds,[33] the Hendersons manufactured pottery with a high degree of Englishness. Pitchers from the Ridgway pottery are closely imitated by the Hendersons' version in the Herculaneum pattern, which is ornamented on the body with such popular classical motifs as scrolls, anthemia, and satyrs' masks (or a vine-crowned Pan), and, on the handle, with a figure of Pan (cat. no. 258).[34] This ware, and in particular "a pair of very handsome and much admired pitchers," was described in 1829 as "equal to the best English and Scotch stone ware."[35] Another pitcher with naturalistic Rococo Revival decoration, this one depicting leaves, acorns, and berries, is a virtual duplicate of a Ridgway model (cat. no. 257).[36] However, a third pitcher, while borrowing an English form, displays what appears to be a uniquely American relief decoration of thistles (perhaps a reference to the Hendersons' native Scotland) on a stippled background that calls to mind patterns used in pressed glass (cat. no. 259). While pitchers were the dominant vessel form made by the firm, an 1830 price list shows that its inventory included butter tubs, coffeepots, teapots, spittoons, flowerpots, and

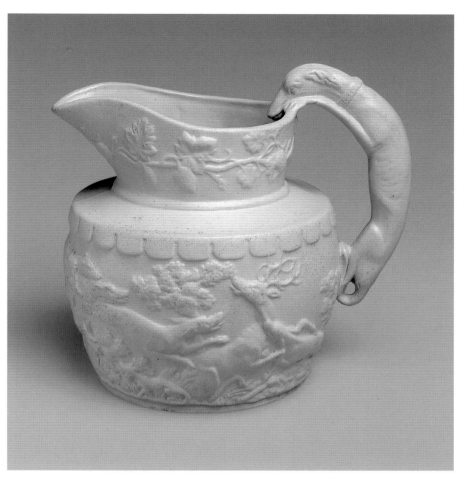

Fig. 272. D. and J. Henderson Flint Stoneware Manufactory, Jersey City, New Jersey, Pitcher, 1828–33. Stoneware, press-molded with applied decoration. The Metropolitan Museum of Art, New York, Gift of John C. Cattus, 1967   67.262.11

inkstands.[37] The most expensive item on the list, the Herculaneum pitcher (cat. no. 258), with its elaborate "embossed" design, sold for $13.50 per dozen. The price list reveals that the Hendersons did not sell directly to consumers but instead relied on retailers to buy and disperse their wares.[38]

In 1833, when the business was reorganized as the American Pottery Manufacturing Company (often abbreviated in the factory mark to American Pottery Company), refined white earthenwares were added to its line of English-style ceramics of medium price; an advertisement in a Washington newspaper specified "cream-color ware, dipped ware, painted and edged earthenware."[39] The firm also produced edged wares, white earthenware with a molded edge design of impressed lines; one surviving piece is a large dish bearing the mark "American Pottery Company" that has both a molded shell edge and sponged decoration in blue (cat. no. 260). English edged wares were being shipped to American markets by the boatload, but American-made examples are extremely rare,

31. "Glass and Earthen Wares," *Niles' Weekly Register,* August 1, 1829, p. 363. The word "flint" had been associated with stoneware since the eighteenth century, when flint was a component of English white saltglaze stoneware.

32. The D. and J. Henderson Flint Stoneware Manufactory was reorganized in 1833 as the American Pottery Manufacturing Company. In 1845 David Henderson was killed in a shooting accident, but the pottery continued in business until about 1855. For more information on the Jersey City potteries, see Diana Stradling and Ellen Paul Denker, *Jersey City: Shaping America's Pottery Industry, 1825–1892* (exh. cat., Jersey City: Jersey City Museum, 1997).

33. The Hendersons acquired at least one master mold from a defunct British factory: the mold for their hound-handled hunt pitcher from the former

Phillips and Bagster Pottery in Staffordshire. See Stradling and Denker, *Jersey City*, p. [3].

34. The Ridgway example appears as design no. 1 in the factory pattern book. See Godden, *Ridgway Porcelains*, p. 141, fig. 155.

35. *Niles' Weekly Register*, August 1, 1829, p. 363.

36. The pitcher matches a design in a pattern book of William Ridgway and Company. For an illustration, see R. K. Henrywood, *Relief-Moulded Jugs, 1820–1900* (Woodbridge, Suffolk: Antique Collectors' Club, 1984), p. 63, fig. 43.

37. "List of Prices of Fine Flint Ware, Embossed and Plain, Manufactured by D. & J. Henderson, Jersey City, New Jersey," 1830, reproduced in *Antiques* 26 (September 1934), p. 109.

38. In about 1840 the Jersey City works employed an agent in New York, retailer George Tingle, to sell its products. According to the "R. and G. Dun Reports," January 23, 1854, Tingle, originally from England, "has been agent for the American Pottery Co. of New Jersey for the past 15 yrs, giving them entire satisfaction. He also commencd the crockery bus last Spring cor Pearl St & Peck Slip, under the style of Tingle & Marsh, & for that bus import most of their goods. . . ." April 9, 1855: "continues his Agency of the Amer Pottery Co." Marsh and Tingle, November 30, 1855, "lost his agency of The American Pottery Co." (New York Vol. 342, p. 288), Baker Library, Harvard University Graduate School of Business Administration. I thank Diana Stradling for bringing the Marsh and Tingle reference to my attention.

39. *The Intelligencer* (Washington, D.C.), July 16, 1833, quoted in Stradling and Denker, *Jersey City*, p. 8.

40. George L. Miller, Ann Smart Martin, and Nancy S. Dickinson, "Changing Consumption Patterns: English Ceramics and the American Market from 1780 to 1840," in *Everyday Life in the Early Republic: 1789–1828*, edited by Catherine E. Hutchins (Winterthur, Delaware: Henry Francis du Pont Winterthur Museum, 1994), pp. 219–48.

41. The House Furnishing Warehouse of Baldwin Gardiner, 149 Broadway, sold to George Hyde Clarke of Cooperstown, for his daughter, "One dining

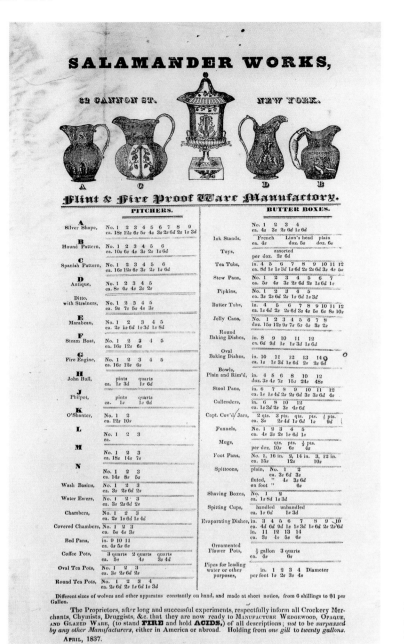

Fig. 273. Advertising broadside for Salamander Works, 62 Cannon Street, New York, 1837. Wood engraving. Collection of The New-York Historical Society, Bella Landauer Collection

suggesting that it was nearly impossible for American manufacturers to undercut the English competition in this type of ceramic.[40]

The Hendersons' ongoing need to attract consumers and stave off the competition of the Staffordshire potteries led them to initiate a line of transfer-printed white earthenware. Several plates with the mark of their pottery display a blue transfer-printed design in the popular Canova pattern (cat. no. 262) that is virtually identical to English examples.[41] The company's response to the 1840 presidential campaign of the business-friendly Whig politician William Henry Harrison was a hexagonal pitcher that featured three transfer-printed images on each panel, showing the candidate's portrait in the center, a log cabin at the top, and the great seal of the United States at bottom (cat. no. 263). Despite its efforts, however, the firm could never fully compete in the market for white earthenware. It did succeed in dominating the molded ware market by hiring talented modelers and designers, among them Daniel Greatbach and James Carr, both trained in Britain. The experience and earnings these two acquired in Jersey City enabled them to move on to other pottery enterprises in America.[42]

The Hendersons' most serious competition was Salamander Works, which was founded as a firebrick

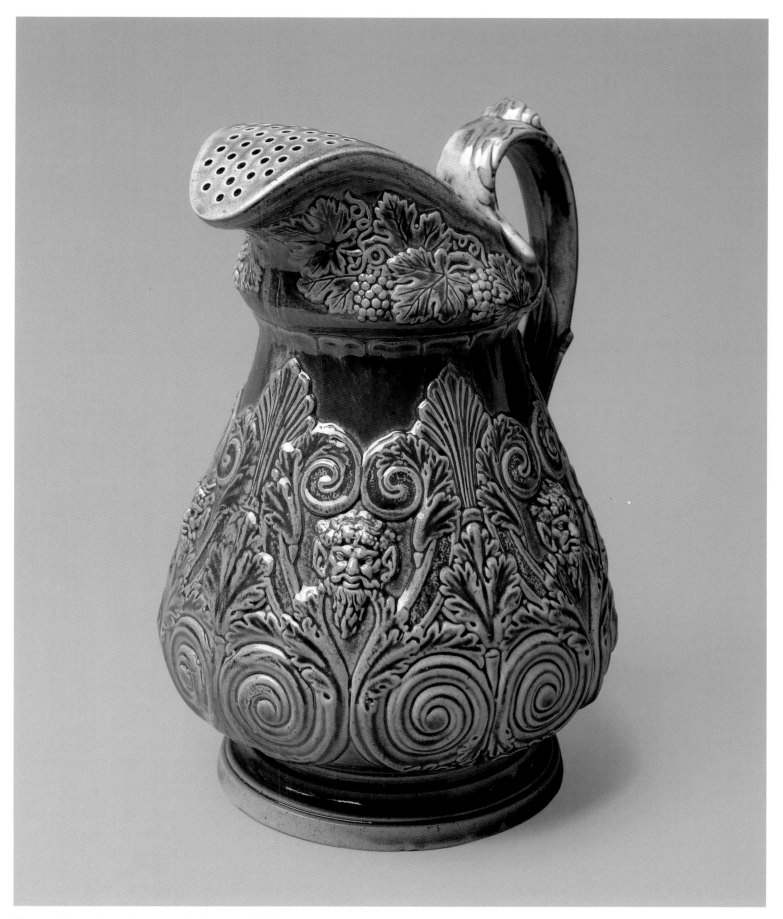

Fig. 274. Salamander Works, New York City or Woodbridge, New Jersey, "Antique" ale pitcher, 1837–45. Stoneware, press-molded with applied decoration. Collection of Mr. and Mrs. Jay Lewis

Set, Blue Canova," consisting of dozens of dinner plates and a wide variety of serving dishes. The cost for the entire service was $25; Clarke paid $500 for an imported French dessert service with elaborate floral decoration on a yellow ground. The bill of sale is in the George Hyde Clarke Family Papers, Division of Rare Books and Manuscripts Collections, Cornell University Library, Ithaca, New York. Thomas Mayer of Staffordshire exported more ware in the Canova pattern to America than any other maker. See Ellen Denker and Diana Stradling, Exhibition Label Checklist for "Jersey City: Shaping America's Pottery Industry, 1825–1892," typescript, Jersey City Museum, 1997, p. 9.

42. Daniel Greatbach left the American Pottery Manufacturing Company about 1851 and probably went directly to Bennington, Vermont, where he worked for Christopher Webber Fenton's United States Pottery Company until it closed in 1858. He later started a pottery in Peoria, Illinois; after it failed in 1863, he returned to New Jersey. James Carr left the Jersey City works in 1852 first to found a pottery in South Amboy, New Jersey, and then start one in New York. His successful New York City Pottery operated from 1856 to 1888.

43. American Institute Fair Report, 1835, in M. Lelyn Branin, *The Early Makers of Handcrafted Earthenware and Stoneware in Central and Southern New Jersey* (Rutherford, New Jersey: Fairleigh Dickinson University Press, 1988), p. 186.

44. Salamander Works Advertising Broadside, 1837, Bella Landauer Collection, New-York Historical Society.

45. The Cartlidge factory brought in feldspar from Connecticut and china clay from Delaware.

46. Edwin Atlee Barber, *Historical Sketch of the Green Point (N.Y.) Porcelain Works of Charles Cartlidge & Co.* (Indianapolis: Clayworker, 1895), pp. 7–9.

47. Godden, *Ridgway Porcelains*, p. 169.

48. Walt Whitman, "Porcelain Manufactories," *Brooklyn Daily Times,* August 3, 1857, in *I Sit and Look Out: Editorials from the* Brooklyn Daily Times *by Walt Whitman,* edited by Emory Holloway and Vernolian Schwarz (New York: Columbia

pottery on Cannon Street between Rivington and Delancey streets, directly behind the original location of the Decasse and Chanou porcelain works. Operated by Michel Lefoulon and Henry Decasse, both from France, the Salamander Works produced several vessels remarkably close in design to those made by the American Pottery Manufacturing Company. The first mention of refined ware produced by Salamander dates to 1835, when the American Institute awarded its proprietors a diploma for "a fine specimen of flint stoneware."[43] In 1837 the company published an illustrated advertising broadside that boasted that it was ready to "manufacture Wedgewood [*sic*], Opaque and Glazed Ware (to stand Fire and hold Acids,) of all descriptions; not to be surpassed by any other Manufacturers, either in America or abroad."[44] A large ceramic water cooler that advertises the pottery and its location in applied clay letters (cat. no. 264) demonstrates the same spirit of vigorous marketing. The pottery remained at the Cannon Street location until 1840, when it was moved to Woodbridge, New Jersey. Salamander's wares, like those produced by the Hendersons' firm, were based on English relief-molded examples. Illustrations of four such pitchers appear as a decorative heading on the company's broadside of 1837 (fig. 273). The first, A, is the simplest, with stylized anthemia around the base. Example B shows a hound handle and a hunt scene. Vessel C is a bulbous-bodied pitcher called "Spanish Pattern" (cat. no. 266). And the last, D, titled "Antique" (fig. 274) is similar to the Hendersons' Herculaneum pitcher (cat. no. 258). The broadside enumerates fourteen different pitcher designs; however, by 1857 the Salamander Works had all but given up the production of such tableware and had reverted to its earlier industrial product line of firebricks, pipes for sewers and drains, tiles, and garden ornaments.

A new demand—for molded ware made of a hard, durable porcelain suitable for use in hotels and porterhouses—prompted the establishment of new manufactories around New York City. Several ambitious entrepreneurs constructed porcelain factories across the river from Manhattan, in the Greenpoint section of Brooklyn, on Newtown Creek. The location was ideal—close to the largest consumer market in the country and also readily accessible by navigable waterways, along which barges could deliver the raw clays required."[45] It is useful to examine one such factory in detail, to gain insights into the tremendous changes that had taken place since the demise of the Decasse and Chanou porcelain enterprise in 1827. The two decades that followed saw crucial developments in

New York, including a wave of energetic entrepreneurship, technological advances, an increase in the number of immigrant workers, and the growth of the middle-income market.

These changes are all reflected in the progress of the firm Charles Cartlidge founded in 1848. Cartlidge, a manufacturer whose origins were in retailing, possessed a firm understanding of the consumer markets for ceramics and glass. An Englishman from the Staffordshire potting district, he began his career in New York in 1832 as an agent for the Staffordshire firm of William Ridgway at 103 Water Street."[46] The demand for goods was growing, Ridgway products were among the most widely sought English earthenwares in America, and in 1841 Cartlidge expanded the business, taking on Herbert Q. Ferguson as a partner to handle operations in New Orleans. Ferguson may have convinced Ridgway of the opportunities for manufacturing in the United States, for in the early 1840s Cartlidge and Ridgway made plans to open a factory in Kentucky."[47] But that enterprise failed and the entire Ridgway firm went out of business in 1848. At that point Cartlidge purchased land in Greenpoint, determined to build his own factory. His first porcelain products were actually fired at the Hendersons' American Pottery Manufacturing Company in Jersey City, but soon Cartlidge's own works was in full-scale operation.

Unlike the earlier generation of New York porcelain factories, which catered exclusively to a taste for high-style, foreign-looking tableware, the Cartlidge firm and its competitors directed their efforts toward the burgeoning market of tradespeople and other members of the middle class, and they did so with a completely new range of products. Walt Whitman, that great chronicler of life in nineteenth-century Brooklyn, in his series of essays for the *Brooklyn Daily Times* wrote a rare eyewitness account of Cartlidge's porcelain factory that leaves an indelible image.[48] The factory scene becomes a metaphor for the times, its array of activities and goods paralleling the speed, bustle, and activity of New Yorkers on Broadway. Whitman located the Cartlidge porcelain factory squarely in the center of the swirl of revolutionary changes taking place in America at large. He cited in particular the company's large number of patented innovations, comparing the new manufacture of doorknobs and doorplates made of porcelain to such inventions as crinoline skirts, gutta-percha, lucifer (friction striking) matches, and street sweepers.

Cartlidge's three-story porcelain works was organized vertically by function. The ground floor was devoted to the storage of raw materials and their

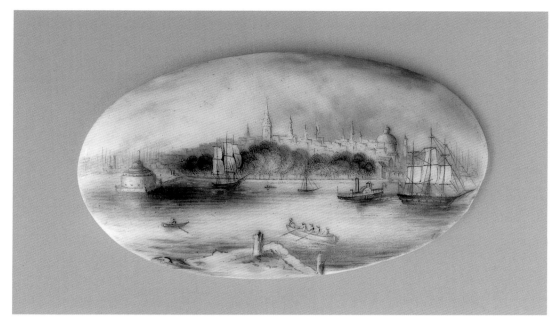

Fig. 275. Charles Cartlidge and Company, Greenpoint (Brooklyn), New York, Doorplate depicting New York Harbor (enlarged), painted by Elijah Tatler, 1848–50. Porcelain with overglaze enamel decoration. Private collection

preparation in various stages. The second floor was the modelers' room, the core of the operation. Here, by means of costly molds that were difficult to produce, the processed raw material was transformed "with marvelous rapidity" into a wide array of unfired forms. These proceeded assembly-line fashion to the dipping kiln, a second firing, and finally to the decorating rooms on the third floor for enameling and gilding, after which they were fired again. Tableware produced included cups and saucers, fine dishes, and enormous ornamental pitchers. Porcelain "trimmings" formed a mainstay of the business, however, bringing the material into a realm hitherto undeveloped. Such trimmings included everything from doorplates of all types to piano keys (said to have been a Cartlidge invention), inkstands, clock faces, buttons, and speaking tubes. As Whitman declared, the quantities as well as the varieties of objects produced were extraordinary: "[of] barrels of 'castor-wheels' for beds and sofas, . . . door-knobs, plain and ornamented, there were enough to supply half the doors in the district, [and] of bell-handles there were enough to break all the bell-wires on the South Side. . . . there were more than sufficient numbers for church-pews, done in nice white and gold letters, than will be called for . . . for some time to come."[49] The decorating rooms contained a "profusion of petty wonders," including "some half dozen costly and richly ornamented 'presentation pitchers' intended for various societies, the least of which was capable of holding a pail of water."[50] Two of the gallon-sized pitchers

were made to be presented to the Assembly and the governor of the State of New York (see cat. no. 267) by the Manufacturing and Mercantile Union, an organization intent on protecting the interests of manufacturers in New York.[51]

The aesthetic merits of the wares elicited far less comment than their novelty and durability, qualities that preoccupied much of New York in this era of invention. Yet the general impression conveyed by these porcelains was of a profusion of decoration, "glittering with gold and variegated colors." Unlike the wares of an earlier generation, which were strict replications of foreign wares, works produced in this period began to display an element of native pride. A diminutive doorplate, for example, featured a delicately painted view of New York Harbor seen from Brooklyn (fig. 275). Pitchers, the staple of the firm's manufacture, featured relief decoration depicting native plants—cornstalks and oak trees—and sported eagles and versions of the United States shield. Of the known surviving pitchers, many were presentations to individuals who could be described as tradesmen—butchers, sailmakers, and coopers, for example—or were made for use in the growing numbers of establishments devoted to leisure and refreshment, such as hotels, boardinghouses, saloons, and porterhouses. One pitcher was presented to Edmund Jones, the proprietor of the Claremont, a popular resort hotel on the Bloomingdale road in New York (cat. no. 268). The vessel bears his name and the name of the hotel and is further inscribed "American Porcela[in]" on one of

University Press, 1932), pp. 132–38.
49. Ibid., p. 137.
50. Ibid., p. 136.
51. For further information on these pitchers, see Alice Cooney Frelinghuysen, *American Porcelain, 1770–1920* (exh. cat., New York: The Metropolitan Museum of Art, 1989), pp. 108–9.

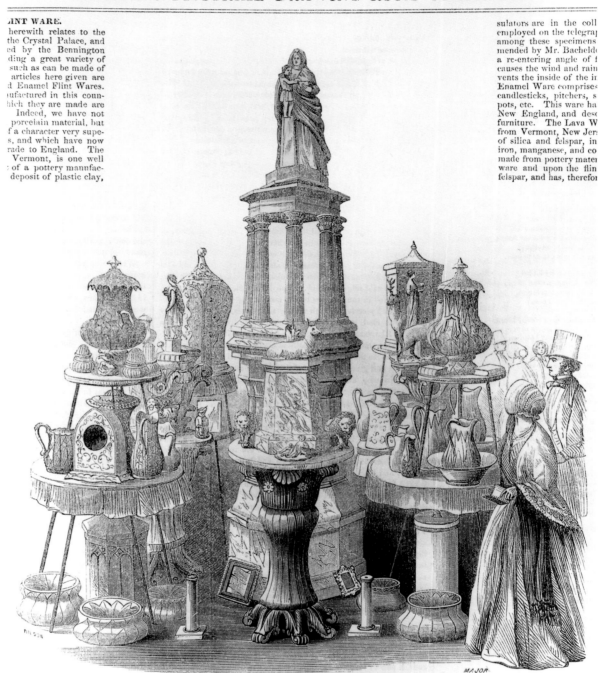

GLEASON'S PICTORIAL DRAWING-ROOM COMPANION.

...INT WARE.

herewith relates to the
the Crystal Palace, and
ed by the Bennington
ding a great variety of
such as can be made of
articles here given are
d Enamel Flint Wares.
ufactured in this coun-
hich they are made are
Indeed, we have not
porcelain material, but
f a character very supe-
s, and which have now
rade to England.   The
Vermont, is one well
: of a pottery manufac-
deposit of plastic clay,

sulators are in the coll
employed on the telegra;
among these specimens
mended by Mr. Bacheld(
a re-entering angle of f
causes the wind and rain
vents the inside of the i
Enamel Ware comprises
candlesticks, pitchers, s
pots, etc.   This ware ha
New England, and desc
furniture.   The Lava W
from Vermont, New Jer;
of silica and felspar, in
iron, manganese, and co
made from pottery mater
ware and upon the flin
felspar, and has, therefor

PORCELAIN AND FLINT WARE, EXHIBITING AT THE CRYSTAL PALACE.

Fig. 276. *Porcelain and Flint Ware, Exhibiting at the Crystal Palace.* Wood engraving by Richard(?) Major, from *Gleason's Pictorial Drawing-Room Companion*, October 22, 1853, p. 266. Courtesy of the American Antiquarian Society, Worcester, Massachusetts

52. For further information on this pitcher and an illustration of the Claremont, see ibid., pp. 110–12.
53. Whitman, *I Sit and Look Out*, p. 133.
54. Ibid., p. 137.

the stripes of the American shield it displays, and thus it served a multiple purpose: dispensing a beverage, honoring a hotel, and promoting the porcelain works.[52]

Porcelain, that most exalted of the ceramic mediums, had entered, as Whitman suggests, "the modest dwelling houses of moderately well-off and poorer classes," a public that would particularly appreciate the product's durability.[53] He vividly recounts how a

factory guide gave a dramatic demonstration of the porcelain's soundness by making "a rash and frantic blow at a tray of these polished and semi-translucent articles, which sent them flying over the floor."[54] The guide then offered the items for inspection to demonstrate that all were intact.

Two Greenpoint porcelain manufactories exhibited their wares at the 1853 New-York Exhibition of the

Industry of All Nations held at the Crystal Palace. New York was deemed the most auspicious site for this fair, America's first great international exposition, "because of its great advantages as a commercial centre, and as the chief entrepôt of European goods."[55] As at the 1851 Crystal Palace exhibition in London, ceramics were among the most widely represented of the useful arts, coming from nations across the world. "The display of fine porcelain," it was written of the New York exposition at the time, "and of objects illustrating several other branches of the ceramic art, is one of the remarkable features of the place, and it is little to say, that it has proved a most novel and instructive spectacle to those who had not before seen the great National Museums of Europe."[56] Of the seven ceramics entries from the United States, those submitted by the two Greenpoint firms made a creditable showing. Charles Cartlidge and Company displayed a "Porcelain tea table and fancy ware" in addition to "door trimmings and sign letters." William Boch and Brothers showed "Stair rods and plates of decorated porcelain. Plain and gilded porcelain trimmings for doors, shutters, drawers, &c."[57] Several other firms, Haughwout and Dailey and Joseph Stouvenel and Brother among them, also exhibited decorated porcelains.

The most impressive of the American exhibits, however, was submitted by a New York retailer, O. A. Gager and Company, representing the United States Pottery Company in Bennington, Vermont. The official catalogue's modest entry describing the work simply as "Fenton's patent flint enameled ware" did not prepare visitors for the ten-foot-high monument made of ceramics that confronted them (cat. no. 270). Singled out by Horace Greeley as an exhibition "which is well worthy of observation by all those who take delight in the progress of American art and skill,"[58] the display was depicted in a woodcut published on the front page of the Boston newspaper *Gleason's Pictorial Drawing-Room Companion* (fig. 276). The monument and the utilitarian objects that surrounded it demonstrated the diversity of the United States Pottery Company's wares and presented examples of the varied clay bodies and glazes for which the firm became well known. The monument itself had four levels. At the bottom was a base of scroddled ware, that is, different colored clays mixed to resemble veined marble. Next came a columnar octagonal section made of the firm's yellow ware, with its famed color-flecked flint enamel glaze. The third section once contained a bust in Parian ware of Christopher Webber Fenton, the founder of the pottery and the inventor of new types of ceramic wares and glazes,

surrounded by a screen of Corinthian columns made of scroddled ware. Resting on the columns was a flint enamel glazed cap that also served as the base for a statue in Parian ware of a Madonna-like figure holding a child and a Bible. Stacked on the floor and on tiered display tables around the monument was a large assortment of practical and ornamental wares, from plates and pitchers to watercoolers and statuettes, all in the firm's signature types of ceramic. In its size and elaborate massing, the United States Pottery Company's display seemed to echo the aesthetic of the Crystal Palace itself. New York, then, was not the only locus of innovative pottery making.

In the New York area Greenpoint remained the center for the manufacture of Parian and heavy-grade porcelain throughout the nineteenth century. Cartlidge's firm remained in business until 1858; William Boch and Brothers (see cat. no. 269) was in operation during approximately the same period, from at least 1844 until 1861 or 1862. And in 1860 Thomas C. Smith founded the Union Porcelain Works, which later became the preeminent porcelain works in Brooklyn and, in spite of increasing competition from the whiteware firms in Trenton, New Jersey, remained a leading manufacturer in the field of hotel china until the early 1920s.

## Glassware Made in New York City

The period from the opening of the Erie Canal to the onset of the Civil War was a time of transition in the American glass industry. Protective tariffs encouraged the development of domestic industry, including glassmaking, and masses of skilled immigrant laborers made it possible to staff large shops that could produce fine-quality tableware of blown, cut, or pressed glass. In the 1820s in New York City several glass factories were founded that produced middle-range and luxury table glass. During the three ensuing decades these firms established themselves securely and created the one serious chapter in the history of New York City glassmaking, but in the 1850s and 1860s many of them closed down one by one. Those that survived reestablished themselves in another part of the country or turned to the manufacture of optical glass or glass for streetlamps. It was not until the late nineteenth century that New York again became a glassmaking center, but this time for the limited production of fine art glass.

The earliest of the nineteenth-century glasshouses were located in Manhattan, outside the heavily populated commercial district. Like potteries, glassmaking

55. *Official Catalogue of the New-York Exhibition of the Industry of All Nations, 1853* (New York: George P. Putnam and Co., 1853), p. 16.

56. B. Silliman Jr. and C. R. Goodrich, eds., *The World of Science, Art, and Industry Illustrated from Examples in the New-York Exhibition, 1853–54* (New York: G. P. Putnam and Company, 1854), p. 186.

57. *Official Catalogue, Industry of All Nations, 1853*, p. 81.

58. Horace Greeley, *Art and Industry as Represented in the Exhibition at the Crystal Palace New York—1853–4, Showing the Progress and State of the Various Useful and Esthetic Pursuits* (New York: Redfield, 1853), p. 120.

59. In 1853 Pittsburgh had eight glasshouses employing five hundred people for the making of utilitarian glass only, and in addition, similar numbers employed in the manufacture of window glass and phials.

60. See [James Boardman], *America and the Americans by a Citizen of the World* (London: Longman, Rees, Orme, Brown, Green, and Longmans, 1833), pp. 21–23.

61. Thomson and Grant advertisement, *New Orleans Argus*, January 18, 1830, quoted in Arlene Palmer, *Glass in Early America: Selections from the Henry Francis du Pont Winterthur Museum* (Winterthur, Delaware: Henry Francis du Pont Winterthur Museum, 1993), p. 137.

62. Brooklyn Flint Glass Company, advertisement, *Carrington's Commissionaire*, January 1, 1856, transcribed in Maynard E. Steiner, "The Brooklyn Flint Glass Company, 1840–1868," *The Acorn, Journal of the Sandwich Glass Museum* 7 (1997), p. 61.

63. Baron Axel Klinkowström, *Baron Klinkowström's America, 1818–1820*, edited by Franklin D. Scott (Evanston, Illinois: Northwestern University Press, 1952), p. 128, quoted in Elisabeth Donaghy Garrett, *At Home: The American Family, 1750–1870* (New York: Harry N. Abrams, 1990), p. 89.

128. Henry Sharp was listed for one additional year (1856–57), when he continued as a glass stainer independent of Steele at the same address.

129. In 1852 William Hannington was awarded a silver medal at the American Institute fair for "a stained glass church window figure of St. Peter." "List of Premiums Awarded by the Managers of the Twenty-fifth Annual Fair of the American Institute, October, 1852," p. 18, New-York Historical Society Library. Hannington received a bronze medal with special approbation at the 1853 New York Crystal Palace exhibition for his entry, a "Stained glass gothic window; stained glass plates, panels, borders, &c., for windows and doors. Stained glass portraits and fancy subjects." *Official Catalogue, Industry of All Nations,* pp. 80–81.

130. Regrettably, Gibson's windows for Trinity Church no longer survive, having been "upgraded" in the later nineteenth century.

131. The windows of Saint Paul's were undoubtedly typical for the day. The aisle windows were described as "of a rich salmon color, in small diamond panes, each pane bearing a *fleur-de-lis.*" See Charles W. Evans, *History of St. Paul's Church, Buffalo, N.Y., 1817 to 1888* (Buffalo and New York: Matthews-Northrup Works, 1903), p. 69. I thank Arlene Palmer for bringing to my attention the Bowdoin College chapel windows and their documentation.

132. List of contractors and merchants mentioned by Alexander Jackson Davis in connection with Litchfield Villa. I thank Amelia Peck for bringing these references to my attention.

133. *The Diary of Philip Hone, 1828–1851,* 2 vols., edited by Allan Nevins (New York: Dodd, Mead and Company, 1927), vol. 2, p. 764.

134. The steeple was taken down in 1906 when the subway was built beneath the church, for fear the train's vibrations would dangerously weaken the structure.

135. Everard M. Upjohn, *Richard Upjohn: Architect and Churchman* (New York: Columbia University Press, 1939), pp. 54–55.

136. William Bolton had studied under Samuel F. B. Morse at the National Academy of Design in

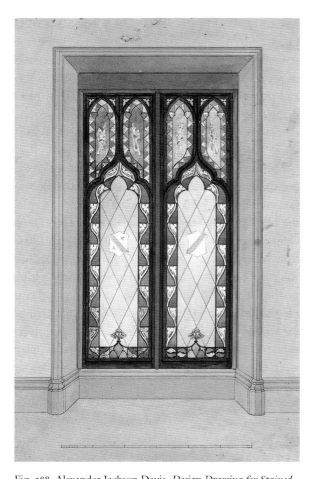

Fig. 288. Alexander Jackson Davis, *Design Drawing for Stained-Glass Window,* ca. 1840. Watercolor and ink. The Metropolitan Museum of Art, New York, Harris Brisbane Dick Fund, 1924 24.66.1042

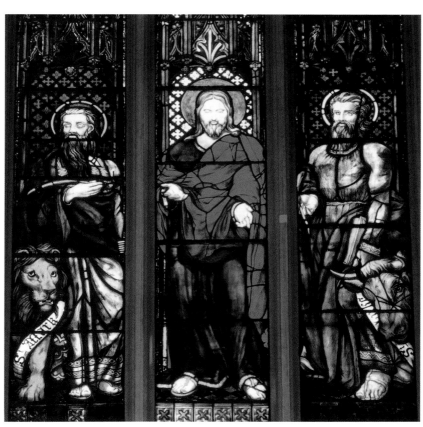

Bartow commissioned Lafever to design a monumental house of worship; the result was a soaring Gothic Revival structure with a tall, attenuated steeple encrusted with Gothic-style ornament.[134] Holy Trinity expresses a new spirit and sense of freedom and represents a departure from the ecclesiastical conservatism of Trinity.

In their process of manufacture as well as their design, the windows embody the differences between the churches themselves. At Trinity, following the traditional European practice, the architect was also the window designer. Upjohn retained complete artistic control; he prepared designs to be painted and glazed by Abner Stevenson, a glazier who erected a small workshop on the church grounds in order to accomplish this enormous task.[135] For the Brooklyn endeavor, which called for an ensemble of some sixty windows on three stories as well as an organ loft window and a majestic chancel window, Lafever hired William Jay Bolton, an artist from Pelham, New York, who served as designer, glazier, and painter at once.[136]

At Trinity, traditional Gothic Revival quarry, or diamond-paned, windows, the style favored by the High Church Anglican movement, were used throughout in the aisles, galleries, and clerestory. Both in their motifs and in their limited use of color, the windows are restrained. Figural designs appear only in the chancel window, where they stand one to a lancet, in

Fig. 289. Richard Upjohn, designer; Abner Stevenson, maker, *Saint Mark, Christ, and Saint Luke,* detail of chancel window, Trinity Church, Wall Street, 1842; photograph by David Finn. Paint and silver stain on pot-metal glass

traditional poses and with their appropriate attributes, surrounded by decorative diaper patterning and set under elaborate architectural canopies (fig. 289). In contrast, the windows at Holy Trinity in Brooklyn, reflecting its less conservative ecclesiastic spirit, carry an exuberant figural program of bold Renaissance-style narrative scenes. Bolton's designs are dense with people in complex compositions and often depart from traditional depictions of their subjects. The aisle windows represent scenes from the Old Testament, and the gallery or balcony windows present scenes from the life of Christ. In *Christ Stills the Tempest* Bolton has shown Christ and his disciples in an open boat in a raging storm on the Sea of Galilee, whose turbulent waves seem ready to engulf the vessel (cat. no. 280). Although illustrations of this miracle usually show Christ sitting peacefully or sleeping, here he is seen with his arms outstretched, about to still the waters, while his disciples regard him in awe. Jesus appears not as the familiar grown man with dark flowing hair and beard but as a clean-shaven youth with short blond hair. He and his disciples are depicted as individualized characters instead of iconic figures. Bolton utilized glass in a wide range of high colors, richly varied silver staining that ranges from pale lemon yellow to a deep amber, and colored enamel painted or, as seen in the stormy sea, sponged on: in short, any material or technique at his disposal that would heighten the artistic effect.

Liberal amounts of white glass also appear in his intricate designs. The traditional diaper patterns found in the windows of Trinity and in certain earlier windows by Bolton are absent here. Trained not as a technician but as an artist, Bolton approached his work from a painterly perspective rather than from the decorative viewpoint of a traditional glass stainer. The result, a series of intensely dramatic compositions, was also a most unusual example of the glass stainer's art.[137]

Bolton's complex, densely figured, individualistic art evokes the city that was its setting: an increasingly complex and populous New York with ever more richly colorful streetscapes and citizens. Yet Bolton's hand-executed craft, practiced in a small workshop next to his Pelham home, is the product of techniques that are the antithesis of the manufacturing developments that profoundly affected industry and its growth in the region. It was the glass and ceramics factories, especially the highly mechanized Brooklyn glassworks; the cutting shops using steam power; the new industrial potteries organized along English factory lines; and the tremendous influx of skilled immigrant labor that forever changed the city and, even more, the nation as a whole. For although after the Civil War neither glass-making nor ceramic manufacture in and around the city was able to attain the production levels of the previous decades, it was in New York that the groundwork had been laid for an impressive further development of those industries in many other parts of the country.

New York, see Willene B. Clark, *The Stained Glass of William Jay Bolton* (Syracuse: Syracuse University Press, 1992), pp. 12–13. Bolton had earlier made a presentation to the vestry of Trinity Church in an attempt to secure the commission for its windows: appealing on the grounds of aesthetics, doctrine, and economy, he proposed a complex Ascension window for the chancel and a figural program for the aisles, a design that was not selected. Letter from William Jay Bolton to William H. Harison of the building committee of Trinity Church, October 19, 1844(?), Trinity Church Parish Archives, New York.

137. I am grateful to David J. Fraser, Stained Glass Conservator, St. Ann and the Holy Trinity Church, Brooklyn, who was responsible for the conservation of this and most of the other windows at the church, for sharing his observations.

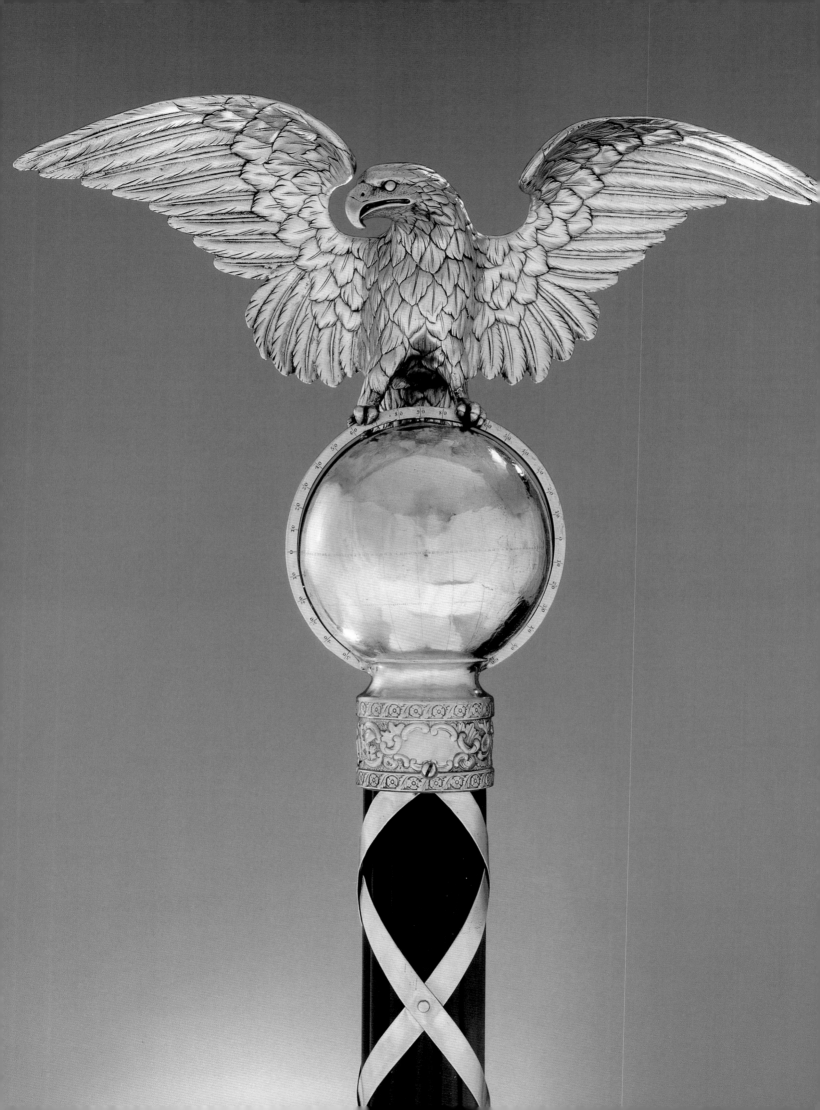

# "Silver Ware in Great Perfection": The Precious-Metals Trades in New York City

*DEBORAH DEPENDAHL WATERS*

Responding to an 1820 federal census questionnaire, New York silverware manufacturer Colin van Gelder Forbes (1776–1859) assessed current conditions in his industry. "From 1795 to 1816," he wrote, "the business was brisk and silver work was during those years in good demand. Since 1816 there has been but little doing."[1] The decline he described was relatively short lived, as the products of New York City's precious-metals trades, described by one observer as "Silver Ware in great perfection,"[2] came to dominate the American market in both artistic merit and quantity during the succeeding forty years, through stylistic, technological, and marketing transformations.

In 1824 a committee of Pearl Street merchants, charged with judging a competition for a pair of vases to be presented to Governor De Witt Clinton in recognition of his efforts in connection with the Erie and related canals, chose a submission by a firm outside New York, despite the presence within the city of some one hundred craftsmen working with precious metals. The well-known Philadelphia silversmith Thomas Fletcher modeled his winning designs (cat. no. 281 A, B; fig. 290) on a colossal Roman urn of the second century A.D. known as the Warwick Vase. They were manufactured in the workshop he owned with Sidney Gardiner. The vases impressed such New Yorkers as businessman and diarist Philip Hone when they were completed and exhibited in the assembly room of the City Hotel in March 1825. Some thirteen years later, Hone visited the shop of Thomas Fletcher in Philadelphia and observed, "Fletcher & Co. are the artists who made the Clinton vases. Nobody in this 'world' of ours hearabouts can compete with them in their kind of work."[3]

By comparison with these monumental Philadelphia vases, the New York–made presentation silver associated with Clinton and the canals is on a domestic scale and utilizes less handwrought ornament. Two years prior to the presentation of the Fletcher and Gardiner vases, the shop of William Gale, established in 1821, produced a covered pitcher (fig. 291) commissioned by a group of New York City flour manufacturers to commemorate the maiden voyage from Seneca Lake to New York City via the Seneca and Erie (Western) canals of the schooner *Mary and Hannah,* laden with a cargo of Western wheat, butter, and beans. Gale elongated the midsection of a typical pitcher form to accommodate a view of New York Harbor engraved after an unidentified source, and he incorporated such topical references in its decoration as die-rolled borders featuring sheaves of wheat alternating with scenes of rural life and a cast sheaf-of-wheat finial.[4]

Closer to the Clinton vases in scale and provenance is a mirrored plateau (fig. 292) struck with the mark of New York silversmith John W. Forbes (1781–1864).[5] More than five feet in length, the tripartite table ornament is in a form that originated in eighteenth-century France and was brought to American tables by stylish European ambassadors and American gentlemen, including George Washington, who ordered plateaus from France in 1789.[6] The frame of the Forbes plateau is closely related to London examples of the early nineteenth century, such as an 1810 model by Paul Storr.[7] The Forbes plateau has two widths of die-rolled floral scroll border centering a pierced central band. The latter is composed of alternating motifs of winged lions supporting an urn and grapevine with grape-cluster scrolls flanking a laurel wreath. Six pedestals with cast spread-eagle finials on cast acanthus-leaf legs terminating in lion's-paw feet support the mirrored frame. Mounted on the central pedestals are relief figures of Flora, the Roman goddess of flowers, and Pomona, the ancient Italian goddess of fruit trees. Ornamenting the two end-pedestals are relief trophies composed of symbolic devices, including a liberty cap on pole, a caduceus, an anchor, and an American flag. The only comparable American example, also marked by Forbes and now at the White House, is similarly ornamented.[8]

Forbes placed an announcement in the *New-York Daily Advertiser* for January 11, 1825, inviting customers and "admirers of good work in general" to examine what he characterized as "a superb Silver Plateau of

1. United States, Census Office, 4th Census, 1820, *Records of the 1820 Census of Manufactures,* National Archives Microfilm Publication, Microcopy no. 279, roll 10.
2. *New-York American,* October 20, 1835, p. 2, col. 3.
3. See Thomas H. Ormsbee, "Gratitude in Silver for Prosperity," *American Collector* 7 (April 1937), p. 3; and *The Diary of Philip Hone, 1828–1851,* 2 vols., edited by Allan Nevins (New York: Dodd, Mead and Company, 1927), vol. 1, pp. 301–2.
4. See Tammis K. Groft and Mary Alice Mackay, eds., *Albany Institute of History and Art: 200 Years of Collecting* (New York: Hudson Hills Press in association with Albany Institute of History and Art, 1998), pp. 198–99, no. 74. The pitcher is marked "w.g." and inscribed "Presented by the undernamed Manufacturers of flour in the City/of new York to John H. Osborne and Samuel S. Seely, of the Town of Hector, Tompkins County owners of the Boat Mary/& Hannah to Commemorate their enterprise in having first navigated/the Western Canal and Hudson River, from Seneca Lake to this/City with a Cargo of Wheat in Bulk, New York 1823" (followed by the names of ten individuals and firms). The reverse is engraved with a view of the *Mary and Hannah* in New York Harbor.
5. John W. Forbes was a second-generation New York silversmith, son of William Garret Forbes and younger brother of silversmith Colin van Gelder Forbes. The plateau is marked "I.W. FORBES" in a rectangle with pseudohallmarks of an anchor, star, monarch's head and the letter C, each in an oval. The center section is marked twice. The end-section with one foot is marked twice on each side. The other end-section is unmarked. For the mark, see Louise Conway Belden, *Marks of American*

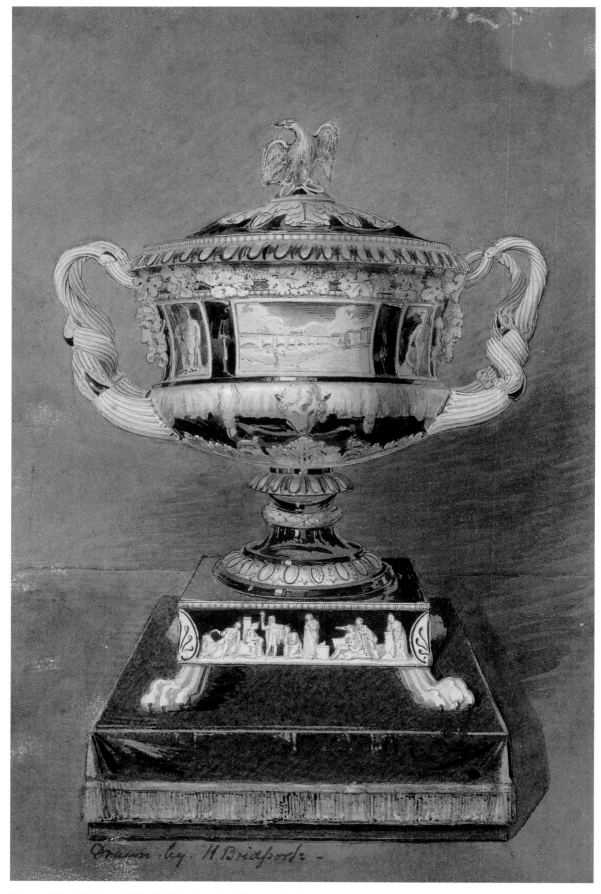

Fig. 290. Hugh Bridport, Philadelphia, artist, after Thomas Fletcher, designer; Fletcher and Gardiner, Philadelphia, manufacturing silversmith. *Drawing of One of the Covered Vases Made for Presentation to Governor De Witt Clinton in March 1825,* ca. 1825. Watercolor. The Metropolitan Museum of Art, New York, The Elisha Whittelsey Collection, The Elisha Whittelsey Fund, 1953  53.652.2

Fig. 291. William Gale, Covered ewer presented to the owners of the boat *Mary and Hannah,* 1823. Silver. Collection of the Albany Institute of History and Art, gift of William Gorham Rice, grandson of Samuel Satterlee Seely x1940.435

Fig. 292. John W. Forbes, Plateau, ca. 1825. Silver, mirrored glass, and walnut. The Metropolitan Museum of Art, New York, Purchase, The AE Fund, Annette de la Renta, The Annenberg Foundation, Mr. and Mrs. Robert G. Goelet, John J. Weber, Dr. and Mrs. Burton P. Fabricand, The Hascoe Family Foundation, Peter G. Terian, and Erving and Joyce Wolf Gifts, and Friends of the American Wing Fund, 1993 1993.167a–c

Fig. 293. Pelletreau, Bennett and Cooke, Pitcher presented to the Honorable Richard Riker, 1826. Silver. The Metropolitan Museum of Art, Purchase, The Overbook Foundation Gift, 1996 1996.559

his own manufacture, which he believes to be, at least, equal to any imported or manufactured in the United States."[9] Although an official presentation of the piece to Clinton cannot be documented, the family history that accompanied the plateau confirms that it is indeed the one on which the Fletcher and Gardiner vases stood—a fact also noted in 1828 in the press coverage of the sale of Clinton's personal effects following his death.[10]

In 1824 and 1825 a series of grand civic celebrations honoring venerable Revolutionary War hero the marquis de Lafayette and the completion of the Erie Canal prompted the production of an array of presentation silver by city craftsmen. Following the Grand Canal Celebration of November 4, 1825, the Corporation of the City of New York ordered a medal coined in commemoration of the successful opening of a water route joining Lake Erie with the Atlantic Ocean (cat. nos. 282A, B, 283A, B). Preparation of the dies required to strike the medal was a collaborative project involving artist Archibald Robertson, engraver and diesinker Charles Cushing Wright, engraver, diesinker, and piercer Richard Trested, and iron- and steelworker William Williams. Silversmith Maltby Pelletreau, of the firm Pelletreau, Bennett and Cooke, struck the medals in gold, silver, and semimetal using a hand-powered screw press with a heavy end-weighted balance lever that drove the screw with sufficient momentum to coin them cleanly.[11] Pelletreau also struck the obverse die—depicting Neptune, Roman god of the sea, and goat-legged Pan, Greek god of forests, pastures, flocks, and shepherds—on the body of a globular silver pitcher (fig. 293) that his firm presented to the Honorable Richard Riker, recorder of New York City. As chairman of the Committee of Arrangements for the Grand Canal Celebration, Riker apparently selected the firm for the prestigious medal commission.

On January 1, 1826, the Corporation of the City of New York acknowledged the contributions of Charles Rhind to the success of the Lafayette visits and the canal celebration by presenting him with a silver service composed of a tea set by master craftsman Garret Eoff (1779–1845) and a tray (fig. 294) and cake basket from the shop of Stephen Richard (1769–1843).[12] Rhind, a Scottish-born merchant who acted as agent for the

Fig. 294. Stephen Richard, retailer; James D. Stout, engraver, Tray presented to Charles Rhind, 1826. Silver. The Metropolitan Museum of Art, New York, Lent by Mr. and Mrs. Samuel Schwartz

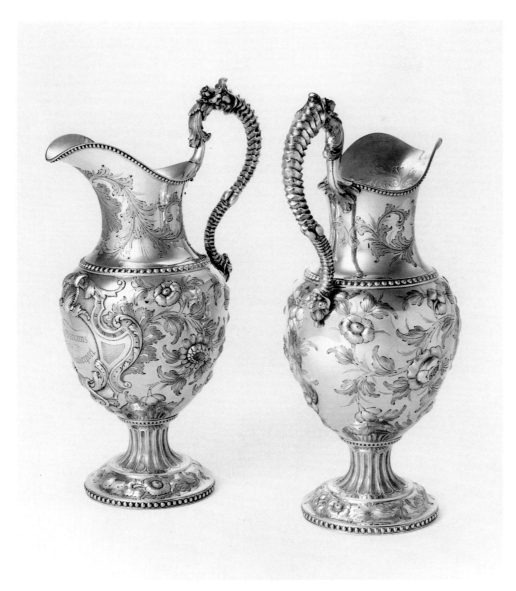

Fig. 295. Edgar Mortimer Eoff and George L. Shepard, silverware manufacturer; Ball, Black and Company, retailer, Pair of pitchers presented to Julie A. Vanderpoel, ca. 1855. Silver. Museum of the City of New York, Gift of Charles E. Loew and Miss Julie V. Loew 44.153.1–2

*Silversmiths in the Ineson-Bissell Collection* (Charlottesville: University Press of Virginia for the Henry Francis du Pont Winterthur Museum, 1980), p. 172, mark d.

6. For plateaus, see Martha Gandy Fales, *Early American Silver for the Cautious Collector* (New York: Funk and Wagnalls, 1970), pp. 148–49.

7. Alain Gruber, *Silver* (New York: Rizzoli International Publications, 1982), p. 186, fig. 265.

8. Graham Hood, *American Silver* (New York: Praeger Publishers, 1971), pp. 201–2, figs. 223, 224.

9. *New-York Daily Advertiser*, January 11, 1825.

10. "The Clinton Vases," *Niles' Weekly Register*, June 14, 1828.

11. For a description of a comparable coinage conducted at the Philadelphia Mint in the early nineteenth century, see the commentary prepared by George Escol Sellers, cited in Edgar P. Richardson, "The Cassin Medal," *Winterthur Portfolio* 4 (1968), pp. 80–81.

12. Marked "S. RICHARD" in a serrated rectangle with rounded corners, the tray is inscribed "Presented by the Corporation of the City of New York to Charles Rhind Esqr. Jany 1st 1826"; "Reception of Majr. Genl. LaFayette A.D. 1824"; "Grand Canal Celebrations A.D. 1825"; and "Engd. by I. D. Stout."

13. Stout advertised the execution of card and doorplate engraving as well as engraving on penknives, spoons, umbrellas, lockets and rings, and silver plate in the *Morning Courier* (New York), April 10, 1832, p. 2, col. 7.

14. The cake basket was illustrated in an advertisement published in *Antiques* 94 (December 1968), p. 795.

15. For example, William Thomson used the border on a tea service that descended in the Osgood-Field family of New York (Museum of the City of New York, 90.65.2).

16. *Minutes of the Common Council of the City of New York, 1784–1831* (New York: City of New York, 1917), vol. 8, August 6, 1816, p. 599.

North River Steam Boat Company, had served as chairman of the reception committee that welcomed Lafayette upon his arrival in New York in 1824 and as admiral of the fleet during the Grand Aquatic Display portion of the Grand Canal Celebration of November 1825. James D. Stout handsomely engraved the tray with a vignette depicting the arms of the city, flanked by its mariner and native American supporters, against a view of the city and its harbor.[13] Used on both the tray and the cake basket (unlocated)[14] is a die-stamped floral border of typical New York design. Like the die-rolled borders and sheaf-of-wheat finial of William Gale's pitcher (fig. 291), it appears on silver objects struck with marks identified with various shops, including that of silver manufacturer William Thomson.[15]

Available documentation suggests that Stephen Richard, active as a jeweler, enameler, and hair worker in New York at various locations in Manhattan between 1801 and 1829, operated a retail store selling both domestic and imported products. In 1816 his firm had provided a gold box presented to Commodore William Bainbridge by the Common Council of the City of New York, so a second city commission a decade later would not have been unexpected.[16] That these pieces for Rhind date from the end of Richard's career—as do other significant presentation commissions, including an undated ewer and salver given to Charles Bancroft by the Phenix Bank of New York (Bayou Bend Collection, Museum of Fine Arts, Houston) and a pair of pitchers presented

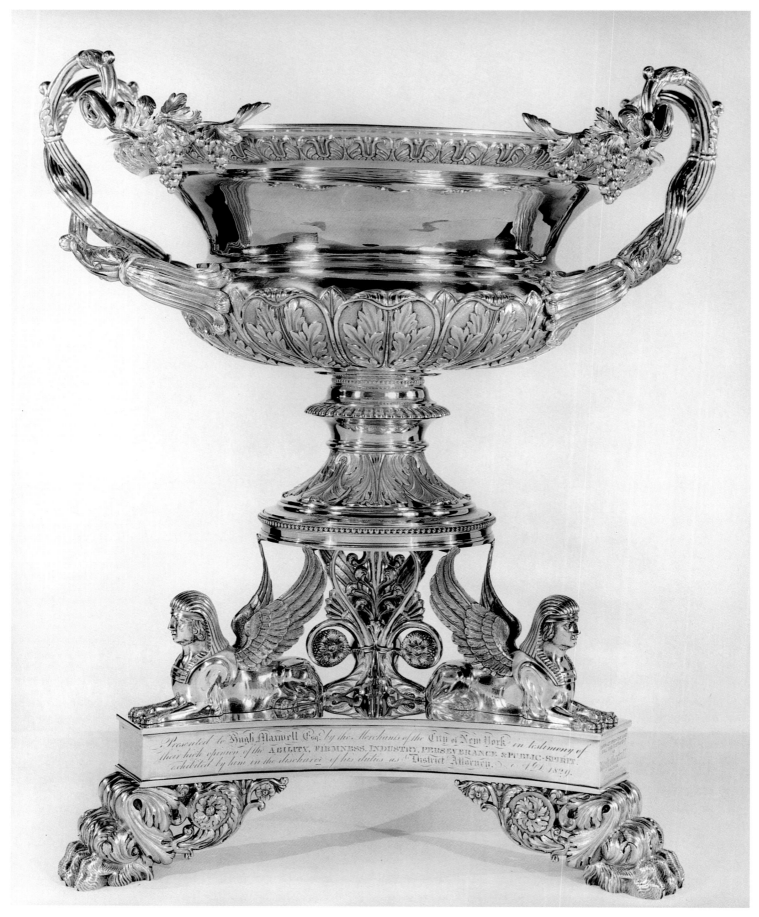

Fig. 296. Thomas Fletcher, Philadelphia, designer and manufacturer; marked by Baldwin Gardiner, retailer, Presentation vase presented by the merchants of New York to District Attorney Hugh Maxwell, Esq., 1828–29. Silver. On loan from The New York Law Institute to The New-York Historical Society

to Jameson Cox in 1829 (Museum of the City of New York)—indicates that Richard's shop either employed skilled journeymen or subcontracted its silver work to such manufacturing silversmiths as Garret Eoff. Eoff had announced his intention to "decline the retail business and confine himself to manufacturing exclusively" in April 1825.[17] Other manufacturing silversmiths, such as John W. Forbes, opposed wholesale selling to retailers. To differentiate himself from others, Forbes advertised that he attended personally to his manufactory, manufactured "solely to order and for cash," and that "all articles of silver of his manufacture [were] sold only by himself."[18]

Traditional kinship and apprenticeship networks continued to link many craftsmen in the luxury-metals trades from the 1820s through the outbreak of the Civil War, even as new models for the organization of the craft evolved. For example, the brothers John W. and Colin van Gelder Forbes continued a family tradition of silversmithing established in the eighteenth century by their father, William Garret Forbes (1751–1840), and their uncle Abraham G. Forbes. In 1826 Colin's son William joined his father's silver manufactory. Nine years later Colin V. G. Forbes and Son produced a distinguished hot-water urn ornamented with relief decoration after a design by Henry Inman (cat. no. 290).[19] The younger Forbes's entry in the 1838 American Institute fair won a silver medal for the best tea set, an award that came at the beginning of his independent career. The Forbes manufactory produced goods distributed by the New York retail silversmith and jewelry firm Ball, Tompkins and Black (see cat. no. 306) and its successor, Ball, Black and Company (active 1851–74), until William's retirement, about 1864. As a master craftsman, John W. Forbes proudly announced to potential customers that he had "served a regular apprenticeship at the business" and would execute all orders "in a masterly manner."[20] He continued to teach apprentices the "art and mystery" of the craft, preferring, as he stated in an advertisement of 1821, "an active lad about 14 years of age, of respectable connexions."[21] Although Forbes called his shop a "manufactory" and owned both a flatting mill (for preparing sheet silver) and an embossing mill (for die-rolling borders), he employed only three men and two boys in 1820, not the minimum workforce of twenty as proposed by historian Sean Wilentz in his definition of "manufactory."[22]

A shortened apprenticeship with Abraham G. Forbes, from April 1793 to April 1798, links Garret Eoff with the extended Forbes clan of silversmiths at the outset of his career. He in turn fostered the early career of John C. Moore when they worked in partnership as Eoff and Moore in 1835. At the beginning of the 1820s Eoff operated a retail silver and jewelry store at 163 Broadway, but in 1825 he decided to discontinue retail sales and to relocate away from the bustle of Broadway. Eoff sold off not only the stock he had on hand but also his shop fixtures, including "three glass side cases, one good awning, and two counter cases."[23]

One of Eoff's heirs, Edgar Mortimer Eoff, carried Garret's eighteenth-century craft legacy into the third quarter of the nineteenth century. As a manufacturing silversmith in partnership first with William M. Phyfe and then, beginning in 1852–53, with George L. Shepard, Eoff supplied goods not only to New York City retailers Ball, Black and Company (see fig. 295) but also to retail silversmiths as far afield as Richmond, Virginia.[24]

As the city grew and prospered following the opening of the Erie Canal, the silver-manufacturing industry offered financial opportunities to a second group of specialists whom Wilentz has identified as "craft entrepreneurs."[25] In the luxury-metals trades, not all entrepreneurs were skilled craftsmen. Often they were merchandisers whose expertise lay in their ability to persuade consumers to acquire goods from ever-changing assortments of domestic and imported merchandise. One of these was Baldwin Gardiner, brother of Sidney Gardiner. Trained as a shopkeeper in the firm of Fletcher and Gardiner, first in Boston and then in Philadelphia, Baldwin moved to New York late in 1826 or early in 1827. In New York he established a fashionable furnishings warehouse at 149 Broadway, at the corner of Liberty Street, where he sold lamps and other goods and filled special local orders for silver. After his brother's untimely death in 1827, Gardiner maintained contact with Thomas Fletcher, to whom he turned when seeking the commission for two pitchers and a vase to be presented to New York district attorney Hugh Maxwell, who had reached the midpoint of his twenty years in office.[26] As Gardiner explained when he requested design drawings from Fletcher in August 1828, "Of course, I should expect to have my name stamped upon the bottoms."

Gardiner received the commission, and the Fletcher shop manufactured the "splendid Vase" (fig. 296), which was stamped with Gardiner's name.[27] In designing the Maxwell vase, Fletcher once again took the Warwick Vase as his model, adapting its rustic grapevine handles, central foot, and repoussé acanthus-leaf decoration. Unlike the Warwick Vase or the earlier De Witt Clinton vases, however, the Maxwell

17. *New-York Evening Post*, April 13, 1825, p. 3, col. 2.

18. *New-York Daily Advertiser*, September 2, 1820; ibid., October 1, 1817, p. 3, col. 5.

19. Several previous publications, including *19th-Century America*, vol. 1, *Furniture and Other Decorative Arts*, by Marilynn Johnson, Marvin D. Schwartz, and Suzanne Boorsch (exh. cat., New York: The Metropolitan Museum of Art, 1970), no. 52; and David B. Warren, Katherine S. Howe, and Michael K. Brown, *Marks of Achievement: Four Centuries of American Presentation Silver* (exh. cat., Houston: Museum of Fine Arts, 1987), pp. 124–25, no. 156, have recorded the members of the firm as Colin van Gelder Forbes and John W. Forbes; John W. Forbes was the younger brother of Colin van Gelder Forbes, not his son.

20. *New-York Daily Advertiser*, December 16, 1819.

21. Ibid., July 30, 1821, p. 1, col. 7.

22. Sean Wilentz, *Chants Democratic: New York City and the Rise of the American Working Class, 1788–1850* (New York: Oxford University Press, 1984), p. 115.

23. *New-York Evening Post*, April 13, 1825, p. 3, col. 2; ibid., April 30, 1825, p. 3, col. 4.

24. See Decorative Arts Photographic Collection Files, Winterthur Library, Henry Francis du Pont Winterthur Museum, Winterthur, Delaware, for examples of Eoff and Phyfe products marked for non–New York retailers, including DAPC 69.1999 and DAPC 78.3897, a handled cup in the collection of the Valentine Museum, Richmond, Virginia.

25. Wilentz, *Chants Democratic*, pp. 35–37, 116–17.

26. David McAdam et al., eds., *History of the Bench and Bar of New York*, 2 vols. (New York: New York History Company, 1897–99), vol. 1, p. 413.

27. Baldwin Gardiner, New York, August 29, 1828, to Thomas Fletcher, Philadelphia, Fletcher Papers, Box 11, Athenaeum of Philadelphia.

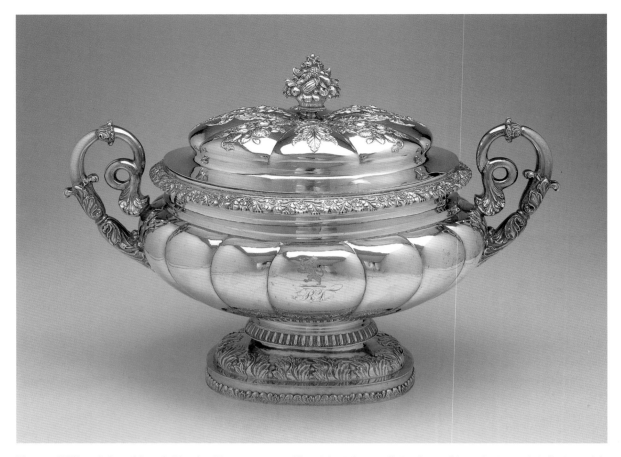

Fig. 297. William Gale and Joseph Moseley, Tureen, ca. 1830. Silver. The Minneapolis Institute of Arts, the James S. Bell Memorial Fund and the Christina N. and Swan J. Turnblad Memorial Fund 80.57

28. *Morning Courier and New-York Enquirer*, October 17, 1833.

29. On the history of J. and I. Cox and its successors, see: *New-York Daily Advertiser*, April 8, 1820, p. 2, col. 6; ibid., January 26, 1826, p. 1, col. 6; ibid., April 6, 1826, p. 1, col. 5; *New-York Evening Post*, October 24, 1826; *The American Advertising Directory for Manufacturers and Dealers for the Year 1832* (New York: Jocelyn, Darling and Co., 1832), p. 105; Thomas Cox, Birmingham, to Thomas Fletcher, Philadelphia, December 2, 1833, Fletcher Papers, Box III, Athenaeum of Philadelphia; *Third Annual Fair of the Mechanics' Institute of the City of New York* (New York, 1837), p. 16 (on the firm's diploma); *The New York Business Directory for 1840 & 1841* (New York: Publication Office, 1840), pp. 152–53; *The New-York City and Co-Partnership Directory for 1843 & 1844* (New York: John Doggett Jr., 1843), pp. 84, 85, 385; Gertrude A. Barber, comp., "Abstracts of Wills for New York County, New York," vol. 15,

presentation piece has an unadorned band around the body. Fletcher mounted the whole on a tripod base with crisply sculpted sphinxes, whose extended wings appear to support the vase above. Robust acanthus-and-paw feet in turn support the plinth. By 1831 Gardiner had his own silver manufactory in operation, with high-pressure steam power available. Two years later, Gardiner's entry in the fair of the American Institute brought praise from a newspaper reporter, who wrote, "We first viewed some superb silverware from the manufactory of B. Gardiner, 149 Broadway. The embossed silver waiters and pitchers were finished in admirable style" (see cat. nos. 284, 286).[28]

Preceding Baldwin Gardiner in New York as merchants of imported fancy hardware and lamps were the brothers Joseph (ca. 1790–1852) and John Cox from Birmingham, England, who traded as J. and I. Cox. In time for inclusion in the 1819–20 edition of *Longworth's Directory*, these merchants had settled at 5 Maiden Lane, near Broadway, at the Sign of the Lamp. The Cox firm, like others in the Maiden Lane neighborhood, moved from sales of imported fancy hardware and lamps to imported and domestic plated goods and furnishings and subsequently added silverware and gas fixtures to its product lines. At the third annual fair of the Mechanics' Institute, held at Niblo's Garden in September 1837, J. and I. Cox won a diploma for its entries of a silver tea set and pitchers, which "displayed great taste, both in design and workmanship." By 1843 two branches of "Cox's Furnishing Warehouse" served consumers, at 15 Maiden Lane and 349 Broadway, on the corner of Leonard Street. In 1848 the firm offered silverware only at the Maiden Lane warehouse. Following the death of Joseph Cox in December 1852, both the silver and gas-fixtures lines of merchandise were transferred to John Cox and Company, 349 Broadway. In 1856–57 John Cox and Company listed itself as an importer of gas fixtures, clocks, bronzes, plated ware, and related goods, and as a manufacturer of silverware, with Joseph's son a member of the firm.[29]

The relationship between manufacturing silversmith and silver retailer was often unclear to the public. J. and I. Cox offered silverware to its customers and entered silver into competitions under its name; its successor firm, John Cox and Company, advertised as

a manufacturer of silverware. In at least one instance, manufacturing silversmiths Cann and Dunn (John Cann and David Dunn; active ca. 1855–57) produced silver also struck with the Cox firm stamp.[30] Cann and Dunn succeeded the partnership Charters, Cann and Dunn (Thomas Charters, John Cann, and David Dunn; active 1848–54). In the 1855–56 edition of *Trow's New York City Directory,* the "old established silver ware manufactory of Cann and Dunn" took a display advertisement to announce its relocation to Brooklyn, where the firm remained the following year. With its new facilities, Cann and Dunn announced it was prepared "to fulfill as usual, all Orders from the Trade for Vases, Urns, Salvers, Pitchers, Tea and Coffee Services, TRUMPETS, / PLATES, GOBLETS, CUPS, &c. / From Designs Original and Selected, / Ancient and Modern."[31]

Silverware manufacturers and retail silversmiths both embraced the neutral showcase for shop products provided by the annual fairs sponsored by the American Institute of the City of New York (beginning in 1828) and those organized by the Mechanics' Institute of the City of New-York (from 1835 on). These juried fairs highlighting American improvements in the mechanical and fine arts quickly became significant venues for the display of new goods and product lines.[32] In each product category, men who had experience within the industry or in a related discipline were chosen as judges. Journalists sympathetic to the cause of protecting American manufactures wrote articles listing the winners of the competitive awards and often featuring specific exhibits or items within displays. Their accounts were printed both in New York and in such national publications as *Niles' Weekly Register.* Although the 1829 American Institute fair had no official class for precious metal objects, judges awarded discretionary premiums to the retail firm of Marquand and Brothers for "superior tea and dinner silver ware" and to silverware manufacturers William Gale and Joseph Moseley for "superior silver forks and spoons," decisions duly reported by *Niles' Weekly Register.*[33] Gale and Moseley produced a presentation coffee urn in 1829 (cat. no. 285) and an imposing handled tureen about 1830 (fig. 297).[34] The following year, in the class designated "Silver, Plated and Tin Ware, Clocks, etc," entrepreneur Baldwin Gardiner won a first premium, as did silver manufacturer Thomson. Retailers Stebbins and Howe won a premium for a case of jewelry, watches, and silverware described as "very tasty and elegant."[35] National pride colored the occasional commentary, as in an 1835 article published in the *Mechanics' Magazine*

*and Register of Inventions and Improvements:* "Silver Ware.—The specimens of Silver Ware exhibited by Mr. Marquand, 181 Broadway, and Mr. James Thompson [*sic*], 129 William-st., produced the most agreeable astonishment, especially to us, who well remember when to produce a common Silver Buckle in this country, was a thing viewed with utter astonishment."[36] Even *Holden's Dollar Magazine,* a publication that questioned the utility and expense of the expositions, noted that "the most showy exhibiters at the fairs are the confectioners, silversmiths, glass cutters, and milliners."[37]

Judges of the American Institute fairs often awarded premiums to one or more manufacturing silversmiths and one firm of retail silversmiths annually during the 1840s. In 1841 the retailer Ball, Tompkins and Black, located at 181 Broadway, was singled out for the best specimens of silver plate and chasing, while manufacturing silversmith William Adams, whose business was at 185 Church Street, received recognition for the second-best effort in those categories. Flatware specialist Albert Coles (1815–1885), then located at 6 Little Green Street, won a silver medal for the best silver knives and forks. The following year, the judges awarded premiums to the same entrants.[38]

Diesinker Moritz Fürst, who won a silver medal for "specimens of very superior die-sinking" at the sixth annual American Institute fair in 1833, subsequently executed prize medals for both the American Institute (cat. no. 291) and the Mechanics' Institute, employing similar designs.[39] American Institute judges awarded large numbers of medals struck in gold and silver as well as silver prize cups. At its eighteenth fair, in 1845, the institute distributed 34 gold medals, 80 silver medals, and 139 silver cups. Two years later, the ratio between the types of prizes had shifted, with 244 silver medals, 28 gold medals, and 44 silver cups awarded.[40]

Although articles on the entries in the fairs praise the products of New York silversmiths without commenting on style, surviving pieces marked by the city's craftsmen show that these artisans were called on to reconcile an increasingly severe Neoclassicism with a resurgence of the Rococo. Between 1830 and 1861 silversmiths needed to pay particular attention to the personal preferences of their patrons when weighing the merits of the Rococo against other historical styles, including not only Neoclassical but also Gothic and other modes. As a result, wares had become decidedly eclectic in style by the 1830s. A key example is a hot-water urn by Colin van Gelder Forbes and his son William Forbes (cat. no. 290). This grand piece

1852–1853, p. 74, typescript, 1950, New York Genealogical and Biographical Society; Gertrude A. Barber, comp., "Deaths Taken from the New York *Evening Post* from September 8, 1852, to September 24, 1853," vol. 29, p. 28, typescript, 1940, New York Genealogical and Biographical Society, New York; Will of Joseph Cox, proved January 17, 1853, New York County Will Liber 105, p. 224, microfilm, New York Genealogical and Biographical Society; "Wilson's Business Directory of New York City," in *Trow's New-York City Directory, 1854–1855,* compiled by H. Wilson (New York: John F. Trow, 1854), pp. 169, 65, 147; H. Wilson, comp., *Trow's New-York City Directory for 1856–1857* (New York: John F. Trow, 1856), p. 184; Albert Ulmann, *Maiden Lane: The Story of A Single Street* (New York: Maiden Lane Historical Society, 1931), p. 61.

30. The Art Institute of Chicago owns a pitcher in the "modern French" (Rococo Revival) taste manufactured by Cann and Dunn and retailed by J. and I. Cox. See Judith A. Barter, Kimberly Rhodes, and Seth A. Thayer, with contributions by Andrew Walker, *American Arts at the Art Institute of Chicago, from Colonial Times to World War I* (Chicago: Art Institute of Chicago, 1998), pp. 179–80, no. 80.

31. H. Wilson, comp., *Trow's New York City Directory for the Year Ending May 1, 1856* (New York: John F. Trow, 1855), advertisement section; William H. Smith, comp., *Smith's Brooklyn City Directory, 1855/56* (Brooklyn, 1855), p. 2; William H. Smith, comp., *Smith's Brooklyn City Directory, 1856/57* (Brooklyn, 1856).

32. Edwin Forrest Murdock, "The American Institute," in *A Century of Industrial Progress,* edited by Frederic W. Wile (Garden City, New York: Doubleday, Doran and Company, 1928), pp. v–xvi.

33. *Niles' Weekly Register,* October 24, 1829, p. 141.

34. The tureen is marked "G & M" in a serrated rectangle and has three pseudohallmarks: a crowned leopard's head, a sovereign's head, and a lion passant. It is inscribed with an unidentified crest of a lion rampant above the initials "RT."

35. *Report of the Third Annual Fair of the American Institute of the*

*City of New York 1830* (New York: J. Seymour, 1830), p. 16.

36. "First Annual Fair of the Mechanics' Institute . . . Report," *Mechanics' Magazine and Register of Inventions and Improvements* 6 (November 1835), p. 270.

37. *Holden's Dollar Magazine* 2 (November 1848), p. 700.

38. *Premiums Awarded by the American Institute at the Fourteenth Annual Fair, October 1841* [New York, 1841], p. 10; and *List of Premiums Awarded by the Managers of the Fifteenth Annual Fair, of the American Institute, October 1842* [New York, 1842], p. 12, copies of both in the Manuscript Department, The New-York Historical Society. Medill Higgins Harvey, Research Assistant, Department of American Decorative Arts, Metropolitan Museum, compiled lists of premium winners from the American Institute files, New-York Historical Society, for which the author thanks her.

39. *Mechanics' Magazine and Journal of the Mechanics' Institute* 2 (October 1833), p. 180; Donald L. Fennimore, *Silver and Pewter* (New York: Alfred A. Knopf, 1984), p. 213.

40. *Niles' National Register*, November 8, 1845, pp. 150–52; ibid., October 30, 1847, p. 131.

41. *New Mirror*, May 18, 1844, p. 106.

42. J. Leander Bishop, *A History of American Manufactures from 1608 to 1860, . . .* 3 vols. (Philadelphia: Edward Young and Co., 1868), vol. 3, pp. 182–89; George F. Heydt, *Charles L. Tiffany and the House of Tiffany & Co.* (New York: Tiffany and Co., 1893), pp. 21–22.

43. Elizabeth L. Kerr Fish, "Edward C. Moore and Tiffany Islamic-Style Silver, c. 1867–1889," *Studies in the Decorative Arts* 6 (spring–summer 1999), pp. 42, 61 n. 3.

44. B. Silliman Jr. and C. R. Goodrich, eds., *The World Of Science, Art, and Industry Illustrated from Examples in the New-York Exhibition, 1853–54* (New York: G. P. Putnam and Company, 1854), p. 45. Since Tiffany, Young and Ellis imported bronzes as early as 1844, and Moore's mark is struck only on the silver dish at the top of the centerpiece, the possibility exists that Moore joined an existing figural base to his dish to create the centerpiece.

45. Ibid., pp. 80, 81, 126, 144, 157, 194.

46. Ibid., p. 194.

47. John Culme, *Nineteenth-Century Silver* (London:

Fig. 298. *Four Elements Centerpiece by Tiffany, Young and Ellis.* Wood engraving by Robert Roberts, from B. Silliman Jr. and C. R. Goodrich, eds., *The World of Science, Art, and Industry Illustrated from Examples in the New-York Exhibition, 1853–54* (New York: G. P. Putnam and Company, 1854), p. 45 (lower right). The Metropolitan Museum of Art, New York, The Thomas J. Watson Library

was presented in 1835 to grocer and longtime New York City resident John Degrauw on his resignation from the post of presiding officer of the board of trustees of the New York Fire Department. Neoclassical relief ornament after a design by New York artist Henry Inman for a discharge certificate cannot hide the inverted pyriform (pear-shaped) body of the urn, a form that was initially popular in the decades preceding the American Revolution.

In the five years between 1837 and 1842 a number of seemingly unrelated events occurred that would contribute to the transformation of silver manufacturing and retailing in New York by the outbreak of the Civil War. These were the establishment of the retailers Tiffany and Young (1837) and Ball, Tompkins and Black (1839) and the passage of the protective tariff of 1842. During the autumn of 1837, two brothers-in-law from Windham County, Connecticut, Charles L. Tiffany and John B. Young, launched a stationery and fancy-goods

business at 259 Broadway, an address north of the district where Marquand and Company and other jewelers and dealers in high-class fancy articles clustered. When J. L. Ellis joined as a partner in the spring of 1841, the firm became Tiffany, Young and Ellis. It specialized in English and Parisian personal luxuries, such as gloves, canes, dress fans, portfolios, and toilette boxes. Three years later, a correspondent for the *New Mirror* wrote admiringly of "the brilliant CURIOSITY SHOP of TIFFANY and YOUNG. No need to go to Paris now for any indulgence of taste, any vagary of fancy. It is as well worth an artist's while as a purchaser's, however, to make the round of this museum of luxuries. . . . I think that shop at the corner of Broadway and Warren is the most curious and visit-worthy spot in New-York—money in your pocket or no money."[41]

In 1847 Tiffany, Young and Ellis moved to more commodious quarters at 271 Broadway, at the corner of Chambers Street. Among its clientele was Swedish singer Jenny Lind, who made the shop one of her first retail stops during her inaugural 1850 American concert tour organized by P. T. Barnum. Although the firm began to manufacture gold and diamond jewelry in 1848, Tiffany, Young and Ellis continued to retail the products of many manufacturing silversmiths until 1851, when it secured the exclusive services of the firm headed by John C. Moore,[42] which had been supplying Tiffany, Young and Ellis with products since 1846.[43]

At the New York Crystal Palace exhibition in 1853, Tiffany, Young and Ellis displayed Moore's Four Elements centerpiece depicting Earth, Air, Water, and Fire as allegorical figures clothed in classical draperies (fig. 298).[44] There it competed successfully for attention with an array of other eye-catching figural centerpieces, many with literary themes, from the shops of such eminent London silversmiths as Joseph Angell, Hunt and Roskell, and R. and S. Garrard. Such centerpieces frequently incorporated candle branches or a dish, as Moore's piece does.[45] Having noted that centerpieces were by far the most costly works in precious metals displayed at the Crystal Palace, the American exhibition reviewers Benjamin Silliman Jr. and Charles R. Goodrich expressed doubt that such pieces should have been included at all: "Sculpture on a large scale in the precious metals is a mistake; and the attempts at exact imitations of fruits, flowers, and foliage, which so largely abound in the exhibited specimens, are absurdities beneath criticism."[46] Neither British nor American silversmiths heeded Silliman and Goodrich, however, and large figural groups

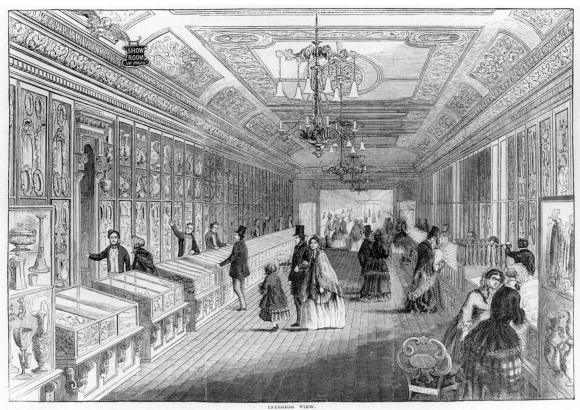

INTERIOR VIEW.

**BALL, BLACK & CO.**

Sign of the Golden Eagle, 247 Broadway, South Corner of Murray Street, opposite City Hall, New York.

HENRY BALL.       WILLIAM BLACK.       EBENEZER MONROE.

Fig. 299. *Interior View of Ball, Black and Company Premises,* 247 Broadway, ca. 1855. Wood engraving, from David Bigelow, *History of Prominent Mercantile and Manufacturing Firms in the United States . . .* (Boston: D. Bigelow and Company, 1857), vol. 6, p. 139. Courtesy of the American Antiquarian Society, Worcester, Massachusetts

Fig. 300. Advertisement for Ball, Black and Company, 1854. Wood engraving, from A. D. Jones, *The Illustrated American Biography* (New York: J. M. Emerson and Company, 1854), vol. 2, p. 206. Courtesy of the American Antiquarian Society, Worcester, Massachusetts

continued to dominate exhibition lists throughout the nineteenth century.[47]

Following the death of Isaac Marquand in 1838, the Marquand family withdrew from the old retail firm of Marquand and Company (see cat. no. 288). It became Ball, Tompkins and Black in 1839, with three former employees, Henry Ball, Erastus O. Tompkins, and William Black, at its helm. The firm remained at 181 Broadway until 1848, when it moved into its own newly built premises at 247 Broadway, on the corner of Murray Street, opposite City Hall (see figs. 299, 300). As an emblem of continuity, Ball, Tompkins and Black retained as its logo the golden eagle adopted by the Marquands.[48] Skillful merchandising—local, national, and international—attracted American merchant and professional families in ever-increasing numbers to the firm's elegant gaslit showrooms lined with cases displaying imported silver-plated ware, watches, clocks, diamonds, jewelry, fancy goods, cutlery, Bohemian glassware, and silverware "in every variety of Style and Patterns."[49] In 1851 the New York *Evening Post* noted: "Their collection of solid silver and silver-plated ware is the most splendid and extensive in the city, and embraces many of the richest looking sets that we have known. In adding a large manufacturing department,

Country Life Books, 1977),
pp. 203–20; Charles L. Venable,
*Silver in America, 1840–1940:
A Century of Splendor* (exh.
cat., Dallas: Dallas Museum of
Art, 1995), pp. 107–21; Charlotte
Gere, "European Decorative Arts
at the World's Fairs: 1850–1900,"
*Metropolitan Museum of Art
Bulletin* 56 (winter 1998–99),
pp. 3–56.

48. "Frederick Marquand," in *The
National Cyclopaedia of Ameri-
can Biography,* vol. 19 (New
York: James T. White and
Company, 1926), p. 399.

49. *Home Journal,* January 1, 1850,
p. 3.

50. *Evening Post* (New York), Sep-
tember 16, 1851, p. 3, col. 4.

51. "Ball, Black & Co.'s New Marble
Store," *Frank Leslie's Illustrated
Newspaper,* October 6, 1860,
pp. 313–14.

52. D. Albert Soeffing, "Ball, Black
& Co. Silverware Merchants,"
*Silver* 30 (November–December
1998), pp. 46–47.

53. Deborah Dependahl Waters,
"From Pure Coin: The Manu-
facture of American Silver Flat-
ware, 1800–1860," *Winterthur
Portfolio* 12 (1977), p. 27.

54. *Jewelers' Circular Keystone,*
June 22, 1892, p. 6.

55. Dorothy T. Rainwater and Judy
Redfield, *Encyclopedia of Ameri-
can Silver Manufacturers,* 4th ed.
(Atglen, Pennsylvania: Schiffer
Publishing, 1998), pp. 121–22.

they have consulted the wishes of their customers as well as their own interests."[50]

In 1860 Ball, Black and Company—the successor to Ball, Tompkins and Black—opened a "superb" store and manufactory constructed of white East Chester marble on the southwest corner of Broadway and Prince Street. Designed by the architectural firm of Kellum and Son, and with interior decorations designed and executed by Charles Greiff, the six-story building had showrooms on the first three floors and manufacturing workrooms on the upper levels. Richly stained wood and gold fittings provided an elegant backdrop for the display of jewelry and silverware on the first floor. The wares offered for sale ranged from "an unadorned eggcup to the most gorgeously chased and exquisitely patterned epergnes, all designed and manufactured on the premises."[51] In 1860 Bostonian Augustus Rogers, John R. Wendt (a talented German-born designer and chaser), and George Wilkinson, the English-born and English-trained chief designer for the Gorham Manufacturing Company in Providence, Rhode Island, formed a short-lived partnership to manufacture silverware for Ball, Black and Company. After his erstwhile partners abandoned the new firm, Wendt moved his operation to the fourth and fifth floors of the new building at Broadway and Prince and supplied unmarked goods to Ball, Black and Company for retail sale.[52]

William Gale patented his roller-die method of producing bas-relief ornament on both surfaces of silver flatware at the same time and throughout the length of the handle.[53] While Gale held the patent on this improvement on the flatting (rolling) mill, his firm had "a great advantage over coexisting competitors, and they controlled the trade in sterling flatware to a great extent in several sections of the United States."[54] However, in December 1840, fourteen years after he had taken it out, his patent expired. Subsequently, spoon mills with roller dies were more widely adapted within the American industry, and more innovative designs appeared. Beginning in the mid-1840s New York designers of flatware, including William Gale, Michael Gibney, and Philo B. Gilbert, took advantage of the extension of patent protection to designs, including those for flatware. Gibney obtained the first flatware design patent in December 1844, for a pattern sold through Ball, Tompkins and Black and its successor, Ball, Black and Company. His Tuscan pattern, patented in 1846, was developed at the request of shipping magnate Edward K. Collins for the dining room of a new transatlantic steamer.[55] The firm of Gale and Hayden obtained

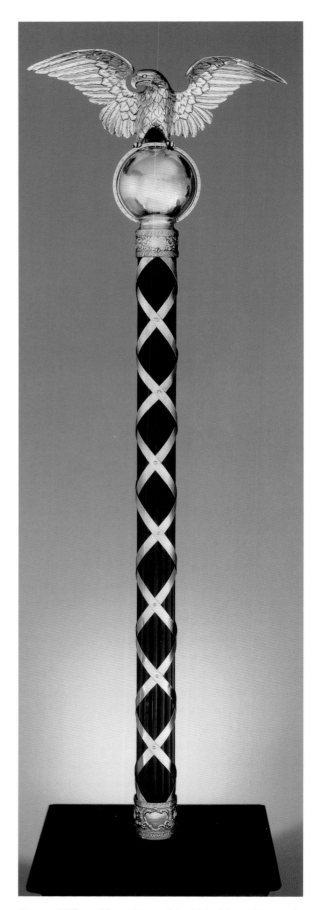

Fig. 301. William Adams, Mace of the United States House of Representatives, 1841. Silver and ebony. United States House of Representatives, Washington, D.C.

design patent 150 in 1847 for its Gothic-pattern flat-ware (cat. nos. 299, 300).

In October 1841 Speaker John White commissioned New York silversmith William Adams to manufacture a mace for the House of Representatives of the United States.[56] White authorized Adams "to have made a *Mace*, similar to the one destroyed by fire in the year 1814" (no sketch or list of specifications survives). On December 30, 1841, Adams signed a receipt for $400 for "Making a Silver Mace surmounted with a Globe and Spread Eagle" (fig. 301). It consists of thirteen cylindrical ebony rods bound around a central shaft by four silver thongs wound spirally from top to bottom. Silver repoussé-chased bands edged with die-rolled floral guilloche borders and with asymmetrical scrolls, flowers, and raffles (ragged-edged acanthus leaves) hold the rods at top and bottom. Surmounting the mace is a hollow silver globe engraved with images of the continents and the meridians of longitude. Grasping an attached band engraved with the degrees of latitude is a cast-silver American eagle with outspread wings. On the lower band, engraved within a cartouche, are the words "Wm. Adams/Manufacturer/New York/1841."[57]

Adams was a native of Troy, New York, where he served his apprenticeship with one Pierre Chicotree (possibly Peter Chitry), whose widow he subsequently married. A nineteenth-century biographer of Adams noted that "by close application and hard industry, combined with stringent economy, he was enabled to save a large amount of money, with which he bought real estate, and upon its certain rise," he became "immensely rich."[58] A competent silversmith, Adams won awards on several occasions for the best or the second-best specimen of silverware displayed at the annual fairs of the American Institute. In 1852 he and two others judged the silverware class. However, Speaker White probably awarded him the mace commission not so much for his skill as for his political activism and his friendship with Kentucky statesman Henry Clay. Like Clay a Whig in his politics, Adams was an assistant alderman and alderman for the Fifth Ward of New York City during the 1840s, and he subsequently served as commissioner of repairs and supplies in 1850 and 1852.[59]

As the shop of William Adams was completing the mace for the House of Representatives in 1841, more than five hundred silversmiths and precious-metals workers from New York signed a petition calling for increased tariff duties on imported plate. Fairs promoting American manufactures had not halted the sale of foreign plated wares, silver goods, and fancy

articles in New York, all of which competed in the marketplace with American-made goods. In 1820 New York retailers such as Henry Cheavens, whose shop was at 143 Broadway, near Liberty Street, advertised connections with British suppliers that would be to the advantage of the American consumer. Auction consignment sales of London, Sheffield, and Birmingham plated ware and silver tablewares and flatware were another source of such goods, at prices often below retail. Agents for the Sheffield plated-ware manufacturer Thomas Bradbury and Son solicited orders directly from such New York firms as J. and I. Cox, Marquand and Company, Baldwin Gardiner, and Ball, Tompkins and Black beginning in the mid-1830s until the late 1840s.[60] When in 1840 manufacturing silversmiths and jewelers Storr and Mortimer of New Bond Street, London, set up shop at 20 Warren Street, near Broadway, with a fashionable assortment of jewelry, plate, and plated ware of "the very best quality & workmanship," the New York crafts community became alarmed, as it was still suffering from the economic dislocations of the Bank War, begun in 1833–34. By the spring of 1841, when Storr and Mortimer, which had moved to 356 Broadway, two doors north of the Carlton House, announced that it was "now enabled to manufacture here every description of Plate & Jewellery,"[61] the threat of foreign competition had become all too real.

Henry Clay, the champion of the American system and protectionism, took up the cause of the silversmiths. In 1842 he drafted and advocated an amendment to tariff legislation pending before Congress that would increase duties on incoming goods. Clay's proposal was adopted, and duties rose on imported silverware and foreign jewelry. The increased tariffs had the desired effect, making imported silver goods no longer competitive in price with domestic products of like quality. Storr and Mortimer's New York branch closed within a year of the implementation of the new tariff.[62]

On October 14, 1842, as part of the Croton Celebration honoring the completion of the Croton Aqueduct, the city's gold and silver artisans marched together as a craft, along with members of the Mercantile Library Association, the Marine Society, the General Society of Mechanics and Tradesmen, the Mechanics' Society school, a delegation of the Home League, the American and Mechanics' institutes, officers of the federal government, and pupils of the Deaf and Dumb Institution. They escorted "a table covered with rich gold and silver ware, which was borne on the shoulders of four colored men."[63] This show of

56. After the original mace was destroyed when the British army burned the Capitol on August 24, 1814, during the War of 1812, a substitute of painted pine was used for twenty-eight years.

57. The pertinent Congressional records are cited and the mace is illustrated in Silvio A. Bedini, "The Mace and the Gavel Symbols of Government in America," *Transactions of the American Philosophical Society* 87, part 4 (1997), pp. 28–33, figs. 13–18.

58. An Old Resident [William Armstrong], *The Aristocracy of New York: Who They Are, and What They Were, Being a Social and Business History of the City for Many Years* (New York: New York Publishing Company, 1848), pp. 10, 12; "Silversmith William Adams," *Jewelers' Circular and Horological Review*, August 5, 1896, p. 34; *Transactions of the American Institute of the City of New-York*, 1852, p. 500.

59. Joan Sayers Brown, "William Adams and the Mace of the United States House of Representatives," *Antiques* 108 (July 1975), pp. 76–77, frontis.

60. *New-York Daily Advertiser*, April 8, 1820; ibid., June 14, 1820; ibid., March 17, 1826, p. 1, col. 4; *New-York Evening Post*, June 21, 1826, p. 3; D. Albert Soeffing, "A Selection of Letters from the Black, Starr & Frost Scrapbooks," *Silver* 29 (November–December 1997), pp. 48–51.

61. *The Albion*, January 25, 1840, p. 32; *Spirit of the Times*, May 1, 1841, p. 105. A four-piece service with a history of ownership in the de Peyster family of New York, now in the collection of the Museum of the City of New York (40.108.4–.8), may have been purchased from Storr and Mortimer in New York. The components of the service are struck variously with London hallmarks used between 1838 and 1840 and the maker's marks of Paul Storr and his successor John Samuel Hunt, as well as an incised "Storr & Mortimer" on the teapot (40.108.4) and coffeepot (40.108.5).

62. Venable, *Silver in America*, p. 19.

63. *Niles' National Register*, October 22, 1842, pp. 124–27; *New World*, October 22, 1842, pp. 268–69.

64. Joan Sayers Brown, "Henry Clay's Silver Urn," *Antiques* 112 (July 1977), pp. 108, 112, frontis.; *Niles' National Register,* October 25, 1845, p. 113; *The New-York City and Co-Partnership Directory for 1843 & 1844* (New York: John Doggett Jr., 1843), pp. 15, 25, 63, 109.

65. N. W. A., "Nationality of Taste," *Home Journal,* April 14, 1849, p. 1.

66. The vase is marked "GALE AND HAYDEN," "G&H," and "1846"; the mark "GOWDEY & PEABODY" appears on the base. The vase is inscribed "Presented to Henry Clay, the gallant champion of the Whig cause by the Whig Ladies of Tennessee. . . ."

67. *New-York Daily Tribune,* November 23, 1846, p. 1; Warren, Howe, and Brown, *Marks of Achievement,* p. 114, no. 139, ill.

68. Paul von Khrum, *Silversmiths of New York City, 1684–1850* (New York: Von Khrum, 1978), pp. 18–19; [Armstrong], *Aristocracy of New York,* pp. 15–16.

69. "Housekeeper's Department," *Home Journal,* May 10, 1851, p. 3.

70. *The Independent,* May 26, 1859, p. 5.

71. "The Decorative Arts in America," *International Monthly Magazine of Literature, Science, and Art* 4 (September 1851), p. 171.

72. *Home Journal,* October 18, 1851, p. 3.

73. United States, Census Office, 7th Census, 1850, New York City, First Election District, Eighth Ward, p. 102, microfilm, New York Public Library; United States, Census Office, 7th Census, 1850, New York State, Products of Industry Schedule, First Election District, Eighth Ward, City and County of New York, p. 443, manuscript, New York State Library, Albany (microfilm, Eleutherian Mills-Hagley Library, Greenville, Delaware); New York State Census, 1855, First Election District, Eighth Ward, manuscript, New York County Clerk's Office, Surrogates' Court Building, 31 Chambers Street, New York. The 1850 federal census records Boyce's age as fifty-four, and five years later the New York State census records his age as fifty-nine, suggesting he was born in 1795 or 1796.

74. *Evening Post* (New York), October 13, 1846, p. 2.

75. Gerardus Boyce used a twelve-sided form for a child's mug (Museum of the City of New York, 36.17). E. Stebbins and Company (active 1835–ca. 1846) provided an octagonal teapot presented by merchant Abraham

corporate craft solidarity reflected the optimism of the industry under tariff protection.

In 1845 the working gold and silver artisans in New York City, both employers and journeymen, once again joined together as a trade group—this time to provide funds for the raw materials and manufacture of an elaborate vase to be presented to Henry Clay in recognition of his role in securing the favorable tariff of 1842. The shop of presentation-committee member Adams fabricated the vase using the classical Greek krater form with an eagle finial similar to the bird perched atop his 1841 mace of the House of Representatives (fig. 301), updated with a Rococo scroll base and handles (cat. no. 296).[64] Four years after its presentation to Clay, a correspondent of the *Home Journal* recalled the "beautiful silver vase" and asked rhetorically "Could London, Paris, or Geneva, have produced anything more tasteful or artistic, of the same value?"[65]

Clay received a second New York City–made silver presentation vase in 1846 (fig. 302). From the New York City manufactory of William Gale and Nathaniel Hayden, the gift presented by the Whig Ladies of Tennessee features a bas-relief portrait medallion of Clay and a crowning three-dimensional figure of Liberty above an architectural base composed of Gothic arches.[66] A writer for the *New-York Daily Tribune* noted that the Gale and Hayden urn was "admirably adapted as a companion to the beautiful vase which had been previously presented to Mr. Clay by the Gold and Silver Smiths of New-York."[67]

With the successful implementation of the tariff of 1842 and continued economic recovery, the precious-metals trades in New York City embarked on a period of expansion, during which a silversmith was elected mayor of the city. A contemporary biographer noted that William V. Brady (1801–1870), listed in city directories from 1834 through 1846–47, had made a large amount of money at his trade, which he had successfully invested in real estate. A Whig, Brady served as alderman of the Fifteenth Ward from 1842 to 1846 before becoming mayor in May 1847.[68]

The widespread application of new technologies—such as an improved method of spinning up round bodies from sheet metal, which was patented in 1834 by Massachusetts metalworker William W. Crossman (see fig. 303), and electroplating, a technique patented by Elkington and Company of Birmingham, England, in 1840—also encouraged the growth of the precious-metals trades. Electroplated tablewares became widely available in the early 1850s from establishments such as Berrains' House-Furnishing Warerooms, at

601 Broadway,[69] and later from Bray and Manvel, manufacturers of silver-plated ware located at 15 Maiden Lane (the former premises of J. and I. Cox).[70] One commentator noted, "though silver is unquestionably silver, the imitation table furniture of the most classical shapes, that is sold now for a fifth of the cost of the coinable metal, looks quite as well upon a salver."[71] Even the French manufacturer C. S. Christofle and Company, which had licensed the Elkington and Company patent for use in France, entered the New York market. The agency distributing Christofle products advertised its line of plated table-service articles warranted for four or five years in household use.[72]

Among the master craftsmen still manufacturing silver in a small shop in the 1840s was Gerardus Boyce (ca. 1795–1880), who had been in business since 1820. In 1835 Boyce had moved to 110 Greene Street, in the Eighth Ward, where he remained until 1857, when he apparently retired. According to the entry under his name in the Products of Industry Schedule of the federal census for 1850, Boyce employed eight men and one woman to produce silverware valued at $11,200. Five years later, his workforce had declined in size to four men and one boy and the shop's output was valued at $6,000. Two apprentice silversmiths, one American and one Irish, lived with Boyce and his family.[73] His entry in the 1846 American Institute fair prompted a complimentary notice in the New York *Evening Post.* The *Post* reporter described Boyce's exhibit as a "case of very beautiful silver ware. These articles are [both] highly chased and plain, and give evidence of superior workmanship. All articles in his line [are] equally well finished," and all were available at his establishment.[74]

Boyce and his contemporaries utilized straight-sided, seamed geometric forms for wares ranging from mugs and footed cups (see fig. 304) to complete tea sets, and they frequently embellished the vertical panels with floral and swag "bright-cut" engraving, in which shallow incisions created the design and refracted available light.[75] The trophy supplied by watchmaker and retail jeweler William F. Ladd for the fledgling New York Yacht Club's first Corinthian regatta, held in the fall of 1846 (cat. no. 297), employed similar construction.

The 1850 federal census also indicates that silver manufacturer Zalmon Bostwick was born Zalmon Stone Bostwick, son of Heman and Belinda Palmer Bostwick, in Hinesburg, Vermont, on September 9, 1811.[76] Unlike Boyce, who had worked for more than twenty-five years in the trade by 1845, Bostwick was a

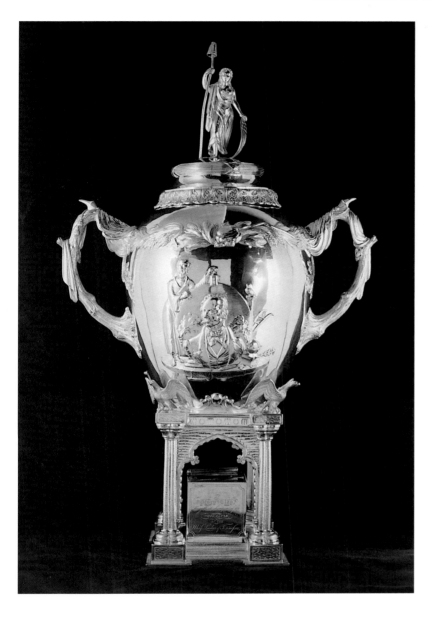

Fig. 302. William Gale and Nathaniel Hayden, silver manufacturer; Thomas Gowdey and John Peabody, Nashville, Tennessee, retailer, Urn presented to Henry Clay by the Whig Ladies of Tennessee, 1846. Silver. Tennessee State Museum Collection, Nashville 83.15

Fig. 303. *Spinning.* Wood engraving by Cornelius T. Hinckley, from *Godey's Lady's Book* 46 (March 1853), p. 201. The Metropolitan Museum of Art, New York, The Thomas J. Watson Library

SPINNING.

newcomer to the business, first recorded as a "silversmith," with premises at 128 William Street, Manhattan, in 1846–47. Bostwick placed an advertisement in the New York *Evening Post* for March 11, 1847, describing himself as "successor to Thompson [*sic*], 128 William street," and announcing his willingness to manufacture "to order a full and complete assortment of SILVER WARE in all its branches, embracing plain, chased and wrought SILVER CUPS, URNS, VASES, &c. Also complete sets of plate of different patterns." The announcement suggests that Bostwick was continuing the business of William Thomson, a firm long established at 129 William Street. Bostwick placed a similarly worded advertisement with illustrations in the *New-York Mercantile Register* for 1848–49. By the 1851–52 edition of the city directory, Bostwick's manufactory of silverware was listed at "r[ear] 19 Beekman"

and his residence at "111 Orchard." The manufactory remained listed at 19 Beekman Street in the 1853–54 edition, but by that date Bostwick had moved his home to Bedford Avenue in East Brooklyn, and then apparently he withdrew from the trade.[77] In addition to English Gothic pitchers and goblets (see cat. no. 298), his shop produced goods in the chased "modern French" (Rococo Revival) style, including an unusual pair of ritual Torah finials, or *rimmonim* (fig. 305).[78]

By 1850 the neighborhood that encompassed Liberty Place and Maiden Lane in the Second Ward housed many of the city's manufacturing silversmiths. Platt and Brother, which operated a gold and silver refinery and bullion office at 4 Liberty Place supplying raw materials to the trade, also wholesaled imported watches, jewelry, cutlery, and fancy goods to its clients

Van Nest to his daughter and her husband about 1838–45 (Museum of the City of New York, 34.73.1). Manufacturing silversmiths Charters, Cann and Dunn produced a five-piece octagonal beverage service for Ball, Tompkins and Black with tapered straight-sided pots, which became part of the silver of a woman who married in 1850 (Museum of the City of New York, 70.68.1a–d–.5).

76. United States, Census Office, 7th Census, 1850, New York City, Tenth Ward, National Archives Microform publication M-432, roll 545, p. 216.

77. Von Khrum, *Silversmiths of New York City*, p. 17; *The New York City Directory for 1851–52* (New York: Doggett and Rode, 1851), p. 66; H. Wilson, comp., *Trow's*

*New-York City Directory for 1853–1854* (New York: John F. Trow, 1853), p. 76.

78. A service at the Museum of the City of New York (33.58.24.a–e) is engraved "AMB / Jany 1st 1849," probably for Adeline Matilda Creamer Brooks, who married Edward Sands Brooks, of the clothier Brooks Brothers, in 1844. The *rimmonim* are marked "ZB" in a diamond with an anchor in an oval and a profile head in an oval. They were sold at Christie's, Amsterdam, June 1, 1999, lot 539; see *Christie's Magazine* 16 (June 1999), p. 26, fig. 2.

79. United States, Census Office, 7th Census, 1850, New York State, Products of Industry Schedule, Second Ward, City and County of New York, pp. 330, 334, 361.

80. See Jennifer M. Swope, "Francis W. Cooper, Silversmith," *Antiques* 155 (February 1999), pp. 290–97. The location of the alms basin is unknown; one paten and one chalice are part of the collection of the Museum of Fine Arts, Boston; see ibid., pl. 1, figs. 1, 2.

81. The set is marked "STEBBINS & Co. / 264 B.way NY." Another octagonal teapot, which recalled medieval Italian baptistries in its architectural ornament, was sold by J. and I. Cox, about 1835–53. See Katherine S. Howe and David B. Warren, *The Gothic Revival Style in America, 1830–1870* (exh. cat., Houston: Museum of Fine Arts, 1976), p. 71, no. 145.

82. *Gleason's Pictorial Drawing-Room Companion*, September 20, 1851, p. 336, described and illustrated the service; *The Independent*, August 21, 1851, p. 139, carried the commentary.

83. United States, Census Office, 7th Census, 1850, New York State, Products of Industry Schedule, Fifth Ward, City and County of New York, p. 380.

84. Charles H. Carpenter Jr. and Janet Zapata, *The Silver of Tiffany & Co., 1850–1987* (exh. cat., Boston: Museum of Fine Arts, 1987), pp. 25, 61–62, no. 68a–c, e–i.

85. Gertrude A. Barber, comp., "Marriages Taken from the *New York Evening Post* from July 8, 1852, to September 26, 1854," vol. 14, typescript, 1937, New York Genealogical and Biographical Society; *The Diary of George Templeton Strong*, edited by Allan Nevins and Milton Halsey Thomas, 4 vols. (New York: Macmillan Company, 1952), vol. 2, p. 126.

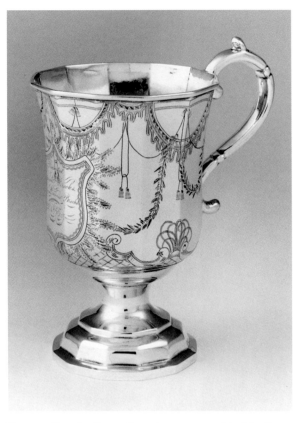

Fig. 304. Gerardus Boyce, Footed cup presented by Mrs. L. Brooks to Mary Lavinia Brooks, ca. 1845. Silver. Museum of the City of New York, Gift of the Reverend William H. Owen  33.58.25

from a wareroom at 20 Maiden Lane. At 6 Liberty Place were the shops of silver-flatware manufacturers Philo B. Gilbert, Albert Coles, and George C. [O.] Smith. Smith specialized in thimbles, combs, and fruit knives, while Gilbert and Coles produced forks and spoons by the dozens. At 8 Liberty Place, Henry David also made silver knives and forks. Of these four firms, both the Gilbert and Coles enterprises used steam power. With five men producing $9,000 worth of flatware annually, Henry David's was the smallest and least productive shop. At the other end of the scale was Gilbert's, where forty-four men and six women produced flatware valued at $65,000 in the year preceding the 1850 census.[79]

Founded in 1848, the New-York Ecclesiological Society promoted the use of correct (Gothic) style in the architecture and decoration of Protestant Episcopal churches. As its official silversmith, Francis W. Cooper had access to designs and communion silver produced by the society's English counterpart, the Anglican Cambridge Camden Society (later the Ecclesiological Society). In 1855 Cooper and his partner, Richard Fisher, began production of an unusually elaborate silver service for Trinity Chapel, Parish of Trinity Church

in the City of New York (cat. no. 304). Composed originally of an alms basin, two chalices for communion wine, a footed paten for consecration of the bread, and two patens for distribution of the bread to communicants, the service was closely modeled on designs drawn by English architect William Butterfield (1814–1900).[80] Although patronage generated by the New-York Ecclesiological Society ended with the demise of the society in 1855, Cooper continued to make Gothic Revival communion silver as well as a wide range of secular silver forms during the course of his career. Other New York silver manufacturers created octagonal domestic silver forms ornamented with a touch of romantic Gothic fantasy. A tea set of this type was marketed about 1850 (fig. 306) by Stebbins and Company, the partnership of William Stebbins and Alexander Rumrill Jr. that succeeded Edwin Stebbins and Company, at 264 Broadway.[81]

Precious-metal wares made in New York first attracted international attention in 1851, when Ball, Tompkins and Black sent to the London Crystal Palace exhibition a $23\frac{1}{2}$-karat California gold beverage service. This impressive set had been commissioned by a group of Manhattan merchants for presentation to shipping magnate Edward K. Collins, who had recently established an American flag line of transatlantic steamers (fig. 307). The four-piece tea service, "finished with the same care that fine jewelry is," stood on a massive silver salver "of exquisitely chaste and simple design." As one commentator reported, "the impression produced is rather that of elegance of form than richness of material, as should be the case with every work of art. Grapes and vine-leaves in high relief are all the ornamental work even to the feet upon which the pieces stand, except that the lids are surmounted by eagles."[82] Its naturalistic "modern French" style won international praise both for Ball, Tompkins and Black and for manufacturing silversmith John C. Moore, who had already employed the rusticated grapevine handles and bodies chased with repoussé grape clusters in the decoration of the Marshall Lefferts beverage service of 1850 (cat. no. 301).

According to the federal census of 1850, Moore's firm, John C. Moore and Son, located at 85 Leonard Street, operated with steam power and employed a workforce numbering twenty men and two women. It produced goods valued at $30,000 in the year covered by the census.[83] The firm continued to produce beverage services in the naturalistic style for Tiffany, Young and Ellis and later for Tiffany and Company, after it entered into an exclusive production agreement with that retail house the following year. A notable

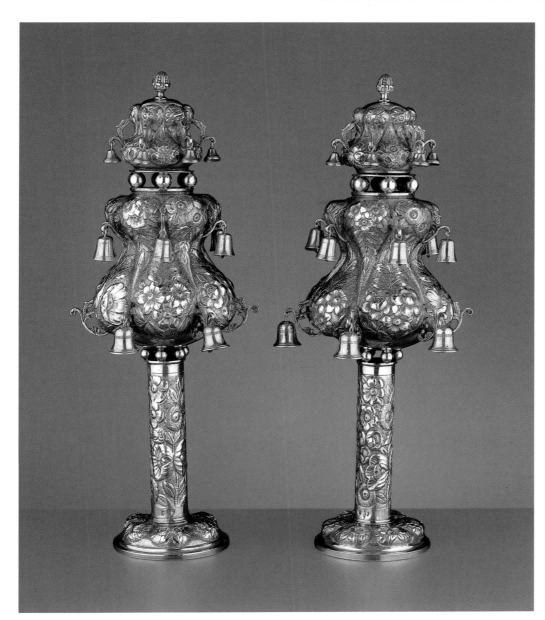

Fig. 305. Zalmon Bostwick, silver manufacturer, *Rimmonim* (Torah finials), ca. 1850. Silver. Location unknown

Fig. 306. Stebbins and Company (William Stebbins and Alexander Rumrill Jr.), retailer, Three-piece tea service in Gothic Revival style, ca. 1850. Silver. Private collection, Houston

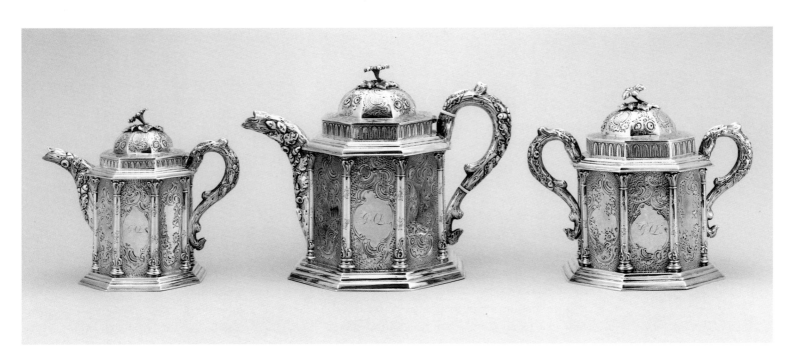

Fig. 307. *Service of Plate Presented by the Citizens of New York to Edward K. Collins.* Wood engraving by Nathaniel Orr, from B. Silliman Jr. and C. R. Goodrich, eds., *The World of Science, Art, and Industry Illustrated from Examples in the New-York Exhibition, 1853–54* (New York: G. P. Putnam and Company, 1854), p. 107. The Metropolitan Museum of Art, New York, The Thomas J. Watson Library

openwork grapevines with a pendant cluster of grapes. Since the Astor service was intended for domestic use, the Moore shop incorporated no references to contemporary technology in its ornament, as it had in the Lefferts hot-water kettle on stand, with its forest of telegraph poles and lines and Zeus-with-thunderbolts finial (cat. no. 301).

During the first half of the nineteenth century, the pieces in a service for dispensing hot beverages with style increased in number and in size, so in those respects the eight-piece Astor service should be considered representative of its era. Additional silver items, including spoons, sugar tongs, and a tray to accommodate the entire ensemble, probably accompanied the surviving pieces when Mrs. Astor served tea at home in her mansion on fashionable Fifth Avenue between Thirty-third and Thirty-fourth streets. The second set of initials engraved on the bases of the pieces may be those of the third Astor daughter, Charlotte Augusta, who married her second husband, George Ogilvy Haig, in London in 1896.[86] The service is exceptional in including both a covered sugar bowl and a sugar basket. Perhaps it was assembled from gifts to the couple from various well-wishers.[87]

J. L. Ellis withdrew from Tiffany, Young and Ellis in February 1850. When John B. Young retired in 1853, the firm was renamed Tiffany and Company, and its retail premises moved farther uptown, to 550 Broadway, between Spring and Prince streets, on or before May 1, 1854 (fig. 308).[88] The change of name coincided with the opening of the New-York Exhibition of the Industry of All Nations at the Crystal Palace. Scheduled to begin in May 1853, the exhibition did not officially open until July 14, when President Franklin Pierce attended the inaugural ceremonies. Among the Crystal Palace's many attractions was

> *a showy service of solid California gold. It is a tea service, and consists of twenty-nine pieces, arranged upon a chaste and beautiful plateau of silver. This work is the contribution of Ball, Black & Co. It is valued at $15,000—a very large sum to be invested in gold cups and saucers; which, although exhibiting a neat design—an embossed vine wreath—are all exact duplicates of each other. The great defect of many of the costly works of the gold and silversmiths represented in the Exhibition, is an almost total lack of* artistic *beauty.*[89]

Ball, Black and Company also displayed the Edward K. Collins service of fine gold made by John C. Moore for Ball, Tompkins and Black (fig. 307). Tiffany and Company exhibited a rich silver toiletry service, a

86. On the William Astors, see John D. Gates, *The Astor Family* (Garden City, New York: Doubleday and Co., 1981), pp. 78–79, 83–84; Derek Wilson, *The Astors, 1763–1992: Landscape with Millionaires* (New York: St. Martin's Press, 1993), pp. 104–5, 193–200; and Edwin G. Burrows and Mike Wallace, *Gotham: A History of New York City to 1898* (New York: Oxford University Press, 1999), pp. 716, 962–63. Their daughter Charlotte Augusta's first husband was James Coleman Drayton; following a scandalous affair and divorce that roiled New York and Newport society, she married Haig and settled in London.

example is the beverage service given to Caroline Webster Schermerhorn, daughter of the noted New York attorney Abraham Schermerhorn, and William Backhouse Astor Jr., a grandson of fur trader and real-estate investor John Jacob Astor, on the occasion of their marriage, in September 1853.[84] (After learning of the Astor-Schermerhorn engagement, diarist George Templeton Strong noted, tongue-in-cheek, "Trust the young couple will be able to live on their little incomes together.")[85] The scroll spout and handles of the Astor kettle on stand are cast as rusticated grapevines. The bodies of all the items in the service are chased with repoussé grape clusters, and the finials are cast

variety of silver articles, including the Four Elements centerpiece (fig. 298), and a dazzling display of gem-set jewelry. Other American firms, including Bailey and Company of Philadelphia, also exhibited. Jones, Ball and Company of Boston once again brought out the vase presented by the citizens of Boston to states-man Daniel Webster in 1835 that had been fashioned by silversmiths Obadiah Rich and Samuel Ward after the Warwick Vase for the firm's predecessor, Jones, Low and Ball.[90]

To acknowledge the services of Admiral Samuel Francis Du Pont as one of two superintendents of the Crystal Palace, the directors of the exhibition voted to allot $2,000 for a testimonial in plate. Offered a choice of something exhibited at the Crystal Palace, Du Pont chose instead an eleven-piece table service (fig. 309) consisting of a tureen, two sauceboats, two vegetable dishes, two vegetable dishes with warmers and stands, and four salts fabricated by Tiffany and Company, for Du Pont thought a presentation service should be "ordered and made by Americans . . . sim-plicity of good taste in design and usefulness of pur-pose is the main thing. The idea of selecting anything ready made . . . is quite repugnant to me . . . and takes away all sentiment and much of the value of the tribute."[91]

The statistics recorded in the New York State cen-sus of 1855 indicate continued expansion within por-tions of the precious-metals trades. William Gale and Son, located at 447 Broome Street, one door west of Broadway, employed sixty-five men and ten boys to produce goods valued at $175,000 in that year. In 1855 the firm initiated newspaper advertising aimed at both the retail and the wholesale markets, which stressed that "every article [is] made on our own premises, under our personal inspection, and [we] are constantly manufacturing to order everything in the line, of any design, either antique or modern, and however rich or elaborate."[92]

In 1855 William Gale and Son's competitors Charles Wood and Jasper W. Hughes—partners in the firm of Wood and Hughes—produced $225,000 worth of sil-ver; their employees numbered sixty men, twenty women, ten boys, and fifteen girls (see cat. no. 305). The firm of silverware manufacturers traced its history back to silversmith William Gale, with whom the original partners, Jacob Wood and Jasper W. Hughes, had apprenticed. The three men then formed the firm of Gale, Wood and Hughes, which was active from 1833 to 1844 or 1845. In 1845 Wood and Hughes estab-lished a partnership of their own. They were joined by Stephen T. Fraprie and Charles Hughes in 1850.

Fig. 308. *Exterior of Tiffany and Company Premises,* 550 Broadway. Wood engraving, from John R. Chapin, *The Historical Picture Gallery; or, Scenes and Incidents in American History* (Boston: D. Bigelow and Company, 1856), vol. 5, p. 413. The New York Public Library, Astor, Lenox and Tilden Foundations, The Irma and Paul Milstein Division of United States History, Local History and Genealogy

Charles Wood, brother of Jacob, had joined the firm by 1855. By 1860 Wood and Hughes had greatly expanded its male workforce—to ninety men—and reduced the number of women and children employed; however, women and girls worked as silver burnishers here, as at most of the major firms, since it was widely thought that female hands were especially suited to burnishing and polishing chores. The firm had also increased its capital investment, using silver valued at $187,000 to make silverware worth $300,000. Steam power, eighteen lathes for spinning up hollowware, and six rolling mills to produce sheet silver and bor-ders all facilitated production.[93]

87. Multiple donors might account for the variation in model num-bers on the various pieces. The two retailers identified by the marks struck on the underside of the various components of the ensemble document a shift one block uptown in the location of the shop of Tiffany, Young and Ellis, from 259 and 260 Broad-way to 271 Broadway. See *Spirit of the Times,* December 19, 1846, p. 514. The firm opened its new store in 1847 with some two hun-dred cases of new stock com-prised of "elegantly USEFUL AND FANCY ARTICLES of a higher order of taste, beauty, and richness

Fig. 309. Tiffany and Company, manufacturing and retail silversmith and jeweler, Partial presentation table service made for Samuel Francis du Pont, 1853–54. Silver. Hagley Museum and Library, Wilmington, Delaware G91.30

than has ever been exhibited in New York." *New-York Mercantile Register*, 1848–49, p. 356.

88. Therefore, the items in the Astor service marked "TIFFANY & CO./ 271 Broadway/J.C.M./85" can be dated to the months between Young's retirement and May 1, 1854. On the changes between 1850 and 1854 at Tiffany, see *Home Journal*, November 17, 1849, p. 3; Heydt, *Charles L. Tiffany*, pp. 11–23; and Venable, *Silver in America*, pp. 28–30.

89. William C. Richards, *A Day in the New York Crystal Palace, and How to Make the Most of It; Being a Popular Companion to the Official Catalogue and a Guide to All the Objects of Special Interest in the New York Exhibition of the Industry of All Nations* (New York: G. P. Putnam and Co., 1853), pp. 152–53.

90. Ibid., p. 127; Wendy A. Cooper, *Classical Taste in America*,

By 1855 Eoff and Shepard (see fig. 295) ranked among the midsized silverware manufacturing operations in Manhattan, with $6,000 invested in tools and machinery. The enterprise used steam power and employed twenty men and five boys. In the year covered by the census, this workforce converted 20,800 ounces of silver, worth more than $26,000, into silverware valued at nearly $37,000. Sometime before 1861, the partners moved from their original quarters at 83 Duane Street to 135 Mercer, where Shepard continued alone in 1861–62. Eoff may have retired or withdrawn from the trade before 1860, a federal census year. The operation continued, with staffing levels and raw-materials consumption constant but with an increase in the value of the flatware and hollowware to $50,000.[94]

Smaller still was the partnership of William Adams and Edmund Kidney, at 38 White Street, near Church Street. Adams lived on Church Street,

between White and Franklin streets. He had $30,000 invested in real estate and $1,000 worth of capital in tools and machinery. His shop used silver valued at $10,000 to produce goods of an unspecified value. The shop had steam power and employed five men and three boys.[95]

It was New York's carriage-trade retailer firms, Ball, Black and Company and Tiffany and Company, that captured public attention through production of both civic presentation pieces and popularly priced keepsakes. One opportunity for such unified marketing came with the completion of the first submarine telegraph cable linking Europe and the United States on August 5, 1858. When the Common Council of the City of New York and the New York Chamber of Commerce chose to honor Cyrus W. Field, the promoter of the venture, and several of his colleagues by commissioning gold boxes and medals, Tiffany

Fig. 310. Tiffany and Company, manufacturing and retail silversmith and jeweler, *Plate Presented by the Merchants of New York to Colonel Duryee, 7th Regiment National Guard*, 1859. Wood engraving, from *Frank Leslie's Illustrated Newspaper*, January 7, 1860, pp. 88–89. Courtesy of The New-York Historical Society

obtained the orders. The boxes and the medals (cat. nos. 307, 308), each enclosed in a rich purple velvet jewel case lined with white satin, bearing the stamp "Tiffany & Co." on the inside of the case, were exhibited at the firm's premises at 550 Broadway.[96] At the same time, capitalizing on the public interest in Field and the transatlantic telegraph cable, several New York City silver and jewelry firms, including Tiffany, Ball, Black and Company, and Dempsey and Fargis, acquired pieces of the cable and offered them to the public as souvenirs. For 50 cents retail, Tiffany sold four-inch lengths mounted "neatly with brass ferrules" and accompanied by copyrighted facsimile certificates signed by Field authenticating the genuineness of the cable (cat. no. 309).[97]

Like 1842, the year 1859 proved to be a watershed for the precious-metals trades in New York. Although the consequences of the great discoveries of silver in

Nevada and other Western territories were initially obscured by the economic turmoil of the Civil War, a flood of silver from the rich Western lodes eventually led to a decline in the price of the raw metal. As the 1850s came to an end, the Moore shop produced for Tiffany a service valued at $5,000 for presentation to citizen-soldier Colonel Abram Duryee upon his retirement from the Seventh Regiment of the New York National Guard (cat. no. 310; fig. 310). The martial theme of the set (which Tiffany later publicized as one of its "notable productions")[98] presaged the ensuing national conflict. In the same year, the Gorham Manufacturing Company of Providence, Rhode Island, opened a wholesale showroom in Manhattan, initiating competition with New York silver manufacturers for access to what had become a national market for "Silver Ware in great perfection."

*1800–1840* (exh. cat., Baltimore: Baltimore Museum of Art; New York: Abbeville Press, 1993), pp. 248–50, no. 201.

91. Quoted in Maureen O'Brien Quimby and Jean Woollens Fernald, "A Matter of Taste and Elegance: Admiral Samuel Francis Du Pont and the Decorative Arts," *Winterthur Portfolio* 21 (summer/autumn 1986), p. 108.

92. *Home Journal*, September 22, 1855, p. 3.

93. United States, Census Office, 7th Census, 1850, New York State, Products of Industry Schedule, Second Ward, New York County, p. 354; New York State Census, 1855, Products of Industry Schedule, First Election District, Second Ward, New York County, manuscript, New York County Clerk's Office, 31 Chambers Street, New York, n.p., original, New York State Library; United States, Census Office, 8th Census, 1860, New York State, Products of Industry Schedule, Second Ward, New York County, p. 24, original, New York State Library.

94. New York State Census, 1855, New York City, First Election District, Sixth Ward, manuscript, New York County Clerk's Office; United States, Census Office, 8th Census, 1860, New York State, Products of Industry Schedule, Third District, Eighth Ward, manuscript, New York State Library.

95. New York State Census, 1855, New York City, Products of Industry Schedule, Third Election District, Fifth Ward, New York County Clerk's Office.

96. *Frank Leslie's Illustrated Newspaper* 8 (July 1859), p. 84. The lithographic firm of Sarony, Major and Knapp, at 449 Broadway, published a lithograph showing the steamships *Niagara, Valorous, Gorgon*, and *Agamemnon* laying the cable, and it is similar to the scene engraved on the lid of the box. For a copy, see Print Archives, Communications-Telegraphy, Folder 3/5, Museum of the City of New York.

97. *The Albion*, August 28, 1858, p. 419.

98. Heydt, *Charles L. Tiffany*, p. 37.

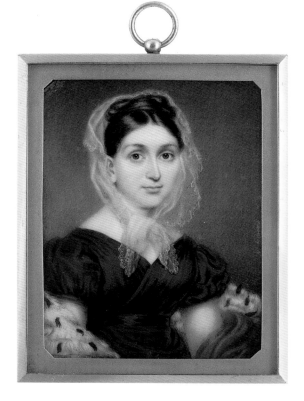

NATHANIEL ROGERS
14. *Mrs. Stephen Van Rensselaer III
(Cornelia Paterson),* 1820s
Watercolor on ivory
The Metropolitan Museum of
Art, New York, Morris K.
Jesup Fund, 1932  32.68

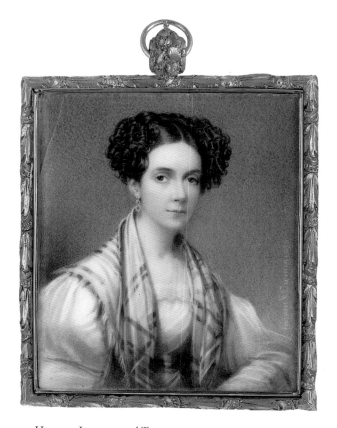

HENRY INMAN *and* THOMAS
SEIR CUMMINGS
15. *Portrait of a Lady,* ca. 1825
Watercolor on ivory
The Metropolitan Museum
of Art, New York, Dale T.
Johnson Fund, 1996  1996.562

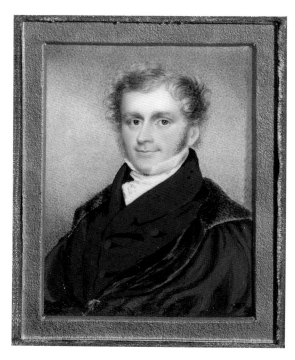

NATHANIEL ROGERS
16. *John Ludlow Morton,* ca. 1829
Watercolor on ivory
Lent by Gloria Manney

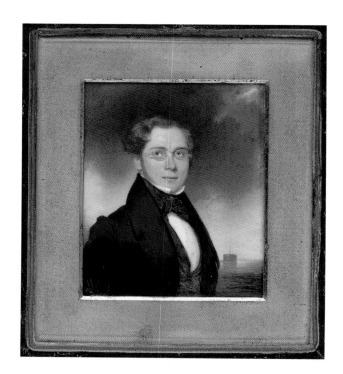

THOMAS SEIR CUMMINGS
17. *Gustavus Adolphus Rollins,*
ca. 1835
Watercolor on ivory
The Metropolitan Museum of Art,
New York, Gift of E. A. Rollins,
through his son, A. C. Rollins, 1933
27.216

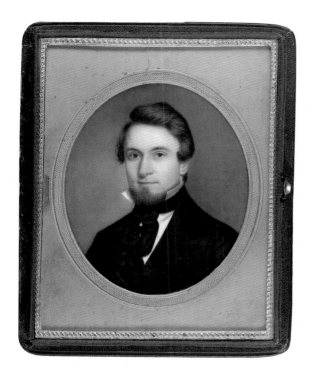

EDWARD S. DODGE
18. *John Wood Dodge*, ca. 1836–37
Watercolor on ivory
Lent by Gloria Manney

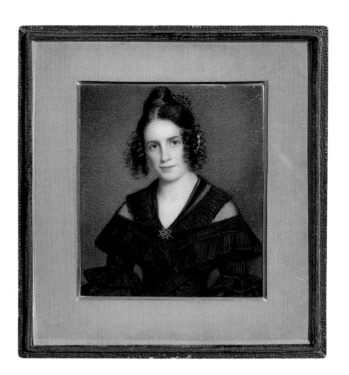

JAMES WHITEHORNE
19. *Nancy Kellogg*, 1838
Watercolor on ivory
Lent by Gloria Manney

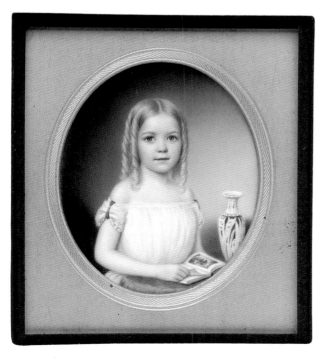

JOHN WOOD DODGE
20. *Kate Roselie Dodge*, 1854
Watercolor on ivory
The Metropolitan Museum of
Art, New York, Morris K.
Jesup Fund, 1988  1988.280

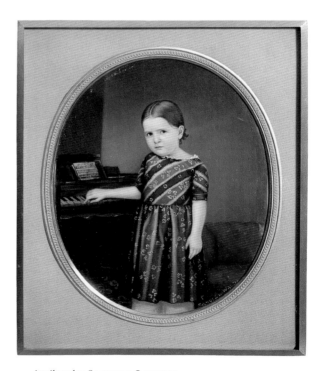

*Attributed to* SAMUEL LOVETT
WALDO
21. *Portrait of a Girl*, after 1854
Oil on panel
The Metropolitan Museum of Art,
New York, Fletcher Fund, 1938
38.146.5

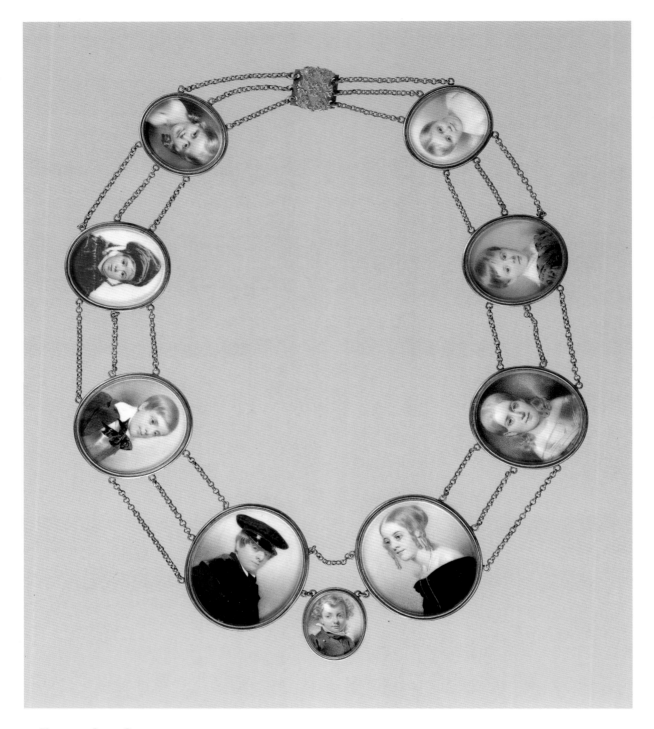

THOMAS SEIR CUMMINGS
22. *A Mother's Pearls (Portraits of the
Artist's Children),* 1841
Watercolor on ivory
The Metropolitan Museum of Art,
New York, Gift of Mrs. Richard B.
Hartshorne and Miss Fanny S.
Cummings (through Miss Estelle
Hartshorne), 1928  28.148.1

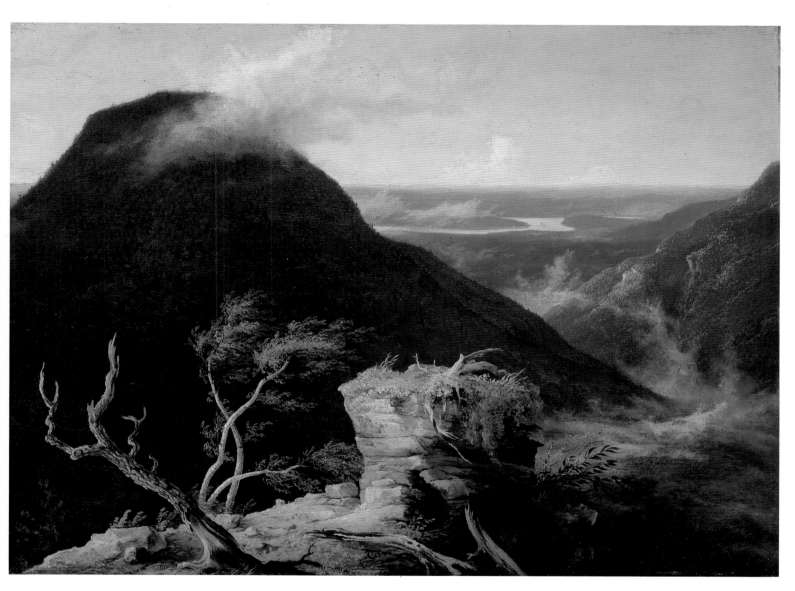

THOMAS COLE
23. *View of the Round-Top in
 the Catskill Mountains,*
 ca. 1827
 Oil on panel
 Museum of Fine Arts,
 Boston, Gift of Martha
 C. Karolik for the M. and
 M. Karolik Collection of
 American Paintings,
 1815–1865  47.1200

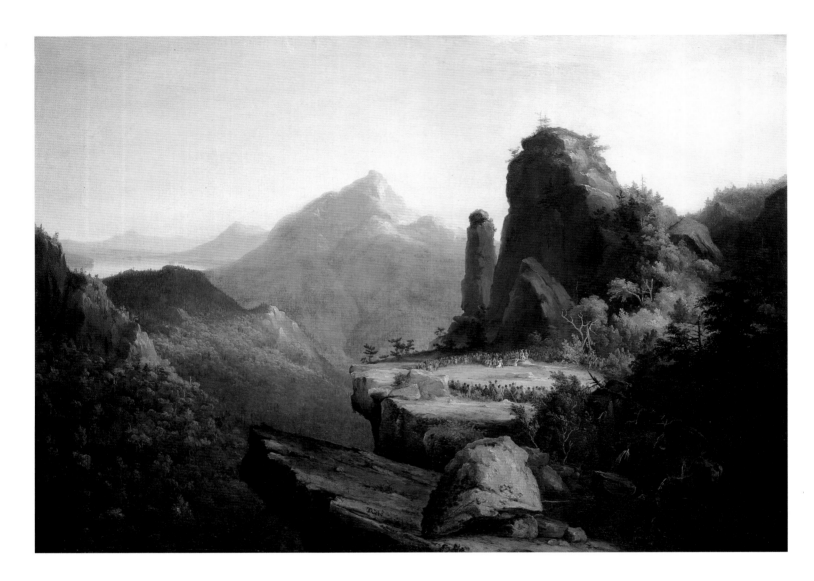

**THOMAS COLE**

24. *Scene from "The Last of the Mohicans": Cora Kneeling at the Feet of Tamenund*, 1827
Based on James Fenimore Cooper's novel (1826)
Oil on canvas
Wadsworth Atheneum, Hartford, Connecticut, Bequest of Alfred Smith 1868.3

**ASHER B. DURAND**

25. *Dance on the Battery in the Presence of Peter Stuyvesant*, 1838
Scene from *A History of New-York* by Washington Irving (under the pseudonym Diedrich Knickerbocker; 1809)
Oil on canvas
Museum of the City of New York, Gift of Jane Rutherford Faile through Kenneth C. Faile, 1955  55.248

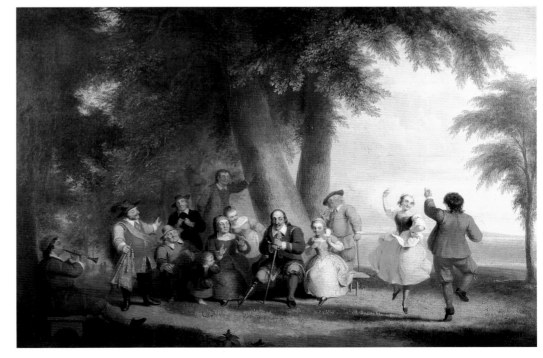

JOHN QUIDOR
26. *The Money Diggers*, 1832
Scene from Washington
Irving's *Tales of a Traveller*
(1824)
Oil on canvas
Brooklyn Museum of Art,
Gift of Mr. and Mrs.
Alastair B. Martin  48.171

ROBERT WALTER
WEIR
27. *A Visit from Saint
Nicholas*, ca. 1837
Scene from Clement
Clarke Moore's poem
(1823)
Oil on panel
The New-York Historical
Society, Gift of George A.
Zabriskie, 1951  1951.76

WILLIAM SIDNEY
MOUNT

28. *Eel Spearing at Setauket*
    *(Recollections of Early Days—*
    *"Fishing along Shore"),* 1845
    Oil on canvas
    New York State Historical
    Association, Cooperstown,
    Gift of Stephen C. Clark

GEORGE CALEB
BINGHAM
29. *Fur Traders Descending the
Missouri*, 1845
Oil on canvas
The Metropolitan
Museum of Art, New
York, Morris K. Jesup
Fund, 1933 33.61

ASHER B. DURAND
31. *In the Woods,* 1855
Oil on canvas
The Metropolitan Museum of Art,
New York, Gift in memory of
Jonathan Sturges by his children,
1895  95.13.1

ASHER B. DURAND
30. *Kindred Spirits,* 1849
Oil on canvas
The New York Public Library,
Gift of Julia Bryant

CHARLES CROMWELL
INGHAM

32. *The Flower Girl*, 1846
Oil on canvas
The Metropolitan
Museum of Art, New
York, Gift of William
Church Osborn, 1902
02.7.1

LILLY MARTIN
SPENCER

33. *Kiss Me and You'll Kiss the
'Lasses*, 1856
Oil on canvas
Brooklyn Museum of Art,
A. Augustus Healy Fund
70.26

EMANUEL LEUTZE
34. *Mrs. Schuyler Burning Her
Wheat Fields on the Approach
of the British,* 1852
Oil on canvas
The Los Angeles County
Museum of Art, Bicentennial
Gift of Mr. and Mrs. J. M.
Schaaf, Mr. and Mrs. William
D. Witherspoon, Mr. and
Mrs. Charles M. Shoemaker,
and Mr. and Mrs. Julian
Ganz, Jr. M.76.91

FITZ HUGH LANE
35. *New York Harbor,* 1850
Oil on canvas
Museum of Fine Arts,
Boston, Gift of Maxim
Karolik for the M. and
M. Karolik Collection of
American Paintings,
1815–1865  48.446

SANFORD ROBINSON
GIFFORD
36. *Lake Nemi,* 1856–57
Oil on canvas
The Toledo Museum of Art,
Toledo, Ohio; Purchased
with funds from the Florence
Scott Libbey Bequest in
Memory of her Father,
Maurice A. Scott  1957.46

JOHN F. KENSETT
37. *Beacon Rock, Newport
Harbor,* 1857
Oil on canvas
National Gallery of Art,
Washington, D.C., Gift
of Frederick Sturges, Jr.
1953.1.1

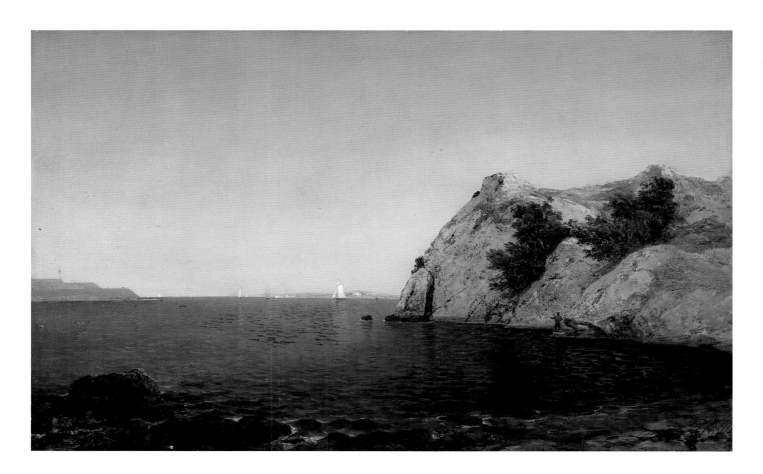

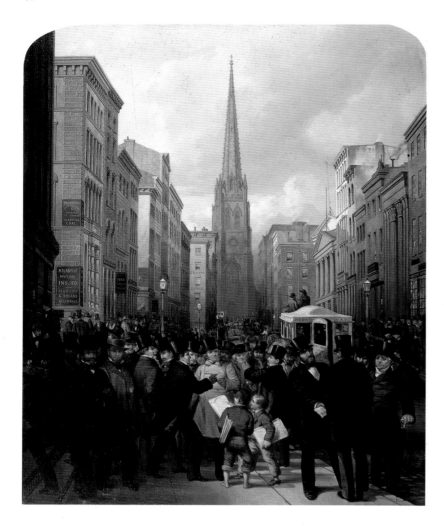

JAMES H. CAFFERTY *and*
CHARLES G. ROSENBERG
38. *Wall Street, Half Past 2 O'Clock,*
    *October 13, 1857,* 1858
    Oil on canvas
    Museum of the City of New
    York, Gift of the Honorable
    Irwin Untermyer  40.54

FRANCIS WILLIAM
EDMONDS
39. *The New Bonnet,* 1858
    Oil on canvas
    The Metropolitan Museum
    of Art, New York, Purchase,
    Erving Wolf Foundation Gift
    and Gift of Hanson K. Corning,
    by exchange, 1975  1975.27.1

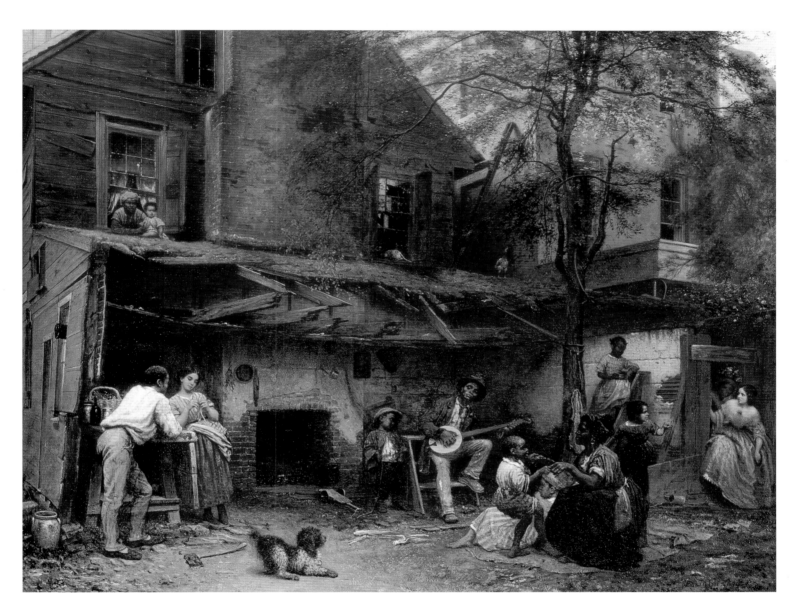

EASTMAN JOHNSON
40. *Negro Life at the South,*
1859
Oil on canvas
The New-York Historical
Society, The Robert L.
Stuart Collection, on
permanent loan from
The New York Public
Library s–225

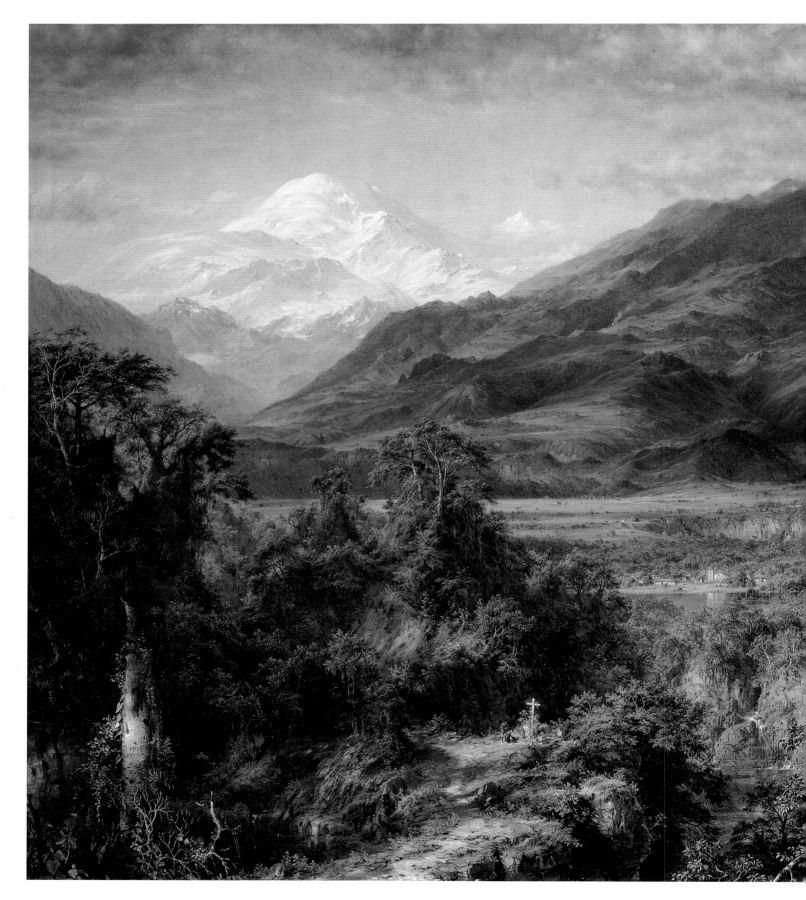

FREDERIC E. CHURCH
41. *The Heart of the Andes*, 1859
Oil on canvas
The Metropolitan Museum of Art, New York,
Bequest of Margaret E. Dows, 1909  09.95

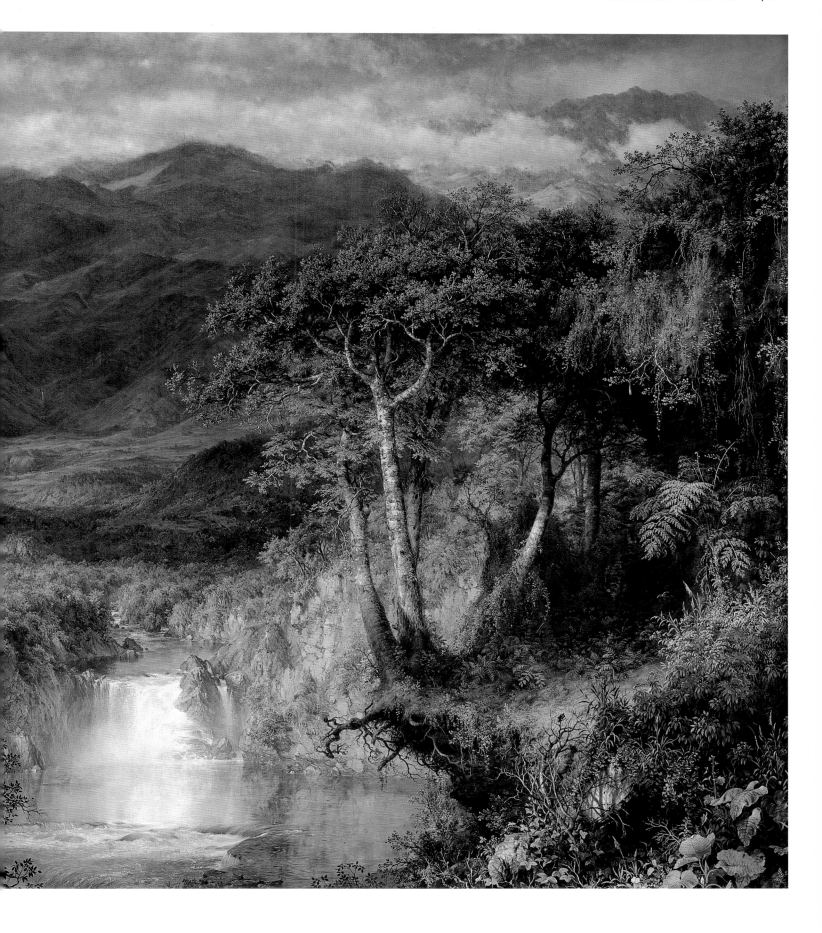

GIOVANNI DI SER
GIOVANNI DI SIMONE
(*called* SCHEGGIA)

42. *The Triumph of Fame,* birth
tray of Lorenzo de'Medici
(recto); *Arms of the Medici
and Tornabuoni Families*
(verso), 1449
Tempera, silver, and gold on
wood
The Metropolitan Museum of
Art, New York, Purchase in
memory of Sir John Pope-
Hennessy: Rogers Fund, The
Annenberg Foundation, Drue
Heinz Foundation, Annette
de la Renta, Mr. and Mrs.
Frank E. Richardson, and The
Vincent Astor Foundation
Gifts, Wrightsman and Gwynne
Andrews Funds, special funds,
and Gift of the children of
Mrs. Harry Payne Whitney,
Gift of Mr. and Mrs. Joshua
Logan, and other gifts and
bequests, by exchange, 1995
1995.7

DAVID TENIERS THE
YOUNGER
43. *Judith with the Head of
Holofernes*, 1650s
Oil on copper
The Metropolitan
Museum of Art, New
York, Gift of Gouverneur
Kemble, 1872  72.2

BARTOLOMÉ
ESTEBAN MURILLO
44. *Four Figures on a Step
(A Spanish Peasant Family),*
ca. 1655–60
Oil on canvas
Kimbell Art Museum,
Fort Worth, Texas
AP1984.18

JAN ABRAHAMSZ.
BEERSTRATEN
45. *Winter Scene*, ca. 1660
Oil on canvas
The New-York Historical
Society, Gift of Thomas J.
Bryan, 1867  1867.84

ARTIST UNKNOWN,
*after* WILLEM KALF
46. *Still Life with Chinese
Sugarbowl, Nautilus
Cup, Glasses, and Fruit,*
ca. 1675–1700
Oil on canvas
The New-York Historical
Society, Luman Reed
Collection—New-York
Gallery of Fine Arts
1858.15

JACOB VAN RUISDAEL
47. *A Landscape with a Ruined Castle and a Church (A Grand Landscape)*, 1665–70
Oil on canvas
The National Gallery, London
NG990

GIOVANNI PAOLO
PANINI (*or* PANNINI)
48. *Modern Rome*, 1757
Oil on canvas
The Metropolitan
Museum of Art, New
York, Gwynne Andrews
Fund, 1952  52.63.2

J. M. W. TURNER
49. *Staffa, Fingal's Cave,*
exhibited 1832
Oil on canvas
Yale Center for British Art,
New Haven, Connecticut,
Paul Mellon Collection
B1978.43.14

ANDREAS
ACHENBACH
50. *Clearing Up—Coast of
Sicily,* 1847
Oil on canvas
The Walters Art Gallery,
Baltimore WAG37.116

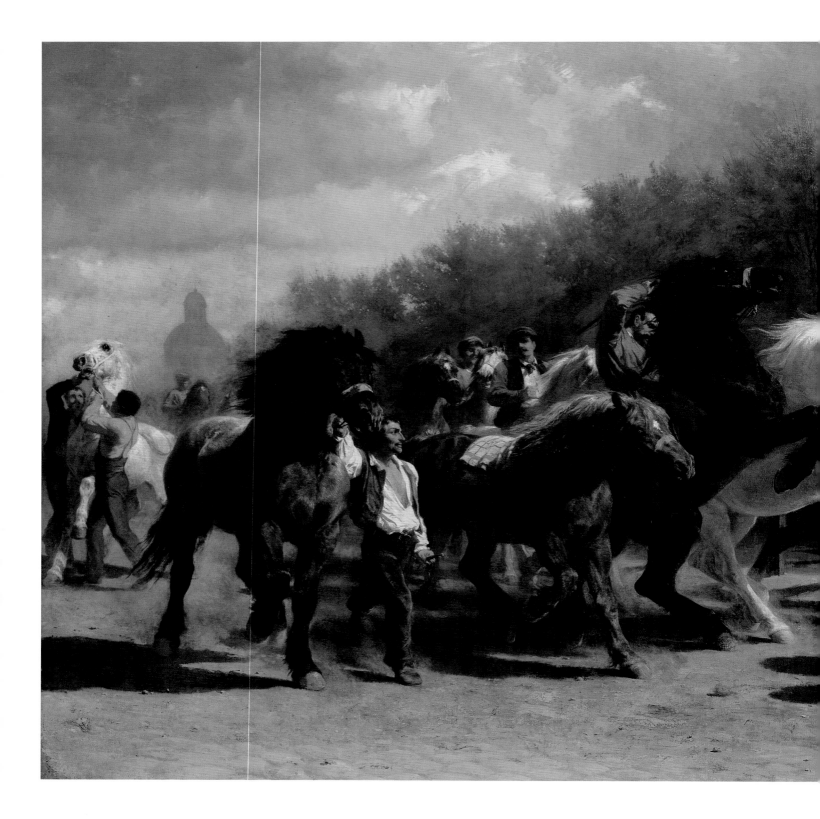

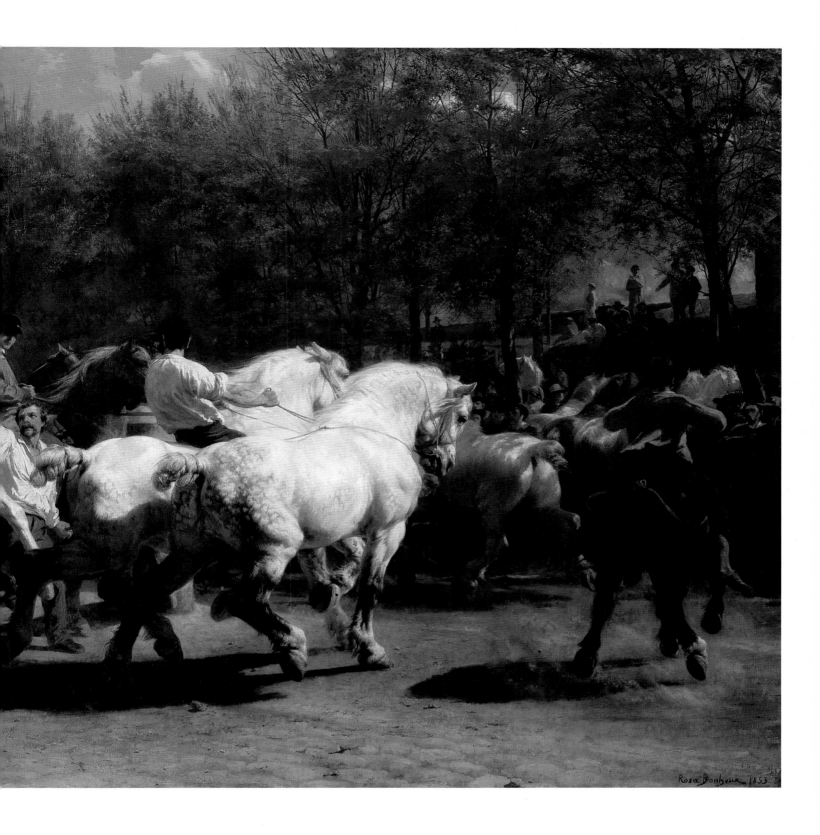

ROSA BONHEUR
51. *The Horse Fair*, 1853;
retouched 1855
Oil on canvas
The Metropolitan
Museum of Art, New
York, Gift of Cornelius
Vanderbilt, 1887 87.25

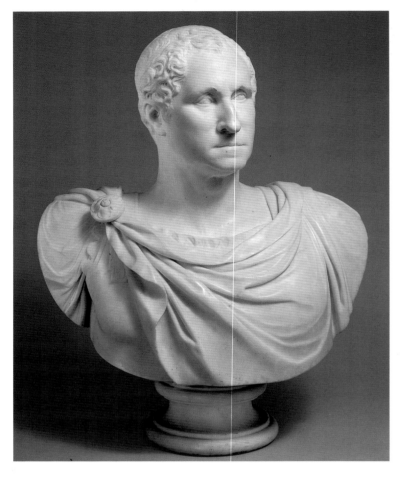

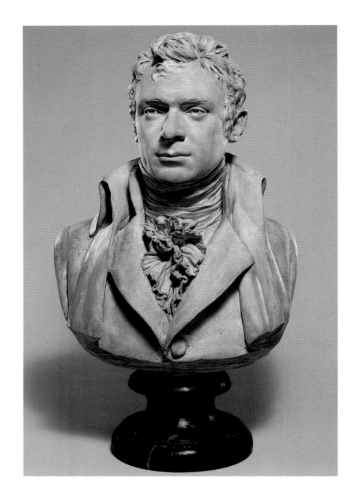

GIUSEPPE CERACCHI
52. *George Washington*, 1795
Marble
The Metropolitan Museum
of Art, New York, Bequest of
John L. Cadwalader, 1914
14.58.235

JEAN-ANTOINE HOUDON
53. *Robert Fulton*, 1803–4
Painted plaster
The Metropolitan Museum of
Art, New York, Wrightsman
Fund, 1989  1989.329

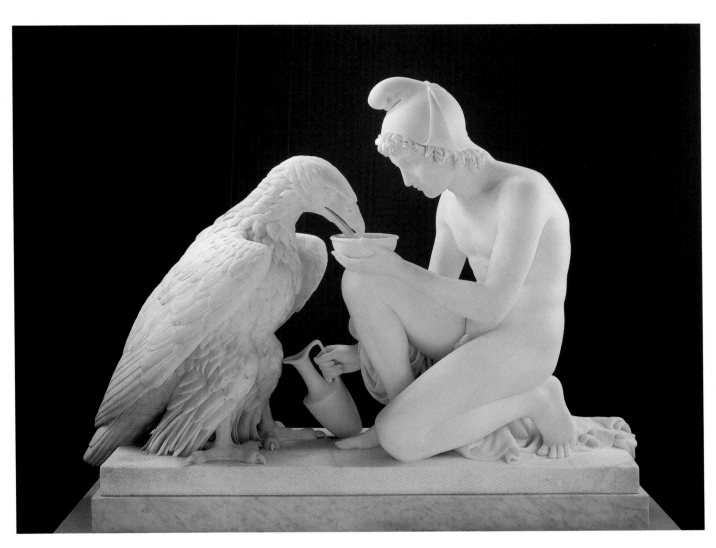

BERTEL THORVALDSEN
54. *Ganymede and the Eagle,*
1817–29
Marble
The Minneapolis Institute of
Arts, Gift of the Morse
Foundation 66.9

HIRAM POWERS
55. *Andrew Jackson,* modeled
    1834–35; carved 1839
    Marble
    The Metropolitan
    Museum of Art, New
    York, Gift of Mrs.
    Frances V. Nash, 1894
    94.14

JOHN FRAZEE
56. *Nathaniel Prime,* 1832–34
    Marble
    National Portrait Gallery,
    Smithsonian Institution,
    Washington, D.C., Gift
    of Sylvester G. Prime
    NPG.84.72

ROBERT BALL HUGHES
57. *John Trumbull,* modeled ca. 1833;
    carved 1834–after 1840
    Marble
    Yale University Art Gallery, New
    Haven, Connecticut, University
    Purchase 1851.2

SHOBAL VAIL
CLEVENGER
58. *Philip Hone,* modeled
1839; carved 1844–46
Marble
Mercantile Library
Association, New York

ROMÆ · MDCCCXLIII ·

THOMAS CRAWFORD
59. *Genius of Mirth,* modeled
    1842; carved 1843
    Marble
    The Metropolitan
    Museum of Art, New
    York, Bequest of Annette
    W. W. Hicks-Lord, 1896
    97.13.1

HIRAM POWERS
60. *Greek Slave,* modeled
    1841–43; carved 1847
    Marble
    The Newark Museum, Gift
    of Franklin Murphy, Jr.,
    1926  26.2755

HENRY KIRKE BROWN
61. *William Cullen Bryant,*
    1846–47
    Marble
    The New-York Historical
    Society, Bequest of Mr.
    Charles M. Leupp  1860.6

HENRY KIRKE BROWN
62. *Thomas Cole,* 1850 or earlier
    Marble
    The Metropolitan Museum
    of Art, New York, Gift in
    memory of Jonathan Sturges,
    by his children, 1895  95.8.1

THOMAS CRAWFORD
63. *Louisa Ward Crawford*, modeled
1845; carved 1846
Marble
Museum of the City of New York,
Gift of James L. Terry, Peter T.
Terry, Lawrence Terry, and Arthur
Terry III 86.173

64

CHAUNCEY BRADLEY IVES
64. *Ruth,* modeled ca. 1849; carved 1851
or later
Marble
Chrysler Museum of Art, Norfolk,
Virginia, Gift of James H. Ricau
and Museum Purchase 86.479

JOSEPH MOZIER
65. *Diana,* ca. 1850
Marble
Huguenot Historical Society,
New Paltz, New York

HENRY KIRKE BROWN
66. *Filatrice,* 1850
Bronze
The Metropolitan Museum of Art,
New York, Purchase, Gifts in memory
of James R. Graham, and Morris K.
Jesup Fund, 1993 1993.13

65

JOHN ROGERS
67. *The Slave Auction*, 1859
Painted plaster
The New-York Historical
Society, Gift of Samuel V.
Hoffman 1928.28

JOHN QUINCY ADAMS
WARD
68. *The Indian Hunter*, modeled
1857–60; cast before 1910
Bronze
The Metropolitan Museum
of Art, New York, Morris K.
Jesup Fund, 1973 1973.257

ERASTUS DOW
PALMER
69. *The White Captive*,
modeled 1857–58;
carved 1858–59
Marble
The Metropolitan
Museum of Art, New
York, Bequest of
Hamilton Fish, 1894
94.9.3

ALEXANDER JACKSON
DAVIS, *artist*
ANTHONY IMBERT,
*lithographer*
*Design attributed to* JOHN
VANDERLYN

70. *The Rotunda, Corner of*
*Chambers and Cross Streets,* fron-
tispiece to *Views of the Public*
*Buildings in the City*
*of New-York,* 1827
Lithograph
The New-York Historical
Society, A. J. Davis Collection 25

ALEXANDER JACKSON
DAVIS, *artist*
ANTHONY IMBERT,
*lithographer*
MARTIN EUCLID
THOMPSON, *architect*

71. *Branch Bank of the United States,*
*15–17 Wall Street,* from *Views*
*of the Public Buildings in the City*
*of New-York,* 1827
Lithograph
The Metropolitan Museum of
Art, New York, The Edward
W. C. Arnold Collection of New
York Prints, Maps, and Pictures,
Bequest of Edward W. C. Arnold,
1954 54.90.672

ALEXANDER JACKSON
DAVIS, *artist*
ANTHONY IMBERT,
*lithographer*
JOSIAH R. BRADY, *architect*

72. *Second Congregational (Unitarian)*
*Church, Corner of Prince and*
*Mercer Streets,* from *Views of the*
*Public Buildings in the City of*
*New-York,* 1827
Lithograph
The New-York Historical Society

ALEXANDER JACKSON
DAVIS, *artist and architect*
ANTHONY IMBERT,
*lithographer*

73. *Design for Improving the Old*
*Almshouse, North Side of City*
*Hall Park, Facing Chambers*
*Street,* 1828
Lithograph
The Metropolitan Museum of
Art, New York, The Elisha
Whittelsey Collection, The
Elisha Whittelsey Fund, 1954
54.546.9

70

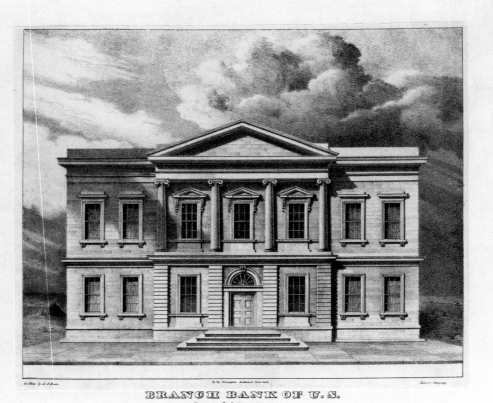

BRANCH BANK OF U.S.
Erected 1825.—Front 75 feet.

71

A.J.Davis del.

J.R.Brady Architect

Imbert's lithography

SECOND CONGREGATIONAL CHURCH N.Y.

Erected 1826 corner of Prince and Mercer Streets. Front Sixty three feet.

72

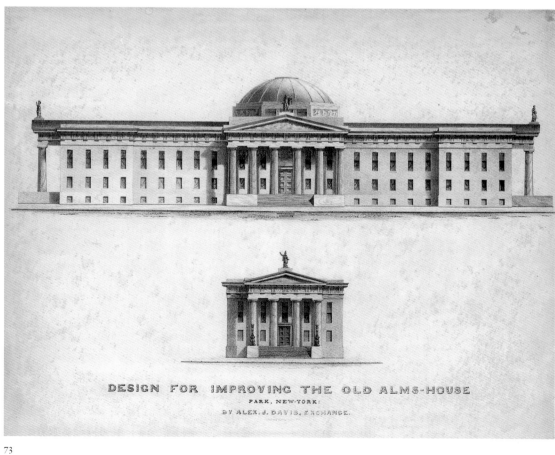

DESIGN FOR IMPROVING THE OLD ALMS-HOUSE

PARK, NEW-YORK:

BY ALEX. J. DAVIS. EXCHANGE.

73

ALEXANDER JACKSON
DAVIS, *artist*
MARTIN EUCLID
THOMPSON *and* JOSIAH
R. BRADY, *architects*
74. *First Merchants' Exchange,*
*35–37 Wall Street, Elevation,*
probably 1826
Ink and wash
The Metropolitan Museum of
Art, New York, The Edward
W. C. Arnold Collection of
New York Prints, Maps, and
Pictures, Bequest of Edward
W. C. Arnold, 1954  54.90.137

ALEXANDER JACKSON
DAVIS, *artist*
MARTIN EUCLID
THOMPSON *and* JOSIAH
R. BRADY, *architects*
75. *First Merchants' Exchange,*
*35–37 Wall Street, First Floor*
*Plan,* probably 1829
Ink and wash
The Metropolitan Museum
of Art, New York, Harris
Brisbane Dick Fund, 1924
24.66.622 (recto)

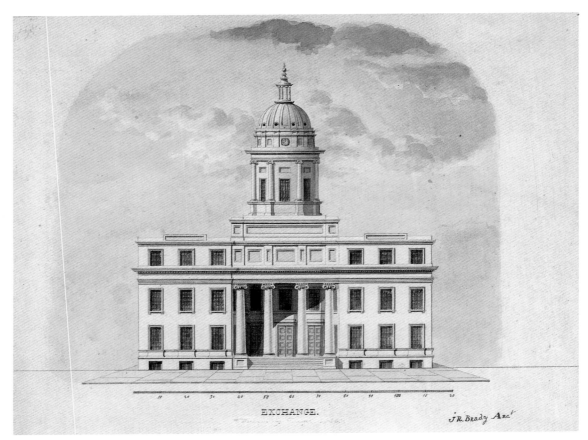

74

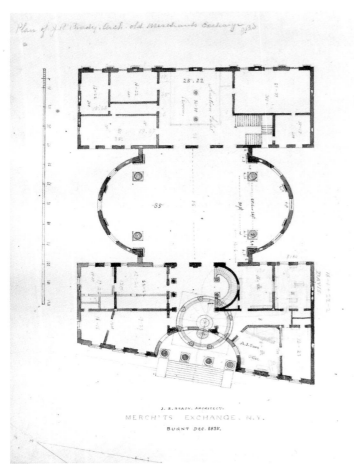

75

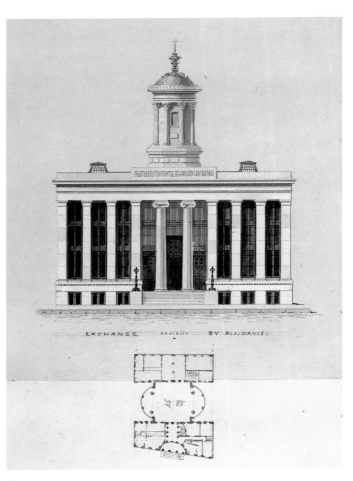

76

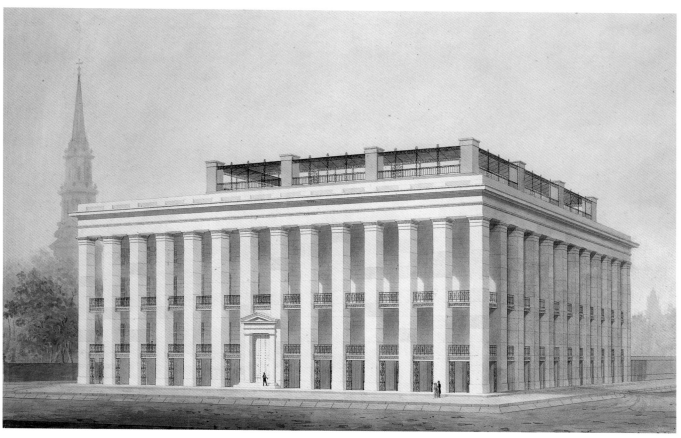

77

ALEXANDER JACKSON
DAVIS

76. *First Merchants' Exchange,
35–37 Wall Street, Alternate,
Unexecuted Elevation and
Plan,* 1829
Ink and wash
The Metropolitan Museum
of Art, New York, Harris
Brisbane Dick Fund, 1924
24.66.621

ALEXANDER JACKSON
DAVIS, *artist*
ITHIEL TOWN *and*
ALEXANDER JACKSON
DAVIS, *architects*

77. *Park Hotel (Later Called
Astor House), Broadway
between Vesey and Barclay
Streets, Proposed, Unexecuted
Design,* 1830
Watercolor
The Metropolitan Museum
of Art, New York, Harris
Brisbane Dick Fund, 1924
24.66.30

ALEXANDER JACKSON
DAVIS, *artist*
ITHIEL TOWN *and*
ALEXANDER JACKSON
DAVIS, *architects*

78. *Park Hotel (Later Called
Astor House), Broadway
between Vesey and Barclay
Streets, Proposed, Unexecuted
Perspective and Plan,* ca. 1830
Watercolor
The New-York Historical
Society, A. J. Davis
Collection 18

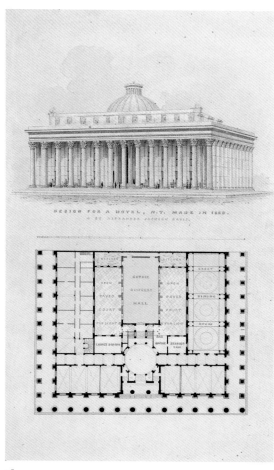

78

ALEXANDER JACKSON
DAVIS, *artist*
ITHIEL TOWN *and*
ALEXANDER JACKSON
DAVIS, *architects*
79. *United States Custom House,
Wall and Nassau Streets,
Longitudinal Section,* 1833
Watercolor and ink
Avery Architectural and Fine
Arts Library, Columbia
University, New York
1940.001.00132

ALEXANDER JACKSON
DAVIS, *artist*
ITHIEL TOWN *and*
ALEXANDER JACKSON
DAVIS, *architects*
80. *United States Custom House,
Wall and Nassau Streets, Plan,*
1833
Watercolor
The Metropolitan Museum
of Art, New York, Harris
Brisbane Dick Fund, 1924
24.66.1403 (45)

ALEXANDER JACKSON
DAVIS, *artist*
ITHIEL TOWN *and*
ALEXANDER JACKSON
DAVIS, *architects*
81. *United States Custom House,
Wall and Nassau Streets,
Perspective,* 1834
Watercolor
The Metropolitan Museum of
Art, New York, The Edward
W. C. Arnold Collection of
New York Prints, Maps, and
Pictures, Bequest of Edward
W. C. Arnold, 1954 54.90.176

JOHN HAVILAND
82. *Halls of Justice and House of
Detention, Centre Street, between
Leonard and Franklin Streets,
First Floor Plan,* 1835
Ink
Royal Institute of British
Architects Library, London,
Drawings Collection W14/6(2)

JOHN HAVILAND
83. *Halls of Justice and House of
Detention, Centre Street, between
Leonard and Franklin Streets,
Bird's-Eye View,* 1835
Ink and wash
Royal Institute of British
Architects Library, London,
Drawings Collection
W14/6(9)

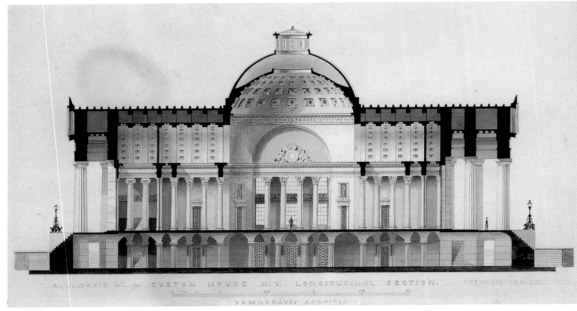

79

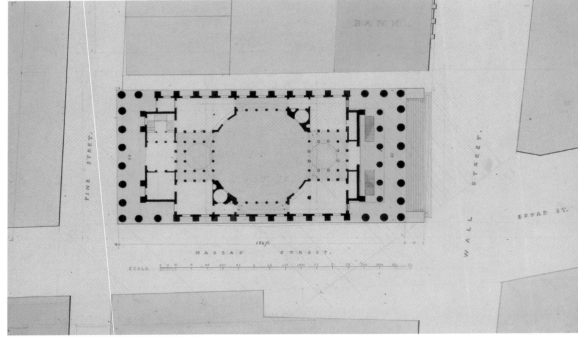

80

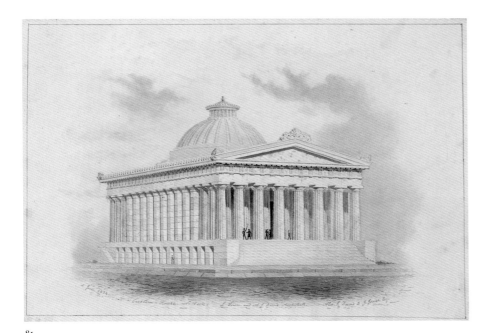

81

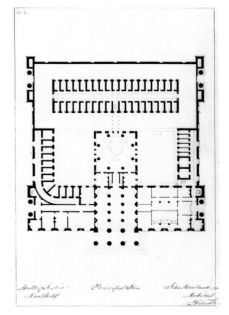

82

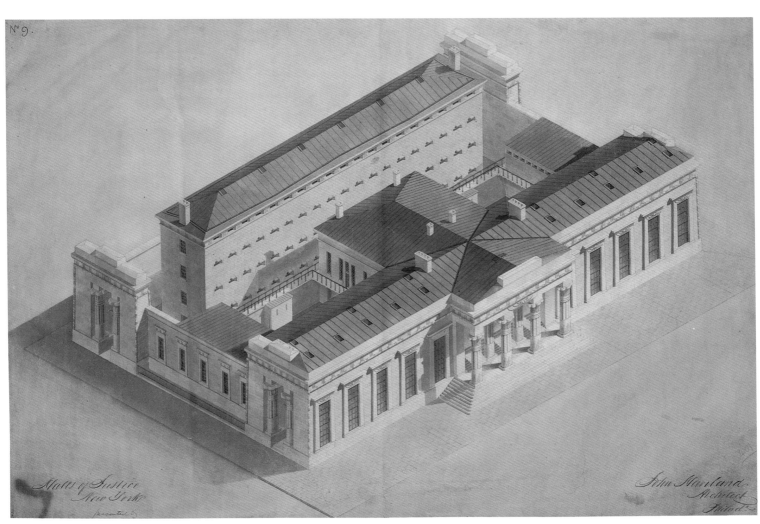

83

ALEXANDER
JACKSON DAVIS
84. *"Syllabus Row,"*
*Proposed, Unexecuted*
*Design for Terrace*
*Houses,* ca. 1830
Watercolor
The Metropolitan
Museum of Art,
New York, The
Edward W. C.
Arnold Collection
of New York Prints,
Maps, and Pictures,
Bequest of Edward
W. C. Arnold, 1954
54.90.140

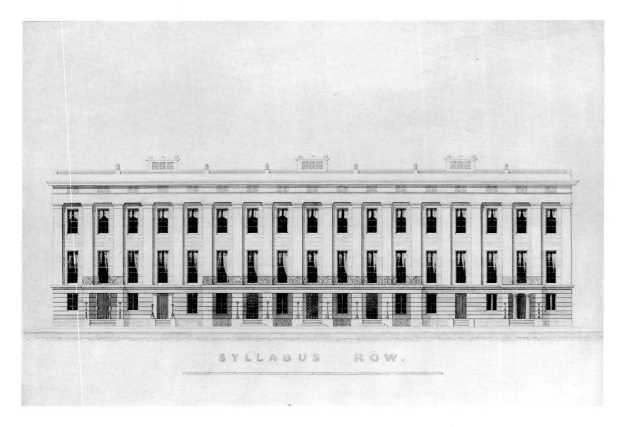

ALEXANDER JACKSON
DAVIS
85. *"Terrace Houses," Proposed,*
*Unexecuted Design for Cross-*
*Block Terrace Development,*
ca. 1831
Watercolor
The Metropolitan Museum
of Art, New York, Harris
Brisbane Dick Fund, 1924
24.66.1291

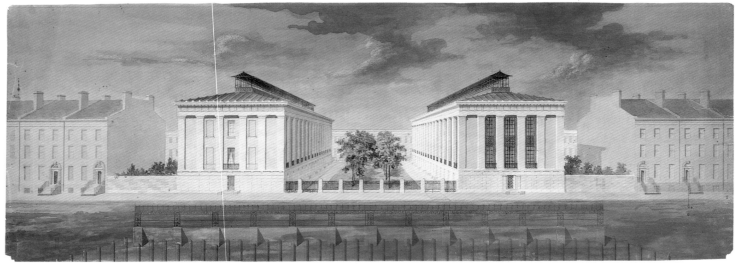

JOHN STIREWALT, *artist*
ALEXANDER JACKSON
DAVIS *and* SETH GEER,
*architects*
86. *Colonnade Row, 428–434*
*Lafayette Street, near Astor*
*Place, Elevation and Plans,*
1833–34
Watercolor
Avery Architectural and Fine
Arts Library, Columbia
University, New York
1940.001.00739

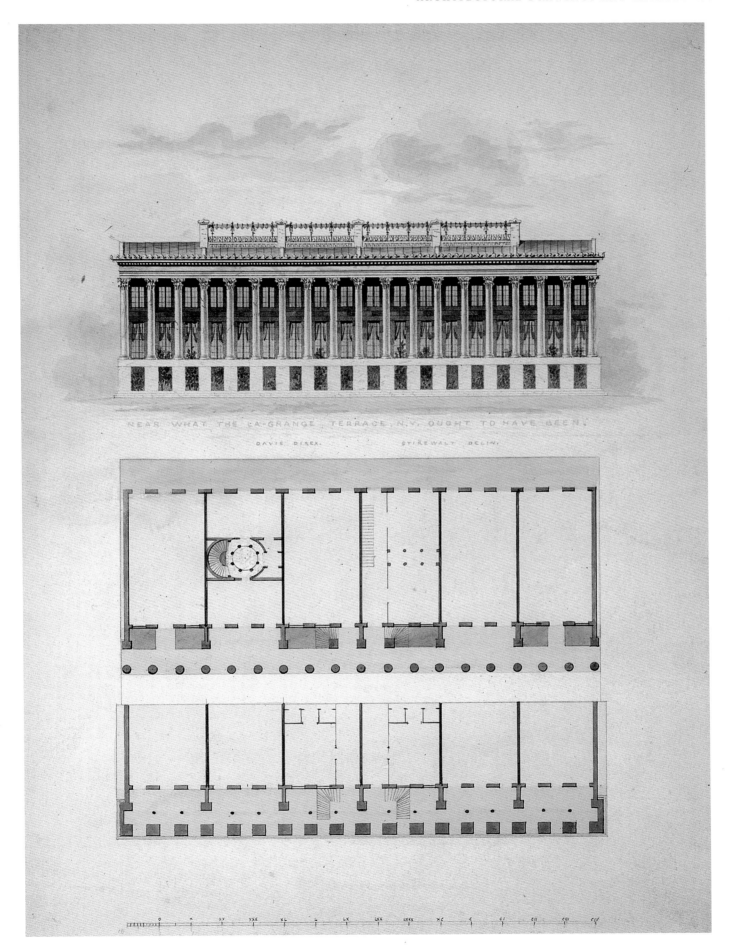

NEAR WHAT THE LA-GRANGE TERRACE N.Y. OUGHT TO HAVE BEEN.

DAVIS DIREX. STIREWALT DELINI.

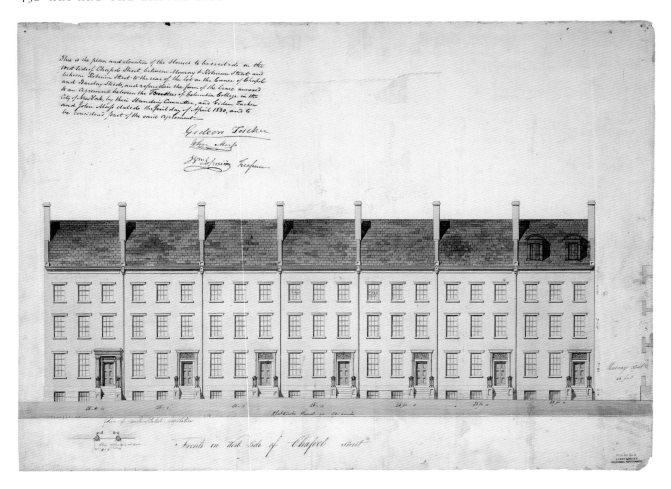

*Attributed to* MARTIN EUCLID
THOMPSON
87. *Row of Houses on Chapel Street,*
*between Murray and Robinson Streets,*
1830
Watercolor and ink on paper,
mounted on board
Avery Architectural and Fine Arts
Library, Columbia University,
New York  Gideon Tucker DR165

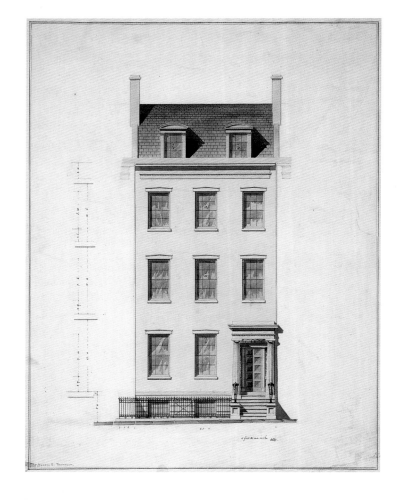

*Attributed to* MARTIN EUCLID
THOMPSON
88. *House on Chapel Street, between*
*Murray and Robinson Streets,* 1830
Watercolor
Avery Architectural and Fine Arts
Library, Columbia University, New
York  1000.010.00013

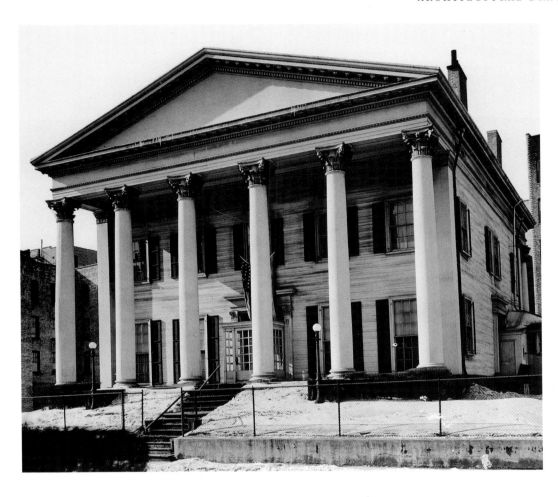

ARCHITECT UNKNOWN
*Clarkson Lawn (Matthew Clarkson Jr. House), Flatbush and Church Avenues, Brooklyn, New York*, built ca. 1835 (demolished 1940); photograph, 1940
Courtesy of the Brooklyn Museum of Art

89A. Door and doorframe from the entry hall of Clarkson Lawn, ca. 1835
Mahogany; painted pine; metal
Brooklyn Museum of Art, Gift of the Young Men's Christian Association, 1940
40.931.2A–B

89B. Pair of pilasters from the double parlor of Clarkson Lawn (capital illustrated), ca. 1835
Painted pine
Brooklyn Museum of Art, Gift of the Young Men's Christian Association, 1940
40.931.3, 4

89A

89B

ARTIST UNKNOWN
RICHARD UPJOHN,
*architect*

93. *Trinity Church, Broadway, opposite Wall Street, Presentation Drawing Depicting View from the Southwest,* probably 1841
Watercolor
Avery Architectural and Fine Arts Library, Columbia University, New York
1000.011.01098

93

94

JAMES RENWICK JR.
94. *Church of the Puritans, Union Square, Fifteenth Street and Broadway,* 1846
Watercolor
The New-York Historical Society

FERDINAND JOACHIM
RICHARDT, *artist*
JAMES RENWICK JR., *architect*
95. *Grace Church, Broadway and Tenth Street,* 1858
Oil on canvas
Grace Church in New York

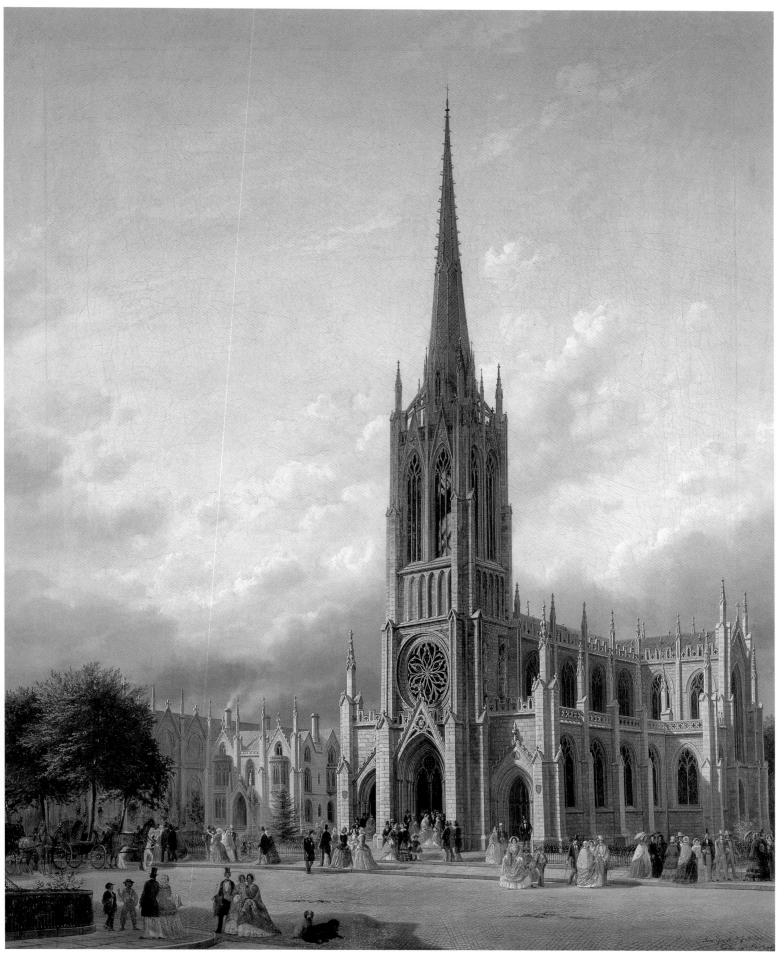

JOSEPH TRENCH *and*
JOHN BUTLER SNOOK
96. *A. T. Stewart Store, Broadway
between Reade and Chambers
Streets, Chambers Street Elevation,*
1849
Watercolor
The New-York Historical
Society

JAMES BOGARDUS, *inventor*
WILLIAM L. MILLER,
*architectural-iron manufacturer*
97. Spandrel panel from Edgar H.
Laing Stores, Washington and
Murray Streets, 1849
Cast iron
The Metropolitan Museum
of Art, New York, Gift of
Margaret H. Tuft, 1979
1979.134

CHAMBER STREET FRONT

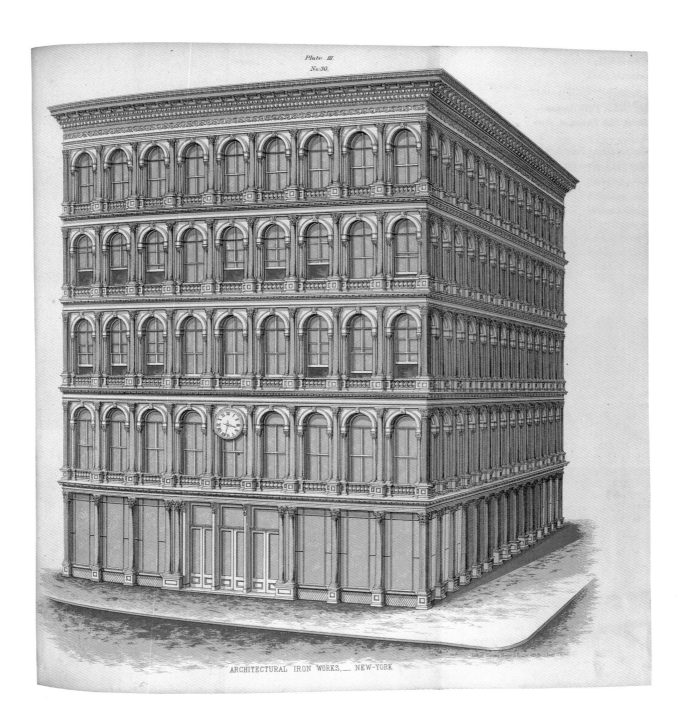

*Plate III.*
*No. 30.*

ARCHITECTURAL IRON WORKS, — NEW-YORK.

JOHN P. GAYNOR, *architect*
DANIEL D. BADGER,
*architectural-iron manufacturer*
SARONY, MAJOR AND KNAPP,
*printer*
98. *Haughwout Building, Broadway and*
*Broome Street,* 1865
Lithograph printed in colors
Smithsonian Institution Libraries,
Washington, D.C.  FNA 3503.7832
1865 XCHRMB

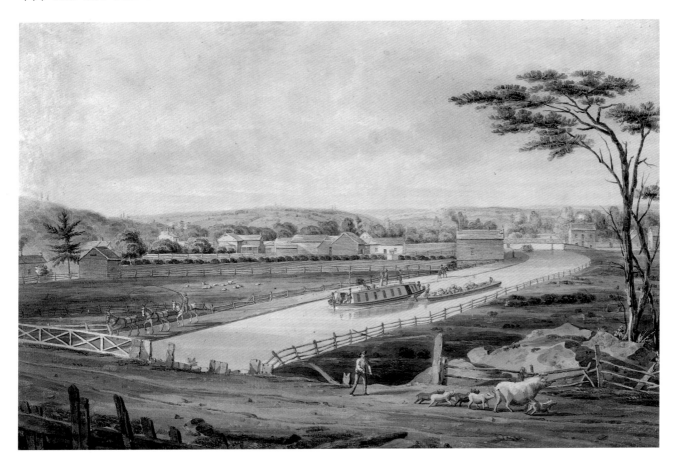

JOHN WILLIAM
HILL
106. *View on the Erie Canal,*
1829
Watercolor
The New York Public
Library, Astor, Lenox
and Tilden Foundations,
Miriam and Ira D. Wallach
Division of Art, Prints
and Photographs, The
Phelps Stokes Collection,
Print Collection
1830–32E–29

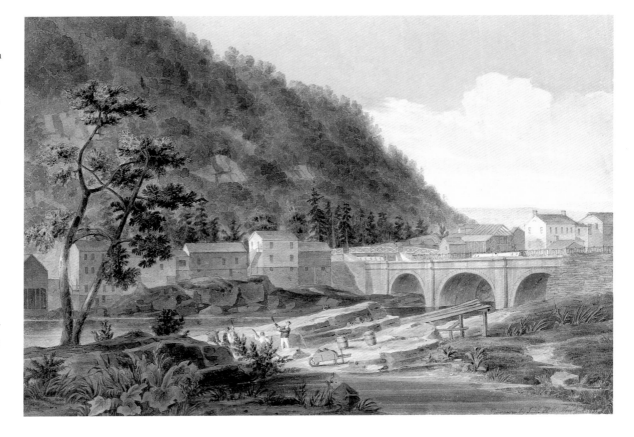

JOHN WILLIAM
HILL
107. *View on the Erie Canal,*
1831
Watercolor
The New York Public
Library, Astor, Lenox
and Tilden Foundations,
Miriam and Ira D. Wallach
Division of Art, Prints
and Photographs, The
Phelps Stokes Collection,
Print Collection
1830–32E–24

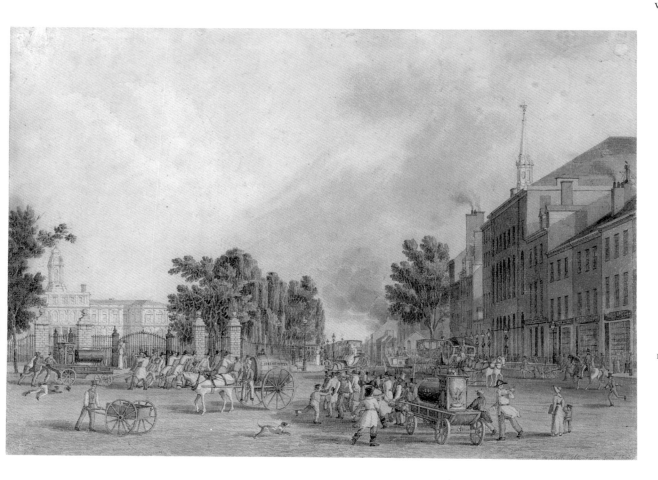

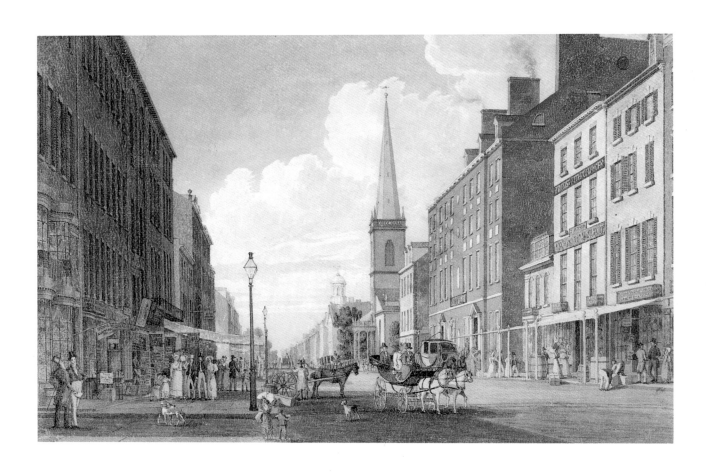

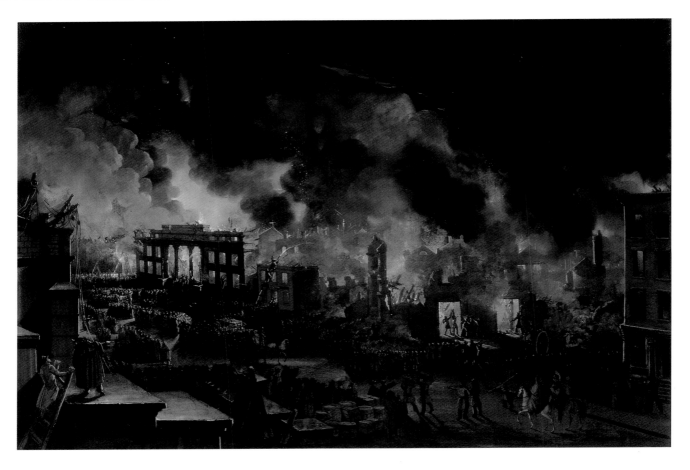

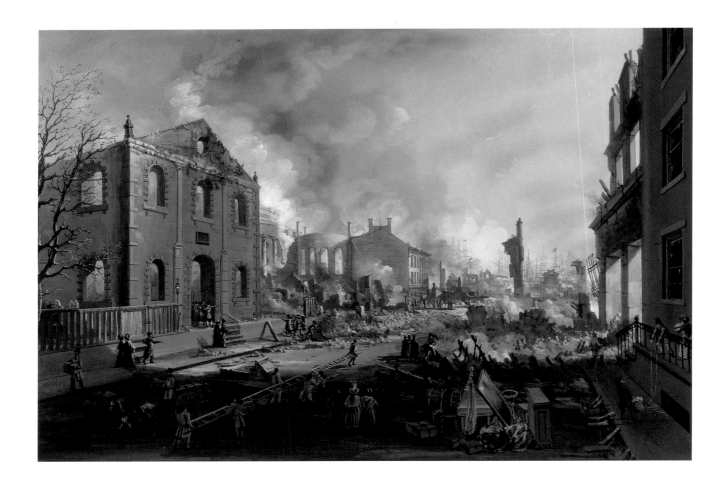

ALEXANDER JACKSON
DAVIS
112. *Greek Revival Double Parlor*,
ca. 1830
Watercolor
The New-York Historical Society,
Gift of Daniel Parish, Jr.
1908.28

JOHN WILLIAM HILL
113. *Chancel of Trinity Chapel*,
ca. 1856
Watercolor, gouache, black ink,
graphite, and gum arabic
The Metropolitan Museum of
Art, New York, The Edward
W. C. Arnold Collection of
New York Prints, Maps, and
Pictures, Bequest of Edward
W. C. Arnold, 1954  54.90.157

NICOLINO CALYO
110. *View of the Great Fire of New
York, December 16 and 17, 1835,
as Seen from the Top of the New
Building of the Bank of America,
Corner Wall and William Streets*,
1836
Gouache on paper, mounted
on canvas
The New-York Historical
Society, Bryan Fund  1980.53

NICOLINO CALYO
111. *View of the Ruins after the Great
Fire in New York, December 16
and 17, 1835, as Seen from Exchange
Place*, 1836
Gouache on paper, mounted
on canvas
The New-York Historical
Society, Bryan Fund  1980.54

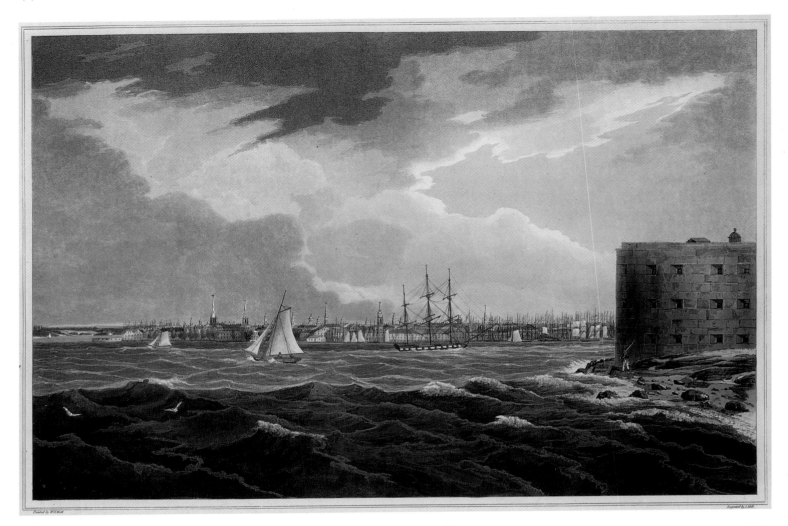

JOHN HILL, *engraver*
*After* WILLIAM GUY WALL,
*artist*
HENRY J. MEGAREY,
*publisher*

114. *New York from Governors Island*,
1823–24, from *The Hudson River
Portfolio* (1821–25)
Aquatint with hand coloring
The Metropolitan Museum of
Art, New York, The Edward W.
C. Arnold Collection of New
York Prints, Maps, and Pictures,
Bequest of Edward W. C.
Arnold, 1954  54.90.1274.18

ASHER B. DURAND,
*engraver*
DURAND, PERKINS AND
COMPANY, *printer and publisher*

115. $1,000 bill for the Greenwich
Bank, City of New York, ca. 1828
Engraving, cancelled proof
The Metropolitan Museum of
Art, New York, Harris Brisbane
Dick Fund, 1917  17.3.3585 (14)

ASHER B. DURAND, *engraver*
DURAND, PERKINS AND
COMPANY, *printer and publisher*

116. Specimen sheet of bank note engraving,
ca. 1828
Engraving
The Metropolitan Museum of Art, New
York, Harris Brisbane Dick Fund, 1917
17.3.3585 (47)

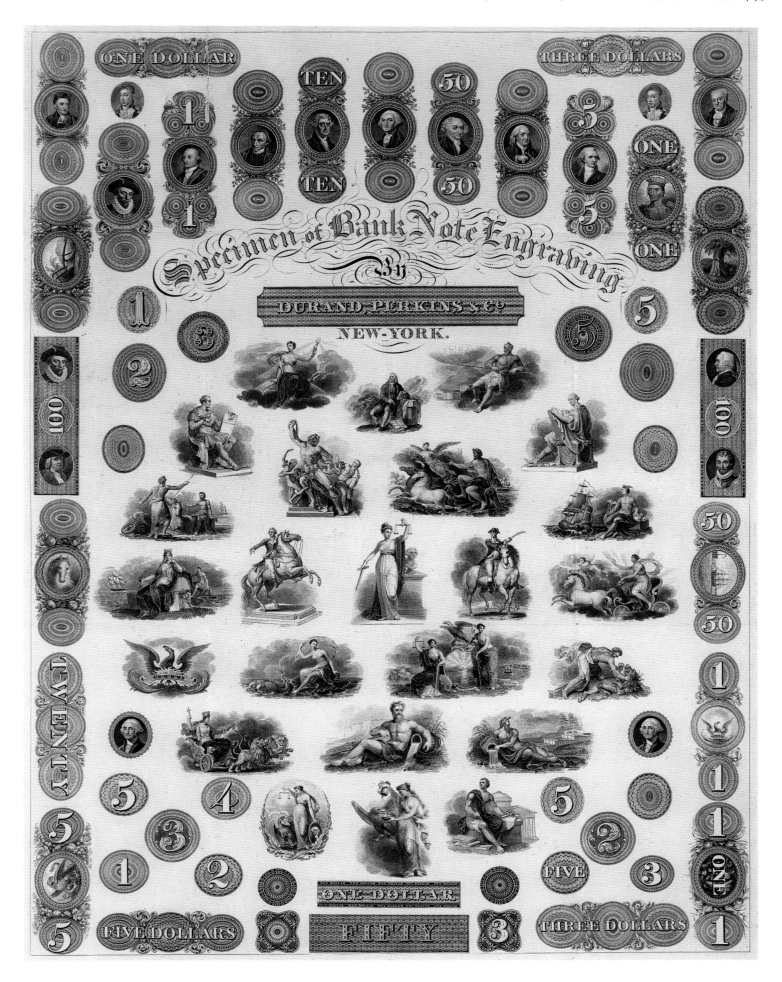

CADWALLADER COLDEN,
*author*
ARCHIBALD ROBERTSON,
*artist*
ANTHONY IMBERT, *printer*
WILSON AND NICHOLLS,
*bookbinder*

117. *Memoir, Prepared at the Request of a Committee of the Common Council of the City of New York, and Presented to the Mayor of the City, at the Celebration of the Completion of the New York Canals,* 1825
Bound in red leather with gold stamping
American Antiquarian Society, Worcester, Massachusetts

ARCHIBALD ROBERTSON,
*artist*
ANTHONY IMBERT,
*printer*

118. *Grand Canal Celebration: View of the Fleet Preparing to Form in Line,* 1825, from Cadwallader Colden, *Memoir* (1825)
Lithograph
The Metropolitan Museum of Art, New York, Harris Brisbane Dick Fund, 1923
23.69.23

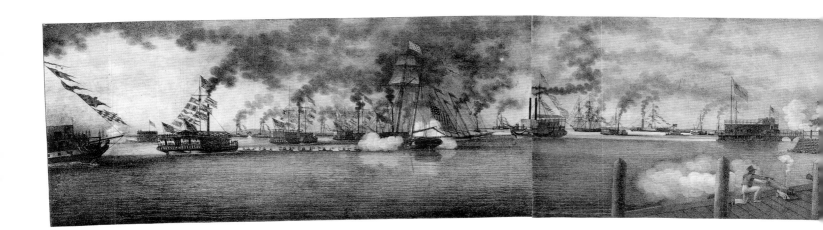

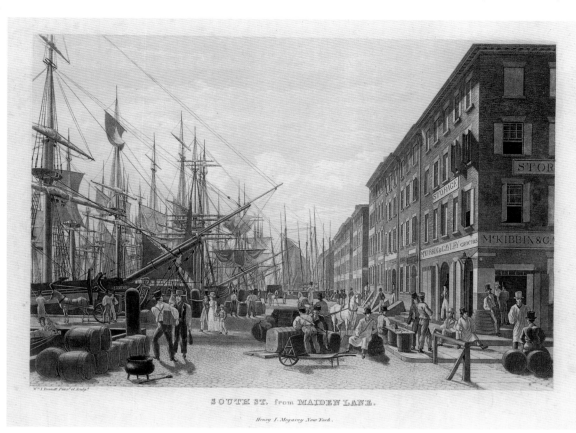

SOUTH ST. from MAIDEN LANE.

Henry I. Megarey New York.

WILLIAM JAMES BENNETT,
*artist and engraver*
HENRY J. MEGAREY,
*publisher*

119. *South Street from Maiden Lane,*
ca. 1828, from *Megarey's Street
Views in the City of New-York*
(1834)
Aquatint
The Metropolitan Museum of
Art, New York, The Edward
W. C. Arnold Collection of
New York Prints, Maps, and
Pictures, Bequest of Edward
W. C. Arnold, 1954  54.90.1177

WILLIAM JAMES BENNETT,
*artist and engraver*
HENRY J. MEGAREY,
*publisher*

120. *Fulton Street and Market,*
1828–30, from *Megarey's Street
Views in the City of New-York*
(1834)
Aquatint
The Metropolitan Museum of
Art, New York, Bequest of
Charles Allen Munn, 1924
24.90.1276

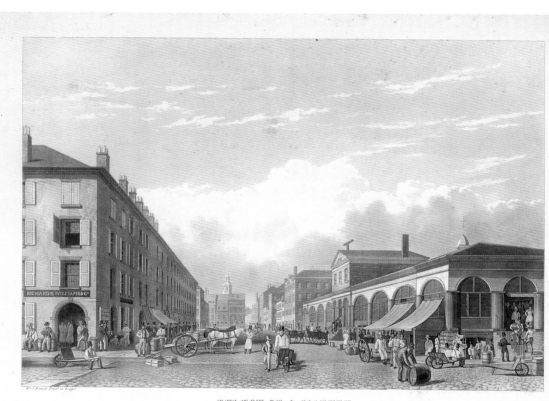

FULTON ST. & MARKET.

Henry I. Megarey New York.

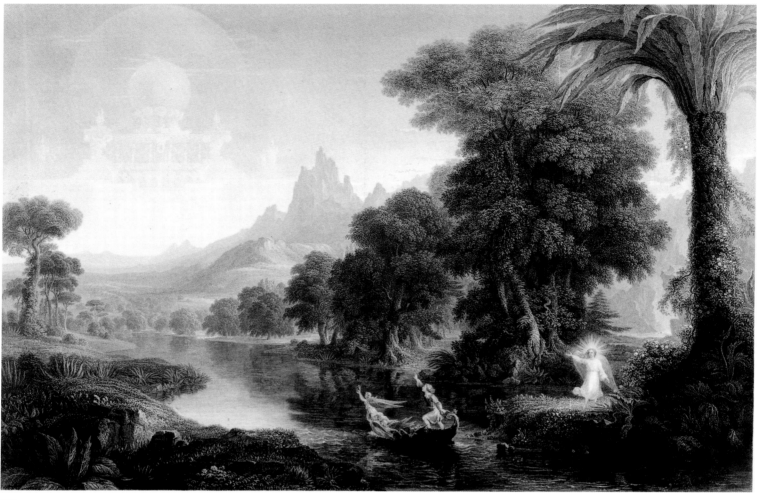

130

131

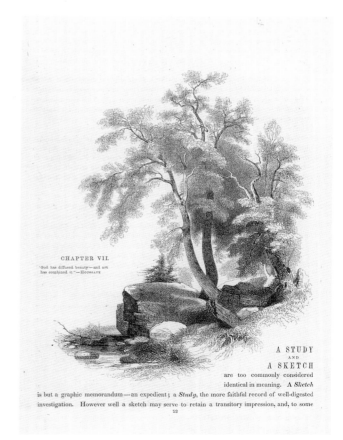

132

JAMES SMILLIE, *engraver*
*After* THOMAS COLE, *artist*
130. *The Voyage of Life: Youth*, 1849
Engraving, proof before letters
Museum of Fine Arts, Boston,
Harvey D. Parker Collection
P12796

GEORGE LORING BROWN
131. *Cascades at Tivoli*, 1854
Etching
Museum of Fine Arts, Boston,
Harvey D. Parker Collection
P12262

ASHER B. DURAND, *artist*
JOHN GADSBY CHAPMAN,
*author*
W. J. WIDDLETON, *publisher*
132. *A Study and a Sketch*, from
*The American Drawing-Book*
(1st ed., 1847)
Reproduction of wood engrav-
ing from 3d edition, 1864
The Metropolitan Museum of
Art, New York, Harris Brisbane
Dick Fund, 1954  54.524.2

WASHINGTON IRVING,
*author*
FELIX OCTAVIUS CARR
DARLEY, *artist and lithographer*
SARONY AND MAJOR,
*printer*
133. Plate 5, *Illustrations of "Rip van
Winkle,"* 1848
Lithograph
The Metropolitan Museum of
Art, New York, Gift of Mrs.
Frederic F. Durand, 1933
33.39.123

WASHINGTON IRVING,
*author*
FELIX OCTAVIUS CARR
DARLEY, *artist and lithographer*
SARONY AND MAJOR,
*printer*
134. Plate 6, *Illustrations of "The
Legend of Sleepy Hollow,"* 1849
Lithograph
The Metropolitan Museum of
Art, New York, Rogers Fund,
transferred from the Library,
1944  44.40.2

133

134

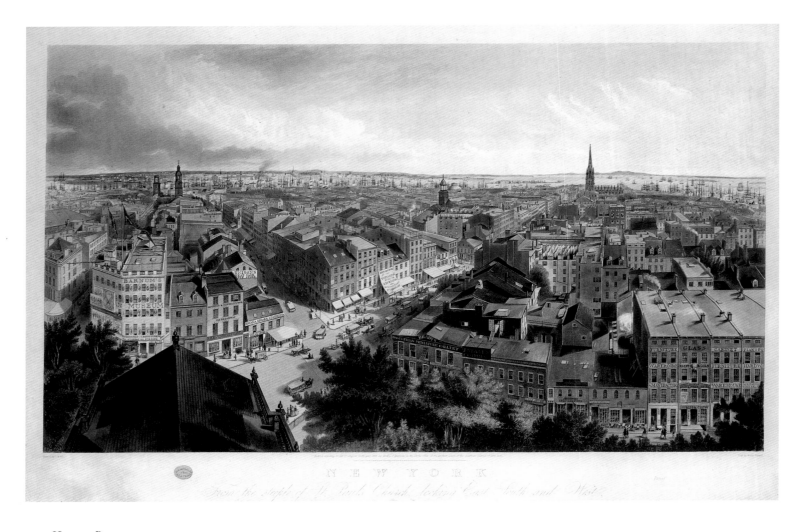

HENRY PAPPRILL,
*engraver*
*After* JOHN WILLIAM
HILL, *artist*
HENRY J. MEGAREY,
*publisher*

135. *New York from the Steeple of Saint Paul's Church, Looking East, South, and West,* ca. 1848
Aquatint printed in colors with hand coloring, second state
The Metropolitan Museum of Art, New York, The Edward W. C. Arnold Collection of New York Prints, Maps, and Pictures, Bequest of Edward W. C. Arnold, 1954  54.90.587

JOHN F. HARRISON, *cartographer*
KOLLNER, CAMP AND COMPANY, *Philadelphia, printer*
MATTHEW DRIPPS, *publisher*

136. *Map of the City of New York, Extending Northward to Fiftieth Street,* 1851
Lithograph with hand coloring
Collection of Mark D. Tomasko

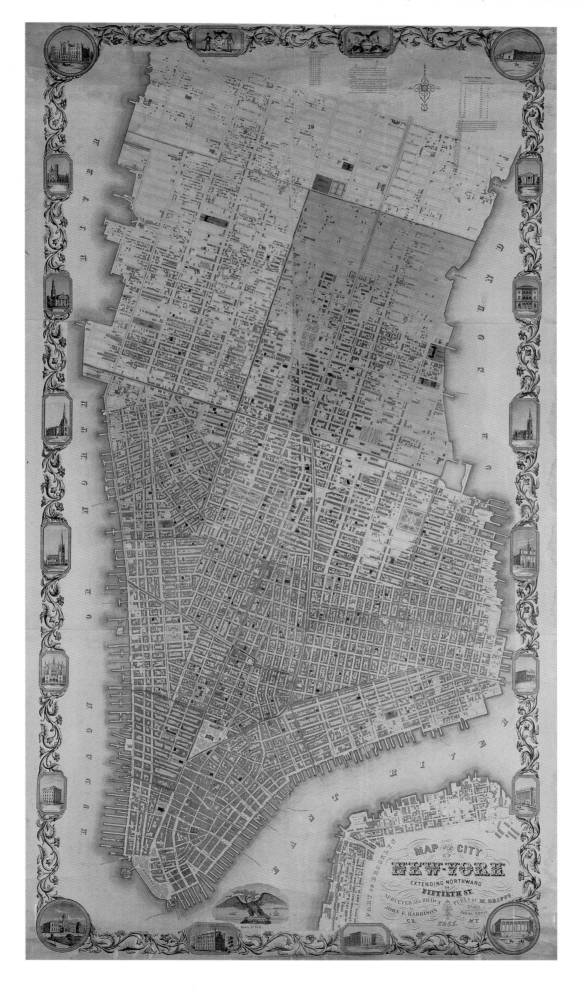

137

138

139

140

WASHINGTON IRVING, *under the pseudonym* DIEDRICH KNICKERBOCKER, *author*
GEORGE P. PUTNAM, *publisher*

137. *A History of New-York from the Beginning of the World to the End of the Dutch Dynasty* (1st ed., 1809), 1850 edition
Bound in blue morocco leather with gold stamping and rose-and-gold inset
American Antiquarian Society, Worcester, Massachusetts, Papantonio Collection

ALFRED ASHLEY, *artist and designer*
W. H. SWEPSTONE, *author*
STRINGER AND TOWNSEND, *publisher*

138. *Christmas Shadows, a Tale of the Poor Needle Woman with Numerous Illustrations on Steel,* New York and London, 1850
Bound in blue cloth with gold stamping
Collection of Jock Elliott

EDWARD WALKER AND SONS, *bookbinder*

139. *The Odd-Fellows Offering,* 1851
Bound in red cloth with gold stamping
American Antiquarian Society, Worcester, Massachusetts, Kenneth G. Leach Collection

SAMUEL HUESTON, *publisher*

140. *The Knickerbocker Gallery,* 1855
Bound in red leather with gold stamped inset
American Antiquarian Society, Worcester, Massachusetts, Papantonio Collection B, Copy 3

JOHN BACHMANN, *artist, printer, and publisher*

141. *Bird's-Eye View of the New York Crystal Palace and Environs,* 1853
Lithograph printed in colors with hand coloring
Museum of the City of New York, The J. Clarence Davies Collection 29.100.2387

CHARLES PARSONS, *artist and lithographer*
ENDICOTT AND COMPANY, *printer*
GEORGE S. APPLETON, *publisher*

142. *An Interior View of the Crystal Palace,* 1853
Lithograph printed in colors
The Metropolitan Museum of Art, New York, The Edward W. C. Arnold Collection of New York Prints, Maps, and Pictures, Bequest of Edward W. C. Arnold, 1954 54.90.1047

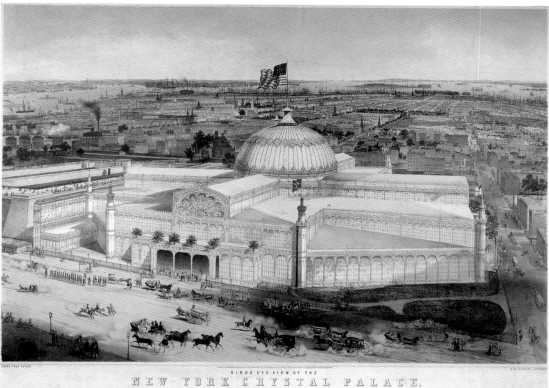

141

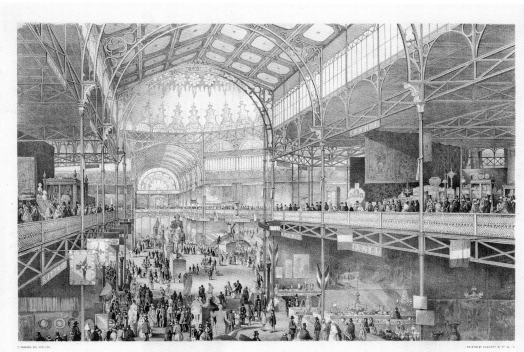

142

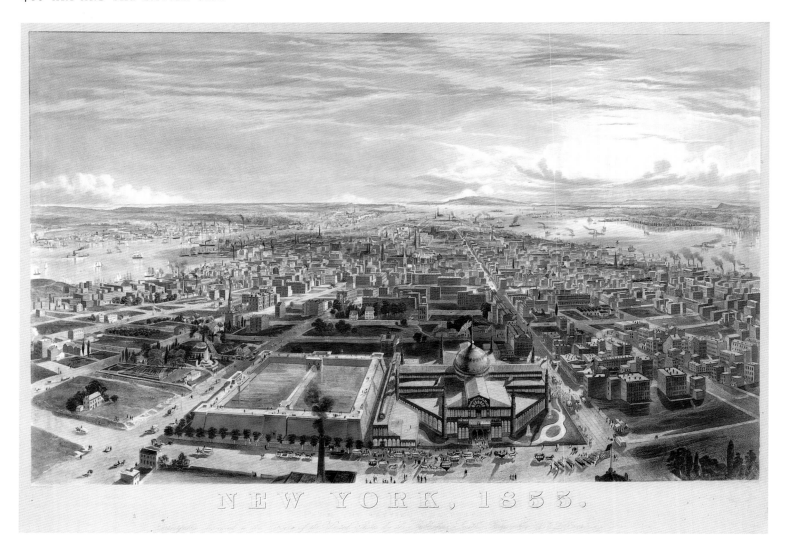

WILLIAM WELLSTOOD, *engraver*
*After* BENJAMIN F. SMITH JR., *artist*
SMITH, FERN AND COMPANY,
*publisher*

143. *New York, 1855, from the Latting Observatory,*
1855
Engraving with hand coloring
The New York Public Library, Astor, Lenox
and Tilden Foundations, Miriam and Ira
D. Wallach Division of Art, Prints and
Photographs, The Phelps Stokes Collection,
Print Collection 1855–E–138

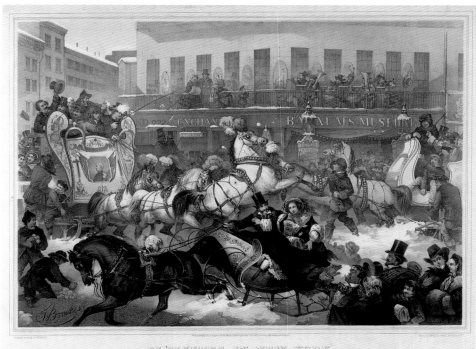

THOMAS BENECKE, *artist*
NAGEL AND LEWIS, *printer*
EMIL SEITZ, *publisher*

144. *Sleighing in New York,* 1855
Lithograph printed in colors with hand
coloring
The Metropolitan Museum of Art,
New York, The Edward W. C. Arnold
Collection of New York Prints, Maps,
and Pictures, Bequest of Edward
W. C. Arnold, 1954  54.90.1061

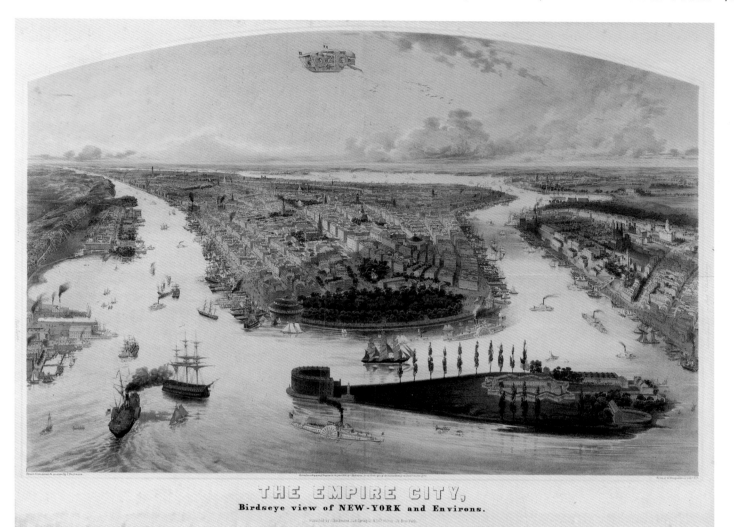

THE EMPIRE CITY,
Birdseye view of NEW-YORK and Environs.

JOHN BACHMANN, *artist*
ADAM WEINGARTNER, *printer*
L. W. SCHMIDT, *publisher*

145. *The Empire City,* 1855
Lithograph printed in colors with
hand coloring
The Metropolitan Museum of Art,
New York, The Edward W. C. Arnold
Collection of New York Prints, Maps,
and Pictures, Bequest of Edward
W. C. Arnold, 1954  54.90.1198

WALT WHITMAN, *author*
146. *Leaves of Grass,* Brooklyn, New York, 1855
Bound in dark green cloth with title stamped in gold

SAMUEL HOLLYER, *engraver*
*After a daguerreotype by* GABRIEL HARRISON
*Walt Whitman,* 1855, from *Leaves of Grass* (1855)
Engraving

Columbia University New York, Rare Book and Manuscript Library, Solton and Julia Engel Collection

JOHN GADSBY CHAPMAN
147. *Italian Goatherd,* 1857
Etching
Museum of Fine Arts, Boston, Gift of Sylvester Rosa Koehler
K858

JEAN-BAPTISTE-ADOLPHE LAFOSSE, *lithographer*
*After* WILLIAM SIDNEY MOUNT, *artist*
FRANÇOIS DELARUE, *printer*
WILLIAM SCHAUS, *publisher*
148. *The Bone Player,* 1857
Lithograph with hand coloring
The Metropolitan Museum of Art, New York, Purchase, Leonard L. Milberg Gift, 1998
1998.416

Painted by W^m S.MOUNT    Entered according to Act of Congress in the year 1869 by W. Schaus, in the clerk's Office of the District Court of the United States for the Southern district of New York.    Lith by LAFOSSE

*The Bone Player.*

New York, pub'd by W.SCHAUS, 629 Broadway    Imp. F^on Delarue Paris.

Wild Turkey. MELEAGRIS GALLOPAVO, Linn. Male.—American Cane, Miegia macrosperma.

JOHN BACHMANN, *artist,
lithographer, and publisher*
C. FATZER, *printer*
150. *New York City and Environs,* 1859
Lithograph printed in colors
Museum of the City of New
York, Gift of James Duane
Taylor, 1931 31.24

JULIUS BIEN, *lithographer*
*After* JOHN JAMES AUDUBON,
*artist, and* ROBERT HAVELL
JR., *engraver*
149. *Wild Turkey,* 1858
Lithograph printed in colors
Brooklyn Museum of Art X633.3

DeWitt Clinton
Hitchcock, *artist*
Hy. J. Crate, *printer*

151. *Central Park, Looking South from the Observatory,* 1859
Lithograph printed in colors with hand coloring
Museum of the City of New York, The J. Clarence Davies Collection
29.100.2299

Arthur Lumley, *artist*
W. R. C. Clark and Meeker, *publisher*

152. *The Empire City, New York, Presented to the Subscribers to "The History of the City of New York,"* 1859
Wood engraving and lithograph printed in colors
The New-York Historical Society

CENTRAL PARK.
NEW YORK CITY.
Looking South from the Observatory

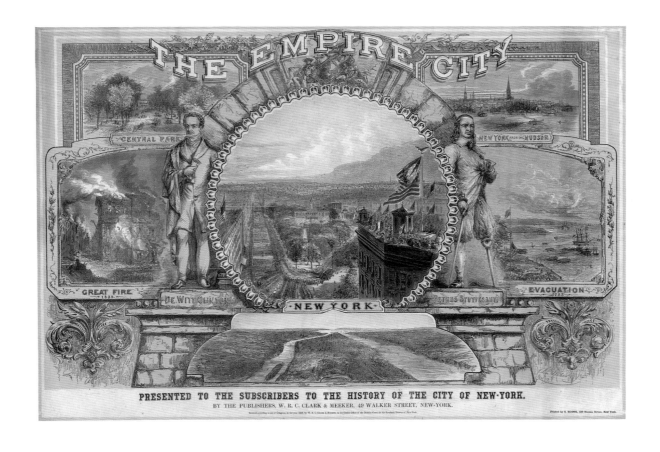

THE EMPIRE CITY

PRESENTED TO THE SUBSCRIBERS TO THE HISTORY OF THE CITY OF NEW-YORK.
BY THE PUBLISHERS, W. R. C. CLARK & MEEKER, 49 WALKER STREET, NEW-YORK.

CENTRAL-PARK, WINTER.
THE SKATING POND.

CHARLES PARSONS,
*artist*
CURRIER AND IVES,
*printer and publisher*
153. *Central Park, Winter: The Skating Pond,* ca. 1861
Lithograph with hand coloring
The Metropolitan Museum of Art, New York, Bequest of Adele S. Colgate, 1962
63.550.266

REMBRANDT VAN
RIJN, *artist*
154. *Saint Jerome Reading in a
Landscape*, ca. 1654
Etching, drypoint, and
engraving, second state
Museum of Fine Arts,
Boston, Harvey D.
Parker Collection P496

CARLO LOSSI, *engraver*
*After* TIZIANO
VECELLI (TITIAN),
*artist*
155. *Bacchus and Ariadne,* 1774
Etching and engraving
The New-York Historical
Society 1858.92.043

WILLIAM SHARP,
*engraver*
*After* BENJAMIN WEST,
*artist*
JOHN AND JOSIAH
BOYDELL, *London,
publisher*
156. *Act 3, Scene 4, from
William Shakespeare's
"King Lear,"* 1793
Engraving
The Metropolitan
Museum of Art, New
York, Gift of Georgiana
W. Sargent, in memory
of John Osborne Sargent,
1924 24.63.1869

JOHN BURNET,
*engraver*
*After* DAVID WILKIE,
*artist*
JOSIAH BOYDELL,
*London, publisher*
157. *The Blind Fiddler,* 1811
Engraving
The New York Public
Library, Astor, Lenox
and Tilden Foundations,
Miriam and Ira D.
Wallach Division of Art,
Prints and Photographs,
Print Collection

154

155

SHAKSPEARE.
*King Lear.*
ACT III, SCENE IV.

156

157

CHARLES MOTTRAM,
*engraver*
*After* JOHN MARTIN, *artist*
WILLIAMS, STEVENS
AND WILLIAMS, *publisher*
159. *The Plains of Heaven,* 1855
Mezzotint, proof before letters
The New York Public Library,
Astor, Lenox and Tilden
Foundations, Miriam and
Ira D. Wallach Division of
Art, Prints and Photographs,
Print Collection

ALPHONSE FRANÇOIS,
*engraver*
*After* PAUL DELAROCHE,
*artist*
158. *Napoleon Crossing the Alps,*
1852
Engraving, proof
The Metropolitan Museum
of Art, New York, The
Elisha Whittelsey Collection,
The Elisha Whittelsey
Fund, 1949  49.40.177

Samuel F. B. Morse
160. *Young Man*, 1840
Daguerreotype
Gilman Paper Company Collection,
New York

MATHEW B. BRADY
161. *Thomas Cole,* 1844–48
Daguerreotype
National Portrait Gallery, Smithsonian
Institution, Washington, D.C., Gift of
Edith Cole Silberstein NPG.76.11

ARTIST UNKNOWN
162. *Asher B. Durand,* ca. 1854
Daguerreotype
The New-York Historical Society
PR–012–2–80

*Attributed to* GABRIEL
HARRISON
163. *Walt Whitman,* ca. 1854
Daguerreotype
The New York Public Library,
Astor, Lenox and Tilden
Foundations, Rare Books Division

164

165A

165B

MATHEW B. BRADY
164. *John James Audubon*, 1847–48
Daguerreotype
Cincinnati Art Museum, Centennial Gift of
Mr. and Mrs. Frank Shaffer, Jr. 1981.144,
1982.268

FRANCIS D'AVIGNON, *lithographer*
*After a daguerreotype by* MATHEW B.
BRADY
165A. *John James Audubon*, 1850, from *The Gallery of
Illustrious Americans* (1850)
Lithograph
The Metropolitan Museum of Art, New York,
Bequest of Charles Allen Munn, 1924 24.90.576

C. EDWARDS LESTER, *editor*
FRANCIS D'AVIGNON, *lithographer*
MATHEW B. BRADY, *daguerreotypist*
BRADY, D'AVIGNON AND COMPANY,
*publisher*
165B. *The Gallery of Illustrious Americans*, 1850
Bound in blue cloth with gold stamping
The Metropolitan Museum of Art, New York,
Bequest of Charles Allen Munn, 1924
24.90.1966

166

167

MATHEW B. BRADY
166. *Jenny Lind*, 1852
Daguerreotype
Chrysler Museum of Art, Norfolk,
Virginia, Museum Purchase and gift of
Kathryn K. Porter and Charles and
Judy Hudson 89.75

JEREMIAH GURNEY
167. *Mrs. Edward Cooper and Son Peter
(Pierre) Who Died*, 1858–60
Daguerreotype
The New-York Historical Society
PR–012–2–811

*Attributed to* SAMUEL ROOT *or*
MARCUS AURELIUS ROOT
168. *P. T. Barnum and Charles Stratton
("Tom Thumb")*, 1843–50
Daguerreotype
National Portrait Gallery, Smithsonian
Institution, Washington, D.C.
NPG.93.254

168

GABRIEL HARRISON
169. *California News,* 1850–51
     Daguerreotype
     Gilman Paper Company
     Collection, New York

MATHEW B. BRADY
170. *The Hurlbutt Boys,* ca. 1850
Daguerreotype
The New-York Historical Society

MATHEW B. BRADY
171. *Young Boy,* 1850–54
Daguerreotype
Hallmark Photographic Collection,
Hallmark Cards, Inc., Kansas City,
Missouri P5.428.013.98

JEREMIAH GURNEY
172. *The Kellogg-Comstock
Family,* 1852–58
Daguerreotype
The New-York
Historical Society

ARTIST UNKNOWN

173. *Brooklyn Grocery Boy with Parcel,*
1850s
Daguerreotype
Hallmark Photographic
Collection, Hallmark Cards,
Inc., Kansas City, Missouri
P5.400.053.96

JEREMIAH GURNEY

174. *Young Girl,* 1858–60
Daguerreotype
Hallmark Photographic
Collection, Hallmark Cards,
Inc., Kansas City, Missouri
P5.424.005.97

ARTIST UNKNOWN

175. *Blind Man and His Reader Holding the*
*"New York Herald,"* 1840s
Daguerreotype
Gilman Paper Company Collection, New York

JEREMIAH GURNEY

176. *A Fireman with His Horn,* ca. 1857
Daguerreotype
Collection of Matthew R. Isenburg

*Attributed to* CHARLES
DEFOREST FREDRICKS
177. *Amos Leeds, Confidence
Operator,* ca. 1860
Salted paper print from glass
negative
Hallmark Photographic
Collection, Hallmark Cards,
Inc., Kansas City, Missouri
P5.390.003.97

ARTIST UNKNOWN
178. *Chatham Square, New York,
1853–55*
Daguerreotype
Gilman Paper Company
Collection, New York

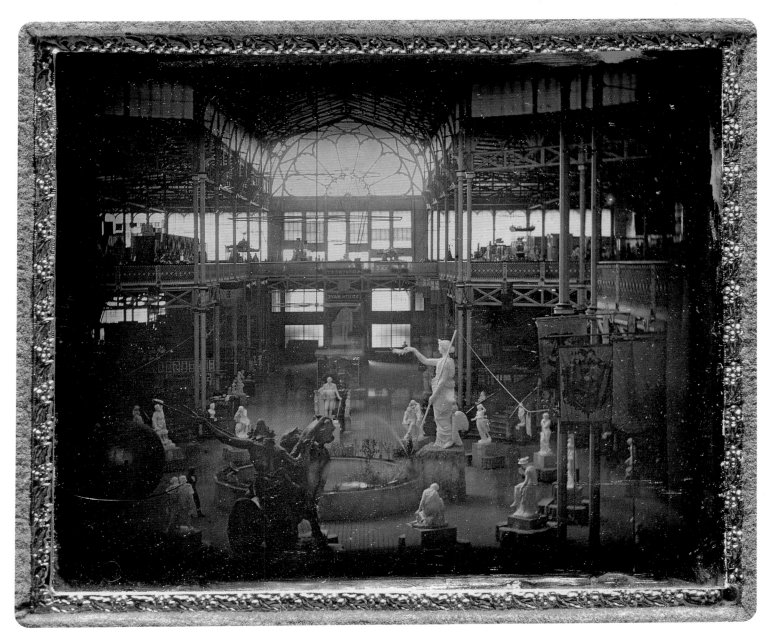

ARTIST UNKNOWN
179. *Interior View of the Crystal Palace Exhibition*, 1853–54
Daguerreotype
The New-York Historical Society

ARTIST UNKNOWN
180. *The New Paving on Broadway, between Franklin and Leonard Streets*, 1850–52
Stereo daguerreotype (left panel illustrated)
Collection of Matthew R. Isenburg

WILLIAM *and* FREDERICK LANGENHEIM
181. *New York City and Vicinity, View from Peter Cooper's Institute toward Astor Place*, ca. 1856
Stereograph glass positive
The New York Public Library, Astor, Lenox and Tilden Foundations, Miriam and Ira D. Wallach Division of Art, Prints and Photographs, Robert N. Dennis Collection of Stereoscopic Views

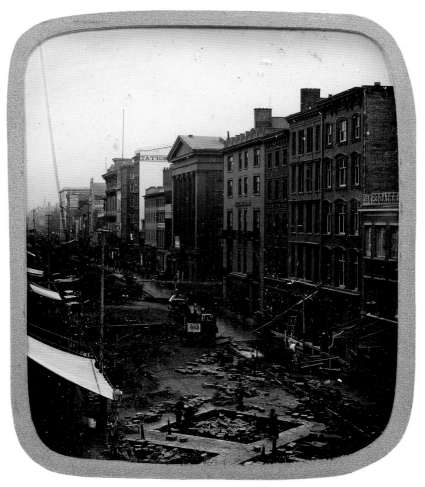

180

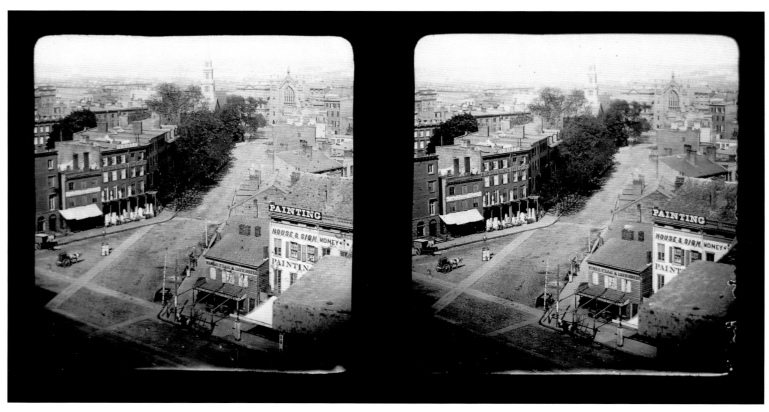

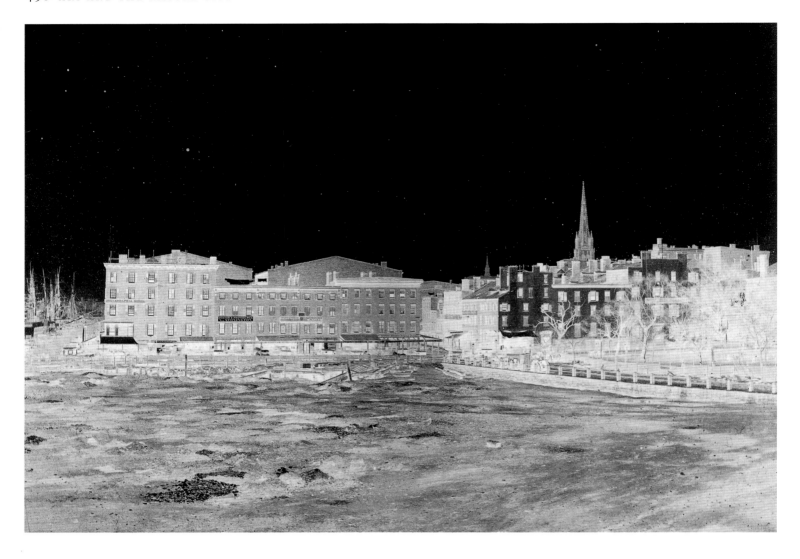

VICTOR PREVOST

182. *Battery Place, Looking North,*
1854
Waxed paper negative
The New-York Historical
Society

VICTOR PREVOST

183. *Looking North toward Madison
Square from Rear Window of
Prevost's Apartment at 28 East
Twenty-eighth Street, Summer,* 1854
Waxed paper negative
The New-York Historical Society

VICTOR PREVOST

184. *Looking North toward Madison
Square from Rear Window of
Prevost's Apartment at 28 East
Twenty-eighth Street, Winter,* 1854
Waxed paper negative
The New-York Historical Society

*Attributed to* SILAS A. HOLMES
*or* CHARLES DEFOREST
FREDRICKS

185. *View down Fifth Avenue,* ca. 1855
Salted paper print from glass
negative
The J. Paul Getty Museum,
Los Angeles 84.XM.351.10

183

184

185

*Attributed to* Silas A. Holmes *or* Charles DeForest Fredricks
186. *City Hall, New York*, ca. 1855
Salted paper print from glass negative
The J. Paul Getty Museum, Los Angeles 84.XM.351.9

*Attributed to* Silas A. Holmes *or* Charles DeForest Fredricks
187. *Washington Square Park Fountain with Pedestrians*, ca. 1855
Salted paper print from glass negative
The J. Paul Getty Museum, Los Angeles 84.XM.351.16

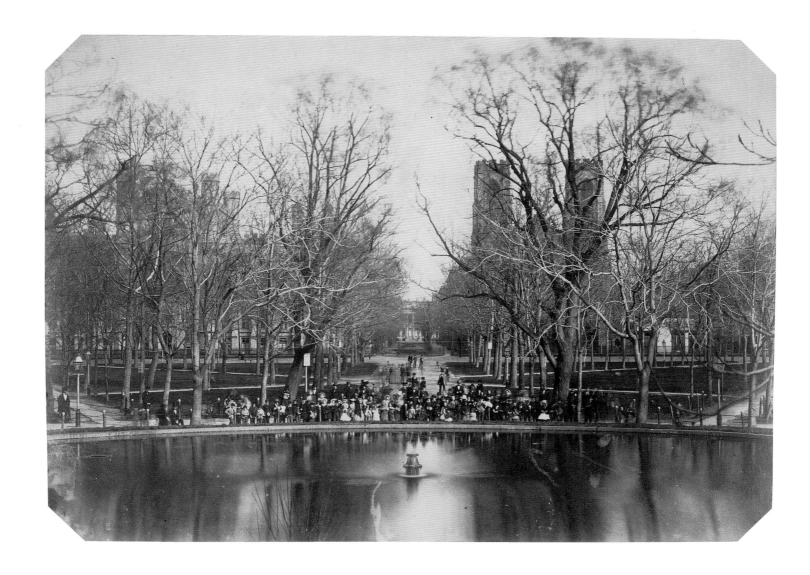

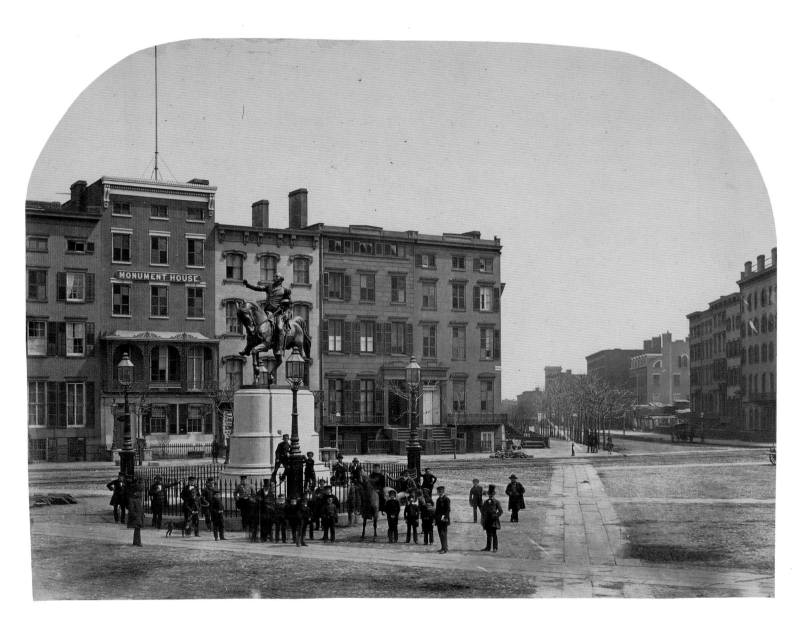

*Attributed to* SILAS A.
HOLMES *or* CHARLES
DEFOREST FREDRICKS
188. *Washington Monument, at
Fourteenth Street and Union
Square,* ca. 1855
Salted paper print from
glass negative
The J. Paul Getty Museum,
Los Angeles 84.XM.351.12

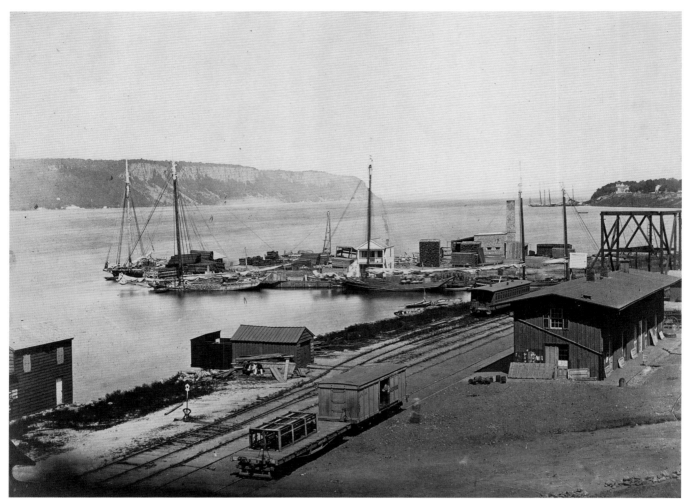

*Attributed to* SILAS A. HOLMES *or*
CHARLES DeFOREST FREDRICKS
189. *Palisades, Hudson River, Yonkers Docks,*
ca. 1855
Salted paper print from glass negative
The J. Paul Getty Museum, Los Angeles
84.XM.351.1

*Attributed to* SILAS A. HOLMES *or*
CHARLES DeFOREST FREDRICKS
190. *Fort Hamilton and Long Island,* ca. 1855
Salted paper print from glass negative
The J. Paul Getty Museum, Los Angeles
84.XM.351.7

*Attributed to* SILAS A. HOLMES *or*
CHARLES DeFOREST FREDRICKS
191. *Fort Hamilton and Long Island,* ca. 1855
Salted paper print from glass negative
The J. Paul Getty Museum, Los Angeles
84.XM.351.14

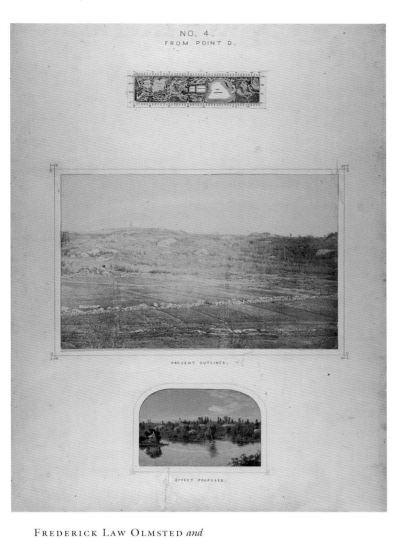

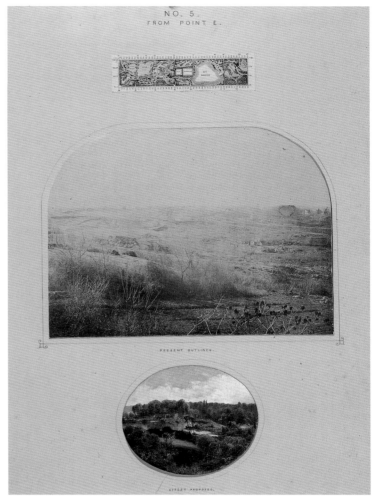

FREDERICK LAW OLMSTED *and*
CALVERT VAUX, *designers*
MATHEW B. BRADY, *photographer*
CALVERT VAUX, *artist*

192. *"Greensward" Plan for Central Park, No. 4: From
Point D, Looking Northeast across a Landscape
Depicting Belvedere Castle, Lake, Gondola, and
Gazebo, 1857*
Lithograph, albumen silver print from glass
negative, and oil on paper, mounted on board
Municipal Archives, Department of Records
and Information Services, City of New York
DPR3084

FREDERICK LAW OLMSTED *and*
CALVERT VAUX, *designers*
MATHEW B. BRADY, *photographer*
CALVERT VAUX, *artist*

193. *"Greensward" Plan for Central Park, No. 5: From
Point E, Looking Southwest, 1857*
Lithograph, albumen silver print from glass
negative, and oil on paper, mounted on board
Municipal Archives, Department of Records
and Information Services, City of New York
DPR3085

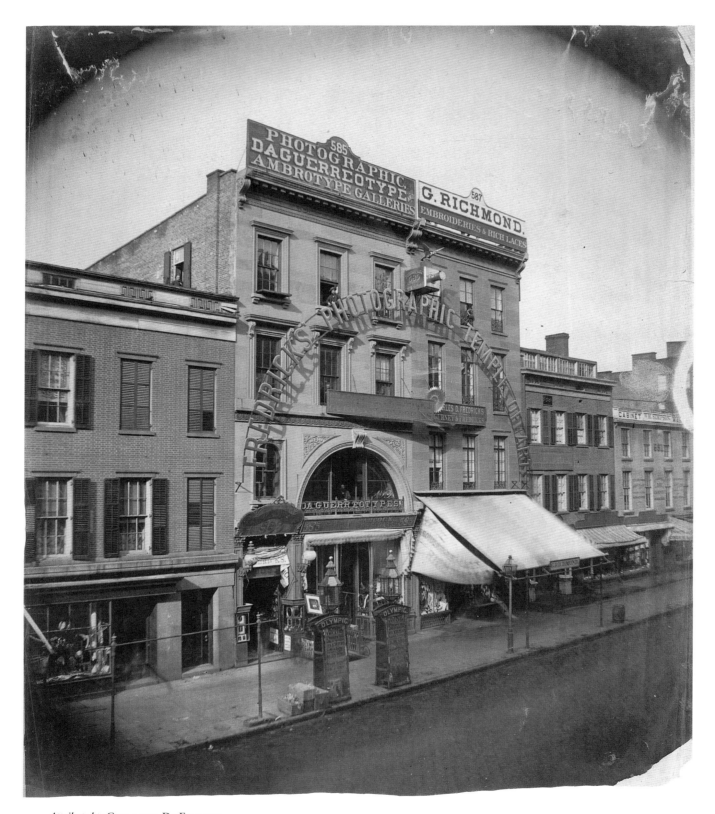

*Attributed to* CHARLES DEFOREST
FREDRICKS

194. *Fredricks's Photographic Temple of Art,*
*New York,* 1857–60
Salted paper print from glass negative
Hallmark Photographic Collection,
Hallmark Cards, Inc., Kansas City,
Missouri P5.390.001.95

MATHEW B. BRADY
195. *Martin Van Buren*, ca. 1860
Salted paper print from glass
negative
The Metropolitan Museum
of Art, New York, David
Hunter McAlpin Fund, 1956
56.517.4

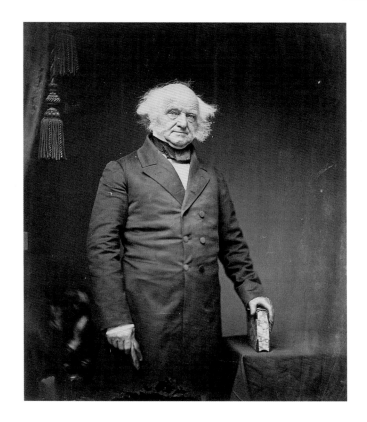

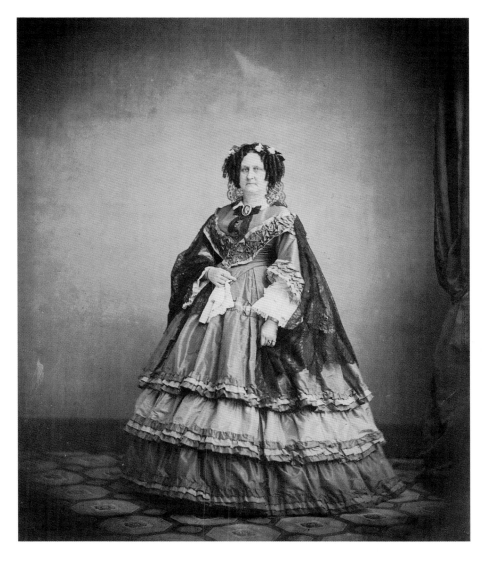

MATHEW B. BRADY
196. *Cornelia Van Ness Roosevelt*, ca. 1860
Salted paper print from glass negative
Gilman Paper Company Collection,
New York

197. Man's tailored ensemble,
English, ca. 1833. The
Metropolitan Museum
of Art, New York

Tail coat, blue silk
Purchase, Catherine
Brayer Van Bomel
Foundation Fund, 1981
1981.210.4

Vest, yellow silk
Purchase, Irene Lewisohn
Bequest, 1976 1976.235.3d

Trousers, natural linen
Purchase, Irene Lewisohn
and Alice L. Crowley
Bequests, 1982 1982.316.11

Stock, black silk and wool
Purchase, Gifts from
various donors, 1983
1983.27.2

Hat, beige beaver
Purchase, Irene Lewisohn
Bequest, 1972 1972.139.1

198. Woman's walking ensem-
ble, American, 1832–33.
The Metropolitan
Museum of Art, New
York

Dress and pelerine,
brown silk
Gift of Randolph Gunter,
1950 50.15a,b

Hat, brown straw
Gift of Mr. Lee Simpson,
1939 39.13.118

Belt, brown woven ribbon
with gilt metal buckle
Purchase, Gifts from vari-
ous donors, 1984
1984.144

Boots, brown leather
and linen
Gift of Mr. Lee Simpson,
1938 38.23.150a,b

Collar, embroidered
muslin
Gift of The New-York
Historical Society, 1979
1979.346.223

Mitts, cotton mesh
Gift of Mrs. Margaret
Putnam, 1946 46.104a,b

Cuffs, embroidered
muslin
Gift of Mrs. Albert S.
Morrow, 1937 37.45.101a,b

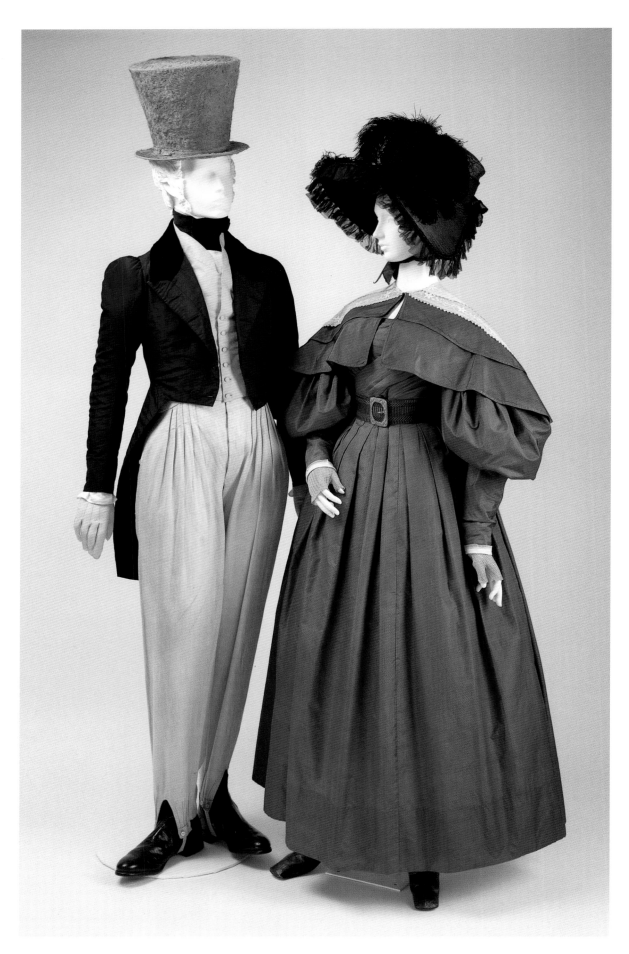

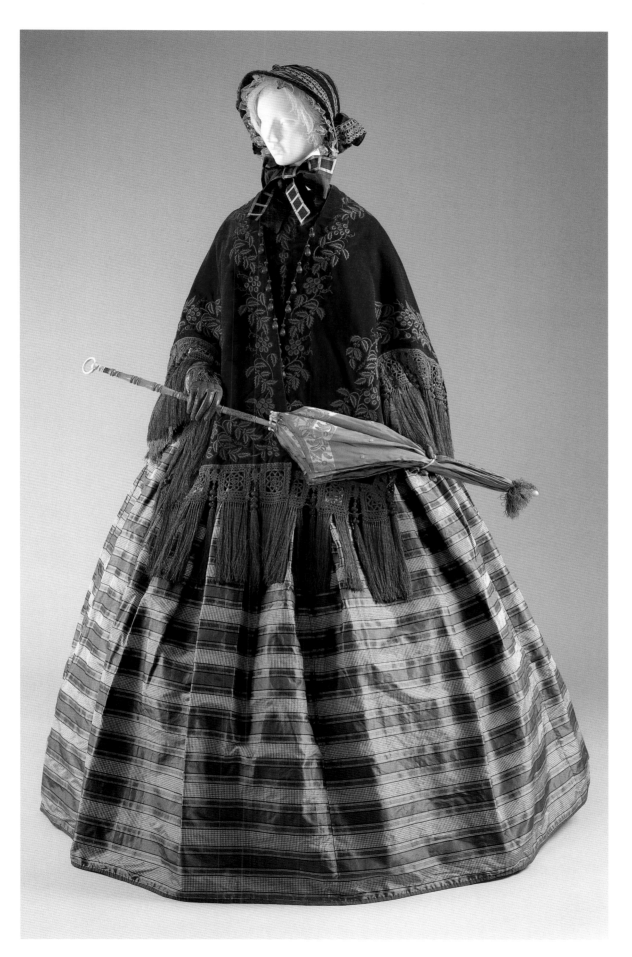

199. Woman's afternoon walking ensemble, American

ARNOLD CONSTABLE AND COMPANY, *retailer*
Two-piece day dress, worn as a wedding gown in 1855 by Mrs. Peter Herrman, 1855
Green-striped taffeta
Museum of the City of New York, Gift of Mrs. Florien P. Gass
44.247.1ab–2ab

*Attributed to* GEORGE BRODIE
Mantilla wrap, worn to the Prince of Wales Ball, ca. 1853
Embroidered red-brown velvet
The Metropolitan Museum of Art, New York, Gift of Mrs. Henry A. Lozier, 1948 48.65

Bonnet, ca. 1856
Straw, lace, and brown velvet
Museum of the City of New York, Gift of Mrs. Cuyler T. Rawlins
59.124.1

S. REDMOND, *manufacturer*
Parasol, ca. 1824–31
Brown silk woven with leaf-and-flower border; turned and carved wood stick
Museum of the City of New York, from the Estate of Miss Jessie Smith, Gift of Clifton H. Smith 70.127

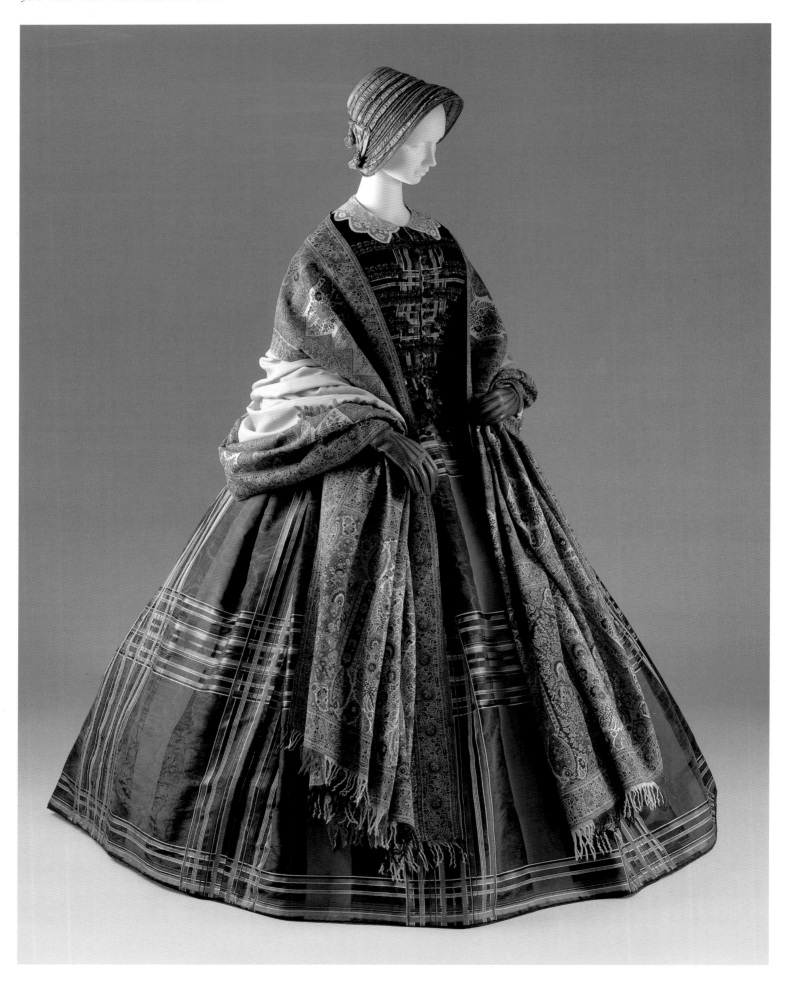

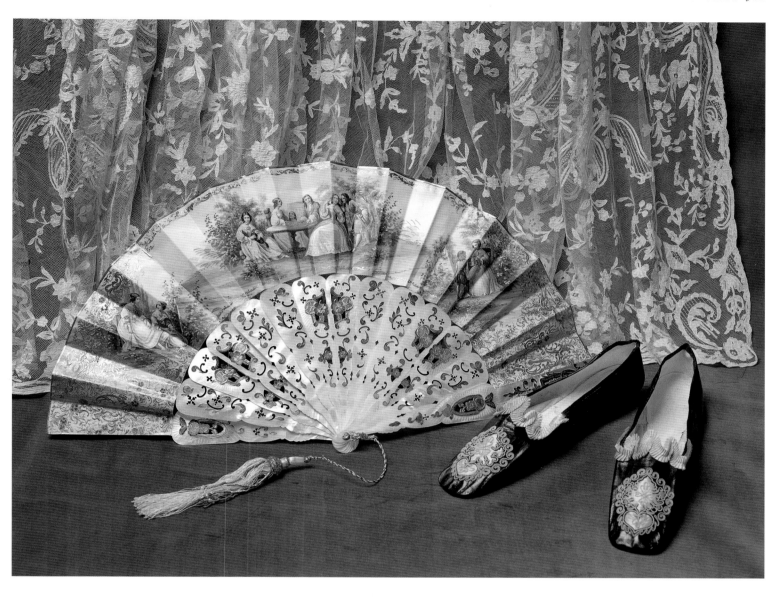

200. Woman's afternoon walking ensemble

Two-piece day dress, American, ca. 1855
Plaid taffeta and silk braid
The Metropolitan Museum of Art, New York, Gift of Mrs. Edwin R. Metcalf, 1969 69.32.2a,b

Paisley shawl, European, mid-19th century
Silk and wool
The Metropolitan Museum of Art, New York, Gift of Mr. E. L. Waid, 1955 CI.55.41

Bonnet, American, ca. 1850
Silk
Museum of the City of New York, Gift of Grant Keehn 62.235.2

A. T. STEWART, *retailer*
201. Wedding veil (detail), Irish, 1850
Net with Carrickmacross appliqué
Valentine Museum, Richmond, Virginia, Gift of Elizabeth Valentine Gray 05.21.10

TIFFANY AND COMPANY, *retailer*
202. Fan, European, 1850s
Printed vellum, carved and gilded mother-of-pearl
The Metropolitan Museum of Art, New York, Gift of Caroline Ferriday, 1981 1981.40

MIDDLETON AND RYCKMAN, *manufacturer*
203. Pair of slippers, 1848–50
Bronze kid with robin's-egg blue embroidery
Museum of the City of New York, Gift of Miss Florence A. Williams 58.212.1a,b

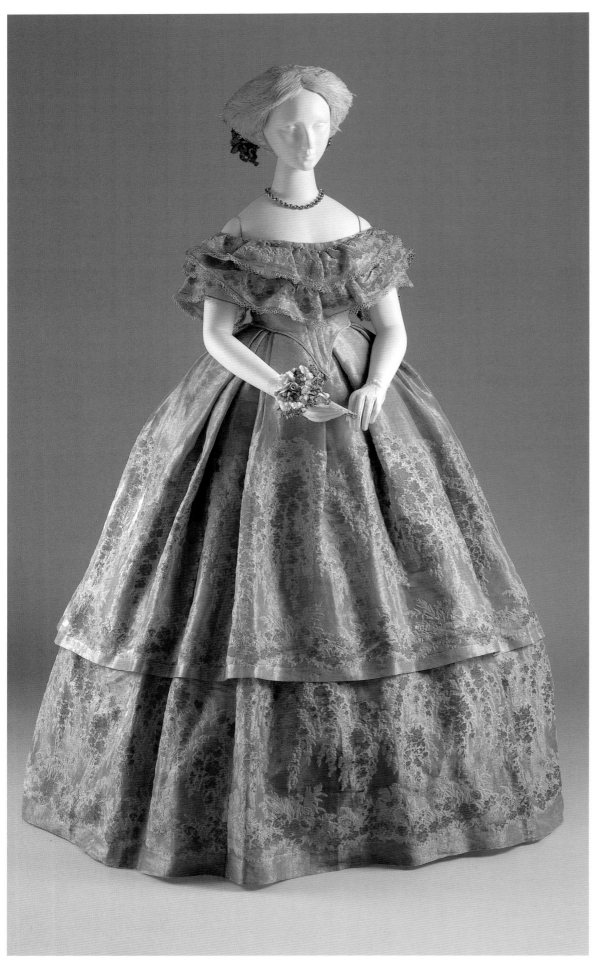

204. Woman's evening toilette, worn to the Prince of Wales Ball, 1860

*Attributed to* WORTH ET BOBERGH, *Paris*
Ball gown, worn by Mrs. David Lyon Gardiner, 1860
Cut velvet, woven in Lyon
Museum of the City of New York, Gift of Miss Sarah Diodati Gardiner 39.26a,b

Bouquet holder, carried by Mrs. Antonio Yznaga, 1860
Gold filigree
Museum of the City of New York, Gift of Lady Lister-Kaye 33.27.1

George IV–style rivière, mid-19th century
Paste, silver, and gold
James II Galleries, Ltd.

Headdress, ca. 1860
Teal chenille with satin glass beads
Museum of the City of New York, Gift of Mrs. John Penn Brock 42.445.9

205. Woman's evening toilette, worn to the Prince of Wales Ball, 1860

Ball gown, worn by the great-aunt of the Misses Braman, 1860
Cut velvet *en disposition* woven in Lyon, point-de-gaze lace
Museum of the City of New York, Gift of the Misses Braman 53.40.16a–d

Fan, carried by Mrs. William H. Sackett, 1860
Black Chantilly lace and mother-of-pearl
Museum of the City of New York, Gift of the Misses Emma C. and Isabel T. Sackett, 1937 37.326.4

Mantilla wrap, worn by Mrs. Jonas C. Dudley, 1860
Black embroidered net
Museum of the City of New York, Gift of Mrs. Russell deC. Greene 49.101

Necklace, American, mid-19th century
Strung pearlwork
The Metropolitan Museum of Art, New York, Gift of Mrs. Alfred Schermerhorn, in memory of Mrs. Ellen Schermerhorn Auchmuty, 1946 46.101.8

Headdress, ca. 1860
Black Chantilly lace, silk-and-wool flowers
Museum of the City of New York, Gift of Miss Martia Leonard 33.143.4

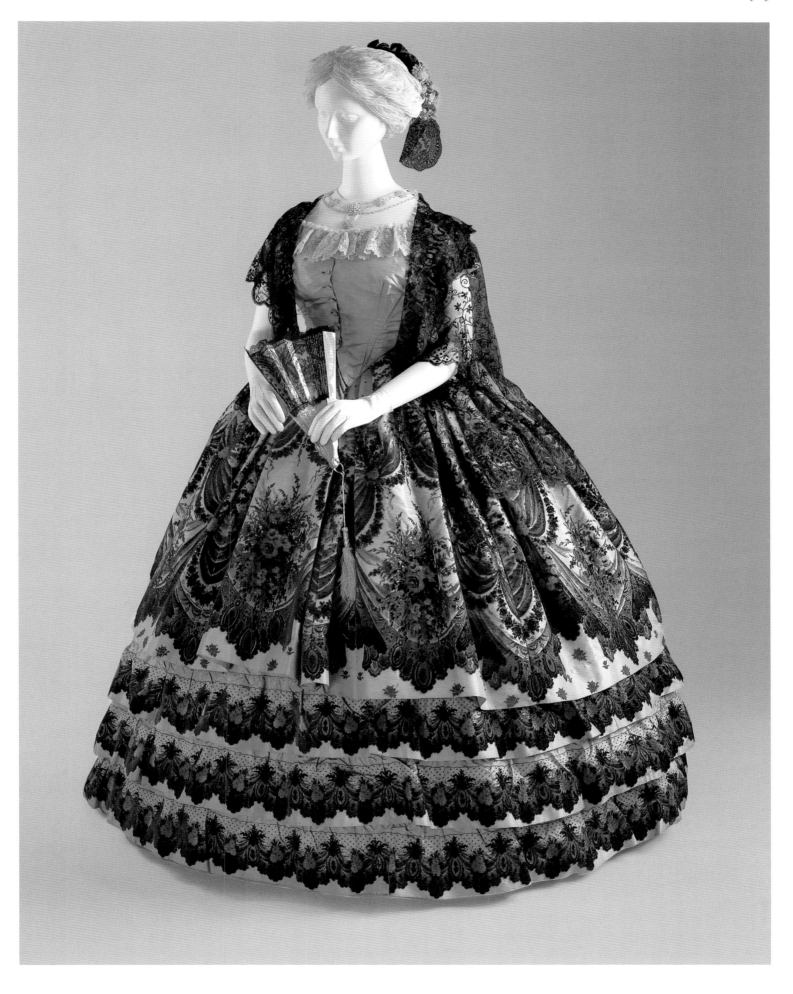

GEORGE W. JAMISON, *cameo cutter*
WILLIAM ROSE, *jeweler*
206. Cameo with portrait bust of Andrew
Jackson, ca. 1835
Helmet conch shell, enamel, and gold
Private collection

GELSTON AND TREADWELL
207. Bouquet holder, 1847
Silver
Historic Hudson Valley, Tarrytown, New
York  ss.75.21a,b

TIFFANY AND COMPANY
208. Five-piece parure in fitted box, 1854–61
Agate, coral, pearls, yellow gold, and black
enamel
Collection of Janet Zapata

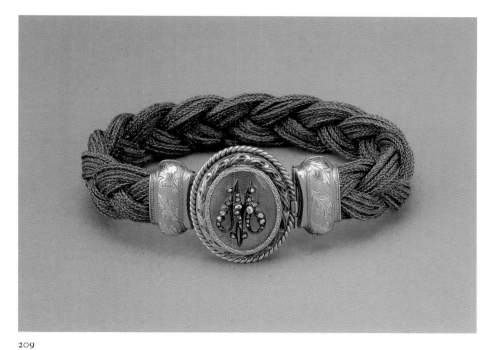

209

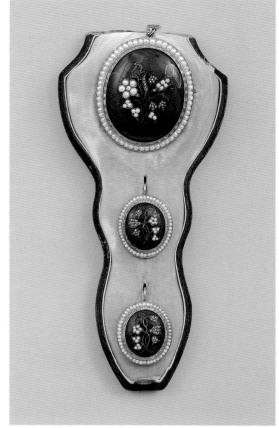

210

TIFFANY AND COMPANY,
*retailer*

209. Hair bracelet, ca. 1850
Hair, yellow gold, glass,
diamonds, silver, and textile
The New-York Historical
Society INV.774

EDWARD BURR

210. Parure (brooch and earrings),
1858–60
Yellow gold, pearls, diamonds,
enamel, and blue enamel
Private collection

TIFFANY AND COMPANY

211. Seed-pearl necklace and pair
of bracelets, purchased by
President Abraham Lincoln
for Mary Todd Lincoln,
ca. 1860
Seed pearls and yellow gold
Library of Congress,
Washington, D.C., Rare Book
and Special Collections
Division 2.87.276.1–3

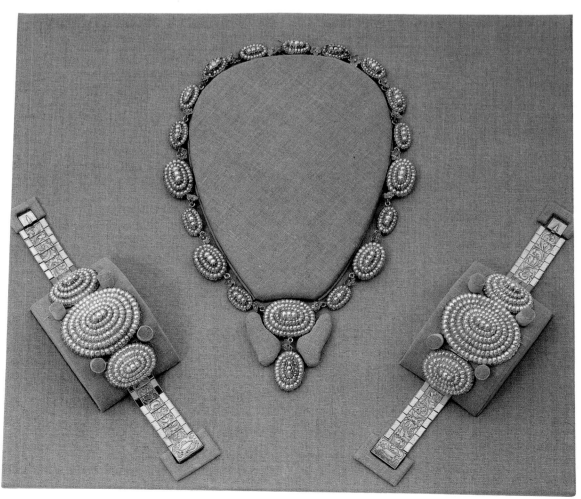

211

MANUFACTURER
UNKNOWN, *British*

212. Ingrain carpet, ca. 1835–40
Wool
The Metropolitan
Museum of Art, New
York, Gift of Mr. and
Mrs. Stuart Feld, 1980
1980.511.8

MANUFACTURER
UNKNOWN, *probably
American*
213. Ingrain carpet, ca. 1850–60
Wool
The Metropolitan
Museum of Art, New
York, Gift of Frances W.
Geyer, 1972  1972.203

ELIZABETH VAN HORNE
CLARKSON
214. Honeycomb quilt, ca. 1830
Cotton
The Metropolitan Museum of
Art, New York, Gift of Mr. and
Mrs. William A. Moore, 1923
23.80.75

State linked to State—Oh, Unity divine!
Our cherished Washington, the praise be thine.
And yet, alas! by thee regarded not,
One curse remains—a monstrous, hideous blot.

But should thy spirit in new form burst forth,
The stain to 'rase that tarnishes the South,
This proffered Quilt would proudly claim to be
Spread o'er the cradle of his infancy.

MARIA THERESA BALDWIN
HOLLANDER
215. Abolition quilt, ca. 1853
Silk embroidered with silk and
silk-chenille thread
Society for the Preservation of
New England Antiquities, Boston,
Loaned by the Estate of Mrs.
Benjamin F. Pitman  2.1923

MANUFACTURER
UNKNOWN, *New York City*
216. Wallpaper depicting the west side
of Wall Street; the Battery and
Castle Garden; Wall Street with
Trinity Church; Grace Church;
and City Hall, ca. 1850
Roller-printed paper
The Metropolitan Museum of Art,
New York, The Edward W. C.
Arnold Collection of New York
Prints, Maps, and Pictures, Bequest
of Edward W. C. Arnold, 1954
54.90.734

Manufacturer unknown,
*probably New York City*
Entrance-hall wallpaper from
the George Collins house,
Unionvale, New York, ca. 1850
Roller-printed paper
The Metropolitan Museum of
Art, New York, Gift of Mrs.
Adrienne A. Sheridan, 1956
56.599.10

Manufacturer unknown,
*probably New York City*
Window shade depicting the
Crystal Palace, 1853
Hand-painted and roller-printed
paper
Cooper-Hewitt, National Design
Museum, Smithsonian Institution,
New York, Museum purchase in
memory of Eleanor and Sarah
Hewitt 1944.66.1

FISHER AND BIRD
220. Mantel depicting scenes
from Jacques-Henri
Bernardin de Saint-Pierre's
*Paul et Virginie* (1788), 1851
Marble
Museum of the City of
New York, Gift of Mrs.
Edward W. Freeman, 1932
32.269a–h,j

MANUFACTURER
UNKNOWN, *French*
219. Brocatelle, ca. 1850–55
Silk and linen
The Metropolitan Museum
of Art, New York, Rogers
Fund, 1948  48.55.4

CABINETMAKER
UNKNOWN, *New York City*

221. Armchair, ca. 1825
Ebonized maple and
cherry; walnut; gilding;
replacement underuphol-
stery and showcover
Winterthur Museum,
Winterthur, Delaware,
Bequest of Henry F. du
Pont 57.0739

DEMING AND
BULKLEY

222. Center table, 1829
Rosewood and mahogany
veneers; pine, chestnut,
mahogany; gilding, rose-
wood graining, bronzing;
"Egyptian" marble; casters
Mulberry Plantation,
Camden, South Carolina

CABINETMAKER
UNKNOWN, *New York City*

223. Secretary-bookcase,
ca. 1830
Ebonized mahogany,
mahogany, mahogany
veneer; pine, poplar,
cherry; gilding, bronzing;
stamped brass orna-
ments; glass drawer pulls;
replacement fabric; glass
The Metropolitan
Museum of Art, New
York, Gift of Francis
Hartman Markoe, 1960
60.29.1a,b

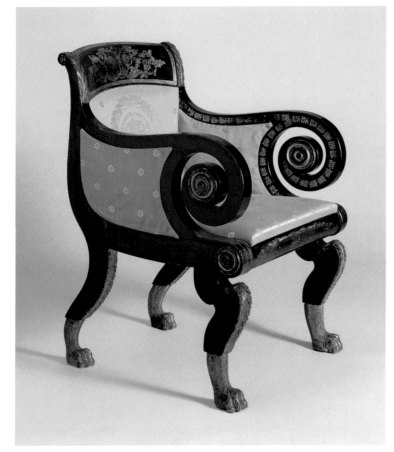

221

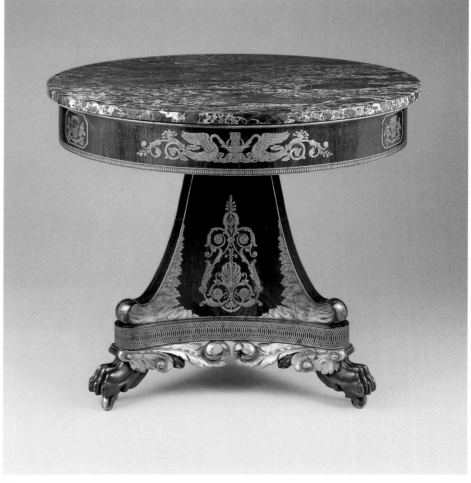

222

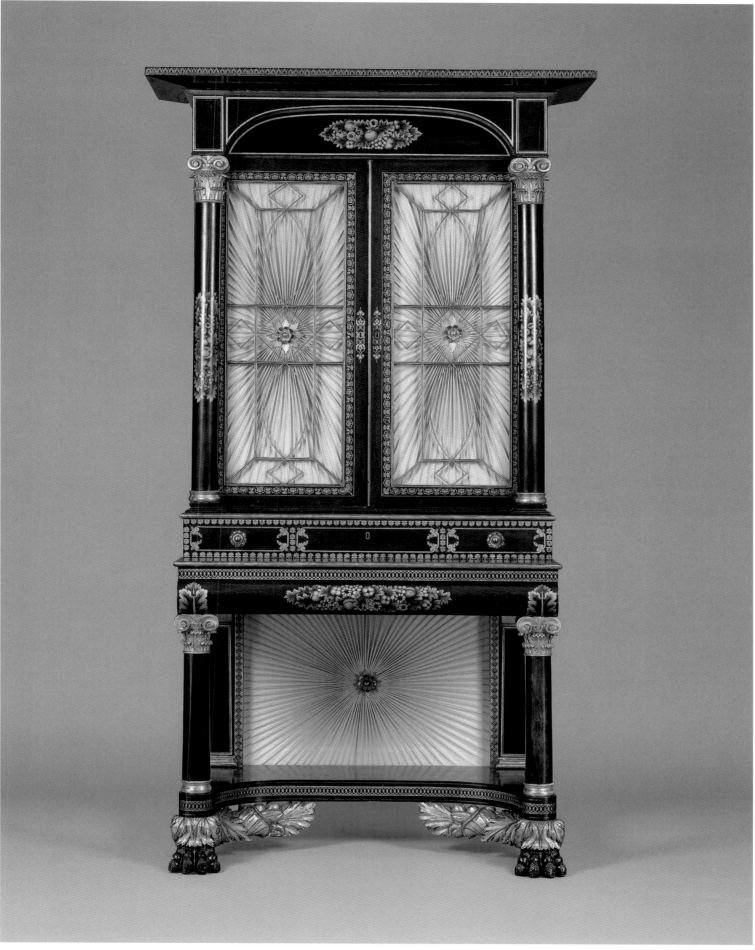

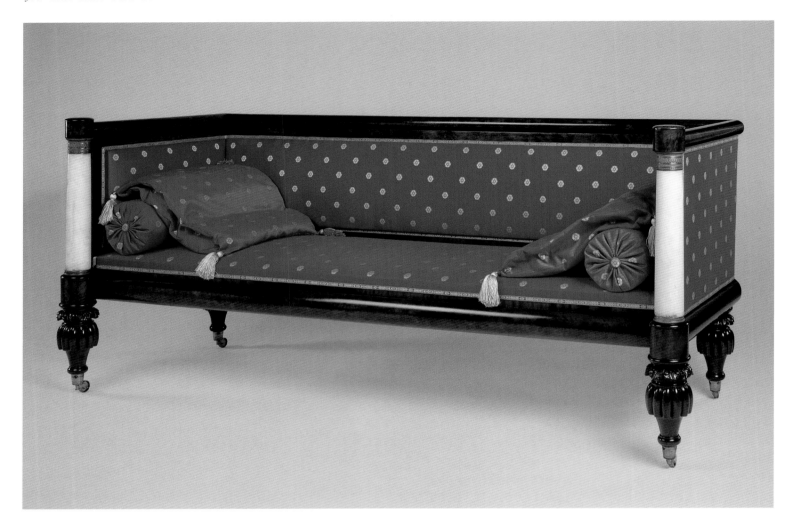

CABINETMAKER
UNKNOWN, *New York City*
224. Sofa, ca. 1830
Mahogany, mahogany
veneer; marble; gilt-bronze
mounts; original under-
upholstery on back and sides,
replacement showcover;
casters
Brooklyn Museum of Art,
Maria L. Emmons Fund
41.1181

ENDICOTT AND SWETT,
*printer and publisher*
225. Broadside for Joseph Meeks and
Sons, 1833
Lithograph with hand coloring
The Metropolitan Museum of
Art, New York, Gift of Mrs.
Reed W. Hyde, 1943  43.15.8

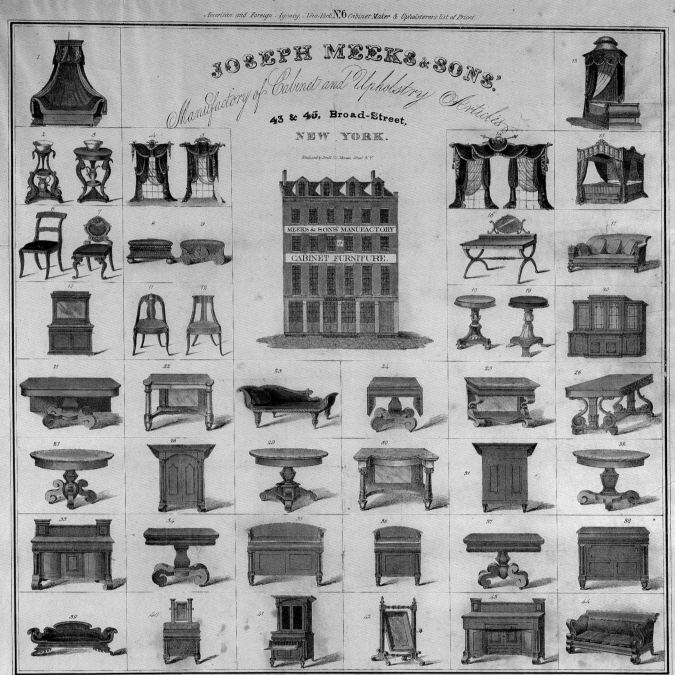

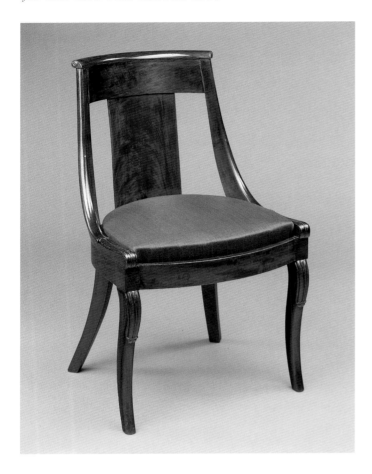

226. French chair, ca. 1830
Mahogany, mahogany veneer;
chestnut; original underupholstery
and showcover fragments, replace-
ment showcover
Private collection

JOSEPH MEEKS AND SONS
227. Pier table, ca. 1835
Mahogany veneer, mahogany;
"Egyptian" marble; mirror glass
Collection of Dr. and Mrs. Emil
F. Pascarelli

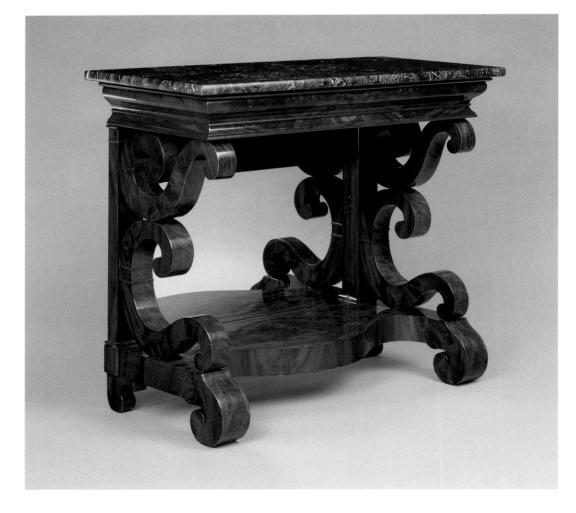

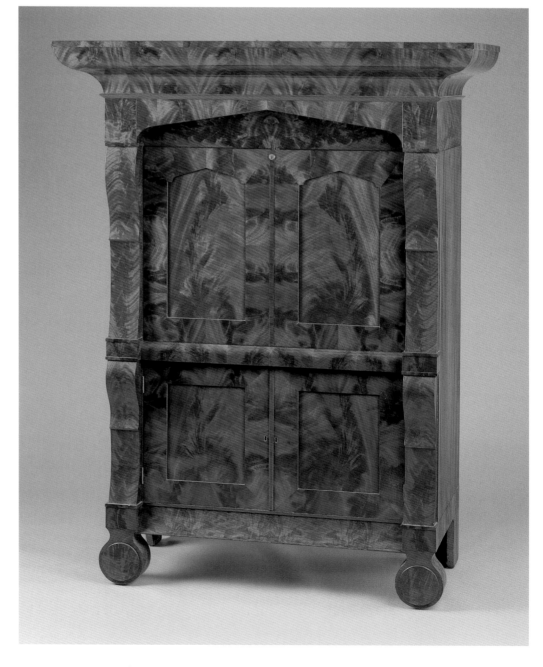

JOHN H. WILLIAMS AND
SON
228. Pier mirror, ca. 1845
Gilded pine; pine; plate-glass
mirror
Collection of Mr. and Mrs. Peter
G. Terian

CABINETMAKER
UNKNOWN, *New York City*
229. Fall-front secretary, 1833–ca. 1841
Mahogany veneer, mahogany,
ebonized wood; pine, poplar,
cherry, white oak; brass; leather;
mirror glass
Collection of Frederick W.
Hughes

DUNCAN PHYFE AND SON

230. Six nested tables, 1841
Rosewood, rosewood veneer; mahogany;
gilding not original
Collection of Mr. and Mrs. Peter G. Terian

DUNCAN PHYFE AND SON

231. Armchair, 1841
Mahogany, mahogany veneer; chestnut;
replacement underupholstery and showcover
Collection of Richard Hampton Jenrette

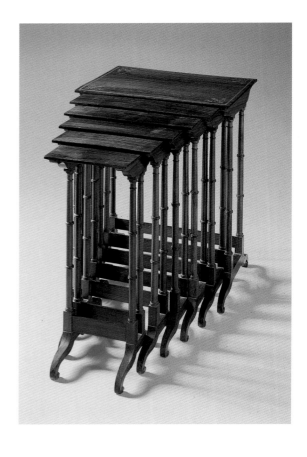

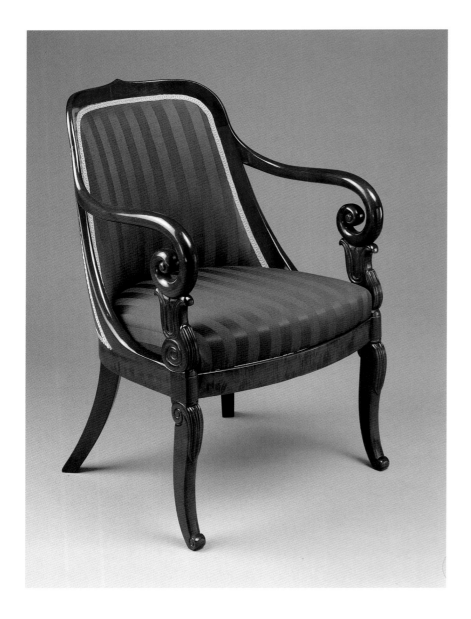

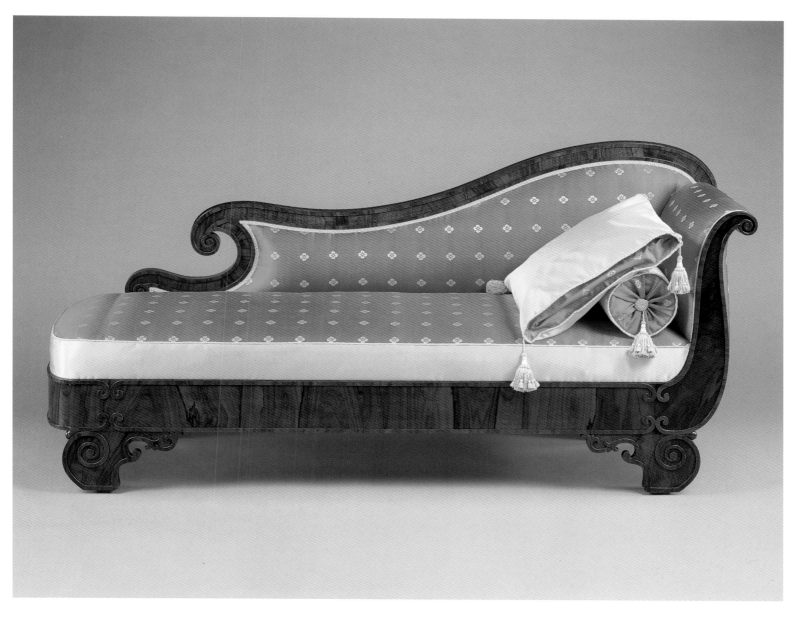

DUNCAN PHYFE AND SON
232. Couch, 1841
Rosewood veneer, rosewood,
mahogany; sugar pine, ash, poplar;
rosewood graining; replacement
underupholstery and showcover
Collection of Richard Hampton
Jenrette

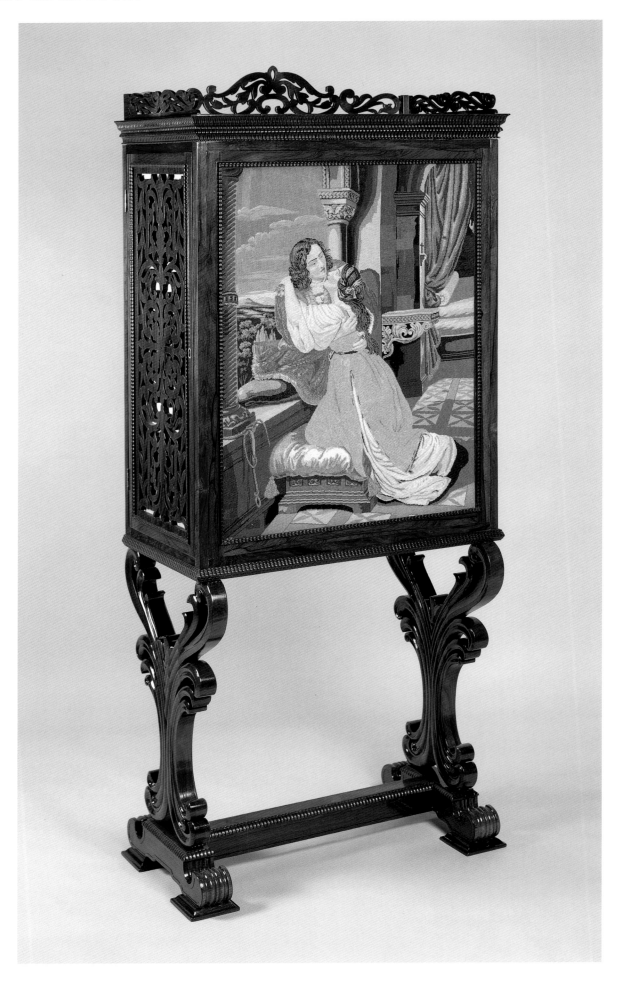

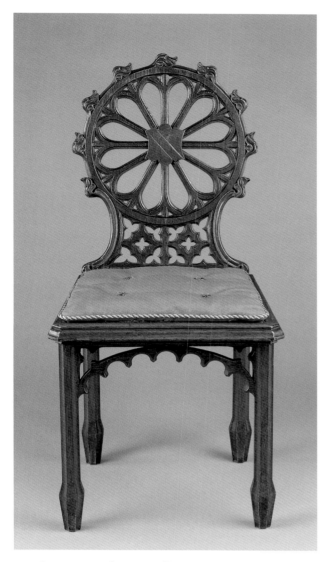

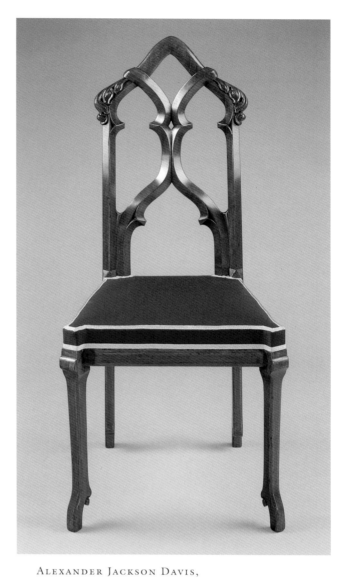

ALEXANDER JACKSON DAVIS,
*designer*
RICHARD BYRNE, *White Plains,*
*New York, cabinetmaker*

234. Hall chair, ca. 1845
Oak; original cane seat, replacement
cushion
Lyndhurst, A National Trust
Historic Site, Tarrytown, New York

ALEXANDER JACKSON DAVIS,
*designer*
*Possibly* BURNS AND BROTHER,
*cabinetmaker*

235. Side chair, ca. 1857
Black walnut; replacement underuphol-
stery and showcover
The Metropolitan Museum of Art,
New York, Gift of Jane B. Davies, in
memory of Lyn Davies, 1995  1995.111

J. AND J. W. MEEKS
233. Portfolio cabinet-on-stand, with a
scene from Shakespeare's *Romeo and*
*Juliet,* ca. 1845
Rosewood; rosewood and maple
veneers; cross-stitched needlepoint
panel; replacement fabric; glass
Collection of Mrs. Sammie Chandler

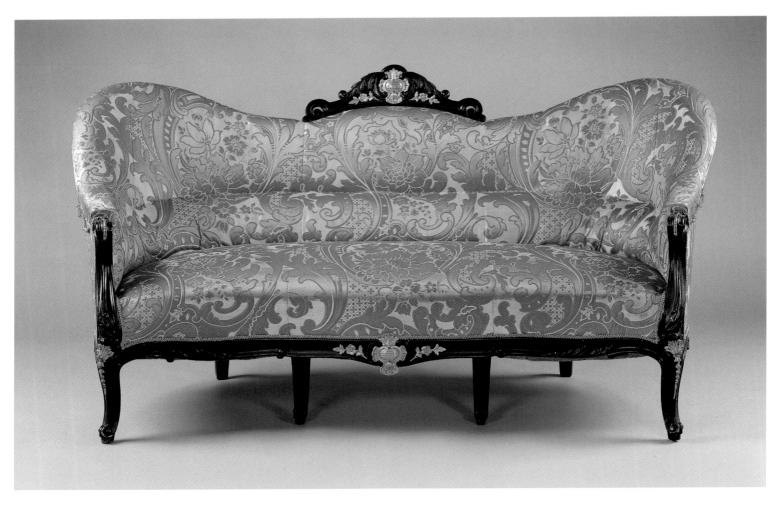

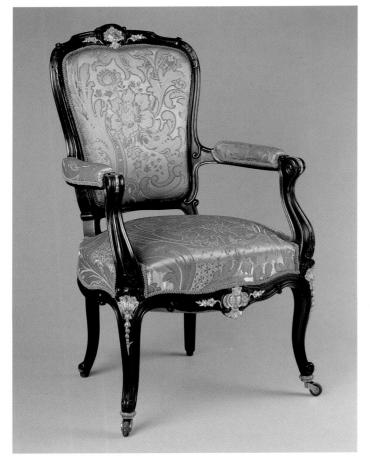

AUGUSTE-ÉMILE
RINGUET-LEPRINCE,
*French (Paris)*
236A, B. Sofa and armchair, 1843
Ebonized fruitwood (apple
or pear); beech; gilt-bronze
mounts; original under-
upholstery and silk brocatelle
showcover; casters (on
armchair)
The Metropolitan Museum
of Art, New York, Gift of
Mrs. Douglas Williams, 1969
69.262.1, 69.262.3

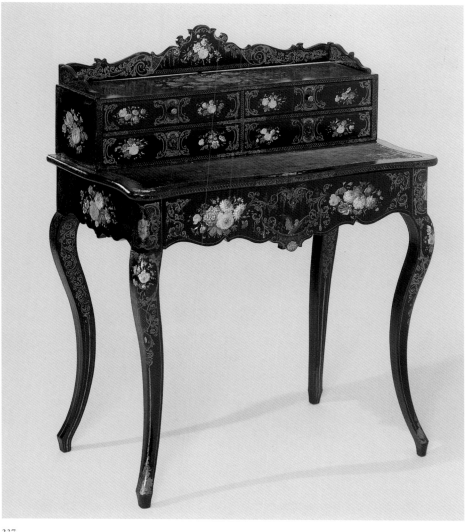

237

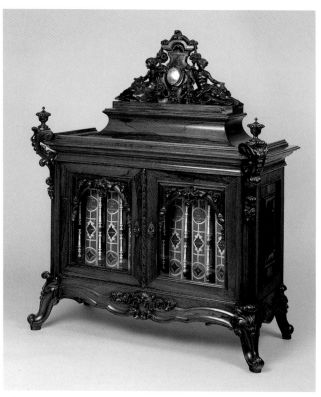

238

CABINETMAKER UNKNOWN,
*probably French (probably Paris)*
*Retailed by* CHARLES A.
BAUDOUINE, *cabinetmaker*

237. Lady's writing desk, 1849–54
Ebonized poplar (aspen or cot-
tonwood); painted and gilded
decoration; velvet
Museum of Fine Arts, Boston, Gift
of the William N. Banks Foundation
in memory of Laurie Crichton
1979.612

THOMAS BROOKS, *Brooklyn,
New York*

238. Table-top bookcase made for Jenny
Lind, 1851
Rosewood; ivory; silver
Museum of the City of New York,
Gift of Arthur S. Vernay  52.24.1a

JOHN T. BOWEN, *Philadelphia,
lithographer*
*After* JOHN JAMES AUDUBON,
*artist, and* ROBERT HAVELL
JR., *engraver*
J. J. AUDUBON AND J. B.
CHEVALIER, *New York and
Philadelphia, publisher*
MATTHEWS AND RIDER,
*bookbinders*

239. *The Birds of America, from Drawings
Made in the United States and Their
Territories,* 1840–44
Bound in ivory, red, green, and
blue leather with gold stamping
Museum of the City of New
York, Gift of Arthur S. Vernay
52.24.2a–g

239

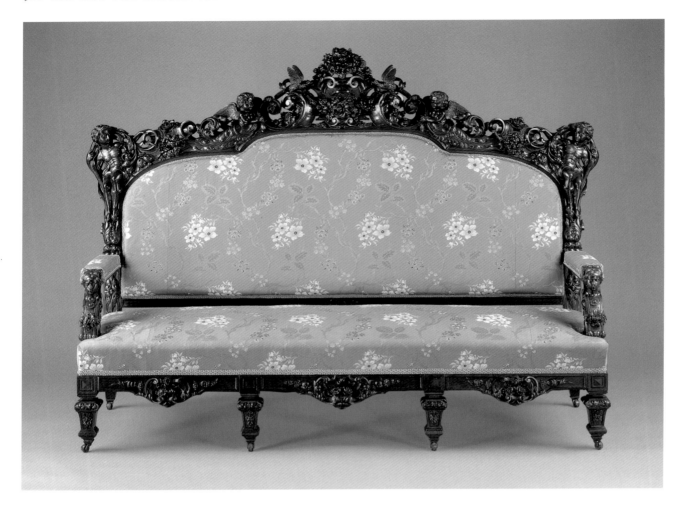

JULIUS DESSOIR
240A–C. Sofa and two armchairs, 1853
Rosewood; chestnut; original
underupholstery and replacement
showcover; casters
The Metropolitan Museum of
Art, New York, Gift of Lily and
Victor Chang, in honor of the
Museum's 125th Anniversary,
1995  1995.150.1–3

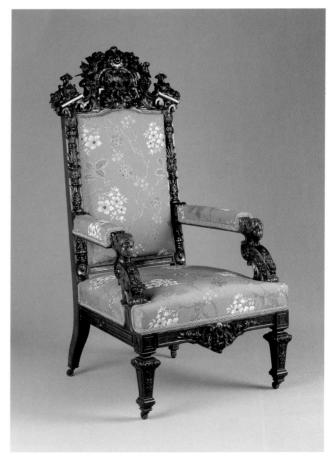

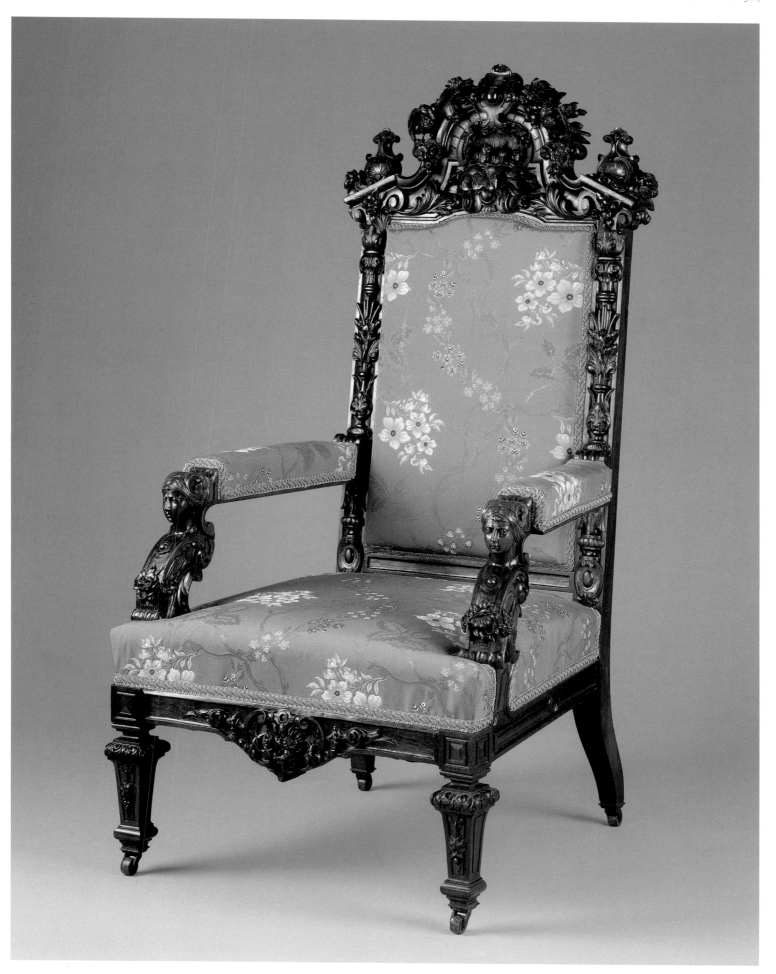

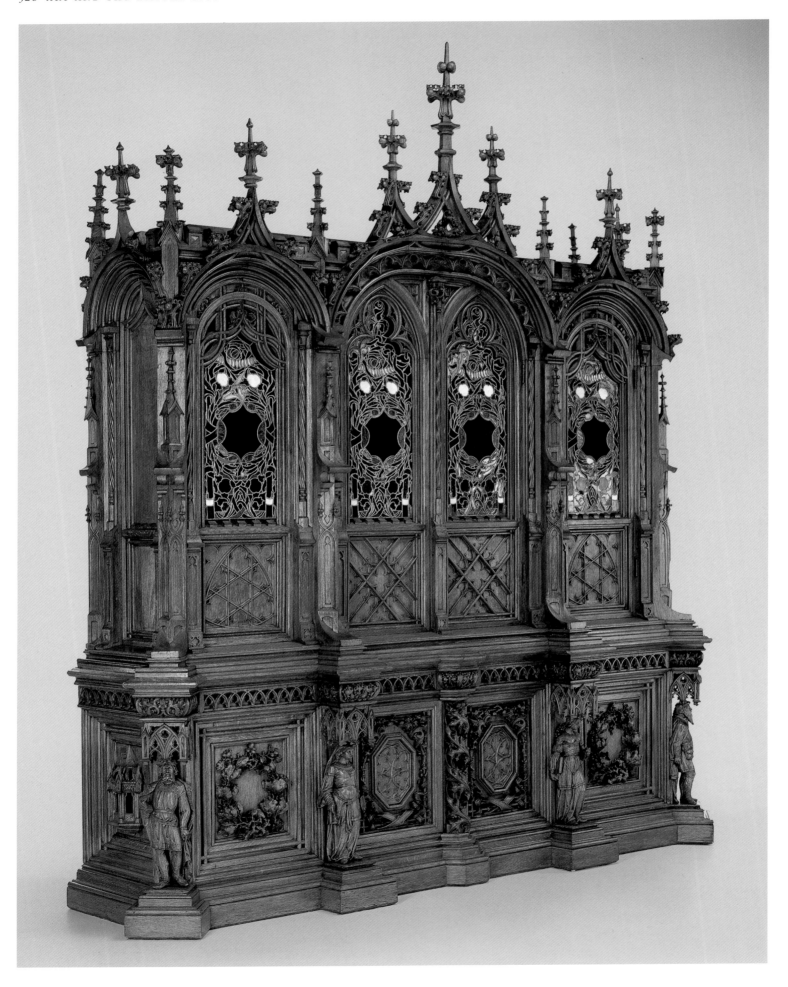

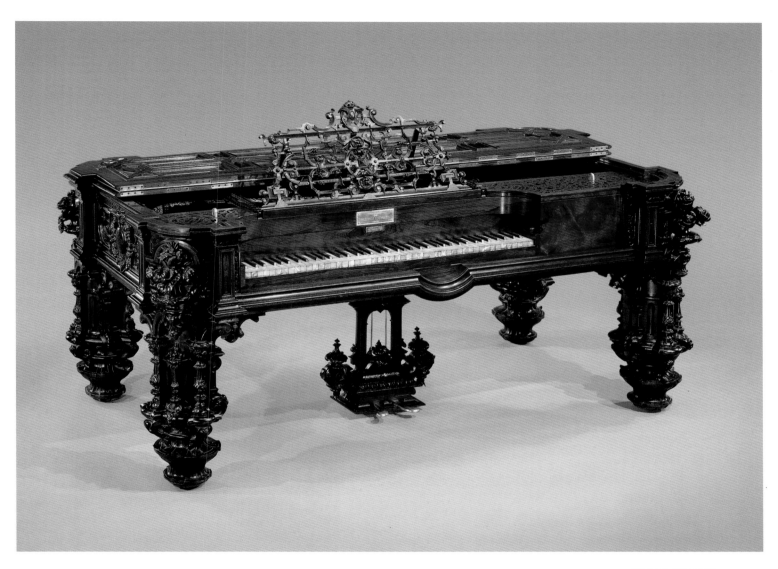

GUSTAVE HERTER,
*designer*
BULKLEY AND HERTER,
*cabinetmaker*

241. Bookcase, 1853
White oak; eastern white
pine, eastern hemlock, yellow
poplar; leaded glass not
original
The Nelson-Atkins Museum
of Art, Kansas City, Missouri
(Purchase: Nelson Trust
through the exchange of gifts
and bequests of numerous
donors and other Trust prop-
erties) 97–35

CABINETMAKER
UNKNOWN, *New York City*
NUNNS AND CLARK,
*piano manufacturer*

242. Square piano, 1853
Rosewood, rosewood veneer;
mother-of-pearl, tortoiseshell,
abalone shell
The Metropolitan Museum
of Art, New York, Gift of
George Lowther, 1906
06.1312

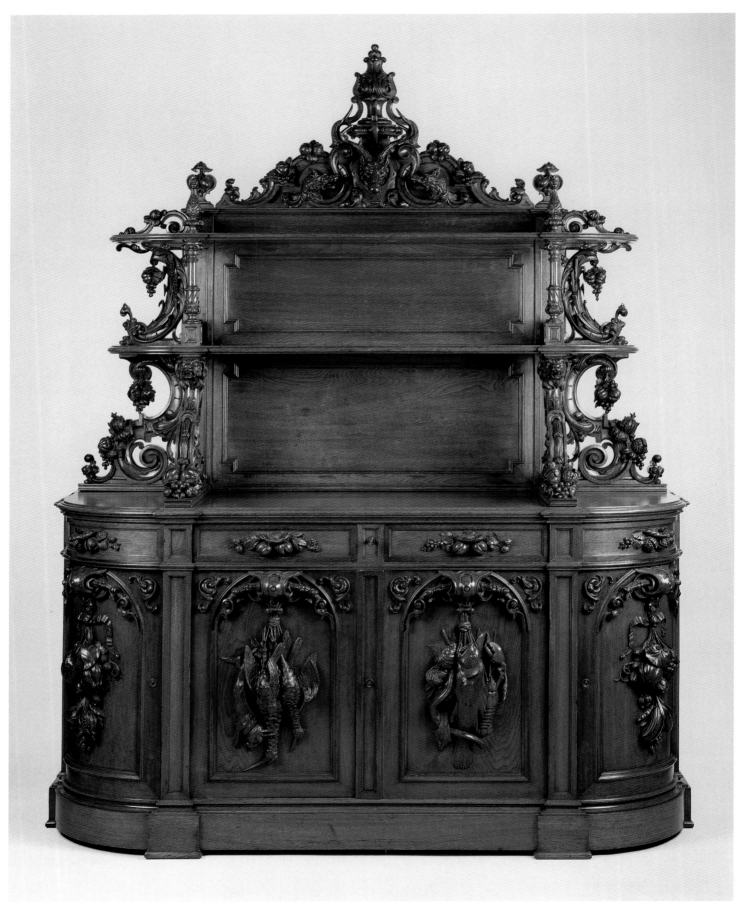

243

ALEXANDER ROUX

243. Étagère-sideboard, ca. 1853–54
Black walnut; pine, poplar
The Metropolitan Museum of Art,
New York, Purchase, Friends of the
American Wing Fund and David
Schwartz Foundation Inc. Gift, 1993
1993.168

CABINETMAKER UNKNOWN,
*French (probably Paris)*

244. Center table, 1855–57
Gilded poplar (possibly aspen or cot-
tonwood); beech; marble top; casters
Brooklyn Museum of Art, Gift of
Marion Litchfield 51.112.9

*Attributed to* J. H. BELTER AND
COMPANY

245. Sofa, ca. 1855
Rosewood; probably replacement
underupholstery, replacement
showcover; casters
Milwaukee Art Museum, Purchase,
Bequest of Mary Jane Rayniak in
Memory of Mr. and Mrs. Joseph G.
Rayniak M1987.16

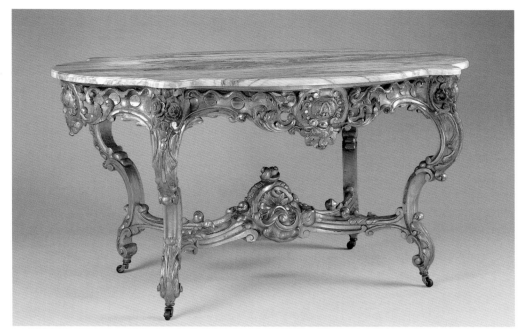

244

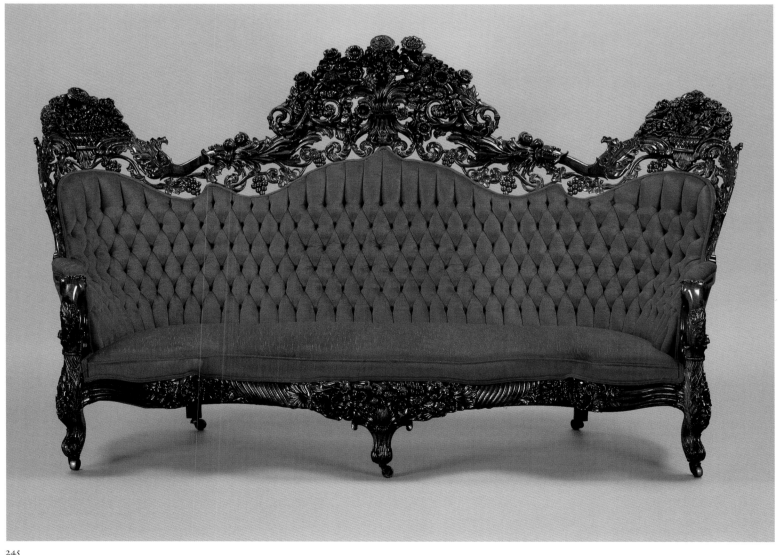

245

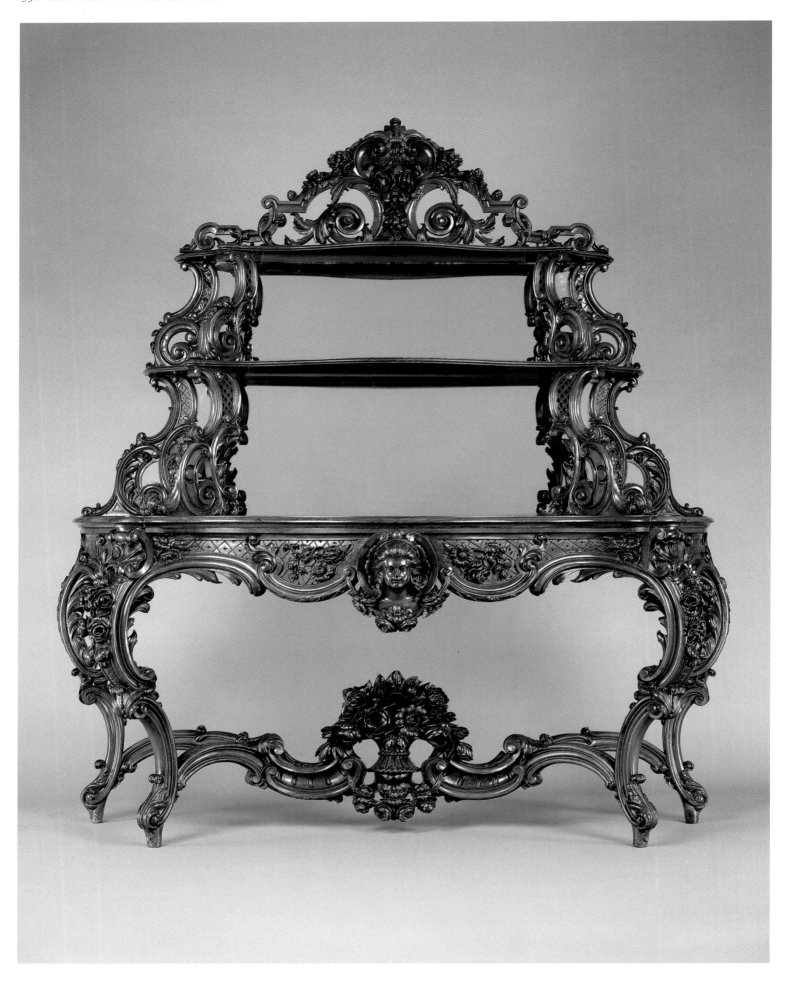

ALEXANDER ROUX
246. Étagère, ca. 1855
Rosewood, rosewood
veneer; chestnut, poplar,
bird's-eye maple veneer;
replacement mirror glass
The Metropolitan Museum
of Art, New York, Sansbury-
Mills Fund, 1971  1971.219

CABINETMAKER
UNKNOWN, *probably New
York City*
247. Fire screen, ca. 1855
Rosewood; white pine;
tent-stitched needlepoint
panel; glass; replacement
silk backing; casters
The Art Institute of
Chicago, Mary Waller
Langhorne Endowment
1989.155

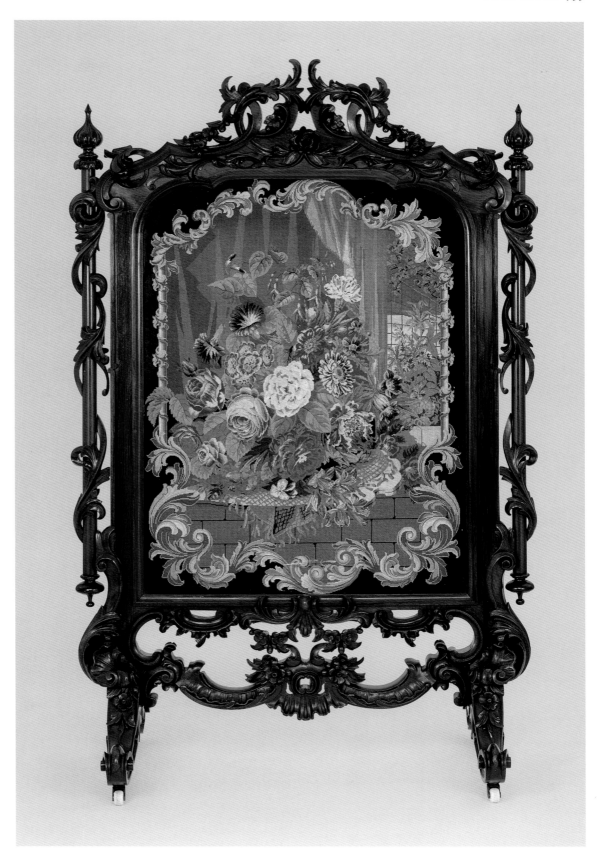

RINGUET-LEPRINCE
AND L. MARCOTTE
248. Armchair, ca. 1856
Ebonized maple; pine; gilt-
bronze mounts; replacement
underupholstery and
showcover; casters
The Metropolitan Museum
of Art, New York, Gift of
Mrs. D. Chester Noyes, 1968
68.69.2

GUSTAVE HERTER
249. Reception-room cabinet,
ca. 1860
Bird's-eye maple, rosewood,
ebony, marquetry of various
woods; white pine, cherry,
poplar, oak; oil on canvas;
gilt-bronze mounts; brass
inlay; gilding; mirror glass
Victoria Mansion, The
Morse-Libby House,
Portland, Maine 1984.65

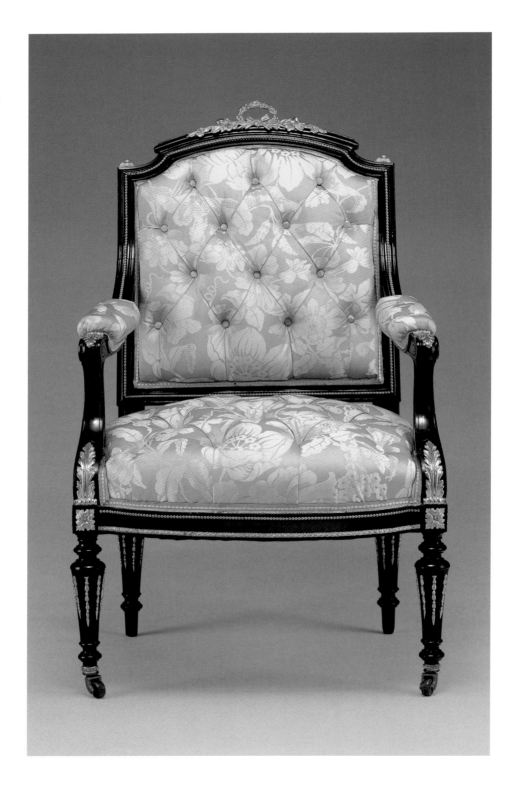

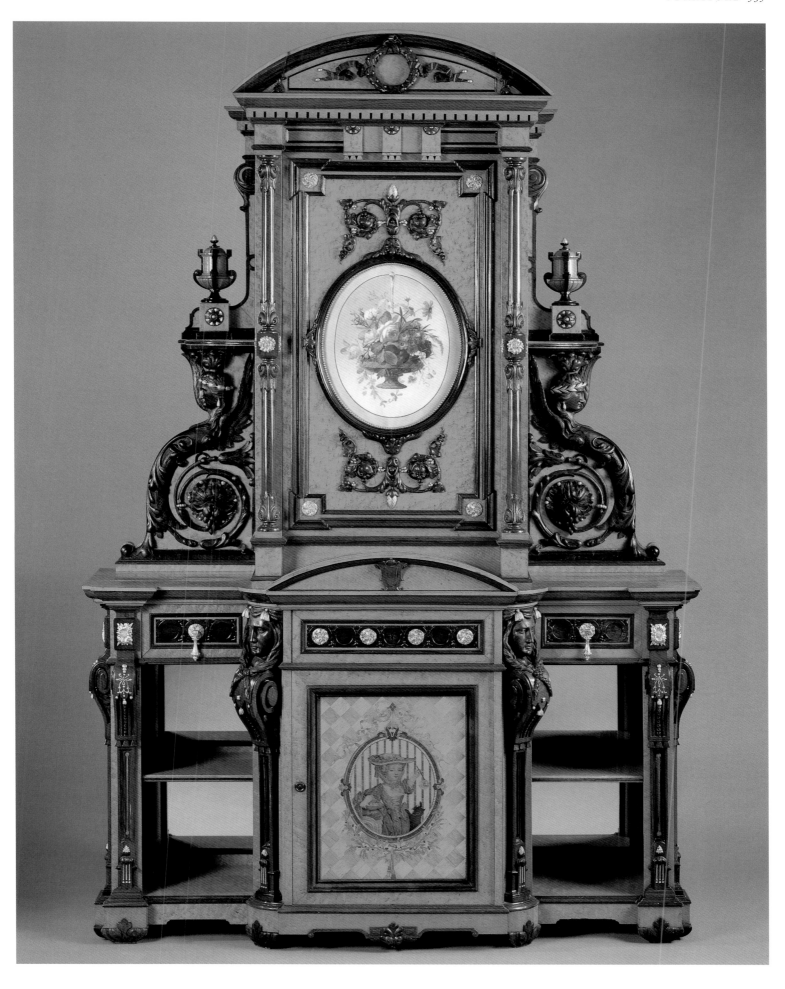

251

MAKER UNKNOWN, *French (Paris)*

250. Vase depicting New York City from Governors Island, ca. 1828–30
Porcelain, overglaze enamel decoration, and gilding
Collection of Mr. and Mrs. Stuart P. Feld

MAKER UNKNOWN, *French (Paris)*

251. Pair of vases depicting a scene on Lower Broadway with Saint Paul's Chapel and an interior view of the First Merchants' Exchange, ca. 1831–35
Porcelain, overglaze enamel decoration, and gilding
The Metropolitan Museum of Art, New York, Harris Brisbane Dick Fund, 1938  38.165.35, 38.165.36

MAKER UNKNOWN, *French (probably Limoges)*

252. Pair of vases with scenes from Harriet Beecher Stowe's *Uncle Tom's Cabin* (1852), ca. 1852–65
Porcelain with gilding
The Newark Museum, Purchase, 1968, Mrs. Parker O. Griffith Fund 68.106a,b

252

JAMES *and* RALPH CLEWS,
*English (Staffordshire)*

253. Platter depicting the Marquis de
Lafayette's arrival at Castle Garden,
August 16, 1824, ca. 1825–34
White earthenware with blue
transfer-printed decoration
Museum of the City of New York,
Gift of Mrs. Harry Horton
Benkard 34.508.2

JOSEPH STUBBS, *English
(Longport, Burslem, Staffordshire)*

254. Pitcher depicting City Hall, New
York, ca. 1826–36
White earthenware with blue
transfer-printed decoration
Winterthur Museum, Winterthur,
Delaware, Bequest of Henry F.
du Pont 58.1819

DECASSE AND CHANOU
255. Tea service, 1824–27
Porcelain with gilding
Kaufman Americana Foundation

D. AND J. HENDERSON
FLINT STONEWARE
MANUFACTORY, *Jersey City,*
*New Jersey*

256. End of the Rabbit Hunt pitcher,
ca. 1828–30
Stoneware, wheel-thrown with
applied decoration
Collection of Mr. and Mrs. Jay
Lewis

D. AND J. HENDERSON
FLINT STONEWARE
MANUFACTORY, *Jersey City,*
*New Jersey*

257. Acorn and Berry pitcher,
ca. 1830–35
Stoneware, press-molded with
applied decoration
The Metropolitan Museum of Art,
New York, Purchase, Dr. and Mrs.
Burton P. Fabricand Gift, 2000
2000.87

D. AND J. HENDERSON
FLINT STONEWARE
MANUFACTORY, *Jersey City,*
*New Jersey*

258. Herculaneum pitcher, ca. 1830–33
Stoneware, press-molded with
applied decoration
Collection of Mr. and Mrs. Jay
Lewis

AMERICAN POTTERY
MANUFACTURING
COMPANY, *Jersey City,*
*New Jersey*
DANIEL GREATBACH,
*probable modeler*

259. Thistle pitcher, 1838–52
Stoneware, press-molded with
brown Rockingham glaze
The Metropolitan Museum of
Art, New York, Gift of Maude B.
Feld and Samuel B. Feld, 1992
1992.230

AMERICAN POTTERY
MANUFACTURING
COMPANY, *Jersey City,*
*New Jersey*

260. Vegetable dish, ca. 1833–45
White earthenware, press-molded
with feather-edged and blue
sponged decoration
The Metropolitan Museum of Art,
New York, Purchase, Herbert
and Jeanine Coyne Foundation
and Cranshaw Corporation Gifts,
1997 1997.105

AMERICAN POTTERY
MANUFACTURING
COMPANY, *Jersey City,*
*New Jersey*

261. Covered hot-milk pot or teapot
and underplate, ca. 1835–45
White earthenware, press-molded
with blue sponged decoration
Collection of Mr. and Mrs. Jay
Lewis

259

260, 261

AMERICAN POTTERY
MANUFACTURING
COMPANY, *Jersey City,
New Jersey*

262. Canova plate, 1835–45
White earthenware, press-
molded with blue underglaze
transfer-printed decoration
Brooklyn Museum of Art
50.144

AMERICAN POTTERY
MANUFACTURING
COMPANY, *Jersey City,
New Jersey*
DANIEL GREATBACH,
*modeler*

263. Pitcher made for William Henry
Harrison's presidential campaign,
1840
Cream-colored earthenware,
press-molded with black
underglaze transfer-printed
decoration
New Jersey State Museum,
Trenton CH1986.11

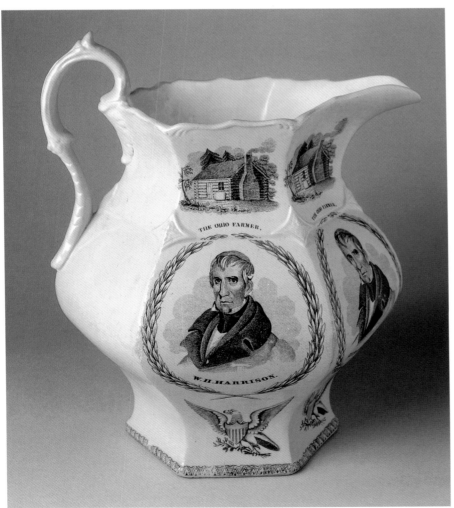

SALAMANDER WORKS, *New York City or Woodbridge, New Jersey*

265. Punch bowl, ca. 1836–42
Stoneware, press-molded with brown Rockingham glaze, porcelain letters
Winterthur Museum, Winterthur, Delaware, Bequest of Henry F. du Pont  59.1937

SALAMANDER WORKS, *New York City or Woodbridge, New Jersey*

264. Water cooler, 1836–45
Stoneware, press-molded with brown Rockingham glaze
New Jersey State Museum, Trenton  1971.70

SALAMANDER WORKS, *New York City or Woodbridge, New Jersey*
266. "Spanish" pitcher, ca. 1837–42
Stoneware, press-molded with brown Rockingham glaze
Collection of Arthur F. and Esther Goldberg

CHARLES CARTLIDGE AND COMPANY, *Greenpoint (Brooklyn), New York*
267. Presentation pitcher for the governor of the state of New York from the Manufacturing and Mercantile Union, 1854–56
Porcelain, with overglaze decoration in polychrome enamels and gilding
Collection of Mr. and Mrs. Jay Lewis

268

UNITED STATES POTTERY
COMPANY, *Bennington,
Vermont*

270. Central monument from the
United States Pottery Company
display at the New-York Exhibition
of the Industry of All Nations
(1853–54), 1851–53
Earthenware, including
Rockingham and Flint enamel-
glazed earthenware, scroddled
ware; parian porcelain
Bennington Museum, Bennington,
Vermont 1989.63

269

CHARLES CARTLIDGE AND
COMPANY, *Greenpoint
(Brooklyn), New York*

268. Pitcher made for the Claremont,
1853–56
Porcelain, with overglaze
decoration in polychrome
enamels and gilding
Museum of the City of New
York, Gift of Miss Dorothy
Rogers and Mrs. Edward H.
Anson 49.44.4

WILLIAM BOCH AND
BROTHERS, *Greenpoint
(Brooklyn), New York*

269. Pitcher, 1844–57
Porcelain
The Metropolitan Museum of
Art, New York, Purchase,
Anonymous Gift, 1968 68.112

270

*Probably* BLOOMINGDALE FLINT
GLASS WORKS *of Richard and John*
*Fisher, New York City, or* BROOKLYN
FLINT GLASS WORKS *of John*
*Gilliland, Brooklyn, New York*

271. Decanter (one of a pair), 1825–45
Blown colorless glass, with cut
decoration
Winterthur Museum, Winterthur,
Delaware, Gift of Mr. and Mrs. Robert
Trump 77.0181.001a,b

JERSEY GLASS COMPANY *of*
*George Dummer, Jersey City, New Jersey*

272. Salt, 1830–40
Pressed green glass
The Metropolitan Museum of Art,
New York, Purchase, Butzi Moffitt
Gift, 1985 1985.129

JERSEY GLASS COMPANY *of*
*George Dummer, Jersey City, New Jersey*
273. Compote, ca. 1830–40
Blown colorless glass, with cut decoration
The Corning Museum of Glass,
Corning, New York 71.4.108

JERSEY GLASS COMPANY *of
George Dummer, Jersey City, New Jersey*

274. Covered box, ca. 1830–40
Blown colorless glass, with cut
decoration; silver cover
The Corning Museum of Glass,
Corning, New York 71.4.110

JERSEY GLASS COMPANY *of
George Dummer, Jersey City, New Jersey*

275. Oval dish, ca. 1830–40
Blown colorless glass, with cut decoration
The Corning Museum of Glass,
Corning, New York 71.4.113

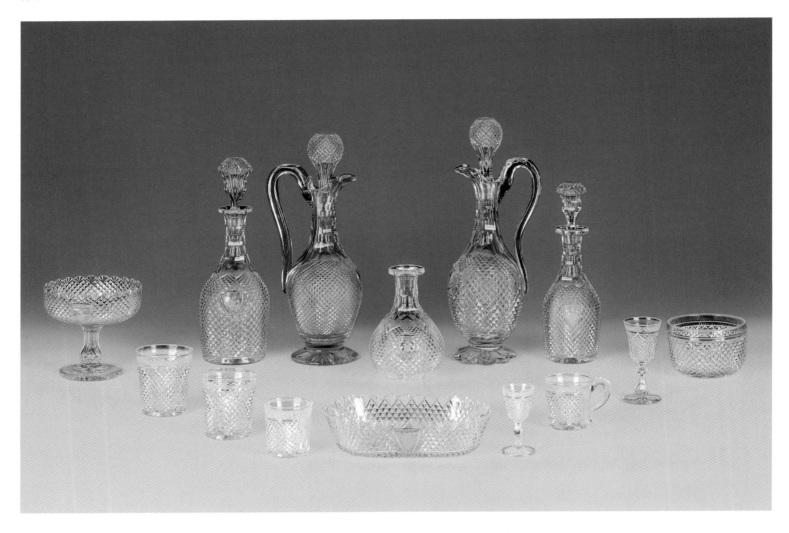

MAKER UNKNOWN, *New York City area*

277. A selection from a service of table glass made for a member of the Weld family, Albany, 1840–59
Blown colorless glass, with cut and engraved decoration
Albany Institute of History and Art
1984.24.3.1–14

LONG ISLAND FLINT GLASS WORKS *of Christian Dorflinger, Brooklyn, New York*

278. Presentation vase for Mrs. Christian Dorflinger from the Dorflinger Guards, 1859
Blown colorless glass, with cut and engraved decoration
The Metropolitan Museum of Art, New York, Gift of Isabel Lambert Dorflinger, 1988 1988.391.1

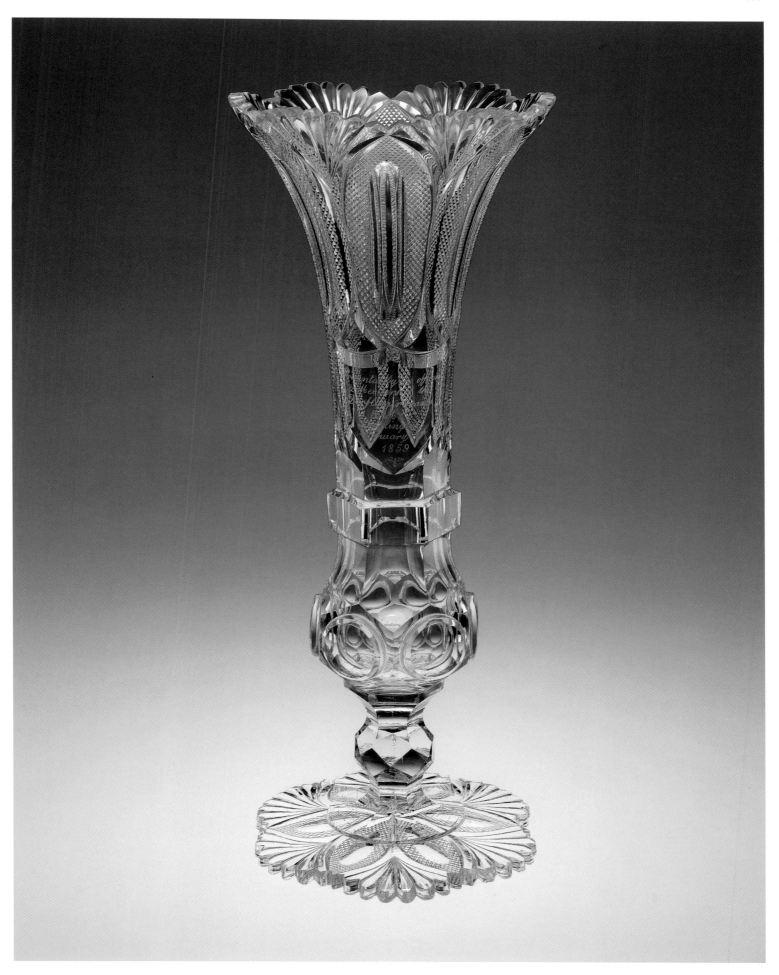

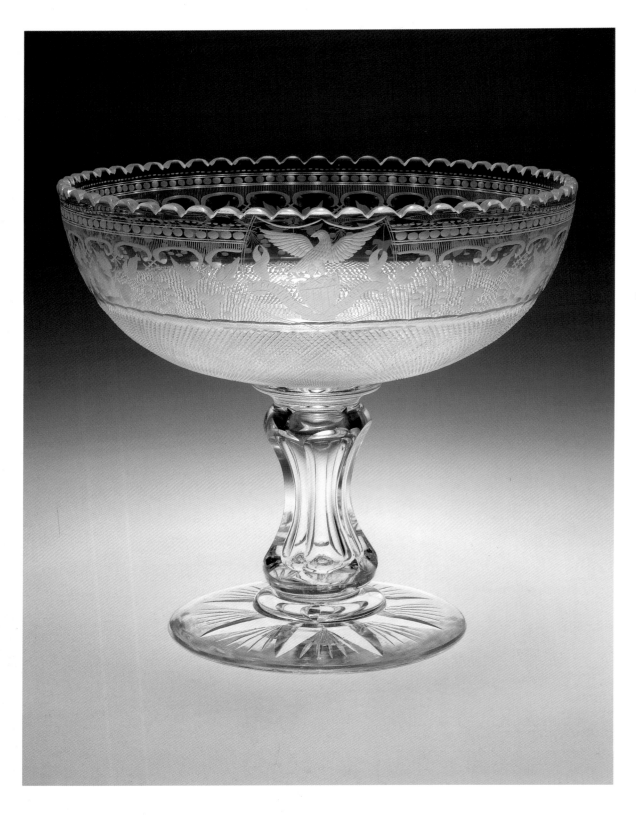

LONG ISLAND FLINT
GLASS WORKS *of
Christian Dorflinger,
Brooklyn, New York*

279. Compote made for the
White House, 1861
Blown colorless glass,
with cut and engraved
decoration
The Metropolitan
Museum of Art, New
York, Gift of Katheryn
Hait Dorflinger Manchee,
1972 1972.232.1

WILLIAM JAY
BOLTON, *assisted by*
JOHN BOLTON

280. *Christ Stills the Tempest*,
one of sixty figural win-
dows made for Holy
Trinity Church (now St.
Ann and the Holy Trinity
Church), Brooklyn,
1844–47
Opaque glass paint,
enamels, and silver stain
on pot-metal glass
St. Ann and the Holy
Trinity Church, Brooklyn,
New York. The window
has been restored with
the support of Catherine
S. Boericke and Francis
T. Chambers, III,
descendants of William
Jay Bolton, and public
funds from The New
York City Department of
Cultural Affairs Cultural
Challenge Program.

282A,B

283A,B

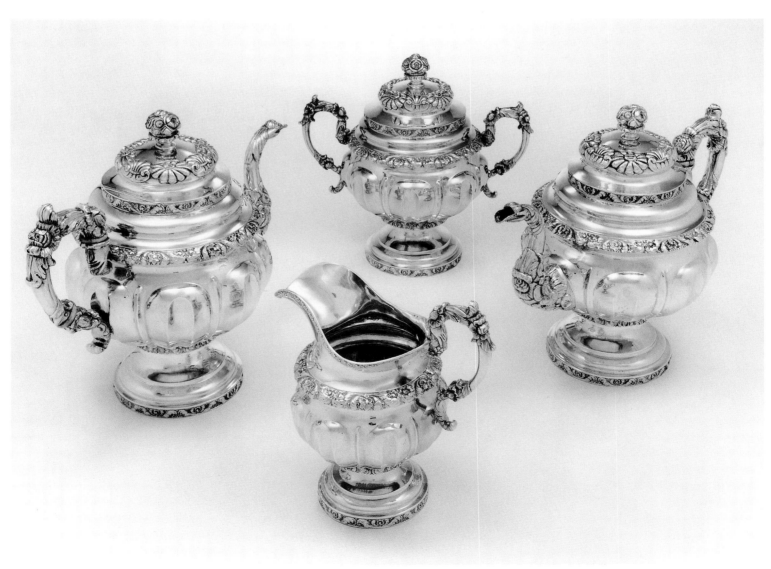

284

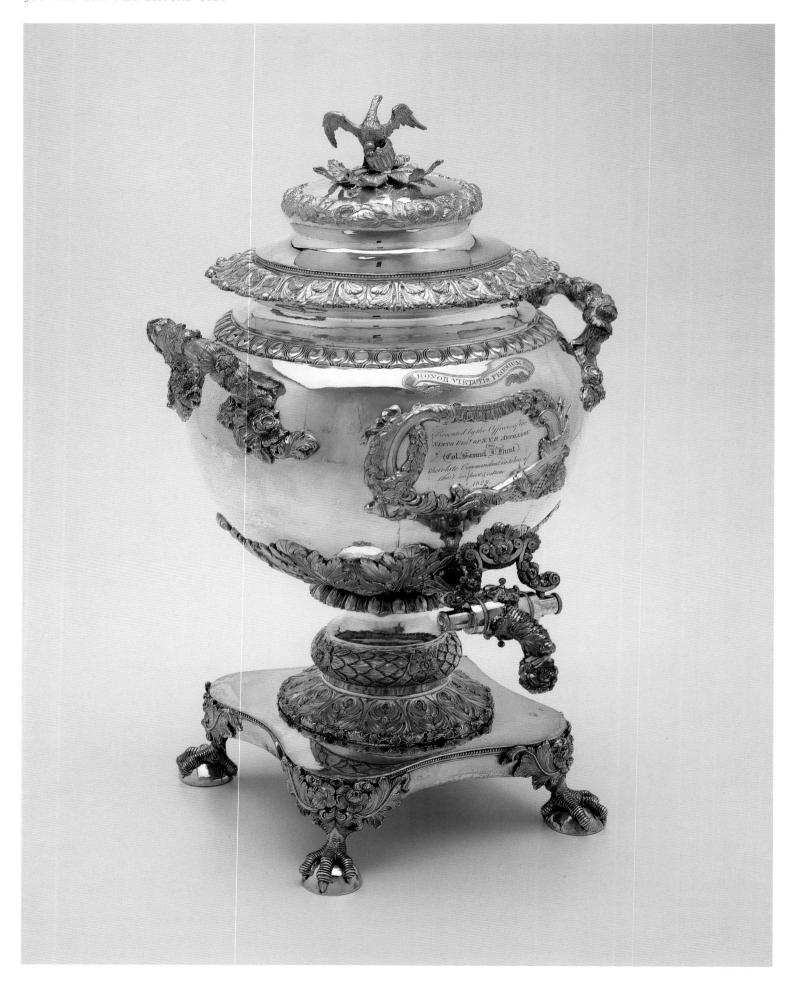

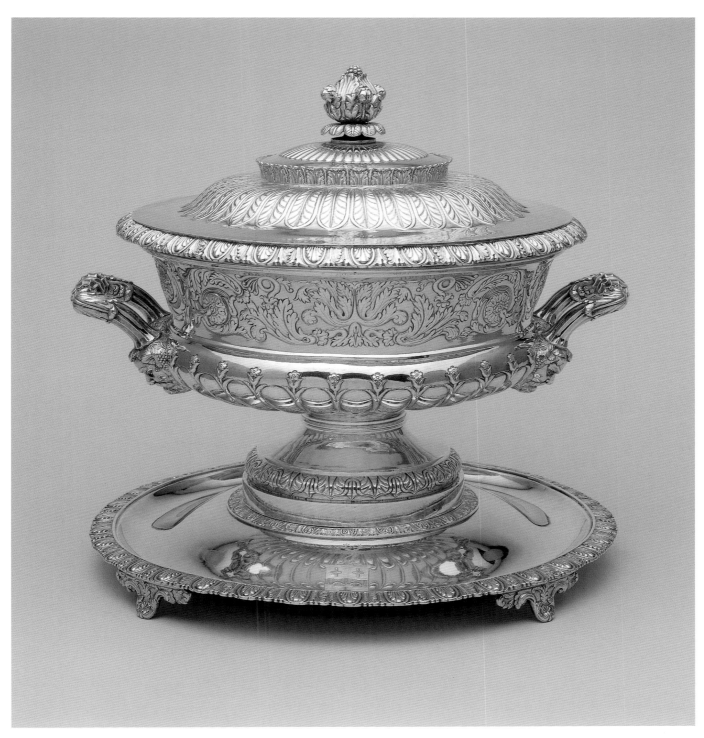

BALDWIN GARDINER, *silverware manufacturer and fancy-hardware retailer*

286. Tureen with cover on stand, ca. 1830
Silver
Private collection 92.24.USa–c

GALE AND MOSELEY, *silverware manufacturer*

285. Coffee urn, 1829
Silver
The Detroit Institute of Arts, Founders Society Purchase, Edward E. Rothman Fund, Mrs. Charles Theron Van Dusen Fund and the Gibbs-Williams Fund
1999.3.a,b

T. BROWN, *designer*
MARQUAND AND BROTHERS, *jeweler*
287. Presentation medal, 1832
Gold
Winterthur Museum, Winterthur, Delaware,
Museum Purchase 78.0113a,b

MARQUAND AND COMPANY, *retail
silversmith and jeweler*
288. Basket, 1833–38
Silver
The Baltimore Museum of Art, Decorative
Arts Fund BMA1988.6

MAKER UNKNOWN, *probably English*
J. AND I. COX (*or* J. AND J. COX),
*retailer*
289. Pair of argand lamps, ca. 1835
Brass and glass
Dallas Museum of Art 1992.B.152.1,2

COLIN V. G. FORBES AND
SON, *manufacturing silversmith*

290. Presentation hot-water urn, 1835
Silver; iron heating core
Collection of Mr. and Mrs.
Gerard L. Eastman, Jr.

MORITZ FÜRST, *engraver and
die sinker*

291. Medal (obverse and reverse),
ca. 1838
Silver
The Metropolitan Museum of
Art, New York, Gift of William
Forbes II, 1952 52.113.2

CHARLES CUSHING
WRIGHT, *engraver*
PETER PAUL DUGGAN,
*designer*

292. American Art-Union medal
depicting Washington Allston,
1847
Bronze
The Metropolitan Museum of
Art, New York, Gift of Janis
Conner and Joel Rosenkranz,
1997 1997.484.1

CHARLES CUSHING
WRIGHT, *engraver*
SALATHIEL ELLIS, *modeler*

293. American Art-Union medal
depicting Gilbert Stuart, 1848
Bronze
The Metropolitan Museum of
Art, New York, Gift of Janis
Conner and Joel Rosenkranz,
1997 1997.484.2

CHARLES CUSHING
WRIGHT, *engraver*
PETER PAUL DUGGAN,
*designer*

294. Seal of the American Art-Union
(reverse of medal depicting
Gilbert Stuart), 1848
Bronze
The Metropolitan Museum of
Art, New York, Gift of Mr. and
Mrs. F. S. Wait, 1907 1907.07.34

CHARLES CUSHING
WRIGHT, *engraver*
ROBERT BALL HUGHES,
*modeler*
PETER PAUL DUGGAN,
*designer of reverse*

295. American Art-Union medal
depicting John Trumbull, 1849
Bronze
The Metropolitan Museum of
Art, New York, Gift of Janis
Conner and Joel Rosenkranz,
1997 1997.484.3

291 (obverse)

291 (reverse)

292

293

294

295

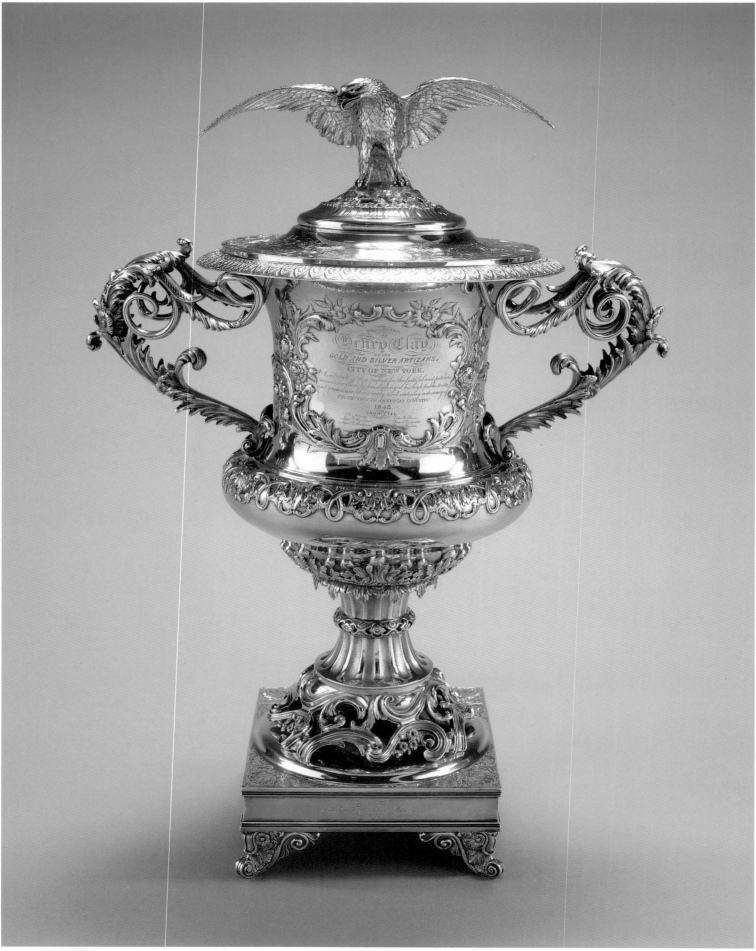

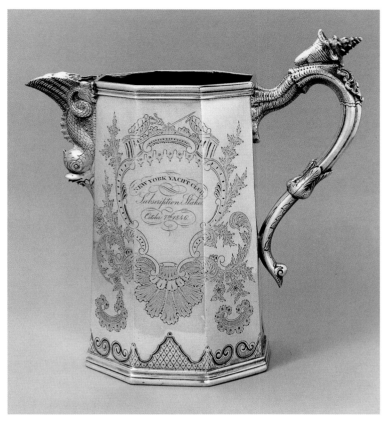

297

WILLIAM ADAMS,
*manufacturing silversmith*

296. Presentation vase with cover,
1845
Silver
The Henry Clay Memorial
Foundation, located at Ashland,
The Henry Clay Estate in
Lexington, Kentucky. Gift of
Colonel Robert Pepper Clay
88.039a,b

WILLIAM F. LADD,
*watchmaker and retail jeweler*

297. Trophy pitcher, 1846
Silver
The New-York Historical
Society, Purchase, Lyndhurst
Corporation Abbott-Lenox Fund
1981.19

ZALMON BOSTWICK,
*silverware manufacturer*

298. Pitcher and goblet, 1845
Silver
Brooklyn Museum of Art, gift of
the Estate of May S. Kelley, by
exchange  81.179.1,2

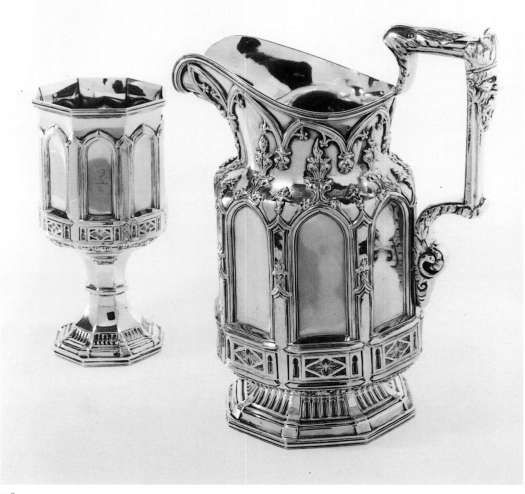

298

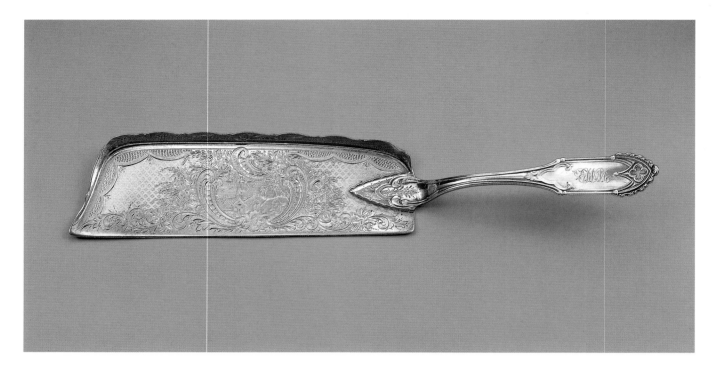

GALE AND HAYDEN,
*patentee of design*
WILLIAM GALE AND
SON, *manufacturing
silversmith*

299. Gothic-pattern crumber,
design patented 1847
Silver
Collection of Robert
Mehlman

GALE AND HAYDEN,
*patentee of design*
WILLIAM GALE AND
SON, *manufacturing
silversmith*

300. Gothic-pattern dessert knife,
sugar sifter, fork, and spoon,
design patented 1847, knife
dated 1852, fork 1853, and
spoon 1848
Silver
Dallas Museum of Art
1991.12 (knife), 1991.101.14.1–3
(sifter, fork, and spoon)

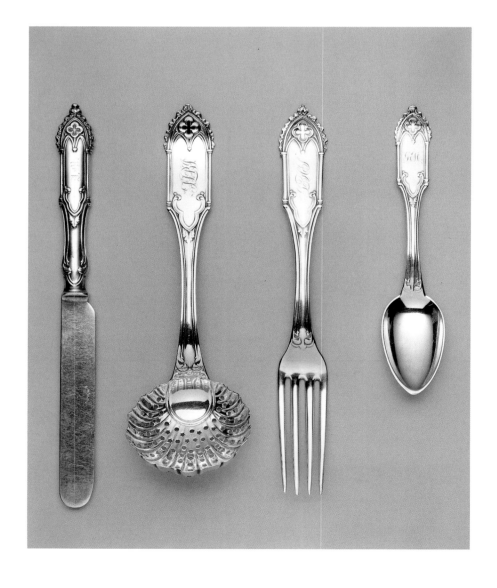

JOHN C. MOORE,
*manufacturing silversmith*
JAMES DIXON AND
SONS, *English (Sheffield),*
*manufacturer of tray*
BALL, TOMPKINS AND
BLACK, *retail silversmith*
*and jeweler*

301. Presentation tea and coffee
service with tray
Silver

Pitcher, 1850
Museum of the City of
New York, gift of Charles
Stedman, Jr. 62.161

Hot-milk pot, 1850
The Metropolitan
Museum of Art, New
York, Gift of Mrs. F. R.
Lefferts, 1969 69.141.3

Hot-water kettle on stand,
1850
The Metropolitan
Museum of Art, New
York, Gift of Mrs. F. R.
Lefferts, 1969 69.141.1a–d

Sugar bowl with cover,
1850
The Metropolitan
Museum of Art, New
York, Gift of Mrs. F. R.
Lefferts, 1969 69.141.2a,b

Tray, ca. 1850
Silver-plated base metal
The Metropolitan
Museum of Art, New
York, Gift of Mrs. F. R.
Lefferts, 1969 69.141.4

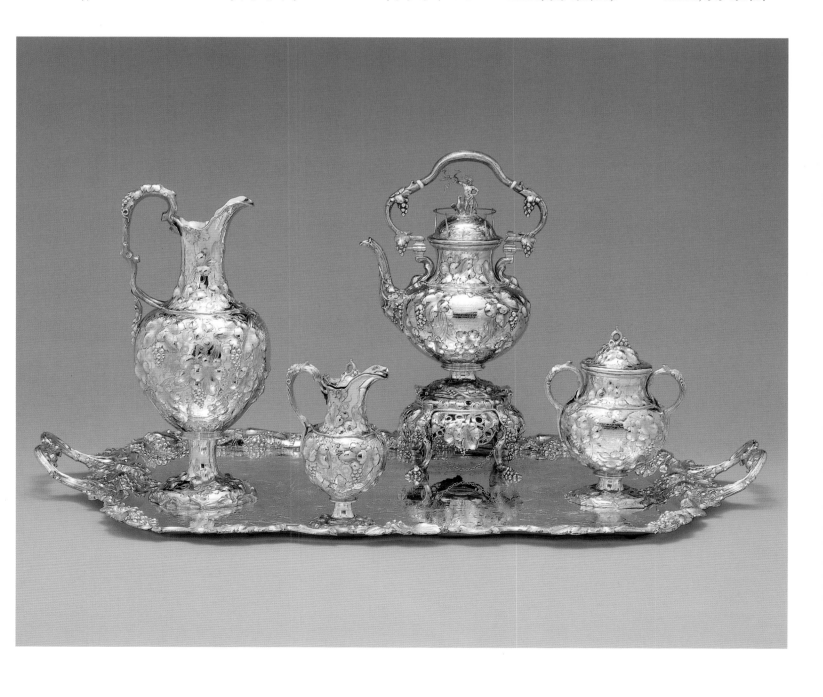

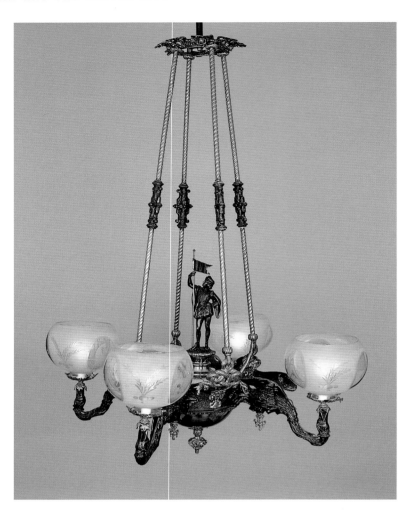

STARR, FELLOWS AND
COMPANY *or* FELLOWS,
HOFFMAN AND
COMPANY

302. Four-branch gasolier with
central figure of Christopher
Columbus, ca. 1857
Patinated spelter, gilt brass,
lacquered brass, iron, and glass
Louisiana State University
Museum of Art, Baton
Rouge, Louisiana, Gift of the
Baton Rouge Coca-Cola
Bottling Company 82.13

DIETZ, BROTHER AND
COMPANY

303. Three-piece girandole set
depicting Louis Kossuth,
leader of the Hungarian
Revolution (1848), 1851
Bronze, lacquer, and brass
The Newark Museum,
Anonymous Gift of Two
Friends of the Decorative
Arts, 1992 92.6a–c

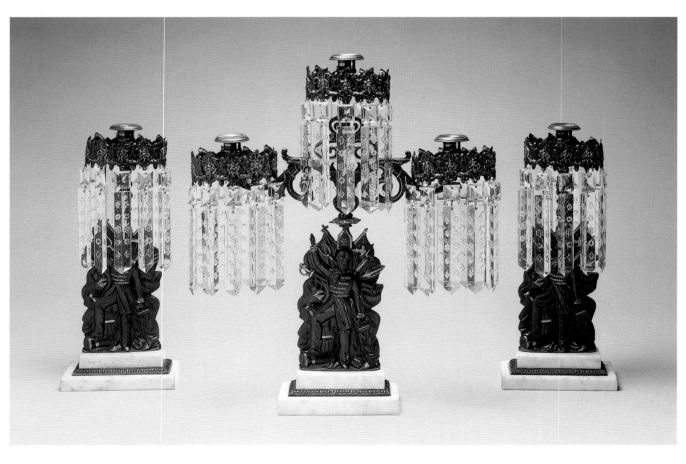

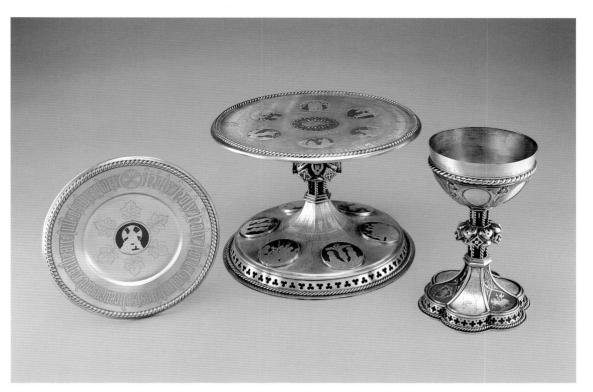

COOPER AND FISHER,
*silverware manufacturer*

304. Chalice, paten, and footed paten, 1855–56
Coin and fine silver, gilding, and enamel
Parish of Trinity Church in the City of New York 80.14.1–3

WOOD AND HUGHES,
*silverware manufacturer*

305. Commemorative pitcher, Kiddush goblets, and tray, 1856
Silver; goblets with gilt interiors
Courtesy of Congregation Emanu-El of the City of New York CEE–29–43a,b (pitcher and tray), CEE–56–1,2 (goblets)

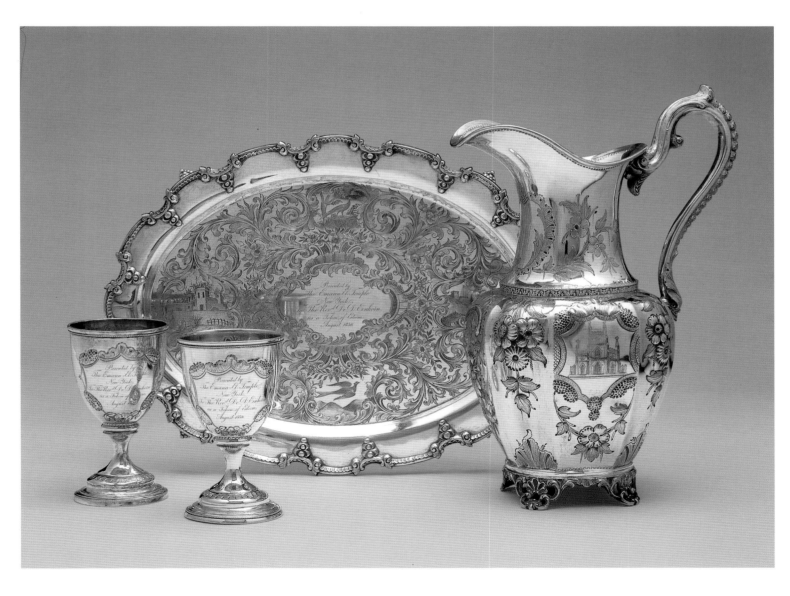

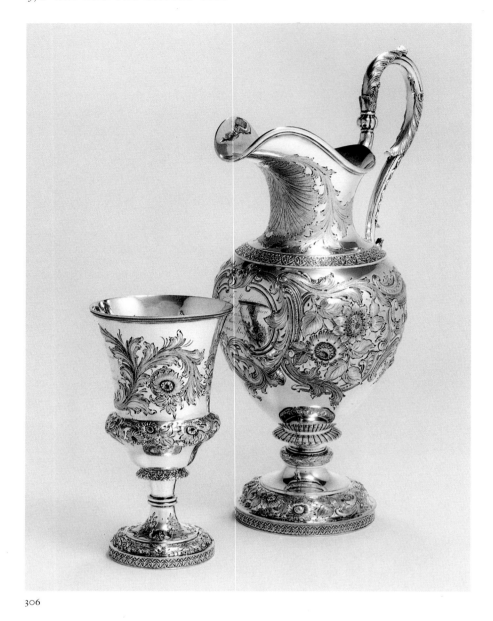

306

307 (obverse)

307 (reverse)

308

309

WILLIAM FORBES,
*manufacturing silversmith*
BALL, TOMPKINS AND
BLACK, *retail silversmith and
jeweler*

306. Pitcher and goblet (one of two),
1851
Silver
Museum of the City of
New York, Gift of Frank D.
Morgans 54.97.1a,b

TIFFANY AND COMPANY,
*manufacturing and retail
silversmith and jeweler*

307. Medal (obverse and reverse),
1859
Gold
The Metropolitan Museum of
Art, New York, Gift of Cyrus
W. Field, 1892 92.10.3

TIFFANY AND COMPANY,
*manufacturing and retail
silversmith and jeweler*

308. Presentation box, 1859
Gold
The Metropolitan Museum of
Art, New York, Gift of Cyrus
W. Field, 1892 92.10.7

TIFFANY AND COMPANY,
*manufacturing and retail
silversmith and jeweler*

309. Mounted section of
transatlantic telegraph
cable, 1858
Steel and brass
Collection of D. Albert
Soeffing

TIFFANY AND COMPANY,
*manufacturing and retail
silversmith and jeweler*

310. Pitcher from a service presented
to Colonel Abram Duryee of
the Seventh Regiment, New
York National Guard, by his
fellow citizens, 1859
Sterling silver
Museum of the City of New
York, Bequest of Emily
Frances Whitney Briggs
55.257.5

310

Signed at lower right: SAMUEL L. WALDO.
The Metropolitan Museum of Art, New York,
Fletcher Fund, 1938 38.146.5

Thomas Seir Cummings, 1804–1894
22. *A Mother's Pearls (Portraits of the Artist's
Children)*, 1841
Watercolor on ivory
L. 17½ in. (44.5 cm)
The Metropolitan Museum of Art, New York,
Gift of Mrs. Richard B. Hartshorne and Miss
Fanny S. Cummings (through Miss Estelle
Hartshorne), 1928 28.148.1
Exhibited at the National Academy of Design
in 1841

AMERICAN PAINTINGS

Thomas Cole, born England, 1801–1848
23. *View of the Round-Top in the Catskill Mountains*,
ca. 1827
Oil on panel
18⅝ x 25⅜ in. (47.3 x 64.5 cm)
Signed at lower center: Cole
Museum of Fine Arts, Boston, Gift of
Martha C. Karolik for the M. and M. Karolik
Collection of American Paintings, 1815–1865
47.1200
Originally owned by Henry Ward; exhibited
at the National Academy of Design in 1828

Thomas Cole, born England, 1801–1848
24. *Scene from "The Last of the Mohicans": Cora
Kneeling at the Feet of Tamenund*, 1827
Oil on canvas
25 x 35 in. (63.5 x 88.9 cm)
Signed on rock at lower center: T. Cole. 1827
Wadsworth Atheneum, Hartford, Connecticut,
Bequest of Alfred Smith 1868.3
Based on James Fenimore Cooper's novel
(1826); exhibited at the National Academy of
Design in 1828

Asher B. Durand, 1796–1886
25. *Dance on the Battery in the Presence of Peter
Stuyvesant*, 1838
Oil on canvas
32 x 46½ in. (81.3 x 118.1 cm)
Museum of the City of New York, Gift of
Jane Rutherford Faile through Kenneth C.
Faile, 1955 55.248
Scene from *A History of New-York* by
Washington Irving (under the pseudonym
Diedrich Knickerbocker; 1809); exhibited
at the National Academy of Design in 1838
and at the New York Gallery of the Fine
Arts in 1844

John Quidor, 1801–1881
26. *The Money Diggers*, 1832
Oil on canvas
16¾ x 21½ in. (42.5 x 54.6 cm)
Signed, dated, and inscribed at center right:
J. Quidor Pinxt/N. York June, 1832
Brooklyn Museum of Art, Gift of Mr. and
Mrs. Alastair B. Martin 48.171

Scene from Washington Irving's *Tales of a
Traveller* (1824); exhibited at the National
Academy of Design in 1833

Robert Walter Weir, 1803–1889
27. *A Visit from Saint Nicholas*, ca. 1837
Oil on panel
30 x 24⅜ in. (76.2 x 61.9 cm)
The New-York Historical Society, Gift of
George A. Zabriskie, 1951 1951.76
Related to a scene from Clement Clarke
Moore's poem (1823) and to the description
of Saint Nicholas in *A History of New-York* by
Washington Irving (under the pseudonym
Diedrich Knickerbocker; 1809)

William Sidney Mount, 1807–1868
28. *Eel Spearing at Setauket (Recollections of Early
Days—"Fishing along Shore")*, 1845
Oil on canvas
28½ x 36 in. (72.4 x 91.4 cm)
Signed and dated at lower right: Wm. S.
Mount/1845
New York State Historical Association,
Cooperstown, Gift of Stephen C. Clark
Commissioned by George Washington
Strong; exhibited at the National Academy
of Design in 1846

George Caleb Bingham, 1811–1879
29. *Fur Traders Descending the Missouri*, 1845
Oil on canvas
29 x 36½ in. (73.7 x 92.7 cm)
The Metropolitan Museum of Art, New York,
Morris K. Jesup Fund, 1933 33.61
Exhibited at the American Art-Union in
1845; awarded to Robert S. Bunker of Mobile,
Alabama, at the Art-Union's annual distribution
of prizes in 1845

Asher B. Durand, 1796–1886
30. *Kindred Spirits*, 1849
Oil on canvas
46 x 36 in. (116.8 x 91.4 cm)
Signed and dated at lower left: A. B. Durand/
1849
Inscribed on a tree at left: Bryant/Cole
The New York Public Library, Gift of Julia Bryant
Commissioned by Jonathan Sturges as a gift
to William Cullen Bryant; exhibited at the
National Academy of Design in 1849

Asher B. Durand, 1796–1886
31. *In the Woods*, 1855
Oil on canvas
60¾ x 48 in. (154.3 x 121.9 cm)
Signed and dated at lower right: A.B. Durand/
1855
The Metropolitan Museum of Art, New York,
Gift in memory of Jonathan Sturges by his
children, 1895 95.13.1
Commissioned by Jonathan Sturges

Charles Cromwell Ingham, born Ireland,
1796–1863
32. *The Flower Girl*, 1846
Oil on canvas
36 x 28⅞ in. (91.4 x 73.3 cm)

Signed and dated on basket handle: C.C.
Ingham/1846
The Metropolitan Museum of Art, New York,
Gift of William Church Osborn, 1902 02.7.1
Exhibited at the National Academy of Design
in 1847; owned thereafter by Jonathan Sturges

Lilly Martin Spencer, 1822–1902
33. *Kiss Me and You'll Kiss the 'Lasses*, 1856
Oil on canvas
30⅛ x 25⅛ in. (76.5 x 63.8 cm)
Signed and dated at lower right: Lilly M.
Spencer/1856
Brooklyn Museum of Art, A. Augustus Healy
Fund 70.26
Exhibited at the Cosmopolitan Art Association
in 1856; awarded to E. A. Carmen of Newark,
New Jersey, at the Association's annual
distribution of prizes in the same year

Emanuel Leutze, born Germany, 1816–1868
34. *Mrs. Schuyler Burning Her Wheat Fields on the
Approach of the British*, 1852
Oil on canvas
32 x 40 in. (81.3 x 101.6 cm)
Signed and dated at lower left: E. Leutze. 1852
The Los Angeles County Museum of Art,
Bicentennial Gift of Mr. and Mrs. J. M. Schaaf,
Mr. and Mrs. William D. Witherspoon, Mr.
and Mrs. Charles M. Shoemaker, and Mr. and
Mrs. Julian Ganz, Jr. M.76.91
Scene from Elizabeth F. Ellet's *Eminent and
Heroic Women of America* (New York, 1846);
owned by Charles M. Leupp and sold at the
noted public auction of his estate in 1860

Fitz Hugh Lane, 1804–1865
35. *New York Harbor*, 1850
Oil on canvas
36 x 60¼ in. (91.4 x 153 cm)
Signed and dated at lower right: Fitz H.
Lane./1850.
Museum of Fine Arts, Boston, Gift of Maxim
Karolik for the M. and M. Karolik Collection
of American Paintings, 1815–1865 48.446
A smaller version of this painting was exhib-
ited at the American Art-Union in 1850.

Sanford Robinson Gifford, 1823–1880
36. *Lake Nemi*, 1856–57
Oil on canvas
39⅝ x 60⅜ in. (100.6 x 153.4 cm)
Signed and dated on reverse (covered by
lining canvas): Nemi/S. R. Gifford/Rome
1856–57
The Toledo Museum of Art, Toledo, Ohio;
Purchased with funds from the Florence Scott
Libbey Bequest in Memory of her Father,
Maurice A. Scott 1957.46
Exhibited at the National Academy of Design
in 1858

John F. Kensett, 1816–1872
37. *Beacon Rock, Newport Harbor*, 1857
Oil on canvas
22½ x 36 in. (57.2 x 91.4 cm)

National Gallery of Art, Washington, D.C.,
Gift of Frederick Sturges, Jr. 1953.1.1
Owned by Jonathan Sturges

James H. Cafferty, 1819–1869, and Charles G.
Rosenberg, 1818–1879

38. *Wall Street, Half Past 2 O'Clock, October 13,
1857,* 1858
Oil on canvas
50 x 39½ in. (127 x 100.3 cm)
Signed and dated on risers of steps at lower
left: Cafferty 58 / Rosenberg
Museum of the City of New York, Gift of the
Honorable Irwin Untermyer 40.54
Exhibited at the National Academy of Design
in 1858

Francis William Edmonds, 1806–1863

39. *The New Bonnet,* 1858
Oil on canvas
25 x 30⅛ in. (63.5 x 76.5 cm)
Signed and dated at lower left: FW Edmonds /
1858
Inscribed: on label on frame, SCHAUS / FINE
ART / REPOSITORY, / 749 Broadway, / NEW
YORK; on paper fragment on frame, The
[New] Bonnet / F. W. Edm[ond]s.
The Metropolitan Museum of Art, New York,
Purchase, Erving Wolf Foundation Gift and
Gift of Hanson K. Corning, by exchange,
1975 1975.27.1
Exhibited at the National Academy of Design
in 1859

Eastman Johnson, 1824–1906

40. *Negro Life at the South,* 1859
Oil on canvas
36 x 45¼ in. (91.4 x 114.9 cm)
Signed and dated at lower right: E. Johnson / 1859
The New-York Historical Society, The Robert L.
Stuart Collection, on permanent loan from
The New York Public Library S–225
Exhibited at the National Academy of Design
in 1859; owned by William P. Wright of
Weehawken, New Jersey, and subsequently
by Robert L. Stuart of New York City

Frederic E. Church, 1826–1900

41. *The Heart of the Andes,* 1859
Oil on canvas
66⅛ x 119¼ in. (168 x 302.9 cm)
Signed and dated on tree at lower left: 1859 /
F.E. CHURCH
The Metropolitan Museum of Art, New York,
Bequest of Margaret E. Dows, 1909 09.95
Exhibited in New York at the Tenth Street
Studio Building in 1859; subsequently toured
Europe for two years, including a much-
heralded show in London; purchased by
William T. Blodgett for $10,000

FOREIGN PAINTINGS

Giovanni di Ser Giovanni di Simone (called
Scheggia), Italian (Florence), 1407–1487

42. *The Triumph of Fame,* birth tray of Lorenzo
de'Medici (recto); *Arms of the Medici and*

*Tornabuoni Families* (verso), 1449
Tempera, silver, and gold on wood
Diam. 36½ in. (92.7 cm) overall with engaged
frame
The Metropolitan Museum of Art, New
York, Purchase in memory of Sir John Pope-
Hennessy: Rogers Fund, The Annenberg
Foundation, Drue Heinz Foundation,
Annette de la Renta, Mr. and Mrs. Frank E.
Richardson, and The Vincent Astor Founda-
tion Gifts, Wrightsman and Gwynne Andrews
Funds, special funds, and Gift of the children
of Mrs. Harry Payne Whitney, Gift of Mr.
and Mrs. Joshua Logan, and other gifts and
bequests, by exchange, 1995 1995.7
Owned by Thomas Jefferson Bryan, who
established the Bryan Gallery of Christian
Art in 1852

David Teniers the Younger, Flemish, 1610–1690

43. *Judith with the Head of Holofernes,* 1650s
Oil on copper
14½ x 10⅜ in. (36.8 x 26.4 cm)
Signed at upper right: O·Teniers·F
The Metropolitan Museum of Art, New York,
Gift of Gouverneur Kemble, 1872 72.2
Owned and exhibited in New York City by
John Trumbull, president of the American
Academy of the Fine Arts

Bartolomé Esteban Murillo, Spanish, 1617–1682

44. *Four Figures on a Step (A Spanish Peasant
Family),* ca. 1655–60
Oil on canvas
43¼ x 56½ in. (109.9 x 143.5 cm)
Kimbell Art Museum, Fort Worth, Texas
AP1984.18
Exhibited by the London dealer Richard
Abraham at the American Academy of the
Fine Arts in 1830

Jan Abrahamsz. Beerstraten, Dutch, 1622–1666

45. *Winter Scene,* ca. 1660
Oil on canvas
35½ x 52 in. (90.2 x 132.1 cm)
Signed at lower left: J. BEERSTRATEN
The New-York Historical Society, Gift of
Thomas J. Bryan, 1867 1867.84
Owned by Thomas Jefferson Bryan, who
established the Bryan Gallery of Christian
Art in 1852

Artist unknown, after Willem Kalf, Dutch,
1619–1693

46. *Still Life with Chinese Sugarbowl, Nautilus Cup,
Glasses, and Fruit,* ca. 1675–1700
Oil on canvas
32 x 27 in. (81.3 x 68.6 cm)
The New-York Historical Society, Luman
Reed Collection—New-York Gallery of Fine
Arts 1858.15
Owned by Luman Reed

Jacob van Ruisdael, Dutch, 1628/29–1682

47. *A Landscape with a Ruined Castle and a
Church (A Grand Landscape),* 1665–70
Oil on canvas

43 x 57½ in. (109.2 x 146.1 cm)
Signed in water at bottom right:
JvRuisdael
The National Gallery, London NG990
Exhibited by the London dealer Richard
Abraham at the American Academy of the
Fine Arts in 1830

Giovanni Paolo Panini (or Pannini), Italian
(Rome), 1691–1765

48. *Modern Rome,* 1757
Oil on canvas
67¾ x 91¾ in. (172.1 x 233 cm)
Signed and dated on base of statue of Moses
at lower center: I.P. PANINI.1757
The Metropolitan Museum of Art, New York,
Gwynne Andrews Fund, 1952 52.63.2
Replica of a painting of the same title
exhibited at the American Academy of the
Fine Arts in 1834

J. M. W. Turner, British, 1775–1851

49. *Staffa, Fingal's Cave,* exhibited 1832
Oil on canvas
35¾ x 47¾ in. (90.8 x 121.3 cm)
Signed lower right: JMW Turner RA
Yale Center for British Art, New Haven,
Connecticut, Paul Mellon Collection
B1978.43.14
Purchased by James Lenox in 1845

Andreas Achenbach, German, 1815–1910

50. *Clearing Up—Coast of Sicily,* 1847
Oil on canvas
32½ x 45¾ in. (82.6 x 116.2 cm)
Signed and dated at lower left: A. Achenbach. /
1847
The Walters Art Gallery, Baltimore WAG37.116
Exhibited at the Düsseldorf Gallery between
1849 and 1857

Rosa Bonheur, French, 1822–1899

51. *The Horse Fair,* 1853; retouched 1855
Oil on canvas
96¼ x 199½ in. (244.5 x 506.7 cm)
Signed and dated at lower right: Rosa
Bonheur 1853.5.
The Metropolitan Museum of Art, New York,
Gift of Cornelius Vanderbilt, 1887 87.25
Exhibited by the London dealer Ernest
Gambart at Williams, Stevens and Williams
in 1857–58; purchased at the exhibition by
William P. Wright of Weehawken, New Jersey

FOREIGN SCULPTURE

Giuseppe Ceracchi, Italian, 1751–1802

52. *George Washington,* Philadelphia, 1795
Marble
28⅞ x 23½ x 13½ in. (73.3 x 59.7 x 34.3 cm)
Signed and dated on back: Ceracchi faciebat /
Philadelphia / 1795
The Metropolitan Museum of Art, New
York, Bequest of John L. Cadwalader, 1914
14.58.235

Exhibited along with Richard Worsam Meade's collection of European paintings at the National Academy of Design in 1831

Jean-Antoine Houdon, French, 1741–1828
53. *Robert Fulton,* Paris, 1803–4
Painted plaster
26⅞ x 15⅜ x 12 in. (68.3 x 39.1 x 30.5 cm)
Signed on right shoulder: houdon f
The Metropolitan Museum of Art, New York, Wrightsman Fund, 1989  1989.329
A version of this bust was in the cast collection of the American Academy of the Fine Arts.

Bertel Thorvaldsen, Danish, 1770–1844
54. *Ganymede and the Eagle,* Rome, 1817–29
Marble
37¼ x 46⅝ x 19½ in. (94.6 x 118.4 x 49.5 cm)
Signed on back of base, at right: THOR-WALDSEN/FECIT
The Minneapolis Institute of Arts, Gift of the Morse Foundation  66.9
Exhibited at the New-York Exhibition of the Industry of All Nations, 1853–54

AMERICAN SCULPTURE

Hiram Powers, 1805–1873
55. *Andrew Jackson,* modeled in Washington, D.C., 1834–35; carved in Florence 1839
Marble
34¾ x 23½ x 15½ in. (88.3 x 59.7 x 39.4 cm)
Signed on back: HIRAM POWERS/Sculp.
The Metropolitan Museum of Art, New York, Gift of Mrs. Frances V. Nash, 1894  94.14
Exhibited with Powers's *Greek Slave* at the Lyceum Gallery in 1849

John Frazee, 1790–1852
56. *Nathaniel Prime,* 1832–34
Marble
28½ x 19 x 9 in. (72.4 x 48.3 x 22.9 cm)
National Portrait Gallery, Smithsonian Institution, Washington, D.C., Gift of Sylvester G. Prime  NPG.84.72
Probably commissioned by Samuel Ward and James Gore King as a retirement gift to Prime

Robert Ball Hughes, 1806–1868
57. *John Trumbull,* modeled ca. 1833; carved 1834–after 1840
Marble
30 x 20¼ x 9¼ in. (76.2 x 51.4 x 23.5 cm)
Yale University Art Gallery, New Haven, Connecticut, University Purchase  1851.2

Shobal Vail Clevenger, 1812–1843
58. *Philip Hone,* modeled 1839; carved in Florence 1844–46
Marble
31⅞ x 22¾ x 14⅝ in. (81 x 57.8 x 37.1 cm)
Signed on back: s. v. CLEVENGER./Sculptor
Inscribed: on front of socle, PHILIP HONE; on top of original pedestal, PRESENTED BY

"A NUMBER OF MERCHANTS OF NEW-YORK" TO THE M. L. A. 1846.
Mercantile Library Association, New York

Thomas Crawford, ca. 1813–1857
59. *Genius of Mirth,* Rome, modeled 1842; carved 1843
Marble
47 x 20 x 24 in. (119.4 x 50.8 x 61 cm)
Signed and dated on front of base: CRAWFORD_FECIT [;] ROMÆ_MDCCCXLIII_
The Metropolitan Museum of Art, New York, Bequest of Annette W. W. Hicks-Lord, 1896  97.13.1
Commissioned by Henry W. Hicks and exhibited at the National Academy of Design in 1844

Hiram Powers, 1805–1873
60. *Greek Slave,* Florence, modeled 1841–43; carved 1847
Marble
H. 65½ in. (166.4 cm); diam. (base) 19 in. (48.3 cm)
Signed and dated on base: Hiram Powers/Sculp./L'anno 1847
The Newark Museum, Gift of Franklin Murphy, Jr., 1926  26.2755
First exhibited in New York City in 1847 at the National Academy of Design, and then at the New-York Exhibition of the Industry of All Nations in 1853–54

Henry Kirke Brown, 1814–1886
61. *William Cullen Bryant,* 1846–47
Marble
26⅜ x 18½ x 11 in. (67 x 47 x 27.9 cm)
Inscribed on brass plaque on socle: WILLIAM CULLEN BRYANT/HENRY K. BROWN
The New-York Historical Society, Bequest of Mr. Charles M. Leupp  1860.6
Commissioned by Charles M. Leupp and exhibited at the National Academy of Design in 1849

Henry Kirke Brown, 1814–1886
62. *Thomas Cole,* 1850 or earlier
Marble
28 x 18 x 12 in. (71.1 x 45.7 x 30.5 cm)
The Metropolitan Museum of Art, New York, Gift in memory of Jonathan Sturges, by his children, 1895  95.8.1
Probably commissioned by Jonathan Sturges; exhibited at the National Academy of Design in 1850

Thomas Crawford, ca. 1813–1857
63. *Louisa Ward Crawford,* Rome, modeled 1845; carved 1846
Marble
31 x 21 x 12 in. (78.7 x 53.3 x 30.5 cm)
Signed, dated, and inscribed on back of base: SI NOMEN QVAERIS/SVM ALOYSIA/MARITVS ME SCVLPSIT/THOMA/DE NOMINE CRAWFORD/CVM NATA ET CONIVGE/IVNGIT

CARVS AMOR/DVLCES ROMA DAT/LARES/MDCCXLVII
Museum of the City of New York, Gift of James L. Terry, Peter T. Terry, Lawrence Terry, and Arthur Terry III  86.173
Exhibited at the American Art-Union in 1849 and at the New-York Exhibition of the Industry of All Nations in 1853–54

Chauncey Bradley Ives, 1810–1894
64. *Ruth,* Rome, modeled ca. 1849; carved 1851 or later
Marble
23¼ x 12½ x 9½ in. (59.1 x 31.8 x 24.1 cm)
Signed on back: C. B. IVES/FECIT.ROMÆ
Chrysler Museum of Art, Norfolk, Virginia, Gift of James H. Ricau and Museum Purchase  86.479
A version of this sculpture was exhibited at the artist's studio in Stoppani's building, 398 Broadway, in 1849; four replicas were commissioned by New Yorkers.

Joseph Mozier, 1812–1870
65. *Diana,* Florence, ca. 1850
Marble
26 x 16⅛ x 10¼ in. (66 x 41 x 26 cm)
Huguenot Historical Society, New Paltz, New York
Commissioned by the American Art-Union in 1850; awarded to Levi Hasbrouck, New Paltz, New York, at the Art-Union's annual distribution of prizes in 1850

Henry Kirke Brown, 1814–1886
66. *Filatrice,* 1850
Bronze
20 x 12 x 8 in. (50.8 x 30.5 x 20.3 cm)
The Metropolitan Museum of Art, New York, Purchase, Gifts in memory of James R. Graham, and Morris K. Jesup Fund, 1993  1993.13
Multiple casts of this figure were awarded by the American Art-Union to various recipients at its annual distribution of prizes in 1850.

John Rogers, 1829–1904
67. *The Slave Auction,* 1859
Painted plaster
13⅜ x 8 x 8¾ in. (34 x 20.3 x 22.2 cm)
Signed on top of base at center: JOHN ROGERS/NEW YORK
Inscribed: on front of base, THE SLAVE AUCTION; on rostrum, GREAT SALE/OF/HORSES CATTLE/NEGROES & OTHER/FARM STOCK/THIS DAY AT/PUBLIC AUCTION
The New-York Historical Society, Gift of Samuel V. Hoffman  1928.28
Exhibited at the National Academy of Design in 1860; examples owned by New York abolitionists Lewis Tappan and Henry Ward Beecher

John Quincy Adams Ward, 1830–1910
68. *The Indian Hunter,* modeled 1857–60; cast before 1910
Bronze
16⅛ x 10½ x 15¼ in. (41 x 26.7 x 38.7 cm)

Signed and dated on top of base, beneath
dog: J.Q.A. WARD/1860
The Metropolitan Museum of Art, New York,
Morris K. Jesup Fund, 1973 1973.257
Exhibited at the Artists' Fund Society in 1859
and at the National Academy of Design in 1862

Erastus Dow Palmer, 1817–1904

69. *The White Captive*, Albany, modeled 1857–58;
carved 1858–59
Marble
65 x 20¼ x 17 in. (165.1 x 51.4 x 43.2 cm)
Signed and dated on left side of base: E.D.
PALMER SC. 1859.
Inscribed on front of base: THE GIFT OF
HAMILTON FISH
The Metropolitan Museum of Art, New York,
Bequest of Hamilton Fish, 1894 94.9.3
Commissioned by Hamilton Fish and displayed
at the gallery of William Schaus in 1859–60

ARCHITECTURAL DRAWINGS AND
RELATED WORKS

Alexander Jackson Davis, 1803–1892, artist
Anthony Imbert, French, active in New York
City 1825–38, lithographer
Design attributed to John Vanderlyn, 1775–1852

70. *The Rotunda, Corner of Chambers and Cross
Streets,* frontispiece to *Views of the Public
Buildings in the City of New-York,* 1827
Building constructed 1818; demolished 1870
Lithograph
19½ x 15⅞ in. (49.5 x 40.3 cm)
Inscribed: Views/Prosper Desobry Scripsit./
OF/THE PUBLIC BUILDINGS/in the/City of
New-York/Correctly drawn on Stone by/A. J.
DAVIS./Printed & Published/by/A. IMBERT/
Lithographer Nº 79 Murray St./NEW-YORK
The New-York Historical Society, A. J. Davis
Collection 25

Alexander Jackson Davis, 1803–1892, artist
Anthony Imbert, French, active in New York
City 1825–38, lithographer
Martin Euclid Thompson, ca. 1786–1877,
architect

71. *Branch Bank of the United States, 15–17 Wall
Street,* from *Views of the Public Buildings in the
City of New-York,* 1827
Building constructed 1822–24; demolished
1915; facade reerected at The Metropolitan
Museum of Art, New York, 1924
Lithograph
12⅝ x 14⅞ in. (32.1 x 37.8 cm)
Inscribed: On Stone by A. J. Davis.[;] E.M.
[*sic*] Thompson Architect New York[;]
Imbert's Lithography./BRANCH BANK OF
U.S./Erected 1825,–Front 75 feet.
The Metropolitan Museum of Art, New York,
The Edward W. C. Arnold Collection of New
York Prints, Maps, and Pictures, Bequest of
Edward W. C. Arnold, 1954 54.90.672

Alexander Jackson Davis, 1803–1892, artist
Anthony Imbert, French, active in New York
City 1825–38, lithographer
Josiah R. Brady, ca. 1760–1832, architect

72. *Second Congregational (Unitarian) Church, Cor-
ner of Prince and Mercer Streets,* from *Views of
the Public Buildings in the City of New-York,* 1827
Building constructed 1826; destroyed by fire
1837
Lithograph
10¼ x 11⅞ in. (26 x 30.2 cm)
Inscribed: A. J. Davis del.[;] J. R. Brady
Architect[;] Imbert's Lithography/SECOND
CONGREGATIONAL CHURCH N. Y./Erected
1826 corner of Prince and Mercer Streets—
Front Sixty three feet.
The New-York Historical Society

Alexander Jackson Davis, 1803–1892, artist
and architect
Anthony Imbert, French, active in New York
City 1825–38, lithographer

73. *Design for Improving the Old Almshouse, North
Side of City Hall Park, Facing Chambers Street,*
1828
Building constructed 1778; destroyed by fire
1853
Lithograph
18 x 22¼ in. (45.7 x 56.5 cm)
Inscribed: DESIGN FOR IMPROVING THE OLD
ALMS-HOUSE/PARK, NEW-YORK:/BY ALEX J.
DAVIS, EXCHANGE./Imbert's Lithograph[y]
[illegible]
The Metropolitan Museum of Art, New York,
The Elisha Whittelsey Collection, The Elisha
Whittelsey Fund, 1954 54.546.9

Alexander Jackson Davis, 1803–1892, artist
Martin Euclid Thompson, ca. 1786–1877, and
Josiah R. Brady, ca. 1760–1832, architects

74. *First Merchants' Exchange, 35–37 Wall Street,
Elevation,* probably 1826
Building constructed 1825–27; destroyed in
the Great Fire of 1835
Ink and wash
8⅛ x 10½ in. (20.6 x 26.7 cm)
Signed at lower right: JR. Brady Arcᵗ
Inscribed: EXCHANGE./Drawn by Davis, 1826
[partially erased]
The Metropolitan Museum of Art, New York,
The Edward W. C. Arnold Collection of New
York Prints, Maps, and Pictures, Bequest of
Edward W. C. Arnold, 1954 54.90.137

Alexander Jackson Davis, 1803–1892, artist
Martin Euclid Thompson, ca. 1786–1877, and
Josiah R. Brady, ca. 1760–1832, architects

75. *First Merchants' Exchange, 35–37 Wall Street,
First Floor Plan,* probably 1829
Building constructed 1825–27; destroyed in
the Great Fire of 1835
Ink and wash
11¼ x 9 in. (28.6 x 22.9 cm)
Inscribed (probably later): J. R. BRADY,
ARCHITECT./MERCH'TS EXCHANGE, N.Y./
BURNT DEC. 1835

The Metropolitan Museum of Art, New York,
Harris Brisbane Dick Fund, 1924 24.66.622
(recto)

Alexander Jackson Davis, 1803–1892

76. *First Merchants' Exchange, 35–37 Wall Street,
Alternate, Unexecuted Elevation and Plan,* 1829
Building constructed 1825–27; destroyed in
the Great Fire of 1835
Ink and wash
10 x 6⅝ in. (25.4 x 16.8 cm)
Inscribed: EXCHANGE DESIGN. BY A.J. DAVIS
The Metropolitan Museum of Art, New York,
Harris Brisbane Dick Fund, 1924 24.66.621

Alexander Jackson Davis, 1803–1892, artist
Ithiel Town, 1784–1844, and Alexander
Jackson Davis, architects

77. *Park Hotel (Later Called Astor House),
Broadway between Vesey and Barclay Streets,
Proposed, Unexecuted Design,* 1830
Building constructed 1834–36; demolished
in stages in 1913 and 1926
Watercolor
20⅜ x 31½ in. (51.8 x 80 cm)
The Metropolitan Museum of Art, New York,
Harris Brisbane Dick Fund, 1924 24.66.30
Commissioned by John Jacob Astor for this
site and ultimately designed by Isaiah Rogers

Alexander Jackson Davis, 1803–1892, artist
Ithiel Town, 1784–1844, and Alexander
Jackson Davis, architects

78. *Park Hotel (Later Called Astor House), Broadway
between Vesey and Barclay Streets, Proposed,
Unexecuted Perspective and Plan,* ca. 1830
Building constructed 1834–36; demolished in
stages in 1913 and 1926
Watercolor
18¾ x 12⅝ in. (47.6 x 32.1 cm)
Inscribed (probably later): DESIGN FOR A
HOTEL, N.Y. MADE IN 1828 / BY ALEXANDER
JACKSON DAVIS
The New-York Historical Society, A. J. Davis
Collection 18

Alexander Jackson Davis, 1803–1892, artist
Ithiel Town, 1784–1844, and Alexander
Jackson Davis, architects

79. *United States Custom House, Wall and Nassau
Streets, Longitudinal Section,* 1833
Building constructed 1833–42; extant
Watercolor and ink
8½ x 14⅜ in. (21.6 x 36.5 cm)
Inscribed: A. J. Davis. del. for CUSTOM HOUSE
N.Y. LONGITUDINAL SECTION. Premium
Design./TOWN & DAVIS ARCHITECTS
Avery Architectural and Fine Arts Library,
Columbia University, New York
1940.001.00132

Alexander Jackson Davis, 1803–1892, artist
Ithiel Town, 1784–1844, and Alexander
Jackson Davis, architects

80. *United States Custom House, Wall and Nassau
Streets, Plan,* 1833

Building constructed 1833–42; extant
Watercolor
9 x 14⅜ in. (22.9 x 36.5 cm)
The Metropolitan Museum of Art, New
York, Harris Brisbane Dick Fund, 1924
24.66.1403 (45)

Alexander Jackson Davis, 1803–1892, artist
Ithiel Town, 1784–1844, and Alexander
Jackson Davis, architects

81. *United States Custom House, Wall and Nassau
Streets, Perspective*, 1834
Building constructed 1833–42; extant
Watercolor
6⅝ x 9½ in. (16.8 x 24.1 cm)
Inscribed: June 1834[;] Custom House N.
York[;] I. Town. and A. J. Davis Architects.[;]
Alex J. Davis to J. Jones, Esq.
The Metropolitan Museum of Art, New York,
The Edward W. C. Arnold Collection of New
York Prints, Maps, and Pictures, Bequest of
Edward W. C. Arnold, 1954 54.90.176

John Haviland, British, 1792–1852, active in
the United States from 1816

82. *Halls of Justice and House of Detention, Centre
Street, between Leonard and Franklin Streets,
First Floor Plan*, 1835
Building constructed 1835–38; demolished
1897
Ink
29⅜ x 17 in. (74.6 x 43.2 cm)
Inscribed: Halls of Justice/New York[;]
Principal Floor[;] John Haviland Archt./
Philadᵃ·
Royal Institute of British Architects Library,
London, Drawings Collection W14/6(2)

John Haviland, British, 1792–1852, active in
the United States from 1816

83. *Halls of Justice and House of Detention, Centre
Street, between Leonard and Franklin Streets,
Bird's-Eye View*, 1835
Building constructed 1835–38; demolished
1897
Ink and wash
23¾ x 33¾ in. (60.3 x 85.7 cm)
Inscribed: Halls of Justice/New York[;] John
Haviland Archt./Philada
Royal Institute of British Architects Library,
London, Drawings Collection W14/6(9)

Alexander Jackson Davis, 1803–1892

84. *"Syllabus Row," Proposed, Unexecuted Design
for Terrace Houses*, ca. 1830
Watercolor
18¾ x 26½ in. (47.6 x 67.3 cm)
Inscribed: SÝLLABUS RŌW.
The Metropolitan Museum of Art, New York,
The Edward W. C. Arnold Collection of New
York Prints, Maps, and Pictures, Bequest of
Edward W. C. Arnold, 1954 54.90.140

Alexander Jackson Davis, 1803–1892

85. *"Terrace Houses," Proposed, Unexecuted Design
for Cross-Block Terrace Development*, ca. 1831

Watercolor
9¾ x 26½ in. (24.8 x 67.3 cm)
The Metropolitan Museum of Art, New York,
Harris Brisbane Dick Fund, 1924 24.66.1291

John Stirewalt, artist
Alexander Jackson Davis, 1803–1892, and
Seth Geer, architects

86. *Colonnade Row, 428–434 Lafayette Street, near
Astor Place, Elevation and Plans*, 1833–34
Buildings constructed 1832–34; partly extant
(16 of 28 bays demolished 1901)
Watercolor
13⅝ x 9⅝ in. (34.6 x 24.4 cm)
Inscribed: NEAR WHAT THE LA-GRANGE
TERRACE, N.Y. OUGHT TO HAVE BEEN/
DAVIS DIREX.[;] STIREWALT DELIN.
Avery Architectural and Fine Arts Library,
Columbia University, New York
1940.001.00739

Attributed to Martin Euclid Thompson,
ca. 1786–1877

87. *Row of Houses on Chapel Street, between Murray
and Robinson Streets*, 1830
Buildings probably constructed 1830;
demolished
Watercolor and ink on paper, mounted
on board
18½ x 25¼ in. (47 x 64.1 cm) sheet
Inscribed: This is the plan and elevation of
the Houses to be erected on the/West side of
Chapel Street, between Murray & Robinson
Street, and/between Robinson Street to the
rear of the lot on the Corner of Chapel/and
Barclay Streets, and referred to in the form of
the lease annexed/to an Agreement between
the Trustees of Columbia College in the/City
of New York, by their Standing Committee,
and Gideon Tucker/and John Morss the first
day of April 1830, and to/be considered part of
the said agreement./[signed] Gideon Tucker/
John Morss/Wm Johnston Treasurer./Fronts
on west side of Chapel street.
Avery Architectural and Fine Arts Library,
Columbia University, New York Gideon
Tucker DR165

Attributed to Martin Euclid Thompson,
ca. 1786–1877

88. *House on Chapel Street, between Murray and
Robinson Streets*, 1830
Building probably constructed 1830
Watercolor
22⅞ x 18 in. (58.1 x 45.7 cm)
Inscribed: 4 feet to an inch
Avery Architectural and Fine Arts Library,
Columbia University, New York
1000.010.00013

Architect unknown
*Clarkson Lawn (Matthew Clarkson Jr. House),
Flatbush and Church Avenues, Brooklyn, New
York*, photograph, 1940
Building constructed ca. 1835; demolished
1940

Courtesy of the Brooklyn Museum of Art

89A. Door and doorframe from the entry hall of
Clarkson Lawn, ca. 1835
Mahogany; painted pine; metal
120⅛ x 72¾ x 5¼ in. (305.1 x 184.9 x 13.3 cm)
Brooklyn Museum of Art, Gift of the
Young Men's Christian Association, 1940
40.931.2A–B

89B. Pair of pilasters from the double parlor of
Clarkson Lawn (capital illustrated), ca. 1835
Painted pine
Each 129¼ x 17⅛ x 4½ in. (328.3 x 43.5 x 11.4 cm)
Brooklyn Museum of Art, Gift of the Young
Men's Christian Association, 1940 40.931.3, 4

John B. Jervis, 1795–1885, chief engineer

90. *Distributing Reservoir of the Croton Aqueduct,
Fifth Avenue between Fortieth and Forty-second
Streets*, 1837–39
Croton Aqueduct constructed 1837–42;
distributing reservoir demolished 1899–1901
Ink and watercolor
Bound in *Reports of J. B. J., Vol. II, N. Y. W. W.*
Book: 15 x 10 in. (38.1 x 25.4 cm)
Inscribed: DISTRIBUTING RESERVOIR./
Elevations of Sides Fronting on Forty-Second
Street & Fifth Avenue.
Jervis Public Library, Rome, New York

John B. Jervis, 1795–1885, chief engineer

91. *High Bridge of the Croton Aqueduct over the
Harlem River, Elevation and Plan*, ca. 1839–40
Croton Aqueduct constructed 1837–42;
bridge extant (central arches removed during
World War II)
Ink and watercolor
16¾ x 24¼ in. (42.5 x 61.6 cm)
Inscribed: Arch at A.[;] Arches at B./
Elevation of a High Bridge for Crossing
Harlaem [sic] River./Scale 32 feet to an Inch./
Plan./Scale 80 feet to an Inch.
Jervis Public Library, Rome, New York
Drawing 249
The Croton Aqueduct system became
operational in 1842, although the bridge was
not completed until 1848.

John B. Jervis, 1795–1885, chief engineer

92. *Manhattan Valley Pipe Chamber of the Croton
Aqueduct*, ca. 1839–40
Croton Aqueduct constructed 1837–42
Ink and watercolor
22⅝ x 33 in. (57.5 x 83.8 cm)
Signed and inscribed: Croton Aqueduct /
John B. Jervis / Chief Engineer / HORIZONTAL
SECTION[;] LONGITUDINAL SECTION/SCALE
5 FEET TO AN INCH[;] ELEVATION[;] SECTION
IN FRONT OF GATES[;] PLAN AND SECTION OF
NUT AND SCREW FOR/WORKING THE GATES/
SCALE IS ⅜ OF AN INCH TO AN INCH/PIPE
CHAMBER[;] MANHATTAN VALLEY/SCALE
4 FEET TO AN INCH
Library of Congress, Washington, D.C.,
Prints and Photographs Division 1997.86.1
Manhattan Valley was the area bounded today

by 100th and 110th streets, Central Park West, and Broadway.

Artist unknown
Richard Upjohn, British, 1802–1878, active in New York City from 1839, architect

93. *Trinity Church, Broadway, opposite Wall Street, Presentation Drawing Depicting View from the Southwest*, probably 1841
Building constructed 1841–46; extant
Watercolor
20¾ x 26⅜ in. (52.7 x 67 cm)
Avery Architectural and Fine Arts Library, Columbia University, New York
1000.011.01098

James Renwick Jr., 1818–1895

94. *Church of the Puritans, Union Square, Fifteenth Street and Broadway*, 1846
Building constructed 1846–47; later moved to West Fifty-seventh Street; demolished
Watercolor
30½ x 20½ in. (77.5 x 52.1 cm)
Signed at bottom right: J. Renwick Jun. Architect
The New-York Historical Society

Ferdinand Joachim Richardt, Danish, 1819–1895, active in New York City 1856–59, artist
James Renwick Jr., 1818–1895, architect

95. *Grace Church, Broadway and Tenth Street*, 1858
Building constructed 1843–46; extant
Oil on canvas
59¼ x 47¼ in. (150.5 x 120 cm)
Signed, dated, and inscribed at lower right: New York [illegible] 1858/Ferdinand Richardt
Grace Church in New York

Joseph Trench, 1810–1879, and John Butler Snook, 1815–1901

96. *A. T. Stewart Store, Broadway between Reade and Chambers Streets, Chambers Street Elevation*, 1849
Building constructed 1846; expanded 1850 and 1852; extant
Watercolor
20½ x 29¼ in. (52.1 x 74.3 cm)
Inscribed: CHAMBER STREET FRONT/ J. TRENCH & CO./ARCHITECTS/12 CHAMBER ST/N.Y.
The New-York Historical Society

James Bogardus, 1800–1874, inventor
William L. Miller, architectural-iron manufacturer

97. Spandrel panel from Edgar H. Laing Stores, Washington and Murray Streets, 1849
Building constructed 1849; demolished 1971
Cast iron
15¾ x 51 x 3¾ in. (40 x 129.5 x 9.5 cm)
The Metropolitan Museum of Art, New York, Gift of Margaret H. Tuft, 1979  1979.134

John P. Gaynor, ca. 1826–1889, architect
Daniel D. Badger, 1806–1884, architectural-iron manufacturer
Sarony, Major and Knapp, printer

98. *Haughwout Building, Broadway and Broome Street*, 1865
Plate 3 in Daniel D. Badger's *Illustrations of Iron Architecture* (New York: Baker and Godwin, 1865)
Building constructed 1856; extant
Lithograph printed in colors; book bound in original green pressed cloth
14 x 24 in. (35.6 x 61 cm) open
Inscribed: ARCHITECTURAL IRON WORKS,_ NEW-YORK.
Smithsonian Institution Libraries, Washington, D.C.  FNA 3503.7832  1865XCHRMB

Detlef Lienau, German (Ütersen, Schleswig-Holstein), 1818–1887, active in New York City from 1848

99. *Hart M. Shiff House, Fifth Avenue and Tenth Street, Front Elevation*, 1850
Building constructed 1850–52; demolished 1923
Pen and ink
16¼ x 11⅜ in. (41.3 x 28.9 cm)
Inscribed on applied label: · Hart M. Shiff, Esq. · S.W. cor., 5th Ave., & 10th St.– ·/ · D. Lienau, Archt. · 1850 ·
Avery Architectural and Fine Arts Library, Columbia University, New York
1936.002.00013

Detlef Lienau, German (Ütersen, Schleswig-Holstein), 1818–1887, active in New York City from 1848

100. *Hart M. Shiff House, Fifth Avenue and Tenth Street, Side Elevation*, 1850
Building constructed 1850–52; demolished 1923
Pen and ink
11⅜ x 16¼ in. (28.9 x 41.3 cm)
Inscribed on applied label: · Hart M. Shiff, Esq. · S.W. cor., 5th Ave., & 10th St. ·/ · D. Lienau, Archt. · 1850 ·
Avery Architectural and Fine Arts Library, Columbia University, New York
1936.002.00014

Richard Morris Hunt, 1827–1895

101. *Thomas P. Rossiter House, 11 West Thirty-eighth Street, Facade Study*, 1855
Building constructed 1855–57; demolished before 1900
Ink and wash
12⅛ x 10½ in. (30.8 x 26.7 cm)
Octagon Museum, Washington, D.C., American Architectural Foundation, Prints and Drawings Collection  81.6617
Hunt's first commission upon his return to New York in 1855 from the École des Beaux-Arts in Paris

Alexander Jackson Davis, 1803–1892

102. *Ericstan (John J. Herrick House), Tarrytown, New York, Rear Elevation*, ca. 1855
Building constructed 1855–59; demolished 1944
Watercolor, ink, and graphite

25⅝ x 30 in. (64.5 x 76.2 cm)
The Metropolitan Museum of Art, New York, Harris Brisbane Dick Fund, 1924  24.66.10

Richard Upjohn, British, 1802–1878, active in New York City from 1839

103. *Henry Evelyn Pierrepont House, 1 Pierrepont Place, Brooklyn, New York, Front Elevation and Section*, 1856
Building constructed 1856–57; demolished 1946
Ink on cloth
26¾ x 19¾ in. (67.9 x 50.2 cm)
Inscribed: Front Elevation/House for H.E. Pierrepont Esq/Richd Upjohn & Co Architects/Trinity Building/New York/ May 19th 1856
Avery Architectural and Fine Arts Library, Columbia University, New York
1985.003.00001

Charles Mettam, Irish, 1819–1897, active in New York City from 1848, and Edmund A. Burke

104. *The New-York Historical Society, Second Avenue and Eleventh Street*, 1855
Building constructed 1855–57; demolished 1920
Watercolor on paper, mounted on cloth
22½ x 31⅝ in. (57.2 x 80.3 cm)
Inscribed: Mettam & Burke/architects/ 18 City Hall Place, N. Y.
The New-York Historical Society  X.370

Peter Bonnett Wight, 1838–1925

105. *National Academy of Design, Fourth Avenue and Twenty-third Street*, 1861
Building constructed 1863–65; demolished 1899 (elements incorporated into Our Lady of Lourdes, 142nd Street between Convent and Amsterdam Avenues, 1904)
Watercolor
20⅞ x 27 in. (53 x 68.6 cm)
Signed and dated at bottom right: P.B. WIGHT, Archt/98 Broadway, N.Y.
Inscribed: ELEVATION OF THE SOUTH FRONT./ Scale ¼ INCH TO A FOOT./The original competition drawing for the Academy of Design/ which was accepted by the Council—1861.
The Art Institute of Chicago, Gift of Peter Bonnett Wight  1992.81.4

WATERCOLORS

John William Hill, 1812–1879

106. *View on the Erie Canal*, 1829
Watercolor
9¾ x 13¾ in. (24.8 x 34.9 cm)
Inscribed at lower left: Drawn by J. W. Hill 1829
The New York Public Library, Astor, Lenox and Tilden Foundations, Miriam and Ira D. Wallach Division of Art, Prints and Photographs, The Phelps Stokes Collection, Print Collection  1830–32E–29

John William Hill, 1812–1879

107. *View on the Erie Canal*, 1831
Watercolor
9⅝ x 13⅝ in. (24.4 x 34.6 cm)

Inscribed at lower right: [Drawn?] by
J. W. Hill 1831
The New York Public Library, Astor, Lenox
and Tilden Foundations, Miriam and Ira D.
Wallach Division of Art, Prints and Photo-
graphs, The Phelps Stokes Collection, Print
Collection 1830–32E–24

John William Hill, 1812–1879
108. *City Hall and Park Row,* 1830
Watercolor
9¾ x 13⅝ in. (24.8 x 34.6 cm)
Signed and dated at lower right: J. W. Hill 1830
The New York Public Library, Astor, Lenox
and Tilden Foundations, Miriam and Ira D.
Wallach Division of Art, Prints and Photo-
graphs, The Phelps Stokes Collection, Print
Collection 1830 E–81

John William Hill, 1812–1879
109. *Broadway and Trinity Church from Liberty
Street,* 1830
Watercolor
9⅝ x 13⅝ in. (24.4 x 34.6 cm)
Signed and dated at lower right: J. W. Hill 1830
The New York Public Library, Astor, Lenox
and Tilden Foundations, Miriam and Ira D.
Wallach Division of Art, Prints and Photo-
graphs, The Phelps Stokes Collection, Print
Collection 1830 E–73
Exhibited at the National Academy of Design
in 1832

Nicolino Calyo, Italian, 1799–1884, active in
the United States from the early 1830s
110. *View of the Great Fire of New York, December 16
and 17, 1835, as Seen from the Top of the New
Building of the Bank of America, Corner Wall
and William Streets,* 1836
Gouache on paper
16⅜ x 24 in. (41.6 x 61 cm)
Inscribed along bottom: Veiw [*sic*] of the
Great Fire of New-York, December 16th &
17th, 1835, was seen from the Top of the New
Building of the Bank of America corner Wall
and William Street.— —New York, Jan, 1836.—
The New-York Historical Society, Bryan
Fund 1980.53
Reproduced as an engraving by William
James Bennett in New York City in 1836

Nicolino Calyo, Italian, 1799–1884, active in
the United States from the early 1830s
111. *View of the Ruins after the Great Fire in New
York, December 16 and 17, 1835, as Seen from
Exchange Place,* 1836
Gouache on paper
16½ x 24 in. (41.9 x 61 cm)
Inscribed along bottom: View of the Ruins
after the Great Fire in New-York, Decem-
ber 16th & 17th 1835, as seen from Exchange
Place.— —New-York, Jan 1836—
The New-York Historical Society, Bryan Fund
1980.54
Reproduced as an engraving by William
James Bennett in New York City in 1836

Alexander Jackson Davis, 1803–1892
112. *Greek Revival Double Parlor,* ca. 1830
Watercolor
13¼ x 18⅛ in. (33.7 x 46 cm)
The New-York Historical Society, Gift of
Daniel Parish, Jr. 1908.28

John William Hill, 1812–1879
113. *Chancel of Trinity Chapel,* ca. 1856
Watercolor, gouache, black ink, graphite, and
gum arabic
18¾ x 14¼ in. (46.7 x 36.2 cm)
Signed at lower right: J. W. Hill
The Metropolitan Museum of Art, New York,
The Edward W. C. Arnold Collection of New
York Prints, Maps, and Pictures, Bequest of
Edward W. C. Arnold, 1954  54.90.157
Exhibited at the National Academy of
Design in 1857

PRINTS, BINDINGS, AND
ILLUSTRATED BOOKS

John Hill, British, 1770–1850, active in New
York City 1822–50, engraver
After William Guy Wall, Irish, 1792–after
1864, artist
Henry J. Megarey, publisher
114. *New York from Governors Island,* 1823–24
From *The Hudson River Portfolio* (1821–25)
Aquatint with hand coloring
14⅛ x 21⅛ in. (35.9 x 53.7 cm) image;
19⅛ x 25¾ in. (48.6 x 65.4) sheet
Inscribed: Painted by W. G. Wall[;] Engraved
by I. [J.] Hill/NEW YORK, FROM GOVERNORS
ISLAND./Nº. 20 of the Hudson River Port
Folio./Published by Henry I. [J.] Megarey
New York.
The Metropolitan Museum of Art, New York,
The Edward W. C. Arnold Collection of New
York Prints, Maps, and Pictures, Bequest of
Edward W. C. Arnold, 1954  54.90.1274.19

Asher B. Durand, 1796–1886, engraver
Durand, Perkins and Company, printer and
publisher
115. *$1,000 bill for the Greenwich Bank, City of
New York,* ca. 1828
Engraving, cancelled proof
2⅞ x 7 in. (7.3 x 17.8 cm) image; 3 x 7⅛ in.
(7.6 x 18.1 cm) sheet
The Metropolitan Museum of Art, New York,
Harris Brisbane Dick Fund, 1917  17.3.3585(14)

Asher B. Durand, 1796–1886, engraver
Durand, Perkins and Company, printer and
publisher
116. *Specimen sheet of bank note engraving,*
ca. 1828
Engraving
16⅞ x 12⅝ in. (42.9 x 32.1 cm) image;
17⅜ x 13⅛ in. (44.1 x 33.3 cm) sheet
The Metropolitan Museum of Art, New York,
Harris Brisbane Dick Fund, 1917  17.3.3585(47)

Cadwallader Colden, 1769–1834, author
Archibald Robertson, Scottish, 1765–1835,
active in New York City 1791–1821, artist
Anthony Imbert, French, active in New York
City 1825–38, printer
Wilson and Nicholls, bookbinder
117. *Memoir, Prepared at the Request of a Committee
of the Common Council of the City of New York,
and Presented to the Mayor of the City, at the
Celebration of the Completion of the New York
Canals,* 1825
Bound in red leather with gold stamping
10⅛ x 8⅜ x 1⅞ in. (25.7 x 21.3 x 4.8 cm)
Stamped on cover: PRESENTED BY THE CITY/
OF NEW YORK/TO/THE HONORABLE GIDEON
LEE/ALDERMAN OF THE 12TH WARD IN THE
YEARS/1829 & 1830/AND MAYOR OF THE/
CITY OF NEW YORK IN THE YEARS 1833 & 1834
American Antiquarian Society, Worcester,
Massachusetts
A copy of this work was presented on board the
steamboat *Washington* on November 4, 1825.

Archibald Robertson, Scottish, 1765–1835,
active in New York City 1791–1821, artist
Anthony Imbert, French, active in New York
City, 1825–38, printer
118. *Grand Canal Celebration: View of the Fleet
Preparing to Form in Line,* 1825
From Cadwallader Colden, *Memoir* (1825)
Lithograph
8½ x 40⅛ in. (21.6 x 101.9 cm)
The Metropolitan Museum of Art, New York,
Harris Brisbane Dick Fund, 1923  23.69.23

William James Bennett, British, 1784–1844,
active in New York City by 1824, artist and
engraver
Henry J. Megarey, active 1818–45, publisher
119. *South Street from Maiden Lane,* ca. 1828
From *Megarey's Street Views in the City of New-
York* (1834)
Aquatint
9½ x 13⅝ in. (24.1 x 34.6 cm) image;
13¾ x 17¾ in. (34.9 x 45.1 cm) sheet
Inscribed: Wᴹ. I. Bennett Pinxᵗ et Sculp.ᵗ/
SOUTH ST. from MAIDEN LANE./Henry I. [J.]
Megarey New York.
The Metropolitan Museum of Art, New York,
The Edward W. C. Arnold Collection of New
York Prints, Maps, and Pictures, Bequest of
Edward W. C. Arnold, 1954  54.90.1177

William James Bennett, British, 1784–1844,
active in New York City by 1824, artist and
engraver
Henry J. Megarey, active 1818–45, publisher
120. *Fulton Street and Market,* 1828–30
From *Megarey's Street Views in the City of New-
York* (1834)
Aquatint
9¼ x 13⅜ in. (23.5 x 34 cm) image; 12¾ x 18⅛ in.
(32.4 x 46 cm) sheet
Inscribed: Wᴹ I. Bennett Pinxᵗ et Sculp.ᵗ/

FULTON ST. & MARKET./Henry I. [J.]
Megarey New York.
The Metropolitan Museum of Art, New York,
Bequest of Charles Allen Munn, 1924
24.90.1276

Thomas Thompson, 1775–1852, artist, lithographer, and publisher
121. *New York Harbor from the Battery,* 1829
Lithograph with hand coloring
24¾ x 59¾ in. (151.8 x 62.9 cm) overall
Inscribed: Drawn on stone by Thoˢ Thompson.[;] Entered according to Act of Congress
May 11th. 1829. by Thoˢ Thompson, N. York.
The Metropolitan Museum of Art, New York,
The Edward W. C. Arnold Collection of New
York Prints, Maps, and Pictures, Bequest of
Edward W. C. Arnold, 1954  54.90.1182(1–3)

James Barton Longacre, 1794–1869, and
James Herring, 1794–1867, publishers
122A. *National Portrait Gallery of Distinguished
Americans,* 1833–39, vol. 3 (1836)
One volume of a four-volume set, bound in
red leather with gold stamping
10¾ x 7¼ x 1⅝ in. (27.3 x 18.4 x 4.1 cm)
The Metropolitan Museum of Art, New York,
Bequest of Charles Allen Munn, 1924
24.90.1911 (vol. 3)
Project directed by James B. Longacre,
Philadelphia, and James Herring, New York
City, under the superintendence of the American Academy of the Fine Arts

Asher B. Durand, 1796–1886, engraver
After Charles Cromwell Ingham, born Ireland, 1796–1863, artist
122B. *De Witt Clinton,* 1834
From *National Portrait Gallery of Distinguished
Americans,* vol. 2 (1835)
Engraving; volume bound in green leather with
gold stamping; ex libris Stephen van Rensselaer
4⅜ x 3½ in. (11.1 x 8.9 cm) platemark;
10¾ x 6⅞ in. (27.3 x 17.5 cm) sheet
The Metropolitan Museum of Art, New York,
Gift of John K. Howat, 1998  1998.520.2

John Hill, British, 1770–1850, active in New
York City 1822–50, engraver
After Thomas Hornor, British, active in New
York City ca. 1828–44, artist
W. Neale, printer
Joseph Stanley and Company, publisher
123. *Broadway, New York, Showing Each Building
from the Hygeian Depot Corner of Canal Street
to beyond Niblo's Garden,* 1836
Aquatint and etching with hand coloring
17⅝ x 26⅞ in. (44.8 x 68.3 cm) image;
22⅝ x 32¼ in. (57.5 x 81.9 cm) sheet
Inscribed: Drawn & Etched by T. Hornor[;]
Aquatinted by J. Hill/BROADWAY, NEW-
YORK./Shewing [*sic*] each Building from the
Hygeian Depot corner of Canal Street, to
beyond Niblo's Garden/Published by JOSEPH
STANLEY & Cº./Printed by W. Neale/Entered
according to act of Congress by Jos.h Stanley

& Co., in the Clerks Office of the Southern
District of New York/January 26, 1836
The Metropolitan Museum of Art, New York,
The Edward W. C. Arnold Collection of New
York Prints, Maps, and Pictures, Bequest of
Edward W. C. Arnold, 1954  54.90.703

David H. Burr, cartographer
J. H. Colton, publisher
S. Stiles and Company, printer
124. *Topographical Map of the City and County of
New York and the Adjacent Country: with Views
in the Border of the Principal Buildings, and
Interesting Scenery of the Island,* 1836
Engraving, first state
29⅜ x 67⅛ in. (74.6 x 170.5 cm)
Inscribed: TOPOGRAPHICAL MAP/OF THE/
City and County/of/NEW-YORK,/and the
adjacent Country:/With views in the border
of the principal Buildings, and interesting
Scenery of the Island/PUBLISHED BY J.H.
COLTON & Cº./No. 4[;] New-York[;] Spruce
St.[;] 1836./Engraved and printed/by/
S. STILES & COMPANY, New-York/Entered
according to act of Congress in the year 1836.
By J.H. Colton & Co. in the Clerks Office of
the District Court of the Southern District
of New York.
Library of Congress, Washington, D.C.,
Geography and Map Division

Asher B. Durand, 1796–1886, engraver and
publisher
After John Vanderlyn, 1775–1852, artist
A. King, printer
125. *Ariadne,* 1835
Engraving, third state, proof before letters;
printed on *chine collé*
14⅛ x 17⅞ in. (35.9 x 45.4 cm) image;
21¼ x 26⅞ in. (54 x 68.3 cm) sheet
Inscribed: Painted by J. Vanderlyn[;] Eng.
By A. B. Durand/Published by A. B. Durand
New York, Hodgson, Boys & Graves, London,
Rittner & Goussil à Paris 1835./Entered
according to act of Congress In the year 1835
by A. B. Durand in the Clerk's Office of the
District Court of the Southern District of
New York./Printed by A. King
Museum of Fine Arts, Boston, Harvey D.
Parker Collection, 1897  P12793
Owned by Henry Foster Sewall; after
Vanderlyn's *Ariadne Asleep on the Isle of Naxos*
of 1812, which was owned by Durand

Henry Heidemans, German, active in New
York City ca. 1840, lithographer
After Henry Inman, 1801–1846, artist
Endicott and Company, printer and publisher
126. *Fanny Elssler,* 1841
Lithograph
27⅞ x 22⅛ in. (70.2 x 56.2 cm) image;
34⅝ x 25⅝ in. (87.9 x 65.1 cm) sheet
Inscribed: [in ink] Deposited in the W. I.
Dist. Court Clk's Office for the/Southern
Dist. Of N.Y. this 25th Nov: 1841/[printed]
Painted from life by Henry Inman[;] Lith of

Endicott[;] Drawn on Stone by Henry Pʰ.
Heidemans/Fanny Elssler/Enterd [*sic*]
according to Act of Congress in the year 1841
by H. Inman in the Clerk's Office of the
District Court of the Southern Diᵗ of N. York
Library of Congress, Washington, D.C.,
Prints and Photographs Division

Thomas Doney, French, active in New York
City 1844–49, engraver
After George Caleb Bingham, 1811–1879, artist
American Art-Union, publisher
Powell and Company, printer
127. *The Jolly Flat Boat Men,* 1847
Mezzotint
18¾ x 24 in. (47.6 x 61 cm) image; 21½ x 26⅜ in.
(54.6 x 67 cm) sheet
Inscribed: PAINTED BY G.C. BINGHAM ESQ[;]
ENGRAVED BY T. DONEY/THE JOLLY FLAT
BOAT MEN./From the Original painting
distributed/by the American Art Union in
1847/Published exclusively for/The Members
of that Year/PRINTED BY POWELL & CO./
Entered according to Act of Congress in the
year 1847 by the American Art Union/in the
Clerk's Office of the U.S. District Court for
the Southern District of New York
The Metropolitan Museum of Art, New York,
Gertrude and Thomas Jefferson Mumford
Collection, Gift of Dorothy Quick Mayer,
1942  42.119.68
After Bingham's painting of 1846

William James Bennett, British, 1784–1844,
active in New York City by 1824, engraver
After John William Hill, 1812–1879
Lewis P. Clover, publisher
128. *New York, from Brooklyn Heights,* ca. 1836
Aquatint printed in colors with hand coloring,
first state
19⅝ x 31¾ in. (49.8 x 80.6 cm) image
Inscribed: Painted by J. W. Hill[;] Published
by L.P. CLOVER New York[;] Engraved by
W. J. Bennett/NEW YORK,/from Brooklyn
Heights / Entered according to Act of Congress
in the Year 1837 by Lewis P. Clover in the
Office of the Southern district of New York
Collection of Leonard L. Milberg

Robert Havell Jr., British, 1793–1878, active in
the United States 1839–78, artist and engraver
W. Neale, printer
Robert Havell Jr., William A. Colman, and
Ackermann and Company, publishers
129. *Panoramic View of New York (Taken from the
North River),* 1844
Aquatint with hand coloring, fifth state
8¾ x 32⅝ in. (22.2 x 82.9 cm) image;
13⅜ x 37½ in. (34 x 95.3 cm) sheet
Inscribed: Clinton Market[;] Washington
Market[;] Shad Fishing[;] Battery[;] British
Queen[;] Narrows[;] Staten Island/Drawn
& Engraved by Robᵗ Havell/PANORAMIC
VIEW OF NEW YORK./(Taken from the North
River)./Entered according to Act of Congress,
in the year 1844, by Robᵗ. Havell, in the

Clerk's office of the District Court, of the Southern District, of New York./Printed by W. Neale/Published by Rob.t Havell Sing Sing New York/and Wm. A. Colman, 203 Broadway/Ackermann & Co 96 Strand London

The Metropolitan Museum of Art, New York, The Edward W. C. Arnold Collection of New York Prints, Maps, and Pictures, Bequest of Edward W. C. Arnold, 1954  54.90.623

The Hudson River is known as the North River at its southern end.

James Smillie, 1807–1884, engraver
After Thomas Cole, born England, 1801–1848, artist

130. *The Voyage of Life: Youth,* 1849
Engraving, proof before letters
15¼ x 22¾ in. (38.7 x 57.8 cm) image;
23¼ x 29⅜ in. (59.1 x 74.6 cm) sheet
Inscribed in pencil: Artist's proof of Smillie's Voyage of Life (Youth) after Cole
Museum of Fine Arts, Boston, Harvey D. Parker Collection  P12796
Owned by Henry Foster Sewall; after Cole's painting of 1840; published by the American Art-Union

George Loring Brown, 1814–1889

131. *Cascades at Tivoli,* 1854
Etching
8¾ x 5⅞ in. (22.2 x 14.9 cm) platemark;
9⅛ x 6½ in. (23.2 x 16.5 cm) sheet
Signed: in plate, G L Brown Rome 1854; in pencil outside plate, at lower left, G L Brown
Museum of Fine Arts, Boston, Harvey D. Parker Collection  P12262
Owned by Henry Foster Sewall

Asher B. Durand, 1796–1886, artist
John Gadsby Chapman, 1808–1889, author
W. J. Widdleton, publisher

132. *A Study and a Sketch*
Frontispiece to chapter 7 of *The American Drawing-Book* (1st ed., 1847)
Reproduction (by stereotype) of wood engraving from 3d edition, 1864
12 x 9½ in. (30.5 x 24.1 cm) sheet
The Metropolitan Museum of Art, New York, Harris Brisbane Dick Fund, 1954  54.524.2

Washington Irving, 1783–1859, author
Felix Octavius Carr Darley, 1822–1888, artist and lithographer
Sarony and Major, printer

133. Plate 5, *Illustrations of "Rip Van Winkle" Designed and Etched by F. O. C. Darley for the Members of the American Art-Union,* 1848
Lithograph
8¾ x 11⅛ in. (22.2 x 28.3 cm) image;
12⅜ x 15⅛ in. (31.4 x 38.4 cm) sheet
Inscribed: Darley invent et sculp.t/Printed by Sarony & Major New York
The Metropolitan Museum of Art, New York, Gift of Mrs. Frederic F. Durand, 1933  33.39.123

Washington Irving, 1783–1859, author
Felix Octavius Carr Darley, 1822–1888, artist and lithographer
Sarony and Major, printer

134. Plate 6, *Illustrations of "The Legend of Sleepy Hollow" Designed and Etched by F. O. C. Darley for the Members of the American Art-Union,* 1849
Lithograph
8½ x 11⅛ in. (21.6 x 28.3 cm) image;
12¼ x 14⅜ in. (31.1 x 36.5 cm) sheet
Inscribed: Darley invent et sculp.t/Printed by Sarony & Major New York
The Metropolitan Museum of Art, New York, Rogers Fund, transferred from the Library, 1944  44.40.2

Henry Papprill, British, died 1896, active in New York City 1846–50, engraver
After John William Hill, 1812–1879, artist
Henry J. Megarey, publisher

135. *New York from the Steeple of Saint Paul's Church, Looking East, South, and West,* ca. 1848
Aquatint printed in colors with hand coloring, second state
21¼ x 36⅝ in. (54 x 93 cm) image; 25¼ x 38⅜ in. (64.1 x 97.5 cm) sheet
Inscribed: Drawing by J. W. Hill[;] Entered according to Act of Congress in the year 1849 by Henry I. [J.] Megarey, in the Clerks office of the District Court of the Southern District of New York.[;] Eng-d by Henry Papprill/[on seal] H. I. [J.] MEGAREY/PUB./NEW YORK/ NEW YORK/from the steeple of St. Paul's Church Looking East, South and West./Proof
The Metropolitan Museum of Art, New York, The Edward W. C. Arnold Collection of New York Prints, Maps, and Pictures, Bequest of Edward W. C. Arnold, 1954  54.90.587
The correct name for Saint Paul's Church was, and remains, Saint Paul's Chapel (built 1764–66); the Chapel is located on Broadway between Fulton and Vesey streets.

John F. Harrison, cartographer
Kollner, Camp and Company, Philadelphia, printer
Matthew Dripps, publisher

136. *Map of the City of New York, Extending Northward to Fiftieth Street,* 1851
Lithograph with hand coloring
78½ x 37¼ in. (199.4 x 94.6 cm) sheet (mounted on original rollers)
Inscribed: MAP OF THE CITY/OF/ NEW-YORK/EXTENDING NORTHWARD/TO FIFTIETH ST./ SURVEYED AND DRAWN BY JOHN F. HARRISON C. E./PUBLD BY M. DRIPPS, NO 403 FULTON STREET/N.Y./1851./Engraved and printed at Kollner, Camp, and Co.'s Lith c Establishment, Phil a
Collection of Mark D. Tomasko

Washington Irving, 1783–1859, author, under the pseudonym Diedrich Knickerbocker
George P. Putnam, publisher

137. *A History of New-York from the Beginning of the World to the End of the Dutch Dynasty* (1st ed., 1809), 1850 edition

Bound in black leather with gold stamping and rose-and-gold inset depicting silhouette of "William the Testy"
8¾ x 6½ x 1⅝ in. (22.2 x 16.5 x 4.1 cm)
American Antiquarian Society, Worcester, Massachusetts, Papantonio Collection

Alfred Ashley, artist and designer
W. H. Swepstone, author
Stringer and Townsend, publisher

138. *Christmas Shadows, a Tale of the Poor Needle Woman with Numerous Illustrations on Steel,* New York and London, 1850
Bound in blue cloth with gold stamping
7⅜ x 5¼ x ⅞ in. (18.7 x 13.3 x 2.2 cm)
Inscribed in ink on the flyleaf: Mademoiselle/ E. Barker/100. Exemptions/C. Reichard/ 24 Juillet 1850
Collection of Jock Elliott

Edward Walker and Sons, active 1835–72, bookbinder

139. *The Odd-Fellows Offering,* 1851
Bound in red leather with gold stamping
8⅜ x 5⅞ x 1¼ in. (22.2 x 14.9 x 3.2 cm)
American Antiquarian Society, Worcester, Massachusetts, Kenneth G. Leach Collection

Samuel Hueston, publisher

140. *The Knickerbocker Gallery,* 1855
Bound in red leather with gold stamped inset of Sunnyside, Washington Irving's home
9¼ x 7 x 2¼ in. (23.5 x 17.8 x 5.7 cm)
American Antiquarian Society, Worcester, Massachusetts, Papantonio Collection B, Copy 3

John Bachmann, German, active in New York City 1849–85, artist, printer, and publisher

141. *Bird's-Eye View of the New York Crystal Palace and Environs,* 1853
Lithograph printed in colors with hand coloring
21 x 31 in. (53.3 x 78.7 cm) image; 25½ x 33¾ in. (64.8 x 85.7 cm) sheet
Inscribed: DRAWN FROM NATURE[;] Entered According to Act of Congress in the Year 1853. by J. Bachman, in the Clerk's Office of the District Court of the Southn Distt of N.Y.[;] & ON STONE BY J. BACHMAN./BIRDS EYE VIEW OF THE/NEW YORK CRYSTAL PALACE./ and Environs.
Museum of the City of New York, The J. Clarence Davies Collection  29.100.2387

Charles Parsons, 1821–1910, artist and lithographer
Endicott and Company, printer
George S. Appleton, publisher

142. *An Interior View of the Crystal Palace,* 1853
Lithograph printed in colors
13½ x 20⅜ in. (34.3 x 51.8 cm) image;
16⅜ x 23 in. (41.6 x 58.4 cm) sheet
Inscribed: C. Parsons, Del and lith.[;] Printed by Endicott & Co. N.Y./AN INTERIOR VIEW OF THE CRYSTAL PALACE. / New York, Published by Geo. S. Appleton, 356 Broadway

N. Y./Entered according to Act of Congress in the year 1853 by Geo. S. Appleton, in the Clerks Office of the district Court of the Southern district of N.Y.
The Metropolitan Museum of Art, New York, The Edward W. C. Arnold Collection of New York Prints, Maps, and Pictures, Bequest of Edward W. C. Arnold, 1954 54.90.1047

William Wellstood, 1819–1900, engraver
After Benjamin F. Smith Jr., 1830–1927, artist
Smith, Fern and Company, publisher
143. *New York, 1855, from the Latting Observatory,* 1855
Engraving with hand coloring
29⅜ x 46⅛ in. (74.6 x 117 cm) image
Inscribed: NEW YORK, 1855./B. F. SMITH, JUN. DEL. W. WELLSTOOD, SC. RESPECTFULLY DEDICATED TO THE CITIZENS OF THE UNITED STATES BY THE PUBLISHERS, SMITH, FERN, & CO. 340 BROADWAY NEW YORK. ENTERED ACCORDING TO ACT OF CONGRESS IN THE YEAR 1855 BY SMITH, FERN & CO. IN THE CLERK'S OFFICE OF THE DISTRICT COURT OF THE UNITED STATES FOR THE SOUTHERN DISTRICT OF NEW YORK.
The New York Public Library, Astor, Lenox and Tilden Foundations, Miriam and Ira D. Wallach Division of Art, Prints and Photographs, The Phelps Stokes Collection, Print Collection 1855–E–138

Thomas Benecke, active in New York City 1855–56, artist
Nagel and Lewis, printer
Emil Seitz, publisher
144. *Sleighing in New York,* 1855
Lithograph printed in colors with hand coloring
21½ x 30⅜ in. (54.4 x 77 cm) image;
27⅞ x 36¼ in. (69.6 x 92 cm) sheet
Signed in stone at lower left: T. Benecke, N.Y.
Inscribed: Composed & lith. by TH. BENECKE[;] Entered according to Act of Congress, in the Year 1855, by L. NAGEL in the Clerks Office of the Dist. Court of the Southern Dist. of New York.[;] Printed by NAGEL & LEWIS, 122 Fulton St. N.Y./SLEIGHING IN NEW YORK./Published by EMIL SEITZ/413 Broadway N.Y.
The Metropolitan Museum of Art, New York, The Edward W. C. Arnold Collection of New York Prints, Maps, and Pictures, Bequest of Edward W. C. Arnold, 1954 54.90.1061

John Bachmann, German, active in New York City 1849–85, artist
Adam Weingartner, active in New York City 1849–56, printer
L. W. Schmidt, publisher
145. *The Empire City,* 1855
Lithograph printed in colors with hand coloring
22⅝ x 33½ in. (57.5 x 85.2 cm) image;
28⅜ x 38¼ in. (72 x 97.1 cm) sheet
Inscribed: Drawn from nature & on stone by

J. Bachmann.[;] Entered according to act of Congress in the year 1855 by J. Bachmann, in the Clerk's Office of the District Court of the South-n District of NY.[;] Print of A. Weingartner's Lith-y N.Y./THE EMPIRE CITY,/Birdseye view of NEW-YORK and Environs./Published by J. Bachmann, 134 Spring St. & 143 Fulton St. New-York
The Metropolitan Museum of Art, New York, The Edward W. C. Arnold Collection of New York Prints, Maps, and Pictures, Bequest of Edward W. C. Arnold, 1954 54.90.1198

Walt Whitman, 1819–1892, author
146A. *Leaves of Grass* (1st ed.), Brooklyn, New York, 1855
Bound in dark green cloth with title stamped in gold
11⅜ x 8⅛ x ½ in. (28.9 x 20.6 x 1.3 cm)
Contains Whitman's own transcription of the letter Ralph Waldo Emerson wrote to him after receiving a copy from Whitman

Samuel Hollyer, 1826–1919, engraver
After a daguerreotype by Gabriel Harrison
146B. *Walt Whitman,* 1855
Frontispiece from *Leaves of Grass* (1855)
Engraving
2⅛ x 2 in. (5.4 x 5.1 cm)
Columbia University, New York, Rare Book and Manuscript Library, Solton and Julia Engel Collection

John Gadsby Chapman, 1808–1889
147. *Italian Goatherd,* 1857
Etching
7¼ x 4⅝ in. (18.4 x 11.7 cm) image;
17⅝ x 12½ in. (44.8 x 31.8 cm) sheet
Signed and dated in graphite at lower left:
J. Chapman fect Rome 1857
Museum of Fine Arts, Boston, Gift of Sylvester Rosa Koehler K858

Jean-Baptiste-Adolphe Lafosse, French, 1810–1879, lithographer
After William Sidney Mount, 1807–1868, artist
François Delarue, French, printer
William Schaus, publisher
148. *The Bone Player,* 1857
Lithograph with hand coloring
25 x 19¾ in. (63.5 x 50.2 cm) image;
32 x 24¼ in. (81.3 x 61.6 cm) sheet
Signed in stone: Lafosse
Inscribed: Painted by WM. S. MOUNT[;] Entered according to Act of Congress in the year 1857, by W. Schaus, in the clerk's Office of the district Court of the United States for the Southern district of New-York[;] Lith. by LAFOSSE./The Bone Player./New-York, pubd. by W. SCHAUS, 629 Broadway[;] Imp. Fois Delarue, Paris
The Metropolitan Museum of Art, New York, Purchase, Leonard L. Milberg Gift, 1998 1998.416
After Mount's painting of 1856

Julius Bien, German (Kassel, Hesse-Kassel), 1826–1909, active in the United States from 1849, lithographer
After John James Audubon, French, born Haiti, 1785–1851, active in the United States 1806–51, artist, and Robert Havell Jr., British, 1793–1878, active in the United States 1839–78, engraver
149. *Wild Turkey,* 1858
Lithograph printed in colors
40 x 27 in. (101.6 x 68.6 cm)
Inscribed: No. 1-1[;] PLATE 287./Drawn from Nature by J. J. Audubon, F.R.S. F.L.S.[;] Wild Turkey MELEAGRIS GALLOPAVO Linn, Male. American Cane Miegea macrosperma[;] chromolith-y. by J. Bien, New York, 1858.
Brooklyn Museum of Art X633.3

John Bachmann, German, active in New York City 1849–85, artist, lithographer, and publisher
C. Fatzer, printer
150. *New York City and Environs,* 1859
Lithograph printed in colors
Diam. 21¾ in. (55.2 cm)
Inscribed: NEW-YORK & ENVIRONS.[;] ASTORIA.[;] GREENPOINT.[;] WILLIAMS-BURG.[;] NAVY YARD.[;] BROOKLYN.[;] CONEY ISLAND.[;] GREENWOOD CEMETERY.[;] FORT LAFAYETTE.[;] FORT RICHMOND.[;] SANDY HOOK.[;] STATEN ISLAND.[;] GOVERNOR'S [*sic*] ISLAND.[;] AMBOY.[;] ELIZABETH PORT.[;] ELIZABETH TOWN.[;] MILLVILLE.[;] ORANGE.[;] BERGEN.[;] NEWARK.[;] BELLVILLE [*sic*].[;] JERSEY CITY.[;] PATERSON.[;] HOBOCKEN[*sic*].[;] HARLEM./Drawn from Nature on Stone by BACHMAN./Publihed [*sic*] by Bachman No. 73 Nassau St NY/Entered according to act of Congress in the year 1859, by H Bachman in the clerk's office of the district Court of the United States of the Southern district of N.Y./Printed by C. FATZER 216 William St. N.Y.
Museum of the City of New York, Gift of James Duane Taylor, 1931 31.24

DeWitt Clinton Hitchcock, active 1845–79, artist
Hy. J. Crate, printer
151. *Central Park, Looking South from the Observatory,* 1859
Lithograph printed in colors with hand coloring
16 x 26 in. (40.6 x 65.9 cm) image;
20⅜ x 28½ in. (51.8 x 72.4 cm) sheet
Inscribed: Printed in Oil Colors by Hy. J. Crate 181 William St. N.Y./Entered according to Act of Congress in the year 1859 by D. C. Hitchcock & Co. in the Clerk's Office of the District Court of the Southern District of N.Y./CENTRAL PARK./NEW YORK CITY/Looking South from the Observatory.
Museum of the City of New York, The J. Clarence Davies Collection 29.100.2299

Arthur Lumley, Irish, active in the United
States ca. 1837–1912, artist
W. R. C. Clark and Meeker, publisher

152. *The Empire City, New York, Presented to the
Subscribers to "The History of the City of New
York,"* 1859
Wood engraving and lithograph printed
in colors
24⅝ x 35⅝ in. (62.5 x 90.5 cm) image;
27 x 38⅜ in. (68.6 x 97.5 cm) sheet
Inscribed: PRESENTED TO THE SUBSCRIBERS
TO THE HISTORY OF THE CITY OF NEW-
YORK,/ BY THE PUBLISHERS, W.R.C. CLARK &
MEEKER, 19 WALKER STREET, NEW-YORK./
Entered according to act of Congress, in the
year 1859, by W.R.C. CLARK & MEEKER, in
the Clerk's Office of District Court for the
Southern District of New-York./ Printed by
S. Booth, 109 Nassau Street, New York.
The New-York Historical Society

Charles Parsons, 1821–1910, artist
Currier and Ives, active 1857–1907, printer
and publisher

153. *Central Park, Winter: The Skating Pond,* ca. 1861
Lithograph with hand coloring
18⅛ x 26⅝ in. (46 x 67.6 cm) image;
21⅞ x 29⅞ in. (55.6 x 75.9 cm) sheet
Signed in stone at lower right: LWA
Inscribed: CURRIER & IVES, LITH. N.Y./
ENTERED ACCORDING TO ACT OF CONGRESS
IN THE YEAR 1862, IN THE CLERK'S OFFICE
OF THE DISTRICT COURT OF THE UNITED
STATES, FOR THE SOUTHERN DISTRICT OF
NEW YORK./ C. PARSONS, DEL./ CENTRAL-
PARK, WINTER./ THE SKATING POND./ NEW
YORK, PUBLISHED BY CURRIER & IVES,
152 NASSAU ST.
The Metropolitan Museum of Art, New York,
Bequest of Adele S. Colgate, 1962 63.550.266

FOREIGN PRINTS

Rembrandt van Rijn, Dutch, 1606–1669

154. *Saint Jerome Reading in a Landscape,* ca. 1654
Etching, drypoint, and engraving, second state
10⅛ x 8¼ in. (25.7 x 21 cm) sheet trimmed
to platemark
Museum of Fine Arts, Boston, Harvey D.
Parker Collection P496
Owned by Henry Foster Sewall

Carlo Lossi, Italian, engraver
After Tiziano Vecelli (Titian), Italian,
1485–1576

155. *Bacchus and Ariadne,* 1774
Etching and engraving
12⅜ x 15¾ in. (31.4 x 40 cm) platemark;
15⅜ x 20 in. (39.1 x 50.8 cm) sheet
Inscribed: AL ILL mo SIG re DON FABIO DELLA
CORGNA/ Titianus inven: Gio Andrea Podesta
Genovese D.D. la presente sua opera/ Supe-
riorum licentia[;] In Roma presso Carlo
Lossi 1774
The New-York Historical Society 1858.92.043
Owned by Luman Reed

William Sharp, British, 1749–1824, engraver
After Benjamin West, 1738–1820, artist
John Boydell, 1719–1804, and Josiah Boydell,
1752–1818, London, publisher

156. *Act 3, Scene 4, from William Shakespeare's
"King Lear,"* 1793
Engraving
17⅞ x 23¼ in. (44.2 x 59.2 cm) image;
19¼ x 24½ in. (48.9 x 62.1 cm) sheet
Inscribed: Painted by B. West Esqr. R. A./ &
Presidt. of the Royal Academy/ Engrav'd by
W. Sharp/ SHAKSPEARE./ King Lear./ Act III.
Scene IV/ Publish'd March 25, 1793, by JOHN
& JOSIAH BOYDELL, at the Shakspeare Gallery,
Pall Mall, & No. 90, Cheapside London./
— Off, off you lendings:/ Come; unbutton
here. — /[Tearing off his clothes.
The Metropolitan Museum of Art, New York,
Gift of Georgiana W. Sargent, in memory of
John Osborne Sargent, 1924 24.63.1869
After West's painting of 1788, which was
commissioned by John and Josiah Boydell
and subsequently owned by Robert Fulton

John Burnet, British, 1784–1868, engraver
After David Wilkie, British, 1785–1841, artist
Josiah Boydell, 1752–1818, London, publisher

157. *The Blind Fiddler,* 1811
Engraving
16 x 21⅝ in. (40.6 x 54.9 cm) image;
22⅝ x 30⅛ in. (57.5 x 76.5 cm) sheet
Inscribed: The Blind Fiddler/ To Sir George
Beaumont Bart/ Whose superior Judgement
& Liberality have led/ him to appreciate &
encourage early &/ extraordinary merit[;]
This Plate, from a Picture painted for him by
Mr. D. Wilkie, is respectfully dedicated by
his obliged & obedt Servt/ Josiah Boydell/
Published 1st Oct 1811 by Messrs Boydell &
Co./ 90 Cheapside London.
The New York Public Library, Astor, Lenox
and Tilden Foundations, Miriam and Ira D.
Wallach Division of Art, Prints and Photo-
graphs, Print Collection
After Wilkie's painting of 1806

Alphonse François, French, 1814–1882,
engraver
After Paul Delaroche, French, 1797–1856, artist

158. *Napoleon Crossing the Alps,* 1852
Engraving, proof
24⅞ x 19 in. (63.2 x 48.3 cm) image;
31¼ x 24⅜ in. (79.4 x 61.9 cm) sheet
Inscribed: PEINT PAR PAUL DELAROCHE./
London_ Published October 1st 1852, by P. &
D. Colnaghi & Co, 13 & 14, Pall Mall East/
GRAVÉ PAR ALPHse FRANÇOIS/ Berlin-Verlag
von Goupil & Cic/ Publié par Goupil & Cie
Paris—London—New York/ Imprimerie de
Goupil & Cie
The Metropolitan Museum of Art, New York,
The Elisha Whittelsey Collection, The Elisha
Whittelsey Fund, 1949 49.40.177
After Delaroche's acclaimed painting of 1848;
exhibited by Goupil that year at the National
Academy of Design and purchased by Wood-
bury Langdon in 1850

Charles Mottram, engraver
After John Martin, British, 1789–1854, artist
William, Stevens and Williams, publisher

159. *The Plains of Heaven,* 1855
Mezzotint, proof before letters
24¼ x 37½ in. (61.6 x 95.3 cm) image;
28⅝ x 43½ in. (72.7 x 110.5 cm) sheet
Embossed stamp at lower left: Printsellers
Association YOR
The New York Public Library, Astor, Lenox
and Tilden Foundations, Miriam and Ira D.
Wallach Division of Art, Prints and Photo-
graphs, Print Collection
After Martin's painting of 1851–53, which
inspired Frederic E. Church's *Niagara Falls*
and *The Heart of the Andes*

PHOTOGRAPHY

Samuel F. B. Morse, 1791–1872

160. *Young Man,* 1840
Daguerreotype
Ninth plate, 2½ x 2 in. (6.4 x 5.1 cm)
Stamped on brass mat: SFB MORSE
Gilman Paper Company Collection, New
York
The earliest, and only, surviving daguerreo-
type by Morse

Mathew B. Brady, 1823/24–1896

161. *Thomas Cole,* 1844–48
Daguerreotype
Half plate, 5½ x 4¼ in. (14 x 10.8 cm)
National Portrait Gallery, Smithsonian
Institution, Washington, D.C., Gift of Edith
Cole Silberstein NPG.76.11
Owned by Thomas Cole

Artist unknown

162. *Asher B. Durand,* ca. 1854
Daguerreotype
Half plate, 5½ x 4¼ in. (14 x 10.8 cm)
The New-York Historical Society
PR-012-2-80
Owned by Nora Durand Woodman

Attributed to Gabriel Harrison, 1818–1902

163. *Walt Whitman,* ca. 1854
Daguerreotype
Quarter plate, 4¼ x 3¼ in. (10.8 x 8.3 cm)
The New York Public Library, Astor, Lenox
and Tilden Foundations, Rare Books
Division

Mathew B. Brady, 1823/24–1896

164. *John James Audubon,* 1847–48
Daguerreotype
Half plate, 5½ x 4¼ in. (14 x 10.8 cm)
Cincinnati Art Museum, Centennial Gift of
Mr. and Mrs. Frank Shaffer, Jr. 1981.144,
1982.268

Francis D'Avignon, French, 1813–1861, active in the United States 1840–60, lithographer
After a daguerreotype by Mathew B. Brady, 1823/24–1896

165A. *John James Audubon,* 1850
From *The Gallery of Illustrious Americans* (1850)
Lithograph
11⅛ x 9⅝ in. (28.3 x 24.4 cm) image; 18⅞ x 13⅜ in. (47.9 x 34 cm) sheet
The Metropolitan Museum of Art, New York, Bequest of Charles Allen Munn, 1924
24.90.576

C. Edwards Lester, editor
Francis D'Avignon, French, 1813–1861, active in the United States 1840–60, lithographer
After Mathew Brady, 1823/24–1896, daguerreotypist
Brady, D'Avignon and Company, publisher

165B. *The Gallery of Illustrious Americans, Containing the Portraits and Biographical Sketches of Twenty-four of the Most Eminent Citizens of the American Republic, since the Death of Washington. From Daguerreotypes by Brady, Engraved by D'Avignon,* 1850
Bound in blue cloth with gold stamping
21¾ x 15½ x ¾ in. (55.2 x 39.4 x 1.9 cm)
The Metropolitan Museum of Art, New York, Bequest of Charles Allen Munn, 1924
24.90.1966

Mathew B. Brady, 1823/24–1896

166. *Jenny Lind,* 1852
Daguerreotype
Sixth plate, 3¼ x 2¾ in. (8.3 x 7 cm)
Chrysler Museum of Art, Norfolk, Virginia, Museum Purchase and gift of Kathryn K. Porter and Charles and Judy Hudson 89.75

Jeremiah Gurney, 1812–after 1886

167. *Mrs. Edward Cooper and Son Peter (Pierre) Who Died,* 1858–60
Daguerreotype
Half plate, 5½ x 4¼ in. (14 x 10.8 cm)
Stamped on brass mat: J. GURNEY[;] 707 BROADWAY N.Y.
The New-York Historical Society
PR-012-2-811

Attributed to Samuel Root, 1819–1889, or Marcus Aurelius Root, 1808–1888

168. *P. T. Barnum and Charles Stratton ("Tom Thumb"),* 1843–50
Daguerreotype
Half plate, 5½ x 4¼ in. (14 x 10.8 cm)
National Portrait Gallery, Smithsonian Institution, Washington, D.C. NPG.93.254

Gabriel Harrison, 1818–1902

169. *California News,* 1850–51
Daguerreotype
Half plate, 5½ x 4¼ in. (14 x 10.8 cm)
Gilman Paper Company Collection, New York

Mathew B. Brady, 1823/24–1896

170. *The Hurlbutt Boys,* ca. 1850
Daguerreotype
Half plate, 5½ x 4¼ in. (14 x 10.8 cm)

Stamped on velvet case lining: BRADY'S GALLERY/205 & 207/BROADWAY, NEW-YORK
The New-York Historical Society

Mathew B. Brady, 1823/24–1896

171. *Young Boy,* 1850–54
Daguerreotype
Half plate, 5½ x 4¼ in. (14 x 10.8 cm)
Stamped on velvet case lining: BRADY'S GALLERY/205 & 207/BROADWAY, NEW-YORK
Hallmark Photographic Collection, Hallmark Cards, Inc., Kansas City, Missouri
P5.428.013.98

Jeremiah Gurney, 1812–after 1886

172. *The Kellogg-Comstock Family,* 1852–58
Daguerreotype
Whole plate, 6½ x 8½ in. (16.5 x 21.6 cm)
Stamped on brass mat: J. GURNEY[;] 349 BROADWAY
The New-York Historical Society

Artist unknown

173. *Brooklyn Grocery Boy with Parcel,* 1850s
Daguerreotype
Sixth plate, 3¼ x 2¾ in. (8.3 x 7 cm)
Hallmark Photographic Collection, Hallmark Cards, Inc., Kansas City, Missouri
P5.400.053.96

Jeremiah Gurney, 1812–after 1886

174. *Young Girl,* 1858–60
Daguerreotype
Sixth plate, 3¼ x 2¾ in. (8.3 x 7 cm)
Stamped on brass mat: J. GURNEY[;] 707 BROADWAY N.Y.
Hallmark Photographic Collection, Hallmark Cards, Inc., Kansas City, Missouri
P5.424.005.97

Artist unknown

175. *Blind Man and His Reader Holding the "New York Herald,"* 1840s
Daguerreotype
Quarter plate, 4¼ x 3¼ in. (10.8 x 8.3 cm)
Gilman Paper Company Collection, New York

Jeremiah Gurney, 1812–after 1886

176. *A Fireman with His Horn,* ca. 1857
Daguerreotype
Quarter plate, 4¼ x 3¼ in. (10.8 x 8.3 cm)
Stamped on brass mat: J. GURNEY[;] 349 BROADWAY
Collection of Matthew R. Isenburg

Attributed to Charles DeForest Fredricks, 1823–1894

177. *Amos Leeds, Confidence Operator,* ca. 1860
Salted paper print from glass negative
8 x 6 in. (20.3 x 15.2 cm)
Inscribed in ink on mount at lower right: Amos Leeds Confidence operator/Alias "Morrison"—/"Comstock"
Hallmark Photographic Collection, Hallmark Cards, Inc., Kansas City, Missouri
P5.390.003.97

Artist unknown

178. *Chatham Square, New York,* 1853–55
Daguerreotype
Half plate, 4¼ x 5½ in. (10.8 x 14 cm)
Inscribed on paper label attached to verso: Chat., Sq./NEW York
Gilman Paper Company Collection, New York

Artist unknown

179. *Interior View of the Crystal Palace Exhibition,* 1853–54
Daguerreotype
Sixth plate, 2¾ x 3¼ in. (7 x 8.3 cm)
The New-York Historical Society

Artist unknown

180. *The New Paving on Broadway, between Franklin and Leonard Streets,* 1850–52
Stereo daguerreotype (left panel illustrated)
3⅛ x 7 in. (7.9 x 17.8 cm) overall
Collection of Matthew R. Isenburg

William Langenheim, born Germany, 1807–1874, and Frederick Langenheim, born Germany, 1809–1879

181. *New York City and Vicinity, View from Peter Cooper's Institute toward Astor Place,* ca. 1856
Stereograph glass positive
3¼ x 6⅞ in. (8.3 x 17.5 cm)
Inscribed on glass mount (not illustrated): NEW YORK CITY & VICINITY/View from Peter Cooper's Institute/towards Astor Place/LANGENHEIM'S PATENT, NOV. 19, 1850/Entered according to Act of Congress in the year 1856, by F. Langenheim, in the Clerk's Office of the District Court for the Eastern District of Pennsylvania
The New York Public Library, Astor, Lenox and Tilden Foundations, Miriam and Ira D. Wallach Division of Art, Prints and Photographs, Robert N. Dennis Collection of Stereoscopic Views

Victor Prevost, French, 1820–1881, active in the United States late 1840s–1850s

182. *Battery Place, Looking North,* 1854
Waxed paper negative
9 x 12⅝ in. (22.9 x 32.1 cm)
The New-York Historical Society

Victor Prevost, French, 1820–1881, active in the United States late 1840s–1850s

183. *Looking North toward Madison Square from Rear Window of Prevost's Apartment at 28 East Twenty-eighth Street, Summer,* 1854
Waxed paper negative
13¼ x 10¼ in. (33.7 x 26 cm)
The New-York Historical Society

Victor Prevost, French, 1820–1881, active in the United States late 1840s–1850s

184. *Looking North toward Madison Square from Rear Window of Prevost's Apartment at 28 East Twenty-eighth Street, Winter,* 1854
Waxed paper negative
13⅜ x 10¼ in. (34 x 26 cm)
The New-York Historical Society

Attributed to Silas A. Holmes, 1820–1886, or
Charles DeForest Fredricks, 1823–1894

185. *View down Fifth Avenue,* ca. 1855
Salted paper print from glass negative
12¾ x 15¾ in. (32.4 x 40 cm)
Inscribed in pencil on mount: 5ᵗʰ avenue
New York & St. Germain Hotel–New York[;]
Holmes ou Fredricks; on printed paper label,
collection/Marguerite Milhau/Paris
The J. Paul Getty Museum, Los Angeles
84.XM.351.10

Attributed to Silas A. Holmes, 1820–1886, or
Charles DeForest Fredricks, 1823–1894

186. *City Hall, New York,* ca. 1855
Salted paper print from glass negative
11½ x 16⅜ in. (29.2 x 41.6 cm)
Inscribed in pencil on mount: City Hall
NY[;] Holmes?
The J. Paul Getty Museum, Los Angeles
84.XM.351.9

Attributed to Silas A. Holmes, 1820–1886, or
Charles DeForest Fredricks, 1823–1894

187. *Washington Square Park Fountain with
Pedestrians,* ca. 1855
Salted paper print from glass negative
11⅝ x 16⅛ in. (29.5 x 41 cm)
Inscribed in pencil on mount: on recto,
Wasingtton [*sic*] Park[;] Fredricks? Holmes?[;]
[erased] phot. Americain, calotype vers 1850;
on verso, col. M[arguerite] M[ilhau]
The J. Paul Getty Museum, Los Angeles
84.XM.351.16

Attributed to Silas A. Holmes, 1820–1886, or
Charles DeForest Fredricks, 1823–1894

188. *Washington Monument, at Fourteenth Street
and Union Square,* ca. 1855
Salted paper print from glass negative
12¼ x 15⅞ in. (31.1 x 40.3 cm)
Inscribed in pencil on mount: on recto,
14ᵗʰ street a Union Square N.Y. vers 1853
Holmes? Fredricks?; on verso, 6730/30150
dans 9 x 14 del.[;] col. M[arguerite] M[ilhau]
The J. Paul Getty Museum, Los Angeles
84.XM.351.12

Attributed to Silas A. Holmes, 1820–1886, or
Charles DeForest Fredricks, 1823–1894

189. *Palisades, Hudson River, Yonkers Docks,* ca. 1855
Salted paper print from glass negative
11½ x 15¼ in. (29.2 x 38.6 cm)
Inscribed in pencil on mount: on recto,
Palisades, Hudson River, Yonkers Docks,
[illegible][;] [erased] vers 1855[;] Fredricks
ou Holmes[;] calotype/collection André
Jammes; on verso, col. M[arguerite] M[ilhau]
The J. Paul Getty Museum, Los Angeles
84.XM.351.1

Attributed to Silas A. Holmes, 1820–1886, or
Charles DeForest Fredricks, 1823–1894

190. *Fort Hamilton and Long Island,* ca. 1855
Salted paper print from glass negative
11¼ x 15½ in. (28.6 x 39.4 cm)

Inscribed in pencil on mount: Fort Hamilton
& Long Island[;] Fredricks ou Holmes?
The J. Paul Getty Museum, Los Angeles
84.XM.351.7

Attributed to Silas A. Holmes, 1820–1886, or
Charles DeForest Fredricks, 1823–1894

191. *Fort Hamilton and Long Island,* ca. 1855
Salted paper print from glass negative
11 x 15⅜ in. (27.8 x 39.2 cm)
Inscribed in pencil on mount: on recto,
Narrows entrée de la Baie de New York[;]
Holmes? Fredricks?[;] [erased] calotype; on
verso, col. M[arguerite] M[ilhau]
The J. Paul Getty Museum, Los Angeles
84.XM.351.14

Frederick Law Olmsted, 1822/23–1903, and
Calvert Vaux, 1824–1895, designers
Mathew B. Brady, 1823/24–1896, photographer
Calvert Vaux, artist

192. *"Greensward" Plan for Central Park, No. 4:
From Point D, Looking Northeast across a
Landscape Depicting Belvedere Castle, Lake,
Gondola, and Gazebo,* 1857
Lithograph, albumen silver print from glass
negative, and oil on paper, mounted on board
28⅝ x 21⅛ in. (72.7 x 53.6 cm)
Municipal Archives, Department of Records
and Information Services, City of New York
DPR 3084

Frederick Law Olmsted, 1822/23–1903, and
Calvert Vaux, 1824–1895, designers
Mathew B. Brady, 1823/24–1896, photographer
Calvert Vaux, artist

193. *"Greensward" Plan for Central Park, No. 5:
From Point E, Looking Southwest,* 1857
Lithograph, albumen silver print from glass
negative, and oil on paper, mounted on board
28⅝ x 21½ in. (72.7 x 54.5 cm)
Municipal Archives, Department of Records
and Information Services, City of New York
DPR 3085

Attributed to Charles DeForest Fredricks,
1823–1894

194. *Fredricks's Photographic Temple of Art, New York,*
1857–60
Salted paper print from glass negative
16⅛ x 13⅞ in. (41 x 35.2 cm)
Stamped on verso, in circle at bottom center,
in dark purple ink: COLLECTION albert GILLES
Inscribed on verso in pencil: (Calotype)
Temple de l'art Photographique/New-York
en 1853
Hallmark Photographic Collection, Hallmark
Cards, Inc., Kansas City, Missouri
P5.390.001.95

Mathew B. Brady, 1823/24–1896

195. *Martin Van Buren,* ca. 1860
Salted paper print from glass negative
19 x 15⅝ in. (48.3 x 39.7 cm)
The Metropolitan Museum of Art, New York,
David Hunter McAlpin Fund, 1956 56.517.4

Mathew B. Brady, 1823/24–1896

196. *Cornelia Van Ness Roosevelt,* ca. 1860
Salted paper print from glass negative
17¾ x 15 in. (45.1 x 38.1 cm)
Gilman Paper Company Collection, New
York

COSTUMES

197. Man's tailored ensemble, English, ca. 1833
The Metropolitan Museum of Art, New York

Tailcoat, blue silk
Purchase, Catherine Brayer Van Bomel
Foundation Fund, 1981 1981.210.4

Vest, yellow silk
Purchase, Irene Lewisohn Bequest, 1976
1976.235.3d

Trousers, natural linen
Purchase, Irene Lewisohn and Alice L.
Crowley Bequests, 1982 1982.316.11

Stock, black silk and wool
Purchase, Gifts from various donors, 1983
1983.27.2

Hat, beige beaver
Purchase, Irene Lewisohn Bequest, 1972
1972.139.1

198. Woman's walking ensemble, American,
1832–33
The Metropolitan Museum of Art, New York

Dress and pelerine, brown silk
Gift of Randolph Gunter, 1950 50.15a,b

Hat, brown straw
Gift of Mr. Lee Simpson, 1939 39.13.118

Belt, brown woven ribbon with gilt metal
buckle
Purchase, Gifts from various donors, 1984
1984.144

Boots, brown leather and linen
Gift of Mr. Lee Simpson, 1938 38.23.150a,b

Collar, embroidered muslin
Gift of The New-York Historical Society, 1979
1979.346.223

Mitts, cotton mesh
Gift of Mrs. Margaret Putnam, 1946
46.104a,b

Cuffs, embroidered muslin
Gift of Mrs. Albert S. Morrow, 1937
37.45.101a,b

199. Woman's afternoon walking ensemble,
American

Arnold Constable and Company, retailer
Two-piece day dress, worn as a wedding
gown in 1855 by Mrs. Peter Herrman, 1855
Green-striped taffeta
Museum of the City of New York, Gift of
Mrs. Florien P. Gass, 44.247.1ab–2ab

Attributed to George Brodie
Mantilla wrap, worn to the Prince of Wales
Ball in 1860, ca. 1853
Embroidered red-brown velvet
The Metropolitan Museum of Art, New York,
Gift of Miss Henry A. Lozier, 1948  48.65

Bonnet, ca. 1856
Straw, lace, and brown velvet
Museum of the City of New York, Gift of
Mrs. Cuyler T. Rawlins  59.124.1

S. Redmond, manufacturer
Parasol, ca. 1824–31
Brown silk woven with leaf-and-flower
border; turned and carved wood stick
Museum of the City of New York, from the
Estate of Miss Jessie Smith, Gift of Clifton H.
Smith  70.127

200. Woman's afternoon walking ensemble

Two-piece day dress, American, ca. 1855
Plaid taffeta and silk braid
The Metropolitan Museum of Art, New York,
Gift of Mrs. Edwin R. Metcalf, 1969
69.32.2a,b

Paisley shawl, European, mid-nineteenth century
Silk and wool
The Metropolitan Museum of Art, New York,
Gift of Mr. E. L. Waid, 1955  CI.55.41

Bonnet, American, ca. 1850
Silk
Museum of the City of New York, Gift of
Grant Keehn  62.235.2

Alexander T. Stewart, active 1823–76, retailer
201. Wedding veil (detail), Irish, 1850
Net with Carrickmacross appliqué
40 x 100 in. (101.5 x 254 cm)
Valentine Museum, Richmond, Virginia, Gift
of Elizabeth Valentine Gray  05.21.10

Tiffany and Company, active 1837–present,
retailer
202. Fan, European, 1850s
Printed vellum, carved and gilded mother-of-
pearl
10⅝ x 20⅛ in. (27 x 51 cm) open
The Metropolitan Museum of Art, New York,
Gift of Caroline Ferriday, 1981  1981.40

Middleton and Ryckman, manufacturer
203. Pair of slippers, 1848–50
Bronze kid with robin's-egg blue embroidery
L. 9 in. (22.8 cm) heel to toe; h. 1⅝ in. (4 cm)
Museum of the City of New York, Gift of
Miss Florence A. Williams  58.212.1a,b

204. Woman's evening toilette, worn to the Prince
of Wales Ball, 1860

Attributed to Worth and Bobergh, active
1857/58–70/71, Paris
Ball gown, worn by Mrs. David Lyon
Gardiner, 1860
Cut velvet, woven in Lyon

Museum of the City of New York, Gift of
Miss Sarah Diodati Gardiner  39.26a,b

Bouquet holder, carried by Mrs. Antonio
Yznaga, 1860
Gold filigree
Museum of the City of New York, Gift of
Lady Lister-Kaye  33.27.1

George IV–style rivière, mid-nineteenth century
Paste, silver, and gold
James II Galleries, Ltd

Headdress, ca. 1860
Teal chenille with satin glass beads
Museum of the City of New York, Gift of
Mrs. John Penn Brock  42.445.9

205. Woman's evening toilette, worn to the Prince
of Wales Ball, 1860

Ball gown, worn by the great-aunt of the
Misses Braman, 1860
Cut velvet *en disposition* woven in Lyon, point-
de-gaze lace
Museum of the City of New York, Gift of the
Misses Braman  53.40.16a–d

Fan, carried by Mrs. William H. Sackett, 1860
Black Chantilly lace and mother-of-pearl
Museum of the City of New York, Gift of the
Misses Emma C. and Isabel T. Sackett, 1937
37.326.4

Mantilla wrap, worn by Mrs. Jonas C.
Dudley, 1860
Black embroidered net
Museum of the City of New York, Gift of
Mrs. Russell deC. Greene  49.101

Necklace, American, mid-nineteenth century
Strung pearlwork
The Metropolitan Museum of Art, New York,
Gift of Mrs. Alfred Schermerhorn, in memory
of Mrs. Ellen Schermerhorn Auchmuty, 1946
46.101.8

Headdress, ca. 1860
Black Chantilly lace, silk-and-wool flowers
Museum of the City of New York, Gift of
Miss Martia Leonard  33.143.4

JEWELRY

George W. Jamison, d. 1868, active in New
York City as a cameo cutter 1835–38
William Rose, active in New York City
1839–50, jeweler
206. Cameo with portrait bust of Andrew Jackson,
ca. 1835
Helmet conch shell, enamel, and gold
2½ x 2¼ in. (6.4 x 5.7 cm)
Signed below cavetto: GJ [in relief]
Inscribed on frame: THE UNION IT MUST AND
SHALL BE PRESERVED
Private collection

Gelston and Treadwell, active 1843/44–1850/51
207. Bouquet holder, 1847

Silver
H. 5⅛ in. (13 cm); diam. 1⅝ in. (4.1 cm)
Impressed on original box: Gelston &
Treadwell/No. 1 Astor House, N. York/
Manufacturers and Importers of/Fine
Jewelry, Watches/& Fancy Goods
Historic Hudson Valley, Tarrytown, New
York  SS.75.21a,b
Presented by Washington Irving to his niece
Charlotte, youngest child of his brother
Ebenezer, on the occasion of her marriage to
William R. Grinnell in 1847

Tiffany and Company, active 1837–present
208. Five-piece parure in fitted box (brooch,
earrings, cuff buttons), 1854–61
Agate, coral, pearls, yellow gold, and black
enamel
Diam. (brooch) 1¼ in. (3.2 cm)
Impressed on interior lid: TIFFANY & CO./
550 B. WAY/NEW-YORK
Collection of Janet Zapata

Tiffany and Company, active 1837–present,
retailer
209. Hair bracelet, ca. 1850
Hair, yellow gold, glass, diamonds, silver,
and textile
L. 7½ in. (19.1 cm); w. 1⅛ in. (2.9 cm)
Glass medallion set with a silver monogram
"M" in diamonds
Engraved on fastener: MEM/10th July 1851
The New-York Historical Society  INV.774

Edward Burr, active in New York City 1838–68
210. Parure (brooch and earrings), ca. 1858–60
Yellow gold, pearls, diamonds, enamel, and
blue enamel
H. (brooch) 2¼ in. (5.7 cm)
Imprinted inside lid of original box: E.W.
BURR/573 B.WAY/NEW-YORK
Private collection

Tiffany and Company, active 1837–present
211. Seed-pearl necklace and pair of bracelets,
ca. 1860
Seed pearls and yellow gold
L. (necklace) 15¼ in. (38.7 cm)
Library of Congress, Washington, D.C., Rare
Book and Special Collections Division
2.87.276.1–3
Purchased (along with matching earrings and
brooch) for $530 by President Abraham
Lincoln for Mary Todd Lincoln, who wore
them to her husband's inaugural ball in 1861

DECORATIONS FOR THE HOME

Manufacturer unknown, British
212. Ingrain carpet, ca. 1835–40
Wool
152⅜ x 35½ in. (387 x 90.2 cm)
The Metropolitan Museum of Art, New York,
Gift of Mr. and Mrs. Stuart Feld, 1980
1980.511.8

Manufacturer unknown, probably American

213. Ingrain carpet, ca. 1850–60
Wool
84 x 34½ in. (213.4 x 87.6 cm)
The Metropolitan Museum of Art, New York,
Gift of Frances W. Geyer, 1972 1972.203

Elizabeth Van Horne Clarkson, 1771–1852

214. Honeycomb quilt, ca. 1830
Cotton
107⅝ x 98¼ in. (273.4 x 249.6 cm)
The Metropolitan Museum of Art, New York,
Gift of Mr. and Mrs. William A. Moore, 1923
23.80.75

Maria Theresa Baldwin Hollander

215. Abolition quilt, ca. 1853
Silk embroidered with silk and silk-chenille
thread
43½ x 43¾ in. (110.5 x 111.1 cm)
Society for the Preservation of New England
Antiquities, Boston, Loaned by the Estate of
Mrs. Benjamin F. Pitman 2.1923
Exhibited at the New-York Exhibition of the
Industry of All Nations, 1853–54

Manufacturer unknown, New York City

216. Wallpaper depicting west side of Wall Street;
the Battery and Castle Garden; Wall Street
with Trinity Church; Grace Church; and
City Hall, ca. 1850
Roller-printed paper
20⅞ x 18½ in. (52.9 x 47 cm) repeat; 20⅞ x
19¾ in. (52.9 x 50.1 cm) paper
The Metropolitan Museum of Art, New York,
The Edward W. C. Arnold Collection of New
York Prints, Maps, and Pictures, Bequest of
Edward W. C. Arnold, 1954 54.90.734

Manufacturer unknown, probably New
York City

217. Entrance-hall wallpaper from the George
Collins house, Unionvale, New York, ca. 1850
Roller-printed paper
26 x 20 in. (66 x 50.8 cm)
The Metropolitan Museum of Art, New York,
Gift of Mrs. Adrienne A. Sheridan, 1956
56.599.10

Manufacturer unknown, probably New
York City

218. Window shade depicting the Crystal Palace,
New York City, 1853
Hand-painted and roller-printed paper
60¼ x 35⅜ in. (153 x 90 cm)
Cooper-Hewitt, National Design Museum,
Smithsonian Institution, New York, Museum
purchase in memory of Eleanor and Sarah
Hewitt 1944.66.1

Manufacturer unknown, French

219. Brocatelle, ca. 1850–55
Silk and linen
98 x 21 in. (248.9 x 53.3 cm)
The Metropolitan Museum of Art, New York,
Rogers Fund, 1948 48.55.4

Fisher and Bird, active 1832–85
(John T. Fisher, d. 1860; Clinton G. Bird,
d. 1861; Michael Bird, d. after 1853)

220. Mantel depicting scenes from Jacques-Henri
Bernardin de Saint-Pierre's *Paul et Virginie*
(1788), 1851
Marble
51¾ x 80 x 26½ in. (131.4 x 203.2 x 67.3 cm)
Museum of the City of New York, Gift of
Mrs. Edward W. Freeman, 1932 32.269 a–h,j
Ordered by Hamilton Fish in 1851 for his
New York parlor

FURNITURE

Cabinetmaker unknown, New York City

221. Armchair, ca. 1825
Ebonized maple and cherry; walnut; gilding;
replacement underupholstery and showcover
38 x 26½ x 27¾ in. (96.5 x 67.3 x 70.5 cm)
Winterthur Museum, Winterthur, Delaware,
Bequest of Henry F. du Pont 57.0739

Deming and Bulkley, active in New York City
ca. 1820–50 and in New York City and
Charleston, South Carolina, ca. 1820–ca. 1840
(Barzilla Deming, 1781–1854, active 1805–50;
Erastus Bulkley, 1798–1872, active ca. 1818–60)

222. Center table, 1829
Rosewood and mahogany veneers; pine, chest-
nut, mahogany; gilding, rosewood graining,
bronzing; "Egyptian" marble; casters
H. 30¼ in. (76.8 cm); diam. 36 in. (91.4 cm)
Mulberry Plantation, Camden, South Carolina
Made for Governor Stephen Decatur Miller,
Camden, South Carolina

Cabinetmaker unknown (possibly Robert
Fisher, active 1824–37), New York City

223. Secretary-bookcase, ca. 1830
Ebonized mahogany, mahogany, mahogany
veneer; pine, poplar, cherry; gilding, bronzing;
stamped brass ornaments; glass drawer pulls;
replacement fabric; glass
101⅛ x 55¾ x 29½ in. (256.9 x 141.6 x 74.9 cm)
The Metropolitan Museum of Art, New York,
Gift of Francis Hartman Markoe, 1960
60.29.1a,b

Cabinetmaker unknown, New York City

224. Sofa, ca. 1830
Mahogany, mahogany veneer; marble; gilt-
bronze mounts; original underupholstery on
back and sides, replacement showcover; casters
36 x 80 x 31 in. (91.4 x 203.2 x 78.7 cm)
Brooklyn Museum of Art, Maria L. Emmons
Fund 41.1181

Endicott and Swett, active 1830–34, printer
and publisher

225. Broadside for Joseph Meeks and Sons (active
1829–35), 1833
Lithograph with hand coloring
21½ x 17 in. (54.6 x 43.2 cm)
Inscribed: American and Foreign. Agency.

New-York Nº 6 Cabinet Maker & Upholster-
ers list of Prices./Joseph Meeks & Sons'./
Manufactory of Cabinet and Upholstery
Articles/43 & 45, Broad-Street,/New York./
Endicott & Swett III Nassau Street N.Y./
Entered according to Act of Congress in the
year 1833 by Joseph Meeks & Sons, in the
Clerks Office of the Des. [*sic*] Ct. of the
S.D. of N.Y.
The Metropolitan Museum of Art, New York,
Gift of Mrs. Reed W. Hyde, 1943 43.15.8

Cabinetmaker unknown, New York City

226. French chair (one of six), ca. 1830
Mahogany, mahogany veneer; chestnut;
original underupholstery and showcover
fragments, replacement showcover
31¾ x 19¼ x 20⅜ in. (80.6 x 48.9 x 51.8 cm)
Private collection

Joseph Meeks and Sons, active 1829–35
(Joseph Meeks, 1771–1868, active 1797–1836;
John Meeks, 1801–1875, active 1829–63; Joseph
W. Meeks, 1805–1878, active 1829–59)

227. Pier table, ca. 1835
Mahogany veneer, mahogany; "Egyptian"
marble; mirror glass
37 x 43 x 20⅛ in. (94 x 109.2 x 51.1 cm)
Printed on fragmentary paper label on inside
face of rear rail: MEEKS & SONS [MANUFAC-
TORY]/[OF]/CABI[NET-FURNITURE]/43 & 45
Br[oad Street]/N[ew-York.]
Collection of Dr. and Mrs. Emil F. Pascarelli

John H. Williams and Son, active ca. 1844–57
(John H. Williams, active ca. 1820–ca. 1862;
George H. Williams, active 1844–ca. 1857)

228. Pier mirror, ca. 1845
Gilded pine; pine; plate-glass mirror
94 x 38½ x 3¼ in. (238.8 x 97.8 x 8.3 cm)
Inscribed in black paint on back: TOP
Stenciled in black ink, twice, on back: From/
J. H. Williams & Son/Nº 315/Pearl Street/
New-York
Collection of Mr. and Mrs. Peter G. Terian

Cabinetmaker unknown, New York City

229. Fall-front secretary, 1833–ca. 1841
Mahogany veneer, mahogany, ebonized
wood; pine, poplar, cherry, white oak; brass;
leather; mirror glass
67⅝ x 50⅛ x 26 in. (171.8 x 127.3 x 66 cm)
Impressed on fall front lock plate, above an eagle:
at left, McKEE CO; at right, TERRYSVILLE CONN.
Impressed on proper left cabinet-door lock
plate: at top, LEWIS · McKEE/& CO.; at
bottom, TERRYSVILLE/CONN.
Collection of Frederick W. Hughes

Duncan Phyfe and Son, active 1840–47
(Duncan Phyfe, Scottish, 1768–1854, active in
New York City 1792–1847; James D. Phyfe,
b. 1797, active 1837–47)

230. Six nested tables, 1841
Rosewood, rosewood veneer; mahogany;
gilding not original

Largest table 29⅜ x 22⅛ x 16 in. (74.6 x 56.2 x 40.6 cm)
Collection of Mr. and Mrs. Peter G. Terian
Made for John Laurence Manning and Susan Hampton Manning, Millford Plantation, Clarendon County, South Carolina

Duncan Phyfe and Son, active 1840–47
(Duncan Phyfe, Scottish, 1768–1854, active in New York City 1792–1847; James D. Phyfe, b. 1797, active 1837–47)

231. Armchair, 1841
Mahogany, mahogany veneer; chestnut; replacement underupholstery and showcover
32½ x 22⅛ x 24 in. (82.4 x 56.2 x 61 cm)
Collection of Richard Hampton Jenrette
Made for John Laurence Manning and Susan Hampton Manning, Millford Plantation, Clarendon County, South Carolina

Duncan Phyfe and Son, active 1840–47
(Duncan Phyfe, Scottish, 1768–1854, active in New York City 1792–1847; James D. Phyfe, b. 1797, active 1837–47)

232. Couch (one of a pair), 1841
Rosewood veneer, rosewood, mahogany; sugar pine, ash, poplar; rosewood graining; replacement underupholstery and showcover
35⅝ x 74⅞ x 22⅞ in. (90.5 x 190.2 x 58.1 cm)
Collection of Richard Hampton Jenrette
Made for John Laurence Manning and Susan Hampton Manning, Millford Plantation, Clarendon County, South Carolina

J. and J. W. Meeks, active 1836–59
(John Meeks, 1801–1875, active 1829–63; Joseph W. Meeks, 1805–1878, active 1829–59)

233. Portfolio cabinet-on-stand, with a scene from Shakespeare's *Romeo and Juliet*, ca. 1845
Rosewood, rosewood and maple veneers; cross-stitched needlepoint panel; replacement fabric; glass
66 x 27⅞ x 16⅞ in. (167.6 x 70.8 x 42.9 cm)
Collection of Mrs. Sammie Chandler

Alexander Jackson Davis, 1803–1892, designer
Richard Byrne, Irish, 1805–1883, active in White Plains, New York, 1845–ca. 1883, cabinetmaker

234. Hall chair (one of a pair), ca. 1845
Oak; original cane seat, replacement cushion
37⅜ x 18¼ x 20¼ in. (94.9 x 47 x 51.4 cm)
Lyndhurst, A National Trust Historic Site, Tarrytown, New York (NT64.25.9[a])
Made for William Paulding and his son Philip for Knoll (later renamed Lyndhurst), Tarrytown, New York

Alexander Jackson Davis, 1803–1892, designer
Possibly Burns and Brother, active 1857–60, cabinetmaker
(William Burns, Scottish, ca. 1807–1867, active in New York City 1835–66; Thomas Burns, Scottish, d. 1860, active in New York City 1854–60)

235. Side chair, ca. 1857
Black walnut; replacement underupholstery and showcover

39⅝ x 18½ x 18½ in. (100.6 x 47 x 47 cm)
The Metropolitan Museum of Art, New York, Gift of Jane B. Davies, in memory of Lyn Davies, 1995 1995.111
Similar to chairs made for Ericstan (John J. Herrick House), Tarrytown, New York

Auguste-Émile Ringuet-Leprince, French, 1801–1886, active in Paris 1840–48 and in New York City 1848–60

236A, B. Sofa and armchair, Paris, 1843
Ebonized fruitwood (apple or pear); beech; gilt-bronze mounts; original underupholstery and silk brocatelle showcover; casters (on chair)
Sofa: 38¼ x 72 x 29¾ in. (97.2 x 182.9 x 75.6 cm)
Armchair: 37⅞ x 23½ x 25⅞ in. (96.2 x 59.7 x 65.7 cm)
The Metropolitan Museum of Art, New York, Gift of Mrs. Douglas Williams, 1969 69.262.1, 69.262.3
From a drawing-room suite made for James C. Colles and Harriet Wetmore Colles, 35 University Place

Cabinetmaker unknown, probably French (probably Paris)
Retailed by Charles A. Baudouine, 1808–1895, active 1829–54, cabinetmaker

237. Lady's writing desk, 1849–54
Ebonized poplar (aspen or cottonwood); painted and gilded decoration; velvet
40¾ x 32½ x 17½ in. (103.5 x 82.6 x 44.5 cm)
Printed on paper label on back: Baudouine's / Fashionable Furniture & Upholstery / Establishment / 335 Broadway / New-York / Keeps constantly on hand the / Largest Assortment of Elegant Furniture / to be found in the United States.
Stenciled in ink on proper left side of apron drawer: From / C.A. Baudouine / 335 / Broadway / New York
Inscribed in ink inside the desk: on left side, G [*Gauche*]; on right side, D [*Droite*]
Museum of Fine Arts, Boston, Gift of the William N. Banks Foundation in memory of Laurie Crichton 1979.612

Thomas Brooks, 1810/11–1887, active 1844–75, Brooklyn, New York

238. Table-top bookcase made for Jenny Lind, 1851
Rosewood; ivory; silver
39 x 32 x 13 in. (99.1 x 81.3 x 33 cm)
Engraved on paper label on underside of drawer: BROOKS' / CABINET WAREHOUSE. / 127 Fulton St. Cor. Sands Brooklyn, N. Y.
Engraved on silver presentation plaque: Presented to / Jenny Lind / by the / Members of / the / Fire Department / of the / City of New York.
Museum of the City of New York, Gift of Arthur S. Vernay 52.24.1a

John T. Bowen, British, ca. 1801–1856, active in New York City 1834–38, active in Philadelphia 1839–56, lithographer
After John James Audubon, French, born Haiti, 1785–1851, active in the United States

1806–51, artist, and Robert Havell Jr., British, 1793–1878, active in the United States 1839–78, engraver
J. J. Audubon and J. B. Chevalier, New York and Philadelphia, publisher
Matthews and Rider, bookbinders

239. *The Birds of America, from Drawings Made in the United States and Their Territories*, 1840–44
Seven volumes; bound in ivory, red, green, and blue leather with gold stamping
10⅝ x 7⅜ x 2⅛ in. (27 x 18.7 x 5.4 cm)
Museum of the City of New York, Gift of Arthur S. Vernay 52.24.2a–g
Specially bound for and presented to Jenny Lind

Julius Dessoir, German (Prussia), 1801–1884, active in New York City ca. 1842–65

240A–C. Sofa and two armchairs, 1853
Rosewood; chestnut; original underupholstery and replacement showcover; casters
Sofa: 59⅛ x 82⅝ x 34½ in. (150.2 x 209.9 x 87.6 cm)
Armchairs: 55 x 28 x 31⅜ in. (139.7 x 71.1 x 79.7 cm)
The Metropolitan Museum of Art, New York, Gift of Lily and Victor Chang, in honor of the Museum's 125th Anniversary, 1995 1995.150.1–3
Exhibited at the New-York Exhibition of the Industry of All Nations, 1853–54

Gustave Herter, German (Stuttgart, Württemberg), 1830–1898, active in New York City 1848–70, designer
Bulkley and Herter, active ca. 1853–58, cabinetmaker
(Erastus Bulkley, 1798–1872, active ca. 1818–60; Gustave Herter)

241. Bookcase, 1853
White oak; eastern white pine, eastern hemlock, yellow poplar; leaded glass not original
134½ x 118¾ x 30¼ in. (341.6 x 301.6 x 76.8 cm)
Inscribed in pencil: on interior face of proper left side of lower case, No. 2[?]; on interior face of proper right side of lower case, No. 3
The Nelson-Atkins Museum of Art, Kansas City, Missouri (Purchase: Nelson Trust through the exchange of gifts and bequests of numerous donors and other Trust properties) 97-35
Exhibited at the New-York Exhibition of the Industry of All Nations, 1853–54

Cabinetmaker unknown, New York City
Nunns and Clark, active 1840–60, piano manufacturer
(Robert Nunns, active 1823–ca. 1860; John Clark, active 1833–57)

242. Square piano, 1853
Rosewood, rosewood veneer; mother-of-pearl, tortoiseshell, abalone shell
37¾ x 87⅞ x 43½ in. (95.9 x 223.3 x 118 cm)

Engraved on silver plate on nameboard:
R. Nunns & Clark./New York.
Inscribed in pencil: on inside left side of case,
Thompson; on underside of soundboard,
Joseph Gassin/Augᵗ 20/1853
Stamped: on pin block, back of nameboard,
right side of key frame, 8054; on lowest key,
D. Perrin[?]
The Metropolitan Museum of Art, New York,
Gift of George Lowther, 1906 06.1312

Alexander Roux, French, 1813–1886, active in
New York City 1836–80

243. Étagère-sideboard, ca. 1853–54
Black walnut; pine, poplar
93 x 72¾ x 26 in. (236.2 x 184.8 x 66 cm)
The Metropolitan Museum of Art, New York,
Purchase, Friends of the American Wing
Fund and David Schwartz Foundation, Inc.
Gift, 1993 1993.168
Similar to the model exhibited at the New-
York Exhibition of the Industry of All
Nations, 1853–54

Cabinetmaker unknown, French (probably
Paris)

244. Center table, 1855–57
Gilded wood (possibly aspen or cottonwood);
beech; marble top; casters
29⅝ x 56⅝ x 37⅞ in. (75.2 x 143.8 x 94.9 cm)
Brooklyn Museum of Art, Gift of Marion
Litchfield 51.112.9
Made for Edwin Clark Litchfield and Grace
Hill Hubbard Litchfield for Grace Hill,
Brooklyn, New York

Attributed to J. H. Belter and Company,
active 1844–66
(John H. Belter, German [Hilter, Hannover],
1804–1863, active in New York City 1833–63)

245. Sofa, ca. 1855
Rosewood; probably replacement under-
upholstery, replacement showcover; casters
54 x 93½ x 40 in. (137.2 x 237.5 x 101.6 cm)
Milwaukee Art Museum, Purchase, Bequest
of Mary Jane Rayniak in Memory of Mr. and
Mrs. Joseph G. Rayniak M1987.16

Alexander Roux, French, 1813–1886, active in
New York City 1836–80

246. Étagère, ca. 1855
Rosewood, rosewood veneer; chestnut,
poplar, bird's-eye maple veneer; replacement
mirror glass
86 x 79½ x 29⅞ in. (218.4 x 201.9 x 75.9 cm )
Engraved on label on back of shelves:
A. Roux 479/481/A. Roux/Gaime.
Guillemot & Co. Roux/Cabinet Maker/
481 Broadway/New-York
The Metropolitan Museum of Art, New York,
Sansbury-Mills Fund, 1971 1971.219

Cabinetmaker unknown, probably New
York City

247. Fire screen, ca. 1855
Rosewood; white pine; tent-stitched

needlepoint panel; glass; replacement silk
backing; casters
67 x 42¾ in. (170.2 x 108.6 cm)
The Art Institute of Chicago, Mary Waller
Langhorne Endowment 1989.155

Ringuet-Leprince and L. Marcotte, active
1848–60
(Auguste-Émile Ringuet-Leprince, French,
1801–1886, active in Paris 1840–48 and in
New York City 1848–60; Léon Marcotte,
French, 1824–1887, active in New York City
1848–87)

248. Armchair, ca. 1856
Ebonized maple; pine; gilt-bronze mounts;
replacement underupholstery and showcover;
casters
40½ x 25¼ x 26½ in. (102.9 x 64.1 x 67.3 cm)
The Metropolitan Museum of Art, New York,
Gift of Mrs. D. Chester Noyes, 1968 68.69.2
From a ballroom suite made for John Taylor
Johnston and Frances Colles Johnston,
8 Fifth Avenue

Gustave Herter, active 1858–64
(Gustave Herter, German [Stuttgart,
Württemberg], 1830–1898, active in New
York City 1848–70)

249. Reception room cabinet, ca. 1860
Bird's-eye maple, rosewood, ebony,
marquetry of various woods; white pine,
cherry, poplar, oak; oil on canvas; gilt-bronze
mounts; brass inlay; gilding; mirror glass
90¼ x 59¾ x 19½ in. (229.2 x 151.8 x 49.5 cm)
Victoria Mansion, The Morse-Libby House,
Portland, Maine 1984.65
Made for the Ruggles Sylvester Morse
and Olive Ring Merrill Morse mansion,
Portland, Maine

CERAMICS

Maker unknown, French (Paris)

250. Vase depicting view of New York City from
Governors Island, ca. 1828–30
Porcelain, overglaze enamel decoration,
and gilding
H. 12⅞ in. (32.7 cm); diam. 9⅛ in. (23.2 cm)
Collection of Mr. and Mrs. Stuart P. Feld
The scene depicted is based on a print in *The
Hudson River Portfolio* (1821–25; see cat. no. 114).

Maker unknown, French (Paris)

251. Pair of vases depicting a scene on Lower
Broadway with Saint Paul's Chapel and
an interior view of the First Merchants'
Exchange, ca. 1831–35
Porcelain, overglaze enamel decoration,
and gilding
H. 13 in. (33 cm); diam. 9⅞ in. (25.1 cm)
The Metropolitan Museum of Art, New York,
Harris Brisbane Dick Fund, 1938 38.165.35,
38.165.36
The scenes depicted are copied from
Theodore Fay's *Views in New York and Its
Environs* (1831–34).

Maker unknown, French (probably Limoges)

252. Pair of vases depicting scenes from Harriet
Beecher Stowe's *Uncle Tom's Cabin* (1852),
ca. 1852–65
Porcelain with gilding
19 x 14 in. (48.3 x 35.6 cm)
The Newark Museum, Purchase, 1968,
Mrs. Parker O. Griffith Fund 68.106a,b

James and Ralph Clews, English
(Staffordshire), active ca. 1815–34

253. Platter depicting the Marquis de Lafayette's
arrival at Castle Garden, August 16, 1824,
ca. 1825–34
White earthenware with blue transfer-printed
decoration
L. 19 in. (48.3 cm); w. 14½ in. (36.8 cm)
Impressed on underside within a circle,
surrounding a crown: CLEWS WARRANTED
STAFFORDSHIRE
Museum of the City of New York, Gift of
Mrs. Harry Horton Benkard 34.508.2

Joseph Stubbs, English (Longport, Burslem,
Staffordshire), active ca. 1822–36

254. Pitcher depicting City Hall, New York,
ca. 1826–36
White earthenware with blue transfer-printed
decoration
7⅝ x 9 x 7½ in. (19.4 x 22.9 x 19.1 cm)
Winterthur Museum, Winterthur, Delaware,
Bequest of Henry F. du Pont 58.1819
The view is after a drawing by William Guy
Wall, which was engraved by John William
Hill in 1826.

Decasse and Chanou, active 1824–27
(Louis-François Decasse, French, b. 1790,
active until 1850; Nicolas-Louis-Édouard
Chanou, French, 1803?–1828)

255. Tea service, 1824–27
Porcelain with gilding
Teapot: 6½ x 11 x 5½ in. (16.5 x 27.9 x 14 cm)
Sugar bowl: 5½ x 7 x 4⅝ in. (14 x 17.8 x 11.7 cm)
Cream pitcher: 4¼ x 6 x 3⅛ in. (10.8 x 15.2 x
7.9 cm)
Cup: 2¼ x 4¼ in. (5.7 x 10.8 cm)
Saucer: diam. 5 in. (12.7 cm)
Plates: diam. 7⅜ in., 8⅜ in. (18.7 cm, 21.3 cm)
Stamped in red on underside within circle
(all pieces except for teapot and large plate):
DECASSE & CHANOU./[eagle]/New York.
Incised on large plate: EC No 3/x
Kaufman Americana Foundation

D. and J. Henderson Flint Stoneware Manu-
factory, Jersey City, New Jersey, active 1828–33
(David Henderson, d. 1845; James Henderson)

256. End of the Rabbit Hunt pitcher, ca. 1828–30
Stoneware, wheel-thrown with applied
decoration
8⅞ x 9 x 7½ in. (22.5 x 22.9 x 19.1 cm)
Inscribed on front: JAMES N. WELLS/38/
Hudson Street
Collection of Mr. and Mrs. Jay Lewis

D. and J. Henderson Flint Stoneware Manufactory, Jersey City, New Jersey, active 1828–33 (David Henderson, d. 1845; James Henderson)

257. Acorn and Berry pitcher, ca. 1830–35
Stoneware, press-molded with applied decoration
8¾ x 6¾ x 8½ in. (22.2 x 17 x 21.7 cm)
Impressed on underside within circle: D & J/Henderson/Jersey/City
The Metropolitan Museum of Art, New York, Purchase, Dr. and Mrs. Burton P. Fabricand Gift, 2000  2000.87

D. and J. Henderson Flint Stoneware Manufactory, Jersey City, New Jersey, active 1828–33 (David Henderson, d. 1845; James Henderson)

258. Herculaneum pitcher, ca. 1830–33
Stoneware, press-molded with applied decoration
10⅜ x 7¾ x 6½ in. (26.4 x 19.7 x 16.5 cm)
Impressed on underside: 8
Collection of Mr. and Mrs. Jay Lewis

American Pottery Manufacturing Company, Jersey City, New Jersey, active 1833–55
Daniel Greatbach, active 1838–58, probable modeler

259. Thistle pitcher, 1838–52
Stoneware, press-molded with brown Rockingham glaze
9⅝ x 9¼ x 7 in. (24.5 x 23.2 x 17.8 cm)
Impressed on underside within circle: AMERICAN/POTTERY, CO/-O-/JERSEY, CITY, N.J.
The Metropolitan Museum of Art, New York, Gift of Maude B. Feld and Samuel B. Feld, 1992  1992.230

American Pottery Manufacturing Company, Jersey City, New Jersey, active 1833–55

260. Vegetable dish, ca. 1833–45
White earthenware, press-molded with feather-edged and blue sponged decoration
H. 2½ in. (6.4 cm); diam. 11 in. (27.9 cm )
Impressed on underside within circle: AMERICAN/POTTERY C⁰/5/JERSEY CITY, N.J.
The Metropolitan Museum of Art, New York, Purchase, Herbert and Jeanine Coyne Foundation and Cranshaw Corporation Gifts, 1997  1997.105

American Pottery Manufacturing Company, Jersey City, New Jersey, active 1833–55

261. Covered hot-milk pot or teapot and underplate, ca. 1835–45
White earthenware, press-molded with blue sponged decoration
Pot (including cover): 6⅜ x 7 x 4¾ in. (16.2 x 17.8 x 12.1 cm)
Plate: diam. 7½ in. (19.1 cm)
Impressed on underside of pot within circle: AMERICAN/POTTERY C⁰/-O-/JERSEY CITY, N.J.
Impressed on underside of plate within circle: AMER[ICAN]/POTTERY [C⁰]/JERSEY [CITY, N.J.]
Collection of Mr. and Mrs. Jay Lewis

American Pottery Manufacturing Company, Jersey City, New Jersey, active 1833–55

262. Canova plate, 1835–45
White earthenware, press-molded with blue underglaze transfer-printed decoration
Diam. 9⅛ in. (23.2 cm)
Printed on underside in ellipse: AMERICAN POTTERY/MANUFACTURING C⁰./CANOVA/JERSEY CITY
Brooklyn Museum of Art  50.144

American Pottery Manufacturing Company, Jersey City, New Jersey, active 1833–55
Daniel Greatbach, active 1849–58, modeler

263. Pitcher made for William Henry Harrison's presidential campaign, 1840
Cream-colored earthenware, press-molded with black underglaze transfer-printed decoration
11⅝ x 8¼ x 10 in. (29.5 x 21 x 25.4 cm)
Printed in black on underside within flag: AM. POTTERY/MANUF^G C⁰/JERSEY CITY
New Jersey State Museum, Trenton  CH1986.11

Salamander Works, New York City or Woodbridge, New Jersey, active 1836–55

264. Water cooler, 1836–45
Stoneware, press-molded with brown Rockingham glaze
H. 18½ in. (47 cm); diam. 11¾ in. (29.8 cm)
Inscribed on front: SALAMANDER/WORKS NEW-YORK
New Jersey State Museum, Trenton  CH1971.70

Salamander Works, New York City or Woodbridge, New Jersey, active 1836–55

265. Punch bowl, ca. 1836–42
Stoneware, press-molded with brown Rockingham glaze, porcelain letters
H. 7 in. (17.8 cm); w. 17 in. (43.2 cm); diam. 14¼ in. (36.2 cm)
Marked with raised white letters applied on the front: J. K. GROSVENOR
Winterthur Museum, Winterthur, Delaware, Bequest of Henry F. du Pont  59.1937

Salamander Works, New York City or Woodbridge, New Jersey, active 1836–55

266. "Spanish" pitcher, ca. 1837–42
Stoneware, press-molded with brown Rockingham glaze
13⅜ x 10¾ x 13⅜ in. (34 x 27.3 x 34 cm)
Raised, molded mark on underside: C1
Collection of Arthur F. and Esther Goldberg

Charles Cartlidge and Company, Greenpoint (Brooklyn), New York, active 1848–56 (Charles Cartlidge, 1800–1860)

267. Presentation pitcher for the governor of the state of New York from the Manufacturing and Mercantile Union, 1854–56
Porcelain, with overglaze decoration in polychrome enamels and gilding
13¼ x 14¼ x 10 in. (33.7 x 36.2 x 25.4 cm)

Inscribed on sides and front in gold: Presented by the/M. & M. Union/To the Governor./Of the state of/New York.
Collection of Mr. and Mrs. Jay Lewis

Charles Cartlidge and Company, Greenpoint (Brooklyn), New York, active 1848–56 (Charles Cartlidge, 1800–1860)

268. Pitcher made for the Claremont, 1853–56
Porcelain, with overglaze decoration in polychrome enamels and gilding
10½ x 11½ x 6½ in. (26.7 x 29.2 x 16.5 cm)
Inscribed on front: E. Jones./CLAREMONT./American Porcela[in]
Museum of the City of New York, Gift of Miss Dorothy Rogers and Mrs. Edward H. Anson  49.44.4
The Claremont was a hotel located at what is now Riverside Drive and 124th Street; Edmund Jones was its proprietor.

William Boch and Brothers, Greenpoint (Brooklyn), New York, active before 1844–1861/62
(William Boch, 1797–1872; Anthony Boch, active 1855–62; Francis Victor Boch, 1855–60)

269. Pitcher, 1844–57
Porcelain
9⅝ x 8½ x 6 in. (24.4 x 21.6 x 15.2 cm)
Impressed on underside, following the oval shape of the base: W B & BR'S/Greenpoint. L. I.
The Metropolitan Museum of Art, New York, Purchase, Anonymous Gift, 1968  68.112

United States Pottery Company, Bennington, Vermont, active 1847–58

270. Central monument from the United States Pottery Company display at the New-York Exhibition of the Industry of All Nations (1853–54), 1851–53
Earthenware, including Rockingham and Flint enamel-glazed earthenware, scroddled ware; parian porcelain
H. 120 in. (304.8 cm)
Bennington Museum, Bennington, Vermont  1989.63
Displayed at the exhibition by O. A. Gager and Company, New York City retailer

## GLASS

Probably Bloomingdale Flint Glass Works of Richard and John Fisher, New York City, active 1820–40, or Brooklyn Flint Glass Works of John Gilliland, Brooklyn, New York, active 1823–68
(Richard Fisher, 1783–1850; John Fisher, d. 1848; John L. Gilliland, 1787–1868)

271. Decanter (one of a pair), 1825–45
Blown colorless glass, with cut decoration
H. 9⅛ in. (23.2 cm); diam. 4 in. (10.2 cm)
Winterthur Museum, Winterthur, Delaware, Gift of Mr. and Mrs. Robert Trump  77.0181.001a,b

Jersey Glass Company of George Dummer, Jersey City, New Jersey, active 1824–62 (George Dummer, 1782–1853)

272. Salt, 1830–40
Pressed green glass
1⅞ x 3 x 2⅜ in. (4.8 x 7.6 x 6 cm)
Impressed on underside: JERSEY/GLASS CO.,/ Nr. N. YORK
The Metropolitan Museum of Art, New York, Purchase, Butzi Moffitt Gift, 1985 1985.129

Jersey Glass Company of George Dummer, Jersey City, New Jersey, active 1824–62 (George Dummer, 1782–1853)

273. Compote, ca. 1830–40
Blown colorless glass, with cut decoration
H. 7½ in. (19 cm); diam. (rim) 10⅛ in. (25.8 cm)
The Corning Museum of Glass, Corning, New York 71.4.108

Jersey Glass Company of George Dummer, Jersey City, New Jersey, active 1824–62 (George Dummer, 1782–1853)

274. Covered box, ca. 1830–40
Blown colorless glass, with cut decoration; silver cover
1¾ x 4⅞ x 1⅞ in. (4.5 x 12.3 x 4.8 cm)
Engraved on cover: Mary Sarah Dummer
The Corning Museum of Glass, Corning, New York 71.4.110

Jersey Glass Company of George Dummer, Jersey City, New Jersey, active 1824–62 (George Dummer, 1782–1853)

275. Oval dish, ca. 1830–40
Blown colorless glass, with cut decoration
L. 7¾ in. (19.7 cm); h. 1¾ in. (4.5 cm)
The Corning Museum of Glass, Corning, New York 71.4.113

Bloomingdale Flint Glass Works of Richard and John Fisher, New York City, active 1820–40, or Brooklyn Glass Works of John Gilliland, Brooklyn, New York, active 1823–68, or Jersey Glass Company of George Dummer, Jersey City, New Jersey, active 1824–62
Possibly cut by Jackson and Baggott
(Richard Fisher, 1783–1850; John Fisher, d. 1848; John L. Gilliland, 1787–1868; George Dummer, 1782–1853; William Jackson, active 1816–30; Joseph Baggott, d. 1839)

276. Decanter and wineglasses, ca. 1825–35
Blown green glass, with cut decoration
Decanter: h. 10⅝ in. (27 cm); diam. 4 in. (10.2 cm)
Wineglasses: 4⅞ in. (12.5 cm); diam. 2⅞ in. (7.3 cm)
The Metropolitan Museum of Art, New York, Gift of Berry B. Tracy, 1972 1972.266.1–7
Owned by Luman Reed, according to tradition

Maker unknown, New York City area

277. A selection from a service of table glass made for a member of the Weld family, Albany, 1840–59
Blown colorless glass, with cut and engraved decoration

Claret decanters with handles: (1984.24.3.1.1a,b) h. 16 in (40.6 cm); circumference 15½ in. (39.4 cm). (1984.24.3.1.2a,b) h. 15¼ in. (38.7 cm); circumference 15¼ in. (39.4 cm)
Compote (1984.24.3.2.1): h. 6⅛ in. (15.6 cm); diam. 6⅛ in. (15.6 cm)
Oval serving bowl (1984.24.3.3.1): 2¼ x 9½ x 6 in. (5.7 x 24.1 x 15.2 cm)
Finger bowl (1984.24.3.4.1): h. 3¼ in. (8.3 cm); diam. (rim) 4⅞ in. (12.4 cm)
Carafe (1984.24.3.5.1): h. 7 in. (17.8 cm); circumference 15½ in. (39.4 cm)
Punch cup (1984.24.3.6.1): h. 2⅞ in. (7.3 cm); diam. (rim) 2⅝ in. (6.7 cm)
Wineglasses: (1984.24.3.7.1) h. 4⅞ in. (12.4 cm); diam. (rim) 2¼ in. (5.7 cm). (1984.24.3.8.1) h. 3⅝ in. (9.2 cm); diam. (rim) 1⅝ in. (4.1 cm)
Tumblers: (1984.24.3.9.1) h. 2¾ in. (7 cm); diam. (rim) 2⅝ in. (6.7 cm). (1984.24.3.10.1) h. 3¾ in. (9.5 cm); diam. (rim) 3⅜ in. (8.6 cm). (1984.24.3.11.1) h. 3⅝ in. (9.2 cm); diam. (rim) 3⅛ in. (7.9 cm)
Decanters: (1984.24.3.12.1a,b) h. 11¾ in. (29.8 cm); circumference 12 in. (30.5 cm). (1984.24.3.14.1a,b) h. 13½ in. (34.3 cm); circumference 14½ in. (36.8 cm)
Engraved on front of each: [Weld family crest with motto:] NIL SINE NUMINE
Albany Institute of History and Art 1984.24.3.1–.14
Made for Harriet Weld Corning (1793–1883) or her niece Harriet Corning Turner Pruyn (1822–1859)

Long Island Flint Glass Works of Christian Dorflinger, Brooklyn, New York, active 1852–63
(Christian Dorflinger, born France [Alsace], 1828–1915)

278. Presentation vase for Mrs. Christian Dorflinger from the Dorflinger Guards, 1859
Blown colorless glass, with cut and engraved decoration
H. 16⅞ in. (42.9 cm); diam. 6⅛ in. (15.4 cm)
Engraved on shield: Presented by the officers/ & Members of the/Dorflinger Guards/To Mrs./Dorflinger/January 14th/1859
The Metropolitan Museum of Art, New York, Gift of Isabel Lambert Dorflinger, 1988 1988.391.1

Long Island Flint Glass Works of Christian Dorflinger, Brooklyn, New York, active 1852–63
(Christian Dorflinger, born France [Alsace], 1828–1915)

279. Compote made for the White House, 1861
Blown colorless glass, with cut and engraved decoration
H. 8⅞ in. (22.5 cm); diam. (rim) 9⅜ in. (23.8 cm)
The Metropolitan Museum of Art, New York, Gift of Katheryn Hait Dorflinger Manchee, 1972 1972.232.1
Part of state service commissioned by Mrs. Abraham Lincoln through a Washington, D.C., retailer

William Jay Bolton, 1816–1884, assisted by John Bolton, 1818–1898

280. *Christ Stills the Tempest*, one of sixty figural windows made for Holy Trinity Church (now St. Ann and the Holy Trinity Church), Brooklyn, 1844–47
Opaque glass paint, enamels, and silver stain on pot-metal glass
Three lancets; each lancet 63¾ x 18¾ (161.9 x 47.6 cm)
St. Ann and the Holy Trinity Church, Brooklyn, New York. The window has been restored with the support of Catherine S. Boericke and Francis T. Chambers, III, descendants of William Jay Bolton, and public funds from The New York City Department of Cultural Affairs Cultural Challenge Program.
The first ensemble of figural stained-glass windows made in America

### SILVER AND OTHER METALWORK

Fletcher and Gardiner, Philadelphia, active 1808–27, manufacturing silversmith
Thomas Fletcher, 1787–1866, designer
(Thomas Fletcher; Sidney Gardiner, 1787–1827)

281A. Presentation vase, 1824
Silver
23⅜ x 20 x 14½ in. (59.4 x 50.8 x 36.8 cm)
Marked on underside: FLETCHER & GARDINER [within two concentric circles] PHILA [in rectangle in center][;] FLETCHER &/ GARDINER [in ribbon]/PHILA [in rectangle]
Engraved below presentation inscription: Fletcher & Gardiner, Makers Philadᵃ December 1824
Inscribed on plaque on front of base: The Merchants of Pearl Street, New York,/TO THE HON. DEWITT CLINTON,/Whose claim to the proud Title of "Public Benefactor,"/is founded on those magnificent works,/The Northern and Western CANALS.
The Metropolitan Museum of Art, New York, Purchase, Louis V. Bell and Rogers Funds; Anonymous and Robert G. Goelet Gifts; and Gifts of Fenton L. B. Brown and of the grandchildren of Mrs. Ranson Spaford Hooker, in her memory, by exchange, 1982 1982.4
The scenic views on this pair of vases (cat. nos. 281A, B) are based on drawings made about 1823 by James Eights (1798–1882) for the Erie Canal geological survey.

Fletcher and Gardiner, Philadelphia, active 1808–27, manufacturing silversmith
Thomas Fletcher, 1787–1866, designer
(Thomas Fletcher; Sidney Gardiner, 1787–1827)

281B. Presentation vase, 1825
Silver
23¾ x 20¾ x 14¾ in. (60.3 x 52.7 x 37.5 cm)
Marked on underside: FLETCHER & GARDINER [within two concentric circles]

PHILA [in rectangle in center]; FLETCHER &/ GARDINER [in ribbon]/PHILA [in rectangle] Engraved below presentation inscription: Fletcher & Gardiner, Makers Philadᵃ February 1825 Inscribed on plaque on front of base: TO THE HON. DEWITT CLINTON,/Who has developed the resources of the State of New York./AND ENNOBLED HER CHARACTER/The Merchants of Pearl Street offer this testimony of their/ GRATITUDE AND RESPECT. The Metropolitan Museum of Art, New York, Gift of the Erving and Joyce Wolf Foundation, 1988 1988.199

Archibald Robertson, Scottish, 1765–1835, active in New York City 1791–ca. 1825, designer Charles Cushing Wright, 1796–1854, engraver and diesinker Lettering by Richard Trested, d. 1829, upon die made by William Williams Struck by Maltby Pelletreau, 1791–1846, silversmith

282A, B. Grand Canal Celebration medal and original box, 1826 Medal: silver; box: bird's-eye maple and paper Medal: diam. 1¾ in. (4.4 cm) Box: diam. 2 in. (5.1 cm) Stamped into obverse: UNION OF THE ERIE WITH THE ATLANTIC[;] R.DEL[;] W. SC Stamped into reverse: ERIE CANAL COMM. 4 JULY 1817 COMP. 26 OCT 1825[;] EXCELSIOR [on banner beneath the eagle, globe, and shield][;] C.C. WRIGHT SC./1826/PRESENTED BY THE CITY OF N. YORK; scratched into reverse: 441 Printed on paper inside box, along top edges: PRESENTED BY THE CITY OF NEW YORK Hand-written on paper inside bottom of box and on inside of box base: 441 New York State Historical Association, Cooperstown, gift of James Fenimore Cooper (1858–1938, grandson of author) NO361.63(1) Box made by Duncan Phyfe, cabinetmaker, and Daniel Karr, turner, from timber transported via the Erie Canal to New York City on the *Seneca Chief*

Archibald Robertson, Scottish, 1765–1835, active in New York City 1791–ca. 1825, designer Charles Cushing Wright, 1796–1854, engraver

283A, B. Grand Canal Celebration medal and presentation case, 1826 Medal: gold; case: wood and red leather Medal: diam. 1¾ in. (4.4 cm) Case: diam. 2¼ in. (5.7 cm) Stamped into obverse: UNION OF THE ERIE WITH THE ATLANTIC[;] R.DEL[;] W. SC Stamped into reverse: ERIE CANAL COMM. 4 JULY 1817 COMP. 26 OCT 1825[;] EXCELSIOR

[on banner beneath the eagle, globe, and shield][;] C.C. WRIGHT SC./1826/PRESENTED BY THE CITY OF N. YORK Box inscribed: Maj. Gen. Andrew Jackson 1827 The New-York Historical Society, Gift of Miss G. Wilbour 1932.68a,b

Baldwin Gardiner, 1791–1869, active in Philadelphia 1814–26 and in New York City 1826–47, silverware manufacturer and fancy-hardware retailer

284. Four-piece tea service, ca. 1830 Silver Pots: (34.292.1) h. 9⅞ in. (25.1 cm); (34292.2) h. 10½ in. (26.7 cm) Sugar bowl (34.292.3): h. 9⅝ in. (24.5 cm) Cream pot (34.292.4): h. 8½ in. (21.6 cm) Marked on underside of base of each piece: B [pellet] GARDINER [in serrated rectangle] Inscribed (later) with initials on each piece: on body, S.S.S.; on foot, S.S.C. Museum of the City of New York, Gift of Mrs. Arthur Percy Clapp 34.292.1–4

Gale and Moseley, active 1828–33, silverware manufacturer (William Gale Sr., 1799–1867; Joseph Moseley, d. 1838)

285. Coffee urn, 1829 Silver 17⅞ x 4⅜ x 11⅜ in. (44.8 x 11.1 x 28.9 cm) Marked on bottom: in serrated rectangle, G & M; pseudo-hallmarks of sovereign's head, lion passant, and crowned leopard's head Inscribed in banner: above cartouche, HONOR VIRTUTIS PROEMIUM; within cartouche, Presented by the Officers of the/NINTH REGᵀ. OF N.Y.S ARTILLERY/To/Col. Samuel I. [J.] Hunt/their late Commandant in token of/ their respect & esteem / 1829. The Detroit Institute of Arts, Founders Society Purchase, Edward E. Rothman Fund, Mrs. Charles Theron Van Dusen Fund, and the Gibbs-Williams Fund 1999.3.a,b Samuel J. Hunt, a New York City hardware merchant and bank director, served as colonel from 1826 to 1829.

Baldwin Gardiner, 1791–1869, active in Philadelphia 1814–26 and in New York City 1826–47, silverware manufacturer and fancy-hardware retailer

286. Tureen with cover on stand, ca. 1830 Silver 14⅛ x 15 x 12¾ in. (35.9 x 38.1 x 32.4 cm) Marked on underside of base of stand and tureen: in serrated rectangles, B. [effaced on stand] [pellet] GARDINER/NEW YORK; in rectangles, pseudo-hallmarks of lion passant, hammer in hand, and letter "G" Engraved with the coat-of-arms and crest of John Gerard Coster of New York City Private collection 92.24.USa–c

T. Brown, designer (possibly Thomas Brown, stone seal engraver, active in New York City 1800–1811 and 1814–50) Marquand and Brothers, active as jewelers 1831/32–1833/34, jeweler (Frederick Marquand, 1799–1882; Josiah P. Marquand, probably died in 1837)

287. Presentation medal, 1832 Gold 6¼ x 4¾ x ⅜ in. (16 x 11.9 x 1.1 cm) Engraved: on obverse on base scroll in Roman caps, PRO [pellet] PATRIA [pellet] ET [pellet] GLORIA; on obverse on partial globe at top, N/AMERICA[;] FRANCE; on reverse in script, Gothic, and Roman lettering, The/ National Guard/27th New York State Artillery/To/La Fayette,/Centennial Anniversary/ of the Birth Day of/Washington/New York/ 22d. February/1832 Winterthur Museum, Winterthur, Delaware, Museum Purchase 78.0113a,b

Marquand and Company, active 1833–38, retail silversmith and jeweler (Frederick Marquand, 1799–1882; Josiah P. Marquand, probably died in 1837; Henry G. Marquand, 1819–1902; Henry Ball; William Black)

288. Basket, 1833–38 Silver 4½ x 16½ in. (11.4 x 41.9 cm) Marked on underside: in curved rectangles, MARQUAND[;] & Co.; in curved, serrated rectangle, NEW-YORK Engraved with initial "W" The Baltimore Museum of Art, Decorative Arts Fund BMA1988.6 This New York–made object has a history of ownership in Natchez, Mississippi.

Maker unknown, probably English J. & I. Cox (or J. and J. Cox), active 1817–52, retailer (John Cox; Joseph Cox, ca. 1790–1852)

289. Pair of argand lamps, ca. 1835 Brass and glass Each 23½ x 18½ x 9 in. (59.7 x 47 x 22.9 cm) Metal stamp on each arm: J & I Cox/ New York Dallas Museum of Art 1992.B.152.1, 2

Colin V. G. Forbes and Son, active 1826–38, manufacturing silversmith (Colin van Gelder Forbes, 1776–1859; William Forbes, baptized 1799)

290. Presentation hot-water urn, 1835 Silver; iron heating core 20 x 13 x 10 in. (50.8 x 33 x 25.4 cm) Marked twice on outer edge of base in three rectangles: FORBES/&/SON Inscribed on body: PRESENTED BY/The Firemen of the City of New York/to John W. Degrauw Esqr./upon his retiring from the active/duties of the department, as a token of/ their approbation for his faithful &/valuable

services as the presiding/officer of the Board of Trustees./NEW-YORK FEBRUARY/1835. Collection of Mr. and Mrs. Gerard L. Eastman, Jr.

Moritz Fürst, born Hungary 1782, active in the United States 1807–ca. 1840, engraver and diesinker

291. Medal (obverse and reverse), ca. 1838
Silver
Diam. 2 in. (5.1 cm)
Inscribed: on obverse, AMERICAN INSTITUTE/NEW-YORK/FURST; on reverse, Awarded to/Wm. Forbes/For the best/Silver Tea Sett [sic]/1838
The Metropolitan Museum of Art, New York, Gift of William Forbes II, 1952 52.113.2

Charles Cushing Wright, 1796–1854, engraver
Peter Paul Duggan, d. 1861, active in New York City 1845–56, designer

292. American Art-Union medal depicting Washington Allston, 1847
Bronze
Diam. 2½ in. (6.4 cm)
Inscribed: on obverse, P. P. DUGGAN DEL. C.C. WRIGHT SC.[;] WASHINGTON/ALLSTON; on reverse, P. P. DUGGAN DEL./C.C. WRIGHT SC.[;] 1847[;] AMERICAN/ART UNION
The Metropolitan Museum of Art, New York, Gift of Janis Conner and Joel Rosenkranz, 1997 1997.484.1

Charles Cushing Wright, 1796–1854, engraver
Salathiel Ellis, 1803–1879, active in New York City, 1842–64, modeler

293. American Art-Union medal depicting Gilbert Stuart, 1848
Bronze
Diam. 2½ in. (6.4 cm)
Inscribed: C.C. WRIGHT F.[;] S. ELLIS DEL[;] AMERICAN/ART-UNION
The Metropolitan Museum of Art, New York, Gift of Janis Conner and Joel Rosenkranz, 1997 1997.484.2

Charles Cushing Wright, 1796–1854, engraver
Peter Paul Duggan, d. 1861, active in New York City 1845–56, designer

294. Seal of the American Art-Union (reverse of medal depicting Gilbert Stuart), 1848
Bronze
Diam. 2½ in. (6.4 cm)
Inscribed: C.C. WRIGHT[;] DUGGAN DEL.
The Metropolitan Museum of Art, New York, Gift of Mr. and Mrs. F. S. Wait 1907.07.34

Charles Cushing Wright, 1796–1854, engraver
Robert Ball Hughes, 1806–1868, modeler
Peter Paul Duggan, d. 1861, active in New York City 1845–56, designer of reverse

295. American Art-Union medal depicting John Trumbull, 1849
Bronze
Diam. 2½ in. (6.4 cm)

Inscribed: on obverse, AMERICAN/ART-UNION[;] C. C. WRIGHT F.[;] B. HUGHES DEL.; on reverse, P.P.D. D. / C.C.W. F.[;] 1849
The Metropolitan Museum of Art, New York, Gift of Janis Conner and Joel Rosenkranz, 1997 1997.484.3

William Adams, active 1829–61, manufacturing silversmith

296. Presentation vase with cover, 1845
Silver
23½ x 19 x 11½ in. (59.7 x 48.3 x 29.2 cm)
Engraved: on front of base, William Adams/Manufacturer of Silver Ware/New York; on right side of base, Manufactured by William Adams
Inscribed: on front of body, Presented/to/Henry Clay/by the/Gold and Silver Artizans [sic],/of the/City of New York./As a tribute of their respect for the faithful and patriotic/manner in which he has discharged his high public trust/and ESPECIALLY for his early and untiring advocacy of/PROTECTION TO AMERICAN INDUSTRY/1845./COMMITTEE/Wm. Adams/Moses G. Baldwin/Alfred G. Peckham/Edward Y. Prime/Daniel Carpenter/David Dunn; on reverse, PROTECTION
The Henry Clay Memorial Foundation, located at Ashland, The Henry Clay Estate in Lexington, Kentucky. Gift of Colonel Robert Pepper Clay 88.039a,b
Clay aided New York silver and gold artisans by sponsoring a provision in the Tariff of 1842 that increased duties on imported silverware and foreign jewelry.

William F. Ladd, active 1829–90, watchmaker and retail jeweler

297. Trophy pitcher, 1846
Silver
10 x 9 x 5 in. (25.4 x 22.9 x 12.7 cm)
Marked on bottom: in rectangle, Wm. F. LADD; in serrated rectangle, NEW-YORK
Inscribed on body: NEW YORK YACHT CLUB/Subscription Stakes/October 7th 1846
The New-York Historical Society, Purchase, Lyndhurst Corporation Abbott-Lenox Fund 1981.19
The sloop *Maria*, owned by New York Yacht Club Commodore John C. Stevens, won this trophy in the club's first Corinthian regatta, held in New York Harbor on October 7, 1846.

Zalmon Bostwick, 1811–before 1876, active ca. 1845–53, silverware manufacturer

298. Pitcher and goblet, 1845
Silver
Pitcher: 11 x 8½ x 5½ in. (27.9 x 21.6 x 14 cm)
Goblet: 7¼ x 3⅞ x 3⅝ in. (18.4 x 9.8 x 9.2 cm)
Marked on underside of pitcher (each stamped twice): Z Bostwick [in script][;] NEW YORK
Inscribed: on base of pitcher, John W. Livingston to/Joseph Sampson/1845; on goblet, JWL to JS 1845
Brooklyn Museum of Art, Gift of the Estate of May S. Kelley, by exchange 81.179.1–.2

Gale and Hayden, active 1845/46–1849/50, patentee of design
(William Gale Sr., 1799–1867; Nathaniel Hayden, 1805–1875)
William Gale and Son, active ca. 1850–59 and 1862–67, manufacturing silversmith
(William Gale Sr.; William Gale Jr., 1825–1885)

299. Gothic-pattern crumber, design patented 1847
Silver
L. 13⅛ in. (33.3 cm)
Marked on back of handle: W. GALE & SON/925 STERLING [incuse]
Engraved on obverse of handle: EWM [in script]
Collection of Robert Mehlman

Gale and Hayden, active 1845/46–1849/50, patentee of design
(William Gale Sr., 1799–1867; Nathaniel Hayden, 1805–1875)
William Gale and Son, active ca. 1850–59 and 1862–67, manufacturing silversmith
(William Gale Sr.; William Gale Jr., 1825–1885)

300. Gothic-pattern dessert knife, sugar sifter, fork, and spoon, design patented 1847, knife dated 1852, fork 1853, and spoon 1848
Silver
Knife: L. 8⅛ in. (20.6 cm); w. ¾ in. (1.9 cm)
Sugar sifter: 7½ x 2⅜ x 1⅝ in. (19.1 x 6 x 4.1 cm)
Fork: 8 x 1 x ¾ in. (20.3 x 2.5 x 1.9 cm)
Spoon: 6 x 1¼ x ¾ in. (15.2 x 3.2 x 1.9 cm)
Knife marked on blade: Church & Batterson/1852/[pellet]/G & S
Engraved: J.M. [knife]; SHJ [sifter]; LTCS [fork]; GEM [spoon]
Dallas Museum of Art, 1991.12 (knife), 1991.101.14.1–3 (sifter, fork, and spoon)

John C. Moore, ca. 1802–1874, manufacturing silversmith
James Dixon and Sons, English (Sheffield), active 1806–after 1887, manufacturer of tray
Ball, Tompkins and Black, active 1839–51, retail silversmith and jeweler
(Henry Ball; Erastus O. Tompkins, d. 1851; William Black)

301. Presentation tea and coffee service with tray
Service: silver; tray: silver-plated base metal

Hot-water kettle on stand, 1850
17⅜ x 10¼ x 7 in. (44 cm x 26 cm x 17.8 cm)
Marked on underside: BALL, TOMPKINS & BLACK/NEW YORK/[incuse in semicircle]/J.C.M./22
Inscribed: in one reserve, To/MARSHALL LEFFERTS, ESQ./President/of the/New York/and/New England/and/New York State/Telegraph Companies; in second reserve, From/the Stockholders/and Associated Press/of New York City;/Viz., Courier & Enquirer,/Journal of Commerce, Express,/Herald, Sun and Tribune;/As a token of the satisfaction and/confidence inspired by his efficient/services in advancing the cause and credit/of the Telegraph System, the noblest/enterprise of this eventful age./New York, June 1850.

The Metropolitan Museum of Art, New York, Gift of Mrs. F. R. Lefferts, 1969 69.141.1a-d

Sugar bowl with cover, 1850
H. 9 in. (22.9 cm); w. 7 in. (17.9 cm); diam. 5⅜ in. (13.5 cm)
Marked on underside of base: BALL, TOMPKINS & BLACK/NEW YORK/[pellet]/ J.C.M./22
Inscription virtually identical to that on urn
The Metropolitan Museum of Art, New York, Gift of Mrs. F. R. Lefferts, 1969 69.141.2a,b

Hot-milk pot, 1850
H. 8¾ in. (21.3 cm); w. 5 in. (12.8 cm); diam. 4⅛ in. (10.6 cm)
Marked on underside of base: BALL, TOMPKINS & BLACK/NEW YORK/[pellet]/ J.C.M./22
Inscription virtually identical to that on urn
The Metropolitan Museum of Art, New York, Gift of Mrs. F. R. Lefferts, 1969 69.141.3

Pitcher, 1850
16⅛ x 7⅝ x 7 in. (41 x 19.4 x 17.8 cm)
Marked on underside of base: BALL, TOMPKINS & BLACK NEW YORK [incuse in semicircle] J.C.M./9
Inscription virtually identical to that on urn
Museum of the City of New York, gift of Charles Stedman, Jr. 62.161

Tray, ca. 1850
23¼ x 36⅞ in. (59.1 x 93.7 cm)
Marked on underside of rim in partial octagon: JAMES DIXON & SONS/SHEFFIELD [below variation on royal coat of arms with lion and unicorn issuing from behind oval shield with motto "[DIEU] ET MON[DRO]IT"
Incised on handle: 358
Stamped on underside of rim on a long side: [small crown device]
Inscription virtually identical to that on urn
The Metropolitan Museum of Art, New York, Gift of Mrs. F. R. Lefferts, 1969 69.141.4
Related in form and decoration to an acclaimed gold service made for E. K. Collins by John C. Moore, shown by Ball, Tompkins and Black at the Great Exhibition, London, in 1851 and at the New-York Exhibition of the Industry of All Nations in 1853-54

Starr, Fellows and Company, active 1850-57, or Fellows, Hoffman, and Company, active 1857-81
(William H. Starr; Charles H. Fellows; Charles O. Hoffman; Jer. A. G. Comstock; James G. Dolbeare; George Nichols)
302. Four-branch gasolier with central figure of Christopher Columbus, ca. 1857
Patinated spelter, gilt brass, lacquered brass, iron, and glass
43 x 29¼ x 29¼ in. (109.2 x 74.3 x 74.3 cm)
Louisiana State University Museum of Art, Baton Rouge, Louisiana. Gift of the Baton Rouge Coca-Cola Bottling Company 82.13

Dietz, Brother and Company, active ca. 1840-55 (Robert Edwin Dietz, 1818-1897; William Henry Dietz, d. 1860)
303. Three-piece girandole set depicting Louis Kossuth, leader of the Hungarian Revolution (1848), 1851
Bronze, lacquer, and brass
92.6a: 20⅛ x 6½ x 3⅝ in. (51 x 16.5 x 9.2 cm)
92.6b: 15⅝ x 6½ x 3⅞ in. ( 39.7 x 16.5 x 9.7 cm)
92.6c: 15½ x 6½ x 3⅞ in. (39.4 x 16.5 x 9.7 cm)
Marked: on back of 92.6a, DIETZ/PATENT/ NEW YORK/DEC. 1851; on back of 92.6b, c, DIETZ/NEW YORK/PATENT/DEC. 1851
The Newark Museum, Anonymous Gift of Two Friends of the Decorative Arts, 1992 92.6a–c

Cooper and Fisher, active 1854-62, silverware manufacturer
(Francis W. Cooper, ca. 1811-1898, silversmith; Richard Fisher, jeweler)
304A–C. Chalice, paten, and footed paten, 1855-56
Coin and fine silver, gilding, and enamel
Chalice: 10 x 6½ in. (25.4 x 16.5 cm)
Paten: diam. 9½ in. (24.1 cm)
Footed paten: h. 9 in. (22.9 cm); diam. 12 in. (30.5 cm)
Marked twice on rims of bases of chalice and footed paten and once on base of paten: COOPER & FISHER/131 AMITY ST NY
Inscribed around rim of paten and on foot of footed paten: Holy:Holy:Holy—Lord God of Hosts—Heaven and Earth Are Full of Thy Glory
Inscribed around rim of footed paten: Holy Holy Holy Lord God of Hosts, Heaven and Earth are Full of Thy Glory. Glory be to Thee O Lord Most High. Amen.[;] Hosanna For The Lord God Omnipotent Reigneth Alleluia.
Parish of Trinity Church in the City of New York 80.14.1–3

Wood and Hughes, active 1845-99, silverware manufacturer
305. Commemorative pitcher, Kiddush goblets, and tray, 1856
Silver; goblets with gilt interiors
Pitcher: 13¾ x 10 in. (34.9 x 25.4 cm)
Goblets: h. 5¾ in. (14.6 cm); diam. 3¾ in. (9.5 cm)
Tray: 15¾ x 12 in. (40 x 30.5 cm)
Marked: W & H / NEW YORK
Inscribed within a cartouche on each object: Presented by/The EMANU-EL TEMPLE/NEW YORK,/To the Revd. Dr. D. Einhorn/as a Token of Esteem/August 1856
Inscribed on the bowl of one goblet: Presented to/Rev. Dr. Samuel Schulman/ By the Einhorn Family/as a Token of Appreciation/May 1909/Bequeathed to/Congregation Emanu-El/by/Rev. Dr. Samuel/ Schulman/1956
Courtesy of Congregation Emanu-El of the City of New York CEE–29–43a,b (pitcher/ tray), CEE–56–1,2 (goblets)
Dr. David Einhorn (1809-1879) was a leading

international advocate of Reform Judaism; the pitcher depicts the congregation's home on East Twelfth Street, occupied from 1854 to 1868.

William Forbes, worked independently in New York 1837-63, manufacturing silversmith Ball, Tompkins and Black, active 1839-51, retail silversmith and jeweler
(Henry Ball; Erastus O. Tompkins, d. 1851; William Black)
306. Pitcher and goblet (one of two), 1851
Silver
Goblet: 4.9 in. (22.9 cm); diam. (rim) 4⅞ in. (12.4 cm)
Pitcher: 18 x 9½ x 7 in. (45.7 x 24.1 x 17.8 cm)
Marked: BALL, TOMPKINS & BLACK [in Roman caps in semicircle]/SUCCESSORS TO [in rectangle]/MARQUAND & CO. [in semicircle]/[an eagle in an oval, struck twice, flanking MARQUAND & CO.]/NEW YORK [in rectangle]/W.F. [in rectangle, struck twice, flanking NEW YORK]
Inscribed within reserve on body: The Members of/the/Board of Aldermen/of 1850 & 51/To/Their President/Morgan Morgans Esqr.
Museum of the City of New York, Gift of Frank D. Morgans 54.97.1a,b

Tiffany and Company, active 1837–present, manufacturing and retail silversmith and jeweler
307. Medal (obverse and reverse), 1859
Gold
Diam. 2¾ in. (7 cm)
Marked on reverse in exergue: TIFFANY & CO. N.Y.
Inscribed in field on obverse: CYRUS W. FIELD/FROM THE CHAMBER OF COMMERCE/ AND CITIZENS OF NEW YORK,
Inscribed in field on obverse in exergue: COMMEMORATIVE OF THE PART TAKEN/BY HIM,/IN LAYING THE FIRST/TELEGRAPHIC CABLE/BETWEEN/EUROPE AND AMERICA, IN AUGUST, A.D. 1858
The Metropolitan Museum of Art, New York, Gift of Cyrus W. Field, 1892 92.10.3

Tiffany and Company, active 1837–present, manufacturing and retail silversmith and jeweler
308. Presentation box, 1859
Gold
1½ x 4½ x 2¾ in. (3.8 cm x 11.4 cm x 7 cm )
Inscribed on lid: on exterior, The City of New York to Cyrus W. Field; on interior, The City of New York to Cyrus W. Field/ Commemorating his Skill Fortitude and Perseverance/in Originating and Completing/ the First Enterprise for an Ocean Telegraph/ successfully accomplished on the 5th August 1858./Uniting Europe and America.
The Metropolitan Museum of Art, New York, Gift of Cyrus W. Field, 1892 92.10.7

Tiffany and Company, active 1837–present, manufacturing and retail silversmith and jeweler

309. Mounted section of transatlantic telegraph cable, 1858
Steel and brass
L. 4 in. (10.2 cm); diam. ¾ in. (1.9 cm)
Marked on mount: ATLANTIC TELEGRAPH CABLE/GUARANTEED BY/TIFFANY & CO./BROADWAY. NEW YORK.
Collection of D. Albert Soeffing
Tiffany and Company offered the public these four-inch lengths of cable, mounted as souvenirs, at a retail cost of fifty cents each.

Tiffany and Company, active 1837–present, manufacturing and retail silversmith and jeweler

310. Pitcher from a service presented to Colonel Abram Duryee of the Seventh Regiment, New York National Guard, by his fellow citizens, 1859
Sterling silver
14½ x 9¾ x 7½ in. (36.8 x 24.8 x 19.1 cm)
Marked on underside of base: TIFFANY & CO./1004/ENGLISH STERLING/925–1000/6248/M [Gothic style in oval]/550 Broadway/M [Gothic style in oval]
Inscribed on body within reserves: To/Colo.

A. Duryee/this testimonial is presented/on his retireing [sic] from the Colonelcy/of the/Seventh Regiment/National Guard/as a mark of high/appreciation From/his fellow citizens/for his soldierlike/qualities and for the/valuable services/rendered by the Regiment during/the eleven years that he/commanded it/New York/1859
Museum of the City of New York, Bequest of Emily Frances Whitney Briggs 55.257.5
The records of Tiffany and Company indicate that this service consisted of two pitchers, six goblets, a twenty-three-inch waiter, and a small waiter.

# Bibliography

Authors' note: This bibliography is a partial listing of the books and articles consulted during the preparation of the exhibition and publication *Art in the Empire City: New York, 1825–1861*. The titles of the nineteenth-century periodicals that were surveyed page-by-page are included, but individual articles from these sources are not itemized here. Nineteenth-century newspapers were consulted as is reflected in the notes to the catalogue essays. Extensive use was made of city directories; for a detailed listing consult Dorothea Spear, *Bibliography of American Directories through 1860* (Worcester, Massachusetts: American Antiquarian Society, 1961).

## PERIODICALS REVIEWED

*The Albion*. New York, weekly, 1822–76.

*American Athenaeum*. New York, weekly, April 21, 1825–March 2, 1826. Merged into *New York Literary Gazette, and American Athenaeum*.

*American Eagle Magazine*. New York, monthly, June–July 1847.

*American Journal of Fine Arts Devoted to Painting, Sculpture, Architecture, Music*. New York, 1844.

*American Journal of Photography and the Allied Arts and Sciences*. New York, weekly, 1852–67.

*American Ladies' Magazine*. Boston, monthly, 1828–36. Merged into *Godey's Lady's Book*.

*American Mechanic*. New York and Boston, weekly, January 8–December 31, 1842.

*American Mechanics' Magazine*. New York, weekly, February 5, 1825–February 11, 1826.

*American Metropolitan Magazine*. New York, monthly, January and February 1849.

*American Monthly Magazine*. New York, monthly, March 1833–October 1838.

*American People's Journal of Science, Literature, and Art*. New York, monthly, January and February 1850.

*American Repertory of Arts, Sciences, and Manufactures*. New York, monthly, February 1840–January 1842.

*American Repertory of Arts, Sciences, and Useful Literature*. Philadelphia, monthly, 1830–July 1832.

*American Turf Register and Sporting Magazine*. Baltimore, monthly, September 1829–38; New York, 1838–December 1844.

*Anglo American*. New York, weekly, April 29, 1843–November 13, 1847. Merged into *The Albion*.

*Appletons' Mechanics' Magazine and Engineers' Journal*. New York, 1851–53.

*Arcturus*. New York, monthly, December 1840–May 1842.

*Arthur's Home Magazine*. Philadelphia, monthly, October 1852–December 1898. Title varies: *Home Magazine*, October 1852–December 1855; *Lady's Home Magazine*, January 1857–December 1859; *Arthur's Home Magazine*, January 1861–June 1863.

*Arthur's Magazine*. Philadelphia, monthly, January 1844–April 1846. Title varies: *Ladies' Magazine of Literature, Fashion and Fine Arts*, January–June 1844; *Arthur's Ladies' Magazine of Elegant Literature and the Fine Arts*, July 1844–December 1845; *Arthur's Magazine*, January–April 1846; merged with *Godey's Lady's Book*.

*The Artist*. New York, monthly, September 1842–May 1843.

*Atlantic Magazine*. New York, monthly, May 1824–April 1825.

*Atlantic Monthly*. Boston, monthly, 1857–62.

*Broadway Journal*. New York, weekly, January 4, 1845–January 3, 1846.

*Brother Jonathan*. New York, weekly, January 1, 1842–December 23, 1843.

*Bulletin of the American Art-Union*. New York, monthly, April 25, 1848–53.

*Burton's Gentleman's Magazine and American Monthly Review*. Philadelphia, monthly, July 1837–December 1840. Title varies: *Gentleman's Magazine*, July 1837–February 1839; *Burton's Gentleman's Magazine and American Monthly Review*, March 1839–November 1840; *Graham's Magazine*, December 1840.

*Christian Parlor Magazine*. New York, monthly, May 1844–55.

*Columbian Lady's and Gentleman's Magazine*. New York, monthly, January 1844–February 1849.

*The Corsair*. New York, weekly, March 16, 1839–March 7, 1840.

*Cosmopolitan Art Journal*. New York, quarterly, 1856–61.

*The Crayon*. New York, monthly, January 1855–July 1861.

*The Critic*. New York, weekly, November 1, 1828–June 20, 1829.

*Dollar Magazine*. New York, monthly, January 1848–December 1851. Title varies: *Holden's Dollar Magazine, . . .* January 1848–December 1850.

*Dramatic Mirror, and Literary Companion*. New York and Philadelphia, weekly, August 14, 1841–May 7, 1842.

*Eclectic Magazine of Foreign Literature*. New York and Philadelphia, monthly, 1844–1907.

*Eclectic Museum of Foreign Literature, Science and Art*. New York and Philadelphia, monthly, January 1843–January 1844.

*Emerson's Magazine and Putnam's Monthly*. New York, monthly, May 1854–November 1858. Title varies: *United States Magazine of Science, Art, Manufactures, Agriculture, Commerce and Trade*, May 15, 1854–April 1856; *United States Magazine*, July 1856–June 1857; *Emerson's United States Magazine*, July–September 1857; *Emerson's Magazine and Putnam's Monthly*, October 1857–November 1858.

*The Expositor*. New York, weekly, December 8, 1838–July 20, 1839.

*Frank Leslie's Illustrated Newspaper*. New York, weekly, December 15, 1855–June 17, 1922. Title varies after 1891.

*Gleason's Pictorial Drawing-Room Companion*. Boston, weekly, May 3, 1851–December 24, 1859. Title varies: *Ballou's Pictorial Drawing-Room Companion*, January 6, 1855–December 24, 1859.

*Godey's Lady's Book*. Philadelphia, monthly, 1830–98. Title varies: variations on *Lady's Book*, 1830–39; *Godey's Lady's Book and Ladies' American Magazine*, 1840–43; *Godey's Magazine and Lady's Book*, January 1844–June 1848; *Godey's Lady's Book*, July 1848–June 1854; *Godey's Lady's Book and Magazine*, July 1854–December 1882.

*Graham's American Monthly Magazine of Literature, Art, and Fashion*. Philadelphia, monthly, January 1826–December 1858. Title varies: *The Casket*, February 1826–December 1830; *Atkinson's Casket*, January 1831–April 1839; *The Casket*, May 1839–November 1840; *Graham's Lady's and Gentleman's Magazine*, January 1841–December 1842; *Graham's Magazine of Literature and Art*, January–June 1843; *Graham's Lady's and Gentleman's Magazine*, July 1843–June 1844; *Graham's American Monthly Magazine of Literature, Art, and Fashion*, July 1844–December 1858.

*Hardware Man's Newspaper and American Manufacturer's Circular*. Middletown, New York, and New York, 1855–59.

*Harper's New Monthly Magazine*. New York, monthly, June 1850–November 1900.

*Harper's Weekly*. New York, weekly, from January 3, 1857.

*Home Journal*. New York, weekly, from February 14, 1846. Title varies: *Morris's National Press, a Journal for Home*, February 14–November 14, 1846.

*Horticulturist and Journal of Rural Art and Rural Taste*. Albany, monthly, from October 1846.

*Humphrey's Journal*. New York, monthly, 1850–early 1870s.

*Hunt's Merchants' Magazine*. New York, monthly, July 1839–December 1870. Title varies: *Hunt's Merchants' Magazine and Commercial Review*; *Merchant's Magazine and Commercial Review*.

*Illustrated Magazine of Art*. New York, monthly, 1853–54.

*Illustrated News*. New York, weekly, January 1–November 26, 1853. Merged into *Gleason's Pictorial Drawing-Room Companion*.

*The Independent*. New York, weekly, December 7, 1848–October 13, 1928.

*International Art-Union Journal*. New York, monthly, February–November 1849.

*International Monthly Magazine of Literature, Science, and Art*. New York, monthly, July 1850–April 1852.

*The Iris; or, Literary Messenger.* New York, monthly, November 1840–October 1841.

*The Knickerbocker.* New York, monthly, January 1833–December 1865. Title varies: *The Knickerbocker; or, New York Monthly Magazine,* January 1833–December 1862.

*Ladies' Companion.* New York, monthly, May 1834–October 1844. Title varies: *Ladies' Companion, a Monthly Magazine,* May 1834–April 1843; *Ladies' Companion, and Literary Expositor,* May 1843–October 1844.

*Ladies' Repository.* Cincinnati and New York, monthly, January 1841–December 1867. Title varies: *Ladies Repository, and Gatherings of the West,* January 1841–December 1848; *Ladies' Repository; a Monthly Periodical, . . .* January 1849–December 1862.

*Ladies' Wreath.* New York, monthly, May, 1846–January 1862.

*Literary Gazette and American Athenaeum.* New York, weekly, September 10, 1825–March 3, 1827. Title varies: *New York Literary Gazette and Phi Beta Kappa Repository,* September 10, 1825–March 4, 1826; *New York Literary Gazette and American Athenaeum,* March 11–September 2, 1826; *Literary Gazette and American Athenaeum,* September 9, 1826–March 3, 1827.

*Literary World.* New York, weekly, February 6, 1847–December 31, 1853.

*Magazine of Useful and Entertaining Knowledge.* New York, monthly, June 15, 1830–May 1831. Title varies: *Mechanics' and Farmers' Magazine of Useful Knowledge,* June 15–July 15, 1830.

*Mechanic's Advocate.* Albany, weekly, December 3, 1846–1848. Succeeded the *New York State Mechanic.*

*Mechanics' Magazine, and Journal of Public Internal Improvement; Devoted to the Useful Arts, and the Recording of Projects, Inventions, and Discoveries of the Age.* Boston, monthly, February 1830–January 1836.

*Mechanics' Magazine, and Journal of the Mechanics' Institute.* New York, monthly, January 1833–August 1837.

*The Minerva.* New York, weekly, April 6, 1822–September 3, 1825. Superseded by the *New York Literary Gazette and Phi Beta Kappa Repository.*

*Monthly Chronicle of Events, Discoveries, Improvements, and Opinions.* Boston, monthly, April 1840–December 1842.

*National Magazine.* New York, monthly, July 1852–December 1858.

*National Police Gazette.* New York, weekly, September 1845–August 31, 1867. (Includes attacks on the Art Union.)

*New Mirror.* New York, weekly, April 8, 1843–September 28, 1844. Supersedes the *New York Mirror* (1823–42). After about a year, it was discontinued in favor of a daily newspaper, the *Evening Mirror,* and its adjunct, the *Weekly Mirror.*

*New World.* New York, weekly, June 6, 1840–May 10, 1845.

*New York Illustrated Magazine of Literature and Art.* New York, weekly, September 20–December 1845; monthly, January 1846–June 1847.

*New York Literary Gazette.* New York, weekly, February 2–July 13, 1839.

*New York Literary Gazette and Journal of Belles Lettres, Arts, Science &c.* New York, semi-monthly, September 1, 1834–March 14, 1835.

*New York Mirror.* New York, weekly, August 2, 1823–December 31, 1842. Title varies: *New-York Mirror, and Ladies' Literary Gazette,* August 2, 1823–July 3, 1830; superseded by *New Mirror.*

*New York Quarterly Devoted to Science, Philosophy and Literature.* New York, quarterly, 1825–55.

*New York Review.* New York, quarterly, March 1837–April 1842.

*New York Review, and Atheneum Magazine.* New York, monthly, June 1825–May 1826.

*New York State Mechanic.* Albany, weekly, November 20, 1841–June 17, 1843.

*The New-Yorker.* New York, weekly, March 26, 1836–September 11, 1841.

*Niles' National Register.* Washington, D.C., Baltimore, and Philadelphia, weekly, September 2, 1837–September 28, 1849.

*Niles' Weekly Register.* Baltimore, weekly, September 7, 1811–August 26, 1837. Title varies: *Weekly Register,* September 7, 1811–August 27, 1814.

*Opera Glass, Devoted to the Fine Arts, Literature and Drama.* New York, September 8–November 3, 1828.

*Peterson's Magazine.* Philadelphia, monthly, January 1842–December 1861. Title varies: *Lady's World of Fashion,* January–December 1842; *Lady's World,* January–May 1843; *Artist and Lady's World,* June 1843; *Ladies' National Magazine,* July 1843–December 1848; *Peterson's Magazine,* January 1849–November 1892.

*Philadelphia Album and Ladies' Literary Port Folio.* Philadelphia, weekly, April 26, 1826–December 27, 1834. Title varies: *Album and Ladies' Weekly Gazette,* June 7, 1826–May 30, 1827; *Philadelphia Album and Ladies' Literary Gazette,* June 6, 1827–July 3, 1830.

*Photographic and Fine Art Journal.* New York, monthly, January 1851–1860. Title varies: *Photographic Art-Journal,* January 1851–December 1853.

*Political Economist.* Philadelphia, weekly, January 24–May 1, 1824.

*Port Folio.* Philadephia, 1801–5, 1806–8, 1809–12, 1813–15, 1816–25, monthly, July 1826–December 1827.

*Putnam's Monthly.* New York, monthly, January 1853–December 1857. New series, titled *Putnam's Magazine,* January 1868–November 1870.

*The Republic: A Monthly Magazine of American Literature, Politics, and Art.* New York, monthly, 1851–52.

*Sargent's New Monthly Magazine, of Literature, Fashion, and the Fine Arts.* New York, monthly, January–June 1843.

*Sartain's Union Magazine of Literature and Art.* New York and Philadelphia, monthly, July 1847–August 1852. Title varies: *Union Magazine of Literature and Art,* July 1847–December 1848; *Sartain's Union Magazine of Literature and Art,* January 1849–August 1852.

*Spirit of the Times.* New York, weekly, December 10, 1831–June 22, 1861. Title varies: *Traveller and Spirit of the Times,* December 1, 1832–October 6, 1833.

*The Talisman.* New York, annually, 1828–30.

*Transactions of the Literary and Philosophical Society of New-York.* New York, irregularly, 1815–25.

*United States Democratic Review.* Washington, D.C., and New York, monthly, October 1837–December 1851. Title varies: *United States Magazine, and Democratic Review,* October 1837–December 1851; *Democrat's Review,* January–December 1852; *United States Review,* January 1853–January 1856.

*United States Review and Literary Gazette.* Boston and New York, monthly, October 1826–September 1827.

*Washington Quarterly Magazine of Arts, Science and Literature.* Washington, D.C., quarterly, July 1823–April 1824.

*Working Man's Advocate.* New York, weekly, October 31, 1829–1836; new series, 1844–49. Title varies: *Workingman's Advocate,* October 31, 1829–June 5, 1830; *New York Sentinel and Working Man's Advocate,* June 9–August 14, 1830; *Workingman's Advocate,* August 21, 1830–August 10, 1833; *Radical, in Continuation of Working Man's Advocate,* January 1841–April 1843; *Workingman's Advocate,* March 16–July 20, 1844; *People's Rights,* July 24–27, 1844; *Workingman's Advocate,* August 3–October 5, 1844; *Subterranean, United with the Workingman's Advocate,* October 12–December 21, 1844; *Workingman's Advocate,* December 28, 1844–March 22, 1845; *Young America,* March 29, 1845–September 23, 1848.

## Books and Journal Articles

Abbott, Jacob. *The Harper Establishment; or, How the Story Books Are Made.* New York: Harper and Brothers Publishers, 1855.

Abdy, Edward S. *Journal of a Residence and Tour in the United States of North America, from April, 1833, to October, 1834.* 3 vols. London: J. Murray, 1835.

Adkins, Nelson F. *Fitz-Greene Halleck, an Early Knickerbocker Wit and Poet.* New Haven: Yale University Press, 1930.

Albion, Robert Greenhalgh. *The Rise of New York Port (1815–1860).* New York: C. Scribner's Sons, 1939. Reprint, Boston: Northeastern University Press, 1984.

Albis, Jean d'. *Haviland.* Paris: Dessin et Tolra, 1988.

Albis, Jean d', and Céleste Romanet. *La porcelaine de Limoges.* Paris: Sous le Vent, 1980.

Allen, Sue. "Machine-Stamped Bookbindings, 1834–1860." *Antiques* 115 (March 1979), pp. 564–72.

Alsop, Susan Mary. "Victoria Mansion in Maine: Preserving a Rare Gustave Herter Interior." *Architectural Digest* 51 (September 1994), pp. 46–56.

American Academy of the Fine Arts. *The Charter and By-laws of the American Academy of Fine*

*Arts, Instituted February 12, 1802, under the Title of the American Academy of the Arts. With an Account of the Statues, Busts, Paintings, Prints, Books, and Other Property Belonging to the Academy.* New York: David Longworth, 1817.

———. *A Descriptive Catalogue of the Paintings, by the Ancient Masters, Including Specimens of the First Class, by the Italian, Venetian, Spanish, Flemish, Dutch, French, and English Schools.* New York: W. Mitchell, 1832.

———. *Exhibition of Rare Paintings at the Academy of Fine Arts, New York.* Exh. cat. New York: American Academy of the Fine Arts, 1828.

*The American Advertising Directory for Manufacturers and Dealers for the Year 1832.* New York: Jocelyn, Darling and Company, 1832.

American Art-Union. *Transactions of the American Art-Union, for the Promotion of the Fine Arts in the United States, for the Year 1844.* New York, 1844.

*America's Successful Men of Affairs: An Encyclopedia of Contemporaneous Biography.* Edited by Henry Hall. New York: New York Tribune, 1895.

Ames, Kenneth L. *Death in the Dining Room and Other Tales of Victorian Culture.* Philadelphia: Temple University Press, 1992.

———. "Designed in France: Notes on the Transmission of French Style to America." *Winterthur Portfolio* 12 (1977), pp. 103–14.

Ampère, J. J. *Promenade en Amérique: États-Unis–Cuba–Mexique.* Paris: Michel Lévy Frères, 1855.

Anderson, Patricia. *The Course of Empire: The Erie Canal and the New York Landscape, 1825–1875.* Exh. cat. Rochester: Memorial Art Gallery of the University of Rochester, 1984.

*The Andrews & Co. Stranger's Guide in the City of New-York.* Boston: Andrews and Company, 1852.

Appleby, Joyce O. *Capitalism and a New Social Order: The Republican Vision of the 1790s.* New York: New York University Press, 1984.

———. *Economic Thought and Ideology in Seventeenth Century England.* Princeton: Princeton University Press, 1978.

Archives of the National Academy of Design. *Constitution and Bylaws of the National Academy of Design with a Catalogue of the Library and Property of the Academy.* New York: I. Sackett, 1843.

Aresty, Esther B. *The Best Behavior: The Course of Good Manners—from Antiquity to the Present—as Seen through Courtesy and Etiquette Books.* New York: Simon and Schuster, 1970.

Arfwedson, Carl David. *The United States and Canada, in 1832, 1833, and 1834.* London: Richard Bentley, 1834.

[Armstrong, William] An Old Resident. *The Aristocracy of New York: Who They Are, and What They Were, Being a Social and Business History of the City for Many Years.* New York: New York Publishing Company, 1848.

Arrington, Joseph Earl. "John Banvard's Moving Panorama of the Mississippi, Missouri, and Ohio Rivers." *Filson Club History Quarterly* 32 (July 1958), pp. 224–27.

*Art and Commerce: American Prints of the Nineteenth Century. Proceedings of a Conference Held in Boston May 8–10, 1975, Museum of Fine Arts, Boston, Massachusetts.* Charlottesville: University Press of Virginia, 1978.

*The Art-Journal Illustrated Catalog: The Industry of All Nations 1851.* Exh. cat. London: George Virtue, 1851.

Ashworth, Henry. *A Tour in the United States, Cuba, and Canada. . . . A Course of Lectures Delivered before Members of the Bolton Mechanics' Institution.* London: A. W. Bennett, 1861.

Aspinwall, W. H. *Descriptive Catalogue of the Pictures of the Gallery of W. H. Aspinwall, No. 99 Tenth Street, New-York.* N.p., 1860.

Association for the Exhibition of the Industry of All Nations. *Official Awards of Juries. . . 1853.* New York: Printed for the Association by William C. Bryant and Company, 1853.

Audubon, John James. *The Birds of America.* 87 parts. London: J. J. Audubon, 1827–38.

———. *The Birds of America from Drawings Made in the United States and Their Territories.* 7 vols. New York and Philadelphia: J. J. Audubon and J. B. Chevalier, 1840–44.

Avery, Kevin J. *Church's Great Picture: The Heart of the Andes.* Exh. cat. New York: The Metropolitan Museum of Art, 1993.

———. "*The Heart of the Andes* Exhibited: Frederic E. Church's Window on the Equatorial World." *American Art Journal* 18 (winter 1986), pp. 52–60.

———. "Movies for Manifest Destiny: The Moving Panorama Phenomenon in America." In *The Grand Moving Panorama of Pilgrim's Progress,* pp. 1–12. Exh. cat. Montclair, New Jersey: Montclair Art Museum, 1999.

———. "The Panorama and Its Manifestation in American Landscape Painting, 1795–1870." Ph.D. dissertation, Columbia University, New York, 1995.

Avery, Kevin J., and Peter L. Fodera. *John Vanderlyn's Panoramic View of the Palace and Gardens of Versailles.* New York: The Metropolitan Museum of Art, 1988.

Bacot, H. Parrott. *Nineteenth Century Lighting: Candle-powered Devices, 1788–1883.* Exton, Pennsylvania: Shiffer Publishing, 1987.

Badger, Daniel D. *Illustrations of Iron Architecture Made by the Architectural Iron Works of the City of New York.* New York: Baker and Godwin, 1865. Reprinted as *Badger's Illustrated Catalogue of Cast-Iron Architecture,* New York: Dover Publications, 1981. See also *Origins of Cast Iron Architecture in America* below.

Bagnall, W. R. *The Textile Industries of the United States . . . .* Cambridge, Massachusetts: Riverside Press, 1893.

Bailey, Rosalie Fellows. *Guide to Genealogical and Biographical Sources for New York City (Manhattan), 1793–1898.* Newton, Massachusetts: Garden City Print, 1954.

Baker, Paul R. *Richard Morris Hunt.* Cambridge, Massachusetts: MIT Press, 1980.

Banham, Joanna. *Encyclopedia of Interior Design.* 2 vols. London and Chicago: Fitzroy Dearborn Publishers, 1997.

Barber, Edwin Atlee. *Historical Sketch of the Green Point (N.Y.) Porcelain Works of Charles Cartlidge & Co.* Indianapolis: Clayworker, 1895.

Barber, John W., and Henry Howe. *Historical Collections of the State of New York.* New York: S. Tuttle, 1842.

Barck, Dorothy C. "Proposed Memorials to Washington in New York City." *New-York Historical Society Quarterly Bulletin* 15 (October 1931), pp. 79–90.

Barger, Helen, Sheldon Butts, and Ray La Tournous. "The Dorflinger Guard Presents." *Glass Club Bulletin of the National Early American Glass Club,* no. 36 (winter 1981–82), pp. 3–4.

Barnum, Phineas T. *Life of P. T. Barnum.* New York: Redfield, 1855.

———. *Struggles and Triumphs; or, Forty Years' Recollections of P. T. Barnum. Written by Himself.* Hartford, Connecticut: J. B. Burr and Company, 1870.

Barry, Charles. *The Travellers' Club House.* London: J. Weale, 1839.

Barter, Judith A., Kimberly Rhodes, and Seth A. Thayer, with contributions by Andrew Walker. *American Arts at the Art Institute of Chicago, from Colonial Times to World War I.* Chicago: Art Institute of Chicago, 1998.

Barth, Gunther. *City People: The Rise of Modern City Culture in Nineteenth-Century America.* New York: Oxford University Press, 1980.

Beach, Moses Y. *The Wealth and Biography of Wealthy Citizens of the City of New York.* New York: The Sun, 1855.

Beall, Karen F. *American Prints in the Library of Congress.* Baltimore: Johns Hopkins Press, 1970. Reprint, Baltimore: Johns Hopkins Press for the Library of Congress, 1981.

Beard, Rick. *In the Mill.* Exh. brochure. Yonkers, New York: Hudson River Museum, 1983.

Beck, Raymond L. "Thomas Constantine's 1823 Senate Speaker's Chair for the North Carolina State House: Its History and Preservation." *Carolina Comments* (Raleigh: North Carolina State Department of Archives and History) 41 (January 1993), pp. 25–30.

Beckert, Sven U. P. "The Making of New York City's Bourgeoisie, 1850–1886." Ph.D. dissertation, Columbia University, New York, 1995.

Bedini, Silvio A. "The Mace and the Gavel Symbols of Government in America." *Transactions of the American Philosophical Society* 87, part 4 (1997), pp. 28–33.

Belden, E[zekiel] Porter. *New-York: Past, Present, and Future: Comprising a History of the City of New-York, a Description of Its Present Condition and an Estimate of Its Future Increase.* 2d ed. New York: G. P. Putnam, 1849.

———. *New-York—As It Is, Being the Counterpart of the Metropolis of America.* New York: John P. Prall, 1849.

Belden, Louise Conway. *Marks of American Silversmiths in the Ineson-Bissell Collection.* Charlottesville: University Press of Virginia for the Henry Francis du Pont Winterthur Museum, 1980.

Bender, Thomas. *New York Intellect: A History of Intellectual Life in New York City from 1750 to the Beginnings of Our Own Time*. New York: Alfred A. Knopf, 1987.

———. *Toward an Urban Vision: Ideas and Institutions in Nineteenth-Century America*. Lexington: University of Kentucky, 1975.

Benisovich, Michel. "Sales of French Collections of Paintings in the United States during the First Half of the Nineteenth Century." *Art Quarterly* 19 (autumn 1956), pp. 288–301.

Bennett, Whitman. *A Practical Guide to American Nineteenth-Century Color Plate Books*. New York: Bennett Book Studios, 1949.

Berger, Max. *The British Traveller in America, 1836–1860*. New York: Columbia University Press, 1943.

Berthoff, Rowland. "Independence and Attachment, Virtue and Interest: From Republican Citizen to Free Enterprise, 1787–1837." In *Uprooted Americans: Essays to Honor Oscar Handlin*, edited by Richard Bushman et al., pp. 97–124. Boston: Little, Brown and Company, 1979.

Bigelow, David. *History of Prominent Mercantile and Manufacturing Firms in the United States, with a Collection of Truthful Illustrations, Representing Mercantile Buildings, Manufacturing Establishments, and Articles Manufactured*. Boston: David Bigelow, 1857.

Bigelow, Erastus B. *The Tariff Question Considered in Regard to the Policy of England and the Interests of the United States; with Statistical and Comparative Tables*. Boston: Little, Brown and Company, 1862.

Binder, Frederick M., and David M. Reimers. *All the Nations under Heaven: An Ethnic and Racial History of New York City*. New York: Columbia University Press, 1995.

*A Biographical and Critical Dictionary of Painters, Engravers, Sculptors, and Architects from Ancient to Modern Times; with Monograms, Ciphers, and Marks Used by Distinguished Artists to Certify Their Works*. New York: George P. Putnam, 1852.

Bird, Isabella Lucy. *The Englishwoman in America*. London: John Murray, 1856. Reprint, Madison: University of Wisconsin Press, 1966.

Bishop, J. Leander. *A History of American Manufactures from 1608 to 1860, Exhibiting the Origin and Growth of the Principal Mechanic Arts and Manufactures from the Earliest Colonial Period to the Adoption of the Constitution; and Comprising Annals of the Industry of the United States in Machinery, Manufactures and Useful Arts, with a Notice of the Important Inventions, Tariffs, and the Results of Each Decennial Census*. 3 vols. Philadelphia: Edward Young and Company, 1868.

Blackmar, Elizabeth. *Manhattan for Rent, 1785–1850*. Ithaca, New York: Cornell University Press, 1989.

———. "Uptown Real Estate and the Creation of Times Square." In *Inventing Times Square: Commerce and Culture at the Crossroads of the World*, edited by William R. Taylor. New York: Russell Sage Foundation, 1991.

Blaugrund, Annette. "John James Audubon: Producer, Promoter, and Publisher." *Imprint* 21 (March 1996), pp. 11–19.

[Blodget, Samuel]. *Thoughts on the Increasing Wealth and National Economy of the United States of America*. Washington, D.C.: Printed by Way and Groff, 1801.

Blumin, Stuart M. *The Emergence of the Middle Class: Social Experience in the American City, 1760–1900*. Cambridge: Cambridge University Press, 1989.

———. "Explaining the New Metropolis: Perception, Depiction, and Analogies in Mid-Nineteenth Century New York City." *Journal of Urban History* 11 (1984), pp. 9–38.

[Boardman, James]. *America and the Americans by a Citizen of the World*. London: Longman, Rees, Orme, Brown, Green, and Longmans, 1833.

[Bobo, William M.]. *Glimpses of New-York City by a South Carolinian (Who Had Nothing Else to Do)*. Charleston: J. J. McCarter, 1852.

Bodder, Geoffrey A. *Ridgway Porcelains*. 2d ed. Woodbridge, Suffolk: Antique Collectors' Club, 1985.

Bode, Carl. *Antebellum Culture*. Carbondale: Southern Illinois University Press, 1970. Originally published in 1959 as *The Anatomy of Popular Culture, 1840–1861*.

Bogardus, James [with John W. Thompson]. *Cast Iron Buildings; Their Construction and Advantages*. New York: J. W. Harrison, 1856. See also *Origins of Cast Iron Architecture in America*.

Bolles, A. S. *The Industrial History of the United States*. Norwich, Connecticut: Henry Bill Publishing Company, 1878.

*Book of Prices of the United Society of Journeymen Cabinet Makers of Cincinnati, for the Manufacture of Cabinet Ware*. Cincinnati: N. S. Johnson, 1836.

Boyer, M. Christine. *Manhattan Manners: Architecture and Style, 1850–1900*. New York: Rizzoli, 1985.

Branin, M. Lelyn. *The Early Makers of Handcrafted Earthenware and Stoneware in Central and Southern New Jersey*. Rutherford, New Jersey: Fairleigh Dickinson University Press, 1988.

Braund, J[ohn]. *Illustrations of Furniture, Candelabra, Musical Instruments from the Great Exhibitions of London and Paris, with Examples of Similar Articles from Royal Palaces and Noble Mansions*. London: J. Braund, 1858.

Bremer, Fredrika. *The Homes of the New World; Impressions of America*. Translated by Mary Howitt. 2 vols. New York: Harper and Brothers, 1853.

Bremner, Robert H. "The Big Flat: History of a New York Tenement House." *American Historical Review* 64 (October 1958), pp. 54–62.

Bridges, Amy. *A City in the Republic: Antebellum New York and the Origins of Machine Politics*. Cambridge: Cambridge University Press, 1984.

Brimo, René. *L'évolution du goût aux États Unis, d'après l'histoire des collections*. Paris: Chez James Fortune, 1938.

Broderick, Mosette. "Fifth Avenue, New York, New York." In *The Grand American Avenue, 1850–1920*, edited by Jan Cigliano and Sarah Bradford Landau, pp. 3–34. Exh. cat. New Orleans: Historic New Orleans Collection; Washington, D.C.: Octagon Museum, 1994.

Bromwell, William J. *History of Immigration to the United States, Exhibiting the Number, Sex, Age, Occupation, and Country of Birth, of Passengers Arriving by Sea from Foreign Countries, from September 30, 1819, to December 31, 1855*. New York: Redfield, 1856.

Brooks, Van Wyck. *The World of Washington Irving*. New York: E. P. Dutton, 1944.

Brown, Charles H. *William Cullen Bryant*. New York: Charles Scribner's Sons, 1971.

Brown, Joan Sayers. "Henry Clay's Silver Urn." *Antiques* 112 (July 1977), pp. 108, 112.

———. "William Adams and the Mace of the United States House of Representatives." *Antiques* 108 (July 1975), pp. 76–77.

Brown, Joshua, and David Ment. *Factories, Foundries, and Refineries: A History of Five Brooklyn Industries*. Brooklyn: Brooklyn Educational and Cultural Alliance, 1980.

Brown, Solyman, ed. *The Citizen and Strangers' Pictorial and Business Directory for the City of New-York and Its Vicinity*. New York: Charles Spalding and Company, 1853.

Bruhn, Thomas P. *The American Print: Originality and Experimentation, 1790–1890*. Additional essay by Kate Steinway. Exh. cat. Storrs: William Benton Museum of Art, University of Connecticut, 1993.

Brumbaugh, Thomas B. "A Ball Hughes Correspondence." *Art Quarterly* 21 (winter 1958), pp. 422–27.

———. "Shobal Clevenger: An Ohio Stonecutter in Search of Fame." *Art Quarterly* 29 (1966), pp. 29–45.

Brust, James, and Wendy Shadwell. "The Many Versions and States of *The Awful Conflagration of the Steam Boat Lexington*." *Imprint* 15 (autumn 1990), pp. 2–13.

Bryant, William Cullen. *A Funeral Oration Occasioned by the Death of Thomas Cole, Delivered before the National Academy of Design, New York, May 4, 1848*. New York: D. Appleton and Company, 1848.

———. *The Letters of William Cullen Bryant*. Edited by Thomas G. Voss. 3 vols. New York: Fordham University Press, 1975.

Buckingham, James S. *America: Historical, Statistic, and Descriptive*. 2 vols. New York: Harper and Brothers, 1841.

Bumgardner, Georgia Brady. "George and William Endicott: Commercial Lithography in New York, 1831–51." In *Prints and Printmakers of New York State, 1825–1940*, edited by David Tatham, pp. 43–66. Syracuse: Syracuse University Press, 1986.

Burkett, Nancy H., and John B. Hench, eds. *Under Its Generous Dome: The Collections and Programs of the American Antiquarian Society*. Worcester, Massachusetts: American Antiquarian Society, 1992.

Burnet, John. *A Practical Treatise on Painting, in Three Parts*. London, 1828.

Burnham, Alan. *New York City: The Development of the Metropolis: An Annotated Bibliography*. New York: Garland, 1988.

Burrows, Edwin G., and Mike Wallace. *Gotham: A History of New York City to 1898*. New York: Oxford University Press, 1999.

Bushman, Richard L. *The Refinement of America: Persons, Houses, Cities*. New York: Alfred A. Knopf, 1992.

Byvanck, Valentijn. "Public Portraits and Portrait Publics." *Explorations in Early American Culture / Pennsylvania History: A Journal of Mid-Atlantic Studies* 65 (1998), pp. 199–242.

———. "Representative Heads: Politics and Portraiture in Antebellum America." Ph.D. dissertation, New York University, 1998.

Callow, James T. "American Art in the Collection of Charles M. Leupp." *Antiques* 118 (November 1980), pp. 998–1009.

———. *Kindred Spirits: Knickerbocker Writers and American Artists, 1807–1855*. Chapel Hill: University of North Carolina Press, 1967.

Campbell, Catherine H., and Marcia Schmidt Blaine. *New Hampshire Scenery: A Dictionary of Nineteenth-Century Artists of New Hampshire Mountain Landscapes*. Canaan, New Hampshire: Published for the New Hampshire Historical Society by Phoenix Pub., 1985.

Campbell, Colin. *The Romantic Ethic and the Spirit of Modern Consumerism*. Oxford: Basil Blackwell, 1987.

Carbone, Teresa A. *American Paintings in the Brooklyn Museum of Art: Artists Born by 1876*. Brooklyn: Brooklyn Museum of Art, forthcoming.

Carbone, Teresa A., and Patricia Hills. *Eastman Johnson: Painting America*. Exh. cat. New York: Brooklyn Museum of Art and Rizzoli International Publications, 1999.

Carman, Harry James, and Arthur W. Thompson. *A Guide to the Principal Sources for American Civilization, 1800–1900, in the City of New York: Manuscripts*. New York: Columbia University Press, 1960.

———. *A Guide to the Principal Sources for American Civilization, 1800–1900, in the City of New York: Printed Materials*. New York: Columbia University Press, 1962.

Caroll, Betty Boyd. *America's First Ladies*. Pleasantville, New York: Reader's Digest, 1996.

Carpenter, Charles H., Jr., with Mary Grace Carpenter. *Tiffany Silver*. New York: Dodd, Mead and Company, 1978.

Carpenter, Charles H., Jr., and Janet Zapata. *The Silver of Tiffany & Co., 1850–1987*. Exh. cat. Boston: Museum of Fine Arts, 1987.

Carr, Gerald L. *Frederic Edwin Church—The Icebergs*. Dallas: Dallas Museum of Fine Arts, 1980.

Carrott, Richard G. *The Egyptian Revival: Its Sources, Monuments, and Meaning, 1808–1858*. Berkeley: University of California Press, 1978.

Carson, Cary, Ronald Hoffman, and Peter J. Albert, eds. *Of Consuming Interests: The Style of Life in the Eighteenth Century*. Charlottesville: University Press of Virginia for the United States Capitol Historical Society, 1994.

Carstensen, George, and Charles Gildemeister. *New York Crystal Palace: Illustrated Description of the Building*. New York: Riker, Thorne, and Company, 1854.

*Catalogue of the Palmer Marbles, at the Hall Belonging to the Church of the Divine Unity, 548 Broadway, New York*. Albany: J. Munsell, 1856.

*A Century of Carpet and Rug Making in America*. New York: Bigelow-Hartford Carpet Company, 1925.

Chamberlain, Georgia Stamm. *Studies on American Painters and Sculptors of the Nineteenth Century*. Annandale, Virginia: Turnpike Press, 1965.

Chapman, John Gadsby. *The American Drawing-Book. A Manual for the Amateur and Basis of Study for the Professional Artist, Especially Adapted to the Use of Public and Private Schools, as Well as Home Instruction*. New York: J. S. Redfield, 1847. Enlarged ed., New York: W. J. Widdleton, 1864.

Chevalier, Michael. *Society, Manners, and Politics in the United States, Being a Series of Letters on North America*. Translated from 3d French ed. Boston: Meeks, Jordon and Company, 1839. Reprint, New York: Augustus M. Kelley, 1966.

Christman, Henry M., ed. *Walt Whitman's New York: A Collection of Walt Whitman's Journalism Celebrating New York from Manhattan to Montauk*. New York: Macmillan Company, 1963.

Cikovsky, Nicolai, Jr., and Franklin Kelley. *Winslow Homer*. Exh. cat. Washington, D.C.: National Gallery of Art, 1995.

Clark, Eliot C. *History of the National Academy of Design, 1825–1953*. New York: Columbia University Press, 1954.

Clark, Henry Nichols Blake. *Francis W. Edmonds: American Master in the Dutch Tradition*. Washington, D.C.: Published for Amon Carter Museum by Smithsonian Institution Press, 1988.

———. *A Marble Quarry: The James H. Ricau Collection of Sculpture at the Chrysler Museum of Art*. New York: Hudson Hills Press, in association with the Chrysler Museum of Art, 1997.

Clark, Victor S. *History of Manufactures in the United States*. 3 vols. New York: McGraw-Hill Book Company, 1929.

Clark, Willene B. *The Stained Glass of William Jay Bolton*. Syracuse, New York: Syracuse University Press, 1992.

Clement, Arthur W. *Our Pioneer Potters*. New York: Privately printed, 1947.

Coes, Amy M. "Thomas Brooks: Cabinetmaker and Interior Decorator." Master's thesis, Bard Graduate Center for Studies in the Decorative Arts, New York, 1999.

Cohen, Ira. "The Auction System in the Port of New York, 1817–1837." *Business History Review*, autumn 1971, pp. 488–510.

Cohen, Paul E., and Robert T. Augustyn. *Manhattan in Maps, 1527–1995*. New York: Rizzoli International Publications, 1997.

Colden, Cadwallader D. *Memoir, Prepared at the Request of a Committee of the Common Council of the City of New York, and Presented to the Mayor of the City, at the Celebration of the Completion of the New York Canals*. New York: Printed by Order of the Corporation of New York by W. A. Davis, 1825. Copy available in the Department of Drawings and Prints, The Metropolitan Museum of Art.

Cole, Arthur H., and Harold F. Williamson. *The American Carpet Manufacture: A History and Analysis*. Cambridge, Massachusetts: Harvard University Press, 1941.

Collins, John. *The City and Scenery of Newport, Rhode Island*. Burlington, New Jersey: Privately published, 1857.

Conningham, Frederic A., and Mary B. Conningham. *An Alphabetical List of 5735 Titles of N. Currier and Currier & Ives Prints, with Dates of Publications, Sizes, and Recent Auction Prices*. New York: Privately printed, 1930.

Constable, William G. *Art Collecting in the United States of America*. London: Thomas Nelson and Sons; Paris: Société Française d'Éditions Nelson, 1963.

Cooney, John D. "Acquisition of the Abbott Collection." *Brooklyn Museum Bulletin* 10 (spring 1949), pp. 16–23.

Cooper, Helen A. *John Trumbull: The Hand and Spirit of a Painter*. With essays by Patricia Mullan Burnham et al. Exh. cat. New Haven: Yale University Art Gallery, 1982.

Cooper, James Fenimore. *America and the Americans: Notions Picked up by a Travelling Bachelor*. 2 vols. 2d ed. London: Published for Henry Colburn by R. Bentley; Edinburgh: Bell and Bradfute; Dublin: John Cuming, 1836. Revised ed., *Notions of the Americans*, Albany: State University of New York Press, 1991.

———. *Excursions in Italy*. 2 vols. London: Richard Bentley, 1838.

———. *The Last of the Mohicans: A Narrative of 1757*. 2 vols. Philadelphia: H. C. Carey and I. Lea, 1826.

———. *The Letters and Journals of James Fenimore Cooper*. Edited by James Franklin Beard. 6 vols. Cambridge, Massachusetts: Belknap Press of Harvard University Press, 1960–68.

———. *New York: Being an Introduction to an Unpublished Manuscript, by the Author, Entitled the Towns of Manhattan*. New York: William Farquhar Payson, 1930.

———. *The Pioneers; or, The Sources of the Susquehanna: A Descriptive Tale*. London: T. Allman, 1823.

Cooper, James Fenimore, ed. *Correspondence of James Fenimore-Cooper*. 2 vols. New Haven: Yale University Press, 1922.

Cooper, Wendy A. *Classical Taste in America, 1800–1840*. Exh. cat. Baltimore: Baltimore Museum of Art; New York: Abbeville Press, 1993.

Cornog, Evan. *The Birth of Empire: De Witt Clinton and the American Experience, 1769–1828*. New York: Oxford University Press, 1998.

Courtney, John A., Jr. "'All that Glitters': Freehand Gilding on Philadelphia Empire Furniture, 1820–1840." Master's thesis, Antioch University, Baltimore, Maryland, 1998.

Cowdrey, Mary Bartlett. *National Academy of Design Exhibition Record, 1826–1860*. 2 vols. New York: New-York Historical Society, 1943.

Cowdrey, Mary Bartlett, and Theodore Sizer. *American Academy of Fine Arts and American Art-Union, 1816–1852. With a History of the American Academy*. 2 vols. Vol. 1: *Introduction*. Vol. 2: *Exhibition Record*. New York: New-York Historical Society, 1953.

Crane, Sylvia E. *White Silence: Greenough, Powers, and Crawford: American Sculptors in Nineteenth-Century Italy*. Coral Gables, Florida: University of Miami Press, 1972.

Craven, Wayne. "Henry Kirke Brown: His Search for an American Art in the 1840's." *American Art Journal* 4 (November 1972), pp. 44–58.

———. *Sculpture in America*. Rev. ed. Newark: University of Delaware Press, 1984.

Crawford, Rachael B. "The Forbes Family of Silversmiths." *Antiques* 107 (April 1975), pp. 730–35.

Culme, John. *Nineteenth-Century Silver*. London: Country Life Books, 1977.

Cummings, Thomas S[eir]. *Historic Annals of the National Academy of Design, New-York Drawing Association, etc., with Occasional Dottings by the Way-side, from 1825 to the Present Time*. Philadelphia: George W. Childs, 1865.

*Currier & Ives: A Catalogue Raisonné. A Comprehensive Catalogue of the Lithographs of Nathaniel Currier, James Merritt Ives, and Charles Currier, Including Ephemera Associated with the Firm, 1834–1907*. Detroit: Gale Research, 1984.

*Currier & Ives: The New Best Fifty*. Fairfield, Connecticut: American Historical Print Collectors Society, 1991.

Curtis, George William. *Lotus-Eating: A Summer Book*. New York: Harper and Brothers, 1852.

D'Ambrosio, Anna Tobin, ed. *Masterpieces of American Furniture from the Munson-Williams-Proctor Institute*. Utica: Munson-Williams-Proctor Institute, 1999.

Darley, Felix Octavius Carr. *The Cooper Vignettes*. New York: James G. Gregory, 1862.

Darrah, William C. *Cartes de visite in Nineteenth Century Photography*. Gettysburg, Pennsylvania: W. C. Darrah, 1981.

Davis, Alexander Jackson. *Rural Residences*. New York: The Author, 1837.

Davis, Elliot Bostwick. "Training the Eye and the Hand: Drawing Books in Nineteenth-Century America." Ph.D. dissertation, Columbia University, New York, 1992.

———. *Training the Eye and the Hand: Fitz Hugh Lane and Nineteenth-Century American Drawing Books*. Exh. cat. Gloucester, Massachusetts: Cape Ann Historical Society, 1993.

Davison, Gideon M. *The Fashionable Tour in 1825: An Excursion to the Springs, Niagara, Quebec, and Boston*. Saragota Springs: G. M. Davison, 1825.

Davison, Nancy Reynolds. "E. W. Clay: American Political Caricaturist of the Jacksonian Era." Ph.D. dissertation, University of Michigan, Ann Arbor, 1980.

Deák, Gloria Gilda. *American Views: Prospects and Vistas*. New York: Viking Press and New York Public Library, 1976.

———. *Picturing America, 1497–1899: Prints, Maps, and Drawings Bearing on the New World Discoveries and on the Development of the Territory That Is Now the United States*. 2 vols. Princeton: Princeton University Press, 1988.

———. *William James Bennett: Master of the Aquatint View*. Exh. cat. New York: New York Public Library, 1988.

Dearinger, David Bernard. "American Neoclassic Sculptors and Their Private Patrons in Boston." 2 vols. Ph.D. dissertation, City University of New York, 1993.

———. "Asher B. Durand and Henry Kirke Brown: An Artistic Friendship." *American Art Journal* 20 (1988), pp. 74–83.

DeBow, J. D. B. *Statistical View of the United States . . . Being a Compendium of the Seventh Census, to Which Are Added the Results of Every Previous Census, Beginning with 1790. . . .* Washington, D.C.: Beverly Tucker, Senate Printer, 1854.

de Forest, Emily Johnston. *James Colles, 1788–1883: Life and Letters*. New York: Privately printed, 1926.

DeLuce, Olive S. "Percival DeLuce and His Heritage." *Northwest Missouri State Teachers College Studies*, June 1, 1948, pp. 71–132.

Depew, Chauncey M., ed. *One Hundred Years in American Commerce (1795–1895)*. 2 vols. New York: D. O. Haynes and Company, 1895.

*Description of J. Frazee's Design for the Washington Monument (in Four Large Drawings) Now Exhibiting at the Art-Union*. New York: Printed by Jared W. Bell, 1848.

Dickens, Charles. *American Notes for General Circulation*. 2 vols. London: Chapman and Hall, 1842; "cheap edition," 1850.

Dietz and Company. *Victorian Lighting: The Dietz Catalogue of 1860, with a New History of Dietz and Victorian Lighting by Ulysses G. Dietz*. Watkins Glen, New York: American Life Foundation, 1982.

Dillistin, William H. "National Bank Notes in the Early Years." *The Numismatist* 61 (December 1948), pp. 791–814.

Dimmick, Lauretta. "A Catalogue of the Portrait Busts and Ideal Works of Thomas Crawford (1813?–1857), American Sculptor in Rome." 3 vols. Ph.D. dissertation, University of Pittsburgh, 1986.

———. "Robert Weir's Saint Nicholas: A Knickerbocker Icon." *Art Bulletin* 66 (September 1984), pp. 465–83.

———. "Thomas Crawford's *Orpheus*: The American *Apollo Belvedere*." *American Art Journal* 19, no. 4 (1987), pp. 47–84.

Disturnell, John. *A Gazetteer of the State of New-York Comprising Its Topography, Geology, Mineralogical Resources, Civil Divisions, Canals, Railroads and Public Institutions, Together with General Statistics, the Whole Alphabetically Arranged: Also, Statistical Tables, Including the Census of 1840, and Tables of Distances, with a New Township Map of the State, Engraved on Steel*. Albany: J. Disturnell, 1842.

[Dix, John Ross]. *A Hand-book of Newport, and Rhode Island*. Newport: C. E. Hammett Jr., 1852.

Dorrill, Lisa K. "Illustrating the Ideal City: Nineteenth-Century American Bird's Eye Views." *Imprint* 18 (autumn 1993), pp. 21–31.

Douglas, Ed Polk. "The Belter Nobody Knows." *New York-Pennsylvania Collector*, October 1981, pp. 11–12, 14–16.

———. "The Furniture of John Henry Belter: Separating Fact from Fiction." *Antiques and Fine Art*, November–December 1990, pp. 112–19.

———. *Rococo Roses: A Series of Articles Describing the Nineteenth Century American Furniture in the Rococo Revival Style Produced by John Henry Belter, J. and J. W. Meeks, and Others*. Pittsford, New York: New York-Pennsylvania Collector [1980]. Reprints of Douglas's articles from *New York-Pennsylvania Collector*, January/February 1979–January/February 1980.

Downing, A[ndrew] J[ackson]. *The Architecture of Country Houses, Including Designs for Cottages, Farmhouses, and Villas, with Remarks on Interiors, Furniture, and the Best Modes of Warming and Ventilating*. New York: D. Appleton and Company, 1850. Reprint, with a new introduction by J. Stewart Johnson, New York: Dover Publications, 1969.

———. *Cottage Residences; or, A Series of Designs for Rural Cottages and Cottage Villas, and Their Gardens and Grounds Adapted to North America*. New York: Wiley and Putnam, 1842.

———. *Rural Essays*. Edited by George W. Curtis. New York: G. P. Putnam, 1853.

———. *A Treatise on the Theory and Practice of Landscape Gardening, Adapted to North America with a View to the Improvement of Country Residences. Comprising Historical Notices and General Principles of the Art, Directions for Laying Out Grounds and Arranging Plantations, the Description and Cultivation of Hardy Trees, Decorative Accompaniments to the House and Grounds, the Formation of Pieces of Artificial Water Flower Gardens, etc. with Remarks on Rural Architecture. . . .* New York and London: Wiley and Putnam; Boston: C. C. Little, 1841.

Dubrow, Eileen, and Richard Dubrow. *American Furniture of the 19th Century, 1840–1880*. Exton, Pennsylvania: Schiffer Publishing, 1983.

Duncan, Carol. *Civilizing Rituals: Inside Public Art Museums*. London: Routledge, 1995.

Dunlap, David W. *On Broadway: A Journey Uptown over Time*. New York: Rizzoli, 1990.

Dunlap, William. *Diary of William Dunlap, 1766–1839. . . .* Edited by Dorothy C. Barck. 3 vols. New York: New-York Historical Society, 1931.

———. *History of the Rise and Progress of the Arts of Design in the United States.* 2 vols. New York: George P. Scott, 1834.

———. *A History of the Rise and Progress of the Arts of Design in the United States.* New ed., edited by Frank W. Bayley and Charles E. Goodspeed. 3 vols. Boston: C. E. Goodspeed and Company, 1918.

Dupee, Frederick W., ed. *Henry James: Autobiography —A Small Boy and Others, Notes of a Son and Brother, The Middle Years.* Princeton: Princeton University Press, 1983.

Durand, Asher B. *Studies in Oil by Asher B. Durand, N. A., Deceased. Engravings by Durand, Raphael Morghen, Turner, W. Sharp, Bartolozzi, Wille, Strange, and Others, . . .* Executor's sale. New York: Ortgies' Art Gallery, 845 and 847 Broadway, April 13–14, 1887.

Durand, John. *The Life and Times of A. B. Durand.* New York: C. Scribner's Sons, 1894. Facsimile ed., New York: Kennedy Graphics, 1970.

[Dwight, Theodore] An American. *A Journal of a Tour in Italy, in the Year 1821.* New York: Printed by Abraham Paul, 1824.

[———]. *The Northern Traveller; Containing the Routes to Niagara, Quebec and the Springs; with Descriptions of the Principal Scenes, and Useful Hints to Strangers.* New York: Wilder and Campbell, 1825.

[———]. *The Northern Traveller; Containing the Routes to Niagara, Quebec and the Springs; with the Tour of New England and the Route to the Coal Mines of Pennsylvania.* 2d ed. New York: A. T. Goodrich, 1826.

[———]. *Sketches of Scenery and Manners in the United States.* New York: A. T. Goodrich, 1829.

———. *Things as They Are; or, Notes of a Traveller through Some of the Middle and Northern States.* New York: Harper and Brothers, 1834.

Dwight, Timothy. *Travels; in New-England and New-York.* 4 vols. New Haven: Timothy Dwight, 1821–22. Facsimile ed., edited by Barbara Miller Solomon, Cambridge, Massachusetts: Belknap Press of Harvard University Press, 1969.

Dyson, Robert H., Jr. "A Gift of Nimrud Sculptures." *Brooklyn Museum Bulletin* 18 (spring 1957), pp. 1–13.

Eastman, Samuel Coffin. *The White Mountain Guide Book.* Concord, New Hampshire: Edson C. Eastman, 1858.

[Eddy, Thomas]. *An Account of the State Prison or Penitentiary House, in the City of New-York; by One of the Inspectors of the Prison.* New York: Isaac Collins and Son, 1801.

Edward, James G. *The Newport Story.* Newport: Remington Ward, 1952.

Edwards, Clive D. *Victorian Furniture: Technology and Design.* Manchester: Manchester University Press, 1993.

Eliot, William H. *A Description of the Tremont House, with Architectural Illustrations.* Boston: Gray and Bowen, 1830.

Ellington, George, pseud. *The Women of New York; or, The Under-world of the Great City. . . .* New York: New York Book Company, 1869.

Elliott, Jock. *"A Ha! Christmas": An Exhibition of Jock Elliott's Christmas Books.* Exh. cat. New York: Grolier Club, 1999.

Ernst, Robert. *Immigrant Life in New York City, 1825–1863.* Ph.D. dissertation, Columbia University, New York, 1949. Reprint, New York: Octagon Books, 1979; Syracuse: Syracuse University Press, 1994.

Falconer, John M. *Catalogue of the Interesting and Valuable Collection of Oil Paintings, Water-Colors and Engravings Formed by the Late John M. Falconer.* Sale cat. New York: Anderson Auction Company, 1904.

Fales, Martha Gandy. *Early American Silver for the Cautious Collector.* New York: Funk and Wagnalls, 1970.

———. *Jewelry in America, 1600–1900.* Woodbridge, Suffolk: Antique Collectors' Club, 1995.

Farrar, Estelle Sinclair, and Jane Shadel Spillman. *The Complete Cut and Engraved Glass of Corning.* New York: Crown Publishers, 1979.

Faxon, Frederick W. *Literary Annuals and Gift Books: A Bibliography, 1823–1903.* Boston, 1912. Reprint, Middlesex, England: Private Libraries Association, 1973.

Fay, Theodore S. *Views of New York and Its Environs.* New York: Peabody and Company, 1831.

Fehl, Philipp. "John Trumbull and Robert Ball Hughes's Restoration of the Statue of Pitt the Elder." *New-York Historical Society Quarterly* 56 (January 1972), pp. 7–28.

Feifer, Maxine. *Going Places: The Ways of the Tourist from Imperial Rome to the Present Day.* London: Macmillan Company, 1985.

Fein, Albert, ed. *Landscape into Cityscape: Frederick Law Olmsted's Plans for a Greater New York City.* Ithaca, New York: Cornell University Press, 1968. Reprint, New York: Van Nostrand Reinhold Co., 1981.

Feller, John Quentin. *Dorflinger: America's Finest Glass, 1852–1921.* Marietta, Ohio: Antique Publications, 1988.

Felton, Mrs. *Life in America: A Narrative of Two Years' City and Country Residence in the United States.* Hull, Massachusetts: Printed by J. Hutchinson, 1838.

Fennimore, Donald L. "Elegant Patterns of Uncommon Good Taste: Domestic Silver by Thomas Fletcher and Sidney Cardiner." Master's thesis, University of Delaware Winterthur Program in Early American Culture, 1972.

———. "Gilding Practices and Processes in Nineteenth-Century American Furniture." In *Gilded Wood: Conservation and History,* pp. 139–51. Madison, Connecticut: Sound View Press, 1991.

———. *Silver and Pewter.* New York: Alfred A. Knopf, 1984.

———. "A Solid Gold Testimonial: An American Medal for Lafayette." *Antiques* 117 (February 1980), pp. 426–30.

Ferber, Linda S., and William H. Gerdts. *The New Path: Ruskin and the American Pre-Raphaelites.* Exh. cat. Brooklyn: Brooklyn Museum, 1985.

Fielding, Mantle. *American Engravers on Copper and Steel: Biographical Sketches and Check-Lists of Engravings. A Supplement to David McNeely Stauffer's American Engravings.* Philadelphia: Privately printed, 1917.

———. *Dictionary of American Painters, Sculptors and Engravers.* Philadelphia: Printed for the Subscribers, 1926.

Fink, Lois M. "French Art in the United States, 1850–1870: Three Dealers and Collectors." *Gazette des Beaux-Arts,* ser. 6, 92 (September 1978), pp. 87–100.

———. "The Role of France in American Art." Ph.D. dissertation, University of Chicago, 1970.

Finlay, Nancy. *Inventing the American Past: The Art of F. O. C. Darley.* Foreword by Roberta Waddell. Exh. cat. New York: New York Public Library, 1999.

Fisher, Sidney George. *A Philadelphia Perspective: The Diary of Sidney George Fisher Covering the Years, 1834–1871.* Edited by Nicholas B. Wainwright. Philadelphia: Historical Society of Pennsylvania, 1967.

Flick, Alexander C., ed. *The History of the State of New York.* 10 vols. New York: Columbia University Press, 1933–37.

Fontaine, Claude G. *Catalogue of Original Paintings. From Italian, Dutch, Flemish and French Masters of the Ancient and Modern Times, Selected by the Best Judges from Eminent Galleries in Europe and Intended for a Private Gallery in America.* Sale cat. New York, April 24, 1821.

Foresta, Merry A., and John Wood. *Secrets of the Dark Chamber: The Art of the American Daguerreotype.* Exh. cat. Washington, D.C.: National Museum of American Art, Smithsonian Institution, 1995.

Foshay, Ella M. *Mr. Luman Reed's Picture Gallery: A Pioneer Collection of American Art.* Introduction by Wayne Craven; catalogue by Timothy Anglin Burgard. New York: New-York Historical Society, 1990.

———. "Luman Reed, a New York Patron of American Art." *Antiques* 138 (November 1990), pp. 1074–85.

Foshay, Ella M., and Sally Mills. *All Seasons and Every Light: Nineteenth Century American Landscapes from the Collection of Elias Lyman Magoon.* Exh. cat. Poughkeepsie, New York: Vassar College Art Gallery, 1983.

Foster, George G. *New York by Gas-Light, and Other Urban Sketches.* Edited by Stuart M. Blumin. Berkeley: University of California Press, 1990.

———. *New York by Gas-Light, with Here and There a Streak of Sunshine.* New York: Dewitt and Davenport, 1850.

———. *New York in Slices: By an Experienced Carver; Being the Original Slices Published in the N.Y. Tribune.* New York: W. F. Burgess, 1849.

Fowble, E. McSherry. "Currier & Ives and the American Parlor." *Imprint* 15 (autumn 1990), pp. 14–19.

———. *Two Centuries of Prints in America, 1680–1880: A Selective Catalogue of the Winterthur Museum Collection.* Charlottesville: University Press of Virginia, 1987.

Fox, Charles Patrick. *Fashion: The Power That Influences the World.* 3d ed. New York: Sheldon and Company, 1872.

Fox, Louis H. *New York City Newspapers, 1820–1850: A Bibliography.* Papers of the Bibliographical Society of America, vol. 21, parts 1–2. Chicago, 1927.

Francis, John Wakefield. *Old New York; or, Reminiscences of the Past Sixty Years.* New York: W. J. Widdleton, 1866.

*Francis's New Guide to the Cities of New-York and Brooklyn, and the Vicinity.* New York: C. S. Francis and Company, 1853.

Frankenstein, Alfred. *William Sidney Mount.* New York: Harry N. Abrams, 1975.

*Frederick Dorflinger Suydam, Christian Dorflinger: A Miracle in Glass.* White Mills, Pennsylvania: Privately printed, 1950.

Freedberg, David. *The Power of Images: Studies in the History and Theory of Response.* Chicago: University of Chicago Press, 1989.

Frelinghuysen, Alice Cooney. *American Porcelain, 1770–1920.* Exh. cat. New York: The Metropolitan Museum of Art, 1989.

———. "Paris Porcelain in America." *Antiques* 153 (April 1998), pp. 554–63.

French, H. W. *Art and Artists in Connecticut.* Boston: Lee and Shepard, 1879. Reprint, New York: Kennedy Graphics, Da Capo Press, 1970.

Fries, Waldemar H. *The Double Elephant Folio: The Story of Audubon's Birds of America.* Chicago: American Library Association, 1973.

Frisch, Michael H., and David J. Walkowitz, eds. *Working Class America: Essays on Labor, Community, and American Society.* Urbana: University of Illinois Press, 1983.

Gale, Robert L. *Thomas Crawford: American Sculptor.* Pittsburgh: University of Pittsburgh Press, 1964.

Gallati, Barbara. *Asher B. Durand, an Engraver's and a Farmer's Art.* Exh. cat. Yonkers: Hudson River Museum, 1983.

Gallier, James. *Autobiography of James Gallier, Architect.* Paris: E. Briere, 1864. Reprint, New York: Da Capo Press, 1973.

Gardner, Albert TenEyck. *Yankee Stonecutters: The First American School of Sculpture, 1800–1850.* New York, Columbia University Press for The Metropolitan Museum of Art, 1945.

Garmey, Stephen. *Gramercy Park: An Illustrated History of a New York Neighborhood.* New York: Balsam Press, 1984.

Garrett, Elisabeth Donaghy. *At Home: The American Family, 1750–1870.* New York: Harry N. Abrams, 1990.

Gates, John D. *The Astor Family.* Garden City, New York: Doubleday and Company, 1981.

Gayle, Margot, and Carol Gayle. *Cast-Iron Architecture in America: The Significance of James Bogardus.* New York: W. W. Norton, 1998.

Gerdts, Abigail Booth, ed. *Catalogue of the Permanent Collection of Paintings and Sculpture of the National Academy of Design.* New York: Hudson Hills Press, forthcoming.

———. "Newly Discovered Records of the New-York Gallery of the Fine Arts." *Archives of American Art Journal* 21, no. 4 (1981), pp. 2–9.

Gerdts, William H. *American Neo-Classic Sculpture: The Marble Resurrection.* New York: Viking Press, 1973.

———. "Die Düsseldorf Gallery." In *Vice Versa: Deutsche Maler in Amerika, amerikanische Maler in Deutschland, 1813–1913,* edited by Katharina Bott and Gerhard Bott, pp. 44–61. Exh. cat. Berlin: Deutsches Historisches Museum; Munich: Hirmer, 1996.

Gere, Charlotte. "European Decorative Arts at the World's Fairs: 1850–1900." *Metropolitan Museum of Art Bulletin* 56 (winter 1998–99).

Gibson, Jane Mork. "The Fairmount Waterworks." *Philadelphia Museum of Art, Bulletin* 84 (summer 1988), pp. 2–11.

Gifford, Don, ed. *The Literature of American Architecture: The Evolution of Architectural Theory and Practice in Nineteenth-Century America.* New York: E. P. Dutton and Company, 1966.

*Gifford Memorial Meeting of The Century . . . November 19th, 1880.* New York: Century Rooms, 1880.

Gilfoyle, Timothy J. *City of Eros: New York City, Prostitution, and the Commercialization of Sex, 1790–1920.* New York: W. W. Norton, 1992.

Gillespie, William Mitchell. *Rome: As Seen by a New Yorker in 1843–4.* New York: Wiley and Putnam, 1845.

Gobright, J[ohn] C[hristopher]. *The Union Sketch-Book: A Reliable Guide, Exhibiting the History and Business Resources of the Leading Mercantile and Manufacturing Firms of New York. . . .* New York: Rudd and Carleton, 1861.

Godden, Geoffrey A. *Ridgway Porcelains.* 2d ed. Woodbridge, Suffolk: Antique Collectors' Club, 1985.

Godwin, Parke. *A Biography of William Cullen Bryant.* 2 vols. New York: Russell and Russell, 1883.

Goldstein, Malcolm. "Paff, Michael." In *American National Biography,* edited by John A. Garraty and Mark C. Carnes, vol. 16, pp. 895–96. New York: Oxford University Press, 1999.

[Goodrich, A. T.]. *The Picture of New-York, and Stranger's Guide to the Commercial Metropolis of the United States.* New York: A. T. Goodrich, 1828.

Goodrich, Charles Rush, ed. *Science and Mechanism: Illustrated by Examples in the New York Exhibition, 1853–54. Including Extended Descriptions of the Most Important Contribution in the Various Departments, with Annotations and Notes Relative to the Progress and Present Date of Applied Science, and the Useful Arts.* New York: G. P. Putnam, 1854.

Gordon, Carol Emily. "The Skidmore House: An Aspect of the Greek Revival in New York." Master's thesis, University of Delaware, Newark, 1978.

Gottesman, Rita S. "Early Commercial Art: Bella C. Landauer Collection in the New-York Historical Society." *Art in America* 43 (December 1955), pp. 34–42.

Grandfort, Marie Fontenay de. *The New World.* Translated by Edward C. Wharton. New Orleans: Sherman, Wharton and Company, 1855.

Gray, Nina. "Leon Marcotte: Cabinetmaker and Interior Decorator." In *American Furniture 1994,* edited by Luke Beckerdite, pp. 49–71. Hanover, New Hampshire: University Press of New England for the Chipstone Foundation, 1994.

*The Great Metropolis; or, New York in 1845. . . . or, Guide to New-York for 1846. . . . or, Guide to New-York for 1847. . . .* 3 annuals. New York: John Doggett Jr., 1844–46.

*The Great Metropolis; or, New-York Almanac for 1850. . . . for 1851. . . . for 1852.* 3 annuals. New York: H. Wilson, 1849; New York: H. Wilson and John F. Trow, 1850–51.

Greeley, Horace. *Art and Industry as Represented in the Exhibition at the Crystal Palace New York—1853–4, Showing the Progress and State of the Various Useful and Esthetic Pursuits.* New York: Redfield, 1853.

Greene, Asa. *A Glance at New York: Embracing the City Government, Theatres, Hotels, Churches, Mobs, Monopolies, Learned Professions, Newspapers, Rogues, Dandies, Fires and Firemen, Water and Other Liquids, &c., &c.* New York: A. Greene, Craighead and Allen, printers, 1837.

Greene, John C. *American Science in the Age of Jefferson.* Ames: Iowa State University Press, 1984.

Greenthal, Kathryn, Paula M. Kozol, and Jan Seidler Ramirez. *American Figurative Sculpture in the Museum of Fine Arts.* Boston: Museum of Fine Arts, 1986.

Grier, Katherine C. *Culture and Comfort: People, Parlors, and Upholstery, 1850–1930.* Exh. cat. Rochester, New York: Strong Museum; Amherst, Massachusetts: University of Massachusetts Press, 1988.

Groce, George C., and David H. Wallace. *The New-York Historical Society's Dictionary of Artists in America, 1564–1860.* New Haven: Yale University Press, 1975.

Groce, Nancy. *Musical Instrument Makers of New York: A Directory of Eighteenth- and Nineteenth-Century Urban Craftsmen.* Stuyvesant, New York: Pendragon Press, 1991.

Groft, Tammis K., and Mary Alice Mackay, eds. *Albany Institute of History and Art: 200 Years of Collecting.* New York: Hudson Hills Press, in association with Albany Institute of History and Art, 1998.

Gross, Sally Lorensen. *Toward an Urban View: The Nineteenth-Century American City in Prints.* Exh. cat. New Haven: Yale University Art Gallery, 1989.

Grossman, Cissy. *A Temple Treasury: The Judaica Collection of Congregation Emanu-El of the City of New York.* New York: Hudson Hills Press, 1989.

Gruber, Alain. *Silver.* New York: Rizzoli International Publications, 1982.

Grund, Francis J. *Aristocracy in America from the Sketch-Book of a German Nobleman.* 2 vols. London: Richard Bentley, 1839.

Guffey, Karen A. "From Paper Stainer to Manufacturer: J. F. Bumstead & Co., Manufacturers and Importers of Paper Hangings." In *Wallpaper*

*in New England*, by Richard Nylander et al., pp. 29–37. Boston: Society for the Preservation of New England Antiquities, 1986.

*A Guide to the Central Park. With a Map of the Proposed Improvements. By an Officer of the Park.* New York: A. O. Moore and Company, 1859.

Guillebon, Régine de Plinval de. *Paris Porcelain, 1770–1850.* Translated by Robin R. Charleston. London: Barrie and Jenkins, 1972.

Guzik, Estelle M., ed. *Genealogical Resources in the New York Metropolitan Area.* New York: Jewish Genealogical Society, 1989.

Hales, Peter B. *Silver Cities: The Photography of American Urbanization, 1839–1915.* Philadelphia: Temple University Press, 1984.

Hall, John. *The Cabinet Makers' Assistant: Embracing the Most Modern Style of Cabinet Furniture.* Baltimore: John Murphy, 1840.

Hall, Margaret Hunter. *The Aristocratic Journey: Being the Outspoken Letters of Mrs. Basil Hall Written During a Fourteen Months' Sojourn in America, 1827–1828.* Edited by Una Pope-Hennessey. New York: G. P. Putnam and Co., 1931.

Halsey, R. T. Haines. *Pictures of Early New York on Dark Blue Staffordshire Pottery, Together with Pictures of Boston and New England, Philadelphia, the South and West.* New York: Dodd, Mead and Company, 1899.

Halttunen, Karen. *Confidence Men and Painted Women: A Study of Middle-Class Culture in America, 1830–1870.* New Haven: Yale University Press, 1982.

Hamilton, Sinclair. *Early American Book Illustrators and Wood Engravers, 1670–1870.* 2 vols. Princeton: Princeton University Press, 1968.

[Hamilton, Thomas]. *Men and Manners in America.* 2 vols. Edinburgh: William Blackwood; Philadelphia: Carey, Lea, and Blanchard, 1833. Reprint, New York: Augustus M. Kelley, 1968.

Hamlin, Talbot. *Greek Revival Architecture in America: Being an Account of Important Trends in American Architecture and American Life Prior to the War between the States.* London: Oxford, 1944. Reprint, New York: Dover Publications, 1964.

Harris, Neil. *The Artist in American Society: The Formative Years, 1790–1860.* New York: Braziller, 1966. Reprint, New York: Clarion Books, 1970.

———. *Humbug: The Art of P. T. Barnum.* Boston: Little, Brown and Company, 1973.

Hart, Charles. "Lithography, Its Theory and Practice. Including a Series of Short Sketches of the Earliest Lithographic Artists, Engravers, and Printers of New York." New York: Charles Hart, 1902. Manuscript Division, New York Public Library.

Hartog, Hendrik. *Public Property and Private Power: The Corporation of the City of New York in American Law, 1730–1870.* Chapel Hill: University of North Carolina Press, 1983.

Haskell, Daniel C., ed. *Manhattan Maps: A Co-operative List.* New York: New York Public Library, 1931.

Haswell, Charles H. *Reminiscences of an Octogenarian of the City of New York (1816 to 1860).* New York: Harper and Brothers, 1896.

Hawley, Henry. "American Furniture of the Mid-Nineteenth Century." *Bulletin of the Cleveland Museum of Art* 74 (May 1987), pp. 186–215.

Hazen, Edward. *The Panorama of Professions and Trades; or, Every Man's Book Embellished with Eighty-Two Engravings.* Philadelphia: Uriah Hunt, 1836.

Hennessy, Thomas F. *Locks and Lockmakers of America.* 3d ed. Park Ridge, Illinois: Locksmith Publishing Company, 1997.

Henrywood, R. K. *Relief-Moulded Jugs, 1820–1900.* Woodbridge, Suffolk: Antique Collectors' Club, 1984.

Heydt, George F. *Charles L. Tiffany and the House of Tiffany & Co.* New York: Tiffany and Company, 1893.

Hills, Patricia. "The American Art-Union as Patron for Expansionist Ideology in the 1840s." In *Art in Bourgeois Society, 1790–1850,* edited by Andrew Hemingway and William Vaughan, pp. 314–39. Cambridge: Cambridge University Press, 1998.

Himmelheber, Georg. *Deutsche Möbelvorlagen, 1800–1900: Ein Bilderlexikon der gedruckten Entwürfe und Vorlagen im deutschen Sprachgebiet.* Munich: Verlag C. H. Beck, 1988.

Hindle, Brooke. *The Pursuit of Science in Revolutionary America, 1735–1789.* Chapel Hill: University of North Carolina Press, 1956.

———. *Technology in Early America: Needs and Opportunities for Study.* Chapel Hill: University of North Carolina Press, 1966.

Hindle, Brooke, and Steven Lubar. *Engines of Change: The American Industrial Revolution, 1790–1860.* Washington, D.C.: Smithsonian Institution Press, 1986.

*History of Architecture and the Building Trade of Greater New York.* 2 vols. New York: Union History Company, 1899.

*The History of Lord & Taylor.* New York: Lord and Taylor, 1926.

Hitchcock, J. R. W. *Etching in America.* New York: White, Stokes, and Allen, 1886.

Hobbes, Clara M. "New York Produced Cut Glass." *New York Sun,* April 1, 1933.

Homberger, Eric. *The Historical Atlas of New York City: A Visual Celebration of Nearly 400 Years of New York City's History.* New York: Henry Holt and Company, 1994.

Hone, Philip. *The Diary of Philip Hone, 1828–1851.* Edited by Allan Nevins. 2 vols. New York: Dodd, Mead and Company, 1927.

———. *The Diary of Philip Hone, 1828–1851.* Edited by Bayard Tuckerman. New York: Dodd, Mead and Company, 1889.

Honour, Hugh. *The European Vision of America.* Exh. cat. Cleveland: Cleveland Museum of Art, 1975.

Hood, Graham. *American Silver.* New York: Praeger Publishers, 1971.

Hope, Thomas. *Household Furniture and Interior Decoration.* London: Longman, Hurst, Rees, and Orme, 1807. Reprinted as *Regency Furniture and Interior Decoration,* with a new introduction by David Watkin, New York: Dover Publications, 1971.

Hosack, David. *Memoir of De Witt Clinton.* New York: J. Seymour, 1829.

Hough, Franklin B., ed. *Census of the State of New York for 1855 Taken in Pursuance of Article Third of the Constitution of the State, and of Chapter Sixty-Four of the Laws of 1855.* Albany: Printed by C. Van Benthuysen, 1857.

Hounshell, David. *From the American System to Mass Production, 1800–1932: The Development of Manufacturing Technology in the United States.* Baltimore: Johns Hopkins University Press, 1984.

Hovey, Charles Mason. *The Fruits of America, Containing Richly Colored Figures and Full Descriptions of All the Choicest Varieties Cultivated in the United States.* 3 vols. Boston: C. C. Little and J. Brown, and Hovey and Company; New York: D. Appleton and Company, 1852–56.

Howat, John K., ed. *American Paradise: The World of the Hudson River School.* Exh. cat. New York: The Metropolitan Museum of Art, 1987.

———. "Washington Crossing the Delaware." *Metropolitan Museum of Art Bulletin* 26 (March 1968), pp. 289–99.

Howe, Julia Ward. *Reminiscences, 1819–1899.* Boston and New York: Houghton Mifflin and Company, 1899.

Howe, Katherine S., Alice Cooney Frelinghuysen, and Catherine Hoover Voorsanger, et al. *Herter Brothers: Furniture and Interiors for a Gilded Age.* Exh. cat. New York: Harry N. Abrams, in association with the Museum of Fine Arts, Houston, 1994.

Howe, Katherine S., and David B. Warren. *The Gothic Revival Style in America, 1830–1870.* Exh. cat. Houston: Museum of Fine Arts, 1976.

Howe, Winifred E. *A History of The Metropolitan Museum of Art.* New York: The Metropolitan Museum of Art, 1913.

*How to See the New York Crystal Palace: Being a Concise Guide to the Principal Objects in the Exhibition as Remodelled, 1854. Part First. General View,—Sculpture,—Paintings.* New York: G. P. Putnam and Company, 1854.

Hugins, Walter. *Jacksonian Democracy and the Working Class: A Study of the New York Workingmen's Movement, 1829–1837.* Stanford: Stanford University Press, 1960.

Hull, Judith Salisbury. "Richard Upjohn: Professional Practice and Domestic Architecture." Ph.D. dissertation, Columbia University, New York, 1987.

Humboldt, Alexander von. *Cosmos: A Sketch of a Physical Description of the Universe.* 5 vols. Translated by E. C. Otté. London: H. G. Bohn, 1849–58.

Humboldt, Alexander von, and Aimé Bonpland. *Personal Narrative of Travels to the Equinoctial Regions of America, during the Years 1799–1804.* 3 vols. Translated and edited by Thomasina Ross. London: H. G. Bohn, 1852–53.

Huxtable, Ada Louise. *Classic New York: Georgian Gentility to Greek Elegance.* Garden City, New York: Doubleday, 1964.

Hyde, Ralph. *Panoramania! The Art and Entertainment of the 'All-Embracing' View.* London: Barbican Art Gallery and Trefoil Publications, 1988.

Hyman, Linda. "From Artisan to Artist: John Frazee and the Politics of Culture in Antebellum America." Ph.D. dissertation, City University of New York, 1978.

———. "*The Greek Slave* by Hiram Powers: High Art as Popular Culture." *Art Journal* 35 (spring 1976), pp. 216–23.

Idzerda, Stanley J., Anne C. Loveland, and Marc H. Miller. *Lafayette, Hero of Two Worlds: The Art and Pageantry of His Farewell Tour of America, 1824–1825: Essays.* Flushing, New York: Queens Museum, 1989.

*An Index to the Illustrations in the Manuals of the Corporation of the City of New York, 1841–1870.* Introduction by William Loring Andrews. New York: Society of Iconophiles, 1906.

Ingerman, Elizabeth A. "Personal Experiences of an Old New York Cabinet-Maker." *Antiques* 84 (November 1963), pp. 576–80.

International Art Union. *Prospectus.* New York: Printed by Oliver and Brother, 1849.

Irving, Pierre M. *The Life and Letters of Washington Irving.* 2 vols. New York: G. P. Putnam, 1862.

Irving, Washington. *History, Tales and Sketches: Letters of Jonathan Oldstyle, Gent.; Salmagundi; . . . A History of New-York; . . . The Sketch Book of Geoffrey Crayon, Gent.* Edited by James W. Tuttleton. New York: Library of America, 1983.

———. *Journals and Notebooks, 1819–1827.* Edited by Walter A. Reichart. Vol. 3 of *Complete Works of Washington Irving,* edited by Henry A. Pochmann. 5 vols. Madison: University of Wisconsin Press, 1970.

———. *Journals of Washington Irving. From July 1815 to July 1842.* Edited by William P. Trent and George S. Hellman. 3 vols. Boston: Bibliophile Society, 1919.

———. *Life of George Washington.* 5 vols. New York: G. P. Putnam, 1857–59.

———. *The Works of Washington Irving.* New ed., revised. 15 vols. New York: G. P. Putnam, 1854–55.

Jackson, Joseph. "Bass Otis, America's First Lithographer." *Pennsylvania Magazine of History and Biography* 37 (1913), pp. 385–94.

Jackson, Kenneth T., ed. *The Encyclopedia of New York City.* New Haven: Yale University Press; New York: New-York Historical Society, 1995.

Jackson, Kenneth T., and Stanley K. Schultz, eds. *Cities in American History.* New York: Alfred A. Knopf, 1972.

Jaffe, Irma B. *John Trumbull: Patriot-Artist of the American Revolution.* Boston: New York Graphic Society, 1975.

James, Henry. *A Small Boy and Others.* London: Macmillan Company, 1913.

Jarves, Deming. *Reminiscences of Glass-making.* 2d ed. New York: Hurd and Houghton, 1865.

Jarves, James Jackson. *The Art-Idea: Sculpture, Painting, and Architecture in America.* New York: Hurd and Houghton, 1864. Reprint, edited by Benjamin Rowland Jr., Cambridge, Massachusetts: Belknap Press of Harvard University Press, 1960.

———. *Italian Sights and Papal Principles, Seen through American Spectacles.* New York: Harper and Brothers, 1856.

Jefferys, C. P. B. *Newport: A Short History.* Newport: Newport Historical Society, 1992.

Jervis, Simon. *High Victorian Design.* Exh. cat. Ottawa: National Gallery of Canada, 1974.

Johns, Elizabeth. *American Genre Painting: The Politics of Everyday Life.* New Haven: Yale University Press, 1991.

Johnson, Deborah J. *William Sidney Mount: Painter of American Life.* Essays by Elizabeth Johns, Deborah J. Johnson, Franklin Kelly, and Bernard F. Reilly Jr. Exh. cat. New York: American Federation of Arts, 1998.

Johnson, Paul. *The Birth of the Modern: World Society 1815–1830.* New York: Harper Collins, 1991.

Johnston, Phillip M. "Dialogues between Designer and Client: Furnishings Proposed by Leon Marcotte to Samuel Colt in the 1850s." *Winterthur Portfolio* 19 (winter 1984), pp. 257–75.

Jones, A[bner] D[umont]. *The Illustrated American Biography, Containing Correct Portraits and Brief Notices of the Principal Actors in American History; Embracing Distinguished Women, Naval and Military Heroes, Statesmen, Civilians, Jurists, Divines, Authors and Artists; Together with Celebrated Indian Chiefs. . . .* 3 vols. New York: J. M. Emerson and Company, 1853–55.

Judd, Sylvester. *Margaret: A Tale of the Real and Ideal, Blight and Bloom, Including Sketches of a Place Not before Described, Called Mons Christi.* Boston: Jordan and Wiley, 1845.

Jullian, Philippe. *Le style Second Empire.* Paris: Bachet et Cie, n.d.

Kane, Elisha Kent. *Arctic Explorations: The Second Grinnell Expedition in Search of Sir John Franklin, 1853, '54, '55.* 2 vols. Philadelphia: Childs and Peterson, 1856. New ed., London: T. Nelson and Sons, 1861.

Kaplan, Justin. *Walt Whitman: A Life.* New York: Simon and Schuster, 1980.

Kasson, John F. *Rudeness and Civility: Manners in Nineteenth-Century Urban America.* New York: Hill and Wang, 1990.

Kasson, Joy S. *Marble Queens and Captives: Women in Nineteenth-Century American Sculpture.* New Haven: Yale University Press, 1990.

Keckley, Elizabeth. *Behind the Scenes: Formerly a Slave, but More Recently Modiste, and Friend to Mrs. Lincoln; or, Thirty Years a Slave and Four Years in the White House.* New York: G. W. Carleton and Company, 1868.

Kelly, Franklin, et al. *Frederic Edwin Church.* Exh. cat. Washington, D.C.: National Gallery of Art, 1989.

Kendall, Isaac C. *The Growth of New York.* New York: G. W. Wood, 1865.

Kent, Douglas R. "History in Houses: Hyde Hall, Otsego County, New York." *Antiques* 92 (August 1967), pp. 187–93.

von Khrum, Paul. *Silversmiths of New York City, 1684–1850.* New York: Von Khrum, 1978.

Kidwell, Claudia, and Margaret C. Christman. *Suiting Everyone: The Democratization of Clothing in America.* Washington, D.C.: National Museum of History and Technology, Smithsonian Institution, 1974.

King, Charles. *A Memoir of the Construction, Cost, and Capacity of the Croton Aqueduct, Compiled from Official Documents; Together with an Account of the Civic Celebration of the Fourteenth October, 1842, on Occasion of the Completion of the Great Work. . . .* New York, 1843.

King, Thomas. *The Modern Style of Cabinet Work Exemplified.* 1829; 2d ed., 1835; expanded 2d ed., London: H. G. Bohn, 1862. Reprinted as *Neo-Classical Furniture Designs,* with a new introduction by Thomas Gordon Smith, New York: Dover Publications, 1995.

King, Thomas Starr. *The White Hills; Their Legends, Landscape and Poetry.* Boston: Isaac N. Andrews, 1859.

Klapthor, Margaret Brown. *Official White House China, 1789 to the Present.* Washington, D.C.: Smithsonian Institution Press, 1975.

Klein, Rachel. "Art and Authority in Antebellum New York City: The Rise and Fall of the American Art-Union." *Journal of American History* 81 (March 1995), pp. 1534–61.

Klinkowström, Baron Axel. *Baron Klinkowström's America, 1818–1820.* Edited by Franklin D. Scott. Evanston, Illinois: Northwestern University Press, 1952.

Klumpke, Anna. *Rosa Bonheur.* Ann Arbor: University of Michigan Press, 1997.

Knapp, Samuel L. *The Life of Thomas Eddy; Comprising an Extensive Correspondence with Many of the Most Distinguished Philosophers and Philanthropists of This and Other Countries.* New York: Conner and Cooke, 1834.

Koke, Richard J. *American Landscape and Genre Paintings in the New-York Historical Society: A Catalogue of the Collection, Including Historical, Narrative, and Marine Art.* 3 vols. New York: New-York Historical Society, 1982.

———. *A Checklist of the American Engravings of John Hill (1770–1850).* New York: New-York Historical Society, 1961.

———. "John Hill, Master of Aquatint, 1770–1850." *New-York Historical Society Quarterly* 43 (January 1959), pp. 51–117.

Kouwenhoven, John A. *The Columbia Historical Portrait of New York: An Essay in Graphic History in Honor of the Tricentennial of New York City and the Bicentennial of Columbia University.* Garden City, New York: Doubleday, 1953.

Kramer, Ellen W. "The Architecture of Detlef Lienau, A Conservative Victorian." Ph.D. dissertation, New York University, 1958.

———. "Contemporary Descriptions of New York City and Its Public Architecture ca. 1850." *Journal of the Society of Architectural Historians* 27 (December 1968), pp. 264–80.

Lafever, Minard. *The Beauties of Modern Architecture Illustrated by Forty-eight Original Plates Designed Expressly for This Work.* New York: D. Appleton, 1835.

———. *Modern Builders' Guide.* New York: Henry C. Sleight, Collins and Hannay, 1833.

———. *The Young Builder's General Instructor Containing the Five Orders of Architecture, Selected from the Best Specimens of the Greek and Roman . . . and a Variety of Mouldings, and Fancy Pilasters, Square and Circle Head Front Doors . . . etc., the Whole Exemplified on Sixty-Six Elegant Copper-Plate Engravings*. Newark, New Jersey: W. Tuttle, 1829.

Lafont-Couturier, Hélène. "'Le bon livre'"; ou, La portée éducative des images éditées et publiées par la maison Goupil." In *État des lieux*. Bordeaux: Musée Goupil, 1994.

Lakier, Alexandr Borisovich. *A Russian Looks at America*. Translated from the 1857 Russian edition. Edited by Arnold Schrier and Joyce Story. Chicago: University of Chicago Press, 1979.

Landau, Sarah Bradford. *P. B. Wight—Architect, Contractor, and Critic, 1838–1925*. Exh. cat. Chicago: Art Institute of Chicago, 1981.

Landau, Sarah Bradford, and Carl W. Condit. *Rise of the New York Skyscraper, 1865–1913*. New Haven: Yale University Press, 1996.

Landy, Jacob. *The Architecture of Minard Lafever*. New York: Columbia University Press, 1970.

———. "The Washington Monument Project in New York." *Journal of the Society of Architectural Historians* 28 (December 1969), pp. 291–97.

Lankton, Larry D. *The "Practicable" Engineer: John B. Jervis and the Old Croton Aqueduct*. Chicago: Public Works Historical Society, 1977.

Lanman, Charles. *Haphazard Personalities; Chiefly of Noted Americans*. New York: Charles T. Dillingham, 1886.

Larkin, Jack. *The Reshaping of Everyday Life, 1790–1840*. New York: Harper and Row, 1988.

Launitz, R. E. *Collection of Monuments and Head Stones, Designed by R. E. Launitz*. New York: L. Prang and Company, 1866.

Laurie, Bruce. *Artisans into Workers: Labor in Nineteenth-Century America*. New York: Hill and Wang, 1989.

Lawrence, Vera Brodsky. *Repercussions, 1857–1862*. Strong on Music, vol. 3. Chicago: University of Chicago Press, 1999.

———. *Strong on Music: The New York Music Scene in the Days of George Templeton Strong, 1836–1875*. New York: Oxford University Press, 1988.

Ledoux-Lebard, Denise. *Le mobilier français du XIXᵉ siècle, 1795–1889: Dictionnaire des ébénistes et des menuisiers*. Paris: Les Éditions de l'Amateur, 1989.

[Lee, Hannah Farnham]. *Familiar Sketches of Sculpture and Sculptors*. 2 vols. Boston: Crosby, Nichols, and Company, 1854.

Lee, James. *The Equestrian Statue of Washington*. New York: John F. Trow, Printer, 1864.

Lehmann-Haupt, Hellmut, ed. *Bookbinding in America: Three Essays. . . .* Portland, Maine: Southworth-Athoensen Press, 1941. Reprint, New York: R. R. Bowker, 1967.

Leris-Laffargue, Janine. *Restauration / Louis Philippe*. Le mobilier français. Paris: Éditions Massin, 1994.

Lester, Charles Edwards. *The Gallery of Illustrious Americans, Containing the Portraits and Biographical Sketches of Twenty-four of the Most Eminent Citizens of the American Republic, since the Death of Washington*. New York: Mathew B. Brady, Francis D'Avignon, C. E. Lester, 1850.

———, ed. *Glances at the Metropolis*. New York: Isaac D. Guyer, 1854.

Levasseur, Auguste. *Lafayette in America in 1824 and 1825; or, Journal of a Voyage to the United States*. Translated by John Godman. 2 vols. Philadelphia: Carey and Lea, 1829.

Levine, Lawrence W. *Highbrow/Lowbrow: The Emergence of Cultural Hierarchy in America*. Cambridge, Massachusetts: Harvard University Press, 1988.

Libin, Laurence. *American Musical Instruments*. New York: The Metropolitan Museum of Art and W. W. Norton Company, 1985.

———. "Keyboard Instruments." *Metropolitan Museum of Art Bulletin* 47 (summer 1989), pp. 1–56.

Licht, Walter. *Industrializing America: The Nineteenth Century*. Baltimore: Johns Hopkins University Press, 1995.

Liedtke, Walter. *Flemish Paintings in America*. Antwerp: Fonds Mercator, 1992.

Lockwood, Charles. *Bricks and Brownstone: The New York Row House, 1783–1929, an Architectural and Social History*. New York: McGraw-Hill, 1972.

———. *Manhattan Moves Uptown: An Illustrated History*. Boston: Houghton Mifflin Company, 1976.

Long, Eleanor Julian Stanley. *Twenty Years at Court, from the Correspondence of the Hon. "Eleanor Stanley, Maid of Honour to Her Late Majesty Queen Victoria, 1842–1862*. London: Nisbeet and Company, 1916.

Longacre, James Barton, and James Herring. *National Portrait Gallery of Distinguished Americans*. 4 vols. Philadelphia: Rice, Rutter, 1834–39.

Lossing, Benson J. *History of New York City*. 2 vols. New York: A. S. Barnes, 1884.

Loudon, J[ohn] C[laudius]. *An Encyclopaedia of Cottage, Farm, and Villa Architecture and Furniture: Containing Numerous Designs for Dwellings . . . Each Design Accompanied by Analytical and Critical Remarks. . . .* London: Longman, Rees, Orme, Brown, Green, and Longmans, 1833. New edition, London: Longman, Brown, Green, and Longmans, 1842.

———. *Loudon Furniture Designs: From the Encyclopaedia of Cottage, Farmhouse and Villa Architecture and Furniture, 1839*. Introduction by Christopher Gilbert. [Yorkshire, England]: S. R. Publishers and *The Connoisseur*, 1970.

Lowenstrom, C. *New-York Pictorial Business Directory of Wall Street*. New York: C. Lowenstrom, 1850.

Ludlow, E. H. *Inventory of Paintings, Statuary, Medals, &c. &c., the Property of the Late Philip Hone . . . Wednesday, April 28, 1852*. Sale cat. New York: P. Miller and Son, 1852.

Lunt, Peter. "Psychological Approaches to Consumption: Varieties of Research—Past, Present and Future." In *Acknowledging Consumption: A Review of New Studies*, edited by Daniel Miller. London: Routledge, 1994.

Lynn, Catherine. *Wallpaper in America: From the Seventeenth Century to World War I*. New York: W. W. Norton and Company, 1980.

Maas, Jeremy. *Gambart: Prince of the Victorian Art World*. London: Barrie and Jenkins, 1975.

Mackay, Alexander. *The Western World; or, Travels in the United States in 1846–47: Exhibiting Them in Their Latest Development, Social, Political, and Industrial; Including a Chapter on California*. 2d ed. 3 vols. London: R. Bentley, 1849.

*Making the American Home: Middle-Class Women and Domestic Material Culture, 1840–1940*. Edited by Marilyn Ferris Motz and Pat Browne. Bowling Green, Ohio: Bowling Green State University Popular Press, 1988.

Mallach, Stanley. "Gothic Furniture Designs by Alexander Jackson Davis." Master's thesis, University of Delaware, Newark, 1966.

Mann, Maybelle. *The American Art-Union*. Exh. cat. Otisville, New York: ALM Associates, 1977; rev. ed., [Jupiter, Florida]: ALM Associates, 1987.

———. "The Arts in Banknote Engraving, 1836–1864." *Imprint* 4 (April 1979), pp. 29–36.

*Manufactures of the United States in 1860; Compiled from the Original Returns of the Eighth Census*. Washington, D.C.: Government Printing Office, 1865.

Mapleson, Thomas W. Gwilt, illuminator. *Lays of the Western World*. New York: Putnam, [1848].

———. *The Songs and Ballads of Shakespeare*. New York: Lockwood, 1849.

*The Marble-Workers' Manual, Designed for the Use of Marble-Workers, Builders, and Owners of Houses*. New York: Sheldon, Blakeman, 1856; Philadelphia: Henry Carey Baird, 1871.

Marcuse, Peter. "The Grid as City Plan: New York City and Laissez-Faire Planning in the Nineteenth Century." *Planning Perspectives* 2 (September 1987), pp. 287–310.

Marshall, Gordon M. "The Golden Age of Illustrated Biographies." In *American Portrait Prints: Proceedings of the Tenth Annual American Print Conference*, edited by Wendy Wick Reaves, pp. 29–82. Charlottesville: University Press of Virginia, for the National Portrait Gallery, Smithsonian Institution, 1984.

Martin, Edgar W. *The Standard of Living in 1860: American Consumption Levels on the Eve of the Civil War*. Chicago: University of Chicago Press, 1942.

Martineau, Harriet. *Retrospect of Western Travel*. 3 vols. London: Saunders and Otley; New York: Harper and Brothers, 1838. Reprint, with a new introduction by Daniel Feller, Armonk, New York: M. E. Sharpe, 2000.

Marzio, Peter C. "Chromolithography as a Popular Art and an Advertising Medium: A Look at Strobridge and Company of Cincinnati." In *Prints of the American West: Papers Presented at the Ninth Annual North American Print*

*Conference*, edited by Ron Tyler. Fort Worth: Amon Carter Museum, 1983.

———. *The Democratic Art, Chromolithography, 1840–1900: Pictures for a 19th-Century America.* Boston: David Godine, 1979.

———. "Mr. Audubon and Mr. Bien: An Early Phase in the History of American Chromolithography." *Prospects*, 1975, pp. 138–54.

Mason, George C. *Newport Illustrated in a Series of Pen and Pencil Sketches.* Newport: C. E. Hammett Jr., 1854.

Maury, Sarah Mytton. *An Englishwoman in America.* London: Thomas Richardson and Son, 1848.

Mayhew, Edgar, and Minor Myers Jr. *A Documentary History of American Interiors: From the Colonial Era to 1915.* New York: Charles Scribner's Sons, 1980.

McAdam, David, Hon., et al., eds. *History of the Bench and Bar of New York.* 2 vols. New York: New York History Company, 1897–99.

McClelland, Nancy. *Duncan Phyfe and the English Regency, 1795–1830.* New York: William R. Scott, 1939. Reprint, New York, Dover Publications, 1980.

McCormick, Heather Jane. "Ernst Plassman, 1822–1877: A New York Carver, Sculptor, Designer and Teacher." Master's thesis, Bard Graduate Center for Studies in the Decorative Arts, 1998.

McGrath, Daniel Francis. "American Colorplate Books, 1800–1900." Ph.D. dissertation, University of Michigan, Ann Arbor, 1966.

McInnis, Maurie D., and Robert A. Leath. "Beautiful Specimens and Elegant Patterns: New York Furniture for the Charleston Market, 1810–1840." In *American Furniture 1996*, edited by Luke Beckerdite, pp. 137–74. Hanover, New Hampshire: University Press of New England for the Chipstone Foundation, 1996.

McKay, Ernest. *The Civil War and New York City.* Syracuse: Syracuse University Press, 1990.

McKearin, George S., and Helen McKearin. *American Glass.* New York: Crown Publishers, 1941.

McKearin, Helen, and George S. McKearin. *Two Hundred Years of American Blown Glass.* New York: Bonanza Books, 1950.

McKendrick, Neil. "Josiah Wedgwood and the Commercialization of the Potteries." In *The Birth of a Consumer Society: The Commercialization of Eighteenth-Century England*, by Neil McKendrick, John Brewer, and J. H. Plumb, pp. 108–12. Bloomington: Indiana University Press, 1982.

McNulty, J. Bard, ed. *The Correspondence of Thomas Cole and Daniel Wadsworth: Letters in the Watkinson Library, Trinity College, Hartford, and in the New York State Library, Albany, New York.* Hartford: Connecticut Historical Society, 1983.

Meier, Henry. "The Origin of the Printing and Roller Press." *Print Collector's Quarterly* 28 (1941), pp. 9–55.

Mercantile Library Association. *The Twenty-third Annual Report of the Board of Directors of the Mercantile Library Association, Clinton Hall, New York, January, 1844.* New York: Printed by George W. Wood, 1844.

Merritt, Jennifer M. "'Communion Plate of the Most Approved and Varied Patterns, in True Ecclesiastical Style': Francis W. Cooper, Silversmith for the New York Ecclesiological Society, 1851 to 1855." Master's thesis, University of Delaware, Newark, 1997.

Meschutt, David. *A Bold Experiment: John Henri Isaac Browere's Life Masks of Prominent Americans.* Cooperstown: New York State Historical Association, 1988.

———. "'A Perfect Likeness': John H. I. Browere's Life Mask of Thomas Jefferson." *American Art Journal* 21, no. 4 (1989), pp. 4–25.

Mesick, Jane Louise. *The English Traveller in America, 1785–1835.* New York: Columbia University Press, 1922. Reprint, Westport, Connecticut: Greenwood Press, 1970.

Metropolitan Museum of Art. *19th-Century America.* Vol. 1, *Furniture and Other Decorative Arts*, by Marilynn Johnson, Marvin D. Schwartz, and Suzanne Boorsch. Vol. 2, *Paintings and Sculpture*, by John K. Howat and Natalie Spassky, et al. Exh. cat. New York: The Metropolitan Museum of Art, 1970.

Milbert, Jacques-Gérard. *Itinéraire pittoresque du fleuve Hudson et des parties latérales de l'Amérique du Nord, d'après les dessins originaux pris sur les lieux.* 3 vols. Paris: H. Gaugain et Cie, 1828–29.

Miller, Agnes. "Centenary of a New York Statue." *New York History* 38 (April 1957), pp. 167–76.

Miller, Angela. *The Empire of the Eye: Landscape Representation and American Cultural Politics, 1825–1875.* Ithaca, New York: Cornell University Press, 1993.

Miller, George L., Ann Smart Martin, and Nancy S. Dickinson. "Changing Consumption Patterns: English Ceramics and the American Market from 1780 to 1840." In *Everyday Life in the Early Republic: 1789–1828*, edited by Catherine E. Hutchins, pp. 219–48. Winterthur, Delaware: Henry Francis du Pont Winterthur Museum, 1994.

Miller, Lillian B. *Patrons and Patriotism: The Encouragement of the Fine Arts in the United States, 1790–1860.* Chicago: University of Chicago Press, 1982.

*Minutes of the Common Council of the City of New York, 1784–1831.* 19 vols. New York: City of New York [M. B. Brown Printing and Binding Company], 1917.

Moebs, Thomas Truxtun. *U.S. Reference-iana: 1481–1899. . . .* Williamsburg: Moebs Publishing Company, 1989.

Moehring, Eugene P. "Public Works and Patterns of Real Estate Growth in Manhattan, 1835–1894." Ph.D. dissertation, City University of New York, 1976.

———. "Space, Economic Growth, and the Public Works Revolution in New York." In *Infrastructure and Urban Growth in the Nineteenth Century.* Chicago: Public Works Historical Society, 1985.

Mollenkopf, John Hull, ed. *Power, Culture, and Place: Essays on New York City.* New York: Russell Sage Foundation, 1988.

Monaghan, Frank. *French Travellers in the United States, 1765–1932: A Bibliography.* New York: New York Public Library, 1933; supplement by Samuel J. Marino, N.p., 1961.

Mooney, Thomas. *Nine Years in America . . . in a Series of Letters to His Cousin, Patrick Mooney, a Farmer in Ireland.* 2d ed. Dublin: James McGlashan, 1850.

Moore, N. Hudson. *Old Glass, European and American.* New York: Tudor, 1941.

Morgan, Ann Lee. "The American Audubons: Julius Bien's Lithographed Edition." *Print Quarterly* 4 (December 1987), pp. 362–78.

Morley, John. *The History of Furniture: Twenty-five Centuries of Style and Design in the Western Tradition.* Boston: Little, Brown and Company, 1999.

Morris, Lloyd. *Incredible New York: High Life and Low Life from 1850 to 1950.* New York: Random House, 1951. Reprint, Syracuse: Syracuse University Press, 1996.

Morse, Edward Lind, ed. *Samuel F. B. Morse, His Letters and Journals.* 2 vols. Boston: Houghton Mifflin, 1914.

Morse, John D., ed. *Prints in and of America to 1850.* Sixteenth Winterthur Conference on Museum Operation and Connoisseurship. Charlottesville: University Press of Virginia, 1970.

Morse, Samuel F. B. *Academies of Arts. A Discourse Delivered on Thursday, May 3, 1827, in the Chapel of Columbia College, before the National Academy of Design, on Its First Anniversary.* New York: G. and C. Carvill, 1827.

———. *Examination of Col. Trumbull's Address, in Opposition to the Projected Union of the American Academy of Fine Arts, and the National Academy of Design.* New York: Clayton and Van Norden, 1833.

Mott, Frank Luther. *American Journalism: A History of Newspapers in the United States through 260 Years: 1690 to 1950.* 4 vols. Rev. ed. New York: Macmillan Company, 1950.

———. *A History of American Magazines.* 5 vols. Cambridge, Massachusetts: Harvard University Press, 1938–68.

Moyer, Cynthia. "Conservation Treatments for Border and Freehand Gilding and Bronze-Powder Stenciling and Freehand Bronze." In *Gilded Wood: Conservation and History*, pp. 331–41. Madison, Connecticut: Sound View Press, 1991.

Murdock, Edwin Forrest. "The American Institute." In *A Century of Industrial Progress*, edited by Frederic W. Wile, pp. v–xvi. Garden City: Doubleday, Doran and Company, 1928.

Murray, Amelia M. *Letters from the United States, Cuba, and Canada.* New York: G. P. Putnam and Company, 1856.

Muthesius, Stefan. "Why Do We Buy Old Furniture? Aspects of the Authentic Antique in Britain, 1870–1910." *Art History* 11 (June 1988), pp. 231–54.

Myers, Andrew B., ed., *The Knickerbocker Tradition: Washington Irving's New York.* Tarrytown: Sleepy Hollow Restorations, 1974.

Myers, Kenneth. *The Catskills: Painters, Writers, and Tourists in the Mountains, 1820–1895*. Exh. cat. Yonkers: Hudson River Museum of Westchester, 1987.

Nadel, Stanley. *Little Germany: Ethnicity, Religion, and Class in New York City, 1845–80*. Urbana: University of Illinois Press, 1990.

National Academy of Design. *Catalogue of Statues, Busts, Studies, etc., Forming the Collection of the Antique School of the National Academy of Design*. New York: Israel Sackett, 1846.

*The National Cyclopaedia of American Biography*. New York: James T. White and Company, 1892–1984.

Nevins, Allan, ed. *American Social History as Recorded by British Travellers*. New York: Henry Holt and Company, 1931.

———. *America through British Eyes*. Gloucester, Massachusetts: Peter Smith, 1968.

Newlin, Alice. "Asher B. Durand, American Engraver." *Metropolitan Museum of Art Bulletin*, n.s., 1 (January 1943), pp. 165–70.

Newman, Harry S. *Best Fifty Currier & Ives Lithographs, Large Folio Size*. New York: Old Print Shop, 1938.

Newton, Roger Hale. *Town & Davis, Architects: Pioneers in American Revivalist Architecture, 1812–1870, Including a Glimpse of Their Times and Their Contemporaries*. New York: Columbia University Press, 1942.

*The New-York Book of Prices for Manufacturing Cabinet and Chair Work*. New York: Printed by J. Seymour, 1817; New York: Printed by Harper and Brothers, 1834.

New-York Historical Society. *Catalogue of American Portraits in the New-York Historical Society*. 2 vols. New Haven: Yale University Press for The New-York Historical Society, 1974.

New York Public Library. "The Eno Collection of New York City Views." *New York Public Library Bulletin* 29 (May 1925), pp. 327–54, 385–414.

Nicholson, Peter. *The New Practical Builder and Workman's Companion*. 2 vols. London: Thomas Kelly, 1823–25.

Nicholson, Peter, and Michael Angelo Nicholson. *The Practical Cabinet-Maker, Upholsterer, and Complete Decorator*. London: H. Fisher, Son, and Company, 1826.

Nissenbaum, Stephen. *The Battle for Christmas*. New York: Alfred A. Knopf, 1996.

Noble, Louis Legrand. *Church's Painting: The Heart of the Andes*. New York: D. Appleton and Company, 1859.

———. *The Course of Empire, Voyage of Life, and Other Pictures of Thomas Cole, N.A., with Selections from His Letters and Miscellaneous Writings: Illustrative of His Life, Character, and Genius*. New York: Cornish, Lamport and Company, 1853. Reprint, edited by Elliot S. Vesell, Hensonville, New York: Black Dome Press, 1997.

North, Douglass C., and Robert P. Thomas, eds. *The Growth of the American Economy to 1860*. New York: Harper and Row, 1968.

Nouvel-Kammerer, Odile. *Napoléon III / années 1880. Le mobilier français*. Paris: Éditions Massin, 1996.

Nygren, Edward C. *Views and Visions: American Landscape before 1830*. Exh. cat. Hartford, Connecticut: Wadsworth Atheneum; Washington, D.C.: Corcoran Gallery of Art, 1986.

Nylander, Richard C., Elizabeth Redmond, and Penny J. Sander. *Wallpaper in New England*. Boston: Society for the Preservation of New England Antiquities, 1986.

O'Brien, Maureen C., and Patricia C. F. Mandel. *The American Painter-Etcher Movement*. Exh. cat. Southampton, New York: Parrish Art Museum, 1984.

O'Connell, Shaun. *Remarkable, Unspeakable New York: A Literary History*. Boston: Beacon Press, 1995.

Oettermann, Stephan. *The Panorama: History of a Mass Medium*. Translated by Deborah L. Schneider. New York: Zone Books, 1997.

*Official Catalogue of the New-York Exhibition of the Industry of All Nations, 1853*. New York: George P. Putnam and Company, 1853.

*Official Catalogue of the Pictures Contributed to the Exhibition of the Industry of All Nations, in the Picture Gallery of the Crystal Palace*. New York: G. P. Putnam and Company, 1853.

*The Old Croton Aqueduct: Rural Resources Meet Urban Needs*. Yonkers: Hudson River Museum of Westchester, 1992.

Olyphant, Robert M. *Mr. Robert M. Olyphant's Collection of Paintings by American Artists. . . .* Sale cat. New York: R. Somerville, December 18, 19, 1877.

*The Origins of Cast Iron Architecture in America; Including Illustrations of Iron Architecture Made by the Architectural Iron Works of the City of New York, and Cast Iron Buildings, Their Construction and Advantages*. New York: Da Capo Press, 1970. Reprint of Badger, *Illustrations of Iron Architecture,* and Bogardus, *Cast Iron Buildings*.

Ormsbee, Thomas H. "Gratitude in Silver for Prosperity." *American Collector* 7 (April 1937), pp. 3, 10–11.

Orosz, Joe. *Curators and Culture: The Museum Movement in America, 1740–1870*. Tuscaloosa: University of Alabama Press, 1990.

Paff, Michael. *Catalogue of the Extensive and Valuable Collection of Pictures, Engravings, and Works of Art . . . Collected by Michael Paff. . . .* Sale cat. New York: A. Levy, Auctioneer, 1838.

Palmer, Arlene. *Glass in Early America: Selections from the Henry Francis du Pont Winterthur Museum*. Winterthur, Delaware: Henry Francis du Pont Winterthur Museum, 1993.

———. *A Guide to Victoria Mansion*. Portland, Maine: Victoria Mansion, 1997.

———. "Gustave Herter's Interiors and Furniture for the Ruggles S. Morse Mansion." *Nineteenth Century* 16 (fall 1996), pp. 3–13.

Palmer, Arlene, and John Quentin Feller. "Christian Dorflinger's Presentation Silver Service." Typescript, 1991.

Panzer, Mary. *Mathew Brady and the Image of History*. Exh. cat. Washington, D.C.: Smithsonian Institution Press for the National Portrait Gallery, 1997.

Papantonio, Michael. *Early American Bookbindings from the Collection of Michael Papantonio*. 2d ed. Worcester, Massachusetts: American Antiquarian Society, 1985.

Parker, Barbara N. "George Harvey and His Atmospheric Landscapes." *Bulletin of the Museum of Fine Arts* (Boston) 41 (February 1943), pp. 7–9.

Parry, Ellwood C., III. *The Art of Thomas Cole: Ambition and Imagination*. Newark: University of Delaware Press, 1988.

———. "Landscape Theater in America." *Art in America* 59 (December 1971), pp. 52–56.

[Paulding, James Kirke] An Amateur. *The New Mirror for Travellers; and Guide to the Springs*. New York: G. and C. Carvill, 1828.

Peck, Amelia, ed. *Alexander Jackson Davis: American Architect, 1803–1892*. Exh. cat. New York: The Metropolitan Museum of Art, in association with Rizzoli, 1992.

Peirce, Donald C. *Art and Enterprise: American Decorative Art, 1825–1917: The Virginia Carroll Crawford Collection*. Exh. cat. Atlanta: High Museum of Art, in association with Antique Collectors' Club, 1999.

Pelletreau, William S. *Early New York Houses (1750–1900) with Historical and Genealogical Notes, in Ten Parts*. New York: Francis P. Harper, 1900.

Penny, Virginia. *How Women Can Make Money, Married or Single, in All Branches of the Arts and Sciences, Professions, Trades, Agricultural and Mechanical Pursuits*. Philadelphia: John E. Potter and Company, 1863. Published also under title *The Employments of Women*. Reprint, New York: Arno Press, 1971.

Pessen, Edward. *Riches, Class, and Power before the Civil War*. Lexington, Massachusetts: D. C. Heath and Company, 1973.

Peters, Harry T. *America on Stone: The Other Printmakers to the American People. A Chronicle of American Lithography Other Than That of Currier & Ives, from Its Beginning, Shortly before 1820, to the Years When the Commercial Single-Stone Hand-Colored Lithograph Disappeared from the American Scene*. Garden City, New York: Doubleday, Doran, and Company, 1931. Reprint, New York: Arno Press, 1976.

———. *Currier & Ives: Printmakers to the American People. A Chronicle of the Firm, and of the Artists and Their Work, with Notes on Collecting; Reproductions of 142 of the Prints and Originals, Forming a Pictorial Record of American Life and Manners in the Last Century; and a Checklist of All Known Prints Published by N. Currier and Currier & Ives*. 2 vols. Garden City, New York: Doubleday, Doran, and Company, 1929–31.

Phelps, H. *Phelps' New-York City Guide and Conductor to Environs for 30 Miles Around: Being a Pocket Directory for Strangers and Citizens to the Prominent Objects of Interest in the Great Commercial Metropolis, and Conductor to Its Environs.*

*With the Engravings of Public Buildings.* New York: T. C. Fanning, 1852.

———. *Phelps' New York City Guide; Being a Pocket Directory for Strangers and Citizens to the Prominent Objects of Interest in the Great Commercial Metropolis, and Conductor to Its Environs. With Engravings of Public Buildings.* New York: Ensign, Bridgman and Fanning, 1854. Includes a large fold-out pocket map.

———. *What to See and How to See It. Phelps' Stranger's and Citizen's Guide to New-York City, with Maps and Engravings.* New York: Gaylord Watson, 1857.

Phyfe, Duncan. *Peremptory and Extensive Auction Sale of Splendid and Valuable Furniture, on . . . April 16, & 17, . . . at the Furniture Ware Rooms of Messrs. Duncan Phyfe & Son, Nos. 192 & 194 Fulton Street.* Sale cat. New York: Halliday and Jenkins [Edgar Jenkins, Auctioneer], 1847.

Pierce, Sally, with Catharina Slautterback and Georgia Brady Barnhill. *Early American Lithography: Images to 1830.* Exh. cat. Boston: Boston Athenaeum, 1997.

Pierson, William H., Jr. *American Buildings and Their Architects.* Vol. 1: *The Colonial and Neoclassical Styles.* Vol. 2: *Technology and the Picturesque: The Corporate and the Early Gothic Styles.* Garden City, New York: Doubleday, 1970, 1978.

Plunz, Richard. *A History of Housing in New York City: Dwelling Type and Social Change in the American Metropolis.* New York: Columbia University Press, 1990.

Pocock, William. *Designs for Churches and Chapels, of Various Dimensions and Styles; Consisting of Plans, Elevations, and Sections, with Estimates: Also Some Designs for Altars, Pulpits, and Steeples.* London: J. Taylor, 1819; [2d ed.], 1824.

Poe, Edgar Allan. *Doings of Gotham, as Described in a Series of Letters to the Editors of "The Columbia Spy" Together with Various Editorial Comments and Criticisms by Poe, also a Poem Entitled "New Year's Address of the Carriers of the Columbia Spy."* Edited by Jacob E. Spannuth and Thomas Ollive Mabbott. Pottsville, Pennsylvania: Jacob E. Spannuth, 1929.

———. *The Literati, Some Honest Opinions about Autorial Merits and Demerits, with Occasional Words of Personality; Together with Marginalia, Suggestions, and Essays.* New York: J. S. Redfield; Boston: B. B. Mussey and Company, 1850.

Pollack, Jodi A. "Three Generations of Meeks Craftsmen, 1797–1869: A History of Their Business and Furniture." Master's thesis, Cooper-Hewitt, National Design Museum, and Parsons School of Design, 1998.

Porter, Glenn, and Harold C. Livesay. *Merchants and Manufacturers: Studies in the Changing Structure of Nineteenth-Century Marketing.* Baltimore: Johns Hopkins University Press, 1971.

Power, Tyrone. *Impressions of America; during the Years 1833, 1834, and 1835.* 2d ed. 2 vols. Philadelphia: Carey, Lea, and Blanchard, 1836.

Prime, Samuel Irenaeus. *The Life of Samuel F. B. Morse, LL.D., Inventor of the Electro-magnetic Recording Telegraph.* New York: D. Appleton and Company, 1875.

Prime, William Cowper. *Boat Life in Egypt and Nubia.* New York: Harper and Brothers, 1857.

———. *Coins, Medals, and Seals, Ancient and Modern Illustrated and Described: With a Sketch of the History of Coins and Coinage, Instructions for Young Collectors, Tables of Comparative Rarity, Price Lists of English and American Coins, Medals and Tokens, &c., &c.* New York: Harper and Brothers, 1861.

———. *The Little Passion of Albert Dürer.* New York: J. W. Bouton, 1868.

———. *Pottery and Porcelain of All Times and Nations with Tables of Factory and Artists' Marks for the Use of Collectors.* New York: Harper and Brothers, 1878.

———. *Tent Life in the Holy Land.* New York: Harper and Brothers, 1857.

Pugin, A. W. N. *The True Principles of Pointed or Christian Architecture Set Forth in Two Lectures Delivered at St. Marie's, Oscott.* London: J. Weale, 1841.

Pugin, Augustus Charles. *Gothic Furniture: Consisting of Twenty-Seven Coloured Engravings from Designs by A. Pugin, with Descriptive Letter-Press.* London: R. Ackermann, [1828].

Pursell, Carroll W. *The Machine in America: A Social History of Technology.* Baltimore: Johns Hopkins University Press, 1995.

Purtell, Joseph. *The Tiffany Touch.* New York: Random House, 1971.

[Putnam, George P.] *The Tourist in Europe: or, A Concise Summary of the Various Routes, Objects of Interest, &c. in Great Britain, France, Switzerland, Italy, Germany, Belgium, and Holland; with Hints on Time, Expenses, Hotels, Conveyances, Passports, Coins, &c.; Memoranda during a Tour of Eight Months in Great Britain and on the Continent.* New York: Wiley and Putnam, 1838.

Quimby, Ian M. G., with Dianne Johnson. *American Silver at Winterthur.* Winterthur, Delaware: The Henry Francis du Pont Winterthur Museum, 1995.

Quimby, Maureen O'Brien, and Jean Woollens Fernald. "A Matter of Taste and Elegance: Admiral Samuel Francis Du Pont and the Decorative Arts." *Winterthur Portfolio* 21 (summer/autumn 1986), pp. 103–32.

Rainey, Sue, and Mildred Abraham. *Embellished with Numerous Engravings: The Works of American Illustrators and Wood Engravers, 1670–1880. . . .* Exh. cat. Charlottesville: University of Virginia Library, 1986.

Rainwater, Dorothy T., and Judy Redfield. *Encyclopedia of American Silver Manufacturers.* 4th ed. Atglen, Pennsylvania: Schiffer Publishing, 1998.

Reaves, Wendy Wick, ed. *American Portrait Prints: Proceedings of the Tenth Annual Print Conference.* Charlottesville: University Press of Virginia, for the National Portrait Gallery, Smithsonian Institution, 1984.

Rebora, Carrie. "The American Academy of the Fine Arts, New York, 1802–1842." 2 vols. Ph.D. dissertation, City University of New York, 1990.

———. "Robert Fulton's Art Collection." *American Art Journal* 22, no. 3 (1990), pp. 41–63.

Redmond, Elizabeth. "American Wallpaper, 1840–1860: The Limited Impact of Early Machine Printing." Master's thesis, University of Delaware, Newark, 1987.

Reese, William S. *Stamped with a National Character: Nineteenth Century American Color Plate Books.* Exh. cat. New York: Grolier Club, 1999.

Reilly, Bernard F., Jr. *American Political Prints, 1766–1876: A Catalog of the Collections in the Library of Congress.* Boston: G. K. Hall and Co., 1991.

Reps, John W. *Bird's Eye Views. Historic Lithographs of North American Cities.* New York: Princeton Architectural Press, 1998.

———. *Views and Viewmakers of Urban America: Lithographs of Towns and Cities in the United States and Canada, Notes on the Artists and Publishers, and a Union Catalog of Their Work, 1825–1925.* Columbia: University of Missouri Press, 1984.

Resseguie, Harry E. "Alexander Turney Stewart and the Department Store." *Business History Review* 39 (1965), pp. 301–22.

———. "Stewart's Marble Palace—the Cradle of the Department Store." *New-York Historical Society Quarterly* 48 (April 1964), pp. 130–62.

Reynolds, David S. *Beneath the American Renaissance: The Subversive Imagination in the Age of Emerson and Melville.* New York: Alfred A. Knopf, 1988.

———. *Walt Whitman's America: A Cultural Biography.* New York: Alfred A. Knopf, 1995.

Reynolds, Donald M. *Monuments and Masterpieces: Histories and Views of Public Sculpture in New York City.* New York: Macmillan Publishing Company; London: Collier Macmillan, 1988.

Richards, William C. *A Day in the New York Crystal Palace and How to Make the Most of It; Being a Popular Companion to the Official Catalogue and a Guide to All the Objects of Special Interest in the New York Exhibition of the Industry of All Nations.* New York: G. P. Putnam and Company, 1853.

Richardson, Edgar P. "The Cassin Medal." *Winterthur Portfolio* 4 (1968), pp. 80–81.

Richmond, John Frances. *New York and Its Institutions, 1609–1872.* New York: E. B. Treat, 1872.

Roberson, Samuel A., and William H. Gerdts. "The Greek Slave." *The Museum* (Newark), n.s., 17 (winter–spring 1965), pp. 1–30.

Rock, Howard B. *Artisans of the New Republic: The Tradesmen of New York in the Age of Jefferson.* New York: New York University Press, 1979.

———. *The New York City Artisan, 1789–1825: A Documentary History.* Albany: State University of New York Press, 1989.

Rock, Howard B., Paul A. Gilje, and Robert Asher, eds. *American Artisans: Crafting Social Identity, 1750–1850.* Baltimore: Johns Hopkins University Press, 1995.

Romaine, Lawrence B. *A Guide to American Trade Catalogs, 1744–1900.* New York: Bowker, 1960.

Roorback, Oliver A., comp. *Biblioteca Americana: A Catalogue of American Publications, Including Reprints and Original Works, from 1820–1852 and 1852–1861.* 4 vols. New York: Peter Smith, 1939.

Root, Marcus A. *The Camera and the Pencil; or, The Heliographic Art. . . .* Philadelphia: M. A. Root, 1864. Reprint, Pawlet, Vermont: Helios, 1971.

Rose, Anne C. *Voices of the Marketplace: American Thought and Culture, 1830–1860.* New York: Twayne Publishing, 1995.

Rosen, Christine Meisner. "Noisome, Noxious, and Offensive Vapors: Fumes and Stenches in American Towns and Cities, 1840–1865." *Historical Geography* 25 (1997), pp. 67–82.

Rosenwaike, Ira. *Population History of New York City.* Syracuse: Syracuse University Press, 1972.

Rosenzweig, Roy, and Elizabeth Blackmar. *The Park and the People: A History of Central Park.* Ithaca, New York: Cornell University Press, 1992.

Ross, Ishbel. *Crusades and Crinolines: The Life and Times of Ellen Curtis Demorest and William Jennings Demorest.* New York: Harper and Row, 1963.

Ross, Joel H. *What I Saw in New York; or, A Bird's Eye View of City Life.* Auburn, New York: Derby and Miller, 1851.

Roux, Alexander. *Catalogue of Rich Cabinet Furniture Comprising a Large and Rich Assortment of Rosewood, Walnut, Oak, Buhl, and Marqueterie, at Alex. Roux & Co., 479 Broadway. . . .* Sale cat. New York: Henry H. Leeds and Co., November 11–12, 1857.

Royall, Anne. *Sketches of History, Life, and Manners in the United States, by a Traveller.* New Haven: Printed for the author, 1826.

Roylance, Dale. *American Graphic Arts. A Chronology to 1900 in Books, Prints, and Drawings.* Princeton: Princeton University Library, 1990.

Roylance, Dale, and Nancy Finlay. *Pride of Place. Early American Views from the Collection of Leonard L. Milberg '53.* Princeton: Princeton University Library, 1983.

Ruskin, John. *Modern Painters.* 5 vols. London: Smith, Elder, and Company, 1843–60.

Rutledge, Anna Wells. "William John Coffee as a Portrait Sculptor." *Gazette des Beaux-Arts,* ser. 6, 28 (November 1945), pp. 297–312.

Ryan, Mary P. *Civic Wars: Democracy and Public Life in the American City during the Nineteenth Century.* Berkeley: University of California Press, 1997.

Sabin, Joseph. *A Catalogue of the Books, Autographs, Engravings, and Miscellaneous Articles Belonging to the Estate of the Late John Allan.* Sale cat. New York, 1864.

———. *Catalogue of the . . . Collection of . . . the Late Mr. E. B. Corwin.* Sale cat. New York: Bangs, Brother and Company, November 10, 1856.

Sabin, Joseph, and Wilberforce Eames. *A Dictionary of Books Relating to America, from Its Discovery to the Present Time.* 29 vols. New York: J. Sabin; New York: Bibliographical Society of America; Portland, Maine, 1868–92, 1927–36.

Santé, Luc. *Low Life: Lures and Snares of Old New York.* New York: Farrar Straus Giroux, 1991.

Sarmiento, Domingo Faustino. *Sarmiento's Travels in the United States in 1847.* Translated by Michael Aaron Rockland. Princeton: Princeton University Press, 1970.

Schaffner, Cynthia Van Allen. "Secrets and 'Receipts': American and British Furniture Finishers' Literature, 1790–1880." Master's thesis, Cooper-Hewitt, National Design Museum, and Parsons School of Design, New York, 1999.

Schaffner, Cynthia Van Allen, and Susan Klein. *American Painted Furniture, 1790–1880.* New York: Clarkson Potter Publishers, 1997.

Schofield, Robert E. "The Science Education of an Enlightened Entrepreneur: Charles Willson Peale and His Philadelphia Museum, 1784–1827." *American Studies* 30 (fall 1989), pp. 21–40.

Schultz, Ronald. *The Republic of Labor: Philadelphia Artisans and the Politics of Class, 1720–1830.* New York: Oxford University Press, 1993.

Schuyler, David. *Apostle of Taste: Andrew Jackson Downing, 1815–1852.* Baltimore: Johns Hopkins University Press, 1996.

———. *The New Urban Landscape: The Redefinition of City Form in Nineteenth-Century America.* Baltimore: Johns Hopkins University Press, 1986.

Schwind, Arlene Palmer. "Joseph Baggott, New York Glasscutter." *Glass Club Bulletin of the National Early American Glass Club,* no. 142 (fall 1984–winter 1985), pp. 9–13.

Scoville, J[oseph] A. *The Old Merchants of New York, by Walter Barrett, Clerk.* 5 vols. in 3 parts. New York: Carleton; M. Doolady, 1864–70.

Scully, Arthur, Jr. *James Dakin, Architect: His Career in New York and the South.* Baton Rouge: Louisiana State University Press, 1973.

Seager, Robert, II. *And Tyler Too, A Biography of John and Julia Gardiner Tyler.* New York: McGraw-Hill Book Company, 1963.

*Second Supplement to the London Chair-Makers' and Carvers' Book of Prices for Workmanship.* 2d ed. London: T. Brettell, 1829.

Sellers, Charles Coleman. *Mr. Peale's Museum: Charles Willson Peale and the First Popular Museum of Natural Science and Art.* New York: W. W. Norton, 1980.

Sellers, Charles Grier. *The Market Revolution: Jacksonian America, 1815–1846.* New York: Oxford University Press, 1991.

Severini, Lois. *The Architecture of Finance: Early Wall Street.* Ann Arbor, Michigan: UMI Research Press, 1983.

Shadwell, Wendy. "Genin, the Celebrated Hatter." *Seaport, New York's History Magazine,* spring 1999, pp. 22–27.

Shapiro, Michael Edward. *Bronze Casting and American Sculpture, 1850–1900.* Newark: University of Delaware Press, 1985.

Sharp, Lewis I. *John Quincy Adams Ward: Dean of American Sculpture.* Newark: University of Delaware Press, 1985.

Shaw, Joshua. *Picturesque Views of American Scenery, 1820.* Philadelphia: M. Carey and Son, 1820.

Shelley, Donald A. "George Harvey and His Atmospheric Landscapes of North America." *New-York Historical Society Quarterly* 32 (April 1948), pp. 104–13.

———. "William Guy Wall and His Watercolors for the Historic *Hudson River Portfolio.*" *New-York Historical Society Quarterly* 31 (January 1947), pp. 25–45.

Sheriff, Carol. *The Artificial River: The Erie Canal and the Paradox of Progress, 1817–1862.* New York: Hill and Wang, 1996.

Sill, Geoffrey M., and Roberta K. Tarbell, eds. *Walt Whitman and the Visual Arts.* New Brunswick, New Jersey: Rutgers University Press, 1992.

Silliman, Benjamin. *A Tour to Quebec in the Autumn of 1819.* London: Sir Richard Phillips and Company, 1822.

Silliman, B[enjamin], Jr., and C[harles] R[ush] Goodrich, eds. *The World of Science, Art, and Industry Illustrated from Examples in the New-York Exhibition, 1853–54.* New York: G. P. Putnam and Company, 1854.

Simon, Janice. "*The Crayon,* 1855–1861: The Voice of Nature in Criticism, Poetry, and the Fine Arts." 2 vols. Ph.D. dissertation, University of Michigan, Ann Arbor, 1990.

Singer, Aaron. "Labor Management Relations at Steinway and Sons, 1853–1896." Ph.D. dissertation, Columbia University, New York, 1977.

Sitt, Martina. *Andreas und Oswald Achenbach, "Das A und O der Landschaft."* Exh. cat. Düsseldorf: Kunstmuseums Düsseldorf; Cologne: Wienand Verlag, 1997.

Sizer, Theodore, ed. *The Autobiography of Colonel John Trumbull, Patriot-Artist, 1756–1843.* New Haven: Yale University Press, 1953.

Smith, Dinitia. "Spirit of Christmas Past and Present, All Stuffed into One Man's Collection." Part 2. *New York Times,* December 15, 1999, p. B17.

Smith, George. *A Collection of Designs for Household Furniture and Interior Decoration in the Most Approved and Elegant Taste . . . with Various Designs for Rooms. . . .* London: J. Taylor, 1808.

———. *Smith's Cabinet-Maker and Upholsterer's Guide: Drawing Book, and Repository of New, and Original Designs for Household Furniture and Interior Decoration in the Most Approved and Modern Taste; Including Specimens of the Egyptian, Grecian, Gothic, Arabesque, French, English, and Other Schools of the Art.* London: Jones and Company, 1828.

Smith, Mary Ann. "The Commercial Architecture of John Butler Snook." Ph.D. dissertation, Pennsylvania State University, University Park, 1974.

———. "John Snook and the Design for A. T. Stewart's Store." *New-York Historical Society Quarterly* 58 (January 1974), pp. 18–33.

Smith, Thomas Gordon. *John Hall and the Grecian Style in America: A Reprint of Three Pattern Books Published in Baltimore in 1840.* New York: Acanthus Press, 1996.

———. "Millford Plantation in South Carolina." *Antiques* 151 (May 1997), pp. 732–41.

———. *Neo-Classical Furniture Designs: A Reprint of Thomas King's "Modern Style of Cabinet Work Exemplified," 1829.* New introduction by Thomas Gordon Smith. New York: Dover Publications, 1995.

Snowman, A. Kenneth, ed. *The Master Jewelers.* New York: Harry N. Abrams, 1990.

Soeffing, D. Albert. "Ball, Black & Co. Silverware Merchants." *Silver* 30 (November–December 1998), pp. 44–49.

————. "A Selection of Letters from the Black, Starr & Frost Scrapbooks." *Silver* 29 (November–December 1997), pp. 48–51.

Spafford, Horatio Gates. *A Gazetteer of the State of New-York. . . .* Albany: H. C. Southwick, 1813.

————. *A Gazetteer of the State of New-York.* Albany: B. D. Packard, 1824. Reprint, Interlaken, New York: Heart of the Lakes Publishing, 1981.

Spann, Edward K. "The Greatest Grid: The New York Plan of 1811." In *Two Centuries of American Planning*, edited by Daniel Schaffer. Baltimore: Johns Hopkins University Press, 1988.

————. *Ideals and Politics: New York Intellectuals and Liberal Democracy, 1820–1880.* Albany: State University of New York Press, 1972.

————. *The New Metropolis: New York City, 1840–1857.* New York: Columbia University Press, 1981.

Spaulding, John H. *Historical Relics of the White Mountains. Also, a Concise White Mountain Guide.* Mt. Washington: J. R. Hitchcock, 1855.

Spear, Dorothea N. *Bibliography of American Directories through 1860.* Worcester, Massachusetts: American Antiquarian Society, 1961. Reprint, Westport, Connecticut: Greenwood Press, 1978.

Spillman, Jane Shadel. "Glasses with American Views—Addenda." *Journal of Glass Studies* 22 (1980), pp. 78–81.

————. *Glass from World's Fairs, 1851–1904.* Corning, New York: Corning Museum of Glass, 1986.

————. *White House Glassware: Two Centuries of Presidential Entertaining.* Washington, D.C.: White House Historical Association, 1989.

Spillman, Jane Shadel, and Alice Cooney Frelinghuysen. "The Dummer Glass and Ceramic Factories in Jersey City, New Jersey." *Antiques* 137 (March 1990), pp. 706–17.

Spooner, Shearjashub. *The American Edition of Boydell's Illustrations of the Dramatic Works of Shakespeare, by the Most Eminent Artists of Great Britain. Restored and Published with Original Descriptions of the Plates.* 2 vols. New York: Shearjashub Spooner, 1852.

————. *An Appeal to the People of the United States in Behalf of Art, Artists, and the Public Weal.* New York: J. J. Reed, Printer, 1854.

————. *A Biographical and Critical Dictionary of Painters, Engravers, Sculptors, and Architects, from Ancient to Modern Times; with the Monograms, Ciphers, and Marks Used by Distinguished Artists to Certify Their Works.* New York: G. P. Putnam and Company, 1852.

Staiti, Paul J. *Samuel F. B. Morse.* Cambridge: Cambridge University Press, 1989.

Stanford, Thomas N. *A Concise Description of the City of New York Giving an Account of Its Early History, Public Buildings, Amusements, Exhibitions, Benevolent and Literary Institutions; Together with Other Interesting Information.* New York: The Author, 1814.

Staniland, Kay. *In Royal Fashion: The Clothes of Princess Charlotte of Wales and Queen Victoria, 1796–1901.* London: Museum of London, 1997.

Stansell, Christine. *City of Women: Sex and Class in New York, 1789–1860.* New York: Alfred A.

Knopf, 1986; Urbana: University of Illinois Press, 1987.

Stanton, Phoebe B. *The Gothic Revival and American Church Architecture: An Episode in Taste, 1840–1856.* Baltimore: Johns Hopkins University Press, 1968. Reprint, 1997.

Stapp, William F. "Daguerreotypes onto Stone: The Life and Work of Francis D'Avignon." In *American Portrait Prints: Proceedings of the Tenth Annual American Print Conference*, edited by Wendy Wick Reaves. Charlottesville: University Press of Virginia, for the National Portrait Gallery, Smithsonian Institution, 1984.

Starr, Fellows and Company. *Illustrated Catalogue of Lamps, Gas Fixtures, &c.* New York: Starr, Fellows and Company, 1856.

Stauffer, David McNeely. *American Engravers upon Copper and Steel.* New York: Grolier Club, 1907.

Stebbins, Theodore E., Jr., et al. *Lure of Italy: American Artists and the Italian Experience, 1760–1914.* Exh. cat. Boston: Museum of Fine Arts, in association with Harry N. Abrams, 1992.

Steege, Gwen W. "The *Book of Plans* and the Early Romanesque Revival in the United States: A Study in Architectural Patronage." *Journal of the Society of Architectural Historians* 46 (September 1987), pp. 215–27.

Stefano, Frank, Jr. "James and Ralph Clews, Nineteenth-Century Potters, Part I: The English Experience." *Antiques* 105 (February 1974), pp. 324–28.

Stehle, R. H. "The Düsseldorf Gallery of New York." *New-York Historical Society Quarterly* 63 (October 1974), pp. 305–14.

Stein, Roger. *John Ruskin and Aesthetic Thought in America, 1840–1900.* Cambridge, Massachusetts: Harvard University Press, 1967.

Steiner, Maynard E. "The Brooklyn Flint Glass Company, 1840–1868." *The Acorn, Journal of the Sandwich Glass Museum* 7 (1997), pp. 38–69.

Stephens, Stephen DeWitt. *The Mavericks, American Engravers.* New Brunswick, New Jersey: Rutgers University Press, 1950.

Stevens, Henry. *Recollections of James Lenox and the Formation of His Library.* Edited by Victor H. Paltsits. New York: New York Public Library, 1951.

Stewart, Robert G. *A Nineteenth-Century Gallery of Distinguished Americans.* Exh. cat. Washington, D.C., National Portrait Gallery, Smithsonian Institution, 1969.

Stiles, Henry R. *The Civil, Political, Professional and Ecclesiastical History and Commercial and Industrial Record of the County of Kings and the City of Brooklyn, New York from 1683 to 1884.* New York: W. W. Munsell and Company, 1884.

Still, Bayrd. *Mirror for Gotham: New York as Seen by Contemporaries from Dutch Days to the Present.* New York: New York University Press, 1956. Reprint, New York: Fordham University Press, 1994.

Stillwell, John E. "Thomas J. Bryan—The First Art Collector and Connoisseur in New York City." *New-York Historical Society Quarterly Bulletin* 1 (January 1918), pp. 103–5.

Stokes, I. N. Phelps. *The Iconography of Manhattan Island, 1498–1909, Compiled from Original Sources and Illustrated by Photo-intaglio Reproductions of Important Maps, Plans, Views, and Documents in Public and Private Collections.* 6 vols. New York: Robert H. Dodd, 1915–28. Reprint, Union, New Jersey: Lawbook Exchange; Mansfield Centre, Connecticut: Martino Fine Books, 1998.

Stokes, I. N. Phelps, and Daniel C. Haskell. *American Historical Prints: Early Views of American Cities, etc. From the Phelps Stokes and Other Collections.* New York: New York Public Library, 1933.

Stott, Richard B. "Hinterland Development and Differences in Work Setting: The New York City Region." In *New York and the Rise of American Capitalism: Economic Development and the Social and Political History of an American State, 1780–1870*, edited by William Pencak and Conrad Edick Wright, pp. 45–71. New York: New-York Historical Society, 1989.

————. *Workers in the Metropolis: Class, Ethnicity, and Youth in Antebellum New York City.* Ithaca, New York: Cornell University Press, 1990.

Stradling, Diana, and Ellen Paul Denker. *Jersey City: Shaping America's Pottery Industry, 1825–1892.* Exh. cat. Jersey City, New Jersey: Jersey City Museum, 1997.

*The Stranger's Guide around New York and Its Vicinity. What to See and What Is to Be Seen, with Hints and Advice to Those Who Visit the Great Metropolis.* New York: W. H. Graham, 1853.

*Stranger's Guide to the City and Crystal Palace, with a Full Description of the City of New York, and a Complete History of the American Industrial Exhibition; Its Origin, Inauguration, and Present Appearance. A Work of Universal Interest.* New York: Union Book Association, 1853.

Strong, George Templeton. *The Diary of George Templeton Strong.* 4 vols. Edited by Allan Nevins and Milton Halsey Thomas. New York: Macmillan Company, 1952.

Stuart, Mrs. R. L. *Catalogue of Mrs. R. L. Stuart's Collection of Paintings.* New York: Privately printed, 1885.

Stuart-Wortley, Lady Emmeline. *Travels in the United States, etc., during 1849 and 1850.* 3 vols. London: R. Bentley, 1851.

Sturges, Henry C., and Richard Henry Stoddard. *The Poetical Works of William Cullen Bryant.* New York: D. Appleton and Company, 1910.

Sturges, Mrs. Jonathan [Mary Pemberton Cady]. *Reminiscences of a Long Life.* New York: F. E. Parrish and Company, 1894.

Suydam, Frederick Dorflinger. *Christian Dorflinger: A Miracle in Glass.* White Mills, Pennsylvania: Privately printed, 1950.

Suydam, James A. *Catalogue of a Choice Private Library. Being the Collection of the Late Mr. James A. Suydam.* Sale cat. New York: Bangs, Merwin and Company, 1865.

Swope, Jennifer M. "Francis W. Cooper, Silversmith." *Antiques* 155 (February 1999), pp. 290–97.

Sypher, F. J. "Sypher & Co., a Pioneer Antique Dealer in New York." *Furniture History: The*

*Journal of the Furniture History Society* 28 (1992), pp. 168–79.

Taft, Kendall B. "*Adam and Eve* in America." *Art Quarterly* 22 (summer 1960), pp. 171–79.

Talbot, William S. *Jasper F. Cropsey, 1823–1900*. Ph.D. dissertation, New York University, 1972. Reprint, New York: Garland Publishing, 1977.

Tatham, David, ed. "The Lithographic Workshop, 1825–1850." In *The Cultivation of Artists in Nineteenth-Century America*, edited by Georgia Brady Barnhill, Diana Korzenik, and Caroline F. Sloat, pp. 45–54. Worcester, Massachusetts: American Antiquarian Society, 1997.

———. *Prints and Printmakers of New York State, 1825–1840*. Syracuse: Syracuse University Press, 1986.

Taussig, F. W. *The Tariff History of the United States*. 5th ed., rev., with additional material. New York: G. P. Putnam's Sons, 1900.

Taylor, George Rogers. *The Transportation Revolution*. New York: Rinehart, 1951. Reprint, Armonk, New York: M. E. Sharpe, 1989.

Taylor, J. Bayard. *Views A-Foot; or, Europe Seen with Knapsack and Staff*. New York: Wiley and Putnam, 1846.

Thistlethwaite, F. "The Atlantic Migration of the Pottery Industry." *Economic History Review* 11 (December 1958), pp. 264–78.

Thom, J. *Exhibition. Tam O'Shanter, Souter Johnny, and the Landlord and Landlady, Executed in Hard Ayrshire Stone, by the Self-taught Artist, Mr. J. Thom*. New York, [1833?].

Thompson, Ralph. *American Literary Annuals and Gift Books*. New York: H. W. Wilson Company, 1936.

Thomson, William. *A Tradesman's Travels in the United States and Canada in the Years 1840, 41, and 42*. Edinburgh: Oliver and Boyd, 1842.

Thornwell, Emily. *The Lady's Guide to Perfect Gentility, in Manners, Dress, and Conversation, in the Family, in Company, at the Piano Forte, the Table, in the Street, and in Gentlemen's Society. Also a Useful Instructor in Letter Writing, Toilet Preparations, Fancy Needlework, Millinery, Dressmaking, Care of Wardrobe, the Hair, Teeth, Hands, Lips, Complexion, etc*. New York: Derby and Jackson, 1858.

Thorp, Margaret Farrand. *The Literary Sculptors*. Durham, North Carolina: Duke University Press, 1965.

Tiffany, Young and Ellis. *Catalogue of Useful and Fancy Articles, Imported by Tiffany, Young & Ellis*. New York, 1845.

de Tocqueville, Alexis. *Democracy in America*. Edited by P. Bradley. 2 vols. New York: Alfred A. Knopf, 1945.

———. *Journey to America*. Edited by J. P. Mayer. New Haven: Yale University Press, 1960.

Tolles, Thayer, ed. *American Sculpture in The Metropolitan Museum of Art. Volume I: A Catalogue of Works by Artists Born before 1865*. New York: The Metropolitan Museum of Art, 1999.

Tomasko, Mark D. *Security for the World: Two Hundred Years of American Bank Note Company*. Exh. cat. New York: Museum of American Financial History, 1995.

Tooker, Elva. *Nathan Trotter, Philadelphia Merchant, 1787–1853*. Cambridge, Massachusetts: Harvard University Press, 1955.

Torres, Louis. "John Frazee and the New York Custom House." *Journal of the Society of Architectural Historians* 23 (October 1964), pp. 143–50.

Torrielli, Andrew J. *Italian Opinion on America as Revealed by Italian Travellers, 1850–1900*. Cambridge, Massachusetts: Harvard University Press, 1941.

Town, Ithiel. *The Outlines of a Plan for Establishing in New-York, an Academy and Institution of the Fine Arts on Such a Scale as Is Required by the Importance of the Subject, and the Wants of a Great and Growing City, the Constant Resort of an Immense Number of Strangers from All Parts of the World. The Result of Some Thoughts on a Favorite Subject*. New York: George F. Hopkins and Son, 1835.

Tracy, Berry, and William Gerdts. *Classical America, 1815–1845*. Exh. cat. Newark: Newark Museum, 1963.

Trollope, Mrs. [Frances]. *Domestic Manners of the Americans*. London: Whittaker, Treacher and Company; New York, reprinted for the booksellers, 1832.

Trumbull, John. *Address Read before the Directors of the American Academy of the Fine Arts, January 28th, 1833*. New York: N. B. Holmes, 1833.

———. *Autobiography, Reminiscences and Letters of John Trumbull, from 1756 to 1841*. New York: Wiley and Putnam, 1841.

———. *Letters Proposing a Plan for the Permanent Encouragement of the Fine Arts, by the National Government, Addressed to the President of the United States*. New York: Printed by William Davis Jr., 1827. Reprint, New York: Olana Gallery, 1973.

Tryon, Warren S., ed. *A Mirror For Americans: Life and Manners in the United States, 1790–1870 As Recorded by American Travelers*. Vol. 1, *Life in the East*. Chicago: University of Chicago Press, 1952.

Tuckerman, Henry T. *America and Her Commentators with a Critical Sketch of Travel in the United States*. New York: Charles Scribner, 1864. Reprint, New York: Augustus M. Kelley, 1970.

———. *Book of the Artists, American Artist Life, Comprising Biographical and Critical Sketches of American Artists: Preceded by an Historical Account of the Rise and Progress of Art in America*. New York: G. P. Putnam and Son; London: Sampson Low and Company, 1867. Reprint, New York: James F. Carr, 1967.

———. *The Italian Sketch Book*. 3d ed., revised and enlarged. New York: J. C. Riker, 1848. First edition published anonymously, Philadelphia, 1835.

Turner, Justin G., and Linda Levitt Turner. *Mary Todd Lincoln: Her Life and Letters*. New York: Alfred A. Knopf, 1972. Reprint, New York: Fromm International, 1987.

*The Twenty-third Annual Report of the Board of Directors of the Mercantile Library Association, Clinton Hall, New York, January, 1844*. New York: Printed by George W. Wood, 1844.

Ulmann, Albert. *Maiden Lane: The Story of a Single Street*. New York: Maiden Lane Historical Society, 1931.

*United States Commercial Register Containing Sketches of the Lives of Distinguished Merchants, Manufacturers, and Artisans with an Advertising Directory at Its Close*. New York: George Prior, 1851.

Upjohn, Everard M. *Richard Upjohn: Architect and Churchman*. New York: Columbia University Press, 1939.

———. *Richard Upjohn and American Architecture*. New York: Columbia University Press, 1939.

Upton, Dell. "Another City: The Urban Cultural Landscape in the Early Republic." In *Everyday Life in the Early Republic*, edited by Catherine E. Hutchins. Winterthur, Delaware: Henry Francis du Pont Winterthur Museum, 1994.

———. "The City as Material Culture." In *The Art and Mystery of Historical Archaeology: Essays in Honor of James Deetz*, edited by Anne E. Yentsch and Mary C. Beaudry. Boca Raton, Florida: CRC Press, 1992.

———. "Lancasterian Schools, Republican Citizenship, and the Spatial Imagination in Early Nineteenth-Century America." *Journal of the Society of Architectural Historians* 55 (September 1996), pp. 238–53.

———. "Pattern Books and Professionalism: Aspects of the Transformation of American Domestic Architecture, 1800–1860." *Winterthur Portfolio* 19 (summer/autumn 1984), pp. 107–50.

Vail, R. W. G. *Knickerbocker Birthday: A Sesqui-Centennial History of the New-York Historical Society, 1804–1954*. New York: New-York Historical Society, 1954.

———. "More Storied Windows." *New-York Historical Society Quarterly* 37 (January 1953), pp. 55–58.

———. "Storied Windows Richly Delight." *New-York Historical Society Quarterly* 36 (April 1952), pp. 149–59.

Valentine, David T. *Valentine's Manuals: A General Index to the Manuals of the Corporation of the City of New York, 1841–1870*. Reprinted from 1906 and 1900 editions. Compiled by Otto Hufeland and Richard Hoe Lawrence Harrison. New York: Harbor Hill Books, 1981.

Vance, William J. *America's Rome*. Vol. 1: *Classical Rome*. New Haven: Yale University Press, 1989.

Van Zandt, Roland. *Chronicle of the Hudson: Three Centuries of Travel and Adventure*. 2d ed. Hensonville, New York: Black Dome Press, 1992.

Venable, Charles L. "Germanic Craftsmen and Furniture Design in Philadelphia, 1820–1850." In *American Furniture 1998*, edited by Luke Beckerdite, pp. 41–80. Hanover, New Hampshire: University Press of New England for the Chipstone Foundation, 1998.

———. *Silver in America, 1840–1940: A Century of Splendor*. Exh. cat. Dallas: Dallas Museum of Art, 1995.

Voorsanger, Catherine Hoover. "Gustave Herter: Cabinetmaker and Decorator." *Antiques* 147 (May 1995), pp. 740–51.

Voorst tot Voorst, J. M. W. van. *Tussen Bieder-meier en Berlage: Meubel en Interieur in Neder-land, 1835–1895*. 2d ed. 2 vols. Amsterdam: De Bataafsche Leeuw, 1994.

Vose, Arthur W. *The White Mountains*. Barre, Massa-chusetts: Barre Publishers, 1968.

Voss, Frederick S., with Dennis Montagna and Jean Henry. *John Frazee, 1790–1852, Sculptor*. Exh. cat. Washington, D.C.: National Portrait Gallery, Smithsonian Institution; Boston: Boston Athenaeum, 1986.

Wainwright, Clive. "The Dark Ages of Art Revived, or Edwards and Roberts and the Regency Revival." *Connoisseur* 198 (1978), pp. 95–105.

Wainwright, Nicholas B., ed. *A Philadelphia Perspec-tive: The Diary of Sidney George Fisher Covering the Years 1834–1871*. Philadelphia: Historical Society of Pennsylvania, 1967.

Waldron, Raymond S., Jr. "The Interior of Litch-field Mansion." *Park Slope Civic Council, Civic News* 29, no. 4 (April 1966), pp. 20–21.

Walker, Alexander. *Woman Physiologically Considered, as to Mind, Morals, Marriage, Matrimonial Slavery, Infidelity and Divorce*. New York: N.p., 1843.

Walker, Mack. *Germany and the Emigration, 1816–1885*. Cambridge, Massachusetts: Harvard Uni-versity Press, 1964.

Wall, Diana diZerega. "The Separation of the Home and Workplace in Early Nineteenth-Century New York City." *American Archeology* (Albuquerque) 5, no. 3 (1985), pp. 185–89.

Wall, William Guy, and John Hill. *The Hudson River Portfolio: Views from the Drawings by W. G. Wall*. New York: Henry J. Megarey, 1821–25.

Wallace, David H. *John Rogers: The People's Sculptor*. Middletown, Connecticut: Wesleyan Univer-sity Press, 1967.

Wallace, Marcia B. "The Great Bear and the Prince of Evil Spirits: The American Response to J. M. W. Turner before the Advent of John Ruskin." 2 vols. Ph.D. dissertation, City University of New York, 1993.

Wallach, Alan. "Long-Term Visions, Short-Term Failures: Art Institutions in the United States, 1800–1860." In *Art in Bourgeois Society, 1790–1850*, edited by Andrew Hemingway and William Vaughan, pp. 297–313. Cambridge: Cambridge University Press, 1998.

———. "Thomas Cole and the Aristocracy." *Arts Magazine* 56 (November 1981), pp. 94–106.

Wallach, Alan, and William H. Truettner, eds. *Thomas Cole: Landscape into History*. Exh. cat. Washington, D.C.: National Museum of American Art, Smithsonian Institution; New Haven: Yale University Press, 1994.

Wallis, George. *New York Industrial Exhibition: Special Report of Mr. George Wallis, Presented to the House of Commons by Command of Her Majesty, 1854*. London: Harrison and Son, 1854.

Ward, Gerald W. R., ed. *The American Illustrated Book in the Nineteenth Century*. Winterthur, Delaware: Henry Francis du Pont Winterthur Museum, 1987.

Warren, David B., Katherine S. Howe, and Michael K. Brown. *Marks of Achievement: Four Centuries of American Presentation Silver*. Exh. cat. Houston: Museum of Fine Arts, 1987.

Waters, Deborah Dependahl, ed. *Elegant Plate: Three Centuries of Precious Metals in New York City, Museum of the City of New York*. Essays by Kristan H. McKinsey, Gerald W. R. Ward, and Deborah Dependahl Waters. New York: Museum of the City of New York, 2000.

———. "From Pure Coin: The Manufacture of American Silver Flatware, 1800–1860." *Winter-thur Portfolio* 12 (1977), pp. 19–33.

———. *A Treasury of New York Silver*. Exhibition Checklist. New York: Museum of the City of New York and the New York Silver Society, 1994.

Watson, John F. *Annals and Occurrences of New York City and State, in the Olden Time Being a Collec-tion of Memoirs, Anecdotes, and Incidents Con-cerning the City, County, and Inhabitants from the Days of the Founders: Intended to Preserve the Recollections of Olden Time, and to Exhibit Society in Its Changes of Manners and Customs, and the City and Country in Their Local Changes and Improvements. Embellished with Pictorial Illus-trations*. Philadelphia: H. F. Anners, 1846.

———. *Annals of Philadelphia, Being a Collection of Memoirs, Anecdotes, and Incidents of the City and Its Inhabitants from the Days of the Pilgrim Founders. Intended to Preserve the Recollections of Olden Time, and to Exhibit Society in Its Changes of Manners and Customs, and the City in Its Local Changes and Improvements. To Which Is Added an Appendix, Containing Olden Time Researches and Reminiscences of New York City. By John F. Watson, Member of the Historical Society of Pennsylvania*. Philadelphia: E. L. Carey and A. Hart; New York: G. & C. & H. Carvill, 1830.

———. *Annals of Philadelphia and Pennsylvania in the Olden Time*. 2d ed. Philadelphia: J. B. Lippincott, 1868.

Weale, John. *Chippendale's One Hundred and Thirty-three Designs of Interior Decorations in the Old French and Antique Styles: For Carvers, Cabinet Makers, Ornamental Painters, Brass Workers, Modellers, Chasers, Silversmiths, General Design-ers, and Architects*. London: J. Weale, 1834.

Webster, J. Carson. *Erastus D. Palmer*. Newark: University of Delaware Press, 1983.

Weeks, Lyman H., ed. *Prominent Families of New York: Being an Account in Biographical Form of Individuals and Families Distinguished as Repre-sentatives of the Social, Professional, and Civic Life of New York City*. New York: Historical Com-pany, 1897.

Wegmann, Edward. *The Water-Supply of the City of New York, 1658–1895*. New York: J. Wiley and Sons, 1896.

Weisberg, Gabriel. *Rosa Bonheur: All Nature's Chil-dren*. Exh. cat. New York: Dahesh Museum, 1998.

Weisman, Winston. "Commercial Palaces of New York: 1845–1875." *Art Bulletin* 36 (December 1954), pp. 285–302.

Weiss, Ila. *Poetic Landscape: The Art and Experience of Sanford R. Gifford*. Newark: University of Delaware Press, 1987.

Weitenkampf, Frank. *American Graphic Art*. Rev. ed. New York: Macmillan Company, 1924. Reprint, with a new introduction by E. Maurice Bloch, New York: Johnson Reprint Corporation, 1970.

———. "F. O. C. Darley, American Illustrator." *Art Quarterly* 10 (March 1947), pp. 100–113.

Weld, Charles Richard. *A Vacation Tour in the United States and Canada*. London: Longman, Brown, Green, and Longmans, 1855.

[White, Richard Grant]. *Catalogue of the Bryan Gal-lery of Christian Art, from the Earliest Masters to the Present Time*. New York: George F. Nesbitt and Company, 1852.

———. *Companion to the Bryan Gallery of Christian Art: Containing Critical Descriptions of the Pic-tures, and Biographical Sketches of the Painters; with an Introductory Essay, and an Index*. New York: Baker, Godwin and Company, 1853.

White, Shane. *Somewhat More Independent: The End of Slavery in New York City, 1770–1810*. Athens: University of Georgia Press, 1991.

Whiteman, George. "The Beginnings of Furnishing with Antiques." *Antique Collector* 43 (February 1972), pp. 21–28.

*The White Mountains: Place and Perceptions*. Exh. cat. Durham: University Art Galleries, Univer-sity of New Hampshire, 1980.

Whitman, Walt. *I Sit and Look Out: Editorials from the* Brooklyn Daily Times *by Walt Whitman*, edited by Emory Holloway and Vernolian Schwarz. New York: Columbia University Press, 1932.

———. *Leaves of Grass*. Garden City, New York: Doubleday and Company, 1855.

———. *New York Dissected: A Sheaf of Recently Discovered Newspaper Articles by the Author of Leaves of Grass*. Edited by Emory Holloway and Ralph Adimari. New York: R. R. Wilson, 1936.

Whitworth, Joseph, and George Wallace. *The Indus-try of the United States in Machinery, Manufac-tures, and Useful and Ornamental Arts*. London: George Routledge and Company, 1854.

Wilentz, Sean. "Artisan Republican Festivals and the Rise of Class Conflict in New York City, 1788–1837." In *Working-Class America: Essays on Labor, Community, and American Society*, edited by Michael H. Frisch and Daniel J. Walkowitz, pp. 37–77. Urbana: University of Illinois Press, 1983.

———. *Chants Democratic: New York City and the Rise of the American Working Class, 1788–1850*. New York: Oxford University Press, 1984.

Wilk, Christopher, ed. *Western Furniture, 1350 to the Present Day, in the Victoria and Albert Museum*. New York: Cross River Press, 1996.

Willey, Benjamin G. *Incidents in White Mountain History: Containing Facts Relating to the Dis-covery and Settlement of the Mountains, Indian History and Traditions, a Minute and Authentic Account of the Destruction of the Willey Family, Geology and Temperature of the Mountains; Together with Numerous Anecdotes Illustrating Life in the Back Woods*. [3d] ed. Boston: Nathaniel Noyes; New York: M. W. Dodd;

Cincinnati, Ohio: H. W. Derby; Portland, Maine: Francis Blake, 1856.

Williams, Caroline. "The Place of the New-York Historical Society in the Growth of American Interest in Egyptology." *New-York Historical Society Quarterly Bulletin* 4 (April 1920), pp. 3–20.

Willis, N. P. *Pencillings by the Way* (1836). "First Complete Edition." New York: Morris and Willis, 1844.

Wilmerding, John. *The Artist's Mount Desert: American Painters on the Maine Coast*. Princeton: Princeton University Press, 1994.

———. *Paintings by Fitz Hugh Lane*. Exh. cat. Washington, D.C.: National Gallery of Art, 1988.

Wilson, Derek. *The Astors, 1763–1992: Landscape with Millionaires*. New York: St. Martin's Press, 1993.

Wilson, James Grant, ed. *Memorial History of the City of New-York and the Hudson River Valley: From Its Settlement to the Year 1892*. 4 vols. [New York]: New York History Company, 1892–96.

Wilson, Kenneth M. "Bohemian Influence on 19th Century American Glass." In *Annales du 5ᵉ Congrès International d'Étude Historique du Verre*. Liège: Association Internationale pour l'Histoire du Verre, 1972.

———. *New England Glass and Glassmaking*. New York: Thomas Y. Crowell Company, 1972.

Winthrop, Theodore. *A Companion to The Heart of the Andes*. New York: D. Appleton, 1859.

Witthoft, Brucia. *The Fine-Arts Etchings of James David Smillie, 1833–1909: A Catalogue Raisonné*. Lewiston, New York: Edwin Mellen Press, 1992.

Wolf, Edwin. *From Gothic Windows to Peacocks: American Embossed Leather Bindings, 1825–1855*. Philadelphia: Library Company of Philadelphia, 1990.

Wood, John, ed. *America and the Daguerreotype*. Iowa City: University of Iowa Press, 1991.

Woods, Mary N. *From Craft to Profession: The Practice of Architecture in Nineteenth-Century America*. Berkeley: University of California Press, 1999.

Woods, Nicholas Augustus. *The Prince of Wales in Canada and the United States*. London: Bradbury and Evans, 1861.

Wright, Frances. *Views of Society and Manners in America in a Series of Letters from That Country to a Friend in England during the Years 1818, 1819, 1820*. London: Longman, Hurst, Rees, Orme and Brown, 1822.

Wright, Gwendolyn. *Building the Dream: A Social History of Housing in America*. New York: Pantheon Books, 1981.

Wright, Nathalia. "The Chanting Cherubs: Horatio Greenough's Marble Group for James Fenimore Cooper." *New York History* 38 (April 1957), pp. 177–97.

———. *Horatio Greenough: The First American Sculptor*. Philadelphia: University of Pennsylvania Press, 1963.

———. *Letters of Horatio Greenough, American Sculptor*. Madison: University of Wisconsin Press, 1972.

Wunder, Richard P. *Hiram Powers: Vermont Sculptor, 1805–1873*. Newark: University of Delaware Press, 1991.

Wynne, James. *Private Libraries of New York*. New York: E. French, 1860.

Yarnall, James L., and William H. Gerdts, with Katherine Fox Stewart and Catherine Hoover Voorsanger, comps. *The National Museum of American Art's Index to American Art Exhibition Catalogues: From the Beginning through the 1876 Centennial Year*. Boston: G. K. Hall, 1986.

Zeisloft, E. Idell, ed. *The New Metropolis: Memorable Events of Three Centuries, 1600–1900, from the Island Mana-hat-ta to Greater New York at the Close of the Nineteenth Century*. New York: D. Appleton and Company, 1899.

Zinnkann, Heidrun. *Mainzer Möbelschreiner der ersten Hälfte des 19. Jahrhunderts*. Frankfurt am Main: Schriften des Historischen Museums, 1985.

## Manuscript Collections

American Academy of the Fine Arts. Papers. The New-York Historical Society.

American Institute of the City of New York for the Encouragement of Science and Invention.

Records, 1828–1941, including reports of judges and awards of the annual fairs. The New-York Historical Society.

Belter, John Henry. Papers, ca. 1856–ca. 1904. The Winterthur Library, Henry Francis du Pont Winterthur Museum, Winterthur, Delaware.

Chesnut Family. Papers, 1741–1900. South Carolina Historical Society, Charleston, South Carolina.

Colles, James. Papers. Manuscripts and Archives Division, New York Public Library. Henry Metcalf, Colles's grandson organized the papers chronologically and transcribed and translated most, though not all of the correspondence. A selection of the transcribed letters was subsequently edited and published with additional commentary by Emily Johnston de Forest in *James Colles, 1788–1883, Life and Letters* (New York: Privately printed, 1926).

Davis, Alexander Jackson. Collections are in the Department of Drawings and Prints, The Metropolitan Museum of Art, New York; the Avery Architectural and Fine Arts Library, Columbia University, New York; and the Manuscripts and Archives Division, New York Public Library. The Museum of the City of New York and The New-York Historical Society have selected manuscripts and drawings.

Dun, R. G., & Co. Credit ledgers, R. G. Dun & Co. Collection, Baker Library, Harvard University Graduate School of Business Administration, Cambridge, Massachusetts.

Hone, Philip. Diary, 1825–51. Complete manuscript, The New-York Historical Society. Microfilm copy, The Thomas J. Watson Library, The Metropolitan Museum of Art.

Strong, George Templeton. Diary, 1837–75. Complete manuscript, The New-York Historical Society.

Williams-Chesnut-Manning Families. Papers. Manuscripts Division, South Caroliniana Library, University of South Carolina, Columbia, South Carolina. Selected letters are on microfilm and microfiche. See also, Chesnut Family Papers, microfilm edition, 1979, Manuscripts Division, State Historical Society of Wisconsin.

# Index

*Italic* page numbers refer to illustrations; **boldface** page numbers, to appendixes and tables citing multiple names and addresses of venues or firms. Em dashes (—) are used to indicate subsubheads. Figure numbers (figs.) and catalogue numbers (nos.) follow the page numbers.

Abbey Church of Saint-Denis, near Paris, 183
Abbott, Dr. Henry, 79, 94–95
Abbott, Jacob, *John True*, frontispiece to, *The Children's Sofa*, 308, *308*; fig. 251
Abdy, Edward S., 32
Abolition quilt, *509*; no. 215
Abraham, Richard, collection, 53, 75
Académie des Sciences, Paris, 227, 229n.8
Academy of Music, 36, 45. *See also* Prince of Wales Ball
Achenbach, Andreas, 92; *Clearing Up— Coast of Sicily*, *407*; no. 50
Ackerman, James, *James Bogardus Factory*, *184*, 185; fig. 145
Ackermann, Rudolph, 193, 196, 197; *Repository of Arts, Literature, Fashions, Manufactures, &c.*, 193, 197, 299–300; —, plate from, *Gothic Furniture*, *299*, 300, 303n.97; fig. 244
Ackermann and Company. *See* Havell, Robert Jr., Colman, William A., and Ackermann and Company
Acorn and Berry pitcher, 333, *540*; no. 257
Adam, Robert, 171n.6
Adams, John, 219n.116; bust of, by Browere, 138, 140, *140*; fig. 106
Adams, John Quincy, photographic portrait of, by Plumbe, 233
Adams, William (pottery), Staffordshire, 330
Adams, William (silversmith), 363, 367, 374; mace of the United States House of Representatives, *366*, 367, 368; fig. 301; presentation vase with cover, 368, *566*; no. 296
advertisements, *345*, *350*, *365*; figs. 282, 287, 300
advertising broadsides, *334*, *347*, *517*; figs. 273, 284, no. 225
African Americans, 13, 17, 28, 30, 32; depicted, *30*, *390*, *399*, *471*; fig. 25, nos. 28, 40, 148
Ahrenfeldt, Charles, 343
Akers, Paul, *Dead Pearl Diver*, 80, 166
Albert, prince consort, 247n.15, 316
*Albion, The*, 61, 223n.134
Albro and Hoyt, 267
ale pitcher, stoneware, *335*; fig. 274
Allan, John, collection, 90, 211
Allen, John K., 71
Allen, Theodore, 72, 73
All-Souls' Church, *186*, 187; fig. 146
Allston, Washington: American Art-Union medal depicting, *565*; no. 292; bust of, by Brackett, *150*, 151; fig. 112
Alson, G. W., collection, 80
Altes Museum, Berlin, 174
American Academy of the Fine Arts, 38, 47, 48, 49, 50–55, 56, 63, **66**, 72, 75, 76, 77, 83, 84, 86, 109, 136, 137, 138, 140–41 and n.23, 144, 148, 169, 192, 199, 210, 211–12n.81
American and Foreign Snuff Store (Mrs. Newcombe's Store), **66**, 76

American Art-Union, 37, 56, 59, **66**, 70, 77, 78, 79, 80, 100, 119, 151, 152, 154, 155–57 and n.76, 160, 163, 192, 197, 201, 206–7 and n.68, 208, 209, 211n.75, 212, 213; building, 61, 64, 65; lottery, view of, by D'Avignon, after Matteson, *Distribution of the American Art-Union Prizes*, 206, *207*; fig. 163; medals, *565*; nos. 292–95; prints published by, 206 and n.60, 207, 212; —, Casilear, after Huntington, *A Sibyl*, 206, *206*; fig. 162; —, Doney, after Bingham, *The Jolly Flat Boat Men*, 206, 207, *459*; no. 127; seal, *565*; no. 294
American Daguerre Association, 231
American Etching Revival, 224
American Express Company, *219*, 220; fig. 175
American Female Guardian Society, **66**, 79
American Institute of Architects (AIA), 38n.229, 169, 187
American Institute of the City of New York, 55, **66**, 75, 76, 77, 78, 79, 149, 230, 248, 250, 262, 264, 269, 275, 277, 283, 284, 313n.182, 331, 341, 345, 346nn.103, 105, 336, 350, 351, 352n.129, 361, 362, 363, 367, 368; prize medals commissioned from Fürst, 363, *565*; no. 291; scene of annual fair at Niblo's Garden, by B. J. Harrison, *249*; fig. 200
American Institution of Architects, 38 and n.229, 181, 187
*American Journal of Science and Art*, 191
*American Metropolitan Magazine*, 57
American Museum (Barnum's Museum), 7, 25, 26, 56, **66**, 76, 140, 219, 230, 231, 235, 305n.125; caricature of, by Weingartner, *The New York Elephant*, 217, 219; fig. 172
American paintings, nos. 23–41
American Pottery Manufacturing Company, Jersey City, 333–34 and nn.32, 38, 336 and n.42; Canova plate, 334, *543*; no. 262; covered hot-milk pot or teapot and underplate, *542*; no. 261; pitcher made for William Henry Harrison's presidential campaign, 334, *543*; no. 263; Thistle pitcher, 333, *542*; no. 259; vegetable dish, 333, *542*; no. 260. *For predecessor firm, see* Henderson, D. and J., Flint Stoneware Manufactory
*American Repertory of Arts, Sciences, and Manufacturers*, 229–30, 296n.63
American Revolution, 3, 4–5, 109, 120, 135
American school, 107, 207n.68
American sculpture, nos. 55–69
Ames, James Tyler, 157
Ames Manufacturing Company, 157, 167
*Ameublement d'un salon (genre Louis XV)*, *306*, 307; fig. 249
Angell, Joseph, firm, London, 364
*Anglo American*, 24
Anglo-Italianate style, 184–85, 187
Annelli, Francesco, 72, 76, 77; *The End of the World*, 77
Ansolell, Richard, *Dogs and Their Game*, 79
Anthony, Edward, 232
*Antietam, battle of*, *240*; fig. 192
"Antique" ale pitcher, 336, *335*; fig. 274
antique dealers, 305 and n.125
Antiques Movement, 303n.110
Apollo Association for the Promotion of the Fine Arts in the United States, 35,

66, 68, 76, 77, 80, 192, 201, 206. *See also* American Art-Union
*Apollo Belvedere*, 143
Appleton, D[aniel], and Company, 66; published by, *31*, *302*; figs. 27, 246. *See also* Appleton's bookstore
Appleton, George S. (publisher), *467*; no. 142
Appleton, William H., mantel purchased by, 262, *262*, 264, *513*; fig. 212, no. 220
Appleton's bookstore, 157, *157*; fig. 117
Appleton's Building, **66**
*Appleton's Mechanics' Magazine*, lithograph from, *41*; fig. 35
aquatint engraving, 193–97, 199
Arcade Baths, **66**, 72, 75
architectural drawings and related works, nos. 70–105
Architectural Iron Works of the City of New York (Badger firm), 30, 185; catalogue, 22, 185; fig. 18. *See also* Badger, Daniel D.
architecture, 14, 16–17, 20–23, 38, 126, 169–87, 300
Arcularious, Jacob. *See* Riell, Henry, and Arcularious, Jacob
argand lamps, *563*; no. 289
armchairs, 93, 284, *285*, *292*, 293–94, 297, 299, *299*, 305, 310, *310*, 312, *316*, *514*, *520*, *524*, *526*, *527*, *534*; figs. 233, 237, 243, 253, 259, nos. 221, 231, 236B, 240B, C, 248; in parlor of Fiedler family, *261*, 305; fig. 211
Arnold, Aaron, collection, 78
Arnold, Edward W. C., collection, 225
Arnot, David H., lithograph after, *Exterior of the Düsseldorf Gallery (Church of the Divine Unity)*, 59, *59*; fig. 48
*Arrival of the Great Western Steam Ship*, 192n.12
Arsenal (Central Park), 103
Arsenal (Elm and Leonard streets), 136
Art Conversazioni, 69
Arthur, T. S., "Sparing to Spend," 260–61
artisan republicanism, 12, 34 and n.193, 41, 287
artisan-type houses, Gay Street, *15*, 16; fig. 8
Artists' Fund Society of New York, **66–67**, 80, 81
Artists' Reception Association, 69
*Art-Journal Illustrated Catalogue: The Industry of All Nations, 1851*, 348, *348*; fig. 285
Ashley, Alfred. *See* Swepstone, W. H.
Ashurnasirpal II: palace of, Nimrud, 97; relief sculpture of, *97*, 97–98; fig. 68
Asians, 32
Aspinwall, William Henry, 101, 103, 104–5; Gallery, **67**, 80, 105, *105*, 106; fig. 77
Assyrian antiquities, *97*, 97–98; fig. 68
Astor, Caroline Webster Schermerhorn, beverage service for (Astor service), 372
Astor, Charlotte Augusta, 372 and n.86
Astor, John Jacob, 13, 16, 85, 103, 174, 372
Astor, John Jacob II, house, 186
Astor, Lenox, and Tilden Foundations, 97
Astor, William Backhouse, 23, 106
Astor, William Backhouse Jr., 372
Astor House hotel, 7, 23, 32, 54, 174–75, *175*, 177, 181, 185, 269; fig. 134; ballroom, fashions shown in, *245*; fig. 196; unexecuted designs for (Park Hotel project), 173, 174, *174*, 175, *427*; fig. 133, nos. 77, 78

Astor Place, 16; view toward, *489*; no. 181
Astor Place Opera House, chandelier for, 311
Athenaeum Building, 72
*Atkinson's Casket*, map from, *10*; fig. 6
Atlantic and St. Lawrence Railroad, 117
*Atlantic Souvenir*, engraving from, *291*; fig. 236
Aubusson carpets, 93, 267, 310; carpet styled after, at Grace Hill, *307*, 308; fig. 250
Aubusson-tapestry panel, 310
auctions and auction houses, 47, 52, 57–58, 67, 68, 69, 70, 71, 72, 73, 74, 75, 76, 77, 78, 79, 80, 81, 303–5 and n.122; mock, 20, 305
Audubon, J. J., and Chevalier, J. B. (publisher), *525*; no. 239
Audubon, John James, 71, 77; daguerreotype of, by Brady, 231, *482*; no. 164; —, lithograph after, by D'Avignon, 219, 230–31, *482*; no. 165A; *Viviparous Quadrupeds of North America*, 221. *See also Birds of America*
Audubon, John Woodhouse, 208, 221, 222
Audubon, Victor, 221
Aufermann, William, **67**
Augur, Hezekiah, 141–44 and n.29, 149; bust after *Apollo Belvedere*, 143; *Jephthah and His Daughter*, 143, *143*; fig. 109
Austen, David Jr., **67**, 79
Austen, Jane, 249
Austin, Henry, 322
Aztec Children, 26, *26*, 28; fig. 21

Bachelors' Fancy Ball (1829), 283
Bachmann, John, 220; *Bird's-Eye View of the New York Crystal Palace and Environs*, 41, 42, 316, *467*; no. 141; *The Empire City*, 4, 221, *469*; no. 145; *New York City and Environs*, 221, *473*; no. 150
Badger, Daniel D., iron works, 22, 30; Cary Building, 185; cast-iron components, 22, *22*; fig. 18; Haughwout Building, 22, 185, *439*; no. 98; shutters for A. T. Stewart store, 184
Baggott, Joseph, glasscutting firm, 344, 345, 346. *See also* Jackson and Baggott
Bailey, John L., furniture auction, 303–5
Bailey, Nathaniel, 349n.118
Bailey and Company, Philadelphia, 373
Baily, Edward Hodges, 140
Bainbridge, William, gold box presented to, 359
Baker, Alfred E., lithograph, "*The Rose of Long Island*," 248, *248*; fig. 199
Baker, Benjamin A., *A Glance at New York*, 33
Baker, John, engraving and etching by, *Fisher and Bird's Marble Yard*, 263, *263*; fig. 214
Baldus, Édouard, 324; *Detail of the Pavillon Rohan, Louvre, Paris*, 322, 324; fig. 264
Ball, Black and Company, 361, *365*, 366, 372, 374, 375; figs. 299, 300; earrings, 247; Moore California gold tea service, 372, *372*; fig. 307; pair of pitchers by Eoff and Shepard, *359*, 361; fig. 295
Ball, Henry, 365
Ball, Thomas, *Daniel Webster*, 160
Ball, Tompkins and Black, 154, 155, 361, 363, 364, 365–66, 367, 369n.75, 370; retailed by, Forbes pitcher and goblet, *572*; no. 306;

—, Moore California gold tea service, 370; —, presentation tea and coffee service with tray (Lefferts service), 361, 370, 372, *569*; no. 301

ball gowns, *250, 251,* 253–54, *254, 255,* 256, *256, 257, 502, 503*; figs. 202, 203, 206, 208, 209, nos. 204, 205

*Ballou's Pictorial Drawing-Room Companion,* 204, 212–13; wood engravings from, *30, 186*; figs. 26, 146

balls, 253–57, 283. *See also* Prince of Wales Ball

Ballston, New York, 112

Baltimore, 137n.8, 327, 340

Bancroft, Charles, ewer and salver presented to, 359

bandboxes, 273, 274–75, *275*; fig. 226

Bangs, 67, 81

Bangs, Brother and Company, 67, 78, 79, 80

Bangs, Merwin and Company, 67, 81

banknotes, 200–201 and n.44, *448, 449*; nos. 115, 116

Bank War, 367

banquet sofa, 296n.54

Banvard, John, panoramas, 133

Barbee, William Randolph, *The Fisher Girl,* 72, 161, *162*; fig. 122; copy after, by J. Rogers, 161

Barbier, Madame, 27–28

Barboza, Don Juan de, depicted in Trumbull, *Sortie Made by the Garrison at Gibraltar,* 46, 51, 52; fig. 38

Barker, Robert, 73

Barnard and Dick, engravings in *Views in New York and Its Environs,* 330n.6

Barnet, William Armand, 191

Barnum, P. T., 25, 26, 42, 66, 158, 219, 231, 235, 314–15, 364; daguerreotype of, attributed to S. or M. A. Root, 25, *483*; no. 168

Barnum's Museum. *See* American Museum

Barocci, Federico, 206

Barry, Charles, 80, 184–85, 298

Bartlett, Truman Howe, 148

Bartolini, Lorenzo, 93

Bartolozzi, Francesco, 91

Bartow, Edgar John, 351–52

basket, silver, *562*; no. 288

*Bathe at Newport, The,* 120, 121; fig. 87

Battery, the, 3; depicted on wallpaper, *510*; no. 216; New York Harbor from, 192, *452–53*; no. 121; in scene by Durand, *388*; no. 25

Battery Place, view to north, 238, *490*; no. 182

Baudouine, Charles A., 282, 289, 290, 291n.28, 295, 306n.137, 312–15 and nn.175, 177, 178, 320 and n.214, 325; armchair, *310,* 313, 319; fig. 253; lady's writing desk, 313 and n.180, *525*; no. 237; label from, *311,* 313; fig. 254

Baxter, Charles, *The Spanish Maid,* 79

Bearns, F. J., 67

Beaufils, Renaissance library bookcase, *321,* 324 and n.232; fig. 263

Beaumont, J. P., collection, 78, 79, 80

Bedell, Elizabeth, 281

Beebe, William, 67

Beekman property, 9

Beerstraten, Jan Abrahamsz., *Winter Scene,* *404*; no. 45

Belden, E. Porter, 10

Bell, Thomas, 76

Bell, Thomas, and Company, 67, 77

Bellevue institutions, *7,* 13

Belmont, August, 65, 103, 105–6; collection and gallery, 65, **67,** 80, 105, 106

Belmont, Mrs., 255

belt, woman's, *498*; no. 198

Belter, J. H., and Company, attributed to, sofa, 320, *531*; no. 245

Belter, John (Johann) H., 289, 305–6, 314, 319–20n.209, 321nn.216, 217, 325

Bembé, Anton, 320 and n.214, 325

Bembé and Kimbel, 320, 322, 325; armchairs for the United States House of Representatives, 322; parlor, *317,* 320; fig. 260

Benecke, Thomas, *Sleighing in New York,* *468*; no. 144

Benjamin, Asher, 171

Bennett, William James, 196–97; engravings after, by Durand, *American Landscape, Weehawken from Turtle Grove,* 201, *201*; fig. 158; —, *The Falls of Sawkill, near Milford,* 201; after Harvey, frontispiece to *Harvey's American Scenery,* 197, *198*; fig. 155; after J. W. Hill, *New York, from Brooklyn Heights,* 197, 220, 460; no. 128. See also *Megarey's Street Views*

Bennington, Vermont, pottery. *See* United States Pottery Company

Benton, Sen. Thomas Hart, photographic portrait of, by Plumbe, 233

Berkeley, Bishop George, 119, 123; *Alciphron,* 123; depicted in Kensett, *Berkeley Rock, Newport,* 122, 123; fig. 90

Bernard, Sen. Simon, 332

Bernardin de Saint-Pierre, Jacques-Henri, *Paul et Virginie,* mantel depicting scenes from, by Fisher and Byrd, 103, 262, *262,* 264, *513*; fig. 212, no. 220

Berrains' House Furnishings Warerooms, 368

Bethune, Dr. George Washington, 305

b'hoys, 33–34, 207

Biedermeier style, 295

Bien, Julius, 220, 224 and n.144; *Broadway, New York, from Canal to Grand Street,* 19, *19,* 20, 31; fig. 13. See also *Birds of America:* chromolithographic version

Bierstadt, Albert, 106

Bigelow, David, *History of Prominent Mercantile and Manufacturing Firms in the United States,* wood engraving from, 365, *365*; fig. 299

Bigelow, Erastus, 267, 268

Bigelow Carpet Company, Massachusetts, 272

billheads, *270, 276*; figs. 221, 227

binderies, 223–24. *See also* books, bound

Bingham, George Caleb, 92; *Fur Traders Descending the Missouri,* 391; no. 29; *The Jolly Flatboatmen,* mezzotint after, by Doney, 206, 207, *459*; no. 127

Birch, Thomas, 110

Bird, Clinton G., 263

Bird, Clinton G. II, 263

Bird, Eliza, 263

Bird, Isabella Lucy, 314–15n.190

Bird, Michael, 263

bird's-eye views, 220–21; of the Crystal Palace and environs, *467*; no. 141; of New York from Brooklyn Heights, 197, *460*; no. 128; of Trinity Church, 182, *182*; fig. 142

*Birds of America, from Drawings Made in the United States and Their Territories, The,* after watercolors by J. J. Audubon, engraved by Havell (1827–38), 197, 208, 231; hand-colored lithographic (octavo) version after, by Bowen (1840–44), 222, 315, *525*; no. 239; —, inscription page from, by Nagel and Weingartner, *220,* 222, 315; fig. 176; chromolithographic version, by Bien (1858), 208, 222; —, *Wild Turkey* from, 208, 222, *472*; no. 149

Birmingham, England, 291, 367

Black, William, 365. *See also* Ball, Tompkins and Black

Blackstone, W. Ellis, 179n.36

Blackwell's (now Roosevelt) Island, 13

Blake, Daniel, collection, 55, 76

Blanchard, Thomas, 144n.29

Bleecker, James, 77, 297, 300n.76, 305–6n.130

Bleecker, James, and Company (Bleecker and Van Dyke), 67, 77, 78

*Blind Man and His Reader Holding the "New York Herald,"* 233, *486*; no. 175

Bloomer, Amelia, 248, 253

Bloomer, Elisha, houses built for, fashions shown in front of, 244, *244*; fig. 195

bloomers, 253

Bloomingdale Flint Glass Works, 341, 342, *342,* 349; fig. 277; examples of cut glass from, 341, *342*; fig. 278

Bloomingdale Flint Glass Works or Brooklyn Flint Glass Works, probably, decanter, 340, *550*; no. 271

Bloomingdale Flint Glass Works or Brooklyn Flint Glass Works or Jersey Glass Company, decanter and wine glasses, 343, *553*; no. 276

B'nai Jeshurun Synagogue, 169, *170*; fig. 129

Boardman, James, 341

Bobo, William, 20, 33

Boch, William, and Brothers, Greenpoint, 339; pitcher, 339, *548*; no. 269

Bogardus, James, 30, 41; cast-iron facades, Bogardus factory, *184,* 185; fig. 145; —, Laing stores, 185, *438*; no. 97; —, Milhau pharmacy, 22, 185

Bogert and Mecamly's, 248, *248,* 249n.15; fig. 199

Bohemian glassware, 343, 348; goblet depicting City Hall, 343, *344*; fig. 281

Boker, John A., collection, 78

Boker, John Godfrey (formerly Johann Gottfried Bocker), 58–59, 62–63, 69

Bolton, John, 349n.119. *See also* Bolton, William Jay, assisted by Bolton, John

Bolton, William Jay, 352 and n.136, 353

Bolton, William Jay, assisted by Bolton, John, *Christ Stills the Tempest,* for Holy Trinity Church, Brooklyn, 183, 353, *557*; no. 280

Bonaparte, Joseph, collection, 78

Bond Street, 16, 177

Bonheur, Rosa, 64, 92, 105, 212; *The Horse Fair,* 64, 65, 69, 80, 107, 133, 222, *408–9*; no. 51; —, lithograph after, by Sarony, 221, 222; fig. 177; portrait of, by Dubufe, 64

Bonnell and Bradley, 345

bonnets, *250, 499, 500*; fig. 201, nos. 199, 200

bookcases, 293, 294–95 and n.52, *314,* 317, *321,* 324, *515, 528*; figs. 239, 257, 263, nos. 223, 241; "old oak," 310–11; table-top, 315–16, *525*; no. 238; with valences, 284

book collections, 90, 97, 202

book illustrations, 222–24

books, bound, *450, 454, 466, 470, 525*; nos. 117, 122A, 137, 138–40, 146, 239

boots, 250; woman's, *498*; no. 198

Bordley, John Beale, after Dubufe, *The Expulsion from Paradise* and *The Temptation of Adam and Eve,* 56

Boston, 37, 95, 110, 119, 141, 146, 149, 152, 161, 169, 202, 205, 221, 244, 257, 287, 327, 340; Tremont House, 174

Boston and Sandwich Glass Company, 342

Boston Athenaeum, 52, 55, 147, 148, 149, 152

*Boston Daily Advertiser,* 207

Boston Museum of Fine Arts, 92–93, 212

Boston Music Hall, organ for, *323,* 325; fig. 265

Bostwick, Zalmon, 368–69, 370n.78; pitcher and goblet, 369, *567*; no. 298; *rimmonim* (Torah finials), 369, 370n.78, *371*; fig. 305

Bottischer, Otto, 220; *Turnout of the Employees of the American Express Company,* 219, 220; fig. 175

Boucher, François, 324

Boudet, D. W., *La Belle Nature* and *Daphne de l'Olympe,* 56, 76

Bouguereau, Adolphe-William, 94, 102

Boulle, André-Charles, 330n.78

bouquet holders, 255, *502, 504*; nos. 204, 207

Bourlier, Alfred J. B., 265

Bourne, George Melksham, 67, 197–99

Bourne's Depository, **67**

Bowditch, Nathaniel, bust of, by Frazee, 147; statue of, by Hughes, 146

Bowdoin College, Brunswick, Maine, 351

Bowen, Henry Chandler, retreat (Roseland Cottage), furniture for, 299

Bowen, John T., Philadelphia, lithographs after J. J. Audubon, *Viviparous Quadrupeds of North America,* 221. See also *Birds of America*

Bowery, the, 6, 7, 11, 20–21, 28, 31, 32–33, 122

*Bowery Boy, A,* 33, *34*; fig. 29

Bowery Boys, 33

Bowery Theatre. *See* New York Theatre

Bowling Green, 6, 7, 135, 177

boxes: glass, *552*; no. 274; gold, 359, 374–75, *572*; no. 308. *See also* bandboxes

box sofas, 295 and n.54, *516*; no. 224

Boyce, Gerardus, 368 and n.75; footed cup, 368, *370*; fig. 304

Boyd, John, 52, 75

Boyd, John T., and Company, 304n.122

Boydell, John, 208

Boydell, John and Josiah, *Shakespeare Gallery,* American edition, 208, 210n.71; engraving from, by Sharp, after West, *King Lear,* 208 and n.70, 211, *477*; no. 156

Boydell, Josiah, *477*; no. 157

Bracassat, Jacques-Raymond, 105

bracelets, 252; hair, *505*; no. 209; seed-pearl, of Mrs. Lincoln, 257, *505*; fig. 209, no. 211

Brackett, Edward Augustus, 148–49, 151; *Shipwrecked Mother and Child,* 37, 38, 78, 79, 161, 162, *162*; fig. 123; *Washington Allston,* 150, 151; fig. 112

Bradbury, Thomas, and Son, 367

Brady, D'Avignon and Company (publisher). See *Gallery of Illustrious Americans*

Brady, John, **67**

Brady, Josiah R., 169–70, 176; B'nai Jeshurun Synagogue, 169, *170*; fig. 129; Second Congregational (Unitarian) Church, 169, *170,* *425*; fig. 129, no. 72. *See also* Thompson, Martin Euclid, and Brady, Josiah R.

Brady, Mathew B., 230–31 and n.18, 232, 233, 236, 240–41; *Abraham Lincoln,* 241, *241*; fig. 193; *Cornelia Van Ness Roosevelt,* 240, *497*; no. 196; *Daniel Webster,* 230; *Greenville Kane,* 239, *239*; fig. 191; *Henry Clay,* 230, *230*; fig. 181; *Henry James Sr. and Henry James Jr.,* 233, *234*; fig. 184; *The Hurlbutt Boys,* *485*; no. 170; *Jenny Lind,* *483*; no. 166; *John C. Calhoun,* 230; *John James Audubon,* 231–32, *482*; nos. 164, 165A; *Martin Van Buren,* 240–41, *497*; no. 195; photographs for Olmsted and Vaux, "Greensward" Plan for Central Park, 241, *495*; nos. 192, 193; *Preinauguration Portrait of Mary Todd Lincoln,* 257,

*257;* fig. 209; *Thomas Cole,* 35, 154, 230, *481;* no. 161; *Young Boy, 485;* no. 171. See also *Gallery of Illustrious Americans*
Brady, William B., 368
Braman, Misses, great-aunt of, ball gown worn by, 256, *503;* no. 205
Branch Bank of the United States, *6, 7,* 18, 169, 170, *170,* 173, *424;* fig. 129, no. 71
Brandis, Charles, **67**
brass: argand lamps, *563;* no. 289; gasolier, *570;* no. 302
Braund, J., *Illustrations of Furniture, Candelabra, Musical Instruments from the Great Exhibitions of London and Paris,* 321, 324; plates from, *319, 321, 321,* 324 and n.232; figs. 261, 263
Bray and Manvel, 368
Bread and Cheese Club, 110
Breed, John B., 279, 280
Bremen, Meyer von, 105
Bremer, Fredrika, 15, 31, 243
Breton, Jules, 64, 102
Brett, John Watkins, 54, 55, 64, 75, 76
Brevoort, Henry, 253
Bricher, Alfred, 123
Bridges, William (publisher), 6–7, *8–9;* fig. 5
Bridport, Hugh, after Fletcher, Thomas (designer), and Fletcher and Gardiner (manufacturer), *Drawing of One of the Covered Vases Made for Presentation to Governor De Witt Clinton in March 1825,* 355, *356;* fig. 290
Brinkerhoff, James, 341n.78
British art, 64–65; painting exhibitions, 64–65, 79, 80; prints, 207–8, 211; water-color school, 193, 196
British floor coverings, 267; Brussels carpet, 267, *267;* fig. 219; ingrain carpet, 297, *506;* no. 212
British Museum, 97–98
broadsides. *See* advertising broadsides
Broadway, 5, *6, 7,* 8, 11, 19–20, 23, 25, 28, 31–32, 33, 34, 60, 135, 183, 185, 187, *195,* 229, 235, 238, 243, 244, 248, 259, 289, 340, 351; from the Bowling Green, *196, 197;* fig. 154; from Canal Street to beyond Niblo's Garden, *455;* no. 123; from Canal to Grand Street, *19;* fig. 13; from Fulton to Cortlandt Street, *252;* fig. 205; from Liberty Street, 31, *445;* no. 109; new paving between Franklin and Leonard streets, 234–35, *489;* no. 180; parade for the Prince of Wales, *255;* fig. 207; between Spring and Prince streets, *226,* 238, 239; fig. 190; street scene (ca. 1834), fig. 153; from Warren to Reade streets, *19;* fig. 14
*Broadway Journal,* 152
*Broadway Sights,* 269, *269;* fig. 220
brocatelle, *517;* no. 219
Brodie, George, 246–47; mantilla, *247;* fig. 198; attributed to, mantilla wrap, 246, *499;* no. 199
bronze: girandole set, *570;* no. 303; medals, *565;* nos. 292–95; sculpture, 155–58, *156, 157,* 160, 421, *422;* figs. 116, 118, nos. 66, 68
Brooklyn, 83, 155, 289, 340, 342
Brooklyn Art Association, 79
*Brooklyn Daily Eagle,* 233
*Brooklyn Daily Times,* 336
*Brooklyn Evening Star,* 343
Brooklyn Flint Glass Works, 340, 341 and n.75, 342, 343, 344, 345, 346, 348, 349, 350; advertising broadside for, *347;* fig. 284; glassware displayed at the Great Exhibition, 346, 348, *348;* fig. 285; trade card of, *343;* fig. 279. *See also* Bloomingdale

Flint Glass Works or Brooklyn Flint Glass Works
Brooklyn Glass Company, 340
*Brooklyn Grocery Boy with Parcel,* 233, *486;* no. 173
Brooklyn Heights, views of New York from, 3, 189, *190,* 197–99, *460;* figs. 1, 147, no. 128
Brooklyn Museum, 95, 98
Brooks, Adeline Matilda Creamer, 370n.78
Brooks, Edward Sands, 370n.78
Brooks, Edwin A., 257n.43
Brooks, Mrs. L., footed cup presented to Mary Lavinia Brooks by, *370;* fig. 304
Brooks, Mary Lavinia, footed cup presented to, *370;* fig. 304
Brooks, Thomas, 315–16; étagère, after a design by Herter, 316n.199, 317; suite for Roseland Cottage, 299; table-top bookcase, 314n.188, 315–16, *525;* no. 238; attributed to, armchair, 299, *299,* 301n.84; fig. 243
*Brother Jonathan,* 305
Browere, John Henri Isaac, 67, 138–40; *Charles Carroll,* 138; *John Adams,* 138, 140, *140;* fig. 106; *Thomas Jefferson,* 138, 140
Browere's Gallery of Busts and Statues, *67,* 140
Brown, George Loring, 81, 224; *The Bay and City of New York (The City and Harbor of New York),* 81, 127n.108; —, etching after, *Bay of New York,* 223, 224; fig. 179; *Cascades at Tivoli,* 224, *462;* no. 131
Brown, Henry Kirke, 78, 135, 151, 154–58, 160, 165, 167; *Boy and Dog,* 155; *The Choosing of the Arrow,* 155 and n.76, 157, *156;* fig. 116; *De Witt Clinton,* 157, 157–58; fig. 118; *Filatrice,* 157, 421; no. 66; *George Washington,* 166, 167; fig. 128; *Good Angel Conducting the Soul to Heaven,* 154, 155; *Plato and His Pupils,* 157, *157;* fig. 117; *Ruth,* 154, 155, *155;* fig. 115; *Thomas Cole,* 35, 154, 155, *418;* no. 62; *William Cullen Bryant,* 100, 154, *418;* no. 61
Brown, T., presentation medal, *562;* no. 287
brownstones: furnishings, 260; row houses, 185
Bruen, George W., 47, 48, 49
Bruen, Matthias, bust of, by Crawford, 152
Brussels carpets, 267, *267,* 268, 272; fig. 219
Bryan, Thomas Jefferson, 36, 65, 103–4, 212, 213n.91; portrait of, by Sully, 103, *103,* 212; fig. 75
Bryan Gallery of Christian Art, 36, 65, *67,* 79, 103–4
Bryant, William Cullen, 110, 119, 141, 148, 151, 154, 201; bust of, by H. K. Brown, 100, 154, *418;* no. 61; *Poems,* 110; portrait of, by Morse, *381;* no. 6; portrayed in Durand, *Kindred Spirits,* 110, *392;* no. 30
Buchan, P. G., 151
Buckham, Dr. George, portrait of, by Inman, *383;* no. 12
Buckham, Mrs. George and Georgianna, portrait of, by Inman, *383;* no. 11
Buffalo, Saint Paul's Church, 351, 352n.131
*buffet étagère. See* étagère-sideboard
buffets, *315,* 317–18; fig. 258. *See also* sideboards
Bufford, John H., 205; lithographs, *Broadway Sights,* 269; fig. 220; —, *Second Merchants' Exchange,* after Warner, *175;* fig. 135
"Buhl" furniture, 93, 300n.78, 310, 321
Bulfinch, Charles, 169
Bulkley, Erastus, 292–93n.37, 317, 322. *See also* Bulkley and Herter; Deming, Barzilla, and Bulkley; Bulkley, Erastus

Bulkley and Herter, 315n.195, 317, 322; book-case, *314,* 315–16nn.197, 198, 317, *528;* fig. 257, no. 241; buffet, *315,* 316–17n.201, 317–18; fig. 258
*Bulletin of the American Art-Union,* 66, 206, 211n.75
Bullock, William, 75
Bulpin, George P., 247
Burckhardt, Baron Christian, collection, 76
Burford, John and Robert, 75
Burke, Edmund A. *See* Mettam, Charles, and Burke, Edmund A.
Burnet, John: *The Blind Fiddler,* after Wilkie, 211, 212, *477;* no. 157; *A Practical Treatise on Painting, in Three Parts,* 212
Burns, James, *Washington Crowned by Equality, Fraternity, and Liberty,* 35
Burns, Robert: statues after poem of, by Thom, 55, 144; statue of, by Thom, 144
Burns, William, 300
Burns and Brother, possibly, after a design by Davis, side chair, 301, *523;* no. 235
Burr, Aaron, 10
Burr, David H., *Topographical Map of the City and County of New York,* 5, 9, *456–57;* no. 124
Burr, Edward, parure (brooch and earrings), 313, *505;* no. 210
Burt, Charles, after Woodville, *The Card Players,* 207
Burt, J. M., collection, 65, 80
Burton, Charles, *Exchange Room, First Merchants' Exchange,* 170, *171;* fig. 130
Burton, William E., collection, 80
*Burton's Gentleman's Magazine,* 230
busts: cameo, *504;* no. 206; marble, *142, 146,* 150, *159,* 410, 412, 413, 414, 415, 418, *419, 420;* figs. 107, 111, 112, 119, nos. 52, 55–58, 61–65; plaster, *85, 139, 140, 410;* figs. 58, 105, 106, no. 53
Butler, Mrs. Benjamin F., 275
Butterfield, William, communion service modeled after designs by, 370, *571;* no. 304
Byard, Henry, 179
Byerly, D. D., collection, 80
Byrne, Richard, 300, 302n.92; after a design by Davis, hall chair, 301, 302n.92, *523;* no. 234
Byron, Lord, 56; *Childe Harold's Pilgrimage,* 127; *Manfred,* 127

cabinetmaking, 287–325; and interior decorating, 289, 312, 313, 322; pattern books, 291, 292, 293–94, 296, 299–30; and upholstery services, 281–82. *See also* furniture
cabinets: portfolio cabinet-on-stand, 302–3, *522;* no. 233; reception-room, 286, 324–25, *535;* no. 249; in "Renaissance" style, *309,* 324; fig. 252. *See also* bookcases; buffets; étagère; gun case; sideboards
Cabus, Joseph, 320n.214, 322, 323n.225, 325
Cady, Jesse, 288n.13
Cafferty, James H., and Rosenberg, Charles G., *Wall Street,* 18, *398;* no. 38
Calame, Alexandre, 99, 105
Calhoun, John C., 220n.117; photographic portrait, by Brady, 230
Callot, Jacques, 93
Calmady, Charles B., daughters of, portrait by Maverick, after Lawrence, *191,* 192; fig. 149
Calyo, Nicolino: *The Hot-Corn Seller,* 28, *30,* 32, 197; fig. 25; New York Harbor scenes, copies after prints by Havell, 197; *View of the Great Fire of New York, December 16 and 17, 1835,* 10, 28, 197, *446;*

no. 110; *View of the Ruins after the Great Fire,* 10, 28, 197, *446;* no. 111
Cambridge Camden Society, England, 370
cameo with portrait bust, *504;* no. 206
Campbell, Colin, 23
Campbell, Thomas, **67**
Canaletto (Giovanni Antonio Canal), 83, 85, 123
Canal Street, 20; at Broadway, *455;* no. 123
*canapé tête à tête,* 307, *524;* no. 236A
Canda, Charlotte, sculpture of, by Launitz, 148n.51
Cann, John, 363
Cann and Dunn, 363; pitcher, 363n.30
Canova, Antonio, 137, 138; *Aerial Hebe,* 137; *Creugas,* 137; *Damoxenes,* 137; *George Washington,* 141n.23; *The Graces,* 137
Canova pattern, 334, 336n.41, *543;* no. 262
capitalism, 12–13
Cardelli, Giorgio (Pietro), 136
carpets, 245, 259, 265–72, 289; Aubusson, 93, 267, 310; Brussels, 267, *267,* 268, 272; fig. 219; ingrain, 260, 267, 268, 297, *506, 507;* nos. 212, 213; Persian, 271; Venetian, 267, *267,* 268; fig. 218; Wilton, 267
Carr, James, 334, 336n.42
Carracci, Lodovico, 53
Carroll, Charles, bust of, by Browere, 138, 140
*Carroll's New York City Directory,* 272
Carse, Robert, 351 and n.127
Carse and Reed, Brooklyn, 351
Carse and West, 350, 351n.127
Carstensen, J. B. *See* Gildemeister, Charles, and Carstensen, J. B.
carte de visite, 240
Carter, Mr. and Mrs. Charles Henry Augustus, portrait of, attributed to Kittell, 297–98, *298,* 299; fig. 242
Cartlidge, Charles, 336
Cartlidge, Charles, and Company, Greenpoint, 336–38 and n.45, 339: doorplate depicting New York Harbor, 337, *337;* fig. 275; pitcher made for the Claremont, 337–38, *548;* no. 268; presentation pitcher for the governor of New York, 337, *547;* no. 267
Cartlidge retail store, 345
Carville, G. and C. and H., firm, 195
Cary Building, 185
Casilear, John, 74, 200; after Huntington, *A Sibyl,* 206, *206;* fig. 162
cast iron: architectural components, *22,* 22–23; fig. 18; building facades and remnant, *184,* 185, *438;* fig. 145, no. 97; furniture, *300,* 301; fig. 245; mantels, *262,* 262–63; fig. 213; rolling shutters, 184
Cast-Iron District, 185
Castle Clinton, 6
Castle Garden, 3, 7, 72, 76, 314, 315; depicted on, bandbox, 274, *275;* fig. 226; —, platter, 330, *538;* no. 253; —, wallpaper, *510;* no. 216. *See also* Lafayette Fête
Catherine Street, 20
Catherwood, Frederick, 77; panoramas, 38, 73, 77. *See also* Crawford, Thomas, and Catherwood, Frederick
Catlin, George, Indian Gallery, 76
Catskill Mountain House hotel, 111, 112
Catskills, 47–48, *48,* 109, 110, 111–12, 120, 126, *129,* 387; figs. 37, 98, no. 23
Cauldwell, Ebenezer, 345
Causici, Enrico, 136; *George Washington* (Baltimore monument), 137n.8; (model for New York monument), 136–37 and n.8, 138–40
cemeteries, 43, 261

centerpieces, silver, 364, *364*, 373; fig. 298
center tables, 291, 305n.129, *307*, 308 and
 n.140, 320, *514*, *531*; fig. 250, nos. 222,
 244; depicted in paintings, 297–98, *298*,
 *383*; fig. 242, no. 13
Central Park, 40, 42–45, 106, 221, *474*;
 no. 151; Greensward Plan, 43–44, *44–45*,
 221, 241, *495*; fig. 36, nos. 192, 193; Skating
 Pond, 43, 205, *205*, *475*; fig. 161, no. 153
Central Park Board of Commissioners, 154
Central Park Museum (the Arsenal), 103
Century Association, *67*, 92, 100
Ceracchi, Giuseppi: *Alexander Hamilton*,
 after Dixey, 144–45; *George Washington*,
 86, *410*; no. 52; *John Jay*, 147
ceramics, 327–39; nos. 250–70. *See also*
 earthenware; porcelain; stoneware
Chair-Makers' Society, 190, 287; banner,
 287, *288*; fig. 234
chairs, *283*, *299*, *523*; figs. 232, 244, no. 234;
 French, 296, 297, *518*; no. 226; reuphol-
 stery costs, 281. *See also* armchairs; side
 chairs
*"chaise de fantasie,"* *304*, *307*; fig. 248
*chaises*, in floor plan, *306*, *307*; fig. 249. *See
 also* side chairs
*chaises légères*, in floor plan, *306*, *307*; fig. 249
chalice, 370, *571*; no. 304
Chambers, Sir William, 171n.6
Champlin, Elizabeth, ball gown worn by,
 253–54, *254*; fig. 206
Champney, Benjamin, 119
Channing, William Ellery, 120
Chanou, Nicolas-Louis-Édouard, 331. *See
 also* Decasse and Chanou
Chapel Street row houses (Columbia
 College houses), 177, *177*, 179, 290, *432*;
 fig. 137, nos. 87, 88
Chapin, John C., *The Historical Picture
 Gallery*, wood engraving from, *373*;
 fig. 308
Chapman, John Gadsby, 38, 78, 204, 224;
 *The American Drawing-Book*, 204; —,
 wood engravings from, *Perspective in a
 Marine Scene*, 204, *204*; fig. 160; —,
 *A Study and a Sketch*, by Durand, 204,
 *462*; no. 132; *Davy Crockett*, 38; *The
 Illuminated Bible*, 204; —, wood
 engraving from, *Christ Healing
 Bartimeus*, *203*, 204; fig. 159; *Italian
 Goatherd*, 224, *470*; no. 147
Charles I, king of England, portrait of, 89
Charles X, king of France, 55
Charleston, South Carolina, 197, 288, 291, 327
Charmois, Christophe, 321
Charters, Cann and Dunn, 363, 369n.75
Charters, Thomas, 363
Chatham Square, *6*, *7*, 20, 235–36, 305, *487*;
 no. 178
Chatham Street, 20, 30, 235
*chauffeuses*, in floor plan, *306*, *307*; fig. 249
Chazournes, F., 272
Cheavens, Henry, 367
Chester, John N., 269
Chester, Stephen M., 269
Chester, Thomas L., carpet store, **268–69**,
 *269*, 270; fig. 220
Chester, W. W. and T. L., 268–69
Chester, William W., **268–70**
Chevalier and Brower, 255
Chevreul, Michel-Eugène, *The Principles of
 Harmony and Contrast of Colours*, 319
Chicotree, Pierre (Peter Chitry?), 367
Childs, John, *68*
Chinese Assembly Rooms, *68*, 78, 79
Chippendale, Thomas, 315n.196, 317
Christofle, C. S., and Company, 368

Christy, Charles R., 277
*Christy, Constant and Company Paper-
 Hangings Manufactory*, *276*, 277; fig. 228
Christy, Constant and Shepherd, 277
Christy, Shepherd and Garrett, 277, *278*;
 fig. 229
Christy, Shepherd and Walcott, 277
Christy, Thomas, 275, 277
Christy, Thomas, and Company, 275, 277
Christy and Constant, **275–77**
Christy and Robinson, 277
chromolithography, 221–22, 224
Church, Frederic E., 57, 92, 97, 99, 101,
 106, 119, 130, 163, 166–67; *The Andes of
 Ecuador*, 61–62, *99*, 101; fig. 70; *Beacon,
 off Mount Desert Island*, 105, *106*; fig. 78;
 *Cotopaxi*, 97; *The Heart of the Andes*, 71,
 80, 130–33, *132*, 166, 400–401; fig. 101,
 no. 41; *The Icebergs*, 81, *131*, 133; fig. 100;
 *Niagara*, 61, *61*, 64, 79, 80, 94, 222,
 223n.134; fig. 50; *Twilight in the Wilder-
 ness*, 94
church architecture, 181–83
Church of the Ascension (Canal Street),
 *172*, 172, 173, 176, 181; fig. 132; (Fifth
 Avenue), 181, 185
Church of the Divine Unity, 63, 68, 69, 79,
 163–65; *See also* Düsseldorf Gallery
Church of the Holy Trinity. *See* Holy
 Trinity Church
Church of the Pilgrims, Brooklyn, 183
Church of the Puritans, 183, *436*; no. 94
cigar smoking, 33–34, *35*; fig. 31
Cisco, John, 40n.233
City Dispensary, 47, 55, *68*, 76
City Hall, *6*, *7*, 8, 11, 135, *135*, 239, *445*, *492*;
 fig. 103, nos. 108, 186; daguerreotypes
 of, 228, 234; depicted on, commemora-
 tive handkerchief, *29*; fig. 24; —, glass
 goblet, 343, *344*; fig. 281; —, pitcher, *538*;
 no. 254; —, wallpaper, *510*; no. 216;
 gallery in (Governor's Room), 35, *69*;
 sculpture for, by Browere, 138; —, by
 Dixey, *Justice*, 135–36; —, by Frazee,
 *John Jay*, *146*, 147; fig. 111
*City Hall, New York*, goblets and vases
 with view from, 342–44n.83, *343*, *344*;
 fig. 281
City Hall Park (the Park), 5, *6*, *7*, 8, 11, 19,
 *136*, 137, 140; fig. 104
City Hotel, 305, 355
City Saloon, *68*, 76
Civil War, 222, 325, 375; photographs of, *240*,
 241; fig. 192
Civil War period, 112, 259, 349; after, 17, 45,
 106, 224, 257, 259, 289, 303, 353; by the
 beginning of, 5, 13, 19, 44, 227, 240, 364
Claremont, pitcher made for, 337–38, *548*;
 no. 268
Clarendon Hotel, 271–72, 330
Clark, Benjamin, pier table made for, *294*,
 295, 296–97 and n.69; fig. 241
Clark, John, collection, 77
Clark, Richard, carpet mill, 268
Clark, W. C. R., and Meeker (publisher),
 *474*; no. 152
Clarke, George Hyde: dishes purchased by,
 327, 334–36n.41; furniture for home,
 304n.122
Clark's Broadway Tailoring, 28
Clarkson, Elizabeth Van Horne, Honey-
 comb quilt, *508*; no. 214
Clarkson, Matthew Jr., mansion (Clarkson
 Lawn), Brooklyn, 179, 291, *433*; no. 89A, B
Claude Lorrain (Claude Gellée), 93, 119, 209
Clay, Edward W., 28; Life in Philadelphia
 series, 193; *The Ruins of Phelps and Peck's

Store*, 19, *20*, 20; fig. 15; *The Smokers*, 33,
 *35*; fig. 31
Clay, Henry, 220n.117, 367; daguerreotype
 of, by Brady, 230, *230*; fig. 181; proposed
 statue of, by Crawford, 153 and n.68;
 urn presented to, 368 and n.66, *369*; fig.
 302; vase presented to, 368, *566*; no. 269
Clevenger, Shobal Vail, 149; *Indian Warrior*,
 149; *James Kent*, 149; *Julia Ward Howe*,
 149; *Philip Hone* (marble), 13, 84, 149,
 *415*; no. 58; (plaster), 84, *85*, 149; fig. 58
Clews, James and Ralph, platter depicting
 Lafayette's arrival at Castle Garden, 330,
 *538*; no. 253
Clews Pottery, 330, 331n.20
Clinton, De Witt, 3, 83, 189, 190, 287–88n.2,
 340, 355; likenesses of, bronze statue, by
 H. K. Brown, *157*, 157–58; fig. 118; —,
 design for statue, by Hughes, 140; —,
 life-mask portrait bust, by Browere, 138;
 —, portrait, by Morse, 3, *380*; no. 4; —,
 print by Lumley, *474*; no. 152; vases
 made for presentation to, 355, *356*, 358,
 361, *558*; fig. 290, no. 281A, B
Clinton Hall, 55, *68*, 72, 77, 78, 140
Clinton Hall Association, 140, 149
Clinton Monument Association, 157
Clive, George, family, portrait of, by
 Reynolds, *53*, 54; fig. 40
clothing: etiquette of, 251–52; manufacture
 of, 249–51. *See also* costumes and fashions
Clover, Lewis P. (publisher), 197, *460*; no. 128
"Coburg" wineglass, 345n.93
Coffee, Thomas, 136
Coffee, William, 136
coffee urn, silver, 363, *560*; no. 285
Coffin family, 295n.50
Colden, Cadwallader D., 190; pitcher with
 arms of, 327n.2. See also *Memoir*
Cole, Thomas, 35, 47–50, 55, 57, 76, 78, 84,
 85, 87, 97, 101, 109–12, 113, 114, 118, 119,
 123, 125, 126, 127, 130, 131, 141, 192–93, 197,
 233; *Angel Appearing to the Shepherds*, 55,
 76; *Aqueduct near Rome*, 126, 127, 128;
 fig. 96; The Course of Empire series, 76,
 87, 89, *124*–25, 126–27, 211; figs. 91–95;
 *Distant View of the Slides That Destroyed
 the Willey Family, White Mountains*,
 lithograph after, by Imbert, 116, *192*, 193
 and n.16; fig. 150; *The Dream of Arcadia*,
 engraving after, by Smillie, 207; *Kaaters-
 kill Clove*, 193; *Lake with Dead Trees
 (Catskill)*, 48, *48*, 50; fig. 37; likenesses
 of, bust, by H. K. Brown, 35, 154, *155*,
 *418*; no. 62; —, daguerreotype, by Brady,
 35, 154, 230, *481*; no. 161; —, portrait,
 by Durand, 35, *382*; no. 10; —, portrayed
 in Durand, *Kindred Spirits*, 57, 110, *392*;
 no. 30; *The Mountain Ford*, 94, 100;
 *The Oxbow*, 193; *Ruins of Fort Putman*,
 48; scenes from Cooper, *The Last of
 the Mohicans*, 112 and n.26; —, *Cora
 Kneeling at the Feet of Tamenund*, 110,
 112, 114, *388*; no. 24; *View of Florence from
 San Miniato*, 127; *View of Kaaterskill Falls*,
 48, 49, 50 and n.9; *View of the Moun-
 tain Pass Called the Notch of the White
 Mountains (Crawford Notch)*, 108, 116,
 *117*; fig. 84; *View of the Round-Top in the
 Catskill Mountains*, 110, *387*; no. 23; *View
 of the White Mountains*, 116, *116*; fig. 83;
 *View on the Catskill, Early Autumn*, 88;
 The Voyage of Life series, 59, 73, 77, 89,
 94, 206–7, 233; —, *Manhood*, 59, 88, 89, 94,
 206; fig. 60; —, *Youth*, 59, 60, 89, 94, 206;
 fig. 49; —, engraving after, by Smillie,
 207, *462*; no. 130

Coles, Albert, 363, 370
Collamore, Davis, and Company, 327, 346
Collamore, Ebenezer, 327
collar, woman's, *498*; no. 198
collectors, 83–107
Collect Pond, 5, 9, 30
Colles, James C., 93, 290, 308, 309 and
 n.144, 311, 312; house, 309–10; —, fur-
 nishings for, 93, 309–10 and n.156,
 312; —, sofa and armchair for, 310, *524*;
 no. 236A, B
Colles, Mrs. James, 309, 310
Collins, Edward K.: California gold tea
 service presented to, 370, 372, *372*; fig. 307;
 flatware pattern developed for, 366
Collins, George, house, Unionvale, entrance-
 hall wallpaper from, *511*; no. 217
Colman, Samuel, 119
Colman, William A., 48, 49, 50, 60, 68, **68**,
 73, 75, 78. *See also* Havell, Robert Jr.,
 Colman, William A., and Ackermann
 and Company
Colonial Revival movement, 303
Colonnade Row. *See* La Grange Terrace
colors: for costume, 254; for upholstery,
 319–20
Colt, Samuel, 312
Colton, J. H. (publisher), *456–57*; no. 124
Columbia College houses. *See* Chapel
 Street houses
Columbian Bank Note Company,
 Washington, D.C., 200
*Columbian Lady's and Gentleman's
 Magazine*, 149
Columbus, Christopher, four-branch
 gasolier with central figure of, *570*;
 no. 302
Comegys, George H., engraving after, by
 Sartain, *The Artist's Dream*, 206n.60
*Commercial Advertiser*, 49, 52
Commissioners' Plan of 1811, 6–9, *8–9*,
 42–43, 44; fig. 5; "Remarks" accompany-
 ing, 6–7, 12. *See also* New York: grid plan
Common Council, 6, 10, 137n.8, 138, 374;
 gold box presented to William Bain-
 bridge by, 359
communion services, silver, 370, *571*; no. 304
compotes, glass, *551*; no. 273; for the White
 House, 348, *556*; no. 279
Concord Street Flint Glass Works, 348
*confortables*, 305, 307
Congregationalists, 183
console, in floor plan, *306*, *307*; fig. 249
Constable, Arnold, and Company, 247;
 dresses from, *250*, *499*; fig. 202, no. 199
Constable, John, 97, 112
Constant, Samuel S., 275, 277
Constantine, Eleanor D., 281, 282, 283
Constantine, John, 273, 281, **282–83** and
 n.92. *See also* Constantine, Thomas, and
 Constantine, John
Constantine, John [Jr.], 282, 283
Constantine, Thomas, 282
Constantine, Thomas, and Constantine,
 John, chair for the Speaker of the North
 Carolina Senate, 282–83, *283*; fig. 232
Continental Bank Note Company, 200
Cook, Clarence, 44
Cook, Edmund L., *68*
Cooke, George, 38, *68*, 75; after Gericault,
 *Raft of the Medusa*, 54, 75
Cooley, 57, *68*, 71
Cooley, James E., 68, 78
Cooley, Keese and Hill, 68, 78
Cooley and Bangs, 67, 68
Cooper, Mrs. Edward, daguerreotype of,
 by Gurney, 232, *483*; no. 167

Cooper, Francis W., 370. *See also* Cooper and Fisher

Cooper, James Fenimore, 110, 125–26 and n.97, 127, 128, 141, 244; bust of, by Greenough, 141, *142*; fig. 107; *The Cooper Vignettes*, illustrations for, by Darley, 223; –, engraving from, *The Bee Hunter*, *222*, 223; fig. 178; *Excursions in Italy*, 126; *The Last of the Mohicans*, 110, 112; –, scenes from, by Cole, 110, 112 and n.26, 114, *388*; no. 24; *The Pioneers*, 110; *The Wept of Wish-ton-Wish*, 166

Cooper, Peter, 68, 210, 213n.91

Cooper, Peter (Pierre), daguerreotype of, by Gurney, 232, *483*; no. 167

Cooper and Fisher, communion service for Trinity Chapel, 370 and n.80, *571*; no. 304

Cooper Union for the Advancement of Science and Art, 67, **68**, 73, 80, 210, 212, 241

*Cooper Vignettes. See* Cooper, James Fenimore

Copeland, W. T., Staffordshire, 161, 331

Copley, John Singleton, 97, 123

copperplate engraving, 191, 201n.44, 202 and n.51

Cor, A., collection, 77

Corlears Hook, 31

Cornelius, Robert, 228–29 and n.8

Corning, Erastus I, 347n.106

Corot, Jean-Baptiste-Camille, 94

Corporation of the City of New York, tray presented to Charles Rhind by, *358*, 358–59; fig. 294

*Corsair, The*, 227, 228

corsets, 250, 253, 255

Corwin, Edward Brush, collection, 79, 90–91, 92

Cosmopolitan Art Association, 37, 40, 63, *63*, **68**, 69, 72, 160–61, 165; fig. 53

*Cosmopolitan Art Journal*, 68, 212; engravings from, *21*, *63*, *161*; figs. 16, 52, 53, 121

costumes and fashions, 243–57; nos. 197–205. *See also* men's costumes; women's costumes

couches, 297, 299n.74, *521*; no. 232

Couture, Thomas, 64

couturiers, 256

Cox, J. and I., 362, 363n.30, 367, 368, 370n.81; pair of argand lamps, *563*; no. 289

Cox, Jameson, pitchers presented to, 359–61

Cox, John, 362

Cox, John, and Company, 362–63

Cox, Joseph, 362

Coxe, D. W., 283

Cozzens, Abraham M., 98, 100–101

Crate, Hy. J. (printer), *474*; no. 151

Crawford, Abel, 115

Crawford, Ethan Allen, 115

Crawford, Louisa Ward, 154; bust of, by T. Crawford, 153–54, 160, *419*; no. 63

Crawford, Thomas, 93, 103, 148, 151, 152–54; *The Babes in the Wood*, 103, 152–53, *153*; fig. 114; *Dancing Girl (Dancing Jenny)*, 80, 154; *Dying Indian Chief*, 154; *Flora*, *102*, 103, 152, 154; fig. 74; *Genius of Mirth*, 152, 153, *416*; no. 59; *George Washington* (Virginia commission), 153; *Louisa Ward Crawford*, 153–54, 160, *419*; no. 63; *Matthias Bruen*, 152; *Mexican Girl Dying*, 152, 153; *Mrs. John James (Mary Hone) Schermerhorn*, 152; *Orpheus*, 152; proposed statue of Henry Clay, 153 and n.68; *William Page*, 148

Crawford, Thomas, and Catherwood, Frederick, design for Washington monument, *151*, 152; fig. 113

Crawford family, 115

Crawford Notch, White Mountains, *108*, 115, *115*, 116, *117*; figs. 82, 84

Crawford's inn, White Mountains, 115, 116

Crayon, Geoffrey. *See* Irving, Washington

*Crayon, The*, 32, 36, 63, 88, 103, 104–6, 118, 240, 322; "Our Private Collection," 98, 99, 100, 101

Crayon Gallery (Nichols Gallery), 68, 80, 81

"Cries of New York," commemorative handkerchief, 28, *29*, 32; fig. 24

crinoline silhouette, *246*, 254, 256; fig. 197

Crockett, Davy, portrait of, by Chapman, 38

Cropsey, Jasper F., 99, 101, 127n.108; *Four Seasons*, 72, 80

Crossman, William W., 368

Croton Aqueduct (Croton Waterworks), 10–11, 19, 43, 180–81, 309, 367; distributing reservoir, 10, 41, 180–81, 316, *434*; no. 90; High Bridge, 10, 181, *435*; no. 91; Manhattan Valley pipe chamber, 181, *435*; no. 92

Croton Celebration (1842), 11, 367–68

crumber, silver, *568*; no. 299

Crumby, John, **68**

Crystal Palace, London, 22, 40, 41, 348. *See also* Great Exhibition of the Works of Industry of All Nations (Crystal Palace exhibition, 1851)

Crystal Palace, New York, 40–42, *41*, 66, **68**, 236, 316, *467*; fig. 35, nos. 141, 142; window shade depicting, 41, 275, *511*; no. 218. *See also* New-York Exhibition of the Industry of All Nations (Crystal Palace exhibition, 1853–54)

cuffs, woman's, *498*; no. 198

Cummings, Thomas Seir, 67, 141n.25; *Gustavus Adolphus Rollins*, *384*; no. 17; *A Mother's Pearls (Portraits of the Artist's Children)*, *386*; no. 22. *See also* Inman, Henry, and Cummings, Thomas Seir

cup, footed, silver, *370*; fig. 304

Currier, Nathaniel, 195, 213, 220, 224; *Awful Conflagration of the Steamboat "Lexington,"* 213, *214*, 220; fig. 168; lithograph printed by, Maurer, *Preparing for Market*, *214*, 217–18; fig. 169

Currier and Ives, 201, 213–18, 219, 220, 224; lithographs printed by, Parsons, *Central Park, Winter: The Skating Pond*, 43, 205, *475*; no. 153; –, Worth, Darktown Comics series, 214

curtains and draperies, 281, 282, 283, 284–85

Curtis, George William, *Lotus-Eating: A Summer Book*, 120, 121–22, 123; wood engraving from, by J. W. Orr (?) after Kensett, *The Cliff Walk, Newport*, 121, 122; fig. 88

Custom House. *See* United States Custom House

Dagoty and Honoré, Paris, 331

Daguerre, Louis-Jacques-Mandé, 227–28, 229, 230, 234, 237

daguerreotypes, 228–36 and nn.3, 10, 25, 30, 237, 239, 240, 316, *484*, *487*, *488*, *489*; nos. 169, 178–80; portraits, 204–5, 228, 230–33, *230*, *232*, *234*, *480*, *481*, *482*, *483*, *485*, *486*; figs. 181, 182, 184, nos. 160–64, 166–68, 170–76

Dailey, Catherine, 346

Dailey, William, 346

Dakin, James H., 175, *176* and n.31, 179n.40; drawing of Lower Broadway, vase scene after, 330n.6, *537*; no. 251. *See also* Town, Ithiel, Davis, Alexander Jackson, and Dakin, James H.

Danby, Francis, *The Opening of the Sixth Seal*, 54, 55, 76; fig. 41

*Daniel in the Lion's Den*, 40

Darley, Felix Octavius Carr, 223; book illustrations, for Cooper's complete works, *The Cooper Vignettes*, 223; –, engraving from, *The Bee Hunter*, *222*, 223; fig. 178; –, for Irving, *Life of George Washington*, 223; –, *Sketch Book* tales, 207, 223, *463*; nos. 133, 134; –, for Judd, *Margaret*, 223

Dartois, J., 257n.46

Dassel, Herminia Borchard, home of, *68*, 80

Daumier, Honoré, 221

David, Henry, 370

David, Jacques-Louis, 55, 209; *Coronation of Napoleon*, 75

Davidson, David, **68**

D'Avignon, Francis, 219, 230, 231; after Matteson, *Distribution of the American Art-Union Prizes at the Tabernacle*, 206, *207*; fig. 163. *See also Gallery of Illustrious Americans*

Davis, Alexander Jackson, 89, 90, 169–70, 172, 173–74, 175 and n.26, 176, 179, 180, 181, 187, 192 and n.14, 292n.36, 293n.45, 299–300 and n.87; architectural designs, *Design for Improving the Old Almshouse*, 35, 172, *425*; no. 73; –, *First Merchants' Exchange*, 173; *426*; no. 76; –, Gothic Chapel, University of the City of New York, 187; –, *Park Hotel (Later Called Astor House)*, 173, 174, *174*, 175, *427*; fig. 133, nos. 77, 78; –, "Syllabus Row," 16, 179, *430*; no. 84; –, "Terrace Houses," 16, 173, 179, *430*; no. 85; –, *United States Custom House*, 28, 173, *428*, *429*; nos. 79–81; –, University of the City of New York (now New York University), Washington Square, 175, *176*, 180; fig. 136; book, *Rural Residences*, 180; *City Hall Park*, *136*, 137; fig. 104; illustrations of others' buildings, *Arthur Tappan Store*, 183, *183*; fig. 144; –, *Elizabeth Street facade, New York (Bowery) Theatre*, 171, *172*; fig. 131; –, *First Merchants' Exchange*, 19, 28, 170, *426*, *427*; nos. 74–75; –, *Public Buildings in the City of New-York*, 169, *170*; fig. 129; –, see also *Views of the Public Buildings in the City of New-York*; residential and interior designs, brownstone double house, 185; –, *Columnar Screen Wall between Parlors*, 179, 180; fig. 140; –, *Design Drawing for Stained-Glass Window*, 351, *352*; fig. 288; –, *Greek Revival Double Parlor*, 180, 291, *447*; no. 112; –, Litchfield Villa (Grace Hill), Brooklyn, 264, *264*, 265 and n.14, *307*, 307–8, 351; figs. 215, 250; –, Ericstan (John J. Herrick House), Tarrytown, 180, 301, 302–3nn.96, 97, *441*, *523*; nos. 102, 235; –, Lyndhurst (formerly Knoll), Tarrytown, 264, *264*, 265n.15, 300–301, 302n.92, *523*; fig. 216, no. 234; –, Reed, Luman, house, 17n.73, 211; –, Stevens, John Cox, house, 180; –, Waddell, William C. H., house, *14*, 16, 180; fig. 7. *See also* Town, Ithiel, and Davis, Alexander Jackson

Davis, Alexander Jackson, and/or Geer, Seth, La Grange Terrace (Colonnade Row), *15*, 16 and n.72, 175, 179 and n.40, 180, *431*; fig. 9, no. 86

Davis, Horatio N., 305n.130

Day, Thomas Jr., 275

*Dead Rabbit, A*, 33, *34*; fig. 30

Dead Rabbits, 33

De Brakekleer collection, 78, 79

decanters, glass, 341, 343, 348, *348*, *550*, *553*; fig. 285, nos. 271, 276; in advertisement, 345, *345*; fig. 282

Decasse, Henry, 336

Decasse, Louis, 331

Decasse and Chanou, 331, 336; mark of, 331, *332*; fig. 271; tea service, 331, *539*; no. 255; –, two plates, or stands, from, 331, *332*; fig. 270

Declaration of Independence, 135, 138; painting by Trumbull, 200, *200*; fig. 157

decorations for the home, 259–25; nos. 212–220. *See also* carpets; mantels; upholstery; wallpaper

decorators. *See* interior decoration and design services

Degrauw, John, hot-water urn presented to, 363–64, *564*; no. 290

Deiden, Madame, 247

De Jongh, James, 73

Delacroix, Eugène, 94, 99

Delaroche, Paul, 63, 209; *Hemicycle*, engraving after, 209; *Marie Antoinette on Her Way from the Tribunal*, 79; *Napoleon at Fontainebleau*, 37, 63, *64*; fig. 54; *Napoleon Crossing the Alps*, 78; –, engraving after, by François, 211, *478*; no. 158

Delarue, François (printer), *471*; no. 148

Delisser, Richard L., 71

Deming, Barzilla, and Bulkley, Erastus (Deming and Bulkley firm), 288, 291, 292–93n.37; center table, 291, 294, *514*; no. 222

Deming, Bulkley and Company, 282

Democrats, 11, 34n.193, 43, 240

Demorest, (Madame) Ellen Curtis, 247, 249, 253; country excursion dress, *251*; fig. 204

Demorest, William Jennings, 247, 249

Dempsey and Fargis, 375

department stores, 184, 244, 245, 259

Derby, A. T., 79

Derby, Chauncey L., 63, 68, 160

Derby, Henry W., 63, 68

De Saireville collection, 75

Dessoir, Julius, 262 and n.8, 289, 305–6 and n.137, 312n.177, 316, 318, 319–20n.209, 322, 325; sofa and two armchairs en suite, 318–19, 320, *526*, *527*; no. 240A–C; –, illustration of armchair from suite, *316*, 318, 319; fig. 259

Dewey, Rev. Orville, 158

Dexter's Store (Elias Dexter), **69**, 81

Diamond Ball. *See* Prince of Wales Ball

diamonds, 255

Diaper, Frederick, 105, 181

Dickens, Charles, 244; *American Notes*, 30–31, 215; *A Christmas Carol in Prose*, 223

Dickie and Murray, 281 and n.86

Dietz, Brother and Company, girandole set depicting Louis Kossuth, *570*; no. 303

dining rooms: Elizabethan, 302; glassware displays, 340; Louis XV-style, 310

dioramas, 76

Dioramic Institute. *See* Marble Buildings

dishes: earthenware, *542*; no. 260; glass, *552*; no. 275

Dix, John Ross, 40n.233; *Hand-book of Newport, and Rhode Island*, 120, 121, 123

Dixey, George, 47, 49, 50, 60

Dixey, John, 135; *Alexander Hamilton*, after Ceracchi, 144–45; *Justice*, for City Hall, 135–36

Dixon, James, and Sons, tray for presentation tea and coffee service, *569*; no. 301

Dobelman, John, 349n.118

Dodge, Charles, 137

Dodge, Edward S., *John Wood Dodge*, *385*; no. 18

Dodge, Jeremiah, 137

Dodge, John Wood: *Kate Roselie Dodge*, *385*; no. 20; portrait of, by E. S. Dodge, *385*; no. 18

Dodge, Kate Roselie, portrait of, by J. W. Dodge, *385*; no. 20

Dodge, S. N., **69**, 80

Dodworth, Allen, 69

Dodworth Studio Building, 61, **69**, 79, 80

Doepler, Carl Emil, 315n.191; wood engraving after, by J. W. Orr, *The Children's Sofa*, 308, *308*; fig. 251

Doge's Palace, Venice, 187

Do-Hum-Me, grave marker for, 148n.51

Domenichino, 49, 86

Donaldson, Robert, 300; window bench made for, by Phyfe, *292*, 294, 300; fig. 238

Doney, Thomas, after Bingham, *The Jolly Flat Boat Men*, 33, 206, 207, *459*; no. 127

Doolittle, Isaac, 191

doorplate depicting New York Harbor, 337, *337*; fig. 275

Dorflinger, Christian, 348–49 and n.118, 350; tea service made for, 349, *349*; fig. 286. *See also* Long Island Flint Glass Works

Dorflinger, Mrs. Christian, presentation vase made for, 348, *555*; no. 278

Dorflinger Guards, 348, 349n.116

Dorflinger Works, 341

Doric order, 171–72 and n.14, 173, 174, 176

Dou, Gerrit ("Gerard Dow"), 85

Doughty, Thomas, 99, 110

Douglas, Sen. Stephen A., statuette of, by Volk, 80

Douglass, A. E., collection, 79

Douglass, David B., 10; University of the City of New York, Washington Square, *176*; fig. 136

Downing, Andrew Jackson, 36, 41, 43, 181, 301–2, 318; *The Architecture of Country Houses*, 180, 212, 298, 302, *302*, 303n.109, 317n.203; fig. 246; *Cottage Residences*, 180; *Treatise on the Theory and Practice of Landscape Gardening*, 180

Doyle, John, **69**

Draper, John, 228, 229n.9, 232, 234

Draper, Simeon, **69**

draperies. *See* curtains and draperies

Drawing Association. *See* New York Association of Artists

drawing-room chairs, *292*, *299*; figs. 237, 244

drawing rooms, furnishings, *290*, *306*, *307*, *308*, 307–8, 310; figs. 235, 249–51; in painting *Family Group*, 297, *383*; no. 13. *See also* parlors

Drayton, James Coleman, 372n.86

dresses, *250*, *251*, 254, 257n.44, *498*, *499*, *500*; figs. 202, 204, nos. 198–200. *See also* ball gowns

dressmakers, 247, 249 and n.28

dressmaking patterns, 247, 249

*dressoirs*, *309*, 311, 322n.221; fig. 252. *See also* buffets; sideboards

Dripps, Matthew (publisher), *465*; no. 136

druggets, 268, 272

dry-goods stores, 23, 245, 247, 259 and n.2

DuBois, Mary Ann Delafield, 148

Dubufe, Claude-Marie, 55–59, 73, 76, 209; Adam and Eve paintings, 54–59, 76, 78; —, copies after, 56; —, engravings after, by Ryall, 55, *57*; figs. 42, 43; *Circassian Slave*, 56; *Don Juan and Haidee*, 56; *Portrait of Rosa Bonheur*, 64; *The Prayer*,

59; *Princess of Capua*, 56; *Saint John in the Wilderness*, 56

Dudley, Mrs. Jonas C., mantilla wrap worn by, *503*; no. 205

Duggan, Peter Paul, American Art-Union medals designed by, *565*; nos. 292, 294, 295

Dumke and Keil, lithograph, *Broadway, from Warren to Reade Streets*, 19; fig. 14

Dummer, George, 331, 342; factories, *see* Jersey Glass Company; Jersey Porcelain and Earthenware Company

Dummer, George, and Company (retail store), 327 and n.2, 341n.78, 342, 345

Dumont and Hosack, 57, **69**, 78

Dunbar, Samuel, 177

Duncan, Thomas, *The Triumphant Entry of Prince Charles Edward into Edinburgh*, 79

Dunlap, William, 48, 49, 50, 53, 55, 75, 84, 85, 107, 110, 140, 141; *Christ Healing the Sick*, after West, 56, 76; *Christ on Calvary*, 75; *Death on the Pale Horse*, 75, 78; *History of the American Theatre*, 84; *History of the Rise and Progress of the Arts of Design*, 84, 85, 86, 14In.25, 143, 147n.48

Dunn, David, 363

Duponchel, Félix, 189

Du Pont, Samuel Francis: pitcher ordered by, 330n.14; presentation table service made for, 373, *374*; fig. 309

Durand, Asher B., 48, 49, 55, 57, 83, 84, 87, 88, 91, 92, 99, 106–7, 109, 114, 118–19, 154, 160, 190, 199–200, 201, 202n.46, 210, *481*; no. 162; *The American Landscape* project, 201; —, engravings for, after Bennett, 201, *201*; fig. 158; *Ariadne*, after Vanderlyn, 199, 201, 205, 212, *458*; no. 125; banknotes, 201, *448*, *449*; nos. 115, 116; *The Beeches*, 101; *Dance on the Battery in the Presence of Peter Stuyvesant*, 388; no. 25; *The Declaration of Independence*, after Trumbull, 200, *200*; fig. 157; *De Witt Clinton*, after Ingham, 3, 202, *454*; no. 122B; *Dover Plains*, engraving after, by Smillie, 207; *Franconia Notch*, 101; *In the Woods*, 88, *393*; no. 31; *Kindred Spirits*, 57, 110, *392*; no. 30; *Lafayette*, 254n.38; "Letters on Landscape Painting," 118; *Luman Reed*, 13, *382*; no. 9; *Musidora*, 90, *91*; fig. 61; *Self-Portrait*, *381*; no. 8; *A Study and a Sketch*, 204, *462*; no. 132; *Thomas Cole*, 35, *382*; no. 10; *The Wife*, after Morse, *291*, 292; fig. 236

Durand, Cyrus, 201

Durand, John, 86; *Life and Times of A. B. Durand*, 106–7

Durand, Perkins and Company (publisher), 201, *448*, *449*; nos. 115, 116

Dürer, Albrecht, 86, 92, 93, 96, 103, 211; *Fall of Man (Adam and Eve)*, 93, *93*, 211; fig. 64

Duryee, Col. Abram, service presented to, 375, *375*, *573*; fig. 310, no. 310

Düsseldorf Academy artists (Düsseldorf School), 79, 80, 78, 80, 99, 107

Düsseldorf Gallery (Church of the Divine Unity), 58–59, *59*, 60, 62–63, *63*, 65, 68, **69**, 78, 80, 107, 154; figs. 48, 52; Powers, *The Greek Slave*, at, 160, *161*; fig. 121

Dutch paintings, 75, 87; prints, 211, 212

Duteis firm, Paris, 247

Duyckinck, Evert, 349–50n.120

Duyckinck, Evert A., 268, 274, 281, 283

Duyckinck, Mrs., 284

Dwight, Theodore, 123; *Journal of a Tour in Italy*, 123–25, 126, 128; *Northern Traveller*, 112, 113–14, 115; —, engraving from, by

Maverick, *Lake George*, 113, 113–14; fig. 80; *Sketches of Scenery and Manners in the United States*, 115, 116; —, engraving from, by Wadsworth, *Avalanches in the White Mountains*, 115, 116; fig. 82

Dwight, Timothy, 4, 111, 112, 115

Dyck, Anthony van, 86, 89

earrings, 247; in parure, *505*; no. 210

earthenware, 330–31, 333–34, 336; hot-milk pot or teapot and underplate, *542*; no. 261; monument, 339, *549*; no. 270; pitchers, *538*, *543*; nos. 254, 263; plate, *543*; no. 262; platter, *538*; no. 253; vegetable dish, *542*; no. 260

Eastman, Samuel, 116–17

Easton's Beach, Newport, 121, 122, 123

Ebbinghausen, George, 312n.177

Eddy, Oliver Tarbell, *The Children of Israel Griffith*, 299n.72

Eddy, Thomas, 14

edged wares, 333–34, *542*; no. 260

Edmonds, Francis William, *The New Bonnet*, *398*; no. 39; *The New Scholar*, engraving after, by A. Jones, 207; *Time to Go*, 62, *62*; fig. 51

Eggleso, A., 282

Egyptian antiquities, 94–95, 229

Egyptian Revival style, 10, 174, 180–81, 293

Egyptian sculpture, *Family Group, Possibly Iru-Ka-Ptah and His Family*, 95, *95*; fig. 66

Ehninger, John W., *Foray*, 62

Eidlitz, Leopold, 181, 186

electroplated tablewares, 368

elevators, 22 and n.96

Eliot, William H., 174

Elizabethan Revival style, 302, 302–3, 305, 309n.145; fig. 246

Elkington and Company, Birmingham, England, 368

Ellet, Charles, 10

Ellington, George, *The Women of New York*, 257

Elliott, Gen. George, depicted in Trumbull, *Sortie Made by the Garrison at Gibraltar*, 46, 51, 52; fig. 38

Ellis, J. L., 364, 372. *See also* Tiffany, Young and Ellis

Ellis, Salathiel, American Art-Union medal, *565*; no. 293

Elmes, James, 181

Elssler, Fanny, portrait of, by Heidemans, after Inman, *458*; no. 126

Elysian Fields, Hoboken, vase depicting, *328*; fig. 266

embroidered goods, 246–47, 252, 253

Emerson, Ralph Waldo, 119

"Empire City," sobriquet, 189, 314n.190. *For prints with this title, see* Bachmann, John; Lumley, Arthur

Empire style, 253, 292. *See also* Grecian style

Endicott, George, lithographic firm, 195, 217, 218–19; after Penniman, *Novelty Iron Works*, 189, *215*, 217, 218; fig. 170; after Schmidt, *Park Hotel*, *175*; fig. 134

Endicott, George and William (G. and W. Endicott firm), 118; after "Spoodlyks" (possibly George T. Sanford), *Santa Claus's Quadrille*, 216, 218–19 and n.114; fig. 171

Endicott and Company, 217, 218; *Christy, Constant and Company*, *276*; fig. 228; *Fanny Elssler*, by Heidemans, after Inman, 218n.110, *458*; no. 126; *An Interior View of the Crystal Palace*, by Parsons, *467*; no. 142

Endicott and Swett (publisher), broadside for Joseph Meeks and Sons, 296, *517*; no. 225

End of the Rabbit Hunt pitcher, 333, 334n.36, *540*; no. 256

England, 125, 227, 267; architecture, 171, 176, 182, 184–85

English: cut-steel necklace, *254*; fig. 206; man's tailored ensemble, 254, *498*; no. 197; platter depicting Lafayette's arrival at Castle Garden, 330, *538*; no. 253; pitcher depicting City Hall, 8, 330, *538*; no. 254; probably, "Cries of New York," commemorative handkerchief, 28, *29*, 32; fig. 24; —, pair of argand lamps, *563*; no. 289

English paintings, 87, 97, 99

Enlightenment, 12, 24, 123

Eno, Amos F., collection, 225

Eno's Hotel, 265

Eoff, Edgar Mortimer, 361, 374

Eoff, Edgar Mortimer, and Shepard, George L. (Eoff and Shepard firm), 374; pair of pitchers presented to Julie A. Vanderpoel, *359*, 361; fig. 295

Eoff, Garret, 361; tea service presented to Charles Rhind, 358

Eoff and Moore, 361

Eoff and Phyfe, 361 and n.24

Episcopal chair, *299*; fig. 244

Episcopal Church, 182, 370

Ericstan (John J. Herrick house), Tarrytown, 180, 301, *441*; no. 102; chairs associated with, 301, 302n.96, *523*; no. 235

Erie Canal (Grand Canal), 3–4, 9, 10, 19, 25, 44, 109, 110, 112, 114, 123, 189–90, 227, 287, 288, 327, 331, 355, 361; depicted, bas-reliefs on base of H. K. Brown, *De Witt Clinton*, 157, *157*; fig. 118; —, views by J. W. Hill, 112, *444*; nos. 106, 107; opening day and celebration, *see* Grand Canal Celebration

étagère, 320, *532*; no. 246

étagère-sideboard (*buffet étagère*), 318, *530*; no. 243

etchings, 224–25

Eugénie, empress of France, 247, 256, 312, 318, 324; gun case purchased by, *319*, 321; fig. 261; portrait of, by Winterhalter, 65, *65*, 80, 312; fig. 56

Europe, travel to, 123. *See also* Grand Tour

European: fan, *254*, *501*; fig. 206, no. 202; paisley shawl, *500*; no. 200

European art, 50, 54, 62, 63, 75, 77, 88, 98–99, 102, 103, 104, 105–6, 107; prints, 207, 211–12

Evans, Edward, 92

Everett, Edward, 161

ewer (pitcher), silver, 355, *357*; fig. 291

Exhibition of the Industry of All Nations. *See* New York Exhibition of the Industry of All Nations

exhibitions and venues, 47–65, **66–74**, 75–81

Exposition Universelle (Paris, 1855), 312, 320–21; case pieces, *319*, 321, *321*, 322n.221, 324 and n.232; figs. 261, 263; silk moiré, 247

fabrics: dressmaking, 247; upholstery, 282

Faed, Thomas, 79

Fagnani, Joseph, collection, 80

Faile, T. H., 88

Falconer, John M., 91–92

Falcon Glass Works, London, 345n.93

fall-front secretary, 296, 297n.68, *519*; no. 229

*Family Group, Possibly Iru-Ka-Ptah and His Family* (Egypt), 95, *95*; fig. 66

fans, *254, 501, 503*; fig. 206, nos. 202, 205
Farmar, Rev. Samuel, collection, 78
fashion and costumes, 243–57; nos. 197–205
fashion magazines, 247 and n.16
fashion plates, 249
Fatzer, C. (printer), *473*; no. 150
*fauteuils*, 305; in floor plan, *306, 307*; fig. 249. *See also* armchairs
Fay, Augustus, 217; *Exterior of Goupil & Co., Fine Art Gallery, 64*; fig. 55; *Temperance, but No Maine-Law, 217, 217*, 219–20; fig. 173
Fay, Augustus, and Cogger, Edward P., wood engraving after Wells, *All-Souls' Church, 186, 187*; fig. 146
Faye, Donnelly and Company, 274
Faye, Thomas, firms, 274, **274–75**, *276*; fig. 227
Federal Hall. *See* United States Custom House
Federal period, 261, 292
Fellows, Hoffman and Company. *See* Starr, Fellows and Company or Fellows, Hoffman and Company
Felton, Mrs., 32
Fenton, Christopher Webber, 336n.42, 339
Ferguson, Herbert Q., 336
Ferrero, Madame V., 247; bonnet from, 247, *250*, 251; fig. 201
Ferrin, Jane, 281
Ferris, John H., 264, 265
Ferris and Taber, 264, 265
Fiedler, Ernest, family, portrait of, by Heinrich, 180, *261, 261*, 305; fig. 211
Field, Cyrus West: furnishings for, 313; medals and presentation boxes honoring, 374–75, *572*; nos. 307, 308; sections of transatlantic cable authenticated by, 375, *572*; no. 309
Field, David Dudley, 313
Field, Henry M., 43
Field, Marshall, store, Chicago, 248
Fifth Avenue, 13, 16, 185, 187, 320, *491*; no. 185
Fifth Avenue Hotel, 185, *328*, 330; fig. 267
Fillmore, Millard, 248
financial panics. *See* Panic of 1837; Panic of 1857
Finden, Edward Francis, 91
fire companies, 33
Fire Department Fund, 315
fires: of 1776, 5; of 1835, *see* Great Fire
fire screen, 320, *533*; no. 247
First Merchants' Exchange (1825–26), 18–19, 28, 34, 169, 170–71, *170, 171*, 172, 173, 175, 181, 214, *426, 427*; figs. 129, 130, nos. 74–76; statue for, by Hughes, *Alexander Hamilton, 34*, 140, 141, 144; vase depicting, 170, *328*, 330n.6, *537*; no. 251
*First Meserole House, Home of Almon Roff, Wallabout, Brooklyn, 234, 235*; fig. 185
First Presbyterian Church, 185
First Reformed Dutch Church, Brooklyn, 176
Fish, Hamilton, 102–3, 152–53, 163, 165, 167; mantel made for, by Fisher and Bird, 103, 262, *262*, 264, *513*; fig. 212, no. 220
Fisher, Henry, 273, 274
Fisher, J. G., 268
Fisher, John, 341, 342
Fisher, John Thomas, 263
Fisher, Richard (glassmaker), 340n.68, 341, 342
Fisher, Richard (silversmith), 370. *See also* Cooper and Fisher
Fisher, Richard and John, glassworks. *See* Bloomingdale Flint Glass Works

Fisher, Robert, secretary-bookcase, *293, 294–95* and nn.50, 52; fig. 239
Fisher, Robert C., 263
Fisher, Sidney George, 4, 273
Fisher and Bird, 137, 263, **263–64**, 265 and nn.13, 14; fig. 214; mantel depicting scenes from *Paul et Virginie*, 103, 262, *262*, 264, *513*; fig. 212, no. 220; mantel for Litchfield Villa, 264, *264*, 265; fig. 215
Fitch, T., and Company, **69**
Five Points district, *7*, 28, 30–31, *32, 33*; Gotham Court, *17*, *17*; fig. 11; Old Brewery, *31*; fig. 27
*Five Senses—No. 1, Seeing, 25, 25*; fig. 20
Flagg, George, 87
Flandin, Pierre, 51, **69**
flatware, silver, 366; Gothic-pattern, 367, *568*; nos. 299, 300
Flaxman, John, 140
Flemish art, 75, 81, 86, 87, 99, 211, 212
Fletcher, J., "Gladiatorial Table," 322n.222
Fletcher, Thomas, 355, 361; presentation vase, *360*, 361–62; fig. 296. *See also* Fletcher and Gardiner
Fletcher and Gardiner, Philadelphia, 361; pair of covered presentation vases presented to De Witt Clinton, 355, *356*, 358, 361, *558*; fig. 290, no. 281A, B
flint glass, term, 341
flint stoneware, 332–33 and n.31, *338*; fig. 276. *See also* stoneware
floor coverings, 265–72. *See also* carpets
Florence, Italy, 95, 126, 127, 135, 141
Fly Market, 8
Fontaine, Claude G., 83
Foot, Samuel, chairs made for, 296, 287n.66
Forbes, Abraham G., 361
Forbes, Colin van Gelder, 355 and n.5, 361 and n.19. *See also* Forbes, Colin V. G., and Son
Forbes, Colin V. G., and Son, 361 and n.19; presentation hot-water urn, 361, 363–64, *564*; no. 290
Forbes, John W., 355–58 and n.5, 361 and n.19; plateaus, 355–58 and n.5, *357*; fig. 292
Forbes, William, 361; pitcher and goblet, *572*; no. 306. *See also* Forbes, Colin V. G., and Son
Forbes, William Garret, 355n.5, 361
Forest, Charles de la, collection, 78
fork, silver, *568*; no. 300
Forrest, Edwin, bust of, by Browere, 138
Forsyth, John, and Mimee, E. W., *Bird's-Eye View, Trinity Church, 182, 182*; fig. 142
Fort Adams, Newport, 122
Fort George, 112, 113
Fort Hamilton, 339, *494*; nos. 190, 191
Fort Ticonderoga, 112, 113
Fort William Henry, 112
Foster, George G., *New York by Gas-Light*, 31, 33, 40
Fourdinois, Alexandre-Georges, 320; chair, 324; sideboard, 318, 321
Fowler, Crampton and Company, 349n.118
Fowler, W. C., 349n.116
Fox, Charles Patrick, 248
Fragonard, Jean-Honoré, 324
France, 125, 228, 238, 267, 290, 311
Francis, Dr. John W., 83, 196
François, Alphonse, after Delaroche, *Napoleon Crossing the Alps, 211, 478*; no. 158
Francophilia, 305
*Frank Leslie's Gazette of Paris, London and New-York Fashions*, wood engravings from, *250, 251*; figs. 201–4

*Frank Leslie's Illustrated Newspaper*, 62, 64, 95; wood engravings from, *34, 58, 256, 375*; figs. 29, 30, 45, 208, 310
*Frank Leslie's Sunday Magazine*, wood engraving from, *17*; fig. 11
Franklin, William H., and Son, **69**, 78
Franklin and Mindurn, 69
Franklin Institute Fair, Philadelphia, 345
Franklin Theatre, 40
Franquinet, William, collection, 77
Fraprie, Stephen T., 373
Frazee, John, 34, 137–38, 140, 141 and n.23, 144, 146–48 and nn.48, 49, 171, 262n.7; *Daniel Webster, 147*; *John Jay, 34, 146*, 147; fig. 111; *John Marshall, 147*; *John Wells Memorial*, 137; *Marquis de Lafayette*, 137; *Nathaniel Bowditch, 147*; *Nathaniel Prime, 147, 413*; no. 56; *Self-Portrait, 138, 139*; fig. 105; United States Custom House, 147, 148; Washington monument, design for, 78, 152
Frazee, William, 137
Frazee and Launitz firm, 147–48
Frazer's Gallery, **69**
Fredricks, Charles DeForest, 232, 239 and n.36, 240; *Amos Leeds, Confidence Operator, 241, 305, 487*; no. 177; attributed to, *Fredricks's Photographic Temple of Art, 239, 496*; no. 194. *See also* Holmes, Silas A., or Fredricks, Charles DeForest
Fredricks's Photographic Temple of Art, 239, *496*; no. 194
French chairs, 296, 297 and nn.65, 66, *518*; no. 226
French fashions, 247, 256, 257, *502*; no. 204
French furniture, 305, 307–9, 310, 312; center table, 305n.129, *307*, 308 and n.140, 320, *531*; fig. 250, no. 244; in drawing room at Grace Hill, *307*, 308; fig. 250; floor plan with, *306, 307*; fig. 249; lady's writing desk, 313 and n.180, *525*; no. 237; sofa and armchair, by Ringuet-Leprince, 93, *307*, 310, *524*; no. 236A, B
French Gothic style, 183
French paintings, 64, 80, 81, 99, 208–9
French polishing, 295–96 and n.60
French porcelain, 327–28, 330, 332; decorated pitchers, *328, 329*, 330; figs. 267, 269; decorated vases, 195, 327–28, *328*, 330, *536, 537*; fig. 266, nos. 250–252; dinner services for White House, *329*, 330; fig. 268
French prints, 208, 211
French Renaissance style, 185–86, 187
French Restoration style, 297
French Revolution, 253
French taste, 305, 324
French textiles, 255–56, *512*; no. 219
French wallpapers, 272–74, *273, 275*, 277, 279, 280; fig. 225
Frère, Charles-Édouard, 64, 92
fretwork (*découpure*), 302, 303n.108
Fullerton, W. R., "Papier Mache Ware-Room," 313n.182, 315
Fulton, Robert, 52, 75, 83, 191, 208n.70; bust of, by Houdon, 137, *410*; no. 53
Fulton Market, 8, *451*; no. 120
Fulton Street, 5, 289, *451*; no. 120
Funk, Peter, Picture Making Establishment, **69**
furniture, 93, 287–325; nos. 221–238, 240–249; gilded, 321n.216; with sculpted figures, 321–22 and n.222; secondhand, 303–5 and n.122, 306n.133
Fürst, Moritz, 363; prize medals, 363, *565*; no. 291

Gager, A. O., and Company, 339
Gainsborough, Thomas, 105
Gale, William, 355, 363, 366, 373; covered ewer presented to the owners of the boat *Mary and Hannah*, 355 and n.4, *357*, 359; fig. 291
Gale, William, and Hayden, Nathaniel (Gale and Hayden firm): Gothic-pattern design patented by, 366–67, *568*; nos. 299, 300; urn presented to Henry Clay, 368 and n.66, *369*; fig. 302
Gale, William, and Moseley, Joseph (Gale and Moseley firm), 363; coffee urn, 363, *560*; no. 285; tureen, *361*, 363 and n.34; fig. 297
Gale, William, and Son, 373; Gothic-pattern silverware, 367, *568*; nos. 299, 300
Gale, Wood and Hughes, 373
*Gallery of Illustrious Americans*, lithographs by D'Avignon, after daguerreotypes by Brady, with text by Lester, 219 and nn.117, 118, 230–31, *482*; no. 165B; Audubon portrait from, 230–31, *482*; no. 165A
Gallery of Old Masters (Gideon Nye collection), 40, 58, 78, 158
Gallier, James, 173, 175–76, 181
Gambart, Ernest, 64, **69**
*Garde-meuble, ancien et moderne, Le*, 306 and n.138, 307; plates from, *304, 306*, 306–7 and n.138, *309*, 311; figs. 248, 249, 252
Gardiner, Baldwin, 327, 334–36n.41, 345, 361–62, 363, 367; four-piece tea service, *559*; no. 284; tureen with cover on stand, *561*; no. 286; retailed for Fletcher, vase presented to Hugh Maxwell, *360*, 361–62; fig. 296
Gardiner, Catherine Peabody, 292n.35
Gardiner, Mrs. David Lyon, 256; ball gown worn by, 253, *502*; no. 204
Gardiner, Julia, 248, *248*, 249n.23; fig. 199
Gardiner, Sidney, 355, 361. *See also* Fletcher and Gardiner
Gardner, Alexander, 240; *Antietam Battle Field, 240*, 241; fig. 192
*Garland, The*, 223
garment industry, 249–51
Garrard, R. and S., London, 364
Garrett, William, 277
gasolier, *570*; no. 302
Gasse, N., *Galileo at Florence*, 79
Gay, Winckworth Allan, 119
Gaynor, John P., Haughwout Building, 21–22, *21, 22, 23*, 185, *439*; figs. 16, 19, no. 98
Gay Street, artisan-type houses, *15*, 16; fig. 8
Geer, Seth, 177; La Grange Terrace (Colonnade Row), *15*, 16; fig. 9. *See also* Davis, Alexander Jackson, and/or Geer, Seth
Gelston and Treadwell, bouquet holder, *504*; no. 207
*Gem, or Fashionable Business Directory*, 313
Gem Saloon, 217, 219–20; fig. 173
General Convention of the Friends of Domestic Industry (1831), 308
Genin, John N., store, 32, 247, 248; ball gown from, *251*; fig. 203; pedestrian bridge across Broadway, 32, *32*; fig. 28
Genings, Michael, **69**
genre scenes, prints, 212
gentility, 27–28, 36, 43
George III, king of England, equestrian statue of, by Wilton, 135
George IV–style rivière, *502*; no. 204
Gericault, Théodore, *Raft of the Medusa*, copy after, by Cooke, 54
German immigrants, 13; cabinetmakers, 289, 290, 295, 305; lithographers, 220

German paintings, 87, 99; prints, 211
Gérôme, Jean-Léon, 64, 94
Gibbon, Edward, 127
Gibbs, James, 171n.6
Gibney, Michael, 366
Gibson, William, 318; Stained Glass Works, 350, *350*, 351, 352n.130; fig. 287
Gifford, Sanford Robinson, 101, 112, 114, 119, 123, 125, 128, 130n.119; *Kaaterskill Clove*, 110, *129*, 130; fig. 98; *Lake Nemi*, 128–30 and n.119, *397*; no. 36; *On the Roman Campagna, a Study*, 128, *128*; fig. 97
Gignoux, Régis-François, 105; *Niagara by Moonlight*, 80
Gilbert, Philo B., 366, 370
Gilded Age, 45, 120, 257, 325
Gildemeister, Charles, and Carstensen, J. B., Crystal Palace, 41; *Ground and Gallery Plans*, 41, *41*; fig. 35
Gillespie, William, *Rome*, 152
Gilliland, John L., 341, 342, 348. *See also* Brooklyn Flint Glass Works
Gilmor, Robert Jr., 48, 50
Giotto di Bondone, 103
girandole set, *570*; no. 303
Girtin, Thomas, 196
*Glances at the Metropolis*, 279
glass, 339–53; nos. 271–280. *See also* glassware; stained glass
glasscutting, 341, 342, 344–46, 348
glass negatives, 239, 240
glass press, 340–41
glassware, 327, 339–50; Bohemian (colored), 343–44; compotes, *551*, *556*; nos. 273, 279; covered box, *552*; no. 274; decanter, *550*; no. 271; decanter and wine glasses, *553*; no. 276; goblet depicting City Hall, 343, *344*; fig. 281; oval dish, *552*; no. 275; presentation vase, *555*; no. 278; product lines and exhibition pieces of various glassworks, *342*, *347*, *346*, *348*; figs. 278, 283–85; salt, *550*; no. 272; service of table glass made for a member of the Weld family, 346, 347n.106, *554*; no. 277
Gleason, Elliot P., Manufacturing Company, 349n.118
*Gleason's Pictorial Drawing-Room Companion*, 202, 314n.188; wood engravings from, *27*, *32*, *311*, *317*, *338*, 339; figs. 22, 28, 255, 260, 276
Gleason-Tiebout Company, 349n.118
Glover, John B., **69**, 77
gloves, 252, *254*, 255; fig. 206
goblets: glass, *344*; fig. 281; silver, *567*, *571*, *572*; nos. 298, 305, 306
*Godey's Lady's Book*, 18, 42, 228–29, 246, 247 and n.15, 253, 261, 268, 272; wood engravings from, *247*, *369*; figs. 198, 303
gold: bouquet holder, *502*; no. 204; box, 359; medals, *559*, *562*, *572*; nos. 283A, B, 287, 307; tea services, 370, 372, *372*; fig. 307
Goldsmith, Deborah, *The Talcott Family*, 267n.26
Goltzius, Hendrik, 83
Goodhue and Company, 53
Goodrich, A. T. (publisher), *115*; fig. 82; visitors' guides, 169, 172, 177
Goodrich, C. R. *See* Silliman, Benjamin Jr., and Goodrich, Charles Rush
Goodwin, Francis, Old Town Hall, Manchester, England, 171
Gordon, Robert, family portrait of, by Guy, 318n.205
Gorham Manufacturing Company, Providence, Rhode Island, 366, 375
Gori, Catherine, 265

Gori, Ottaviano, 184, **265**, *266*, fig. 217
Gori and Bourlier, 265
*Gotham Court, Five Points*, 17, *17*, 30; fig. 11
*Gothic Furniture*, 299, 300; fig. 244
Gothic-pattern silverware, 367, *568*; nos. 299, 300
Gothic Revival style, 152, 169, 172, 175, 176, 180, 181–83, 186, 187, 264, 297, 298–301, 316, 317, 350, 351–52, 363, 369, 370
Goupil, Adolphe, 208
Goupil, Léon, 208
Goupil, Vibert and Company, 58, 69, 78, 208–9
Goupil and Company, 59, 60, 63–64, *64*, 65, 69, **69**, 70, 74, 79, 80, 81, 208–9, 211nn.75, 77; fig. 55
Gouraud, M., 229 and n.8
Gouvello, Marquis de, collection, 55, 76
Governors Island, vases depicting New York City from, 195, 327–28 and n.5, *328*, 330n.6, *536*; fig. 266, no. 250
Governor's Room, City Hall, **69**
Gowans, William, **69**, 72
Gowdy, Thomas, and Peabody, John, urn presented to Henry Clay, 368 and n.66, *369*; fig. 302
Grace Church (Broadway and Rector), sculpture for, by Frazee, *John Wells Memorial*, 137; (Broadway and Tenth Street), *7*, *168*, 182–83, *437*; no. 95; —, depicted on wallpaper, *510*; no. 216
Grace Hill, Brooklyn. *See* Litchfield Villa
Gracie, William, 48, 50
Gradual Manumission Act (1799), 13
Graham, Curtis Burr, lithograph, *244*; fig. 195
Graham, Mr. (blind poet), 55, 144
Grand Canal Celebration (1825), 3, 25, 189, 287, 358, 359, *450–51*; nos. 117, 118; commemorative medals, 287, 358, *559*; nos. 282A, B, 283A, B; commemorative volume, see *Memoir*; pitcher presented to chairman of Committee of Arrangements, 358, *358*; fig. 293; tray presented to admiral of Grand Aquatic Display fleet, *358*, 358–59; fig. 294
Grand Street, 20
Grand Tour, 123, 126, 130, 173, 211, 224, 303
Granet, François-Marius, *Capuchin Chapel*, 75
Granite Buildings, 77
Gray, Henry Peters, 154
Greatbach, Daniel, 334, 336n.42; pitcher made for William Henry Harrison's presidential campaign, 334, *543*; no. 263; probably modeled by, Thistle pitcher, *542*; no. 259
Great Exhibition of the Works of Industry of All Nations (Crystal Palace exhibition; London, 1851), 40, 41, 42, 162, 219, 220n.117, 234, 236, 248, 314n.189, 316, 318, 321, 322n.222, 324, 331, 332n.22, 339, 346–48, 370; Brooklyn Flint Glass Works exhibit, 346, 348, *348*; fig. 285
Great Fire of 1835, 10, *10*, 19, 28, 34, 145, 175, 180, 197, *446*; fig. 6, nos. 110, 111
Grecian ("modern") style, 170–71, 173, 292–98, 299, 320. *See also* Greek Revival style
Greco-Roman classicism, 176
Greek Revival style, 28, 169, 171–73 and n.14, 175, 176, 177, 179, 180, 292; double parlor, 180, 291, *447*; no. 112. *See also* Grecian style
Greek War of Independence, 158, 166
Greeley, Horace, 158, 322, 339
Greenfield, John, 330, 331n.20

Greenough, Horatio, 141 and n.25, 148, 151, 161; *Chanting Cherubs*, 54, 75, 141, *143*, 144, 145n.38, 147; fig. 108; *George Washington*, 36, 144, 145n.39; *James Fenimore Cooper*, 141, *142*; fig. 107; Washington monument, model for, 144
Greenough, Richard, *Young Shepherd Boy Attacked by an Eagle*, 79
Greenpoint, Brooklyn, 336, 339
Greenpoint Glass Works, 348, 349n.118
Greensward Plan of 1858. *See* Central Park
Greenwich Bank of New York, engraving of $1,000 bill for, by Durand, 201, *448*; no. 115
Greenwich Street, 32, 179
Greenwich Village, 13, 177; artisan and tenement housing, *15*, *16*; figs. 8, 10
Green-Wood Cemetery, Brooklyn, 43, 148 and n.51, 160; sculpture for, by H. K. Brown, *De Witt Clinton*, *157*, 157–58; fig. 118
Greiff, Charles, 366
Griffen, James, **70**
Grinnell, Minturn and Company, 92
Grotin, Hugo, 40
Grove Court, rear tenements, *16*, 17; fig. 10
Grund, Francis J., 27, 43
Guéret Frères, chimneypiece, 322n.222
Guérin, Pierre-Narcisse, 209
Guidicini, Giuseppi, attributed to, painted wall and ceiling decorations, Victoria Mansion, Portland, Maine, 286
Guilmard, Désiré, 306, 320; "*chaise de fantasie*," *304*, 307; fig. 248; "Renaissance" oak sideboard, 324. *See also* Garde-meuble
gun case, *319*, 321; fig. 261
Gurley, George H., *70*. *See also* Royal Gurley
Gurley and Hill, 70
Gurney, J., and Son, possibly, "*The Heart of the Andes" in Its Original Frame, on Exhibition at the Metropolitan Fair*, 130, *132*, 133; fig. 101
Gurney, Jeremiah, 69, 231–33 and n.24, 236, 239; Daguerreian Gallery of, 231–32, *233*; fig. 183; *A Fireman with His Horn*, 33, 233, *486*; no. 176; *The Kellogg-Comstock Family*, 232, *485*; no. 172; *Mrs. Edward Cooper and Son Peter (Pierre) Who Died*, 232, *483*; no. 167; *Two Girls in Identical Dresses*, 232, *232*; fig. 182; *Young Girl*, 232–33, *486*; no. 174
Gurney, Jeremiah, and Fredricks, Charles DeForest, firm, 239, 240
Gutenberg Bible, 97
Guy, Francis, 75
Guy, Seymour, *The Contest for the Bouquet: The Family of Robert Gordon*, 318n.205

Hagen, Ernest, 295, 296–97n.65, 313, 314–15 and n.192
Haig, George Ogilvy, 372 and n.86
Haight, Richard K., 103, 152, 154
hair bracelet, *505*; no. 209
Hall, Mrs. Basil, 340
Hall, George H., 80
Hall, John, *Cabinet Maker's Assistant*, 296 and n.63
hall chair, 301, *523*; no. 234
Halleck, Fitz-Green, 110; portrait of, by Morse, *380*; no. 5
Halls of Justice. *See* New York Halls of Justice and House of Detention
Halsted, Oliver, **70**
Hamilton, Alexander: bust of, by Dixey, after Ceracchi, 144–45; portrait of, by Trumbull, 34, *378*; no. 1; statue and

statuettes of, by Hughes, 34, 140, 141, 144–45, *145*; fig. 110
Hamilton, Col. Thomas, 298, 300n.78
Hamilton Square, 152
Hamson, R. N., and Levy, A., 71, 75
handbill, *343*; fig. 280
handkerchief. *See* "Cries of New York"
Hannington, Henry, 351 and n.127
Hannington, William J., 349n.119, 350, 351 and n.127, 352n.129
Hardenbergh, John P., 279
Harding, George M., 70
Harper, James, 202 and n.47
Harper and Brothers, 202, 204, 224; wood engravings published by, *121*, *203*, *308*; figs. 88, 159, 251
*Harper's New Monthly Magazine*, 4, 23, 42, 65; wood engravings from, *18*, *25*; figs. 12, 20
*Harper's Weekly*, 95, 106, 205; wood engravings from, *37*, *105*, *120*, *205*, *243*, *255*; figs. 32, 77, 87, 161, 194, 207
Harrington, H., panorama and dioramas, 76
Harrington, W. J. and H., 71
Harris, Madame, 247, 257n.46
Harrison, Benjamin J., *Annual Fair of the American Institute at Niblo's Garden*, *249*, 250; fig. 200
Harrison, Gabriel, 234, 236; *California News*, 234, *484*; no. 169; *Walt Whitman*, engraving after, by Hollyer, 204–5 and n.57, 234, *470*; no. 146; attributed to, *Walt Whitman* ("Christ likeness"), 204, 234, *481*; no. 163
Harrison, John F., *Map of the City of New York, Extending Northward to Fiftieth Street*, 5, *465*; no. 136
Harrison, William Henry, pitcher made for presidential campaign, 334, *543*; no. 263
Hart, Charles, 219, 224
Hart, Henry I., 285 and n.107
Hartford Carpet Company, 268, 272
Harvey, George, 77, 197; frontispiece after, by Bennett, *Harvey's American Scenery, Representing Different Atmospheric Effects at Different Times of Day*, 197, *198*; fig. 155
Hasbrouck, Levi, 152
Haseltine, William Stanley, 101, 119, 123
Hasenclever, Johann Peter, 99
hats, 247, 248, 250, *498*; nos. 197, 198
hatters, 247, 248
Haughwout, E. V., 330 and n.11
Haughwout, E. V., and Company, 21, 22n.96, 23, 185, 327, 330 and nn.11, 13, 14, 345, 346; dinner service for White House exhibited by, 330; —, plates from, *329*; fig. 268; pitcher decorated by, *328*, 330; fig. 267. *See also* Haughwout and Dailey; Haughwout Building
Haughwout, P. N., and Son, 330n.11
Haughwout and Dailey, 330n.11, 339, 346; pitcher decorated by, *329*, 330; fig. 269
Haughwout Building, *7*, 21–22 and n.96, *21*, *22*, 23, 185, *439*; figs. 16, 19, 20, no. 98
Havell, Robert Jr., 127n.108, 197; *Panoramic View of New York (Taken from the North River)*, 197, 220, 460–61; no. 129; *Panoramic View of New York, from the East River*, 197, *199*; fig. 156. *See also Birds of America*
Havell, Robert Jr., Colman, William A., and Ackermann and Company (publishers), 460–61; no. 129
Haviland, D. G. and D., 328, 330 and n.8, 345
Haviland, David, 330n.8

Haviland, John, 174, 181; *Halls of Justice and House of Detention*, 14–15, 174, *429*; nos. 82, 83

Haviland Brothers and Company, 330 and n.8

Hawley, Amos, **70**

Hayden, Nathaniel. *See* Gale, William, and Hayden, Nathaniel

Hayward, W., collection, 76, 77

H. D., *Bay of New York from the Battery*, 192 n.12

headdresses, 255, *502*, *503*; nos. 204, 205

Hearn, George A., 256n.42, 257n.46

Heger, Heinrich Anton, *Cathedral at Halberstadt*, 81

Heidemans, Henry, after Inman, *Fanny Elssler*, *458*; no. 126

Heinrich, Francis H., *The Ernest Fiedler Family*, 180, 261, *261*, 305; fig. 211

Henderson, D. and J., Flint Stoneware Manufactory, Jersey City, 332–33 and nn.32, 33; Acorn and Berry pitcher, 333, *540*; no. 257; End of the Rabbit Hunt pitcher, 333, 334n.36, *540*; no. 256; Herculaneum pitcher, 333, 336, *541*; no. 258; pitcher, 333, *333*; fig. 252. *For successor firm, see* American Pottery Manufacturing Company

Henderson, David, 332, 333 and n.32, 334

Henderson, Howard, 308

Henderson, James, 332, 333, 334

Henry, Michael, 52, 75

Henry, Mr., New-York Gallery of Fine Arts, **70**, 74, 75

"Henry 7th" style, 309n.145

Herculaneum, 116, 123–24

Herculaneum pitcher, 333, 336, *541*; no. 258

Hering, George, *The Village Blacksmith*, 80

Herrick, John J., house. *See* Ericstan

Herring, James, 66, 202. *See also* Longacre, James Barton, and Herring, James

Herrman, Mrs. Peter, wedding gown of, *499*; no. 199

Herter, Gustave, 282, 289, 305–6, 316–18, 320n.209, 321, 322–25; bookcase, *314*, 315–16nn.197, 198, 317, *528*; fig. 257, no. 241; buffet, *315*, 316–17n.201, 317–18; fig. 258; étagère, 316n.199, 317; organ casework, *323*, 325; fig. 265; Victoria Mansion (Morse-Libby House), interiors, 322–25 and nn.230, 237; —, reception room, *286*, 324; —, reception-room cabinet, *286*, 324–25, *535*; no. 249

Herter Brothers, 322n.222

Hewitt family, 261

Heyvetter, A. d', collection, 81

Hicks, Eliza, 155

Hicks, Henry, 152, 153

Higgins, A. and E. S., 267, 268, 270–71

Higgins, Alvin, 268

Higgins, Elias S., 268

High Bridge, 10, 181, *435*; no. 91

Hill, Caroline, 195

Hill, Catherine, 195

Hill, Horatio, **70**, 72

Hill, John, 110–11, 112, 193–95, 196 and n.24; *Broadway, New York*, after Hornor, 5, 19, 31, 196, 235, *455*; no. 123; *City Hall*, after Wall, *135*, 136; fig. 103; *Drawing Book of Landscape Scenery*, 194; *Picturesque Views of American Scenery*, after Shaw, 111, 194. See also *Hudson River Portfolio*

Hill, Mrs. John, 195

Hill, John William, 195; *Broadway and Trinity Church from Liberty Street*, 19, 31, *445*; no. 109; *Chancel of Trinity Chapel*, *447*; no. 113; *City Hall and Park Row*, *445*;

no. 108; *New York, from Brooklyn Heights*, aquatint after, by Bennett, 197, 220, *460*; no. 128; *New York from the Steeple of Saint Paul's Church*, aquatint after, by Papprill, 3, 220, *464*; no. 135; *View on the Erie Canal* (1829), 112, *444*; no. 106; (1831), *444*; no. 107

Hinckley, Cornelius T., *Spinning*, *369*; fig. 303

Hinckley, Thomas Hewes, 99, 105

Hitchcock, DeWitt Clinton, *Central Park, Looking South from the Observatory*, 43, 221, *474*; no. 151

Hitchcock, J. R. W., 92

Hoare, Burns and Dailey, 346

Hoare, John, 346, 350

Hobart, Bishop John Henry, portrait of, by Hughes, 140

Hobbema, Meindert, 85

*Holden's Dollar Magazine*, 363

Hollander, Maria Theresa Baldwin, Abolition quilt, *509*; no. 215

Hollyer, Samuel, after daguerreotype by G. Harrison, *Walt Whitman*, 204–5 and n.57, 234, *470*; no. 146

Holmes, Silas A., 239 and n.36

Holmes, Silas A., or Fredricks, Charles DeForest, attributed to, *Broadway between Spring and Prince Streets*, 226, 238, 239; fig. 190; *City Hall, New York*, 8, 239, *492*; no. 186; *Fort Hamilton and Long Island*, 239, *494*; nos. 190, 191; *Palisades, Hudson River, Yonkers Docks*, 239, *494*; no. 189; *View down Fifth Avenue*, 13, 16, *491*; no. 185; *Washington Monument, at Fourteenth Street and Union Square*, 16, 239, *493*; no. 188; *Washington Square Park Fountain with Pedestrians*, 239, *492*; no. 187

Holy Trinity Church (now St. Ann and the Holy Trinity Church), Brooklyn Heights, *182*, 183, 351–52 and n.134, 353; fig. 143; window for, *Christ Stills the Tempest*, 183, 353, *557*; no. 280

home decorations, 259–85; nos. 212–220. *See also* carpets; mantels; upholstery; wallpaper

*Home Journal*, 17, 27, 36, 239, 274, 279, 303, 315, 368

*Home of American Statesmen*, 237

Homer, Winslow, 205; *Prisoners from the Front*, 94; after, *April Showers*, 243, *243*; fig. 194; —, *The Ladies' Skating Pond in the Central Park, New York*, 205, *205*; fig. 161

Hone, Philip, 13, 18, 27, 35, 48, 50, 83, 84, 136, 140, 153 and n.68, 158, 229, 303–5, 355; busts by Browere, 138; —, by Clevenger, (marble), 13, 84, 149, *415*; no. 58; —, by Clevenger (plaster), 84, *85*, 149; fig. 58; collection, 71, 78, 84–85; "Dress," 27

Honoré, Édouard, 331

hoop skirts, 253, 254–55

Hope, Thomas, 291; *Household Furniture and Interior Decoration*, 291, 292n.36, 293, 294; —, plate from, *Drawing-Room*, *290*, 291; fig. 235

Hoppin, William J., 206

Hornor, Thomas: *Broadway, New York*, *195*, 196; fig. 153; —, aquatint after, by J. Hill, 5, 19, 31, 196, 235, *455*; no. 123; *New York Harbor*, 196

Hosack, David, 54, 83, 84, 136; portrait bust of, by Browere, 138

Hosier, Abraham, *Hall of the Roger Morris or Jumel Mansion*, 84, *84*; fig. 57

hot-milk pot, silver, *569*; no. 301

hot-water kettle on stand, silver, *569*; no. 301

hot-water urn, silver, 361, 363–64, *564*; no. 290

Houdon, Jean-Antoine, 137; *George Washington*, 167; *Robert Fulton*, 137, *410*; no. 53

Houghton family, 350

housing, 16–18, 176–80, 290–91

Houston Street, 5, 177

Hovey, Charles Mason, *Fruits of America*, 222

How, Calvin W., and Company, 272

Howe, Julia Ward, 89; bust of, by Clevenger, 149

Howland, William (?), trade card for Leavitt, Delisser and Company, *58*; fig. 44

Hubard, William James, **70**; Gallery, **70**

*Hudson River Portfolio*, after watercolors by Wall, engraved by J. Hill, 110–11, 194–96 and n.20, 197; *New York from Governors Island*, 110, *448*; no. 114; —, vase with scene after, 195, 327n.5, *536*; no. 250; *New York from the Heights near Brooklyn*, 197–99; —, original watercolor, 3; fig. 1; *New York from Weehawk*, 199; —, original watercolor, 127n.108; *Palisades*, 110, *194*, 195; 196; —, probable proof for, 196; *View near Hudson*, 110, *111*; fig. 79

Hudson River School, 106, 109, 110, 112, 113, 114, 122, 128–30, 195, 197

Hudson Square (Saint John's Square), 5, *6*, *7*

Hueston, Samuel (publisher), *466*; no. 140

Hughes, Arthur, 64

Hughes, Charles, 373. *See also* Wood and Hughes

Hughes, Jasper W., 373. *See also* Wood and Hughes

Hughes, Robert Ball, 140–41 and n.23, 144–46, 147, 151, 161; *Alexander Hamilton* (large marble), 34, 140, 141, 144–45; —, (statuettes), 145, *145*; fig. 110; American Art-Union medal depicting John Trumbull, *565*; no. 295; *Bishop John Henry Hobart Memorial*, 140; *John Trumbull*, 141, *414*; no. 57; *Nathaniel Bowditch*, 146; *Uncle Toby and Widow Wadman*, 55, 76, 144 and n.37; *Washington Irving*, replicas of, 145

Huguenot Historical Society, New Paltz, 152

Humboldt, Alexander von, 131, 133; *Cosmos*, 132; *Personal Narrative of Travels to the Equinoctial Regions of America*, 131–32; portrait of, by Schrader, *130*, 131; fig. 99

Humphrey, George S., 270, 271. *See also* Peterson and Humphrey

Humphrey, G. S., and Company, 271

Hunt, John Samuel, 367n.61

Hunt, Richard Morris, 73, 74, 97, 186, 187; Lenox Library, 97; *Thomas P. Rossiter House*, 186, *441*; no. 101

Hunt, William Holman, 64

Hunt and Roskell, London, 364

Huntington, Daniel, 57, 78, 97, 105, 154, 155, 163; *Pilgrim's Progress*, 77; *A Sibyl*, engraving after, by Casilear, 206, *206*; fig. 162

Hurlbut boys, daguerreotype of, by Brady, *485*; no. 170

Hutchings, Edward Whitehead, 289, 312n.177, 316, 322, 323n.227, 351n.127

Hyatt, George E. L., 267–68

Ibbotson, Henry L., 313n.182, 315

Illinois State Capitol, Springfield, 174

*Illustrated American Biography, The*, by A. D. Jones, wood engravings from, *258*, *270*, *280*, *365*; figs. 222, 230, 231, 300

illustrated gift books, 221–22

*Illustrated News*, wood engraving from, *143*; fig. 108

illustrated newspapers, 202

Imbert, Anthony, 189–90, 192 and n.14, 193, 214; *Design for Improving the Old Almshouse*, after Davis, 35, 172, *425*; no. 73; *Distant View of the Slides That Destroyed the Willey Family, White Mountains*, after Cole, 116, *192*, 193; fig. 150; Life in New York series, 193; —, *No. 4, Inconveniency of Tight Lacing, Saint John's Park*, 28, *28*, 193; fig. 23; *Mr. John Roulstone of the New York Riding School*, 193, *193*; fig. 151. See also *Memoir*; *Views of the Public Buildings in the City of New-York*

immigrants, 13, 28, 30, 43, 181, 220, 260, 262, 289, 290

*Independent, The*, 277

Indiana State Capitol, Indianapolis, 173

"Infernal Regions" panorama, 38

Ingham, Charles Cromwell: *De Witt Clinton*, engraving after, by Durand, 3, 202, *454*; no. 122B; *The Flower Girl*, 88, *394*; no. 32; *Gulian Crommelin Verplanck*, *381*; no. 7

ingrain carpets, 260, 267, 268, 297, *506*, *507*; nos. 212, 213

Inman, Henry, 77, 97; *Dr. George Buckham*, *383*; no. 12; *Fanny Elssler*, lithograph after, by Heidemans, *458*; no. 126; Gallery of Portraits of American Indians, after King, 76; *Georgianna Buckham and Her Mother*, *383*; no. 11; hot-water urn with decoration after a design by, 361, 363–64, *564*; no. 290

Inman, Henry, and Cummings, Thomas Seir, *Portrait of a Lady*, *384*; no. 15

Institute of Fine Arts, 63, 68, 69, 80. *See also* Cosmopolitan Art Association

intaglio prints, 211–12, 213

interior decoration and design services: by cabinetmakers, 282, 289, 310, 312, 313, 322; by professional decorators, 273–74, 282, 312n.174; by upholsterers, 282, 284

International Art Union, 59, 63, 69, **70**, 78, 80, 208–9

Irish, the, 11, 13, 28, 33, 43, 260

Irish wedding veil, *501*; no. 201

iron foundries, 189

Irving, Washington, 84, 110, 197; *A History of New-York* (under the pseudonym Diedrich Knickerbocker), 110, 223–24, *466*; no. 137; —, scene from, by Durand, 388; no. 25; "The Legend of Sleepy Hollow," illustrations of, by Darley, 207, 223, *463*; no. 134; *Life of George Washington*, engravings for, by Darley, 223; likenesses of, bust, by Hughes, 145; portrait, by Jarvis, *380*; no. 3; "Rip Van Winkle," 110; —, illustrations of, by Darley, 207, 223, *463*; no. 133; *The Sketch Book of Geoffrey Crayon*, 110; *Tales of a Traveller*, scene from, by Quidor, *389*; no. 26

Irving, William, and Company, **70**, 79

Isabey, Jean-Baptiste, 94

Italian, probably, mantel with caryatid supports, *260*, 261; fig. 210

Italianate style, 184–85, 186, 308, 320

Italian immigrants, 262

Italian marble, 262 and n.7

Italian Opera House, 20

Italian paintings, 86, 87

Italian Renaissance masters, prints of, 211, 212, 224

Italy, 109, 123–30, 148, 149, 262; scenes of, *126*, *128*, *397*, *407*; figs. 96, 97, nos. 36, 50

Ives, Chauncey Bradley, 73, 77, 149, 151; *Ruth*, 149, *420*; no. 64
Ives, James, 213. *See also* Currier and Ives

Jackson, Andrew, 240; bust of, by Powers, 34, 40, 158, *412*; no. 55; cameo portrait bust of, cut by Jamison, *504*; no. 206
Jackson, James, 284
Jackson, Thomas R., 186
Jackson, William, 344
Jackson and Baggott, 344–45 and n.90, *345*; fig. 282; possibly cut by, decanter and wine glasses, 343, *553*; no. 276
James, Henry, 60, 62–63, 104, 177; daguerreotype of, by Brady, 233, *234*; fig. 184
James, Henry Sr., 233; daguerreotype of, by Brady, 233, *234*; fig. 184
Jameson, Anna, 89
Jamison, George W., cameo portrait bust of Andrew Jackson, *504*; no. 206
Jarves, Deming, 342
Jarves, James Jackson, *Italian Sights and Papal Principles*, 128
Jarves collection, 80
Jarvis, John Wesley, *Washington Irving*, *380*; no. 3
Jaudon, Mrs. Samuel, 309
Jay, John, bust of, by Frazee, after Ceracchi, 34, *146*, 147; fig. 111
Jay, Peter Augustus, 141
Jeanselme, Joseph, 318n.205, 324
Jeanselme and Son: Louis XIII gun case, *319*, 321; fig. 261; "Renaissance" cabinet, 324
Jefferson, Thomas, 136, 169, 194, 219n.116; bust of, by Browere, 138, 140
Jenkins collection, 80
Jennens, Bettridge and Sons, 313n.182, 315
Jersey City, 331–32, 340
Jersey Glass Company, Jersey City, 341, 342, 343, *343*, 349; fig. 280; compote, 342, *551*; no. 273; covered box, 342, *552*; no. 274; oval dish, 342, *552*; no. 275; salt, 342, *550*; no. 272. *See also* Bloomingdale Flint Glass Works or Brooklyn Flint Glass Works or Jersey Glass Company
Jersey Porcelain and Earthenware Company, Jersey City, 331–32 and n.28
Jervis, John B., 10; Croton Aqueduct, 10, 181; *Distributing Reservoir*, 10, 181, *434*; no. 90; *High Bridge*, 10, 181, *435*; no. 91; *Manhattan Valley Pipe Chamber*, 181, *435*; no. 92
jewelry, 247, 252, 253, 255; nos. 206–11; bracelets, 252, *505*; nos. 209, 211; cameo, *504*; no. 206; necklaces, *254*, *503*, *505*; fig. 206, nos. 205, 211; parures, 253, *254*, 255, *257*, 313, *504*, *505*; figs. 206, 209, nos. 208, 210
Jews, the, 20, 285
Johnson, David, 112, 113, 114, 119; *Study, North Conway, New Hampshire*, *118*, 119; fig. 86
Johnson, Eastman, 99, 101; *Negro Life at the South*, 101–2, *399*; no. 40
Johnson, John, 230
Johnston, Frances Colles, 312
Johnston, John Taylor, 93–94, 100, 312; house, ballroom decor, 312
Johnston, William, 177
Jones, A. D. *See The Illustrated American Biography*
Jones, Alfred: engravings, after Edmonds, *The New Scholar*, 207; —, after Leutze, *The Image Breakers*, 207
Jones, Anthony W., 66, 76

Jones, Ball and Company, Boston, 373
Jones, Edmund, pitcher presented to, 337–38, *548*; no. 268
Jones, Low and Ball, vase presented to Daniel Webster, 373
Jones Wood, 43
Jordan and Norton, **70**
Journeay, James, collection, 80
Jouvenet, Jean, 209
Judd, Sylvester, *Margaret*, illustrations for, by Darley, 223
Jumel, Eliza, 83–84
Jumel, Stephen, 83
Jumel (now Morris-Jumel) Mansion, 83–84, *84*; fig. 57

Kaaterskill Clove, 110, 111, *129*, 130, 193; fig. 98
Kaaterskill Falls, 110, 112; view of, by Cole, 48, 49, 50
Kalf, Willem, after, *Still Life with Chinese Sugarbowl, Nautilus Cup, Glasses, and Fruit*, *404*; no. 46
Kane, Elisha Kent, *Arctic Explorations*, 133
Kane, Greenville, ambrotype of, by Brady, 239, *239*; fig. 191
Karr, Daniel. *See* Phyfe, Duncan, and Karr, Daniel
Kaufmann, Theodore, 79
Kearny, Philip, 149
Keckley, Elizabeth, 257
Keefe, Philip, **70**
Keese, John, **70**
Kelbley, Joseph, **70**
Kellogg, Elijah C., **70**
Kellogg, Minor, 158
Kellogg, Nancy, portrait of, by Whitehorne, *385*; no. 19
Kellogg-Comstock family, 232; daguerreotype of, by Gurney, 232, *485*; no. 172
Kellum and Son, 366
Kemble, Gouverneur, 86
Kensett, John F., 62, 74, 92, 99, 101, 105, 112, 113, 114, 119, 122–23, 128, 195, 200; *Beacon Rock, Newport*, 122, *397*; no. 37; *Berkeley Rock, Newport*, 122, *123*; fig. 90; *Forty Steps, Newport*, *121*, 122; fig. 89; illustrations for Curtis, *Lotus-Eating*, 121, 122; —, *The Cliff Walk, Newport*, wood engraving after, by J. W. Orr (?), *121*, 122; fig. 88; *Lake George*, 113, *114*; fig. 81; *Mount Washington from the Valley of Conway*, steel engraving after, by Smillie, *118*, 119; fig. 85; Shrewsbury River series, 195; *White Mountain Scenery*, 100, 101; fig. 72
Kensington Glass Works, Philadelphia, 345
Kent, James, bust of, by Clevenger, 149
Kermit, Robert, glassware purchased by, 342
Kerr, J. K., 327
kettle, silver, *569*; no. 301
Kiddush goblets, silver, *571*; no. 305
Kidney, Edmund, 374
Kimbel, Anthony, 305–6 and n.137, 320 and n.214, 325; *A Parlor View in a New York Dwelling House*, *317*, 320; fig. 260. *See also* Bembé and Kimbel
Kimbel, Wilhelm, 307n.139
Kimbel and Cabus, 320–21n.214, 323n.225, 325
King, A. (printer), *458*; no. 125
King, James Gore, 147
King, M. W., 282
King, Thomas, *Modern Style of Cabinet Work Exemplified*, 292, 299n.74
King, Thomas Starr, *The White Hills*, 118, 119
Kirkland, Caroline M., 13, 23, 27
Kiss, August, *Amazon*, 160, 161

Kittle, Nicholas Biddle, attributed to, *Mr. and Mrs. Charles Henry Augustus Carter*, 297–98, *298*, 299; fig. 242
Kleindeutschland, 289, 305, 312n.174
Kleynenberg collection, 77
Knapp, Joseph, 222. *See also* Sarony, Major and Knapp
Kneeland, Horace, 151; *George Washington*, 157
Knickerbocker, Diedrich. *See* Irving, Washington
*Knickerbocker, The*, 55, 229
Knickerbocker circle and culture, 13, 47, 110n.6, 127, 145, 224, 309
*Knickerbocker Gallery, The*, 224, *466*; no. 140
Knoedler, Michael, 63–64, 69, 70, 208
Knoedler, Michael, and Company, 69, **70**
Knoll, Tarrytown. *See* Lyndhurst
Koeble, Joseph, **70**
Koehler, Sylvester R., 92–93
Koekkoek, Barend Cornelius, 99, 105
Köhler, Christian, 62
Kollner, Camp and Company (printer), *465*; no. 136
Kossuth, Louis, girandole set depicting, *570*; no. 303
Kraus collection, 59

Labrouste, Henri, 185
lace goods, 245, 247, 252, 255, 256, 257, *501*; no. 201
Ladd, Franklin R., 73
Ladd, William F., 368; trophy pitcher, 368, *567*; no. 297
lady's writing desk, 313 and n.180, *525*; no. 237
Lafarge Building, 58, 78
Lafayette, Marquis de, 137, 248, 255, 358; balls in honor of, New York, *see* Lafayette Fête; —, Virginia, 254 and n.38; busts of, by Browere, 138; —, by Frazee, 137; platter depicting arrival at Castle Garden, 330, *538*; no. 253; portrait of, by Morse, 34, *379*; no. 2; products inspired by, 331nn.19, 20; reception committee for, silver tray presented to chairman of, 358, *358*–59; fig. 294
Lafayette Fête (Castle Garden, 1824), 253, 255, 257; ball gown worn to, 253–54, *254*; fig. 206
Lafever, Minard, 35, 171, 173, 175–76, 180, 181, 183; *Beauties of Modern Architecture*, 175, 176 and n.31, 180; Church of the Holy Trinity, Brooklyn, *182*, 183, 351–52; fig. 143; First Reformed Dutch Church, Brooklyn, 176; *Modern Builders' Guide*, 176; Washington monument, design for, 152; *Young Builder's General Instructor*, 171, 173, 176
Lafosse, Jean-Baptiste-Adolphe, after Mount, *The Bone Player*, *471*; no. 148
La Grange Terrace (Colonnade Row), 7, *15*, 16, 175, 179 and n.40, 180, 261, *431*; fig. 9, no. 86
Laing, Edgar H., stores, 7, 185; cast-iron spandrel panel from, 185, *438*; no. 97
Lairesse, Gérard de, 209
Lake Champlain, 110, 112
Lake George, 109, 110, 112–14, *113*, *114*, 120, 126; figs. 80, 81
Lambert, George, **70**
Landscape Gallery, **70**, 76
landscape painting, 109–33; prints after, 192–93, 201
Lane, Fitz Hugh, 204; *New York Harbor*, 2, 3, 204, *396*; no. 35
Lang, Louis, 74, 99

Langenheim, William and Frederick, *New York City and Vicinity from Peter Cooper's Institute toward Astor Place*, *489*; no. 181
Latro, Joseph Capece, collection, 68, 76
Latrobe, Benjamin Henry, 169, 181
Latting, Waring, Observatory, 42; view from, 42, 221, *468*; no. 143
Lauderback, David, 179n.36
Launitz, Robert E., 147–48 and n.51, 151; *Charlotte Canda*, 148n.51; grave marker for Do-Hum-Me, Green-Wood Cemetery, 148n.51; New York Firemen's Monument, 148n.51
Laurens Street (now West Broadway), 17, 31
Law Buildings, 70
Lawrence, Martin, 233–34, 236
Lawrence, Thomas, 105; *The Daughters of Charles B. Calmady*, lithograph after, by Maverick, *191*, 192; fig. 149
Layard, Austen Henry, 97
Leavitt, 57, 68, **70–71**, 71
Leavitt, Delisser and Company, 70; salesroom, 57, *58*; fig. 45; trade card, 57, *58*; fig. 44
Leavitt, George A., 71
Leavitt, George A., and Company, 70
Leavitt, Jonathan, 70
Leavitt, Strebeigh and Company, 70
Le Brun, Charles, 209
Lecomte, Narcisse, after Scheffer, *Dante and Beatrice*, 209, *209*; fig. 165
Lee, James, 167
Leeds, 57, 65, 68, **71**, 78, 79
Leeds, Amos, photographic portrait of, by Fredricks, 241, 305; *487*; no. 177
Leeds, Henry H., 72, 312n.178, 322
Leeds, Henry H., and Company, 71, 78, 79, 80, 81
Lefferts, Marshall, presentation tea and coffee service for, 370, 372, *569*; no. 301
Lefoulon, Michel, 336
Lefuel, Hector, 324
Le Gray, Gustave, 237
Lemonge, Joseph, **71**
Lenox, James, 97–98 and n.52
Lenox, Robert, 97
Lenox Collection of Nineveh Sculptures, 97–98
Lenox Library, 97, 98
Leonardo da Vinci, 93, 105, 210, 211; *The Last Supper*, engraving after, by Morghen, 210, *210*; fig. 166; *Virgin of the Rocks*, 53
Le Prince, Jean-Baptiste, 193
Leseur, William, 191
Leslie, Charles Robert, 85, 97, 99; *Slender, Shallow, and Anne Page*, 84–85
Leslie and Hooper, wood engraving after Waites, *250*; fig. 202
Lessing, Karl Friedrich, 62
Lester, Charles Edwards. *See Gallery of Illustrious Americans*
Le Sueur, Eustache, 209
Leupp, Charles M., 71, 81, 98, 99–100, 154, 155
Leutze, Emanuel, 57, 62, 101, 209, 211n.75; *Columbus before the Queen*, 101; *The Court of Henry VIII*, 78; *The Image Breakers*, engraving after, by A. Jones, 207; *Mrs. Schuyler Burning Her Wheat Fields on the Approach of the British*, 100, *395*; no. 34; *Washington Crossing the Delaware*, 78, *100*, 101, 209; fig. 71
Levy, Philip, **71**
Levy and Spooner, 71, 77
Levy's Auction Room (Aaron Levy), **71**, 76, 77

Lewis, McKee and Company, Cincinnati, 297n.68

*Lexington* disaster, *213*, 214, 220; fig. 168

Liberty Place firms, 369–70

Liberty Street, 5; view from, *445*; no. 109

libraries, residential, 301. *See also* book collections

Liénard, Michel, Louis XIII gun case, *319*, 321; fig. 261

Lienau, Detlef, 181, 185; *Hart M. Shiff House*, 185–86, *440*; nos. 99, 100

Life in New York series. *See* Imbert, Anthony

life masks, 138

lighting: argand lamps, *563*; no. 289; gasolier, *570*; no. 302

*Lily, The*, 248

limestone (ancient) sculpture, *95*, *97*; figs. 66, 68

Limoges, 328, 330, 331; probably from, pair of vases with scenes from *Uncle Tom's Cabin*, *330*, *537*; no. 252

Lincoln, Abraham, 241; necklace and bracelets purchased by, *257*, *505*; fig. 209, no. 211; photographic portrait of, by Brady, 241, *241*; fig. 193

Lincoln, Mary Todd, 247, 257; necklace and bracelets purchased for, *505*; no. 211; photographic portrait of, by Brady, 257, *257*; fig. 209; tableware ordered for the White House, glass compote, 348, *556*; no. 279; –, porcelain service, 330

Lind, Jenny, 222, 248, 314–16, 364; daguerreotype of, by Brady, *483*; no. 166; table-top bookcase made for, by Brooks, 314n.188, 315–16, *525*; no. 238

Litchfield, Edwin Clark and Grace Hill Hubbard, 364, 308; house, *see* Litchfield Villa

Litchfield Villa (Grace Hill), Brooklyn: drawing room, 305n.129, *307*, 307–8 and n.140; fig. 250; –, center table from, 305n.129, *307*, 308 and n.140, 320, *531*; no. 244; mantels, 264, *264*, 265 and n.14; fig. 215; stained glass, 351

*Literary World*, 36–37, 38, 41, 56, 204, 206–7, 207

Lithographic Office, **71**

lithography, 189, 190–93, 212, 213–222, 224 and n.144, 225

Livesay, Robert. *See* West, Benjamin, and Livesay, Robert

Livingston, Edward, 83

Livingston, Robert, 83, 137

Locust Lawn (Hasbrouck house), New Paltz, 152

Loewenherz, S. L., **71**

London, 61, 193, 207–8, 236, 244, 259, 287, 288, 367; architectural models, 171, 184–85; *see also* Crystal Palace, London

*London Art Journal*, 207, 212

London Great Exhibition (Crystal Palace exhibition, 1851). *See* Great Exhibition of the Works of Industry of All Nations

Longacre, James Barton, 190, 202

Longacre, James Barton, and Herring, James (publishers), *National Portrait Gallery of Distinguished Americans*, 201, 202, 205, *454*; no. 122A, B

Longfellow, Henry Wadsworth, 119

Long Island Flint Glass Works, Brooklyn, 348, 349 and n.118; compote made for the White House, 348, *556*; no. 279; presentation vase for Mrs. Christian Dorflinger, 348, *555*; no. 278; tea service depicting, 349, *349*; fig. 286

Longworth, Nicholas, 148–49

Longworth's city directory, 169, 177, 294, 317n.203, 362

Lord, G. W., and Company, **71**

Lord and Carlile, Philadelphia, 71

Lord and Taylor, 247, 259 and n.2

Lossi, Carlo, after Titian (Tiziano Vecelli), *Bacchus and Ariadne*, 211, *476*; no. 155

Loudon, J. C., 36, 300, 301; *An Encyclopedia of Cottage, Farm, and Villa Architecture and Furniture*, 300, 301n.87, 303n.97; –, wood engraving from, *Cast Iron Table Supports Designed by Robert Mallet*, *300*, 301; fig. 245

"Louis XIII style," gun case, *319*, 321; fig. 261

Louis XIV style, 293, 297, 303, 305, 309, 310, 313, 318; sofa and armchairs, *316*, 318–19, *526*, *527*; fig. 259, no. 240A–C

Louis XV style, 293, 303, 310, 313, 320, 324; floor plan, *306*, 307; fig. 249

Louis XVI style, 295, 310, 312, 321

Louis-Philippe, king of France, 256

Louis-Philippe period, 296, 310

Louvre, 312, 324; museum holdings, 97–98, 210; Pavillon de la Bibliothèque, 186; Pavillon Rohan, *322*, 324; fig. 264

Lower East Side, 5

Lucas, Fielding, 194

Lucas van Leyden, 211, 212

Ludlow, E. H., and Company, **71**, 78, 80, 81

Lumley, Arthur, *The Empire City*, 4, *474*; no. 152

Lutz, Valentine, **71**

Lyceum Buildings, 56, 78

Lyceum Gallery (Lyceum of Natural History), 57–58, **71**, 77, 78, 158, 173n.23

Lyman, 68, 71, **71**, 77

Lyman, Lewis, and Company, 71

Lyman and Rawdon, 71, 78

Lyndhurst (formerly Knoll), Tarrytown, 265n.15; interior designs for, by Davis, 300–301; –, hall chair, 301, 302n.92, *523*; no. 234; –, mantels, 264, *264*; fig. 216

Lyon, silk from, 255–56

Lyrique Hall, **71**, 80

McComb, John Jr., 170–71n.6

McComb, John Jr., and Mangin, Joseph-François, City Hall, 135–36

McCrea, Jane, 166

mace of the United States House of Representatives, *366*, 367 and n.56, 368; fig. 301

McGavin, W., **71**

McKinney, Colonel, collection, 74

McKinney, Mary B., 281

Maclise, Daniel, *Sacrifice of Noah*, 79

McMurran home, Natchez. *See* Melrose

McNevin, John, wood engraving by, *255*; fig. 207

McQuillin, Bernard, **71**

Madison, Dolley, 254

Madisonian, 24–25

Madison Square, 5, 13

Magnus, Charles, 220

Magoon, Rev. Elias L., collection, 98, 99

Maiden Lane firms, 362, 369

Major, Henry B., 220

Major, Richard(?), *Porcelain and Flint Ware, Exhibiting at the Crystal Palace*, *338*, 339; fig. 276

Malibran, E., 272–73

Mallet, Robert, cast-iron table supports designed by, *300*, 301; fig. 245

Manchester, England, Old Town Hall, 171

Mangin, Joseph-François. *See* McComb, John Jr., and Mangin, Joseph-François

Manhattan Company, 10 and n.38, 11

Manhattan Island: population (1825), 4, 83, 342; –, (1861), 83; reshaping of, 9; water courses, 5; fig. 2

manners, and fashion, 251–53

Manning, John L. and Susan Hampton, house. *See* Millford Plantation

mantels, 103, 261–65, *260*, *261*, *262*, 264, *513*; figs. 210–13, 215, no. 220; study for, 264, *264*; fig. 216

Mantilla Emporium, 247

mantillas, 246, 247, *247*, 499, *503*; fig. 198, nos. 199, 205

manufactory, term, 361

Manufacturing and Mercantile Union, pitcher presented to the governor by, 337, *547*; no. 267

Mapleson, Thomas W. G., *Lays of the Western World* and *Songs and Ballads of Shakespeare*, 222

maps: Commissioners' Plan of 1811, *8–9*; fig. 5; Great Fire of 1835, *10*; fig. 6; City of New York to Fiftieth Street (1851), 5, *465*; no. 136; New York settlement (1820), *6*; fig. 3; –, (1860), *7*; fig. 4; topography of the City and County of New York (1836), *456–57*; no. 124; water courses of Manhattan, 5; fig. 2

Marat, Jean-Paul, portrait of, 100

Marble Buildings (Dioramic Institute), 47, 55, 66, **71**, 76

marble mantels, 103, 261–62, 263–65; with caryatid supports, *260*, 261, *261*; figs. 210, 211; with figural supports, 264, *264*; fig. 215; with scenes from Bernardin de Saint-Pierre, *Paul et Virginie*, 103, 262, *262*, 264, *513*; fig. 212, no. 220

Marble Palace. *See* Stewart, A. T., store

marble sculpture, *101*, *102*, *143*, *153*, *155*, *162*, *163*, *164*, *411*, *416*, *417*, *423*; figs. 73, 74, 109, 114, 115, 122–25, nos. 54, 59, 60, 69; busts, *142*, *146*, *150*, *159*, *410*, *412*, *413*, *414*, *415*, *418*, *419*, *420*; figs. 107, 111, 112, 119, nos. 52, 55–58, 61–65; relief medallions, *165*; figs. 126, 127. *See also* marble mantels

marble-working industries and supplies, 137, 138, 259, 261, 262 and n.7, 263, 264–65

Marcotte, L., and Company, 312

Marcotte, Léon, 282, 289–90, 310n.156, 311, 312. *See also* Ringuet-Leprince and L. Marcotte

Marie-Antoinette, queen of France, 312

Marley, Daniel, 305 and n.125

Marochetti, Baron Carlo, *George Washington*, 160

Marquand, Henry G., 154

Marquand, Isaac, 365

Marquand and Brothers, 363; presentation medal, *562*; no. 287

Marquand and Company, 364, 365, 367; basket, 365, *562*; no. 288

marquetry, 291. *See also* "Buhl" furniture

Marshall, John, bust of, by Frazee, 147

Marsh and Tingle. *See* Tingle and Marsh

Martin, John: Judgment series, 79, 133; –, *The Plains of Heaven*, engraving after, by Mottram, 133, *479*; no. 159

Martineau, Harriet, 113, 115

*Mary and Hannah* (boat), ewer presented to owners of, 355 and n.4, *357*, 359; fig. 291

Mason, George C., *Newport Illustrated*, 120

Masonic Hall, 26, 55, 66, **71**, 169, *170*; fig. 129

Matteson, T. H., engraving after, by D'Avignon, *Distribution of the American Art-Union Prizes at the Tabernacle, Broadway, New York*, 206, *207*; fig. 163

Matthews and Rider (bookbinders), *525*; no. 239

Maurer, Louis, 215, 217–18; *Preparing for Market*, 214, 217–18; fig. 169

Maverick, Peter, 190, 191–92, 199–200; *The Daughters of Charles B. Calmady*, after Lawrence, 191, 192; fig. 149; *Lake George*, 113, *113*; fig. 80

Maverick and Durand, 200

Maxwell, Hugh, vase presented to, 360, 361–62; fig. 296

May and Company, 257n.46

*May Day* (Moving Day), 18, *18*, 303; fig. 12

Mayer, E., and Son, 330

Mayer, John, 331n.21

Mayer, Thomas, 336n.41

Mayo, Rev. A. D., 165

Mead, Dr. Henry, 331, 332 and n.25

Mead, William, and Company, **71**

Meade, Mrs. Richard Worsam, 86

Meade, Richard Worsam, collection, 72, 75, 86

Meade Brothers, 237

Mechanics' Institute of the City of New York, *72*, 76, 136, 362, 363, 367; prize medals commissioned from Fürst, 363

*Mechanics' Magazine and Register of Inventions and Improvements*, 363

medallions, marble, *165*; figs. 126, 127

medals, *562*; no. 287; American Art-Union issues, *565*; nos. 292–95; American Institute prize medals, 363, *565*; no. 291; Grand Canal Celebration commemoratives, 287, 358, *559*; nos. 282A, 283A; transatlantic cable commemorative, 375, *572*; no. 307

Medici, Lorenzo de', birth tray of, by Scheggia, 103, *402*; no. 42

Medici family, 95; arms of, *402*; no. 42

Meeks, J. and J. W., 289, 302; portfolio cabinet-on-stand, 302–3 and n.107, *522*; no. 233; attributed to, chair, 307n.139; possibly by, side chair, *304*, 306–7; fig. 247

Meeks, John, 325

Meeks, Joseph, 281, 300n.79

Meeks, Joseph, and Sons, 288, 289, 295nn.52, 53, 296, 298, 300nn.76, 80; broadside for, 281, 296, 298, *517*; no. 225; center table at Melrose, 298, 300n.80; pier tables, ca. 1830, *294*, 295 and n.53, 297; fig. 240; –, ca. 1835, 295, 296, 297, *518*; no. 227

Meeks, Joseph W., 325

Megarey, Henry J. (publisher), 194, 195, 197, *464*; no. 135. See also *Hudson River Portfolio; Megarey's Street Views*

*Megarey's Street Views in the City of New York*, aquatints by Bennett, 197; *Broadway from the Bowling Green*, 196, 197; fig. 154; *Fulton Street and Market*, 8, 197, *451*; no. 120; *South Street from Maiden Lane*, 5, 197, *451*; no. 119

Meissonier, Ernest, 94, 105

Melrose (McMurran home), Natchez, Mississippi, center table at, 298, 300n.80

*Memoir, Prepared at the Request of a Committee of the Council of the City of New York, and Presented to the Mayor of the City, at the Celebration of the Completion of the New York Canals*, by Colden (author), Robertson (artist), and Imbert (printer), 189–90 and n.3, 193, 190–21; lithographs from, Imbert, *Chair-Makers' Emblems*, 190, 287, 288; fig. 234; –, Imbert, after Robertson, *Grand Canal*

*Celebration: View of the Fleet Preparing to Form in Line*, 3, 189–90, 450–51; no. 118
Menger's, **72**, 80
men's costumes, 244, *244*, 245, 251, 252, 254, *498*; figs. 195, 196, no. 197
Mercantile Library Association, 149, 367; sculpture for, by Clevenger, *Philip Hone*, 149, *415*; no. 58
Merchants' Exchange, 24, 171n.8; as a venue, 34, **72**, 79, 147. *See also* First Merchants' Exchange; Second Merchants' Exchange
Merchant's House Museum (Tredwell house), 177
Merle, Hugues, 102
Mésangère, Pierre de la, *Collection de meubles et objects de goût*, 295–96n.54
Meserole House, *235*; fig. 185
metal-plate engravings, 202, 204
Metella, Cecilia, tomb of, 127
Metropolitan Hotel, 185
Metropolitan Museum of Art, 45, 86, 90, 92, 93, 96, 99, 103, 104, 107, 225, 261
Mettam, Charles, and Burke, Edmund A., *The New-York Historical Society*, 35, 186, *442*; no. 104
Metz, Conrad, after Michelangelo, *Detail from the "Last Judgment,"* 211, *211*; fig. 167
Mexican War, prints of, 218, 220; fig. 174
Michelangelo, 211; *Last Judgment*, etching after, by Metz, 211, *211*; fig. 167; *Last Supper*, work offered as, 86; sibyls, 206
Michelin, Francis, after Crawford and Catherwood, *Proposed Colossal Statue of Washington*, 151, 152; fig. 113
Middle-Tint the Second. *See* Browere, John Henri Isaac
Middleton and Ryckman, pair of slippers, *501*; no. 203
Mignot, Louis Remy. *See* Rossiter, Thomas, and Mignot, Louis Remy
Milhau, Dr. John, pharmacy, 22, 185
Miller, Alfred J., 77
Miller, Gov. Stephen D., table for, 291, *514*; no. 222
Miller, Thomas J., and Morris, William L. Jr., **72**
Miller, William L., spandrel panel from Edgar H. Laing stores, *438*; no. 97
Millford Plantation (John L. Manning house), South Carolina, furniture for, 297; armchairs, 284, *285*, 297, 305, *520*; fig. 233, no. 231; couch, 297, *521*; no. 232; nested tables, 297, *520*; no. 230
milliners, 247
Mills, **72**
Mills and Minton, **72**, 75
Mimee, E. W. *See* Forsyth, John, and Mimee, E. W.
miniature portraits, nos. 14–22; and the daguerreotype, 232–33 and n.25
Minton pottery, Staffordshire, 331
mirrors: for Colles house, 310; at Gem Saloon, *217*, 220; fig. 173. *See also* pier mirrors
mitts, woman's, *498*; no. 198
Mobile, Alabama, 197, 340
"modern" style. *See* Grecian style
"modern French" style, 369, 370
Moffat, Dr., house, parlor sliding door, *179*, 180; fig. 141
monumental sculpture, 135, 136. *See also* Washington Monument
Mooney, Thomas, 289 and n., 304–5n.122
Moore, Charles Herbert, 127n.108
Moore, Clement Clarke, 9, 182; *A Visit from Saint Nicholas*, scene from, by Weir, *389*; no. 27

Moore, John C., 361, 364, 370; Four Elements centerpiece, 364 and n.44, *364*, 373; fig. 298; presentation tea and coffee service (Lefferts beverage service), 370, 372, *569*; no. 301; presentation tea service for Edward K. Collins, 370, 372, *372*; fig. 307
Moore, John C., and Son, 370–72; for Tiffany and Company: Astor beverage service, 372; —, service presented to Colonel Abram Duryee, 375, *375*, *573*; fig. 310, no. 310
Moore, T. M., and Company, **72**, 75
Morgan, Edwin D., 163
Morgan, Homer, **72**, 78
Morgan, Matthew, 290–91, 309 and n.148, 311
Morgan, Mrs., 255
Morghen, Raphael (Raffaelo), 91; after Leonardo da Vinci, *The Last Supper*, 210, *210*; fig. 166
*Morning Courier and New-York Enquirer*, 42, 53
*Morning Herald*, 253
Morris, Mr., 38
Morris, William L. Jr., 72
Morris and Kain, 137
Morris-Jumel Mansion, 83–84, *84*; fig. 57
*Morris's National Press*, 231, 309
Morse, Ruggles Sylvester and Olive Ring Merrill, 325; mansion, *see* Morse-Libby House
Morse, Samuel F. B., 3, 35, 38, 50, 52, 83, 84, 85, 97, 141, 143, 144n.29, 148, 160, 171, 210, 227–28, 230, 232, 234, 236, 352n.136; *De Witt Clinton*, 3, *380*; no. 4; *Fitz-Greene Halleck*, *380*; no. 5; *Gallery of the Louvre*, 76; *Head of a Young Man*, 228, *229*; fig. 180; *Marquis de Lafayette*, 34, *379*; no. 2; *The Wife*, engraving after, by Durand, *291*, 292; fig. 236; *William Cullen Bryant*, *381*; no. 6; *Young Man*, 228, *480*; no. 160
Morse-Libby House (Victoria Mansion), Portland, Maine, 322–25 and nn.230, 237; reception room, *286*, 324; reception-room cabinet, *286*, 324–25, *535*; no. 249
Morss, John, 177
Morton, John Ludlow, 110n.8; portrait of, by N. Rogers, *384*; no. 16
Mosaic Picture of the Ruins of Paestum, 76
Moseley, Joseph, 363. *See also* Gale, William, and Moseley, Joseph
Mott, Dr. Valentine, house, *237*; fig. 189
Mottram, Charles, after Martin, *The Plains of Heaven*, 133, *479*; no. 159
Mould, Jacob Wrey, 40n.233, 181, 186; All-Souls' Church, *186*, 187; fig. 146
Mount, William Sidney, 37, 63, 87, 88, 91, 99, 209, 211n.77, 212; *Bargaining for a Horse*, 82, 87, *87*; fig. 59; *The Bone Player*, lithograph after, by Lafosse, *471*; no. 148; *California News*, 234; —, related daguerreotype, by G. Harrison, 234, *484*; no. 169; *Eel Spearing at Setauket (Recollections of Early Days—"Fishing along Shore")*, *390*; no. 28; *Farmers Nooning*, 88; *Just in Tune*, 211n.77; *The Power of Music*, 79, *98*, 100; fig. 69; —, lithograph after, by Noël, 63, *208*, 209; fig. 164
Mount Chocorua, 114
Mt. St. Vincent buildings, Central Park, 103
Mount Washington, 115, 116, 117, 118, *118*, 119, 131; fig. 85
Moving Day (May Day), 18, *18*; fig. 12
Mozier, Joseph, 149, 151–52; *Diana*, 151–52, *420*; no. 65

*Mr. Brown Visits a Picture Factory*, 36, *37*; fig. 32
Munroe, Alfred, and Company, *237*; fig. 188
Murillo, Bartolomé Esteban, 85, 86; *Four Figures on a Step (A Spanish Peasant Family)*, 53, *403*; no. 44; *The Immaculate Conception*, 104, 104–5, *105*; figs. 76, 77
Murray, Amelia M., quoted, 248
Musée Napoleon, Paris, 66
Museum and Gallery of the Fine Arts, 25, **73**; 75
Museum of the City of New York, 294, 236–37, 255n.41
muslin, 253; ball gown, 253–54, *254*; fig. 206

Nadar (Gaspard-Félix Tournachon), 221
Nagel and Lewis (printer), *468*; no. 144
Nagel and Weingartner, 219; inscription page for Audubon, *Birds of America*, *220*, 222, 315; fig. 176
Naples, 126
Napoleon, 100, 256; portrayed by David, 55, 75, 209; portrayed by Delaroche, *Napoleon at Fontainbleau*, 37, 63, *64*; fig. 54; —, *Napoleon Crossing the Alps*, 78; —, engraving after *Napoleon Crossing the Alps*, by François, 211, *478*; no. 158
Napoleon III, 128, 256, 312, 318, 322n.221, 324; gun case purchased for, *319*, 321; fig. 26
Napoleonic Wars, 123
Nassau Street, 5
National Academy of Design, 36, 38, 47, 50, 52, 55, 56–57, 59, 60, 61–62, 64, 65, 66, 67, 68, 69, 72, **72**, 73, 75, 76, 77, 78, 79, 80, 81, 84, 86, 88, 89, 92, 100, 101, 105, 136, 138, 140, 141, 143, 144, 148, 149–51, 153, 154, 155, 158, 169, 171, 172, 183, 186, 192, 210, 227, 228; building, 186–87, *443*; no. 105
*National Advocate*, 47
"National Gallery of Paintings," 38
*National Portrait Gallery of Distinguished Americans. See* Longacre, James Barton, and Herring, James
*National Register. See* Niles' Weekly Register
National Sculpture Society, 149
National Theatre, 20
Native Americans, 25 and n.127, 26, 112, 155, *156*, 162, *163*, *164*, 165; figs. 116, 124, 125
Neal, Alice B., 24
Neale, W. (printer), *455*, 460–61; nos. 123, 129
necklaces: cut-steel, 253, *254*; fig. 206; pearl-work, *503*; no. 205; seed-pearl, of Mrs. Lincoln, 257, *505*; fig. 209, no. 211
Neoclassical style, 137, 138, 140, 152, 153, 292, 297–98, 363, 364. *See also* Grecian style; Greek Revival style
Newark Museum, 103
New Bowery Theatre, 172 and n.15. *See also* New York Theatre
Newcombe, Mrs. George, Store, 66
New England, 109, 110, 117, 273, 340, 341, 343
New England Glass Company, Massachusetts, 341, 345, 348; covered cut-glass urn, 341
New Jersey, 289
*New Mirror*, 303, 305, 364
New Orleans, 9, 38, 175, 244, 288, 298, 340, 351; Trinity Church, 351, 352n.130
*New Paving on Broadway, between Franklin and Leonard Streets, The*, 19, 234–35, *489*; no. 180
Newport, 91, 109, 119–23, *120*, *121*, *122*, *397*; figs. 62, 87–90, no. 37
newspapers, illustrations for, 202

Newton, Gilbert Stuart, 85; *Old Age Reading and Youth Sleeping*, 84–85
*New World*, 11
New York: as an architectural center, 169; daguerreotype street views, 234–36, *487*, *489*; nos. 178, 180; grid plan, 20, 43, 169, 176–77, 179; —, *see also* Commissioner's Plan of 1811; as an industrial center, for furniture manufacturing, 287; —, for glasscutting, 344; —, for shipbuilding, 137; institutions for the poor, 13; as a painting subject, 127; population (1820), 287–88; —, (1825), 4, 83, 288; —, (1850), 4; —, (1855), 288; —, (1860), 288; —, (1861), 83; as a port, 3, 120, 189; —, *see also* New York Harbor; as a print-making center, 189, 205, 207–8; settlement (1820), 5, *6*; fig. 3; —, (1860), 5, *7*, 30; fig. 4; views of, on porcelain vases, 327–28, *328*, *536*; fig. 266, no. 250; —, prints, 189, *190*, *199*, 220–21, 460–61, *464*, *468*, *473*, *469*; figs. 147, 156, nos. 128, 129, 135, 143, 145, 150; water supply, 9–11; —, *see also* Croton Aqueduct. *See also* Brooklyn; "Empire City"; Manhattan Island; maps
New York Academy of Arts, 66, 199
*New-York American*, 56
New York Association of Artists (Drawing Association), 50, 72
*New-York Athenaeum*, 47, **72**, 76
New York Bay, *223*; fig. 179. *See also* New York Harbor
*New-York Book of Prices*, 294, 295, 297
New York Chamber of Commerce, 374
New York City from Governors Island, vase depicting, 327–28, *328*, 330n.6; fig. 266
New York City Pottery, 336n.42
*New-York Commercial Advertiser*, 145, 284
*New-York Daily Advertiser*, 355
*New-York Daily Times*, 61
*New-York Daily Tribune*, 158, 322, 368
New-York Ecclesiological Society, 370
New York Etching Club, 224
New York *Evening Post*, 9, 50, 54, 110, 365, 368, 369
New-York Exhibition of the Industry of All Nations (Crystal Palace exhibition, 1853–54), 40–42, 68, 79, 103, 133, 158–60, 185, 219, 236–37, 248, 314n.189, 316, 338–39, 346–48, 372–73, *488*; no. 179; catalogue, *see* Silliman, Benjamin Jr., and Goodrich, Charles Rush, *World of Science, Art, and Industry*; exhibits and awards, carpeting, 268; —, ceramics, *329*, 330, *338*, 338–39, *549*; figs. 268, 276, no. 270; —, clothing, 247, 250; —, furniture, *132*, 133, 312, 313, *314*, *315*, 316 and n.199, 317–18, *528*; figs. 102, 257, 258, no. 241; —, glassware, 343, 345, *346*; fig. 283; —, machinery, *236*, 237; fig. 186; —, mantelpieces, 265; —, photography, 236; —, piano, 321n.218; —, prints, 209; —, sculpture, 153, 154, 158–60, *160*, 236, 237; figs. 120, 186; —, silver, 364; —, stained glass, 349n.119, 350, 352n.129; —, upholstery, 284–85. *See also* Crystal Palace, New York
New York Female Moral Reform Society, 66
New-York Gallery of the Fine Arts, 59, 66, 68, **72**, 72–73, 77, 78, 79, 88, 89, 155
New York Glass Works. *See* Bloomingdale Flint Glass Works
New York Halls of Justice and House of Detention (The Tombs), 7, 14–15, 31, 174, *429*; nos. 82, 83

New York Harbor, 2, 3, *3*, 9, 126, 189, *190*, 192, 196, 197, *199*, 204, 220, 337, *337*, 396, *450–51*, *452–53*, *460–61*; figs. 1, 147, 156, 275, nos. 35, 118, 121, 129

*New York Herald*, 40, 288

New-York Historical Society, 35, 47, 67, 72, **72**, 87, 94–95, 98, 104, 135, 144, 149, 154, 192n.14, 232, 236–37; building, 186, *442*; no. 104

*New York in 1855*, 29, *30*; fig. 26

New York Institution, 53, 66, 72

New-York Long Room, 69, 70, **72**

New York Marbleized Iron Works, 263

New York Mechanical and Scientific Institute, 341n.75

*New-York Mercantile Register*, 264, 277, 369

*New-York Mirror*, 55, 56, 86, 145, 147, 169, 199, 201, 219 and n.114, 235, 283, 288, 345

*New-York Mirror, and Ladies' Literary Gazette*, 24; wood engraving from, 169, *170*; fig. 129

New York Monument Association, 144

New York Philharmonic, 27

New York Public Library, 10, 97, 102, 225

*New-York Review*, 85

*New-York Review, and Atheneum Magazine*, 110

New York Riding School, 193, *193*; fig. 151

New-York Rotunda, 6, 7, 38, 55, 56, 72, **72–73**, 75, 77, 155, 169, *170*, *424*; fig. 129, no. 70; panorama for, by Vanderlyn, *Palace and Gardens of Versailles*, 38, *39*, 72; figs. 33, 34

New-York School of Design for Women, 68, **73**

New York Society Library, 26, 56, 72, **73**, 77, 78, 105, 270

New York State, 13, 40–41, 135, 144

New York State prisons, 6, 13, 14

*New York Sun*, photograph from, 341, *342*; fig. 278

New York Theatre (rebuilt as Bowery Theatre), 20, 171–72 and nn.14, 15, *172*; fig. 131

*New-York Times*, 239, 246, 255

New York University, *7*, 74. See also University of the City of New York

New York Yacht Club regatta, trophy pitcher for, 368, *567*; no. 297

Niagara Falls, views of, 38, 79, 80, 237. *See also* Church, Frederic E.: *Niagara*

Niblo, William, 26–27, 73

Niblo's Garden, 7, 26–27, *27*, 66, 72, **73**, 76, 78, *249*, 362; figs. 22, 200

Nicholas II, czar of Russia, 23

Nichols, G. W., Gallery. *See* Crayon Gallery

Nichols, George Ward, 68

Nicholson, Michael Angelo, *The Practical Cabinet-Maker, Upholsterer, and Complete Decorator*, 295n.51

Nicholson, Peter, 171, 176

Nicolay, Albert H., **73**, 79

Niles, Hezekiah, 331, 332n.28, 344

*Niles' Weekly* (later *National*) *Register*, 10, 229, 306n.132, 331, 332–33, 344, 363

Nineveh Marbles, *97*, 97–98; fig. 68

Noah, Mordecai Manuel, 148

Noël, Alphonse-Léon, after Mount, *The Power of Music*, 63, *208*, 209; fig. 164

North Carolina State Capitol, Raleigh, 173–74; draperies, 282, 283; Speaker's chair, 282–83, *283*; fig. 232; statue by Canova, *George Washington*, 141n.23

North Conway, New Hampshire, 118, *118*, 119; fig. 86

Northern Renaissance prints, 197, 211, 212

North River, 189; panoramic view from, 197, *460–61*; no. 129. *See also* Hudson River Notch (Crawford Notch), White Mountains, *108*, 115, *115*, 116, *117*; figs. 82, 84

Novelty Iron Works, *215*, 218; fig. 170

nudes, 55n.29, 155 and n.76, 158, 199, 201

Nunns and Clark, piano, 320, 321n.218, *529*; no. 242

Nye, Gideon, collection, 57–58, 71, 78, 80, 148

Oakley, C. W., 72

Oatman, Olive, 166

Ogden, Ferguson and Company, 330

oilcloths, 265, 267, 268, 272

Old Almshouse, 6, *7*, 35, 172, *425*; no. 73

*Old Brewery, The*, 30, *31*; fig. 27

"Old French" styles, 297, 303, 316, 320. *See also* Louis XIV style; Louis XV style; Rococo Revival style

old masters: auctions and exhibitions, 49, 50, 51, 55, 56, 75, 76, 77, 78, 80; dubious, fraudulent, or copied, 37, 40, 53, 85, 86, 93

"old oak" furniture, 310–11, *309*; fig. 252

Olmsted, Frederick Law, and Vaux, Calvert, Greensward Plan for Central Park, 43–44, *44–45*, 221, 241, *495*; fig. 36, nos. 192, 193

Olyphant, Robert M., collection, 100, 101

Opera House (Astor Place), chandelier for, 311

organ, *323*, 325; fig. 265

Ornamental Iron Furniture company, 315

Orr, John William, wood engravings: *Antique Apartment—Elizabethan Style*, *302*; fig. 246; *Armchair*, *316*; fig. 259; *Buffet*, *315*; fig. 258; *The Children's Sofa*, after Doepler, *308*; fig. 251; *Genin's New and Novel Bridge, Extending Across Broadway*, *32*; fig. 28; *Oak Sideboard by Rochefort and Skarren*, *132*; fig. 102; perhaps by, *The Cliff Walk, Newport*, after Kensett, *121*, 122; fig. 88

Orr, Nathaniel, wood engravings: *Interior of Peterson and Humphrey's Carpet Store*, *258*, 270, *270*; fig. 222; *Interior View of the Cosmopolitan Art Association, Norman Hall*, 63; fig. 53; *Interior View of the Düsseldorf Gallery*, 63; fig. 52; *A Parlor View in a New York Dwelling House*, *317*, 320; fig. 260; *Service of Plate Presented by the Citizens of New York to Edward K. Collins*, *372*; fig. 307

Orr, Nathaniel, and Company, wood engraving, *Salesroom, Main Floor, Haughwout Building*, *21*; fig. 16

Osborne, John H., 355n.4

Osler, F. and C., firm, Birmingham, England, 348

Ostade, Adriaen van, 85, 92, 93

Otis, Bass, 191; after Dubufe, *Expulsion from Paradise* and *The Temptation of Adam and Eve*, 56

Otis, Elisha, 22n.96

Ovington Brothers, 327

Paestum, mosaic picture of the ruins of, 76

Paff, Michael, 71, 73, 76, 85–86, 89

Paff's Gallery of the Fine Arts, 49, **73**, 85, 86

Page, William, 166; bust of, by Crawford, 148

Painters' and Sculptors' Art Union, 59

Painting Rooms, **73**

paintings, *see* American paintings; foreign paintings; landscape painting; miniature portraits; portraits. *See also* entries for specific nationalities, e.g., English paintings; French paintings; Spanish paintings

paisley shawl, *500*; no. 200

Palagi, Filippo Pelagio, 292n.35

palazzo style, 184–85, 186

Palisades, 126, *194*, 195, 239, *494*; fig. 152, no. 189

Palladian style, 170

Palmer, Erastus Dow, 35, 79, 102, 162–67; *Evening*, 165, *165*; fig. 127; *Indian Girl* or *The Dawn of Christianity*, 103, *134*, *164*, 165; fig. 125; *Morning*, 163, 165, *165*; fig. 126; *Spring*, 165; *The White Captive*, 35, 40, 80, 103, 165–66, *423*; no. 69

Palmer, Fanny, 215, 217

Palmer, Fanny and Seymour, *Church of the Holy Trinity, Brooklyn*, 182, 183; fig. 143

Panic of 1837, 89, 145, 181, 185, 202, 294, 303, 304n.122, 309

Panic of 1857, 60, 212, 265, 271, 280, 322

Panini (or Pannini), Giovanni Paolo, 55, 76; *Modern Rome*, 55, *406*; no. 48

Panorama Building, **73**

panoramas, 38, 40, 56, 75, 76, 77, 79, 132–33 and n.126; New York Harbor, 197, *199*, 220, *460–61*; fig. 156, no. 129; prints, 189, 192; Versailles, 38, *39*, 72; figs. 33, 34

Panorama Saloon, 40

pantograph, 189

paper dressmaking patterns, 247, 249

paper hangings. *See* wallpaper

paper photography, 237, 240

papier-mâché goods, 313–14 and nn.180, 182, 315; worktable, *312*, 314; fig. 256

Papprill, Henry, after J. W. Hill, *New York from the Steeple of Saint Paul's Church*, 3, 220, *464*; no. 135

parasol, *499*; no. 199

Pares, Francis [and Company], **274–75** and n.61

Pares and Faye, 274, 275

Parian ware, 22, 331, 339; in ceramic monument, 339, *549*; no. 270; reproductive sculpture, 160, 161

Paris, 236, 238, 244, 256, 259, 287, 288, 290, 309, 328

Paris Diorama theater, 227, 228

Paris Exposition Universelle (1855). *See* Exposition Universelle

Paris Industrial Exposition (1849), 318n.205

Park, The. *See* City Hall Park

Parker, Ann, 83–84

Parker, Harvey D., 92–93

Park Hotel. *See* Astor House hotel

Park Place House, 68, **73**, 75, 143

Park Row, 235, *445*, *487*; nos. 108, 178

parks, 42–43. *See also* Central Park

Parliament, Houses of, England, 298

parlors: by Bembé and Kimbel, *317*, 320; fig. 260; of Fiedler family, *261*, 305; fig. 211; Greek Revival style, 180, *447*; no. 112; in Morse painting, *291*, 292; fig. 236. *See also* drawing rooms

Parris, Alexander, 181

Parsons, Charles, 217; *Central Park, Winter: The Skating Pond*, 43, 205, *475*; no. 153; *An Interior View of the Crystal Palace*, 176, *467*; no. 142

Parthenon, New York, 73

parures, 255, *257*, *504*, *505*; fig. 209, nos. 208, 210; necklace from, *254*; fig. 206

patens, 370, *571*; no. 304

Patent Office, Washington, D.C., 174

Paulding, James Kirke, *New Mirror for Travellers*, 112

Paulding, Philip R., 264, 300; house (Knoll), *see* Lyndhurst

Paulding, Mayor William, 264; house (Knoll), *see* Lyndhurst

Pauline, Madame, 40

Paxton, Joseph, 41

Payne, John Howard, 220n.117

Peabody, John. *See* Gowdy, Thomas, and Peabody, John

Peabody, Joseph, 292n.35

Peale, Charles Willson, Philadelphia Museum, 12, 25, 42, 73

Peale, Rembrandt, 62, 73, 85; *Court of Death*, 62, 66, 79, 222; portraits of Washington, 62

Peale, Rubens, 25, 73

Peale's New York Museum and Gallery of the Fine Arts, 25, **73**, 75

Pearl Street, 19, 259, 340, 355

Pearson, Isaac G., 17n.73; Reed house, 16, 17n.73, 87; Ward house, 16, 17n.73

Pearson, J., 72, **73**

Pearson and Gurley, 70

Peele, John Thomas, 99

Peirce, B. K., *A Half Century with Juvenile Delinquents*, wood engraving from, *31*; fig. 27

pelerine, *498*; no. 198

Pell, W. F., and Company, 305n.130

Pellatt, Apsley, 345n.93

Pelletreau, Bennett and Cooke, 358; pitcher presented to Richard Riker, 358, *358*; fig. 293

Pelletreau, Maltby, struck by: Grand Canal Celebration medal, 358, *559*; no. 282A; pitcher presented to Richard Riker, 358, *358*; fig. 293

Penniman, J., lithograph after, by Endicott, *Novelty Iron Works*, 189, *215*, 217, 218; fig. 170

Penniman, James, house, Elizabethan dining room, 302

Penny, Virginia, 287

Pepoon, Marshall, **73**, 81

Perkins, Jacob, 201 and n.44

Perry, Commodore Matthew C., 220

Persian rugs, 175

Peters, Harry, 214–15

Peterson, E. A., and Company, 271

Peterson, Edwin A., 271

Peterson, George F., 270, 271

Peterson, Humphrey and Ross, 271

Peterson and Humphrey, *258*, 268, *270*, **270–71**, 272n.45; figs. 221, 222

*Peterson's Magazine*, 319

Pettich, Chevalier, 80

Pfeiffer, John, **73**

Phelps, Isaac Newton, 149

Phelps and Peck's Store, ruins of, *20*; fig. 15

Phenix Bank, 171–72, 176, 359

Phidias, "Yankee" version, 143

Philadelphia, 3, 4, 9, 20, 37, 109–10, 119, 169, 174, 181, 202, 205, 221, 236, 244, 257, 273, 287, 327, 340, 345, 355

Phillips and Bagster Pottery, Staffordshire, 334n.33

*Photographic Art-Journal*, 234 and n.30

photography, 227–41; nos. 160–196; glass negatives, 239; Talbot's paper-print process, 237. *See also* daguerreotypes

Phyfe, **283–84**

Phyfe, Duncan, 283, 284, 289, 296–97 and n.67, 298n.69, 305, 313, 325; auction furniture purportedly by, 304n.122, 305; chairs for Samuel Foot, 296, 297n.66; pier table for Benjamin Clark, *294*, 295, 296–97 and nn.67, 69; fig. 241; suite, for Robert Donaldson, 294; —, window bench from, *292*, 294, 300; fig. 238; suite, for Lewis Stirling, 297, 298n.70

Phyfe, Duncan, and Karr, Daniel, presentation boxes for Grand Canal Celebration medals, 287, *559*; no. 282B

Phyfe, Duncan, and Son, 298n.69, 300n.76; Millford Plantation commission, 284, 297; —, armchair, 297, 299–300n.75, *520*; no. 231; —, couch, 297, 299n.73, *521*; no. 232; —, six nested tables, 297, *520*; no. 230; pier table for Eliza Phyfe Vail, 297–98n.69

Phyfe, Duncan, and Son and Phyfe and Brother, attributed to, armchair for Millford Plantation, 284, *285*, 305; fig. 233

Phyfe, Duncan, and Sons, 298n.69

Phyfe, George W., 283, 284

Phyfe, Isaac M., 281, 283, **284**

Phyfe, J. and W. F., 283, 284

Phyfe, James, 283, 284, 298n.69

Phyfe, James Duncan, 284

Phyfe, John, 283

Phyfe, John G., 283, 284

Phyfe, R. and W. F., 284

Phyfe, Robert, 283, 284

Phyfe, William, 283, 298n.69

Phyfe, William M., 361

Phyfe and Brother, 273, 284; upholstery goods and decorations for Millford Plantation, 284; —, armchair, 284, *285*, 305; fig. 233

Phyfe and Company, 284

Phyfe and Jackson, 284

pianos, 315, 320, *529*; no. 242

Pierce, Franklin, 372; seal of, plates with, *329*, 330; fig. 268

pier mirrors, 297, 299n.72, *519*; no. 228

Pierrepont, Henry Evelyn, house, Brooklyn Heights, 186, 322, 442; no. 103

pier tables, *294*, *295*, 296–97, *518*; figs. 240, 241, no. 227

Pietro da Cortona, 83

Pine Orchard, Catskills, 111, 112

Pingat, Émile, ball gown by, 256, *257* and n.41

Pintard, John, 13

Piranesi, Roman scenes, etchings of, 90

pitchers, ceramic: earthenware, *538*, *543*; nos. 254, 263; porcelain, *328*, *329*, 330, 337–39, *547*, *548*; figs. 267, 269, nos. 267–269; stoneware, 333, *333*, *335*, *540*, *541*, *542*, *546*; figs. 272, 274, nos. 256–259, 266

pitchers, silver, *358*, *359*, *567*, *569*, *573*; figs. 295, 293, nos. 297, 301, 310; with matching goblets, *567*, *571*, *572*; nos. 298, 305, 306

Pitt, William, sculpture of, by Wilton, 135, 141n.23

Pittsburgh, 339n.59, 340

Pius IX, pope, 128

Plassman, Ernst, 316n.198; buffet possibly carved by, *315*, 316–17n.201, 318; fig. 258

plaster sculpture, *145*, *422*; fig. 110, no. 67; busts, *85*, *139*, *140*, *410*; figs. 58, 105, 106, no. 53

plateaus, silver, 355–58, *357*; fig. 292

plates: earthenware, *543*; no. 262; porcelain, *329*, *332*; figs. 268, 270

Platt, George, 273–74, 282, 318, 322

Platt, Mr., Store, 71, 76

Platt and Brother, 369–70

platter, earthenware, 330, *538*; no. 253

Plazanet, Madame, 247

Plumbe, John, 233; *James K. Polk*, 233; *John Quincy Adams*, 233; *Senator Thomas Hart Benton*, 233

Plymouth Glass Works, 149n.118

Pocock, William, 171

Poe, Edgar Allan, 308–9

political prints, 219–20

Polk, James K., portraits of: by Brady, 231; by Plumbe, 233

Pollard, Calvin, 177; *Parlor Sliding Door, Dr. Moffat's House*, *179*, 180; fig. 141; Washington monument, design for, 152

Pompeii, 116, 123–24

Pomroy, Harriet, 281

Pontormo (Jacopo Carucci), 105

porcelain, 327–30, 331–32, 336–39; Crystal Palace exhibits (London, 1851), *338*, *339*; fig. 276; doorplate, *337*; fig. 275; pitchers, *328*, *329*, 330, *547*, *548*; fig. 267, 269, nos. 267–269; plates, *329*, *332*; figs. 268, 270; tea service, *539*; no. 255; vases, *326*, 327–28, *328*, *536*, *537*; fig. 266, nos. 250–252. *See also* Parian ware

portfolio cabinet-on-stand, 302–3, *522*; no. 233

portraits, nos. 1–22. *See also* daguerreotypes: portraits

Pottier, Auguste, 316–17

Pottier and Stymus, 282

Poussin, Nicolas, 40, 90, 103, 209

Powell and Company (printer), *459*; no. 127

Power, L., and Company, *73*, 75

Powers, Hiram, 38, 78, 103, 148, 149, 151, 158–60, 161, 162; *Andrew Jackson*, 34, 40, 158, *412*; no. 55; *Eve Tempted*, at the Crystal Palace, 158, *160*; fig. 120; *Fisher Boy*, 40, *101*, 103, 158; fig. 73; *Greek Slave*, 38, 40, 41, 72, 78, 79, 80, 103, 158 and n.79, 160, 162, 165–66, *417*; no. 60; —, at the Crystal Palace, 158, 160, *236*, 237; fig. 186; —, replica at the Düsseldorf Gallery, 160, *161*; fig. 121; *Proserpine*, 40, 158, *159*; fig. 119; *Washington at the Masonic Altar*, 80

Pratt (later Pratt and Hardenbergh), **277–79**

Pratt, Henry Cheever, 114

Pratt, J. H. and J. M., 279

Pratt, James H., 279

Pratt, John M., 279

Praxiteles, 158

precious-metals trades, 355–75. *See also* gold; silver

Pre-Raphaelites, 64

present plain style, 295

Prevost, Victor, 236–39; *Alfred Munroe and Company*, 237, *237*; fig. 188; *Battery Place, Looking North*, 238, *490*; no. 182; *Daniel Appleton's Bookstore*, 157, *157*; fig. 117; *Display of Machinery at the Crystal Palace*, *236*, 237; fig. 187; *Dr. Valentine Mott House*, 237, *237*; fig. 189; *Hiram Powers's "Eve Tempted" at the Crystal Palace*, 158, *160*; fig. 120; *Hiram Powers's "Greek Slave" at the Crystal Palace*, 158, 160, *236*, 237; fig. 186; *Jeremiah Gurney's Daguerreian Gallery*, 232, *233*; fig. 183; *Looking North toward Madison Square from the Rear Window of Prevost's Apartment*, 238, *491*; nos. 183, 184; *Ottaviano Gori's Marble Establishment*, 237, 265, *266*; fig. 217; *W. and J. Sloane Carpet Warehouse . . . and Solomon and Hart Upholstery Warehouse*, 271, *271*; fig. 223

Prime, Mary Trumbull, 95

Prime, Nathaniel, bust of, by Frazee, 147, *413*; no. 56

Prime, William Cowper, 94, 95–97; portrait of, by Schlegel, *96*; fig. 67

Prince of Wales Ball (Diamond Ball; Academy of Music, 1860), 253, 255–57; mantilla wrap worn to, *499*; no. 199; women's evening toilettes worn to, 253, 256, *256*, *502*, *503*; fig. 208, nos. 204, 205

print collections, 88, 90–93, 210–13

*Printing the Paper*, interior views of Christy, Shepherd and Garrett, 277, *278*; fig. 229

printing trade, 189, 205, 224

prints, bindings, and illustrated books, 189–225; nos. 114–153. *See also entries for specific processes and applications, e.g.*, aquatint engraving; banknotes; lithography; reproductive prints; wood engraving

prisons, 13, 14. *See also* New York Halls of Justice and House of Detention

promenades, 43, 252

Pruyn, Schaick Lansing, 347n.106

public gardens, 26–27

public monuments, 135, 136

Pugin, A. C., *Gothic Furniture*, 299

Pugin, A. W. N., 182, 298, 299, 301; *Gothic Furniture in the Style of the Fifteenth Century*, 300; *True Principles of Pointed or Christian Architecture*, 182

punch bowl, stoneware, *545*; no. 265

Putnam, G. P., and Company (publisher), *132*, 223, *315*, 316, *329*, 346, *364*, *372*; figs. 102, 258, 259, 268, 283, 298, 307; Irving, *A History of New-York*, 223–24, *466*; no. 137

Putnam, George P., *Tourist in Europe*, 123; as publisher, *see* Putnam, G. P., and Company

*Putnam's Kaleidoscope*, 61

*Putnam's Monthly*, 5, 209, 288

pyrography, 146

Quaker ball gown, 256 and n.42

Quidor, John, *The Money Diggers*, 389; no. 26

quilts, *508*, *509*; nos. 214, 215

Raeburn, Sir Henry, 97

Ralling, Madame, 247

Randel, John Jr., 6–8; *This Map of the City of New York and Island of Manhattan as Laid Out by the Commissioners*, 6–8, *8–9*; fig. 5

Ranney, William T., 69, 80

Raphael, 86, 92, 93, 103, 206, 211; *Adoration*, 53; *Madonna of the Baldachino*, 141; tapestries after cartoons of, 76

Raphael, school of, 105

Read, Joseph, 351n.127

Read, T. Buchanan, *Spirit of the Waterfall*, 80

ready-to-wear clothing, 249–51

reception room, 286

reception-room cabinet, 324–25, 286, *535*; no. 249

Redmond, S., parasol, *499*; no. 199

Reed, Luman, 13, 35, 37, 73, 86–87, 88, 89, 193, 210–11, 212; gallery and collection, 59, 72, **73**, 87, 88, 89, 93, 211; glassware purportedly owned by, 343, *553*; no. 276; house, 16, 17n.73, 87, 290–91; portrait of, by Durand, 13, *382*; no. 9

Rees, Thomas A., 327, 328, 330nn.7, 8

Reform Club, London, 185

Regency style, 171, 291, 340, 342, 343, 345

Regnault, Henri, 209

Reichard's Art Rooms, 55, **73**, 77

Reinagle, Hugh: *Belshazzar's Feast*, 75; Masonic Hall, 169

Rembrandt van Rijn, 86, 92, 93, 103, 212, 228; *Adoration of the Shepherds*, 92; *Descent from the Cross*, 92, *92*; fig. 63; *Raising of Lazarus*, 92; *Saint Jerome Reading in a Landscape*, 211, 212, *476*; no. 154

Renaissance Revival style, 316, 324, 353; bookcase, *321*, 324; fig. 262; *dressoir*, *309*, 311; fig. 252. *See also* Italianate style

Renwick, James Jr., 183, 232; Aspinwall's Gallery, 105; *Church of the Puritans*, 183, *436*; no. 94; Grace Church, *168*, 183, *437*; no. 95; Saint Patrick's Cathedral, 183

reproductive prints, 90, 91–92, 200, 201, 205–13

*Republic, The*, wood engraving from, *26*; fig. 21

republicanism, 11–15, 24–26, 27, 287; and the arts, 34–40; style associated with, 253, 298

residential architecture, 16–18, 176–77, 185–86

Revett, Nicholas. *See* Stuart, James, and Revett, Nicholas

Revolutionary War. *See* American Revolution

Revolution of 1848, 220, 316

Reynolds, Sir Joshua, 97; *George Clive (1720–1779) and His Family*, 53, 54; fig. 40; *Self-Portrait in Doctoral Robes*, 54

"Rhenish-Belgian Gallery," 79

Rhind, Charles, 358–59; silver presented to, cake basket, 358, 359; —, tea service, 358; —, tray, 358, 359 and n.12, *358*; fig. 294

Ribaillier, Pierre, *dressoir-Renaissance* ("old oak"), *309*, 311; fig. 252

Ribaillier, Pierre, and Mazaroz, Paul, *buffet dressoir*, 322n.221

Rich, Obadiah, and Ward, Samuel, vase presented to Daniel Webster, 373

Richard, Stephen, 359–61; cake basket presented to Charles Rhind, 358, 359; ewer and salver presented to Charles Bancroft, 359; gold box presented to William Bainbridge, 359; pair of pitchers presented to Jameson Cox, 359–61; tray presented to Charles Rhind, 358–59 and n.12, *358*; fig. 294

Richards, William Trost, 99, 119

Richardson, Andrew, 70

"Richardson's Gallery of Landscape Paintings," 70, 76

Richardt, Ferdinand Joachim, *Grace Church, Broadway and Tenth Street*, *168*, 183, *437*; no. 95; Niagara Gallery, 79

Richmond, Virginia, 340, 361. *See also* Virginia State House

Ridgway, John, pottery, 330–31 and n.21, 332n.22, 333

Ridgway, William, and Company, 334n.36, 336

Ridner, John (publisher), *207*; fig. 163

Ridner, John P., 163

Riell, Henry E., 77

Riell, Henry E., and Arcularius, Jacob, **73**, 77

Riker, Richard, pitcher presented to, 358, *358*; fig. 293

Riley, Joseph N., 282

*rimmonim* (Torah finials), 369, 370n.78, *371*; fig. 305

Ringuet-Leprince, Auguste-Émile, 93, 289, 309–12, 318n.205, 325; furnishings for Colles house, 93, 309–11 and n.156; —, sofa and armchair from drawing-room suite, 307, 310, *524*; no. 236A, B

Ringuet-Leprince and L. Marcotte, 312, 313, 316; Johnston suite, 312; —, armchair from, 312, *534*; no. 248

Ritch, John, Workingmen's Home, 17

rivière, George IV–style, *502*; no. 204

Robert-Fleury, Tony, 64

Roberts, David, 26

Roberts, K. W., wood engraving, *Iron Warehouse of John B. Wickersham*, *311*; fig. 255

Roberts, Marshall O., 98, 100, 101, 149

Roberts, Robert, wood engravings: *Four Elements Centerpiece by Tiffany, Young and Ellis*, *364*, 364, 373; fig. 298; *Glassware from the Brooklyn Flint Glass Works*, *348*, *348*; fig. 285; *Two Plates with the*

*Cipher and the Arms of the United States,* 329, 330; fig. 268

Roberts, William, wood engravings: after Voight, *247*; fig. 198; —, after Waud (?), *Sutphen and Breed's Paper-Hanging Store,* 280; figs. 230, 231

Robertson, Alexander, Seibert, Henry, and Shearman, James A., lithographed bill-head, *276*; fig. 227

Robertson, Archibald, 189, 190–91, 199; Grand Canal Celebration medals, gold medal and presentation case, *559*; no. 283A, B; —, silver medal and original box, 287, 358, *559*; no. 282A, B; *Grand Canal Celebration: View of the Fleet Preparing to Form in Line,* 3, 189–90, *450–51*; no. 118. See also *Memoir*

Robinson, John D., 277

Rochefort and Skarren, 316; oak sideboard, *132*, *133*, 136, 318; fig. 102

rococo, term, 303

Rococo Revival style, 293, 307, 320, 330, 333, 363, 369, 370. See also "Old French" styles; "modern French" style

Rodgers, Charles T., *American Superiority at the World's Fair,* lithograph from, *347*; fig. 284

Rodgers, Mr., collection, 75

Roff, Almon, house, Brooklyn, *235*; fig. 185

Rogers, Augustus, 366

Rogers, Isaiah, 18, 174–75, 181; Astor House, 174–75; *175*; fig. 134; Second Merchants' Exchange, 28, 175, *175*; fig. 135; Tremont House, Boston, 174

Rogers, John, 161; plaster after Barbee, *The Fisher Girl,* 161; *The Slave Auction,* 422; no. 67

Rogers, Nathaniel, *John Ludlow Morton,* *384*; no. 16; *Mrs. Stephen Van Rensselaer III,* *384*; no. 14

Rollins, Gustavus Adolphus, portrait of, by Cummings, *384*; no. 17

Roman Campagna, 124, *126*, 127–28, *128*; figs. 96, 97

Romanesque style, 183, 186

"Roman Gallery of Ancient Pictures," 78

Romantics, 119, 127

Rome, 10, 123, 124–25, 126–27, 128, 148, 224; views of, *55*, *406*; no. 48. See also Roman Campagna

Romney, George, 105

Roosevelt, Cornelia Van Ness, photographic portrait of, by Brady, 240, *497*; no. 196

Roosevelt, James J., 240

Root, Samuel, or Root, Marcus Aurelius, attributed to, *P. T. Barnum and Charles Stratton ("Tom Thumb"),* 25, *483*; no. 168

Rose, William, cameo, with portrait bust of Andrew Jackson, *504*; no. 206

Rosebrook family, 115

Roseland Cottage, Woodstock, Connecticut, furniture for, 299

Rosenberg, Charles G. See Cafferty, James H., and Rosenberg, Charles G.

Ross, David S., 271

Rossiter, T. P., Studio House, **73**, 80

Rossiter, Thomas P., 73, 74, 80, 166, 186; house, 186, *441*; no. 101

Rossiter, Thomas P., and Mignot, Louis Remy, *The Home of Washington after the War,* 80, 166

Rotunda. See New-York Rotunda

Roulstone, John, 193, *193*; fig. 151

Rousseau, Theodore, 105

Roux, Alexander, 262 and n.8, 281–82 and n.89, 289–90, 303n.109, 305–6, 308, 312n.177, 313, 316, 317n.203, 318 and

nn.204, 205, 322 and n.224, 323n.225, 325; étagère, 320, *532*; no. 246; étagère-sideboard, 318 and n.208, *530*; no. 243; attributed to, sideboard, *319*, 321–22; fig. 262

Row, The, 177

Rowand, Carrie A., 212

row houses, 176, 179–80, 185, 261. See also Chapel Street houses; La Grange Terrace; "Syllabus Row"

Royal Academy of Arts, London, 55, 72, 140, 196

Royal Gurley, 57, 68, **70**, 72, 78

Rubens, Peter Paul, 86, 90, 103; *Amazons on the Moravian Bridge,* engraving after, 211; *Crucifixion,* 76

Ruisdael, Jacob van, 85; *A Landscape with a Ruined Castle and a Church,* 53, *405*; no. 47

Rumrill, Alexander Jr., 370. See also Stebbins and Company

Ruskin, John, 107, 118, 128, 187; *Modern Painters,* 118

Russ pavement, laying of, on Broadway, 234–35, *489*; no. 180

Rust, Thomas, 172

Rutgers, Henry, 5

Ryall, Henry Thomas, engravings after Dubufe, *The Temptation of Adam and Eve* and *The Expulsion from Paradise,* 54–55, *57*; figs. 42, 43

Sabin, J., and Company, **73**

Sabin, Joseph, 90–91

Sackett, Mrs. William H., fan carried by, *503*; no. 205

Saco River, 115

Sailors' Snug Harbor, 13

St. Ann and the Holy Trinity Church, Brooklyn Heights. See Holy Trinity Church

Saint George's Church, 183

Saint John's Church, 5

Saint John's (Hudson) Square, 5, *6*, 7

Saint John's Park, 28; fig. 23

Saint-Mémin, Charles-Balthazar-Julien Févret de, 69, 81, 192; *A View of the City of New York from Brooklyn Heights,* 189, *190*; fig. 147

Saint Nicholas Hotel, 23, 185

Saint Patrick's Cathedral, 183

Saint Paul's Chapel, 32, 238; sculpture transferred to, by Frazee, *John Wells Memorial,* 137; vase depicting, 328, *537*; no. 251; view from, 3, 220, *464*; no. 135

Saint Peter's Church, Buffalo, 351

Saint Peter's Church, Chelsea, 182

Salamander Marble Company, 262–63

Salamander Works, 334–36; advertising broadside, *334*, 336; fig. 273; "Antique" ale pitcher, 336, *335*; fig. 274; punch bowl, *545*; no. 265; "Spanish" pitcher, 336, *546*; no. 266; water cooler, 336, *544*; no. 264

salts and saltcellars, glass, 342, 343, *550*; no. 272

Sandby, Paul, 193

Sandford, Rollin, collection, 80

Sanford, George T. See "Spoodlyks"

Sanguinetti collection, 76

Santa Claus, 216, 218–19; fig. 171

Saratoga, 112, 122

Saratoga Springs, 112–13, 120

Sarony, Major and Knapp, printed or published by, 375n.96; Architectural Iron Works, *Haughwout Building,* *439*; no. 98; Rembrandt Peale, *Court of Death,* 223; Sarony, *The Horse Fair, after . . . Rosa*

*Bonheur,* 221, 222; fig. 177; Walker, *The Storming of Chapultepec,* 218, 220; fig. 174

Sarony, Napoleon, 220, 224 and n.144; *The Horse Fair, after . . . Rosa Bonheur,* 221, 222; fig. 177; *Squier's Ancient Monuments of the Mississippi Valley,* 222; published by, Currier, *Awful Conflagration of the Steamboat "Lexington,"* 213, 214, 220; fig. 168

Sarony and Major, 220, 222; printed or published by, Bottischer, *Turnout of the Employees of the American Express Company,* 219, 220; fig. 175; —, Darley, illustrations of "Rip van Winkle" and "The Legend of Sleepy Hollow," 463; nos. 133, 134; —, D'Avignon, after Matteson, *Distribution of the American Art-Union Prizes,* 207; fig. 163

Sartain, John, 318, 206n.60

Sarti, Antonio, collection, 51, 52, 75

Sarto, Andrea del, 53, 93

Saunders, Mr., collection, 76

Saxony and Major, fashions by, *245*; fig. 196

Sayre and Yates, 346n.105

scarves, 246

Schaus, William, 63, 74, 208; collection, 79; published by, *471*; no. 148

Schaus Gallery, **73–74**, 79, 80, 165

Scheffer, Ary, 63, 92, 105, 209; *Dante and Beatrice,* 79, 209; —, engraving after, by Lecomte, 209, *209*; fig. 165; *The Holy Women at the Sepulchre,* 58, *58*; fig. 46

Scheggia (Giovanni di Ser Giovanni di Simone), 103; *The Triumph of Fame and Arms of the Medici and Tornabuoni Families,* 402; no. 42

Schelfhout, Andreas, 99

Schenck, **74**, 81

Schenck, Edward, 74

Schenck, Edward and F. H., 74, 81

Schermerhorn, Abraham, 372

Schermerhorn, Caroline Webster, 372

Schermerhorn, Mrs. John James (Mary Hone), bust of, by Crawford, 152

Schinkel, Karl Friedrich, Altes Museum, Berlin, 174

Schlegel, Fridolin, *William Cowper Prime,* 96; fig. 67

Schmidt, Frederick, *Park Hotel (Later Called the Astor House),* 174, *175*; fig. 134

Schmidt, L. W. (publisher), *469*; no. 145

Schoff, Alonzo, after Vanderlyn, *Caius Marius on the Ruins of Carthage,* 206

Schrader, Julius, *Baron Alexander von Humboldt,* *130,* 131; fig. 99

Schuyler, Mrs., 100, *395*; no. 34

*Scientific American,* front page, *278*; fig. 229

Scott, Sir Walter, 302; statue of, by James, 144

Scottish paintings, 87

Scudder, John, American Museum, 66, 140

sculpture, 135–67; nos. 52–69. *For specific materials, see* bronze: sculpture; limestone sculpture; marble sculpture; plaster sculpture; *for specific forms, see* busts; medallions; monumental sculpture

sculpture exhibitions: first one-person show, 154; single-sculpture shows, 141–44; venues and forums, 149–51

Seagar, D. W., 228 and n.3; "Table of General Rules for Exposure of the Plate," 229–30

Second Congregational (Unitarian) Church, 169, *170,* *425*; fig. 129, no. 72

Second Empire style, 185, 313, 323–24, 325

Second Merchants' Exchange, *7,* 18, 28, 153, 160, 174, *175,* *175*; fig. 135; in 1855, 29, *30*; fig. 26

Second Unitarian Church. See Second Congregational (Unitarian) Church

secretary, 296, 297n.68, *519*; no. 229

secretary-bookcases, 293, 294–95 and n.52, *515*; fig. 239, no. 223

Sedgwick, Theodore, 153

Seely, Samuel S., 355n.4

Seibert, Henry. See Robertson, Alexander, Seibert, Henry, and Shearman, James A.

Seitz, Emil (publisher), *468*; no. 144

Seneca Canal, 355

*Seneca Chief* (canal boat), 3, 189, 287

Senefelder, Aloys, 191

Sewall, Henry Foster, 92–93, 201, 212

Sewall, Samuel, 92

Shakespearean subjects: house at Stratford-on-Avon, 237; *Romeo and Juliet,* portfolio cabinet-on-stand with scene from, 302–3, *522*; no. 233; *Songs and Ballads,* 222. See also West, Benjamin: *King Lear, Ophelia*

Sharp, Henry, 351, 352n.128

Sharp, William, 91, 224n.144; after West, *King Lear,* 208 and n.70, 211, *477*; no. 156

Sharp and Steele, 351

Shattuck, Aaron, 119

Shaw, Henry, *Specimens of Ancient Furniture,* 300

Shaw, Joshua, engravings after, by J. Hill, *Picturesque Views of American Scenery,* 111

shawls, 245, 257; paisley, *500*; no. 200

Shearman, James A. See Robertson, Alexander, Seibert, Henry, and Shearman, James A.

sheet-music covers, 218

Sheffield plated ware, 367

Shepard, George L., 361, 374

Shepherd, T. H., *Metropolitan Improvements,* 171

Shepherd, Thomas Christy, 277

Sheraton, Thomas, *Cabinet Directory,* 297

Shiff, Hart M., 185, 312; house, 185–86, *440*; nos. 99, 100

shipbuilding, 137

shoes, 250. See also boots; slippers

shopping, 23–24, 247–48, 252, 259–60, 303

side chairs, 301, *304,* 306–7, *523*; fig. 247, no. 235

sideboards, *132,* *133,* 288n.2, 316, 318 and n.208, *319,* *530*; figs. 102, 262, no. 243. *See also* buffets

Sigourney, Lydia H., 90

silk and silk goods, 247, 250, 254, 255–56, 257, 259, 281

silkscreen, 225

Silliman, Benjamin Jr., 113

Silliman, Benjamin Jr., and Goodrich, Charles Rush, *The World of Science, Art, and Industry Illustrated from Examples in the New-York Exhibition, 1853–54,* 237, 316 and n.199, 318, 364; wood engravings from, 315n.191, 316; —, *Glassware from Joseph Stouvenel and Company,* 345, *346;* fig. 283; —, by J. W. Orr, *Armchair,* 316, 318–19; fig. 259; —, *Buffet,* *315,* 316–17n.201, 318; fig. 258; —, *Oak Sideboard by Rochefort and Skarren,* *132,* *133,* 316, 318; fig. 102; —, by N. Orr, *Service of Plate Presented by the Citizens of New York to Edward K. Collins,* 370, 372, *372;* fig. 307; —, by R. Roberts, *Four Elements Centerpiece by Tiffany, Young and Ellis,* 364, *364,* 373; fig. 298; —, *Two Plates with the Cipher and the Arms of the United States,* 329, 330; fig. 268

silver, 355–75; basket, *562*; no. 288; centerpieces, 364, *364*, 373; fig. 298; coffee urn, *560*; no. 285; communion set, 370, *571*; no. 304; covered ewer, *357*; fig. 291; footed cup, *370*; fig. 304; hot-water urn, 361, *564*; no. 290; mace, *366*, 367, 368; fig. 301; medals, *559*, *565*; nos. 282A, B, 291; pitcher, trophy, *567*; no. 297; pitchers, *358*, *359*, *573*; figs. 293, 295, no. 310; pitchers with goblets, *567*, *571*, *572*; nos. 298, 305, 306; plateau, 355, *357*; fig. 292; *rimmonim* (Torah finials), 369, 370n.78, *571*; fig. 305; table service, *374*; fig. 309; tea and coffee service with tray, *569*; no. 301; tea services, *349*, *371*, *559*; figs. 286, 306, no. 284; tray, *358*; fig. 294; tureens, *361*, *561*; fig. 297, no. 286; urn, *369*; fig. 302; vases, *356*, *360*, *566*; figs. 290, 296, no. 296

silver flatware, 366–67, 370; Gothic-pattern, crumber, *568*; no. 299; —, dessert knife, sugar sifter, fork, and spoon, 367, *568*; no. 300

silver-plate wares, 368

Sketch Club, 110 and n.8

Skidmore, Samuel Tredwell, 268, 269, 271; house, 177–79, *178*, 180, 269; figs. 138, 139

slavery: debate over, 158; manumission act, 13

slippers, pair of, *501*; no. 203

Sloane, John (William's brother), 271, 272

Sloane, John (William's son), 272

Sloane, W. and J., 268, **271–72**; Carpet Warehouse, 271, *271*; fig. 223

Sloane, William, 271–72

Smillie, James, 200; after Cole, *The Dream of Arcadia*, 20; —, The Voyage of Life series, 79; —, *Youth*, 207, *462*; no. 130; after Durand, *Dover Plains*, 207; after Kensett, *Mount Washington from the Valley of Conway*, 118, 119; fig. 85

Smirke, Robert, 176; Saint Mary's, Wyndham Place, 171

Smith, Alexander, carpet factories, 267, 268

Smith, Alexander, and Sons Carpet Company, Yonkers, 272

Smith, Alfred, 120

Smith, Benjamin F. Jr., *New York, 1855, from the Latting Observatory*, engraving after, by Wellstood, 42, 221, *468*; no. 143

Smith, B. J., *Drawing Room of Grace Hill*, *307*, 307–8; fig. *250*

Smith, C. S., **74**, 77

Smith, Fern and Company (publisher), *468*; no. 143

Smith, George, *A Collection of Designs for Household Furniture and Interior Decoration*, 293–94, 296n.54; —, plate from, *Drawing-Room Chair*, *292*, 294; fig. 237; *Cabinet-Maker and Upholsterer's Guide*, 292, 293n.42, 296

Smith, George C. [O.], 370

Smith, H., 212

Smith, James, 304n.122

Smith, John Rowson, *Panorama of the Tour of Europe*, 79

Smith, John Rubens, 111, 194; *Portrait of a Lady [Mrs. John Rubens Smith?]*, 191, *191*; fig. 148

Smith, Thomas C., 339

Smith, William D., wood engraving after Davis, *Public Buildings in the City of New-York*, *170*; fig. 129

Snedecor, John, 74

Snedecor's, **74**, 80, 81

Snook, John Butler, 184. *See also* Trench, Joseph, and Snook, John Butler

Snooks, Mr., 283

Soane, John, 176; Holy Trinity, Marylebone, 171

Society of Iconophiles, 224, 225

sofas, 295 and n.54, 299n.74, 308, *308*, 318–19, 320, *516*, *524*, *526*, *531*; fig. 251, nos. 224, 236A, 240A, 245; in Greek Revival parlor, 291, *447*; no. 112; in Louis XV floor plan, *306*, 307; fig. 249; in Morse painting, 291, 292; fig. 236

Solomon, B. L., and Sons, 285

Solomon, Barnett L., 273, 285 and n.107

Solomon, Isaac S., 285

Solomon, Solomon B., 285

Solomon and Hart, 281, 283, **284–85**; Upholstery Warehouse, *271*; fig. 223

Sonntag, Louis, *Dream of Italy*, 80

Sonntag, William L., 166

Southack, J. and W. C., 282

South Street, 19; view of, *451*; no. 119

Southworth, Albert Sands, 230n.18

"sovereigns," 36, 42, 43

Spafford, Horatio, *Gazetteer of the State of New-York*, 111, 112

spandrel panel, cast-iron, *438*; no. 97

Spanish paintings, 86

"Spanish" pitcher, stoneware, 336, *546*; no. 266

Sparrow, John, 163

Spaulding, John H., 117

Spencer, Asa, 201

Spencer, Frederick R., 105; *Family Group*, 297, 320, *383*; no. 13

Spencer, Lilly Martin, 79; *Kiss Me and You'll Kiss the 'Lasses*, *394*; no. 33

Spingler Institute, 79

spinning, from sheet metal, 368, *369*; fig. 303

"Spoodlyks" (possibly George T. Sanford), lithograph after, by G. and W. Endicott, *Santa Claus's Quadrille*, *216*, 218–19 and n.114; fig. 171

spoon, silver, *568*; no. 300

Spooner, Shearjashub, 80, 207, 208, 209, 210, 211; American edition of J. and J. Boydell, *Shakespeare Gallery*, 208 and n.70, 210n.71; *Appeal to the People of the United States*, 210; *A Biographical and Critical Dictionary of Painters, Engravers, Sculptors, and Architects*, 210

*Squier's Ancient Monuments of the Mississippi Valley*, 222

Staffordshire, England, pottery, 330, 333, 334, 336, *538*; nos. 253, 254

stained glass, 350–53, *350*, *352*, *557*; figs. 287–89, no. 280

Stanfield, Clarkson, 99

Stanfield's Great Moving Panorama, 76

Stanley, Joseph, and Company (publisher), *455*; no. 123

Stanton, Daniel, collection, 78

Starr, Fellows and Company or Fellows, Hoffman and Company, gasolier, *570*; no. 302

State Street, 177

steam power: elevators, 22 and n.96; glass-cutting lathe, 340; ocean vessels, 123; presses, 224; tools, 340

Stebbins, E[dwin], and Company, 370; octagonal teapot, 368–69n.75

Stebbins, William, 370

Stebbins and Company, retailed by, tea service in Gothic Revival style, 370, *371*; fig. 306

Stebbins and Howe, 363

Steele, William, 351, 352n.118. *See also* Sharp and Steele

steel-plate engraving, 201n.44, 202, 205n.51

Stephens, Ann S., *Fashion and Famine*, 260

Stephenson, Peter, *The Wounded Indian*, 78, 162, *163*; fig. 124

stereoscopic images, 234–35, *489*; nos. 180, 181

Sterne, Laurence, *Tristram Shandy*, sculpture drawn from, by Hughes, *Uncle Toby and Widow Wadman*, 55, 76, 144 and n.37

Stevens, Colonel, 74

Stevens, Henry, 97

Stevens, John Cox, house, 180

Stevenson, Abner, stained glass for Trinity Church, 352; *Saint Mark, Christ, and Saint Luke*, 352; fig. 289

Stewart, A. T., store (Marble Palace), 7, 23–24, 32, 42, 183–85, 244, 245–46 and n.10, *246*, 247, 248, 249n.23, 257, 259, 265, *438*; fig. 197, no. 96; ball gowns from, *250*, *251*; figs. 202, 203; wedding veil from, 24, 245 and n.10, *501*; no. 201

Stewart, Alexander T., 23, 70, 160, 183, 184, 245

Stiles, S., and Company (printer), *456–57*; no. 124

Stirewalt, John, *Colonnade Row*, 16, 175, 179, 180, *431*; no. 86

Stirling, Lewis, suite commisioned from Phyfe, 297, 298n.70

stock, *498*; no. 197

Stokes, Isaac Newton Phelps, 225; *The Iconography of Manhattan Island*, 189; —, plates from, *166*, *175*; figs. 128, 134, 135

Stollenwerck, *Mechanical Panorama*, 74

Stollenwerck and Brothers (Washington Divan), **74**, 76

stonecutters, 137

stoneware, 332–33, 336; pitchers, *333*, *335*, *540*, *541*, *542*, *546*; figs. 272, 274, nos. 256–259, 266; punch bowl, *545*; no. 265; water cooler, 336, *544*; no. 264

Stoppani's Building, 78

storefronts, 20–21, 183–84

Storr, Paul, 367n.61; plateau, 355

Storr and Mortimer, 367 and n.61

Stout, James D., 359n.13; tray presented to Charles Rhind, *358*, 358–59 and n.12; fig. 294

Stouvenel, Joseph, 346n.102

Stouvenel, Joseph, and Brother, 339, 345

Stouvenel, J[oseph], and Company, 345, 346 and n.103; glassware exhibited at New York Crystal Palace Exhibition, 345–46, *346*; fig. 283

Stowe, Harriet Beecher, *Uncle Tom's Cabin*, 260; vases with scenes from, 330, *537*; no. 252

Strange, Robert, 91

Stratton, Charles ("Tom Thumb"), 25; daguerreotype of, attributed to S. or M. A. Root, *483*; no. 168

straw matting, 265–67

Strickland, William, 181

Stringer and Townsend (publisher), *466*; no. 138

Strong, Ellen, 313

Strong, George Templeton, 18, 29, 31, 32, 33, 40n.233, 42, 43, 92, 152, 313, 372

Stuart, Gilbert, American Art-Union medal, *565*; no. 293; *George Washington*, 105

Stuart, James, and Revett, Nicholas, *Antiquities of Athens*, 171, 173, 176, 293 and n.45

Stuart, Robert L., collection, 100, 101–2

Stuart-Wortley, Lady Emmeline, 244

Stubbs, Joseph, pitcher depicting City Hall, 8, 330, *538*; no. 251

Sturges, Jonathan, 72, 73, 87–88, 89, 93, 98, 100, 122, 151, 154, 155

Sturges, Mrs. Jonathan, 86–87

Stuyvesant, Peter, 56, 110; in print by Lumley, *474*, no. 152; in scene by Durand, *388*; no. 25

Stuyvesant Institute, 55, 56, **74**, 76, 77, 78, 79, 94, 161, 162, 228n.3

Stuyvesant Square, 7, 183

sugar bowl with cover, silver, *569*; no. 301

sugar sifter, silver, *568*; no. 300

Sully, Thomas, *Queen Victoria*, 76, 77; *Thomas Jefferson Bryan*, 103, *103*, 212; fig. 75

Sumner, Charles, 152

Sutphen, Teneyck, 279, 280

Sutphen and Breed (later Sutphen and Weeks), **279–80**, *280*; figs. 230, 231

Suydam, James A., 92; *Paradise Rocks*, 91, 92; fig. 62

Swepstone, W. H. (author), and Ashley, Alfred (artist), *Christmas Shadows, a Tale of the Poor Needle Woman*, 223, *466*; no. 138

Swift, Abel, 312n.177

Swinbourne, J., collection, 80

"Syllabus Row," 16, 179, *430*; no. 84

Sypher and Company, 305n.125

Taber, Augustus, 264, 265

tableaux vivants, 40

*table de canapé* (sofa table), 307

tables, 291, *514*; no. 222; console, 307; nested, 297, 300n.76, *520*; no. 230. *See also* center tables; pier tables; worktable

table supports, cast-iron, 300, 301; fig. 245

table-top bookcase, 314n.188, 315–16, *525*; no. 238

tailcoat, *498*; no. 197

Tait, Arthur Fitzwilliam, 101

Talbot, William Henry Fox, 237

Tallis, J. and F. (publisher), *City Hall, New York*, 342–44n.83; goblet with, 343, *344*; fig. 281

Tammany Museum, 66

Tappan, Arthur, store, 21n.93, 184, *183*; fig. 144

tariffs, 308, 331, 339; of 1842, 364, 367–68

Tatler, Elijah, scene of New York Harbor on doorplate, 337, *337*; fig. 275

Taylor, Alexander H., **74**

Taylor, Bayard, *Views A-Foot*, 123, 127

Taylor, Zachary, 220n.117

tea and coffee service with tray, *569*; no. 301

Tea Island, Lake George, 113

tea services: porcelain, *332*, *539*; figs. 270, 271, no. 255; silver, *349*, *371*, *559*; figs. 286, 306, no. 284

telegraph, 227, 228, 236. *See also* transatlantic telegraph cable

Templeton, James, and Company, Glasgow, carpet, 286

tenements, 17; Grove Court, *16*, 17; fig. 10

Teniers, David the Younger, *Judith with the Head of Holofernes*, *403*; no. 43

"Ten Thousand Things on China" exhibition, 78

Tenth Street Studio Building, 61, **74**, 79, 80

"Terrace Houses," 16, 173, 179, *430*; no. 85

textiles, 23–24n.108, 257, 284; brocatelle, *512*; no. 219. *See also* carpets; curtains and draperies; lace; muslin; quilts; silk; upholstery

Thaw, Robert, engraving by, *161*; fig. 121

Thistle pitcher, stoneware, 333, *542*; no. 259

Thom, James, 55, 144 and nn.34, 35, 161; *Old Mortality and His Pony, Willie and Allan*, 144; *Robert Burns*, 144; *Sir Walter Scott*, 144; *Tam O'Shanter, Souter Johnny, the Landlord and Landlady*, 55, 76, 144 and n.35, 147

Thomas, Griffith, 181

Thomas, Griffith, and Washburn, William, Fifth Avenue Hotel, 185

Thomas, Thomas (architect), 181

Thomas, Thomas (glass stainer), 351 and n.127

Thomas, Thomas, and Son (architects), 177–79; *Samuel T. Skidmore House*, 177–79, *178*, 180; figs. 138, 139

Thompson, Martin Euclid, 169–70, 171, 172–73, 176; Branch Bank of the United States, 170, *170*, 173, *424*; fig. 129, no. 71; Phenix Bank, 171–72, 176; attributed to, plot plan and drawings for Columbia College Chapel Street houses, 16, 177, *177*, 179, 290, *432*; fig. 137, nos. 87, 88

Thompson, Martin Euclid, and Brady, Josiah R., First Merchants' Exchange, 18–19, 28, 170–71, *171*, 172, 173, 175, 181, *426*, *537*; figs. 129, 130, nos. 74, 75, 251

Thompson, Martin Euclid, and Town, Ithiel, Church of the Ascension (Canal Street), 172, *172*, 176, 181; fig. 132

Thompson, Thomas, 192; *New York Harbor from the Battery*, 9, 192 and n.12, 197, *452–53*; no. 121

Thompson and Company, 271 and n.46, 272

Thomson, James, collection, 78

Thomson, James, *The Seasons*, scene from, by Durand, *Musidora*, 90, *91*; fig. 61

Thomson, James (silver manufacturer), 363

Thomson, William, 359 and n.15, 363, 369

Thorne, Col. Herman, house, 185

Thorvaldsen, Bertel, 105, 137, 141, 147, 148, 160; *Christ and the Apostles*, 160; *Ganymede and the Eagle*, 160, *411*; no. 54; *Night* and *Day*, 161

Thumb, Tom. *See* Stratton, Charles

Tiebout, Cornelius H., 349

Tiepolo, Giovanni Battista, 53

Tiffany, Charles L., 364

Tiffany, W. L., 36

Tiffany, Young and Ellis, 314, 316, 364 and n.44, 370, 372, 373–74n.87; Four Elements centerpiece, 364 and n.44, *364*, 373; fig. 298; worktable, *312*, 313n.183, 314; fig. 256

Tiffany and Company, 255, 289, 370, 372–73, *373*, 374–75 and n.88; fig. 308; Astor service, 372; fan, *501*; no. 202; five-piece parure in fitted box, 255, *504*; no. 208; hair bracelet, *505*; no. 209; medal and presentation box (transatlantic cable commemorative), 9, 375 and n.96, *572*; nos. 307, 308; mounted section of transatlantic telegraph cable, 9, 375, *572*; no. 309; seed-pearl necklace and pair of bracelets for Mrs. Lincoln, *257*, *505*; fig. 209, no. 211; service presented to Samuel Francis Du Pont, 373, *374*; fig. 309; service presented to Col. Abram Duryee, 375, *375*, *573*; fig. 310, no. 310

Tiffany and Young, 364

Tillman, Madame, 247

Tilton, John Rollin, 105

Tingle, George, 334n.38, 345

Tingle and Marsh, 327, 334n.38

Tintoretto (Jacopo Robusti), 86

Titian (Tiziano Vecelli), 86, 105; *Bacchus and Ariadne*, engraving after, by Lossi, 211, *476*; no. 155; *Magdalen in the Wilderness*, 53; *Venus*, 77

Tombs. *See* New York Halls of Justice and House of Detention

Tompkins, Erastus O., 365. *See also* Ball, Tompkins and Black

Tompkins Square, *7*

Tom Thumb. *See* Stratton, Charles

Tontine Coffee House, 171n.8

Tornabuoni family, arms of, *402*; no. 42

tourism, and landscape painting, 111–33. *See also* Grand Tour

Town, Ithiel, 89–90, 171, 172–74, 175, 176, 177, 180, 181, 299; Arthur Tappan Store, 21n.93, 183, *183*; fig. 144; New York Theatre (Bowery Theatre), 171–72 and nn.14, 15, *172*; fig. 131; *Outline of a Plan for Establishing in New-York an Academy and Institution of the Fine Arts*, 89–90; project for Henry Byard, 179. *See also* Thompson, Martin Euclid, and Town, Ithiel

Town, Ithiel, and Davis, Alexander Jackson, 89, 173–74 and n.23, 175, 179, 180; designs for Park Hotel (Astor House), 173, 174, *174*, 175, *427*; fig. 133, nos. 77, 78; Indiana State Capitol, Indianapolis, 173; Lyceum of Natural History, 173n.23; North Carolina State Capitol, Raleigh, 173–74; United States Custom House, 28, 173, 175, 181, *428*, *429*; nos. 79–81

Town, Ithiel, Davis, Alexander Jackson, and Dakin, James H.: University of the City of New York (New York University), Washington Square, 173n.23, 175, *176*, 180; fig. 136; Washington Street Methodist Episcopal Church, Brooklyn, 175

Townsend, W. A., and Company, 223

trade cards, *58*, *343*; figs. 44, 279

Trainque, Peter, 300

transatlantic telegraph cable, 9, 374–75; commemorative medals and presentation boxes, 374–75, *572*; nos. 307, 308; mounted section, 9, 375, *572*; no. 309

Travellers' Club, London, 184–85

trays: painted, birth tray of Lorenzo de' Medici, *402*; no. 42; silver, *358*, *569*, *571*; fig. 294, nos. 301, 305

Tredwell, Seabury, house, 177

Tremont House, Boston, 174

Trench, Joseph, 23, 184

Trench, Joseph, and Snook, John Butler, *A. T. Stewart Store*, 23, 184, 245, *438*; no. 96; Metropolitan Hotel, 185; Saint Nicholas Hotel, 185; Thorne, Col. Herman, house, 185

Trentanove, Raimondo, 137

Trenton Falls, Catskills, 112

Trested, Richard, lettering upon die for Grand Canal Celebration medal, 358, *559*; no. 282A

Trinity Building, 186

Trinity Chapel, *447*; no. 113; communion service for, 370 and n.80, *571*; no. 304

Trinity Church, New Orleans, 351

Trinity Church, New York, 5, 28; sculpture for, by Hughes, *Bishop John Henry Hobart Memorial*, 140; second building (1790), 182, 351; —, viewed from Liberty Street, *445*; no. 109; third building (1846), 7, 144n.34, 182, *182*, 183, 238, 351, 352–53 and n.136, *436*; fig. 142, no. 93; —, chancel window with *Saint Mark, Christ, and Saint Luke*, 351, 352, 352–53; fig. 289; —, depicted on wallpaper, *510*; no. 216

Trollope, Frances, 199, 255, 290, 291

trophy pitcher, silver, 368, *567*; no. 297

trousers, *498*; no. 197

trousseau, 245–46n.10

Troye, Edward, 80

Troyon, Constant, 64, 105

Trumbull, John, 48, 49, 50–55, 69, 75, 76, 83, 84, 90, 109, 136, 137 and n.9, 138,

140–41 and n.23, 144, 200; *Alexander Hamilton*, 34, *378*; no. 1; American Art-Union medal depicting, *565*; no. 295; bust of, by Hughes, 141, *414*; no. 57; *Declaration of Independence*, engraving after, by Durand, 200, *200*; fig. 157; *Sortie Made by the Garrison at Gibraltar*, 46, *51*, 51–52; fig. 38

Trumbull, Mary, 95

Tucker, Gideon, 177

Tucker, Thomas, 332

Tucker and Morss, Columbia College houses, 177

Tuckerman, Henry T., 68, 87–88, 101, 103, 163, 166; *Book of the Artists, American Artist Life*, 106; *Italian Sketchbook*, 127, 128; "Newport Beach," 120

Tuileries, Paris, 312; dress worn to ball at, 256, *257* and n.43

turbans, 254

tureens, silver, *361*, *561*; fig. 297, no. 286

Turkish trousers, 253

Turner, Harriet Corning, 347n.106

Turner, J. M. W., 85, 88, 91, 92, 97, 99, 119, 196; *Crossing the Brook*, print after, 88; *Slave Ship, England*, 94, *94*; fig. 65; *Staffa, Fingal's Cave*, 97, *407*; no. 49

Turtle Grove, 201, *201*; fig. 158

Tuscan-pattern flatware, 366

Tuttle and Ducluzeau, *74*, 77

Twelfth Night Festival, 67

Tyler, John, 248, 249n.23

Tyler, Julia Gardiner, 248, *248*, 249n.23, 256; fig. 199

Tyndale, Richard, 345

typing, of New Yorkers' characters, 28

Uhlfelder, E., 257n.46

Underhill, Edmund, 264

Underhill and Ferris, **264–65**; mantels for Knoll (later Lyndhurst), after designs by Davis, 264, *264*; fig. 216

Union Army, 325

Union Club, 186

Union Glass Works, Philadelphia, 345

*Union Magazine*, 158

Union Porcelain Works, Brooklyn, 339

Union Square, *7*, 11, 16, 183; Washington Monument, *166*, 167, 239, *493*; fig. 128, no. 188

Unitarian Church, early photograph of, 228

United States, great seal of: on plates and matching pitcher, 329, 330; figs. 268, 269; on pitcher made for Harrison campaign, 334, *543*; no. 263; on pottery mark, 331, *332*; fig. 271

United States Bank Branch (Wall Street), 6, 7, 18, 169, 170, *170*, 173, *424*; fig. 129, no. 71

United States Capitol, 34, 174, 322; commissions to Crawford, 153, 154; sculpture for rotunda, by Greenough, *George Washington*, 144, 145n.39

United States Congress, 34, 147, 200, 227, 367

United States Custom House (now Federal Hall), 7, 18, 28, 147 and n.49, 148, 173, 175, 181, *428*, *429*; nos. 79–81

United States House of Representatives; armchairs for, 322; mace of, *366*, 367 and n.56, 368; fig. 301

*United States Magazine*, 36

*United States Magazine and Democratic Review*, 149

United States Pottery Company, Bennington, Vermont, display at the New-York Exhibition of the Industry of All Nations, *338*, 339; fig. 276; central monument from, 339, *549*; no. 270

United States Senate, chairs for, 282

United States Supreme Court, sculpture for, by Frazee, *John Jay*, 34, *146*, 147; fig. 111

University Building, **74**

University of the City of New York (now New York University), 7, 74, 153n.23, 175, *176*, 180, 205, 227, 228, 270; fig. 136; Gothic Chapel, 187

upholsterers, 280–85; cabinetmakers as, 281–82; female, 281; as interior decorators, 282, 284; as wallpaper retailers, 272, 273, 282

upholstery, 259, 280–85, 289; chairs attributable to upholstery shops, *283*, *285*; figs. 232, 233. *For other upholstered pieces, see* chairs; couches; sofas; window bench

Upjohn, Richard, 38n.229, 181–82, 186, 187, 351; Bowdoin College chapel, Maine, 351; Church of the Ascension (Fifth Avenue and Tenth Street), 181; Church of the Pilgrims, Brooklyn, 183; *Henry Evelyn Pierrepont House, Brooklyn*, 186, 322, *442*; no. 103; Saint Paul's Church, Buffalo, 351; Trinity Building, 186; Trinity Church, 182, 351, 352–53, *436*; no. 93; —, detail of chancel window designed for, *Saint Mark, Christ, and Saint Luke*, 352; fig. 289

Upjohn, Richard Michell, 186

Upper East Side, 43

urns: glass, 341; silver, *361*, *369*, *560*, *564*; fig. 302, nos. 285, 290

Utica, 288

Valentine, Elizabeth Ann, trousseau, 245–46n.10

Van Buren, Martin, 240–41, 275; photographic portrait of, by Brady, 240–41, *497*; no. 195

Vance, Robert H., views of California, 237

Vanderlyn, John, 38, 56, 72, 83, 85; *Ariadne Asleep on the Island of Naxos*, engraving after, by Durand, 199, 201, 205, 212, *458*; no. 125; *Caius Marius on the Ruins of Carthage*, engraving after, by Schoff, 206; *Landing of Columbus*, 78; *The Palace and Gardens of Versailles*, 38, *39*, 72; figs. 33, 34; attributed to, architectural design for the New-York Rotunda, 38, 55, 169, *424*; no. 70

Vanderpoel, Julie A., pair of pitchers presented to, 359; fig. 295

Vandewater, John L., and Company, **74**

Van Gorder, Mr., 275 and n.61

Van Nest, Abraham, 368–69n.5

Van Rensselaer, Mrs. Stephen III, portrait of, by N. Rogers, 384; no. 14

vases: glass, 348, *555*; no. 278; porcelain, 195, 327–28, *328*, 330, *536*, *537*; fig. 266, nos. 250–252; silver, *356*, 360, *555*, *558*, *566*; figs. 290, 296, nos. 278, 281A, B, 296

Vassar College, 99

Vatican galleries, 125, 148

Vattemare, Alexander, collection, 77

Vaux, Calvert, 43, 45, 181; *"Greensward" Plan for Central Park*, 43, 241, *495*; nos. 192, 193. *See also* Olmsted, Frederick Law, and Vaux, Calvert

Vauxhall Gardens, 6, 16

Vedder, Elihu, 101

vegetable dish, earthenware, *542*; no. 260

Velázquez, Diego, 53; *Charles I*, 78

Venetian (striped) carpets, 267 and n.26, *267*, 268; fig. 218

Venice, 123; Doge's Palace, 187

venues, for art exhibitions, 47–65, **66–74**

Verboeckhoven, Eugène, 102

Vernet, Horace, 63, 64, 105; *Joseph and His Brothers*, 79; *Joseph Sold by His Brothers*, print after, 209

Vernets, the, 209

Veronese, 86

Verplanck, Gulian Crommelin, 83, 84, 137; portrait of, by Ingham, *381*; no. 7

vest, *498*; no. 197

Vibert, 69. *See also* Goupil, Vibert and Company

Victoria, queen of England, 240, 248 and n.21; portraits of, 31, 215, 247n.15; —, by Sully, 76, 77

Victoria and Albert Museum, London, 90

Victoria Mansion, Maine. *See* Morse-Libby House

Viele, Egbert L., *Sanitary and Topographical Map of the City and Island of New York*, line drawings after, *5, 6, 7*; figs. 2–4

*Views in New York and Its Environs*, 330n.6

*Views of the Public Buildings in the City of New-York*, illustrations by Davis, lithographed by Imbert, 169, 180, 192, 197, 212, *424*, *425*; nos. 70–72; *Branch Bank of the United States*, 18, 170, 173, *424*; no. 71; *The Rotunda*, 38, 55, *424*; no. 70; *Second Congregational (Unitarian) Church*, 169, *425*; no. 72

Virginia, balls in honor of Lafayette, gowns worn to, 254n.38

Virginia State House, Richmond, Washington monument, by Crawford, 153

Visconti, Louis, 324

Voight, Lewis Towson, wood engraving after, by W. Roberts, *247*; fig. 198

Volk, Leonard, statuette of Senator Douglas, 80

Volney, Comte de, 127

Waddell, William C. H., house, *14*, 16, 180; fig. 7

Wadleigh, J. C., collection, 77

Wadsworth, Daniel, 48, 50, 114, 116, 117; *Avalanches in the White Mountains*, *115*, 116; fig. 82

Wadsworth Atheneum, Hartford, 66

Wainwright, Dr. Jonathan Mayhew, 181–82

Waites, Edward, wood engraving after, *250*; fig. 202

Wakefield Plantation, near Saint Francisville, Louisiana, furnishings ordered for, 297

Walcker, E. F., and Company, Germany, organ for Boston Music Hall, *323*, 325; fig. 265

Walcott (of Christy, Shepherd and Walcott), 277

Waldmüller, Ferdinand Georg, 99; *Letting Out of School*, 58, *58*; fig. 47

Waldo, Samuel Lovett, attributed to, *Portrait of a Girl*, *385*; no. 21

Wales, Albert Edward, Prince of, 255; ball for, *see* Prince of Wales Ball; Broadway parade for, *255*; fig. 207; painting presented to, *see* Brown, George Loring, *Bay and City of New York*

Walker, Edward, and Sons, *The Odd-Fellows Offering*, *466*; no. 139

Walker, James A., *The Storming of Chapultepec*, *218*, 220; fig. 174

Wall, William Guy, 85, 110–11, 194; *City Hall*, aquatint after, by J. Hill, 136, *135*; fig. 103; *New York from the Heights near Brooklyn*, 3, *3*, 197–99; fig. 1; *New York from Weehawk*, 127n.108, 199. *See also Hudson River Portfolio*

Wallhalla, 40

wallpaper (paper hangings), 259, 260, 272–80, *273*, 281, 282, 284–85, 289, *510*, *511*; figs. 224, 225, nos. 216, 217

Wall Street, 6, 7, 18, 19, 28–30, 32, 171, 187, *398*; no. 38; depicted on wallpaper, *510*; no. 216

Walter, Thomas Ustick, 17n.73, 174, 181, 187, 322

Ward, James, 75

Ward, John Quincy Adams, 167; *The Indian Hunter*, *422*; no. 68

Ward, Samuel (banker), 13, 89, 147, 152; house, 16, 17n.73

Ward, Samuel (silversmith). *See* Rich, Obadiah, and Ward, Samuel

Ward, Samuel Jr., 89

Ward, Thomas Wren, 147

Ward family, 149

Warner, Cyrus L., *Second Merchants' Exchange*, 175, *175*; fig. 135

War of 1812, 3, 259, 268, 330, 331, 367n.56

Warwick Vase, 355, 361, 373

Washburn, William. *See* Thomas, Griffith, and Washburn, William

Washington, D.C., 169

Washington, George, 136, 219n.116, 223, 251–52, 355; busts of, by Ceracchi, 86, *410*; no. 52; —, by Houdon, 167; —, by Kneeland, 157; colossal seated statue, by Greenough, 36, 144, 145n.39; equestrian statues, by H. K. Brown, *166*, 167, 239, *493*; fig. 128, no. 188; —, by Causici, 136–37, 138–40; —, by Marochetti, 41, 160; historical and allegorical scenes, 66, 223; —, by Burns, *Washington Crowned by Equality, Fraternity, and Liberty*, 35; —, by Darley, *The Triumph of Patriotism*, 223; —, by Leutze, *Washington Crossing the Delaware*, *100*, 101, 209; fig. 71; —, by Powers, *Washington at the Masonic Altar*, 80; —, by Rossiter and Mignot, *The Home of Washington after the War*, 80; portraits of, 31, 84, 215; by Rembrandt Peale, 62; —, by Stuart, 105

Washington Divan. *See* Stollenwerck and Brothers

Washington Exhibition in Aid of the New-York Gallery of the Fine Arts, 79

Washington Gallery of Art, 79

Washington Hall, 75

Washington Market, 8

Washington Monument, Union Square, by H. K. Brown, *168*, 169, 239, *493*; fig. 128, no. 188; earlier proposals, designs, and models, 136, 144, 152; —, by Causici, 136–37 and n.8, 138–40; —, by Crawford and Catherwood, *151*, 152; fig. 113; —, by Frazee, 152; —, by Greenough, 144, 145n.38; —, by Lefever, 152; —, by Pollard, 152

Washington Monument Association of the City of New York, 152

Washington Square, *7*, 16, 19, 185, 309; Row, 177

Washington Square Park, 239, *492*; no. 187

Washington Street Methodist Episcopal Church, Brooklyn, 175

watercolors, nos. 106–113

water cooler, stoneware, 336, *544*; no. 264

Water Street, wholesale store, 20, *21*; fig. 17

Watson, John Fanning, 4, 12, 20

Watteau, Jean-Antoine, 53, 103, 212

Waud (?), A., wood engravings after, *280*; figs. 230, 231

Waverly House, **74**

Waverly Sales Room, 69

Weale, John, 315n.196

Webster, Daniel, 27, 219n.116, 220n.117; bust of, by Frazee, 147; photographic portrait of, by Brady, 230; statuette of, by Ball, 160; vase presented to, 373

wedding veil, 245 and n.10, *501*; no. 201

Wedgwood, Josiah, 23

Weehawken, New Jersey, 201, *201*; fig. 158; view of New York from, 127n.108, 199

Weeks, Fielder S., 279, 280

Weeks, James H., **74**

Weingartner, Adam, 219; *The New York Elephant*, *217*, 219; fig. 172; printed by, Bachmann, *The Empire City*, *469*; no. 145. *See also* Nagel and Weingartner

Weir, Robert Walter, 85, 99; *Embarkation of the Pilgrims*, 77, 79; *The Microscope*, 101; *A Visit from Saint Nicholas*, *389*; no. 27

Weld, Charles Richard, 320

Weld, Harriet, 347n.106

Weld family, service of table glass made for a member of, 346, 347n.106, *554*; no. 277

Wells, Jacob, *All-Souls' Church, Fourth Avenue at Twentieth Street*, 186, 187; fig. 146

Wells, John, bust of, by Frazee, 137

Wellstood, William, after Smith, Benjamin F. Jr., *New York, 1855, from the Latting Observatory*, 42, 221; *468*; no. 143

Wendt, John R., 366

Wenzler, F., *A Scene in Berkshire County, Mass.*, 80

West, Benjamin, 75, 90, 123, 140; *Christ Healing the Sick*, 38; —, copy after, by Dunlap, 56, 76; *Christ Rejected*, 77; *Death on the Pale Horse*, 76; *King Lear*, 52, *52*, 208 and n.70; fig. 39; —, engraving after, by Sharp, 208 and n.70, 211, *477*; no. 156; *Ophelia before the King and Queen*, 52, 208n.70

West, Benjamin, and Livesay, Robert, *Introduction of the Duchess of York to the Royal Family of England*, 54

West, James, 351 and n.127. *See also* Carse and West

Westall, Richard, 196

West Broadway, 31

Westmore, William Shepherd, 312

Wheeler, Asa H., lithograph by, *245*; fig. 196

Whig Ladies of Tennessee, vase presented to Henry Clay by, 368 and n.66, *369*; fig. 302

Whigs, 33, 34n.193, 334, 367, 368

White, John, 367

White, John Blake, *General Marion Inviting a British Officer to Dinner*, engraving after, by Sartain, 206n.60

White, Richard Grant, 103; *Catalogue of the Bryan Gallery of Christian Art*, 103–4

White, Stanford, 103

Whitehorne, James, *Nancy Kellogg*, *385*; no. 19

White House: glass compote, 348, *556*; no. 279; porcelain service, 330; silver plateau, 355

White Mountains, *100*, 108, 109, 114–19, *115*, *116*, *117*, 120, 126, *192*, 193; figs. 72, 82–84, 150. *See also* Mount Washington

Whitley, T. W., 37–38

Whitman, Walt, 33, 233, 336, 338; *Leaves of Grass*, 204–5, 234, *470*; no. 146; portraits of, "Christ likeness," attributed to G. Harrison, 204, 234, *481*; no. 163; —, engraving by Hollyer, after daguerreotype by G. Harrison, 204–5 and n.57, 234, *470*; no. 146

Whitney, Stephen and Harriet, armchairs acquired by, 294

Whittel, B. Jr., *J. and R. Fisher's Bloomingdale Flint Glass Works*, 341, *342*; fig. 277

Whittemore, H., 315n.191

Whittier, John Greenleaf, 119

Whittle, B., *Bloomingdale Flint Glass Works*, 340n.68

Whittredge, Worthington, 101, 119, 130 and n.119

Wickersham, John B., iron warehouse, *311*; fig. 255

Widdleton, W. J. (publisher), *204*, *462*; fig. 160, no. 132

Wiggins and Pearson, **74**, 75

Wight, Peter Bonnett, 186; *National Academy of Design*, 38, 186–87, *443*; no. 105

Wightman, George, 346n.103

Wilkie, David, 91, 92, 212; *The Blind Fiddler*, engraving after, by Burnet, 211, 212, *477*; no. 157

Wilkins, Rollins and Company, **74**, 77

Wilkinson, George, 366

Wille, Johan Georg, 91

Willey, Benjamin, 116

Willey family, and avalanche, 115, 116–17, *192*, 193 and n.16; fig. 150

Williams, George H., **74**

Williams, James Watson, furniture purchased by, 313; armchair, *310*, 313, 319; fig. 253

Williams, John H., **74**

Williams, John H., and Son, pier mirror, 297, *519*; no. 228

Williams, Michael, *Church of the Ascension, Canal Street*, 172, 181; fig. 132

Williams, Stevens and Williams, 60, 61, 64, 69, **74**, 78, 79, 80, 105, 220–21, 222, 223n.134; published by, *479*; no. 159

Williams, William (diemaker), Grand Canal Celebration medal, 358, *559*; no. 282A

Willis, Nathaniel Parker, 31; *Pencillings by the Way*, 127–28

Wills and Ellsworth, **74**

Wilson, James G., fashions by, *244*; fig. 195

Wilson and Nicholls (bookbinder), *450*; no. 117

Wilton, Joseph, 135; *King George*, 135; *William Pitt, Earl of Chatham*, 135, 141n.23

Wilton carpeting, 267

window bench, *292*, 294, 300; fig. 238

window shades, 275, 282, *511*; no. 218

wineglasses, 343, *553*; no. 276

Winterhalter, Franz Xaver, *The Empress Eugénie Surrounded by Her Ladies-in-Waiting*, 65, *65*, 80, 312; fig. 56

Withers, Frederick, 181

Wolcott, A. S., 230

Wolfe, Catharine Lorillard, collection, 99

Wolfe, John, collection, 98, 99, 107

women: dressmakers and milliners, 247; as shoppers, 24, 248, 259; upholsterers, 281

women's costumes, 244, *244*, 245–46n.10, 246–47, *246*, 247, 248, 249, *250*, 251, *251*, 252–57, *254*, *256*, 257, *501*; figs. 195, 197–99, 201–4, 206, 208, 209, nos. 198–205; evening toilettes worn to Prince of Wales Ball, *502*, *503*; nos. 204, 205; walking ensembles, *498*, *499*, *500*; nos. 198–200

Wood, Charles, 373. *See also* Wood and Hughes

Wood, Fernando, 43

Wood, Jacob, 373

Wood, Silas, Gotham Court, 17, *17*; fig. 11

Wood and Hughes, 373; commemorative pitcher, Kiddush goblets, and tray, *571*; no. 305; tea service depicting views of

Long Island Flint Glass Works, 349, *349*; fig. 286
wood carving, 137
wood engravings, 202–4, 205 and nn.51, 53
wood imports, 295
wood mantels, 261, 262
Woodville, Richard Caton, 105; *The Card Players*, engraving after, by Burt, 207
wool goods, 250

Wollett, William, 91
Woram and Haughwout, 330n.11
Workingmen's Home (Big Flat), 17
Workingmen's Party, 34–35 and n.193
worktable, papier mâché, *312*, 313n.183, 314; fig. 256
Worth, Charles Frederick, 256
Worth, Thomas, 217, 219; Darktown Comics, 214

Worth et Bobergh, Paris, 256: attributed to, ball gown, 253, *502*; no. 204
Wren, Sir Christopher, 171n.6
Wright, Ambrose, 300
Wright, Charles Cushing: American Art-Union medals, *565*; nos. 292–295; Grand Canal Celebration medal, 358, *559*; no. 282A
writing desk, lady's, 313, *525*; no. 237

Yale University, 143
Yates, Edward, 346n.105
Yonkers Docks, 239, *494*; no. 189
Young, John B., 364, 372. *SDee also* Tiffany, Young and Ellis
Yznaga, Mrs. Antonio, bouquet holder carried by, *502*; no. 204

Zuber firm, Paris, 279, 280

# Photograph Credits

© Allen Memorial Art Museum: fig. 37

David Allison: cat. no. 280

Jörg P. Anders: fig. 40

Jörg P. Anders, 1975: fig. 47

© 1999 The Art Institute of Chicago: cat. no. 105

Gavin Ashworth, Courtesy of *The Magazine* ANTIQUES: cat. no. 304

Michael Bodycomb: cat. no. 44

Davis Bohl, Courtesy of *The Magazine* ANTIQUES: fig. 266

Erik Borg 1987: fig. 81

© The British Museum: figs. 42, 43

Nicholas L. Bruen: fig. 211

Richard Caspole, Yale Center for British Art: cat. no. 49

Courtesy of Christie's, Amsterdam: fig. 306

© Chrysler Museum of Art, Norfolk, Va.: cat. nos. 64, 166; fig. 124

© 1999 The Cleveland Museum of Art: fig. 241

© 2000 The Cleveland Museum of Art: figs. 69, 86

A. C. Cooper, © Royal Institute of British Architects: cat. no. 82

© 1989 Dallas Museum of Art: cat. no. 289

© 1993 Dallas Museum of Art: cat. nos. 300, 309

© 1995 Dallas Museum of Art: fig. 100

© 1989 The Detroit Institute of Arts: fig. 76

© 1999 The Detroit Institute of Arts: cat. no. 285

G. R. Farley: fig. 60

G. R. Farley Photography: cat. nos. 90, 91

David Finn: fig. 290

Courtesy of Flomaton Antique Auction, 1999: fig. 213

Matt Flynn: cat. nos. 98, 218

Matt Flynn/Art Resource, N.Y.: fig. 18

Richard Goodbody, 1999/© The Newark Museum: cat. no. 60

Helga Photo Studio: cat. nos. 25, 63, 141, 151, 238, 239, 253, 290, 310; figs. 110, 176

Alt Lee, Courtesy of *The Magazine* ANTIQUES: fig. 233

Schecter Lee: figs. 271, 276

Schecter Lee/Courtesy of The Metropolitan Museum of Art: cat. no. 255

Schecter Lee for The Metropolitan Museum of Art/Courtesy of the Museum of the City of New York: cat. no. 268

Hanz Lorenz of Colonial Williamsburg Foundation, 1992: fig. 232

Melville McLean, Fine Art Photography: cat. no. 249; fig. 234

Maertens: fig. 54

© Manchester City Art Galleries: fig. 46

The Metropolitan Museum of Art, New York, The Photograph Studio: cat. nos. 2, 18, 46, 58, 61, 65, 67, 70, 78, 94, 95, 104, 110–12, 128, 136, 138, 155, 160, 162, 167, 169, 170, 172, 175, 178, 179, 182–84, 196, 201, 208, 222, 226–29, 231, 232, 256, 258, 261, 263, 264, 266, 267, 283, 286, 297; figs. 126, 127, 130, 167, 182, 186, 215, 220, 221, 226, 228, 240, 275

The Metropolitan Museum of Art, New York, The Photograph Studio/ Courtesy of the Museum of the City of New York: cat. nos. 150, 199 (dress and bonnet), 200 (bonnet), 203, 204 (evening gown and headdress), 205 (evening gown, fan, wrap, and headdress), 220, 301

© 1998 Museum Associates, Los Angeles County Museum of Art: cat. no. 34

© 1999 Museum of Fine Arts, Boston: cat. nos. 11, 35, 125, 130, 131, 147, 154, 237; fig. 39

© 2000 Museum of Fine Arts, Boston: cat. no. 23; figs. 64, 65

© 1999 The Museum of Modern Art, New York: fig. 181

© Museum of the City of New York: cat. no. 38; figs. 25, 57, 145, 179, 185, 196, 197, 199, 212

© 2000 Board of Trustees, National Gallery of Art, Washington, D.C.: fig. 84

The Newark Museum/Art Resource, N.Y.: fig. 74

Robert Newcombe/© 1998 The Nelson Gallery Foundation: cat. no. 241; fig. 258

© Collection of the New-York Historical Society: figs. 15 (neg. no. 2684), 44 (neg. no. 36263), 48 (neg. no. 52607), 58 (neg. no. 2090), 59 (neg. no. 6352), 67, 72 (neg. no. 27194), 75 (neg. no. 41267), 91–95, 115 (neg. no. 1025), 117 (neg. no. 26115), 120 (neg. no. 26153), 129 (neg. no. 73286), 141 (neg. no. 47399T), 151 (neg. no. 73287), 183 (neg. no. 26134), 187 (neg. no. 26131), 188 (neg. no. 26143), 189 (neg. no. 26142), 195 (neg. no. 60778), 209 (neg. no. 73292), 217 (neg. no. 26140), 223 (neg. no. 26120), 274 (neg. no. 23279), 278 (neg. no. 6252), 297 (neg. no. 43251)

©The New-York Historical Society: cat. nos. 7, 27, 40, 45, 72 (neg. no. 43759), 96 (neg. no. 52485T), 152, 209

John Parnell: cat. nos. 284, 306; figs. 296, 305

Photo Archives, Bob Lorenzon, Courtesy of T. Augustyn and Paul E. Cohen: fig. 36

© Photo Réunion des Musées Nationaux: fig. 56

Mark Rabinowitz: fig. 118

M. S. Rezny Photography: cat. no. 296

© Royal Institute of British Architects: cat. no. 83

Larry Sanders: cat. no. 245

Courtesy of Sotheby's, New York: cat. no. 230

Lee Stalsworth: cat. no. 101

John Bigelow Taylor: fig. 254

Don Templeton: figs. 11, 21, 128, 134, 135, 236, 238, 245, 279, 280, 284–86, 304

Jerry L. Thompson: cat. nos. 16, 19, 21, 55, 57, 59, 62, 68, 69, 206, 207, 210, 299; figs. 73, 111, 112, 114, 125, 143

Courtesy of Phyllis Tucker Antiques: fig. 307

Richard Walker/© New York State Historical Association, Cooperstown, N.Y.: cat. nos. 28, 282

Scott Wolff, 2000: fig. 119

© Worcester Art Museum: fig. 123

# Black American History

## by Ronda Racha Penrice

A Wiley Brand

# Black American History For Dummies®

Published by: **John Wiley & Sons, Inc.,** 111 River Street, Hoboken, NJ 07030-5774, www.wiley.com

Copyright © 2021 by John Wiley & Sons, Inc., Hoboken, New Jersey

Published simultaneously in Canada

For general information on our other products and services, please contact our Customer Care Department within the U.S. at 877-762-2974, outside the U.S. at 317-572-3993, or fax 317-572-4002. For technical support, please visit https://hub.wiley.com/community/support/dummies.

Wiley publishes in a variety of print and electronic formats and by print-on-demand. Some material included with standard print versions of this book may not be included in e-books or in print-on-demand. If this book refers to media such as a CD or DVD that is not included in the version you purchased, you may download this material at http://booksupport.wiley.com. For more information about Wiley products, visit www.wiley.com.

Library of Congress Control Number: 2021935715

ISBN: 978-1-119-78085-4

ISBN: 978-1-119-78086-1 (ebk); ISBN: 978-1-119-78087-8 (ebk)

Manufactured in the United States of America

SKY10026204_041221

# Contents at a Glance

**Introduction** . . . . . . . . . . . . . . . . . . . . . . . . . . . . . . . . . . . . . . . . . . . . . . . . . 1

**Part 1: Coming to America** . . . . . . . . . . . . . . . . . . . . . . . . . . . . . . . . . . 7
CHAPTER 1: The Soul of America . . . . . . . . . . . . . . . . . . . . . . . . . . . . . . . . . 9
CHAPTER 2: From Empires to Bondage: Bringing Africans to the Americas. . . . . . . 33
CHAPTER 3: The Founding of Black America . . . . . . . . . . . . . . . . . . . . . . . . . 49

**Part 2: Long Road to Freedom** . . . . . . . . . . . . . . . . . . . . . . . . . . . . . . 63
CHAPTER 4: American Slavery, American Freedom . . . . . . . . . . . . . . . . . . . . . 65
CHAPTER 5: Bringing Down the House: Marching toward Civil
War and Freedom. . . . . . . . . . . . . . . . . . . . . . . . . . . . . . . . . . . . 85
CHAPTER 6: Up from Slavery: Civil War and Reconstruction. . . . . . . . . . . . . . . 109

**Part 3: Pillars of Change: The Civil Rights Movement** . . . . . 135
CHAPTER 7: Living Jim Crow . . . . . . . . . . . . . . . . . . . . . . . . . . . . . . . . . . . 137
CHAPTER 8: I, Too, Sing America: The Civil Rights Movement, 1954–1963. . . . . . . 163
CHAPTER 9: Turning Up the Heat (1963–1968) . . . . . . . . . . . . . . . . . . . . . . . 187
CHAPTER 10: Where Do We Go from Here? Post–Civil Rights. . . . . . . . . . . . . . . 207
CHAPTER 11: The New Civil Rights — Obama, Black Lives Matter, and Beyond . . . . 233

**Part 4: Cultural Foundations**. . . . . . . . . . . . . . . . . . . . . . . . . . . . . . . 259
CHAPTER 12: Somebody Say "Amen": The Black Church . . . . . . . . . . . . . . . . . . 261
CHAPTER 13: More Than Reading and Writing: Education . . . . . . . . . . . . . . . . 285
CHAPTER 14: Writing Down the Bones: Black Literature . . . . . . . . . . . . . . . . . 307
CHAPTER 15: The Great Black Way: Theater and Dance . . . . . . . . . . . . . . . . . . 331

**Part 5: A Touch of Genius: Music, Film, TV, and Sports**. . . . 357
CHAPTER 16: Give Me a Beat: Black Music . . . . . . . . . . . . . . . . . . . . . . . . . . 359
CHAPTER 17: Black Hollywood: Film and Comedy . . . . . . . . . . . . . . . . . . . . . 393
CHAPTER 18: Black Hollywood: TV . . . . . . . . . . . . . . . . . . . . . . . . . . . . . . . 427
CHAPTER 19: Winning Ain't Easy: Race and Sports . . . . . . . . . . . . . . . . . . . . . 449

**Part 6: The Part of Tens** . . . . . . . . . . . . . . . . . . . . . . . . . . . . . . . . . . 479
CHAPTER 20: Ten Black American Firsts . . . . . . . . . . . . . . . . . . . . . . . . . . . . 481
CHAPTER 21: Ten Black Literary Classics. . . . . . . . . . . . . . . . . . . . . . . . . . . . 487
CHAPTER 22: Ten (Plus One) Influential Black American Visual Artists . . . . . . . . . . 493

**Index** . . . . . . . . . . . . . . . . . . . . . . . . . . . . . . . . . . . . . . . . . . . . . . . . 501

# Table of Contents

**INTRODUCTION** . . . . . . . . . . . . . . . . . . . . . . . . . . . . . . . . . . . . . . . . 1

    About This Book. . . . . . . . . . . . . . . . . . . . . . . . . . . . . . . . . . . . . . . 2

    Foolish Assumptions. . . . . . . . . . . . . . . . . . . . . . . . . . . . . . . . . . . . 3

    Icons Used in This Book . . . . . . . . . . . . . . . . . . . . . . . . . . . . . . . . . 4

    Where to Go from Here . . . . . . . . . . . . . . . . . . . . . . . . . . . . . . . . . . 5

**PART 1: COMING TO AMERICA**. . . . . . . . . . . . . . . . . . . . . . . . . . . . 7

**CHAPTER 1:** **The Soul of America** . . . . . . . . . . . . . . . . . . . . . . . . 9

    A Peek at the Past . . . . . . . . . . . . . . . . . . . . . . . . . . . . . . . . . . . . . . 10

        Life before slavery. . . . . . . . . . . . . . . . . . . . . . . . . . . . . . . . . 11

        Life before emancipation . . . . . . . . . . . . . . . . . . . . . . . . . . 11

        Life before civil rights . . . . . . . . . . . . . . . . . . . . . . . . . . . . . 12

    Being Black in America Today . . . . . . . . . . . . . . . . . . . . . . . . . . . . 14

        Contributions to history and culture . . . . . . . . . . . . . . . . . 15

        Challenges . . . . . . . . . . . . . . . . . . . . . . . . . . . . . . . . . . . . . . 19

    Black Pride Goes Mainstream . . . . . . . . . . . . . . . . . . . . . . . . . . . . 22

        Celebrating Black heritage . . . . . . . . . . . . . . . . . . . . . . . . . 23

        Black cultural tourism booms . . . . . . . . . . . . . . . . . . . . . . . 24

    Reconciling the Past to Create the Future . . . . . . . . . . . . . . . . . 26

        Slavery as an American (not Southern) institution . . . . . . . . . . . . 28

        Flagging the issue . . . . . . . . . . . . . . . . . . . . . . . . . . . . . . . . 28

        A question of reparations. . . . . . . . . . . . . . . . . . . . . . . . . . . 30

**CHAPTER 2:** **From Empires to Bondage: Bringing Africans to the Americas** . . . . . . . . . . . . . . . . . . . . . . . . . . . 33

    Touring African Empires. . . . . . . . . . . . . . . . . . . . . . . . . . . . . . . . . 34

        Ghana Empire . . . . . . . . . . . . . . . . . . . . . . . . . . . . . . . . . . . 35

        Mali . . . . . . . . . . . . . . . . . . . . . . . . . . . . . . . . . . . . . . . . . . . 35

        Songhai . . . . . . . . . . . . . . . . . . . . . . . . . . . . . . . . . . . . . . . . 36

        Interaction with the rest of the world. . . . . . . . . . . . . . . . . 37

    Origins of the Transatlantic Slave Trade . . . . . . . . . . . . . . . . . . . 38

        Slavery on the African continent. . . . . . . . . . . . . . . . . . . . . 38

        Launching the European slave trade . . . . . . . . . . . . . . . . . 39

    Enslaving Africans in Latin America and the Caribbean . . . . . . . . . . . 41

        Sanctioning and opposing slavery . . . . . . . . . . . . . . . . . . . 42

        Dealing with life enslaved. . . . . . . . . . . . . . . . . . . . . . . . . . 44

        Seeking freedom . . . . . . . . . . . . . . . . . . . . . . . . . . . . . . . . . 45

CHAPTER 3: **The Founding of Black America** . . . . . . . . . . . . . . . . . . . . . 49

From Servitude to Slavery . . . . . . . . . . . . . . . . . . . . . . . . . . . . . . . . . .49
Inching toward slavery . . . . . . . . . . . . . . . . . . . . . . . . . . . . . . . . .50
Why Africans? . . . . . . . . . . . . . . . . . . . . . . . . . . . . . . . . . . . . . . . .51
The Triangular Trade. . . . . . . . . . . . . . . . . . . . . . . . . . . . . . . . . . . . . .51
The Middle Passage . . . . . . . . . . . . . . . . . . . . . . . . . . . . . . . . . . . . . .52
The capture . . . . . . . . . . . . . . . . . . . . . . . . . . . . . . . . . . . . . . . . .52
The voyage . . . . . . . . . . . . . . . . . . . . . . . . . . . . . . . . . . . . . . . . .54
Safe arrival . . . . . . . . . . . . . . . . . . . . . . . . . . . . . . . . . . . . . . . . .55
Black Americans and the Revolution . . . . . . . . . . . . . . . . . . . . . . . . .57
A bit of background. . . . . . . . . . . . . . . . . . . . . . . . . . . . . . . . . . . .58
Fighting for freedom. . . . . . . . . . . . . . . . . . . . . . . . . . . . . . . . . . .58
Hope and disappointment. . . . . . . . . . . . . . . . . . . . . . . . . . . . . . .60
The Free African Society and the Birth of Black America. . . . . . . . . . . .61

PART 2: LONG ROAD TO FREEDOM . . . . . . . . . . . . . . . . . . . . . . . . 63

CHAPTER 4: **American Slavery, American Freedom** . . . . . . . . 65

American Bondage . . . . . . . . . . . . . . . . . . . . . . . . . . . . . . . . . . . . . . .66
Northern slavery . . . . . . . . . . . . . . . . . . . . . . . . . . . . . . . . . . . . . .66
Enslaved life in the South. . . . . . . . . . . . . . . . . . . . . . . . . . . . . . . .69
Before I'd Be a Slave: Fighting the System. . . . . . . . . . . . . . . . . . . . . .73
The Slave Codes. . . . . . . . . . . . . . . . . . . . . . . . . . . . . . . . . . . . . .74
Rebellions . . . . . . . . . . . . . . . . . . . . . . . . . . . . . . . . . . . . . . . . . .75
Running away. . . . . . . . . . . . . . . . . . . . . . . . . . . . . . . . . . . . . . . .79
"Free" Black People . . . . . . . . . . . . . . . . . . . . . . . . . . . . . . . . . . . . . .81
Different paths to freedom . . . . . . . . . . . . . . . . . . . . . . . . . . . . . .82
Perhaps free, but not equal . . . . . . . . . . . . . . . . . . . . . . . . . . . . . .82

CHAPTER 5: **Bringing Down the House: Marching
toward Civil War and Freedom**. . . . . . . . . . . . . . . . . . 85

Picking Fights . . . . . . . . . . . . . . . . . . . . . . . . . . . . . . . . . . . . . . . . . .86
Arguing against slavery. . . . . . . . . . . . . . . . . . . . . . . . . . . . . . . . .87
Arguing for slavery . . . . . . . . . . . . . . . . . . . . . . . . . . . . . . . . . . . .88
Leading the Antislavery Assault: Key Abolitionists . . . . . . . . . . . . . . . .89
Anthony Benezet . . . . . . . . . . . . . . . . . . . . . . . . . . . . . . . . . . . . .89
David Walker . . . . . . . . . . . . . . . . . . . . . . . . . . . . . . . . . . . . . . . .90
William Lloyd Garrison . . . . . . . . . . . . . . . . . . . . . . . . . . . . . . . . .90
Frederick Douglass . . . . . . . . . . . . . . . . . . . . . . . . . . . . . . . . . . . .91
Fighting with Words . . . . . . . . . . . . . . . . . . . . . . . . . . . . . . . . . . . . .92
Slave narratives . . . . . . . . . . . . . . . . . . . . . . . . . . . . . . . . . . . . . .92
Origins of the Black press. . . . . . . . . . . . . . . . . . . . . . . . . . . . . . . .93
Colonization (or Emigration) Movement . . . . . . . . . . . . . . . . . . . . . .94
Early resettlement efforts . . . . . . . . . . . . . . . . . . . . . . . . . . . . . . .95
Cuffe: Man on a mission. . . . . . . . . . . . . . . . . . . . . . . . . . . . . . . .95
Questioning motives. . . . . . . . . . . . . . . . . . . . . . . . . . . . . . . . . . .96

The Effects of Proslavery Politics . . . . . . . . . . . . . . . . . . . . . . . . . . . . . . . . .96
    The Fugitive Slave Clause . . . . . . . . . . . . . . . . . . . . . . . . . . . . . . . . . . .96
    Stronger fugitive slave measures: Fugitive Slave Act of 1793 . . . . .97
    Battling over the slave status of new land . . . . . . . . . . . . . . . . . . . .97
    The Missouri Compromise . . . . . . . . . . . . . . . . . . . . . . . . . . . . . . . . .98
The Underground Railroad . . . . . . . . . . . . . . . . . . . . . . . . . . . . . . . . . . . . .98
    Operation Freedom . . . . . . . . . . . . . . . . . . . . . . . . . . . . . . . . . . . . . . .99
    Key people along the line . . . . . . . . . . . . . . . . . . . . . . . . . . . . . . . . .99
    Message in the music . . . . . . . . . . . . . . . . . . . . . . . . . . . . . . . . . . . .103
The Breaking Point . . . . . . . . . . . . . . . . . . . . . . . . . . . . . . . . . . . . . . . . . .103
    Straining North-South relations . . . . . . . . . . . . . . . . . . . . . . . . . . .104
    The Compromise of 1850 . . . . . . . . . . . . . . . . . . . . . . . . . . . . . . . . .104
    The Kansas-Nebraska Act . . . . . . . . . . . . . . . . . . . . . . . . . . . . . . . .105
    Slavery continues . . . . . . . . . . . . . . . . . . . . . . . . . . . . . . . . . . . . . . .105
    Dred Scott: A strike against freedom . . . . . . . . . . . . . . . . . . . . . . .106
    Defining events at Harpers Ferry . . . . . . . . . . . . . . . . . . . . . . . . . .106
Facing the Moment of Truth . . . . . . . . . . . . . . . . . . . . . . . . . . . . . . . . . .107

CHAPTER 6: **Up from Slavery: Civil War and Reconstruction** . . . .109
The Question: To End Slavery or Not? . . . . . . . . . . . . . . . . . . . . . . . . . .110
    Teetering on a tightrope . . . . . . . . . . . . . . . . . . . . . . . . . . . . . . . . .110
    The first Confiscation Act, 1861 . . . . . . . . . . . . . . . . . . . . . . . . . . .111
Black People in the Early Days of the Civil War . . . . . . . . . . . . . . . . . . .111
    Serving the Union . . . . . . . . . . . . . . . . . . . . . . . . . . . . . . . . . . . . . .112
    Surviving in the South . . . . . . . . . . . . . . . . . . . . . . . . . . . . . . . . . . .112
Moving toward the Emancipation Proclamation . . . . . . . . . . . . . . . . .113
    Shutting down the illegal slave trade . . . . . . . . . . . . . . . . . . . . . . .113
    Passing the Second Confiscation Act . . . . . . . . . . . . . . . . . . . . . . .114
    Courting England's support . . . . . . . . . . . . . . . . . . . . . . . . . . . . . .114
Free at Last (Well, Sort of): The Emancipation Proclamation . . . . . . .114
    What the Proclamation did . . . . . . . . . . . . . . . . . . . . . . . . . . . . . . .115
    Reaction to the order . . . . . . . . . . . . . . . . . . . . . . . . . . . . . . . . . . . .115
Finally in the Fight . . . . . . . . . . . . . . . . . . . . . . . . . . . . . . . . . . . . . . . . .116
    As Union soldiers . . . . . . . . . . . . . . . . . . . . . . . . . . . . . . . . . . . . . . .116
    As Confederate soldiers . . . . . . . . . . . . . . . . . . . . . . . . . . . . . . . . .118
The War's End and the Thirteenth Amendment . . . . . . . . . . . . . . . . .119
(Re)constructing Democracy . . . . . . . . . . . . . . . . . . . . . . . . . . . . . . . . .121
    Undermining Lincoln's plan . . . . . . . . . . . . . . . . . . . . . . . . . . . . . . .121
    Taking back the power: Reconstruction Act of 1867 . . . . . . . . . . .123
A Mixed Bag of Hope and Despair . . . . . . . . . . . . . . . . . . . . . . . . . . . .123
    The Freedmen's Bureau . . . . . . . . . . . . . . . . . . . . . . . . . . . . . . . . . .123
    Where's my 40 acres and a mule? . . . . . . . . . . . . . . . . . . . . . . . . . .124
    Back to the land . . . . . . . . . . . . . . . . . . . . . . . . . . . . . . . . . . . . . . . .127
    Finding a new way . . . . . . . . . . . . . . . . . . . . . . . . . . . . . . . . . . . . . .128
    Banking on wealth . . . . . . . . . . . . . . . . . . . . . . . . . . . . . . . . . . . . . .128
    Taking office . . . . . . . . . . . . . . . . . . . . . . . . . . . . . . . . . . . . . . . . . . .129

The Fifteenth Amendment . . . . . . . . . . . . . . . . . . . . . . . . . . . . . . . .130
A Turn for the Worse: The End of Reconstruction . . . . . . . . . . . . .131
    The Redeemers . . . . . . . . . . . . . . . . . . . . . . . . . . . . . . . . . . . .131
    The Mississippi Plan . . . . . . . . . . . . . . . . . . . . . . . . . . . . . . . .132
    Civil Rights Act of 1875 . . . . . . . . . . . . . . . . . . . . . . . . . . . . . .132
    Pulling the plug . . . . . . . . . . . . . . . . . . . . . . . . . . . . . . . . . . . .132

## PART 3: PILLARS OF CHANGE: THE CIVIL RIGHTS MOVEMENT

. . . . . . . . . . . . . . . . . . . . . . .135

### CHAPTER 7: Living Jim Crow

. . . . . . . . . . . . . . . . . . . . . . . . . . .137
Post-Reconstruction Blues . . . . . . . . . . . . . . . . . . . . . . . . . . . . . . . .137
    The Exoduster Movement . . . . . . . . . . . . . . . . . . . . . . . . . . . .138
    Black Town, U.S.A. . . . . . . . . . . . . . . . . . . . . . . . . . . . . . . . . .139
    Lynchings and riots/massacres . . . . . . . . . . . . . . . . . . . . . . .140
Instituting Jim Crow: Plessy v. Ferguson . . . . . . . . . . . . . . . . . . . . .146
    Court cases before Plessy . . . . . . . . . . . . . . . . . . . . . . . . . . .146
    The actual case: Plessy v. Ferguson . . . . . . . . . . . . . . . . . . . .147
Strategies for Achieving Equality . . . . . . . . . . . . . . . . . . . . . . . . . .147
    Booker T. Washington: The Accommodationist . . . . . . . . . . .148
    W.E.B. Du Bois: The Integrationist . . . . . . . . . . . . . . . . . . . . .148
Organizing for Freedom . . . . . . . . . . . . . . . . . . . . . . . . . . . . . . . . .150
    National Afro-American Council . . . . . . . . . . . . . . . . . . . . . .150
    The National Negro Business League . . . . . . . . . . . . . . . . . . .150
    The Niagara Movement . . . . . . . . . . . . . . . . . . . . . . . . . . . . .152
    The NAACP . . . . . . . . . . . . . . . . . . . . . . . . . . . . . . . . . . . . . .153
    The National Urban League . . . . . . . . . . . . . . . . . . . . . . . . . .154
Keep on Moving: The Great Migration . . . . . . . . . . . . . . . . . . . . . .154
    Leaving the South . . . . . . . . . . . . . . . . . . . . . . . . . . . . . . . . .154
    Life up North . . . . . . . . . . . . . . . . . . . . . . . . . . . . . . . . . . . . .156
Marcus Garvey: Man with a Plan . . . . . . . . . . . . . . . . . . . . . . . . . .156
    Advocating racial pride . . . . . . . . . . . . . . . . . . . . . . . . . . . . .157
    Going "Back to Africa" . . . . . . . . . . . . . . . . . . . . . . . . . . . . . .157
    Powerful enemies . . . . . . . . . . . . . . . . . . . . . . . . . . . . . . . . .158
Can't Catch a Break: The Depression Years and FDR . . . . . . . . . . . .158
    FDR: Friend or foe? . . . . . . . . . . . . . . . . . . . . . . . . . . . . . . . .159
    Striking a new deal . . . . . . . . . . . . . . . . . . . . . . . . . . . . . . . .159
Can't Fool Us Twice: Black Americans and WWII . . . . . . . . . . . . . . .161

### CHAPTER 8: I, Too, Sing America: The Civil Rights Movement, 1954–1963

. . . . . . . . . . . . . . . . . . .163
The Tide Turns: Brown v. Board of Education (1954) . . . . . . . . . . . .163
    The 1954 ruling and the reaction . . . . . . . . . . . . . . . . . . . . .164
    Desegregating Central High School . . . . . . . . . . . . . . . . . . . .167
    Massive resistance follows in Virginia . . . . . . . . . . . . . . . . . .169

Putting a Face to Racial Violence: Emmett Till...................169
    Emmett Till's murder..........................170
    The outrage of the nation ....................170
A New Twist in Leadership: Reverend Dr. Martin Luther King Jr.....171
    Adopting the philosophy of nonviolence....................172
    Founding the Southern Christian Leadership
    Conference (SCLC)........................173
Sit-ins, Boycotts, and Marches: The King Era of the
Civil Rights Movement Begins ...................173
    The Montgomery Bus Boycott and Rosa Parks.................174
    Sitting in for justice ........................177
    Founding SNCC .........................179
    Riding for freedom ......................179
    The Albany Movement: A chink in the armor ...............180
Integrating Ole Miss and Increasing Federal Involvement ........181
1963: A Bloody Year ......................182
    Not-so-sweet home Alabama: Birmingham ................182
    Murder in Mississippi: Medgar Evers ...................184
March of All Marches: The March on Washington for
Jobs and Freedom (1963)........................185

CHAPTER 9: **Turning Up the Heat (1963–1968)** ...................187
Suffering Two Tragic Blows .......................187
    Four innocent victims.........................188
    JFK dies .............................189
The Civil Rights Act of 1964 .....................189
Targeting Mississippi for Voter Registration: Freedom Summer ....190
    Getting ready ..........................190
    Getting out the Black vote ....................191
    Mississippi burning .......................192
    The success of Freedom Summer.................192
Oh Lord Selma: Back in Alabama ..................193
    Getting arrested again ......................194
    Marching from Selma to Montgomery................194
The Voting Rights Act of 1965 ...................195
Black Power Rising .......................196
    The Nation of Islam........................196
    Malcolm X...........................197
    The Black Panther Party ....................199
    The transformation of SNCC ..................200
Race Relations in the North ....................201
    Rioting in Watts ........................201
    The Chicago Freedom Movement...............202
    The Poor People's March ....................203

Death of a King . . . . . . . . . . . . . . . . . . . . . . . . . . . . . . . . . . . . . . . .203
   The night of his death and the mourning after. . . . . . . . . . . . . .204
   Continuing his work . . . . . . . . . . . . . . . . . . . . . . . . . . . . . . . . . . . .204

CHAPTER 10: **Where Do We Go from Here? Post–Civil Rights** . . . . 207
The Panthers Stumble . . . . . . . . . . . . . . . . . . . . . . . . . . . . . . . . . . . .208
   Huey Newton: A symbol of Black Power . . . . . . . . . . . . . . . . . . .208
   The BPP encounters challenges . . . . . . . . . . . . . . . . . . . . . . . . . .208
   Changing focus: Embracing nonviolence and women's
   leadership. . . . . . . . . . . . . . . . . . . . . . . . . . . . . . . . . . . . . . . . . . .213
Fighting Vietnam . . . . . . . . . . . . . . . . . . . . . . . . . . . . . . . . . . . . . . . .214
   An unfair fight . . . . . . . . . . . . . . . . . . . . . . . . . . . . . . . . . . . . . . . .214
   Reacting to the war . . . . . . . . . . . . . . . . . . . . . . . . . . . . . . . . . . .215
   Coming home. . . . . . . . . . . . . . . . . . . . . . . . . . . . . . . . . . . . . . . . .215
Black Women Taking a Stand . . . . . . . . . . . . . . . . . . . . . . . . . . . . . .217
A Race to Political Office. . . . . . . . . . . . . . . . . . . . . . . . . . . . . . . . . . .219
   Getting a foot in the door in the 1960s . . . . . . . . . . . . . . . . . . .220
   Making political strides in the 1970s . . . . . . . . . . . . . . . . . . . . .220
   Eyeing a bigger prize in the 1980s . . . . . . . . . . . . . . . . . . . . . . .221
   Still thriving in the 1990s and early 2000s. . . . . . . . . . . . . . . . . .222
Money, Money, Money. . . . . . . . . . . . . . . . . . . . . . . . . . . . . . . . . . . .222
   Looking at homeownership. . . . . . . . . . . . . . . . . . . . . . . . . . . . . .222
   Facing barriers in business. . . . . . . . . . . . . . . . . . . . . . . . . . . . . .223
   Successful Black-owned businesses . . . . . . . . . . . . . . . . . . . . . .224
Unforeseen Enemies. . . . . . . . . . . . . . . . . . . . . . . . . . . . . . . . . . . . . .226
   Crack cocaine . . . . . . . . . . . . . . . . . . . . . . . . . . . . . . . . . . . . . . . .226
   HIV/AIDS . . . . . . . . . . . . . . . . . . . . . . . . . . . . . . . . . . . . . . . . . . . . .228
The Racial Divide . . . . . . . . . . . . . . . . . . . . . . . . . . . . . . . . . . . . . . . .229
   L.A. riots . . . . . . . . . . . . . . . . . . . . . . . . . . . . . . . . . . . . . . . . . . . . .230
   The O.J. Simpson verdict. . . . . . . . . . . . . . . . . . . . . . . . . . . . . . . .230
   A modern-day lynching. . . . . . . . . . . . . . . . . . . . . . . . . . . . . . . . .231
   Hurricane Katrina . . . . . . . . . . . . . . . . . . . . . . . . . . . . . . . . . . . . .232

CHAPTER 11: **The New Civil Rights — Obama, Black Lives
Matter, and Beyond** . . . . . . . . . . . . . . . . . . . . . . . . . . . . . . . . . .233
Gaining the Presidency. . . . . . . . . . . . . . . . . . . . . . . . . . . . . . . . . . . .234
   Obama's 2008 campaign . . . . . . . . . . . . . . . . . . . . . . . . . . . . . . .234
   The Age of Obama, 2008–2016 . . . . . . . . . . . . . . . . . . . . . . . . . .235
   Black community gains. . . . . . . . . . . . . . . . . . . . . . . . . . . . . . . . .236
Black Lives Matter Emerges. . . . . . . . . . . . . . . . . . . . . . . . . . . . . . . .238
   I am Trayvon. . . . . . . . . . . . . . . . . . . . . . . . . . . . . . . . . . . . . . . . . .239
   Ferguson explodes: Michael Brown and the impact
   of Eric Garner's death . . . . . . . . . . . . . . . . . . . . . . . . . . . . . . . .242
   Police killings continue: Tamir Rice and Laquan McDonald . . . . .243
   Baltimore Rising: Freddie Gray . . . . . . . . . . . . . . . . . . . . . . . . . .243

The Charleston Church Massacre . . . . . . . . . . . . . . . . . . . . . . . . . . . .244

Say her name: Sandra Bland . . . . . . . . . . . . . . . . . . . . . . . . . . . . . .244

Colin Kaepernick Kneels and Donald Trump Reacts . . . . . . . . . . . . .245

Trump responds . . . . . . . . . . . . . . . . . . . . . . . . . . . . . . . . . . . . .246

Kaepernick opts out of his contract . . . . . . . . . . . . . . . . . . . . . . .247

Change Gone Come: Trump, COVID-19, and George Floyd . . . . . . .247

Trump's attacks continue . . . . . . . . . . . . . . . . . . . . . . . . . . . . . . .248

Stacey Abrams runs for governor in Georgia . . . . . . . . . . . . . . . .249

COVID-19 exposes racial disparities . . . . . . . . . . . . . . . . . . . . . . .249

"Stop killing us": George Floyd and Breonna Taylor . . . . . . . . . . .251

The 2020 Election . . . . . . . . . . . . . . . . . . . . . . . . . . . . . . . . . . . . . .253

Voting in the era of COVID-19 . . . . . . . . . . . . . . . . . . . . . . . . . . . .253

Trump and the U.S. Capitol riot . . . . . . . . . . . . . . . . . . . . . . . . . . .256

**PART 4: CULTURAL FOUNDATIONS** . . . . . . . . . . . . . . . . . . . . . . . .259

CHAPTER 12: **Somebody Say "Amen": The Black Church** . . . . . . . .261

Converting to Christianity . . . . . . . . . . . . . . . . . . . . . . . . . . . . . . . .262

Early objections, early conversions . . . . . . . . . . . . . . . . . . . . . . . .262

The Great Awakenings: Called to convert . . . . . . . . . . . . . . . . . . .263

Christianity, Black American style . . . . . . . . . . . . . . . . . . . . . . . . .264

Building and Sustaining the Black Church . . . . . . . . . . . . . . . . . . . .266

Black churches in the North . . . . . . . . . . . . . . . . . . . . . . . . . . . . .267

The Black church in the antebellum South . . . . . . . . . . . . . . . . . .268

Post–Civil War and Reconstruction . . . . . . . . . . . . . . . . . . . . . . . .270

Worship in the early 20th century . . . . . . . . . . . . . . . . . . . . . . . . .271

The modern era: Megachurches . . . . . . . . . . . . . . . . . . . . . . . . . .273

The changing role of women . . . . . . . . . . . . . . . . . . . . . . . . . . . .274

Politics and the Church . . . . . . . . . . . . . . . . . . . . . . . . . . . . . . . . . .275

Getting more political . . . . . . . . . . . . . . . . . . . . . . . . . . . . . . . . . .276

Minister-politicians: Pulling double duty . . . . . . . . . . . . . . . . . . . .276

Fighting for civil rights: Minister-activists . . . . . . . . . . . . . . . . . . .277

Continuing the struggle . . . . . . . . . . . . . . . . . . . . . . . . . . . . . . . .278

Worshiping Outside the Black Christian Mainstream . . . . . . . . . . . .279

Muslims and the Nation of Islam . . . . . . . . . . . . . . . . . . . . . . . . .279

Black Catholics . . . . . . . . . . . . . . . . . . . . . . . . . . . . . . . . . . . . . . .281

Jehovah's Witnesses . . . . . . . . . . . . . . . . . . . . . . . . . . . . . . . . . . .282

Seventh-day Adventists . . . . . . . . . . . . . . . . . . . . . . . . . . . . . . . .283

Black demagogues . . . . . . . . . . . . . . . . . . . . . . . . . . . . . . . . . . . .283

CHAPTER 13: **More Than Reading and Writing: Education** . . . . . . .285

A Brief History of Early Black American Education . . . . . . . . . . . . . .286

Revolting education . . . . . . . . . . . . . . . . . . . . . . . . . . . . . . . . . . . .286

Reconstructing: Education post–Civil War . . . . . . . . . . . . . . . . . . .289

20th-Century Educational Milestones . . . . . . . . . . . . . . . . . . . . . . 290
        Mixing it up with the Brown case . . . . . . . . . . . . . . . . . . . . 290
        Turning back the clock? . . . . . . . . . . . . . . . . . . . . . . . . . . . . 292
        Vouchers and school choice . . . . . . . . . . . . . . . . . . . . . . . . 292
        Leaving no child behind? Maybe . . . . . . . . . . . . . . . . . . . . 293
        Atlanta Public Schools cheating scandal . . . . . . . . . . . . . . 294
        Obama and Trump on education . . . . . . . . . . . . . . . . . . . . 294
    Higher Learning . . . . . . . . . . . . . . . . . . . . . . . . . . . . . . . . . . . . . 295
        Launching higher ed for the Black masses . . . . . . . . . . . . 296
        The Morrill Acts: Making it stick . . . . . . . . . . . . . . . . . . . . 298
        Determining the goal of higher education . . . . . . . . . . . . . 299
        Desegregating higher education . . . . . . . . . . . . . . . . . . . . 303
        School Daze: The Black Greek system . . . . . . . . . . . . . . . . 304

CHAPTER 14: **Writing Down the Bones: Black Literature** . . . . . . . . 307
    Troubled Beginnings . . . . . . . . . . . . . . . . . . . . . . . . . . . . . . . . . 308
        Early poets . . . . . . . . . . . . . . . . . . . . . . . . . . . . . . . . . . . . . 308
        Slave narratives . . . . . . . . . . . . . . . . . . . . . . . . . . . . . . . . . 310
        A novel journey . . . . . . . . . . . . . . . . . . . . . . . . . . . . . . . . . 311
    Writers' Party: The Harlem Renaissance . . . . . . . . . . . . . . . . . 314
        Why Harlem? . . . . . . . . . . . . . . . . . . . . . . . . . . . . . . . . . . . 315
        Key Renaissance artists and themes . . . . . . . . . . . . . . . . 316
    Post–World War II, Civil Rights–era Literature . . . . . . . . . . . . 319
        Richard Wright . . . . . . . . . . . . . . . . . . . . . . . . . . . . . . . . . . 320
        Ralph Ellison . . . . . . . . . . . . . . . . . . . . . . . . . . . . . . . . . . . 320
        James Baldwin . . . . . . . . . . . . . . . . . . . . . . . . . . . . . . . . . . 321
        Frank Yerby . . . . . . . . . . . . . . . . . . . . . . . . . . . . . . . . . . . . 321
    The Breakthrough: The Black Arts Movement . . . . . . . . . . . . 322
        The beginning of the movement . . . . . . . . . . . . . . . . . . . . 322
        Welcoming new voices . . . . . . . . . . . . . . . . . . . . . . . . . . . . 322
        The Black Arts Movement legacy . . . . . . . . . . . . . . . . . . . . 323
        Anthologies from the Black Arts Movement . . . . . . . . . . . 323
    Black Women's Words . . . . . . . . . . . . . . . . . . . . . . . . . . . . . . . 324
        Alice Walker . . . . . . . . . . . . . . . . . . . . . . . . . . . . . . . . . . . . 324
        Toni Morrison . . . . . . . . . . . . . . . . . . . . . . . . . . . . . . . . . . . 325
    Black Books from the 1990s On . . . . . . . . . . . . . . . . . . . . . . . 327

CHAPTER 15: **The Great Black Way: Theater and Dance** . . . . . . . . . 331
    Making an Early Statement . . . . . . . . . . . . . . . . . . . . . . . . . . . 332
    Minstrelsy: Performing in Blackface . . . . . . . . . . . . . . . . . . . . 333
        White minstrels . . . . . . . . . . . . . . . . . . . . . . . . . . . . . . . . . 333
        Black minstrels . . . . . . . . . . . . . . . . . . . . . . . . . . . . . . . . . . 334

Moving toward Broadway: Black Musical Theater . . . . . . . . . . . . . . .335
    More than minstrels . . . . . . . . . . . . . . . . . . . . . . . . . . . . . . . . . .336
    Williams and Walker on Broadway . . . . . . . . . . . . . . . . . . . . . . . .336
    The rumblings of serious Black theater . . . . . . . . . . . . . . . . . . . .337
    Shuffling ahead . . . . . . . . . . . . . . . . . . . . . . . . . . . . . . . . . . . . . .340
Black Theater Comes of Age . . . . . . . . . . . . . . . . . . . . . . . . . . . . . .342
    The Federal Theater Project and Black drama . . . . . . . . . . . . . . .342
    The American Negro Theater (ANT) . . . . . . . . . . . . . . . . . . . . . . .343
    A place to call home . . . . . . . . . . . . . . . . . . . . . . . . . . . . . . . . . .344
    Black musicals, 1940s and beyond . . . . . . . . . . . . . . . . . . . . . . . .345
Two Visionaries . . . . . . . . . . . . . . . . . . . . . . . . . . . . . . . . . . . . . . . .346
    August Wilson . . . . . . . . . . . . . . . . . . . . . . . . . . . . . . . . . . . . . . .346
    George C. Wolfe . . . . . . . . . . . . . . . . . . . . . . . . . . . . . . . . . . . . .347
Black Theater in the 21st Century . . . . . . . . . . . . . . . . . . . . . . . . . .348
    Kenny Leon . . . . . . . . . . . . . . . . . . . . . . . . . . . . . . . . . . . . . . . . .348
    Suzan-Lori Parks, Lynn Nottage, Tarell Alvin McCraney,
    and beyond . . . . . . . . . . . . . . . . . . . . . . . . . . . . . . . . . . . . . . . . .349
Black Dance in America . . . . . . . . . . . . . . . . . . . . . . . . . . . . . . . . . .351
    Early dances . . . . . . . . . . . . . . . . . . . . . . . . . . . . . . . . . . . . . . . .351
    Tap dance . . . . . . . . . . . . . . . . . . . . . . . . . . . . . . . . . . . . . . . . . .352
    Breakdancing . . . . . . . . . . . . . . . . . . . . . . . . . . . . . . . . . . . . . . .353
    Classical dance forms . . . . . . . . . . . . . . . . . . . . . . . . . . . . . . . . .354

## PART 5: A TOUCH OF GENIUS: MUSIC, FILM, TV, AND SPORTS . . . . . . . . . . . . . . . . . . . . . . . . . . . . . . . . . . . . . .357

### CHAPTER 16: Give Me a Beat: Black Music . . . . . . . . . . . . . . . . . . . . . . . .359

African Roots . . . . . . . . . . . . . . . . . . . . . . . . . . . . . . . . . . . . . . . . . .359
Black Music Fundamentals . . . . . . . . . . . . . . . . . . . . . . . . . . . . . . . .360
Feeling the Spirit: The Spirituals . . . . . . . . . . . . . . . . . . . . . . . . . . .361
Ragtime . . . . . . . . . . . . . . . . . . . . . . . . . . . . . . . . . . . . . . . . . . . . . .362
Singing the Blues . . . . . . . . . . . . . . . . . . . . . . . . . . . . . . . . . . . . . . .363
    Blues basics . . . . . . . . . . . . . . . . . . . . . . . . . . . . . . . . . . . . . . . . .363
    Blues genres . . . . . . . . . . . . . . . . . . . . . . . . . . . . . . . . . . . . . . . .364
    Famous blues musicians . . . . . . . . . . . . . . . . . . . . . . . . . . . . . . .365
Let the Good Times Roll: Jazz . . . . . . . . . . . . . . . . . . . . . . . . . . . . . .367
    The evolution of jazz styles . . . . . . . . . . . . . . . . . . . . . . . . . . . . .367
    Jazz singers . . . . . . . . . . . . . . . . . . . . . . . . . . . . . . . . . . . . . . . . .371
    Great jazz instrumentalists . . . . . . . . . . . . . . . . . . . . . . . . . . . . .372
    Keeping the tradition alive . . . . . . . . . . . . . . . . . . . . . . . . . . . . .374
Spreading the Gospel . . . . . . . . . . . . . . . . . . . . . . . . . . . . . . . . . . .375
    Kirk Franklin and the new gospel sound . . . . . . . . . . . . . . . . . . .377
Mainstreaming Black Music . . . . . . . . . . . . . . . . . . . . . . . . . . . . . . .378
    R&B . . . . . . . . . . . . . . . . . . . . . . . . . . . . . . . . . . . . . . . . . . . . . . .378
    Rocking and rolling . . . . . . . . . . . . . . . . . . . . . . . . . . . . . . . . . . .379

       Motown. . . . . . . . . . . . . . . . . . . . . . . . . . . . . . . . . . . . . . . . . . . . . .381

       Giving America soul. . . . . . . . . . . . . . . . . . . . . . . . . . . . . . . . . . .383

       Post-soul Black music. . . . . . . . . . . . . . . . . . . . . . . . . . . . . . . . . .384

       Getting funky and popping off . . . . . . . . . . . . . . . . . . . . . . . . . .384

       The hip-hop age of R&B . . . . . . . . . . . . . . . . . . . . . . . . . . . . . . . .385

   Taking the Rap . . . . . . . . . . . . . . . . . . . . . . . . . . . . . . . . . . . . . . . . . .388

       Hip hop matures . . . . . . . . . . . . . . . . . . . . . . . . . . . . . . . . . . . . . .388

       The West Coast opens up rap . . . . . . . . . . . . . . . . . . . . . . . . . . .389

       Women take the mic. . . . . . . . . . . . . . . . . . . . . . . . . . . . . . . . . . .390

       Trap music emerges . . . . . . . . . . . . . . . . . . . . . . . . . . . . . . . . . . .391

       Lyrical emcees return . . . . . . . . . . . . . . . . . . . . . . . . . . . . . . . . . .392

**CHAPTER 17: Black Hollywood: Film and Comedy**. . . . . . . . . . . . . . . 393

   Making Movies Black. . . . . . . . . . . . . . . . . . . . . . . . . . . . . . . . . . . . . .394

       Race movies: Introducing all-Black casts . . . . . . . . . . . . . . . . . .395

       Early Black roles in major studio films . . . . . . . . . . . . . . . . . . . .398

       1940s–1960s: Exploring new themes . . . . . . . . . . . . . . . . . . . . .401

       1960s–1970s: Blaxploitation films. . . . . . . . . . . . . . . . . . . . . . . .402

       Spike Lee and a Black film renaissance . . . . . . . . . . . . . . . . . . .403

       Hood films . . . . . . . . . . . . . . . . . . . . . . . . . . . . . . . . . . . . . . . . . .404

       Stepping out of the hood genre . . . . . . . . . . . . . . . . . . . . . . . . .405

   The Rise of Black Directors. . . . . . . . . . . . . . . . . . . . . . . . . . . . . . . . .406

       Spike Lee: Getting personal . . . . . . . . . . . . . . . . . . . . . . . . . . . . .406

       1990s and early 2000s: The music video launch. . . . . . . . . . . .407

       The 2010s: Drama, horror, heroes, and more. . . . . . . . . . . . . . .408

       2020: A stream of Black women directors . . . . . . . . . . . . . . . . .411

   Black Film Stars: From Song to Celluloid . . . . . . . . . . . . . . . . . . . . .412

       Singers-turned-actors . . . . . . . . . . . . . . . . . . . . . . . . . . . . . . . . .413

       Rappers-turned-actors/producers . . . . . . . . . . . . . . . . . . . . . . .413

   Kings and Queens of Comedy. . . . . . . . . . . . . . . . . . . . . . . . . . . . . .415

       Richard Pryor . . . . . . . . . . . . . . . . . . . . . . . . . . . . . . . . . . . . . . . .415

       Eddie Murphy. . . . . . . . . . . . . . . . . . . . . . . . . . . . . . . . . . . . . . . .415

       Male comedians who followed Pryor and Murphy. . . . . . . . . . .416

       Whoopi Goldberg . . . . . . . . . . . . . . . . . . . . . . . . . . . . . . . . . . . . .419

       Other comediennes . . . . . . . . . . . . . . . . . . . . . . . . . . . . . . . . . . .419

   Enter Stage Left: Serious Actors . . . . . . . . . . . . . . . . . . . . . . . . . . . .421

       Sidney Poitier. . . . . . . . . . . . . . . . . . . . . . . . . . . . . . . . . . . . . . . .421

       Cicely Tyson . . . . . . . . . . . . . . . . . . . . . . . . . . . . . . . . . . . . . . . . .422

       Denzel Washington. . . . . . . . . . . . . . . . . . . . . . . . . . . . . . . . . . . .422

       Morgan Freeman. . . . . . . . . . . . . . . . . . . . . . . . . . . . . . . . . . . . . .423

       Wesley Snipes . . . . . . . . . . . . . . . . . . . . . . . . . . . . . . . . . . . . . . .423

       Samuel L. Jackson . . . . . . . . . . . . . . . . . . . . . . . . . . . . . . . . . . . .424

       Halle Berry . . . . . . . . . . . . . . . . . . . . . . . . . . . . . . . . . . . . . . . . . .424

       Viola Davis . . . . . . . . . . . . . . . . . . . . . . . . . . . . . . . . . . . . . . . . . .425

   And the Award Goes to?. . . . . . . . . . . . . . . . . . . . . . . . . . . . . . . . . . .426

**CHAPTER 18: Black Hollywood: TV** . . . . . . . . . . . . . . . . . . . . . . . . . . . . . . . 427

Early Black TV Comedies . . . . . . . . . . . . . . . . . . . . . . . . . . . . . . . . . . . . 428

Opening the doors wider . . . . . . . . . . . . . . . . . . . . . . . . . . . . . . . . 428

Getting an edge . . . . . . . . . . . . . . . . . . . . . . . . . . . . . . . . . . . . . . . 429

Kid comedies . . . . . . . . . . . . . . . . . . . . . . . . . . . . . . . . . . . . . . . . . 429

Cue the Huxtables and A Different World . . . . . . . . . . . . . . . . . . . 430

Targeting the Black Hip-Hop Audience . . . . . . . . . . . . . . . . . . . . . . . . 432

Cable TV Opens the Door to More . . . . . . . . . . . . . . . . . . . . . . . . . . . 432

Black Women Comedians Contribute on TV . . . . . . . . . . . . . . . . . . . . 434

No More Drama with Dramas . . . . . . . . . . . . . . . . . . . . . . . . . . . . . . . 435

The Rhimes effect . . . . . . . . . . . . . . . . . . . . . . . . . . . . . . . . . . . . . 435

Made-for-TV movies . . . . . . . . . . . . . . . . . . . . . . . . . . . . . . . . . . . 436

Black actors in cable TV series . . . . . . . . . . . . . . . . . . . . . . . . . . . 437

Network dramas . . . . . . . . . . . . . . . . . . . . . . . . . . . . . . . . . . . . . . 440

Highlighting Black LGBTQ stories . . . . . . . . . . . . . . . . . . . . . . . . . 440

Black women TV executives . . . . . . . . . . . . . . . . . . . . . . . . . . . . . 442

The Next Level: Building Black Television and Film Empires . . . . . . . 443

The billion-dollar BET . . . . . . . . . . . . . . . . . . . . . . . . . . . . . . . . . . 443

The big "O" . . . . . . . . . . . . . . . . . . . . . . . . . . . . . . . . . . . . . . . . . . 444

Tyler Perry builds his own table . . . . . . . . . . . . . . . . . . . . . . . . . . 445

**CHAPTER 19: Winning Ain't Easy: Race and Sports** . . . . . . . . . . . . . . 449

Baseball . . . . . . . . . . . . . . . . . . . . . . . . . . . . . . . . . . . . . . . . . . . . . . 449

The Negro Leagues . . . . . . . . . . . . . . . . . . . . . . . . . . . . . . . . . . . 450

Jackie Robinson: Integrating baseball . . . . . . . . . . . . . . . . . . . . . . 454

The modern era . . . . . . . . . . . . . . . . . . . . . . . . . . . . . . . . . . . . . . 455

Basketball . . . . . . . . . . . . . . . . . . . . . . . . . . . . . . . . . . . . . . . . . . . . 456

College ball . . . . . . . . . . . . . . . . . . . . . . . . . . . . . . . . . . . . . . . . . 457

Pro ball . . . . . . . . . . . . . . . . . . . . . . . . . . . . . . . . . . . . . . . . . . . . 458

Women's basketball . . . . . . . . . . . . . . . . . . . . . . . . . . . . . . . . . . . 462

Boxing . . . . . . . . . . . . . . . . . . . . . . . . . . . . . . . . . . . . . . . . . . . . . . . 464

Football . . . . . . . . . . . . . . . . . . . . . . . . . . . . . . . . . . . . . . . . . . . . . . 467

Pro football . . . . . . . . . . . . . . . . . . . . . . . . . . . . . . . . . . . . . . . . . 467

College football . . . . . . . . . . . . . . . . . . . . . . . . . . . . . . . . . . . . . . 469

Track and Field . . . . . . . . . . . . . . . . . . . . . . . . . . . . . . . . . . . . . . . . 470

Tennis . . . . . . . . . . . . . . . . . . . . . . . . . . . . . . . . . . . . . . . . . . . . . . . 474

Arthur Ashe . . . . . . . . . . . . . . . . . . . . . . . . . . . . . . . . . . . . . . . . . 474

Venus and Serena Williams . . . . . . . . . . . . . . . . . . . . . . . . . . . . . 475

Golf . . . . . . . . . . . . . . . . . . . . . . . . . . . . . . . . . . . . . . . . . . . . . . . . . 475

Other Sports . . . . . . . . . . . . . . . . . . . . . . . . . . . . . . . . . . . . . . . . . . 476

## PART 6: THE PART OF TENS ................................................... 479

**CHAPTER 20: Ten Black American Firsts** ...................................... 481

Medicine (1837) ................................................................. 481
Law (1845) ...................................................................... 482
Kentucky Derby (1875) ........................................................... 482
Congressional Medal of Honor (1900) ............................................. 483
Rhodes Scholar (1907) ........................................................... 483
Exploration (1909) .............................................................. 483
Television (1939) ............................................................... 484
Nobel Peace Prize (1950) ........................................................ 484
Pulitzer Prize (1950) ........................................................... 484
Fashion (1988) .................................................................. 485

**CHAPTER 21: Ten Black Literary Classics** ................................... 487

Narrative of the Life of Frederick Douglass, An American
Slave Written by Himself (1845) ................................................. 488
Up from Slavery: An Autobiography by Booker
T. Washington (1901) ............................................................ 488
The Souls of Black Folk by W.E.B. Du Bois (1903) ................................ 489
The Mis-Education of the Negro by Carter G. Woodson (1933) ...................... 489
Their Eyes Were Watching God by Zora Neale Hurston (1937) ....................... 490
Native Son by Richard Wright (1940) ............................................. 490
Invisible Man by Ralph Ellison (1952) ........................................... 491
The Autobiography of Malcolm X (As Told to Alex Haley)
by Alex Haley and Malcolm X (1965) .............................................. 491
The Color Purple by Alice Walker (1982) ......................................... 492
Beloved by Toni Morrison (1987) ................................................. 492

**CHAPTER 22: Ten (Plus One) Influential Black American
Visual Artists** ................................................................ 493

Joshua Johnson (c. 1763–1832) ................................................... 494
Edmonia Lewis (c. 1844–1907) .................................................... 494
Henry Ossawa Tanner (1859–1937) ................................................. 495
Aaron Douglas (1899–1979) ....................................................... 495
Horace Pippin (1888–1946) ....................................................... 496
Loïs Mailou Jones (1905–1998) ................................................... 497
Jacob Lawrence (1917–2000) ...................................................... 498
Romare Bearden (1911–1988) ...................................................... 498
John Biggers (1924–2001) ........................................................ 499
Samella Lewis, Ph.D. (1924–) .................................................... 499
Jean-Michel Basquiat (1960–1988) ................................................ 500

## INDEX ......................................................................... 501

# Introduction

Black history as American history is a truth that has become increasingly more accepted since *African American History For Dummies* appeared more than a decade ago. The mainstream amplification of the 1921 Tulsa Massacre in such shows as *Watchmen* and *Lovecraft Country*, both from HBO, along with triumphant hidden history like mathematician Katherine Johnson's role in putting a man on the moon as shown in the Oscar-nominated *Hidden Figures*, have highlighted how little the average American, Black, white, Latino, Asian, indigenous, and more, actually knows about Black American history aside from the obvious Black History Month mainstays. For many, the police killings of George Floyd, Breonna Taylor, Laquan McDonald, Michael Brown, and more point to the devastating role this nation's history of racial discrimination plays in modern policing. All these events drive home the pressing need for a more inclusionary American history curriculum.

Carter G. Woodson, the man who created Negro History Week, which evolved into Black History Month, actually envisioned a time when general American history would incorporate Black American history. He believed that this important aspect of the nation's collective history was for all to know. It's a core belief that modern Black history experts cosign.

"Black history is American history, and American history is Black history. You can't have one without the other," Dr. Dwight McBride, an African American studies expert who became president of The New School in New York City in 2020, has said. "And if you're going to tell a story of America, and leave out Black people, it's going to be a very incomplete, not to mention unsatisfying and dishonest, story."

Black American history is so much more than a handful of extraordinary individuals or cruel institutions like slavery and Jim Crow, or the ongoing battle for civil and human rights steeped in the Black Lives Matter movement. A lot of it is painful, but it's also inspiring and triumphant. History can give people the courage and strength to become better, to do better. "You can never know where you are going unless you know where you have been," said civil rights trailblazer Amelia Boynton Robinson, who almost lost her life on the Edmund Pettus Bridge during Bloody Sunday in 1965.

Sadly, it has taken the Civil War, the civil rights movement of the 1950s and 1960s, and a lot of struggle in between — and after — to even begin securing Black Americans the basic right of citizenship that many white Americans take for granted. *Black American History For Dummies* isn't a big sermon on this struggle; instead, it's a straightforward, interesting, and honest overview of Black American history from Africa through the transatlantic slave trade, slavery, the Civil War, Reconstruction, Jim Crow, and the civil rights movement of the 1950s and 1960s up to today. I hope this history sheds light on both the significance of Barack Obama's election as president and why the Black Lives Matter movement exists. Along the way, this history has birthed a culture that includes the Black church and education, as well as music, literature, film, television, and sports.

# About This Book

Making this book as thorough (within the page constraints) and as engaging as possible has been a top priority for me. So consider *Black American History For Dummies* an introduction to a vast and vastly interesting subject. I hope it inspires you to seek out more information (in addition to books, I suggest quite a few documentaries and other movies that bring history to life). At the very least, look at the contributions of Black Americans with new eyes.

Of course, in deciding what to include, I tried to be as objective as possible. I sifted through many history books and online sources, and checked and double-checked numerous dates and facts so that you could trust the information contained in this book. Because that information is often ugly, there is objectionable language in quotes, songs, movie titles, and the overall history itself. So do know that keeping the context of the times in mind is required.

I have a personal connection to the book. My grandfather, a Mississippian from birth to death, came from a family of sharecroppers. My great aunt sang blues songs at family gatherings and told the best stories, some of which I later found in a book of "Negro" folklore. My grandmother never tired of sharing family stories with me, even a tragic one about the unsolved murder of her brother who migrated to Chicago in the 1930s. Of course, my whole family has plenty of stories about the civil rights movement, and, yes, I wish I had first learned about the Ku Klux Klan in books or on TV.

I've lived a little bit of Black American history myself, too. I was a middle school student when Harold Washington became Chicago's first Black mayor, and, wouldn't you know, David Dinkins became the first Black mayor of New York City when I moved there for college? Did I know that LL Cool J would become a global rap pioneer or a successful actor when I bumped into him at NYC clubs? Certainly

not, but in Los Angeles, I did know that meeting Fayard Nicholas of the legendary Nicholas Brothers dance duo was a huge privilege. I also cherished seeing Halle Berry, Will Smith, and Denzel Washington at the Academy Awards luncheon the year Berry and Washington won their Oscars. Braving the cold for Barack Obama's historic 2009 inauguration as the nation's first Black president was simply amazing. Still, one of my biggest thrills in life was meeting Muhammad Ali in Chicago when I was young.

*Black American History For Dummies* is the actual history behind these personal experiences and hopefully explains why these events mean so much. In my effort to reveal the interesting side of history (believe me, there is one!), I hope you'll also embrace this history and share it. The ultimate goal of this book for me is to make Black American history accessible without sacrificing, well, the history.

This book is chock-full of interesting information and stories to help give you a more complete picture of Black American history. Specifically, you can find details about the following:

>> The role the deaths of Trayvon Martin and Michael Brown played in sparking the Black Lives Matter movement

>> How Black TV and film exploded in the 2010s

>> The resurgence of political activism among Black athletes

>> How Black literature has further expanded

>> The changes afoot in the Black church

# Foolish Assumptions

In writing (and revising) *Black American History For Dummies*, I had to make some assumptions about you, the reader. On top of my main assumption — that Black American history is important for everyone, not just Black Americans — here are a few others:

>> You suspect that Black American contributions to American history run deeper than you learned in required history classes but don't know how to prove it.

>> At one point, you tried to read about Black American history, but just couldn't find enough of what you needed to know in one spot and don't like the idea of having to dust off your high school or college research skills or cultivate them.

>> You picked up bits and pieces of Black American history here and there but want an accessible reference where you can go to find out more.

>> You're naturally inquisitive and open to finding out more about Black Americans and their struggles and triumphs, as well as their contributions to the nation overall.

# Icons Used in This Book

The little pictures you see attached to paragraphs throughout the book are another of the standard, helpful *For Dummies* features. They flag information that's special and important for one reason or another. *Black American History For Dummies* uses the following icons:

**HISTORICAL ROOTS**

This icon accompanies information that explains where something — an organization, an event, and so on — originates. Perhaps you didn't know, for example, that other civil rights activists used sit-ins before they became popular in the 1960s.

**BLACK AMERICAN FACES**

This icon of a magnifying glass focuses on the details of Black Americans, especially those not typically spotlighted, who did some outstanding things that warrant further explanation.

**IN THEIR OWN WORDS**

Words say a lot. Surely, someone who made the brave decision to flee can better tell you how scary running away really was or what freedom truly means than I can. Besides, many of the quotations and excerpts that carry this icon are just outright inspiring.

Although I find everything in this book enlightening, I admit that it isn't all necessary in order to understand the topic. This icon points out what you may want to read but don't have to. It also highlights some interesting facts you might not know, like the fact that Mississippi didn't ratify the Thirteenth Amendment abolishing slavery until 1995.

**TECHNICAL STUFF**

**REMEMBER**

This icon points to facts or ideas that you should, well. . . remember. Essentially, it's important stuff that's had a major impact on Black American and American history and therefore shouldn't be overlooked.

# Where to Go from Here

Now's the time to dive into this book in the way that best suits you: I can't tell you which chapter to choose or part to read. Flip to the Table of Contents or index and find a topic that interests you. Skip around. Fast forward ahead or travel back in time. Within each chapter, sidestep sidebars or read only the text with Remember icons. Or if you like, read *Black American History For Dummies* from cover to cover. If you want a good overview of the book, start with Chapter 1 and find a topic that interests you. Part 2 delves deeper into slavery, the Civil War, and Reconstruction. Or if you want to read more about how Black Americans have contributed to culture and sports, start with Part 5. For a handy reference guide, head to www. dummies.com and search for the "Black American History For Dummies Cheat Sheet." It's completely up to you.

# 1

# Coming to America

Get an overview of Black American history and culture, touching on the legacy of Carter G. Woodson who pioneered the field, identifying the past and present challenges stemming from anti-Blackness, exploring how Black Americans embrace the past personally and institutionally, as well as uncovering the push behind reparations.

Discover how Africans found themselves in the New World and the horrors they endured as commodities who largely built the American colonies effectively making England a world power in the process.

Understand how despite the disappointment of the American Revolution that promised freedom to all but denied it to the enslaved, they managed to become a nation within a nation, continuing the fight for freedom from enslavement that lasted roughly another 100 years.

» **Examining advances and challenges for Black Americans**

» **Exposing all Americans to Black American history**

» **Remaining conscious of unresolved issues**

Chapter **1**

# The Soul of America

The word "Sankofa" from the Akan people in present–day Ghana and the Ivory Coast roughly translates to "knowing the past to know your future." The collective recognition of Black American history has come in stages and is frankly still evolving. In the mid–1970s, Americans felt that connection to a certain degree when Alex Haley's book *Roots* (1976) and the television miniseries sparked a nationwide fervor among Black Americans and others to learn more about Black Americans and their connection to Africa.

That passion was certainly reignited in the 2000s and 2010s as interest in DNA testing through companies like the Black-owned African Ancestry, allowing Black people, in particular, to see from which part of the African continent they may hail, exploded. So did interest in genealogy research, especially through online genealogy sites. Black scholar Henry Louis Gates proved this with the success of his 2006 PBS docuseries *African American Lives,* where he used DNA testing as well as historical and genealogical research to connect the American and African lineages of such participants as Oprah Winfrey, Chris Tucker, and Whoopi Goldberg. In 2008, he followed it with *Finding Your Roots* and later began incorporating white Americans, too.

Although the nation as a whole appeared to have a thirst for their roots, this quest seemed to once again take on special significance for Black Americans, who, through more than two centuries of slavery, had been routinely robbed of a direct, continuous connection to their African heritage. But what has that quest for

identity, belonging meant, especially in a country where it has been generally denied and suppressed? How does ignorance of Black American history contribute to the police killings of Black Americans like George Floyd, Breonna Taylor, Eric Garner, Michael Brown and Tamir Rice? Or to the Capitol Riot at the top of 2021? Why is Black Lives Matter even necessary in the 21st century and why are folks like Stacey Abrams fighting voter suppression?

Not knowing the contributions of Black Americans to overall American history isn't just a disservice to Black Americans. "I want American history taught," celebrated writer James Baldwin once demanded. "Unless I'm in the book, you're not in it either." This chapter presents a general overview of Black American history, underscoring its importance to Black Americans and *all* Americans.

# A Peek at the Past

Perhaps no one individual did as much for the study and popularization of Black American history as Carter G. Woodson, the man responsible for Black History Month. Born in 1875 in Virginia to parents who were formerly enslaved, Woodson received his B.A. at Kentucky's Berea College, his M.A. at the University of Chicago, and his Ph.D. at Harvard.

Woodson, who taught and led public schools even after receiving his graduate degrees, spearheaded the 1915 founding of the Association for the Study of Negro Life and History (ASNLH), presently the Association for the Study of African American Life and History (ASALH), which began publishing what is now the *Journal of African American History*. After overseeing the organization for more than 30 years, Woodson passed away in 1950 at the age of 74, but the organization still stands and is more than 100 years old.

**IN THEIR OWN WORDS**

Woodson believed that preserving Black American history was essential to Black American survival. "If a race has no history, if it has no worthwhile tradition," Woodson reasoned. "It becomes a negligible factor in the thought of the world, and it stands in danger of being exterminated." He also felt that omitting Black American contributions from general American history sanctioned and perpetuated racism. "The philosophy and ethics resulting from our educational system have justified slavery, peonage, segregation, and lynching," he noted. Looking at matters from this perspective, it's little wonder that Black Americans have been vilified.

The only way to move forward is to recognize this reality. And that can only be done by acknowledging the history. The following sections examine some moments in Black history.

# Life before slavery

"What is Africa to me?" Countee Cullen asks in his 1930 poem "Heritage." It is a question that should resonate with more than just Black Americans. European interaction with the African continent profoundly changed the world — Black, white, and otherwise — and nowhere else is that fact more evident than in the United States.

With the exception of South Carolina, Africans were largely the racial minority in early America, partially because white colonists adamantly restricted their numbers. Even in small numbers, though, Africans had an enormous impact on American history. The truth is that America has a dual history rooted in both Europe and Africa. Despite what you see in many textbooks, Black American history didn't begin with slavery; like other Americans, Black Americans have a beginning that predates the Americas.

Kidnapped Africans transported to the Americas through the slave trade generally hailed from Western and Central Africa, an area that includes present-day Ghana, Nigeria, the Ivory Coast (also known as Côte d'Ivoire), Mali, Senegal, Angola, and the Congo. Of Africa's many empires, Ghana, Mali, and Songhay are the most important to Black American history. Some unique features of these empires included religious tolerance, attempts at representative government, and somewhat egalitarian attitudes concerning the contributions of women. Chapter 2 provides more information about these empires.

Although Egypt attracted European attention centuries before the slave trade began, tales of Africa's enormous riches reignited European interest in the continent. Portugal, which beat other European countries to Africa, didn't go there to become enslavers but rather to gain material wealth. And although the Portuguese captured Africans during those early trips, they weren't doomed to a lifetime of enslavement. Columbus's "discovery" of the New World and Spain's claim on the land changed that. When Spain instituted slavery to capitalize on cash crops like sugar, Portugal served as the primary supplier of Africans kidnapped from their homes. As Chapter 3 explains, England entered the slave trade relatively late but excelled quickly.

# Life before emancipation

The first Africans to arrive in Virginia to Point Comfort and, later, Jamestown in 1619 were brought in on slave ships. Historians of the past argued that these people weren't enslaved; however, when John Punch (believed to be an ancestor of Barack Obama on his mother's side and Nobel Prize winner Ralph Bunche) ran away from Virginia to Maryland with two indentured servants who were white in 1640, only he received a punishment of lifetime enslavement when captured. Still

the evidence shows that Africans, by and large, never resigned themselves to being enslaved and kept trying for their freedom, either through running away, challenging their status in court, or trying to appeal to the moral consciences of colonists.

Enslaved life was harsh, with human beings reduced to nothing more than property. Laws ensured that those enslaved had no control over their lives. Slaveholders had the legal right to dictate their every move and mistreat them with no recourse. Consequently, slaveholders separated families without a second thought, and rapes and unwanted pregnancies were far from unusual occurrences for enslaved girls and women.

Still, free Blacks and their enslaved brethren never abandoned their hope for freedom. Whether they ran away, rallied sympathetic white people toward emancipation or helped carry others to freedom using the Underground Railroad, they did whatever they could to force the new nation to live up to its promise of freedom and equality. Less than a century into the new nation's existence, the inevitable happened with the onset of the Civil War.

## Life before civil rights

Long before Lincoln's Emancipation Proclamation and the ratification of the Thirteenth Amendment abolishing slavery, Black Americans firmly set their minds on attaining freedom. When Lincoln wavered about ending slavery during the Civil War, Black Americans like Frederick Douglass continued lobbying for freedom.

Reconstruction (the period of recovery, particularly in the South, following the Civil War) revealed that most white Americans had never seriously entertained the idea of Black American freedom. Even some white abolitionists who believed that Black people shouldn't be enslaved didn't necessarily believe that they should enjoy the same rights and freedoms as other white people. White Congressman Thaddeus Stevens was the grand exception. He and others battled to right the wrongs of the past tied to slavery through various actions like proposing an amendment to the 1866 Freedmen's Bureau Bill for 40 acre lots for freedmen or supporting bills like the Civil Rights Act of 1866 declaring all men born in the country free with the aid of newly inaugurated Black American congressmen. White Southerners, evidenced by their subsequent push for poll taxes, grandfather clauses, and new state constitutions often excluding Black people, refused to change the status quo, and the North largely sat back and watched.

When Reconstruction ended, Black Americans continued the fight for racial equality as white mob violence compromised their freedom and Jim Crow ruled their lives determining where they could live, eat and socialize. In the 20th century,

Black American leaders like W.E.B. Du Bois and Ida B. Wells–Barnett seized every opportunity to challenge the "white only" claim.

Searching for better jobs and freedom from Jim Crow, Black Americans migrated North. Although the Promised Land wasn't all they had imagined, they didn't abandon each other. Battling mob violence in the North, the nation saw that Black Americans never accepted lynching or Jim Crow; there wasn't really a "New Negro" at work but rather the old one in plain view. Marcus Garvey capitalized on that spirit when he launched his brand of Black Nationalism and pan–Africanism. (You can read about Du Bois, Wells–Barnett, Garvey, and others, as well as the Great Migration, in Chapter 7.)

The demographic shift created a new power base for Black Americans. Prompted by the shameful treatment Black Americans received during the Great Depression, Black leaders demanded a piece of Franklin Delano Roosevelt's New Deal program and switched from the Republican to the Democratic Party. By the time World War II rolled around, strong leaders, remembering the broken promises of World War I, wouldn't back down from their new demands. By the 1950s and 1960s (see Chapters 7 and 8), the weapons critical to winning the battle against inequality were in place.

**BLACK AMERICAN FACES**

# PROPHETS LOOKING BACKWARD: BLACK AMERICAN HISTORIANS

If, as German scholar Friedrich von Schlegel observed, "the historian is a backward-looking prophet," then a number of prophets have emerged from Black American history. Celebrated Black American intellectual W.E.B. Du Bois, the first Black American to receive a Ph.D. from Harvard University, chose the African slave trade as the subject of his doctoral dissertation and in 1896 published *The Suppression of the African Slave Trade to the United States of America.* Twelve years prior to Du Bois's work, in George Washington Williams, the first "colored" member of the Ohio legislature, published *History of the Negro Race in America From 1619 to 1880.*

Despite the scholarship of these men, Carter G. Woodson, the man frequently referenced as the Father of Black History, became one of the foremost advocates of Black American history. He wrote some of the most influential works on the Black American experience. He also established Negro History Week in 1926, which blossomed into Black History Month, with the hope that one day general American history would rightfully include the vital and numerous contributions of Black Americans.

*(continued)*

(continued)

Woodson didn't do this solo and worked with historians Charles H. Wesley, with whom he wrote *The Negro in Our History* (1962), and Lorenzo Greene, with whom he wrote *The Negro Wage Earner* (1930), among others. Black historians who have continued Woodson's push include the following:

- John Hope Franklin (1915–2009), author of arguably the most widely used Black American history textbook, *From Slavery to Freedom* (1947)

- Lerone Bennett (1928–2018), former executive editor of *Ebony* magazine and author of *Before the Mayflower* (1963)

- John W. Blassingame (1940–2000), historian and Yale professor who authored several groundbreaking histories, including the 1972 *The Slave Community: Plantation Life in the Antebellum South* (Oxford University Press); it centered on the voices of Black people, most notably allowing enslaved people to be seen in their own history

- Sterling Stuckey (1932–2018), important historian who advanced the idea that Black people retained their African culture during slavery and impacted the rest of the nation primarily through his 1987 groundbreaking book *Slave Culture: Nationalist Theory and the Foundations of Black America* (Oxford University Press)

- David Levering Lewis, Pulitzer Prize–winning historian known for the 1981 *When Harlem Was in Vogue* (Penguin Books) and his two-volume biography series, *W.E.B. Du Bois: Biography of a Race, 1868–1919* (1993) and *W.E.B. Du Bois, 1919-1963: The Fight for Equality and the American Century* (2000) (Holt)

- Paula Giddings, author of the 1983 *When and Where I Enter* (W. Morrow), the 1988 *In Search of Sisterhood* (William Morrow Paperbacks), and the 2008 *Ida: A Sword among Lions* (Amistad)

- Nell Irvin Painter, author of the 1996 *Sojourner Truth: A Life, a Symbol* (W. W. Norton & Company) and the 2006 *Creating Black Americans* (Oxford University Press)

- Robin D.G. Kelley, coeditor of the 2000 *To Make Our World Anew: A History of African Americans* (Oxford University Press) and author of the 1991 *Hammer and Hoe: Alabama Communists during the Great Depression* (University of North Carolina Press)

# Being Black in America Today

The Supreme Court ruling in *Brown v. Board of Education* (1954) dealt a powerful blow to the Jim Crow bully, but Emmett Till's brutal murder in Mississippi in 1955 as the result of an innocent encounter with a white woman shook thousands out

of their complacency. When Martin Luther King Jr. emerged on the scene a few months later, "Ain't Gonna Let Nobody Turn Me 'Round" became an anthem for change.

The nonviolent direct action favored by Gandhi, which the Reverend Dr. Martin Luther King Jr. followed, also worked in the United States. However, Malcolm X, the Black Panther Party, and eventually the Student Nonviolent Coordinating Committee (SNCC) felt that Black Power was a more effective strategy and refused to turn the other cheek. Despite their differences, the two factions had the same ultimate goals: freedom and equality.

Throughout the 1970s and 1980s, Black Americans amassed a vast assortment of incredible achievements. From serving as mayors in major cities like Los Angeles, New York, and Chicago to selling millions of records worldwide, Black Americans excelled in both expected and unexpected areas. Black household incomes consistently soared to record heights. The picture wasn't rosy for everyone, however. The effects of crack cocaine ravished Black neighborhoods, gun violence robbed mothers of their children, and prisons often sucked up those who survived.

So much has changed for the better for Black Americans since King and Malcolm X had their lives taken. Visible "colored only" and "white only" signs no longer exist, and Black people aren't physically assaulted for daring to vote. Many of the obstacles that limited opportunities for Black Americans at one time are gone. Yet vestiges of racism linger. On the one hand, hip-hop moguls such as Sean "Diddy" Combs and Jay-Z have turned themselves into global brands. On the other hand, news cameras documented Black men, women, and children stranded on rooftops for days during Hurricane Katrina while elected officials placed blame instead of expediting rescue efforts, and cellphone cameras have captured unarmed Black people being killed by the police. Not even the election of Barack Obama as the nation's first Black president in 2008 could change this reality. And under his successor, one-time reality star Donald Trump, whose presidency spanned from 2017 to 2021, the nation's barometer for anti-Blackness only worsened.

## Contributions to history and culture

Black American contributions to American history are tremendous. It's not a stretch to say that enslaved African labor, for example, is one of the reasons the U.S. exists as it does today. In the colonies, Africans cleared land and built houses in addition to cultivating cash crops such as rice, tobacco, and cotton. Black Americans weren't absent in the U.S. expansion westward either. In the North, enslaved Black Americans worked in the shipping industry as well as early factories. Black soldiers fought in the American Revolution, the War of 1812, and the Civil War.

# WHAT'S IN A NAME? "NEGRO," THE N-WORD, AND MANY OTHERS

"African," "Afro-American," "colored," "Negro," "Black," and "African American" are just some of the names used to describe people who trace their roots to the African continent. The constantly evolving terms largely reflect developments in Black American culture and its relationship to the dominant white culture. The changes also reveal Black Americans' ongoing quest for self-identity and self-determination.

Surprisingly, "Negro" didn't always refer to Black people. At times, it included Asians and, in the New World, Native Americans. In 19th-century runaway announcements, the term "negro" identified Black Americans. Progressive institutions such as the African Methodist Episcopal Church preferred the term "African," but "colored" was widely used. In 1829, David Walker addressed his famous appeal to the "coloured citizens of the world." The use of "colored" by the National Association for the Advancement of Colored People (NAACP) indicates the term's positive value in the early 20th century; in the years between the two world wars, the NAACP actually spearheaded the use of "Negro" with a capital *n,* and that usage persisted into the 1960s.

As the civil rights movement gave way to the Black Power movement, "Black" replaced "Negro." The 1980s ushered in the use of "African American," which supporters such as Jesse Jackson insisted reflected both an African and American identity. However, some argue that it isn't specific enough because white African immigrants such as actress Charlize Theron and business mogul Elon Musk are technically African American. Today, people often use "African American" and "Black" interchangeably.

Enslaved people sometimes referred to themselves as niggers in front of white slaveholders to indicate their servility, and the term was widely used in European and early American history to refer to Black Americans, including usage in novels such as Mark Twain's *Adventures of Huckleberry Finn* (1884). Although widely used, "nigger" was rarely a positive term, a point underscored during the civil rights movement when newspapers and television frequently quoted hostile white Americans using the word freely.

Some Black Americans, especially with the onset of rap music, made distinctions between "nigger" and "nigga." Some Black Americans view the latter more positively when used among Black Americans, although saying it aggressively can indicate hostility. Even though hip-hop songs and comedy routines use the term liberally, it's generally unacceptable for non-Black Americans to use it under any circumstances. The unwritten rule is that Black people can use the term, and non-Black people can't. Of course, many Black Americans believe that absolutely no one should.

Black American contributions in music are celebrated the world over. Few authentic American music genres are without African roots, including rock and roll, which counts Chuck Berry, Little Richard, the infamous Ike Turner, and the lesser-known Roy Brown and Wynonie Harris among its early pioneers. Black American dance has influenced American culture since slavery. Literature and sports have also played key roles. So have less well-known contributions in medicine and architecture, among other fields. The following is a brief sampling of those contributions.

## In music and dance

Trying to keep up with Black American contributions in music and dance is dizzying. Jazz is an indigenous American art form birthed from Black American culture, as are hip hop, blues, ragtime, and spirituals. Many argue that jazz put the United States on the world's cultural radar. Few musicians of any color have matched jazz maestro Duke Ellington's volume of compositions. And are there many gospel singers more well-known than Mahalia Jackson? "Precious Lord, Take My Hand" is easily one of the most popular gospel songs. On a similar note, Motown's catalog grows more timeless each year. To read about Black American music and musical influences, go to Chapter 16.

Throughout history, white Americans have borrowed Black American dances. Actually, the dance that gave Jim Crow, America's caste system, its name originated with a Black performer. Both the Lindy Hop and the Charleston got a lift from Black Americans, and many scholars have great reason to believe that tap dancing, as it's known today, was developed during slavery. In contemporary terms, Black artists never seemed to run out of new dances in the 1950s and 1960s, and dancers and choreographers Katherine Dunham and Alvin Ailey garnered international praise for their mastery and innovation in the fields of ballet and modern dance. You can find out about Black American dance in Chapter 15.

## In literature

Toni Morrison's 1993 Nobel Prize in Literature wasn't an anomaly in the context of the tradition from which she hails. To start, slave narratives captivated readers in America as well as abroad. White Americans may have questioned the talent of Phillis Wheatley, the remarkable poet who was enslaved, in court, but the English accepted her talent with ease. Richard Wright, James Baldwin, Alice Walker, and so many other Black writers are American treasures whose voices have carried throughout the world. Chapter 14 discusses Black literature in detail.

## In sports

Many Black Americans have excelled in all types of sports. Muhammad Ali, Tiger Woods, Venus and Serena Williams, Michael Jordan, Arthur Ashe, Wilma Rudolph, Jesse Owens, and Major Taylor are just a few Black American sports greats. (Read about Black athletes in Chapter 19.)

Black athletes have also played crucial roles in key social issues. Jackie Robinson helped the nation take a critical step toward racial desegregation when he broke Major League Baseball's color line in 1947. Ali's refusal to fight in Vietnam boosted antiwar efforts. Without question, Colin Kaepernick kneeling during the National Anthem as the San Francisco 49ers quarterback during the 2016 season heightened awareness of racial injustice, police brutality, and Black Lives Matter. LeBron James's outspokenness also brought increased awareness to Black Lives Matter, with him and his colleagues in the NBA and WNBA using their platform during the pandemic to speak out against the murders of George Floyd, Breonna Taylor, and more.

## Pioneers, inventors, and other contributors

Black American contributions outside sports, entertainment, and the arts are usually less known but are equally substantial. Dr. Charles Drew pioneered the blood bank. Based on his doctoral dissertation about "banked blood," he spearheaded the "Blood for Britain" project, which ultimately saved many of those wounded in World War II's critical Battle of Dunkirk. In 1941, he served as the director of the American Red Cross's plasma storage program for U.S. armed forces.

Both Colin Powell and Condoleezza Rice fit into their individual appointments as Secretary of State so easily that most Americans spent little time pondering the historic appointment of a Black American to this critical position, nor the unprecedented succession of a Black American by another Black American. It's safe to assume most travelers to the Los Angeles International Airport (LAX) during the 1984 Olympics were completely unaware that Black female architect Norma Merrick Sklarek designed Terminal One.

**BLACK AMERICAN FACES**

Is it mere coincidence that Lewis Latimer served as draftsman for both Alexander Graham Bell and Thomas Edison for the two inventions that people take for granted today? There's no doubt that Latimer's version of the light bulb using a carbon filament helped it stay bright longer. Without Garrett A. Morgan, the traffic light and the gas mask might not exist.

Discounting the enormity of Black American contributions to American history and culture overall is a big mistake. Black Americans have used their talents to benefit not just Black Americans but also all Americans and the world at large.

# Challenges

Black Americans have excelled against tremendous odds. Few cultures have produced as many titans who hail from such humble backgrounds as slavery and Jim Crow. The formerly enslaved Frederick Douglass and Booker T. Washington were among the most prominent Americans of their day. Billionaire Oprah Winfrey, born poor in the Jim Crow South, was raised in a time when doing laundry for wealthy white people was as far as many Black women could aspire.

With each of these extraordinary individuals, education was the difference maker. Yet for much of American history, Black Americans haven't had access to the ladders by which most Americans climb to success.

## Getting equal education

Securing a solid education has been crucial in the overall fight for equality. Education has provided the critical foundation from which Black Americans have waged their fight against countless other inequities, be it inferior housing, discriminatory hiring practices, or police brutality.

Despite hard-won battles against inequities in education, affirmative action is a constant target. Civil rights activists charged that Proposition 209, an amendment to the California constitution purportedly aimed at ending racial discrimination in public education and other public areas of interest, has, according to a 2020 report from EdSource, a nonprofit reporting on California's education challenges, resulted in a lower Black student enrollment in California State University and University of California institutions disproportionate to their Black high school graduation rates.

School desegregation efforts in the South and throughout the nation that only began in earnest in the 1970s has proven that the ills of 200-plus years of slavery and nearly 100 more of Jim Crow can't be erased in just 50 years or more. The impact of No Child Left Behind and an administration with Betsy DeVos heading the Department of Education, not to mention the effects of the COVID-19 pandemic and student loans, only compounded the racial disparities in education, particularly as it pertained to the racial technology gap impacting less wealthy Black and other marginalized communities.

## Achieving the American dream

Historically, the American dream eluded Black Americans. Immediately following the civil rights and Black Power movements, it no longer seemed true. Black Americans began voting and electing Black politicians. Poverty levels among Black Americans began falling as the Black middle class began expanding in the latter part of the 20th century. Better yet, a larger number of Black Americans became wealthy without hitting the lottery or becoming sports or entertainment celebrities.

In recent years, there's been less to cheer about. Shaking the vestiges of slavery and Jim Crow hasn't been easy for all. And although some Black Americans continue to excel financially and otherwise, many others are backtracking. As civil rights activist Reverend Jesse Jackson often reminded Americans, the playing field is still unequal in many ways:

>> **Income:** Even though the white poor constitute 8 percent of the total white population, nearly 25 percent of the Black American population lives in poverty. Black American household income has been 60 percent of white American household income since 1980.

>> **Wealth:** *Wealth* is the difference between assets (like homes and retirement accounts) and debt. The 2019 Survey of Consumer Finances (SCF), sponsored by the Federal Reserve Board in cooperation with the U.S. Treasury Department, found that white families, with median family wealth totaling $188,200, outpaced that of Black families, with median family wealth of just $24,100.

>> **Discriminatory policies:** Revelations of unwritten discriminatory policies against Black Americans by corporations and other entities have come to light. In 1997, Avis Rent-A-Car paid a $3.3 million settlement for ignoring numerous complaints about a North Carolina franchisee that required higher credit card maximums and proof of employment from prospective Black customers but not others. Several studies revealed that it's not uncommon for Black Americans with the same credit history and assets as white Americans to pay more for a home mortgage or to sell their homes for considerably less.

>> **Healthcare:** Healthcare disparities are even broader. According to statistics from 2019, Black infants were more than twice as likely to die as white infants, with Black mothers dying at three and four times the rates of white mothers. The COVID-19 pandemic, which took off in the U.S. in early 2020, revealed many more disparities in the healthcare system; Black people, even by November 2020, were nearly three times as likely to die from it.

## Addressing the criminal justice system

According to the Sentencing Project, an advocacy group aimed at achieving a more equitable criminal justice system, 98,000 Black Americans were incarcerated in 1954 and 50 years later 884,500 were incarcerated in 2004. According to the Pew Research Center, in 2018, Black Americans, mostly men, composed nearly 33 percent of the prison population when the Black population as a whole, male and female, was just around 12 to 13 percent. And although the prison population dropped during Obama's presidency, the most significant change was among the white and Latino population.

# GEORGE FLOYD AND OTHER POLICE KILLINGS

Video of the police killing of George Floyd on May 25, 2020, sent collective shock through many in the United States and globally. For 8 minutes and 46 seconds, Minneapolis police officer Derek Chauvin pressed his knee against Floyd's neck and did not remove it even when Floyd, who was completely unarmed, called for his mother. Instead, Chauvin waited until Floyd was dead at age 46. Floyd's crime? He was accused of passing off a counterfeit $20 bill. Seventeen-year-old Darnella Frazier captured it all on her cellphone. The public response, even during the COVID-19 pandemic, was an outpouring of protests largely in the name of Black Lives Matter by Americans of all races and ages in cities, big and small. Internationally, people protested in solidarity. Historically speaking, the fact that Chauvin was charged with any degree of murder for George Floyd's death marked progress.

Prior to Floyd's death, other Black people who had lost their lives at the hands of the police had become news headlines and hashtags. On August 9, 2014, Ferguson, Missouri, police officer Darren Wilson killed unarmed 18-year-old Michael Brown, who was later accused of stealing a box of Swisher Sweets cigars from a convenience store. Attempts to bring charges against Wilson failed under Black county prosecutor Wesley Bell, who had been elected in 2018 to replace Bob McCulloch, a white man who had been in the office since 1991.

Brown's killing came weeks after the July 17 death of Eric Garner, a 43-year-old father of six, in Staten Island. He was held in a chokehold by New York City police officer Daniel Pantaleo for unconfirmed allegations of him illegally selling cigarettes. Pantaleo ignored Garner's cries of "I can't breathe." Garner's death, captured on video, sparked outrage.

Outrage over Floyd's killing helped bring national attention to Breonna Taylor's shooting death. At just age 26, she was killed in her apartment by Louisville Metro police officers Jonathan Mattingly, Brett Hankison, and Myles Cosgrove on March 13, 2020. That attention prompted public responses from noted Black celebrities, with Oprah Winfrey, rapper Megan Thee Stallion, and LeBron James among them. Yet by February 2021, no arrests had materialized in Taylor's killing despite Kentucky's Republican attorney general Daniel Cameron being Black.

After witnessing Floyd's execution, something snapped for many Americans, who previously couldn't fathom that this kind of tragedy wasn't an anomaly. That response was much like that to Bloody Sunday in Selma, Alabama — the epic civil rights tragedy on the Edmund Pettus Bridge on March 7, 1965, when Alabama state troopers, along with random white men deputized that morning, physically attacked peaceful protesters, including John Lewis; television cameras captured the events. As with Trayvon Martin's death, Floyd's created a ripple whose impact would be felt for years to come.

As activism around unfair sentencing and the decriminalization of marijuana heated up, however, those arguments became more mainstream. Books like the 2010 *The New Jim Crow: Mass Incarceration in the Age of Colorblindness* (The New Press) by civil rights litigator and legal scholar Michelle Alexander and documentaries like Ava DuVernay's *13th* (2016), which was nominated for an Oscar and won an Emmy, greatly helped reinvigorate the fight. The greatest difference maker, however, has been the Black Lives Matter movement.

Black Lives Matter was founded by Alicia Garza, Patrisse Cullors, and Opal Tometi in 2013 in response to the acquittal of 28-year-old George Zimmerman. Zimmerman, a neighborhood watch volunteer, had shot to death unarmed 17-year-old Trayvon Martin, whom he deemed suspicious, on February 26, 2012, in Sanford, Florida. Known for its hashtag #BlackLivesMatter, the movement has been most often associated with its stance against police brutality and killings as well as the persistence of white supremacy and institutionalized racism.

## Fighting systemic racism

Prior to the 2010s, people dismayed by the erosion of civil rights gains argued that the fight was more difficult because dismantling covert racism wasn't as galvanizing as dismantling overt racism. During the 1950s and 1960s, activists could point to "colored only" water fountains, public schools, and other visible manifestations of racial discrimination as clear evidence of racial injustice. Convincing Americans that the disproportionately high incarceration rates for Black Americans was rooted in slavery and Jim Crow was less compelling in the early 2000s. Plus there were also people who simply felt powerless to change it.

Anti-racism work, most notably by Ibram X. Kendi, author of the 2016 *Stamped from the Beginning* (Bold Type Books) and the 2019 *How to Be an Antiracist* (One World), found its way on mainstream news programs, as did the work of attorney and activist Bryan Stevenson to free Black men wrongly sentenced to death row. This raised awareness of the lynching of Black people throughout American history. Historian and political theorist Manning Marable, well-known for his scholarly work surrounding racism prior to his 2011 death, and other civil rights activists consistently argued that recognizing that the events of the past are indeed connected to the present is the first step in creating any strategy for a more equitable American society for all citizens.

# Black Pride Goes Mainstream

During the 1960s, an especially turbulent time for the nation in general, Black Americans appeared to vocalize racial pride more, although that impression may have been the result of increased media attention. (In the 1920s, for example, tens

of thousands of Black people were members of Marcus Garvey's Universal Negro Improvement Association, which emphasized racial pride.)

James Brown's hit 1968 single "Say It Loud — I'm Black and I'm Proud" largely ended the usage of "colored" or "Negro" among Black Americans and others. Slogans such as "Black is beautiful" helped define the early 1970s. Black Americans began to expect more of other Americans, and total ignorance of Black American culture was no longer acceptable. Since the 1970s, it's been customary for the President of the United States to acknowledge Black History Month at the very least.

## Celebrating Black heritage

Interest in Black American history spread beyond a few individuals. Demand for more information about Black American history resulted in corporate-funded PBS breakthrough series such as *Eyes on the Prize, Africans in America, The Rise and Fall of Jim Crow,* and *Slavery and the Making of America.* New scholarship and public demand inspired increasingly more in-depth coverage of critical aspects of Black American and American history that have shown, among other things, that slavery was an American institution and not just a peculiarity of the South.

General American culture also began embracing and acknowledging aspects of Black American culture. Curiously many now consider the Reverend Dr. Martin Luther King Jr., who was strongly disliked when he was killed in 1968, one of this nation's greatest Americans, and some white Americans proudly count themselves as allies to Black people and various anti-Black causes. Even with the pushback during the Donald Trump administration, it wasn't uncommon to find Black History Month celebrated in schools with few or no Black students.

During the Obama presidency (2009–2017), there was a notable shift in positive expressions of Black culture. President Obama and First Lady Michelle Obama consistently incorporated historic and contemporary Black American culture into the White House, including

>> Hosting screenings of films such as 2016's *Hidden Figures,* about the role Black women played in getting American astronauts to the moon

>> Acquiring art pieces like the 1940s-era *Lift Up Thy Voice and Sing* by William H. Johnson

>> Sponsoring musical performances featuring the hip-hop band The Roots, rapper Common, singers Jill Scott and John Legend, and even hip-hop R&B trio BBD (Ricky Bell, Michael Bivins, and Ronnie Devoe of 1980s New Edition fame)

>> Sparking the full production of Lin-Manuel Miranda's groundbreaking theatrical phenom *Hamilton,* which created stars out of several Black actors, including Leslie Odom Jr., Daveed Diggs, Jasmine Cephas Jones, and Renée Goldsberry

American literature classes include the works of Black Americans. *The Narrative of Frederick Douglass* is widely read in high schools, and general Southern Literature courses include the work of Black Southern writers Zora Neale Hurston, Ernest Gaines, and Alice Walker. In fact, Ernest Gaines arguably became one of the most celebrated Southern writers since William Faulkner, and Nobel Prize–winner Toni Morrison is widely considered one of the greatest writers the nation has ever produced.

In the pop culture landscape, more than just Black Americans helped the 2018 film *Black Panther,* the Marvel Cinematic Universe's first Black cast offering, top the box office. Black culture clearly began scoring major wins in all aspects of American life.

# Black cultural tourism booms

A boom in cultural tourism in the early 2000s reflected the growing interest in the Black American experience. People of all races attended landmark exhibits such as the New York Historical Society's "Slavery in New York." Almost every state uncovered enough information of specific relevance to Black Americans to create an American heritage tour. Many exhibits have gone online; for example, the Library of Congress long ago began digitizing some of its collection. The same is true of the New York Public Library's Schomburg Center for Research in Black Culture.

Cultural tourism specifically addressing slavery and emancipation increased in popularity, even in the South, where the institution of slavery was more pervasive. This heightened interest contributed to unique museums such as

>> **The National Underground Railroad Freedom Center:** This museum in Cincinnati, Ohio, gives visitors a taste of the Underground Railroad, along with the various escape strategies used by those who were enslaved.

>> **The Whitney Plantation Historic District:** Less than an hour outside of New Orleans, this former sugar plantation dating back to 1872 has served as a slavery museum, dismantling the myths since 2014.

**»  The Legacy Museum: From Enslavement to Mass Incarceration:** Operated by celebrated civil and human rights attorney and activist Bryan Stevenson's EJI in Montgomery since 2018, this museum sits where enslaved people were once warehoused not far from an auction block and other sites where Black people were harmed.

Black communities across the nation have a long history of creating institutions to preserve their history. In time, those institutions began attracting visitors beyond the communities they served. Notable institutions include Chicago's venerable DuSable Museum of African American History, named for the Haitian fur trader Jean Baptiste Pointe du Sable, the city's first permanent settler and founder, and the Weeksville Heritage Center, one of the few intact remnants of a free Black Northern pre-Civil War community, in Brooklyn, New York.

Then there are institutions commemorating the Rev. Dr. Martin Luther King Jr.'s life and death, including the King Center in Atlanta (envisioned by Coretta Scott King), the National Civil Rights Museum in Memphis (located at the Lorraine Motel, the site of King's assassination), and the national memorial in Washington, D.C. The following sections cover this memorial as well as the Smithsonian's National Museum of African American History and Culture.

## A memorial for a King

On November 13, 2006, not far from the Capitol building (which Black enslaved labor largely built) and Pennsylvania Avenue (where enslaved Black Americans were once sold), three of Dr. Martin Luther King Jr.'s children were present for the groundbreaking of the national Dr. Martin Luther King Jr. Memorial. "We give Martin Luther King his rightful place among the many Americans honored on the National Mall," President George W. Bush told a crowd of several thousand that included former President Clinton, who had signed the bill authorizing the memorial; poet Maya Angelou; and King's longtime civil rights friends and comrades Jesse Jackson and Ambassador Andrew Young. King, Bush said, "redeemed the promise of America."

Congressman John Lewis, who spoke at the historic March on Washington for Freedom and Jobs in 1963 when King delivered his majestic "I have a dream" speech, broke ground on the memorial in an emotional moment. Not so many decades before, police violently had beaten Lewis, a former president of the Student Nonviolent Coordinating Committee (SNCC), as he marched with King from Selma to Montgomery, seeking the justice to which all Americans are entitled.

Conceived by King's Alpha Phi Alpha fraternity brothers in 1983, the Martin Luther King Jr. Memorial opened in 2011 as a fitting tribute. Hurricane Irene disrupted the original August 23, 2011, dedication, but the reset for October 16, just four years shy of 1995's historic Million Man March held on the same day, went well.

Back in 1964, King predicted that the country would elect a Black president between 25 and 40 years later. On the day of the dedication of his memorial, President Obama said, "Our work is not done. And so on this day, in which we celebrate a man and a movement that did so much for this country, let us draw strength from those earlier struggles. First and foremost, let us remember that change has never been quick."

## A Black American museum on the National Mall

In 2003, when President George W. Bush signed a bill to create the Smithsonian Institution's National Museum of African American History and Culture (NMAAHC) on the National Mall, there was no way to gauge how much of a sensation it would become. When the museum, which had been a concept dating as far back as 1915, opened September 24, 2016, President Barack Obama was in the last months of his presidency. The design chosen back in 2009 came from Black American architects Philip Freelon and J. Max Bond Jr., along with Ghanaian-British architect David Adjaye. Black billionaires Oprah Winfrey and Robert Smith donated $21 and $20 million, respectively, to help build the museum, which was constructed in part by two Black-owned construction companies, Smoot Construction of Columbus, Ohio, and H.J. Russell & Company of Atlanta, Georgia.

Joined by four generations of the Bonner family, including 99-year-old matriarch Ruth, whose father had been born enslaved in Mississippi, President Obama helped ring the Freedom Bell, borrowed to officially open the museum headed by Lonnie Bunch III. The bell had been acquired in 1886 by the First Baptist Church of Williamsburg, Virginia, one of the oldest Black churches in the nation (dating back to 1776). In just four months, a million people visited the 350,000-square-foot, 10-story museum, making it one of the Smithsonian's most visited museums. It has more than 40,000 items in its collection.

# Reconciling the Past to Create the Future

Slavery remains a topic chock-full of emotions for many Americans, as former Virginia Governor L. Douglas Wilder, the first elected Black governor in the nation and the grandson of enslaved people, learned in his quest to launch the United States National Slavery Museum in Fredericksburg, Virginia. Attracting the support of both corporate and individual donors proved difficult for Wilder because many people don't consider a museum about slavery a healing mechanism that can foster reconciliation with the past.

# THE 1619 PROJECT

History, for a long time, suggested the first Africans who arrived in British North America, as opposed to Africans who were already in other parts of the "New World," held a legal status closer to indentured servants. This classification, however, completely ignored the fact that those Africans were kidnapped from present-day Angola and arrived in what is now Virginia on a pirated slave ship. Although their status wasn't clearly an enslaved one legally, it was in practice. In fewer than 50 years, however, "African" and "slave" would indeed become legally interchangeable.

In 2019, *The New York Times* commemorated the 400 years since those Africans' arrival with its ambitious longform journalism initiative, the 1619 Project, intended to place slavery and Black American contributions at the center of the American narrative. In her introductory essay, staff writer and 1619 Project lead Nikole Hannah-Jones, who received her bachelor's degree in history and African American Studies from Notre Dame, argued that preserving slavery was a motivating factor behind the American Revolution.

That sweeping generalization threatened to derail the great enthusiasm around the project, which included journalists (Wesley Morris and Trymaine Lee), artists (filmmakers, poets, writers, playwrights like Barry Jenkins, Yusef Komunyakaa, Jacqueline Woodson and Jesmyn Ward, and Lynn Nottage), activists (Bryan Stevenson), and a handful of academics (Khalil Gibran Muhammad), tackling a myriad of issues, including the prison system, the racial wealth gap, and other fallout connected to slavery and Jim Crow, a system in which Black people were legally discriminated against based on race alone generally associated with the American south where there were even separate "white" and "colored" water fountains.

Historians of varying political persuasions pushed back against Hannah-Jones's assertion, with respected white Princeton historian Sean Wilentz even circulating a letter objecting to the project. Black historian Leslie M. Harris wrote an opinion piece titled "I Helped Fact-Check the 1619 Project. The Times Ignored Me" for *Politico* in March 2020. She claimed her objections to Hannah-Jones's assertion that slavery prompted the Revolutionary War were initially dismissed but also acknowledged that Hannah-Jones later promised to amend it and that, even with its issues, the 1619 Project was "a much-needed corrective to the blindly celebratory histories." Even with Republican politicians like Tom Cotton in Arkansas threatening to prohibit K-12 schools from accessing federal funds for any curriculum related to the 1619 Project, the climate of racial reckoning that had inhabited the country could not be stopped.

*(continued)*

*(continued)*

Prior to Hannah-Jones and the 1619 Project, Ta-Nehisi Coates ignited a fire with his 2014 article "The Case for Reparations," for *The Atlantic*. Coates traced the nation's injustice against Black Americans by following Clyde Ross as he moved from being raised in a sharecropping family in 1920s Mississippi through serving in the military to trying to buy a house in Chicago. "The Case for Reparations" awakened many Americans to the reality that Jim Crow wasn't just a Southern institution or practice. It also helped many of them to connect the dots between slavery, Jim Crow, and the racial injustice Black Americans still face.

## Slavery as an American (not Southern) institution

Slavery, as evidenced by the 1619 Project (see the nearby sidebar), is the primary unresolved issue in race relations in this country. Despite the nation's tremendous gains, many people still fail to acknowledge the magnitude of slavery within the United States. They either don't understand or refuse to acknowledge that it was the economic backbone of the colonies and later the country. Although some businesses, such as Philip Morris and Wachovia Bank, have acknowledged their ties to slavery, many others have not. Enslaved labor, for example, helped build early railroad lines and institutions such as Brown University. Ultimately slavery continues to matter centuries later because its white supremacist ideology subjugating Black Americans has historically been transferred to federal, state, and city government levels, as well as other entities, resulting in Black Americans experiencing racial bias, job discrimination, redlining, and other inequities only based on race.

**TECHNICAL STUFF**

Deadria Farmer-Paellmann, a pioneering force behind the Corporate Restitution Movement (see the upcoming section "A question of reparations") who is also credited for energizing the contemporary reparations movement, began tracing corporate ties to slavery in 1997. She rose to national prominence in 2000 when insurance giant Aetna apologized for its ties to slavery after learning that a subsidiary of the company insured those enslaved at one time. Farmer-Paellmann, an attorney, then uncovered similar links for over 50 companies. Because of Farmer-Paellmann's actions, several local and state governments now require that companies seeking public contracts disclose any links to slavery.

## Flagging the issue

The Confederate battle flag flew during Civil War battles fought by the Confederacy to preserve its right to practice slavery. Yet for a long time, many non-Black Americans, and a few Black Americans as well, couldn't understand why the presence of the Confederate battle flag, particularly in government facilities or in the Mississippi state flag, bothered so many Black Americans.

Those who defended displaying the Confederate battle flag, also known as the Southern Cross, charged that Black Americans were too sensitive and that the flag merely represented Southern heritage and honored the Confederate dead and veterans. Supporters then often failed to address the link between white Southern heritage and slavery and Jim Crow. Although they defended the gentility of the antebellum South in the symbol of the Confederacy, others simply could not ignore the savagery of enslaving millions of people.

The fact that the Confederate battle flag, the most well-known of the three flags associated with the Confederacy during the Civil War, resurfaced in the South during the intense struggle to dismantle Jim Crow compounded the issue. South Carolina, for example, began flying the Confederate battle flag over the statehouse in 1961 to commemorate the centennial of the beginning of the Civil War in 1861 at Fort Sumter near Charleston (read about the Civil War in Chapter 6). It wasn't until 2000, after the NAACP spearheaded an economic boycott of the state, that the flag was taken down from atop the Capitol dome.

Instead of South Carolina lawmakers ending its allegiance to the Confederate battle flag, it compromised to shift it to a nearby monument for Confederate soldiers on statehouse grounds. And making matters worse, South Carolina lawmakers passed the 2000 Heritage Act, requiring a two-thirds vote of each house of the General Assembly to change it, to protect the flag as well as Confederate and Civil War monuments across the state.

Change came only after activist Bree Newsome was arrested June 27, 2015, for removing the Confederate battle flag from South Carolina statehouse grounds to protest the Charleston church massacre just ten days earlier on June 17, when a 21-year-old white South Carolinian killed nine Black South Carolinians during Bible study at historic Emanuel African Methodist Episcopal Church, well known as Emanuel AME, founded in 1817. Although the flag was back flying within an hour, it permanently came down July 10, with Governor Nikki Haley, the daughter of Indian immigrants, reversing her previous stance to never remove the flag.

In 2020, the impossible happened in Mississippi. On the heels of the Southeastern Conference (SEC) — one of the most powerful sports entities in all of college sports — and the National Collegiate Athletic Association (NCAA), which governs all college sports, vowed not to hold official championship events in the state as long as the Mississippi state flag continued to incorporate the Confederate battle flag. The state legislature voted to change the state flag on June 28, 2020, with Governor Tate Reeves signing it into law on June 30. Mississippi voters overwhelmingly approved the flag's new design prominently featuring a magnolia, the state flower, on November 3, 2020, with the new flag becoming official January 11, 2021.

# A question of reparations

Although there has never been a lack of evidence that slavery was indeed real, supporters of the reparations movement in its various iterations seeking to obtain acknowledgment and compensation for the descendants of those enslaved and, in some instances, Jim Crow, have historically encountered tremendous resistance. Simply pondering a formal apology for slavery created a furor during the Bill Clinton presidency in 1998. President George W. Bush's 2003 apology in Goree Island in Senegal, from which kidnapped Africans were transported into slavery, didn't attract the same furor. Although there were mixed reactions to the Senate passing an apology for enslaving Black Americans and their African descendants for more than two centuries as well as subsequent decades of racial segregation and injustice that followed in 2009, it did help open another important window.

In the 2010s, American Descendants of Slavery (ADOS) gained steam among many Black Americans both as a movement associated with leaders Yvette Carnell and Antonio Moore and as a general concept of Black Americans who trace their lineage back to those enslaved in the United States. For many, white and Black, Ta-Nehisi Coates's groundbreaking 2014 article "The Case for Reparations" in *The Atlantic* helped ground the movement.

Coates, who gained an incredible following after the article, was even called upon to testify before a House Judiciary subcommittee hearing on H.R. 40, a bill sponsored by Texas Democrat Congresswoman Sheila Jackson Lee that Michigan Democrat Congressman John Conyers introduced back in 1989; it coincided with Juneteenth, a celebration dating back to June 19, 1865, popularly described as commemorating when enslaved Black people in Galveston, Texas first learned of Abraham Lincoln's Emancipation Proclamation, and believed themselves free. The H.R. 40 Bill to Commission to Study and Develop Reparation Proposals for African-Americans Act remained in discussion even in February 2021.

Contrary to popular belief, reparations isn't a concept specific to Black Americans. For example, the U.S. government offered the following reparations:

>> Many Confederate slaveholders who lost their land during the war got it back.

>> Slaveholders in Washington, D.C., who emancipated those they enslaved received compensation for their losses.

>> When 11 Italian men were killed via lynching in New Orleans on March 14, 1891, the U.S. government, under President Benjamin Harrison, paid $2,211.90 to each of their families in Italy, a total amount of $24,330.90.

>> The federal government paid a settlement to Japanese Americans wrongfully interred in camps during World War II.

>> In 1994, Florida compensated survivors and descendants of the 1923 Rosewood Massacre, in which white Floridians attacked Black Floridians. (Read about the Rosewood Massacre in Chapter 7.)

The "forty acres and a mule" that General William Sherman promised to Black Americans after the Civil War didn't really pan out (refer to Chapter 6), and no form of reparations were paid on a systematic scale to those formerly enslaved. Those who advocated compensation for ex-slaves, as they were referred to, include Alabama native William R. Vaughan, a white Democrat who proposed an ex-slave pension and succeeded in getting nine such bills introduced in Congress from 1890 to 1903 but not in passing them.

**IN THEIR OWN WORDS**

Some advocates of reparations have argued that the movement was about more than money. Prior to his 2011 passing, respected historian and political theorist Manning Marable argued that reparations efforts served a greater purpose. "What it's about is an effort to reengage the American people in a discussion of racism in American life," Marable explained. "It's not about the money. [We want to] restart a genuine dialogue about racism and the economic consequences of slavery." Citing the Black-white income gap and denied access to capital, among other injustices, some economists estimate that racism costs Black Americans as much as $10 billion annually.

**BLACK AMERICAN FACES**

## CALLIE HOUSE

Born enslaved in 1861, Callie House was a washerwoman and widow living in Nashville, Tennessee. She was an important force in the ex-slave pension or reparations movement through her work with the National Ex-Slave Mutual Relief, Bounty and Pension Association, which began in the 1890s. Basing her argument on the fact that ex-Union soldiers received pensions, House specifically targeted the $68 million collected in taxes on rebel cotton to compensate ex-slaves. Trumped-up charges of postal fraud erroneously suggested that her organization, which succeeded in galvanizing 300,000 ex-slaves across several states, was without merit. House's imprisonment in 1917 on postal fraud ended her fight but not her legacy. Historian and law professor Mary Frances Berry brought the efforts of Callie House into heated contemporary reparations debates with her book *My Face Is Black Is True: Callie House and the Struggle for Ex-Slave Reparations* (2005).

Cash payouts for reparations, however, is what most Americans, good or bad, envision. By some estimates, that number, should it ever materialize on a federal level, could hit between $10 and $12 trillion. BET (Black Entertainment Television) co-founder Bob Johnson and one-time billionaire proposed a $14 trillion plan in 2020. In 2019, the Evanston city council, in the Chicago metro area, agreed to a reparations effort led by Black Alderwoman Robin Rue Simmons for housing discrimination. Two years later, the city made national news with its proposal to make its $25,000 reparations payments for home improvements or mortgage assistance to its Black residents who suffered discriminatory housing practices who had lived in or had been descended from an Evanston resident dating back to before 1969 through a marijuana tax.

Chapter **2**

# From Empires to Bondage: Bringing Africans to the Americas

Mass enslavement is perhaps the most profound consequence of Columbus's so-called "discovery" of the New World. European nations, led by Portugal and Spain, came to the New World in search of riches, but they lacked a workforce necessary to procure them. Attempts to use the indigenous population proved unsatisfactory, so the eventual solution was to import Africans. This decision changed the complexion of what became the Americas. Spain and Portugal's early dominance prompted England and other countries to seek their fortunes in the New World, ultimately leading to the establishment of Black American culture in what would become the United States.

Before delving into the specifics of Black American history, it's necessary to recognize the chain of events that brought Africans to the Americas and weigh the impact of those events. The African continent was rich with history long before Europeans began pillaging it. When Europeans arrived there, they found three main empires: Ghana, Mali, and Songhai. This chapter explores these African empires. It also examines the origins of the transatlantic slave trade as well as the implementation of mass enslavement in Latin America and the Caribbean.

# Touring African Empires

Fifty-four countries exist on the African continent with more than 1.3 billion people who speak between 1,500 and 2,000 languages. However, most Black Americans trace their roots to West Africa and Central Africa. Countries in this area are plentiful and include Ghana, Côte d'Ivoire (Ivory Coast), Nigeria, Mali, and Senegal, as well as Congo, Chad, Cameroon, and Democratic Republic of Congo.

The African continent had a tremendous history before Europeans ever set foot there. In Black American history, three empires — Ghana, Mali, and Songhai (which I discuss in the following sections) — are particularly important because many enslaved Africans hailed from these regions (see Figure 2-1).

**FIGURE 2-1:**
Ghana, Mali, and
Songhai Empires.

© John Wiley & Sons, Inc.

**REMEMBER**  Slavery existed throughout the world, and on the African continent it differed from what would become institutionalized in the United States (see Chapter 3). It's important to acknowledge that Black Americans, like most Americans, have a story whose beginnings predate life in the Americas.

# Ghana Empire

Located on the western coast of Africa in what is now eastern Senegal, southwest Mali, Ghana, and southern Mauritania, the Ghana Empire, populated by the Soninke, rose in the 5th century. Its capital city, Koumbi Saleh (also Kumbi Saleh), became the center of the important trans-Saharan trade connecting West Africa with Mediterranean countries. Trading gold and salt, in particular, made Ghana rich.

Historians often single out the rule of Tenkamenin (sometimes Tunka Manin), who came to power in 1062, because of his expert governance. Every day, Tenkamenin went among the people and listened to their concerns, giving them an audience until justice prevailed. Although Ghana tolerated Islam during that time, particularly because Muslim traders generated wealth, it hadn't converted, unlike other parts of Africa. The Almoravids, a band of Muslims, first attempted to bring Ghana under Islamic rule in 1068, but Ghana fought them off until 1076. Eventually the Soninke regained control of Ghana, but it was too late to prevent its complete decline by the 13th century.

**HISTORICAL ROOTS**

Ghana's people, the Soninke, know Ghana as Wagadu, meaning "Land of Herds," by written accounts and as "Land of the Great Herds" by oral accounts. Europeans, however, took their lead from the term "ghana," meaning "warrior king" — a term used to describe Wagadu's ruler — and renamed the region the Ghana Empire. The European term is the more commonly used one in Western culture.

# Mali

According to oral history, between 1235 and 1238, Sundiata Keita (sometimes Mari Jata) defeated Sumanguru, Ghana's last great ruler, to end Ghana's dominance and begin the Mali Empire, which included parts of Nigeria and the Guinea forests. However, Mansa Musa (sometimes Mansa Moussa), Mali's Muslim ruler from roughly 1307 to 1332, attracted the most attention for Mali outside Africa with the empire's tremendous wealth, largely accumulated through Ghana's salt and gold mines.

**TECHNICAL STUFF**

In 1324, Mansa Musa's Hajj, the annual pilgrimage to Mecca, became legendary. As the legend goes, Mansa Musa traveled with a caravan of 60,000 — including 12,000 enslaved people, 500 of them equipped with staffs of gold — and distributed 80 camel loads of gold dust to the poor. He gave so much gold away in Egypt that gold prices reportedly plummeted.

During Mansa Musa's rule, elaborate mosques were built in Timbuktu, Jenne, and Gao, among other places. Eventually Timbuktu became a highly respected intellectual and commercial center. Good government is cited frequently as one of the main reasons behind Mali's relatively long reign as an important African empire. But in the 15th century, Europeans, captivated by Africa's wealth, began penetrating the continent. These incursions coincided with Mali's decline.

## Songhai

By the 15th century, the Songhai (also Songhay) Empire emerged and, under the leadership of Sonni Ali (sometimes Sunni Ali or Sonni Ali Ber), took over the Niger region and encompassed the once-mighty Mali Empire. Taking advantage of Mali's declining empire, Ali conquered Timbuktu in 1469; this move immediately established Songhai as a major power. In 1493, Askia Mohammad, a powerful general, overthrew the government. During his rule, Songhai became an intellectual center, and he used his Hajj to connect with scholars and other heads of state in his efforts to strengthen the Songhai Empire and assist Islam's expansion into West Africa. With that knowledge, he standardized trade, policed trade routes, and instituted a bureaucratic system of government. His son, Askia Musa, overthrew him in 1528. The Songhai Empire fell in the 16th century when the Moroccans overtook it.

## WHICH WAY TO TIMBUKTU?

Prosperous trans-Saharan trade routes transformed Timbuktu into a major economic and cultural powerhouse beginning in the 13th century. A city on par with ancient Rome, Timbuktu grew even more in stature during the Mali Empire, which controlled the wealthy gold-salt trade routes in the area. It was during the Songhai (Songhay) Empire, however, that Timbuktu really emerged as the spiritual and intellectual center of the Muslim world. Its great Koranic Sankore University not only attracted some of the world's best minds but also garnered praise from many non-Muslims.

Sadly, when the Songhai Empire declined in the late 16th century, so did Timbuktu. When the Atlantic slave trade began, Portugal traders ended Timbuktu's reign as a major commercial center. Contemporary Timbuktu hasn't fared well, either. In 1990, because of increasing desertification that has destroyed the vegetation and water supply, Timbuktu made UNESCO's List of World Heritage in Danger. (UNESCO is the United Nations Educational, Scientific, and Cultural Organization.) Sand threatens to bury the city and its great monuments completely.

# Interaction with the rest of the world

Africans weren't isolated from the rest of the world. European and Asian contact with Africans was substantial, as evidenced by the following facts:

>> East African societies were in contact with their Asian counterparts very early on, and the interaction was markedly strong. Beginning in 900 AD, African sailors and merchants were traveling to South Asia.

>> Ethiopians lived in Greece around the fifth century BC.

>> Because of trade on and off the continent, Africans traveled to many European countries for business.

>> In 711, the Moors, Muslims who hailed from North Africa, began their rule over the Iberian Peninsula (present-day Spain and Portugal). Portugal freed itself from Moorish rule in the late 13th century, but Spain didn't completely free itself of Moorish rule until 1492.

## THE EGYPTIAN DEBATE

Denied knowledge of their specific lineage, many Black Americans have long claimed the entire African continent as their "Motherland." That includes Egypt, with its pyramids and pharaohs. Although most Black Americans can't trace their direct ancestry back to Egypt, there is no denying that Egypt is in Africa. Yet, historically, there has been intense debate around whether ancient Egyptians were Black and whether they made significant contributions to civilization at large. Scholars who addressed Egyptian contributions and race include W.E.B. Du Bois, Cheikh Anta Diop, and Martin Bernal, particularly their books *The World and Africa* (1947), *The African Origin of Civilization: Myth or Reality* (1989), and the three-volume *Black Athena* (1987, 1991, 2006). The stance for these scholars is earlier Egyptians were Black.

Hollywood has traditionally cast white actors as Egyptians in various films, including Elizabeth Taylor in *Cleopatra* (1963) and Christian Bale in *Exodus: Gods and Kings* (2014). Michael Jackson countered this tendency in his 1992 John Singleton–directed "Remember the Time" video/short film by depicting ancient Egyptians as Black, with Eddie Murphy starring as Pharaoh Ramses II and model Iman as Queen Nefertiti.

**TECHNICAL STUFF**

There's also reason to believe that West African traders established commercial relationships with the indigenous American people long before Christopher Columbus's famous 1492 voyage. In fact, archaeologists have found artifacts to strengthen the idea of Africans in the area of Mexico. Mali, according to some Arabic records, sent at least two expeditions across the Atlantic between 1305 and 1312. Some scholars also claim that Columbus, in his journals, noted that Africans were already in the New World when he arrived. Certainly the discovery of skeletal remains resembling those of Africans in Central America, coupled with the African features found in the art of indigenous Americans and the similarities between the language patterns of early Americans and Africans, strongly suggest Africans could have preceded Columbus to the Americas. Ivan Van Sertima's *They Came Before Columbus*, published in 1976, is a classic text on the African presence in the Americas prior to the transatlantic slave trade.

# Origins of the Transatlantic Slave Trade

Portugal's search for wealth, aided by it and Spain settling the Americas, launched the lucrative transatlantic slave trade. As other European countries scrambled for their own riches in the New World, trafficking Africans became more competitive. By 1650, the Dutch, English, and French challenged Portugal's monopoly. Africans also aided the transatlantic slave trade.

Because Europeans arrived in Africa during financially challenging years, participation in the slave trade generated wealth for some of Africa's poorer states. That wealth became so attractive that Dahomey, a West African kingdom that had vowed not to contribute to the slave trade, eventually became a key trading center. When Africans began resisting the institution in the 18th century, Europeans, who possessed gunpowder and other warfare advantages, easily repelled them. Initially Africans participated in the slave trade primarily because slavery, inside and outside the continent, had been a common practice for centuries.

## Slavery on the African continent

Unfortunately, every major civilization and almost every ethnic group has practiced slavery in one form or another. Africa was no different: Slavery existed on the African continent prior to the Atlantic or transatlantic slave trade. No matter who practiced it, however, there's little evidence that slavery was ever pleasant. Slaveholders in ancient Greece, Rome, India, and China beat and killed those they enslaved at will, and during elaborate rituals, the Aztecs may have cut out the hearts of those they enslaved. Prior to Portugal's initiation of the Atlantic and transatlantic slave trade, this was largely the case in Africa.

## ELMINA CASTLE

Built in 1482 by the Portuguese to protect Portugal's interests on the Gold Coast and owned by the Dutch and the British at different points in its history, Elmina Castle (originally São Jorge da Mina or St. George's Castle) is the oldest surviving European structure south of the Sahara. By the 1500s, it became a site for the deadly transatlantic slave trade. Beginning in 1637, when the Dutch took control of the fort, Elmina Castle saw at least 30,000 African captives pass through its halls annually until 1814. Held in dungeons and packed on top of each other, often for days, these Africans were forced through "the door of no return." Elmina Castle was such an important outpost during the height of the transatlantic slave trade that it housed cannons to protect itself from other European slave traders.

England, Elmina's last owner, seized control in 1872 and relinquished the fort to Ghanaian leader Kwame Nkrumah in 1957. During the 1990s, Ghana began an exhaustive renovation of the site and the surrounding area, which includes Cape Coast Castle, another important fixture in the slave trade visited by President Barack Obama and his family in 2009. Today, Elmina Castle is a tourist attraction and a UNESCO World Heritage Monument. It was prominent in Ghana's Year of Return campaign coinciding with the 400-year commemoration of the arrival of the first Africans in Virginia in 1619.

Captors either sold or kept Africans they captured. (Early slavery on the African continent was also a punishment for crime, retribution, and so forth.) Usually these Africans became the property of the chief or the head of the family. Some of those enslaved served as human sacrifices in royal ceremonies. For the most part, children couldn't be sold and often became trusted family members. When Muslims invaded Africa, the system changed slightly. Purchasing enslaved people became more common than capturing them. Sometimes Muslims seized women for their harems and forced men to serve in the military and perform menial services. Some of those enslaved ended up in Arabia and Persia, among other Islamic strongholds. Still, even under Muslim rule, slavery wasn't as harsh as it would become in the Americas, particularly in the United States. In Africa an enslaved individual could rise to a prominent position and even purchase an enslaved individual. This changed with the European slave trade and its development in the New World.

## Launching the European slave trade

Moved by tales of Africa's great wealth, the Portuguese prince known as Henry the Navigator sponsored several voyages to Africa as early as the 1420s. These voyages followed Portugal's 1415 seizure of Ceuta, a Moor stronghold in Morocco, which halted the spread of Islam and promoted Christianity in the region instead. In 1441, Henry's explorers penetrated Africa deeper than previous Europeans had and brought back 12 Africans caught near the coast of northern Mauritania.

Most sources cite the 1444 voyage that resulted in the capture and eventual sale of around 240 Africans in Lisbon as the first slave voyage to Africa. Within ten years, Portugal imported roughly 1,000 Africans a year to meet the tremendous demand for domestics, *stevedores* (dockworkers to load and unload ships), and agricultural workers. Because Henry the Navigator considered himself a devout Christian, his ships sailed under the Order of Christ. Therefore, those African captives often converted to Christianity.

**REMEMBER**

Initially, Europeans captured Africans themselves. (They also purchased men who were being held for crimes.) They didn't involve other Africans until later. Additionally, the first Africans enslaved by the Portuguese weren't subjected to race-based discrimination because race didn't predetermine their servitude at that time, and race wasn't constructed at this time either.

Even though the success of these voyages stimulated more competition, the Portuguese ruled the slave trade for nearly a century. The 1479 Treaty of Alcáçovas settled the Castilian succession of Spain, allowing Isabella to become queen; in return, Spain conceded the slave trade to Portugal in addition to allowing Portugal to supply her with Africans to enslave. Settling those concerns allowed Portugal to expand its dominion over the slave trade; one example of this expansion was the construction of the fort Elmina Castle in 1482 in what is now Ghana (see the nearby sidebar for more about Elmina Castle).

When Columbus gave Spain a claim to the New World in 1492, it took little time for Spain to introduce slavery there. By 1501, the governor of Hispaniola (the island now occupied by Haiti and the Dominican Republic) was already requesting enslaved African labor. The first African captives arrived in Hispaniola in 1502. Reportedly these enslaved people, relatively few in number, came directly from Spain, which had a long history of slavery. After the cultivation of sugar began in the New World, the demand for enslaved labor increased. By 1518, Portugal was supplying Spain with African captives in large numbers. As Portugal established its own colonies, notably Brazil, in the Americas and Spain expanded its colonies as well, the transatlantic slave trade grew.

**HISTORICAL ROOTS**

As the Renaissance swept across Europe, new ideas took hold. The end of feudalism resulted in the emergence of cities and a greater reliance on commercial trade. By the time the Industrial Revolution hit its stride in the mid to late 18th century, a culture of greed and profit already existed. These changes created a greater demand for enslaved labor. Although Spain, Portugal, France, England, and the Netherlands, among other countries, played major roles in the transatlantic slave trade and slavery, the Catholic Church and Africans weren't innocent bystanders.

## AFRICANS HITCH A RIDE WITH NEW WORLD EXPLORERS

Although many scholars refuse to entertain the idea that Africans beat Columbus to the New World, they do concede that Africans were prominent in conventional stories of the New World's discovery. It was once widely believed that Pedro Alonso Niño (also Pietro Alonso), Columbus's navigator on his 1492 voyage uncovering America, was African. Today scholars claim Niño was erroneously translated into "nignus" and then "El Negro." Also, at the time of the journey, the Spanish banned Africans from traveling to the New World. After Spain lifted its ban in 1501, there's no denying the many Africans who traveled to the New World, however.

Accounts of Africans accompanying explorers include the following:

- Thirty Africans were present when Vasco Núñez de Balboa discovered the Pacific Ocean.

- Africans were with Hernán Cortés in Mexico.

- Esteban (sometimes Estevanico) was pivotal to Alvar Núñez Cabeza de Vaca's exploration of the modern-day southwestern United States. Although Native Americans killed Esteban, his travels to the southwestern interior greatly aided the Spanish conquest of the Southwest.

- French explorations, especially voyages to the Mississippi Valley and Canada, included Africans.

# Enslaving Africans in Latin America and the Caribbean

Following the arrival of the first African captives to Hispaniola in 1502, it didn't take long to institute slavery into other colonies such as the Spanish-controlled islands of Puerto Rico, Cuba, and Jamaica as well as into Mexico, Peru, Venezuela, and the Portuguese-controlled Brazil. By 1620, 300,000 Africans had arrived in the Americas. Portugal, which supplied an estimated 130,000 African captives to Brazil alone and at least 80,000 African captives to Mexico, was initially the largest importer of enslaved labor.

Columbus crossed the Atlantic to find wealth, so Spain, which claimed one-fifth of the wealth discovered, had ample motivation to sanction enslaved labor for mining copper, gold, and silver. Work in the mines was very taxing, but Africans

seemed in greater supply than the quickly dwindling indigenous population. When mining appeared to be a financial bust, cultivating sugar seemed lucrative. Hispaniola built the Caribbean's first sugar mill in 1516. Spain had numerous sugar mills in various locations of its European empire, so it already had an enslaved African population experienced in cultivating sugar. The industry grew so rapidly, however — and those enslaved died so quickly because of the hard labor associated with cultivating sugar — that Spain didn't have enough Africans already enslaved in Europe to feed the New World demand.

Working in the sugar mills and fields was almost as grueling and dangerous as working in the mines. Being poorly fed didn't help. Unbelievably, many of those enslaved in Latin America (the region comprising South and Central America) weren't given food to eat and were expected to find food in between their many working hours. Despite the toll on human life, the sugar industry flourished in the Americas, with Brazil and Mexico initially leading the way. By the 17th and 18th centuries, the Caribbean islands of Jamaica, Barbados, and Cuba were also significant sugar producers and exporters.

Enslaved African labor wasn't just used on sugar plantations or in discovering wealth. Africans helped build the New World by working as bricklayers, plasterers, and blacksmiths. They planted and maintained crops and tended to sheep and cattle. As they had in Spain, both enslaved and free Africans worked as domestics, caring for children, cooking, and cleaning. (See the section, "Seeking freedom," later in this chapter for more on free Africans in the colonies.) Only a few areas in the New World were devoid of African contributions.

By paving the way for slavery in the New World, Spain and Portugal specifically established the economic framework tying enslaved labor to industrial enterprises. American slaveholders, to a certain degree, took cues from Latin American and Caribbean slavery and, as a result, regulated enslaved behavior much more rigorously than either Spain or Portugal had.

## Sanctioning and opposing slavery

Europeans didn't immediately turn to enslaved African labor as the solution to their labor challenges in Latin America and the Caribbean. At first, Europeans used both Native Americans and Africans for labor, but the hard work and European diseases such as smallpox decimated the Native American population. In one part of Hispaniola, the native population went from one million to only a few thousand in two decades. By contrast, Africans became the ideal solution because they seemed plentiful.

With the papal bull *Dum Diversas*, Pope Nicholas V invested Portugal's King Alfonso V with the authority to enslave non-Christians in 1452. So, early on, the transatlantic slave trade had the Catholic Church's blessing. King Charles I of Spain (also Holy Roman Emperor Charles V) sanctioned the transatlantic slave trade from Africa to the Americas by permitting the importation of 4,000 Africans to New Spain in 1518.

Ironically, the biggest boost to African enslavement came from a man who fervently opposed slavery — for the native population, anyway: Bishop Bartolomé de Las Casas initially supported importing African captives because he saw it as a means to keep Native Americans free and alive. He later regretted his decision.

There was, however, early opposition to the transatlantic slave trade and slavery.

>> Pope Pius II issued a letter in October 1462 condemning the slave trade.

>> Pope Leo X decried both slavery and the slave trade in a papal bull in 1514. When Christian pirates presented him with the captured Granadan Leo Africanus, who later wrote about Africa, the pope freed him.

>> Pope John III issued the *Sublimis Deus* (often erroneously cited as *Sublimus Dei*) in 1537, decrying enslaving indigenous people in the Americas and others simply because they weren't Christians.

>> The Archbishop of Mexico, Alonso de Montúfar, wrote the Spanish Crown in 1560 questioning African enslavement.

>> Fray Tomás de Mercado, also an economist, questioned the slave trade as early as 1569 but most extensively in *A Critique of the Slave Trade* in 1587.

>> Mexican professor Bartolomé de Albornoz cast doubt on the slave trade's morality and legality when he published *Arte de los contratos (The Art of Contracts)* in 1573.

Though many Africans presumably opposed the slave trade, few are on record. Afonso I or Afonso I Mvemba a Nzinga, a Christian convert who ruled the Kingdom of Kongo (northern Angola and the western portion of the Democratic Republic of Congo today), is an exception. Wanting to grow and modernize his kingdom, Afonso I traded with the Portuguese and sought their counsel. Enslaved labor existed in the kingdom, and in exchange for goods and services, Afonso I even sent captives as slaves to Portugal. Those captives, however, had been prisoners of war. Afonso I's discovery of the illegal slave trade, involving the capture of free people, along with the realization of its harmful effects, made

him uneasy. In a 1526 letter to John III (or João III), King of Portugal, he sought to end the slave trade:

> [W]e need from [your] kingdoms no other than priests and people to teach in schools, and no other goods but wine and flour for the holy sacrament: that is why we beg of Your Highness to help and assist us in this matter, commanding the factors that they should send here neither merchants nor wares, because it is our will that in these kingdoms [of the Kongo] there should not be any trade in slaves nor market for slaves.

His pleas were futile. Portugal was the major power player in the transatlantic slave trade, and demand for enslaved labor was increasing. Spain already had flourishing colonies in the New World, and the French, Dutch, and English, along with Portugal, later established successful colonies. As commercial enterprises such as the sugar industry increased, slavery became further entrenched in the New World. It would be at least a few hundred years more before ending slavery and the slave trade received serious consideration.

## Dealing with life enslaved

Racial and class distinctions existed among the Spanish and Portuguese who settled in the New World; the breakdown was as follows, in this order:

1. **White elite**
2. **Mestizos:** Those of mixed European and Native American heritage
3. **Mulattos:** Those of mixed European and African heritage
4. **Native Americans**
5. **Africans**
   1. **Ladinos:** Those born in Africa but who had lived in Spain long enough to know some Spanish and familiarize themselves with Spanish culture
   2. **Bozales:** Those coming straight from Africa to the Americas; they could become ladinos by learning Spanish and converting to Christianity
   3. **Criollos (Creoles):** Those born in the Americas

Soon after their arrival in the Americas, African captives received Spanish or Portuguese first names. Popular names include Fernando, Juan, Ricardo, and José for men and Mariá, Louisa, and Ana for women. Very rarely did those enslaved receive a last name. Rather, in paperwork, the country of their origin usually followed their first name, as in Ricardo Angola. Learning Spanish or Portuguese was also necessary in some colonies, especially among enslaved individuals who were considered domestic house workers.

Marriage among enslaved people was acceptable and sanctioned by the government and the Catholic Church, with the latter bestowing those married with official documentation. When applying for marriage licenses, enslaved people had to declare their ethnic backgrounds. Interestingly, the enslaved tended to marry within the same background. In theory, enslaved people who were married weren't subject to separation through sale, so perhaps that made marriage more appealing. Family life was desirable to those enslaved. Plus cohabitation was greatly discouraged, and bigamy was disdained. Some evidence suggests, however, that some Africans continued to practice polygamy in the New World. In their culture, if men outnumbered women, it was acceptable for a man to have more than one wife. Colonial authorities broke up these unions whenever possible.

Because African men outnumbered African women in the Americas, the men often became involved with indigenous women, another practice discouraged by colonial authorities. Known as *zambos,* the children of free indigenous women and African men were born free. To prevent such relationships, authorities passed many restrictions, including keeping Africans and indigenous people from living in the same areas and not allowing them to trade with one another. Because indigenous people and Africans outnumbered whites, it wasn't always easy to enforce such laws.

**HISTORICAL ROOTS**

Even today, Latin America and the Caribbean generally demonstrate a higher retention of African cultural values, and this is mainly because Africans greatly outnumbered whites. Unlike the United States, which carefully regulated the ratio of whites to Africans and often had white slaveholders directly supervise enslaved labor, Latin America and the Caribbean teemed with nonwhites. Absentee owners weren't at all uncommon, and many overseers were *mestizos.* This population imbalance, coupled with Spain and Portugal's early tendency not to separate ethnic groups, allowed for greater cultural retention. For example, in religious practices, Africans simply mingled their own religious beliefs and practices with Catholicism.

# Seeking freedom

Despite being able to retain key characteristics of their African culture, Africans enslaved in the New World still desired freedom. And there were various ways through which freedom could be obtained.

## Grants and purchases of freedom

Enslaved people could be granted freedom by their masters. Slaveholders sometimes freed the elderly and loyal among those they enslaved, as well as their children with enslaved mistresses and sometimes the enslaved mistresses themselves. Some enslaved people purchased their freedom. Because the Spanish felt that

Africans were inferior, freedom, itself, was relative. The Spanish believed Africans required supervision and therefore regulated African behavior, sometimes extremely. In Lima, Peru, for example, free Blacks weren't buried in coffins because coffins were reserved for whites. Skin color also distinguished free Africans, with higher social status accorded to those with fairer skin.

## Escapes

For men aged 14 to 25 who were most needed in the labor force, freedom was harder to attain, so many of them escaped. Africans actually began escaping as soon as they reached the New World. In 1503, a colony governor complained to Spanish officials in Spain about such flight. Eventually the Spanish labeled those escapees *cimarrones.* Those who escaped later formed *maroon communities* in remote areas.

As long as these maroons lived quietly, the Spanish, who seemed to anticipate a certain number of runaways, seemed unconcerned. It wasn't at all uncommon for maroons to attack their former masters to help others who were still enslaved escape. Sometimes authorities insisted on re-enslaving maroons. The British fought the maroons in Jamaica for decades before agreeing to a treaty. One of the earliest and most well-known maroon communities is Yanga in Mexico (see the nearby sidebar). In 1609, Yanga and the Spanish came to an agreement that allowed the maroon community to continue.

## Rebellions

In addition to escaping, those enslaved in Latin America and the Caribbean plotted their freedom through rebellions. The Spanish, however, were especially quick to quell any rebellious activity, often hanging those even rumored of conspiring. The most famous successful slave revolt is the Haitian Revolution (1791–1803), in which Africans (enslaved and free) embraced the ideals of the French Revolution and won their right to citizenship, defeating the French to establish the free republic of Haiti on January 1, 1804.

Another notable revolt included the Christmas rebellion of Jamaica. The Baptist War, also known as the Sam Sharpe Rebellion, the Christmas Rebellion, the Christmas Uprising, and the Great Jamaican Slave Revolt of 1831–32, was an 11-day rebellion that started on December 25, 1831 and involved up to 60,000 of the 300,000 slaves in Jamaica.

## YANGA, MEXICO

One of the New World's earliest maroon communities, San Lorenzo de los Negros, was renamed Yanga for its founder, the formerly enslaved African Gaspar Yanga, in 1932. Yanga, whose name can also be spelled Nyanga or Ñanga, similar to a Yoruba word for "pride," is frequently referred to as the "first liberator of the Americas." Revolting against the Spanish near the port city of Veracruz (then a part of New Spain, now Mexico) in 1570, Yanga, who was also a Muslim and even rumored to be royalty, led a group into the highlands where they established their free colony. In 1606 and again in 1609, the Spanish colonial government sent troops to destroy the community, but each time they encountered greater resistance than they anticipated.

Reportedly when Yanga became too elderly to lead the active resistance, Francisco de la Matosa, an Angolan who merged Yanga's community with the maroon community he led, handled tactical confrontations with the colonial government. When Spanish troops burned the community, Yanga and his crew resettled nearby. Eventually, the Spanish agreed to a treaty.

In the late 19th century, Mexican author and historian Vicente Riva Palacio, a former Mexico City mayor and grandson of Mexico's "Black President" Vicente Guerrero, brought Yanga's story to widespread attention. A statue of Yanga can be found near Veracruz, Mexico, where the town remains.

## The official abolition of slavery

Even though many Caribbean and Latin American colonies wouldn't earn independent governance until well into the 20th century, the European powers did abolish slavery in Latin America and the Caribbean in the 19th century. Slavery ended in the British colonies in 1833 and in the French colonies in 1848. In Puerto Rico, Cuba, and Brazil, slavery wouldn't end until 1873, 1886, and 1888, respectively.

# Chapter **3**

# The Founding of Black America

The year 1619 marks the official arrival of Africans to what would become the United States of America. Enslaved Africans weren't uncommon in other parts of the Americas, including some areas that would later make up the United States (refer to Chapter 2). Indentured Africans and indentured European servants weren't always treated the same.

This chapter explores slavery's early development in British North America, touching upon the transatlantic slave trade and its horrible Middle Passage before turning attention to how white colonists, in the course of their own fight for freedom, established a democracy rooted in the bondage of others.

## From Servitude to Slavery

In the early 17th century, two British ships raided a Portuguese slave ship, the *San Juan Bautista*. One of those ships, the *White Lion*, which flew a Dutch flag, landed in Jamestown Colony on August 20, 1619. According to John Rolfe, Jamestown's most well-known early settler, the ship swapped "20 and odd Negroes" (presumably taken from the *San Juan Batista*) for "victuale." The other ship, *Treasurer*, arrived

later, leaving more African captives from the Ndongo region of what is now Angola.

After the arrival of these first Africans, the Black population grew steadily. Historical records show that parents Isabella and Antony (or Antoney) baptized their son, William, the first Black child born in the English colonies; however, in 1624, the vast majority of early Africans, like those early white settlers, arrived by boat. Approximately 300 Africans lived in Virginia in 1649, at a time when race still didn't absolutely predetermine one's enslaved status. Although these early Africans were enslaved, they may not have been so for life. In 1673, a Virginia court case forced a slaveholder to free Andrew Moore for his service.

The Virginia colony wasn't an anomaly. When the ship *Desire* arrived in Massachusetts in 1638, the Africans on board weren't automatically enslaved for life. The same was true in New York, then a Dutch colony known as New Netherland. In 1644, 11 Black people filed a petition for their freedom and secured it. In fact, records from 1651 and 1652 show that some Black people owned their own property and even had indentured servants themselves. This quasi-indentured status was short-lived, however. During the same time that many Africans gained their freedom through indentured servitude, measures leading to the lifelong enslavement of Africans based solely on race were falling into place.

## Inching toward slavery

The 1640 sentencing of John Punch to a lifetime of servitude to his slaveholder was a pivotal event in the eventual enslavement of Black people based solely on race. Punch's sentence is noteworthy because although he ran away from his Virginia slaveholder with two white servants — and the only offense cited was running away — the white servants received only four additional years of servitude, not a lifelong sentence. It wasn't completely unexpected, however; a year before, Virginia had passed a statute to distribute arms and ammunition to "all persons except Negroes."

Laws inching the colonies closer and closer to enslaving Africans based solely on race followed in both Virginia and Maryland, especially in the 1660s:

>> A 1662 Virginia statute established the mother's status determined a child's freedom.

>> Both Virginia, in 1667, and Maryland, in 1671, established laws that Christian conversion didn't change one's slave status (heathenism was once a justification for slavery).

>> A 1669 Virginia statute specifically equating "negroes" and "slaves" stated that a master wasn't responsible if a slave died while he was administering punishment.

The Virginia Slave Codes of 1705, a series of laws defining and regulating enslaved status and behavior, left no speculation regarding how the colonists viewed Africans. Ultimately, various factors contributed to the formal enslavement of Africans in the colonies.

## Why Africans?

Like the Spanish (refer to Chapter 2), the English found that enslaving the indigenous population wasn't plausible. Not only were Native Americans sickly due to their inability to ward off the foreign ailments that the colonists brought, but they also knew the lay of the land and could escape easily. In the free-labor system that included both Black and white people, white people (designated as English, Irish, or Dutch and not by race then) proved inept workers; they had no knowledge of the land and how to grow crops in the Americas. They also had the protection of a government, and if they managed to escape, they could blend in with other non–African settlers. From the proslavery perspective, Africans offered several advantages:

>> Because of their dark skin, Africans were easily identifiable.

>> Africans were strong as well as skilled at agriculture and other tasks.

>> Granted a monopoly on the British slave trade, the success of the Royal African Company, formed in 1672, made enslaved African labor more accessible and affordable to colonists.

**REMEMBER**

Slave trading became one of Britain's most competitive enterprises. All this activity coincided with the increased commercial production of rice, tobacco, cotton, and other goods, which made slavery an indispensable means to wealth in the North American colonies.

# The Triangular Trade

Slavery's formal acceptance by the colonies significantly changed the lives of Africans, and the transatlantic slave trade, coupled with the goods produced by her colonies, made England a superpower. For England, the slave trade reached its peak during the 18th century as a very profitable three-way exchange, known as the *Triangular Trade*, developed. Here's how it worked:

>> **Leg 1:** Typically, a shipment of goods, which could include beads, cloth, hardware, rum, salt, and guns, left England (particularly London, Bristol, or Liverpool) for West Africa.

>> **Leg 2:** In West Africa, the goods were swapped for captured Africans who were packed into slave ships by the hundreds to journey across the Atlantic Ocean to the Americas. They were taken to the Caribbean, Brazil, and North America.

>> **Leg 3:** In the Americas, Africans were unloaded and replaced with molasses, rum, sugar, tobacco, or any other hot commodity before heading back to England.

REMEMBER

The term *Triangular Trade* stemmed from the fact that the route, which could take a full year to complete, actually formed a triangle on a map. In time, however, the "triangle" referred more to the route's three-way exchange system of goods for African captives for more goods.

Not all ships that sailed back and forth to Africa originated in England. Soon the colonies set up a triangular trade of their own that bypassed England. New England distilled sugar and molasses from Caribbean plantations and then shipped them to Africa in exchange for African captives who, in turn, produced more sugar in the Caribbean before beginning the process again. Some of those enslaved also wound up in New England; by 1755, New England had an enslaved population of more than 13,000. (The molasses and sugar also were shipped to England.)

TECHNICAL STUFF

The first slave ship from British North America left Boston in 1644. By the 1670s, Massachusetts slave traders regularly carried African captives from Africa to the Caribbean. Rhode Island entered the slave trade around 1700 and had as many as 20 ships sailing from Newport to Africa by the 1750s; an estimated 60 percent of the North American ships involved in the slave trade were from Rhode Island. The arrival of slaves to British North America reached its peak during the 18th century. Overall, it's believed that between 500,000 and 550,000 of the colonies' enslaved population came from Africa, mainly via the Caribbean.

# The Middle Passage

Named for the middle leg of the Triangular Trade from Africa to the Americas, the *Middle Passage*, which involved hundreds of Africans packed into ships for months, claimed the lives of many Africans. Death toll estimates vary widely, but approximately 1 to 3 million of the estimated 11 to 18 million Africans reportedly transported to the Americas and the Caribbean through the transatlantic slave trade between the 16th and early 19th centuries died before ever reaching land.

## The capture

By the slave trade's peak in the 18th century, European nations had established an intricate system of trading posts and forts along the West African coast. Largely

ignorant of the African interior, European traders relied on Africans to capture other Africans deep in the continent.

**REMEMBER**

Although African slavery differed greatly from the form of slavery that took hold in the Americas, greed still motivated the Africans who assisted European traders in exchange for goods or even guns to give them an advantage over other Africans with whom they were in conflict.

Principal regions from which Africans were captured included Senegambia, Sierra Leone, the Windward Coast, the Gold Coast, Bight of Benin, Bight of Biafra, and Central Africa (primarily Angola). Among the Africans captured — some were the spoils of war; others, kidnapping victims — there was no discrimination. They hailed from various ethnic cultural groups with no distinctions made between servants and royalty. No one was safe: Even the Africans selling other Africans could become enslaved.

# AYUBA SULEIMAN DIALLO, OR JOB BEN SOLOMON

**BLACK AMERICAN FACES**

Born in the Bundu region (in today's Senegal) around 1702, Ayuba Suleiman Diallo, also Job ben Solomon, is one of the rare African captives who returned to Africa. He had been kidnapped and sold to Stephen Pike, captain of the *Arabella,* which was moored on the Gambia River. Immediately after his capture, Diallo sent a note to his wealthy father for help, but the ship sailed before his father could respond.

In Annapolis, Maryland, Alexander Tolsey, a planter from Queen Anne's County, purchased Diallo, whose job as a cattle herder gave him the opportunity to plan his escape. Easily caught, Diallo went to jail. Not giving up, Diallo, who hailed from a prominent family of Islamic religious leaders and political influence, wrote a letter in Arabic to Vachell Denton, the man who had sold him on the auction block. Curious, Denton forwarded the letter to William Hunt, an investor in the *Arabella,* in London.

Believing that Diallo's powerful relatives could prove beneficial for future African trading ventures, James Oglethorpe, a Royal African Company official, purchased Diallo's freedom. By 1733, Diallo was on a ship from Annapolis to London. He returned to the Gambia River area soon after only to find his once prosperous country poor, his father dead, and his wife living with another man. He was even seized by the French but regained his freedom again. Still Diallo, unlike numerous others, returned home to Africa. Biographer Thomas Bluett recorded his remarkable story in *Some Memoirs of the Life of Job,* published in 1734.

Capture was only the beginning. Some African captives had to walk 500 miles to the coast, often naked and barefoot and often in chains, to reach the dungeons or "negroe houses" they occupied at the forts and factories that dotted the coast. After surgeons examined them, acceptable captives were branded on the breast by a hot iron bearing the imprint of whichever company had purchased them, maybe for as little as the equivalent of $25 in goods.

## The voyage

Branded and chained, African captives were packed into ships with literally no room to move for a voyage that could last anywhere from six to ten or more weeks (see Figure 3-1). Length of voyage (the shorter, the better) rather than ship size (smaller ships were more common than larger ones) determined survival rates. Diseases such as dysentery and smallpox only exacerbated already horrifically unsanitary conditions. Crews threw so many dead bodies overboard that sharks often followed slave ships. Even worse, when the journey ended, some captives remained chained to dead bodies.

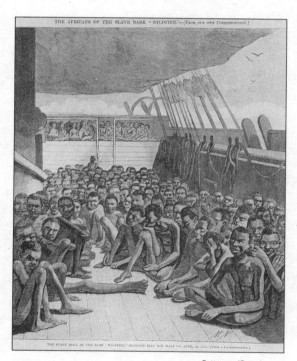

**FIGURE 3-1:**
Slave deck
of the *Wildfire*.

*Bettmann/Getty Images*

## THE WRECK OF THE *HENRIETTA MARIE,* A SLAVE SHIP

In 1972, diver Moe Molinar, a member of renowned treasure hunter Mel Fisher's team, was searching for the sunken Spanish ship *Nuestra Señora de Atocha* off the coast of Key West, Florida. He didn't quite know what to make of the shackles he uncovered instead.

A decade after Molinar's discovery, archaeologist David Moore and salvor Henry Taylor arranged to inspect the ship more closely. They found a bell inscribed with "THE HENRIETTA MARIE 1699." Further study revealed that the ship was a 120-ton British slave ship that had set sail from London in 1700 for Africa's Guinea Coast, which spanned modern-day Sierra Leone to Lagos, Nigeria. In Africa, the ship took on 250 men, women, and children before heading to Jamaica and its wealthy sugar plantations. Fourteen weeks later, the *Henrietta Marie* reached Port Royal, Jamaica, with 190 captives for sale. It's estimated that the ship's cargo grossed more than $400,000. In June 1700, on its way back to England, the *Henrietta Marie* shipwrecked near Key West.

Today, the *Henrietta Marie* is the rare fully recovered slave ship in the United States. More than 7,000 artifacts, including shackles, Venetian glass trade beads, and ivory "elephant's teeth," make up the U.S.'s first major museum exhibition devoted to the transatlantic slave trade. For more info on the *Henrietta Marie,* visit www.melfisher.org/ henrietta-marie-1700.

It's estimated that two out of every ten Africans who left the African coast didn't survive the Middle Passage. White crewmembers didn't fare well, either. Yet even with the high death tolls, these voyages were still very profitable.

## Safe arrival

A captive's transatlantic journey could be torturous due to trade winds or storms, but the last leg was usually the most pleasant. With the intended destination in close proximity, captives received more food to fatten them up for sale. After the ship docked, doctors examined captives either on the ship or in quarantine stations, locations holding Africans before sale. Slave brokers determined price, discounting those captives who weren't in great health.

In the Caribbean, especially on smaller islands, buyers purchased survivors straight from the ships. Most British ships, however, headed to Jamaica and Barbados, two of Britain's largest slavery strongholds in the Caribbean. Slave traders often sold captives who reached North America in public auctions in Virginia and New England, where taverns and stores could sell captives. Figure 3-2 shows a poster announcing the arrival of slaves.

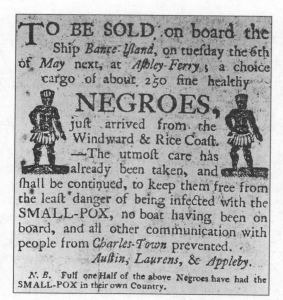

**FIGURE 3-2:**
Poster
announcing
the new slave
arrivals.

## GORÉE ISLAND AND SULLIVAN'S ISLAND

On Gorée Island near Dakar, Senegal, the House of Slaves — a prime holding station for Africans prior to their dispatch to the Americas in the transatlantic slave trade — has become a popular tourist destination for many Black Americans partaking in heritage tours. The majority of Black Americans, however, can't trace their ancestors directly back to this holding station, which was controlled mostly by the French, unless they're from the Louisiana area, including parts of Alabama (Mobile mostly) and Mississippi, which was once a French territory.

Sullivan's Island, just north of Charleston Harbor in South Carolina, is a more accurate heritage spot for many Black Americans. According to respected historian Ira Berlin, almost 400,000 enslaved Africans entered the United States through the Lowcountry or South Carolina region. Between 1787 and 1808 (the year that importing enslaved people became illegal), slaveholders purchased more than 100,000 Africans. Therefore, a substantial number of Black Americans, anywhere from 40 to 75 percent, depending on the source, can trace their ancestors' entry into the United States to Sullivan's Island.

At the auctions, such as the one depicted in the print in Figure 3-3, captives sold for $150 or more. Women of childbearing age often yielded higher prices. Usually, families were broken up prior to the voyage, and if they remained intact, those who oversaw the auction made little effort to keep them together. In the early 19th century, when the domestic slave trade replaced the transatlantic slave trade, prices and the ruthlessness of traders both rose considerably.

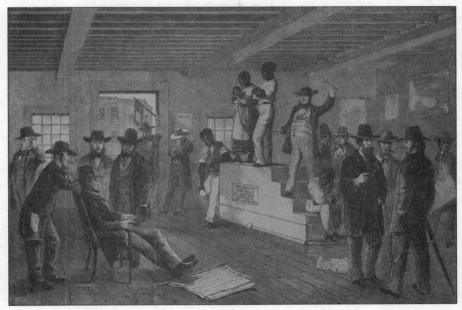

**FIGURE 3-3:**
A slave auction.

*Rischgitz/Getty Images*

# Black Americans and the Revolution

By the time of the American Revolution, slavery was entrenched in British North America. During this time, not one colony banned it. Despite this dim reality, when the colonists began to describe their relationship with England using the master-slave paradigm, freedom had to seem attainable to many Black Americans. Surely, those who *felt* enslaved could empathize with those who *were* enslaved. Therefore, many Black Americans embraced the American Revolution.

# A bit of background

Because of various countries' extensive investment in the New World, Europe's battles for power didn't exclude the Americas. During the French and Indian War (known as the Seven Years' War in Europe), Americans such as George Washington got their first taste of military action. Although England emerged from the battle with possession of Florida and Canada, the war changed how the English interacted with the colonists.

Prior to the French and Indian War, English intrusion in the colonists' lives had been minimal. The war, however, created a lot of debt. Because England felt it couldn't afford additional wars, King George III mandated that colonists not settle beyond the crest of the Appalachian Mountains. The problem was that many colonists had supported the British precisely so that they could expand westward.

Making matters worse, the British passed a series of laws — the Revenue Act, also known as the Sugar Act (1764), the Stamp Act (1765), and the Townshend Act (1767) — that taxed the colonists for the first time. With their political and economic freedom threatened, the colonists began to entertain new ideas regarding their relationship with England, frequently referring to themselves as *slaves* to English tyranny.

**IN THEIR OWN WORDS**

Recognizing the colonists' hypocritical position, Abigail Adams bluntly expressed her sentiments in a 1774 letter to her husband John Adams, who would become the second U.S. president: "It always appeared a most iniquitous scheme to me to fight ourselves for what we are daily robbing and plundering from those who have as good a right to freedom as we have."

# Fighting for freedom

In 1770, at the Boston Massacre, Crispus Attucks (see the nearby sidebar), a Black man, was not only the first to die but also encouraged those around him, whites included, to stand their ground against the British. Because of Attucks, unarmed American colonists stood eye to eye against armed British soldiers. Yet Attucks was far from the only Black American who stood up for freedom. A couple of years shy of the official start of the American Revolution, four enslaved Bostonians petitioned the colonial legislature in Massachusetts for their freedom in 1773.

A year later, Black people directly asked Thomas Gage, the military governor of Massachusetts who was also the general who commanded all British forces in North America for more than a decade, to abolish slavery. So when the fighting actually began in the American Revolution, Black people fought on both sides. The British offered freedom to those enslaved and the ideology of freedom was linked with those fighting for independence from British.

# CRISPUS ATTUCKS

An escapee for more than 20 years, Crispus Attucks instigated the Boston Massacre of 1770, a pivotal event that led to the American Revolution. The son of an African father believed to have been enslaved and an indigenous mother from the Wampanoag (sometimes Natick, Nantucket) people, Attucks worked on a whaling crew that sailed out of Boston Harbor. His animosity toward the British was the product of a number of factors, including the competition he faced from British troops who took part-time jobs during off-duty hours for lower wages and his fear of being drafted into the British navy.

Three days prior to the fateful March 5, a fight erupted between ropemakers and three British soldiers. Thus, when a British soldier entered a pub looking for work, he found a group of angry seamen, including Attucks, instead. About 30 men tormented the job-seeker before soldiers came to his rescue. Despite being unarmed, Attucks and his crew didn't back down, and Attucks was the first of five to die. The significance of Attucks's actions wasn't lost on those who dubbed the incident the Boston Massacre and elevated Attucks to martyr status. Despite laws and customs restricting the burial of Black people, Attucks's body rested with the others in Park Street Cemetery.

Ironically, John Adams, later a U.S. president, painted Attucks a rogue in court to defend the British soldiers, who won an acquittal. That outcome outraged the colonists and made the American Revolution even more attractive. In 1858, Black abolitionists honored the revolutionary with Crispus Attucks Day. Thirty years later, in 1888, objections from both the Massachusetts Historical Society and the New England Historic Genealogical Society, which considered him a villain, couldn't prevent the erection of the Crispus Attucks Monument in Boston Common.

At the same time that Attucks and Peter Salem (who distinguished himself enough at Bunker Hill to grace a postage stamp) were siding with the revolutionaries, George Washington, who would later become the new country's first president, took steps to bar Black people from American forces. In July 1775, he sent an order to recruiting officers instructing them not to enlist Black soldiers. (Existing Black soldiers remained in service.)

Months later, Lord Dunmore of Virginia, in what is known as Lord Dunmore's Proclamation, countered by declaring free all Black people indentured or enslaved who fought for the Crown. As a result, other Black people, such as Southerners Thomas Jeremiah and a dockworker named Sambo, joined the British camp. On December 31, 1775, Washington, backed by the Continental Congress, days later reversed his policy slightly to allow free Black men to serve.

Those enslaved in New Hampshire and New York were offered their freedom to fight with the Americans. Georgia and South Carolina, however, refused to enlist anyone enslaved even when the Continental Congress offered to pay for every enslaved person recruited. Despite this, there were some Black sailors in the South who served bravely on several vessels.

In all, about 5,000 Black Americans fought for the American cause. Massachusetts, Connecticut, and Rhode Island even had a few all-Black companies. Black soldiers Prince Whipple and Oliver Cromwell were with Washington when he crossed the Delaware on Christmas Day in 1776. Free Black Haitians even came to fight for the patriots' cause. Thus, Africans made substantial contributions to the victory that established the United States of America.

## Hope and disappointment

Prior to the actual start of the American Revolution, Black Americans had many reasons to believe freedom was near. Although John Locke, in *The Fundamental Constitutions of Carolina* (which guided the form of government and society for the colony) made it clear that the enslaved had no say in government, there were other rays of hope. In the two variations of Quaker abolitionist John Woolman's *Considerations On Keeping Negroes*, as well as works by James Otis and Thomas Paine, it was clear that some white people were questioning slavery. Even without a passage specifically decrying slavery in the Declaration of Independence, Black Americans had every reason to feel encouraged by the document's statement that "all men are created equal, that they are endowed by their Creator with certain unalienable Rights, that among these are Life, Liberty and the pursuit of Happiness."

A few encouraging signs included some white people's extension of revolutionary ideology to Black Americans and the emergence of *manumission* (freedom) societies with the intent of emancipating those still enslaved. This spirit directly resulted in the freedom of the many Black soldiers who fought in the war and their families. On a larger scale, Massachusetts, Connecticut, and Rhode Island made early moves to abolish slavery, with New York and New Jersey not far behind. In 1775, the Quakers began establishing antislavery organizations.

Still, it was clear that independence from England alone wouldn't change conditions for most Black Americans. Despite signs that the new Constitution would live up to the promise made in the Declaration — that all men are created equal — compromises that undermined the promise of freedom were also made. Though the Constitution included a provision to ban the slave trade in 1808, it also designated those enslaved as "three-fifths of a person" (an agreement reached to appease Southern delegates). These actions foreshadowed that long and arduous road to abolishing slavery ahead.

## THE SUPPRESSED PASSAGE

Thomas Jefferson wrote the following passage, which condemns slavery but it didn't make it into the Declaration of Independence:

"[George III] has waged cruel war against human nature itself, violating its most sacred rights of life and liberty in the persons of a distant people who never offended him, captivating and carrying them into slavery in another hemisphere, or to incur miserable death, in their transportation thither. This piratical warfare, the opprobrium of *infidel* powers, is warfare of the Christian King of Great Britain. Determined to keep open a market where Men should be bought and sold, he has prostituted his negative [veto] for suppressing every legislative attempt to prohibit or to restrain this execrable commerce: and that this assemblage of horrors might want no fact of distinguished die, he is now exciting those very people to rise in arms among us, and to purchase that liberty of which he has deprived them, and murdering the people upon whom he also obtruded them; thus paying off former crimes committed against the *liberties* of one people, with crimes he urges them to commit against the *lives* of another."

# The Free African Society and the Birth of Black America

As Black people — even those who had fought for American independence — were excluded in efforts to create the new nation, eight Black men took matters into their own hands to help form the basic foundation of Black America.

REMEMBER

On April 12, 1787, a month before the U.S. Constitutional Convention, Absalom Jones and Richard Allen, along with six others, gathered in Philadelphia to create the Free African Society, a nondenominational organization formed to address the needs of the larger Black community. Unlike the Newport, Rhode Island–based Free African Union Society preceding it, members of the Free African Society weren't interested in repatriating to Africa. "This land, which we have watered with our tears and our blood is now our mother country," Allen declared years later.

The creation of the Free African Society was a pivotal first step in establishing Black America. Its mission and duties, coupled with the Black church (which you can read more about in Chapter 12) and social and fraternal organizations such as the African Lodge, the main organ of Black Masons, began to address critical issues regarding Black people. These efforts recognized the unique position Black people held in the United States, a position W.E.B. Du Bois labeled *double consciousness,* his belief that Black Americans possessed a "twoness" that made them both American and African.

**HISTORICAL ROOTS**

# A BLACK AMERICAN LODGE

The African Lodge traces its roots back to March 6, 1775, when a British Lodge of Freemasons near Boston initiated 15 Black Americans, including Prince Hall, who hailed from Barbados. Following a rejection from white Americans to establish a Black American chapter for Masons in Boston, a subsequent appeal by Hall and others to the Grand Lodge of England in 1784 resulted in African Lodge No. 459, which received its full charter in 1787. Under Hall's leadership, Black Masons organized Grand Lodges, and their movement, which often took on civic causes such as education, steadily grew. Today, to honor its pioneer, this form of Freemasonry is labeled Prince Hall Masonry.

# 2

# Long Road to Freedom

## IN THIS PART . . .

Examine how the issue of slavery escalated. As the United States started to grow in the 19th century, the question of slavery became more contentious.

Discover how countless people impatient with how long the government was taking to end slavery began working to free the enslaved via the Underground Railroad.

See how enslaved people staged violent rebellions and how Southern slaveholders responded by pushing for stronger fugitive slave laws.

Understand what led up to the outbreak of the Civil War.

Explore the war's outcome in terms of emancipating the enslaved and the effect efforts to rebuild the union during Reconstruction had on Black Americans.

# Chapter 4

# American Slavery, American Freedom

Banning the importation of enslaved labor in 1808 did little to reduce slavery's intensity in the United States. Despite being founded on a platform of freedom, the U.S. wasn't ready to leave slavery behind. During the early 19th century, the domestic slave trade proved as inhumane and ruthless as the transatlantic slave trade had been. Major economic changes contributed to slavery's growth.

The Industrial Revolution in England eventually created a greater demand for cotton in the booming textile industry. Similar developments in the North added to the demand and the South eagerly responded to the call. With the advent of the cotton gin in 1793, cotton plantations began to boom, requiring more enslaved labor to perform the labor-intensive work of cultivating cotton. The low cost of enslaved labor coupled with the payoff of increased cotton production, in addition to staple cash crops such as rice and sugar, meant planters needed more enslaved labor.

This chapter explores the intricacies of the domestic slave trade and the ins and outs of enslaved life in the North and the South, as well as the shaky life free Black people experienced, even in the North. Also, in the North the need for enslaved labor was dwindling. Agriculture and the growth of cotton wasn't as important in the North. Furthermore, the industrial North didn't demand enslaved labor. According to historians, the Civil War was fueled by states' rights with the major issue being slavery.

## THE LUCRATIVE DOMESTIC SLAVE TRADE

"I wish you may visit me early this Spring to make some arrangements about your Negroes. If they continue high I would advise you to sell them in this country on one and two years credit bearing 8 per ct interest. The present high price of Negroes can not continue long and if you will make me a partner in the sale on reasonable terms I will bring them out this Fall from VA and sell them for you and release you from all troubles. On a credit your Negroes would bring here about $120 to $130,000 bearing 8 per ct interest. My object is to make a fortune here as soon as possible by industry and economy, and then return [to Virginia] to enjoy myself. Therefore I am willing to aid you in any way as far as reason will permit."

(Henry A. Tayloe of Marengo County, Alabama, to "Dear Brother" [B.O. Tayloe] on January 5, 1835)

# American Bondage

While the first Africans to arrive to the North American colony of Jamestown, Virginia, weren't really indentured servants, their skin color wasn't yet completely synonymous with the institution of slavery (refer to Chapter 3). As time went on, however, being born Black equated to a lifetime of enslavement, even for those of biracial parentage, most typically the father. Enslaved people who managed to win their freedom or those born free weren't safe either.

In the U.S., the law designated enslaved people as property, with a value no greater than furniture or cattle, yet slavery was practiced differently depending on region. Theses sections describe slavery in the North and South.

**TECHNICAL STUFF**

There is an ongoing debate of how many Africans came to the Americas via the transatlantic slave trade. On the low end 500,000 Africans arrived to the United States. Other historians cite more than 600,000 came. The later population increase among those enslaved came mainly through the birth rate, however. In 1800, more than a million people were enslaved in the nation. By the onset of the Civil War, that number was approximately 4 million.

## Northern slavery

Today many still view slavery as a Southern institution, but in reality, it was an American institution. Slavery was big business that involved much of the nation either directly or indirectly. Therefore, blame doesn't rest solely with the South.

## Northern slaveholders: A sampling

Northern slaveholders and slave traders are often ignored because of their small number of enslaved people and the non-existence of plantations, but they did exist. Douglas Harper, author of several books on the Civil War, launched the website Slavery in the North at www.slavenorth.com in the early 2000s. He identified Northern families who profited from slavery.

According to Harper, "A list of the leading slave merchants is almost identical with a list of the region's prominent families: the Faneuils, Royalls, and Cabots of Massachusetts; the Wantons, Browns, and Champlins of Rhode Island; the Whipples of New Hampshire; the Eastons of Connecticut; Willing and Morris of Philadelphia." In 1641, Massachusetts, under the leadership of Governor John Winthrop, also a slaveholder, became the first New England colony to legalize slavery. Documents show that more than 1,100 slave voyages, mainly engaged in the triangular trade, originated from New England.

## UNIVERSITY TIES TO SLAVERY

Some of the North's and the world's most prestigious universities also have ties to slavery. Perhaps the most prominent is Brown University. The Brown family, an early benefactor to its eventual namesake, owned several businesses tied directly and indirectly to slavery, particularly the triangular trade. Family member John Brown was actually a prosecuted slave trader. Brown's University Hall was built by enslaved labor. Cognizant of this history, Brown's president Ruth Simmons, the descendant of enslaved people and the Ivy League's first female and first Black president, took proactive measures and organized a committee to examine those ties as well as propose how Brown could reconcile that history in 2004.

Although three Yale graduate students helped spark Brown's introspection with their 2001 report questioning Yale's ties to slavery, Yale resisted further inspection until 2020. Then Yale President Richard Levin's attitude was "American history is full of embarrassments. We know today that slavery was very widespread in the North as well as the South, at least prior to the Revolutionary War. There are a number of early leaders of this institution who were slave owners. It's simply a fact of history."

In 2016, a *New York Times* article revealed that, in 1838, Georgetown University paid its debts, thereby saving the institution, by selling 272 women, men, and children to a Louisiana plantation. Proposed reparations came in Georgetown in renaming two buildings after two Black people — Isaac Hawkins Hall, after one of the men sold in Louisiana, and Anne Marie Becraft Hall for the free Black woman who ran one of Georgetown's first schools for Black girls and became one of the nation's first Black nuns. Other renowned institutions such as Columbia, Harvard, and the University of Pennsylvania also have early ties to slavery.

## Enslaved life in the North

Slavery in the North wasn't necessarily any less cruel than slavery in the South. As in the South, those enslaved in the North were also purposely bred for market, families were separated (as evidenced by a 1732 advertisement announcing that a 19-year-old Black woman and her child could be sold together or separately), and far too many suffered maltreatment at the hands of their owners. Philadelphia brickmaker John Coats, for example, reportedly kept his enslaved workers in iron collars with shackles.

REMEMBER

In the U.S., enslaved families, either from the North or the South, didn't often remain intact. Indebted slaveholders either sold the enslaved or traded them to settle their accounts. A slaveholder's heirs didn't always honor their benefactor's intention to keep those enslaved together. In other instances, wills scattered enslaved individuals throughout the family. Circumstances such as these separated children from their mothers, husbands from their wives.

Historian Ira Berlin wrote extensively about Northern slavery, noting enslaved individuals worked the fields, as domestics, in bars and hotels, in coal mines, and other menial labor. Smaller households enslaved fewer people, which meant that those individuals often lived in slaveholder households instead of in separate quarters. As cities emerged, many enslaved individuals, particularly women and children, worked as domestics.

## SLAVERY, MARRIAGE, AND EVEN SEXUAL ASSAULT

Although the law didn't recognize enslaved marriages, many slaveholders encouraged them mainly because settled families were less likely to flee. *Broad marriages,* marriages between enslaved people with different owners, were less desirable, however. Although it wasn't uncommon for slaveholders to perform marriage ceremonies, that recognition didn't necessarily protect enslaved women from sexual assaults. Young women were even more vulnerable, and children fathered by male slaveholders weren't uncommon. It was even a ritual among some young white men to have their first sexual experience with an enslaved girl.

## Northern slavery after the Revolution

Northern slavery declined following the American Revolution, in part because some enslaved won their freedom during the war. Increased industrialization and wage labor also contributed to slavery's decline in the North, even though some companies did rely on enslaved labor.

REMEMBER

Although most of the North legally abolished slavery following the American Revolution, that fact is misleading: Gradual emancipation was far more common than immediate freedom. According to the 1800 census, New England was home to 1,488 enslaved people. Connecticut, for example, didn't completely abolish slavery until 1848, and in 1850, 236 people were still enslaved in New Jersey. In addition, New England–based slave ships transported almost all the 156,000 people who were enslaved in the United States between 1801 and 1808. Even after Congress legally ended the slave trade in 1808, it continued, albeit to a lesser degree, due to poor enforcement. Northern ships, however, carried goods from enslaved labor to various destinations up until the Civil War. Northern factories also transformed Southern cash crops created with enslaved labor such as cotton into marketable consumer goods.

# Enslaved life in the South

Slavery wasn't a hidden institution in the South, but the reality wasn't quite the same as traditional depictions in the years since. For example, large plantations resembling those seen in *Gone with the Wind* and the *North and South* miniseries weren't the norm. In reality, relatively few Southerners owned huge plantations with large numbers of enslaved people. Of the 8 million white people who lived in the South in 1860, 384,884 were slaveholders, with 200,000 of them enslaving five or fewer people. Yet even white Southerners who didn't use enslaved labor generally felt invested in the system.

There's much more information about slaveholders with plantations enslaving 20 or more. According to thorough accounts from enslaved individuals, the owning of humans on larger plantations was a serious business.

## Labor on plantations

The complexion of the American plantation changed tremendously between the late 17th century and the 19th century. Plantation size and the crops cultivated greatly affected enslaved culture. Backbreaking labor, however, was consistent regardless of plantation size or crop cultivation, with the duties of those enslaved extending well beyond planting and harvesting crops.

## RICE PLANTATIONS

On South Carolina's rice plantations, enslaved laborers from the Sierra Leone region of Africa, as well as the West Indies, were often more skilled in rice cultivation than their slaveholders. Consequently, they were charged with the back-breaking work of carving rice fields out of the tidal swamp area; clearing cypress and gum trees from low-lying lands; and building canals, dikes, and small flood-gates that drained and flooded the fields in correlation to the high and low tides. In addition, they planted, maintained, and harvested the crop.

Rice plantations, particularly in South Carolina and Georgia, worked on the *task system*, with the enslaved receiving and performing specific duties. Tasks could include clearing the land for rice, draining the rice fields, harvesting rice, and milling the rice. Uncompleted tasks warranted punishment, usually whippings. Grueling work, as well as rampant malaria and fever, killed many enslaved young people. Life in South Carolina was so hard that few white people survived it, especially in its early years. As a result, the Black population, some of whom became immune to malaria, greatly outnumbered whites in parts of South Carolina, sometimes by as much as a three-to-one ratio.

## SMOKING: NOT THE ONLY WAY TOBACCO KILLS

Tobacco cultivation included as many as 36 steps. Planting, weeding, and harvesting tobacco wasn't a simple undertaking. Beginning in January and February, some enslaved laborers selected seedbeds, cleared them, and burned them. In mid-March, they sowed tobacco seeds into a layer of ashes and covered the plants with pine branches to protect them. Because those enslaved eventually transplanted the successful plants, they cleared a field and plowed it into knee-high hills that were 3 to 4 feet apart. The plants couldn't be transferred until it rained and, even then, they might not take. Because of the fragility of the tobacco plant, these tasks sometimes had to be performed several times to ensure a decent crop.

To ward off weeds and deter cutworms, enslaved laborers cultivated the plants weekly with a hoe and their hands while also removing leaves at various stages before harvesting the crop in late August or early September. The crop then cured for four to six weeks. Before the tobacco leaves shipped, they had to "sweat" for another week or two and then go through sorting.

## TOBACCO PLANTATIONS

Another crop that was labor intensive was tobacco. Slaveholders needed large numbers of enslaved labor for the long process. They also used enslaved labor to make the shipping barrels, to build the tobacco barns, to load the barrels into the ships, and, later, to work in the factories that manufactured tobacco products. In the late 1700s, however, soil depletion and falling tobacco prices tempered Virginia's once mighty tobacco plantations.

## COTTON AND SUGAR PLANTATIONS

With Eli Whitney's invention of the cotton gin in 1793 and the advent of the Industrial Revolution, cotton became a boom crop. By efficiently separating cotton fibers from seedpods and sticky seeds, the cotton gin greatly increased cotton production from 10,000 bales in 1793 to more than 400,000 by 1820. Greater productivity created a greater demand for enslaved labor: Every 100 acres of cotton required 10 to 20 enslaved people. Jean Étienne de Boré added to that demand when he opened a successful sugar mill in Louisiana in 1794. Others followed, giving the South two huge crops with cotton and sugar.

American cotton and sugar plantations adopted the popular *gang system* of labor favored in the Caribbean and used on tobacco plantations. Considered more productive than other work systems, the gang system organized the enslaved into three groups based on physical abilities. An overseer, usually white, and a driver, usually Black, supervised the groups with enslaved laborers being told when to work, when to eat, and when to stop. In general, there was one enslaved person for every 3 acres of cotton. Clearing land, burning underbrush, spreading fertilizer, and breaking soil were just some of the duties performed, in addition to planting, cultivating, and picking cotton.

Clearing land as well as cutting and carrying the sugar cane for milling may have been the easiest part of working on a sugar plantation. The dangerous part came with transforming the sugar cane into sugar. Using a method known as "the Jamaica Train," sugar cane was boiled in four to five open kettles, arranged from largest to smallest. Teams of enslaved laborers ladled the hot liquid from kettle to kettle until it reached the right temperature and consistency to crystallize. Even with a large number of enslaved people dying (historians and researchers estimated the life of someone enslaved who worked on sugar plantations to be seven to ten years shorter), huge amounts of sugar lost, and the enormous quantities of wood needed to provide heat, sugar plantations were still hugely profitable.

**TECHNICAL STUFF**

The multiple-effect evaporator, an invention by Norbert Rillieux, the free offspring of a slaveholder and an enslaved person, made sugar plantations more efficient and profitable. The multiple-effect evaporator, still used today in various other industries, reduced the manpower and danger of making sugar by piping the juice from one container to the next. Instead of heating all the containers, the first

one received heat and the other chambers relied on latent heat. Around 1845, Louisiana plantations began using the new system.

## House slaves and field slaves

On larger plantations, enslaved workers' duties were specialized, with the main division being between those labeled house slaves and field slaves.

>> **House slaves:** *House slaves* were dedicated to the slaveholder's house and other duties outside the field. Unlike other enslaved people, they interacted with the slaveholder's family and his associates. Their primary duties included cooking and cleaning. Some enslaved women served as *mammies* caring for and, in some cases, even nursing white children. Others served as *aunties,* caring for enslaved children while their mothers worked. Because the work of house slaves placed them in close proximity to the white power structure, they received intense scrutiny. Sometimes, the benefits of domestic work included better quarters (although they often slept on a pallet at the foot of the slaveowner's bed just in case something was needed at night), more food, hand-me-down clothes from the slaveholder's household, and even an education. (They were secretly educated by the slaveowner's children or a sympathetic mistress. Sometimes the education was just enough for an enslaved to learn and understand European etiquette.)

To serve the needs of the slaveholder's household, house slaves often lived in the big house or at least stayed overnight frequently. In some cases, loyal house slaves received their freedom when a master or mistress died, but more often than not, heirs inherited house slaves as cherished and prized possessions.

>> **Field slaves:** *Field slaves* often reported to work at sunup and worked until sunset. Eighteen-hour days were typical during harvest time, with women working the same hours as men and pregnant women working until child-birth. Children were sent into the fields sometimes as early as age 5 or 6; beginner tasks included carrying water to the fields. Even though field slaves usually received less food and poorer clothing and performed harder tasks than house slaves, many preferred the field to the big house because of the camaraderie. Working in the house led to a greater sense of isolation from the rest of the enslaved community.

Regardless of whether they worked in the big house or in the fields, enslaved people typically received very little food. Weekly meal rations usually consisted of a few pounds of meat (typically salt pork) with rice, peas, corn, and/or sweet potatoes, among other vegetables. Sometimes those enslaved were fortunate enough to have their own gardens and raise chickens, but many slaveholders

discouraged such activities that could divert attention away from the primary duties given to those enslaved.

## Overseers

On plantations with 20 enslaved people or more, an *overseer*, usually a white man who owned no land or any enslaved labor, supervised the work. Sometimes the overseer system yielded dramatic results. For example, in 1830, 14 people enslaved in Mississippi picked an average of 323 pounds of cotton when 150 pounds was typical. Yet plantation owners and overseers frequently complained of enslaved people being lazy and punished those they felt weren't working hard enough or whom they considered otherwise disruptive. Backbreaking work and cruel treatment only intensified the desire to be free, with the enslaved frequently taking matters into their own hands to achieve it.

## Drivers

Drivers, usually physically imposing enslaved Black men, assisted overseers in supervising enslaved labor and frequently administered whippings. Although those formerly enslaved often deemed the driver as the "meanest" Black man on the plantation, in recent years, historians have argued that the driver wasn't simply the slaveholder's or overseer's flunkey. In the gang system, it wasn't uncommon for the driver to serve as the lead worker. He often set the tone and rhythm for work, even leading the group in songs.

Ultimately, the driver worked as the middleman between the slaveholder, overseer, and enslaved and sometimes negotiated perks as well as punishment. Drivers usually came to power during their late 30s, and they usually served long tenures that could last as long as 20 years. The slaveholder and overseer frequently trusted the driver's judgment regarding agricultural matters. In addition, the driver policed the living quarters (where he also resided) for potential escapes and rebellions. For these services, he received special privileges. Drivers also would often intervene in the punishment of other enslaved individuals.

# Before I'd Be a Slave: Fighting the System

Africans were never content with slavery and rebelled from the start. Revolts were so common on slave ships that traders could even get insurance against it, and many of the first Africans who reached land committed suicide. Two boatloads of Africans who arrived in Charleston in 1807, for example, starved themselves to death. Even after slavery was firmly established, Africans were still unwilling to submit to it and were among the first to use the court system to secure their

freedom, even though the results rarely favored them. Laws declaring that Christian conversion didn't change one's enslaved status, for example, emanated from enslaved people's challenges for freedom.

Most enslaved people couldn't turn to the legal system for help, but they resisted slavery on a daily basis nonetheless. Some feigned illnesses to avoid work, and some even harmed themselves by cutting off their fingers or shooting themselves in the foot or hand. In many cases, slaveholders still found something for them to do. Enslaved women who found themselves pregnant would induce miscarriages through drinking teas made of roots and herbs or by other means. Sometimes enslaved mothers would kill their infants especially infant girls to prevent them from living a life of bondage.

Enslaved people also resisted slavery by directly harming their slaveholders. It wasn't uncommon for an enslaved person (usually female) to poison the slaveholder. Some enslaved people stabbed or choked unusually cruel slaveholders, despite the punishment. Any enslaved person who murdered or harmed a slaveholder rarely escaped death. Hanging was most common, but there's at least one report about an enslaved person being burned alive.

With the courts ruling enslaved people as property, the law, which couldn't restrict the treatment of one's property, offered no relief from cruel slaveholders. (Some states did have laws regarding the treatment of the enslaved, but they weren't enforced on a regular basis.) Because white people feared rebellion the most, they took great measures to prevent it.

## The Slave Codes

American slaveholders believed in heavily regulating enslaved behavior; they also believed maintaining a careful balance between those enslaved and white supervisors curtailed violence against white people. In 1705, Virginia passed the Slave Codes. These laws emphasized enslaved people as property and greatly restricted enslaved behavior to safeguard the white population.

The Slave Codes included the following laws:

>> No leaving plantations without authorization.

>> Bearing weapons was banned.

>> Striking a white person under any circumstances was prohibited.

Whenever word of a conspiracy surfaced or an actual attempt at rebellion occurred, colonists passed more laws similar to these.

HISTORICAL
ROOTS

To enforce the Slave Codes, militia-like slave patrols were set up in which free white men served usually for one-, three-, or six-month periods. Those who didn't want to serve were fined. These patrols returned enslaved people to plantations, conducted random searches of living quarters, and generally policed those enslaved. During times of perceived or demonstrated danger, a vigilance committee that generally disregarded caution took over, often killing any Black person, enslaved or free, guilty or innocent, found during the group's rampage. These patrols were a precursor to the Ku Klux Klan, which historically had two incarnations, one in 1866 and another in 1915. Some argue that early American policing, particularly its fascination with overly criminalizing Black men especially, evolved from these patrols. A foundation for that argument can be found in Sally E. Hadden's 2001 book *Slave Patrols: Law and Violence in Virginia and the Carolinas* (Harvard University Press).

## Rebellions

The Slave Codes made it difficult to rebel, but they didn't prevent insurrection. The four rebellions that U.S. historians generally consider most important are the Stono Rebellion (1739), Gabriel's Rebellion (1800), Denmark Vesey's Uprising (1822), and Nat Turner's Rebellion (1831).

### STONO REBELLION

On September 9, 1739, an enslaved Angolan named Jemmy led 20 enslaved people at the Stono River outside of Charleston, South Carolina, in a rebellion. First they marched to a local shop and armed themselves before killing the two shopkeepers. From there, they marched to the home of a local man, killing him and his son and daughter. Although they stopped at Wallace's Tavern, they spared the owner, reportedly because he was kind to those he enslaved. The people at the next six or so houses weren't so lucky. As the march continued, more people joined, with numbers growing as large as 100 according to some historians.

By the time they reached the Edisto River the following afternoon, they had killed 20 to 25 white people and had a group of white people hot on their trail. In the ensuing gunfire, at least 30 members of the Stono Rebellion lay dead while 30 others escaped. Colonists captured and executed most of them within a month, however. The Negro Act, which reinforced restrictions against Black people assembling in groups and reading, among other things, quickly passed after the Stono Rebellion.

TECHNICAL
STUFF

The timing of the Stono Rebellion and the fact that it occurred on a Sunday has led some to suggest that it triggered the Security Act, which required all white men to carry guns on Sundays to ward off possible insurrections. Those who didn't were fined. The Stono Rebellion also resulted in a ban against drums. Slaveholders discovered the enslaved used them to communicate between plantations.

## GABRIEL'S REBELLION

Gabriel Prosser was a trained blacksmith on Thomas Prosser's tobacco plantation in Henrico County, Virginia. When Thomas died, his son took over the plantation operations and hired out Gabriel and his brother Solomon. While working outside the plantation in Richmond, Gabriel encountered enslaved and free Black people, as well as working-class white people, who exposed him to the ideas of the American Revolution and alerted him to the successful uprising in Haiti (1791–1803) led by enslaved men, which inspired him.

Following a month spent in jail for stealing a pig, Gabriel started plotting an outright rebellion. He recruited several enslaved people and at least two Frenchmen. His plan included seizing Capitol Square in Richmond and taking Governor James Monroe hostage.

Originally, the rebellion was to occur on August 30, 1800. The goal of gathering 1,000 enslaved people at the appointed meeting place on that day was thwarted, however, by heavy rain. That forced them to postpone action until the next day. In the interim, two enslaved people gave the group away. Within days, authorities captured 30 enslaved people, but Gabriel remained at large. To crack the case, officials offered pardons in exchange for testimonies. Assisted by a former overseer who had since changed his mind about slavery, Gabriel attempted to escape by boat, but an enslaved man with hopes of buying his own freedom with the reward money alerted authorities of Gabriel's presence. After a speedy trial, Gabriel was hanged.

Estimates of the number of enslaved people involved range from 500 to 5,000. In all, authorities tried at least 65 enslaved people, executing an estimated 35 of them for participating in the rebellion. They then transported arrested enslaved and free Black people they hadn't executed out of the area. The silence of the majority of the participants astounded and scared white people. Like Gabriel, most accepted their deaths and refused to divulge any significant information regarding the rebellion. Long after discovering the plot, Virginians remained paranoid. The rebellion also proved costly. Hanging 25 people, for instance, cost $8,899.91 in compensation to their slaveholders, with the militia alone costing $5,431, according to Douglas R. Egerton's 1993 book *Gabriel's Rebellion: The Virginia Slave Conspiracies of 1800 and 1802* (University of North Carolina Press). At that time, those were hefty sums.

## DENMARK VESEY'S UPRISING

Denmark Vesey's unsuccessful 1822 plot captivated many historians not for its effectiveness but rather for its organization. A successful carpenter and property owner, Vesey, who purchased his own freedom in 1800, plotted for several years to free others in the Charleston, South Carolina, area. He carefully selected his

collaborators, even reaching out to Haitians for assistance. Vesey reportedly collected 250 pike heads and bayonets along with 300 daggers. When details of his plot leaked, he moved up the original July date for action, but white authorities had already started responding. Although estimates of involvement in Vesey's Uprising ran as high as 9,000 and included enslaved and free Black people, as well as a few white people, authorities arrested 131 Black people, killing 35, including Vesey. In 2014, the Denmark Vesey monument, in the works since 1996 and designed by Black American sculptor Ed Dwight, was finally revealed in Charleston's Hampton Park.

**TECHNICAL STUFF**

With his 2001 article "Denmark Vesey and His Co-Conspirators," published in *The William and Mary Quarterly,* an academic journal dedicated to early American history, historian Michael P. Johnson revived a claim made in 1964 by Richard C. Wade questioning whether Denmark Vesey's Uprising was real. According to Johnson, Charleston's mayor used the alleged plot to discredit his political rival and advance his own career. Plus, white Charlestonians wanted to rid the city of free Black people. For some years, scholars debated Johnson's claim. Those claims, however, have never matched the initial accounts of the uprising.

## THE FAR REACH OF THE HAITIAN REVOLUTION

Once known as Saint-Domingue, modern-day Haiti traces its roots back to a rebellion that began in 1791, when enslaved Black people murdered their white slaveholders for refusing to extend the same freedoms white Frenchmen were fighting for in the French Revolution. France sent forces immediately to Haiti, but the conflict lasted at least two years. In 1794, enslaved Haitians received their freedom, and relative calm returned under the rule of Toussaint L'Ouverture, a self-educated former house slave. However, in 1800, Napoleon, anxious to dominate the entire Western Hemisphere, sent additional French troops to Haiti and ousted L'Ouverture. France believed it had won back control, but when Napoleon tried to reinstitute slavery, others took up the fight. Aided by a number of factors, including yellow fever, which decimated the French troops, Haiti remained free and, on January 1, 1804, Haiti declared its independence to the world.

The United States watched the events in Haiti intensely. Thomas Jefferson denounced the revolution and later refused to engage in trade with Haiti. American slaveholders, fearing those they enslaved would also rise up, placed more restrictions on them. Efforts to keep word of the Haitian Revolution from those enslaved in the U.S. failed. Gabriel Prosser and Denmark Vesey weren't the only Black Americans inspired by the Haitian Revolution; although they all didn't attempt rebellions of their own, many others were inspired to keep the struggle for freedom alive.

## NAT TURNER'S REBELLION

Without a doubt, Nat Turner's Rebellion is the most well-known American slave revolt. Unlike other leaders of rebellions, Nat Turner left little to speculation and provided his own version of events that fell in line with his Christian beliefs. Although born enslaved in Virginia, Turner successfully escaped slavery at age 21 but later returned to Virginia to fulfill a greater vision. A deeply religious man and a powerful figure, Turner's alleged mystical powers, coupled with his distant and pious nature, made an impression on both Black and white people.

**IN THEIR OWN WORDS**

Driven by a vision he saw during a rare solar eclipse on February 12, 1831, Turner, labeled a prophet by some, concluded, "I should arise and prepare myself and slay my enemies with their own weapons."

Turner quickly chose his four disciples and decided that July 4 would be the fateful day as he headed toward Jerusalem, Virginia. Turner postponed his plan when he became ill. Another sign received on August 13 prompted him to take action on August 21.

Convening on the banks of Cabin Pond, Turner, his disciples, and two other men, armed with a hatchet and a broadax, first went to the home of Turner's slaveholder, Joseph Travis. They killed Travis, his wife, and three children before moving on to other homes. (One poor white family who weren't slaveholders was spared.) Traveling by horse, Turner and his crew continued on to Jerusalem, picking up more participants along the way. Three miles from Jerusalem, they encountered a group of armed whites, but Turner escaped, waiting for his disciples at Cabin Pond before digging a cave for his hideout.

Meanwhile, overseers received orders to single out any enslaved individuals they distrusted and shoot them if they tried to escape. By the time they captured Turner on October 30 (see Figure 4-1), 60 white people and more than 100 enslaved people had died. Turner was executed on November 11.

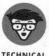

**TECHNICAL STUFF**

On November 11, Turner was killed and skinned like an animal. Legend has it that one white man owned a money purse made of Turner's hide and another one kept his skeleton for years.

Nat Turner's Rebellion sent ripples throughout the South and the nation. Whites everywhere, North and South, passed even more laws restricting the actions of enslaved people. Fearing another insurrection of this magnitude, some slaveholders tried to improve how they treated those they enslaved. One of the major turning points in American history, Nat Turner's Rebellion underscored slavery's true cycle of viciousness. In 2016, actor Nate Parker made headlines with a bidding war for his directorial debut, *The Birth of a Nation*, a film version of Nat Turner's Rebellion in which he also starred, at Sundance.

**FIGURE 4-1:**
Print showing
the discovery of
Nat Turner.

*Universal History Archive/Getty Images*

## Running away

Running away was far more common than rebellions as a form of resistance. Sometimes enslaved people who could read and write forged papers of freedom and successfully left enslaved life behind them. Many others took their chances in unfamiliar swamps and forests. Hiding during the day and scouring for food with bloodhounds on their trails, many enslaved people had little more than the North Star to guide them as they traveled at night. Most failed in their escape attempts. Once captured, most times within days, they often received severe punishment — some unsuccessful runaways suffered more than 100 lashes for their effort (see Figure 4-2).

These conditions are the reason Harriet Tubman, the famous conductor of the Underground Railroad (see Chapter 5), is so heralded. Not only did she make it to freedom, but she also risked it and her own life repeatedly to free many others. She and Frederick Douglass are two of the best-known runaways.

**TECHNICAL STUFF**

The many runaways who escaped to the North are documented more in history than the others who remained in the South (particularly in Virginia, the Carolinas, Georgia, Louisiana, and Florida), in some cases living solo in caves or dugouts or forming pods of enslaved runaways known as *maroon communities.* One such

community was the Black Seminoles or Seminole Maroons, enslaved people from coastal South Carolina and Georgia who fled to Florida and lived among the Seminole Indians as early as the 1600s. The Great Dismal Swamp in Virginia and North Carolina is a maroon community that thrived in the 1700s and 1800s. Sylviane A. Diouf's 2014 book *Slavery's Exiles: The Story of the American Maroons* (NYU Press) is one of the rare and accessible deep dives into marronage.

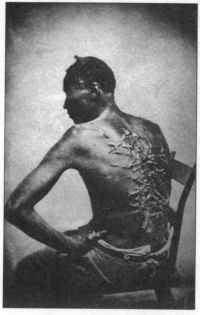

**FIGURE 4-2:**
Scars from a brutal beating.

MPI/Getty Images

Escaping slavery was extremely difficult, and some people developed ingenious plans for success. There was no end to the lengths enslaved people would go to obtain their freedom. Here are a few examples:

>> No longer able to cope with her slaveholder's sexual advances, Harriet Jacobs hid in a crawl space in her grandmother's attic for seven years to escape molestation before finally fleeing North to freedom.

>> Husband and wife William and Ellen Craft escaped slavery in Macon, Georgia, when the fair-skinned Ellen posed as a young and sickly slaveholder accompanied by his property.

>> Henry "Box" Brown placed himself in a box with a jug of water and some biscuits and mailed himself from Richmond, Virginia, to Philadelphia.

**TECHNICAL STUFF**

It has been estimated that 89 percent of all enslaved runaways were male, with 76 percent of them under age 35. Women, especially mothers, rarely ran away, and husbands often were reluctant to leave their wives, children, and other close family members, which is why many historians now argue that slaveholders encouraged family life on their plantations. More closely supervised house slaves rarely had opportunities to flee. However, enslaved individuals who worked in the house did help those enslaved who were seeking to run away.

# "Free" Black People

Not all Black Americans in the United States were enslaved. But "free" Black Americans were far from free; often resented by white people (both slaveholders and non-slaveholders), free Black people faced tremendous restrictions. In the South especially, they had to carry papers proving their freedom to avoid enslavement. In addition, slave codes regularly included restrictions on free Black people. For example, they had to have sponsors if they wanted to purchase property.

# Different paths to freedom

Enslaved Black people gained their freedom in several ways:

>> By running away from slaveholders and moving to the North.

>> By being freed by slaveholders who became Christians and had a change of heart regarding slavery. As the years wore on, some states discouraged this activity, which sometimes resulted in as many as 400 enslaved people receiving their freedom at once.

>> By being freed upon their slaveholders' deaths.

>> By being fathered by slaveholders, who sometimes felt compelled to free their children and their children's mothers. In his will, Thomas Jefferson legally freed two of his four surviving children with Sally Hemings. Prior to his death, the other two were reportedly allowed to leave but not legally freed.

>> By performing such exceptional acts as fighting valiantly in the American Revolution.

>> By purchasing their freedom. With the permission of their slaveholders, enslaved people such as blacksmiths and carpenters hired themselves out, collected pay for their work, and purchased their freedom. The price could range from $800 to more than $1,200. Husbands in the North sometimes labored for years to purchase the freedom of their children and wives.

>> By being born to a free mother. The mother's condition determined freedom (laws dictated that children born to free women were free). For this reason, many Black men who could purchase their freedom opted to free their wives first, particularly if they hadn't had children yet, so that their children would be born free.

>> Be being born to a white mother. Although it was very uncommon, there are a few documented incidences of white women fleeing with their Black lovers.

# Perhaps free, but not equal

Regardless of how free Black people came to be free, they did enjoy some of freedom's benefits. In 1800, Philadelphia's free Black community owned almost 100 houses and lots. In 1837, New York's Black community owned $1.4 million in property. Free Blacks in the South also owned property, with some amassing considerable amounts. Despite the backlash following Nat Turner's Rebellion in 1831 (see the section "Nat Turner's Rebellion" earlier in the chapter), Virginia's free

Black population owned 60,000 acres of farmland in 1860. By far, New Orleans had the wealthiest community of free Black people: In 1860, they owned in excess of $15 million worth of property. Thomy Lafon, a wealthy New Orleans real estate broker born free in 1810, was so philanthropic that the Louisiana State Legislature commissioned a bust of him following his death in 1893.

Some few free Black people like Mississippi's William Johnson, known as the Barber of Natchez, were slaveholders (see the nearby sidebar). However, a larger number of wealthy free Black people purchased their own family members out of bondage as well as helped fund various antislavery causes.

Amassing wealth wasn't easy, but many Black Americans were very industrious. Free Black people in Massachusetts (Boston in particular) worked as engravers, tailors, teachers, and lawyers. Skilled Black people working as blacksmiths and carpenters weren't uncommon in such Southern cities as Charleston, Atlanta, and Richmond. There were also Black shopkeepers, barbers, and builders. Domestic work was common as well. Whites who objected to Black people working in factories or in the shipyards relented when western expansion created a shortage of white workers. European immigrants who began coming to the U.S. in droves, however, greatly threatened the economic stability of many free Black people.

**BLACK AMERICAN FACES**

# BLACK SLAVEHOLDER WILLIAM JOHNSON

Born enslaved in 1809 and emancipated by his slaveholder, most likely his father, in 1820, William Johnson, a barber by trade, established a barbershop and bathhouse in Natchez, Mississippi, and acquired several landholdings. He has become a notable figure not because of his achievements but because his personal journals are a rare glimpse into the life of a Black slaveholder.

In his diaries, Johnson, who legally owned 15 people when he died in 1851, details attending auctions and purchasing and enslaving other Black people. He even discusses whipping them. Sometimes, being cognizant of the limitations placed on his race, Johnson arranged for white associates to attend auctions and make purchases on his behalf. He also recounts witnessing a free Black person being kidnapped into slavery.

To historians' dismay, Johnson never explored his own feelings regarding his contradictory status. In 1951, Johnson's diaries were published in the book *William Johnson's Natchez: The Ante-Bellum Diary of a Free Negro* (LSU Press).

Despite the wealth free Black people amassed or the industriousness with which they worked and lived, they weren't equal to white Americans. In order to sell corn, wheat, or tobacco in Maryland in 1805, for example, free Black people needed a license; white people didn't. Although states such as Maryland, Tennessee, New York, and Pennsylvania gave free Black people the right to vote prior to the American Revolution, that privilege ended in the 19th century. Maryland's free Black community lost the right to vote in 1810, while those in Tennessee and North Carolina lost the right in 1834 and 1835, respectively. Thomas Jefferson signed an 1802 bill banning free Black people from voting in the nation's capital of Washington, D.C., and, in 1821, New York instituted a voting-related property qualification that applied only to Black people. Ironically, even without the right to vote, Black people were still required to pay taxes, sometimes more than their white counterparts who could vote.

Toward the middle of the 19th century, some Southerners advocated enslaving all Black people. Already this new nation based in freedom had purchased the liberty of its white citizens by denying the same right to its Black citizens. Perhaps no other group recognized this hypocrisy as clearly as free Black people. Throughout the early 19th century, proslavery and antislavery camps galvanized. In the decades leading up to the Civil War, the majority of Black Americans, enslaved and free, assisted by some moral and courageous white people, inched closer and closer to ending slavery.

IN THIS CHAPTER

» **Organizing to end slavery**

» **Spreading the abolitionist message**

» **Considering the emigration option**

» **Going underground**

» **Stretching the divided nation too far**

# Chapter **5**

# Bringing Down the House: Marching toward Civil War and Freedom

The American Revolution that I discuss in Chapter 3, awakened many white Americans to the paradox of American slavery and American freedom. That awakening profoundly affected Black people and the nation overall. As a number of white Americans enlisted in the fight to end slavery, emotions rose considerably in the new nation. After the War of 1812, antislavery and proslavery arguments grew more intense. While the North moved toward manufacturing and nonagricultural work where enslaved labor wasn't needed, the South remained committed to agriculture and enslaved labor.

Those two disparate economic realities created a form of sectionalism that still marks the nation. Expanding the new nation westward only exacerbated those tensions. With lines drawn, mainly along the lines of North and South, tensions spilled over into many facets of American life. Nowhere was the animosity more dramatic than in the halls of government.

This chapter explores the abolition movement and its impact on a growing complex nation. It delves into the Underground Railroad and the founding of the Black press, as well as examines the key legal cases and governmental showdowns that finally brought the nation to civil war.

# Picking Fights

Prior to the American Revolution, some white colonists began questioning the institution of slavery. In 1763, James Otis of Massachusetts, who is credited with coining the phrase "no taxation without representation," argued in his pamphlet *The Rights of the British Colonies Asserted and Proved* that all men, white and Black, are born free. The Quakers, popularly known as the Society of Friends, were the first white people to organize against slavery, although some Quakers did own slaves at one time. They began speaking out against slavery as early as 1688 and published their first antislavery tract in 1693. Most of the Quakers' antislavery activity filtered through the Society of Friends, which championed religious freedom, education, and egalitarianism.

Abolitionist societies such as the following were formed (interestingly, abolition and manumission societies, especially early organizations, didn't necessarily include Black members):

» **Pennsylvania Abolition Society (PAS):** Founded by well-known Quaker Anthony Benezet in 1775, the Society for the Relief of Free Negroes Unlawfully Held in Bondage was the first acknowledged American abolition society. The organization, later known as the Pennsylvania Abolition Society, suspended meetings during the American Revolution but reorganized itself in 1784 and 1787, incorporating in 1789. Former slaveholder Benjamin Franklin served as president, even bringing a petition for the abolition of slavery and the slave trade to the nation's first Congress just months prior to his death in 1790.

» **New York Manumission Society:** Founded in 1785, this organization, with leadership from Founding Fathers John Jay and Alexander Hamilton, succeeded in ending slavery in New York. *Note:* Hamilton had a history of buying and trading enslaved people during his early years it was revealed in 2020, and it's been said he also bought and sold enslaved Africans for his wife's family.

» **New England Anti-Slavery Society:** Massachusetts, particularly Boston, became another abolition stronghold. Prominent white abolitionist William Lloyd Garrison helped establish this society in 1832. The Society's goals were to abolish slavery in the United States and secure equal civil and political rights for Black Americans.

» **American Anti-Slavery Society:** Established in Philadelphia in 1833 and led by William Lloyd Garrison, the society's stated goal was to end slavery in the United States.

Although relatively few in number, antislavery organizations did exist in the South during the early 19th century. That changed in time, particularly following Nat Turner's Rebellion (refer to Chapter 4), when all abolitionist activity in the South came under fire and the mere suspicion of antislavery behavior invited retaliation. Individuals who were involved were faced with the possibility of arrest and charged with criminal activity.

Of course, proslavery forces sprouted to counter antislavery activity. Prominent proslavery supporters included Southern politician John C. Calhoun, who proclaimed slavery "a positive good" before the U.S. Senate in 1837, and Samuel F.B. Morse, the man behind the telegraph and Morse code. White Southerners had a number of proslavery organizations, but the American Colonization Society, with its mission to send free Black Americans back to Africa, is among their more well-known efforts.

During this charged period, antislavery and proslavery forces defined and refined their arguments. With sides clearly drawn, they fought steadily well into the Civil War. The following sections outline key arguments for both sides.

## Arguing against slavery

**IN THEIR OWN WORDS**

Ironically, much of the credit for the increased intensity in antislavery efforts goes to the English and other Europeans, who began to question slavery as an institution. Scottish philosopher and economist Adam Smith, the author of fundamental texts on capitalism, free trade, and economics in general, claimed slavery wasn't profitable and actually retarded progress. "From the experience of all ages and nations, I believe, that the work done by free men comes cheaper in the end than the work performed by slaves. Whatever work he does, beyond what is sufficient to purchase his own maintenance, can be squeezed out of him by violence only, and not by any interest of his own," he wrote in his influential *The Wealth of Nations.*

Other arguments against slavery included the following:

>> **It was anti-Christian.** Many antislavery advocates were deeply religious and used Christianity to argue against slavery. They insisted Jesus Christ taught universal brotherhood and established the equality of all men as a cardinal principle of Christianity.

>> **It violated American values.** Antislavery factions argued that slavery violated the core American value of freedom that Americans had fought for and won during the American Revolution.

>> **It threatened the security of the nation.** Slavery not only was inefficient but also threatened the peace and security of the nation because white Southerners lived in fear of slave revolts such as Nat Turner's Rebellion in 1831 (see Chapter 4 for more on rebellions).

# Arguing for slavery

"Black inferiority" formed the cornerstone of the proslavery argument. According to slavery's strongest supporters, Black people weren't quite fully human and retained childlike qualities even in adulthood. Because Black people weren't intellectually and socially equipped for freedom, this *social paternalism* argument continued, slavery was a public good borne out of necessity. Proslavery supporters often denied slavery's brutality, insisting only extreme misbehavior prompted extreme force.

Following are other arguments supporting slavery:

>> **It was biblical.** Proslavery proponents noted the many instances of slavery in the Bible. The curse of Ham, when Noah punished Ham's son Canaan to life as a servant, was immediate proof of God's intention that Black people (then often referred to as the children of Ham) be enslaved. Jesus, according to proslavery supporters, never denounced slavery.

**IN THEIR OWN WORDS**

"We assert that the Bible teaches that the relation of master and slave is perfectly lawful and right, provided only its duties be lawfully fulfilled," wrote Southern theologian Robert Lewis Dabney in his proslavery book *A Defence of Virginia* (1867).

>> **It was used to "tame" and proselytize.** Slavery was used as a means for "civilizing" Africans and introducing Christianity.

>> **It allowed American advancement.** According to Edward Brown in *Notes on the Origin and Necessity of Slavery* (1826), "slavery has ever been the stepladder by which countries have passed from barbarism to civilization." South Carolina Governor and one-time U.S. Senator James Henry Hammond in his 1858 address to the Senate contributed his mudsill theory to that rationale, proclaiming that "in all social systems there must be a class to do the menial duties, to perform the drudgery of life."

>> **It ensured the security of the nation.** Proslavery forces contended that slavery helped maintain the social order. Without it, they argued, violence would erupt and white people, especially white women, would be unsafe. Slavery, in their assessment, was a positive good.

# Leading the Antislavery Assault: Key Abolitionists

Some of the most outspoken Black antislavery advocates had been formerly enslaved. Frederick Douglass, Harriet Tubman, and Isabella Baumfree, better known as Sojourner Truth, are the most well-known among the once enslaved turned abolitionists, but author William Wells Brown and activist Henry Highland Garnet were also popular. Free-born Black Americans also identified with the struggle against enslavement. Siblings Charles Lenox Redmond and Sarah Parker Redmond, as well as author Frances E.W. Harper, frequently lectured against enslavement. Noted mathematician Benjamin Banneker, who was born free, even sent a plea for justice and equality to Thomas Jefferson.

Although Black Americans spearheaded their own freedom efforts, the nation was predominantly white. Thus, white abolitionists and their resources were critical in the fight to end the institution. Two such abolitionists, Anthony Benezet and William Lloyd Garrison, were among the movement's most revered figures. This section provides details about a handful of the many abolitionists who were particularly influential in the fight against slavery.

**REMEMBER**

As free Black people increased their resources, they became more vocal not just about ending slavery but also about Black Americans attaining true equality. The latter was especially important because white abolitionists didn't necessarily believe that Black Americans should receive the same treatment as white Americans.

## Anthony Benezet

Anthony Benezet, whose family fled religious persecution in France, was one of the first in the abolition movement. A Quaker convert who studied Africa to better aid his cause, Benezet wrote influential antislavery pamphlets:

>> His *A Short Account of That Part of Africa, Inhabited by the Negroes* (1762) helped British antislavery leader Thomas Clarkson clarify his position on slavery.

>> Methodism's founder John Wesley incorporated Benezet's *Some Historical Account of Guinea* (1771) into his sermons in Britain against the slave trade.

Benezet, a pioneering force behind the nation's first abolition society better known as the Pennsylvania Abolition Society (see the earlier section "Picking Fights"), also worked overtime to ensure the passage of the Act for the Gradual Abolition of Slavery by the Pennsylvania Assembly in 1780.

# David Walker

Few abolitionists, Black or white, matched David Walker's revolutionary spirit, especially in the 1820s when calls for gradual emancipation prevailed.

**REMEMBER**

In 1829, David Walker, born in North Carolina to a free mother and an enslaved father, published his highly controversial *Walker's Appeal.* In his *Appeal,* Walker praised enslaved people who defended themselves against their masters. At a time when many Black people, even abolitionists, refrained from advocating violent and rebellious action against slavery, Walker dared to suggest enslaved people kill their masters for their freedom. Of course, this scared many slaveholders who already feared slave rebellions. It also scared many white abolitionists who usually favored gradual emancipation. Walker's direct address to enslaved and free Black people to take the fight for freedom into their own hands, even if it meant using violence, distinguished his *Appeal* the most.

Walker's message was deemed so incendiary that a bounty of $3,000 was placed on his head, with some Southern states offering $10,000 to anyone who brought him in alive. In some places in the South, those caught with *Walker's Appeal* risked fines and imprisonment. When Nat Turner and others enslaved later rebelled, white Southerners didn't blame slavery for the rebellion but rather *Walker's Appeal* for encouraging it. Despite the risks, Walker refused to hide and instead produced more editions of the controversial treatise. Shortly after the third edition was distributed in 1830, Walker was found dead. At the time, it was assumed to be murder, but today many historians believe he died of tuberculosis, which also killed his daughter.

# William Lloyd Garrison

Born in Massachusetts, William Lloyd Garrison, mentored by abolitionist publisher Benjamin Lundy, initially advocated for gradual emancipation and supported recolonization efforts in Africa to free Black people. By the 1830s, however, he supported immediate emancipation and distanced himself from the American Colonization Society.

To reinforce his newfound advocacy of *militant abolitionism,* or the immediate abolishment of slavery without violence, Garrison launched his own antislavery publication, *Liberator,* in 1831. Garrison didn't relegate his brand of militant abolitionism (known as *Garrisonism*) to his newspaper. Instead, he established the New England Anti-Slavery Society in 1832 and spearheaded the American Anti-Slavery Society, which began publishing the *National Anti-Slavery Standard* in 1840.

**TECHNICAL STUFF**

Over the years, Garrison rejected not only slavery but the Constitution as well. He and Frederick Douglass were divided on this issue. Garrison supported burning the Constitution, which he contended was a proslavery document, whereas Douglass favored using it as a tool to end slavery. Undoubtedly, the House of Representatives' 1836 decision to ignore petitions against slavery, a policy that lasted until 1845, only reinforced Garrison's point. Garrison's unwillingness to accept Douglass's independence also created a rift between them. When the two disagreed on John Brown and his actions, for instance, Garrison presumed Douglass wasn't thinking independently. He also discouraged Douglass from pursuits independent of him.

## Frederick Douglass

Born into slavery in Maryland in 1818, Frederick Douglass, shown in Figure 5-1, is perhaps America's most well-known abolitionist. One of the first truly prominent Black Americans on both a national and international level, Douglass, the son of a slave mother who died when he was 7 and an unknown white man, learned to read and write at an early age. Set on freedom, Douglass, after one failed escape attempt, finally succeeded in 1838. After spending a brief time in New York where he was also married, he and his new wife settled in New Bedford, Massachusetts.

**FIGURE 5-1:** Frederick Douglass.

MPI/Getty Images

A *Liberator* subscriber, Douglass went to see Garrison speak in 1841 and impressed Garrison, who became a mentor. Days after that meeting, Douglass delivered a speech of his own, and his career as a master orator began. Encouraged to write

about his personal experience with slavery, Douglass published his classic text *Narrative of the Life of Frederick Douglass* in 1845. Fearing that the text could prompt his re-enslavement, Douglass went to Europe, where he lectured in England, Scotland, and Ireland.

Back in the United States, Douglass began publishing his own newspaper and developing his own ideas about freedom. He campaigned relentlessly to end slavery and procure equal rights for Black Americans. Thus, he became a titan within the Black American community until his death in 1895.

# Fighting with Words

Many Black abolitionists favored moderate and strategic action over violence to end slavery. Because white Americans outnumbered Black Americans, violence wasn't a viable option. Even in communities where Black people weren't outnumbered, their behavior was so restricted that amassing substantial firepower would have been difficult. So the pen became one of the biggest weapons against slavery.

REMEMBER

Fearing Black literacy, proslavery factions passed many laws restricting the teaching of reading and writing to Black people. Mere suspicion of being able to read and write posed a danger to many Black Southerners, enslaved or free (read more about education in Chapter 13).

## Slave narratives

Early accounts of how enslaved Blacks lived was distorted and didn't show how they actually lived. Slave narratives were open testimony from those who actually survived the horrors, and they enlightened those who were clueless about life in bondage. Slave narratives such as *Narrative of the Life of Frederick Douglass* (1845) and Solomon Northrup's *Twelve Years a Slave* (1853) were important antislavery treatises that in the United States and in England.

Douglass's narrative like other slave narratives created an emotional connection with readers; his provided details about slavery's horrors that made readers feel how horrible slavery was. Other narratives outlined the injustices, but Douglass tugged at readers' heartstrings. His work underscored the fact that Black people were indeed human beings. Slave narratives' ability to create a human connection also played an important role in the early development of Black American literature, which you can read about in Chapter 14.

# Origins of the Black press

White abolitionists proved that newspapers such as Benjamin Lundy's two publications, *The Philanthropist* and *The Genius of Universal Emancipation*, and Garrison's *Liberator* could be very effective tools in the fight against slavery. Black publishers found that newspapers specifically targeting Black people created forums in which they could truly express who they were and where they were going. Early Black newspapers began the important legacy of providing the Black community with a voice that celebrated Black milestones as well as agitated for equal rights. The Black press also became an important mechanism for galvanizing Black people nationally.

Prior to the Civil War, more than 40 newspapers emerged, but *Freedom's Journal*, launched by Samuel E. Cornish and John B. Russwurm, and *The North Star*, launched by Frederick Douglas, were two of the most important.

>> **Freedom's Journal:** The nation's first Black newspaper, *Freedom's Journal* pushed for an end to slavery and informed the more than 300,000 free Black people in the U.S. about national and international news. The newspaper included profiles of great Black Americans as well as stories about often-ignored historic achievements.

**TECHNICAL STUFF**

At its height, *Freedom's Journal*'s distribution spanned 11 states; Washington, D.C.; Haiti; Europe; and Canada. Unfortunately, it folded in March 1829, in part because coeditors Russwurm and Cornish disagreed over the issue of colonization.

>> **The North Star:** Frederick Douglass's *The North Star,* first published in 1847, became the most prominent of all early Black newspapers mainly because of Douglass's stature. *The North Star* went beyond just advocating slavery's end and equal rights for Black Americans; it also championed equal rights for women. Its motto was "Right is of no Sex — Truth is of no Color — God is the Father of us all, and we are all brethren."

Within these pages, Douglass expanded his vision of freedom and, like *Freedom's Journal,* provided a forum for critical Black issues overlooked by white abolitionist papers. The paper was far from a financial success, however. To stay afloat, Douglass continued lecturing. In 1851, he merged his paper with the *Liberty Party Paper* to form *Frederick Douglass' Paper*, which published until 1860. Douglass published a monthly before settling into political life in the 1870s.

# Colonization (or Emigration) Movement

Proslavery Southerners frequently argued that liberating Black people would create chaos and endanger the republic. Ironically, many white abolitionists didn't necessarily intend for Black Americans to live among them. For members of both camps, *colonization* answered the question of what to do with emancipated Black people.

Colonization became one of the main objectives for the Connecticut Emancipation Society, and in 1777, Thomas Jefferson headed a Virginia legislative committee intended to gradually emancipate and deport enslaved people. Interestingly, some of the most definitive steps taken toward colonization came from Black Americans, who preferred the term emigration.

# Early resettlement efforts

Prompted by the poor treatment free Black people who didn't live in bondage received, leaders of the Free African Union Society (founded in Newport, Rhode Island, in 1780) decided in January 1787 to create their own settlement in Africa.

The Free African Union Society eventually connected with free Black people in Boston whose goals matched their own. Led by Prince Hall, founder of the first Black lodge of Freemasons (refer to Chapter 3), 75 Black Americans had already petitioned the Massachusetts legislature for its assistance in relocating them back to Africa. The Society also connected with London's Granville Sharp, who was working with the proposed Sierra Leone settlement intended to rid England of unemployed Africans, many of whom were former enslaved Americans freed by the British during the American Revolution.

Despite its best intentions, the Free African Union Society never succeeded in its goal to resettle Black people in Africa. (Internal wars with natives of Sierra Leone also hampered efforts.)

# Cuffe: Man on a mission

The efforts of Paul Cuffe, a successful Black maritime entrepreneur and whaling captain with Native American roots, met with different results, however. Dismayed by the treatment of free Black people, Cuffe, a converted Quaker, felt that for most Black people, returning to Africa would be better than remaining in the United States.

He consulted with the African Institution, a British organization established in 1807 to address the welfare of Africans and the suppression of the slave trade with special interests in Sierra Leone, before traveling to Sierra Leone with a crew of nine Black seamen. He met with chiefs and other local officials to assess Sierra Leone's potential as a home for Black people. From there, he visited England, which received him well. Pressured by the African Institution, England granted Cuffe a trading license as well as land in Sierra Leone.

The War of 1812 and family trials delayed but didn't destroy Cuffe's plans. In December 1815, using his own money, Cuffe departed the United States for Sierra Leone. In February 1816, he delivered 38 Black settlers, nine families comprising 18 adults and 20 children, with settling in Sierra Leone.

**HISTORICAL ROOTS**

Although Cuffe, who died in 1817, never emigrated himself, his success in resettling others prompted white colonization proponents to form the American Colonization Society in 1816. In 1820, the American Colonization Society, whose membership included prominent white Americans such as Henry Clay, sent its

first group of free Black people to Sierra Leone. By 1830, 1,420 Black people had settled near Sierra Leone in their own colony, Liberia, whose capital Monrovia they named in honor of U.S. President James Monroe.

## Questioning motives

Public positions on the issue of Black colonization varied. Slaveholders supported colonization efforts primarily because they viewed colonization as a solution to dealing with free Black people. Many free Black people opposed to colonization because they felt that their removal would allow slavery to flourish. Black abolitionist and politician Martin R. Delany didn't oppose Black emigration but did object to the American Colonization Society. Delany, who later established his own organization to resettle Black Americans in Liberia, charged that the society's goal was to eliminate Black people from the United States and labeled its leaders "anti-Christian" and "hypocrites."

Some free Black people participated in colonization efforts in Africa in order to spread Christianity, but overwhelmingly, Black people refused to leave the United States and chose to fight for the emancipation of all Black people in it.

# The Effects of Proslavery Politics

Of course, antislavery activity didn't sit well with proslavery factions. Each year, proslavery and antislavery forces appeared more divided. Those tensions only intensified as new territories sought entry into the union. As the antislavery factions tried to tilt the nation toward freedom, proslavery supporters put more pressure on the government and the legal system. They focused their efforts on the U.S. Constitution and the new Western territories.

## The Fugitive Slave Clause

Since antislavery activity began prior to the American Revolution, slavery was a major issue during the formation of the United States. Some Northern states had already made the decision to abolish slavery before the Constitution became a reality.

**TECHNICAL STUFF**

Vermont, with its 1777 constitution, has the distinction of being the first state to ban slavery.

Unlike the three-fifths compromise and the agreement to abolish the slave trade in 1808, the Fugitive Slave Clause came late in the proceedings at the Constitutional Convention and curiously invited little resistance from Northerners. Without specifically using the terms "slave" or "slavery," Article IV, Section 2 of the Constitution established the following protocol:

> No person engaged in service in one state could escape that service by fleeing to another state. Once the person to whom service was due made a claim, that person had to return.

## Stronger fugitive slave measures: Fugitive Slave Act of 1793

It didn't take long for Southerners and Northerners to clash over the fugitive slave issue. When three Virginia men kidnapped a fugitive slave living freely in Pennsylvania, the governor there demanded that Virginia expedite the captured. Virginia's noncompliance prompted Pennsylvania to appeal to President George Washington who referred the matter to Congress. In response, Congress passed the Fugitive Slave Act of 1793, which made the recovery of fugitives a federal matter.

With the federal government's blessing, slaveholders could follow those who escaped slavery to the North, seize them, and appear before a judge who could side with them without allowing the enslaved person to present his or her side of the story. This one-sidedness also left free Black people and children born to fugitives vulnerable to enslavement. That reality compelled more Northerners to join the Underground Railroad.

## Battling over the slave status of new land

Originally, the Northwest Ordinance of 1787 (passed under the Articles of Confederation a few months before the ratification of the U.S. Constitution) banned slavery in new territories but mandated the return of fugitive slaves. As the United States expanded, however, that policy changed, with new territories becoming fair game for slavery or freedom. Westward expansion, a movement largely facilitated by the Louisiana Purchase of 1803, ignited tension between the North and the South. The purchase garnered the U.S. land encompassing all or parts of modern-day Arkansas, Iowa, Kansas, Louisiana, Missouri, Montana, Nebraska, New Mexico, North Dakota, Oklahoma, South Dakota, Texas, and Wyoming, among other areas.

The issue of whether these areas were free or slave territories came to a head in 1819 when Missouri applied for statehood. Attempts to balance the number of slave and free states and various territories only created greater division between the two sides of the argument.

## The Missouri Compromise

When Missouri sought statehood in 1819, Northerners attempted to block its entry as a slave state, a major problem because slavery already existed in the territory. (*Remember:* Missouri was considered a southern state.) New York Congressman James Tallmadge introduced an amendment that limited slavery in Missouri and even proposed to free the children of those already enslaved. The measure passed the House but failed the Senate. Complicating matters further, Alabama gained admission to the Union as a slave state in 1819, balancing the number of slave states and free states. Known as the Missouri Compromise of 1820 (sometimes the Compromise of 1820), Maine entered the Union as a free state, thus allowing Missouri to enter the Union as a slave state, making the count 12 slave states and 12 free states.

REMEMBER

The Missouri Compromise extended the Mason–Dixon line, which divided the North from the South, free states from slave states, westward.

# The Underground Railroad

In the face of Constitutional amendments protecting slavery and rancorous debate over whether new states would be free or slave (as described in the preceding section), some abolitionists decided to take stronger proactive measures to end slavery by helping enslaved people escape to freedom.

Runaways or freedom seekers from the South often found liberty in Northern states, especially as the North began to ban slavery. Yet the odds of successfully eluding a slaveholder and actually making it to the North was nearly impossible, especially if one was unassisted. To increase the success rate of such bold action, the Underground Railroad developed. Although scholars believe that this complex system of escape tactics and routes, secret agents, and safe houses began in 1787, it reached its height between 1810 and 1850. An estimated 30,000 to 100,000 slaves escaped via the Underground Railroad over the course of its operation.

Heavily staffed by Quakers and free Black people, the Underground Railroad evolved over time. Initially some slaveholders permitted the purchase of runaways, so members of the Underground Railroad gathered funds to facilitate

freedom in that manner. As more enslaved people fled, however, slaveholders insisted on their return. Underground Railroad supporters remained undaunted. Sometimes entire towns backed the Underground Railroad and stood firm against slaveholders or their agents who tried to retrieve fugitives.

## Operation Freedom

To avoid capture, runaways typically traveled at night, using the North Star as their guide and travelling along rivers. Therefore, the Underground Railroad became most useful during the day, so abolitionists established secret stations along the way to provide places to rest.

These stations were particularly critical in the South, where the free Black population remained small and recovery efforts were particularly intense. Either someone escorted those seeking freedom to stations or safe houses or the runaway slaves typically identified safe houses by a quilt hanging in the window, a lit lantern at the front of the house, or other signs (like clovers). Secrecy was required within the safe houses as well, so they often contained secret passageways, water wells, and attics where runaways could hide.

Usually, it was the responsibility of enslaved people to plan their own escape. Sometimes, free Black people came to plantations posing as enslaved people to help others flee. Other times runaway slaves had to reach certain points where agents known as conductors greeted them. The journey north was usually a combination of travel by foot, by horse and buggy, and even by boat. For example, Calvin Fairbanks, a white man who developed his distaste for slavery while attending Oberlin College, regularly transported fugitives who made it to Kentucky across the Ohio River to freedom. Because slave catchers also patrolled the North, some runaways settled in Canada.

In order to escape from slavery, individuals needed money, food, and clothes. Participating in the Underground Railroad was very dangerous, even for white people. Fairbanks spent more than a decade in a Kentucky prison for his role in aiding fugitives. It was also costly. Thomas Garrett of Wilmington, Delaware, went bankrupt paying a $10,000 fine for his admitted role in assisting fugitives.

## Key people along the line

Historians believe that the Underground Railroad may have originated with the Quakers in the late 1780s (or when the first enslaved person ran away), so it's no surprise that they compose a large portion of white supporters. White participants, even those who weren't Quakers, tended to be religious and included

Presbyterians, Baptists, Methodists, Episcopalians, and Catholics. For them, God's law superseded human laws. Their occupations ranged from preachers and politicians to ordinary citizens. Jacob M. Howard, a Michigan Underground Railroad supporter who later became a Republican senator, introduced the Thirteenth Amendment, which abolished slavery.

Ohio, Pennsylvania, Illinois, and Michigan were just a few Underground Railroad strongholds. It wasn't completely uncommon for entire towns to participate. Oberlin and Ripley in Ohio had a large number of participants, many of them unknown. Levi Coffin and John Fairfield were two of the more prominent white participants of the Underground Railroad:

>> **Levi Coffin:** Sometimes called "the President of the Underground Railroad," North Carolina–born Levi Coffin and his wife Catharine used their strategic location in southern Indiana, the modern-day Fountain City, to help more than 2,000 enslaved people escape to freedom over the course of nearly 20 years. A successful merchant, Coffin personally helped finance many Underground Railroad efforts, so many fugitives came through his home that people renamed it "Grand Central Station." Coffin's reputation as a model citizen inspired other white people to become involved with the Underground Railroad. His 1847 relocation to Cincinnati, Ohio, where he died many years later, didn't end his Underground Railroad activities.

>> **John Fairfield:** Hailing from a slaveholding family in Virginia, John Fairfield, who abhorred slavery, became involved in the Underground Railroad when he helped an enslaved friend escape to Canada. Subsequently, other Black people, presumably in the Ohio area where he spent a lot of time, sought him out and paid him to help their relatives and friends escape. Posing as a slaveholder, a slave trader, and sometimes a peddler, Fairfield was able to gain the confidence of white people, which made it easier for him to lead escapees to freedom. One of his most impressive feats was helping to free 28 enslaved people by staging a funeral procession. While he led many of his charges to Canada, others he delivered to Coffin, who handled the remainder of their escape.

Black people were intrinsically involved in the Underground Railroad beyond just being fugitives. It was understandably harder for white participants to convince Black Americans to flee. Fugitives were particularly convincing, and a large number risked their own freedom to free others. Besides, it was also easier for Black people to blend in, especially on large plantations.

Black people had a higher emotional investment because many had relatives and close friends still in bondage. Their job didn't end with the escape though. Fugitives often stayed with other Black folks. They frequently settled in Black

communities where they learned where to look for work as well as how to conduct themselves, among other things. Despite the tremendous risks of recapture or becoming enslaved for the first time, Black people on all levels vigorously participated in the Underground Railroad and other antislavery efforts. Douglass's Rochester, New York, home was a well-known station.

Other courageous figures of the Underground Railroad include the following:

>> **William Still:** Philadelphia abolitionist Still, revered as "the Father of the Underground Railroad," assisted as many as 60 escapees a month. Despite the great need for secrecy, the New Jersey–born Still kept meticulous records. Those biographies and details of how each individual escaped later composed the book *The Underground Railroad* (1872).

>> **Elijah Anderson:** Anderson, a fugitive with light skin who sometimes posed as a slaveholder, reportedly led 1,000 fellow escapees to freedom. Following a conviction for violating the Kentucky law against "enticing slaves to run away," he was suspiciously found dead in a Kentucky prison the day of his release.

>> **Jane Lewis:** New Lebanon, Ohio, resident Lewis rowed countless escapees across the Ohio River to freedom.

>> **Arnold Gragston:** Though enslaved himself in Kentucky, Gragston rowed countless others across the river to freedom in Ohio for at least four years until having to seek freedom himself to avoid being killed.

>> **John Mason:** Mason, a fugitive from Kentucky who was once recaptured only to escape again, helped more than 1,000 escapees to freedom. In just 19 months, he reportedly delivered 256 escapees to Rev. W. M. Mitchell's Ohio home.

>> **Rev. W. M. Mitchell:** Mitchell was born free to a Native American mother and a Black father in North Carolina but was orphaned at a young age. As a child, he was an apprentice to a plantation owner and witnessed the horror of enslavement up close. In Ohio, he operated the Underground Railroad safe house utilized by Mason. Mitchell, who later continued his work as a reverend and missionary in Canada, is said to be the only person to write a book, *The Under-ground Railroad* (1860), about the network while it was illegal.

>> **Harriet Tubman:** No Underground Railroad figure matches the legend of Harriet Tubman, one of its rare known female conductors (see Figure 5-2). Even as a young enslaved girl, Tubman, born Araminta Ross in Maryland around 1820, selflessly protected others: While shielding a field slave from an angry overseer, she received a blow on the head that made her prone to falling into a deep sleep at times throughout her life. Unwilling to be sold, Tubman fled north in 1849. She got a job in Philadelphia but traveled back the next year to free her sister and her sister's two children. Tubman made an amazing

BLACK
AMERICAN
FACES

19 trips back South, personally freeing at least 70 other enslaved people, including her parents.

Often dubbed "Moses" for leading "her people" out of bondage, Tubman died in 1913 in her adopted home of Auburn, New York. "[I]n the point of courage, shrewdness, and disinterested exertions to rescue her fellowman," wrote William Still, "she was without equal."

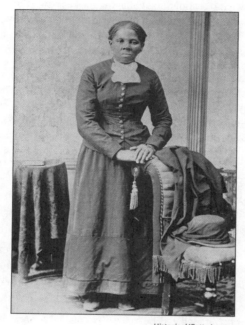

**FIGURE 5-2:**
Harriet Tubman.

*Historical/Getty Images*

**TECHNICAL
STUFF**

Because runaway notices weren't posted until Monday, Tubman favored traveling on Saturdays, often carrying a drug to silence crying babies and a gun to urge on fugitives who wanted to give up along the way. Tubman, who reportedly made her last trip south in 1860, was never caught. During the Civil War, she worked various jobs, sometimes concurrently, as a laundress, nurse, and spy. As a mastermind and key strategist of the Combahee Ferry Raid in South Carolina in June 1863, she and 150 Black Union soldiers rescued more than 700 enslaved people, making her the first American woman to lead a major military operation.

## Message in the music

When it came to the Underground Railroad, spirituals were much more than songs of worship. As Douglass indicated in *My Bondage, My Freedom*, spirituals held deep meaning. Just as the drums had allowed the enslaved to communicate from plantation to plantation, so did the spirituals. Countless numbers of enslaved people were able to escape through the Underground Railroad in part due to spirituals.

Certain songs delivered messages about secret meetings or clues about escape routes. "Follow the Drinkin' Gourd" directed runaways to travel in the direction of the Big Dipper while "Steal Away" and "Swing Low, Sweet Chariot" often signaled someone was going to flee. (It also indicated when the river was low enough to cross or an individual would be nearby to help anyone wanting to run.) When Tubman went to forage for food for her "passengers," she would reportedly assure them she had returned by singing "Dark and thorny is de pathway/Where de pilgrim makes his ways/But beyond dis vale of sorrow/Lie de fields of endless days." Another song, "Go Down Moses" — with the lyrics "Oh go down, Moses/Way down into Egypt's land/Tell old Pharoah/Let my people go" — is often sung in tribute to Tubman, honoring her as the Moses of her people. Read more about music in Chapter 16.

# The Breaking Point

Marching into the 1850s, the divide between slavery and freedom became harder to manage. Foreseeing victory in the Mexican–American War (1846–1848) and the new territory that would come with it, political leaders sought ways to determine the status of any new territory:

>> The Wilmot Proviso proposed to outlaw slavery in any annexed territory.

>> Some leaders insisted that new territory follow the precedent of the Missouri Compromise and be equally divided into slave and free states (refer to the section, "The Missouri Compromise," earlier in the chapter).

>> Illinois Congressman Stephen A. Douglas, who championed popular sovereignty to allow the people of those territories to side with slavery or freedom, voted against the Wilmot Proviso.

>> Proslavery stalwart John C. Calhoun argued that slavery couldn't be excluded anywhere.

# Straining North-South relations

The Fugitive Slave Law (or Fugitive Slave Act) caused the most aggravation for Black Americans (refer to the section, "Stronger fugitive slave measures: Fugitive Slave Act of 1793," earlier in this chapter). Claiming fugitives was difficult for Southern slaveholders, but the Fugitive Slave Law mandated that officials arrest people fleeing slavery and return them to their legal owners or be fined heavily. This law threatened the success of the Underground Railroad, which depended on the lax enforcement of fugitive slave laws. For many abolitionists and those straddling the fence, the Fugitive Slave Law spurred them to greater action. As Southern slaveholders intensified their efforts to capture fugitives in the North, many Northerners chose to stand their ground, which only flamed the seething tensions between North and South.

Harriet Beecher Stowe's abolitionist novel *Uncle Tom's Cabin* (1852) further strained North–South relations. Not only did the influential book sell more than 300,000 copies in its first year, but the theatrical counterpart also did well. By humanizing the suffering of those enslaved, Stowe took many white Americans beyond the facts of slavery. Proslavery supporters denounced the book as fervently as antislavery proponents welcomed it. Many proslavery supporters contended that Stowe exaggerated slavery's brutality. Still, Stowe's novel became the rallying cry that shocked more white Americans into action against slavery.

# The Compromise of 1850

When California petitioned for statehood, there were 15 slave states and 15 free states. Accepting California as a free state would have tilted that balance, and that proposition angered Southerners. The situation was so critical that several Southern states, led by elder South Carolina statesman John C. Calhoun, seriously considered seceding from the Union. A series of dramatic debates produced the pivotal Compromise of 1850 under which the following occurred:

>> California entered the Union as a free state.

>> Other territories deferred the slavery question until later.

>> Texas received compensation for ceding land to New Mexico.

>> The District of Columbia abolished the slave trade.

>> A stricter fugitive slave law passed to appease Southern slaveholders.

Only a temporary fix to the country's much larger problem, the Compromise of 1850 couldn't stop the Union from unraveling.

# The Kansas-Nebraska Act

In 1854, Illinois Senator Stephen A. Douglas accelerated the probability of civil war with the Kansas-Nebraska Act, which repealed the Missouri Compromise and allowed the legislatures of territories that should have been free to determine their own slave or free status. Kansas literally became a battleground as proslavery and antislavery factions flocked there.

In the midst of this chaos, the Northern Whigs, Free Soilers, and antislavery Democrats united to form the Republican Party, which set out to attract both antislavery and indifferent voters. Unlike the South, where many non-slaveholders vehemently defended slavery, a sizable number of Northerners opposed to slavery were reluctant to end it. Thus, attracting those voters would strengthen the Republicans and their political base.

Bleeding Kansas was a mini civil war between proslavery and antislavery forces that occurred in Kansas from 1856 to 1865. The government's approval of the Kansas-Nebraska Act helped lead to the formation of the Republican Party, a political party, which was centered in the North, dedicated to preventing slavery's expansion.

# Slavery continues

Southerners pushed the envelope beyond just insisting upon slavery's expansion; they also demanded that the slave trade (early human trafficking) reopen, a sore spot because the slave trade's illegal continuation already agitated Northerners. As late as the 1850s, a complex web of illegal trafficking persisted in the nation. The ship the *Echo* and its crew traveled from New York and New Orleans to Cuba, the African coast, and Charleston. Other instances of illegal slave trading include the following:

>> The *Wanderer,* which sailed between New York and Africa, delivered roughly 400 Africans to Jekyll Island, Georgia, in 1858. Although William Corrie and Charles Lamar were among those charged for slave trading and piracy, a conviction never followed, dismaying antislavery supporters. The Wanderer Memorial honors those survivors.

>> Timothy Meaher, a wealthy shipyard owner in Mobile, Alabama, bet a Northerner he could defy the slave trade ban without punishment, so he sent the *Clotilda* to Africa. In 1860, the ship returned with more than 100 Africans. Officials apprehended Meaher, his brother Burns, and his associate John Dabney but later dismissed the charges. In 1927, writer Zora Neale Hurston

interviewed Cudjo Lewis, the ship's last living survivor, in Africatown (the Mobile, Alabama, community he and other *Clotilda* survivors helped found); however, *Barracoon* (Amistad), her book telling the story, wasn't published until 2018. Official announcement of the *Clotilda*'s discovery came the next year, in 2019.

## Dred Scott: A strike against freedom

The Supreme Court's 1857 Dred Scott decision showed the Civil War's inevitably. In 1847, Scott went to trial in Missouri to gain freedom for himself and his wife Harriet. Under the Missouri Compromise, Scott claimed he was entitled to freedom because his legal owner Dr. John Emerson (since deceased) had taken him into Illinois and other free areas. When a lower court ruled that Scott and his family were free, the Missouri Supreme Court reversed the decision, with the United States Circuit Court in Missouri upholding the decision. Scott and his lawyers appealed it to the United States Supreme Court but fared even worse at the hands of the highest court in the land.

**REMEMBER**

Stacked with proslavery justices, the Supreme Court decided that because Scott was Black, he wasn't a citizen and therefore couldn't sue anybody. To top it off, the Court ruled that the Missouri Compromise was unconstitutional. While the South cheered, abolitionists struggled to remain optimistic.

## Defining events at Harpers Ferry

If it wasn't already clear that the nation was headed toward civil war, John Brown and his actions in Harpers Ferry, Virginia, left little doubt. A stalwart abolitionist, Brown was born into a religious family in Connecticut in 1800. Although never rich, Brown didn't let lack of funds prevent him from supporting the antislavery cause. He helped finance the publication of *Walker's Appeal* (see the section, "David Walker," earlier in this chapter) and was among the few who supported Henry Highland Garnet's very radical "Call To Rebellion" speech at the 1843 National Negro Convention in Buffalo, New York. Apparently, Brown took Garnet's message to rebel to heart.

With Kansas up for grabs (courtesy of the Kansas–Nebraska Act), Kansans had to determine whether it would have free or slave status. To sway the decision, Brown and five of his sons went to Kansas and fought proslavery forces in Lawrence, with Brown killing five proslavery settlers in another town. Still, these feats paled in comparison to his plan for Harpers Ferry.

## HENRY HIGHLAND GARNET'S "CALL TO REBELLION"

**IN THEIR OWN WORDS**

"Brethren, arise, arise! Strike for your lives and liberties. Now is the day and the hour. Let every slave throughout the land do this, and the days of slavery are numbered. You cannot be more oppressed than you have been — you cannot suffer greater cruelties than you have already. Rather die freemen than live to be slaves. Remember that you are FOUR MILLIONS!"

(Given at the National Negro Convention, Buffalo, New York, 1843)

Increasingly convinced that only violence would end slavery, Brown raised money throughout the North for a dramatic scheme to arm his own army against slavery. On October 16, 1859, Brown and 21 men (5 Black and 16 white) raided the federal arsenal at Harpers Ferry. They planned to secure enough firepower to battle Virginia slaveholders but didn't get very far. Federal and state troops swooped in almost immediately and captured Brown, who was hanged on December 2, 1859. Although the plot failed, Brown's actions terrified Southerners and inspired Northerners. (In 2020, Showtime aired the limited series *The Good Lord Bird*, adapted from the novel of the same name by Black author James McBride, dramatizing Brown's actions.)

**IN THEIR OWN WORDS**

Before his hearing sentence, Brown addressed the court: "Now, if it be deemed necessary that I should forfeit my life for the furtherance of the ends of justice, and mingle my blood further with the blood of my children, and with the blood of millions in this slave country whose rights are disregarded by wicked, cruel, and unjust enactments, I submit: so let it be done."

# Facing the Moment of Truth

A year prior to Brown's 1859 rebellion at Harpers Ferry, Abraham Lincoln delivered his famous declaration that "a house divided against itself cannot stand" when he accepted the Republican nomination to represent Illinois in the Senate:

**IN THEIR OWN WORDS**

"A house divided against itself cannot stand. I believe this government cannot endure permanently half slave and half free. I do not expect the Union to be dissolved — I do not expect the house to fall — but I do expect it will cease to be divided. It will become all one thing, or all the other."

A pivotal figure in establishing a strong Republican party, Lincoln became the Republican nominee for president in 1860. When he won with nearly 60 percent of electoral votes (but less than 40 percent of the popular vote), Southern states didn't secede immediately. Speculation regarding their actions ended on April 12, 1861, when shots rang out at Fort Sumter, South Carolina, to launch the Civil War.

**IN THEIR OWN WORDS**

States' rights notwithstanding, the Confederate States of America and its president Jefferson Davis made it clear that the Civil War was about enslaving Black Americans. Lincoln wasn't as clear. In 1862, *New York Tribune* editor Horace Greeley wrote an open letter to Lincoln urging him to end slavery. Lincoln responded: "If I could save the Union without freeing any slave, I would do it; and if I could save it by freeing all the slaves, I would do it: and if I could save it by freeing some and leaving others alone, I would also do that." Lincoln wasn't alone. Many white Northerners weren't sure how slavery factored into the Civil War. In time, the North changed its course and waged a war not just to save the Union but to finally end slavery.

» Seeing the impact of emancipation on the war effort

» Constructing a new union with freed Black people in mind

» Tracking the end of Reconstruction

Chapter **6**

# Up from Slavery: Civil War and Reconstruction

After decades of trying to balance slavery and freedom, the United States finally reached the breaking point and ended up at war with itself. Although the Confederacy was clearly of the view that slavery was at the heart of the disagreement (even if later cries for states' rights veiled that sentiment), President Abraham Lincoln initially refused to acknowledge slavery's role at all. Many Black people knew that the Civil War ran deeper than keeping the Union together, and they fought hard off the battlefield — and eventually on it — to determine their own destiny and have the government formally acknowledge what they knew to be truth that they were indeed people as well as Americans.

This chapter delves into the struggle to make the Civil War a final blow to the institution of slavery. It also discusses the issues that initially prevented Black Americans from fighting. The Black American resolve for freedom manifested itself during Reconstruction, the nation's brief experiment to achieve true democracy, largely through political participation and the quest for an education, following the war. The Union victory in the war, however, was only the beginning of how hard securing change in the United States would be. In this chapter, you also find out about the complex struggles between Lincoln's successor and Congress, the North and the South, and white Southerners and newly freed Black Americans.

# The Question: To End Slavery or Not?

To the dismay of Black people and white abolitionists, Lincoln, during the early part of his presidency and in the early years of the Civil War, refused to take a firm stance about ending slavery. But he felt trapped; to save the Union, he had to avoid pushing slaveholding states that hadn't seceded (and that physically separated the North from the South) into the ranks of the Confederacy. Not offending other white Southerners further wasn't Lincoln's only worry. He also had to avoid riling proslavery factions and Northerners fearful of ending slavery. Eventually, however, Lincoln moved toward emancipation, one of the defining triumphs of his presidency.

## Teetering on a tightrope

Before Lincoln took office in February 1861, seven states had seceded. Aware that the nation was at stake, Lincoln hoped to prevent further defections and took care in his inaugural address to condemn individuals for secession and not the South overall. His guarded words, however, didn't prevent the new nation of seceding states, the Confederate States of America (CSA), led by Mississippian Jefferson Davis, from firing the shot that launched the Civil War on April 12, 1861.

Initially, the North, even those who voted against Lincoln, lent their support to restoring the Union. The North had more people and greater resources, and Lincoln and his supporters felt the war would end quickly, with the Union victorious. As the Union lost several battles, that support began to fizzle. White and Black Northern abolitionists wanted the war to end slavery, but that prospect scared other Northerners, many of whom feared Black people uprising.

In addition, slavery was alive and well in the border states that stuck with the Union. Lincoln understood that keeping these states was critical to the Union's success, and he worked overtime not to lose them.

**TECHNICAL STUFF**

The key border states were Maryland, Missouri, Kentucky, and Delaware. Some historians also include West Virginia, even though it didn't officially become a state until 1863.

Lincoln hoped the *Crittenden-Johnson Resolution* would reassure border states practicing slavery. The resolution, sponsored by Kentucky Senator John J. Crittenden and Tennessee's Andrew Johnson (the only Southern senator not to quit his post even when Tennessee seceded), emphasized that the federal government was fighting to preserve the Union and not to disturb any institutions already in practice.

# The first Confiscation Act, 1861

As the war progressed, the issue of what to do about slavery became even more relevant. When Union forces began penetrating the South, able-bodied enslaved men sought refuge, but Union generals didn't know what to do with them. Their varying reactions, as evident in the following, only underscored that there was no federal policy pertaining to the scores of enslaved people fleeing:

>> Some generals proclaimed those fleeing slavery free.

>> Some generals seized those claiming freedom as contraband and put them to work.

>> Some refused to take in those enslaved seeking freedom.

>> Some actively returned those fleeing to their slaveholders.

>> One Union general requested permission to allow slaveholders to cross Union lines and recover those they enslaved.

In response to all this confusion, Congress passed its first Confiscation Act in August 1861. This act established a federal policy for dealing with enslaved people. With this act, it became federal policy to seize enslaved people directly used in military action in support of the Confederacy, but the act made no direct mention of freeing anyone. Instead, it simply deprived rebelling slaveholders of any enslaved labor used against the Union. Even with no mention of freeing anyone, Lincoln worried how the Union's bordering proslavery states would react to the legislation.

# Black People in the Early Days of the Civil War

As Lincoln pondered how slavery factored into the Civil War and moved toward emancipation, many Black Americans never doubted that this was the war to end slavery. When the Civil War began, Black Americans were eager to contribute.

Even though Black men wanted to fight for the Union and freedom, the War Department initially turned them away. Lincoln and other Unionists feared that allowing Black men to fight would imply that the war was about ending slavery and not preserving the Union, an action that would alienate border states that they felt were crucial to winning the war. Also, there was a fear that allowing

Black Americans to fight would turn the Civil War into a rebellion, forcing white soldiers to battle both Black Americans and the Confederacy. Thus, Black Americans had to fight to enlist in the Union army. A few Black Americans did serve in the navy early on, however. Others formed military clubs such as the Hannibal Guards of Pittsburgh and the Crispus Attucks Guards of Albany, Ohio, to prepare for battle should the call come.

## Serving the Union

The rising death toll of white Union soldiers convinced white Northerners that white soldiers shouldn't be the only ones sacrificed to win the war. In addition, slim Union victories like Shiloh and defeats such as the Second Bull Run threatened recruitment. When a voluntary call for 300,000 Union soldiers yielded only 90,000, Lincoln had to consider his options.

With the Militia Act passed in July 1862 (essentially overturning a 1792 law prohibiting Black men from bearing arms), Lincoln and Congress started paving the way for Black Americans to join Union forces. Several sections of that act specifically addressed Black American enlistment, establishing pay rates as well as potentially emancipating the mothers, wives, and children of these soldiers.

## Surviving in the South

The Confederacy faced its own crisis: As enslaved people realized that their freedom was indeed within reach, instead of running away, some just walked off plantations and other places where they were enslaved. Many individuals ended up in Union camps and eventually enlisted with the Union to defeat the Confederacy. Some enslaved people who didn't leave refused to submit to white authority.

Tempering reactions by those enslaved to what was happening with the war became a big concern for the Confederacy, so strengthening *slave patrols*, militia-like units that regulated enslaved behavior, including hunting down runaways, was first on the list (go to Chapter 4 for more information about slave patrols). All the proslavery rhetoric from previous decades about enslaved people loving their masters flew out the window. Exemptions from patrol duties ended as the Confederacy instituted punishments in the form of fines and imprisonment to those who didn't attend to their duties.

# Moving toward the Emancipation Proclamation

Long before becoming president, Lincoln favored setting aside money for Black Americans' voluntary emigration or colonization to Haiti or Liberia and compensating slaveholders for their losses. That position didn't change with the Civil War, especially because Lincoln needed to keep the Union's bordering slaveholding states loyal. His repeated pleas to Delaware, Maryland, Kentucky, and Missouri in 1862 to accept compensated emancipation may have gone unheard, but the wheels of emancipation were already in motion.

## Shutting down the illegal slave trade

Shutting down the illegal slave trade was one of Lincoln's first moves toward eventual emancipation. Despite numerous bans spanning several decades, an illegal slave trade continued well into the 1860s, with the last official slave ship to the U.S., the *Clotilda*, arriving in 1860 (refer to Chapter 5). To stop the trade, Lincoln did the following during the first half of 1862:

>> **Sanctioned the hanging of Captain Nathaniel Gordon, a known enslaver from Portland, Maine.** Gordon was the first slave trader ever executed under the Piracy Act of 1820, which defined slave trading as piracy.

>> **Launched negotiations to allow Britain, which had become one of the world's leading antislavery forces, to search American ships.** For decades, the U.S. had refused these searches; as a result, the illegal slave trade flourished. The resulting treaty with Britain (signed April 25, 1862) helped end the slave trade. More importantly, the treaty attracted British sympathy to the Union's cause.

>> **Approved a bill to end slavery in Washington, D.C.** This bill was the Civil War's only instance of compensated emancipation: $1 million was set aside to pay D.C. slaveholders up to $300 per enslaved person, and there was another $100,000 to fund voluntary emigration.

>> **Signed a law outlawing slavery in the territories.** The debate about the status of slavery in the territories had arguably led the country to the Civil War in the first place (check out Chapter 5 for more details).

## Passing the Second Confiscation Act

With the illegal slave trade finally quashed, the nation's priority was to get through the Civil War. The Second Confiscation Act became a pivotal turning point. Signed by Lincoln in July 1862, the Second Confiscation Act was an important step toward the Emancipation Proclamation because it freed those enslaved by rebelling citizens, in addition to allowing for the seizure of other property. (The First Confiscation Act purposely avoided any reference to emancipation.)

## Courting England's support

The Confederacy was actively seeking England's support. Cotton was one of the primary reasons the Southern states had been so quick to secede. Because the South enjoyed a virtual monopoly over one of the world's most dominant crops, leaders figured that world powers had to side with their main cotton supplier, even if they opposed slavery. Obviously, if England supported the South, the Union would be at a distinct disadvantage.

Lincoln believed that European powers, particularly England, wouldn't support a proslavery government; the problem was that the Union didn't necessarily stand for freedom. Officially, federal forces were fighting to keep the United States unified rather than to end slavery. Winning England's support became another factor leading Lincoln toward the Emancipation Proclamation.

# Free at Last (Well, Sort of): The Emancipation Proclamation

On July 22, Lincoln surprised his cabinet members by reading a preliminary draft of his executive order for emancipation. Only two cabinet members fully endorsed the Proclamation, and one cabinet member suggested that Lincoln share his decision with the public after a Union battle victory, advice Lincoln heeded.

His moment came after the September 17, 1862 Battle of Antietam (also known as the Battle of Sharpsburg) in Maryland, in which Major General George B. McClellan successfully pushed back Confederate forces commanded by General Robert E. Lee. Lincoln readdressed his cabinet on September 22 for advice on the document's wording, not on the issue of whether he should deliver it or not, and shortly thereafter issued a preliminary Emancipation Proclamation. He issued the formal Emancipation Proclamation 100 days later on January 1, 1863.

# What the Proclamation did

In the Emancipation Proclamation, Lincoln vowed that if rebellion continued, "all persons held as slaves within any State or designated part of a State, the people whereof shall then be in rebellion against the United States, shall be then, thence–forward, and forever free."

**REMEMBER**

Although many people assume the Proclamation freed all those enslaved in the U.S., it actually didn't. Here are the finer points:

>> The Proclamation declared those enslaved in *rebelling* states free.

>> It did *not* free those in slaveholding border states or areas within Confederate territory already under Union control.

>> It welcomed acceptably freed enslaved people to join the armed services.

# Reaction to the order

Despite Lincoln's great strategic pains in taking the Emancipation Proclamation public, he pleased no one at first:

>> **Northern whites:** The perceived shift from saving the Union to ending slavery so angered many Northern white people that some soldiers resigned. During the fall elections, Republicans lost key seats to Democrats who didn't generally support such so-called radical changes, narrowing the Republican advantage in the House to just 18 votes.

>> **Abolitionists:** Because Lincoln's proposed emancipation was more than he had committed to since the war began, white and Black abolitionists didn't criticize it publicly. Privately, they didn't think Lincoln had gone far enough and wished that he had abolished slavery completely. Still, they considered the Proclamation a step in the right direction.

>> **The English:** The proclamation didn't move the English populace. Commenting on Lincoln's proposed emancipation, one London newspaper wrote, "the principle is not that a human being cannot justly own another, but that he cannot own him unless he is loyal to the United States."

**TECHNICAL STUFF**

In fact, England may have never committed to either side in the U.S. Civil War had Jefferson Davis, the president of the Confederate States, not demanded the return of enslaved people back to slaveholding states, where death awaited them, with his own proclamation. After that, the working population of Manchester, England, let Lincoln know that their sympathies rested with the Union. A short time later, England supported the Union.

> **» Black Americans:** Although many Black people, especially in the targeted South, were unaware of the Emancipation Proclamation, those who did know of it assigned the document greater value than Lincoln intended. Although heralded as "the Great Emancipator" throughout history, that title stems from the war's end result and not from any definitive stance Lincoln took against slavery as president.

# Finally in the Fight

After the Emancipation Proclamation, it became easier for Black American soldiers to join the Union army. Many historians agree that these extra bodies, along with a few other factors, ultimately secured a Union victory.

With the ground cleared for Black men to enlist in the military, recruitment became ferocious. Luminaries such as Frederick Douglass served as recruiting agents, and recruitment rallies took place throughout the North. A number of Black soldiers were already prepared for war and quickly stepped up. An estimated 180,000 Black men — roughly 10 percent of the total forces — joined the Union cause.

## As Union soldiers

Bringing about an end to slavery may have become the Union's new direction in the Civil War, but many Black Americans didn't feel the love. The War Department established the U.S. Bureau of Colored Troops and created the U.S. Colored Troops to segregate Black and white soldiers. White Americans doubted the courage of Black soldiers early on but were proved wrong when Black soldiers repeatedly demonstrated the depths of their courage.

One such display occurred just days after the official establishment of the U.S. Colored Troops at Port Hudson, Louisiana, when two Black American units charged the Confederate enemy repeatedly, suffering 200 casualties. One such casualty was Captain André Cailloux. Born enslaved but freed at age 21, the beloved New Orleans native valiantly lost his life on that battlefield on May 27, 1863, where it laid for weeks. Thousands attended his funeral on July 29, 1863, in New Orleans.

## Their role

Even though large numbers of Black Americans served as cooks and performed other duties, the establishment of the U.S. Colored Troops created more combat

opportunities for Black Americans. On the field, Black Americans fought fiercely and bravely, giving Union forces a significant and much-needed lift. Serving as spies and scouts by passing themselves off as being enslaved, Black Americans also offered the Union unique advantages.

In the last stages of the Civil War especially, Black men and some women were present and critical in key battles, including the Battle of Vicksburg in Mississippi, Milliken's Bend in Louisiana, and the all-important surrender at Appomattox Courthouse on April 9, 1865, in Virginia. A few soldiers such as Decatur Dorsey and James Daniel Gardner (sometimes Gardiner) did receive medals for their services, but some received their just due posthumously.

**TECHNICAL STUFF**

Black soldiers participated in 410 military battles overall, 39 of them deemed major. According to some scholars, more than 38,000 Black soldiers died during the Civil War, a figure some argue is almost 40 percent greater than that of white soldiers.

## Their pay

Black soldiers received $7 a month for service whereas white soldiers received $13. Members of the 54th Massachusetts Regiment protested the discriminatory policy by serving for an entire year uncompensated. The protests worked, and in 1864, the War Department granted Black soldiers equal pay.

**BLACK AMERICAN FACES**

# SUSIE KING TAYLOR: BLACK AMERICAN WOMEN AND THE CIVIL WAR

In *A Black Woman's Civil War Memoirs* (1902), Susie King Taylor provides unmatched insight into the life of a Black American woman during the Civil War. Born enslaved near Savannah, Georgia, the former Susie Baker secretly learned to read and write as a child. When the Union forces arrived in 1862, her uncle took her along with his family to safety behind Union lines.

King Taylor's many talents served the Union well. She worked as a laundress, nurse, and teacher, among other things. Not content to share her accomplishments only, King Taylor, who married a Union soldier, noted, "There were hundreds of [Black women] who assisted the Union soldiers by hiding them and helping them escape. Many were punished for taking food to the prison stockades for the prisoners." King Taylor, who died in 1912, believed "these things should be kept in history before the people."

## Soldiering alongside whites

White and Black soldiers served in separate regiments. Even in segregated units, however, Black officers rarely led Black soldiers. Exceptions included two regiments of General Butler's Corps d'Afrique that were led by Major F.E. Dumas and Captain P.B.S. Pinchback, who would become the first Black governor of Louisiana, albeit briefly. Major Martin R. Delany (who was also a surgeon, abolitionist, and journalist), Captain O.S.B. Wall, Captain H. Ford Douglass, and First Lieutenant W.D. Matthews were also Black officers. Black surgeons and chaplains were a bit more numerous.

Convincing white people to lead all-Black forces wasn't easy at first. Those who were willing usually became officers. Thanks to the film *Glory* (1989), Colonel Robert Gould Shaw, the 54th Massachusetts Regiment commander who wrote more than 200 letters to family and friends during the Civil War, is the best-known white leader of Black troops.

## The dangers they faced

Fighting for the Union was particularly dangerous for Black soldiers because Confederate forces didn't care for them. In 1862, Jefferson Davis threatened to return all enslaved people captured in arms to the slaveholding states to which they belonged. Lincoln countered that for every Union soldier killed in a manner that violated the laws of war a Confederate soldier would also die. For those enslaved by the Confederates, Lincoln promised that a Rebel soldier would also endure hard labor.

Still, Confederate soldiers treated Black prisoners of war differently. By the war's end, there were many Black prisoners of war, but to make examples of them, Confederates killed Black prisoners more readily than they did white prisoners. Sometimes Confederate units didn't even report Black captives. When Fort Pillow in Tennessee fell to Confederate forces led by Major General Nathan Bedford Forrest in April 1864, Black soldiers overwhelmingly weren't even allowed to surrender; Confederates shot some and burned others alive. An estimated 300 Black soldiers died in what is known as the Fort Pillow Massacre.

# As Confederate soldiers

Some Black men also served with the Confederacy. Determining their actual numbers, however, is difficult because many were enslaved, especially early in the war. Gauging how many Black men fought for the Confederacy after Lincoln issued the Emancipation Proclamation is also difficult, given that many Black Southerners didn't learn of the Proclamation until months after it went public.

Black men in the Confederate military often served as cooks, as musicians, as guards, and in other noncombatant positions. Some operated as double agents, like Charleston's Robert Smalls, who along with his wife, Hannah, successfully delivered a Confederate boat to Union forces.

BLACK AMERICAN FACES

## THOMAS MORRIS CHESTER: CIVIL WAR CORRESPONDENT

Liberian émigré Thomas Morris Chester, the college-educated son of a mother who was a fugitive, served an important and unique function during the Civil War. An early U.S. Colored Troops recruiter, Chester, who helped form the Massachusetts 54th and 55th Regiments as well as two Black companies in his native Harrisburg, Pennsylvania, was reluctant to join the military himself because Black soldiers rarely rose above the rank of sergeant. Instead, Chester served as a Civil War correspondent for *The Philadelphia Press* in 1864 and 1865. In that position, he covered Black American troops in Virginia, especially during the critical fall of Richmond.

Captured in the book *Thomas Morris Chester, Black Civil War Correspondent,* his observations are the only detailed firsthand accounts of Black American soldiers in combat during the Civil War. In addition to describing camp life for Black troops, Chester also wrote about how Confederate soldiers and civilians reacted to them. After the war, Chester, who died in 1892, also helped with Reconstruction.

REMEMBER

Well into 1864, the Confederacy was understandably reluctant to arm those they enslaved. Early in the war, many white Southerners feared uprisings from the enslaved. But with an ever-growing number of wounded and dead, the Confederacy, like the Union, had little choice but to turn to free and enslaved Black men. Although the 1865 Confederate Senate committed to enlisting 200,000 Black men, there's little evidence the Confederacy ever reached anywhere near that number. Continued fear of arming enslaved people prompted Jefferson Davis to sign a bill on March 13, 1865, mandating that the number of enslaved people enlisted not exceed 25 percent of the total able-bodied enslaved male population of each state. It's especially important to note that enslaved Black people who fought for the Confederacy were promised their own freedom.

# The War's End and the Thirteenth Amendment

With Lincoln newly reelected in 1864 and the South's surrender, the future looked bright for America in 1865. On January 31, 1865, the 13th Amendment abolishing slavery passed the House with considerable political maneuvering by Lincoln.

On April 9, 1865, General Lee surrendered to Union General Ulysses S. Grant. But five days later, John Wilkes Booth, a Confederate sympathizer, crept into the presidential box of Ford's Theatre in Washington, D.C., and shot Lincoln, who died the next day, April 15.

As the constitutional amendment made the rounds from state to state, seeking the critical three-fourths vote needed for ratification, Black men, like those in Figure 6-1, realized that their world had changed. The Civil War was over, but the important work of reconstructing the nation was only beginning. Tensions ran as high in "peace" as they had in conflict.

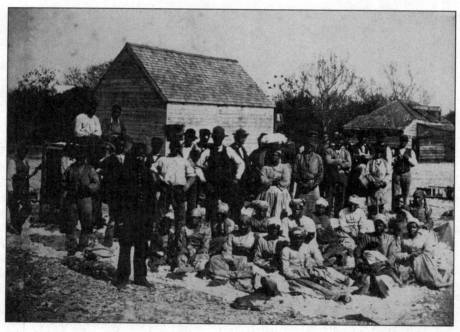

**FIGURE 6-1:**
Freed slaves.

*Historical/Getty Images*

**TECHNICAL STUFF**

Mississippi, a state that sent two Black American men to the U.S. Senate and a few more to the House of Representatives during Reconstruction, didn't ratify the 13th Amendment abolishing slavery until 1995, not 1895.

# (Re)constructing Democracy

*Reconstruction,* the period roughly spanning 1865 to 1877, presented the United States with the unique opportunity to exercise true democracy. For his part, Lincoln devised a plan to reestablish the Union long before the Civil War ended. On December 8, 1863, he proposed his Proclamation of Amnesty and Reconstruction, which carried these key points:

>> Amnesty didn't extend to high-ranking Confederate government and military officials or soldiers who had abused Black and white prisoners of war.

>> In accordance with the Ten Percent Plan, a state could gain readmission to the Union if no less than one-tenth of the number of its citizens who voted in the 1860 election took an oath of loyalty to the Union and accepted emancipation.

**IN THEIR OWN WORDS**

Lincoln's assassination profoundly affected Black Americans, and there was reason to worry. Andrew Johnson, Lincoln's Southern vice-president, didn't share Lincoln's views. Johnson proclaimed, "This is a country for white men, and by God, as long as I am President, it shall be a government for white men." Unfortunately, he was true to his words.

## Undermining Lincoln's plan

In May 1865, President Johnson issued his own plan for Reconstruction. On paper, the plan differed little from Lincoln's plan. By issuing his plan while Congress wasn't in session, however, Johnson showed that he intended to act by presidential authority alone, eliminating Congress from the process. Some refer to Johnson's proposal as *Presidential Reconstruction.* Black Americans suffered due to Congress not participating in Reconstruction plans.

**TECHNICAL STUFF**

Lincoln and the Republican Party had selected Johnson as their vice presidential candidate in order to appeal to the more moderate Democrats who didn't support emancipation. Johnson was a former slaveholder and the only Southern senator not to resign during secession.

Still, there were those in Congress who continued to work toward the original intent of Lincoln's plans for Reconstruction. Thaddeus Stevens and Charles Sumner, labeled Radical Republicans, were the key forces behind much of the progressive legislation benefiting Black Americans. Stevens, a Northerner whom white Southerners considered a *carpetbagger* (usually a white Northerner active in Republican politics who "interfered" with the South after the Civil War), had been critical in repealing the 1861 Crittenden-Johnson Resolution, a bill cosponsored by then-Senator Johnson that emphasized the Union's intention to preserve the Union and not to end slavery.

## The Black Codes

With a president sympathetic to ex-Confederates, Reconstruction took a turn for the worse. Southern states may have been willing to concede to the 13th Amendment (refer to the earlier section "The War's End and the 13th Amendment"), but they weren't ready to embrace Black Americans fully. Insisting that Black Americans required white supervision, Southern states passed the Black Codes in 1865 to regulate Black American behavior and social movement. Reminiscent of the Slave Codes (refer to Chapter 4), the Black Codes, which varied from state to state, did the following:

>> Restricted where Black Americans could live

>> Regulated their work habits, even arresting and imprisoning them if they quit their jobs

>> Prohibited Black citizens from testifying against white citizens

## Presidential vetoes

With many of the former Confederacy's top brass in critical Congressional seats again, national politics looked as vulnerable as local politics. Pennsylvania senator Thaddeus Stevens fought to restore Congressional control over Reconstruction, but Johnson used his veto power to quash many of the bills that Stevens tried to push through. Luckily, Congress overrode Johnson's veto of the Civil Rights Act of 1866. Intended to counter the Black Codes, this act reaffirmed the rights of *all* citizens to sue and be sued; to testify in court against anyone, regardless of race; and to buy or rent any piece of property anywhere, among other things.

## Emergence of white supremacist groups

Angry Southerners refused to back down in the face of federal legislation. Just as they had resurrected the Slave Codes in the form of the Black Codes, they brought back the essence of slave patrols. In no time, white supremacist organizations emerged, such as the Knights of the White Camellia, the White Brotherhood, and the Ku Klux Klan (KKK), to name only a few.

As Reconstruction continued, membership in these organizations increased, and new organizations formed. If they couldn't intimidate Black Americans legally, the organization's members were determined to do it with violence, regularly beating and lynching Black Americans they felt stepped out of line. With law enforcement personnel in their ranks as well as a willingness by nonmembers to turn a blind eye, the pre- and post–Civil War South differed little for many Black Americans.

## Taking back the power: Reconstruction Act of 1867

Stevens, who didn't take the turn of events in the South lightly, established the Joint Committee on Reconstruction. Around the same time, more Radical Republicans won offices in the 1866 elections. With the Reconstruction Act of 1867, Congress took back the reins. The act

» Divided the South into five military districts ruled by a governor

» Declared that in order to have federal troops removed, Southern states had to ratify the Fourteenth Amendment, which maintains that all persons born or naturalized in the U.S. are citizens of both the U.S. and the state in which they reside and are subject to equal protection under the law

Things looked brighter for Black Americans with Congress back in control. For example, when Johnson wanted to pull the plug on the Freedmen's Bureau, which provided much-needed assistance for newly freed Black Americans, Congress revived it. That light wouldn't shine long, however.

# A Mixed Bag of Hope and Despair

Leading abolitionists such as Frederick Douglass worked so hard to end slavery that they'd given little thought to what freedom would actually mean. What would newly emancipated Black people do to support themselves? Private Northern mutual aid societies were among the first to address the need and descended on the South in droves as early as 1861. For them, education and religious piety was a positive start, and Black Americans poured themselves into both. (Read more about education in Chapter 13 and religion in Chapter 12.) Yet, despite best efforts, many of the leaders of these organizations realized that only government intervention could sufficiently address the problems confronting Black Americans. Some began appealing to the government as early as 1863 for a government organization that could fulfill this purpose.

## The Freedmen's Bureau

Just before the war officially ended, the Bureau of Refugees, Freedmen, and Abandoned Lands, better known as the *Freedmen's Bureau*, came into formal existence in March 1865. Assisting the newly emancipated and transitioning them to freedom was the Bureau's priority, and its duties varied widely. For example, many of those formerly enslaved wanted to make their marriages official, so the Bureau

issued countless marriage licenses. But the Bureau also helped a small number of poor whites as well. A laundry list of primary functions included

>> **Food rations:** Hunger was a major problem among the newly emancipated, so the Bureau distributed food rations. Between 1865 and 1869, the Bureau distributed approximately 21 million food rations, with an estimated 5 million going to poor white people.

>> **Education:** Illiteracy was a major problem among the recently freed, so establishing schools became one of the Bureau's main functions. Expanded educational opportunities didn't just benefit the newly emancipated; they also helped poor white Southerners who were also mostly illiterate.

>> **Hospitals:** Many of the newly emancipated needed medical care but had no money to pay for it nor facilities available to them for treatment. Amazingly, the Freedmen's Bureau established 46 hospitals in just two years. By June 1869, more than 500,000 patients had received treatment.

>> **Labor mediation:** Freedmen were concerned about working for white Southerners, and many tried to avoid returning to the land, mainly because it reminded them of slavery. With little recourse, freedmen often appealed to the Bureau to help negotiate fairer wages with white employers. For serious grievances, the Bureau had its own courts because justice, especially against white Southerners, was difficult for Black Americans to achieve in Southern courts.

Dedicated workers and beneficiaries truly appreciated the Freedmen's Bureau, but some white Northerners questioned the need for such an agency because the Civil War had ended. White Southerners simply objected to government intervention of any kind but particularly to an agency whose main intention, they felt, was to enfranchise Black Americans.

In addition to trying to sabotage Bureau posts by intimidating its workers or raiding its ration houses, angry white Southerners burned houses, raped Black women, boldly robbed hardworking Black citizens, and shot at or killed others. In Memphis and New Orleans, angry white people massacred scores of Black Americans, killing nearly 100 men, women, and children and injuring countless others. Shocked by these incidents, Congress authorized an investigation. But without troops, the Freedmen's Bureau could do little more than file incident reports and document the injustices.

## Where's my 40 acres and a mule?

Resolving the issue of abandoned or confiscated land was complex. During the war, Rufus Saxton, Union head of the Department of the South, proposed the

general plan of allotting Black families 2 acres per working hand and furnishing them with tools necessary to plant corn and potatoes for their own use as they cultivated a specified amount of cotton for the government. The Treasury Department, however, contested the War Department's right to take such action. When both Lincoln's and Johnson's Amnesty Proclamations returned a large portion of confiscated land to the original owners, the matter was complicated further.

## Special Field Order No. 15

On January 16, 1865, General William T. Sherman issued his Special Field Order No. 15, in which approximately 40,000 Black Americans received roughly 400,000 acres of confiscated land in South Carolina, Georgia, and Florida. Section 4 of the Freedmen's Bureau Act (passed in March 1865) supported Sherman's order by allowing for the lease of not more than 40 acres of land for a period of three years to freedmen, who could purchase the land when the lease ended. But by the summer of 1865, President Johnson, who had promised to return confiscated land to those he had pardoned, ordered the Freedmen's Bureau to comply with his promises. He ignored the fact that Black families were already living on the land in question.

**IN THEIR OWN WORDS**

Freedmen's Bureau Chief General Oliver Howard came face to face with some of those families in October 1865 on South Carolina's Edisto Island. As expected, the bad news wasn't well-received. When Howard suggested that the families "lay aside their bitter feelings" and "become reconciled to their old masters," one response was "You only lost your right arm in war and might forgive them."

For his part, Saxton stood by the freedmen and helped them fight to keep their land. Those with deeds from government sales were able to keep their land. Ironically, the government sent in Black soldiers to remove many Black South Carolinians from their land. By the end of 1866, only 1,565 out of 40,000 who received land through Sherman's Special Field Order remained on that land in South Carolina.

Some scholars contend that the government never promised Black Americans 40 acres and a mule, that the policy was just a rumor borne from Sherman's Special Field Order and the Army's practice of loaning extra mules out to Black American families.

## Southern Homestead Act of 1866

Some freedmen received land through the Southern Homestead Act of 1866 when the government placed 46 million acres of public land in Alabama, Arkansas,

Florida, Louisiana, and Mississippi up for sale. Many Black Southerners benefited, as evidenced by the following statistics:

>> In Florida, the newly emancipated gained possession of around 160,960 acres in just one year.

>> In Arkansas, the newly emancipated possessed 116 of the 243 homesteads granted.

>> In Georgia, Black Americans held more than 350,000 acres in 1874.

By June 1876, however, Congress repealed the Southern Homestead Act, along with other Reconstruction-era legislation. Acting independently of the federal government, South Carolina, which enjoyed a Black majority and a high number of Black American state legislators, helped freedmen purchase land. As plantations came up for sale, a local land commissioner bought, divided, and sold the land, often on credit.

## The Treaty of 1866

In the Treaty of 1866 with various slaveholding indigenous nations like the Choctaw, Cherokee, and Chickasaw, Congress ended the practice of communal landownership, forcing indigenous nations to divide up the land as well as adopt Black people as citizens that they had once enslaved. Over time, especially around 1902, Black freedmen in Indigenous nations generally received 40 acres of land at the very least.

Mary Grayson, born in the Creek nation because her mother was transported to Oklahoma by her Creek slaveholder as part of the Trail of Tears, shared this history in her 1937 Works Progress Administration (WPA) interview in Oklahoma. Indigenous nations like the Chickasaw objected to being forced to actions the United States refused to do itself. "The Chickasaw people cannot see any reason or just cause why they should be required to do more for their freed slaves than the white people have done in the slave-holding states for theirs," they stated in a resolution.

In 2008, scholar Henry Louis Gates's PBS special *African American Lives 2* traced some of actor Don Cheadle's (*Hotel Rwanda*, *Devil in a Blue Dress*, *House of Lives*) ancestry back to the Chickasaw Nation. Respected historian Barbara Krauthamer's 2015 book, *Black Slaves, Indian Masters: Slavery, Emancipation, and Citizenship in the Native American South* (University of North Carolina Press), is among the handful of books offering insight into this history.

# Back to the land

During Reconstruction, most of the newly emancipated received no land and had to return to agricultural work, many to the same plantations they had fled. Interestingly, a model for what would become sharecropping emerged during the Civil War.

## Working for hire

At the end of the Civil War and into Reconstruction, many of the newly emancipated agreed to work contracts in which they were to receive monthly wages ranging from $9 to $15 for men and $5 to $10 for women. The contracts often included provisions for food and shelter.

**HISTORICAL ROOTS**

Work contract agreements trace their roots to 1862, when General Grant delegated fugitives to Chaplain John Eaton. The chaplain set up a special camp for them at Grand Junction, Tennessee, where he supervised hiring them out. General Benjamin Butler did the same in Louisiana.

Work contracts weren't always honored, even those negotiated by the Freedmen's Bureau. Some had loopholes, but quite simply, good faith was essential to the agreements' success, and it was in short supply. As power returned to white Southerners (many of them former high-ranking Confederate officials), Black Americans had no recourse if the contracts were broken.

## Sharecropping

*Sharecropping* was a system in which Black people and some poor white people worked the land in exchange for anywhere from a quarter to half of a crop, usually cotton or corn. It eventually became the more dangerous system compared to work contracts. Sharecroppers received land and housing as well as seeds, animals, and equipment, but they had to wait until harvest time to receive any payment for their share of a crop.

Martin R. Delany, who served as a high-ranking Black official in the Freedmen's Bureau, worked overtime to safeguard freedmen's rights. In addition to distributing copies of fair contracts for sharecroppers to use, Delany, who was based in Hilton Head, South Carolina, also negotiated more favorable cotton prices for freedmen. When a Freedmen's Bureau agent ran off with some of those funds, however, Delany's Cotton Agency closed. By September 1868, Delany was out of the Freedmen's Bureau.

As time went on, the dangers of sharecropping became more apparent. Share-croppers faced the unavoidable evil of purchasing necessities on credit at local stores, often owned by their landowners. High interest rates made it nearly impossible for sharecroppers to bury their debt, which often meant that they had to continue working for the landowners. Falling cotton prices and a depression in 1873 only worsened the sharecroppers' plight. From Reconstruction into the early 20th century, sharecropping adversely affected Black Southerners.

## Finding a new way

Moving north wasn't a much better option for Black Americans in the South than working the land because white workers in the North feared an influx of Black labor. Employers pounced on these fears and purposely hired Black workers to undermine white labor unions. Suspicious of Black workers, many white labor unions refused to accept Black workers. Unable to join the National Labor Union, Black Americans founded the National Negro Labor Union in 1869. Blacksmiths, bricklayers, and other artisans had trouble finding work because white employers favored white immigrant labor, thus forcing skilled Black men to work menial and low-paying jobs. Black women usually became domestics or independent washerwomen.

Many Black men chose to move west to work as cooks and cowboys, which for Black men was often the same. Some used the Homestead Act to become farmers, whereas others joined the U.S. Army, which formed the all-Black 9th and 10th Cavalry in 1866 and the 24th and 25th Infantry, more popularly known as Buffalo Soldiers, in 1869. In addition to protecting settlers mainly from Native Americans being forced from the land, Black troops built roads, installed telegraph lines, and performed other duties that further aided westward expansion. Some became railroad workers, miners, and sailors.

## Banking on wealth

Even before the Civil War ended, those formerly enslaved were encouraged to save their money. More popularly known as the Freedman's Bank, the Freedman's Savings and Trust Company was the primary beneficiary of this thrifty spirit. By 1872, the bank had 34 branches, mostly in the South, as well as $3,299,201 in total deposits in 1874. Unfortunately, poor accounting, speculation, and bogus loans by its white board, led by Henry Cooke (brother of Jay Cooke, a Union financier whose dubious financial practices helped bring on the nation's 1873 depression), sank the Freedman's Bank.

When the board faltered in 1873, Frederick Douglass stepped in and, when he realized the extent of the financial difficulties, even pumped some of his own money into the bank to keep it afloat. He was too late. In 1874, the Freedman's Bank failed, literally swallowing up the nickels and dimes of far too many of the newly emancipated. Although the public blamed many of the nation's Black leaders for the crash, the real culprits, Cooke and his gang, weren't held accountable

## Taking office

Politically, Black Americans fared better when Congress controlled Reconstruction. To regain admission to the Union, states were required to draft new constitutions, and Black Americans were present at the constitutional conventions held to accomplish this task. Only South Carolina boasted a Black majority, but even states like Texas, which had a small Black population, had Black American representation. In addition to abolishing slavery, many of these new state constitutions further enhanced the democratic process by ending property qualifications for voting and holding office.

Attending state constitutional conventions was just the beginning of the Black political presence. At one point, the South Carolina legislature had 87 Black and just 40 white members. Black Americans Alonzo J. Ransier and Richard H. Gleaves served as lieutenant governors of the state in 1870 and 1872, respectively. In 1872 and 1874, the speaker of the house was Black, and a Black man, Francis L. Cardozo, served as secretary of state and treasurer between 1868 and 1876.

Mississippi also had a significant number of Black politicians. A.K. Davis, James Hill, T.W. Cardozo, and John Roy Lynch served as lieutenant governor, secretary of state, superintendent of education, and speaker of the house, respectively. (Years later, Lynch published *The Facts of Reconstruction* in 1913.) Louisiana didn't match South Carolina and Mississippi in great numbers of significant political positions held by Black Americans, but Oscar J. Dunn, P.B.S. Pinchback, and C.C. Antoine served as lieutenant governors of the state. Pinchback even became the governor for 43 days after Henry C. Warmoth's removal in 1872.

Despite these early political gains, a Black man wasn't *elected* governor in the United States until Virginia's L. Douglas Wilder, who served from 1990 to 1994. In 2006, Massachusetts elected Deval Patrick as its governor. In 2018, Stacey Abrams in Georgia almost became the nation's first and only Black female governor, coming within 1.4 percent or roughly just 55,000 votes of a win. Chapter 11 discusses Abrams in more detail.

Many of these Black political leaders rose to national prominence. Ironically, in 1870, the nation's first Black American senator, Hiram Revels, filled a seat vacated by former president of the Confederate States Jefferson Davis. Blanche K. Bruce,

another Mississippian, became the first Black American elected to a full Senate term in 1874, a feat not matched again until Massachusetts elected Edward Brooke in 1966. With his knack for amassing public offices, P.B.S. Pinchback got himself elected to the U.S. House of Representatives in 1872 and to the Senate in 1873. After a long debate, however, the Senate denied Pinchback his seat because of charges of campaign fraud and election errors.

The U.S. House of Representatives was more colorful and, at various times, included South Carolina's J.H. Rainey (the nation's first Black Congressman), war hero Robert Smalls, Robert De Large, and Robert Brown Elliott, as well as John Roy Lynch, Florida's Josiah T. Walls, Alabama's Benjamin Turner, and Georgia's Jefferson Long, among others. At least one Black American remained in Congress until 1901.

# The Fifteenth Amendment

Civil War general Ulysses S. Grant won the 1868 presidential election, which was a fortuitous turn of events in the fight for equal rights. Had Grant not been elected, it's doubtful if the all-important Fifteenth Amendment, giving Black men the right to vote, would have made it to the ratification phase.

But Grant did win, and the Fifteenth Amendment was ratified in 1870. This amendment states, "The right of citizens of the United States to vote shall not be denied or abridged by the United States or by any State on account of race, color, or previous condition of servitude."

**TECHNICAL STUFF**

The Fifteenth Amendment created a rift between longtime women's rights supporter Frederick Douglass and prominent suffragists Susan B. Anthony and Elizabeth Cady Stanton. Anthony and Stanton took issue with the Fifteenth Amendment not including gender. It came to a head during the third annual meeting of the American Equal Rights Association on May 12, 1869. Douglass argued that of the two, it was more life or death for Black men to have the vote than white women. Stanton argued that educated white women deserved the vote more and even stated "Think of Patrick and Sambo and Hans and Yung Tung, who do not know the difference between a monarchy and a republic, who cannot read the Declaration of Independence or Webster's spelling book, making laws...," a sentiment she had also shared earlier in the year. Anthony backed that up with various arguments, including "if you will not give the whole loaf of suffrage to the entire people, give it to the most intelligent first." By "most intelligent," Anthony meant white women. Frances Ellen Watkins Harper and Sojourner Truth addressed the exclusion of Black women throughout the entire discussion of the Fifteenth Amendment and women's suffrage.

# A Turn for the Worse: The End of Reconstruction

Despite the ratification of the Fourteenth and Fifteenth Amendments, all wasn't well in the fight for civil rights. White Southerners were determined to regain power and turn back civil rights advances, and white Northerners were growing weary of the fight.

## The Redeemers

Known as Redeemers, white Southerners who were determined to seize back power from Black Americans by any means unleashed another reign of violence throughout the South. During elections, they intimidated Black voters at the polls and at their homes. If that didn't work, murder was also an option. Frequently outgunned, Black Americans often suffered as they tried to defend themselves:

>> **Massacre at Colfax Courthouse, Louisiana (1873):** When Louisiana's progressive-minded Radical Republican governor William Kellogg replaced the sheriff and judge from the opposing party with Radical Republicans, Black men, anticipating trouble, went on the offensive and turned the courthouse into a fortress. Almost 200 members of the White League descended on the courthouse on behalf of the ousted sheriff, shooting and setting the building on fire. Although only two white people died, more than 50 Black men, including those who surrendered, died.

>> **Attacks in Opelousas, Louisiana (1868):** A mob killed as many as 200 Black Americans in days. The attackers had been angry that Black people had come to the rescue of a white editor of the local Republican newspaper and a Freedmen's Bureau teacher whom three local whites had attacked.

>> **Murders in Coushatta, Louisiana (1874):** When white Northerner and Union veteran Marshall Twitchell attempted to extend Black civil rights, members of the White League rounded up Black and white Republicans, forced them to leave town, and then murdered at least 24 of them on their way out.

The murders in Coushatta, Louisiana, prompted President Grant to send in federal troops, a move unpopular with white Southerners and many white Northerners who had grown tired of Reconstruction. Months later, when the White Man's Party went on a killing spree in Vicksburg, Mississippi, in an attempt to oust the Black sheriff Peter Crosby, Grant sent troops to Mississippi.

# The Mississippi Plan

As Mississippi marched into the critical 1875 elections, white Democrats enacted the *Mississippi Plan* to gain back the government from the more progressive Republicans. Because Mississippi had a Black majority population that was solidly Republican, Democrats used economic intimidation such as firing those who voted Republican and violent attacks such as riots and burning homes to either keep Black Americans from the polls or force them to vote Democrat. There were some claims that white people actually held guns on Black Americans brave enough to go to the polls to ensure they voted for Democrats.

Mississippi Governor Adelbert Ames asked President Grant several times to send federal troops to Mississippi to stop the Mississippi Plan, but Grant, scarred by white Northerners' criticism of his earlier use of federal troops, refused Ames's requests in order to protect Republican chances for the presidency in 1876. Not so coincidentally, Democrats won big at the polls that November, carrying a 30,000 or more margin of votes in a state considered a Republican stronghold. Not only did Mississippi's Democrats practice this intimidation tactic in elections well into the 1960s, but Louisiana, South Carolina, and other Southern states emulated the plan.

# Civil Rights Act of 1875

Distressed by the harsh reality of his Reconstruction efforts, President Grant, no doubt unsure of his options, made a frustrated appeal to Congress in January 1875 for some type of action. They responded with the Civil Rights Act originally proposed in 1870. Although school desegregation was no longer included in the bill, it did contain an important provision regarding equal access to public accommodations.

By the time it passed, however, there wasn't much fight left in Congress as far as Reconstruction was concerned. Both Stevens and Sumner were dead. White Southerners opposed to Reconstruction were regaining congressional and Senate seats. Worse yet, white Northerners appeared less and less interested in Reconstruction.

# Pulling the plug

By 1870, the Union was back together, but as President Grant's trials attest, it was far from smooth sailing. After winning reelection in 1872, scandal rocked Grant's administration, and with him out of the race for the 1876 election, white Democrats and Redeemers knew that ending Reconstruction was within reach.

Discontinuing the Freedmen's Bureau in 1872 wasn't enough. The process of ending Reconstruction really began to take form in 1873, 1874, and 1875 with confrontations like Colfax and Coushatta in Louisiana and various disturbances in Mississippi (refer to the earlier section 'The Redeemers'). With the Democratic candidate Samuel Tilden (former governor of New York who rose to national prominence for crushing a corruption ring there) and the Republican candidate Rutherford B. Hayes (whose scrupulousness also scored him points) both opposed to Reconstruction, the end was inevitable.

Reconstruction was essentially over before its official ending as white Southerners killed and terrorized Black Americans and some white Republicans with impunity. In its March 1876 decision in the case *United States v. Cruikshank*, the Supreme Court overturned the federal convictions of the Colfax Massacre participants and undermined the Enforcement Act of 1870, which sought to repel the KKK and other white supremacist organizations and which had made the Colfax convictions possible.

**REMEMBER**

The Supreme Court's decision in *United States v. Cruikshank* under Chief Justice Morrison Remick "Mott" Waite set the dangerous precedent that only local and state authorities could prosecute individual crimes against others. The Supreme Court maintained that the due process and equal protection clauses of the Fourteenth Amendment permitted federal government intervention only when states denied rights to citizens.

Another critical blow came in the 1876 case of *United States v. Reese* regarding the Kentucky voting tax intended to prevent Black Americans from voting. The Supreme Court ruled that the Fifteenth Amendment, which guaranteed Black men the right to vote, only meant that citizens couldn't be denied the right to vote based on "race, color, or previous condition of servitude."

**REMEMBER**

With this ruling, the United States sanctioned — or rather encouraged — the development of poll taxes, *grandfather clauses* (exemptions from certain laws and practices based on past privilege), and other strategies later used to disenfranchise Black Americans, therefore undermining Reconstruction's purpose.

With slavery abolished, key pro-Reconstruction activists dead, and President Hayes opposed to Reconstruction, white Americans willing to wage the good fight on behalf of Black Americans were hard to find. After the Civil War and 12 long years of wrestling for democracy, Black Americans were again out in the cold. Adding insult to injury, Jefferson Davis, who led the Confederacy, spent just two years in jail and never stood trial for treason. Other key ex-Confederates also escaped significant punishment.

In 1877, a year after the U.S.'s centennial celebration of independence, Black Americans didn't know how far the tide would turn. They were free and educating themselves and each other in record numbers, but the war wasn't over. Although temporarily scorned, the Fourteenth and Fifteenth Amendments would prove to be invaluable building blocks for true democracy. Despite the disappointment of Reconstruction's end, Black Americans continued the fight for equality, even when despair greatly overshadowed hope.

# 3

# Pillars of Change: The Civil Rights Movement

Examine the early days of Jim Crow, noting the subjugation of Black Americans as well as the impact of community leaders, such as Booker T. Washington and W.E.B. Du Bois, who stepped up and proposed ways of executing change.

Look closer at the civil rights era and discover the various organizations that sprouted to bring about change by raising awareness of ongoing injustices against Black Americans.

Read about the actions of key figures including the Reverend Dr. Martin Luther King Jr. and Malcolm X during the Civil Rights and Black Power movements.

Track how post-Civil Rights America, despite its promise of integrated life, including sports teams, colleges, workplaces, political offices and more, came with other challenges still largely rooted in racism.

Find out how electing the country's first Black president further exposed the nation's racial scars, with the killings of Trayvon Martin and Michael Brown among others, mostly by the police, providing fuel to Black Lives Matter, the 21st century civil rights movement.

See how battling Trump, along with COVID-19 and the deaths of George Floyd and Breonna Taylor by Minneapolis and Louisville police spurred new political action determined to build a new future even in the wake of a white supremacist attack on the U.S. Capitol.

» **Finding ways to escape segregation in the South**

» **Surveying Black American leaders of varying positions**

» **Falling in line behind Marcus Garvey**

» **Taking a turn in the mid–20th century**

# Chapter **7**

# Living Jim Crow

B lack Americans soon felt the pinch of Reconstruction's end. White Southerners made it no secret that they longed for the good ole days, and although slavery's return was doubtful, racial equality eluded Black Americans. The racial oppression Black Americans faced in the South was given a name, and that name was Jim Crow, making Black Americans free in name only. In the North, the situation was only slightly better.

This chapter addresses the legal institution of Jim Crow and how it affected Black Americans, particularly in the South. But more than just dwelling on the injustices perpetrated against Black Americans, this chapter shows the various ways Black Americans fought Jim Crow, even highlighting how they disagreed with one another on which direction to take. Most importantly, it connects the fight to abolish slavery with the fight to abolish inequality and sets the stage for the culmination of these struggles in the 1950s and 1960s.

## Post-Reconstruction Blues

As turbulent as Reconstruction had been (refer to Chapter 6), there were many hopeful moments. Black Americans were pursuing education; joining the professional ranks as teachers, congressmen, and doctors; becoming landowners; and

voting in record numbers for the first time. Throughout Reconstruction, especially toward its end, some white Southerners began to employ shady means to disenfranchise Black Americans. With the federal government's withdrawal from the South in 1877, Black Southerners were largely on their own. White Southerners knew this and went to extreme lengths to return their part of the country as close to slavery as possible.

**TECHNICAL STUFF**

Black American historian Rayford Logan, who received his M.A. and Ph.D. from Harvard University, called the period spanning from Reconstruction's end in 1877 to roughly around 1901 the *nadir,* or the lowest point of race relations at that time in history. The longtime Howard University historian outlined this history in his 1954 book, *The Negro in American Life and Thought: The Nadir, 1877–1901.* Other scholars like John Hope Franklin extended the nadir's end to the 1920s.

Expanding *sharecropping,* a system in which farmers worked the land first in hopes of "sharing the crops" (and/or profits) later, and completely disenfranchising Black Americans became the two chief strategies used by white Southerners to turn back the clock. In addition, they threatened economic repercussions such as firing workers or using violence to prevent Black Southerners from voting Republican. White Southerners believed that white Northerners would rule over them if they were given political power. (White Southerners began to institute poll taxes, literacy tests, and grandfather clauses to keep Black Southerners from voting. Many giving the literacy tests didn't know the answers to the questions.)

Wealthy white Southerners also feared the rise of the Populist Party, also known as the People's Party, which advocated having poor white and Black Americans set aside their racial differences in favor of economic self-interest for both. In 1888, for example, Black farmers in Lovejoy, Texas, formed the Colored Farmers' National Alliance and Cooperative Union, which later aligned itself with similar white organizations in the South and Midwest to improve conditions for all farmers.

When some Black Americans thrived economically, white Southerners used *lynching* (death by a mob without due process of the law) as a warning to other Black Americans to stay in their place. White Southerners also began to pass laws mandating racial segregation in restaurants, on railroad cars, and in any other areas of social interaction. As during slavery, white Southerners forced Black Americans to defer to them or suffer the consequences. Some Black Americans didn't wait for things to get worse to make a move — literally.

## The Exoduster Movement

As conditions worsened in the South, many Black Americans began to believe that leaving the South was the only solution. Benjamin "Pap" Singleton, who was formerly enslaved, was one of the many Black Americans who believed that greater

freedom awaited Black Americans elsewhere (specifically, in the Great Plains). He and his partner Columbus M. Johnson established a colony for Black Americans near Dunlap, Kansas.

Known as the *Black Exodus* (as well as the Great Exodus or the Exoduster Movement of 1879), thousands of Black Southerners responded enthusiastically to such efforts. Between 1879 and 1881, at least 50,000 Black Americans fled Southern states for Kansas, Missouri, Indiana, and Illinois.

**TECHNICAL STUFF**

The sheer numbers in the Black Exodus shocked white Northerners. In 1880, the U.S. Senate conducted hearings to discern the forces behind the exodus. In addition to Singleton, who dubbed himself the "Moses of the Colored Exodus," exodus supporter Henry Adams, a war veteran who was formerly enslaved, testified. Adams explained that he based his support for the exodus on the findings by a secret council of Black Americans who, after Reconstruction ended, traveled the South to investigate the true conditions of Black Southerners. Adams also claimed he and his group had sent President Hayes and Congress a petition signed by 98,000 Black Southerners asking that a territory be set aside for them to live in peace. When the petition went unanswered, Adams, through the Colonization Council, encouraged Black Americans to leave the South for Kansas without the government's support.

Not all Black Americans supported exodus. Established Black leadership such as Frederick Douglass felt that leaving the South acknowledged defeat and, to win their freedom, Black Americans had to stand their ground and remain. Many others disagreed. Less than three decades later, Black Americans would once again turn to migration to escape the South's injustice.

## Black Town, U.S.A.

Celebrated writer Zora Neale Hurston wrote often about Eatonville, Florida, the all-Black town where she grew up, but it was far from the only Black incorporated town. Between 1865 and 1900, Black Americans founded more than 100 predominantly Black towns. Still, all-Black towns got a boon from the Exoduster Movement.

In Oklahoma, more than 50 Black towns or settlements sprouted from 1865 to 1920. Oklahoma had so many Black towns, in fact, that Edwin T. McCabe, who founded all-Black Langston, Oklahoma, tried to convince President Benjamin Harrison to designate Oklahoma a Black state. Ironically, Jim Crow laws immediately followed Oklahoma's statehood.

**TECHNICAL STUFF**

Founded in 1887 by Isaiah T. Montgomery and his cousin Benjamin T. Green, both born into slavery, Mississippi's Mound Bayou was one of the most prosperous all-Black towns. Designated the Jewel of the Delta by President Teddy Roosevelt, Mound Bayou, home to the nation's only Black-owned cottonseed mill, boasted a nearly 100 percent literacy rate before 1900.

**REMEMBER**

A philosophy of self-help and self-reliance permeated the Black town movement. As the focus of the American economy moved from agriculture to industry, Black towns, which were largely agricultural, declined around 1910. Already hard-hit, surviving towns couldn't withstand the later onset of the Great Depression.

## Lynchings and riots/massacres

Rural areas in the South were especially vulnerable to riots during and after Reconstruction. Cities weren't safe either. Ida B. Wells-Barnett's investigative reporting shed more light on the details surrounding the lynching deaths of Black Americans. Through examining statistics and combing newspapers for details around reported lynchings, she found 728 Black men and women were killed via lynching (see Figure 7-1) between 1883 and 1891. Of that number, roughly a third had been accused of rape.

**FIGURE 7-1:**
An all-too-common sight in America during the early 20th century.

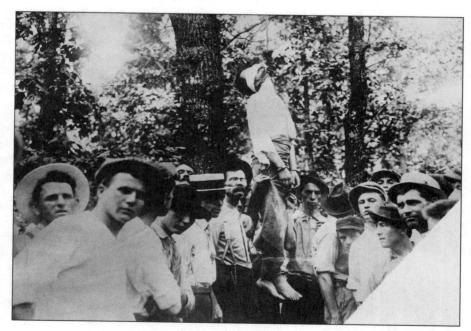

*George Rinhart/Getty Images*

**BLACK AMERICAN FACES**

# IDA B. WELLS-BARNETT

Segregated railroad cars served as the Mississippian Ida B. Wells-Barnett's formal induction into the Black American fight for equality. In May 1884, she refused to move when a railroad conductor insisted she leave the first-class car she'd paid for simply because of her race. To enforce the 1882 Tennessee law requiring separate accommodations for white and Black people, the conductor and two other railroad employees literally dragged Wells-Barnett off the train. Confident of a victory, Wells-Barnett immediately filed suit, but the December 1884 decision in her favor was short-lived. In 1887, the Tennessee Supreme Court overturned the decision.

When angry white Memphians lynched her friends Thomas Moss, Calvin McDowell, and Henry Stewart — successful grocers in direct competition with a white grocer — Wells-Barnett, a partner in *The Free Speech,* a Black newspaper in Memphis, became one of the foremost authorities on lynching, investigating 728 of them by traveling to actual sites and interviewing eyewitnesses. After the publication of her editorial that questioned the "moral reputation" of Southern white women, Wells couldn't return to the South and eventually settled in Chicago. *Crusade for Justice: The Autobiography of Ida B. Wells* (University of Chicago Press), published decades after her 1931 death, offers insight into her life and work.

Particularly angered by claims that Black male lynching victims had raped white women, Wells–Barnett found that economic success, not rape, often prompted deadly action against Black men. She also discovered that false rape charges often masked consensual sex between Black men and white women. Equally important, Wells–Barnett exposed the lynchings of Black women, which are often overlooked. She initially published her findings in *The New York Age* in 1892. With financial assistance from various organizations, she expanded that work by publishing the pamphlets *Southern Horrors: Lynch Law in All Its Phases* and *Red Record.*

Most often, riots (or, more accurately, massacres) and lynchings went hand and hand. And sadly, they were far too common. Some pretty well–known ones from 1898 into the early 1920s include the following.

## Wilmington, North Carolina (1898)

The Wilmington Massacre, Insurrection, or Coup of 1898 occurred after a coalition of Black Republicans and white Populists won statewide political power (including a progressive white governor and, in turn, a progressive white mayor of majority Black Wilmington) in the 1896 election. To counter this inclusive leadership, especially that of Black men, an extensive statewide white supremacy campaign was launched in 1897.

Months prior to the statewide November 1898 election, Alex Manly, editor and co-owner of *Daily Record*, Wilmington's Black newspaper, had published an editorial in response to published comments that Rebecca Felton had made in Georgia in support of lynching Black men to protect white women from rape. The state's white newspapers used it to fan the white supremacist flames. On November 10, two days after the election, a coup, engineered by white supremacists, forcibly replaced Mayor Silas P. Wright, whose administration included Black men, with Alfred M. Waddell. White men, including those of influence — bankers, lawyers, merchants, and even clergymen — also went on a violent spree against Wilmington's Black population, torching the *Daily Record*'s office and killing anywhere between 60 and 300 Black people. Their actions decimated the city's Black voter rolls, with many residents permanently fleeing.

## Atlanta, Georgia (1906)

To gain favor with white voters, Georgia's two gubernatorial candidates debated how best to manage Atlanta's growing Black populace, which had grown from roughly 9,000 in 1880 to 35,000 in 1900. Meanwhile, local newspapers boasted of lynchings and called for a revival of the Ku Klux Klan, which, despite its secrecy, was generally well-regarded among segregationist white people (see Figure 7-2).

**FIGURE 7-2:**
A family affair for white segregationists.

*Bettmann/Getty Images*

Reports of four assaults of white women, presumably by Black men, drove white people to mob action. On September 22, thousands of white people from the country and the city gathered in downtown Atlanta and began randomly assaulting innocent Black people. For three days, the Atlanta Race Riot of 1906 continued. When it ended, at least 25 Black Atlantans had died.

**IN THEIR OWN WORDS**

Walter White, who would become an important civil rights activist, was just a boy at the time of the riot, when he witnessed a mob club a defenseless young boy to death outside a Black-owned barbershop. Evelyn Witherspoon, a 10-year-old white girl, awakened in the middle of night and joined her sister and mother kneeling by the window. "And there I saw a man strung up to the light pole," she remembered. "Men and boys on the street below were shooting at him, until they riddled his body with bullets. He was kicking, flailing his legs, when I looked out."

## Springfield, Illinois (1908)

Violence erupted in Springfield, Illinois, in 1908 when George Richardson, accused by a white woman of sexual assault, and Joe James, another Black man accused of murdering a white man, were moved to a neighboring town. The move angered Springfield's white residents, who seized guns and other weapons and burned buildings. Over the course of the violence, two Black men were lynched, four white men died, and more than 70 people suffered injuries. Hundreds of Springfield's Black residents fled for safety, with many later returning to rebuild their lives.

## East St. Louis, Illinois (1917)

In July 1917, an aluminum plant in East St. Louis hired Black workers to break a strike, and white trade unionists met with the mayor and demanded that the city stop Black people from migrating there. After the meeting, a rumor circulated that a Black man had intentionally shot a white man in an altercation that included insults against white women. Unchecked by local officials, white mobs took to the streets and drove through Black neighborhoods, firing shots indiscriminately. In the end, nearly 40 Black people died, with hundreds more injured. An estimated 6,000 Black people were driven from their homes. At least 300 buildings were destroyed.

## Houston, Texas (1917)

Almost immediately when the army ordered the Third Battalion of the Black Twenty-Fourth U.S. Infantry to Camp Logan in Houston, problems occurred. Whenever the soldiers went into town, they encountered racial backlash, which all came to a head August 23, 1917, when two white police officers arrested one Black soldier for interfering with their arrest of a Black woman. When Black military policeman Corporal Charles Baltimore inquired about the arrest, an argument ensued and he was hit over the head, fired on three times, chased into an unoccupied house, and taken to police headquarters.

News spread that Baltimore had been killed and that a white mob was headed to the camp. A group of more than 100 Black soldiers marched into the city. The Black soldiers were accused of killing 15 white people, including two police officers, and wounding 12 people, out of which another police officer died. Four Black soldiers died, with two believed to have been shot by their own men. A curfew was imposed on Houston the next day.

On August 25, the Third Battalion was taken to Columbus, New Mexico, where seven of the Black soldiers agreed to testify against their fellow soldiers in exchange for clemency. The military tribunals resulted in the indictment of 118 Black soldiers, with 110 being found guilty. Nineteen Black soldiers were hanged, and 63 received life sentences in federal prison. The two white officers who faced court-martial were released. No white civilians were brought to trial. (Filmmaker Kevin Willmott, a longtime Spike Lee collaborator, dramatized the tragedy in the 2020 feature film *The 24th*.)

## Various cities, the Red Summer of 1919

So many race riots or massacres — 26 to be exact — took place in the summer and fall of 1919 in the North and the South that writer and civil rights activist James Weldon Johnson dubbed it "the Red Summer of 1919." Following are just two:

» **Longview, Texas:** Anger over a *Chicago Defender* article about the bullet-riddled body of Lemuel Walters by a white mob, who had taken him from the Longview jail where he was being held for allegedly making advances toward a white woman, resulted in more violence. When white townspeople ordered Samuel L. Jones (the Black high school teacher they believed had penned the article suggesting a consensual interracial relationship) and Dr. Calvin P. Davis to leave town, a group of armed Black men gathered at the teacher's house instead and fired back when a white mob attacked them, killing four white people and wounding several others. White townspeople then burned several houses and murdered the doctor's father-in-law before order was restored.

» **Chicago, Illinois:** When several Black youth drifted into the waters of a public beach whites claimed as their own, white bathers threw rocks at the boys, one of whom drowned during the attack. When a Black man was arrested and a white man identified as the rock thrower wasn't, Black Chicagoans attacked the arresting officer. For five days, violence raged on Chicago's South Side. When the violence ended, 15 white people and 23 Black people were dead, 537 people (mostly Black) were injured, and between 1,000 to 2,000 people (mostly Black) were homeless.

Violence also erupted in Knoxville, Tennessee; Omaha, Nebraska; and Elaine, Arkansas. Although differing in specifics, all the riots (massacres) during Red Summer highlighted the growing racial tension and divide, and in all, Black Americans actively fought back against their attackers. Led by the summer's tumultuous events, Claude McKay summed up this "New Negro" at the end of his classic poem "If We Must Die": "Like men we'll face the murderous, cowardly pack/Pressed to the wall, dying, but fighting back!"

## Tulsa, Oklahoma (1921)

When the *Tulsa Tribune* published a story on May 31, 1921, exaggerating the details of an alleged sexual assault of a white woman by a Black man who was arrested and jailed, a white mob surrounded the jail that night intending to lynch Dick Rowland, the accused Black man. Determined to prevent Rowland's death, an armed group of Black men showed up. Trouble escalated when a member of the white mob tried to grab the gun of one of the Black men and it went off. Mayhem ensued as the mob went wild, assaulting Black Americans on the streets and burning down Greenwood, which had a reputation as the Negro's Wall Street of America for its prosperity.

By the time the National Guard stepped in, most of the violence, now known as the Tulsa Massacre of 1921, had ended. The official death toll was 39, but subsequent investigations have estimated the number to be as high as 300. The homeless numbered into the thousands. Using its own resources, Black Tulsa eventually rebuilt itself but never achieved its previous stature. (Tulsa figured prominently in the storylines of two HBO series: *Watchmen* (2019) and *Lovecraft Country* (2020).)

## Rosewood, Florida (1923)

The massacre that occurred in Rosewood, Florida, in January 1923 began after a white woman reported being attacked by an unidentified Black man. Convinced that Black residents were hiding the guilty Black prisoner who had reportedly escaped a chain gang, a white mob apprehended one Black man, whom the sheriff got out of town, only to kill another Black man later. In the ensuing mayhem, the white mob attacked the homes of Black people. During the attack, two white men died; meanwhile, the people in the house were either killed or seriously injured, prompting other Black people in the area to flee into the swamps.

Over a course of days, white people from surrounding areas converged on Rosewood, killing more Black Americans as well as burning their homes and churches. When the attacks finally ended, a grand jury convened to investigate the incident but found "insufficient evidence" to move forward. (John Singleton directed the 1997 film *Rosewood* about the Rosewood Massacre of 1923. Florida paid reparations to nine Rosewood survivors in 1994.)

# Instituting Jim Crow: Plessy v. Ferguson

Quite literally, as noted scholar and political activist W.E.B. Du Bois wrote in his classic work *The Souls of Black Folk* (1903), "The problem of the Twentieth Century is the problem of the color-line." This was certainly evident in the efforts to deny Black Americans full rights as citizens. Their rights under attack, Black Americans looked to the courts for redress. Yet in 1896, instead of protecting those rights, the Supreme Court's *Plessy v. Ferguson* ruling legalized the color line that divided the nation.

**REMEMBER**

For years, the Supreme Court had inched toward legalizing segregation. With its devastating *Plessy v. Ferguson* decision in 1896, it formally sanctioned Jim Crow in the South and across the country.

**TECHNICAL STUFF**

The term *Jim Crow* comes from a popular tune by white minstrel show performer Thomas "Daddy" Rice. See Chapter 15 for more on minstrel shows.

## Court cases before Plessy

With its 1876 rulings in *United States v. Cruikshank* and *United States v. Reese*, the Supreme Court curtailed the Fourteenth and Fifteenth Amendments' protection for Black Americans. According to *Cruikshank*, the Fourteenth Amendment gave the federal government jurisdiction over state actions, not individual actions. Therefore, the federal government couldn't prosecute individuals for intimidating Black Americans at the polls; states had to address it. *Reese* allowed states to enact poll taxes (refer to Chapter 6 for the details surrounding these decisions).

If that weren't enough, in the *Civil Rights Cases of 1883* (a consolidation of five lower court cases), the Supreme Court declared the Civil Rights Act of 1875 prohibiting private institutions from discriminating against Black Americans unconstitutional. Justice Joseph P. Bradley noted that neither the Thirteenth nor Fourteenth Amendment allowed Congress to address racial discrimination in the private sector. John Marshall Harlan, in his lone dissent, noted that Congress was only attempting to secure the same rights of white citizens for Black Americans.

## The actual case: Plessy v. Ferguson

When the Louisiana Separate Car Act of 1890 requiring "equal but separate" accommodations for white and Black people passed, New Orleans's Creole community attacked the law in various ways, including newspaper editorials. Enlisting the help of Homer Plessy, whom authorities arrested in 1892, the Creole community never anticipated that the U.S. Supreme Court would rule in favor of such discriminatory law.

**IN THEIR OWN WORDS**

Although "separate but equal" doesn't actually appear in the decision, the court upheld the 1890 law, stating that "We consider the underlying fallacy of the plaintiff's argument to consist in the assumption that the enforced separation of the two races stamps the colored race with a badge of inferiority. If this be so, it is not by reason of anything found in the act, but solely because the colored race chooses to put that construction upon it." As in the Civil Rights Cases of 1883, Justice John Marshall Harlan was the lone dissenter.

After the ruling, Southern states passed even more Jim Crow laws. "White Only" and "Colored Only" eventually marked everything from restaurants to railroad stations. Although racial discrimination also existed in the North, the South wore its discriminatory practices like a badge of honor. From lynchings to political disenfranchisement via poll taxes and literacy tests (not to mention the pettiest of human degradation), Black Americans, an overwhelming 90 percent of whom lived in the South, bore the brunt of "living" Jim Crow.

# Strategies for Achieving Equality

How to address racism's latest tactics became the primary question facing Black leadership as it underwent tremendous change at the turn of the 20th century. In February 1895, Frederick Douglass died at the age of 77, and two Black American intellectuals — Booker T. Washington and W.E.B. Du Bois — were polar opposites in their ideologies regarding how to achieve equality. Washington favored the *accommodationist* policy of forgoing political power in favor of economic progress,

whereas Du Bois advocated the *integrationist* policy advocating immediate political agitation to achieve social equality. Quite simply, one accepted Jim Crow, and the other rejected it.

# Booker T. Washington: The Accommodationist

A year before the *Plessy* decision, Booker T. Washington, the man born enslaved who built Alabama's Tuskegee Institute into an institution of national renown, delivered his highly controversial address known as the Atlanta Compromise at the Cotton States and International Exposition in Atlanta on September 18, 1895. The Atlanta Compromise articulated Washington's message of accommodation.

**REMEMBER**

Aware of the potential threat European immigrants posed to positions traditionally held by Black Americans, Washington emphasized Black Americans' loyalty, reminding his audience of who had nursed their children and cared for their dying parents. Washington advised white and Black people to "cast your bucket down where you are." If whites "cast their buckets" with Black Americans, he insisted, the South would progress economically without upsetting the social balance. "In all things that are purely social," he reassured his audience, "we can be as separate as the fingers, yet one as the hand in all things essential to mutual progress."

In the context of the times, Washington's message wasn't outlandish. "We wear the mask that grins and lies," wrote Paul Laurence Dunbar in his famous poem "We Wear the Mask." Especially during slavery, many Black Americans learned to mask their true feelings from slaveholders and other white people for survival. Few wore that mask as expertly as Washington did. In public, he advised Black Americans to focus on industrial education and work, not on political injustices, and he, in the eyes of others, ignored or excused lynchings. Privately, Washington supported lawsuits challenging the disenfranchisement of Black American voters and consistently funded efforts to pass an anti-lynching bill. Defying Jim Crow laws, Washington often rode alongside whites in first-class train cars, dined in whites-only facilities, and met with President Teddy Roosevelt at the White House.

# W.E.B. Du Bois: The Integrationist

W.E.B. Du Bois's criticism of Washington's Atlanta Compromise address in *The Souls of Black Folk* (1903) helped establish him as a Black leader in opposition to Washington (see Figure 7-3). Du Bois, reversing his earlier support for Washington's 1895 speech, later disagreed with Washington's acceptance of Jim Crow and believed that Black Americans should agitate for political change.

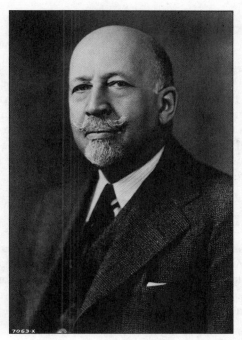

**FIGURE 7-3:**
W.E.B. Du Bois.

*Library of Congress/Getty Images*

At the time of their break, however, there were few Black organizations — or any white or integrated organizations for that matter — dedicated to Du Bois's strategy. There had been various antislavery organizations during slavery, but after slavery ended, they disbanded and nothing concerted sprouted in their place until the early 1890s and the early 20th century. In 1905, Du Bois cofounded the Niagara Movement with William Monroe Trotter before later settling in with the National Association for the Advancement of Colored People (NAACP). (Read more about these organizations in the next section.)

Although Du Bois believed in first-class citizenship for Black Americans, which included full voting rights, his approach was elitist by some people's standards. Du Bois supported the concept of a "Talented Tenth," first proposed by abolitionist and elder statesman Alexander Crummell in 1897 at the founding of the American Negro Academy, the nation's first major Black intellectual society. The Talented Tenth were the best and brightest of the Black race charged with the responsibility of leading the masses and shaping their goals and aspirations. These men (although some women were included) also represented Black American interests to the white power structure (Chapter 13 has more on the Talented Tenth).

# Organizing for Freedom

The horrendous experiences of Black Americans post-Reconstruction underscored the absence of organizations addressing racial violence, job discrimination, segregated housing, and the many other ills confronting Black Americans. At the turn of the 20th century, that need was recognized and several organizations, such as those outlined in the following sections, emerged. By the time of Washington's death in 1915, two of these organizations in particular — the NAACP and the National Urban League — would play especially strong roles in addressing some of Black America's greatest challenges in the 20th century.

## National Afro-American Council

*New York Age* publisher T. Thomas Fortune helped spearhead the 1890 formation of the National Afro-American League, a precursor to the NAACP. When the league failed in 1893, Fortune didn't give up. Instead, he helped form the National Afro-American Council in 1898, which adopted a form of militant protest. The council's objectives included

>> Investigating and reporting lynchings

>> Assisting efforts that tested the constitutionality of laws oppressing Black Americans

>> Encouraging both industrial and higher education among Black Americans

By 1902, followers of Washington, known as *Bookerites*, had taken over the organization. They tempered the organization's militancy and diverted its economic initiatives to the National Negro Business League before its demise in 1906.

## The National Negro Business League

The National Negro Business League (NNBL) had controversial beginnings. Following an 1899 conference talk titled "The Negro in Business," in which Du Bois documented an estimated 5,000 Black entrepreneurs, he became the director of the Business Bureau of the National Afro-American Council. In what probably wasn't a coincidence, Washington asked Du Bois for a list of potential members before hosting the first conference of the NNBL in Boston in August 1900, without Du Bois.

**IN THEIR OWN WORDS**

Because white Americans weren't interested in employing Black Americans, it was only reasonable for Black Americans to employ each other. Recognizing the need to cultivate Black businesses, Washington said in his last annual address to the NNBL, "At the bottom of education, at the bottom of politics, even at the bottom of religion itself there must be for our race, as for all races, an economic foundation, economic prosperity, [and] economic independence."

## WOMEN'S WORK

In addition to supporting general organizations dedicated to racial and social equality, Black women formed their own organizations. The First National Conference of the Colored Women of America resulted in the formation of the National Federation of Afro-American Women, headed by Booker T. Washington's wife, Margaret Murray Washington. In 1896, that organization merged with the National League of Colored Women, headed by Mary Church Terrell, and spawned the National Association of Colored Women (NACW), whose membership boasted the nation's most prominent Black women.

While the NACW supported the women's suffrage movement, some white women who were opposed to integration excluded Black women from their suffrage efforts. This prompted Mary Ann Shad Cary to form the Colored Women's Progressive Franchise Association as an auxiliary of the predominantly white National American Women Suffrage Association (NAWSA). (To keep Black female suffragists in the South in the loop, Adella Hunt Logan often passed for white to attend NAWSA's Southern meetings.)

The overall goal for Black women, as articulated by writer Frances Ellen Watkins Harper at the predominantly white World's Congress of Representative Women, held in Chicago in 1893, was "Demand justice, simple justice, as the right of every race."

Under Washington's direct leadership, the NNBL and its national convention in particular served several functions:

>> Fostering economic development as a primary means of obtaining racial equality

>> Uniting Black business owners to fellowship and to exchange innovative ideas to promote economic growth

>> Tracking Black business development and growth

NNBL participants such as William Pettiford (an early pastor of what is now the Sixteenth Street Baptist Church and founder of Penny Savings Bank in Birmingham, established in 1890) clearly understood their important role in the community. Pettiford, for example, knew that 90 percent of his customers had never held a bank account before, so his bank took great pains to educate customers on how to save and invest wisely. He believed this knowledge stimulated the desire for property ownership and other responsible fiscal behavior that contributed to the overall well-being of the Black American community.

# MADAM C.J. WALKER

Of the early Black female entrepreneurs, Madam C.J. Walker, born Sarah Breedlove in Louisiana two years after the Civil War ended, is the most famous. Despite being orphaned at age 7 and becoming a widow by age 20, Walker built a national empire around Black haircare and cosmetics by 1917. She was so successful that she owned a manufacturing plant in Indianapolis and employed almost 1,000 sales agents nationally.

Arguably one of the most successful Black entrepreneurs — male or female — of her time, Walker was also a noted philanthropist who donated to the NAACP and such educational institutions as Tuskegee Institute. Although Walker's former employer, Annie Turnbo Malone, who first patented the straightening (or pressing) comb, might have achieved the millionaire status first, Walker served as the prototype for the Black female entrepreneur for many years. Walker's great-great-granddaughter A'Lelia Bundles published *On Her Own Ground: The Life and Times of Madam C.J. Walker*, a definitive biography, in 2001 (Scribner).

# The Niagara Movement

Former Harvard schoolmates William Monroe Trotter (founder of the Black newspaper *The Guardian* and who had long opposed Washington's accommodationist politics) and Du Bois convened a group of prominent Black Americans in June 1905 in Fort Erie, Ontario, near Niagara Falls. The purpose of the conference was to discuss a more proactive strategy to achieve first-class citizenship for Black Americans and to launch the Niagara Movement.

The Niagara Movement marked the official launch of the 20th-century movement for civil rights and produced a clear platform that included demands for freedom of speech, full voting rights, and the end of segregation.

Unlike many other prominent Black Americans, Trotter routinely criticized Washington. Consequently, Washington reportedly planted spies to stay abreast of the Niagara Movement's actions. He even used his influence with the Black press to limit the organization's press attention.

Despite having fewer than 200 members and virtually no press attention, the Niagara Movement distributed pamphlets, lobbied against Jim Crow, and even sent protest letters to the President. Ultimately, clashes between the more radical Trotter and the comparatively reserved Du Bois (not scant funding and organizational weakness) led to the Niagara Movement's demise.

# The NAACP

**HISTORICAL ROOTS**

Contrary to popular belief, DuBois didn't conceive the NAACP. Instead, the NAACP began with a group of white activists spurred to action by the horrendous Springfield Race Riot of 1908 (refer to the earlier section "Lynchings and riots"). William English Walling, the son of a former slaveholding family, and his wife were in Illinois when violence erupted. Particularly disturbed that this type of violence occurred in a city so closely aligned with Abraham Lincoln, Walling wrote an article, "Race War in the North," that provoked a response from Mary White Ovington, a white social worker who had served Black Americans in New York City. Early in 1909, Walling, Ovington, and Dr. Henry Moskowitz met in a New York City apartment and conceived what would become the NAACP. They issued a call for a national conference to tackle the problems of Black Americans on Lincoln's birthday, February 10, 1909.

Endorsers of the NAACP, evident through their attendance at the national conference, included Du Bois, social reformer and Nobel Peace Prize winner Jane Addams, psychologist and education reformer John Dewey, and Ida B. Wells-Barnett, among many others. On May 31 and June 1, 1909, conference attendees laid the groundwork necessary for the NAACP. (Highly suspicious of white people, William Monroe Trotter didn't attend.)

In 1910, the NAACP began formal operations with one Black member among its officers: Du Bois served as Director of Publicity and Research. Under his leadership, *The Crisis*, the NAACP's official magazine, took a strong stance against lynching and mob violence. People responded enthusiastically and, three years later, the NAACP had 1,100 members. By 1921, it claimed more than 400 branches.

**REMEMBER**

Spearheaded by Arthur Spingarn, the NAACP's legal team became one of its most enduring legacies. With white and Black attorneys working together, the NAACP began a diligent legal assault that chipped away at Jim Crow. Almost immediately, the team won three key Supreme Court cases:

>> *Guinn v. United States* (1915) upheld the 15th Amendment, voiding Oklahoma's grandfather clauses.

>> *Buchanan v. Warley* (1917) declared Louisville ordinances forcing Black Americans to live in certain areas unconstitutional.

>> *Moore v. Dempsey* (1923) forced a new trial for a Black man convicted of murder in Arkansas, partially because no Black Americans sat on the jury.

## The National Urban League

A direct result of Black Southerners moving North to escape Jim Crow, the National Urban League (NUL) sought to address the problems of Black migrants. It combined the goals of all the civil rights organizations with the economic concerns of the National Negro Business League. As more migrants flooded into the cities, the NUL grew rapidly, opening a Chicago office in 1912. By 1941, it had expanded to 30 cities. During the Great Migration, the NUL was at the forefront of one of Black America's most tumultuous times of change and opportunity.

Fulfilling its primary mission of aiding migrants in their transition to life in the North, the NUL battled employment discrimination; poor housing, education, and healthcare; and discriminatory local, state, and federal economic and social policies.

**HISTORICAL ROOTS**

Anticipating the Great Migration, the mass relocation of Black Americans from the South spanning roughly from 1914 to 1940, the NUL was the brainchild of Ruth Standish Baldwin (the widow of a railroad magnate) and Dr. Edmund Haynes (a Fisk graduate and Columbia University's first Black Ph.D. recipient). They established the Committee on Urban Conditions Among Negroes in 1910, merging it with the Committee for the Improvement of Industrial Conditions Among Negroes in New York (founded in 1906) and the National League for the Protection of Colored Women (founded in 1905) to create the National League on Urban Conditions Among Negroes in 1911. It became simply the National Urban League in 1920.

# Keep on Moving: The Great Migration

As Du Bois and others argued about top-down Black leadership, the Black masses didn't wait for the Court to make decisions. In search of better jobs, educational opportunities, and an escape from racial violence, the Black population of Northern cities swelled. New York City's Black population rose 66 percent between 1910 and 1920 — a modest increase compared to Chicago's 148 percent, Philadelphia's amazing 500 percent, and Detroit's unbelievable 611 percent. The Great Migration profoundly changed life in the U.S.

## Leaving the South

In addition to lynchings and other forms of terrorism (refer to the earlier section "Post-Reconstruction Blues"), two key reasons Black Southerners left the South included

- » **Mother Nature:** Beginning in 1898, boll weevils infested cotton crops in Texas and spread that devastation all over the South well into the 1910s. Because the South was slow to industrialize, it couldn't rebound as quickly, and agricultural work became scarce. Next to the boll weevils, the Great Mississippi Flood of 1927 sent Southerners north. Poor treatment after the flood — insufficient relief funds and inadequate or no housing, for example — drove Black Southerners out of the South.

- » **Better jobs and opportunities:** World War I significantly curtailed European immigration at the same time that white American men joined the war effort, leaving an abundance of factory jobs unfilled. In Detroit, Henry Ford offered Black Americans jobs with equal pay. Some companies were so desperate for workers that they paid people's way north. In addition to better wages, schooling was slightly improved. The *Chicago Defender,* with its front-page stories on lynchings and tales of migrants who struck it rich, played such a prominent role in motivating Black Southerners to leave that it was banned in many parts of the South.

Hard choices and sacrifices followed the decision to migrate. Potential migrants, typically Black men ages 18 to 35, saved money for months. Some families chipped in to help with tickets. Others sold their last possessions. Sometimes migrants stopped en route and worked in smaller towns until they could make it to bigger cities like Chicago or Philadelphia. Children sometimes stayed with grandparents and relatives until their parents could afford to send for them. Unfortunately, for many migrants, the North wasn't as welcoming as they believed.

## OH, WON'T YOU STAY, JUST A LITTLE BIT LONGER?

Curiously, white Southerners had difficulty understanding why Black Americans wanted to leave the South. During the Great Migration, local authorities blocked white recruiting agents' access to Black communities, and they pulled willing migrants off trains. In addition, white employers refused to hire Black Americans in order to keep them from earning the money they needed for the trip. In a case of twisted logic, Southern whites felt that further terrorizing Black people and keeping them impoverished would make them want to stay.

## Life up North

The National Urban League, as well as the Young Men's Christian Association (YMCA) and its sister organization, Young Women's Christian Association (YWCA), were a huge help in providing migrants with housing information and job leads. Yet life in the North was far from grand for most Black Americans. Racism, they discovered, was a national problem. Key challenges for Black Americans included

>> **Substandard housing:** Migrants paid substantially more than white workers for housing, most often *kitchenettes,* one-room apartments created by greedy landlords capitalizing on the limited housing for Black Americans. Often four to five adults lived in one room. In addition, landlords were slow to perform necessary maintenance, but migrants were so afraid of not finding other housing that they usually didn't complain.

>> **Poor healthcare and crime:** Overcrowding, poverty, and inadequate healthcare created innumerable health concerns. Infectious disease raged, and many migrants, especially children under the age of 10, died in high numbers. Black babies frequently died at twice the rate of white babies. These conditions also produced crime. The hungry stole food. The broke robbed others. Some confrontations turned violent and resulted in death.

In time, migrants and their leaders learned to parlay their significant population into politics, as astute leaders realized that there was strength in numbers. At the very least, Black Northerners could vote, and they began to use that right more effectively with each passing year.

# Marcus Garvey: Man with a Plan

The racial pride and self-reliance that were respected qualities during Booker T. Washington's reign reached even greater heights during the Great Migration. Jamaican immigrant Marcus Mosiah Garvey recognized the power of racial pride as well as the alienation that migrants felt from middle-class leaders; in response, he offered his Universal Negro Improvement Association (UNIA) movement as the solution. The UNIA was the first mass movement among Black Americans in the 20th century.

**TECHNICAL STUFF**

Garvey brought the UNIA, established in 1914 in Jamaica, to Harlem, New York, in 1916. By 1924, there were more than 700 branches of the UNIA in 38 states and more than 200 branches throughout the world, including the African continent. Within the United States, the circulation of *Negro World,* the UNIA's official newspaper, reached a height of 50,000 to 60,000 subscribers in the mid-1920s and boasted an overall domestic and international circulation of 200,000 *weekly.*

# Advocating racial pride

Seizing upon the ideology and rhetoric of self-determination surrounding World War I, Garvey spoke strongly of racial pride as a basis of global unity among African descendants. "Africa for the Africans at home and abroad" is just one of the slogans he popularized to reinforce his Pan-African perspective.

**IN THEIR OWN WORDS**

Garvey encouraged his followers to have Black heroes. He also preached Africa's greatness to them and insisted that they possessed that greatness as well. "When Europe was inhabited by savages, heathens, and pagans," he told them, "Africa was peopled with a race of cultured Black men, who were masters in art, science, and literature. Whatsoever a Black man has done, a Black man can do."

Like Washington (refer to the earlier section "Booker T. Washington: The Accommodationist"), Garvey emphasized Black self-reliance and solidarity to ameliorate economic conditions for Black Americans and African people globally. In 1919, he established the Negro Factories Corporation, which operated several businesses, including grocery stores, restaurants, a printing plant, and a steam laundry.

# Going "Back to Africa"

Imperialism thrived during the 1920s as European nations began dividing countries (and continents) among themselves. Garvey believed that it was up to people of African descent to stop them. "Whether it is saving this one nation or that one government," he declared in 1923, "we are going to seek a method of saving Africa first. Why? And why Africa? Because Africa has become the grand prize of the nations. Africa has become the big game of the nation hunters."

**REMEMBER**

Garvey's "Back to Africa" message was more complex than is generally perceived. Unlike the colonization movement of the 19th century (refer to Chapter 5), Garvey didn't necessarily advocate going "back to Africa" to flee white racism. Instead, his message was one of empowerment.

Black Americans and Black people from various parts of the world responded strongly to Garvey's message. Regardless of whether they wanted to immigrate to Africa, they believed they had a responsibility to support any efforts to restore her greatness. In June 1919, Garvey established his Black Star Line Steamship Corporation and later purchased three ships to carry Africans back to Africa. Garvey's lack of shipping knowledge, coupled with the incompetence or greed of his accountants, not to mention outside sabotage, doomed the Black Star Line, however.

**REMEMBER**

Garvey's message of African nations, Black businesses, and institutions free of white influence resonated strongly, along with his mantra of "Up, you mighty race, you can accomplish what you will."

## Powerful enemies

Established Black leadership didn't applaud Garvey's success. His broad appeal confounded them. They couldn't comprehend how he launched so many successful ventures with no white support. Garvey further alienated the established Black leadership, some near white in appearance, with charges of "brown" racism (discrimination against Black Americans of darker hues). One leader was so angry he sued Garvey for libel and won.

Du Bois and Garvey had a tenuous relationship that developed early. In 1919, Garvey suspected that Du Bois was responsible for the State Department's denying passports to special UNIA delegates who were to attend the Versailles Peace Conference and blasted Du Bois personally. For his part, Du Bois secretly tried to dig up information on Garvey from the State Department with no success before publishing an article on Garvey titled "Lunatic or Traitor" in *The Crisis*.

Garvey's actions also attracted the attention of FBI director J. Edgar Hoover, who built a case for Garvey's deportation. In 1923, Garvey received a mail fraud conviction in association with the Black Star Line and served three months. Arrested again in 1925, he was sent to an Atlanta penitentiary to serve a five-year sentence. In 1927, President Calvin Coolidge pardoned and deported Garvey, who eventually died in London in 1940.

# Can't Catch a Break: The Depression Years and FDR

The Great Depression was especially brutal for Black Americans. A drastic drop in cotton prices crushed about 2 million Black farmers, and many white Southerners refused to give federal relief to Black Southerners. Conditions were only slightly better in cities. The end of World War I halted the wartime economy that had produced jobs for both Black and white Americans, but Black Americans were especially vulnerable as they competed with unemployed whites. In both the South and the North, white workers demanded that employers replace Black workers with white workers, even in the most menial of jobs. Black women lost their lower-level jobs to white women, and the Depression forced Black domestics to work for as little as $5 a week.

Relief rates for Black Americans in the North and South were as much as four times that of white Americans. In Norfolk, Virginia, for example, an estimated 80 percent of the Black population required public assistance. Yet Black Americans who received relief got just over half of what white Americans received. Even in the face of national starvation, racism prevailed when many soup kitchens, some run by churches, refused to feed Black Americans.

Dissatisfied with President Herbert Hoover's response to the Great Depression, white Americans replaced him with Franklin D. Roosevelt. Although Black Americans were still largely Republican, Black Americans who voted for FDR in the 1932 election foreshadowed Black America's seismic Democratic shift.

## FDR: Friend or foe?

Initially, Black Americans saw little to encourage them that Roosevelt's policies would address their needs. In lobbying for his New Deal legislation, Roosevelt argued that supporting anti-lynching efforts would alienate Congress's Southern politicians, jeopardizing the crucial legislation needed to battle the Great Depression. In addition, the provisions of some New Deal initiatives didn't necessarily extend to Black Americans:

>> **NIRA (National Industrial Recovery Act):** The NIRA attempted to set a minimum wage and standard work hours and recommended that employers recognize unions; however, accepting these changes was voluntary, not mandatory, and therefore offered no real protection for Black — or any — employees. In addition, many who accepted the NIRA fired Black Americans instead of extending the NIRA recommendations to them. Black domestic workers and those in other menial jobs weren't covered by the NIRA.

>> **AAA (Agricultural Adjustment Association):** Exclusion from the AAA, which paid farmers not to produce cotton in order to create a shortage that would drive the price up, led Black farmers to lose their land and become sharecroppers.

## Striking a new deal

At the peak of the Great Migration, Black leaders began to leverage the Black vote. Recognizing the importance of the Black vote in his reelection efforts, FDR declared during a national radio broadcast that lynching was murder. He also appointed two Black Americans — Mary McLeod Bethune to head the Negro

Division of the National Youth Administration and *Pittsburgh Courier* editor Robert L. Vann to serve as special assistant to the U.S. Attorney General. Between 1933 and 1946, the number of Black Americans employed by the federal government rose from roughly 50,000 to about 200,000.

First Lady Eleanor Roosevelt, who enjoyed a close friendship with Mary McLeod Bethune, helped push her husband toward a stronger position on civil rights. New Dealers such as Harold Ickes (Secretary of the Interior and administrator for the Public Works Administration) and the Works Progress Administration's Harry Hopkins also pitched in. Ickes ended segregation in the Department of the Interior's restrooms and cafeteria, while Hopkins ended discrimination in WPA relief efforts.

On June 18, 1941, FDR issued Executive Order 8802, banning racial discrimination in government employment, defense industries, and training programs and establishing the Fair Employment Practices Committee (FEPC). This order also helped seal many Black Americans to the Democratic Party and set a precedent for government involvement against racial injustice in the 20th century. It also paved the way for President Harry S. Truman to pass Executive Order 9981 in July 1948, desegregating the military.

## MARY McLeod BETHUNE

Born Mary Jane McLeod to enslaved parents near Maysville, South Carolina, in 1875, Mary McLeod Bethune was a prized student. In 1904, Bethune moved to Daytona Beach, Florida, and founded the Daytona Literary and Industrial School for Training Negro Girls, part of modern-day Bethune-Cookman University. Adding civic leader to her many skills and positions, Bethune led voter registration drives and served as president of the State Federation of Colored Women's Clubs before becoming president of the National Association of Colored Women in 1924. As her reputation grew, Bethune attended several presidential conferences and served on numerous boards. Bethune became a member of Roosevelt's "Black Cabinet," spearheading minority affairs for the National Youth Administration.

A woman of international significance, Bethune received prestigious medals from Haiti and Liberia. Following the landmark *Brown v. Board* of Education Supreme Court decision, Bethune wrote in her *Chicago Defender* column that "there can be no divided democracy, no class government, no half-free county, under the constitution." Throughout her life, Bethune fully lived her mantra "not for myself, but for others."

## A. PHILIP RANDOLPH

Few Black leaders were as forceful as A. Philip Randolph, who helped spearhead and lead the Brotherhood of Sleeping Car Porters, founded in 1925. He also helped found the Harlem-based radical publication *The Messenger,* which circulated from 1917 to 1928. An expert at compromising without sacrificing his principles, Randolph became one of this nation's most effective civil rights leaders. Seeking evidence of real change for the Black working class in particular, Randolph threatened a March on Washington by establishing offices in various cities and joining forces with the NAACP, National Urban League, churches, and fraternal and sorority orders. As the momentum for the March grew, FDR buckled. The result: Executive Order 8802.

# Can't Fool Us Twice: Black Americans and WWII

During World War I, Black American soldiers fought alongside the French and strolled Paris and other French cities free of Jim Crow restrictions (although some military bases still implemented restrictions, such as Black and white soldiers fraternizing or utilizing the same facilities). These experiences left an indelible impression that made accepting Jim Crow back home even more difficult. That their contributions in the War for Democracy were celebrated only by other Black Americans and largely ignored by white Americans just worsened matters. When World War II broke out, even though Black Americans supported the war, they refused to subjugate their own interests again.

The Black press, led by the *Pittsburgh Courier,* refused to remain silent against racial discrimination in the military and at home and, in 1942, waged a "Double V" campaign highlighting the struggle on both fronts. Lobbying — and winning — for Black war correspondents, the Black press wasn't the only Black entity taking the offensive. Mabel K. Staupers, executive director of the National Association of Colored Graduate Nurses, fought to integrate the Army and Navy Nurses Corps and succeeded when a nurse shortage hit in 1945. The NAACP attacked the racial discrimination practiced by war industries receiving government contracts, charging that Black Americans paid taxes for warplanes they couldn't build, repair, or fly.

World War II yielded some other successes, including the Tuskegee Airmen, so-named for their training at Tuskegee Institute. At war's end, the Tuskegee Airmen received two Presidential Unit Citations and 150 Distinguished Flying Crosses, among other honors. Partially acknowledging the racial barriers they battled the 1945 propaganda short *Wings for This Man,* which praised the extraordinary wartime achievements of these airmen.

» **Feeling the impact of Emmett Till's murder**

» **Following Reverend Dr. Martin Luther King Jr.'s lead**

» **Marching on Washington for Jobs and Freedom**

## Chapter **8**

# I, Too, Sing America: The Civil Rights Movement, 1954–1963

The mid–1950s set the stage for another major revolution in the United States. Just as the Civil War tested the nation's core values almost a century earlier (refer to Chapter 6), the civil rights movement in the mid–20th century tested these values once again. This chapter examines this era's leaders (greatest among them being Martin Luther King Jr.), the events that transpired during these volatile years, and the 1963 March on Washington, where King gave voice to millions, Black and white, in a speech that defined America as it should be and not as it was.

## The Tide Turns: Brown v. Board of Education (1954)

The dramatic battles that set the tone for much of the 1960s didn't just happen. Several events preceded those battles, perhaps none more important than the 1954 Supreme Court decision of *Brown v. Board of Education.* That decision

overturned the 1896 *Plessy v. Ferguson* edict, which set the precedent for legalized segregation (refer to Chapter 7 for info on the *Plessy* case).

Before the 1950s, most court cases challenging segregated schooling targeted higher education. Longtime Howard Law School dean Charles Hamilton Houston, the first Black editor of the *Harvard Law Review*, crafted the brilliant strategy to challenge Jim Crow's "separate but equal" mandate in graduate education in the 1930s when he led the NAACP Legal Defense Fund. Consequently, the NAACP legal team, which had tried many of the key segregation cases since 1935, gained momentum with these 1950 landmark decisions:

>> *Sweatt v. Painter:* Denied admission to the University of Texas School of Law in 1946 despite meeting all requirements but race, Heman Marion Sweatt pursued legal action to force the school to accept him. Because a law school admitting Black students opened in 1947 while his case was still being heard, the Texas courts upheld the University of Texas's denial of admission. The Supreme Court overturned the Texas courts' decision, citing that the University of Texas had substantially more professors and students plus a larger law library than the Black law school, marking the first time the Court factored in issues of substantive quality and not just the existence of a separate school. In 1950, he enrolled in the University of Texas School of Law, though he eventually withdrew.

>> *McLaurin v. Oklahoma State Regents:* Although admitted to the University of Oklahoma, doctoral student George W. McLaurin was forced to sit in a designated row in class, at a separate table for lunch, and at a special desk in the library. Oklahoma courts denied McLaurin's appeal to remove these separate restrictions. The Supreme Court overturned the lower court's decision, ruling that Oklahoma State's treatment of McLaurin violated the Fourteenth Amendment, which prevents any separate treatment based on race.

In essence, these decisions undermined the rationale behind the Supreme Court's 1896 ruling in *Plessy v. Ferguson* — that separate facilities were equal. In June 1950, NAACP lead attorney Thurgood Marshall, who later became the nation's first Black Supreme Court Justice, convened the NAACP's board of directors and some of the nation's top lawyers to discuss the next phase of attack. They decided that the NAACP, which had already initiated some lawsuits, would pursue a full-out legal assault on school segregation.

## The 1954 ruling and the reaction

Wanting to form a representative sample of the nation as a whole, the Supreme Court consolidated five cases to form the more popularly known *Brown v. Board of Education* (see the sidebar for details on these five cases).

**TECHNICAL STUFF**

To get *Plessy* overturned, Marshall and his team knew they had to show that segregation, in and of itself, harmed Black children. To do so, he relied on the research of Dr. Kenneth Clark and his wife Mamie Phipps Clark, the first and second Black Americans to receive doctorates in psychology from Columbia University. To figure out how Black children viewed themselves, the Clarks placed white and Black dolls before Black children and asked them to identify the "nice" and "bad" doll, as well as choose the one most like them. Most children identified the white doll as "nice" and the Black doll as "bad," even when they identified themselves with the Black doll. Based on these findings, the Clarks concluded that Black children had impaired self-images.

**IN THEIR OWN WORDS**

Few expected the unanimous decision finally delivered on May 17, 1954. "In the field of public education the doctrine of 'separate but equal' has no place," ruled the Supreme Court. "Separate educational facilities are inherently unequal." A year later, on May 31, 1955, with the case known as *Brown II*, the Court established guidelines to desegregate all public education.

As the implementation of the *Brown* ruling began, the nation discovered that instituting equality and applying its principles were two different battles. Although many white people didn't fully support the Supreme Court's decision, they abided by it. Others simply refused. In parts of the South, resistance reached dramatic heights.

## CASES THAT BUILT BROWN

Although the decision in the anti-segregation case is commonly referred to as *Brown v. Board of Education,* the final ruling by the Supreme Court comes from a consolidation of several cases:

- *Briggs v. Elliott:* In 1947, when Clarendon County, South Carolina, school superintendent R.M. Elliot denied the request from Black parents for a bus to transport their children to school (even though a little boy had drowned crossing a reservoir on a common route to school), they sued. With the assistance of Reverend Joseph A. DeLaine (a schoolteacher and African Methodist Episcopal pastor) and Modjeska Monteith Simpkins, Harry Briggs and at least 19 other parents took bold action, later backed by Thurgood Marshall and the NAACP Legal Defense Fund, that led to a demand not just for a bus but for equal schools for Black students in Clarendon County. Heard by the Supreme Court in 1952, *Briggs v. Elliot* directly challenged the "separate but equal" doctrine established by *Plessy v. Ferguson,* making it the nation's first desegregation case to reach the Supreme Court.

*(continued)*

*(continued)*

- **Bolling v. Sharpe:** To avoid sending their children to dilapidated schools, a group of parents, in a calculated move, marched to the newly built John Philip Sousa Junior High School on September 11, 1950, and attempted to enroll 11 Black students. The school's principal turned them away. *Bolling v. Sharpe,* the resulting lawsuit, broke with the accepted strategy of demanding equal facilities and directly challenged segregation. The U.S. District Court dismissed the case; the Supreme Court decided to hear the case on appeal. *Note:* When the Court finally rendered its decision, it ruled on *Bolling v. Sharpe* separately because Washington, D.C., wasn't a state and couldn't be grouped as such.

- **Brown v. Board of Education of Topeka, Kansas:** Topeka had four Black elementary schools and 18 white schools. Following a strategy conceived by the Topeka NAACP chapter, Black parents attempted to enroll their children in the nearest school and were turned away due to race. Strengthened by the denied enrollments, the NAACP filed *Oliver Brown et al v. the Board of Education of Topeka, Kansas,* involving 13 parents and 20 children, in the District Court on February 28, 1951. When the District Court ruled in favor of the school board, the NAACP took the case to the U.S. Supreme Court.

- **Davis v. County School Board of Prince Edward County:** Conditions for Black students at R.R. Moton High School in Farmville, Virginia, were horrendous, and the all-white school board consistently refused to allocate more money to the school, even as overcrowding resulted in some classes being held in an old school bus. Students, led by 16-year-old Barbara Rose Johns (the niece of Vernon Johns, the civil rights leader who helmed Dexter Avenue Baptist Church in Montgomery, Alabama, before Martin Luther King Jr.), walked out in protest of the school's unacceptable conditions. Johns and fellow organizer Carrie Stokes secured Richmond NAACP counsel Oliver Hill, who filed the case on May 23, 1951. Rejected by the U.S. District Court, the NAACP filed an appeal to the Supreme Court.

- **Belton v. Gebhart** and **Bulah v. Gebhart:** In *Belton v. Gebhart,* Ethel Belton and six other parents challenged policies that forced their children to attend run-down Howard High School in downtown Wilmington over the perfectly fine school in their community only due to race. In *Bulah v. Gebhart,* parent Sarah Bulah, dismayed that her daughter had to walk to school when a school bus of white children regularly passed their house, tried to secure transportation for her child. When her attempts failed, she secured counsel and filed a case. Delaware Judge Collin Seitz ruled that the circumstances of both grievances violated the "separate but equal" doctrine and ordered that Black students be admitted to the "white" schools. This ruling, however, didn't extend throughout the state of Delaware.

# Desegregating Central High School

No one planned on Arkansas serving as a major desegregation battleground. The Little Rock School Board issued a statement that it would comply with the Supreme Court decision and adopted an integration plan. The board selected Central High School as the first school to be integrated at the beginning of the 1957–1958 school year. Careful not to jump hastily into integration's deepest waters, the Little Rock School Board decided to keep its high school for Black students open, allowing just a handful of students to attend Central High that first year.

## The Little Rock Nine and white resistance

A few Black students tried to enroll in Central High School in January 1956. Because the attempt was made ahead of schedule, a judge denied the students' enrollment, but that made little difference: White citizens opposed to integration took notice, and signs of resistance and threats began to show. Months before the September 3, 1957, initiation date, the Capital Citizens' Council (Little Rock's version of the White Citizens' Council, a segregationist group spawned in Mississippi) and the Mothers' League of Central High, considered the second most important segregationist club and sponsored by the Capital Citizens' Council to give the opposition to desegregating Central High a feminine edge, launched an anti-integration media campaign.

Given the increased stakes, the school board solicited volunteers to attend Central High School and selected 17 students. Before any school doors opened, however, anti-integrationists went to work, and that number dwindled to nine: Minnijean Brown, Elizabeth Eckford, Ernest Green, Thelma Mothershed, Melba Patillo, Gloria Ray, Terrence Roberts, Jefferson Thomas, and Carlotta Walls. Arkansas NAACP head Daisy Bates served as their personal coach and counselor.

On August 29, a suit filed by a member of the Mothers' League prompted the county chancellor to issue a temporary injunction preventing Black students from enrolling in Central High. Federal District Judge Ronald N. Davies nullified the injunction the next day and ordered the school board to continue with its September 3 plans.

## Faubus makes his move

On the night of September 2, the Arkansas National Guard and state police surrounded the school on orders from Arkansas Governor Orval Faubus to admit only white students, teachers, and school officials. A mob of roughly 300 gathered by morning.

When the nine Black students, called the Little Rock Nine, tried to enroll in Central High the next day, members of the Arkansas National Guard turned them away. Frantic, the school board requested a stay of the integration order on September 7, but Judge Davies rejected the request. On September 10, Governor Faubus received a federal summons; he also held a press conference and announced that the armed presence outside the school would remain. Wisely, the Little Rock Nine didn't attempt to enroll again before the hearings. On September 20, Faubus, following a court order, removed the troops.

## Eisenhower steps in and the students enroll

On September 23, the Little Rock Nine made another attempt to enroll in Central High, but uncontrolled violence erupted and they left school before the day ended, spurring President Dwight D. Eisenhower to intervene. Although far from a drum major for integration, Eisenhower wouldn't permit blatant disregard for the laws of the land.

**IN THEIR OWN WORDS**

On September 24, President Eisenhower addressed the American public on national television to explain his decision to intervene. He said, "The very basis of our individual rights and freedoms rests upon the certainty that the president and the executive branch of government will support and insure the carrying out of the decisions of the federal courts." He insisted, "The interest of the nation in the proper fulfillment of the law's requirements cannot yield to opposition and demonstrations by some few persons. Mob rule cannot be allowed to override the decisions of our courts."

**REMEMBER**

Protected by federal troops, the Little Rock Nine enrolled in Central High on September 25, 1957, but they continued to be victimized. White students verbally and physically abused them, and segregationists harassed their families and members of the Black community in general. Bowing to the pressure, Minnijean Brown poured a bowl of chili over a white student's head and was expelled. Ernest Green, the group's only senior, graduated from Central High on May 27, 1958, but the others didn't get their chance.

## Faubus closes the schools

In August 1958, Governor Faubus called a special session of the state legislature and passed a law allowing him to close all the public schools. The schools remained closed until September 1959, when federal authority via the courts finally won out. In the interim, two of the Little Rock Nine had moved away with their families, and the others had graduated from other schools in Arkansas. Governor Faubus served as governor of Arkansas for 12 years before losing in the 1970 election.

## Massive resistance follows in Virginia

Arkansas wasn't alone in its efforts to circumvent school desegregation. The board of supervisors in Prince Edward County, Virginia, withheld all funding from the county school board, closing all public schools for the 1959–1960 school year. This policy, known as *massive resistance*, stems from U.S. Senator Harry F. Byrd Sr.'s solicitation of the support of other influential Virginians to prevent school desegregation in 1956.

When the courts reopened the desegregated Prince Edward County schools in February 1959, no white students attended. Instead, their parents enrolled them in *segregation academies*, schools established to prevent integration. This battle waged into the 1970s, with many Southern schools desegregating in theory but not in practice. Today, many argue that public school education in both the North and South operates under a system of *de facto* segregation.

# Putting a Face to Racial Violence: Emmett Till

Credited as the birthplace of the White Citizens' Council (WCC), an organization composed of civic leaders determined to fight integration that spread throughout the South, Mississippi had a reputation for extreme racism. Although Black Mississippians made up an estimated 45 percent of the state population in the 1950s, only 5 percent were registered voters because both registering to vote and voting itself were so dangerous.

Consider these examples: Grocery store owner and NAACP field worker Reverend George Lee was shot and killed in Belzoni, Mississippi, for trying to vote. Weeks

later, in Brookhaven, someone shot Lamar Smith dead in broad daylight, with witnesses present, for casting a ballot. No arrests were made for either murder. These are the conditions Emmett Till, a 14-year-old-boy raised on Chicago's South Side, encountered.

## Emmett Till's murder

Although born in Mississippi, Emmett Till's mother, Mamie Till, grew up in Illinois and had limited experience in Mississippi. In August 1955, she sent Emmett, accompanied by family members, to visit his great-uncle, Mose Wright, near Money, Mississippi. Shortly after Emmett's arrival in Mississippi, he and a few others, including his cousin Simeon Wright, went to the general store in Money. He bought candy from Carolyn Bryant, a 21-year-old white woman who worked as cashier of her family-owned store, and she claimed Emmett flirted with her — some accounts say he whistled at her. Three days later, Bryant's husband Roy and his half-brother J.W. Milam came to Wright's home at night and kidnapped Emmett at gunpoint.

Although arrested for kidnapping, Bryant and Milam insisted that they had only talked to Emmett and had released him alive. A couple of days later, on August 31, a boy fishing in the Tallahatchie River found Emmett Till's badly decomposed body. Authorities found a 75-pound fan from a cotton gin attached to his neck with barbed wire, a detached eye, and a bullet lodged in the skull, among other atrocities.

## The outrage of the nation

Despite attempts by some white Mississippians to bury Emmett there, Mamie returned her son's body to Chicago and held an open-casket funeral to expose his brutalization to the world. An estimated 50,000 people viewed his body.

REMEMBER

Photos of the body, published by *Jet Magazine,* hit a nerve with Black Americans. White American as well as the world also responded strongly. Emmett's mutilated body exposed the horrors of Jim Crow in the South, prompting thousands of dollars in donations to civil rights organizations.

With most of the nation outraged, Mississippi tried Bryant and Milam for murder. Testifying against the men in court, Wright, Till's uncle, boldly pointed them out. Carolyn Bryant, on the decision of the judge, didn't testify at all. After deliberating for only an hour and seven minutes, the all-white jury in Sumner, Mississippi, acquitted the two men. The acquittal generated more outrage, making Emmett Till a martyr. Many who later joined civil rights movements cited the lynching of Emmett Till as an impetus.

## THE TILL CASE REVISITED

Prompted by evidence, including facts pointing to false accusations of Emmett Till whistling and other actions, uncovered by Louisiana filmmaker Keith Beauchamp while researching his documentary *The Untold Story of Emmett Louis Till,* the Department of Justice and Mississippi District Attorney's office for the Fourth District opened an investigation into the murder on May 10, 2004. Although both Bryant and Milam, who had admitted to killing Till (and even sold details to the magazine *Look* in 1956), were dead, Beauchamp's research pointed to others, Black (more than likely coerced into participating) and white, who assisted in the murder. As many as three others, including Carolyn Bryant, may have come to Wright's house the night he was kidnapped.

Ultimately, the investigation yielded no new convictions. The significance of Till's brutal murder can't be overstated, however. His mother, Mamie Till, before her death in 2003, said of her son's heartbreaking death, "Men stood up who had never stood up before." Indeed, her son's brutal murder spoke of hatred's most insidious transgressions against human existence and impelled Black and white people to join those committed to freedom and equality for Black Americans.

# A New Twist in Leadership: Reverend Dr. Martin Luther King Jr.

Born in Atlanta, Georgia, on January 15, 1929, Martin Luther King Jr., shown in Figure 8-1, originally planned to be a scholar and a minister. King attended Morehouse College and excelled at Crozer Theological Seminary in Chester, Pennsylvania, before pursuing graduate studies at Boston University. It wasn't until he accepted the position of pastor at Dexter Avenue Baptist Church in Montgomery, Alabama and was tapped by Montgomery's Black male leaders to lead the newly created Montgomery Improvement Association, that King, age 26 at the time, began his public civil rights journey.

King infused the civil rights movement with a greater moral and philosophical purpose. By insisting that God's law and love truly did conquer all and through his advocacy of *nonviolent direct action*, the process of challenging societal wrongs via protest marches, boycotts, and sit-ins, among other strategies, without the use of violence, he was able to bring an initially reluctant America closer to the dream of true equality for all races.

**FIGURE 8-1:**
Martin Luther
King Jr. speaking
in Cleveland.

# Adopting the philosophy of nonviolence

Sparked by a 1950 lecture about the philosophy of Indian activist Mahatma (Mohandas) Gandhi, King began seriously studying Gandhi while a student at Crozer Theological Seminary. He was particularly intrigued by the concept of *satyagraha. Satya* means "truth," which also equals love; *agraha* means "force." Therefore, a direct translation means truth-force or love-force.

King found that Gandhi's teachings jelled with his own Christian beliefs (specifically the biblical philosophy to "turn the other cheek" and "love your enemies") as well as his intolerance for racial injustice. He melded these ideas with the concept of nonviolent resistance, which he encountered during his first year at Morehouse while reading Henry David Thoreau's *Essay on Civil Disobedience.* King became convinced that a philosophy based on love could succeed as a "powerful and effective social force on a large scale" and adopted the philosophy of nonviolent direct action.

Even when confronted with violence, practitioners figuratively and sometimes literally turn the other cheek and love, instead of hate, those who wrong them. The Montgomery Bus Boycott (see the section "The Montgomery Bus Boycott and Rosa Parks" for details on the boycott) became King's first opportunity to use nonviolent direct action.

As the civil rights movement progressed, King's ideology matured. Although Gandhi's principles provided the foundation for the Congress of Racial Equality (CORE), an active civil rights organization founded in 1942 preceding him, King developed the link between Gandhi and the civil rights movement further. In subsequent writings and speeches, not only did King define the relationship between Gandhi and nonviolent direct action, but he also explained why Christian leaders and all members of society had a moral obligation to rise above the limitations of manmade laws steeped in hatred.

## Founding the Southern Christian Leadership Conference (SCLC)

Buoyed by his success in Montgomery (see the section "The Montgomery Bus Boycott and Rosa Parks" for details), King and others founded the Southern Christian Leadership Conference (SCLC), an organization of ministers and others dedicated to duplicating the changes of Montgomery throughout the South. The SCLC

» Adopted nonviolent mass action as its chief strategy

» Made a commitment to affiliate with local community organizations across the South to widen the reach for social change

» Vowed to be open to all regardless of race, religion, or background

**HISTORICAL ROOTS**

In 1957, King invited Southern preachers to the Negro Leaders Conference on Nonviolent Integration. Sixty respondents representing ten states met at Ebenezer Baptist Church, King's home church in Atlanta, and formed the SCLC. Held in Washington, D.C., on May 17, 1957, to commemorate the third anniversary of the *Brown v. Board of Education* decision, the Prayer Pilgrimage for Freedom, which attracted 20,000 attendees, became the SCLC's first public act. In August of that same year, the organization convened its very first convention in Montgomery. SCLC is a national organization still based in Atlanta.

# Sit-ins, Boycotts, and Marches: The King Era of the Civil Rights Movement Begins

With its rulings regarding school desegregation (see the earlier section "The Tide Turns: Brown v. Board of Education (1954)"), the Supreme Court had spoken loudly, but so too had those opposing justice. Turbulent times lay ahead for the nation. Black people all across America were tired of being sick and tired. Unlike

the NAACP's legal team, they didn't begin with a grand strategy. Instead, ordinary folks challenged racism and racist policies with small, individual acts of defiance — such as drinking from the "white only" water fountain or demanding service at a "white only" restaurant. Actions such as these erupted into a national movement.

## The Montgomery Bus Boycott and Rosa Parks

The Montgomery Bus Boycott became a powerful display of what ordinary Black Americans could achieve. *Plessy v. Ferguson*'s declaration of separate but equal permeated every aspect of Southern life. (See Chapter 6 for more on this landmark case.) In Montgomery, Alabama, and other parts of the South, Black and white people rode the same public buses but never sat together. Custom and law dictated that white people sit in the front and Black people sit in the back. The law prohibited a white rider from sharing a seat with a Black rider. So if the white section filled up and a white person needed a seat, a Black rider had to move back and relinquish his or her seat.

In December 1955, Rosa Parks, shown in Figure 8-2, sat in the fifth row of a bus with three other Black people. A white man boarded the bus, but there were no seats left in the white section, so the bus driver directed the Black riders to move back one row. Three complied. Rosa Parks refused. The driver had her arrested. E.D. Nixon, leader of the Montgomery NAACP for whom Parks served as secretary, and white attorney Clifford Durr, a former employer of Parks and friend, bailed Parks out. The devoted wife had an exemplary background, and with permission from her husband and mother, she agreed to pursue the case. Newly minted Black attorney Fred Gray and Durr represented Parks.

**IN THEIR OWN WORDS**

The popular version of the story is that the 42-year-old Parks, a sometime seamstress and volunteer secretary of the NAACP, was too tired to give up her seat. In her autobiography *Rosa Parks: My Story*, she explains, "People always say that I didn't give up my seat because I was tired, but that isn't true . . . No, the only tired I was, was tired of giving in."

Rosa Parks didn't stumble into the fledgling civil rights movement unwittingly; she walked into it defiantly. In fact, months earlier, Parks had supported teenager Claudette Colvin, who had also been arrested for refusing to give up her seat. However, E.D. and others didn't fully pursue Colvin's case because it wasn't deemed strong enough to pursue legally (not because she became pregnant as some rumored). Viola White, a Black woman Parks also knew, unsuccessfully challenged bus segregation in 1944 when Alabama's white power structure stalled her case in court, prompting later cases to aim for the U.S. Supreme Court. Aurelia Browder, Susie McDonald, and Mary Louise Smith, who were all involved in

challenges to bus segregation prior to Parks's arrest in the same year, joined Colvin for the subsequent Supreme Court case *Browder v. Gayle* (see "Death knells for bus segregation") that had a huge impact.

**FIGURE 8-2:**
Rosa Parks.

Bettmann/Getty Images

## Organizing — and then extending — the boycott

Alabama State College professor and Women's Political Council leader Jo Ann Robinson, who had been challenging Montgomery bus segregation for years, sprang to action immediately. Black residents in Montgomery received flyers asking them not to ride buses on Monday, December 5. Organizers urged local ministers, one of whom was Martin Luther King Jr., to speak of the boycott in their Sunday sermons. These efforts resulted in nearly 90 percent of Black Montgomery residents not riding the buses.

**HISTORICAL ROOTS**

The success of the one-day bus boycott inspired the city's mostly Black male leadership of ministers and community leaders to form the Montgomery Improvement Association (MIA), which selected King as its president. After his first address in his new capacity, given at Montgomery's Holt Street Baptist Church on December 5, Black attendees numbering in the thousands voted to continue the boycott.

At first, boycott organizers' demands were modest. As early as December 8, the MIA approached the bus company with a plan not to eliminate the segregated bus system but for more equitable bus seating. The bus company refused.

## The long haul: Keeping the boycott going despite resistance

As white people in Montgomery tried to end the boycott, Black people strategized ways to keep it going. To counter the ten-cent fare Black cabdrivers charged boycott participants, for example, the city passed an ordinance forbidding cab services to charge less than a 45-cent fare. To keep the boycott going, the MIA organized a private taxi service of Black citizens who owned their own cars. Similar to buses, the service had designated routes and pickup times. In another move to divide the Black community and end the boycott, city commissioners negotiated with three non-MIA ministers who accepted their terms. A story announcing the boycott's end leaked to the Sunday papers, and word got back to the MIA leadership. To inform the Black community that the story was a hoax, MIA members, ministers among them, hit the bars Saturday night. The boycott remained intact.

Unable to stop the boycott through false negotiations, Montgomery officials turned to intimidating the protestors. In January, Montgomery police arrested King, who had begun receiving death threats, for speeding five miles above the speed limit. When the MIA Executive Board filed the federal lawsuit *Browder v. Gayle* challenging the constitutionality of segregated bus laws on January 30, intimidation efforts only increased. King's house was bombed, as was E.D. Nixon's house. When, on February 20, attendees at a mass MIA meeting rejected a settlement from the Men of Montgomery (a group of white businessmen), a Montgomery grand jury indicted King and 88 other bus boycott leaders for violating a 1921 Alabama statute barring boycotts without "just cause." To top it off, the Alabama state legislature introduced bills to *strengthen* bus segregation.

In March, a grand jury tried King on conspiracy charges. Although found guilty, his punishment of a year in jail or a $500 fine was suspended as he appealed the decision. By this time, the Montgomery Bus Boycott was a major national story, and a number of cities observed a National Deliverance Day of Prayer in support of the boycotters.

## Death knells for bus segregation

In May, the *Browder v. Gayle* trial challenging the constitutionality of Montgomery's segregated buses finally began in federal district court. Two of the three judges ruled that segregated buses in Montgomery were unconstitutional. On appeal, the Supreme Court unanimously upheld the unconstitutionality of Montgomery's segregated bus system.

**TECHNICAL STUFF**

The court order ending Montgomery's segregated bus system arrived in Montgomery on December 20. The next day, King, Nixon, and local Baptist minister Ralph David Abernathy (a King comrade who would become a significant figure throughout King's civil rights administration) rode in the front section of a Montgomery bus.

Victory wasn't easy, though. Two days later, a sniper fired shots into King's home. Some passengers became victims of assault by white people who opposed desegregating buses, and others were the victims of sniper fire. It was clear that although King and his team, greatly assisted by Robinson and the Women's Political Council, as well as brave women like Browder and Colvin who filed federal suit challenging bus segregation, had won an important battle, they hadn't won the war.

## Sitting in for justice

On February 1, 1960, four Black college students — Joseph McNeil, Ezell Blair Jr., Franklin McClain, and David Richmond — sat at a Woolworth's lunch counter reserved for "white only" in downtown Greensboro, North Carolina. This simple act added fuel to the burgeoning civil rights movement.

**HISTORICAL ROOTS**

Sit-ins weren't a new civil rights technique. In the early 1940s, CORE successfully used sit-ins to desegregate public facilities, in Chicago primarily. Howard University students also had success in 1944 when they used the sit-in tactic to desegregate a cafeteria in Washington, D.C. These incidents were more isolated, however. The four students in North Carolina sparked a wave of additional sit-ins throughout the South and set the stage for the creation of a new organization that quickly gained momentum within the civil rights movement: the Student Nonviolent Coordinating Committee (SNCC).

The day after the first sit-in at the Greensboro Woolworths, more students from North Carolina Agricultural and Technical College, the historically Black college the original four attended, descended on the store. Even though there were no confrontations, the local media covered the second sit-in. When the national media picked up the story, it struck a chord with other students who began to duplicate the sit-ins in other locations.

**REMEMBER**

F.W. Woolworth Company discount stores represented Americana. One of the nation's few chains, Woolworths helped create a national identity. The lunch counters at the front of the stores were popular meeting spots. Civil rights leadership recognized Woolworth's symbolic power and acted quickly to organize more sit-ins. Within two weeks, students in 11 cities had staged sit-ins at Woolworths and S.H. Kress stores. To show their support, Northern students, both Black and white, picketed local branches of chain stores that practiced racial segregation in the South.

## Sit-ins in Nashville

Nashville was a pivotal city in the sit-in movement. With the national spotlight created by the Greensboro sit-in, students from four predominantly Black schools took action in Nashville in February 1960.

The first wave of sit-ins was peaceful, but that changed on February 27, 1960, when a group of white teenagers attacked sit-in participants. Nashville police didn't stop the attack. Instead, they arrested the sit-in participants for disorderly conduct. A new group quickly replaced the arrested students. Nashville police arrested approximately 81 students during this period.

**IN THEIR OWN WORDS**

When the Black community rallied behind the students with money to bail them out, the students refused the bail money and opted to serve jail terms. Fisk student Diane Nash, a former beauty pageant contestant who became one of the civil rights movement's young leaders, explained, "We feel that if we pay these fines we would be contributing to and supporting the injustice and immoral practices that have been performed in the arrest and conviction of the defendants."

By April, Nashville, long considered a moderate city in regard with race relations, had lost considerable tourist dollars. When segregationists bombed the home of Z. Alexander Looby, the Black attorney who represented the participating students, 2,500 people, some white people among them, marched to city hall and addressed Nashville Mayor Ben West. A turning point in the Nashville movement came when Nash asked West if he believed it was wrong to discriminate against a person solely on the basis of race and West answered "yes." Weeks later, lunch counters in Nashville were desegregated.

## Beyond lunch counters

The sit-in tactic helped integrate other facilities. By August 1961, an estimated 70,000 people had participated in sit-ins across the country (more than 3,000 people were arrested). One of the most important results of these actions was that students from across the country became active participants in the civil rights movement.

**REMEMBER**

The sit-ins demonstrated that mass nonviolent direct action could be successful and brought national media attention to the new era of the civil rights movement. Additionally, the *jail-in* tactic of not paying bail to protest legal injustice became another important strategy. For the first time, the battle to end racial injustice combined legal action with direct public protest.

# Founding SNCC

SCLC administrator Ella Baker, a former NAACP and National Urban League worker, convinced SCLC leadership to sponsor a gathering of student sit-in leaders and participants. Baker encouraged the students to form an independent, grassroots unit. The result was the Student Nonviolent Coordinating Committee (SNCC, pronounced *snick*), run by students. Throughout the 1960s, SNCC was an important fixture of the civil rights movement.

**TECHNICAL STUFF**

Marion Barry, who later became mayor of Washington, D.C., served as SNCC's first chairman. Other key SNCC leaders included Diane Nash, John Lewis, James Forman, and Stokely Carmichael (later known as Kwame Ture).

## Riding for freedom

Under the direction of James Farmer, CORE implemented the influential Freedom Rides of 1961. Organized to test the enforcement of *Boynton v. Virginia* (1960), which desegregated all interstate transportation facilities, including bus terminals, 13 Freedom Riders — 7 Black (including Farmer) and 6 white, some of them college students — boarded a Greyhound bus in Washington, D.C., on May 4, 1961, with New Orleans as their ultimate destination.

The riders traveled through Virginia and North Carolina with no incident, but John Lewis and another rider were attacked in Rock Hill, South Carolina, for trying to enter a "white only" waiting room. Upon entering Alabama, the group split in two. According to Birmingham Public Safety Commissioner "Bull" Connor, who would become a poster child for segregation, no officers were available to escort or protect the riders because it was Mothers' Day. When a mob of about 200 white people brandishing guns surrounded one of the buses (disabled by blown tires), someone threw a bomb through a broken bus window. As the riders left the bus, the mob attacked them. The second group fared little better. Pictures of the burning Greyhound bus and the severely injured passengers landed on the front pages of national and international newspapers.

Caught up in the Cold War, President John F. Kennedy wasn't prepared for this kind of domestic volatility. He complained to U.S. Justice Department official Harris Wofford, who was close to key players in the civil rights movement that the Freedom Rides needed to end, but Farmer and CORE couldn't stop them, especially the determined college students, even if they wanted to. Even after Alabama officials escorted the riders to Tennessee, Fisk students John Lewis and Diane Nash found a way back to Birmingham, rallying new riders to continue the journey. Aware of the danger, some riders even drafted wills. When Greyhound bus drivers refused to drive them, Attorney General Robert F. Kennedy called a Greyhound superintendent in Birmingham and demanded a bus, noting that the law entitled the riders to transportation.

When the riders reached Montgomery, the police escort accompanying them from Birmingham disappeared. As they stepped off the bus, a group of angry whites attacked them and nearby reporters. Even though a police station was nearby, no local law enforcement appeared at the scene. Eventually federal marshals saved the day. When the riders landed in Jackson, Mississippi, authorities immediately arrested them for attempting to use "white only" facilities. Yet the riders continued on.

Over the next four months, several hundred more volunteers descended on Mississippi despite the risks. Finally, bowing to pressure from Robert Kennedy, the Interstate Commerce Commission tightened regulations against segregated bus and train terminals, and the Freedom Rides ended.

# The Albany Movement: A chink in the armor

Unlike previous movements, where the goal had been to desegregate buses or schools specifically, the Albany Movement, founded in 1961, set out to desegregate the entire city of Albany, Georgia, and to challenge the city's white power structure. Albany's Black community, hailing from various socioeconomic backgrounds, participated in numerous protest efforts, such as sitting-in at a local bus terminal and contesting police brutality. More than 500 people were jailed before mid-December, prompting organizers to call in King to attract more national attention. As soon as King and Ralph David Abernathy joined an Albany protest march on December 16, authorities arrested them, Albany Movement president Dr. William Anderson, and about 200 others.

To undermine the efforts of the protestors, city officials changed their tactics:

>> Unlike other Southern law enforcement entities, Albany Police Chief Laurie Pritchett, who favored arrests over public beatings, forbade his officers from mistreating anyone in the presence of the news media.

>> As King vowed to spend Christmas in jail, Black leaders and city officials struck a deal to halt the demonstrations in exchange for the release of jailed protestors and other concessions. King didn't spend Christmas in jail, but the city didn't alter any of its segregationist policies, a move that embarrassed King and the SCLC.

>> When King and Abernathy returned to Albany in July 1962 for sentencing, they couldn't serve their full 45-day sentence because city officials claimed an anonymous Black man paid their fine just two days into their sentence. When King managed another arrest later, Albany officials suspended his sentence.

>> When police beat Marion King, the pregnant wife of the Albany Movement's vice president Slater King, while delivering food to Black prisoners, members of Albany's Black community responded violently. Delighting in this break in nonviolent direct action, Pritchett directed news attention to "them nonviolent rocks," prompting Dr. King to call for a day of penance and halt protests. King understood that the retaliation of protesters would help justify action against them and take the attention away from desegregation.

**REMEMBER**

In Albany, city officials made sure that there were no obvious incidents of brutality. With police not beating participants and not permitting King or his close associates to serve jail time, Albany lessened the impact of the protestors and at the same time made no significant concessions regarding segregation.

In August 1962, King left Albany. Because nothing happened while King was there, his efforts seemed futile. Members of the Albany Movement didn't view their campaign as a failure, however, because much of the city legally desegregated in 1962.

# Integrating Ole Miss and Increasing Federal Involvement

By 1962, the nation had experience with university integration, yet the reaction to James Meredith's entry into the University of Mississippi in Oxford, Mississippi, was especially hostile. Led by Governor Ross Barnett, Mississippi held firmly to its segregationist reputation. Mississippi's obstinacy in refusing to allow Meredith's enrollment spurred Robert Kennedy to extend the federal government's involvement in the civil rights movement further.

The trouble began when the Mississippi-born Meredith decided to transfer from Jackson State, a Black college in Mississippi, to Ole Miss. Denied admission twice, Meredith appealed to the courts. Eventually a federal district court ordered Ole Miss to admit Meredith. On September 20, 1962, when Meredith attempted to register for school, Governor Barnett himself blocked Meredith's path. After speaking with Barnett directly, Robert Kennedy sent 500 federal marshals to escort Meredith onto the campus and into his dorm room on September 30, but an angry crowd of students and outside agitators gathered in opposition to Meredith's enrollment.

Federal marshals tried unsuccessfully to disperse the rock-throwing crowd with tear gas. More outside agitators poured into Ole Miss and used bottles, bricks, and gunshots to attack the marshals, who heeded Justice Department orders not to use their rifles. In the end, 160 marshals were wounded (28 by gunshot), and two

people were killed. Reluctantly, Kennedy sent in the first wave of 5,000 army troops, who controlled the crowd without using their rifles. Although the number of troops eventually declined, Meredith attended Ole Miss with federal protection until his graduation in 1963.

**REMEMBER**

The incident at Ole Miss changed President Kennedy's position on dealing with the civil rights movement. He finally realized that federal intervention was necessary and, furthermore, that most of the American voting public didn't view such intervention negatively, even in the South.

# 1963: A Bloody Year

In 1963, the confrontations and violence associated with the civil rights movement escalated. Black America's patience had worn thin waiting on justice. The Freedom Rides (see "Riding for freedom") and the Albany Movement (see "The Albany Movement: A chink in the armor") hadn't moved the nation as far along as civil rights leaders had hoped. The SCLC, perhaps urged on by criticism from the much younger SNCC, took bolder action.

## Not-so-sweet home Alabama: Birmingham

Dubbed "Bombingham" by some for its extreme racial violence, Birmingham became a significant project for civil rights leaders. SCLC executive director Wyatt Tee Walker believed that the South would follow Birmingham; if civil rights protests succeeded there, they could succeed anywhere.

**REMEMBER**

What happened in Birmingham demonstrated that Black Americans wouldn't wait any longer for freedom and equality. It was an important turning point in the civil rights war, but it was by no means the last battle.

### Project C

On April 3, 1963, the first protest of what Walker called *Project C*, for "confrontation," began, and 20 people were arrested. Three days later, a march led by local Reverend Fred Shuttlesworth, founder of the Alabama Christian Movement for Human Rights, also ended in nonviolent arrests, which were uncharacteristic for segregationist Bull Connor. However, on April 7, when King's brother Reverend A.D. King marched with other ministers to City Hall, they encountered dogs and nightsticks. Despite an injunction telling him not to lead a march, on April 13, Martin Luther King Jr. and buddy Ralph David Abernathy did so anyway and went straight to jail.

# LETTER FROM BIRMINGHAM JAIL

King's "Letter from Birmingham Jail," a response to a letter published by white clergyman denouncing the demonstrations and urging patience, made this jail visit different from others. In the widely published letter, King explained why Black Americans could no longer wait for freedom. Written on scraps of paper with a pen smuggled into the jail during King's eight-day stay, the letter articulated the desires of those who marched while also justifying their defiance of unjust laws. "We know through painful experience that freedom is never voluntarily given by the oppressor," he wrote. "It must be demanded by the oppressed."

## The children's march

After King left jail on bail, he saw that volunteers in Birmingham had dwindled. James Bevel, fresh from the Nashville sit-ins, suggested using high school students. A dilemma emerged when the students' brothers and sisters of all ages also turned up for nonviolent resistance training. After much deliberation, the decision was made to let the children march on May 2. Although Connor didn't use violence during the march, he and his team arrested an estimated 900 children. When more people marched the next day, Connor ordered the use of clubs, dogs, and fire hoses against the participants. The melee made national headlines, demanding the attention of President Kennedy.

The children kept coming, and the police kept arresting them, making national headlines and filling the jails. In days, police arrested at least 2,000 people, the bulk of them children. As the number of young people increased, the situation became more charged. Negotiating with city officials, civil rights leaders agreed that protests would start around noon on May 7, but the children came early, and some began taunting the police. A disturbance broke out. Fearful of greater violence, civil rights leadership halted the next day's protest. White leadership also feared greater violence and decided to negotiate.

## Negotiating for desegregation

On May 10, Birmingham's white merchants made a pact with the SCLC to desegregate as well as hire Black workers during the next three months if the organization put a stop to the demonstrations. Not everyone was pleased, however. Some Black people criticized King for yielding to promises.

The Ku Klux Klan (KKK) responded by bombing A.D. King's home and a motel where they believed Martin Luther King Jr. and his aides were staying. These bombings induced rioting among some Black people. The federal government sent

in 3,000 army troops, among other resources, and the bombings ended. Aided by Birmingham's moderate mayor, desegregation in Birmingham finally began.

**IN THEIR OWN WORDS**

When Alabama Governor George Wallace vowed to bar two Black students from registering at the University of Alabama in Tuscaloosa in June 1963, President Kennedy ended his public silence on civil rights. In a public broadcast that evening, Kennedy stated that "all Americans are to be afforded equal rights and equal opportunities." The support of the federal government for desegregation was finally in place, but turbulent times still lay ahead.

## Murder in Mississippi: Medgar Evers

News of President Kennedy's commitment to civil rights only angered segregationists further. White Mississippians refused to give up segregation. The murder of Medgar Evers one day after Kennedy's speech made that clear.

Evers, the Mississippi NAACP field secretary, kept Mississippi in the fight for civil rights. His work included helping establish NAACP chapters throughout the state, investigating violent crimes against Black people, and organizing boycotts of segregated stores in Jackson, as well as Jackson gas stations that wouldn't allow Black people to use the restrooms. Just before his death, he began a full-scale campaign to desegregate downtown Jackson. When Mayor Allen C. Thompson went on television asking Black people not to participate, Evers went on television, too. A sit-in at the Woolworths lunch counter proved successful enough that the mayor promised to desegregate some public facilities. Bowing to pressure from the White Citizens Council and other segregationists, however, he backed down from his promise.

Evers's successes, even if they were small in comparison to the successes in other cities, no doubt sealed his fate. On the evening of June 12, 1963, in front of his house, Evers was shot in the back. With Evers seen as a martyr, his death added urgency to the civil rights movement.

## CLOSING THE EVERS CASE

Following Medgar Evers's murder, an all-white jury acquitted his assassin, Byron De La Beckwith. Thanks to the efforts of Evers's widow Myrlie Evers-Williams, Mississippi finally retried and convicted De La Beckwith of murder on February 5, 1994. The 1996 film *Ghosts of Mississippi*, starring Whoopi Goldberg, dramatizes those efforts. De La Beckwith appealed the case, with the Mississippi Supreme Court upholding the conviction in 1997.

# March of All Marches: The March on Washington for Jobs and Freedom (1963)

Orchestrated by labor organizer A. Philip Randolph (see Chapter 7) and unsung civil rights activist Bayard Rustin, the March on Washington for Jobs and Freedom, held in the nation's capital on August 28, 1963, was the march of all marches. More than 250,000 people, with an estimated 50,000 white people among them, representing various organizations converged on the Lincoln Memorial to demonstrate for Black equality — politically, socially, and economically.

**TECHNICAL STUFF**

In addition to King, other participating civil rights leaders included the National Urban League's Whitney Young Jr., the NAACP's Roy Wilkins, and CORE's James Farmer. Entertainers such as gospel great Mahalia Jackson, Joan Baez, and Bob Dylan were present, as well as movie stars Sidney Poitier, Charlton Heston, and Marlon Brando.

Prior to the March, White House officials warned organizers that such a march could create a conservative backlash against the movement. Adjustments occurred, as the march's site shifted from the White House to the Lincoln Memorial. Organizers also agreed to censor militant speakers.

**TECHNICAL STUFF**

The speech by Freedom Rider and SNCC Chairman John Lewis sparked controversy for its militant message. Lewis voiced his and others' frustration with waiting on the government for hundreds of years for freedom, as well as his pronouncement that Black people would no longer wait. He also noted that both the Democrats and Republicans had betrayed the Declaration of Independence.

**IN THEIR OWN WORDS**

Considered one of the greatest moments of the 20th century, King's address dispelled any potential for trouble. In his famous "I have a dream" speech, King gave voice to hope: "I have a dream that one day this nation will rise up and live out the true meaning of its creed: 'We hold these truths to be self-evident: that all men are created equal.'" As he continued, the crowd's "amens" grew louder. King's dream that his "four little children will one day live in a nation where they will not be judged by the color of their skin but by the content of their character" moved both white and Black people. That vision resonated so loudly that his words regarding the nation's long record of persistent Black economic inequality have frequently been overlooked.

So parts of his speech like "We refuse to believe that there are insufficient funds in the great vaults of opportunity of this nation. And so we've come to cash this check, a check that will give us upon demand the riches of freedom and the

security of justice," are unrecognizable to many. With some of King's skeptics even acknowledging the power of his vision, his "I have a dream" speech was able to expand the national conversation on race to one of a broader American society inclusive of all. Those words resonated even more with President Kennedy, who had been lukewarm about the gathering. Afterward, he invited key march organizers to the White House. Unfortunately, the high of the March on Washington for Jobs and Freedom didn't last long.

» **Understanding key civil rights legislation**

» **Risking it all to register Black voters**

» **Unleashing Black Power**

» **Dying for freedom**

Chapter **9**

# Turning Up the Heat (1963–1968)

lthough civil rights organizations had gathered at the March on Washington for Jobs and Freedom in a show of unity, some opponents of integration weren't easily swayed. Still, proponents had much reason to be optimistic. Right before their eyes, the America they had known was finally changing. Throughout the South, "white only" and "colored only" signs began to gradually disappear.

This chapter explores the violence of the civil rights era in the mid- to late 1960s. Particular topics of note are the impact of JFK's assassination, the events of Freedom Summer, and the rise of Malcolm X and the Black Power movement. This chapter also familiarizes you with the heated civil rights battles in Alabama, the passage of key civil rights legislation, and the impact on the nation of Martin Luther King Jr.'s murder.

## Suffering Two Tragic Blows

Most civil rights participants knew that death was a very real consequence for their actions. In some Southern states, Black residents avoided civil rights activity because of the fear of retaliation, but segregationists made no distinctions between

participants and nonparticipants. White Americans weren't safe either. Some argue that some white Southerners didn't actively resist desegregation primarily to avoid physical harm. In the fall of 1963, the lengths to which segregationists would go to prevent integration shocked and saddened the nation.

# Four innocent victims

When a bomb exploded at Birmingham's Sixteenth Street Baptist Church just minutes before the 11 a.m. service on September 15, 1963, the whole nation felt the jolt. Four little girls — 11-year-old Denise McNair and 14-year-olds Cynthia Wesley, Carole Robertson, and Addie Mae Collins — died instantly from the dynamite blast emanating from the church basement. More than 20 others were injured. Ironically, "The Love That Forgives" was the message planned for the day's service.

A hub for civil rights activity, the Sixteenth Street Baptist Church was a center of Birmingham's Black community and served as a central checkpoint for the first phase of what Southern Christian Leadership Conference (SCLC) executive director Wyatt Tee Walker dubbed *Project C* (the "c" stood for confrontation), waged only a few months prior (refer to Chapter 8). Therefore, the church represented Black Alabamans' progress, and that progress didn't sit well with the state's extreme segregationists, including Governor George Wallace.

## The community's reaction

Despite King's pleas for nonviolence, Black Birmingham reacted violently to the church bombing. Alabama authorities responded with fire hoses, brutal beatings, vicious dogs, and mass arrests. Adding to the already tragic situation, police shot and killed 16-year-old Johnny Robinson, and two white people killed another Black youth, 13-year-old Virgil Ware. Six young Black people lost their lives that day.

**IN THEIR OWN WORDS**

A funeral service was held for three of the four girls killed in the bombing (one family insisted on a separate ceremony). Over 8,000 mourners and clergymen of both races attended the service, but city officials, no doubt fearful of angry and emotionally charged crowds, stayed away. Delivering a stirring eulogy, the Reverend Dr. Martin Luther King Jr. hoped that "the innocent blood of these little girls may well serve as the redemptive force that will bring new light to this dark city." The Scripture, he reminded attendees, said "a little child shall lead them."

Just days after the funeral service, Birmingham's Public Safety Commissioner Bull Connor proclaimed to a gathering of White Citizens Council (WCC) supporters that the Supreme Court was responsible for the girls' deaths because of the *Brown v. Board of Education* decision. He even suggested that King's supporters bombed the church themselves.

### The aftermath

Instead of stopping civil rights activity, the tragic bombing attracted national and international attention, pressuring the FBI to investigate the incident. Little was done though and, as was later learned, FBI head J. Edgar Hoover blocked the release of critical evidence to prosecutors. Only years later, in 1977, was Ku Klux Klan member Robert Edward Chambliss convicted. A 2000 reopening of the case brought convictions for two others: Thomas Blanton in 2001 and Bobby Frank Cherry in 2002. (The fourth man involved in the bombing, Herman Cash, died in 1994 and avoided prosecution.)

**TECHNICAL STUFF**

Acclaimed filmmaker Spike Lee received a 1998 Academy Award nomination for his documentary *Four Little Girls* about the 1963 bombing and its effects on the nation and the girls' families.

## JFK dies

On November 22, 1963, the civil rights movement received another crushing blow. With President John F. Kennedy behind civil rights efforts and actively pushing Congress for the passage of a major civil rights bill, the prospect of achieving full Black equality appeared within reach. But during a visit to Dallas, as Kennedy rode with his wife Jackie in a convertible in a parade, three shots rang out, two of which hit Kennedy in the head and neck. He died shortly thereafter.

Kennedy's absence made the future of civil rights legislation uncertain. Because Vice President Lyndon B. Johnson hailed from Texas, few pegged him as a civil rights champion. Johnson's actions as president, however, surprised many, especially white Southerners.

# The Civil Rights Act of 1964

Ironically, Kennedy's assassination strengthened the proposed civil rights bill. Prior to his death, any civil rights legislation would have required significant compromise to pass both houses of Congress. After his death, President Johnson refused to compromise.

With an upcoming presidential election, Johnson's strong endorsement of the Civil Rights Act would normally have been a huge political risk. Yet with key Republicans emerging as allies and other lawmakers less inclined to squabble over a bill an assassinated president had supported, the bill passed both houses of

Congress with no significant changes. On July 2, 1964, Johnson signed the Civil Rights Act of 1964 into law. The law did the following:

>> It prohibited racial discrimination in any public accommodations engaged in interstate commerce.

>> It enforced public school desegregation.

>> It withdrew federal funding from any institution or program that endorsed discrimination.

>> It outlawed all employment discrimination and established the Equal Employment Opportunity Commission (EEOC) to monitor any violations.

>> It ensured equal voter registration.

In November 1964, Johnson easily won the presidential election.

# Targeting Mississippi for Voter Registration: Freedom Summer

In the summer of 1964, Mississippi, where Emmett Till, Medgar Evers, and countless others were boldly murdered without consequence (refer to Chapter 8), continued its reign as a segregationist stronghold. Just as the SCLC figured that victories in Alabama would significantly pave the way to integrate other Southern cities, Bob Moses, a former SCLC volunteer and a Student Nonviolent Coordinating Committee (SNCC) leader, counted on change in Mississippi would greatly influence the nation. The goal? Register Black voters. During that summer, volunteers poured into the state determined to make a difference.

**REMEMBER**

As more and more white people, especially students, signed up for duty in the fight for Black equality, civil rights leaders shifted their goal from desegregation to voting rights. Although the Fourteenth and Fifteenth Amendments established voting rights for Black Americans, white Americans in many Southern states either intimidated Black voters or established barriers such as poll taxes and literacy tests to keep them from voting.

## Getting ready

Beginning a voter registration project in Mississippi was challenging, to say the least. On the surface, McComb, in southwest Mississippi, wasn't an ideal place to

launch a voter registration campaign: Shortly after New York math teacher Bob Moses's arrival, Mississippi state legislator E.H. Hurst was acquitted for shooting Herbert Lee, a Black man, reportedly for his involvement with SNCC. Louis Allen, one of the witnesses who lied to authorities for Hurst's acquittal to protect his life, was later beaten and killed when his visit to the FBI (presumably to tell the truth) was revealed to local police.

Considering the racial climate, older Black people in McComb were understandably cautious about Moses. McComb's Black youth, however, eagerly embraced change. One ambitious youth lied about her age and led a sit-in that got her expelled from high school and sent to reform school. Some parents were outraged, but many students kept on agitating, even choosing civil rights work over school. Harassment, murders, and beatings didn't deter them.

Throughout the state, Black Mississippians stepped up. Medgar Evers is probably the best-known (refer to Chapter 8 for information about him), but Aaron Henry, Fannie Lou Hamer, Dr. T.R.M. Howard, and Amzie Moore were also noted local leaders in the voter registration campaign, not to mention countless others whose names don't grace the history books. Promised much-needed funding by Attorney General Robert Kennedy, the Voter Education Project launched in April 1962.

A mock election called Freedom Vote held in 1963 drew almost 80,000 Black voters, proving that Black Mississippians very much wanted to vote. Encouraged by this and the presence of white volunteers, Bob Moses proposed Freedom Summer.

## Getting out the Black vote

Robert Kennedy, who arranged funding for Black voter registration campaigns, wouldn't commit federal protection for volunteers. Moses was convinced that placing college students, preferably white, in Black communities throughout Mississippi to register Black residents to vote as well as teach them reading and math would secure federal protection.

At orientation sessions held in Ohio, Freedom Summer organizers emphasized potential risks such as arrest, jail time, or death to volunteers. The volunteers were also required to bring $500 in bail money and instructed not to antagonize Mississippi police officers who arrested them. In June, hundreds of volunteers, mostly white, poured into Mississippi. Given Mississippi's volatile racial history, the Johnson administration worried about the safety of Freedom Summer participants and the potential impact on the nation.

By the time Freedom Summer kicked off, 900 volunteers had signed up for the fight. The central battleground became Greenwood, Mississippi, situated in the Mississippi Delta region between Memphis, Tennessee, and Jackson, Mississippi.

## Mississippi burning

Tragedy struck early for the volunteers pouring into Mississippi. On June 21, 1964, after investigating a church bombing in Lawndale, local police stopped two white Northerners Andrew Goodman and Michael Schwerner and Black Mississippian James Chaney for speeding and took them to jail. Although reportedly released that same night, the three men disappeared. Instead of investigating, state police claimed that the trio staged their own disappearance as a publicity stunt.

The FBI got involved, and as the investigation dragged on, public outcry pressed the search on. On August 4, just days before the all-important Democratic National Convention, the three bodies surfaced just outside Philadelphia, Mississippi. Adding to the horror, Chaney had been castrated. Their deaths shifted public attention to Freedom Summer and its mission in Mississippi.

By the end of the year, the FBI had arrested 18 people, mostly Ku Klux Klan members, in relation to the murders. Although most of the people arrested received convictions, the convictions were for breach of civil rights, not murder (this case is the basis for the 1988 film *Mississippi Burning*). A manslaughter conviction came more than 40 years later when mastermind Edgar Ray Killen, a minister, received a 60-year sentence on January 6, 2005. The conviction, which Killen appealed, was upheld on April 12, 2007. He died in prison in 2018.

## The success of Freedom Summer

Prior to Freedom Summer, just under 7 percent of Mississippi's voting-age Black population had registered to vote. By 1969, that number had climbed to nearly 67 percent. The 17,000 Black Mississippians who attempted to vote during the turbulent project helped achieve these numbers; so did the 1,600 who actually voted. This success rate contributed to the passage of the Voting Rights Act of 1965 (see the later section "The Voting Rights Act of 1965").

Forty-one freedom schools helped educate Black Mississippians about much more than learning how to vote. Likewise, Black Mississippians taught the students and the world that hope could thrive in the direst circumstances. Most importantly, Freedom Summer demonstrated the positive impact that all Americans, regardless of race or income level, could have on the nation overall.

## THE MISSISSIPPI FREEDOM DEMOCRATIC PARTY (MFDP)

With support from SNCC, the Mississippi Freedom Democratic Party (MFDP) launched in 1964 as an alternative to Mississippi's reigning Democratic party, which promoted white supremacy. MFDP elected its own delegates: Annie Devine, Victoria Gray, and the charismatic Fannie Lou Hamer being the most well-known, who had endured severe beatings in her quest to secure the freedom to vote for herself and her fellow Mississippians.

Fearing the backlash from Mississippi's "official" Democratic party, President Lyndon B. Johnson tried to prevent the MFDP from attending the Democratic National Convention in Atlantic City, New Jersey. But MFDP delegates didn't back down and took their case to the credentials board, where Hamer testified about the beatings she had endured in Mississippi for trying to vote.

Still, MFDP was barred from entering the Convention, so members borrowed passes from sympathetic delegates. When their seats were removed the second day, they remained and sang freedom songs. Although disappointed by the chilly reception in 1964, the MFDP went on to attend the 1968 Democratic National Convention in Chicago.

# Oh Lord Selma: Back in Alabama

Alabama had been a bittersweet site for the King-led contributions to the civil rights movement. Although the successful Montgomery Bus Boycott made the Reverend Dr. King a national figure (see Chapter 8), the deaths of Birmingham's four little girls and countless others had been tough to swallow. Yet King and others under his SCLC umbrella returned to the contentious state in January 1965 to begin Project Alabama, a campaign to secure federal protection for voting rights.

**TECHNICAL STUFF**

Project Alabama experienced some of the same challenges as the Albany Movement in Georgia, with tensions between SCLC and SNCC ranking supreme. As in Albany, SNCC had arrived in the area before SCLC. For months, SNCC battled the many obstacles preventing Black voter registration, such as educating Black Alabamans about their voting rights. In addition, SNCC navigated bureaucracy such as voter registration offices only opening two days of the month and the endless paperwork. Many SNCC members felt that King and SCLC would receive credit for SNCC's hard work. Other prominent SNCC leaders like John Lewis continued to support King. Although these tensions were strong, neither side voiced them to the public.

# Getting arrested again

To bring attention to Alabama's voting inequities, King needed authorities to arrest him and others. On February 1, he succeeded by leading a group of demonstrators in defiance of the July 1963 judgment banning all meetings and marches in Selma. When authorities, led by Sheriff Jim Clark, arrested him, local Black students marched in defiance and police arrested them, which is what King had anticipated. The national media captured the sequence of events.

**IN THEIR OWN WORDS**

From a jail cell on February 1, during his first arrest since Birmingham, King wrote in a letter to the American public: "There are more Negroes in jail with me than there are on the voting rolls."

During a peaceful march on February 18, the situation became very dramatic when 26-year-old Jimmie Lee Jackson was shot and killed trying to protect his mother from the blows of a billy club. His death galvanized momentum for a federal voter registration law. Once again, the American public placed civil rights at the top of the nation's agenda.

Then on Sunday, March 7, a group of 600 people led by SNCC Chairman John Lewis and SCLC's Hosea Williams attempted to cross the Edmund Pettus Bridge, defying the armed Alabama state troopers blocking their way. As the group marched, ignoring Major John Cloud's demand to turn around, officers charged them, in the process trampling them, whipping them, beating them, and tear-gassing them. Referred to as *Bloody Sunday*, the event was captured by the media and broadcast nationwide on the evening news. The ABC network even preempted its showing of the film *Judgment at Nuremberg* with coverage from Selma.

# Marching from Selma to Montgomery

After Bloody Sunday, a court order banned King from leading a second march on March 9, so King took the group of protesters to the edge of the Edmund Pettus Bridge, knelt in prayer, and turned the group back. Emotions ran higher as on that same night, white men severely beat Reverend James Reeb, a white minister from Boston. Two days later, he died.

With court approval and the protection of armed forces, King led a third march from Selma to Montgomery on Sunday, March 21. King, with wife Coretta by his side as well as Rosa Parks and several other key civil rights leaders, reached the state capitol on March 25. Approximately 25,000 people attended the victory rally. *Selma*, the 2014 film directed by Ava DuVernay, captures these events.

# The Voting Rights Act of 1965

Without Freedom Summer and Selma, it's doubtful the Voting Rights Act of 1965 would have ever passed. Although Black men received the right to vote with the Fifteenth Amendment and the Nineteenth Amendment extended voting rights to women, Southern states actively hindered Black people from voting, using several methods, the two most popular being the poll tax and literacy tests:

» **Poll tax:** Black voters, many of whom were poor, were charged fees to deter them from voting.

» **Literacy test:** In order to vote, Black Southerners, many of them with little formal education, were given a myriad of tasks such as reciting parts of the Constitution to the administrator's satisfaction, transcribing passages from the Constitution, and answering obscure technical questions such as "how many people can testify against a person denying his guilt of treason?"

With Southern states actively stopping Black people from voting, a practice that had gone on for decades, the federal government finally stepped in. On August 6, 1965, President Johnson signed the Voting Rights Act (VRA) into law. Key features of the law include

» **Federal supervision of voter registration in areas where less than 50 percent of the nonwhite population had registered to vote:** Instead of waiting for grievances to be filed, the federal government became proactive in identifying areas where white authorities were intimidating Black people not to vote.

» **Federal approval of change in local voting laws:** In areas with a history of disenfranchisement as well as less than 50 percent of the Black population registered to vote, the federal government had to approve any changes in voting requirements.

» **Prohibition of literacy tests:** The federal government banned the use of literacy tests for all American voters.

» **Authorizing the U.S. attorney general to investigate the use of poll taxes:** Although the act itself didn't ban poll taxes, that change did come eventually. While the Twenty-fourth Amendment, passed in 1964, banned the use of poll taxes in federal elections, the Supreme Court banned the use of poll taxes in state elections in 1966 with *Harper v. Virginia Board of Elections*.

**REMEMBER**

The Voting Rights Act of 1965 made it emphatically clear that the nation as a whole would no longer tolerate blatant voter discrimination. The law made an immediate impact. Within three weeks, more than 27,000 Black Americans in Mississippi, Alabama, and Louisiana had registered to vote. Renewed four times since its passage, the act received a 25-year extension with the Voting Rights Act Reauthorization and Amendments Act of 2006 during President George W. Bush's administration.

# Black Power Rising

Not all Black Americans were committed to King's doctrine of nonviolence. As white supremacists became increasingly more violent, some Black Americans felt compelled to fight back. During the mounting tensions of the 1960s, messages of Black empowerment became louder and louder. Prominent spokespersons such as Malcolm X and organizations like the Nation of Islam and the Black Panther Party began to command as much attention as King and civil rights organizations such as the NAACP, CORE, and SCLC. These developments directly affected SNCC, which began a metamorphosis.

As Black Americans became more publicly outspoken, conflicts erupted in both the North and the South. The days of patiently waiting for change were long gone. With direct nonviolent action (refer to Chapter 8) continuing in the South and rioting breaking out in the North, the nation found itself battling many wars.

## The Nation of Islam

Until the 1960s, most Americans weren't very familiar about the Nation of Islam (NOI), which was founded in Detroit, Michigan, in the 1930s and is currently headquartered in Chicago, Illinois. Although its premise was religious, the NOI's strongest selling points for many Black Americans became its endorsement of Black nationalism and Black self-sufficiency. Its emphasis on Black separatism, including its insistence that white people were devils, greatly distinguished it from SCLC and other civil rights organizations that emphasized Christian love and forgiveness regardless of the transgression.

**REMEMBER**

Unlike King and his followers, the NOI sanctioned violent retaliation against acts of violence against NOI. Its stance on self-preservation and defending one's self appealed most to the nation's urban areas. Actively recruiting its membership from the prison system, the NOI found great success. NOI membership often gave prison converts the discipline they required to survive imprisonment. Once released, many found employment with the NOI, which operated several businesses.

Even though NOI leader Elijah Muhammad built the NOI into a formidable organization that exceeded its humble 1930 origins, Malcolm X propelled the NOI into mainstream awareness. (You can read more about the Nation of Islam in Chapter 12.)

**TECHNICAL STUFF**

Although not recognized by mainstream Islamic organizations until recently because of significant theological differences that have since been altered, NOI members followed certain aspects of mainstream Islam such as reading the Koran (also Quran or Qur'an) and observing Muslim practices such as the separation of the sexes during worship. Religious services, as well as the NOI's schools, emphasized the values of self-sufficiency and self-discipline.

## Malcolm X

Although best known for slogans such as "By Any Means Necessary" as well as posters depicting him with a gun, Malcolm X, shown in Figure 9-1, was a complex man. Formerly incarcerated, Malcolm X exhibited strength, charisma, and intelligence that only underscored the potential the nation had tucked away in its prison systems. *The Autobiography of Malcolm X,* published months after his death, offered insight into who he once was, who he became, and who he might have been.

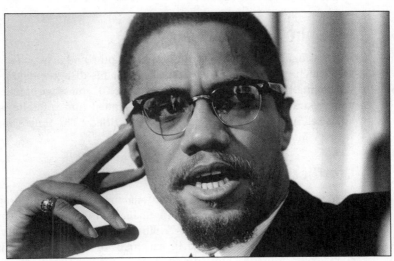

**FIGURE 9-1:**
Malcolm X.

*Michael Ochs Archives/Getty Images*

His initial views proclaiming white people as devils, a view consistent with the NOI and its leader Elijah Muhammad, whom Malcolm X followed, propelled him to the attention of the news media — that and the tens of thousands who came to hear him. Ultimately, Malcolm X's break with the NOI, as well as his renunciation

of equating white people to the devil, placed him in greater favor with many, Black and white. Unfortunately, he was killed, but his legacy kept him one of the 20th century's elite freedom fighters.

## The rise of Malcolm X

As a child, Nebraska-born Malcolm Little's life was torn apart when a group of white extremists murdered his father. Forced to go on welfare, the Little household became unstable, with the children often living in foster homes. Little dropped out of school when a white teacher told him that becoming a lawyer "was no realistic goal for a nigger."

With limited opportunities available to him, Little ventured into a life of crime. While serving a ten-year sentence for burglary, he seriously explored the NOI and eventually dedicated himself to the group, even conversing with leader Elijah Muhammad.

By the time Little was released from prison in 1952, he had met Elijah Muhammad and officially joined the NOI, adopting the name Malcolm X to rid himself of what he characterized as his slave surname. He moved to Chicago and studied directly under Muhammad, who sent Malcolm X to spearhead a Harlem branch for the NOI as part of his plan to expand the organization's reach.

## Malcolm's message

As a national NOI spokesperson, the handsome and articulate Malcolm X generated much media attention, particularly for his disagreements with King's nonviolent methods of protest as well as for the NOI's message of Black self-sufficiency and separatism. Malcolm X's criticism landed him a public platform when he appeared in a weeklong television special titled "The Hate That Hate Produced" with TV journalist Mike Wallace in 1959.

## Conflicts with the Nation of Islam

As Malcolm X's public stature grew, tensions developed within the NOI. Malcolm X, also known as El-Hajj Malik El-Shabazz, lived by a strict moral code. After becoming a Muslim, he remained celibate until he married Betty Shabazz in 1958. In addition, he didn't engage in extramarital affairs (as confirmed by the FBI agents who followed him). In 1963, he discovered that Elijah Muhammad had engaged in sexual relations with as many as six women in the NOI and that some of those affairs had produced children. Muhammad's moral failings greatly contributed to Malcolm X's eventual split from the NOI.

Around the same time, Malcolm X offended many with his response to President Kennedy's assassination. According to Malcolm X, Kennedy "never foresaw that the chickens would come home to roost so soon," meaning that white Americans or presidents weren't exempt from the violence that denied life and liberty to Black Americans. Although Elijah Muhammad suspended and silenced Malcolm X for 90 days for his statements, Malcolm X suspected that Muhammad had other reasons for silencing him. In March 1964, Malcolm X left the NOI and formed Muslim Mosque, Inc.

But he wasn't finished evolving. After traveling to Mecca, Saudi Arabia, in April 1964 and sharing his religious pilgrimage with Muslims of all races, Malcolm X returned to the U.S. and softened his stance on racial separatism. In May 1964, he founded the Organization of Afro-American Unity.

### His death

By early 1965, it was clear that Malcolm X was marked for assassination. On February 14, someone firebombed his family's New York home, but the family escaped unharmed. On February 21, Malcolm X wasn't so lucky: During a speech at the Audubon Ballroom in Harlem, three men later revealed to be members of the NOI (a fact some people debate) fatally shot Malcolm X multiple times at close range. Many contend that the three men, convicted of first-degree murder in 1966, had colluded with the FBI. The 2020 docuseries *Who Killed Malcolm X*, directed by Rachel Dretzin and Phil Bertelsen, explores his murder. In February 2021, new information emerged suggesting the NYPD and FBI conspired to kill Malcolm X.

Although it's impossible to know where Malcolm X would have directed his talents, many believe that he would have worked more closely with the Reverend Dr. Martin Luther King Jr. Despite depictions of the two as opponents, Malcolm X shared King's commitment to freedom and equality, although they met only once in person. Just before his death, he had corresponded with King about his efforts in Selma. In addition, Malcolm X had become increasingly more pan-Africanist in his view: Before his death, he began to draw great correlations between the American oppression of Black Americans and the worldwide oppression of people of color in general. Without him, the Organization of Afro-American Unity ended.

## The Black Panther Party

Like the NOI, the Black Panther Party for Self-Defense, spearheaded in 1966 by Bobby Seale and Huey Newton, rejected assimilation and advocated Black power and Black liberation. The party's demands for full employment, decent education, and affordable housing in their Ten Point Plan didn't differ greatly from the goals

of many mainstream civil rights organizations. The difference was mainly in their application. Two key points of the plan included

>> **An immediate end to police brutality:** Although members of the Black Panthers often donned berets and sometimes brandished guns, the Black Panthers didn't necessarily advocate violence. Instead, they believed that Black Americans could use their inalienable right guaranteed by the Bill of Rights to bear arms to protect themselves against police brutality.

>> **Full employment:** The Black Panthers demanded that the government provide jobs for Black Americans. Employment, they believed, would improve the standard of living in Black neighborhoods.

On October 28, 1967, the arrest of Newton for allegedly killing white police officer John Frey became a turning point for the organization. Although the details are still sketchy, a jury convicted Newton of manslaughter, and he received a sentence of 2 to 15 years in prison. Convinced of Newton's innocence, the Black Panthers united in a "Free Huey" movement that turned Newton into a symbol of oppression and police brutality.

## The transformation of SNCC

The appeal of Black power and the Black Panther Party became apparent to SNCC's Stokely Carmichael (later Kwame Ture), who had grown frustrated with the consequences of nonviolent tactics. A Freedom Summer veteran (see the earlier section "Targeting Mississippi for Voter Registration: Freedom Summer"), Carmichael's Black Power stirrings manifested during his participation in the James Meredith March Against Fear campaign.

James Meredith, who had integrated Ole Miss in 1962 (refer to Chapter 8) with the assistance of federal forces, proposed a lone, 220-mile walk through Mississippi in June 1966 to encourage Black people to exercise their right to vote. Beginning his journey in Memphis, Meredith was barely a day into the march when a sniper, later revealed as a KKK member, shot him as he crossed the Mississippi-Tennessee border.

King, SNCC Chairman Carmichael, and CORE's new leader Fred McKissick flocked to Meredith's bedside to get his blessing to continue the march. Meredith agreed to their proposal. As the various civil rights groups prepared to continue the march, dissension emerged. CORE and SNCC participants denounced nonviolence, proclaiming that, if struck, they would strike back. SNCC's appeal to Louisiana's Deacons for Defense and Justice, a group of armed Black men (many of them war veterans who had organized in 1964 to protect civil rights workers and activities) further demonstrated its more militant leanings. In addition, Carmichael wanted an all-Black march.

Carmichael's insistence on an all-Black march horrified the NAACP's Roy Wilkins; Carmichael's arguments that nonviolent resistance had outgrown its usefulness disturbed Wilkins even more. Both Wilkins and the National Urban League's Whitney Young believed that marching without white people and abandoning nonviolence was equivalent to suicide. Disgust for this new attitude among CORE and SNCC members prompted Wilkins and Young to leave Memphis. King stayed on the condition that CORE and SNCC participants adhere to his rule of nonviolence. Because King's presence guaranteed the media attention necessary to navigate Mississippi successfully, participants agreed.

**IN THEIR OWN WORDS**

In Greenwood, Mississippi, the nonviolent agenda changed when a SNCC member yelled "Black Power" to a crowd of Black Mississippians, and they shouted back in approval. Arrested in a June 16 rally in Greenwood, Carmichael emerged from jail and publicly revealed his newly adopted militant attitude. "We been saying 'freedom' for six years," he said, "and we ain't got nothin'. What we gonna start saying now is 'Black Power!'" As before, the crowd responded approvingly.

Carmichael went on to coauthor a book titled *Black Power* and briefly affiliated himself with the Black Panther Party in Oakland, California. Although Black people in both the North and the South had grown impatient with nonviolent resistance, race relations in the North began to take center stage.

# Race Relations in the North

While the South seemed to move forward, race relations in the North were an enigma. Although free of signs segregating Black people from white people, racial discrimination manifested itself in the North primarily through Black unemployment. Police brutality was also a problem in the North, but television cameras didn't capture these transgressions like they did in the South. In many ways, the Watts riots/uprisings in the Black neighborhood in southern Los Angeles, California, shifted national attention from the obvious racial problems in the South to the less obvious but just as severe problems in the North.

## Rioting in Watts

On August 11, 1965, when a police officer stopped Marquette Frye in urban an Watts neighborhood in Los Angeles, a riot was the furthest thing from his mind. As he and Frye bantered back and forth, a crowd gathered. Concerned, the officer called for backup. Matters intensified when Frye's mother showed up. Eventually police arrested the entire Frye family (Frye's brother had been in the car with him when he was stopped). Even with a crowd gathered, there were reports that the

situation appeared to be resolved. As with most riots or uprisings, however, definitive details leading up to the actual eruption of violence are sketchy. What is clear, however, is that the Watts riot, also known as the Watts Uprising or Watts Rebellion, surprised the nation.

For six days, homes and businesses burned or fell to looters. As the National Guard and police tried to contain the violence, some rioters reportedly retaliated using guns. After the smoke cleared, 34 people, mostly Black, were dead. The injured list numbered another 1,000, with police arresting an estimated 4,000. Property damage ranged from $50 million to $100 million. Reverend Dr. Martin Luther King Jr., prompted by events in Watts, took the movement "up south."

# The Chicago Freedom Movement

As the nation pondered what caused the riots in Watts, Martin Luther King Jr. decided that Black America's urban centers also needed him and turned his attention to Chicago. Perhaps Chicago's appeal to King rested in its immense population of Southern Black people, its active Black clergy, its strong political leadership, its organized unions, and its liberal white community.

In 1966, King, supported by other civil rights organizations, launched the Chicago Freedom Movement (CFM), which brought the civil rights movement north. King even moved himself and his family to a neighborhood on Chicago's West Side. Discriminatory housing practices such as *redlining*, unfair economic practices based on race that included denying loans to Blacks to keep them from living in certain areas, served as the CFM's main target.

King attempted a strategy of marches, sit-ins, and boycotts in Chicago. Much like white Southerners, white Northerners also used violence such as throwing rocks in resistance to any efforts to end racial inequality. In addition, Chicago Mayor Richard Daley was as formidable a foe as any mayor or governor that King had faced in the South. King's difficulties in Chicago, along with the unrest in Watts, forced him and the nation to acknowledge that racism wasn't just a Southern problem but a national problem. The difference in the North, however, was that no signs pointed out the lines.

Before King left Chicago, however, city officials signed the ten-point agreement intended to strengthen laws such as the city's 1963 open housing ordinance and other measures that addressed housing discrimination in Chicago. Realtors agreed to become more open-minded while lenders agreed to practice more equitable lending. Because the agreement was more self-policing and lacked an emphasis on outside enforcement, many considered King's and the CFM's efforts a failure. Those with a more realistic view of the national impact of racism, however, recognized that the battle was long term.

## The Poor People's March

Although King had once remarked that taking a broad approach to segregation in Albany, Georgia, during the Albany Movement contributed to his failure there (refer to Chapter 8), he ignored those earlier concerns with the launch of the Poor People's Campaign in 1967. A broad-based movement, the Poor People's Campaign sought to address poverty in the U.S. Unlike the civil rights movement of the 1950s and early 1960s, the Poor People's Campaign was diverse and included individuals from all racial, ethnic, and religious backgrounds. Economic inequality replaced racial inequality as the main culprit for unrest. To bring attention to the plight of America's poor, King proposed another march on Washington, D.C., dubbed *The Poor People's March.* This effort led to his fateful trip to Memphis in March 1968.

At the behest of friend and colleague Rev. Billy Kyles, King led a march on March 28, 1968, in Memphis in support of striking sanitation workers. Unfortunately, not all the 6,000 demonstrators followed King's nonviolent tactics. Some contend that the disrupters were planted. Nonetheless, when someone broke a window, violence erupted, with police using nightsticks, mace, tear gas, and gunfire to restore order. At the end of the scuffle, 16-year-old Larry Payne lay dead of a gunshot wound. With 60 people injured and another 280 arrested, the state legislature issued a 7 p.m. curfew. Four thousand National Guardsmen also moved into Memphis as an added precaution.

**IN THEIR OWN WORDS**

On April 3, King returned to Memphis and delivered one of his most fiery speeches at Mason Temple Church of God in Christ, in hindsight a foreshadowing of his own death. "We've got some difficult days ahead," he told the crowd. "But it doesn't matter with me now. Because I've been to the mountaintop. And I don't mind. Like anybody, I would like to live a long life. Longevity has its place. But I'm not concerned about that now. I just want to do God's will. And He's allowed me to go up to the mountain. And I've looked over. And I've seen the Promised Land. I may not get there with you. But I want you to know tonight, that we, as a people will get to the Promised Land."

# Death of a King

Very few people doubt the Reverend Dr. Martin Luther King Jr. knew that his days were numbered. The fates of other figureheads and leaders in the civil rights movement — particularly the murders of Medgar Evers and President John F. Kennedy in 1963 and Malcolm X in 1965 — greatly clarified the risk that accompanied King's work. Even after battling Alabama's notorious Bull Connor and enduring repeated jailings and assaults, King pressed on, lending his leadership

and influence to various efforts, most notably in Chicago and Memphis. He seemed unfazed by or perhaps resigned to the prospect of death.

## The night of his death and the mourning after

On April 4, 1968, at the Lorraine Motel in Memphis, King stood alone on the second-floor balcony. At around 6 p.m., a single shot hit him in the neck. King's longtime friend Ralph David Abernathy was among the handful who immediately rushed to his side. At 7:05 p.m., not even a full hour later, doctors at St. Joseph's Hospital pronounced him dead. Before the night's end, President Johnson addressed the American public on all major networks and urged unity in this time of crisis. A national day of mourning followed.

For many Americans, especially Black Americans, more than King died on that motel balcony that fateful evening. In no less than 60 cities, including Chicago, Washington, D.C., and New York, Black Americans lashed out in violence as the reality of King's assassination sank in. Civil disorder was so high that as many as 40,000 regular and National Guardsmen filtered throughout the nation. Some cities adopted curfews to curtail the violence. Nationwide, an estimated 46 people died. Injuries were as high as 3,000, but authorities arrested many thousands more, mostly for looting.

**IN THEIR OWN WORDS**

Instead of canceling his appearance before a Black audience in Indianapolis, presidential hopeful Robert F. Kennedy bravely informed the crowd of King's death. "We can do well in this country," he told the crowd, trying to restore hope. "We will have difficult times. We've had difficult times in the past. And we will have difficult times in the future. . . But the vast majority of white people and the vast majority of Black people in this country want to live together, want to improve the quality of our life, and want justice for all human beings that abide in our land."

On April 9, Jacqueline Kennedy, Vice President Hubert Humphrey, U.S. Supreme Court Justice Thurgood Marshall, and other dignitaries descended on Atlanta to attend King's funeral. An estimated 100,000 people walked behind King's body during the funeral procession, and millions more watched the event on television.

## Continuing his work

Those closest to King, despite their grief, bravely marched to tie up some of King's loose ends. On April 8, just days after King's assassination, Ralph David Abernathy and Coretta Scott King led a silent march of 20,000 through Memphis in support

of the Memphis Sanitation Workers' Strike, the cause that had brought King to Memphis in the first place. The 65-day strike ended with a bittersweet settlement just 8 days later.

That May, Abernathy, as the SCLC's new president, tried to keep King's Poor People's Campaign alive by establishing Resurrection City, where more than 2,000 people of varying ages and races camped out near the Lincoln Mall. The optimism of Resurrection City ended with the news of Robert F. Kennedy's assassination on June 5.

Two days following King's funeral, Congress passed the Civil Rights Act of 1968. Most people know Title VIII of the act as the Fair Housing Act. It's significant because it prohibited discrimination based on "race, color, religion, or national origin" in selling or renting property. It also made designating any preference in advertising the rent or sale of a property based on race, color, religion, or national origin illegal.

Despite this victory, the civil rights movement was never the same. So many people had given their lives for freedom and equality. Black America was at a crossroads. King's assassination, which many believed wasn't the lone work of James Earl Ray, was a hard blow. Only time would tell if America's deepest scars would heal.

IN THIS CHAPTER

» Chronicling the demise of the Black Panther Party

» Getting political with the Vietnam War, feminism, and elected officials

» Eyeing the economic playing field

» Battling crack cocaine and HIV/AIDS

» Tracking the racial divide well into the 21st century

# Chapter **10**

# Where Do We Go from Here? Post–Civil Rights

The Reverend Dr. Martin Luther King Jr.'s death in 1968 put the civil rights movement in limbo. As its leadership struggled to regain momentum, cries for Black Power grew louder, with the Black Panther Party becoming the biggest beneficiary. However, its dominance wouldn't last long. It simply couldn't survive with its key leaders either behind bars or dead, largely due to targeting by the FBI and local law enforcement. At the same time, the Vietnam War presented other challenges.

If the 1960s were about dismantling the nation, for many, the 1970s were about trying to put it back together better than before. Like George Jefferson of the 1970s sitcom *The Jeffersons*, many Black Americans were moving on up, with Black elected officials heading cities and walking the halls of state legislatures and Congress, even in the midst of urban blight. Crack cocaine's emergence in the 1980s presented unique challenges, as did the advent of HIV/AIDS. Still the racial divide continued well into the top of the 21st century, indicating that some battles come with multiple wars.

This chapter explores those challenges while reflecting on the remarkable journey, heartbreaking and inspiring, that still fuels the drive to the final destination Dr. King, Malcolm X, Marcus Garvey, W.E.B. Du Bois, Ida B. Wells-Barnett, Booker T. Washington, Harriet Tubman, Frederick Douglass, and countless others fought so hard to achieve without losing sight that the war wasn't won.

# The Panthers Stumble

Black Power rumblings began before King's death in 1968. During a march through Mississippi in 1966 with King, Stokely Carmichael, the chairman of the Student Nonviolent Coordinating Committee (SNCC), announced his allegiance to a Black Power ideology. (Refer to Chapter 9 for details on Carmichael's rejection of nonviolence or more accurately nonviolent direct action.) Carmichael, who later became Kwame Ture, affiliated with the Oakland-based Black Panther Party (BPP) for Self-Defense, an organization founded in October 1966 by Bobby Seale, Huey Newton, and a handful of others at Merritt College and credited for the Black Power movement. In the late 1960s and early 1970s, the BPP, which coincidentally worked with many white activists, was the nation's most prominent representative of Black Power.

## Huey Newton: A symbol of Black Power

**IN THEIR OWN WORDS**

The 1967 arrest of Huey Newton for allegedly killing a white police officer sparked a "Free Huey" campaign. Newton and his impending trial came to represent the condition of Black people everywhere. The truth of that belief wasn't lost on Newton; in his 1973 book *Revolutionary Suicide,* he wrote, "Every day they kept me there I grew as a symbol of the brutalization of the poor and Black as well as a living reproach to society's indifference to the inequities of the legal system."

Ample propaganda furthered the association. Newton's image and the "Free Huey" slogan showed up on flags, buttons, T-shirts, and posters. Curiously, Newton became a living martyr. King's death had left a void that the fight to free Newton filled in many ways. Although there was no shortage of great causes to fight, there were few symbols to galvanize the public's interest. Newton became one such symbol.

## The BPP encounters challenges

Ultimately, Newton's incarceration and the notoriety of the Black Panthers became a detriment. Matters worsened when BPP cofounder Bobby Seale received an indictment as part of the Chicago 8, a group of activists accused of crossing state

lines to incite rioting during the 1968 Democratic National Convention in Chicago. Judge Abbie Hoffman declared a mistrial and sentenced Seale to four years of prison for contempt of court (which an appeal later overturned), making the Chicago 8 the Chicago 7. With both Newton and Seale out of the Panthers' active picture, the BPP began to change.

## Cleaver and the party's growing association with violence

Eldridge Cleaver, considered more radical than either Newton or Seale at the time, seized control of the BPP. Cleaver, shortly after being released from prison, joined the Panthers mere months after its founding. As the BPP's minister of information and spokesperson, he advocated for armed struggle for liberation, which eventually put him and Newton at odds because BPP used guns for self-defense.

In 1968, only two days after King's assassination in Memphis, Cleaver and 13 other Panthers were involved in a shootout with police in Oakland. One to four officers were wounded, and one of the BPP's own died. Despite surrendering unarmed, with his hands up (according to several witnesses), 17-year-old Bobby Hutton (known as Lil Bobby Hutton), the Panthers' first recruit and treasurer, died after being shot with an estimated 12 bullets by the police.

When that incident threatened to return Cleaver to jail, he fled to Algeria. His wife, Kathleen Neal Cleaver (whom he met at a 1967 SNCC conference at Fisk University), became the BPP's communications secretary, a position she created when she relocated to Oakland that same year. She later joined her husband in Algeria.

## ELDRIDGE CHANGES: *SOUL ON ICE*

Although Eldridge Cleaver returned to the United States from exile in 1975, and renounced the Black Panther Party (BPP), most Americans remember him as a Black Panther because of his book *Soul on Ice,* released in March 1968. Cleaver's admission to raping Black and white women helped fuel the many myths associated with the BPP. Other books such as *Seize the Time* (1970), by BPP founders Huey Newton and Bobby Seale, and former BPP chair Elaine Brown's *A Taste of Power* (1992) offer more balanced insight into the BPP.

As the years wore on, Cleaver, who passed away in 1998 after battling addiction, greatly altered his political views. He became a conservative Republican in the 1980s and unsuccessfully ran for both Berkeley City Council and the United States Senate in California.

Other incidents followed. In 1970 George Jackson, who had established a BPP chapter at California's Soledad Prison, and two other prisoners, Fleeta Drumgo, and John Clutchette, were charged with murdering a prison guard reportedly in retaliation for the murder of several Black prisoners. Jackson, imprisoned since age 18 for a gas station robbery of $70 he disputed, was introduced to Marxist and Maoist political thought by fellow inmates and reading. Jackson and Angela Davis, a professor at UCLA affiliated with the BPP who gained notoriety when California Governor Ronald Reagan pushed the UC Board of Regents to fire her for being a member of the Communist Party, became connected when Jackson wrote her. Davis's involvement in the Soledad Brothers' case helped bring awareness to the condition of the prison population. Jackson and the case gained even more attention when his younger brother Jonathan snuck guns into a California courtroom. Jonathan, along with the two Soledad prisoners in the courtroom, took the judge and four others hostage before being gunned down.

The case also put Davis, who was later revealed to have a personal relationship with George Jackson, on the FBI's Ten Most Wanted Fugitive List when registration for Jonathan Jackson's guns traced back to Davis, whom he was reportedly protecting though she was unaware of his plans, and she ran. After her arrest, Davis spent 18 months in jail without bail before eventually receiving an acquittal in 1972.

In 1971, guards at California's San Quentin Prison killed George Jackson, who had gained fame for his 1970 book *Soledad Brother: The Prison Letters of George Jackson* (Chicago Review Press), for a purported escape attempt; however, their account of the events kept changing. Deeper dives into Jackson's imprisonment for 11 of his 29 years uncovered many inconsistencies. Davis, whose life during this time was chronicled by filmmaker Shola Lynch in the 2012 documentary *Free Angela and All the Political Prisoners*, continued to be a progressive symbol.

Another notable case includes the Panther 21 in New York City when 21 members of the BPP Harlem chapter were indicted on April 2, 1969 on 156 counts for conspiring to blow up subway and police stations as well as department stores, railroads, and even the New York Botanical Garden. Bail was set at $100,000 each, collectively totaling $2.1 million, with the Panther 21 spending several months up to two years in jail. One of the accused was Afeni Shakur, the mother of rapper Tupac; she represented herself in the trial and was acquitted in May 1971, weeks before her son's birth.

## The Black Liberation Army emerges

During the legal trials of Newton and Seale, the Black Liberation Army (BLA) gained prominence. The underground revolutionary organization, active from 1970 to 1976, contained many former Panthers. Cleaver, whom Newton had expelled from the BPP in 1971, never officially led the BLA; however, many of the ideas he encountered from revolutionaries in the countries in which he was exiled (including Cuba, Algeria, and France) reportedly influenced the BLA to embrace armed retaliation against oppression. Despite being painted as radicals, many BLA values remain relevant.

**IN THEIR OWN WORDS**

"We are anti-capitalist, anti-imperialist, anti-racist, and anti-sexist," BLA members proclaimed. "We must of necessity strive for the abolishment of these systems and for the institution of socialistic relationships in which Black people have total and absolute control over their own destiny as a people," they stated, among other core principles.

Assata Shakur, formerly JoAnne Deborah Chesimard, is among BLA's most well-known members. A series of alleged criminal activities, including bank robberies and clashes with law enforcement, one in which a New Jersey state trooper was killed in 1973, made Shakur notorious. She escaped from a New Jersey correctional facility in 1979, and resurfaced in Cuba in 1984. In early 2021, Shakur was still in political asylum in Cuba despite repeated demands from the U.S. government over several decades that she be extradited.

## Fred Hampton, a murder in Chicago

Fred Hampton, an activist since at least age 12, worked with both the NAACP and SNCC. Attracted mainly by the BPP's Ten Point Plan (see Chapter 9) as well as its emphasis on class struggle, Hampton joined the Panthers in 1968, at age 20. Along with Bobby Rush and others, he helped transform the Illinois chapter, established by former SNCC leader Bob Brown in 1967, into a formidable force. Committed to community development, Hampton's key successes included the following:

» Spearheading the signature Black Panther Party Free Breakfast for School Children Program in Chicago. (The first program had been established in January 1969 in Oakland to provide nutritious breakfasts to Black schoolchildren.)

» Establishing a free medical center and implementing door-to-door testing for sickle cell anemia, an inherited blood disorder largely affecting people of African ancestry.

Chicago police cut Hampton's good deeds short on December 4, 1969, during a special raid on the apartment Hampton shared with Deborah Wilson (Akua Njeri), who was pregnant with their son. Their apartment was also a BPP gathering spot. Cook County state's attorney Edward Hanrahan claimed the Black Panthers surprise attacked Chicago police, 14 in all, as they tried to execute a search warrant for illegal weapons in the apartment. Coming on the heels of the murder of two Chicago policemen allegedly by the Black Panthers a month earlier, perhaps made the raid, which left Hampton and fellow Black Panther Mark Clark dead, more believable at the time. Hampton was just 21. Further investigation, however, revealed a far uglier truth.

## FURTHER INVESTIGATIONS AND COINTELPRO

In 1975, the Church Committee (nicknamed for its leader, Idaho Senator Frank Church) uncovered information about the FBI's Counter Intelligence Program (COINTELPRO), confirming the Black community's suspicions about FBI interference in the affairs of the Black Panthers, as well as those of civil rights leader Martin Luther King Jr., among others.

Two years prior, William "Bill" O'Neal, who had served as a security chief in the Illinois Black Panther Party, had been exposed as a paid FBI informant through COINTELPRO. O'Neal, who was in the Federal Witness Protection Program in California as William Hart before returning to Chicago in 1984, sat for an interview admitting to his double agency with *Eyes on the Prize II: America at the Racial Crossroads 1965–1985,* which aired in 1990. Hours later, he was hit by a car with his death being ruled a suicide. O'Neal reportedly provided the blueprint of Hampton's apartment used by the Chicago Police, as well as put barbiturates in Hampton's drink during a meal O'Neal prepared. The FBI, it was later revealed, started a file on Hampton in 1967, prior to him even joining the Black Panther Party. Also documents released in early 2021 suggest that J. Edgar Hoover was directly aware of the raid that killed Hampton.

O'Neal's betrayal of Hampton was explored in the 2021 film *Judas and the Black Messiah.* Stanley Nelson explored the Black Panthers more fully in the 2015 PBS documentary *The Black Panthers: Vanguard of the Revolution.*

**TECHNICAL STUFF**

Police claimed that they had killed Hampton, who had an FBI file dating back to 1967, and Clark in response to shots first fired by the Black Panthers. Because "militant" quotes by Hampton in the *Chicago Sun-Times* had already put white Chicago on guard, the police account only confirmed their perceptions of the Black Panthers as armed thugs. Yet subsequent investigations revealed that of the 99 shots fired that day, only one came from the Panthers.

## Changing focus: Embracing nonviolence and women's leadership

By the early 1970s, the BPP had become a nonviolent direct-action organization in line with Dr. King's vision that began to work within the system for social change. Seale, who had beaten the charges against him, ran for mayor of Oakland in 1973. Although he lost, his strong showing was encouraging. Other BPP members also ran for office, and the BPP successfully supported the election of other Black Americans to political offices.

In 1974, another murder accusation against Huey Newton, who had been cleared of his earlier charges, prompted him to flee to Cuba, where he lived in exile for three years before eventually receiving an acquittal. Elaine Brown succeeded Newton to become the BPP's first female chair that same year. Committing the party to women's rights initiatives, Brown led the BPP until 1977. In addition to Brown and BPP's communications secretary Kathleen Neal Cleaver, other prominent women in BPP's inner circle included Ericka (Jenkins) Huggins, who led the BPP's New Haven, Connecticut chapter and even stood trial in a BPP-related incident in 1970 where she, along Seale, was accused of murder, kidnapping, and conspiracy in relation to a suspected informant but was acquitted in 1971. In fact, the BPP boasted a substantially active female membership across the country. (Refer to the section, "Black Women Taking a Stand," later in this chapter for more information on Black women leadership.)

Legal cases involving BPP activity dating back to the 1960s and 70s continued throughout the 1980s and, in some instances, until the year 2000, when prominent attorney Johnnie Cochran finally succeeded in securing BPP political prisoner Geronimo Pratt's release. In 1989, Newton became a victim of urban crime and died of a gunshot wound in Oakland. Seale continued to work with the youth. Although the BPP faltered in the late 1970s, officially shutting down in 1982, its legacy and spirit live on, especially in Oakland.

# Fighting Vietnam

Starting in the mid-1960s, the Vietnam War was a hot-button issue for many Americans. The conflict began when Vietnam split into two factions: communist and noncommunist. Although President John F. Kennedy first sent military advisors into Vietnam before his 1963 assassination, the number of American troops escalated during Lyndon B. Johnson's presidency, and their advisory role ended. With mounting fatalities, no exit strategy in place, and no visible American gain to the war's outcome, college campuses across the nation bustled with antiwar activity, which continued until the war ended.

In accordance with President Harry Truman's executive order, the military was almost completely desegregated by the end of the Korean War in 1950. Subsequently, more Black American men served in the Vietnam War than in any other war preceding it.

## An unfair fight

Military draft deferments for college attendance and certain civilian occupations favored privileged white men. Moreover, Project 100,000, a Great Society program initiated in 1966 that made military entrance requirements like mental aptitude and physical ailments more lenient in order to bolster forces, only increased those disparities. An estimated 41 percent of the 350,000 new enlistees were Black American men, mainly from poverty-stricken areas. Even more disturbing, 40 percent of those enlistees drew combat assignments and suffered twice the casualty rates of other military enlistees.

Overall Black American male casualty rates constituted almost 20 percent of all combat deaths between 1961 and 1966; Black Americans, however, made up only 13 percent of the U.S. population as a whole and 9 to 10 percent of the military. The numbers were so high that the military worked hard to bring them down. By the time the war ended in 1975, the 12.5 percent overall Black casualty rate was a vast improvement. At the same time, Black military personnel had also increased significantly. In 1976, Black Americans, mostly men, constituted 15 percent of the military.

# Reacting to the war

The BPP vehemently opposed the war in Vietnam. The group's Ten Point Plan demanded "an immediate end to all wars of aggression." Specifically, the BPP objected to Black American men serving and dying in disproportionate numbers, especially because their own country treated them poorly. Not surprisingly, the SNCC and the Congress of Racial Equality (CORE) also opposed the Vietnam War. The Reverend Dr. Martin Luther King Jr.'s public opposition to the Vietnam War was surprising, however, and very unpopular among the civil rights mainstream, particularly because he was connected to civil rights issues and many didn't view the Vietnam War as a civil rights issue.

So King, who had won the Nobel Prize for Peace in 1964, shocked many when he linked his opposition of the Vietnam War to the civil rights movement and attacked President Johnson's administration directly in an April 1967 speech titled "Declaration of Independence from the War in Vietnam," also known as "A Time to Break Silence." For King, the resources used for the Vietnam War could be better used to fight poverty.

*The New York Times* denounced King, as did civil rights leader Bayard Rustin, political scientist and fellow Nobel Prize winner Ralph Bunche, and Major League Baseball player Jackie Robinson, among others. The NAACP and the National Urban League worried that opposing the Vietnam War would adversely affect funding for civil rights initiatives. When President Johnson admonished King, telling him to stick to civil rights, King refused to alter his position, which won him respect with Black Power stalwarts even though many of them still disagreed with his nonviolent approach.

# Coming home

Once at home, many Black Vietnam veterans publicly supported the war and defended themselves against antiwar protestors — a lonely position, given that unlike in previous wars, discharges from Vietnam were staggered, so veterans couldn't defend themselves or the war in large numbers. It also didn't help that in Vietnam, some soldiers had become addicted to heroin while others became alcoholics — a sad scenario that resulted in a stereotype that many veterans resented.

# BLACK WOMEN CIVIL RIGHTS LEADERS

After Reconstruction, Black women became critical in civil rights efforts. Ida B. Wells-Barnett, Mary McLeod Bethune, and Mary Church Terrell were just three of the powerful female leaders in the Black community at the end of the 19th century and into the early 20th century. Here are some of the main players:

- **Ida B. Wells-Barnett** ignited the ire of Southern white men with her investigations of lynchings, revealing that Black men were most often economic targets, that Black women were lynched too, and that white women frequently consented to sex with Black men. She was also a key figure in the women's suffrage movement that secured the 19th Amendment granting women the vote. (Read about Wells-Barnett in Chapter 7.)

- **Mary McLeod Bethune** founded the National Council of Negro Women (NCNW), active for more than 85 years, and a school that eventually became Bethune-Cookman College. She was extremely active in Black American affairs, calling national conferences and frequently visiting the White House during Theodore Roosevelt's presidency. She brought Black leaders from various organizations together for the Federal Council of Negro Affairs, better known as the Black Cabinet.

- **Dorothy Height** dedicated the bulk of her life to service primarily to Black women, first in social work, mostly with the YWCA, and most prominently as a national president of Delta Sigma Theta. She later led the National Council of Negro Women, founded by her mentor Mary McLeod Bethune, for more than 50 years. Height, a key organizer of the March on Washington for Jobs and Freedom, ensured Black women sat at the civil rights table.

- **Mary Church Terrell,** an Oberlin graduate, NAACP co-founder, educator, and prominent speaker and writer against segregation, fought for civil rights throughout her life. At the age of 86, she actively participated in efforts to desegregate Washington, D.C. restaurants in 1950.

- **Ella Baker** was a principal force in the Southern Christian Leadership Conference (SCLC) during the civil rights movement of the 1960s and later the Student Nonviolent Coordinating Committee (SNCC), which she nurtured. (Read about the fruits of her efforts in Chapter 8.)

- **Daisy Bates,** an NAACP activist and newspaper publisher, was a pivotal figure in integrating Central High School in Little Rock, Arkansas, in 1957. (Read about Central High in Chapter 8.)

- **Fannie Lou Hamer,** who grew up a sharecropper in the Mississippi Delta, was critical to civil rights efforts in Mississippi. Boldly challenging white supremacy in her native state, Hamer endured beatings for daring to speak up and act. An SNCC organizer and key component of Freedom Summer as well as a founder of the Mississippi Freedom Democratic Party, Hamer was a fearless leader. (Read about Freedom Summer and the Mississippi Freedom Democratic Party in Chapter 9.)

- **Pauli Murray**, civil rights activist, attorney, National Organization for Women (NOW) cofounder, and a member of the LGBTQ community, inspired successful arguments on race and gender early in their careers for later Supreme Court Justices Thurgood Marshall and Ruth Bader Ginsburg. The documentary *My Name Is Pauli Murray*, exploring her impact, premiered at the 2021 Sundance Film Festival. In 2012, Murray, who became a priest later in life, was sainted by the Episcopal Church.

# Black Women Taking a Stand

From the mid–1960s to the early 1970s, Black women were in a difficult position. Between the civil rights and feminist movements, where did they fit in? They had been the backbone of the civil rights movement, but their contributions were deemphasized as Black men, often emasculated by white society, felt compelled to adopt patriarchal roles. In many respects, they fared better in the BPP. When Black women flocked to the feminist movement, white women frequently discriminated against them and devoted little attention to class issues that seriously affected Black women, who also tended to be poor.

**REMEMBER**

Historically, Black women have prioritized race over gender concerns. This choice was especially poignant during Reconstruction, when Black female leaders such as active suffragist Frances Ellen Watkins Harper supported the Fifteenth Amendment, giving Black men the right to vote, over the objections of white women suffragists with whom she had worked for a long time.

Black women have a long feminist tradition that includes 19th–century activists such as Maria W. Stewart and Sojourner Truth as well as organizations like the National Association of Colored Women's Clubs (NACWC) and the National Council of Negro Women, founded in 1896 and 1935, respectively. The 1960s and 1970s, not to mention Black men's changing attitudes regarding the role of Black women, piqued interest around new concerns such as race, gender, and class, and these organizations attempted to address issues:

>> **The ANC (Aid to Needy Children) Mothers Anonymous of Watts and the National Welfare Rights Organization (NWRO):** Johnnie Tillmon was an early pioneer of addressing the concerns of poor Black women. A welfare mother living in Los Angeles's Nickerson Projects, Tillmon helped found Aid to Needy Children Mothers Anonymous of Watts in 1963. She was later tapped to lead the National Welfare Rights Organization, founded in 1966. Through these organizations, she addressed issues such as equal pay for women, childcare, and voter registration.

>> **Black Women's Liberation Committee (BWLC):** SNCC member Francis Beal was one of the founders of the Black Women's Liberation Committee in 1968.

In 1969, she helped clarify the struggles of Black women in the influential essay "Double Jeopardy: To Be Black and Female," which also appeared in the landmark 1970 anthology *The Black Woman* (Washington Square Press); that book ushered in a new wave of Black female writers (read about this literary movement in Chapter 14). Beal identified capitalism as a key factor in the chasm between Black men and women. During the early 1970s, the BWLC evolved into the Third World Women's Alliance.

>> **National Organization for Women (NOW):** Reverend Dr. Anna Pauline (Pauli) Murray is a cofounder of the nation's most prominent feminist organization, the National Organization for Women, founded in 1966. (Refer to the nearby sidebar for more about Murray.)

>> **The National Black Feminist Organization:** While many Black women remain active in mainstream feminist organizations only, other Black women have created organizations aimed at addressing Black women's unique concerns more effectively. The National Black Feminist Organization launched in 1973, with the specific goal of including Black women of all ages, classes, and sexual orientation. Although it and similar organizations didn't outlive the 1970s, the legacy of Black feminism lives on.

## CLARENCE THOMAS HEARINGS, 1991

Conflicts between Black women's allegiance to race or gender came to a head in 1991 during the Senate confirmation hearings of Clarence Thomas to replace Thurgood Marshall, the first Black person to hold that seat, on the Supreme Court. During the hearings, Black law professor Anita Hill, who had worked for Thomas at the Equal Employment Opportunity Commission (EEOC), was vilified by many Black Americans for accusing Thomas of sexual harassment and testifying that he had made sexually inappropriate comments to her during their working relationship. Hill, who received considerable support from white women, was accused of being a pawn to block the ascension of a Black man.

Thomas, during his testimony, referred to the hearing as a "high-tech lynching," bringing attention to the all-white male Senate Judiciary Committee presiding over it and the nation's history of violence against Black men. Over time, however, Hill became seen as a champion of women and was lauded for her bravery. In 2016, the HBO film *Confirmation* starring Kerry Washington, chronicled Hill's life and the historic moment. As the Me Too movement, founded in 2006 by Tarana Burke and distinguished by the hashtag #MeToo heated up in the late 2010s, the Oklahoma native became even more of a hero.

During the 2020 presidential race, candidate Joe Biden, who had served as chairman of the Senate Judiciary Committee, expressed his regrets for his handling of the hearings and treatment of Hill.

In 1983, Alice Walker coined the term *womanism*, a feminist ideology that addresses the Black woman's unique history of racial and gender oppression. Women such as Angela Davis; law professor Kimberlé Crenshaw; academics Patricia Hill Collins, Beverly Guy Sheftall, and bell hooks; and historians Darlene Clark Hine, Paula Giddings, and Deborah Gray White have greatly expanded the context in which Black women and their history and activism are discussed. They underscored Black women's issues related to race, gender, and class as well as the active role Black women have played in the fight for equality for all women.

# A Race to Political Office

Black Americans voted in unprecedented numbers after the passage of the Voting Rights Act of 1965, and Black politicians became the main beneficiaries. From the mid-1960s into the 1970s, Black politicians became congressmen, state legislators, and mayors in record numbers. By the end of the 1980s, both Chicago and New York, the second largest and largest cities in the nation at the time, had elected Black mayors with Harold Washington in 1983 and David Dinkins in 1989.

Jesse Jackson also made two historic presidential runs. Carol Mosley Braun, the nation's first Black female senator, took office in 1993, but the 1990s, especially during Bill Clinton's presidency, became defined more by historic Black appointments, a trend that largely continued into the 2000s. In 2008, Barack Obama took the top office in the nation and served two terms (refer to Chapter 11). And in the 2010s, the numbers of Black politicians capturing major offices exploded. The following sections offer a few highlights of the political power that the legendary activist W.E.B. Du Bois advocated in the early 20th century.

**HISTORICAL ROOTS**

## ELECTION DAY

A replica of colonial elections, Election Day began in Connecticut around 1750 and continued being held in some areas for at least a century. Black Americans took the opportunity to elect their own officials, who governed their enslaved communities, primarily settling disputes. Both serious and fun-filled, festivities culminated in an impressive parade. Historian William Piersen argued that such celebrations helped shape the nation's parade tradition.

**REMEMBER**

Registering Black voters became an essential strategy for electing Black officials. In addition, the success of Black politicians — such as Oscar DePriest, the first Black person elected to serve in Congress in the 20th century, and New York City's firebrand Congressman Adam Clayton Powell Jr. — was significantly influenced by the Great Migration, the mass relocation of Black Americans from the South to the North. Large Black voter turnout helped these men secure victory, a lesson that wasn't lost on Black politicians in the late 1960s and into the 1980s.

## Getting a foot in the door in the 1960s

In the late 1960s, Black politicians got the ball rolling by winning a number of key elected positions:

>> In 1966, Massachusetts's Edward W. Brooke III, a Republican, became the first Black politician elected to the U.S. Senate since Reconstruction. Black female politicians Yvonne Braithwaite Burke in California and Barbara Jordan in Texas won offices within their respective state governments.

>> In 1967, Black mayors Richard B. Hatcher and Carl B. Stokes headed the Midwestern cities of Gary, Indiana, and Cleveland, Ohio.

>> In 1968, more Black candidates than ever were elected to their state legislatures, and to top it off, Brooklyn's Shirley Chisholm became the first Black woman elected to Congress. Nationwide, 370 Black politicians won elections that year.

## Making political strides in the 1970s

In the 1970s, Black elected officials flourished. Organizations such as the Black Panther Party embraced the political process as a significant agent of change for Black America.

**HISTORICAL ROOTS**

## THE CONGRESSIONAL BLACK CAUCUS

In January 1969, Black members of the House of Representatives, including Shirley Chisholm, Louis Stokes, and William L. Clay, founded the Democratic Select Committee, which became the Congressional Black Caucus in 1971. Functioning primarily as a lobbying group to the larger Congressional Democratic Party, the Caucus focuses on issues affecting Black Americans. It launched with nine members; in 2005, it was 43. In 2021, the number was more than 50.

Wisely, Black candidates cut their teeth on smaller offices before tackling bigger jobs. Because so many had participated in civil rights organizations, they were already familiar with government bureaucracy. Julian Bond, for example, went straight from SNCC to the Georgia legislature, and Andrew Young, a close aide of King's, served as a congressman, the mayor of Atlanta, and U.S. ambassador to the United Nations.

As important as serving in a federal office was, Black politicians also exerted considerable power by leading major cities. The 1973 elections of Coleman Young and Maynard Jackson as the first Black mayors of Detroit and Atlanta were important milestones. That same year, Tom Bradley's election as mayor of Los Angeles offered more promise, because unlike Atlanta and Detroit, which had sizeable Black populations, Los Angeles was only 15 percent Black. Bradley's win that same year signaled that some white Americans were willing to elect Black officials to major positions. By the end of the 1970s, Washington, D.C. had officially made Walter Washington its first ever *elected* mayor, with Richmond, Virginia (Henry L. Marsh, 1977); Oakland (Lionel Wilson, 1978); New Orleans (Ernest Nathan Morial, 1978); and Birmingham, Alabama (Richard Arrington Jr., 1979) all electing their first Black mayors.

## Eyeing a bigger prize in the 1980s

In addition to Chicago and New York City, other cities that elected their first Black mayors in the 1980s include Little Rock, Arkansas (Charles E. Bussey, Jr., 1981); Charlotte (Harvey Gantt, 1983); Philadelphia (Wilson Goode, 1984); Baltimore (Kurt Schmoke, 1989); and Seattle (Norm Rice, 1989).

With more Black mayors, state legislators, and congressmen in office, civil rights leader Jesse Jackson began eyeing the presidency. He also helped usher in a new concept in Black political leadership by building a coalition among Black, Latino, gay, and other voting groups. He was the third Black candidate to mount a noteworthy nationwide presidential campaign. (Congresswoman Shirley Chisholm became the second in 1972, while George Edwin Taylor, the son of an enslaved father and free mother running on the all-Black independent National Liberty Party in 1904, was the first.) Jackson, founder of Operation PUSH (People United to Save Humanity), surprised numerous political pundits when he placed third in the Democratic primaries in 1984.

During Jackson's second run in 1988, he won an unprecedented 11 primaries, and by the time he had reached the Democratic National Convention in Atlanta, he was a serious candidate to win the nomination. Despite a stirring speech in which he commiserated with the nation's poor, he failed to capture the nomination, yet he brought much-needed dialogue to national politics.

Similar to King's Poor People's Campaign (refer to Chapter 9) and Fred Hampton's movement of the same name formed in 1969, the mission of the National Rainbow Coalition, which Jackson established in 1985, strived to bring all races together on a variety of issues, including employment, fair housing, and affirmative action. In 1997, Operation PUSH and the National Rainbow Coalition merged to form the Rainbow PUSH Coalition.

## Still thriving in the 1990s and early 2000s

The 1990s were very active, as several major cities elected their first Black mayors, including Memphis, Tennessee (W.W. Herenton, 1991); Denver (Wellington Webb, 1991); Kansas City, Missouri (Emanuel Cleaver, 1991); St. Louis (Freeman Bosley Jr., 1993); Rochester, New York (William A. Johnson Jr., 1993); Dallas (Ron Kirk, 1995); San Francisco (Willie Brown, 1996), Jackson, Mississippi (Harvey Johnson Jr., 1997); and Houston (Lee P. Brown, 1997). Washington, D.C. elected Sharon Pratt Kelly its first Black woman mayor in 1991, and Minneapolis, Minnesota elected Sharon Sayles Belton its first Black and female mayor in 1994.

President Bill Clinton, who received a large majority of the Black vote, appointed five Black people to his cabinet in 1993, including Ron Brown as Secretary of Commerce and Hazel O'Leary as Secretary of Energy. Despite an overall decrease in Black presidential appointees during George W. Bush's administration, Colin Powell did become the nation's first Black Secretary of State in 2001; Condoleezza Rice, who succeeded him, became the nation's first Black woman Secretary of State in 2005.

# Money, Money, Money

More than a century ago, Booker T. Washington encouraged Black Americans to concentrate on economic empowerment over political empowerment. Since the civil rights victories of the 1960s, however, it wasn't a question of gaining one at the expense of the other. Increasingly, Black Americans used political power to address the economic inequities created by racism. For almost 50 years, affirmative action has been one of the main strategies used to address those inequities.

## Looking at homeownership

Undoing the long-term effects of systematic racist practices such as *redlining*, the practice of charging Black people more to live in certain areas or not granting them loans to live in others, hasn't been easy. Historically, redlining reduced

Black homeownership, a proven determinant of wealth. Because Black Americans as a whole have historically possessed less individual and communal wealth than white Americans, surviving economic hardships such as unemployment has been more difficult.

In the 2004 book *The Hidden Cost of Being African American: How Wealth Perpetuates Inequality* (Oxford University Press), sociology professor Thomas M. Shapiro found that economic inequities persist in the United States because white Americans tend to inherit and generate more wealth than Black Americans. Discriminatory housing practices like Black people being denied loans on the same criteria as white people have received them has historically prevented Black homeowners who live in largely Black neighborhoods from accumulating significant wealth in their homes.

In the late 1990s, early 2000s, and into the 2010s, as more white Americans (mostly in higher income brackets) moved into traditionally Black neighborhoods in cities all across the United States, home equity soared; this practice is commonly referred to as *gentrification*. At the same time, those higher prices, accompanied by higher taxes, displaced Black Americans, many of whom had lived in these neighborhoods for generations, even fueling homelessness in some instances. Conditions such as these, argues Shapiro, create disparities that aren't easily solved through programs that increase Black American income.

## Facing barriers in business

Historically, the federal government played a significant role in undermining the wealth of Black Americans. Roy Innis, who took over CORE in 1968, was one of the first civil rights activists to advocate for government assistance, such as providing government loans to encourage Black entrepreneurship, as a corrective.

In the late 1960s and 1970s Jackson led economic boycotts to increase Black employment at businesses Black consumers supported. Eyeing a bigger slice of the pie for Black Americans, however, he turned his attention to corporate America in 1996, with the Wall Street Project. The project's two main goals were to increase the number of nonwhite executives working in corporate America and to expand contracting opportunities for nonwhite firms.

During the 1990s and early 2000s, several large companies such as Texaco, Coca-Cola, and Denny's Restaurants paid out huge racial bias settlements for mistreating Black consumers and/or employees. In 1996, Texaco (acquired by Chevron in 2000) paid out $176 million on a suit filed by six employees on behalf of 1,500 employees after executives were caught on tape making racially insensitive comments. Coca-Cola settled a racial discrimination suit for $192.5 million.

**REMEMBER**

*Empowerment zones,* economic-challenged areas where government entities grant tax breaks and other incentives to companies and individuals that invest in them, have helped spark economic growth in once-depressed urban communities. In the late 1990s and early 2000s, these efforts were credited with revitalizing several areas in such cities as Chicago, Atlanta, D.C., and New York City. As with gentrification, however, the same charges of local Black businesses being squeezed out through higher taxes applied. In addition, young Black entrepreneurs weren't initially being granted similar opportunities as their white counterparts to own and operate businesses in these areas.

# Successful Black-owned businesses

Historically, Black-owned businesses succeeded by filling a void ignored by mainstream businesses. Successful businesses included media, beauty, real estate, and food companies, among others. In the 21st century, Black-owned investing and tech firms began making their mark as well.

## Black-owned media

Publications such as *Ebony, Black Enterprise,* and *Essence* owed a portion of their success to white publications' overlooking Black consumers. Similarly, Robert Johnson, often credited as the nation's first Black billionaire, launched Black Entertainment Television (BET) in 1980 to serve Black consumers with the help of his then-wife and businesswoman Sheila Johnson.

In 1980, Cathy Hughes founded Radio One with the Washington, D.C. station WOL. Hughes, along with her only child, Alfred Liggins, who took over as CEO in 1997, built a Black media empire of more than 50 radio stations. That foundation encouraged the company, which was renamed Urban One in 2018, to launch the cable networks TV One in 2004 and CLEO TV, targeting millennial and Generation X Black women in 2019.

In the 1990s and 2000s, many mainstream companies began buying into or swallowing companies that served the Black consumer market. Viacom purchased BET in 2000 for $3 billion, making Johnson and his wife billionaires, though he alone is usually credited. Time Warner, then owner of *TIME* magazine, became sole owner of *Essence* in 2005. Mainstream companies also formed alliances with popular Black personalities to capture the Black consumer market. Southwest Airlines and McDonald's are just two companies that enjoyed lengthy partnerships with leading Black radio personality Tom Joyner, who retired in 2019 after helming his nationally syndicated *The Tom Joyner Morning Show* for 25 years.

Companies also began creating partnerships with Black businesses to invest in Black neighborhoods. For example, prior to becoming a part-owner of the Los

Angeles Dodgers in 2012, former NBA star Magic Johnson's Johnson Development Corporation successfully partnered with Sony Pictures Entertainment Loews Movie Theatres and Starbucks to bring his Magic Johnson Theatres and Starbucks franchises to Black neighborhoods in Los Angeles, Atlanta, New York City, and more.

## Beauty companies

In 1998, global beauty conglomerate L'Oréal bought the Black-owned hair company Soft Sheen. It followed that acquisition with Carson Inc., a manufacturer of several products catering to Black consumers, including Dark & Lovely.

In 2000, according to *Forbes,* "ethnic hair care" was a $1.2 billion market, with Black consumers accounting for a whopping 30 percent of the total U.S. hair care market. Historically, Black haircare and beauty needs had given birth to entrepreneurs like the more well-known Madam C.J. Walker; Poro empire founder Annie Malone, who preceded Walker; and Apex founder Sarah Spencer Washington, who followed her in the early 20th century. During the latter part of the 20th century, Luster, Dudley's, and Bronner Bros. (known for the Bronner Bros. International Beauty Show, which comedian Chris Rock captured in his 2009 docufilm *Good Hair*) were among the more well-known Black-owned haircare brands.

## Restaurants and food

As Black Americans migrated from the countryside to the city or from the South to the North during Reconstruction, the Great Migration, and beyond, they often longed for the food of their past. That desire birthed some of the Black community's first strong businesses. In New York City, Chicago, Philadelphia, Detroit, and other cities, gifted cooks parlayed their talents into solid businesses, some even generational, that even attracted white consumers. Examples include Sylvia's in New York City's Harlem, Harold's Chicken Shack in Chicago, and Roscoe's House of Chicken and Waffles in Los Angeles. Food companies like Michele Foods, founded in 1984 by Michele Hoskins, opted for the retail route; the family's syrup recipe originating from an enslaved ancestor had been passed down for generations.

In 1987, corporate attorney Reginald F. Lewis orchestrated one of the biggest business coups with a buyout of Beatrice International to form TLC Beatrice, a snack food, beverage, and grocery store conglomerate. TLC Beatrice became the largest Black-owned company at the time, as well as the first Black-owned business with sales exceeding $1 billion. Lewis's book, *Why Should White Guys Have All the Fun?* (Black Classic Press), was published posthumously in 1994.

Glory Foods, spearheaded by William F. "Bill" Williams, along with Iris Cooper and white founding partner Dan Charna, started in 1989 with Williams's "vision of providing authentic soul food in a can." When Williams passed away in 2001, Glory continued until McCall Farms bought it in 2010.

# Unforeseen Enemies

During the mid-1980s and 1990s, two unforeseen enemies — crack cocaine and HIV/AIDS — hit Black communities hard. Crack cocaine ravaged Black neighborhoods in innumerable ways, while the HIV/AIDS epidemic simply confounded Black Americans. Following is a rundown of these two formidable enemies.

## Crack cocaine

Illicit activity has historically plagued poor Black communities primarily due to many Black Americans historically being denied access to better paying jobs for a myriad of reasons. Until the 1980s and 1990s, however, such activity remained a significant subculture. Crack cocaine changed that. During the 1980s and early 1990s, crack cocaine devastated the Black community. Suddenly, "crack addicts" and "crack pipes" were household terms among Black Americans. Drug dealers, in some communities, became more common than buses. Republican president Ronald Reagan's policies didn't help either, especially with rumors that the government played a role in importing the drugs to funnel money to the Sandinistas in Nicaragua.

**TECHNICAL STUFF**

When street gangs began selling crack, conditions worsened as crack cocaine found a wider national network. Studies estimate that crack hit Detroit in 1985, New York and Los Angeles in 1986, and Chicago in 1988 before expanding to smaller cities in the 1990s.

Labeled "the poor man's cocaine," crack, a derivative of powder cocaine, could literally be mass-produced into rocks that created a powerful high when smoked. Because the drug could be cooked up in the kitchen and packaged for sale in mass quantities, the number of drug dealers and crack users escalated quickly. Highly addictive, crack resulted in broken homes as "crackheads" lost control and lost their jobs. This course of events greatly undermined the economic stability of many Black households and neighborhoods:

>> **Unemployment and neighborhood violence:** The Reagan administration's massive social service cuts and the demise of manufacturing jobs allowed crack cocaine distribution to grow. As unemployment rates surged, hitting

Black men especially hard, greater distribution networks for crack cocaine generated unbelievably large sums of money. Soon enough, disputes over territory and other factors generated massive violence. Urban neighborhoods became war zones.

**TECHNICAL STUFF**

According to one source, Black males aged 14 to 24 made up only 1 percent of the population in the mid-1990s, but were 17 percent of homicide victims and 30 percent of homicide perpetrators.

» **Imprisonment:** As the drug trade grew, Black boys and men became increasingly entangled in the legal system for drug possession, drug dealing, homicide, and a plethora of other offenses, many of them nonviolent. One study reported that between 1979 and 1990, the percentage of Black people admitted to state and federal prisons increased from 39 to 53 percent of all offenders. Probation tied another significant portion of Black men to the legal system. Although most Black men worked or attended school and weren't engaged in illicit activity, the growing numbers of incarcerated Black men were still alarming.

**TECHNICAL STUFF**

Prior to 1980, Black men ages 18 to 24 in college greatly outnumbered Black men in the same age range in prison. In 2000, the ratio of Black men in college was roughly 2.6 to every 1 incarcerated Black man in the same age group. The number for white males in the same age group was 28 to 1.

» **Effect on families:** Single-parent households in Black communities were already on the rise prior to the advent of crack cocaine, but crack cocaine added to the problem. High incarceration rates among Black men and unbelievably high homicide rates helped increase the numbers of single-parent households.

» **Class wars in the Black community:** Often fleeing drug war zones, wealthier Black Americans relocated to the suburbs. This move deepened class issues within the Black community, which was traditionally made up of Black people of all classes. At no other point in American history, however, had Black Americans been so prosperous. Some have argued that the disappearance of these role models made drug dealing and drug use more appealing to Black youth.

Black activism, however, helped turn the tide. Statistics show that outrage in Black communities manifested in antiviolence campaigns, youth programs, and other initiatives since the late 1990s were a difference-maker. Homicide and other crimes, as well as crack cocaine use and drug dealing, went down significantly. Sentencing disparities related to the possession of crack and powdered cocaine were addressed. More educational and mentoring opportunities also emerged. The FX series *Snowfall* (2017–present), which *Boyz n the Hood* director/screenwriter John Singleton co-created, centers the onset of crack cocaine in Los Angeles and its impact on the Black community.

## DANGEROUS ACCUSATIONS: THE GOVERNMENT'S ROLE IN DRUG TRAFFICKING

Many in the Black community have long insisted that because Black people don't own the planes and boats that ship cocaine into the country or manufacture guns, the government has to be involved in trafficking drugs to Black communities.

In August 1996, the *San Jose Mercury* published "Dark Alliance," a three-part investigative series by white staff writer Gary Webb. It alleges that Nicaraguan drug traffickers supplied cocaine to Los Angeles drug dealers, including Freeway Rick Ross, in the 1980s. Webb contended that the CIA knew that the profits from such activity helped fund the Nicaraguan Contras, which the Reagan administration supported in its fight against the Sandinistas, Nicaragua's ruling party and a Cuban ally. Numerous outlets, including *The Washington Post,* attacked Webb's claims. Webb published his book *Dark Alliance* in 1998 and included declassified documents related to the story. In 2004, Webb died from two gunshot wounds to the head, a reported suicide.

Jeremy Renner played Webb in the 2014 film *Kill the Messenger,* and Webb's allegations were addressed in the 2015 documentary *Freeway: Crack in the System,* about Freeway Rick Ross and what is known as the CIA-Contra-Cocaine connection.

## HIV/AIDS

At the initial discovery of HIV/AIDS in the 1980s, most people viewed it as a disease that afflicted gay white men. Although an HIV/AIDS epidemic began hitting the African continent hard in the late 1980s, few suspected the Black American community was at great risk. Most people thought the 1993 AIDS-related death of tennis great Arthur Ashe, who contracted HIV through a blood transfusion, was an isolated incident. Two years earlier, however, NBA great Earvin "Magic" Johnson generated concern when he announced that he was HIV-positive. The 1995 death of West Coast rapper Eric "Eazy-E" Wright reportedly from AIDS-related complications was another indication that heterosexuals were also at risk of contracting HIV/AIDS.

Numbers for the 2000s are startling. According to the Centers for Disease Control and Prevention (CDC), Black Americans accounted for 50 percent of all new HIV/AIDS cases in 2004. Seventy-three percent of the infants diagnosed with HIV/AIDS that year were also Black. In 2002, HIV/AIDS was among the top three causes of death for Black men aged 25 to 54 and one of the top four causes of death for Black women aged 25 to 34.

Although unsafe sexual practices has often been cited as a big reason Black Americans suffered higher rates of HIV/AIDS infection, many placed blame on

*down-low* men (originally a term popularized by R&B artists to refer to furtive heterosexual relationships) who presented as heterosexual to conceal their bisexuality. Given the traditional homophobic attitudes in the Black community plus incidents of faithful wives and girlfriends contracting HIV/AIDS from their "committed" partners, mass hysteria developed among some Black Americans. In 2004, *The Oprah Winfrey Show* even dedicated an episode to the down-low phenomenon and the HIV/AIDS crisis. J.L. King, the author of *On the Down Low: A Journey into the Lives of "Straight" Men Who Sleep with Men* (Harmony), was a primary guest.

Several organizations specifically addressing HIV/AIDS in the Black community sprouted. One of the most prominent is the Los Angeles–based Black AIDS Institute, cofounded in 1999 by Phil Wilson, a gay Black man living with HIV/AIDS. The Black AIDS Institute mobilized Black media and Black institutions such as churches to acknowledge the HIV/AIDS epidemic in order to prevent its spread early in the epidemic. It also provided the latest information on treatment and government funding. BET's "Rap It Up" campaign enlisted Black celebrities such as singer Mary J. Blige and rapper Common for public service announcements that encouraged Black Americans, especially teenagers, to take an HIV test. Raniyah Copeland took over as president of the Black AIDS Institute from Wilson in 2019.

The Atlanta-based SisterLove Inc., founded in 1989, was among the first organizations to specifically cater to Black women affected by HIV/AIDS. Efforts from organizations such as these contributed significantly to limiting the spread of HIV/AIDS. According to HIV.gov, HIV diagnoses for Black women fell 20 percent from 2011 to 2015, but in 2016, Black women still accounted for 61 percent of all HIV diagnoses for women. And in 2018, Black people, according to the CDC, were 42 percent of the nearly 40,000 new HIV cases at only 13 percent of the total population.

# The Racial Divide

Several events in the 1990s indicated that opinions held by Black and white Americans on race differed greatly. Two of the most explosive events occurred in Los Angeles — the 1992 L.A. riots and the 1995 O.J. Simpson verdict. Riots in other cities such as Cincinnati in 2001 showed that L.A. wasn't an isolated incident. The 41 shots NYC police officers fired in the 1999 death of Amadou Diallo and the 50 shots NYC police officers fired in the death of Sean Bell a day before his wedding in 2006 were further evidence of the persistence of police brutality. In addition, there was also the horrific 1998 dragging death of James Byrd Jr. by three white male supremacists Shawn Berry, Lawrence Brewer, and John William King in Jasper, Texas that left Byrd's remains in 81 places, including his severed right arm and head.

For many Americans, Black and white, the local, state, and federal response to the many Black Americans standing atop roofs following Hurricane Katrina had racial

and class undertones unacceptable for the 21st century. Even as the world settled into a new century, the racism and bigotry of the old centuries continued.

# L.A. riots

Charges of police brutality in Los Angeles largely went unheard until the Rodney King incident. Rappers and political activists had long proclaimed the LAPD was out of control. Proof wasn't delivered, however, until a wayward video camera captured the brutal police beating of Rodney King by four LAPD officers (three white and one Latino) in March 1991.

As news programs around the nation broadcast the footage, few banked on any jury acquitting the four officers. On April 29, 1992, when a mostly white jury in predominantly white Simi Valley did just that, the predominantly Black South Central Los Angeles erupted in violence within hours. Two days later, the violence, which included rampant looting, reached its highest intensity; it continued for almost a week before the California National Guard and federal troops quelled the disturbance.

Between 50 and 60 people lost their lives, and as many as 2,000 suffered injuries. News cameras caught Black youth brutally beating white truck driver Reginald Denny. Authorities arrested nearly 10,000 people, mostly Black or Latino. Property damage estimates ranged up to $1 billion with more than 1,000 buildings destroyed. Korean merchants suffered greatly, but so did Black business owners.

Latasha Harlins's killing also played a role in the riots. Two weeks after King's savage beating in March, a security camera captured Korean shop owner Soon Ja Du fatally shooting Harlins for allegedly stealing a $1.79 bottle of orange juice. Du's suspended sentence, 400 hours of community service, $500 restitution, and five-year probation angered Black Angelenos. For Black Los Angeles, the overall disregard for Black life by the courts was unacceptable.

# The O.J. Simpson verdict

Perhaps few other incidents illuminated racial chasms better than the O.J. Simpson verdict. One of the nation's most popular celebrities at the time, former NFL star Simpson was charged with the murder of his ex-wife Nicole Brown Simpson and her friend Ron Goldman, both white, in June 1994. Simpson spent a reported $4 million on his legal team, which included Black attorney Johnnie Cochran. Christopher Darden, another Black attorney, worked for the prosecution. The defense's accusation of the LAPD planting evidence gained credence when police officer Mark Fuhrman lied under oath, testifying that he'd never used racial epithets yet was later heard on audiotapes doing otherwise. A glove found at the crime scene became another prominent feature of the case when it didn't fit

Simpson's hand. In his closing argument, Cochran told the jury, "If it doesn't fit, you must acquit," and that's exactly what happened on October 3, 1995.

Racial perceptions make Simpson's acquittal significant. White Americans felt Simpson was guilty but acquitted because of his money and celebrity status. While many Black Americans didn't disagree with that conclusion, they weren't outraged by the verdict; instead, they felt Simpson simply bought his acquittal just as wealthy white men in similar positions had done for years. Mainstream white circles ostracized Simpson; Black Americans who believed he was guilty didn't react as strongly. When it came to dispelling doubts about whether he committed the double murders, Simpson proved to be his own worst enemy. His proposed 2006 book *If I Did It* generated such outrage that the publisher's parent company refused to release the completed book.

Popular culture relived the O.J. saga in 2016, first with *The People v. O.J. Simpson: American Crime Story,* a limited series on FX in the first part of the year. It was followed a few months later by the documentary *O.J.: Made in America* on both ABC and ESPN. Although *The People v. O.J. Simpson*, which aired from February to April, had laser focus on the murders and the trial, the five-part, nearly eight-hour documentary *O.J.: Made in America,* spearheaded by Black director/producer Ezra Edelman, put his focus on what made O.J. in the first place; it reminded audiences exactly why he captivated the country as well as how it all went wrong. The documentary won both an Oscar and an Emmy while Courtney B. Vance and Sterling K. Brown won Emmys for their performances as Johnnie Cochran and Christopher Darden.

## A modern-day lynching

Random violence against Black Americans persisted into the latter half of the 20th century. Perhaps most brutal was the 1998 dragging death of James Byrd Jr. in Jasper, Texas. Byrd accepted a ride home from three white men who severely beat him, chained him to the back of their truck, and dragged him about 3 miles, severing his head. They even dumped his torso in front of a Black church and cemetery.

Unlike in decades before, however, justice was swift, as two men received the death penalty and one received life in prison. In response to the crime, some Texans pushed for the passage of hate crime legislation, which then-Governor George W. Bush opposed. In 2001, the Texas legislature passed the James Byrd Jr. Hate Crimes Act. The bill underscored intolerance for crimes motivated by factors such as race and sexual orientation by enhancing penalties for these crimes. Again, this was a strong and positive change in race relations. In 2019, nearly 21 years after Byrd's death, John William King was executed for the murder; Lawrence Brewer was executed in 2011.

# Hurricane Katrina

Most of the nation watched news broadcasts stunned as Hurricane Katrina, a Category 3 storm, ravaged New Orleans and the Mississippi Gulf Coast in August 2005. As television news crews and others entered New Orleans to cover the story, people began to question why the Federal Emergency Management Agency (FEMA) wasn't already on site doing something. When the levees broke, many viewers couldn't believe their eyes as day after day, fellow Americans, overwhelmingly Black and impoverished, stood on rooftops seeking refuge from the floodwater and waiting for help that was extremely delayed. In too many instances, it took six days for help to arrive.

When help finally arrived, New Orleans's Black Mayor Ray Nagin and Louisiana's white female governor Kathleen Blanco played the blame game. In the midst of all this, Black Americans in particular began asking, "Where is Bush?" Rapper/producer Kanye West expressed the unspoken thoughts of many when he stated, "George [W.] Bush doesn't care about Black people" during a live telethon to benefit Hurricane Katrina victims.

Although more Black Americans than white Americans already believed race and class motivated the government inaction on the behalf of Black Americans, Hurricane Katrina brought more mainstream attention and evidence to those issues. Media outlets referred to fleeing New Orleans residents as "refugees" instead of "evacuees" or portrayed hungry Black Americans as looters and white Americans as "finding food"; these differences opened up long overdue discussions about race and class in the media. *The New York Times* even apologized for not addressing poverty in New Orleans during most of its coverage. CNN anchor Soledad O'Brien took FEMA director Mike Brown to task on air for the agency's lack of urgent response.

Ordinary citizens responded to the needs of survivors far more quickly than FEMA or other governmental agencies. They rallied about how the government and insurance companies didn't provide much-needed assistance like food, clothing, housing, and money. Various cities, large and small, began accepting longtime Black New Orleanians among its residents. There were also pushes to restore New Orleans so generational residents could return.

In addition to efforts to rebuild housing and reopen schools, businesses were encouraged to invest in New Orleans to get the city back up and running. ESSENCE Fest, one of the city's biggest events and arguably the biggest attracting Black attendees, returned in 2007. Later that same year, *City Journal,* a Manhattan Institute publication, reported that prior to Katrina, New Orleans had nearly 326,000 Black residents. In 2020, it had only 233,000. What became clear is that race was still a paramount issue well into the 21st century. Director Spike Lee highlighted these issues in his HBO docuseries, *When the Levees Broke: A Requiem in Four Acts* (2006) and *If God Is Willing and da Creek Don't Rise* (2010). As the nation dug even deeper into the new century, it just couldn't hide the impact systemic racism continued to have on it.

» **Electing the first Black president**

» **Fighting for justice with Black Lives Matter**

» **Standing up for democracy**

Chapter **11**

# The New Civil Rights — Obama, Black Lives Matter, and Beyond

As the 2000s truly got going, it became increasingly clear that the new millennium wasn't the complete reset many had hoped. The government's poor response to victims of Hurricane Katrina, who were overwhelmingly Black and poor in New Orleans demonstrated that the nation hadn't moved nearly as far as it had promised. Still the 2000s did offer glimmers of hope. What the political power leaders like Frederick Douglass, W.E.B. Du Bois, Marcus Garvey, Malcolm X, Martin Luther King, Jr., and others envisioned was becoming reality, with one of the biggest prizes being realized. But one thing wouldn't change: Racial injustice seemed to be a fixture of American life.

Beginning with the death of Trayvon Martin, the heartbreak wouldn't stop. And the police were among the main culprits. In city after city, Black people were being shot to death, and there appeared to be zero accountability. Proclaiming that "Black Lives Matter" was necessary, and so began the "New Civil Rights Movement," only it wasn't new at all. As Donald J. Trump's presidency echoed the nation's ugly past, the present kept getting uglier — not because he was the spark, but because many things had sadly never changed. Minneapolis police officer

Derek Chauvin's foot to George Floyd's neck as he called for his mother, captured on video, was the lightbulb for many others who hadn't gotten the message previously. That, followed by the realization that Louisville police killed Breonna Taylor in her home and walked away, further underscored how deeply unjust the country remained. And not even elation over the ascension of Kamala Harris to Vice President of the United States, the first woman to ever hold the position, could offset the persistence of racism and injustice further exposed by the global COVID-19 pandemic and the Capitol Riot on January 6, 2021. This chapter chronicles that reality as the nation, Black Americans specifically, remained at the crossroads.

# Gaining the Presidency

On February 10, 2007, when Barack Obama, then the only Black senator in Congress, joined the 2008 presidential race, political pundits welcomed him as a Democratic candidate to watch. Few, however, gave Obama a shot at actually winning. Born in Honolulu, Hawaii on August 4, 1961 to a white mother from Wichita, Kansas, and a Kenyan father, his story just didn't fit any script. A month prior, former first lady Hillary Clinton had announced her candidacy and was a presumed frontrunner. As an Illinois state senator in the race for the U.S. Senate, Obama had given the 2004 Democratic National Convention keynote address (during which John Kerry was officially nominated for president) and became an instant favorite predicted to one day become president. But, again, only a few could see that day coming so soon.

## Obama's 2008 campaign

Despite being a graduate of both Columbia University and Harvard Law School and meeting his future wife, Michelle LaVaughn Robinson, a Chicago native who had graduated from Princeton as well as Harvard Law School, while working for a law firm in Chicago, Obama had a personal narrative relatable to many newer Americans. He was biracial and had one parent, albeit absent, who was an immigrant. As a longtime community organizer, he had been at the forefront of helping people. For Black Americans, he had the benefit of living in Chicago, recognized as a premier Black city with a long tradition of Black power brokers and a history of being at the forefront of issues confronting Black people. He also was married to a Black woman whose roots were firmly planted in this country for generations.

The campaign wasn't smooth and had racial hiccups along the way:

>> Michelle was portrayed as an "angry Black woman" as early as June 2008, with the notoriously conservative Fox News leading the charge.

>> Obama, himself, was questioned about his faith, with some conservatives alleging he was secretly Muslim, a charge that had been leveled at him when he campaigned for his Senate seat in 2004. One rumor was he had used the Qur'an instead of a Bible to be sworn into his Senate seat. The reasoning behind these attacks was that the many Americans who presumed Muslims to be terrorists would make the same connection with Obama. The rumor of him being an undercover Muslim became so prominent that presidential debate moderator Brian Williams asked him about it during the January 15, 2008 presidential debate.

>> In addition, his longtime Christian pastor Jeremiah Wright of Chicago's Trinity United Church of Christ was accused of being anti-American, with news outlets like ABC News offering several of his sermons as proof. Obama denounced Wright's controversial remarks in an impassioned speech "A More Perfect Union," strategically delivered at the National Constitution Center in Philadelphia on March 18, 2008. That May, he and wife Michelle withdrew their membership from Trinity.

Still, by building a coalition consisting of young voters of various ethnic and racial backgrounds, including the Black community, Obama became the nation's 44th president (see Figure 11-1), serving two terms with former longtime Delaware Senator Joe Biden as his vice president. During his victory speech in Chicago's Grant Park November 4, 2008, with Michelle and daughters Sasha and Malia by his side, cameras caught longtime civil rights leader Jesse Jackson, who had coincidentally been critical of Obama early in his run, in the crowd with tears of pride in his eyes.

Celebrations took place in various cities. Atlanta-based rapper Young Jeezy released "My President," also known as "My President Is Black," featuring New York City rapper Nas on November 15 and the video on November 23. Hip hop had been an important political factor in Obama's win, especially in motivating ex-felons to regain their voting rights or advocating for them, and the community was elated by his win.

## The Age of Obama, 2008–2016

Obama's inauguration on January 20, 2009, was the largest attended presidential inauguration in the nation's history. For reelection in 2012, Obama once again won convincingly. For his second inauguration, held January 21, 2013, he was sworn in using bibles from both Abraham Lincoln and the Reverend Dr. Martin Luther King Jr.

**FIGURE 11-1:**
President Barack
Obama with
his family.

A Black family in the White House was a tremendous boon to many aspects of American life. Never before had the country had such representation at its highest governmental level. That diversity or portrait of a Black family, or what many termed "Black excellence," appeared to spur more Black inclusion in various industries, including book publishing as well as film and TV. In addition to openly embracing Black culture, the Obamas welcomed and championed diversity and inclusion across the board. That, however, didn't shield them from criticism by the Republicans. Also some Black Americans felt that Obama, because he was so multicultural, wasn't doing enough for the specific needs of the Black community. But that was far from the truth. Under Obama, there were actually tremendous gains for the Black community. (Many of President Trump's later policies overturned them.)

## Black community gains

During Obama's two terms, the Black community made some notable gains. Black incarceration rates fell every year of his presidency, with imprisonment rates for Black men and women dropping to their lowest levels since the late 1980s and 1990s. On the federal bench, Obama made 62 lifetime appointments of Black judges, 26 of them women. In fact, he appointed more Black women judges than any other president in history. Spelman alum Judge Tanya Walton Pratt, who became the first Black federal judge in Indiana history, and Mississippi native Judge Debra M. Brown, the first Black woman to be confirmed to a federal judgeship in Mississippi, are among them. In all, 19 percent of Obama's confirmed judges were Black, as compared to 16 percent by Clinton, 7 percent by Bush, and 4 percent by Trump.

## BLACK AND LGBTQ

The Black LGBTQ (Lesbian Gay Bisexual Transgender Queer) community has historically been a vital part of the Black community at large. From blues legend Ma Rainey to Moms Mabley and Langston Hughes, to James Baldwin and Alvin Ailey, the contributions have been countless. The HIV/AIDS crisis, however, stigmatized the Black LGBTQ community for a while.

In the past, LGBTQ leaders like civil rights activist Bayard Rustin — a key advisor to the Reverend Dr. Martin Luther King Jr. and the main organizer of the March on Washington for Jobs and Freedom — among many others who made significant contributions weren't recognized in their full truth. Some experts argue that the Black Church played a key role in shaping anti-gay attitudes, even though homosexuality's harshest critics frequently cite the Bible as justification for their condemnation of homosexuality across the board.

In the early 2000s, activists such as political expert Keith Boykin and Jasmyne Cannick challenged those attitudes and were among the many who helped raise positive awareness for the Black LGBTQ community. Pop culture, however, has played one of the biggest roles in changing attitudes. Director Barry Jenkins's 2016 film *Moonlight,* a coming-of-age story spanning from childhood, adolescence, and adulthood charting one man's recognition and acceptance of his sexuality, helped to paint a tender and more accepting picture for many people; the story was inspired by a Tarell Alvin McCraney play.

Actress Gabrielle Union and her retired NBA husband Dwyane Wade publicly sharing their support of Wade's trans teen Zaya (born Zion) Wade, who came out publicly in 2019, was a beacon of light to many. Best known for his country-tinged hit rap single "Old Town Road," initially released in 2018, Atlanta-based rapper Lil Nas X made a big impact when he publicly revealed he was gay on June 30, 2019, the last day of Pride month. Trans actress Laverne Cox of *Orange Is the New Black* fame, comedian Wanda Sykes, news trailblazers Don Lemon and Robin Roberts, actress/producer Raven-Symoné, bounce rap artist Big Freedia, fashion guru Andre Leon Talley, and activist Angela Davis are just a sampling of those in the Black LGBTQ community whose substantial contributions continue to benefit the Black community at large. Arguably the most impactful of them all are Alicia Garza and Patrisse Cullors — two of the three Black Lives Matter founders — who identify as queer.

Black unemployment fell from 16.8 percent in March 2010 to 8.3 percent in December 2015, its lowest level since September 2007. Bailing out the auto industry, according to *Black Enterprise,* was a lifesaver to countless Black businesses; their presence in that supply chain represented roughly 42 percent of the $24.6 billion in 2011 revenue generated by those on the magazine's BE 100s list,

which ranks the top 100 black enterprises. In addition, the Affordable Care Act (ACA), popularly known as Obamacare, provided many independent contractors and employees of small businesses with much-needed healthcare. Most importantly, many average Black Americans gained access to healthcare that otherwise wouldn't have had it.

Throughout 2020, *The New York Times,* Vox.com, and other outlets credited the Affordable Care Act with helping millions during the COVID-19 pandemic. (In fact, *U.S. News & World Report* contributor Jonathan Metzl called President Donald Trump's continued efforts to repeal the Affordable Care Act — even during a pandemic — "among his most racially divisive acts.") Black lifespan even expanded under Obama, and the rate of Black children in poverty fell by 4.2 percent.

The Black high school graduation rate hit its highest level. Pell Grant funding for Historically Black Colleges and Universities (HBCUs) grew from $523 million in 2007 to $824 million under Obama. To help young boys and teens of color reach their full potential, Obama launched the My Brother's Keeper initiative in 2014. In addition, Obama's many progressive LGBTQ initiatives, such as making way for the Supreme Court to approve same-sex marriage, and his 2014 executive order prohibiting discrimination from federal contractors across the board, benefitted the Black LGBTQ community (see the nearby sidebar).

# Black Lives Matter Emerges

As much as Obama accomplished for Black Americans during his two terms as president, combating racial injustice remained a challenge. Early in his presidency, in 2009, he stumbled while addressing racial profiling in his response to Cambridge, Massachusetts police arresting Harvard professor Henry Louis Gates as he attempted to break into his own house after misplacing his keys. That resulted in an awkward and highly criticized "Beer Summit" at the White House with Gates, the arresting officer James Crowley, Vice President Biden, and Obama.

Just as his first administration came to a close, the question of race exploded in a way reminiscent of Emmett Till's tragic death in 1955 with the killing of Florida teen Trayvon Martin. The circumstances surrounding his death and the judicial response, coupled with the explosion of social media, placed the fight for justice back in the national spotlight.

# I am Trayvon

On February 26, 2012, 17-year-old Trayvon Martin was killed by 28-year-old George Zimmerman. Wearing a hoodie and talking to his friend Rachel Jeantel on his cell, with Skittles and Arizona Watermelon fruit juice cocktail in hand, Martin was followed by Zimmerman, a neighborhood watch volunteer, in Sanford, Florida. Martin was staying in the gated community with his father, Tracy Martin, and his father's fiancée, Natalie Jackson. Zimmerman had called 911 and reported Martin as suspicious. Although he was instructed by the 911 operator not to follow Martin, he did anyway.

Zimmerman claimed Martin attacked him, jumping him and beating him up to the point that he feared for his life. Consequently, he fatally shot him with a 9 mm semiautomatic handgun. Martin was unarmed. Zimmerman, who didn't go to the hospital, was taken in for questioning and released, with the Sanford Police Department declaring that its questioning and investigation revealed that Zimmerman had acted in self-defense in his killing of Trayvon Martin. A later medical report revealed that Zimmerman had a broken nose, black eyes, cuts on the back of his head, and a minor back injury. These injuries were offered as justification for him fatally shooting Martin.

Because Martin had no identification on him, his body was sent to the morgue and he was tagged "John Doe." His family learned of his death only after his father Tracy filed a missing person's report on February 28, 2012.

## Bringing charges

Tracy and Trayvon's mother, Sabrina Fulton, brought in Florida-based attorney Benjamin Crump, who had a successful history representing families in similar cases. He, however, had no legal recourse to deal with Zimmerman criminally. Florida Governor Rick Scott appointed Angela Corey, the state attorney for the Florida counties Duval, Clay, and Nassau, as special prosecutor in the Martin investigation on March 22, 2012. On April 11, 2012, Zimmerman was charged with second-degree murder.

The circumstances surrounding Martin's killing created much dialogue around racial profiling and the lack of accountability when Black people are killed, as well as around Stand Your Ground laws. The Sanford Police Department consistently maintained that there was no evidence of wrongdoing on Zimmerman's part, validating his claims of self-defense.

Some people asked how Martin was suspicious or planning to rob anybody if he was in conversation on his cell phone. In Zimmerman's 911 call, he told the dispatcher, "This guy looks like he's up to no good, or he's on drugs or something. It's raining, and he's just walking around." Martin was walking home after going

to the store. Also, Zimmerman ignored instructions to remain in his car until the police arrived and confronted Martin anyway. Profiling actually played a role in his being charged. The Florida Department of Law Enforcement, the U.S. Department of Justice under U.S. Attorney General Eric Holder, and the FBI, all investigated the case.

On TV, some legal experts, overwhelmingly white, shifted the blame to Martin, claiming, as Zimmerman had, that he shot the unarmed teen in self-defense. They questioned his style of dress. Fox News host Geraldo Rivera claimed that Martin's hoodie was to blame. Supporters of Martin, like NBA players LeBron James and Dwyane Wade of the Miami Heat, donned hoodies in protest. Florida high school students staged walkouts.

Opening statements for *Florida v. George Zimmerman* began June 24, 2013, with Zimmerman being acquitted on July 13, 2013. Legal scholars long criticized Corey for charging Zimmerman with second-degree murder because they doubted the charge would result in a conviction. Others questioned if the American legal system had any measures to even protect the nation's Trayvon Martins. The various investigations, including the one by Holder's Department of Justice, closed without further charging Zimmerman, largely citing insufficient evidence. Some would later tie Zimmerman's defense and acquittal to the controversial "Stand Your Ground" legislation, allowing people to use deadly force to defend themselves that often resulted in legal conclusions overwhelmingly justifying the actions of white alleged killers when the victims were Black, but Zimmerman never used it for his defense. He used basic self-defense in his acquittal.

## Obama's response

After the failed Beer Summit, Obama rarely made overtly racial addresses but spoke up a few times in the tragic killing of Martin in 2012, his re-election year, and 2013, the first year of his second term. Speaking from the Rose Garden on March 23, 2012, President Obama, in a rare racial address as president, offered words of comfort to Martin's family and told reporters, "If I had a son, he'd look like Trayvon." After the verdict acquitting Zimmerman, he spoke again.

**IN THEIR OWN WORDS**

On July 19, 2013, after a week of robust dialogue in the nation, President Obama told reporters "You know, when Trayvon Martin was first shot I said that this could have been my son. Another way of saying that is Trayvon Martin could have been me 35 years ago. And when you think about why, in the African American community at least, there's a lot of pain around what happened here, I think it's important to recognize that the African American community is looking at this issue through a set of experiences and a history that doesn't go away. There are very few African American men in this country who haven't had the experience of being followed when they were shopping in a department store. That includes me."

# Enter #BlackLivesMatter

Bay Area queer activist Alicia Garza's response to Zimmerman's acquittal of killing Martin, often described as the "Emmett Till" of the 21st century, was a Facebook post where she wrote "btw stop saying we are not surprised. that's a damn shame in itself. I continue to be surprised at how little Black lives matter. And I will continue that. stop giving up on black life."

Her friend and fellow West Coast–based queer activist Patrisse Cullors captured Garza's sentiments in the hashtag #BlackLivesMatter, and their other fellow activist Opal Tometi, who was based in New York and specializing in immigration, created the movement's social media presence. Together, the three of them launched the seeds of Black Lives Matter (BLM), a loose confederation of organizations and individuals challenging police brutality and advocating for racial justice. It would become increasingly impactful during the following year and throughout the Trump administration.

Although the official name Black Lives Matter (see Figure 11-2) can be pinpointed to the day Zimmerman was acquitted for killing Martin, the spirit of the work and core values that guide BLM, according to Garza, began in the Bay Area with the police killing of Oscar Grant. Less than three years prior to Martin's killing, BART (Bay Area Rapid Transit) police officer Johannes Mehserle fatally shot 22-year-old Oscar Grant in the wee hours of New Year's Day 2009. Garza became involved in the protests demanding justice through her trans male activist partner Malachi Garza. *Black Panther* and *Creed* director Ryan Coogler dramatized the killing in his 2013 film, *Fruitvale Station;* its release coincided with Zimmerman's trial.

**FIGURE 11-2:**
Black Lives
Matter.

Jamie Grill/AGE Fotostock

# Ferguson explodes: Michael Brown and the impact of Eric Garner's death

The 2014 uprisings in Ferguson, Missouri, a Black enclave just outside St. Louis, may have put the biggest spotlight on BLM. The protests erupted after 22-year-old police officer Darren Wilson fatally shot 18-year-old Michael Brown on August 9, 2014, and left his body lying in the street for four hours. Brown's crime was stealing Swisher cigarettes from a corner store, but there was considerable reason to believe that the officer wasn't even aware of that allegation. Brown was unarmed. According to Wilson, Brown tried to reach into his police car and take his gun. Within 90 seconds of answering the call, Wilson had shot Brown dead with six gunshots.

Just a few weeks prior, on July 17, 2014, two New York City Police Department officers, particularly Daniel Pantaleo, reportedly used a chokehold that killed 43-year-old Eric Garner, a father of six and grandfather of three. Although Garner's alleged crime that day was selling loose cigarettes illegally, no evidence was ever discovered of him even doing so. Copwatch member Ramsey Orta videoed the killing. On the video, Garner could be heard saying, "I can't breathe" 11 times while face down on the sidewalk. An autopsy ruled his death a homicide. So that was already the temperature when Michael Brown was fatally shot by Wilson in Ferguson.

Brooklyn-based writer/activist Darnell Moore, also a friend of BLM co-founder Patrisse Cullors, began coordinating "freedom rides" from various cities, including New York City, Philadelphia, Chicago, and Los Angeles. Baltimore native DeRay McKesson, a teacher in Minneapolis at the time, connected with fellow Teach for America alum Britney Packnett prior to arriving and also connected with Johnetta Elzie. Together they provided updates via social media about the Ferguson protests, which had significant grassroots organizers. In fact, some people have contested the credit given to BLM because they had no chapter in the area and didn't officially spearhead the protests there. But the protests in Ferguson was still in line with the BLM platform to stand up against police brutality.

By the time mainstream media began showing images from Ferguson, police in riot gear had moved in. Protesters were tear gassed, and prompted by some witness accounts that Brown had put his hands up prior to being killed, began raising their hands, chanting "hands up, don't shoot." Less-controlled factions also moved into Ferguson, escalating the violence and the arrests. Protests in Ferguson lasted over several months. Yet no charges against the officers were issued for the deaths of Michael Brown or Eric Garner in either city.

# Police killings continue: Tamir Rice and Laquan McDonald

The police killings didn't stop, however. White police officer Timothy Loehmann reportedly fatally shot 12-year-old Tamir Rice, who had been playing with a toy gun in a Cleveland park on November 22, 2014. A year later, a grand jury declined to indict. Both Loehmann and his partner, Frank Garmback, had questionable backgrounds. Loehmann's previous police department in Independence, Ohio, only miles away from Cleveland, claimed that Loehmann had resigned to avoid termination due to his lack of emotional stability to function as a police officer. That same year, the City of Cleveland had settled an excessive force lawsuit brought against Garmback for $100,000 that hadn't been placed in his file.

Before 2017 closed out, Chicago erupted in protests, too. Dashcam video of Chicago police officer Jason Van Dyke firing 16 shots at 17-year-old Laquan McDonald, killing him on October 20, 2014, was released on November 24, 2015. It was also revealed that Chicago Mayor Rahm Emanuel had delayed the video's release after seeing it. On the heels of this and other offenses, Emanuel didn't seek a third term as mayor. In 2018, Van Dyke became the first Chicago police officer convicted of murder for an on-duty police shooting in roughly 50 years.

# Baltimore Rising: Freddie Gray

In 2015, BLM continued to be a needed reminder as several protests took place throughout the country. On April 12, 2015, Baltimore City Police arrested 25-year-old Freddie Gray for possessing a knife, later revealed to be a legal pocketknife. During police van transport, Gray suffered injuries to his neck, spinal cord, and vocal box, requiring hospitalization. Not long after, he fell into a coma. There was no explanation regarding what caused his injuries, though he was fine when he was arrested.

Hundreds of protesters gathered outside the police station, protesting Gray's mistreatment on April 18, some in the name of BLM. When he passed away the next day, the outrage only grew. Two days later, on April 21, the Baltimore Police Department released the names of the six officers. By the end of the month, chaos was afoot, with the protests taking its most violent turn in some areas on April 27 after Gray's service and burial. Vehicles and some buildings were set on fire. More than 200 people were arrested.

The next day, the national guard was brought in. The unrest continued from April 29 to May 3. In between all of this, an autopsy ruling Gray's death a homicide prompted Maryland Attorney General Marilyn Mosby to charge all six officers on May 1. Both Baltimore Mayor Stephanie Rawlings-Blake and Obama denounced

the violence. Obama had strong words for the "criminals and thugs who tore up" Baltimore and was criticized for his references.

Gray and the Baltimore Uprisings, or Baltimore Riots, as some call them, showed that anti-Black police brutality could even happen in a city like Baltimore, with a Black mayor and Black police officers not far from a White House occupied by a Black president. A year later, three of the six officers were acquitted with charges against the remaining three dropped.

## The Charleston Church Massacre

Not long after the unrest in Baltimore, another tragedy occurred. During Bible study at Charleston, South Carolina's Emanuel African Methodist Episcopal Church, better known as Mother Emanuel, on June 17, a 21-year-old white supremacist Dylan Roof opened fire, killing nine people, including its 41-year-old senior pastor and state senator Clementa Pinckney. Cynthia Marie Graham Hurd (54); Susie Jackson (87); Ethel Lee Vance (70); Depayne Middleton Doctor (49); Tywanza Sanders (26); Daniel L. Simmons (74); Sharonda Coleman-Singleton (45); and Myra Thompson (59) were the other victims.

Founded in 1818, Mother Emanuel is one of the oldest continuous Black churches in the nation. The culprit, however, wasn't gunned down when he was apprehended in a manhunt the next morning about 245 miles away from the crime. Authorities found white supremacist material, as well as a website touting white supremacy and communication with other white supremacists. Brought up on state and federal charges, he was sentenced to both life in prison and death, the latter of which he appealed.

President Obama gave the eulogy at the service for Reverend Pinckney on June 26, unexpectedly leading attendees in a moving rendition of "Amazing Grace." A couple of weeks later, on July 10, South Carolina finally removed the Confederate battle flag from its statehouse grounds.

## Say Her Name: Sandra Bland

On July 13 in Waller County, Texas, 28-year-old Sandra Bland's body was found hanging from a jail cell. Bland, a Chicago-area native, had attended college at Prairie View A&M, an HBCU in Waller County, where she was set to begin a job. Bland was stopped by Texas state trooper Brian Encinia on July 10 for failure to signal a lane change after she had changed lanes to allow him to pass because he was following her closely.

When Bland indicated she was irritated and asked why she had to put her cigarette out, Encinia requested that Bland, who was involved in BLM activism, get out of the car. Initially she refused. When she did exit, dashcam and independently shot video show they argued, with Bland at some point not visible but heard screaming and crying. Bland was arrested and hit with a $5,000 bond but couldn't find anyone with the $500 to bail her out. On July 13, police reported they found Bland, who was later reported to have mental health and substance issues, dead, hanging in her cell via a plastic bag. An autopsy ruled her death a suicide and noted unusually high THC levels connected to marijuana use in her body. All of these details seemed to detract from why Bland was stopped in the first place.

Investigations yielded no convictions. Encinia, the arresting officer, was himself arrested for perjury, but that charge was ultimately dropped in exchange for him never seeking any employment in law enforcement. A wrongful death lawsuit was settled for $1.9 million. The state passed the Texas Senate Bill 1849, also known as the Sandra Bland Act, changing corrections and policing policy for dealing with those with mental health and substance issues that went into effect on September 1, 2017.

**IN THEIR OWN WORDS**

Because the bill failed to address critical issues in Bland's arrest, her sister Sharon Cooper, who also served as the family's spokesperson, blasted it before it even became law. "It's a complete oversight of the root causes of why she was jailed in the first place," she told The Texas Tribune in May 2017. The 2018 documentary, *Say Her Name: The Life and Death of Sandra Bland*, exploring the incident aired on HBO. Bland's death served as a reminder to many that Black men weren't the only targets of injustice. That awareness resulted in the use of the "Say Her Name" hashtag (#sayhername) to amplify the deaths of Black women by police like unarmed 22-year-old Rekia Boyd who was fatally shot in 2012 by Chicago Police officer Dante Servin, whom a judge acquitted in 2015.

# Colin Kaepernick Kneels and Donald Trump Reacts

The summer prior to the start of the 2016–2017 NFL season, San Francisco 49ers quarterback Colin Kaepernick began sharing various posts about the police killings of Alton Sterling and Philando Castile. Sterling was a Baton Rouge, Louisiana man whom police officer Blane Salamoni had fatally shot six times while he and his partner Howie Lake had him pinned down. Castile was fatally shot by officer Jeronimo Yanez on July 6, 2016, during a traffic stop in a suburb of St. Paul, Minnesota, as Castile's girlfriend, Diamond Reynolds, recorded the incident on Facebook Live with her 4-year-old daughter in the car. Kaepernick also commented about the Baltimore police acquittal in Freddie Gray's death.

These incidents prompted Kaepernick to remain seated for the national anthem. After three preseason games of not standing, NFL media reporter Steve Wyche asked him about it. Kaepernick responded, "I am not going to stand up to show pride in a flag for a country that oppresses [B]lack people and people of color . . .. To me, this is bigger than football and it would be selfish on my part to look the other way. There are bodies in the street and people getting paid leave and getting away with murder."

Kaepernick, joined by his teammate Eric Reid, later switched to kneeling, a more respectful posture. In his September 25, 2017 op-ed "Eric Reid: Why Colin Kaepernick and I Decided To Take A Knee" for *The New York Times*, Reid, who approached Kaepernick after their last preseason August 26, 2016 about getting involved with his protest and how they could make a more powerful statement, explained.

"After hours of careful consideration, and even a visit from Nate Boyer, a retired Green Beret and former NFL player, we came to the conclusion that we should kneel, rather than sit, the next day during the anthem as a peaceful protest," Reid wrote. "We chose to kneel because it's a respectful gesture. I remember thinking our posture was like a flag flown at half-mast to mark a tragedy."

Throughout the season, as Kaepernick knelt instead of standing, the protest became a hotbed issue, as other NFL players and collegiate and high school athletes began to join. Donald J. Trump had criticized Kaepernick almost immediately. On August 29, 2016, he told a conservative talk show radio host in Seattle that Kaepernick's actions were "a terrible thing" and suggested "maybe he should find a country that works better for him."

## Trump responds

During his presidency, Trump was even more relentless in his opposition to Kaepernick and the kneeling he sparked. During a September 2017 rally in Alabama, Trump told the mostly white crowd, "Wouldn't you love to see one of these NFL owners, when somebody disrespects our flag, to say, 'Get that son of a b**** off the field right now. Out! He's fired. He's fired'" Days later, he claimed that the protests had resulted in an NFL ratings dip.

That same month, Trump also turned his Twitter ire on longtime sports journalist Jemele Hill, one of the rare Black women prominent in the field. The month before Hill, who was the co-host of *SC6* or *The Six*, which was a rebranded hour of the ESPN program *SportsCenter* that had just launched that February, got into a heated Twitter exchange on September 11. Subsequently, Hill tweeted a series of tweets, including "Donald Trump is a white supremacist who has largely surrounded himself w/ other white supremacists" and "Trump is the most ignorant, offensive president of my lifetime. His rise is a direct result of white supremacy. Period."

Hill's tweets came just weeks after violence erupted during the "Unite the Right" rally organized by white supremacists and white nationalists in Charlottesville, Virginia, that resulted in the death of white counter-protester Heather Heyer. Trump was criticized for not strongly condemning the violence and rally organizers.

Trump referenced Hill via Twitter. On October 10, he tweeted: "With Jemele Hill at the mike, it is no wonder ESPN ratings have "tanked," in fact, tanked so badly it is the talk of the industry!" Days after the initial series of tweets, White House secretary Sarah Huckabee Sanders called Hill's comments regarding President Trump "a fireable offense" during a White House press briefing. Hill stood by her comments, issuing an apology only to her employer ESPN for making them in "a public way."

Trump praised Dallas Cowboys owner Jerry Jones that same month for his statement to ESPN that players should face consequences for kneeling. "A big salute to Jerry Jones, owner of the Dallas Cowboys, who will BENCH players who disrespect our Flag. 'Stand for Anthem or sit for game!'," he tweeted.

## Kaepernick opts out of his contract

In 2017, Kaepernick opted out of his contract after being informed he wouldn't start under new coach Kyle Shanahan. Players, however, continued to kneel and Trump continued to criticize NFL commissioner Roger Goodell for "allowing" players to kneel. In July 2018, he tweeted that "The NFL National Anthem Debate is alive and well again — can't believe it! Isn't it in contract that players must stand at attention, hand on heart?" He also urged Goodell to take action and suggested how. "The $40,000,000 Commissioner must now make a stand. First time kneeling, out for game. Second time kneeling, out for season/no pay!" he tweeted.

Kaepernick never played in the NFL again. Legal challenges to the NFL resulted in a settlement. Kaepernick, also a Nike spokesperson, became a powerful symbol in the BLM movement.

# Change Gone Come: Trump, COVID-19, and George Floyd

Obama's election in 2008 inspired other Black people to run for various offices throughout the 2010s. Black women especially answered the call and were elected mayor in numerous cities, including Savannah, Georgia (Edna Johnson, 2011);

Gary, Indiana (Karen Freeman-Wilson, 2012); San Antonio, Texas (Ivy Taylor, 2014); Shreveport, Louisiana (Ollie Taylor, 2014); Rochester, New York (Lovely Warren, 2014); Flint, Michigan (Karen Weaver, 2015); Charlotte, North Carolina (Vi Lyles, 2017); New Orleans, (LaToya Cantrell, 2017); and San Francisco (London Breed, 2018). In 2019, Chicago elected Lori Lightfoot, making her the first woman and Black woman mayor of a top-three major American city as well as the first openly gay one.

But one of the most powerful sparks for this new political reawakening was the continued racial injustice, most exemplified by police killings of Black people often captured via cell phones, and Trump's presidency, where one of the main goals was rolling back all the gains achieved during Obama's administration. Very few areas were spared. In 2019, Democrats.org posted the article, "Trump's Policies Have Hurt African Americans" in response to Trump kicking off his Black Voices for Trump Coalition initiative.

Several points made include that Trump rolled back efforts that protected Black students from racially biased school discipline, sought to make legal aid less accessible plus contended that federal prisoners shouldn't be allowed to challenge their sentences in court, encouraged harsher sentences for drug offenses, reinstated the death penalty, rescinded Obama efforts to encourage diversity in public schools. and delayed implementing regulations addressing racial disparities in special needs programs in public schools.

## Trump's attacks continue

Trump, who was a prominent voice in the birther attacks claiming that Obama wasn't born in this country and thus not eligible to serve as president, consistently made racially biased statements. *The New York Times* reported that two officials present during a 2017 meeting with Trump claimed Trump commented that Haitians had AIDS and Nigerians lived in huts. In July 2019, Trump shared a lengthy Twitter post proclaiming "Cumming [sic] District is a disgusting, rat and rodent infested mess," among other observations in reference to the predominantly Black Maryland district U.S. Congressman Elijah Cumming represented.

In July 2018, Trump referred to Maxine Waters, a veteran U.S. Congresswoman from California and one of his fiercest critics, as "an extraordinarily low IQ person," via tweet. The 2018 midterm elections in November resulted in the election of a record-number of women. One of Trump's new targets became The Squad, a group of progressive Congress members, overwhelmingly female, launched in 2018 with Representative Ayanna Pressley (the first Black woman elected to Congress from Massachusetts), Ilhan Omar of Minnesota (the first

Somali American to serve in Congress), Alexandria Ocasio-Cortez (AOC) from the Bronx in New York City, and Michigan's Muslim Congresswoman Rashida Tlaib.

In July 2019, Trump also tweeted "So interesting to see "Progressive" Democrat Congresswomen, who originally came from countries whose governments are a complete and total catastrophe, the worst, most corrupt and inept anywhere in the world (if they even have a functioning government at all), now loudly . . ."

## Stacey Abrams runs for governor in Georgia

Mississippi and Georgia-raised Stacey Abrams captured the nation's attention when she ran as the Democratic nominee for governor of Georgia in 2018, making her the first Black female major party gubernatorial candidate in the nation. An alum of Spelman College, University of Texas at Austin, and Yale Law School, she served in the Georgia House of Representatives from 2007 to 2017, taking on the role of minority leader from 2011 to 2017, prior to stepping down to run for governor.

Abrams's Republican opponent Brian Kemp, an unabashed Trump supporter, kept his job as Secretary of State even though his office oversaw the election. There was also evidence suggesting voter suppression on Kemp's part in his capacity as Secretary of State. In the end, Abrams lost by roughly 53,000 votes in what she and many others maintained wasn't a fair election.

## COVID-19 exposes racial disparities

By March 2020, it started to become clear that the coronavirus pandemic first reported out of Wuhan, China in late 2019, was greatly impacting the United States, too. Initially, as President Trump hosted White House coronavirus (as it was popularly referred to then) briefings with Vice President Mike Pence technically serving as White House Coronavirus Task Force lead, Black Americans weren't addressed as a primary risk group. Some news media, like ABC's *Nightline*, were among the first to pick up on how hard the pandemic was hitting Black Americans. *Nightline* ran an early story about the 20 people or so who contracted the virus at funerals in the same funeral home between February 29 and March 7 in Albany, Georgia, which was more than 70 percent Black. For some, that was the first indication that corona or the 'rona, as many people called it, might be disproportionately affecting Black people.

As the world and the nation shut down, the reality that Black Americans were dying at disproportionately higher rates became impossible to ignore. In Chicago, for example, the American Medical Association noted that Black Chicagoans made up more than half of the city's COVID-19 deaths, though Black people were only 29 percent of the city's population. Numbers released by the Louisiana Department of Health on April 6, 2020, showed that Black Americans were 70 percent of all the state's COVID-19 deaths, despite being just 33 percent of the state's total population. The majority Black population of New Orleans was hardest hit. Mayor Cantrell took immediate action, canceling large gatherings. ESSENCE Festival of Culture, a huge source of revenue for the city attracting tens of thousands of Black people to the city, was officially canceled April 15.

Unable to wait on the government to help its Black citizens, community organizers and churches sprang into action. In Philadelphia, Dr. Ala Stanford formed the Black Doctors COVID-19 Consortium and offered free testing in church parking lots. Way Christian Center Pastor Michael McBride, in West Berkeley, California, joined forces with comedian W. Kamau Bell to launch Masks for the People, a joint initiative with Live Free and the Black Church Action Fund, to get personal protective equipment (PPE), hand sanitizer, and testing kits to nonmedical essential workers, those incarcerated, the homeless population, and others in poor urban and rural communities.

A September 2020 University of Utah Health study noted that Black essential workers died at higher rates than other Americans because they were far more likely to work in more vulnerable occupations, including food preparation, buildings and grounds maintenance, childcare, and more. Attention was also brought to the fact that many Black communities lacked adequate healthcare options, including hospitals and urgent care facilities.

**REMEMBER**

As vaccines became more readily available in early 2021, campaigns to erase many Black Americans' uneasiness to even take the vaccine were mounted. Distrust created by the history of the Tuskegee Syphilis Experiment, where Black men were injected with syphilis and largely untreated for it through a study by the U.S. Public Health Service at Tuskegee Institute (later University) from 1932 to 1972, among others lingered. Some became more at ease after learning that Dr. Kizzmekia "Kizzy" Corbett was a key leader in developing the Moderna vaccine. Black Americans willing to take a vaccine generally found that, as sparse as vaccines initially were in the nation at large, they were even harder to access in predominantly Black communities. As with testing and treatment throughout the pandemic, vaccines were also disproportionately unavailable to Black Americans initially.

# "Stop killing us": George Floyd and Breonna Taylor

On May 25, 2020, an 8-minute, 46-second video shook the nation. It showed Minneapolis police officer Derek Chauvin holding his knee on 46-year-old George Floyd's neck and as Floyd said he could not breathe and called out for his mother — all over Floyd's alleged use of a $20 counterfeit bill at a local store. Officers J. Alexander Kueng and Thomas Lane helped Chauvin restrain Floyd as officer Tou Thao kept bystanders from interfering with Floyd's death.

Despite the COVID-19 pandemic, which made gathering in large crowds a health risk, tens of thousands of Americans of various racial and ethnic identities took to the streets in protest. That effort was matched abroad as well. Trump, however, didn't welcome the outrage, referring to Minneapolis protesters as "thugs." Aggressive policing only helped aggravate the situation in Minneapolis, especially where looting and the burning of some buildings also came into play.

Many believe the heightened attention George Floyd's killing brought to police brutality, systemic racism, and the overall lack of accountability in policing Black people and Black communities was a result of the COVID-19 shutdown. Also, news of the February killing of 25-year-ikd Ahmaud Arbery while he was jogging in Brunswick, Georgia, by two white men, loosely associated with law enforcement, was relatively fresh. The spotlight on Floyd also brought attention to the Louisville Metro Police Department's fatal shooting of 26-year-old Breonna Taylor in her home on March 13, especially the idea that officers Jonathan Mattingly, Brett Hankison, and Myles Cosgrove hadn't been charged. Celebrities like Oprah Winfrey lent their voices and platforms. Others such as Jamie Foxx, Ariana Grande, Machine Gun Kelly, Tessa Thompson, and Sophia Bush marched in BLM protests.

As the police killings continued with Rayshard Brooks in Atlanta and Andre Maurice Hill in Columbus, Ohio, cries for solutions to reform or defund the police — diverting more police funding into social services and even shifting 911 responses from police officers to social workers and other professionals — became louder. Some people even viewed the 2020 presidential election between Republican Donald Trump and Democrat Joe Biden as a referendum on police brutality that could decide the nation's course on anti-Black violence as well as the pandemic response.

# CORPORATE AMERICA'S RESPONSE POST-GEORGE FLOYD

**REMEMBER**

Corporations across the board announced broad investments promoting Black inclusion after George Floyd's death. Here are a few examples:

- PepsiCo unveiled a five-year, $400 million initiative to increase Black managerial representation by 30 percent as well as more than double the business it did with Black-owned suppliers.

- Bank of America pledged $1 billion to enhance economic opportunities in communities of color over a four-year period.

- Netflix announced its plan to put 2 percent of its cash holdings, starting with an initial $25 million, in Black financial institutions.

Other American institutions began to examine the structural barriers barring Black Americans from broader economic access, particularly as it related to Black business ownership. The reality has been that most Black entrepreneurs have historically been blocked from realizing significant wealth via business ownership. Lack of access to capital, especially via bank lending, was just one of the many inequities exposed by the COVID-19 pandemic. The July 20, 2020, *Kellogg Insight* article "Black-Owned Businesses Often Struggle to Access Capital. Here's How Financial Institutions Can Change That," from the Kellogg School of Management at Northwestern University, cited that "One of the biggest barriers to Black and minority entrepreneurship stems from long-held beliefs by banks and other financial institutions that these entrepreneurs are higher-risk candidates for mortgages and other loans."

William Towns, adjunct lecturer of social impact at Kellogg and managing director of 4 S Bay Partners, LLC, a private equity fund targeting minority-operating businesses within opportunity zones in the Chicago area, observed that JPMorgan did more loans in the predominantly white Lincoln Park area of Chicago than it did in all the predominantly Black areas in the city combined.

And the December 31, 2020 article "To Expand the Economy, Invest in Black Businesses," by Andre M. Perry and Carl Romer from the Brookings Institution noted that according to the most recent Census Bureau data, "Black businesses comprise only 2.2% of the nation's 5.7 million employer businesses (firms with more than one employee)." Using data from the Stanford Institute for Economic Policy Research, it noted that "only 1% of Black business owners were able to obtain loans in their founding year, compared to 7% of white business owners." In addition to Black entrepreneurs being denied loans or granted them at much lower amounts but at higher interest rates than their white counterparts, the article also noted that "only 1% of funded startup founders were Black, according to data analytics from CB Insights." So very clear barriers deterring Black business ownerships remained well into the 21st century.

# The 2020 Election

On June 6, 2020, Joseph R. Biden officially became the Democratic nominee for president. U.S. Senators Cory Booker, who was once mayor of Newark, New Jersey, and Kamala Harris, the multiracial daughter of immigrants (with a mother from India and a father from Jamaica) who had served as California's attorney general, were unsuccessful in their 2020 presidential bids. Interestingly, Biden seized his victory largely due to a huge turnaround in the polls in South Carolina at the end of February driven by Black voters. Backed by South Carolina Congressman and House Majority Whip James "Jim" Clyburn, a respected Black leader, Biden grabbed 49 percent of the vote, overwhelmingly winning the Black vote and crushing all candidates.

As speculation mounted about Biden's choice for running mate, whom he had committed to making a woman, several Black women, including former Georgia gubernatorial candidate Stacey Abrams, Atlanta Mayor and early Biden supporter Keisha Lance Bottoms, along with U.S. Congresswomen Val Demings from Florida and Karen Bass from California, appeared on the list. To the surprise of many, on August 11, Biden chose Harris, who, next to Vermont's Senator Bernie Sanders, had been among his fiercest challengers during their 2020 presidential bids.

## Voting in the era of COVID-19

As the COVID pandemic continued, killing hundreds of thousands of Americans and wreaking havoc on the economy, disproportionately impacting Black Americans, and additional police killings and shootings without legal ramifications, democracy seemed more urgent than ever. Black groups got to work, especially in the South with Black Voters Matter headed by its co-founder LaTosha Brown and Fair Fight from Stacey Abrams.

Given the long lines during the 2018 elections prompted by broken voting machines in Crown Heights, Brooklyn, lack of voting machines at predominantly Black voting precincts in Atlanta, and more, there was ample reason to be proactive. As BLM protests continued and pro athletes like LeBron James and the entire WNBA lent their support, Trump's behavior worsened, with him calling for additional law enforcement to contain what he described as "anarchy."

### Rappers get presidential

Defeating Trump was the order of the day, but not all Black people were on board the Democrat train to do it. In the weeks leading up to the election, rumblings against Black people blindly voting Democrat without any significant gains surfaced, most prominently through rapper/actor/film producer/Big3 team owner Ice Cube. Ice Cube came up with the Contract with Black America and caught flack in October 2020 for meeting with representatives of the Trump campaign, which added aspects of the Contract with Black America to Trump's Platinum Plan.

Days before the election, rapper Lil Wayne endorsed Trump, but it was also revealed that he was facing a criminal case and might need a pardon down the line. Rapper Kanye West even made a feeble attempt to run for president, securing ballot placements in 12 states. He reportedly garnered 60,000 votes.

## The paperchase

With people not able to go to the polls in the way they were used to pre-COVID, voting via absentee ballots became one of the most viable options. Radio shows like the syndicated *Keeping It Real with Al Sharpton*, along with *The Karen Hunter Show* and *The Joe Madison Show* on the SiriusXM UrbanView channel on XM Satellite Radio, put extra effort into educating their listeners on how to vote either in person or via absentee voting, including when to mail ballots or use drop boxes, as well as how to find them. Virtual and in-person socially distanced rallies were held. Trump, by contrast, insisted on holding huge rallies that became super-spreader events. Black Republican Herman Cain passed from COVID after attending a June Trump rally in Tulsa. Phone banking, along with ample promo mailing, were also popular for reaching voters. Social media, like Facebook, Instagram, Twitter, and the iPhone-only app Clubhouse, became important platforms.

From the beginning, Trump, who had greatly downplayed the pandemic since the top of 2020, encouraged his base to ignore absentee voting in favor of voting in person. Legal teams working on behalf of Trump tried to limit the length of time in which ballots could be counted in several states, as well as get ballots that physically arrived after the November 3 election date thrown out. Ultimately, however, the laws in those states prevailed. Although absentee ballots weren't new to the voting process, they had never been this extensively used. Political experts warned that it would take days to declare a presidential winner.

## Biden-Harris win

After numerous Trump legal challenges and endless claims of voter fraud, not to mention pro-Trump protests at key poll counting sites in Michigan, Arizona, and Pennsylvania, Trump, showing his racial bias, challenged Biden votes in predominantly Black areas like Detroit, Philadelphia, and Atlanta. Still, on November 7, the Biden-Harris win became official.

**IN THEIR OWN WORDS**

That night, in Wilmington, Delaware, Harris, wearing a suffragette white pantsuit (see Figure 11-3), spoke of her Indian mother who immigrated to the United States, as well as the many women who had paved the way. She especially honored Black women's contributions to the fight for suffrage, equality and civil rights, acknowledging that Black women leaders are "too often overlooked, but so often prove that they are the backbone of our democracy." Stacey Abrams was among those women lauded for her efforts.

**FIGURE 11-3:**
Vice President
Kamala Harris.

*Biden Campaign via CNP/Biden Campaign via CNP/AGE Fotostock*

Former first lady and one-time New York U.S. Senator Hillary Clinton, who mounted two unsuccessful presidential runs in 2008 and 2016, was on pace to break the political glass ceiling for women. Instead, that distinction went to Harris, a graduate of the historically Black Howard University in Washington, D.C. as vice president, not president. "While I may be the first woman in this office, I will not be the last," Harris promised during her speech.

And it was the Black vote that largely carried the Biden-Harris team to victory, as they earned 87 percent of the Black vote, including victories in several states like Pennsylvania, Michigan, and especially Georgia, which voted blue in the presidential election for the first time since 1992. Feeling that Georgia was close, the Democrats sent out Obama, Harris, and Biden to campaign at drive-in or socially distanced rallies close to the election.

Overall 66 percent of eligible Americans voted, casting a total of 158 million ballots with Biden-Harris receiving 81 votes to roughly 74 million votes for Trump-Pence, indicating that Trump still had a strong grip on significant portions of the country.

## Other election firsts

The 2020 election brought about some significant firsts. Promising news came out of Ferguson, Missouri, which was the site of a major racial reckoning in 2014. Less than a decade removed from the nationwide protests surrounding the police killing of Michael Brown, Ella Jones's election as the city's first Black mayor was significant. Similarly, Ferguson activist Cori Bush's win against a candidate whose family had occupied that seat for 52 years to become the first Black woman from Missouri to serve in Congress, was another one. In Congress, Bush immediately joined "The Squad."

On January 5, 2021, the two U.S. Senate seats in Georgia were up for grabs in a critical runoff. To get a clear Biden–Harris mandate for the senate, the Democrats needed to win both seats. Georgia native, Morehouse alum, and longtime pastor of Dr. King's home church, Ebenezer Baptist Church, Raphael Warnock, faced off against Republican and Trump supporter Kelly Loeffler for one. In December 2019, Georgia's Republican Governor Brian Kemp, a Trump supporter, appointed Loeffler to the seat when longtime Senator Johnny Isakson resigned for health reasons. The other candidate Jon Ossoff, a Jewish Georgian, was facing off against David Perdue. Through the efforts of Stacey Abrams and others, both Ossoff, who had worked under Congressman John Lewis, and Warnock, who was Lewis's longtime pastor, prevailed. Coming just months after the passing of Lewis (1940–2020), along with two other key civil rights titans — the Reverend Joseph E. Lowery (1921–2020) and the Reverend C.T. Vivian (1924–2020), these victories offered hope that the ideals of the Civil Rights Movement of the 1950s and 1960s could one day become real. With his victory, Warnock became the very first Black U.S. Senator elected from Georgia.

# Trump and the U.S. Capitol riot

Trump rejected the presidential election results. Refusing to concede to Biden, Trump hyped up his base of more than 70 million Americans that the election was fake and that he had actually won, despite the substantial math to the contrary and professional assessments from Trump's former director of the Cybersecurity and Infrastructure Security Agency Christopher Krebs and his Attorney General Will Barr, that there was no evidence of election fraud. In addition, his legal team lost more than 50 court challenges. Trump's denial that he lost the election resulted in a rally of Trump supporters that he personally addressed on January 6, 2021. It culminated in an attack on the U.S. Capitol building the day that Congress was to certify election results.

The event was reminiscent of actions taken in Wilmington, North Carolina, in 1898, when a white mob attacked city hall; they dumped the white mayor who had won his election through a progressive coalition of white and Black male voters, replacing them and shutting off Black political access. *Wilmington's Lie: The Murderous Coup of 1898 and the Rise of White Supremacy* by David Zucchino (Atlantic Monthly Press) chronicles that history.

Unlike in Wilmington, the 2021 Capitol riot didn't succeed in changing election results. Still, it was a sad indicator of just how racially polarized the nation was, as the overwhelmingly white mob descended on the Capitol, vandalizing property, busting out windows, and igniting violence that resulted in five deaths. Subsequent videos revealed participants shouting racial epithets and carrying Confederate battle flags.

# STACEY ABRAMS: FIGHTING VOTER SUPPRESSION

BLACK AMERICAN FACES

Stacey Abrams's run for Georgia governor and refusal to remain silent about unfair voting practices, even after her opponent Brian Kemp took office in 2019, put her in national political circles and conversation. There was even talk of her being a vice presidential running mate. Instead, Abrams, who worked to register voters through the New Georgia Project, which she had founded in 2014, rededicated herself to voting rights by launching Fair Fight and its affiliate Fair Fight Action after losing the 2018 governor's race.

Fair Fight registered voters, tallied allegations of voter suppression, and facilitated investigations of those claims. She even starred in and produced the 2020 documentary, *All In: The Fight for Democracy*, addressing voting rights and voter suppression released prior to the election. Her efforts were largely credited for the unexpected result of Georgia turning blue and voting for Democrats Joe Biden and Kamala Harris in 2021.

Fair Fight also helped send Jewish American Jon Ossoff and Savannah native Reverend Raphael Warnock, a Morehouse College alum and pastor of Ebenezer Baptist Church (Martin Luther King Jr.'s family church in Atlanta), to the U.S. Senate. Warnock became the first Black senator from Georgia.

People familiar with police response to peaceful BLM–themed protests couldn't help but notice the difference between how leniently violent white protesters were treated in comparison to peaceful Black ones. Arrests weren't made immediately, with Trump and other Republicans downplaying the violence. For many, the Capitol riot was yet another indication of what had been historically true in the United States in that there were indeed two Americas — one for white Americans and another for Black Americans. And even with the changing demographics, creating an even more multiracial nation, racial polarization hadn't ended.

Despite the violence, Biden and Harris were sworn in as president and vice president. The moment, while triumphant, was bittersweet, however, as Dr. King Jr.'s question presented in his 1967 book *Where Do We Go From Here: Chaos or Community* seemed more timely than ever. That question became even more pressing March 25, 2021, when Georgia Governor Brian Kemp, one of the states that gave the Democrats the upper hand in the 2020 elections, signed Senate Bill 202 tightening voting restrictions into law. Rushed through the Georgia House by Republicans, the bill put new limitations on absentee voting, criminalized passing out food and drinks to voters standing in line, and made it possible for the State Election Board and lawmakers to take over elections from the Secretary of State. Like the Capitol riot, Georgia's new bill further restricting voting only indicated that the battle was far from won.

# FLINT WATER CRISIS: A REMINDER OF SYSTEMIC RACISM'S HIGH COST

In the summer of 2014, Flint, Michigan resident complaints about the smell, color, taste and negative impact on their skin were ignored. To save money, the city had switched from Lake Huron water in Detroit, about an hour away, to Flint River water, which it had to treat, in April 2014. Because a financial emergency was declared in Flint, Michigan, Governor Rick Snyder appointed several emergency managers, superseding the authority of Flint Mayor Dayne Walling, between 2011 and 2015. Ed Kurtz presided during the water source switch.

Despite several boiled water advisories, the city maintained the water was fine. Yet the city permitted a General Motors plant to switch back to Lake Huron water in October 2014. The Flint Public Library stopped using the water, offering bottled water instead. When the Detroit Water and Sewage Department (DWSD) offered to reconnect Flint, emergency manager Jerry Ambrose declined. Residents voted to switch back to DWSD, but that didn't happen.

Because Flint's pipes were bad and needed replacing, there were toxic lead levels in the water. During a September 2015 press conference at Hurley Children's Hospital, Dr. Mona Hanna-Attisha, a pediatrician, revealed study results of doubling lead levels in infants and children tied to the city's water source switch. A return to the Detroit water source, Mayor Walling and other city officials insisted, would financially bankrupt the city.

On January 5, 2016, Governor Snyder declared a state of emergency for the crisis. President Obama sent assistance from FEMA and the Department of Homeland Security. Thousands of bottles of water arrived; high-profile fundraisers were held. Drinking toxic water caused developmental issues for many of the city's kids. A 2020 study revealed that 80 percent of 174 Flint children would need special education services. When Mayor Karen Weaver, the Black woman who replaced Walling, appealed to Governor Snyder for help, he dismissed her. White kids, white people, wouldn't be denied safe drinking water, many concluded. Systemic racism played a key role in the fate of the nearly 60 percent Black population of Flint, studies revealed.

In January 2021, former Michigan governor Snyder was charged with two counts of willful neglect of duty. Although Flint pipes were said to be free of lead and the water safe to drink nearly a decade later, the effects on kids, particularly poor and, of course, Black, persisted. Although climate change was more responsible for the water crisis that hit predominantly Black Jackson, Mississippi, from February to March 2021, the white governor's lack of urgency and the sparse media attention echoed the systemic racism at the heart of the Flint crisis.

# 4

# Cultural Foundations

## IN THIS PART . . .

Delve into the spiritual and religious journey of Black Americans and find out how they had already begun establishing their own churches before emancipation. Discover what role the Black church would play post-emancipation and throughout the 20th century, standing at the forefront of many of Black America's and the nation's most transformative moments.

Marvel at how fiercely Black Americans pursued education in the fight for freedom and see how education has historically been a heated battlefield that persists now, with many debates raging around the issues of affirmative action and how failing public schools affect the futures of Black children, while also appreciating the challenges and living legacy of Historically Black Colleges and Universities (HBCUs).

Explore Black American literature and its early origins in the African oral tradition as well as the slave narrative, along with its rise to prominence during the Harlem Renaissance and other similar movements all the way to the breakout 1970s when Black women began raising their voices even louder to now.

Develop an appreciation for Black theater and its trials and triumphs through minstrelsy and early musical theater to creating serious drama. Examine the journey and evolution of Black dance through the art form's greatest innovators.

Christianity

» Developing the Black church tradition

» Blurring the line between politics and religion

» Exploring other Black religions

# Chapter 12

# Somebody Say "Amen": The Black Church

Early enslaved Africans weren't overwhelmingly Christian, but converting to Christianity didn't change Black Americans as much as Black Americans changed Christianity. As the first uniquely Black institution in American culture, the Black church is unparalleled in its impact on the overall development of Black American culture. Historically, the Black church has been more than a place of worship; it's also served as a community center, a relief society, a political think tank, and an educational center.

This chapter traces the development of the Black church back to the politics of Christian conversion and explores the church's emergence, its social impact and influence, its political backbone, and its shortcomings. It also acknowledges that while Christianity has ruled much of Black America for centuries; not all Black Americans were (or are) Protestant Christians. There's a reason Black Americans have been solidly religious for centuries, and this chapter explains why.

# Converting to Christianity

Differences between how white and Black Americans worship haven't gone unnoted. The Black church's divergence from European-based Christianity reflects the early religious differences between Europeans and Africans and the contrasting realities of life for Black and white Americans, as well as the enduring legacy of retained characteristics of African religious practices.

**TECHNICAL STUFF**

Religiously, Africa has never been an inactive continent. Because religion is a focal point of most cultures, invading forces promoted their own religious beliefs. Initially, Muslims made the biggest impact on Africa, particularly in West Africa, where a large percentage of enslaved Africans in the United States hailed from. (Historians note that Arab Muslims coming into many African countries would enslave Africans, but upon conversion to Islam they'd release those that were enslaved.) Islam, however, coexisted alongside distinctly West African religious practices. Coinciding with the onset of the transatlantic slave trade, Christian forces also made headway.

## Early objections, early conversions

During the 1660s in New England, Puritan minister John Eliot argued that slaveholders had a duty to provide religious instruction to those they enslaved. Eliot believed that teaching the enslaved to read the Bible expedited their Christian conversion. Slaveholders hesitated at the prospect, probably because slavery itself was a relatively new and unstable practice. Later, slaveholders greatly feared that teaching those enslaved to read and interpret the Bible would incite rebellions. Nat Turner, the leader of one of America's most notorious enslaved uprisings, for example, was deeply religious (see Chapter 4 for more about him). Because many of the enslaved achieved literacy through religious organizations, slaveholders associated those insurrections with religious instruction.

**IN THEIR OWN WORDS**

Some of the enslaved who were baptized successfully gained their freedom by challenging the lifetime enslavement of Christians, prompting some white religious leaders, like Rev. James Blair, a representative of the bishop of London in Virginia, to suspect that some enslaved people converted to Christianity purely in hopes of gaining freedom. "I doubt not," he wrote his superior in 1729, "some of the Negroes are sincere Converts, but the far greater part of them little mind the serious part, only are in hopes that they will meet with so much more respect, and that some time or other Christianity will help them to their freedom."

**REMEMBER**

To alleviate slaveholders' worries that conversion to Christianity could result in the freedom of those they enslaved, colonial legislators passed laws stating that Christian baptism didn't alter one's legal slave status. By 1706, at least six colonial legislatures had passed such laws. Because African heathenism had once been one of the main justifications for African enslavement, such legislation was a major shift. Gradually, race alone became the backbone of American slavery.

Eliot continued his mission to convert the enslaved through religious education by promising slaveholders he would teach only Scripture to those enslaved. Cotton Mather, his successor, appeased slaveholders further with his 1693 leaflet "Rules for the Society of Negroes." Working with the enslaved in Massachusetts, Mather used religion as a form of social control by twisting the Ten Commandments into a doctrine that demanded those enslaved give their legalized masters the same respect as God.

Still, many slaveholders objected, for purely capitalistic reasons, to the religious instruction of those they enslaved. To appeal to their profit-minded motives, some missionaries stressed that enslaved people who were converted to Christianity worked more efficiently and therefore yielded greater profits. Tax incentives sometimes enticed slaveholders to allow spiritual instruction to those they enslaved.

Of course, some of the men and women weren't always receptive to conversion attempts, naturally preferring their own religious practices to those of their slaveholders'. It wasn't until the Great Awakenings that African conversion to Christianity gained momentum.

## The Great Awakenings: Called to convert

The First Great Awakening, a religious movement in the 1730s and 1740s that began in New England, radicalized religion by making it more personalized. Suddenly individuals could exert some control over their own salvation. They were also encouraged to express their emotions. The Second Great Awakening occurred during the 1820s and 1830s.

Distinguished by their revival style, a novel concept at the time, the Great Awakenings, especially the first one, had a lasting impact on Black Americans even though the movement's main messengers, Jonathan Edwards, George Whitefield, and Gilbert Tennent, were white. These leaders noticed almost immediately the impact their meetings, often held outside to accommodate large numbers of attendees, had on Black people. Leaders such as Samuel Davies, a minister who became president of the College of New Jersey (Princeton), actively evangelized Black people.

**REMEMBER**

Historians have argued that the Great Awakenings had such a profound effect because their fervent worship style and emphasis on a personal relationship with God meshed with core African religious beliefs. Despite the multitude of languages and cultures that existed among enslaved Africans, common threads allowed them to bond with one another. When the First Great Awakening emerged, they were able to embed their existing beliefs into a form of religious expression that was acceptable to whites.

The rise of plantation missions coincided with the Second Great Awakening. Advocates such as Charles Colcock Jones contended that rural enslaved people weren't receiving proper religious instruction and appealed to various religious and secular parties, including slaveholders, to remedy the situation with plantation missions. As abolitionism gained momentum, plantation missions became a complicated proposition. Slaveholders worried about those they enslaved receiving the same religious instruction as whites. They also feared that religious instruction encouraged rebellions. To ease their concerns, plantation missions ministered orally to the enslaved. Its advocates also reminded plantation owners that religious instruction could teach the enslaved discipline and encourage obedience. Southern Methodists made the biggest inroads with plantation missions.

## Christianity, Black American style

Culturally, Black Christianity has distinctive features. Like Europeans, West Africans in particular believed in an ultimate supreme being, but unlike Europeans, lesser deities aided their supreme being. Scholars believe that in Latin America and the Caribbean, Catholicism's patron saints replaced African deities. So Christianity, scholars argue, resonated with Black Americans for a variety of reasons.

### FUSING CHRISTIAN AND AFRICAN RELIGIONS

In the Caribbean and Latin America, religious practices such as Voudou (or Voodoo), Obeah, Santería, and Candomblé prominently featured African deities and spiritual forces. These religious practices rose out of a combination of African religions and Catholicism. Religious scholars have noted that Africans in Latin America and the Caribbean acquiesced to Catholicism by substituting Catholic patron saints for their own African deities. This allowed enslaved Africans to continue to pray and worship their deities while seemingly practicing Catholicism. Ultimately, these religious practices emphasize a personal connection to a guiding spiritual force or forces. This sense of personal connection, many historians argue, is what drew Africans to Christianity in large numbers. Others have argued, however, that Africans had little choice but to convert to Christianity.

## Black liberation theology

Although some argue that the concept of the Trinity — God, Jesus Christ, and the Holy Ghost — attracted Black people to Christianity; others believe that the Bible's biggest selling point became the many circumstances that approximated the Black American experience with enslavement. C. Eric Lincoln, one of the foremost authorities on the Black church, observed in his seminal work with Lawrence H. Mamiya, *The Black Church in the African American Experience* (Duke University Press), that Black Christianity places a "symbolic importance" on the concept of freedom. It wasn't hard for Black people to believe that they were God's chosen people who would be led out of bondage. Very few Black Americans, enslaved or free, accepted enslavement as the natural order. Just because death ensured freedom didn't mean that one couldn't achieve it while living.

During the 1970s, James H. Cone, author of the groundbreaking *Black Theology and Black Power,* formalized this concept of freedom and became a leading proponent of *Black liberation theology.* Cone argued that for Black people, Christianity should reflect their unique experience of oppression. Cone advocated a communal approach to Christianity for Black Americans, rejecting a focus on the individual. He also encouraged Black Americans to view God in their own image. In many ways, Cone just confirmed how Black Christianity had functioned for a few centuries.

**HISTORICAL ROOTS**

Viewing God as Black wasn't an entirely new concept. Speaking before the turn of the 20th century, African Methodist Episcopal Bishop Henry McNeil Turner made it clear that Black people "have as much right biblically and otherwise to believe that God is Negro." Certainly, there had been others before him, as well as those like Marcus Garvey and others after him, who expressed similar sentiments.

## Music for the soul

Music is one of the most distinguishable aspects of Black Christianity. Many historians trace Black music and dance back to the ring shout, a religious ritual that is the oldest documented African performance style in this country. Typically performed after formal worship, the *ring shout* — which includes two groups, shouters (or dancers) and singers organized in a circle — exemplifies two key characteristics of the Black church and Black music:

>> **Call-and-response:** The leader sings (or calls) and the group responds. Black preachers often perform the same function with their congregations during sermons. They also tend to speak rhythmically, using their voice in ways similar to vocalists that many scholars cite as a precursor to rap.

>> **Use of rhythm:** Slaveholders banned drums after the Stono Rebellion in 1739 (see Chapter 4), so clapping and foot tapping provided the rhythm considered essential to African music. Often performed in unison, songs themselves embodied the communal nature of many African cultures, especially because freedom served as a major theme in early spirituals. (Read more about Black music in Chapter 16.)

# Building and Sustaining the Black Church

The African Baptist (or "Bluestone") Church, founded on the William Byrd plantation near the Bluestone River in Mecklenburg, Virginia in 1758, could be the first established Black church in America, but that distinction frequently goes to the Silver Bluff Baptist Church in Beech Island, South Carolina. Silver Bluff's offshoots, the Springfield Baptist Church in Augusta, Georgia, and the First African Baptist Church in Savannah, Georgia, are also among the oldest Black churches in the United States. While these early Black churches existed in the South, the North, which tended to have more documentation, especially surrounding the important creation of the African Methodist Episcopal (AME) and African Methodist Episcopal Zion (AMEZ) orders, dominates early Black church history.

**HISTORICAL ROOTS**

## SILVER BLUFF BAPTIST CHURCH

Located on the estate of slaveholder George Galphin, Silver Bluff Baptist Church got its start between 1773 and 1775 through the work of white minister Gait Palmer, who baptized those enslaved by Galphin, including David George and Jesse Peters (also known as Jesse Peters Galphin). Georgia-based Black preacher George Liele, a childhood friend of George's, also preached at Silver Bluff.

During the Revolutionary War, the congregation of about 30 sought the protection of the British in Savannah, who promised freedom to any enslaved person who sided with them. After the British defeat, George relocated to Nova Scotia, where he established a church, before continuing his ministry in Sierra Leone. Liele left the United States in 1782 for Jamaica and established a church. Before leaving, he converted an enslaved man named Andrew Bryan, who went on to lead the First African Baptist Church of Savannah, which predates the white Baptist church there.

Peters didn't flee following the Revolutionary War. Instead, he returned to Silver Bluff and eventually gained his freedom. Around 1787, he established the Springfield Baptist Church, located in Augusta, Georgia. Morehouse College traces its roots back to this historic church. Today, Silver Bluff, Springfield, and First African are still active churches.

# Black churches in the North

Racial mistreatment within churches produced the independent Black church movement in the North. Two important orders, the African Methodist Episcopal (AME) and the African Methodist Episcopal Zion (AMEZ), didn't necessarily set out to become independent Black churches. Both of these orders began with parishioners who were content to worship with white people of faith. Generally, white parishioners didn't feel the same.

## The African Methodist Episcopal (AME) Church

At St. George's Methodist Episcopal Church in Philadelphia, Pennsylvania, the congregation included Black and white worshippers. When the white membership decided to segregate worship and force the Black membership to the back of the church in 1787, two Black members, Absalom Jones and Richard Allen, made plans to establish their own church. Historians believe that Jones and Allen left St. George's several months after they formed the Free African Society (see Chapter 3) that same year. By 1794, the two men had successfully spearheaded the African Episcopal Church of St. Thomas.

Plans changed when the Methodist Church refused to supply the church a minister. A majority of the St. Thomas congregation voted to affiliate with the Episcopal Church, so Allen, a die-hard Methodist, detached himself from the church and Jones, credited as the first Black ordained Episcopal priest, led the congregation. Allen began a congregation within the official confines of Methodism, but by 1816, united Black congregations in Pennsylvania, New York, New Jersey, Delaware, and Maryland formed the African Methodist Episcopal (AME) Church, a uniquely Black organization operated by Black people. Allen, who had purchased his freedom at age 38, became the AME Church's first bishop. His Philadelphia church, Bethel AME, frequently referred to as "Mother Bethel," served as the order's anchor.

**IN THEIR OWN WORDS**

Allen explained his refusal to abandon Methodism with this observation: "I was confident that no religious sect or denominations would suit the capacity of the colored people so well as Methodists, for the plain simple gospel suits best for any people, for the unlearned can understand, and the learned are sure to understand."

## The African Methodist Episcopal Zion (AMEZ) Church

Despite their similar names, the AME and AME Zion Church aren't the same. The AME Zion Church traces its roots back to 1796 to the John Street Methodist Church of New York City. Although the Methodist Church, in keeping with founder John Wesley, opposed slavery, it refused to ordain Black ministers, among other things. So in 1796, Black members broke off and, by 1801, had their own church, the African Methodist Episcopal Church of the City of New York, also known as Zion.

Although separate, Zion and its affiliate churches operated under the guidance of the white-controlled Methodist Episcopal Church (MEC) for a number of years. Once they decided to make a clean break, they teetered over joining forces with the AME Church, headed by Allen, but formed their own order, AME Zion or AMEZ, instead.

James Varick assumed leadership around 1820 and became sanctioned by the general Methodist Episcopal Church in 1822. They didn't completely break from the MEC until 1824, however. High-profile abolitionist members such as Frederick Douglass, Harriet Tubman, and Sojourner Truth earned the AMEZ Church the label "the Freedom Church."

# The Black church in the antebellum South

Black people found worshiping in the South more precarious. Southern laws generally prohibited literacy, which was practically synonymous with religious instruction. Even before the increase in the religious conversion of the enslaved, laws prevented enslaved people from gathering in large numbers. As the Christian conversion became more common among the enslaved, some Southern states prohibited Black people from ministering to each other and punished such acts with whippings, among other things.

As a result, many Black preachers conducted ministries in secret. Meeting in the woods, Black people weren't just free to worship but, more importantly, were able to worship freely. Those who could read the Bible didn't have to hide that fact in these gatherings. Even the most learned, however, kept the gospel simple to appeal to everyone. One of Christianity's biggest draws for those enslaved was the reaffirmation of their humanity.

Threats of violent consequences didn't deter preachers who maintained that if Jesus died on the cross for their sins, they could withstand beatings for ministering God's word. Surprisingly, however, many slaveholders didn't object to their holding worship services as long as it didn't interfere with their work. During times of rebellion or on suspicion of insurrection, slaveholders were more restrictive. Perhaps some slaveholders acquiesced to separate worship services because proving that the Bible sanctioned Black enslavement was a cornerstone of early conversion efforts, particularly in the South. Nonetheless, some scholars refer to these meetings, secret and open, as the *invisible church.*

Not all early Black churches in the South were unorganized, however. Pockets of the South such as Richmond, Virginia; Charleston, South Carolina; and New Orleans, Louisiana, had free Black communities that established churches that drew Black people who were both enslaved and free. Baptists and Methodists were the predominant denominations of Southern Black people, mostly because of the

Great Awakenings (refer to the earlier section "The Great Awakenings: Called to convert"). The South had an estimated 468,000 Black church members in 1859.

## Baptist churches in the South

The earliest known Black churches in the South were largely Baptist. In the midst of enslavement, there were still Black churches (such as the African Huntsville Church in Alabama and the Rose Hill Church in Natchez, Mississippi) that white religious orders recognized. Churches such as the Grand Gulf Church in Mississippi and Mount Lebanon Church in Louisiana, though technically integrated, had relatively few white members. Border states such as Kentucky also boasted independent Black churches prior to the Civil War.

These churches weren't necessarily white-controlled either. Sir Charles Lyell, in his book *A Second Visit to the United States of North America*, marveled at the First African [Baptist] Church of Savannah in 1846. Noting that he was the only white man out of about 600 Black people, Lyell commented favorably not just on the excellent singing; the preaching also impressed him. He wrote that the minister, Andrew Cox Marshall, preached his sermon "without notes, in good style and for the most part in good English." Lyell also felt Marshall's preaching style was very imaginative and held the congregation's attention. Lyell concluded that his experience at First African marked "an astonishing step in civilization."

**BLACK AMERICAN FACES**

# GOWAN PAMPHLET

Gowan Pamphlet, the property of a female tavern owner, began preaching in Williamsburg, Virginia, in the 1770s. Undeterred by the local Baptist organization's decision that "no person of color should be allowed to preach," Pamphlet persisted and negotiated with her to get time away to attend to his ministry. By 1781, his congregation was possibly as large as 200.

When Pamphlet's owner relocated her business, he didn't abandon his ministry. With a new slaveowner, he returned to Williamsburg In 1791. Confident in his congregation of about 500 and faithful that he could evade the law prohibiting the enslaved from preaching, Pamphlet applied to the Dover Baptist Association for official recognition and received it after a two-year inspection period.

During the antebellum period, after Pamphlet was long gone, his church weathered many storms, including being shut down for a year due to Nat Turner's Rebellion. In 1843, decades after Pamphlet's death, forced reorganization subordinated the church's Black pastors, but Black leadership resumed after the Civil War. A testament to Pamphlet's legacy, First Baptist Church, which preceded white Baptist churches in Williamsburg, is still standing.

## The Methodist Church in the South

While the AME church grew very slowly in the South, there were AME churches in Baltimore, Maryland; Charleston, South Carolina; and New Orleans, Louisiana. Through the efforts of Daniel Coker, Black Methodists in Maryland, a critical border state during the Civil War, were among the original AME founders in 1816. Morris Brown led the African Church of Charleston until local authorities uncovered Denmark Vesey's plots for rebellion (see Chapter 4). Barely escaping death, Brown made it north, but Black Methodism didn't return to Charleston until after the Civil War.

New Orleans, well-known for its large Black Catholic population, had four Black Methodist churches, three led by enslaved preachers supervised by white ministers, before the Civil War. The exception was St. James AME, led by Charles Doughty. In Missouri, two free Black men led Black Methodists there.

White Methodists, however, usually ministered to Black Methodists, largely enslaved, in the South, a curiosity because Methodism's founder, John Wesley, opposed slavery. Such ministries, however, were directly born out of early attempts to convert the enslaved. During the early 1800s, the Methodist Episcopal Church (MEC) softened its stance on slavery. Interestingly, its ministry to the enslaved accounted for a significant portion of the church's growth in the 19th century.

**TECHNICAL STUFF**

Even with a softened stance on slavery, it was generally unacceptable for Methodist clergy to enslave others. When Rev. James Osgood Andrew in Georgia inherited an enslaved woman in 1840, conflict erupted, but he wasn't expelled. When Andrew later married a woman who was also a slaveholder, he had a choice to either free those enslaved or leave the church, which created a rift among Methodists. In 1844, Southern Methodists broke away and formed the Methodist Episcopal Church, South. Up until the Civil War, the Black Methodist population, largely enslaved, continued to grow.

# Post–Civil War and Reconstruction

After gaining freedom at the Civil War's end, Black Southerners wanted to seize control over their own spiritual needs, and Black churches of all denominations flourished in the postwar South. Both the AME and AMEZ church made considerable inroads outside the Northeast.

New denominations that emerged included the Colored Methodist Episcopal Church (renamed the Christian Methodist Episcopal Church in the 1950s) when, with the blessings of their white Methodist counterparts, 41 men gathered in Jackson, Tennessee in December 1870 to form the church. At least three-fourths

of the South's estimated 200,000 Black Methodists joined the CME, taking $1.5 million in buildings and properties with them.

As more Baptist churches emerged, they began to assert their racial heritage more. They also began forming more-complex Black-led Baptist organizations. Prior to the Civil War, Black Baptists in the North had already attempted to form greater affiliations. On the brink of Civil War, Black Baptists in Illinois and Ohio were among the first to form successful all-Black Baptist organizations on a larger scale. Nearly 2 million formerly enslaved people helped bolster the Baptist membership rolls, further increasing the need to organize.

Of the many organizations that emerged, the National Baptist Convention, U.S.A. (formed in 1895 at Friendship Baptist Church in Atlanta), is one of the most significant. Although several Baptist organizations merged to create the National Baptist Convention, U.S.A., key splits in 1915 and 1961 splintered the organization into the National Baptist Convention of America and the Progressive National Baptist Convention, whose original membership included Reverend Dr. Martin Luther King Jr. In 1988, the National Missionary Baptist Convention also joined those ranks. Disputes involving publishing concerns were the reason for some of the splits, but differing opinions regarding the Black church's role in the civil rights movement were also at play (read more in the section, "Politics and the Church," later in this chapter.).

## Worship in the early 20th century

In the 20th century, the biggest shift for Black Christians became the advent of the Church of God in Christ (COGIC). Emerging around the turn of the 20th century, the Church of God in Christ, a Pentecostal offshoot, mainly traces its roots back to Rev. Charles Harrison Mason. After being expelled from one Baptist college and dropping out of another, Mason found kindred spirits in Arkansas minister J.A. Jeter and Mississippi ministers Charles Price Jones and W.S. Pleasant.

Relieved of his duties at a Baptist church in Arkansas over his beliefs in sanctification, Mason, along with his newfound colleagues, hosted a revival for Black Baptists in Jackson, Mississippi in 1896. Filled with the spirit, the revival, while a success, alienated even more-traditional Black Baptists, who considered Mason and his cohorts' behavior extreme.

According to Mason, he and his group "only wanted to exalt Jesus and put down man-made traditions." When the local Baptist association ostracized Mason and Jones for their adherence to the doctrine of sanctification, they felt they had no choice but to create something new. In 1897, Mason, who claimed that the name came to him as he walked down a street in Little Rock, Arkansas, birthed COGIC. His journey, however, wasn't complete.

# WILLIAM JOSEPH SEYMOUR

An important catalyst to the global Pentecostal movement and considered by some the father of Pentecostalism, William Joseph Seymour was born to formerly enslaved parents in Louisiana. As a child, Seymour, who was raised Baptist, had visions. His holiness teachings began when he relocated to Cincinnati, Ohio in 1901 and joined the "reformation" Church of God. Around 1903, he joined a Houston church pastored by Lucy Farrow, a Black woman, who connected him with white evangelist Charles Fox Parham, whose students spoke in tongues.

With the aid of Farrow and Parham, Seymour relocated to Los Angeles and eventually found a home for his Pentecostal message. To accommodate the large number of people drawn to him and his teachings, he held services in a warehouse on Azusa Street. His main message was one of "love, faith, and unity," but Los Angeles newspapers concentrated more on the congregation's practice of speaking in tongues. Negative press actually drew more people to Seymour's Azusa Street Revival, which peaked between 1906 and 1909.

Although Seymour inspired many, including COGIC founder Charles Harrison Mason, his movement collapsed. Some attribute Seymour's failure to a jealous female member taking his mailing list. Others believe his rift with his white Chicago leader William Howard Durham diluted his movement's white membership. Regardless, Seymour, who died in 1922, made great contributions to the modern Pentecostal movement.

Looking for an even more meaningful and complete experience, Mason later changed COGIC's direction after encountering Pentecostal pioneer William Joseph Seymour (see the nearby sidebar). In line with the Holiness Movement, which focused on restoring the personal holiness and connection originally taught by John Wesley, COGIC began placing special emphasis on the resurrection of Christ. COGIC followers believe in the Trinity. They believe that God grants repentance and salvation to all Christian believers who ask for it. In addition, they're known to speak in tongues; as a result, their services are usually spirited. Although they believe in divine healing, they don't eschew modern medical services. Jeter and Jones rejected Mason's Pentecostal message, and the three men split.

COGIC continued to grow, especially as Black people migrated to the cities, largely because Mason sent evangelists to urban centers such as Detroit and Chicago to help migrants, who responded to the more fervent style of worship many of them knew from their rural communities. So although COGIC, headquartered in Memphis, began as a more rural religion, by the time Mason died in 1961, its membership was largely urban.

# The modern era: Megachurches

At the close of the 20th century and start of the 21st, megachurches helmed by Black pastors became increasingly visible. Even as overall church membership or the number of smaller-sized churches dipped in the Black community, charismatic Black religious leaders began attracting large flocks ranging from 5,000 to 20,000 members and more. Schools, childcare, and banking are a few of the services Black megachurches offer.

In her book *The Black Megachurch: Theology, Gender, and the Politics of Public Engagement* (Baylor University Press), professor Tamelyn Tucker-Worgs observes that "like the storefront churches of the early twentieth century fulfilled the socioreligious needs of black migrants from the South, black megachurches fulfill the needs of the new black middle-class suburbanites." Tucker-Worgs notes that the circumstances, and thus the needs, of modern Black churchgoers differ from many decades before. Modernity, along with prosperity, became important.

Few have arguably adapted to this new reality better than T.D. Jakes, who leads Potter's House in Dallas. Jakes found initial success in his native West Virginia through his "Woman, Thou Art Loosed" mission reclaiming Black survivors of sexual abuse. Black ministers like Jakes are also televangelists who have built multimedia empires by creating successful YouTube channels, producing large events, publishing books, and even producing films as Jakes has done with the big screen version of *Woman Thou Art Loosed*, starring Kimberly Elise, and *Not Easily Broken* with Taraji P. Henson and Morris Chestnut. This exposure has made many of these churches even global. OWN (Oprah Winfrey Network) captured this phenomenon with its groundbreaking megachurch drama *Greenleaf*, which premiered June 21, 2016, and ran for five seasons, ending in 2020.

As megachurches boomed, Black believers also began joining multiracial congregations. Black pastors also welcomed non-Black believers, particularly Hispanic or Latinx, to their congregations. White pastors such as Joel Osteen and Paula White attracted large numbers of Black believers in the early 2000s. During Donald Trump's presidency, Paula White, who served as one of Trump's spiritual advisers, lost her appeal. Though there were rumors of Osteen having an affiliation with the 45th president, known for his divisive racial politics, the Houston-based pastor, unlike White, never officially supported him. Multiracial megachurches, as well as white ministers, began to lose some of their appeal during Black Lives Matter for being slow to condemn police killings and racial injustice.

# A MUSICAL FOUNDATION

Music led to another major turning point in the church during the 20th century. After the Civil War, many outside the Black community learned of spirituals. Most churches rejected secular music genres such as blues and jazz, even though spirituals had contributed greatly to their creation. Still, the church wasn't unaffected by the rise of Black secular music. During the 1930s, Thomas Andrew Dorsey, a former blues piano player, began mingling the blues with sacred music. Eventually that resulted in gospel music, which injected more instrumentation and individuality into Black church music. It's noteworthy that Pentecostal/Holiness churches often had full bands that included drums and other instruments, a huge contrast to the organ-based music of many Northern churches. In this way, music was one of the main ways COGIC and other Pentecostal/Holiness churches distinguished themselves from more traditional Black churches.

By the 1950s, gospel music, thanks in large part to Sister Rosetta Tharpe and Mahalia Jackson, was a widely known byproduct of the Black church. Gospel singers such as Sam Cooke brought greater attention to the music of the Black church. During civil rights marches and other protest efforts, songs of the church were commonplace. Music was and is an important component of the Black church.

The rise of "prosperity gospel," as practiced by Osteen and Atlanta-based Black pastor Creflo Dollar, noted for his jet and other trappings of wealth not uncommon to megachurch ministers, seemed to wane as mass protests against racial injustice and police killings erupted and the COVID-19 pandemic dragged on in 2020. Megachurches (especially those with large digital outreach capabilities) that sprang into action to feed the hungry, offer free COVID-19 testing, pay the bills of the needy, and speak up for racial equity fared better.

## The changing role of women

Following the civil rights and Black Power movements, not to mention the advent of a stronger feminist movement, reconciling the role of women in the church became a major issue. Historically, Black women had assumed key leadership roles. Born enslaved in 1797, Sojourner Truth is one of the earliest known Black preachers. In 1819, Richard Allen authorized Jarena Lee to preach eight years after her initial request. Lee, however, found it difficult to sustain a ministry and became an itinerant preacher. Rebecca Cox Jackson, who had a significant Black female following, led her own community of Shakers (a female-founded religious order).

In the 20th century, however, sexism kept Black women out of the pulpit. Black men generally viewed the church as one of the few arenas where they could exert power. Quietly, however, Black women ran everything from church-based schools to church fundraisers. This was particularly evident during the civil rights era. When many ministers tried to close the church's doors to civil rights workers, Black female church leaders opened them.

During the 1970s, more Black women began seeking official leadership roles, particularly in the pulpit traditionally reserved for men. Prior to this push, a few Black women held leadership roles, exceptions that didn't all date back to the 19th century. Ordained in the 1950s, Reverend Dr. Johnnie Coleman, for example, the founding minister of Christ Universal Temple in Chicago, led a megachurch during a time when the highest leadership positions available to most Black women included church secretary and the title of first lady as the minister's wife.

In recent years, Black women such as Dr. Vashti Murphy McKenzie, the AME Church's first female bishop, have made additional strides. Congregations led by husband-and-wife spiritual teams became more common, however. Some high-profile ministers do acknowledge their wives as spiritual leaders. Creflo Dollar of World Changers Church International in Atlanta has been credited with doing so with his wife Taffi Dollar. Prior to their divorce, co-pastors June Robinson and Kenneth O. Robinson led Restoring Life International Church in Maryland from 1991 to 2011.

Though the role of minister remained largely male in many Black churches even as women dominated their congregations, the numbers of women pursuing the ministry increased. From 1988 to 1998, the Association of Theological Schools reported that Black women graduates of their affiliated schools tripled. That growth more than doubled by 2018. Black women have taken increasingly proactive roles to usher other Black women into the pulpit. WomenPreach! Inc. from Reverend Valerie Bridgeman, dean of the Methodist Theological School in Ohio, offers a Jarena Lee Preaching Academy. At the end of 2019, Reverend Dr. Jacqueline Thompson took the helm of Oakland's historic Allen Temple Baptist Church, one of the oldest Black churches in California, to become the first woman pastor in its 100-year history and just its ninth pastor.

# Politics and the Church

The Black church is no stranger to politics. Even before its formal inception, politics dominated the Black church. From debates regarding whether to convert enslaved Black Americans to the role the Black church played in eliminating slavery, building schools, and supplying the civil rights movement with its army,

religion has been a powerful political force in the lives of Black people — so much so that some Black religious leaders have assumed national positions of power outside the church.

## Getting more political

During the mid-1950s and 1960s, Black churches actively battled Jim Crow. White supremacists burned countless churches in recognition of the power that the Black church wielded among Black Americans. More conservative Black church leaders, especially those whom local white politicians controlled, didn't embrace the civil rights movement, but the Reverend Dr. Martin Luther King Jr. became a leading national figure (see Chapters 8–10). During the 1970s and 1980s, Black churches became more active in the political process, mainly through voter registration drives, to help elect Black politicians and others.

On the heels of the Black Power movement, younger Black people began to view the Black church as a place where Black people, as Malcolm X consistently charged, worshiped the "white man's god" and followed "the white man's religion." Countering that charge, some churches embraced Black Power. James H. Cone termed this new philosophy *Black liberation theology* (refer to the earlier section "Christianity, Black American style"). Potential members, in other cases, embraced alternative religious organizations such as the Nation of Islam.

## Minister-politicians: Pulling double duty

Some ministers directly mixed formal politics with the pulpit. Ordained AME minister Hiram Revels, who ironically replaced Jefferson Davis, the Confederate president, became the first Black American member in the Senate during Reconstruction. Powerful U.S. congressman Adam Clayton Powell Jr., pastor of New York's legendary Abyssinian Baptist Church, was arguably the most prominently active minister-politician on the national level.

**BLACK AMERICAN FACES**

Using the power of Abyssinian, Powell became a prominent civil rights leader during the Great Depression. Through mass meetings, rent strikes, and public campaigns, Powell forced companies and utilities, including Harlem Hospital, to hire or promote Black employees. In 1941, he became New York City's first Black councilman and then, in 1945, he began service as New York's first Black congressman in the House of Representatives. Congress attempted to remove Powell, who had served on several important committees, in 1967 on charges of misappropriating funds for personal use. Charles Rangel defeated Powell in the election of 1970.

## JESSE JACKSON AND AL SHARPTON

One of the chief beneficiaries of the King legacy, Reverend Jesse Jackson made two credible runs for the presidency of the United States using a Christian foundation as his base. A proponent of economic rights, Jackson has led many successful boycotts as well as advocated that Black Americans cultivate wealth, mainly through Wall Street. Active internationally, Jackson has successfully negotiated the release of American prisoners and hostages from hotspots around the world (read more about Jackson in Chapter 10).

Reverend Al Sharpton, who acknowledges Jackson as a mentor, has created a career similar to Jackson's. Ordained at age 10, Sharpton served as youth director of Jackson's Operation Breadbasket as a teenager and founded the National Youth Movement. Through the National Action Network, founded in 1991, Sharpton has expanded his political and social activism. Yet his support in 1987 of Tawana Brawley, a New York teen whose claim of rape by several white men was ruled unfounded, damaged his credibility in many circles. Sharpton, often ridiculed for the signature processed hairstyle he wears to honor music legend James Brown (for whom he once worked), has failed to win his bids for a U.S. Senate seat, New York City mayor, and the U.S. presidency. Sharpton, however, became even more viable through political media with his radio show, *Keepin' It Real,* and the MSNBC show *Politics Nation with Al Sharpton.*

On the national level, former congressman Floyd Flake, of the influential Greater Allen A.M.E. Cathedral of New York in Jamaica, Queens, in New York City, has been the most prominent Black minister to serve in the federal government in recent years. Reverend Raphael Warnock, the longtime pastor of Martin Luther King Jr.'s family church, Ebenezer Baptist Church, in Atlanta, attracted national attention when he won a U.S. Senate seat in Georgia in a January 2021 runoff. Reverends Jesse Jackson and Al Sharpton have both unsuccessfully sought the presidency of the United States (see the nearby sidebar).

## Fighting for civil rights: Minister-activists

The majority of Black ministers have been active on the issue of civil rights and equality without ever holding or seeking an elective office. The Reverend Dr. Martin Luther King Jr., for example, brought national and international attention to the prominent role the Black church played in politics and issues of moral righteousness. Far from the first Christian minister to involve his congregation in the fight for civil rights, King is still considered the most successful one to date. Through the Southern Christian Leadership Conference (SCLC), King and his colleagues spurred other ministers to greater political action.

Thirty-three delegates, including King, representing 14 states formed the Progressive National Baptist Convention (PNBC) in 1961. The PNBC gladly supported the efforts of the NAACP Legal Defense Fund, the March on Washington for Jobs and Freedom, the Civil Rights Act of 1964, and the Voting Rights Act of 1965. True to the one-time tagline "A people of faith and action," the PNBC continues to uphold an activist tradition.

## Continuing the struggle

The Black church remains the single most influential institution in the Black community, and that power hasn't gone unnoticed in the battle to address many issues critical to Black Americans. In recent years, the Black church, despite being absent early, has become effective in the ongoing battle against HIV/AIDS. Black churches have also become health and wellness advocates for healthy eating and exercise in the fight against diabetes, high blood pressure, and other diseases that disproportionately impact Black Americans. During the COVID-19 pandemic, Black churches like Philadelphia's Enon Tabernacle Baptist Church pivoted to digital church services, amplified their food drive initiatives, and stepped up to become testing sites.

Politically, some religious leaders denounced the complacency that set in with many Black churches in the late 1970s and throughout the 1980s and 1990s, encouraging them to return to more activist stances. Pastor Jamal Harrison Bryant and his New Birth Missionary Baptist Church congregation, in partnership with rapper/actor T.I. and VH1 reality personality Scrapp Deleon, made headlines in 2019 for posting bail for nonviolent offenders in the Atlanta metro area. Named for the Virginia-born pastor who was a mentor and friend to the Reverend Dr. Martin Luther King Jr., the Samuel DeWitt Proctor Conference, founded in 2003, is composed of a cross-section of progressive Black faith leaders and their congregations, whose action items prominently address mass incarceration.

As the Black Lives Matter movement (read more about it in Chapter 11) gained steam in the 2010s, religious leaders like Reverend Dr. William Barber, co-chair of King's resurrected Poor People's Campaign, became more visible to the mainstream. On the heels of the police killings of Eric Garner in New York City; Michael Brown in Ferguson, Missouri; and Tamir Rice in Cleveland, Ohio, esteemed Bishop John R. Bryant suggested churches hold National Black Solidarity Sunday, which took place December 14, 2014. Members wore all black as pastors incorporated messages on systemic racism and peaceful protesting into their sermons.

During Donald J. Trump's presidency, several Black pastors, including Dale Bronner of Word of Faith Family Worship Cathedral in Atlanta; Michael E. Freeman of Spirit of Faith Christian Center in Prince George's County, Maryland; and John Gray of Relentless Church in Greenville, South Carolina, drew widespread

criticism in the Black community for meeting with the nation's 45th president. Prior to becoming president, Trump had been an outspoken leader of the Birther Movement, questioning whether President Barack Obama was born in the United States to undermine his leadership.

# Worshiping Outside the Black Christian Mainstream

Although Baptists, Methodists, and Pentecostals dominate the Black American religious experience, Black people have considerable roots outside the Black Christian mainstream. While the Black religious net is wide, Muslims, Catholics, Jehovah's Witnesses, and Seventh-day Adventists constitute the majority of those outside the Black Christian mainstream. Religious leaders, considered demagogues, have also played major roles in the Black community, especially in the 20th century.

## Muslims and the Nation of Islam

Muslims made tremendous inroads into Africa prior to the transatlantic slave trade and made up as much as 20 percent of the enslaved population of some plantations. Yet large numbers of the African Islam influence didn't survive that period. In the 20th century, however, universally recognized Islamic traditions haven't attracted as much media attention as prototypical Islamic organizations such as the Moorish Science Temple and the Nation of Islam (NOI), which emphasized Black nationalism despite the fact that Islam doesn't generally make racial distinctions.

### The Moorish Science Temple

Founded in Newark, New Jersey, in 1913 by the Prophet Noble Drew Ali (born Timothy Drew), the Moorish Science Temple began as the Canaanite Temple and contended that Black Americans were of Asiatic descent and thus were originally Islamic. Ali, who relocated his movement to Chicago in 1925, admired Marcus Garvey and considered him a prophet (refer to Chapter 7). Like Garvey, Ali supported Black Power but insisted on referring to Black people as "Moorish Americans." Trademarks of the Moorish Science Temple include fezzes, turbans, membership cards, the star and crescent, and adding an "El" or "Bey" to one's surname. Its main teachings come from the *Holy Koran of the Moorish Science Temple of America.*

# The Nation of Islam

The Nation of Islam (NOI) is perhaps the most well-known alternative to the traditional Black church in the Black community. Influenced by Noble Drew Ali and Marcus Garvey, Wallace D. Fard infused the Allah Temple of Islam, a precursor to the NOI that he founded in 1930, with elements of Black nationalism, Islam, and Christianity. The NOI is focused on community development and leaders speak out on white supremacy unlike traditional Islam.

Working in various professions such as door-to-door salesman and a street vendor in Detroit, Fard attracted several thousand followers. Black separatism was at the core of Fard's teaching, and so was the belief that white people were inherently evil. Elijah Muhammad, born Elijah Poole in Georgia, discovered Fard's teachings in Detroit and seized control of the NOI in Chicago. Muhammad's many improvements included the introduction of the newspaper *The Final Call to Islam* in 1934 (which evolved into *Muhammad Speaks* in the 1960s and later as *The Final Call*). Muhammad also created an NOI school. Under Muhammad's leadership, the NOI's strict moral code against drinking, smoking, and premarital and extramarital sex provided well-received discipline to the many formerly incarcerated people that the organization targeted for membership.

The NOI's most legendary member was Malcolm X (whom you can read about in Chapter 9). After his departure and murder, the NOI lost its momentum. Muhammad's death in 1975, divided the organization into two factions; an estimated 100,000 members followed Muhammad's son, Imam Warith Deen Muhammad, later Warith Deen Mohammed, who favored Islam in its more traditional form. Displeased with Warith Deen Mohammed's vision, Louis Farrakhan assumed leadership of the NOI in 1978, but reportedly restored the organization closer to its original form in 1981, emphasizing the organization's Black separatist tradition.

A controversial leader, Farrakhan, despite frequent accusations of anti-Semitism, is highly regarded among many Black Americans, even those who find it difficult to accept the NOI's philosophical beliefs, primarily because of his willingness to challenge white authority. Others respect the NOI's policing of tough, urban areas and its continued outreach to people who have served time in prison. The hip-hop community, especially in its early years, embraced the NOI's aggressive efforts to fight urban decay. For many Black Americans, 1995's Million Man March remains Farrakhan's crowning achievement.

It can't go unnoted that most Black Muslims don't belong to the NOI. Significant numbers of ex-NOI members even belong to more traditional Islamic organizations, yet the NOI tends to garner more mainstream media attention.

# Black Catholics

The United States has approximately 3 million Black Catholics according to demographics from the U.S. Conference of Catholic Bishops. Interestingly, however, Black Catholics — with their early presence in areas such as St. Augustine (Florida), Los Angeles, Chicago, and Baltimore — predate the formation of the United States. Following the Louisiana Purchase in 1803, New Orleans became the predominant Black Catholic haven. New Orleans, along with pockets of Mobile, Alabama, where the religion is more closely associated with Creoles or mixed-race Black Americans, has retained strong Catholic identities over the years.

The Black Catholic population in the U.S. increased significantly after the Civil War. Similar to other Christian religions, white Catholics also discriminated against Black people. Patrick Francis Healy (see the nearby sidebar) and his brother James Augustine Healy succeeded in the Jesuit order, but because they were light-skinned, their race was unknown. Father Augustus Tolton, who was born enslaved in Missouri, was ordained in Rome in 1886. He led several congregations in Illinois before making his mark as the founding father of Black Catholics in Chicago with St. Monica's, the city's first Black Catholic church.

Boosting Black Catholicism, Daniel Rudd, born enslaved to Catholic parents, founded *The American Catholic Tribune,* the first national Catholic newspaper owned and operated by a Black man. He also spearheaded the National Black Catholic Congress, the first mass meeting of Black Catholics, in 1889. For reasons unknown, the group stopped meeting in 1894, but resumed activities in 1987, many decades after Rudd's death in 1933. Over the years, other Black Catholic organizations have included the Federated Colored Catholics, the National Office of Black Catholics, and the National Black Catholic Clergy Caucus.

**BLACK AMERICAN FACES**

## PATRICK FRANCIS HEALY

Born in Macon, Georgia, to a white Irish-American father and a mixed-race enslaved mother, Patrick Francis Healy, along with his siblings, attended a Jesuit school in the North to escape the South's racial limitations. When discovery of Patrick Francis Healy's race threatened to disrupt his studies, his father sent him to a university in Belgium, where he received his Ph.D. Ordained as a priest in 1864, Healy returned to the United States in 1866, and began teaching philosophy at Georgetown University, where he eventually became president. Often referred to as Georgetown's "second founder," he's buried on university grounds, and Healy Hall was named for him. His brother James Augustine Healy became bishop of Portland, Maine. Some additional Healy siblings served as priests and nuns.

Historically, stellar secondary educational institutions, especially in urban centers, were a gateway for Catholics into Black communities. Mother Katharine Drexel, a white heiress, was instrumental in increasing the Black and indigenous Catholic population by building schools and parishes for them. Actions from other white Catholics like North Carolina Bishop Vincent Waters to integrate Catholic schools in 1953, prior to the *Brown v. Board of Education* Supreme Court decision the next year, sowed goodwill among some Black people. In later years, in Chicago, the dominant Irish-Catholic political structure also contributed significantly to the rise in the Black Catholic population, manifested particularly in several historic Black Catholic elementary and high schools. New York's and Miami's large Haitian populations and growing Afro-Latinx populations typically brought a long-standing Catholic tradition with them. New Orleans, where Xavier University is still the nation's only Black Catholic university, remains a Black Catholic stronghold.

On the leadership level, Archbishop Wilton D. Gregory, the first Black American to head the U.S. Conference of Catholic Bishops (2001–2004), was a leading voice during the Catholic Church's sex abuse scandal. Many credit him for restoring faith in the Catholic Church in general by quickly denouncing priests guilty of child molestation. Gregory's historic position also reinforced the Catholic Church's commitment to serve all its members. On November 28, 2020, Gregory made history again as the Catholic Church's first Black American Cardinal.

## Jehovah's Witnesses

Jehovah's Witnesses trace their origins back to the Bible Students, a group organized by Charles T. Russell in the 1870s. Once influenced by Nelson H. Barbour's predictions that Christ would visibly return to earth, Russell broke from Barbour in 1879 over substitutionary atonement, the belief that Jesus died for all people's sins. In 1881, Russell established the Watch Tower Bible and Tract Society in Pennsylvania. He also founded the International Bible Students Association in the United Kingdom.

Followers adopted 1914 as the beginning of Christ's presence (albeit invisibly) on earth and his enthronement as king, thus kicking off "the last days." By 1922, the organization, believing that God selected them as his people, began to emphasize preaching house to house. Although they began calling themselves Jehovah's Witnesses in 1931, the organization thrived after Nathan Horner Knorr took over in 1942. During his leadership, membership rose from just over 100,000 to more than 2 million in 1975. That number was more than 6.6 million worldwide in 2005.

According to the Pew Research Center, Jehovah's Witnesses are extremely diverse, with 27 percent of its membership being Black and 6 percent multiracial in 2016. Although Jehovah's Witnesses believe all humans are God's children and don't

track race in their religion, critics have noted that its core leadership remained largely white throughout much of the 20th century. Some even point to racially insensitive references to Black people found in issues of *Watchtower*, its main publication, throughout the early 20th century.

Traditionally Jehovah's Witnesses have dressed very moderately and abstained from many popular activities. They don't celebrate holidays or birthdays, don't believe in whole-blood transfusions, and typically oppose political involvement. Well-known Black Americans who grew up as Jehovah's Witnesses include the Jackson and Wayans families, Serena and Venus Williams, and singer Jill Scott. Global music icon Prince, who grew up Seventh-day Adventist, was a practicing Jehovah's Witness at the time of his unexpected death in 2016.

## Seventh-day Adventists

Less restrictive than Jehovah's Witnesses, Seventh-day Adventists trace their roots back to followers of the Baptist lay leader William Miller of the early 19th century, who believed that the Bible contained coded language regarding the end of the world and the second coming of Jesus. Miller is credited for inspiring the Second Great Awakening (refer to the earlier section "The Great Awakenings: Called to convert" for details on how this event contributed to the early Christian conversion of Black Americans). Black Seventh-day Adventists constitute around 27 percent of the estimated 14 million members worldwide. Alabama's Oakwood College, alma mater to Al Jarreau, Take 6, and Brian McKnight, who all grew up in the faith, is a predominantly Black Seventh-day Adventist institution.

Seventh-day Adventists celebrate the Sabbath on Saturday. They also believe in higher education and have a special concern for health issues. Religious tenets such as original sin and the resurrection of Christ are in line with conservative Christian beliefs. While Seventh-day Adventists contend that Christ's return is imminent, they don't necessarily believe in spiritual immortality.

## Black demagogues

Father Divine, Sweet Daddy Grace, and Reverend Ike are three of the most well-known Black demagogues, with all three of these religious leaders boasting considerable numbers of followers that include Blacks and white people:

>> **Father Divine:** According to *The New York Times,* Father Divine's International Peace Mission Movement had 50,000 members in the 1930s. Father Divine, who claimed himself as God, had an admirable social agenda that fought lynching and opposed school segregation. He also didn't believe in racial segregation. After his death in 1965, his second wife and widow, who was

white and nearly 50 years his junior, carried on his movement (which, interestingly, forbade sex) until her death in 2017. When Jim Jones, proclaiming himself a follower of Father Divine, led a mass suicide in Guyana in 1974 that claimed 914 lives, remaining momentum for the movement dramatically slowed. The 2017 documentary *Father's Kingdom* details the movement and its remnants.

» **Sweet Daddy Grace:** Born in Brava, Cape Verde Islands, Charles "Sweet Daddy" Grace immigrated to the United States in the early 1900s. He built his United Houses of Prayer for All People in Massachusetts, North Carolina, Washington, D.C., and Egypt. Unlike Father Divine, Sweet Daddy Grace used the Bible as his main text. A flamboyant dresser frequently accused of exploiting poor people, Grace and his followers performed ample community service and modeled Black economic self-sufficiency. Although Grace died in 1960, the United House of Prayer, which celebrated its centennial in 2019, continues to boast millions of members.

» **Reverend Ike:** A pioneer of "the gospel of prosperity," Dr. Frederick Eikerenkoetter, or Reverend Ike, peaked in the 1970s when some 1,700 television and radio stations broadcasted his message from his Christ Community United Church in New York City. Once quoted as saying, "The lack of money is the root of all evil," a less flamboyant Reverend Ike later stressed "Thinkonomics," encouraging followers to reject thoughts of limitation and lack to create abundance, a message consistent with many popular New Age teachings against scarcity. Well into the later years of his life, Reverend Ike continued operating a mail campaign and website. Upon his passing in 2009, his son, Xavier, continued his legacy.

education

» **Moving up to higher education**

» **Recognizing the impact of Historically Black Colleges and Universities (HBCUs)**

» **Examining the uniqueness of the Black Greek system**

# Chapter **13**

# More Than Reading and Writing: Education

Perhaps no other group of Americans has had its access to education blocked more than Black people. During the period of slavery learning to read and write was punishable by beatings, fines, and even death. Yet Black Americans persevered, eventually building formidable educational institutions of their own as well as excelling in the country's most prestigious schools.

Triumph over Jim Crow and its grossly underfunded and under-resourced schools in the early 20th century (see Chapter 7) didn't end education-related struggles; busing and affirmative action addressed new challenges. This chapter walks you through key periods and events in the history of both early and higher education for Black Americans. It also examines some important education-related institutions — Historically Black Colleges and Universities (HBCUs), the Black Greek system, and the United Negro College Fund (UNCF) — that have had pivotal roles in the progression of Black American education.

# A Brief History of Early Black American Education

Slave narratives, which were critical to rallying antislavery supporters, showed how much Black Americans had to gain from literacy. Prior to the Civil War, the majority of Black Americans were illiterate. With few exceptions, there was largely no formal educational system in place to educate Black Americans. Those who could read at all were largely independently taught. The benefit of education for Black Americans was clear.

After the Civil War, due to the efforts of Black Americans and many Northerners, education was made more accessible to Black Americans, but educational resources weren't. Plus, students and teachers alike continued to face harassment and fines. Making matters worse was the Supreme Court ruling in *Plessy v. Ferguson* (1896), which said that separate facilities for Black and white Americans were acceptable as long as they were equal. In many Southern states, however, "equal" was simply having a building available to Black Americans, not resources. (Refer to Chapter 7 for details on the *Plessy* decision.)

## Revolting education

Like enslaved Africans, many slaveholders equated education with empowerment. For them, illiteracy was essential to keeping the slave system intact because enslaved people who became literate were more likely to run away. The line of thinking was that enslaved people who knew how to read and write could forge the papers that free Black people were required to carry in some areas or could map their way to freedom, as many did.

**HISTORICAL ROOTS**

### COTTON MATHER, THE BIBLE, AND SLAVERY

As early as the 17th century, intense debate raged as to whether enslaved Black people should learn to read the Bible. Massachusetts colonist and Puritan minister Cotton Mather solved the dilemma by twisting religious instruction into a justification for enslaving Black people. Mather interpreted the Ten Commandments to give slaveholders the same respect as God. Thus, Christian conversion of the enslaved became a means of reinforcing the enslaved status of Africans, shifting the justification for enslavement from *heathenism* (not believing in Christianity) to race.

**REMEMBER**

Overwhelmingly, revolts were the most feared consequence of educating enslaved people, and when rebellions did occur, abolishing access to education was often a response. Reactions to the Stono Rebellion in Charleston in 1739, for example, included the passage of the Negro Act of 1740, which prohibited the education of all enslaved people in South Carolina. Following Nat Turner's Rebellion in 1831, Virginia passed even more legislation reinforcing punishments for Black American literacy. (To find out more about these and other significant rebellions and uprisings, go to Chapter 4.)

After the American Revolution ended in 1783, Massachusetts led many Northern states in abolishing slavery. Amid the growing chasm that formed between North and South regarding slavery, educating enslaved people quickly became one of the most highly contested issues.

## In the South

As antislavery activity intensified in the 1800s, Southern states held tightly to slavery and resurrected old laws as well as passed new ones known as the *Slave Codes* (refer to Chapter 4). Among other things, these laws increased the penalties for teaching enslaved people to read and write. The punishments reflected one's status in society:

>> **Free Black people:** Free Black people could be beaten, fined, jailed, and even enslaved.

>> **Enslaved Black people:** To deter other enslaved Black people, slaveholders severely punished those daring to educate themselves, sometimes killing them.

>> **White people:** In Georgia, in 1829, the law fined white people $500 in addition to possible imprisonment for teaching enslaved or free Black people to read. More often, in many of the Southern colonies or states, other white people ran them out of town.

Not even the threat of death quelled Black Americans' thirst for knowledge. But because of the laws prohibiting literacy, education for those enslaved was mostly unorganized and supervised:

>> **By other enslaved people in secret meetings:** Enslaved people who could read and write, even at the most rudimentary levels, were compelled to teach others. In the South, *camp meetings,* similar to secret meetings held in West Africa to discuss important issues, were held in the woods. In more urban areas, *Sabbath school* lessons were conducted in secret in a house or a church, usually on a Sunday or whenever those enslaved could steal some free time.

>> **By slaveholders:** Curiously, some enslaved people learned how to read with the help of their slaveholders, who were sometimes their fathers. Other slaveholders had experienced religious conversions and thus believed in the religious value of Black American literacy.

>> **By luck:** Sometimes by serving as companions to the slaveholders' children, enslaved people lucked out and were educated simply by being in the right place at the right time.

Frederick Douglass expressed the thirst for education in his *Narrative of the Life of Frederick Douglass, an American Slave Written by Himself* (1845) when he wrote, "These dear souls came not to Sabbath school because it was popular to do so, nor did I teach them because it was reputable to be thus engaged. Every moment they spent in that school, they were liable to be taken up, and given thirty-nine lashes. They came because they wished to learn."

Underground schooling ruled much of the South, with churches often shouldering that responsibility. But even churches weren't safe. When a Richmond newspaper commented on Black children carrying books on Sundays, local law enforcement raided the church. Laws restricting education for Black Americans persisted in the South, even after the Civil War.

Just because free Black people couldn't legally attend schools in the South didn't mean they didn't pay for them. For example, free Black people in Baltimore (then considered a solid part of the South) were forced to pay taxes for schools they weren't allowed to attend.

## In the North

Leading up to the Civil War, educational opportunities for free Black people improved considerably in the North. In 1758, the Anglican-affiliated Associates of Dr. Bray opened a school for free Black people in Philadelphia. By 1770, Frenchman Anthony Benezet, a teacher who educated enslaved children in his home, had established the Negro School of Philadelphia with his Quaker peers. In addition to private education efforts, public education for Black Americans developed in the North, including the following:

>> **Boston:** In 1820, the city established a Black public school, and in 1855, Boston became the first school system in the country to integrate public school education.

>> **Philadelphia:** The city's first public school for Black Americans began in 1822, and by 1850, there were eight such schools.

>> **New York City:** The first Free African School opened in 1787, followed by another school in 1820, which housed 500 boys. By the early 1830s, there were four other such schools in the city, and Black Americans took full control of them in 1832 until a public school system emerged in 1834.

Even with the rise of education among free Black people, resistance continued to simmer in the North. New York, Connecticut, Rhode Island, Indiana, and Ohio began developing policies, sometimes informal, of segregated education. White taxpayers were known to object to funding public schools for Black children as well as effectively delay the construction of schools for them.

## Reconstructing: Education post–Civil War

During Reconstruction, education for Black Americans changed significantly. For the first time in American history, educating Black Americans became a national public policy issue of major concern. Prompted by secular aid societies and prominent philanthropists who later felt that only the government could handle the tremendous educational demands of the recently emancipated, the Bureau of Refugees, Freedmen, and Abandoned Lands — more popularly known as the Freedmen's Bureau — shouldered the responsibility of educating Black Americans. By 1867, the Freedmen's Bureau had opened almost 4,500 schools, many of them free. By the 1870s, an estimated 250,000 students had enrolled.

Many white Southerners weren't moved by this passion to educate Black Americans, so they burned schools intended for Black children and taunted and beat white teachers who taught Black students. As a means of maintaining a system of white supremacy, white Southerners who acquiesced to educating Black Americans often insisted upon elementary education only.

Interestingly, efforts to educate the recently emancipated helped create a nationwide public school system that also benefited poor white people. When Reconstruction ended in 1877, however, the federal government didn't become actively involved in educating Black Americans again until the Supreme Court's landmark 1954 *Brown v. Board of Education* decision that legally desegregated public schools (see Chapter 8).

**REMEMBER**

Emboldened by the end of Reconstruction and the landmark Supreme Court *Plessy v. Ferguson* decision in 1896 proclaiming that separate institutions for Black and white Americans were acceptable if they were "equal," white Southerners showed no pity when it came to educating Black Americans. A year before the *Plessy* ruling, South Carolina spent $3.11 per white pupil compared to a paltry $1.05 per Black pupil. By 1930, that gap had widened to an $52.89 per white pupil and just $5.20 per Black pupil. In addition, Black teachers received a third of the salary white

teachers received. With these realities, it's no surprise that, in 1915, there were more privately owned Black schools than county-owned ones in Georgia, for example. These schools were often funded by local churches and Black benevolent societies.

Even with great numbers of Black Americans migrating North, schools for Black Southerners were still in high demand. By the 1930s, Black school attendance equaled that of white students. Black students, however, attended school in shorter terms, mainly because of the *sharecropping* system in which families worked land they didn't own in exchange for a wage or portion of the land's crop profits; parents often needed their children's help plus the landowners, as well as government officials, kept the kids out of school.

Curiously, the Great Depression (from the late 1920s through the 1930s) increased educational opportunities for Black children. With less cotton to pick, there was more time for school. Black high school enrollment, for example, was five times greater during this period than in 1920. Lack of facilities, however, tempered much of that growth. Separate schools required funds, and with funds low due to the Depression, there simply weren't enough schools to accommodate the demand.

# 20th-Century Educational Milestones

Despite the many challenges, there were amazing wins in the struggle to educate school-age Black children who, not too long prior, were punished for even wanting to learn to read. Contemporary public school education advanced considerably, especially considering that the idea of a nationwide public school system wasn't even two centuries old and that a fully equitable school system not legally determined by race was even younger.

## Mixing it up with the Brown case

On a national level, legal cases challenging school segregation largely focused on higher education. Various protests were mounted, but in the North and in some Southern cities, Black people focused their energies on improving school facilities, building new schools, and securing more Black teachers, among other issues. Then, with *Brown v. Board of Education* (1954), the Supreme Court ruled in favor of integration in public schools, essentially overturning *Plessy v. Ferguson* (see Chapter 8 for the details of the *Brown* case).

## In the South

White Southerners vehemently resented the federal intervention of the *Brown* ruling. In 1957, an angry white mob greeted the nine Black students who attempted to integrate Central High School in Little Rock, Arkansas. To force compliance with the Supreme Court's decision, President Dwight D. Eisenhower sent federal troops to escort the students (see Chapter 8 for details).

In 1960, six-year-old Ruby Bridges attended a New Orleans public school for a year by herself with one white teacher because white parents and school officials spurned integration. Other efforts to integrate also met with resistance and required the presence of federal troops to enforce the law. In fact, many Southern schools didn't desegregate until the early 1970s.

## In the North

Prior to the 1930s, many Northern schools could be deemed integrated when they really weren't. Although the North didn't have a formal policy of segregation in place, Black Americans, already relegated to all-Black neighborhoods, were forced into all-Black schools. Thus, segregation in the North was more informal and therefore harder to challenge than in the South.

The 1971 Supreme Court decision in the case of *Swann v. Charlotte-Mecklenburg Board of Education* helped change that. Although the case specifically addressed conditions in North Carolina, the ruling also affected the North. The Supreme Court upheld a judge's decision to achieve desegregation through busing Black students to white schools. It rejected de facto (unofficially sanctioned) racial segregation and cleared the way for similar desegregating strategies in Northern school systems.

In the 1973 case *Keyes v. Denver School District No. 1*, Denver became the first major city outside of the South to have its school policies in respect to desegregation challenged before the Supreme Court. This case is significant for two primary reasons:

>> It turned school desegregation into a national and not just Southern problem.

>> It established that schools with substantial numbers of Black American and Hispanic (Latinx) students weren't desegregated because the two groups suffered similar conditions.

The Supreme Court gave Denver instructions to use school busing to achieve school desegregation.

Prior to this case, busing had already been in use in certain areas like Berkeley, California. During the 2019 Democratic presidential primary debates, California Senator Kamala Harris spoke of being bussed as a little girl in Berkeley. Local NAACP leader Reverend Roy Nichols, who began advocating this strategy in the 1950s, was pivotal to the city's early push behind busing to remedy school segregation. It was an effort that the Reverend Dr. Martin Luther King Jr., whom Nichols knew, was aware of and approved prior to his untimely death in 1968.

As the Supreme Court continued handing down key decisions on the heels of its critical 1954 *Brown v. Board of Education* decision, which helped transform the nation, busing became a key strategy in ongoing efforts to desegregate the nation's public schools in both the North and the South throughout the 1970s into the 1980s.

## Turning back the clock?

More than 50 years after *Brown v. Board of Education*, some activists in the 1990s and 2000s argued that the United States had returned to de facto segregation in education. Others asked whether school desegregation should still be the goal. At issue with the *Brown* decision was the assumption that separate, by its very nature, was deemed not equal; therefore, the only way to equalize the quality of education was to integrate schools. Some civil rights activists contended that two 2006 cases (*Meredith v. Jefferson County [Kentucky] Board of Education* and *Parents Involved in Community Schools v. Seattle School District No. 1*) challenging the use of race to achieve school diversity could reverse the historic *Brown* decision. With the absence of retired Justice Sandra Day O'Connor and the addition of conservatives Justice Samuel Alito and Chief Justice John G. Roberts Jr., an end to *Brown* wasn't inconceivable. Deciphering the impact of the reversal in terms of affirmative action initiatives in elementary, secondary, and higher education has been difficult, especially as ideology around how to deliver equality in education has changed.

## Vouchers and school choice

Because a student's residency determines where that student attends public school, Black parents, especially those who are poor, have had relatively fewer choices regarding where they can send their children if their neighborhood school is inadequate. Therefore, *public vouchers,* government-funded tax credits that allow poorer students to attend private schools, and *public charter schools,* publicly funded schools exempted from certain local and state regulations to allow for more creative education solutions, became viable educational alternatives for many Black Americans.

## RE-SEGREGATING?

One study of the nation's largest school systems during the 1997–1998 school year revealed that cities like New York, Chicago, Los Angeles, and Dallas had public school enrollments that were less than 20 percent white, even though public school enrollment for predominantly white neighborhoods remained quite high nationwide. This suggested that

- In areas with substantial nonwhite populations, white parents don't send their kids to public schools at the same rate as parents in predominantly white neighborhoods.

- Because public school attendance continues to reflect the complexion of the neighborhoods in which the schools are located, white Americans even into the 21st century, may still elect to live in predominantly white areas, even when more-diverse areas are an option.

Supporters of voucher programs and charter schools argue that these initiatives provide alternatives to lower-income families while also challenging public schools to improve or lose students. Those opposed to the initiatives warn that voucher programs and charter schools can only help a handful of students and fail to address how public schools can work for all students.

The idea of voucher programs and charter schools is a divided topic with Black Americans. In a public opinion poll conducted in 2000 in Milwaukee and Cleveland, each with public voucher programs, 57 percent of Black Americans favored public vouchers. Despite constituting 17 percent of the public school population nationally during the 2000–2001 school year, Black Americans made up an estimated 33 percent of the charter school population. What's not completely clear is how big a difference these initiatives have made and whether Black children have benefited significantly.

## Leaving no child behind? Maybe

Congress's approval of the No Child Left Behind Act in 2001, generated more nationwide dialogue around elementary school reform than any other legislation in at least two decades. The cornerstone of No Child Left Behind was creating accountability for the nation's failing public schools. Some key provisions included

>> Allowing parents to transfer their children to better-performing schools

>> Providing financial assistance for tutoring and summer programs

>> Making reading a mandate for every child

>> Improving teaching quality

>> Expanding federal support for charter schools

Critics of No Child Left Behind, which passed Congress with bipartisan support, charged that because the program was severely underfunded, schools couldn't meet the benchmarks No Child Left Behind mandated.

Many Black Americans appeared to support No Child Left Behind in theory. Some seemed to like the idea of a national report card presenting student performances categorized by race, and others believed that No Child Left Behind could help identify and eliminate core racial problems in public education.

## Atlanta Public Schools cheating scandal

No Child Left Behind critics saw their worst fears realized in 2009, when the *Atlanta Journal-Constitution* published an article pointing out statistical discrepancies in Criterion-Referenced Competency Tests (CRCT) results from Atlanta Public Schools. An investigation by the Georgia Bureau of Investigation (GBI) revealed in 2011 that 44 of 56 schools cheated on their CRCT. No Child Left Behind critics argued that the Atlanta Public Schools cheating scandal was a result of the pressures No Child Left Behind put on schools to meet mandated benchmarks, not educate students.

As many as 178 educators were accused of correcting student answers during testing. Thirty-five people were indicted. Everyone took a plea deal except for 12 of the accused, who chose to stand trial. All but one person, Dessa Curb, were convicted of racketeering and received sentences ranging from 5 years of probation to 20 years of prison time, as well as fines as high as $25,000. Two appealed and lost.

The GBI determined that once-celebrated Superintendent Beverly Hall either knew of the wrongdoing or should have known about the scandal. She was indicted but died from breast cancer before her case could be resolved.

## Obama and Trump on education

After more than a decade of No Child Left Behind, the 50-year-old Elementary and Secondary Education Act (ESEA) was restored when President Barack Obama signed the Every Student Succeeds Act (ESSA) into law on December 10, 2015. ESSA committed to increasing access to preschool education and demanded high academic standards to prepare students for success in college and careers. ESEA had

been passed in 1965 under President Lyndon B. Johnson, with the primary goal of full educational opportunity as a civil right.

President Donald J. Trump had different ideas regarding education. His appointment of Betsy DeVos, a generous Republican donor from one of the country's wealthiest families as Secretary of Education was controversial for several reasons, including DeVos's lack of professional experience and expertise in education as well as her fervent support of charter and private schools over improving and fortifying public school education. Under DeVos, the education budget was slashed repeatedly. DeVos also rescinded Obama-era protections against racial disparities in school discipline.

During the coronavirus pandemic in 2020, DeVos remained committed to using government funding to support private school education. Of the $13.5 billion set aside for elementary and secondary schools, she used $180 million to encourage states to create "microgrants" to help parents pay for private schools. She also advised several school districts to divert money intended to serve low-income students to wealthy private schools. For example, in one school guidance document issued by DeVos and the United States Department of Education, Louisiana could legally increase private school funding by 267 percent using government money. For these reasons and more, champions of public school education heralded the 2020 election of Joe Biden as President of the United States as a welcome change.

# Higher Learning

In the 19th century, higher education was rare for the majority of Americans — Black or white. College was reserved for the wealthy. Still, Black Americans strongly believed that their fate as a race depended on education. With the majority of Black Americans enslaved, education was viewed as a prerequisite for achieving universal freedom for all Black Americans. Most historically Black colleges got their start as institutes where Black people of all ages could learn to read and write. These schools would later become well-known institutions of higher education. The founding of the following colleges and universities laid the foundation for the higher education of Black Americans:

>> **Cheyney University:** Cheyney University was created in 1837 with $10,000 from Quaker philanthropist Richard Humphreys, first as the African Institute and then the Institute for Colored Youth before eventually becoming Cheyney in the 20th century. In its early years, it educated Black youth, prepared teachers, and taught trades and agriculture skills. It remains the oldest of all Historically Black Colleges and Universities (HBCUs) in the United States, as well as the

oldest of the 14 charter institutions of the Pennsylvania State System of Higher Education. Distinguished alumni include beloved *60 Minutes* journalist Ed Bradley and influential civil rights leader Bayard Rustin.

>> **Oberlin Collegiate Institute:** Nudged along by a conditional donation from Arthur Tappan, a 19th-century white abolitionist and wealthy businessman, this Ohio institution was established in 1833. It became the first college in the U.S. to adopt an open policy with respect to all qualified Black students instead of accepting them on a case-by-case basis. Oberlin's first Black graduate was George Boyer Vashon, son of abolitionist and Underground Railroad conductor George Bethune Vashon.

>> **Berea College:** Conceived as an institution for Black and white students, Berea College, located in Kentucky, began its troubled history in 1855. After operating as an integrated institution after the Civil War, it became a segregated institution from 1904 until 1954 due to a Kentucky law.

>> **Wilberforce University:** This university was founded in 1856, by the African Methodist Episcopal (AME) Church, an important force in establishing Black higher education. In 1963, Ohio African University merged with Union Seminary and changed its name to Wilberforce in honor of William Wilberforce, the Englishman instrumental in outlawing the slave trade in Britain. It was the first college owned and operated by Black Americans. Former congressman Floyd Flake became the school's 19th president in 2002.

>> **Lincoln University:** Renamed for Abraham Lincoln in 1866, Lincoln University began in 1854 as the Ashmun Institute, named after Jehudi Ashmun, a white advocate of emigration who served as Liberia's first president. It was the first institution of higher education in the country dedicated to providing arts and sciences education for Black men. Distinguished Lincoln alumni include Thurgood Marshall, Cab Calloway, Gil Scott-Heron, and Kwame Nkrumah, Ghana's first president.

**TECHNICAL STUFF**

Despite the inroads made by some institutions of higher education in the years leading up to the Civil War, only an estimated 28 Black people had bachelor's degrees by the time the war began.

## Launching higher ed for the Black masses

The Civil War was a boon to Black American education. Between 1861 and 1890, Northern churches and missionary groups created more than 200 Black private schools in the South. The Freedmen's Bureau (refer to Chapter 6) later joined that effort.

# THE FALL OF NOYES ACADEMY

Some members of the New England Anti-Slavery Society and the American Anti-Slavery Society (both established in the early 1830s) took a practical approach to higher education for Black Americans. From 1832 to 1834, they collected funds for what was known as the Manual Labor School, a college preparatory high school open to white and Black students.

Canaan, New Hampshire, was the location for what later became the Noyes Academy. In March 1835, 28 white students and 14 Black students, including Alexander Crummell (who would go on to become a noted Black American intellectual), began classes at Noyes Academy. The school was short-lived, however. After Noyes Academy's own anti-slavery society president, a Black student, delivered a fiery public antislavery speech on the Fourth of July to thunderous applause, some of Canaan's white residents gave the school a month to close. When the school didn't comply, Canaan's white residents and residents of neighboring towns reportedly used 100 oxen to remove the school from its foundation and dump it into a nearby swamp.

Most of these schools, public and private, didn't start out as full-fledged colleges and universities but rather as *normal* (a term for *teacher's college*) schools and institutes, many with an emphasis on agricultural and industrial education. Because of the high illiteracy rate among Black Americans, the more-advanced institutions initially functioned as high schools. In keeping with the early beginnings of Black American education, these institutions produced preachers and teachers whose mission was to teach and prepare others. By 1872, institutions such as Atlanta University began granting baccalaureate degrees, and two institutions ventured into medicine:

>> **Howard University** in Washington, D.C., chartered by an act of Congress in 1867, enjoyed close ties with the Freedmen's Bureau. That relationship resulted in the establishment of the Freedmen's Hospital in 1868, and Howard University College of Medicine in 1869.

>> **Meharry Medical College** in Nashville, founded under the auspices of the Freedman's Aid Society of the Methodist Episcopal Church in 1876, is the largest and second-oldest historically Black medical school.

**TECHNICAL
STUFF**

Until the 1970s, Meharry and Howard trained nearly 80 percent of the nation's Black physicians. Even today, the two institutions, along with the Morehouse School of Medicine in Atlanta and the Charles R. Drew University of Medicine and Science, which operates a college of medicine in conjunction with UCLA, train a high percentage of the nation's Black doctors.

# THE ROLE OF WHITE PEOPLE IN BLACK COLLEGES

With the end of Reconstruction and the Supreme Court sanction of separate but equal in *Plessy v. Ferguson* in 1896, Black colleges were in a precarious position. Ill-meaning whites who controlled Black public colleges in some Southern states withheld needed funds. Some well-intentioned whites exhibited paternalistic attitudes that reinforced plantation values despite their mission to educate and uplift Black students.

White leadership dominated many Black colleges simply because initially there weren't enough Black Americans qualified for such positions. (Well into the 1960s, some Black colleges never had nonwhite presidents.) Without white support, many Black colleges wouldn't have survived.

When the Freedmen's Bureau closed in 1872, Northern missionary organizations didn't abandon their original missions. One such organization was the all-important American Missionary Association that was created in 1846, specifically to educate and prepare Black Americans to lead themselves. Aid from missionary and benevolent aid societies as well as donations from Black people kept Black colleges afloat. After 1900, *Negro colleges,* as they were called, benefited greatly from the expansion of aid from secular foundations, particularly those created by Northern philanthropists. Funding from organizations such as the General Education Board of the Rockefeller Foundation, the Southern Education Board, the Julius Rosenwald Fund, the Phelps-Stokes Fund, and the Carnegie Foundation helped Black colleges thrive.

## The Morrill Acts: Making it stick

The Morrill Acts are some of the most important pieces of legislation for higher education in the United States. In 1857, Vermont representative Justin Morrill introduced a bill to the House of Representatives proposing that the government set aside land for each state to create at least one "land-grant college" to educate those who worked the land. Morrill's system would provide liberal and practical education to farmers and laborers, among others, especially in the agricultural and mechanical arts (hence the A&M moniker in the name of many land-grant colleges). Originally vetoed by President James Buchanan, the Morrill Act was reintroduced and passed by Congress in the midst of the Civil War. A second Morrill Act in 1890 demanded that states either distribute equal funding to Black land-grant colleges or admit Black students to the existing, predominantly white institutions.

**REMEMBER**

Although Southern states, in particular, continued to underfund comparable Black institutions and bar Black students from attending predominantly white institutions, the Morrill Acts set important precedents in higher education that the NAACP Legal Defense Fund used in later decades in its attempts to desegregate higher education (refer to Chapter 8 for more).

## Determining the goal of higher education

An intense intellectual debate divided Black American intellectuals for nearly half a century. Booker T. Washington, the elder statesman, and W.E.B. Du Bois, an emerging leader, differed on the most beneficial kind of education for Black Americans. Washington was in the industrial education camp; Du Bois favored liberal arts education.

**REMEMBER**

While historically Du Bois and Washington, whom you can read more about in the political realm in Chapter 7, have been portrayed as polar opposites, the truth is that they weren't diametrically opposed to one another. Given the fact that Washington often said one thing while secretly doing another and that Tuskegee offered courses in what are traditionally considered liberal arts areas, Washington and Du Bois may have had more middle ground than the academic community at large suspected. Ultimately, both men were deeply concerned with the overall well-being of Black people, and each worked tirelessly to uplift the race. Although Black educators bitterly debated their arguments long after Washington's death in 1915, each man's argument has some truth to it. The right answer for Black higher education may be a combination of both philosophies.

### Booker T. Washington's position

At the turn of the 20th century, Booker T. Washington, shown in Figure 13-1, was the most powerful Black man in the United States and one of the nation's most powerful men of any color. Born in Virginia in slavery's last days, Washington studied to become a teacher at Hampton Normal and Agriculture Institute. Inspired by the white principal's emphasis on industrial education, moral fortitude, and manual labor, Washington eventually headed the newly formed Tuskegee Normal and Industrial Institute in Alabama and built a formidable institution steeped in the values he had learned at Hampton.

Washington influenced countless other institutions, big and small, across the educational spectrum. Known as "the Wizard" for all his complex maneuvering, his ability to relate to various audiences aided him well. Careful not to offend Southern white planters, Washington managed to "stay in his place" while attracting large amounts of money from Northern philanthropists.

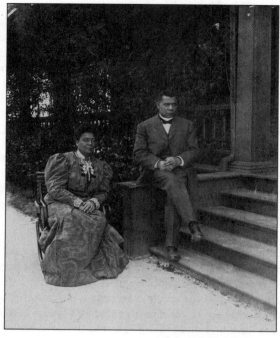

**FIGURE 13-1:**
Booker T. Washington with his wife Margaret Murray.

Washington's emphasis on trade or industrial education addressed the realities of the recently freed masses. In the late 19th and early 20th centuries, Washington knew Black Americans had a strong connection to agriculture and used Tuskegee to address those immediate needs. Thanks to the work of scholar George Washington Carver (see the nearby sidebar), an important agricultural science pioneer, Tuskegee taught local farmers new techniques that allowed them to get the most from the land. The Tuskegee model empowered students to become self-sufficient and to spread that message to other Black people by teaching and serving as examples, in addition to founding their own schools.

## W.E.B. Du Bois's position

Born in 1868 in Great Barrington, Massachusetts, where he was one of just 50 Black people, Du Bois's experience differed from that of most Black Americans. Unable to afford Harvard, he attended Fisk College in Nashville, where he encountered the plight of Black Southerners for the first time. After graduating, Du Bois was able to enter Harvard and eventually became the first Black student to complete a Ph.D. there. He also spent a year of study in Berlin.

# GEORGE WASHINGTON CARVER

Tuskegee's George Washington Carver favored fields and labs to the spotlight. Carver was an agricultural genius, and his outstanding work is still relevant today. Born enslaved around 1864 or 1865, Carver spent much of his early life with his one-time slaveholders Moses and Susan Carver, who also raised his brother.

A sickly child, Carver showed an early aptitude for horticulture. Susan Carver encouraged his education, and Carver, who wasn't permitted to attend school in his hometown in Missouri, set out for high school in Kansas at age 13. Rejected by several colleges because of his race, Carver eventually attended Simpson College in Iowa, where he excelled in art and music before transferring to Iowa State Agricultural College. Asked to pursue graduate studies, Carter received national recognition as a botanist for his work in plant pathology and mycology, the study of fungi.

In 1896, Booker T. Washington recruited Carver to Tuskegee Normal and Industrial Institute in Alabama, where Carver remained until his death in 1943. At Tuskegee, Carver tackled the plight of Black farmers: To solve the problem of soil depletion, he suggested they alternate planting cotton crops with legumes such as peanuts or sweet potatoes to restore depleted nutrients to the soil. He also created new uses for crops, especially peanuts, to make them more profitable. Even President Teddy Roosevelt praised Carver's work. Today, Carver's innovations regarding multiple uses for peanuts and soy continue to set the tone for agricultural study.

Du Bois was an influential faculty member at Atlanta University, now Clark Atlanta University, the leading institution in the Atlanta University system. During his lifetime, he authored several pioneering scholarly works, including *The Suppression of the African Slave Trade to the United States of America 1638–1870* (1896) and *The Philadelphia Negro* (1899).

Highly educated and an impeccable scholar, Du Bois applied a scientific approach to the so-called "Negro Problem." Unlike Washington, whose educational approach favored the Black masses, Du Bois believed in educating a *Talented Tenth*, the best and brightest members of the race who would then lead the Black masses. Although Du Bois acknowledged a need for industrial education, he didn't view industrial education as a means of elevating the race overall. Du Bois believed that only the exceptional men of the race could save it and that Black colleges had a responsibility to train this Talented Tenth to become "leaders of thought" and "missionaries of culture." Therefore, he advocated a classical education steeped in languages, such as Latin and French, and texts by Aristotle and Plato.

Du Bois's emphasis on a classical education didn't exclude Black culture. As the author of numerous books, many scientific and sociological in scope, Du Bois pioneered early Black American–focused education. Nor did Du Bois believe in excluding Black women from receiving a classical education. When citing men who embodied his ideals of the Talented Tenth, Du Bois often mentioned that their wives read Homer or other venerable works.

**HISTORICAL ROOTS**

# THE UNITED NEGRO COLLEGE FUND

Private Black colleges faced serious financial challenges in the 1940s. Although they were educating an estimated half of the South's Black students, the Great Depression and World War II complicated fund-raising efforts. Faced with this financial crisis, Tuskegee Institute's third president, Dr. Frederick D. Patterson, published an open letter in *The Pittsburgh Courier* urging other presidents of Black private colleges and universities to pool their resources and raise funds cooperatively. The next year, with 27 colleges and universities on board, the United Negro College Fund (UNCF) raised nearly $800,000.

Pending school desegregation threatened to undermine the UNCF's efforts: With white institutions theoretically opened to Black students, the UNCF had to work harder to convince donors to give to Black institutions. Always full of surprises, the UNCF kicked off its second capital campaign in 1963 at the White House; the event was hosted by President John F. Kennedy, who donated the Pulitzer Prize money he had received for his book *Profiles in Courage.*

In 1972, the UNCF adopted the slogan "A Mind Is a Terrible Thing to Waste," which was destined to become one of the most recognizable slogans in American advertising history. First televised in 1979, the star-studded telethon *The Lou Rawls Parade of Stars,* now *An Evening of Stars,* has contributed more than $200 million to the UNCF. Publishing magnate Walter Annenberg's $50 million gift to UNCF in 1990, was the largest single contribution to Black colleges.

UNCF donor and Black billionaire Robert F. Smith attracted national attention during his 2019 commencement address at UNCF member institution Morehouse, the nation's only all-male HBCU, when he pledged to pay off the student loans of the graduating class, totaling $34 million. In response to the police killing of George Floyd captured on video in Minnesota on May 25, 2020 (read more about it in Chapter 11), Netflix co-founder Reed Hastings and his wife Patty Quillin donated $120 million, giving $40 million to UNCF and its member institutions Morehouse and Spelman in Atlanta. UNCF is also a participant in the $1 billion Gates Millennium Scholars Program, funded by Bill and Melinda Gates. For more on the UNCF, check out www.uncf.org.

# Desegregating higher education

Black American attendance at predominantly white institutions dates as far back as the 18th century, with a number of Black students graduating from mainstream universities in the 19th century. The bulk of Black students, however, entered white colleges in significant numbers in the 1960s and 1970s on the heels of *Brown v. Board of Education.* Today, Black students continue to attend and graduate in significant numbers.

To ensure diversity on college campuses, many schools instituted affirmative action programs in the 1970s. Because some of these programs utilized racial quotas to meet their diversity goals, legal challenges contesting this practice began. The most notable was *Bakke v. California Board of Regents* in 1978. Although the Supreme Court ruled against the use of racial quotas as the main criterion for admitting a student, it decided that a college or university could consider race as one of its criteria in admission policies.

Beginning in the 1990s, attacks on affirmative action increased. In 1996, California voters passed Proposition 209, which eliminated affirmative action in public school admissions and government hiring. Civil rights activists contend that, as a direct result of Proposition 209, Black and Latinx enrollments in California colleges plummeted to all-time lows. States such as Michigan and Florida adopted similar measures. Despite overwhelmingly choosing former Vice President Joe Biden to replace Donald Trump as President of the United States during the November 3, 2020 election, Californians solidly voted against Proposition 16, which would have repealed Proposition 209.

**REMEMBER**

Historically competitive colleges and universities, like those in the Ivy League, use a number of factors when considering enrollment, including region, community service, and socioeconomic status. In addition, they use test scores and academic performance, which remain the strongest requirements for entry. By insisting Black and other minority students have been admitted to some of the nation's most prestigious institutions based solely on race, affirmative action challengers (many of them white and male) have created the perception of Black intellectual inferiority.

**TECHNICAL STUFF**

John Singleton's 1995 film *Higher Learning* centers on the challenges of college life, particularly for Black students, at a predominantly white institution.

# HBCUs: NATIONAL TREASURES

The Higher Education Act of 1965, which introduced the label "HBCU," declared such institutions national treasures. Increased Black enrollment at predominantly white institutions and declining numbers at some HBCUs raised concerns, however, about the viability of HBCUs into the 1980s, 1990s, and early 2000s, especially financially. Presidents from Jimmy Carter to George W. Bush signed executive orders intended to enhance HBCUs. Despite evidence that state and federal funding for these educational institutions increased considerably since 1965, HBCUs still struggled. Inequities in funding for predominantly Black and white universities, as charged in the 30-year court case of *Ayers v. Fordice* involving predominantly Black public institutions such as Jackson State University, haven't disappeared. In 2002, an agreement was reached to distribute $503 million to Mississippi's Black public universities — Jackson State, Alcorn, and Mississippi Valley State — over 17 years.

Private HBCUs such as Atlanta's all-female Spelman College started sidestepping financial limitations with aggressive individual fundraising efforts in the 1990s. Under the leadership of then-president Dr. Johnnetta B. Cole, Spelman raked in more than $100 million. In December 2020, MacKenzie Scott, ex-wife of Amazon leader Jeff Bezos, donated an estimated $560 million to various HBCUs, including gifts of $50 million to Prairie View A&M University in Texas and $40 million to Morgan State University in Maryland. Scott kicked off the giving spree early with gifts of $20 million and $40 million to Morehouse College and Howard University, respectively.

According to an October 2019 article by *The Hechinger Report*, HBCUs have produced 80 percent of the country's Black judges, 50 percent of its Black doctors, 27 percent of its Black graduates with STEM degrees, and roughly 50 percent of its Black teachers, despite making up just 3 percent of all four-year colleges. Notable HBCU alums, including Martin Luther King Jr. (Morehouse), Oprah Winfrey (Tennessee State University), and Vice President Kamala Harris (Howard University), are too numerous to name in full. The enrollment spike at some HBCUs in the early 21st century has been attributed to increased racial harassment at predominantly white institutions as well as in the nation at large, particularly under President Donald Trump.

# School Daze: The Black Greek system

Marshaling the spirit of racial uplift with a commitment to academic excellence, community service, and brotherhood/sisterhood, Black Greek Letter Organizations (BGLOs) are one of the few institutions uniting Black students at both mainstream universities and HBCUs. Outside Black collegiate circles, knowledge of the *Divine Nine* — the nine fraternities and sororities that compose the National Panhellenic Council (NPHC), the governing body of Black Greek organizations — is rare. Yet they remain an important force in the overall Black community.

BGLOs' historical relevance is profound. Particularly during the early 20th century, BGLO membership at mainstream universities provided a social network to students often isolated because of race. In some cases, funding from BGLOs provided housing in close proximity to schools during a time when Black students couldn't live in dorms and often traveled long distances to pursue their educations at predominantly white institutions. Aspiring members must meet acceptance criteria that includes a designated grade-point average, letters of recommendation, and a commitment to community service.

Five fraternities and four sororities (see Table 13-1) make up the Divine Nine; five of these organizations trace their origins to Howard University. Each BGLO is an intense network that connects students and alumni of undergraduate and graduate colleges and universities across the nation and even across the globe for a lifetime, not just their school years. In addition to chapter meetings, BGLOs have regional meetings and national conventions.

**TABLE 13-1**    **The Divine Nine**

| Organization | Date Founded | Founding College | Colors | Prominent Members |
|---|---|---|---|---|
| **Fraternities** | | | | |
| Alpha Phi Alpha | 1906 | Cornell University | Black and Old Gold | W.E.B. Du Bois, Martin Luther King Jr., former Atlanta mayors Maynard Jackson and Andrew Young, Supreme Court Justice Thurgood Marshall, actor Paul Robeson, billionaire Robert F. Smith |
| Kappa Alpha Psi | 1911 | Indiana University | Crimson and Cream | Former NFL player Colin Kaepernick, BET Founder Bob Johnson, former L.A. Mayor Tom Bradley, tennis legend Arthur Ashe |
| Omega Psi Phi | 1911 | Howard University | Royal Purple and Old Gold | Historian Carter G. Woodson, Jesse Jackson, NBA great Shaquille O'Neal, legendary radio broadcaster Tom Joyner, comedians Rickey Smiley and Steve Harvey |
| Phi Beta Sigma | 1913 | Howard University | Royal Blue and Pure White | Black Panther cofounder Huey P. Newton, Ghanaian President Kwame Nkrumah, NFL Hall of Famer Emmitt Smith, gospel music legend Bobby Jones, civil rights activist John Lewis |
| Iota Phi Theta | 1963 | Morgan State University | Charcoal Brown and Gilded Gold | *Good Morning America* weatherman Spencer Christian, journalist Michael Frisby, Baltimore Commissioner of Housing Daniel Henson |
| **Sororities** | | | | |
| Alpha Kappa Alpha | 1908 | Howard University | Salmon Pink and Apple Green | Actress Phylicia Rashad, astronaut Dr. Mae Jemison, Vice President Kamala Harris, Miss America 1990 Debbye Turner |

*(continued)*

**TABLE 13-1** *(continued)*

| Organization | Date Founded | Founding College | Colors | Prominent Members |
|---|---|---|---|---|
| Delta Sigma Theta | 1913 | Howard University | Crimson and Cream | Journalist Ida B. Wells-Barnett, Senator Carol Moseley Braun, Olympic gold medalist Wilma Rudolph, AME Bishop Vashti Murphy McKenzie |
| Zeta Phi Beta | 1920 | Howard University | Royal Blue and White | Writer/folklorist Zora Neale Hurston, opera singer Grace Bumbry, comedian Sheryl Underwood, poet Gwendolyn Brooks |
| Sigma Gamma Rho | 1922 | Butler University | Royal Blue and Gold | Finance author Cheryl Broussard, actress Hattie McDaniel, gospel singer Vanessa Bell Armstrong, artist Ruth Russell Williams, U.S. Congresswoman Robin Kelly |

# BGLOs IN POP CULTURE

*Step shows,* one of the BGLOs' most recognized cultural activities, are elaborate productions in which opposing Greek organizations or chapters of the same organization demonstrate coordinated body and dance moves that feature rhythmic stomping and clapping accompanied by boastful chanting. Many historians have noted the African retentions in these rituals.

Beyoncé exposed a large segment of the world to this tradition with her 2018 Coachella performance, dubbed "Beychella," and her subsequent 2019 Netflix documentary *Homecoming.* In addition to putting Black marching band culture in the spotlight, Beyoncé also put BGLOs there as well, creating her own sorority, BDK, Beta Delta Kappa, for the occasion.

The Black Greek experience also inspired the 2017 film *Burning Sands,* starring Trevor Jackson, as well as the 2007 film *Stomp the Yard,* produced by Will Packer and Rob Hardy, both members of Alpha Phi Alpha. Although the 2002 film *Drumline* centered on the grand Black marching band tradition, glimpses of Black Greek life were also evident. Spike Lee's 1988 film *School Daze* is arguably the first film to really explore the Black college experience with a huge spotlight on the Black Greek experience. (*School Daze* was also about colorism and the division amongst Black people.) On television, that distinction largely belongs to the long-running Black college series *A Different World* on NBC.

personal narratives

» Reflecting the post–Civil War experience

» Exploring Harlem Renaissance artists and those who followed

» Following the rise of Black women writers

» Looking at Black literature since the 1990s

Chapter **14**

# Writing Down the Bones: Black Literature

ecause enslaved Black people were prohibited from learning how to read or write for much of the nation's early years, a greater portion of Black Americans were illiterate until after the Civil War. But despite the fact that Black Americans were denied basic literacy, some Black people, like Phillis Wheatley, who was praised for her ability to learn the English language quickly, still created works of great literary merit. As with music (which you can read more about in Chapter 16), Black American literary roots can be traced back to the African continent.

This chapter explores those roots, from a rich oral tradition to early novels by writers such as William Wells Brown, 20th-century literary high points like the Harlem Renaissance, and the explosion of Black women writers in the 1970s and 1980s.

# Troubled Beginnings

English wasn't the native tongue of the Africans who arrived in what would become the United States. The first enslaved Africans hailed from different parts of the African continent, with some arriving in the colonies by way of the Caribbean. Consequently, enslaved people didn't share a common African language. However, they did share several similar traits, including the all-important oral tradition. Eventually they melded those similarities with their new European-inspired environment and adapted to the characteristics that would come to define the nation overall.

**REMEMBER**

Africans valued spoken language, and that continued in the New World, especially given the many barriers preventing them from learning to read and write English. On the African continent, official storytellers known as *griots* were responsible for keeping the history of their respective villages. They also passed on morality tales and tales of creation, better known as *folktales.* Although some of the details changed to reflect American realities, these tales remained essentially the same as their African predecessors. Folklore became an important means of transferring essential information, particularly survival mechanisms and key Black values such as the importance of community.

As literature developed in the Black community, folktales were the first stories of Black culture and among the first for the broader American culture. The *griot's* role as a historian proved to be a vital one as the oral history tradition became the method by which many Black people preserved their collective and individual histories. Early published works by Black writers, however, didn't directly reflect Black folk traditions. Many such works rarely contained any indications of race.

## Early poets

Separated from those who spoke their language, enslaved Africans had to find a way to communicate with each other as well as their white slaveholders. In the early 18th century, American literature was still developing and Black literature generally didn't exist. Yet despite these limitations, some Black writers beat the odds to lay the foundation. First among them are

» **Lucy Terry:** Although published a little more than 100 years after it was composed in 1746, Lucy Terry's only surviving poem, "Bars Fight," about the Indian massacre of two white families in Deerfield, Massachusetts, makes her, for many scholars, the first published Black writer in the United States. In the poem, Terry's race is undetectable, even though she was born in Africa and kidnapped into slavery.

» **Jupiter Hammon:** Frequently credited as the first published Black writer, Jupiter Hammon, who was born enslaved, composed "An Evening Thought: Salvation

by Christ, with Penitential Cries," in 1760. Enslaved by several generations of the Lloyd family in Long Island, New York, Hammon was formally educated.

>> **Phillis Wheatley:** Phillis Wheatley, who was captured from her native Senegal in West Africa and was enslaved at age 7, mastered English by the age of 13 and became the most famous of the early Black poets. Wheatley's slaveholders, John and Susanna Wheatley, cultivated her intellectual abilities by permitting her to study Greek, Latin, mythology, and history. By 1767, the 13-year-old published her first poem. Many sources cite Wheatley's work in poetry as the genesis of Black literature.

**TECHNICAL STUFF**

Because asserting that the intellectual inferiority of enslaved Africans was a cornerstone of American slavery (see Chapters 4 and 5 for details), some colonists, including Thomas Jefferson, questioned Wheatley's authorship, forcing Wheatley to prove her authenticity in court in 1772. Boston luminaries like John Hancock certified Wheatley as genuine. When a London publisher published Wheatley's *Poems on Various Subjects, Religious and Moral* a year later, it included a certificate of authenticity. Because of Wheatley's race, Boston publishers had refused to publish the book.

## OTHER EARLY WORKS ABOUT AND BY BLACK WRITERS

The designation of Black poets Lucy Terry and Jupiter Hammon as the first published Black writers in this nation isn't controversy-free. Books about Black Americans, including some credited to Black Americans, preceded these works. Typically, however, these early Black American works were "as told to" stories. Examples include the following:

- *Adam Negro's Tryall,* which appeared in 1703, arose from a case in which Adam Negro, an indentured servant, sued John Saffin for not honoring his freedom and enslaving him. Negro eventually won the case, mainly through the aid of Samuel Sewell, who disdained Saffin. Because *Adam Negro's Tryall* contains an amalgamation of documents surrounding the case and lacks one clear author, many scholars have decided that it isn't a true slave narrative.

- *The Declaration and Confession of Jeffrey, a Negro, who was executed at Worchester, October 17, 1745, for the murder of Mrs. Tabitha Sanford, at Mendon, the 12th of September Preceding* is a criminal narrative with questionable Black authorship.

- *Some Memoirs of the Life of Job, the Son of Solomon, the High Priest of Boonda in Africa,* a 1734 book by white author Thomas Bluett, tells the story of ex-slave Job Ben Solomon (also known as Ayuba Suleiman Diallo) who was reputed to be from an influential family. (For more on this story, refer to Chapter 3.)

In later decades, religious conversion to Christianity became the primary context in which Black Americans, enslaved and free, learned to read. Under that circumstance, the Bible became increasingly more important to early Black writers. (Flip to Chapter 12 for more on religious conversion and literacy during enslavement.)

## Slave narratives

After the American Revolution, the North and South began to divide themselves as antislavery and proslavery. Unlike the work of the earliest known Black writers in this country, race was a primary concern of Black writers during this period. As a result, a new genre known as the *slave narrative* emerged. Even though these narratives were autobiographies to an extent, they served a greater abolitionist function (read about slavery and abolitionism in Chapters 4 and 5). Slave narratives share certain key characteristics:

>> **Claim of authorship:** Proslavery factions often accused those opposed to slavery of making up horrific stories about slavery. Therefore, it was critical for slave narratives to establish the authenticity of the individual telling the story. As the slave narrative developed, many were written by the formerly enslaved themselves, but some were dictated to others.

>> **Testimonial from a respected white abolitionist or editor:** Few slave narratives went unauthenticated. The words of William Lloyd Garrison and Wendell Phillips, two of the nation's most prominent abolitionists, appeared at the beginning of Frederick Douglass's 1845 slave narrative.

>> **Tales of bondage:** "I was born" begins the first sentence of many slave narratives as authors (usually male) shared the early details of their lives. Quite often, the author's father was white or unknown. Recognition of one's status as being enslaved was critical in the early part of the narrative. Meanwhile, the bulk of the narrative discussed the actual bondage experience, with the author frequently including details about Christian conversion and learning to read. Whippings that they themselves or others received was another prominent feature, as were tales of separated family members and failed escape attempts by themselves or others.

>> **Escape and freedom:** Typically, considerable planning went into successful escapes, and in the narratives, the authors disclosed enough details without being too specific, for fear that too many details would prevent others from escaping. Becoming free was the ultimate goal, so slave narratives ended with the author's freedom.

Although proslavery factions frequently accused the slave narrative authors of exaggerating the horrors of slavery, more often than not, the authors hadn't exaggerated the incidents but rather humanized them. Because slavery functioned on a belief in the inhumanity of Black people, slave narratives rebuked this thinking by asserting and affirming that humanity.

Before 1865, an estimated 100 slave narratives were published, with the bulk of them published between 1830 and 1860. Given the high illiteracy rates among both whites and Black people in early America, the number of published narratives is quite high. Scholars frequently cite *The Interesting Narrative of the Life of Olaudah Equiano or Gustavus Vassa* as the first published slave narrative.

### Narrative of the Life of Frederick Douglass, an American Slave

Slave narratives became an important tool to advance abolitionism, and few were as influential as Frederick Douglass's *Narrative of the Life of Frederick Douglass, an American Slave,* published in 1845. A skilled orator, Douglass already had quite an abolitionist following prior to the publication of his *Narrative.* Although simple and full of the slave narrative tropes discussed earlier, Douglass's writing possessed an uncommon eloquence.

More than contributing eloquence, Douglass brought attention to the hidden messages in "slave" or *sorrow* songs, suggesting enslaved Black people developed strategies to manage slavery. As later generations discovered, Douglass's work revealed that Black Americans possessed a unique culture that was distinct from that of white Americans. That reality fueled Black literature for generations.

### Incidents in the Life of a Slave Girl

Orators such as Maria Stewart and Sojourner Truth discussed sex and sexuality before Harriet Jacobs, but their prose lacked the emotional and sustained punch of Jacobs's slave narrative, *Incidents in the Life of a Slave Girl,* published in 1861.

Because *Incidents in the Life of a Slave Girl* came out in the same year the Civil War began, it made a greater impact in the 20th century as a direct testimony of the sexual exploitation experienced by enslaved women.

## A novel journey

By providing the first portraits of Black heroes, slave narratives played a key role in the development of the Black American novel. Readers of slave narratives learned that Black Americans possessed great intellect and tremendous courage, remarkable qualities for fictional characters. Therefore, it's of little surprise that

slavery figured so prominently in *Clotel; or The President's Daughter*, the first Black American novel. After all, its author, William Wells Brown, published his successful slave narrative, *Narrative of William W. Brown, a Fugitive Slave*, in 1847.

Published in London in 1853 and inspired by Thomas Jefferson's long-rumored relationship with Sally Hemings, whom he enslaved, *Clotel* traces several generations of racially mixed women linked to Thomas Jefferson. Brown, whose father and grandfather were white, established the *tragic mulatto* as a key literary archetype in Black literature. Historically, the tragic mulatto has been a female tormented by being neither Black nor white. *Clotel* was so successful that it went through several editions. (Nella Larsen successfully explored this archetype in her 1928 and 1929 novels, *Quicksand* and *Passing*.)

Other key early novels include the following:

**TECHNICAL STUFF**

>> ***Our Nig,* by Harriet E. Wilson (published in 1859):** Like Brown, Wilson used the tragic mulatto theme but went a step further by also presenting an interracial marriage. Much of *Our Nig* mirrored Wilson's life.

  *Our Nig* is the first novel published in the United States by a Black American female. Until Harvard's Henry Louis Gates rediscovered *Our Nig* in the early 1980s, however, it was a forgotten text.

>> ***The Garies and Their Friends* (1857), by Frank J. Webb:** This rarely studied novel, published in London, was the first known work to feature free Black people as well as a lynch mob. It was also among the first works to discuss the concept of passing for white in detail.

>> ***Blake,* by Martin Delany (serialized in two Black publications in 1859 and 1860):** *Blake*, whose full title is *Blake; Or the Huts of America: A Tale of the Mississippi Valley, the Southern United States, and Cuba,* is noteworthy for its trailblazing Black nationalist and Pan-Africanist sensibilities. Unlike in *Clotel* or *Our Nig,* Delany's protagonist isn't biracial. In addition, *Blake* is largely about a rebellious plot to liberate both Black Americans and Black Cubans. First published in book form in 1970, the novel advocates Black self-reliance over white benevolence and boldly references white oppression of Black people.

  The newer edition of *Blake*, prepared by textual scholar Jerome McGann, offers the first correct printing of the work in book form. It establishes an accurate text, supplies contextual notes and commentaries, and presents an authoritative account of the work's composition and publication history. In a lively introduction, McGann argues that Delany employs the resources of fiction to develop a critical account of the interconnected structure of racist power as it operated throughout the American Atlantic. He likens *Blake* to Upton Sinclair's *The Jungle,* in its willful determination to transform a living and terrible present.

After the Civil War, racial inequality replaced slavery as the hot-button issue, and literary works by Black Americans reflected that. As Black literacy rates increased, Black writers could no longer assume their audience was almost exclusively white. Two key developments during this period include *racial uplift* and the *Black folk tradition*.

## Racial uplift

The concept of racial uplift prevalent in Black American works from the late 19th and early 20th centuries acknowledged the challenges of racial inequality but remained hopeful that Black Americans could rise above them. Therefore, many of the early protagonists in these works were model characters, often suppressing their individual wants for the greater good of the larger Black community while also communicating the middle-class values white people found acceptable. The work of Pauline E. Hopkins and others reflected these tensions. The most popular texts embodying the "racial uplift" mantra include

» *Iola Leroy* **by Frances Ellen Watkins Harper:** Although better known as a poet, Harper published the novel *Iola Leroy* in 1892. Set at the close of the Civil War and the onset of Reconstruction, the novel covers some important historical events such as reuniting with family after the war. Ultimately, the biracial heroine, though raised as white, chooses not to marry a white suitor who insists that she never reveal her race. Instead, she marries a biracial Black doctor, and they dedicate themselves to uplifting the race.

» *Up From Slavery* **by Booker T. Washington:** Tracing Washington's life from his birth and experience of being enslaved to his journey to educate himself before becoming Tuskegee's renowned leader, *Up From Slavery* champions middle-class values, emphasizing education and hard work as key qualities to help Black people overcome racial inequality. Read more about *Up From Slavery* in Chapter 21.

**TECHNICAL STUFF**

Some people consider *Up From Slavery* the last of the great slave narratives because Washington was born enslaved. However, more often, the book, published in 1901, in the 20th century, is acknowledged as the first great Black American autobiography.

» *The Souls of Black Folk* **by W.E.B. Du Bois:** W.E.B. Du Bois's influential work, *The Souls of Black Folk* (1903), is a myriad of things: social commentary, history, poetry, and sociological treatise. Du Bois's essays highlight the challenges Black Americans face, particularly the "twoness" of Black culture, or simply the reality of being Black in a white world. In *The Souls of Black Folk,* Du Bois advocates the idea of a *Talented Tenth,* in which the best and brightest of the Black community would bear the responsibility of advancing the race. This concept fueled many debates during the Harlem Renaissance. (See the next section for information on the Harlem Renaissance and turn to Chapter 21 for more about *The Souls of Black Folk.*)

## Black folk tradition

A few Black writers began incorporating Black vernacular and folk culture in their work. This development didn't occur in a vacuum, however. White writers, most notably Mark Twain, were also embracing "common" folk and their speech. Others, such as Thomas Nelson Page, Joel Chandler Harris, and George Washington Cable, were writing tales where the plantation played a prominent role. Two early Black pioneers of Black folk tradition are

>> **Paul Laurence Dunbar:** With his book *Lyrics of a Lowly Life* (1896), combining two previously published volumes, Dunbar became the first Black poet since Phillis Wheatley to enjoy widespread popularity. The Dayton, Ohio native's expert mixture of English and dialect brought Black American folk traditions into Black literature. His two notable fiction works include *The Strength of Gideon and Other Stories* (1900), dealing with the plantation and featuring only Black Americans as the primary characters, and *The Sport of the Gods* (1902), one of the first novels set in Harlem as well as one of the first to deal with the negative aspects of city life.

>> **Charles Chesnutt:** Considered the first major Black fiction writer, Chesnutt consciously employed Black folk tradition to counter the proslavery spin white authors such as Joel Chandler Harris, who penned the popular Uncle Remus series, put on Black American folklore. Chesnutt's Uncle Julius in *The Conjure Woman, and Conjure Tales* (1899), his most popular work of fiction, outsmarts a transplanted white Northerner. Black folklore served as tales of both morality and survival, a function not always communicated by Harris and others. Chesnutt went beyond simply using Black folk tradition; he also placed emphasis on the positive aspects of that tradition, which Harlem Renaissance writer Zora Neale Hurston later expanded.

**REMEMBER**

In the face of racial uplift, the creative choices of using Black folk tradition appeared counterproductive, especially to those who felt literature could show that Black Americans possessed the same values the white population treasured. Other Black Americans felt that emphasizing and embracing Black folk culture and speech could empower Black Americans.

# Writers' Party: The Harlem Renaissance

No period of Black literary history receives as much attention as the Harlem Renaissance, which roughly spanned from the beginning of World War I to the Great Depression. For the first time, Black artists from various realms — literature, art, and music — formed a collective movement that hit in various parts of the

country. Harlem still gets most of the credit, but Washington, D.C., specifically Howard University, was also another extremely important site, mainly because of the role Howard University professor Alain Locke played in this movement.

Influenced heavily by his studies abroad, when he explored the African influence on Western civilization, Locke, the nation's first Black Rhodes scholar (see Chapter 20), encouraged Black American artists to look to Africa for inspiration and weave that influence into their own work. Lack of culture was one of the reasons cited to justify enslaving Black people. Locke felt that disproving that theory would affect both Black and white people positively. In addition to identifying artists and hosting discussions among them, Locke published the important anthology *The New Negro*, a collection of essays about Black contributions to the arts as well as a sampling of fiction and poetry by emerging Black artists in 1925.

Even though he received much of the attention, Locke wasn't the only one who recognized the impact Black artists could have in improving race relations. Both the National Urban League (NUL) and the NAACP, the nation's two leading civil rights organizations, played significant roles in cultivating writers in particular. From 1923 to 1928, the NUL's Charles S. Johnson fostered the careers of many artists by organizing dinners that allowed writers to network with book publishers, magazine editors, and other writers as well as by establishing literary contests with monetary prizes. Jessie Redmon Fauset, a noted Harlem Renaissance writer in her own right, also nurtured new talent by publishing their works in the pages of the NAACP magazine, *The Crisis*.

## Why Harlem?

Several factors outside of New York serving as the headquarters for both the NAACP and the NUL contributed to Harlem serving as the mecca for this movement:

>> **Harlem was a cultural center for Black Americans.** The Black Broadway invasion (refer to Chapter 15) generated more interest in Black culture among white people. White dramatists such as Eugene O' Neill took a strong interest in Black life and culture. In 1920, O'Neill's play *The Emperor Jones* starred a Black American. The next year, the Black Broadway musical, *Shuffle Along*, captivated both Black and white audiences. All this coincided with the increasing popularity of jazz, and Harlem was a major nucleus for it all. Several clubs such as the Cotton Club purposely catered to white patrons intrigued by Black culture.

>> **Harlem was one of the primary destinations for the Great Migration.** The Great Migration refers to the mass exodus of Black people from the South that began in 1914 (flip to Chapter 7 to read about the Great Migration). As a

result, Harlem artists hailed from various parts of the United States, creating an atmosphere full of new ideas. At the same time, Harlem wasn't shielded from the migration's negative effects, such as overcrowding, segregated housing, and race riots, either. Therefore, many of the works created by the artists who lived in Harlem or at least visited it regularly reflected a national Black identity.

**TECHNICAL STUFF**

The movement wasn't originally dubbed the Harlem Renaissance. Alain Locke and others referred to it as the *New Negro Movement*, which reflected the sweeping changes Black Americans all over the nation were experiencing. Jacksonville, Florida native James Weldon Johnson, a writer who became an NAACP leader, coined the term the "Harlem Renaissance," and the name stuck.

## Key Renaissance artists and themes

A large number of artists representing various parts of the country participated in the Harlem Renaissance. The overwhelming majority were highly educated, hailing from some of the most prestigious Black and mainstream universities. Many were very accomplished in other professions. For example, Rudolph Fisher, noted author of *City of Refuge*, was also a medical doctor.

Harlem Renaissance writers embraced a myriad of themes, but middle-class Black America figured prominently in many of their works, as did the theme of *passing*, an expansion of the tragic mulatto theme first introduced in the mid-19th century (refer to the earlier section "A novel journey"). Nella Larsen's *Passing* (1929), about a chance encounter reuniting two childhood female friends, one who is passing for white and another living as a Black person, is an influential work. Another highly regarded book on the subject is James Weldon Johnson's *The Autobiography of an Ex-Coloured Man* (1912). Written as a fictional autobiography of a man who ultimately chooses to pass as white to free himself from the mistreatment Black people receive, the book achieved popularity when it was reissued in 1927.

Ultimately, class tensions created a sizable rift among many Harlem Renaissance writers, with Langston Hughes and Zora Neale Hurston becoming the most famous advocates of common Black folk. Both Hughes and Hurston rebuffed arguments that writing about the Black middle class would improve race relations by showing white readers how alike they and many Black Americans were. Hurston and Hughes's critics felt that embracing common Black folk reinforced primitive stereotypes about Black people instead of setting the record straight. Other Black people internalized feelings of Black life and culture as inferior to that of white Americans.

## Jean Toomer

Jean Toomer's background was racially mixed, and he didn't identify himself as Black American until time spent in Sparta, Georgia, brought him into intimate contact with Black rural life. *Cane* (1923), a mixture of poems, short stories, and drama, presents Black Southern culture as well as the Black Southerner's adaptation to the urban North before reconciling those two realities in the Black South.

**REMEMBER**

In critical ways, *Cane* encapsulated the massive search for Black identity that underscored the key debates of the Harlem Renaissance. Many artists and leaders, even those who embraced their racial heritage, weren't quite sure how to incorporate their past into their present. While this tension wasn't a new concern, rendering it in a distinctly artistic mode was unique. *Cane* demonstrated the artistic potential and merit of these tensions as grounding forces for great literary work.

**TECHNICAL STUFF**

Scholars include Toomer's *Cane* in the Harlem Renaissance and consider him part of the Lost Generation, a group of World War I–era American writers that included F. Scott Fitzgerald, Ernest Hemingway, and T.S. Eliot.

## Langston Hughes

One of the Harlem Renaissance's first published writers, Hughes's poem "The Negro Speaks of Rivers" appeared in the NAACP magazine *The Crisis* in 1921. Even though Harlem Renaissance artists were encouraged to depict Black life, some advisors championed Black middle-class life and values over those of the working class. Hughes disagreed, and in his influential 1926 essay "The Negro Artist and the Racial Mountaintop," he asserted that the Black artist who ran away from himself couldn't be great. Hughes, a Midwesterner, championed Black art reflective of Black life, not just Black life palatable to white people. Hughes was later known for his seminal 1951 poem "Harlem," often erroneously labeled "A Dream Deferred" for its famous line of "what happens to a dream deferred?" and other works.

## Zora Neale Hurston

Zora Neale Hurston never outgrew her Harlem Renaissance fame. A student of anthropology who studied with Columbia University's Franz Boas, Hurston also worked for noted Black historian Carter G. Woodson and accompanied Alan Lomax on some of his folklore missions. Raised in the all-Black town of Eatonville, Florida, Hurston was an outspoken supporter of rural Black people and Black folk traditions. Hurston's white patronage did trouble many of her Black contemporaries who accused her of pandering to them.

# SUPPORTING THE ARTS

Alain Locke, Charles S. Johnson, and Jessie Redmon Fauset may have been intimately involved in fostering black artists, but these artists still required financial support and additional exposure. Therefore, several patrons, white and Black, including a few key white organizations, facilitated that process. Here are some of the more prominent:

- **Charlotte Osgood Mason:** The influential Charlotte Osgood Mason, a financial patron to both Langston Hughes and Zora Neale Hurston, became involved in the Harlem Renaissance after hearing Alain Locke lecture on Black artists in 1927. Extremely meddlesome, Mason, who hosted many gatherings for Black artists in her Park Avenue apartment, tried to dictate Hughes's whereabouts and reportedly had Hurston sign an agreement not to publish anything without her approval. Both writers had fallen out with her by 1932. Soon after, she withdrew all financial support from the Harlem Renaissance.

- **Carl Van Vechten:** A writer himself, Carl Van Vechten was fascinated with Harlem's vices and frequently commented on the "exoticism" and "primitivism" of Black culture, which bothered many people because he, himself, was white. His 1926 novel titled *Nigger Heaven* didn't alleviate those concerns. Still, he brought a lot of mainstream attention to Harlem and Black artists in various genres. A photographer as well, Van Vechten included a number of prominent Black artists among his famous portraits.

- **The Harmon Foundation:** Although more noted for its contributions to Black artists, the Harmon Foundation, endowed by white real estate tycoon William E. Harmon, also provided financial awards to writers. While its influence extended beyond the Harlem Renaissance years, it first established its reputation as a premier supporter of Black fine arts and artists during the Harlem Renaissance.

- **A'Lelia Walker:** One of the few Black patrons, A'Lelia Walker, the only daughter of Madame C.J. Walker (who became a millionaire in the Black haircare industry), was notorious for her well-attended Harlem parties but not for any outright monetary gifts to Harlem Renaissance artists.

To the dismay of artists such as Claude McKay, these patrons sometimes had their own creative ideas and dictated them to the artists. Faced with the threat of withdrawal of funds, some artists acquiesced to their demanding patrons.

Despite winning several contests for impressive short stories like "Spunk" and writing for a number of noted publications during the height of the Harlem Renaissance, Hurston published most of her acclaimed works in the 1930s, during the Harlem Renaissance's decline. After Alice Walker's rediscovery of *Their Eyes Were Watching God* (1937) in the 1970s, the novel became an important text in the

Black literary canon and in many Southern literature classes as well. (For more on this work, check out Chapter 21.)

### Other noteworthy artists

Other important Harlem Renaissance figures include Wallace Thurman, best known for *The Blacker the Berry* (1929); poet Countee Cullen, noted for his poem "Heritage"; and poet Claude McKay, known for his poem "If We Must Die" and the novel *Home to Harlem* (1928).

# Post–World War II, Civil Rights–era Literature

Literary scholars are often at a loss in clearly defining the literary period following the Harlem Renaissance. Although Richard Wright began his writing career during the last years of the Harlem Renaissance, he became the dominant Black literary voice of the 1940s. He was such a literary titan that critics frequently dubbed male writers who followed him as "sons of Richard Wright." Ralph Ellison and James Baldwin wrote in Wright's shadow.

Naturalism, realism, and modernism became the predominant literary styles of this period. Much of Wright's early work follows the rules of *naturalism*, where an author attempts to apply scientific principles to human behavior. *Realism*, as its name suggests, is a realistic rendering of life even in fiction. Therefore, many Black writers embraced the common Black man and woman, specifically tying the unrealized potential of Black Americans to racism.

Rejection of previous traditions is a key component of *modernism*, and a number of Black writers embraced this concept as well. They broke with the Harlem Renaissance theme of using literature for the purpose of social acceptance but didn't unconditionally embrace all things "folk." In addition to experimentation with form, the incorporation of Black American myth and ritual became important elements that would later resurface in works by Toni Morrison and Gloria Naylor in particular. Black writers during this period continued to grapple with the effects of the Great Migration, which ebbed and flowed. Although the city took center stage, vestiges of rural Southern life remained, often resulting in underlying tensions relating to class and culture.

While a number of very good writers such as Ann Petry, Pulitzer Prize–winning poet Gwendolyn Brooks, William Attaway, Chester Himes, and Dorothy West (who is lumped with Harlem Renaissance writers) emerged in the post-Renaissance,

pre–Black Arts Movement of Black literature, Richard Wright, Ralph Ellison, and James Baldwin are the most well-known.

## Richard Wright

A legend in his lifetime, the Mississippi-born Richard Wright became the benchmark for Black writers. Black writers, especially male writers, either embraced him or spurned him, but they couldn't ignore him. Although he joined other Black artists like Josephine Baker in Paris to escape American racism in 1946, he remained an American literary titan, even after his death in 1960. A few of his most notable literary achievements include

>> ***Uncle Tom's Children*** **(1938):** Wright first attracted attention with this collection of four novellas exploring the brutal reality of surviving racism in the American South. Trying to find dignity and a realization of self within the systematic oppression of Jim Crow was a unifying theme for the collection. In "Big Boy Leaves Home," for example, white mob violence mars an innocent outing to the swimming hole, prompting Big Boy to flee the South. Another edition of *Uncle Tom's Children,* with a couple of new stories, appeared in 1940.

>> ***Native Son*** **(1940):** In this novel, Bigger Thomas, poor and uneducated, takes a menial job with a rich white family. When the daughter ignores the social taboos dictating proper contact between a white woman and black man, Thomas becomes fearful to the point that he accidentally kills her. During his trial, where the main objective becomes saving Thomas from the death penalty, Wright emphasizes that American racism turns many well-meaning black men into Bigger Thomas on a routine basis. Although Bigger is guilty, Wright makes a strong argument that forces beyond his control have crippled his life by severely limiting his choices. (Chapter 21 discusses this book in greater detail.)

>> ***12 Million Black Voices: A Folk History of the Negro in the United States*** **(1941):** Like Wright's autobiography *Black Boy* (1945), *12 Million Black Voices* addresses the Great Migration, among other pivotal events. In this work, Wright's poetic words match the powerful images of Black American history.

## Ralph Ellison

Unlike Richard Wright and James Baldwin, Ralph Ellison produced few works (*Juneteenth*, his second novel, was published posthumously). Ellison's novel *Invisible Man* (1952) is such a crowning achievement, however, that it alone has solidified his place not only in Black literature but also in the broader category of American literature. In *Invisible Man*, an unnamed Black protagonist born, raised,

and partially educated in the South tracks his 20-year journey of social invisibility from the South to New York City, documenting his transformation from racial naiveté to enlightenment. He also documents his journey from subscribing to the belief that the fabled American dream is a possibility for Black Americans to the ultimate realization that that belief is untrue. In the North, he finds that while the color line isn't as firmly fixed as in the South, it still exists. Yet he holds onto his grandfather's deathbed advice to, in essence, keep living.

**REMEMBER**

Unlike protagonists in novels of the past, Ellison's unnamed protagonist doesn't seek the social acceptance of white America, nor is he uncritical of Black America. Prominent Black Americans such as Booker T. Washington and Marcus Garvey, albeit fictionally rendered, aren't safe from Ellison's social critiques. *Invisible Man* draws from a broad historical context but doesn't reject the Black folk past, either. The novel embraces the uniquely American art forms of jazz and blues, particularly in the context of a Black American experience marked by racism and oppression.

## James Baldwin

Primarily with the novel *Another Country* (1962), James Baldwin stretched conversations regarding personal and racial identity issues further by adding homosexuality and consensual interracial relationships to the Black literary discussion. The Harlem native was also among the first to criticize the Black church beyond a Black-white dynamic; in his largely autobiographical first novel, *Go Tell It on the Mountain* (1955), Baldwin, a former child-preacher tormented by his preacher stepfather, places the Black church under a microscope, examining its historical function as well as its repressive effects. Even though the Black church disdains homosexuality, the novel has an unstated homoerotic tension. An outspoken civil rights supporter, Baldwin's essays *Notes of a Native Son* (1955) and *The Fire Next Time* (1963) proved as popular as his works of fiction, some of which didn't feature any Black characters.

## Frank Yerby

Successful writer Frank Yerby enjoyed quiet success with best-selling novels like *The Foxes of Harrow* (1946), which became an Oscar-nominated film starring Rex Harrison and Maureen O'Hara. A thorough researcher, the Augusta, Georgia native often footnoted his historical novels. Before he died in 1991, Yerby published 33 novels, including *The Dahomean* (1971), later published as *The Man from Dahomey.*

# The Breakthrough: The Black Arts Movement

By the late 1960s and early 1970s, Black writers had become more secure with their own identities and no longer felt obligated to speak to white audiences directly. Instead, they turned inward, bringing their literary journey full circle to embrace the values advocated by the Black Arts Movement.

**IN THEIR OWN WORDS**

Unlike the Harlem Renaissance, the Black Arts Movement was free of white patronage and Black middle-class restraints; essentially, it was far more self-contained. According to Larry Neal, one of the movement's chief architects, "The Black Arts Movement is radically opposed to any concept of the artist that alienates him from his community. Black arts is the aesthetic and the spiritual sister of the Black Power concept. As such, it envisions an art that speaks directly to the needs and aspirations of Black Americans."

## The beginning of the movement

Acknowledged as a leading force of the Black Arts Movement, LeRoi Jones, who adopted the name Amiri Baraka, enjoyed considerable mainstream success before embracing Black nationalism. His critically acclaimed tome *Blues People* (1963) tied Black music to various social and political developments. His 1964 play *Dutchman*, which uses the flirtation between a Black man and white woman to attack the white racist power structure, won an Obie (the Off-Broadway theater award), which it shared with Adrienne Kennedy's *Funnyhouse of a Negro*. Yet despite these successes and his position as an influential Beat poet, he severed his ties to the white community, including his white wife, Hettie Cohen Jones.

Prompted by Malcolm X's assassination in 1965, Jones left Manhattan's Lower East Side to establish the Black Arts Repertory Theatre/School (BARTS) with a group of other artists in Harlem. For many, this marked the formal beginning of the Black Arts Movement. Although BARTS was short-lived, its formation inspired others in Chicago, Detroit, the Bay Area, and other urban centers. More importantly, artists in these areas embraced the Black Arts ideology as national publications such as the *Negro Digest* (later known as *Black World*) kept the Black Arts concept in the public eye.

## Welcoming new voices

Many new Black voices, particularly that of poets, emerged during the Black Arts Movement. In Detroit, Dudley Randall's Broadside Press published a slew of new

poets, including Nikki Giovanni, Sonia Sanchez, Etheridge Knight, and Don L. Lee (better known as Haki Madhubuti). Acclaimed poet Gwendolyn Brooks, who, in 1950, became the first Black writer to win the coveted Pulitzer Prize, served as a treasured advisor and member of the Chicago-Detroit arm of the Black Arts Movement. Other popular Black Arts affiliates included spoken-word artists The Last Poets and Gil Scott-Heron.

Theater was also a major component of the Black Arts Movement, with Barbara Ann Teer's National Black Theatre in New York and Val Gray Ward's Kuumba Theatre in Chicago serving as hallmarks. On the university level, professor Nathan Hare helped lead the charge for universities to establish Black studies programs. Dismissed by Howard University in 1967 for his Black Power activities, including his demand that Howard become an institution more responsive to the Black community, Hare, who coined the term "ethnic studies," was key in establishing the nation's first official Black studies program at San Francisco State in 1968. He and Robert Chrisman also established *The Black Scholar*, the first journal of Black studies and research.

## The Black Arts Movement legacy

By the mid-1970s, the Black Arts Movement, along with other organizations tied to the Black Power movement, began to diminish. However, its legacy of creating art for and about Black people lived on in an entirely new generation of Black artists who refused to compromise their identities. Ultimately, the movement, as Langston Hughes suggested in his 1926 essay "The Negro Artist and the Racial Mountaintop," recognized that the new Black artist had to step away from Du Bois's notion of double consciousness as well as resist dialoguing with the white reading public at the expense of communicating with Black people about Black people.

## Anthologies from the Black Arts Movement

Key publications representative of the Black Arts Movement include these:

>> *Black Fire*, **edited by Amiri Baraka and Larry Neal (1968):** A signature work with more than 180 selections, including essays, poetry, and short stories, from 75 writers.

>> *Black Voices*, **edited by Abraham Chapman (1968):** An impressive collection drawing from Black voices such as Frederick Douglass, Richard Wright, Malcolm X, Mari Evans, and historian John Henrik Clarke spanning over a century.

# Black Women's Words

Men have historically dominated Black literature. Before the 1970s, only a handful of Black women writers had created what many scholars touted as "important work." Toni Cade Bambara's 1970 anthology *The Black Woman* helped launch an entirely new literary movement. This momentous work celebrating the unique voices of Black women was unprecedented and helped change the core of Black literature, taking it to new heights both creatively and commercially.

As Black women writers like Toni Cade Bambara, Alice Walker, Toni Morrison, Maya Angelou, and a host of others focused on Black women in their work, a fuller sense of the Black community emerged. Not just consumed with racial equality, Black women writers contemplated questions of self-love, motherhood, and sexuality. They tackled serious explorations of how women related to men and how women related to each other.

Unlike other literary movements, there's little debate over when the Black women writers' explosion began. With the publication of Bambara's anthology, *The Black Woman*; Alice Walker's *The Third Life of Grange Copeland*; and Toni Morrison's *The Bluest Eye*, 1970 was a watershed year for Black women's literature. Although many excellent writers emerged during this time, Alice Walker and Toni Morrison became the most prominent.

With Walker and Morrison leading the charge as literary innovators, Black women writers ushered in a new generation of women writers; the Brooklyn-born Gloria Naylor, author of *The Women of Brewster Place* (1982) and *Mama Day* (1988), stood out from the bunch. Black women writers dominated the period so completely that, aside from Ernest Gaines, few Black male writers received considerable attention.

## Alice Walker

Born to sharecroppers in 1944 in Eatonton, Georgia, and active in the predominantly white feminist movement, Alice Walker pushed the literary boundaries of Black female characters. Her most enduring work, *The Color Purple* (1982), which discussed the rape and sexual exploitation of Black women by Black men, angered some Black men and women who accused her of airing the Black community's dirty laundry. Her depiction of Black lesbianism also generated criticism.

A former civil rights worker, Walker, mainly in her novel *Meridian* (1976), was among the first writers to use fiction to explore the complexities of that movement, especially from the perspective of a Black woman. Aware of Black women's displacement in both Black and women's literature, Walker restored Hurston's literary legacy when she discovered her work in the 1970s.

## BLACK WOMEN WRITERS BEFORE 1970

Black women writers began building a literary tradition long before 1970. Writers such as Harriet Jacobs, Harriet E. Wilson, and Frances Ellen Watkins Harper, among others, from the slavery and Reconstruction eras were early pioneers of the Black female literary tradition. The lesser known Alice Dunbar-Nelson drew from her New Orleans Creole upbringing for her unique stories before the more well-known Jessie Redmon Fauset, Nella Larsen, and Zora Neale Hurston emerged. Hard return Gwendolyn Brooks, Ann Petry, and Dorothy West were the prominent female writers of the 1940s and 1950s. In 1959, Paule Marshall published her groundbreaking *Brown Girl, Brownstones*, which injected the voice of the Black female immigrant into the American literary landscape. Margaret Walker Alexander, best known for her acclaimed collection of poetry, *For My People*, contributed the novel *Jubilee* in 1966, which showed the literary possibilities of the neo–slave narrative from a female perspective.

Recognizing feminism's limitations regarding Black women, Walker proposed a new context in which to view Black women's experiences that she labeled *womanism* in her book of essays *In Search of Our Mothers' Gardens* (1983). Derived from the Black Southern term "womanish," usually applied to little girls who act older than their years, womanism is a feminist view that addresses the Black woman's unique experience of double marginalization as both Black and female.

## Toni Morrison

Born Chloe Ardelia Wofford in Lorain, Ohio, in 1931, Toni Morrison (see Figure 14-1) didn't pursue writing until in her late 30s. A graduate of Howard and Cornell Universities, Morrison taught at the college level for several years before becoming a book editor. As an editor at Random House, she shepherded Black writers such as Toni Cade Bambara and Gayl Jones. Morrison also edited *The Black Book* (1974), an overview of Black American history. While working on it, Morrison encountered the story of Margaret Garner an enslaved fugitive from Kentucky who killed her child and was attempting to kill another child before her recapture because she didn't want her children to return to slavery, an event that became the seed for Morrison's Pulitzer Prize–winning novel *Beloved* (1987), which was adapted into the 1998 film starring Oprah Winfrey.

**FIGURE 14-1:**
Toni Morrison.

Rich in ritual, fable, and folklore, Morrison's Gothic approach (also laced in historical embellishment) to Black literature distinguished her as one of the greatest American writers of the 20th century. In 1993, she received the Nobel Prize for Literature, making her the first Black woman to receive the Nobel Prize. Her tremendous body of work also includes *Sula* (1973), *Song of Solomon* (1977), *Jazz* (1992), and *Home* (2012). Packed with Black American history, Morrison's work explores the complexity of Black culture, racism, and sexism in a nuanced manner that's both individual and collective. The Middle Passage, where countless Africans lost their lives making the journey from the African continent to the New World, slavery, the Great Migration, and Jim Crow are just a few of the topics she explores in depth. In 2012, President Barack Obama awarded Morrison the Presidential Medal of Freedom. Morrison passed away in 2019 at age 88. She participated in a handful documentaries about her work, including *Toni Morrison: The Pieces I Am*, released months before her death.

# Black Books from the 1990s On

Black literature continued its considerable strides into the 1990s, hitting *The New York Times* Best Seller list with regularity, a major departure from the one or two at a time in years past. Authors of these best sellers didn't necessarily become spokespersons for all Black people either, and few of the books were hailed as definitive platforms for improving the nation's race relations even as most of them significantly featured Black life and culture.

# OCTAVIA E. BUTLER

Born in Pasadena, California, in 1947, Octavia E. Butler rose to become the most prominent Black author in science fiction and arguably one of the most popular figures of the entire genre. Raised an only child by a widowed mother, Butler, who was extremely shy and bullied as a child, turned to books early in her life, finding solace in science fiction. By age 10, she was already writing her own stories. As a college freshman, she won a short story competition. Her career got a huge boon when she met renowned science fiction writer Harlan Ellison, who was instrumental in her attending the Clarion Science Fiction Workshop (where she began a lifelong friendship with fellow Black science fiction pioneer Samuel Delany) who even purchased one of her early short stories. Still, Butler struggled for years to establish herself as a writer.

Attending college during the Black Power movement as well as being raised by a mother who did domestic work impacted Butler's writing. Race, sex, and power figures appeared prominently in Butler's work. Intertwining Black history with science fiction is considered one of the most compelling aspects of her writing. Butler's more than 15 books are largely grouped in series: *Patternist, Xenogenesis (Lilith's Brood),* and *Parable (Earthseed).*

The Patternist series, spanning from the 17th century into the far future and featuring telepaths, consists of five books, including the popular *Wild Seed* (1980) and *Mind of My Mind* (1977). *Xenogenesis,* also *Lilith's Brood,* is a trilogy that includes *Dawn* (1987) and centers on the main character Lilith, the human responsible for the series' subsequent human-Oankali people. *Parable (Earthseed),* which deals with the political and socioeconomic collapse of the 21st century, consists of two of her most popular books, *Parable of the Sower* (1993) and *Parable of the Talents* (1998). Butler's blockbuster standalone novel *Kindred* (1979) about a Black woman traveling back to the 19th century and meeting her ancestors, a white slaveholder and a free Black woman who is enslaved, expanded her audience beyond science fiction.

Celebrated later in her career, Butler became the first science fiction writer to win a MacArthur "Genius Grant" Fellowship and received a Lifetime Achievement Award from the PEN American Center in 2000. Butler, who struggled with depression, died in 2006 at age 58. Her legacy, however, lives on. Her success paved a wider road for other Black science fiction writers. She even contributed a story to the groundbreaking anthology *Dark Matter: A Century of Speculative Fiction from the African Diaspora* (2000) edited by Sheree Renée Thomas, which helped introduce new voices such as Nalo Hopinkson and included established ones like Samuel R. Delany, Stephen Barnes, and Charles R. Saunders as well as acknowledged contributions from unsung figures like W.E.B. Du Bois and Charles W. Chestnut.

Some also consider Butler's work as a key inspiration to *Afrofuturism,* which is a loose cultural framework in which Black artists can apply a creative lens to examine and explore Black culture and life, facilitating conversations with the past, present, and/or future, separately or simultaneously.

Los Angeles native Walter Mosley, who published his first novel in 1990, scored big with his Easy Rawlins mysteries (even claiming former President Bill Clinton as a fan), which include *Devil in a Blue Dress.* Some best-selling Black authors self-published before a major publisher picked them up. E. Lynn Harris's unlikely best seller, *Invisible Life* (1991), in which the lead male character takes readers into a world where seemingly heterosexual Black men secretly engage in homosexual behavior, is a good example of a self-published novel that attracted a major publisher. However, few authors of any race top the self-published-to-mainstream success of Terry McMillan.

Seizing on a formula that has dominated women's commercial fiction for decades, Michigan-born Terry McMillan's novel *Waiting to Exhale* (1992) engaged white and Black readers with the standard tale of four female friends who maintain their friendship throughout their individual trials and tribulations. It was so successful that it hit its tenth printing only three weeks after its release! A subsequent film starring Whitney Houston and Angela Bassett made McMillan one of the first commercial Black writers to achieve multimillionaire status.

Looking for the next big Black writer, mainstream publishers signed up Black authors in unprecedented numbers. In addition to *Black chick lit,* a category referring to books by Black women writers duplicating Terry McMillan's style, other commercial genres sprouted. Zane, author of *Addicted* (2001) and *The Sex Chronicles* (2001), pioneered Black erotica, even adapting her work for both film and TV. Taking inspiration from the late 1960s and early 1970s *street literature* of Donald Goines and Iceberg Slim, the momentum for the contemporary street literature movement reignited with Teri Woods's self-published novel *True to the Game* (1998) and activist Sister Souljah's *The Coldest Winter Ever* (1999). Carl Weber, author of *Baby Momma Drama* (2003), and Vickie Stringer, a former drug dealer who wrote *Let That Be the Reason* (2002), published other writers in the genre through their respective publishing companies, Urban Books and Triple Crown Publications. In the 2010s, Woods's *True to the Game* became two feature films, and Weber found success with his *The Family Business* series with BET.

# BLACK CHILDREN'S AND YOUNG ADULT BOOKS

Amelia E. Johnson is credited as the first Black children's book writer with *Clarence and Corinne, Or, God's Way*, published in 1890; others point to Paul Laurence Dunbar's 1895 collection of poems titled *Little Brown Baby* as the first.

Walter Dean Myers, with more than 100 books to his credit, and Virginia Hamilton, who wrote 41 books, are generally acknowledged as the two biggest trailblazers for Black children's literature. *The People Could Fly: American Black Folktales* (1985) is one of Hamilton's most well-known children's books. Myers, whose many popular books include *Monster* and the controversial *Fallen Angels* about the Vietnam War, pioneered the Young Adult (YA) space for Black writers. Others like Jacqueline Woodson, recipient of the MacArthur "Genius Grant" Fellowship, and Tonya Bolden, winner of several Coretta Scott King Awards, have also elevated the space.

In the 2000s, newer voices addressing younger, multicultural audiences as they tackled difficult topics like police brutality and interracial dating emerged. Angie Thomas's *The Hate U Give* (2017) and both Nicola Yoon's *Everything, Everything* (2015) and *The Sun Is Also a Star* (2016), which all topped the *New York Times* Best Seller list, were made into Hollywood feature films.

Married couples who have been influential in publishing Black children's books include Cheryl and Wade Hudson, who launched Just Us Books in 1987, as well as award-winners writer/editor Andrea Davis Pinkney and illustrator Brian Pinkney. In 1998, Davis Pinkney was a founder of *Jump at the Sun* at Hyperion, the first Black children's book imprint at a major publisher. Just US Books, which has published many books, made its initial splash with *AFRO-BETS ABC Book*. The Pinkneys have collaborated on several books as writer and illustrator that include *Sit In: How Four Friends Stood Up by Sitting Down* and *Dear Benjamin Banneker*. In 2019, prolific *New York Times* bestselling author Denene Millner, whose many collaborations include Steve Harvey's *Act Like a Lady, Think Like a Man* (2009) and R&B singer Charlie Wilson's memoir *I Am Charlie Wilson* (2015), moved her children's book imprint, Denene Millner Books, to Simon & Schuster.

» Singing out through musical theater

» Staking claims on the dramatic scene

» Expanding the American dance repertoire

# Chapter **15**

# The Great Black Way: Theater and Dance

Eighteenth-century performances of Shakespeare's *Othello*, about a Moor (someone typically Black from northern Africa) who kills his white wife Desdemona, for example, almost never featured a Black actor as Othello. In the 18th-century English comic opera *Padlock*, a white actor in blackface typically played the drunken West Indian slave named Mungo who speaks in dialect. In addition, early American plays such as *The Fall of British Tyranny* faithfully included Black characters but never Black actors.

In time, Black theater took root, starting with Black musicals. As Black dancers wowed Broadway, American society began co-opting popular Black dances. This chapter traces Black theater from its early beginnings to the more recent triumphs of George C. Wolfe and the late, great August Wilson. It also touches upon Black dance history, celebrating masters like Katherine Dunham, Alvin Ailey, and Arthur Mitchell.

# Making an Early Statement

In 1821, after being denied an opportunity to participate in mainstream theater (even when productions called for Black Americans), James Henry Brown and James Hewlett founded the African Grove Theater, the first known Black theater in the United States. The African Grove Theater grew out of gatherings that began around 1816, and were held in Brown's backyard. After hiring a group of actors, the theater company's performances included Shakespeare's *Richard III* and *Othello.* There's also evidence that the company staged *King Shotaway*, a play Brown penned about a 1796 uprising of Black Caribs on the island of Saint Vincent; it's believed to be the first full-length Black American play.

White patrons weren't excluded from African Grove Theater performances or relegated to the balcony, but their typically unruly behavior relegated them to seats in the back of the theater. Because of disturbances by white patrons and the police, the African Grove Theater relocated several times. In 1823, the African Grove Theater burned down, but its demise didn't squash Black Americans' desire to master the stage.

**BLACK AMERICAN FACES**

## IRA ALDRIDGE

A graduate of New York's African Free School, Ira Aldridge launched his acting career at the African Grove Theater. Frustrated by American racism, Aldridge relocated to England to further his career. He served as a dresser to a British actor before taking to the stage. Eventually, Aldridge's talent, especially his portrayal of Othello, overwhelmed British audiences, and by 1825, Aldridge had top billing at London's prestigious Royal Coburg Theater as Oroonoko in *The Revolt of Surinam, or A Slave's Revenge*. Aldridge used his talent in many antislavery productions. He also played white characters, donning whiteface for the title role in Shakespeare's *Richard III* and Shylock in *The Merchant of Venice.*

As Aldridge's reputation grew, he toured Europe and Russia. Aldridge died in 1867 in Poland before a planned trip back to the United States. Of the 33 actors of the English stage who have bronze plaques at the Shakespeare Memorial Theater at Stratford-upon-Avon, Aldridge is the only Black American actor.

# Minstrelsy: Performing in Blackface

Almost like a sad, cruel joke, the origins of minstrelsy are traceable to the many talented enslaved dancers, comedians, and musicians who performed, often for their owners, on their respective plantations. In the early 1800s, white performers in America and England darkened their faces with burnt cork and either imitated those performances or simply performed the popular English and Irish dances of the day.

**REMEMBER**

Performing in *blackface* wasn't new — even for dramatic performers — but duplicating the rhythms of Black performers was. As the antislavery movement heated up in the 1850s, minstrel shows became decidedly proslavery.

## White minstrels

Minstrelsy as an American institution, which began around 1830 when white performer Thomas Rice, more popularly known as Daddy Rice, observed an old Black man singing and dancing. Rice found the performance hilarious, co-opted it, and began performing a song and dance number, "Jump Jim Crow." Rice's performance spawned many imitators.

**HISTORICAL ROOTS**

By the 1880s, the term "Jim Crow" had moved beyond its minstrel roots and become synonymous with racial segregation. You can read about Jim Crow and life in the segregated South in Chapter 7.

*Ethiopian minstrelsy* was the label some used to describe the practice of white performers consciously imitating Black American songs, dances, and humor. It was not until 1843, however, at New York's Bowery Amphitheater that four actors calling themselves the Virginia Minstrels ushered in the *minstrel show* by performing comic skits and songs in blackface continuously. Until the Virginia Minstrels, minstrel performances supported a main show, such as the circus; they weren't the main show themselves.

**TECHNICAL STUFF**

Proslavery factions twisted Harriet Beecher Stowe's antislavery treatise *Uncle Tom's Cabin* through unauthorized stage adaptations. These contributed to the portrayal of Uncle Tom, for example, as a harmless yes-man eager to please his white slaveholder — a misinterpretation that has persisted for generations.

# Black minstrels

Around 1855, minstrel shows with Black performers emerged. Despite being billed as more authentic than their white counterparts, Black minstrels still followed the same conventions as white minstrels: They too blackened their faces and painted their lips white and outlined them in red to exaggerate their size. They also perpetuated the two common stereotypes: the plantation darky, who had a happy and nostalgic view of slavery, and the Northern dandy, who was typically a lazy and overdressed city boy concerned with having a good time. As scholars such as Robert Toll have noted, these were the conventions Black minstrels inherited, not what they created.

In addition to attracting white audiences, Black minstrel shows appealed to Black audiences despite the genre's many proslavery conventions. Scholars have suggested that Black minstrel shows contained a subversive element that escaped the attention of white audiences. Perhaps Black audiences simply enjoyed seeing Black performers. As this form of entertainment grew in popularity, Black minstrels incorporated new dances into their shows, created new jokes, and introduced a new music now known as *ragtime* (see Chapter 16).

**REMEMBER**

Black minstrel shows were the first large-scale opportunity for Black Americans to enter show business. Overall, the minstrel show formalized the incorporation of Black American culture into general American entertainment.

**BLACK AMERICAN FACES**

## WILLIAM HENRY LANE

William Henry Lane, better known as Master Juba, helped pave the way for other Black performers. Tutored by "Uncle" Jim Lowe, an older Black dancer, and named after the *juba,* the African dance he had mastered, Lane became so popular that he and John Diamond, the reigning white dance champion, squared off several times. Although both Lane and Diamond declared themselves victorious, the contests bolstered Lane's career. Until Lane, minstrel shows were a white-only affair. Lane was such a masterful talent that he began receiving top billing at white minstrel shows by 1845. Far from just an American sensation, Lane took London by storm in 1848. He remained there and died in 1852 at age 27. Frequently credited as the creator of modern tap dance, Lane is among America's first great Black performers.

# Moving toward Broadway: Black Musical Theater

As Black musical theater developed, the racist conventions of the minstrel show slowly began to fade. The change was gradual, however, and was influenced by the following artists and their productions, which helped move the Black minstrel show closer to the modern musical format:

>> **Sisters Anna Madah and Emma Louise Hyers and *Out of Bondage*:** Better known as the Hyers Sisters, these women played a frequently uncredited role in the development of Black musical theater. Born in California in the 1850s, they were trained opera singers and performed outside the general minstrel tradition. In 1876, they began performing a musical play initially called *Out of the Wilderness* but changed to *Out of Bondage* because the general story traced the lives of Black Americans from slavery until after the Civil War. Before they disbanded in the 1890s, the Hyers Sisters staged several similar productions.

>> **Pauline Elizabeth Hopkins and *Slaves' Escape*:** A prolific writer and early Black literary pioneer born in Portland, Maine, and raised in Boston, Massachusetts, Hopkins, whose most well-known novel is *Contending Forces: A Romance Illustrative of Negro Life, North and South* (1900), got her start early. She wrote the musical play *Slaves' Escape; or, The Underground Railroad* (later revised as *Peculiar Sam; or, The Underground Railroad*), when she was just 20. By presenting the requisite "plantation darky" as unhappy, *Slaves' Escape*, which ran in Boston from 1879 to 1881, subtly critiqued one of the minstrel show's most potent racial stereotypes. Hopkins, a performer who later also became distinguished for her political writing, performed in various productions of the play with her family, the Hopkins Colored Troubadours.

**REMEMBER**

>> **Sam T. Jack and *The Creole Show*:** This production, which ran from 1890 to 1897, changed Black entertainment the most. By adding a chorus of 16 beautiful Black women performers, *The Creole Show*, produced by Sam T. Jack, a white man, shook up the all-male Black minstrel show formula and greatly expanded opportunities for Black female performers. It also embraced contemporary costumes, a significant departure from the plantation gear featured in previous shows.

>> **John W. Isham and *The Octoroons* and *Oriental America*:** With the 1895 production of *The Octoroons*, Isham, who could pass for white, pushed the envelope by including more female talent and boasting a continuous plot. His 1896 production of *Oriental America*, credited as the first Black show on Broadway, distanced itself even further from the minstrel show by replacing the customary minstrel finale with a medley of operatic-style solos and choral numbers. Acclaimed singer Sissieretta Jones, dubbed the "Black Patti" after reigning opera diva Adelina Patti, expanded on the musical innovation Isham had introduced with her own *Black Patti Troubadours*.

# More than minstrels

Considered the first true Black musical, *A Trip to Coontown* (1897) — composers Bob Cole and Billy Johnson's take on the white Broadway hit *A Trip to Chinatown* — was the first major show conceived, written, produced, performed, and managed by Black Americans. Despite its frequent use of the term "coon" and other such words (which were common at the time), the production was revolutionary, especially its final song, "No Coons Allowed," which dramatized a man's inability to treat his girl to a night out at the city's "finest" restaurant because "no coons were allowed." There was no recourse, either, because coons weren't allowed in the courthouse. Such parody wasn't lost on the Black audience. Cole, along with Rosamond Johnson (civil rights activist James Weldon Johnson's brother) also created *The Shoo-Fly Regiment* (1906) and *Red Moon* (1909).

*Clorindy, the Origin of the Cakewalk*, which opened in 1898, mixed comedy, songs, and dances. Presented by composer Will Marion Cook, *Clorindy* marked the first time a Broadway cast of any color danced and sang simultaneously. Thrilling audiences, *Clorindy* ushered in a new creative force, making the Black musical a Broadway staple.

# Williams and Walker on Broadway

Bert Williams and George Walker started out as a minstrel duo before becoming one of Broadway's most successful teams. Partnering with Will Marion Cook and celebrated poet Paul Laurence Dunbar, Williams and Walker created *In Dahomey* (1902).

Unlike other Black musicals, *In Dahomey* positively incorporated African themes. The song "Evah Dahkey is a King," translated today as "every Black person is a king," is just one example. Well-received, the show toured England. Williams and Walker became more ambitious with African themes in *Abyssinia* (1906), but that play didn't match the success of *In Dahomey*. For *Bandana Land* (1908), they focused on the South.

While touring with *Bandana Land* in 1909, Walker fell ill. He died in 1911, before he was even 40. After Walker's death, it became more difficult for Black Americans to appear in groups on Broadway. One factor was the tense atmosphere following New York's 1910 race riot in response to Black heavyweight Jack Johnson's defeat of boxing's "great white hope," Jim Jeffries (see Chapter 19). Williams, however, continued to perform to critical acclaim, primarily as a member of the *Ziegfeld Follies*, which he joined in 1910. Performing in blackface obscured his talent so much that he became a poster child for all Black American blackface performers.

From 1913 to 1917, Williams was the only Black artist on Broadway. His loyalty to the race was so great that, though frustrated by the limited but acclaimed work he did with the *Ziegfeld Follies*, he remained with the group for ten years. Without him, he feared that there would be no Black artists on Broadway. "We've got our foot in the door," Williams said. "We mustn't let it close again."

Marlon Riggs's classic 1978 documentary *Ethnic Notions* used Williams as an anchor to examine the deeply rooted anti-Black stereotypes in American culture. Spike Lee also linked his lead characters to Williams in his 2000 film *Bamboozled*, which tackled the perpetuation of the minstrel show tradition.

## The rumblings of serious Black theater

Outside minstrel work, 19th-century stage roles for Black Americans were those of servants and slaves. George Aiken's 1852 stage adaptation of *Uncle Tom's Cabin* allowed Black actors — especially in the roles of Uncle Tom, the dutiful slave, and Topsy, the unruly enslaved girl transformed by love — to demonstrate their acting skills. Perhaps the lost *King Shotaway*, written by African Grove Theater cofounder James Henry Brown and assumed to be the first play by a Black American (see the earlier section, "Making an Early Statement") had richer roles.

Not until 1858 did another play by a Black American appear. Yet that play — William Wells Brown's *The Escape; or, A Leap of Freedom*, which tells the story of two enslaved people from different plantations who marry and try to escape to freedom via the Underground Railroad — was never produced. Instead, Brown, who published the novel *Clotel* in 1853, frequently read the play at antislavery gatherings.

While musicals such as *Out of Bondage* and *Slaves' Escape* provided a transitional point between the Black musical and the Black drama, several dramatic associations also existed in various locations, particularly in the 1880s. Washington, D.C. had the Lawrence Barrett Dramatic Club (1882), Baltimore, Maryland had the Our Boys Dramatic Club (1888), and there was the Aldridge Dramatic Association (1889) in New Haven, Connecticut.

Black theater became a more serious enterprise in the 20th century. Playwright Loften Mitchell, who wrote *Black Drama: The Story of the American Negro in the Theater* (1967), referred to the period between 1909 and 1917 as the First Harlem Theater Movement, even though Harlem wasn't the only city active in cultivating serious Black actors and Black drama.

Prompted primarily by the 1915 release of the anti-Black film *The Birth of a Nation*, about the KKK, the NAACP's Washington, D.C. branch organized the Drama Committee, which successfully presented Angelina Weld Grimke's *Rachel*, a play about

the impact witnessing lynching and other forms of racial violence had on the choices the Black female lead made. It was the first drama written, performed, and produced by Black Americans.

## Early Black theater companies

Although early Black theater companies didn't embrace material by Black Americans initially, they did play important roles in cultivating Black actors. Here are the two most influential:

>> **Pekin Stock Company:** This Chicago-based company, also known as the Pekin Players, was the first high-profile Black theater company to present serious drama. Organized in 1906, the Pekin Players produced several "white" plays such as well-known dramatist Bronson Howard's *Young Mrs. Winthrop,* about a husband and wife bound by their child. These productions showed white critics especially that Black actors were more than the caricatures infused into the minstrel show format.

In its "serious" format, the Pekin Players championed mainstream (read "white") productions. When it committed itself to musicals, however, it vowed to present those written by Black Americans. One standout was *The Mayor of Dixie,* a work by the successful writing team of Flournoy Miller and Aubrey Lyles, who later took Broadway by storm with *Shuffle Along* (read more in the upcoming section "Shuffling ahead").

>> **The Lafayette Players:** The Lafayette Players, the most famous of the early Black theater companies, shared the Pekin Players' original mission to feature Black actors in productions that usually excluded them. To demonstrate that Black Americans could play any role, the Lafayette Stock Company performed Shakespeare, *Dr. Jekyll and Mr. Hyde* (with Clarence Muse, known for his butler roles in film, performing in whiteface), and *The Three Musketeers,* among others.

## Hitting the larger stage

As Black theater companies provided new opportunities for Black actors, white playwrights began discovering Black life and culture. During the Harlem Renaissance, white playwrights created several key productions. In 1917, Ridgely Torrence made the first big splash with the following three plays:

>> *Granny Maumee:* The story of a grandmother who went blind after a lynch mob killed her innocent son and now anxiously awaits another male heir before her death

>> **The Rider of Dreams:** A story centered on a husband and wife who possess different ideas about spending and saving money

>> **Simon the Cyrenian:** A story based on the biblical account of Simon from Cyrene, who played a key role during the crucifixion of Jesus

White critics and the largely white audience were very receptive to Torrence's presentation of Black actors in dramatic roles, a Broadway first.

Eugene O'Neill kept the momentum going with *The Emperor Jones,* first staged in 1920. Charles Gilpin, a former member of both the Lafayette and Pekin Players, played the lead to critical acclaim. Harlem audiences weren't bowled over by the story of a prison escapee who establishes himself as a king on a Caribbean island, but white audiences loved it. In contrast, O'Neill's 1924 play *All God's Chillun Got Wings,* a story about an interracial marriage starring Paul Robeson and white actress Mary Blair, generated bomb threats in addition to vilification from the press for its interracial casting and subject matter.

Other productions by white playwrights featuring Black actors include

>> *In Abraham's Bosom* (1926): Paul Green won the Pulitzer Prize for his play about a Black Southerner's tragic attempt to start a school for Black children in North Carolina.

>> *Porgy* (1927): Set in Charleston, South Carolina, on fictitious Catfish Row, *Porgy,* a story about a beggar, achieved critical acclaim for its unique presentation of Southern Black life and use of Gullah language, a creolized form of English with significant Africanisms. Husband-and-wife team Dorothy and DuBose Heyward created the play from DuBose's 1925 novel.

>> *The Green Pastures* (1930): Adapted from a folk novel by Roark Bradford, Marc Connelly's *The Green Pastures,* about a child who sees the Bible through her own eyes, won the Pulitzer Prize in 1930.

>> *Porgy and Bess* (1935): Intrigued by the original *Porgy,* George Gershwin collaborated with its creator DuBose Heyward to create a folk opera about Black Southern life in Catfish Row. Problematic from the start, many Black actors and Black audiences in general viewed *Porgy and Bess* as stereotypical, especially for its attempts at Southern Black dialect and its focus on poverty and violence. Although criticized musically as well for approximating jazz and other forms of Black music, *Porgy and Bess* did produce the classic American song "Summertime."

# Shuffling ahead

As influential as some of the dramas by white playwrights featuring Black actors became, the Black musical *Shuffle Along* generated the most excitement about Black talent and, in many eyes, officially ushered in the Harlem Renaissance.

Known as the Dixie Duo, Noble Sissle and Eubie Blake were one of the first Black acts to perform without blackface and in elegant dress on the white vaudeville circuit. At an NAACP benefit, the duo met Flournoy Miller and Aubrey Lyles, show-biz veterans who once had a blackface comedy-dancing act. Together, the four created the musical revue *Shuffle Along*, which became a surprise hit when it opened in 1921.

The breathtaking choreography and energetic songs overwhelmed Broadway's white audiences. Barriers were broken when, during the run of *Shuffle Along*, Black audiences, though still segregated, were allowed to sit beyond the balcony, and white audiences, which had previously rejected presentations of romantic love scenes, applauded the song "Love Will Find a Way" and its accompanying love scene. "I'm Just Wild About Harry" also became a popular song. Dance, which you can read about in the section, "Black Dance in America," later in this chapter was another important contribution from *Shuffle Along. Shuffle Along*'s success spawned many similar shows, including *Runnin' Wild*, another Flournoy Miller and Aubrey Lyles collaboration.

## Encouraging more serious fare

Civil rights leaders such as W.E.B. Du Bois weren't content with having just white dramatists and Black musical phenoms represent the Black experience. During this time, the NAACP and the National Urban League, primarily via awards presented by *Opportunity* magazine, stepped up to reward and encourage Black creative development with more serious fare. The following theater companies were also critical in nurturing that talent:

>> **Krigwa Players:** In 1925, inspired by the NAACP Drama Committee, Du Bois cofounded the New York–based Krigwa Players with Regina Anderson (also Regina Andrews) to encourage the creation of serious stage work by and for Black Americans that spoke to the political issues of the day. Two plays written by Anderson — *Climbing Jacob's Ladder,* about a lynching, and *Underground,* about the Underground Railroad — were among the plays produced.

>> **The Howard Players:** Formally founded in 1919, with roots tracing back to the College Dramatic Club (led by Ernest Everett Just), The Howard Players of Howard University became a prominent voice and example for Black theater. Shaped by T. Montgomery Gregory (also T.M. Gregory and Thomas Montgomery Gregory), with assistance from Alain Locke (a professor and

leading voice in the New Negro/Harlem Renaissance Movement), as well as Coralie Franklin Cooke and Marie Moore-Forest, The Howard Players diverged from Du Bois's vision of Black drama to focus not so much on the message and the political propaganda as on the artistic development of Black actors and, later, playwrights. In 1923, Jean Toomer's *Balo, A Sketch of Negro Life,* about a Black peasant in Georgia, became among the first plays by a Black American the group produced. Ossie Davis, sisters Phylicia Rashad and Debbie Allen, Taraji P. Henson, Isaiah Washington, and Chadwick Boseman, among other actors, later honed their craft with The Howard Players.

» **Gilpin Players:** With beginnings as the Dumas Dramatic Club in 1920, the Gilpin Players were renamed in 1922 as an homage to pioneering actor Charles Sidney Gilpin, noted for his trailblazing stage performance in *The Emperor Jones.* The Gilpin Players became the gold standard for Black theatrical performances. They operated out of the Cleveland, Ohio Playhouse Settlement (officially renamed Karamu House in 1941), the nation's oldest Black theater, which had been founded by husband and wife Russell and Rowena Jelliffe. The Gilpin Players (later the Karamu Players) attracted top Black theater talent, including actors and playwrights. Especially noteworthy are their early productions of plays by one-time Cleveland resident Langston Hughes, such as *Joy to My Soul,* a comedy about the Cleveland underworld.

## Early noteworthy dramas

Plays about Black life written by white dramatists dominated early Broadway, but some plays by Black Americans did break through. In 1923, pioneering Black dramatist Willis Richardson's one-act play, *The Chip Woman's Fortune,* about a younger man conspiring to rob an older woman of her hidden fortune, was the first serious, nonmusical play by a Black American to have a Broadway run. Former bellhop Garland Anderson's *Appearances,* about the incidents in the life of a bellboy, followed Richardson's in 1925, and has the distinction of being the first full-length, nonmusical play on Broadway by a Black American. The show's mixed-race casting, which was illegal at the time, created quite a stir.

In 1929, *Harlem,* the play Wallace Thurman co-wrote with a white writer about the struggles of a Black family who migrated from the South, received mixed reviews and had limited success. Thurman is best known for the book *The Blacker the Berry,* about intraracial prejudices within the Black community.

Technically, Langston Hughes's 1935 play, *Mulatto,* believed to be autobiographical for its story about a white father's rejection of his mulatto son, was the first hit Broadway production written by a Black American. Hughes, however, was displeased because the show's white producer added a rape scene and made other changes without his knowledge.

The Harlem Renaissance period would only crack open Broadway's doors to Black actors and playwrights; it would take continued pushing to open them. Plays such as Zora Neale Hurston's *Color Struck* and Georgia Douglass Johnson's *Blue Blood*, exploring intraracial and interracial strife, along with the continued development of Black theater companies to train Black actors, generated excitement for Black theater overall.

# Black Theater Comes of Age

Musicals, Black and white, declined when the Great Depression took root in the 1930s. Hollywood absorbed a considerable amount of Broadway's white talent, but Black performers, with the primary exception of dancers, had little recourse. Hope for Black dramatic productions came from the most unlikely of sources: the Negro Theater Unit of the Works Progress Administration's Federal Theater Project (FTP).

Although the Federal Theater Project lasted only a short four years before the House Committee on Un-American Activities (HCUA) ended it in 1939, it had a tremendous decades-long impact on Black theater and drama. As Black theater moved into the 1940s, the need for Black artists and their communities to cultivate their talents remained, and other theater companies, most notably the American Negro Theater, stepped up to fill the void.

## The Federal Theater Project and Black drama

Headed by Hallie Flanagan, previously a drama professor at Vassar, the Federal Theater Project operated in various regions throughout the country, with the Harlem and Chicago units being among the most popular. Unlike Broadway, the Federal Theater Project favored dramatic productions featuring Black Americans that enabled Black actors to develop their craft and prepared them for more mainstream fare and encouraged Black-oriented productions.

In addition to all-Black versions of mainstream plays, such as Shakespeare's *Macbeth*, the classic tale of power and betrayal, and George Bernard Shaw's *Androcles and the Lion*, about a slave saved by a lion, other key Federal Theater Project performances included new plays written by Black Americans:

>> **_Walk Together Chillun,_** by Frank Wilson, about the trials of Georgia laborers who migrated to New York after World War I and the division that migration created within the Northern Black community

>> **_Conjur Man Dies,_** by Rudolph Fisher, a Harlem murder mystery featuring a Black Sherlock Holmes–inspired detective

>> **_Big White Fog,_** by Theodore Ward, about a father who invests his family's money in Marcus Garvey's UNIA Movement while Garvey sits in prison (see Chapter 7 for details on Marcus Garvey)

Artistic disagreements between white administrators and Black talent, coupled with censorship from the government and other entities, played a role in the slow production of plays by Black dramatists. Another factor was the expectation of the audience — both Black and white — to see singing and dancing popularized by Black musical and vaudeville acts. Nonetheless, the Federal Theater Project helped prepare actors, dramatists, other Black theater professionals, and equally important, audiences, Black and white, for the bolder Black theater that emerged during the civil rights era.

## The American Negro Theater (ANT)

One of the most influential institutions that emerged during the 1940s was the American Negro Theater (ANT). Spearheaded by playwright Abram Hill and actor Frederick O'Neal, the ANT launched in Harlem in 1940 as an artist cooperative, with the artists agreeing to work as a collective and to donate 2 percent of any income they made back to the ANT. Hill's _On Striver Row,_ a satire of Black middle-class social climbing, became the ANT's first successful production. By 1942, the ANT added the Studio Theater, a training program for actors that Sidney Poitier, Harry Belafonte, and Ruby Dee, among others, attended.

_Anna Lucasta,_ a Polish drama about a prostitute and her family dynamic adapted for a Black cast, became such a success that it opened on Broadway in 1944, and ran continuously until 1946. Broadway success, however, undermined the ANT, moving it away from its community roots to achieving Broadway acclaim. By 1949, the ANT was no more, but its legacy paved the way for more dramatic success. ANT alums included playwrights such as Alice Childress, best known for her 1970s play and film _A Hero Ain't Nothin' But a Sandwich,_ about a young Black boy caught up in drugs and crime.

# CIVIL RIGHTS THEATER: THE FREE SOUTHERN THEATER

The Free Southern Theater (FST), founded in 1963 by Student Nonviolent Coordinating Committee (SNCC) field directors Doris Derby and John O'Neal, along with *Mississippi Free Press* writer Gilbert Moses, was an offshoot of the civil rights movement. Well-supported by established actors, both black and white, the FST took theater productions to areas throughout Mississippi that had never been exposed to live theater. Continual harassment in Jackson forced the FST to relocate to New Orleans. Debates about direction and form, among other issues, resulted in the company's disbanding in 1971.

## A place to call home

With more Black theatrical talent than available roles or plays in mainstream theater, Black Americans once again turned inward. Several influential dramatic enterprises began in the late 1960s and the early 1970s:

>> **The Negro Ensemble Company (NEC):** Douglas Turner Ward and Robert Hooks officially founded the Negro Ensemble Company in 1967, to nurture actors and playwrights. In addition to esteemed NEC participants such as Esther Rolle and Roscoe Lee Browne, the NEC also welcomed talented playwright Charles Fuller, noted most for his Pulitzer Prize–winning *A Soldier's Play,* about the murder of a Black soldier on a Southern army base. Ward's own *A Day of Absence,* a play performed in whiteface about a town whose Black population disappears, and Joseph A. Walker's *The River Niger,* about a Harlem family's struggles in the 1970s, were among the first plays the NEC produced.

>> **The New Federal Theater:** Unlike other theaters that struggled to survive from the beginning, the New Federal Theater, founded in 1970 by Woodie King Jr., scored early with classics such as Ntozake Shange's *For Colored Girls Who Have Considered Suicide/When the Rainbow Is Enuf* and actors such as Denzel Washington.

>> **Frank Silvera Writers' Workshop:** Counting Morgan Freeman among its early founders, the Frank Silvera Writers' Workshop (FSWW), spearheaded by stage manager Garland Lee Thompson, set up shop in Harlem in 1973. It was named for Jamaican-born actor Frank Silvera, who nurtured Black theater talent out of his own pocket. Talent the FSWW supported included Richard Wesley, who served as writer for the Sidney Poitier/Bill Cosby films *Let's Do It Again* and *Uptown Saturday Night.*

## LORRAINE HANSBERRY

Lorraine Hansberry became the first Black American and youngest playwright to win the New York Drama Critics Circle Award with her play *A Raisin in the Sun,* which opened on Broadway in 1959. Inspired by her own family's experience integrating a white neighborhood in Chicago, Hansberry's play presented a complex portrait of a working-class Black family's human struggle with one of the most complex issues of the day. The play starred Sidney Poitier, Ruby Dee, and Louis Gossett, and it was the first play on Broadway directed by a Black American (Lloyd Richards).

Phylicia Rashad, best known as Clair Huxtable from *The Cosby Show,* became the first Black actress to win the Tony Award for Best Performance by a Leading Actress in a Play for the 2004 Broadway revival of *A Raisin in the Sun,* which also starred rapper/producer Sean "Diddy" Combs, Hollywood actress Sanaa Lathan, and Broadway titan Audra McDonald (winner of more Tony Awards than any other actor).

# Black musicals, 1940s and beyond

During the 1940s, *Carmen Jones,* the Black version of the Georges Bizet opera *Carmen,* hit big, but shows such as *St. Louis Woman,* set among the Black horse-racing set, flopped. Despite Lena Horne's successful Broadway debut in *Jamaica* and a revival of *Porgy and Bess,* Black performers were largely absent from Broadway in the 1950s. The 1960s were slightly improved. Influenced by the success of *A Raisin in the Sun* and the turbulent times, musicals took on a sharper social edge. Diahann Carroll starred in the 1962 musical *No Strings* as the Black model girlfriend of a white expatriate writer living in Paris. *Golden Boy,* the 1964 musical starring Sammy Davis Jr. infused the civil rights struggle into the musical with Davis playing a boxer from Harlem whose brother worked for the Congress of Racial Equality.

In 1961, *Purlie,* the Black musical version of *Purlie Victorious,* written by veteran actor Ossie Davis and set on a cotton plantation in Georgia, not only made Melba Moore a star but also kicked off the 1970s Black musical revival. In the 1970s, *The Wiz,* a Black version of the *Wizard of Oz,* literally averted financial ruin by appealing directly to Black audiences. Other musicals like *Ain't Misbehavin',* which used the music of Fats Waller, and *Sophisticated Ladies,* based on the music of Duke Ellington, were also Broadway hits.

Nothing compared to the 1981 debut of *Dreamgirls,* as the Supremes-inspired musical enthralled audiences, making stars of Sheryl Lee Ralph and Loretta Devine and a legend of Jennifer Holiday and her big song "And I'm Tellin' You," which jumped straight to classic status. At the Tony Awards, *Dreamgirls* won an impressive 6 of its 13 Tony Award nominations. In 2007, Jennifer Hudson won the

Academy Award for Best Supporting Actress for playing Effie in the 2006 film version also starring Oscar winner Jamie Foxx and Beyoncé Knowles (read about it in Chapter 17).

Dance-heavy musicals such as *Black and Blue* and *Jelly's Last Jam* (read about some of Broadway's best dancers and choreographers in the later section "Black Dance in America") dominated the end of the 1980s and 1990s. Also in the 1980s, *Mama, I Want to Sing!* — a gospel stage play about a shy, church-honed singer who ventures into secular music — ushered in an entire movement that in recent years helped propel the Christian-inspired plays of Tyler Perry, best known for his role as the mouthy older woman Madea. *Diary of a Mad Black Woman,* his dramatic adaptation of Bishop T.D. Jakes's best-selling self-help book for women who've survived sexual abuse, is his most well-known stage play. Perry's stage success became his launch pad to building a trailblazing film and TV empire (read about it in Chapter 18).

David E. Talbert's stage plays, while largely Christian in theme, scored by dealing more directly with romantic relationships and, in recent years, embracing R&B-tinged songs. Shelly Garrett, best known for his popular relationship-gone-wrong play *Beauty Shop,* set in a beauty shop during the late 1980s, inspired Talbert, whose best-known plays include *The Fabric of a Man,* involving a love triangle between a successful fashion designer, her disgruntled husband, and a sexy tailor. Like Perry, Talbert also embarked on a Hollywood career.

# Two Visionaries

Beginning in the 1980s, two visionaries — August Wilson and George C. Wolfe — emerged, representing different spectrums but both bringing a fuller and more textured portrait of Black American life and culture to the stage. Together they, more than any other individuals in the 1980s and 1990s, challenged the theater's cultural gatekeepers and audiences to delve deeper into the Black American experience and to see music, in particular, as an extension, not simply a product, of that experience. Quite often, they didn't choose, as many had before them, to elevate music over drama, or vice versa. Instead, they celebrated that richness in all its glory, bringing the beauty and pathos of jazz and blues to life in ways never before imagined.

## August Wilson

Easily among the greatest American playwrights of the 20th century, August Wilson almost singlehandedly reshaped the American theater's perception of

Black American life. Meshing drama with music and laughter with tears, Wilson proposed and delivered his astounding ten-play series known as *The Pittsburgh Cycle.* With one play for each decade, it documents Black American life throughout the 20th century.

Wilson used his native Pittsburgh as his primary canvas, painting majestic characters and situations of everyday people and everyday life. *Fences* — a complex story of a former Negro League baseball player turned garbage man at odds with his athletically gifted son in the 1950s — won the Pulitzer Prize. The Pulitzer Prize–winning *The Piano Lesson* is a story about a sister and brother from Mississippi at odds over the family's ancestral piano. In this work, Wilson, who changed his name to honor his mother, used the piano as a metaphor for the tug between discarding the past and its pain in order to begin anew and maintaining a balance in order to inherit and maintain the strength that's made survival possible.

Wilson frequently collaborated with Yale School of Drama dean Lloyd Richards, who directed *A Raisin in the Sun* on Broadway. Wilson's plays, therefore featured top Yale talent such as Angela Bassett, Charles Dutton, and Courtney B. Vance. The first and last installments of *The Pittsburgh Cycle, Gem of the Ocean* for the 1900s and *Radio Golf* for the 1990s, were staged in 2003 and 2005, respectively. Sadly, Wilson died of liver cancer in 2005.

Theater titan Kenny Leon (see the later section "Black Theater in the 21st Century") and legendary actor Denzel Washington (see Chapter 17) are the two most prominent advocates of Wilson's work, with Leon keeping Wilson's legacy alive primarily on stage and Washington committed to bringing all of Wilson's work to the big screen. Washington directed Wilson's *Fences* (2016), which scored an Academy Award nomination for Best Actor and earned Viola Davis the Oscar for Best Supporting Actress. He also produced *Ma Rainey's Black Bottom* (2020), which earned multiple Oscar and Golden Globe nominations, including Best Actress and Best Supporting Actor nods for Viola Davis and Chadwick Boseman (which he posthumously won a Golden Globe).

# George C. Wolfe

Raised in segregated Kentucky in the 1950s and 1960s, playwright and director George C. Wolfe opened the theater to Black Americans and other underrepresented populations in his role as artistic director and producer of the New York Shakespeare Festival/Public Theater from 1993 to 2004. After cutting his teeth at Los Angeles's Inner City Cultural Center, Wolfe made noise off-Broadway with his satirical look at slavery and other events in Black American culture in *The Colored Museum.* He took the Black Broadway musical to new heights with *Jelly's Last Jam,* which combined great music and dance numbers with an introspective story of jazz's self-proclaimed founder, Jelly Roll Morton.

In a departure from Black-themed material, the openly gay Wolfe directed Tony Kushner's groundbreaking AIDS drama *Angels in America* to critical acclaim, winning a Tony for his direction. He also directed Suzan-Lori Parks's *Topdog/Underdog*, a contemporary story of two brothers grappling with their lives past and present, which won the 2002 Pulitzer Prize.

Wolfe conceived and directed *Bring in Da Noise, Bring in Da Funk*, tap dancer Savion Glover's star-turning vehicle that earned them both Tony Awards for direction and choreography, respectively. He directed playwright/actress Anna Deavere Smith in her solo rendition of the L.A. riots in 1994's *Twilight: Los Angeles 1992* as well as *Shuffle Along* in 2016 and *The Iceman Cometh*, starring Denzel Washington, in 2018. Wolfe also expanded his talents to film. His many films, mostly for TV, include *Lackawanna Blues* (2005) and August Wilson's *Ma Rainey's Black Bottom* (2020) from the stage, as well as *The Immortal Life of Henrietta Lacks* (2017) and *Nights in Rodanthe* (2008).

# Black Theater in the 21st Century

Black professionals, both on and off stage, have continued to make contributions in the theater in the 21st century. The following sections identify some.

## Kenny Leon

A native Floridian born in 1956, Kenny Leon began his theater career as an actor. Leon thrived in Atlanta, Georgia, where he attended what is now Clark-Atlanta University, making moves on stage and behind it. In 1990, Leon made national headlines when he became artistic director of the Alliance Theater Company in Atlanta, a rarity for a mainstream, predominantly white arts institution in the South. During his decade-long tenure, Leon staged various productions, premiering Pearl Cleage's *Blues for an Alabama Sky* and the musical *Aida* from Elton John and Tim Rice, which went on to hit big on Broadway.

In 2002, he co-founded True Colors Theater Company. Though based initially in both Washington, D.C. and Atlanta, the latter increasingly won out as the primary city. Operating largely out of the Southwest Arts Center in a predominantly Black community in Atlanta, True Colors, with its abundance of classic and new works created by Black playwrights and featuring Black life and culture, became reminiscent of the imprint made by Jomandi Productions, Atlanta's legendary Black theater company operating from 1978 into 2000.

Leon expanded his reach as a director with Broadway productions like his 2004 revival of Loraine Hansberry's groundbreaking *A Raisin in the Sun*, with Sean "Diddy" Combs, Sanaa Lathan, Audra McDonald, and Phylicia Rashad (for which she won a Tony); he also directed the production for ABC in 2008. Meanwhile, he doubled down on his personal commitment to preserving and elevating the legacy of Wilson, especially *The Pittsburgh Cycle*. He directed the Broadway premieres of the first and last installments of *The Pittsburgh Cycle* with *Gem of the Ocean* in 2004 and *Radio Golf* in 2007. Leon's 2010 Broadway revival of *Fences* resulted in Tony wins for Denzel Washington and Viola Davis. On the heels of Wilson's 2005 death, Leon and Todd Kreidler, longtime collaborators of the theatrical great, created the August Wilson Monologue Competition for young people, a national and annual competition depicted in the 2020 Netflix documentary *Giving Voice*.

Beyond Wilson, Leon has kept Black theater in the mainstream, directing productions such as the 2005 opera *Margaret Garner* with a libretto by Toni Morrison, the 2014 Tupac-inspired musical *Holler If Ya Hear Me*, the 2015 NBC broadcast of *The Wiz Live!*, as well as the 2020 Broadway premiere of Charles Fuller's Pulitzer Prize–winning play, *A Soldier's Play*, starring Blair Underwood and David Alan Grier. Leon's film and TV work as a director includes the 2012 Black cast version of *Steel Magnolias* starring Queen Latifah, 2019's *American Son* starring Kerry Washington (which he also directed on Broadway the year before), *Private Practice*, and the CW's *Dynasty*.

## Suzan-Lori Parks, Lynn Nottage, Tarell Alvin McCraney, and beyond

Although Suzan-Lori Parks, born in Kentucky in 1963, wrote plays well before the 2000s, she didn't make a huge splash until her play *Topdog/Underdog* received rave reviews in its off-Broadway and Broadway runs in 2001 and 2002. Directed by George C. Wolfe, *Topdog/Underdog* originally starred Jeffrey Wright and Don Cheadle (rapper/actor Mos Def replaced Cheadle in a later production) in the roles of two brothers, Booth and Lincoln, as they cope with a myriad of issues, including poverty and racism. Parks became the first Black woman to win the Pulitzer Prize for Drama in 2002. *Father Comes Home From the Wars, Parts 1, 2, & 3*, her provocative 2014 off-Broadway play that was also presented by The Public Theater, was a finalist for the 2015 Pulitzer Prize. Set during the Civil War, it explores questions of power, identity, and freedom.

Like Parks, Brooklyn native Lynn Nottage only began attracting popular attention in the early 2000s with the following plays:

>> ***Intimate Apparel* (2003)**, about a Black woman pursuing her dreams as a seamstress in New York City; it resulted in several award wins, including the Drama Desk Award for Outstanding Actress for Viola Davis

>> *Ruined* **(2008)**, about the struggles of women in civil war–torn Democratic Republic of Congo; it won the 2009 Pulitzer Prize for Drama

>> *By the Way, Meet Vera Stark* **(2011)**, exploring the long-term relationship of a Black maid and her white boss, a Hollywood star, particularly around their roles in an epic Southern film that starred Sanaa Lathan

>> *Sweat* **(2015)**, set in a working-class bar, exploring race and identity, especially among Black and white women factory workers in the midst of a struggling and changing economy; it won the 2017 Pulitzer Prize for Drama after running on Broadway

While a Yale grad student, Tarell Alvin McCraney was an assistant to Wilson for the 2005 production of *Radio Golf*, Wilson's final play, with the Yale Repertory Theater. Born in 1980 in Liberty City, Florida and raised by a drug-addicted mother alongside a brother who was in and out of prison, McCraney began making a name for his own work early. His *The Brother/Sister Plays* is a set of three plays exploring complex relationships, both heterosexual and gay, against a backdrop of societal expectations, police injustice, and more in the Louisiana projects. The plays include *In the Red and Brown Water* and *The Brothers Size*, both Yoruba-influenced, and the Louisiana-influenced *Marcus; Or the Secret of Sweet*, first presented between 2007 and 2010.

McCraney, whose 2019 Broadway production of *Choir Boy* earned several Tony Awards, received the MacArthur "Genius Grant" Fellowship in 2013. *Moonlight*, the groundbreaking 2016 coming-of-age LGBTQ film that won the Academy Award for Best Picture, adapted from the openly gay McCraney's semiautobiographical play, *In Moonlight Black Boys Look Blue*, also earned him an Academy Award for Best Adapted Screenplay. Other film and TV productions from McCraney, who became the playwriting chair at the Yale School of Drama in 2017, include the film *High Flying Bird* (2019) and the OWN series *David Makes Man* (2019).

With these playwrights and more, the Black theatrical presence has a strong future. Standouts include the following:

>> Dominique Morrisseau, a 2018 MacArthur "Genius Grant" Fellowship recipient known for her three-play cycle, *The Detroit Projects*, including *Detroit '67*

>> D.C.-born Branden Jacob-Jenkins, a 2016 MacArthur "Genius Grant" Fellowship recipient, known for writing Black characters in plays such as *Gloria* and *Everybody*, both finalists for the Pulitzer Prize for Drama in 2016 and 2018, respectively

>> Zimbabwean-American and noted actress Danai Gurira, who was nominated for a Tony Award for Best Play for the 2016 Broadway production of *Eclipsed*

>> Jeremy O. Harris, known for his controversial 2019 *Slave Play*, which received 12 Tony nominations, the most for a nonmusical

## NATIONAL BLACK THEATER FESTIVAL

Larry Leon Hamlin, founder of the North Carolina Black Repertory Company, created the National Black Theater Festival (NBTF) in 1989, to unite Black theaters, actors, and other stage professionals from across the nation. The festival is held once every two years in Winston-Salem, North Carolina. Maya Angelou served as the NBTF's first chairperson. The 2005 NBTF boasted over 100 performances. In 2019, the festival drew more than 60,000 attendees.

# Black Dance in America

Unlike dance in the Caribbean, which retained a more pronounced African influence, Black dance in America almost immediately combined African and European influences. Africans' dancing didn't bother the Catholic Church, so the French and Spanish rarely prohibited enslaved people in their Latin American and Caribbean colonies from dancing. In the United States, however, some Protestant churches strongly disapproved of dancing. Slaveholders and other Europeans didn't understand the strong link between music and dance that enslaved Africans cherished.

## Early dances

Protestant restrictions notwithstanding, few slaveholders objected to dance competitions. One of the early dances to emerge was the *cakewalk,* in which Black dancers parodied white dancers by combining their stiff upper-body movements with the fancy footwork common in many African dances.

Still, professional dance was the province of white people. In the 1830s, the white minstrel Thomas Rice traveled extensively, performing the song-and-dance number "Jump Jim Crow" he'd lifted from Black culture (see the earlier section "White minstrels"). Black American William Henry Lane was unusual for his time. He wasn't just allowed to dance; he was celebrated for it. Lane was said to be the first performer to add syncopation and improvisation to his act, making him a strong candidate as an early tap dance innovator.

By the 1900s, Black American dance found a wider audience. Black composers wrote songs that described how dances were performed, and Black vernacular dance slowly crept into white society circles. The musical *Darktown Follies* at the Lafayette Theater in Harlem in 1911, featured dances including the cakewalk, Ballin' the Jack, and the Texas Tommy, a forerunner to the Lindy; the show changed how white producers approached all-white shows in that they began

coopting Black musicals. Instead of coopting, Broadway impresario Florenz Ziegfeld Jr., of *Ziegfeld Follies* fame, purchased a circle dance from *Darktown Follies* for his own Broadway show.

# Tap dance

Quite possibly, tap dance grew out of a ban on drums by slaveholders following the Stono Rebellion (see Chapter 4 for details); because they couldn't use drums, enslaved people often created rhythms with their feet and sometimes by clapping their hands. Although flamenco, clogging, and other dance forms were also influential, tap dance still bears a strong African influence.

The 1921 musical *Shuffle Along* really injected Black dance into popular American dance, introducing both the Charleston and tap dancing to white audiences. The Charleston reached frenzied heights after being featured in the 1923 musical *Runnin' Wild. Runnin' Wild* made dancer Florence Mills, who thrilled audiences with her high kicks, a star. Josephine Baker, whose unique style made her a star in France, made an impression in the chorus line.

Throughout the 1920s, dance accompanied the jazz craze. Tap dance, in particular, came into its own during the swing jazz era. Tap dancers accompanied some of the biggest names in jazz and added even more finesse to those musical performances with their elegant dance moves, often achieved while wearing a tuxedo with tails. Those smooth and thrilling routines full of jumps and synchronized moves landed some of the best of the best tap dancers onto the big screen.

Famous Black tap dancers include the following:

>> **Bill "Bojangles" Robinson:** One of the first Black Americans to become a tap star, Robinson, best known for his role as a docile servant who danced with Shirley Temple in films from the 1930s, didn't become a star until 50, when he landed a breakout role in the Broadway musical *Blackbirds of 1928.* An innovative dancer, Robinson wore wooden-soled shoes and could duplicate any rhythmic sound from a drum.

>> **The Nicholas Brothers:** Known for their high acrobatic moves, the Philadelphia-raised Fayard and Harold Nicholas worked at the famed Cotton Club along with Duke Ellington, Cab Calloway, and other luminaries. They also worked on Broadway in productions like *The Ziegfeld Follies of 1936.* Their extensive film career, which includes *Stormy Weather,* began in 1934 and spanned several decades.

>> **Charles Atkinson:** Better known as Cholly Atkins, Atkinson earned fame as the man behind the smooth Motown moves. As the in-house Motown

choreographer, Atkins worked with many groups, most notably the Temptations. While the Temptations didn't tap dance, they did emit a collected cool typically associated with the best tap dancers of the time. In 1988, Atkinson, Fayard Nicholas, and a few others choreographed the Broadway musical *Black and Blue,* which won a Tony Award.

>> **Sammy Davis Jr.:** He began his notable career as a dancer in the Will Mastin Trio with his father (Sammy Davis Sr.) and "uncle" Will Mastin. An all-around entertainer, Sammy Davis Jr. inspired Gregory Hines, one of tap's most noted dancers of the late 20th century.

>> **Gregory Hines:** Tony winner Hines helped keep tap alive. He began his career at an early age as one-third of the family trio Hines, with his father and brother. When he later moved into film and television, he worked hard to bring the spotlight back to tap dancing in films like *Tap* (1989) and *Bojangles* (2001), about the life of Bill "Bojangles" Robinson. Hines enjoyed a Tony Award–winning turn in *Jelly's Last Jam,* which he also helped choreograph. He passed the tap dance baton to the young Savion Glover, with whom he worked in *Jelly's Last Jam.*

>> **Savion Glover:** In 1996, Glover helped create the groundbreaking *Bring in Da Noise, Bring in Da Funk,* which tells Black American history through tap dance. Glover, who won a Tony for his choreography of that show, also appeared in *Bamboozled* (2000), a film that explores the legacy of racism on film and TV. Glover continued to push the boundaries of tap dance with edgy collaborations, such as with the band IF TRANE WUZ HERE, in which a poet, a dancer, and a saxophonist all interpret the music of jazz great John Coltrane.

# Breakdancing

Like other popular dance crazes, breakdancing and other forms of hip-hop dance took the country by storm in the 1970s and 1980s. A recognizable element of hip-hop culture developed alongside rap music in the South Bronx in the 1970s, and breakdancing eventually had an identity of its own. Signature moves that include the head-spin and the *windmill,* in which the dancer rotates their body on the ground using one arm, also developed. Break dancing, which contains many moves that bear a striking resemblance to the Brazilian martial art form Capoeira, developed by enslaved Africans, broke into the mainstream in 1983 when Michael Jackson featured it in his groundbreaking video for the song "Beat It." From then, *breaking,* as it's also called, benefited from greater exposure in films such as *Beat Street* (1984) and *Breakin'* (1984), in addition to many rap videos. Far from dead, breakdancing was announced as a new Olympic sport in 2020 for the 2024 Olympics.

# Classical dance forms

Black Americans didn't distinguish themselves only in popular dance. Masters such as Katherine Dunham, Pearl Primus, Alvin Ailey, and Arthur Mitchell contributed to the transformation of modern dance in America. Both trained anthropologists, Dunham and Primus imbued their work with a cultural backbone that hadn't existed before. Numerous other dancers and choreographers, such as Bill T. Jones, Donald McKayle, Debbie Allen, and Misty Copeland are also integral parts of Black dance history.

## Katherine Dunham

Katherine Dunham insisted that her dancers understand the cultural significance of her choreography before they danced it. She was so serious about unearthing those connections that she studied dance in the Caribbean, most notably in Haiti. Although Dunham appeared in several films and Broadway productions, she blazed her own trails. In 1945, she opened the Dunham School of Dance in New York, and the following year she received critical acclaim for *Bal Negre,* a dance revue. The New York Metropolitan Opera commissioned Dunham to choreograph its 1963 production of *Aida.* Dunham also wrote several books. Until her death in 2006, she lived in East St. Louis, Illinois, where she used the arts to combat poverty.

## Pearl Primus

Pearl Primus drew inspiration directly from Africa. Her intention wasn't to dance as a black dancer but rather as a dancer who had African roots. She favored imbuing her work with strong social commentary. For example, her Broadway debut in 1944 featured the piece "Strange Fruit," in which a woman reacts to a lynching. Her 1952 show *Dark Rhythm* reflected her travels to Africa, which incorporated dances from Liberia, Sierra Leone, and others.

## Alvin Ailey

Alvin Ailey was inspired to dance by Dunham. A former athlete, he made his debut in 1953 with the Lester Horton Dance Theater in *Bal Caribe.* An instant star, he danced in the film *Carmen Jones* (1954) and appeared on Broadway with noted dancer Carmen de Lavallade in *House of Flowers.* Ailey continued his dance training and studied with masters like Martha Graham.

By 1962, Ailey had formed the Alvin Ailey American Dance Theater (AAADT), an integrated company of dancers committed to presenting new works along with older works, both Black and white. Artistic director Judith Jamison, one of Ailey's star dancers, took over the AAADT after his death in 1989, and continued Ailey's

pioneering efforts until handing the baton in 2011 to Robert Battle, who had been a frequent choreographer and artist in residence with Ailey since 1999.

## Arthur Mitchell

Arthur Mitchell was the first Black American to become a principal dancer at the prestigious New York City Ballet. Classically trained, Mitchell rarely danced specifically Black parts. For example, he won acclaim for his role as Puck in *A Midsummer Night's Dream.*

Knowing firsthand the limited opportunities available for Black Americans to train in classical ballet, Mitchell cofounded the Dance Theater of Harlem (DTH) in 1969. For decades, DTH trained dancers in some of the most prestigious companies in the U.S. and the world, including founding member and principal ballerina Virginia Johnson, whose career spanned nearly 30 years. After DTH was closed from 2004 to 2012 due to financial difficulties, Mitchell invited her to step in as artistic director in 2013. Mitchell passed away in 2018 at age 84.

## Debbie Allen

Debbie Allen's professional career began in 1970 on Broadway in the chorus of *Purlie.* One of the highlights of her Broadway career includes the Drama Desk Award and the Tony nomination for Best Featured Actress in a Musical, which she received in 1980 for her role as Anita in the Broadway revival of *West Side Story.* She earned a second Tony nomination in 1986 for *Sweet Charity.* She became the first Black actress to win the Golden Globe for Best Actress in a Television Series Musical or Comedy in 1983, for her role as dance teacher Lydia Grant on the hit 1980s series *Fame.* She also won three Primetime Emmys for Outstanding Choreography — two for *Fame* and one for *The Motown 25th Anniversary Special.* She choreographed the Academy Awards for a record-breaking ten times.

In 2001, Allen, who is also a director and producer, opened the Debbie Allen Dance Academy in Los Angeles. The Shonda Rhimes–produced 2020 documentary *Dance Dreams: Hot Chocolate Nutcracker* offered a glimpse into the school's work by capturing the behind-the-scenes of the holiday production.

## Misty Copeland

Misty Copeland, like many Black ballerinas, didn't have a smooth journey. Yet on June 30, 2015, she became a symbol of hope to many when she was named the first Black ballerina promoted to principal dancer in the 75-year history of the storied American Ballet Theater (ABT). Growing up, Copeland faced significant challenges, including a childhood marked by uncertainty and financial struggle. Her formal introduction to ballet came in 1996 at age 13 through classes first at a California Boys & Girls Club, followed by formal study at the San Pedro Dance Center.

Training in ballet required Copeland to move in with her mentor, Cynthia Bradley, with whom she and her mother, Sylvia DelaCerna, signed a management contract entitling the Bradleys to 20 percent of her future earnings. Copeland visited her family only on the weekends until 1998, when her mother and Bradley and her husband publicly clashed. Eventually Copeland returned home, pursuing dance less intensively than before. Despite early offers to join companies, Copeland's mother insisted she graduate from high school before joining the ABT Studio Company in September 2000.

As Copeland's body began to change, she suffered body-conscious issues commonly associated with dancers of color in the largely white world of ballet. Copeland herself talks about how she was told her body wasn't that of a ballet dancer. As she continued to excel, becoming one of the youngest ABT dancers promoted to soloist in 2007, overcoming those challenges made her a role model to other aspiring ballerinas of color as well as young girls overall. From 2008 to 2020, Copeland was the only Black woman ballerina at ABT. Copeland, who overcame a number of injuries, made a mark dancing in classics such as *The Sleeping Beauty*, *The Nutcracker*, and *Firebird*, which became a signature performance for her — so much so that it became the basis and title of her debut picture book in 2014.

From dancing tour dates with Prince to numerous endorsement deals like Under Armour, Dannon, and Estée Lauder — not to mention her 2015 documentary *A Ballerina's Tale* and various television appearances and numerous books, including her 2014 memoir, *Life in Motion: An Unlikely Ballerina* — Copeland's reach extended well beyond the insular world of ballet.

# 5

# A Touch of Genius: Music, Film, TV, and Sports

Ponder Black music's African roots while also exploring its evolution across various genres, beginning with the spirituals and the blues, as well as through jazz, rock and roll, soul, and R&B all the way to hip hop as it tops the charts and makes people move.

Consider the mainstream film industry's harmful stereotyping of Black Americans from its beginning and how Black filmmakers turned to the new medium immediately to counter with their own films, carrying on to deliver more balanced and rich representations even today.

Chew on how impactful television has been in perpetuating harmful myths and stereotypes about Black people as well as how Black actors, directors, and more have seized the medium to defuse that harm with ongoing success through thoughtful content that probes, entertains, and educates.

Think about the important and active role sports has played and continues to play in civil rights even before Jackie Robinson broke Major League Baseball's color line well into the 21st century, with Black athletes raising their voices and lending their platforms to fight systemic racism.

» **Pioneering new types of American music**

» **Singing out through gospel and mainstream music**

» **Taking rap to the airwaves**

# Chapter **16**

# Give Me a Beat: Black Music

O f Black people's many contributions to American culture, music is often the most widely acknowledged one. Enslaved Africans melded their traditional musical styles with the influences and realities of their new surroundings to create even more innovative sounds. Recognized and cherished the world over, Black American musical genres include blues, jazz, gospel, R&B, and hip hop, as well as their many variations.

This chapter explores those roots and traces today's sounds back to the views early Africans held about music and how they manifested those views during slavery. It also explores jazz, blues, gospel, and R&B as well as hip hop's path from humble beginnings to global exposure.

## African Roots

Every African village had musicians. In fact, most villages regarded musicians. Some worked directly for kings or chiefs, and many times such positions were hereditary. In some cultures, musicians sat near the king or chief during various ceremonies to indicate their valued status. Africans used several types of instruments, but a variety of drums such as the congas and bongos were the most common. Frequently, the drum served as a royal or sacred instrument. *Idiophones,*

instruments most typically represented by bells, gong-gongs, and xylophones, in addition to the more well-known bass and drums, were also popular. Early European travelers, who noted that Africans highly valued music, also wrote about *chordophones,* string instruments that resembled fiddles. The human voice was another important instrument.

During 18th-century voyages, slave traders intentionally separated Africans from their own cultural groups to prevent revolts. So when the Africans sang aboard ships, slave traders never imagined they were forming new alliances. Perhaps Africans, themselves, didn't initially know that music would become one of their defining cultural links.

**TECHNICAL STUFF**

Ironically, slaveholders also valued the musical ability of those they enslaved and sometimes included it as an attractive feature in sale announcements. Enslaved people performed at auctions, and notices for runaways even referenced musical talents. Some slaveholders hired talented musicians out, spawning the culture of Black people exclusively entertaining white people.

# Black Music Fundamentals

To illustrate the fundamentals of Black American music overall, scholars often point to the *ring shout,* a religious ritual performed in a circle composed of shouters (or dancers) and singers. The ring shout is the oldest known Black American performance style. Its common features are

>> **Call-and-response:** Also known as *antiphony,* the leader sings a line, and the other participants answer in unison, which was a significant part of early religious culture.

**REMEMBER**

Music wasn't a solitary act. Observers were encouraged to participate by clapping, dancing, and joining in the refrain. This call-and-response format is an important feature of all African-based music, especially Black American music.

>> **Vocality:** *Vocality* includes cries, calls, hollers, and moans, among other expressions. In addition, singers display an intense emotionality as well as vocal versatility.

>> **Rhythm:** *Polyrhythm,* the existence of two contrasting rhythms, as well as improvisation and *syncopation,* the stressing of a normally unstressed beat, are typical in Black American music.

>> **Texture:** *Texture* includes harmony and the simultaneous performance of the same melodic line with individual variations. In the absence of drums and other instrumental accompaniment, clapping and foot-tapping enhance the texture of the voice.

# Feeling the Spirit: The Spirituals

Spirituals represent the greatest body of Black American songs created before the Civil War. Distinguished American folklorist and musicologist Alan Lomax noted that the repetition, relaxed vocalization, and polyrhythmic accompaniment common in spirituals was consistent with the performance style found throughout Africa. Some spirituals even contain African melodies. Although all traditional spirituals feature the call-and-response element routinely found in Black American music, thematic content makes them uniquely Black American. Freedom, faith, struggle, hope, and patience are themes born directly out of enslavement.

Drawing inspiration from the Bible, spirituals often highlighted Jacob, Daniel, Moses, and Gabriel, among other biblical figures. Death was particularly prominent, and heaven differed greatly from the real-life degradation of slavery. Enslaved people envisioned an afterlife with no white people or work. Also, spirituals were assigned different purposes. Certain songs accompanied funeral services, the ring shout, and everyday life as well as formal worship services.

**TECHNICAL STUFF**

Most white people were completely unaware of spirituals until after the 1867 publication of *Slave Songs of the United States*. This collection represented the first systematic effort to collect and preserve these songs. Lead editor William Francis Allen, a Harvard graduate, began collecting the songs from formerly enslaved people while working on St. Helena Island in South Carolina as part of the Freedmen's Aid Commission. The book categorizes the songs by state and includes other notations.

## THE FISK JUBILEE SINGERS

Beginning in 1871, the Fisk Jubilee singers of Fisk University, located in Nashville, helped spread spirituals to a larger audience through touring. University treasurer and music professor George L. White borrowed money and took nine students — seven formerly enslaved and two children of those formerly enslaved — on the road. In high demand, the Fisk Jubilee Singers traveled throughout the United States and Europe popularizing spirituals. Most important, however, is that the Fisk Jubilee Singers, who inspired the formation of similar groups at other Black colleges, set a precedent for Black Americans to perform Black American-oriented material abroad and break down barriers domestically. Undoubtedly, the Fisk Jubilee Singers' success contributed to the later spread of ragtime, jazz, and other forms of Black American music globally.

**REMEMBER**

Spirituals were much more than songs of worship. Certain songs contained messages regarding secret meetings, as well as clues about escape routes for those running away. Flip to Chapter 5 for information on the role music played for those trying to escape slavery.

# Ragtime

Toward the end of the 19th century, popular or secular Black music emerged in the form of *ragtime*, also known as *jig piano*. Named for its signature syncopation, ragtime is the first truly American musical genre.

The exact date ragtime emerged remains unknown, but Rudi Blesh's *They All Played Ragtime: The True Story of an American Music* (1950) points to early rumblings of it with *Le Bamboula: Danse des négres,* a music piece from celebrated 19th-century composer and pianist Louis Moreau Gottschalk in 1848. The New Orleans native was the product of a white English cotton broker and a New Orleans–born French Creole mother with reportedly non-African roots in Saint-Domingue (modern-day Haiti); however, he claimed that his *Bamboula*, which is named for the drum made out of a rum barrel as well as the dance accompanying it, was influenced by Congo Square (see the nearby sidebar), an open plaza where enslaved people were allowed to gather on Sundays in the early 1800s, with African culture on display, primarily music and dance.

Ragtime was an important milestone in Black American music because it marked a departure from the fiddles and banjos that characterized Black music before the Civil War. After slavery ended, some Black families purchased small organs on installment plans that lasted a lifetime. Those organs, as well as pianos, were pivotal to the development of ragtime.

Ragtime's popularity increased during the 1890s. However, to even get songs published or performed, usually on the minstrel stage, Black Americans had to write "coon songs," a term popular for the times. One particular song, "All the Coons Look Alike to Me" (1896) by Black songwriter Ernest Hogan was such a hit that semifinalists in the Ragtime Championship of the World Competition in 1900 were asked to rag it.

**BLACK AMERICAN FACES**

Scott Joplin became ragtime's most famous figure. Although music publishers rejected his most famous composition, "Maple Leaf Rag," in 1898, Joplin made it popular by playing it constantly at the Maple Leaf Club in Sedalia, Missouri, where he worked as a pianist. When a small publisher released the work in 1899, "Maple Leaf Rag" quickly became the model for classic ragtime. Later in his career, Joplin taught in New York and even published a ragtime manual for musicians titled *The School of Ragtime* (1908). In addition to creating ragtime classics, including the

1902 rag "The Entertainer" that was featured in the 1973 classic Oscar-winning film *The Sting*, starring Robert Redford and Paul Newman, Joplin created the folk opera *Treemonisha* (1911), extolling the value of education for Black Americans. It wasn't staged until 1972 in a joint production between Morehouse College and Atlanta Symphony Orchestra, with dance legend Katherine Dunham directing and choreographing. Joplin also created *The Ragtime Dance*, a ballet first performed in Sedalia in 1899, and published in 1902. Despite his tremendous influence, he wasn't wealthy when he died in 1917. In recognition of his contributions to American music, he was posthumously awarded the Pulitzer Prize in 1976.

# Singing the Blues

The blues grew out of backbreaking work conditions. Cotton plantations sprouted in the Mississippi Delta, Alabama, Tennessee, Louisiana, and Texas as a direct result of the invention of the cotton gin in 1793 and the Louisiana Purchase in 1803. Singing spirituals and work songs made the work tolerable. The rhythm of work songs established a steady work pace. The blues, broken down in its simplest form, merges the saddest spirituals with work songs.

**REMEMBER**

Born out of the American experience of slavery and Jim Crow, the blues also comes from Black American oral tradition (refer to Chapter 14) and tells a unique story of hardship and heartache. Although the blues is considered sad music, Southern writer Albert Murray, author of "bluesy" novels like *Train Whistle Guitar*, argued that while the blues identifies life's harshest realities, it is also a coping mechanism for transcending them.

## Blues basics

Blues lyrics typically follow an AAB poetic form: A different third line follows two identical lines. In Bessie Smith's "Lost Your Head Blues," for example, she sings, "I was with you, baby, when you didn't have a dime" twice before singing, "Now since you've got plenty of money, you have throwed your good gal down." In addition, many early blues songs reference the supernatural, which some have argued reflects an African cosmology. The devil is also prominent but bears a greater resemblance to the trickster figures of African folktales than to the Christian concept of an evil being.

Like the wandering verses of spirituals, blues verses freely float from one song to another, especially in early songs. The guitar is the most commonly used instrument, probably because it's a close cousin to the banjo (see the sidebar "African origins of the banjo"). Early blues artists used various guitar techniques, such as sliding a knife or other device along the strings to achieve a particular sound.

**HISTORICAL ROOTS**

# AFRICAN ORIGINS OF THE BANJO

Descriptions of banjo-like African instruments made of drinking gourds with strings attached appear in Richard Jobson's *The Golden Trade* (1623) as well as works by other Europeans. Banjos may have been present on slave ships as well, because Adrien Dessalles, son of a Martinican sugar plantation owner and author of *Histoire Générale Des Antilles* (1847), implied that the *banza,* a banjo-like instrument, was widely used in musical celebrations in Martinique by 1678.

On American plantations, the banjo, known as a *bandore* or *banjer,* was quite common among enslaved musicians. In the 19th century, the banjo became a fixture in minstrel shows, which may explain why Black Americans abandoned the instrument in the early 20th century. White musicians, particularly in the Southern Appalachian region, embraced the banjo, a prominent instrument in bluegrass music.

**BLACK AMERICAN FACES**

Generally regarded as the Father of the Blues, W.C. Handy popularized the blues, particularly the 12-bar blues structure, which typically has four beats in every measure and a chord progression that rises and falls. Always intrigued by the work songs and spirituals he heard growing up in Alabama, Handy really learned about the blues while working as a bandmaster and director of dance orchestras in the Mississippi Delta region, around Clarksdale, Mississippi. A better blues composer than player, Handy, who relocated to Memphis, attempted to publish blues music several times. Finally, in 1912, he self-financed the publication of "Memphis Blues," which became hugely popular. His 1914 composition "St. Louis Blues" became a classic.

## Blues genres

The blues flourished and spawned several genres, including classic blues, Delta blues, and urban blues:

>> **Classic blues:** Today, blues is largely associated with men, but as blues rose to prominence during the 1920s, women became the stars and songs about no-good men were extremely popular. Classic blues singers Gertrude "Ma" Rainey and Bessie Smith were two of the most popular Black American singers of their time. Both women honed their talents on the minstrel and vaudeville circuits.

>> **The Delta blues:** Texas-born Blind Lemon Jefferson became the first popular male blues artist, but Mississippi-born bluesmen dominated the genre, even creating a subgenre known as the Delta blues. It was characterized by hardships such as imprisonment at Mississippi's notorious Parchman Penitentiary, unemployment, jealous women and husbands, and raunchy good times in juke joints. The Delta blues became popular with stars such as Charley Patton and Robert Johnson.

## RACE RECORDS

Music recording wasn't widely open to Black musicians until Perry Bradford, a seasoned vaudeville and minstrel show performer and musician, convinced Okeh Records to record Mamie Smith when white singer Sophie Tucker became too ill to do it. The two songs Smith cut in February 1920 ("That Thing Called Love" and "You Can't Keep a Good Man Down") performed well enough that Okeh allowed Smith to record "Crazy Blues" that summer. Okeh Records promoted Smith, and "Crazy Blues" sold 1 million copies, alerting white companies to the potential of the Black American market. Other companies such as Columbia entered the business to record Black artists specifically to sell to Black audiences.

In 1921, the Black-owned Pace Phonograph Company, founded by W.C. Handy's former partner, Harry Pace, began recording artists under the label Black Swan Records, named in honor of the Black Swan Elizabeth Taylor Greenfield. Initially the company floundered, but fortunes changed when Black Swan signed Bessie Smith. The recording scored big with the public. White-owned companies took note and entered the Black music market in a fury. By 1923, Paramount had purchased Black Swan Records.

>> **The urban blues:** Before Black Americans migrated to Northern cities like Chicago during the Great Migration (see Chapter 7), they went to Southern cities like Memphis, Tennessee, known for its famed Beale Street, which evolved into an important hub for the blues and later both R&B and rock and roll. Beginning in the 1940s, Chicago became another important home for the blues, with Maxwell Street occupying a similar importance as Beale Street in Memphis. Chicago was home to many transplanted Black Southerners, a significant number of them from Mississippi. A genre called urban or Chicago blues, characterized by electric guitars and a fuller band sound, sprouted there. Muddy Waters arguably became the genre's most successful artist.

## Famous blues musicians

There were countless successful blues artists, many of whom recorded 150 songs or more. Yet many artists, even those who were stars, died broke. Here is just a sampling of some of the many influential blues artists:

>> **Gertrude "Ma" Rainey:** Billed as the "Mother of the Blues," Rainey, born in 1886, began singing in the blues style as early as 1902, some years before her first recording in 1923. Touring the Theater Owners Booking Association (TOBA) circuit helped her career peak in the 1920s, as she sold an impressive

number of records. From 1923 to 1928, she recorded nearly 100 records but retired to her native Columbus, Georgia in 1935, on the heels of the deaths of her mother and sister. She suffered a massive heart attack and died in 1939. Oscar winner Viola Davis played her in the 2020 Netflix adaptation of Pulitzer Prize-winning playwright August Wilson's 1982 play *Ma Rainey's Black Bottom*. Oscar winner Mo'Nique played Ma Rainey in the 2015 HBO film *Bessie*.

**TECHNICAL STUFF**

One-time Black vaudeville performer Sherman H. Dudley spearheaded what would become TOBA, an organization of clubs where Black acts performed for Black audiences throughout the South mainly, dating from roughly 1909 to the 1920s. Some refer to it as the Chitlin' Circuit.

>> **Bessie Smith:** Chattanooga, Tennessee native Bessie Smith, known as the "Empress of the Blues," recorded mainly for Columbia Records. She was once a protégé of (as well as a rumored lover of) Ma Rainey. Smith's recording career lasted for roughly a decade, from 1923 until around 1933. Unsung blues pioneer Alberta Hunter wrote "Down Hearted Blues," one of Smith's many hits. Credited with creating a demand for a grittier blues style, Smith influenced artists such as Billie Holiday and Mahalia Jackson. A car accident in Clarksdale, Mississippi, cut her life short in 1937 at age 43. Queen Latifah played her in the 2015 HBO film *Bessie* directed by Dee Rees.

>> **Charley Patton:** Often called the "King of the Delta Blues," Charley Patton, who recorded his first record in 1929, was a great influence on fellow Mississippians and Delta blues artists like Willie Brown, Son House, and the legendary Robert Johnson.

>> **Robert Johnson:** Johnson is the most legendary Delta blues figure. In his short lifetime (he died in 1938 at age 27), Johnson wasn't an overwhelming blues success, but his distinctive guitar style, coupled with the tale that he sold his soul to the devil in exchange for his much-improved guitar skills, fueled his legend.

>> **Muddy Waters:** Born on a Mississippi plantation, Muddy Waters was the most successful urban blues artist. By 1947, Waters, who had upgraded to using an amplified guitar, was recording for Chess Records in Chicago. Waters used the slide guitar technique and the traditional AAB blues form. Artists he influenced include Junior Wells and Buddy Guy, who played for him, and the Rolling Stones, who took their name from the Waters song "Rollin' Stone."

>> **B.B. King:** Born in the Mississippi Delta in 1925, B.B. King sang gospel as a child but hit his stride singing about everyday life, particularly romantic relationships. Combining his smooth vocals with guitar expertise, he recorded no less than 50 albums. Together, he and Lucille (the name he gave to all his guitars as a reminder of the night he ran into a burning building in Arkansas to save his precious instrument) took blues, particularly his signature song "The Thrill Is Gone," all around the globe.

It's nearly impossible to list all the other influential blues artists. Those born in Mississippi alone include Chester "Howlin' Wolf" Burnett, Sonny Boy Williamson II, Willie Dixon (known as the "Granddaddy of Chicago Blues"), Skip James, Mississippi John Hurt, Bukka White, John Lee Hooker, and R.L. Burnside. Innovators of the Piedmont blues, a style from the Carolinas and Georgia, include Tampa Red. Louisiana has contributed Huddie "Leadbelly" Ledbetter and Lonnie Johnson. Lightnin' Hopkins and T-Bone Walker hailed from Texas. Bobby Blue Bland straddled the fence between blues and soul. More contemporary blues artists include Taj Mahal, Bobby Rush, Robert Cray, and Gary Clark Jr, who emerged in the late 1990s. Female blues singers include long-gone legends like Memphis Minnie and Big Mama Thornton, as well as Chicago blues legend Koko Taylor, whose rendition of "Sweet Home Chicago" became a classic long before her death in 2009.

# Let the Good Times Roll: Jazz

In simple terms, jazz is a fusion of blues and ragtime with brass-band music and syncopated dance music. Common features are *blue notes* (notes played or sung below the major scale), polyrhythm, and improvisation, along with other aspects of Black American music.

**TECHNICAL STUFF**

Several theories on the origins of the word *jazz* abound. Some have traced it to an itinerant Black musician in the Mississippi River Valley region named Jazbo Brown. Others claim it emanated from the musician Boisey James, who became known as "Old Jas" and played "Jas's music." In 1910, a Chicago sign painter wrote that "Music will be furnished by Jas.' Band." The white Original Dixieland Jass Band in New Orleans is credited as the first to record jazz and introduce it to the larger public. By 1918, *jazz* was a common term.

## The evolution of jazz styles

Like blues and ragtime, pinpointing when or where jazz started is hard. New Orleans jazz great Jelly Roll Morton, an early jazz innovator, untruthfully boasted that he invented jazz. (In 1915, "Jelly Roll's Blues" became the first published jazz arrangement, however.) Ragtime and its offshoot, boogie-woogie, were pivotal to jazz's early development, and Morton was a top ragtime pianist. Eventually Morton, like many of his peers, began playing jazz, particularly in Storyville, a red-light district known for prostitution and hot music near New Orleans's French Quarter.

Jazz didn't begin in Storyville, but Storyville was important to jazz's overall development. New Orleans thrived as a major port city, thereby creating an environment in which great musicians like ragtime pianist Tony Jackson, who greatly influenced Morton, honed their craft.

# CONGO SQUARE

Scholars have linked New Orleans's innovation in Black American music to the African-based musical heritage nurtured in Congo Square. Dating back to the 18th century, when the French ruled New Orleans, enslaved people from the Tremé plantation gathered on Sundays in Congo Square near the French Quarter and held a market where they played music, sang, and danced. In 1817, a municipal order officially sanctioned Congo Square, but it didn't begin attracting mainstream attention until around 1848, most notably when composer and musician Louis Moreau Gottschalk cited it as an influence for his popular composition *Le Bamboula: Danse des négres*.

In the 1870s and 1880s, white writers George Washington Cable and Lafcadio Hearn greatly amplified the mythology of Congo Square by writing both nonfiction and fictional stories about it in mainstream publications. Considering that Cable was a Confederate veteran who came from a slaveholding family, his contribution to Black music and culture was quite unexpected. Yet his writings greatly elevated not just Congo Square but also African contributions and innovations in American music. The World's Industrial and Cotton Centennial Exposition, held in New Orleans's Audubon Park from December 16, 1884, to June 1, 1885, brought added attention. Today, Congo Square, located at the southern corner of Louis Armstrong Park, is on the National Register of Historic Places for the pivotal role it played in New Orleans's noted musical history.

Cornetist Charles "Buddy" Bolden, in particular, had a tremendous impact on New Orleans and jazz overall. Making a living through music alone was hard, however. By 1904, Morton, like other musicians, began traveling to other cities for work. When the federal government shut down Storyville in 1917, many New Orleans musicians migrated to Chicago.

## Jazzing up the North with red hot jazz

In Chicago, New Orleans musicians ushered in an era of jazz that has several names, including red hot, Dixieland, and classic jazz. Common features included a rhythm section, group and collective improvisation, cornet or trumpet as lead instrument, an infusion of emotion, and an overall jazz swing feel.

Arriving in Chicago in 1917 during the first phase of the Great Migration, Bill Johnson was one of the earliest New Orleans musicians to establish himself. By 1919, Joseph "King" Oliver, one of New Orleans's most respected musicians of the time, had joined Johnson's band in Chicago; by 1920, he was leading his own band, King Oliver's Creole Jazz Band. Louis Armstrong, whom Oliver mentored in New Orleans, joined Oliver in Chicago in 1922. Other notable New Orleans musicians who lived in Chicago included Freddie Keppard (who reportedly succeeded Bolden as "king," only to have Oliver take it later), trombonist Edward "Kid" Ory (his Kid Ory's Creole Jazz Band, or Kid Ory's Sunshine Band, was the first Black New Orleans band to record in 1922), clarinetist Sidney Bechet, and Jelly Roll Morton.

## Big band jazz

Taking a lead from red hot jazz, big bands emerged during the 1920s. Unlike previous bands, where there was a greater degree of improvisation, big bands had arrangers that structured the music more but also allowed for more breakout solo improvisation. Suddenly bandleaders like Fletcher Henderson, Cab Calloway, Duke Ellington (see Figure 16-1), and Chick Webb flourished at places like Club Alabam, the Savoy Ballroom in Harlem, and on the road. Earl "Fatha" Hines and Count Basie led the Midwest's biggest big bands. Although Hines began leading his band, or "organization," as he preferred, in Chicago, Basie would later relocate there from Kansas City. Lionel Hampton, who got his start in Chicago, kept the big band tradition alive well through the Lionel Hampton Orchestra throughout the 1980s.

## Swing jazz

In the 1930s, Kansas City musicians were among the first to adopt the swing style of jazz, which stressed all the beats equally, producing a smooth rhythm. Typically, in swing jazz, a large number of musicians, backed by an especially strong rhythm section, played in a medium to fast tempo. Duke Ellington's 1932 hit "It Don't Mean a Thing If It Ain't Got That Swing" provided a name for this new style of jazz, which was very danceable.

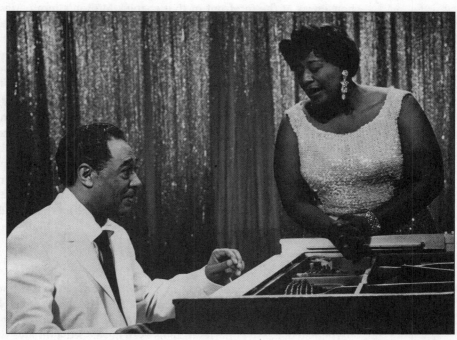

**FIGURE 16-1:** Duke Ellington with Ella Fitzgerald.

*Bettmann/Getty Images*

## Central Avenue jazz

From roughly 1920 to 1955, Los Angeles was a hotspot for jazz, attracting some of its biggest icons. And Central Avenue, the hub of L.A.'s Black community, served as its headquarters. Yet it's routinely overlooked. Jelly Roll Morton, encouraged by musicians he knew who had gone to L.A. as early as 1908, arrived in L.A. in 1917 for a gig. When Kid Ory's Creole Band recorded the first jazz record by a Black band in 1922, it was in L.A. Over the years, the Dunbar Hotel became the epicenter of the scene, as artists as big as Louis Armstrong himself stayed and played there.

Thomas Jefferson High School, most notably Samuel Rodney Browne, L.A. public schools' first Black music teacher who was also a musician, helped funnel talent like saxophonist Dexter Gordon, trumpeter Don Cherry, and violinist Ginger Smock into the scene. From 1945 to 1955, Black businessman Leon Hefflin Sr.'s Cavalcade of Jazz, the largest outdoor jazz festival of its kind, showcased over 125 jazz artists, including titans such as Count Basie, Lionel Hampton, and Louis Armstrong. Homegrown talent Charles Mingus was a leader of the various bebop sounds.

## Bebop: More than dancing

During the 1940s, jazz began changing, and the Harlem nightclub Minton's Play-house was at the forefront of that change. Minton's luminaries included pianist Thelonious Monk, drummers Kenny Clarke and Max Roach, guitarist Charlie Christian, trumpeter Dizzy Gillespie, and saxophonists Charlie "Bird" Parker and Lester "the Prez" Young.

Out of this gathering of talent, bebop emerged. Characterized by complex polyrhythms, dissonant harmonies, and irregular phrases, bebop broke away from the more regimented style of jazz play. Typically, two horns — trumpet and saxophone — began in unison, followed by a series of improvisations before the horns concluded the song by repeating the first sequence in unison. Bebop discarded the melodies of standard pieces such as "Stomping at the Savoy" and created new melodies over the old harmonic progressions. By emphasizing technical skill, bebop demanded that audiences really listen to the music. Thelonious Monk is credited as saying, "We wanted a music that they couldn't play" (where "they" referred to white musicians).

## Hard bop

Bebop gave way to hard bop, a more rhythmically driven sound associated with drummers like Art Blakely and saxophonist Cannonball Adderly. Musicians such as Miles Davis and saxophonist Sonny Rollins, who cut their teeth on bebop, also participated. Bassist Charles Mingus even developed a funkier side to hard bop by incorporating popular Black music like soul.

## Avant garde, or free, jazz

Jazz continued to evolve throughout the 1960s. Saxophonists Ornette Coleman and John Coltrane were harbingers of the free jazz era. Coleman emphasized harmonic freedom, as showcased in the albums *The Shape of Jazz to Come* and *Free Jazz*. Incorporating elements of African, Arabic, and Indian music, Coltrane infused his music with a deep spirituality, captured by albums like *A Love Supreme* and *Meditation*. Pianist Charles Mingus revived the art of collective improvisation, reining in the trend of solo improvisation.

# Jazz singers

As jazz progressed, skillful singers adopted a scatting technique in which the voice functioned more like an instrument. Following are some of the most prominent singers.

## Billie "Lady Day" Holiday

Born to teenage parents in 1915, Billie Holiday had a challenging childhood in Baltimore. And so was the beginning of her career in New York City. Her first record, made in 1933, didn't sell well. Successful performances at Harlem's Apollo Theater in 1935, however, helped change the trajectory of Holiday's career. Touring with white jazz musician Artie Shaw introduced Holiday's distinctive voice, punctuated by unique phrasings and a heart-wrenching delivery, to a wider audience, but traveling in the South came at a high price.

Repeated performances of the anti-lynching song "Strange Fruit" at New York City's integrated Café Society in 1939, secured her legend but maybe also her early death. When the federal government via Federal Bureau of Narcotics head Henry Anslinger demanded Holiday (dubbed "Lady Day" by her trusted friend, great jazz saxophonist Lester "Prez" Young) stop singing "Strange Fruit," she refused. So, as detailed in the first chapter of Johann Hari's 2015 book, *Chasing the Scream: The First and Last Days of the War on Drugs* (Bloomsbury, USA), Federal Bureau of Narcotics head Harry Anslinger targeted her, using her drug and alcohol struggles against her, even resorting to framing her for drug possession. When she died in 1959, she was handcuffed to her hospital bed.

The 2021 Lee Daniels film *The United States vs. Billie Holiday,* with singer Andra Day, explores this aspect of Holiday's life as an important civil rights milestone, which differs from the love story angle of the 1972 film Lady Sings the Blues, starring Diana Ross (who was nominated for an Academy Award for Best Actress), Billy Dee Williams, and Richard Pryor.

More than 80 years later, "Strange Fruit" still ranks high among protest songs. In 2013, rapper/producer Kanye West incorporated "Strange Fruit" into his 2013 hit "Blood on the Leaves," using Nina Simone's cover.

## Sarah Vaughan

Newark's Sarah Vaughan, whose roots dated back to swing, was one of the few singers of the bebop era. Like bebop instrumentalists, Vaughan, along with her friend and colleague Billy Eckstine, improvised melodic lines based on the chord progressions of standard songs.

## Ella Fitzgerald

One of jazz's few female bandleaders, Ella Fitzgerald (refer to Figure 16-1) rose to fame with Chick Webb's band and hit with songs such as "A-Tisket, A-Tasket." After Webb died, she changed the group's name and toured as Ella Fitzgerald and Her Famous Orchestra. In 1941, she went solo and became most noted for her *Great American Songbook* series with Verve, in which she sang Cole Porter, Duke Ellington, and Irving Berlin standards.

## Betty Carter

Known for her innovative scatting and a voice more akin to a physical instrument, Betty Carter carved out a lane all her own. She began her career in her teens in Detroit, where she was raised. Joining the Lionel Hampton Orchestra in 1948 was her first big break. Teaming up with Ray Charles for the 1961 album *Ray Charles and Betty Carter*, featuring their celebrated version of "Baby, It's Cold Outside," was her second.

Taking her career in her own hands in 1969, Carter started releasing her own records through her own Bet-Car Productions. In 1988, she began a fruitful relationship with Verve Records, resulting in her Grammy-winning 1994 album, *Look What I Got!*

Prior to her death in 1998, Carter became a bridge to the genre's next generation through her *Jazz Ahead* series, which began with the Brooklyn Academy of Music and became an important residency program at the Kennedy Center in D.C. Talent Carter is credited for nurturing throughout her career include double bassist Curtis Lundy, pianist Cyrus Chestnut, and drummer Kenny Washington.

# Great jazz instrumentalists

The following jazz artists did more than excel individually. They either nurtured the genre in its formative stages or took it to greater heights:

>> **Charles "Buddy" Bolden:** Bolden is acknowledged as the first New Orleans cornetist and bandleader to play jazz music. By 1901, he was the most well-known musician in New Orleans. He predated jazz recordings, but his music still fueled future New Orleans legends like Joseph "King" Oliver and Louis Armstrong. Bolden, who died in 1931, is known for the songs "Buddy Bolden's Blues" and "Make Me a Pallet on the Floor."

>> **James Reese Europe:** Credited with prepping Europe for jazz, the appropriately named James Reese Europe gave World War I soldiers a lift with his Harlem Hellfighters band, drawn from New York's all-Black 369th Infantry. Europe's recordings demonstrated the transition from ragtime and blues to jazz. By the time of his death (he was stabbed by a band member), he was the most prominent Black American bandleader.

>> **Louis Armstrong:** "Satchmo," as many knew him, was one of jazz's first stars. Before mastering the trumpet, Armstrong began his musical career singing for pennies as a boy. At the Colored Waifs' Home for Boys, he learned to play several instruments and eventually led the home's brass band. After leaving the home, he got various gigs in New Orleans nightclubs and bars before moving on to Chicago, Los Angeles, and New York City. He put his trumpet and voice to good use in the 1967 classic "What a Wonderful World."

>> **Edward Kennedy "Duke" Ellington:** Known for his smartly dressed orchestra of precise musicians who performed in perfect unison, Ellington, born in Washington, D.C. in 1899, was one of the nation's greatest composers, leaving a catalog of more than 2,000 compositions when he died in 1974. He and frequent collaborator Billy Strayhorn, with whom he composed the classic "Take the A Train," were so in sync they often didn't know who had contributed what.

>> **Charlie "Bird" Parker:** Noted as bebop's coarchitect (along with Dizzy Gillespie), Charlie Parker, born in 1920, came from Kansas City's entrenched jazz tradition. A master of the saxophone, he took many musical risks, such as recording with strings, which resulted in the best-selling album *Charlie Parker with Strings*. Unfortunately, drugs cut his genius short in 1955.

>> **Miles Davis:** A key member of Charlie Parker's quintet (see the earlier section "Bebop: More than dancing"), Davis led his own group of nine musicians by 1948. Using unconventional instrumentation such as the French horn and tuba, Davis charted new territory. He followed his well-received 1957 album *Birth of the Cool* with the platinum-selling *Kind of Blue* two years later. Over his long career, Davis infused jazz, soul, rock, and rhythm and blues in his music, a spirit he captured in his highly regarded 1970 album *Bitches Brew*. Davis, who won a Grammy in 1987, remained a respected jazz innovator until his death in 1991.

Although men have dominated much of jazz's early history, women instrumentalists weren't uncommon: Pianist Lil Hardin Armstrong, wife of Louis Armstrong, played with King Oliver. Mary Lou Williams, another pianist, contributed swing

band scores to Benny Goodman and Earl Hines. Louis Armstrong tagged Valaida Snow as the best trumpeter after himself. Pianist and songwriter Irene Higginbotham co-wrote Billie Holiday's "Good Morning Heartache," and the Grammy Award–winning Shirley Horn frequently accompanied herself on the piano.

International Sweethearts of Rhythm, touted as the first interracial all-woman band in the nation, was dominated by Black musicians and, at various times, included trombonist Helen Jones Woods, guitarist and vocalist Carline Ray, drummer Pauline Braddy, saxophonist and bandleader Violet May "Vi" Burnside, trumpeters Ernestine "Tiny" Davis, Cora Bryant, and more. There were also all-Black female bands like the Harlem Playgirls, in which Burnside and Davis played; Myrtle Young and Her Rays, with drummer Hetty (sometimes Hettie) Smith; Darlings of Rhythm, formed by baritone and tenor saxophonist Lorraine Brown; and Tiny Davis Hell Divers, among others.

Violinist Ginger Smock was a West Coast pioneer, especially in L.A.'s important Central Avenue jazz scene, even leading the first Black band to host a TV program in 1951. Seattle pianist, composer, and singer Patti Brown played with Billy Eckstine, toured Europe with Quincy Jones, recorded with Aretha Franklin and James Brown, plus served as musical director for bands accompanying Dinah Washington and Sarah Vaughan.

Some challenges early women jazz instrumentalists faced included pressures to sing in addition to or in lieu of playing their instruments as well as be attractive and/or sexy and economic exploitation. Later female jazz instrumentalists include pianists Patrice Rushen and Geri Allen, flautist Bobbi Humphrey, violinist Regina Carter, and drummer Terri Lyne Carrington. Superstar singer Beyoncé kept the spirit of female instrumentalists alive with her all-female band, the Suga Mamas (also the Suga Mama Band) for her 2007 tour, *The Beyoncé Experience* in support of her second studio album *B'Day* (2006). Members included saxophonist Tia Fuller; keyboardist Brittani Washington; drummers Kimberly Thompson, Nikki Glaspie, and Venzella Joy; guitarists Bibi McGill and Kat Rodriguez; and bassist Divinity Roxx, among others.

**IN THEIR OWN WORDS**

"When I was younger, I wish I had more females who played instruments to look up to. I played piano for like a second but then I stopped," Beyoncé told BlogHer. "I just wanted to do something which would inspire other young females to get involved in music, so I put together an all-woman band."

## Keeping the tradition alive

In the 1970s, jazz continued to be a free-for-all stylistically, but pianists including McCoy Tyner, Ramsey Lewis, and Keith Jarrett led the field. Pianist Herbie Hancock pioneered the use of synthesized instruments and absorbed funk

elements into jazz. New Orleans–born, Julliard-trained trumpeter Wynton Marsalis, who emerged in the 1980s, objected to these deviations and called for a reinstatement of "classic" jazz style. To that end, Marsalis supplemented his recordings alongside his work with Jazz at Lincoln Center, which elevated jazz to American classical music.

Traditional or not, jazz artists such as singers Nancy Wilson, Abbey Lincoln, Cassandra Wilson, and Dianne Reeves; musicians such as pianist Marcus Roberts; trumpeters Terence Blanchard, Roy Hargrove, Russell Gunn, Nicolas Payton, Christian Scott, and Tunde Adjuah; and saxophonists Branford Marsalis, Henry Threadgill, and Joshua Redmon pushed the genre forward. Twenty-first century jazz artists pushing the genre to younger audiences include Robert Glasper, Esperanza Spalding, Ambrose Akinmusire, Trombone Shorty, Gregory Porter, Kamasi Washington, and James Francies.

# Spreading the Gospel

Thomas Andrew Dorsey, a pianist for Ma Rainey known as Georgia Tom in the world of blues and jazz, changed religious music for Black Americans beginning in the 1930s, when he championed meshing elements of blues and jazz with Black sacred music, which is the base of contemporary gospel music. Inspired by early innovator Rev. Dr. Charles Tindley — an influential Methodist minister and composer out of Philadelphia whose compositions really picked up steam in the early 1900s — Dorsey, who later served as musical director of Chicago's Pilgrim Baptist Church for decades, didn't just create music in Tindley's style; he was also instrumental in spreading this new sound to Black churches.

In 1933, the longtime Chicago resident also tapped Sallie Martin, a gospel pioneer in her own right, among others, to organize the very first gathering of the National Convention of Gospel Choirs and Choruses (NCGCC), which he had founded the year before. Singer Willie Mae Ford Smith, who founded the NCGCC's Soloist (Council) Bureau, was also a big aid to Dorsey's efforts in popularizing this brand of gospel music. Michael W. Harris's 1992 book *The Rise of Gospel Blues: The Music of Thomas Andrew Dorsey in the Urban Church* (Oxford University Press) offers insight into Dorsey's journey and achievements, which includes NCGCC's enduring legacy nearly 100 years later.

**TECHNICAL STUFF**

A prolific songwriter, Dorsey, who established his own gospel music publishing house, wrote over 1,000 gospel songs in his lifetime. To cope with the grief of losing his wife and son in childbirth, Dorsey wrote "Precious Lord" in 1932. In 1937, he penned "Peace in the Valley" for Mahalia Jackson, who would, at one point, become the world's most famous gospel singer. Elvis Presley also covered the song in 1957.

# MAHALIA JACKSON

New Orleans–born Mahalia Jackson moved to Chicago in 1927, to join the Johnson Brothers but pursued a solo career when they broke up. "Move On Up a Little Higher," released in 1948, catapulted her to international stardom, making her the world's most recognizable gospel star. By 1954, she had her own CBS radio series. A great friend and supporter of Martin Luther King Jr., Jackson sang at the March on Washington for Jobs and Freedom, where she encouraged him to go off script and share his "dream" in 1963. She also sang at his funeral in 1968.

Jackson, who was born in 1911, died in Chicago in 1972. In 2021, ABC's *GMA (Good Morning America)* anchor Robin Roberts produced the 2021 Lifetime biopic *The Mahalia Jackson Story* starring Tony nominee and Grammy winner Danielle Brooks of *Orange Is the New Black*.

Gospel music has many pioneers, several of them unsung. Following are just a few individuals and groups who made significant contributions to the evolution of gospel music:

>> **Sister Rosetta Tharpe:** As both a guitarist and singer, Tharpe mixed the sacred with the secular. She appeared on the pop charts with "This Train," played the Apollo Theater, and enjoyed success with hit songs such as "Up Above My Head."

>> **Clara Ward:** A great influence on Aretha Franklin, Ward's group, the Famous Ward Singers, pushed the boundaries of gospel artists even further. From the 1940s into the 1960s, they appeared at the Newport Jazz Festival and sang at Radio City Music Hall. They also injected glamour into gospel with their jewelry and more-contemporary clothing.

>> **Willie Mae Ford Smith:** A gospel purist, Smith emphasized the ministerial role of gospel singing and introduced the style of *song and sermonette,* singing coupled with testimony.

>> **Reverend James Cleveland:** The man behind the modern gospel sound, James Cleveland paired jazz and pop influences with complex arrangements to create intricate harmonies specifically for the mass choir. To teach this new style, he created the Gospel Singers Workshop Convention (GSWC) within the Gospel Workshop of America, which he founded with mentor Albertina Walker. Kirk Franklin and John P. Kee are just two GSWC alums.

>> **The Soul Stirrers:** Sam Cooke's former group set the standard of the lead singer supported by four-part harmony.

» **Dr. Mattie Moss Clark:** Although more widely known as the mother of gospel legends The Clark Sisters (which began with Karen, Dorinda, Jacky, Twinkie, and Denise or Niecy), Mattie Moss Clark was a legendary trailblazer in her own right. As the longest-serving International Minister of Music for the Church of God in Christ (COGIC), she helped shape gospel choir music for generations. By swapping out the traditional two-part textures that characterized earlier gospel choir music in favor of three-part musical settings for soprano, alto, and tenor, the Detroit transplant from Selma innovated gospel choir music.

A composer and songwriter, in addition to a choir leader and musician, she created more than 100 songs, including the eventual standards "Salvation Is Free" and "Save Hallelujah." She recorded more than 50 albums, three of which went gold, selling more than 500,000 copies each.

Her daughter Elbernita "Twinkie" Clark followed in her footsteps musically, creating the signature sound of The Clark Sisters as well as penning their most well-known hits like "Is My Living in Vain" (1980), earning her the title of "Mother of Contemporary Gospel Music." The 2020 Lifetime film *The Clark Sisters: First Ladies of Gospel,* with actress Aunjanue Ellis portraying Dr. Mattie Moss Clark, captured their struggles and triumphs.

» **The Winans:** Originally, the Winans were brothers Marvin, Carvin, Michael, and Ronald. The Detroit family of ten, however, has also contributed duo BeBe and CeCe Winans (who both went on to successful solo careers), younger sisters Angie and Debbie Winans, and Marvin's former wife, Vickie Winans.

# Kirk Franklin and the new gospel sound

As artists like Shirley Caesar, The Blind Boys of Alabama, Andraé Crouch, Dottie Peoples, the Anointed Pace Sisters, and Albertina Walker continued a more traditional style of gospel, others rumbled for change. Injecting secular music back into gospel wasn't a new concept. Crossover successes included The Clark Sisters' "You Brought the Sunshine (To My Life)" (1981), incorporating Stevie Wonder's 1980 hit "Master Blaster (Jammin)"; "Lost Without You" (1988), from brother-and-sister duo BeBe and CeCe Winans, and Donnie McClurkins' "Stand" (1996); the smooth R&B stylings of Commissioned with recordings like "I Am Here" (1990) and of Yolanda Adams with "Open My Heart" (1999), showcasing her powerhouse vocals; and the jazzy vibes of Kim Burrell with hits such as "Everlasting Life" (1998).

Embracing hip hop, however, was a much bolder move, especially in the 1990s, when the gospel and Black church community at large universally shunned it. Yet Kirk Franklin found overwhelming success when he began infusing his music with hip hop sensibilities. His 1997 hit "Stomp" propelled *God's Property from Kirk Franklin's Nu Nation,* his fourth album, to the top of the R&B/Hip hop Albums

charts as well as a number-three debut on the Billboard 200, a first for a gospel album. The song featured a new jack swing beat fashioned from the Funkadelic hit "One Nation Under a Groove" (1978), a verse from iconic female rapper Salt of Salt-N-Pepa for the remix, and background vocals from his own youth choir known as God's Property.

Although the Dallas native would later abandon the mass choir format, which at one time included The Family and One Nation Crew (1NC), along with God's Property, he continued meshing hip hop and other secular sounds in his music. That formula consistently placed him at the top of the charts. With nearly 20 Grammy Awards to his credit, Franklin is, without question, the most pivotal contemporary gospel figure to emerge in the decades spanning from the 1990s into the 2020s.

Franklin's success rippled throughout the genre, ushering in many other performers, including sister duo Mary Mary, who hit big with their 2000 hit "Shackles (Praise You)." In 2004, secular rapper Kanye West, assisted by songwriter Rhymefest, certainly showed the possibilities of combining gospel music and hip hop with his mammoth hit "Jesus Walks," which won a Grammy for Best Rap Song. As the genre continued to expand, gospel artists with a variety of styles, including rappers, emerged. Notable gospel artists throughout the 2000s include Tamela Mann, Tasha Cobbs Leonard, Smokie Norful, Israel & New Breed, rappers Lecrae and Canton Jones, Jekalyn Carr, Le'Andria Johnson, Kierra "Kiki" Sheard, Koryn Hawthorne, and Tye Tribbett, along with mainstays such as Marvin Sapp, Fred Hammond, Hezekiah Walker, and sisters Dorinda Clark Cole and Karen Clark Sheard. Although not officially a gospel artist, Chance the Rapper brought positive attention to the genre through his music when he began releasing music in the early 2010s. Kanye West's 2019 album, *Jesus Is King*, which won for both top Christian and Gospel albums at the 2020 *Billboard* Music Awards, the first album to ever to do so, further extended that reach.

# Mainstreaming Black Music

New genres of Black music emerged in the mid–20th century, taking Black music to even greater heights. Race music gave way to rhythm and blues (R&B). Not much later, R&B led to the creation of rock and roll. As rock and roll began to exclude Black Americans, soul music took over.

## R&B

Drawing heavily from blues and gospel, R&B meshed rhythm with blues. Consistent with other forms of Black American music, early R&B incorporated the call-

and-response pattern and improvisation into its performance style. Black pop quartets, such as the jazz group Ink Spots and the Mills Brothers, which started as a barbershop quartet, also played a role in R&B's early development. Their mainstream sound, as well as that of singers Nat King Cole and Billy Eckstine, lost its appeal with many Black Americans, however. Eventually R&B became the bridge between that sound and soul.

**TECHNICAL STUFF**

Although largely forgotten today, Louis Jordan, known for hits such as "Is You Is or Is You Ain't My Baby" and "Caldonia," was one of the first artists to demonstrate the crossover appeal that early R&B could have without adjusting it for white audiences. In 1943, Jordan, whose music later inspired the 1992 Broadway hit *Five Guys Named Moe*, topped both the Black and white charts with "Ration Blues." Jordan's early experimentation with *soundies,* American musical films about three minutes in length produced between 1940 and 1947, anticipated the music video.

## Rocking and rolling

Early rock and roll has Black roots, a fact that surprises some people. Ike Turner's 1951 recording "Rocket 88," the first boasting a distorted guitar, contained the driving backbeat and electric guitar that became commonplace in rock and roll. "Sh-boom," the first acknowledged rock and roll song, was recorded by the R&B group The Chords. Other Black artists contributed to the genre in its early stages.

Despite rock's early ties to Black musicians, covers by white artists of early rock and roll songs from Black Americans topped the charts: The Crew Cuts, a white group from Canada, took "Sh-boom" straight to number one on the Billboard charts in 1954; Bill Haley and the Comets scored with Joe Turner's "Shake, Rattle, and Roll"; and Pat Boone covered Fats Domino's "Ain't That a Shame" and Little Richard's "Tutti Frutti."

**REMEMBER**

Historian Carl Belz, who wrote *The Story of Rock* (1969), observed white audiences felt more comfortable with how white artists softened the new, exotic sound of rock and roll. As landmark decisions dismantling segregation became more common, white America's racial gatekeepers didn't overlook rock and roll's Black origins. Taunts of "white nigger" directed toward Elvis, who recorded at Sun Studios in Memphis, the first home for many Black artists, were prompted by rock and roll's Black roots.

Some Black artists broke through the racial matrix, however. Guitarist Chuck Berry had a hit with "Maybelline," blues pianist Fats Domino scored big with "Blueberry Hill," and Little Richard had "Good Golly, Miss Molly." British groups like the Beatles and the Rolling Stones had no problems commending Black artists

for their talents, particularly Muddy Waters and Bo Diddley, who are often cited as a key figures in the transition of R&B to rock and roll. T-Bone Walker, who fits into blues and R&B, pioneered the electric guitar sound. Although classified as R&B during the 1960s and 1970s, Ike and Tina Turner's style, in retrospect, was more rock-oriented, as evidenced on "Proud Mary. Jimi Hendrix wasn't only accepted; he was exalted.

Sly Stone, along with his brother and two sisters, exerted considerable influence with his group Sly and the Family Stone. From 1967 to 1975, the rock group, whose members were predominantly Black, created the hits "Everyday People," "Hot Fun in the Summertime," and "Thank You (Falettinme Be Mice Elf Agin)." Mixing funk, soul, and the psychedelic culture of Bay Area hippies, Sly and the Family Stone created a rock sound and look that still distinguishes them. Black rock groups Living Colour, Fishbone and Bad Brains, Tina Turner in her solo turn, and singer/songwriter/guitarist Darius Rucker of Hootie and the Blowfish actively continued that rock and roll legacy into the 1980s and 1990s especially.

# JIMI HENDRIX

**BLACK AMERICAN FACES**

Widely considered the greatest guitarist ever, Seattle native Jimi Hendrix grew up in great struggle, personally and financially. A self-taught musician, he didn't get a guitar until his teens. Playing in and around Seattle in bands he formed or joined didn't keep him out of trouble. To avoid jail, he joined the Army just before he turned 19. There he met fellow musician Billy Cox, and after the Army, they began gigging around Tennessee. After playing on the Black club circuit popularly known as the chitlin circuit, he made his way to New York City and ended up playing with The Isley Brothers, even recording with them and later Little Richard, with whom he also played.

A move to the Village in New York City contributed to Hendrix further developing his rock style. Eventually, that led him to London, where he began recording with his own band, the Jimi Hendrix Experience, whose third and final studio album, *Electric Ladyland* (1968), is among the best ever.

Back in the United States, Hendrix, who is also known for his hits "Purple Haze" and "Voodoo Child (Slight Return)," began cultivating his legend on the festival circuit, particularly with his 1969 appearance at Woodstock, where he and his Band of Gypsys played a mind-blowing rendition of "The Star-Spangled Banner."

Drug use was a feature of rock and roll, and Hendrix was known to indulge. Already a rock legend and arguably the highest paid musician of his time, Hendrix, whose reputation on the guitar is akin to that of bluesman Robert Johnson, shot to cult status after his sudden death in London in 1970 at age 27. More than a half century later, Hendrix's legend lives on.

Other notable rockers include Mother's Finest, particularly vocalist Joyce Kennedy; Rage Against the Machine co-founder Tom Morello; guitarist Slash of Guns N' Roses; and singer Lajon Witherspoon of Sevendust fame. Prince, who created a lane all his own, and undisputed rocker Lenny Kravitz became undeniable super-stars. 2000s-era rockers include William DuVall, best known as a vocalist for Alice In Chains; singer/songwriter Tommy Vext, known for Vext, Divine Heresy, West-field Massacre, and Bad Wolves; and the group TV on the Radio.

## Motown

As rock and roll took hold in the 1950s, Berry Gordy, songwriter and record shop owner, created a winning formula that combined the best of R&B, pop, gospel, and big band. Within a year of its launch, Gordy's label, popularly known as Motown, produced the top R&B single "Shop Around" from Smokey Robinson and the Miracles. Black-owned record labels such as Chicago-based Vee-Jay Records, home of the Dells, Impressions, and solo artists Jerry Butler and Gene Chandler, also existed, but Motown truly earned its "Hitsville, U.S.A." label.

The hits kept coming: 1961 to 1963 brought the Marvelettes' "Please, Mr. Postman," the Contours' "Do You Love Me," the teenaged Stevie Wonder's "Fingertips," and Martha and the Vandellas' "(Love Is Like a) Heat Wave." In 1964, the Supremes began their historic journey at the top of the charts. In its heyday, Motown was packed with some of music's biggest stars, including Marvin Gaye, the Four Tops, and the Temptations. Gladys Knight and the Pips even recorded with Motown.

**BLACK AMERICAN FACES**

## THE SUPREMES

Launched as the Primettes, Diana Ross, Mary Wilson, and Florence Ballard, who became the Supremes, weren't hitmakers at first. They finally topped the charts in 1964 with "Where Did Our Love Go." Berry Gordy's controversial decision to replace the more soulful Ballard with the more crossover-friendly voice and look of Diana Ross (a move common to girl groups loosely chronicled in the hit Broadway musical *Dreamgirls*, which would later be made into a film) was a difference-maker. With their 1966 album *Supremes A' Go-Go,* the Supremes became the first female group in history to have a number one album. Fully accepted by white audiences, the Supremes were among the first Black artists to appear on such iconic programs as *The Ed Sullivan Show.* The Supremes also topped international charts. Their success opened the doors for many artists, not just their Motown peers.

# THE GODFATHER AND QUEEN OF SOUL: JAMES BROWN AND ARETHA FRANKLIN

Despite their very different backgrounds — she had the gospel background befitting soul royalty, and he was born poor and spent time in prison — Aretha Franklin and James Brown were soul music's biggest stars.

- **James Brown:** Born extremely poor in South Carolina during the Great Depression, abandoned by his parents, and raised by an aunt in Augusta, Georgia, James Brown overcame huge obstacles. He achieved some early success with his group James Brown and the Famous Flames (formed with Bobby Byrd, whom he met in prison) when their song "Please, Please, Please" secured the group a record deal and reached number five on the Billboard charts. The group had other hits, including the number one "Try Me" in the late 1950s.

  Brown, known for his live performance antics, eventually dropped the Flames, and using his own money, recorded *Live at the Apollo* in October 1962, over his record label's objections. The album's success (it hit number two on Billboard) demonstrated the general viability of the soul album. (Previously, many black artists cut only singles.) Ultimately, James Brown's emphasis on rhythm meshed with the rebellious tension of the times, providing the soundtrack to Black America's transition from the civil rights movement to the Black power movement. His 1968 hit "Say It Loud — I'm Black and I'm Proud" served as the perfect anthem. Brown's hits slowed around 1976, but he resurfaced in the 1980s, when hip hop artists used his sounds to spark another Black music revolution.

- **Aretha Franklin:** The daughter of noted preacher C.L. Franklin, who recorded his sermons with the Chicago-based Chess (the label behind Muddy Waters and Chuck Berry), Aretha Franklin released a gospel album and recorded with Columbia Records as a teenager. Despite these successes, she truly came into her own when she signed with Atlantic Records, where she was encouraged to be herself and exert the full power of her voice. When her album *I Never Loved a Man the Way I Love You* hit in 1967, Franklin instantly became the Queen of Soul as her songs topped both the R&B and pop charts. Between 1967 and 1992, Franklin had 89 Top 40 entries, 17 of which hit number one.

  Although shy and soft-spoken, Franklin never wavered in her support for the civil rights movement, lending her voice whenever needed. Interestingly, her "soul sister" status within the Black community bolstered her popularity among white music lovers. Her funeral services, held on August 31, 2018, in her native Detroit at Greater Grace Temple (where services for Rosa Parks and Aretha's father, the Reverend C.L. Franklin, were also held in 2005 and 1984, respectively) were an epic affair that lasted for eight hours. Participants included Jesse Jackson, Chaka Khan, former President Bill Clinton, Ariana Grande, The Clark Sisters (including Twinkie

More than just a label, Motown had its own finishing school and insisted that most of its artists present a refined and sophisticated image. Later in the 1960s, as the civil rights movement gave way to the Black power movement (refer to Chapters 9 and 10), Motown's controlled image was not aggressive enough for many Black Americans. Consequently, the grittier sound of soul music became more alluring.

## Giving America soul

By today's standards, Ray Charles's 1955 number one hit "I Got a Woman" is tame. At that time, however, adapting a gospel song or sound for secular purposes — the basis of soul music — was controversial, especially within the gospel community. Charles continued to convert gospel songs to secular subject matter. "This Little Girl of Mine" and "Hallelujah, I Love Her So," among others, also became hits.

Charles's success encouraged Sam Cooke, a member of the legendary Soul Stirrers and one of gospel's brightest stars, to record secular records in 1957. Cooke became one of the biggest gospel stars to crossover to both the R&B and pop charts. The business-minded Cooke, who produced and wrote songs, also co-owned record label SAR. Following his untimely death in 1964, Cooke hit with the posthumous release of "A Change Is Gonna Come," an instant classic addressing the turbulent 1960s.

Solomon Burke's vocal techniques, such as rhythmically stuttering words, influenced the style of many subsequent soul singers, but Stax Records, an independent, Memphis-based label, gave soul music its biggest boost. Artists such as Otis Redding, Rufus Thomas, and Thomas's daughter Carla firmly established Stax and soul music. Otis Redding put a smooth spin on soul: His hits like "Try a Little Tenderness" and "I've Been Loving You Too Long (To Stop Now)," though secular, are reminiscent of gospel songs in feeling, if not content. Stax also had Sam & Dave, known for the hits "Soul Man" and "Hold On, I'm Comin'," co-written with Isaac Hayes.

Other influential soul artists included Wilson Pickett, best known for "In the Midnight Hour"; Percy Sledge, of "When a Man Loves a Woman" fame; and Etta James, who hit it big with "At Last." James Brown, dubbed "soul brother number one," and Aretha Franklin, the Queen of Soul, became some of soul music's biggest stars.

# Post-soul Black music

Black music underwent more changes in the 1970s, as artists began to move beyond the Motown sound, which favored material concerned with relationships, to include social issues like war and poverty. *What's Going On*, Marvin Gaye's 1971 album addressing the Vietnam War, became his most successful album to date. *Let's Get It On*, his sexy follow-up, was also a major success. Gaye resurfaced in the 1980s with the hit single "Sexual Healing" before his tragic death at the hands of his father in 1984. Stevie Wonder hit big with "Superstition" and "Living for the City" and eventually won several Grammy awards, especially for his 1976 double album *Songs in the Key of Life*.

But Wonder and Gaye weren't the only soul artists from the 1960s flexing their expanded creative visions in the 1970s. More than anyone, Curtis Mayfield, the former member of the Impressions who penned the memorable civil rights songs "Keep On Pushin'" and "People Get Ready," literally created the soundtrack for so-called "ghetto life." *Superfly*, which accompanied the film of the same name in 1972, included "Freddie's Dead" and "Pusherman," songs that spoke to drug use and trafficking in urban communities. He duplicated that magic for the films *Claudine* (1974) and *Sparkle* (1975), which yielded the Aretha Franklin hit "Something He Can Feel."

# Getting funky and popping off

Rhythm-heavy and instrumentally driven, *funk*, an offshoot of R&B and soul, came into its own during the 1970s, aided by the George Clinton Parliament Funkadelic movement, which included brothers Bootsy and Catfish Collins. George Clinton's brand of funk hit its stride in 1978, with *One Nation Under a Groove*. Clinton began recording in the 1980s as George Clinton and the P-Funk All-Stars. Other pivotal funk groups included the Ohio Players, Graham Central Station, and the Bar-Kays.

Overall, bands were hugely popular in the 1970s and the early 1980s. The most well-known include Earth, Wind & Fire; Rufus featuring Chaka Khan; the Commodores; Morris Day and the Time; and Cameo. Each of these groups mixed elements of R&B and soul with funk and incorporated their own signature styles into their recordings. Zapp, which included four brothers, most notably Roger Troutman, who went on to a solo career, was a bridge between disco and funk in the 1980s. Troutman pioneered the "talk box," synthesized vocals resembling a robot.

The 1970s hits "ABC," "I'll Be There," and "Never Can Say Goodbye" set the Jackson Five, comprised of brothers Tito, Marlon, Jermaine, Jackie, and Michael Jackson, up for global pop success. Selling more than 20 million records worldwide, *Off the Wall*, with the hit "Rock with You," helped set Michael Jackson on

pace for solo superstardom. It also marked Jackson's first collaboration with renowned trumpeter, producer, and composer Quincy Jones. Their 1983 collaboration, *Thriller*, sold a then-unprecedented 51 million copies worldwide; spawned seven hit singles, including "Billie Jean," which became MTV's first video by a Black artist; and won seven Grammys.

More importantly, Jackson's movie-like video for "Thriller" changed the music video format, instantly elevating it. Black America's first undisputed international pop superstar, Michael Jackson, like James Brown and others before him, arguably opened the door to global success for others like his sister Janet, Whitney Houston, Mariah Carey, Alicia Keys, and Beyoncé. Michael Jackson contemporary, Minneapolis's own Prince also achieved trailblazing success. His, however, struck a unique balance between musicianship and showmanship, especially with his 1984 album and film *Purple Rain*, which also earned him two Oscars.

## The hip-hop age of R&B

R&B music, especially tinged with hip hop, seemed to fare well with Yonkers, New York's Mary J. Blige, Atlanta's Usher, and Chicago's R. Kelly leading the charge from the 1990s well into the 2000s, and later joined by Chris Brown. New Edition, the 1980s singing group, comprised of Boston natives Ralph Tresvant, Bobby Brown, Michael Bivins, Ronnie Devoe, and Ricky Bell (later joined by Johnny Gill) who were modeled off the legendary Temptations, had already begun to explore that connection. Their spinoff group Bell Biv Devoe, made up of Ricky Bell, Michael Bivins, and Ronnie Devoe, found great success with such songs as the 1990 hits "Poison" and "Do Me."

Mary J. Blige's debut album *What's the 411?*, powered by Uptown Records led by former rapper Andre Harrell and guided by rising music impresario Sean "Puff Daddy/Puffy" Combs, in 1992, put an exclamation point on it, immediately establishing her as a star. Subsequently dubbed the "Queen of Hip Hop Soul," Blige was heralded as a voice for young urban women and a bridge between hip hop and R&B, which was in great contrast to singer Whitney Houston whose hard-edged Newark roots were largely disguised. Blige's many hits include the 1995 duet "I'll Be There for You/You're All I Need to Get By," with the latter part of the title reworking the 1968 Marvin Gaye/Tammi Terrell classic, with Method Man and "Not Gon Cry" from the soundtrack of the 1996 film *Waiting To Exhale* ironically starring Houston.

*Neo-soul,* a term coined by music executive Kedar Massenburg to describe the sound of late 1990s artists like Erykah Badu, D'Angelo, Musiq Soulchild, India Arie, and Jill Scott that recalled the essence of soul music only filtered through an era ruled by hip hop, never took full flight. More urban-edged R&B continued to take off. Teen singers Brandy in L.A. and Monica in Atlanta illustrated this with the respective hit songs like the 1994 "I Wanna Be Down" remix featuring female

rappers Queen Latifah, Yo-Yo, and MC Lyte and the 2003 hit "So Gone" with rapper/producer/songwriter Missy Elliott. Although the two found success with their far more pop-leaning 1998 single "The Boy Is Mine," the majority of their records were more reflective of the harder urban/hip hop–edged R&B sound that continued to dominate. The 1990s girl group En Vogue, who fell more in line with the Supremes, were a notable exception but that sound wasn't largely duplicated. Hip hop, as Teddy Riley demonstrated with the creation of the sound known as *new jack swing* in the late 1980s with the group Guy, singer Bobby Brown of New Edition fame and Keith Sweat, continued to lead the way.

Singer Aaliyah was able to establish herself on her own terms through the Southern hip hop–tinged sound of Timbaland and Missy Elliott for her 1996 sophomore album *One in a Million* with hits like the title track and "If Your Girl Only Knew." Further proving hip hop's driving power, Atlanta-based singer Usher, whose many hits range from "You Make Me Wanna. . ." (1997) to "Confessions Part II" (2004), released his diamond-seller *Confessions* in 2004. Executive produced by longtime mentor Jermaine Dupri, who introduced teen hip hop sensations Kris Kross back in 1992, *Confessions* went platinum its first week of release at a time when album sales were very low.

As popular as Usher, who was also known for his dancing, was, R. Kelly was the undeniable "King of R&B," churning out hits as both a singer and songwriter that include "Bump n Grind" (1994), "I Believe I Can Fly" (1996) from the *Space Jam* soundtrack, "Step in the Name of Love (Remix)" (2003), and his highly regarded multiplatinum albums *12 Play* (1993) and *The Chocolate Factory* (2003), along with the 2002 joint album *The Best of Both Worlds* with Jay-Z. He also penned songs like "You Are Not Alone" (1996) for Michael Jackson. But there was a dark side to Kelly's success. Inappropriate relationships with underage girls dogged the Chicago native throughout his career, especially after a marriage license to his 15-year-old protégé Aaliyah when he was 27 surfaced in 1994, on the heels of her debut album, *Age Ain't Nothing But a Number*. In 2008, Kelly was acquitted in a trial where he faced several counts of child pornography stemming from a 2002 sex tape allegedly of him with a minor teenage girl he urinated on. Allegations of sexual exploitation of young girls and grown women, long reported by music journalist and critic Jim DeRogatis, exposed in the 2019 Lifetime docuseries *Surviving R. Kelly*, coupled with the Mute R. Kelly movement ended his music career and landed him behind bars.

Chris Brown, who hit with his 2005 single "Run It" and self-titled debut album, was poised for global superstardom. His violent reaction to an argument with girlfriend and star Rihanna in 2009 resulted in her canceling her Grammy Awards show appearance due to her bruised face, killed his mainstream momentum. However he continued to elevate in the R&B/urban music genre, scoring continuous hits with many successful albums including *F.A.M.E.* (2011) and *Heartbreak on a Full Moon*

(2017), and such singles as "New Flame" (2014) with Usher and rapper Rick Ross, "No Guidance" (2019) with Drake, and "Go Crazy" (2020) with rapper Young Thug.

With his many hip hop–assisted hits including "Say Aah" (2010) with rapper Fabolous, Virginia native Trey Songz contributed to this sound while singer/songwriter Ne-Yo, who first scored with his 2006 hit "So Sick," straddled the line between traditional and urban R&B. North Carolina soulsters Fantasia and Anthony Hamilton, preceded by the R&B group Jodeci, also from Virginia, fell into similar territory. Midwesterner and Ivy League–educated John Legend, who emerged through rap superstar Kanye West in the early 2000s, created his own lane reminiscent of Marvin Gaye but also in keeping with the era, even scoring Grammy and Oscar wins for the song "Glory" for the 2014 Ava DuVernay-directed film *Selma* with rapper Common.

**BLACK AMERICAN FACES**

# KENNETH GAMBLE AND LEON HUFF

As the home of soul singer Solomon Burke, classical vocalist Marian Anderson, and rock and roll pioneer Chubby Checker, not to mention an early incubator for jazz greats John Coltrane and Dizzy Gillespie, Philadelphia had long established itself as a music hub by 1971. Remarkably, with the formation of Philadelphia International Records that year, songwriters and producers Kenneth Gamble and Leon Huff were able to add to the city's already substantial music legacy. Songs such as Harold Melvin and the Blue Notes' "If You Don't Know Me by Now," the O'Jays' "Back Stabbers," and the Grammy winner "Me and Mrs. Jones" by Billy Paul injected a new sound into Black music that some dub "The Sound of Philadelphia" (which was also a 1973 hit by MFSB for the label).

Distinctively, Philadelphia International matched its male artists' strong, masculine voices with thumping bass lines and other new music techniques. Those featured bass lines, also found in funk and hip hop, later resurfaced in a new genre called disco. In the late 1970s and 1980s, Gamble and Huff collaborated to produce the classics "Close the Door" and "Somebody Loves You Back" for Teddy Pendergrass as well as Patti LaBelle's classic 1983 album *I'm in Love Again,* with the hits "Love, Need, and Want You" and "If Only You Knew." Gamble also played a pivotal role in President Jimmy Carter's designating June as Black Music Month in 1979.

In the 2000s, the City of Brotherly Love experienced a musical resurgence largely led by the neo-soul musical stylings from natives Musiq Soulchild, Jill Scott, and Bilal; British transplants Floetry; and outsiders like John Legend and Erykah Badu, coupled with a little edge from the hip hop band The Roots. Reminiscent of many of the Philadelphia International sound, this musical development was living proof of Gamble and Huff's enduring legacy.

# Taking the Rap

In the mid-1970s, *hip hop,* a brash mixture of rhythm and boastful talking, took hold in New York City. The Sugarhill Gang's "Rapper's Delight," rhymed over CHIC's "Good Times" and cut in 1979, became a commercial hit on the R&B, pop, and U.K. charts. By the early 1980s, hip hop pioneers such as Grandmaster Flash and the Furious Five, Kurtis Blow (the first rapper signed to a major label, Mercury Records), the Funky Four Plus One, and Run-D.M.C. were changing the music scene. Run-D.M.C.'s 1986 album *Raising Hell,* which became the first rap album on the Billboard Top 10, along with their rock collaboration with white rock band Aerosmith on "Walk This Way," paved the way for hip hop's subsequent dominance.

In the 1990s, rap opened up to include various genres and various areas. Rappers who kept the genre moving forward in the 1990s include New Yorkers Nas, Jay-Z, Busta Rhymes, the Wu-Tang Clan, and DMX from Ruff Ryders. Rappers with platinum albums in the 1990s and early 2000s, include Texas's the Geto Boys, Scarface, and UGK; Atlanta's OutKast, Goodie Mob, Lil Jon (who became known for crunk music), Ludacris, and T.I.; New Orleans's Master P (with his No Limit Soldiers) and the Cash Money Millionaires; Memphis's 8Ball & MJG and Three 6 Mafia; Miami's Trick Daddy and Rick Ross; Chicago's Common and Kanye West; St. Louis's Nelly; Compton's The Game; and New York City's Ja Rule, Fabolous, and 50 Cent.

## Hip hop matures

Grandmaster Flash and the Furious Five had shown rap's political potential with 1982's "The Message" (which detailed the horrendous conditions of ghetto life), but Public Enemy completely embodied it. Signed to Def Jam Records, Public Enemy, marked by lead rapper Chuck D's preacher-like presentation, directly politicized rap in the late 1980s and beyond with hits like "Fight the Power," created for Spike Lee's 1989 film *Do the Right Thing.*

Hip hop also came into its own artistically. The Bomb Squad, Public Enemy's producers, took hip hop production to another level with multitextured layering and customized beats. Artists such as Rakim from Eric B. & Rakim and KRS-One placed a greater emphasis on lyricism, as metaphors became a hip hop staple. Others such as X-Clan, the Jungle Brothers, and A Tribe Called Quest comfortably flexed their Afrocentric views. During the late 1980s into the early 1990s, a variety of styles flourished. Def Jam's first artist, LL Cool J, and Big Daddy Kane also emerged as rap music's first sex symbols.

# The West Coast opens up rap

The West Coast was the first area to expand hip hop beyond the East Coast in a substantial way. Initially, Too Short, Ice T, and N.W.A. were the artists who shone the brightest. Too Short injected the pimp game into rap lyrics, and Ice T incorporated themes of pimping and hustling into his rhymes. N.W.A., however, would have the biggest mainstream impact.

Original members of N.W.A. (Niggaz Wit Attitudes), which originated out of Compton, California in the Los Angeles metro area, include Eric "Eazy-E" Wright, Andre "Dr. Dre" Young, O'Shea "Ice Cube" Jackson, Lorenzo "MC Ren" Patterson, Kim "Arabian Prince" Nazel, and Antoine "DJ Yella" Carraby. In 1987, Ruthless Records, owned by Wright, released its first hit, "Boyz-n-the-Hood," a collaborative effort involving all of N.W.A., as an Eazy-E record.

On the heels of that record's buzz, N.W.A. later released its signature album, *Straight Outta Compton*, in 1988. Guns, women, liquor, and other aspects of urban life weren't new to hip hop, but those things viewed from the perspective of a gangster were. Ironically, N.W.A. uncovered both the hopelessness and the resiliency born out of oppressed conditions. "F@!# tha Police," a response to police brutality, placed N.W.A. on the FBI's official radar, which labeled hip hop "gangsta rap" specifically America's public enemy number one, suggesting that violence in Black communities emanated from rap music.

After leaving N.W.A., Ice Cube successfully established a solo career as a lyricist from the West Coast with his 1990 debut, *AmeriKKKa's Most Wanted.* Meanwhile, Dr. Dre's 1992 multiplatinum solo debut, *The Chronic,* officially ended the East Coast's rap dominance. It also formalized a new sound, G-Funk, inspired by the music of funkateers Roger Troutman (and Zapp) and George Clinton, and established Snoop Doggy Dogg as a star; Snoop's 1993 debut *Doggystyle* entered the charts at number one. Heavily influenced by his family's Mississippi roots, Snoop's rap style arguably made the Southern drawl more acceptable to the rap audience at large. The platinum success of Cleveland group Bone Thugs-N-Harmony (whom Eazy-E signed to his Ruthless Records prior to his 1995 death) helped to open up hip hop more widely beyond New York and L.A. Their 1996 number one hit, "Tha Crossroads," won a Grammy.

Personal arguments and misunderstandings between the West and East Coast rap communities, most notably label owners Suge Knight of Death Row Records and Sean Combs (then better known as Puff Daddy or Puffy) of Bad Boys Records and their rappers 2Pac or Tupac Shakur and the Notorious B.I.G. (also Biggie), culminated in the violent, unsolved murders of Tupac in 1996 and Biggie in 1997. Stunned by the tragic loss of two hip hop titans, the rap community took steps to mend the rift between the coasts. Violence, however, remained an issue. Run-D.M.C.'s Jam Master Jay became another victim of violence in 2002, and in 2019 the murder of L.A. rapper Nipsey Hussle, who advocated for economic empowerment, especially in his

Crenshaw neighborhood, was another huge blow. Equally frustrating to the hip hop community has been the police's inability to make arrests in many of these murders.

# Women take the mic

Rap has continually battled allegations of misrepresenting women. Miami-based 2 Live Crew and its more well-known Luther Campbell fueled those objections with its signature Miami Bass music, featuring pulsating rhythms and sexually explicit lyrics such as those in the 1989 hit "Me So Horny," from the *As Nasty As They Wanna Be* album. The mostly naked women featured on the group's album covers and in its videos generated more outrage.

Some women grabbed the mic to represent themselves. Rap's most visible female pioneers have been the New York City-based Roxanne Shanté, Salt-N-Pepa (Cheryl "Salt" James and Sandra "Pepa" Denton), MC Lyte, Queen Latifah, and Yo-Yo on the West Coast. Guided by Atlanta-based hip hop producer Jermaine Dupri, Chicago native Da Brat became the first female solo rapper to go platinum with 1994's *Funkdafied*. Beginning in the mid-1990s, Lauryn Hill made a big splash, first as a member of the Fugees and then as a solo artist with her hip hop infused 1998 album *The Miseducation of Lauryn Hill*, winning five Grammys.

## TUPAC'S LEGACY

An international cult figure, Tupac Amaru Shakur has remained influential with no less than five released albums since his death on September 13, 1996, at age 25. Some of the nation's top universities designed courses examining his philosophy of THUG LIFE, an acronym for "The Hate U Give Little Infants F@#! Everybody." Academics such as Michael Eric Dyson and Jamal Joseph wrote books addressing his legacy. Shakur's post-humous documentary *Tupac: Resurrection* (2003), narrated by him through his many interviews, even received an Oscar nomination. Young Adult author Angie Thomas's 2017 *New York Times* bestseller *The Hate U Give* (Balzer + Bray, inspired by Tupac and THUG LIFE, was also adapted into the 2018 film of the same name.

His impact remained so strong some rappers still cited him as an influence two decades following his death. As an actor, he memorably starred in the 1992 film *Juice* and the 1993 film *Poetic Justice*, directed by John Singleton and co-starring Janet Jackson. To keep his memory alive and expand his vision, his mother, one-time Black Panther Afeni Shakur, established the Tupac Amaru Shakur Center for the Arts in Stone Mountain, Georgia, in the Atlanta metro area in 2005. "Dear Mama," the song dedicated to his mother on his multiplatinum 1995 album *Me Against the World*, is a classic that is played every single Mother's Day. The biopic *All Eyez on Me* was released in 2017, the same year Shakur became the first solo rapper inducted into the Rock and Roll Hall of Fame.

Lil' Kim, Foxy Brown, Mia X, Missy Elliott, Eve, and Trina created a second wave of female rappers, with all but Missy Elliott, Mia X, and Eve adopting highly sexualized imagery and lyrics. Mary J. Blige, known as the queen of hip hop soul, mastered the fusion of hip hop with R&B, especially with her 1992 debut *What's the 411?* to give the everyday young urban woman a voice within the hard-edged genre.

Nicki Minaj, who was born in Trinidad and raised in New York City, also had a game-changing impact. By the 2010s, she wasn't just the most successful female rapper in the music industry but also one of the most successful rappers overall. (Prior to Minaj, Remy Ma, whose legal troubles and incarceration in the late 2000s hindered her career, was among the most well-known female rappers from New York. She, however, never reached Minaj's heights.)

Beginning with Minaj's 2010 debut album, *Pink Friday,* which entered the Billboard 200 at number two, Minaj became arguably the most dominant female rapper of all time. That dominance opened the doors for other female rappers, including Bronx Afro-Latina rapper and one-time reality TV personality Cardi B, who scored big with her 2017 single "Bodak Yellow (Money Moves)." That single became just the second solo effort from a female rapper to hit number one since Lauryn Hill did with "Doo Wop (That Thing)" in 1998.

In 2019, Houston rapper Megan Thee Stallion further upgraded the status of female rappers when she began dominating the charts with hits such as "Big Ole Freak" and "Hot Girl Summer," featuring Nicki Minaj. In 2020, "Savage," featuring fellow Houstonian Beyoncé, became Megan Thee Stallion's first number one single.

Cardi B's sex-positive and sexually explicit single "WAP," featuring Megan Thee Stallion, debuted at number one on the Billboard Hot 100. Doja Cat also reached number one with her "Say So" remix featuring Nicki Minaj. City Girls, Rapsody, Saweetie, and Chika are among the many other notable female rappers who began impacting the music industry in the late 2010s into the 2020s.

## Trap music emerges

Throughout the 2000s, Atlanta began to dominate hip hop music specifically and the music industry at large with the genre known as *trap music,* named for the house that drugs were often dealt from or for drug dealing itself. In addition to T.I., who is credited with coining the genre's name through his 2003 platinum-selling album *Trap Muzik,* rappers Young Jeezy (later Jeezy), Gucci Mane, 2 Chainz, Waka Flocka Flame, Future, Young Thug, 21 Savage, Lil Baby, and Migos (the platinum-selling rap trio who further helped elevate Atlanta musically), gave the genre longevity. This was achieved through producers such as DJ Toomp, Shawty Redd, Zaytoven, Metro Boomin, and Sonny Digital.

# Lyrical emcees return

One development of the 2010s was the return of lyrical emcees. With his 2006 album, Nas declared *Hip Hop Is Dead*. Until the 2010s, highly regarded emcees like Nas, Jay-Z, white rapper Eminem, Method Man, Busta Rhymes, Redman, and more had actually broken through in the 1990s.

Other emcees who emerged during the 2010s into the 2020s or came on stronger, lyrical or not, include Big Sean, Future, Wiz Khalifa, Travis Scott, Meek Mill, Migos, 21 Savage, Lil Baby, DaBaby, Roddie Rich, Kodak Black, Tyler, the Creator, Chance the Rapper, G Herbo and YG. Nas, Jay Z, Kanye West, Lil Wayne, 2 Chainz, Jeezy, Yo Gotti, TI, Gucci Mane, and Rick Ross were among the artists who proved to have staying power.

**BLACK AMERICAN FACES**

## DRAKE MAKES RAP TRULY GLOBAL

Prior to becoming a rapper, Toronto native Aubrey Drake Graham was better known for his role as Jimmy Brooks, a basketball player who becomes paralyzed, in the Canadian teen drama *Degrassi: The Next Generation* from 2001 to 2009. Some critics credited that charisma to his musical success. His musical domination provided rap music with its first true global superstar, opening the door for not just crossover from non-U.S. rappers but also the incorporation of more global musical sounds. In short, Drake's success created an interactive conversation between rap birthed in the US and the rest of the world.

Drake, the son of a white Jewish mother from Canada and a Black father from Memphis, has a true musical pedigree. His father, Dennis Graham, was a drummer for Jerry Lee Lewis. Drake's uncles Teenie Hodges played and cowrote with Al Green and Larry Graham played with Sly and the Family Stone, fronted his own band Graham Central Station, and collaborated with Prince.

Drake dominated musically throughout the 2010s, beginning with his 2010 official album debut *Thank Me Later*, which entered the Billboard 200 at number one. Drake became one of the bestselling artists, not just rappers, of all time.

genre

» **Following the rise of popular Black actors**

» **Connecting with audiences through comedy**

» **Building Black film and TV empires**

# Chapter **17**

# Black Hollywood: Film and Comedy

J ust as early minstrel shows conspired to keep Black Americans in their place (refer to Chapter 15), so did early Hollywood, which relegated Black actors to playing mammies, maids, and butlers. Some early Black actors actually got their big break working as servants to Hollywood's white stars and industry brass. Film historian Donald Bogle explores this history in his classic book *Toms, Coons, Mulattoes, Mammies, and Bucks: An Interpretive History of Blacks in American Films* (Bloomsbury Academic), first published in 1973. A great deal has changed since those early days.

This chapter explores Black Americans' humble beginnings in early Hollywood, with a nod to comedy, touching on race movies as well as Black American contributions behind the camera; this skill and talent prompted the creation of the NAACP Image Awards in 1969. It also notes the impact of Black directors, from early film pioneers Oscar Micheaux and Spencer Williams to Gordon Parks, Michael Schultz, Spike Lee, John Singleton, Ava DuVernay, Ryan Coogler, Jordan Peele, and Barry Jenkins.

# Making Movies Black

*The Birth of a Nation* (1915), originally titled *The Clansman*, was the movie industry's first feature-length blockbuster film. Director D.W. Griffith's creation was such a national hit that President Woodrow Wilson privately screened it at the White House. It had been adapted by Thomas Dixon from his novel *The Clansman: An Historical Romance of the Ku Klux Klan*, which centered revisionist post-Reconstruction history painting Black people as threats to white people. Most of the Black characters were portrayed by white actors in blackface, with the notable exception of Madame Sul-Te-Wan, who appeared in an uncredited role and went on to have a long career in largely subservient roles on the big screen. The movie was so anti-Black and pro-segregation that activist William Monroe Trotter and the NAACP protested it, officially launching Black Americans' battle with Hollywood over its distortion of Black people. (That protest is captured in the 2017 PBS documentary *Birth of a Movement*.)

The concept of the 1918 film *The Birth of a Race* was to refute *The Birth of a Nation* by presenting the history and achievement of Black people. Emmett J. Scott, who was a close adviser to Booker T. Washington (see Chapters 7 and 13), spearheaded the project. According to a *Variety* review of the film, the white-owned Selig Polyscope Company, the film's most influential producer, undermined the project. "A large quantity of film, depicting certain phases of the advancement of the Negro race, was dropped," it reported. Instead of celebrating Black Americans, the film shifted its focus to white people.

The 1920 Oscar Micheaux film, *Within Our Gates*, starring Evelyn Preer, known to Black audiences as "The First Lady of the Screen" fares much better. The story shows both racial terrorism via lynching and racial uplift through education.

Evidence suggests films prior to *The Birth of a Nation* with actual Black actors. In 2018, the 1898 short film *Something Good — Negro Kiss* from Selig Polyscope (the same company that sabotaged *The Birth of a Race*) was rediscovered. Roughly 30 seconds long, the film starring Saint Suttle and popular vaudeville performer Gertie Brown is a twist on the 1896 film *The Kiss* and is noteworthy for showing Black love and romance.

Other films starring Black actors prior to 1915 include *A Fool and His Money* (1912), whose director Alice Guy, a white French woman, is considered the industry's first female director; *The Railroad Porter* (1912, sometimes 1913), starring Black vaudeville superstar Bert Williams and directed by William Foster, believed to be the first film by a Black director; and *Lime Kiln Club Field Day* (1913), also starring Williams. *Aladdin Jones* and *Two Knights of Vaudeville* were both released in 1915. Some of these movies, like *Two Knights of Vaudeville*, also presented problematic imagery.

# Race movies: Introducing all-Black casts

In theory, *race movies*, films with all-Black casts, should have offset the negative depictions of Black Americans in *The Birth of a Nation*. Only a handful of the companies that produced them, however, had Black talent in key behind-the-scenes roles, especially as directors, producers, and writers. Good and bad, race movies expanded the roles of Black actors (many of whom were seasoned vaudeville performers) beyond maids, butlers, and other stereotypical roles that had been present since film began. More than 500 race movies were produced from 1910 to 1950.

**REMEMBER**

While combating the negative stereotypes in mainstream films, race movies created some of their own. In many race movies, leading men and women with lighter complexions were often shown as good and beautiful, whereas the characters played by actors with darker complexions were presented as bad and unattractive. In addition, critics accused race movies of focusing too much attention on crime.

## Mostly white-owned companies

Chicago-based Ebony Film Corporation was one of the most prominent examples of the many white-owned companies that made race films from screenplays primarily written by white writers. In a reorganization, the company absorbed the Historical Feature Film Company, makers of *Two Knights of Vaudeville*. Ads for its Ebony Comedies such as *A Reckless Rover* and *Spying the Spy* from 1918, also welcomed white audiences by employing stereotypes like "the race of music and laughter," despite having Luther J. Pollard (brother to sports pioneer Fritz Pollard), the company's only Black employee, as president. Prior to Ebony Film Corporation folding in 1919, *The Chicago Defender* observed that the stereotypical content of its films caused "respectable ladies and gentleman to blush with shame and humiliation."

Other companies, like the mostly white-owned Philadelphia-based The Colored Players Film Corporation — cofounded by Sherman H. Dudley (also S.H. Dudley), who had success in minstrel shows and had created his own theater circuit — fared better. In 1926, it released the highly regarded *Scar of Shame*, which explored intraracial class tensions. *Scar of Shame* starred respected stage actor Charles Gilpin, who played the title role in Eugene O'Neill's hit play *The Emperor Jones* in 1920.

Reol Productions was founded in New York City by Robert Levy, a white British-born booking agent who mounted more than 100 high-quality all-Black cast plays. It set a high bar in 1921 with its model of primarily adapting works by Black writers, like Paul Laurence Dunbar's *Sport of the Gods*, which was the company's first film. In addition, Reol Productions worked with a roster of talented Black actors, including Edna Morton (dubbed the "colored Mary Pickford" to indicate her star status in the Black community), Clarence Muse, Lawrence Chenault, and Inez Clough. Other hit Reol films include *The Burden of Race* (1921), *The Call of His People* (1922), *Easy Money* (1922), and *Spitfire* (1922). Despite having high artistic standards and generating great critical acclaim, Reol Productions folded in 1924.

Over the years, various other companies produced race films. The Newark-based Frederick Douglass Film Company, which adapted Paul Laurence Dunbar's *The Scapegoat* to the screen, is one example. Another was the Booker T. Film Company of Los Angeles, whose only production, the western *The Ten Thousand Dollar Trail* (1921), starred its founder and lead actor Sidney P. Dones.

## Expanded roles for women

There is no record of Black women owning any of these film companies, but some women found opportunities not readily available to them. They included Dora Mitchell, who wrote *The Ten Thousand Trail,* and Theresa "Tressie" Souders, a domestic for much of her life, whose 1922 film *A Women's Error* is believed to be the first to be directed by a Black woman. On screen, Black women had an early presence primarily through Bertha Regustus, who played a dental patient in the 1907 film *Laughing Gas,* as well as maids in the 1903 film *What Happened in the Tunnel* and 1905's *The Servant Girl Problem.*

Though film was male-dominated, Madame E. Toussaint Welcome (also known as Jennie Louise Van der Zee, sister to famed Harlem Renaissance photographer James Van der Zee) co-founded the Toussaint Motion Picture Exchange in Harlem with her husband Ernest Toussaint Welcome. She directed the documentary film *Doing Their Bit,* about Black soldiers returning from Europe between 1919 and 1922; the film is now lost.

Working with her husband James Gist, an evangelist, Eloyce Gist, co-directed three films, arguably precursors to faith-based entertainment, in the 1930s, including *Verdict: Not Guilty.* Popular with the NAACP, its story revolves around Satan putting the soul of a woman who dies in childbirth on trial.

Celebrated writer Zora Neale Hurston is rarely lauded for the documentary film work done in her work as an anthropologist, such as the 1928 and 1929 films *Children's Games* and *Baptism,* probably due to their lack of commercial liability. But it's believed that Hurston, who worked as a personal assistant from 1925 to 1926 to Fannie Hurst, greatly influenced the author's most famous book, *Imitation of Life,* which was adapted into film in both 1934 and 1959, by giving her a glimpse into Black life and culture. Hurston also worked as a staff screenwriter at Paramount in 1941, but her Hollywood career, like that of so many Black women, just never took off.

## Black men making race movies

The more noteworthy of the noticeably male Black-owned or Black-partnered film entities that made measurable and significant contributions include

>> **Foster Photoplay Company:** Founded by former vaudeville publicity and booking agent William Foster in 1910, the Foster Photoplay Company produced several well-received comical shorts like *The Railroad Porter* (1912, sometimes 1913) that white audiences also saw. The company folded in 1916.

**TECHNICAL STUFF**

Theatres catering to white audiences showed race movies during matinee or *midnight ramble* hours, the term used for segregation-era midnight showings for Black audiences.

>> **Lincoln Motion Picture Company:** Founded by brothers Noble (an actor) and George Johnson (the U.S. Post Office's first Black employee), the Lincoln Motion Picture Company was one of the most prominent independent Black film companies, known for *The Realization of a Negro's Ambition* (1916) and *The Trooper of Troop K* (1917). Actors Clarence Brooks and Beulah Hall played key roles. The ride came to an end in 1923, not long after Universal Pictures, for which Noble Johnson was contracted, forced him to resign from his own company and demanded the company not use his likeness even though he starred in all its films.

>> **Micheaux Film Corporation:** The Lincoln Motion Picture Company got Midwestern writer and homesteader Oscar Micheaux in the film business. When they approached Micheaux to adapt his novel *The Homesteader* into a film, their failure to come to terms prompted Micheaux to make his first film titled *The Homesteader* in 1919, followed by *Within Our Gates* in 1920. Micheaux's topical films tackled everything from residential segregation to separatism versus assimilation, from interracial marriage to crooked preachers — one such film, *Body and Soul* (1925), served as Paul Robeson's film debut.

Initially, Black audiences applauded Micheaux's work. After several years, however, they expected more, and some Black newspapers even took Micheaux to task for dedicating too much attention to gambling and other seedy elements. Still, Micheaux, who wrote, produced, directed, and distributed more than 40 films, is the most consistent and prolific of early Black filmmakers and many filmmakers overall.

His second wife, Alice B. Russell Micheaux (also credited as A. Burton Russell), greatly aided him in his trailblazing cinematic pursuits. She appeared in nearly a dozen films, produced four to six films (including *Murder in Harlem*, starring Clarence Brooks, in which she also appeared), helped administer the Micheaux Film Company, and more.

>> **Million Dollar Productions:** Ralph Cooper, better known as founder of the Apollo Theater's world-famous Amateur Night, partnered with the white Popkin brothers in 1937, to form Million Dollar Productions. Months prior to Million Dollar Productions, Cooper owned the production company Cooper-Randol Productions with fellow Black actor George Randol, and together they produced just one film, the popular *Dark Manhattan*.

Dubbed the "Dark Gable," Cooper, who often starred in the company's productions, contributed entertaining if not groundbreaking films to the mix. One of Cooper's greatest contributions was the casting of a then-unknown Lena Horne in 1938's *The Duke Is Tops,* rereleased as *The Bronze Venus* in 1943. The movie business proved too taxing for Cooper, who left it altogether. Million Dollar Productions folded in 1940.

>> **Herb Jeffries, various projects:** Detroit native Herb Jeffries (sometimes Jeffrey) wanted to make movies and persuaded white producer Jed Buell to take a chance on him. The two created *Harlem on the Prairie* (1937), starring the fair-skinned, wavy-haired Jeffries as a singing cowboy. Encouraged by the film's success and favorable reviews, another independent producer, Richard Khan, tapped Jeffries to star in additional films such as *Harlem Rides the Range* (1939).

>> **Spencer Williams, various projects, Amnegro Films:** Best known as Andy from the oft-criticized 1950s comedy *Amos 'n' Andy,* Spencer Williams began his entertainment odyssey when he came to New York City as a teenager. There, he worked as a stagehand for Oscar Hammerstein and was mentored by vaudeville star Bert Williams. By the time he arrived in Hollywood in 1923, he had attended college and served in the U.S. Army during World War I, traveling to various countries.

Working behind the scenes as a sound tech and writing dialogue for Black characters as well as acting, Williams was involved in important films like *The Melancholy Dame* (1929), starring Evelyn Preer, which he co-wrote and touted as the first Black talkie. He wrote many films, including *Harlem Rides the Range* (1939) and the celebrated *Son of Ingagi* (1940), considered the first all-Black cast sci-fi horror film. Williams's biggest contribution came from making films for his own Amnegro Films, including his 1941 classic *The Blood of Jesus.*

## Early Black roles in major studio films

By 1929, Hollywood studios such as MGM were making films with Black casts. Despite having Black casts and greater resources, many of these major studio films still perpetuated harmful stereotypes and cast Black actors in stereotypical roles.

### Starting as servants: Clarence Muse and Hattie McDaniel

Many Black actors portrayed servants. Of these, the two best known are the multitalented Clarence Muse and Hattie McDaniel. Baltimore native Muse was a lawyer, director, writer, and composer, as well as an actor who appeared in more

than 150 films, dating from his debut in 1921 in *The Custard Nine* to his last film *The Black Stallion*, released just around his death in 1979. Muse played Cudjo in *Buck and the Preacher* (1972) and Snapper in *Car Wash* (1976).

The Denver-raised McDaniel became the first Black American to win a Best Supporting Actress Academy Award (or any Academy Award, for that matter) for her role of Mammy in *Gone with the Wind* in 1940. Although defined by her stereotypical maid roles to the larger society, McDaniel's Black fans saw her many talents. One of 13 children born in 1893 to formerly enslaved parents, McDaniel began her career performing on the minstrel circuit with her siblings, most notably in the all-female *The McDaniel Sisters' Company* with her sister Etta Goff from 1914 until roughly 1916. In the 1920s, McDaniel leaned into music, singing on the radio as well as recording for Okeh and Paramount Records from 1926 to 1929.

In her early on-screen Hollywood career, which began roughly around 1932 with mostly uncredited roles as maids until 1936, she would even work as a maid off screen to make ends meet. That changed after *Gone with the Wind* (where Butterfly McQueen also played Prissy). Until 1949, she appeared regularly in films, even amid heavy criticism from the NAACP and the Black community at large.

In 1947, she began voicing the lead of the controversial radio show *Beulah*, about a Black maid caring for a white suburban family; the show's roots went back to 1939, when a white man voiced the character. By 1951, she was playing the lead on television after Ethel Waters left the title role. In 1952, McDaniel, at age 59, lost her battle with breast cancer. She has the distinction of having two stars on the Hollywood Walk of Fame — one for radio and one for motion pictures.

## Reinforcing and escaping stereotypes

Other common stereotypes were *Sambo* roles, portraying Black people as lazy and shiftless. The key characters Gummy and Zeke in the films *Hearts in Dixie* (1929) and *Hallelujah!* (1929), starring Stepin Fetchit and Daniel L. Haynes, reinforced the stereotype of the lazy Black man, avidly avoiding work. *Hearts in Dixie*, which marked Clarence Muse's studio debut, was a major film for Fetchit (see the sidebar for more information about him).

Dramatic films offered some hope. These included *Imitation of Life* (1934), with its strong performance from Black co-star Louise Beavers as stereotypically loyal employee Delilah and the side story of her daughter Peola, a young Black girl who could pass for white, played with gravitas by Fredi Washington. A non-Black actress plays the role in the 1959 remake. Another standout was the film version of Eugene O'Neill's 1920 play *The Emperor Jones* (1933), starring Paul Robeson as a nefarious character who ends up leading a small Caribbean island.

# STEPIN FETCHIT

Stepin Fetchit's many comedic appearances in mainstream films like *Judge Priest* (1934) and all-Black films like *Miracle in Harlem* (1948) opened doors for other Black actors. Because he played Sambo roles, however, he was vilified as the poster child for Hollywood's Black stereotypes (although these were largely the only roles available to Black actors of his day).

Born Lincoln Theodore Monroe Andrew Perry in Key West, Florida to Caribbean immigrants, Stepin Fetchit ("step and fetch it," a name he earned on the vaudeville circuit) willingly submitted to Hollywood's malicious portrayals of Black men. Despite a decent education and an interest in classical music, he allowed the studio machine to paint him as an authentic "darky." By pretending to be illiterate, he reinforced white studio executives' stereotypes and ignorance of Black people. Consequently, he became one of the first Black movie stars, appearing in more than 50 films.

Although he was the first Black actor to earn more than $1 million in film, his lavish lifestyle plunged him into bankruptcy. Eventually, protests by civil rights organizations against Black stereotypes in films sank his career in the early 1950s.

Escaping stereotypical roles was difficult for those who wanted to work in an industry pervaded by racism. Even when the studios adapted Broadway hits that contained more subtle stereotypes, film magnified them. Because theater was a more intimate affair that gave actors a greater degree of flexibility, a skillful actor could sometimes diffuse a stereotypical character. In film, even talented actors like Paul Robeson found it difficult to make a bad character better. For example, Black critics lauded Robeson's acting and singing as Joe, the shiftless Black male character in the Universal Pictures 1936 film *Show Boat*, but still found the character itself stereotypical. That was also true of *The Green Pastures*, an award-winning play that reenacted stories from the Old Testament with a Black cast speaking in Black American vernacular.

**REMEMBER**

Although mainstream Hollywood slowly embraced Black actors, top Black entertainers, known as *specialty acts*, were frequently included in top white films in the 1940s, usually in nightclub settings. Count Basie, Duke Ellington, Louis Armstrong, Hazel Scott, and others appeared in films like *Stage Door Canteen* (1943), *Atlantic City* (1944), *Reveille with Beverly* (1943), *Hit Parade of 1943* (1943), and *Rhapsody in Blue* (1945). Black dancers such as Katherine Dunham and the famed Nicholas brothers, Fayard and Harold, also scored screen time. Vaudeville veterans Buck and Bubbles shined on screen with their humor-infused tap dance, song and piano-playing routines in numerous films, including *Varsity Show* (1937) and *A Song Is Born* (1948). At various points before the 1960s, Hollywood got behind several all-Black musicals, including *Cabin in the Sky* (1943), *Stormy Weather* (1943), *Carmen Jones* (1954), *St. Louis Blues* (1958), and *Porgy and Bess* (1959).

# 1940s–1960s: Exploring new themes

Responding to protests from the NAACP and other civil rights groups, in addition to the nation's ongoing changes in race relations, Hollywood began including Black characters, usually one or two, in nontraditional roles. For example, war movies, beginning in 1949, with the groundbreaking casting of James Edwards in *Home of the Brave*, began prominently featuring at least one Black soldier, a move cultural critic Gerald Early suggested was prompted by President Truman integrating the military in 1948. Following are themes that some films of this era began to explore:

>> **Racism:** Racism became a driving theme. Edwards's character in *Home of the Brave* was one of Hollywood's early attempts to communicate to white Americans how racism impacted Black Americans. In *No Way Out* (1950), a racist white man blames a Black prison doctor for his brother's death. Playing Dr. Luther Brooks is Sidney Poitier, the most famous actor from this period.

>> **"Passing":** Although early Hollywood films addressed the theme of "passing for white," films such as *Show Boat* (in which a "white" character's true Black heritage is discovered), *Lost Boundaries* (1949), *Pinky* (1949), and the remake of *Imitation of Life* (1959) are the most famous of this later era. The 2021 film *Passing,* adapted from Nella Larsen's 1929 novel of the same name, revisited this theme.

>> **Interracial relationships:** Although *Guess Who's Coming to Dinner* (1967), starring Sidney Poitier and Katherine Hepburn, is the more famous film, *One Potato, Two Potato* (1964), starring the lesser known Bernie Hamilton, took a more serious look at societal restrictions against interracial relationships. Poitier's 1965 film *A Patch of Blue,* in which he and a blind white woman fall in love, actively reminded audiences that love is blind.

>> **Love stories involving Black protagonists:** Although Black screen couples were rare in general, especially in serious Hollywood films, two films in particular are outstanding exceptions. Romance isn't the main story in *Bright Road* (1953), about a dedicated schoolteacher (played by Dorothy Dandridge) trying to reach one of her students, but Harry Belafonte's character doesn't hide his tender feelings for the schoolteacher. Directed by Michael Roemer and starring Ivan Dixon and Abbey Lincoln, *Nothing But a Man* is distinctive for its more realistic portrayal of a Black couple's trials and tribulations in the Jim Crow South, with the civil rights movement serving as a backdrop.

>> **Racist taboos:** Films such as *Intruder in the Dust* (1949), adapted from William Faulkner's best-selling novel, and *To Kill A Mockingbird* (1962), based on Harper Lee's Pulitzer Prize–winning novel, were courtroom dramas about innocent Black men facing death because of racist taboos. Although Black characters didn't dominate screen time, films such as these attempted to analyze racism from a moral perspective.

In some ways, films like *To Kill a Mockingbird* are the precursors to Hollywood films known as "white savior movies," where white characters save Black characters from social ills. Two more recent examples from the 2010s include Best Picture Oscar nominee *The Help* (2011) and Best Picture Oscar winner *Green Book* (2018). *The Help*, about Black maids, is told through the eyes of a young white woman; the film included breakout roles for Octavia Spencer, who won the Best Supporting Actress Oscar playing Minny Jackson, and Viola Davis, who received a Best Actress Oscar nomination for playing Aibileen Clark. *Green Book*, for which Mahershala Ali won the Best Supporting Actor Oscar for playing real-life classical and jazz pianist Don Shirley, focuses on the white man Frank "Tony Lip" Vallelonga. Vallelonga chauffeured Shirley during a Southern tour using *The Negro Motorist Green Book*, published by Victor Hugo Green, as a guide of safe places Black travelers could stay and dine during Jim Crow.

## 1960s–1970s: Blaxploitation films

By the 1960s, Black Americans were just 15 percent of the national population but accounted for 30 percent of moviegoers. During this time, Black characters in mainstream films became increasingly more aggressive, a marked difference from early servant roles and Poitier's many model minorities (discussed in the later section "Sidney Poitier"). With several movie roles, particularly in the films *The Dirty Dozen* (1967), *The Split* (1968), and *100 Rifles* (1969), retired NFL player Jim Brown contributed to the depiction of this newly aggressive Black male that also coincided with the rising Black Power movement. Although many Black movie characters died following outbursts against "the man" (a reference to the white power structure), Black audiences still applauded.

Melvin Van Peebles's 1971 film *Sweet Sweetback's Baadasssss Song* (1971) marked the official birth of *blaxploitation*, a genre of Black cast films they were largely white-financed and produced that, according to Black Panther activist Afeni Shakur, was impacted by the Black Power movement. In this film, the Black male protagonist, an embodiment of several stereotypes including the "sexual Mandingo" and the "buck," becomes the hero. Made on a shoestring budget, *Sweet Sweetback's Baadasssss Song* grossed more than $10 million. Equally impressive box office receipts from *Shaft* (1971), starring Richard Roundtree as a Black detective who battles the community's bad guys, solidified the movement.

The combined success of *Sweet Sweetback's Baadasssss Song* and *Shaft* opened a floodgate for a barrage of titles to emerge during the 1970s. *Superfly* (1972), *The Mack* (1973), *Blacula* (1972), *Three the Hard Way* (1974), *Black Caesar* (1973), and *Truck Turner* (1974) are a few of the standouts.

**BLACK AMERICAN FACES**

# PAM GRIER

One of the very few women to reach iconic status during the blaxploitation film period, Pam Grier starred in the cult classics *Foxy Brown* (1974), *Coffy* (1973), and *Sheba Baby* (1975). The North Carolina–born beauty got her big break while working as a receptionist for a film company when film producer Roger Corman noticed her and cast her in *The Big Dollhouse* (1971). Her unique beauty and imposing physique struck a chord with moviegoers.

Grier continued to act when blaxploitation's heyday ended but remained in the shadows until she starred in Quentin Tarantino's *Jackie Brown* (1997), which paid homage to blaxploitation films. In *Jackie Brown*, Grier stars as a flight attendant coerced into bringing down an arms dealer. Of her subsequent television appearances, her roles as Eleanor Winthrop and Kate "Kit" Porter on Showtime's political comedy *Linc's* (1998–2000) and its groundbreaking lesbian-centered series *The L Word* stand out most.

**REMEMBER**

America's urban ghettos, as they were known, were the main settings for blaxploitation films, with pimps and gangsters serving as major characters. Sex, violence, and opposition to the white power structure were also constant elements in the films. Some people argue that blaxploitation films, many of them financed, produced, and even directed by white talent, only reinforced negative stereotypes that justified the casting of Black actors as prostitutes, pimps, and other criminals in mainstream films. Others defend them, arguing that the genre served as escapist fare for Black audiences frustrated by racism that subtly undermined those stereotypes. That flipping of stereotypes attracted Black audiences, but was often so subtle that it drew lots of criticism as well as confusion.

During this same period, other films emerged that many Black audiences embraced. *Lady Sings the Blues* (1972), a Billie Holiday biopic, and *Mahogany* (1975), about a Black woman from urban Chicago striving to become a top fashion designer, are particularly notable for their romantic pairing of Billy Dee Williams and Diana Ross, which serves as one of the first high-profile symbols of #BlackLove. *Cooley High* (1975), helmed by Black director Michael Shultz, who also directed *Car Wash* (1976), is one of the most beloved urban coming-of-age stories of all time. Musical films such as *Sparkle* (1976), about three sisters trying to make it in the music industry, and *The Wiz* (1978), an urban version of *The Wizard of Oz* starring Diana Ross and Michael Jackson, stood out if only for the music and several endearing performances.

## Spike Lee and a Black film renaissance

Several Black directors like *Cooley High*'s Michael Schultz and Sidney Poitier, with his popular *Uptown Saturday Night*, *Let's Do It Again*, and *A Piece of the Action* films,

stepped forward during the 1970s, but they, in the context of the 1990s and beyond, had a more subtle approach in addressing Hollywood's discriminatory history. They also stayed away from many controversial issues within the Black community. That changed when Spike Lee, proud alum of historically Black Morehouse College, came on the scene. Prior to Lee's emergence, successful Black-oriented films of the 1980s were largely music-driven, such as the semiautobiographical *Purple Rain* (1984) starring Prince. Lee, however, almost single-handedly innovated Black film, inspiring a bold new Black film movement.

Lee's first feature film was *She's Gotta Have It* (1986), about a woman juggling three lovers. The film's success (made on a shoestring budget, it grossed about $7 million) gave Lee a national platform. Never one to shy away from controversy, Lee used his early work in particular to address issues such as *colorism* (a preference for lighter skin over dark skin within the Black community) and Black fraternities and sororities on Black college campuses in *School Daze* (1988). In *Do the Right Thing* (1989), Lee examined the tenuous nature of race relations between Italians (and by proxy white people in general) and Black Americans in Brooklyn. The 1992 film *Malcolm X*, starring Denzel Washington, was an epic triumph for Lee who was able to bring the iconic leader's life to the big screen, with Washington receiving his first Oscar nomination for Best Actor.

**TECHNICAL STUFF**

Lee's films with primarily Black casts served as platforms for next level or breakout performances by many Black actors, including Wesley Snipes and Denzel Washington in *Mo' Better Blues* (1990), Samuel L. Jackson in *Jungle Fever* (1991), Delroy Lindo in *Crooklyn* (1994), and Mekhi Phifer in *Clockers* (1995). Although Washington, in particular, had earned two Oscar nominations and a win prior to his film debut with Lee, his work with the director helped solidify him as a bankable leading man. You can read more about Spike Lee's work in the later section on Black directors.

## Hood films

In the early 1990s, USC film graduate John Singleton, inspired by Spike Lee, looked to his native Los Angeles to enhance his craft. His debut film, *Boyz n the Hood* (1991), garnered him an Academy Award nomination for Best Director, a first for any Black director. Whereas Lee's films posed theoretical questions about Black Americans and race in the U.S., Singleton's debut grappled with the contemporary issues of single-parent homes and escalating gang violence against young Black males in inner-city communities.

Violence is also a potent theme in *New Jack City* (1991), set in Harlem. Directed by Mario Van Peebles (whose father Melvin Van Peebles helmed *Sweet Sweetback's Baadasssss Song*), *New Jack City* explored the Black drug empire in a manner never before seen on the big screen. Films like *Boyz* and *New Jack City* brought the

realities of the drug world into the Black urban sphere, with much of the action on screen centered in individual neighborhoods. At the same time, brothers Reginald and Warrington Hudlin began exploring a lighter side of urban neighborhoods by directing and producing the *House Party* franchise, which began in 1990.

**REMEMBER**

Both *Boyz N the Hood* and *New Jack City* attempted a creative translation of the realities of contemporary urban life to screen and paved the way for a colossal wave of *hood films.* With the exception of a few films, however, including *Menace II Society* (1993), directed by the Hughes Brothers, and the F. Gary Gray–helmed *Set It Off* (1996), about four young Black women trying to escape the hood through bank robberies, hood films became stagnant and clichéd. Over the years, Black audiences embraced these films less and less as movie theater fare, preferring to consume them in the direct-to-video and DVD markets initially and later streaming and paid video-on-demand.

Urban film directors also graduated to mainstream studio films. In 2000, with *Scary Movie,* a spoof of Hollywood horror films, Keenan Ivory Wayans became the first Black director to direct a mainstream film grossing more than $150 million. (Previously, Sidney Poitier had reached the $100 million mark distinction with *Stir Crazy* in 1980.) F. Gary Gray and John Singleton also reached the $100 million mark with the mainstream films *The Italian Job* and *2Fast 2Furious* in 2003. Well into the 2000s, 2010s, and beyond, other Black directors skipped the hood genre altogether.

## Stepping out of the hood genre

Atlanta-based filmmaker Tyler Perry, well-known for his character Madea, an outspoken, over-the-top grandmother developed through his numerous traveling stage plays (flip to Chapter 14 for details), scored big in the 2000s. These light-hearted films grappled with drug abuse, juvenile delinquency, infidelity, molestation, and other serious issues through laughter and an underlying Christian theme. His first film, *Diary of a Mad Black Woman* (2005), directed by Darren Grant, and follow-up, *Madea's Family Reunion* (2006), were each made for under $7 million but grossed more than $50 million at the box office. His third film, *Daddy's Little Girls,* released in February 2007, starred Idris Elba and Gabrielle Union, while *Why Did I Get Married?,* released a few months later, starred Tyler Perry in a non-Madea role alongside Jill Scott and Janet Jackson.

Likewise, Atlanta-based independent film production company Rainforest Films performed surprisingly well with sexually tinged films such as *Trois* (2002) and *Pandora's Box* (2002), featuring more upwardly mobile Black characters. In January 2007, *Stomp the Yard,* a film about Black fraternities and step shows at a Black college, grossed more than $38 million at the box office in two weeks for Rainforest. Main players Will Packer and Rob Hardy later dissolved Rainforest, with Hardy

going on to direct primarily in television. Packer, through Will Packer Productions, became one of the most successful Black producers in Hollywood with his *Ride Along* and *Think Like a Man* franchises, along with the 2017 summer blockbuster *Girls Trip*.

# The Rise of Black Directors

Black directors became more and more visible in the late 20th and early 21st centuries with Spike Lee at the forefront. These sections identify some of the directors who made a name for themselves.

## Spike Lee: Getting personal

From the 1986 film *She's Gotta Have It* to his later work on Netflix, Spike Lee truly helped inspire a generation of filmmakers (see the earlier section "Spike Lee and the Black film renaissance" for info on his influence).

In 2006, Lee, whose career had always been marked by generating his own projects, helmed a rare studio film, *Inside Man,* starring Denzel Washington, Jodie Foster, and Clive Owen; it became the highest grossing film of his career at roughly $88 million in the U.S. and Canada and more than $95 million overseas. Lee hit high marks with critics for his 2002 movie *25th Hour,* his rare film with white main leads (Edward Norton and Philip Seymour Hoffman) and not-so-high critical marks with his 2008 film *Miracle at St. Anna*, a film he specifically made reclaiming Black WWII history Hollywood films consistently erased.

Lee's 2015 film *Chi-Raq*, a musical drama he and co-writer Kevin Willmott adapted from the Greek play *Lysistrata* by Aristophanes to a modern-day Chicago notorious for its violence, became Lee's first film collaboration with a streaming service. Amazon Studios provided a limited theatrical release December 4 ahead of its December 29 streaming date.

His 2018 film *BlacKkKlansman*, written by him, Kevin Willmott, David Rabinowitz, and Charlie Wachtel, became an Academy Award darling; it was adapted from Rob Stallworth's 2014 memoir *Black Klansman* about his efforts as a Black man to thwart the Ku Klux Klan in Colorado. Starring John David Washington, son of Lee's frequent collaborator Denzel Washington, and Adam Driver, *BlacKkKlansman*, which grossed more than $90 million worldwide, was nominated for six Academy Awards, winning one for Best Adapted Screenplay — a first for Lee, who had received an honorary Oscar for his contribution to film in 2015.

Over his prolific feature film career, Lee had only received one nomination, in 1990 for Best Original Screenplay for *Do the Right Thing*. He fared slightly better with documentaries, receiving a nomination for his provocative *4 Little Girls* (1997), chronicling the murder of four girls in the Birmingham church bombing in 1963 (refer to Chapter 9). Other provocative documentaries from Lee include *When the Levees Broke: A Requiem in Four Acts* (2006), his highly acclaimed exploration of post-Hurricane Katrina New Orleans for HBO, featuring survivors, as well as his 2010 follow-up *If God Is Willing and da Creek Don't Rise*.

In 2020, Lee released *Da 5 Bloods* via Netflix. This epic Vietnam veteran tale reteamed him with Delroy Lindo (from *Crooklyn*) and Clarke Peters (from his 2012 film *Red Hook Summer*) and marked his first time working with newcomer Jonathan Majors as well as with Chadwick Boseman. With *Da 5 Bloods*, Lee achieved the distinction of having released films in five different decades, from the 1980s to the 2020s. He even refashioned *She's Gotta Have It* into a Netflix series starring DeWanda Wise as Nola Darling that ran from 2017 to 2019. An avid music and sports lover, Lee also helmed documentaries on Jim Brown, Kobe Bryant, and Michael Jackson, among others.

Lee, a long-time professor at his film school alma mater, helped produce films of several filmmakers, including Gina Prince-Bythewood's feature debut *Love & Basketball* in 2000.

## 1990s and early 2000s: The music video launch

The rise of hip-hop music gave Black directors opportunities to showcase their vision and skill in music videos. Both Spike Lee and John Singleton directed music videos, most notably Public Enemy's "Fight the Power" for Lee and Michael Jackson's "Remember the Time" for Singleton. Hype Williams elevated music videos with his innovative "The Rain (Supa Dupa Fly)" (1997) by Missy Elliott and "Big Pimpin'" (2000) by Jay-Z and UGK, among many greats. Williams's debut 1998 film *Belly* helped introduce rapper DMX as a leading man. Music video directors like F. Gary Gray, Tim Story, Antoine Fuqua, and Millicent Shelton began transitioning primarily into film.

Gray would hit with *Friday* (1995) and *Set It Off* (1996), starring rappers Ice Cube and Queen Latifah, respectively, on his way to later direct *The Italian Job* (2003), which made more than $175 million worldwide; *Straight Outta Compton* (2015), which made more than $160 million domestically and $200 million globally; and *Fate of the Furious* (2017) in the mighty *The Fast and the Furious* franchise, making him the first Black American director to have a film reach $1 billion dollars in global box office receipts.

With his films for the *Fantastic Four* and *Ride Along* franchises all grossing more than $100 million and more globally, Tim Story established himself as one of the most financially successful Black directors around.

Black directors without strong music video roots were also active at this time, including Carl Franklin with *Devil in a Blue Dress* (1995), Rick Famuyiwa with *The Wood* (1999), Malcolm D. Lee with *The Best Man* (1999), and Gina Prince-Bythewood with *Love & Basketball* (2000).

Lee Daniels, who produced *Monster's Ball* (2001), for which Halle Berry became the first Black woman to win the Academy Award for Best Actress, directed several films that made a huge impact. They included the 2009 film *Precious*, which was adapted from Sapphire's 1996 book *Push* and introduced actress Gabourey Sidibe; it was nominated for six Academy Awards, including Best Picture and Best Director, with Mo'Nique winning the Oscar for Best Supporting Actress and Geoffrey Fletcher becoming the first Black screenwriter to win the Oscar for Best Adapted Screenplay. Daniels' 2013 film *Lee Daniels' The Butler,* inspired by the true story of a Black man who worked for eight presidents in the White House, grossed more than $176.6 million globally; it starred Forest Whitaker and Oprah Winfrey. Turning to TV, Daniels scored big with the sensational hip-hop centered series *Empire* (2015–2020), starring Terrence Howard and Taraji P. Henson, about a rapper with three sons who built a music empire largely due to their mother serving 17 years in prison. He also surprised again with his 2021 film *The United States vs. Billie Holiday* starring singer Andra Day, who won several awards and critical acclaim, in her very first acting role.

# The 2010s: Drama, horror, heroes, and more

The late 1990s and early 2000s gave only a glimpse into what was to come. The 2010s ushered in Black directors who experienced even more notable breakthroughs, most notably Ava DuVernay, Barry Jenkins, Jordan Peele, and Ryan Coogler.

## Ava DuVernay

Ava DuVernay, a Los Angeles area native, began her Hollywood career as a film publicist specializing in outreach to Black audiences. She worked on a string of successful films, including *The Brothers* (2001), *Shrek 2* (2004), and *Dreamgirls* (2006), which launched Jennifer Hudson's career.

She directed several small films prior to breaking through at Sundance, first with *I Will Follow* in 2011 and then with *Middle of Nowhere* in 2012, with which she became the first Black female director to win its U.S. Directing Award: Dramatic.

As her career progressed, DuVernay became acclaimed for both her filmmaking and her bold advocacy for inclusion. Filming *Selma* (2014), the first Hollywood feature film directly centered on Martin Luther King Jr., brought together DuVernay and Oprah Winfrey, who portrayed the real-life Annie Lee Cooper and her courageous struggle to vote in Jim Crow Alabama. That led to DuVernay's spearheading the dramatic series *Queen Sugar*, adapted from Natalie Baszile's 2014 novel and revolving around three siblings from the Bordelon clan, as its creator and visionary. With its launch in 2016, DuVernay committed *Queen Sugar* to utilizing all female directors, which opened up additional opportunities for Black women directors like Julie Dash, the first Black woman director to have a film distributed theatrically with her 1991 film *Daughters of the Dust*; Tina Mabry, known for *Mississippi Damned*; Channing Godfrey Peoples, known for *Miss Juneteenth*; and Felicia Pride, known for the short *Tender*.

With her 2018 film *A Wrinkle in Time*, adapted from Madeleine L'Engle's classic 1962 novel and starring Storm Reid, along with Oprah Winfrey, Reese Witherspoon, and Mindy Kaling, DuVernay became the first Black woman director to have a film pass $100 million at the box office.

**REMEMBER**

Through the streaming platform Netflix, DuVernay was able to make profound social justice statements, particularly through her 2016 documentary *13th*, exploring the constitutional amendment and its relation to the mass incarceration of Black people. This documentary won four Emmys and an NAACP Image Award and garnered an Oscar nomination. Her Netflix limited series *When They See Us*, about the Central Park Five (later known as the Exonerated Five), who were falsely imprisoned for the 1989 rape of the Central Park jogger, won several African American Film Critics Association (AAFCA) and NAACP Image Awards, as well as the Emmy for Outstanding Lead Actor in a Limited Series or a Movie for Jharrel Jerome, a first for an Afro-Latino actor.

## Barry Jenkins

Director Barry Jenkins's 2016 film *Moonlight* is a tender coming-of-age story based on playwright Tarell Alvin McCraney's unpublished semiautobiographical play *InMoonlightBlack Boys Look Blue*, centered on a young man exploring his sexuality. It surprised critics and fans when it won the Oscar for Best Picture in 2017 over frontrunner *La La Land* after a dramatic mix-up initially announced *La La Land* as the winner.

Jenkins's 2018 film adaptation of James Baldwin's celebrated 1974 novel *If Beale Street Could Talk*, addressing mass incarceration, resulted in actress Regina King winning her first Oscar for Best Supporting Actress. *The Underground Railroad*, Jenkins's limited series for Amazon, a first for him, was adapted from Colson Whitehead's Pulitzer Prize–winning novel.

## Jordan Peele

Jordan Peele surprised many when his 2017 feature film debut *Get Out* garnered him a Best Director and a Best Picture Oscar nomination, a first-time combo for a Black director. It was also a win for Black horror films and horror in general. The film, starring British actor Daniel Kaluuya, takes a turn when he and his white girlfriend visit her parents and he begins meeting Black people in a "sunken place" devoid of their essence or souls. He suspects it's intentional and tries to escape the same fate. Made for less than $5 million, *Get Out*, also starring Lil Rel Howery, LaKeith Stanfield, and Betty Gabriel, grossed $255.5 million worldwide. Peele, who had previously been best known for his Comedy Central sketch comedy show *Key & Peele* (2012–2015) with Keegan-Michael Key, followed *Get Out* with *Us* (2019), starring Oscar winner Lupita Nyong'o as both the protagonist and the antagonist, grossing more than $255 million worldwide.

## Peter Ramsey

The often-overlooked animated director Peter Ramsey, whose films include *Monsters vs. Aliens: Mutant Pumpkins from Outer Space* (2009) and *Rise of the Guardians* (2012), became the first Black Oscar nominee and winner for the Best Animated Feature with *Spider-Man: Into the Spiderverse* (2018), featuring an Afro-Latino as Spider-Man; he co-directed the film with Bob Persichetti and Rodney Rothman.

## Ryan Coogler

California Bay Area native Ryan Coogler's first feature film, *Fruitvale Station* — about the 2008 Bay Area Rapid Transit (BART) cop killing of 22-year-old Oscar Grant III — was released in 2013, at the same time as the acquittal of George Zimmerman in the murder of Trayvon Martin (see Chapter 11). It starred Michael B. Jordan, who was just starting to make a real push toward the big screen. *Fruitvale Station* was the rare film that humanized the victims of cop killings and not just the cop.

From there, Coogler turned his attention to Sylvester Stallone's iconic *Rocky* franchise and created *Creed*, his 2015 film, shifting the focus to Adonis "Donnie" Creed. *Creed* starred Michael B. Jordan as an offspring of Apollo Creed and starred Sylvester Stallone as Rocky. That film grossed more than $170 million worldwide.

None of Coogler's previous achievements, as impressive as they were for a director, especially one younger than 30 and Black, foreshadowed how significantly he would change the film landscape as the co-writer and director of *Black Panther*, the first standalone Black-cast film in the Marvel Cinematic Universe. It starred Chadwick Boseman as T'Challa/Black Panther, the would-be king of the fictional African nation of Wakanda and Michael B. Jordan as Killmonger, a challenger to the throne. Other characters, played by Black actors from all over the African

Diaspora, include T'Challa's sister Shuri (Letitia Wright); long-time love Nakia (Best Supporting Actress winner Lupita Nyong'o for *12 Years a Slave*); Okoye (Danai Gurira), leader of Wakanda's all-women fighting squad, the Dora Milaje; queen mother Ramonda (Angela Bassett); King T'Chaka (Forest Whitaker); W'Kabi (Daniel Kaluuya), T'Challa's friend and security expert; and M'Baku (Winston Duke), a disgruntled Wakandan tribal leader. At the heart of the narrative, T'Challa must be a good leader and fend off challenges to his authority while trying to shield Wakanda and its treasured natural resource vibranium from the dangers of the outside world.

Released February 16, 2018, to critical and popular acclaim, *Black Panther,* with its African Diasporic casting of actors from the United States, England, various parts of the African Continent, and the Caribbean, proved to be a global sensation. In the United States, Black patrons embraced the fictional African nation and showed up in African attire to watch the movie. In the United States and Canada alone, the film grossed more than $700 million on its way to a worldwide gross of more than $1.3 billion, making Coogler the highest-grossing Black director, just ahead of Gray's *The Fate of the Furious,* which grossed more than $1.2 billion in 2017.

"Wakanda Forever," a recurring phrase in the film accompanied by the gesture of folding arms over the chest in the fashion of pharaohs in Egyptian burials (also reflecting the symbol for "love" or "hug" in American Sign Language), became a widely embraced pop culture phrase and gesture. People were also stunned by the world of Wakanda on screen, as well as its magnificent costuming created by Hannah Beachler and Ruth E. Carter, who became the first Black Oscar winners in production design and costume design. Carter had received previous nominations for her work on *Amistad* and *Malcolm X.* Beachler was also the first Black person ever nominated for Best Production Design at the Academy Awards.

The love and pride audiences have for *Black Panther* made the unexpected passing of Chadwick Boseman on August 28, 2020, at age 43 a cause of national and international mourning. He had also played real-life Black heroes Jackie Robinson, James Brown, and Thurgood Marshall. Boseman, who many noticed had lost a lot of weight in the few years prior to his death, kept his battle with colon cancer hidden as he continued to work, even turning in stellar performances for Spike Lee's 2020 film *Da 5 Bloods* and the Denzel Washington-produced film adaptation of August Wilson's play *Ma Rainey's Black Bottom* (2020) with Viola Davis, Glynn Turman, and Colman Domingo, directed by George C. Wolfe.

## 2020: A stream of Black women directors

A high point of 2020 was the emergence of Black women directors, with a Black woman-directed feature-length film released almost every month. It began with Numa Perrier's *Jezebel* on Netflix in January 2020, followed by Radha Blank's *The*

*40-Year-Old Version*, which won Sundance's U.S. Dramatic Competition Directing Award prior to being shown on Netflix that October. That February, Canadian-American director Stella Meghie released *The Photograph*, which she wrote and directed, starring Issa Rae and LaKeith Stanfield on the big screen.

Other films that followed include the high school mean-girl tale *Selah and the Spades* from writer/director Tayarisha Poe on Amazon Prime Video; writer/director Channing Godfrey Peoples' *Miss Juneteenth*, starring Nicole Beharie, on video-on-demand; Gina Prince-Bythewood's action film *The Old Guard* for Netflix starring white South African Charlize Theron and Black actress KiKi Layne; writer/director Ekwa Msangi's IFC film *Farewell Amor*, showcasing an African immigrant experience in the U.S.; and actress Regina King's feature film directorial debut *One Night in Miami*.

In the year prior, 2019, Melina Matsoukas, a music video master known for her collaborations with Beyoncé, Rihanna, and even Whitney Houston, had gotten the party started early with her feature film debut *Queen & Slim*, starring Kaluuya and Jodie Turner Smith. It generated considerable buzz. So did the announcement that Nia DaCosta, whose anticipated *Candyman* reboot was pushed to 2021, would direct the next *Captain Marvel* film in the Marvel Cinematic Universe.

Alano Mayo and Nicole Brown's respective ascension as heads of Orion Pictures (under MGM) and TriStar Pictures in 2020, coupled with more capable Black directors than ever and Black talent overall, certainly created an expectation of more opportunities for Black filmmakers and storytellers overall and Black women specifically.

# Black Film Stars: From Song to Celluloid

Black actors have come a long way since Hollywood's beginnings, widening the range of roles available to them far beyond the maid and the butler ones that dominated Hollywood studio films in the early 20th century. Secret agents, dignitaries, music legends, and any other imaginable characters are all within reach. During the mid-20th century, Black entertainers (most notably musicians and comedians) sometimes had a leg up — a fact that was still relatively true in the latter part of the 20th century as rappers and comedians became the latest crop of Black performers tapped for the big screen. Still, the backbone of Black Hollywood, as it has been for Hollywood in general, is the serious actor, and those ranks have grown stronger as well.

Hollywood has long considered Black musicians as prime candidates for film. Following is a sampling of a few notable entertainers, past and present, who've made an impact on the big screen.

## Singers-turned-actors

Considered two of the most beautiful singers of their time, Lena Horne and Dorothy Dandridge never realized their full potential but left a legacy nonetheless. Horne, one of the first Black actors to sign a long-term studio contract, broke many of Hollywood's social customs by eating in the studio's commissary and appearing in mainstream magazines. She was also the first Black actor to land the cover of a fan publication. Dandridge became the first Black woman nominated for the Best Actress Oscar (for her role in *Carmen Jones*, a Black version of the classic opera).

Robeson, Harry Belafonte, and Sammy Davis Jr. are perhaps the more prominent men fitting this category. Robeson was athletic and intellectual, with a pleasing singing voice and impressive acting ability, but his career was very short, with *The Emperor Jones* (1933) serving as his most memorable role. Likewise, Belafonte, who popularized calypso music, left strong impressions with *Carmen Jones* and *Island in the Sun*. The multi-talented Davis Jr.'s film credits include the films *Porgy and Bess* (1959), *Anna Lucasta* (1959), and the original *Ocean's Eleven* (1960).

## Rappers-turned-actors/producers

Here are some Black rappers turned actors or producers who have contributed to movies:

>> **Will Smith,** with Oscar nominations for *The Pursuit of Happyness* (2006) and *Ali* (2001), not to mention his successful *Bad Boys* and *Men In Black* franchises, summer blockbusters like *Independence Day* (1996) and classic TV sitcom *The Fresh Prince of Bel-Air* (1990–1996), which served as his launching pad, leads the pack of "raptors." His Overbrook Entertainment has had a hand in producing most of his projects, as well as other films like Gina Prince-Bythewood's *The Secret Life of Bees* (2008) and *The Karate Kid* (2010), starring his son Jaden Smith.

>> **Queen Latifah,** another prominent rapper-turned-actor, received an Oscar nomination for her performance as Mama Morton in *Chicago* (2002), a long way from her debut film role as a waitress in *Jungle Fever* (1991). Her Flavor Unit Entertainment produced most of her projects, including the 2021 series

reboot of *The Equalizer* on CBS, the Dee Rees–directed film *Bessie* (2015), *The Last Holiday* (2006) with LL Cool J, *Beauty Shop* (2005), and the 2017 comedy summer blockbuster *Girls Trip*.

>> **Ice Cube** went from a reluctant actor in John Singleton's *Boyz n the Hood* (1991) to an accomplished actor/producer with films such as *Friday* (1995), *Are We There Yet?* (2005), and the *Barbershop* and *Ride Along* franchises, most funneled through his own production company, Cube Vision.

>> **LL Cool J** made his first mark on the TV comedy *In the House* (1995–1998) but expanded to taking on many roles, including Julian Washington in *Any Given Sunday* (1999) and Dwayne Gittens/God in *In Too Deep* (1999), as well as Sam Hanna on the successful CBS series *NCIS: Los Angeles,* launched in 2009.

>> **Wu-Tang's Method Man** built a solid acting career that includes fun fare like the 2001 film *How High* (with fellow rapper Redman), *The Wire,* and *Power Book II: Ghost*.

>> **DMX** was on pace to be a major film star with films like *Exit Wounds* (2001), *Cradle 2 the Grave* (2003), and *Never Die Alone* (2004), but personal issues, including drug use, derailed him.

>> **Mos Def/Yasiin Bey** received acclaim for his roles in *The Italian Job* (2003), *Cadillac Records* (2008), and as Brother Sam on Showtime's acclaimed drama *Dexter* in 2011.

>> **Common**, one of the busiest raptors, with credits including *Just Wright* (2010) with Queen Latifah; *Barbershop: The Next Cut* (2016) with rappers Ice Cube, Eve, and Nicki Minaj; *John Wick: Chapter 2* (2017); and *The Hate U Give* (2018). He and John Legend won an Oscar for the song "Glory" for director Ava DuVernay's 2014 civil rights film *Selma*. He also served as executive producer for the 2020 documentary *40 Years a Prisoner* and for the Showtime series *The Chi,* created by Lena Waithe in 2018, in which he also acted.

Atlanta rappers Bow Wow, Ludacris, and T.I. have starred in a variety of projects, with Bow Wow in *Roll Bounce* (2005) and *Like Mike* (2002); Ludacris in *Crash* (2004), which won the Best Picture Oscar, and *The Fast and Furious* franchise; and T.I. in *ATL* (2006), *Takers* (2010), and the *Ant-Man* franchise. Despite appearing in numerous films, including his semiautobiographical 2005 debut *Get Rich or Die Tryin'*, also the title of his 2003 debut album, and 2018's *Den of Thieves*, Curtis "50 Cent" Jackson's biggest impact has been in television and is highlighted in Chapter 18.

# Kings and Queens of Comedy

Comedy has long proved a good segue into television and film for Black men in particular. Before Redd Foxx, Flip Wilson, and Bill Cosby became television stars, they were successful comedians with several hit comedy albums to their credit. For most Black standup comedians working their way up on comedy stages across the country, Richard Pryor, followed by Eddie Murphy, joined by arguably Jamie Foxx, Chris Rock, and Dave Chappelle, are the standards. As for Black female comedians, Whoopi Goldberg remains supreme.

## Richard Pryor

The drama of Richard Pryor's personal life, including his notorious 1980 freebasing incident in which he set himself on fire, never overshadowed how much wider he opened Hollywood's doors for Black performers. Initially, Pryor found comedy success copying the clean-cut stage style of Bill Cosby. Later, he infused his comedy with personal experiences and stinging social commentary. Frequently, he's credited with changing American standup comedy overall. *That Nigger's Crazy* and *Is It Something I Said?* are just two of his five Grammy wins for his classic comedy albums.

**REMEMBER**

Pryor's influence extends well beyond the Black community. Among Black comedians, however, Pryor's influence has remained intact well into the 21st century. Some even divide the genre of Black American comedy into two categories: before Richard Pryor and after Richard Pryor.

Pryor flipped his success as a comedian into film roles. He won acclaim for his nuanced performance as a drug-addicted piano player in the 1972 Billie Holiday biopic *Lady Sings the Blues*; he played an impressive three characters in the comedy *Which Way Is Up?* (1977); and he starred as Wendell Pierce, the nation's first Black stock racing champion, in *Greased Lightning* (1977). Still, some audiences remember him fondly for his films with Gene Wilder: *Silver Streak* (1976), *Stir Crazy* (1980), and *See No Evil, Hear No Evil* (1989). A gifted writer, Pryor contributed to Mel Brooks's *Blazing Saddles* (1974) and television projects like *Sanford and Son*, his own short-lived series *The Richard Pryor Show*, and Lily Tomlin's Emmy Award–winning *Lily*.

## Eddie Murphy

Eddie Murphy got his start at age 19 on television's *Saturday Night Live* (SNL), where he created memorable characters such as Buckwheat and Gumby. Before leaving the show in 1984, Murphy tested the movie waters opposite Nick Nolte in

*48 Hours* (1982), a comedy about a cop who is paired with a convict to track down a killer. Murphy followed that film with the successful cable comedy special *Delirious* as well as box office hits *Trading Places* (1983) (with fellow SNL alum Dan Aykroyd) and the *Beverly Hills Cop* franchise.

Murphy's concert film *Raw* (1987), in addition to *Coming to America* (1988) and *Boomerang* (1992), remain favorites among audiences. *Harlem Nights* (1989), which he wrote and directed, was a dream project pairing him with comedic greats and personal idols Pryor and Redd Foxx. The *Nutty Professor* and *Dr. Doolittle* franchises from the 1990s and 2000s, as well as *Shrek*, the animated franchise to which he lent his voice, are among his biggest box office successes. For the 2006 film adaptation of the legendary Broadway hit musical *Dreamgirls*, Murphy tackled a rare dramatic role and received a Best Supporting Actor Oscar nomination and other honors for his efforts.

Although his box office numbers cooled with films such as *The Adventures of Pluto Nash* (2002), *Norbit* (2007), *Meet the Dave* (2008), and *Mr. Church* (2016), Murphy never lost his star status. In 2015, he was awarded the prestigious Mark Twain Prize for American Humor. Earlier that same year, he appeared on *The Saturday Night Live 40th Anniversary Special* but disappointed fans by telling no jokes or doing any skits. That was rectified when he hosted *SNL* in December 2019, receiving his first-ever Emmy for Outstanding Guest Actor in a Comedy Series.

He also rehabilitated his movie star image with the Netflix film *Dolemite Is My Name*, a biographical comedy about the underground comedian and independent filmmaker Rudy Ray Moore. In March 2021, he also released the long-awaited sequel *Coming 2 America* on Amazon. A film veteran with more than 40 films, mostly as the star, and 30 years of experience under his belt, Murphy ranks among the highest grossing and most prolific leading actors of all time and arguably has few equals among comedians-turned-actors of any race. Like his idol Pryor, he also inspired a new generation of comics.

## Male comedians who followed Pryor and Murphy

Following is a sampling of comedians/actors who might have found breaking into film and TV much harder without the success of Pryor and Murphy:

>> **Arsenio Hall:** Hall is a long-time collaborator of Eddie Murphy's, and he was especially memorable in their iconic 1988 film *Coming to America*. Hall carved a lane all his very own with *The Arsenio Hall Show,* arguably the first successful late-night show with a Black host. The show ran from 1989 to 1994. Hall is credited for expanding the reach of hip-hop as well as for breaking a plethora

of new music artists, including TLC, Mariah Carey, Toni Braxton, Boyz II Men, and Bobby Brown, who all got their first break on Hall's show.

» **Martin Lawrence:** On the heels of his humble beginnings in *House Party* (1990), Martin Lawrence first hit big on TV as the host of Russell Simmons's *Def Comedy Jam* on HBO in 1992 and then as the star of the sitcom *Martin* (1992–1997). He made even greater strides on the big screen in the hit franchises *Big Momma's House,* as well as the buddy cop action romp *Bad Boys* with Will Smith, whose 2020 installment *Bad Boys for Life,* the sequel to 2003's *Bad Boys II,* grossed more than $400 million worldwide.

» **Jamie Foxx:** Even before winning the Best Actor Oscar for his turn as Ray Charles in the biopic *Ray* (2004), Jamie Foxx fared better than other Black comedians at the box office in noncomedic roles, most notably in *Any Given Sunday* (1999) and *Ali* (2001). The Texas native got his start on television in the irreverent comedy sketch show *In Living Color* from 1991 to 1994 before helming *The Jamie Foxx Show* from 1996 to 2001. Other roles for which he has received critical and popular acclaim include Quentin Tarantino's *Django Unchained* (2012), *Just Mercy* (2019), and the animated film *Soul* (2020).

» **Chris Rock:** Despite appearing in a slew of films, Chris Rock enjoyed some of his greatest successes on stage, namely with comedy specials like his break-through 1996 HBO special *Chris Rock: Bring the Pain* and his 2018 Netflix special *Chris Rock: Tamborine.* On the small screen, he scored with both his own weekly late-night talk show, *The Chris Rock Show* (1997–2000), and his breakout series *Everybody Hates Chris,* loosely based on his own childhood growing up in a Black neighborhood in Brooklyn and attending a predomi-nantly white school. In 2019, he took a well-publicized dramatic turn in the FX hit series *Fargo* as mobster Loy Cannon. Rock is one of the few Black comedi-ans to host the Oscars twice, in 2005 and 2016.

» **The Original Kings of Comedy:** Capitalizing on the successful late 1990s comedy tour, the success of the Spike Lee–directed 2000 standup film *The Original Kings of Comedy* helped firmly establish the quartet:

- **Bernie Mac:** Bernie Mac, thanks in large part to showrunner Larry Wilmore, had subsequent success with *The Bernie Mac Show.* He also added to his *Players Club* fame with other films, most notably the 2001 remake of *Ocean's Eleven.* Mac died in 2008.

- **D.L. Hughley:** D.L. Hughley maintained an active standup career, venturing into more political fare as well as hosting his own radio show while also making timely television appearances and starring in the successful sitcom *The Hughleys* (1998-2002).

- **Cedric the Entertainer:** St. Louis native Cedric the Entertainer parlayed his elevated star status into several TV shows, including TV Land's *Soul Man* (2012–2016) and *The Neighborhood* (opposite Tichina Arnold of *Martin* and

*Everybody Hates Chris* fame), which launched in 2018. He also starred in films like the *Barbershop* franchise and had various hosting gigs.

- **Steve Harvey:** Cleveland's own Steve Harvey created a multimedia empire, hosting the successful radio show *The Steve Harvey Morning Show*, penning books like the 2009 bestseller *Act Like a Lady, Think Like a Man*, which became the successful *Think Like a Man* franchise, starring in his long-running sitcom, *The Steve Harvey Show* (1996-2002), hosting his own talk show *Steve*, and taking over *The Family Feud* game show as well as memorably hosting the *Miss Universe* pageant.

» **Chris Tucker:** Although his role as Smokey in *Friday*, opposite Ice Cube, was his big break, Chris Tucker's greatest box office success came through the profitable *Rush Hour* franchise alongside Chinese martial artist and action star Jackie Chan. It grossed more than $800 million worldwide with three films in 1998, 2001, and 2007.

» **Dave Chappelle:** More of a pure standup comic than a TV or film star, Dave Chappelle rose to fame through his groundbreaking 2003 show, *Chappelle's Show*, on Comedy Central. Irreverent skits centered on Prince, Rick James, Tupac, and R. Kelly, as well as characters like Clayton Bigsby, a blind white supremacist who doesn't know he's Black. Unsatisfied with Comedy Central mandates for the show in Season 3 in 2005, Chappelle shocked many people by walking away from a $50 million contract.

After a relatively long hiatus, Chappelle made a comeback in the 2010s through standup that led to his first *Saturday Night Live* hosting stint, which earned him an Emmy, the Saturday following Donald Trump's presidential election. That appearance also affirmed Chappelle as a leading political voice. Within weeks, Netflix announced a three-comedy special with Chappelle, for which it paid him $20 million for each show. The special successfully kicked off in March 2017.

» **Kevin Hart:** Philadelphia native Kevin Hart took the industry by storm when he began hitting with his successful comedy tours, including 2011's *Laugh at My Pain* and 2013's *Let Me Explain*, which became successful standup films. Teaming with Will Packer for the Tim Story–directed ensemble film *Think Like a Man*, adapted from comedian Steve Harvey's 2009 bestselling relationship book, was another major breakthrough for Hart. Co-starring with Ice Cube for the *Ride Along* franchise, once again directed by Tim Story and produced by Will Packer, resulted in two $100 million–plus films in 2014 and 2016 that established Hart as a major box office draw.

# DEF COMEDY JAM

From 1992 to 1997, Russell Simmons's *Def Comedy Jam* introduced HBO audiences to some of the rawest and funniest Black comedians in the nation. Boldly mixing hip hop with comedy, the 30-minute shows created instant celebrities and revolutionized American comedy. Chris Tucker, Bernie Mac, Bill Bellamy, Adele Givens, and Eddie Griffin are just a few of the comedians who appeared on *Def Comedy Jam.* Martin Lawrence hosted the shows, and New York DJ Kid Capri provided the music.

## Whoopi Goldberg

By entertainment standards, Whoopi Goldberg became the most successful Black female comedian in American history almost instantly. On October 24, a few weeks before her 30th birthday in 1984, her one-woman show *Whoopi Goldberg* hit Broadway. It closed to critical acclaim in March 1985, and aired to more acclaim on HBO as *Whoopi Goldberg: Direct from Broadway.*

Steven Spielberg caught Goldberg's Broadway show early and cast her as the lead of Celie in *The Color Purple,* released limitedly in December 1985 and wide in February 1986. Globally, the film grossed more than \$142 million, and Goldberg was nominated for Best Actress at the Academy Awards. After that, her career shot off like a rocket. From 1985 to 1996, she appeared in at least one film a year and as many as three films some years. Her rapid success was something the vaudeville veteran and pioneering Black female comedian Moms Mabley — whose life Goldberg chronicled in the 2013 HBO documentary *Whoopi Goldberg Presents Moms Mabley: I Got Somethin' to Tell You* — probably couldn't fathom.

In addition to scoring big with the *Sister Act* franchise, Goldberg continued to flex her dramatic chops with the civil rights films *The Long Walk Home* (1990) and *Ghosts of Mississippi* (1996), where she played Myrlie Evers, wife of murdered civil rights activist Medgar Evers, along with *Ghost* (1990), for which she won the Best Supporting Actress Oscar for playing shady psychic Oda Mae Brown.

In 1994, Goldberg became the first female comedian and the first Black comedian to host the Academy Awards solo (Richard Pryor had co-hosted twice). In all, she hosted the Oscars four times (1994, 1996, 1999, and 2002). Chris Rock and Ellen DeGeneres, who have both hosted multiple times, became the second Black comedian and second female comedian to host the iconic awards show solo. By 2020, no other Black female comedian had hosted the Oscars.

## Other comediennes

Here are some of the more notable comediennes.

## Wanda Sykes

Wanda Sykes, who grew up in the Baltimore–DC metro area, was among the few post-Goldberg Black female comedians who made a major name for herself. Sykes, who got her big break on *The Chris Rock Show*, built perhaps the purest comedy career of the majority of super-successful Black comedians, sticking primarily to comedic roles on CBS's *The New Adventures of Old Christine*, HBO's *Curb Your Enthusiasm*, and ABC's *Black-ish*.

She also guest-hosted late-night comedy shows, even attempting her own politically slanted *The Wanda Sykes Show* on FOX in 2009 and several specials. In her HBO comedy special, *I'ma Be Me*, she infused her comedy with her truth as a Black LGBTQ woman without missing a laugh.

## Mo'Nique

Introduced to the larger entertainment landscape as Nikki Parker on the UPN sitcom *The Parkers* (1999–2004), Mo'Nique also scored with *The Queens of Comedy*, a 2001 standup special, and 2005's *Mo'Nique's F.A.T. Chance*, a plus-size beauty pageant. The comedian made the greatest impact with her dramatic skills, earning the Best Supporting Actress Oscar for the 2009 film *Precious* nearly 20 years after Whoopi Goldberg won hers (approximately 50 years after Hattie McDaniel won the very first one).

In the late 2010s, Mo'Nique became negatively vocal about her *Precious* awards campaign experience, calling out director Lee Daniels as well as executive producers Tyler Perry and Oprah Winfrey. Not long after, in 2018, Mo'Nique called for a boycott of Netflix for paying Black women comedians unfairly. The following year, she filed a lawsuit charging the streaming service with racial and gender discrimination; the suit later was permitted to proceed through the courts. Other memorable roles by Mo'Nique include her Emmy-nominated portrayal of blues singer Ma' Rainey (who didn't hide her same-sex attraction) in the 2015 HBO film *Bessie* by openly LGBTQ director Dee Rees. Mo'Nique's late-night show on BET, *The Mo'Nique Show*, which ran from 2009 to 2011, received positive fan feedback.

## Tiffany Haddish

Tiffany Haddish's first major TV breakthrough came via the edgy NBC sitcom *The Carmichael Show* (2015–2017), starring comedian Jerrod Carmichael. But her role as Dina in the summer 2017 blockbuster comedy *Girls Trip*, starring Queen Latifah, Jada Pinkett-Smith, and Regina Hall, transformed her into one of the most recognizable female comedians in Hollywood. That fall, she became the first Black female comedian to host *SNL* —she won the Best Outstanding Actress in a Comedy Series Emmy. Her memoir *The Last Black Unicorn* (Gallery Books) became a *NY Times* bestseller.

In addition to starring in comedy specials like *She Ready! From the Hood to Hollywood* for Showtime, Haddish became an in-demand film actress, starring in *Night School* with Kevin Hart, in Tyler Perry's *Nobody's Fool* and *Uncle Drew* (with *The Carmichael Show* castmate Lil Rel Howery) in 2018, and in *The Kitchen* (2019) with Melissa McCarthy. She also lent her voice to animated films such as *The Angry Birds Movie 2* and *Secret Lives of Pets 2*. Haddish also starred in the TV series *The Last O.G.* (2018–2020) with Tracy Morgan as well as the limited series *Self Made: Inspired by the Life of Madam C.J. Walker* (2020). In 2021, she became the second Black female comedian, after Whoopi Goldberg, to win the Grammy for Best Comedy album and only the fourth woman to ever win in that category in Grammy history.

# Enter Stage Left: Serious Actors

Early Black film actors such as Lena Horne, Sammy Davis Jr., and Harry Belafonte built their acting careers from their musical gifts, but toward the middle of the 20th century, dedicated Black actors with no musical foundation began to emerge. The following sections introduce a few of the many venerable Black actors.

## Sidney Poitier

Defying Hollywood typecasting, Sidney Poitier received plum roles from the beginning of his career, playing a doctor in his first film, *No Way Out* (1950), and a reverend in *Cry, the Beloved Country* (1951). He exuded dignity even when playing a convict in *The Defiant Ones* (1958), for which he received an Oscar nomination. In 1961, he revived his powerful stage role as Walter Lee Younger in the film version of the Broadway hit *A Raisin in the Sun*. He also became the first Black actor to win an Academy Award for Best Actor for his starring role in *Lilies of the Field* (1963), in which his character unwillingly aids impoverished nuns. He also helped put interracial dating and marriage front and center with the 1967 film *Guess Who's Coming to Dinner* just months after the Supreme Court decision in *Loving v. Virginia* overturned laws banning interracial marriage. In the 1970s, he starred, alongside Bill Cosby, in the successful Black films *Uptown Saturday Night, Let's Do It Again,* and *A Piece of the Action*, which he also directed. Poitier, who would also become the first Black director to release a $100 million-grossing film with *Stir Crazy* (1980) starring Richard Pryor and Gene Wilder, proved he could also appeal to the masses.

**TECHNICAL STUFF**

Raised in the Bahamas, Sidney Poitier came to New York as a teenager. Initially rejected by the American Negro Theater (ANT; see Chapter 15) because of his thick accent, Poitier worked hard to lose it. Determined to become an actor, Poitier worked as a janitor at the ANT in exchange for acting lessons.

Yet Poitier's career wasn't without controversy. Black critics of his day charged that Poitier, whom they characterized as "nonthreatening" to white audiences, ushered in a new stereotype of the "ebony saint." Others noted that Poitier rarely enjoyed the on-screen romantic associations of other leading men. Today, however, Poitier's legendary status is never in question.

## Cicely Tyson

Born in 1924 in Harlem to Caribbean immigrants from Nevis, Cicely Tyson set a high bar in acting, intentionally playing roles that brought dignity and humanity to Black women specifically and Black people as a whole.

Tyson, who began her career on stage, landed her first film role in her early 30s playing Dottie in *Carib Gold* (1956), opposite the great Ethel Waters. After more than a decade spent mostly in TV, Tyson hit her stride in the 1970s with notable films and miniseries. Her role in the 1972 film *Sounder* earned her an Oscar nomination, while *The Autobiography of Miss Jane Pittman* in 1974 got her an Emmy. Her roles in *The River Niger* (1977) and *A Hero Ain't Nothin' but a Sandwich* (1978) earned her the first of numerous NAACP Image Awards. Real-life heroines she played include Wilma Rudolph, Harriet Tubman, Coretta Scott King, and super educator Marva Collins.

Even in her later years, Tyson remained at the top of her craft, including a Tony Award-winning performance in *A Trip to Bountiful* in 2013, which marked her first Broadway play in 20 years. Her presence in Tyler Perry films introduced newer fans to her excellence. A year prior to her death in 2021 at age 96, she delivered stellar performances in Tyler Perry's *A Fall from Grace*, in Ava DuVernay's anthology *Cherish the Day* on the Oprah Winfrey Network (OWN), and opposite Viola Davis on the Shonda Rhimes-produced *How to Get Away with Murder*.

## Denzel Washington

Like Poitier, Denzel Washington distinguished himself in one spectacular role after the next. After making only a handful of films, he earned his first Oscar nomination for Best Supporting Actor for playing Steve Biko in *Cry Freedom* (1987). Two years later, Washington won the Best Supporting Actor Oscar, his first, for the film *Glory* (1989).

Teaming up with director Spike Lee for the jazz-themed *Mo' Better Blues* (1990) launched a collaboration that would include three more films, including *Malcolm X* (1992), for which Washington received his first Best Actor nomination and help establish him as a solid leading actor. He won his first Best Actor Oscar for playing a corrupt cop in *Training Day* (2001), directed by Antoine Fuqua. Other Best Actor

nominations came from his performances in *The Hurricane* (1999), *Flight* (2012), *Fences* (2016), and *Roman J. Israel, Esq.* (2017).

*Fences,* the long-awaited big-screen adaptation of August Wilson's Pulitzer Prize–winning play, which Washington also directed, earned a Best Picture Oscar nomination as well as an Oscar win as Best Supporting Actress for Viola Davis. Both Washington and Davis received Tony Awards for the Broadway production. *Fences,* as well as the 2020 Netflix film *Ma Rainey's Black Bottom,* which Washington produced, starring Viola Davis and Chadwick Boseman, are part of Washington's commitment to make feature-length adaptations of all ten of August Wilson's Pittsburgh Cycle (also known as Century Cycle).

Washington's other films as a director include *Antwone Fisher* (2002), Derek Luke's feature film debut; *The Great Debaters* (2007), starring Nate Parker; and *Journal for Jordan,* starring Michael B. Jordan, which wrapped up filming in 2021.

Washington's many other standout films include *The Equalizer* films (2014, 2018) and *The Magnificent 7* (2016) with Antoine Fuqua. Each crossed the $100 million mark in global box office receipts, three of the more than 20 films he appeared in that grossed more than $100 million worldwide.

## Morgan Freeman

Prior to his roles on the big screen, Morgan Freeman's most notable role had been on the PBS children's show *The Electric Company.* Freeman's Oscar-nominated roles include three Best Actor nominations for *Driving Miss Daisy* (1989), *The Shawshank Redemption* (2004), and *Invictus* (2009). Freeman, who received his first Oscar nomination for Best Supporting Actor in *Street Smart* (1987), won the Best Supporting Actor Oscar for *Million Dollar Baby* (2004). Freeman's many beloved roles include tough high school principal Joe Clark in *Lean on Me* (1989). He also starred in *Se7en* (1995), *Batman Begins* (2005), *The Dark Knight* (2008), and *The Dolphin Tale* (2011).

## Wesley Snipes

An actor with range, Wesley Snipes co-starred with Denzel Washington in *Mo' Better Blues* (1990), played opposite Angela Bassett in *Waiting to Exhale* (1995), and donned heels for *To Wong Foo, Thanks for Everything! Julie Newmar* (1995). But Snipes, who has the distinction of appearing in Michael Jackson's historic "Bad" video (1987), is perhaps best known as a pioneering action star.

Snipes emerged as a bankable star with his role as drug kingpin Nino Brown in the 1991 film *New Jack City.* He followed with Spike Lee's *Jungle Fever* (1991) and *White Men Can't Jump* (1992). Snipes, who had begun studying martial arts as age 12,

connected as an action star in countless films, including *Passenger 57* (1992), *Demolition Man* (1993), and the *Blade* trilogy (which kicked off in 1998) to become one of the biggest stars in the 1990s.

Eight of his films crossed the $100 million domestic box office mark, and collectively he's exceeded more than a billion dollars in global box office. An income tax conviction resulted in prison time from 2010 to 2013, pausing his career, but Snipes got back in the swing with *The Expendables 3* (2014) with Sylvester Stallone and a bevy of action stars, as well as *Dolemite Is My Name* (2019) and *Coming 2 America* (2021) with Eddie Murphy.

## Samuel L. Jackson

In a career spanning at least four decades, Chattanooga-raised Morehouse alum Samuel L. Jackson earned more than 190 acting roles, most of them in film. He generated a collective box office of more than $27 billion worldwide, essentially making him the highest grossing actor of all time.

Playing the Bible-quoting hitman Jules with a penchant for the word "mother-f---er" in writer/director Quentin Tarantino's 1995 smash *Pulp Fiction* put Jackson — who had appeared in various films, including Spike Lee's *School Daze* (1988) and *Jungle Fever* (1991) — on the fast track to stardom. He followed with films such as *Die Hard with a Vengeance* (1995), *A Time to Kill* (1996), and *Star Wars: Episode I—The Phantom Menace* (1999), in addition to starring in Kasie Lemmons' debut feature *Eve's Bayou* (1997).

In the 2000s, Jackson kicked into overdrive, starring in *Shaft* (2000) and *Unbreakable* (2001), continuing his *Star Wars* appearances, and voicing the animated 2007 series *Afro-Samurai* as well as Gin Rummy in *The Boondocks* (2005–2010). In the 2010s, he officially joined the Marvel Cinematic Universe as Nick Fury in *Iron Man 2* (2010). He appeared in its various films, including *The Avengers* (2012) and *Captain Marvel* (2019). He also appeared in smaller films such as *The Banker* (2020), voiced Lucius Best/Frozone in *The Incredibles* franchise, and played the villain in Quentin Tarantino's 2012 film *Django Unchained*.

## Halle Berry

Former beauty pageant runner-up Halle Berry will be forever remembered for becoming the first Black woman to win the Oscar for Best Actress in 2002 (the same year Denzel Washington won his Best Actor Oscar) for her role as Leticia in the independent film *Monster's Ball* (2001), produced by Lee Daniels. Just a few years prior, the Cleveland native had won the Emmy for Lead Actress in a Limited Series for her 1999 HBO film *Introducing Dorothy Dandridge*. There, she played the

actress who, with the 1954 film *Carmen Jones*, was the first Black woman to even be nominated for the Best Actress Oscar.

Berry's debut feature film role was as a crack addict opposite Samuel L. Jackson in Spike Lee's *Jungle Fever* (1991). Other films Berry is known for include *Boomerang* (1992), *B.A.P.S.* (1997), the Bond film *Die Another Day* (2002), and the *X-Men* franchise as Storm, spanning 2000 to 2014.

## Viola Davis

Prior to making her mark on the big and small screens in the 2000s, South Carolina-born, Rhode Island-raised, Juilliard-trained Viola Davis made it on the stage with notable appearances in four of August Wilson's Pittsburgh Cycle, also known as the American Century Cycle. She won a Tony as Tonya for the 2001 production of *King Hedley II*, the ninth play in Wilson's Cycle, the Obie in 1999 for her lead performance in *Everybody's Ruby*, and the 2004 Drama Desk Award for award-winning playwright Lynn Nottage's *Intimate Apparel*.

Perhaps fitting, her Hollywood breakthrough came with *Doubt* (2008), the film adaptation of the acclaimed 2004 play for which she received her first Oscar nomination for Best Supporting Actress, sharing the category with Taraji P. Henson who received a nomination for *The Curious Case of Benjamin Button* (2008), in 2009. From there, she continued to soar, garnering an Oscar nomination as Best Actress for the 2011 film *The Help*.

Working opposite Washington in *Fences* (2016), another adapted Wilson play, Davis won her first Oscar for Best Supporting Actress in 2017. Not content with just her own success, Davis, who launched JuVee Productions in 2011 with her actor/producer husband Julius Tennon, became a loud voice for Black actresses in particular, advocating for more opportunities in which to demonstrate their talents.

Davis, herself, made history, becoming the first Black actress to win the Emmy as lead in a drama series as well as the most Oscar-nominated Black actress, with her 2021 Best Actress nomination for the film adaptation of August Wilson's *Ma Rainey's Black Bottom*, produced by Denzel Washington; she shared the category with newcomer, singer Andra Day in the Lee Daniels-directed *The United States vs. Billie Holiday*, making it the first time since 1973 that two Black women were nominated for Best Actress in the same year and only the second time ever in Oscar history.

# And the Award Goes to . . .

With both Washington and Berry winning Oscars for Best Actor and Best Actress, and Will Smith being a Best Actor nominee for *Ali*, the 21st century looked brighter for Black actors in terms of mainstream recognition. Several actors received nominations and wins with some notable highlights:

>> **2005:** Jamie Foxx, a double nominee for Best Supporting Actor for *Collateral*, won his Best Actor Oscar for the 2004 Ray Charles biopic *Ray* (find more on Jamie Foxx in the "Kings and queens of comedy" section earlier in the chapter). The same year, Freeman won for Best Supporting Actor, with Don Cheadle also nominated for Best Actor for *Hotel Rwanda*, playing Paul Rusesabagina during a war.

>> **2007:** Forest Whitaker won the Best Actor Oscar for playing Ugandan president Idi Amin in *The Last King of Scotland* (2006). Smith was nominated for Best Actor for *The Pursuit of Happyness*, inspired by the real-life story of businessman Chris Gardner and his son. Jennifer Hudson won Best Supporting Actress for *Dreamgirls*, with her co-star Eddie Murphy also receiving a nomination for Best Supporting Actor.

>> **2010:** The 2009 film *Precious* garnered nominations for Gabourey Sidibe for Best Actress and a win for Mo'Nique for Best Supporting Actress.

>> **2012:** Octavia Spencer won the Oscar for Best Supporting Actress for *The Help* (2011).

>> **2014:** Lupita Nyong'o won the Best Supporting Actress Oscar for *12 Years a Slave* (2013).

>> **2017:** Davis won the Best Supporting Actress Oscar for *Fences* (2016) and Mahershala Ali won the Best Supporting Actor Oscar for *Moonlight* (2016).

>> **2019:** Ali won the Best Supporting Actor Oscar for *Green Book* (2018) and Regina King won the Best Supporting Actress Oscar for *If Beale Street Could Talk* (2018).

In 2015, the Academy awarded all 20 acting nominations to white actors, prompting April Reign to create the hashtag #OscarsSoWhite in protest. The same lack of representation happened for the 2016 Academy Awards, curiously during the tenure of Cheryl Boone Isaacs, the first Black president of the Academy of Motion Picture Arts and Sciences. The heightened awareness generated by #OscarsSoWhite created necessary conversation around diversity and inclusion in the industry overall. The NAACP Image Awards and the AAFCA Awards from the African American Film Critics Association (which began as a group of critics in 2003 but blossomed into an advocacy group championing diversity and inclusion) are two awards shows that honor the best in film and TV, with a focus on Black talent and content.

» **Tracking comedy's impact**

» **Bringing the drama**

» **Facing Black reality TV**

» **Creating empires**

# Chapter **18**

# Black Hollywood: TV

Most Americans can't imagine a time when Black people appeared on television so infrequently that it was an event for Black viewers. As this chapter discusses, Black people have made significant contributions to the small screen.

Black Hollywood scholar Donald Bogle traces the beginnings of Black Americans on television to the one-night-only broadcast of *The Ethel Waters Show* by NBC in 1939, when television was still in its experimental stage. Other early Black shows Bogle notes include *The Bob Howard Show* on CBS in 1948, which has the distinction of being television's first regular broadcast show with a Black host; *Sugar Hill Times* (1949), a short-lived variety show starring Harry Belafonte that was the first network show with an all-Black cast; as well as *The Hazel Scott Show* (1950), starring the beautiful pianist; and the *Nat "King" Cole Show* (1956) showcasing the pioneering singer. When these shows went off the air, Black Americans showed up on television mainly as entertainers through guest appearances on programs like *The Ed Sullivan Show* until 1965. The actors who appeared in the comedies *Beulah* and *The Amos 'n' Andy Show* were exceptions.

That changed in 1965, when Bill Cosby revolutionized weekly television as agent Alexander Scott in the espionage drama series *I Spy*. Others like Greg Morris in *Mission Impossible*, Nichelle Nichols in *Star Trek*, and Clarence Williams III in *The Mod Squad* quickly followed. There was even an integrated high school drama, *Room 222*, chronicling the experiences of the Black male teacher Pete Dixon played by Lloyd Haynes. Comedy, however, ruled as the primary vehicle for Black talent.

# Early Black TV Comedies

As early as the 1950s, two TV comedies prominently featured Black characters: *Beulah* and *The Amos 'n' Andy Show*. Both series had beginnings in radio, in which white actors voiced the Black characters. When *Beulah* was adapted from radio to television, it was clear that although the Black maid was technically the star, her role was to cater to the white family she served.

The fact that Amos and Andy, played by Alvin Childress and Spencer Williams, were intended to be buffoonish didn't sit well with many Black Americans, who largely objected to the main characters speaking what they perceived as "poor English." The many Black lawyers, judges, and other professionals on the show couldn't balance out the stereotypical images for its critics. The NAACP even protested the show. Despite flashes of genuine humor, CBS pulled *Amos 'n' Andy* after two years but syndicated it until 1966. From that time until the late 1960s, Black Americans were largely absent from television comedies on a routine basis.

## Opening the doors wider

During the late 1960s into the 1970s, television underwent major changes. Although Bill Cosby secured his first solo comedy series with 1969's *The Bill Cosby Show*, two other shows from that period had a bigger impact:

» *Julia:* Diahann Carroll's 1968 series *Julia,* in which she starred as a widowed mother working as a nurse, was a rare show with a positive view of the life of a professional, Black single mother, especially for a comedy. But many critics charged that although it was nice, it wasn't groundbreaking. With the Black Power movement on the rise, for some Black and white critics, Carroll, as Julia, wasn't "Black enough." Despite the times, race was rarely a prominent storyline, with the show's white writers opting to emphasize Julia's middle-class status. Still the series ran from 1968 to 1971. In the 1980s, Carroll made television history again as the wealthy Dominique Deveraux on TV's top-rated soapy drama *Dynasty.*

» *The Flip Wilson Show:* Variety shows were a staple of early television, and several Black Americans, including Sammy Davis Jr., starred in their own shows. None, however, had the impact of Flip Wilson in the early 1970s. Characters like Reverend LeRoy of the Church of What's Happening Now, Sonny the White House janitor, and of course, Wilson's alter ego Geraldine Jones made the show a hit. *TIME* magazine even heralded Wilson as "TV's First Black Superstar" on its cover in 1972. Television executives took note of Wilson's popularity, whereas Black intellectuals criticized Wilson for his comedy routines, which they felt reveled in the same stereotypes apparent in shows like *The Amos 'n' Andy Show.*

# Getting an edge

As TV became slightly edgier in the 1970s, so did its Black shows. *Sanford and Son*, *Good Times*, and *The Jeffersons* are three of the most memorable. Interestingly, a number of these shows experienced clashes between white writers and Black actors:

» **Sanford and Son:** Despite conflict off-camera, Red Foxx scored as Fred Sanford, a cantankerous Los Angeles junkman who lived with his son. *Sanford and Son* was one of the most popular shows of its time. Its five-year run ended in 1977, but the series continues to air in syndication.

» **Good Times:** *Good Times,* built around a character played by Esther Rolle on the 1972 television series *Maude,* featured a family trying to make ends meet in a Chicago housing project. Originally, the show's producers wanted Rolle to play a single mother, but she refused. Unlike other shows, *Good Times* brought dignity and humanity to poorer Black people. Sensitive to negative portrayals of Black Americans, stage actors Rolle and John Amos, who played her husband, objected to the increasing prominence of Jimmie Walker's character J.J. To them, he appeared buffoonish with his signature exclamation "Dyn-o-mite!" and disdain for school. Amos eventually left the show, and Rolle soon followed. Problems and all, *Good Times* remains an important part of television history, as evidenced by its success in syndication.

» **The Jeffersons:** Another groundbreaking series for the time, *The Jeffersons* depicted wealthy Black Americans. Like Archie Bunker from *All in the Family* — the show that first introduced the Jeffersons — George Jefferson, who gained wealth as a dry cleaner, was written to be as bigoted against white people as Archie was against everybody else but became a bigger symbol of Black business success and excellence. In addition, *The Jeffersons* regularly depicted a committed interracial marriage through George and Louise's neighbors, Tom and Helen Willis.

# Kid comedies

Sitcoms came and went throughout the 1970s and early 1980s. For a time, all-Black shows like *What's Happening!!* (loosely based on the popular 1975 film *Cooley High*) lingered, but they soon gave way to broader comedies featuring Black characters, particularly children. Here are a few examples:

» Gary Coleman and Todd Bridges became fast celebrities from *Diff'rent Strokes,* a series about a rich white single father who adopts two orphaned Black kids.

» Kim Fields played the lone Black kid in *The Facts of Life,* a series about life at a boarding school.

>> Emmanuel Lewis played a Black orphan cared for by a former white football player and his wife in the hit series *Webster*.

In the late 1990s and 2000s, the Disney Channel and Nickelodeon helped change the TV landscape, leading the way for shows that either prominently featured Black kid actors or, better yet, starred them, most notably with Kel Mitchell and Kenan Thompson on Nickelodeon's *All That* from 1994 to 2005. Their popular "Good Burger" skit became a movie in 1997. They also had their own show, *Kenan & Kel* (1996–2000). Other examples include the ABC/CBS series *Family Matters* (1989-1998), which made Steve Urkel, played by Jaleel White, a pop culture icon and is ranked among TV's longest-running Black cast comedies; ABC/WB sitcom *Sister, Sister* (1994–1999), starring twin sisters Tia and Tamera Mowry; Nickelodeon's *Cousin Skeeter* (1998–2001), starring Robert Ri'chard and Meagan Good; Disney's *The Famous Jett Jackson* (1998–2001), starring Lee Thompson Young; former *The Cosby Show* star Raven Symone on Disney's *That's So Raven* (2003–2007); Keke Palmer in Nickelodeon's *True Jackson, VP* (2008–2011); and Zendaya in Disney's *K.C. Undercover* (2015–2018).

**HISTORICAL ROOTS**

Interestingly, the film shorts *Our Gang*, better known as *The Little Rascals*, which appeared before television introduced Black child actors to Hollywood. In the 1950s and into the 1970s, *Our Gang* showed up on television. Despite reinforcing stereotypes such as Black children routinely eating watermelon and fried chicken, *Our Gang*'s Ernie Morrison, who played Sunshine Sammy, was the first Black actor signed to a long-term Hollywood contract. Most people, however, are more familiar with Billie Thomas, who played Buckwheat, known for his signature unruly hair, because of Eddie Murphy's parodies of him on *Saturday Night Live*.

## Cue the Huxtables and A Different World

It's really impossible to overstate the significance of *The Cosby Show* in television history, even as Bill Cosby, a once-revered father figure, lost his stature when he was imprisoned for sexual assault in 2018. A sitcom about the lives of an upper-middle class Black family headed by a husband and wife who were a doctor and lawyer, *The Cosby Show* was the most-watched show by all Americans during its eight-year run in the 1980s and early 1990s. For years, Cosby, who also created the Saturday morning cartoon classic *Fat Albert and the Cosby Kids*, which premiered in 1972 and ran until 1985, received "top television dad" honors.

Beyond its entertainment value, *The Cosby Show* educated Americans about Black American history and culture in a noninvasive way: The family home showcased Black art; Cosby's character Cliff Huxtable was a huge jazz buff, and some episodes featured legends like Lena Horne; and generational storylines showed complete families on both sides. The show sometimes ventured into political waters,

addressing the civil rights movement as well as apartheid in South Africa. Overall, the show was simultaneously traditionally American and Black American, creating stars out of Phylicia Rashad, who played matriarch Clair Huxtable, and their children Denise, Theo, Vanessa, and Sondra, played by Lisa Bonet, Malcolm-Jamal Warner, Tempestt Bledsoe, and Sabrina Le Beauf.

*A Different World* (1987–1993), a spinoff of *The Cosby Show* initially starring Lisa Bonet, highlighted the Black college experience at the fictional HBCU Hillman (find more about Historically Black Colleges and Universities in Chapter 12). The show also starred Jasmine Guy as Whitley, Kadeem Hardison as Dwayne Wayne, Daryl M. Bell as Ron Johnson, Cree Summer as Freddie Brooks, and more, including Jada Pinkett (Smith) as Lena. With Howard University Alum Debbie Allen at the helm, *A Different World* explored many important issues, including date rape, apartheid, racism, classism, and Black Greek life.

**HISTORICAL ROOTS**

Emmy winner and prolific TV producer Lena Waithe named her development and production company Hillman Grad Productions in homage to the fictional HBCU on *A Different World*.

## BLACK WOMEN IN THE SNL CAST

Black female comedians on the variety sketch show *Saturday Night Live* have been scarce. Without question, Maya Rudolph had the best run. From May 6, 2000, until November 3, 2007, Rudolph (the biracial daughter of celebrated singer Minnie Riperton) was an *SNL* regular who continued in a recurring presence even into 2020, treating audiences to her portrayals of various personalities, including Beyoncé, First Lady Michelle Obama, Secretary of State Condoleezza Rice, Gayle King, Whitney Houston, and Kamala Harris, particularly along the 2020 presidential campaign trail and as Vice President Elect.

Rudolph went on to star in several movies, including *Bridesmaids,* as well as TV shows such as *The Good Place.* She also lent her voice to various animated projects in TV and film, including *Big Mouth, The Willoughbys,* and *The Angry Birds* franchise. In 2020, Rudolph won two of her three Emmy nominations for portraying Harris on *SNL* and voicing Connie the Hormone Monstress in *Big Mouth.*

Prior to Rudolph, only three Black women, Yvonne Hudson, Danitra Vance, and Ellen Cleghorne, had been *SNL* regulars. In 2014, Sasheer Zamata and Leslie Jones joined *SNL,* leaving in 2017 and 2019, respectively. Going into 2021, Ego Nwodim, who joined the show in 2018, was the last Black woman *SNL* regular.

# Targeting the Black Hip-Hop Audience

New networks Fox and The WB zeroed in on the young Black hip-hop audience in the early 1990s with several shows that included

>> **In Living Color,** an in-your-face sketch comedy show that incorporated popular culture, including a hip-hop DJ and dancers; the show made the Wayans family stars — Damon in front of the camera and Keenan behind — along with Jamie Foxx (not to mention white actor Jim Carey)

>> **The Fresh Prince of Bel Air,** a comedy starring rapper Will Smith whose mother sends him from his rough Philadelphia neighborhood to Los Angeles, to Bel-Air, to live with his wealthy uncle Phil and his family

>> **Martin,** a comedy built around a Detroit radio personality (played by Martin Lawrence), his girlfriend, and their friends

>> **Living Single,** a comedy starring Queen Latifah and Kim Fields revolving around six friends, four women and two men, that preceded the all-white NBC hit *Friends* by a year

Interestingly, Fox, The WB, and even UPN, which created Black shows like *Moesha, Girlfriends,* and *The Parkers,* began distancing themselves from the Black audience after they gained firmer footing as a network to pursue non-Black TV audiences. NBC, ABC, and CBS had presented few Black-oriented shows since the 1970s and 1980s, choosing to have one show on one night at a time and never in a block like UPN did on Monday nights, with its entire comedy block featuring Black cast sit-coms like *The Parkers, Eve, Girlfriends,* and *Half & Half* in 2003.

The merger of UPN and The WB to form The CW in 2006 left the fate of the Black-oriented sitcom there mostly up in the air. *The Game* (2006–2009, 2011–2015) from *Girlfriends* creator Mara Brock Akil made it to the new network, but relocated to BET two years after its 2009 cancellation by The CW. The show, about a fictional football team, its players, and the women in their lives, starred Tia Mowry from *Sister, Sister* (1994–1999). Immensely popular, the show enjoyed later success on BET for four additional seasons, plus thrived in syndication.

# Cable TV Opens the Door to More

In contrast to network TV, cable was largely dedicated to Black comedy, particularly comedians, initially through influential shows such as HBO's *Def Comedy Jam* and *The Chris Rock Show,* along with numerous standup comedy specials from Whoopi Goldberg, Chris Rock, Mike Epps, Cedric the Entertainer, and others in the

1990s and 2000s. Comedian Dave Chappelle shook up basic cable with his edgy sketch comedy program *Chappelle's Show* in 2003 on Comedy Central before discontinuing the show in 2005.

Cartoon Network raised the temperature with its Adult Swim animated show *The Boondocks* (2005–2014) from comic artist Aaron McGruder. Its two main characters, Huey and Riley, voiced by Regina King, often criticize Black political leadership and offer blunt cultural commentary. In this time, Tyler Perry also proved that he had a TV audience with his sitcoms *House of Payne* (2006) and *Meet the Browns* (2009–2011) on TBS.

In the 2010s, however, television seemed to get the memo, offering up more complex Black TV comedies like Issa Rae's *Insecure* (2016–2021), placing *The Mis-Adventures of Awkward Black Girl* star in her native Inglewood in the Los Angeles metro area to explore relationships and work from a Black millennial perspective. FX's off-kilter *Atlanta* (2016–present) stars Donald Glover as the underachieving Earn, who attempts to manage his cousin Paper Boi's transition from drug dealer to rapper. The show amplified Glover's stardom while making fast stars of Brian Tyree Henry and LaKeith Stanfield, who play Alfred "Paper Boi" Miles and his main friend Darius.

## BLACK-ISH MAKES A SPLASH

Kenya Barris's breakthrough in 2014 with his ABC comedy *Black-ish* opened up TV for his *ish* universe, including *Grown-ish* (2018) and *Mixed-ish* (2019). *Black-ish* features Anthony Anderson, who had success in *Two Can Play That Game* (2001), *Scary Movie 3* and *4* (2003, 2006), and the 2000s *Barbershop* franchise as Andre "Dre" Johnson. Barris used his own life, including his then-five kids with longtime wife Rainbow and his challenging childhood growing up in Inglewood, California, as a blueprint to create a multigenerational comedy. *Black-ish* tells the story of a husband and father from humble means managing his affluent lifestyle with his biracial wife Bow (or Rainbow), their four kids (the school-age twins Diane and Jack and teenagers Zoey and Junior), and his parents, Pop and Ruby, played by Laurence Fishburne and Jenifer Lewis.

*Black-ish*'s penchant for addressing serious issues of the day such as police killings of unarmed Black men both courted controversy and praise. Since its debut, *Black-ish* was among TV's top comedies. *Grown-ish,* exploring oldest daughter Zoey's (Yara Shahidi) college experience on Freeform, didn't shy away from controversial issues like drugs, sex, and college loan debt, whereas *Mixed-ish* is a throwback to Bow's childhood, navigating life as biracial. Based on the success of these three shows, Barris, who also co-penned scripts for films like 2017's *Girls Trip,* launched his own show, *#BlackAF,* on Netflix as part of a 2018 deal with the streamer for a reported $100 million.

# Black Women Comedians Contribute on TV

On TV, Black female comedians haven't fared as well as their Black male counterparts. Black male comedians who have led their own sitcoms especially are too numerous to name (see Chapter 17 for a rundown). Although Black women comedians haven't received TV shows in record numbers, their presences did grow in the 2000s. Some of the highlights in daytime television include Sherri Shepherd on ABC's *The View* (2007–2014); Sheryl Underwood on the CBS show *The Talk* (2011–), along with Aisha Tyler (2011–2017); and Loni Love on FOX's *The Real* (2011–). Robin Thede created *A Black Lady Sketch Show* for HBO in 2019. Amber Ruffin, who rose to fame through her appearances on *Late Night with Seth Meyers*, for which she also wrote, launched *The Amber Ruffin Show* on Peacock in 2020. Comedians who emerged in the 2010s include Dulce Sloan, who rose to fame on *The Daily Show;* former *SNL* writer Sam Jay; Nicole Byer of *Nailed It* fame; Yvonne Orji, best known for HBO's *Insecure*; and Michelle Buteau of *The First Wives Club* on BET Plus.

## BLACK SOAP STARS

Most people are surprised to discover that Cicely Tyson, James Earl Jones, Phylicia Rashad, and Laurence Fishburne are among the long list of Black actors who appeared on soap operas at some point in their careers. Vivica A. Fox even shared how she got the role of Will Smith's girlfriend in the film *Independence Day* (1996) when the producer's wife saw her as Dr. Stephanie Simmons on *The Young and the Restless.*

In the 1980s, a storyline on *All My Children* involving the characters Angie and Jessie (played by Debi Morgan and Darnell Williams) broke the soap opera mold by prominently featuring a Black couple. On *Days of Our Lives,* actor-turned-screenwriter Tina Andrews's interracial relationship was so controversial with viewers that she was fired. In time, interracial relationships weren't automatic deal breakers on soap operas. Kristoff St. John, who played Neil Winters, on CBS's *The Young & the Restless* from 1991 until his death in 2019, was a true trailblazer and soap icon. Neil's love triangle with Victoria Rowell as Drucilla and Shemar Moore as his brother Malcolm casting doubt if Lily (Christel Khalil) was his child was a pioneering storyline for Black soap actors. In addition, St. John helped anchor the short-lived *Generations* (1989-1991), which was the first soap opera to incorporate a Black family at its inception. Other notable Black actors who appeared on soaps include Nia Long, Lauryn Hill, Michael B. Jordan, Lamman Rucker, and Taye Diggs.

By 2020, daytime soap operas had almost completely faded from the TV landscape, with the exception of *The Young and the Restless* and *The Bold and the Beautiful* on CBS, ABC's *General Hospital,* and NBC's *Days of Our Lives.*

TV's many unsung Black female comedic trailblazers include LaWanda Page, best known as Aunt Esther from *Sanford and Son*; Marsha Warfield, who played Roz Russell on *Night Court*; Thea Vidale from the sitcom *Thea*; Kim Wayans from *In Living Color*; Kim Coles from *Living Single*; and Kim Whitley from various projects, including *Black Dynamite* in film and TV, as well as Adele Givens and Sommore of *Def Comedy Jam* fame.

# No More Drama with Dramas

For a long time, very few networks attempted all-Black dramatic series or those depicting multiple strong Black characters. In television, ensemble casts, particularly for hospital dramas and cop shows, served as the winning strategy for including Black actors. *Hill Street Blues, St. Elsewhere, Miami Vice, L.A. Law,* and others provided weekly exposure for actors such as Michael Warren, Denzel Washington, Philip Michael Thomas, and Blair Underwood. In the 1990s, the cop genre even became more hip-hop-oriented; *New York Undercover,* for example, which paired a Black and Latino cop, relied heavily on hip-hop dress, slang, music, and attitude. By the early 2000s, shows such as *ER* had firmly established a standard for using Black talent sparingly.

## The Rhimes effect

Pioneering Black showrunner Shonda Rhimes shook up the formula a bit with multiracial casting of her long-running flagship ABC series, *Grey's Anatomy* (2005–present), and then broke the mold completely with *Scandal* (2012–2018), with Kerry Washington becoming the first Black actress to lead a primetime drama series. Her character, political fixer Olivia Pope, and her ongoing affair with the president of the United States Fitz became embedded in television history.

Rhimes then followed *Scandal* by executive producing ABC's *How to Get Away with Murder* (2014–2020), starring Viola Davis as the complex lawyer and professor Annalise Keating. In this role, Davis became the first Black woman to win the Emmy for Outstanding Actress in a Drama Series in 2015. Prior to Rhimes and her Shondaland empire, network television offered little variety for Black actors in dramatic series, but many of them fared better with cable series.

# BLACK REALITY SHOWS

Bravo's expansion of its *Real Housewives* brand to Atlanta in 2008 set off waves. The popularity of the previously unknown NeNe Leakes — coupled with the addition of celebrities such as 1990s girl group Xscape singer/songwriter/producer Kandi Burruss and former Miss USA Kenya Moore — created a fervor among more than just the Black audiences. In 2010, basketball great Shaquille O'Neal's ex-wife Shaunie O'Neal fed the fervor with the launch of VH1's *Basketball Wives*.

Then, in 2011, successful music industry manager Mona Scott-Young effectively changed the game with the *Love & Hip Hop* franchise by centering known rappers like Jim Jones and Fabolous in New York, who helped launch the franchise, as well as Lil Scrappy for the Atlanta spinoff, and Trina and Trick Daddy in Miami with Keyshia Cole and Ray J in Hollywood. In no time, there was the *Black Ink Crew* franchise, revolving around tattoo artists, and *Growing Up Hip Hop*, featuring the offspring of hip-hop pioneers like Run-DMC, Dame Dash, and Master P. Whereas *Run's House* from 2005 had been more family-oriented, the new crop of hip-hop–inspired reality shows appeared to make every effort possible to be as sensational or "ratchet" as possible to record-setting ratings.

Some argue that the Bravo reality series *Being Bobby Brown,* which appeared around the same time as *Run's House,* showcased what some contended was the dysfunctional marriage of the late 1980s — early 1990s Bobby Brown to music superstar Whitney Houston, whose image on the reality show was completely opposite to the one her record label painted. Even as debates raged among certain segments of the Black community about the harmful imagery and the promotion of violence, ratings continued to grow, leaving many to wonder if reality TV was a permanent fixture of Black television and entertainment at large.

## Made-for-TV movies

From the 1990s to the early 2000s, made–for–TV movies, particularly those by HBO, became real standouts, with many of them winning numerous awards. Highlights include the following:

>> *Miss Evers' Boys,* this intense 1997 film about the controversial 1930s Tuskegee Syphilis Experiment, which injected Black men, without their knowledge, with syphilis and didn't treat them

>> *Don King: Only in America,* this 1997 biopic of the infamous boxing promoter (flip to Chapter 19 for more details about Don King)

>> *The Corner,* this 2000 groundbreaking miniseries about a Baltimore family's struggles with crack and poverty

» **_Lackawanna Blues,_** this 2005 drama about a young boy's colorful childhood growing up in a rooming house in civil rights–era Lackawanna in upstate New York, for which S. Epatha Merkerson won the Emmy for Outstanding Lead Actress in a Movie or Miniseries

In the late 2010s, HBO would expand its investment in Black content with original films such as the Dee Rees–directed _Bessie_ (2015), starring Queen Latifah; the Rick Famuyiwa–directed _Confirmation_ (2016), with Kerry Washington as Anita Hill and Wendell Pierce as Clarence Thomas; the George C. Wolfe–directed, Oprah Winfrey–produced _The Immortal Life of Henrietta Lacks_ (2017), starring Winfrey and _Hamilton_'s Renée Elise Goldsberry; _Fahrenheit 451_ (2018), which Michael B. Jordan produced and starred in; and _O.G._ (2019), starring Jeffrey Wright. Long the leader in Black original movies and edgy content in general, HBO faced more competition in the late 2010s, especially from Netflix.

With films such as the rap biopic _Roxanne, Roxanne_ (2017), the sci-fi teen social justice film _See You Yesterday_ (2019), the Dee Rees–directed Southern period drama _Mudbound_ (2017) (which earned Mary J. Blige two Oscar nominations for best song and best supporting actress), and the film adaptation of August Wilson's celebrated play _Ma Rainey's Black Bottom_ (2020), starring Viola Davis and Chadwick Boseman, Netflix definitely shored up its arsenal. Netflix doubled down in 2021 with films like _Malcolm & Marie_, starring Zendaya and John David Washington, fresh off his 2020 Christopher Nolan–directed action film _Tenet_. Amazon Prime video made noise at the end of 2020 and the top of 2021, particularly with _Sylvie's Love_, starring Tessa Thompson and Nnamdi Asomugha, and _One Night In Miami_, actress Regina King's feature-length directorial debut.

Lifetime, which tangoed with Black audiences from time to time, made a pretty loud statement with the success of the Christine Swanson–directed 2020 film _The Clark Sisters: The First Ladies of Gospel_. It featured an award-worthy performance by Aunjanue Ellis as the family matriarch, Dr. Mattie Moss Clark. Lifetime also featured the Kenny Leon–directed _Robin Roberts Presents: The Mahalia Jackson Story_ (2021), starring Danielle Brooks as the legendary gospel singer. Brooks is known for being in _The Color Purple_ on Broadway and on the Netflix show _Orange Is the New Black_.

## Black actors in cable TV series

FX's _The Shield_ featured CCH Pounder and Forest Whitaker. HBO's _Six Feet Under_ broke all the rules with the character Keith Charles, a Black police officer turned private security expert played by Matthew St. Patrick in a gay, interracial relationship. HBO's innovative prison drama _Oz_ featured many Black actors. _The Wire_

continued that innovation by showing Baltimore's drug scene from the perspective of law enforcement and the drug dealers. Its many Black actors, including Wood Harris, Michael K. Williams, Sonja Sohn, Wendell Pierce, Clarke Peters, Jaime Hector, and, of course, Michael B. Jordan and British actor Idris Elba, who became movie stars, established strong acting careers.

Showtime had success with *Soul Food*, a Black-cast family drama based on the hit 1997 film. In 2005, LOGO, the LGBTQ cable channel, launched Patrik-Ian Polk's all-Black series *Noah's Arc*, based on the 2004 film showcasing romance and friendship among Black gay men. (Refer to the later section, "Highlighting Black LGBTQ stories," in this chapter.)

## AMERICA DISCOVERS ITS *ROOTS*

The success of the 1974 television movie *The Autobiography of Miss Jane Pittman*, based on the Ernest Gaines novel about a Black woman whose life spans from Reconstruction to the civil rights movement, convinced ABC executives to greenlight the larger-than-life 1977 miniseries *Roots*, based on Alex Haley's best-selling novel. (Television's key Black actress during the 1970s and 1980s, Cicely Tyson, who starred as Miss Jane Pittman, also had a role in *Roots*.)

More than shattering television records during its unprecedented eight-night broadcast, *Roots* dramatically impacted the nation's racial consciousness, inspiring dialogue in schools and at work. On average, 80 million Americans watched each of the seven episodes, and 100 million (almost half the country) tuned in for the eighth and final episode.

With its multigenerational storyline and its intimate look at the institution of slavery, *Roots* underscored the idea that despite enduring the brutality of beatings, rapes, and other atrocities during slavery, Black Americans maintained a strong sense of family as humane and dignified as that of any other Americans. Although Haley later settled a plagiarism suit with Harold Courlander, who wrote a similar novel, *The African*, in 1968, the impact of his work never faded.

*Roots* didn't make the world perfect, but it proved that television could make a difference by entertaining, educating, and inspiring dialogue about taboo subjects. By today's standards, *Roots* is a tame and gross oversimplification of this critical period in our nation's history. At the time, however, it was a monumental step forward for race relations. Even today, it remains one of the few television programs watched by almost all Americans in its era or any era.

In August 2020, HBO premiered the sci-fi series *Lovecraft Country*, backed by Jordan Peele and J.J. Abrams and created by *Underground*'s Misha Green. Jurnee Smollett (of *Eve's Bayou* and HBO series *True Blood* fame) and Jonathan Majors, then a relative newcomer with *Da 5 Bloods* (2020) and *The Last Black Man In San Francisco* (2019) under his belt, led the charge as Leticia "Leti" Lewis and Atticus "Tic" Freeman. *Lovecraft Country* mixed cosmic horror and Jim Crow, raising the question of whether the make-believe monsters were as scary as the real-life white supremacist ones. Adapted from the book written by white author Matt Ruff to flip the racist legacy of white cosmic horror pioneer H.P. Lovecraft, *Lovecraft Country* brought Black history to life in many of its episodes. It revisited Emmett Till's tragic murder as well as the 1921 Tulsa Massacre.

The Tulsa Massacre was also a point of entry for *Watchmen*, another important HBO series based on a comic about masked vigilantes that preceded *Lovecraft Country*. It premiered on October 20, 2019, and starred Regina King as Angela Abar/Sister Night. Months prior, in June 2019, HBO premiered *Euphoria*, a disturbing teen drama wrapped around drug abuse and sex, starring former Disney star Zendaya. In 2020, she became the youngest and second Black actress to win the Emmy for Outstanding Lead Actress in a Drama. That same Emmys, King won her fourth Emmy in six years for Outstanding Lead Actress in a Limited Series or Movie for *Watchmen*. Yahya Abdul-Mateen II, who played Abar's husband Cal Abar/Dr. Manhattan opposite King in *Watchmen*, won his first Emmy for Outstanding Supporting Actor in a Limited Series or Movie.

Nigerian-American actress Uzo Aduba, known for playing Suzanne "Crazy Eyes" Warren in *Orange Is the New Black*, won her third Emmy for Outstanding Supporting Actress in a Limited Series or Movie playing Shirley Chisholm, the trailblazing Black congresswoman who boldly ran for president in 1972, in the 2020 FX on Hulu series *Mrs. America*. The limited series revolved around white conservative Phyllis Schlafly and her role in the failure to pass the Equal Rights Amendment.

Notable network series with Black casts or Black leads on The CW include superhero series *Black Lightning* (2018–2021) from husband-and-wife team Salim Akil and Mara Brock Akil; the 2021 second season of its *Batwoman* series, where Black LGBTQ actress Javicia Leslie assumed the lead role; and the high school football drama *All American* (2018–) set in Los Angeles led by Nigerian American showrunner Nkechi Okoro Carroll.

From the moment the FX series *Snowfall*, co-created by John Singleton, premiered in July 2017, it offered a glimpse into how crack cocaine ravaged Black neighborhoods in 1990s Los Angeles. The Starz series *Power*, created by Courtney Kemp and backed by Curtis "50 Cent" Jackson, starred Omari Hardwick as drug kingpin James "Ghost" St. Patrick who wanted to go legit; the show captivated audiences for six seasons, from 2014 to 2020, creating a foundation for a *Power*-verse of

spinoff series, including the 2020 series *Power Book II: Ghost,* with Mary J. Blige and Method Man joining the St. Patrick clan after Ghost's death. By contrast, FOX's groundbreaking series *Empire,* from director/producer Lee Daniels and starring Oscar nominees Terrence Howard and Taraji P. Henson, launched in January 2015, but seemed to just fade away when it ended in April 2020.

## Network dramas

The courtroom drama series *All Rise,* starring Simone Missick, was most notable for being a trailblazing CBS series with a Black female lead when it launched in 2019. In 2021, Queen Latifah launched a reboot of *The Equalizer* and brought the network's count up to two. Shemar Moore's Los Angeles–set police drama *S.W.A.T.* launched in 2017. On ABC, the 50-Cent produced drama *For Life* was the lone ABC legal drama centered on criminal justice led solely by a Black man when it launched in 2020. In the long-running NBC juggernaut *This Is Us,* Sterling K. Brown's Randall Pearson and his wife Beth continued to serve as a rare symbol of Black love in a mainstream show with white actors.

## Highlighting Black LGBTQ stories

Patrik-Ian Polk is a hidden figure in carving a space for Black LGBTQ stories. The native Mississippian scored his biggest break with his 2000 film *Punks,* described by some as the gay *Waiting To Exhale,* referencing the 1995 film adapting Terry McMillan's 1992 novel of the same name. Polk followed up *Punks'* success with his groundbreaking series *Noah's Arc* in 2005 on LOGO, a cable network targeting the LGBTQ community.

Like *Punks,* *Noah's Arc* revolved around friendship and searching for love. Set in Los Angeles, Darryl Stephens played Noah, a struggling screenwriter, surrounded by a core group of friends — HIV/AIDS educator Alex (Rodney Chester), promiscuous boutique owner Ricky (Christian Vincent), and economics professor Chance (Doug Spearman). One of the notable developments of the show became Noah finding love with Wade (Jensen Atwood). Their relationship was the first consistent romantic one between two Black gay men chronicled on the small screen. Even though the series lasted just two seasons, it was highly influential. It even put a spotlight on the gay marriage ban with its 2008 film *Noah's Arc: Jumping the Broom,* almost a decade before the historic 2015 Supreme Court ruling striking it.

Prior to *Noah's Arc,* Michael Kenneth Williams' portrayal of Omar on the HBO series *The Wire* proved pioneering. Although fans of HBO's *Six Feet Under* (2001-2005) had seen Keith Charles, played by Matthew St. Patrick in a gay, interracial relationship, Williams hit different with Omar. One of the main reasons is that Omar, as a character, was television's first regularly portrayal of a Black gay man

living in the heart of the city. Prior to Williams, Black gay men from urban areas were stereotyped as being effeminate and unable to protect themselves in rougher environments. Omar dispelled all those myths, helping to widely transform people's perceptions of Black gay men overall.

Netflix really opened up representations of Black lesbians and transwomen with *Orange Is the New Black* (2013-2019). The prison drama made Laverne Cox, the transgender actress who played Sophia Burset, a star. It also regularly featured the Black lesbian characters Poussey Washington, played by Samira Wiley, who was later outed in her actual life and embraced, and Suzanne "Crazy Eyes" Warren, played by Uzo Aduba, who won two Emmys for Outstanding Supporting Actress for her role.

Through *Empire* (2015-2020), Oscar-nominated director Lee Daniels, the series co-creator, challenged homophobia in the Black community. As the gay middle son of superstar rapper and record label owner Lucious Lyon, Jamal Lyon, played by Jussie Smollett, served as the show's main catalyst exploring a myriad of issues, including homophobia in hip hop as well as within the Black family. Evolution became one of the show's greatest strengths as audiences followed Lucious from shunning his son because of his sexuality at the show's beginning to his acceptance of both Jamal and the man he loved by show's end. Daniels kept that momentum going with *Star,* another musically driven series but about a girl group trying to make it in the industry. One of the show's major storylines revolved around salon owner and music manager Carlotta, played by Queen Latifah, not accepting her transgender daughter Cotton, played by trans actress Amiyah Scott. The show also featured gender nonconforming actor Miss Lawrence as Miss Bruce.

FX made their biggest mark with the Black LGTBQ drama *Pose*, which premiered in 2018. Co-created by openly queer Afro-Latino writer/producer Steven Canals with TV powerhouses Ryan Murphy and Brad Falchuk (whose credits include *Glee* and *American Horror Story*) centered its drama on the 1980s and 1990s, a period when the Black LGBTQ community was so often erased. With openly queer and trans actors such as Billy Porter (who won the Primetime Emmy for Outstanding Lead Actor in a Drama Series in 2019), Angelica Ross, Mj Rodriguez, Indya Moore, and Dominique Jackson, *Pose* provided much-needed representation and a voice for the Black and brown LGBTQ community and beyond, also pushing trans writer/producer/director Janet Mock to the forefront. The series, whose filming was disrupted by COVID in 2020, marked its end with its third season in 2021.

LGBTQ writer/producer Lena Waithe — who rose to prominence as the first Black woman to win an Emmy for comedy writing with her episode of comedian Aziz Ansari's *Master of None* based on her own coming out experience — pushed the envelope by incorporating Black LGBTQ prominently into Black shows. *Boomerang*, the small screen reimagining of the hit film that premiered on BET in 2019,

included the sexually fluid and active character Ari (Leland B. Martin) and former stripper and lesbian Tia (Lala Milan).

*The Chi*, the Showtime series Waithe created with the backing of rapper Common about their shared hometown, also incorporated prominent Black LGBTQ storylines. In its third season in 2020, Waithe even played the show's mayor, mirroring Chicago's openly gay mayor Lori Lightfoot. That season also featured the groundbreaking storyline of a cisgender Black man, played by R&B singer Luke James, in a romantic relationship with a Black trans woman. Waithe's semiautobiographical comedy series *Twenties*, following Hattie (Jonica T. Gibbs), a queer Black girl with two straight best friends, as she tries to make her mark in Hollywood, premiered on BET in 2020.

The prominence of LGBTQ characters like Uncle Clifford, a nonbinary strip club owner who dresses femininely while wearing a full beard, on the Southern strip club drama, *P-Valley* on Starz, and Michael Kenneth Williams' Montrose, the closeted father of the show's leading character Atticus on the HBO limited series *Lovecraft Country* in the summer of 2020, offered new hope. The presence of these characters and the focus placed on their lives in their respective shows suggested that Black TV had entered a new era in which Black LGBTQ experiences were viewed as integral to the Black experience at large.

One of the rare popular mainstream LGBTQ reality shows, RuPaul's Drag Race, spearheaded by LGBTQ pioneer RuPaul since 2009, has been groundbreaking in its depiction of drag queens, many of them Black, as they seek to be "America's next drag superstar." The show, for which RuPaul is an executive producer and host, won several Primetime Emmys for Outstanding Reality-Competition Program and Outstanding Host for a Reality or Reality-Competition Program.

## Black women TV executives

In 2020, Black women executives especially made major moves in mainstream television, offering hope that more opportunities would become available to Black creators across wider platforms. Former TV One head Wonya Lucas took the helm of Crown Media Family Networks, whose flagship is the Hallmark Channel; Tara Duncan took over Freeform; Vanessa Morrison became the president of streaming at Walt Disney Studios Motion Picture Production, particularly over Disney Plus; and Pearlena Igbokwe and Channing Dungey, who made history becoming ABC Entertainment Group president in 2016, became chairs of Universal Studio Group and Warner Bros. Television Group, respectively, placing the power of virtually all TV production in this country and the world in their hands.

Meanwhile, Michelle Rice became president of both TV One and CLEO in October 2020, Tina Perry took over as OWN president in 2019, and Michelle Sneed became president of production and development of Tyler Perry Studios in 2018.

# The Next Level: Building Black Television and Film Empires

In just a few decades, two Mississippi-born media powerhouses, Robert Johnson and Oprah Winfrey, broke through television's glass ceiling. Johnson built the formidable cable network Black Entertainment Television (BET), and talk show host Oprah Winfrey became one of the most powerful individuals in television history, eventually parlaying that power into the Oprah Winfrey Network (OWN). Aspire, Revolt, The Africa Channel, CLEO, and Bounce, in addition to TV One, are just a handful of the cable networks to specifically target Black audiences. BET, however, began the dance, with OWN and Tyler Perry arguably creating a move all their very own.

## The billion-dollar BET

In 1980, former cable industry lobbyist Robert Johnson launched BET as a weekly, two-hour Friday-night block on USA Network (a 2002 divorce from his wife of 33 years, Sheila Crump Johnson, resulted in her mainstream recognition as a BET cofounder). Three years later, BET was a full-fledged, 24-hour network of its own. Even with its shaky history with Black viewers — the network was frequently criticized for its abundance of sexually charged rap videos — BET has many milestones. Four of its shows — *Bobby Jones Gospel*, launched in 1980; *Rap City*, launched in 1989; *ComicView*, launched in 1992; and *106 & Park*, launched in 2000 — are among the longest running Black shows in television history.

**REMEMBER**

BET was also one of the first Black-owned companies to go public. Over the years, BET attempted public affairs shows such as the nightly talk program *BET Tonight* (which launched the career of PBS host Tavis Smiley), *BET Nightly News*, and *Teen Summit*. BET's success inspired other channels, such as TV One, a joint venture between Black radio giant Radio One and cable giant Comcast. In 2000, media giant Viacom purchased BET for $3 billion.

In the 2010s, BET, first under Debra Lee's leadership until Scott Mills took over as president in 2018, successfully shook up its programming in the 2010s with various series and mini/limited series, including the Mara Brock-Akil original series *Being Mary Jane* (2013–2019), starring Gabrielle Union; *The New Edition Story* (2017); and the Lena Waithe comedies *Boomerang* (2019–present) and *Twenties* (2020–present). The Tyler Perry series *The Oval* and *Sistas* both launched in 2019.

Two shows helped launched the network's streaming platform BET Plus in 2019: *Girls Trip* co-writer Tracy Oliver's Black–cast series adaptation of the 1996 film *The First Wives Club*, starring Jill Scott, Ryan Michelle Bathe, and Michelle Buteau,

and the Will Packer–produced comedy *Bigger*, centered on the lives of Black millennials who are alums of Historically Black Colleges and Universities as they navigate love and career. In 2015, Johnson launched the Urban Movie Channel streaming service, acquired by AMC Networks in 2018. In 2021, the service changed its name to ALLBLK.

# The big "O"

Born poor in Mississippi and raised in Milwaukee and Nashville, Oprah Winfrey landed her first media job in radio at age 17. Before leaving for Chicago in 1984, where she dethroned Phil Donahue, the reigning king of talk, she cohosted a talk show in Baltimore. In 1985, *The Oprah Winfrey Show*, which tackled issues from sexual molestation to racism and sexism, went national.

An avid reader, Winfrey gave the publishing industry a boost with her Oprah Winfrey Book Club; her recommendation literally sent books to the top of the best-seller lists.

As an actress, Winfrey was nominated for both the Oscar and Golden Globe for her role as Sophia in the film version of *The Color Purple* (1985), which she produced as a Tony Award–winning Broadway musical in 2006. Early film and TV projects Winfrey produced include *Beloved* (1998) and Zora Neale Hurston's *Their Eyes Were Watching God* (2005), starring Halle Berry, for ABC.

One of Winfrey's biggest pivots in that space, however, came when she partnered with Discovery Inc. to create OWN in 2011. The network floundered initially and didn't find its footing until it started to target Black audiences. The reality series *Welcome to Sweetie Pie's* (2011–2018), starring Ms. Robbie Montgomery (a former Ike and Tina Turner backup singer turned soul food queen) gave the network a life, attracting Black audiences.

Building on that, OWN added *Iyanla: Fix My Life,* starring life coach and author Iyanla Vanzant, in 2012. Winfrey struck a deal with longtime friend Tyler Perry to bring two shows to the network in 2013. Perry's soapy melodrama *The Haves and the Have Nots* was a ratings sensation that helped give the OWN network more solid footing. The addition of *Queen Sugar*, the Louisiana-set drama created by Ava DuVernay from Natalie Baszile's 2014 novel, and the Memphis-set megachurch drama *Greenleaf,* which Winfrey tapped white writer and showrunner Craig Wright to create in 2016, helped the network solidify a winning content strategy centering on Black women, particularly in the South.

Homing in on love and relationships, the network successfully launched the docuseries *Black Love*, featuring celebrity and noncelebrity couples as they describe how they met, their marital challenges, and their triumphs in 2017; the dating

relationship show *Ready For Love* from successful Black film producer Will Packer in 2018; and the reality show *Love & Marriage: Huntsville*, featuring three couples in Huntsville, Alabama in 2019.

# Tyler Perry builds his own table

Born Emmitt Perry Jr. in New Orleans on September 13, 1969, Tyler Perry frequently felt unsafe as a child in large part due to his abusive father. Watching *The Oprah Winfrey Show* inspired Perry, a high school dropout who got his GED, to capture his daily thoughts and experiences in letters to himself. That eventually led him to write his first play, *I Know I've Been Changed*, in 1992 and produce it himself. The crowds initially didn't come, but Perry kept going and relocated to Atlanta after attending Freaknic (also Freaknik), a popular spring break event in Atlanta dating back to the early 1980s, and seeing Black people in important and powerful roles, including as mayor and business owners. He created 13 plays over 13 years, birthing the character Mabel "Madea" Earlene Simmons, inspired by his mother and his aunt.

## Going to the movies

In 2005, Perry bet on himself: Already successful through his stage plays, where *Madea* was a hit, he put in his own money to finance the 2005 film version of his successful touring play, *Diary of a Mad Black Woman*. The movie directed by Darren Grant starred Kimberly Elise, Shemar Moore, and Perry himself as the irreverent, not-so-grandmotherly Madea. It hit number one at the box office and Perry kept rolling, amassing at least 10 number-one films, including *Madea Goes to Jail* (2009) and *Boo 2! A Madea Halloween* (2017), which topped Tom Cruise's *Jack Reacher: Never Go Back* on opening weekend.

Despite heavy criticism from his white and Black critics, who often straight-out declared his work trash, Perry, thanks to his underserved base of mostly Black churchgoing women in the South, rarely released a film that didn't make the top five opening weekend. Other actors Perry has worked with include Idris Elba, Gabrielle Union, Viola Davis, Taraj P. Henson, Jurnee Smollett, Sanaa Lathan, Angela Bassett, Alfre Woodard, Vanessa L. Williams, Derek Luke, Thandie Newton, Blair Underwood, Lynn Whitfield, Boris Kodjoe, and Cicely Tyson.

For his 2010 film adaptation of Ntozoke Shange's classic 1975 *choreopoem* (a poem presented as a play), "for colored girls who have considered suicide / when the rainbow is enuf," titled simply *For Colored Girls*, Perry assembled an outstanding roster of talent, including Whoopi Goldberg, Thandie Newton, Phylicia Rashad, Kerry Washington, Anika Noni Rose, Loretta Devine, Kimberly Elise, Janet Jackson, and Macy Gray, packing more Black actresses in one film than Hollywood had

used in its major releases all year. By 2021, Perry's films, which include *Why Did I Get Married?* (2007) and its sequel *Why Did I Get Married Too?* (2010) starring Jill Scott, Janet Jackson, and a non–Madea Tyler Perry, had exceeded $1 billion in box office receipts.

## Signing TV deals

Perry turned his eye to TV early, creating *Tyler Perry's House of Payne* (2006–2012), where he signed a $200 million, 100-episode deal for TBS, and *Tyler Perry's Meet the Browns* (2009–2011). By 2008, Perry had established his first studio in two former Delta Airlines buildings, with 200,000 square feet of set and office space, in the predominantly Black Greenbriar area of Southwest Atlanta.

Just as he was moving out of his TBS deal, Perry struck an exclusive multi-year partnership with his friend Winfrey and OWN to bring content to the network, resulting in the soapy melodrama *The Haves and the Have Nots,* based on his 2011 play of the same name. *The Haves and the Have Nots* centers on three families, with the Young family, which is Black, on the "nots" spectrum. The Youngs include Crystal Fox as Hanna the mother and Tyler Lepley and Tika Sumpter as her children, Benny and Candace. On May 28, 2013, the show became the very first scripted show to premiere on OWN.

Just as Perry was winding down his deal with OWN, for which he had created more than 500 episodes of programming since 2013, he struck another deal with Viacom (later ViacomCBS) in 2017: He would essentially create 90 episodes of original drama and comedy series annually primarily for BET and BET Plus (the streaming service in which he also financially partnered) and offer Paramount Pictures first-look rights to his feature films until 2024. On October 23, 2019, Perry premiered two series, his own White House drama *The Oval* and *Sistas,* which tells the story of four best friends primarily struggling with their love lives.

## Opening Tyler Perry Studios

A little more than two weeks before Perry premiered his shows on BET, he hosted an extravagant, once-in-a-lifetime star-studded opening of his dream Tyler Perry Studios, located on the historic Fort McPherson military base (once utilized by Confederate soldiers) on October 5, 2019. Perry purchased the 330-acre property with some controversy in a deal facilitated by Atlanta Mayor Kasim Reed in 2015 to create the first major Black-owned studio in the country as well as one of the largest and most impressive of any studio.

In addition to the 40 buildings — including one in which President Franklin Delano Roosevelt once stayed — there are 12 state-of-the-art sound stages named

for Black Hollywood trailblazers, including Cicely Tyson, Oprah Winfrey, Sidney Poitier, Harry Belafonte, and Spike Lee, that even the Atlanta-filmed *Black Panther* helped christen by being among the first to film there. There's also a replica of the White House at Tyler Perry Studios. Beyoncé and Jay-Z, Halle Berry, Whoopi Goldberg, Samuel L. Jackson, Denzel Washington, Cicely Tyson, Viola Davis, former President Bill Clinton and Secretary Hillary Clinton, Debbie Allen, Phylicia Rashad, Jennifer Hudson, Patti LaBelle, Chris Tucker, Taraji P. Henson, and more were among the 800 guests in attendance for the two-day event that included a gospel brunch.

**IN THEIR OWN WORDS**

"While everybody was fighting for a seat at the table talking about #OscarsSoWhite, #OscarsSoWhite, I said, 'Y'all go ahead and do that,'" Perry shared during his acceptance speech for the Ultimate Icon Award at the 2019 BET Awards in Los Angeles on June 23, about three months before his Tyler Perry Studios grand opening on October 5. "But while you're fighting for a seat at the table, I'll be down in Atlanta building my own. Because what I know for sure is that if I could just build this table, God will prepare it for me in the presence of my enemies."

# Chapter **19**

# Winning Ain't Easy: Race and Sports

Looking at the NBA, NFL, and other popular sports leagues today, it's hard to imagine a time when Black Americans weren't welcomed in the general sports world. In a time when racism made no exceptions for talented athletes, barriers against Black Americans were as prevalent in sports as they were in any other part of American society. Therefore, sports became an important civil rights battlefield, with the success of early Black athletes resonating far beyond the individual.

This chapter covers the many sports arenas, such as baseball, boxing, and track and field, in which Black American athletes have not only participated but excelled. It also explores some of their milestones and highlights important figures, both historically and in the contemporary sports world, who contributed both to their respective sports and to overall social change.

## Baseball

The first known Black American baseball game occurred in 1860 when the Weeksville of New York and the Colored Union Club played in Hoboken, New Jersey. James H. Francis and Francis Wood formed the Pythians in the Philadelphia area

in the 1860s, but when the Pythians applied to the National Association of Base Ball Players (NABBP) for official recognition in 1867, that organization resolved to ban any club that included Black Americans. Other baseball organizations, particularly professional ones, didn't have an outright ban against Black American players. As a result, Bud Fowler, William Edward White, Moses Fleetwood "Fleet" Walker, and his brother Welday Walker played baseball at a high level in the late 19th century.

Playing baseball in overwhelmingly white environments wasn't easy. At first, many white players tolerated the few Black players. As the 20th century drew closer, however, anti-Black attitudes intensified. In the International League, an early minor league in which Walker and Fowler played, some white players refused to play against the "colored" talent of opposing teams. Others wouldn't pose next to their own Black teammates for team pictures. In 1887, International League owners voted against extending contracts to future Black players but agreed to honor the contracts of existing players. When the Supreme Court officially sanctioned segregation in its 1896 *Plessy v. Ferguson* decision (refer to Chapter 7), Black Americans didn't play alongside white players in Major League Baseball (MLB) until Jackie Robinson broke that color line in 1947.

Thanks to early player/manager/sportswriter King Solomon White, better known as Sol White, early Black American baseball history wasn't lost. White published his seminal work, *History of Colored Base Ball*, in 1907.

# The Negro Leagues

Professional Black American baseball players didn't solely turn to predominantly white baseball clubs to play. In 1885, the Babylon Black Panthers (of New York), later renamed the Cuban Giants, became the first Black professional team. Shortly thereafter, the first Negro League took root. Others soon followed. These leagues, the key personalities that populated them, and other developments paved the way for Jackie Robinson's historic entry into Major League Baseball.

Players in the Negro Leagues came mostly from the East, Midwest, and South, but others came from Puerto Rico, Cuba, and other nearby countries.

## Famous leagues

The Negro Leagues, which included several leagues composed of countless baseball clubs, some more successful than others, really shone in the early 20th century. But the idea of independent Black baseball began before then with early organizations such as the Southern League of Colored Base Ballists, formed in 1886, and the National Colored Base Ball League, established in 1887.

# WOMEN AND GIRLS TAKE THE FIELD

In the 1940s and '50s, three women, Toni Stone, Connie Morgan, and Mamie Johnson, played in the Negro Leagues. Lydia R. Diamond, the Black woman playwright known for plays such as *Stick Fly,* wrote a play titled *Toni Stone* chronicling and championing her amazing journey. It was performed for the first time in 2019.

In 2014, 13-year-old little leaguer Mo'Ne Davis, from Philadelphia, became the first girl in Little League World Series history to pitch a winning game as well as pitch a shutout in postseason. She is the first Black American girl to play in the Little League World Series and just the fourth American girl to ever play in the series overall. This milestone was achieved during the 75th anniversary of Little League Baseball. That same year, Davis became the first Little Leaguer to appear on the cover of *Sports Illustrated*.

In 2021, Bianca Smith became a minor league coach for the Boston Red Sox, making her the first Black woman to coach in Major League Baseball (MLB). And prior to Kim Ng becoming MLB's first female general manager in 2020, Elaine Weddington Steward, who grew up in Queens in New York City, became the woman with the highest ranking in MLB when the Boston Red Sox appointed her assistant general manager in 1990. Her MLB career, spanning more than 30 years, certainly makes Steward, who rose to vice president and counsel of the Red Sox, a pioneering executive.

Interestingly, the short-lived 2016 Fox TV series *Pitch* picked Black Canadian-American actress Kylie Bunbury to star as Ginny Baker, the first woman to become an MLB pitcher, offering hope that a woman would play for MLB for real.

Equally important in developing early Black baseball were the Colored All Americans, a traveling barnstorming unit pitting the legendary Cuban Giants against their rivals, the New York Gorhams. Both teams gained admission to the white Middle States League before later hitting the road. The following leagues, however, directly inform what most people think of as the Negro Leagues:

>> **Negro National League:** The Black workers substituting for the depleted white force during World War I gave Black baseball enough of a financial boon to help create the Negro National League in 1920, with Andrew "Rube" Foster serving as league president. Founding teams included Foster's Chicago American Giants, the legendary Kansas City Monarchs, and the St. Louis Giants.

In 1921, the semi-pro Negro Southern League, whose impressive roster included pitcher Satchel Paige, strengthened the NNL, but it still folded in 1931. The next year, Homestead Grays' owner Cumberland Posey's East-West League tried to replace the NNL but also failed. In 1933, reputed gangster and Pittsburgh Crawfords' owner Gus Greenlee successfully revived the NNL until 1948.

# ANDREW "RUBE" FOSTER

Considered the father of Black baseball, Texas-born Andrew "Rube" Foster began as a pitcher with the Cuban X-Giants. When he led them to victory over the Philadelphia Giants in the 1903 Colored Championship, the Philadelphia Giants' white owner, H. Walter Schlichter, hired Foster, and the very next year they topped the X-Giants. In 1907, Foster left the Philadelphia Giants, which early Black baseball historian Sol Whilte led, to manage and play for the Chicago Leland Giants.

On the field, Foster created a more aggressive team known for seeking extra bases. He also fine-tuned the pitchers. Off the field, he took over bookings and increased the team's gate take from 10 percent to 40 percent. Confident of his skills, Foster threatened to leave the team if owner Frank Leland didn't step away from all baseball operations, but Leland refused. Eventually, Foster gained legal control of the Leland Giants name, forcing Leland to start the Chicago Giants. Foster's Leland Giants later became the Chicago American Giants.

In 1920, Foster created the National Negro League (NNL) but became mentally ill in the late 1920s and died in 1930. Without him, the league faltered and folded in 1931. Revived in 1933, the NNL thrived until 1948.

>> **Eastern Colored League:** Spearheaded in 1923 by Pennsylvania's Ed Bolden (owner of the Hilldale Daisies) and Nat Strong (a white businessman), the Eastern Colored League (ECL) rivaled the NNL. The two leagues reconciled in 1924, and agreed to play each other in the Negro League World Series. The ECL folded in 1928.

>> **Negro American League:** Considered the last great Black baseball league, the Negro American League, formed in 1937, is the league for which Jackie Robinson played. Dr. J.B. Martin, a Memphis dentist who, along with his brother B.B. Martin, built a baseball powerhouse with the Memphis Red Sox, led Black baseball during one of its most explosive periods. Even after Major League Baseball began raiding its rosters, Martin tried to keep the league going through the 1950s before folding in the early 1960s.

## Key people

Cool Papa Bell, Oscar Charleston, Martín Dihigo, and Buck Leonard, all in the Baseball Hall of Fame, are just a handful of the great players that electrified the Negro Leagues. Two of the most famous players from that era, however, may just be Josh Gibson and Satchel Paige:

>> **Josh Gibson:** Baseball historians regularly place catcher Josh Gibson, who played with the Homestead Grays and Pittsburgh Crawfords among baseball's all-time greatest hitters. Often compared to Babe Ruth, the Georgia-born Gibson, who had a career batting average that exceeded .350, reportedly hit nearly 800 home runs throughout 17 years. Sadly, he died at age 35, just months before Major League Baseball (MLB) integrated.

>> **Satchel Paige:** Born in Mobile, Alabama, Leroy "Satchel" Paige, the Negro Leagues' most well-known pitcher, had an illustrious career that included stints with the Pittsburgh Crawfords and the Kansas City Monarchs. His crowd-pleasing showmanship was such a draw that he was often loaned out to help struggling teams improve their attendance records and stay afloat. Paige reportedly pitched 300 shutouts. MLB's oldest rookie at age 42 in 1948, he became the first Black pitcher to pitch in the 1948 World Series, which his club, the Cleveland Indians, won.

## Key events

In addition to regular play, the Negro Leagues hosted many special games. The early prototype for generating interest in Black baseball was *barnstorming*, the practice of traveling around and presenting special events. Other crowd-pleasing contests also developed. As early as 1896, the first Colored Championships occurred, and there were similar contests throughout the Negro Leagues' long history:

>> **All-Star games:** These games were the Negro Leagues' biggest draw. First held in 1933, the All-Star game allowed fans to select deserving players and often attracted more than 40,000 fans.

>> **Contests between all-Black and all-white teams:** Black players couldn't play alongside white players, but many did play against and beat white players.

**REMEMBER**

Negro Leagues players and their many Black owners were well aware of America's racial climate. Many, like the Newark Eagles, which hosted Anti-Lynching Day in 1939, often stepped up in civic matters.

## The demise of the Negro Leagues

The integration of MLB devastated the Negro Leagues as more and more players, following Jackie Robinson's lead, headed to the majors. Larry Doby, Don Newcombe, Willie Mays, Ernie Banks, and Henry "Hank" Aaron were just some of the distinguished MLB players with Negro League roots (see the later section "The modern era" for details on some of these players). In 1958, the Negro American League played its last game. The Indianapolis Clowns, the team Hank Aaron initially played for, continued to play exhibition games into the 1980s, but Black baseball never recovered.

## NEGRO LEAGUES PLAYERS IN THE BASEBALL HALL OF FAME

It took years of intense debates, including a plea from baseball great Ted Williams and the 1970 publication of Robert Peterson's influential *Only the Ball Was White,* before the Baseball Hall of Fame began inducting Negro Leagues players. In 1971, Josh Gibson, Cool Papa Bell, Satchel Paige, and Oscar Charleston were among the first Negro Leaguers inducted. Hall of Fame recognition, along with the Negro Leagues Baseball Museum in Kansas City, Missouri, has ensured that this critical chapter in American sports history won't be forgotten. Nearing the close of 2020, MLB announced that they would add Negro Leagues to their official records.

## Jackie Robinson: Integrating baseball

Brooklyn Dodgers President and General Manager Branch Rickey challenged MLB's unwritten policy against Black players when he signed the Kansas City Monarchs' Jack Roosevelt "Jackie" Robinson. On April 15, 1947, the 28-year-old Robinson debuted as a Brooklyn Dodger and changed modern-day baseball forever. Over the course of his ten seasons with the Dodgers, the team won six pennants and a World Series. Robinson, who led the league in stolen bases his first year, achieved individual honors including Rookie of the Year and National League MVP.

While it has generally been acknowledged that Robinson wasn't the Negro Leagues' best player, Rickey believed that Robinson, who had attended UCLA and served in the military, could withstand the abuse that would accompany integrating MLB. Rickey made Robinson promise that he wouldn't retaliate against any racial provocations or publicly address them for an entire year. Well aware that Robinson once faced court-martial for protesting segregation in the army, Rickey sent Robinson to a minor league club in Canada to prep him for playing ball in MLB.

Before Robinson even suited up, white players from his own squad and others considered protesting his entry. On the field, white fans taunted him with racial slurs. He also received many death threats. Still, in the face of such pressures, Robinson persevered and excelled. By the end of his first season, Robinson, who enjoyed a faithful Black fan base, could also count on his ever-growing white fan base.

## "QUEEN OF THE NEGRO LEAGUES": EFFA MANLEY

Much more than an owner's wife, Effa Manley, who many assumed to be Black, was a player advocate who took an active role in managing the Newark Eagles, often fighting for better schedules and salaries. Civic-minded, Manley, who insisted she was white but raised in biracial households, served as treasurer of the NAACP's Newark chapter and involved the team in many civil rights causes. When MLB began raiding the Negro Leagues rosters, Manley was outspoken about MLB compensating owners like her and her husband, Abe Manley. Although Manley, who kept a scrapbook of Black baseball's glory days, died in 1981, she became the first woman inducted into the Baseball Hall of Fame in 2006.

## The modern era

MLB wasted little time embracing Black players. Following are a few prominent players from the 1950s to the end of the 1970s:

>> **Willie Mays:** This legendary center fielder for the New York–turned–San Francisco Giants amassed an amazing 3,283 hits, 660 home runs, 12 Gold Gloves, 24 All-Star game appearances, and four World Series appearances (and 1 win) during a major league career that began in 1951 and ended in 1973.

>> **Bob Gibson:** In the 1967 World Series, St. Louis Cardinals pitcher and eventual two-time Cy Young winner Bob Gibson allowed just three earned runs in three complete game victories and hit an important home run himself. In 1968, he set a World Series record by striking out 17 Detroit Tigers in the very first game.

>> **Curt Flood:** Outstanding player Flood made his mark off the field when he refused a 1969 trade from the St. Louis Cardinals to the Philadelphia Phillies, taking his case all the way to the Supreme Court. Although he lost the legal battle, many agree that he opened the door to today's era of free agency. As a result, the salaries of today's baseball players represent a much larger portion of their team's and the league's overall wealth.

>> **Hank Aaron:** Before 53,775 fans, on April 8, 1974, Atlanta Braves right fielder Hank "the Hammer" Aaron broke Babe Ruth's long-standing home run record of 714 home runs. When Aaron retired from baseball in 1976, he had 755 career home runs.

>> **Reggie Jackson:** Known as Mr. October and considered Major League Baseball's first Black megastar, Reggie Jackson played in five World Series and sealed his legend in the final game of the 1977 World Series. Playing for the

New York Yankees, Jackson hit three home runs off three different pitchers. His two MVP World Series honors for two separate teams, the Oakland Athletics and the New York Yankees, also placed him in the elite company of Babe Ruth.

From the 1980s and 1990s into the 2000s, quite a few Black American baseball players accepted the torch. In his first year of eligibility, longtime San Diego Padres right fielder Tony Gwynn got the go-ahead for the Baseball Hall of Fame. Oakland Athletics player Rickey Henderson, baseball's stolen-base king, was inducted in 2009. Seattle Mariner great Ken Griffey Jr., who earned his spot in Cooperstown when he surpassed Mickey Mantle on baseball's home run list, was officially inducted in 2016. Despite his reign as baseball's home run king with 762 career home runs and arguably being the greatest player of all time, former Pittsburgh Pirates and longtime San Francisco Giants franchise player Barry Bonds may never be inducted into the Baseball Hall of Fame due to longtime allegations of steroid use. By contrast, former New York Yankees shortstop Derek Jeter, a five-time World Series champion whose father played shortstop at Fisk University, was elected to the Hall of Fame his first time out by a vote of 396 out of 397 in 2020. In 2017, Jeter, who played for the Yankees from 1995 to 2014, became a part-owner and CEO for the Florida Marlins, a first for a former Black MLB player. NBA all-time great Magic Johnson became an owner in the LA Dodgers in 2012.

# Basketball

It didn't take long for the U.S. to embrace basketball, invented by Canadian-born James A Naismith in 1891. By the 1900s, the U.S. had a few professional teams. In 1902, Massachusetts native Harry "Bucky" Lew became the first Black American pro player. Harvard-educated physical education instructor Edwin Bancroft Henderson, who many call "the father of Black basketball," introduced the game to Black schools in Washington, D.C. in 1904.

**HISTORICAL ROOTS**

Henderson recognized basketball's potential in the area of civil rights. Through the all-Black Interscholastic Athletic Association of the Middle States (ISAA), established in 1905, Henderson encouraged competitive basketball among Black Americans, as did New York's Smart Set Athletic Club of Brooklyn and the St. Christopher Club of New York City. The latter organizations, along with three others, formed the Olympian Athletic League in 1907. For years, these organizations fostered Black basketball talent and took it to new heights, planting the seeds for both collegiate and professional play among Black Americans. Even today, basketball's communal spirit thrives as basketball courts and programs are very prominent throughout the nation, particularly in urban areas.

## HOLCOMBE RUCKER AND RUCKER PARK

In 1946, longtime NYC Department of Parks worker Holcombe Rucker created a neighborhood basketball program to keep kids off Harlem's mean streets. Rucker, whose motto was "each one, teach one," emphasized education and checked report cards to decide who played in his program. He even tutored his charges in the fundamentals of English and life. With his help, over 700 program participants attended college on athletic scholarships.

Rucker's idea of pitting professional players like Wilt Chamberlain and Nate "Tiny" Archibald against celebrated local talent like Richard "Pee Wee" Kirkland and Earl "The Goat" Manigault (whom Don Cheadle played in the 1996 HBO film *Rebound*) made his tournaments legendary. Even after Rucker died in 1965, the tournaments survived, relocating to what became Rucker Park in 1974.

Concerned about injuries, NBA players stayed away from Rucker Park until the Entertainers Basketball Classic brought them back in the 1980s. Today, the park is the site of epic court battles between street ball talent and NBA legends like Allen Iverson and Kobe Bryant. Music luminaries such as P. Diddy and Fat Joe have sponsored teams. Music from hip-hop DJs and colorful and funny commentary also distinguish the Rucker Park experience.

# College ball

Basketball eventually evolved into a viable option for Black American men in particular to attend college and then later as a means to a professional career. Following is a quick glimpse into the college game and its overall impact.

## Black colleges

Black colleges quickly embraced basketball and provided the first opportunity for Black Americans, male and female, to play the sport. Black coaches and schools were among basketball's early innovators, and the most enduring legacies have come from two head coaches:

>> **Tennessee State's John B. McClendon:** A sports civil rights pioneer, McClendon cofounded the CIAA Tournament in 1946, Black college basketball's premier contest. He made a significant breakthrough when his team beat a white school for a national championship in 1957. Credited with creating fast-break basketball and the half-court press, McClendon coached all-Black teams that beat all-white teams during the height of racial segregation. In 1961, McClendon, who spearheaded other Black college programs,

became the first Black coach of a professional mainstream team in 1961. In 1966, he became the first Black coach hired by a predominantly white college, Cleveland State. He was also the first Black Olympic coach in 1968, as well as the first Black coach of the American Basketball Association's Denver Rockets in 1969.

» **Winston-Salem State's Clarence "Big House" Gaines:** Gaines's teams won 12 CIAA titles in his 47-year tenure as head coach, with him amassing 828 wins. Both Black and white college teams absorbed his fast-breaking style of play with athletic and fast players. NBA great Earl "the Pearl" Monroe and sports commentator Stephen A. Smith are two players he coached.

## Mainstream colleges

Prior to World War I, Fenwick Watkins, Cumberland Posey, and Paul Robeson played basketball on predominantly white teams at predominantly white universities. Such strides continued into the 1930s, when Columbia University's George Gregory Jr. became the first Black All-American basketball player and Long Island University's William "Dolly" King became the first Black player to participate in the National Amateur Athletic Union. William Garrett continued that movement into the Midwest when he integrated the Big Ten at Indiana University in 1947.

Loyola University Chicago ended the customary practice of playing only three Black players at any given time, regularly playing four players and sometimes five. In 1963, in the NCAA Championship game, Loyola started four Black players and played five in its upset win over Cincinnati, which was looking for a three-peat. College basketball's racial walls were torn down completely when Texas Tech, as dramatized in the 2006 film *Glory Road,* went with an all-Black starting lineup to defeat the all-white basketball powerhouse University of Kentucky in the 1966 NCAA championship. Until Texas Tech's monumental victory, there were still a number of Southern colleges that didn't play Black players at all.

Since then, Black Americans have dominated college basketball. Along the way, great coaches like Georgetown's John Thompson, former Temple University coach John Chaney, and former University of Arkansas coach Nolan Richardson paved the way for other Division I Black college coaches.

## Pro ball

Early Black men's basketball flourished, especially in the cities, during what is often referred to as the Black Fives Era. Professional play emerged as early as 1909, with Pittsburgh's Monticello Rifles, owned by Cumberland Posey, being the most popular team. Countless college students emulated the players' fast-paced style.

In 1913, Posey created the Loendi Big Five in Pittsburgh. This team ruled Black basketball until Robert Douglas formed the New York Renaissance, a Harlem-based basketball powerhouse. Known as the Rens, they proved their superiority by defeating the National Basketball League (NBL) champion all-white Oshkosh All-Stars in the World Professional Basketball Tournament in 1939. During the 1948–1949 season, the franchise moved to Ohio and joined the NBL, becoming the first all-Black franchise in a white league. Although the NBL folded, the Dayton Rens/New York Rens are in the Naismith Memorial Basketball Hall of Fame in Springfield, Massachusetts.

**HISTORICAL ROOTS**

Because the American Basketball Association excluded Black Americans when it launched in 1925, players from Chicago's Wendell Phillips High School formed the Savoy Big Five in 1927. Renamed the Harlem Globetrotters when agent Abe Saperstein took over, the team suffered many racial indignities during its journey to become a credible basketball team. In 1940, the Harlem Globetrotters defeated the Chicago Bruins in the World Professional Basketball Tournament and then beat the World Champion Minneapolis Lakers, now in Los Angeles, two out of three times in 1948 and 1949. Despite those competitive beginnings, the Harlem Globetrotters became a novelty act in later years.

## Integration on the court

Prompted by World War II's effect on the white player pool, the NBL chose to welcome Black players instead of folding. In 1942, the Toledo Jim White Chevrolets in Ohio signed four Black players, while the Chicago Studebakers signed five former Harlem Globetrotters. Curiously, though, the NBL had only one Black player in 1943. Still the move was positive, as the West Coast professional leagues began integrating in 1944. The Basketball Association of America (BAA), which banned Black players in 1946, merged with the NBL to create the National Basketball Association (NBA) during the 1949–1950 season, making integration the norm. Chuck Cooper, signed by the Boston Celtics, became the NBA's first Black draft pick, though the Washington Capitols' Earl Lloyd was the first Black American to play in the NBA.

Unlike other sports, the NBA had Black coaches and general managers early. Bill Russell opened the doors as the NBA's first Black coach. Of the many who've followed in his footsteps, his former college teammate K.C. Jones (who also coached the Celtics) and Lenny Wilkens (who followed Russell as the Seattle Supersonics' coach) both won NBA championships.

Having Black Americans in upper management also wasn't rare in the NBA. Elgin Baylor, Joe Dumars, and Isiah Thomas are just three former players who have been attached to high-profile teams. In 2003, the NBA made history when Black Entertainment Television co-founder Robert Johnson became the nation's first Black

majority owner of an NBA franchise with the Charlotte Bobcats. That franchise reached another milestone in 2010 when Michael Jordan, who previously owned a minority stake became team owner of what is now the Charlotte Hornets, making him the first former NBA player to be a majority owner of an NBA team.

## Great players

Many great Black American players helped build as well as sustain the NBA. Some notable Hall of Famers include

>> **Bill Russell:** With legendary center Russell, who served as the team's coach as well as a player from 1966 to 1969, the Boston Celtics won an astonishing 11 NBA championships in 13 seasons. Russell set many playoff scoring and defensive records that remain untouched.

>> **Wilt Chamberlain:** Revered center Chamberlain is still the only NBA player to score 100 points in a single game. He holds nearly 100 NBA records, making him arguably the greatest NBA player of all time.

>> **Elgin Baylor:** Baylor is considered one of the NBA's purest scorers. Many credit him for saving the Lakers franchise, located in Minneapolis at the time of his draft. Baylor's double-digit scoring brought out the crowds and helped the Lakers make the playoffs. His many accomplishments include a 71-point game against the Knicks in 1960 and a 61-point playoff effort against the Celtics in 1962.

>> **Oscar Robertson:** King of the triple doubles, Robertson, who earned Player of the Year honors for three consecutive seasons while a student at the University of Cincinnati in the late 1950s, became the NBA prototype for the all-around player. Robinson filed an anti-trust lawsuit against the NBA in 1970 when he was the president of the National Basketball Players Association (a position he held from 1965 to 1974). The NBA's 1976 settlement, which created free agency, is known as the Oscar Robertson Rule.

>> **Julius "Dr. J" Erving:** Dr. J's electrifying play changed the game of basketball forever. Thanks to him, the dunk went from a rare treat to a regular feature. He also combined energetic showmanship with dignity and grace. It's often been said that the NBA merged with the American Basketball Association (ABA) just to get Erving.

>> **Earvin "Magic" Johnson:** Magic Johnson helped curtail declining interest in the NBA during the late 1970s when he and Larry Bird carried their college rivalry into the NBA in 1979. Playing in Los Angeles, point guard Johnson, aided by great center Kareem Abdul-Jabbar and a host of other all-stars, regenerated fan excitement and directly contributed to the NBA's survival. Post-NBA, Johnson also succeeded in business, which included owning Starbucks franchises and Magic Johnson Theatres in predominantly Black

neighborhoods, before eventually becoming a co-owner of the LA Dodgers in 2012. He also served time as president of basketball operations for the Lakers, where he helped bring LeBron James to the storied franchise in 2018.

>> **Michael Jordan:** When the Chicago Bulls drafted Michael Jordan in 1984, few had any idea he would become the most famous basketball player on the planet. But his unbelievable rookie-year scoring offered only a glimpse into the player he would become. Jordan's spectacular offensive and defensive play on his way to six NBA championships put him in the running for the honor of greatest NBA player of all time. Off the court, his Nike partnership launching the iconic Air Jordan brand to the public in 1985 created a more lucrative athlete endorsement blueprint, freeing many athletes from being dependent on just the team for which they played for their income. *Forbes* revealed that Jordan was a billionaire with a net worth of $2.1 billion in 2020, making him the world's richest former athlete.

>> **Allen "AI" Iverson:** From cornrows to tattoos, baggy jeans and beyond, the All Star and NBA Hall of Famer, most prominently associated with the Philadelphia 76ers, was the primary catalyst for bringing hip-hop culture to the NBA in the mid-1990s, just as it was on the brink of exploding into the mainstream, nationally and globally.

>> **LeBron James:** Among the last crop of high school players going straight to the NBA, LeBron James entered the league in 2003 playing for the Cleveland Cavaliers, very much home for the Akron, Ohio, native. He later won two NBA championships with the Miami Heat. Comparisons of him as a player to both Michael Jordan and Kobe Bryant polarized NBA fans.

*The Decision,* a live TV announcement of James's decision to play alongside Dwyane Wade and Chris Bosh for the Miami Heat as a free agent in 2010 was controversial. So was his decision to leave Cleveland for the Los Angeles Lakers in 2018, after delivering the franchise's first-ever championship. These moves, however, contributed to the power shift in the NBA in favor of the player.

>> **Kobe Bryant:** As a player, especially one who went straight from high school to the NBA, few have done better than Kobe Bryant. A lifetime Lakers player, he was a five-time NBA champion, an 18-time NBA All-Star, a 12-time All-Defensive player, and a two-time Olympic gold medalist in basketball. His 81-point game in 2006 against the Toronto Raptors is second only to Wilt Chamberlain's 100-point game.

On January 26, 2020, Kobe Bryant, Giana "Gigi" Bryant (his 13-year-old daughter and a budding basketball player in her own right who had been pegged to elevate women's basketball), and seven other people were killed in a helicopter crash in Calabasas, California. The news devastated more than Lakers fans. At just 41, Bryant had created a great post-NBA rhythm coaching his daughter, supporting the WNBA, publishing books, and even winning an Oscar for his 2017 short, *Dear Basketball.*

# LeBron JAMES ON RACIAL INJUSTICE

Lebron James's outspokenness against racial injustice is one of his most enduring legacies. He has never hesitated to speak out against injustice, be it George Zimmerman killing Trayvon Martin in 2012, or the police killings of Eric Garner and Michael Brown in 2014. When cellphone video captured Minneapolis police officer Derek Chauvin's horrific killing of George Floyd in 2020, James, who had been unafraid to criticize the racial maneuverings of President Donald Trump in the late 2010s, continued to speak out.

As the NBA continued its *season in the bubble* (the term applied to the players isolating in Orlando to carry out the playoffs in 2020) due to COVID-19, James and his fellow players, with the blessing of the NBA and its commissioner Adam Silver, adapted their uniforms with Black Lives Matter messaging. During press conferences, James and other players, including those in the WNBA, spoke of the murders of Breonna Taylor in her home by the Louisville police, and more. When police shot unarmed Jacob Blake seven times while he was with his kids in Kenosha, Wisconsin, in August 2020, James, his Lakers teammates, and the rest of the NBA players in the playoffs supported the Milwaukee Bucks in their boycott by sitting out game five in the playoffs. When play resumed, James and his cohorts continued to speak out, defying their "shut up and dribble" critics who insisted they keep their social activism off the court.

## Women's basketball

Black women in basketball have traveled a much harder road than men, but the Black community embraced Black women's basketball early. New York and Philadelphia had a few teams before World War I, and both the Chicago Romas and the Philadelphia Tribunes, the first professional sports teams for Black women, were very popular. The Philadelphia Tribunes even traveled extensively throughout the South to introduce young girls to the sport.

### Women's college basketball

REMEMBER

As early as the 1920s — long before Title IX of the Educational Amendment of 1972 mandated that federally funded colleges provide women access to sports and scholarships — Black colleges began investing in women's basketball programs. Games were well-attended, and Black newspapers extensively covered collegiate women's basketball into the 1940s. At that time, white institutions and the white community in general didn't support female athletics in the same manner.

Title IX forced many mainstream universities to establish or invest more in women's sports programs. Coupled with ongoing desegregation efforts, the legislation benefited Black female athletes, and college players like Lusia Harris, who attended Mississippi's Delta State University, received more opportunities to

display their talents. In 1971, the women's game went from a half-court to a full-court game.

Competition heightened further when the NCAA Women's Basketball Championship kicked off in 1982. Powerhouse women's programs at the University of Tennessee, University of Connecticut, and Louisiana Tech emerged. In addition to players, those institutions also snatched up Black female coaching talent like C. Vivian Stringer, one of the all-time greats.

## The Olympics

Women's basketball grew in stature when it debuted at the 1976 Olympics, and the U.S. team, on which Lusia Harris played, won a silver medal. A surprising gold medal win at the 1984 Olympics gave women's basketball another huge boost. Key team members included Cheryl Miller, now a sports commentator, and Lynette Woodard, who was the first woman to play with the Harlem Globetrotters. At the 1996 Olympics, Team USA went undefeated. Teresa Edwards, Dawn Staley, and Nikki McCray are just a few of the outstanding players from those teams.

## The WNBA

The NBA-supported WNBA started in 1997. Early on, top talent included Sheryl Swoopes, the first female basketball player to receive her own shoe from Nike; Olympic gold medalist Cynthia Cooper; and two-time Olympic gold medalist Tina Thompson. They all played for the Houston Comets, which won the first four WNBA championships. Lisa Leslie, the L.A. Sparks' dominating center, also attracted fans to the league. Leadership from women's basketball pioneers like Cheryl Miller made the league credible.

As the nation's premier league for women's basketball, the WNBA — as demonstrated in the 2000 film *Love & Basketball*, directed by Gina Prince-Bythewood — offered female college basketball players an opportunity to play in the United States and not just overseas.

That became more evident in the 2000s, when college superstars like Chamique Holdsclaw, Tamika Catchings, Ivory Latta, Candace Parker, Kristi Toliver, Angel McCoughtry, Seimone Augustus, and more entered the league from women basketball powerhouse schools such as Tennessee, UConn, Rutgers, North Carolina, and more, attracting their already sizeable fan bases. That continued into the 2010s as Tina Charles, Maya Moore, Skylar Diggins, Brittney Griner, Breanna Stewart, A'Ja Wilson, and Napheesa Collier entered the league, playing for teams such as the Minnesota Lynx, Phoenix Mercury, and Seattle Storm. As an NBA analyst on TNT, alongside basketball Hall of Famers like Shaquille O'Neal as well as for the NCAA men's basketball, Parker, especially helped advance not just the WNBA but women's basketball overall as a respected artery of the game as a whole.

In 2005, BET co-founder Sheila Johnson, the first Black woman to attain billionaire status and ex-wife of original Charlotte NBA franchise owner Bob Johnson, became the WNBA's first female owner with the Washington Mystics. She also scored stakes in the NHL's Washington Capitals and the NBA's Washington Wizards.

As the WNBA increased in popularity, pay discrepancies came more to the fore. In 2020, the WNBA and the WNBPA reached a groundbreaking collective bargaining agreement, resulting in a more than 50 percent increase in pay, ensuring that all players would at least make six figures, even if it was on the lower scale. Revenue-sharing as well as increased cash bonuses, paid maternity leave, and earlier unrestricted free agency were also a part of the deal. COVID-19 may have derailed the full implementation of the new agreement, but the WNBA continued to prove its staying power.

During the 2020 season, the Atlanta Dream made headlines by supporting Democrat Raphael Warnock over its owner Kelly Loeffler in the Georgia U.S. Senate race, which she lost, making Warnock the state's first-ever Black U.S. senator. In addition, the WNBA, like the NBA, raised awareness of the police killing of Breonna Taylor in Louisville, as well as that of George Floyd and others as they did press conferences and hit the court.

# Boxing

Slaveholders were notorious for staging fights between those they enslaved, and that's precisely how some early Black boxers got the bulk of their boxing experience. As professional boxing developed in 19th-century America, promoters generally banned Black Americans from challenging white fighters, especially in the heavyweight category. To gain credibility, fighters like Tom Molineaux, an enslaved boxer whose skill eventually freed him, went to England, boxing's mecca (the British championship was equivalent to the world championship). In 1810, Molineaux earned a shot at reigning heavyweight champion Tom Cribb. Although he lost that bout and a rematch with Cribb, he proved a formidable foe.

During the late 19th century, a Black boxing circuit developed, but competing for the titles that white fighters held was still difficult. That changed in the 20th century. Following are several of boxing's key Black figures:

>> **Jack Johnson (1878–1946):** Although lightweight boxer Joe Gans's 1902 world title opened doors for other Black boxers, heavyweight John Arthur "Jack" Johnson's battles epitomized Jim Crow America. In 1903, he became the Colored Heavyweight Champion, but the reigning white world champion,

Jim Jeffries, refused to fight him. When Johnson easily defeated Canadian Tommy Burns in 1908 to win the title and other white fighters failed to avenge Burns's defeat, Jeffries was lured out of retirement. Billed as "the Great White Hope" in the "Fight of the Century," Jeffries fell to Johnson on July 4, 1910. Johnson's victory sparked a wave of race riots and resulted in certain states refusing to film his victories over white fighters. The critically acclaimed 2004 PBS documentary *Unforgivable Blackness: The Rise and Fall of Jack Johnson*, directed by Ken Burns, explores his career in the context of American race relations.

» **Joe Louis (1914–1981):** From his boxing debut in 1934 and throughout most of his career, Joe Louis's signature was knocking his opponents out. In his prime, Louis, nicknamed the Brown Bomber, rarely lost a fight. An upset loss to German boxer Max Schmeling in 1936 rattled Louis to the point that he insisted on a rematch until he got one in 1938. With the U.S. on the brink of entering World War II, the fight reached an international audience via the radio. More than a personal achievement, Louis's win symbolized a win for democracy. From 1937 to 1949, Louis successfully defended his title 25 times.

» **Sugar Ray Robinson (1921–1989):** In his long career, welterweight-middleweight champion Sugar Ray Robinson won 202 fights (108 by knockouts) and lost only 19, most of them at the end of his prime. A hard hitter with quick feet and hands, Robinson, whom many still consider the best pound-for-pound boxer of all time, fought all over the world.

» **Muhammad Ali (1942–2016):** Through the 1960s and 1970s, no fighter captivated the public like Kentucky native Muhammad Ali, born Cassius Clay (see Figure 19-1). The 1960 Olympic gold medalist's 1964 win over Sonny Liston ushered in boxing's new era. Known for his fancy footwork, his boastful, witty rhymes, and his stunning good looks, Ali — a convert to the Nation of Islam — paid for his outspokenness. When he refused his Vietnam draft order on religious grounds, he was stripped of his title and received a five-year prison sentence in 1967. The Supreme Court later reversed the decision.

Ali went on to defeat George Foreman in the 1974 Don King–produced Rumble in the Jungle, where he won back his undisputed heavyweight title. In the following year's fight defending his title, Thrilla in Manila, against Joe Frazier, the referee ended the fight out of concern for the badly beaten Frazier. After a brief retirement, Ali returned to the ring in 1980 and lost his heavyweight title for good to Larry Holmes. Ali retired the next year, in 1981.

» **Sugar Ray Leonard (1956–):** At his prime in the late 1970s and throughout the 1980s, the North Carolina–born Leonard battled some of boxing's most formidable opponents, including Thomas "Hitman" Hearns, "Marvelous" Marvin Hagler, and Panama's Roberto Duran. Leonard won an Olympic gold medal in 1976.

**FIGURE 19-1:**
Muhammad Ali.

>> **Mike Tyson (1966–):** In 1986, 20-year-old Brooklynite Tyson became boxing's youngest heavyweight champion. During 1987, "Iron" Mike defeated James "Bonecrusher" Smith and Tony Tucker to become the undisputed heavyweight champion of the world. Although Tyson beat the aging Larry Holmes in 1988, his unbelievable defeat of Michael Spinks in a fight that lasted only 1 minute and 31 seconds elevated his cult status. Troubles outside the ring, including a high-profile divorce from actress Robin Givens and a rape conviction, hindered Tyson's boxing career. After jail, Tyson appeared more troubled and, in a 1997 fight against Evander Holyfield, bit a part of Holyfield's ear off, presumably frustrated by Holyfield's repeated head-butting. Tyson retired in 2005.

Even when boxing no longer captivated the masses on the level it once did, Roy Jones Jr., Sugar Shane Mosley, and Floyd Mayweather Jr., among others, became recognized names. Muhammad Ali's daughter Laila Ali also made a name for herself in the sport while blazing a trail for female boxers. Flint, Michigan, native Claressa Shields helped break additional barriers for female boxers with her consecutive gold medal wins as a middleweight in the 2012 and 2016 Olympics, a first for any American boxer.

## DON KING

"Only in America," to use a phrase coined by Don King, could a former street hustler who served nearly four years in prison for murder become one of sports' most famous figures. Known for his eccentric hair and creative use of the English language, the boxing promoter's career began in 1972, when he convinced Muhammad Ali to participate in a fundraiser to save a Black hospital in his native Cleveland. In 1974, King staged one of the greatest fights in boxing history, the Rumble in the Jungle in Zaire, in which Ali defeated George Foreman. Thrilla in Manila, in which Ali beat Joe Frazier in the Philippines, followed.

King headliners since the 1970s include Sugar Ray Leonard, Mike Tyson, Larry Holmes, Felix Trinidad, Evander Holyfield, and Oscar de la Hoya. King is credited with almost single-handedly transforming boxing into a multibillion-dollar global industry known for its lucrative live and pay-per-view events. King survived numerous lawsuits, from Muhammad Ali to Mike Tyson, charging that he robbed his boxers of millions. Ving Rhames played King in the 1997 HBO film *Don King: Only in America*.

# Football

As far as American traditions go, football is second only to baseball. Like baseball, pro football welcomed Black American talent in the late 1940s. Curiously, college football, which absorbed Black Americans into its ranks early, lagged behind pro football from the 1950s into the 1970s, mainly because Southern colleges refused to embrace Black football players. At the same time, their football programs had increased in stature. Even in regard to Black Americans holding leadership positions in coaching and upper management, the college level, in some respects, lags behind the pro game, which has often been criticized for its lack of diversity.

## Pro football

The American Professional Football Association, renamed the National Football League (NFL) in 1922, didn't begin as an exclusionary organization in 1920. Black Americans Robert "Rube" Marshall and Frederick Douglass "Fritz" Pollard played through intense racial harassment. As the NFL grew, it reversed its position and began excluding Black Americans in 1933. That color line remained in place until the Los Angeles Rams signed Kenny Washington and Woody Strode in 1946. Penn State's Wally Triplett became the first Black American draftee to play in the NFL in 1949. Arguably, in 1957, Jim Brown became the NFL's first legendary Black player.

Recognizing that segregation remained strong in the collegiate ranks, the NFL didn't bypass Black college talent. Grambling's Paul "Tank" Younger, who played with the Los Angeles Rams, became the NFL's first Black college star to join their ranks. Other Black college all-stars who excelled in the NFL include Jackson State's Walter Payton, who dominated as running back for the Chicago Bears; Mississippi Valley State's Jerry Rice, who stunned fans as a standout wide receiver for the San Francisco 49ers; and Grambling's Doug Williams, who in 1988 became the first Black American quarterback to win a Super Bowl. He was leading the Washington Redskins and was named MVP.

Although the Chicago Bears' Willie Thrower became the NFL's first Black quarterback in 1953 and Denver's Marlin Briscoe and Buffalo's James Harris were starting quarterbacks in the late 1960s, Black players were largely restricted from holding the position. In the 1980s, stellar play from Warren Moon (who proved himself in the Canadian Football League first) and Randall Cunningham helped move other Black quarterbacks to the forefront. Still, despite Doug Williams's Super Bowl win, some white fans repeatedly complained well into the 2000s about the NFL's many outstanding Black quarterbacks, particularly Michael Vick of the Atlanta Falcons, not emulating the white "pocket" quarterback, who stayed in one spot as the offensive line protected him long enough to throw the ball. This persisted even when Vick and others compiled winning records, leading their teams to championships and even Super Bowls. Vick's overall impact, was, however, derailed by a 2010 conviction for dog fighting.

Another point of contention for the NFL has been in coaching. Whereas basketball has integrated Black talent in almost all areas of the game, such change in the NFL has come relatively late. In 1989, the Los Angeles Raiders made Art Shell the first Black NFL head coach since Fritz Pollard.

**TECHNICAL STUFF**

The NFL really shook things up after attorneys Johnnie Cochran and Cyrus Mehri unveiled a report showing that while the NFL's few Black coaches typically had superior performance records, fewer head coaching opportunities existed for Black coaches. In response, the NFL instituted the "Rooney Rule," named for Pittsburgh Steelers owner Dan Rooney, requiring teams to interview at least one minority candidate while filling a head coaching vacancy or pay a fine. The Detroit Lions paid a $200,000 fine for hiring Steve Mariucci in 2003 and not interviewing anyone, white or Black.

At the top of 2007, however, Black coaches got a huge boost when Lovie Smith (Chicago Bears) and Tony Dungy (Indianapolis Colts) became the first Black coaches to lead their teams to the Super Bowl, with Dungy's team winning. Thirty-four-year-old Mike Tomlin's ascension as head coach of the Pittsburgh Steelers during that same time also signaled a major change.

## COLIN KAEPERNICK TAKES A KNEE

Perhaps no one exposed the NFL's and the nation's racial issues more than Colin Kaepernick. Compelled by the police killings of Alton Sterling in Baton Rouge, Louisiana, and of Philando Castile near St. Paul, Minnesota, Kaepernick, who led his longtime team, the San Francisco 49ers, to the Super Bowl in 2013, started the 2016 NFL pre-season sitting out the National Anthem, eventually adjusting to kneeling to show more respect to veterans as he protested throughout the season. Early on NFL media reporter Steve Wyche noticed Kaepernick sitting out the National Anthem almost immediately and questioned him.

"I am not going to stand up to show pride in a flag for a country that oppresses Black people and people of color," Kaepernick told Wyche after the 49ers' August 26 loss to the Green Bay Packers at Levi's Stadium in California. As other players began kneeling with Kaepernick, NFL commissioner Roger Goodell spoke up, siding mostly with President Donald Trump who shared his displeasure over Kaepernick and others kneeling during the anthem.

After opting out of his contract with the 49ers, Kaepernick was unable to find another job. That, however, didn't keep him from kneeling or speaking out. On the heels of the mass protests against the police killing of George Floyd, ironically Goodell spoke up. On June 5, 2020, Goodell issued a statement. "We, the National Football League, condemn racism and the systematic oppression of black people. We, the National Football League, admit we were wrong for not listening to NFL players earlier, and encourage all to speak out and peacefully protest." Many, especially on social media, slammed the statement because neither Goodell nor the NFL apologized to Colin Kaepernick.

Ozzie Newsome (Baltimore Ravens) became the NFL's first Black general manager in 2002. In 2006, 2007, and 2008, things moved a little faster in the general manager ranks as Jim Reese (New York Giants), Rick Smith (Houston Texans), and Martin Mayhew (Detroit Lions) joined him. In 2016, the Miami Dolphins hired Chris Grier as its general manager, followed by Andrew Berry with the Cleveland Browns in 2020 and Terry Fontenot with the Atlanta Falcons in 2021. In 2020, the Washington Football Team made Jason Wright the first Black team president in the NFL.

# College football

Black Americans have found a way to participate in college football almost from the beginning. William Henry Lewis, who played football at Amherst and Harvard, became an All-American in 1892 and 1893. In 1916, Fritz Pollard was the first Black college player to appear in the Rose Bowl. Black athletes in Northern

colleges endured racial harassment in addition to segregation from other athletes; many predominantly white universities in the South refused to accept Black students, in defiance of the Supreme Court.

Black colleges developed strong football programs in response to this reality. None, however, would prove as great as that of Louisiana's Grambling State University, where Eddie Robinson, beginning in 1941, built a football powerhouse that sent 210 players, more than any other college coach, to the NFL. In 1985, Robinson broke Bear Bryant's record as college football's winningest coach, and by 1995, his 400 career wins put him in a class of his own. Upon retirement in 1997, Robinson had amassed an astonishing 408 wins, 165 losses, and 15 ties.

It took a luminary such as Bryant to open up predominantly white college football programs in the South to Black players. In 1971, the University of Southern California opened its season against the University of Alabama. USC's integrated team trounced the all-white team from Alabama. Many have speculated that Bryant, who reportedly tried to integrate his football program at the University of Kentucky, intentionally scheduled the game to make a case for integration. Shortly thereafter, junior college transfer John Mitchell became the first Black player to play for Alabama. When Mitchell joined Bryant's coaching staff in 1973, nearly a third of Alabama's starters were Black.

In recent years, there's been no lack of Black talent on the field, but college football, like the NFL, has been accused of overlooking Black Americans in other positions. Of the 117 Division I-A schools in 2002, only four had Black head coaches. Those who applauded the iconic Notre Dame for signing Ty Willingham on as head coach were disappointed when the school dumped Willingham, who had a poor record in 2004, after just three of his contracted six seasons. Although the University of Washington quickly snatched him up, the consensus was that had he been able to succeed at Notre Dame, coaching walls could have tumbled for Black coaches. With that grand experiment failed, the ball shifted to former Bryant player Sylvester Croom, who became the first Black head coach in the Southeastern Conference (SEC) when he accepted the top job for the Mississippi State Bulldogs in 2003. In 2008, coming off a devastating loss to rival Ole Miss, Croom was asked to resign and never coached college football again. In 2020, there were 14 Black head coaches out of 130 NCAA Division I programs.

# Track and Field

Black Americans have participated in track and field since the 1890s, with both Black and predominantly white colleges in the North cultivating their talents early on (predominantly white Southern colleges refused Black Americans admission

well until the middle of the 20th century). Tuskegee Institute, which hired its first athletic director, James B. Washington, in 1890, was competitive in track and field by 1893. Notable 19th-century track stars include William Tecumseh Sherman (Amherst's 1890 champion half-sprinter) and Harvard's Napoleon Bonaparte Marshall (who ran the 440 dash in 51.2 seconds). Other notable track and field stars include the following:

>> **George Poage (1880–1962):** The University of Wisconsin's Poage became the first Black American to win an Olympic medal when he came away with two bronze medals in the 1904 Olympics.

>> **John "Doc" Taylor (1882–1908):** The University of Pennsylvania's Taylor became the first Black collegiate track and field champion in 1907, and the first Black American to win an Olympic gold medal in the 1908 games in London.

>> **Howard Drew (1890–1957):** Injury prevented Howard Porter Drew from competing in the 1912 Olympics, but he set the standard for running the 100-yard dash in under 10 seconds and was the first Black American to be tagged the world's fastest human.

>> **Jesse Owens (1913–1980):** Before dominating track and field as a student at Ohio State University, the Alabama-born Owens broke world records in high school. His college success led him to the 1936 Berlin Olympics, where at the height of Hitler's assertion of Aryan supremacy, he won an unprecedented four gold medals. Owens was the first American to accomplish that feat. The 2016 documentary *Olympic Pride, American Prejudice* chronicles the lives of the 17 other Black Olympians in 1936, including Jackie Robinson's older brother Mack Robinson, who went to Germany with Owens.

>> **Alice Coachman (1923–2014):** In the 1948 Olympics in London, master high jumper Coachman, whose talent was nurtured at Tuskegee Institute, became the first Black woman to win a gold medal and the first American woman to win a gold medal in track and field.

>> **Wilma Rudolph (1940–1994):** One of 22 children and stricken with polio early in her life, Rudolph overcame tremendous obstacles to set the bar for female track. Her standout play in basketball in junior high school attracted the attention of legendary track coach Ed Temple of Tennessee State University (TSU). At age 16, she won a bronze medal in the 1956 Olympics in Melbourne, Australia, running with TSU Tigerbelles Isabelle Daniels, Mae Faggs, and Margaret Matthews. In the 1960 Olympics, where Temple served as head women's track and field coach, she became the first American woman to win three gold medals.

>> **Bob Beamon (1946–):** Bob Beamon shattered the long jump record by an unbelievable 21+ inches to capture gold in the 1968 Olympics. His record stood for 23 years before Mike Powell broke it in 1991.

>> **Edwin Moses (1955–):** In the late 1970s and early 1980s, Edwin Moses, who attended Morehouse College in Atlanta, Dr. King's alma mater, ruled the hurdles, winning gold medals in the 1976 and 1984 Olympics in Montreal and Los Angeles. Between 1977 and 1987, Moses won 122 consecutive races.

>> **Carl Lewis (1961–):** One of the most accomplished athletes of all time, Lewis won ten Olympic medals (nine gold and one silver) and set countless world records during his career. Voted the Olympic Athlete of the Century, Lewis competed and medaled in the 1984, 1988, 1992, and 1996 Olympics.

>> **Jackie Joyner-Kersee (1962–):** Joyner-Kersee, a heptathlon pioneer, was raised in East St. Louis, Illinois. Aided by her accomplished track and field coach husband Bob Kersee, she scored gold in both the long jump and the heptathlon, becoming the first American woman to win gold in either (while setting records for both) at the 1988 Olympics. That same year, she became the first woman to win the *Sporting News* Man of the Year honors. With six Olympic medals and four World Championship golds, Joyner-Kersee remains one of the greatest athletes of all time.

>> **Florence "Flo Jo" Griffith Joyner (1959–1998):** Known for her bold fashion and colorful nails, Flo Jo, as many affectionately called her, lived up to her "fastest woman of all time" billing. More than 30 years later, records she set for the 100-meter and 200-meter dash in 1988 were still unbroken. In her 1984 Olympic debut in her native Los Angeles, she won silver. In the 1988 Olympics in Seoul, Joyner, sister-in-law to Jackie Joyner-Kersee, ran away with three gold medals. Her death at age 38 in her sleep, officially tied to an epileptic seizure, devastated the track world and her many fans.

>> **Kevin Young (1966–):** Competing in the 1992 Olympics in Barcelona, Young won gold in the 400-meter hurdles and set a World and Olympic record of 46.78 seconds, marking the first time 47 seconds had ever been broken. The record remained untouched over 25 years later.

>> **Michael Johnson (1967–):** Competing in the 1992, 1996, and 2000 Olympics, the self-proclaimed fastest man in the world amassed an impressive five gold medals.

>> **Marion Jones (1975–):** Dubbed the fastest woman on earth, California native Jones made Olympic history in 2000 in Sydney, Australia, when she became the first female athlete to win five medals (three gold and two bronze) in a single Olympics. Although she was stripped of her medals in 2007 due to allegations of illegal drug use, some people still consider Jones to be one of the world's greatest female athletes.

>> **Michelle Carter (1985-):** Carter, from Red Oak, Texas, is a three-time Olympian who competed in the 2008, 2012, and 2016 Olympics in Beijing, London, and Rio de Janeiro. In Rio, she became the first American woman to

ever win gold in the shot put and only the second American woman to win any medal in the event. Before Carter, Earlene Brown, an affiliate of Wilma Rudoph and the Tennessee State University Tigerbelles, had won the bronze in Rome in 1960.

## MAKING A STATEMENT AT THE 1968 OLYMPICS

Emotions ran high at the 1968 Olympics in Mexico City when track and field gold medalist Tommie Smith and bronze medalist John Carlos raised black-gloved fists in the air to represent Black Power and Black unity as the U.S. national anthem played. Inspired by sociologist Dr. Harry Edwards, who had asked them and other Black Olympians to boycott the games, Smith and Carlos paid for their silent protest with a suspension from the national team and a ban from the Olympic Village. Back home, they received death threats and struggled with employment for years. Since then, they've become heroes for using their grand moment to stand up for equality. HBO chronicled this pivotal event in the 1999 documentary *Fists of Freedom: The Story of the '68 Summer Games.*

(C) Bettmann/Getty Images

At the 2004 Athens Olympics, Shawn Crawford, Justin Gatlin, Joanna Hayes, and long jumper Dwight Phillips all won gold medals. In the 2016 Olympics in Rio, Brianna Rollins, Nia Ali, and Kristi Castlin completely swept the Women's 100-meter hurdles for Team USA. That same Olympics, Allyson Felix, with two gold medal wins, became the first woman in track and field to amass six gold medals, winning her first in 2008, and three in 2012. Dalilah Muhammad, who is Muslim, also made history as the first American woman to win gold in the Women's 400-meter hurdles.

# Tennis

Black colleges formed tennis teams as early as the 1890s, but the American Tennis Association (ATA), formed in 1916 in response to the U.S. Lawn Tennis Association (USLTA) policy banning Black players, really nurtured Black American tennis players. One of the oldest Black sports organizations in the United States, the ATA sponsored its first tournament in 1917 in Baltimore, Maryland. Black tennis greats Althea Gibson, Arthur Ashe, Zina Garrison-Jackson, Lori McNeil, and Chanda Rubin all played on the ATA circuit. The ATA Junior Development Program, created by Dr. Robert Walter Johnson in the 1950s, continues to nurture new talent.

Tennis's color line was broken in 1950 when Althea Gibson, winner of ten ATA championships, competed in the now-defunct U.S. Nationals. In 1956, the New York–raised Gibson won the French Open. She also won consecutive Wimbledon titles in 1957 and 1958, as well as major doubles and mixed doubles titles. This section looks at other Black American tennis champs.

## Arthur Ashe

Arthur Ashe pioneered men's tennis by becoming the first Black American named to the Davis Cup team in 1963. He also led UCLA to the NCAA tennis championship in 1965. In 1968, Ashe became the first Black man to win the U.S. Open and followed that victory with wins at the Australian Open in 1970 and Wimbledon in 1975. To honor Ashe, the USTA National Tennis Center in Queens, New York City, where the U.S. Open is played, renamed its main stadium the Arthur Ashe Stadium. In 2006, James Blake became the first Black male tennis player ranked number one in the United States since Ashe.

Ashe was a very outspoken civil rights advocate and one of the first prominent HIV/AIDS activists, educating the public about the disease before losing his battle in 1993. He had contracted the disease through a blood transfusion.

## Venus and Serena Williams

Hailing from Compton, California, the Williams sisters, beginning in the late 1980s and early 1990s, raised Black American awareness of tennis, especially among young people. The older, Venus, won both Wimbledon and the U.S. Open in 2000 and 2001. In 2002 and 2003, Serena defeated her big sister to win the U.S. Open, French Open, Wimbledon, and the Australian Open.

The sisters became the first two women in Grand Slam history to square off in four consecutive finals and often swapped the top ranking in all of women's tennis. In 2008, Venus won her last Grand Slam, defeating Serena to earn her fifth Wimbledon title. After that, Serena, overcoming injury, regained her first number-one ranking since 2003 that same year and began creating her own lane. From 2008 to 2017, Serena won four of her six U.S. Open titles and five of her seven Wimbledon titles. After giving birth to her daughter in 2017, Serena continued to play and, in 2020, became the first woman to have at least one title in four decades (1990s, 2000s, 2010s, 2020s) and the first tennis player to reach the Grand Slam and U.S. Open semifinals in four decades.

In Olympics play, Venus has five medals, four gold and one silver, while Serena has four medals, all gold. They share three of the gold medals from doubles wins. Throughout their career, the Williams sisters endured racial slights. They also stood up for equal pay for the women's purse in tournaments. Serena boldly challenged umpires over unfair calls.

The Williams sisters' success inspired other Black women to play tennis, including Madison Keys, Sloane Stephens, Coco Gauff, and Naomi Osaka. Osaka, the daughter of Japanese and Haitian parents, plays for Japan. She defeated Serena in the 2018 U.S. Open. In March 2021, Serena was ranked No. 7 by the WTA (Women's Tennis Association).

# Golf

Established as a white-only organization in 1916, the Professional Golf Association (PGA) and its prestigious Masters Tournament (instituted in 1934) allowed Black Americans in only as caddies and groundsmen. In response to their racist policy, the United Golfers Association (UGA) and its National Colored Golf Tournament took root in 1925.

**TECHNICAL STUFF**

World War II veteran and golfer Bill Powell found his own solution to golf's discrimination: He created his own golf course. He began designing Clearview Golf Course in East Canton, Ohio in 1946 and opened the first 9 holes to the public just two years later. The course became an 18-hole course in 1978. Named a National

Historic Site in 2001, Clearview is the first golf course built, owned, and operated by a Black American.

When Black golfers Ted Rhodes, Bill Spiller, and Madison Gunther filed a civil suit against the PGA in 1948, the PGA adopted an invitation-only policy to continue its discriminatory practices. Finally, in 1961, the PGA bowed to public pressure and let Black Americans play. The following year, Charlie Sifford became the first Black golfer on the PGA tour, and in 1964, Pete Brown became the first Black American to win a PGA title. Before the 1990s, Lee Elder, the first Black golfer to play at the coveted Masters Tournament in 1975 and the first to play on the U.S.'s Ryder Cup team in 1979, had been the most successful Black player.

In the 1990s, Tiger Woods emerged on the golfing scene. His mother hailed from Thailand and his father came from Kansas, prompting him to refer to himself as "Cablinasian" to reflect his Caucasian, Black, Native American, and Asian ancestry. Even before Woods could talk, his father Earl nurtured his talents. In August 1996, at age 20, Woods turned pro, winning his first Masters just eight months later on April 13, 1997, at age 21. From then on, he continued breaking records.

Woods's quest to become the best golfer of all time seemed derailed by multiple allegations of infidelity in 2009, resulting in Woods taking a brief break from the game. When he resumed play, however, his performance lagged and continued that way for years. Yet in 2019, Woods defied the odds, winning the Masters at age 43, becoming the second oldest player to Jack Nicklaus's 46 to do so. He also pulled in closer to Nicklaus's all-time record of 18 majors with 15. In 2019, Woods also locked in his 82nd win, tying all-time PGA Tour winner Sam Snead, who died in 2002. A horrific car accident in February 2021, however, appeared to cap Woods's golf career.

# Other Sports

Black American sports milestones are plentiful and extend to sports not typically associated with Black Americans. Following is a sampling of those achievements:

>> **Horse racing:** Black Americans dominated horse racing in its early years, with 13 Black jockeys of 15 competing in the first Kentucky Derby in 1875. (See Chapter 20 for more about this historic feat.) In fact, Black American Oscar Lewis was the first winner of that race. Beginning in the late 1890s, the numbers of Black Americans in the sport decreased due in part to racial discrimination, as well as Black Americans moving from the country to the city during the Great Migration. When Marlon St. Julien competed in the 2000 Kentucky Derby, he was

the first Black American to do so since 1921. U.S. Virgin Islands native Kevin Krigger mounted in the 2013 Kentucky Derby.

>> **Cycling:** In 1899, cyclist Marshall "Major" Taylor became the first Black American to hold an international title when he won the world championship in Montreal. Al Whaley became the first Black American cycling champion of the modern era when he won the Masters World Championship in 1997.

>> **Winter sports:** Figure skater Debi Thomas's bronze medal in 1988 made her the first Black American to win a medal in the Winter Olympics. Bobsledder Vonetta Flowers won a team gold medal in the 2002 Olympics.

In 2006, speed skater Shani Davis became the first Black American to win gold in an individual sport (1,000 meters) in the Winter Olympics; he also won a silver medal. At the 2010 Winter Olympics, Davis won another gold and silver. His two back-to-back Olympic gold medals for 1,000-meter speed skating made him the first man to ever achieve this feat. In 2018, Davis received backlash for tweeting his outrage about not being selected as the American flagbearer for the opening ceremonies followed by the hashtag, #blackhistorymonth. The next year, he retired.

>> **Gymnastics:** Dominique Dawes's individual bronze medal in the 1996 Olympics made her the first Black American woman to win an individual medal in gymnastics. Dawes's Olympic gold medal team win in the 1996 Olympics also made her the first Black gymnast to win gold. At the 1992 Summer Olympics, she and Uganda-born teammate Elizabeth "Betty" Okino were on the U.S. bronze medal team. Dawes is also the only American gymnast to be on three medal-winning Olympic teams (1992, 1996, 2000). Jair Lynch became the first Black man to win an Olympic silver medal on the parallel bars during the 1996 Olympics.

Gabby Douglas became the first Black American woman, as well as first woman of any color from any country, to win the individual all-around event at the 2012 Olympics in London. Simone Biles won five medals — individual gold in the all-around, vault and floor events, and a team gold and a bronze in balance beam during the 2016 Olympics in Rio de Janeiro — making her the most decorated Black female gymnast in a single Olympics. With 30 Olympic and World Championship medals, Biles possessed the most of any American gymnast in history and ranked third all-time in the entire sport in 2020.

>> **Fencing:** Six-time Olympian Peter Westbrook won the bronze medal in fencing at the 1984 Olympics. In 2003, Westbrook protégé Keeth Smart became the first American male fencer to be top-ranked in the world. Elite Black American female fencers include three-time Olympian Sharon Montplaisir as well as Smart's sister Erin, who made the Olympic team for the first time in 2004. At the 2008 Olympics in Beijing, the Smart siblings each won team silver medals; Erin in foil and Keeth in saber. At the 2016 Olympics

in Rio de Janeiro, Daryl Homer became the first American to win a silver medal in saber in 112 years.

>> **Volleyball:** Known for her signature "Flying Clutchman," a spike traveling at 110 miles per hour, team captain Flora "Flo" Hyman, with assistance from fellow Black team members Rita "The Rocket" Crockett and Rose Magers, led the U.S. Olympic women's volleyball team to a silver medal in the 1984 Olympics in Los Angeles. In 1992, sisters Kim and Elaina Oden, along with Tara Cross-Battle, were key members of the team that won the bronze medal in Barcelona. From 1996 to 2012, Danielle Scott-Arruda appeared in a record-setting five Olympics and was crucial to winning silver in 2008 and 2012, with Megan (Hodge) Easy contributing to the latter.

>> **Rowing:** U.S. women's rowing team captain Anita DeFrantz led her team to a bronze medal at the 1976 Olympics. Denied a chance at gold, DeFrantz, an attorney, sued the U.S. Olympic Committee for boycotting the 1980 Olympics and lost; later, she received the International Olympic Committee's (IOC) Olympic Order medal, the IOC's highest honor for those who exemplify Olympic values. In 1986, DeFrantz became a lifetime member of the IOC, the first Black American and the first American woman to serve on the committee.

>> **Swimming:** Afro-Puerto Rican Maritza Correia, who is credited as the first Black American to set a world and American swimming record, earned team silver in the 2004 Olympics in Athens. Cullen Jones, who is the first Black American male to hold a world record in swimming, won a team gold medal in the 2008 Olympics in Beijing, and later, in the 2012 Olympics in London, he won an individual silver in the 50-meter freestyle and team gold and silver.

Competing in the 100-meter freestyle at the 2016 Olympics in Rio de Janeiro, Simone Manuel became the first Black woman to win an individual gold medal in swimming. She won team gold and silver, as well as an individual silver for the 50-meter freestyle, bringing her to a single Olympics total of four medals. Lia Neal won team bronze and silver medals in the 2012 and 2016 Olympics. Technically, Anthony Ervin, of Jewish and Black American descent who grew up in a largely white environment and appears white, is credited as being the first Black American Olympic medalist in swimming. He won gold in the 2000 Olympics in Sydney.

# 6

# The Part of Tens

Chapter **20**

# Ten Black American Firsts

Firsts are always milestones, but when a member of a marginalized group achieves them, the effects are even more profound. Culled from various fields, the ten Black American firsts in this chapter aren't as well-known as Barack Obama, son of a white Midwestern mother and Kenyan father, being elected the nation's first Black president in 2008 or Kamala Harris, daughter of immigrant parents — a mother from India and a father from Jamaica — becoming the first woman elected vice president in 2020. Other Black Americans have achieved other important milestones. Think of them as representations of the broad impact Black Americans have had on both the Black American community and the nation across the board.

## Medicine (1837)

Dr. James Derham (sometimes Durham), circa 1780s, is generally cited as the first Black person to practice medicine in the United States, but the first licensed Black doctor in the nation was James McCune Smith. Born enslaved in New York City, Smith was emancipated in 1827, when the state abolished slavery. Educated at the African Free School, he didn't attend college or medical school in the United States due to his race. In Scotland at the University of Glasgow, Smith received several degrees, including his medical degree.

After completing a medical internship in Paris, Smith returned to the United States in 1837 as a doctor, opening a successful pharmacy and a racially integrated medical practice. He also worked at the Colored Orphan Asylum. A noted abolitionist, Smith kept company with Frederick Douglass, with whom he helped found the National Council of Colored People in the 1850s. He also debunked racist medical theories, becoming the first Black medical doctor to publish in medical journals like the *New York Journal of Medicine*, but was never admitted to the American Medical Association. A founding member of the New York Statistics Institute, Smith was also elected to the American Geographical Society. The University of Glasgow's James McCune Smith Learning Hub honors his legacy.

# Law (1845)

Born in Indiana in 1816, Macon B. Allen is generally acknowledged as the first Black American to legally practice law in the U.S. In Portland, Maine, Allen, who apprenticed under abolitionist attorney Samuel Fessenden, passed the bar a month before his 28th birthday in 1844. Because Black residents generally could not hire him, and the white residents typically refused to, he relocated to Boston in 1845, where he passed the bar. He and Robert Morris, Jr. opened the first Black-owned law firm in the nation but couldn't sustain it. By 1850, Allen had become a justice of the peace in Middlesex County, Massachusetts. At the end of the Civil War, Allen moved to Charleston to practice law, becoming a probate judge there in 1874. Post-Reconstruction, he made another move to Washington, D.C. to work as an attorney for the Land and Improvement Association. He remained there practicing law until his death in 1894 at age 78.

# Kentucky Derby (1875)

A little-known fact about the Kentucky Derby is that Black Americans were an integral part of its early history. Oliver Lewis, who rode Aristides, a horse trained by Ansel Williamson (also a Black American), wasn't just the first Black American jockey to win the Kentucky Derby but also the first jockey to win *period*. Interestingly, Black American jockeys won 15 of the first 28 Kentucky Derbies. Not only did Isaac Murphy become the first jockey of any race to win three Kentucky Derbies, but he was also the very first jockey inducted into the Jockey Hall of Fame. (Read more about Black American contributions to sports in Chapter 19.)

# Congressional Medal of Honor (1900)

Nearly four decades after his heroic actions, Civil War hero Sgt. William H. Carney received the Congressional Medal of Honor, the first awarded to a Black American. Born enslaved in Virginia, his father reportedly escaped to Massachusetts via the Underground Railroad. His family joined him later. An inspiration for the film *Glory,* Carney distinguished himself during the crucial 1863 battle at Fort Wagner in Charleston, South Carolina. He spotted a wounded soldier about to drop the flag, a signal of defeat, and although wounded himself, Carney picked up the flag and refused to let it drop, even after Confederate soldiers shot him several more times. Carney survived, receiving his historic medal May 23, 1900, more than 35 years later, eight years before his death. Today, that same flag is enshrined in Boston's Memorial Hall. (Read more about the Civil War in Chapter 6.)

# Rhodes Scholar (1907)

Philadelphia native and Phi Beta Kappa Harvard graduate Alain Locke was the first Black American Rhodes Scholar. A Howard University professor for 40 years, he was a pivotal figure during the Harlem Renaissance (see Chapter 14). Considered the "Father of the Harlem Renaissance," Locke, who edited the Harlem Renaissance's key manifesto *The New Negro,* encouraged Black artists, including artist Aaron Douglass and writers Langston Hughes and Zora Neale Hurston, to draw creative inspiration from their African heritage.

# Exploration (1909)

A chance meeting with Robert E. Peary changed Matthew Alexander Henson's life as the pair spent almost two decades trying to reach the North Pole. Without Henson, who quickly learned the Inuit language and culture as well as arctic survival skills, it's doubtful Peary would have reached the North Pole. Although Peary seemed to acknowledge Henson's contributions, even admitting he couldn't "get along without Henson" and penning the foreword to Henson's 1912 book *A Black Explorer at the North Pole,* he barely spoke to Henson afterward.

Not uncommon for the Jim Crow era, mainstream organizations honoring the feat often excluded Henson. Black American organizations, however, regularly recognized his significant achievement. Slightly before his death in 1955, Henson, who some claim reached the North Pole 45 minutes before Peary, did receive more

mainstream praise, including a presidential commendation from Eisenhower in 1954. Posthumously, Henson's great honors include reinterment in Arlington National Cemetery near Peary as well as receiving the Hubbard Award, the National Geographic Society's highest honor.

## Television (1939)

Noted film and television historian Donald Bogle credits Ethel Waters as the first Black American to broadcast a show on network television. *The Ethel Waters Show,* which NBC aired on June 14, 1939, featured several skits, including a dramatic sequence from Waters's hit play, *Mamba's Daughters.* In 1962, Waters, who often played an on-screen maid, became the first Black actress nominated for a primetime Emmy. (To read more about Black Americans in television, go to Chapter 18.)

## Nobel Peace Prize (1950)

Longtime Howard University professor Ralph Bunche, who chaired the political science department from 1928 until 1950, and was an active participant in the civil rights movement, began working with the United Nations in 1946. From 1947 to 1949, Bunche, who spent his teenage years in Los Angeles where he excelled in high school and in college at the University of California Los Angeles where he graduated Phi Beta Kappa, tackled the deadly conflict in Palestine, eventually persuading Israel and the Arab States to sign the 1949 Armistice Agreements, thus ending the Arab–Israeli War. In 1950, Bunche became the first Black American to receive the Nobel Peace Prize. During the latter part of his life, Bunche served on several boards, including the New York City Board of Education, the Board of Overseers of Harvard University, the Board of the Institute of International Education, and as a trustee of Oberlin College, Lincoln University, and the New Lincoln School.

## Pulitzer Prize (1950)

Poet Gwendolyn Brooks was the first Black American writer to win the Pulitzer Prize. Raised and nurtured on Chicago's South Side, a key feature in much of her work, Brooks published her first poem, *Eventide,* in 1930 in the legendary Black

newspaper the *Chicago Defender*. Her first book of poetry, *A Street in Bronzeville*, published in 1945 and set in the historic Chicago Black community of Bronzeville, received critical acclaim. Brooks's second collection of poetry, *Annie Allen*, paints a vivid picture of life as a young Black woman and won the coveted Pulitzer Prize. In addition to receiving a Guggenheim Fellowship, Brooks also became an American Academy of Arts and Letters fellow, as well as the state of Illinois's poet laureate. (You can read more about Black American literature in Chapter 14.)

# Fashion (1988)

Fashion designer Patrick Kelly infused his work with the folk sensibilities of his Southern upbringing, including imagery some considered racist. Born in 1954, Kelly became the first American designer inducted in 1988 into the Chambre Syndicale, the elite French fashion industry organization to which Yves Saint Laurent and Christian Lacroix belong. He attended Mississippi's Jackson State University, an HBCU, before relocating to Atlanta, where he once hocked his refashioned thrift-store wares on the streets and worked as a window dresser for an upscale boutique. After a stint in New York where he attended Parsons School of Design, Kelly went to Paris and found great success. Sadly, in 1990, Kelly, on the brink of fashion superstardom, died, reportedly of AIDS complications.

# Chapter **21**

# Ten Black Literary Classics

You're probably thinking there can't possibly be such a thing as a definitive work of Black culture. You're right! There is no one perfect work. The ten classic books in this chapter, however, represent a sampling of the books many people encounter in Black literature and other courses. One notable exception is from Carter G. Woodson, which many Black students, in particular, continue to find outside established curriculums. Black writers have been presenting diverse representations of Black culture and illuminating the human experience for centuries. Most of these works feature the timeless theme of freedom. Collectively, they also provide a broad overview of Black American history well into the 20th century, as well as raise key questions such as the value of education, the role of communal responsibility, and the true meaning of personal happiness that are just as relevant today as they were at the time these books were written.

**REMEMBER**

These ten books only scratch the surface. There just isn't enough space to include every phenomenal classic by a Black American author. Therefore, absences such as James Baldwin's *The Fire Next Time* or *Notes from a Native Son* and Ernest Gaines's *The Autobiography of Miss Jane Pittman*, not to mention more recent work like Ta-Nehisi Coates's *Between the World and Me* and Colson Whitehead's Pulitzer Prize winners, *The Underground Railroad* and *The Nickel Boys*, are simply reminders that the Black literary canon is especially deep. To find out more about Black literature, visit Chapter 14.

# Narrative of the Life of Frederick Douglass, An American Slave Written by Himself (1845)

*Narrative of the Life of Frederick Douglass* is written in the slave narrative tradition, a literary style important to the overall development of Black or African American literature (refer to Chapter 14 for more on this style). Because white critics of the time often questioned whether slave narratives were written by the author or even real, a white man typically authenticated them. But even though William Lloyd Garrison followed that practice for this book, many white critics, like they had for Phillis Wheatley's work in the 18th century, still questioned Frederick Douglass's authorship especially given its eloquence

In the book — which helped the one-time fugitive become, arguably, the most important Black American leader of the 19th century — Douglass detailed his experiences of being enslaved, including his escape at age 20. Fearing his recapture, friends encouraged Douglass to spend time in Europe. While there, he helped bring international attention to slavery in the United States. Although he published his own newspaper, wrote other books, and was a noted orator and statesman after he returned to the United States, his *Narrative* still reigns as his most notable literary achievement.

# Up from Slavery: An Autobiography by Booker T. Washington (1901)

Without argument, Booker T. Washington was the most dominant Black leader of his time, especially representing a Black educational institution. Even in the 21st century, it's hard not to find a school named for Washington in areas with a significant Black population. When his autobiography *Up from Slavery* appeared in 1901, it became an instant classic. Enslaved until he was 9 years old, Washington was nearly a teenager before he learned to read, yet he graduated with honors from Virginia's Hampton Institute (modern-day Hampton University).

While he was just a teacher at Hampton, Hampton's white president recommended him to the founders of Tuskegee Institute. Washington's remarkable feat of building (literally and figuratively) Tuskegee out of nothing into the nation's premier Black American institution of the time often placed him in prominent political circles. His public statements that vocational education served the Black

masses better than intellectual education alone and that Black Americans should be patient about full political equality fueled controversy among Black people for decades. Still, his own "up from slavery" odyssey, touching on many of those points, remains a treasured text.

# The Souls of Black Folk by W.E.B. Du Bois (1903)

The cultural significance of W.E.B. Du Bois's *The Souls of Black Folk* was immediately apparent when *The New York Times* and other revered mainstream publications reviewed the book. A poetic and eloquent tome of essays by the first Black American to receive a Ph.D. from Harvard, *The Souls of Black Folk* provides a personal, sociological, and philosophical examination of being Black in white America.

Its impact was so far-reaching that Du Bois's direct challenge of Washington's accommodationist attitude toward segregation divided Black leadership into two camps for decades. In *The Souls of Black Folk,* Du Bois, one of the NAACP's 60 founders, asserted that the "problem of the Twentieth century is the problem of the color-line." He also advanced the concept of the Talented Tenth, his belief that the top 10 percent of Black Americans had a responsibility to lead the masses. To this day, Du Bois's many other publications have yet to surpass the popularity of this seminal work.

# The Mis-Education of the Negro by Carter G. Woodson (1933)

Known as the "father of Black history," Carter G. Woodson pioneered scholarly study of Black/African American history and culture and, beginning with Negro History Week in 1926, is responsible for the ultimate establishment of Black History Month. In *The Mis-Education of the Negro,* Woodson questions the value of Eurocentric education for Black Americans and advocates for a more balanced educational system that doesn't ignore the tremendous contributions of Black people to American history and the world. Sadly, the book's continuing popularity among both students and nonstudents stems from the harsh reality that Woodson's interrogation of the American educational system's value to Black Americans remains valid.

Woodson's work inspired the title of Lauryn Hill's 1998 Grammy-winning album *The Miseducation of Lauryn Hill.*

# Their Eyes Were Watching God by Zora Neale Hurston (1937)

A major player during the Harlem Renaissance, Zora Neale Hurston also studied with noted anthropologist Franz Boas as a student at New York City's Barnard College and even collected Southern folk music alongside famed folklorist Alan Lomax for the Library of Congress. This substantial study of "Negro folklore," coupled with her own personal experiences, permeate her timeless novel *Their Eyes Were Watching God.* Set mostly in Eatonville, Florida, the all-Black town where she grew up, *Their Eyes Were Watching God* illustrates Hurston's poetic command of language.

In recent decades, female scholars have specifically praised Hurston's ability to capture protagonist Janie Crawford's frustrations as she struggles to find herself in the 1930s during a time when a Black woman, as Janie's grandmother Nanny tells her, is "de mule uh de world." Although once a heralded writer, Hurston died penniless in 1960. Largely ignored until celebrated writer Alice Walker resurrected her legacy in the 1970s, Hurston's classic novel reached an even larger audience when Oprah Winfrey produced the book's first film version starring Halle Berry for ABC in 2005.

# Native Son by Richard Wright (1940)

Mississippi-born writer Richard Wright's "protest" novel *Native Son,* which deals head-on with racism and its sociological causes and effects, sold a whopping 250,000 copies during its first run. Set mainly on Chicago's poor and predominantly Black South Side during the 1930s, *Native Son* tells the tragic story of 20-year-old Bigger Thomas as his life spirals into an uncontrollable and tangled web of fear and murder.

A one-time member of the Communist Party, Wright, who escaped the Jim Crow South only to endure intense racial segregation in Chicago, uses Thomas's highly questionable actions to dramatize racism's devastating effects. An influential titan of 20th-century Black literature, Wright's use of the literary style of naturalism to depict Black Americans as victims of larger social forces defined Black (male) writers for decades.

# Invisible Man by Ralph Ellison (1952)

Oklahoma native and one-time music student Ralph Ellison left Tuskegee Institute in 1936 for New York City. There he met Richard Wright and became affiliated with the influential Federal Writers' Project. In 1952, Ellison published his first novel, *Invisible Man*, to critical acclaim. In *Invisible Man*, the unnamed protagonist searches for his own identity, only to find it marred by American racism. Ellison mixes and matches American and Black American cultural traditions as he reveals that Black Americans or Negro Americans at the time, the unnamed protagonist included, are largely invisible in mainstream American society.

Through the fictional characters of Dr. Bledsoe and Ras the Exhorter (fictionalized versions of Booker T. Washington and Marcus Garvey and their respective positions), Ellison analyzes the various strategies Black Americans employ and have employed to achieve racial equality. Ellison's decision to infuse jazz, a uniquely American art form created by Black Americans, throughout the text subtly establishes an aesthetic perspective that is simultaneously American and Black American. Although another novel, *Juneteenth*, was published after his death, *Invisible Man* remains his American masterpiece.

# The Autobiography of Malcolm X (As Told to Alex Haley) by Alex Haley and Malcolm X (1965)

Published just months following Malcolm X's assassination in February 1965, *TIME* magazine deemed *The Autobiography of Malcolm X* one of the 20th century's ten most important nonfiction books. Dictated to Alex Haley, who later wrote *Roots, The Autobiography of Malcolm X* details Malcolm Little's life from once-promising student to hustler as well as his rise from a prison convict to one of Black America's most charismatic leaders.

Unlike Martin Luther King, Jr., Malcolm X, who rose to prominence as a member of the Nation of Islam, didn't advocate nonviolence as a means of improving the overall condition of Black people in America. He favored a more militant approach to Black freedom and equality that proved especially popular in urban centers. Although incomplete, *The Autobiography of Malcolm X* provides an intimate window into one of the 20th century's most intriguing and controversial figures of any race.

# The Color Purple by Alice Walker (1982)

In *The Color Purple*, longtime activist Alice Walker, who coined the term "womanism" to distinguish Black American feminism, scored critically and commercially with the Pulitzer Prize–winning story of Celie, a young Black woman who overcomes poverty and sexual abuse in the rural South to realize her own self-worth. In *The Color Purple*, Walker uses folkloric techniques reminiscent of her literary mother, Zora Neale Hurston.

Infused with a womanist energy, *The Color Purple* questions taboo subjects (especially for the era) such as misogyny, sexual abuse, and homosexuality, as well as traditional religious beliefs within the Black community. Despite the critical acclaim Walker received for *The Color Purple*, many Black men accused Walker of portraying Black men negatively, especially after the film was released in 1985. Controversy aside, *The Color Purple* remains a widely read staple.

# Beloved by Toni Morrison (1987)

Six years after she published *Beloved*, Toni Morrison became the first Black American recipient of the Nobel Prize for Literature for her collected works. Partly inspired by the true story of Margaret Garner, an enslaved woman who elected to kill her children rather than return them to slavery, *Beloved* follows the life of Sethe, a woman haunted by both her enslaved past and the ghost of the infant daughter she kills to protect her from slave hunters tracking her down. Shunned by the Black community and living quietly with her daughter, as well as her mother-in-law Baby Suggs for a spell, in a house presumably haunted by the ghost of the dead baby girl, Sethe gets another chance at life and love when Paul D, an associate from her former plantation, comes to town. That's all shattered when Beloved, whom Sethe believes is her dead child reborn, appears.

A beacon of achievement in both Black literature and literature overall, *Beloved* represents the maturation of a genre rooted in the critical slave narrative tradition by paying homage to and transcending those origins. Refreshing in its multifaceted approach to enslavement and Reconstruction, *Beloved* examines the shackles, literally and figuratively, of the enslaved past of both Sethe as well as that of the nation at large.

Chapter **22**

# Ten (Plus One) Influential Black American Visual Artists

As a result of the special significance artisans held in African culture, woodcarving, pottery, basket weaving, ironworks, and other crafts largely characterized early visual art from Black Americans. Even though portrait artists did emerge prior to the Civil War, Black American artists recognized in the mainstream were relatively few until after the Civil War. During the Harlem Renaissance or the New Negro Movement, as many knew it, of the late 1910s into the early 1930s that was evident throughout the nation, many Black American artists' embrace of their African heritage was reflected in their work. Today, the permanent collections of many world-class museums include work from Black American artists.

The ten (plus one) influential Black American artists featured in this chapter are far from definitive. Instead, they serve as a representative taste of a Black/African-American art tradition that continues to grow and evolve.

# Joshua Johnson (c. 1763–1832)

Believed to be the first successful Black American artist, Joshua Johnson (sometimes Johnston), who was likely born enslaved in the West Indies, worked in the Baltimore area between the 1790s and early 1800s, where he painted prominent middle-class families, including free Black Americans. His talent and fame rivaled that of his white contemporary Charles Wilson Peale, whom some scholars believe Johnson knew personally. More than 80 of his portraits hang in some of the world's most prestigious museums, including the American Museum in Bath, England.

# Edmonia Lewis (c. 1844–1907)

Born to a Haitian-American father and a mother with Native American ancestry and orphaned at a young age, sculptor Edmonia Lewis, largely supported by her wealthy older half-brother early in her career, was among the few successful female artists of her time. Unlike other Black artists, Lewis, who survived racial tensions at Oberlin Collegiate Institute, despite its reputation as one of the first mainstream institutions to admit Black students, didn't hide her heritage and liked being photographed with her work.

A bust of Colonel Robert Gould Shaw, the white commander of the Union army's legendary all-Black 54th Regiment, earned Lewis, who also sold medallions of prominent abolitionists, widespread acclaim and enough money to move to Rome, then a thriving center for writers, poets, and artists often visited by wealthy Americans. There, Lewis flourished but still exhibited her work in the United States.

Her most well-known work, *The Death of Cleopatra*, was lost for years. After not selling the piece, which exhibited at both the 1876 Philadelphia Centennial Exposition and the 1878 Chicago Interstate Exposition, Lewis couldn't afford to ship the piece to Rome and instead stored it. Until its discovery in 1988, the famous piece made several rounds, including spending time in a Chicago saloon and serving as a grave marker for a horse named Cleopatra. Today, the restored masterpiece resides in the Smithsonian National Museum of American Art. Other institutions with work from Lewis include the Howard University Gallery of Art and the Metropolitan Museum of Art.

## FACE VESSELS

Functional pottery modeled in the shape of human faces, known as *face vessels* or *face jugs,* emerged prior to the Civil War. Although first noted in the North around 1810, those created by enslaved people in Edgefield, South Carolina, are especially distinctive. Marked by their alkaline-glazed stoneware and simple, earthy tones, face vessels have been found in other parts of the South. Their creators, however, haven't been satisfactorily identified.

While people in various parts of the world, including Africa, use face vessel–like objects in specific rituals, scholars have been unable to determine whether the face vessels created during the antebellum period functioned beyond mundane tasks such as holding water. Given the number of face vessels recovered along key Underground Railroad routes, however, there is reason to believe they served a greater purpose. Face vessel production waned after 1865, but they still serve as a reminder of the existence of early Black American artists.

# Henry Ossawa Tanner (1859–1937)

Largely touted as the first Black artist to achieve international fame, Henry Ossawa Tanner, the son of an African Methodist Episcopal minister father and a mother who escaped enslavement through the Underground Railroad, infused his art with spiritual and natural themes. Early paintings depicting Black Americans from Tanner, who studied art at the prestigious Pennsylvania Academy of the Fine Arts, are especially rare and valuable. After a failed photography studio in Atlanta, Tanner made his way to Paris in 1893, where he studied at the Académie Julian. Inspired by the Paul Laurence Dunbar poem "A Banjo Song," Tanner created his most famous work, *The Banjo Lesson,* an emotionally moving portrait of an elderly man teaching the banjo to the young boy on his knee. The famed painting has been housed by the Hampton University Museum since 1894. Although Tanner held exhibitions in the United States, he lived the rest of his life in France with his wife and child.

# Aaron Douglas (1899–1979)

Known as the "father of Black American art," Aaron Douglas, born in Kansas, made a bold artistic and political statement by incorporating African and Black American influences in his work. During the Harlem Renaissance, Douglas's work

regularly appeared on the cover of the magazine *Opportunity* as well as in books by Harlem Renaissance writers such as James Weldon Johnson. Douglas served as the first president of the Harlem Artists Guild, which succeeded in getting Black artists accepted for projects with the Works Progress Administration (WPA), created during FDR's administration.

Through the WPA, Douglas created one of his most famous murals, *Aspects of Negro Life*, in 1934 for the 135th Street branch of the New York Public Library, later renamed for Harlem Renaissance luminary Countee Cullen and now absorbed into the renowned Schomburg Center for Research in Black Culture in New York City. First commissioned to paint murals for Fisk University, Douglas went on to help create the school's art department in the late 1930s but didn't become a full-time art professor there until 1944. Douglas, who also chaired the art department, remained at Fisk until his retirement in 1966. Today, his work, including his signature murals, remains a valued feature of the historic campus.

**TECHNICAL STUFF**

In 1938, WPA alumnus Hale Woodruff was commissioned to create the extraordinary *Amistad* murals, depicting the famous slave ship rebellion of 1839 for Talladega College in Alabama. The 1997 Steven Spielberg-directed, Debbie Allen-produced historical drama *Amistad* detailed the story of how African captives represented by former president John Quincy Adams regained their freedom, as well as other historic events. For nearly 70 years, the murals hung above the school's Savery Library before being taken down in 2008 for much-needed conservation in collaboration with Atlanta's High Museum of Art, followed by a multiyear tour to museums in major urban centers. The murals, valued at $50 million, returned to the school in 2020, in the newly opened Dr. William R. Harvey Museum of Art.

# Horace Pippin (1888–1946)

Formally pursuing art as a child was too expensive for Horace Pippin, so he taught himself. At age 14, Pippin, who grew up mostly in Goshen and Middleton in New York, left school altogether to help support his family. As a member of the famed all-Black 369th Infantry Regiment (more popularly known as the Harlem Hellfighters), which fought honorably alongside the French in World War I, he was wounded by enemy fire and lost normal use of his right arm. Back in his West Chester, Pennsylvania birthplace, Pippin and his wife eked out a modest living on his disability, income from odd jobs, and her earnings as a laundress as they raised her son.

Unable to erase the horrors of war from his mind, Pippin returned to art at around age 40. Presumably triggered by his injury, Pippen's first painting, *The End of the War: Starting Home*, took a reported three years to complete. Artist N.C. Wyeth and

art critic Christian Brinton, who lived in the area, were key in introducing Pippin's work to a wider audience. The art world embraced Pippin's bold use of colors, his depictions of Black American life, and his antiwar, religious, and landscape paintings. Four of Pippin's works were included in a 1938 traveling show for the Museum of Modern Art. Just as he was becoming more famous, Pippin died of a stroke in 1946 at age 58.

# Loïs Mailou Jones (1905–1998)

Artist Loïs Mailou Jones, a Howard University art professor from 1930 until 1977, developed her own gift while nurturing younger artists such as sculptor Elizabeth Catlett and African American art advocate David Driskell. Jones began her impressive art career, which spanned more than six decades, in her native Boston, where she graduated from the School of the Museum of Fine Arts in 1927. Dissatisfied with the anonymity of life as a textile designer, Jones sought a teaching career to complement her art career, but racism forced her south. She began developing the art department at North Carolina's Palmer Memorial Institute before Howard University wooed her away.

Jones, who secretly entered her work in contests barring Black artists and won, explored her craft freely during a sabbatical in Paris in the late 1930s, where she studied, visited museums, and painted. There, she created *Les Fétiches*, her celebrated piece of African masks. In 1953, Jones married acclaimed Haitian graphic artist Louis Vergniaud Pierre-Noel, adding regular travel between Haiti, where she had lived and taught, and Washington, D.C. to her routine. Fascinated with Haiti's strong African retentions, Jones integrated that influence into her work and later traveled and studied in various African countries, which also impacted her work. Important pieces from the artist, who created new work practically up until her death in 1998, can be found in the permanent collections of several art institutions, including the Studio Museum in Harlem and the Smithsonian American Art Museum.

**HISTORICAL ROOTS**

Loïs Mailou Jones student and accomplished artist David Driskell (1931-2020), who passed due to COVID-19, also championed Black artists as both an art historian and curator. His landmark 1976 exhibition *Two Centuries of Black American Art* that he curated featuring 63 artists and more than 200 works inspired Sam Pollard's 2021 HBO documentary *Black Art: In the Absence of Light* highlighting not only prominent artists like Jacob Lawrence and Romare Bearden, but also addressing sexism in Black art with Faith Ringgold even as it highlights such artists as Kehinde Wiley, Amy Sherald, Kerry James Marshall, Carrie Mae Weems, and Radcliffe Bailey.

# Jacob Lawrence (1917–2000)

Jacob Lawrence directly benefited from the cultural richness of the Harlem Renaissance and, at an early age, took classes with respected artists Charles Alston and Augusta Savage. A child of the Great Migration, Lawrence used his personal experiences, along with historical research collected at the 135th Street Library (now the Schomburg Center for Research in Black Culture), to create his highly acclaimed series, *The Migration of the Negro,* also known as *The Migration Series,* in 1940 and 1941. Although Lawrence created several impressive series around historical figures such as Haiti's revolutionary leader Toussaint L'Ouverture, *The Migration Series* catapulted him into mainstream American art circles. Today, at least 200 museums house Lawrence's work, including the National Gallery of Art and the Metropolitan Museum of Art.

Elected to the prestigious American Academy of Arts and Letters in 1983, Lawrence, who painted until his death in 2000, created a large body of work documenting varying aspects of Black American life in an astonishingly beautiful and provocative modernist style. One of the most well-known American artists of the 20th century, Lawrence, who also taught art, helped widen the parameters of American art and opened doors previously closed to Black American artists.

# Romare Bearden (1911–1988)

The Harlem Renaissance and the Great Migration greatly influenced the North Carolina–born and Harlem-raised artist Romare Bearden. Although Bearden (whose mother was a noted journalist) created cartoons for mainstream and Black American publications early in his life, the World War II veteran and longtime social worker didn't make his mark in the art world until later. During the 1960s and 1970s, Bearden began cultivating his now-famous collage technique, which resembles Black American quilts on canvas.

Greatly inspired by jazz, the one-time jazz artist incorporated that love into famous works such as *Jammin' at the Savoy.* Equally important, Bearden, with his insightful essays and such books as *A History of African American Artists: From 1792 to the Present,* published posthumously by his coauthor Harry Henderson, helped elevate the Black American artist as a thinking, creative person whose gifts extended beyond raw talent. Bearden also played key roles in establishing Black institutions such as the Studio Museum in Harlem and the Black Academy of Arts and Letters in Dallas. Recognizing Bearden's importance as an artist, in 2003, the National Gallery of Art hosted *The Art of Romare Bearden,* its first major retrospective of a Black American artist.

# John Biggers (1924–2001)

The youngest of seven children born to parents in Gastonia, North Carolina, John Biggers, under the guidance of respected Austrian-born art educator Viktor Lowenfeld, began his artistic journey at Hampton Institute, where another mentor, Charles White, served as artist-in-residence. Following a two-year stint in the Navy, Biggers, at the urging of Lowenfeld, came to Pennsylvania State University, where he earned several degrees, including his Ph.D. In 1949, Biggers began developing the art department at what is now Texas Southern University. A 1957 UNESCO fellowship allowing Biggers to travel to Africa deeply affected him and his work. He shared that experience in his 1962 book *Ananse: The Web of Life in Africa*, where he mixed his drawings with his personal observations of countries such as Ghana and Nigeria.

Influenced by great Mexican muralists such as Diego Rivera, Biggers, who spent more than 30 years at Texas Southern University, created several treasured murals in Houston. Known for his rich and complex style, Biggers created works that often highlighted Black women. Distinctive for their mythic quality as well as their resounding beauty, some of Biggers's many well-known works include *Birth from the Sea* and *The Contribution of Negro Women to American Life and Education*.

# Samella Lewis, Ph.D. (1924–)

Born and raised in New Orleans in the 1920s, and mentored by the great Elizabeth Catlett and Charles White at Dillard University, Dr. Samella Lewis made contributions early on. As an art professor at such institutions as Morgan State University, Florida A&M, and Scripps College, Lewis, who earned doctorates in art and art history, a first for a Black woman, nurtured other artists as well as fostered a greater appreciation of Black art in general.

A founder of what became The International Review of African American Art as well as of the Museum of African American Art in Los Angeles, Lewis also wrote numerous books, including the textbook, *Art: African American* in 1978. Some of her cherished work as an artist includes the 2005 linocut "I See You" and the 1992 lithograph "House of Shango." In 2021, the College Art Association awarded Lewis the Distinguished Artist Award for Lifetime Achievement at age 96.

# Jean-Michel Basquiat (1960–1988)

Jean-Michel Basquiat's rapid commercial success remains enigmatic to many. Born in Brooklyn, New York, of Haitian and Puerto Rican ancestry, Basquiat rose to fame as a graffiti artist behind the tag "SAMO," a concept meaning "same old s**t" developed with high school friend Al Diaz. In addition to creating graffiti images, accompanied by such provocative slogan-esque statements as "SAMO© . . .4 THE SO-CALLED AVANT-GARDE" in and around New York City's influential Soho art community, Basquiat also gained notoriety through appearances on the public access show *TV Party*. His inclusion in the multi-artist exhibition, The Times Square Show, in 1980, followed by an *Artforum* article by Rene Ricard lauding his work, served as critical launching pads for his meteoric international art career. A brief friendship with Andy Warhol only elevated his profile.

Staple features of Basquiat's work, typically characterized as *neo-expressionist*, include primitive-like figures and words. Descriptions of his work by some white critics as simply "primitive" conjure up racist assumptions questioning the artistic merit of Black American artists. His unexpected death to a heroin overdose in 1988 at just 27 years old only fueled his legend. Although Basquiat isn't specifically tied to Black American cultural traditions in the same ways as pioneering artists such as Jacob Lawrence, his commercial success raised critical questions about what is Black or African-American art while also expanding general notions regarding acceptable and unacceptable content for Black American artists. Because his ascendancy accompanied that of hip-hop, Basquiat, who collaborated with rappers, is associated in that space as well.

Even in death, he remains influential, prompting the 1996 film *Basquiat,* with actor Jeffrey Wright drawing early acclaim portraying him, and numerous documentaries, including 2017's *Boom for Real: The Late Teenage Years of Jean-Michel Basquiat.* In 2016 and 2017, Japanese billionaire Yusaku Maezawa set records, acquiring untitled works by Basquiat for $57.3 million and $110.5 million. The latter marked the highest price for which any work by an American artist had been purchased through auction. Both ensured that Basquiat's legend would live on.

# Index

## A

Aaron, Hank, 455

Abernathy, Ralph David, 177, 180, 182, 204–205

abolition movement
about, 85
arguing for/against slavery, 87–88
colonization (emigration) movement, 94–96
effects of proslavery politics, 96–98
Emancipation Proclamation and, 115
key abolitionists, 89–92
Lincoln and, 107–108
managing divide between slavery and freedom, 103–107
reading and writing, 92–94
societies, 86
Underground Railroad, 98–103

Abrams, Stacey, 10, 129, 249, 253, 257

*Abyssinia* (musical), 336

accommodationist policy, 147–148

*Adam Negro's Tryall,* 309

Adams, Abigail, 58

Adams, Henry, 139

Adams, John, 58, 59

*Addicted* (Zane), 328

Adjaye, David, 26

*Adventures of Huckleberry Finn* (Twain), 16

Affordable Care Act (ACA), 238

Afonso I, 43–44

Africa, 33–47

"African," as a term, 16

"African American," as a term, 16

*African American History For Dummies* (Penrice), 1

*African American Lives* (docuseries), 9, 126

African Baptist ("Bluestone") Church, 266

African Grove Theater, 332

African Institution, 95

African Lodge, 62

African Methodist Episcopal (AME), 16, 266, 267

African Methodist Episcopal Zion (AMEX), 266, 267–268

*The African Origin of Civilization* (Diop), 37

Africanus, Leo, 43

"Afro-American," as a term, 16

Agricultural Adjustment Association (AAA), 159

AIDS, 228–229

Aiken, George, 337

Ailey, Alvin, 17, 237, 354–355

Alabama, 182–184, 187–189, 193–194

Alabama Christian Movement, 182

Albany Movement, 180–181, 203

Aldridge, Ira, 332

Alexander, Margaret Walker, 325

Alexander, Michelle, 22

Alfonso V, King of Portugal, 43

Ali, Muhammed, 3, 18, 465, 466

Ali, Noble Drew, 279–280

Alito, Samuel, 292

*All God's Chilun Got Wings* (play), 339

*All In* (documentary), 257

all-Black casts, 395–398

Allen, Debbie, 355

Allen, Louis, 191

Allen, Macon B., 482

Allen, Richard, 61, 267, 274

Allen, William Francis, 362

Almoravids, 35

Alpha Kappa Alpha, 305

Alpha Phi Alpha, 25, 305

American Anti-Slavery Society, 86, 90

American Colonization Society, 90, 95–96

American Descendants of Slavery (ADOS), 30

"American dream," achieving the, 19–20

American Negro Academy, 149

American Negro Theater (ANT), 343

American Revolution, 57–61, 69

Ames, Adelbert, 132

Amnegro Films, 398

ANC (Aid to Needy Children) Mothers Anonymous of Watts, 217

Anderson, Elijah, 101

Anderson, Garland, 341

Anderson, William, 180

Andrew, James Osgood, 270

Angelou, Maya, 324

*Anna Lucasta* (play), 343

*Annie Allen* (Brooks), 485

*Another Country* (Baldwin), 321

Anthony, Susan B., 130

antiphony. *See* call-and-response music

Antoine, C.C., 129

*Appearances* (play), 341

Appomattox Courthouse, 117

*Arabella* (ship), 53

Arbery, Ahmaud, 251

Arkansas, 125–126

Armstrong, Louis, 369, 373

Arrington, Richard, Jr., 221

*Arte de los contratos* (de Albornoz), 43

Ashe, Arthur, 18, 474

Association for the Study of African American Life and History (ASALH), 10

Association for the Study of Negro Life and History (ASNLH), 10

Atkinson, Charles, 352–353

Atlanta Compromise, 148

Atlanta Public Schools cheating scandal, 294

Atlanta Race Riot (1906), 142–143

Attaway, William, 319

Attucks, Crispus, 58, 59

*The Autobiography of Malcolm X* (Haley and Malcolm X), 197, 491

*The Autobiography of an Ex-Coloured Man* (Johnson), 316

avant garde jazz, 371

## B

*Baby Momma Drama* (Weber), 328

Baez, Joan, 185

Baker, Ella, 179, 216

*Bakke v. California Board of Regents,* 303

Baldwin, James, 10, 17, 237, 319, 320, 321

Baldwin, Ruth Standish, 154

Bale, Christian, 37

Baltimore, Charles, 143

Baltimore Riots, 243–244

Bambara, Toni Cade, 324

*Bandana Land* (musical), 336

banjo, 364

Bank of America, 252

banking, 128–129

Banneker, Benjamin, 89

Baptist War, 46

Baraka, Amiri, 322, 323

Barber, William, 278

Barbour, Nelson H., 282

Barnes, Stephen, 326

Barnett, Ross, 181

Barr, Will, 256

*Barraccoon,* 106

Barry, Marion, 179

baseball, 449–456

basketball, 456–464

Basquiat, Jean-Michel, 500

Bass, Karen, 253

Bates, Daisy, 216

Battle of Antietam (Sharpsburg), 114

Battle of Vicksburg, 117

Baylor, Elgin, 460

Beal, Francis, 217–218

Beamon, Bob, 471

Bearden, Romare, 498

beauty companies, 225

*Beauty Shop* (play), 346

bebop, 370–371

*Before the Mayflower* (Bennett), 14

Bel, Ricky, 23

Bell, Alexander Graham, 18

Bell, Sean, 229

Bell, W. Kamau, 250

*Beloved* (Morrison), 325, 492

Belton, Ethel, 166

Belton, Sharon Sayles, 222

*Belton v. Gebhart,* 166

Benezet, Anthony, 86, 89, 288

Bennett, Lerone, 14

Berea College, 296

Berlin, Ira, 67

Bernal, Martin, 37

Berry, Chuck, 17

Berry, Halle, 3, 424–425

Berry, Mary Frances, 31

Berry, Shawn, 229

Bertelsen, Phil, 199

Bethune, Mary McLeod, 159–160, 216

Bevel, James, 183

Beyoncé, 306

Biden, Joe, 218, 235, 251, 253–258

big band jazz, 369

Big Freedia, 237

Big White Fog *(play),* 343

Biggers, John, 499

Birther Movement, 279

*The Birth of a Nation* (film), 78, 337–338, 394

Bivins, Michael, 23

"Black," as a term, 16

Black activism, 227

Black AIDS Institute, 229

Black American Faces icon, 4

*Black and Blue* (musical), 346

Black Arts Movement, 322–323

*Black Athena,* 37

Black Catholics, 281–282

Black Caucus, 220

Black church, 266–275

Black Church Action Fund, 250

Black Codes, 122

Black demagogues, 283–284

Black Doctors COVID-19 Consortium, 250

*Black Drama* (Mitchell), 337

Black Entertainment Television (BET), 32, 224, 443–444

Black Exodus, 138–139

*Black Fire* (Baraka and Neal), 323

Black Greek Letter Organizations (BGLOs), 304–306

Black heritage, celebrating, 23–24

Black History Month, 1, 10, 13, 23

Black inferiority, 88

Black Liberation Army (BLA), 211

Black liberation theology, 276

Black literature, 307–329

Black Lives Matter (BLM), 1, 2, 3, 10, 18, 21, 22, 238–245, 278

Black Masons, 61, 62

Black Nationalism, 13

*Black Panther* (film), 24

Black Panther Party (BPP), 15, 199–200, 208–213

Black Power movement, 16, 196. *See also specific topics*

Black pride, 22–24

*Black Slaves, Indian Masters* (Krauthamer), 126

Black Star Line Steamship Corporation, 157, 158

*Black Theology and Black Power* (Cone), 265

Black towns, 139–140

*Black Voices* (Chapman), 323

Black Women's Liberation Committee (BWLC), 217–218

*A Black Explorer at the North Pole* (Henson), 483

*A Black Woman's Civil War Memoirs* (King Taylor), 117

*The Blacker the Berry* (Thurman), 319, 341

blackface, 333

Black-ish *(TV show),* 433

#BlackLivesMatter, 241

*The Black Book* (Morrison), 325

*The Black Church in the African American Experience* (Lincoln and Mamiya), 265

*The Black Megachurch* (Tucker-Worgs), 273

*The Black Panthers* (documentary), 212

*The Black Woman* (Bambara), 218, 324

Blair, Ezell, Jr., 177–178

Blair, James, 262

*Blake* (Delany), 312

Blake, Eubie, 340

Blanco, Kathleen, 232

Bland, Sandra, 244–245

Blanton, Thomas, 189

Blassingame, John W., 14

Blesh, Rudi, 362

Blige, Mary J., 229

blood bank, 18

Bloody Sunday (1965), 1, 194

*Blue Blood* (play), 342

blue notes, 367

blues, 363–367

*Blues People* (Baraka), 322

*The Bluest Eye* (Morrison), 324

Bluett, Thomas, 53

Boaz, Franz, 317

Bogle, Donald, 484

Bolden, Charles "Buddy," 368, 373

*Bolling v. Sharpe,* 166

Bond, J. Max., Jr., 26

Bond, Julian, 221

Bonner family, 26

Booker, Cory, 253

Bookerites, 150

Booth, John Wilkes, 120

Bosley, Freeman, Jr., 222

Boston Massacre, 58, 59

Bottoms, Keisha Lance, 253

boxing, 464–467

boycotts, 174–177

Boyer, Nate, 246

Boykin, Keith, 237

*Boynton v. Virginia,* 179

Bradford, Perry, 365

Bradley, Joseph P., 147

Bradley, Tom, 221

Brando, Marlon, 185

Braun, Carol Mosley, 219

breakdancing, 353

Breed, London, 247–248

Breedlove, Sarah, 152

Brewer, Lawrence, 229, 231

Bridgeman, Valerie, 275

Bridges, Ruby, 291

Briggs, Harry, 165

*Briggs v. Elliott,* 165

broad marriages, 68

Bronner, Dale, 278–279

Brooke, Edward, 130

Brooke, Edward W., III, 220

Brooks, Gwendolyn, 319, 323, 325, 484–485

Brooks, Rayshard, 251

Brotherhood of Sleeping Car Porters, 161

Browder, Aurelia, 174–175

*Browder v. Gayle,* 174–175, 176

Brown, Bob, 211

Brown, Debra M., 236

Brown, Edward, 88

Brown, Elaine, 213

Brown, James, 23, 277, 383

Brown, James Henry, 332

Brown, Jazebo, 367

Brown, John, 68, 91, 106–107

Brown, LaTosha, 253

Brown, Lee P., 222

Brown, Michael, 1, 3, 10, 21, 242, 256, 278

Brown, Mike, 232

Brown, Morris, 270

Brown, Ron, 222

Brown, Rory, 17

Brown, Sterling K., 231

Brown, William Wells, 89, 312, 337

Brown, Willie, 222

Brown University, 68

*Brown v. Board of Education,* 14–15, 160, 163–169, 173, 188, 282, 289, 290–292, 303

Bruce, Blanche K., 129–130

Bryan, Andrew, 266

Bryant, Carolyn, 170, 171

Bryant, Jamal Harrison, 278

Bryant, Kobe, 461

*Buchanan v. Warley,* 153

Bulah, Sarah, 166

*Bulah v. Gebhart,* 166

Bunch, Lonnie, III, 26

Bunche, Ralph, 11, 215, 484

Bundles, A'Lelia, 152

Burke, Tarana, 218

Burke, Yvonne Braithwaite, 220

Bush, Cori, 256

Bush, George W., 25, 26, 30, 196, 222, 231, 232, 304

business, 223–226

Bussey, Charles E., Jr., 221

Butler, Benjamin, 127

Butler, Octavia E., 326

*By the Way, Meet Vera Stark* (play), 350

Byrd, Harry F., Sr., 169

Byrd, James, Jr., 229, 231

Byrd, William, 266

**C**

Cable, George Washington, 314, 368

Caillous, André, 116

cakewalk, 351

Calhoun, John C., 86, 103, 104

California, 104

call-and-response music, 265, 360

Cameron, Daniel, 21

*Cane* (Toomer), 317

Cannick, Jasmyne, 237

Cantrell, LaToya, 247–248, 250

Cardozo, Francis L., 129

Cardozo, T.W., 129

Caribbean slavery, 41–47

*Carmen Jones* (musical), 345

Carmichael, Stokely, 179, 200–201, 208

Carnell, Yvette, 30

Carney, William H., 483

carpetbagger, 121

Carter, Betty, 372–373

Carter, Jimmy, 304

Carter, Michelle, 472–473

Carver, George Washington, 301

Cary, Mary Ann Shad, 151

Cash, Herman, 189

Castile, Philando, 245

Catholicism, 264, 281–282

Cedric the Entertainer, 417–418

Central Avenue jazz, 369–370

Central High School, 167–169, 291

Chamberlain, Wilt, 460

Chambliss, Robert Edward, 189

Chaney, James, 192

Chapman, Abraham, 323

Chappelle, Dave, 418

Charles I, King of Spain, 43

Charleston Church Massacre, 244

Charna, Dan, 225–226

Chauvin, Derek, 21, 233–234, 251–252

Cheat Sheet (website), 5

Cherry, Bobby Frank, 189

Chesnutt, Charles, 314

Chester, Thomas Morris, 119

Chestnut, Charles W., 326

Cheyney University, 295–296

Chicago, Illinois, 144

Chicago Freedom Movement (CFM), 202

children's march, 183

*The Chip Woman's Fortune* (play), 341

Chisholm, Shirley, 220, 221

Chrisman, Robert, 323

Christianity, 262–266

Christmas Uprising, 46

church, 261–284

Church, Frank, 212

Church of God in Christ (COGIC), 271–272

cimarrones, 46

*City of Refuge* (Fisher), 316

civil rights

about, 187–188, 233–234

Birmingham, Alabama, 187–189

Black Literature from, 319–321

Black Power, 196–201

Civil Rights Act (1964), 189–190

death of King, Jr., 203–205

Freedom Summer, 190–193

post-, 207–232

pre-, 12–13

Project Alabama, 193–194

race relations in the north, 201–203

Voting Rights Act (1965), 195–196

Civil Rights Act (1866), 12

Civil Rights Act (1875), 132, 147

Civil Rights Act (1964), 189–190

Civil Rights Act (1968), 205

*Civil Rights Cases of 1883*, 147

Civil Rights movement. *See also Brown v. Board of Education; King, Martin Luther, Jr.*

about, 16, 163

boycotts, 173–181

increasing Federal involvement, 181–182

March on Washington for Jobs and Freedom (1963), 185–186

marches, 173–181

1963, 182–184

Ole Miss, 181–182

sit-ins, 173–181

Till, Emmett, 169–171

Civil War

about, 109

Confederate Army, 118–119

early days of, 111–112

Emancipation Proclamation, 113–116

end of, 119–120

end of Reconstruction, 131–134

Fifteenth Amendment, 130

government intervention and, 123–130

post-, 270–271, 289–290

Reconstruction, 121–123

slavery and, 110–111

Thirteenth Amendment, 119–120

Union Army and, 116–118

Clark, Jim, 194

Clark, Kenneth, 165

Clark, Mamie Phipps, 165

Clark, Mark, 212, 213

Clark, Mattie Moss, 377–378

Clarkson, Thomas, 89

class distinctions, 44–45

class wars, cocaine and, 227

classic blues, 365

classical dance, 354–356

Clay, Henry, 95–96

Clay, William L., 220

Cleaver, Eldridge, 209, 211

Cleaver, Emmanuel, 222

Cleaver, Kathleen Neal, 213

*Cleopatra* (film), 37

Cleveland, James, 377

Clinton, Bill, 25, 30, 219, 222

Clinton, Hillary, 234, 255

*Clorindy, the Origin of the Cakewalk* (musical), 336

*Clotel*, 312

*Clotilda* (ship), 105–106, 113

Cloud, John, 194

Clutchette, John, 210

Clyburn, James "Jim," 253

Coachman, Alice, 471

Coates, Ta-Nehisi, 28, 30

Coats, John, 67

cocaine, 226–228

Cochran, Johnnie, 230–231

Cochran, Thad, 146

Coffin, Catharine, 100

Coffin, Levi, 100

cohabitation, among enslaved people, 45

*The Coldest Winter Ever* (Souljah), 328

Cole, Bob, 336

Cole, Johnetta B., 304

Coleman, Johnnie, 275

Coleman-Singleton, Sharonda, 244

Colfax Courthouse, Massacre at, 131

Collins, Addie Mae, 188

Collins, Patricia Hill, 219

Colonization Council, 139

colonization (emigration) movement, 94–96

*Color Struck* (play), 342

"colored," as a term, 16

Colored Farmers' National Alliance and Cooperative Union, 138

Colored Women of America, 151

Colored Women's Progressive Franchise Association, 151

The Colored Players Film Corporation, 395

*The Color Purple* (Walker), 324, 492

Columbus, Christopher, 38, 39, 41–42

Colvin, Claudette, 174–175

Combs, Sean "Diddy," 15

comedy, 415–412, 428–431

Committee for the Improvement of Industrial Conditions Among Negroes, 154

Committee on Urban Conditions Among Negroes, 154

Common, 23, 229, 414

Compromise of 1850, 104

Cone, James H., 265

Confederate battle flag, 28–29

Confederate soldiers, 112, 118–119

Confederate States of America (CSA), 110

*Confirmation* (film), 218

Confiscation Acts (1861 and 1862), 111, 114

Congo, 43

Congo Square, 368

Congress of Racial Equality (CORE), 173, 215

Congressional Medal of Honor, first Black recipient of, 483

*Conjur Man Dies* (play), 343

*The Conjure Woman, and Conjure Tales* (Chesnutt), 314

Connecticut, 60

Connecticut Emancipation Society, 94

Connor, Bull, 179, 203–204

*Considerations On Keeping Negroes* (Woolman), 60

Conyers, John, 30

Coogler, Ryan, 241, 410–411

Cook, Will Marion, 336

Cooke, Henry, 128

Cooke, Jay, 128

Coolidge, Calvin, 158

Cooper, Iris, 225–226

Copeland, Misty, 355–356

Copeland, Raniyah, 229

Corbett, Kizzmekia "Kizzy," 250

*The Corner* (film), 436

Cornish, Samuel E., 93, 94

Corporate Restitution Movement, 28

Corrie, William, 105

Cortés, Hernán, 41

*The Cosby Show* (TV show), 430–431

Cosgrove, Myles, 21, 251

Cotton, Tom, 27

cotton gin, 71

cotton plantations, 65, 71–72

Counter Intelligence Program (COINTELPRO), 212

Coushatta, murders in, 131

COVID-19, 249–250, 253–256

Cox, Laverne, 237

crack cocaine, 226–228

*Creating Black Americans* (Painter), 14

Crenshaw, Kimberlé, 219

*The Creole Show* (musical theater), 335

crime and the criminal justice system, 20–22, 156

*The Crisis* (magazine), 153

*A Critique of the Slave Trade* (de Mercado), 43

Crittenden, John J., 110

Crittenden-Johnson Resolution, 110, 121

Cromwell, Oliver, 60

Crosby, Peter, 131

Crowley, James, 238

Crummell, Alexander, 149

Crump, Benjamin, 239

*Crusade for Justice*, 141

Cuffe, Paul, 95–96

Cullen, Countee, 11, 319

Cullors, Patrisse, 22, 241, 242

cultural contributions, 15–18

cultural tourism, 24–26

Cumming, Elijah, 248

curse of Ham, 88

cycling, 477

# D

Dabney, John, 105–106

Dabney, Robert Lewis, 88

*The Dahomean* (Yerby), 321

Daley, Richard, 202

dance, 17, 351–356

Darden, Christopher, 230

*Dark Alliance* (Webb), 228

*Dark Matter* (Butler), 326

*Darktown Follies* (musical), 351

Davies, Ronald N., 167–168

Davies, Samuel, 263

Davis, A.K., 129

Davis, Angela, 210, 219, 237

Davis, Calvin P., 144

Davis, Jefferson, 108, 110, 115, 118, 129, 133

Davis, Miles, 374

Davis, Ossie, 345

Davis, Sammy, Jr., 353

Davis, Viola, 425

*Davis v. County School Board of Prince Edward County*, 166

de Albornoz, Bartolomé, 43

de Balboa, Vasco Núñez, 41

de Boré, Jean Étienne, 71

De La Beckwith, Byron, 184

de la Matosa, Francisco, 47

de Mercado, Fray Tomás, 43

de Montúfar, Alonso, 43

de Vaca, Alvar Núñez Cabeza, 41

Declaration of Independence, 60, 61

*The Declaration and Confession of Jeffrey, a Negro*, 309

Def Comedy Jam, 419

*A Defence of Virginia* (Dabney), 88

DeLaine, Joseph A., 165

Delany, Martin R., 96, 118, 127, 312

Delany, Samuel R., 326

DeLarge, Robert, 130

Delaware, 110, 113

Delta blues, 365

Delta Sigma Theta, 306

Demings, Val, 253

"Denmark Vesey and His Co-Conspirators" (Johnson), 77

Denmark Vesey's Uprising, 76–77

Denny, Reginald, 230

Denton, Vachell, 53

DePriest, Oscar, 220

Derby, Doris, 344

Derham, James, 481–482

desegregation, 167–169, 183–184, 303

*Desire* (slave ship), 50

*Devil in a Blue Dress* (Mosley), 328

Devine, Annie, 193

Devoe, Ronnie, 23

DeVos, Betsy, 19, 295

Diallo, Amadou, 229

Diallo, Ayuba Suleiman, 53

*Diary of a Mad Black Woman* (musical), 346

*A Different World* (TV show), 431

*Diffrent Strokes* (TV show), 429

Diggs, Daveed, 24

Dinkins, David, 2, 219

Diop, Cheikh Anta, 37

Diouf, Sylvanie A., 80

discriminatory policies, inequalities in, 20

Divine, Father, 283–284

Divine Nine, 304–306

DMX, 414

DNA testing, 9

Doctor, Depayne Middleton, 244

Dollar, Creflo, 274

Dollar, Taffi, 275

*Don King* (film), 436

Dorsey, Decatur, 117

Dorsey, Thomas Andrew, 274, 375–376

double consciousness, 61

"Double V" campaign, 161

Doughty, Charles, 270

Douglas, Aaron, 483, 495–496

Douglas, Stephen A., 103, 105

Douglass, Frederick, 12, 19, 79, 89, 91–93, 103, 116, 123, 129, 130, 139, 147, 268, 288, 311, 482, 488

Douglass, H. Ford, 118

*Dreamgirls* (musical), 345–346

Dretzin, Rachel, 199

Drew, Charles, 18

Drew, Howard, 471

Drexel, Katharine, 282

drivers, 73

drug trafficking, 228

Drumgo, Fleeta, 210

Du, Soon Ja, 230

Du Bois, W.E.B., 13, 37, 61, 146–150, 152–154, 158, 219, 299–302, 313, 326, 340, 489

du Sable, Jean Baptiste Pointe, 25

Dumas, F.E., 118

Dunbar, Paul Laurence, 148, 314, 329, 336

Dunbar-Nelson, Alice, 325

Dunham, Katherine, 17, 354

Dunmore, Lord, 59

Dunn, Oscar J., 129

Durham, William Howard, 272

Durr, Clifford, 174

DuSable Museum of African American History, 25

*Dutchman* (play), 322

DuVernay, Ava, 22, 194, 408–409

Dwight, Ed, 77

Dylan, Bob, 185

**E**

East St. Louis riots (1917), 143

Eastern Colored League, 452

Eaton, John, 127

Ebony Film Corporation, 395

*Echo* (ship), 105

economic empowerment, 222–226

Edison, Thomas, 18

education, 19, 124, 285–306

Edwards, Jonathan, 263

Egerton, Douglas R., 76

Egypt, 37

Eisenhower, Dwight D., 168, 291

election, 2020, 253–258

Election Day, 219

Elementary and Secondary Education Act (ESEA), 294–295

Eliot, John, 262–263

Ellington, Edward Kennedy "Duke," 17, 373

Elliott, Robert Brown, 130, 165

Ellison, Ralph, 319–321, 491

Elmina Castle, 39

emancipation, pre-, 11–12

Emancipation Proclamation, 30, 113–116

Emanuel, Rahm, 243

Emanuel African Methodist Episcopal Church, 29, 244

Emerson, John, 106

emigration (colonization) movement, 94–96

Emmett Till Antilynching Act, 146

*The Emperor Jones* (play), 339

empires, African, 34–38

empowerment zones, 224

Encinia, Brian, 244–245

Enforcement Act (1870), 133

England, 114, 115

equal education, 19

Equal Rights Association, 130

equality, strategies for achieving, 147–149

Erving, Julius "Dr. J.," 460

escape, from slavery, 46

*The Escape; or, a Leap of Freedom* (play), 337

*Essay on Civil Disobedience* (Thoreau), 172

Ethiopian minstrelsy, 333

*Ethnic Notions* (documentary), 337

Europe, James Reese, 373

European slave trade, 39–40

*Eventide* (poem), 484–485

Evers, Medgar, 184, 191, 203

Every Student Succeeds Act (ESSA), 294–295

Executive Order 8802, 160, 161

Executive Order 9981, 160

*Exodus* (film), 37

Exoduster Movement of 1879, 138–139

explorers, first Black, 483–484

*Eyes on the Prize II,* 212

## F

*The Fabric of a Man* (play), 346

face vessels, 495

*The Facts of Life* (TV show), 429

*The Facts of Reconstruction* (Lynch), 129

Fair Employment Practices Committee (FEPC), 160

Fair Fight, 257

Fair Housing Act, 205

Fairbanks, Calvin, 99

Fairfield, John, 100

family life, 45, 227

Fard, Wallace D., 280

Farmer, James, 179, 185

Farmer-Paellmann, Deadria, 28

Farrakhan, Louis, 280

Farrow, Lucy, 272

fashion designer, first Black, 485

Faubus, Orval, 167–169

Faulkner, William, 24

Fauset, Jessie Redmon, 318, 325

Federal Theater Project (FTP), 342–343

Felton, Rebecca, 142

fencing, 477–478

Ferguson, Missouri, 242

Fetchit, Stepin, 400

field slaves, 72–73

Fifteenth Amendment, 130, 146, 190, 195, 217

films
about, 393–394
all-Black casts, 395–398
awards, 426
Black actors/actresses, 412–414, 421–425
Black directors, 406–412
early Black roles, 398–400
hood films, 404–405
Lee, Spike, 403–404
1940s-1960s, 401–402
1960s-1970s, 402–403
non-hood genre, 405–406

*Finding Your Roots* (Haley), 9

*The Fire Next Time* (Baldwin), 321

First Baptist Church of Williamsburg, 26

Fisher, Mel, 55

Fisher, Rudolph, 316

Fisk Jubilee Singers, 361

Fitzgerald, Ella, 372

Flake, Floyd, 277

Flanagan, Hallie, 342

*The Flip Wilson Show* (TV show), 428

Flood, Curt, 455

Florida, 125–126

*Florida v. George Zimmerman,* 240

Floyd, George, 1, 10, 18, 21, 233–234, 251–252, 302

folktales, 308

food and food rations, 124, 225–226

football, 467–470

Ford, Henry, 155

Forman, James, 179

Forrest, Nathan Bedford, 118

Fort Pillow Massacre, 118

Fortune, T. Thomas, 150

Foster, Andrew "Rube," 452

Foster Photoplay Company, 397

*Four Little Girls* (film), 189

Fourteenth Amendment, 146, 147, 190

*The Foxes of Harrow* (Yerby), 321

Foxx, Jamie, 417

Frank Silvera Writers' Workshop (FSWW), 344

Franklin, Aretha, 383–384

Franklin, Benjamin, 86

Franklin, John Hope, 14

Franklin, Kirk, 378–379

fraternities, 304–306

Frazier, Darnella, 21

*Frederick Douglass' Paper* (newspaper), 93

Free African Society, 61, 267

Free African Union Society, 95

"free" Black Americans, 81–84

Free Black Haitians, 60

free jazz, 371

Free Southern Theater (FST), 344

Freedman's Bank, 128–129

Freedman's Bureau Bill (1866), 12

Freedmen's Bureau, 123–124, 127, 133, 289, 296, 298

Freedmen's Bureau Act, 125

freedom, from slavery, 45–47, 58–60, 82, 150–154

Freedom Rides, 179–180

Freedom Summer, 190–193

Freedom Vote, 191

*Freedom's Journal* (newspaper), 93

Freelon, Philip, 26

Freeman, Michael E., 278–279

Freeman, Morgan, 423

Freeman-Wilson, Karen, 247–248

*The Free Speech* (newspaper), 141

French and Indian War, 58

*The Fresh Prince of Bel Air* (TV show), 432

*From Slavery to Freedom* (Franklin), 14

*Fruitvale Station* (film), 241

Frye, Marquette, 201–202

Fugitive Slave Act (1793), 97, 104

Fugitive Slave Clause, 96–97

Fuhrman, Mark, 230

Fulton, Sabrina, 239

*The Fundamental Constitutions of Carolina* (Locke), 60

funk, 385

F.W. Woolworth Company, 177–178

## G

Gabriel's Rebellion, 76

*Gabriel's Rebellion* (Egerton), 76

Gage, Thomas, 58

Gaines, Clarence "Big House," 458

Gaines, Ernest, 24

Galpin, George, 266

Gamble, Kenneth, 387

Gandhi, Mahatma (Mohandas), 15, 172–173

Gantt, Harvey, 221

Gardner, James Daniel, 117

*The Garles and Their Friends* (Webb), 312

Garmback, Frank, 243

Garner, Eric, 10, 21, 242, 278

Garnet, Henry Highland, 89, 106, 107

Garrett, Thomas, 99

Garrison, William Lloyd, 86, 89, 90–91, 93

Garrisonism, 90

Garvey, Marcus, 13, 22–23, 156–158, 265, 279–280

Garza, Alicia, 22, 241

Garza, Malachi, 241

Gates, Henry Louis, 9, 126, 238, 312

*The Genius of Universal Emancipation* (newspaper), 93

George, David, 266

George III, King of England, 58

Georgetown University, 68

Georgia, 125–126

Ghana, 35

Gibson, Bob, 455

Gibson, Josh, 453

Giddings, Paula, 14, 219

Gilpin, Charles, 339

Gilpin Players, 341

Ginsburg, Ruth Bader, 217

Giovanni, Nikki, 322–323

Gleaves, Richard H., 129

*Glory* (film), 118

Glover, Savion, 353

*Go Tell It on the Mountain* (Baldwin), 321

Goldberg, Whoopi, 9, 419

*Golden Boy* (musical), 345

Goldman, Ron, 230

Goldsberry, Renée, 24

golf, 475–476

*Good Times* (TV show), 429

Goode, Wilson, 221

Goodell, Roger, 247

Goodman, Andrew, 192

Gordon, Nathaniel, 113

Gorée Island, 56

Gospel music, 375–379

Gottschalk, Louis Moreau, 362

Gragston, Arnold, 101

grandfather clauses, 133

*Granny Moumee* (play), 338

Grant, Oscar, 241

Grant, Ulysses S., 120, 127, 130, 131, 132

grants, 45–46

Gray, Fred, 174

Gray, Freddie, 243–244, 245

Gray, John, 278–279

Gray, Victoria, 193

Grayson, Mary, 126

Great Awakenings, 263–264

Great Depression, 158–161, 290

Great Dismal Swamp, 80

Great Exodus, 138–139

Great Jamaican Slave Revolt, 46

Great Migration, 154–156, 315–316

Greeley, Horace, 108

Green, Benjamin T., 140

Green, Ernest, 168

Greene, Lorenzo, 14

*The Green Pastures* (play), 339

Gregory, Wilton D., 282

Grier, Pam, 403

Guerrero, Vicente, 47

*Guinn v. United States,* 153

Gurira, Danai, 350

gymnastics, 477

## H

Haddish, Tiffany, 420–421

Haitian Revolution, 46, 77

Haley, Alex, 9, 491

Haley, Nikki, 29

Hall, Anne Marie Becraft, 68

Hall, Arsenio, 416–417

Hall, Isaac Hawkins, 68

Hall, Prince, 62, 95

Hamer, Fannie Lou, 191, 193, 216

*Hamilton* (show), 24

Hamilton, Alexander, 86

Hamlin, Larry Leon, 351
*Hammer and Hoe* (Kelley), 14
Hammon, Jupiter, 308–309
Hammond, Henry, 88
Hampton, Fred, 211–213, 222
Hancock, John, 309
Handy, W.C., 364
Hankison, Brett, 21, 251
Hannah-Jones, Nikole, 27–28
Hanrahan, Edward, 212
Hansberry, Lorraine, 345
hard bop, 371
Harlan, John Marshall, 147
*Harlem* (play), 341
Harlem Renaissance, 314–319
Harlin, Latasha, 230
Harmon, William E., 318
Harmon Foundation, 318
Harper, Douglas, 67
Harper, Frances E.W., 89, 130, 151, 313, 325
*Harper v. Virginia Board of Elections,* 195
Harpers Ferry, 106–107
Harris, E. Lynn, 328
Harris, Jeremy O., 350
Harris, Joel Chandler, 314
Harris, Kamala, 234, 253–258, 292
Harris, Leslie M., 27
Harris, Michael W., 376
Harris, Wynonie, 17
Harrison, Benjamin, 30, 139
Hart, Kevin, 418
Harvey, Steve, 329, 418
Hatcher, Richard B., 220
Hayes, Rutherford B., 133
Haynes, Edmund, 154
HBCUs, 304
healthcare, 20, 156

Healy, Patrick Francis, 281
Hearn, Lafcadio, 368
Height, Dorothy, 216
Hemings, Sally, 312
Hendrix, Jimi, 381
*Henrietta Marie* (slave ship), 55
Henry, Aaron, 191
Henry the Navigator, 39–40
Henson, Matthew Alexander, 483–484
Herenton, W.W., 222
"Heritage" (poem), 11
Heritage Act (2000), 29
Heston, Charlton, 185
Hewlett, James, 332
*Hidden Figures* (film), 1, 23
*The Hidden Cost of Being African American* (Shapiro), 223
Higher Education Act (1965), 304
higher learning, 295–306
Highley, D.L., 417
Hill, Abram, 343
Hill, Andre Maurice, 251
Hill, Anita, 218
Hill, James, 129
Hill, Jemele, 246–247
Himes, Chester, 319
Hine, Darlene Clark, 219
Hines, Gregory, 353
hip-hop, 386–388
historians, 13–14
Historical Roots icon, 4
*History of the Negro Race in America from 1619 to 1880* (Washington), 13
HIV, 228–229
Hoffman, Abbie, 209
Hogan, Ernest, 362
Holder, Eric, 240
Holiday, Billie "Lady Day," 371–372

*Home* (Morrison), 327
homeownership, 222–223
Homestead Act, 128
hood films, 404–405
hooks, bell, 219
Hooks, Robert, 344
Hoover, J. Edgar, 158, 159, 189
Hopkins, Harry, 160
Hopkins, Pauline E., 313, 335
Horne, Lena, 345
horse racing, 476–477
Hoskins, Michele, 225
hospitals, 124
House, Callie, 31
house slaves, 72–73
housing, 156
Houston, Charles Hamilton, 164
Houston riots (1917), 143–144
Howard, Jacob M., 100
Howard, Oliver, 125
Howard, T.R.M., 191
Howard University, 297
The Howard Players, 340–341
Howell, Adam Clayton, Jr., 220
H.R. 40 Bill to Commission to Study and Develop Reparation Proposals for African-Americans Act, 30
Hudson, Cheryl and Wade, 329
Huff, Leon, 387
Huggins, Ericka (Jenkins), 213
Hughes, Cathy, 224
Hughes, Langston, 237, 316, 317, 318, 323, 341, 483
Humphrey, Hubert, 204
Humphreys, Richard, 295
Hunt, William, 53
Hurd, Cynthia Marie Graham, 244
Hurricane Katrina, 232
Hurst, E.H., 191

Hurston, Zora Neale, 24, 105–106, 139, 314, 316, 317–319, 325, 342, 483, 490

Hutton, Bobby, 209

Hyers, Emma Louise, 335

# I

Ice Cube, 253–254, 414

icons, explained, 4

*Ida* (Giddings), 14

*If God Is Willing and da Creek Don't Rise* (docuseries), 232

*If I Did It* (Simpson), 231

Ike, Reverend, 284

Imperialism, 157

imprisonment, cocaine and, 227

*In Abraham's Bosom* (play), 339

*In Dahoney* (musical), 336

*In Living Color* (TV show), 432

*In Search of Our Mothers' Gardens* (Walker), 325

In Their Own Words icon, 4

*Incidents in the Life of a Slave Girl* (Jacobs), 311

income inequalities, 20

Industrial Revolution, 65

Innis, Roy, 223

*The Interesting Narrative of the Life of Olaudah Equiano or Gustavus Vasa,* 311

International Sweethearts of Rhythm, 374

interracial relationships, as a theme in films, 401

*Intimate Apparel* (play), 349

inventors, 18

*Invisible Life* (Harris), 328

*Invisible Man* (Ellison), 321, 491

*Iola Leroy* (Harper), 313

Iota Phi Theta, 305

Isham, John W., 335

Iverson, Allen "Al," 461

# J

Jack, Sam T., 335

Jackson, George, 210

Jackson, Jesse, 16, 20, 219, 221–222, 235, 277

Jackson, Jimmie Lee, 194

Jackson, Mahalia, 17, 185, 274, 376

Jackson, Maynard, 221

Jackson, Michael, 37, 353

Jackson, Natalie, 239

Jackson, Rebecca Cox, 274

Jackson, Reggie, 455–456

Jackson, Samuel L., 424

Jackson, Susie, 244

Jacob-Jenkins, Branden, 350

Jacobs, Harriet, 311

Jakes, T.D., 273

*Jamaica* (musical), 345

"the Jamaica train," 71

James, Joe, 143

James, LeBron, 18, 21, 253, 461, 462

James Byrd Jr. Hate Crimes Act, 231

Jay, John, 86

Jay-Z, 15

jazz, 17, 352, 367–375

*Jazz* (Morrison), 327

Jeantel, Rachel, 239

Jefferson, Lemon, 365

Jefferson, Thomas, 61, 77, 84, 89, 94, 309, 312

*The Jeffersons* (TV show), 429

Jeffries, Herb, 398

Jeffries, Jim, 336

Jehovah's Witnesses, 282–283

*Jelly's Last Jam* (musical), 346

Jenkins, Barry, 27, 237, 409

Jeremiah, Thomas, 59

Jeter, J.A., 271

Jim Crow
about, 12–13, 17, 20, 30, 137, 146–147

Black Exodus, 138–139

Black towns, 139–140

Great Depression, 158–161

Great Migration, 154–156

lynchings, 140–146

organizations, 150–154

*Plessy v. Ferguson,* 146–147

post-Reconstruction, 137–146

riots/massacres, 140–146

strategies for achieving equality, 147–149

World War II, 161

John III, King of Portugal, 44

John III, Pope, 43

Johns, Barbara Rose, 166

Johns, Vernon, 166

Johnson, Amelia E., 329

Johnson, Andrew, 121, 122, 123, 125, 204

Johnson, Bill, 336, 369

Johnson, Bob, 32

Johnson, Charles S., 315, 318

Johnson, Columbus M., 139

Johnson, Earvin "Magic," 224–225, 228, 460–461

Johnson, Edna, 247–248

Johnson, Georgia Douglas, 342

Johnson, Harvey, Jr., 222

Johnson, Jack, 336, 464–465

Johnson, James Weldon, 316

Johnson, Joshua, 494

Johnson, Lyndon B., 189–190, 193, 195, 214, 215

Johnson, Michael, 77, 472

Johnson, Robert, 224, 366

Johnson, Rosamond, 336

Johnson, William, 23, 83

Jones, Absalom, 61, 267

Jones, Charles Colock, 264

Jones, Charles Price, 271

Jones, Ella, 256

Jones, Jasmine Cephas, 24

Jones, Jerry, 247

Jones, LeRoi, 322

Jones, Loïs Mailou, 497

Jones, Marion, 472

Jones, Samuel L., 144

Joplin, Scott, 363

Jordan, Louis, 379

Jordan, Michael, 18, 461

*Journal of African American History*, 10

Joyner, Florence "Flo Jo," 472

Joyner, Tom, 224

Joyner-Kersee, Jackie, 472

*Judas and the Black Messiah* (film), 212

*Julia* (TV series), 428

## K

Kaepernick, Colin, 18, 245–247, 469

Kansas-Nebraska Act (1854), 105

Kappa Alpha Psi, 305

Kelley, Robin D.G., 14

Kellogg, William, 131

Kelly, Patrick, 485

Kelly, Sharon Pratt, 222

Kemp, Brian, 249, 256, 257

Kendi, Ibram X., 22

Kennedy, Jacqueline, 204

Kennedy, John F., 179, 189, 203, 214

Kennedy, Robert F., 179, 181–182, 184, 191, 204, 205

Kentucky, 110, 113

Kentucky Derby, 482

*Keyes v. Denver School District N. 1*, 291

Killen, Edgar Ray, 192

King, A.D., 182, 183

King, B.B., 367

King, Coretta Scott, 25, 204–205

King, Don, 467

King, J.L., 229

King, John William, 229, 231

King, Marion, 181, 276

King, Martin Luther, Jr.
about, 14–15, 23, 25–26, 171–172, 173–174
Albany Movement, 180–181
Birmingham, Alabama, 187–189
Chicago Freedom Movement, 202
death of, 203–205
Freedom Rides, 179–180
March on Washington for Jobs and Freedom, 185–186
as a minister-activist, 277, 278
Montgomery Bus Boycott, 174–177
philosophy of nonviolence, 172–173
Project Alabama, 193–194
sit-ins, 177–178
Southern Christian Leadership Conference (SCLC), 173
Student Nonviolent Coordinating Committee (SNCC), 179
*Where Do We Go From Here*, 258

King, Rodney, 230

King, Slater, 181

King, Woodie, Jr., 344

King Center, 25

King Taylor, Susie, 117

kitchenettes, 156

kneeling, for the National Anthem, 245–247

Knight, Etheridge, 322–323

Knorr, Nathan Horner, 282

Komunyakaa, Yusef, 27

Krauthamer, Barbara, 126

Krebs, Christopher, 256

Krigwa Players, 340

Ku Klux Klan, 142–143, 183–184

Kueng, J. Alexander, 251

Kyles, Billy, 203

## L

L.A. riots, 230

labor, 69–72, 124

*Lackawanna Blues* (film), 437

The Lafayette Players, 338

Lafon, Thomy, 83

Lake, Howie, 245

Lamar, Charles, 105

Lane, Thomas, 251

Lane, William Henry, 334, 351

Larsen, Nella, 316, 325

Las Casas, Bartolomé de, 43

Latifa, Queen, 413–414

Latimer, Lewis, 18

Latin America, slavery in, 41–47

law, first Black people practicing, 482

Lawrence, Jacob, 498

Lawrence, Martin, 417

Lee, Don L., 322–323

Lee, George, 169–170

Lee, Jarena, 274

Lee, Robert E., 114, 120

Lee, Sheila Jackson, 30

Lee, Spike, 144, 189, 232, 403–404, 406–407

Lee, Trymaine, 27

Legacy Museum From Enslavement to Mass Incarceration, 25

Legend, John, 23

Lemon, Don, 237

Leo X, Pope, 43

Leon, Kenny, 348–349

Leonard, Sugar Ray, 465

Lesbian Gay Bisexual Transgender Queer (LGBTQ), 237, 440–442

*Let That Be the Reason* (Stringer), 328

Levin, Richard, 68

Lewis, Carl, 472

Lewis, Cudjo, 105–106

Lewis, David Levering, 14

Lewis, Edmonia, 494

Lewis, Jane, 101

Lewis, John, 21, 25, 179, 185, 194, 256

Lewis, Oliver, 482

Lewis, Reginald F., 225

Lewis, Samella, 499

*Liberator* (newspaper), 90, 93

*Liberty Party Paper* (newspaper), 93

Liele, George, 266

*Lift Up Thy Voice* (song), 23

Liggins, Alfred, 224

Lil Nas X, 237

Lil Wayne, 254

*Lilith's Brood (Butler),* 326

Lincoln, Abraham, 30, 107–108, 110, 112, 113, 118, 119–120, 121, 125, 153, 235, 296

Lincoln, C. Eric, 265

Lincoln Motion Picture Company, 397

Lincoln University, 296

literacy test, 195

literary classics, 487–492

literature, contributions in, 17

Live Free, 250

*Living Single* (TV show), 432

LL Cool J, 2, 414

Locke, Alain, 315, 318, 483

Locke, John, 60

Loeffler, Kelly, 256

Loehmann, Timothy, 243

Logan, Rayford, 138

Long, Jefferson, 130

Longvie, Texas, 144

Looby, Z. Alexander, 178

Lord Dunmore's Proclamation, 59

Lott, Trent, 146

Louis, Joe, 465

Louisiana Purchase (1803), 97

Lousiana Separate Car Act (19890), 147

L'Ouverture, Toussaint, 77

love stories, as a theme in films, 401

*Lovecraft Country* (TV show), 1

Lowe, Jim, 334

Lowery, Joseph E., 256

Lundy, Benjamin, 93

Lyell, Charles, 269

Lyles, Aubrey, 340

Lyles, Vi, 247–248

Lynch, John Roy, 129, 130

lynchings, 140–146, 231

*Lyrics of a Lowly Life* (Dunbar), 314

## M

Mabley, Moms, 237

Mac, Bernie, 417

Madah, Anna, 335

made-for-TV movies, 436–437

mainstream music, 379–388

Malcolm X, 15, 197–199, 276, 280, 491

Mali, 35–36

Malone, Annie Tumbo, 152, 225

*Mama, I Want to Sing!* (musical), 346

*Mama Day* (Naylor), 324

Mamiya, Lawrence H., 265

Manley, Effa, 455

Manly, Alex, 142

Mansa Musa, 35–36

*The Man from Dahomey* (Yerby), 321

manumission, 60

Marable, Manning, 22, 31

March on Washington for Jobs and Freedom (1963), 185–186

maroon communities, 46, 79–80

marriage, 45, 68

Marsh, Henry L., 221

Marshall, Andrew Cox, 269

Marshall, Paule, 325

Marshall, Thurgood, 164, 165, 204, 217, 218

*Martin* (TV show), 432

Martin, Sallie, 376

Martin, Tracy, 239

Martin, Trayvon, 3, 21, 22, 233, 238, 239–240

Martin Luther King Jr. Memorial, 25–26

Maryland, 84, 110, 113

Masks for the People, 250

Mason, Charles Harrison, 271

Mason, Charlotte Osgood, 318

Mason, John, 101

Mason-Dixon line, 98

Massachusetts, 52, 60

Massacre at Colfax Courthouse, 131

massacres, 140–146

Mather, Cotton, 286

Matthews, W.D., 118

Mattingly, Jonathan, 21, 251

Mays, Willie, 455

McBride, Dwight, 1

McBride, Michael, 250

McCabe, Edwin T., 139

McClain, Franklin, 177–178

McClellan, George B., 114

McClendon, John B., 457–458

McCraney, Tarell Alvin, 237, 348–349

McCulloch, Bob, 21

McDaniel, Hattie, 398–399

McDonald, Laquan, 1, 243

McDonald, Susie, 174–175

McDonald's, 224

McDowell, Calvin, 141

McKay, Claude, 145, 319

McKenzie, Vashti Murphy, 275

McKesson, DeRay, 242

McKissick, Fred, 200

McLaurin, George W., 164

*McLaurin v. Oklahoma State Regents,* 164

McMillan, Terry, 328

McNair, Denise, 188

McNeil, Joseph, 177–178

Me Too movement, 218

Meaher, Burns, 105–106

Meaher, Timothy, 105–106

media, black-owned, 224–225

medicine, first Black people practicing, 481–482

megachurches, 273–274

Megan Thee Stallion, 21

Meharry Medical College, 297

Mehserle, Johannes, 241

Meredith, James, 181, 200

*Meridian* (Walker), 324

*The Messenger,* 161

Metzl, Jonathan, 238

Mexican-American War, 103

Micheaux Film Corporation, 397

Middle Passage, 52–57

Milam, J.W., 170, 171

militant abolitionism, 90

military, 214

Militia Act (1862), 112

Miller, Flournoy, 340

Miller, William, 283

Milliken's Bend, 117

Million Dollar Productions, 397–398

Milner, Denene, 329

*Mind of My Mind* (Butler), 326

minister-activists, 277–278

minister-politicians, 276–277

minstrelsy, 333–334

Miranda, Lin-Manuel, 24

*The Mis-Education of the Negro* (Woodson), 489–490

*Miss Evers' Boys* (film), 436

Mississippi, 120, 140, 181–182, 192

*Mississippi Burning* (film), 192

Mississippi Freedom Democratic Party (MFDP), 193

Mississippi Plan, 132

Missouri, 110, 113

Missouri Compromise (1820), 98, 103, 105, 106

Mitchell, Arthur, 355

Mitchell, Loften, 337

Mitchell, W.M., 101

modernism, 319

Molinar, Moe, 55

Mo'Nique, 420

Monroe, James, 76, 96

Montgomery, Isaiah T., 140

Montgomery Bus Boycott, 172, 174–177

Montgomery Improvement Association (MIA), 175, 176

Moore, Amzie, 191

Moore, Antonio, 30

Moore, Darnell, 242

Moore, David, 55

*Moore v. Dempsey,* 153

Moorish Science Temple, 279

Moors, 37

Morga, Garrett A., 18

Morial, Ernest Nathan, 221

Morrill, Justin, 298

Morrill Acts, 298–299

Morris, Robert, Jr., 482

Morris, Wesley, 27

Morrison, Toni, 17, 24, 319, 324, 325, 327, 492

Morrisseau, Dominique, 350

Morse, Samuel F.B., 86

Morse code, 86

Morton, Jelly Roll, 368

Mos Def/Yaslin Bey, 414

Mosby, Marilyn, 243–244

Moses, Bob, 190, 191

Moses, Edwin, 472

Moskowitz, Henry, 153

Mosley, Walter, 328

Moss, Thomas, 141

Motown, 381–382

Mound Bayou, 140

Muhammad, Elijah, 197, 198, 199, 280

Muhammad, Khalil Gibran, 27

Muhammad, Warith Deen, 280

*Mulatto* (play), 341

multiple-effect evaporator, 71–72

Murphy, Eddie, 37, 415–416

Murphy, Isaac, 482

Murray, Anna Pauline (Pauli), 217, 218

Muse, Clarence, 398–399

music, 17, 265–266, 274, 359–392

music videos, 407–408

Musk, Elon, 16

Muslims, 279–280

*My Bondage, My Freedom* (Douglass), 103

My Brother's Keeper, 238

*My Face is Black is True* (Berry), 31

*My Name Is Pauli Murray* (documentary), 217

Myers, Walter Dean, 329

# N

NAACP Legal Defense Fund, 164, 165

nadir, 138

Nagin, Ray, 232

*Narrative of the Life of Frederick Douglass* (Douglass), 24, 92, 288, 311, 488

Nash, Diane, 179

Nashville, 178

Nat Turner's Rebellion, 78–79, 287

Nation of Islam (NOI), 196–197, 279–280

National Afro-American Council, 150

National American Women Suffrage Association (NAWSA), 151

National Anthem, kneeling for the, 245–247

*National Anti-Slavery Standard,* 90

National Association for the Advancement of Colored People (NAACP), 16, 149, 153

National Association of Colored Women (NACW), 151

National Association of Colored Women's Clubs (NACWC), 217

National Black Feminist Organization, 218

National Black Theater Festival (NBTF), 351

National Civil Rights Museum, 25

National Collegiate Athletic Association (NCAA), 29

National Council of Colored People, 482

National Council of Negro Women, 217

National Ex Slave Mutual Relief, Bounty and Pension Association, 31

National Federation of Afro-American Women, 151

National Football League (NFL), 467–469

National Industrial Recovery Act (NIRA), 159

National Labor Union, 128

National League for the Protection of Colored Women, 154

National Negro Business League (NNBL), 150–151

National Negro Labor Union, 128

National Organization for Women (NOW), 218

National Rainbow Coalition, 222

National Underground Railroad Freedom Center, 24

National Urban League (NUL), 154, 156

National Welfare Rights Organization (NWRO), 217

National Youth Administration, 160

*Native Son* (Wright), 320, 490

naturalism, 319

Naylor, Gloria, 319, 324

Neal, Larry, 322, 323

"Negro," as a term, 16

Negro Act (1740), 287

Negro American League, 452

Negro Factories Corporation, 157

Negro History Week, 1, 13

Negro Leagues, 450–454

Negro National League, 451

*Negro World* (newspaper), 156

The Negro Ensemble Company (NEC), 344

*The Negro in American Life and Thought* (Logan), 138

*The Negro in Our History* (Woodson and Wesley), 14

*The Negro Wage Earner* (Woodson and Greene), 14

neighborhood violence, cocaine and, 226–227

Nelson, Stanley, 212

Netflix, 252

New Birth Missionary Baptist Church, 278

New Deal, 13, 159–160

New England, 52

New England Anti-Slavery Society, 86, 90

New Georgia Project, 257

New Negro Movement. *See* Harlem Renaissance

New World, 41

New York Manumission Society, 86

Newsome, Bree, 29

The New Federal Theater, 344

*The New Jim Crow* (Alexander), 22

Newton, Huey, 199–200, 208, 209, 211, 213

Niagara Movement, 149, 152

Nicholas, Fayard, 2–3

Nicholas V, Pope, 43

The Nicholas Brothers, 352

Nichols, Ray, 292

"nigger," as a term, 16

*Nigger Heaven* (Van Vechten), 318

Nineteenth Amendment, 195

Niño, Pedro Alonso, 41

Nixon, E.D., 174, 177

Nkrumah, Kwame, 39

No Child Left Behind, 19, 293–294

*No Strings* (musical), 345

Nobel Peace Prize, first Black recipient of, 484

nonviolence, 172–173, 213

nonviolent direct action, 171

normal schools, 297

northern churches, 267–268

northern education, 288–289, 291–292

northern slavery, 66–69

Northrup, Solomon, 92

*The North Star* (newspaper), 93

Northwest Ordinance (1787), 97

*Notes of a Native Son* (Baldwin), 321

*Notes on the Origin and Necessity of Slavery* (Brown), 88

Nottage, Lynn, 27, 348–349

novels, 311–314

Noyes Academy, 297

*Nuestra Señora de Atocha* (ship), 55

## O

O' Neal, Frederick, 343

Obama, Barack, 3, 11, 15, 23, 26, 39, 146, 219, 234–238, 240, 294–295. *See also* Black Lives Matter

Obama, Michelle, 23, 234

Oberlin Collegiate Institute, 296

O'Brien, Soledad, 232

Ocasio-Cortez, Alexandria, 248–249

O'Connor, Sandra Day, 292

*The Octoroons* (musical theater), 335

Odom, Leslie, Jr., 24

Oglethorpe, James, 53

*O.J.* (documentary), 231

Okeh Records, 365

Oklahoma, 139

Ole Miss, 181–182

O'Leary, Hazel, 222

Oliver, Joseph "King," 369

Olympics, 463, 473

Omar, Ilhan, 248–249

Omega Psi Phi, 305

*On Her Own Ground* (Bundles), 152

*On Striver Row* (play), 343

*On the Down Low* (King), 229

O'Neal, John, 344

O'Neal, William "Bill," 212

O'Neill, Eugene, 339

Opelousas, attacks in, 131

opposing slavery, 42–44

organizations, for freedom, 150–154

*Oriental America* (musical theater), 335

Orta, Ramsey, 242

Ossoff, Joe, 256, 257

Osteen, Joel, 273–274

Otis, James, 86

*Our Nig* (Wilson), 312

*Out of Bondage* (musical theater), 335, 337

overseers, 73

Ovington, Mary White, 153

Owens, Jesse, 18, 471

## P

Pace Phonograph Company, 365

Page, Thomas Nelson, 314

Paige, Satchel, 453

Painter, Neil Irvin, 14

Palacio, Vicente Riva, 47

Pamphlet, Gowan, 269

pan-Africanism, 13

Pantaleo, Daniel, 242

Parham, Charles Fox, 272

Parker, Charlie "Bird," 374

Parks, Rosa, 174–177, 194

Parks, Suzan-Lori, 348–349

passing, 316, 401

*Passing* (Larsen), 316

Patrick, Deval, 129

Patterson, Frederick P., 302

Patton, Charley, 366

Paul, Rand, 146

pay, for Union soldiers, 117

Payne, Larry, 203

Peary, Robert E., 483–484

Peele, Jordan, 410

Pekin Stock Company, 338

Pence, Mike, 249

Pennsylvania Abolition Society (PAS), 86, 89

Penrice, Ronda Racha, 1

People United to Save Humanity (PUSH), 221–222

People's Party, 138

*The People v. O.J. Simpson* (TV series), 231

PepsiCo, 252

Perdue, David, 256

Perry, Andre M., 252

Perry, Tyler, 445–447

Peters, Jesse, 266

Petry, Ann, 319, 325

Pettiford, William, 151

Phi Beta Sigma, 305

*The Philadelphia Negro* (Du Bois), 301

*The Philanthropist* (newspaper), 93

Piersen, William, 219

Pike, Stephen, 53

Pinchback, P.B.S., 118, 129, 130

Pinckney, Clementa, 244

Pinkney, Andrea Davis, 329

Pinkney, Brian, 329

pioneers, 18

Pippin, Horace, 496

Pius II, Pope, 43

plantation missions, 264

plantations, 69–72

Pleasant, W.S., 271

*Plessy v. Ferguson,* 146–147, 163–164, 165, 174, 289, 290, 298

Poage, George, 471

*Poems on Various Subjects* (Wheatley), 309

poets, 308–310

Poitier, Sidney, 185, 421–422

police killings, 21, 239–245, 251–252, 278

political office, 129–130, 219–222, 247–248

politics, church and, 275–279

poll tax, 195

Poor People's March, 203, 205, 222, 278

pop culture, BLGOs in, 306

Populist Party, 138

*Porgy* (play), 339

*Porgy and Bess* (play), 339

post-Civil War

post-World War II, Black Literature from, 319–321

Powell, Adam Clayton, Jr., 276

Powell, Colin, 18

Pratt, Geronimo, 213

Pratt, Tanya Walton, 236

Prayer Pilgrimmage for Freedom, 173

presidency, 234–238

Presidential Reconstruction, 121

Pressley, Ayanna, 248

Primus, Pearl, 354

Pritchett, Laurie, 180

Progressive National Baptist Convention (PNBC), 278

Project 100,000, 214

Project Alabama, 193–194

Project C, 182

Promised Land, 13

prophets, 13–14

Proposition 209, 19

proslavery politics, effects of, 96–98

prosperity gospel, 274

Prosser, Gabriel, 76, 77

Prosser, Thomas, 76

Pryor, Richard, 415

public charter schools, 292–293

public vouchers, 292–293

Pullitzer Prize, first Black recipient of, 484–485

Punch, John, 11, 50

*Purlie* (musical), 345

## Q

Quakers, 86. *See also* Underground Railroad

## R

race relations, in the north, 201–203

racial distinctions, 44–45

racial divide, 229–232

racial pride, 157

racism, as a theme in films, 401

racist taboos, as a theme in films, 401

Radical Republicans, 121, 123

Radio One, 224

radio shows, during 2020 election, 254

ragtime, 362–363

rainbow coalition, 212

Rainey, Gertrude "Ma," 237, 365, 366

Rainey, J.H., 130

*A Raisin in the Sun* (play), 345

Ramsey, Peter, 410

Randall, Dudley, 322–323

Randolph, A. Philip, 161, 185

Rangel, Charles, 276

Ransier, Alonzo J., 129

rap music, 388–392

rappers, 253–254

Rashad, Phylicia, 345, 431

Rawlings-Blake, Stephanie, 243–244

R&B, 379

reading and writing, 92–94

Reagan, Ronald, 210

realism, 319

reality TV shows, 436

Reconstruction, 12, 121–123, 131–134, 137–146, 270–271, 289–290

Reconstruction Act (1967), 123

Red Summer (1919), 144–145

Redeemers, 131

Redmond, Sarah Parker, 89

Redmong, Charles Lenox, 89

Reeb, James, 194

Reeves, Tate, 29

Reid, Eric, 246

relief rates, 159

religion. *See* church

Remember icon, 4

Renaissance, 40

Reol Productions, 395

reparations, 30–32

re-segregating, 293

restaurants, 225–226

Revels, Hiram, 129, 276

Revenue Act (1764), 58

revolts and rebellions, 73–74. *See also specific revolts and rebellions*

*Revolutionary Suicide* (Newton), 208

Reynolds, Diamond, 245

Rhimes, Shonda, 435

Rhode Island, 52, 60

Rhodes Scholar, first Black, 483

rhythm, in music, 266, 361

Rice, Condoleezza, 18, 222

Rice, Norm, 221

Rice, Tamir, 10, 243, 278

Rice, Thomas, 333, 351

rice plantations, 70–71

Richard, Little, 17

Richardson, George, 143

Richardson, Willis, 341

Richmond, David, 177–178

*The Rider of Dreams* (play), 339

Riggs, Marlon, 337

*The Rights of the British Colonies Asserted and Proved* pamphlet, 86

Rillieux, Norbert, 71–72

ring shout, 265, 360

riots, 140–146. *See also specific roits*

*The Rise of Gospel Blues* (Harris), 376

Rivera, Geraldo, 240

Roberts, John G., Jr., 292

Roberts, Robin, 237

Robertson, Carole, 188

Robertson, Oscar, 460

Robinson, Amelia Boynton, 1

Robinson, Jackie, 18, 215, 454

Robinson, Jo Ann, 175

Robinson, June, 275

Robinson, Kenneth O., 275

Robinson, Sugar Ray, 465

Rock, Chris, 225, 417

rock and roll, 380–381

Rolfe, John, 49–50

Romer, Carl, 252

Roof, Dylan, 244

Roosevelt, Eleanor, 160

Roosevelt, Franklin Delano, 13, 158–161

Roosevelt, Theodore, 140, 148

*Roots* (Haley), 9

Roots (TV show), 438

The Roots, 23

*Rosa Parks* (Parks), 174

Rosewood Massacre (1923), 145

Ross, Clyde, 28

Ross, Rick, 228

rowing, 478

Rowland, Dick, 145

Rucker, Holcombe, 457

Rucker Park, 457

Rudd, Daniel, 281

Rudolph, Wilma, 18, 471

*Ruined* (play), 350

running away, from slavery, 79–81

Rush, Bobby, 211

Russell, Bill, 460

Russell, Charles T., 282

Russwurm, John B., 93, 94

Rustin, Bayard, 185, 215, 237

## S

Salamoni, Blane, 245

Salem, Peter, 59

Sam Sharpe Rebellion. *See* Baptist War

Samuel DeWitt Proctor Conference, 278

*San Juan Bautista* (slave ship), 49

San Lorenzo de los Negros, 47

Sanchez, Sonia, 322–323

sanctioning slavery, 42–44

Sanders, Bernie, 253

Sanders, Sarah Huckabee, 247

Sanders, Tywanza, 244

Sandra Bland Act, 245

*Sanford and Sons* (TV show), 429

"Sankofa," 9

satagraha, 172

*Saturday Night Live* (TV show), 431

Saunders, Charles R., 326

Saxton, Rufus, 124–125

*Say Her Name* (documentary), 245

Schlegel, Friedrich von, 13

Schmoke, Kurt, 221

Schwerner, Michael, 192

Scott, Dred, 106

Scott, Jill, 23

Scott, MacKenzie, 304

Scott, Rick, 239

Seale, Bobby, 199, 208–209

*Search of Sisterhood* (Giddings), 14

*A Second Visit to the United States of North America* (Lyell), 269

Security Act, 75

Seitz, Collin, 166

*Seize the Time* (Newton and Seale), 209

Selma, Alabama, 193–194

Sentencing Project, 20

Sertima, Ivan Van, 38

Servin, Dante, 245

Seventh-Day Adventists, 283

*The Sex Chronicles* (Zane), 328

sexual assault, slavery and, 68

Seymour, William Joseph, 272

Shakur, Afeni, 210

Shakur, Assata, 211

Shanahan, Kyle, 247

Shapiro, Thomas M., 223

sharecropping, 127–128, 290

Sharp, Granville, 95

Sharpton, Al, 277

Shaw, Robert Gould, 118

Sheftall, Beverly Guy, 219

Sherman, William, 31

Sherman, William T., 125

*A Short Account of That Part of Africa, Inhabited by the Negroes* (Benezet), 89

*Shuffle Along* (musical), 340, 352

Shuttlesworth, Fred, 182

Sierra Leone, 95–96

Sigma Gamma Rho, 306

Silver Bluff Baptist Church, 266

Simmons, Daniel L., 244

Simmons, Robin Sue, 32

Simmons, Ruth, 68

*Simon the Cyrenian* (play), 339

Simpkins, Modjeska Monteith, 165

Simpson, Nicole Brown, 230

Simpson, O.J., 229, 230–231

Singleton, Benjamin "Pap," 138–139

Singleton, John, 37, 145, 227, 303

Sissle, Noble, 340

SisterLove Inc., 229

sit-ins, 177–178

1619 Project, 27–28

Sixteenth Street Baptist Church, 188

Sklarek, Norma Merrick, 18

Slave Codes, 74–75, 122

*Slave Culture* (Stuckey), 14

slave narratives, 310–311

slave patrols, 112

*Slave Songs of the United States*, 362

slave trade, illegal, 113

slaveholders, northern, 67

slavery
about, 65
on African continent, 38–39
as an institution, 28
arguing against, 87–88
arguing for, 88
Civil War and, 110–111
continuation of, 105–106
European, 39–40
"free" Black Americans, 81–84
in Latin America and Caribbean, 41–47
life enslaved, 44–45
lucrative nature of, 66
marriage, 68
northern, 66–69
official abolition of, 47
opposing, 42–44
pre-, 11
revolts and rebellions, 73–81
sanctioning, 42–44
seeking freedom, 45–47
sexual assault, 68
smoking, 70
southern, 69–73
statistics on, 66
universities and, 68

Slavery in the North (website), 67

*Slavery's Exiles* (Diouf), 80

*Slaves' Escape* (musical theater), 335, 337

*The Slave Community* (Blassingame), 14

Smalls, Robert, 130

Smith, Adam, 87

Smith, Bessie, 363, 365, 366

Smith, James McCune, 481–482

Smith, Lamar, 170

Smith, Mamie, 365

Smith, Mary Louise, 174–175

Smith, Robert, 26, 302

Smith, Will, 3, 413

Smith, Willie Mae Ford, 377

Smithsonian National Museum of African American History and Culture (NMAAHC), 25, 26

Smock, Ginger, 374

smoking, 70

Snipes, Wesley, 423–424

*Snowfall* (TV series), 227

soap stars, 434

social paternalism, 88

Society for the Relief of Free Negroes, 86

Society of Friends, 86

*Sojourner Truth* (Painter), 14

*Soledad Brother* (Jackson), 210

Solomon, Job ben, 53

*Some Historical Account of Guinea* (Benezet), 89

*Some Memoirs of the Life of Job* (Bluett), 53, 309

*Song of Solomon* (Morrison), 327

Songhai, 36

songs and singing, 103

Soninke, 35

Sonni Ali, 36

sororities, 304–306

soul music, 382–384

*The Souls of Black Folk* (Du Bois), 146, 148, 313, 489

The Soul Stirrers, 377

Southeastern Conference (SEC), 29

Southern Christian Leadership Conference (SCLC), 173, 188, 277

southern churches, 268–270

Southern Cross, 28–29

southern education, 287–288, 291

Southern Homestead Act (1876), 125–126

southern slavery, 69–73

Southwest, 224

Spanish Crown, 43

Special Field Order No. 15, 125

"sperate but equal," 147

Spingarn, Arthur, 153

spirituals, 361–362

sports, 18, 449–478

*The Sport of the Gods* (Dunbar), 314

Springfield Baptist Church, 266

Springfield Race Riot (1908), 153

Springfield riots (1908), 143

*St. Louis Woman* (musical), 345

Stamp Act (1765), 58

*Stamped from the Beginning* (Kendi), 22

Stanford, Ala, 250

Stanton, Elizabeth Cady, 130

Staupers, Mabel K., 161

Sterling, Alton, 245

Stevens, Thaddeus, 12, 122

Stevenson, Bryan, 22, 25, 27

Stewart, Henry, 141

Stewart, Maria W., 217, 311

Still, William, 101

Stokes, Carl B., 220

Stokes, Carrie, 166

Stokes, Louis, 220

Stono Rebellion, 75, 287

Stowe, Harriet Beecher, 104, 333

*A Street in Bronzeville* (Brooks), 485

*The Strength of Gideon and Other Stories* (Dunbar), 314

Stringer, Vickie, 328

Stuckey, Sterling, 14

Student Nonviolent Coordinating Committee (SNCC), 15, 25, 177–178, 179, 200–201

Sugar Act (1764), 58

sugar plantations, 71–72

*Sula* (Morrison), 327

Sullivan's Island, 56

Sumanguru, 35

Sumner, Charles, 121

Sundiata Keita, 35

*The Suppression of the African Slave Trade to the United States of America* (Du Bois), 13, 301

The Supremes, 382

*Swann v. Charlotte-Mecklenburg Board of Education*, 291

*Sweat* (play), 350

*Sweatt v. Painter*, 164

Sweet Daddy Grace, 284

swimming, 478

swing jazz, 369

Sykes, Wanda, 237, 420

Symoné, Raven, 237

systemic racism, 22

### T

Talbert, David E., 346

Talented Tenth, 149

Talley, Leon, 237

Tallmadge, James, 98

Tanner, Henry Ossawa, 495

tap dance, 352–353

Tappan, Arthur, 296

task system, 70

Taylor, Breonna, 1, 10, 18, 21, 234, 251–252

Taylor, Elizabeth, 37

Taylor, George Edwin, 221

Taylor, Henry, 55

Taylor, Ivy, 247–248

Taylor, John "Doc," 471

Taylor, Major, 18

Taylor, Ollie, 247–248

teacher's college, 297

Technical Stuff icon, 4

Teer, Barbara Ann, 323

television personality, first Black, 484

Ten Point Plan, 215

Tenkamenin, 35

Tennent, Gilbert, 263

Tennessee, 141

tennis, 474–475

terminology, 16

Terrell, Mary Church, 151, 216

Terry, Lucy, 308, 309

texture, in music, 361

Tharpe, Rosetta, 274

Tharpe, Sister Rosetta, 377

theater, 323, 331–351

*Their Eyes Were Watching God* (Hurston), 318, 490

Theron, Charlize, 16

*They Came Before Columbus* (Sertima), 38

*The Third Life of Grange Copeland* (Walker), 324

Thirteenth Amendment, 100, 119–120, 147

Thomas, Angie, 329

Thomas, Clarence, 218

Thompson, Allen C., 184

Thompson, Garland Lee, 344

Thompson, Jacqueline, 275

Thompson, Myra, 244

Thoreau, Henry David, 172

Thurman, Wallace, 319, 341

Tilden, Samuel, 133

Till, Emmett, 14–15, 169–171, 238

Till, Mamie, 170

Tillmon, Johnnie, 217

Timbuktu, 36

Time Warner, 224

Tindley, Charles, 376

Tlaib, Rashida, 248–249

TLC Beatrice, 225

*To Make Our World Anew* (Kelley), 14

tobacco plantations, 70, 71

Toll, Robert, 334

Tolsey, Alexander, 53

Tolton, Augustus, 281

Tometi, Opal, 22

Toomer, Jean, 317

Torrence, Ridgely, 338–339

Towns, William, 252

Townshend Act (1767), 58

track and field, 470–474

tragic mulatto, 312

Trail of Tears, 126

transatlantic slave trade, 38–41, 66

Travis, Joseph, 78

*Treasurer* (slave ship), 49–50

Treaty of 1866, 126

Treaty of Alcáçovas (1479), 39

Triangular Trade, 51–52

*A Trip to Coontown* (musical), 336

Trotter, William Monroe, 149, 152, 153

True Colors Theater Company, 348

*True to the Game* (Woods), 328

Truman, Harry S., 160, 214

Trump, Donald J., 23, 233, 238, 245–251, 253–258, 273, 278–279, 294–295, 303

Truth, Sojourner, 89, 217, 268, 274, 311

Tubman, Harriet, 79, 89, 101–102, 268

Tucker, Chris, 9, 418

Tucker-Worgs, Tamelyn, 273

Tulsa Massacre (1921), 1, 145

Tupac, 391

Ture, Kwame. *See* Carmichael, Stokely

Turner, Benjamin, 130

Turner, Henry McNeil, 265

Turner, Ike, 17

Turner, Nat, 78–79, 90

Tuskegee Airmen, 161

TV, 427–447

Twain, Mark, 16

*Twelve Years a Slave* (Northrup), 92

*12 Million Black Voices* (Wright), 320

Twenty-Fourth Amendment, 195

Tyler Perry Studios, 446–447

Tyson, Cicely, 422

Tyson, Mike, 466

**U**

*Uncle Tom's Cabin* (play), 337

*Uncle Tom's Cabin* (Stowe), 104, 333

*Uncle Tom's Children* (Wright), 320

Underground Railroad, 12, 79, 98–103

*The Underground Railroad,* 101

*The Under-ground Railroad* (Mitchell), 101

unemployment, cocaine and, 226–227

Union, Gabrielle, 237

Union soldiers, 112, 116–118

United Nations Educational, Scientific, and Cultural Organization (UNESCO), 36

United Negro College Fund (UNCF), 302

United States National Slavery Museum, 26

*United States v. Cruikshank,* 133, 146

*United States v. Reese,* 133, 146

Universal Negro Improvement Association (UNIA), 22–23, 156

universities, 68

university funding, 238

*The Untold Story of Emmett Till* (documentary), 171

*Up from Slavery* (Washington), 313, 488–489

urban blues, 365

U.S. Bureau of Colored Troops, 116

U.S. Capitol riot, 256–258

U.S. Colored Troops, 116–117

**V**

vaccines, 250

Van Dyke, Jason, 243

Van Vechten, Carl, 318

Vance, Courtney B., 231

Vance, Ethel Lee, 244

Vann, Robert L., 159–160

Varick, James, 268

Vashon, George Boyer, 296

Vaughan, Sarah, 372

Vaughan, William R., 31

Vermont, 96

Vesey, Denmark, 76–77

Viacom, 224

Vietnam, 214–215

Virginia Slave Codes (1705), 51

visual artists, 493–500

Vivian, C.T., 256

vocality, 360

volleyball, 478

voting, in Mississippi, 190–193

Voting Rights Act (1965), 195–196, 219

# W

Wade, Dwayne, 237

Wade, Richard C., 77

Wade, Zaya, 237

Waite, Morrison Remick "Mott," 133

*Waiting to Exhale* (McMillan), 328

*Walk Together Chilun* (play), 343

Walker, A'Lelia, 318

Walker, Alice, 17, 24, 219, 318, 324–325, 492

Walker, David, 16, 90, 106

Walker, George, 336–337

Walker, Madam C.J., 152, 225, 318

Walker, Wyatt Tee, 182, 188

*Walker's Appeal* (Walker), 90, 106

Wall, O.S.B., 118

Wall Street Project, 223

Wallace, George, 184

Walling, William English, 153

Walls, Josiah T., 130

Walters, Lemuel, 144

*Wanderer* (ship), 105

War of 1812, 95

Ward, Clara, 377

Ward, Douglas Turner, 344

Ward, Jesmyn, 27

Ward, Val Gray, 323

Warmoth, Henry C., 129

Warnock, Raphael, 256, 257, 277

Warren, Lovely, 247–248

Washington, Booker T., 19, 147, 148, 150, 151, 222, 299–300, 301, 313, 488–489

Washington, Denzel, 3, 422–423

Washington, George, 58, 59, 97

Washington, Harold, 2, 219

Washington, Sarah Spencer, 225

Washington, Walter, 221

*Watchmen* (TV show), 1

Waters, Ethel, 484

Waters, Maxine, 248

Waters, Muddy, 366–367

Waters, Vincent, 282

Watkins, Frances Ellen, 217

Watts riots, 201–202

"We Wear the Mask" (poem), 148

wealth inequalities, 20

*The Wealth of Nations* (Smith), 87

Weaver, Karen, 247–248

*W.E.B. Du Bois* (Lewis), 14

*W.E.B. Du Bois, 1919-1963* (Lewis), 14

Webb, Frank J., 312

Webb, Gary, 228

Webb, Wellington, 222

Weber, Carl, 328

*Webster* (TV show), 430

Weeksville Heritage Center, 25

Wells-Barnett, Ida B., 13, 140, 141, 216

Wesley, Charles H., 14

Wesley, Cynthia, 188

Wesley, John, 89, 267–268, 270

West, Ben, 178

West, Dorothy, 319, 325

West, Kanye, 232

West Virginia, 110

Wheatley, Philip, 17

Wheatley, Phillis, 309

*When and Where I Enter* (Giddings), 14

*When Harlem Was in Vogue* (Lewis), 14

*When the Levees Broke* (docuseries), 232

*Where Do We Go From Here* (King), 258

Whiney, Eli, 71

Whipple, Prince, 60

White, Deborah Gray, 219

White, Paula, 273

White, Viola, 174

White, Walter, 143

White Citizens' Council (WCC), 169, 188

White Lion (slave ship), 49

white supremacist groups, 122

Whitefield, George, 263

Whitney Plantation Historic District, 24

*Who Killed Malcolm X* (docuseries), 199

*Why Should White Guys Have All the Fun?* (Lewis), 225

Wilberforce, William, 296

Wilberforce University, 296

*Wild Seed* (Butler), 326

Wilder, Douglas, 26, 129

Wilentz, Sean, 27

Wilkins, Roy, 185

*William Johnson's Natchez,* 83

Williams, Bert, 336–337

Williams, Brian, 235

Williams, George Washington, 13

Williams, Hosea, 194

Williams, Myrlie Evers, 184

Williams, Spencer, 398

Williams, Venus and Serena, 18, 475

Williams, William F. "Bill," 225–226

Williamson, Ansel, 482

Willkins, Roy, 200–201

Willmott, Kevin, 144

Wilmington Massacre (1898), 141–142

*Wilmington's Lie* (Zucchino), 257

Wilmot Proviso, 103

Wilson, August, 346–347, 348

Wilson, Charlie, 329

Wilson, Darren, 21, 242

Wilson, Deborah, 212

Wilson, Harriet E., 312, 325

Wilson, Lionel, 221

Wilson, Phil, 229

The Winans, 378

Winfrey, Oprah, 9, 19, 21, 26, 444–445

*Wings for This Man* (film), 161

winter sports, 477

Winthrop, George, 67

Witherspoon, Evelyn, 143

*The Wiz* (musical), 345

WNBA, 463–464

Wofford, Harris, 179

Wolfe, George C., 331, 347–348

womanism, 219, 325

women

  in basketball, 462–464

  Black comedians, 434–435

  Black literature and, 324–327

  in the church, 274–275

  film directors, 411–412

  film roles for, 396

HIV/AIDS and, 229

in the Negro Leagues, 451

rap and, 390–392

women's rights, 213, 216–219

*The Women of Brewster Place* (Naylor), 324

Woods, Teri, 328

Woods, Tiger, 18, 476

Woodson, Carter G, 317, 489–490

Woodson, Carter G., 1, 10, 13–14

Woodson, Jacqueline, 27, 329

Woolman, John, 60

work contract agreements, 127

Works Progress Administration (WPA), 126, 160

World War II, 161

*The World and Africa,* 37

Wright, Jeremiah, 235

Wright, Mose, 170

Wright, Richard, 17, 319, 320, 490

Wright, Silas P., 142

Wright, Simeon, 170

Wu-Tang's Method Man, 414

Wyche, Steve, 246

**X**

*Xenogenesis* (Butler), 326

**Y**

Yale University, 68

Yanga, 47

Yerby, Frank, 321

Yoon, Nicola, 329

Young, Andrew, 221

Young, Coleman, 221

Young, Kevin, 472

Young, Whitney, Jr., 185, 201

Young Jeezy, 235

Young Men's Christian Association (YMCA), 156

Young Women's Christian Association (YWCA), 156

**Z**

Zeta Phi Beta, 306

*Ziegfeld Follies,* 336–337, 352

Zimmerman, George, 22, 239–240

Zucchino, David, 257

# About the Author

Ronda Racha Penrice is a self-proclaimed Chissippian (Chicago native with deep Mississippi roots) who has worked with various publications, including *The Quarterly Black Review of Books, Rap Pages, Essence.com, Medium's Zora and Momentum, NBC THINK, Atlanta Journal-Constitution, Upscale Magazine,* and *UptownMagazine.com,* among others. The Columbia University alumna, who also attended the M.A. program in Southern Studies at the University of Mississippi, is a lifelong student of Black American history and culture. She currently resides in Atlanta.

# Dedication

I humbly dedicate this book to my grandparents, Dessie Ree Shannon Stapleton Beard (1925–1998) and Willie Beard (1920–2002),who taught me honor, integrity, pride, and humanity by example. Because of their unconditional love and support for me and my love of reading and writing, I am here today, always striving to make them proud.

I also dedicate this book to my great aunt, Ada Beard Humphries (1918–2000). In her frequent retellings of transporting me from Chicago to Mississippi when I was just 6 weeks old, she made my humble beginnings appear almost as magical as the birth of Jesus Christ and convinced me that I could do and be anything.

With this book, I also love and honor my mother, Tyrethis "Geanette" Beard Penrice (1947–2020). Without her, I wouldn't be as courageous, opinionated, or driven. Only looking back am I fully realizing all that she gave me. Rest well, Mama! I love and thank you!

In Memoriam: my uncle, John Curtis Beard (1957–1978) and his son, Curtis Rodriguez Beard (1977–1999); Dr. Endesha Ida Mae Holland (1944–2006); my aunt Alberta Bennard Ford (1949–2017); my dear friend Kimberly Ward (1973–2017); and my cousin Kerwin Allen Holman (1966–2020).

# Author's Acknowledgments

All thanks go to God first. I haven't always been the most faithful servant, but He's blessed me anyway.

Tonya Bolden, I owe you so much. You exemplify the values my grandparents deemed most important. You've always been supportive and have never hesitated to share an opportunity, including this amazing one. Keep blessing the world with your incredible books sharing Black history and culture with young readers.

I can't say enough about my agent, Matt Wagner of Fresh Books, who championed me every step of the way. Thank you, Lindsay Lefevre at Wiley, for granting me another great opportunity with this title, as well as for your patience. Chad Sievers, I also thank you for your patience, which is unrivaled. Your ability to keep calm in the most threatening of storms is so appreciated. It's impossible to over-express my gratitude for your confidence and your willingness to pick up the balls whenever I dropped them.

I also have to thank my village because, without them, I would be lost: My former employer, surrogate mother, and frequent sponsor, Roz Stevenson (along with her husband Robert), has been my angel on earth; my brothers, Raefeael Tylin Penrice and Darryl Russell Penrice; my aunts Willie Ann Beard Benjamin and Carolyn Beard Humphries, their husbands and my uncles Lawrence and Kirby, my aunt Dorethen Beard Holman, and my uncle Lawrence Lee Beard, who has literally been here for me from the moment I was born, and his wife and my aunt Nellie; first cousins Cedric Beard, Dwayne Beard, James Beard, LaShawnda Benjamin, Kristy Holman Dixon, Sharletha Smith Beard Gayten, Trelva Humphries Harvey, Kendall Holman, and their families; and guardian cousins Ora Beard, Stanley Smith, and M.H. Stapleton. I also thank my paternal aunts Dr. Angela Wellman and Lori Wellman, and my many friends: Joane Amay, Jana Hicks, Gil Robertson, Rasheena Nash (and Angelica), Sheree Renée Thomas (and Jackie and Jada), Wilson Morales, Kenya Byrd, Cantranette McCrimon, Jevalier Jefferson, Chianti Phillips, Ebonette Bates, Tony Murphy (and his lovely Norma Intriago), Raqiyah Mays, Darralynn Hutson, Deborah Cook, Jina DuVernay, Seve Chambers, David F.A. Walker, Chris and Erika Webber, Napoleon Johnson Jr., Janet Smith, Odell Hall, Nicole Smith, Karu F. Daniels, Landras Mitchell, Sonya (Soni) Ede, Nashé Scott, Karu F. Daniels, Sheila Eldridge, Evelyn Coleman, Jawn Murray, A.R. Shaw, Errol Wilks, Dayo Adebiyi, Sharon Collins, Annika Harris, Kym A. Backer, Mariellen Ballier (and Wyatt), Paras Griffin, Jolon Martin, Trent Tate, Patrik Henry Bass, and Jocelyn Coley; my beloved AAFCA (African American Film Critics Association), BWFN (Black Women Film Network), and BAMG (Black Automotive Media Group) families; my extensive Facebook, Twitter, and Instagram network; and the many, many others I didn't name.

## Publisher's Acknowledgments

**Executive Editor:** Lindsay Lefevere

**Project Editor:** Chad R. Sievers

**Copy Editor:** Danielle Ridgway

**Technical Editor:** Carolyn Toliver Bennett

**Production Editor:** Tamilmani Varadharaj

**Cover Image:** © Lightspring/Shutterstock

# PERSONAL ENRICHMENT

 Staying Sharp
9781119187790
USA $26.00
CAN $31.99
UK £19.99

 Facebook
9781119179030
USA $21.99
CAN $25.99
UK £16.99

 Guitar
9781119293354
USA $24.99
CAN $29.99
UK £17.99

 Investing
9781119293347
USA $22.99
CAN $27.99
UK £16.99

 Beekeeping
9781119310068
USA $22.99
CAN $27.99
UK £16.99

 Digital Photography
9781119235606
USA $24.99
CAN $29.99
UK £17.99

 Meditation
9781119251163
USA $24.99
CAN $29.99
UK £17.99

 Pregnancy
9781119235491
USA $26.99
CAN $31.99
UK £19.99

 Samsung Galaxy S7
9781119279952
USA $24.99
CAN $29.99
UK £17.99

 iPhone
9781119283133
USA $24.99
CAN $29.99
UK £17.99

 Crocheting
9781119287117
USA $24.99
CAN $29.99
UK £16.99

 Nutrition
9781119130246
USA $22.99
CAN $27.99
UK £16.99

# PROFESSIONAL DEVELOPMENT

 Windows 10
9781119311041
USA $24.99
CAN $29.99
UK £17.99

 AutoCAD
9781119255796
USA $39.99
CAN $47.99
UK £27.99

 Excel 2016
9781119293439
USA $26.99
CAN $31.99
UK £19.99

 QuickBooks 2017
9781119281467
USA $26.99
CAN $31.99
UK £19.99

 macOS Sierra
9781119280651
USA $29.99
CAN $35.99
UK £21.99

 LinkedIn
9781119251132
USA $24.99
CAN $29.99
UK £17.99

 Windows 10
9781119310563
USA $34.00
CAN $41.99
UK £24.99

 SharePoint 2016
9781119181705
USA $29.99
CAN $35.99
UK £21.99

 Fundamental Analysis
9781119263593
USA $26.99
CAN $31.99
UK £19.99

 Networking
9781119257769
USA $29.99
CAN $35.99
UK £21.99

 Office 2016
9781119293477
USA $26.99
CAN $31.99
UK £19.99

 Office 365
9781119265313
USA $24.99
CAN $29.99
UK £17.99

 Salesforce.com
9781119239314
USA $29.99
CAN $35.99
UK £21.99

 Coding
9781119293323
USA $29.99
CAN $35.99
UK £21.99

# dummies.com

**dummies®**
A Wiley Brand